★ KN-321-016

A 8029 00 146741

16

100

N 2000

BAUHAUS

BAUHAUS

UweWestphal

S T U D I O E D I T I O N S

The Bauhaus

Published in 1991 by Studio Editions Ltd. Princess House, 50 Eastcastle Street, London W1N 7AP, England

Copyright © Studio Editions Ltd., 1991

The right of Uwe Westphal to be identified as the author of this work has been asserted by him in accordance with the Copyright, Designs and Patents Act, 1988.

All rights reserved. No part of this publication may be reproduced, stored in a retrieval system, or transmitted, in any form or by any means, electronic, mechanical, photocopying, recording, or otherwise, without the prior permission of the copyright holder.

Printed and bound in Hong Kong

Designed by David Wire

Translated by John Harrison

LEWISHAM LIBRARY SERVICE

PRANCH ADDA

LEN.

CLASS
NUMBER

CATEGORY
H.D.F.

BOOKSELLEIONAS

ACC.
NUMBER

5208037

Acknowledgements

I would like to thank Joanna Newman, whose patience and good advice enabled me to write this book, also John Harrison for his invaluable suggestions for the translation.

Thanks to the painter Hugo Puck-Dachinger for his welcome inspiration, and to Axel Westphal for his help in my research.

Uwe Westphal, London, 1990.

Contents

6 Introduction

1. The Art-Historical Background

- 13
- 14 Expressionism
- 18 Cubism, Surrealism and Suprematism
- 23 Da Da
- 25 Painting and the Bauhaus
- 28 Architecture
- 2. Pedagogy and Training at the Bauhaus:

Preliminary Courses

- 40 Itten
- 46 Moholy-Nagy
- 50 Albers
- 53 Kandinsky
- 57 Klee
- 60 Schlemmer

3. The Workshops

- 73 The Furniture Workshop
- 83 The Metal Workshop
- 90 From the Graphic Press to the Printing and Advertising Workshop
- 97 Photography
- 115 The Bauhaus Stage
- 122 The Wall-Painting Workshop
- 126 The Ceramics Workshop
- 130 The Weaving Workshop
- 135 How a Whole Is Produced from Many Parts: Architecture at the Bauhaus

4. The Idea Lives on

- 157
- 167 Chronology
- 168 List of Illustrations
- 170 Picture Credits
- 171 Bibliography
- 173 Index

Introduction

The question of when a particular style, tendency, or approach in art first arose can never fully be answered unless we consider the circumstances in which it occurred. For no movement in the history of art has simply emerged out of a vacuum, or from the ideas of a few gifted geniuses. Rembrandt, Turner, Picasso – none of them created their pictures out of nothing; like other artists, they belonged to, and were expressions of, their time – or they saw tendencies developing which they reflected in their paintings. Though this may apply generally to all movements and ideas in the history of art, it is particularly true of the Bauhaus. The initial idea of a 'new form' in architecture and design in the period following the First World War was one very much rooted in the context of its time. And it is no less important to us today, since in our daily lives we are all faced with practical examples of the Bauhaus idea. Few other ideas and innovations in the history of art and architecture have had such a lasting impact on building, not only in Europe, but also world-wide.

When trying to find out what the essence of the Bauhaus movement was, we must first recognize that it did not consist of a homogenous group with coordinated ideas. Its ideas sprang from the Bauhaus teachers' various interpretations of generally acknowledged constants, though these were by no means accepted unquestioningly by the individuals studying and working at the Bauhaus. Perhaps it was the very fact that they did not follow a uniform style. with the constrictions this involves, that gave the Bauhaus such flexibility and facility for development. Its creative climate was born out of conflict and the struggle for a new understanding of art, rather than from the veneration of any artistic father-figure. But it was also the period itself that favoured these new developments. The Bauhaus Manifesto, written by Walter Gropius in 1919, remains to this day a living document of the idea, of its background, and of a movement which only years later finally came to be

recognized and understood. It reads:

the complete building is the final aim of the visual arts. their noblest function was once the decoration of buildings. they were inseparable parts of the great art of building. today they exist in an isolation from which they can be rescued only through the concious, cooperative effort of all craftsmen. architects, painters and sculptors must recognize anew the composite character of a building as an entity: only then will their work be imbued with the architectonic spirit which it has lost as 'salon art'.

the old art schools were unable to create this unity. how could they, since art cannot be taught? they must once more become part of the workshop: the world of drawing and painting, of designers and handicraftartists must at last become a building world again. if a young man who feels inclined towards creative activity begins his career by learning a trade, as in the past, then the unproductive 'artist' is no longer condemned to exercise his art incompletely, for his talents are now preserved for the trade in which he might achieve excellence.

architects, sculptors, painters, we must all turn to the crafts. art is not a 'profession'. there is no essential difference between the artist and the craftsman. the artist is an exalted craftsman. in rare moments of inspiration, moments beyond the control of his will, the grace of heaven may cause his work to blossom into art. but proficiency in his craft is essential to every artist. therein lies a source of creative imagination.

... let us create a new guild of craftsmen, without the class distinctions which raise an arrogant barrier between craftsman and artist. together let us conceive and create the new building of the future, which will embrace architecture and sculpture and painting in

> 1 Lyonel Feininger, woodcut, cover illustration (Cathedral) for the Bauhaus Manifesto, 1919.

a single unity, and which will rise one day towards heaven from the hands of a million workers like the crystal symbol of a new faith.

It is clear from these words how enthusiastic Gropius was about building a new world. (He had experienced the massacre of the First World War at first hand as a

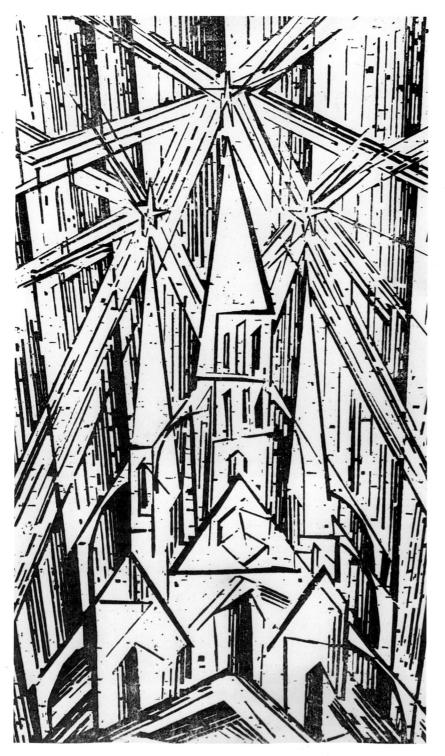

lieutenant in the hussars.) After the collapse of the German empire, the effect of the war and the time he spent as a trainee architect in Peter Behrens' studio in Berlin before the war led Gropius to pursue the ideal of a new kind of architecture: it was to be conscious of its responsibilities and responsive to human needs, but at the same time would seek to bridge the gap between advanced technology and craftsmanship. Gropius had already shown his leaning towards social themes and architecture with a social purpose in the Fagus Works in Alfeld (1911), and the office building for the 1914 Werkbund Exposition in Cologne. Both buildings were inspired by the idea of transparency in a dual sense: on the one hand the human workforce were to enjoy the daylight streaming through large glass façades; on the other, this would also introduce clarity into the work process. All in all, work was to be freed of its traditional dreary image.

Gropius himself saw the need, particularly after the war, for an intellectual re-orientation, and a complete change in approach. Architecture was to serve man and strengthen his social bonds; it was not to become a burden to him:

i saw that, first of all, a new scope for architecture had to be outlined, which i could not hope to realize, however, by my own architectural contributions alone, but which would have to be achieved by training and preparing a new generation of architects in close contact with modern means of production in a pilot school which must succeed in acquiring authoritative significance.

i saw also that to make this possible would require a whole staff of collaborators and assistants, men who would work, not as an orchestra obeying the conductor's baton, but independently, although in close co-operation to further a common cause.

consequently i tried to put the emphasis of my work on integration and co-ordination, on inclusiveness not

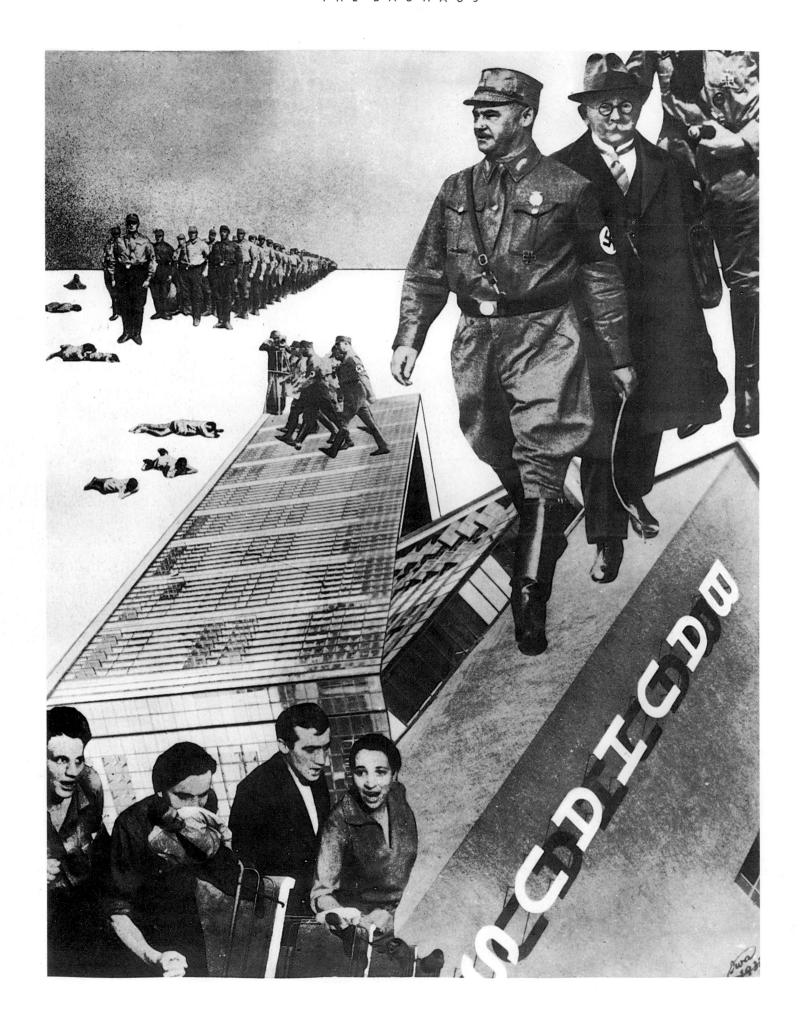

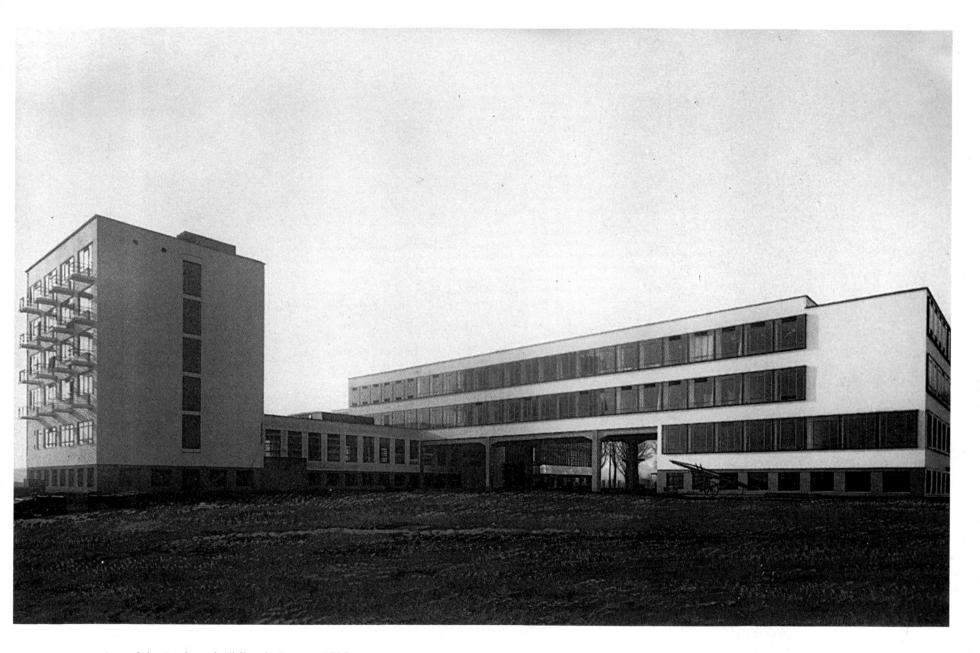

3 View of the Bauhaus building in Dessau, 1926. Photo by Lucia Moholy.

exclusiveness, for i felt that the art of building is contingent upon the co-ordinated teamwork of a band of active collaborators whose co-operation symbolizes the co-operative organism of what we call society.

thus the bauhaus was inaugurated in 1919 with the specific object of realizing a modern architectonic art, which like human nature was meant to be all-

2 Iwao Yamawaki, Attack on the Bauhaus (Der Schlag gegen das Bauhaus), photo collage, 1933. embracing in its scope. it deliberately concentrated primarily on what has now become a work of imperative urgency – averting the machine's enslavement of mankind by saving the mass-product and the home from mechanical anarchy and by restoring purpose, sense and life to them. this means evolving goods and buildings specifically designed for industrial production. our object was to eliminate the drawbacks of the machine without sacrificing any of its real advantages. we aimed at realizing standards of

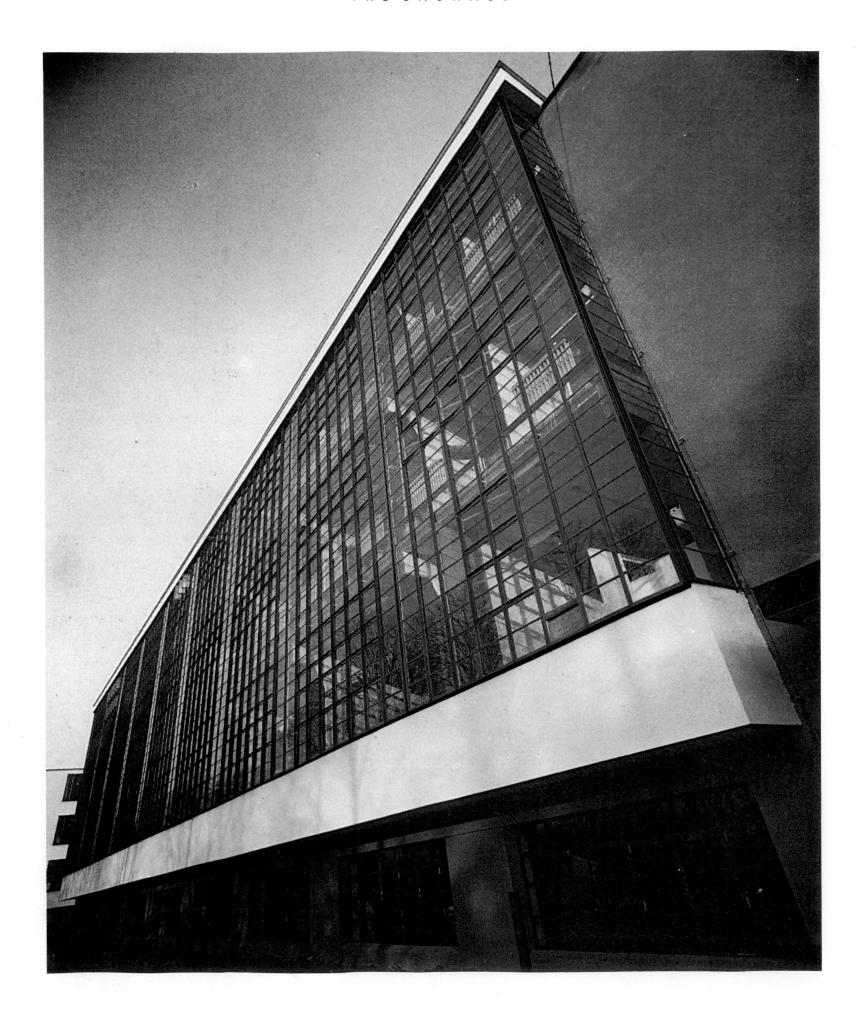

excellence, not creating transient novelties. experiment once more became the centre of architecture, and that demands a broad, co-ordinating mind, not the narrow specialist. (Walter Gropius, 'my conception of the bauhaus idea'.)

The co-operation between architects, painters and sculptors stressed by the Bauhaus Manifesto attacked the excesses of turn-of-the-century ornamentation as well as received ideas about the structure of buildings. Gropius thought the time was right to combine the technical possibilities of architecture with art, uniting the two in a human concept. The artist was to function not as a remote free spirit – the pure artist – but by learning and practising his skilled trade. This vocational approach also meant refraining from unnecessary ornamentation and regarding the form of an object as a reflection of its function. Gropius' words about the new building of the future and the 'crystal symbol of a new faith' may strike us as excessive today, but the Bauhaus Manifesto does provide an accurate picture of its time, and of the path then being taken by a younger generation of artists. Lyonel Feininger's woodcut of a cathedral, which he made for the manifesto, depicts in quasi-religious imagery this belief in another, better future. The cathedral symbolizes the trinity of the arts expressed by Gropius, and illustrated in the Cubist and Constructivist pictures of, amongst others, Robert Delaunay and Piet Mondrian.

Yet too strong a religious interpretation would be out of place here. The picture evokes, rather, the mood of departure felt by a new generation of artists, who were aiming to create values that could be applied universally, with man as the measure of everything. There can be no doubt that, despite frequent criticisms of later developments in Bauhaus practice, the Bauhäusler (as they called themselves) have to this day continued to make valuable statements and to produce successful works of art. It is no surprise that the National Socialists were responsible for closing Germany's Bauhaus schools. For the spirit these schools engendered, quite apart from any influence from socialist ideas, was fundamentally at odds with the authoritarian character of Hitler's dictatorship. Freedom of thought for the individual, coupled with a responsibility to society, did not square with Nazi ideas. The Bauhaus Institute in Dessau closed, under pressure from the Gestapo, on 20 July 1933. A period of personal persecution now began for the members of the Bauhaus, driving Walter Gropius to emigrate first to England in 1934, then later to the USA. Of the many other Bauhäusler who suffered under the Nazi regime twelve are thought to have died in Hitler's concentration camps, though the precise number is difficult to establish.

⁴ View of the Bauhaus building in Dessau, 1926. Photo by Lucia Moholy.

1. The Art-Historical Background

Expressionism

'We threw ourselves into the artistic adventures of a difficult period,' remembers Lothar Schreyer, director of the theatre workshop at the Bauhaus in Weimar from 1921 to 1923. 'The Bauhaus became a "stronghold" for expressionism when the rest of the world saw it as a sign of world decline.' (Neumann,

5 August Macke, With a Yellow Jacket, watercolour, 1913.

Bauhaus und die Bauhäusler, p. 122.)

Schreyer uses the words 'threw', 'adventures', and 'world decline' to describe the Bauhäuslers' feelings towards an important, if not central influence on the stylistic precursors of the Bauhaus: Expressionism. Van Gogh's well-known words of 1880, used to describe his own work: 'instead of trying to record what I see. I use colour arbitrarily to express my feelings', reveal something of the ambience surrounding the early

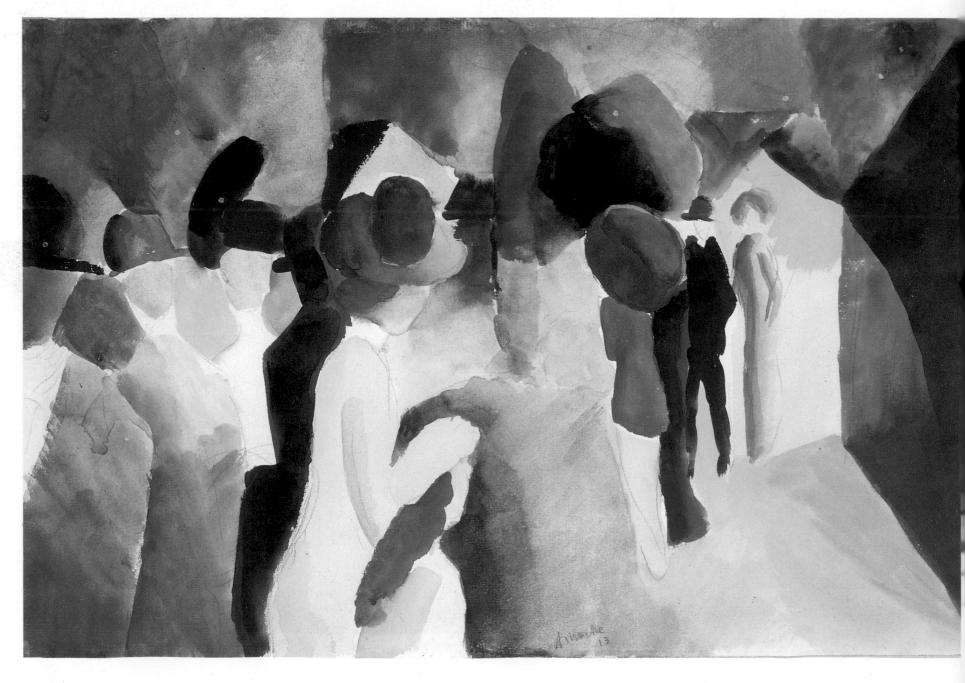

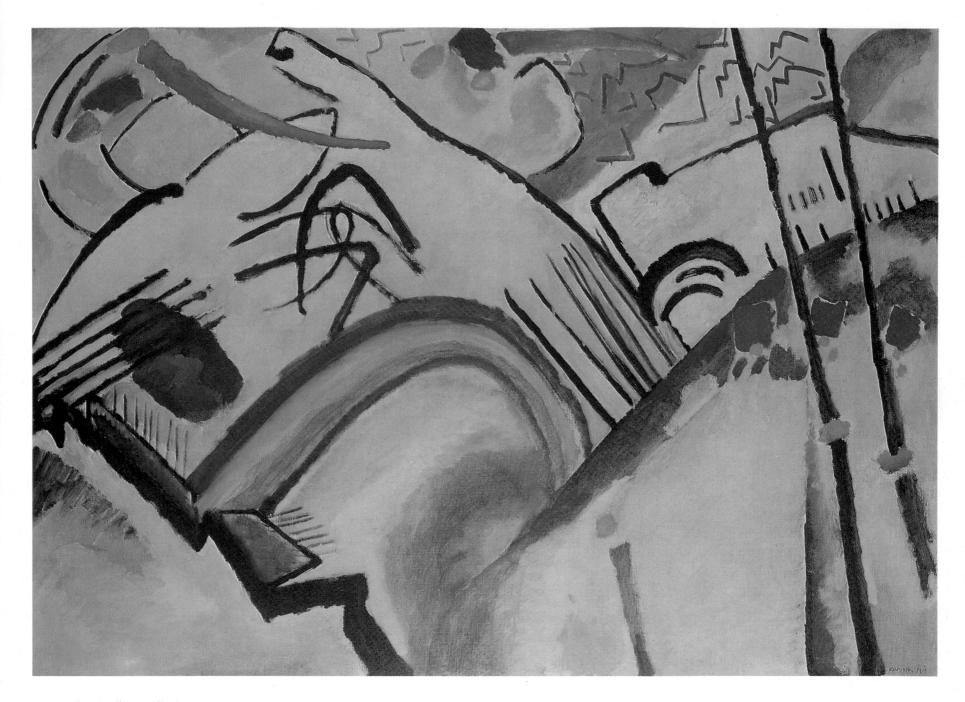

6 Wassily Kandinsky, Composition Study, 1910. Kandinsky was one of the leading representatives of abstract painting at the Bauhaus.

Bauhaus teachers and pupils, who had grown up or studied during the main period of German Expressionism (c. 1910–20). Together with other artistic currents, Expressionism was a major influence on the Bauhaus, and although some of today's art critics view this statement with scepticism, the painting that emerged from the Bauhaus would have been

inconceivable without it. What, however, were the distinguishing features of Expressionism? And what was its link with Bauhaus art? Far more than an artistic style which lasted over a particular period, Expressionism reflected a way of thinking and of being, at a time of considerable social and political upheaval. The values that shaped intellectual life during the years

7 Paul Klee, Precious Container for Stars, watercolour, ink and pen, 1922.

shortly before and after the turn of the last century were shifting and in a state of collapse.

In their search for a new order, new models, and

a new aesthetic no longer oriented towards the old traditions, the Expressionist painters saw themselves very much as part of a movement that sought to give an authentic artistic expression to its feelings. They felt the need to convey, from a new perspective, the inner emptiness that resulted from a bewilderingly rapid change in the economic climate, which was itself a product of increasing industrialization in Germany before the First World War.

In France, it was above all the Fauvists influenced by Van Gogh, Cézanne and Matisse who gave Expressionism its distinctive quality, with their intense forms and vivid colours. They made a strong impression on painters in Germany, such as Franz Marc, August Macke, Wassily Kandinsky (later at the Bauhaus) and Jawlensky. Coming together under the name 'Der Blaue Reiter' ('The Blue Rider'), this group — and especially Kandinsky – also opened the door to analytic and futuristic painting. The Blaue Reiter group, which held its first exhibition in 1911, became the most powerful influence in Expressionist painting. The Munich artist Franz Marc had an almost religious attitude to painting. In contrast to Kandinsky, he was reluctant to abandon painting from objects, but he did stress the expressive importance of colour, which he applied in a strict, quasi-analytical way. His crystallized arrangement of colours and motifs – reminiscent of Feininger's woodcut of 1919 – depicts a creation in harmony with itself. In its search for authentic values, following the catastrophe of war, the painting evokes a sense of primeval order. Marc, who was killed in 1916 at Verdun, was strongly influenced, along with August Macke, by Cubism and Constructivism, both of which were prominent at the time. Nothing is left to chance (if there is such a thing in painting): his pictures are thoroughly ordered, and powerful in their use of colour and form, the most famous example being his Tower of the Blue Horses. The central importance of the impact of colour combinations is also evident in the works of August Macke: With a Yellow Jacket of 1913, for example. The factors involved in colour choice were later to become a major preoccupation of the Bauhaus.

Wassily Kandinsky, who was born in 1866 in Moscow, first studied law and economics, before coming to Munich in 1896 and abandoning his legal ambitions. His initial involvement with painting — in 1909 he founded the 'Neue Münchner Künstlervereinigung' ('New Munich Artists' Group') — was primarily on an intellectual level. In 1910, after years of internal debate and development, he painted his first non-representational watercolour, *Abstract Watercolour*, about which he wrote, 'I feel ever more certain that the inner essence of the object constitutes its form. Art and nature became increasingly separated

8 Lyonel Feininger, Halle, Am Trödel, oil on canvas, 1929.

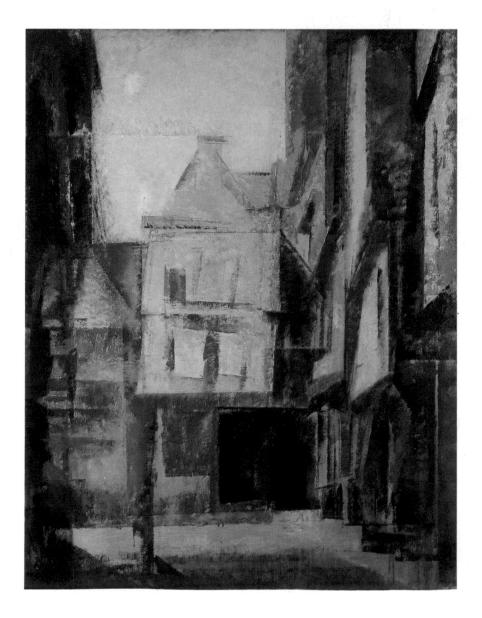

within me, until I was able to view each as independent and entirely distinct from the other.'

This remark is interesting in the context of the Bauhaus and its development in later years, for it is evidence that Kandinsky was developing an analytic method, which he advocated extensively at the Bauhaus, and which was to play a major role in the education of its students.

During his 'Blaue Reiter' phase Kandinsky met Paul Klee, who in 1922 was to exercise a great influence on colour theory at the Bauhaus in Weimar. By that time scientific interest in painting and the constructive method underlying its composition had been widely stimulated by Kandinsky, who also occupied himself with Johann Wolfgang von Goethe's Theory of Colours (1805–10). In this work Goethe provided an analytical study of the psychological effect of colours, and recorded detailed accounts of his findings. The nearmathematical precision of Kandinsky's method not only freed his painting from the mysticism and transfigured quality of the Jugendstil (the German equivalent of Art Nouveau), it also opened the door to a greater use of the imagination and the freedom to experiment with new forms of expression, both of which contributed significantly to the innovative force of the Bauhaus.

Cubism, Surrealism and Suprematism

Whilst Expressionism stressed colour, and its effect on the observer, there were also other currents at work in the world of painting that would later come to influence the Bauhaus. One such movement was Cubism, the creation of Picasso, Braque, Juan Gris and Léger, who, between 1907 and 1914, provided a new and revolutionary variation on the theme of art and our reaction to it. As the name suggests, Cubist paintings represent their subject-matter using geometric shapes. Familiar objects and bodies, whose symmetry demands no kind of explanation, are removed from their usual context and rendered unfamiliar. A new way of seeing emerges. Nature is no longer to be imitated, the real experience should be one of colour and form. The Cubist painters often used musical instruments. animals, bottles, and so on, as motifs, though these all still bore some relation to the real world, and were not entirely abstracted from it as in Kandinsky's art. Although there is no direct proof, we may assume that the Cubists' use of other materials, such as cloth, sand, cardboard, wood and paper (particularly newsprint), exerted some influence on the Bauhaus and its future teachers. For in their case, too, we find the most diverse kinds of materials being used.

Another of the effects of Cubism was to stimulate the artists of the Dutch 'de Stijl' group. Unlike Expressionism, with its emphasis on feeling, de Stijl aimed to create pictures that were purely technical and geometric in composition. Having developed from a rejection of traditional Dutch figure painting, and a search for the inner structure of objects, de Stijl sought complete abstraction from the real world. Among the main representatives of the school were Theo van Doesburg and Piet Mondrian. It is not surprising that van Doesburg was later a frequent guest of the Bauhaus in Weimar and Dessau, for his ideas on paintings were also directly applicable to architecture and had a considerable influence on Kandinsky.

The 'technoide', as the fashionable jargon of the time put it, a distancing from the apparent claim of the world of objects, was also familiar to Giorgio de Chirico. Born in 1880 (his father came from Sicily), de Chirico spent the years from 1911 to 1915 in Paris. A railway engineer by profession, he was fascinated by the possibility of combining this technical knowledge with his own specific form of painting, metaphysical

pictures. He, too, abstracted concrete things and forms from their usual settings, and placed them in new contexts in the clearly partitioned picture. This use of a meta-level indicates that the individual elements of the picture have been removed from their original contexts.

In his *Grand Metaphysical Interior* of 1917, the real world appears only as a picture within a picture, which itself appears as part of an artificial arrangement involving other pictures. By means of this duplication, the picture within a picture, the painter attempts to

9 Pablo Picasso, Restaurant, Still Life, oil on canvas, 1914.

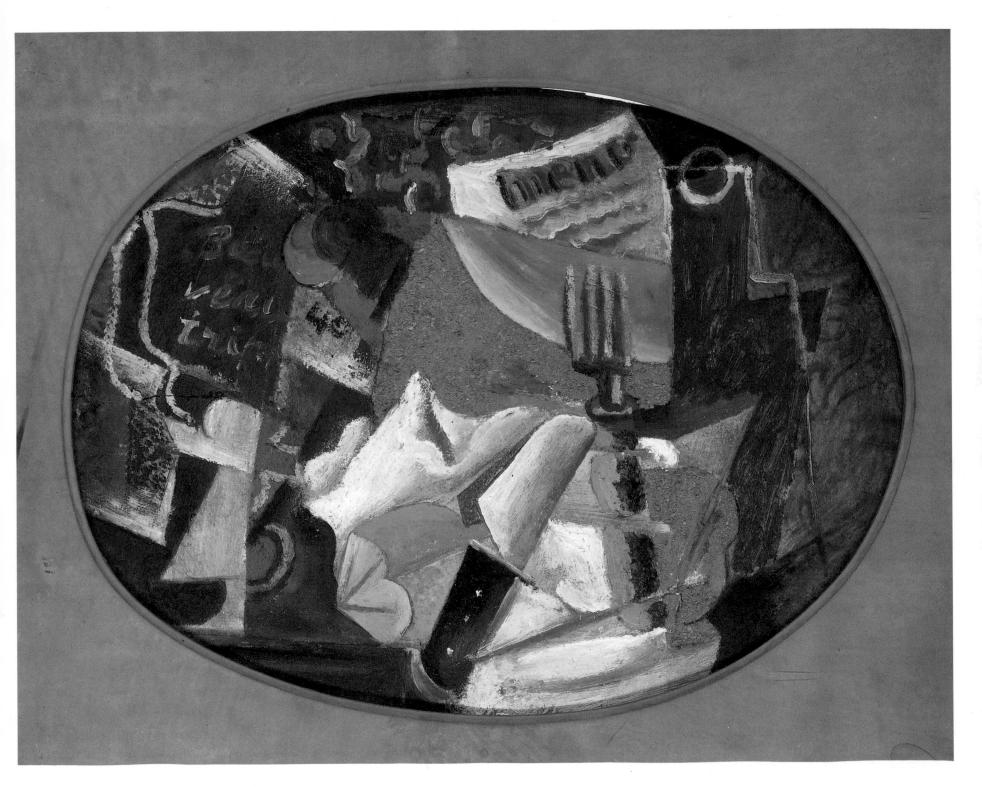

reveal the contradiction his work presents to traditional painting. De Chirico wishes to provoke the observer into an intellectual confrontation with the phenomena of the time in order to interpret the picture. Relying on surrealistic techniques, he consigns the modern world, as he sees it, to the grave, and hopes for another, better world. *The Duo*, of 1915, makes clear reference to the isolation of the individual in the world, reflecting the melancholy feelings which informed de Chirico's cultural critique. The atmosphere and ambience of the present dominate, as men and women are turned into ahistorical, asexual beings. The composition of his pictures, some of them appearing almost to have been created like collages, does suggest parallels with the DaDa group which had first formed in Switzerland.

10 Theo van Doesburg, Composición en blanco y negro. Van Doesburg condemned the romantic direction temporarily taken by Bauhaus teaching.

Composed of intellectuals, it launched a critical, cynical attack on the existing post-war order in graphics, literature and painting.

Carlo Carrà, with whom de Chirico formed a friendship whilst in Italy, belonged to the 'Manifesto of Futurist Painters' group, and was moving in a similar direction. His painting, though, was more strongly influenced by Cubism, as the picture *Funeral of the Anarchist Galli* impressively shows. Although neither de Chirico nor Carrà had any direct contact with the Bauhaus, their work influenced Weimar, not least because of its expressive use of colour. The artistic affinity between them and the Bauhaus is also evident in their abstract compositions of familiar things and objects.

Italian influences took the shape, mostly between 1910 and 1917, of a stream of manifestos. Leaving barely any area of human relations and art untouched, they ranged from aggressive statements about the government and diverse political issues, to the analysis of sexual practices. Basically, they were Futurist in tendency. Gino Severini should also be mentioned.

After the October Revolution, Kandinsky returned to Moscow from Germany, where he took up important official posts and positions at the university. Along with Kandinsky, Kasimir Malevich was one of the most powerful and provocative figures on the Russian art scene to exert a European influence. Born in Kiev in 1878, he was strongly influenced by the Fauvists and inclined towards Léger's style of painting. In 1915 he turned towards the Cubist movement with a *Suprematist Manifesto* (the urge to communicate had reached the same proportions as in Italy). Malevich's

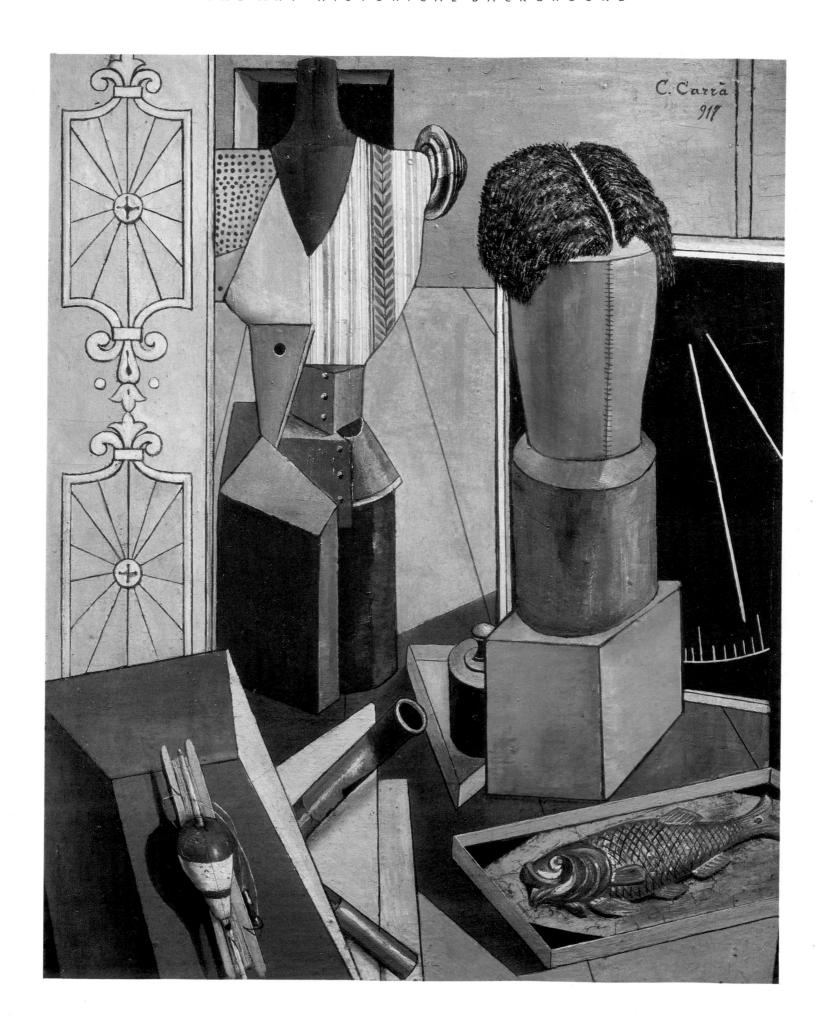

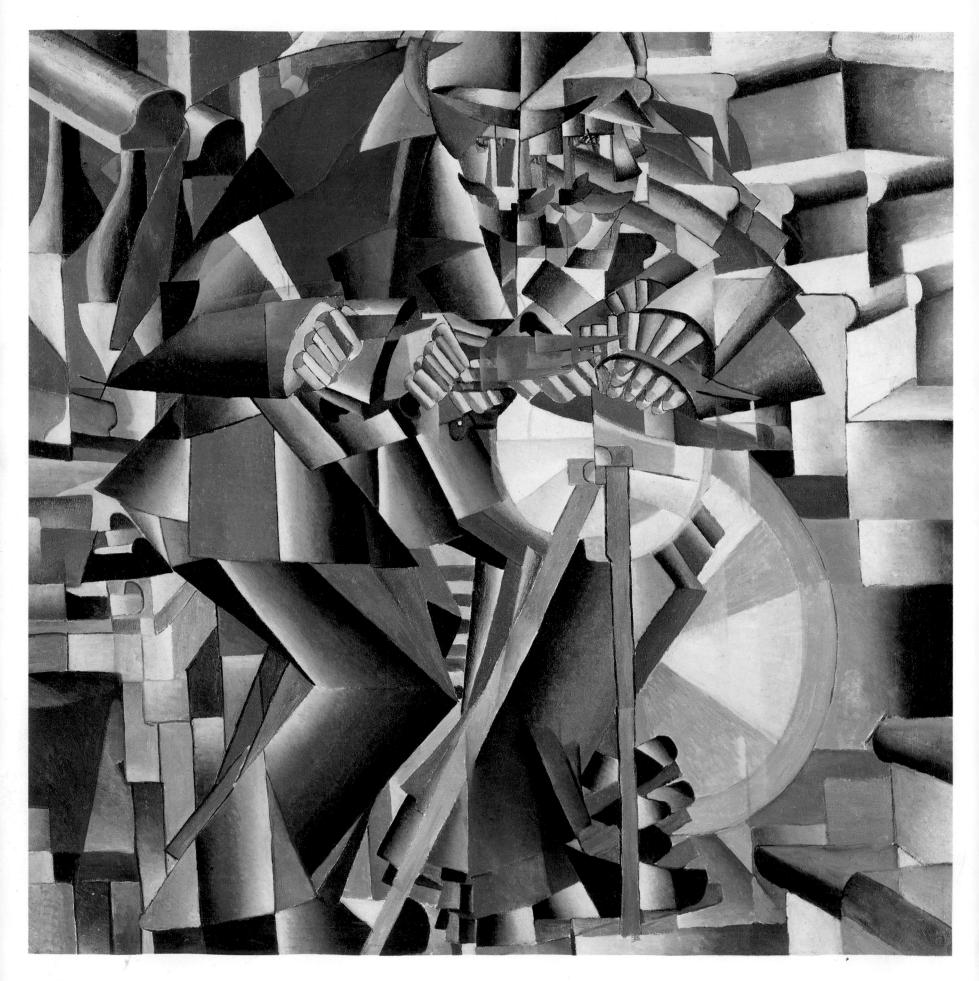

minimalistic pictures explored the limits by reducing everything to form and colour. The paintings were arrangements of squares and circles, the rectangle being the suprematist foundation, and they bore no relation to the 'visible' nature of things. Malevich regarded his non-figurative pictures as being equivalent to, or as valid as, representational paintings. He later painted variations on Black Rectangle on a White Background of 1913, retaining the same arrangement, but using different colours. He saw this as another expression of realism in painting, which did not necessarily involve the faithful reproduction of what could be observed in nature. Fame came with his suprematist composition of a white rectangle on a white background (White on White) of 1918. Like Kandinsky, Malevich was searching for an underlying structure in his pictures, for a solution to the problem of 'what makes a picture a picture'. His achievement was to stimulate new ways of thinking about visual reactions, and these bore fruit a year later through Kandinsky at the Bauhaus.

which originated in the bitterness of the battles of the First World War and the disillusionment (after 1919, at least) of seeing any hopes for a better society frustrated. DaDa was also very much the product of an eccentric obstinacy.

Franz Marc and de Chirico were represented alongside Kandinsky, Lyonel Feininger and Paul Klee at the first DaDa exhibition in 1917. The most important cult figure, however, was Marcel Duchamp, who attracted attention in New York with his 'readymades', objects from everyday life in unfamiliar settings.

The DaDaists in Zurich, Hannover, and Berlin especially, saw themselves as intellectuals who opposed the prevailing business culture with cynicism, satire and wit (the name 'DaDa' was said to have been a random discovery in a dictionary). Attacks were aimed at German militarism, the bourgeois who still supported the deposed Kaiser, and the new war millionaires. For a short time, literature and painting pursued the same

13 Carlo Carrà, Funeral of the Anarchist Galli, oil on canvas, 1911. Carra exercised a strong influence on the Bauhaus artists.

DaDa

It is worth stressing at this point that like Expressionism, the artistic mainstream of the day, the Bauhaus was taking issue with an outmoded view of culture.

Certainly, the First World War contributed decisively to the forcible dismantling of antiquated structures, as did those movements to the left of the political spectrum. However, the personal involvement in this process of those who later became Bauhaus teachers never led them to advocate artistic dogma. A similar absence of fixed doctrine was evident in the DaDa movement,

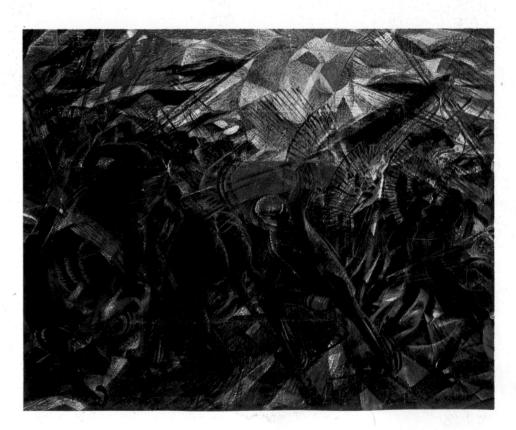

12 Kasimir Malevich, Scissors Grinder, oil on canvas, 1912.

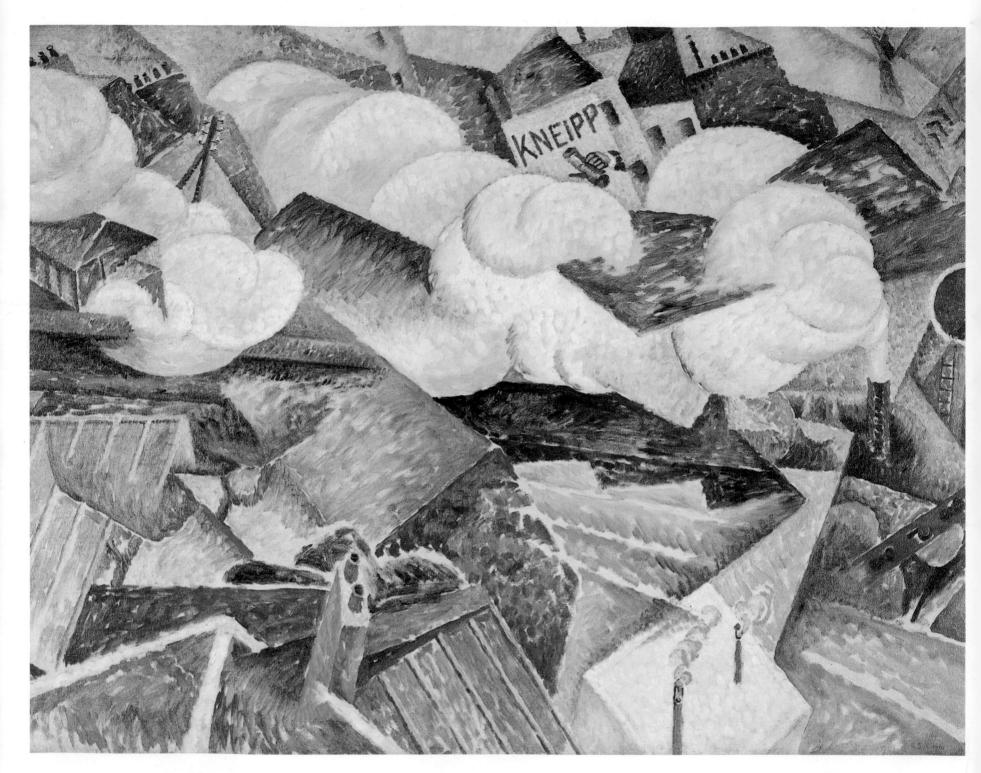

14 Gino Severini, Suburban Train, oil on canvas, 1915.

ends, as artists from different areas were united in common ideals and protestation. A year later, there was to be a similar convergence of a variety of artistic and creative tendencies at the Bauhaus.

The many influences affecting the Bauhaus and its

founders through painting had one essential thing in common, even if they did appear under an almost bewildering variety of names. Expressionism, Fauvism, Futurism and Cubism: all channelled their energies into the clearly necessary work of breaking with artistic

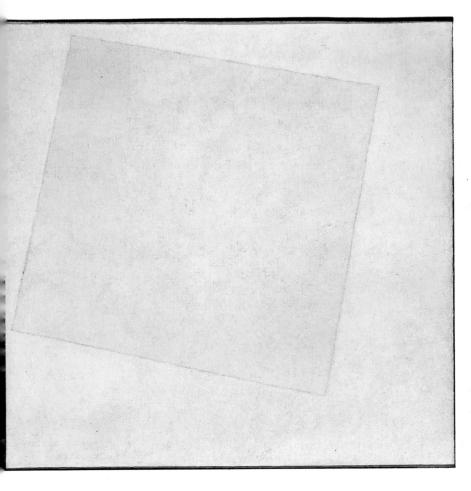

15 Kasimir Malevich, Suprematist Composition, White on White, oil on canvas, 1918.

traditions which were now proving to be an obstacle to progress. The creation of something original was called for, something that would bring a 'new' consciousness and make the coming age more humane and democratic, and hence free. This is very clear from Gropius's manifesto for the founding of the Bauhaus in 1919.

Painting and the Bauhaus

Fittingly, it was Gropius who created in the Bauhaus a focal point for all the positive and creative tendencies in painting. For Weimar, inspired by Gropius, now became the focus of hope for all those prepared for change – a

development, incidentally, which, from the viewpoint of art history, was to recur in Germany only in 1975. Although in the 1919 manifesto Walter Gropius advocated the primacy of architecture amongst the arts, under which heading painting and sculpture were also included, he nevertheless realized the crucial role painting had to play at the Bauhaus. Not only was it one of the most popular art forms of the day, but the painters themselves registered the vibrations of the age more quickly than other artists, mainly because they pursued their debates more vigorously than other groups. Of course literature and the theatre were also at the forefront of avant-garde Bauhaus thinking, and of its interpretation of contemporary events. Many in fact perceived themselves as DaDaists, as they polemicized in intelligent, sarcastic tirades against the government and the establishment. Gropius was well aware of the dominant influence and potential role of painting, as can be seen from the fact that he appointed numerous painters as teachers at the Bauhaus, and invited them there even when their ideas did not tally with his own.

Apart from those already mentioned, Georg Muche, Oskar Schlemmer, Lothar Schreyer, the sculptors Gerhard Marcks and Laszlo Moholy-Nagy, all taught at the Bauhaus. Some painters also involved themselves in the architectural field, drawing up their own plans and designs. This move was hardly surprising, since painting was pervaded by the analytical tendencies which had given birth to Constructivism as a variation on or a move away from Expressionism.

Cubism and Constructivism found expression, for the most part, in abstract geometric forms. Architecture then took the results of these analyses and applied them in its own field, as can be seen in the architectural aesthetic of the Dessau Meisterhäuser. Rectangles and squares made from a variety of materials were fitted together like boxes to form residential living spaces. The layout of Gropius's prefabricated houses of 1923 resembles in structure the pictures of Piet Mondrian or de Chirico. Kasimir Malevich had made arrangements of different cubes in his Constructivist pictures, thereby anticipating the ideas of Bauhaus architecture. The 'architectona' he developed, consisting of stone cut to various sizes and joined together to produce buildings and living units, was architecture in the Bauhaus spirit,

16 Lothar Schreyer, woodcut, Bauhaus Weimar, 1923.

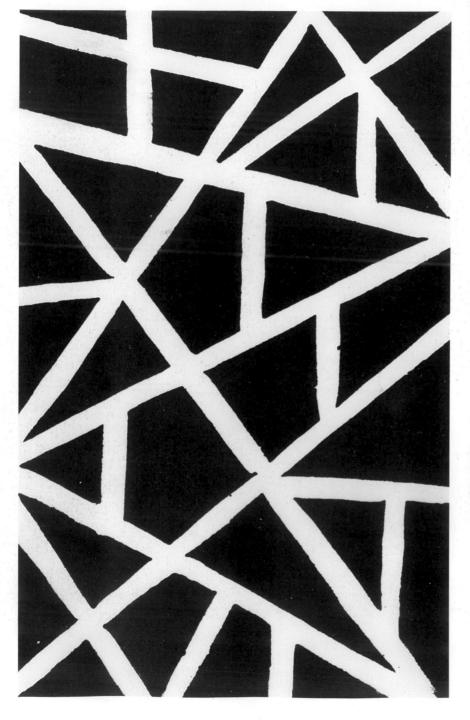

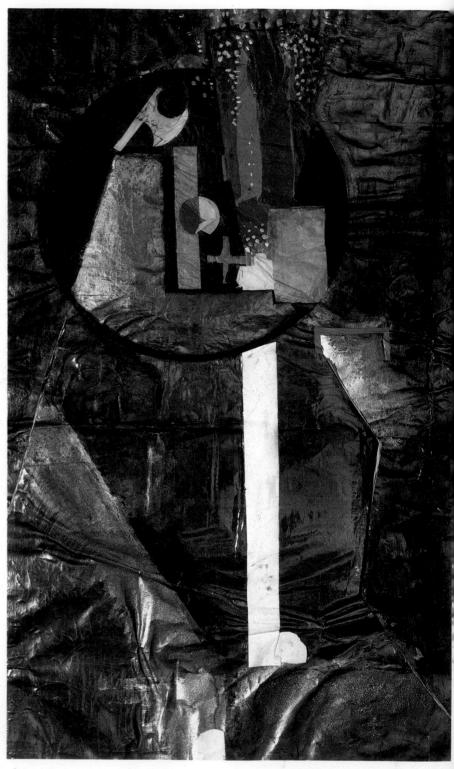

17 Johannes Itten, Coloured Composition, paper collage, 1920.

though too futuristic perhaps even for Gropius.

Similarly, the de Stijl group around Theo van

Doesburg explored the interplay between the two
disciplines. Van Doesburg, who was already making

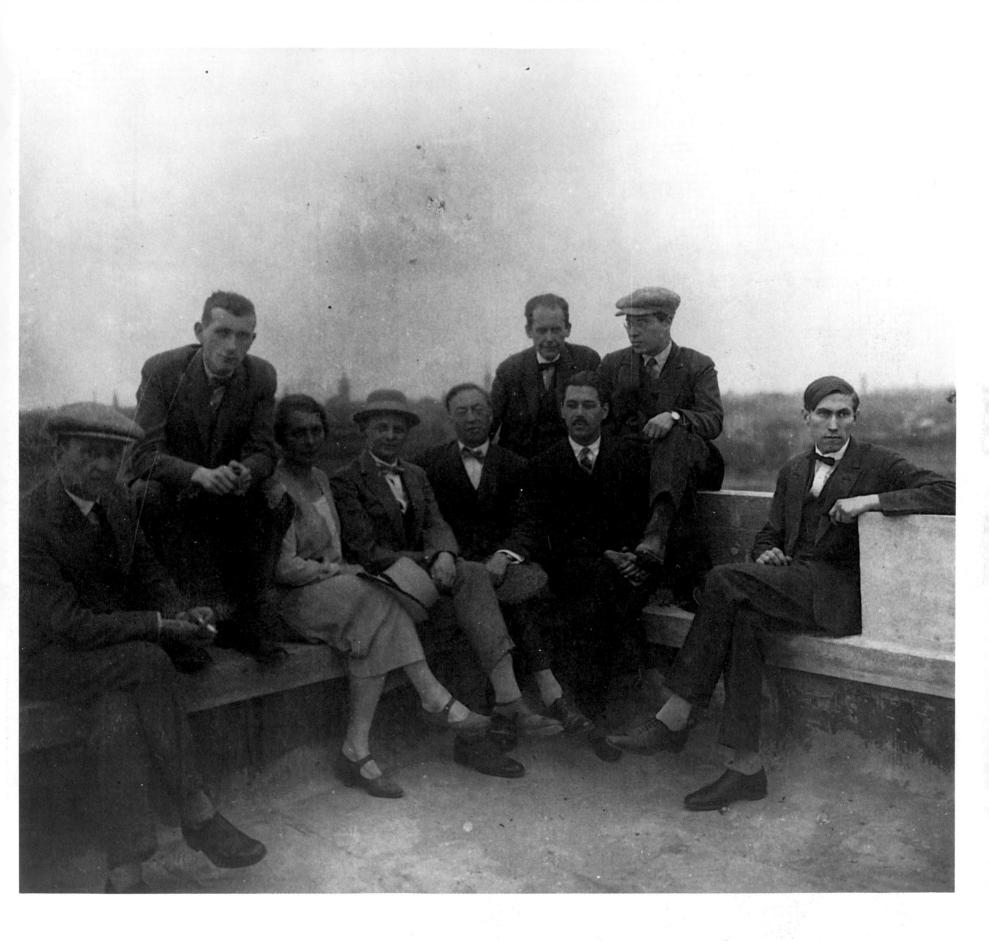

18 Members of the Bauhaus at Dessau on top of the roof, 1927; Left to right: Josef Albers, Marcel Breuer, Gunta Stölzl, Oskar

Schlemmer, Wassily Kandinsky, Walter Gropius, Herbert Bayer, Laszlo Moholy-Nagy, Hinnerk Scheper. Photo by Lucia Moholy.

19 Piet Mondrian, Composition with Yellow and Blue, oil on canvas 1929.

theoretical statements in 1910 about the relationship of architecture to painting, painted a series of pictures between 1916 and 1918 and published writings which were to prove highly influential in Germany. His strictly geometrical, rectangular surfaces, mainly arranged at right angles in the picture, might easily be simplified bird's-eye-view photographs of a Bauhaus housing estate. *De Stijl (Style)*, the journal started by van Doesburg in 1917, provided a vital stimulus for the Bauhaus, although Gropius did not always respond well to van Doesburg's brash style of self-advancement in Weimar. It could be said that the men shared something of a love-hate relationship.

Werner Graeff, a Bauhaus student at the time, remembers the Dutchman, who lived in Weimar from 1921–23, as someone who

fought it out certainly with at least half of his teaching colleagues and contemporaries at the Bauhaus. His only reason for staying in Weimar was to fight on as an outsider. He failed to understand how Gropius, who, in 1911 [with the Fagus Works building] and 1914 [with the building at the Werkbund Exposition in Cologne] had already provided such daring examples of his ideas on construction, and of his ability to create new forms, could at the start of his directorship of the Bauhaus cause or even allow, a return to expressionism and the excesses of romanticism . . . Doesburg argued the case for the machine and the modern mass production of well formed goods. He anticipated as early as 1921/22 part of the later Bauhaus programme. (Neumann, Bauhaus und die Bauhäusler, p. 131.)

On the subject of architecture, the feud between Gropius and van Doesburg was basically a confrontation between two contrasting views on

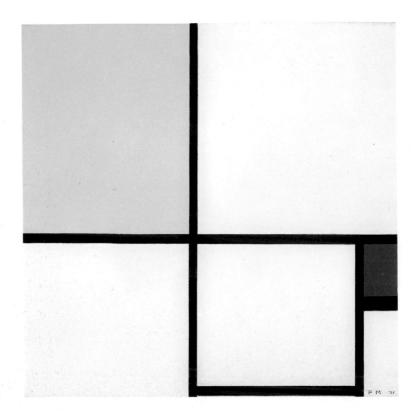

aesthetics — involving the relationship between the meaning, purpose and form of a building — and had its roots in developments at the beginning of the century.

Architecture

In the period shortly before and after the year 1900 the world of architecture was shaken by the need to respond to new demands. After centuries of building cities along age-old lines, the growth of vast cities with populations of millions and with expanding industrial areas, now called for different measures. The people who came streaming in from the rural areas needed the kind of living space which could not be provided by the old ten-roomed city houses. The workers' estates which sprang up near the factories seldom allowed a standard of living compatible with human dignity. And so, in the congested conurbations of Berlin, the Ruhr and Leipzig,

20 Walter Gropius, Fagus building near Hannover, 1911.

there were outbreaks of violent social unrest, due mainly to miserable living conditions.

By the turn of the century, the idea of building as a means of promoting social reform had spread only to isolated groups of architects. Joseph Maria Olbrich from Vienna, who with his Viennese Secession Building tried to establish new building standards, and Peter Behrens, for whom Gropius later worked, certainly belonged to such circles. But however much they tried, they were unable to rid themselves of a certain traditionalism, and deserved no prizes for social awareness in their building. Moreover, most architects were too isolated to be able to subscribe to any radical attempts at

21 Werner Graeff, Rhythm-Study, black on yellow paper, 1920.

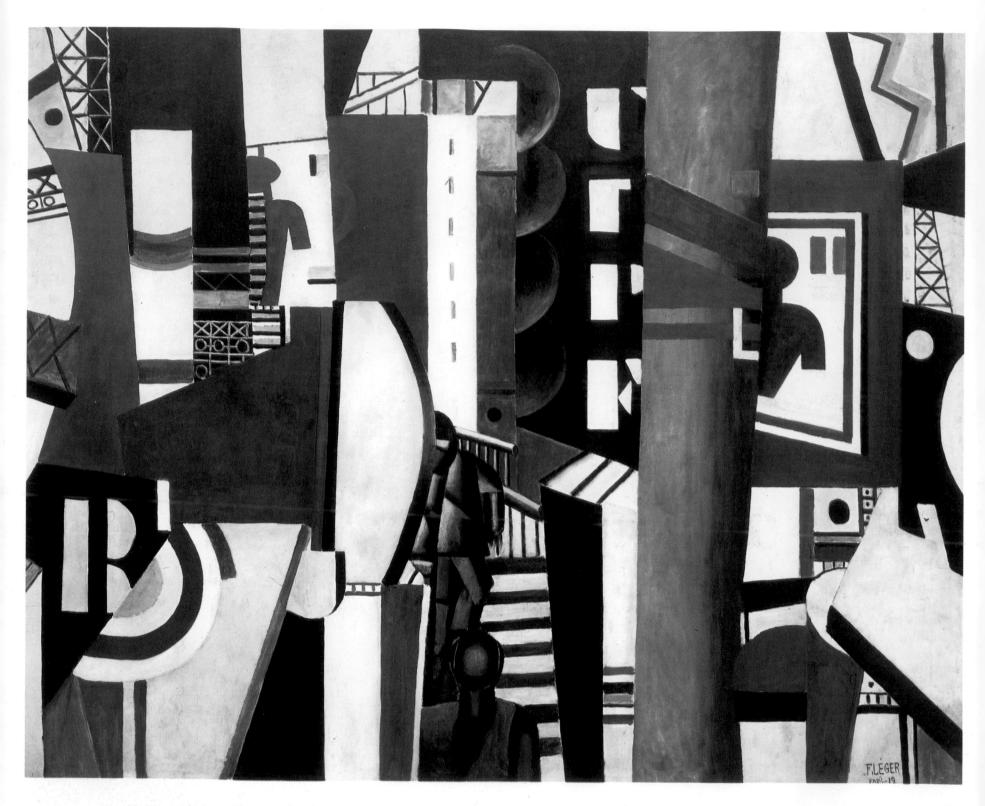

22 Fernand Léger, The City, oil on canvas, 1919.

innovation. This may have been partly because of the privileged standing their profession had long enjoyed at the royal courts, or perhaps because innovative ideas tended to spread more slowly in architecture: a building

always requires an owner as well as a plot to stand on. Besides, what was required now was not prestige buildings but a form of architecture made necessary by rapid industrialization, which was bringing together more and more people in a confined space. The painters, who were the first artists to take up the new ideas and trends, had, on the face of it, a simpler task.

Architects were still under the influence of the Jugendstil, which was in full flower around 1900, or, like Olbrich and Behrens, actively promoted it. The extent of their confusion in the early years of the century is only too apparent from obscure declarations of intent, which stemmed from muddled metaphysics rather than from any clear knowledge of the real world. The designing and construction of houses developed virtually into a sacred act, an aspiring, stylized, religious act of creation, which remained in the realms of the fanciful. Concepts such as the 'city of light', the 'cathedral of dreams', the 'house of heaven' or the 'golden glass pyramid' were bandied about in the circles of the architectural elite. (And when the architects themselves were not inspired to take up their pens, the writers who worked alongside them could be relied upon to produce vague, unrealistic descriptions.) These products of fantasy – the architect Bruno Taut designed the 'valley of blossoms' and 'crystal mountain' in alpine architecture, otherwise such ideas hardly ever passed the sketch stage – were for the most part inspired by the new building materials. By 1905/6, glass architecture had gained a position of paramount importance – since it was supposed to achieve in buildings a transparency which the architect was no longer able to find in his surroundings. Hence Taut's heady and emphatic tone when he wrote in 1914: 'glass architecture is bringing the European cultural revolution . . . it turns a vain, limited creature of habit into a bright, alert, refined and tender human being."

Such ideas were not far removed from similar notions about building a supposedly brighter future for mankind: plans such as the so-called 'people's houses' and 'cathedrals of the future', which would place popular housing in a new perspective. Christian, socialist and futuristic ideas all combined into an

amalgam, which if not realistic, still remained intriguing. Utopianism of this sort was also nurtured by the use of concrete and of steel constructions. Gropius himself admired the steel skeletons of American multi-storey buildings and Frank Lloyd Wright's designs, whilst Behrens, Taut and Olbrich were able to take advantage of the possibilities concrete provided for creating new building forms. At the same time these technical developments gave some architects a welcome chance to avoid an absolute break with traditional building styles. When we look at what inspired the ideas of turn-of-the-century architects, it is noticeable that in Germany, Holland, Austria, Czechoslovakia and Russia, there was a great desire to abandon architectural tradition, despite a certain harking back to the early nineteenth century. The English, on the other hand, and the Viennese architect Otto Wagner, campaigned doggedly for new views on building forms to be combined with traditional ones.

23 Walter Gropius, Wassily Kandinsky and Oud in Weimar, 1923.

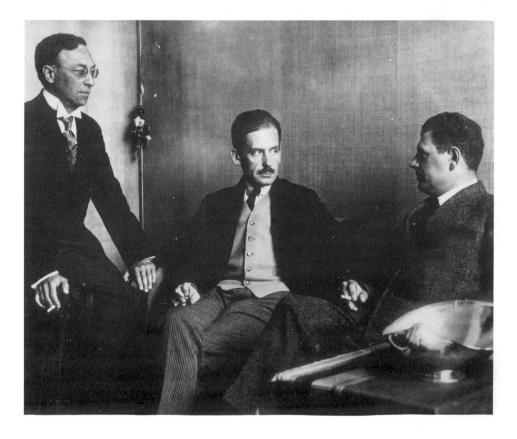

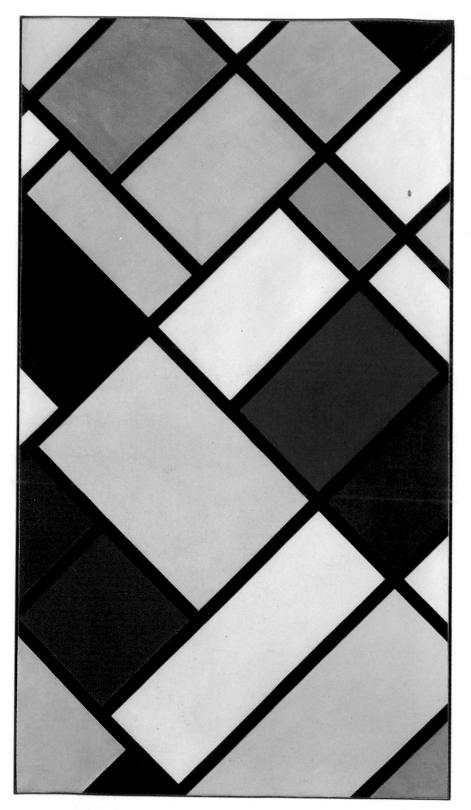

24 Theo van Doesburg, contra-compositie, oil on canvas, 1925.

Before the Bauhaus, the Englishmen John Ruskin and William Morris had anticipated – in a similar way to Gropius's manifesto of 1919 – a theoretical unity of art

and craftsmanship. In England, however, the traditions of art and design enabled such theories to be carried to their logical conclusion. In Germany the demand for a radical break with tradition was not so much inspired by theoreticians and artists, but more a response to the political situation, where social pressures and governmental crises kindled a revolutionary zeal, making it more easy to contemplate change without retaining the ballast of tradition.

To express their sense of a shared responsibility in matters of design and the proper use of materials, a group of entrepreneurs, writers and journalists in Munich joined with architects in 1907 to form the *Deutscher Werkbund* (an industrially subsidized association of artists and technicians). Its purpose was to promote German excellence in design both in theory and in practice. Walter Gropius was a member and executed a series of works on its behalf. His 1910 proposal, suggesting a standardized form of terraced house, can be traced back to the *Werkbund* and its architects. Yet the *Werkbund* itself was little more than a meeting place, where ideas could be discussed, and a source of stimuli.

Whatever the architectural pecursors of the Bauhaus may have been, there can be no doubt that painting was the strongest influence on the Bauhäusler. And however hard Expressionism tried to shake off all traces of romanticism, the early period of the Bauhaus had much idealism and fantasy to offer. And yet those years up to 1923 furnished an important part of the overall concept, for without them the Bauhaus would have been the poorer in creative terms. Indeed it might not even have existed.

Details from 23

Opposite **25 Walter Gropius**.

Overleaf

26 Wassily Kandinsky. 27 Oud.

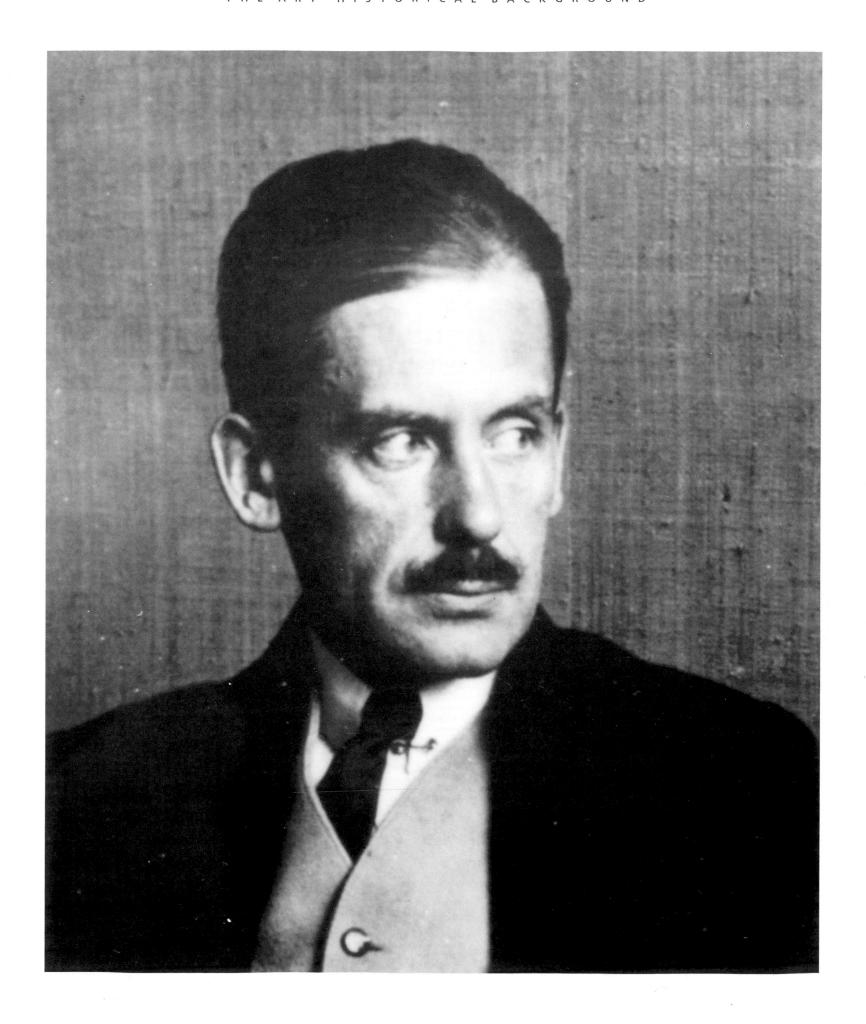

2. Pedagogy and Training at the Bauhaus:
Preliminary Courses

The word pedagogy may be translated from the Greek as the science or theory of education, and, in so far as Bauhaus pedagogy existed as a unified concept, it undoubtedly achieved great things. First in Weimar, and then in Dessau and Berlin, instruction was innovative in that it aimed to create an overall method for the teaching of art. To form a better understanding of art instruction at the Bauhaus, it is helpful if we return to Gropius's manifesto. In 1919, he wrote:

. . . architects, painters and sculptors must learn to know and to understand the many aspects of building both in its totality and in all its separate parts. only then will their work be imbued again with the architectonic spirit it has lost as 'salon art'.

the old art schools were unable to create this unity. how could they, since art cannot be taught? they must once more become part of the workshop. this world of drawing and painting, of designers and handicraftartists must at last become a world of building again . . . for there is no such thing as 'art as a profession'.

This was an uncompromising position to adopt, and one which, not surprisingly, drew protests from the more traditionally minded. Like others before him, Gropius attacked the ideas of the conservatively biased art world of the post-war period, with its self-centred view of culture and its elitist claim that art was the preserve of a small, select minority. Nevertheless, behind all the modern, enlightened thinking was the light of a tradition which had survived every revolutionary break with the past: the almost medieval concept of craftsmanship embodied in the idea of the workshops. Not that this was a nostalgic yearning for an order of guilds in a conservative sense. Gropius felt that the acquisition of the craftsman's skills had an important part to play in the making of an artist by bringing him down from his ivory tower.

Gropius was still serving as a soldier in the First

28 Johannes Itten, Horizontal-Vertical, oil on canvas, 1917.

World War when Henry van de Velde, director until 1915 of the Arts and Crafts School of the Grand Duke of Saxony, proposed him as his successor. He accepted the position in 1918, whilst still a member of the 'Work Council for Art' that had formed during the days of revolution in Berlin. As a first step towards reforming the old system of education, and in order to find new formulations for his own ideas, he dissolved the existing school and founded the Staatliches Bauhaus Weimar.

Decades later he looked back at what his intentions had been.

When I founded the Bauhaus, I had come to realize that an autocratic, subjective teaching method frustrates the innate potential of students with different gifts, for the teacher, even with the best intentions, imposes on them the results of his own thinking and work. In clear contrast to van de Velde's method I became convinced that the teacher must desist from passing on his own vocabulary of forms to the student, and that the student must instead find his own way, even if it involves him in detours. If the teacher encounters in the student the beginnings of a tendency to think and feel for himself, he should encourage it. Attempts at imitation, on the other hand,

he should vigorously oppose, or at least let the student know that he is harvesting on foreign soil. The student must proceed objectively and, as a basis for the creative process, build up his study of natural phenomena, which can then slowly be understood through properly directed observation of the biological and psychological facts. At the Bauhaus we tried, with the co-operation of many artists, to find a common denominator for design, to develop, so to speak, a design science . . . Because the teaching method is just

29 Paul Klee in his Dessau atelier, c. 1927.

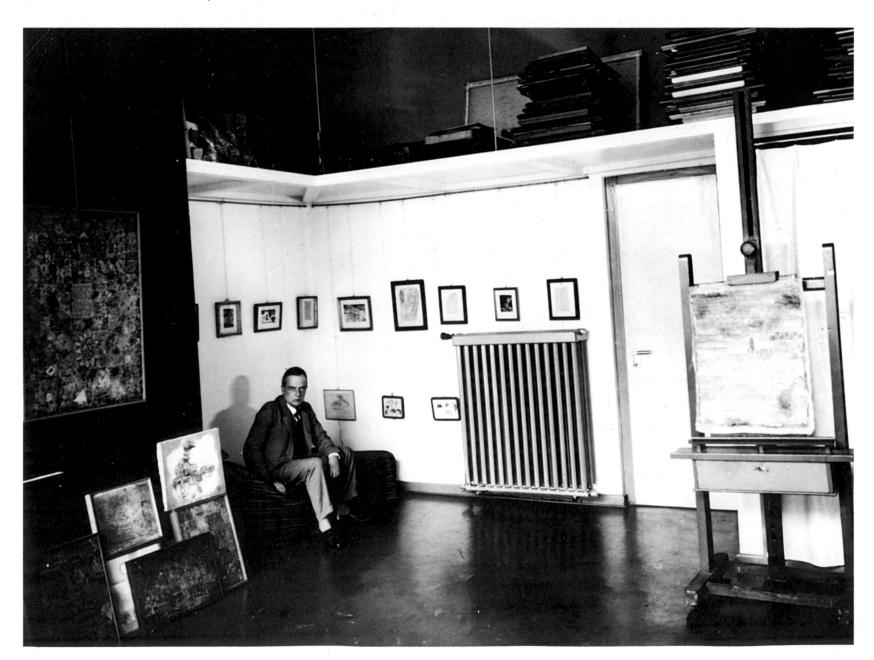

as important as the ability of the teacher – a fact which is still so often misunderstood today – I wanted to assess this problem in the area of teaching once more; for I am convinced that the objective teaching method, even if it follows a much longer and thornier path than the autocratic method, not only protects us from copying and imitation; it also preserves both the uniqueness in each creative personality and a common cultural link with the age. (Neumann, Bauhaus und die Bauhäusler, p. 17f.)

Viewed in their historical context, the theses and pedagogical ideas of Gropius have affinities with the English Arts and Crafts movement of Ruskin and Morris, as well as with reformist educationalists such as Rousseau, Pestalozzi and Froebel. The core of the whole theory and its practice was free, voluntary participation in a liberal, universal education which would produce confident, self-aware human beings. At the Bauhaus narrow specialization was out from the start. In a 1920 address to the Thuringian Parliament, where he was constantly subjected to strict control, Gropius referred to the fact that 'something is being accomplished at the Bauhaus that must develop continuously throughout the country, as it already is . . . The Bauhaus stands for a continuation, not the demolition, of tradition.' This was his response in particular to those politicians, often with right-wing, nationalist leanings, who looked on in suspicion and regarded the Bauhaus project as a sort of conspiracy. For the students' unconventional behaviour and approach to study contrasted conspicuously with the accepted image of the art school.

The entry procedure for students comprised interviews and the inspection of portfolios. To give them a solid grounding, they had first to attend a preliminary course, which was followed by workshop training leading to the Bauhaus diploma. The educational method pursued in the preliminary course was so successful that it is still widely imitated today.

Itten

Johannes Itten, who directed his own private art school in Vienna, had developed his particular teaching methods there, and, drawing on these experiences, was the first to introduce a preliminary course to the Bauhaus at Weimar. Itten, whose authority at the Bauhaus remained undisputed until 1923 – though there was no lack of controversy – described the method and aims of his preliminary course as follows:

- 1. To free the creative powers and thus the artistic gifts of the students. Their own experiences and knowledge were to lead to genuine work. The pupils were to free themselves gradually from all moribund convention and acquire an enthusiasm for original work.
- 2. Career choice was to be made easier for the students. Exercises with materials and textures were a valuable aid here. Each student soon established which material appealed to him, whether it was wood, metal, glass, stone, clay or woven textile inspired him to be creative. At the time, unfortunately, the preliminary course had no craft workshop in which basic tools, such as planes, files, saws, clamps, adhesives and solders, might have been made.
- 3. For their future professions as artists, the students were to be taught the basic laws of painting. The laws governing form and colour opened the students' eyes to the objective world. In the course of their work, the subjective and objective problems of form and colour could permeate each other in many different ways. (Peter Hahn, Experiment Bauhaus, p. 10.)

Itten's method in his preliminary course was to provide a comprehensive training in artistic form, handicrafts and technical skills, and in social and human concerns, so that every student, whether as pupil or potential artist, could become a responsible member of society.

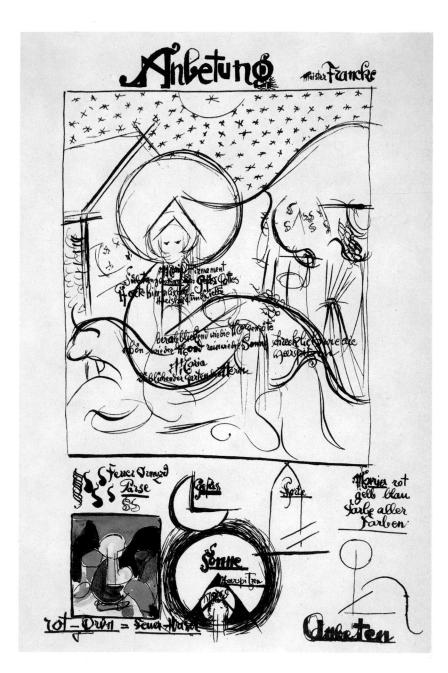

30 Johannes Itten, Worship Meister Francke, Weimar, 1921. Itten analysed pictures by Old Masters in his preliminary course from 1920 to 1923.

finger exercises. Already, in these initial sessions we sensed how rhythm arises; endless movements in a circle, starting as if from the finger tips, with movement flooding through the wrist, elbow and shoulder until it reached the heart – this is what one had to feel when forming each stroke and each line. – No more drawing without feeling or with half-understood rhythm.

Drawing was not reproducing what is seen, but letting what one feels from external stimuli (and from inner ones too, of course) stream through the whole body.

Then it would re-emerge as something absolutely one's own, as some artistic creation or other, or simply as

31a (b,c overleaf) Vincent Weber, Three Material Studies, wood and wire, 1920/21. Weber attended Itten's preliminary course.

Gunta Stölzl, who in autumn 1919 became a pupil at the mural-painting workshop in Weimar, later remembered the practical course of teaching in Itten's class.

His opening words were about rhythm. Firstly one had to train one's hand and make the fingers flexible. Just as a piano player does finger exercises, so we too did

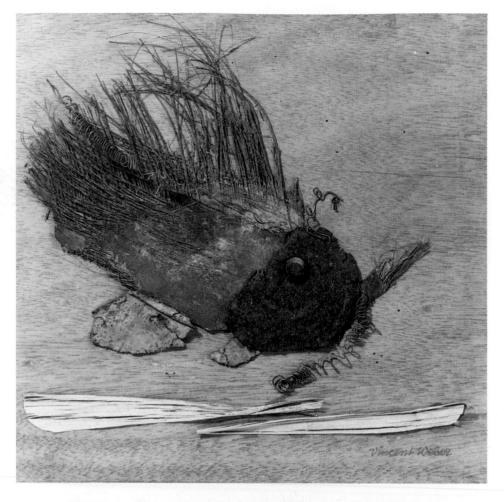

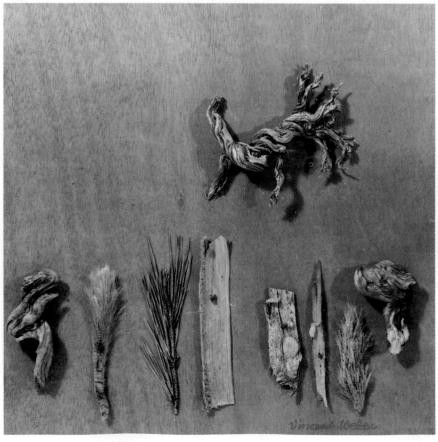

pulsating life. (Gunta Stölzl, diary entries, Bauhaus-Archiv Berlin, p. 36ff.)

We can clearly see from this description the method used to teach students how to abstract what is felt from what is seen. Itten's system involved instruction in how to reach this meta-level and utilize the transitive force in the draftsman's own rhythm. He himself and many of his pupils were attracted by meditation and the transcendental penetration of the 'object world'. Itten and his supporters followed a mystical doctrine with anthroposophical leanings, called Mazdaznan. This cult had its centre in Switzerland and the voluntary training included special diets and nutritional programmes, together with physical exercises and periods of resting.

Perhaps it was the fascination of Itten's personality that attracted so many of his pupils to a ritual which presented a bizarre spectacle to the external observer. With their simple, uniform clothing, heads shaved bald, and a constant smile playing about their lips, they provoked irritation among the people of Weimar and those who viewed the Bauhaus with scepticism. Yet for a long time Gropius gave Itten a free rein, and only Georg Muche, employed from 1920 as the second preliminary course teacher, worked with and deputized for him.

Gropius had a high appreciation of Itten's humanistic and artistic qualities. Between 1919 and 1923, when he and Gropius fell out, Itten, a former pupil of the Stuttgart painter Adolf Hoelzel, developed a theory of universal form at the Bauhaus. He later stressed the uniqueness of the 'method of representing and creating artistic form' being taught here systematically for the first time. Itten's basic preliminary course work was achieved during the first phase of the consolidation of the Bauhaus in Weimar. It therefore marks a decisive moment in the development and transformation of Bauhaus ideas during the early years. Idealism, enthusiasm and free creation untrammelled

32 Oskar Schlemmer, Concentric Group, oil on canvas, 1925.

by objective and material factors were all part of the foundations Itten laid for Bauhaus pedagogy.

The dispute and break with Gropius came at a point when discussions were being held on a new direction for the Bauhaus and efforts were consequently being made to tighten the teaching framework. External political factors, represented by the right-wing, nationalist, conservative majority in the Weimar

Parliament, were not the only source of pressure on the Bauhaus. Gropius was beginning to insist more emphatically than before on the acquisition of technical skills, as he sought to establish a connection with industrial production, in order to influence manufactured designs more effectively than before. This, however, clashed with Itten's freer views on art teaching and the structure of the preliminary course.

In 1923, therefore, Itten left Weimar in order to devote himself to his own work. By this time Kandinsky, Moholy-Nagy and Oskar Schlemmer had been given teaching posts, and Muche had come to regard the Bauhaus theory of form as outmoded. A new era was beginning in Bauhaus teaching. Although the works produced in Itten's preliminary course are today rightly viewed as works of art, we should not lose sight of the fact that they were for the most part workshop studies.

An impression of the simplicity of Itten's theory can be obtained from three quotations by the artist himself:

We speak of contrast when clear differences or intervals can be established between the comparative effects of two colours. When these differences become maximal, we speak of matching opposites or polar contrasts. Hence large—small, black—white, and cold—hot are, in their extremes, polar contrasts. Our sense organs can only provide the means of comparing perceptions. A line is perceived as short when a longer one is beside it for comparison, but as long if one beside it is shorter . . . Similarly, the effects of colours can be enhanced or weakened when they are contrasted. If we examine the characteristic ways in which colours take effect, we can establish seven different types of contrast . . . The seven colour contrasts are:

- 1. The contrast inherent in colours.
- 2. The light dark contrast.
- 3. The cold warm contrast.

33 Johannes Itten, Tower of Fire, wood and coloured glass, 1922.

- 4. Complementary contrast.
- 5. Simultaneous contrast.
- 6. Quality contrast.
- 7. Quantity contrast.

All of these contrasts can be experienced by the senses, objectified by the understanding and created synthetically . . . The colours black and white are the strongest means of expressing light and dark. Between

black and white lies the realm of grey tones and of colours... A grey tone appears light or dark according to whether it is compared with a lighter or darker tone. Dark forms take effect against a light background, and light forms against a dark background. The contrast between light and dark is the medium for creating light, shadow and plastic forms; it finds useful employment in studies of nature...

For a genuine feeling to be expressed in a surface or a line, it must first of all resound within the creative individual himself. Externally fixed sight, fluctuating thought and wilful action must give way to inner vision. If, while a form is being created, the heart and hand work as a unity, then the form becomes the bearer of a spiritual content. If this content can be experienced again through its formal representation, one experiences the effect of a work of art.

It is particularly valuable for the senses to grasp the characteristic properties of all things. In order that various textures may be assessed, chromatic series [coloured and progressing in half-tones] are first of all made from real materials, then montages of contrasting materials are constructed. In order to deepen and develop control of the experience, objects made from wood, bark and hide should be looked at, handled and drawn, until these materials can be drawn by heart, from one's inner feel for them, without referring to the originals in nature . . . (Itten, 'Katalog der Wanderausstellung', in Johannes Itten – Der Unterricht, 1973.)

Johannes Itten founded his own art school in Berlin in 1926, but it was closed in 1934. Four years later he emigrated to Amsterdam and in 1943 returned to Switzerland. He published two books on teaching in the 1960s. Itten died in 1967, in Zurich.

Itten's departure was not the only factor to stimulate discussion about a new concept of education

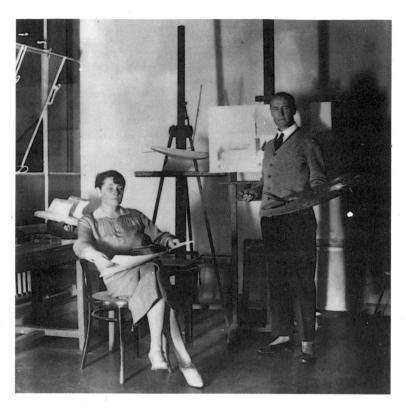

34 Lyonel Feininger with his wife in the Dessau atelier. Feininger taught from 1919 to 1932 as a Bauhaus master.

at the Bauhaus. The Weimar authorities were having to introduce more severe financial cut-backs, not least because of inflation, and in 1922 they asked the school to produce some evidence of its work to justify its existence. The resulting exhibition of works from the Bauhaus in the summer of 1923, though a response to pressure from the authorities, was highly successful, and attracted new pupils to seek entry to the school.

Gropius's new direction, expressed in the motto 'art and technology: a new unity', developed a dynamic of its own, thanks to the succession of preliminary course teachers who now followed. Georg Muche, Laszlo Moholy-Nagy, Josef Albers, Wassily Kandinsky, Oskar Schlemmer and Paul Klee did not always see eye to eye with Gropius, but this was neither expected nor considered necessary. After all, the Bauhaus principle was to guarantee the individual the greatest possible

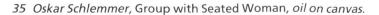

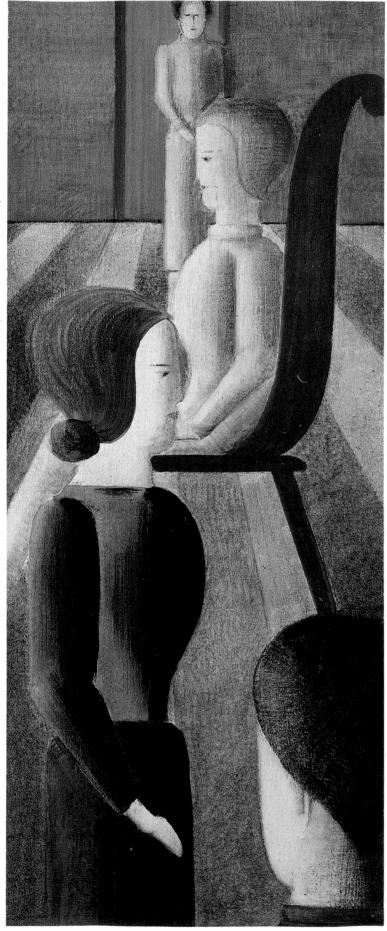

scope to develop as an artist and to express his own views. Inevitably there were tensions and strong differences of opinion over teaching plans and the direction in which the Bauhaus should develop. Discussions oscillated between a stronger emphasis on artistic training and the pursuit of more practical work.

This dichotomy touched on the fundamental pedagogical principle of the Bauhaus teaching programme, whereby it was obligatory for students to be trained both on the artistic, formal level, and on the material, work-oriented level. In this now famous system of instruction with its two strands, formal aspects of teaching were left to the painters, who also directed certain workshops as 'Formmeister' [Masters of Form]. Though they did not strive for any formal or stylized unity, in many areas this nevertheless came of its accord. (Peter Hahn, Experiment Bauhaus, p. 350.)

The variety of preliminary courses that were now organized, extending to two or three semesters with an intermediate test, directly reflected the artistic personalities and educational theories of the teachers and demonstrated those aspects of their teaching they considered most important. Johannes Itten's immediate successor was Laszlo Moholy-Nagy, who directed the preliminary courses from 1923 to 1928.

Moholy-Nagy

Moholy, who was born in Hungary in 1895, began his painting career after being wounded as a soldier in the First World War. He became a doctor of law in 1918 in Budapest, and soon established contact with Gropius through an exhibition of his pictures in 1921, at the Berlin gallery 'Der Sturm'.

He organized his ideas on painting into scientific

treatises many of which were later published in book form by the Bauhaus. Like Itten, he investigated the structure of objects and tried to identify their basic characteristics, in order to assist the students in their work. His teaching method was thus destined to have a major influence on design work at the Bauhaus.

In his book *From Material to Architecture*, Moholy set out the foundations of his theory of education.

Concerning a general course on elements. A general course of elements is built on the relationships of:

- Existing forms:
 mathematical-geometric forms
 biotechnical forms
- 2. Newly produced forms and complexes of forms The creation of new forms can be based on:
- Ratios and measurements (medial sections and other proportions)
 position (measurable in angles)
 Movement, speed, direction,
 displacement, penetration, crossing
- 2. Material values
 structure
 texture
 facture (accumulation)
- 3. Light (colour, optical, illusion)
 The relationships of forms can become effective as:
- 1. Contrasts
- 2. Deviations
- 3. Variations (a) shifting (friction) (b) rotation (c) reflection.

There is clear evidence here of Moholy's primary concern with the ways in which things function. Following in the tradition of the Constructivists, he emphasized more than anyone at the Bauhaus had done before him the relationship between form and function, and rejected any suggestion that one should

take precedence over the other. He conceived the preliminary course as a way of training the students' senses so that they would learn to distinguish clearly between objects by analysing their properties. Moholy differentiated between the structure, texture and make of objects, or, to put it more simply, he insisted that students were to acquaint themselves with the various qualities of the materials. Glass, for example, has characteristics and uses entirely different from those of wood. Many of the tasks set by Moholy for the students were to help them to grasp what these essential characteristics were, and then to use the materials accordingly. This resulted in three-dimensional figures of considerable aesthetic appeal.

The sense of touch could be trained by placing together various materials and asking students to feel the differences between them so that they might learn to identify the relation between a material and its possible use. Equipped with such knowledge, they could then set about the task of putting together figures, or small sculptures. Moholy was careful to draw a distinction between composition and construction:

elements and their relations. This could often be achieved even during the course of the work by introducing new elements and altering the overall composition. A construction, on the other hand, should have all aspects of its artistic and technical relations fixed from the beginning. Any change in its execution would bring to nothing the entire division of forces intended. Compared with composition, therefore, construction requires additional knowledge, though this does not mean that there can be any lack of intuitive momentum. (Peter Hahn, Experiment Bauhaus, p. 32.)

The balancing of three-dimensional figures, which for

36 Portrait of Laszlo Moholy-Nagy, 1926. Photo by Lucia Moholy.

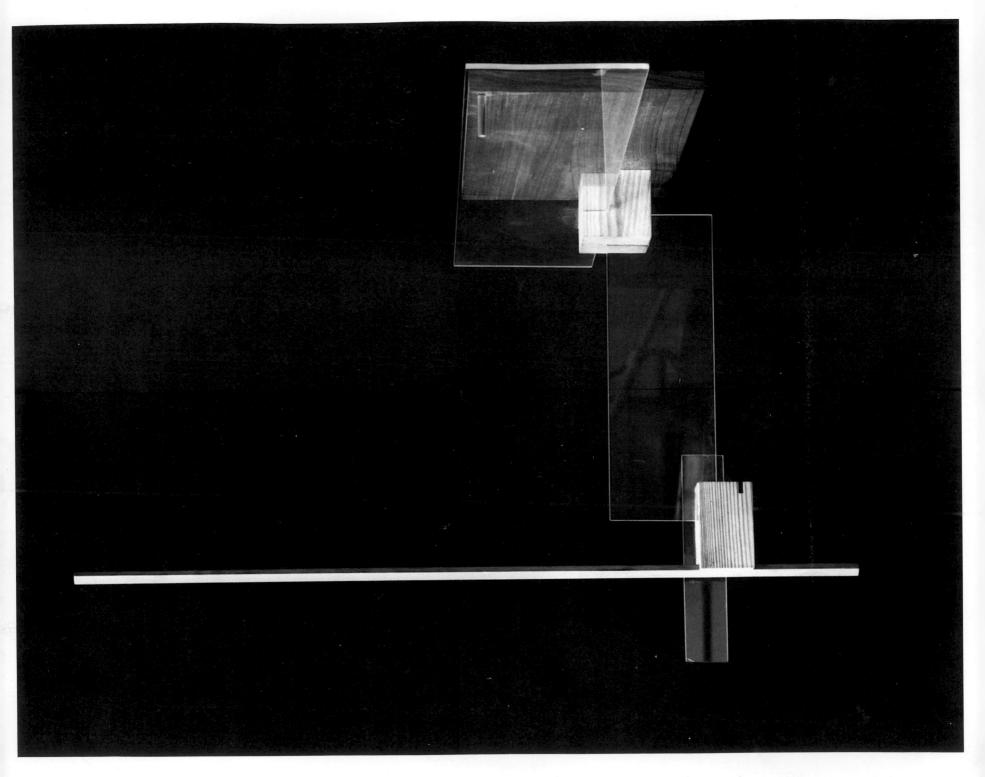

37 Artist unknown, study from the Moholy-Nagy preliminary course, wood and glass, 1923.

the most part rested on a single, small point and owed nothing to symmetry, involved exercises in experiencing and dividing up space which tied in with the ideas of Constructivism. The materials most often used were wood, string and various metals, since they could be found everywhere in their basic forms. New forms were also created by deliberately reducing the amount of material used. The impact these exercises had on

architectural ideas was welcomed by Moholy. But he went far beyond that, directing his artistic gifts towards an unceasing exploration of the technical materials of the age. The preliminary course teaching included the study and construction of designs, experimenting with light and its reflexes, blueprints for typography and stage-design, kinetic metal constructions, and experiments in film and photography. Thus, during his time at the Bauhaus Moholy made two short films: Marseilles (1926), and Berliner Stadtleben (Berlin City Life) (1927). Others followed over the next few years. His photographic work – he was one of the first to take photograms (film exposures without a camera) – influenced the Bauhaus students, as we can see from the numerous works of experimental art photography. Moholy-Nagy's keen and innovative approach to the use of all kinds of modern technical equipment reflected his own open-mindedness and youth. It is easy to see why the students under his direction were so enthusiastic about the preliminary courses. From these new potential areas for artistic activity, he also developed a new conceptual approach to modern art. 'In theory it does not matter whether a work of art is plastic, linear, painted, black and white, coloured, a photograph, or produced in some other way. In practice, though, it goes without saying today that a work of art produced by mechanical, technical means is preferable to one created by laborious, visual, manual means.' (Moholy-Nagy, Vivos Voco, Vol. V.) Such statements were quite fashionable, and also corresponded with scientific and critical discussion about the general possibilities of reproduction in art in the writings of Walter Benjamin and others.

The clear and continued development of these approaches at the Bauhaus, which moved to Dessau in 1925 after its funding had been completely cut, must have appealed greatly to the students. To incorporate his new ideas into the programme Moholy updated the teaching, whilst retaining the basic instruction in colour,

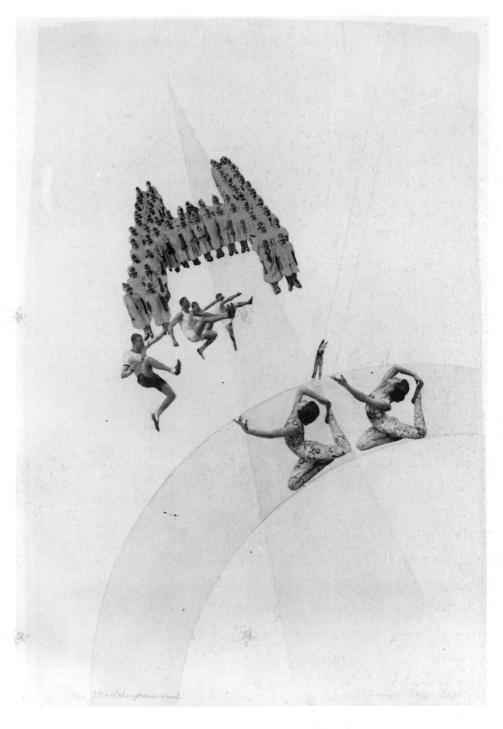

38 Laszlo Moholy-Nagy, The Girls' Boarding School, photo collage, 1925.

form, construction and composition.

As artistic director of the metal workshop, first in Weimar, then in Dessau, he had considerable influence on the nature and function of the works designed there. Under his leadership and the tutition of master craftsman Christian Dell, the metal workshop played a

central role for the first time, producing vessels, lamps and table services. In 1928, the critic Wilhelm Lotz noticed the link between the craftsmanship being practised in the workshops, the education of the students, and their inclination towards industrial design.

I think that Moholy-Nagy has a completely different concept of the craftsman: he is not the craftsman who creates with his hands, but the person controlling and overseeing the handicrafts production process, as in industry. Through being able to control and oversee, it is possible for him to influence the formation process. It makes no difference whether he happens to rely on the skill of his hands to produce the model for industry, or whether he can use a machine to do it. In either case he creates form logically and consistently in the sense of the mechanical process. In fact he is the creator of forms in industry . . . (Bauhaus-Archiv, kl. Katalog, Berlin, p. 46.)

So the metal workshop, which began by producing mainly jewellery, developed into a design workshop offering models for industrial mass production.

Particularly well-known were the table lamps of Marianne Brandt, Wilhelm Wagenfeld, Christian Dell and Karl J. Junker, the prototypes of which were designed and created at the Bauhaus.

There can be no doubt that during the five years of Moholy-Nagy's directorship, the preliminary course and workshop work had undergone a complete change of direction. Gropius's demand for 'art and technology: a new unity' was now beginning to take shape. Moholy-Nagy emigrated in 1934 to Holland, and two years later to England, from where in 1937 he was invited to the 'New Bauhaus' being founded in Chicago. He continued, from 1939, to pursue a successful teaching career at the School of Design and died in Chicago in 1946.

Albers

Josef Albers was a Bauhaus master and teacher who became better known for the works he produced after the war in America than for what he created at the Bauhaus.

After coming to Weimar as a student in 1920, he directed part of the preliminary course with Moholy-Nagy from 1925, and took over all teaching of the preliminary course after Moholy had left. His speciality

39 Petra Kessinger-Petitpierre, study from the Albers preliminary course, pen and ink, 1929/30.

was a thorough examination and knowledge, for both artistic and educational purposes, of the basic materials to be used, and he set great store by this in his work with the preliminary course students. One of these, Hannes Beckmann, recalls his impressions of Albers:

I still have vivid memories of the first day's teaching: Josef Albers entered the room with a bundle of newspapers under his arm and had them distributed amongst the students. Then he turned to us and said: 'Ladies and Gentlemen, we are poor, not rich. We cannot afford to waste time and material. We must make the most of what we have. Each work of art starts from its own basic material, so first of all we must examine the nature of this material. To do this we must first – without actually producing anything – experiment with it. For the time being skill comes before beauty. The cost of the forms we create depends on the material with which we work. Remember that often you achieve more by doing less. Our studies are to encourage constructive thought. Do I make myself clear? I would like you to take the papers you have been given and to turn them into something more than they are at present. I would also like you to respect the material, and to give it meaningful shape, without losing sight of its basic qualities. If you can manage this without such aids as knives, scissors or glue, so much the better. Have fun!' Hours later he came back and had us spread out the results in front of him on the floor . . . This preliminary course opened up for us an entirely new world of seeing and thinking. Almost all the students had come to the Bauhaus with set ideas about art and design. For the most part they were romantic clichés . . . The preliminary course was like group therapy. By looking at and comparing all the solutions found by the other students, we quickly learned how to discover which solution to a task was most worth pursuing. And we learnt self-criticism, which was considered more important than criticizing

others. There is no doubt that the sort of 'brain washing' we went through in the preliminary course led to clear thinking. (Neumann, Bauhaus und die Bauhäusler, p. 275ff.)

Practical exercises of this kind did indeed change received attitudes and approaches to art. Studies of materials, often in the form of positive—negative representations, assembled almost like collages, or depicting the different gradations between black and white, all trained the students to perceive the relations between material, colour, form and construction, as in Moholy's courses. Although it was seldom intentional, the courses in preliminary studies pursued by various teachers complemented each other.

Building on the foundations laid by Itten in the earlier classes, Albers placed greater emphasis in his teaching method on practical and technical exercises. One of the students' tasks was to try to create an impression of three-dimensionality in a two-dimensional drawing; another involved extensive studies for figurative drawings from nature. This type of drawing instruction was devoted less to creating an image that was true to nature (though this was not neglected), and more to grasping what was essential in the object being drawn. In this too, he was working along the same lines as Itten.

Under the directorship of Mies van de Rohe, who took over in 1930, the demands on the students grew, as the general emphasis on architecture called for a greater understanding of technical drawing. Overall, the preliminary courses in Albers' final years as director became more concrete in character, more geared to achieving results. His own artistic development only achieved public recognition after his Bauhaus experience, in the USA. In the 1950s Albers was rightly regarded as having paved the way for Op-Art. In America, too, the fundamentals of Bauhaus colour theory were evident in his painted compositions. He

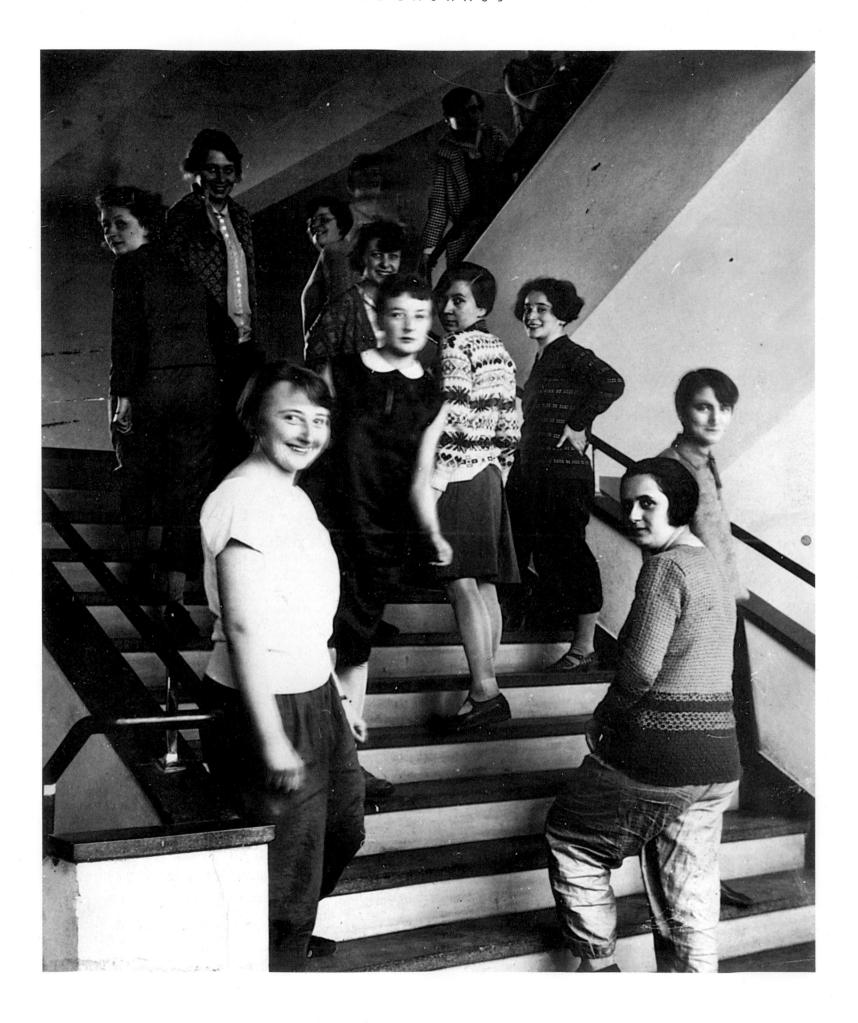

40 Staircase in the Dessau building with students, 1927.

was Professor at Black Mountain College from 1933 to 1949, and until 1959 director of the Department of Design at Yale University. Albers died in 1976 in New Haven, Connecticut.

Kandinsky

When the young Ursula Schuh came to the Bauhaus in 1931 and joined Kandinsky's class, she felt considerable respect and reverence for the great master, whose name was already familiar to her. For when Kandinsky left Moscow to work at the Bauhaus in 1922 at the invitation of Gropius, he was 56 and had achieved the sort of eminence in the art world that casts a long artistic shadow. It would, however, be quite wrong to assume that he was in any way behind the times. Ursula Schuh gives a moving description of the impression he made on her then:

His art and artistic experiments coincided exactly with the way we, as a generation, felt about life. We loved exploding old conventions just as we loved precision in fixing and formulating new knowledge, no matter what the area, and whatever the form of artistic manifestation. We loved abstraction and saw everything as 'abstract'. Significantly, it was never our aim to do 'modern' painting, nor did we think in terms of directions (we left both to the skilled observer). We were far more concerned with finding the one particular form which corresponded to our own personal way of experiencing things . . . 'Arranging' pictures was taboo. If a painting was 'arranged', this meant that it was a rectangle containing more or less pleasing forms, filled out with some skill but without any real experience. It was not composed, i.e. inner

experience and formal dexterity did not become a unity.

The qualities that made Kandinsky a great artistic phenomenon were his relentlessness, his consistency, and his artistic love of the truth. He set the great example by which the young generation could measure itself, even if later it was to, or had to, break completely free. For the more consistent this generation was, the more it went its own way. (Neumann, Bauhaus und die Bauhäusler, p. 241f.)

The fascination evident in these words even today provides a vivid picture of the magnetism which Kandinsky possessed, and which he exercised over other pupils at the Bauhaus as well. Critics or admirers often claimed that there was a mystical aura surrounding him. The unerring aim Kandinsky showed in his work was even attributed to his half-Asian ancestry. But the man's work had no connection with magic or sorcery, nor did the Bauhaus contribute in any way to his mysteriousness. The structure of his teaching in the preliminary courses revealed, like his artistic work overall, an analytical thought process, which was to lead students to the basic concepts of design in painting. In his compulsory basic course, 'analytical drawing', which he ran from 1922 to 1925, students were first asked to produce a still life that was true to nature. This was just a transitional stage, though, on the path to recognizing basic forms, which he held to be far more important than studies from nature, or drawing objects. The next stage was to work out the existing tensions between the individual forms and objects, and how these interrelate. A further stage in the process led to abstracting from the objects perceived. In the journal Bauhaus published by the Bauhaus in 1928. Kandinsky explained his method of analytical drawing and the individual stages leading up to it.

First stage:

the students began with still-life compositions, and their first analytical problems were:

- 1. the reduction of the whole composition to a simple major form which has to be precisely drawn within the limits determined by the student himself.
- 2. distinguishing the characteristic forms of individual parts of the still life seen separately and in relation to the rest.
- 3. the presentation of the whole composition in a simplified line drawing.

Gradual transition to

Second stage:

- 1. clarification of the stresses discovered in the composition which are represented by linear forms.
- 2. emphasis on the principal stresses through broader lines or, later, through colour.
- 3. indication of the constructional net with starting and focal points.

Third stage:

1. the objects are considered exclusively as energy

41 Lothar Lang, Colour Scheme, from Kandinsky preliminary course, tempera, 1926/27.

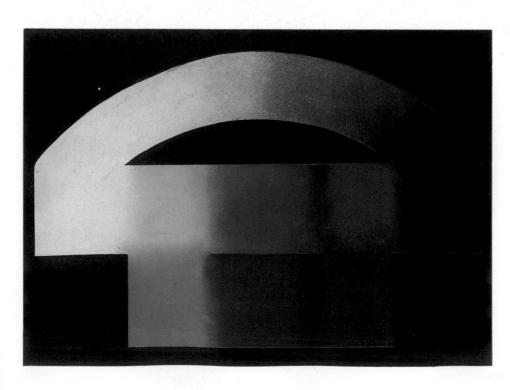

42 Fritz Tschaschnig, study from the Kandinsky colour seminar, tempera, 1931.

tensions and the composition is confined to arrangements of lines.

- 2. differences in structural possibilities: obvious and hidden construction.
- 3. exercises in the most far-reaching simplification of the overall complex and individual tensions close, exact expression . . . Drawing instruction at the Bauhaus is a training in perception, exact observation and exact presentation not of the outward appearance of an object, but of its

constructional elements, their logical forces or tensions, which are to be discovered in the objects themselves, and in the logical arrangement of them. The handling of plane surfaces is preliminary to the handling of space. (Kandinsky, Bauhaus (1928), 2–3, pp. 10–11.)

To the superficial observer, the diagonals, lines, squares and triangles at first seem to be arranged arbitrarily, and to lack any inner cohesion. This changes the moment one tries to trace the origins of the composition. An exercise taken from Kandinsky's preliminary course may serve as an example. A still life consisting of a stepladder, a chair, two baskets and a blanket loosely draped about the ladder, is sketched in outline. Unimportant details such as the wickerwork of the basket or the texture of the blanket are omitted. The outlines of the whole structure now come more strongly to the fore, and, as the drawing progresses, the triangle of the stepladder, the circle of the basket and the square of the chair clearly emerge. After it has been reduced to its geometric figuration, the whole construction of the picture consists only of a single connecting guideline, and of the draped blanket only the bold outline remains in the picture. This configuration is now the starting point for further work on the picture, using paint, for example. Kandinsky called this enciphering of objects, 'presenting the overall structure in the sparsest scheme possible'. As a teaching process, it aimed to lead students away from their attachment to the objects, and make them aware of the essential formal and structural elements in any picture or still life with an artificial or naturally occurring order.

In his statements on colour theory, Kandinsky tried to develop an independently ordered system involving the three basic colours, red, yellow and blue, along with the grey scale between white and black. In Lothar Lang's colour scale (1926–7), this functions as follows:

Work is dominated by a horizontal white, yellow, green, blue and black scale, amongst whose three middle bands the colours orange, red and violet occur: black and white are linked by a semicircular grey scale, the colours of which flow into one another. Kandinsky treated grey and green as corresponding to red, since he saw them as mediating between the light and dark poles on the scale of tonal values. Green was able to

43 Bauhaus balconies in Dessau.

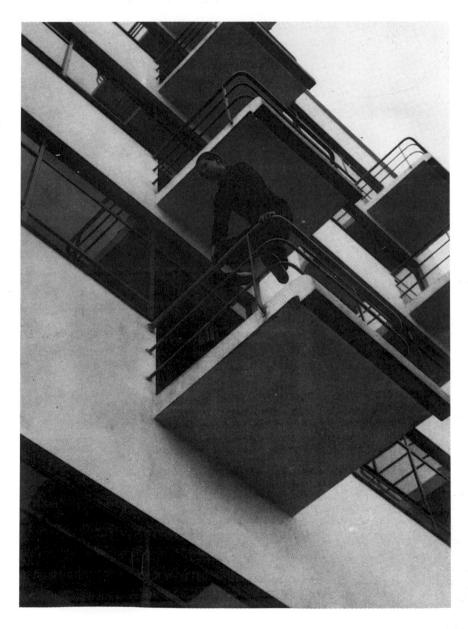

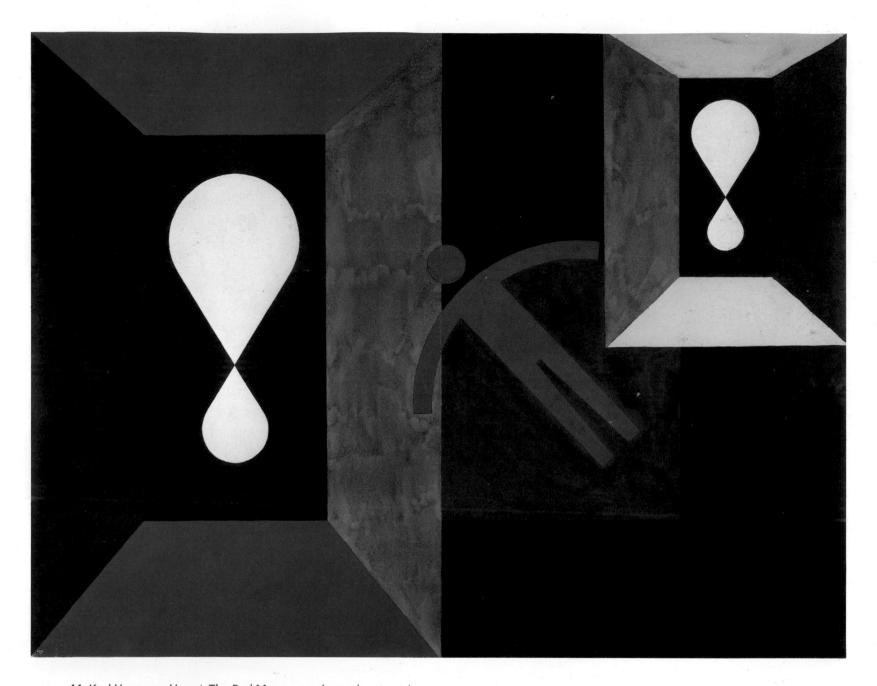

44 Karl Hermann Haupt, The Red Man, gouache and watercolour on paper, 1925. Haupt attended the preliminary course with Albers and Moholy-Nagy, 1923/24.

take the place of red in the diagrams, since it fitted in between yellow and blue, as the result of their mixing. (Christian Wolfsdorff, Experiment Bauhaus, p. 40.)

Best known of all, in this assigning of colours to geometric shapes, were the yellow pyramid, red cube, and blue sphere. This arrangement, which is still often used today, almost became a Bauhaus trademark. Of course Kandinsky had already developed his theoretical observations on colour theory years before the Bauhaus. The attributing of colours to abstract geometric constructions effectively turned them into independent works of art, though few actually grasped the underlying process.

Starting from the allocation of colours to forms, Kandinsky worked on Goethe's *Theory of Colours* to develop his own ideas on the psychological effect of colours. He often did this by using contrasting pairs such as order and chaos, or lightness and heaviness. Many of Kandinsky's conceptualizations in this context were borrowed from his understanding of music, in which he took a keen interest, as we can see from such picture titles as *Fugue*, *Crescendo* and *Allegro*.

As Formmeister (Master of Form) in the muralpainting workshop, he also applied his painting technique to the decoration of interior walls. Yet it was Oskar Schlemmer, despite the fact that he did not belong to this workshop, who established the practice of mural-painting at the Bauhaus in 1923. Kandinsky himself set no great store by it. Far more significant to him was the foundation at Dessau in 1927 of a free painting class under his direction. This supplied important stimuli not only for painting in general at the Bauhaus but also for Gropius's architecture. The essays Kandinsky wrote during his time at the Bauhaus (such as 'Point and Line to Plane' of 1926), his analytical teaching method, and his theoretical observations impressed scientists and artists, musicians and writers the world over. Thus he also served as a catalyst in creating numerous contacts abroad and stimulating keen international interest in the work of the institution, which became a major factor in attracting a larger number of foreign students to the Bauhaus in Dessau. However, the greater the recognition achieved by the Bauhaus abroad and the more widely its influence spread, the greater the opposition it encountered at home in Germany. In an interview Kandinsky's wife, Nina, looked back at this period. Asked whether there was still any hope of political life stabilizing, once the National Socialist majority on the Dessau city council had illegally cut their funds, she replied:

No, but there was always the hope that we would be able to continue on our own, alone, but able to work in peace. Unfortunately, though, the school was suddenly closed early in 1933 . . . in March. Not for good, that is, but provisionally. Investigations were carried out, with all the usual phrases attacking communists and Jews. Nothing was found, but then they told Mies van de Rohe that the school could only continue on two conditions: Kandinsky was not to be allowed to stay – he was too dangerous a presence – and the architect Hilbersheimer could not stay either, since he was in the Social Democratic Party. Of course Mies van de Rohe refused to accept these two conditions, and the school was closed for good. (Neumann, Bauhaus und die Bauhäusler, p. 238.)

After this Kandinsky turned down all further offers of teaching posts. Josef Albers tried to continue working with him, but Kandinsky refused. Following the closure of the Bauhaus, and the confiscation and labelling of his pictures as 'degenerate art' by the Nazis, he wanted only to work on his own.

Kandinsky's theories and teaching practice, which, amongst other achievements, turned the Bauhaus into the 'Hochschule für Gestaltung' (School of Design), remain extremely topical and significant to this day. He died in France in 1944.

Klee

We turn now to the role played at the Bauhaus by Paul Klee. That Klee should have been there was no mere accident for he and Kandinsky had been close friends since 1912. 'I could have been his pupil', confessed Klee on Kandinsky's sixtieth birthday, 'and in a certain sense I was, for some of his words managed to encourage, confirm and clarify my striving.' (Klee, *The Thinking Eye. Notebooks of Paul Klee*, p. 521f.)

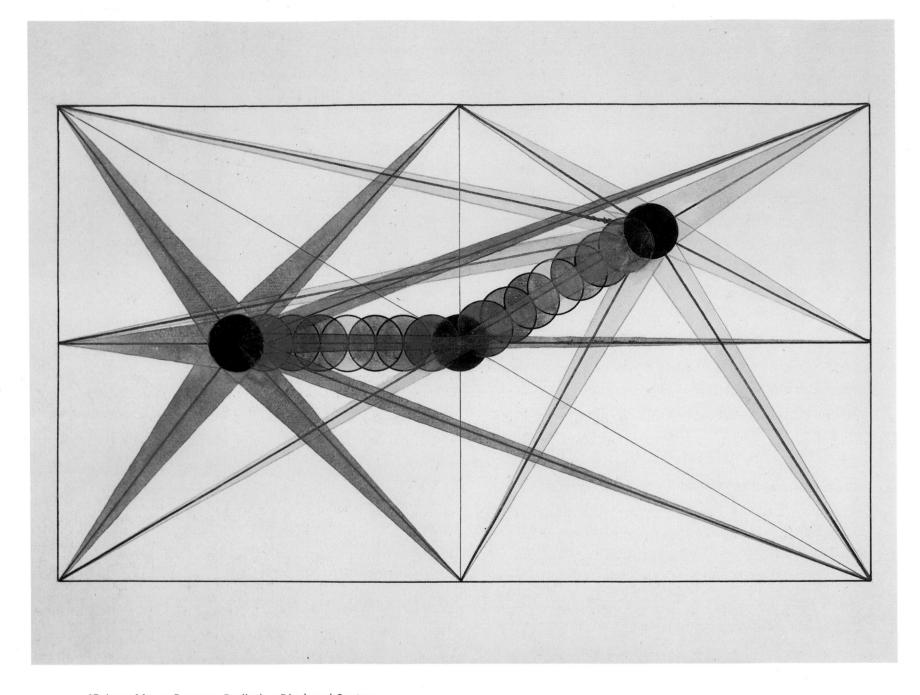

45 Lena Meyer-Bergner, Radiating Displaced Centre, water-colour from the Klee course, 1927.

Like Kandinsky and Feininger, Klee was a figure of major artistic importance at the Bauhaus. From 1928 to 1931 he taught the compulsory course 'Elementary Theory of Surface Forms', in which second-semester students were allowed to participate — 'allowed' because the painter and his pictures were venerated to an almost extraordinary degree at the Bauhaus. Even though, as we have seen, painting instruction was

never formally organized at the Bauhaus, or included in the syllabus, painting still played a major role. Free painting classes were established in 1927 and although they formed only a marginal part of the overall teaching framework, they were nevertheless a central influence on the design work of the students. Klee, who taught at the Bauhaus from 1920 to 1931, developed a complex framework for his teaching method, which explored the

analysis of sensory perception, picture construction, and colour theory on a more profound level. It would. however, be a gross oversimplification to try to reduce Klee's teaching notes, which fill several thousand pages, to a uniform scheme. Indeed, his programme scarcely invites this: it is all-embracing in its vision, which transcends the object world in its interpretation of feelings and painting technique. 'Art', wrote Klee, 'goes beyond the object, whether real or imaginary. It plays an innocent game with things. Just as a child imitates us in its play, so in our play we imitate the forces that created, and go on creating, the world.' (Knaur's Lexikon moderner Kunst, p. 149.) Some years later he expanded on his insights and intentions: 'Previously, artists depicted things which could be seen on the earth, which people liked, or would have liked, to see. Now the reality of visible things is revealed, and at the same time the belief is expressed that, in relation to the whole, the visible world is only an isolated example, that there is a latent majority of other truths. Things appear in an extended, manifold sense, seemingly contradicting the rational experience of yesterday. We strive to transform the incidental into the essential . . . Art is like an allegory of the creation. It is always an example, in much the same way as the earthly is a cosmic example.' (Ibid.)

This statement shows the clear impact of two fundamental influences on Klee: firstly, that of Expressionism, since his search for the essence of things and his attempt to discover their inner truth was Expressionist in spirit; secondly, the influence of the sciences, for in his search for information that would help answer the questions he posed, he took an interest in the state and development of the sciences, and especially of the natural sciences. Indeed, his knowledge of mathematics, physics, politics, in fact of world events generally, formed an integral part of his approach to art. It is evident, too, from his Bauhaus lectures, in which he put over to students his own ideas

about art's context, that he kept in touch with reality.

In art, too, there is room enough for precise research, and for some time now the gates have been wide open. The field of painting shows the beginnings, at least, of what had already been achieved in music by the end of the eighteenth century. Mathematics and physics offer the means in the form of rules which may be observed or broken. Salutary here is the fact that one is compelled to deal first with functions and not with the finished form. Algebraic and geometric tasks are factors that train one to think in terms of the essential and functional, as opposed to the impressive. One learns to see behind the façade, to get to the root of things . . . one learns to substantiate and to analyse. One learns to have scant regard for the formalistic, and to avoid taking on what has already been finished . . . (Paul Klee, quoted by Hans Wingler, Bauhaus Archiv Berlin, p. 63.)

Klee published his fundamental ideas on painting and construction in his *Pedagogical Sketchbook*, which the Bauhaus published in 1925. Starting, like Kandinsky, from the line and its variations, he moved on to its arrangement in space, 'to the complicated artistic phenomena of creating structure, dimension and movement, and the problems involved in drawing them. Klee's teaching was from beginning to end a dialogue with nature.' (Ibid.) He practised his method of analytical drawing and painting with his students, among them Gertrud Arndt and Lena Meyer-Bergner. Set tasks included drawing geometric figurations from mathematical calculations, and assigning colours to them, as well as the study of his theory and method of artistic perceptions. His schematic representation of the synthesis formed by the eye of the externally observed world and his path of inner reflection led to an abstraction from the optical, physical phenomenon to a dynamic process, and this led, in turn, through the

46 Oskar Schlemmer, Nature, Art, Man, ink on paper, c. 1928. This is a schematic representation of Schlemmer's complex theory.

stage of a non-optical 'cosmic identity' and the 'nonoptical path of a common earthly root'. (Both factors worked reciprocally on the process of perception.) Put more simply, this schematic, theoretical statement meant that the artist's perception of the world must become a conscious process, during which he should be aware that he is 'transforming' the pictures, enciphering or deciphering them. The extremely complicated system of calculations Klee used in his pictures also meant that, particularly in his later phase, the process was impossible for others to copy. His erudition and personal charisma contributed decisively to the success of his practical classes (which were more like lectures), and played a major part in creating a positive atmosphere at the Bauhaus. Even if Klee did regard with scepticism the strong technical orientation that later prevailed at the Bauhaus, his theories, which rested partly on findings of the natural sciences, fitted

in well there. Indeed they represented a synthesis of the ideas that prevailed during Itten's period of teaching at the Bauhaus and developments after 1925. The important influence of Klee, who had contacts with such leading artists as Picasso, Marc, Apollinaire, and Robert Delaunay, points again to the role Expressionism played at the Bauhaus: at the centre of everything stood man and nature. Although, as the years passed, debate persisted about the applicability of this maxim to the Bauhaus, Klee's contribution remained undisputed. After his voluntary departure from the Bauhaus in 1931, he became Professor at the Düsseldorf Academy of Art. Two years later he returned to Bern in Switzerland, where he died in 1940, aged 61.

Schlemmer

Oskar Schlemmer was born in Stuttgart in 1888, and in the context of the Bauhaus his name is always associated with the theatre. Although it is impossible to quantify, the impact of his work remains undiminished to this day, and evidence of his influence on modern stage design and costume is still very much with us. The figures from his *Triadic Ballet*, first performed in 1922, have lost none of their fascination, and Schlemmer's reputation as a great optimist and a highly gifted artist is amply supported by numerous photographs both of the man himself and of his productions. At the age of 15 he began a two-year apprenticeship in mosaics, after which he studied until 1909 at the Stuttgart Academy of Art. Two years before the war, and from 1918 to 1920, Schlemmer studied with Adolf Hoelzel, who also taught Johannes Itten. Though a painter, Schlemmer was also a man of many other talents, as can be seen most clearly from the dance experiments which he began in 1912, and resumed during the second part

of his studies with Hoelzel. Of course this developing talent also meant that Schlemmer became deeply involved with music and movement. He himself directed, appeared as a dancer and designed both costumes and scenery. Perhaps it was because of his theatrical activities that Schlemmer devoted himself increasingly to an all-round study of the body, and the ways in which human movement depicts certain forms

47 and 48 Oskar Schlemmer, Simple Head Construction, pencil on paper, c. 1928.

of expression, character and action. For theatre does not merely require individual actors — it aspires to appeal comprehensively to all the senses, and can move from being fantastic to being serious, or sad. It is both life and play. And at the centre there is always man, with his wishes, hopes and fears.

Schlemmer's all-encompassing view of the theatre was clearly reflected on the Bauhaus stage, which he

directed from 1923 to 1929, making it the principal focus of his artistic activities. As a result the theatre workshop now began to attract the attention of the Bauhaus teachers and students and of the general public, although it had been in existence since 1921. Groupius's concept of the unity of the arts under architecture did not, after all, exclude theatrical work and the first director of the theatre workshop was Lothar Schreyer, whom Schlemmer replaced. Indeed Gropius (who brought Schlemmer to the Bauhaus in 1921) himself stressed the importance of the connection between the theatre and architecture. 'Stage work, as an orchestral unity, has an inner relationship to architecture. Each receives from, and gives to, the other.' (Experiment Bauhaus, p. 250.) While this statement is hardly a concrete expression of Gropius's attitude to stage work, he never missed an opportunity to support the Bauhaus theatre. In the Dessau Bauhaus building, the theatre itself was situated between the workshop wing and the studio building. As a result the stage was centrally placed between the great hall and the canteen, and the auditorium could be opened on both sides.

An article for the *Bauhauskompendium* of 1927 reveals how novel Schlemmer's theatrical theories and their practical application were. In a clear departure from traditional notions of theatre decor, he aims to create impressions that will appeal to the imagination, thereby showing a marked artistic proximity to Bauhaus ideas and teachings in general:

Moreover since we are not intent on creating a naturalistic illusion, and therefore do not paint scenery in order to transplant a sort of second nature onto the stage; since it is not our wish to create an illusion of wood, rooms, mountains and water – we make wooden screens covered with white linen, line them up so that they can be drawn along on parallel rails, and project our light onto them. Or we create transparent

walls and with them an illusion in the higher sense, produced by our own direct method. We do not want to use our lighting to create sun and moonlight, morning, midday, evening and night. We want the light to achieve its own effect, as yellow, blue, green, red, violet etc. – Let us not burden these simple phenomena with concepts such as red = demonic, blue-violet = mystical, orange = evening etc., let us rather open our eyes and react to the pure force of light and colour. (Bauhaus 3/1927, p. 3, in Experiment Bauhaus, p. 270.)

The abstraction from the object world already being taught in other areas by Bauhaus teachers was absorbed by Schlemmer into his own framework of ideas for the theatre. Significant and, for many, contradictory was the fact that whereas Schlemmer's theory of art was essentially focused on human beings, in his productions the human body disappeared behind the costumes and geometric forms. Similarly, many of his pictures show very simplified human forms in outline - the naturalistic details are unimportant to him. This is only an apparent contradiction, however, since through his painting and stage work Schlemmer sought to unite all the arts in a synthesis, with man as the measure of everything. His understanding of human beings, like that of Klee, Kandinsky or Itten, was not derived from externals. He sought truth via the transcendent penetration of appearances by artistic means. From 1922 his life-drawing classes were intended to enable his students to achieve this for themselves. In the course unit 'Man', which started in 1928, Schlemmer analysed the human body almost as Leonardo da Vinci or Albrecht Dürer had done. In his own words:

The 'Man' class is preceded the previous evening by

49 Oskar Schlemmer, copper, brass and nickel, figure in nickel-plated zinc, 1930/31.

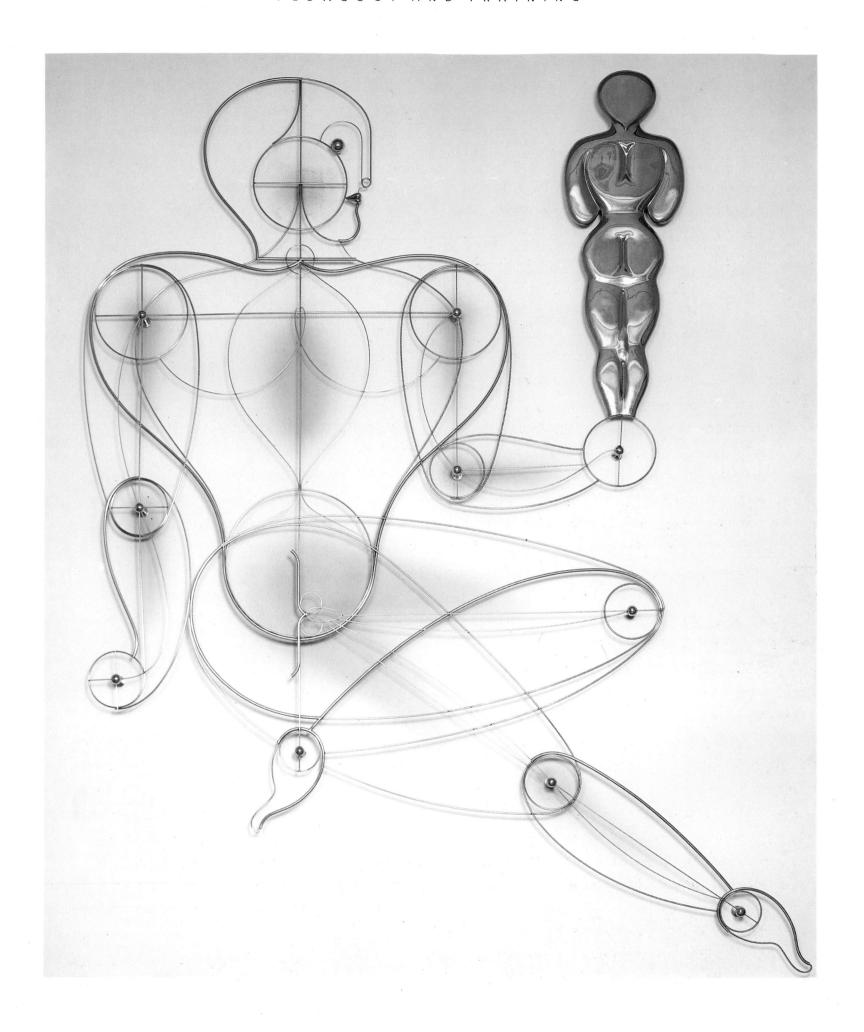

drawing a live model. In the absence of good models the students resort to self-help, taking it in turns to model. This guarantees much variety in the bodies being drawn. The drawing of nudes is then transferred to the stage or great hall, where, in contrast to the

sober classroom, with its monotonous, constant light, stimulation and diversity are created by the sets, equipment, spotlights and, from time to time, by gramophone music also. When the nude pose is held for between one and two hours, with no quick

50 Sculpture workshop with works by Schlemmer, Weimar, 1923.

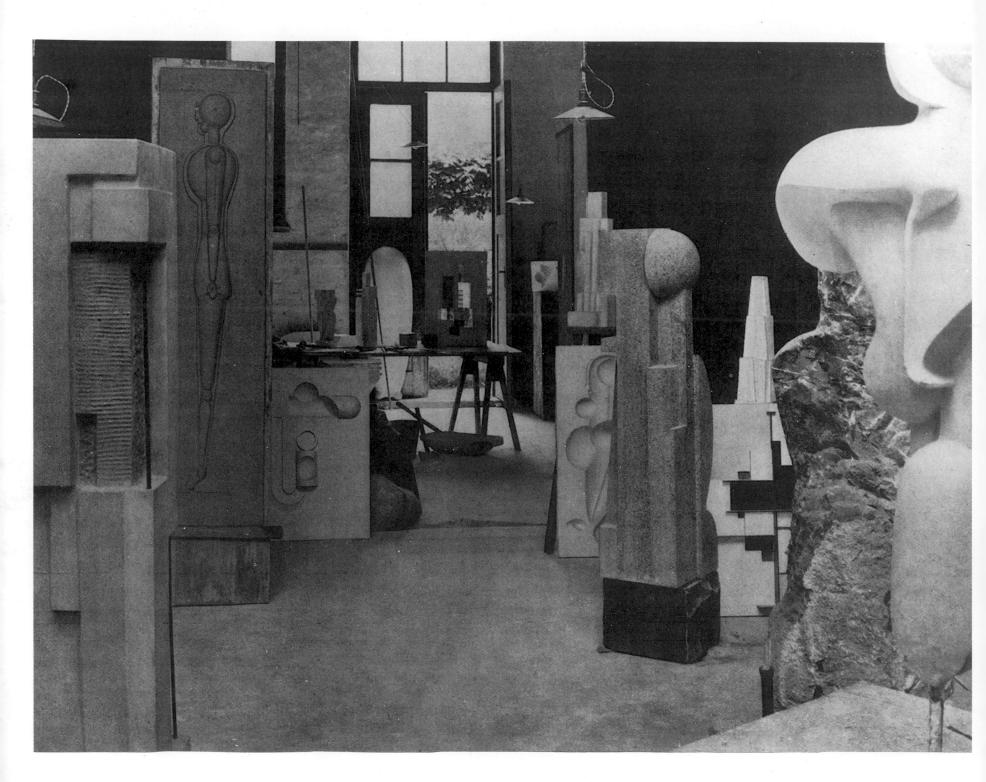

sequences of movement, we do a blackboard analysis during the break, highlighting the essentials: the basic forms, the axes of movements, bone structure and musculature, light and shadow. (Schlemmer 'Aktzeichen', from Zeitschrift Bauhaus, No.2/3, 1928, p. 23, in Experiment Bauhaus, p. 54.)

Schlemmer's drawing course and teaching method were based on the assumption that the student must first of all understand the underlying concepts of drawing and proportion, and recognize the body's relationship to space. Schlemmer, however, went a step further: 'The standard measure, theories of proportion, Dürer's measurement, and the Golden Section deal with the schemes and systems governing line, surface and the plasticity of bodies. From these develop the laws of motion, the mechanics and kinetics of a body, both in itself and in space, natural space as well as cultural space (the building). The last mentioned carries particular weight, of course: man's relation to his dwelling and to its furnishings, or objects.' (Ibid.)

So on the one hand Schlemmer's teaching employed traditional drawing techniques and analyses, and on the other he developed them further by refusing to include in his programme anything that he considered to originate in barren theories devoid of experience or feeling.

Drawing, in his opinion, should create surprises and unexpected results, as in fact it did. In this way the synthesis that was so typical of Schlemmer's work could be achieved, leading, as it developed further, to abstraction. His studies of movement sequences have had an impact on the training of stage and costume designers which has lasted to the present day. Apart from his extensive teaching and stage activities, Schlemmer also produced important work as a painter. Here, too, his theme was the human figure in space. By reducing it to essential details, he created a sculptural impression, as in the 1928 picture *Group*

with a Seated Woman (Five Figures in Space). The perspective of the converging floorboards gives this strictly composed picture its impression of space. The near facelessness of the women, together with the barely suggested hands and simplified proportions, reveal in the context of the whole picture, with its raised, rectangular surface, a central theme of Schlemmer: the relationship of the human figure to space. In addition to the many pictures he left behind at his death in 1943 near Stuttgart, there were also some extraordinary three-dimensional works. He had taken his first steps towards sculpture in 1919 with some wall reliefs. At the Bauhaus he extended his activity to wall-painting and attempted to achieve a more plastic effect from the painted wall surfaces in rooms. The cast-iron reliefs he began making from 1923 give a further insight into the construction method described above in the context of the drawing class. Figures are depicted in simplified form, in proportional cubes, with the introduction of an additional factor in the shape of the prevailing light in the rooms to be decorated. Like his stage costumes, they are all geometrically divided and segmented. This is still more evident in his freestanding sculptures. In 1921–23 he sculpted his Abstract Figure, about which he wrote, 'The plastic is three-dimensional (height, breadth, depth) . . . It can be grasped not in one moment but in a time sequence, as the observer changes position. Because the plastic cannot be known exhaustively from one viewpoint, the observer is compelled to move, for only by walking around it can he come to grasp it and the sum of its impressions.' (Diary, 8.1.1924, in Schlemmer, Briefe und Tagebeucher, in Experiment Bauhaus, p. 398.) This multifaceted demand on the observer leads to the core of abstract sculpture, for it is not the external character of things which must be grasped, but their inner nature. Once again, Schlemmer insists here on his conception of the ideal human image. When he borrows from the sculpture of Ancient Greece, in this case from the

51 Oskar Schlemmer, Solitary Figure on Grey Background, oil on tempera on linen, c. 1928.

Apollo of the Temple of Zeus at Olympia, he does so consciously. He was constantly moved and fascinated by classical art.

Shortly after the departure of Walter Gropius in 1929, Schlemmer also left the Bauhaus to take up a professorship at the Breslau Academy. However, the strength of radically right-wing political influences there forced the Academy to close in 1932, and he went to Berlin, to the State Art School. The political oppression of Schlemmer was to continue unabated. An exhibition of his works in March 1933, in Stuttgart, was closed by storm troopers and he was dismissed from his teaching job in Berlin. To make matters worse, shortly after his move to Seheringen, near Stuttgart, his work was banned by the Nazis in their exhibition of 'Degenerate Art'. Faced with such opposition, Schlemmer increasingly withdrew. No longer able to pursue his own work in Germany, he earned his living as a painter's assistant. In 1940 he took a job in the colour laboratory of a chemicals factory in Wuppertal, where he worked alongside Willi Baumeister, Georg Muche and Gerhard Marcks, all of whom he knew from his time at the Bauhaus. By now it was simply a question of survival, and eventually Schlemmer gave up the struggle. He died on 13 April 1943 in Baden-Baden. His inexhaustible optimism as an artist had made him a figure of central importance at the Bauhaus and the major stimulus he provided has lasted to this day. He also had a taste for simplicity to match his predilection for the fantastic. Visionary-like, he wrote:

When one considers the entire phalanx of human figuration, from the naked human being to the costumed, to the figure in art and the marionette, to

52 Oskar Schlemmer, abstract figure, plaster and metal, 1921/23.

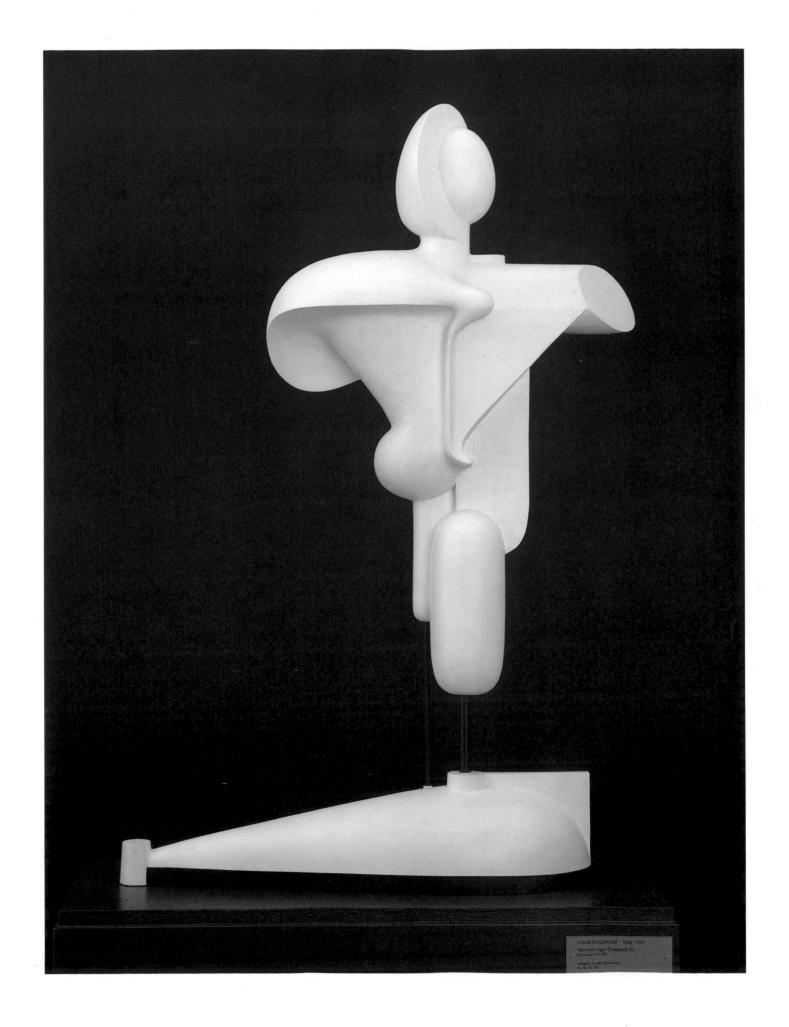

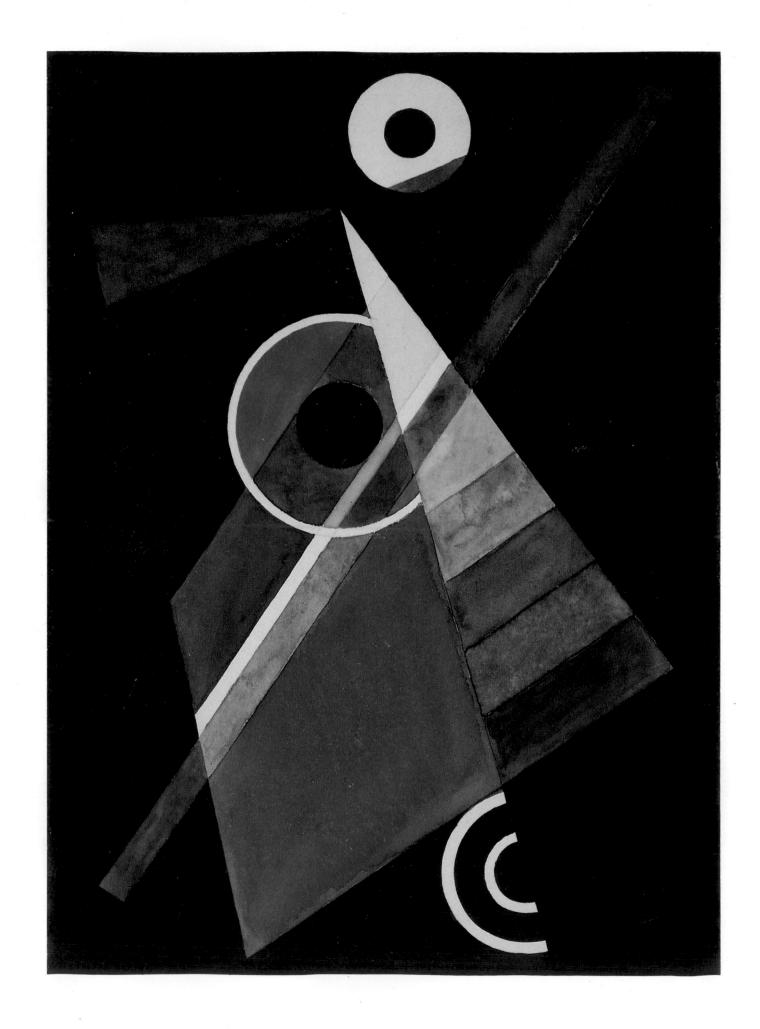

the larger-than-life fantasy figure: when one considers the whole spread from the comic-grotesque to the heroic and pathetic.

. . . when one considers the music of the spheres, the organized waves of the ether, or the music that can be created by mechanical-dynamic means which has an unprecedented intensity of sound, and of which a Busoni dreamed:

when one considers that the poets – stirred by the new possibilities – will arrive at completely new ideas and subjects, that they will then think less in terms of pictures, and more in terms of spatial, plastic architecture:

when one considers the progress made in the area of optics and mechanics, and above all, that these means can be an end in themselves, so that they do not serve to produce the illusion of a second nature on the stage, but can affect one directly through the elementary force of what they are: then indeed one can say that creative fantasy has possibilities that are virtually endless. (Neumann, Bauhaus und die Bauhäusler, p. 232.)

At this point it is worth mentioning an unusual aspect of the Bauhaus: its position as a centre for the arts. The artists discussed so far were brought there by Gropius, and were for the most part directly involved on the teaching side. In keeping, however, with the spirit of the place, a number of other figures were drawn to the institution, who did not come to teach, or only in a peripheral way. Many were attracted by the opportunity to associate freely with artists whom they venerated, or for political reasons, to guarantee protection for their work, or simply to find artistic inspiration. Albert Einstein was a guest at some events. The painter Alexei von Jawlensky, whom Kandinsky knew from his earlier years, admired the work of the

53 Karl-Hermann Haupt, Composition, watercolour, 1925.

Bauhaus, just as Kandinsky himself was influenced by the music of Arnold Schoenberg and Stravinsky. Then there were the recurrent links with the 'Blaue Reiter' group: Franz Marc, Klee, Macke and Campendonk. Lyonel Feininger, too, belonged to the circle of teachers who stamped their personality on the Bauhaus, even if, after designing the 'Cathedral of the Future' for the Bauhaus Manifesto in April 1919, he was only peripherally involved in Weimar, and later took no part in the teaching at Dessau. Hans Wingler, the great chronicler of the Bauhaus, wrote of Feininger: 'His mature culture and humanity were what made his presence at the Bauhaus so significant. Although he hardly ever appeared, we were constantly aware of his proximity; we sought his advice . . . So Feininger was indirectly more influential than many others actively engaged in teaching. The regenerative power of his early humour should not be underestimated, nor should the fine musical sense with which he liked to surprise friends, as he improvised on the harmonium or the organ.' (Hans Wingler, Bauhaus–Archiv Berlin, p. 60.)

Walter Gropius must take the credit for having brought together so many prominent figures at the Bauhaus, for he was well aware of the influence that even the mere presence of such artists would have on the students. As a result, the school's sphere of activity was extended; Gropius's circle developed increasingly into an international centre for creative potential. Foreign students came to Dessau, eager to absorb the new teaching, and they then passed it on. A fundamental factor behind this success was the structure of teaching in the preliminary courses, where the workshops played a leading role. Although they were later reorganised to meet the need for a more technical orientation, they provided an important link between theoretical knowledge and its practical application. It is therefore crucial to trace the role of the workshops. Here, as in architecture, Gropius saw the creative idea turn first into a design and then into material shape.

3. The Workshops

The path leading from educational ideas to practical reality was a long and often thorny one. The workshops Gropius found at Weimar in 1919–20 looked more like an empty house than rooms which might function as studios or lecture halls. Yet the overall concept was clear: students were to acquire solid craft skills, so that they would have some activity to fall back on when times were hard. Moreover, the fact remained that only through familiarizing themselves with their preferred material and acquiring a basic know-

ledge of its particular qualities, could they really learn to work with it.

So, as time passed, a total of eight workshops were opened, all of which achieved extraordinary results in their respective areas, each a reflection of the interests of the various directors. They comprised:

the furniture workshop the metal workshop the print and advertising workshop

54 Albert Henning, Bauhaus students before an excursion, 1932.

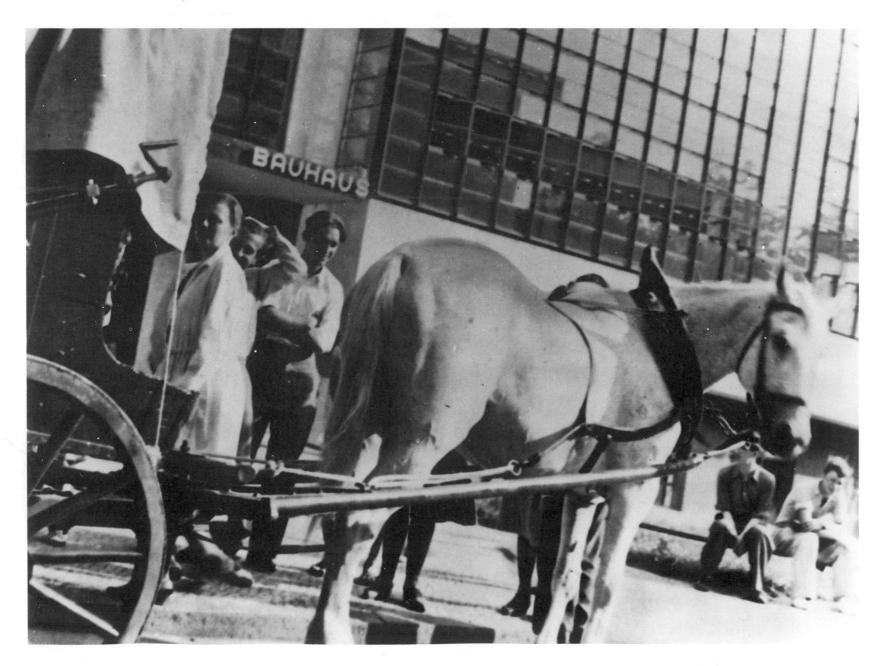

55 Laszlo Moholy-Nagy, letterhead and cover for Bauhaus Verlag, printed on paper, 1923.

the photography workshop the theatre workshop the wall-painting workshop the ceramics workshop and the weaving workshop.

Basically, the history of the development of the workshops falls into two phases. The Weimar period, until 1925, was devoted to experimental work, although it was not without its successes. The Bauhaus began to test the connection between theoretical instruction and practical application. The motto initially adopted by Gropius and expounded in the 1919 Manifesto, 'art and craftsmanship: a new unity', set the tone for the workshops and the approach to work in them. The ability to produce designs that would be acceptable to industry did not emerge until the original motto had been adapted to read 'art and technology: a new unity'. The effects of this reformulation varied and can best be assessed by looking at the individual workshops. The roles of their respective teachers and master craftsmen will then become more apparent.

The Furniture Workshop

One of the predictable outcomes of the far-reaching ideas behind the Bauhaus was its involvement in furniture-making. In our daily lives we are surrounded by pieces of furniture – we live and work with them. It is possible to regard a traditional piece of furniture, a chair for example, simply as something to sit on. But since sitting is not restricted to one particular type of chair, throughout history a variety of chair forms have developed as styles of art have changed. The ancient world, the rococo period, and the nineteenth century all produced their own distinctive forms of furniture. Apart from its function, furniture can also make a statement (as does a king's throne, for example) and, like architecture, acts as a source of information about the culture in which it was made, and with which it remains inextricably linked. (The same applies to clothes and fashions.) The Bauhaus involvement in furniture design therefore comes as no surprise. Just as changes were becoming noticeable in art in 1918 after the war, in furniture design too there was a reform, if not an upheaval, of traditional ideas about how people should live. Pretentious ornament and unnecessary decoration were to be shelved, and the appearance of furniture was to be determined by a new emphasis on the rational and the functional. Johannes Itten, the first director of the furniture workshop, opposed any notions of adaptation to suit the demands of industry as disruptive to teaching, and was prepared to fight the matter out with Gropius. When Itten left the Bauhaus in 1923 because of this and other differences of opinion, Gropius himself became Formmeister, or Master, of a newly structured course. The main discussion now centred on basic approaches to furniture design, and revealed an analytical tendency that was also the hallmark of Kandinsky, who arrived at the Bauhaus in the middle of 1922. Before choosing the material,

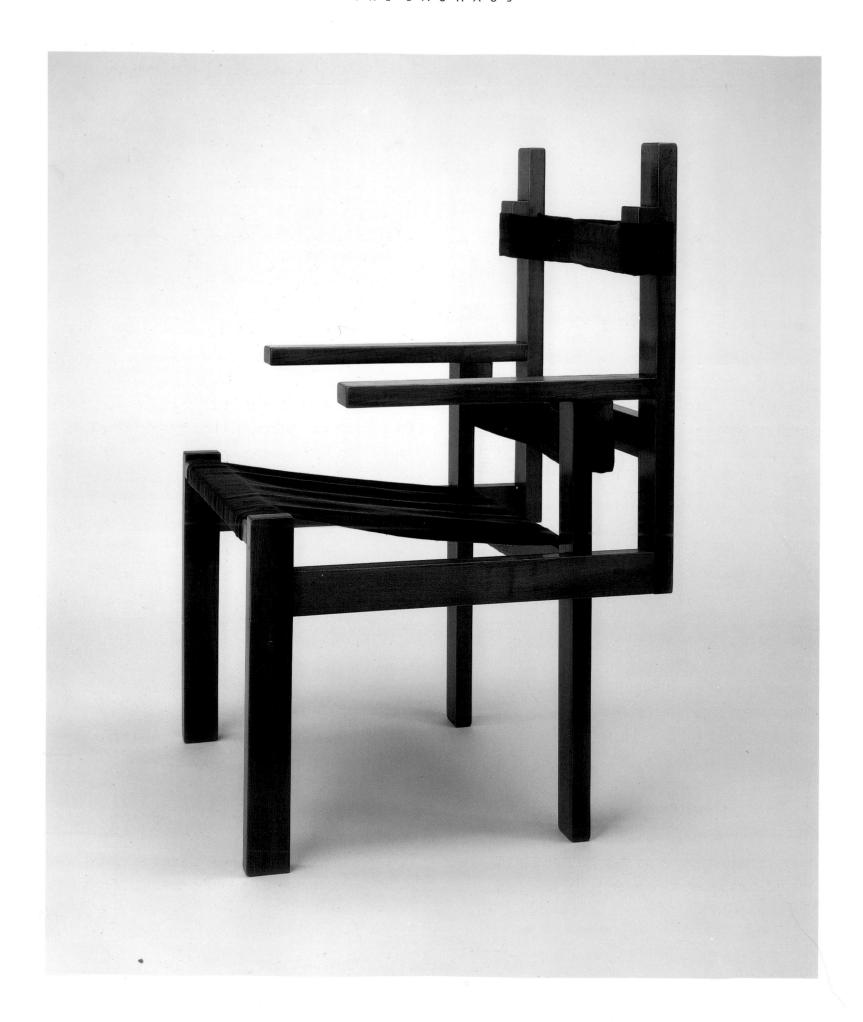

developing a new idea and starting construction work, students had to conduct an analysis of the proposed item of furniture and its function. Such a procedure was typical of the Bauhaus, and showed the clear influence of the Constructivists — particularly those close to Theo van Doesburg. (Van Doesburg was staying in Weimar at the time and campaigning — with some success — against Expressionism at the Bauhaus.)

There can be few better examples of the connection between functional analysis and the finished article than the chair designed and made at the Bauhaus by Marcel Breuer in 1922. Born in Hungary in 1902, Breuer came to the Bauhaus in 1920. In his first four years he completed an apprenticeship as a cabinet-maker, and in the years that followed went on to become a *Bauhausmeister* and a central figure in modern furniture design.

He himself describes his 'armchair with fabric seat, fabric back and cross support' as having developed out of the following considerations:

The starting point for the chair was the problem of how to combine comfortable seating with the simplest construction. Hence the following requirements were established:

- a) An elastic seat and back support, but no upholstery, since it is heavy, expensive, and attracts dust.
- b) A slanting seat, so that the whole extent of the thigh is supported without the pressure that occurs with a level seat.
- c) The upper body in a reclining position.
- d) The spine left free, since any pressure on it is uncomfortable, besides being unhealthy.

 This was achieved by the introduction of an elastic cross support. Thus only the small of the back and the shoulder blades are supported by the skeleton, elastically in fact, and the sensitive backbone is left

56 Marcel Breuer, lattice chair, wood and black fabric, 1922.

entirely free. Everything else emerged as an economic solution to these requirements. Another factor determining construction was the static principle: positioning the broader dimensions of the wood against the pull of the fabric and pressure from the sitting body. (Experiment Bauhaus, p. 102.)

Although anyone reading these lines may wonder whether it is remotely possible to sit on such a construction, and anyone seeing the result may be reminded of anything but a chair, the practical test of sitting on it is convincing enough.

Breuer's description and his work clearly illustrate the unusual development process that was so important to the Bauhaus. The complete rejection of decorative elements, and the prominence given to the basic material in the construction method were both new and have provoked sharp comments from critics past and present. Although this chair was among Breuer's earliest works it remains his most significant, since it provides the most obvious example in furniture-making of Gropius's new approach.

As in painting and architecture, the search for solutions and for the essence of things was evident in the furniture workshops. A rejection of traditional forms was also strongly marked here, with Gropius himself repeatedly directing operations towards industry. At the same time it was important to identify absolute statements concerning design, for the aim was to arrive at a type which would answer all further questions of form (at least for the foreseeable future). In his 'Principles of Bauhaus Production' of 1926, Gropius wrote: 'There can only be one firm solution to the creation of a quality article: the type.' (Experiment Bauhaus, p. 98.) Though one may question this assertion, it nevertheless demonstrates that Gropius was very much in harmony with industry, even if industry was not always quick to realize this. Industrial production generally had reached the point where it

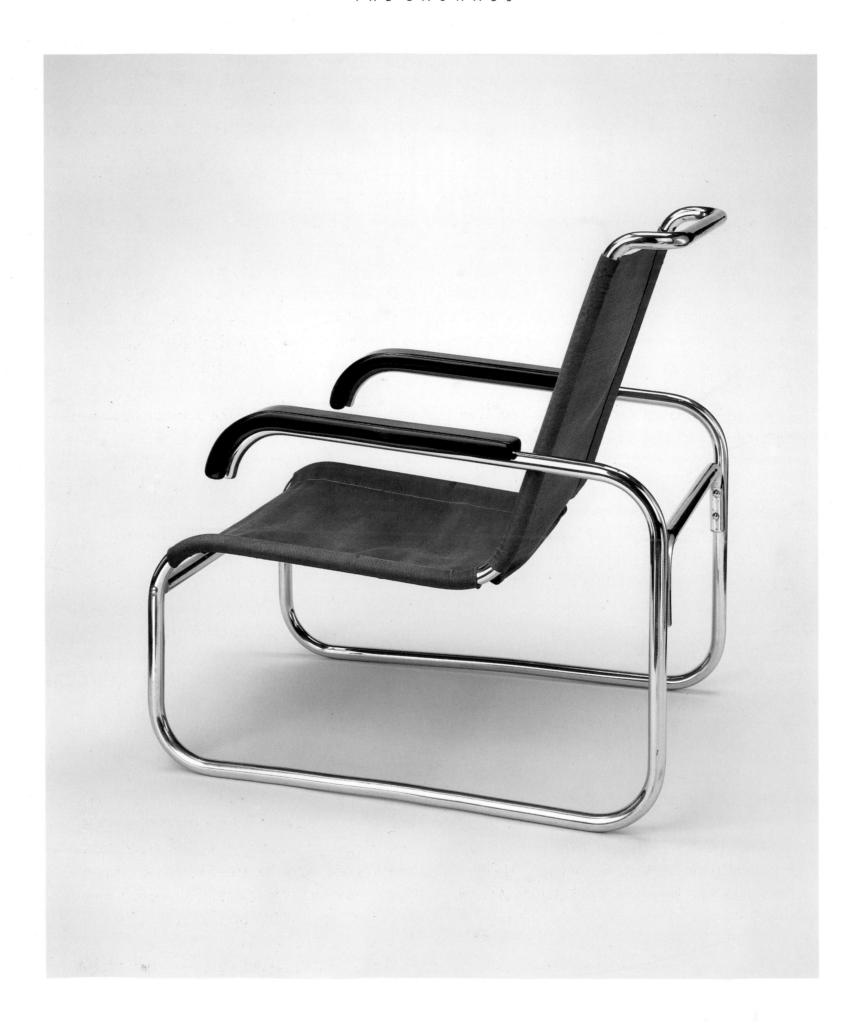

could repeat a series, that is, a standardized form, almost indefinitely. At the same time there was a growing demand for new furniture, which went hand in hand with manufacturers' desire for cheaper raw materials than wood. These developments coincided with the aim of the Bauhaus to create a new architecture, which in its turn was to produce a new concept of living. Ideas also came from other cities and other furniture-makers. The Dutch designer Rietveld, under the influence of van Doesburg's de Stijl group constructed a wooden chair, named the Red-Blue Chair; and in Frankfurt, Ferdinand Kramer designed and produced a series of furniture types. In Stuttgart, Adolf Schneck was working on similar plans and designs.

Part and parcel of the reforms in furniture and life-style – which affected Bauhaus architecture as well as the furniture workshop – were the newly developed ground-plans for houses. Boxed into a narrow space were kitchen, bedroom, living room and nursery. Hallways and staircases were dispensed with. An analysis was made beforehand of the function and purpose of each of the rooms. The kitchen – previously almost sacred to German architects – was equipped with the necessary fittings economically and in such a way as to conserve space. On the same basis, new furniture was accommodated in the home, with smaller pieces being pushed under tables or sideboards. Some Bauhaus designers must have had inscribed on their drawing boards Le Corbusier's remark that a house should be a 'machine for living'. There was, however, another aspect to the furniture being built. Apart from being an integral part of the total architectural conception, which was much more convenient to live in than many older buildings, it also represented a much freer attitude to the whole subject of interior design.

For a short time, between 1924 and 1925. Marcel Breuer left the Bauhaus. When Gropius summoned him from Paris to be director of the furniture workshop in Dessau, he was quick to respond. There now followed a time of heightened creativity. In the months that followed, after noting that steel tubes could be bent, Breuer designed and constructed an innovative and influential series of pieces of furniture based on tubular steel. Tables, stools, chairs and armchairs of all kinds were now produced in collaboration with industry, and the newly built houses of the Meistersiedlung in Dessau (1926) were furnished with them. The bending of steel tubes into curves drew directly on six years of practice and experience at the Bauhaus. A recognizable form was created which had a transparency already familiar from the designs of Laszlo Moholy-Nagy and Oskar Schlemmer. Breuer's analytical approach to the task was also in the same spirit. The state-commissioned Weissenhof scheme, built in Stuttgart in 1927 under the direction of Mies van der Rohe (other collaborating architects included Le Corbusier, Mart Stam and Oud from the Netherlands, Walter Gropius, the Taut brothers and Peter Behrens from Germany) was the ideal setting for the new furniture. Conceived as a 'workers' settlement', the need for workers' accommodation being acute, it was intended to give people an impression of the new architecture and furniture. But it was a project that involved many contradictions. The occupants, who were deprived of any traditional decoration and ornamentation. described the houses as too cold and heartless. And so they were rejected by the very people for whom they had been built – the workers. The conflict this created made the designers aware of their limitations: an analytical building with similarly analytical internal furnishings might seem perfectly rational, but it by no means necessarily guarantees a homely atmosphere. Practical evidence of such a realization only came years later, after March 1928, when Hannes Meyer took over the direction of the Bauhaus.

Breuer's tubular steel furniture was immediately

57 Marcel Breuer, chair, tubular steel and black fabric, 1928/29.

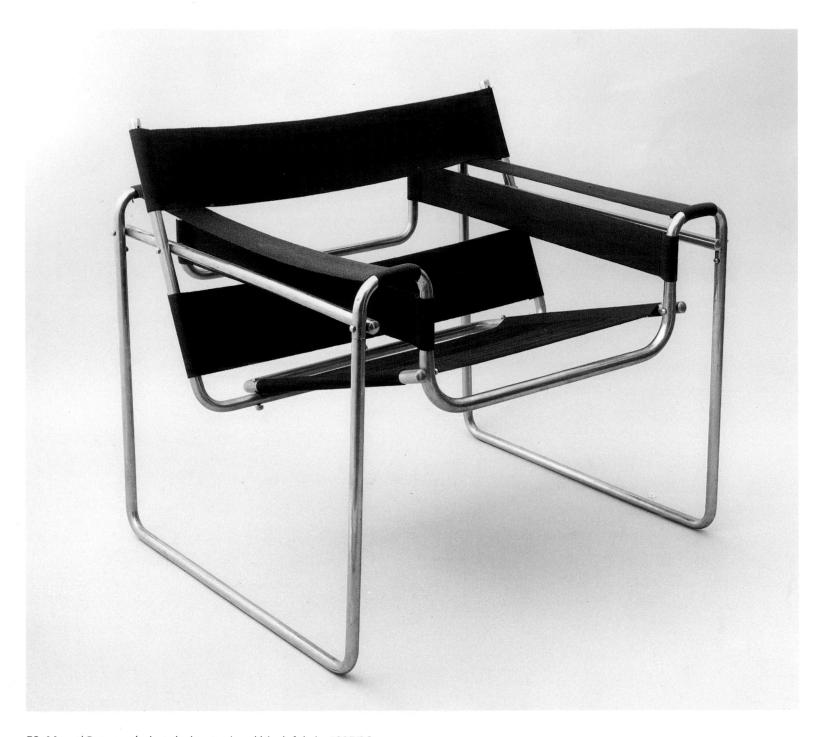

58 Marcel Breuer, chair, tubular steel and black fabric, 1925/26.

produced in relatively large quantities by various other firms, though admittedly examples of it were more likely to be found in the studios and residences of architects and intellectuals than in the houses of ordinary working people. Apart from numerous pieces of furniture for everyday use, during his Bauhaus years Marcel Breuer also constructed a basic tubular steel

chair which broke new ground in design and which other designers have continued to copy to this day.

In March 1928, Breuer left Dessau to work on interior furnishings. Between 1935 and 1937 he

59 Mies van der Rohe, Weissenhof chair, tubular steel and cane, 1927.

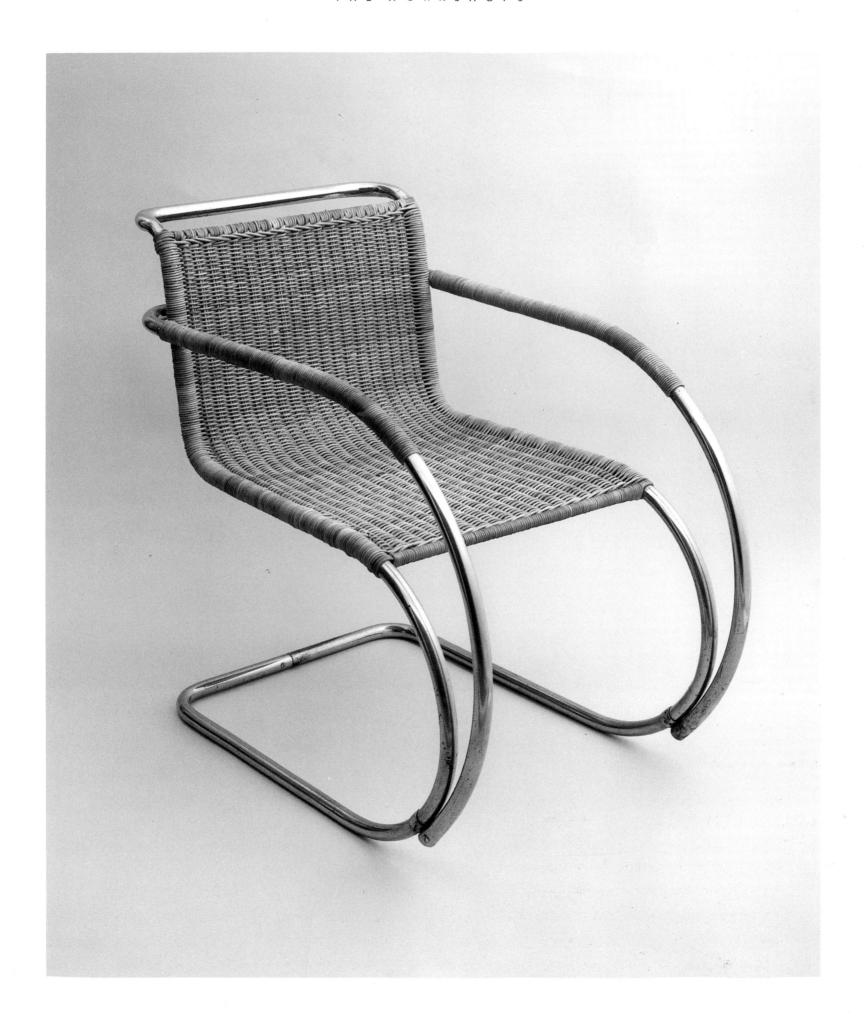

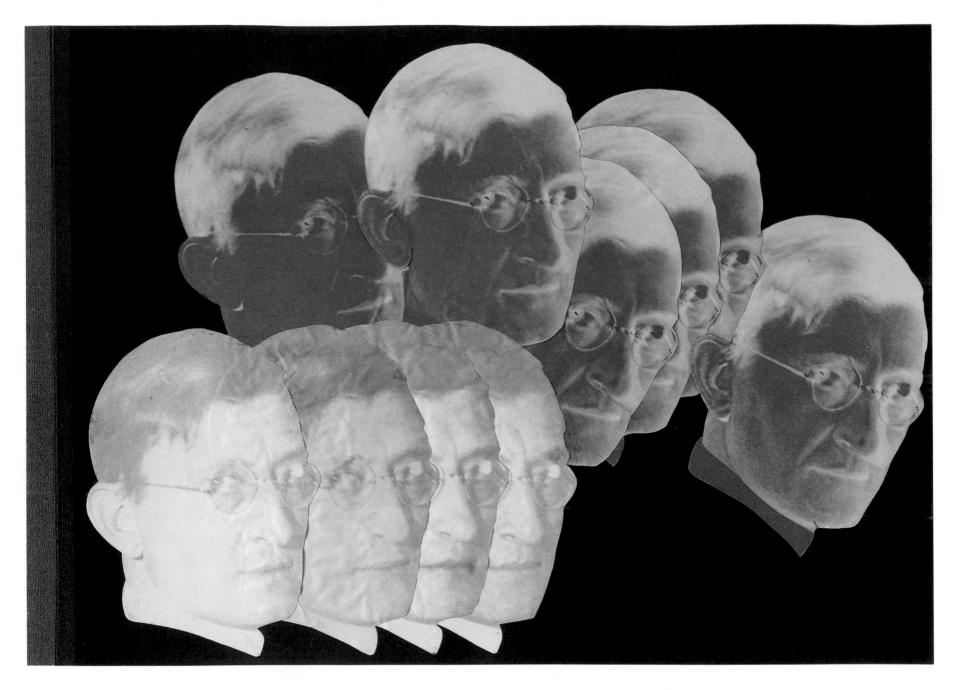

60 Photographer unknown, portrait collage of Josef Albers, c. 1928.

worked as an architect in London, from where he was invited to become Professor of Architecture at Harvard University. He died in New York, after a successful career as an architect and furniture-designer, in 1981.

Josef Albers, who was in charge of the workshop between 1928 and 1929, designed and built, together with the students, a series of simple pieces of furniture including writing tables, chairs and armchairs, which were worlds away from Breuer's ambitious projects, even if they too resulted from an initial process of functional analysis. Overall, Meyer's directorship was characterized by a trend towards simple furniture. Whilst teaching at the Bauhaus from 1927 to 1928, he had already criticized a tendency to overstylize, and held Gropius responsible for divorcing design from social needs. Meyer's affiliation to the political left then

gave rise to some impressive practical achievements in furniture design: for example, the entire furnishings and fitting of the Bundesschule des Allgemeinen Deutschen Gewerkschaftsbundes (ADGB) in Bernau, and a doctor's house in Mayen in der Eifel.

After Hannes Meyer had been dismissed following political and artistic differences of opinion, Mies van der Rohe took over the directorship of the workshop. He rejected social themes just as strongly as Meyer had embraced them, and he gradually reduced the role played by the furniture workshop, since he was mainly interested in architecture. The few, but very famous,

furniture designs Mies created also show a different emphasis from those of Meyer. His 'chair without back legs', which came to be known as the *Freischwinger* or 'free swinger', was in fact designed for the Weissenhof Settlement. With long curves of steel tubing supporting the wickerwork seat and back as well as the arm rests, it displayed all the qualities associated with interior design on a grand scale, and required a good deal of space, although one of the major problems of the Weissenhof Settlement was precisely its lack of space. Mies gave little thought to such problems, a fact which doubtless contributed to the exclusion of the Bauhaus from

61 Heinrich Bormann, interior architecture, 1932.

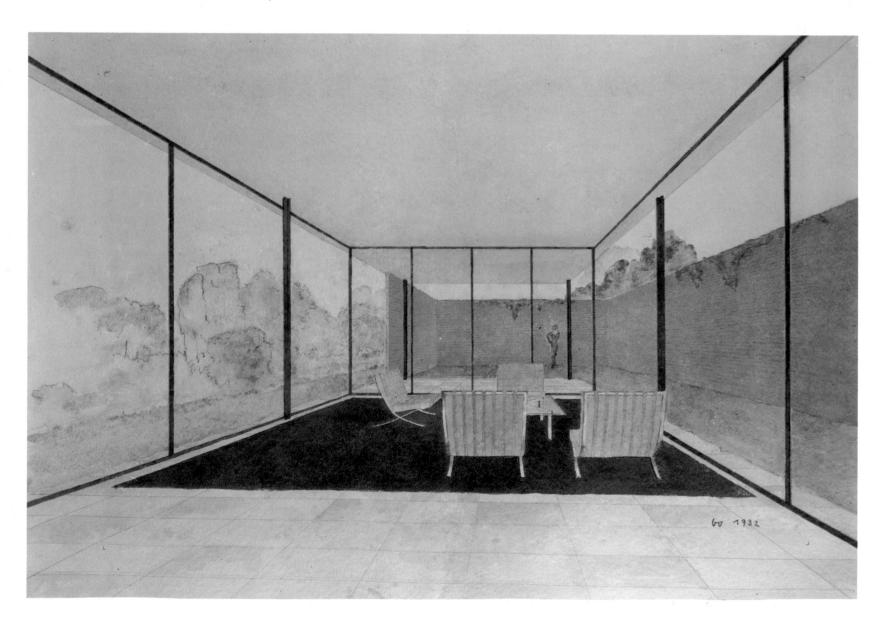

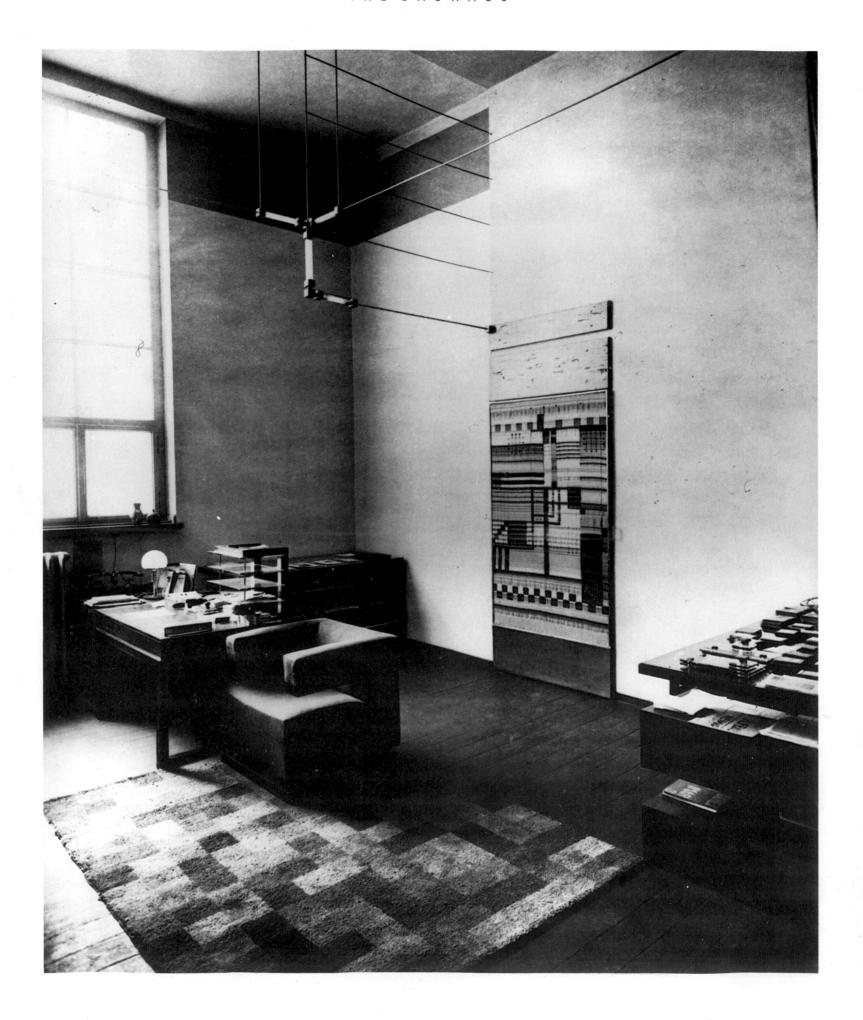

62 Walter Gropius's office, Weimar, 1923.

international discussion about the 'home as a minimum of existence'. On the other hand, he supported another tendency, evident all over Europe, towards towering, visionary high-rise buildings and futuristic details. As far as the furniture workshop was concerned, though, it was Marcel Breuer who developed through his chairs a new way of relating ideas to material conditions, and it was under his direction that the workshop truly blossomed.

The Metal Workshop

Because the two areas overlapped in many ways, there was a close link between the furniture and metal departments. However, as with the furniture workshop, in 1919 Gropius found the building vacated by van der

63 Metal workshop in Dessau, Marianne Brandt and Hin Bredendieck.

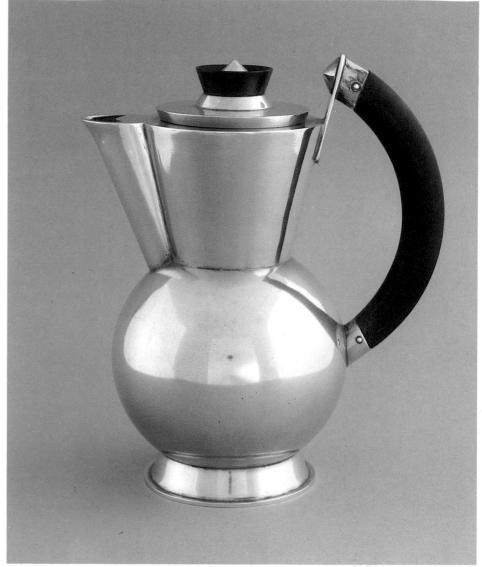

64 Christian Dell, wine jug, plain silver and ebony, c. 1925.

Velde almost completely empty. So the initial months were taken up with acquiring the neccessary tools and machines. The aim of the establishment was to provide a comprehensive education in metals and their uses, and the timetable consequently included the following: beating, embossing, and mounting, alloys, tin-plating, etching, dyeing, gilding and silver-plating. Skills and basic knowledge were also to be taught in welding and rolling. According to Gropius, all these activities were to concentrate on domestic fittings, for architecture, as ever, was his prime concern, and the workshop was intended to serve it. The beginnings, however, were

modest indeed. Instead of resembling a gold- or silversmith's studio, or an experimental laboratory for testing Itten's theories, the workshop contained teachers and students working away on their own schemes, unnoticed by the rest of the world. This was due more to the initial emphasis on uniting art and craftsmanship than to Itten himself (who made no secret of his dislike of industrial production). Changes were brought about as a result of Itten's departure; the appointment of Christian Dell in 1922 as Master Craftsman, and particularly the appointment of Moholy-Nagy as director until 1928. The workshop was commissioned to develop the lighting for the model house 'Musterhaus am Horn' in Weimar. Part of the Bauhaus exhibition of 1923, it was designed and built by Georg Muche as the only one of a proposed series.

Moholy had the following memories of the period: 'When Gropius transferred the directorship of the metal workshop to me, he asked me to build it up again from scratch, bearing in mind the industrial design aspect . . . Changing the way the workshop worked amounted to a revolution as professional pride forbade the gold- and silversmith's from using iron, nickel and chrome. They were quite repelled by the idea of producing models for electrical household equipment.' (Experiment Bauhaus, p. 125.) Nevertheless the new emphasis began to bear fruit: the glass table lamp by Jucker and Wagenfeld, as well as Marianne Brandt's tea service, we're produced in small series. A few examples of work from the metal workshop were on display at the 'Werkbund' exhibition in Stuttgart in 1924 under the heading 'Form'. At the same time the Bauhaus in Weimar was plunging further and further into a financial crisis, and this naturally influenced what was happening in the workshops. A 'circle of friends' was formed to give the Bauhaus, now under pressure from local government, intellectual and moral support. Albert Einstein, Peter Behrens and Arnold Schoenberg were all members of this circle. The permanent state of financial crisis may have been a

major hindrance to work in the workshop, but it was not the only problem.

It was during this difficult period that Marianne Brandt joined the metal workshop at the recommendation of Moholy Nagy:

At first I was not exactly welcomed with open arms: a woman's place, they felt, was not in a metal workshop. They admitted as much later on, and expressed their opinion by giving me work which was for the most part boring and laborious . . . We subsequently adjusted splendidly to each other.

Gradually, by visiting industrial concerns, inspecting them and having on the spot discussions, we approached our main goal, of industrial design, with Moholy Nagy's tireless energy supplying the impetus. Two lighting companies were particularly open to our proposals . . . We strove for a sensible assembly plan, one which would not compromise the appearance of the lamps, whilst also minimizing the risk of dust building up etc., etc. - considerations which in my experience are no longer regarded as prerequisites in the production of a first-class lamp. . . . It was far more difficult to persuade industry to accept our table accessories and other appliances than our electric lights, and not very many reached production. So we acquired the reputation of being something of a lighting department. We furnished entire buildings with our industrially produced lights, and only rarely did we plan and produce special items in our workshop for rooms that were unusual or on a grand scale. At the time I held the conviction that a thing should function as efficiently as possible, whilst expressing the quality of the material from which it was made. Later, however, I came to realize that what counts in the end is artistic personality. My error was due to the fact that we were living in a community made up for the most

65 Wilhelm Wagenfeld, gravy boat, silver and ebony, 1924.

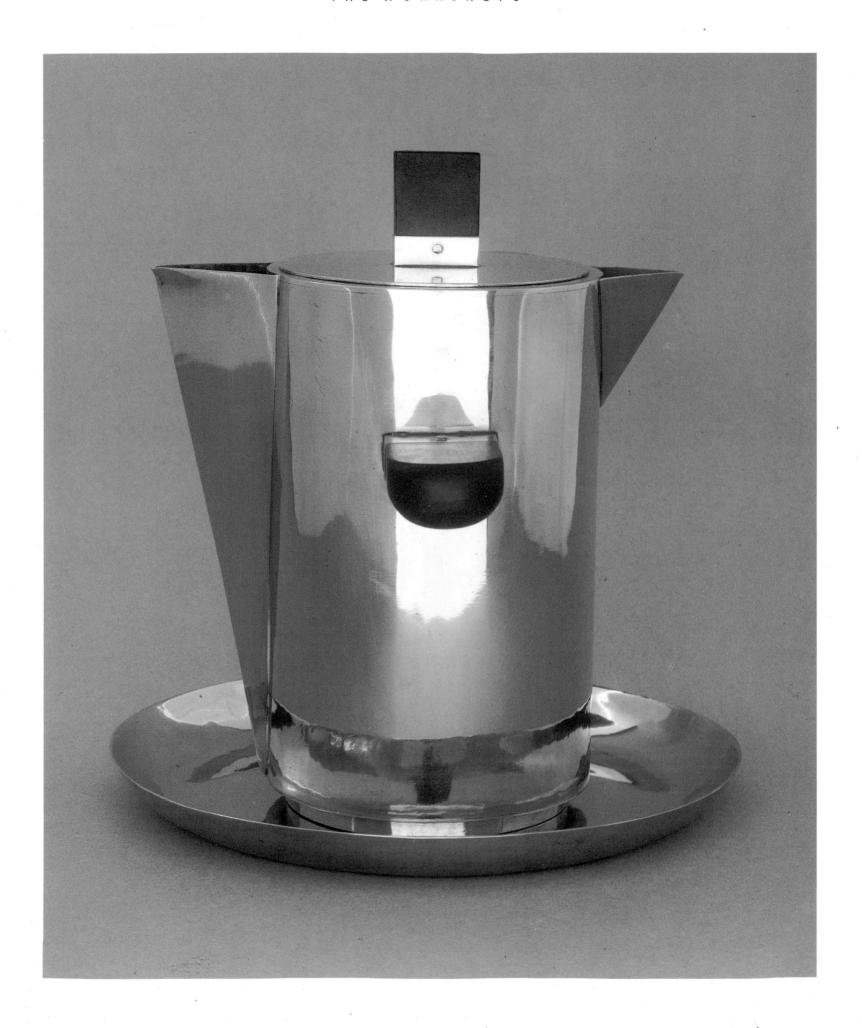

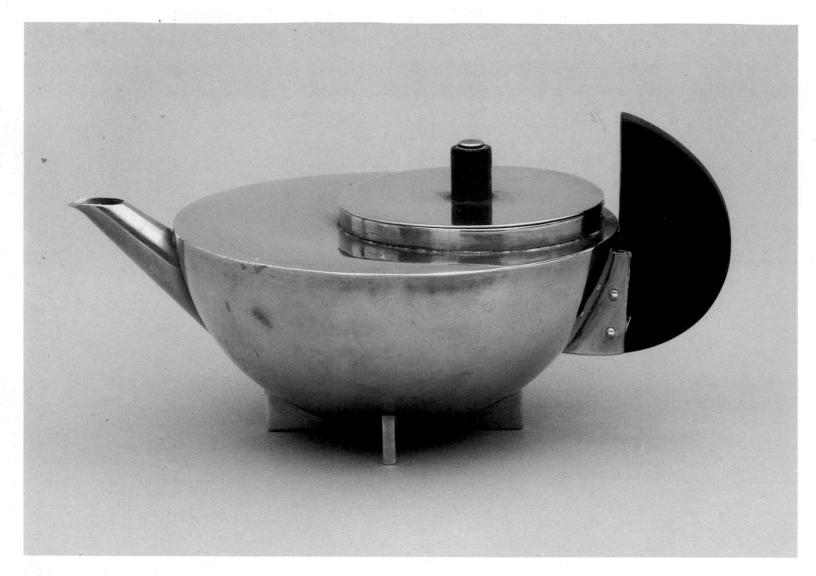

66 Marianne Brandt, teapot, brass and ebony, 1924.

part of such personalities, the high quality of whose work was taken for granted. (Neumann, Bauhaus und die Bauhäusler, p. 159.)

The work of Marianne Brandt, who took the preliminary course with Albers and Moholy, but also attended the courses of Klee and Kandinsky, clearly had an analytical, or, as she puts it, functional character. One of the most gifted of the workshop members — she temporarily took over its direction from 1928—29. Her work contributed greatly to Bauhaus metal work becoming more widely known.

The move to Dessau on 1 April 1925 was an

important step, but Gropius still criticized the progress of work in the metal workshop for being too slow. 'In the metal workshop it is still as necessary as ever that the production of receptacles be restricted and a preference shown for objects with a potential for industrial production. That means, above all, lamps. We are failing to take advantage of the start already made in this area in Weimar. Here, too, systematic preparatory work is necessary . . . so that the business

67 Metal workshop in Weimar, 1922: back, left to right: Hans Przyrembel, Wolf Rossger, Marianne Brandt, Werkmeister Schwarz; front, left to right: Otto Rittweger, Joseph Knau.

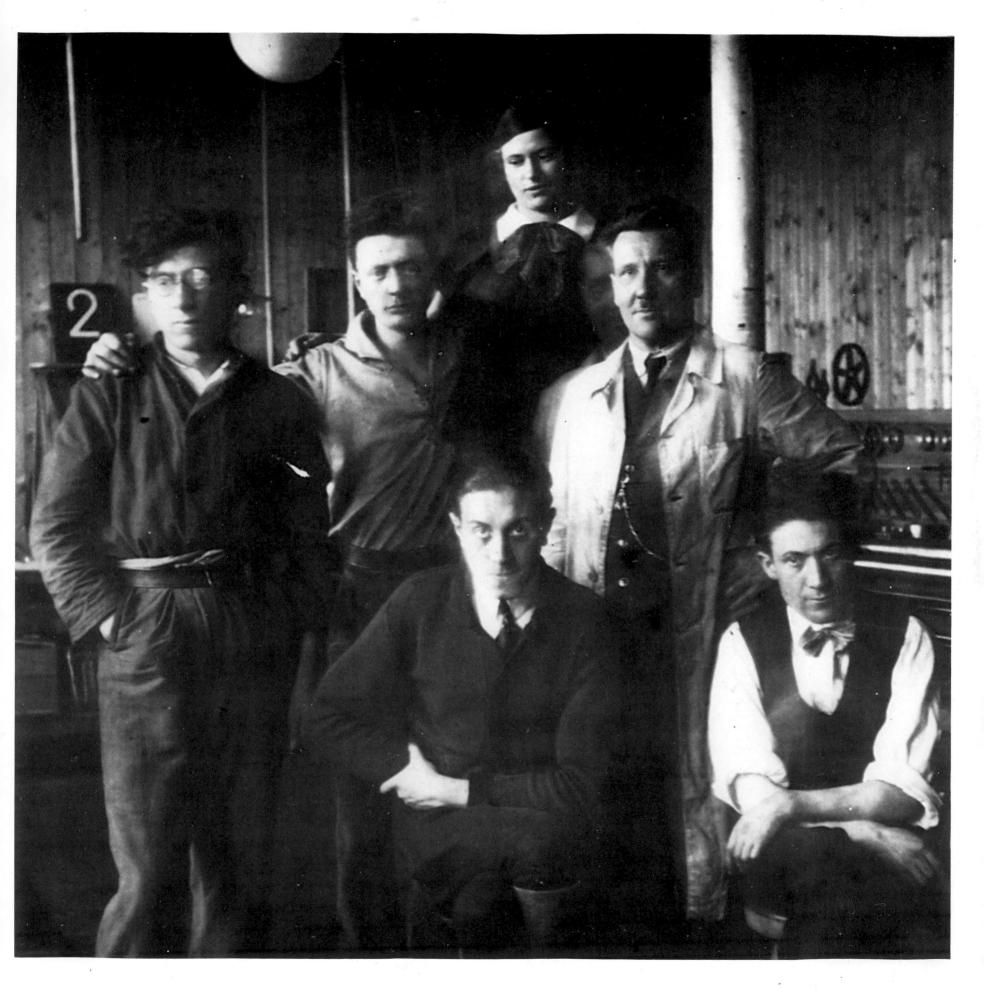

department has a basis for attracting orders'. (*Experiment Bauhaus*, p. 126.) The breakthrough on the business side at the Bauhaus only came once Hannes Meyer was director. Two contracts for co-operation with outside firms brought long-awaited and deserved success. Jucker and Wagenfeld's table lamp went into industrial production, along with the bedside-table lamp by Marianne Brandt and Hin Bredendieck. By 1931, over 50,000 lamps and lights from Bauhaus designs had been produced and sold.

Now that their designs were being put to more effective use, in July 1929 Meyer set about reorganizing the workshops. The most important step was to amalgamate the metal workshop with those for wall-painting and furniture, in order to create an enlarged workshop complex for architecture and interior design. This also marked a temporary departure from highly ambitious developments, since the emphasis was now on designing articles for mass production. There was, however, no question of a reduction in quality. With this move towards creating practical furniture, the

68 Josef Albers, teacup, porcelain, glass and steel, 1926.

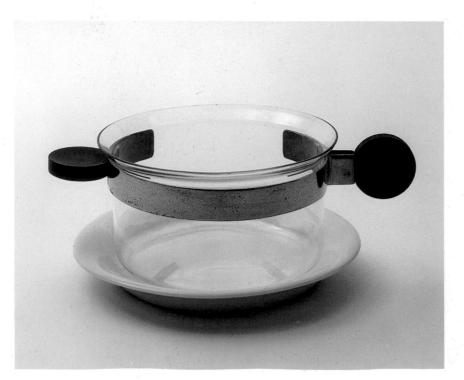

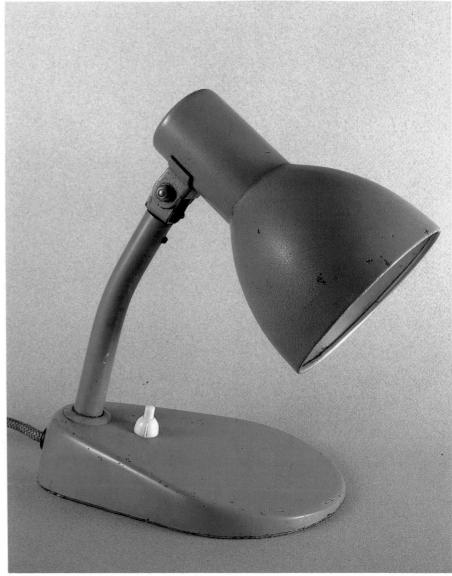

69 Marianne Brandt, bedside Kandem lamp, metal, c. 1928.

students' work on the applications of steel tubing began to yield impressive results in the form of stools, folding seats and work chairs. Of the Bauhaus orientation towards standardized products, Hannes Meyer wrote: 'Not every commission offered to the Bauhaus from outside was typical enough to be standardized . . . and the individual workshops ran the risk of resembling the branch of some producing firm or other. In selecting from offers, preference had to be shown for those which set a task posing the most

70 Wilhelm Wagenfeld, desklamp, metal and white glass, 1923/24.

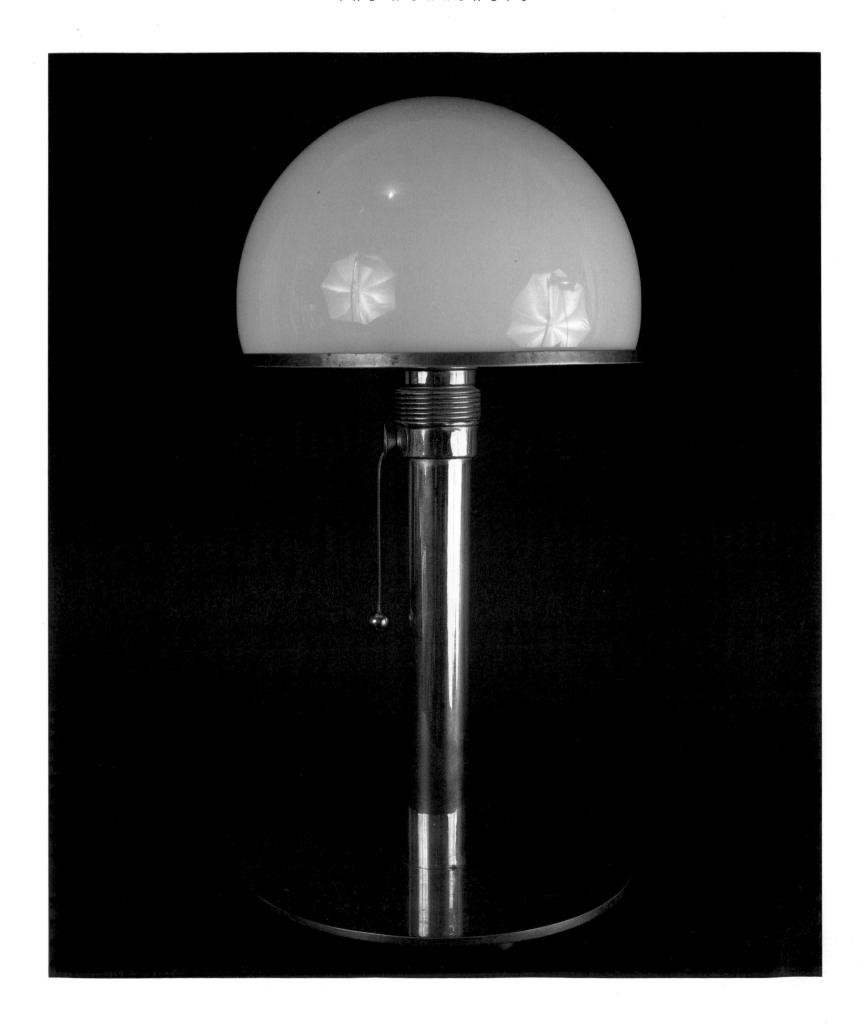

general demands, since this would contribute most to the continuing development of the traditional types of lamp, work chair, and furniture fabric etc.' (*Experiment Bauhaus*, p. 127.)

The new enlarged workshop was under the direction of *Bauhausmeister* Alfred Arndt. In May 1929 the Bauhaus mounted an exhibition of its work at the Industrial Museum in Basel and took part in the International Exhibition in Barcelona. Political developments led to Meyer's dismissal in 1930 as a precondition set by the city of Dessau for the institution's continued funding. Meyer, with his leftist political ideas, was thus sacrificed, and Mies, with the

71 Christian Dell, wine jug, plain silver with ebony handle and finial, stamped CD, 1924.

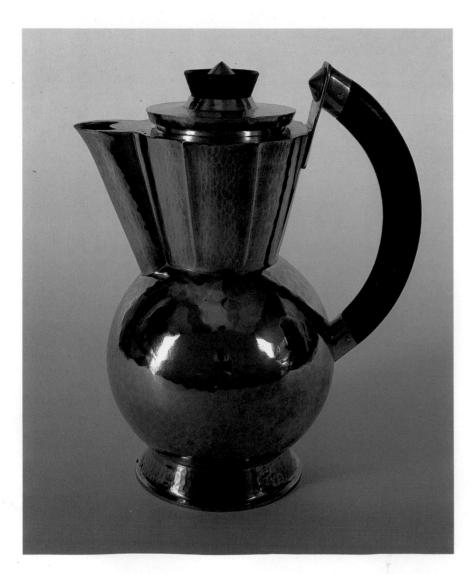

help of Gropius, took over as director. As a consequence, the Bauhaus lost interest to some extent in industrial designs for utility furniture and in the lamps it had previously produced. The new workshop was now redirected by Mies towards architectural tasks. There was more teaching, with the range of subjects expanded to include structural engineering, iron and building construction, heating, air-conditioning, installation, and lighting. And so the metal workshop ceased finally to exist as a separate entity.

From the Graphic Press to the Printing and Advertising Workshop

Today anyone who examines the numerous prints that have been reproduced of pictures by Bauhaus masters will find that some of them bear the small stamp 'Kunstdruckerei des Staatlichen Bauhauses-Weimar' ('Art Press of the State Bauhaus-Weimar'). This means that they are not prints advertising or cataloguing Bauhaus products, but valuable prints of pictures by Klee, Kandinsky, Kokoschka or Feininger.

The first graphic press at Weimar was established shortly after the establishment of the Bauhaus in 1919. As the workshops of van de Velde's earlier art school were still in reasonable condition, it was possible for work to begin straight away. In contrast to the other workshops, where connections with industrial production took years to develop, the graphic press immediately accepted and completed a small number of commissions from outside. Carl Zaubitzer, the printer, was director of the workshop until 1926. However, its work bore the stigma of non-creativity, since the press by its very nature reproduced rather than

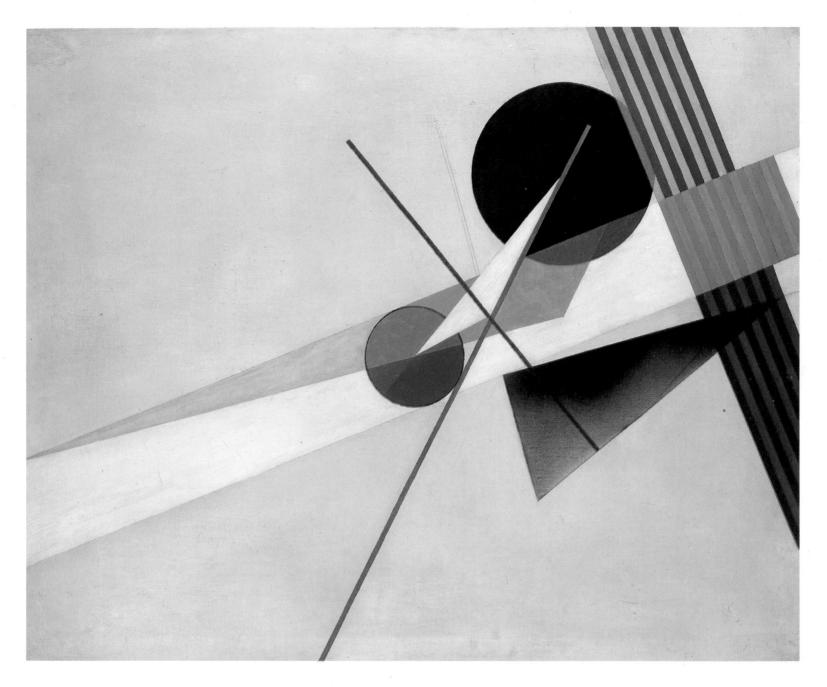

72 Laszlo Moholy-Nagy, untitled, oil on canvas, 1925.

produced its own creations. Although traditional fine art printing had long been valued as a craft in its own right, the workshop remained somewhat peripheral to the advances in new techniques and to the general mood of change at the Bauhaus. This was noted by the students, who were soon protesting about it. Gropius intervened in 1920, recommending that the students should have individual portfolios of their own graphic prints, and that a fresh start be made in book illustration.

Lyonel Feininger, who directed the press as *Form-meister* (Master of Form) from 1919 to 1923, produced an impressive series of prints. Various techniques were employed including woodcut, lithography and etching:

Some of the most important achievements of the graphic press were the graphic cycles and portfolio works it produced in rapid succession after 1921, beginning with Feininger's 'Twelve Woodcuts' and

Georg Muche's cycle 'Y'. In 1922 Kandinsky's portfolio 'Little Worlds' appeared, and 1923 saw a series of polychromatic lithographs by Lothar Schreyer, the 'Wielandlied' sequence of woodcuts by Gerhard Marcks, Schlemmer's cycle 'Game with Heads', and the 'Master Portfolio of the State Bauhaus', which brought together eight examples of prints by Bauhaus masters. (Experiment Bauhaus, p. 146.)

73 Joost Schmidt, printed poster for the Bauhaus Exhibition, 1923.

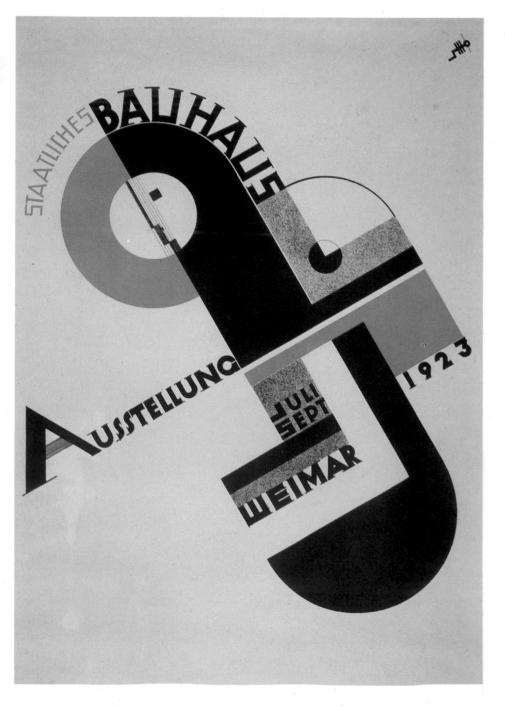

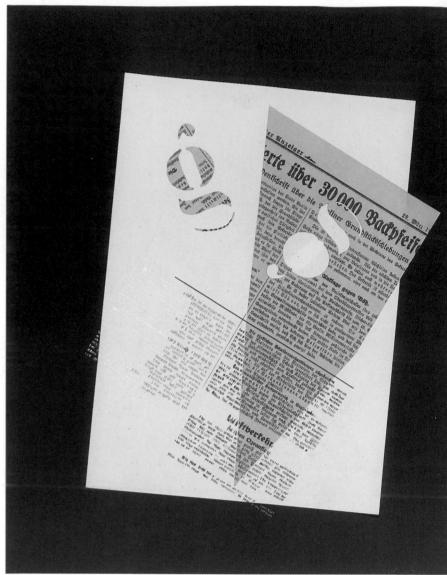

74 Eugen Batz, typographic study from Albers preliminary course, collage with newspaper and posterpaint, 1929/30.

The workshop maintained its links with contemporary and avant-garde artists through a series of prints of works by international artists, including Beckmann, Grosz, Schwitters, Baumeister, Kirchner, and Heckel from Germany; Chagall, Larionov, and Goncharova from Russia; Carrà, de Chirico, Boccioni and Severini from Italy, and the French artists Léger and Marcoussis. Although the project was unfortunately never completed, it clearly shows the links with the

international artists of Expressionism, the painters of 'Die Brücke', and the Futurists and Constructivists, who all played an important part in the artistic development of the Bauhaus. The work — one could almost call it the concerted action — of the graphic press under Feininger set standards, albeit for the last time, by which this type of work might be assessed. Until the move to Dessau, where the graphic workshop in its original form was not re-established, all invitations, posters and prospectuses advertising the Bauhaus, including those for the 1923 exhibition, were printed in Weimar, with Moholy-Nagy relying on his own ingenuity to produce the typography for the exhibition catalogue.

Gropius and Moholy in fact deliberately steered the new course towards advertising, and the inauguration of the new printing and advertising workshop in Dessau ushered in a highly innovative phase in graphic design and typography. This development from fine art to technical achievement is characteristic of the whole of Bauhaus history and of the general changes that had occurred at intervals since the *Bauhaus Manifesto* of 1919.

It came as no surprise when an advertising department was added to the press in Dessau, since many advertising commissions had already been accepted at Weimar. Apart from the desire to have an impact on advertising forms, which had rapidly become established since the turn of the century, the Bauhaus showed a particular fascination for commercial art, not least because it hoped to attract greater attention to itself through better advertising. Whilst in England and America there had, by about 1918, been huge developments in the area of commercial art and science, German advertising specialists and graphic artists were linked only by a few professional associations, and the Bauhaus was relatively late in devoting itself systematically to advertising. Outstanding graphic artists such as Lucian Bernhard and Fritz Rosen from Berlin, as well as others who might well have contributed much to the Bauhaus in the area of style and graphics, did not feature in Dessau. Instead the major influences included the work of van Doesburg and the script developed by El Lissitzky. Most probably this was because members of the Bauhäusler circle were initially limited very much to their own ideas; in other words, they were slow to build on existing contacts. Moreover, the starting point for many new developments was non-commercial. Moholy developed

75 Herbert Bayer, printed poster, 1930.

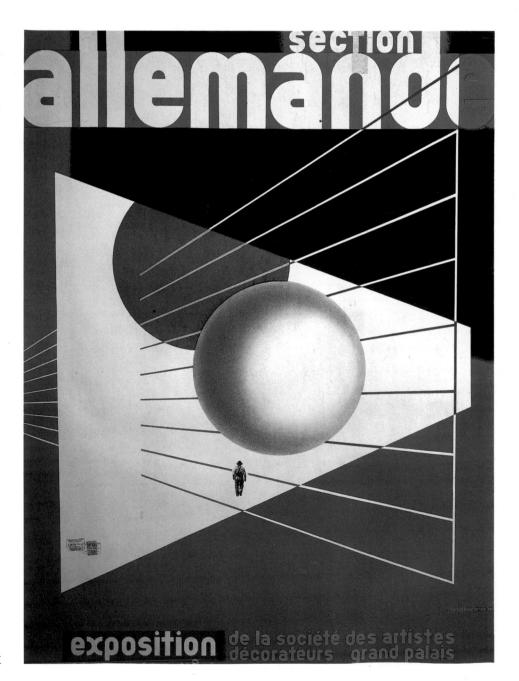

76 Erich Mrozek, printed poster for matches, 1932.

his 'new typography' and its layout from his experience and knowledge of the arrangement of space and surfaces in painting composition. His statement that one should convey 'a clear message in the most penetrating form' suggests that he was thinking along aesthetic lines, whilst also reproducing the truisms of 1920s' advertising. These were voiced in a variety of

77 and 78 Joost Schmidt, Bauhaus wallpaper for the Bauhaus catalogue. 1930/31. Text: 'The future belongs to Bauhaus wallpaper'.

ways, particularly by American sociologists, at the World Advertising Congress in Berlin, in 1929. Together with the metal industry, advertising was among the fastest growing areas of German industrial expansion during this period, and a sign of the times was the effect it had on graphic and fine artists.

The difference between commercial art in general and the way it developed at the Bauhaus first became apparent under Herbert Bayer, who had attended Itten's preliminary course and been taught by Paul Klee. He took over direction of the print and advertising workshop in 1925, and devoted himself to the study of typography. Picking up where other theoreticians had left off, in 1927 he developed his reflections on the 'universal alphabet', that is, a universally applicable typeface based on geometric building blocks. Joost Schmidt, who had been at the Bauhaus since 1919, taught the students typography as part of the preliminary course, and developed his own typeface, which was then put into use. Albers, too, developed new possibilities for artistic representation with the typefaces and letters he introduced in his preliminary course.

It was Herbert Bayer, however, who finally liberated typography from the ornamental excesses of the

79 Herbert Bayer, Xanti Schawinsky and Walter Gropius in Ascona, 1933.

previous century. In the process of working out his designs he clearly demonstrated the mathematical and analytical nature of his procedure. His 'Plan for a Newspaper Kiosk' of 1924 has all the individual elements of the typical Bauhaus composition. Looking almost as if it has been constructed from a variety of square boxes, it displays extremely large advertising surfaces, which are painted yellow, blue and red (to emphasize the visual effect) and bear inscriptions indicating the purpose for which it has been made. Basically then, the kiosk is a purpose-built construction, and its collage-like character points to a relationship with the DaDaists. The design belongs to a seven-part

series by Bayer, in which he breaks radically with traditional ideas and follows the functionalism of Gropius. Along with other typographical works, it must have been shown at the convention of the Association of German Advertisers, when they met in Dessau in 1927, for a 'week of instruction'. Interest in the new ideas had plainly banished the mutual reserve amongst professional advertisers. The appointment of Hannes Meyer as director had the same effect on the printing workshop as on the metal workshop. Between 1928 and 1930, the advertising workshop received a variety of commissions, and worked in the closest co-operation with the printing workshop, which used its designs. The

commercial art class, which started in 1929 (shortly after Bayer's departure from the Bauhaus) was a logical offshoot of this collaboration. Almost two years later, the advertising classes organized by Joost Schmidt were extended to include basic concepts of the psychology of perception, and of the ways in which advertising takes effect. The connection between photography and typography elaborated at the Bauhaus proved to be the most telling and progressive development in advertising at the time. The arrangement of image and type was somewhat reminiscent of Surrealism, and proved extremely successful in practice, since the break with convention made advertisements more eye-catching. The desire for reform also extended to orthography, with the proposal that German spelling should discard the use of capital letters at the beginnings of words and sentences. But these ideas were not successful – or at any rate they did not catch on.

After leaving the Bauhaus, Herbert Bayer became an independent commercial artist and worked in Hitler's Berlin until 1938. Numerous commissions, including the designing of exhibitions, enhanced his reputation as a graphic artist. In 1938 he moved to New York, where in the same year he designed the exhibition 'Bauhaus 1919–1928'. After 1946 he worked in Aspen, Colorado, for private and public clients.

The advertising department at the Bauhaus never developed into a smoothly running financial concern, and was consequently never in danger of acquiring the limited outlook of an advertising agency. Commercial exploitation was not regarded as a principal aim, and the changes the department achieved were, rather, long-term, as can be seen from the frequent use of its typography in the years that followed. To this day graphic artists still copy Bayer's 'universal alphabet'. He died in 1985 in Santa Barbara, California.

Joost Schmidt replaced Bayer as director of the advertising department until the time of the Bauhaus ban, after which he was employed as a teacher at the

Reimannsschule in Berlin between 1935 and 1936. In 1946 he became Professor at the Hochschule für Bildende Künste, also in Berlin, where he ran the preliminary courses for the architecture students. He died in 1948, in Nuremberg.

Photography

The inclusion of photography among the other crafts to be taught may require some explanation today. Unlike activities in many of the other workshops, which had been in operation since 1919, or were founded shortly

80 Laszlo Moholy-Nagy, photogram with Eiffel Tower, c. 1929.

81 Herbert Bayer, Nude on the Beach, 1929/30.

82 Photographer unknown, Peterhans course, c. 1929.

83 Laszlo Moholy-Nagy, Double Torso, 1927.

after that, photography only became established as a subject at the Bauhaus in 1929, under the direction of Walter Peterhans. Camera work could not of course be compared with the institutionalized form of work in the other workshops. After all, it involved a relatively young medium which was still developing technically, in contrast to such traditional crafts and skills as cabinet-making, weaving and toolmaking. At first photography was used, mainly between 1924 and 1928, for catalogue illustrations, in other words, for advertising purposes. A major part of the collection at the Bauhaus archive in Berlin today consists of so-called private photography

which gives an important insight into life at the Bauhaus, and its famous 'atmosphere'. This collection contains the early Bauhaus attempts at experimental photography (which might most favourably be described as playful). It includes the first photographic works of Georg Muche, who in 1921–22 took still-life pictures in the workshop, using reflected light from chromium-plated metal spheres. The compositional character of the pictures, which show a conscious use

84 Herbert Bayer, Eye, 1929. From a series of pictures of Ilse Gropius.

of stylistic devices, is already very evident. Muche is making a break with traditional pictorial photography, that is, with the most authentic possible presentation of what is seen. Such a departure from conventional approaches was typical of the Bauhaus.

As we have already seen, Moholy-Nagy also conducted early experiments with his photograms, or film exposure without a camera. The pictures he created in this way between 1922 and 1925 reflect the compositional method of the Russian Constructivists. Moholy-Nagy was amongst the first of those engaged in photography at the Bauhaus to advocate a turning away from traditional exposure by means of a camera: 'Where photography is used without a camera – as in a photogram, or light imprint – the contrasts between deepest black and lightest white, with all the fine

85 Photographer unknown, double portrait of Holde Rantzsch and Miriam Manuckiam, c. 1927.

shadings of grey in between, suffice to create a language of light, which, although it has no object-related meaning, is capable of producing a direct visual experience.' (Moholy-Nagy, *Experiment Bauhaus*, p. 199.)

In an almost visionary way, Moholy takes up a strand of thought, the 'language of light', which suggests a universal concept of communication. By reducing photography to structures, or distinctions between light and dark, he comes closer and closer to authentic representation. For at the time, photography (particularly journalistic photography) had already shown itself to be a manipulative medium that leaves a great deal of scope for interpretation on the part of the observer. So any aim to reproduce reality, whatever one takes this to be, can only be partly achieved. We all know that when a group of people are looking at a photograph, very different opinions may emerge about what it represents. Often a photograph in a paper will acquire its full meaning only from the caption. Changing the caption can produce a completely new interpretation. Such subjects were discussed in the 1920s by, amongst others, the photographer Renger-Patsch, and Moholy, in his quest for 'pure photography' and clarity of statement, will have taken notice. So in the photography workshop, too, we find the general Bauhaus desire to arrive at statements that would be universally valid and comprehensible to all. And, as Johannes Itten stressed, this was only possible by revealing the true nature of things. It is all the more astonishing that for a long time photography had no significance at the Bauhaus and no role to play as an artistic medium or area for experimental and analytical work. Gropius saw photography almost exclusively as a documentary medium, and in his time as director until

86 Ilse Fehling and Nicol Wassilieff, 1926. Photo by Umbo (Otto Umbehr). Umbehr studied from 1921 to 1923 at the Bauhaus, Weimar, where he attended the Itten preliminary course.

88 Irene Hoffmann, detail from an ashtray, c. 1928. Peterhans course.

1929, there were no plans for its integration in a workshop.

In some ways it must have been seen as a challenge to the Bauhaus, given its Expressionist history, when, in 1925, Moholy published his book *Painting*, *Photography and Film*. In it he expressed his respect for new technical devices, including photography, almost setting them up in opposition to painting, which was held in such esteem at the Bauhaus. Would the machine now replace the hand of the artist? As Moholy wrote: 'In the mechanically exact processes of film and photography we possess a means of representation

87 Laszlo Moholy-Nagy, Tactile Exercises, photo montage, 1938.

which functions incomparably better than the manual process already familiar to us in representational painting.' (*Experiment Bauhaus*, p. 200.) It would be quite wrong to assume from this that Moholy wished to abolish painting: his aim was to extend the possibilities of art by using new methods.

At this point mention must also be made of his wife, Lucia. On a practical and theoretical level, Lucia Moholy was an expert photographer who developed her own style through the Bauhaus. She soon came to be regarded as the documentary photographer of the Bauhaus Catalogue and exhibitions — almost all the photographs of work from the workshops are by her, though she also took portraits and general pictures of

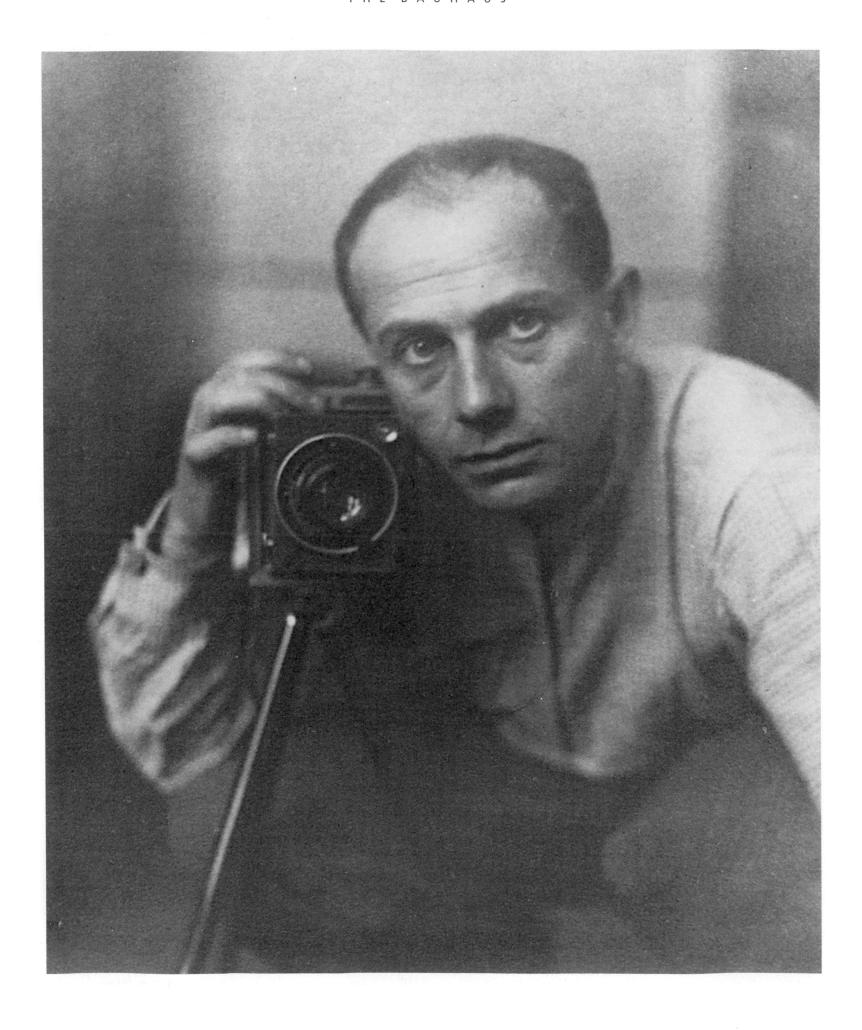

89 Paul Citroen, Self-Portrait, 1932.

human subjects. The innumerable photographs of students and teachers provide us today with a unique insight into the life of the Bauhaus and its personalities. The continuity in her photography and the intensive work she put into the Bauhaus publications show her to have been much more than the wife at Laszlo Moholy's side in his avid quest for glory. Her role as an important representative of the Bauhaus to the outside world was certainly underestimated at the male-dominated institution, revealing a particularly unenlightened side of Gropius and the other staff. Through her position as an editor at the Rowohlt-Verlag in Berlin she had been able to gather a wealth of experience from the

90 Marianne Brandt on her balcony at the Bauhaus atelier.

publishing world, and possessed an expertise few others at the Bauhaus could equal. After her separation from Laszlo Moholy in 1929, she emigrated in 1934 to London, where she taught at the London School of Printing and Graphic Art, and at the Central School of Arts and Crafts. In 1948 she was made a member of the Royal Photographic Society. After further photographic work, she devoted her old age to publishing her Bauhaus photographs, and died in 1989 at the age of 94, in Switzerland.

In addition to Lucia Moholy's photographs documenting everyday life, many others were also taken which give an impression of the lively atmosphere at the school. They also show that the students regarded themselves as 'special' – it is possible to detect

Dessau, c. 1928. Photo by Werner Zimmerman.

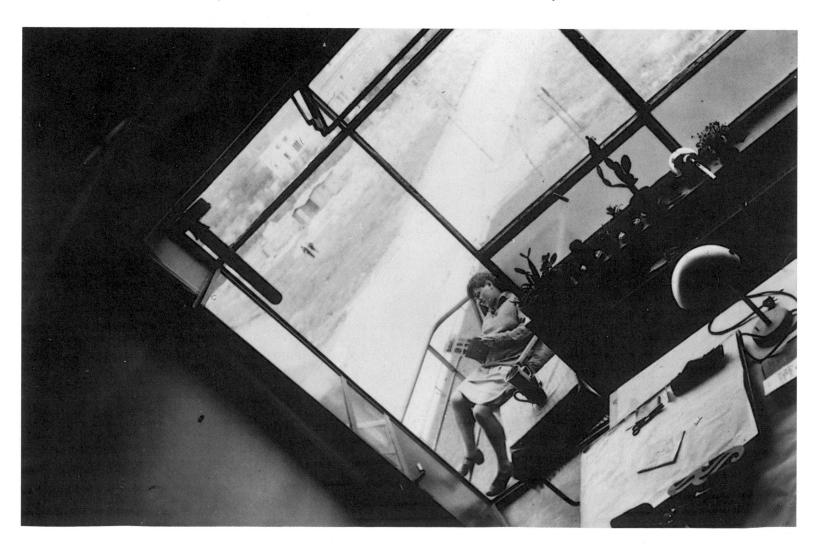

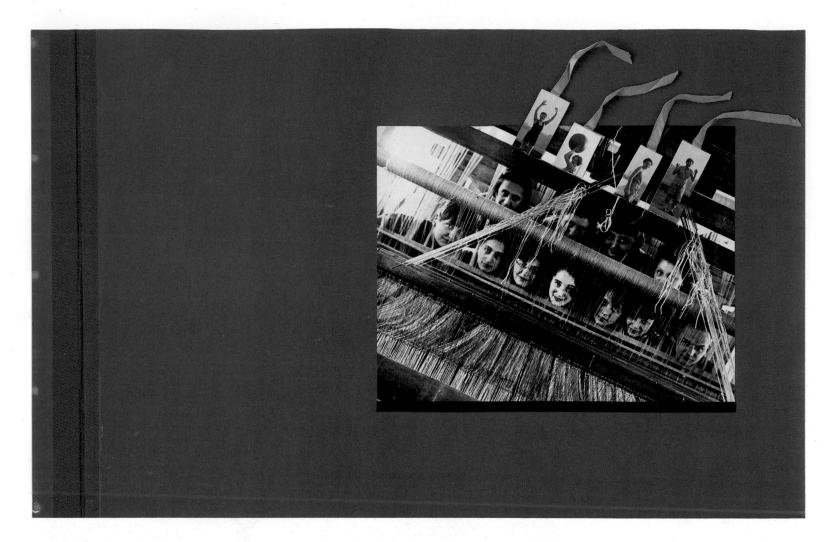

91 T. Lux Feininger, Collage of Weaving Workshop, 1928.

a certain pose even in their pranks and light-hearted games.

A further important development and the opportunity to measure themselves by the standards of others came when the Bauhaus experimental photographers took part in various photographic exhibitions. At the 1926 'German Photography Exhibition' in Frankfurt, Moholy-Nagy may still have been in the amateur section, but two years later his work was gaining increased recognition at the Jena exhibition 'New Paths in Photography', alongside photos by Lucia Moholy, Renger-Patsch, Peterhans and Umbo. The 'Film and Photo' exhibition (FiFo) of 1929 in Stuttgart brought the first breakthrough for Bauhaus work. Almost without realizing it, the students and teachers achieved a new resonance

which attracted international attention:

It was possible to gauge how widespread photography had become in the Bauhaus at the time from the number of Bauhaus students and teachers taking part at the FiFo in 1929. The students included Marianne Brandt, Edmund Collein, Max Enderlin, Lux Feininger, Werner Feist, Walter Funkat, Lotte Gerson, Fritz Heinze, Willy Jungmittag, Fritz Kuhr, Keinz Loew, Naf Rubinstein and Hinnerk Scheper. Then there were the former Bauhäusler, Bauhaus teachers and members of the Bauhaus circle: Irene and Herbert Bayer, Andreas Feininger, Werner Graeff, Florence Henri, Lucia and Laszlo Maholy-Nagy and Otto Umbehr ('Umbo'). This attendance is all the more astonishing when one

considers that photography had not been introduced as a teaching subject at the Bauhaus until 1928/29. The change was only to come once Walter Gropius had been replaced as director by Hannes Meyer, who was keen to apply the arts and recognized the importance of photography for advertising and reportage. Thus, as part of a substantial reorganization of the workshops and change of timetables, he established photography as an official teaching subject. The photography class was not granted the status of an independent workshop. Instead it became amalgamated as a special

department within the advertising workshop and press, which at this time were being directed by Joost Schmitdt. (Jeannine Fiedler, Experiment Bauhaus, p. 202.)

Walter Peterhans, a trained photographer by profession, had studied philosophy, mathematics and art history before taking up photography. From the beginning of his time as Bauhaus director of photography, he made clear his opposition to Moholy-Nagy's stance. Experimenting with photography and its

92 Lou Scheper, Collage, 1928.

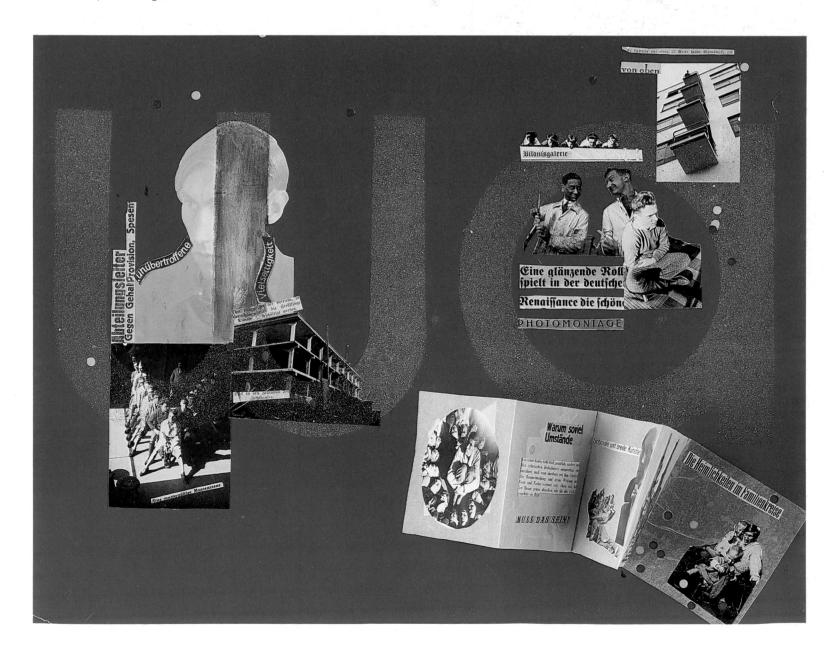

93 Photographer unknown, picture from the Peterhans course, 1929.

constructive use had no appeal for him: he was concerned that the photographed image should be technically perfect and as optically correct as possible – perhaps because he was the son of one of the largest manufacturers of optical instruments in Germany. Much greater, however, was the influence of Hannes Meyer, who pressed for a more factual approach to work. The whole of the restructured teaching programme clearly bore his stamp. A broad range

of scientific instruction was introduced, to give the students a sound basis for their future professions. Kurt Kranz, who joined Peterhans's class as a young student in April 1930, remembers it clearly: 'To most students, the Peterhans course seemed very technical and mathematical. He devoted a good deal of theoretical interest to chemical processes. We were only able to follow the lens-calculations imperfectly, since most of us had large gaps in our mathematical

knowledge. So Peterhans also gave us coaching in algebra.' (Neumann, *Bauhaus und die Bauhäusler*, p. 347.)

Thus experimental photography gave birth to applied photographic technology. The photography department offered a comprehensive programme of courses which gave the students every opportunity to learn their profession as photographers. There was no lack of demand for them, since photography had now become part of all the printed media, and illustrated magazines were a regular feature of the journalistic world. Moreover, advertising was calling for more and more new photographers with fresh ideas. Amongst those who graduated from the Bauhaus were Ellen Auerbach, Grete Stern, Eugen Batz, Charlotte Kuhnert, Herbert Schuermann and, last but not least, Kurt Kranz. Not long after leaving the Bauhaus, Lux Feininger and Willy Jungmittag started up picture archives and photographic agencies.

Amongst many others, it is possible to single out Lux Feininger (Theodore Lucas Feininger), who took the preliminary course with Albers and was the son of Lyonel. He has left us with splendid documents of life at the Bauhaus, many of his snapshot-like pictures recording Schlemmer's stage work. Then there is Otto Umbehr, whose photography was the complete opposite of Moholy's technical, experimental work. Umbehr (better known by his nickname 'Umbo') had attended Itten's preliminary course and belonged to that generation which, after experiencing the disaster of the war, reacted against the hypocrisy of glorified murder. His photography was direct and unpretentious, although he also remained open to experiment and did not pursue a particular theory, at least not systematically. His mastery of the medium is revealed in practically every photograph he took. One particular example is his 1927 photograph of Ilse Fehling and Nicol Wassilieff, which reflects, in this case literally, a bohemian scene from the artists' lives at the Bauhaus.

'Here Umbo has combined the doubly alienating effect of mirrors and perspective to produce a picture which distorts all natural relations. Wine, coffee and cigarettes are all sustainers of life in an artist's world that has thrown off all restraint, in which the mirror image of things is experienced more truly and intensively than the things themselves, in which, viewed from a "normal" standpoint, everything seems to stand on its proverbial "head". In 1927 there was not another photograph like it, at least not in Germany.' (Herbert Molderings, *Fotographie am Bauhaus*, p. 36.) After turning his back on photography for a short time, Umbo took it up again in 1933 as a commercial artist

94 Herbert Bayer, Portrait of Ilse Gropius, 1928.

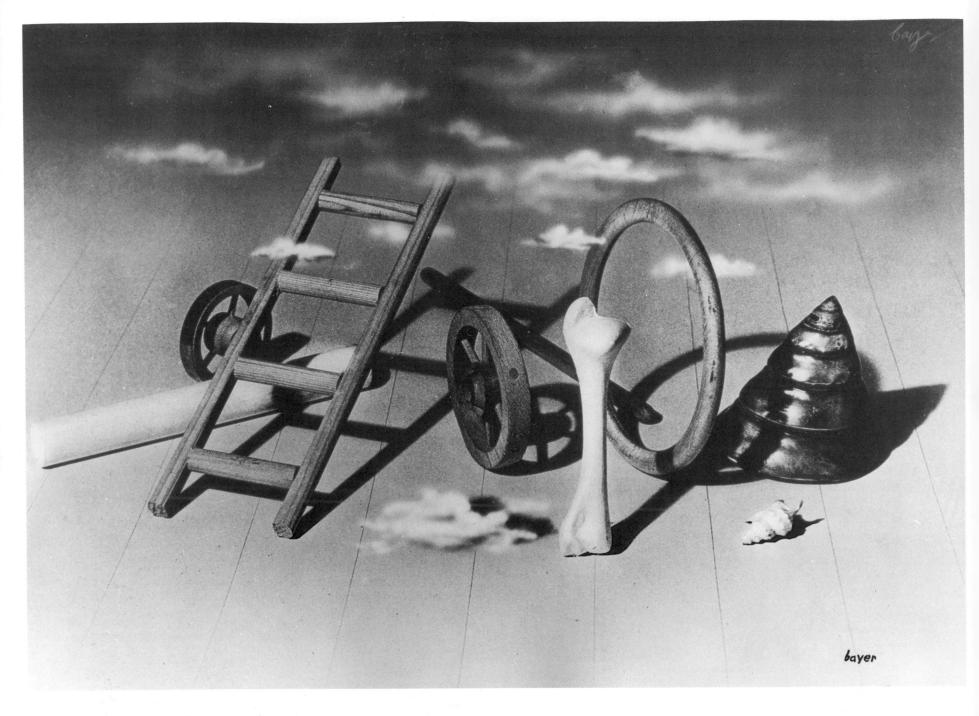

95 Herbert Bayer, Still Life, 1936. The picture construction is reminiscent of Salvador Dali's surrealist paintings.

and local reporter. Between 1957 and 1974 he taught photography, and died in 1980 in Hannover.

Florence Henri, who spent part of 1927 at the Bauhaus, where she made remarkable photographic portraits of the teachers and others, is a figure whose work would virtually have been forgotten, had it not been preserved by Anne and Jürgen Wilde at a Cologne

gallery. Originally a painter, she studied with Léger and others in Paris, and with Moholy in Dessau, where she started to take photographs. Back in Paris she discovered the possibilities of achieving certain photographic effects with mirrors. In the years that followed she took photographic still—lives which followed the Cubist painting tradition. Only in the

1960s, after she had returned to painting, were small exhibitions of her photographic work mounted. Florence Henri died in 1982, in France.

Herbert Bayer, born in 1900 in Upper Austria, trained in typography before beginning his studies at the Bauhaus in 1921. In 1925 he turned to photography, and after completing his apprenticeship under Kandinsky, was made director of the print and advertising workshop in Dessau. Following an initial series of close-ups (some extremely close, in the case of portraits), he took further photographs in which

the structures of things are more clearly worked out analytically, and with unusual perspectives. Adopting Moholy's ideas, Bayer placed increased significance on the colour gradations between black and white and frequently explored the possibilities of photo-montage. He applied his gift for graphic design to Bauhaus advertising, and in 1928 began work for a Berlin advertising agency. His series of surrealistic photographs, which Bayer himself described as 'photo plastics', brought a fresh stimulus to photography generally. The photograph itself now formed part of

96 Florence Henri, Fruits, 1929.

97 Laszlo Moholy-Nagy, portrait of Ellen Frank, 1929.

the construction and composition of the picture, in a process which demonstrated strict objectivity and great skill and craftsmanship. The creation of series, as on an industrial conveyor belt, fascinated him and inspired him to see everyday things in new ways. Bayer's contact with the Surrealists, including Salvador Dali, with whom he spent his winter holidays, had a pronounced influence on this genius of photography and form. After moving to the USA in 1938, he was much involved in extensive design projects, at the Aspen cultural centre for example, and as an artistic advisor to the Atlantic Richfield Company.

The Bauhaus Stage

On 4 March 1929, a theatre critic wrote in the Berlin Boersen-Courier, ' . . . the stage at the Bauhaus has recognized its own special mission. It is the art of movement in relation to the pure expression of space and the pure expression of material; the integration of human rhythm into the rhythm of absolute structure. Today it is what we might in the broadest sense call "dance". It is a path between Wigman and Granowski. If prominent figures from the dance world show themselves on it, then it may be called art. In Dessau, it remains more idea, will, or doctrine. But it does stimulate.' (Experiment Bauhaus, p. 256f.) These lines can scarcely have caused Oskar Schlemmer himself any distress. He was aware of how advanced his theatrical method was, and expected his pieces to encounter resistance. Yet it would be misleading to describe the performances as pieces. If the traditional aim of theatre was to convey messages and to communicate in the form of drama or comedy, and if the sets and actors

were intended to create an illusion of reality, then Schlemmer's work marked a break with tradition. Before portraying anything, theatre was to be reduced to its original elements, namely light, figural arrangement and sound in an artificial space. 'The human being in space . . . as the original theatrical situation, is the starting-point for his considerations. Schlemmer presupposes the cubic abstract space of the stage as a creation of proportion and numbers, consisting of point, line, surface, flat forms and bodily forms. If these formal elements are joined by light, colour and movement, the result is what Schlemmer calls the "stage for an optical event", which includes man only to steer its mechanism.' (Dirk Scheper, Experiment Bauhaus, p. 251.) Schlemmer distinguishes between mechanical movement motivated by the understanding and organic movement motivated by feeling. Both, ideally, should be combined in the dancer. These views were also evident in his earlier ballet products in Stuttgart. After Schreyer's departure from Weimar following a dispute, Schlemmer succeeded him as stage director in 1932 and continued to experiment. Particularly impressive were the costumes he made in the workshop, which he developed as four types. First, if the space is cubically determined, the costume responds by being cubical also. He calls this 'changing architecture'. Second, if the laws according to which the human body functions in space (i.e. its physiology) are the determining factor, a so-called puppet costume is designed, which reacts in its own way to the performing space. Third, if the 'laws governing the movement of the human body in space' are expressed on their own in a costume, the result is the 'technical organism':

The fourth basic type of stage costume is intended as the visible expression of what Schlemmer calls the 'metaphysical anatomy' of the human being. It illustrates the concept 'dematerialization', by stressing,

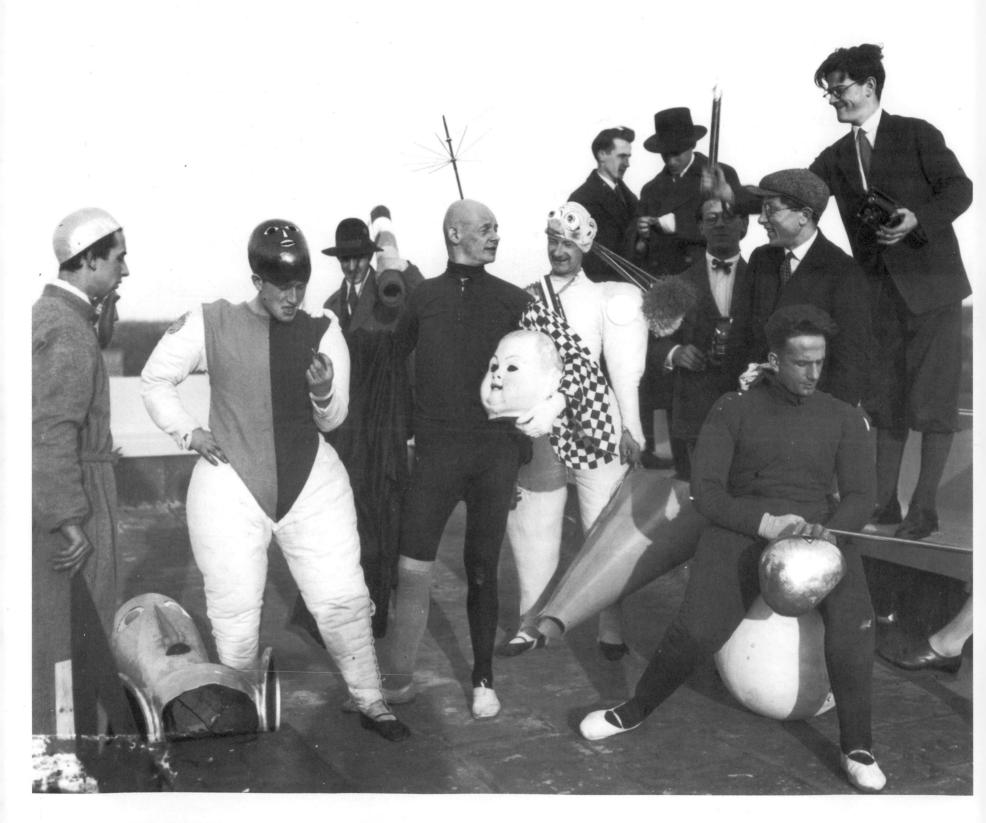

98 Pupils from the stage workshop on top of the roof in Dessau, 1927. Oskar Schlemmer in the middle of the picture. Photo by Irene Bayer.

for example, 'the star shape of the open hand, the infinity sign of crossed arms, and the cross formed by backbone and shoulder', but also shows the division and dissolution of forms, as well as the deforming of the human body by costume . . . Schlemmer wants his costume suggestions, developed out of the elementary functions of costume and space, to be understood as basic types for contemporary stage costumes, from which a new individualization, 'appropriate to the

99 Oskar Schlemmer, Figurine Plan for the Triadic Ballet I, pen, ink, watercolour, posterpaint and bronze on paper, 1924–26.

actor's function and the meaning of the production', can emerge. (lbid, p. 251f.)

Among the works performed with the co-operation of the students were: *The Figural Cabinet*, 1923; *Meta, or The Pantomime of Places*, 1924, on which the group around Kurt Schmidt worked, and *The Adventures of the Little Hunchback*, a puppet play of 1923/4 from an idea by Kurt Schmidt.

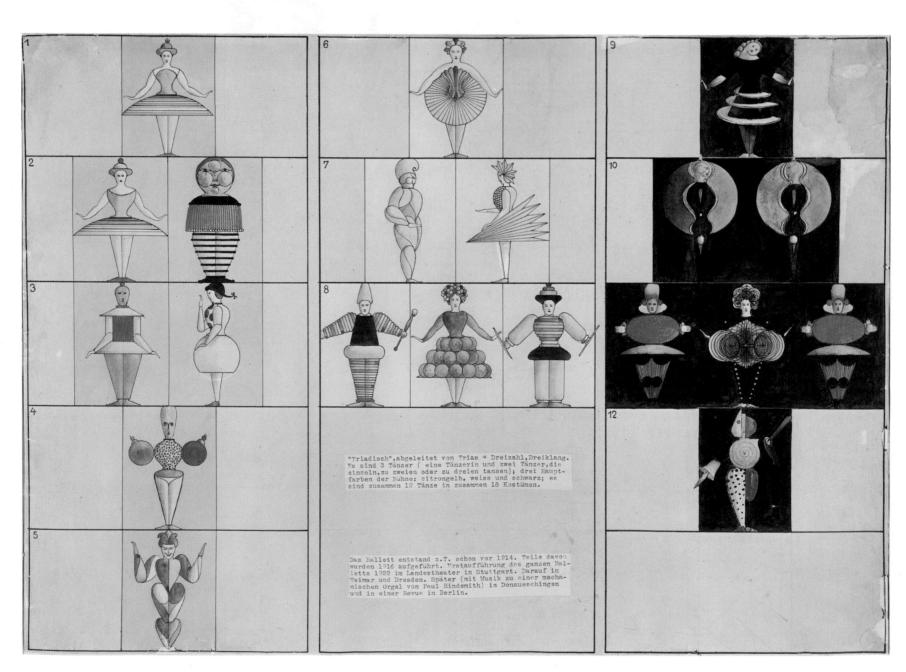

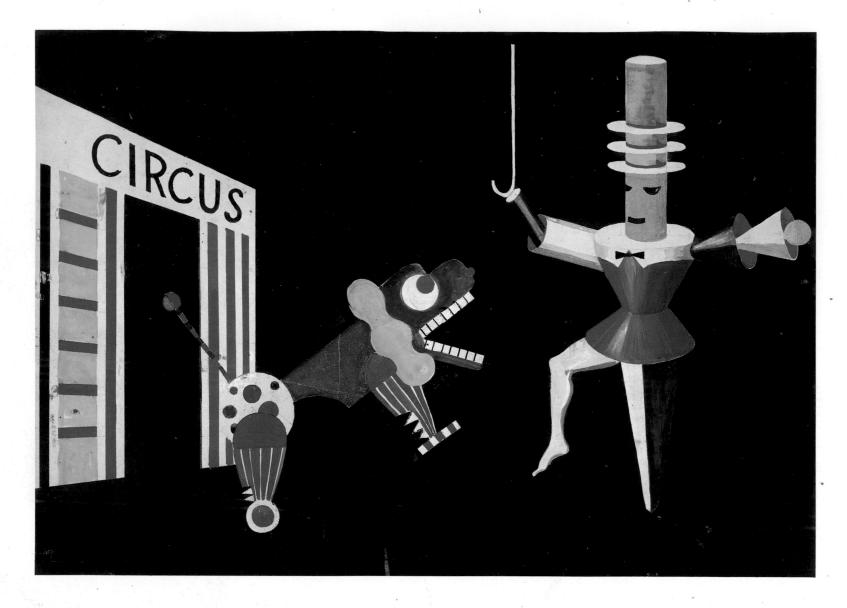

100 Xanti Schawinsky, Circus, tempera, ink and silver bronze on paper, c. 1924.

In 1926, the newly constructed theatre in Dessau was named 'an experimental stage for dancers, actors and directors', reflecting its purpose more clearly. There were many experiments with new seating arrangements for the spectators, which provided a different viewpoint for the audience from the usual one facing the stage. There was also, until 1927/28, a series of experimental workshops and performances. The Darmstadt ballet teacher, Manda von Kreibig, helped to gain a more prominent role for dance, which was becoming more professional. Moods and themes almost reminiscent of the Commedia del Arte were expressed

through dance, also by other dancers such as Palucca, during the 'wild' Twenties in Berlin. Schlemmer worked together with von Kreibig in 1928–29 on a tour programme which included the following elements: dance of slats, dance with hoops, dance in space, dance of forms, dance of gestures, dance of the stage wings, game with building blocks, dance in metal, glass dance, women's dance, and the masked chorus. All the pieces were performed to piano accompaniment, and various percussion instruments were added, such as sirens or alarm clocks. There were guest performances in Frankfurt, Basel, Stuttgart, Breslau and Berlin, although

101 Kurt Schmidt, The Man at the Keyboard, tempera, ink and silver bronze on paper, c. 1924.

Schlemmer was modest enough to describe them as purely experimental. When Hannes Meyer took over from Gropius as director and the emphasis shifted to more technological considerations, Schlemmer's work became the subject of dispute and was accorded less recognition. As life in general at the Bauhaus became increasingly politicized, he was criticized for his 'unpolitical' approach in the theatre. After Schlemmer's departure in 1929, the Bauhaus theatre ceased to function.

102 Heinz Loew, mechanical stage, model, 1927.

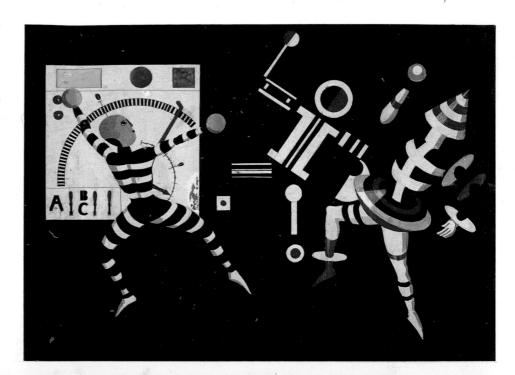

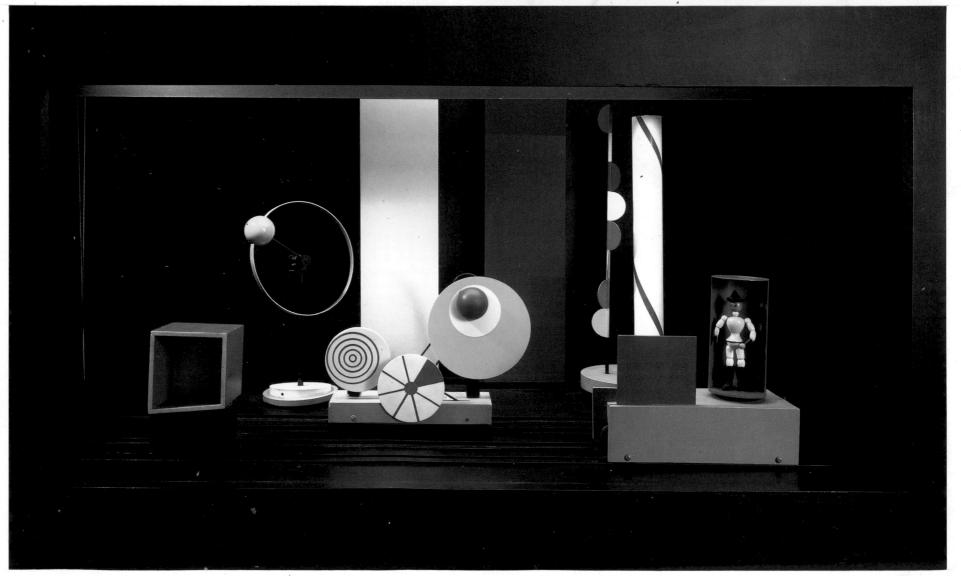

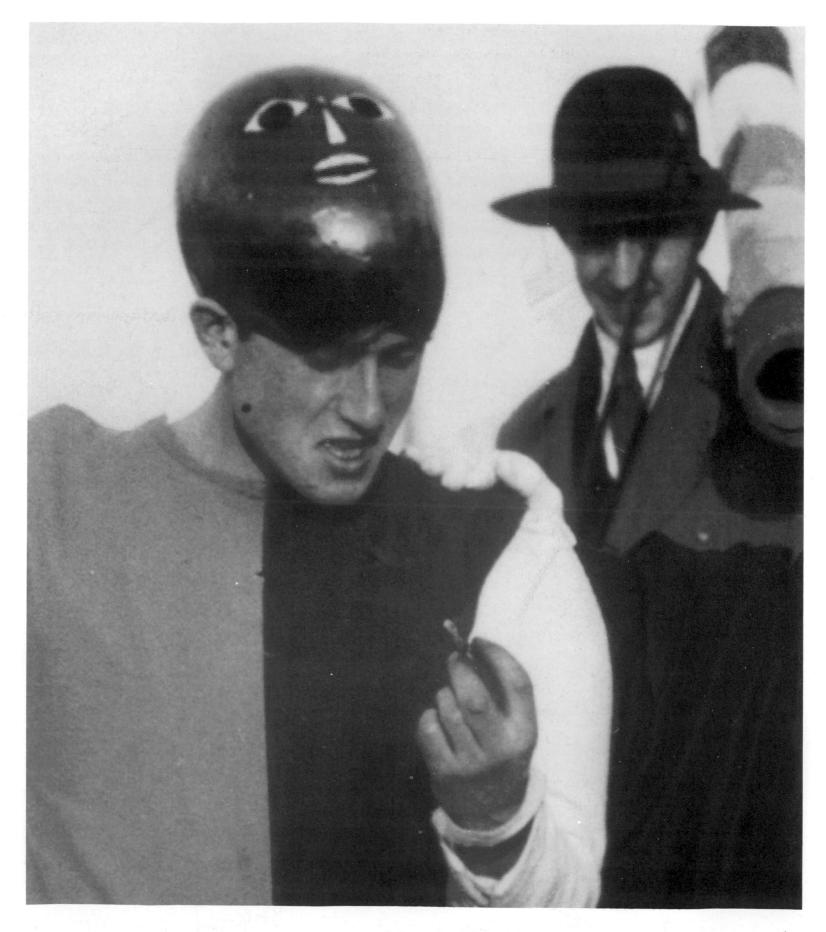

Details from 98

103 (above) two students.

104 (opposite) Oskar Schlemmer and student.

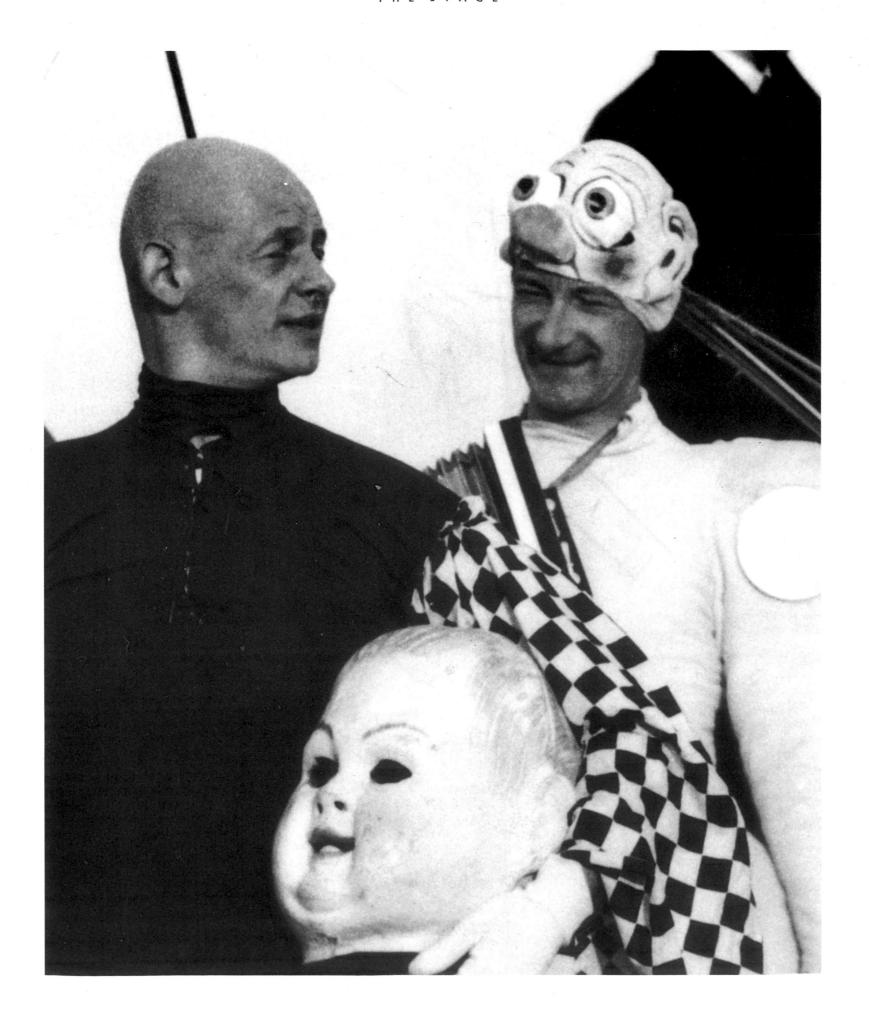

The Wall-Painting Workshop

Johannes Itten, who directed the wall-painting workshop (established in 1919), earned as little applause for his proposals for the Bauhaus walls at Weimar as the students did with their spontaneous decorating. Although Itten had a preference for darker shades, in 1920 the newspapers were continually raging at the motley mixture of colours being gleefully applied to the Bauhaus corridor walls by the students. Typically for the Bauhaus, there was intense discussion over the question of what the wall paintings should look like, and various serious suggestions were made, even for painting the canteen. Lou Scheper remembers:

In its early period the workshop was like everywhere else in the Bauhaus: here, too, the functional approach to work was combined with play. So when the canteen was being painted, the walls and the ceiling constructions, the last corners of which could only be reached by throwing up sponges soaked in paint, became a rough and tumble of swirling small-scale decorations in vibrant colours. Unleashed by Peter Roehl, we gaily painted and squirted away together with a bad conscience, for we were aware that what we were doing was completely unfunctional and inappropriate in a room intended for eating and relaxation. And all this at a time when people were already starting to talk about the psychological effect of colour, then being methodically taught at the Bauhaus! Itten, who made the rules, demanded that we cover our expressive excesses with a friendly, contemplative greyish green, as the background for an oriental maxim to edify us during meals. (Christian Wolfsdorff, Experiment Bauhaus, p. 283.)

Walter Gropius himself had no particularly clear idea of the workshop's purpose. He made suggestions, for

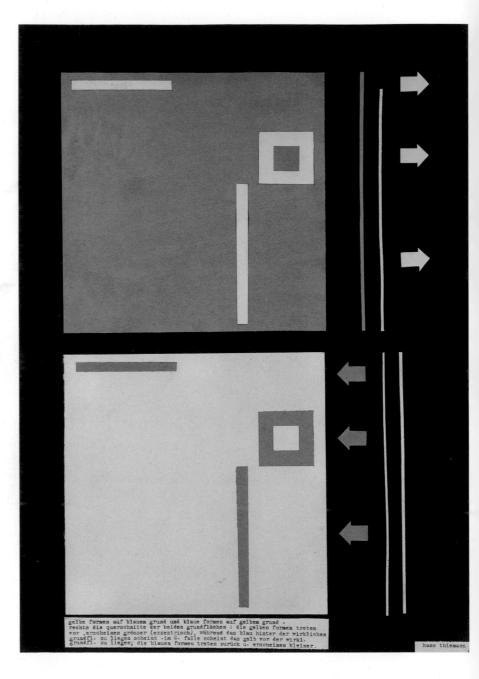

105 Hans Thiemann, Yellow shapes on blue background – blue shapes on yellow background, 1930.

instance, that the Weimar town hall be painted by Bauhaus students, but the citizens reacted less than enthusiastically and his request was turned down. The new colour theories of the Bauhaus were not universally appreciated when in 1922 he painted an eighteenth-century Weimar house cornflower blue. Kandinsky, the workshop's first director, was particularly interested in

106 Oskar Schlemmer, Bauhaus Stairway, oil on canvas, 1932.

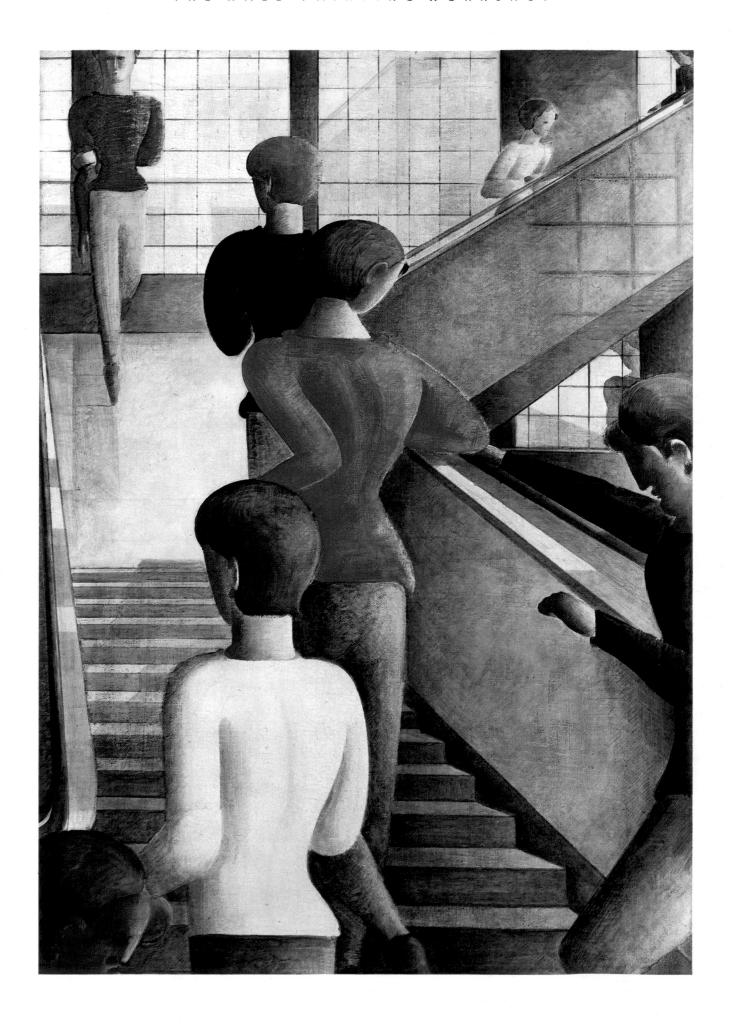

107 Herbert Bayer, kiosk design, tempera and collage on paper, 1924.

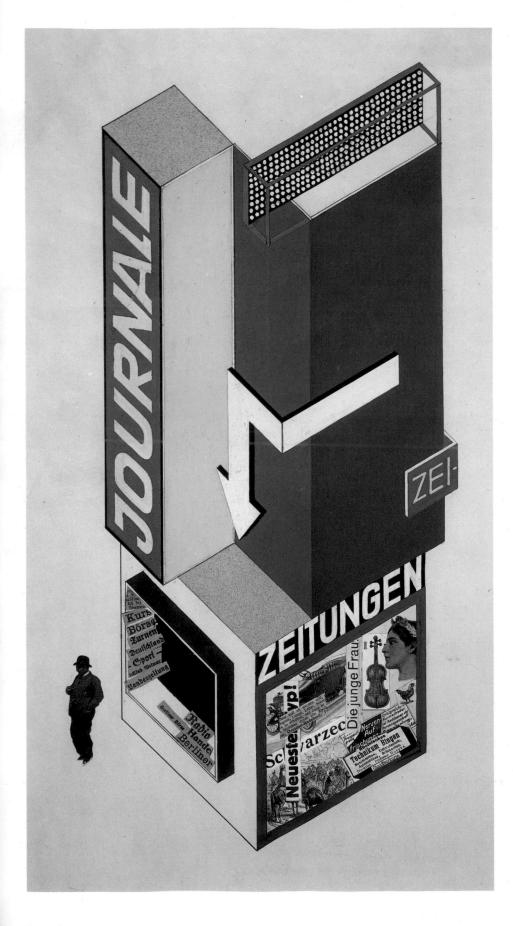

wall-painting as a larger-scale extension of his own painting. Oskar Schlemmer, who took it in turns with Itten to run the course until 1922, produced a few murals, but these were similarly oriented towards his other work. Only after 1923 was there a teaching plan which included a variety of techniques and exercises in wall-painting. This introduced the possibility of creating spatial effects with colour, and distinguished between two basic variations:

- 1. Concurrence of the colour with the given form, so that the effect of the latter is enhanced, giving rise to a new form:
- 2. the conflict of the colour with the given form, so that its form is transmuted.

One of these two forces must necessarily be employed whenever colour is applied to form.

The resulting power of colour to shape the given room in this way or that is one of the most important concerns facing the Bauhaus. (Ibid, p. 284.)

Kandinsky, as well as Gropius, associated colour in space with the possibility of creating tension by pairing opposite colours. The psychological effect of colours was also taken into account and utilized by Hinnerk Scheper, director of the workshop from 1925, who concentrated mainly on the painting of exterior walls. After three years as an independent architectural planner, Scheper's experience was varied, and he worked on colour schemes for clinics as well as historical museums such as the Folkwang Museum in Essen. Stressing the use of pastel shades, he avoided primary colours. Stronger tones were used only to emphasize the parts of buildings that were architectonically significant. In 1926 he also developed his own course for the students in Dessau, dealing with

108 Florence Henri, Non-Objective Composition, oil on board, 1926.

questions of colour. Since neither Scheper nor the other workshop teachers have left behind any written notes on a particular teaching method for wall-painting, the history and extent of the workshop's influence remain somewhat obscure. Although Scheper, Kandinsky and Gropius were certainly familiar with the great murals in Mexico, it is not known whether these had any influence on the Bauhaus. Hinnerk Scheper accepted an invitation to Moscow in 1929, where he received numerous commissions to carry out exterior design work on housing estates.

A small but highly lucrative sideline for Scheper and the workshop was the development of wallpapers. As early as 1929 the small collection of Bauhaus wallpapers, produced by a firm near Osnabrück, was distributed to a number of wallpaper dealers. (Hannes Meyer was ultimately responsible for the workshop also being able to operate as a business.) In the years that followed, wallpaper designs at the Bauhaus concentrated on small patterns, profiting from investigations into a variety of materials.

The Ceramics Workshop

If any one workshop illustrated the Bauhaus manifesto's almost medieval tendency towards craftsmanship, then that workshop was the Bauhaus pottery. One reason for this may have been that, due to a lack of space in the Bauhaus at Weimar, the pottery moved to a traditional handicrafts centre which already existed in Dornburg, 40 kilometres away. Another reason, however, was clearly the nature of the work itself. The production of vessels, pots and bowls is one of the oldest craft forms in human history, as archaeological excavations all over the world continue to show. Clay is a natural substance, and pottery calls for skill, an understanding of form, a

knowledge of the object's function, and artistic ability.

It is no coincidence, then, that the ceramics workshop was located at the centre of the Thüringen potteries, which are still in operation to this day. The seven groups of students who attended therefore received a form of training entirely in accord with traditional pottery craftsmanship. Gerhard Marcks, who had previously worked with the sculptor Richard Scheibe, was artistic director of the workshop. Master potter Max Krehan was employed as a handicrafts teacher in September 1920. The students (who included Marguerite Friedlaender, Johannes Driesch, Otto Lindig and Theodor Bogler) found in him an instructor who taught pottery the old, traditional way. Marcks also devoted himself particularly to experimental work in clay and ceramics. In due course, numerous new forms were produced which attracted attention at the first Bauhaus exhibition in 1923. Some of the pieces were then sold to industry, where they were used as production models. In a letter to Marcks in 1923, Gropius combined words of praise with some advice concerning this work: 'Yesterday I looked at the many new vessels you have made. They are almost all unique, and it would be wrong not to seek ways of making the fine work you have achieved in them available to more people . . . We must find ways of reproducing some of the pieces by machine.' (Klaus Weber, Experiment Bauhaus, p. 58.)

Marcks, in an oversensitive reaction to Gropius's proposal, warned him against turning too quickly to industry, since that would mean the workshop developing into one of many production centres. For Marcks, the craftsman's training was of paramount importance. Like Itten before him he inevitably quarrelled with Gropius. At the beginning of 1924, Otto Lindig took over as technical director, and Bogler as business director. Marcks left the Bauhaus at the beginning of 1925. Negotiations with the state manufacturers of porcelain in Berlin led to sales of the

109 Theodor Bogler, little teapot, 1923.

plaster moulds developed, particularly by Bogler, for articles of tableware. Yet industry was still reluctant to place large orders, despite the positive response enjoyed by the workshop when it took part in fairs at Leipzig and Frankfurt. Although Bogler withdrew, Otto Lindig continued the Dornburg pottery as part of the Bauhaus, before assuming full responsibility for it himself in 1930.

110 Margarete Wildenhain-Friedlaender, jug, 1932.

111 Max Krehan (shape), Gerhard Marcks (decoration), bottle with handle. A work showing the clear influence of Marcks.

113 Gunta Stölzl, tapestry, 1926/27.

Although the history of this workshop produced less spectacular results than the other workshops, during its short period of operation it provided important stimuli for ceramic forms.

The Weaving Workshop

Because it was able to take over the looms of van de Velde's old school in Weimar, the weaving workshop was one of the first to start work at the Bauhaus. Initially the syllabus included many aspects of textile production, including crochet, knitting and sewing:

yet within a short time the workshop was specializing in designs for industry. From 1921 Georg Muche was artistic director and he lost no time in promoting the production of textiles with forms influenced by Itten. Due to the lack of well-qualified teachers in the subject, many women students began to experiment with weaving, using basic colours and forms from the preliminary course. Even so, breaking the ties with traditional woven motifs for carpets and wall-hangings, for example, was no easy matter. Only under the growing influence of Kandinsky and Moholy did work

112 Weaving workshop in Weimar, 1923.

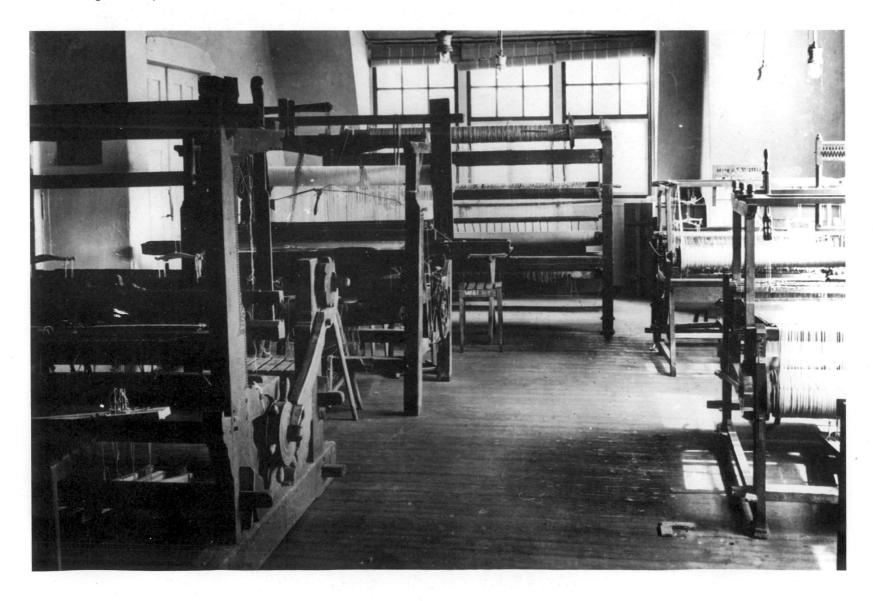

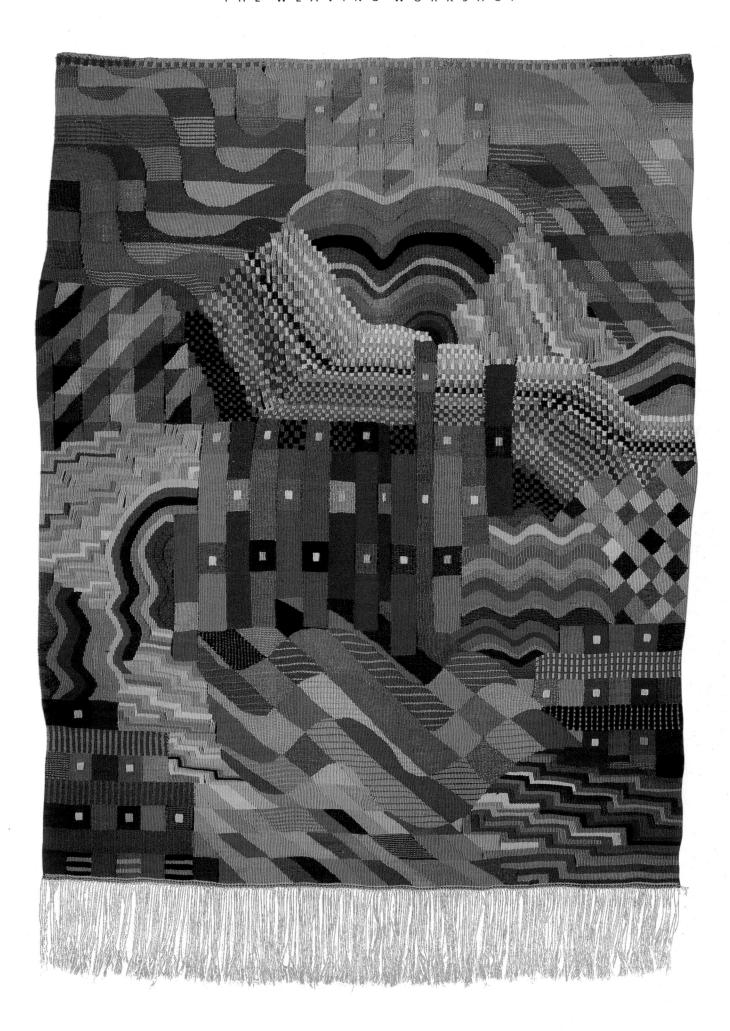

here achieve a clarity of expression that was in line with what the other workshops were creating. The weaving workshop produced numerous carpets, curtains and wall-hangings for the Weimar Bauhaus exhibition in 1923, and because of its close involvement with the

114 Gunta Stölzl, outline for a carpet, gouache on paper, c. 1926.

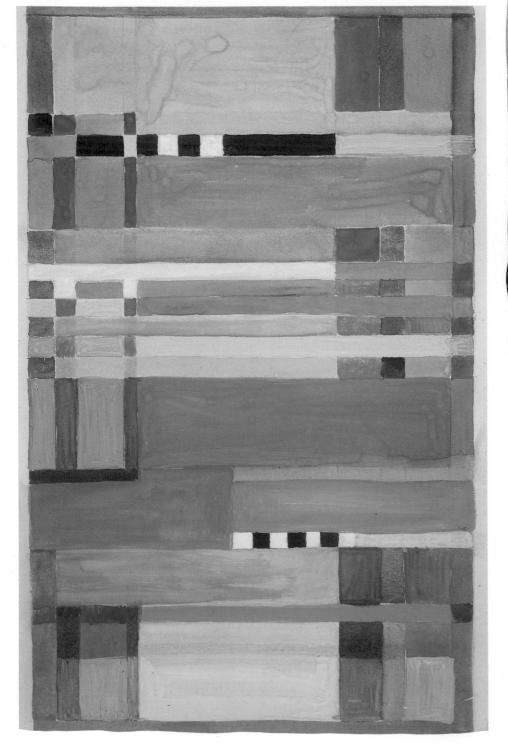

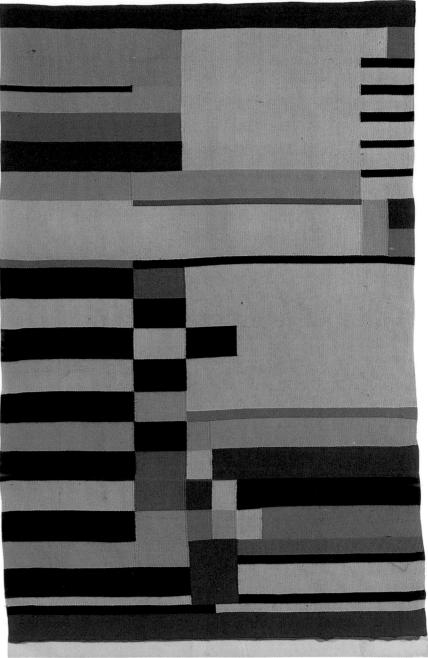

115 Ruth Hollos-Consemüller, tapestry, c. 1926.

other workshops it received a variety of commissions that kept it in touch with developments elsewhere in the institution. By 1925, it had produced quilts, carpets, children's clothes and ribbons, as well as chair covers.

Gunta Stölzl, a pupil of Itten, proved to be the most talented of the 130 or so students. After the move to

116 Anni Albers, tapestry, 1926.

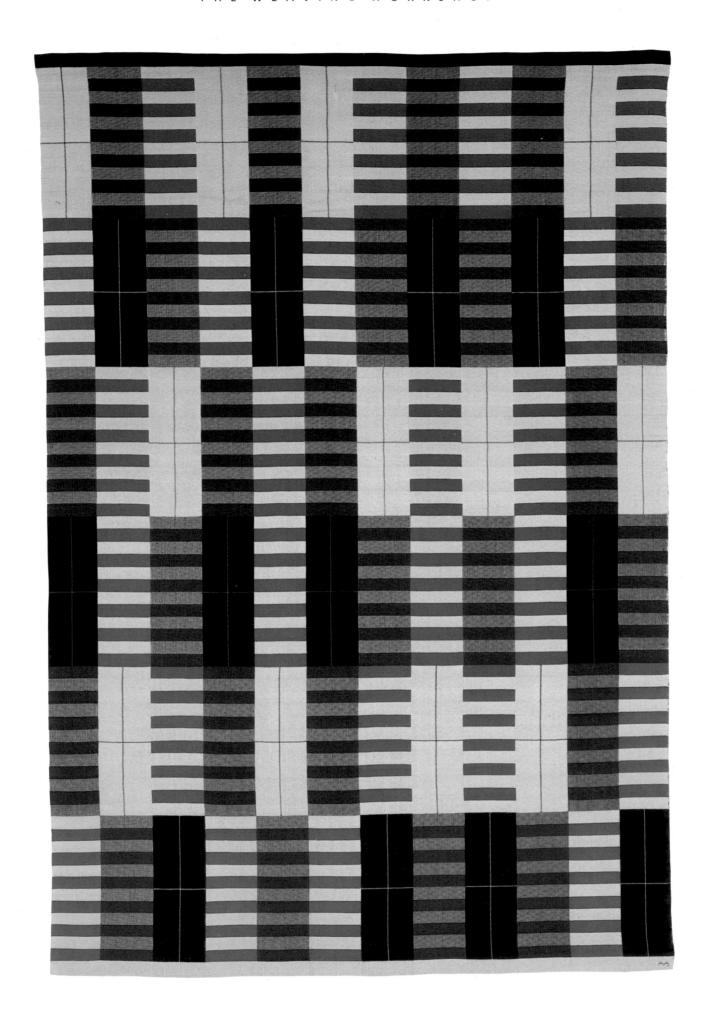

Dessau, she was entrusted by Gropius with establishing the new workshop. In 1927, after Muche had left the Bauhaus, she became director of the weaving workshop, and, with the benefit of her previous experience, was able to renew contacts with industry. Designs were sold to firms in Munich and Stuttgart, which were then produced there under licence. Clearly, though, the workshop's capacities were not being fully exploited, possibly because its achievements were underestimated by Gropius. Indeed, there was a general prejudice against the weaving workshop, and some, like Moholy, talked very disapragingly of the women there. Gropius himself, distinguishing, albeit euphemistically, between 'the beautiful and the strong sex', contributed little to the reputation of the workshop (though he was quick to claim its products for his office). The main cause of the weaving workshop's difficulties, however, was the fact that the possibilities inherent in textile design were not being properly recognized. In that respect, little has changed to this day. Of course the financial crisis which affected the whole school during the Weimar period was also responsible for work potential not being exploited. The emphasis on craft skills was very slow to loosen its grip on the workshop, despite the staunch efforts of Gunta Stölzl. She tried, with courses on dyeing and the mechanized manufacture of materials in factories, to introduce a more professional approach to work, but her days at the Bauhaus were numbered. Political quarrels and intrigues led to her resignation in 1931.

Stölzl was replaced by Lilly Reich, who was invited to the Bauhaus by Mies van der Rohe. As the preeminence of architecture now became increasingly pronounced, the weaving workshop lagged further and further behind as one of the institution's attractions.

Its influence was principally in two areas. Firstly, the

theories on colour and form developed by the various Bauhaus teachers were absorbed into industrial manufacture: new designs were produced which found their way into people's homes. Secondly, it was realized, only many years later, that weaving was a field of artistic expression in its own right, on a par with painting and sculpture. Many examples may still be seen today of the influence of Bauhaus textiles in design work — at tapestry exhibitions, for example in Italy, or at the Documenta in Kassel. Gunta Stölzl left for Switzerland in 1931, and until her death in 1983 worked mainly on carpets, and as a designer of textiles.

How a Whole is Produced from Many Parts: Architecture at the Bauhaus

There is a much repeated phrase, which tends to be uttered on such public occasions as the formal opening of an important building or the laying of a foundation stone, or at exhibitions, or indeed any event where the champagne is flowing and art is in the air: 'Typical Bauhaus!' If a house shows a clear, practical use of line, and a well-planned structure, the names of Gropius or Mies van der Rohe inevitably crop up in conversation. Such supposedly profound knowledge of 'Bauhaus style' is calculated to inspire awe in those listening with rapt attention. Yet at the same time the name 'Bauhaus' is simply not used today in connection with supermarkets, with Italian designer chairs or with fasion. In other words, there is an inability to grasp the complex and partly contradictory nature of the period when the Bauhaus was a developing influence.

Looking for a 'Bauhaus style' of design is an altogether futile pursuit — there was no such thing. Similarly, in architecture there was no 'Bauhaus house'.

117 Ida Kerkovius, outline for a wall carpet, tempera and pencil, 1921.

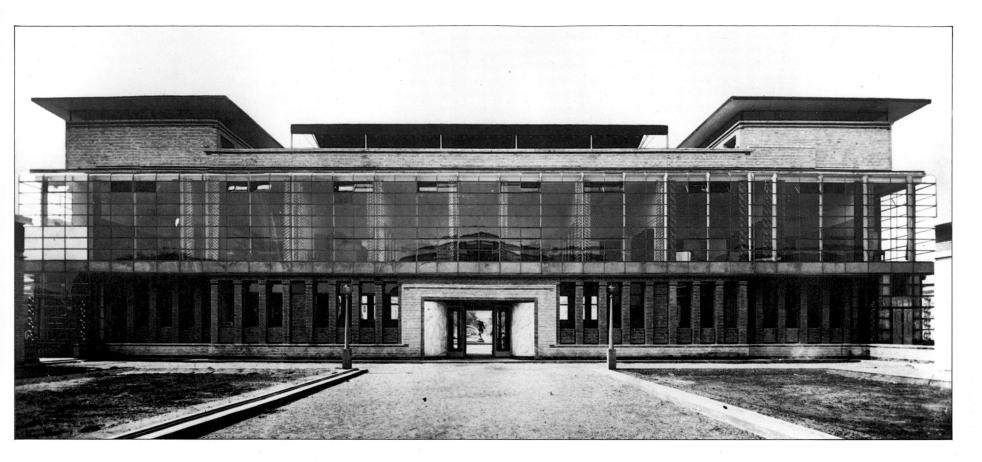

119 Walter Gropius, design for the Deutscher Werkbund.

Yet why is there such a desire to simplify and stylize, particularly when Bauhaus architecture is being discussed? The answer is to be found solely in our present-day attitudes towards architecture. Buildings have become another form of prestige symbol. There is nothing wrong with symbols — as long as there is something for them to symbolize, they will exist. Nor is there any point in reopening the discussion as to whether high-rise buildings should exist or not. Instead it is our concept of achitecture as a whole that can provide the key to an understanding of the Bauhaus.

There can be no doubt that the spirit behind the founding of the Bauhaus in 1919 supplied the basis for its subsequent development. The overturning or rejection of traditional, outmoded values led to new ideas which culminated in this unique institution. The

118 Rudolf Lutz, preliminary course, probably with Itten.

result was not a uniform entity but a cross-section of the various currents of the time. For this reason, any attempt to standardize the activities of the Bauhaus, however well-intentioned, betray a misunderstanding of the subject.

Even Bauhaus enthusiasts may be surprised to discover that, despite the promise expressed in the 1919 Manifesto, it was not until 1927 that the teaching of architecture was finally organized into a structured programme at Dessau. Before that architects received their training in the office of Walter Gropius and his colleague Adolf Meyer. At the time, in fact, the professional label 'architect' guaranteed nothing. Often people who called themselves architects had trained in building or technical drawing and attended a building trade school. 'The training involved co-operating on projects which Gropius and Meyer happened to be engaged in. Gropius also made constant efforts to

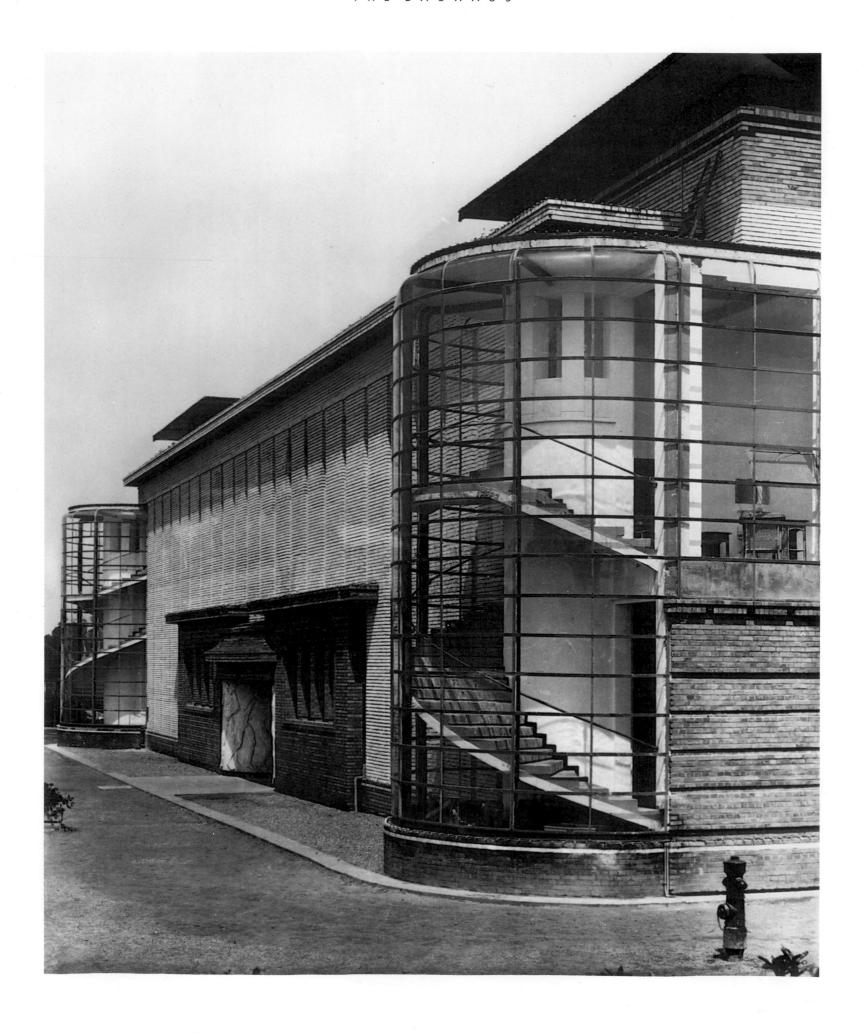

121 Alfred Arndt, colour plan for the 'Haus Auerbach', 1924.

involve the Bauhaus workshops in carrying out commissions, though they never participated in projects at the formation stage . . . The most extensive and lengthy commission was the Bauhaus settlement, on which Fred Forbat at first worked alone. Later, further individual suggestions were permitted and the whole project was rounded off with the building of the "Haus

120 Walter Gropius and Adolf Meyer, office building in Cologne, visible staircase, 1914.

am Horn" in 1923.' (Christian Wolfsdorff, *Experiment Bauhaus*, p. 310.)

As director, Gropius clearly played an important part in selecting projects, and the workshops were integral to their further development, though not merely as centres supplying the various parts necessary to the whole. The 'Haus am Horn' provided a very clear example of how interdependent the individual areas were. Workshop autonomy went hand in hand with collective collaboration. The aim was to create a

122 Alfred Arndt, colour plan for the 'Haus Auerbach', 1924.

building in which the various arts and handicrafts would unite to produce a *Gesamtkunstwerk* (total work of art) for the benefit of the potential occupants. This was precisely what Gropius had referred to in his manifesto, and offers the only real key to understanding the creative impetus behind the Bauhaus. The future was being built — the architects left no-one in any doubt of that. Critics who are troubled because they find the designs too fantastic, should always bear this in mind. For whoever attempts to turn his back on tradition and

123 Farkas Molnar, outline for a one-family house, 1922.

outmoded structures – in whatever area – should be conceded the right to indulge his fantasy.

The 'Haus am Horn', finally realized in Georg Muche's designs, holds the distinction of having been the first building to be produced entirely under the direction of the Bauhaus. Together with Marcel Breuer and Farkas Molnar (the only trained architect), Muche further explored its theoretical aspects before publishing their findings in a memorandum in 1924. They proposed the organization of a 'working group for architecture', firstly to structure the training of young architecture students, and secondly to suggest concrete projects for its planning. All were convinced that the potential occupants of these houses would adapt to their aesthetic criteria: a new architecture for new people. Architectonically this was expressed particularly in the layout of the rooms. The tone was set by a large central area, around which were grouped the smaller, functional units such as kitchen and bathroom. The central room was to be a point of communication, to maintain and even to create social values. This idea was a revolutionary break with the tendency of contemporary house-building to create separate rooms, and yet it remained traditional in the sense that it sought to revive the ancient idea of the communal area. However, since the building materials were to be glass, concrete and steel, the new design was by no means a return to the cave. Futurist and Expressionist influences were both in evidence, the latter promoted by the Gropius Bauhaus Manifesto and its motto of art and craftsmanship in unity (though this idea, too, had some basis in tradition).

The designs of the group led by Breuer were ahead of their time. The idealistic notion that the new inhabitants were to share the aesthetic tastes of the architects should not prejudice our assessment of these works too much, as it reflected a general trend amongst intellectual circles of the left.

More representative of the Dessau Bauhaus were

the five summerhouses on the estate at Törten, designed by Gropius in collaboration with Hannes Meyer in 1926:

Their special quality was their technical solidity and economical ground-plan. Each building comprised 18 flats, containing three rooms and ancillary rooms over just 48 square metres in surface area — without seeming cramped. The rooms were oriented to the garden side (South) and the staircases accommodated in a covered stairwell on the North side, from which the flats could be reached via open balcony-like access galleries (pergolas). This solution was a response to . . . social-hygienic and psychological considerations. Planning was preceded by systematic investigations into the effects of the environment, prospective neighbourly relations and other factors. (Hans Wingler, Bauhaus-Archiv Berlin (1989), p. 110.)

Following the introduction of these fundamental ideas about economizing in living space, still stronger reference was made to the industrial estate in the architecture course organized at the Bauhaus by Hannes Meyer in 1927, after he had taken over as director. He set out his ideas, which contrasted sharply with those of Gropius, in the Bauhaus publication Bauen (Building):

Building means the considered organization of life processes.

- The technical operation of building is therefore only part of the process.
- The functional diagram and economic program are the decisive guidelines of the building plan.
- Building no longer panders to the ambition of the individual architect.
- Building is a co-operative effort involving workers and inventors. Only he who himself masters the living process through working together with others . . . is a

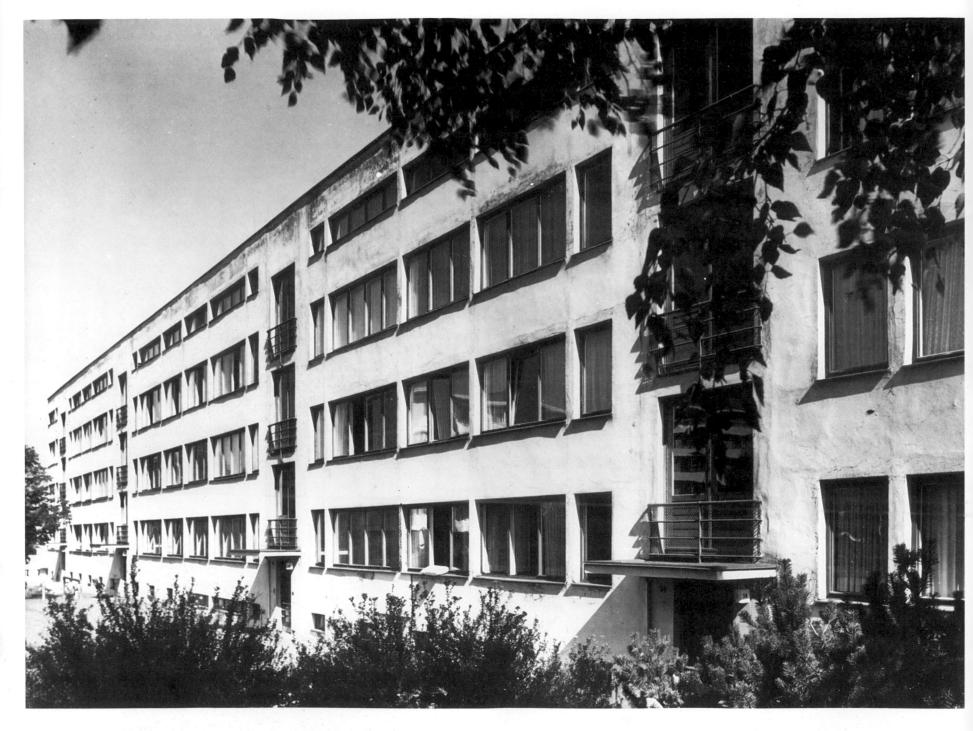

124 Mies van der Rohe, apartment house Weissenhof, 1927. Street-side view. The houses were unpopular with the inhabitants.

master builder.

- Building thus changes from being the private concern of individuals (furthered by unemployment and homelessness), into the collective concern of comrades of the people.
- Building is only organization: social, technical,

economic, psychological organization.

Hannes Meyer, who presumably had the Communist

125 and 126 Hannes Meyer and Hans Wittwer, Bundesschule ADGB in Bernau, 1928–30. Designed in Dessau.

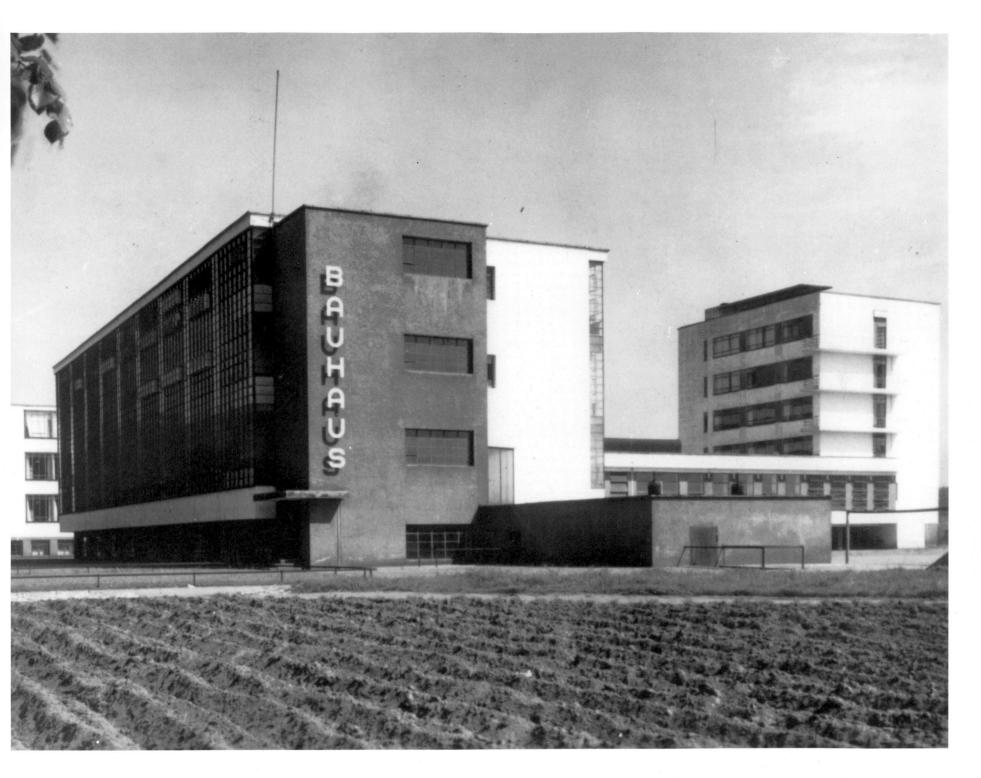

128 Walter Gropius, Bauhaus Dessau, 1925/26. Photo by Walter Funkat.

Party programme close to hand when writing these lines, introduced for the students' benefit a broad sweep of subjects culminating in the scientific study

127 Photo collage with Hannes Meyer, 1928.

of building design, a topic which until then had never before been taught at the Bauhaus. Their principles of design were based on a diagram representing the living space and habits of the future occupants of the houses, which paid particular attention to the light conditions and the relationship with landscape. Meyer's practically determined rejection of any architectural aesthetic of the kind still being practised to a certain extent before his time, was shared by the architect Ludwig Hilbersheimer, whom he invited to the Bauhaus in 1929. Two years previously, Hilbersheimer had

130 Mies van der Rohe, 1933. Portrait photo by Werner Rohde.

designed a house for the Stuttgart Weissenhof Settlement. All in all it can be said that considerable advances were made during the short period of Meyer's directorship in pointing the Bauhaus towards the real

129 Hannes Meyer and Hans Wittwer, Bundesschule ADGB in Bernau, 1928–30. Connecting hall.

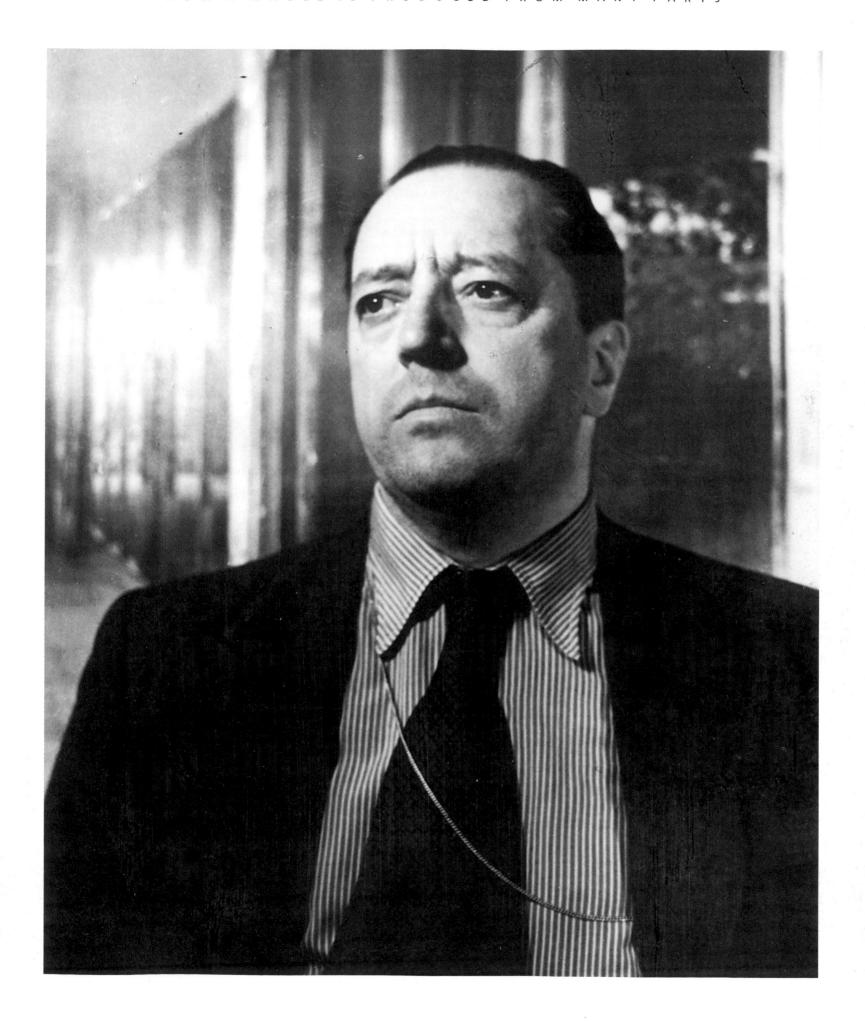

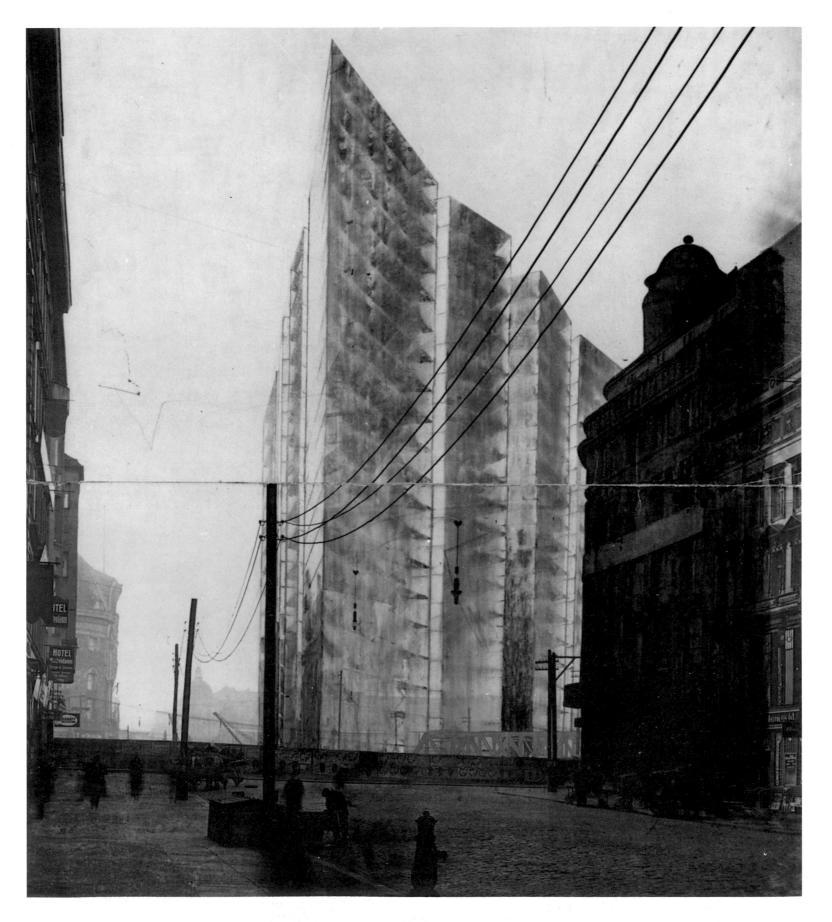

131 Mies van der Rohe, model for skyscraper project, 1921.

132 Mies van der Rohe, competition entry for Friedrichstrasse, Berlin.

133 Hinnerk Scheper, colour plan for an interior design, c. 1930.

world. Nor was artistic work neglected, though this accusation is repeatedly levelled against him. It is a comment that would seem to have more to do with his politics than with his qualifications as an architect.

When Mies van der Rohe became director, the teaching structure was retained, but the study-time was reduced to six semesters and scientific architectural training became more intensive. The extent to which this period represented a clean break from the Weimar school is evident in Mies's rather off-hand remark: 'I don't want a marmalade of workshop and school, I want school.' This statement was directed against the free form of teaching that had long prevailed in the preliminary courses and workshops, which Mies opposed. His approach soon had an impact on the new students, almost all of whom had undergone some prior training in architecture and were using the

Bauhaus to pursue their studies. In this way Mies contributed further to the existing predominance of architecture at the Bauhaus, which moved to Berlin in 1932, following the closure of the Dessau institution.

At the opening of the new Bauhaus in Berlin, Mies outlined his ideas in an interview:

Our aim is to train architects to have a command of the whole area of architecture, from the smallest building to the city building — not just the building itself, but also the whole development down to the textiles used. In our architecture we are striving for nothing less than a form of 'Gesamtkunstwerk' . . . Out of all the classes we hold, it is strictly speaking only the photography

134 Hannes Meyer and Hans Wittwer, Bundesschule ADGB, 1928–30.

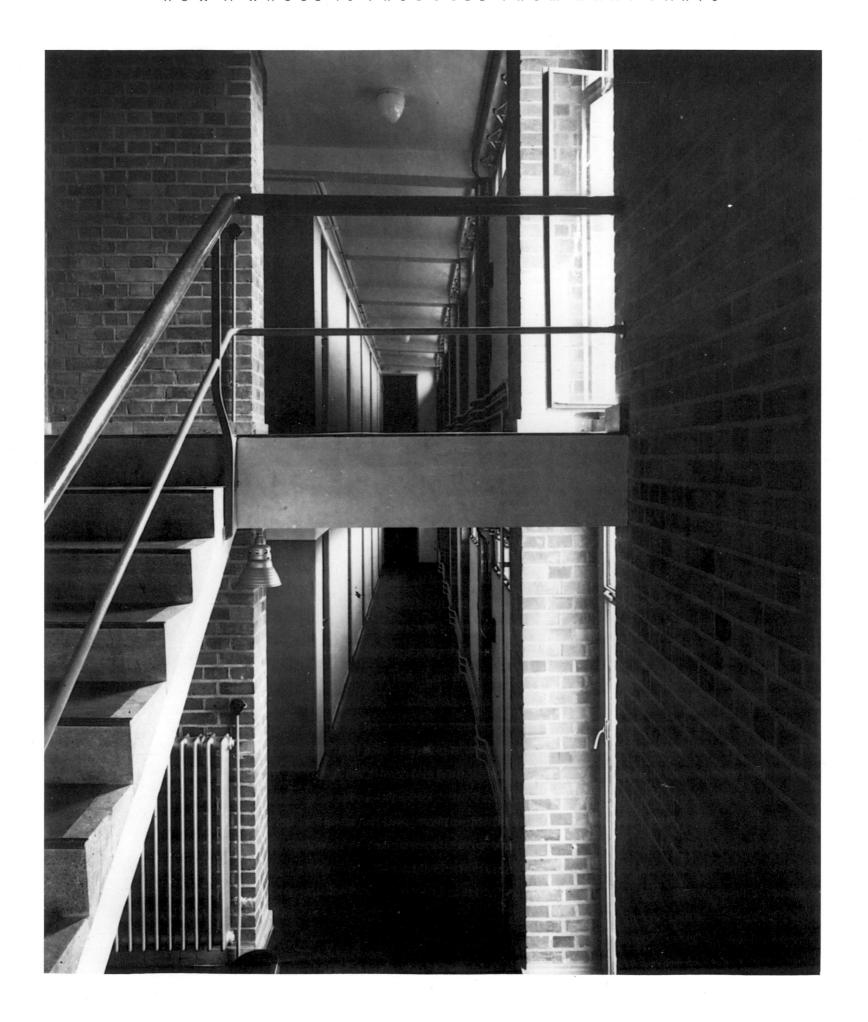

class, and, in a certain sense, the painting class, that transcend these limits. If the means were available, we would bring in still more painters and a sculptor, too, as it seems to me absolutely right that all young architects should learn lessons from the visual artists. Large workshops . . . make it possible for teaching to have a foundation in craftsmanship. Also models are produced for industry in the workshops. There has been no basic change in the aims of the Bauhaus since it was founded. (Experiment Bauhaus, p. 312.)

This is not the place to decide whether any 'basic' change had occurred or not — the arguments involved are too complex, and would go well beyond the bounds of our discussion here. What clearly emerges, however, is that Mies had again taken up the original idea of the *Gesamtkunstwerk* as a building, and once more harnessed the energies of the Bauhaus to that goal, albeit under different circumstances. It was only to be for a short time, however, since the ban on the institution was already imminent.

Before the move to Berlin, there had been a period

135 Walter Gropius, outline for Wannsee buildings, 1930.

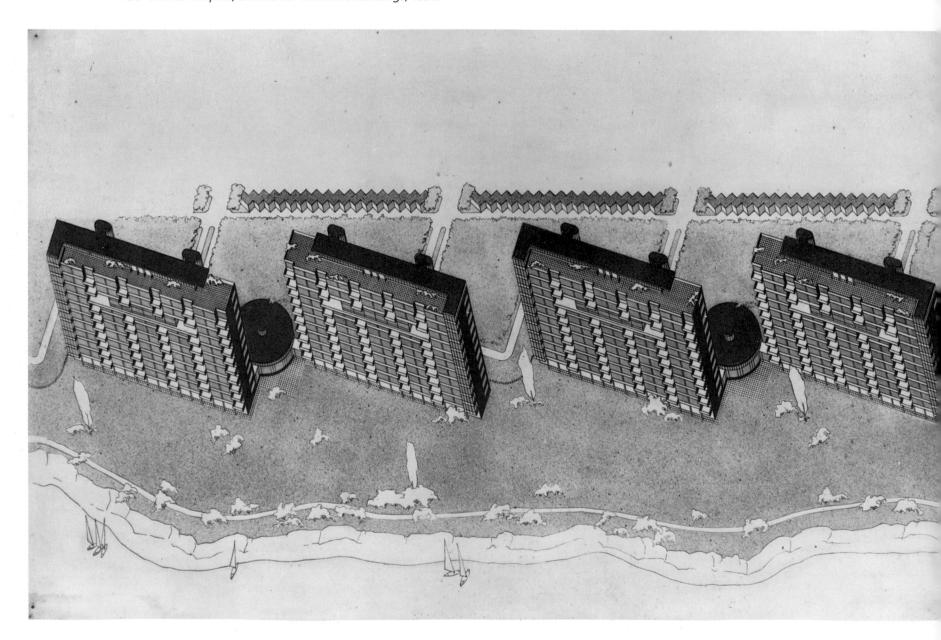

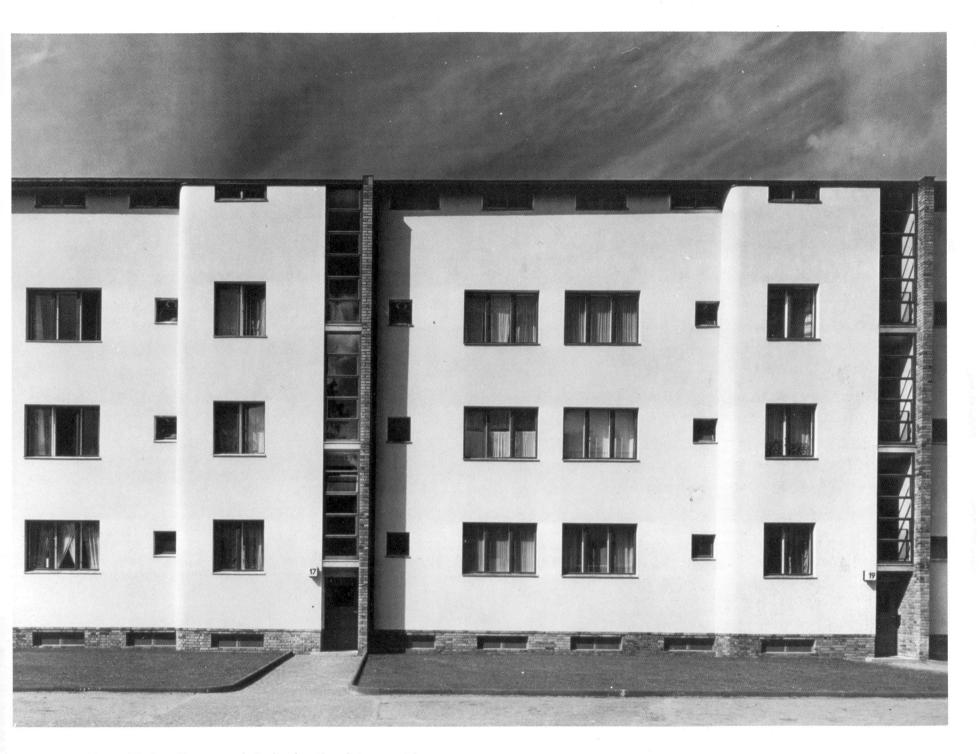

136 Fred Forbat, Siemensstadt Berlin, functional stereometric architecture, 1930/31.

of trouble in Dessau. In 1932 the building was temporarily closed. The students' displeasure at the dismissal of Hannes Meyer had led to gatherings in the great hall, where Mies was challenged to make a statement. He responded by having the police clear the canteen, a uniquely scandalous event for the institution.

The mayor of Dessau then closed the Bauhaus for a few weeks, in the hope that the waves would subside. However, Mies was still widely criticized for what had happened. The students in any case found him unapproachable: he was surrounded by the self-made aura of the architect as a being who inhabits higher

spheres. His personal reputation was enhanced by his creation of the latest architectonic type of building, which he had introduced at the international exhibition in Barcelona. Then there was his radical use of glass, steel and concrete for powerful, visionary high-rise

buildings. His entry for the competition to design a high-rise building at the Friedrichstrasse Railway Station in Berlin in 1921 shows the model high-rise structure surrounded by buildings of traditional architecture. The abandon with which he was prepared to impose such a

137 Fred Forbat, Siemensstadt Berlin, east view of Buildings 1, 2 and 3, 1929–30.

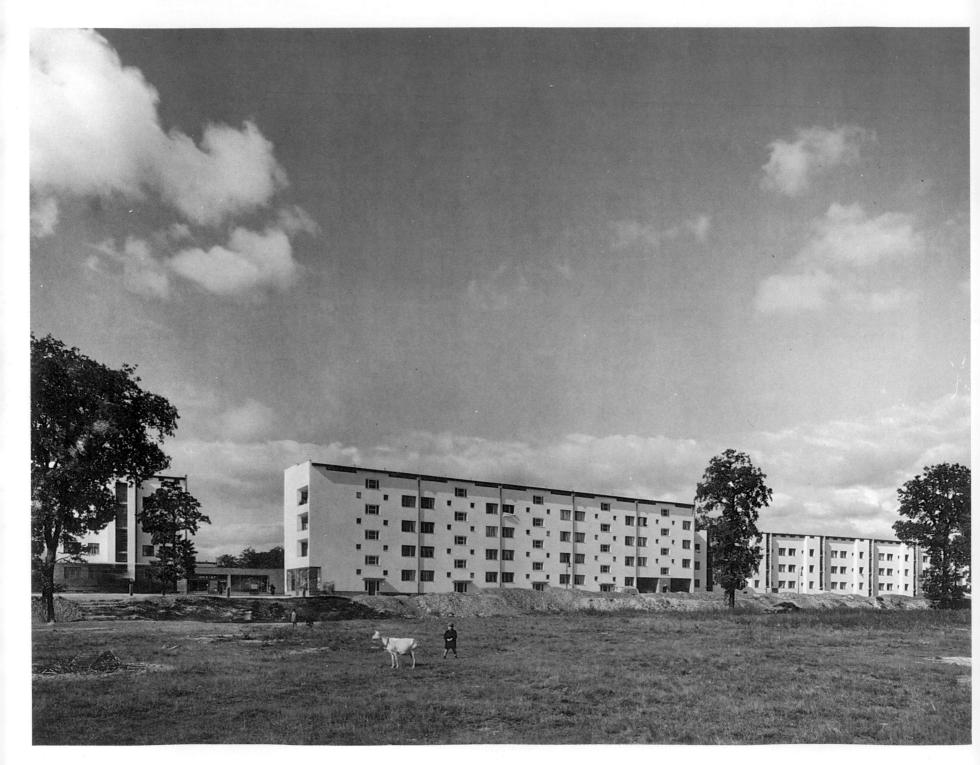

sensational concept, even though the project was not pursued, is a clear indication of how ready he was to break with tradition.

Rohe's personality was described by many students as complex and difficult. He presented a marked contrast to Hannes Meyer's almost anti-authoritarian behaviour and teaching style, and also to other teachers such as Ludwig Hilbersheimer, who continued to work on at the Bauhaus, serving as an important mediator between Mies and the students. Hilbersheimer's architecture had greater credibility than the paper plans of Mies.

The principles advocated by Hilbersheimer . . . were not generally recognized, however. If one compares them with what was happening in building in Germany at the time, only a few points of agreement can be established. Neither his low building estates nor the 'mixed' building estates he propagated were generally discussed. The commonest form of building at the time, the three- or four-storey block of flats is only of secondary importance to him . . . His theoretical concepts of low and mixed building estates . . . their anticipatory character and the way in which they are geared to meet the needs of the lower classes have not helped them to gain general acceptance. For the students they were of great importance: not only did they counterbalance the teaching of Mies, which was strongly oriented to aesthetics, with practically directed considerations, their ideological tendency made Hilbersheimer, in contrast to Mies, also seem acceptable to left-wing students, even though it was not bound to any party and hence did not exclude those of other persuasions. (Christian Wolfsdorff, Experiment Bauhaus, p. 313.)

The directors were forced by the Nazis to dismiss Hilbersheimer in July 1933, in order that teaching might continue. He emigrated to the USA in 1938, as Mies had done in 1937.

On 20 July 1933, a meeting of the teaching staff decided to wind up the Bauhaus, which since October 1932 had been run in Berlin as a private institute under the direction of Mies.

Under its three directors, Gropius, Meyer and Mies, the tasks addressed by the Bauhaus had changed, and so, too, had people's perception of it. Each of these personalities left his own individual stamp on architecture. Whereas Gropius stressed Wahrhaftigkeit (truthfulness) and the functional purpose of the building, Meyer insisted that the architect's duty was to relate it to the needs of society. Mies was committed to his own aesthetic vision, which had little more than a theoretical link with reality. He too was moving, albeit along a different path, towards the idea of the Gesamtkunstwerk. In view of the political disturbances at the time and the violent upheavals caused by Hitler's dictatorship, there was a certain irony in this. And yet perhaps it is precisely at such times that fantastic visionaries will emerge, in order to ward off harsh reality.

4. The Idea Lives on

Although it has been common practice, in numerous publications, to connect the spread and impact of the Bauhaus idea in all its variations with the ban on the Bauhaus and its destruction as an institution in 1933, this rests on a false assumption. For it would be quite wrong to date the international influence of the Bauhaus on design and architecture in general from Hitler's coming to power and the emigration of many Bauhaus members.

If we return to the roots of the ideals expressed in the *Bauhaus Manifesto*, with its Expressionist and Futurist influences, the picture that emerges is one of a European culture — of artists who predominantly viewed themselves as cosmopolitan, who intellectually rejected all types of national chauvinism and who defined themselves as artistically free and united with artists of whatever nationality. For this was the spirit that inspired the ideas, the works and the many different contacts which distinguished the Bauhaus right from the time of its foundation and won it early fame.

During the 1920s, for example, Kandinsky was represented by his pictures at six New York exhibitions, and after 1925 his work was shown with that of Feininger, Klee and Jawlensky. From as early as 1930, Hannes Meyer built numerous forward-looking housing projects in the Soviet Union, and a small Bauhaus exhibition took place in New York in 1931. The art crtitic H.R. Hitchcock and the architect Philip Johnson visited the Dessau Bauhaus whilst preparing a book and an exhibition on 'The International Style'. Along with many students from all over Europe, as well as Japan, the American Howard Dearstyne came to study at Dessau in 1928. In the 1930s he contributed to the spread of Bauhaus ideas in American architecture and was later, from 1957, Professor at the Illinois Institute of Technology in Chicago. Many other instances of the

international role played by the Bauhaus might be cited: all show that, long before Hitler's expulsion of the artists, the idea of a new form of design and building as practised in Weimar, Dessau and Berlin was gaining world-wide recognition. It seems necessary to stress this since the emigration of the artists and the spread of their influence abroad, particularly in the USA has repeatedly been represented as a positive consequence of the Nazi regime.

If the Bauhaus met with a warmer welcome in America this was partly because radical design proposals, oriented to modern technological media such as reinforced concrete and glass for building purposes, were more readily accepted there than in a Europe on the verge of war. People were far more open to new ideas in design. Leading figures from the Bauhaus, including Gropius, Mies, Albers and Moholy-Nagy, found their way to America in the 1930s, often via England.

Through Gropius, Cambridge in Massachusetts became . . . a Bauhaus centre . . . As Professor and Director of the Architecture Department of the Harvard Graduate School of Design, he had pupils from all over the world, over 250 of whom later filled teaching posts at universities, technical colleges and schools of design. Gropius passed on his social-ethical maxims, teaching his conviction that in education the stress should not be on the 'personal', that imitation should be neither a means nor an end, but that 'objective' facts had to be conveyed as they are given to us by nature and psychology. From 1946, strengthened by his emeritus status in 1952, he was busily engaged in building activities with 'The Architects Collaborative' (TAC). which attracted all the more public discussion as it involved some unusually large commissions, (Wingler, Bauhaus in Amerika, p. 6f.)

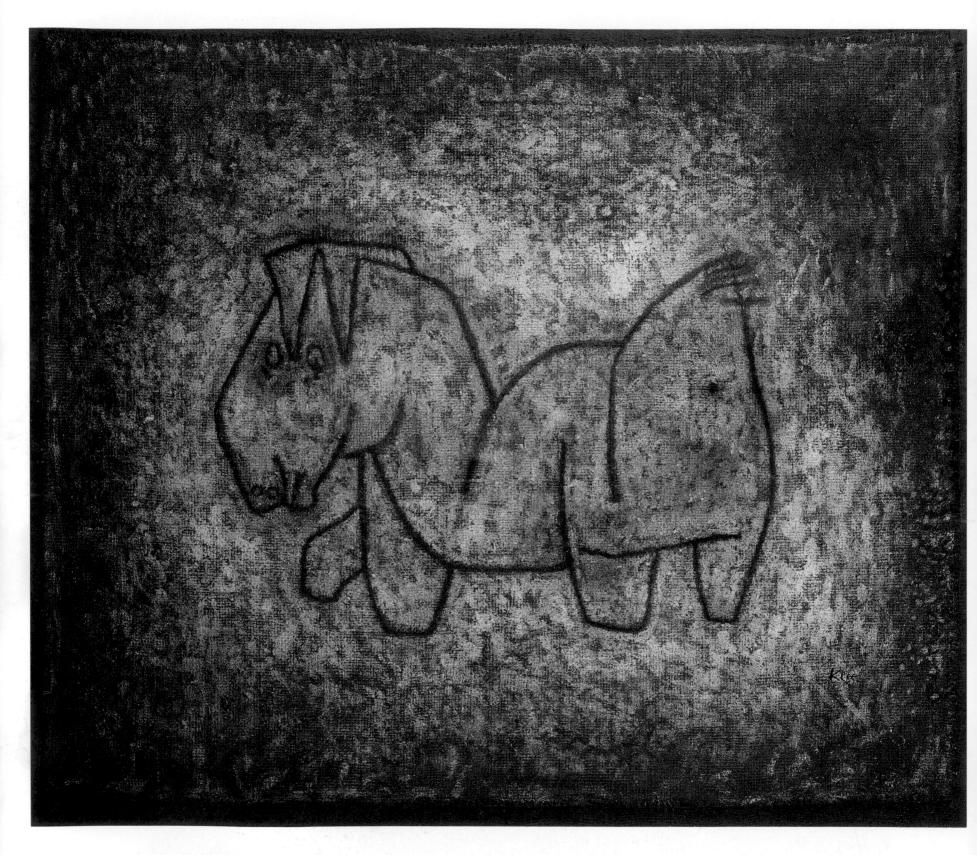

139 Paul Klee, Bastard, glue, tempera and oil on jute, 1939.

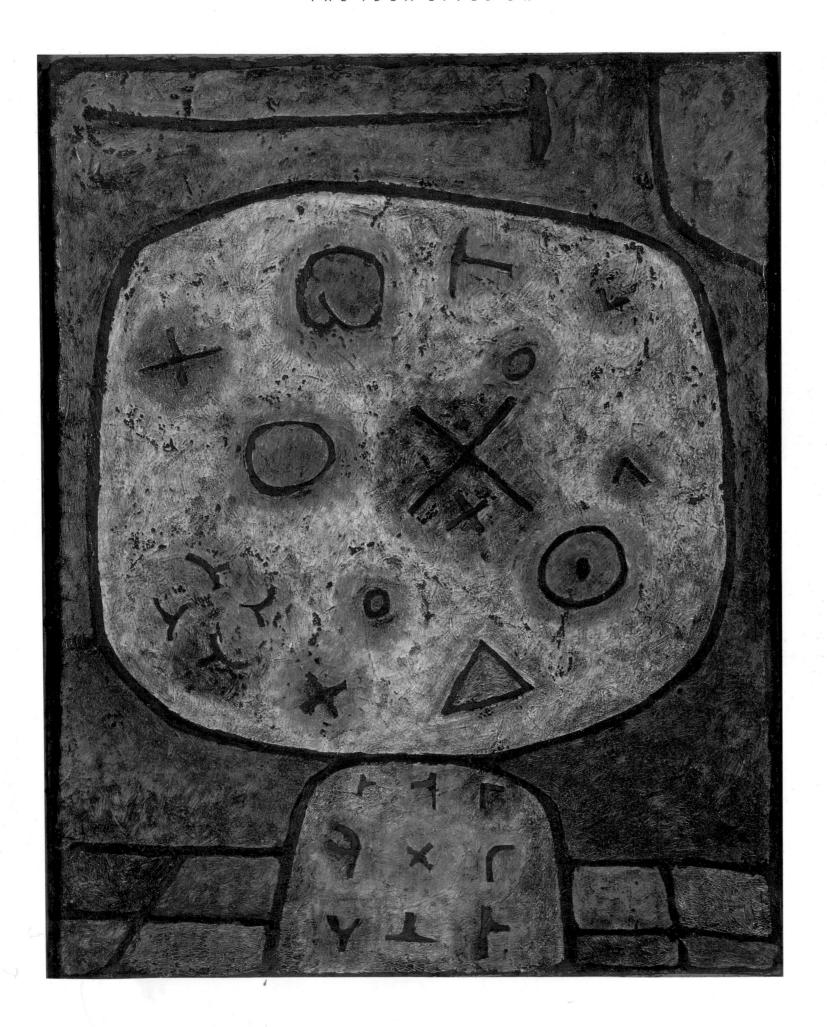

Weimar, the central figure around whom many former Bauhäusler gathered. At his suggestion, Moholy-Nagy, who was living in England, was invited in 1937 to Chicago, where at the initiative of the 'Association of Arts and Industries' he founded and directed the 'New Bauhaus', before finally closing it again after barely one year. Apart from financial difficulties, there were problems about the content of the training and the role of authority. Richard Koppe, a former student of the New Bauhaus, criticized Moholy-Nagy's teaching system for being 'alien to American society. The special system of apprentice, journeyman and master . . . did not in practice exist in the United States.' (Neumann, Bauhaus und die Bauhäusler, p. 364.) So the transference of training practice became an obstacle to integration, as did the reputations of the Bauhaus teachers, which elevated them to the rarified sphere of the inaccessible artist. Whether Gropius, Mies van der Rohe and Moholy-Nagy liked it or not, conflicts which they could no longer resolve through their teaching were coming to a head in the United States.

The 1938 Bauhaus Exhibition in the Museum of Modern Art played an essential part in making the works of the Bauhaus and its ideas better known. So, too, did the work of Josef Albers, who from 1933 taught at Black Mountain College in North Carolina. As Professor at Yale University in New Haven, 1950 to 1959, he became an impressive and well-known figure in the art world. Working from the basis of the investigations and colour analyses of the German Bauhaus he became a precursor of 1960s' Op-Art. Robert Rauschenberg was a product of his school. In 1939 the indefatigable Moholy-Nagy founded the 'School of Design', which numbered Johannes Molzahn, Marli Ehrmann and Frank Levistik amongst the teaching staff. After it had been recognized as a college and changed its name to the 'Institute of Design' in 1944, it attracted increasing numbers of students, for the teaching plan too had been modified

and adapted to American conditions. Three years later the Institute of Design was incorporated into the Illinois Institute of Technology, where Mies and Ludwig Hilbersheimer were already teaching architecture and town-planning. Walter Peterhans was running the preliminary course for the architecture students, and Howard Dearstyne,

a former student of the Dessau Bauhaus, was also on the teaching staff. Other former Bauhäusler such as Andreas Feininger, Marcel Breuer, Herbert Bayer and Xanti Schawinsky, to name but a few, achieved considerable success as employees or free-lance workers in design and commercial art in New York, where they exerted a fundamental artistic influence. But it was not so much product design that caused a stir in the 1950s and 1960s as the architecture of Gropius, Mies and their faithful followers in America, such as Philip Johnson and Louis Kahn. The author Tom Wolfe lampooned them in 1981 as 'white gods' who were able to preserve their status only through professional connections and the fact that architectural criticism in any normal sense had gone by the board. Like the criticism previously expressed in Europe after the war, his brilliant jibes are aimed at the soulless, puristic, formalistic funtionalism of architecture, and its subservience to the right-angle. Examples he gives are the Seagram Building by Mies ('he was a big, fleshy, though still good-looking individual, who smoked expensive cigars') and the glass-, concrete- and ironbearing boxes of ('Silver Prince') Gropius.

This criticism is justified to the extent that after Dessau the Bauhaus showed a tendency to believe in technology and the apparently unlimited possibility of developing formal solutions. On the other hand, the Bauhaus cannot be held responsible for every cubic building form, every uncomfortable tubular steel chair

141 Laszlo Moholy-Nagy, title page from The New Bauhaus, photograph, 1937.

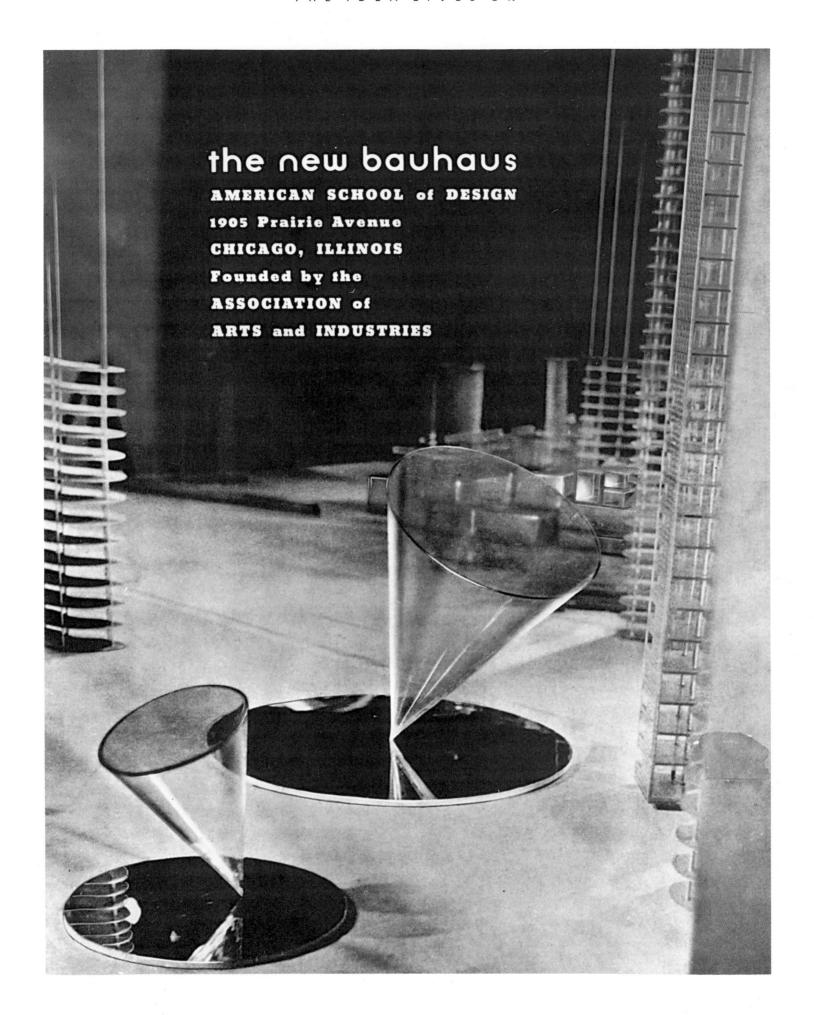

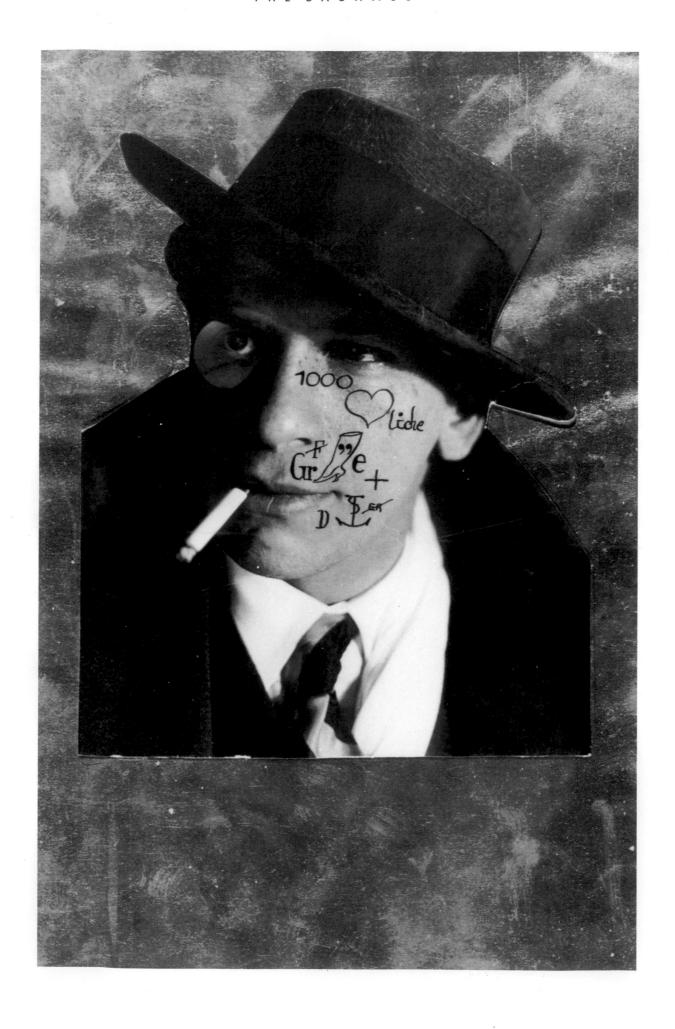

or unsuccessful blue-yellow-red combination. If today the parameters of architecture and design have shifted — if, for reasons of conservation, for example, the scarcity of resources has led designers and architects to copy Bauhaus ideas uncritically, then that is in no way a reflection on the original concepts from Weimar, Dessau and Berlin. Similarly, it would be a mistake to blame the graphics and advertisements developed and used by the Bauhaus for those instances where they were misused in Nazi publications.

On the contrary the ideas of the Bauhaus continued to reject authoritarian state structures, rousing renewed opposition in Germany even after the war. Hence the failure of the initiative, in which the former Bauhaus student Hubert Hoffmann took part, to re-establish the Bauhaus in Dessau after 1945. 'We were surrounded by Stalin's ideas on graphic and pictorial art, which were surprisingly similar to those of the Third Reich.' (Neumann, *Bauhaus und die Bauhäusler*, p. 374.) It was not until the late 1970s that the East Germans decided no longer to categorize the work of the Bauhaus as 'bourgeois art', but this decision came far too late and to no avail.

An attempt by former Bauhaus student Inge Scholl to build up a School of Design in Ulm, West Germany, encountered massive resistance in the 1960s and 1970s from the Baden-Würtemberg regional government, under the leadership of the former Nazi judge Filbinger. Once again, liberal teaching principles and innovative ideas fell victim to financial restraints.

These developments should be borne in mind by anyone who seeks to censure the Bauhaus. 'Any criticism should be directed not against the Bauhaus but against our modern world, which has taken away the ground from under the Bauhaus and destroyed it . . . without even being aware of it.' (J. Mohlzahn, in Neumann, *Bauhaus und die Bauhäusler*, p. 75.)

Certainly, the Bauhaus should be approached with an open mind. To be receptive to the stimuli of ideas from Weimar, Dessau and Berlin, as well as from institutions and individuals all over the world with affinities to the Bauhaus, to reflect them and to develop their use, are activities which bring their own rewards.

Chronology

- 1907 Hermann Muthesius founds the *Deutsche Werkbund* in order to foster co-operation between artists and industry.
- 1912 Walter Gropius joins the Werkbund.
- 1919 April: Gropius is appointed director of the State
 Bauhaus at Weimar, an amalgamation of the former
 Weimar Academy of Fine Art and the Weimar Arts
 and Crafts School. He issues the Bauhaus Manifesto,
 proclaiming a new unity of arts and crafts. In the first
 year Johannes Itten, Gerhard Marcks and Lyonel
 Feininger are appointed Masters of Form. Students
 are to follow a basic course and then to be taught
 in craft workshops.

Autumn: Itten establishes the preliminary course.

1920 Pottery workshop moves to Dornburg.

in Weimar.

- 1921 Sommerfeld House in Berlin, designed by Gropius and Adolf Meyer with collaboration of Bauhaus workshops, is completed. Paul Klee and Oskar Schlemmer join the teaching staff as Masters of Form.
 Van Doesburg begins publishing De Stijl magazine
- 1922 Wassily Kandinsky joins the teaching staff as Masters of Form.
- 1923 Itten resigns and Laszlo Moholoy-Nagy is appointed to run the preliminary course. Emphasis of school changes slightly to unity of art and technology.

 August-September: first full-scale Bauhaus
 Exhibition includes the experimental house 'Am Horn', equipped entirely by Bauhaus workshops.
- 1924 Nationalists with majority in local parliament and cut funds to school by half. Gropius announces Bauhaus will close the following year.

- 1925 The school moves to a purpose-built building in Dessau. Former Weimar students, Josef Albers (preliminary course), Herbert Bayer (printing), Marcel Breuer (furniture), Hinnerk Scheper (wall-painting), Joost Schmidt (sculpture) and Gunta Stölzl (weaving), join the teaching staff as Young Masters.
- 1927 Gropius sets up an architecture department under Hannes Meyer.
- 1928 Gropius resigns. Meyer becomes director and brings a new emphasis on designing for cheap mass production.
- 1929 Bauhaus exhibits works at the Industrial Museum in Basel and takes part in the International Exhibition in Barcelona.
- 1930 Meyer is forced to resign for political reasons (he is too left-wing) and Mies van der Rohe is appointed director. The furniture, metal and wall-painting workshops are combined to form the interior design workshop.
- 1931 Nazis take control of Dessau city government.
- 1932 Nazis close Dessau Bauhaus. Mies rents disused factory near Berlin where teaching can be continued.
- 1933 After police and stormtroopers close the new building, Mies announces that the faculty has decided to dissolve the Bauhaus. Many staff flee Germany.
- 1937 Moholy-Nagy founds the 'New Bauhaus' in Chicago. It closes after only one year.

List of III lustrations

- 1 Lyonel Feininger, cover illustration (Cathedral) for the Bauhaus Manifesto, woodcut, 1919.
- 2 Iwao Yamawaki, Attack on the Bauhaus (Der Schlag gegen das Bauhaus), photo collage, 1933.
- 3, 4 View of the Bauhaus building in Dessau, 1926, Photo by Lucia Moholy.
- 5 August Macke, With a Yellow Jacket, watercolour 1913.
- 6 Wassily Kandinsky, Composition Study, 1910.
- 7 Paul Klee, Precious Container for Stars, watercolour, ink and pen, 1922.
- 8 Lyonel Feininger, Halle, Am Trodel, oil on canvas, 1929.
- 9 Pablo Picasso, Restaurant, Still Life, oil on canvas, 1914.
- 10 Theo van Doesburg, Composición en blanco y negro.
- 11 Carlo Carrà, The Enchanted Room, acrylic, 1917.
- 12 Kasimir Malevich, Scissors Grinder, oil on canvas, 1912.
- 13 Carlo Carrà, Funeral of the Anarchist Galli, oil on canvas, 1911.
- 14 Gino Severini, Suburban Train, oil on canvas, 1915.
- 15 Kasimir Malevich, Suprematist Composition, White on White, oil on canvas, 1918.
- 16 Lothar Schreyer, woodcut, Bauhaus Weimar, 1923.
- 17 Johannes Itten, Coloured Composition, paper collage, 1920.
- 18 Members of the Bauhaus at Dessau on top of the roof, 1927. Photo by Lucia Moholy.
- 19 Piet Mondrian, Composition with Yellow and Blue, oil on canvas, 1929.
- 20 Walter Gropius, Fagus building near Hannover, 1911.
- 21 Werner Graeff, Rhythm-Study, black on yellow paper, 1920.
- 22 Fernand Léger, The City, oil on canvas, 1919.
- 23 Walter Gropius, Kandinsky and Oud in Weimar, 1923.
- 24 Theo van Doesburg, contra-compositie, oil on canvas, 1925.
- 25 Walter Gropius in Weimar, 1923.
- 26 Wassily Kandinsky in Weimar, 1923.
- 27 Oud in Weimar, 1923.
- 28 Johannes Itten, Horizontal-Vertical, oil on canvas, 1917.
- 29 Paul Klee in his Dessau atelier, c. 1927.
- 30 Johannes Itten, Workshop Meister Francke, Weimar, 1921.
- 31a, b, c Vincent Weber, Three Material Studies, wood and wire, 1920–21.
- 32 Oskar Schlemmer, Concentric Group, oil on canvas, 1925.
- 33 Johannes Itten, Tower of Fire, wood and coloured glass, 1922.
- 34 Lyonel Feininger with his wife in the Dessau atelier.
- 35 Oskar Schlemmer, Group with Seated Woman, oil on canvas, 1928.
- 36 Portrait of Laszlo Moholy-Nagy preliminary course, wood and glass, 1923. Artist unknown.
- 37 Study from the Moholy-Nagy preliminary course, wood and glass, 1923. Artist unknown.
- 38 Laszlo Moholy-Nagy, The girls Boarding School, photo collage, 1925.

- 39 Petra Kessinger Petitipierre, study from the Albers preliminary course, pen and ink, 1929–30.
- 40 Gunta Stölzl and weaving workshop students on the staircase. of the Dessau building, 1927.
- 41 Lothar Lang, Colour Scheme, tempera, 1926-27.
- 42 Fritz Tschaschnig, study from the Kandinsky colour seminar, tempera, 1931.
- 43 Bauhaus balconies in Dessau.
- 44 Karl Hermann Haupt, The Red Man, gouache and watercolour on paper, 1925.
- 45 Lena Meyer-Bergner, Radiating Displaced Centre, watercolour, 1927.
- 46 Oskar Schlemmer, Nature, Art, Man, ink on paper, c. 1928.
- 47, 48 Oskar Schlemmer, Simple Head Construction, pencil on paper, c. 1928.
- 49 Oskar Schlemmer, copper, brass and nickel figure in nickel-plated zinc, 1930–31.
- 50 Sculpture workshop with works by Schlemmer, Weimar, 1923.
- 51 Oskar Schlemmer, Solitary Figure on Grey Background, oil on tempera on linen, c. 1928.
- 52 Oskar Schlemmer, abstract figure, plaster and metal, 1921–23.
- 53 Karl Hermann Haupt, Composition, watercolour, 1925.
- 54 Albert Henning, Bauhaus students before an excursion, 1932.
- 55 Laszlo Moholy-Nagy, letterhead and cover for Bauhaus Verlag, printed on paper, 1923.
- 56 Marcel Breuer, lattice chair, wood and black fabric, 1922.
- 57 Marcel Breuer, chair, tubular steel and black fabric, 1928–29.
- 58 Marcel Breuer, chair, tubular steel and black fabric, 1925–26.
- 59 Mies van der Rohe, Weissenhof chair, tubular steel and cane, 1927.
- 60 Portrait collage of Josef Albers, c. 1928. Photographer unknown.
- 61 Heinrich Bormann, interior architecture, 1932.
- 62 Walter Gropius's office, Weimar, 1923.
- 63 Metal workshop in Dessau, Marianne Brandt and Hin Bredendieck.
- 64 Christian Dell, wine jug, plain silver and ebony, c. 1925.
- 65 Wilhelm Wagenfeld, gravy boat, silver and ebony, 1924.
- 66 Marianne Brandt, teapot, brass and ebony, 1924.
- 67 Metal workshop in Weimar, 1922, including Hans Przyrembel, standing left, Marianne Brandt, centre, and Otto Rittweger, seated left.
- 68 Josef Albers, teacup, porcelain, glass and steel, 1926.
- 69 Marianne Brandt, bedside Kandem lamp, metal, c. 1928.
- 70 Wilhelm Wagenfeld, desklamp, metal and glass, 1923-24.
- 71 Christian Dell, wine jug, plain silver with ebony handle and finial, 1924.
- 72 Laszlo Moholy-Nagy, Untitled, oil on canvas, 1925.
- 73 Joost Schmidt, printed poster for the Bauhaus exhibition, 1923.

- 74 Eugen Batz, typographic study from Albers's preliminary course, collage with newspaper and posterpaint, 1929–30.
- 75 Herbert Bayer, printed poster, 1930.
- 76 Erich Mrozek, printed poster for matches, 1932.
- 77, 78 Joost Schmidt, wallpaper for the Bauhaus catalogue, 1930–31.
- 79 Herbert Bayer, Xanti Schawinsky and Walter Gropius in Ascona, 1933.
- 80 Laszlo Moholy-Nagy, photogram with the Eiffel Tower, c. 1929.
- 81 Herbert Bayer, Nude on the Beach, 1929-30.
- 82 Peterhans course, c. 1929. Photographer unknown.
- 83 Laszlo Moholy-Nagy, Double Torso, 1927.
- 84 Herbert Bayer, Eye, 1929.
- 85 Double portrait of Holde Rantzsch and Miriam Manuckiam, c. 1927. Photographer unknown.
- 86 Ilse Fehling and Nicol Wassilieff, 1926. Photograph by Otto Umbehr (Umbo).
- 87 Laszlo Moholy-Nagy, Tactile Exercises, photo montage, 1938.
- 88 Irene Hoffmann, detail from an ashtray, c. 1928.
- 89 Paul Citroen, Self-Portrait, 1932.
- 90 Werner Zimmerman, photo of Marianne Brandt on her balcony at the Bauhaus atelier, Dessau, c. 1928.
- 91 T. Lux Feininger, Collage of Weaving Workshop, 1928.
- 92 Lou Scheper, Collage, 1928.
- 93 From the Peterhans course, 1929. Photographer unknown.
- 94 Herbert Bayer, Portrait of Ilse Gropius, 1928.
- 95 Herbert Bayer, Still Life, 1936.
- 96 Florence Henri, Fruits, 1929.
- 97 Laszlo Moholy-Nagy, Portrait of Ellen Frank, 1929.
- 98 Pupils from the stage workshop on top of the roof, Dessau, 1927. Photograph by Irene Bayer.
- 99 Oskar Schlemmer, plan for the Triadic Ballet I, pen, ink, watercolour, posterpaint and bronze on paper, 1924–26.
- 100 Xanti Schawinsky, Circus, tempera, ink and silver bronze on paper, c. 1924.
- 101 Kurt Schmidt, The Man at the Keyboard, tempera, ink and silver bronze on paper, c. 1924.
- 102 Heinz Loew, mechanical stage, model, 1927.
- 103 Two students from the stage workshop on top of the roof, Dessau, 1927. Photograph by Irene Bayer, (detail).
- 104 Oskar Schlemmer and student from the stage workshop on top of the roof, Dessau, 1927. Photograph by Irene Bayer, (detail).
- 105 Hans Thiemann, Yellow Shapes on Blue Background Blue Shapes on Yellow Background, 1930.
- 106 Oskar Schlemmer, Bauhaus Stairway, oil on canvas, 1932.
- 107 Herbert Bayer, Kiosk Design, tempera and collage on paper, 1924.

- 108 Florence Henri, Non-Objective Composition, oil on board, 1926.
- 109 Theodor Bogler, little teapot, 1923.
- 110 Margarete Wildenhain-Friedlaender, jug, 1932.
- 111 Max Kehan (shape) and Gerhard Marcks (decoration), bottle with handle.
- 112 Weaving workshop in Weimar, 1923.
- 113 Gunta Stölzl, tapestry, 1926–27.
- 114 Gunta Stölzl, outline for a carpet, gouache on paper, c. 1926.
- 115 Ruth Holles-Consemuller, tapestry, c. 1926.
- 116 Anni Albers, tapestry, 1926.
- 117 Ida Kerkorins, outline for a wall carpet, tempera and pencil, 1921.
- 118 Rudolf Lutz, preliminary course, probably with Itten.
- 119 Walter Gropius, design for the Deutscher Werkbund.
- 120 Walter Gropius and Adolf Meyer, office building in Cologne, visible staircase, 1914.
- 121, 122 Alfred Arndt, colour plan for the "Haus Auerbach" 1924.
- 123 Farkas Molnar, outline for a one-family house, 1922.
- 124 Mies van der Rohe, apartment house, Weissenhof, 1927.
- 125, 126 Hannes Meyer and Hans Wittwer, Bundesschule ADGB in Bernau, 1928–30.
- 127 Photo collage with Hannes Meyer, 1928.
- 128 Walter Gropius, Bauhaus Dessau, 1925–26. Photograph by Walter Funkat.
- 129 Hannes Meyer and Hans Wittwer, Bundesschule ADGB in Bernau, 1928–30. Connecting hall.
- 130 Portrait of Mies van der Rohe, 1933. Photograph by Werner Rhode
- 131 Mies van der Rohe, model for skyscraper project, 1921.
- 132 Mies van der Rohe, competititon entry for Friedrichstrasse, Berlin.
- 133 Hinnerk Scheper, colour plan for an interior design, c. 1930.
- 134 Hannes Meyer and Hans Wittwer, Bundesschule ADGB, 1928–30.
- 135 Walter Gropius, outline for Wannsee buildings, 1930.
- 136 Fred Forbat, Siemensstadt Berlin, functional stereometric architecture, 1930–31.
- 137 Fred Forbat, Siemensstadt Berlin, east view of Buildings, 1, 2 and 3, 1929–30.
- 138 Xanti Schawinsky, Floating Architecture, oil on canvas.
- 139 Paul Klee, Bastard, glue, tempera and oil on jute, 1939.
- 140 Paul Klee, Flowers in Stone, oil on cardboard, 1939.
- 141 Laszlo Moholy-Nagy, title page from the New Bauhaus, photograph, 1937.
- 142 Xanti Schawinsky, Enigma Collage: A Thousand Hearty Greetings and Thanks, photo and ink, 1928.

Picture Credits

Bauhaus Archiv, Berlin 1, 2, 3, 4, 8, 16, 17, 18, 20, 21, 23, 28, 29, 30, 31a, b, c, 33–37,

39–42, 45, 50, 54–58, 62–66, 73–79, 82, 85–98, 100–105, 107,

109-116, 117-142

Kunstbibliothek, Staatliche Museen Preussischer 80

Kulturbesitz, Berlin

Boymans van Beuningen Museum, Rotterdam 19

Bridgeman Art Library 14, 64, 142

E.T. Archive 6, 9

Museum Folkwang, Essen 83

Barry Friedman, New York 44, 51, 52, 53, 61, 69–71, 108, 114

Haags Gemeentemuseum, The Hague 24

Kunstmuseum Basel (Emanuel Hoffman Foundation) 10

The Museum of Modern Art, New York (Lillie P. Bliss bequest) 13

The Museum of Modern Art, New York (Gift of Philip Johnson) 106

The Museum of Modern Art, New York 15

Philadelphia Museum of Art (A.E. Gallatin Collection) 22

Scala 10

32, 46-69, 99

72

 ${\hbox{\Large \textcircled{\tiny C}}}$ The Oskar Schlemmer Family Estate and The Oskar

Schlemmer Theater Estate

Ulmer Museum 5

Westfalisches Landesmuseum

für Kunst und Kulturgeschichte, Munster

Yale University Art Gallery (Collection Société Anonyme) 7, 12

Bibliography

Adorno, Theodor, W., *Aesthetische Theorie*, Frankfurt 1970.

Andresen, Troels, *Malevich, Catalogue Raisonnée of the Berlin Exhibition*, Stedeljik Museum, Amsterdam 1970.

Apollonio, Umbro, Futurist Manifestos, London 1973.

Bauhaus Idee/Form/Zweck/Zeit, Catalogue, Goeppinger Galerie, Frankfurt/M. 1964.

Bauhaus and Bauhaus People, Personal opinions and recollections of former Bauhaus members and their contemporaries, edited by Eckard Neumann, New York 1970.

Bauhaus, 50 years, Catalogue of the Exhibition in the Royal Academy of Arts, London 1968.

Bauhaus, 50 Jahre new bauhaus, Bauhausnachfolge in Chicago, edited by Peter Hahn, Berlin 1987.

Bauhaus Utopien, Arbeiten auf Papier, edited by Wulf Herzogenrath, catalogue, Köln, Stuttgart 1988.

Bauhaus 1919–1933, Meister und Schülerarbeiten, Weimar, Dessau, Berlin, Zürich 1988.

The Bauhaus, Masters and Students, New York 1988.

Bauhaus – a teaching idea, Exhibition Catalogue, Carpenter Centre for the Visual Arts, Harvard University, Cambridge, Mass. 1967.

Berndt, Heide/Lorenz, Alfred/Horn, Klaus, *Architektur als Ideologie*, Frankfurt 1968.

Bloch, Ernst, *Erbschaft dieser Zeit*, Zürich 1935.

Bloch, Ernst, *Vom Hasard in die Katastrophe, Politische Aufsaetze aus den Jahren 1934–1939*, Frankfurt 1972.

Collins, Peter, *Changing Ideals in Modern Architecture 1750–1950*, London 1971.

Dube, Wolf-Dieter, The Expressionists, London 1985.

Experiment Bauhaus, Bauhaus Archiv, Berlin, 1988.

Franciscono, Marcel, *Walter Gropius and the Creation of the Bauhaus in Weimar*, University of Illinois 1971.

Gay, Peter, *Weimar Culture, The Outsider as Insider*, London 1969.

Glaeser, Ludwig, *Ludwig Mies van de Rohe, Drawings in the Collection of the Museum of Modern Art*, New York 1969.

Giedion, Siegfried, *Space, Time and Architecture, The Growth of a New Tradition*, Cambrdige, Mass. 1947.

Gropius, Walter, Bauhausbauten Dessau, München 1930.

Gropius, Walter, *Internationale Architektur*, München 1925.

Grote, Ludwig, *Exhibition Catalogue*, *Die Maler am Bauhaus*, München 1950.

Hitchcock, Henry-Russel, *Architecture, Nineteenth and Twentieth Centuries*, London 1963.

Hitchcock, Henry-Russel and Johnson, Philipp, *The International Style, Architecture since 1922*, New York 1966.

Horkheimer, Max, *Gesammelte Schriften Band 5:* 'Dialektik der Aufklärung' und Schriften 1940–1950, Frankfurt 1987.

Hughes, Robert, *The Shock of the New*, London 1980.

Johnson, Phillip, *Mies van de Rohe*, Museum of Modern Art, New York 1947.

Jordy, William, H., American Buildings and their Architects, Progressive and Academic Ideals at the Turn of the 20th Century, New York 1972.

THEBAUHAUS

Kepes, Gyorgy, Language of Vision, Chicago 1944.

Le Corbusier/Jeanneret, Pierre, Œuvre Compléte, Les Editions d'Architecture Artemis, 8th edn. Zurich 1967.

Lasch, Hanna, *Architekten-Bibliographie*, Deutschsprachige *Veroeffentlichungen 1920–1960*, Leipzig 1962.

Malewitsch, Kasimir, *Suprematismus, Die gegenstandslose Welt*, Köln 1962.

Mies van de Rohe, Ludwig, *Katalog der Ausstellung der Akademie der Bildenden Künste Berlin*, 1968.

Moholy-Nagy, Laszlo, Vision in Motion, Chicago 1947.

Moholy-Nagy, Sybil, *Moholy-Nagy – Experiment in Totality*, New York 1950.

Murray, Peter and Linda, Art and Artists, London 1979.

Neumann, Eckard (ed.) *Bauhaus und die Bauhäusler, Erinnerungen und Bekenntnisse*, Köln 1985.

Pevsner, Nikolaus, *Wegbereiter moderner Formgebung, Von Morris bis Gropius*, Hamburg 1957.

Rassegna, quarterly, Year XI, 40/4, December 1989.

Schmidt, Diether, *Bauhaus Weimar 1919–1925, Dessau 1925–1932, Berlin 1928–1933*, Dresden 1966.

Teut, Anna, *Architektur im Dritten Reich 1933–1945*, Berlin, Frankfurt, Wien 1967.

Tisdall, Caroline, *Futurism*, London 1985.

Wesepohl, Edgar, *Die Weissenhofsiedlung der Werkbundausstellung 'Die Wohnung' in Stuttgart 1927, Wasmuths Monatshefte Für Baukunst XI*, 1927.

Westphal, Uwe, Werbung im Dritten Reich, Berlin 1989.

Wick, Rainer, *Bauhaus Paedagogik*, Köln, 1975.

Wingler, Hans-Maria, *The Bauhaus 1919–1933*, Cambridge, Mass. 1968.

Wingler, Hans-Maria, *The Bauhaus Weimar Dessau Berlin Chicago*, Cambridge, Mass. 1969.

Wolfe, Tom, *Mit dem Bauhaus leben = From Bauhaus to our house*, Frankfurt 1986.

I n d e x

Albers, Josef, 45, 50–53, 57, 80, 86, 111, 159, 162 Arndt, Alfred, 90 Arndt, Gertrud, 59 Art Press of the State Bauhaus-Weimar, 90 Auerbach, Ellen, 111

Batz, Eugen, 111
'Bauhaus' Magazine, 53
Bauhaus Manifesto, The, 6, 11, 69, 93, 137, 141, 159
Bauhauskompendium, The, 62
Baumeister, Willi, 66, 92
Bayer, Herbert, 95–96, 97, 108, 113–115, 162
Bayer, Irene, 108

Behrens, Peter, 29, 31, 77, 84
Bernhard, Lucian, 93
Boccioni, Umberto, 92
Bogler, Theodore, 126, 127
Brandt, Marianne, 50, 84–86, 108
Braque, Georges, 18

Beckmann, Max, 92

Breuer, Marcel, 75, 77–80, 83, 141, 162

Campendonk, Heinrich, 69

Carrà, Carlo, 20, 92 Cézanne, Paul, 17 Chagall, Marc, 92 Chirico, Giorgio de, 18–20, 23, 92 Collein, Edmund, 108 Constructivism, 17, 25, 47, 48, 75, 93 Cubism, 17, 18–23, 25, 112

DaDa, 23–25, 96
Dali, Salvador, 115
de Stijl group, The, 18, 26–28, 77
'Der Blaue Reiter', 17
Dearstyne, Howard, 162
Delaunay, Robert, 11, 60
Dell, Christian, 49, 50, 84
Der Sturm, Berlin, 46
Dessau Meisterhaueser, 25
Deutscher Werkbund, The, 32
Doesberg, Theo van, 18, 26–28, 75, 77, 93
Driesch, Johannes, 126
Dürer, Albrecht, 62, 65

Einstein, Albert, 69, 84 Enderlin, Max, 108 Expressionism, 14–18, 59, 93, 141

Feininger, Andreas, 108, 162
Feininger, Lucas Theodore, 111
Feininger, Lyonel, 11, 58, 69, 90, 91, 93, 108, 111, 159
Feist, Werner, 108
Film & Photo Exhibition, The, 108
Forbat, Fred, 139
Friedlaender, Marguerite, 126
Funkat, Walter, 108

Gerson, Lotte, 108
Goethe, Walter von,
'Theory of Colours', 18, 56
Golden Section, The, 65
Goncharova, Natalia, 92
Graeff, Werner, 28, 108
Gris, Juan, 18
Gropius, Walter, 6–11, 25–26

Gris, Juan, 18

Gropius, Walter, 6–11, 25–26, 28, 31, 32, 38, 40, 42, 43, 45, 46, 50, 57, 62, 66, 69, 72, 73, 75, 77, 80, 83, 86–88, 90, 91, 93, 96, 102–105, 109, 119, 122, 126, 135, 137–140, 155, 159–162

Fagus Works, The, 7, 28

Werkbund Exhibition building, 7

Grosz, Georg, 92

Haus am Horn, The, 139, 141
Heckel, Erich, 92
Heinze, Fritz, 108
Henri, Florence, 108, 112–113
Hilbersheimer, Ludwig, 146, 155, 162
Hitler, Adolf, 11
Hoelzel, Adolf, 42, 60–61
Hoffmann, Hubert, 165

Itten, Johannes, 40-46, 62, 73, 84, 102, 122, 132

Jawlensky, Alexei von, 69, 159 Jucker, Karl Jacob, 84, 88 Jugendstil, Der 18, 31 Jungmittag, Willy, 108 Junker, Karl J., 50

THEBAUHAUS

Kandinsky, Nina, 57 Kandinsky, Wassily, 17, 18, 20, 43, 45, 53–57, 62, 73, 86, 90, 92, 113, 122–124, 126, 130, 159 Kirchner, Ernst, 92 Klee, Paul, 18, 45, 57–60, 62, 69, 86, 90, 95, 159 Pedagogical Sketchbook, The, 59 Kokoschka, Oskar, 90 Koppe, Richard, 162 Kramer, Ferdinand, 77 Kranz, Kurt, 110, 111 Krehan, Max, 126

Lang, Lothar, 55 Larionov, Mikhail, 92 Le Corbusier, Charles-Édouard, 77 Léger, Fernand, 18, 20, 92, 112 Lindig, Otto, 126, 127 Lissitzky, El, 93 Loew, Keinz, 108 Lotz, Wilhelm, 50

Kreibig, Manda von, 118 Kuhnert, Charlotte, 111

Kuhr, Fritz, 108

Macke, August, 17, 69 Malevich, Kasimir, 20-23, 26 Marc, Franz, 17, 23, 60, 69 Marcks, Gerhard, 25, 66, 92, 126 Marcoussis, Ludwig, 92 Mazdaznan, 42 Meyer, Hannes, 77, 80–81, 88–90, 96, 109, 110, 119, 126, 137, 141, 142–150, 153, 155, 159 Meyer-Bergner, Lena, 59 Mies van der Rohe, Ludwig, 51, 57, 77, 81–83, 90, 135, 150–155,

159, 162 Moholy-Nagy, Laszlo, 25, 43, 45, 46–50, 77, 84, 86, 93–95, 102, 105, 107, 108, 109, 111, 112, 113, 130, 159, 162 Berliner Stadtleben, 49 From Material to Architecture, 46 Marseilles, 49 Moholy-Nagy, Lucia, 105-108 Molnar, Farkas, 141 Mondrian, Piet, 11, 18

Muche, Georg, 25, 42, 43, 45, 66, 84, 92, 100–102, 130, 135

National Socialist Party, the, 11, 57, 66, 155, 159 New Bauhaus, The, 50 New Munich Arts Group, 17

Olbrich, Joseph Maria, 29, 31 Op-Art, 51 Oud, Jacobus, 77

Ruskin, John, 32, 40

Peterhans, Walter, 100, 108, 109-111, 162 Picasso, Pablo, 18, 60

Reich, Lily, 135 Renger-Patsch, 102, 108 Rietveld, Gerrit, 77 Rohe, Mies van de, 51, 57, 77, 81–83, 90, 135, 150–155, 159, 162 Rosen, Fritz, 93 Rubenstein, Naf, 108

Schawinsky, Xanti, 162 Scheibe, Richard, 126 Scheper, Hinnerk, 108 Scheper, Hinnerk, 124-126 Scheuermann, Herbert, 111 Schlemmer, Oskar, 25, 43, 45, 57, 60–69, 77, 92, 111, 115–117, 118-119, 124 Triadic Ballet, The, 60 Schmidt, Joost, 95, 97, 109 Schneck, Adolf, 77

Schoenberg, Albert, 69, 84 Scholl, Inge, 165 Schreyer, Lothar, 14, 25, 62, 92, 115

Schuh, Ursula, 53 Schwitters, Kurt, 92 Severini, Gino, 20, 92 Stam, Mart, 77 Stern, Grete, 111 Stölzl, Gunta, 41, 132-135

Stravinsky, Igor, 69

Taut, Bruno, 31, 77

Morris, William, 32, 40

INDEX

Umbehr, Otto, 108, 111–112 Umbo, see Umbehr, Otto,

Van Gogh, 14, 17 Velde, Henry van de, 38, 83, 90, 130

Wagenfeld, Wilhelm, 50, 84, 88 Wagner, Otto, 31 Wilde, Anne & Juergen, 112 Wingler, Hans, 69 Wolfe, Tom, 162 Work Council for Art, The, 38 Workshops, The, 71–155
ceramics, 73, 126–130
furniture, 72, 73–83
metal, 72, 83–90
photography, 73, 97–115
print and advertising, 72, 90–97
theatre, 62, 73, 115–122
wall-painting, 73, 122–126
weaving, 73, 130–135
Wright, Frank Lloyd, 31

Zaubitzer, Carl, 90–91

•			
		•	
		*	
			,

				4		
					· ·	
					-	
	 ,					

PHILIP'S

CONCISE ENCYCLOPEDIA

98.

PHILIP'S

CONCISE ENCYCLOPEDIA

First published in Great Britain in 1997 by George Philip Limited, Michelin House, 81 Fulham Road, London SW3 6RB

Copyright © 1997 George Philip Limited

CL21160

This edition published in 1998 for Colour Library Direct, Godalming Business Centre, Woolsack Way, Godalming, Surrey GU7 1XW

EDITOR Steve Luck ART EDITOR Mike Brown

TEXT EDITORS
Chris Humphries
Frances Adlington
Lisa Deer

PICTURE RESEARCH Emily Hedges

PRODUCTION
Claudette Morris

Reproduction by Colourpath Ltd, London

Printed and bound in Germany by Mohndruck Graphische Betriebe GmbH

A CIP catalogue record for this book is available from the British Library.

ISBN 1-85833-622-8

All rights reserved. Apart from any fair dealing for the purpose of private study, research, criticism or review, as permitted under the Copyright, Designs and Patents Act, 1988, no part of this publication may be reproduced, stored in a retrieval system, or transmitted in any form or by any means, electronic, electrical, chemical, mechanical, optical, photocopying, recording, or otherwise, without prior written permission. All enquiries should be addressed to the Publisher.

PREFACE

The *Philip's Concise Encyclopedia* has been created as a stimulating reference source for everyday family use – as a study aid for secondary school students, a first stop for general enquiries and puzzle answers, and a treasure-trove for browsers. The 13,000 alphabetically organized entries provide clear, essential information on a vast variety of subjects, from world affairs to science and the arts. The wealth of colour illustration, including maps, photographs, technological "cutaways" and artworks conveys visual information far beyond the descriptive power of many thousands of words.

When choosing a single-volume encyclopedia, the most important consideration for the user is the criteria by which the articles have been selected. *Philip's Concise Encyclopedia* has been created with secondary school students particularly in mind. Core subjects (science and technology, English, history, maths, geography, art and music) have been given the greatest attention. The articles, compatible with and complementary to what is learned in the classroom, are up-to-date to March 1998, and have been written with exceptional clarity so that even complex concepts can be understood by readers as young as thirteen or fourteen.

An encyclopedia, however, must contain more than just a comprehensive coverage of core subjects. Equally full in their treatment are the articles that cover leisure interests, such as sports and popular music, animals and plants, cinema and current affairs, making this encyclopedia ideal for home reference as well as an important resource at school or college.

Ready Reference

Supplementing the main body of the Encyclopedia, the Ready Reference section collates the kind of information best presented in tables and lists. Along with standard items such as conversion units and lists of international leaders, the Ready Reference section provides rapid access to many areas of interest, from major sporting results to how a chess board is set up. The contents are listed in full on the first page of the section.

Cross-references

The *Philip's Concise Encyclopedia* has more than 30,000 individual cross-references, indicated by SMALL CAPITAL letters, which take the reader from one article to other articles that provide useful related information. For example, contained within the "pancreas" article are cross-references to SMALL INTESTINE, AMYLASE, TRYPSIN, INSULIN and DIABETES.

Alphabetical order

The order of articles is strictly alphabetical, except that Mc is treated as if it were spelt Mac, and abbreviations as if spelt out in full, thus St is treated as Saint. Articles that have more than one word in the heading, such as "Panama Canal", are ordered as if there were no space between the words. Articles that share the same main heading follow the basic hierarchy of people, places and things – for example:

Washington, Booker T. (Taliaferro) Washington, George Washington Washington, D.C. Washington, Treaty of

The hierarchy for biographical entries is: saints, popes, emperors, kings, queens, princes, dukes, knights, com-

moners. However, when popes, emperors, kings and queens share the same name, they are collected together by country and then follow in chronological order. Thus Henry I, Henry II, Henry III, etc. (of England) are grouped together, followed by Henry II, Henry III, Henry IV (of France).

Places that share a name are ordered by the alphabetical order of the country. Foreign place names have been anglicized, with the local spelling in brackets, for example, Florence (Firenze); Moscow (Moskya).

Alternative spellings

For Chinese spellings the Pinyin system of transliteration is generally preferred, with cross-references to the Wade-Giles system where appropriate, for example, Peking *See* Beijing. Wade-Giles transliterations have also been retained where they remain in common use, for example, Chiang Kai-shek.

Alternative spellings and names of headwords are followed in parenthesis, for example, Dalai Lama (Grand Lama).

International coverage

The importance of cultures beyond the English-speaking world is deliberately emphasized. In an age when international barriers are being steadily removed, the *Philip's Concise Encyclopedia* provides a greater proportion of entries than any other single-volume encyclopedia on peoples, cultures, religions and beliefs.

Science

In keeping with the methods taught in schools and colleges, modern scientific names have been used. For example information on "acetaldehyde" will be found under "ethanal". Where less well-known modern names are used, cross-references from the old names will take the reader to the new headings.

Metric units have been used throughout with corresponding imperial measurements following in brackets.

▲ pollination

CONSULTANTS

Anatomy/ Dentistry

Prof. A.E. Walsby University of Bristol

Animals and Agriculture

Prof. K. Simkiss University of Reading

Archaeology

David Miles Director of The Oxford

Archaeological Unit

Art

Prof. Martin Pitts Middlesex University

Aviation

Dr I. Hall Victoria University of Manchester

Biology

Prof. T. Halliday Open University

Botany

Prof. A.E. Walsby University of Bristol

Chemistry

Dr A.S. Bailey University of Oxford

Earth Sciences/ Atmospheric Sciences/ Geology

Prof. Michael Tooley University of St Andrews

Economics

Prof. A. Thirlwall

University of Kent at Canterbury

Education

Dr Charles Beresford (Institute of Education) University College London

History (to 1300)

Dr P.J. Heather University College London

History (1301 to present)

Dr Rick Halpern University College London
Dr Jonathan Morris University College London

Language

Prof. Richard Coates University of Sussex

Literature/ Drama

Dr Mary Peace

Roehampton Institute, London

Mathematics

Dr Jan Brandts University of Bristol

Medicine

Prof. S.L. Lightman University of Bristol

Motion Pictures/ Media and Publishing/ Television and Radio/ Communications

Uma Dinsmore Goldsmiths College, London **Music**

Dr Derrick Puffett *University of Cambridge* **Mythology**

Dr Allan Griffiths University College London

Philosophy/ Computing

Prof. Ron Chrisley *University of Sussex*

Physics

Prof. John Gribbin University of Sussex

Politics

Prof. Brian Barry London School of Economics and Political Science

Psychology/ Psychiatry

Prof. Margaret Boden University of Sussex

Religion

Prof. Colin Gunton Kings College London

Sport

Bob Peach The Sports Council

Technology and Industrial Processes/ Engineering/ Material Science

Dr P.L. Domone University College London

EDITORIAL CREDITS

Peter Astley
Jill Bailey
John Bailie
Richard Bird
Richard Brzezinski
Ian Chilvers
Roy Carr
John O.E. Clark
Sean Connolly
Peter Cowie
Mike Darton
Stephanie Driver
Harry Drost
Roger Few

William Gould

Jane Alden

Neil Grant Miles Gregory Clare Haworth-Maden Tony Holmes William Houston Elisabeth Ingles Caroline Juler Louise B. Lang Jacqueline Lewis Keith Lye Angela Mackworth-Young Judith Millidge Eddie Mizzi Paulette Pratt Jenny Roberts A.T.H. Rowland-Entwistle

Tom Ruppel Jennifer Story Clint Twist Neil Wenborn Keith Wicks Richard Widdows John D. Wright Richard Wright lain Zaczek

Curriculum consultants

Duncan Hawley David J. McHugh Silvia Newton Brian Speed Jane Wheatley

PICTURE CREDITS

Bridgeman Art Library /Belvoir Castle, Leicestershire 315, /British Museum, London 513 top right, /Christie's, London 699 bottom, /Crown Estate, Institute of Directors, London 216 bottom right, /Fitzwilliam Museum, University of Cambridge 643, 715 top, /Giraudon /Louvre, Paris 156 top, /Glasgow Art Gallery and Museum 201, /Guildhall Art Gallery, Corporation of London 472 bottom right, /Guildhall Library, Corporation of London 468, /Historisches Museum der Stadt, Vienna 75, /Index /Prado, Madrid 96 bottom right, 219 /Index /Private Collection / © Demart Pro Arte BV/DACS 1997, 196 bottom right, /Kunsthistorisches Museum, Vienna 125, /Art Institute of Chicago, USA 21, /Philip Mould, Historical Portraits Ltd, London 231 bottom right, 651 top right, /Musee d'Orsay, Paris 565 right, /Musee de la Tapisserie, Bayeux, with special authorisation of the city of Bayeux /Giraudon 72, /Nasjonalgalleriet, Oslo/The Munch Museum/The Munch-Ellingsen Group/DACS 1997 463 bottom, /National Museum of Wales, Cardiff 142, /National Palace, Mexico City 571 bottom right, /Novosti 393 top right, /Palazzo Medici-Riccardi, Florence 437, /Private Collection/ARS, NY and DACS. London 1997 2, 306, 452 top left, /Rafael Valls Gallery, London 531 right, /Schloss Immendorf, Austria 375, /Solomon R Guggenheim Museum, New York/ADAGP, Paris and DACS, London 1997 367, /Tate Gallery, London 577, /The Trustees of the Weston Park Foundation 321, /Vatican Museums and Galleries, Rome 443, /Wilhelm Lehmbruck Museum, Duisburg 484 bottom left.

Hulton Getty Picture Collection 79, 89, 92, 130, 144,145 bottom right, 158, 180

bottom right, 193 top right, 203 top left, 211 top right, 220 top left, 227 top right, 234, 238, 249 top right, 269, 275, 293 top right, 301 top right, 314 top left, 328 top left, 334 bottom left, 364, 369, 373 bottom right, 382, 383, 400 left of centre, 431 top right, 439 top right, 440 top left, 457 bottom right, 480 top left, 495 bottom right, 502 top left, 509 top right, 514, 542 left, 548 top left, 550 top left, 552 top left, 582, 587 bottom right, 591, 598 top left, 608, 641 bottom, 673 top right, 724, 725, 730, 735 top, 744. Picture Bank 4, 16 bottom, 26 bottom, 256 bottom left, 460, 479 top right, 479 bottom right, 503 bottom left, 552 bottom left, 638 top left, 641 top, 655 top right, 675. Rex Features 24, 26 top right, 73, 80, 154, 168 right of centre, 181, 184 top left, 203 bottom right, 207, 247, 255 bottom right, 263 bottom, 273 right of centre, 277, 284 top left, 291, 307, 311 bottom, 311 top right, 312 top left, 314 bottom, 319, 320 bottom, 355 right of centre, 360, 370, 385 top left, 390, 395 bottom, 419 bottom right, 420 left of centre, 433, 456, 522 top right, 527 left, 562 top right, 569 bottom right, 573 top right, 579 bottom right, 601, 605, 609 top right, 613 bottom right, 634 top left, 638 bottom, 648 bottom left, 659 bottom right, 663 bottom right, 700, 714 bottom, 735 bottom, /Action Press 519 top right, /Stephen Barker 18, /Michel Boudin 112 top. /Mark Brewer 305 top right, /Peter Brooker 261 bottom left, /Paul Brown 322 top, /Julian Calder 666, /David Cole 200, /Frederick de Klerk 425 right of centre, /Delahaye 138, /Demulder 34, /Doc Pele 392 top left, /Farnood 557 bottom right, /Fotex /Zone 5 199 top right, /Richard Gardner 217, /Gilson 489, /Grande 276 top left, /Chris Harris 685 bottom right, /David Hartley 164 top, /Percy Hatchman 719, /Peter Heimsath 39 bottom right, /Nils Jorgensen 88 bottom, /JSU/Sutton-Hibert 543, /Charles Knight 621 bottom right, /Dave Lewis 297, 479 centre right, /Miladinovic 310 left of centre, /NASA 327, /Rangefinders 350, /Larry Reider 135 bottom right, /Lehtikuva Oy 629/Tim Rooke 292 above centre, 588, /Setboun 330 top left, /Sichov 374 bottom, 623, /Sipa Press 57 top right, 143, 157 top, 170, 177 bottom right, 203 top right, 222 top left, 259 bottom, 330 bottom left, 344, 409, 469 bottom right, 491, 570 bottom left, /Stills 406, /SUU/Joffet 103 top, /Today 386, /Trippett 556, 561 bottom right, /Scott Wachter 362, /Gerry Whitmont 245, /Geoff Wilkinson 596, /Richard Young 417, 696 bottom. Science Photo Library 732, /CERN, P. Loiex 110.

Front Jacket: bottom right: Rex Features/David Hartley Technology Illustrations Ted McCausland

Aachen (Aix-la-Chapelle) City in sw North Rhine-Westphalia, w Germany. The city is noted for its hot sulphur baths, used by the Romans and the hottest in N Europe. It was the site of medieval imperial diets and the coronations of the monarchs of the Holy Roman Empire from 1349 to 1531. The local economy is dominated by manufacturing. Industries: iron and steel, machinery, textiles. Pop. (1993) 246,100. **Aalto, Alvar** (1898–1976) Finnish architect and furniture designer, famous for his imaginative handling of floor levels and use of natural materials and irregular forms. His work includes the municipal library at Viipuri (1927–35), the Baker House at the Massachusetts Institute of Technology (1947–49), the Säynätsalo town hall complex (1950–52) and Finlandia House, Helsinki (1967–71). See also INTERNATIONAL STYLE

aardvark Nocturnal, bristly haired mammal of central and southern Africa. It feeds on termites and ants, which it scoops up with its sticky 30cm (12in) tongue. Length: up to 1.5m (5ft); weight: up to 70kg (155lb). It is the only representative of the order *Tubulidentata*.

Aaron Brother of Moses chosen by God to be the first Jewish high priest. According to the biblical book of Exodus, he helped to obtain the release of the Israelites from slavery in Egypt. He lapsed into idolatry, and made a golden calf for the people to worship, but was later restored to divine favour.

Aaron, Hank (Henry Louis) (1934–) US baseball player. Aaron was one of the first African-Americans to play in a major league when he joined (1954) the Milwaukee (later Atlanta) Braves of the National League. In 1974 he surpassed Babe RUTH's major-league career home run record of 714. In 1976 Aaron retired from playing, having scored a world record of 755 home runs. He was elected to the Baseball Hall of Fame in 1982.

abacus Archaic mathematical tool used since ancient times in the Middle and Far East for addition and subtraction. One form of abacus consists of beads strung on wires and arranged in columns.

abalone Seashore gastropod *mollusc* with a single flattened spiral shell perforated by a row of respiratory holes; it is found on Mediterranean, Atlantic and N Pacific shores and off the coasts of South Africa and Australia. Length: to 30cm (12in). Family Haliotidae; species include *Haliotis rufescens*. **Abbado, Claudio** (1933–) Italian conductor. In 1971 he was made principal conductor of the Vienna Philharmonic Orchestra, he was musical director at LA SCALA in Milan (1972–86), and of the London Symphony Orchestra (1983–88). He has been music director of the Berlin Philharmonic Orchestra since 1989.

Abbas I (the Great) (1571–1629) Shah of Persia (1588–1629). The outstanding ruler of the SAFAVID dynasty, he restored Persia as a great power, waging war successfully against the invading Uzbeks and Ottoman Turks and recapturing Hormuz from the Portuguese. Tolerant in religion, he encouraged Dutch and English merchants and admitted Christian missionaries. He made ISFAHAN his capital and turned it into one of the world's most beautiful cities.

Abbasid Muslim CALIPH dynasty (750–1258). They traced their descent from al-Abbas, the uncle of MUHAMMAD, and came to power by defeating the UMAYYADS. The Abbasids moved the caliphate from Damascus to Baghdad in 862, where it achieved great splendour. From the 10th century Abbasid caliphs ceased to exercise political power, becoming religious figureheads. After the family's downfall in 1258, following the fall of Baghdad to the Mongols, one member was invited by the MAMELUKE sultan to Cairo where the dynasty was recognized until the 16th century.

abbey Complex of buildings that constitute a religious community, the centre of which is the abbey church. Since the decline of MONASTICISM often only the church remains.

Abbey Theatre Theatre erected on Abbey St, Dublin (1904), by Annie E.F. Horniman to house the Irish National Theatre Society. In 1925 the Abbey became the National Theatre of Ireland. Works by W.B. YEATS, Lady Gregory, J.M. SYNGE, and Sean O'CASEY have been introduced here and the Theatre is renowned for its support of new writers.

Abd al-Kadir (1808–83) Algerian leader and emir of Mas-

cara. Between 1832 and 1839 he displaced the French and Turks from N Algeria, and then launched a holy war against the French. After four years of fighting, he was forced to retreat to Morocco, where he enlisted the support of the sultan. Abd al-Kadir and his Moroccan forces were defeated at Isly (1844). He was imprisoned in France (1847–52).

Abdullah (1882–1951) King of Jordan (1946–51), son of Hussein. In 1921, after aiding Britain in World War 1, he became emir of Transjordan. He lost control of Hejaz to Ibn Saud. In World War 2 he resisted the Axis. He fought Israel, annexed land, and signed an armistice (1949). He was assassinated in Jerusalem, and Talal ascended the throne.

Abélard, Pierre (1079–1142) French philosopher, noted for his application of LOGIC in approaching theological questions. In his famous work *Sic et Non* he attempted to reconcile differences between the Fathers of the Church by using the Aristotelian method of DIALECTIC. His views were condemned by the Council of Sens (1140). He is perhaps best known for the tragic love affair with his young female pupil Héloise. The affair scandalized Abélard's contemporaries. He was castrated and became a monk, while Héloise was forced to enter a convent. These events inspired Abélard's work *Historia Calamitatum Mearum*.

Aberdeen City and seaport in NE Scotland, called "the Granite City" after its famous grey granite architecture. Aberdeen has gained considerably in importance since the development of the North Sea oilfields in the late 1970s. It is also the centre of the waning Scottish fishing industry. Pop. (1991) 204,885.

aberration In physics, defect in lens and mirror images arising when the incident light is not at or near the centre of the lens or mirror. **Spherical** aberration occurs when rays falling on the periphery of a lens or mirror are not brought to the same focus as light at the centre; the image is blurred. **Chromatic** aberration occurs when the wavelengths of the dispersed light are not brought to the same focus; the image is falsely coloured.

aberration of light Apparent slight change of position of a star due to the effect of the Earth's orbital motion on the direction of the light's arrival. A telescope must be inclined by an angle of up to about 20° to compensate for it. Aberration of light was discovered in 1728 and used to prove the Earth orbits the Sun.

Abidjan Former capital of the Ivory Coast (and the largest city in w Africa) situated on the Ebrié Lagoon, inland from the Gulf of Guinea. Ivory Coast's chief port and commercial centre, it was founded by French colonists at the end of the 19th century. Although it lost capital status to YAMOUSSOUKRO in 1983, Abidjan remains a lively, cultural city and is a popular tourist resort. Other industries: textile manufactures, sawmilling. Pop. (1988) 1,929,079.

Abkhazia Autonomous republic on the Black Sea coast of GEORGIA; the capital is Sukhumi. The area was conquered by Romans, Byzantines, Arabs and Turks before becoming a Russian protectorate in 1910. It was made a Soviet republic in 1921 and an autonomous republic within Georgia in 1930. After the establishment of an independent Georgia, the Abkhazian parliament declared independence in 1992. The following year Abkhazian forces seized the capital. In May

■ aardvark Found throughout much of Africa, the termite-eating aardvark (*Orycteropus afer*) is a shy, nocturnal animal. Its presence may be detected by the

large burrows it digs, using the

hoof-like claws on its front feet.

A/a, first letter of the Roman alphabet. It evolved from the ancient Egyptian hieroglyph representing the head of an ox through the Hebrew word aleph, meaning ox, to the Greek alpha.

1994 a cease-fire deployed 2,500 peacekeeping Russian soldiers, and in November a new constitution proclaimed Abkhazian sovereignty. Its independent status was confirmed by a new Georgian constitution in 1995. Tobacco, tea, grapes and citrus fruits are the main crops. Area: 8,600sq km (3,320sq mi). Pop. (1990) 537,500.

abolitionist Person who sought to end SLAVERY. In the US and the UK, the abolitionist movement was particularly active in the early 19th century. In the US, the American Anti-Slavery Society was formed in 1833, while in the UK, William WILBERFORCE headed the movement that led to the cessation of Britain's role in the slave trade in 1807.

aborigines Strictly, the indigenous inhabitants of a country. The term is usually applied to NATIVE AUSTRALIANS.

abortion Loss of a fetus before it is sufficiently advanced to survive outside the UTERUS; commonly called a miscarriage. A medical abortion is the termination of pregnancy by drugs or surgery. The rights of the fetus and the mother's right to choose provoke much political and ethical debate.

Abraham In the Old Testament, progenitor of the Hebrews and founder of Judaism. God tested his loyalty by demanding he sacrifice his son, ISAAC. He is esteemed by Muslims who regard him as the ancestor, through his son ISHMAEL, of the Arabs.

abrasive Hard and rough substances used to grind and polish surfaces. Some abrasives are used as fine powders, others in larger fragments with sharp cutting edges. Most natural abrasives are minerals.

Absalom In the Old Testament, third and favourite son of King DAVID. A youth of uncontrollable arrogance, he murdered his brother Amnon, led a rebellion against David and was routed. Trapped in flight when his hair became entangled in the branches of an oak, he was killed by David's general Joab.

abscess Collection of pus anywhere in the body, contained in a cavity of inflamed tissue. It is caused by bacterial infection.

absolute zero Temperature at which all parts of a system are at the lowest energy permitted by the laws of QUANTUM

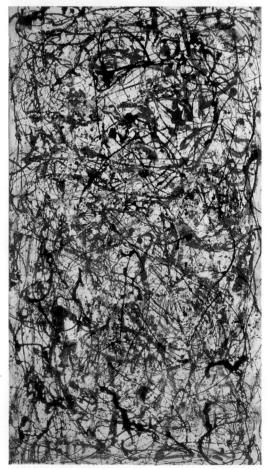

Black and White (1948) by Jackson Pollock. Pollock's "action painting" is often regarded as the quintessential form of abstract expressionism. It was the first US art movement to influence European trends

▶ abstract expressionism

MECHANICS; zero on the Kelvin temperature scale, which is -273.16°C (-459.67°F). At this temperature the system's ENTROPY, its energy available for useful work, is also zero, although the total energy of the system may not be zero.

absolution Formal rite carried out by a Christian priest in which repentant sinners are forgiven the sins they have confessed. The rite is based on the authority given by Christ to his apostles to forgive sins (John 20). See also CONFESSION; PENANCE

absolutism Government with unlimited power vested in one individual or group. The term is primarily used to describe 18th-century European monarchies that claimed a divine hereditary right to rule.

absorption Taking up chemically or physically of molecules of one substance into another. The absorbed matter permeates all of the absorber. This includes a gas taken in by a liquid and a liquid or gas absorbed by a solid. The process is often utilized commercially, such as the purification of natural gas by the absorption of hydrogen sulphide in aqueous ethanolamine. See also ADSORPTION

abstract art Art in which recognizable objects are reduced to schematic marks. Although abstraction was evident in the IMPRESSIONISM, neo- and POST-IMPRESSIONISM movements of the late 19th century, a separate identity did not become established until the early 20th century. Its most radical form is called non-objective or non-iconic art. In this, the artist creates marks, signs, or three-dimensional constructions which have no connection with images or objects in the visible world. There are two main types of non-objective art: EXPRESSIONISM, which is fundamentally emotional, spontaneous and personal; and geometrical, which works from the premise that geometry is the only discipline precise and universal enough to express our intellectual and emotional longings. Art historians often credit Wassilv KANDINSKY with being the first to explore expressionist abstraction in 1910. It was Kandinsky's influence that inspired the BLAUE REITER group, and his work which helped to pave the way towards ABSTRACT EXPRESSIONISM, ACTION PAINTING and Tachism. Geometrical abstraction found its most adept, early exponents in Russia, c.1913. The pioneers included Kasimir MALEVICH, who invented SUPREMATISM, and El LISSITZKY, a leading proponent of CONSTRUCTIVISM. They developed what amounted to prototype virtual realities in two and three dimensions (some even claimed they could represent the fourth dimension). The French Section d'Or worked in parallel to the Russians. Other individuals who provided landmarks in geometrical abstraction include Piet Mondrian, Naum GABO and Ben NICHOLSON; influential movements include De STIJL and concrete art.

abstract expressionism Mainly US art movement in which the creative process itself is examined and explored. It is neither wholly abstract nor wholly expressionist. One of the most influential of all 20th-century North American art movements, the term originally applied to paintings created (1945-55) by about 15 artists from the New York School. Although very different in temperament and style, these individuals shared a fascination with SURREALISM and "psychic automatism" as well as other progressive European styles. Towards the early 1950s, two distinct groups emerged with Willem DE KOONING and Jackson POLLOCK heading the most aggressive trend (loosely known as ACTION PAINTING), which involved dripping or throwing paint on the canvas. Barnett NEWMAN, Ad Reinhardt and Mark ROTHKO were more contemplative.

Absurd, Theatre of the Dramatic and literary critical term developed in the early 1960s from the philosophy of Albert CAMUS to describe discordant human experience in an inhuman world. Exponents include Samuel BECKETT, Eugène IONESCO, Jean GENET and Edward ALBEE. Such drama attempts to abandon logical, linguistic processes. The connection between language and meaning is fractured (often by the use of repetition) and dramatic characters appear dislocated from their surroundings. Beckett's play Waiting for Godot (1952) is a classic of the genre.

Abu Bakr (573-634) First Muslim CALIPH (632-34). One of

the earliest converts to Islam, Abu Bakr was chief adviser to the Prophet Muhammad. After Muhammad's death he was elected leader of the Muslim community. During his short reign, he defeated the tribes that revolted against Muslim rule in Medina and restored them to Islam. By invading the Byzantine Christian provinces of Syria and Palestine and the Persian province of Iraq, he launched the series of Holy Wars through which the first major expansion of Islam was accomplished.

Abu Dhabi (Abu Zaby) Largest and wealthiest of the seven UNITED ARAB EMIRATES, lying on the s coast of the Persian Gulf. Also the name of its capital city (1984 pop. 242,975), federal capital of the UAE. It has been ruled since the 18th century by the Al-bu-Falah clan of the Bani Yas tribe. There are long-standing frontier disputes with Saudi Arabia and Oman. Since the discovery of oil in the late 1950s, Abu Dhabi's economy has been based almost entirely on crude oil production. It has an international airport and a modern container port. Area: 67,340sq km (26,000sq mi). Pop. (1985) 670,125.

Abuja Nigeria's administrative capital since December 1991. The new city was designed by the Japanese architect Kenzo Tange, and work began in 1976. Government offices began moving in the 1980s to relieve pressure on the infrastructure of LAGOS. Pop. (1992 est.) 305,900.

Abu Simbel Ancient Egyptian village on the w bank of the Nile River, near the border with Sudan; the location of two rock-cut sandstone temples built by RAMSES II (c.1292–1225 BC). In a huge operation (1963–66), the temples and statuary were moved further inland. This was to prevent their disappearance under the waters of Lake Nasser, created by the construction of the new ASWAN High Dam.

abyssal zone Division of the ocean that begins at about the 2,000-m (6,600-ft) depth and includes the rest of the deep ocean. The water temperature ranges from -1° C to 5° C (30–40°F). The zone has no light so there are no seasons and no plants, but there are many forms of life, such as glass sponges, crinoids (sea lilies), and brachiopods (lamp shells). The bottom is covered by deposits of biogenic oozes formed by the remains of microscopic plankton, and non-biogenic sediments (red clavs).

acacia (mimosa) Evergreen shrubs and trees widely distributed in tropical and subtropical regions, especially Australia. They have compound leaves made up of many small leaflets, and yellow or white flowers. Height: 1.2–18m (4–59ft). Family Leguminosae; genus *Acacia*.

Académie Française Official French literary society, now part of the Institut de France. Originating as a private discussion group whose members were persuaded by Cardinal RICHELIEU to become an official body in 1635, the society is the guardian of the French language and of literary conventions. Past members have included many of the giants of French literature, such as RACINE, VOLTAIRE and HUGO.

Academy School of philosophy founded (*c*.387 BC) by PLATO. Plato met his pupils, including ARISTOTLE in a garden outside Athens, said to have belonged to a Greek hero called Academus. Academies were founded in Europe, notably in the Renaissance era. By the 18th century they had become known generally as universities, but the name continues to be applied to scholarly institutions.

Academy Award See OSCAR

acanthus Perennial plant with thistle-like leaves, found in Africa, the Mediterranean region, India and Malaysia. It has lobed, often spiny leaves and white or coloured flower spikes. The pattern of the leaves is a common classical architectural motif. Family Acanthaceae

Acapulco (Acapulco de Juárez) City on the sw coast of Mexico. Founded in 1550, it was for 250 years an important port on the Manila galleon route linking Spain and the Philippines. Now the country's most famous Pacific resort, it is noted for beautiful scenery, deep-sea fishing and luxurious hotels. The port exports cotton, fruit, hides and tobacco. Pop. (1990) 593,212.

acceleration Amount by which the VELOCITY of an object increases in a certain time. It can be found by applying the equation acceleration = (change in velocity)/(time taken for change). It is measured in metres per second per second (m/s²).

■ accordion Invented in the 1820s, the accordion is a reed organ working along the same principle as the mouth organ — that is a separate reed is provided for each note. Air is forced through the reeds by bellows that form the centre of the instrument. The right hand plays the melody on the keyboard, while the left hand operates the buttons for accompanying chords.

accelerator, particle Machine for increasing the energy of charged particles by increasing their speed. Accelerators are used mostly in PARTICLE PHYSICS' experiments, in which highenergy particles are forced to collide with other particles. The way the fragments of particles behave following the collision provides physicists with information on the forces found within atoms. In a linear accelerator, the particles travel in a straight line. The world's longest is 3.2km (2mi) long. In a cyclotron, particles are acclerated in a spiral path between pairs of D-shaped magnets with an alternating voltage between them. A synchrocyclotron synchronizes the accelerating electric current to the time it takes to make one revolution. The CERN synchrotron accelerator in Geneva, Switzerland, has a circumference of 27km (16.7mi).

accessory In law, person associated with a criminal act. An accessory before the fact consults, encourages and advises the criminal. An accessory after the fact is one who, with knowledge of a crime, receives or assists the criminal.

accomplice In law, person associated with another or others in the commission of a crime. Unlike an ACCESSORY, an accomplice generally takes an active part in the crime.

accordion Musical instrument of the reed organ type. It has an organ-like tone produced by air from the bellows vibrating reeds. The melody is played on a piano-type keyboard with chordal accompaniment controlled by buttons. It was invented in 1822 and is widely used in folk music. It has also been used in some classical music.

accountancy Profession that assesses and produces financial information for and about a company or individual for the benefit of the company's management, the investing public and official tax and financial regulatory authorities. *See also* BOOK-KEEPING

Accra Capital and largest city of Ghana, on the Gulf of Guinea. Occupied by the Ga people since the 15th century, it became the capital of Britain's Gold Coast colony in 1875. Today it is a major port and economic centre, the site of the University of Ghana (founded 1948), and the headquarters of the Defence Commission of the Organization of African Unity (OAU). Industries: engineering, timber, textiles and chemicals. The principal export is cacao. Pop. (1988 est.) 949,113.

accumulator (secondary cell, storage battery) Voltaic cell (BATTERY) that can be recharged. The most common car battery is a lead-acid accumulator.

acetaldehyde See ETHANAL

acetate (ethanoate) Salt or ester of acetic (ethanoic) acid. It is used in synthetic acetate fibres, in lacquers and in acetate film. **acetone** (propanone) Colourless flammable liquid (CH₃COCH₃) made by oxidizing isopropyl alcohol. It is a raw material for the manufacture of many organic chemicals and is a widely used solvent. Properties: r.d. 0.79; m.p. -94.8° C (-138.6° F); b.p. 56.2° C (133.2° F).

acetylene See ETHYNE

Achaemenid Ruling dynasty of the first Persian Empire, which stretched from the River Nile as far E as modern Afghanistan. The dynasty was founded by Cyrus the Great (r.559–529 BC) and named after his ancestor, Achaemenes. Its last ruler, Darius III (r.336–330 BC), was defeated by ALEXANDER THE GREAT.

Achebe, (Albert) Chinua (Chinualumogu) (1930–) Nigerian novelist. Achebe's work deals primarily with the search for identity in modern Africa and explores the effects of cultural change. His highly acclaimed first novel, *Things Fall Apart* (1958), depicts life in an African village before and after the arrival of missionaries. He received the Nobel Prize for literature in 1989. Other works include *No Longer at Ease* (1960), *Arrow of God* (1964) and *Anthills of the Savannah* (1987). The volume of poems *Beware Soul Brothers* (1971) deals with Achebe's experience of the Nigerian civil war.

Acheson, Dean (1893–1971) US statesman, secretary of state (1949–53) under Harry S Truman. Acheson's desire to restrict the growth of communism was fundamental to the establishment of the North Atlantic Treaty Organization (NATO), the ANZUS Pact and the Marshall Plan. He was criticized for his lack of support for the new state of Taiwan and his advocacy of US military involvement in South Korea. Achilles In the Greek epic tradition, a formidable warrior, the most fearless Greek fighter of the Trojan War and the hero of Homer's *Iliad*. Legend held him invulnerable from weapons because he had been dipped by his mother, Thetis, in the River Styx at birth, except for the heel by which he was held. Achilles sought glory fighting at Troy, but an arrow shot by Paris struck his heel and killed him.

Achilles tendon Strong band of elastic connective tissue at the back of the ankle. One of the largest tendons in the body, it connects the calf muscles to the heel bone. The spring provided by this tendon is very important in walking, running and jumping.

acid Chemical compound containing hydrogen that can be replaced by a metal or other positive ION to form a SALT. Acids dissociate in water to yield aqueous hydrogen ions (H⁺), thus acting as proton donors. The solutions are corrosive, have a sour taste, and have a PH below 7. Strong acids are fully dissociated into ions whereas weak acids are only partly dissociated. *See also* BASE

acidosis Abnormal condition in which the acidity of the body tissues and fluids is unduly high. It may arise in a number of conditions, including kidney failure, severe diabetes, shock and some forms of poisoning. Symptoms include breathlessness, weakness and general malaise.

acid rain Rain that is highly acidic because of sulphur oxides, nitrogen oxides, and other air pollutants dissolved in it. Acid rain may have a pH value as low as 2.8. Acid rain can severely damage both plant and animal life. Certain lakes, for example, have lost all fish and plant life because of its toxic effects. acne Inflammatory disorder of the sebaceous (oil-producing) glands of the SKIN resulting in skin eruptions such as blackheads and infected spots; it is seen mostly on the face, neck, back and chest. Acne is extremely common in both sexes at PUBERTY, but is usually more pronounced in boys. It does not usually persist beyond early adulthood.

Aconcagua Mountain in the Andes range on the border between Argentina and Chile. The highest peak outside Asia at 6,960m (22,834ft), the snow-capped extinct volcano was first climbed in 1897 by Edward Fitzgerald's expedition. The western slopes are in Chile, but the summit lies wholly in Argentina. The River Aconcagua rises at its NW foot and enters the Pacific N of Valparaiso.

acorn Fruit of an OAK tree

acoustics Study of sound, especially the behaviour of

sound waves. Experts apply acoustics to the design of concert and lecture halls, microphones, loudspeakers and musical instruments. Audiologists use acoustics to assess degrees of abnormality in the hearing of their patients. See also ANECHOIC CHAMBER

Acquired Immune Deficiency Syndrome (AIDS) Fatal disease caused by a retrovirus, called Human Immunodeficiency Virus (HIV), that renders the body's IMMUNE SYSTEM incapable of resisting infection. The first diagnosis was in New York in 1979. In 1983-84 scientists at the Pasteur Institute in France and the National Cancer Institute in the USA isolated HIV as the cause of the disease. The virus can remain dormant in infected cells for up to 10 years. Initial AIDS-related complex (ARC) symptoms include severe weight loss and fatigue. It may develop into the AIDS syndrome, characterized by secondary infections, neurological damage and cancers. AIDS is transmitted only by a direct exchange of body fluids. Transmission is most commonly through sexual intercourse, the sharing of contaminated needles by intravenous drug users, and the uterus of infected mothers to their babies. Before effective screening procedures were introduced many haemophiliacs were infected through transfusions of contaminated blood. In the USA and Europe, over 90% of victims have been homosexual or bisexual men. However, 90% of reported cases are in the developing world and many victims are heterosexual. Recent combinations of drugs have met with some success in controlling symptoms. By 1996 over 6.4 million people had died from AIDS.

acre Unit of area measurement in English-speaking countries, equal to 0.405ha (4,840sq yd).

acropolis Hill-top fortress of an ancient Greek city. The earliest known examples were fortified castles built for the Mycenaean kings, and it was only later that they became the symbolic homes of the gods. The most famous acropolis, in Athens, had walls by the 13th century BC, but the Persians destroyed the complex and the surviving buildings date from the late 5th century BC. They include the PARTHENON, the Erechtheion, the Propylaea and the Temple of Athena Nike.

acrylic Type of plastic, one of a group of synthetic, short-chain unsaturated carboxylic acid derivatives. Variations include hard and transparent, soft and resilient, or liquid forms. They are used for moulded structural parts, adhesives and paints.

actinide series Group of radioactive elements with similar chemical properties. Their atomic numbers range from 89 to 103. Each element is analogous to the corresponding LANTHANIDE SERIES (rare-earth) group. The most important of the group is uranium. Those having atomic numbers greater than 92 are the TRANSURANIC ELEMENTS.

actinium (symbol Ac) Radioactive metallic element, the first of the ACTINIDE SERIES, discovered in 1899 by the French chemist André Debierne. It is found associated with uranium ores. Ac²²⁷, a decay product of U²³⁵, emits beta particles (electrons) during disintegration. Properties: at.no.89; r.d.10.07 (calc.); m.p. 1,100°C (1,900°F); b.p. 3,200°C (5,800°F); most stable isotope Ac²²⁷ (half-life 21.8 yr).

action painting Act and result of applying paint spontaneously. A dynamic style, it gained momentum in 1952 when painters such as Willem DE KOONING and Jackson POLLOCK moved away from ABSTRACT EXPRESSIONISM to make pictures with spontaneous gestures, such as dripping and pouring paint onto their canvases. Its purpose is to stimulate vision and to show a record of passing emotions. Other practitioners include Alan Davie and Robert MOTHERWELL.

action potential Change that occurs in the electrical potential between the outside and the inside of a nerve fibre or muscle fibre when stimulated by the transmission of a nerve impulse. At rest the fibre is electrically negative inside and positive outside. When the nerve or muscle is stimulated, the charges are momentarily reversed.

Actium, Battle of (31 BC) Naval battle in which the fleet of Octavian (later AUGUSTUS), commanded by Marcus Vipsanius AGRIPPA, defeated the fleets of Mark ANTONY and CLEOPATRA. Mark Antony's army surrendered a week later, and Octavian became sole ruler of the Roman empire.

▶ acropolis The fortified high point of many Greek cities, the most famous acropolis is that of Athens. It is dominated by the Parthenon, one of the world's most impressive structures. Built as an expression of Athens' supremacy, it housed a vast ivory and gold statue of Athena, the Greek goddess of war, wisdom and the arts.

active transport Energy-requiring process by which molecules or ions are transported across the membranes of living cells against a concentration gradient. It is particularly important in the uptake of food across the gut lining, in the reabsorption of water and salts from the urine in the kidney before excretion, and in the uptake of minerals by the plant root. Active transport enables cells to maintain an internal chemical environment which is of a different composition from that of their surroundings.

act of Congress Statute adopted by the US Congress. It overrides conflicting legislation from any other source, though the SUPREME COURT may rule that an act of Congress is unconstitutional.

act of Parliament Statute created in Britain when a bill, having passed through various stages in both the HOUSE OF COMMONS and HOUSE OF LORDS, receives the royal assent. Embodying the supreme force of British law, an act remains in force until it is repealed by Parliament.

Act of Union See Union, ACTS OF

Actors' Studio Theatre workshop founded (1947) in New York by Elia Kazan, Cheryl Crawford and Robert Lewis. It is noted for a "method" approach to acting, developed by Lee Strasberg. In the 1960s it also produced plays on Broadway. An enduring and influential workshop, its students include Marlon Brando, Dustin Hoffman and Robert DE NIRO.

Acts of the Apostles Book of the New Testament describing the spread of the Gospel of Christ immediately after his death and resurrection. It mainly focuses on St Peter and St Paul. The book was probably written c.65 AD by the author of the gospel of St Luke.

acupuncture System of medical treatment in which long needles are inserted into the body to assist healing, relieve pain or for anaesthetic purposes. Of ancient Chinese origin, it enables surgery to be done with the patient conscious and free of pain. It has so far defied scientific explanation.

ACV See AIR-CUSHION VEHICLE (ACV)

Adam In the Old Testament (Genesis 2), first man and progenitor of all mankind, created from dust by God in his own image. He and his wife EvE were cast out of the Garden of EDEN to become mortal after they ate forbidden fruit from the Tree of the Knowledge of Good and Evil.

Adam, Robert (1728–92) Scottish architect, best known of four brothers all of whom were architects. Adam was the greatest British architect of the late-18th century and his refined neoclassical style was widely influential. He was also a brilliant interior decorator and furniture designer. The vast Adelphi complex, London (begun 1768) was his most ambitious project. His interior designs include Kenwood House, London (1767) and Syon House, Middlesex (1762–69).

Adams, Ansel (1902–84) US photographer. Adams' first book, *Taos Pueblo* (1930), established his reputation for photos of the grand landscapes of sw USA, especially Yosemite Valley and the High Sierra. Adams was a co-founder of the influential *f*/64 Group and helped to found the first photographic department in a museum at the Musuem of Modern Art, New York City. He also wrote *Basic Photo-Books*, a classic series of technical manuals.

Adams, Brooks (1848–1927) US historian. Brother of Henry Brooks Adams, his influential book *Law of Civilization and Decay* (1895) held that civilizations rise and fall with the growth and decline of commerce. In *America's Economic Supremacy* (1900), Adams predicted the decline of Western Europe and proposed that within 50 years only the USA and Russia would be great powers.

Adams, Gerry (1948–) Northern Irish politician, president of SINN FÉIN (1983–). Adams was interned (1972–78) by the British for his involvement in the IRISH REPUBLICAN ARMY (IRA). He was vice president (1978–83) of Sinn Féin. Adams is seen as a pivotal figure between the "ballot box" and "bullet" factions of the Republican movement. Adams served (1983–92, 1997–) as MP for Belfast West, but refused to take his seat at Westminster. His negotiations with John HUME led to an IRA cease-fire (1994). He headed the Sinn Féin delegation in the 1997 peace talks, and became the first Republican leader to meet a British prime minister since 1921.

The various honeycreepers of Hawaii in the Pacific evolved from one species of bird now long extinct (centre). Over millions of years the honeycreepers evolved different methods of feeding. This ensured the island's various habitat niches could be exploited, resulting in less

competition among the birds and therefore allowing more to survive. The main adaptation was the dramatic change in the shape of the beaks. A few species evolved beaks best suited to feed on nectar (1), others feed purely on insects (2), while some feed on fruit (3) or seeds (4).

Adams, Henry Brooks (1838–1918) US historian and writer. A direct descendant of John Adams and John Quincy Adams, his best-known work is *The Education of Henry Adams* (1907), an ironic analysis of a technological society.

Adams, John (1735–1826) Second US president (1797–1801). Influenced by his radical cousin Samuel Adams, he helped draft the DECLARATION OF INDEPENDENCE (1776) and the Treaty of Paris (1783) which ended the AMERICAN REVOLUTION. Adams was George WASHINGTON's vice president (1789–97). His presidency was marked by conflict between the FEDERALIST PARTY led by Alexander HAMILTON and Thomas JEFFERSON'S DEMOCRATIC REPUBLICAN PARTY. Adams' moderate stance enabled a negotiated settlement of the XYZ AFFAIR (1797–98). He reluctantly endorsed the ALIEN AND SEDITION ACTS (1798). He was succeeded by Thomas Jefferson.

Adams, John (1947-) US composer. Influenced by composers such as John CAGE and Morton FELDMAN, Adams' work is a fusion of electronics, jazz and MINIMALISM. He won a Grammy Award (1989) for his opera Nixon in China (1987). Adams, John Quincy (1767-1848) Sixth US president (1825-29), son of the second president John ADAMS. Adams served in his father's administration, before acting (1803–08) as FEDERALIST PARTY representative in the US senate. Adams was secretary of state (1817-24) for James Monroe. He was largely responsible for formulating the MONROE DOCTRINE and negotiating the ADAMS-ONÍS TREATY (1819). Adams became president without an electoral majority, his appointment confirmed by the House of Representatives. Adams' lack of a mandate and non-partisan approach contributed to his electoral defeat by Andrew Jackson. Adams served in the House of Representatives (1830-48).

Adams, Samuel (1722–1803) US politician, chief spokesman for the AMERICAN REVOLUTION. As a member of the Massachusetts legislature (1765–74) Adams led resistance to British rule. He headed the "no taxation without representation" protest against the STAMP ACT (1765), and helped plan the BOSTON TEA PARTY (1773). Adams was a member (1774–81) of the CONTINENTAL CONGRESS. He and John ADAMS signed the DECLARATION OF INDEPENDENCE (1776).

Adams-Onís Treaty (1819) Agreement between the USA and Spain. Negotiated by secretary of state John Quincy Adams and Spanish minister Luis de Onís, Spain gave up its land E of the Mississippi River and its claims to the Oregon Territory; the US assumed debts of \$5 million and gave up claims to Texas.

adaptation Adjustment by a living organism to its surround-

► adrenal gland Located just above the kidneys (1), the two adrenal glands (2) are well supplied with blood entering from the aorta (3). Each gland consists of an outer layer (the cortex) and a central medulla. The cortex produces steroid hormones, and hormones involved in maintaining waterbalance, and small quantities of sex hormones. The medulla produces adrenaline and noradrenaline, both of which prepare the body for an emergency situation.

ings. Animals and plants adapt to changes in their environment through variations in structure, reproduction or organization within communities. Some such changes are temporary (acclimatization), while others may involve changes in the genetic material (DNA) and be inherited by offspring (EVOLUTION). The word is also used to describe a particular characteristic (such as body size, shape, colour, physiology or behaviour), that enables an organism to survive in its environment.

adaptive radiation In biology, the EVOLUTION of different forms of living organisms from a common ancestral stock, as different populations adapt to different environmental conditions or modes of life. Eventually the populations may become so different that they constitute separate species. Examples are the many different kinds of finches in the GALÁPAGOS ISLANDS, which diversified to specialize in different kinds of food, feeding methods and HABITATS. See also ADAPTATION

Addams, Jane (1860–1935) US social reformer. Addams shared the 1931 Nobel Peace Prize with Nicholas Murray Butler. In 1889 she founded Hull House, Chicago, an early social settlement house. She pioneered labour, housing, health and legal reforms, and campaigned for female suffrage, pacifism and the rights of immigrants.

adder Any of several snakes in various parts of the world, some poisonous and others harmless. The European viper (*Vipera berus*) is called an adder in Britain. The puff adder (*Bitis arietans*) is a large African viper, and the death adder (*Acanthophis antarticus*) is a dangerous Australian elapid.

addiction Inability to control the use of a particular substance, resulting in physiological or psychological dependence. It is most frequently associated with DRUG ADDICTION. In a medical context, addiction requires a physical dependence. When the dose of a drug is reduced or withdrawn, the addict experiences withdrawal syndromes. Psychological dependence on activities such as gambling or exercise are difficult to distinguish from a disorder or MANIA.

Addis Ababa (Amharic, "new flower") Capital and largest city in Ethiopia, located on a plateau at *c.*2,440m (8,000ft) in the highlands of Shewa province. Addis Ababa was made capital of Ethiopia in 1889. It is the headquarters of the Organization of African Unity (OAU). The university (1961) is noted for its museum of art and ethnology. Its most famous building is an eight-sided Coptic cathedral (1896). It is the main centre for the country's vital coffee trade. Industries: food, tanning, textiles, wood products. Pop. (1990 est.) 1,700,000.

Addison, Joseph (1672–1719) English essayist, poet and politician. Addison's poetic celebration of Marlborough's victory at the Battle of Blenheim, *The Campaign* (1704), led to a government appointment. He is chiefly remembered as a brilliant essayist. His stylish articles on literature, philosophy, politics and morals were a major reason for the success of the newly-established *Tatler* and *Spectator* periodicals. He was secretary of state (1717–18) and served as an MP (1708–19). addition reaction Chemical reaction in which two substances combine to form a third substance, with no other substance being produced. Addition reactions are most common-

ly used in organic CHEMISTRY, particularly by adding a simple molecule across a carbon-carbon double bond in an UNSATURATED COMPOUND. See also SUBSTITUTION

Adelaide Capital of the state of SOUTH AUSTRALIA, situated at the mouth of the River Torrens on the Gulf of St Vincent. Founded in 1836 and named after the wife of William IV, Adelaide is noted for its fine churches and cathedrals. There are two universities. The port provides facilities for an extensive hinterland and exports wool, fruit, wine and wheat. Adelaide is the venue for the Australian Grand Prix, and since 1960 has held a prestigious biennial arts festival. Industries: oil refining, machinery, motor vehicle assembly, electronics, chemicals, textiles. Pop. (1994) 1,076,400.

Aden Commercial capital and largest city of Yemen, historic capital of the Aden Protectorate (1937–67) and the former (southern) People's Democratic Republic of Yemen (1967–90). A seaport city on the Gulf of Aden, 160km (100 mi) E of the Red Sea, Aden was an important Roman trading port. With the opening of the SUEZ CANAL in 1869, its importance increased. It was made a crown colony in 1937 and the surrounding territory became the Aden Protectorate. When the (northern) Yemen Arab Republic and the (southern) People's Democratic Republic of Yemen combined to form the united Republic of Yemen in 1990, SANA'A became the official capital. Industries: cigarette manufacture, oil and salt refining. Pop. (1995) 562,000.

Adenauer, Konrad (1876–1967) German statesman, first chancellor of the Federal Republic of Germany (1949–63). He was Lord Mayor of Cologne (1917–33) and was twice imprisoned by the Nazis. He helped to create the Christian Democratic Union (CDU), West Germany's dominant postwar party, and was its leader (1946–66). Adenauer led West Germany into NATO (1955) and campaigned for the establishment of the European Economic Community.

adenoids Masses of LYMPH tissue in the upper part of the PHARYNX (throat) behind the NOSE; part of a child's defences against disease, they normally disappear by the age of ten.

adhesion In medicine, fibrous band of connective tissue developing at a site of inflammation or damage; it may bind together adjacent tissues, such as loops of intestine, occasionally causing obstruction. Most adhesions result from inflammation or surgery.

adipose tissue (fatty tissue) Connective tissue made up of body cells which store large globules of fat.

Adirondack Mountains Circular mountain group located in NE New York State, USA, reaching from Mohawk valley in the s to the St Lawrence River in the N. There are many gorges, waterfalls and lakes. Much of the area makes up the Adirondack Forest Preserve. Noted for its resorts (including Lake Placid) its highest point is Mount Marcy, at 1,629m (5,344ft). adjutant stork Large scavenging bird found in Africa, India and SE Asia, named for its military gait. It has white, black and grey plumage and throat pouches; it feeds on carrion. Length:

up to 152cm (60in). Species Leptoptilos crumeniferus.

Adler, Alfred (1870–1937) Austrian psychiatrist. After working with Sigmund Freud (1902–11), Adler broke away to found his own school of "individual psychology". He believed that striving for social success and power was fundamental to human motivation. According to his theory, individuals develop problems and maladjustments when they cannot surmount feelings of inferiority acquired in childhood. This inferiority complex is often compensated for by assertive or aggressive behaviour.

Adler, Felix (1851–1933) US ethical philosopher, b. Germany. Like KANT he stressed the importance of the individual, and believed that ETHICS need not be founded on religious or philosophical beliefs nor assume the existence of a supreme being. In 1876 he founded the Society for Ethical Culture, the forerunner of the international Ethical Movement. Among its aims were the economic, social and intellectual development of disadvantaged people. Adler also supported social reforms, such as improved housing and the abolition of child labour. His books include Creed and Deed (1877), The Moral Instruction of Children (1892) and An Ethical Philosophy of Life (1918).

Admiral's Cup International yachting competition, established in 1957 and held biennially at Cowes, Isle of Wight. Teams of three yachts from each participating country compete in four events.

Adonis In Phoenician and Greek myth, a youth of remarkable beauty, loved by Persephone and Aphrodite. Adonis was gored to death by a boar and, during his afterlife, Zeus decided that Adonis should spend part of the year with Persephone, queen of the underworld, and part with Aphrodite.

adoption Act of a person legally taking as a child one who is not his/her own by birth or law. Today's laws require that the adopting parents satisfy the authorities that they are suitable, and that the child (if over a certain age) consents to being adopted. In most Western countries, adopted children have a right to locate or find out about their natural parents if they so desire.

adrenal gland One of a pair of small endocrine glands situated on top of the KIDNEYS. They produce many STEROIDS that regulate the blood's salt and water balance and are concerned with the METABOLISM of carbohydrates, proteins and fats, and the HORMONES ADRENALINE and noradrenaline. *See also* ENDOCRINE SYSTEM

adrenaline HORMONE secreted by the ADRENAL GLANDS, important in preparing the body's response to stress. It has widespread effects in the body, increasing the strength and rate of heartbeat and the rate and depth of BREATHING, diverting blood from the SKIN and DIGESTIVE SYSTEM to the heart and muscles, and stimulating the release of GLUCOSE from the LIVER to increase energy supply by promoting increased RESPIRATION. Adrenaline is used medicinally in some situations, especially in the resuscitation of patients in shock or following cardiac arrest.

Adrian IV (c.1100–59) Pope (1154–59), b. Nicholas Breakspear. The only English pope, Adrian crowned Emperor FREDERICK I (BARBAROSSA) in 1155.

Adriatic Sea Shallow arm of the Mediterranean Sea, separated from the Ionian Sea by the Strait of Otranto, between Albania and the "heel" of Italy. Lobsters and sardines are the chief catches of local fisheries. Length: *c*.800km (500mi). Max. depth: 1,230m (4,035ft).

adsorption Attraction of a gas or liquid to the surface of a solid or liquid. It involves attraction of molecules at the surface, unlike ABSORPTION that implies incorporation. The amounts adsorbed and the rate of adsorption depend on the structure exposed, the chemical identities and concentrations of the substances involved, and the temperature.

Advent (Lat. coming) Liturgical season preceding Christmas. It begins on the Sunday nearest 30 November (St Andrew's Day). In many countries, observances during Advent include the lighting of candles. Advent refers both to Christ's birth and his coming in glory as judge at the end of history.

Adventists Christians belonging to any of a group of churches who believe in the imminent Second Coming of Christ. William Miller (1782–1849) formed the first organized Adventist movement in the USA in 1831. Christ's failure to return on dates forecast by Miller led to splits in the movement. The largest group to emerge was the SEVENTH-DAY ADVENTISTS.

Aegean civilization (*c*.3000–1100 BC) Bronze Age cultures, chiefly MINOAN and MYCENAEAN, of Greece and the Aegean islands.

Aegean Sea Part of the Mediterranean Sea between Greece and Turkey, bounded by Crete to the s and connected to the Black Sea and the Sea of Marmara by the Dardanelles to the NE. Oil and natural gas have been discovered in the area, but the principal income is derived from tourism, fishing and crops such as citrus fruits, olives and grapes.

Aeneas In Greek mythology, the son of Anchises and APHRODITE. Active in the defence of TROY, he led the Trojans to Italy. The Romans acknowledged Aeneas and his Trojan company as their ancestors.

Aeneid Poem written (30–19 BC) by the Roman poet VIRGIL. The *Aeneid* recounts (in 12 books) the legendary founding of the town of Lavinium by the Trojan AENEAS. It was the Roman national epic.

aerial (antenna) Conductor component of radio and television

systems for the broadcast and transmission of signals. An aerial's design usually depends on the wavelength of the signal.

aerobic Connected with, or dependent on, the presence of free oxygen or air. An aerobic organism can only survive in the presence of oxygen and depends on it for breaking down glucose and other foods to release energy. This process is called aerobic respiration. *See also* ANAEROBIC

aerodynamics Science of gases in motion and the forces acting on objects, such as aircraft, in motion through the air. An aircraft designer must consider four main factors and their interrelationships: weight of the aircraft and the load it will carry; lift to overcome the pull of gravity; drag, or the forces that retard motion; and thrust, the driving force. Air resistance (drag) increases as the square of an object's speed and is minimized by streamlining. Engineers use the wind tunnel and computer systems to predict aerodynamic performance.

aerofoil Any shape or surface, such as a wing, tail or propeller blade on an aircraft, that has as its major function the deflection of airflow to produce a pressure differential or LIFT. A typical aerofoil has a leading and trailing edge, and an upper and lower camber.

aeronautics Study of flight and the control of AIRCRAFT involving AERODYNAMICS, aircraft structures and methods of propulsion. Aeronautics started with the study of the BAL-LOON, which mainly concerned the raising of a load by means of BUOYANCY. It later included the heavier-than-air flight of gliders, planes, helicopters and rockets. A HELICOPTER utilizes LIFT provided by a rotor. Gliders and planes use wings to provide lift, but a minimum forward speed is essential to maintain height. A plane is pulled forward by propeller, or is pushed by the reaction forces of expanding gases from one or more jet or ROCKET engines. The increased speeds of modern aircraft to supersonic (speeds in excess of that of sound, c.1,200km/h or 750mph) and the accompanying shock waves this produces has brought changes in wing and fuselage designs to improve streamlining. While with hypersonic speeds (in excess of five times the speed of sound or Mach 5), the forces involved again change fundamentally requiring further design adjustments.

aeroplane See AIRCRAFT

aerosol Suspension of liquid or solid particles in a gas. Fog – millions of tiny water droplets suspended in air – is a liquid-based example; airborne dust or smoke is a solid-based equivalent. Manufactured aerosols are used in products such as deodorants, cosmetics, paints and household sprays. *See also* CHLOROFLUOROCARBON (CFC)

As air passing over the top edge of an aerofoil (1) has to travel further than the air flowing beneath it (2), an area of low pressure forms above the wing that generates lift (3). In modern high-lift aerofoils (A) the centre of pressure is further towards the rear of the wing (4). By moving the point of

maximum lift backwards the aerofoil has a more even distribution of lift allowing a plane to fly more slowly without stalling.

Aeschylus (525–456 BC) Greek dramatist. The earliest of the great Greek playwrights. He is said to have been responsible for the development of TRAGEDY as a dramatic form through his addition of a second actor and reduction of the role of the chorus. He was also the first to introduce scenery. His best-known work is the trilogy *Oresteia*, which comprises *Agamemnon*, *The Choephori* and *The Eumenides*.

Aesir Primary group of Nordic gods who lived in Asgard. Woden (Odin), Thor (Donar) and Tyr (Tiw), with a few others, were the object of a cult that extended throughout the lands inhabited by Germanic peoples. Secondary to the Aesir was a group of gods known as the Vanir.

Aesop (620–560 BC) Semi-legendary Greek fabulist. The reputed creator of numerous short tales about animals, all illustrating human virtues and failings (they are almost certainly written by several people). According to one tradition, he was a former slave.

aesthetic movement Late 19th-century English cult of beauty. It grew out of aestheticism, a philosophy which spread across Europe in reaction to industrialization and UTILITARIANISM. The principal figures of the movement were Aubrey BEARDSLEY, Walter Pater, J.M. WHISTLER and Oscar WILDE. **aesthetics** (Gk. aisthēsis, perception) Specialized branch of

philosophy concerned with the arts. PLATO's classical formulation of art as a mirror of nature was developed by ARISTO-TLE in his Poetics. As a distinct discipline, aesthetics dates from Alexander Baumgarten's Reflections on Poetry (1735). Common problems in aesthetics include a definition of beauty and the ascribing of artistic value. For Plato and Aristotle beauty is objective, it resides in the object. While Plato argued that art represented the form of particular objects, Aristotle believed that art imitated a universal essence through a particular form. David HUME argued that the value of art was dependent on subjective perception. Immanuel KANT in his Critique of Judgement (1790) mediated between the two, arguing that artistic value may be subjective, but it has universal validity in the form of pleasure. Later philosophers, such as George SANTANYANA and Benedetto CROCE have focused on art as a socially symbolic act.

affidavit Formal written statement testifying on oath that a specified fact or account is true. Countersigned (usually with an official seal) by a witness of juridical authority, affidavits may be used as evidence in court and tribunal proceedings, or to guarantee the identity of a person claiming legal rights.

Afghanistan Landlocked republic in s central Asia. *See* country feature

AFGHANISTAN

Introduced in December 1992, this flag uses the colours of the Mujaheddin ("holy warriors") who fought against Afghanistan's socialist government and then the Soviet occupation from the 1970s. The flag bears the new national arms of the country.

Afghanistan is bordered by Turkmenistan, Uzbekistan, Tajikistan, China, Pakistan and Iran. The central highlands make up nearly 75% of total land area and, in the E, reach a height of more than 7,600m (25,000ft). The capital, KABUL, lies in the foothills of the main range, the HINDU KUSH. The River Kabul flows E to the KHYBER PASS border with Pakistan. North of the central highlands are smaller hills and broad plateaux. Southern Afganistan is mainly lowland, with vast stretches of desert in the Sw.

CLIMATE

Afghanistan's altitude and remote position have a great effect on its climate. In winter, northerly winds bring extremely cold weather to the highlands. Summers are hot and dry. Southern Afghanistan has lower rainfall and higher average temperatures.

VEGETATION

Grassland covers much of the N, while the vegetation in the dry s is sparse. Trees are rare, but forests of conifers grow on the mountain slopes. Alder, ash and juniper grow in the valleys.

HISTORY

Afghanistan's location on the overland routes between Iran, the Indian subcontinent and Central Asia has encouraged numerous invasions. Its situation, however, has helped to repulse many attacks. In ancient times, Afghanistan was invaded successively by Aryans, Persians, Greeks, Macedonians and warrior armies from central Asia. Buddhism was introduced in the 2nd century BC and Arab armies brought Islam in the late 7th century. NADIR SHAH extended Persian rule to encompass most of Afghanistan. His successor, AHMAD SHAH, founded the Durrani dynasty and established the first unified state in 1747. In 1818 the dynasty died and Russia and Britain competed for control: Russia sought an outlet to the Indian Ocean, while Britain tried to protect its Indian territories. The first Afghan War (1838-42) was inconclusive. The second Afghan War (1878-80) ended with the accession of Abd ar-Rahman Khan as emir. The dominance of British interests was recognized in the Anglo-Russian Agreement (1907). Following the Third Afghan War, Afghanistan became fully independent under Amanullah (1921). He established a unstable monarchy, constantly threatened by religious and tribal divisions. The status of the PATHANS in the NORTH-WEST FRONTIER province of Pakistan proved a continuing source of conflict between AREA: 652,090sq km (251,773sq mi) POPULATION: 19,062,000

CAPITAL (POPULATION): Kabul (700,000)

GOVERNMENT: Islamic republic

ETHNIC GROUPS: Pathan (Pashtun) 52%, Tajik 20%, Uzbek 9%, Hazara 9%, Chahar 3%,

Turkmen 2%, Baluchi 1%

LANGUAGES: Pashto, Dari (Persian) – both

official

RELIGIONS: Islam (Sunni Muslim 74%, Shiite Muslim 25%)

currency: Afghani = 100 puls

the two states. Afghanistan remained neutral during the Cold War. In 1973 an army coup overthrew the monarchy and established a republic. In 1978 the military government was deposed in a Marxist coup backed by the Soviet Union. The costly Afghanistan War (1979-89) was fought between governmentbacked Soviet troops and MUJAHEDDIN guerrillas. In 1988-89 Soviet troops withdrew, but the civil war raged on and the number of refugees continued to mount. In 1992 Mujaheddin forces captured Kabul and set up a moderate Islamic government. Fundamentalists continued to agitate. In 1996 the TALIBAN (Persian, "students"), based in the s city of KANDAHAR. captured much of Afghanistan (including Kabul) and formed an interim government. Rival factions mounted a joint offensive against the Talibaan and fighting continued throughout 1997.

ECONOMY

Afghanistan is one of the world's poorest countries. Agriculture employs c.60% of the workforce. Most of the highland farming is seminomadic herding. Wheat is the chief crop of the sedentary farming of the valleys. Afghanistan has many mineral deposits, but most are undeveloped. Natural gas is produced, together with some coal, copper, gold, lapis lazuli and salt. Afghanistan has few manufacturing industries. The main exports are karakul skins, cotton, dried and fresh fruit and nuts.

Africa Second-largest continent (after Asia), straddling the equator and lying largely within the tropics. Land Africa forms a plateau between the Atlantic and Indian oceans. Its highest features include the ATLAS and Ahaggar mountains in the NW, the Ethiopian Highlands in the E, the Drakensberg Mountains in the s and Mount KILIMANJARO. Lake Assal in the Afar Depression of Djibouti is the lowest point at -153m (-502ft). The huge sunken strip in the E is the African section of the Great RIFT VALLEY. The SAHARA stretches across the N and the KALAHARI and NAMIB are smaller deserts in the s and sw. Madagascar lies off the se coast. Structure and geology Africa is composed largely of ancient metamorphic rocks overlain with tertiary Mesozoic and Palaeozoic sediments. The mountains of the NW are folded sedimentary material, roughly contemporaneous with the Alps. The Great Rift Valley, formed by the progressive movement of the Arabian Peninsula away from Africa, is mainly igneous in the N and mainly older pre-Cambrian in the s. Lakes and rivers The Rift Valley contains the lakes ALBERT, MALAWI and TAN-

GANYIKA. VICTORIA to the E is Africa's largest lake; Lake CHAD which shrinks to a salt pan in dry periods, lies in the s Sahara. Rivers include the NILE, NIGER, CONGO and ZAMBEZI. Climate and vegetation Much of the continent is hot and (outside the desert areas) humid. The belt along the equator receives more than 250cm (100in) of precipitation a year and is covered by tropical rainforest. The forest gives way both in the N and S to areas of acacia and brush and then through savanna grassland to desert. The N strip of the continent and the area around the Cape have a Mediterranean climate. Peoples Africa is home to over 13% of the world's population divided into more than 700 culturally distinct tribes and groups. North of the Sahara Arabs and Berbers predominate, while to the S tribes include the FULANI, GALLA, HAUSA, HOT-TENTOTS, IGBO, MASAI, MOSSI, SAN, YORUBA and ZULU. Indians and Europeans also form significant minorities. Africa is relatively thinly populated and c.75% of the population is rural. Economy Agriculture is restricted in central Africa by the large expanse of tropical rainforest, though cash crops

South America once formed a vast supercontinent, known as Pangaea. Plate tectonics are also thought to be responsible for the spectacular Great Rift Valley, which dominates the landscape of E Africa. Africa's highest mountain, the volcanic Kilimanjaro, is associated with the rift formation. The world's longest river, the Nile, flows over 6,600km (4,100mi) from Lake Victoria to the Mediterranean Sea. The world's largest desert, the Sahara, forms an ethnic and cultural divide. North of the Sahara, Arabs and Islam predominate in coastal areas, Berbers and Tuareg in the interior Sub-Saharan Africa is more ethnically diverse. Africa's first great civilization emerged in ancient Egypt in c.3400 BC. Carthage was founded by Phoenicians in the 9th century BC. In the 7th century Islam spread throughout North Africa. Due to the oral nature of its culture, the pre-16th century history of Sub-Saharan Africa is unclear. In 1498 Vasco da Gama landed in E Africa and centuries of European domination followed. The slave trade increased dramatically in the 17th century. The 19th century discovery of mineral wealth in Africa's interior spurred European imperialism and colonization as European powers scrambled to divide up the continent. Post-1945, the process of decolonization was rapid.

■ Africa Africa and

▲ African art Sculpture and the decorative arts are among the most varied and finest throughout Africa. The illustration shows beads, a large carved ancestral figure from Nigeria, and a colonial carving.

such as cocoa, rubber and peanuts are grown on plantations. Along the N coast, crops such as citrus fruits, olives and cereals are grown. The Sahara is largely unproductive, supporting only a nomadic herding community. East and s Africa are the richest agricultural areas, containing large mixed farms and cattle ranching. Apart from South Africa, the entire continent is industrially underdeveloped. Mining is the most important industry. Zambia has the world's largest deposits of copper ore. Bauxite is extracted in w Africa and oil is produced in Nigeria, Libya and Algeria. South Africa is extremely rich in minerals, gold, diamonds and coal being the most important. Recent History Before the 1880s Europeans were, except in South Africa, largely confined to the coastal regions. By the end of the 19th century the whole continent, except for Liberia and Ethiopia, was under foreign domination either by European powers, or (in the N) by the Ottoman Empire. Starting in the 1950s, the colonies secured their independence within the space of 40 years, but this process of rapid decolonization brought unrest and instability to much of Africa. A major cause of unrest was (and continues to be) the artificial boundaries created by COLONIALISM. Lasting democracy proved difficult to achieve in many countries and military rule is prevalent, often based on pre-colonial tribal divisions of power. Area: c.30,000,000sq km (11,700,000sq mi) Highest mountain Kilimanjaro (Tanzania) 5,895m (19,340ft) Longest river Nile 6,670km (4,140mi) Population (1990 est.) 647,518,000 Largest cities CAIRO (6,663,000); KINSHASA (3,804,000); ALEXANDRIA (3,170,000); CAPE (2,350,000) See also articles on individual countries

African art Naturalistic rock paintings and engravings, from before 4000 BC are found in the Sahara Desert. They are similar to European PALAEOLITHIC ART. Later African tribal art is inseparable from the ritual life of the community. Examples include: body painting and dance; music and musical instruments (especially the drum); ceremonial masks and small SCULPTURES used in ANCESTOR WORSHIP; weapons and everyday utensils (such as bowls and stools). Wood is the most commonly used material. Artists were usually professionals and received great respect and cultural status. Except EGYPT-IAN ART, the most fertile artistic region is sub-Saharan Africa. The Nok terracotta heads from Nigeria are the earliest examples of African sculpture yet discovered (c.500 BC). The naturalistic bronze heads produced by the YORUBA at Ife, sw Nigeria, reveal an early (12th-15th century) mastery of the CIRE PERDUE process. This skill passed to the ASHANTI of Ghana, who produced highly exaggerated figurative sculpture. The Dogon of Mali are renowned for their wooden sculpture, especially stylized wooden masks featuring recessed rectangles. The stonework of GREAT ZIMBABWE reveals a highly advanced grasp of architectural design. It was only through its influence on early modern European art, especially Picasso's development of cubism and MODIGLIANI's figurative paintings, that interest in African art flourished. See also ISLAMIC ART AND ARCHITECTURE

African mythology North Africans are predominantly Islamic, but the many peoples in sub-Saharan Africa have a rich and varied collection of traditional beliefs. Almost all recognize a supreme being who created the universe. There are also innumerable other gods, whose cults flourish in w Africa. Many Africans believe in the power of the spirit world. Spirits are thought to be capable of exerting a friendly or malignant influence (See ANIMISM). Many of these spirits are associated with agriculture and receive special offerings at harvest time. Belief in reincarnation is widespread in Africa and ANCESTOR WORSHIP is an important social ritual. The dead are feared because they possess greater powers than the living. Many Africans believe that people are reborn in living animals or in inanimate objects. MAGIC plays an important part in people's everyday lives. Medicine men make amulets, necklaces and other kinds of charms which are believed to ward off evil. Other objects are used to protect crops and houses or to bring rain. Belief in magic has proved more enduring than the traditional mythologies, which have declined with the advance of Christianity and Islam.

African National Congress (ANC) South African politi-

cal party. It was formed in 1912 with the aim of securing racial equality and full political rights for nonwhites. By the 1950s it had become the principal opposition to the APARTHEID regime. A military wing, *Umkhonte We Sizwe* (Spear of the Nation), was set up in the aftermath of the SHARPEVILLE Massacre. It engaged in economic and industrial sabotage. In 1961 the ANC was banned and many of its leaders were arrested or forced into exile. In 1964 the leaders of the ANC, Nelson MANDELA and Walter SISULU, began their long sentences as political prisoners. In 1990 the ANC was legalized, Mandela was released from Robben Island and many of the legislative pillars of apartheid were dismantled. In 1994, in South Africa's first multiracial elections, the ANC gained over 60% of the popular vote. Nelson Mandela became the first post-apartheid president of South Africa.

Afrikaans One of 11 official languages of the Republic of South Africa. It is derived from the language spoken by AFRIKANERS of the 17th century but quickly evolved its own forms to become a distinct language. Afrikaans is regarded as a cultural focal point by South Africans of Dutch origin, and it has had a powerful influence on South Africa's political history. It is the everyday means of communication for some three million speakers of European, African and mixed descent.

Afrika Korps German armoured force in World War 2 that operated in the N African desert. Under the command of General Erwin ROMMEL, it had spectacular early successes against the British. Montgomery's victory at EL ALAMEIN (1942) turned the tide and the Afrika Korps beat a long retreat.

Afrikaner (Boer, farmer) Descendant of the predominantly Dutch settlers in SOUTH AFRICA. Afrikaners first settled around the Cape region in the 17th century. To avoid British control, the Afrikaners spread N and E from the Cape in the GREAT TREK and founded the independent South African Republic (TRANSVAAL) and Orange Free State. Defeat in the SOUTH AFRICAN WAR (1899–1902) led to the republics merging in the Union of South Africa (1910). See also CAPE PROVINCE

Afro-Asiatic languages (Hamito-Semitic) Only family of languages common to both Asia and Africa. They are spoken by c.130 million people in N Africa, the Sahara, parts of E, W and central Africa, and W Asia. On the African continent, it includes such languages as Berber and the now extinct Coptic and ancient Egyptian. It also includes the SEMITIC LANGUAGES, notably Arabic and Hebrew, that originated in Syria, Mesopotamia, Arabia and Palestine. With a few exceptions, the family uses a script that is read from right to left.

Agadir Atlantic seaport, sw Morocco. In 1960 Agadir suffered a disastrous earthquake, but it was rebuilt as a tourist centre and is now a popular European topurist destination. Fishing is the other main economic activity. Pop. (1990) 439,000.

Aga Khan Since 1818, title of the leader of the ISHMAILI sect of SHITTE Muslims. Aga Khan III (1877–1957) was the best known. He headed the All-India Muslim League in support of British rule in 1906. He moved to Europe and was known for his enormous wealth and love of horse racing. His son, Karim, became Aga Khan IV in 1957 and has continued the family traditions.

Agamemnon In Greek mythology, king of Mycenae, and brother of Menelaus. According to Homer's *Iliad*, he led the Greeks at the siege of Troy. When Troy fell, Agamemnon returned home but was murdered by his wife CLYTEMNESTRA and her lover Aegisthus.

agar Complex substance extracted from seaweed; its powder forms a "solid" gel in solution. It is used as a thickening agent in foods; as an adhesive; as a medium for growing bacteria, MOULD, YEAST and other microorganisms; as a medium for TISSUE CULTURE; and as a gel for ELECTROPHORESIS.

agaric Order of fungi that includes edible mushrooms, ink caps and the poisonous AMANITA. Their spores are borne on the surface of gills or pores on the under-surface of the cap.

Agassiz, Alexander (1835–1910) US marine zoologist, b. Switzerland. He was influential in the development of modern systematic zoology, and made important studies of the SEAFLOOR. In 1874 he succeeded his father, Louis, as curator of the Harvard Museum of Natural History.

agate Microscrystalline form of quartz with parallel bands

of colour. It is regarded as a semi-precious stone and is used for making jewellery. Hardness c.6.5; s.g. c.2.6.

agave Succulent, flowering plant found in tropical, subtropical and temperate regions. Agaves have narrow, lance-shaped leaves clustered at the base of the plant, and many have large flower clusters. The flower of the well-known century plant (*Agave americana*) of sw North America grows up to 7.6m (25ft) in one season. The century plant was thought to flower only once in 100 years, but in fact it flowers every 20–30 years. Other species are sisal (*A. sisalana*) and mescal (*Lophophora williamsii*), whose fermented sap forms the basis of the liqueur tequila. Family Agavaceae.

Agee, James (1909–55) US writer. A novelist, poet, influential film critic and screenwriter for films such as *The African Queen* (1951, co-scripted with John HUSTON) and *The Night of the Hunter* (1955). He is perhaps best known for his study of rural poverty, *Let Us Now Praise Famous Men* (1941). His novel *A Death in the Family* (1957) won a Pulitzer Prize.

Agency for International Development (AID) US government agency that carries out assistance programmes designed to help less developed countries develop human and economic resources and increase production capacities.

agglutination Clumping of BACTERIA or red blood cells by ANTIBODIES that react with ANTIGENS on the cell surface.

Agincourt Village in Pas de Calais, NE France. It is the site of the English King Henry V's victory (1415) over the French during the HUNDRED YEARS WAR. Despite being outnumbered, England won due to poor French tactics and the superiority of the English longbow over the French crossbow. Agnew, Spiro Theodore (1918–96) US statesman, vice president (1969–73). Agnew became governor of his native Maryland (1967). He was a staunch advocate of US involvement in the VIETNAM WAR. Re-elected as vice president in 1972, he was forced to resign after the discovery of political bribery and corruption in Maryland. He did not contest further charges of tax evasion and was given a three-year probationary sentence and fined \$10,000.

Agni Fire god in Vedic mythology, revered as god of the home and appearing in lightning and the Sun as a nature deity. agnosticism Philosophical viewpoint according to which it is impossible either to demonstrate or refute the existence of a supreme being or ultimate cause on the basis of available evidence. It was particularly associated with the rationalism of Thomas HUXLEY, and is used as a reasoned basis for the rejection of both Christianity and ATHEISM.

Agra City in Uttar Pradesh, and site of the Taj Mahal, N central India. It was founded (1566) by Akbar I. Agra's importance declined after 1658 when the Mogul capital moved to Delhi. It was annexed to the British empire in 1803 and later became the capital of North-West Province (1835–62). Agra's fine Mogul architecture make it a major tourist destination. An important rail junction and commercial and administrative centre. Industries: glass, shoes, textiles. Pop. (1991) 892,200.

Agricultural Revolution Series of changes in farming practice in the 18th and early 19th centuries. The main changes comprised crop rotation, new machinery, increased capital investment, scientific breeding, land reclamation and enclosure of common lands. Originating in Britain, these advances led to greatly increased agricultural productivity in Europe.

agriculture Practice of cultivating crops and raising livestock. Early humans were hunters and gatherers, but development of husbandry and crop farming skills enabled them to produce food on a small scale. Modern archaeological dating techniques suggest that the production of CEREALS and the domestication of animals were widespread throughout E Mediterranean countries by c.7000 BC. The Egyptians and Mesopotamians (c.3000 BC) were the earliest peoples to organize agriculture on a large scale, using irrigation techniques and manure as fertilizer. Farming formed the foundations of later societies in China, India, Europe, Mexico and Peru. By Roman times (200 BC-AD 400), crop farming and the domestication of animals were commonplace in w Europe. In 17thand 18th-century Europe, selective breeding improved milk and meat yields. The use of the four-field system of crop rotation meant that fields could be used continuously for production with no deterioration in yield or quality of the crops. The greatest changes in agriculture came with the Industrial Revolution. Many items of farm machinery were introduced in the 19th century. This equipment became widespread in the UK in the 1840s. In Western Europe and North America, mechanization has advanced greatly and a large proportion of agricultural production is now carried out by FACTORY FARMING methods. The enormous food-producing regions of the American Midwest and the Russian steppes consist largely of farms given over to the production of either grain or livestock. In much of the underdeveloped world, agriculture (especially RICE production) is still labour intensive. Three-quarters of the world's workforce is engaged in farming.

Agrippa, Marcus Vipsanius (b.63 BC) Roman general, adviser to Octavian (later Augustus). He helped Octavian to power by winning naval battles against Sextus Pompeius (36 BC) and Mark Antony at the Battle of Actium (31 BC).

agronomy Science of soil management and improvement in the interests of AGRICULTURE. It includes the studies of particular plants and soils and their interrelationships. Agronomy involves disease-resistant plants, selective breeding and the development of chemical fertilizers.

Ahern, Bertie (1951–) Irish statesman, taoiseach (1997–). Ahern was first elected to the Dáil Éireann in 1977. He served as vice president (1983–94) of FIANNA FÁIL, before becoming leader. He succeeded John Bruton as taoiseach.

ahimsa Non-violence or non-injury to both people and animals. It is a central concept of JAINISM and BUDDHISM, and is also important in HINDUISM. This belief inspired the passive resistance of Mahatma GANDHI.

Ahmadabad (Ahmedabad) City on the Sabarmati River, Gujarat, w India. Founded in 1411 by Ahmad Shah, the Muslim ruler of Gujurat, it is the cultural and commercial centre of Gujarat, with many magnificent mosques, temples and tombs. Ahmadabad is the headquarters of the Indian National Congress movement. Industries: cotton. Pop. (1991) 2,954,526.

Ahmad Shah Durrani (1722–73) Emir of Afghanistan (1747–73) and founder of the Durrani dynasty. He united the Afghan tribes and is sometimes known as the founder of modern Afghanistan.

Ahura Mazdah (Ormazd, Ormuzd) In ZOROASTRIANISM, the supreme deity and god of light and wisdom. Ahura Mazdah created the universe and the twin spirits of good and evil. He later became identified with the good spirit, who was in constant conflict with Ahriman, the evil spirit and god of darkness. aid, development Funds, goods, equipment and expertise donated or loaned by the world's richer countries to poorer countries and used to promote development. The largest amount of development aid is paid out by the WORLD BANK, specifically through its International Development Association (IDA). All industrialized member states of the UNITED NATIONS (UN) allocate a specific proportion of their own GROSS NATIONAL PRODUCT (GNP) for development projects. Aid is often given to schemes that that promote self-reliance, rather than encourage dependence.

Aidan, Saint (d.651) Irish monk from Iona who brought Christianity to NE England. He became the first Bishop of Lindisfarne, where he established a monastery and sent out missionaries all over N England. His feast day is 31 August.

AIDS ACTORISM for ACQUIRED IMMUNE DEFICIENCY SYNDROME

Aiken, Conrad Potter (1889–1973) US poet, novelist and critic. Aiken's *Selcted Poems* (1929) won him a Pulitzer Prize. His interest in psychoanalysis and muscial form are evident in *Collected Poems* (1953). His also wrote five novels and an autobiography *Ushant* (1952).

aikido Martial art based on an ancient Japanese system of self-defence. Unlike some other martial art forms, in which force is met with counter-force, aikido employs the technique of avoiding action by making use of an opponent's forward impetus, causing the attacker to suffer a temporary loss of balance. Some forms of aikido, such as tomiki, are also sports.

aileron Hinged control surface on the outer trailing edge of each wing of an AIRCRAFT. By moving down or up in opposite directions, ailerons cause the aeroplane to roll, or bank.

AIR-CUSHION VEHICLE (ACV)

Air-cushion vehicles, or hovercraft, float on a bed of air allowing them to operate on both land and water. A turbine (1) powers a propeller (2) for forward motion. Two main fans (3) provide lift by pulling air into the skirt (4) beneath the vehicle. Two smaller fans (5) blow air through directable

nozzles on top of the craft providing manouevrability. The skirt is divided into cells (6) that seal the air cushion and act as a giant shock absorber.

Ailey, Alvin (1931–89) US modern dancer and choreographer. Ailey studied dance with Martha Graham. In 1958 he formed the American Dance Theater and acted as its artistic director (1958–89). The company introduced many leading African-American and Asian dancers to worldwide audiences. His works, such as *Roots of the Blues* (1961), incorporate elements of jazz, African and MODERN DANCE.

Ainu Aboriginal people of Hokkaidō (N Japan), Sakhalin and the Kuril islands. Traditionally hunters, fishermen and trappers, they practise ANIMISM and are famed for their bear cult. **air** Gases above the Earth's surface. *See* ATMOSPHERE

aircraft Any vehicle capable of travelling in the Earth's atmosphere. By far the most common aircraft is the airplane (aeroplane or plane). The airplane is a heavier-than-air flying machine that depends upon fixed wings for LIFT in the air, as it moves under the THRUST of its engines. This thrust may be provided by an airscrew (propeller) turned by a piston or turbine engine, or by the exhaust gases of a JET engine or rocket motor. Gliders differ from planes only in their dependence upon air currents to keep them airborne. The main body of a plane is the fuselage, to which are attached the wings and tail assembly. Engines may be incorporated into (or slung below) the wings, but are sometimes mounted on the fuselage towards the tail or, as in some fighter aircraft, built into the fuselage near the wings. The landing gear (undercarriage), with its heavy wheels and stout shock absorbers, is usually completely retractable into the wings or fuselage. High-speed fighters have slim, often swept-back or adjustable wings that minimize air resistance (drag) at high speeds. Heavy air freighters need broader wings in order to achieve the necessary lift at take-off. A delta wing is a broad wing, or fuselage extension, that is aerodynamically suited for both large and small high-speed planes. A plane is steered by flaps and AILERONS on the wings, and rudder and elevators on the tail assembly. This deflects the pressure of air on the aerofoil surfaces, causing the plane to rise or descend, to bank (tilt) or

swing and turn in the air. RADAR systems aid NAVIGATION and an AUTOPILOT keeps the aircraft on a steady, fixed course. Pressurized cabins allow passenger planes to fly at heights exceeding 10,000m (33,000ft). See also AIRSHIP; AERODYNAMICS; AEROFOIL; BALLOON; GLIDING; HELICOPTER

aircraft carrier Military vessel with a wide open deck that serves as a runway for the launching and landing of aircraft. A modern nuclear-powered carrier may have a flight deck c.300m (1,000ft) long, a displacement of c.75,000 tonnes, a 4,000-man crew and carry 90 aircraft of various types. Some carriers have large, angled decks to permit launching and landing simultaneously.

air-cushion vehicle (ACV) Vehicle that is lifted from the ground by air as it is forced out from under the craft. The best-known example is a HOVERCRAFT.

air force Military air power, first used in World War 1. In 1918 the British government formed the Royal Air Force (RAF), the world's first separate air force. The United States Air Force (USAF) was created in 1947.

Air Force, Royal (RAF) Youngest of the British armed services, formed in 1918 by the amalgamation of the Royal Naval Air Service and the Royal Flying Corps. It was controlled by the Air Ministry from 1919–64, when it was merged into the Ministry of Defence. Total personnel (1996): 68,000. Air Force, US (USAF) One of the three major military services established under the Department of Defense in the

vices established under the Department of Defense in the National Security Act of 1947. It began as the Aeronautical Division of the Army in 1907, became the Aviation Section of the Signal Corps in 1914, the Air Service in 1918, the Army Air Corps in 1926, and the Army Air Forces in 1941. It is the world's largest air force. Total personnel (1994): 426,000.

airship (dirigible) Powered lighter-than-air craft able to control its direction of motion. A gas that is less dense than air, nowadays helium, provides LIFT. A rigid airship, or Zeppelin, maintains its form with a framework of girders covered by fabric or aluminium alloy. Non-rigid airships, or blimps, have no internal structure. They rely on the pressure of the contained gas to maintain the shape.

Aix-en-Provence City in SE France. Founded (123 BC) by the Romans, Aix-en-Provence is a cultural centre with a university (1409), an 11th–13th-century cathedral and several art galleries. Industries: winemaking equipment, electrical apparatus. Agricultural products include olives and almonds. Pop. (1990) 123,842.

Aix-la-Chapelle, Treaty of (1748) Diplomatic agreement, principally between France and Britain, that ended the War of the AUSTRIAN SUCCESSION (1740–48). The treaty, which contributed to the rise of Prussia, provided for the restitution of conquests made during the war and confirmed British control of the American slave trade. An earlier treaty signed at Aix-la-Chapelle ended the War of Devolution (1668).

Ajax In Greek mythology, name given to two heroes who fought for Greece against Troy. The Greater Ajax is depicted in Homer's *Iliad* as a courageous warrior who led the troops of Salamis against Troy. The Lesser Ajax was shipwrecked by ATHENA for raping CASSANDRA.

Akbar I (the Great) (1542-1605) Emperor of India (1556-1605). Generally regarded as the greatest ruler of the MOGUL EMPIRE, he assumed personal control in 1560 and set out to establish Mogul control of the whole of India, extending his authority as far s as Ahmadnagar. Akbar built a new capital at Fatehpur Sikri and endeavoured to unify his empire by conciliation with Hindus. He also tolerated Christian missionaries. Akhmatova, Anna (1889-1966) Russian poet. Akhmatova's simple, intense lyrics and personal themes appear in The Rosary (1914) and The Willow Tree (1940). Her longest work, Poem Without a Hero (trans. 1971), is her masterpiece. Although officially ostracized for "bourgeois decadence", she remained popular in the Soviet Union. Her poems, published in full in 1990, confirmed her as one of Russia's greatest poets. **Akhnaten** (d. c.1362 BC) Ancient Egyptian king of the 18th dynasty (r. c.1379-1362 BC). He succeeded his father, AMEN-HOTEP III, as Amenhotep IV. In an attempt to overthrow the influence of the priests of the Temple of AMUN at LUXOR, he renounced the old gods and introduced an almost monotheis-

ALABAMA Statehood :

14 December 1819

Nickname:

The Heart of Dixie State bird :

Yellowhammer

State flower:

Camellia

State tree : Southern pine

State motto :

We dare defend our rights

tic worship of the sun god, ATEN. He adopted the name Akhnaten and established a new capital at Akhetaten (modern Tell el-Amarna). After his death TUTANKHAMUN reinstated Amun as national god, and the capital reverted to Luxor.

Akiba Ben Joseph (50–135) Jewish rabbi and martyr in Palestine. He developed a new method of interpreting the Halakah, Hebrew oral laws, and supported a revolt (132) against the Roman emperor, HADRIAN. He was imprisoned by the Romans and tortured to death.

Akihito (1933–) Emperor of Japan (1989–). In 1959 Akihito married a commoner, Michiko Shoda, the first such marriage in the history of the imperial dynasty. Akihito succeeded his father, HIROHITO.

Akron City on the River Cuyahoga, NE Ohio, USA. The Ohio and Erie Canal (1827) spurred Akron's growth. Once "the rubber capital of the world", the first tyre factory opened here in 1871, and it remains the headquarters of Goodyear. Other industries: plastics, chemicals. Pop. (1992) 223,621.

Alabama State in SE USA in the chief cotton-growing region; the state capital is MONTGOMERY. BIRMINGHAM is the largest city and a leading iron and steel centre. The N of the state lies in the Appalachian Highlands, which have coal, iron ore and other mineral deposits, and the rest consists of the Gulf coastal plain, crossed by a wide strip of fertile agricultural land. The River Mobile and its tributaries form the chief river system. Settled by the French in 1702, the region was acquired by Britain in 1763. Most of it was ceded to the USA after the American Revolution in 1783, and Alabama was admitted as the 22nd state of the Union in 1819. It seceded in 1861 as one of the original six states of the Confederacy, and was readmitted to the Union in 1868. In the 1960s it was a centre of the civil rights movement. The principal crops are peanuts, soya beans and maize, with cotton decreasingly important. Industries: chemicals, textiles, electronics, metal and paper products. Area: 133,915sq km (51,705sq mi). Pop. (1992) 4,137,511.

Alabama claims (1872) Award of \$155 million compensation to the USA against the UK for damage inflicted by Confederate ships built in England during the US CIVIL WAR (1861–65). An international tribunal ruled that the British government had violated its neutrality by allowing the ships to be built on British territory.

alabaster Fine-grained, massive variety of GYPSUM (calcium sulphate), snow-white and translucent in its natural form. It can be dyed or made opaque by heating and is used for making statues and other ornaments.

Alamein, El See El Alamein

Alamo Mission in San Antonio, Texas, scene of a battle between Mexico and the Republic of Texas (1836). About 180 Texans, led by William Travis, Davy Crockett and James Bowie, were overwhelmed by superior Mexican forces numbering in the thousands following a siege of 11 days.

Alaric (370–410) King and founder of a group of GOTHS called the Visigoths (395–410). His forces ravaged Thrace, Macedonia and Greece and occupied Epirus (395–96). He invaded Italy and besieged (408) and sacked (410) Rome when Emperor Honorius would not grant him a position at court. He planned an invasion of Sicily and Africa, but his fleet was destroyed in a storm.

Alaska State in NW North America, separated from the rest of continental USA by the province of British Columbia, Canada, and from Russia by the Bering Strait. The capital is JUNEAU. The largest city is ANCHORAGE on the s coast. The USA purchased Alaska for \$7.2 million from Russia (1867). Fishing drew settlers and, after the gold rush of the 1890s, the population doubled within a decade. It became the 49th state of the Union in 1959. About 25% lies inside the Arctic Circle. The main Alaska Range includes Mount McKINLEY, the highest peak in North America. The chief river is the YUKON. The Alaskan economy is based on fish, natural gas, timber, quartz and, primarily, oil. The national parks encourage tourism. Because of its strategic position and oil reserves, Alaska has been developed as a military area and is linked to the rest of the USA by the 2,450km (1,500mi) Alaska Highway. Although by far the largest US state, it has the second smallest population (after Vermont). Of the total state population (1990), 85,698 are

Native Americans (mainly Inuit-Aleut Eskimos). Area: 1,530,700sq km (591,004sq mi). Pop. (1992) 587,766.

Alaskan Boundary Dispute (1902-03) Dispute between the USA and Britain, representing Canada, over possession of the inlets between Alaska and Canada after the Klondike gold strike. It was settled by a six-man panel in favour of the USA. Albania Balkan republic; the capital is TIRANA. Land and climate About 70% of Albania is mountainous, rising to Mount Korab at 2,764m (9,068ft) on the Macedonian border. Most Albanians live in the farming regions of the w coastal lowlands. Albania is subject to severe earthquakes. The coastal regions of Albania have a typical Mediterranean climate, with fairly dry, sunny summers and cool, moist winters. The highlands have heavy winter snowfalls. Maquis covers much of the lowlands. Economy Albania is Europe's poorest country, 56% of the workforce are engaged in agriculture. Under communism, the land was divided into large state and collective farms, but private ownership has been encouraged since 1991. Crops include fruits, maize, olives, potatoes, sugar beet, vegetables and wheat. Livestock farming is also important. Albania has some mineral reserves. Chromite, copper and nickel are exported. Other resources include oil, brown coal and hydroelectricity. Albania's heavy industry has caused severe pollution in some areas. History In ancient times,

ALASKA Statehood: 3 January 1959 Nickname: The Last Frontier State bird: Willow ptarmigan

State flower:
Forget-me-not
State tree:
Sitka spruce

State motto : North to the future

ALBANIA

AREA: 28,750sq km

POPULATION: 3,363,000

(11,100sq mi)

CAPITAL (POPULATION): Tirana (251,000) **GOVERNMENT:** Multiparty republic ETHNIC GROUPS: Albanian 98%, Greek 1.8%, Macedonian, Montenegrin, Gypsy LANGUAGES: Albanian (offi-**RELIGIONS:** Many people say they are nonbelievers; of the believers, 65% follow Islam, and 33% Christianity (Orthodox 20%, Roman Catholics 13%) currency: Lek = 100 qindars (official)

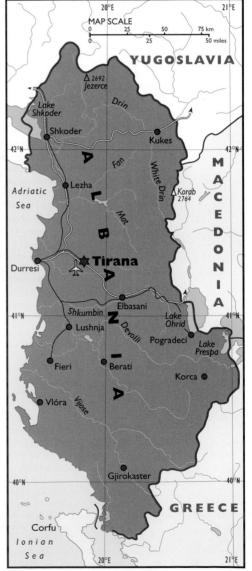

A male and female both carrying a recessive gene (green) for albinism (A) will have three normally pigmented children (B, D and E) to every one albino (C). The corresponding normal gene (orange or purple) in both produces normal skin colour. This is due to an amino acid,

phenyl-alanine (1), which has been converted to tyrosine (2) and then to the pigment melanin (3). However, a recessive gene in double quantity only allows the conversion of phenyl-alanine to tyrosine (F) resulting in an albino with a lack of pigment in the skin, hair and eyes.

Albania was part of ILLYRIA, and in 167 BC became part of the ROMAN EMPIRE. Until his death in 1468, Scanderbeg successfully led Albanian resistance to Turkish incursions. Between 1469 and 1912 Albania formed part of the OTTOMAN EMPIRE. Italy invaded Albania in 1939, and German forces occupied Albania in 1943. In 1944 Albanian communists, led by Enver HOXHA, took power. In the early 1960s, Albania broke with the Soviet Union after Soviet criticism of the Chinese Com-MUNIST PARTY to which it was allied until the late 1970s. In the early 1990s the Albanian government abandoned communism and allowed the formation of opposition parties. Recent events In 1996 the Democratic Party, headed by Sali Berisha, won a sweeping victory. In 1997 the collapse of nationwide pyramid finance schemes sparked a large-scale rebellion in s Albania and a state of emergency was proclaimed. Berisha formed a government of national reconciliation and agreed to new elections. The Socialist Party of Albania was victorious and Rexhep Mejdani became president.

Alban, Saint First British martyr, from the Roman town of Verulamium (now St Albans). He was killed for hiding a Christian priest from the Romans. In 797 King Offa founded an abbey on the site of Alban's execution. His feast day is 22 June. Albany Capital of New York State, on the Hudson River. Settled by the Dutch in 1614 and British from 1664, it replaced New York as state capital in 1797 and has many fine old buildings. Albany developed in the 1820s with the building of the Erie Canal, linking it to the Great Lakes, and it remains an important river port. Industries: paper, brewing, machine tools, metal products, textiles. Pop. (1992) 99,708.

Albany Congress (1754) North American colonial conference to discuss Native American relations. Representatives from seven northern and middle colonies met Iroquois leaders and negotiated an alliance against the French. At this meeting Benjamin Franklin proposed a plan for union of the colonies, which was rejected by the colonial governments.

albatross Large, migratory oceanic bird of the Southern Hemisphere famed for its effortless gliding flight. There are 13 species. The wandering albatross has a long, hooked bill, short tail, webbed toes and the greatest wing span of any living bird – 3.5m (11.5ft) or more. Length: 0.7–1.4m (2.3–4.4ft). Family Diomedeidae.

albedo Fraction of light or other radiation that is reflected from a surface. An ideal reflector has an albedo of 1; those of real reflectors are less, that of the Earth, viewed from satellites, is 0.35.

Albee, Edward Franklin (1928–) US playwright. Albee's debut play *The Zoo Story* (1959) is a classic text of the Theatre of the ABSURD. His best-known play *Who's Afraid of Virginia Woolf?* (1962) is an intense portrait of a destructive marriage. Other works include *The Ballad of the Sad Cafe* (1963). A *Delicate Balance* (1966) and *Seascape* (1975) won Pulitzer prizes. Albéniz, Isaac (1860–1909) Spanish Romantic composer and pianist, one of the most important composers in Spain's

ad pianist, one of the most important composers in Spain's musical history. The majority of his compositions are for piano. He often used Spanish folk elements in his compositions, notably in the piano suite *Iberia* (1906–09).

Albert, Lake Lake on the border between Zaïre and Uganda, in the Rift Valley of E central Africa. Albert is fed by the Semliki River and the Victoria Nile and drained by the Albert Nile (*Bahr el Jebel*). Ugandans call it Lake Nyanza and the Zaïrians named it Lake Mobuto Sese Seko. Length: 160km (100mi). Average width: 35km (22mi). Max. depth: 51m (168ft). Area: 5,350sq km (2,050sq mi).

Alberta Province of w Canada bounded on the w mainly by the Rocky Mountains and in the s by the USA; the capital is EDMONTON. Other major cities include CALGARY. Most of Alberta is prairie land. The principal rivers are the Athabasca, Peace, North and South Saskatchewan. Lesser Slave Lake is the largest of the many lakes. The area was part of a large territory granted (1670) by Charles II to the Hudson's Bay COMPANY, and in 1870 the government of Canada bought the region from the company. Migrants arrived from other Canadian provinces, the USA and Europe. In 1882 Northwest Territories was divided into four districts and Alberta was created (named after Queen Victoria's fourth daughter). Alberta was admitted to the confederation as a province in 1905. The fertile plains support wheat farming and livestock. Major resources are coal, minerals and wood from the forests in the N. Oil and natural gas fields in central Alberta have been a major stimulus to the post-1945 economy. Industries: petroleum products, metals, chemicals, food, wood products. Area: 661,188sq km (255,285sq mi). Pop. (1991) 2,545,553.

Alberti, Leon Battista (1404–72) Italian architect, humanist and writer. The first major art theorist of the RENAISSANCE, Alberti's treatise *On Painting* (1435) was highly influential. His buildings include the Rucellai Palace, Florence, Tempio Malatestiano, Rimini and the Church of San Andrea, Mantua. Albigenses (Cathars) Members of a heretical religious sect that existed in southern France from the 11th to the early 14th centuries and took its name from the French city of Albi. Pope Innocent III ordered a crusade against them in 1200, which caused much damage in Languedoc and Provence.

albino Person or animal with a rare hereditary absence of pigment from the skin, hair and eyes. The hair is white and the skin and eyes are pink because, in the absence of pigment, the blood vessels are visible. The eyes are abnormally sensitive to light and vision is often poor.

Albinoni, Tomaso (1671–1750) Italian violinist and composer. He worked mainly in Venice, where he was a friend of Vivaldi. He was one of the first composers of CONCERTOS for a solo instrument; he also wrote nearly 50 operas.

Albright, Madeleine Korbel (1937–) US stateswoman, secretary of state (1997–), b. Czechoslovakia. Following Bill CLINTON's re-election (1996), Albright became the first woman to hold the office of secretary of state. She was a hawkish advocate of US military involvement in the GULF WAR and the war in BOSNIA.

albumin (albumen) Type of water-soluble PROTEIN occurring in animal tissues and fluids. Principal forms are egg albumin (egg white), milk albumin and blood albumin. In a healthy human, it constitutes about 5% of the body's total weight. It is composed of a colourless, transparent fluid called plasma in which are suspended microscopic ERYTHROCYTES (red blood cells), LEUCOCYTES (white blood cells) and PLATELETS.

Albuquerque City in w central New Mexico, USA, on the Upper Rio Grande, and by far the state's largest city. Tradi-

tionally a centre for rail workshops and the livestock trade, it now is a centre for high-technology industries and is home to the federal Atomic Energy Commission). A popular health resort, its population increased by nearly 20% between 1980 and 1992. Pop. (1992) 398,492.

Alcatraz (Sp. *álcatraces*, pelican) Island in San Francisco Bay, celebrated as an escape-proof prison surrounded by shark-infested waters. Discovered by the Spanish in 1769, it served as a fort and then US federal prison (1933–63). In 1972 it became part of the Golden Gate National Recreational Area. alchemy Primitive form of chemistry practised in Western Europe from early Christian times until the 17th century, popularly supposed to involve a search for the philosopher's stone – capable of transmuting base metals into gold – and the elixir of life. It actually involved a combination of practical chemistry, astrology, philosophy and mysticism. Similar movements existed in China and India.

Alcock, Sir John William (1892–1919) Pioneer British airman who, together with Arthur Whitten-Brown, was the first to fly non-stop across the Atlantic Ocean. Their transatlantic flight began in St John's, Newfoundland on 14 June 1919 and landed 16.5 hours later near Clifden, Ireland.

alcohol Organic compound having a hydroxyl (-OH) group bound to a carbon atom. ETHANOL, the alcohol found in alcoholic drinks, has the formula C_2H_5OH . Alcohols are used to make dyes and perfumes and as SOLVENTS in lacquers and varnishes.

Alcott, (Amos) Bronson (1799–1888) US philosopher, teacher and reformer, father of Louisa May ALCOTT. A leading figure in TRANSCENDENTALISM, Alcott helped found the utopian community of Fruitlands, Massachusetts.

Alcott, Louisa May (1832–1888) US writer, daughter of Bronson Alcott. Her debut book Flower Fables (1854) helped ease the family's financial troubles. Hospital Sketches (1863) is an account of her experiences as a nurse in the US Civil War. Little Women (1868) is one of the most successful children's books ever written. It was the first of a semi-autobiographical quartet of novels about the New England upbringing of the four March sisters. The series includes Good Wives (1869), An Old-Fashioned Girl (1870), Little Men (1871) and Jo's Boys (1886).

Aldrin, "Buzz" (Edwin) (1930–) US astronaut. Aldrin piloted the Gemini XII orbital-rendezvous space flight (November 1966) and the lunar module for the first Moon landing (20 July 1969). He followed Neil ARMSTRONG to become the second man on the Moon.

Aleichem, Sholem (1859–1916) Yiddish novelist, dramatist and short story writer, b. Sholem Yakov Rabinowitz. He portrayed the oppression of Russian Jews with humour and compassion. Aleichem's numerous works include *Tevye the Dairyman* (c.1949), which was later adapted as the musical *Fiddler on the Roof* (1964), and *The Old Country* (1954).

Alembert, Jean le Rond d' (1717-83) French mathematician and philosopher. D'Alembert was a leading figure in the ENLIGHTENMENT. He was DIDEROT's co-editor on the first edition of the Encyclopédie (1751) and contributed the "Preliminary Discourse". His systematic Treatise on Dynamics (1743) provided a solution (D'Alembert's principle) which enables Newton's third law of motion to be applied to moving objects. Aleppo (Halab) City in NW Syria; Syria's second largest city. Like the capital DAMASCUS, it claims to be the oldest continually inhabited city in the world. A part of Syria since 1924, it has a 12th-century citadel, the Great Mosque (715) and a covered bazaar more than 800m (2,625ft) long. Industries: cotton products, silk weaving, dried nuts and fruit. Pop. (1993) 1,494,000. Alessandria City in the Piemonte region of NW Italy and capital of Alessandria province. Founded in the 12th century as Civitas Nova, it was renamed after Pope ALEXANDER III. Industries: hat making, furniture. It is also a market for wine and agricultural produce. Pop. (1990) 93,350.

Aleut Branch of the Eskimo people who occupy the ALEUT-IAN ISLANDS and Alaska Peninsula. They are divided into two major language groups, the Unalaska and Atka. About 4,000 Aleuts live in scattered villages throughout sw Alaska.

Aleutian Islands Volcanic island chain, separating the

Bering Sea from the Pacific Ocean. They were purchased with Alaska by the USA in 1867. The islands have several US military bases and wildlife reserves. Industries: fishing and furs. Area: 17,666sq km (6,821sq mi). Pop. (1990) 11,942.

A-level See GENERAL CERTIFICATE OF EDUCATION (GCE)

Alexander III (c.1105–81) Pope (1159–81), b. Orlando Bandinelli. His election to the papacy was opposed by Emperor Frederick I, who had an antipope, Victor IV, elected. The ensuing schism ended 17 years later with the victory of the LOMBARD LEAGUE over Frederick at the Battle of Legnano.

Alexander I (1777–1825) Russian tsar (1801–25). After repulsing Napoleon's attempt to conquer Russia (1812), he led his troops across Europe and into Paris (1814). Under the influence of various mystical groups, he helped form the Holy Alliance with other European powers. He was named constitutional monarch of Poland in 1815 and also annexed Finland, Georgia and Bessarabia to Russia.

Alexander II (1818–81) Russian tsar (1855–81). Alexander was known as the "Tsar Liberator" for his emancipation of the serfs in 1861. He warred with Turkey (1877–78) and gained much influence in the Balkans. He sold Alaska (1867), but expanded the eastern part of the empire. Alexander brutally suppressed a revolt in Poland (1863). He was assassinated by revolutionaries.

Alexander III (1845–94) Russian tsar (1881–94). He introduced reactionary measures limiting local government; censorship of the press was enforced and arbitrary arrest and exile became common. Ethnic minorities were persecuted. Toward the end of his reign, he formed an alliance with France.

Alexander I (1888–1934) King of the Serbs, Croats and Slovenes (1921–29) and king of Yugoslavia (1929–34). In his efforts to forge a united country from the rival national groups and ethnically divided political parties, he created an autocratic police state. He was assassinated by a Croatian terrorist.

Alexander Nevski, Saint (1220–63) Russian ruler, Grand Duke of Novgorod and Grand Duke of Vladimir. He pragmatically submitted to Mongol rule following their invasion of Russia, and the Great Khan appointed him Grand Duke of Kiev. He defeated the Swedes on the River Neva in 1240 (hence the name "Nevski") and the Teutonic Knights on the frozen Lake Peipus in 1242. He was canonized by the Russian Orthodox Church in 1547.

Alexander the Great (356–323 BC) King of Macedonia (336–323 BC), considered the greatest conqueror of classical

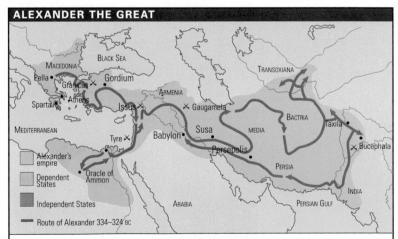

In the spring of 334 BC Alexander's army of 32,000 infantry, 5,000 cavalry and 160 ships crossed the Hellespont and defeated the Persians at the Battle of Granicus. In 333 BC he won another victory against the Persians at Issus. He then marched on and besieged Tyre, before advancing into Egypt where he founded the city of Alexandria. In 331 BC he left Egypt and again defeated the Persians at Guagamela, before capturing Babylon and the Persian cities of Susa and Persepolis. In pursuit of Darius he penetrated the heart of Asia, overcoming the Iranians.

At the foot of the Himalayas, his army refused to cross the daunting barrier and Alexander turned south, following the Indus River to the Indian Ocean, before marching west through Gedrosia. Alexander returned to Babylon where he died at the age of 32.

A

▲algae Many unicellular (single-celled) algae are said to be motile, that is they move in response to changes in their environment, in particular to light. This is achieved with tail-like flagella (1) which propel them through the water. The illustration shows three types of algae. (A) Gonyaulax tamarensis, (B) Chlamydomonas and (C) Prymnesium parvum. Algae have been found in rocks over 2,700 million years old. They are a vital source of oxygen.

times. Son of Phillip II of Macedonia and tutored by Aristotle, Alexander rapidly consolidated Macedonian power in Greece. In 334 BC he began his destruction of the vast Achaemenid Persian empire, conquering w Asia Minor and storming Tyre in 332 BC. He subdued Egypt and occupied Babylon, marching N in 330 BC to Media and then conquering central Asia in 328 BC. In 327 BC he invaded India but was prevented from advancing beyond the Punjab by the threat of mutiny. He died in Babylon, planning new conquests in Arabia. Although his empire did not outlive him, for he left no heir, he was chiefly responsible for the spread of Greek civilization in the Mediterranean and w Asia.

Alexandria Chief port and second largest city of Egypt, situated on the w extremity of the Nile delta. Founded by ALEXANDER THE GREAT in 332 BC, it became a great centre of Greek (and Jewish) culture. An offshore island housed the 3rd-century BC Pharos lighthouse, one of the SEVEN WONDERS OF THE WORLD, and the city contained a great library (founded by Ptolemy I and said to contain 700,000 volumes). Today it is a deep-water port handling over 75% of Egypt's trade. Alexandria is the Middle East headquarters for the WORLD HEALTH ORGANIZATION (WHO). Industries: oil refining, cotton textiles, plastics, paper. Pop. (1990 est.) 3,170,000.

Alexandrian school Group of Greek poets including Aratus, Apollonius Rhodius and THEOCRITUS who worked in Alexandria between the 3rd and 1st centuries BC.

Alexius I (1048–1118) Byzantine emperor (1081–1118), founder of the Comnenian dynasty. He held off the Normans, who threatened Constantinople and turned the Western armies of the First Crusade to his own advantage by using them to reconquer parts of Anatolia.

alfalfa (lucerne) Leguminous, perennial plant with spiral pods and purple, clover-like flowers. Like other legumes, it has the ability to enrich the soil with nitrogen and is often grown by farmers and then ploughed under. It is a valuable fodder plant. Height: 0.5–1.2m (1.5–4ft). Species *Medicago sativa*. Family Leguminosae. *See also* NITROGEN FIXATION

Alfonso Name of a number of rulers of Spanish kingdoms. Alfonso V (994–1028) became king of León and Asturias after his supporters took the city of León in 999. He was killed in battle against the Moors. Alfonso VIII (1155–1214) succeeded his father Sancho III as king of Castile (1158–1214). He took personal control of his kingdom in 1166 and at first opposed both Moors and fellow-Christian kings. In 1212 he forged a coalition with Christian rulers and won a major victory over the ALMOHADS at Las Navas de Tolosa. Alfonso X (1221–84), king of Castile and León (1252–84), was the son and successor of Ferdinand III. He continued the war against the Moors, but his chief ambition was to become Holy Roman emperor. A distinguished scholar, he codified the law and wrote histories of Spain and the world. Alfonso V (1396–1458) was king of Aragon

►Alhambra Built in the 13th—14th centuries, the Alhambra complex in Granada, s Spain, is considered a masterpiece of Moorish architecture. The Court of the Lions (shown) is surrounded by delicate columns and features a marble fountain supported by a circle of stone-carved lions, and is believed to represent the Muslim idea of paradise.

(1416–58). He pursued military activity to protect his Eastern trade and to curb Turkish power. **Alfonso XIII** (1886–1941), king of Spain (1886–1931), was born after the death of his father, Alfonso XII, and his mother acted as regent until 1902. Though personally popular, he could not quell competing political factions. In 1923 he supported the establishment of a military dictatorship under General Miguel PRIMO DE RIVERA. The dictatorship fell in 1930 and a republic was proclaimed.

Alfred the Great (849–99) King of Wessex (871–99). A warrior and scholar, Alfred saved Wessex from the Danes and laid the foundations of a united English kingdom. After the Danish invasion of 878, he escaped to Athelney in Somerset, returning to defeat the Danes at Edington and recover the kingdom. In a pact with the Danish leader, Guthrum (who accepted Christian baptism), England was roughly divided in two; the DANELAW occupying the NE. Although he controlled only Wessex and part of Mercia, Alfred's leadership was widely recognized throughout England after his capture of London (886). To strengthen Wessex against future attack, he built a fleet of ships, constructed forts and reorganized the army.

algae Large group of essentially aquatic photosynthetic organisms found in salt and freshwater worldwide. Algae are a primary source of food for molluses, fish and other aquatic animals. Algae are directly important to humans as food and FERTILIZERS. They range in size from unicellular microscopic organisms, such as those that form green pond scum, to huge brown SEAWEEDS more than 45m (150ft) long. Algae belong to the kingdom PROTOCTISTA. See also GREEN ALGAE; PHOTOSYNTHESIS; RED ALGAE

Algarve Southernmost province of Portugal, and the country's most popular tourist area; the capital is Faro. Irrigated orchards produce almonds, oranges, figs and olives, and the main fish catches are tuna and sardines. Area: 4,986sq km (1,925sq mi). Pop. (1994 est.) 344,300.

algebra Type of MATHEMATICS in which symbols replace numbers. Thus 3+5=8 is a statement in ARITHMETIC; x+y=8 is one in algebra, involving the variables x and y. Boolean algebra (an example of a higher algebra) can be applied to sets and to logical propositions. Algebraic operations are the arithmetical operations: addition, subtraction, multiplication and division. Operations that involve infinite series and functions such as $\log x$ are not algebraic as they depend on the use of limits.

Algeria Republic in NW Africa. See country feature

Algiers Capital and largest city of Algeria, on the Bay of Algiers, N Africa's chief port on the Mediterranean. Founded by the Phoenicians, it has been colonized by Romans, Berber Arabs, Turks (Barbarossa) and Muslim Barbary pirates. In 1830 the French invaded and made Algiers the capital of the French colony of Algeria. In World War 2 it was the head-quarters of the Allies and seat of the French provisional government. During the 1950s and 1960s it was a focus for the violent struggle for independence. The famous old city is based round a 16th-century Turkish citadel. The 11th-century Sidi Abderrahman Mosque is a major destination for Muslim pilgrims. Industries: oil refining, phosphates, wine, metallurgy, cement, tobacco. Pop. (1995) 2,168,000.

Algonquin (Algonkin) Group of Canadian Native American tribes that gave their name to the Algonquian languages of North America. The Algonquin people occupied the Ottawa River area c. AD 1600. Driven from their home by the IROQUOIS in the 17th century, they were eventually absorbed into other related tribes in Canada.

algorithm Step-by-step set of instructions needed to obtain some result from given starting data. The term is also used in computer science for the method of a computer in following an established series of steps in the solution of a problem.

Alhambra Spanish citadel of the sultans of Granada; a world heritage site and major tourist attraction. Standing on a plateau overlooking Granada, s Spain, it is one of the most beautiful and well-preserved examples of medieval ISLAMIC ART AND ARCHITECTURE. Most of the complex dates from the period of the Nasrid dynasty (1238–1358).

Ali (*c*.600–61) Fourth Muslim CALIPH (656–61), cousin and son-in-law of the Prophet MUHAMMAD. Ali was married to FATIMA. He is regarded by the SHITTES as the first Imam and

The star and crescent and the colour green on Algeria's flag are traditional symbols of the Islamic religion. The liberation movement which fought for independence from French rule from 1954 used this design, which was adopted as the national flag when Algeria became independent in 1962.

AREA: 2,381,700sq km (919,590sq mi)

POPULATION: 26,346,000

CAPITAL (POPULATION): Algiers (2,168,000)
GOVERNMENT: Socialist republic
ETHNIC GROUPS: Arab, Berber, French
LANGUAGES: Arabic (official), Berber, French
RELIGIONS: Sunni Muslim 98%, Christianity

(Roman Catholic)

CURRENCY: Algerian dinar = 100 centimes

Algeria is the second largest country in Africa. Most of the people live in the N, either on the fertile coastal plains and hill country bordering the Mediterranean Sea, or in the capital ALGIERS, or the second-largest city, ORAN. South of this region are the high plateaux and ranges of the ATLAS Mountains. Over 80% of Algeria is part of the empty wastes of the SAHARA. Some TUAREG nomads roam the desert with their herds.

CLIMATE

Algiers has a Mediterranean climate: summers are warm and dry, and winters are mild and moist. The highlands in the N tend to have colder winters and warmer summers. The annual rainfall is less than 200mm (8in). The Sahara is very hot by day but becomes cool at night. In the summer, the SIROCCO blows from the Sahara.

VEGETATION

The N has areas of scrub and farmland, with forests on mountain slopes. The Sahara contains regions of erg (sand dunes), but most of the desert is gravel-strewn plain and bare rock. Date palms and crops flourish around every oasis.

HISTORY AND POLITICS

By 2000 BC BERBERS had established village communities. In the 9th century BC, coastal Algeria (Numidia) formed part of CARTHAGE's trading empire. By the end of the 2nd century BC Rome had gained control of the coast and parts of the immediate interior. Numidia became an integral part of the Roman empire. St Augus-TINE OF HIPPO (now Annaba) was a casualty of the 5th-century invasion of the VANDALS. In the late 7th century Arabs conquered Algeria and converted the local population to Islam. Arabic became the main language. In the early 10th century the FATIMIDS rapidly built an empire from their base in NE Algeria. In the late 15th century, as part of the reconquest of s Spain, the Spanish gained control of coastal Algeria. The Spanish were ousted by the Ottomans and Algeria's coast became a haven for pirates and slave traders. In 1830 France invaded Algeria and rapidly began the process of colonization. ABD AL-KADIR led Algerian resistance until 1847. The European domination of the economy exacerbated discontent among the Muslim population. During World War 2, Algiers served as Allied headquaters in North Africas. At the end

of the war nationalist demands intensified. In 1954 the National Liberation Front (FLN) launched a nationwide revolt against French rule. By 1957 the 500,000-strong French military force had quashed the revolt, but not demands for independence. Despite the opposition of the one million French colonists (colons) and a section of the French army (the OAS), Charles DE GAULLE persisted with an accord to grant Algeria independence. Following the endorsement of De Gaulle's policy in a 1962 French referendum, the OAS launched a shortlived terrorist campaign against Muslims. The colonists rapidly left Algeria. On 3 July 1962 France declared Algeria independent. The war had claimed c.250,000 lives. Ahmed Ben Bella became prime minister, then president of the newly-reformed republic. In 1965 Ben Bella was overthrown in a military coup, led by the defence minister Colonel Houari Boumédienne. Boumédienne established a revolutionary council and stepped up the pace of reform. In 1971 he nationalized the French-owned oil and gas industries. In 1973 a National Health Service was established. Boumédienne died in 1978 and was succeeded by Colonel Chadli Benjedid. In 1980 a massive earthquake struck the NW coast, claiming nearly 5,000 lives. Anti-government demonstrations and riots led to the legalization of opposition parties in 1989. The first round of elections in December 1991 saw a decisive victory for the opposition Islamic Salvation Front (FIS), and Benjedid resigned as president. The second round of voting was cancelled and a military government assumed power. In 1992 the FIS was banned and Benjedid's successor, Muhammad Boudiaf, was assassinated. A terrorist campaign was launched by Muslim fundamentalists. In 1995 elections General Liamine Zeroual won a second term as president. Between 1992 and 1997 it is estimated that the civil war has claimed 100,000 civilian lives. In 1997 the terrorist campaign intensified.

Mediterrante di Mostaganem Oran Skikda Annaba SPAIN Algiers ATLANTIC 4 OCEAN Biskra Djelfa 2 Chott Laghouat MOROCCO 5 Touggourt Ghardaïa 🛊 Ouargla Béchar L El Goléa 30 ı Timimoun R A B Bordj Omar Tademait Plateau Driss Tindouf In Salah Y A 250) 25°N M Sahara Deser Djanet 6 AURIT Mountains Tahat Tamanrasset AN Bordj-Mokhtar A 20°N MAP SCALE NIGER 10°E

ECONOMY

Algeria is a developing country (1995 GDP per capita, US\$3,800). Its chief resources are oil and natural gas, which were first discovered under the Sahara in 1956. Its natural gas reserves are the fifth-largest in the world; oil the 14th-largest. Gas and oil account for more than 90% of Algeria's exports. Manufactures include cement, iron and steel, textiles and vehicles (Algeria is one of the few African states to have its own car plant). While most larger industries are owned by the government, much of light industry is under private control. Farming employs c.14% of the workforce. Barley, citrus fruits, dates, grapes, olives, potatoes and wheat are the major crops. In 1995 unemployment stood at over 25% of the workforce, and many Algerians work abroad, especially in France.

▲ Ali Perhaps the greatest heavyweight boxer of all time, Muhammad Ali's skilful footwork and stylish boxing were matched by his quick-fire wit. In 1984 it was revealed that Ali was suffering from Parkinson's disease, probably caused and certainly exacerbated by the punches he received in a long boxing career.

rightful heir of Muhammad. Ali succeeded OTHMAN as caliph, despite opposition from Aishah and Muawiya. He was assassinated and his first son, Hasan, abdicated in favour of Muawiya, who founded the UMAYYAD dynasty. His second son, Husayn, led the insurrection against the Umayyads, but was defeated and killed at the Battle of Karbala (680).

Ali, Muhammad (1942–) US boxer, b. Cassius Marcellus Clay. As Cassius Clay, he defeated Sonny Liston to gain the world heavyweight championship (1964). Clay converted to Islam and joined the BLACK MUSLIMS. Ali successfully defended the title nine times. In 1967 he refused to fight in the Vietnam War. The World Boxing Association (WBA) took away his title. In 1971 the US Supreme Court upheld Ali's appeal against the ban, but he was defeated by reigning champion Joe Frazier. He regained the title from George Foreman in the 1974 "rumble in the jungle" fight. In 1978 Ali was defeated by Leon Spinks, but won the rematch, becoming the first heavyweight to win the title three times.

Alice Springs Town on the River Todd, s Northern Territory, central Australia. Founded in 1860, it is a crucial railhead, livestock shipping centre and supply source for a vast area that includes AYERS ROCK. It is the headquarters of the Flying Doctor Service and the School of the Air (radio-linked classes for children living in the "outback"). It is the state's second largest town (after Darwin). Pop. (1994) 24,852.

Alien and Sedition Acts (1798) Four US acts designed to curb criticism of the government at a time when war with France seemed imminent. Many of the severest critics were refugees from Europe who were regarded as disloyal. The acts imposed stringent rules on residency before naturalization, and gave the president unprecedented powers to deport undesirable foreigners or imprison them in time of war.

alienation Term used in PSYCHOLOGY to mean a feeling of estrangement and separation from other people. In existential psychology this meaning is extended to include the perception that one is alienated or estranged from one's "real self" because of being forced to conform to society's expectations. In the USA "alienist" refers to a psychiatrist who deals with the legal aspects of insanity.

alimentary canal Digestive tract of an animal that begins with the MOUTH, continues through the OESOPHAGUS to the STOMACH and INTESTINES, and ends at the anus. It is about 9m (30ft) long in humans. See also DIGESTIVE SYSTEM

aliphatic compound Any organic chemical compound whose carbon atoms are linked in straight chains, not closed rings. They include the ALKANES, ALKENES and ALKYNES.

alkali Soluble BASE that reacts with an ACID to form a SALT and water. A solution of an alkali has a pH greater than 7. Alkali solutions are used as cleaning materials. Strong alkalis include the hydroxides of the ALKALI METALS and ammonium hydroxide. The carbonates of these metals are weak alkalis. alkali metals Univalent metals forming Group I of the periodic table: LITHIUM, SODIUM, POTASSIUM, RUBIDIUM, CAESIUM and FRANCIUM. They are soft silvery-white metals that tarnish rapidly in air and react violently with water to form hydroxides. alkaline-earth metals Bivalent metals forming Group II of

the periodic table: BERYLLIUM, MAGNESIUM, CALCIUM, STRON-TIUM, BARIUM and RADIUM. They are all light, soft and highly reactive. All, except beryllium and magnesium, react with cold water to form hydroxides (though magnesium reacts with hot water). Radium is important for its radioactive properties. alkaloid Member of a class of complex nitrogen-containing organic compounds found in certain plants. They are sometimes bitter and highly poisonous substances, used as DRUGS. Examples include codeine, morphine, nicotine and quinine.

alkane Hydrocarbon compound with the general formula $C_n H_{2n+2}$. Alkanes have a single carbon-carbon bond and form an homologous series whose first members are METHANE, ETHANE, PROPANE and BUTANE. Because alkanes are SATURATED COMPOUNDS they are relatively unreactive. Alkanes are used as fuels. See also PARAFFIN

alkene (olefin) Unsaturated HYDROCARBON compound with the general formula $C_nH_{2n'}$ Alkenes have a carbon-carbon double bond and form an homologous series whose first members are ETHENE and PROPENE. They are reactive, particularly

in ADDITION reactions. Alkenes are made by the dehydration of alcohols, and are used as fuels and to make POLYMERS.

alkyne (acetylene) Unsaturated HYDROCARBON compound with the general formula C_nH_{2n-2} . Alkynes have a carbon-carbon triple bond and form an homologous series whose first members are ETHYNE and propyne.

Allah One and only God of ISLAM. His name is probably derived from Arabic *al-Illāh*, meaning "the God". Allah is the omnipresent and merciful rewarder, the creator and judge of all. Unreserved surrender to Allah, as preached in the KORAN, is the very heart of the Islamic faith.

Allahabad City at the confluence of the Ganges and Yamuna rivers, Uttar Pradesh state, N central India. Allahabad is a pilgrimage centre for Hindus because of the belief that the goddess Sarasvatī joined the two rivers at this point. The Kumbh Mela fair, a religious celebration, takes place here every 12 years. It has one of the oldest universities in India (1887) and is also an agricultural trade centre. Pop. (1991) 806,000.

All Blacks National RUGBY union team of New Zealand. The first New Zealand touring side visited the British Isles and France in 1905–06. They won 32 of their 33 matches, establishing the All Blacks as the world's leading rugby team. The All Blacks won the inaugural World Cup (1987). The team is famous for the "haka", a ceremonial Maori war dance performed before each match.

allegory Literary work in either prose or verse in which more than one level of meaning is expressed simultaneously. The fables of Aesop and La Fontaine are examples of simple allegory. *Pilgrim's Progress* (1684) by John Bunyan is a sophisticated religious allegory.

allele One of two or more alternative forms of a particular GENE. Different alleles may give rise to different forms of the characteristic for which the gene codes. Different flower colour in peas is due to the presence of different alleles of a

single gene. See also Gregor MENDEL

Allen, Woody (1935-) US film director, actor and screenwriter, b. Allen Stewart Konigsberg. Allen made his debut as an actor and screenwriter in What's New Pussycat? (1965). His directorial debut was Take the Money and Run (1969). During the 1970s he established his trademark style of urbane, angst-ridden New York-based comedies. Allen won Academy awards for Best Picture, Best Screenplay and Best Director for Annie Hall (1977). He gained an Oscar nomination for his first serious drama, the BERGMAN-like Interiors (1978). His next film, Manhattan (1979), marked a return to the semi-autobiographical format. Hannah and Her Sisters (1986) won Allen an Oscar for Best Screenplay. Other films include Zelig (1983), The Purple Rose of Cairo (1985), Crimes and Misdememanors (1989) and Mighty Aphrodite (1996). His separation (1992) from Mia Farrow, his longstanding partner and co-star, was acriminous and litigious.

Allende Gossens, Salvador (1908–73) Chilean statesman, president (1970–73). Allende was one of the founders of the Chilean Socialist Party (1933), and served as minister of health (1939–42) and head of the senate (1965–69). Allende's narrow election victory led to the introduction of democratic socialist reforms, which anatagonized the Chilean establishment. The nationalization of the US-owned copper industry resulted in a US trade embargo. The CIA, helped by a deteriorating economy, began a covert campaign of destabilization. Allende was overthrown and died in a military coup led by General PINOCHET.

allergy Disorder in which the body mounts a hypersensitive reaction to one or more substances (allergens) not normally considered harmful. Typical allergic reactions are sneezing (HAY FEVER), "wheezing" and difficulty in breathing (ASTHMA) and skin cruptions and itching (ECZEMA). A tendency to allergic reactions is often hereditary.

Allies Term used in World War 1 and World War 2 for the forces that fought the Central Powers and Axis Powers respectively. In World War 1 they numbered 23 and included Belgium, Britain and its Commonwealth, France, Italy, Japan, Russia and the USA. In World War 2 the 49 Allies included Belgium, Britain and the Commonwealth, France, the Netherlands, the Soviet Union and the USA.

alligator Broad-snouted crocodilian reptile found only in the USA and China. The American alligator, *Alligator missis-sippiensis*, is found in the SE USA; it grows up to 5.8m (19ft) long. The almost extinct smaller Chinese alligator, *A. sinensis*, is restricted to the Yangtze-Kiang river basin. Length: up to 1.5m (5ft). Family Alligatoridea.

allium See ONION

allotropy Property of some chemical elements that enables them to exist in two or more distinct physical forms. Each form (an allotrope) can have different chemical properties but can be changed into another allotrope – given suitable conditions. Examples of allotropes are molecular oxygen and ozone; white and yellow phosphorous; and graphite and diamond (carbon). **alloy** Combination of two or more metals. An alloy's proper-

alloy Combination of two or more metals. An alloy's properties are different from those of its constituent elements. Alloys are generally harder and stronger, and have lower melting points. Most alloys are prepared by mixing when molten. Some mixtures that combine a metal with a nonmetal, such as steel, are also referred to as alloys.

All Saints' Day In the Christian liturgical calendar, the day on which all the saints are commemorated. The feast is observed on 1 November in the West and on the first Sunday after Pentecost (Whitsun) in the East. The eve of the day is celebrated in some western countries as HALLOWE'EN.

All Souls' Day Day of remembrance and prayer for all the departed souls. Observed by Roman Catholics and High Church Anglicans on 2 November, or 3 November if the former falls on a Sunday.

allspice (pimento) Aromatic tree native to the West Indies and Central America. The fruits are used as a spice, in perfume and in medicine. Height: up to 12m (40ft). Family Myrtaceae; species *Pimenta officinalis*

Allston, Washington (1779–1843) US romantic painter. A pupil of Benjamin West at London's Royal Academy, Allston was the pioneer of romantic LANDSCAPE PAINTING in the US and a precursor of the HUDSON RIVER SCHOOL. His work in England includes a portrait of Coleridge (1814). In 1818 he returned to the USA. Allston's most famous work is the lyrical Moonlit Landscape (1819). He spent 20 years working on the disappointing Belshazzar's Feast. It remained unfinished. alluvial fan Generally fan-shaped area of ALLUVIUM (water-borne sediment) deposited by a river when the stream reaches a plain on lower ground, and the water velocity is abruptly reduced. Organic matter is also transported, making the soil highly fertile. Valuable minerals such as cassiterite (tin ore, SnO₂), diamonds, gold and platinum are often found in alluvial fans.

alluvium General term that describes the sediments sand, silt and mud, deposited by flowing water along the banks, delta or flood-plain of a river or stream. Fine textured sediments that contain organic matter form soil.

Almaty (formerly Alma-Ata) Largest city and, until 2000, capital of Kazakstan, near the SE border with Kyrgyzstan. In 1991 it hosted the meeting of 11 former Soviet republics that led to the Alma-Ata Declaration, which created the COMMON-WEALTH OF INDEPENDENT STATES (CIS). In 1995 the government decided to move the capital to AOMOLA. Industries: foodstuffs, tobacco, timber, printing, film-making, leather, machinery. Pop. (1991) 1,515,300.

Almohad Berber Muslim dynasty (1145–1269) in North Africa and Spain, the followers of a reform movement within Islam. It was founded by Muhammad ibn Tumart, who set out from the Atlas Mountains to purify Islam and oust the Almoravide from Morocco and eventually Spain. In 1212 Alfonso VIII of Castile routed the Almohads, and in 1269 their capital, Marrakesh, fell to the Marinids.

almond Small tree native to the E Mediterranean region and sw Asia; also the seed of its nut-like fruit. Family Rosaceae; species *Prunus dulcis*.

Almoravid Berber Muslim dynasty (1054–1145) in Morocco and Spain. They rose to power under Abdullah ibn Yasin who converted Saharan tribes in a religious revival. Abu Bakr founded Marrakesh as their capital in 1070; his brother Yusuf ibn Tashufin defeated Alfonso VI of Castile in 1086. Almoravid rule was ended by the rise of the Almohads.

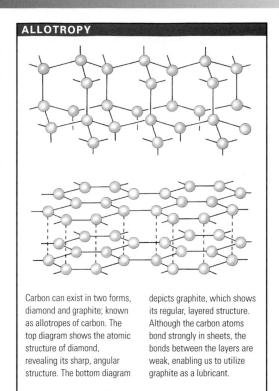

aloe Genus of plants native to s Africa, with spiny-edged, fleshy leaves. Aloe grows in dense rosettes and has drooping red, orange or yellow flower clusters. Family Liliaceae.

alpaca See LLAMA

aiphabet System of letters representing the sounds of speech. The word alphabet is derived from the first two letters of the Greek alphabet, *alpha* and *beta*. The most important alphabets in use today are Roman, CYRILLIC, GREEK, ARABIC, HEBREW and Devanagari. Because an alphabet permits a language to be written, it facilitates the dissemination and preservation of knowledge. The Latin alphabet, which grew out of the Greek by way of the Etruscan, was perfected around AD 100 and is the foundation on which Western alphabets are based. In some alphabets, such as the Devanagari of India, each character represents a syllable. BRAILLE and MORSE code are alphabets invented to meet special needs.

Alpha Centauri Brightest star in the constellation Centaurus, and the third-brightest star in the sky. It is a visual BINARY. alpha particles (alpha rays) Stable, positively charged particles emitted spontaneously from the nuclei of certain radioactive isotopes undergoing alpha decay. They consist of two protons and two neutrons and are identical to the nuclei of helium atoms. Their penetrating power is low compared with that of beta particles (electrons) but they cause intense ionization along their track. This ionization is used to detect them. See also RADIOACTIVITY; Ernest RUTHERFORD

Alps Mountain system in s central Europe, extending $c.1,200 \mathrm{km}$ (750mi) in a broad arc from near the Gulf of Genoa on the Mediterranean Sea through France, Italy, Switzerland, Liechtenstein, Austria, Germany and Slovenia. The system was formed by the collision of the European and African tectonic plates. The highest peak is Mont Blanc at 4,807m (15,771ft).

Alsace Region in E France, comprising the départements of Bas-Rhin and Haut-Rhin. Strasbourg is the leading city, Mulhouse and Colmar are the main industrial centres. Separated from Germany by the River Rhine, the Alsace-Lorral region has often caused friction between France and Germany. The culture and architecture reflect both national influences. There are rich deposits of iron ore and potash. Most of the region is fertile and productive, with Germanstyle, riesling wine the major agricultural product. Industries: steel, textiles, chemicals. Area: 8,280sq km (3,200sq mi). Pop. (1990) 1,624,400.

▼ almond Bitter and sweet almonds are related to the stone fruits such as the peach, and are cultivated in temperate climates. Sweet almonds are edible, but the kernel of the bitter variety is inedible and used only for the extraction of its oil.

Altai Complex mountain system in central Asia, stretching from Kazakstan into N China and W Mongolia, and from S Siberia to the Gobi Desert. A densely forested area, it is the source of the Irtyš and Ob rivers. The average height is 2,000–3,000m (6,500–10,000ft), and the highest peak is Mount Belukha, on the Kazakstan–Russia border, at 4,506m (14,783ft).

Altaic languages Family of languages spoken by *c*.80 million people in parts of Turkey, Iran, Mongolia, the former Soviet Union and China. It consists of three branches: the Turkic, Mongolian, and Tungusic. They are named after the ALTAI Mountains.

Altair (Alpha Aquilae) Star whose luminosity is ten times that of the Sun. Characteristics: apparent mag. 0.77; spectral type A7; distance 16 light-years.

Altamira World heritage site of notable PALAEOLITHIC ART $(c.14,000-9,500\,$ BC), including cave paintings and engravings, near Santander, N Spain. The roof of the lateral chamber is covered with paintings of animals, particularly bison, boldly executed in vivid black, red and violet. There are also eight engraved anthropomorphic figures. They were accepted as genuine in 1902.

alternating current (AC) See ELECTRIC CURRENT

alternation of generations Two generation cycle by which plants and some algae reproduce. The asexual diploid SPOROPHYTE form produces haploid SPORES that, in turn, grow into the sexual (GAMETOPHYTE) form. The gametophyte produces the egg cell that is fertilized by a male gamete to produce a diploid zygote that grows into another sporophyte.

alternative energy See RENEWABLE ENERGY

alternator Electrical generator that produces an alternating ELECTRIC CURRENT.

altimeter Instrument for measuring altitude. The simplest type is a form of aneroid BAROMETER. As height increases, air pressure decreases, so the barometer scale can be calibrated to show altitude. Some aircraft have a radar altimeter, which measures the time taken to bounce a radar signal off the ground.

Altiplano High plain in the South American Andes of Peru and w Bolivia. It has an average elevation of c.3,650m (12,000ft).

altitude In astronomy, the angular distance of a celestial body above the observer's horizon. It is measured in degrees from 0 (on the horizon) to 90 (at the zenith) along the great circle passing through the body and the zenith. If the object is below the horizon, the altitude is negative.

Altman, Robert (1925–) US independent film director. Altman gained his first Oscar nomination for M*A*S*H (1970). A second Oscar nomination followed for Nashville (1975). Following a series of theatre adaptations, he returned to exposing the reality behind the myth in The Player (1992). Short Cuts (1993) was a successful adaptation of Raymond Carver's short stories. Kansas City (1996) was also well received.

alto In singing, the highest male voice, also called COUNTERTENOR; or the lowest female voice, also called CONTRALTO. It is also used to describe that member of a family of instruments with a range that corresponds to the alto voice; for example, an alto FLUTE is a fourth lower than a standard one. alumina (aluminium oxide, Al₂O₃) Mineral used as an abrasive, electrical insulator and furnace lining. Other forms of alumina include corundum, two impure varieties of which are the gemstones SAPPHIRE and RUBY.

aluminium (symbol Al) Metallic silvery white element of group III of the periodic table. It is the most common metal in the Earth's crust; the chief ore is BAUXITE from which the metal is extracted by electrolysis. Alloyed with other metals, it is used extensively in machined and moulded articles, particularly where lightness is important, such as aircraft. It is protected from oxidation (corrosion) by a thin, natural layer of oxide. Properties: at.no. 13; r.a.m. 26.98; r.d. 2.69; m.p. 660.2°C (1,220.38°F); b.p. 1,800°C (3,272°F); most common isotope Al²⁷. See also ANODIZING

Alvarez, Luis Walter (1911–88) US physicist who won the 1968 Nobel Prize for physics for developing the liquid-hydrogen BUBBLE CHAMBER. Alvarez used it to identify many "resonances" (very short-lived particles). He also helped con-

struct the first proton linear ACCELERATOR. Alvarez worked on the MANHATTAN PROJECT to develop the atom bomb and invented a RADAR guidance system for aircraft.

alveolus (pl. alveoli) One of a cluster of microscopic tiny air-sacs that open out from the alveolar ducts at the far end of each bronchiole in the LUNGS. The alveolus is the site for the exchange of gases between the air and the bloodstream, and is covered in a network of CAPILLARY blood vessels. *See also* GAS EXCHANGE; RESPIRATORY SYSTEM

Alzheimer's disease Degenerative condition characterized by memory loss and progressive mental impairment; it is the commonest cause of DEMENTIA. Sometimes seen in the middle years, Alzheimer's becomes increasingly common with advancing age. Many factors have been implicated, but the precise cause is unknown.

AM Abbreviation of AMPLITUDE MODULATION

Amado, Jorge (1912–) Brazilian novelist. Amado's early novels, such as *Sweat* (1934) and *The Violent Land* (1942) are powerful, bleak realist novels on poverty in Brazil. His later works, such as *Dona Flor and Her Two Husbands* (1966), are more lyrical, using folklore and humour to examine contemporary Brazilian society.

Amal (Arabic "hope", in full Afwaj al-Muqawama al-Lubnaniyya "Masses of the Lebanese resistance") Lebanese Shitte political movement. Amal was established in 1974 by Musa Sadr to press for greater Shitte political representation in Lebanon. It split into extremist and moderate groups in 1982. Backed variously by Syria and the Palestinian Liberation Organization (PLO), its members have perpetrated a number of terrorist acts, such as the kidnappings in Lebanon during the 1980s. In 1991 the Lebanese National Assembly decreed the dissolution of all militias and the Amal moderated their stance. amalgam Solid or liquid alloy of mercury with other metals. Dentists once filled teeth with amalgams usually containing copper and zinc. Most metals dissolve in mercury, although iron and platinum are exceptions.

amanita Large, widely distributed genus of fungi. Amanitas usually have distinct stalks and the prominent remains of a veil in a fleshy ring under the cap and at the bulbous base. They include some of the most poisonous fungi known, such as the DEATH CAP and destroying angel. See also FLY AGARIC

amaryllis Genus consisting of a single species of bulbous plant, *Amaryllis belladona*, the belladonna lily, which has several trumpet-shaped pink or white flowers. Amaryllis is also the common name for *Hippeastrum*, a bulbous houseplant.

Amaterasu Sun goddess of the Shinto pantheon, considered to be the ancestor of the Japanese imperial clan.

Amati Family of Italian violinmakers in Cremona in the 16th and 17th centuries. They included Andrea (*c*.1520–78), the founder of the Cremona school of violinmaking; his two sons Antonio (*c*.1550–1638) and Girolamo (1551–1635); and Girolamo's son Nicolo (1596–1684) and grandson Girolamo (1649–1740). The Amati family are credited with establishing the design of the modern violin.

Amazon World's second-longest river, draining the vast RAINFOREST basin of N South America. The Amazon carries by far the greatest volume of water of any river in the world: the average rate of discharge is *c*.95,000m³ (3,355,000ft³) every second, nearly three times as much as its nearest rival, the CoNGO. The flow is so great that its silt discolours the water up to 200km (125mi) into the Atlantic. At around 7 million sq km (2.7 million sq mi), the Amazon River basin comprises nearly 40% of the continent of South America. Length: *c*.6,430km (3,990mi).

Amazon In Greek mythology, a race of female warriors who formed a totally matriarchal society. HERACLES, THESEUS and other Greek heroes challenged the Amazons. As allies of the Trojans, they took part in the defence of TROY, where their queen Penthesilea was slain by ACHILLES.

amber Hard, yellow or brown, translucent fossil resin, mainly from pine trees. Amber is most often found in alluvial soils, in lignite beds or around seashores, especially the BALTIC SEA. The resin sometimes occurs with embedded fossil insects or plants. Amber can be polished to a high degree and is used to make necklaces and other items of jewellery.

ambergris Musky, waxy, solid formed in the intestine of a SPERM WHALE. It is used in perfumes as a fixative for the scent. Ambrose, Saint (339–97) Roman cleric who, as Bishop of Milan from 374, resisted demands to surrender Milan's churches to the Arians and refused to compromise his orthodox position. He was the author of works on theology and ethics that greatly influenced the thought of the Western church. His feast day is 7 December. See also Arianism

Amenhotep III (c.1417-c.1379 BC) King of ancient Egypt. He succeeded his father, Thutmose IV. The 18th dynasty was at its height during his reign. He maintained peace throughout the empire and undertook extensive building works. His wife, Queen Tiy, played an important role in state affairs. He was succeeded by his son, who took the name AKHNATEN.

Amenhotep IV See AKHNATEN

America Western hemisphere, consisting of the continents of North America and South America, joined by the isthmus of Central America. It extends from n of the Arctic Circle to 56° s, separating the Atlantic Ocean from the Pacific. Native Americans settled the entire continent by 8000 BC. Norsemen were probably the first Europeans to explore America in the 8th century, but Christopher Columbus is popularly credited with the first European discovery in 1492. The name "America" was first applied to the lands in 1507 and derives from Amerigo Vespucci, a Florentine navigator who was falsely believed to be the first European to set foot on the mainland.

American Academy and Institute of Arts and Letters US association formed by the merger in 1977 of the National Institute of Arts and Letters and the American Academy of Arts and Letters. The association's membership is limited to 250 individuals of literary, musical or artistic achievement. Awards are given annually for distinguished and creative work in painting, sculpture, literature and drama.

American art During the colonial era, American art reflected the taste of European settlers. In Spanish territories, the main demand was for religious art; while in Dutch and English areas, there was a greater emphasis on portraiture. In the 18th century, America produced its first artists of international standing, John Singleton COPLEY and Benjamin WEST. Both spent much of their career in England, where they became leading exponents of history painting. After independence, there was a gradual movement away from European traditions. This was most evident in the field of LANDSCAPE PAINT-ING, where artists from the HUDSON RIVER SCHOOL and the Rocky Mountain School recorded the beauty of the wilderness. Thomas Eakins and Winslow Homer also celebrated the American way of life, although in a more realistic vein. Realism was the cornerstone of the ASHCAN SCHOOL. In the 20th century, the key event was the ARMORY SHOW of 1913, which encouraged the spread of modern art. Alfred STIEGLITZ was a seminal figure in the development of modern art in the US. Georgia O'KEEFFE and Edward HOPPER were arguably its two greatest stylists. With the development of ABSTRACT EXPRES-SIONISM in the 1940s, US artists became the standard-bearers of the avant-garde, a role they have never relinquished. See also Luminism; Native North American art

American Bar Association (ABA) US organization whose members are attorneys admitted to the bar of any state. Founded in 1878, the association attempts to ensure parity of law nationwide, improve the efficiency of the legal system, and maintain high standards. The association comprises over 25 committees, each responsible for specialized areas of law. By the mid-1990s the association boasted over 400,000 members. American Colonization Society Group founded in 1817 by Robert Finley to return free African-Americans to Africa for settlement. More than 11,000 African-Americans were transported to Sierra Leone and, after 1821, Monrovia. Leading members of the society included James Monroe, James Madison and John Marshall.

American Federation of Labor and Congress of Industrial Organizations (AFL-CIO) US labor organization, the largest union in North America. It is a federation of individual trade unions from the USA, Canada, Mexico, Panama and some US dependencies. It was formed in 1955 by the merger of the American Federation of Labor (AFL)

and Congress of Industrial Organizations (CIO). Although each union within the federation is fully autonomous, the ultimate governing body of the AFL-CIO is an executive council made up of president, vice presidents and secretary-treasurer. In recent years, the reduction of union membership (c.15% of US workers in 1995) has seen the AFL-CIO concentrate on recruiting public sector workers.

American Fur Company First US business monopoly, owned by John Jacob ASTOR. John Jay's Treaty of 1794 permitted US fur trading in the Pacific Northwest to compete with Montreal interests and the North West Company. Fort Astoria was set up in Oregon in 1805. During the WAR OF 1812 the USA was unable to defend Astoria, and Astor was forced to sell out to the North West Company. As the fur trade declined in the 1840s, Fort Astoria reverted to US control.

American Indians Alternative name for NATIVE AMERICANS American Legion Association of US military veterans. Founded in Paris in 1919, its US headquarters are at Indianapolis, Indiana. Qualifications for membership are honourable service or honourable discharge. It sponsors many social causes, notably education and sports for young people, and care of sick and disabled veterans.

American literature English explorers and early colonists produced literary accounts of North America. The first English language work published in New England was the Bay Psalm Book (1640). Early colonial literature was often an expression of Puritan piety, designed as a moral framework for a religious colony. Many of the leading figures in the AMERICAN REVOLUTION, such as Thomas PAINE and Benjamin FRANKLIN, produced important literary works. Early 19th-century writers, such as Washington IRVING and James Fenimore COOPER were influenced by European romanticism. The preeminent US romantic poet was Henry Wadsworth Longfel-LOW. TRANSCENDENTALISM was the first truly distinctive national literary movement. Leading writers included the essayists Henry David THOREAU, Ralph Waldo EMERSON, Oliver Wendell HOLMES and Louisa May ALCOTT. Walt WHIT-MAN's free-verse epic Leaves of Grass (1855-92) is perhaps the most fully realized poetic expression of transcendentalism. The 1840s and 1850s produced many American fiction classics, such as Herman MELVILLE's Moby Dick (1851), and Nathaniel HAWTHORNE'S The Scarlet Letter (1850). Harriet Beecher STOWE's anti-slavery story Uncle Tom's Cabin (1852) was the best-selling novel of the 19th century. Literature of the immediate post-Civil War period is characterized by parochialism. The two great exceptions to the trend (and precursors of a new realism) were Henry JAMES and Mark TWAIN. While James emigrated to Europe and embraced psychologi-

■ American art The Actor's Studio by James Abbot McNeil Whistler (1834–1903). Like many 19th-century American artists Whistler was heavily influenced by European art and spent much of his life in London. His assertion that art should be independent of moral and social concerns influenced the development of abstract art, but also resulted in a lawsuit with John Ruskin.

cal realism in novels such as Portrait of a Lady (1881), Twain used distinctive national dialects in humorous classics such as Huckleberry Finn (1885). Realism fed into NATURALISM, producing writers who either focused on the development of cities (Theodore DRIESER and Edith WHARTON), or those who concentrated on a hostile wilderness, such as Jack London. Stephen Crane's Red Badge of Courage (1895) was groundbreaking in its naturalistic treatment of the American Civil War. Emily DICKINSON was finally published posthumously in 1890. In the early 20th century many US writers went into exile. In Paris, Gertrude STEIN held court over the "Lost Generation", a large group of emigrés that included Ernest HEM-INGWAY and Henry MILLER. T.S. ELIOT and Ezra POUND led the search for experimental poetic forms. Eliot's bleak and fragmentary poem The Wasteland (1922) is often viewed as the archetype of high MODERNISM. Wallace STEVENS and William Carlos WILLIAMS developed the new poetry. William FAULKN-ER is regarded as one of the leading modernist novelists. The HARLEM RENAISSANCE witnessed the emergence of African-American writers, such as Langston Hughes. The style and decadence of the "jazz age" in 1920s New York was captured by F. Scott FITZGERALD in The Great Gatsby (1925). The 1920s also witnessed the debut of the first great American dramatist, Eugene O'NEILL. Writers such as John STEINBECK, Carson McCullers and Eudora Welty emerged in the 1930s. Post-World War 2 literature and drama can be characterized by a sense of despair and the meaningless absurdity of artistic expression when confronted by the violence of the 20th century. In the 1950s major dramatists such as Arthur MILLER, Edward ALBEE and Sam SHEPARD developed the American theatre. African-American writers, such as Richard WRIGHT, Ralph Ellison and James Baldwin, dealt with racial inequality and violence in contemporary US society. Maya ANGELOU and Toni Morrison focused on the 20th century history of African-American women. During the 1960s novelists such as Saul Bellow, Philip ROTH and Joseph Heller examined the Jewish urban intellectual approach to American society, often adopting a deeply ironic tone. Humour was also a major outlet for writers such as John UPDIKE, Kurt VONNEGUT and Thomas PYNCHON. Norman MAILER used a more muscular, controversialist approach. The BEAT MOVEMENT (including Jack KER-OUAC and Allen GINSBERG) urged the rejection of the established order and embraced alternative values. A major trend in American poetry was the "confessional" style of personal revelation by poets such as Robert Lowell and Sylvia PLATH. Post-modernism has informed the work of authors such as Kathy Acker and Bret Easton Ellis.

American Medical Association (AMA) US federation of 54 state and territorial medical associations, founded in 1847. The AMA develops programmes to provide scientific information for the profession and health-education materials for the public. By the mid-1990s there were about 300,000 members. American Revolution (1775–83) (American War of Independence) Successful revolt by the THIRTEEN COLONIES in North America against British rule. A number of issues provoked the conflict including restrictions on trade and manufacturing imposed by the NAVIGATION ACTS, restrictions on land settlement in the West, and attempts to raise revenue in America by such means as the STAMP ACT (1765) and the Tea Act (1773) that led to the BOSTON TEA PARTY. "No taxation without representation" became the colonial radicals' rallying cry. The intellectual battle for independence was led by Thomas Paine, Thomas Jefferson and Benjamin Franklin. A CONTINENTAL CONGRESS was summoned in 1774, and the first shots were fired at LEXINGTON AND CONCORD, Massachusetts, in April 1775. The second Continental Congress met in May at Philadelphia and assumed the role of a revolutionary government. George WASHINGTON established an army. On 4 July 1776 the DECLARATION OF INDEPENDENCE made the break with Britain decisive. Initially the Americans suffered a series of military defeats, which saw Washington retreat from New York to Pennsylvania. Crossing the River Delaware, he surprised and captured the British at TRENTON (26 December 1776). On 3 January 1777, he defeated the British at PRINCE-TON, further strengthening American morale. The British attempted a three-pronged attack, focusing on New York State. The strategy failed with the first decisive colonial victory at Saratoga (17 October 1777), and the entry of France into the war against Britain. During the winter of 1777, Washington's forces reorganized in Pennsylvania. In 1778 the British forces concentrated on the South, taking Savannah in December 1778. Following the defeat at King's Mountain in 1780, the British, under General Charles Cornwallis, were forced to withdraw N to Yorktown, Virginia. In 1781, surrounded by American forces and the French navy, Cornwallis was forced to surrender. Fighting ceased and the war was formally ended by the Peace of Paris (1783), which recognized the independence of the USA.

American Samoa US-administered group of five volcanic islands and two coral atolls of the SAMOA island chain in the s Pacific, c.1,050km (650mi) NE of Fiji. The principal islands are Tutuila, the Manu'a group (Ta'u, Ofu and Olosega) and Aun'u. In 1899, a treaty between the USA, Germany and the UK granted the USA rights to the islands E of 171° longitude, and Germany the rights to the w sector. American Samoa remained under the jurisdiction of the US Navy until 1951, when the US naval base at the capital Pago Pago closed down. Administration was transferred to the Department of the Interior. In 1978 the first gubernatorial elections took place. The population is largely Polynesian, who are considered US nationals. The US government and the tuna fish canning industry are the main sources of employment. Pop. (1990) 46,773.

America's Cup International competition for racing yachts. A trophy was established in 1857 by the New York Yacht Club. Until the 1950s most challenges came from British yacht clubs. Now several countries compete in a series of eliminators, before challenging the previous winners. The USA has won the best-of-seven series on almost every occasion, and traditionally hosts the contest off Newport, Rhode Island. Technological advances have led to rule changes during the 1980s and 1990s.

Americium (symbol Am) Radioactive metallic element of the ACTINIDE SERIES, first made in 1944 by Glenn Seaborg and others by neutron bombardment of plutonium. It is used in home smoke detectors, and Am²⁴¹ is a source of gamma rays. Properties: at.no. 95; r.a.m. 243.13; r.d. 13.67; m.p. 995°C (1,821°F); b.p. unknown; most stable isotope Am²⁴³ (half-life 7,650 yr).

amethyst Transparent, violet variety of crystallized OUARTZ, containing more iron oxide than other varieties. It is found mainly in Brazil, Uruguay, Ontario, Canada and North Carolina, USA. Amethyst is valued as a semi-precious gem.

Amin, Idi (1925–) President of Uganda (1971–79). He gained power by a military coup in 1971, overthrowing Milton OBOTE. He established a dictatorship marked by atrocities, and expelled about 80,000 Asian Ugandans in 1972. When Tanzanian forces joined rebel Ugandans in a march on KAMPALA, Amin fled to Libya.

amine Any of a group of organic compounds derived from AMMONIA by replacing hydrogen atoms with alkyl groups. Methylamine (CH₃NH₂) has one hydrogen replaced. Replacement of two hydrogens gives a secondary amine and of three hydrogens, a tertiary amine. Amines are produced in the putrefaction of organic matter and are weakly basic. See also ALKALOID

amino acid Organic acid containing at least one carboxyl group (COOH) and at least one amino group (NH₂). Amino acids are of great biological importance because they combine together to form PROTEIN. Amino acids form PEPTIDES by the reaction of adjacent amino and carboxyl groups. Proteins are polypeptide chains consisting of hundreds of amino acids. About 20 amino acids occur in proteins; not all organisms are those that an organism has to obtain ready-made from its environment. There are ten essential amino acids for humans: arginine, histidine, isoleucine, leucine, lysine, methionine, phenylalnine, threonine, tryptophan and valine.

Amis, Kingsley (1922–95) British novelist, father of Martin Amis. Amis' debut novel *Lucky Jim* (1954) is a classic of post-1945 British fiction. A sparkling satire on academia, it estab-

lished Amis as one of the ANGRY YOUNG MEN. Other novels include *That Uncertain Feeling* (1955), *Take a Girl Like You* (1960), *One Fat Englishman* (1963), *Girl*, *20* (1971) and *Stanley and the Women* (1984). Amis wrote a James Bond novel, *Colonel Sun* (1968), under the pseudonym Robert Markham. His tragicomedy *The Old Devils* (1986) won the Booker Prize. **Amis, Martin** (1949–) British novelist and journalist, son of Kingsley AMIS. Amis' debut novel, *The Rachel Papers* (1974), won the Somerset Maugham Award. His humour is more bawdy and dark than his father's. *Money* (1984) is a stylish critique of the dehumanizing tendencies of late capitalism. *Einstein's Monsters* (1987) is a collection of five short stories on nuclear war. *Time's Arrow* (1991) is a complex work on the holocaust. Other novels include *Success* (1978) and *Night Train* (1997).

Amish Highly conservative Protestant sect of North America, whose members form an offshoot of the Anabaptist Mennonite Church. The strict Old Order Amish Mennonite Church, to which most sect members belong, was founded in Switzerland in 1693 by Jakob Ammann (c.1645–c.1730). The Amish began migrating to North America in 1720 and eventually died out in Europe. In the USA and Canada they established small closed agricultural communities. After 1850, tensions between traditionalist "old order" Amish and more liberal "new order" communities split the sect. Today a few groups of traditionalist Amish still work the land, practice non-cooperation with the state, wear plain, homemade clothes and shun modern conveniences such as telephones and cars.

Amman Capital and largest city of Jordan, 80km (50 mi) ENE of Jerusalem. Known as Rabbath-Ammon, it was the chief city of the Ammonites in biblical times. Ptolemy II Philadelphus renamed it Philadelphia. A new city was built on seven hills from 1875, and it became the capital of Trans-Jordan in 1921. From 1948 it grew rapidly, partly as a result of the influx of Palestinian refugees. Industries: cement, textiles, tobacco, leather. Pop. (1994 est.) 1,300,042.

ammeter Instrument for measuring ELECTRIC CURRENT in AMPERES. An ammeter is connected in series in a circuit. In the moving-coil type for direct current (DC), the current to be measured passes through a coil suspended in a magnetic field and deflects a needle attached to the coil. In the moving-iron type for both direct and alternating current (AC), current through a fixed coil magnetizes two pieces of soft iron that repel each other and deflect the needle. Digital ammeters are now also commonly used.

ammonia Colourless nonflammable pungent gas (NH_3) manufactured by the HABER PROCESS. It is used to make nitrogenous fertilisers. Ammonia solutions are used in cleaning and bleaching. The gas is extremely soluble in water, forming an alkaline solution of ammonium hydroxide (NH_4OH) that can give rise to ammonium salts containing the ion NH_4^+ . Chief properties: r.d. 0.59; m.p. $-77.7^{\circ}C$ $(-107.9^{\circ}F)$; b.p. $-33.4^{\circ}C$ $(-28.1^{\circ}F)$.

ammonite Any of an extinct group of shelled cephalopod MOLLUSCS. Most ammonites had a spiral shell, and they are believed to be related to the nautiloids, whose only surviving form is the pearly NAUTILUS. They are common as FOSSILS in marine rocks.

Amnesty International Human rights organization, founded in 1961 by Peter Benenson. It campaigns on behalf of prisoners of conscience. Based in the UK and funded entirely by private donations, it champions the rights of individuals detained for political or religious reasons. Advocating non-violence, and politically impartial, it opposes the use of torture and the death penalty. By the mid-1990s, Amnesty had over 1 million members and offices in more than 40 countries. It was awarded the Nobel Peace Prize in 1977.

amnion Membrane or sac that encloses the EMBRYO of a reptile, bird or mammal. The embryo floats in the amniotic fluid within the sac. *See also* UTERUS

amoeba Microscopic, almost transparent, single-celled protozoan animal that has a constantly changing, irregular shape. Found in ponds, damp soil and animal intestines, it consists of a thin outer cell membrane, a large nucleus, food and contractile vacuoles and fat globules. It reproduces by binary fis-

ammonite 2 1 syphon jaws operculum gills tentacles

Ammonites had a soft anatomy, similar to that of the modern nautilus which lives in the open end of its shell. As the animal grew it secreted more shell and moved forward into the new part, walling off the old section with a septum (1). The walled-off chambers

were used for buoyancy, being supplied with air from a tissue filament or siphuncle (2) connecting them all. The septa met the shell wall in suture lines that had identifiable patterns for each species and became more complex as the group advanced.

sion. Length: up to 3mm (0.lin). Class Sarcodina; species include the common *Amoeba proteus* and *Entamoeba histolytica*, which causes amoebic DYSENTERY.

Amos (active c.750 BC) Old Testament prophet. He was named as the author of the Book of Amos, the third of the 12 books of the Minor Prophets.

Ampère, André Marie (1775–1836) French physicist and mathematician. He founded electrodynamics (now called ELECTROMAGNETISM) and performed numerous experiments to investigate the magnetic effects of ELECTRIC CURRENTS. He devised techniques for detecting and measuring currents, and constructed an early type of galvanometer. Ampère's law – proposed by him – is a mathematical description of the magnetic force between two electric currents. His name is also commemorated in the fundamental unit of current, the AMPERE (A).

ampere (symbol A) SI unit of ELECTRIC CURRENT. It is defined as the current in a pair of straight, parallel conductors of infinite length and 1m (39in) apart in a vacuum that produces a force of 2×10^{-7} newton per metre in their length. This force may be measured on a current balance instrument, the standard against which current meters, such as an AMMETER, are calibrated.

amphetamine DRUG that stimulate the central NERVOUS SYSTEM. These drugs (known as "pep pills" or "speed") can lead to drug abuse and dependence. They can induce a temporary sense of well-being, often followed by fatigue and depression. *See also* ADDICTION

amphibian Class of egg-laying VERTEBRATES, whose larval stages (tadpoles) are usually spent in water but whose adult life is normally spent on land. Amphibians have smooth, moist skin and are cold-blooded. Larvae breathe through gills; adults usually have lungs. All adults are carnivorous but larvae are frequently herbivorous. There are three living orders: Urodela (NEWTS and SALAMANDERS); Anura (FROGS and TOADS) and Apoda or CAECILIANS.

amphibole Any of a large group of complex rock-forming minerals characterized by a double-chain silicate structure (Si₄O₁₁). They all contain water as OH⁻ ions and usually calcium, magnesium, iron. Found in IGNEOUS and METAMORPHIC rocks, they form wedge-shaped fragments on cleavage. Crystals are orthorhombic or monoclinic.

amphitheatre In ancient Rome and the Roman empire, a large circular or oval building with the performance space surrounded by tiered seating. It was used as a theatre for gladiatorial contests, wild-animal shows and similar events. Many ruined amphitheatres remain; the best-known being the

▼ amoeba In order to move, an amoeba pushes out projections called pseudopods (lit. fake foot) from its body. Cytoplasm - the fluid content of the cell - flows into the pseudopod, constantly enlarging it until all the cytoplasm has entered and the amoeba as a whole has moved. Pseudopods are also used in feeding: they move out to engulf a food particle (1), which then becomes enclosed in a membrane-bound food vacuole (2). Digestive enzymes enter the vacuole, which gradually shrinks as the food is broken down (3). Undigested material is discharged by the vacuole and left behind as the amoeba moves on (4).

▲ Amritsar The Golden Temple of Amritsar in the NW Indian state of Punjab is a holy Sikh shrine. In 1984, armed Sikh extremists demanding greater autonomy in the Punjab, took refuge in the Temple and fierce gun battles with security forces ensued. Some 400 Sikhs were killed in the assault on the Temple. In a act of revenge, the Indian prime minister Indira Gandhi was assassinated.

COLOSSEUM in Rome. The term is now used generically to refer to any open, banked arena.

amplifier Device for changing the magnitude (size) of a signal, such as voltage or current, but not the way it varies. Amplifiers are used in radio and television transmitters and receivers, and in audio equipment. *See also* THERMIONICS

amplitude modulation (AM) Form of RADIO transmission. Broadcasts on the short-, medium- and long-wave bands are transmitted by amplitude modulation. The sound signals to be transmitted are superimposed on a constant-amplitude radio signal called the carrier. The resulting modulated radio signal varies in amplitude according to the strength of the sound signal. See also FREQUENCY MODULATION (FM)

Amritsar City in Punjab state, NW India. Founded in 1577, Amritsar is the religious centre of SIKHISM, and site of its holiest shrine, the Golden Temple. It was the scene of the Amritsar Massacre (1919), when hundreds of Indian nationalists were killed by British troops. Amritsar is noted for its handicrafts. Industries: textiles, silk weaving. Pop. (1991) 709,000. Amsterdam Capital and largest city in The Netherlands, on the River Amstel and linked to the North Sea by the North Sea Canal. Amsterdam was chartered in c.1300 and joined the Hanseatic League in 1369. The Dutch East India Company (1602) brought great prosperity to the city. It became a notable centre of learning and book printing during the 17th century. Its commerce and importance declined when captured by the French in 1795 and blockaded by the British during the Napoleonic Wars. A major European port and one of its leading financial and cultural centres, it has an important stock exchange and diamondcutting industry. It has many interesting buildings, including the 13th-century Old Church, the house of Rembrandt, the Royal Palace, the Rijksmuseum and Anne Frank House. Industries: iron and steel, oil refining, rolling stock, chemicals, glass, shipbuilding. Pop. (1994) 724,096.

Amun (Amon) Ancient Egyptian deity of reproduction or the animating force. The "invisible one", Amun is commonly represented as a human being wearing ram's horns and a twinfeathered crown. He gradually assimilated other Egyptian gods, becoming Amun-Ra (the supreme creator). During the dynasties of the New Kingdom, Amun was worshipped as a victorious national god. His cult temple was at Weset (LUXOR). Amundsen, Roald (1872-1928) Norwegian explorer and the first man to reach the SOUTH POLE. In 1903-06 Amundsen became the first man to sail through the NORTHWEST PASSAGE and determined the exact position of the magnetic NORTH POLE. He was beaten by Robert PEARY in the race to the North Pole and he turned to ANTARCTICA. Amundsen reached the South Pole on 14 December 1911 (35 days before Scott). In 1918 he sailed for the Northeast Passage. In 1926 Amundsen and Umberto Nobile made the first flight across the North Pole. He died in a plane crash while searching for Nobile.

amylase Digestive enzyme secreted by the SALIVARY GLANDS (salivary amylase) and the PANCREAS (pancreatic amylase. It aids digestion by breaking down starch into MAL-TOSE (a disaccharide) and then GLUCOSE (a monosaccharide). Anabaptists Radical Protestant sects in the REFORMATION who shared the belief that infant baptism is not authorized by Scripture, and that it was necessary to be baptized as an adult. The first such baptisms were conducted by the Swiss Brethren sect in Zürich (1525). The sect were the first to completely separate church from state, when they rejected Ulrich ZWINGLI'S Reformed Church. Aided by social upheavals (such as the PEASANTS WAR) and the theological arguments of Martin LUTHER and Thomas Münzer, Anabaptism spread rapidly to Germany and the Netherlands. It stressed the community of believers. The communal theocracy established by John of Leiden at Münster was brutally suppressed (1535).

anabolic steroid Any of a group of hormones that stimulate the growth of tissue. Synthetic versions are used in medicine to treat OSTEOPOROSIS and some types of ANAEMIA; they may also be prescribed to aid weight gain in severely ill or elderly patients. These drugs are associated with a number of side effects, including acne, fluid retention, liver damage and masculinization in women. Some athletes have been known to abuse anabolic steroids in order to increase muscle bulk.

anabolism See METABOLISM

anaconda Large constricting SNAKE of South America, the heaviest snake in the world. It feeds mainly on birds and small mammals. Females give birth to up to 75 live young. Species *Eunectes murinus*. Length: up to 9m (30ft).

anaemia Condition in which there is a shortage of HAEMO-GLOBIN, the oxygen-carrying pigment contained in ERYTHRO-CYTES (red blood cells). Symptoms include weakness, pallor, breathlessness, faintness, palpitations and lowered resistance to infection. It may be due to a decrease in the production of haemoglobin or red blood cells or excessive destruction of red blood cells or blood loss. Worldwide, iron deficiency is the commonest cause of anaemia.

anaerobic Connected with the absence of oxygen or air, or not dependent on oxygen or air for survival. An anaerobic organism (anaerobe) is a microorganism that can survive by releasing energy from GLUCOSE and other foods in the absence of oxygen. The process by which it does so is called anaerobic respiration. Most anaerobes can survive in oxygen but do not need it for RESPIRATION. *See also* AEROBIC

anaesthesia State of insensibility or loss of sensation produced by disease or by various anaesthetic drugs used during surgical procedures. During general, or total, anaesthesia the entire body becomes insensible and the individual sleeps; in local anaesthesia only a specific part of the body is rendered insensible and the patient remains conscious. A general anaesthetic may be either an injected drug, such as the barbiturate thiopentone, used to induce unconsciousness, or an inhalation agent such as halothane, which is used to maintain anaesthesia for surgery. Local anaesthetics, such as lignocaine, numb the relevant part of the body by blocking the transmission of impulses through the sensory nerves which supply it.

analgesic DRUG that relieves or prevents pain without causing loss of consciousness. It does not cure the cause of the pain, but helps to deaden the sensation. Some analgesics are also NARCOTICS, and many have valuable anti-inflammatory properties. Common analgesics include aspirin, codeine and morphine. See also ANAESTHESIA

analogue signal In telecommunications and electronics, transmission of information by means of variation in a continuous waveform. An analogue signal varies (usually in AMPLITUDE or FREQUENCY) in direct proportion to the information content of the signal.

anarchism (Gk. "no government") Political theory that regards the abolition of the state as a prerequisite for equality and social justice. In place of government, anarchy is a social form based upon voluntary cooperation between individuals. The STOICS leader, ZENO OF CITIUM is regarded as the father of anarchism. Millenarian movements of the Reformation, such as the Anabaptists, espoused a form of anarchism. As a modern political philosophy, anarchism dates from mid-19th

century, and writers such as P.J. PROUDHON. Often in conflict with emerging COMMUNISM, Mikhail BAKUNIN's brand of violent, revolutionary anarchism led to his expulsion from the First International (1872). Anarchism has been a popular political force only in conjunction with SYNDICALISM. Its support of civil disobedience and sometimes political violence has led to its marginalization. Following the assassination (1901) of President McKinley, the USA has barred anarchists from its shores. The Sacco and Vanzetti Case (1920) led to further hysteria over the threat of anarchism.

Anatolia See Asia Minor

anatomy Branch of biological science that studies the structure of an organism. The study of anatomy can be divided in several ways. On the basis of size, there is gross anatomy, which is studying structures with the naked eye; microscopic anatomy, studying finer detail with a light microscope; submicroscopic anatomy, studying even finer structural detail with an electron microscope; and molecular anatomy, studying with sophisticated instruments the molecular make-up of an organism. Microscopic and submicroscopic anatomy involve two closely related sciences: HISTOLOGY and CYTOLOGY. Anatomy can also be classified according to the type of organism studied, plant, invertebrate, vertebrate or human anatomy. See also PHYSIOLOGY

Anaximander (611–547 BC) Greek philosopher, student of THALES. Anaximander's lasting reputation is based on his notion of *apeiron* (Gr. infinite), a non-perceivable substance which he regarded as the primary source material of the natural world. His ideas are regarded as the precursor of a modern conception of the indestructability of matter. He also anticipated the theory of evolution and is said to have made the first map of the Earth, which he conceived of as a self-supporting immobile cylindrical object at the centre of the universe.

ancestor worship Any of various religious beliefs and practices found in societies where kinship is strong. The spirits of dead ancestors or tribal members, believed capable of good or harm, are propitiated by prayers and sacrifices. It is practised chiefly in sub-Saharan Africa and Melanesia.

Anchorage City in s central Alaska. By far the state's largest city, Anchorage was founded as a railway town in 1914 and became the supply centre for the gold- and coal-mining regions of N Alaska. It suffered a severe earthquake in 1964. Industries: tourism, oil and natural gas. Pop. (1992) 245,866. anchovy Commercially valuable food marine fish found worldwide in shoals in temperate and tropical seas. There are more than 100 species, including the European anchovy Engraulis encrasicholus. Length: 10–25cm (4–10in). Family Engraulidae.

ancien régime Term used to describe the political, legal and social system in France before the FRENCH REVOLUTION of 1789. It was characterized by a rigid social order, a fiscal system weighted in favour of the rich, and an absolutist monarchy. Andalusia (Andalucía) Largest, most populous and southernmost region of Spain, crossed by the River Guadalquivir, and comprising eight provinces. The capital is SEVILLE, other major cities include MÁLAGA, GRANADA and CÓRDOBA. In the N are the Sierra Morena mountains, which are rich in minerals. In the s are the Sierra Nevada, rising to Mulhacén (Spain's highest point), at 3,378m (11,411ft). Farms in the low-lying sw raise horses and cattle (including fighting bulls) and grow most of the country's cereals; other important crops are citrus fruits, olives, sugar and grapes. Sherry is made from grapes grown in the environs of Jerez de la Frontera, near Cádiz. The region has many fine buildings (such as the ALHAMBRA) dating from between 711-1492, when the region was ruled by the Moors. Area: 87,268sq km (33,707sq mi). Pop. (1991) 6,940,522.

Andaman and Nicobar Islands Territory of India comprising two chains of islands in the Bay of Bengal. The capital is Port Blair (on South Andaman). The main exports are timber, coffee, coconuts and copra. The population of the islands (one of India's seven union territories) almost doubled in the decade to 1991. Area: 8,300sq km (3,200sq mi). Pop. (1991) 280,661.

Andean Indians See Native Americans

Andersen, Hans Christian (1805-75) Danish writer of

some of the world's best-loved fairy tales. He gained a reputation as a poet and novelist before his talent found its true expression. His humorous, delicate but frequently melancholic stories, were first published in 1835. They include "The Ugly Duckling", "The Little Mermaid", "The Little Match Girl" and "The Emperor's New Clothes".

Anderson, Carl David (1905–91) US physicist who shared the 1936 Nobel Prize for physics with Victor Hess. In 1932 he discovered the first known particle of antimatter, the POSITRON or anti-electron. He later helped to discover the muon, an elementary particle.

Anderson, Elizabeth Garrett (1836–1917) British physician and pioneer of women's rights. She had to overcome intense prejudice against women doctors to become one of the first English women to practise medicine. Later she became England's first woman mayor.

Anderson, Marian (1902–93) US contralto. She secured her reputation as a singer by touring America and Europe in recitals (1925–35). She made her debut with the METROPOLITAN OPERA COMPANY in 1955 as Ulrica in Verdi's *Un Ballo in Maschera*; this was the first appearance of a black singer in a leading role at the Metropolitan Opera.

Andes Chain of mountains in South America, extending along the whole length of the w coast. The longest mountain range in the world, they stretch for 8,900km (5,500mi). At their widest they are c.800km (500mi) across. There are more than 50 peaks over 6,700m (22,000ft) high. They contain many active volcanoes, including COTOPAXI in Ecuador. Earthquakes are common, and cities such as LIMA, VALPARAÍso and Callao have been severely damaged. The highest peak is ACONCAGUA, rising 6,960m (22,834ft) in Argentina. Lake TITICACA, the world's highest lake at 3,810m (12,500ft), lies in the Andes on the Peru-Bolivia border.

Andhra Pradesh State in SE India on the Bay of Bengal; the capital is HYDERABAD. It was created in 1953 from part of MADRAS, and in 1956 it incorporated the princely state of Hyderabad. Though mountainous to the NE, most of the region is flat coastal plain. Products include rice and groundnuts; coal, chrome and manganese are mined. The principal language is Teluga. Area: 276,814sq km (106,878sq mi). Pop. (1991) 66,508,008.

Andorra Small independent state situated high in the E Pyrenees between France and Spain. Andorra consists mainly of six valleys that drain to the River Valira. These deep glaciated valleys lie at altitudes of 1,000–2,900m (3,300–9,500ft). In the N, a lofty watershed forms the frontier with France, and to the s the land falls away to the Segre Valley in Spain. It is a rare surviving example of a medieval principality. In 1993 a new democratic constitution was adopted. The main sources of income include livestock rearing and agriculture, especially tobacco; the sale of water and hydroelectricity to Catalonia; tourism, particularly skiing; and the sale of duty-free goods. Area: 453sq km (175sq mi). Pop. (1993) 61,599.

Andrea del Sarto (1486–1531) (Andrea d'Agnolo di Francesco) Florentine Classical artist. A contemporary of MICHELANGELO and RAPHAEL, he was one of the outstanding painters and draughtsmen of the High RENAISSANCE. He was an excellent portraitist, a master of composition, and he produced many frescos and altarpieces. His frescos include the cycles in the cloister of SS. Annunziata (1514–24) and the terra verde grisailles in the Chiostro dello Scalzo (1511–26), Florence.

Andrew, Saint In the New Testament, brother of Simon Peter and one of the original 12 disciples of Jesus. According to tradition he was crucified on an x-shaped cross. He is patron saint of Scotland and Russia; his feast day is 30 November.

Androcles In Roman legend, a Roman slave who ran away from his master and hid in a cave. Androcles removed a thorn from the paw of a suffering lion. When he later faced the same lion in the Roman Arena, the lion refused to harm him.

■ anchovy A member of the herring family, the tiny anchovy is fished mainly in the Mediterranean. They are cured, using a fermentation process. The American anchovy, Engraulis encrasicholus, belongs to the related family Engralidae.

▲ anemone The white wood anemone A. nemorosa is found in European and Asian woodland. Like all anemones, what appear to be petals are actually sepals. In Greek mythology, anenomes grew from the blood of Adonis. In Chinese mythology, they represent death. Anemones contain the poison anemonin.

He was immortalized in George Bernard Shaw's play Androcles and the Lion (1912).

androgen General name for male sex HORMONES, such as TESTOSTERONE.

Andromeda In Greek mythology, daughter of Cepheus and Cassiopea, king and queen of Ethiopia. When her country was under threat from a sea dragon, Andromeda was offered as a sacrifice and chained to a rock by the sea. She was saved by PERSEUS.

Andromeda Large constellation of the Northern Hemisphere, adjoining the Square of Pegasus. The main stars lie in a line leading away from Pegasus, and the star Alpha Andromedae actually forms one corner of the Square. The most famous object in the constellation is the ANDROMEDA GALAXY

Andromeda Galaxy Spiral GALAXY 2.2 million light-years away in the constellation ANDROMEDA, the most distant object visible to the naked eye. The Andromeda Galaxy has a mass of over 300,000 million Suns. Its diameter is *c*.150,000 light-years, somewhat larger than our own Galaxy.

Andropov, Yuri Vladimirovich (1914–84) Soviet statesman, president of the Soviet Union (1983–84), general secretary of the Communist Party (1982–84). Andropov first gained attention for his role in the suppression of the Hungarian uprising (1956). As head of the KGB (1967–82), Andropov took a hardline against political dissidence, supporting Soviet intervention in Czechoslovakia (1968) and Poland (1981). He joined the Politburo in 1973. Andropov succeeded Leonid BREZHNEV as leader. His term in office was the shortest in Soviet history. Perhaps his most significant decision was the promotion of Mikhail GORBACHEV. He was succeeded by Konstantin Chernenko.

anechoic chamber (dead room) Room designed to be echo-free so that it can be used in acoustic laboratories to measure sound reflection and transmission, and to test audio equipment. The walls, floor and ceiling must be insulated and all surfaces covered with an absorbent material such as rubber, often over inward-pointing pyramid shapes to reduce reflection. The room is usually asymmetrical to reduce stationary waves. *See also* ACOUSTICS

anemometer Instrument using pressure tubes or rotating cups, vanes, or propellers to measure the speed or force of the wind

anemone (windflower) Perennial plant found worldwide. Anemones have sepals resembling petals, and numerous stamens and pistils covering a central knob; two or three deeply toothed leaves appear in a whorl midway up the stem. Many are wild flowers, such as the wood anemone (*Anemone nemorosa*), common in Britain and Europe. There are 120 species. Family Ranunculaceae. *See also* BUTTERCUP; SEA ANEMONE

angel (Gk. messenger) Spiritual being superior to man but inferior to God. In the Bible, angels appear on Earth as messengers and servants of God. Angels form an integral part of Judaism and Islam. In Christian theology, there is a hierarchy of angels consisting of nine orders: Seraphim, Cherubim, Thrones, Dominations, Virtues, Powers, Principalities, Archangels and Angels.

Angel Falls World's highest uninterrupted waterfall, in La Gran Sabrana, E Venezuela. Part of the River Caroni, it was discovered in 1935 and named after Jimmy Angel, a US aviator who died in a crash near the Falls. Total drop: 980m (3,212ft)

▲ Angelou, Maya Angelou's varied and often tragic life is evoked in her influential volumes of autobiography. She was a singer and actor before taking an active role in the US civil rights movement.

angelfish Tropical fish found in the Atlantic and Indo-Pacific oceans, popular as an aquarium fish because of its graceful, trailing fins and beautiful markings. Length: 2–10cm (1–4in). Family Cichlidae.

Angelico, Fra (1400–55) (Guido di Pietro) Florentine painter and Dominican friar. Angelico and his assistants painted a cycle of some 50 devotional frescos in the friary of San Marco, Florence (c.1438–45). These pictures show great technical skill and are the key to Angelico's reputation as an artist of extraordinary sweetness and serenity. Despite being part of a strict order, Angelico stayed in touch with developments in contemporary Florentine art and later travelled widely on commissions. International Gothic influenced his early work but he also found great inspiration in representations of architectural perspective by MASACCIO. His style showed a marked change towards narrative detail in frescos carried out for Pope Nicholas V's Vatican chapel (1447–50). Angelou, Maya (1928–) US writer, editor and entertainer.

Angelou, Maya (1928–) US writer, editor and entertainer. She is best known for five volumes of autobiography, starting with I Know Why the Caged Bird Sings (1970). Evoking her childhood in 1930s Arkansas, it relates the rape that left Angelou mute for the next five years. The fourth volume, The Heart of a Woman, deals with her involvement in the 1960s CIVIL RIGHTS movement as the Northern Coordinator for Martin Luther KING. She read her poem "On the Pulse of Morning" at the inauguration of President CLINTON in 1993.

Angevins English royal dynasty named after King Henry II, son of the Count of Anjou (and grandson of Henry I), who ascended the throne in 1154. The Angevins, who later became the Plantagenet royal line, retained the crown until 1485.

angina Pain in the chest due to an insufficient blood supply to the heart, usually associated with diseased coronary arteries. Generally induced by exertion or stress, it is treated with drugs, such as glyceryl trinitrate, or surgery.

angiosperm Plants with true flowers, as distinct from GYMNOSPERM and other non-flowering plants. They include most trees, bushes and non-woody herbs. There are two main groups: MONOCOTYLEDONS, such as grasses and daffodils (which have one seed leaf) and DICOTYLEDONS, such as peas and oak (which have two seed leaves).

Angkor Ancient KHMER capital and temple complex, NW Cambodia. The site contains the ruins of several stone temples erected by Khmer rulers, many of which lie within the walled enclosure of Angkor Thom, the capital built 1181–95 by Jayavarman VII (c.1120–1215). Angkor Wat, the greatest structure in terms of its size and the quality of its carving, lies outside the main Angkor Thom complex. Thai invaders destroyed the Angkor complex in 1431, and it remained virtually neglected until French travellers rediscovered it in 1858. Conservationists restored Angkor Wat piece by piece until the followers of Pol Pot ravaged Cambodia in the civil war (1970–75).

angle Measure of the inclination of two straight lines or planes to each other. One complete revolution is divided into 360 degrees or 2π radians. One degree may be subdivided into 60 minutes, and one minute into 60 seconds.

Angles Germanic tribe from a district of Schleswig-Holstein now called Angeln. In the 5th century they invaded England with neighbouring tribes, JUTES, SAXONS and others. They settled mainly in Northumbria and East Anglia. The name England (Angle-land) derives from them.

Anglesey (Ynys Môn) Island off the NW coast of Wales, separated from the mainland by the narrow Menai Strait. Formerly a Welsh county, it became part of GWYNEDD in 1974. The chief town is Beaumaris, famous for a moated castle built by Edward I (1295). Holyhead is a major ferry terminus for Ireland. Area: 718sq km (276sq mi). Pop. (1991) 67,800. Anglican Communion Fellowship of 37 independent national or provincial worldwide churches, many of which are in Commonwealth nations and originated from missionary work by the Church of England. An exception is the Episco-PAL CHURCH in the USA, founded by the Scottish Episcopal Church. There is no single governing authority, but all recognize the leadership of the Archbishop of CANTERBURY. Worship is liturgical, based on the Book of COMMON PRAYER. Once a decade, the bishops of the Communion meet at the Lambeth Conference. The 1968 Conference established a Consultative Council to discuss issues that arise between conferences. In 1982 diplomatic ties with the Roman Catholic Chuch were

restored. In 1988 the Conference passed a resolution in support of the ordination of women as preists. In 1997 there were c.70 million Anglicans organized into about 30,000 parishes.

angling Popular freshwater or marine sport. The two basic types of freshwater FISHING are game fishing and coarse fishing. Game fishing uses artificial bait, such as spinning lures and flies (imitation insects), and is undertaken in fast-moving water where salmon and trout can be found. Coarse fishing takes place in slow-moving water and uses either live bait, such as maggots and worms, or cereal bait, such as sweetcorn. Saltwater fishing requires heavier rods and reels, and includes trolling and big-game fishing. Flatfish, mackerel and sea bass are among the more common seafish caught, while tuna, swordfish, marlin and shark are landed in big-game fishing.

Anglo-Irish Agreement (Hillsborough Agreement)
Treaty on the status of Northern Ireland, signed (1985) by
Margaret Thatcher and Garret Fitzgerald. Aiming to clarify the status of Northern Ireland, it gave the Republic of Ireland the right of consultation; it asserted that any future changes would have to be ratified by a majority of the people of Northern Ireland; and it set up the Anglo-Irish Intergovernmental Conference (AIIC) to promote cooperation. The agreement was denounced by the Northern Irish Unionists.

ANGOLA

The flag is based on the flag of the Popular Movement for the Liberation of Angola (MPLA) during the independence struggle. The emblem includes a star symbolizing socialism, one half of a gearwheel to represent industry, and a machete to illustrate agriculture.

Angola is more than twice the size of France. Most of the country, besides a narrow coastal plain in the w, is part of a huge plateau which makes up the interior of s Africa. In the NE, several rivers flow N into the River CONGO. In the s some rivers, including the Cubango (or Okavango) and the Cuanda, flow sE into the interior of Africa.

CLIMATE

Angola has a tropical climate with temperatures of over 20°C (68°F) throughout the year, though the higher areas are cooler. Rainfall is minimal along the coast s of LUANDA, but increases to the N and E. The rainy season is between November and April.

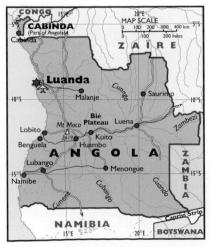

VEGETATION

Grassland covers much of Angola. The coastal plain has little vegetation and the s coast is a desert region that merges into the bleak NAMIB DESERT. Some rainforest grows in N Angola towards Zaïre.

HISTORY AND POLITICS

Bantu-speaking people from the N settled in Angola c.2,000 years ago. In the later part of the 15th century Portuguese navigators, seeking a route to Asia round Africa, explored the coast and, in the early 1600s, the Portuguese set up supply bases. Angola became important as a source of slaves for the Portuguese colony of Brazil. After the decline of the slave trade, Portuguese settlers began to develop the land, and the Portuguese population increased dramatically in the early 20th century. In the 1950s, nationalists began to demand independence. In 1956 the Popular Movement for the Liberation of Angola (MPLA) was founded, drawing support from the Mbundu tribe and mestizos (people of African and European descent). The MPLA led a revolt in Luanda in 1961, but it was put down by Portuguese troops. Other opposition movements developed among different ethnic groups. In the N, the Kongo set up the FNLA (Front for the Liberation of Angola), and in 1966 southern peoples, including many of the Ovimbundu, formed the National Union for the Total Independence of Angola (UNITA). Portugal granted independence in 1975, but a power struggle developed among rival nationalist forces. The MPLA formed a government, but UNITA troops (supported by South Africa) AREA: -1,246,700sq km (481,351sq mi)

POPULATION: 10,609,000

CAPITAL (POPULATION): Luanda (1,544,000) **GOVERNMENT:** Multiparty republic

ETHNIC GROUPS: Ovimbundu 37%, Mbundu 22%, Kongo 13%, Luimbe-Nganguela 5%, Nyaneka-Humbe 5%. Chokwe. Luvale. Luchazi

LANGUAGES: Portuguese (official)

RELIGIONS: Christianity (Roman Catholic 69%, Protestant 20%), traditional beliefs 10%

CURRENCY: Kwanza = 100 lwe

launched a civil war. After 16 crippling years a peace treaty was signed (1991) and multiparty elections were held in 1992.

The MPLA, which had renounced its Marxist ideology, won a resounding victory, but civil strife resumed as UNITA refused to accept the result. A new peace accord was signed in Lusaka in 1994, which provided for the formation of a government of national unity, composed of both UNITA and MPLA leaders. In April 1997 the new government was inaugurated. Dos SANTOS remained president, but UNITA leader, Jonas Savimbi, rejected the vice presidency. UNITA retained military control of c.50% of Angola. Fighting continued between government and UNITA forces in rebel-held territory. In September 1997 the UN imposed sanctions on UNITA for failing to comply with the 1994 Lusaka Protocol.

ECONOMY

Angola is a poor, developing country with huge huge economic potential. More than 70% of the workforce are engaged in subsistence agriculture. The main food crops are cassava and maize and coffee is exported. Angola has large oil reserves, near Luanda and in the Cabinda enclave (separated from Angola by a strip of land belonging to Zaïre). Oil is by far the leading export. Angola is a major diamond producer, and has reserves of copper, manganese and phosphates. It also has a growing manufacturing sector, much of it based on hydroelectric power.

Anglo-Saxon art and architecture Art and architecture produced in Britain from the 5th to the 11th centuries, following the invasions by the ANGLO-SAXONS. The most famous archaeological find is the pagan ship-burial at SUTTON HOO. Anglo-Saxon art is predominantly Christian, consisting of stone crosses, ivory carvings and illuminated manuscripts (the most important being the LINDISFARNE GOSPELS). Anglo-Saxon churches are characterized by square apses, aisles or side chambers (porticus), pilaster strips and distinctive timber work. Anglo-Saxons People of Germanic origin comprising ANGLES, SAXONS and other tribes who began to invade England from the mid-5th century, when Roman power was in decline. By 600 they were well established in most of England. They were converted to Christianity in the 7th century. Early tribal groups were led by warrior lords whose thegas (noblemen) provided military service in exchange for rewards and protection. The tribal groups eventually developed into larger kingdoms, such as Northumbria and WES-SEX. The term Anglo-Saxon was first used in the late 8th century to distinguish the Saxon settlers in England from the "Old Saxons" of N Germany, and became synonymous with "English". The Anglo-Saxon period of English history ended with the Norman Conquest (1066).

Angola Republic in sw Africa. *See* country feature, p.27 **Angora** *See* ANKARA

Angry Young Men Loose literary and dramatic term, applied to an anti-establishment group of British writers in the 1950s. Taken from Leslie Allen Paul's autobiography *Angry Young Man* (1951), it was popularized through John OSBORNE's play *Look Back in Anger* (1956). The group included Kingsley AMIS, Arnold WESKER and Alan SILLITOE. **Angstrom** (angstrom unit) (symbol Å) Obsolete unit of length, equal to 10^{-10} m or 0.1nm (nanometre). It is used to express the wavelength of light and ultraviolet radiation, interatomic and intermolecular distances.

Anguilla Island in the West Indies, most northerly of the Leeward Islands; the capital is The Valley. Settled in the 17th century by English colonists, it eventually became part of the St Kitts-Nevis-Anguilla group. Declared independent in 1967, it re-adopted British colonial status in 1980, and is now a self-governing dependency. The economy of the flat, coral island is based on fishing and tourism. Area: 91sq km (35sq mi). Pop. (1992) 8,960. *See* WEST INDIES map

aniline (phenylamine) Highly poisonous, colourless oily liquid ($C_6H_5NH_2$) made by the reduction of nitrobenzene. It is an important starting material for making organic compounds such as drugs, explosives and dyes. Properties: r.d. 1.02; m.p. -6.2° C (20.8°F); b.p. 184.1°C (363.4°F). See also AMINE

animal Living organism of the animal kingdom, usually distinguishable from members of the PLANT kingdom by its power of locomotion (at least during some stage of its existence); a well-defined body shape; limited growth; its feeding exclusively on organic matter; the production of two different kinds of sex cells; and the formation of an embryo or larva during the developmental stage. Higher animals, such as the VERTEBRATES, are easily distinguishable from plants, but the distinction becomes blurred with the lower forms. Some onecelled organisms could easily be assigned to either category. Scientists have classified about a million different kinds of animals in more than twenty phyla. The simplest (least highly evolved) animals include the PROTOZOA, SPONGES, JELLYFISH, and WORMS. Other invertebrate phyla include ARTHROPODS (arachnids, crustaceans and insects), MOLLUSCS (shellfish, octopus and squid) and ECHINODERMS (sea urchins and starfish). Vertebrates belong to the CHORDATA phylum, which includes fish, amphibians, reptiles, birds and mammals.

animal rights Freedom from subjection to pain and distress, especially applied to animals used in scientific experiments for human purposes. Experiments using animals decreased greatly during the 1980s, but continue particularly in determining the effects of new medicinal preparations, and of the long-term use of consumer products such as alcoholic drinks, cigarettes and facial cosmetics. Animal rights activists wish to extend animal rights to include all animals kept, transported or slaughtered in conditions perceived to be inhumane. See also VIVISECTION

animation Illusion of motion created by projecting successive images of still drawings or objects. Drawn cartoons are the most common form. Each of a series of drawings is photographed singly. The illusion of motion is created when the photographs are displayed in rapid succession. Developments in computer animation have advanced the process to a point where the drawings themselves are no longer a necessity.

animism Belief that within every animal, plant or inanimate object dwells an individual spirit capable of governing its existence and influencing human affairs. Natural objects and phenomena are regarded as possessing life, consciousness and a spirit. In animism, the spirits of dead animals live on, and (if the animals have been killed improperly) can inflict harm. These beliefs are widespread among tribal peoples and were once thought to represent the beginnings of organized religion.

anion Negative ION attracted to the ANODE during electrolysis. **Anjou** Region and former province in w France, straddling the lower Loire valley. It was ruled by Henry II of England after his marriage to Eleanor of Aquitaine, and Louis XI annexed it to the French crown in 1480. Known for its sauvignon wine, it ceased to be a province in 1790.

Ankara Capital of Turkey, at the confluence of the Cubuk and Ankara rivers. In ancient times it was known as Ancyra, and was an important commercial centre as early as the 8th century BC. It was a Roman provincial capital and flourished under Augustus. Tamerlane took the city in 1402. In the late 19th century it declined in importance, until Kemal ATATÜRK set up a provisional government here in 1920. It replaced Istanbul as the capital in 1923, changing its name to Ankara in 1930. It is noted for its angora wool (a mixture of sheep's wool and rabbit hair) and mohair. Pop. (1990) 2,541,899.

Annam Former kingdom on E coast of INDOCHINA, now in Vietnam; the capital was Hué. The ancient empire fell to China in 214 BC. It regained self-government but was again ruled by China from 939–1428. The French obtained missionary and trade agreements in 1787, and a protectorate was established (1883–84). During World War 2 it was occupied by the Japanese; in 1949 it was incorporated into the Republic of VIETNAM. Annan, Kofi (1938–) Ghanaian diplomat, seventh secretary-general of the United Nations (UN) (1997–). Annan was the first black African secretary-general. In 1993 he became under-secretary-general for peacekeeping. His efficient handling of the withdrawal of UN troops from Bosnia earned him the support of the USA and Britain.

Annapolis Seaport capital of Maryland, USA, on the s bank of the Severn River on Chesapeake Bay. It was founded in 1649 by Puritans from Virginia, and in 1694 was laid out as the state capital. The site of the signing of the peace treaty ending the American Revolution, it has many buildings dating from colonial times. It is also the seat of the US Naval Academy (founded 1845). Industries: boatyards, seafood packing. Pop. (1992) 34,070.

Annapurna Mountain massif in the HIMALAYAS, N central Nepal, notoriously dangerous to climbers. It has two of the world's highest peaks: Annapurna 1 in the w rises to 8,078m (26,504ft); Annapurna 2 in the E rises to 7,937m (26,041ft).

Anne (1665-1714) Queen of Great Britain and Ireland (1702-14). The second daughter of JAMES II, Anne succeeded WILLIAM III as the last STUART sovereign and, after the Act of UNION (1707), the first monarch of the United Kingdom of England and Scotland. Brought up a Protestant, she married Prince George of Denmark (1683). Despite 18 pregnancies, no child survived her. The War of the SPANISH SUCCESSION (1701-14) dominated her reign, and is often called Queen Anne's War. Anne was the last English monarch to exercise the royal veto over legislation (1707), but the rise of parliamentary government was inexorable. The military success of the Duke of Marlborough increased the influence that his wife, Sarah Churchill, had over domestic policy. Tories, sceptical of military involvement, were removed from high office. Tory victory in the elections of 1710 led to the dismisal of the Marlboroughs. Abigail Masham and Robert Harley emerged as the queen's new favourites. The JACOBITE cause was crushed when Anne was succeeded by GEORGE I. The most lasting aspect of her reign was the strength of contemporary arts and culture.

annealing Slow heating and cooling of a metal, alloy or glass to relieve internal stresses and make up dislocations or vacancies introduced during mechanical shaping, such as rolling or extruding (ejection). Annealing increases the material's workability and durability. *See also* TEMPERING

Anne Boleyn See Boleyn, Anne

annelid Animal phylum of segmented worms. All have encircling grooves usually corresponding to internal partitions of the body. A digestive tube, nerves and blood vessels run through the entire body, but each segment has its own set of internal organs. Annelids form an important part of the diets of many animals. The three main classes are: Polychaeta, marine worms; Oligochaeta, freshwater or terrestrial worms and Hirudinea LEECHES.

Anne of Austria (1601–66) Daughter of Philip III of Spain, wife of Louis XIII of France and mother of Louis XIV. Her husband died in 1643, and she ruled France as regent in close alliance with Cardinal MAZARIN until her death. The era was immortalized by Alexandre Dumas in his novels, *The Three Musketeers* (1844) and *Twenty Years After* (1845).

Anne of Cleves (1515–57) Fourth wife of HENRY VIII of England. Her marriage (1540) was a political alliance joining Henry with the German Protestants, and was never consummated, being declared null after only six months. Anne received a pension, and remained in England until her death. annual Plant that completes its life cycle in one growing season, such as the sweet pea, sunflower, wheat. Annual plants overwinter as seeds. See also BIENNIAL; PERENNIAL

annual ring (growth ring) Concentric circles visible in cross-sections of woody stems or trunks. Each year the CAMBIUM layer produces a layer of XYLEM, the vessels of which are large and thin-walled in the spring and smaller and thick-walled in the summer, creating a contrast between the rings. Used to determine the age of trees, the thickness of these rings also reveals environmental conditions during a tree's lifetime.

Annunciation Announcement made to the Virgin Mary by the Angel Gabriel that she was to be the mother of Christ (Luke 1). In many Christian churches the Feast of the Annunciation is kept on 25 March, a date often called "Lady Day". **anode** Positive electrode of an electrolytic cell that attracts ANIONS during ELECTROLYSIS.

anodizing Electrolytic process to coat ALUMINIUM or MAGNESIUM with a thin layer of oxide to help prevent corrosion. The process makes the metal the ANODE in an acid solution. The protective coating, steamed to seal the pores, is insoluble

and a good insulator. It can be dyed bright colours, many of which are resistant to sunlight.

anorexia nervosa Abnormal loss of the desire to eat. A pathological condition, it is seen mainly in women anxious to lose weight. It can result in severe emaciation and in rare cases may be life-threatening.

Anouilh, Jean (1910–87) French playwright and screenwriter. A major dramatist of the mid-20th century, influenced by NEO-CLASSICISM. Often reinterpreting Greek myth as a means of exploring oppression, *Antigone* (1944) is perhaps his most celebrated play. Other works include *Becket* (1959). Anschluss (1938) Enforced unification of Austria and Germany by Adolf HITLER. Prohibited by treaty at the end of World War 1, expressly to limit the strength of Germany, Anschluss was nevertheless favoured by many Germans and Austrians. It was dissolved by the Allies in 1945.

Anselm of Canterbury, Saint (1033–1109) English theologian, b. Italy. He was an early scholastic philosopher and became Archbishop of Canterbury in 1093. His belief in the rational character of Christian belief led him to propose an ontological argument for the existence of God. His feast day is 21 April. *See also* ONTOLOGY

ant Social insect belonging to a family that also includes the BEE and WASP. A typical ant colony consists of one or more queens (fertile females), workers (sterile females) and winged males. Some species also have a caste of soldier ants which guard the colony. Ants range in length from 2–25mm (0.08–1.0in) and are found worldwide except in Antarctica. They feed on plants, nectar and other insects. Most ants are wingless except at times of dispersal. Family Formicidae.

Antakya (formerly Antioch, now also Hatay) City in s Turkey on the River Orontes; capital of Hatay province. Founded *c*.300 Bc by Seleucus I, it earned the title "queen of the east". It was taken by Pompey (64 BC). The modern city occupies only a small part of the ancient Roman site. Remains include an aqueduct, theatre and castle. Products include olives, tobacco, cotton and cereals. Pop. (1990) 118,433.

Antananarivo (Tananarive) Capital and largest city of Madagascar. Founded *c*.1625, the city became the residence for Imerina rulers in 1794 and the capital of Madagascar. Antananarivo was taken by the French in 1895 and became part of a French protectorate. It is the seat of the University of Madagascar (1961). A trade centre for a rice-producing region, it has textile, tobacco and leather industries. Pop. (1990) 802,000.

Antarctica Fifth-largest continent (larger than Europe or

▲ ant Most ant societies are made up of different types of ant known as castes. Shown here are the gueen (1), soldier (2) and small worker (3) of the leaf-cutter species Atta caphalotes. Females develop from fertilized and males from unfertilized eggs. Nutrition determines whether a female becomes a queen or worker. First generation larvae are fed entirely by the queen's saliva. Mating takes place in flight, after which the male dies. The queen proceeds to lay eggs for the remainder of her life (up to 15 years).

■ Antarctica The mountainous archipelago of w Antarctica is inined to the continental shield of E Antarctica by a vast ice sheet. Over 95% of Antarctica remains covered in ice throughout the year. Ross Sea and Weddell Sea form the two major coastlines. Its interior is the coldest place on Earth, with temperatures as low as -90° C (-130° F). The severity of its climate makes it inhospitable for almost all life, except for nematode worms, some mosses and plants. The krill-rich waters of the Antarctic Ocean attract whales, seals and penguins. Captain Cook was the first to cross the Antarctic Circle (1772-75). In the early 19th century, humans were attracted by the commercial value of seal fur. In the 1890s, Antarctica became the centre of the whaling industry and the focus of many scientific studies. In 1911 Roald Amundsen beat Captain Scott in the race to become the first man to reach the South Pole

Australasia) and covering almost 10% of the world's total land area. Surrounding the SOUTH POLE, it is bordered by the ANTARCTIC OCEAN and the s sections of the Atlantic, Pacific and Indian oceans. Almost entirely within the ANTARCTIC CIRCLE, it is of great strategic and scientific interest. No people live here permanently, though scientists frequently stay for short periods to conduct research and exploration. Seven nations lay claim to sectors of it. Covered by an ice-sheet with an average thickness of c.1,800m (5,900ft), it contains c.90% of the world's ice and over 70% of its freshwater.

Land Resembling an open fan, with the Antarctic Peninsula as a handle, the continent is a snowy desert covering c.14.2 million sq km (5.5 million sq mi). The land is a high plateau, having an average elevation of 1,800m (6,000ft) and rising to 5,140m (16,863ft) in the Vinson Massif. Mountain ranges occur near the coasts. The interior, or South Polar Plateau, lies beneath c.2,000m (6,500ft) of snow, accumulated over tens of thousands of years. Mineral deposits exist in the mountains, but their recovery has not become practicable. Coal may be plentiful, but the value of known deposits of copper, nickel, gold and iron will not repay the expenses of extracting and exporting them. Seas and glaciers Antarctic rivers are frozen, inching towards the sea, and instead of lakes there are large bodies of ice along the coasts. The great Beardmore Glacier creeps down from the South Polar Plateau, and eventually becomes part of the Ross Ice Shelf. The southernmost part of the Atlantic is the portion of the Antarctic Ocean known as the Weddell Sea. Climate and vegetation Antarctica remains cold all year, with only a few coastal areas being free from snow or ice in summer (December to February). On most of the continent the temperature remains below freezing, and in August it has been recorded at nearly -90° C (-130° F). Precipitation generally amounts to 18-38cm (7-15in) of snow a year, but melting is less than that, allowing a build-up over the centuries. Nevertheless, mosses manage to survive on rocks along the outer rim of the continent. Certain algae grow on the snow, and others appear in pools of freshwater when melting occurs. History Antarctic islands were sighted first in the 18th century, and in 1820 Nathaniel Palmer reached the Antarctic Peninsula. Between 1838 and 1840 the US explorer Charles Wilkes discovered enough of the coast to prove that a continent existed, and the English explorer James Clark Ross made coastal maps. Towards the end of the 19th century, exploration of the interior developed into a race for the SOUTH POLE. Roald AMUNDSEN reached the Pole on 14 December 1911, a month before Robert Falcon Scott. The aeroplane brought a new era of exploration, and Richard E. Byrd became the best-known of the airborne polar explorers. The Antarctic Treaty (1959), which pledged international scientific co-operation, was renewed and extended in 1991, banning commercial exploitation of the area.

Antarctic Circle Southernmost of the Earth's parallels, 66.5° s of the Equator. At this latitude the sun neither sets on the day of summer SOLSTICE (December 22) nor rises on the day of winter solstice (June 21). *See also* ARCTIC CIRCLE

anteater Toothless, mainly nocturnal, insect-eating mammal that lives in swamps and savannahs of tropical America. It has a long, sticky tongue and powerful claws. Length: up to 152cm (60in). Family Myrmecophagidae. See also EDENTATE antelope Hollow-horned, speedy RUMINANT found throughout the Old World except in Madagascar, Malaysia and Australasia; most antelopes occur in Africa. They range in size from that of a rabbit to that of an ox. In some species both sexes bear horns of varied shapes and sizes; in others, only the males are horned. Family Bovidae.

▶ anteater The giant anteater (Myrmecophaga tridactyla) is found in South America, particularly in the swampy regions of the Chaco in Argentina. It uses its claws to rip open termite mounds before scooping up the termites with its long tongue.

antenna (aerial) Part of a radio system from which the signal is either radiated into space (transmitting antenna), or received from space (receiving antenna). The shape and structure of the antenna depend on the frequency of the radiation and the directional requirements of the system. For example, a beam antenna is required to transmit a radar beam, while a simple wire may suffice for an amplitude-modulated RADIO receiver. anthem Choral composition in Anglican and other Englishlanguage church services, analogous to the Roman Catholic MOTET in Latin. Developed in the 16th century as a verse anthem with soloists, the anthem was later performed with orchestral accompaniment and by a choir without soloists.

anther In botany, the fertile part of a male sex organ in a flower. The anther produces and distributes pollen, and together with its connecting filament forms a STAMEN.

Composers of anthems include Henry Purcell and Ralph

VAUGHAN WILLIAMS.

Anthony, Saint (*c*.250–*c*.355) Egyptian saint and first Christian monk. He withdrew into complete solitude at the age of 20 to practise ascetic devotion. The monastic ideal, outlined by St ATHANASIUS in the *Life of St Anthony*, attracted many devotees. By the time of St Anthony's death, Christian MONASTICISM was well established. His feast day is 17 January.

Anthony, Susan Brownell (1820–1906) US reformer and woman suffragist. She established the first woman's TEMPERANCE association and, with Elizabeth Cady Stanton, she coorganized the National Woman Suffrage Association (1869). It later became (1890) the National American Woman Suffrage Association and she acted as president (1892–1900). See also SUFFRAGETTE MOVEMENT

anthracite Form of COAL consisting of more than 90% CARBON, relatively hard, black and with a metallic lustre. It burns with the hot pale-blue flame of complete combustion. It is the final form in the series of fuels: PEAT, lignite, bituminous coal and black coal.

anthrax Contagious disease, chiefly of livestock, caused by the microbe *Bacillus anthracis*. Human beings can catch anthrax from contact with infected animals or their hides.

anthropoidea Suborder of primates including monkeys, apes and human beings. Anthropoids have flatter, more human like faces, larger brains and are larger in size than prosimian PRIMATES.

anthropology Scientific study of human development and how different societies are interrelated. It is concerned with the chronological and geographical range of human societies. Modern anthropology stems from the first half of the 19th century. Public interest in cultural EVOLUTION followed the publication of *On the Origin of Species* by Charles DARWIN (1859). Physical anthropologists are concerned with the history of human evolution in its biological sense. Social anthropologists study living societies in order to learn about cultural and social evolution. Applied anthropology is the specific study of a particular community and its collective and individual relationships. See also ETHNOGRAPHY; ETHNOLOGY

antibiotic Substance that is capable of stopping the growth of, or destroying, BACTERIA and other microorganisms. Antibiotics are GERMICIDES that are safe enough to be eaten or injected into the body. The post-1945 introduction of antibiotics has revolutionized medical science, making possible the virtual elimination of once widespread and often fatal diseases, including TYPHOID FEVER, PLAGUE and CHOLERA. Some antibiotics are selective – that is, effective against specific microorganisms; those effective against a large number of microorganisms are known as broad-spectrum antibiotics. Important antibiotics include PENICILLIN, the first widely used antibiotic, streptomycin and the tetracyclines. Some bacteria have developed ANTIBIOTIC RESISTANCE. See also ANTISEPTIC

antibiotic resistance Resistance to antibiotic drugs acquired by many bacteria and other PATHOGENS. Because they survive while non-resistant strains are killed, they pass their resistance to their progeny and resistance increases in the population. Some bacteria have the ability to pass the genes for antibiotic resistance to other organisms of different species on plasmids (small lengths of DNA). Spread of resistance is accelerated by routine prescription of antibiotics to humans and

unregulated application to farm animals for the purpose of disease prevention rather than cure. An inadequate dose or failure to complete a course of antibiotics increases the chances of resistant microorganisms surviving to breed. This may lead to the return of epidemics of untreatable infectious disease.

antibody Protein synthesized in the BLOOD in response to the entry of "foreign" substances or organisms into the body. Each episode of bacterial or viral infection prompts the production of a specific antibody to fight the disease in question. After the infection has cleared, the antibody remains in the blood to fight off any future invasion.

Antichrist Term loosely referring to the supreme enemy of Christ. It is used in the letters of St John to refer to a force that will appear at the end of time. Martin Luther and other leaders of the Reformation applied it to the papacy.

anticline Arch-shaped fold in rock strata. Unless the formation has been overturned, the oldest rocks are found in the centre with younger rocks symmetrically on each side of it.

Anti-Corn Law League Organization formed (1839) in Manchester, England, to agitate for the removal of import duties on grain. It was led by the Radical MPs, Richard COBDEN and John BRIGHT. By holding mass meetings, distributing pamphlets and contesting elections it helped bring about the repeal of the CORN LAWS in 1846.

anticyclone Area of high atmospheric pressure around which air circulates. The direction of air circulation is clockwise in the Northern Hemisphere and anticlockwise in the Southern Hemisphere. Anticyclones are often associated with settled weather conditions. In middle latitudes, they bring periods of hot, dry weather in summer, and cold, often foggy, weather in winter.

Antietam, Battle of (17 September 1862) Fought around Sharpsburg, Maryland, during the American Civil War. General George McClellan's Army of the Potomac made a series of assaults on the Confederates of General Robert E. Lee. Casualties were very heavy. McClellan's forces, c.12,000, were slightly greater, but Lee was forced to abandon his Maryland campaign and retreat to Virginia.

Anti-Federalist Party Organized in 1792 to oppose the proposed Constitution, mainly on the grounds that it gave the central government power. Anti-Federalist leaders included Richard Henry Lee and Patrick Henry of Virginia and George Clinton of New York. Their support came mostly from the back country and agricultural sections.

antifreeze Substance dissolved in a liquid to lower its freezing point. Ethylene glycol (ethane diol, HOC₂H₄OH) is commonly used in car radiators.

antigen Substance or organism that induces the production of an ANTIBODY, part of the body's defence mechanism against disease. An antibody reacts specifically with the antigen.

Antigonus I (382–301 BC) General of ALEXANDER THE GREAT. He became governor of Phrygia (333 BC) and, in the struggles over the regency, defeated challengers to gain control of Mesopotamia, Syria and Asia Minor. In 306 BC he defeated his former ally, Ptolemy I, at Salamis. He was killed at Ipsus.

Antigua and Barbuda Caribbean islands in the Leeward Islands group, part of the Lesser Antilles. The capital is St John's (on Antigua). Antigua is atypical of the Leeward Islands in that, despite its height – rising to 405m (1,328ft) – it has no rivers or forests; Barbuda, in contrast, is a well-wooded low coral atoll. Only 1,400 people live on the game reserve island of Barbuda, where lobster fishing is the main occupation, and none on the rocky island of Redondo. Antigua and Barbuda were linked by Britain after 1860, gained internal self-government in 1967 and independence in 1981. The islands are dependent on tourism, though some attempts at diversification (notably Sea Island cotton) have been successful. Other industries: livestock rearing, market gardening, fishing. Area: 440sq km (170sq mi). Pop. (1994) 65,000. See West Indies map

antihistamine Any one of certain drugs that counteracts or otherwise prevents the effects of histamine, a natural substance released by the body in response to injury, or more often as part of an allergic reaction. Histamine can produce symptoms such as sneezing, running nose and burning eyes. See also HAY FEVER

Antilles Collective name for the two major island groups in the West Indies archipelago, between the Atlantic Ocean and the Caribbean Sea, stretching in an arc from Puerto Rico to the N coast of Venezuela. The Greater Antilles (larger of the two groups) includes Cuba, Hispaniola, Jamaica, Puerto Rico and the CAYMAN ISLANDS. The Lesser Antilles comprises mainly the British VIRGIN ISLANDS, the US VIRGIN ISLANDS, the LEEWARD ISLANDS and WINDWARD ISLANDS, plus small islands off the coast of South America. See WEST INDIES map antimatter Matter made up of antiparticles, identical to ordinary particles in every way except the charge, SPIN and magnetic moment are reversed. When an antiparticle, such as a positron (anti-electron), antiproton or antineutron meets its respective particle, both are annihilated. Since a PHOTON is its own antiparticle the possibility exists that there are stars or galaxies composed entirely of antimatter. See also SUBATOMIC PARTICLES

antimony (symbol Sb) Toxic semimetallic element of group V of the PERIODIC TABLE. Stibnite (a sulphide) is its commonest ore. It is used in some alloys, particularly in hardening lead for batteries and type metal, and in semiconductors. The element has two allotropes: a silvery white metallic and an amorphous grey form. Properties: at.no. 51; r.a.m. 121.75; r.d. 6.68; m.p. 630.5°C (1,166.9°F); b.p. 1,750°C (3,182°F); most common isotope Sb¹²¹ (57.25%).

Antioch See ANTAKYA

Antiochus III (242–187 BC) King of Syria (223–187 BC), son of Seleucus II. After his defeat at Rafa (217 BC) by Ptolemy IV, he invaded Egypt (212–202 BC), seizing land from Ptolemy V with the help of Philip V of Macedon. He recaptured Palestine, Asia Minor, and the Thracian Cheronese. The Romans overwhelmed him at Thermopylae (191 BC) and at Magnesia (190 BC). The rebuilt Seleucid empire shrank when he gave up all possessions w of the Taurus. Seleucus IV succeeded him.

antiphon Alternate short verses or phrases (usually of a psalm or canticle) sung by two spatially separated halves of a choir (designated *decani* and *cantoris*). More generally, antiphon refers to a short piece of PLAINSONG, during the recitation of divine office. The text of the antiphon usually serves to reinforce a psalm's Christian significance. The music and text of antiphons is contained in a collection called an antiphonal, or antiphonary.

antipope Name given to rivals of legitimately elected popes, generally "appointed" by unauthorized religious factions. The first was HIPPOLYTUS (217–35), a Trinitarian heretic and rival of Calixtus I. The most famous were the AVIGNON popes, who rivalled those of ROME during the GREAT SCHISM (1378–1417). antiseptic Chemicals that destroy or stop the growth of many microorganisms. Antiseptics are weak germicides that can be used on the skin. The English surgeon Joseph Lister pioneered the use of antiseptics in 1867. One commonly used is ALCOHOL. See also ANTIBIOTIC

antitoxin Antibody produced by the body in response to a TOXIN. It is specific in action and neutralizes the toxin. Antitoxin sera are used to treat and prevent bacterial diseases such as TETANUS and DIPHTHERIA.

antler Bony outgrowth on the skulls of male DEER (and female reindeer). In temperate-zone species, antlers begin to grow in early summer. They are soft, well supplied with blood and covered with thin, velvety skin. Later, the blood recedes and the dried skin is rubbed off. Antlers then serve as sexual ornaments and weapons until they are shed the following spring. First-year males grow short spikes. More branches (points) are added each year until maturity is reached.

ant lion Larva of the neuropteran family Myrmeleontidea, found in most parts of the world. Carnivorous, with large, sickle-shaped jaws, it digs a pit in dry sand where it lies waiting for ants and other insects to fall in. See also LACEWING

Antofagasta Seaport and rail centre on the coast of N Chile and capital of Antofagasta province. Built in 1870 to provide port facilities for the nitrate and copper deposits in the ATACAMA DESERT, it has both ore refining and concentration plants. The Chuquicamata open-cast copper mine, 220km (135mi) to the NE, is the world's largest. Pop. (1992) 226,749. Antonello da Messina (1430–79) Sicilian artist. A pio-

neer of oil painting in Italy, he spent much of his working life in Milan, Naples, Venice and Rome. He probably learned the oil technique in Naples, a centre for Dutch artists. His work married Netherlandish taste for detail with Italian clarity. Apart from religious paintings, such as *Salvator Mundi* (1465) and *Ecce Homo* (1470), he produced some remarkable male portraits. His knowledge of oil glazes had a great influence on Venetian painters, notably Giovanni BELLINI.

Antony, Mark (82-30 BC) (Marcus Antonius) Roman general and statesman. Antony fought with distinction in Julius CAE-SAR's campaign in Gaul (54-50 BC). In 49 BC Antony became tribune. Civil war broke out between POMPEY and Caesar, and after the decisive Battle of Pharsala, Antony was made consul. After Caesar's assassination (44 BC), Antony inspired the mob to drive the conspirators, Brutus and Cassius, from Rome. Octavian (later Augustus) emerged as Antony's main rival. Octavian and Brutus joined forces and Antony retreated to Transalpine Gaul. Antony sued for peace. Antony, Octavian and Lepidus formed the Second Triumverate, which divided up the ROMAN EMPIRE: Antony received Asia. He and CLEOPA-TRA, queen of Egypt, became lovers. CICERO, Antony's great rival, was killed. In 40 BC Antony married Octavian's sister Octavia, but Antony continued to live with Cleopatra in Alexandria and became isolated from Rome. In 32 BC the senate deprived Antony of his posts. He was defeated at the Battle of ACTIUM (31 BC). Antony and Cleopatra committed suicide.

Antrim County in Northern Ireland, bounded N by the Atlantic Ocean and E by the North Channel. The capital is BELFAST. Other notable centres are Ballymena, Antrim (on the N shore of Lough Neagh), and the ferry port of Larne. Mainly a low basalt plateau, it is noted for the GIANT'S CAUSEWAY. It is chiefly an agricultural region, cereals and livestock being most important. Industries: linen and shipbuilding, concentrated in Belfast. Area: 3,043sq km (1,175sq mi). Pop. (1991) 665,013. Antwerp (Flemish Antwerpen, Fr. Anvers) Port city on the River Scheldt, capital of Antwerp province and Belgium's second-largest city. Antwerp rose to prominence in the 15th century and became a centre for English mercantile interests. It was the site of Europe's first stock exchange (1460). Sites include the State University Centre (1965), the Royal Museum of Fine Arts (1880-90), and the 14th-century Cathedral of Notre Dame. Though heavily bombed during World War 2, it retains many attractive old, narrow streets and fine buildings. Industries: oil refining, food processing, tobacco, diamond

Anubis In Egyptian mythology, a jackal-headed god. Son of Nephthys and Osiris, he conducted the souls of the dead to the underworld and presided over mummification and funerals. Anubis accompanied Osiris on his world conquest and buried him after his murder.

cutting. Pop. (1993 est.) 462,880.

ANZAC (acronym for Australian and New Zealand Army Corps) Volunteer force of 30,000 men which spearheaded the disastrous Gallipoli Campaign in World War 1. Troops landed at Gallipoli on 25 April 1915. Anzac Day (25 April) is a public holiday in Australia and New Zealand. About 8,500 Anzac troops were killed during World War 1.

ANZUS Pact (Australia-New Zealand-United States Treaty Organization) Military alliance organized by the US in 1951. ANZUS was set up in response to waning British power, the Korean War, and alarm at increasing Soviet influence in the Pacific. The treaty stated that an attack on any one of the three countries would be considered as an attack on them all. It was replaced in 1954 by the SOUTHEAST ASIA TREATY ORGANIZATION (SEATO).

aorta Principal ARTERY in the body. Carrying freshly oxygenated blood, the aorta leaves the left ventricle of the heart and descends the length of the trunk, finally dividing to form the two main arteries that serve the legs. *See also* CIRCULATORY SYSTEM; HEART

Apache Athabascan-speaking tribe of Native North Americans that live in Arizona, New Mexico and Colorado. Divided culturally into Eastern Apache (including Mescalero and Kiowa) and Western Apache (including Coyotero and Tonto), they migrated from the NW with the NAVAJO in about AD 1000 but separated to form a distinct tribal group. They

retained their earlier nomadic raiding customs, which brought them into military conflict with Mexico and the USA during the 19th century. The total population is now c.11,000.

Apache Wars Series of battles in Arizona, New Mexico.

Texas and Oklahoma between the Apache and white settlers. One Apache chief, Cochise, made peace in 1872, but GERON-IMO fought on until 1886. Atrocities occurred on both sides. apartheid Policy of racial segregation practised by the South African government from 1948 to 1990. Racial inequality and restricted rights for non-whites were institutionalized when the AFRIKANER-dominated National Party came to power in 1948. Officially a framework for "separate development" of races, in practice apartheid enforced white-minority rule. It was based on segregation in all aspects of life including residence, land ownership and education. Non-whites, around 80% of the population, were also given separate political structures and quasiautonomous homelands or bantustans. The system was underpinned by extensive repression, and measures such as pass laws which severely restricted the movements of non-whites. Increasingly isolated internationally and beset by economic difficulties and domestic unrest, in 1990 the government pledged to dismantle the system. The transition to nonracial democracy was completed with the elections in April 1994. See also African National Congress (ANC)

ape Term usually applied to the anthropoid apes (PRIMATES) that are the closest relatives of humans. There are three great apes – CHIMPANZEE, GORILLA and ORANGUTAN – and one lesser, the GIBBON. An ape differs from a MONKEY in being larger, having no visible tail and in possessing a more complex brain. Two monkeys are also called "apes" – the BARBARY APE of N Africa and Gibraltar, and the black ape of Celebes.

Apennines (Appennino) Mountain range extending the length of Italy, a continuation of the Pennine Alps. The "backbone" of Italy, stretching c.1,350km (840mi) from the Genoese Riviera to the tip of the country's "toe". Unselective deforestation over the years has caused deep erosion and landslides. The Apennines are the location of numerous hydroelectric plants. Sheep and goats are grazed on its slopes. The highest point is Mount Corno, at 2,914m (9,560ft).

aperture In photography, a hole that allows light to pass through the lens onto the film. Modern cameras usually have a diaphragm aperture which works like the iris of a human eye. The photographer can widen or narrow the diaphragm according to a series of points on the lens dial called "f-numbers" or "f-stops". The individual f-numbers represent the focal length of the lens divided by the diameter of the aperture. As the aperture narrows, it gives a longer depth of field. **aphasia** Group of disorders of language arising from disease of or damage to the brain. In aphasia, a person has problems formulating or comprehending speech and difficulty in reading and writing. *See also* BRAIN DISORDERS

aphid (plant louse) Winged or wingless, soft-bodied insect found worldwide. It transmits virus diseases of plants when sucking plant juices. Females reproduce with or without mating, producing one to several generations annually. Common species are also known as blackfly and greenfly. Length: to 5mm (0.2in). Family Aphididae.

Aphrodite Greek goddess of love, beauty and fruitfulness, identified by the Romans as VENUS. She was the daughter of ZEUS and Dione. Her husband was HEPHAESTUS (in Roman mythology, VULCAN). Among her many lovers were ARES, ADONIS (whose death left her broken-hearted) and Anchises, the father of AENEAS. Statues of her include the Venus de Milo (Paris) and Aphrodite of Cnidus (Rome).

Apocrypha Certain books included in the Bible as an appendix to the OLD TESTAMENT in the SEPTUAGINT and in St Jerome's Vulgate translation but not forming part of the Hebrew canon. Nine books are accepted as canonical by the Roman Catholic Church. They are: Tobit, Judith, Wisdom, Ecclesiasticus, Baruch (including the Letter to Jeremiah), 1 and 2 Maccabees, and parts of Esther and Daniel. Other books are found in Eastern Orthodox bibles and in the appendix to the Roman Catholic Old Testament. Anglican and Protestant translations of the Bible have, since the 16th century, placed books of the Apocrypha between the Old and New Testaments.

▲ aphid The greenfly (*Aphis* sp) occurs in enormous numbers, and the 2,000 or species probably inflict more damage on crops than any other insect pest. Their remarkable power of reproduction is due to the fact that the females are parthenogenetic, that is they can produce young without fertilization by a male.

Apollinaire, Guillaume (1880–1918) (Wilhelm Apollinaris de Kostrowitzky) French experimental poet, essayist and playwright. One of the most extraordinary artists of early 20th-century Paris, his *Peintres Cubistes* (1913) was the first attempt to define CUBISM. He also experimented with typography in his poetry collection, *Calligrammes* (1918). His masterpiece was the wholly unpunctuated *Alcools* (1913), in which he relived the wild romances of his youth.

Apollo In Greek mythology, god of the Sun, archery and prophecy; patron of musicians, poets and physicians; founder of cities and giver of laws. He was the son of Zeus and Leto, twin to ARTEMIS. In the Trojan War he sided with Troy, sending a plague against the Greeks.

Apollonius of Perga (c.262–190 BC) Greek mathematician and astronomer. He built on the foundations laid by EUCLID. In *Conics* he showed that an ELLIPSE, a PARABOLA and a HYPERBOLA can be obtained by taking plane sections at different angles through a cone. In astronomy, he described the motion of the planets in terms of epicycles, which remained the basis of the system used until the time of COPERNICUS.

Apollo program US SPACE EXPLORATION project to land men on the MOON. Initiated in May 1961 by President John Kennedy, it achieved its objective on 20 July 1969, when Neil ARMSTRONG set foot on the Moon. It placed more than 30 astronauts in space and 12 on the Moon.

Apostle Missionary sent out and empowered by divine authority to preach the gospel and heal the sick. Jesus commissioned his 12 original DISCIPLES to carry out the purpose of God for man's salvation (Mark 3, Matthew 10, Luke 6). The first qualification for being an apostle was to have "seen the Lord". The 12 disciples thus became the first and original Apostles. The term is also applied in the New Testament to St Paul. In modern usage it is sometimes given to the leader of the first Christian mission to a country. For example, St Patrick is described as the "Apostle of Ireland".

Apostles' Creed Statement of Christian faith. The last section affirms the tradition of the "holy Catholic Church; the communion of saints; the forgiveness of sins; the resurrection of the body; and the life everlasting". The text evolved gradually, and its present form was fixed by the early 7th century. It is used widely in private and public worship in all the major Churches in the West. *See also* NICENE CREED

Appalachians Mountain system stretching 2,570km (1,600mi) from E Canada to Alabama, USA. Comprising a series of parallel ridges divided by wide valleys, the mountains restricted early European settlers to the E coast. It includes the White Mountains, Green Mountains, Catskills, Alleghenies, Blue Ridge and Cumberland Mountains; the highest point is Mount Mitchell in North Carolina at 2,037m (6,684ft). Rich in timber and coal; the ranges are home to many NATIONAL PARKS.

appeasement Policy in which one government grants unilateral concessions to another to forestall a political, economic or military threat. The 1938 MUNICH AGREEMENT is considered a classic example of appeasement.

Appel, Karel (1921–) Dutch painter, sculptor and muralist. In the 1940s, he was one of several painters who reacted against the strict formalism of De STIJL, and invented a wildly expressionist language of his own, similar to ABSTRACT EXPRESSIONISM. His most powerful work, often portraying fantastic, aggressive and tragic figures, anticipated *Art Informel*. Appel is one of the most important post-1945 Dutch artists.

appendicitis Inflammation of the APPENDIX caused by obstruction and infection. Symptoms include severe pain in the central abdomen, nausea and vomiting. Acute appendicitis is generally treated by surgery. A ruptured appendix can cause peritonitis and even death.

appendix In some mammals, finger-shaped organ, c.10cm (4in) long, located near the junction of the small and large intestines, usually in the lower right part of the abdomen. It has no known function in humans but can become inflamed or infected (APPENDICITIS).

apple Common name for the most widely cultivated fruit tree of temperate climates. Developed from a tree native to Europe and sw Asia, apple trees are propagated by budding

or grafting. From the flowers, which require cross-pollination, the fleshy fruit grows in a variety of sizes, shapes and acidities; it is generally roundish, 5–10cm (2–4in) in diameter, and a shade of yellow, green or red. A mature tree may yield up to 1cu m (30 bushels) of fruit in a single growing season. Europe produces 50–60% of the world's annual crop, and the USA 16–20%. Cider is made from fermented apple juice. Family Rosaceae; genus *Malus*.

apricot Tree cultivated throughout temperate regions, believed to have originated in China. The large, spreading tree with dark green leaves and white blossoms bears yellow or yellowish-orange edible fruit, with a large stone. Family Rosaceae; species *Prunus armeniaca*.

apsis (pl. apsides) Either of two points in an object's orbit. The closest point to the primary body is known as the **periapsis**, and the furthest the **apapsis**. The apsides of the Earth's orbit are its perihelion and aphelion; in the Moon's orbit they are its perigee and apogee. The line of apsides connect these points.

aptitude test Test used to measure potential for educational achievement. Some (such as "intelligence tests") purport to measure general capacity. Others are designed to measure potential for a specific aptitude.

Aqaba (Al 'Aqabah) Only seaport of Jordan, at the head of the Gulf of AQABA on the NE end of the Red Sea. It was an important part of medieval Palestine, in 1917 it was captured from the Turks by T.E. Lawrence, and finally ceded to Jordan in 1925. It is crucial to Jordan's phosphate exports, and is expanding as a port and diving resort. Pop. (1992 est.) 58,000. Agaba, Gulf of Northeast arm of the Red Sea between the Sinai Peninsula and Saudi Arabia. AQABA and ELAT lie at the N end of the Gulf. The gulf has played an important role in ARAB-ISRAELI WARS. It was blockaded by the Arabs (1949-56), and again in 1967, when Israel held strategic points along the Strait of Tiran to guarantee open passage for ships. The Gulf has excellent coral beds and rich marine life. Aqmola (Akmola, lit. "white grave") Capital-designate of Kazakstan, on the River Ishim in the steppes of N central Kazakstan. Under Soviet rule, Agmola functioned as capital

Tselinograd. Pop. (1990) 281,400. aquaculture See FISH CULTURE aqualung See SCUBA DIVING

aquamarine See BERYL

Aquarius (water-bearer) Eleventh constellation of the zodiac, represented by a figure pouring water from a jar.

of the Virgin Lands. From 1961 to 1993 it was known as

aquatint Method of engraving on metal plates. Acquatint was invented in the mid-18th century to imitate the effect of brush drawing or watercolour. It involves sprinkling a plate with fine grains of acid-resistant resin, fusing the resin to the metal (modern enamel spray makes this unnecessary) and letting acid bite around and through some of the grains. Printmakers can achieve extremely varied effects depending on the thickness of the resin and the immersion time. Acquatint enables line engraving or drawing on the resin with an acid-resistant varnish. GOYA and PICASSO were masters of the process.

aqueduct Artificial channel for conducting water from its source to its distribution point. While the ancient Romans were not the first to build these conduits, their aqueducts are the most famous because of their graceful architectural structures. One of their most extensive water systems, which served Rome itself, consisted of 11 aqueducts and took 500 years to complete. California has the world's largest conduit system: it carries water over a distance of more than 800km (500mi).

aquifer Rock, often sandstone or limestone, which is capable of both storing and transmitting water owing to its porosity and permeability. Much of the world's human population depends on aquifers for its water supply. They may be directly exploited by sinking wells.

Aquinas, Saint Thomas (1225–74) Italian theologian and philosopher, Doctor of the Church. St Thomas is the greatest figure of SCHOLASTICISM. His Summa Theologiae (Theological Digest, 1267–73) was declared (1879) by Pope Leo XIII to be the basis of official Catholic philosophy. Thomas joined the Dominican Order (1244) and studied under the Aristotelian philosopher Albertus Magnus. In 1252 he became a professor

▲ appendicitis In appendicitis, the tissues lining the appendix become infected and inflamed, which causes the organ to swell (1) and its vascularization to increase (2). Prompt surgical removal is usually carried out to prevent the appendix bursting and causing peritonitis by the spread of its infection.

▼ apple Grown predominantly in temperate regions since prehistoric times, the apple is thought to be native to the Caucasus. China and the United States (particularly Washington state) are the world's largest producers. Its juice is fully fermented to make vinegar. The apple is often believed to be the forbidden fruit in the Garden of Eden.

of theology in Paris, and rapidly distinguished himself as a major authority on ARISTOTLE. Aquinas disagreed with the Averroist and Augustinian schools by arguing that faith and reason are two complementary realms; both are gifts of God, but reason is autonomous. His four hymns for the feast of Corpus Christi are among the greatest devotional pieces. Thomas was canonized in 1323. Thomist METAPHYSICS, a moderate form of REALISM, was the dominant world view until the mid-17th century. Other writings include *Commentary in the Sentences* (1254–56) and *Summa Contra Gentiles* (Against the Errors of the Infidels, 1259–64). His feast day is 7 March.

Aquino, (Maria) Cory (Corazon) (1933–) Philippine stateswoman, president (1986–92), b. Maria Corazon. In 1954 she married Benigno Aquino (1932–83), an outspoken opponent of the MARCOS regime. While he was in prison (1973–81), Cory campaigned tirelessly for his release. Benigno was assassinated by Marcos' agents. Cory claimed to have defeated Marcos in the 1986 presidential election and accused the government of vote-rigging. A bloodless "people's revolution" forced Marcos into exile. Aquino's administration was beset by economic obstacles and she survived a coup attempt only with US help (1989). Aquino declined to run for re-election in 1992, but supported the campaign of her successor Fidel Ramos.

Arab Peoples of many nationalities, found predominantly in the Middle East and North Africa, who share a common heritage in the religion of ISLAM and their language (ARABIC). The patriarchal family is the basic social unit in a strongly traditional culture that has been little affected by external influences. Wealth from oil has brought rapid modernization in some Arab countries, but a great deal of economic inequality exists.

Arabia Peninsular region of sw Asia bordered by the Persian Gulf (E), the Arabian Sea (s), the Syrian Desert (N) and the Red Sea (W). The original homeland of the Arabs, it is the world's largest peninsula, consisting largely of a plateau of crystalline rock. It is mostly desert, including the vast, barren Rub al-Khali (Empty Quarter) in the s and the An Nafud in the N. The area was unified by the Muslims in the 7th century, and dominated by Ottoman Turks after 1517. Hussein ibn Ali led a successful revolt against the Turks and founded an independent state in the Hejaz region in 1916, but was subsequently defeated by the Saud family, who founded SAUDI ARABIA in 1925. After World War 2 independent Arab states emerged, many of them exploiting the peninsula's vast reserves of oil. Area: c.2.6 million sq km (1 million sq mi).

now spoken in a variety of dialects throughout North Africa

► Arafat Following a 30-year struggle with Israel, Palestine Liberation Organization (PLO) leader Yasir Arafat returned to Jericho on 1 July, 1994 as head of the Palestinian National Authority. He was elected president in 1996. His leadership was criticized by some Palestinians for relinquishing too much to Israel, and by Israeli prime minister Benjamin Netanyahu for harbouring Palestinian extremists. Arafat's ill heath prompted speculation concerning a crisis of succession. and the Middle East. It is a Semitic language, belonging to a major subfamily of Afro-Asiatic languages. Classical Arabic is the language of the Koran. It began to spread during the Islamic expansion of the 7th and 8th centuries. It is estimated that more than 100 million people are native speakers. Arabic uses a script written from right to left. The script has been borrowed for rendering other languages such as Urdu.

Arab-Israeli Wars (1948-49, 1956, 1967, 1973-74) Conflicts between Israel and the Arab states. After the creation of the state of Israel (14 May 1948), troops from Egypt, Iraq, Lebanon, Syria and Transjordan (modern Jordan) invaded the new nation. Initial Arab gains were halted and armistices arranged at Rhodes (January-July 1949). UN security forces upheld the truce until October 1956, when Israeli forces under Moshe Dayan attacked the Sinai Peninsula with support from France and Britain, alarmed at Egypt's nationalization of the Suez Canal. International opinion forced a ceasefire in November. In 1967 guerrilla raids led to Israeli mobilization, and in the ensuing SIX DAY WAR, Israel captured Sinai, the GOLAN HEIGHTS on the Syrian border and the Old City of JERUSALEM. In the October War of 1973 (after intermittent hostilities) Egypt and Syria invaded on the Jewish holiday of Yom KIPPUR (6 October), Israel pushed back their advance after severe losses. Fighting lasted 18 days. Subsequent disengagement agreements were supervised by the UN. In 1979 Israel signed a peace treaty with Egypt, but relations with other Arab states remained hostile. Israeli forces invaded Lebanon in 1982 in an effort to destroy bases of the Palestine Liberation Organization (PLO). They were withdrawn (1984) after widespread international criticism. After 1988 the PLO renounced terrorism and gained concessions, including limited autonomy in parts of the occupied territories. Israeli relations with some Arab neighbours generally improved after the GULF WAR (1991).

Arab League Organization formed in 1945 to give a collective political voice to the Arab nations. Its members include Syria, Lebanon, Iraq, Jordan, Sudan, Algeria, Kuwait, Saudi Arabia, Libya, Morocco, Tunisia, Yemen, Qatar and the United Arab Emirates. It has often been divided, notably by the Egyptian peace treaty with Israel (1979) and over the GULF WAR (1991) and has been politically less effective than its founders hoped.

arachnid Arthropod of the class Arachnida, which includes the SPIDER, TICK, MITE, SCORPION and HARVESTMAN. Arachnids have four pairs of jointed legs, two distinct body segments (cephalothorax and abdomen), and chelicerate jaws (consisting of clawed pincers). They lack antennae and wings.

Arafat, Yasir (1929–) Palestinian statesman, first president of Palestine (1996–), leader of the Palestine Liberation Organization (PLO). From a base in Lebanon, Arafat led the anti-Israel guerrilla organization, Fatah. He sought the abolition of Israel and the creation of a secular Palestinian state. The Intifada in Israel's occupied territories (Gaza and the West Bank) prompted secret talks between Israel and the PLO. In 1993 Arafat and Yitzhak Rabin signed an agreement in which Arafat renounced terrorism and recognized the state of Israel. In return, Rabin recognized the PLO as the legitimate representative of Palestinians and agreed to a withdrawal of Israeli troops from parts of the occupied territories. In 1994 the Palestinian National Authority, headed by Arafat, assumed limited self-rule in the territories relinquished by the Israeli army. In 1996 elections Arafat became president.

Aragón Region in NE Spain. In 1479 the Kingdom of Aragón became part of Spain, but retained its own government, currency and military forces until the early 18th century. It is now an autonomous region, comprising the provinces of Huesca, Teruel and Zaragoza. It produces grapes, wheat and sugar-beet. Industries: textiles, chemicals, iron ore, marble and limestone. Area: 47,670sq km (18,500sq mi). Pop. (1991) 1,188,817.

Aral Sea (Aralskoye More) Inland sea in central Asia, sw Kazakstan and Nw Uzbekistan. Once the world's fourth largest inland body of water, it has no outlet, contains many small islands and is fed by the rivers Syrdarya in the NE and Amudarya (Oxus) in the s. It is generally shallow and only slightly saline. The diversion of the rivers for irrigation by the

Soviet government led to its area shrinking by more than a third between 1960 and 1995. Many fishing communities were left stranded. Area (1993): 33,642sq km (12,989sq mi).

Aramaic Ancient Semitic language used as a means of everyday communication in Palestine and other parts of the Middle East at the time of Christ. Originally the language of nomadic groups who established small states in Mesopotamia during the late 2nd millennium BC, it became the common spoken and written language of the Middle East under the Persian Empire until replaced by Arabic. Parts of the Old Testament were originally written in Aramaic, and it was the language that Jesus spoke. Minor dialects still persist today in small Christian communities of the Near and Middle East.

Arapaho Algonquian-speaking tribe of Native North Americans. Their original home was in the Red River valley; they moved across the Missouri River and split into two groups. After the Treaty of Medicine Lodge (1847), one group joined the Southern Cheyenne in Oklahoma, while the northern band joined the SHOSHONE on the Wind River Reservation. A Plains tribe, they joined with the Cheyenne in raiding migrating white settlers. Today, they number *c.*3,000.

Ararat, Mount (Ağri Daği) Two extinct volcanic peaks in the E extremity of Turkey. The highest peaks in Turkey, they are just N of where Noah's Ark is said to have come to rest (Genesis 8). Boundary treaties with the Soviet Union (1921) and Iran (1932) located the mountains completely in Turkey. There are two peaks: Great Ararat, 5,165m (16,945ft), (last eruption 1840), and Little Ararat, 3,925m (12,877ft).

Araucanian Independent language family of South American Indians who live in Chile and Argentina. A loose confederation of Araucanian-speaking sub-tribes (including the Picunche, Mapuche and Huilliche) offered strong resistance to the Spanish invasion under Diego de Almagro in 1536. They drove the Spaniards back to the River Bio-Bio in 1598, and retained possession of interior portions of Chile to the present time. Their descendants prefer the name *Mapuche* (land people). The population has declined from *c*.1 million in the 16th century to *c*.300,000 today.

Arawak Largest and most widely spread Native South American language family, at one time spoken from the Caribbean to the GRAN CHACO. Today, some 40 Arawak tribes remain in Brazil.

arbitration Resolution of a dispute by an unbiased referee (arbiter) chosen by the parties in conflict. In some countries the arbiter's ruling or decision may be enforced by government. While arbitration may be utilized by individuals in conflict, the procedure is most commonly applied in commercial and industrial disputes and overseen by independent bodies such as the Advisory, Conciliation and Arbitration Service (ACAS) in the UK, or the American Arbitration Association in the USA. International cases are often brought before the United Nations International Court of Justice, based at The Hague. Netherlands.

arbor vitae Common name for five species of trees or shrubs of the genus *Thuja*, resinous, evergreen conifers of the cypress family native to North America and E Asia. They have thin outer bark, fibrous inner bark, and characteristically flattened branches. Family Cupressaceae.

arc Portion of a curve. For a circle, the length (s) of an arc is found either by $2r\pi \times \theta/360$ or the product of the radius (r) and the angle (θ) , measured in RADIANS, that it subtends at the centre: that is, $s = r \theta$.

Arc de Triomphe TRIUMPHAL ARCH in the Place Charles de Gaulle, Paris. The Arc de Triomphe de l'Etoile is a generalized copy of the triumphal arches erected in ancient Rome to commemorate the victories of individual emperors. Napoleon I commissioned J.F. Chalgrin to design this version, completed in 1836. It is one of the city's most celebrated landmarks. arch Upward-pointing or curving arrangement of masonry blocks or other load-bearing materials, also used in architectural decoration. The ancient Romans invented traditional masonry arches but later cultures extended their repertoire to include many different and elaborate shapes. The basic structure of a masonry arch consists of wedge-shaped blocks (voussoirs) placed on top of each other and a central keystone which holds

■ archaeopteryx The earliest known recognizable bird, archaeopteryx dates from the upper Jurassic period. The presence of wings and feathers define it as a bird, but the skeleton is quite reptilian. The wings, instead of being the specialized flying limbs of modern birds, were really elongated forelimbs, complete with claws. The tail resembles a lizard's and the skull had teeth. The small breastbone shows it was a poor flyer.

them together at the top. Modern materials, such as steel and reinforced concrete, are strong and flexible enough to stand on their own and can also stretch across much wider areas. The form of an arch helps to date a building. See also VAULT

Archaean Sub-division of pre-Cambrian geological time. It ended *c.*2.5 billion years ago.

archaebacteria Sub-kingdom of the kingdom Prokary-OTAE, which on the basis of both RNA and DNA composition and biochemistry differ significantly from other BACTERIA. They are thought to resemble ancient bacteria that first arose in extreme environments such as sulphur-rich, deep-sea vents. Archaebacteria have unique protein-like cell walls and cell membrane chemistry, and distinctive RIBOSOMES. They include methane-producing bacteria, which use simple organic compounds such as methanol and acetate as food, combining them with carbon dioxide and hydrogen gas from the air, and releasing methane as a by-product. The bacteria of hot springs and saline areas have a variety of ways of obtaining food and energy, including the use of minerals instead of organic compounds. They include both AEROBIC and ANAERO-BIC bacteria. Some hot springs bacteria can tolerate temperatures up to 88°C (190°F) and acidities as low as pH 0.9. One species, Thermoplasma, may be related to the ancestor of the nucleus and cytoplasm of the more advanced EUKARYOTE cells. Some taxonomists consider archaebacteria to be so different from other living organisms that they constitute a higher grouping called a DOMAIN. See also TAXONOMY

archaeology Scientific study of former human life and activities through material remains such as artefacts and buildings. An archaeologist excavates and retrieves remains from the ground or seabed; recording and interpreting the circumstances in which objects were found, such as their level in the soil and association with other objects. This information can then be used to build a picture of the culture that produced the objects. archaeopteryx First known bird. About the size of a crow and fully feathered, its fossilized skeleton is more like that of a reptile than a modern bird, and its beak had pronounced jaws with teeth. It was capable probably only of weak flight. Archangel (Archangel'sk) City and major port on the North Dvina delta, NW Russia. Archangel was opened to European trade in c.1600 and prospered as Russia's only port until 1703. The monastery of Archangel Michael was built here (1685-99). The port received supplies from Allied convoys during World War 2. In the winter, icebreakers keep the large harbour clear, but the port remains ice-free for about six months - a crucial factor for commerce in N European Russia. Timber and wood products are the main exports. Industries: building, paper. Pop. (1994) 407,000.

archbishop Chief or highest-ranking bishop who is head of an ecclesiastical province or archdiocese. The main function of an archbishop is to supervise the work of BISHOPS.

archery Target sport that makes use of a bow and arrow or a crossbow and bolt. Commonly, archers use a longbow to shoot arrows at a target that consists of concentric scoring

rings of five colours. The three other divisions of archery are field, flight and crossbow. The sport's world authority is the Fédération Internationale de Tir à l'Arc (FITA), based in Milan, Italy. Archery returned to the Olympic Games in 1972. Archimedes (287–212 BC) Greek mathematician and engineer. He developed a method for expressing large numbers and made outstanding discoveries about the determination of areas and volumes, which led to a new accurate method of measuring π (pi). In his work On Floating Bodies he stated Archimedes' Principle. He also invented the Archimedes' Screw.

Archimedes' principle Observation by Archimedes that a body immersed in a FLUID is pushed up by a force equal to the weight of the displaced fluid. He supposedly formulated this principle after stepping into a bath and watching it overflow. Archimedes' screw Machine used for raising water, thought to have been invented by Archimedes in the 3rd century Bc. The most common form of the machine is a cylindrical pipe enclosing a helix, inclined at a 45° angle to the horizontal with its lower end in the water. When the machine rotates, water rises through the pipe.

Archipenko, Alexander (1887–1964) Russian-US modernist sculptor, one of the most radical innovators of his day.

Largely self-taught, he helped to introduce the idea of making space an integral element of sculpture, as in the cubist *Walking Woman* (1912). He also developed a form of sculpture using light. He took part in the Armory Show (1913) and opened a sculpture school in New York in the late 1930s. His work influenced GABO and Henry MOORE.

architecture Art and science of designing permanent buildings for human use. Architecture can express aesthetic ideas from the most restrained UTILITARIANISM to extravagantly ornate decoration. The difference between "architecture" and "building" is a subject that has exercised theorists since the discipline was invented. In reality, architecture is usually a compromise between aesthetic creation and the demands of practicality. There are many different areas of architecture and apart from the stylistic and historical periods (see individual articles), it comes under such broad categories as civic, commercial, religious, recreational and domestic. In the 20th century, traditional barriers between separate artistic disciplines have gradually dissolved, so that it is possible to see architecture as a type of sculpture. Key figures in the development of western architectural theory include VITRUVIUS, who believed that architecture was merely a form of applied mathematics, and ALBERTI whose pioneering treatise De re

ARGENTINA

The sky blue and white stripes were the symbols of independence around the city of Buenos Aires, where an independent government was set up in 1810. It became the national flag in 1816, and the gold May Sun was added two years later.

Argentina is the second largest country in South America and the eighth largest in the world. The high Andes Mountains in the w contain Aconcagua, the highest peak outside Asia. In s Argentina the Andes overlook Patagonia, a plateau region. In E-central Argentina lies a fertile plain called the Pampas, which includes the capital Buenos Aires. Gran Chaco lies w of the River Paraná, while Mesopotamia is a fertile plain between the Paraná and Uruguay rivers.

CLIMATE

Argentina's climate ranges from sub-tropical in the $\mbox{\scriptsize N}$ to temperate in the s, with extremly harsh conditions in the high Andes. Rainfall is abundant in the NE.

VEGETATION

Gran Chaco is a forested region, known for its quebracho trees. Mesopotamia and the Pampas are grassy regions with large farms. Patagonia is too dry for crops.

HISTORY AND POLITICS

Spanish explorers reached the coast in 1516 and settlers followed in search of silver and gold, Spanish rule continued until revolutionaries, led by General Belgrano, overthrew the viceroy in 1810. By 1816 liberation was complete and Argentina declared independence. A long civil war ensued between centralizers and federalists. Following General Juan Manuel de Rosas' dictatorship (1835–52), Argentina adopted a federal constitution (1853). The presidency of General Julio Roca (1880–86, 1898–1904) saw the triumph of federalism and the development of

BRAZIL PARAGUAY URUGUAY Buenos Aires Mar del Plata Bahía Blanca San Matias Gul Valdés Penir Rawson ATLANTIC Comodoro Rivadavia San Jorge Gulf OCEAN MAP SCALE Falkland Islands Río Gallegos Tierra del Fuego

AREA: 2,766,890sq km (1,068,296sq mi)

POPULATION: 33,101,000

CAPITAL (POPULATION): Buenos Aires

(11,662,050)

GOVERNMENT: Federal republic

ETHNIC GROUPS: European 85%, Mestizo,

Native American

LANGUAGES: Spanish (official)

RELIGIONS: Christianity (Roman Catholic 92%)

currency: Peso = 100 centavos

Argentina's trading economy. For much of World War 2 Argentina was a pro-Axis "neutral" power. In 1944 Ramón Castillo was overthrown in a military coup led by Juan PERÓN and Argentina switched to the Allies. With the aid of his wife, Eva, Perón established a popular dictatorship. In 1955 Perón was overthrown by a military coup and Perónism was suppressed. Political instability dominated the 1960s, with the military seeking to dampen Perónist support. In 1973 an ailing Perón returned from exile to head a civilian government. He was succeeded (1974) by his third wife, Isabel Martinez Perón, who was in turn deposed by a military coup (1976). Military rule (1976-83) was characterized by the so-called "Dirty War". Torture, "disappearances" and wrongful imprisonment were commonplace. In 1982 Argentina invaded the FALK-LAND ISLANDS, precipitating the FALKLANDS WAR. Britain quickly recaptured the islands and in 1983 the junta was forced to hold elections. Civilian government was restored. In 1989 the Perónist Carlos MENEM was elected president. He was re-elected in 1995.

ECONOMY

Argentina is an upper-middle-income developing country (1994 GNP per capita, US\$8,060). The economy is dominated by agriculture, its main products and exports are beef, maize and wheat. Other major crops include citrus fruits, cotton, grapes for wine, sorghum, soya and sugar cane. Almost 90% of the population live in urban areas. Industries include the manufacture of cars, electrical equipment and textiles.

Aedificatoria (1485) introduced the idea that architecture was an art form in its own right. After the 18th century, European architects tended to regard "building" as a cheap substitute for their profession and something that engineers carried out. Architects began to swing back in the other direction with the arrival of the ARTS AND CRAFTS MOVEMENT, and the introduction of efficient, mass-produced materials. The 20th-century modernists, such as Walter GROPIUS, believed that the form of a building should follow its function. The relationship between the two extremes is continually changing.

Arctic Vast region of icy seas and cold lands around the NORTH POLE, often defined as extending from the Pole to the ARCTIC CIRCLE. In areas N of latitude 66° 30'N, the sun does not set during the height of summer, nor rise during the depths of winter. Many place the s limit of the Arctic proper at the northern boundary of forest growth, others make the limit the summer isotherm of 18°C (50°F). The more southerly areas are frequently referred to as the subarctic. At the centre of the Arctic is the ARCTIC OCEAN, with its many seas and inlets. In the region around the North Pole, the waters of the Arctic are permanently covered with sheet ice or a floating mass of ice debris called the ice pack, but some parts of the ocean are frozen only in winter. When the ice starts to melt in the spring it disintegrates into floes and drifting pack ice. Icebergs have their origins in freshwater glaciers flowing into the ocean from the surrounding lands. Lands and climate Bordering the Arctic Ocean are the most northerly lands of Asia, Europe and North America. By far the greater part of the huge frozen island of GREENLAND lies N of the Arctic Circle. Five-sixths of Greenland's surface is always hidden by a thick ice-cap. Arctic lands generally have a summer free from ice and snow. Most of the Arctic tundra is flat and marshy in summer but the subsoil is PERMAFROST. For most of the year Arctic temperatures are below freezing point. In spring the sun appears, and some Arctic lands have sunshine every day from March to September. People Despite the severity of the climate and the restricted food resources, many peoples live in the Arctic. The most scattered are the c.60,000 ESKIMOS spread across polar North America, Greenland, and NE Siberia. Several culturally separate groups of people live in N Siberia. In the European part of Russia there are the numerous Zyryans, and in LAPLAND the LAPPS. Most of these peoples follow ancient, traditional patterns of life, but the discovery of great mineral wealth, especially in Alaska and Russia, has brought huge change to their homelands. History The region was first explored by Norsemen as early as the 9th century. The search for the NORTHWEST PASSAGE gave impetus to further explorations in the 16th and 17th centuries, though a route was not found until the early 1900s. The North Pole was first reached in 1909 by the American Robert PEARY, and the first crossing of the Arctic Ocean under the polar ice-cap was completed in 1959.

Arctic Circle Northernmost of the Earth's parallels, 66.5° N of the equator. At this latitude the sun neither sets on the day of summer SOLSTICE (June 21) nor rises on the day of winter solstice (December 22). *See also* ANTARCTIC CIRCLE

Arctic Ocean Ocean N of the Arctic Circle, between North America and Eurasia. Almost totally landlocked and the Earth's smallest ocean, it is bordered by Greenland, Canada, Alaska, Russia, and Norway. Connected to the Pacific Ocean by the Bering Strait, and to the Atlantic Ocean by the Davis Strait and Greenland Sea, it includes the Barents, Beaufort, Chukchi, Greenland and Norwegian seas. There is animal life (plankton) in all Arctic water and polar bears, seals, and gulls up to about 88° N. Area: 14 million sq km (5.4 million sq mi). Arctic tern Sea bird whose migrations are the longest of any bird – from summer breeding areas in the far N to wintering areas in Antarctica, a round trip of c.35,500km (22,000mi). It has grey, black and white feathers and a reddish bill and feet. It nests in colonies and lays one to four eggs in a sandy scrape nest. Length: 38cm (15in). Species Sterna paradisaea.

Ardennes Sparsely populated wooded plateau in SE Belgium, N Luxembourg and the Ardennes département of N France. The capital is Charleville-Mézières. It was the scene of heavy fighting in both world wars; notably in the Battle of

the Bulge. In the well-preserved forest regions wild game is abundant and cleared areas support arable and dairy farming. **area** Two-dimensional measurement of a plane figure or body (such as this page) given in square units, such as $\rm cm^2$ or $\rm m^2$. The area of a rectangle of sides a and b is ab; the areas of triangles and other polygons can be determined using TRIGONOMETRY. Areas of curved figures and surfaces can be determined by integral CALCULUS.

Arequipa Second-largest city of Peru and capital of Arequipa department. It was established in 1540 by Francisco Pizarro on the site of an INCA settlement. Located at the foot of the extinct volcano El Misti (5,822m/19,100ft), it is known as the "White City" because many of its buildings are made of white volcanic stone. A regional trade centre, its main industries are wool processing, textiles and leather. Pop. (1993) 619,156.

Ares In Greek mythology, the god of war, identified with the Roman god Mars. He was the son of Zeus and Hera and lover of APHRODITE. In the Trojan War he sided with the Trojans. Among his offspring was the cruel Cycnus, who was slain by Heracles.

Argentina Republic in s South America. *See* country feature **argon** (symbol Ar) Monatomic (single-atom), colourless and odourless gaseous element that is the most abundant NOBLE GAS (inert gas). Argon was discovered in 1894 by the chemists Lord Rayleigh and Sir William Ramsay. It makes up 0.93% of the atmosphere by volume. Obtained commercially by the fractionation of liquid air, it is used in electric light bulbs, fluorescent tubes, argon lasers, are welding and semiconductor production. The element has no known true compounds. Properties: at.no. 18; r.a.m. 39.948; r.d. 0.0017837g cm⁻³; m.p. –189.4 °C (–308.9°F); b.p. –185.9°C (–302.6°F).

Argonauts In Greek legend, 50 heroes, including Heracles, Orpheus, and Castor and Pollux, who sailed the ship *Argo* to Colchis, a kingdom at the E end of the Black Sea, in search of the Golden Fleece. Their leader was Jason, husband of Medea.

aria Solo song with instrumental accompaniment, or a lyrical instrumental piece. An important element of operas, cantatas and oratorios, the aria form originated in the 17th century.

Ariadne In Greek mythology, Cretan princess (daughter of MINOS) who fell in love with THESEUS but was abandoned by him after saving him from the Minotaur. She was consoled by the god DIONYSUS whom she later married.

Arianism Theological school based on the teachings of Arius (c.AD 250-336), considered heretical by orthodox Christianity. Arius taught that Christ was a created being, and that the Son, though divine, was neither equal nor co-eternal with the Father. Arianism was condemned by the first Council of NICAEA (325). **Aries** (Ram) First constellation of the zodiac. In mythology, it represents the lamb with the golden fleece.

Aristarchus of Samos (310–230 BC) Greek mathematician and astronomer. He tried to calculate the distances of the Sun and Moon from Earth, as well as their sizes. Though his method was sound the results were inaccurate. He was the first to propose that the Sun is the centre of the Universe (heliocentric theory); the idea was not taken up because it did not seem to make the calculation of planetary positions any easier.

Aristophanes (448–380 BC) Greek writer of comedies. Of his more than 40 plays, only 11 survive, the only extant comedies from the period. All follow the same basic plan: caricatures of contemporary Athenians become involved in absurd situations. Graceful, choral lyrics frame caustic personal attacks. A conservative, Aristophanes parodied Euripides' innovations in drama, and satirized the philosophical radicalism of Socrates and Athens' expansionist policies. The importance of the chorus in the early works is reflected in titles, such as *The Wasps* (422 BC), *The Birds* (414 BC) and *The Frogs* (405 BC). Other notable plays include *The Clouds* (423 BC) and *Lysistrata* (411 BC).

Aristotle (384–322 BC) Greek philosopher, founder of the science of LOGIC and one of the greatest figures in Western philosophy, b. Macedonia. Aristotle studied (367–347 BC) under PLATO at the ACADEMY in Athens. After Plato's death he tutored the young ALEXANDER THE GREAT, before founding the Lyceum (335 BC). Anti-Macedonian disturbances forced Aris-

ARMENIA

AREA: 29,800sq km (11,506sq mi)
POPULATION: 3,667,000
CAPITAL (POPULATION):
Yerevan (1,254,000)
GOVERNMENT: Multiparty republic
ETHNIC GROUPS: Armenian 93%, Azerbaijani 3%, Russian, Kurd
LANGUAGES: Armenian

(official)

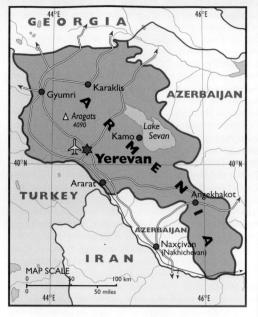

RELIGIONS: Christianity (mainly Armenian Apostolic)

currency: Dram = 100 couma

totle to flee (323 BC) to Chalcis on the island of Euboea, where he died. In direct opposition to Plato's IDEALISM, Aristotle's METAPHYSICS is based on the principle that all knowledge proceeds directly from observation of the particular. Aristotle argued that a particular object can only be explained through an understanding of causality. He outlined four causes: the material cause (an object's substance); formal cause (design); efficent cause (maker) and the final cause (function). For Aristotle this final cause was the primary one. Form was inherent in matter. His ethical philosophy stressed the exercise of rationality in political and intellectual life. Aristotle's writings cover nearly every branch of human knowledge, from statecraft to astronomy. His principal works are the Organon (six tratises on logic and SYLLOGISM); Politics (the conduct of the state); Poetics (analysis of poetry and TRAGEDY) and Rhetoric. After the decline of the Roman empire, Aristotle was forgotten by the West. But he had a profound effect on the development of Islamic philosophy, and it was through Arab scholarship that his thought filtered into medieval Christian SCHOLASTICISM and in particular the work of Saint Thomas AQUINAS.

arithmetic Calculations and reckoning using numbers and operations such as addition, subtraction, multiplication and division. The study of arithmetic traditionally involved learning procedures for operations such as long division and extraction of square roots. The procedures of arithmetic were put on a formal axiomatic basis by Guiseppe Peano in the late 19th century. Using certain postulates, including that there is a unique natural number, 1, it is possible to give formal definition of the set of natural numbers and the arithmetical operations. Thus, addition is interpretable in terms of combining sets: in 2 + 7 = 9, 9 is the cardinal number of a set produced by combining sets of 2 and 7.

arithmetic progression Sequence of numbers in which each term is produced by adding a constant term (the common difference d) to the preceding one. It has the form a, a + d, a + 2d, and so on. An example is the sequence 1, 3, 5, The sum of such a progression, a + (a + d) + (a + 2d) + ... is an arithmetic series. For n terms, it has a value $\frac{1}{2}n \left[2a + 0.5(n - 1) d\right]$. **Arizona** State in the sw USA, bordering on Mexico; the capital is PHOENIX, other cities include Tucson and Mesa. After the end of the Mexican War (1848), Mexico ceded most of the present state to the USA, and it became the 48th state of the Union in 1912. The Colorado Plateau occupies the N part

of the state, and is cut by many steep canyons, notably the GRAND CANYON, through which the COLORADO RIVER flows. Arizona's mineral resources, grazing and farmland have long been mainstays of the economy. Mining and agriculture are still important, but since the 1950s manufacturing has been the most profitable sector. The state has many scenic attractions (including the Petrified Forest, Fort Apache, and the reconstructed London Bridge at Lake Havasu). Tourism is now a major source of income. It also has the largest Native American population of any US state (203,527 in 1990), with Indian reservations comprising 28% of the land area. Between 1950 and 1970 Arizona's population more than doubled, in the 1970s its annual growth rate was more than 35%, and it grew a further 41% between 1980 and 1892. Area: 295,025sq km (113,909sq mi). Pop. (1992) 3,832,368. ark According to Genesis 6, the floating house Noah was ordered to build and live in with his family and one pair of each living creature during the flood. As the flood waters receded, it came to rest on a mountain top, believed to be Mount ARARAT. Arkansas State in s central USA, bounded on the E by the Mississippi River. The capital (and only large city) is LITTLE ROCK. It was acquired by the LOUISIANA PURCHASE (1803) and was admitted to the Union as the 25th state in 1836. Arkansas was one of the 11 Confederate states during the American Civil War. In the E and S the land is low, providing excellent farmland for cotton, rice and soya beans. The principal waterway is the ARKANSAS RIVER which (like all the state's rivers) drains into the Mississippi. The NW of the state, including part of the Ozarks, is higher land. Little Rock is located on the Arkansas, where the hills meet the plains. Forests are extensive and economically important. Bauxite processing, timber and chemicals are the main industries. Noted for its resistance to black equality in the 1960s. Arkansas is home to Democratic president Bill CLINTON. Area: 137,539sq km (53,104sq mi). Pop. (1992) 2,394,253.

Arkansas River River with its source high up in the Rockies of central Colorado, USA, and flowing 2,335km (1,450mi) to the Mississippi River in SE Arkansas. Fourthlongest river in the US, it flows E through Kansas and SE across the NE corner of Oklahoma, and SE to Arkansas.

Ark of the Covenant In Jewish tradition, a gold-covered chest of acacia that contained the stone tablets on which the TEN COMMANDMENTS were inscribed. It rested in the Holy of Holies within the tabernacle. Only the high priest could look upon the Ark and no one could touch it. In Palestine, the Israelites set up a permanent resting place for the ark in Shiloh. In the 10th century BC, the Ark was moved to the temple built by King SOLOMON in Jerusalem. After the destruction of Solomon's temple in 586 BC, there is no further record of the Ark's location. In today's synagogues, the Ark of the Covenant is a closet or recess in which the sacred scrolls of the congregation are kept.

Arkwright, Sir Richard (1732–92) British inventor and industrialist. He introduced powered machinery to the textile industry with his water-driven frame for spinning; he started work on the machine in 1764 and patented his invention in 1769. He opened textile factories in Nottingham.

Arlington County in N Virginia, across the Potomac River from Washington, D.C. Since 1943 it has been the location of the PENTAGON. The 200-ha (500-acre) Arlington National Cemetery was built (1864) on the former estate of Robert E. Lee. It contains the Tomb of the Unknown Soldier, a memorial amphitheatre and the graves of many servicemen and prominent Americans. Originally a part of the District of Columbia, it became a county of Virginia in 1847. Pop. (1990) 170,936.

Armada, Spanish (1588) Fleet launched by the Catholic Philip II of Spain against England to overthrow the Protestant Elizabeth I. English support for the rebels in the Spanish Netherlands and pirate attacks on Spanish possessions convinced Philip that England must be conquered. The 130 ships of the Armada were supposed to collect troops from the Netherlands but, hampered by English attacks and poor planning, it proved impossible. After an indecisive engagement with the English off Gravelines, the Spanish ships ran out of ammunition. Their commander, the Duke of Medina Sidonia,

Statehood : 14 February 1912 Nickname :

The Grand Canyon State

State bird : Cactus wren

State flower:

Saguaro (giant cactus)

State tree : Paloverde

State motto : God enriches

withdrew around N Scotland, suffering severe losses through shipwreck and disease. Though a blow to Spanish prestige, the defeat had little effect on the balance of naval power.

armadillo Nocturnal burrowing mammal found from Texas to Argentina, noted for the armour of bony plates that protect its back and sides. When attacked, some species roll into a defensive ball. It eats insects, carrion and plants. Length: 130-150cm (50-59in). Family Dasypodidae.

Armageddon Place referred to in Revelation 16, where the final battle between the demonic kings of the Earth and the forces of God will be fought at the end of the world. The name is derived from the Hebrew har megiddo ("hill of MEGIDDO"). Armagh City and county in SE Northern Ireland, between Lough Neagh and the border with the Republic. Armagh became an ecclesiastical centre in the 5th century (founded, in legend, by St Patrick) and is now the seat of Roman Catholic

and Protestant archbishops. It was settled by Protestants in the 16th century. The county is low-lying in the N and hilly in the S. Much of the land is used for farming and the town acts as a market for agricultural produce. Lurgan and Portadown are centres for textiles and various light industries. Area: 676sq km (261sq mi). Pop. (county, 1991) 67,128; (town, 1991) 14,625. Armenia Republic in the s Caucasus; the capital is YEREVAN. Land and climate Armenia is a rugged mountainous republic, the highest peak is Mount Aragats, 4,090m (13,420ft). Armenia has severe winters and cool summers, but the total yearly rainfall is generally low (between 200-800mm (8-31in). The lowest land is in the NE and NW, where Yerevan is situated. Armenia has many fast-flowing rivers, which have cut deep gorges in the plateau. The major river is the Araks. The largest lake is Lake Sevan, containing 90% of all Armenia's standing water. Vegetation ranges from tundra to grassy steppe. Oak forests are found in the SE, beech in the NE. Originally it was a much larger independent kingdom, centred on Mount ARARAT; incorporating present-day NE Turkey and parts of NW Iran. History and politics Armenia was an advanced ancient kingdom, considered to be one of the original sites of iron and bronze smelting. A nation was established in the 6th century BC, and Alexander the Great expelled the Persians in 330 BC. In 69 BC Armenia was incorporated into the Roman empire. In AD 303 Armenia became the first country to adopt Christianity as its state religion. From 886-1046 Armenia was an independent kingdom. From the 11th-15th centuries the Mongols were the greatest power in the region. By the 16th century Armenia was controlled by the Ottoman empire. Despite religious discrimination, the Armenians generally prospered under Turkish rule. Eastern Armenia was the battleground between the rival Ottoman and Persian empires. In 1828 Russia acquired Persian Armenia, and (with promises of religious toleration) many Armenians moved into the Russian-controlled area. In Turkish Armenia, nationalist movements were encouraged by British promises of protection. The Turkish response was uncompromising and it is estimated that 200,000 Armenians were killed in 1896 alone. In the Russian sector, a process of Russification was enforced. During World War 1, Armenia was the battleground for the Turkish and Russian armies. Armenians were accused of aiding the Russians, and Turkish atrocities intensified. Over 600,000 Armenians were killed by Turkish troops, and 1.75 million were deported to Syria and Palestine. In 1918 Russian Armenia became the Armenian Autonomous Republic, the w part remained part of Turkey and the NW part of Iran. In 1922 Armenia, Azerbaijan and Georgia were federated to form the Transcaucasian Soviet Socialist Republic (one of the four original republics in the Soviet Union). In 1936 Armenia became a separate republic. Earthquakes in 1984 and 1988 destroyed many cities and killed over 80,000 people. In 1988 war broke out between Armenia and Azerbaijan over NAGORNO-KARABAKH (an Armenian enclave in Azerbaijan). In 1990 the Armenian parliament voted to break from the Soviet Union, and in 1991 joined the newly-established Com-MONWEALTH OF INDEPENDENT STATES (CIS). In 1992 Armenia invaded Azerbaijan and occupied Nagorno-Karabakh. In 1994, an uneasy cease-fire left Armenia in control of about 20% of Azerbaijan. Economy Armenia is a lower-middle-

income nation. The economy, badly hit by war with Azerbaijan, is in a state of transition. Under communist rule, most economic activity was controlled by the state. Since 1991 the government has encouraged free enterprise, selling farmland and state-owned businesses. Armenia is highly industrialized, production is dominated by mining and chemicals. Copper is the chief metal; gold, lead and zinc are also mined. Agriculture (centred around the River Araks) is the second-largest sector, with cotton, tobacco, fruit and rice the main products. Despite significant increases in production, Armenia is still dependent on food imports.

Arminius, Jacobus (1560–1609) Dutch theologian whose system of beliefs, especially concerning salvation, became widespread and was later known as Arminianism. He rejected the notion of PREDESTINATION developed by John CALVIN, in favour of a more liberal concept of conditional election and universal redemption. Arminius believed that God will elect to everlasting life those who are prepared to respond in faith to the offer of divine salvation. Arminianism, though at first bitterly rejected, finally achieved official recognition in the Netherlands in 1795. It was a major influence on METHODISM. Armistice Day Day of remembrance for the dead of the two world wars, held on 11 November, the day World War 1 ended in 1918. In the USA it was renamed Veterans Day in 1954 in honour of the dead in all wars

Armory Show (1913) Landmark exhibition of contemporary American and European art held in New York, USA. The European section of the exhibition caused the greatest excitement. It looked back to IMPRESSIONISM, tracing the history of modernism through NEO-IMPRESSIONISM and POST-IMPRES-SIONISM with examples of work by GAUGUIN, VAN GOGH and the Nabis, but came right up to date with examples of CUBISM, ORPHISM and DADA. The exhibition travelled successfully to Chicago and Boston, attracting an estimated half a million visitors. It put avant-garde European art on the American map and revolutionized the nation's attitudes.

arms control Activity undertaken by powerful nations to prevent mutual destruction in warfare, especially with nuclear weapons. The nations attempt to maintain a balance of power by regulating each other's stockpile of weapons. See also DIS-ARMAMENT; STRATEGIC ARMS LIMITATION TALKS (SALT)

arms race Rivalry between states or blocs of states to achieve supremacy in military strength. The first modern instance was the race between Germany and Britain to build up their navies before World War 1. The term refers principally to the race in nuclear weapons between the Soviet Union in the COLD WAR. Examples of arms races at regional level are that of Israel and the Arab states in the Middle East, which started in the 1950s, and of Iran and Iraq since the 1980s.

Armstrong, (Daniel) Louis (1900–71) US jazz trumpeter, singer and bandleader, nicknamed "Satchmo". Armstrong was one of the most distinctive sounds in 20th-century music. His career spanned over half a century. He learned to play in New Orleans and in 1922 joined the King Oliver band. The Hot Fives and Hot Sevens recordings (1925-29) are some of the most influential in the history of jazz. In the 1930s he became a successful bandleader, his deep, bluesy voice featured on tunes like "Mack the Knife". He also appeared in films such as Pennies from Heaven (1936), New Orleans (1947) and High Society (1956).

Armstrong, Neil Alden (1930-) US astronaut. He was

ARKANSAS Statehood:

15 June 1836 Nickname:

The Land of Opportunity

State bird : Mockingbird State flower: Apple Blossom

State tree: Pine tree

State motto: The people rule

■ Armstrong Neil Armstrong (second from the left), commander of Apollo 11, will forever be remembered as the first man to walk on the Moon (20 July 1969). After retiring as an astronaut, he remained an influential figure in the world of aerospace and aeronautics.

▲ arrowroot The island of St Vincent in the West Indies is the main source of arrowroot (*Maranta arundinacea*). It has rhizomes that produce a light starch used in food preparation.

▲ art deco Examples of art deco-style goods, fashionable during the 1920s and 1930s.

chosen as a NASA astronaut in 1962 and was the command pilot for the Gemini 8 orbital flight in 1966. On 20th July 1969 he became the first man to walk on the Moon, remarking that it was "one small step for man, one giant leap for mankind."

army Organized group of soldiers trained to fight on land, usually rigidly hierarchical in structure. The first evidence of an army comes from Sumer in the third millennium BC. The use of cavalry was a Hittite development and the Assyrians added archers and developed siege machines. In the Middle Ages, major improvements were made to armour and weapons. The short-term feudal levy by which armies were raised proved inflexible, and this led to the use of mercenaries. Heavy cavalry was replaced by a combination of infantry and archery. The end of the Hundred Years War saw the inception of royal standing armies and an end to the chaos caused by mercenary armies. Muskets and bayonets replaced the combinations of longbow, pike and infantry, and ARTILLERY was much improved. In the French Revolutionary Wars, a citizen army was raised by CONSCRIPTION and contained various specialist groups. Other European armies followed suit and the age of the mass national army began. The MACHINE GUN caused deadlock in the World War 1 trenches, and was broken only by the invention of the TANK. World War 2 saw highly mechanized and mobile armies whose logistics of supply and support demanded an integration of the land, sea and air forces. Since World War 2 nuclear weapons have been deployed both tactically and strategically, and again the nature of weaponry has determined an army's structure.

Army, British Ground service of the UK armed forces. In 1995 Regular Army personnel numbered c.116,000, including c.6,000 women and c.10,000 personnel overseas. Since 1945 it has formed part of NORTH ATLANTIC TREATY ORGANI-ZATION (NATO) forces and maintained overseas garrisons in such areas as Falklands, Cyprus and Gibraltar. There are three main sections of the British Army: staff, who plan and organize operations; fighting troops, which include the Household Cavalry, Royal Armoured Corps, Royal Regiment of Artillery, Corps of Royal Engineers, Royal Corp of Signals and Infantry and Army Air Corp; and administrative troops, who provide essential services such as medical attention, engineering and technical support. These include Royal Army Medical Corps; Royal Military Police and Royal Electrical and Mechanical Engineers. The monarch is the official head of the British Army. Control of all British armed forces is exercised by the Ministry of DEFENCE, headed by the secretary of state for defence. General supervision of the army is conducted by the chief of the general staff, who heads an army council. In addition to the Regular Army there is a reserve force of c.230,000, over 80,000 of which is in the Territorial Army (TA) and the remainder in the Regular Army Reserve. The end of the Cold War and financial pressures have seen major reductions in conventional forces.

Army, US Ground service of the US armed forces. In 1995 Active Army personnel numbered c.525,000, 32% stationed overseas. Army personnel are under the general supervision of the secretary of the army and his advisor, the army chief of staff, who is the army's highest ranking officer and a member of the Joint Chiefs of Staff (JCS). The president is commander-in-chief of the armed forces. The department of the Army is charged with the organization, training, and equipping of these forces, but not their military deployment. The army also provides assistance in disaster relief, conducts weapons research, carries on training at civilian colleges and administers the US Military Academy at West Point, The army has 16 active divisions and helps to maintain 8 National Guard and 12 reserve divisions; major overseas commands are the Seventh Army in Europe and the Eighth Army in South Korea. The Continental Army existed from 1775, but the first regular standing army was authorized by Congress in 1785. The war department was established in 1789. The department of War became the department of the Army in 1947, and in 1949 it became a part of the Department of Defense. The US Army participated in all major wars between the War of 1812 and the Vietnam War (1954-75). A draft was occasionally employed and was used in peacetime after World War 2. In 1973 Congress established an all-volunteer army. In 1980 Congress resumed draft registration for 18 year old men and, for the first time women were among the graduates at West Point.

Arnhem City in E central Netherlands. An important trading centre since medieval times, Arnhem was almost destroyed by an abortive Allied airborne attack in 1944. Industries: metallurgy, textiles, electrical equipment, chemicals. Pop. (1994 est.) 133,670.

Arnold, Benedict (1741–1801) American colonial soldier. During the American Revolution he commanded Philadelphia (1778), after being wounded at the Battle of SARATOGA. In 1780 he became commander of West Point, a fort he planned to betray to the British for money. After the plot was discovered, Arnold fled to the British. His name has become proverbial in modern US usage for treachery.

Arnold, Malcolm (1921–) English composer. He started his career as principal trumpet with the London Philharmonic Orchestra but won acclaim for his accessible compositions. His output includes symphonies, concertos, overtures (*Beckus the Dandipratt*, 1943), ballets (*Homage to the Queen*, 1953) and film scores (*The Bridge on the River Kwai*, 1957).

Arnold, Matthew (1822–88) British poet and critic. Arnold held the Oxford chair in poetry (1857–67). A school inspector (1851–86), his writings include literary criticism, such as *Essays in Criticism* (series 1, 1865; series 2, 1888), and social studies, such as *Culture and Anarchy* (1869), as well as classic Victorian poems, such as "Dover Beach" and "The Scholar Gypsy". His theories about the social and moral benefits of culture were largely responsible for the establishment of English literature as a "core" subject in schools and universities.

Aroostook War (1838–39) Dispute over the Maine-New Brunswick boundary. The Aroostook Valley was claimed by both Canada and the USA and a conflict arose over Canadian lumber operations in the area. In 1839 a contingent of 50 Maine militia men also moved into the valley. War loomed, but General Winfield Scott negotiated a truce, and the dispute was submitted to a commission. It was settled by the Webster-Ashburton Treaty (1842).

Arp, Jean (Hans) (1887–1966) Alsatian sculptor, painter and poet. He founded the Zurich DADA movement with the Romanian artists Tristan Tzara, Marcel Janco and others during World War 1. He worked briefly with the BLAUE RETTER group, and in the 1920s joined the SURREALISM movement. His sculpture spans the divide between Dada humour and the purity of non-iconic ABSTRACT ART. Navel Shirt and Head (1926) and Human Concretion (1935) are typical.

arrowroot Tropical and subtropical perennial plant found in wet habitats of North and South America, and some islands of the West Indies. Its leaves are lance-shaped and the flowers are usually white. The dried and ground roots are used in cooking. Family Marantaceae; species *Maranta undinaceae*. **arsenic** (symbol As) Semimetallic element of group V of the periodic table, probably obtained in 1250 by Albertus Magnus. Arsenic compounds are used as a poison, and to harden lead and make semiconductors. Three allotropes are known: white arsenic, black arsenic and a yellow nonmetallic form. Properties: at.no. 33; r.a.m. 74.9216; r.d. 5.7; m.p. 986°C; sublimes 613°C (1,135°F); most common isotope As⁷⁵ (100%). **Artaud, Antonin** (1896–1948) Influential French drama

theorist and director. In 1927 he co-founded the Théâtre Alfred Jarry, which produced surreal, symbolist plays. His most significant contribution to 20th-century drama was his concept of the theatre of CRUELTY. Influenced by the psychoanalytical theories of Carl Jung, he proposed a physical theatre based on unconscious myth and symbol rather than narrative and psychological realism. His most important work was the volume of essays The Theatre and its Double (1938). art deco Fashionable style of design and interior decoration in the 1920s and 1930s. It took its name from the Exposition Internationale des Arts Décoratifs et Industriels Modernes held in Paris in 1925. The art deco style is characterized by sleek forms, simplified lines and geometric patterns. It began as a luxury style, an example of modern design fashioned from expensive, hand-crafted materials. After the Depression, art deco shifted towards mass production and low-cost materials.

Artemis In Greek mythology, the goddess of hunting and light, identified as DIANA by the Romans. She was the daughter of Zeus and Leto, and twin sister of APOLLO. Associated with the Moon, she was a virgin who assisted in childbirth and protected infants and animals.

arteriosclerosis Blanket term for degenerative diseases of the arteries, in particular atherosclerosis (hardening of the arteries). It is caused by deposits of fatty materials and scar tissue on the ARTERY walls, which narrow the channel and restrict blood flow, causing an increased risk of heart disease, stroke or gangrene. Evidence suggests that predisposition to the disease is hereditary. Risk factors include cigarette smoking, inactivity, obesity and a diet rich in animal fats and refined sugar. Treatment is by drugs and, in some cases, surgery to replace a diseased length of artery.

artery One of the BLOOD VESSELS that carry BLOOD away from the HEART. The **pulmonary** artery carries deoxygenated blood from the heart to the lungs, but all other arteries carry oxygenated blood to the body's tissues. An artery's walls are thick, elastic and muscular and pulsate as they carry the blood. A severed artery causes major HAEMORRHAGE.

artesian well Well from which water is forced out naturally under pressure. Artesian wells are bored where water in a layer of porous rock is sandwiched between two layers of impervious rock. The water-filled layer is called an AQUIFER. Water flows up to the surface because distant parts of the aquifer are higher than the well-head.

arthritis Inflammation of the joints, with pain and restricted mobility. The most common forms are osteoarthritis and rheumatoid arthritis. Osteoarthritis, common among the elderly, occurs with erosion of joint cartilage and degenerative changes in the underlying bone. It is treated with analgesics and anti-inflammatories and, in some cases (especially a diseased hip), by joint replacement surgery. Rheumatoid arthritis, more common in women, is generally more disabling. It is an autoimmune disease which may disappear of its own accord but is usually slowly progressive. Treatment includes analgesics to relieve pain. The severest cases may need to be treated with CORTISONE injections, drugs to suppress immune activity or joint replacement surgery. See also RHEUMATISM

arthropod Member of the largest animal phylum, Arthropoda. Living forms include CRUSTACEA, ARACHNID, CENTIPEDE, MILLIPEDE and INSECT. The species (numbering well over 1 million) are thought to have evolved from ANNELIDS. All have a hard outer skin of CHITIN that is attached to the muscular system on the inside. The body is divided into segments, modified among different groups, with each segment originally carrying a pair of jointed legs. In some animals, legs have evolved into jaws, sucking organs or weapons. Arthropods have well-developed digestive, circulatory and nervous systems. Land forms use tracheae for respiration.

Arthur Legendary British king who was said to rule the Knights of the Round Table. Two medieval chroniclers, Gildas and Nennius, tell of Arthur's fighting against the invading West Saxons and his final defeat of them at Mount Badon (possibly Badbury Hill, Dorset) in the early 6th century. However, some consider these sources unreliable and a modern view is that Arthur was a professional soldier in service to the British kings after the Roman occupation. Geoffrey of Monmouth's 12th century *Historia Regum Brittaniae*, based on Nennius and Welsh folklore, gave the legend — with the Round Table, Camelot, Lancelot, Guinevere and the Holy Grail — the form in which it was transmitted through the Middle Ages. Malory's *Morte D'Arthur* (1470) was based on Monmouth's version.

Arthur, Chester Álan (1830–86) 21st US president (1881–85). In 1880 Arthur was nominated by the Republican Party as vice president in the (justified) hope that he could deliver New York. He became president after the assassination of James GARFIELD and tried to reform the spoils system, in which incoming presidents replaced government staff with their own appointees. A Civil Service Commission with a merit system was created, but Arthur's modest reforms were often frustrated by Congress. Gentlemanly but uninspiring, and suffering from incurable illness, he was not renominated (1884). He was succeeded by Grover CLEVELAND.

There are two main types of arthritis. In rheumatoid arthritis (A) the synovial membrane (1) becomes inflamed and thickened and produces increased synovial fluid within the joint (2). The capsule and

surrounding tissues (3) become inflamed, while joint cartilage is damaged (4). Peripheral joints, such as hands and feet, are most commonly affected. Blood tests show rheumatoid factor. Osteoarthritis (B), a

degenerative disease, involves thinning of cartilage (5), loss of joint space (6) and bone damage (7). Heavily used or weight-bearing joints, such as knees and feet, are affected. Blood tests are normal.

artichoke (globe artichoke) Tall, thistle-like perennial plant with large, edible, immature flower heads, native to the Mediterranean region. It has spiny leaves and blue flowers. Height: 0.9–1.5m (3–5ft). Family Asteraceae/Compositae; species *Cynara scolymus*. A different plant, the Jerusalem artichoke, is grown for its edible tubers. Family Asteraceae/Compositae; species *Helianthus tuberosus*.

Articles of Confederation (1781) First Federal constitution of the USA, drafted by the Continental Congress in 1777. Distrust of central authority and state rivalries produced a weak central government, with Congress dependent on the states and unable to enforce its own legislation. The weakness of the Articles were analysed by Alexander Hamilton and James Madison in *The Federalist*, and the Constitutional Convention met in 1787 to draft a new constitution.

artificial insemination Method of inducing PREGNANCY without sexual intercourse by injecting SPERM into the female genital tract. Used extensively in livestock farming, artificial insemination allows proven sires to breed with many females at low cost.

artificial intelligence (AI) Science concerned with developing computers that model high-level human intelligence. A computer may be programmed to answer questions on a specialized subject. Such "expert systems" are said to display the human ability to perform expert reasoning tasks. A branch of

■ arthropod The most numerous invertebrates (animals without a backbone) are the arthropods (joint-legged animals), such as the centipede. They owe their success to the exoskeleton that covers their bodies and allows the development of jointed limbs. Body segments are encased in a rigid protein cuticle (1) and body flexibility is permitted by an overlapping membrane (2). The strength of the exoskeleton ensures that muscles (3) can be anchored to the inside of the cuticle. Groups of muscles (4) are used to move the leas.

A

▲ art nouveau A decorative style from the turn of the 19th century, examples of art nouveau are mainly found in architecture and the applied arts, such as jewellery and glass design.

▼ ash The white ash (*Fraxinus* americana) of E North America grows to 41m (135ft). The leaves of the ash are distinctive in being split into many small leaflets giving the impression of very fine foliage.

cognitive science termed "artificial life" is concerned with more low-level intelligence. For example, a ROBOT may be programmed to find its way around a maze, displaying the basic ability to physically interact with its surroundings.

artificial selection Breeding of plants, animals or other organisms in which the parents are individually selected in order to perpetuate certain desired traits and eliminate others from the captive population. By this means, most of our domestic crops, livestock and pets have arisen. Artificial selection can be accelerated by techniques such as plant TISSUE CULTURE and the ARTIFICIAL INSEMINATION of livestock. See also CLONE; GENETIC ENGINEERING

artillery Projectile-firing weapons with a carriage or mount. An artillery piece is generally one of four types: gun, howitzer, mortar, or missile launcher. Modern artillery is classified according to calibre; ranging from under 105mm for light artillery to more than 155mm for heavy. Artillery changed the whole strategy and tactics of siege warfare. Advances in the 19th century such as smokeless powder, elongated shells, rifling and rapid-fire breach loading, made artillery indispensable in battle. See also ARMY; CANNON

art nouveau Ornamental style which flourished in most of central and w Europe and the USA from c.1890 to World War 1. The idea originated in England with the ARTS AND CRAFTS MOVEMENT. Focusing mainly on the decorative arts, its most characteristic forms come from sinuous distortions of plant forms and asymmetrical lines. It is sometimes known in France by its English name, the "Modern Style". Outstanding art nouveau graphic artists include Beardsley, Tiffany and Mucha. Charles Rennie Mackintosh, Antonio Gaudi and Victor Horta were among its most gifted architects.

Arts and Crafts Movement Late 19th- and early 20th-century British movement, led by artists who wanted to revitalize the decorative arts by returning to the ideals of medieval craftsmanship. Inspired by William Morris, the movement contributed to European ART NOUVEAU, but was eventually transformed by the acceptance of modern industrial methods. Aruba Dutch island in the Caribbean, off the coast of NW Venezuela; the capital is Oranjestad. It was part of the Netherlands Antilles until 1986, when it broke away as a step to full independence. This was revoked in 1990, at Aruba's request, and it is now an autonomous part of the Netherlands. Industries: oil refining, phosphates, tourism. Area: 193sq km (75sq mi). Pop. (1991) 68,897.

arum See CUCKOOPINT **Arunachal Pradesh** State of the eastern Himalayas in the far NE of India; the capital is Itanagar. Once a district of ASSAM, it was invaded by the Chinese (1962), but returned to India in 1963. It became a union territory in 1972 and the 24th state of India in 1986. Most of the state is mountainous forest and jungle. Its main products are coffee, rubber, fruit, spices and rice. It is India's least densely populated state. Area: 81,426sq km (31,438sq mi). Pop. (1991) 864,558.

Aryan Language of an ancient people in the region between the Caspian Sea and Hindu Kush mountains. About 1500 BC one branch entered India, introducing the SANSKRIT language; another branch migrated to Europe. In their 1930s racist propaganda, the Nazis traced German descent from Aryans.

asbestos Group of fibrous, naturally occurring, silicate minerals used in insulating, fireproofing, brake lining and in astronaut suits. Several types exist, the most common being white asbestos. Many countries have banned the use of asbestos, as it can cause lung cancer and asbestosis, a lung disease.

Ascension Island in the s Atlantic Ocean; a UK dependency administered from the colony of ST HELENA. Discovered by the Portuguese in 1501, it was occupied by Britain in the early 19th century. It now serves as an Anglo-American intercontinental telecommunications centre, and was an important base for British forces and supplies during the FALKLANDS WAR. Area: 88sq km (34sq mi). Pop. (1993) 1,117.

Ascension Day Christian feast day that commemorates Christ's ascension into heaven, 40 days after his resurrection. It falls on a Thursday, the 40th day after EASTER. It used to be called Holy Thursday.

ascorbic acid See VITAMIN

asexual reproduction Type of reproduction in organisms that does not involve the union of male and female reproductive cells. It occurs in several forms: FISSION, BUDDING and VEGETATIVE REPRODUCTION. See also CLONE; SEXUAL REPRODUCTION ash Group of mainly deciduous trees of the genus Fraxinus growing in temperate regions, usually having leaves made up of many small leaflets, and winged fruits. The wood is elastic, strong and shock-resistant, and is widely used for furniture. Species include manna ash, F. ornus, the flowering ash of S Europe and Asia Minor; the European ash, F. excelsior, which grows to 45m (148ft) tall; and F. floribunda, a native of the Himalayas. Family Oleaceae. The mountain ash of Europe and Asia (Sorbus aucuparia) comes from a different family.

Ashanti Administrative region and ethnic group of central Ghana, w Africa. The capital is Kuması. The Ashanti people (a matrilineal society) established a powerful empire based on the slave trade with the British and Dutch. In the 18th century their influence extended into Togo and the Ivory Coast. Conflicts with the British throughout the 19th century were finally resolved in 1902, when the Ashanti territories (a British protectorate since 1896) were declared a crown colony. The society is traditionally agricultural. The region is the main area of Ghana's vital cocoa production. The Ashanti are renowned for their crafts, including high-quality goldwork (a gold-encrusted stool was a symbol of their sovereignty) and weaving. Today, Ashanti is the most populous of Ghana's ten regions. Area: 24,390sq km (9,414sq mi). Pop. (1984) 2,090,100.

Ashcan school Nickname given to a group of late 19th-and early 20th-century US artists, including George Bellows, Robert Henri and Edward Hopper, who rejected academic and traditional artistic subjects for the seamier aspects of urban life (especially New York). The inspiration for the group's interest in everyday life came from four core members William Glackens, John Sloan, George Luks and Everett Shinn, all of whom worked as artist-reporters in Philadelphia before joining Henri's circle.

Ashdown, Paddy (Jeremy John Durham) (1941–) British politician, first leader of the Social and LIBERAL DEMOCRATS (1988–), b. India. Ashdown was a commander in the Royal Marines (1960–72), before becoming a diplomat. In 1983 he entered parliament as a LIBERAL PARTY MP and quickly became a leading spokesman for the party. Ashdown succeeded David STEEL, who stood down as Liberal leader when the merger with the SOCIAL DEMOCRATIC PARTY (SDP) was formalized. Ashdown also acts as the party's spokesman on Northern Ireland. His active image helped to boost the party's electoral base in s England.

Ashes, The Cricket trophy nominally held by the winners of the Test series between England and Australia. The actual trophy, an urn containing the ashes of a burned bail, is always kept at Lord's Cricket Ground, London.

Ashgabat (formerly Ashkhabad) Capital of the central Asian republic of Turkmenistan, located 40km (25mi) from the Iranian border. Founded in 1881 as a Russian fortress between the Kara-Kum Desert and the Kopet Dagh Mountains, it was largely rebuilt after a severe earthquake in 1948. The city was known as Poltaratsk from 1919 to 1927. Its present name was adopted after the republic attained independence from the former Soviet Union in 1992. Industries: textiles, carpets, silk, metalware, glass, light machinery. Pop. (1990) 411,000.

Ashkenazim Jews who originally settled in Nw Europe, as distinguished from the SEPHARDIM, who settled in Spain and Portugal.

Ashkenazy, Vladimir (1937–) Icelandic pianist and conductor, b. Russia. He studied at the Central Music School of Moscow and the Conservatoire, Moscow. In 1956 he won the Queen Elizabeth International Piano Competition in Brussels, and in 1962 he shared first prize in the Tchaikovsky Piano Competition in Moscow. Since 1980 he has concentrated on conducting, winning respect for his varied and adventurous programming.

Ashoka (c.271–238 BC) Indian emperor (r.264–238 BC). The greatest emperor of the MAURYA EMPIRE, he at first fought to expand his empire. He was revolted by the bloodshed of war and, renouncing conquest by force, embraced BUDDHISM. He

became one of its most fervent supporters and spread its ideas through missionaries to neighbouring countries and through edicts engraved on pillars. His empire encompassed most of India and large areas of Afghanistan.

Ashton, Sir Frederick (1904–88) British choreographer and ballet director. In 1935 he joined the Sadler's Wells Ballet (now the Royal Ballet) in London and was its chief choreographer until 1963, then its director (1963–70). His gifted work for dancers such as Margot Fonteryn and Ninette de VALOIS earned him a reputation as Britain's greatest choreographer. His major pieces include Cinderella (1948), Ondine (1958) and Marguèrite and Armand (1963).

Ashurbanipal (d. c.626 BC) (Assurbanipal) Last great king of Assyria (669–633 BC). During his reign, Assyria reached its largest extent, encompassing Upper Egypt, before a rapid decline. Excavations at NINEVEH after 1850 revealed an advanced civilization.

Ash Wednesday First day of LENT

Asia World's largest continent. Entirely in the Eastern Hemisphere, it extends from N of the Arctic Circle in Russia to s of the Equator in Indonesia. Land On the W, Asia's boundary with Europe follows a line through the Ural Mountains, W of the CASPIAN SEA and along the Caucasus. Geographically, Europe and Asia are one enormous continent (Eurasia) but historically they have always been regarded as separate continents. Asia has six regions, each largely defined by mountain ranges. Northern Asia includes the massive inhospitable region of SIBERIA. A large part lies within the Arctic Circle forming a vast cold, treeless plain (tundra) where the soil, except on the surface, is permanently frozen to depths exceeding 700m (2,000ft). Southern Siberia includes great

coniferous forests (taiga) and the Russian steppes. Its s boundary runs through the TIAN SHAN and Yablonovy mountains and Lake BAIKAL, the world's deepest lake. The high plateau area of Central Asia extends s to the HIMALAYAS and includes the w Chinese provinces of TIBET and XINJIANG as well as Mongolia. This is a region of low rainfall and very low winter temperatures. Much of the area is desert, the largest being the GOBI and Takla Makan. The Tibetan plateau is mostly barren. Eastern Asia lies between the plateaux of Central Asia and the Pacific. It is a region of highlands and plains, watered by broad rivers. Off the E coast there are many islands, the most important being the Japanese islands of HOKKAIDŌ, HONSHŪ and KYŪSHŪ, and the Chinese island of TAIWAN, Southeast Asia includes the INDOCHINA peninsula, part of which forms the MALAY PENINSULA, BURMA and a large number of islands, among which the PHILIPPINES and INDONESIA are the most important. The N of this region is mountainous and the s mainly low-lying. Southern Asia consists of the Indian subcontinent and the island of SRI LANKA. In the N it is bounded by the HINDU KUSH, Pamir, KARAKO-RAM and Himalayan mountains. In the Himalayas is Mount EVEREST, the world's highest mountain. To the s of the mountains lie wide plains, crossed by rivers flowing from the Himalayas. Farther s is the DECCAN plateau that rises on its E and w edges culminating in the E and w GHATS. South-west Asia includes most of the region known as the MIDDLE EAST. It is made up largely of two peninsulas; Anatolia (ASIA MINOR) and the vast Arabian Peninsula. It is also a region of large inland seas: the Aral, Caspian, Dead and Black seas. Structure and geology The most striking feature of the continent is the massive range of Himalayan fold mountains that

▼ Asia Geographically, Asia and Europe form one vast continent (Furasia). Asia is home to 60% of Earth's total population. Its climate and topography determine settlement, economic and cultural patterns. North, Central and NW Asia witnessed dramatic political upheavals in the 20th century, with the rise and fall of the Soviet Union. Northern Asia is dominated by the wastelands of Siberia. East Asia is the most industrialized region and its history has been determined largely by the civilizations along the Yangtze and Huang He rivers. The dominant religion of E Asia is Buddhism. The monsoon region of Southeast Asia is a fusion of Indian and Chinese cultures. South Asia is isolated from the rest of the continent by huge mountain ranges. The arid deserts of Southwest Asia are a strategic crossroads between Africa, Asia and Europe, Islam is the principal religion and the regional economy is dominated by the petroleum industry.

were formed when the Indo-Australian and Eurasian tectonic plates collided in the Mesozoic era. Most of China and s central Asia is composed of folded Palaeozoic and Mesozoic sediments, and large expanses of central Siberia consist of flat-lying sediments of the same age, some completely exposed. The Indian subcontinent is largely pre-Cambrian except for the Deccan Plateau which is a complex series of lava flows. Lakes and rivers Most of the major Asian lakes are found in the centre of the continent, and include the Caspian Sea (the largest landlocked body of water in the world), the ARAL SEA, and Lake BALKHASH. The River YANGTZE in China, is Asia's longest. The River HUANG HE (Yellow) is China's other major river and, until control measures were taken, it flooded regularly, drowning thousands of people. Like these rivers, the three principal waterways of SE Asia (IRRAWADDY, SALWEEN, MEKONG) rise on the Tibetan plateau but flow s instead of E. The INDUS, BRAHMAPUTRA and GANGES are the largest rivers of the Indian subcontinent, and the OB, YENISEI and LENA are the continent's major N-flowing rivers, emptying into the Arctic Ocean. Climate and vegetation Except for the w temperate seaboards, all the world's major climatic divisions (with local variations) are represented in the continent. The monsoon climates of India and Southeast Asia are peculiar to these regions and, apart from extremes of heat and cold, typify the continent. Large expanses are covered by desert and semi-arid grassland, with belts of coniferous forest to the N and tropical forest to the s. People Asians constitute 60% of the world's population. The main language groups are Indo-Aryan, Sino-Tibetan, Ural-Altaic, Malayan and Semitic. Mandarin Chinese is the most numerous (if not the most widespread) language. HINDUISM is the religion with the most adherents, although it is confined to India and SE Asia. ISLAM, CONFUCIANISM, BUDDHISM, SHINTO, CHRISTIANITY, TAOISM and JUDAISM are also important, with the Islamic influence stretching from Turkey to Indonesia. **Economy** Agriculture is important, though less than 10% of the continent is cultivated. Asia produces more than 90% of the world's rice, rubber, cotton and tobacco. Rice is the major crop in the E and S, wheat and barley are grown in the W and N. China, Japan and Russia are the most highly industrialized countries in terms of traditional heavy materials. Since the 1960s there has been dramatic commercial growth in several SE and E Asian countries based on a combination of household and high-tech products. Following Japan's example, South Korea, Taiwan, Hong Kong, Singapore, Malaysia and Thailand form the "tiger" economies; so successful in global markets that they began to invest in European countries and North America. Oil is the most important export of many Middle East countries. Recent history Since World War 2, the history of Asia has been dominated by three main themes: the legacy of COLONIALISM, the growth of communism, and the rise of Islamic FUNDAMENTALISM. The Indian subcontinent gained its independence from Britain in 1947, when India and Pakistan became separate nations. Indonesia achieved formal independence from the Netherlands in 1949. During the 1950s, Indochina and Malaysia won independence from France and Britain respectively after military confrontations. The spread of communism began with the victory of MAO ZEDONG in China in 1949. North Korea failed, in its war with South Korea (1950-53), to establish a united communist state and communism was also repulsed with Western help, in Indonesia. Communism did finally gain control of Vietnam and Cambodia, following the VIETNAM WAR. The break-up of the Soviet Union led to the creation of eight "new" countries in central Asia, few of which were politically stable or economically strong. In the Middle East, Israel remained on uneasy terms with its Arab neighbours, and Iraq was involved in a prolonged war with fundamentalist Iran (1980-88) and later with an international coalition, headed by the USA, following Iraq's invasion of Kuwait. Total area: 44,391,206sq km (17,139,445sq mi) Highest mountain Mount Everest (Nepal) 8,848m (29,029ft) Longest river Yangtze (China) 6,300km (3,900mi) Population 3,193,000,000 Largest cities Shanghai (8,760,000); Tokyo (7,894,000); Beijing (6,560,000) See also articles on individual countries

Asia Minor (Anatolia) Great peninsula of w Asia making up most of modern Turkey. The Bosporus, the Sea of Marmara and the DARDANELLES divide both Turkey and Europe from Asia. Apart from a very narrow coastal plain, the area is a high, arid plateau. In the SE the Taurus Range rises to more than 3,750m (12,000ft). The area has been inhabited since the Bronze Age, with civilizations such as Troy. The HITTITES established a kingdom here in c.1800 BC. From the 8th century BC the Greeks established colonies in the area; the Persians invaded in the 6th century BC and the PERSIAN WARS followed. ALEXANDER THE GREAT'S empire included this region, although it split into several states after his death. The Romans unified the area in the 2nd century AD. By the 6th century it had become part of the Byzantine empire. In the 13th-15th centuries it was conquered by the Ottoman Turks and remained part of the Ottoman empire until the establishment of the Republic of Turkey in 1923.

Asimov, Isaac (1920–92) US author and scientist, b. Russia. Though he published several serious scientific works, he is best known for his science fiction stories. His prolific output contains some of the finest novels in the genre, including *I, Robot* (1950) and *The Foundation Trilogy* (1951–53).

Asmara (Asmera) Capital of Eritrea, NE Africa. Occupied by Italy in 1889, it was their colonial capital and the main base for the invasion of Ethiopia (1935–36). It was captured by the British in 1941 and, in the 1950s, the US built Africa's biggest military communications centre here. The city was absorbed by Ethiopia in 1952, and was the main garrison in the fight against Eritrean rebels seeking independence. In 1993 Asmara became the capital of independent ERITREA. Though ravaged by drought, famine and war, it began a strong recovery based on numerous light industries, including ceramics, footwear, and textiles. Pop. (1991) 367,300.

asp Popular name for two species of VIPER, the asp viper of S Europe (*Vipera aspis*), and the Egyptian asp, a horned, sidewinding viper of N Africa (*Cerastes cerastes*). Both are weakly venomous and eat small animals. Family: Viperidae. **aspen** One of three species of trees of the genus *Populus*, with toothed, rounded leaves. Closely related to poplars, they are native to temperate Eurasia, North Africa and North America, they grow up to 30m (100ft). Family Salicaceae.

asphalt Naturally occurring black or brown semi-solid BITU-MEN, used mainly for road covering and roofing. Asphalt deposits occur in many parts of the world, including Trinidad, Venezuela, Alabama and Texas. Asphalt also occurs in petroleum, and is extracted in oil refineries.

aspirin (acetylsalicylic acid) DRUG widely used to reduce fever, and as an ANALGESIC to relieve minor pain. Recent evidence indicates aspirin can inhibit the formation of blood clots and in low doses can reduce the danger of heart attack and stroke. Aspirin can irritate the stomach and in overdose is toxic and can cause death.

Asquith, Herbert Henry, 1st Earl of Oxford and Asquith (1852-1928) British statesman, last Liberal prime minister (1908-16). Asquith entered parliament in 1886 and served as GLADSTONE's home secretary (1892-95). His support of FREE TRADE helped the Liberals win the 1905 general election. Asquith served as chancellor of the exchequer under Sir Henry Campbell-Bannerman, and succeeded him as prime minister. His administration was notable for its social welfare legislation, such as the introduction of old age pensions (1908) and unemployment insurance (1911). David LLOYD GEORGE's radical budget (1909) to finance these reforms and strengthen the navy was rejected by the House of Lords. Asquith responded by passing the Parliament Act (1911), which ended the Lords' power of veto over Commons legislation. Other constitutional reforms included the introduction of salaries for MPs. His attempts to establish Home Rule for Ireland were rejected by Conservatives and Unionists. Asquith took Britain into WORLD WAR 1, but was an ineffective wartime leader and Lord Northcliffe's newspapers vilified him. In 1915 he formed a coalition government with the Conservative Party. He was replaced as prime minister in a cabinet coup led by Lloyd George. Asquith stayed on as LIBERAL PARTY leader until 1926. He was ennobled in 1925.

ass Wild, speedy, long-eared member of the HORSE family found in African and Asian desert and mountain areas. Smaller than the horse, it has a short mane and tail, small hoofs and dorsal stripes. The three African races (species *Equus asinus*) are the Nubian, North African and the rare Somali. Height: 90–150cm (3–5ft) at shoulder. Asian races are the kiang and the ONAGER. Family Equidae.

Assad, Hafez al- (1928–) Syrian statesman, president (1970–). Assad served as minister of defence (1965–70), before seizing power in a military coup. He was elected president in 1971. Assad took a hardline stance against Israel and Syrian troops participated in the 1973 Arab-Israel War. He was accused of harbouring terrorists. In 1976 Syrian troops were deployed in the Lebanese civil war. In 1987 the Syrian army moved into Beirut to restore order. In the mid-1990s, Assad's stance towards Israel softened and he played an vital role in the Israeli-Palestinian peace negotiations. Syria supported the coalition forces arrayed against Iraq in the GULF War.

Assam State in NE India, almost separated from the rest of the country by Bangladesh. The capital is Dispur and the largest city is Guwahati. It became a state in 1950, but its people have resented, and forcibly resisted, immigration from West Bengal and Bangladesh. The Bodo minority continue to push for a separate state N of the River Brahmaputra. Industries: tea, jute, timber, oil. Area: 78,438sq km (30,277sq mi). Pop. (1991) 22,414,322.

assassin (Arabic, users of hashish) Name given to a Muslim sect of Ismails, founded c.1090 by Hasan ibn al-Sabbah. They fought against orthodox Muslims and Christian Crusaders and committed many political murders, until their eventual defeat in the 13th century.

assay Test to determine the amount of a metal present in a sample of material such as ores and alloys. The term is normally reserved for finding the proportion of gold, silver or platinum present. *See also* HALLMARK

Assemblies of God Largest PENTECOSTAL religious sect in the US. Founded in 1914 by preachers of the Church of God in Hot Springs, Arkansas, in 1916 it was incorporated and titled General Council of Assemblies of God. There are *c*.600,000 current members.

asset Anything owned by a person or a company that has a money value. **Current** assets can be easily liquidated to produce their cash value. **Fixed** assets include buildings, machinery and land. Goodwill and PATENTS are described as **intangible** assets, because they have potential, rather than actual, money value. Asset stripping is the practice of taking over a business and selling off its assets.

assimilation Process by which an organism uses substances taken in from its surroundings to make new living protoplasm or to provide energy for metabolic processes. It includes the incorporation of the products of food digestion into living tissues in animals, and the synthesis of new organic material by a plant during photosynthesis.

Assiniboine Nomadic North American Native tribe. Their language is Siouan, and they are related to the Dakotas, though they migrated w from Minnesota to Saskatchewan and the Lake Winnepeg area. Their culture is that of the Plains Indians. They were trading partners of the English HUDSON'S BAY COMPANY, and their trade helped to destroy the French monopoly among tribes of the region. Today they number *c.*5,000; 4,000 on reservations in Montana and 1,000 in Canada.

Association of Southeast Asian Nations (ASEAN) Regional alliance formed in 1967 to promote economic cooperation. Its membership comprises Indonesia, Malaysia, Philippines, Singapore, Thailand, Brunei and Vietnam. Based in Jakarta, Indonesia, it took over the nonmilitary aspects of the SOUTHEAST ASIA TREATY ORGANISATION (SEATO) in 1975.

associative law Rule of combination in mathematics, in which the result of two or more operations on terms does not depend on the way in which they are grouped. Thus, normal addition and multiplication of numbers follows the associative law, since a + (b + c) = (a + b) + c, and $a \times (b \times c) = (a \times b) \times c$.

Assumption In the Roman Catholic Church, principal feast of the Blessed Virgin Mary. It is celebrated on 15 August, and

marks the occasion when she was taken up into heaven at the end of her life on Earth.

Assyria Ancient empire of the Middle East. It took its name from the city of Ashur (Assur) on the River Tigris, near modern Mosul, Iraq. The Assyrian empire was established in the 3rd millennium BC and reached its zenith between the 9th and 7th centuries BC, when it extended from the Nile to the Persian Gulf and N into Anatolia. Thereafter it declined and was absorbed by the Persian empire. Under ASHURBANIPAL, art (especially bas-relief sculpture) and learning reached their peak. The luxuriance of Ashurbanipal's court at NINEVEH was legendary and, combined with the cost of maintaining his huge armies, fatally weakened the empire. The capture of Nineveh in 612 BC marked the terminal decline of Assyria.

Assyro-Babylonian mythology Early mythology of the Middle East (Mesopotamia) that described a cosmic order of heaven, Earth and an underworld. Some 4,000 deities and demons directed the physical and spiritual activities of the world.

Astaire, Fred (1899–1987) US dancer, actor and choreographer. Astaire's sparkling, improvised solo dances redefined the musical. In 1933 cinema's greatest partnership was formed, when he starred opposite Ginger ROGERS in Flying Down to Rio. Fred and Ginger made ten films together. Their first major MGM musical was The Gay Divorcee (1934). Classics include Top Hat (1935) and Swing Time (1936). The Barkleys of Broadway (1949) was their last film together. Other dance partners included: Audrey HEPBURN, Funny Face (1957); Rita Hayworth, You Were Never Lovelier (1942) and Judy GARLAND, Easter Parade (1948). In 1949 he received a special Academy Award for his contribution to film.

astatine (symbol At) Semimetallic radioactive element that is one of the HALOGENS (group VII of the PERIODIC TABLE). It is rare in nature, and is found in radioactive decay. At²¹¹ will collect in the thyroid gland and is used in medicine as a radioactive tracer. Properties: at.no. 85; r.a.m. 211; m.p. 302°C (575.6°F); b.p. 377°C (710.6°F); most stable isotope At²¹⁰ (half-life 8.3hr).

aster Genus of mostly perennial, leafy stemmed plants native to the Americas and Eurasia. Asters are popular garden plants and most bear daisy-like flowers. Family Asteraceae/Compositae.

asteroid Small body in an independent orbit around the Sun. The majority move between the orbits of Mars and Jupiter, in the main asteroid belt. The largest asteroid (and the first to be discovered) was CERES, with a diameter of 913km (567mi). There are thought to be a million asteroids with a diameter greater than 1km (0.6mi); below this, they decrease in size to dust particles. Some very small objects find their way to Earth as METEORITES. So far nearly 6,000 asteroids have been catalogued and have had their orbits calculated. This figure is increasing by several hundred a year. At least 10,000 more have been observed, but not often enough for an orbit to be calculated. Some of the larger asteroids are spherical, but most are irregularly shaped, and a wide variety of compositional types have been identified. Asteroids almost certainly originate from the time of the formation of the SOLAR SYSTEM and are not remnants of a large planet that disintegrated, as was once thought. asthma Disorder of the respiratory system in which the bronchi (air passages) of the lungs go into spasm, making breathing difficult. It can be triggered by infection, air pollu-

▲ Assyria The alabaster relief, originally painted, shows King Assurbanipal's lion hunt. This is part of a series of narrative wall reliefs, c.650 found in the Northern Palace, Nineveh, and representing the highest achievement of Assyrian art.

ASTRONAUT 6

Astronauts on NASA's shuttle use spacesuits (1) that allow the crew members to work in space for up to seven hours. The suit is multi-layered with eight materials combined. The outside is treated nylon to stop damage from tiny meteorites. Four layers of aluminium material then provide a heat shield from solar radiation backed by a fire and tear-resistant layer. The astronaut is protected from the vacuum of space by a pressure suit of nylon coated with polyeurathane and is kept comfortable in extremes of heat and cold by

water pumped through a network of tubes in a nylon chiffon undergarment (2) The manned manouevring unit (MMU) allows an astronaut to move away from the shuttle. Power comes from 24 thrusters arranged at the corners of the MMU. By releasing pressurized nitrogen from two tanks (3) through nozzles the astronaut can propel himself/herself through the vacuum. The hand controllers regulate rotation (4) and speed (5). A video camera (6) sends pictures to the shuttle and records the work carried out.

tion, allergy, certain drugs, exertion or emotional stress. Allergic asthma may be treated by injections aimed at lessening sensitivity to specific allergens. Otherwise treatment is with bronchodilators to relax the bronchial muscles and ease breathing; in severe asthma, inhaled steroids may be given. Children often outgrow asthma, while some people suddenly acquire the disease in middle age. Air pollution is increasing the number of asthma sufferers. See also BRONCHITIS; EMPHYSEMA; LUNGS

astigmatism Defect of vision in which the curvature of the lens differs from one perpendicular plane to another. It can be compensated for by use of corrective lenses.

Aston, Francis William (1877–1945) British physicist awarded the 1922 Nobel prize for chemistry for his work on ISOTOPES. He developed the MASS SPECTROGRAPH, which he used it to identify 212 naturally occurring isotopes.

Astor, John Jacob (1763–1848) US financier, b. Germany. Astor founded the AMERICAN FUR COMPANY in 1808 and, after 1812, acquired a virtual monopoly of the US fur trade. In the 1830s he concentrated on land investment and became the wealthiest man in the USA. His great-great-grandson, Viscount (William Waldorf) Astor (1879–1952), was married to Nancy ASTOR. Viscount Astor was owner of the *Observer* newspaper and his brother, John Jacob (1886–1971), 1st Baron Astor of Hever, was owner (1922–66) of *The Times*.

Astor, Nancy Witcher (Langhorne), Viscountess (1879–1964) British politician, b. USA, the first woman elected to the House of Commons (1919–45). A Conservative, she advocated temperance, educational reform, and women's and children's welfare. In the 1930s she and her husband William

Waldorf Astor (Viscount Astor) headed a group of influential proponents of APPEASEMENT toward Nazi Germany.

Astrakhan (Astrachan) City in s Russia, a port on the Caspian Sea. It was developed by the Mongols in the 13th century. In the Russian civil war (1917–20) the city remained in "White" Russian hands, becoming a base for the Caspian Sea conquest of 1920. It possesses a walled kremlin (1587–89) and cathedral (1700–10). A railway, airline and oil shipping terminal, it is also an important trade centre. Industries: fishing, shipbuilding, engineering, oil-refining. Pop. (1992) 512,000.

astrolabe Early astronomical instrument for showing the appearance of the celestial sphere at a given moment and for determining the altitude of celestial bodies. The basic form consisted of two concentric disks, one with a star map and one with a scale of angles around its rim, joined and pivoted at their centres (rather like a modern planisphere), with a sighting device attached. Astrolabes were used from the time of the ancient Greeks until the 17th century for navigation, measuring time, and terrestrial measurement of height and angles.

astrology Study of the influence supposedly exerted by stars and planets on the natures and lives of human beings. Western astrology draws specifically on the movements of the Sun, Moon and major planets of the Solar System in relation to the stars that make up the 12 constellations known as the ZODIAC. Astrology originated in ancient Babylon and Persia *c.*3,900 years ago, and rapidly spread through Europe, the Middle East and Asia. In Europe the growing influence of Christianity saw the demise of astrologers. Popular HOROSCOPES still appear in some daily newspapers.

astronaut (Rus. *cosmonaut*) Person who navigates or rides in a space vehicle. The first man to orbit the Earth was the Russian Yuri GAGARIN in 1961. The first man to walk on the Moon was the American Neil Armstrong in 1969. The first woman in space was the Russian Valentina Tereshkova in 1963.

astronomical unit (AU) Mean distance between the Earth and the Sun, used as a fundamental unit of distance, particularly for distances in the Solar System. It is equal to 149,598,000km (92,956,000mi).

astronomy Branch of science studied since ancient times and concerned with the universe and its components in terms of the relative motions of celestial bodies, their positions on the celestial sphere, physical and chemical structure, evolution and the phenomena occurring on them. It includes celestial mechanics, ASTROPHYSICS, COSMOLOGY and astrometry. Waves in all regions of the ELECTROMAGNETIC spectrum can now be studied either with ground-based instruments or, where no atmospheric window exists, by observations and measurements made from satellites, space probes and rockets. History Astronomy was first used practically to develop a calendar, the units of which were determined by observing the heavens. The Chinese had a calendar in the 14th century BC. The Greeks developed the science between 600 BC and AD 200. THALES introduced geometrical ideas and PYTHAGORAS saw the universe as a series of concentric spheres. ARISTOTLE believed the EARTH to be stationary but he explained lunar eclipses correctly. ARISTARCHUS put forward a heliocentric theory. HIPPARCHUS used trigonometry to determine astronomical distances. The system devised by PTOLEMY was a geometrical representation of the SOLAR SYSTEM that predicted the motions of the planets with great accuracy. From then on astronomy remained dormant until the scientific revolution of the 16th and 17th centuries, when COPERNICUS stated his theory that the Earth rotates on its axis and, with all the other planets, revolves round the Sun. This had a profound effect upon contemporary religion and philosophy. KEPLER and his laws of planetary motion refined the theory of heliocentric motion, and his contemporary, GALILEO, made use of the TELESCOPE and discovered the moons of JUPITER. Isaac NEWTON combined the sciences of astronomy and physics. His laws of motion and universal theory of GRAVITATION provided a physical basis for Kepler's laws and enabled the later prediction of HALLEY'S COMET and the discovery of the planets URANUS, NEPTUNE and PLUTO. By the early 19th century the science of celestial mechanics (the study of the motions of bodies in space as they move under the influence of their mutual gravitation) had become highly advanced and new mathematical techniques permitted the solution of the remaining problems of classical gravitation theory as applied to the Solar System. In the second half of the 19th century astronomy was revolutionized by the introduction of techniques based on photography and SPECTROSCOPY. These encouraged investigation into the physical composition of stars, rather than their position. Ejnar HERTZSPRUNG and H.N. Russell studied the relationship between the colour of a star and its luminosity. By this time larger telescopes were being constructed, which extended the limits of the universe known to man. Harlow SHAPLEY determined the shape and size of our galaxy and E.P. HUBBLE's study of distant galaxies led to his theory of an expanding universe. The BIG BANG and STEADY-STATE THEORY of the origins of the universe were formulated. In recent years, space exploration and observation in different parts of the electromagnetic spectrum have contributed to the discovery and postulation of such phenomena as the QUASAR, PULSAR and BLACK HOLE. There are various branches of modern astronomy: Optical astronomy is the oldest branch and studies sources of light in space. Light rays can penetrate the atmosphere but, because of disturbances, many observations are now made from above the atmosphere. Gamma-ray, infrared, ultraviolet and xray astronomy are branches which study the emission of radiation (at all wavelengths) from astronomical objects. Higher wavelengths can be studied from the ground, while lower wavelengths require the use of satellites and balloons. Other branches within astronomy include RADAR ASTRONOMY and RADIO ASTRONOMY.

astrophysics Branch of ASTRONOMY that studies the physical and chemical nature of celestial bodies and their evolution. Many branches of physics, including nuclear physics, plasma physics, relativity and SPECTROSCOPY, are used to predict properties of stars, planets and other celestial bodies. Astrophysicists also interpret the information obtained from astronomical studies of the electromagnetic spectrum, including light, x-rays and radio waves.

Asturias Region in NW Spain, bordering the Bay of Biscay and traversed by the Cantabrian Mountains. The capital is Oviedo. Asturias was named by the Iberians in the 2nd century BC and is famous for its cider. Its coal mines are the richest in Spain. Industries: coal, manganese, mining, steel and nonferrous metal production, fishing, fruit. Pop. (1991) 1,093,937. Asunción Capital, chief port and largest city of Paraguay, located on the E bank of the Paraguay River near its junction with the River Pilcomayo. Founded by the Spanish c.1536 as a trading post, Asunción was the scene of the Communeros rebellion against Spanish rule in 1721 and was later occupied by Brazil (1868-76). City sites include the Pantéon Nacional (a tomb for national heroes), Encarnación Church, National University (1889) and the Catholic University (1960). It is an administrative, industrial and cultural centre. Industries: vegetable oil, textiles. Pop. (1992) 637,737.

Aswan City on the E bank of the River NILE just above Lake Nasser, SE Egypt. Aswan was of strategic importance in ancient times because it controlled all shipping and communications above the first cataract of the Nile. The modern city is a commercial and winter resort centre and has benefited greatly from the construction of the Aswan High Dam. The dam, built with Soviet aid between 1960 and 1970, has a generating capacity of 10,000 million kilowatt-hours and supersedes the first Aswan Dam completed in 1902 to establish flood control on the Nile. Many Nubians displaced by the dam's construction have moved to Aswan. The AGA KHAN's tomb overlooks the city from the w bank of the Nile. The rock terrain surrounding Lake Nasser abounds in Egyptian and Greek temples and, though some sites were submerged, the temples of ABU SIMBEL were saved. Industries: copper, steel, textiles. Pop. (1992) 220,000.

Atacama Desert Desert of N Chile, stretching c.1,000km (600mi) s from the Peru border. Despite its proximity to the Pacific Ocean it is considered to be the most arid in the world; some areas had no recorded rainfall in 400 years. Except where it is artificially irrigated, it is devoid of vegetation. Until the advent of synthetic fertilizers, the desert was extensively mined

for sodium nitrate. Large deposits of copper and other minerals remain. Nitrates and iodine are extracted from the salt basins.

Atahualpa (1502–33) (Atabalipa) Last INCA ruler of Peru. The son of Huayna Capac, upon his father's death he inherited Quito, while his half-brother Huáscar controlled the rest of the Inca kingdom. In 1532 Atahualpa defeated Huáscar, but in November 1532 Francisco Pizarro captured Atahualpa and he was later executed.

Atatürk, (Mustafa) Kemal (1881–1938) Turkish general and statesman, first president (1923-38) of the Turkish republic. As a young soldier he joined the Young Turks and was chief of staff to ENVER PASHA in the successful revolution (1908). He fought against the Italians in Tripoli (1911) and defended Gallipoli in the BALKAN WARS. During World War 1 he led resistance to the Allies' GALLIPOLI CAMPAIGN. The defeat of the OTTOMAN EMPIRE and the capitulation of the sultan persuaded Mustafa Kemal to organize the Turkish Nationalist Party (1919) and set up a rival government in ANKARA. The Treaty of Sèvres (1920) forced him on the offensive. His expulsion of the Greeks from ASIA MINOR (1921-22) led the sultan to flee Istanbul. The Treaty of Lausanne (1923) saw the creation of a independent republic. His dictatorship undertook sweeping reforms, which transformed Turkey into a secular, industrial nation. In 1934 he adopted the title Atatürk (Turkish, father of the Turks). He was succeeded by Ismet Inönü.

ataxia In medicine, a condition where muscles are uncoordinated. It results in clumsiness, irregular and uncontrolled movements, and difficulties with speech. It may be caused by physical injury to the brain or nervous system, by a STROKE, or by disease.

Aten Ancient Egyptian god. Originally referring to the disc of the Sun, Aten entered into the Egyptian pantheon as the sun god. AKHNATEN elevated his status and virtually established the first monotheistic religion. After Akhnaten's death, the worship of AMUN was restored.

Athabasca Lake in w central Canada, on the border of NE Alberta and NW Saskatchewan. The fourth-largest lake in Canada, it is fed by the Athabasca River from the s and drained by the Slave River to the N. Fort Chipewyan (1788) is preserved at the w end of the lake. There are gold and uranium deposits nearby. Area: 8,080sq km (3,120sq mi).

Athabascan (Athapascan or Slave Indians) Tribe and language group of Native North Americans, inhabiting NW Canada. They were forced N to the Great Slave Lake and Fort Nelson by the Cree. The term Slave Indian derives from the domination and forced labour exacted by the Cree. The Athabascan tribe has always been closely linked to the Chipewyan people, and some regard them as one group. The Athabascan language is a subgroup of the Na-Dené linguistic phylum. A distinctive characteristic is their tendency to use prefixes to distinguish verb tenses. It covers the largest geographical area of all Native North American groups, including Alaska, Yukon, N and W Canada, Oregon, California, New Mexico, and W Arizona. By the mid-1980s the number of Athabascan speakers was believed to exceed 160,000, including the Apache (with more than 13,000) and Navajo.

Athanasian Creed Christian profession of faith, probably written in the 6th century, that explains the teachings of the Church on the Trinity and the incarnation. The Roman Catholic and some Protestant churches accept its authority.

Athanasius, Saint (d.373) Early Christian leader. As patriarch of Alexandria he confuted Arianism, and in various writings defended the teaching that the Son and the Holy Spirit were of equal divinity with God the Father and so shared a three-fold being. He is no longer considered the author of the Athanasian Creed, but he did write the *Life of St Anthony*. His feast day is 2 May.

atheism Philosophical denial of the existence of God or any supernatural or spiritual being. The first Christians were called atheists because they denied Roman religions but the term is now used to indicate the denial of Christian theism. During the 18th-century ENLIGHTENMENT, David HUME, Immanuel KANT and the Encyclopedists laid the foundations for atheism. In the 19th century Karl Marx, Friedrich Nietzsche and Sigmund FREUD all accommodated some form of atheism into their

respective philosophical creeds. In the 20th century, many individuals and groups advocate atheism. See also AGNOSTICISM

Athena In Greek mythology, the goddess of war, wisdom and patroness of the arts and industry, identified with MINER-VA. Athena emerged from the head of Zeus fully grown and armed; thereafter, she was her father's most reliable supporter, and the sponsor of heroes such as Heracles, Perseus and Odysseus. In the Trojan War she sided with the Greeks. She helped Argus build the ship *Argo* for Jason and the Argonauts. She received special worship at Athens, where her main temples were the Parthenon and the Erechtheum.

Athens (Athinai) Capital and largest city of Greece, situated on the Saronic Gulf. The ancient city was built around the Acropolis, a fortified citadel, and was the greatest artistic and cultural centre in ancient Greece, gaining importance after the Persian Wars (500-449 BC). Athens prospered under Cimon and PERICLES during the 5th century BC and provided a climate in which the great classical works of philosophy and drama were created. The most noted artistic treasures are the PARTHENON (438 BC); Athena Parthenos (a Doric statue); the Erechtheum (406 BC); and the Theatre of Dionysus (c.500 BC, the oldest of the Greek theatres). Modern Athens and its port of PIRAEUS form a major Mediterranean transport and economic centre. Overcrowding and severe air pollution are damaging the ancient sites and the tourist industry. Other industries: shipbuilding, paper, steel machinery, textiles, pottery, brewing, chemicals and glass. Pop. (1991) 3,072,922.

athletics (track and field) Composite sport that includes running and hurdling events on the track, jumping and throwing field events, cross-country and long-distance road running and walking. The first ancient Greek OLYMPIC GAMES (held in 775 BC) featured many athletics events. The first modern Olympic Games were held at Athens in 1896. The world's governing body, the International Amateur Athletic Federation (IAAF), was established in 1912 and the sport maintained its amateur

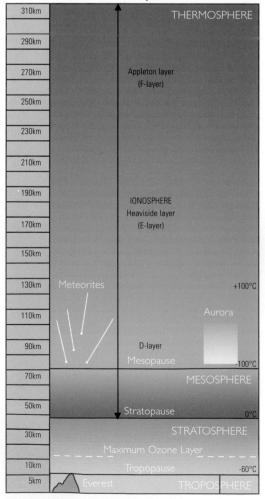

▶ atmosphere The Earth's atmosphere is formed of various layers. It is believed that the atmosphere has changed three times during the Earth's history. The present atmosphere consists mainly of nitrogen and oxygen.

status. During the 1980s and 1990s commercial sponsorship and media coverage has ended top flight amateurism and introduced professional grand prix events.

Atlanta Capital of Georgia, USA, in the NW centre of the state. The land was ceded to Georgia in 1821 by the CREEK and was settled in 1833. The city was founded in 1837 at the E end of the Western and Atlantic Railroad, Originally called Terminus. it became Marthasville (1845) and Atlanta in 1947. It served as a Confederate supply depot and communications centre during the American CIVIL WAR. On 2 September 1864, it fell to General Sherman, whose army razed the city. Atlanta was rapidly rebuilt and soon recovered its importance as a transport and cotton manufacturing centre. It became the permanent state capital in 1887. In the late 20th century, Atlanta became a major US city. It is the headquarters of Coca Cola. It contains the High Museum of Art and Emory University (founded 1836). Atlanta hosted the 1996 summer Olympic Games. Despite a bomb and complaints about public transport provisions, the Games were judged a success. Industries: textiles, chemicals, iron and steel, electronics. Pop. (1992) 394,848.

Atlantic, Battle of the (1939–43) Campaign for control of the Atlantic sea routes waged by air and naval forces during World War 2. The Germans hoped to starve Britain into submission by U-boat attacks on merchant shipping, and later to prevent US reinforcements reaching the Mediterranean and Europe. More than 14 million tonnes of shipping were destroyed.

Atlantic Charter Joint declaration of peace aims issued in August 1941 by US president Franklin D. ROOSEVELT and British prime minister Winston CHURCHILL. It affirmed the right of all nations to choose their own form of government, promised to restore sovereignty to all nations, and advocated the disarmament of aggressor nations.

Atlantic City Resort city in SE New Jersey, built on a 16km (10mi) sandbar in the Atlantic Ocean and settled as a fishing village in 1790. Famous for its 6km (4mi) boardwalk (1896) and its annual Miss America pageant (started in 1921), it is a centre for political and business conventions. In 1976 gambling was legalized and, since the first casinos were opened in 1978, Atlantic City has become a major tourist centre and stage for sporting events (especially boxing). Pop. (1990) 37,986.

Atlantic Ocean World's second largest ocean stretching from the Arctic Circle in the N to the Antarctic Ocean in the S. Its name derives from the ATLAS Mountains, which, for the ancient Greeks, marked the western boundary between the known and the unknown world. Its most striking feature is the MID-ATLANTIC RIDGE, which runs N – S for its entire length. At the crest, the ridge is cleft by a deep rift valley which is frequently offset by E - W transform faults. The age of the crust steadily increases with distance from the central rift, and so there is little doubt that the rift has evolved by seafloor spreading and is associated with the movement of the Americas away from Europe and Africa at a rate of 2-4cm (0.8-1.6in) a year. The average depth of the Atlantic is 3,700m (12,100ft). The greatest known depth is the Milwaukee Deep in the Puerto Rico Trench, at 8,650m (28,370ft). The N clockwise gyre is dominated by the fast-flowing GULF STREAM, travelling at speeds of up to 130km (80mi) a day, and forming the w boundary current of the gyre. The s anti-clockwise gyre is atypical in having a weak western boundary current, the Brazil Current. Apart from oil (found mainly in the Gulf of Guinea), sand and gravel are the most important minerals from the Atlantic. The world's largest single offshore mining operation is located at Ocean Cay on the Grand Bahamas bank, where calcium carbonate is extracted in the form of aragonite. Valuable diamond deposits occur off the coast of Namibia. The North Atlantic contains the most valuable fishing grounds in the world, namely the cod fisheries around Iceland, s Greenland and the Grand Banks of Newfoundland. The relatively unexploited fisheries of the South Atlantic are probably less stable than those of the N. Area: 82 million sq km (32 million sq mi).

Atlantis Mythical island in the Atlantic Ocean from which, according to Plato, a great empire tried to subdue the Mediterranean countries. It has been identified by some with the Greek island of Thera, destroyed by an earthquake $c.1450~\mathrm{BC}$.

Atlas Mountain system in NW Africa, comprising several folded and roughly parallel chains extending 2,400km (1,500mi) from the coast of sw Morocco to the coast of N Tunisia. North Africa's highest peak, Djebel Toubkal, 4,170m (13,671ft), is found in the Grand Atlas range in w Morocco.

Atlas In Greek mythology, one of the TITANS, brother of PROMETHEUS. Having fought against Zeus, he was condemned to hold up the heavens.

atman Human soul or self in Hindu religion. See BRAHMAN atmosphere Envelope of gases surrounding the Earth, that shields the planet from the harsh environment of space. The gases it contains are vital to life. About 95% by weight of the Earth's atmosphere lies below the 25km (15mi) altitude; the mixture of gases in the lower atmosphere is commonly called air. The atmosphere's composition by weight is: nitrogen 78.09%, oxygen 20.9%, argon 0.93%, 0.03% of carbon dioxide, plus 0.05% of hydrogen, the inert gases and varying amounts of water vapour. The atmosphere can be conceived as concentric shells; the innermost is the troposphere, in which dust and water vapour create the clouds and weather. The stratosphere extends from 10-55km (8-36mi) and is cooler and clearer and contains ozone. Above, to a height of 70km (43mi), is the mesosphere in which chemical reactions occur, powered by sunlight. The temperature climbs steadily in the thermosphere, which gives way to the exosphere at c.400km (250mi), where helium and hydrogen may be lost into space. The IONOSPHERE ranges from c.50km (30mi) out into the VAN ALLEN RADIATION BELTS.

atmospheric pressure Pressure exerted by the atmosphere because of its weight (gravitational attraction to the Earth or other body), measured by barometers and usually expressed in units of mercury. Standard atmospheric pressure at sea level is 760mm (29.92in) of mercury. The column of air above each cm² of Earth's surface weighs *c*.1kg (2.2lb), or *c*.6.7kg (14.7lb) above each in².

atoll Ring-shaped REEF of CORAL enclosing a shallow LAGOON. An atoll begins as a reef surrounding a slowly subsiding island, usually volcanic. As the island sinks, the coral continues to grow upwards until eventually the island is below sea level and only a ring of coral is left at the surface.

atom Smallest particle of matter that can take part in a chemical reaction, every element having its own characteristic atoms. The atom, once thought indivisible, consists of a central, positively charged NUCLEUS orbited by negatively charged ELECTRONS. The nucleus (identified in 1911 by Ernest RUTHERFORD) is composed of tightly packed protons and neutrons. It occupies a small fraction of the atomic space but accounts for almost all of the mass of the atom. In 1913 Niels BOHR suggested that electrons moved in fixed orbits. The study of QUANTUM MECHANICS has since modified the concept of orbits: the Heisenberg UNCERTAINTY PRINCIPLE says it is impossible to know the exact position and MOMENTUM of a subatomic particle. The number of electrons in an atom and their configuration determine its chemical properties. Adding or removing one or more electrons produces an ION.

atomic bomb See NUCLEAR WEAPON

atomic clock Most accurate of terrestrial CLOCKS. It is an electric clock regulated by such natural periodic phenomena as emitted radiation or atomic vibration; the atoms of CAE-SIUM are most commonly used. Clocks that run on radiation from hydrogen atoms lose one second in 1.7 million years.

atomic energy See NUCLEAR ENERGY

atomic mass number (nucleon number) Number of nucleons (protons and neutrons) in the nucleus of an atom. It is represented by the symbol A. In nuclear notation, such as 7_3 Li, the mass number is the upper number and the ATOMIC NUMBER (the number of protons) is the lower one. ISOTOPES of an element have different mass numbers but identical atomic numbers.

atomic mass unit (a.m.u.) Unit of mass used to compare relative atomic masses, defined since 1961 as 1/12th the mass of the most abundant isotope of carbon, carbon-12 (6 electrons, 6 protons and 6 neutrons). One amu is equal to 1.66033×10^{-27} kg.

atomic number (proton number) Number of protons in the nucleus of an atom of an element, which is equal to the num-

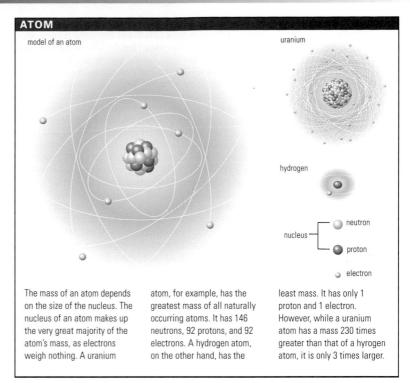

ber of electrons moving around that nucleus. It is abbreviated to at. no. and represented by the symbol Z. The atomic number determines the chemical properties of an element and its position in the PERIODIC TABLE. ISOTOPES of an element all have the same atomic number but a different ATOMIC MASS NUMBER.

atomism (Gk. atmos uncuttable) Philosophical theory originated in Greece by Leucippus and elaborated by DEMOCRITUS during the 5th and 4th centuries BC. It held that everything is made of immutable and indivisible particles called atoms. The theory was an attempt to reconcile the single immutable substance theory of being, espoused by Parmenides and other Eleatic philosophers, with HERACLITUS' view that all things are subject to change.

atonality Musical composition without reference to traditional KEYS and HARMONY. Examples include *Pierrot Lunaire* (1912) by Arnold SCHOENBERG. *See also* SERIALISM

atonement In religion, the process by which a sinner seeks forgiveness from and reconciliation with God, through an act of expiation such as prayer, fasting or good works. In Christian theology, Jesus Christ atoned for the sins of the world by his sacrifice on the cross. Jews observe YOM KIPPUR, their most sacred feast, as a day of repentance.

atrophy In medicine, shrinking or wastage of tissues or organs. It may be associated with disease, malnutrition, or, in the case of muscle atrophy, with disuse.

atropine Poisonous ALKALOID drug ($C_{17}H_{23}NO_3N$) obtained from certain plants such as *Atropa belladonna* (DEADLY NIGHTSHADE). Atropine is used medicinally to regularize the heartbeat during anaesthesia, to dilate the pupil of the eye and to treat motion sickness.

attar of roses (otto) Essential oil obtained from rose petals, and used as a perfume and perfumery agent. Attar is any fragrant oil derived from plants, though attar of roses (produced by crushing and distilling petals from the damask rose cultivated in the Balkans) is by far the best known.

Attenborough, Sir David Frederick (1926–) British naturalist and broadcaster; brother of Richard Attenborough. He was controller of BBC2 television (1965–68). From 1954 he has travelled on zoological and ethnographical filming expeditions, which have formed the basis of such landmark natural history series as *Life on Earth* (1979), *The Living Planet* (1984), *The Trials of Life* (1990), and *The Private Life of Plants* (1995). He was knighted in 1985.

Attenborough, Sir Richard (1923–) British film actor and director. His career has spanned over 50 years beginning with

▲ aubergine Grown widely in tropical Asia, the aubergine or eggplant (Solanum melongena), although commonly thought of as vegetables, are in fact fruits.

In Which We Serve (1942). He delivered a menacing performance in Brighton Rock (1947). His directorial debut was the World War 1 satire Oh! What a Lovely War (1971). His acting and directorial style appear to suit biographical films: Gandhi (1982) won Best Film and Best Director Oscars. Cry Freedom (1987) was the story of Stephen Biko. Shadowlands (1993), his biopic of C.S. Lewis, brought further critical praise.

Attila (406–453) King of the HUNS (c.439–53), co-ruler with his elder brother until 445. Attila defeated the Eastern Roman emperor THEODOSIUS II, extorting land and tribute, and invaded Gaul in 451. Although his army suffered heavy losses, he invaded Italy in 452, but disease forced his withdrawal. Attila has a reputation as a fierce warrior, but was fair to his subjects and encouraged learning. On his death the empire fell apart.

Attlee, Clement Richard, 1st Earl (1883-1967) British statesman, prime minister (1945-51). Attlee joined the Fabian Society in 1907 and became a Labour MP in 1922. He joined the Labour government in 1930, but resigned when Ramsay MACDONALD formed a National Coalition (1931). Attlee became leader of the LABOUR PARTY in 1935. During World War 2, he served in Winston Churchill's wartime cabinet, first as Dominions Secretary (1942-43) and then as deputy prime minister (1942-45). Attlee won a landslide victory in the 1945 general election. His administration was notable for the introduction of important social reforms, such as the NATIONAL HEALTH SERVICE (NHS) and the nationalization of the power industries, the railways and the BANK OF ENGLAND. He also granted independence to India (1947) and Burma (1948). Attlee was re-elected in 1950, but was defeated by Winston Churchill in the 1951 general election. He continued to serve as leader of the opposition until he retired and accepted an earldom in 1955.

attorney general Principal law officer. In the USA, the attorney general is the highest law officer of the government and head of the department of justice, and advises the president and heads of the executive department. In the UK, it is the chief law officer of the crown and head of the English bar, and also legal advisor to the House of Commons and the government.

Atwood, Margaret Eleanor (1939–) Canadian novelist, poet and critic. Best known outside Canada for her novels, she has also published numerous volumes of poetry. Her debut novel, *The Edible Woman* (1969), received immediate acclaim for its stylish and articulate treatment of complex gender relationships. Other novels include *Surfacing* (1972), the award-winning *The Handmaid's Tale* (1985), *The Robber Bride* (1993) and *Alias Grace* (1996).

Auber, Daniel-François-Esprit (1782–1871) French composer. He studied under Cherubini and wrote more than 40 operas, often collaborating with the librettist Scribe. His operas include *La Muette de Portici* (or *Masaniello*) and *Fra Diavolo*. He is regarded as the founder of French grand opera. aubergine (eggplant) Tropical member of the potato (and nightshade) family. The fruit may be eaten as a vegetable. A bushy perennial with violet flowers native to the New World, it is now widely cultivated in temperate regions. Family Solanaceae; species *Solanum melongena*.

Auckland Largest city and chief port of New Zealand, lying on an isthmus on Nw North Island. The port, built on land purchased from the Maoris in 1840, handles around 60% of New Zealand's trade. The first immigrants arrived from Scotland in 1842 and in 1854 the first New Zealand parliament opened here. It remained the capital until 1865. It is the chief base of New Zealand's navy and contains the War Memorial Museum. Within the city there are many volcanic cones. Industries: vehicle assembly, boatbuilding, footwear, food canning, chemicals. Auckland has the largest Polynesian population (c.65,000) of any city in the world. Pop. (1994) 929,300.

Auden, W.H. (Wystan Hugh) (1907–73) Anglo-American poet, b. England, one of the major poets of the 20th century. Auden's first volume of poetry, *Poems* (1930), established him as the leading voice in a group of left-wing writers, which included Stephen SPENDER, Louis MACNEICE, Cecil DAY-LEWIS and Christopher ISHERWOOD. Auden and Isherwood collaborated on a series of plays, such as *The Ascent of F6* (1936). Auden joined the Republican cause in

the Spanish Civil War and wrote *Spain* (1937). In 1939 he emigrated to New York and became a US citizen in 1946. His volume *The Age of Anxiety* (1947) won a Pulitzer Prize. From 1956 to 1961 he was professor of poetry at Oxford University. Auden's poetry adopts many tones, often utilizing colloquial and everyday language. His later poetry is more serious and epistolary, reflecting his conversion to Anglicanism. Auden's *Collected Poems* were published in 1976.

auditory canal Tube leading from the outer EAR to the eardrum. It is about 2.5cm (1in) long.

Audubon, John James (1785–1851) US ornithologist and artist. His remarkable series of some 400 watercolours of birds, often in action, were published in *Birds of America* (1827–38). Augsburg Historical city on the River Lech, Bavaria, Germany. Founded by the Romans (c.15 BC) and named after the Emperor Augustus, it became a free imperial city in 1276 and was a prosperous banking and commercial centre in the 15th and 16th centuries. The Augsburg Confession was presented and the Peace of Augsburg (1555) was signed here. The cathedral (started 994) claims the oldest stained-glass windows in Europe (11th century). Industries: textiles, engineering, motor vehicles. Pop. (1993) 265,000.

Augsburg Confession (1530) Summation of the Lutheran faith, presented to Emperor Charles V at the Diet of Augsburg. Its 28 articles were formulated from earlier Lutheran statements principally by Philip Melanchthon. It was denounced by the Roman Catholic Church, but became a model for later Protestant creeds.

Augsburg, League of (1686) Alliance of the enemies of the French King Louis XIV. Composed of Spain, Sweden, the Holy Roman Empire and lesser states, its formation under the Emperor Leopold I was a reaction to French encroachment on the land bordering the Holy Roman Empire. Following the French attack on the PALATINATE in 1688, a new coalition against the French, the Grand Alliance, was formed (1689).

Augsburg, Peace of (1555) Agreement reached by the Diet of the Holy Roman Empire in Augsburg ending the conflict between Roman Catholics and Lutherans in Germany. It established the right of each prince to decide on the nature of religions practice in his lands, cuius regio, cuius religio. Dissenters were allowed to sell their lands and move. Free cities and imperial cities were open to both Catholics and Lutherans. The exclusion of other Protestant sects such as Calvinism proved to be a source of future conflict.

Augusta State capital of Maine, USA, on the Kennebec River, 72km (45mi) from the Atlantic Ocean. Founded by settlers from Plymouth as a trading post in 1628, it was incorporated in 1797. A dam built across the Kennebec River in 1837 led to Augusta's industry changing from shipping to manufacturing textiles, paper and steel. The city also benefits from tourism. Pop. (1990) 21,325.

Augustine, Saint (354–430) Christian theologian and philosopher. Augustine's *Confessions* provide an intimate psychological self-portrait of a spirit in search of ultimate purpose. This he believed he found in his conversion to Christianity in 386. As Bishop of Hippo, North Africa (395–430), he defended Christian orthodoxy against Manichaeism, Donatism, and Pelagianism. In his *Enchiridion* (421) he tended to emphasize the corruption of human will and the freedom of the divine gift of grace. *The City of God* (426) is a model of Christian apologetic literature. Of the Four Fathers of the Latin Church, AMBROSE, JEROME, and GREGORY I, Augustine is considered the greatest. His feast day is 28 August.

Augustine of Canterbury, Saint (d.604) First Archbishop of Canterbury. He was sent from Rome in 596 by Pope Gregory I, at the head of a 40-strong mission. Arriving in Kent in 597, Augustine converted King Ethelbert and introduced Roman ecclesiatical practices into England. This brought him into conflict with the Celtic monks of Britain and Ireland whose traditions had developed in isolation from the continent. The Synod of Whitby (663) settled disputes in favour of Roman custom. St Augustine's feast day is 28 May (26 May in England and Wales).

Augustinian Name of two distinct and long-established Christian orders. The order of Augustinian Canons was

founded in the 11th century. Based on the recommendations of St Augustine of Hippo, its discipline was milder than those of full monastic orders. The mendicant order of Augustinian Hermits or Friars was founded in the 13th century and modelled on the Dominicans.

Augustus (63 BC-AD 14) (Gaius Julius Caesar Octavianus) First Roman emperor (27 BC-14 AD), also called Octavian. Nephew and adopted heir of Julius CAESAR, he formed the Second Triumvirate with Mark ANTONY and Lepidus after Caesar's assassination. They defeated Brutus and Cassius at Philippi in 42 BC and divided the empire between them. Rivalry between Antony and Octavian was resolved by the defeat of Antony at Actium in 31 BC. While preserving the form of the republic, Octavian held supreme power. He introduced peace and prosperity after years of civil war. He built up the power and prestige of Rome, encouraging patriotic literature and rebuilding much of the city in marble. He extended the frontiers and fostered colonization, took general censuses, and attempted to make taxation more equitable. He tried to arrange the succession to avoid future conflicts, though had to acknowledge an unloved stepson, TIBERIUS, as his successor.

Augustus II (1670–1733) King of Poland (1697–1704, 1709–33) and, as Frederick Augustus I, elector of Saxony (1694–1733). He was elected by the Polish nobles in order to secure an alliance with Saxony, but the result was to draw Poland into the Great NORTHERN WAR on the side of Russia. Augustus was forced to give up the crown to Stanislas I Lesz-cyński in 1704. Civil war (1704–09) and invasion by Charles XII of Sweden weakened the Polish state. Augustus was restored to the throne after Peter the Great defeated Sweden at the Battle of Poltava in 1709, but at the cost of growing Russian dominance in Polish affairs

auk Squat-bodied sea bird of colder Northern Hemisphere coastlines. The flightless great auk (*Pinguinus impennis*), or the Atlantic penguin, became extinct in the 1840s; height: 76cm (30in). The razorbill auk (*Alca torda*) is the largest of living species. Family Alcidae.

Aung San (1914–47) Burmese politician who opposed British rule, father of Aung San Suu Kyı. Initially collaborating with the Japanese (1942), he later helped expel the invaders. He was assassinated shortly after his appointment as deputy chairman of the executive council.

Aung San Suu Kyi, Daw (1945–) Burmese civil rights activist. The daughter of AUNG SAN, she was placed under house arrest (1989–95) for leadership of the National League for Democracy, a coalition opposed to Myanmar's oppressive military junta. In 1991 she was awarded the Nobel Peace Prize and the Sakharov Prize (for human rights).

Aurangzeb (1619–1707) Emperor of India (1659–1707). The last of the great MOGUL emperors, Aurangzeb seized the throne from his enfeebled father, SHAH JEHAN. He reigned over an even greater area, and spent most of his reign defending it. Aurangzeb was a devout Muslim, whose intolerance of Hinduism provoked long wars with the MARATHA. The empire was already breaking up before his death.

Aurelian (c.215–75) Roman emperor. Having risen through the army ranks, he succeeded Claudius II in 270. His victories against the Goths, reconquest of Palmyra and recovery of Gaul and Britain earned him the title "Restorer of the World". He built the Aurelian Wall to protect Rome and was assassinated in a complex military plot.

Aurelius, Marcus See Marcus Aurelius (Antoninus) **aurochs** (urus) Extinct European wild ox, the long-horned ancestor of modern domesticated cattle. Once found throughout the forests of Europe and central and se Asia, it became extinct in 1627. A dark, shaggy animal, it stood up to 2m (7ft) tall at the shoulder. Family Bovidae; species Bos primigenius.

See also BISON

Aurora In Roman mythology, the goddess of dawn, equivalent to the Greek goddess Eos.

aurora Sporadic, radiant display of coloured light in the night sky, caused by charged particles from the Sun interacting with air molecules in the Earth's magnetic field. Auroras occur in polar regions and are known as **aurora borealis** in the N, and **aurora australis** in the S.

Auschwitz (Pol. Oświęcim) Town in Poland. It was the site of a German concentration camp during World War 2. A group of three main camps, with 39 smaller camps nearby, Auschwitz was Hitler's most "efficient" extermination centre. Between June 1940 and January 1945 more than 4 million people were executed here, mostly Jews, and comprising about 40 different nationalities, principally Polish. The vast majority were gassed in its chambers, but many others were shot, starved or tortured to death. The buildings have been preserved as the National Museum of Martyrology. Together with the world's largest burial ground at Brzezinka (Birkenau), one of the other two main camps, Auschwitz is now a place of pilgrimage. Pop. (1989 est.) 45,400.

Austen, Jane (1775–1817) English novelist. She completed six novels of great art, insight and wit, casting an ironic but ultimately sympathetic light on the society of upper-middle-class England. In order of composition they are: Northanger Abbey (1818), a parody on the contemporary Gothic novel; Sense and Sensibility (1811); Pride and Prejudice (1813); Mansfield Park (1814); Emma (1816) and Persuasion (1818). Not particularly successful in their time, they have since established their place among the most popular and well-crafted works in English literature. Austen's letters to her sister Cassandra serve to further illuminate the social context of her fiction. Her work has recently undergone an enthusiastic revival in the public imagination, following several film adaptations, most notably Sense and Sensibility (1995).

Austerlitz, Battle of (2 December 1805) The French led by NAPOLEON I defeated the Austrians and Russians under

■ Austerlitz, Battle of

Napoleon's defeat of the Allied forces at the Battle of Austerlitz was one of his greatest triumphs. By evacuating Austerlitz and the Pratzen Heights, Napoleon feigned weakness. The Allied forces camped on the heights (A). Their plan was to overwhelm the (deliberately) weak French right flank, before heading north to envelop the French as they headed for Brünn. Beneath the cover of mist, elements of the French forces manoeuvred beneath the Pratzen Heights. The Allies attacked the French right flank. While the Allies were engaged in battle to the south, French forces marched up and occupied the Pratzen Heights (B). Additional support was provided by other French forces that had initially engaged the Allies to the north. Together the French forces dispersed the Allies, driving them on to the frozen lakes near Telnitz, where many drowned as Napoleon ordered his artillery to open fire, breaking the ice (C).

ustralia is the world's sixth largest country.

Australia is the world's state angel.

The huge Western Plateau makes up 66%

of its land area, and is mainly flat and dry. Off

the coast of NE Queensland lies the GREAT BAR-

RIER REEF. The GREAT DIVIDING RANGE extends

down the entire E coast and into VICTORIA. The

mountains of TASMANIA are a southerly exten-

sion of the range. The highlands separate the E

coastal plains from the Central Lowlands and

include Australia's highest peak, Mount

KOSCIUSKO, in New South Wales. The capital,

CANBERRA, lies in the foothills. The sE lowlands

are drained by the MURRAY and Darling, Aus-

The national flag, top right, was adopted in 1901. It includes the British Union Flag. revealing Australia's historic links with Britain. In 1995, the Australian government put the flag used by Native Australians, bottom right, on the same footing as the national one.

continent's largest lake. It lies on the edge of the Simpson Desert and is a dry salt flat for most of the year. ALICE SPRINGS lies in the heart of the continent, close to AYERS ROCK. CLIMATE

Only 10% of Australia has an average annual rainfall greater than 1,000mm (39in). These areas include some of the tropical N, where DAR-WIN is situated, the NE coast and the SE. The coasts are usually warm and many parts of the s and sw, including PERTH, enjoy a Mediterranean climate of dry summers and moist winters. The interior is dry and many rivers are only seasonal.

AREA: 7,686,850sq km (2,967,893sq mi)

POPULATION: 17,529,000

CAPITAL (POPULATION): Canberra (324,600) GOVERNMENT: Federal constitutional

monarchy

ETHNIC GROUPS: White 95%, Native Australian

1.5%, Asian 1.3%

LANGUAGES: English (official)

RELIGIONS: Christianity (Roman Catholic 26%,

Anglican 24%, others 20%), Islam,

Buddhism, Judaism

currency: Australian dollar = 100 cents

VEGETATION

Much of the Western Plateau is desert, although areas of grass and low shrubs are found on its margins. The grasslands of the Central Lowlands are used to raise livestock. The N has areas of savanna and rainforest. In dry areas, acacias are common. Eucalyptus grows in wetter regions.

HISTORY AND POLITICS

NATIVE AUSTRALIANS (Aborigines) entered the continent from Southeast Asia more than

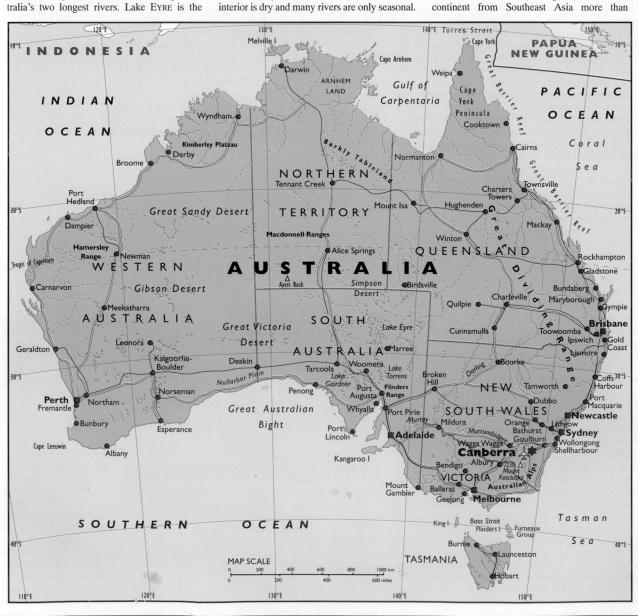

AUSTRALIA

50,000 years ago. They settled throughout the country and remained isolated from the rest of the world until the first European explorers, the Dutch, arrived in the 17th century. The Dutch did not settle. In 1770 the English explorer Captain James Cook reached Botany Bay and claimed the E coast for Great Britain. In 1788 the first British settlement was established (for convicts) on the site of present-day SYDNEY. The first free settlers arrived three years later. In the 19th century, the economy developed rapidly, based on mining and and sheep-rearing. The continent was divided into colonies, which later became states. In 1901 the states of QUEENS-LAND, Victoria, Tasmania, New South Wales, SOUTH AUSTRALIA and WESTERN AUSTRALIA. federated to create the Commonwealth of Australia. NORTHERN TERRITORY joined the federation in 1911. A range of progressive social welfare policies were adopted, such as old-age pensions (1909). The federal capital was established (1927) at Canberra, in Australian Capi-TAL TERRITORY. Australia fought as a member of the Allies in both world wars. The Battle of the Coral Sea (1942) prevented a full-scale attack on the continent. Post-1945 Australia steadily realigned itself with its Asian neighbours. Robert MENZIES, Australia's longestserving prime minister, oversaw many economic and social reforms and dispatched Australian

troops to the Vietnam War. In 1977 prime minister Gough WHITLAM was removed from office by the British governor-general. He was succeeded by Malcolm Fraser. In 1983 elections Fraser's Liberal Party were defeated by the Labour Party, and Bob HAWKE became prime minister. His shrewd handling of industrial disputes and economic recession helped him win a record four terms in office. In 1991 Hawke was forced to resign as leader and was succeeded by Paul KEATING. Backed by a series of opinion polls, KEATING proposed that Australia should become a republic by the year 2001. Keating won the 1993 general election and persevered with his free market reforms. In 1996 elections, Keating was defeated by a coalition led by John HOWARD. In 2000 Sydney will host the 28th Olympic Games and 2001 is the centenary of Australian nationhood. The historic maltreatment of Native Australians remains a contentious political issue. In 1993 the government passed the Native Title Act which restored to Native Australians land rights over their traditional hunting and sacred areas.

ECONOMY

Australia is a prosperous country. Its economy was originally based on agriculture, although crops can be grown on only 6% of the land. The country remains a major producer and exporter

of farm products, particularly cattle, wheat and wool. Grapes grown for winemaking are also important. Australia is rich in natural resources and is a major producer of minerals, such as bauxite, coal, copper, diamonds, gold, iron ore, manganese, nickel, silver, tin, tungsten and zinc. Australia also produces some oil and natural gas. The majority of Australia's imports are manufactured products. They include machinery and other capital goods required by factories. The country has a highly developed manufacturing sector; the major products include consumer goods, notably foodstuffs and household articles. Tourism is a vital industry (1992 receipts, US\$4,000 million).

Matthew Flinders, a British explorer, sailed around Australia in 1801–02, accurately mapping much of its coastline. This stamp depicting Flinders was issued to commemorate Australia Day in 1980.

Mikhail Kutuzov in Bohemia. One of Napoleon's greatest victories, it was also called the Battle of the Three Emperors. **Austin, Stephen** (1793–1836) US pioneer. On his father's death in 1821, he acquired a grant in the Spanish territory that was to become Texas. He settled the first English-speaking colony here, and was followed by many other colonists. Mexico opposed this colonization, and Austin went to Mexico City to argue his case, but was arrested. On his return in 1835 he became a leader in the fight for Texan independence.

Austin Capital of Texas, on the Colorado River, USA. Originally called Waterloo, it was first settled in 1835 and renamed after Stephen AUSTIN (the "father of Texas") in 1839. It has some fine 19th-century architecture, including the Capitol building. The market centre for a farming and ranching area, Austin hosts national conventions. Industries: high-tech electronics, furniture, machinery, building materials, food processing. Pop. (1992) 492,329.

Australasia Region that includes Australia, New Zealand and Papua New Guinea. The term Australasia is not exact. It is sometimes used to include various Asian countries (principally Indonesia and Malaysia) or extended to include Pacific island groups and the Australian and New Zealand territories in Antarctica. Many botanists and zoologists use the term to mean the lands and seas to the E and S of Wallace's Line. The native flora and fauna on one side of the line differ from those on the other

Australia Earth's smallest continent, between the Pacific and Indian Oceans. Combined with the island of TASMANIA, it forms the independent Commonwealth country of Australia. *See* country feature

Australia Day Annual national holiday in Australia, on the Monday following 26 January. It commemorates the arrival of the First Fleet (carrying the first colonists) at Port Jackson, Sydney on the 26 January 1788.

Australian art Term applied to art produced by Native Australians and also that produced by descendants of European settlers. The art of Native Australians dates back to prehistoric times. They painted on a variety of surfaces, including rock, bark and shells. The most remarkable examples are the so-called x-ray paintings in Arnhem Land, in which hunters

depicted the internal anatomy of the beasts they killed, and the wondjina figures, which were found near water holes in the NW. European influence on the continent dates from 1788, when the first penal colony was established. The Australian landscape attracted a significant number of foreign painters, such as John Glover (1767-1849) and Conrad Martens (1801-78); however, Australian artists still felt the need to train in Europe. The late 19th-century Heidelberg School, based in Heidelberg, Victoria, represented the first truly national movement in Australian art. It was led by Tom Roberts, whose impressionist-inspired landscapes influenced Australian art for many decades. In the 20th century, the Melbourne journal Angry Penguins (1940-46) proved a seminal influence, fostering the talents of many avant-garde painters. Among these were the two most celebrated names in Australian art, Sir Sidney NoLAN and Arthur Boyd.

Australian Capital Territory (ACT) (Commonwealth Territory) District within New South Wales but administratively independent of it. It contains the Australian capital, Canberra. The area was first settled in 1824 and was set aside as the capital territory in 1908. In 1915 an additional 72sq km (28sq mi) were added, making a total of 2,432sq km (939sq mi). Pop. (1993 est.) 299,400.

Australopithecus See HUMAN EVOLUTION

Austria Landlocked republic in the heart of Europe. *See* country feature, p.54

Austrian Succession, War of the (1740–48) Overall name for several related wars. They included the war for the Austrian succession itself, in which France supported Spain's claim to part of the Habsburg domains; the first and second Silesian wars, in which FREDERICK II of Prussia took Silesia from Austria; and the war between France and Britain over colonial possessions, known in North America as King George's War.

Austro-Hungarian empire (1867–1918) Organization of the old Austrian empire into the kingdom of Hungary and the empire of Austria, also known as the "Dual Empire". The emperor of Austria and the king of Hungary were the same person, but each nation had its own parliament and controlled its internal affairs. This arrangement ignored other nationalist

minorities and pleased neither the Hungarians, who wanted greater autonomy, nor the Austrians, many of whom wanted a realignment with other German states. After World War 1 Hungary and Czechoslovakia declared their independence, the Emperor Charles abdicated and Austria became a republic. **Austronesian languages** (Malayo-Polynesian) Family that includes Malay, Indonesian, Tagalog, Malagasy, and numerous other languages spoken in Indonesia, the Philippines, and the islands of the Pacific Ocean. There are four branches: Indonesian. Melanesian (which includes Fijian), Micronesian (which includes Chamorro, spoken on Guam), and the Polynesian languages, which include Maori, Tongan, Tahitian and Samoan. There are about 175 million speakers in all.

Austro-Prussian War (1866) Conflict between Prussia and Austria, also known as the Seven Weeks War. Otto von BISMARCK engineered the war to further Prussia's supremacy in Germany and reduce Austrian influence. Defeat at Sadowa forced Austria out of the German Confederation (a federation of 39 German principalities set up by the Congress of Vienna to replace the HOLY ROMAN EMPIRE).

auteur In film theory, the notion that the director is the prime creator, or "author" of a film. Developed by François TRUFFAUT in 1954, the theory focuses on directorial style and use of recur-

ring motifs to develop a canon of auteurs. Its popularity has waned because it neglects the importance of collaboration.

authoritarianism System of government that concentrates power in the hands of one person or small group of people not responsible to the population as a whole. Freedom of the press and of political organization are suppressed. Many authoritarian regimes arise from military takeovers.

autism Disorder, usually first appearing in early childhood, characterized by a withdrawal from social behaviour, communication difficulties and ritualistic behaviour. Autistic people have difficulty understanding themselves or others as agents with varying beliefs and desires. The causes of autism may originate in genetics, brain damage or psychology.

autobiography Narrative account of a person's life, written by the subject. The modern autobiography has become a distinctive literary form. The first important example of the genre was the 4th-century *Confessions* of Saint Augustine. The modern, introspective autobiography, dealing frankly with all aspects of life, is usually dated from the remarkable *Confessions* of Rousseau (1765–72; pub. 1782). *See also* BIOGRAPHY **autochrome** Method developed by the Lumière brothers for colour Photography, first marketed in 1907. This process enabled simple colour photography. The screen plate

AUSTRIA

According to legend, the simple colours on Austria's flag date back to a battle in 1191, during the Third Crusade, when an Austrian duke's tunic was stained with blood except under his swordbelt, where it remained white. The flag was officially adopted in 1918.

AREA: 83,850sq km (32,347sq mi)

POPULATION: 7,884,000

CAPITAL (POPULATION): Vienna (1,589,052) **GOVERNMENT:** Federal republic

ETHNIC GROUPS: Austrian 93%, Slav 2%,

Turkish, German

LANGUAGES: German (official)

RELIGIONS: Christianity (Roman Catholic 78%,

Protestant 6%), Islam

currency: Schilling = 100 Groschen

Austria lies at the crossroads of Europe. Mountains constitute about 75% of total land area. The River Danube flows through the Vienna Basin, Austria's main farming region and the location of its capital. Southern Austria contains ranges of the E Alps, which rise to 3,979m (12,457ft) at Gross Glockner. Graz is the major southern city. SALZBURG lies close to the German border.

CLIMATE AND VEGETATION

Austria's climate is influenced by westerly and easterly winds. Westerlies bring rain and snow and help moderate temperatures. Easterlies

bring cold weather in winter and hot weather in summer. Crops are grown on 18% of the land, and another 24% is pasture. Austria has the highest proportion of forest (39%) in Europe.

HISTORY AND POLITICS

Austria was part of the HOLY ROMAN EMPIRE, and in 1526 it was united with Bohemia and Hungary. Under Habsburg rule it became the most important state in the empire. The succession of Maria Theresa (1740) prompted the War of the Austrian Succession. Joseph II's reforms encountered fierce resistance. The French Revolutionary Wars and the Napoleonic Wars.

culminating in defeat at AUSTERLITZ, led to the dissolution of the Holy Roman Empire (1806). Through the auspices of Prince METTERNICH, however, Austria continued to dominate European politics. The REVOLUTIONS OF 1848 forced the succession of FRANZ JOSEPH. Austrian power was further reduced in the AUSTRO-PRUSSIAN WAR (1866). In 1867 Austria and Hungary set up the Austro-Hungarian empire, whose disregard for individual nationalities precipitated WORLD WAR 1. The defeat of the Central Powers led to the establishment of an Austrian republic. ANSCHLUSS with Germany was forbidden, Engelbert Dollfuss established a totalitarian state, but was unable to stem the rise of Germany. In 1938 Germany annexed Austria, and they jointly fought in WORLD WAR 2. In 1945 the Allies partitioned and occupied Austria. In 1955 Allied forces withdrew and Austria became a neutral federal republic. A succession of coalition governments was halted by the election of a People's Party government (1970), led by Bruno Kreisky, Kreisky remained chancellor until 1983. In 1995 Austria joined the European Union.

ECONOMY

Austria is a wealthy nation which, despite plenty of hydroelectric power, is dependent on the import of fossil fuels. Austria's leading economic activity is the manufacture of metals. Vienna is the main industrial centre. Dairy and livestock farming are the principal agricultural activities. Austria's 20 million annual visitors (1995) are drawn by its historic cities and the winter sports facilities, especially in the TIROL.

A modern car is designed with crumple zones at the front and rear to absorb the energy of a crash and protect the car's passengers. Side-impact protection bars (1) give strength to the side of the vehicle and spread energy to either side of the passenger cell. Fuel tanks (2) are situated in front of the rear axle to protect the tank if the car is hit

from behind. Some manufacturers have replaced the traditional rear brake lights with LEDs (3) which light more quickly. The cover is stepped (4) to prevent the light being obscured by dirt. The suspension, a MacPherson strut (5) system, allows vertical movement through the spring (5) while the wishbone (6) and anti-roll bar (7)

keep the wheels in position and stop excessive roll respectively. Anti-skid braking systems (ABS) (8) prevent the wheels locking under heavy braking or in poor weather. Sensors (9) detect when a wheel is about to lock and release the brake pads for a fraction of a second. An explosive charge inflates the air bag (10) which prevents the driver

or passenger from hitting the steering wheel or dashboard. The steering column (11) is designed to collapse so the driver is not impaled. Seat belt tensioners use the impact to pull the belt tight (12) holding the passenger in place. The headrest (13) helps stop whiplash injuries when heads snap back in the aftermath of the impact.

consisted of glass on one side coated with round particles of starch grains, dyed red, blue and green and mixed at random and compressed. Carbon black was laid between the dots and the whole plate covered with a varnish. An emulsion was applied to the reverse side. In widespread use for over 30 years, this method was an improvement over the earlier 3-colour screen method.

autocracy System of government in which a single person or small group of people wields absolute power. It is imposed and generally aimed at furthering the interests of specific individual s or groups. The term is applied usually to those regimes which came before the development of modern technology and state institutions which made TOTALITARIANISM possible.

autoimmune disease Any one of a group of disorders caused by the body's production of antibodies which attack the body's own tissues. One example of such an autoimmune disease is systemic LUPUS ERYTHEMATOSUS (SLE), an inflammation of the connective tissue occuring most often in young women. The occasional presence of so-called auto-antibodies in an individual does not necessarily indicate autoimmune disease.

Autolycus In Greek mythology, son of Hermes and the mortal Chione. He received from his father the gift of making whatever he touched invisible. In this way he was able to commit numerous thefts until one day he was caught by Sisy-Phus, whose oxen he had stolen.

automation Use of self-governing machines to carry out

manufacturing, distribution and other processes automatically. By using FEEDBACK, sensors check a system's operations and send signals to a computer that automatically regulates the process. *See also* MASS PRODUCTION; ROBOT

automobile Road vehicle that first appeared in the 19th century. The first cars were propelled by steam, but were not a success. The age of the motor car really dates from the introduction (1885-86) of the petrol-driven carriages of Gottlieb Daimler and Karl Benz. The INTERNAL COMBUSTION ENGINE for these cars had been developed earlier by several engineers (most notably Nikolaus Otto in 1876). The main components of a motor car remain unchanged. A body (chassis) to which are attached all other parts including: an engine or power plant; a transmission system for transferring the drive to the wheels, and steering, braking and suspension for guiding, stopping and supporting the car. Early cars were assembled by a few experts, but modern mass-production began in the early 1900s with Henry FORD and R.E. Olds in the USA. In most modern motor factories, component parts are put together on assembly lines. Each worker has a specific task (such as fitting doors or crankshafts). Bodies and engines are made on separate assembly lines which converge when the engine is installed. Overhead rail conveyors move heavy components along the assembly lines, lowering them into position. The final stages of assembly include the fitting of items such as lamps and paint spraying. Electrical, braking and control systems are checked. The assembled car is tested before sale. Recent technology has seen the introduction of robots (properly, robotic arms secured to the workshop floor) on the assembly line. They are usually used for welding and painting. Increasing concern over the environmental impact of the car (such as congestion, pollution and energy consumption) has encouraged governments to examine alternative forms of mass transport, oil companies to produce cleaner fuels, and car manufacturers to look at alternative power plants (such as electric- or gas-powered motors).

autonomic nervous system (ANS) Part of the body's nervous system that regulates the body's involuntary functions. It helps to regulate the body's internal environment by controlling the rate of heart beat, PERISTALSIS and sweating. *See also* HOMEOSTASIS; INVOLUNTARY MUSCL

autopilot (automatic pilot) Electronic and mechanical control system that ensures an aircraft follows a pre-programmed

The diagram shows how a typical autopilot system works. A pre-programmed flight plan is loaded into the aircraft's computers (1). After take-off the autopilot is engaged. Two visual display units (2) show the aircraft's position, its intended route and its attitude. The change in movement of small vanes (3) on the outside of the aircraft alert the computers to any change in the aircraft's orientation. (4) The aircraft

uses a Global Positioning
System (GPS) to determine its
position. The receiver is
located on top of the aircraft
(5). The computers track the
aircraft's route and
automatically make any
adjustments via servos (6)
which control the rudder (7),
elevators (8), aerlirons (9),
flaps (10) and throttle settings
on the engines (11). The pilots
can override the automatic
system at anytime and revert
to manual controls (12).

flight plan. It monitors the course and speed of the aircraft and corrects any deviations from the flight plan. Systems range from simple wing-levellers in light aircraft to computer-operated units consisting of: a GYROSCOPE; an electric SERVOMECHANISM unit and an accelerometer, which measures the acceleration of the aircraft.

Auvergne Region and former province of s France, comprising the départements of Allier, Puy-de-Dôme, Cantal and Haute-Loire. The capital is Clermont-Ferrand. Running N-S are the Auvergne Mountains, a scenic chain of extinct volcanoes, with the highest peak at Puy de Sancy, 1,886m (6,188ft). Area: 26,013sq km (10,047sq mi). Pop. (1990) 1,321,200.

auxin Plant hormone produced mainly in the growing tips of plant stems. Auxins accelerate plant growth by stimulating cell division and enlargement, and by interacting with other hormones. Actions include the elongation of cells in geotropism and phototropism (by increasing the elasticity of cell walls, allowing the cells to take up more water), fruit drop and leaf fall. See also GIBBERELLIN

Avalokitesvara In Buddhism, one of the most distinguished of the Bodhisattvas. Noted for his compassion and mercy, he has remained on Earth in order to bring help to the suffering. Dalai Lamas are considered reincarnations of Avalokitesvara. **avatar** In Hinduism, an incarnation of a god (especially Vishnu) in human or animal form that appears on Earth to combate evil and restore virtue. In Hindu tradition there have been nine incarnations of Vishnu and a tenth is yet to come: these include Buddha, Krishna and Rama.

average In statistics, the one score that most typifies an entire set of scores. It is the arithmetic MEAN of the scores. Other calculations that are also used to express what is typical in a set of scores are the mode (the one score that occurs most often), and the median (the middle score in a range which thus divides the set of scores into upper and lower halves).

Averröes (Abu-al-Walid Ibn-Rushd) (1126–98) Leading Islamic philosopher in Spain. He became physician to the caliph of Marrakesh in 1182, but was banished to Spain in 1195 for advocating reason over religion. His major work, *Incoherence of the Incoherence*, defends Neoplatonism and ARISTOTLE. He exercised a powerful influence on Christian thought that persisted into the Renaissance. *See also* Saint Thomas AQUINAS; SCHOLASTICISM

Avesta (Zend-Avesta) Sacred book of ZOROASTRIANISM. Most of the original was apparently lost when ALEXANDER THE GREAT burned Persepolis, the capital of ancient Persia, in 331 BC. The Gathas, forming the oldest part, originated with Zoroaster. The other remaining parts are the Yashts, Yasna and Vendidad and prayers. Together they contain the world picture, law and liturgy of Zoroastrianism. The writings were systematized under the Sassanid kings of Persia between the 3rd and 7th centuries AD.

Avicenna (979–1037) (Abu Ali al-Husayn ibn abd Allah ibn Sina) Persian physician and philosopher whose work influenced the science of medicine for many centuries. He was the greatest philosopher and scientist of the golden age of Islamic learning. His *Canon Medicinae* became a standard work. He also made enduring contributions in the field of Aristotelian philosophy.

Avignon City at the confluence of the Rhône and Durance rivers, in the Vaucluse département, Provence, SE France. A thriving city under Roman rule, it was the seat of the Popes during their exile from Rome in the 14th century. There is a Papal Palace begun in 1316 and a Romanesque cathedral. The papacy held Avignon until 1791, when it was annexed to France by the Revolutionary authorities. Industries: tourism. soap, wine, grain, leather. Pop. (1990) 83,939.

avocado Evergreen, broad-leafed tree native to the tropical New World. The name is extended to its green to dark purple, pear-shaped fruit. Avocados have a high oil content and a nutty flavour. Weight: 200g (7oz) but exceptionally up to 2kg (4.4lb). Family Lauraceae; species *Persea americana*.

Avogadro, Amedeo, Conte di Quaregna (1776–1856) Italian physicist and chemist. His hypothesis, Avogadro's law (1811), states that equal volumes of gases at the same pressure and temperature contain an equal number of molecules. This

led later physicists to determine that the number of molecules in one gram molecule (the relative molecular mass expressed in grams) is constant for all gases. This number, called Avogadro's number, equals 6.02257×10^{23} . It is both the ratio of the universal gas constant to Boltzmann's constant and of Faraday's constant to the charge of the electron.

Avon Former county in sw England, created in 1974 from areas of Gloucestershire and Somerset. It was replaced in 1996 by the unitary authorities of BATH and North-East SOMERSET, BRISTOL, North-West Somerset and South GLOUCESTERSHIRE.

Avon Name of four British rivers. The **Bristol** (Lower) Avon rises in the Cotswold Hills in Gloucestershire and flows s and then w through Bristol, entering the Severn estuary at Avonmouth. Length: 121km (75mi). The **Warwickshire** (Upper) Avon rises in Northamptonshire, and flows sw through Stratford-on-Avon to join the River Severn at Tewkesbury. Length: 155km (96mi). The **Wiltshire** (East) Avon rises near Devizes and flows s into the English Channel. Length: 77km (48mi). The **Scottish** Avon flows E into the Firth of Forth. Length: 29km (18mi).

axiom Assumption used as a basis for deductive reasoning. The axiomatic method is fundamental to the philosophy of modern mathematics: it was used by the Greeks and formalized early in the 20th century by David Hilbert (1862–1943). In an axiomatic system, certain undefined entities (**terms**) are taken and described by a set of axioms. Other, often unsuspected, relationships (**theorems**) are then deduced by logical reasoning. For example, the points, lines and angles of Euclidean geometry are connected by postulates; theorems, such as Pythagoras' theorem, can be deduced. This geometry describes measurements of position, distance and angle in space.

axis Imaginary straight line about which a body rotates. In mechanics, an axis runs longitudinally through the centre of an axle or rotating shaft. In geography and astronomy, it is a line through the centre of a planet or star, about which the planet or star rotates. Earth's axis between the North and South geographic poles is 12,700km (7,900mi) long and is inclined at an angle of 66.5° to the plane in which the Earth orbits the Sun. A mathematical axis is a fixed line, such as the x, y or z axis, chosen for reference.

Axis Powers Term applied to Germany and Italy after they signed the Rome-Berlin Axis in October 1936. It included Japan after it joined them in the Tripartite Pact (September 1940). Other states that joined the Axis were Hungary and Romania (1940) and Bulgaria (1941).

axolotl Larval form of certain species of SALAMANDER native to w USA and Mexico. Axolotls are aquatic amphibians that normally mature and reproduce without developing into adult salamanders. Length: *c*.25cm (10in). Family Ambystomidae. **ayatollah** (Arabic, reflection of God) Honorific title, bestowed upon a Muslim leader who has attained significant distinction and, often, political influence. *See also* Ayatollah Ruhollah KHOMEINI

aye-aye (aare) Primitive, squirrel-like LEMUR of Madagascar. Nocturnal and tree-dwelling, it has dark shaggy fur and an elongated third finger with which it scrapes insects and pulp from bamboo canes. Length: 40cm (16in) excluding tail. Species *Daubentonia madagascariensis*.

Ayer, Sir A.J. (Alfred Jules) (1910–89) British philosopher. Building on the ideas of the Vienna Circle of positivists and of George Berkeley, David Hume, Bertrand Russell and Ludwig Wittgenstein, he introduced logical positivism into British and US philosophy. His works include Language, Truth and Logic (1936) and Philosophy and Language (1960). Ayers Rock Outcrop of rock, 448km (280mi) sw of Alice Springs, Northern Territory, Australia. Named after the prominent South Australian politician Sir Henry Ayers (1821–97), it remained undiscovered by Europeans until 1872. It stands 348m (1,142ft) high, and is the largest single rock in the world – the distance around its base is about 10km (6mi). The rock, caves of which are decorated with ancient paintings, is of great religious significance to Native Australians. It is known to them as Uluru.

Aymara Major tribe of Native South Americans who live in the highlands of Bolivia and Peru. By 1500 they had been

brought into the INCA empire, which was subsequently conquered by the Spanish. Today, the Aymara number c.1,360,000. Their struggle to survive in a harsh, semi-desert region accounts for their lack of an artistic heritage. The Ayamara language is spoken by about a million people in Bolivia and 3 million people in Peru.

Ayub Khan, Muhammad (1907–74) Pakistani general and statesman, president (1958–69). After the partition of British India, Ayub Khan assumed control of the army in East Pakistan (now Bangladesh). In 1951 he became commander in chief of the army and served as defence minister (1954–56). In 1958 Ayub Khan led the military coup that overthrew Iskander Mirza. He was confirmed as president in a 1960 referendum. His administration was notable for its economic modernization and reforms to the political system. The failure of his regime to deal with poverty and social inequality forced him to resign.

Ayurveda System of medicine practised by the ancient Hindus and derived from the VEDAS. It is still practised in India. **azalea** Name given to certain shrubs and small trees of the genus *Rhododendron*, from temperate regions of Asia and North America. Mostly deciduous, they have leathery leaves and funnel-shaped red, pink, magenta, orange, yellow or white flowers, sometimes variegated. Family Ericaceae.

Azerbaijan Republic in sw Asia. See country feature, p.58 **azimuth** Angle between the vertical plane through a celestial body and the N – s direction. Astronomers measure the angle eastwards from the N point of the observer's horizon. Navigators and surveyors measure it westwards from the s point. Altitude and azimuth form an astronomical co-ordinate system for defining position.

Aznar, Jose Maria (1953–) Spanish statesman, prime minister (1996–). Aznar became president of the Popular Party in 1990. His centrist policies led to him heading a minority government.

Azores Portuguese island group in the N Atlantic Ocean, 1,290km (800mi) w of Portugal. The capital and chief port is Ponta Delgada (on São Miguel). Although they were known to early explorers, such as the Phoenicians and the Norsemen, they were first settled by the Portuguese in the 15th century. In both world wars they were used as military bases. Volcanic in origin, they consist of nine main islands, divided into three groups. A variety of fruits, vegetables and fish are exported. The islands' economy, dependent on small-scale farming and fishing, has improved with the development of tourism. Since 1976 the islands have formed an autonomous region of Portugal. Pico Alto at 2,351m (7,713ft) is Portugal's highest mountain. Area: 2,247sq km (868sq mi). Pop. (1994 est.) 239,900. Azov, Sea of (Azovskoye More) Northern arm of the Black Sea. A shallow sea with only slight salinity, Azov has fishing ports on its E and S coasts. The marshes and lagoons at the w (Crimean peninsula) end were so noxious that the sea was known as Sivash (putrid lake). Area: 37,607sq km (14,520sq mi).

▲ Ayers Rock The site of many ancient cave paintings, Ayers Rock is now officially known by its Native Australian name, Uluru. Lying in Northern Territory, Australia, it is the largest outcrop of free-standing rock in the

▼ avocado A member of the laurel family, the fruit of the avocado tree (*Persea americana*) contains a single large seed surrounded by pale green flesh. When the skin of an avocado is soft it is ripe to eat. It was probably first cultivated by the Aztecs. Mexico is the world's largest producer

Aztec (Tenochca) Native American civilization that rose to a position of dominance in the central valley of MEXICO in *c*.AD 1450. A warlike group, the Aztec settled near Lake Texcoco in about 1325, where they founded their capital Tenochtitlan (now Mexico City). They established an empire that included most of modern Mexico and extended s as far as Guatemala. The state was theocratic, with a number of deities whose wor-

ship included human sacrifice. The Aztec built temples, pyramids and palaces and adorned them with stone images and symbolic carvings. At the time of the Spanish conquest, Aztec society was based on the exploitation of labour. As a result Hernán Cortés was able to use disaffected labourers to help him defeat the Aztec in 1521. See also Central and South American Mythology

AZERBAIJAN

Azerbaijan's flag was adopted in 1991. The blue stands for the sky, the red for freedom and the green for the land and for Islam. The crescent and the star also symbolize Islam. The points of the star represent the eight groups of people in Azerbaijan.

AREA: 86,600sq km (33,436sq mi)

POPULATION: 7,398,000

CAPITAL (POPULATION): Baku (1,100,000)
GOVERNMENT: Federal multiparty republic
ETHNIC GROUPS: Azerbaijani 83%, Russian 6%,
Armenian 6%, Lezgin, Avar, Ukrainian, Tatar

LANGUAGES: Azerbaijani (official)
RELIGIONS: Islam (Shiite Muslim)
CURRENCY: Manat = 100 gopik

Azerbaijan lies in E Transcaucasia, bordering the CASPIAN SEa to the E. The CAUCASUS Mountains are in the N and include Azerbaijan's highest peak, Mount Bazar-Dyuzi, at 4,480m (14,698ft). Another highland region, including the Little Caucasus Mountains and part of the rugged Armenian plateau, lies in the sw. Between these regions lies a broad plain drained by the River Kura; its eastern part (s of the captial, BAKU) lies below sea level. Azerbaijan also includes the autonomous republic of NAKHICHEVAN on the Iran frontier, totally cut off from the rest of the state by ARMENIA.

CLIMATE AND VEGETATION

Azerbaijan has hot summers and cool winters. The rainfall is low on the plains, ranging from c.130–380mm (5–15in) a year, but is much

higher in the highlands and on the subtropical SE coast. Forests of beech, oak and pine trees grow on the mountain slopes, while the dry lowlands comprise grassy steppe or semi-desert.

HISTORY AND POLITICS

In ancient times the area now called Azerbaijan was invaded many times. Arab armies introduced Islam in 642, but most modern Azerbaijanis are descendants of Persians and Turkic peoples who migrated to the area from the E by the 9th century. Azerbaijan was ruled by the the MONGOLS between the \$\pi\$3th and 15th centuries and then by the Persian SAFAVID dynasty. By the early 19th century it was under Russian control.

After the Russian Revolution of 1917, attempts were made to form a Transcaucasian Federation made up of Armenia, Azerbaijan and GEORGIA. When these attempts failed, Azerbaijanis set up an independent state, but Soviet forces occupied the area in 1920. Finally, in 1922 Azerbaijan became part of the Soviet Republic of TRANSCAUCASIA, but in 1936 it gained the status of a separate socialist republic within the SOVIET UNION.

Under Mikhail GORBACHEV, the Soviet Union began to introduce social and political reforms in the late 1980s. By 1991 the Soviet Union was defunct and, like its neighbours, Azerbaijan became an independent nation. In 1993 Gaidar Aliev was elected president and Azerbaijan joined the Commonwealth of Independent States (CIS).

Since independence, economic progress has been slow, largely because of civil unrest in NAGORNO-KARABAKH, a large enclave within Azerbaijan where the majority of the population are Christian Armenians. In 1992 Armenia occupied the area between its E border and Nagorno-Karabakh, while ethnic Armenians took over Nagorno-Karabakh itself. The ensuing war killed thousands of people and resulted in large migrations of both Armenians and Azerbaijanis. A cease-fire was agreed in 1994, with c.20% of Azerbaijan territory remaining under Armenian control. There was little sign of a long-term solution to the problem, however, and sporadic fighting continued into 1997.

ECONOMY

With its economy in disarray since the dissolution of the Soviet Union, Azerbaijan now ranks among the world's lower-middle-income countries (1992 GDP per capita, US\$2,550). Its chief resource is oil - Azerbaijan is one of the world's oldest centres of production - with the main oilfields in the Baku region, both on the shore of the Caspian Sea and in the sea itself. In 1994 Azerbaijan invited Western companies to develop and exploit the offshore oil deposits. Manufacturing, including oil refining and the production of chemicals, machinery and textiles, is the most valuable activity. Large areas of land are irrigated and crops include cotton, fruit, grains, tea, tobacco and vegetables. Fishing is still important, although the Caspian Sea is becoming increasingly polluted. Under the communists, most economic activity was subject to strict state control, but (as with most other former Soviet republics) private enterprise is now encouraged.

Baade, Walter (1893–1960) US astronomer, b. Germany. From Mount Wilson Observatory, in the 1943 wartime black-out, he observed individual stars in the Andromeda Galaxy and distinguished the younger, bluer Population I stars from the older, redder Population II stars. He went on to improve the use of CEPHEID VARIABLE stars as distance indicators, and showed that the Universe was older and larger than had been thought.

Baalbek Town in E Lebanon. An early Phoenician settlement, it was occupied by the Greeks in 323 BC and renamed Heliopolis. It was colonized by the Romans in the 1st century BC. It is noted for its Greek and Roman remains, especially the Temple of Jupiter.

Ba'ath Party Arab political party, founded in 1943. Its major objectives are socialism and Arab unity. It is strongest in Iraq and Syria, and militaristic elements of the Ba'ath Party seized power in those countries in 1968 and 1970 respectively. *See also* Saddam HUSSEIN

Babbage, Charles (1791–1871) British mathematician. He compiled the first actuarial tables and planned a mechanical calculating machine, the forerunner of the modern COMPUTER. He failed to complete the construction of the machine because the financial support recommended by the Royal Society was refused by the British government.

Babbitt, Milton (1916–) US composer, musicologist and teacher. Babbitt studied with Roger Sessions and his mathematical background influenced his music. He systematized the analysis of TWELVE-TONE MUSIC. His compositions include vocal, piano and chamber music, as well as electronic music.

Babel, Isaac Emmanuelovich (1894–1941) Russian short-story writer. His works, many of which are informed by his military service and experience of persecution, include *Tales of Odessa* (1924) and *Red Cavalry* (1926). He died a victim of Stalinist purges in a Siberian concentration camp.

Babel, Tower of Tower begun on the plain of Shinar, in Babylonia, by the descendants of NoAH as a means of reaching heaven (Genesis 11). God prevented its completion by confusing the speech of the people and scattering them throughout the world. The Genesis story was probably inspired by a ZIGGURAT or staged temple-tower in Babylon, seven storeys high and with a shrine to the god Marduk on its top.

Babi faith (Babism) Muslim religious sect founded in 1844 in Persia (Iran) by Sayyid Ali Muhammad, the self-proclaimed prophet Bab (Arabic, "gate"). Drawing on the teachings of existing branches of Islam, Babists believed in the imminent coming of the Promised One. In 1848 they declared secession from Islam, but their rebellion against the new shah of Iran was crushed and their founder was executed in 1850.

baboon Large African MONKEY with a dog-like face, which walks on all fours. Its buttocks have callus-like pads surrounded by brilliantly coloured skin. Baboons are ground dwellers and active by day, travelling in families and larger troops led by old males, usually in open, rocky country. Their diet consists of plants, insects and small animals. They can carry food in their cheek pouches. The males have large canine teeth up to 5cm (2in) long. Weight: 14–41kg (30–90lb). Genus *Chaeropithecus* (or *Papio*).

Babur (1483–1530) First Mogul emperor of India (1526–30), b. Zahir ud-Din Muhammad. Babur (Turk. tiger) became ruler of FERGANA in 1495 and engaged in a long conflict for control of SAMARKAND, but ultimately lost both territories. Raising an army, he captured KABUL and carved out a new kingdom for himself in Afghanistan. From here he invaded India, gaining Delhi (1526) and Agra (his future capital) (1527), and conquering N India as far as Bengal.

Babylon Ancient city on the River Euphrates in Mesopotamia, capital of the empire Babylonia. It was rebuilt after being destroyed by Assyria c.689 BC, and its new buildings included the Hanging Gardens, one of the Seven Wonders of the World. This was the period, under Nebuchadnezzar, of the Babylonian Captivity of the Jews. Babylon declined after 275 BC, as Seleucia ascended.

Babylonia Ancient region and empire of MESOPOTAMIA, based on the city of BABYLON. The Babylonian empire was first established in the early 18th century BC by HAMMURABI the Great, but declined under the impact of HITTITES and Kas-

sites in c.1595 BC. After a long period of weakness and confusion, the empire eventually fell to Assyria in the 8th century BC. Babylon's greatness was restored and in c.625 BC its independence was won by Nabopolassar, who captured the Assyrian capital of Nineveh. This New Babylonian (Chaldaean) empire defeated Egypt and took the Jews to captivity in Babylon in 586 BC. In 538 BC it fell to the Persians.

Babylonian Captivity Deportation of the Jews to Babylon, between the capture of Jerusalem in 586 BC by NEB-UCHADNEZZAR and the reformation of a Palestinian Jewish state (c.538 BC) by CYRUS THE GREAT. Many Jewish religious institutions, such as SYNAGOGUES, were founded in the period of exile and parts of the Hebrew Bible also date from this time. The term was later applied to the exile of the popes at AVIGNON (1309–77). See also DIASPORA; GREAT SCHISM

Bacall, Lauren (1924–) US film actress. Following her screen debut opposite Humphrey BOGART, in *To Have and Have Not* (1944), the two married in 1945. They starred together in a further three films, including the classics *The Big Sleep* (1946) and *Key Largo* (1948). She wrote an autobiography, *Lauren Bacall by Myself* (1979).

Bacchus In Roman mythology, the god of wine and fertility, identified with the Greek god DIONYSUS.

Bach, Carl Philipp Emanuel (1714–88) German composer, second surviving son of J.S. BACH. The most prolific and famous of Bach's sons, he wrote over 150 keyboard sonatas, 20 symphonies, c.50 harpsichord concertos, numerous chamber works, much sacred music and c.300 songs. He was widely esteemed as a keyboard player and became a leading theorist with his Essay on the True Art of Keyboard Playing (1753–62). Bach, Johann Christian (1735–82) German composer, youngest son of J.S. BACH. He was organist at Milan Cathedral, composed operas that were staged in Turin and Naples, but soon moved to London where his operas were better received. In 1763 he was made music-master to Queen Charlotte. Besides 11 operas, he wrote many instrumental and vocal works. He was much admired by Mozart.

Bach, Johann Sebastian (1685-1750) Prolific German BAROQUE composer. He held a series of successive court positions as organist and music director and had 20 children, four of whom were also composers. Bach brought contrapuntal forms to their highest expression and is unrivaled in his ability to interweave melodies within the exacting rules of baroque harmony and counterpoint. While at the court in Weimar (1708–17), he wrote many of his great organ works (preludes, fugues, toccatas), such as the Fugue in C minor. At Köthen (1717–23), he wrote instrumental works for keyboard, such as Book I of the The Well-Tempered Clavier, and the six Brandenburg Concertos for chamber orchestra. As musical director of St Thomas, Leipzig (1723-50), Bach wrote his celebrated church music, including St Matthew Passion (1729) and Mass in B Minor. Other works included the Goldberg Variations (1742). The Art of Fugue remained incomplete at his death.

B/b, second letter of the alphabet. It is probably derived from an Egyptian hieroglyph for a house (c.3000 BC), which entered the Semitic alphabet 1,500 years later as the letter beth. From there it was taken to Greece to become beta, which was a similar shape to the modern B.

■ Babylon Early Babylon was often rebuilt. The excavated, sophisticated layout we see today was created mainly by Nebuchadnezzar II (c.604-561 BC). Old city (1) and new (2) are separated by the River Euphrates (3), and contained within two fortification walls, reinforced by a moat (10) and accessible through fortified gateways connected to the major streets. A SE outer wall gave additional protection. The ritual Processional Way (4) enters the new city through the Ishtar Gate (5), passing a fortress (6) and the main citadel complex (7) of administration and garrison buildings, palaces and vaulted Hanging Gardens. Skirting Etemenanki enclosure with its ziggurat (8) - possibly that of Babel - it turns w past the temple of Marduk (9) and crosses the five-pier bridge to the old city. Navigable canals irrigated the dry soil and helped prevent flooding of the Euphrates.

shapes: spherical forms called cocci (A), rod-like bacilli (B), and spiral spirilla (C). Cocci can occur in clumps known as staphylococci (1), groups of two called diplococci (2) or chains called streptococci (3). Unlike cocci, which do not move, bacilli are freely mobile; some are termed peritrichous and use many

flagellae (4) to swim about, while other monotrichous forms use a single flagellum (5). Bacilli can also form spores (6) to survive unfavourable conditions. Spirilla may be either corkscrew-shaped spirochaetes like Leptospira (7), or less coiled and flagellated, such as Spirillum (8) (magnification x 5,000).

bacillus Genus of rod-like BACTERIA present eveywhere in the air and soil. One example of a species that is pathogenic in man is *Bacillus anthracis*, which causes ANTHRAX.

background radiation Radiation that is normally present in an environment. Such radiation must be taken into account when measuring radiation from a particular source. On Earth, background radiation is caused by the decay of naturally occurring radioactive substances in surface rocks. In space, the socalled "microwave background" is attributed to the BIG BANG. Bacon, Francis (1561–1626) British philosopher, statesman and early advocate of the scientific method. He was also an important essayist. Successively attorney general, lord keeper and lord chancellor, he was forced to resign his offices in 1621 when found guilty of corruption. None of this interrupted his efforts to break the hold of Aristotelian LOGIC and establish an inductive EMPIRICISM. He entertained the idea of cataloguing all useful knowledge in his Advancement of Learning (1605) and Novum Organum (1620). The New Atlantis (1627) discusses his philosophy as practised in an imaginary nation.

Bacon, Francis (1909–92) British painter, one of the most controversial artists of his generation. He changed the face of English painting in 1945 when he exhibited his TRIPTYCH, Three Studies for Figures at the Base of a Crucifixion. The shock of the distorted representations of grieving people in his work stems from his violent handling of paint as much as from the subjects themselves. Precedents for Bacon's nightmarish scenes lie in the vengeful images of medieval doom paintings. The religious focus of his work continued in an astonishingly savage series of portraits of Roman Catholic popes. The protagonists of his pictures are usually set against a formless, blank background. For much of his life Bacon was shunned by the critical establishment.

bacteria Simple unicellular microscopic organisms. They lack a clearly defined nucleus and most are without CHLORO-PHYLL. Many are motile, swimming by means of whip-like flagella. Most multiply by FISSION. In adverse conditions, many can remain dormant inside highly resistant SPORES with thick protective coverings. Bacteria may be AEROBIC or ANAEROBIC. Though pathogenic bacteria are a major cause of human dis-

ease, many bacteria are harmless or even beneficial to humans by providing an important link in FOOD CHAINS, by decomposing plant and animal tissue, or converting free nitrogen and sulphur into AMINO ACIDS and other compounds that plants and animals can use. Some contain a form of chlorophyll and carry out PHOTOSYNTHESIS. Bacteria belong to the kingdom Prokaryotae. See also ARCHAEBACTERIA: EUBACTERIA

bacteriology Scientific study of BACTERIA. Bacteria were first observed in the 17th century by Anton van LEEUWENHOEK, but it was not until the mid-19th century researches of Louis PASTEUR and Robert Koch that bacteriology was established as a scientific discipline.

bacteriophage Virus that lives on and infects BACTERIA. It has a protein head containing a core of DNA and a protein tail. Discovered in 1915, it is important in the study of GENETICS.

Baden-Powell, Robert Stephenson Smyth, Baron of Gilwell (1857–1941) British soldier and founder of the Boy Scout movement. He held Mafeking against the Boers (1899–1900). His sister Agnes (1858–1945) founded the GIRL GUIDES (1910). His wife, Lady Olave (1889–1977), also did much to promote these movements worldwide.

Baden-Württemberg State in sw Germany, formed in 1952 by the merger of Baden, Württemberg-Baden and Württemberg-Hohenzollern; the capital is STUTTGART. A forested and fertile region drained by the Rhine and Danube rivers, agriculture and livestock-rearing are important, but industry is the main economic activity. Chief manufactures include electrical goods, machinery and vehicle-assembly at the industrial centres of Stuttgart, MANNHEIM and Karlsruhe. There are famous universities at HEIDELBERG and Freiburg im Breisgau. A popular tourist region, visitors are drawn to the spa at Baden-Baden and the beauty of the Neckar Valley and the Black Forest. Area: 35,750sq km (13,803sq mi). Pop. (1993) 10,234,000.

badger Burrowing, nocturnal mammal that lives in Eurasia, North America and Africa. It has a stocky body with short legs and tail. Eurasian badgers (*Meles meles*) have grey bodies with black-and-white striped heads. American badgers (*Taxidea taxus*) are smaller and have grey-brown to red fur with a white head stripe. Length: 41–71cm (16–28in); weight: 10–20kg (22–44lb). Family Mustelidae.

badlands Area with very little vegetation where severe stream erosion has produced closely-spaced deep gullies and ravines. An example is the badlands in Nw Nebraska, USA. **badminton** Court game for two or four players, popular since

the 1870s. The rules were drawn up in Pune, India and codified with the formation of the Badminton Association (1893). The object is to use a light racket to volley a shuttlecock over a net until missed or hit out of bounds by an opponent. Only the player serving can score a point; games are played to 15 points. **Baekeland, Leo Hendrik** (1863–1944) US chemist, b. Belgium. He invented a type of photographic paper, Velox, capable of being developed under artificial light. He also invented the first thermosetting PLASTIC, BAKELITE.

Baffin, William (1584–1622) English navigator and explorer. He took part in several expeditions (1612–16) in search of the Northwest Passage. He discovered the Canadian Arctic seaways, the island now named after him and Lancaster Sound. An outstanding navigator, he published a method of determining longitude by the stars, using nautical tables, and was possibly the first to make lunar observations at sea.

Baffin Island Largest and most easterly island of the Canadian Arctic Archipelago, separated from QUEBEC province by the Hudson Strait. It is the fifth-largest island in the world, with largely mountainous terrain and an almost entirely Inuit population. Area: 507,451sq km (195,928sq mi).

▶ badger Eurasian badgers (Meles meles) of s China live in large family groups in large burrows known as setts. Setts have a complex network of tunnels and chambers, each serving a particular function.

Bagehot, Walter (1826–77) British economist and writer. Editor of *The Economist* (1860–77), he is chiefly remembered for his influential treatise *The English Constitution* (1867).

Baghdad Capital of Iraq, on the River Tigris. Established in 762 as capital of the ABBASID caliphate, it became a centre of Islamic civilization and focus of caravan routes between Asia and Europe. It was almost destroyed by the Mongols in 1258. In 1921 Baghdad became the capital of newly independent Iraq. It was badly damaged during the Gulf War (1991). Notable sites include the 13th-century Abbasid Palace. Industries: building materials, textiles, tanning, bookbinding. Pop. (1987 est.) 3,850,000.

bagpipes Musical instrument with reed pipes connected to a windbag held under the arm and filled by mouth or bellows. The chanter pipe has finger-holes for melody, while drone pipes produce monotone accompaniment.

Baha'i Religion founded in the 1860s by BAHAULLAH as an outgrowth of the BABI FAITH. Its headquarters are in HAIFA, Israel. It seeks world peace through the unification of all religions and stresses a simple life dedicated to serving others. It recognizes Bahaullah as the latest prophet of God.

Bahamas Small independent state in the West Indies, in the W Atlantic, SE of Florida. It consists of c.700 islands, 2,000 cays and numerous coral reefs. The largest island is Grand Bahama and the capital is NASSAU (on New Providence). The islands consist mainly of limestone and coral, and the rocky terrain provides little chance for agricultural development. Most of the islands are low, flat and riverless with mangrove swamps. The climate is subtropical, with temperatures averaging 21-32°C (70-90°F). The population is 90% African or African-European, and the majority live on New Providence. Anglicanism is the predominant religion, and English the official language. Before the arrival of the Europeans, the islands were inhabited by the Lucayos, who were later exterminated by the Spanish. San Salvador island is traditionally believed to have been the first stop of Christopher Columbus in his quest of the New World (1492). The islands were partially settled by England's Eleutherian Adventurers (1648). Charles II granted the islands to six lord proprietors of Carolina in 1670, but development was continually hindered by pirates. Britain assumed direct control by 1729, expelling militants and restoring civil order. Held briefly by Spain (1782) during the American Revolution, the islands were given back to England by the Treaty of Versailles (1783) in exchange for E Florida. In 1834 slavery was abolished. During World War 2 the Bahamas were used by US and British forces for training and air bases. In 1963 a new constitution provided for parliamentary government. In 1973 the Bahamas became an independent nation. Industries: tourism, commercial fishing, salt, rum, handicrafts. Area: 13,860sq km (5,350sq mi). Pop. (1992 est.) 264,000. See West Indies map Bahaullah (1817-92) Name adopted by Mirza Husayn Ali Nuri, Persian religious leader and founder of the BAHA'I faith. He embraced the BABI FAITH in 1850 but broke away in 1867, proclaiming himself Bahaullah ("The Glory of Allah"), the Promised One foretold by Bab. His work, the Katabi ikan (Book of Certitude) is the Baha'i holy book.

Bahia Coastal state in E Brazil; the capital is SALVADOR. Portuguese explorers reached Bahia in 1501. Declared a province in 1823, it achieved statehood in 1889. Products: cacao, tobacco, hardwood, natural gas, lead, asbestos, hydroelectricity. Area: 561,026sq km (216,612sq mi). Pop. (1991) 11,801,810. Bahrain Emirate archipelago in the Persian (Arabian) Gulf, sw Asia; the capital is MANAMA. Comprising 34 small islands and the largest island of Bahrain, oil was discovered in 1932 and the sheikhdom led the regional development of oil production. It is a hot, desert kingdom linked by a causeway to the Saudi Arabian mainland. From 1861 to 1971 Bahrain was a British protectorate. Since the late 18th century Bahrain has been governed by the Khalifa family. The 1970s' drop in oil production led to economic diversification. Bahrain's aluminium-smelting plant is the Gulf's largest non-oil industrial complex. While other economic sectors have grown, oil still accounts for 80% of Bahrain's exports and 20% of its GDP. Over 25% of Bahrain's population are migrant workers, mainly from India and Pakistan. Bahrain is a predominantly

■ bagpipes Although associated with Celtic music, the bagpipes probably originated in Asia. The drone usually has a single reed. Somewhat limited by its short range, the bagpipes are associated with folk and military music.

Muslim nation. Tensions exist between the SUNNI and majority SHIITE population, the latter pressing for an Islamic republic. During the IRAN-IRAQ WAR (1980–88), Bahrain supported Iraq, prompting Iran to reiterate its territorial claims to the archipelago. Bahrain also has a long-standing dispute with QATAR over a cluster of oil-rich islands and reefs. Area: 678sq km (262sq mi). Pop. (1995 est) 558,000.

Baikal, Lake (Baykal) World's deepest lake in s Siberia, Russia; the largest freshwater feature in Asia. Fed by numerous small rivers, its outlet is the River Angara. Framed by mountains, it has rich fish stocks and the only freshwater seal species. Its ecology has been threatened by pollutants from lakeside factories and government schemes have been introduced to protect the environment. Irkutsk lies on its N shore and the Trans-Siberian Railway runs along its s edge. Area: 31,494sq km (12,160sq mi). Max. depth: 1,743m (5,714ft).

Baird, John Logie (1888–1946) Scottish electrical engineer, inventor of TELEVISION. In 1926 he demonstrated the first working television to members of the Royal Institution, London. In 1928 he transmitted to a ship at sea, and in 1929 was granted experimental broadcasting facilities by the BRITISH BROADCASTING CORPORATION (BBC). His 240-line, part-mechanical, television system was used for the world's first public television service by the BBC in 1936. In 1937 it was superseded by MARCONI's fully electronic scanning.

Baja California (Lower California) Peninsula of NW Mexico, extending SSE for 1,220km (760mi) between the Gulf of California and the Pacific Ocean. The peninsula consists of two states, Baja California Norte (capital: Mexicali) and Baja California Sur (capital: La Paz). The chief product of the region is long-staple cotton and the main industry is tourism. Area: 143,790sq km (55,517sq mi). Pop. (1990) 1,978,619.

Bakelite Trade name (coined by Leo BAEKELAND) for a thermosetting plastic used for insulating purposes and in making paint. It was the first PLASTIC made by the process of condensation, in which many molecules of two chemicals (in this case phenol and formaldehyde) are joined together to form large polymer molecules, by splitting off water molecules.

Baker, James Addison (1930–) US Republican Party politician. After serving under Ronald REAGAN as White House chief of staff (1981–85) and secretary of the treasury (1985–88), Baker managed the successful 1988 presidential election campaign of George Bush. As Bush's secretary of state (1989–92), much of his focus was on the Middle East, particularly Iraq's invasion of Kuwait (1990) and the subsequent GULF WAR (1991). In 1992 Baker became Bush's chief of staff and supervised his unsuccessful bid for re-election.

Baker, Dame Janet Abbott (1933–) English mezzosoprano. She was renowned as a singer of *Lieder*, oratorio and opera. Well known at the ROYAL OPERA HOUSE (Covent Garden), Sadler's Wells and GLYNDEBOURNE, she is particularly admired for her interpretations of Mahler's song cycles. Baker, Josephine (1906–75) US dancer and singer. After a sensational 1925 Paris debut in *La Revue Nègre*, she became internationally famous for her jazz singing and dancing. Her outrageous art deco costumes and regal stage act made her one of the most photographed stars of the era. She took French citizenship in 1937 and was made a member of the French Legion of Honour for her work in the resistance.

Bakke Case (1978) US Supreme Court case involving Allan Bakke, who was refused admission (1972) to the University of California. He sued the university on a charge that he had been passed over in favor of less qualified applicants. The Supreme Court ruled that Bakke had been a victim of reverse discrimination and must be admitted to the university.

Baku Capital of Azerbaijan, a port on the w coast of the Caspian Sea. A trade and craft centre in the Middle Ages, Baku prospered under the Shirvan shahs in the 15th century. Commercial oil production began in the 1870s. At the beginning of the 20th century, Baku lay at the centre of the world's largest oil field. The port handles a vast quantity of oil and petroleum products. Industries: oil processing and equipment, shipbuilding, electrical machinery, chemicals. Pop. (1993) 1,100,000.

Bakunin, Mikhail Alexandrovich (1814–76) Russian political philosopher. He became a believer in violent revolution while in Paris in 1848, and was active in the first Communist International until expelled by Karl Marx in 1872. His approach, known as revolutionary ANARCHISM, repudiates all forms of governmental authority as fundamentally at variance with human freedom and dignity. In God and the State (1882) Bakunin argued that only natural law is consistent with liberty. Balaclava (Balaklava) Town in the Crimea, site of an inconclusive battle (1854) during the CRIMEAN WAR. The British, French and Turks held off a Russian attack on their supply port of Balaclava. The battle is famous for a disastrous charge by Lord Cardigan's Light Brigade to capture Russian guns, as recorded in a poem by Alfred TENNYSON.

Balakirev, Mili Alexeyevich (1837–1910) Russian composer. He was one of the RUSSIAN FIVE dedicated to promoting Russian nationalism in 19th-century music. To this end he incorporated Russian folk idioms into his compositional style. His best-known compositions are two symphonies, Islamey (1869) and incidental music to King Lear (1858–61). He founded the St Petersburg Free School of Music in 1862. balalaika Triangular musical instrument popular in Russia. Strings (usually three) are fingered on a fretted neck and may be picked, or plucked with the fingers. It sounds similar to the MANDOLIN.

balance of payments Overall surplus or deficit that occurs as a result of the exchange of all goods and services between one nation and the rest of the world. A country with a balance of payments deficit must finance it by borrowing from other countries or the International Monetary Fund (IMF), or by using foreign currency reserves. Such deficits, if frequent, can pose a serious problem, because they cause a reduction in the reserves. This in turn leads to economic pressure for Devaluation in order to correct the imbalance. A country with a surplus is in a favourable position, but may come under international pressure to revalue its currency.

Balanchine, George (1904–83) US choreographer and ballet dancer. One of the greatest artists in 20th-century ballet, in 1924 Balanchine defected from Russia to work as principal dancer and choreographer for DIAGHILEV and the BALLETS RUSSES. He moved to the USA in 1933, established the School of American Ballet and was director of the Metropolitan Opera ballet (1934–37). He became the first artistic director and choreographer of the New York City Ballet (1948). Credited with creating US neoclassical ballet, he also undertook film choreography for the Ziegfeld and Goldwyn Follies. Ballet pieces include *The Prodigal Son* (1929), *The Nutcracker* (1954) and *Don Quixote* (1965).

Balaton Largest lake in central Europe, sw of Budapest, in

central Hungary. Rich in fish, many holiday resorts and vineyards line its shores. Area: 600sqkm (232sq mi).

Balboa, Vasco Núñez de (1475–1519) Spanish conquistador, the first European to see the Pacific Ocean. He went to Hispaniola in 1500 and to Darién (Panama) ten years later. In September 1513, accompanied by a group of locals he crossed the isthmus and saw the Pacific, which he called the South Sea. He was later executed on a false charge by the governor. bald cypress (swamp cypress) Deciduous tree growing in shallow water in SE USA. They have woody growth on the roots that grow above water and lose their feathery, light green needles in autumn. Height: to 15ft (4.6m). Family Taxodiaceae; species *Taxodium distichum*.

bald-headed eagle Large bird of prey that lives in North America, where it feeds on fish and small mammals. It is brown with a white head and tail and a yellow bill. Its tail feathers were used in the head-dresses of some Native Americans and it is the national emblem of the USA. Though now protected by law, it remains an endangered species. Species *Haliaeetus leucocephalus*

Baldwin, James (1924–87) US author. Badlwin's work explores social prejudice experienced by African-American and gay communities. His prose is inflected with blues and gospel rhythms. His first novel, Go Tell It on the Mountain (1953), was semi-autobiogaphical and has become an American classic. In the novel Giovanni's Room (1956), he explored issues of gay love. His most celebrated novel is Another Country (1962). Essay collections include Notes of a Native Son (1955), Nobody Knows My Name (1961) and The Fire Next Time (1963). Baldwin was prominent in the US CIVIL RIGHTS movement.

Baldwin, Robert (1804–58) Canadian statesman. He shared the first premiership of united Canada with Louis la Fontaine, who represented the French of Lower Canada (1841–43, 1847–51). He advocated cooperation between French and British Canadians, organized an effective system of municipal government for Ontario and reorganized the courts.

Baldwin, Stanley, 1st Earl of Bewdley (1867–1947) British Conservative statesman and prime minister (1923–24, 1924–29, 1935–37). He entered parliament in 1908, and was chancellor of the exchequer (1922–23) before succeeding Bonar Law as prime minister. Baldwin responded to the General Strike (1926) by passing the Trades Disputes Acts (1927), which made any subsequent general strikes illegal. Baldwin opposed EDWARD VIII's marriage to Wallis Simpson and secured his abdication (1936). Baldwin's APPEASEMENT of European fascism is often cited as a cause of Britain's lack of preparedness at the start of World War 2.

Balearic Islands Group of Spanish islands in the W Mediterranean, off the E coast of Spain; the capital is PALMA. The islands were successively occupied by all the great Mediterranean civilizations of antiquity. In the 11th century a Moorish kingdom used them as a base for piracy. The chief islands are MAJORCA, Minorca and IBIZA. Industries: tourism, silverworking, olive oil, wine, fruit. Area: 5,014sq km (1,936sq mi). Pop. (1991) 709,138.

Balfour, Arthur James Balfour, 1st Earl of (1848–1930) British statesman, prime minister (1902–05), b. Scotland. Balfour succeeded his uncle, the Marquess of Salisbury, as prime minister. His government introduced educational reforms (1902), but the Conservative Party fractured over the tariff reform proposed by Joseph Chamberlain. Balfour resigned and the Conservatives lost the ensuing general election. Balfour returned to the cabinet in the coalition governments of Herbert Asquirth and David Lloyd George. As foreign secretary, he issued the Balfour Declaration (1917).

Balfour Declaration (1917) Letter written by British foreign minister Arthur Balfour to the British Zionist Federation pledging support for the settlement of Jews in Palestine. Jews were admitted to the area when it became a British mandated territory after World War 1. See also Zionism

Bali Island province off the E tip of Java, between the Bali Sea and the Indian Ocean, Indonesia. The main town is Denpasar. Under Javanese control from the 10th century, Bali was a Dutch possession from 1908 to 1949, apart from Japanese

occupation during World War 2. It is the centre of Majaphit Hinduism. Its scenic beauty and native culture make it a popular tourist resort. The island is fertile and densely populated. Industries: rice, sweet potatoes, cassava, copra, meat processing. Area: 5,561sq km (2,147sq mi). Pop. (1990) 2,777,811.

Balkan Mountains Major mountain range of the Balkan Peninsula extending from E Serbia through central Bulgaria to the Black Sea; a continuation of the CARPATHIAN MOUNTAINS. It is rich in minerals and forms a climatic barrier for the inland regions. The highest pass is Shipka Pass, c.1,270m (4,166ft), and the highest peak is Botev, 2,375m (7,793ft).

Balkan states Group of countries in the Balkan Peninsula, SE Europe, consisting of Albania, Bosnia-Herzegovina, Bulgaria, Croatia, Greece, Macedonia, Romania, Serbia and European Turkey. From the 3rd century ad the region was ruled by Byzantium. It was later invaded by Slav peoples, and then for 500 years formed part of the Ottoman empire. The individual countries regained independence in the 19th century. Balkan Wars (1912–13) Two wars involving the Balkan States and the Ottoman empire. In the first, the Balkan League (Serbia, Bulgaria, Greece and Montenegro) conquered most of the European territory of the Ottoman empire. The second war (mainly between Serbia and Bulgaria) arose out of dissatisfaction with the distribution of these lands. Serbia's victory added to the regional tension before World War 1.

Balkhash (Balchas) Lake in SE Kazakstan extending from the Kazak Hills (NE) to the desert steppes (sw). It has no outlet. The chief inlet is the freshwater Ili River, therefore the w half of the lake is freshwater, with salinity increasing towards the E. Area: 18,428sq km (7,115sq mi). Max. depth: 26m (85ft).

Balla, Giacomo (1871–1958) Italian artist. Influenced by the poet MARINETTI, founder of FUTURISM, Balla adopted the movement's philosophical outlook and urged artists to use art as a means to change Italy's culture through the acceptance of science and technology. His works, which emphasize movement and abstraction, include *The Street Light – Study of Light* (1909) and *Dynamism of Dog on a Leash* (1912).

ballad (Lat. ballare, to dance) Form of popular poetry which is regularly sung, narrative in style with simple metre, rhyme and often a refrain. The first surviving examples date from medieval times, and typically consist of four-line stanzas. The ballad was a vital means of perpetuating community myth, the traditions of storytelling and the celebration of rites. Notable later examples include Lyrical Ballads (1798), written by Wordsworth in collaboration with Coleridge. The late-18th century revival of the ballad was central to the rise of ROMANTICISM. It was also used by SWINBURNE, Sir Walter Scott and Rudyard KIPLING.

Balladur, Edouard (1929–) French statesman, Gaullist prime minister (1993–95). Balladur was elected to parliament in 1986 and became (1988) minister of economy and finance. In 1995 his lacklustre campaign for the presidency was tainted by charges of corruption, and he lost to Jacques CHIRAC.

Ballard, J.G. (James Graham) (1930–) British novelist and short story writer. He was initially associated with sophisticated science fiction through novels such as *The Wind from Nowhere* (1962), *The Drought* (1965) and *The Crystal World* (1966). The popular, semi-autobiographical novel *Empire of the Sun* (1984), dealt with his childhood experiences of a World War 2 Japanese prisoner of war camp. Its sequel was *The Kindness of Women* (1991).

Ballesteros, Severiano (1957–) Spanish golfer. After winning the Spanish Young Professional title (1974), he won the British Open (1979) as the youngest champion this century, and in 1980 became the youngest player to win the US Masters. Regarded as one of the most exciting golfers of his era, he won the Masters again in 1983 and the British Open in 1984 and 1988. He was an inspiring member of the European Ryder Cup teams from 1985 and captained them to victory in 1997.

ballet Theatrical dance form set to music. The first formal ballet, *Ballet comique de la Reine*, was performed at the court of Catherine de' Medici (1581). Thoinot Arbeau (1519–95) wrote the first treatise on ballet, *Orchésographie* (1588) and LOUIS XIV founded the Royal Academy of Dance in 1661. Exclusively performed by male dancers, ballet was confined to the

French court. The Triumph of Love (1681) was the first ballet to use trained female dancers. The first public performance of a ballet was in 1708. Choreographic notation was developed, and Pierre Beauchamp (1631-1719) established the five classical positions. Jean-Georges Noverre (1727-1810), the most influential choreographer of the 18th century, argued for a greater naturalism. In 1820 Carlo Blasis (1797-1878) codified the turn out technique, which facilitated the freer movement of the dancer. The 1832 performance of Les Sylphides set the choreographic model for 19th-century Romantic ballets, stressing the role of the prima ballerina. Dancing on the toes (sur les pointes) was introduced. At the end of the 19th century Russian ballet emphasized technique and virtuosity. Subsequently, Sergei DIAGHILEV and his BALLETS RUSSES revolutionized ballet with dynamic choreography and dancing. Today, the preeminence of Russian ballet is maintained by the KIROV and BOL-SHOI companies. In 1930 Dame Marie RAMBERT founded the first English ballet school and in 1931 Dame Ninette de Valois established the Sadler's Wells Ballet (now the Royal Ballet). Rudolf Nureyev's influential work for the Royal Ballet enlarged the role and dramatic range of the male dancer. In 1934 the first major US ballet school was instituted under the direction of George BALANCHINE. In 1948 the New York City Ballet was established; it is now one of the world's principal ballet companies. American ballet introduced a more abstract style and eclectic approach, fusing elements of classical ballet, jazz, popular and MODERN DANCE. See also MASQUE

Ballets Russes Dance company founded in 1909 in Paris by Sergei Diaghillev, with Michel Fokine as chief choreographer. It revitalized and reshaped ballet by bringing together great dancers (Paylova and Niinsky) and choreographers (Massine, Nijinsky and Balanchine). Leading composers, such as Stravinsky, Debussy and Richard Strauss composed music for the company, and top artists such as Picasso, Chagall and Matisse designed sets and costumes. It disbanded soon after Diaghilev's death in 1929.

ballistics Science of projectiles, including bullets, shells, bombs, rockets and guided MISSILES. Interior ballistics deal with the propulsion and motion of the projectile within the firing device. Exterior ballistics investigate the trajectory of the projectile in flight. Terminal ballistics is concerned with the impact and effect of the projectile at the target. At each stage, scientists try to maximize the performance of the gun and projectile by improving their design. Ballistic technology has developed alongside ARTILLERY, and with the invention of instruments to monitor variables, such as the ignition and burning of the propellant explosive, the stress on a gun barrel, or the effect of air resistance and gravity on the trajectory.

balloon Unsteerable lighter-than-air craft, usually made of

■ balloon Man's first balloon flight took place on 21 November 1783, when the Montgolfier brothers' travelled about 8km (5mi) across Paris. Made of paper-lined linen and coated with alum to reduce the fire risk, the balloon was 15m (50ft) high, and weighed 785kg (1,730lb). The air inside was heated by a large mass of burning straw resting on a wire grid in the centre of the gallery.

▶ bamboo Woody members of the grass family, bamboos can vary in height from a few centimetres to several metres. While most bamboo grows in dense clumps in tropical regions, some bamboo such as Arundinaria alpina (shown here) grows on mountainsides and can withstand cold conditions. Though hollow, bamboo is surprisingly strong for its weight, and is used sometimes for building houses and making furniture.

nylon. Balloons are used for recreation, scientific and military purposes. A gas that is lighter than air lifts the balloon from the ground. The first balloons to fly were of the open-necked hot-air type. The first human flight was in a hot-air balloon piloted by Jacques and Joseph Montgolfier (21 November 1783). This type of balloon uses propane gas to inflate the balloon. Controlled descent is achieved through regulated deflation. Unmanned military, meteorological or other scientific balloons are usually filled with hydrogen, least dense of all gases but dangerously flammable. Manned balloons are generally filled with safer helium gas, or hot-air. ballot Object used to cast a vote, or process of voting in an election. The word derives from the Italian ballotta (little ball) and since 5th-century BC Athens, balls have been used to cast votes. Today the ballot is a sheet (or sheets) of paper, although in some countries voting machines are used to register votes. **balm** Resin from a BALSAM plant and the name of various aromatic plants, particularly those of the genera Melissa and Melittis, both family Lamiaceae/Labiatae. Also, an old name

for any soothing ointment. **Balmoral** Private residence of the British monarch, in the Scottish Highlands, 85km (53mi) w of Aberdeen. Built in the reign of Queen Victoria, it was left to her by Prince Albert on his death in 1861.

balsa Lightweight wood obtained from a South American tree, used for modelling and for building rafts. Family Bombacaceae; species *Ochroma lagopus*.

balsam Aromatic RESIN obtained from plants; or healing preparations, especially those with benzoic and cinnamic acid added to the resin; or balsam-yielding trees, such as the balsam fir and balsam poplar. The name is also given to numerous species of the family Balsaminaceae that are plants of moist areas, with pendent flowers. *See also* IMPATIENS

Baltic Sea Part of the Atlantic extending past Denmark, along the N coasts of Germany and Poland, and the E coasts of the BALTIC STATES, and separating Sweden from Russia and Finland. The sea extends N – S with an arm reaching out to the E. The N part is the Gulf of Bothnia, the E part of the Gulf of Finland. The Baltic is the largest body of brackish water in the world. Its low salinity (due to its large catchment area, about four times the area of the sea) accounts for the ease with which the Gulf of Bothnia freezes in the winter. The tidal range is low and currents are weak. During the Middle Ages there was an important herring fishing industry. Its decline at the end of the 15th century is thought to be a contributory factor in the demise of the Hanseatic League. Area: 414,400sq km (160,000sq mi).

Baltic states Countries of ESTONIA, LATVIA and LITHUANIA, on the E coast of the BALTIC SEA. Settled by various tribes in the 7th century, it remained mostly under Danish, Russian or Polish rule until the 20th century. After the Russian Revolution (1917), each state became independent, but were submerged into the Soviet Union in 1940. They regained independence after the break-up of the Soviet Union in 1991.

Baltimore City and port in N Maryland, USA, at the mouth of the Patapsco River, on Chesapeake Bay. Founded by the Irish baronial family of Baltimore as a tobacco port in 1729. During the 19th century it became an important shipbuilding centre. It is a notable centre of commerce and education, with three universities, and a major port. Industries: steelworks, oil refineries, shipbuilding, aerospace equipment. Pop. (1990) 736,014

Baltimore oriole American songbird named because its colours are the same as the coat of arms of the Baltimore family, founders of Maryland. The male has black head, neck, back, and wings and orange breast, rump, and outer tail feathers. Females (olive upper and yellow lower body), build long, slender weed-and-bark nests in high trees. Length: to 20cm (8in). Species *Icterus galbula*.

Baluchistan Region and province in central and sw Pakistan, bordered by Iran (w), Afghanistan (N) and the Arabian Sea (s). Quetta is the capital. The boundaries with Iran and Afghanistan were settled in 1885–96. The region became part of Pakistan in 1947. The terrain is mostly hilly desert and is inhabited by nomadic tribes such as the Baluchi. Much of the population is employed in sheep raising. Some cotton is grown and fishing is the chief occupation on the coast. Natural gas is extracted and exported, along with salt and fish. Area: 347,190sq km (134,102sq mi). Pop. (1985 est.) 4,908,000.

Balzac, Honoré de (1799–1850) French novelist. One of the greatest novelists of the 19th century, Balzac's first success was *Les Chouans* (1829). More than 90 novels and short stories followed during a lifetime of extraordinary creative effort. He organized these works into a grand fictional scheme, intended as a detailed, realistic study of the whole of contemporary French society, which he called *La Comédie Humaine* (*The Human Comedy*). Among his best-known novels are *Eugénie Grandet* (1833), *Le Pére Goriot* (1834–35) and *La Cousine Bette* (1846).

Bamako Capital of Mali, on the River Niger, 145km (90mi) NE of the border with Guinea, w Africa. Once a centre of Muslim learning (11th–15th centuries), it was occupied by the French in 1883 and became capital of the French Sudan (1908). Industries: shipping, groundnuts, meat, metal products. Pop. (1990 est.) 646,000.

bamboo Tall, tree-like GRASS native to tropical and subtropical regions. The hollow, woody stems grow in branching clusters from a thick rhizome and the leaves are stalked blades. It is used in house construction and for household implements. Some bamboo shoots are eaten. The pulp and fibre may form a basis for paper production. Height: to 40m (131ft). There are 1,000 species. Family Poaceae/Gramineae; genus *Bambusa*.

banana Long, curved, yellow or reddish fruit of the tree of the same name. It has soft, creamy flesh. A spike of yellow, clustered flowers grows from the centre of the crown of the tree and bends downwards and develops into bunches of 50–150 fruits in "hands" of 10–20. More than 100 varieties are cultivated. Fruits used for cooking are called plantains. Height: 3–9m (10–30ft). Family Musaceae; genus *Musa*.

Bancroft, George (1800–91) US diplomat and historian. He was appointed secretary of the navy in 1845 and established the US Naval Academy at Annapolis, Maryland. He served as ambassador to Britain (1846–49) and to Germany (1867–74). His *History of the United States* (10 vols., 1834–74) is a classic account.

band Instrumental ensemble, usually consisting of wind and percussion instruments. A big band performs swing music and has about 16 musicians in four sections: trumpets, trombones, saxophones and a rhythm section. A brass band contains only brass and percussion instruments. A dance band has a rhythm section to provide the strict beat and melody instruments such as saxophone and violin to play the tunes. A jazz band varies according to the style of jazz: a traditional rhythm section; a modern jazz quartet may feature saxophone, piano, drums and bass. A military (marching) band contains brass and woodwind instruments with percussion. A rock band has a core of electric guitar, bass guitar and drums to which singers and other instruments may be added.

Banda, Hastings Kamuzu (1902-97) Malawian states-

man, the country's first president (1966–94). He guided Nyasaland to independence as Malawi (1964) establishing an autocratic regime. He was named president-for-life in 1971. He was the only African leader to maintain friendly relations with the South African apartheid regime. After two years of political unrest and economic crisis, he was forced to allow multiparty elections in 1994, which he lost. **Bandaranaike, Sirimavo Ratwatte Dias** (1916–) Sri Lankan stateswoman, prime minister (1960–65, 1970–77, 1994–). Following the assassination (1959) of her husband, Solomon Bandaranaike, she assumed control of the Sri Lanka Freedom Party and became the world's first woman prime minister. Her daughter, Kumaratunga, became president in 1994, and Sirimavo returned as prime minister.

Bandaranaike, Solomon West Ridgeway Dias (1899–1959) Ceylonese statesman, prime minister (1956–59). He made Sinhalese the official language and founded the Sri Lanka Freedom Party to unite nationalists and socialists. He was assassinated by a dissident Buddhist monk and his wife, Sirimavo BANDARANAIKE, succeeded him.

Bandar Seri Begawan (formerly Brunei Town) Capital of Brunei, Borneo, se Asia. The town port was superseded in 1972 by a new deepwater harbour at Maura. The capital includes the Sultan Omar Ali Saifuddin Masjid, se Asia's largest mosque. Pop. (1991) 45,867.

bandicoot Australian MARSUPIAL about the size of a rabbit and with similarly long ears, hopping gait and burrowing habits. It eats insects rather than vegetation, and its long pointed snout is probably adapted for its diet. Genus *Perameles*.

Bandung Capital of West Java province, Indonesia. Founded in 1810, it was the administrative centre of the Dutch East Indies, and is now the third largest city in Indonesia. A centre for Sundanese culture, the non-aligned movement of less-developed nations met here in 1955. Industries: canning, chemicals, quinine and textiles. Pop. (1990) 2,026,893.

Bandung Conference (1955) International meeting in BANDUNG, Indonesia. Representatives of 29 non-aligned countries of Asia and Africa, including China, met to express their united opposition to colonialism and to gain recognition for less developed nations.

Bangalore (Bangalur) Capital of Karnataka state, s central India. Established in 1537 by the Mysore dynasty, the city was retained by Britain as a military headquarters until 1947. It is the sixth largest city in India, and an important industrial and communications centre. Main products include aircraft and machine tools. Pop. (1991) 3,302,296.

Bangkok Capital and chief port of Thailand, on the E bank of the River Menam (Chao Phraya). Bangkok became the capital in 1782 when King Rama I built a royal palace here. It quickly became Thailand's largest city. The Grand Palace (including the sacred Emerald Buddha) and more than 400 Buddhist temples (*wats*) are notable examples of Thai culture, and help make the capital a popular tourist destination. It has a large Chinese minority. During World War 2 it was occupied by the Japanese. Today, Bangkok is a busy market centre, much of the city's commerce taking place on the numerous canals. The port handles most of Thailand's imports and exports. Industries: building materials, rice processing, textiles, jewellery. Pop. (1993) 5,572,712.

Bangladesh Republic in s Asia. *See* country feature, p.66 **Bangui** Capital of the Central African Republic, on the River Ubangi, near the Zaïre border. Founded in 1889 by the French, it is the nation's chief port for international trade. Industries: textiles, food processing, beer, soap. Pop. (1988) 451,690.

banjo Musical instrument with four to nine strings, a body of stretched parchment on a metal hoop, and a long, fretted neck. It is played with a plectrum or the fingers. Probably of African origin, it was taken to the USA by slaves. It is most often used in Dixieland jazz and folk-music.

Banjul (Bathurst) Capital of Gambia, w Africa, on St Mary's Island, where the River Gambia enters the Atlantic Ocean. Founded as a trading post by the British in 1816, it is Ganbia's chief port and commercial centre. The main industry is groundnut processing, though tourism is growing rapidly. Pop. (1983) 44,188.

banking Commercial process providing a wide range of financial services, such as holding and transferring money, providing loans and giving stability to the financial sector of the economy. There are a variety of sectors in the banking industry. Clearing banks in the UK and commercial banks in the USA deal with the public, as well as with small and medium-sized businesses and corporations; MERCHANT BANKS or investment banks provide services to business and industry, such as investment loans or share flotations. In many countries there are other providers of banking services, such as insurance companies and credit card firms, as well as BUILDING SOCIETIES in the UK and SAVINGS AND LOAN ASSOCIATIONS in the USA. A country's CENTRAL BANK, sometimes under government control, is the bankers' bank and can be used to regulate an economy.

Bank of England Britain's central banking institution, founded in 1694 by a group of London merchants. Nationalized in 1946, it regulates foreign exchange, issues bank notes, advises the government on monetary matters and acts as the government's financial agent. Since 1997, following legislation put forward by Gordon Brown, the Bank has the power to set national interest rates. It is situated in Threadneedle Street, City of London. The governor of the Bank of England is appointed by the government.

Bank of the United States Two US national banks. The first was established in 1791 and aimed to provide the USA with a solid economic basis. Though it was soundly operated, autonomous state banking interests defeated its rechartering in 1811. Following the War of 1812, a second national bank was chartered by Congress in 1816. There was much opposition to its power to establish local branches that could compete with state-chartered banks, and many in western states believed the bank favoured eastern business interests. President Andrew JACKSON supported the bank's opponents, and vetoed its rechartering. The bank became obsolete in 1836. It was not until the creation of the FEDERAL RESERVE SYSTEM (1913) that the USA achieved a central banking system.

bankruptcy Legally determined status of a person or company, usually when debts greatly exceed income and assets. A person or company may ask to be declared bankrupt by the court, or else the creditors may do so. A court-appointed receiver takes charge of the bankrupt's property with the aim of meeting, as far as possible, the bankrupt's financial obligations to his or her creditors.

Banks, Sir Joseph (1743–1820) English botanist. He was the senior scientist of the group who sailed to Tahiti with Captain James Cook aboard *HMS Endeavour* in 1768. At Botany Bay, Australia, Banks collected (1770) examples of plants hitherto unknown in Europe, including the shrub BANKSIA named in his honour. Upon his return, he helped establish the Royal Botanic Gardens at Kew, w London, and financed several international plant-collecting expeditions. In 1778 he became president of the Royal Society.

banksia Any of about 70 species of flowering shrubs and small trees found in Australia and New Guinea that belong to the genus *Banksia*. Their evergreen leaves are long and leathery, and they bear tube-shaped heads of yellowish or reddish flowers. The genus was discovered by Sir Joseph BANKS. Most banksias are pollinated by birds, but some are pollinated by the honey possum, a small, mouse-like marsupial that feeds on their nectar and pollen. Family Proteaceae.

Bannister, Sir Roger Gilbert (1929–) British track and field athlete. On 6 May 1954, Bannister became the first man to run a mile in less than four minutes (3min. 59.4sec). He was knighted in 1975 and in 1995 was appointed chair of a government scheme to introduce sports scholarships.

Bannockburn Town and moor in central Scotland, scene of a Scottish victory over the English in 1314. The English army of EDWARD II, advancing on Stirling, was intercepted by Scottish troops under ROBERT I (THE BRUCE). The Scots held a dominant position above the Bannock burn, while the more heavily armed English were caught in swampy ground. Fighting began at dawn and before noon the English survivors were in flight. Though conflict continued for many years, the victory secured Scottish independence from the English, who made no serious effort to regain territory in Scotland.

▲ banjo Originating in the 18th century, the banjo is popularly supposed to have been brought by slaves from Africa to the USA. By the middle of the 19th century it had become the traditional instrument of African-Americans. It has four or more strings, which are plucked, and a resonating body consisting of parchment stretched over a metal hoop.

Banting, Sir Frederick Grant (1891-1941) Canadian physician. He shared, with J.J.R. Macleod, the 1923 Nobel Prize for physiology or medicine for his work in extracting the hormone INSULIN from the PANCREAS. This made possible the effective treatment of DIABETES.

Bantu Group of African languages generally considered as forming part of the Benue-Congo branch of the Niger-Congo family. Among the most widely-spoken of the several hundred languagess spoken from the Congo Basin to South Africa are SWAHILI, XHOSA and ZULU. There are more than 70 million speakers of Bantu languages and they are widely used in schools. They are almost all tone languages.

banyan Evergreen tree of E India. The branches send down aerial shoots that take root, forming new trunks. Such trunks from a single tree may form a circle up to 100m (330ft) across. Height: to 30m (100ft). Family Moraceae; species Ficus benghalensis.

baobab Tropical tree native to Africa. It has a stout trunk containing water storage tissue, and short, stubby branches with sparse foliage. Fibre from its bark is used for rope. Its gourdlike fruit is edible. Height: to 18m (60ft); trunk diameter: to 12m (40ft). Family Bombacaceae; species Adansonia digitata.

baptism Pouring of water on a person's forehead or the immersion of the body in water, used as a rite of initiation into the Christian church. Baptism is one of the SACRAMENTS of the Christian church. The water symbolizes regeneration. Total immersion is practised by the BAPTISTS. In churches which practise infant baptism, the rite is usually referred to as christening and is the occasion when a child is named.

Baptist Member of various Protestant and Evangelical sects who practise BAPTISM of believers and regard immersion as the only legitimate form sanctioned by the New Testament. Like the ANABAPTISTS, to whom they have an affinity but no formal links, they generally reject the practice of infant baptism, insisting that initiates must have freedom of thought and expression and must already be believers. Baptists originated among English dissenters of the 17th century, but have spread worldwide through emigration and missionary work. They uphold the principle of religious liberty. There is no official creed nor hierarchy and individual churches are autonomous. Baptists traditionally advocate the separation of church and state. The Baptist World Alliance (founded 1905) holds regular international congresses. In the mid-1990s, the number of Baptists worldwide was estimated at more than 31 million.

BANGLADESH

Bangladesh adopted this flag in 1971, following the country's independence from Pakistan. The green is said to represent the fertility of the land. The red disc is the sun of independence and commemorates the blood shed during the struggle for freedom.

AREA: 144,000sq km (55,598sq mi)

POPULATION: 119,288,000

CAPITAL (POPULATION): Dhaka (Dacca, 3,397,187)

GOVERNMENT: Multiparty republic ETHNIC GROUPS: Bengali 98%, tribal groups

LANGUAGES: Bengali (official) RELIGIONS: Islam (Sunni Muslim) 87%, Hinduism 12%, Buddhism, Christianity

currency: Taka = 100 paisa

Bangladesh is the world's most densely populated country: (1990) 803 people per sq km (2,080 per sq mi). Most of Bangladesh is flat and covered by fertile alluvium spread by the rivers GANGES, BRAHMAPUTRA and Meghna. The capital, DHAKA, is situated on the Ganges delta. The rivers overflow when swollen by the annual monsoon. Floods also occur with the cyclones

that periodically strike along its coast. These storms cause great human suffering. The death toll from the 1991 delta cyclone was 132,000 and more than 5 million people were made homeless.

CLIMATE

Bangladesh has a tropical monsoon climate. In winter, dry winds blow from the N. In spring, moist winds from the s bring heavy rain. The coldest month is January. It remains hot throughout the monsoon season (June-August).

VEGETATION

Though most of Bangladesh is low and cultivated, forests cover c.16% of the land. The mangrove swamps of the Sundarbans region are the last sanctuary of the Bengal tiger. On the jungle border with Burma there are large areas of mahogany forests and rubber plantations.

HISTORY AND POLITICS

The early history of Bangladesh is synonymous with that of BENGAL. Islam was introduced in the 13th century. In 1576 Bengal became part of the vast Mogul Empire under Akbar I (THE GREAT). In the late-18th century Bengal fell under the control of the British EAST INDIA COMPANY. In 1905 the British divided Bengal into East and West portions. East Bengal (roughly equivalent to modern Bangladesh) was mainly Muslim. In 1947 British India was partitioned between the mainly Hindu India and Muslim PAKISTAN. Pakistan consisted of two provinces, one to the w of India, and the other to the E, known intially as East Bengal then East Pakistan. The two provinces were separated by c.1,500km (1,000mi) of India. The majority population of East Pakistan complained of ethnic and economic discrimination by West Pakistan. Complaints turned into riots. In 1970 elections, the Awami League, led by Sheikh Mujibur Rahman, won a landslide victory. In March 1971 the League unilaterally declared independence and civil war ensued. During nine months of fighting, over 1 million East Bengalis were killed and millions more forced into exile, mainly to India. With Indian military assistance, Pakistan was defeated and Bangladesh gained independence. Sheikh Rahman became prime minister. In 1974 President Zulfikar Bhutto of Pakistan recognized the state of Bangladesh. The new state was beset by famine and economic crises. In 1975 Sheikh Rahman assumed the presidency. In 1976 he was assassinated in a military coup and martial law declared. Several coups followed and the military remained in power for the next 15 years. In 1991 Bangladesh held its first free elections since independence. The Bangladesh National Party (BNP) gained a parliamentary majority. In 1994 opposition parties withdrew from parliament and held a series of strikes and demonstrations. In 1996 elections the Awami League, led by Sheikh Hasina, returned to power.

ECONOMY

Bangladesh is one of the world's poorest countries, agriculture employs over 50% of the workforce. Rice is the chief crop. Jute processing is the largest manufacturing industry and export. Some 60% of internal trade is by boat, though this is becoming more difficult as the Ganges delta silts up, due to deforestation in Nepal.

bar Unit of pressure, the pressure created by a column of mercury 75.007cm high. It is equal to 10⁵ pascals. Standard atmospheric pressure (at sea level) is 1.01325 bars, or 1.013.25 millibars.

Bar, the See INNS OF COURT

Barabbas In the New Testament, convicted criminal or terrorist who was in prison at the time of Jesus Christ's trial before Pontius Pilate. In accordance with a Passover custom, Pilate offered to release a prisoner. The Jerusalem mob, given the choice of which prisoner should be allowed to go free, nominated Barabbas and called for Christ to be crucified (Matthew 27, Mark 15, Luke 23, John 18).

Barbados Island state in the Windward Islands, West Islands; the capital is BRIDGEPORT. Barbados' warm climate has encouraged the growth of its two largest industries, sugar cane and tourism. It was settled by the British in 1627, and dominated by British plantation owners (using African slave labour until the abolition of slavery) for the next 300 years. It gained independence in 1966. Area: 430sq km (166sq mi). Pop. (1993) 263,900. See WEST INDIES map

barbarians Term given to all uncivilized tribes by the ancient Greeks and Romans. It is more specifically used to apply to the Germanic and Slavonic tribes that invaded the Roman Empire after about 50 BC and eventually overthrew it. Barbarossa (1466–1546) (Redbeard) Name given by Christians to two Muslim privateers in the Mediterranean, Aruj (d.1518) and Khizr, or Khayr ad-Din (d.1546) Aruj was killed in battle against the Spanish, but Khayr seized Algiers from Spain (1533), took Tunis (1534), raided Christian coasts and shipping and gained control of the Barbary States. He acknowledged the Ottoman sultan as his overlord, and was commander (1533–44) of the fleet of Suleiman the Magnificent, which controlled the E Mediterranean. His forces were finally defeated by Spain and Italy in the battle of Lepanto.

Barbary ape Tailless, yellowish-brown ape-like MONKEY native to Algeria and Morocco, and introduced into Gibraltar. It is the size of a small dog. The Gibraltar Barbary apes are the only wild monkeys in Europe. Species *Macaca sylvana*. See also MACAQUE; PRIMATE

barbel (barb) CARP-like freshwater fish of w Asia and s central Europe. A game and food fish, it has an elongated body, flattened underside and two pairs of fleshy mouth whiskers (barbels). It is a strong swimmer well adapted to fast-flowing rivers. Length: 50–90cm (20–35in); weight: 16kg (35lb). Family Cyprinidae; species *Barbus barbus*.

Barber, Samuel (1910–81) US composer. He composed chamber music, notably *Dover Beach* (1931) for voice and string quartet, two symphonies, a piano concerto (1962) and three operas, including *Vanessa* (1958) and *Antony and Cleopatra* (1966). His style, initially quite romantic, became increasingly dissonant. He won two Pulitzer Prizes for music. barberry *See* BERBERIS

barbet Brightly coloured, poor-flying tropical bird, known for its monotonous call. It is stout-bodied with a large head, heavy bill, beard-like bristles and short legs. The female lays 2–5 white eggs in a nest hollowed out of a tree branch. Length: 9–30cm (3.5–12in). Family Capitonidae. Genus *Megalaima*.

Barbie, Klaus (1913–91) Nazi chief of the German Gestapo in France during World War 2. He was known as the "Butcher of Lyon" for his persecution and murder of French Resistance fighters and Jews. He sent thousands of people to Auschwitz. After the war, he worked for US counter-intelligence before escaping to Bolivia in 1951. He was captured in 1987, brought back to Lyon and sentenced to life imprisonment.

Barbirolli, Sir John (1899–1970) English conductor who won international acclaim for his sensitive interpretations. He conducted the New York Philharmonic (1937–42), and was then resident with the Hallé Orchestra, Manchester (1943–68), which he transformed into a world-class ensemble.

barbiturate DRUG used as a sedative or to induce sleep. Highly addictive and dangerous in high doses, or in combination with other drugs such as alcohol or tranquillizers, most barbiturates are no longer prescribed. Short-acting barbiturates are used in surgery to induce general anaesthesia; longacting formulations are prescribed for epilepsy.

Bar codes represent information concerning a product and its manufacturer in a series of thick and thin black and white lines (1). A laser (2) is reflected through a glass screen (3) onto the bar code by a rotating multi-

faceted mirror (4). The laser light is scattered by the white lines and absorbed by the black lines. A sensor (5) detects the reflected laser light and compares the relative width of the lines. Because the relative widths are compared,

the bar code does not have to be on a flat surface. The sensor passes the bar code information to the till (6) for billing the customer, and a central store computer (7) monitors stock levels and order supplies of goods.

Barbizon School French school of landscape painting in the 19th century. Led by Théodore ROUSSEAU in the late 1840s, the group worked in the forest of Fontainebleau near Barbizon, N France. Artists included Charles Daubigny, Diaz de la Peña, Jules Dupré and Constant Troyon. They embraced a longing for the freedom of nature, escaping the restraints of Parisian art. In working directly from nature they were forerunners of IMPRESSIONISM. They were inspired by CONSTABLE and 17th-century Dutch landscapists.

Barcelona City and Mediterranean port in NE Spain, capital of CATALONIA and Spain's second-largest city. Reputedly founded by the Carthaginian Barca family, it was ruled by Romans, Visigoths and Moors and by the late Middle Ages had become a major trading centre. It is the focus of radical political and Catalan separatist movements. The autonomous Catalan government based here (1932-39) was swept away by the Spanish CIVIL WAR. Modern Barcelona is the cosmopolitan, cultural capital of Spain. The 1992 summer Olympics were held here. Historic buildings include the gothic Cathedral of Santa Eulalia (13th-15th century), the Church of the Sagrada Familia designed by Antonio GAUDí (begun 1882), and the Monument to Christopher Columbus. There are two universities, a Museum of Modern Art and the Picasso Museum. Barcelona is an important shipping, banking and financial centre. Industries: vehicles, textiles, machinery, petrochemicals, electrical goods. Pop. (1991) 1,625,542.

bar code Coded information consisting of thick and thin lines, and designed for computer recognition. At supermarket checkouts, a laser beam scans the bar code and a light-sensitive detector picks up the reflected signal, which consists of a pattern of pulses. The store's computer translates this into information, including the product's name, weight or size. The computer refers to a price list data file to see how much to charge the customer.

Bardeen, John (1908–91) US physicist known for his research into SEMICONDUCTORS. He worked (1945–51) with the Bell Telephone Laboratories and was professor of physics (1951–75) at the University of Illinois. He was the first person to win the Nobel Prize twice in the same field, physics: in 1956 he shared it with William SHOCKLEY and Walter BRAITAIN, for their invention of the TRANSISTOR and in 1972 with Leon Cooper and John Schrieffer, for the theory of SUPERCONDUCTIVITY.

Barebone's Parliament (Parliament of the Saints, July–December 1653) Last Parliament of the English Commonwealth. Successor to the Rump Parliament, it was named after a prominent member, Praise-God Barebone. Members were hand-picked by Oliver Cromwell and the Puritan army chiefs. Religious disputes ruined its effectiveness. It voted its own dissolution and handed over power to Cromwell as Lord Protector.

Barenboim, Daniel (1942–) Israeli pianist and conductor, b. Argentina. An eclectic musician, he has performed with many of the world's leading orchestras, such as the New York and Berlin philharmonics, the London Symphony Orchesta and the Orchestre de Paris. He was married to Jacqueline DU PRÉ.

Barents, Willem (d.1597) Dutch navigator and Arctic explorer. He made three expeditions (1594–97) in search of the NORTHEAST PASSAGE. On his third voyage, he discovered SVALBARD and, crossing the sea now named after him, reached Novaya Zemlya. His ship was trapped by ice and the Dutch sailors built a shelter; most survived until the thaw the following year. Barents died before they reached safety.

Barents Sea Part of the Arctic Ocean lying between SVALBARD and Novaya Zemlya, it was named after Willem BARENTS. The seafloor consists of an uneven surface distribution of Quaternary sediments. Deeper, older sediments bear evidence of long periods above sea level. The fishing-grounds are particularly rich in cod and herring. Area: 1,370,360sq km (529,096sq mi).

barite Translucent, white or yellow mineral, barium sulphate (BaSO₄), found in sedimentary rocks and in ore veins in limestone. Radiating clusters of crystals are called "barite roses". It occurs as a gangue mineral with ores of lead, copper and zinc, and as a replacement for limestone. It is used as a weighting agent in oil-rig drilling, and in the chemical industry for paper-making, rubber manufacture, high-quality paints and x-rays. Hardness: 3–3.5; s.g. 4.5.

barium (symbol Ba) Metallic element of the alkaline-earth group, discovered in 1808 by the English chemist Sir Humphry DAVY. It is a soft, silvery-white metal whose chief sources are heavy spar (barium sulphate) and witherite (barium carbonate). Barium compounds are used as rodent poison, pigments for paints and as drying agents. Barium sulphate (BaSO₄) is swallowed to allow x-ray examination of the stomach and intestines because barium atoms are opaque to x-rays. Properties: at.no. 56; r.a.m. 137.34; r.d. 3.51; m.p. 725°C (1,337°F); b.p. 1,640°C (2,984°F); most common isotope Ba¹³⁸ (71.66%).

bark Outer protective covering of a woody plant stem. It is made up of several layers. The CORK layer, waxy and waterproof, is the thickest and hardens into the tough, fissured outer covering. Lenticels (pores) in the bark allow GAS EXCHANGE between the stem and the atmosphere. *See also* CAMBIUM

Barker, Pat (1943–) British novelist. Barker's novels focus on the plight of women, usually in the N of England. Her debut novel was *Union Street* (1982). Other works include *Blow Your House Down* (1984) and *The Century's Daughter* (1986). *Regeneration* (1991) and *The Eye in the Door* (1993) were the first volumes of a World War 1 trilogy. The final part, *The Ghost Road*, won the 1995 Booker Prize.

Barlach, Ernst (1870–1938) German sculptor, graphic artist, writer and dramatist. He was a pioneer of the German EXPRESSIONISM movement. His distinctive style was influenced by medieval German woodcarving and have a raw quality and vigour. His plays are illustrated with woodcuts and lithographs. barley Cereal Grass native to Asia and Ethiopia, cultivated perhaps since 5000 Bc. Three cultivated species are: Hordeum distichum, commonly grown in Europe; H. vulgare, favoured in the USA; and H. irregulare, grown in Ethiopia. Barley is eaten by humans and animals, and is used to make malt beverages. Family Poaceae/Gramineae.

bar mitzvah Jewish ceremony in which a young male is initiated into the religious community. At the ceremony, which traditionally takes place when he is aged 13 years and 1 day, he reads a portion of the TORAH in a synagogue. The religious rite is followed by a social celebration. Some non-orthodox communities also celebrate a bas (or bat) mitzvah for girls.

barn (symbol b) Scientific unit of area used in nuclear

physics to measure the cross-sections in interactions of particles. A barn equals $10^{-24}~\rm cm^2$ per nucleus. This area is a measure of the probability that FISSION will occur when a neutron moves towards a heavy nucleus.

Barnabas, Saint Early Christian apostle, originally named Joseph, who was a companion of St PAUL. He travelled with Paul on two proselytizing missions to Cyprus and the European mainland. His feast day is 11 June.

barnacle Crustacean that lives mostly on rocks and floating timber. Some barnacles live on whales, turtles and fish without being parasitic, although there are also parasitic species. The larvae swim freely until ready to become adults, when they settle permanently on their heads; their bodies become covered with calcareous plates. The adult uses its feathery appendages to scoop food into its mouth. Two main types are those with stalks (goose barnacles) and those without (acorn barnacles). Subclass Cirripedia.

Barnard, Christiaan (1922–) South African surgeon. He was the first to perform a human heart transplant (3 December 1967). In 1974 he was the first to implant a second heart in a patient and to link the circulations of the hearts so that they worked together as one.

Barnardo, Thomas John (1845–1905) British philanthropist who founded the Dr Barnardo homes for destitute children. In 1867 he founded the East End Mission for orphan children. These homes spread rapidly throughout the UK.

Barnard's Star Red dwarf star six light years away in the constellation Ophiuchus. It is the closest star to the Sun after the ALPHA CENTAURI system and was discovered in 1916 by the US astronomer Edward Barnard.

barn owl Generally nocturnal bird of prey that lives mainly in the Eastern hemisphere. The widely distributed common barn owL (*Tyto alba*) has a heart-shaped face and long legs. It sometimes lives in buildings, and acute hearing enables it to locate rodents and other prey in almost total darkness. Family Tytonidae.

Barnum, Phineas Taylor (1810–91) US showman. He established the American Museum in New York City (1842), where he presented the "dwarf" Tom Thumb, the Fijian mermaid and other "freaks". In 1847 he introduced the Swedish soprano Jenny LIND to US audiences. In 1871 he opened his circus, billed as "The Greatest Show on Earth". He merged with rival James Bailey in 1881, to form Barnum and Bailey's Circus.

barometer Instrument for measuring atmospheric pressure. There are two basic types. A mercury barometer has a vertical column of mercury, whose length alters with changes in atmospheric pressure. An aneroid barometer has a chamber containing a partial vacuum, and the chamber changes shape with shifts in pressure. Barometers are used in WEATHER FORECASTING to predict local weather changes: a rising barometer (increasing pressure) indicates dry weather; a falling barometer indicates wet weather. In a barograph, the pointer of an aneroid barometer is replaced by a pen that traces variations in pressure on a revolving cylindrical chart. A barometer can also be used in an ALTIMETER to measure altitude by indicating changes in atmospheric pressure. See also BAR

baroque Term (perhaps derived from the Portuguese barroca, a misshapen pearl) applied to the style of art and architecture prevalent in Europe in the 17th and early 18th centuries. Baroque was at its height in the Rome of BERNINI, BORROMINI and Pietro de Cortona (c.1630-80) and in s Germany with Balthazar Neumann and Fischer von Erlach (c.1700-50). The best of high baroque was a union of architecture, painting and sculpture in a blend of light, colour and movement, calculated to overwhelm the spectator by a direct emotional appeal. Paintings contained visual illusions; sculpture exploited the effect of light on surface and contour. Architecture was created in a series of geometrically controlled spaces (squares, circles, ovals and triangles) which enclosed, adjoined and superimposed each other to create the illusion of rhythmic movement. Buildings were heavily decorated with stucco ornament and free-standing sculpture. Baroque was closely linked to the COUNTER-REFORMATION and was therefore strongest in Roman Catholic countries.

Baroque became increasingly florid before merging with the lighter style of Rococo. The term is often used to describe the period as well as the style. In music, the period is notable for several stylistic developments. Musical textures became increasingly contrapuntal (polyphonic), culminating in the masterpieces of J.S. BACH and HANDEL. Many purely instrumental forms, such as the fugue, sonata, concerto, suite, toccata, passacaglia and chaconne emerged and became popular and involved increasing virtuosity.

barracuda Marine fish found in tropical Atlantic and Pacific waters. Known to attack people, it has a large mouth with many large, razor-sharp teeth. It is long, slender and olive green. Length: usually 1.2–1.8m (4–6ft); weight: 1.4–22.7kg (3–50lb). The great barracuda of the Florida coast grows to 2.5m (8ft). Family Sphyraenidae; there are 20 species.

Barrie, Sir J.M. (James Matthew) (1860–1937) Scottish dramatist and novelist. He is chiefly remembered as the writer of *Peter Pan* (1904), an ever-popular play about a boy who refuses to grow up. Though criticized for sentimentality, his best works are clever, romantic fantasies. Other plays include *The Admirable Crichton* (1902), *What Every Woman Knows* (1908) and *Dear Brutus* (1917).

barrier reef Long narrow CORAL REEF lying some distance from, and roughly parallel to, the shore, and separated by a lagoon. Australia's GREAT BARRIER REEF is the most famous. **Barrow** Village in Alaska; the northernmost US community. The US Navy operates a research station nearby. Whaling is the chief industry. Pop. (1990) 3,469.

barrow In archaeology, a prehistoric burial mound. Various types of barrow are found, but in Europe they are usually either long or round. **Long** barrows were built in the NEOLITHIC period, and consisted of a long vault built of huge stones, roofed with stone slabs and covered with soil or chalk. Many long barrows were used for multiple burials. **Round** barrows primarily date to the early BRONZE AGE, but some in England were built as late as Roman and Saxon times. Usually containing a single body, round barrows vary in diameter from 1.5–50m (4.5–160ft) and are often surrounded by banks and ditches.

Barry, Sir Charles (1795–1860) British architect. He redesigned the HOUSES OF PARLIAMENT at Westminster, London in a Gothic style after the original building burned down. He worked on the project with Augustus Pugin, who was responsible for much of the exterior and interior decoration. Barry's preference for Italian Renaissance architecture is apparent in the palace's classical ground plan.

Barrymore US family of actors. Maurice (1847–1905) made his stage debut in London in 1872. In 1875 he emigrated to the USA, where he married the actress Georgiana Drew. They had three children. **Lionel** (1878–1954), a fine character actor, made many films, including *Dinner at Eight* (1933) and *A Free Soul* (1931), for which he won an Oscar for Best Actor. **Ethel** (1879–1959) was best known for her stage performances in *A Doll's House* (1905) and *The Corn is Green* (1942). She won an Oscar for Best Supporting Actress in *None but the Lonely Heart* (1944). John (1882–1942) was a matinee idol. His many films include *Beau Brummel* (1924), *Don Juan* (1926) and *Grand Hotel* (1932). **Drew** Barrymore (1975–) became a childhood star in *E.T. The Extra-Terrestrial* (1982).

Barth, John Simmons (1930–) US author and founder of post-modern literary pastiche. His best known novels include *The End of the Road* (1958), *The Sot-Weed Factor* (1960) and *Giles Goat-Boy* (1966). In 1973 he won the US National Book Award for his three novellas, collectively entitled *Chimera* (1972). Later works include *Sabbatical* (1982), *The Tidewater Tales* (1987) and *The Last Voyage of Somebody the Sailor* (1991).

Barth, Karl (1886–1968) Swiss theologian. Barth was a leading thinker of 20th-century Protestantism, and tried to lead theology back to principles of the REFORMATION. He emphasized the revelation of God through Jesus Christ. His school has been called dialectical theology or theology of the word. In 1935 he was suspended from his position at the University of Bonn for his anti-Nazi stance, and he returned to Switzerland. His works include *Epistle to the Romans* (1919). **Barthes, Roland** (1915–80) French academic, writer and

cultural critic. A leading proponent of STRUCTURALISM and SEMIOTICS, his notion of the literary text as a "system of signs" was informed by Ferdinand de SAUSSURE. Perhaps his best-known contribution to literary theory was the notion of the "death of the author", in which the meaning of a text is generated by the reader, rather than by reference to biographical detail. His diverse works include *Writing Degree Zero* (1953), *Mythologies* (1957), *S/Z* (1970) and *Camera Lucida* (1980).

Bartholdi, Frédéric Auguste (1834–1904) French sculptor His most famous piece is *Liberty Enlightening the World* (The Statue of Liberty) in New York harbour, which was dedicated in 1886. The colossal *Lion of Belfort* at Belfort, France, is considered his best work.

Bartók, Béla (1881–1945) Hungarian composer and pianist. With Zoltán Kodály, Bartók amassed a definitive collection of Hungarian folk music that became the basis of many of his compositions. His orchestral works include *Music for Strings, Percussion, and Celesta* (1936), two violin concertos (1908 and 1938) and the Concerto for Orchestra (1943). He wrote one opera, *Bluebeard's Castle* (1911). He also composed three piano concertos and six five-string quartets. His compositional style combines folk music idioms with dissonance and great rhythmic energy.

Bartolommeo, Fra (1457–1517) (Bartolommeo della Porta) Florentine draughtsman and Dominican friar. In parallel with RAPHAEL, he contributed to the development of a new type of Madonna with Saints, specific to the High RENAISSANCE, in which the Madonna acts as a central point for the whole composition. Bartolommeo's characteristic style is one of restraint combined with monumentality, exemplified by *The Mystical Marriage of St Catherine* (1511). He was an exceptional draughtsman and, in his later career, his drawings of figures, landscape and subjects in the natural world expressed his mysticism more profoundly than his painting. **baryon** Any elementary particle affected by the strong inter-

action of nuclear force. The baryon consists of three QUARK. Baryons are subclasses of HADRON. The only stable baryons are the PROTON and (provided it is inside a nucleus) the NEUTRON. Heavier baryons are called hyperons. *See also* LEPTON; MESON Baryshnikov, Mikhail (1948–) American ballet dancer, b. Russia. A leading member (1969–74) of the KIROV BALLET, his defection to the West received much publicity. He was with the American Ballet Theater as principal dancer (1974–78) and artistic director (1980–89). He starred in several films and set up the White Oak Dance Project.

basal metabolic rate (BMR) Minimum amount of energy required by the body to sustain basic life processes, including breathing, circulation and tissue repair. It is calculated by measuring oxygen consumption. Metabolic rate increases well above BMR during vigorous physical activity or fever, or under the influence of some drugs (including caffeine). It falls below BMR during sleep, general ANAESTHESIA or starvation. BMR is highest in children and decreases with age. See also METABOLISM

basalt Hard, fine-grained, basic IGNEOUS ROCK, which may be intrusive or extrusive. Its colour can be dark green, brown, dark grey or black. It can have a glassy appearance. There are many types of basalt with different proportions of elements. It may be compact or vesicular (porous) because of gas bubbles contained in the lava while it was cooling. If the vesicles are subsequently filled with secondary minerals, such as quartz or calcite, it is called amygdaloidal basalt. Basalts are the main rocks of ocean floors, and form the world's major lava flows, such as the Deccan Trap, India.

base Chemical compound that accepts protons. A base will neutralise an ACID to form a SALT and water. Most are oxides or hydroxides of metals; others, such as ammonia, are compounds that yield hydroxide IONS in water. Soluble bases are called ALKALIS. Strong bases are fully dissociated into ions; weak bases are partially dissociated in solution. See also NEUTRALIZATION

base In mathematics, the number of units in a number system that is equivalent to one unit in the next higher counting place. Thus 10 is the base of the decimal system: only the ten digits 0–9 can be used in the units, tens, hundreds, and so on. Each

▲ Baryshnikov One of the world's leading ballet dancers, Baryshnikov is known for the brilliance of his technique and the strength of his character interpretations. As well as performing in all the standard ballets, Baryshnikov has starred in several films, including *The Turning Point* (1977), *White Nights* (1985) and *The Cabinet of Dr Ramirez* (1991)

▲ bat The large mouse-eared bat (Myotis myotis) is the biggest of all European bats. It has a wingspan of up to 38cm (15in) and migrates up to 200km (125mi) from its summer habitat in s Europe to the Middle East where it spends the winter months. Though it prefers open farmland and woodland, the large mouse-eared bat is sometimes known to live in cellars or the attics of houses. A nocturnal animal, it lives on insects, particularly moths.

number system has a number of symbols equal to its base. In the BINARY SYSTEM (base 2) there are two symbols, 0 and 1.

baseball National summer sport of the USA and Canada, also popular in the Far East, Latin America, Australia and Europe. A baseball field comprises an inner diamond 27m (90ft) on each side, and an outfield. The diamond has a central pitcher's mound with bases at three corners. The batter stands at the fourth, home plate. Each team has nine players: pitcher, catcher, four infielders and three outfielders. One run is scored every time a batter runs around all three bases and reaches home plate (there cannot be two batters on a base, so those on base must also run). To get back to home base with a single strike is a home run. A game is divided into nine innings (during which each team bats once): a team's innings ends when a third batter or runner is out, either by missing three consecutive valid pitches (strikes) or making fouls, by a field catch, or by not making it to the next base before a fielder throws the ball to the player on that base. Games tied at the end of nine innings are played until there is a winner. Every autumn the top teams of the two major leagues (American and National), including Canadian teams, compete in a bestof-seven "World Series". The basic rules of the modern game were compiled by Alexander J. Cartwright in 1845.

Basel (Bale or Basle) City and river port on the River Rhine; capital of Basel-Stadt canton, NW Switzerland. Basel joined the Swiss Confederation in 1501. It is an economic, financial and historically important cultural centre. There is a cathedral (where Erasmus is buried); a 15th-century university and a 16th-century town hall. It is the centre of the Swiss chemical and pharmaceutical industries. Other industries: publishing, silk, electrical engineering, metal goods. Pop. (1992) 173,800. Basel, Council of Ecumenical council convoked at BASEL in 1431. It instituted church reforms and conciliated the HUSTITES in Bohemia. Conflict with Pope Eugene IV over conciliar authority led the pope to denounce the council in 1437. In 1439 the council declared Eugene deposed and chose an antipope, Amadeus of Savoy, as Pope Felix V. Felix resigned in 1449 and the council was dissolved.

BASIC (Beginners' All-purpose Symbolic Instruction Code) Computer programming language. BASIC is easy to learn and uses many ordinary English words and simple mathematical expressions. Many low-cost home computers accept programs written in BASIC. An interpreter translates the BASIC computer PROGRAM into a machine code required by a computer's MICROPROCESSOR.

Basil i (c.813–86) Byzantine emperor (r.867–86) and founder of the Macedonian dynasty. Emperor Michael III assisted Basil in his rise to power. After Michael designated him coemperor, Basil had his former patron murdered and assumed sole power in Byzantium. Basil's most effective policies include: the conversion of the Bulgars to Orthodox Christianity, military campaigns against the Paulician religious sect in Asia Minor and a revision of Roman legal codes.

Basil II (*c*.958–1025) Byzantine emperor (976–1025), surnamed Bulgaroctonus ("Bulgar-slayer"). One of Byzantium's ablest rulers, Basil reigned during the heyday of the empire. He is best known for his military victory over the Bulgarian tsar Samuel in 1014, which brought the entire Balkan peninsula under Byzantine control. During Basil's reign, Byzantium's sphere of influence was extended by the conversion of Kievan Russia to Orthodox Christianity.

basil Common name for a tropical plant of the MINT family, whose dried leaves are used for flavouring. It has white or purple flowers. Family Lamiaceae/Labiatae; species *Ocimum basilicum*.

basilica Roman colonnaded hall used for public business; also an early Christian church based on this design. The main characteristics of a basilica church, established by the 4th century AD, were: a rectangular plan with a longitudinal axis, a wooden roof and an E end, which was either rectangular or contained a semicircular apse. The body of the church usually had a central nave and two flanking aisles.

basilisk Semi-aquatic LIZARD found in trees near streams of tropical America. It has a compressed greenish body, whip-like tail, a crest along its back and an inflatable pouch on its

head. It can run over water for short distances on its hindlegs, and eats plants and insects. Length: up to 61cm (2ft). Family Iguanidae; genus *Basiliscus*. The basilisk is also a legendary serpent with the body of a cockerel.

Basil the Great, Saint (329–79) Doctor of the Church and one of the four Fathers of the Greek Church. He founded a monastic community and in 370 was ordained bishop of Caesarea, Cappadocia. Basil established the dominance of the NICENE CREED and was a fierce opponent of ARIANISM. He is thought to have composed the *Liturgy of St Basil*, which is still used in the Eastern Orthodox Church. His feast day is 2 January in the West; 1 January in the East.

basketball Worldwide ball game that originated in the USA. Devised in 1891 by Dr James Naismith, it has been an Olympic sport since 1936. It is played by two teams of five people (plus substitutes), on a court up to 27.8m (91ft) long and 15m (49ft) wide. At each end of the court is a backboard on which a bottomless netting basket hangs 3m (10ft) above the floor. The object of the game is to throw the ball down through the hoop of the opposing team's basket, thus scoring points. Players may move with the ball when bouncing it onehanded; a ball taken two-handed must be passed within two steps; no physical contact with opponents is permitted, though "blocking" with the arms is a feature of the defensive game. There are additional time factors in the rules. Each basket (thrown during normal play) counts 2 or 3 points and a successful free throw (penalty shot) counts 1 point. With commercialization and the worldwide transmission of the US National Basketball Association (NBA), basketball is now one of the world's most popular spectator sports.

Basle See BASEL

Basov, Nikolai Gennadiyevich (1922–) Soviet physicist who developed the MASER, which amplifies microwaves, and the LASER, which amplifies light. For these contributions, Basov and his co-worker Alexander Prokhorov shared the 1964 Nobel Prize for physics with the US physicist Charles Townes (who had made similar discoveries independently).

Basque Country Region of the w Pyrenees in both Spain and France, consisting of the provinces of Alava, Guipúzcoa, part of Navarra and Vizcaya in Spain and Basse-Navarre, Labourd and Soule in France. The main towns are BILBAO and San Sebastian. The region is populated by the BASQUES. It lost its autonomy in the late 18th and early 19th centuries and separatist movements were formed in response.

Basques Indigenous people of the western Pyrenees in N Spain and sw France, numbering c.3,900,000. Their language is not related to any other European tongue. Throughout history they have tenaciously maintained their cultural identity. The kingdom of Navarre, which existed for 350 years, was home to most of the Basques. After its dissolution in 1512, most Spanish Basques enjoyed a degree of political autonomy. This autonomy was revoked in 1873, and Basque unrest followed. Some local autonomy was restored in 1978–79, but Basque separatists (ETA) continue to agitate for an independent state.

Basra (Al-Basrah) City and chief port on Shatt al-Arab channel, s Iraq; capital of Basra province. An ancient centre of Arabic learning, it was captured by the Turks in 1668. In the early 20th century, large oilfields were discovered nearby, resulting in Basra's revival as a commercial and industrial centre. It suffered serious damage during the Iran-Iraq and Gulf wars. Industries: oil refining, flour, wool. Pop. (1992 est.) 746,000.

bass Any of several bony fishes, both freshwater and marine, and not all closely related. Together they make up a valuable commercial and game fish. They include the white, black, striped, rock and calico basses. The two main bass families are Serranidae and Centrarchidae.

bass Term denoting low or deep pitch. It is used of the lowest-pitched part of a composition, or the lowest-pitched member of a family of instruments. It applies to the deepest male singing voice. The bass line in a composition is the bottom note of a chord or the lowest line in polyphony, and plays an important role in the harmonic structure of the piece.

basset Short-legged hunting hound, originally bred in France to flush out game. After the BLOODHOUND, it has the most highly developed sense of smell among dogs. Bassets

have long bodies and long floppy ears. The short coat is generally tan and white. Standard size: 30-38cm (12-15in) at the shoulder; weight: 11.3-22.7kg (25-50lb).

Basseterre Capital and chief port of the federated state of ST KITTS-NEVIS, on the sw coast of St Kitts, in the Leeward Islands, E Caribbean. Founded in 1627, it is an important commercial centre. Industries: sugar-refining. Pop. (1990) 14,283. bassoon Bass woodpwind instrument with a range of three octaves, corresponding to that of the CELLO. It has a double-reed mouthpiece and a conical bore, the tube bending back on symphonic and chamber music. The double bassoons are used in symphonic and chamber music. The double bassoon or contrabassoon is the lowest-pitched woodwind instrument, sounding an octave below the bassoon. The modern form of the instrument dates from the late 19th century.

Bastille Fortress and prison in Paris, built in the late 14th century and destroyed during the French Revolution. Political prisoners were incarcerated here, and it became a symbol of royal oppression. On 14 July 1789, now a national holiday in France, a revolutionary mob stormed it, captured the ammunition store and released its seven prisoners. The Bastille was pulled down soon afterwards.

bat Only MAMMAL that has true flight (though a few mammals can glide). Bats are nocturnal and found in all tropical and temperate regions. Most are brown, grey or black. A bat's wing is formed by a sheet of skin stretched over a frame of greatly elongated bones. Bats are able to navigate in complete darkness by means of a kind of SONAR, which uses echoes of the bat's own supersonic squeaks to locate obstacles and prey. Many bats live largely on insects, some are carnivorous, some drink blood, some live on nectar and pollen, and one group—flying foxes—subsist on fruit. Most are small, although they range in wingspan from 25cm—147cm (10—58in). The 178 genera of bats make up the order Chiroptera.

Bates, H.E. (Herbert Ernest) (1905–74) British novelist, playwright and short story writer. His novels include Fair Stood the Wind for France (1944), The Jacaranda Tree (1949), and a popular series featuring the Larkin family, including The Darling Buds of May (1958), Oh! To Be in England (1963) and A Little of What You Fancy (1970).

Bath Spa city on the River Avon, sw England. The centre of the new unitary authority of Bath and North-East Somerset, Bath has been designated a world heritage site. Its hot springs were discovered in the 1st century AD by the Romans, who named the city Aquae Sulis (waters of the sun). The bathing complex and temple are the finest Roman remains in Britain. Bath flourished as a centre of the cloth and wool industries. The 15th-century Roman bath museum is adjacent to the ornate, gothic Bath Abbey. In the 18th century (under the direction of Beau Nash) the city became a fashionable resort. John Wood transformed the city into a showcase for Georgian architecture. The Royal Crescent, Queen Square and the Circus are among his notable achievements. Bath hosts an annual arts festival. The University of Bath was established in 1966. Industries: tourism, printing, bookbinding, engineering, clothing. Pop. (1991) 79,900.

batholith Huge mass of igneous rock at the Earth's surface that has an exposed surface of more than 100sq km (40sq mi). It may have originated as an intrusive igneous structure that was gradually eroded and which became surface material. Most batholiths consist of granite rock types, and are associated with the mountain-building phases of PLATE TECTONICS.

batik Method of decorating textiles, practised for centuries in Indonesia and introduced into Europe by Dutch traders. Molten wax is applied to the parts of a fabric that are to remain undyed, before the fabric is dipped into cool vegetable dye. The fabric is then dipped in hot water to remove the wax from the undyed areas. The process may be repeated, using different coloured dyes to form intricate patterns.

Batista y Zaldívar, Fulgencio (1901–73) Cuban political leader. A sergeant in the army, he led a successful coup in 1933 and ruled through a succession of figurehead presidents. In 1940 he was elected president. He retired in 1944 and moved to Florida, but in 1952 a military coup returned him to power. In 1959 he was overthrown by Fidel CASTRO.

Baton Rouge Capital of Louisiana, USA, on the Mississippi River. Founded in 1719 by French colonists, it was ceded to Britain by France in 1763, and to the USA with the Louisiana Purchase (1803). It became the state capital in 1849. The city contains both Louisiana State University and Southern University and is the site of a large petrochemical complex. Industries: natural gas, chemicals, plastics, wood products. Pop. (1990) 219,531.

battery Collection of voltaic cells that convert chemical energy into direct current (DC) electricity. The term is also commonly used for a single cell, particularly the dry, electrochemical CELL used in electronic equipment. Most primary cell batteries are not rechargeable; some types of primary cell – such as nickelcadmium (Nicad) batteries – and all accumulators (storage batteries) can be recharged when a current passed through them in the reverse direction restores the original chemical state.

battleship Most powerful type of naval warship in use during the late 19th and early 20th centuries. The largest battleships, the *Musachi* and the *Yamato*, displaced over 72,000 tonnes and were built by the Japanese. Both were sunk during World War 2. Battleships combined the thickest armour and the most powerful naval guns. Modern battleships also carry a variety of missile systems. *See also* AIRCRAFT CARRIER; CRUISER

baud Unit for measuring the speed at which a digital communications device carries information. One baud is equal to one BIT per second. Although the term **baud rate** is still widely used, the speed of modern equipment is often expressed in kilobits per second.

Baudelaire, Charles Pierre (1821–67) French poet and critic. His collection of poems, *Les Fleurs du Mal* (1857), represents one of the highest achievements of 19th century French poetry. He explores the poetic theory of correspondences (scent, sound and colour), and the aesthetic creed of the inseparability of beauty and corruption. The poems were condemned by the censor, and six of them were subsequently suppressed. Baudelaire was much influenced by Edgar Allan POE, whose poetry he translated and whose works figure prominently in his major pieces of criticism *Curiosités Esthetiques* and *L'Art Romantique* (both 1869).

Bauhaus German school for architecture and the applied

Sodium sulphur batteries are the newest type of battery and are much lighter than nickel cadmium types. They have a carbon anode (1) and a metal cathode (2). The reactants are arranged in rings around the central anode. An inner core of sodium (3) is separated from an outer ring of sulphur (4) by

a layer of aluminium (5). The sodium (6) reacts with the aluminium layer (7) giving up electrons (8) which stream to the anode. The cathode gives electrons to the sulphur atoms (9) which bond with the sodium ions to form sodium sulphide. The process creates a voltage.

▲ Bayeux tapestry The tapestry (strictly an embroidery) depicts the history of the Norman Conquest of England. It begins with Harold's visit to France, and ends with his defeat by the forces of William the Conqueror. This section of the tapestry depicts Breton cavalry forces floundering in marshy ground having failed to break the English line of foot soldiers located on the top of a small hill. The English soldiers are always shown with large moustaches.

arts, which played an important role in developing links between design and industry. Founded by Walter GROPIUS in 1919, it aimed to combine great craftsmanship with an ideal of an all-embracing modern art in which the division beween monumental and decorative elements would no longer exist. Though Bauhaus specialized in architecture and design, several progressive painters, including KANDINSKY and KLEE, taught there. The studios focused on designing products for manufacturing industry, especially furniture, textiles and electric light fittings. Typical Bauhaus design was severe and impersonal. In 1928 Hannes Meyer succeeded Gropius as director. MIES VAN DER ROHE took Meyer's place in 1930 but in 1933, after it moved to Berlin, the Nazis closed the school. Many students and staff emigrated, taking Bauhaus style and ethos with them. Bauhaus theory had an enormous influence on Western design. MOHOLY-NAGY, a Hungarian designer who taught at the Bauhaus in the 1920s, founded the New Bauhaus in Chicago in 1937. This later became the Institute of Design. bauxite Rock from which most aluminium is extracted. Bauxite is a mixture of several minerals, such as diaspore, gibbsite, boehmite and iron. It is formed by prolonged weathering and leaching of rocks containing aluminium silicates.

Bavaria (Bayern) Largest state in Germany; the capital is MUNICH. Part of the Roman empire until the 6th century, it was taken by CHARLEMAGNE in 788, forming part of the Holy Roman Empire until the 10th century. Incorporated into Germany in 1871, it remained a kingdom until 1918, becoming a state within the German Federal Republic in 1946. Industries: glass, porcelain, brewing. Area: 70,553sq km (27,256sq mi). Pop. (1993) 11,863,313.

bay Tree or shrub of the LAUREL family, the leaves of some varieties are used as to flavour food. In the classical tradition, head wreaths of bay leaves were awarded as tokens to conquerors and bards. Family Lauraceae; species Laurus nobilis. Bayeux tapestry (c.1080) Strip of linen embroidered in wool, measuring 70m × 48cm (231ft × 19in) and depicting (in more than 70 scenes) the life of HAROLD II of England and the NORMAN CONQUEST. An unfounded tradition attributes its design to Matilda, wife of WILLIAM I (THE CONQUERER), but it was probably commissioned by William's half-brother Odo, Bishop of Bayeux. It is now in a museum in Bayeux, N France. Bay of Pigs (17 April 1961) Unsuccessful effort by Cuban exiles (aided by the USA) to overthrow Fidel CASTRO by invading Cuba near the Bay of Pigs. About 1,500 Cubans, trained, equipped and transported by the US government, were involved. The invasion was badly planned and the Cuban army defeated the exiles within three days. US president John F. KENNEDY initially denied US involvement and was later subject to criticism for its failure. See also CUBAN MISSILE CRISIS Bayreuth City in Bavaria, Germany, where an annual festival is held, staging exclusively the work of composer Richard WAGNER. The festivals are held in the Festspielhaus, built to Wagner's specifications for the performance of great German theatre. The first festival was held in 1876

BBC See British Broadcasting Corporation (BBC)

BCG (Bacille Calmette Guérin) Vaccine against tuberculosis. It was named after its discoverers, the French bacteriologists Albert Calmette and Camille Guérin.

beach Sloping zone of the shore, covered by sediment, sand, or pebbles, that extends from the low-water line to the limit of the highest storm waves. The sediment is derived from coastal

erosion or river alluvium. Waves breaking on the beach sift the sediment back and forth, so the heavier pebbles remain on the upper beach and the sand moves down towards the water.

Beadle, George Wells (1903–89) US geneticist. During his study of MUTATIONS in bread mould (*Neurospora crassa*), he and Edward Tatum found that GENES are responsible for the synthesis of ENZYMES, and that these enzymes control each step of all biochemical reactions occurring in an organism. For this discovery they shared, with J. Lederberg, the 1958 Nobel Prize for physiology or medicine.

beagle Hunting dog, used to chase and follow small game. Of ancient origin, the modern breed was developed in England in the mid-1800s. It has a long, slightly domed head with a square-cut muzzle, long, hanging ears and widely set, large, eyes. Average size: (two varieties) not exceeding 38cm (15in) at the shoulder; weight: 8–14kg (18–31lb).

Beagle, HMS British survey ship that carried Charles DARWIN as ship's naturalist. The *Beagle* left England in December 1831 and for five years explored parts of South America and the Pacific islands. Darwin's observations formed the basis for his theory of EVOLUTION by NATURAL SELECTION.

bean Plant grown for its edible seeds and seed pods. The broad bean (*Vicia faba*) is native to N Africa. The string bean (*Phaseolus vulgaris*) is native to tropical South America, and is common in the USA; several varieties are cultivated. The runner (*Phaseolus coccineus*) has scarlet, rather than white or lilac flowers, and shorter, broader seeds. *See also* SOYA BEAN **bear** Large, omnivorous mammal with a stocky body, thick coarse fur and a short tail. Bears are native to the Americas and Eurasia. The sun bear is the smallest species, the Kodiak brown

coarse fur and a short tail. Bears are native to the Americas and Eurasia. The sun bear is the smallest species, the Kodiak brown bear the largest. Bears have poor sight and only fair hearing, but an excellent sense of smell. Except for the POLAR BEAR, which lives almost exclusively on fish, walruses and seals, bears eat a wide variety of plant and animal foods. They kill prey with a blow from their powerful forepaws. In cold regions most bears become dormant or hibernate in winter. Length: 1.3–3m (4–10ft); weight: 45–725kg (100–1,600lb). Order Carnivora; family Ursidae; there are approximately nine species.

Bear Flag Revolt (June 1846) Uprising by US settlers in Sonoma, California. During the MEXICAN WAR, a group of US emigrants in the Mexican territory of California proclaimed the Republic of California and raised the "bear flag". The republic lasted until US troops arrived in July and replaced the bear flag with the Stars and Stripes.

beatitudes Blessings spoken by Jesus at the opening of his SERMON ON THE MOUNT upon those worthy of admission to the Kingdom of God. (Luke 6, Matthew 5).

Beatles, The British rock group. Perhaps the most influential band in the history of 20th-century popular music. Formed in Liverpool in 1960, The Beatles initially consisted of John Lennon (1940-80), Paul McCartney (1942-), George Harrison (1943-) and Pete Best (1941-). In 1962 Best was replaced by Ringo Starr (Richard Starkey) (1940-). The Beatles' early style was US-derivative rhythm and blues blended with Lennon and McCartney's song-writing talent and attractive harmonies. Between 1964 and 1970, they dominated pop music with 18 albums, including Rubber Soul (1965), Revolver (1966) and Sgt. Pepper's Lonely Hearts Club Band (1967). After 1966 they never publicly performed live. The group made four feature films: A Hard Day's Night (1964), Help! (1965), Magical Mystery Tour (1968) and Let It Be (1970), and supplied the soundtrack for the cartoon Yellow Submarine (1968). The Beatles disbanded in 1970 to pursue individual careers. Their influence on contemporary popular music remains undiminished.

beat movement Term derived from John Clellon Holmes' novel Go (1952) and applied to a group of US writers in the 1950s, who rejected middle-class values and commercialism. They also experimented with different states of perception through drugs and meditation. The group included the poets Allen GINSBERG, Gregory Corso and Lawrence FERLINGHETTI and the novelists Jack KEROUAC and William BURROUGHS.

Beaton, Sir Cecil Walter Hardy (1904–80) British photographer, costume and stage designer, and writer. He began his career as a fashion photographer in the 1920s, and took up

stage design in the 1930s. His film and stage designs include *Gigi* (1951), *My Fair Lady* (stage, 1956; film, 1964) and *Coco* (1969). Beaton's books include *The Wandering Years* (1962). **Beaufort, Henry** (1374–1447) English statesman and prelate, illegitimate son of John of Gaunt. As chancellor to Henry IV and Henry V, Beaufort considerably influenced English domestic and foreign policy. Guardian of Henry VI (1422), he controlled England in the 1430s.

Beaufort wind scale Range of numbers from 0–17 representing the force of winds, together with descriptions of the corresponding land or sea effects. Beaufort 0 means calm wind less than 1km/h (0.6mph), with smoke rising vertically. Beaufort 3 means light breeze, 12–19km/h (8–12mph), with leaves in constant motion. Beaufort 11 is a storm, 103–116km/h (64–72mph). Beaufort 12–17 is a hurricane, 117.5–219+km/h (73–136+mph), with devastation. The scale is named after its inventor, Admiral Sir Francis Beaufort (1774–1857)

Beauharnais, Josephine de See Joséphine

Beaumarchais, Pierre Augustin Caron de (1732–99) French dramatist. Beaumarchais' principal plays were the related court satires, *The Barber of Seville* (1775) and *The Marriage of Figaro*, which were tansformed into operas by ROSSINI and MOZART respectively. He was also employed as a secret agent by the French to supply arms to the Americans during the American Revolution.

Beaumont, Sir Francis (1584–1616) English dramatist closely associated with John FLETCHER. Between 1607 and 1613 they produced at least ten plays, including *Philaster*, *The Maid's Tragedy* and *A King and No King*. Beaumont is usually credited with sole authorship of two plays, *The Woman Hater* (1607) and *The Knight of the Burning Pestle* (c.1607). Beauregard, Pierre Gustave Toutant de (1818–93) Confederate general in the American Civil War. He served in the Mexican War, and was superintendent of West Point when Civil War broke out in 1861. On 13 April 1861 he forced the Union surrender of Fort Sumter in the first action of the war.

Beauvoir, Simone de (1908–86) French novelist, essayist and critic. Her novels *She Came to Stay* (1943) and *The Mandarins* (1954) are portraits of the existentialist intellectual circle of which she and her lifelong companion, Jean-Paul SARTRE, were members. Her best-known work remains the feminist treatise *The Second Sex* (1949). Other significant works include *The Prime of Life* (1960), *A Very Easy Death* (1964) and *Old Age* (1970). *See also* EXISTENTIALISM

beaver Large RODENT with fine brown to black fur, webbed hind feet, and a broad scaly tail; it lives in streams and lakes of Europe, North America and Asia. Beavers build "lodges" of trees and branches above water level and dam streams and rivers with stones, sticks and mud. In many places they are hunted for fur. Length: to 1.2m (4ft); weight: up to 32kg (70lb). Family Castoridae; species *Castor fiber*.

Beaverbrook, William Maxwell Aitken, 1st Baron (1879–1964) British newspaper proprietor and politician, b. Canada. He entered parliament in 1910 and was made a peer in 1917. He was chancellor of the Duchy of Lancaster (1918–22) and a member of Winston Churchill.'s war cabinet (1940–45). He bought a majority interest in the *Daily Express* (1916) and later founded the *Sunday Express* and the *Evening Standard*.

bebop (bop) Form of JAZZ with subtle harmonies and shifting rhythms. It arose in the late 1940s as a development from the simpler SWING style. Complex and dynamic, involving the extensive use of improvisation, the movement was pioneered by musicians such as Charlie PARKER and Dizzy GILLESPIE.

Beckenbauer, Franz (1945–) German footballer. An attacking centre back, Beckenbauer was captain of the West German squad that won the 1974 World Cup and the Bayern Munich team that won the European Cup (1974–76). In 1990, as coach of the German national team, he became the only person to captain and manage a World Cup-winning team.

Becker, Boris (1967–) German tennis player. Becker rose from obscurity to win the 1985 Wimbledon men's singles. His booming serve and athleticism gained him two more Wimbledon titles (1986, 1989). He won the US Open (1989) and the Australian Open (1991, 1996). He retired in 1997.

Becket, Saint Thomas à (1118-70) English Church

leader. He was appointed chancellor of England (1155) and became a friend of Henry II. In 1162 Henry made him archbishop of Canterbury, hoping for his support in asserting royal control, but Becket devoted his loyalty to the church. His defence of clerical privileges against the crown led to fierce conflict. Becket spent six years in exile. Reconciliation was short-lived, as Becket turned on those, including the king, who had violated his rights during exile. Four of Henry's knights, falsely assuming they would gain the king's gratitude, killed Becket in Canterbury Cathedral. Henry did penance and Becket was acclaimed a martyr. He was canonized in 1173.

Beckett, Samuel (1906–89) Irish playwright and novelist. One of the most influential European writers of the 20th-century, Beckett wrote in both French and English. He emigrated to Paris in the 1920s and became an assistant to James JOYCE. His first published work was a volume of verse Whoroscope (1930). His first novel was Murphy (1938). Beckett's reputation is largely due to his three full-length plays, Waiting for Godot (1952), Endgame (1957) and Happy Days (1961), which explore notions of suffering, paralysis and endurance. His work is often linked to the Theatre of the ABSURD with its repetitive, inventive language and obsession with futility and meaninglessness. His short plays include Krapp's Last Tape (1958), Not I (1973) and Footfalls (1975). His stark staging and prioritization of the spoken over the visual is often unsettling. Other novels include the French trilogy Mollov (1951), Malone Dies (1951) and The Unnameable (1953). He was awarded the 1969 Nobel Prize for literature.

Beckmann, Max (1884–1950) German expressionist painter. He was disturbed by his experiences as a medical orderly in World War 1 and changed his painting style to reflect his awareness of human brutality. His EXPRESSIONISM often took the form of allegory and he drew inspiration from German gothic art. In 1933, after being dismissed from teaching by the Nazis, he started work on *Departure*, the first of nine TRIPTYCHS that express the sense of dislocation he felt in the modern world. As a result of Nazi harassment, he moved to Amsterdam and then to the USA. He came to regard art as a matter of ethical necessity rather than aesthetics.

Becquerel, Antoine Henri (1852–1908) French physicist. He was professor of physics at the Paris Museum of Natural History, and later at the Ecole Polytechnique. In 1896 he discovered RADIOACTIVITY in uranium salts, for which he shared the 1903 Nobel Prize for physics with Pierre and Marie Curie. The becquerel standard unit for measuring radioactivity, which has replaced the Curie, was named after him. See also BETA PARTICLE

bed In geology, a layer of sedimentary rock. Usually deposited in a broadly horizontal sheet, it underlies the surface material (regolith) except where regolith has been removed by EROSION.

bedbug Broad, flat, wingless insect found worldwide. It

▼ The Beatles Their clean-cut image and the songwriting talents of Paul McCartney and John Lennon, ensured that "Beatlemania" was a transatlantic phenomena. The Beatles dominated the pop charts in the 1960s. Their later albums such as Sgt Pepper's Lonely Hearts Club Band (1967) and the White Album (1968) were more experimental.

▲ beech Beech trees are found in the Northern and Southern Hemispheres. The northern beech (A) (European Fagus sylvatica; US Fagus grandifolia) thrives on chalky soil. Male flowers grow in clusters, separate from the female. The Antarctic beech (C) (Nothofagus antarctica) grows to 30m (100ft) and is found in the Andes, SE Australia and New Zealand. It differs from its northern cousin in being an evergreen species. Although the eastern beech (B) belongs to the same genus as the Antarctic, like the northern it grows up to 36m (120ft) high.

The nest of the honeybee consists of a number of wax combs suspended in a shelter, such as a hollowed-out tree. The cells of the outer edges of the comb (1) contain nectar mixed with saliva, which the workers fan with their wings to evaporate excess water before the cell is capped with wax; this mixture eventually turns into honey. Other cells are used to contain reserves of pollen (2). Developing larvae (3) in open cells are kept clean by worker bees to prevent fungal infestations. They are fed by young workers with regurgitated food, and

with honey and pollen from the storage cells. When a newly formed worker emerges from its cell it is fed regurgitated pollen and nectar from another worker (4). Its vacated cell is thoroughly cleaned and re-used. The queen (5), surrounded by a retinue of workers, rests on a group of capped cells, each of which contains a worker pupa. Eggs (6) are laid by the queen in the centre of the comb. When new queens are needed, the workers construct extra large cells at the edge of the comb (7) in order to accommodate them.

feeds by sucking blood from mammals, including human beings. Bedbugs usually gorge themselves at night and remain hidden during the day. Length: to 6mm (0.25in). Family Cimicidae; species *Cimex lectularius*.

Bede, Saint (673–735) (Venerable Bede) English monk and scholar. He spent his life in the Northumbrian monasteries of Wearmouth and Jarrow. His most important work is the *Ecclesiastical History of the English Nation*, an indispensable primary source of early English history (54 BC–AD 697). His works were profoundly influential in early medieval Europe.

Bedfordshire County in central s England; the county town is Bedford, other major towns include Luton and Dunstable. There are traces of early Bronze Age settlements. The land is mostly flat with low chalk hills, the Chilterns, in the s. The region (drained by the River Ouse) is fertile, and agriculture is the chief economic activity. This includes the growing of cereal crops, cattle raising and market gardening. Industries: motorvehicle manufacture, electrical equipment, precision instruments. Area: 1,235sq km (477sq mi). Pop. (1991) 524,105.

Bedouin Nomadic, desert-dwelling ARAB peoples of the Middle East and followers of ISLAM. Traditionally they live in tents, moving with their herds across vast areas of arid land in search of grazing areas. Bedouin society is patrilineal. They are renowned for their hospitality, honesty and fierce independence. In the 20th century, many Bedouin have been forced to abandon the nomadic way of life and work in towns.

bee Insect distinguished from other members of the order Hymenoptera, such as ants and wasps, by the presence of specially adapted hairs, with which they collect POLLEN; all bees feed their young NECTAR and pollen. The body is usually quite

hairy and the hairs are multi-branched (plumose). Although the honeybee and BUMBLEBEE are social insects living in well-organized colonies, many other bees are solitary, and some species even live in the colonies of other bees. Found world-wide, except in polar regions, they are important pollinators of flowers. Entomologists recognize c.12,000 species, but only the honeybee provides the HONEY that we eat. It builds combs of six-sided cells with wax from glands on its abdomen. A honeybee colony may have up to 60,000 individuals, consisting mainly of infertile female workers, with a few male drones and one egg-laying queen.

beech Deciduous tree native to the Northern Hemisphere. Beeches have wide-spreading branches, smooth grey bark and alternate, coarse-toothed leaves. Male flowers hang from thin stems; pairs of female flowers hang on hairy stems and develop into triangular, edible nuts enclosed by burs. The American beech (*Fagus grandifolia*) and the European beech (*F. sylvatica*) are important timber trees used for furniture and tool handles. Height: to 36m (117ft). Family Fagaceae; there are 10 species. All belong to the genus *Nothofagus*.

Beecham, Sir Thomas (1869–1961) English conductor, one of the greatest of his era. He founded (1906) the New Symphony Orchestra, the London Philharmonic (1932) and the Royal Philharmonic (1947). In 1933 Beecham became artistic director of Covent Garden Opera, introduced the operas of Richard Strauss to English audiences. He was widely respected as an interpreter of Delius and Sibelius.

Beecher, Henry Ward (1813–87) US Congregational minister, outstanding preacher and influential advocate of social reform, grandfather of Harriet Beecher Stowe. In 1847 Beecher became pastor of the Plymouth Congregational Church, Brooklyn, New York. Famed for his opposition to slavery, he supported women's voting rights and the scientific theory of evolution. He wrote several books of sermons, a life of Jesus Christ, and a novel Norwood: A Tale of Village Life in New England (1867).

bee-eater Tropical BIRD of the E hemisphere that catches flying bees and wasps. It has a long, curved beak, bright, colourful plumage and a long tail. It nests in large colonies and builds a tunnel to its egg chamber. Length:15–38cm (6–15in). Family Meropidae.

Beelzebub Name used for Satan or the Devil. The word was originally *Beelzebul* ("Lord of demons") but was corrupted deliberately in Syrian texts and the (Latin) Vulgate to *Beelzebub* ("Lord of flies") as a gesture of contempt. Originally an aspect of Baal, it was used in its present sense in the New Testament (Matthew 10, Mark 3 and Luke 11).

beer Alcoholic beverage produced by the soaking, boiling and fermentation of a cereal extract (often malted barley) flavoured with a bitter substance (hops). Other ingredients are water, sugar and yeast. The alcohol content of most beer ranges from c.2.5% to 12%. Among the major types of beer are: ales, which classically have fewer hops added; stouts and porters, which classically have fewer hops added; stouts and porters, which are darker and have a persistent head; lagers and pilsners, which are usually fizzy and matured over a longer period of time; bitter, which has additional hops; mild, which has few hops and is low in alcohol; and brown ale, similar to stout.

Beersheba (Be'er Sheva) Chief city of the Negev region, S Israel. It was the southernmost point of biblical PALESTINE. It flourished under Byzantine rule, but declined until restored by the Ottoman Turks *c*.1900. Industries: chemicals, textiles, ceramics. Pop. (1992 est.) 128,400.

beet Vegetable native to Europe and parts of Asia, and cultivated in most cool regions. Its leaves are green or red and edible, though it is generally grown for its thick red or golden root. Some varieties are eaten as a vegetable, others are a source of sugar and some are used as fodder. Family Chenopodiaceae; species *Beta vulgaris*. *See also* SUGAR BEET **Beethoven**, **Ludwig van** (1770–1827) German composer, a profound influence on the development of Western classical music. He provides a link between the formal CLASSICAL style of HAYDN and MOZART and the ROMANTICISM of WAGNER, BRAHMS and BRUCKNER. Born in Bonn, Beethoven visited Vienna in 1787 and was taught briefly by Mozart; he made Vienna his home from 1792 and took lessons from Haydn.

Beethoven's early works, such as the piano sonatas *Pathétique* (1789) and *Mooonlight* (1801), betray the influences of his teachers. The year 1801 marks the onset of Beethoven's deafness and a shift in style. His third SYMPHONY (Eroica, 1804) was a decisive break from the classical tradition, both in terms of its form and its dedication to Napoleon I. This middle period also includes his fifth piano concerto (Emperor, 1809) and his only opera, *Fidelio* (1805). Beethoven's final period coincides with his complete loss of hearing (1817) and is marked by works of even greater length and complexity. These include the Hammerklavier Sonata (1818) and his ninth symphony (*Ode to Joy*, 1817–23). Beethoven increased the dramatic scope of the symphony and expanded the size of the orchestra.

beetle Insect characterized by horny front wings that serve as protective covers for the membranous hind wings. These protective sheaths are often brightly coloured. Beetles are usually stout-bodied and their mouthparts are adapted for biting and chewing. They are poor fliers, but (like all insects) are protected from injury and drying up by an exoskeleton. Beetles are the most numerous of the insects. More than 250,000 species are known and new ones are still being discovered. They include SCARAB BEETLES, LADYBIRDS and WEEVILS. Most feed on plants, some prey on small animals, including other insects, whereas others are scavengers. Beetles undergo complete METAMORPHOSIS. Their larvae (grubs) usually have three pairs of legs and distinct heads, usually dark in colour. Length: 0.5mm—6cm (0.02—6.3in). Order Coleoptera.

Begin, Menachem (1913–92) Israeli statesman, prime minister (1977-83). A Polish-born Zionist, Begin was sentenced to eight years slave-labour but was released in 1941 to fight in the new Polish army. As commander of the paramilitary Irgun Zeva'i Leumi, he led resistance to British rule until Israeli independence in 1948. As leader of the Freedom Party (Herut), Begin clashed with David BEN-GURION and the conflict was only resolved by the SIX DAY WAR (1967). In 1973 Begin became leader of the Likud coalition. In 1977 Likud formed a coalition government with Begin as prime minister. Though a fervent nationalist, he sought reconciliation with Egypt and signed a peace treaty with Anwar SADAT in 1979. In recognition of their efforts they shared the 1978 Nobel Peace Prize. Re-elected by a narrow margin in 1981, Begin maintained a hardline stance towards the West Bank and Gaza Strip. His popularity waned after Israel's 1982 invasion of Lebanon and he was succeeded by Yitzhak Shamir.

Behan, Brendan (1923–64) Irish writer, notorious for his riotous lifestyle. Behan became a member of the IRA at the age of 14 and served several years in borstal, as described in his autobiography *Borstal Boy* (1958). His first play, *The Quare Fellow*, was produced in 1954. Influenced by the work of BRECHT, his second play was *The Hostage* (1959).

behavioural ecology Study of the complex relationship between environment and animal behaviour. This involves drawing on natural history to study the adaptive features of an organism within its habitat. Human behaviour is similarly studied. *See also* ECOLOGY; ETHOLOGY; ADAPTATION

behaviourism School of psychology that seeks to explain all animal and human behaviour primarily in terms of observable and measurable responses to stimuli. Its method of research often involves laboratory experiments. Pavlov's work on conditioned reflexes was a source for the early behaviourists such as J.B. Watson. They rejected the evidence introspection gives of conscious feelings, motives and will. Later behaviourists such as B.F. SKINNER explain learning and development by "operant conditioning". See also DEVELOPMENTAL PSYCHOLOGY

Behn, Aphra (1640–89) English playwright, poet and novelist. The first English professional female writer. A proto-feminist, Behn attracted much contemporary scandal. She produced 15 risqué comic plays, the most well-known being *The Rover* (1677). She also wrote poetry under an assumed name, but is principally remembered for the first English philosophical novel, *Oroonoko* (1688), an anti-slavery love story.

Behring, Emil Adolph von (1854–1917) German bacteriologist and pioneer immunologist. In 1901 he was awarded the first Nobel Prize for physiology or medicine for his work

on serum therapy, developing immunization against DIPHTHE-RIA (1890) and TETANUS (1892) by injections of antitoxins. His discoveries led to the treatment of many childhood diseases.

Beijing (Peking) Capital of the People's Republic of CHINA, on a vast plain between the Pei and Hun rivers, NE China. A settlement since c.1000 BC, Beijing served as China's capital from 1421 to 1911. After the establishment of the Chinese Republic (1911-12), Beijing remained the political centre of China. The seat of government was transferred to NANKING in 1928. Beijing ("northern capital") became known as Pei-p'ing ("northern peace"). Occupied by the Japanese in 1937, it was restored to China in 1945 and came under Communist control in 1949. Its name was restored as capital of the People's Republic. The city comprises two walled sections: the Inner (Tatar) City, which houses the Forbidden City (imperial palace complex), and the Outer (Chinese) city. Beijing is the political, cultural, educational, financial and transport centre of China. Since 1949 heavy industry has been introduced, and textiles, iron and steel are now produced. Pop. (1993 est.) 6,560,000. See also Tiananmen Square

Beirut (Bayrūt) Capital and chief port of Lebanon, on the Mediterranean coast at the foot of the Lebanon Mountains. The city was taken by the Arabs in AD 635. In 1110 it was captured by the Christian crusaders, and it remained part of the Latin Kingdom of Jerusalem until 1291. In 1516, under DRUSE control, Beirut became part of the Ottoman Empire. During the 19th century it was the centre of a revolt against the Ottoman empire led by MUHAMMAD ALI. In 1830 Beirut was captured by Egyptians, but in 1840 British and French forces restored Ottoman control. In 1920 it became capital of Lebanon under French mandate. With the creation of Israel, thousands of Arabs sought refuge in Beirut. During the 1950s and 1960s Beirut was a popular tourist destination. In 1976 civil war broke out, and Beirut rapidly fractured along religious lines. In 1982 West Beirut was devastated by Israel in the war against the PALESTINE LIBERATION ORGANIZATION (PLO). Israel began a phased withdrawal in 1985. In 1987 Syrian troops entered Beirut as part of an Arab peacekeeping force. In 1990 Syrian troops dismantled the "Green Line" separating Muslim West from Christian East Beirut and reopened the Beirut-Damascus highway. By 1991 all militias had withdrawn from the city and restoration work began. The infrastructure, economy and culture of Beirut suffered terribly during the civil war and only small-scale industries remain. Pop. (1993 est.) 1,500,000.

Béjart, Maurice Jean (1927–) French ballet dancer and choreographer. One of the most innovative modern choreographer.

■ Beethoven A seminal figure in the development of Western classical music. Beethoven's work is often divided into three periods. His piano sonatas are most representative of the early period (1795-1801). His third symphony, Eroica (1804), was originally dedicated to Napoleon I. This middle period (1801-16) also includes his sixth (Pastoral) symphony. From 1817 Beethoven was completely deaf. This last period is marked by his ninth symphony (with a finale based on Schiller's "Ode to Joy") and a great mass Missa Solemnis (1823).

raphers. He experimented with avant-garde modern dance techniques and acrobatics, incorporating them into classical movements. He founded and became director of the Ballet of the 20th Century in Brussels in 1960.

Belarus Republic in NE Europe. See country feature

Belau (formerly Palau) Self-governing island group in the Caroline Islands of the w Pacific, consisting of about 200 islands, only eight of which are inhabited; the capital is Koror. A Spanish possession (1710–1898), Belau was then held by Germany until 1914, when Japan occupied it. At the end of World War 2 control passed to the USA, which administered Belau as part of the US Trust Territory of the Pacific Islands. Self-government was instituted in 1981 and full independence followed in 1994. Most of the population are Micronesian, engaged in subsistence agriculture. Commercial fishing and copra processing are important economic activities. Area: 460sq km (189sq mi). Pop. (1986) 13,870.

Belfast Capital of Northern Ireland, at the mouth of the River Legan on Belfast Lough. The city was founded in 1177 but did not develop until after the Industrial Revolution. Belfast is now the centre for the manufacture of Irish linen. Since the 19th century, religious and political differences

between Protestants and Catholics have been a source of tension. In the late 1960s these differences erupted into violence and civil unrest. Shipbuilding is a major industry and Belfast's harbour includes the Harland and Wolff yard, which has produced many of the world's largest liners. Other industries: aircraft, machinery, tobacco. Pop. (1991) 283,746.

Belgium Kingdom in NW Europe. *See* country feature, p.78 **Belgrade** (Beograd) Capital of Serbia and of rump Yugoslavia, situated at the confluence of the Sava and Danube rivers. In the 12th century it became capital of Serbia, but was later ruled by Ottoman Turks. It was incorporated into the area which came to be known as Yugoslavia in 1929 and suffered much damage under German occupation in World War 2. In 1996 Belgrade witnessed huge demonstrations against the government. Industries: chemicals, metals, machine tools, textiles. Pop. (1991) 1,168,454.

Belize (formerly British Honduras) Republic in Central America, on the Caribbean Sea. **Land and climate** Swamp vegetation and rainforest cover large areas. North Belize is mostly low-lying and swampy. Behind the s coastal plain, the land rises to 1,122m (3,681ft) at Victoria Peak in the Maya Mountains. The River Belize flows across the centre of the

BELARUS

In September 1991, Belarus adopted a red and white flag to replace the flag used in the Soviet era. In June 1995, following a referendum in which Belarussians voted to improve relations with Russia, this was replaced with a design similar to the flag of 1958 but without the hammer and sickle.

Belarus (Belorussia), formerly part of the Soviet Union, is a landlocked country in E Europe. The land is low-lying and mostly flat. In s Belarus is the Pripet Marshes, Europe's largest area of marsh and peat bog. A hilly region extends from NE to SW through the centre of Belarus, and includes its highest point, at 346m (1,135ft), near the capital MINSK.

CLIMATE

Belarus is affected both by the moderating influence of the Baltic Sea and by continental conditions to the E. Winters are cold and summers warm and the average annual rainfall is about 550–700mm (22–28in).

VEGETATION

Forests cover about a third of Belarus. The cold-

er N has trees such as alder, birch and pine. Ash and oak grow in the warmer s. Farmland and pasture have replaced most of the original forest.

History and Politics

Slavic people settled in Belarus c.1,500 years ago. In the 9th century, the area became part of the first East Slavic state of Kievan Rus. In the 13th century, MONGOL armies overran the area and, in the 14th century, Belarus became part of LITHUANIA. In 1569 Lithuania, including Belarus, became part of Poland. In the 18th century, Russia took over most of eastern Poland, including Belarus. In the NAPOLEONIC WARS Belarus was razed by the retreating Russian army (1812). Bealrus was again destroyed in World War 1. In 1918 Belarus unilaterally declared its independence from Russia. In 1919 it was declared a socialist republic of the Soviet Union. In the Treaty of Riga (1921), w Belorussia was handed to Poland, while the eastern part became a founder republic of the Soviet Union (1922). In 1939 w Belorussia was captured by the Red Army. During World War 2, Belarus was once more a battlefield for major European powers and a quarter of its population perished. The Nazis murdered most of the Jewish population. In 1945 Belarus became a member of the United nations (UN). In 1991, after the breakup of the Soviet Union, Belarus declared its independence and was a founder member of the COMMONWEALTH OF INDEPENDENT STATES (CIS). The CIS administrative centre is located in Minsk. In 1997, despite opposition from nationalists, Belarus signed a Union Treaty with Russia, committing it to integration with Russia.

AREA: 207,600sq km (80,154sq mi)

POPULATION: 10,297,000

CAPITAL (POPULATION): Minsk (1,633,600)
GOVERNMENT: Multiparty republic
ETHNIC GROUPS: Belarussian 80%, Russian,

Polish, Ukrainian, Jewish

LANGUAGES: Belarussian, Russian (both

official)

RELIGIONS: Christianity (mainly Belarussian Orthodox, with Roman Catholics in the w

and Evangelicals in the sw)

currency: Belarussian rouble = 100 kopecks

ECONOMY

Belarus is an upper-middle-income economy (1992 GDP per capita, US\$6,440). Like several former republics of the Soviet Union, it has faced problems in the transition from to a free-market economy. Under communism, many manufacturing industries, such as agricultural equipment relied on raw materials from the Soviet Union. In 1995 an agreement with Russia enabled Belarus to recieve subsidized fuel supplies. Agriculture, especially meat and dairy farming, is important.

The former national flag, adopted in 1991 but replaced in 1995, flying above an outline of Belarus, is the subject of this 5-rouble stamp issued in 1992. The site of the capital city, Minsk, whose name is written in the Cyrillic alphabet, is marked on the centre of the map.

country. Belize has a humid tropical climate, with high annual temperatures and an average annual rainfall ranging from 1,300mm (50in) in the N to over 3,800mm (150in) in the S. Belize is prone to hurricanes. In the N, ironwood, mahogany and sapote predominate, while cedar, oak and pine are found in the s. The coastal plains are covered by savanna, while mangrove swamps line the coast. Economy Belize is a lowermiddle-income developing country. The economy is based on agriculture. Sugar cane is the chief commercial crop. Other crops include bananas, beans, citrus fruits, maize and rice. Forestry, fishing and tourism are important. History Between c.300 BC and AD 1000, Belize was part of the MAYA empire, which had declined long before Spanish explorers reached the coast in the early 16th century. Spain claimed the area but did not settle. Shipwrecked British sailors founded the first European settlement in 1638. Over the next 150 years Britain gradually took control of Belize and established sugar plantations using slave labour. In 1862 Belize became the colony of British Honduras. In 1973 it became known as Belize and achieved independence in 1981. Recent events Guatemala has claimed Belize since the early 19th century and objected to its newly independent status. British troops remained in Belize to prevent a possible invasion. In 1983 Guatemala reduced its claim to the s fifth of Belize. In 1992 Guatemala recognized its independence and in 1993 Britain began to withdraw its troops.

Bell, Alexander Graham (1847–1922) Scottish-born scientist, inventor of the TELEPHONE. He first worked with his father, inventor of a system for educating the deaf. The family moved to Canada in 1870, and Bell taught speech at Boston University (1873–77). His work on the transmission of sound by electricity led to the first demonstration of the telephone in 1876 and the founding of Bell Telephone Company (USA) in 1877. **belladonna** *See* Atropine; Nightshade

Bellini, Giovanni (c.1430-1516) Italian painter, from a famous artistic family. Giovanni's father, Jacopo (c.1400c.1470), was a pupil of GENTILE DA FABRIANO. His major surviving works are two sketchbooks, the source of many works by his son-in-law Andrea MANTEGNA and his two sons Giovanni and Gentile. Gentile (c.1429–1507) was famous for his narrative works (such as The Miracle of the True Cross) which became the prototype of the genre in Venice. Giovanni was the greatest painter of the family and single-handedly transformed Venice into a great centre of the RENAISSANCE. The most important influences on his work were Mantegna and Antonello da Messina, from whom he learned to paint in oils. In his early works, the treatment of nature was precise and realistic but it gradually became poetic and monumental. Despite an extraordinary series of allegorical and mythological paintings, he is chiefly remembered as a religious painter. His pictures emphasize light and colour as a means of expression. Many of the leading painters of Venice trained in his studio, including TITIAN, Palma Vecchio, Sebastiano del Piombo and possibly GIORGIONE.

Bellini, Vincenzo (1801–35) Italian composer of operas. His most notable works were *Norma* and *La Sonnambula* (both in 1831) and *I Puritani* (1835). His characteristically flowing melodies require great vocal skill. These *bel canto* operas were widely popular during the 19th century.

Belloc, (Joseph) Hilaire (Pierre-René) (1870–1953) British writer, b. France. Belloc became a British citizen in 1902 and was a Liberal MP (1906–10). A versatile writer, his work includes satirical novels (some illustrated by his long-term collaborator, G.K. CHESTERTON), biographies, historical works and travel writing. He is best-known for his light verse, especially the children's classic, Cautionary Tales (1907).

Bellow, Saul (1915–) US writer, b. Canada. His work demonstrates an intense moral preoccupation with the plight of the individual. His debut novel was *The Dangling Man* (1944). Later novels include *The Adventures of Augie March* (1953), *Herzog* (1964), *Mr Sammler's Planet* (1970), *Humboldt's Gift* (1975) and *The Dean's December* (1982). Awarded the 1976 Nobel Prize for literature, he has also written plays and short stories. Other works include *The Bellarosa Connection* (1989) and *Something to Remember Me By* (1991).

Bellows, George Wesley (1882–1925) US painter and printmaker. He was taught by Robert Henri and worked with the ASHCAN SCHOOL. He is best known for his paintings of boxing matches and street scenes such as the impressionistic *Stag at Sharkey's* (1907), which depicts an illegal boxing match. He helped to organize the ARMORY SHOW (1913).

Bell's palsy Paralysis of a facial nerve causing weakness of the muscles on one side of the face. The condition, which may be due to viral infection, usually disappears spontaneously, or may be treated with drugs or, rarely, surgery.

Belmopan Capital of Belize, on the River Belize. It replaced Belize City, 80km (50mi) upstream, as capital in 1970, the latter having been largely destroyed by a hurricane in 1961. The building of Belmopan began in 1966. Pop. (1991) 3,558.

Belo Horizonte City in E Brazil; capital of Minas Gerais state. It was built in 1895–97, and was Brazil's first planned city. Today it is a popular resort and distribution and processing centre for a prosperous farming and mining region, whose mineral deposits include iron ore, manganese and diamonds. Industries: steel, textiles, cement. Pop. (1991) 2,048,861.

Belsen Village in Lower Saxony, Germany, site of a CONCENTRATION CAMP established by the Nazis during World War 2. Originally it housed Jews to be exchanged for German prisoners of war, but an estimated 30,000 people were murdered or died here of starvation and disease, before the camp was liberated in April 1945.

Belshazzar In the Old Testament, the son of Nebuchadnezzar and last king of Babylon. The Book of Daniel relates how Belshazzar organized a great feast during which a disembodied hand wrote upon the wall, "Mene, mene tekel upharsin". Daniel translated it as "Thou art weighed in the balance and found wanting." and said it signified Babylon's

BELIZE 89°W Bahia Chetumo Orange Walk Hill Bank G Belmopan AREA: 22,960sq km U acio (8,865sq mi) BELIZE A **POPULATION: 198,000** Dangriga 17°N CAPITAL (POPULATION): Caribbean Belmonan (3.558) E △ Victoria Peak Sea GOVERNMENT: M Constitutional monarchy Blair Atholl ETHNIC GROUPS: Mestizo A (Spanish-Indian) 44%, Creole (mainly African-American) 30%, Mayan Indian 11%, Garifuna Gulf of (Black-Carib Indian) 7%, Honduras Punta Gorda White 4%, East Indian 3% LANGUAGES: English (offi-**RELIGIONS:** Christianity (Roman Catholic 58%, Protestant 29%). Lago de Hinduism 2% Izabel HONDURAS currency: Belize dollar = 100 cents 88°W 89°W

downfall. Modern archaeological investigations have identified Belshazzar with Bel-shar-usur (d.539 BC), the son of Nabonidus, king of Babylon (556–539 BC).

beluga (white whale) Small, toothed Arctic whale that is milky white when mature. It preys on fish, squid and crustaceans and is valued by Eskimos for its meat, hide and blubber. Length: *c*.4m (13ft). Species: *Delphinapterus leucas*. Beluga is also a type of sturgeon, whose roe is sold as CAVIAR. **Benares** See VARANASI

bends (decompression sickness) Syndrome, mostly seen in divers, featuring pain in the joints, dizziness, nausea and paralysis. It is caused by the release of nitrogen into the tissues and blood. This occurs if there is a too rapid return to normal atmospheric pressure after a period of breathing high-pressure air (when the body absorbs more nitrogen). Treatment involves gradual decompression in a hyperbaric chamber.

Benedict XV (1854–22) Pope (1914–22), b. Giacomo della Chiesa. During World War 1, he strove for peace among nations, stressing pacifist idealism. He tried to unite all Roman Catholics, made changes in the Curia, and published a new Code of Canon Law.

Benedict (of Nursia), Saint (480-547) Roman Christian

figure, founder of Western monasticism and of the BENEDICTINE order. St Benedict was of noble birth and educated in Rome. Shocked by the city's lawlessness, he retired to a cave above Subiaco, where he acquired a reputation for austerity and sanctity. A community grew up around him and he established 12 monasteries. His feast day is 11 July.

Benedictines Monks and nuns of a monastic order, the Order of St Benedict, who follow the Rule laid down by St BENEDICT (OF NURSIA) in the 6th century. The order played a leading role in bringing Christianity and civilization to western Europe in the 7th century, and in preserving the traditions of Christianity throughout the medieval period. During the REFORMATION most Benedictine monasteries and nunneries in Europe, including 300 in England, were suppressed. The order revived in France and Germany during the 17th century. Benedictine monks and nuns returned to England in the late 19th century and the Benedictine Order spread to North and South America. Beneš, Eduard (1884–1948) Czech statesman, president (1935-38). A follower of Tomás MASARYK, he promoted Czech independence while abroad during World War 1 and became Czechoslovakia's first foreign minister (1918-35). He resigned (1938) from the presidency in protest against the

BELGIUM

Belgium's national flag was adopted in 1830, when the country won its independence from the Netherlands. The colours come from the arms of the province of Brabant, in central Belgium, which rebelled against Austrian rule in 1787.

Belgium is a densely populated nation. Behind the North Sea coastline, which extends for c.60km (40mi), lie coastal plains, including some polders – low-lying areas which have been drained and are protected from the sea by dykes. Central Belgium consists of low plateaux and the only hilly region is the ARDENNES, in the SE. The chief rivers, which occupy fertile valleys, are the Schelde in the w and the Sambre and Meuse flowing between the central plateau and the Ardennes. The capital is BRUSSELS, other major cities include BRUGES, ANTWERP, GHENT and Liège.

CLIMATE

Belgium has a cool temperate climate. Moist winds from the Atlantic bring fairly heavy rain, and the Ardennes has heavy winter snowfalls. Brussels has mild winters and warm summers.

VEGETATION

Farmland and pasture cover c.50% of Belgium. The forests, especially in the Ardennes, contain trees such as beech, birch, elm and oak, but in the N, the birch forests and heathland have largely been replaced by plantations of evergreen trees.

HISTORY

One of the Low Countries, in the Middle Ages Belgium was split into small duchies, such as Brabant. In the 15th century the country was united by the dukes of BURGUNDY. From 1482 until 1794, Belgium was ruled by Netherlands, Spain and Austria. Occupied during the French revolutionary wars, it passed to France in 1797. In 1815 it was subsumed into the Netherlands. Dutch discrimination led to rebellion and Belgium declared independence in 1830. LEOPOLD I became king. His successor, LEOPOLD II, encouraged industrialization and colonialism, notably in the Congo. In August 1914 Germany invaded Belgium, prompting British entry into World War 1. Belgium stoutly resisted German occupation and it formed a major battleground in the war. In May 1940 Germany again invaded Belgium and LEOPOLD III capitulated. In 1951 Leopold III was forced to abdicate and was succeeded by Baudouin. Despite the damage inflicted during World War 2, the economy recovered quickly, helped by the Benelux customs union with Netherlands and Luxembourg (1958) and the formation of the European Common Market. Lying at the heart of Europe, Brussels has been the headquarters for the European Union (EU) since its inception and is also the headquarters for the North Atlantic Treaty Organization (NATO).

AREA: 30,510sq km (11,780sq mi)

POPULATION: 9,998,000

CAPITAL (POPULATION): Brussels (Brussel,

Bruxelles, 949,070)

GOVERNMENT: Federal constitutional monarchy **ETHNIC GROUPS:** Belgian 91% (Fleming 55%,

Walloon 34%), Italian, French, Dutch,

Turkish, Moroccan

LANGUAGES: Dutch, French, German (all

official)

RELIGIONS: Christianity (Roman Catholic 72%)
CURRENCY: Belgian franc = 100 centimes

POLITICS

Belgium's relationship with its former colony, Zaïre, has been problematic. It has sent troops to deal with coups in 1964 and 1978. A central domestic issue has been the tension between Dutch-speaking Flemings and French-speaking WALLOONS. In 1971 Belgium was divided into three economic regions: FLANDERS, Wallonia and bilingual BRUSSELS. During the 1980s, Belgium had a succession of coailtion governments, led by Wilfried Martens. In 1993 it adopted a federal system of government, and each of the regions has its own parliament. The first elections under this new system were held in 1995. During 1996 and 1997 Belgium was shocked by large-scale child-abuse scandals. Demonstrations called for the resignation of Jean-Luc Dehaene's government.

ECONOMY

Belgium is a major trading nation (Antwerp is one of the world's largest ports) with a highly developed transport system. Belgium's coal industry has declined since the 1970s and it has to import many raw materials and fuels. The leading activity is manufacturing, products include steel and chemicals. Other industries include oil-refining, textiles, diamond cutting and glassware. Agriculture employs only 3% of the workforce, but the country is mostly self-sufficient. Barley and wheat are the chief crops, but the most valuable activities are dairy farming and livestock rearing.

MUNICH AGREEMENT. Re-elected in 1946, he resigned again in 1948 after the communist takeover.

Bengal Former province of India. Now a region of the Indian subcontinent that includes WEST BENGAL in India, and East Bengal, which became part of BANGLADESH. Much of Bengal lies in the deltas of the Ganges and Brahmaputra rivers. Bengal was the richest region in the 16th-century Mogul empire of AKBAR I (THE GREAT). Conquered by the British in 1757, it became the centre of British India, with CALCUTTA as the capital. It was made an autonomous region in 1937 and the present boundaries were fixed in 1947. Area: 200,575sq km (77,442sq mi).

Bengal, Bay of North-east gulf of the Indian Ocean, bounded by India and Sri Lanka (w), India and Bangladesh (N), Burma (E) and the Indian Ocean (s). Many rivers empty into the Bay, including the GANGES, BRAHMAPUTRA, Krishna and Mahanadi. The chief ports are MADRAS and CALCUTTA.

Bengali Major language of the Indian subcontinent. It is spoken by virtually all of the 85 million inhabitants of BANGLADESH, and by 45 million in the Indian province of WEST BENGAL. Bengali belongs to the Indic branch of the Indo-European family of languages.

Benghazi (Banghazi) City in Libya, on the NE shore of the Gulf of Sidra. Founded by the Greeks in the 6th century BC, the Italians captured Benghazi in 1911 and, during the 1930s, developed its air and naval facilities. Libya's second largest city, Benghazi is a commercial and industrial centre for Cyrenaica province. Industries: salt processing, shipping, oil refining. Pop. (1988 est.) 446,250.

Ben-Gurion, David (1886–1973) Israeli statesman, one of the founders of the state of Israel, prime minister (1948–53, 1955–63). Born in Poland, Ben-Gurion became leader of the Zionist labour movement in Palestine and founded the Mapai (Labour) Party in 1930. After World War 2, he led the campaign for an independent Jewish state and became Israel's first prime minister.

Benin Republic in w Africa. See country feature, p.81

Benin Kingdom in w Nigeria that flourished in the 14th–17th centuries. It is remembered chiefly for its bronze sculptures and wood and ivory carvings, considered among the finest African art. Ruled autocratically by a divine sovereign, it was prosperous and peaceful and was compared favourably with Amsterdam by an early Dutch visitor. Central authority disintegrated in the era of firearms and the slave trade.

Benn, Tony (Anthony Neil Wedgwood) (1925–) British politician. He first entered parliament in 1950 and in 1963 disclaimed an inherited peerage in order to remain a member of the House of Commons. He held several cabinet posts in the Labour governments of the 1960s and 1970s. During the 1980s, Benn was a leading opposition spokesman on the left wing of the LABOUR PARTY.

Bennett, Alan (1934–) British playwright, actor and director. Bennett's gentle, satiric observations of British eccentricities began in *Beyond the Fringe* (1960). His first play was *Forty Years On* (1968). Other plays include *Kafka's Dick* (1986). His series of monologues *Talking Heads* (1987) and an autobiography *Writing Home* were highly successful. He also wrote the screenplay for *The Madness of King George* (1995). **Bennett, (Enoch) Arnold** (1867–1931) British writer who made a significant contribution to realism. He is best known for his novels of the "Five Towns", which portray provincial life in

Bennett, (Enoch) Arnold (1867–1931) British writer who made a significant contribution to realism. He is best known for his novels of the "Five Towns", which portray provincial life in the industrial Midlands, England. They include Anna of the Five Towns (1902), The Old Wives' Tale (1908) and the trilogy, Clayhanger (1910), Hilda Lessways (1911) and These Twain (1916). His later novel, The Riceyman Steps (1923), is set in London. He also wrote plays and short stories.

Ben Nevis Highest peak in the British Isles, in the Highlands region of w central Scotland. Ben Nevis is in the central Grampian Mountain range (overlooking Glen Nevis), near Fort William. It rises to 1,343m (4,406ft).

Bentham, Jeremy (1748–1832) British philosopher, jurist and social reformer. Bentham developed the theory of UTILITARIANISM based on the premise that "the greatest happiness of the greatest number" should be the object of individual and government action. This philosophy was defined in his *Intro-*

duction to the Principles of Morals and Legislation (1789). His theories influenced much of England's early reform legislation. **Bentley, John Francis** (1839–1902) British church architect. His most famous design is the Byzantine-style Roman Catholic cathedral in Westminster, London.

Benton, Thomas Hart (1889–1975) US painter. A realist, he concentrated on painting rural and small-town US life. His work includes several murals, notably in the New School for Social Research, New York City (1930–31) and the Whitney Museum of American Art. Jackson POLLOCK was his most famous pupil.

Benz, Karl (1844–1929) German pioneer of the INTERNAL COMBUSTION ENGINE. After some success with an earlier TWO-STROKE ENGINE, he built a FOUR-STROKE ENGINE in 1885 that was first applied to a tricycle. Benz achieved great success when he installed the engine in a four-wheel vehicle in 1893. Benz was the first to make and sell light, self-propelled vehicles built to a standardized pattern.

benzene Colourless, volatile, sweet-smelling, flammable liquid HYDROCARBON (C_6H_6), a product of petroleum refining. A benzene molecule is a hexagonal ring of six unsaturated carbon atoms (benzene ring). It is a raw material for manufacturing many organic chemicals and plastics, drugs and dyes. Properties: r.d. 0.88; m.p. 5.5°C (41.9°F); b.p. 80.1°C (176.2°F). Benzene is carcinogenic and should be handled with caution.

benzodiazepine Any of a group of mood-altering drugs, such as librium and valium, that are used primarily to treat severe anxiety or insomnia. They intervene in the transmission of nerve signals in the CENTRAL NERVOUS SYSTEM and were originally developed as muscle relaxants. Today they are the most widely prescribed tranquillizers.

benzoin Fragrant resinous polymer, once obtained from the balsam resin found in the trees of the genus *Styrax* in tropical SE Asia, now made synthetically. It is used in perfumes and decongestant cough linctus.

Ben-zvi, Itzhak (1884–1963) Israeli statesman, president (1952–63). After fleeing his native Russia, he settled in PALESTINE in 1907. Exiled (1915–18), he worked with David BENGURION and other Zionist leaders to create the institutions basic to the formation of the state of Israel, including Histadrut, the leading labour organization, and the Mapai (Labour) Party.

Beowulf Oldest English epic poem, dating from around the 8th century, and the most important surviving example of Anglo-Saxon verse. It tells how a young prince, Beowulf, slays the monster Grendel and his vengeful mother. Some 50 years later, Beowulf (now king) fights and slays a fire-breathing dragon but dies from his wounds. The poem ends with Beowulf's funeral and a lament. The text, which exists in a single 10th century manuscript, was transcribed by more than one hand and the many explicitly Christian interpretations were probably added by monks.

berberis (barberry) Genus of about 450 species of shrubs native to temperate regions. The bark and wood are yellow, the stems are usually spiny, and the golden flowers give way to sour blue berries. The stamens are sensitive to touch. It is a host for the plant disease rust. Family Berberidaceae.

Berbers Caucasian Muslim people of N Africa and the Sahara Desert. Some are herdsmen and subsistence farmers; others, like the TUAREG, roam the desert with their animal herds. The farmers live in independent villages, governed by tribesmen. Their remarkably stable culture dates back to

■ Ben-Gurion Known as the "Father of the Nation", Ben-Gurion was Israel's first prime minister and played a key role in cementing the establishment of a Jewish state. He sanctioned the use of force to remove the British from Palestine and took a hardline stance against the new state's Arab neighbours.

before 2400 BC. After the Arab conquest of the 7th century, there were Berber empires in the 11th and 12th century. Berber languages are spoken by more than 10 million people. **Berg, Alban** (1885–1935) Austrian composer. A student of Arnold Schoenberg, he composed his later works in a complex, highly individualized style based on Schoenberg's TWELVE-TONE MUSIC technique. His *Wozzeck* (1925) is regarded as one of the masterpieces of 20th-century opera. He also composed a fine violin concerto (1935). Another opera, *Lulu*, unfinished at his death, was completed by Friedrich Cerha.

Bergama Market town in Izmir province, w Turkey, site of the ancient city of Pergamum. It became capital of Mysia (an important kingdom in the Attalid dynasty) in the 3rd century BC and flourished as a centre of Hellenistic civilization. An agricultural and mining centre, it was also known for its arts and culture. It was bequeathed to Rome by Attalus III in 133 BC. Above the new town (containing fine old Ottoman townhouses and the Red Mosque) stands the hilltop remains of the ancient city. Pop. (1990) 101,421.

bergamot Herb of the genus *Monarda*, including horsemint and Oswego tea. Family Labiatae. Also refers to the pear-shaped fruit of *Citrus bergamia*, grown in Italy for its oil, which is used in perfumery. Family Rutaceae.

Bergen Port on the N Atlantic Ocean; capital of Hordaland county, sw Norway. Founded in the 11th century, Bergen was Norway's chief city and the residence of medieval kings. It is now an industrial and cultural centre with a university (1948), national theatre (1850) and 13th-century Viking hall. Industries: shipbuilding, textiles, fishing. Pop. (1990) 212,944.

Bergman, Ingmar (1918–) Swedish film director. With a versatile company of actors and a strong personal vision, Bergman created dark allegories, satires on sex and complex studies of human relationships. Major films include *The Seventh Seal* (1956), *Wild Strawberries* (1957), *The Virgin Spring* (1960), *Persona* (1966), *Scenes from a Marriage* (1974) and *The Magic Flute* (1975). The intimate and poignant *Fanny and Alexander* (1983) is considered his finest achievement.

Bergman, Ingrid (1915–82) Swedish stage and film actress. Bergman's first major film was *Intermezzo* (1936). In 1939 she moved to Hollywood, starring in films such as *Casablanca* (1943). She won an Academy Award for Best Actress for *Gaslight* (1944). Other classics followed, such as *Spellbound* (1945) and *Notorious* (1946). She gained another Best Actress Oscar for *Anastasia* (1956). Towards the end of her career, she won a third Oscar as Best Supporting Actress in *Murder on the Orient Express* (1974). Her last film was *Autumn Sonata* (1978). She was married (1950–58) to Roberto ROSSELLINI.

Bergson, Henri (1859–1941) French philosopher of evolution. He saw existence as a struggle between a person's life-force (*élan vital*) and the material world: people perceive the material world through the use of intellect, whereas the life-force is perceived through intuition. Bergson received the Nobel Prize for literature in 1927. His works include *Time and Free Will* (1889) and *Creative Evolution* (1907).

Beria, Lavrenti Pavlovich (1899–1953) Soviet politician, chief (1938–53) of the secret police (NKVD). Beria headed the Cheka, predecessor of the NKVD, in Transcaucasia in the 1920s. He helped Stalin to conduct the purges of the Communist Party and ruthlessly controlled internal security. When Stalin died he was arrested and executed for treason.

beriberi Disease caused by a deficiency of vitamin B_1 (thiamine), and other vitamins in the diet. Symptoms include weakness, oedema (waterlogging of the tissues) and degeneration of nerves. The disease is rare in the developed world.

Bering, Vitus Jonassen (1680–1741) Danish naval officer and explorer in Russian service who gave his name to the Bering Strait and Bering Sea. In 1728 he sailed N from Kamchatka, NE Siberia, to the Bering Strait to discover whether Asia and North America were joined. He turned back before he was certain, incurring some criticism in St Petersburg, but set out again in 1741, this time reaching Alaska. Returning, he was shipwrecked and died on what is now Bering Island. Bering Sea Northernmost reach of the Pacific Ocean, bounded by Siberia (NW), Alaska (NE), and separated from the Pacific by the ALEUTIAN ISLANDS; it is connected to the Arctic Ocean

by the Bering Strait. It is icebound in the winter months. Vitus Bering's explorations in the early 18th century drew international attention to the seal-fur resource. Widespread disagreement over the protection of seals resulted in the Bering Sea Controversy (1886). Seal hunting regulations were imposed in 1893. Area: c.2,292,000sq km (885,000sq mi).

Bering Sea Controversy Dispute between various nations (mainly the USA, Britain and Canada) concerning control of the ε Bering Sea and its lucrative seal-fur trade. After 1867 US hunters endangered the seal population of the region by overhunting. In 1881 US citizens demanded control of the entire region, seized British ships, and weakened Canadian commercial interests. In 1893 an international board of arbitration ruled in favour of the British. An agreement (1911) between Britain, Japan, Russia, and the USA limited hunting and made concessions to Canadian interests.

Bering Strait Strait at the N end of the Bering Sea separating W Alaska from E Siberia and connecting the BERING SEA to the ARCTIC OCEAN. It was named after Vitus BERING, who sailed through it in 1728. Min. width: 85km (53mi).

Berio, Luciano (1925–) Italian composer. He was in the forefront of post-war avant-garde composers, and used electronic and chance effects in many of his works, which include *Nones* (1953), *Différences* (1958–60), *Visage* (1961) and *Opera* (1970). He also wrote a series of virtuosic *Sequenzas* for solo instruments (1958–84).

Berkeley, George (1685–1753) Irish philosopher and churchman. He discussed the meaning of "existence" of objects in terms of their being. He criticised the work of LOCKE and concluded, in the tradition of IDEALISM, that only ideas exist. He believed it absurd to suggest that an observer knows anything of a world external to experience.

Berkeley, Sir Lennox Randal Francis (1903–89) English composer. He was a pupil (1927–33) of Nadia BOULANGER in Paris. His early works, such as Serenade for Strings and Symphony (1939–40), betray the influence of Igor Stravinsky. His major choral work is the *Stabat Mater* (1946); he also wrote four operas, including *Nelson* (1954), four symphonies, sacred and chamber music.

berkelium (symbol Bk) Radioactive metallic element, of the ACTINIDE SERIES. It does not occur in nature and was first made in 1949 by alpha-particle bombardment of americium-241 at the University of California at Berkeley (after which it is named). Nine isotopes are known. Properties: at.no. 97; r.d. (calculated) 14; m.p. 986°C (1,807°F); most stable isotope Bk²⁴⁷ (half-life 1.4×10³ yr).

Berkshire County in s central England, almost entirely within the River Thames basin, which marks the N border; the county town is Reading. The Berkshire Downs run across the county. It is an agricultural area; dairy cattle and poultry are important, and barley is the main crop. Industries: nuclear research. Area: 1,255sq km (485sq mi). Pop. (1991) 734,246.

Berlin, Irving (1888–1989) US songwriter and composer. A prolific artist, he wrote nearly 1,000 songs. His most popular include "Alexander's Ragtime Band", "God Bless America" and "There's No Business Like Show Business". His successful Broadway musicals include Annie Get Your Gun (1946) and Call Me Madam (1950). He composed the scores for the films Easter Parade (1948) and White Christmas (1954).

Berlin, Sir Isaiah (1909–97) British philosopher and historian of ideas, b. Latvia. Berlin and A.J. AYER introduced logical positivism into British philosophy. He was a staunch defender of pluralism and liberalism. Two Concepts of Liberty was his influential, inaugural lecture as Chichele professor (1957-67) of social and political theory, Oxford. Berlin's essay on Tolstoy, The Hedgehog and the Fox (1953), is a classic historical study. Berlin Capital of Germany, lying on the River Spree, NE Germany. Berlin was founded in the 13th century. It became the residence of the Hohenzollerns and the capital of Brandenburg, and later of Prussia. It rose to prominence in the 18th century as a manufacturing town and became the capital of the newly formed state of Germany in 1871. Berlin continued to expand, its importance reflecting Prussian dominance in the new state. In the early 20th century it was the second-largest city in Europe. Virtually destroyed at the end of World War 2, Berlin

▲ Bergman A three-time Oscar winner, Ingrid Bergman married Roberto Rossellini after making the film *Stromboli* (1949) together. The ensuing scandal almost wrecked her career.

was divided into four sectors; British, French, US and Soviet. On the formation of East Germany, the Soviet sector became East Berlin and the rest West Berlin. The BERLIN WALL was erected by East Germany in 1961, and separated the two parts of the city until 1989. On the reunification of Germany in 1990, East and West Berlin were amalgamated. Sights include the Brandenberg Gate, the ruins of Kaiser Wilhelm Memorial Church and the Victory Column in Tiergarten Park. Parts of the Berlin Wall remain as a monument. Berlin has two universities, important museums and art galleries, a famous opera house and is home to the Berlin Philharmonic Orchestra. Industries: chemicals and electronics. Pop. (1993) 3,466,000.

Berlin Airlift (1948–49) Operation to supply BERLIN with food and other necessities after the Soviet Union closed all road and rail links between the city and West Germany. For 15 months British and US aircraft flew more than 270,000 flights, delivering food and supplies.

Berlin, Congress of (1878) Meeting of European powers to revise the Treaty of San Stefano (1878), which had increased Russian power in SE Europe to an extent unacceptable to other powers. The purpose of the Congress, under the presidency of BISMARCK, was to modify its terms. The main territorial adjustment was to reduce the Russian-sponsored Greater Bulgaria.

Berlin Wall Heavily fortified and defended wall, 49km (30mi) long, that divided East and West Berlin. It was built by East Germany in 1961, in order to prevent refugees fleeing to West Germany. Some individuals succeeded in crossing it, others were killed in the attempt. It was dismantled in 1989, after the collapse of East Germany's communist regime

Berlioz, (Louis) Hector (1803–69) Pre-eminent French romantic composer. He is noted for innovative, progressive orchestral writing, the use of large forces and the emphasis he laid on orchestral colour. His best-known works include the *Symphonie Fantastique* (1830), *Harold in Italy* for viola and orchestra (1834), the operas *Benvenuto Cellini* (1838) and *The Trojans* (1855–58), and the *Requiem* (1837). He also wrote an extremely influential treatise on orchestration (1844).

Bermuda (formerly Somers Island) British dependency, consisting of c.300 islands in the w Atlantic Ocean, 940km (580mi) E of North Carolina; the capital is Hamilton (Bermuda Island). Discovered c.1503, the islands were claimed for Britain by Sir George Somers in the early 17th century. They became a crown colony in 1684, eventually achieving internal self-government in 1968. Tourism is important. Agricultural products include vegetables, bananas and citrus fruits. Area: 53sq km (21sq mi). Pop. (1994 est.) 60,500.

BENIN

The colours on the flag, used by Africa's oldest independent nation, Ethiopia, symbolize African unity. Benin adopted this flag after independence in 1960. A flag with a red star replaced it between 1975 and 1990, after which Benin dropped its communist policies.

GOVERNMENT: Multiparty republic ETHNIC GROUPS: Fon, Adja, Bariba, Yoruba, Fulani, Somba LANGUAGES: French (official) RELIGIONS: Traditional beliefs 60%, Christianity 23%, Islam 15%

currency: CFA franc = 100 centimes

CAPITAL (POPULATION): Porto-Novo (208,258)

AREA: 112,620sq km (43,483sq mi) **POPULATION:** 4,889,000

Benin is one of Africa's smallest countries, extending N–s for only c.620km (390mi). Yet is also one of the most heavily populated parts of West Africa. Its Atlantic coastline, 100km (62mi) long, is fringed with lagoons. Benin has no natural harbour. The capital PORTO-NOVO lies on the E shore of a large lagoon and COTONOU, Benin's main port and biggest city, lies on its N shore and has a manmade harbour. Adjacent to the coast, a flat plain gives way to the wide Lama marsh. Central Benin consists of low plateaux, rising most steeply to the forests in the NW. Northern Benin is savanna and has two national parks, the Penjari and the "W" (the latter shared with its neighbours Burkina Faso and Niger). The parks are home to water buffalo, elephants and lions

CLIMATE

Benin has a hot, wet climate, with an average annual temperature on the coast of $c.25^{\circ}\mathrm{C}$ (77°F) and an average rainfall 1,330mm (52in). The inland plains are wetter, but rainfall decreases to the N, which has a short rainy season and a very dry winter.

HISTORY

The ancient kingdom of Dahomey had its capital at Abomey, in modern s Benin. In the 17th century the kings of Dahomey became involved in the lucrative slave trade, and by 1700 over 200,000 slaves were being annually transported from the "slave coast". The Portuguese shipped many Dahomeans to Brazil. Despite the abolition of slavery, the trade persisted well into the

MAP SCALE

O 50 100 km

O 50 miles

BURKINA

FASO

Atakora

Mountains

A 635

Natitingou

Djougou

Parakou

Parakou

Allada

Quidah

Coundan

Grand

Grand

Grand

Grand

Popo

Bight of Benin

19th century. In 1892 the French established a protectorate in Dahomey, and in 1904 the colony became part of the giant federation of French West Africa. The French developed the country's infrastructure and institutions. In 1958 Dahomey achieved self-governing status within the French Community. In 1960 it achieved full independence. The new nation was beset with economic and social difficulties and in 1963 the military seized power. In 1972 a power-sharing arrangement between N and S Benin collapsed and the army, led by General Kerekou, again intervened. In 1975 Dahomey became the People's Republic of Benin.

POLITICS

Adopting Marxism-Leninism as the state ideology, alliances were sought with European communism. In 1989 communism was abandoned and 1991 multi-party elections led to the formation of a provisional government. In 1996 elections Kerekou returned to power.

ECONOMY

Benin is a poor developing country and c.70% of the workforce are engaged in agriculture, mainly at subsistence level. Major food crops include beans, cassava, maize, millet, rice, sorghum and yams, while the chief cash crops are cotton, palm products, groundnuts and coffee. Forestry is an important activity. Benin also produces oil (1994, 192,000 tonnes), but there is little manufacturing. In 1994 the IMF approved a loan of US\$72.6 million to help economic reforms.

Bern (Berne) Capital of Switzerland, on the River Aare in Bern region. Founded in 1191 as a military post, it became part of the Swiss Confederation in 1353. Bern was occupied by French troops during the French Revolutionary Wars (1798). It has a notable Gothic cathedral, a 15th-century town hall, and is the headquarters of the Swiss National Library. Industries: precision instruments, chemicals, textiles, chocolate manufacture, tourism. Pop. (1992) 135,600.

Bernard of Clairvaux, Saint (1090–1153) French mystic and religious leader. He was abbot of the Cistercian monastery of Clairvaux from 1115 until his death. Under his direction nearly 100 new monasteries were founded. He was canonized in 1174. His feast day is 20 August.

Bernhardt, Sarah (1845–1923) Legendary French actress. The greatest tragedienne of her era, Bernhardt rose to prominence in the Comédie Française (1872-80). Her superb portravals in Phédre (1874) and Hernani (1877) earned her the title "Divine Sarah". In the 1880s, she gained international fame touring Europe and the USA. In 1899 she founded the Théatre Sarah Bernhardt in Paris, where she played the lead in Hamlet (1899) and L'Aiglon. She also appeared in silent films. Bernini, Gianlorenzo (1598-1680) Italian architect and sculptor. The outstanding personality of the Italian BAROQUE, his work combines astonishing, flamboyant energy with great clarity of detail. He was also a skilful painter. His architecture was splendid in conception, lavish in use of marble and dramatic lighting, and often grand in scale. As the favourite of several popes, he was given unparalleled design opportunities. His large-scale commissions in and around St Peter's include the baldacchino (canopy) above the high altar (1633), Barbarini Palace (1638), Cathedra Petri (1657–66) and (from 1656 onwards) the great elliptical piazza and enclosing colonnades in front of ST PETER'S. Bernini, more than any other architect, gave Rome its Baroque character.

Bernoulli, Daniel (1700–82) Swiss mathematician and physicist. His work on hydrodynamics demonstrated that pressure in a FLUID decreases as the velocity of fluid flow increases. This fact, which explains the LIFT of an aircraft, has become known as Bernoulli's principle. Bernoulli also formulated Bernoulli's LAW and made the first statement of the KINETIC THEORY of gases.

Bernoulli's law For a steadily flowing fluid, the sum of the pressure, kinetic energy and potential energy per unit volume is constant at any point in the fluid. Using this relationship, formulated by Daniel Bernoulli, it is possible to measure the velocity of a liquid by measuring its pressure at two points with a manometer or Pitot tube.

Bernstein, Leonard (1918–90) US conductor, composer and pianist. He was conductor with the New York Philharmonic (1957–58) and then musical director (1958–69), winning large audiences and world fame through his recordings. His compositions include three symphonies, the oratorio *Kaddish* (1963), the *Chichester Psalms* (1965) and *Mass* (1971), ballets, and the musicals *Candide* (1956) and *West Side Story* (1957).

Berryman, John (1914–72) US poet and critic. His noted works include the critical biography Stephen Crane (1950), Homage to Mistress Bradstreet (1956), Berryman's Sonnets (1967), and Love and Fame (1970). His major work, The Dream Songs (1969), combines 77 Dream Songs (1964), winner of the 1965 Pulitzer prize, and His Toy, His Dream, His Rest (1968), winner of the 1969 National Book Award.

Bertolucci, Bernardo (1940—) Italian film director. A filmmaker of spectacular, poetic epics, often dealing with the conflict between the personal and the political. Bertolucci began his career as assistant director to Pier Pasolini. His full directorial debut was *The Grim Reaper* (1962). His most influential film was probably *The Conformist* (1969). Last Tango in Paris (1972) was his first commercial success. The Last Emperor (1987) gained Oscars for Best Director and Best Film.

beryl Mineral, beryllium silicate. Its crystals are usually hexagonal prisms of the hexagonal system. Gemstone varieties are aquamarine (pale blue-green) from Brazil; emerald (deep green) from Colombia; and morganite (pink) from Madagascar. Cut stones have little brilliance, but are valued for their intense colour. Hardness 8; s.g. 2.6–2.8.

beryllium (symbol Be) Strong, light silver-grey, metallic alkaline-earth element, first isolated in 1828 by Friedrich Wöhler and A.A.B. Bussy. It occurs in many minerals (mostly forms of BERYL) and is used in alloys that combine lightness with rigidity. Properties: at.no. 4; r.a.m. 9.012; r.d. 1.85; m.p. 1,285°C (2,345°F); b.p. 2,970°C (5,378°F); most common isotope Be⁹ (100%).

Berzelius, Jöns Jakob, Baron (1779–1848) Swedish chemist, one of the founders of modern chemistry. His accomplishments include the discovery of cerium, selenium and thorium; the isolation of the elements silicon, zirconium and titanium; the determination of relative atomic masses; and the devising of a modern system of chemical symbols. He prepared the first PERIODIC TABLE of relative atomic masses and contributed to the founding of the theory of radicals.

Besant, Annie (1847–1933) British theosophist and social reformer. Besant was president (1907–33) of the Theosophical Society. She established (1898) the Central Hindu College at Varanasi. Besant was active in the struggle for Indian independence and was president (1917) of the Indian National Congress. *See also* THEOSOPHY

Bessel, Friedrich Wilhelm (1784–1846) German astronomer and mathematician. He devised a system for analysing and reducing astronomical observations, made the first accepted measurements of the distance of a star (61 Cygni) and accurately predicted that SIRIUS and PROCYON are binary stars. He devised Bessel functions, a type of mathematical function, after observing perturbations of the planets. Bessemer process First method for the mass production of steel. The process was patented in 1856 by the British engineer and inventor Sir Henry Bessemer (1813–98). In a Bessemer converter, cast iron is converted into steel by blowing air through the molten iron to remove impurities. Precise amounts of carbon and metals are then added to give the desired properties to the steel.

Best, Charles Herbert (1899–1978) Canadian physiologist. He and F.G. BANTING discovered INSULIN in 1921. He was head of the department of physiology at the University of Toronto (1929–65) and chief of the Banting-Best department of medical research there after Banting's death.

beta-blocker Any of a class of DRUGS that block impulses to beta nerve receptors in various tissues throughout the body, including the heart, airways and periperhal arteries. These drugs are mainly prescribed to regulate the heartbeat, reduce blood pressure and relieve ANGINA. They are also being used in an increasingly wide range of other conditions, including GLAUCOMA, liver disease, thyrotoxicosis, MIGRAINE and anxiety states. Beta-blockers are not suitable for patients with asthma or severe lung disease.

beta particle Energetic electron emitted spontaneously by certain radioactive ISOTOPES. Beta decay results from the breakdown of a neutron to a proton, electron and antineutrino. *See also* RADIOACTIVITY

Betelgeuse (Alpha Orionis) Red supergiant star, and the second-brightest in the constellation of Orion. It is a pulsating variable whose diameter fluctuates between 300 to 400 times that of the Sun. Characteristics: apparent mag. 0.85 (mean); absolute mag. 25.5 (mean); spectral type M2; distance 500 light years.

Bethe, Hans Albrecht (1906–) US nuclear physicist, b. Germany. He left Germany when Hitler came to power and was professor of theoretical physics at Cornell University (1935–75). He worked on stellar energy processes and helped develop the atomic bomb. He is noted for his theories on atomic and nuclear properties. Bethe was awarded the 1967 Nobel Prize for physics for his work on the origin of solar and stellar energy.

Bethlehem (Bayt Lahm) Town on the w bank of the River Jordan, 8km (5mi) ssw of Jerusalem, administered by the Palestinian National Authority since 1994. The traditional birthplace of Jesus Christ, it was the early home of King David and the site of the biblical Massacre of the Innocents. The Church of the Nativity, built by Constantine in AD 330, is the oldest Christian church still in use. Under the rule of the Ottoman empire (1571–1916), it then became part of the

British Palestine mandate until 1948, when was handed to Jordan. It has been occupied by Israel since the Six Day War (1967). Tourism is the main industry. Pop. (1993 est.) 20,300. **Betjeman, Sir John** (1906–84) English poet. Traditional in form, accessible in sentiment, and often apparently parochial in his concern with English social and domestic life. The seriousness and accomplishment of Betjeman's poetry has often been obscured by its popularity. His *Collected Poems* (1958; rev. 1962) was a bestseller. Poet Laureate from 1972, Betjeman was also a broadcaster and idiosyncratic architectural critic.

Bevan, Aneurin (1897–1960) British socialist politician. Bevan entered parliament in 1929. A stirring orator, he assumed leadership of the Labour Party's left wing and was editor (1940–45) of *Tribune* magazine. As minister of health (1945–51), he founded the NATIONAL HEALTH SERVICE (1946). Beveridge, William Henry, Baron (1879–1963) British academic and social reformer. A director (1909–16) of the labour exchanges, he later became director (1919–37) of the London School of Economics and master (1937–45) of University College, Oxford. As chairman (1941–42) of the Committee on Social Insurance and Allied Services, he wrote the "Beveridge Report", the basis of the British WELFARE STATE.

Bevin, Ernest (1881–1951) British trade unionist and Labour politician. As general secretary (1922–40) of the Transport and General Workers' Union (TGWU), Bevin helped to plan the GENERAL STRIKE (1926). He was minister of labour and national service in the wartime coalition government (1940–45). As foreign minister in the ATTLEE government (1945–51), he helped to establish the NORTH ATLANTIC TREATY ORGANIZATION (NATO).

Bhagavad Gita (Hindi "Song of the Lord") Popular episode in the sixth book of the Hindu epic, the Mahabharata. Written in Sanskrit verse, probably in the 1st or 2nd century AD, it presents Krishna as an incarnation of the god Vishnu who, if worshipped, will save people.

Bharatiya Janata Party (BJP) Indian political party. In the "emergency" of 1975–77, most of the non-communist left-of-centre and right-wing parties formed the coalition Janata Party in opposition to Indira Gandhi's ruling Congress Party. The alliance collapsed in 1979 and the BJP emerged as one of the principal remnants. Broadly right-wing, the BJP is in favour of the creation of a Hindu state, Hindustan.

Bhopal State capital of MADHYA PRADESH, central India. Founded in 1728, it is noted for its terraced lakes, mosques and prehistoric paintings. In 1984 poisonous gas from the Union Carbide insecticide plant killed *c.*2,500 people, the world's worst industrial disaster. Bhopal is an industrial and trade centre with food processing, electrical engineering, flour milling and cotton textile industries. Pop. (1991) 1,063,000.

Bhutan Kingdom in the Himalayan, on the NE border of India and the s border of China; the capital is Thimbu. Bhutan's economy is based on agriculture and craft industries (such as metal and leather work). Area: 47,000sq km (18,147sq mi). Pop. (1991 est.) 700,000.

Bhutto, Benazir (1953–) Pakistani stateswoman, prime minister (1988–90, 1993–96), daughter of Zulfikar Ali Bhutto. Benazir was long considered the leader of the Pakistani People's Party, but was subject to house arrest and forced into exile. Her return (1986) was marked by jubilation and violence. In 1988 Bhutto proclaimed a "people's revolution" and overcame splits within the party to become the first woman prime minister of Pakistan. Amidst charges of corruption, she was removed from office. Bhutto was re-elected in 1993. Further accusations of corruption led to her dismisal in 1996.

Bhutto, Zulfikar Ali (1928–79) Pakistani statesman, prime minister (1973–77), father of Benazir Bhutto. In 1963 Bhutto joined Muhammad Ayub Khan's cabinet. Bhutto founded (1967) the Pakistan People's Party. In 1970 elections, Bhutto gained a majority in West Pakistan but the Awami League controlled East Pakistan. Bhutto's refusal to grant autonomy to East Pakistan led to civil war (1971). Defeat led to the formation of Bangladesh and Bhutto became president. He retained political power until overthrown in a military coup, led by General Zia. Bhutto was convicted of conspiracy to murder and executed.

Biafra Former state in W Africa, formed from the E region of Nigeria. It was established in 1967 when the IGBO attempted to secede from Nigeria. A bitter civil war ensued, ending in 1970 when Biafra surrendered and was reincorporated into Nigeria.

Bible Sacred scriptures of Judaism and Christianity. Partly a history of the tribes of Israel, it is regarded as a source of divine revelation and of prescriptions and prohibitions for moral living. The Bible, in the form in which it has developed up to the present day, consists of two main sections. The OLD TESTAMENT, excluding the APOCRYPHA, is accepted as sacred by both Jews and Christians. The Roman Catholic and Eastern Orthodox Churches accept parts of the Apocrypha as sacred and include them in the Old Testament. Jews and Protestants for the most part reject them. The New Testament is accepted as sacred only by Christians.

Bichat, Marie François Xavier (1771–1802) French anatomist, pathologist and physiologist. His study and classification of TISSUE laid the foundations of modern HISTOLOGY. bicycle Two-wheeled vehicle propelled by the rider. The earliest design dates from about 1790. Karl von Drais of Germany developed an improved version around 1816. An Englishman, J. Starley, demonstrated the first successful chain drive in 1871. Bicycles have been a popular means of transport and recreation in many countries since the late 1800s. See also CYCLING

biennial Plant that completes its life cycle in two years, producing flowers and seed during the second year, such as an onion. This distinguishes it from an ANNUAL and a PERENNIAL. Bierce, Ambrose Gwinett (1842–1914) US satirical writer and journalist. A one-time associate of Mark TWAIN, Bierce is best-known for his collection of epigrammatic definitions, *The Devil's Dictionary* (1906).

New designs of mountain bikes have reduced weight without sacrificing strength and have added suspension to both front (1) and rear wheels (2) to allow greater speed over rough terrain. The front suspension has twin pistons in the forks with elastomer cores (3) that

allow travel and absorb vibration. Oil and air can also be used in the pistons. The rear suspension has a single, oil-filled piston (4) which damps the spring (5). Rear suspension units come in different forms (6). New frame materials include carbon fibre, titanium

and aluminium. A V-shaped frame (7) allows bike designers to use the more exotic substances which are difficult to use in a traditional tubular frame. Some bikes have softer compounds of rubber for the back wheels to give greater grip on steep slopes.

Big Bang Theory advanced to explain the origin of the Universe. It states that a giant explosion 10 to 20 thousand million years ago began the expansion of the Universe, which still continues. Everything in the Universe once constituted an exceedingly hot and compressed gas with a temperature exceeding 10,000 million degrees. When the Universe was only a few minutes old, its temperature would have been 1,000 million degrees. As it cooled, nuclear reactions took place that led to material emerging from the fireball consisting of about 75% hydrogen and 25% helium by mass, the composition of the Universe as we observe it today. There were local fluctuations in the density or expansion rate. Slightly denser regions of gas whose expansion rate lagged behind the mean value collapsed to form galaxies when the Universe was perhaps a tenth of its present age. The cosmic microwave background radiation detected in 1965 is considered to be the residual radiation of the Big Bang explosion.

Big Ben Bell in the clock tower forming part of the Houses of Parliament at Westminster, London. Its name comes from Sir Benjamin Hall who was commissioner of works (1859) when the bell was installed. The name can refer to the whole tower. Bihar State in NE India; the capital is Patna. Bihar was a centre of Indian civilization from the 6th century BC to the 7th century AD. It became a province in the Mogul empire. A rich agricultural region, drained by the River Ganges, it produces more than 40% of India's total mineral output. Industries: mica, coal and copper and iron ore. Area: 173,877sq km (57,160sq mi). Pop. (1994 est.) 93,080,000.

Bikini Atoli Group of 36 islands in the w central Pacific and part of the US-administered MARSHALL ISLANDS. The USA used the area to conduct atomic weapons tests (1946–56). The islands were affected by fallout and (although considered safe in 1969) were re-evacuated in 1978. Area: 5sq km (2sq mi).

Bilbao Seaport on the estuary of the River Nervión, near the Bay of Biscay; capital of the BASQUE COUNTRY province of Vizcaya. Founded c.1300, it grew prosperous through the export of wool and later by trade with Spain's American colonies. It is the home of the University of Bilbao (1968). Lying at the centre of an industrial region, it is now Spain's major port and a flourishing commercial centre. Industries: iron and steel, fishing, shipbuilding, oil refining, chemicals. Pop. (1991) 368,710.

bilberry (blueberry or whortleberry) Deciduous evergreen shrub native to N Europe and E North America, which produces a small, dark purple fruit. Family Ericaceae; genus Vaccinium. **bile** Bitter yellow, brown or green alkaline fluid, secreted by the LIVER and stored in the GALL BLADDER. Important in digestion, it enters the duodenum via the bile duct. The bile salts it contains emulsify fats (allowing easier digestion and absorption) and neutralize stomach acids.

Bill of Rights (1689) British statute enshrining the constitutional principles won during the GLORIOUS REVOLUTION. It confirmed the abdication of JAMES II and bestowed the throne on WILLIAM III and MARY II. It excluded Roman Catholics from the succession and outlawed some of James' abuses of the royal prerogative, such as manipulation of the legal system and use of a standing army. In general, its provisions hastened the trend towards the supremacy of parliament over the crown. Bill of Rights Name given to the first ten amendments to the US Constitution, ratified 1791. Several states had agreed to ratify the Constitution (1787) only after George Washington promised to add such a list of liberties. The main rights confirmed were: freedom of worship, of speech, of the press, and of assembly; the right to bear arms; freedom from unreasonable search and seizure; the right to a speedy trial by jury; and protection from self-incrimination. Powers not granted specifically to the federal government were reserved for the states.

binary star Two stars in orbit around a common centre of mass. Visual binaries can be seen as separate stars with the naked eye or through a telescope. In an eclipsing binary, one star periodically passes in front of the other, so that the total light output appears to fluctuate. Most eclipsing binaries are also spectroscopic binaries. A spectroscopic binary is a system too close for their separation to be measured visually and must be measured spectroscopically.

binary system In mathematics, number system having a BASE of 2 (the DECIMAL SYSTEM has a base of 10). It is most appropriate to computers since it is simple and corresponds to the open (0), and closed (1) states of switch, or logic gate, on which computers are based.

Binchois, Gilles de (*c*.1400–60) Franco-Flemish composer and organist. After Dufay, the most influential composer of the early to mid-15th century. He was organist at Mons (1419–23), and served at the Burgundian court (1430–53), before becoming provost of St Vincent, Soignies. Some sacred music survives, including several Magnificat settings, but he is best known for his secular songs, of which 60 survive.

bindweed Climbing plant with white or pink trumpetshaped flowers. Species include *Calystegia sepium*, hedge bindweed, and *Convolvulus arvensis*, field bindweed. Family Convolvulaceae.

Binet, Alfred (1857–1911) French psychologist. He established the first French psychology laboratory (1889) and the first French psychology journal (1895). His best-known achievement was devising the first practical intelligence tests (1905–11), which profoundly influenced the assessment of abilities in psychology and education. See also APTITUDE TEST Bingham, Hiram (1875–1956) US archaeologist. His 1911 discovery, and subsequent excavation, of the INCA mountain city of MACHU PICCHU in the Peruvian Andes helped historians unravel the story of Peru before the Spanish conquest.

binoculars Optical device, used with both eyes simultaneously, which produces a magnified image of a distant object or scene. It consists of a pair of identical telescopes, one for each eye, both containing an objective lens, an eyepiece lens and an optical system (usually prisms), to form an upright image.

binomial nomenclature System of categorizing organisms by giving them a two-part Latin name. The first part of the name is the GENUS and the second part, the SPECIES. For example, *Homo sapiens* is the binomial name for humans. The system was developed by the Swedish botanist Carolus LINNAEUS in the 18th century. *See also* TAXONOMY

binomial theorem Mathematical rule for expanding (as a series) an algebraic expression of the form $(x + y)^n$, where x and y are numerical quantities and n is a positive integer. For n = 2, its expansion is given by $(x + y)^2 = x^2 + 2xy + y^2$.

biochemistry Science of the CHEMISTRY of life. It attempts to use the methods and concepts of organic and physical chemistry to investigate living matter and systems. Biochemists study the structure and properties of all the constituents of living matter, such as fats, proteins, enzymes, hormones, vitamins, DNA, Cells, membranes and organs) – together with the complex reactions and pathways of these in metabolism.

biodegradable Property of a substance that enables it to be decomposed by microorganisms. The end result of decay is stable, simple compounds (such as water and carbon dioxide). This property has been designed into materials such as plastics to aid refuse disposal and reduce pollution.

bioengineering Application of engineering techniques to medical and biological problems such as devices to aid or replace defective or inadequate body organs, as in the production of artificial limbs and hearing aids.

biofeedback In alternative medicine, the use of monitoring systems to provide information about body processes to enable them to be controlled voluntarily. By observing data on events which are normally involuntary, such as breathing and the heartbeat, many people learn to gain control over them to some extent in order to improve well-being. The technique has proved helpful in a number of conditions, including migraine and hypertension.

biogenesis Biological principle maintaining that all living organisms derive from parent(s) generally similar to themselves. This long-held principle was originally established in opposition to the idea of spontaneous generation of life. On the whole, it still holds good, despite variations in individuals caused by mutations, hybridization and other genetic effects. See also GENETICS

biogenetic law (recapitulation theory) Principle that the stages of embryonic development reflect the stages of an organism's evolutionary development.

biography Literary form which describes the events of a person's life. Any fragment may be biographical, but the first known biographies were *Lives* by PLUTARCH in the 1st century. In English literature the first biographies appeared in the 17th century, notably *Lives* (1640–70) by Izaak Walton and *Lives of Eminent Men* (1813) by John Aubrey. The first modern biography was the monumental *Life of Samuel Johnson* (1791) by BOSWELL, which is rich in detail and first-hand recollections. Biography has evolved into a sophisticated and popular form of literature, aiming at a critically balanced assessment of its subject's life. *See also* AUTOBIOGRAPHY

biological clock Internal system in organisms that relates behaviour to natural rhythms. Functions, such as growth, feeding, or reproduction, coincide with certain external events, including day and night, tides, and seasons. These "clocks" seem to be set by environmental conditions, but if organisms are isolated from these conditions, they still function according to the usual rhythm. If conditions change gradually, the organisms adjust their behaviour gradually.

biological warfare Use of disease microbes and their toxins in warfare. The extensive use of mustard gas during World War 1, prompted the prohibition of biological warfare by the Geneva Convention (1925). However, many nations have maintained costly research programmes for the production of harmful microorganisms and discovery of more effective antidotes to their pathogenic effects. These microbes include plant pathogens for the destruction of food crops. None has yet been used, although US forces employed a variety of biological warfare, such as the use of the defoliant Agent Orange during the Vietnam War.

biology Science of life and living organisms. Its branches include BOTANY, ZOOLOGY, ECOLOGY, PHYSIOLOGY, CYTOLOGY, GENETICS, TAXONOMY, EMBRYOLOGY and MICROBIOLOGY. These sciences deal with the origin, history, structure, development and function of living organisms, their relationships to each other and their environment, and the differences between living and non-living organisms.

bioluminescence Production of light, with very little heat, by some living organisms. Its biological function is varied: in some species, such as fireflies, it is a recognition signal in mating; in others, such as squids, it is a method of warding off predators, and in angler fish it is used to attract prey. The light-emitting substance (luciferin) in most species is an organic molecule that emits light when it is oxidized by molecular oxygen in the presence of an enzyme (luciferase). Each species has different forms of luciferin and luciferase.

biomass Total mass (excluding water content) of the plants and/or animals in a particular place. The term is often used to refer to the totality of living things on Earth; or those occupying a part of the Earth, such as the oceans. It may also refer to plant material that can be exploited, either as fuel or as raw material for an industrial or chemical process.

biome Extensive community of animals and plants whose make-up is determined by soil type and climate. There is generally distinctive, dominant vegetation, and characteristic climate and animal life in each biome. Ecologists divide the Earth (including the seas, lakes and rivers) into ten biomes.

biophysics Study of biological phenomena in terms of the laws and techniques of physics. Techniques include x-ray diffraction and SPECTROSCOPY. Subjects studied include the structure and function of molecules, the conduction of electricity by nerves, the visual mechanism, the transport of molecules across cell membranes, muscle contraction (using electron microscopy) and energy transformations in living organisms. biopsy Removal of a small piece of tissue from a patient for examination for evidence of disease. An example is the cervical biopsy ("smear test"), performed in order to screen for pre-cancerous changes that can lead to cervical cancer.

biosphere Portion of the Earth from its crust to the surrounding atmosphere that contains living organisms. It includes the oceans, a thin layer of the Earth's crust and the lower reaches of the atmosphere.

biosynthesis Process in living cells by which complex chemical substances, such as PROTEIN, are made from simpler substances. A GENE "orders" a molecule of RNA to be made,

In a ripe tomato, rotting is caused by an enzyme formed by the copying of a gene in the plant DNA (1) in a messenger molecule mRNA (2). The mRNA is changed into the enzyme (3) which damages the cell wall (4). In a genetically altered tomato, a mirror duplicate of the gene that starts the process is present (5). The result is that two mirror-image mRNA molecules are released (6) and they bind together preventing the creation of the rotting enzyme.

The result is longer-lasting tomatoes. Introducing the necessary DNA through the rigid cell wall is accomplished by using a bacteria (7) which naturally copies its own DNA onto that of a plant. It is easy to introduce the mirror DNA (8) into the bacteria and once the bacteria has infected the cell the DNA is transferred (9). All cells then replicated have the new DNA in their chromosomes and can be grown to create the new variety of plant.

which carries the genetic instructions from the DNA. On the RIBOSOMES of the cell, the protein is built up from molecules of AMINO ACIDS, in the order determined by the genetic instructions carried by the RNA.

biotechnology Use of biological processes for medical, industrial or manufacturing purposes. Humans have long used yeast for brewing and bacteria for products such as cheese and yoghurt. Biotechnology now enjoys a wider application. By growing microorganisms in the laboratory, new drugs and chemicals are produced. GENETIC ENGINEERING techniques of cloning, splicing and mixing genes facilitate, for example, the growing of crops outside their normal environment, and vaccines that fight specific diseases. Hormones are also produced, such as INSULIN for treating diabetes.

birch Any of about 40 species of trees and shrubs native to cooler areas of the Northern Hemisphere. The double-toothed leaves are oval or triangular with blunt bases and arranged alternately along branches. The smooth, resinous bark peels off in papery sheets. Male catkins droop, whereas smaller female catkins stand upright and develop into cone-like clusters with tiny, one-seeded nuts. Well-known species include the grey, silver, sweet and yellow birches. Height: up to 40m (130ft). Family Betulaceae; genus *Betula*.

bird Any one of about 8,600 species of feathered vertebrates that occupy most natural habitats from deserts and tropics to polar wastes. Birds are warm-blooded and have forelimbs modified as wings, hind-limbs for walking and jaws elongated into a toothless beak. They lay eggs (usually in nests),

▲ birch From the Betulaceae family, birches are found throughout the Northern Hemisphere. The paper birch (Betula papyferia) is found in many regions of North America and grows to a height of 39m (130ft). Native Americans used the tree to make birch-bark canoes.

▶ bird of paradise The magnificent bird of paradise (Diphyllodes magnificus) is found in the tropical forest regions of New Guinea. Like other species of bird of paradise, the magnificent bird of paradise performs elaborate courtship displays, involving ruffling the feathers on his breast and neck. Before he displays, he clears an area on the ground, using the branches of young saplings as perches. The name derives from 16th-century Spanish explorers, who believed that they must be visitors from paradise. During the 19th century, their skins were highly prized.

incubate the eggs and care for young. As a group they feed on seeds, nectar, fruit and carrion, and hunt live prey ranging from insects to small mammals, although individual species may be very specialized in their diet. Sight is the dominant sense, smell the poorest. Size ranges from the bee hummingbird, 6.4cm (2.5in) to the wandering albatross, whose wingspread reaches 3.5m (11.5ft). The 2.4m (8ft) tall ostrich is the largest of living birds, but several extinct flightless birds were even bigger. Of the 27 orders of birds, the perching birds (Passeriformes) include more species than all others combined. A bird's body is adapted primarily for flight, with all its parts modified accordingly. There are several groups of large flightless land birds, including the ostrich, rhea, emu, cassowary, kiwi and penguin. Birds are descended from Theocodonts (reptiles), and the first fossil bird, ARCHAEOPTERYX, dates from late Jurassic times. Class Aves. bird of paradise Brightly coloured, ornately plumed, perching bird of Australia, New Guinea forests and nearby regions. Most species have stocky bodies, rounded wings, short legs and a squarish tail. The males' plumes are black, orange, red, yellow, blue or green and are raised during elaborate courtship and associated rituals. Length: 12.5-100cm (5-40in). Family Paradisaeidae.

bird of prey Bird that usually has a sharp, hooked beak and curved talons with which it captures its prey. Two orders of birds fit this description: the hawks, falcons, eagles, vultures and secretary bird (order Falconiformes); and the owls (order Strigiformes).

Birdseye, Clarence (1886–1956) US industrialist and inventor, who developed a technique for deep-freezing foods. He experimented on freezing food in 1917 and sold frozen fish in 1924. He was a founder of General Foods Corporation, and found new ways of reducing the time to freeze foods.

Birmingham Britain's second-largest city, in the West Midlands, England. A small town in the Middle Ages, during the Industrial Revolution it became one of Britain's chief manufacturing cities. James WATT designed and built his steamengine here. Later it became known for the manufacture of cheap goods ("Brummagem ware"). The Birmingham Repertory Theatre (opened 1913) has a justly high reputation. The city also possesses a well-known symphony orchestra, three universities, a museum and an art gallery. An important centre for rail, road and water transport, the town's network of intersecting motorways are known as "Spaghetti Junction". Industries: car manufacture, mechanical and electrical engineering, machine tools, metallurgy. Pop. (1990) 961,041.

Birmingham Largest city in Alabama, USA. It was founded in 1871 as a rail junction at the centre of a mineral-rich region. It now has a university and three colleges. Industries: iron and steel, metalworking, construction materials, transport equipment. Pop. (1990) 265,968.

Birmingham Six Six Irishmen convicted by an English court in 1974 of carrying out terrorist bombings in two public houses in Birmingham, England. Their life sentences were quashed in 1991. The Court of Appeal ruled that methods used by the police in producing some written statements were

inappropriate. The court also found that much of the circumstantial forensic evidence by expert witnesses was unreliable. Five of the men were duly released; the sixth had died in prison. Their case became notorious as a modern miscarriage of British justice. See also Guildford Four

birth, Caesarean Delivery of a baby by a surgical incision made through the abdomen and UTERUS of the mother. It is carried out for various medical reasons; the mother usually recovers quickly, without complications. The procedure is named after Julius Caesar, who is reputed to have been born this way. birth control Alternative term for CONTRACEPTION

Birtwistle, Harrison (1934—) English composer. Influenced by Igor Straninsky and by medieval and Renaissance music, he has written a wide variety of works consolidating his position as a leading modern composer. His pieces include the instrumental motet *The World is Discovered* (1960), *Verses for Ensembles* (1970) and *The Triumph of Time* (1972). He has written four operas, the one-act chamber opera *Punch and Judy* (1967), *The Mask of Orpheus* (performed 1986), which incorporates electronic music, *Gawain* (1991) and *The Second Mrs Kong* (1995).

Biscay, Bay of Inlet of the Atlantic Ocean, w of France and N of Spain. It is noted for its strong currents, sudden storms and sardine fishing grounds. The chief ports are BILBAO, San Sebastián and Santander in Spain, and LA ROCHELLE, Bayonne and St-Nazaire in France.

Bishkek (formerly Frunze) Capital of Kyrgyzstan, central Asia, on the River Chu. Founded in 1862 as Pishpek, it was the birthplace of a Soviet general, Mikhail Frunze, after whom it was renamed in 1926 when it became administrative centre of the Kirghiz Soviet Republic. Its name changed to Bishkek in 1991, when Kyrgyzstan declared independence. The city has a university. Industries: textiles, food processing, agricultural machinery. Pop. (1991 est.) 641,400.

bishop In Christian churches, the highest order in the ministry. Bishops are distinguished from priests chiefly by their powers to confer holy orders and to administer CONFIRMATION. Bismarck, Otto von (1815-98) German statesman, responsible for 19th-century German unification. He was born into a wealthy Prussian family and made an impression during the revolution of 1848 as a diehard reactionary. In 1862 Wilhelm I named him chancellor of Prussia. Victory in the Franco-Prussian War (1870-71) brought the s German states into the Prussian-led North German Confederation, and in 1871 Bismarck became the first chancellor of the empire. In 1882 he formed the TRIPLE ALLIANCE with Austro-Hungary and Italy. Bismarck encouraged industry and a paternalist programme of social welfare at home, and colonization overseas. He found it difficult to work with Wilhelm II, and in 1890 the "Iron Chancellor" was forced to resign.

Bismarck State capital of North Dakota, USA, overlooking

bison The American bison (bison bison) was almost hunted to extinction by European settlers who wanted to free the land for farming and deprive some of the Native Americans of their herds. Strict conservation programmes subsequently have ensured the survival of large numbers of this animal in protected areas.

the Missouri River. It originated in the 1830s, becoming a distribution centre for grain and cattle and was later an important stop on the Northern Pacific Railroad. Industries: livestock raising, dairying, woodworking. Pop. (1990) 49,256.

bismuth (symbol Bi) Metallic, silvery-white element of group V of the PERIODIC TABLE, first identified as a separate element in 1753. The chief ores are bismite (Bi₂O₃) and bismuthnite (Bi₂S₃). A poor heat conductor, it is put into lowmelting alloys used in automatic sprinkler systems. Bismuth is also used in insoluble compounds to treat gastric ulcers and skin injuries. It expands when it solidifies, a property exploited in several bismuth alloys for castings. Properties: at.no. 83; r.a.m. 208.98; r.d. 9.75; m.p. 271.3°C (520.3 °F); b.p. 1,560°C (2,840°F); most common isotope Bi²⁰⁹ (100%).

bison Two species of wild oxen formerly ranging over the grasslands and open woodlands of most of North America and Europe. Once numbered in millions, the American bison (often incorrectly called a BUFFALO) is now almost extinct in the wild. The wisent (European bison) was reduced to two herds by the 18th century. Both species now survive in protected areas. The American species is not as massive or as shaggy as the European. Length: to 3.5m (138in); height: to 3m (118in); weight: to 1,350kg (2,976lb). Family Bovidae; species American Bison bison; wisent Bison bonasus.

Bissau Capital of Guinea-Bissau, near the mouth of the River Geba, w Africa. Established in 1687 by the Portuguese as a slave-trading centre, it became a free port in 1869. It replaced Bonama as capital in 1941. The port has recently been improved. Industries: oil processing. Pop. (1985 est.) 126,900. bit Abbreviation for binary digit, a 1 or 0 used in binary arithmetic. In computing, a bit is the smallest element of storage. Groups of bits form a BYTE of binary code representing letters and other characters. Binary code is used in computing because it is easy to represent each 1 or 0 by the presence or absence of an electrical voltage. The code is also easy to store on disk as a magnetic or optical pattern.

bittern Solitary, heron-like wading bird with a characteristic booming call found in marshes worldwide. A heavy-bodied bird, it is brownish with streaks and spots which help to disguise it. The female lays 3-6 eggs. Length: 25-90cm (10in-3ft). Family Ardeidae, species Botaurus stellaris.

bittersweet See NIGHTSHADE

bitumen (asphalt) Material used for roadmaking and for proofing timber against rot. It consists of a mixture of hydrocarbons and other organic chemical compounds. Some bitumen occurs naturally in pitch lakes, notably in Trinidad. The material is also made by distilling tar from coal or wood, and a little is obtained during the refining of petroleum.

bivalve Animal that has a shell with two halves or parts hinged together. The term most usually applies to a class of MOLLUSCS - Pelecypoda or Lamellibranchiata - with left and right shells, such as clams, cockles, mussels and oysters. It also refers to animals of the phylum BRACHIOPODA with dorsal and ventral shells. Length: 2mm-1.2m (0.17in-4ft).

Biwa-ko Lake in w central Honshū, Japan, and namesake of the Japanese musical instrument whose shape it resembles. It is the largest lake in Japan and yields freshwater fish. Length: 64km (40mi); width 3-19km (2-12mi); depth 96m (315ft).

Bizet, Georges (1838-75) French Romantic composer. His

opera Carmen (1875), although a failure at its first performance, has become one of the most popular operas of all time. Bizet also composed other operas, notably Les pêcheurs de perles (1863) and orchestral works, including the Symphony in C (1855) and L'arlésienne suites (1872).

Black, Joseph (1728–99) British chemist and physicist. Rediscovering "fixed air" (carbon dioxide), he found that this gas is produced by respiration, burning of charcoal and FER-MENTATION, that it behaves as an ACID, and that it is probably found in the atmosphere. He also discovered hydrogen carbonates (bicarbonates) and investigated LATENT HEAT and specific heat but was unable to reconcile it with the PHLOGISTON theory. black bear BEAR found in North America and Asia. The American black bear lives in forests from Canada to central Mexico. It eats a variety of plant and animal foods, including carrion. It is timid and avoids humans. Length: 1.5-1.8m (5-6ft); weight: 120-150kg (265-330lb). Species Euarctos americanus. The Asiatic black bear lives in bush or forest areas of E and S Asia. Smaller than the American black bear, it has a white crescent marking on its chest. It has been known to kill livestock and people. Species Selenarctos thibetanos.

blackberry (bramble) Fruit-bearing bush, native to northern temperate regions. The prickly stems may be erect or trailing, the leaves oval and toothed, and the blossoms white, pink or red. The edible berries are black or dark red. Family Rosaceae; genus Rubus.

blackbird Songbird of the THRUSH family, common in gardens and woodland throughout most of Europe, the Near East, Australia and New Zealand. The male has jet-black plumage and a bright orange bill. The female is brown, with a brown bill. The blackbird feeds on earthworms and other invertebrates. Length: to 25cm (10in). Species Turdus merula.

black body In physics, an ideal body that absorbs all incident radiation and reflects none. Such a body would look "perfectly" black - hence the name. The study of black bodies has been important in the history of physics. Wien's law, Stefan's law and PLANCK's law of black body radiation grew out of this study, as did Planck's discoveries in quantum mechanics.

blackbuck (Indian antelope) Medium-sized ANTELOPE of the open plains of India. Females and young are fawn coloured and males are dark. The underparts are white, and there are also patches of white on the muzzle. Only males carry long, spiral horns. Length: to 1.2m (47in); height: to 81cm (32in) at the shoulder. Family Bovidae; species Antilope cervicapra.

Black Codes (1865-66) Laws passed in former US Confederate states restricting the civil and political rights of newly freed blacks. They limited freedom of employment, freedom of movement, right to own land, and freedom to testify in court. The Black Codes were outlawed by the 14th amendment to the US Constitution (1868).

Black Death (1348–50) Pandemic of PLAGUE, both bubonic and pneumonic, which killed about one-third of the population of Europe in two years. It was first carried to Mediterranean ports from the Crimea and spread throughout Europe, carried by fleas infesting rats. Plague recurred less severely in 1361 and other years, until the 18th century.

blackfly See APHID

Blackfoot Nomadic, warlike Native North American tribes. They are made up of three Algonquian-speaking tribes: the

▼ Black Death Orginating in China (c.1333), the Black Death spread w across Asia and Europe via trade and pilgrimage routes, reaching the Crimea in 1347. Rats were the disease's original hosts, but when they died their infected fleas would transfer to humans. Contemporary descriptions suggest that the infection was bubonic plague, a disease characterized by swollen lymphatic glands, or buboes, and an extremely high mortality rate. Recurring for short spells throughout much of the late 1300s, by 1400, it is estimated that the European population declined by 50%

wholly from the plague

Route of plague's spread

Area infected by plague

Regions sparred partly or

Approximate extent of plague in Europe at 6 monthly intervals from 31 December, 1347 to 30 June, 1350

▲ black widow The European black widow spider (*Latrodectus tredecimguttatus*) has characteristic red marks on its rounded abdomen that warn other animals that it is poisonous. On rare occasions, the female will eat the male once he has fertilized the eggs.

Siksika, or Blackfeet proper; the Kainah; and the Pikuni (Piegan). Living on the N Great Plains $\rm E$ of the Rockies, they depended largely on the bison (buffalo), which was hunted on horseback. Something of their richly ceremonial culture survives among the c.8,000 Blackfeet living today on reservations in Alberta, Canada and Montana, USA.

Black Forest (Schwarzwald) Mountainous region between the rivers Rhine and Neckar, Baden-Württemburg, sw Germany. It is heavily forested in the higher areas, particularly around the sources of the Danube and the Neckar. The highest peak is Feldberg, 1,493m (4,898ft). Industries: tourism, timber, mechanical toys, clocks. Area: *c.*6,000sq km (2,320sq mi).

Black Friday (24 September 1869) Day of financial panic in the USA. The financiers Jay Gould and James Fisk attempted to corner the gold market and drove the price of gold up. The price fell after the US government sold part of its gold reserve, and many speculators were ruined.

black hole Postulated end-product of the total gravitational collapse of a massive star into itself following exhaustion of its nuclear fuel; the matter inside is crushed to unimaginably high density. It is an empty region of distorted space-time that acts as a centre of gravitational attraction; matter is drawn towards it and once inside nothing can escape. Its boundary (the event horizon) is a demarcation line, rather than a material surface. Black holes can have an immense range of sizes. Since no light or other radiation can escape from black holes, they are extremely difficult to detect. Not all black holes result from stellar collapse. During the Big Bang, some regions of space might have become so compressed that they formed socalled primordial black holes. Such black holes would not be completely black, because radiation could still "tunnel out" of the event horizon at a steady rate, leading to the evaporation of the hole. Primordial black holes could therefore be very hot. See also Stephen HAWKING

Black Hole of Calcutta Prison in Calcutta, India, where 64 or more British soldiers were placed by the Nawab Siraj-ad-Dawlah of Bengal in June 1756. The cell was $5.5 \times 4.5 \text{m}$ (18 \times 15ft) and most of the soldiers died of suffocation.

Blackmore, R.D. (Richard Doddridge) (1825–1900) English novelist and poet. He studied law but later abandoned it due to ill-health and turned instead to writing. He wrote several novels and many volumes of poetry, but is chiefly known for his historical romance *Lorna Doone* (1869).

Black Mountain Poets Designation for writers affiliated with Black Mountain College in North Carolina in the 1950s. There the writers came under the influence of Charles Olson. Poets from this school include Robert Creeley, Robert Duncan, Denise Levertov and Joel Oppenheimer.

Black Muslims African-American nationalist movement in the USA. It aims to establish a separatist black Muslim state. Founded in Detroit by Wallace D. Farad in 1930, the movement was led (1934–76) by Elijah MUHAMMAD. The movement grew rapidly from 1945–60, helped by the rhetorical power of the preacher MALCOLM X. Factions developed within the movement, and Malcolm was suspended in 1963. In 1976 the movement split into the American Muslim Mission and the Nation of Islam. The former (led by Elijah's son, Wallace D. Muhammad) preach a more integrationist message, and align themselves with other Islamic organizations worldwide. The Nation of Islam, led by LOUIS FARRAKHAN, claims to uphold the true doctrines of Elijah Muhammad, and preach-

Labour Pew Britain es a more racially exclusive message. During the 1980s and 1990s, the Nation of Islam has gained greater popularity in the USA. Mass demonstrations, such as the "Million Man March" in Washington, D.C., and controversial speeches have generated great media attention. Total membership is *c.*10,000.

Black Panthers Revolutionary party of African-Americans in the 1960s and 1970s. It was founded by Huey Newton and Bobby Seale in 1966. The Black Panthers called for the establishment of an autonomous black state, armed resistance to white repression, and the provision of social welfare organizations in poor black areas. Armed clashes with police occurred and several leaders, including Newton, fled abroad to escape prosecution. Leadership conflicts and the decline of black militancy reduced the influence of the Panthers in the 1970s.

Blackpool Town on the Irish Sea, Lancashire, NW England. One of Britain's most popular resorts. It has 11km (7mi) of sandy beaches, a 158m (520ft) tower (built 1895), many indoor and outdoor entertainments and a promenade which is illuminated every autumn. Industries: confectionery, tourism. Pop. (1991) 146,069.

Black Sea (Kara Sea) Inland sea between Europe and Asia, connected to the Aegean Sea by the Bosporus, the Sea of Marmara and the Dardanelles. It receives many rivers (including the Danube) and is a major outlet for Russian shipping. Subject to violent storms in winter, it remains free of ice except in the remote Nw. The Black Sea yields large quantities of fish (especially sturgeon). It is comprised of two layers of water. The upper layer has lower salinity and supports most of the marine life; the lower layer supports anaerobic bacteria only. Area: 413,365sq km (159,662sq mi).

blackthorn Tree or shrub of the ROSE family, which bears white flowers early in the year and has small plum-like fruits (sloes) and long black thorns that give it its name. The flowers appear before the leaves in spring. Family Rosaceae; species *Prunus spinosa*.

black widow Common name for a small SPIDER found in many warm regions of the world. It is black and has red hourglass-shaped marks on the underside. Its bite is poisonous, though rarely fatal to humans. Length: 25mm (1in); the male is smaller. Family Therididae; genus *Latrodectus*.

bladder Large, elastic-walled organ in the lower abdomen in which URINE is stored. Urine passes from each KIDNEY by way of two narrow tubes (ureters) to the bladder, where it is stored until it can be voided. When pressure in the bladder becomes too great, nervous impulses signal the need for emptying. Urine leaves the bladder through a tube called the URETHRA.

bladderwort Mat-like, aquatic INSECTIVOROUS PLANT found in bogs and ponds. It has feathery thread-like leaves with small bladders in which insects and other small creatures are trapped and drowned. Upright stems bear purple or dark pink flowers. Family Lentibulariaceae; genus *Utricularia*.

Blaine, James Gillespie (1830-93) US statesman, secretary of state (1881, 1889-92). An influential Maine Republican, he served as state legislator (1858-62), congressman (1863-76), speaker of the house (1869-75), and US senator (1876-81). He ran for president in 1884 but lost the election to the Democratic candidate, Grover CLEVELAND, partly because of the defection of reform Republicans (MUGWUMPS). Blair, Tony (Anthony Charles Lynton) (1953-) British statesman, prime minister (1997-). Blair entered parliament in 1983 and joined the shadow cabinet in 1988. He was elected leader of the LABOUR PARTY after the death of John SMITH (1994), and rapidly established himself as a modernizer. His reform of the party's structure and constitution ("new Labour") helped him achieve a landslide victory in the 1997 general election. Britain's youngest prime minister of the 20th century, Blair succeeded John MAJOR. Adopting a more presidential approach, his reforms included giving the Bank of England independence in the setting of interest rates and winning the referenda on devolution for Scotland and Wales. Blake, William (1757–1827) British poet, philosopher and artist, one of the most extraordinary personalities to emerge during the period of ROMANTICISM. A visionary, he believed that spiritual reality lies hidden behind the visible world of the senses and he attempted to create a symbolic language to rep-

introduced important constitutional reforms, such as devolution for Scotland and Wales. More controversial policies included the "Welfare to Work" package of reforms to social security.

► Blair Britain's youngest prime

modernization of the Labour Party

minister since the Earl of

Liverpool (1812), Tony Blair's

helped to achieve a landslide

victory in 1997. His government

resent his spiritual visions. He worked as a commercial engraver in the 1780s, but from c.1787 he began printing his own illustrated poems in colour. The first example was Songs of Innocence (1789). Blake's two patrons, Thomas Butts and John Linnell, enabled him to pursue his individual path as a poet-illustrator, producing notable engravings for Jerusalem (1804-20). Towards the end of his life, he joined a circle of younger artists who appreciated his remarkable powers, notably Samuel PALMER and Edward Calvert. It was not until the late 19th century that Blake's work achieved general recognition. He was extremely prolific and his prints, illustrations and TEMPERA paintings can be found in several important public collections in England and the USA. Among his other productions were Songs of Experience (1794), prophetic books portraying his private mythologies such as The Book of Urizen (1794) and The Four Zoas (1797), and illustrations to The Book of Job and to the Divine Comedy by DANTE

Blanc, Mont See MONT BLANC

blank verse Unrhymed verse, especially iambic pentameter or unrhymed heroic couplets, widely used in English dramatic and epic poetry. Henry Howard introduced blank verse into England in the 16th century with his translation of Virgil's Aeneid. Christopher Marlowe and William Shakespeare transformed it into the characteristic medium of Elizabethan and Jacobean drama. John Milton employed it in Paradise Lost (1667) and William Wordsworth used it in his long autobiography The Prelude (1850). It continues to be popular as a form and technical device in contemporary poetry.

Blanqui, Louis Auguste (1805–81) French socialist leader. A legendary revolutionary campaigner who spent much of his life in prison. He participated in the revolutions of 1830 and 1848, and in the overthrow of NAPOLEON III in 1870. He became a symbol for European socialists and was president of the Paris Commune.

Blasco Ibáñez, Vicente (1867–1928) Spanish novelist, influenced by Zola and Maupassant. His best works, such as *The Cabin* (1898) and *Reeds and Mud* (1902), deal with rural life in Valencia and express his fervent Republican beliefs. *Blood and Sand* (1908) and *The Four Horsemen of the Apocalypse* (1916) established his international reputation.

blasphemy Speech or action manifesting contempt for God or religion. Severe penalties were prescribed for it in the Old Testament and also by medieval CANON LAW. Jesus Christ was crucified for blasphemy against Judaism. The statutes of many secular countries still include laws against blasphemy. Britain, for example, retains its law, originally designed to ensure social conformity to Anglicanism. The law is rarely invoked, and only applies to Christianity.

blast furnace Cylindrical smelting furnace. It is used in the extraction of metals, mainly iron and copper, from their ores. The ore is mixed with coke and a FLUX (limestone in the case of iron ore). A blast of hot, compressed air is piped in at the bottom of the furnace to force up temperatures so that the oxide ore is reduced to impure metal. The molten metal sinks to the bottom and is tapped off. Waste "slag" floats to the top of the metal and is piped off. See also OXIDATION-REDUCTION

blastula Stage in the development of the EMBRYO in animals. The blastula consists of a hollow cavity (blastocoel) surrounded by one or more spherical layers of cells. Commonly called the hollow ball of cells stage, it occurs at or near the end of cleavage and precedes the gastrulation stage.

Blaue Reiter, der Loosely organized group of German expressionist painters. Formed in 1911, it took its name from a picture by KANDINSKY, one of the group's leading members. Other members included Paul KLEE, August MACKE, Alexei von Jawlensky and Franz Marc. Influenced by CUBISM, the group was the most important manifestation of German modern art before World War 1. The artists sought to express the struggle of inner impulses and a repressed spirituality, which they felt that IMPRESSIONISM had overlooked. See also EXPRESSIONISM

Blenheim, Battle of (1704) Decisive battle in the War of the SPANISH SUCCESSION. The Duke of MARLBOROUGH and Prince EUGÈNE OF SAVOY defeated the French at Blenheim in Bavaria. Vienna was saved and Bavaria taken by the anti-

French allies. Marlborough was granted a royal manor near Oxford where he built Blenheim Palace, birthplace of his descendant Winston Churchill.

Blériot, Louis (1872–1936) French aircraft designer and aviator. In 1909 he became the first man to fly an aircraft across the English Channel. The flight from Calais to Dover took 37 minutes. As a designer, Blériot was responsible for various innovations, including a system by which the pilot could operate AILERONS by remote control.

Bleuler, Paul Eugen (1857–1939) Swiss psychiatrist, pioneer in the diagnosis and treatment of PSYCHOSIS. He coined the term SCHIZOPHRENIA and, unlike his predecessors, attributed the symptoms to psychological rather than physiological origins.

Bligh, William (1754–1817) British naval officer. He was captain of the *Bounty* in 1789, when his mutinous crew cast him adrift. With a few loyal companions, he sailed nearly 6,500km (4,000mi) to Timor. While governor of New South Wales (1805–08) he was arrested by mutineers led by his deputy and sent back to England. He was exonerated.

blight Yellowing, browning and withering of plant tissues caused by various diseases; alternatively, the diseases themselves. Blights may be caused by microorganisms, such as bacteria and fungi, or by environmental factors such as drought. Common blights induced by microorganisms include fire, bean, late and potato blight. They typically affect leaves more severely than other parts.

blindness Severe impairment (or complete absence of) vision. It may be due to heredity, accident, disease or old age. Worldwide, the commonest cause of blindness is TRACHOMA. In developed countries, it is most often due to severe DIABETES, GLAUCOMA, CATARACT or degenerative changes associated with ageing.

blind spot Small area on the retina of the EYE where no visual image can be formed because of the absence of light-sensitive cells, the rods and cones. It is the area where the optic nerve leaves the eye.

Bliss, Sir Arthur (1891–1975) English composer. He was a pupil of Charles Villiers Stanford, Ralph Vaughan Williams and Gustav Holst. His works include the *Colour Symphony* (1932), quintets for oboe (1927) and clarinet (1931), a piano concerto (1938), two operas and a number of choral works. From 1953 he was Master of the Queen's Music.

Blitz Name used by the British to describe the night bombings of British cities by the German *Luftwaffe* (air force) in 1940–41. It is an abbreviation of *Blitzkrieg* (lightning war), the name used by the German army to describe hard-hitting, surprise attacks on enemy forces.

Blixen, Karen See DINESEN, ISAK

Bloch, Felix (1905–83) US nuclear physicist, b. Switzerland. He shared the 1952 Nobel Prize for physics with the US physicist Edward Mills Purcell for their separate development of the technique of nuclear MAGNETIC RESONANCE (NMR), used to study the interactions between atomic nuclei. Bloch was the first director (1954–55) of the Conseil Européen pour la Recherche Nucléaire (CERN), the European centre in Geneva for research into high-energy PARTICLE PHYSICS.

Bloemfontein City and judicial capital of South Africa; capital of Free State. Dutch farmers settled here in the early 19th century. It contains the oldest Dutch Reformed church in South Africa. The modern city is an important educational centre. Industries: furniture, glassware. Pop. (1991) 300,150.

■ Blitz The aerial bombardment of London and other major cities in Britain, such as Coventry (shown here) by the German airforce in World War 2. It was most intense during the Battle of Britain (July–December 1940). The Blitz aimed not only to destroy key industrial centres, but also to undermine the spirit of British civilians and overseas forces. Some 23,000 civilians died during the Blitz.

Spun in a high-speed centrifuge, blood separates out into plasma (A), layers of white cells and platelets (B) and red cells (C). Fluid plasma, almost 90% water, contains salts and proteins. Three main types of white cells (shown in magnification) are polymorphonuclearcytes (1–3), responsible for the destruction of invading bacteria and

removal of dead or damaged tissue, small and large lymphocytes (4 and 5), which assist in the body's immune system, and monocytes (6), which form a further line of the body's defence. Platelets (7) are vital clotting agents. Red cells (8) are the most numerous, and are concerned with the transport of oxygen around the body.

blood Fluid circulating in the body that transports oxygen and nutrients to all the cells and removes wastes such as carbon dioxide. In a healthy human, it constitutes *c.5%* of the body's total weight; by volume, it comprises *c.5.5* litres (9.7 pints). It is composed of a colourless, transparent fluid called plasma in which are suspended microscopic ERYTHROCYTES, LEUCOCYTES and PLATELETS.

blood clotting Protective mechanism that prevents excessive blood loss after injury. A mesh of tight fibres (of insoluble FIBRIN) coagulates at the site of injury through a complex series of chemical reactions. This mesh traps blood cells to form a clot which dries to form a scab. This prevents further loss of blood, and also prevents bacteria getting into the wound. Normal clotting takes place within five minutes. The clotting mechanism is impaired in some diseases, such as HAEMOPHILIA.

blood group Any of the types into which blood is classified according to which ANTIGENS are present on the surface of its red cells. There are four major types: A, B, AB or O. Each group in the ABO system may also contain the rhesus factor (Rh), in which case it is Rh-positive; otherwise it is Rh-negative. Such typing is essential before BLOOD TRANSFUSION since using blood of the wrong group may produce a dangerous or even fatal reaction. See also LANDSTEINER, KARL

bloodhound Hunting DOG with long tapered head, loose hanging jowls and ears, and a characteristically wrinkled skin. The smooth coat may be black, tan, or red and tan. Weight: up to 50kg (110lb). Height: (at shoulder) up to 69cm (27in).

blood poisoning (septicaemia) Presence in the blood of bacteria or their toxins in sufficient quantity to cause illness. Symptoms include chills and fever, sweating and collapse. It is most often seen in people who are already in some way vulnerable, such as the young or old, the critically ill or injured, or those whose immune systems have been suppressed.

blood pressure Force exerted by circulating BLOOD on the walls of blood vessels due to the pumping action of the HEART. This is measured, using a gauge known as a SPHYGMO-MANOMETER. It is greatest when the heart contracts and lowest when it relaxes. High blood pressure is associated with an

increased risk of heart attacks and strokes; abnormally low blood pressure is mostly seen in people in shock or following excessive loss of fluid or blood.

blood transfusion Transfer of blood or a component of blood from one body to another to make up for a deficiency. This is possible only if the BLOOD GROUPS of the donor and recipient are compatible. It is often done to counteract life-threatening SHOCK following excessive blood loss. Donated blood is scrutinized for readily transmissible diseases such as HEPATITIS B and ACQUIRED IMMUNE DEFICIENCY SYNDROME (AIDS).

blood vessel Closed channels that carry blood throughout the body. An ARTERY carries oxygenated blood away from the heart; these give way to smaller arterioles and finally to tiny capillaries deep in the tissues, where oxygen and nutrients are exchanged for cellular wastes. The deoxygenated blood is returned to the heart by way of the VEINS.

Bloody Assizes (1685) Trials held in the w of England following Monmouth's Rebellion against James II. Judge Jeffreys conducted the trials. He sentenced about 200 people to be hanged, 800 to transportation, and hundreds more to flogging, imprisonment or fines.

bloom Dense population of microscopic algae or CYANOBACTERIA on the surface of lakes or seas, often colouring the water. They may appear suddenly through migration of the population to the water surface. This occurs when the cells (previously mixed down into the water column by wind action) float or swim to the surface under calm conditions. They may arise also through rapid multiplication in response to large increases in nutrients. This happens when sewage, or other mineral-rich water, enters a lake or sea. Some blooms produce toxins, which can be harmful to marine life.

Bloomer, Amelia Jenks (1818–94) US women's rights campaigner. She published *Lily*, the first US magazine for women, between 1849–54. She subsequently continued as editor and wrote articles on education, marriage laws and female suffrage. As part of her campaign, she popularized the full trousers for women that became known as "bloomers".

Arteries (A) and veins (B) conduct blood around the body. They have a common structure consisting of four layers: a protective fibrous coat (1); a middle layer of smooth muscle and elastic tissue (2), which is thickest in the largest arteries; a thin layer of connective tissue (3); and a smooth layer of cells — endothelium (4). Arteries have thicker walls and a smaller

diameter. In veins, inner coat layers are often indistinguishable. A comparison of the two vessels is shown in half sections of arteries and veins found in the body. Arteries divide into smaller ones, and finally into arterioles (5), where the blood flow can be controlled by autonomic nerves supplying the layer of smooth muscle.

Bloomsbury Group Intellectuals who met in Bloomsbury, London from about 1907. They included the art critics Roger Fry and Clive Bell; novelists E.M. FORSTER and Virginia WOOLF; her husband Leonard, a publisher; economist John Maynard KEYNES and biographer Lytton STRACHEY. The group's attitudes were influenced by the empiricist philosopher G.E. Moore, and are encapsulated in his statement: "the rational ultimate end of human progress consists in the pleasures of human intercourse and the enjoyment of beautiful objects."

bluebell Spring-flowering blue flower, native to Europe. It grows from a bulb, especially in woodlands, and bears a drooping head of bell-shaped flowers. Height: 20–50cm (8–20in). Family Liliaceae; species *Hyacinthoides non-scripta*.

blueberry See BILBERRY

bluebird North American songbird with blue plumage, a member of the thrush subfamily. There are three species. Typically, a bluebird lays its eggs (usually 4–6) in a grass-and-weed-lined nest in a hole in a tree or fence post. Length: 7in (17.8cm). Genus *Sialia*.

bluebottle Black or metallic blue-green FLY, slightly larger but similar in habits to the house fly. The larvae (maggots) usually feed on carrion and refuse containing meat. Like the greenbottle, it is often also called a blowfly. Family Calliphoridae. Genus *Calliphora*. Length: 6–11mm (0.23–0.43in).

bluefish Marine fish found in most tropical and temperate seas. A voracious predator, it travels in large schools. Fished widely for food and sport, it has an elongated blue/green body, and a large mouth with sharp teeth. Length: 1.2m (4ft). Family Pomatomidae; species *Pomatomus saltatrix*.

bluegrass Type of grass that grows in temperate and Arctic regions and is used extensively for food by grazing animals. Family Poaceae/Gramineae; genus *Poa*.

blue-green algae See CYANOBACTERIA

Blue Ridge Mountains East and SE range of the APPALACHIAN Mountains, extending from s Pennsylvania into Georgia. A narrow ridge, 15km (10mi) wide in the N, widens to 110km (70mi) in North Carolina. Heavily forested, with few lakes, it includes Great Smoky Mountains National Park, North Carolina, and Shenandoah National Park, Virginia. The Appalachian Trail runs across the top of range. The highest peak is Mount Mitchell, North Carolina, at 6,684ft (2,039m). blues Form of African-American music, originating in the late 19th-century folk traditions of the American South. It evolved from gospel and work songs. The standard verse pattern is the 12-bar blues: three sets of four bars, the second set being a repetition of the first. The syncopated melodic structure uses microtonal "blue" notes (flattened thirds, fifths and sevenths) as the basis for improvisation. The first published blues piece was "The Memphis Blues" by W.C. HANDY (1912). "Jelly Roll" MORTON incorporated a jazzier style in "Jelly Roll Blues". Great vocalists such as Bessie Smith ("Empress of the Blues"), Robert Johnson, Huddie LEDBETTER and "Ma" Rainey, helped popularize the blues. The northerly migration of African-Americans in the 1930s saw the emergence of a brasher, urban blues tradition based around Chicago. After World War 2, instruments were amplified, and the electric guitar became the dominant voice, with artists such as Muddy Waters and John Lee Hooker. In the 1950s, new forms such as rhythm and blues, and rock and roll drew on the blues. During the 1960s rock and pop bands, such as the Rolling Stones, were also directly influenced by the tradition.

blue shift In astronomy, an effect in which the lines in the SPECTRUM of a celestial object are displaced towards the blue end of the spectrum. It results from the DOPPLER EFFECT because the object and the observer are moving towards each other. The closing speed can be calculated from the extent of the shift. *See also* RED SHIFT

blue whale Largest animal ever to have lived on Earth, related to the rorquals. It has been overhunted and is now in danger of extinction. Species *Balaenoptera musculus*.

Blum, Léon (1872–1950) French statesman, prime minister (1936–37). He served in the chamber of deputies (1919–40) as a leader of the Socialist Party. Blum formed the Popular Front, which became a coalition government. His administration rapidly embarked on a programme of nationalization. Opposed

by Conservatives, Blum was forced to resign and became deputy prime minister. He opposed the MUNICH AGREEMENT (1938). Interned by the VICHY GOVERNMENT (1940–45), he briefly (1946–47) led a provisional government.

Blunt, Anthony (1907–83) English art historian. Blunt was director (1947–74) of the Courtauld Institute of Art, London, and surveyor of the king's (later queen's) pictures (1945–72). In 1979 his reputation was tarnished when it was disclosed that he was a Soviet spy during World War 2. Blunt was a formidable scholar, earning praise for his work on Nicolas POUSSIN.

boa Large constricting SNAKE that gives birth to live young. The boa constrictor (*Constrictor constrictor*) of the American tropics can grow to 3.7m (12ft) in length. The iridescent rainbow boa, the emerald tree boa and the rosy boa are smaller species. Most boas are tree-dwellers, but the rubber boa of the w USA is a burrowing species. Family Boidae.

Boadicea (Boudicca) (d. AD 62) Queen of the ICENI in East Britain. She was the wife of King Prasutagus who, on his death, left his daughters and the Roman emperor as coheirs. The Romans seized his domain and Boadicea led a revolt against them. After initial successes, during which her army is thought to have killed as many as 70,000 Roman soldiers, she was eventually defeated and poisoned herself. *See also* ROMAN BRITAIN

boar Male domestic PIG (particularly one that has not been castrated) or, more specifically, the wild pig of Europe, Africa and Asia. In almost all its habitats it is hunted, either for food or for sport. The European wild boar is species *Sus scrofa*.

boat Vehicle for passenger and freight transport by water. Today it usually refers to a craft that can be removed from the water; a larger vessel is called a SHIP. The first boats, made in prehistoric times, included rafts, hollowed-out logs and vessels made from plaited reeds. Among the first maritime peoples were the Phoenicians. They built fleets of galleys, propelled by sails and oars, for their extensive trading in the Mediterranean and adjoining areas. The later Viking longboats, also square-sailed, were slimmer and speedier. Lateen Ctriangular) sails were probably imported from the Persian Gulf and introduced to the West by the empire-building Arabs. Modern boats include SAILING vessels, used mainly for pleasure, motorboats and launches.

boat people Refugees that flee their country by sea to avoid political persecution, or to find greater economic opportunities. The term is closely associated with South Vietnamese refugees, of whom, since 1975, some 150,000 have sailed to Hong Kong and other Southeast Asian countries. Many have been picked up at sea and kept in camps, while others have been repatriated. Other boat people include Cubans fleeing to the USA and Asians ferried by racketeers to the E coast of England from Germany and Holland.

Boat Race Annual rowing contest between Oxford and Cambridge University eights, first held in 1829. It is rowed on a 6.8km (4.25mi) course on the River Thames in London, from Putney to Mortlake. Staged on the present course since 1845, the race takes place in March or April.

bobcat (wild cat or red lynx) Vicious, short-tailed cat found throughout swamp, forest and grassland regions of the USA, s Canada and Central America. Its reddish-brown coat has black spots with white underparts. The bobcat feeds on rodents and gives birth to 2–4 young following a gestation period of 50–60 days. Length: body 64–76cm (25–30in). Family Felidae; species *Lynx rufus*.

Boccaccio, Giovanni (1313–75) Italian poet, prose writer and scholar, considered to be one of the founders of the Ital-

■ boa The boa constrictor (Constrictor constrictor) is found in many areas of South America. It feeds on birds and small mammals, such as rats and agoutis, which it kills by restricting their ability to breathe. A large snake, it grows to c.3.6m (12ft) in length.

▲ bluebell A spring-flowering bulb, the bluebell (*Endymion nonsciptus*) is a monocotyledon. The bulb is a storage organ for the plant and provides a means of vegetative reproduction.

▲ Bolsheviks Following the 1917 October Revolution, the Bolsheviks, led by Lenin, gained power. A significant element of support was provided by soldiers and sailors returning home from World War 1, seen here at a rally in the Catherine Hall of the Tauride Palace, Petrograd (now St Petersburg).

ian Renaissance. His early work, the Filocolo (c.1336) is considered by many to be the first European novel, but he is best known for his masterpiece the Decameron (1348–58), a series of prose stories of contemporary mores, which exercised a tremendous influence on the development of RENAISSANCE literature. His poetry includes Il Filostrato (c.1338) and Il Ninfale Fiesolano (c.1344–45). Much of his later output consists of Latin scholarly works.

Bode's law In astronomy, empirical numerical relationship for the mean distances of the planets from the Sun, named after the German astronomer Johann Bode (1747–1826). If 4 is added to the sequence 0, 3, 6, 12, 24, 48, 96 and 192, the result correspnds reasonably with the mean planetary distances, Earth's distance being equal to 10. This aided the discovery of Uranus (1781), but does not work for Neptune.

Bodhidharma (active 6th century AD) Indian Buddhist monk who travelled to China and founded ZEN Buddhism. bodhisattya (bodhista) In THERAYADA Buddhism, an individ-

bodhisattva (bodhista) In THERAVADA Buddhism, an individual who is about to reach NIRVANA. In MAHAYANA Buddhism, the term is used to denote an individual on the verge of enlightenment who delays his salvation in order to help mankind.

Bodin, Jean (1530–96) French lawyer and political philosopher. In *Six Books of the Republic* (1576) he treated anarchy as the supreme political evil and order as the supreme human need. He supported absolute monarchy and an unrestricted secular sovereignty residing in the state.

Boer (Afrikaans, farmer) Alternative name for Afrikaner **Boer Wars** See South African Wars

Boethius (*c*.480–524) (Anicius Manlius Severinus) Roman statesman and philosopher under the Emperor Theodoric. He attempted to eliminate corruption, but was imprisoned on a charge of conspiracy. In prison at Pavia, where he was subsequently tortured and executed, he wrote *On the Consolation of Philosophy* (523), a dialogue based on neo-Platonist and Aristotelian principles. Next to the Bible, this was medieval Europe's most influential book.

bog Spongy wet soil consisting of decayed vegetable matter; often called a peat bog. It develops in a depression with little or no drainage, where the water is cold and acidic and almost devoid of oxygen and nitrogen. A bog rarely has standing water like a MARSH, but plants such as cranberry and the carnivorous SUNDEW readily grow there.

Bogart, Humphrey DeForest (1899–1957) Legendary US film actor, often cast as a cynical, wisecracking anti-hero. In 1941, an association with FILM NOIR and John HUSTON began with roles in *High Sierra* and *The Maltese Falcon*. He starred in *Casablanca* (1942). In 1945 he married Lauren Bacall; their sexual magnetism was evident in the *film noir* classic *The Big Sleep* (1946). In 1948 Bogart starred in another two Huston classics, *The Treasure of the Sierra Madre* and *Key Largo*. He won a Best Actor Oscar for *The African Queen* (1951). His final film was *The Harder They Fall* (1956).

Bogotá Capital of Colombia, in the centre of the country on a fertile plateau. It was founded in 1538 by the Spanish on the site of a Chibcha Indian settlement. In 1819 it was made the capital of Greater Colombia, part of which later became Colombia. Today it is a centre for culture, education and finance. It has some fine examples of Spanish colonial architecture. Industries: tobacco, sugar, flour, textiles, engineering, chemicals. Pop. (1992) 4,921,264.

Bohemia Historic region which (with MORAVIA) now comprises the CZECH REPUBLIC. Bohemia was first unified in the 10th century when it became part of the Holy Roman Empire, coming under Habsburg control in 1526. It was the centre of occasional religious or nationalistic revolts against Austrian rule, including that of the Hussites and the episode that sparked the Thirty Years War (1618). It became part of CZECHOSLOVAKIA in 1918 and the Czech Republic in 1992.

Bohr, Aage Niels (1922–) Danish physicist, son of Niels BOHR. With Benjamin Mottelson and James Rainwater, he shared the 1975 Nobel Prize for physics for devising a "collective model" of the atomic nucleus that assumes the collective vibration of all nucleons and their individual motion.

Bohr, Niels Henrik David (1885–1962) Danish physicist, major contributor to the QUANTUM THEORY and the first person to apply it successfully to atomic structure. Bohr worked with J.J. THOMSON and Ernest RUTHERFORD in Britain before teaching theoretical physics at the University of Copenhagen. He escaped from German-occupied Denmark during World War 2, and worked briefly on developing the atom bomb in the USA. He later returned to Copenhagen and worked for international cooperation. Bohr used the quantum theory to explain the spectrum of hydrogen and in the 1920s helped develop the "standard model" of QUANTUM THEORY, known as the Copenhagen Interpretation. He was awarded the 1922 Nobel Prize for physics for his work on atomic structure, and in 1957 received the first Atoms for Peace Award.

boil (furuncle) Small, pus-filled swelling on the skin, often around a hair follicle or SEBACEOUS GLAND. Most boils are caused by infection from a bacterium (STAPHYLOCOCCUS).

boiling point Temperature at which a substance changes phase (state) from a liquid to a vapour or gas. The boiling point increases as the external pressure increases and falls as pressure decreases. It is usually measured at standard pressure of one atmosphere (760mm of mercury). The boiling point of pure water at standard pressure is 100°C (212°F).

Boise Capital and largest city of Idaho, USA, in the valley of the Boise River. Founded in 1863 as a supply post for gold miners, it is now a trade centre for the agricultural region of sw Idaho and E Oregon. Crops: sugar beets, potatoes, alfalfa, onions. Industries: steel, sheet metal, furniture, electrical equipment, timber products. Pop. (1990) 125,738.

Bokassa, Jean Bedel (1921–96) Emperor of the Central African Empire (1977–79). Bokassa came to power in 1966 in a military coup. After serving as president (1966–77) of the Central African Republic, he crowned himself emperor. His regime was brutal. A 1979 coup (with French military aid) removed Bokassa, who went into exile in France, and replaced him with his cousin David Dacko.

boletus Genus of terrestrial fungi, whose spore-bearing parts are tubes instead of the usual gills. There are many species, all of which have a fleshy cap on a central stem and many of which are edible. Some poisonous kinds have red tube mouths. The edible cep is *Boletus edulis*.

Boleyn, Anne (1507–1536) Second wife of HENRY VIII of England and mother of ELIZABETH I. They were married in 1533, when his first marriage, to CATHERINE OF ARAGON, had been annulled. Henry was desperate for an heir, and following the birth of a stillborn boy (1536), Anne was accused of adultery and executed for treason. It is thought that her Protestant sympathies, besides Henry's need for a divorce, pushed the king towards the break with Rome that unleashed the English REFORMATION.

Bolingbroke See HENRY IV (of England)

Bolingbroke, Henry St John, Viscount (1678–1751) English political leader. A prominent Tory minister under Anne, he fled to France in 1714 and joined the JACOBITES. He

was allowed to return to England in 1723, and continued to oppose the Whig regime, attacking the corruption of politics under Robert WALPOLE. The best known of his many philosophical and political writings is *The Idea of a Patriot King* (1749), upholding the role of monarchy in government.

Bolívar, Simón (1783–1830) Latin American revolutionary leader, known as "the Liberator". His experiences in Napoleonic Europe influenced his untiring attempts to free South America from Spanish rule. He achieved no real success until 1819, when his victory at Boyacá led to the liberation of New Granada (later Colombia) in 1821. The liberation of Venezuela (1821), Ecuador (1822), Peru (1824) and Upper Peru (1825) followed, the latter renaming itself Bolivia in his honour. Despite the removal of Spanish hegemony from the continent, his hopes of uniting South America into one confederation were dashed by rivalry between the new states.

Bolivia Landlocked republic in w central South America. *See* country feature

Bologna City at the foot of Apennines, N central Italy; capital of Bologna and Emilia-Romagna province. Originally an Etruscan town, Felsina, it was colonized by Rome in the 2nd century BC. It has an 11th-century university, the incomplete

Bolivia can be divided into two regions. The w is dominated by two parallel ranges of

the ANDES Mountains. The w cordillera forms

Bolivia's border with Chile. The E range runs

through the heart of Bolivia. Between the two,

lies the Altiplano. The most densely populated

region of Bolivia and site of famous ruins, it

includes the seat of government, LA PAZ, close

to Lake TITICACA. SUCRE, the legal capital, lies

in the Andean foothills. The E is a relatively

unexplored region of lush, tropical rainforest,

Church of San Petronio (1390) and the Palazzo Comunale. Industries: mechanical and electrical engineering, agricultural machinery, publishing, chemicals, Pop. (1992) 401,308.

Bolsheviks (Rus. majority) Marxist revolutionaries led by Lenin who seized power in the Russian Revolution of 1917. They narrowly defeated the Mensheviks at the Second Congress of the All-Russian Soviet Democratic Workers' Party in London (1903). The split, on tactics as much as doctrine, centred on the means of achieving revolution. The Bolsheviks believed it could be obtained only by professional revolutionaries leading the PROLETARIAT. The Bolsheviks were able to overthrow the Provisional government of Kerensky through their support in the soviets of Moscow and Petrograd. See also Marxism

Bolshoi Ballet One of the world's leading ballet companies. It adopted its present name in 1825 but was founded as the Petrovsky Theatre in 1776. Based at the Bolshoi Theatre, its choreographers have included Yuri Grigorovich, Marius PETIPA and Alexander Gorsky, and its leading dancers Galina ULANOVA and Mikhial Lavrovsky.

Bolshoi Opera Leading Russian opera company, founded in 1780 in Moscow. It performs mostly Russian works.

BOLIVIA

This flag, which has been Bolivia's national and merchant flag since 1888, dates back to 1825 when the country became independent. The red stands for Bolivia's animals and the courage of the army, the yellow for its mineral resources, and the green for its agricultural wealth.

CLIMATE AND VEGETATION

Bolivia's climate varies greatly according to altitude. The highest Andean peaks are permanently covered in snow, while the E plains have a humid climate. The main rainy season is between December and February. The windswept altiplano is a grassland region. The semi-arid Gran Chaco is a vast lowland plain, drained by the River Madeira, a tributary of the AMAZON.

HISTORY AND POLITICS

The ruins of Tiahuanaco indicate that the Altiplano was the site of one of the great pre-Columbian civilizations. At the time of the Spanish conquest (1532) the AYMARÁ had already been subsumed into the Inca empire by the QUECHUA. The Spanish exploited the Andean silver mines with native forced labour. The Spanish were expelled finally with the victory of Antonio José de Sucre, Simón Bolívar's general, in 1824. For the next century, the new nation of Bolivia was plagued by corruption and instability. In a succession of military reverses, Bolivia lost vital territory to its neighbours. War (1932-35) with Paraguay led to the loss of most of GRAN CHACO. During World War 2, the need for tin provided a short respite for Bolivia's ravaged economy. In 1941 Victor Paz Estenssoro founded the pro-miner National Revolutionary Movement (MNR) which seized power in 1943 and 1952. Paz nationalized the mines and instituted land reforms for the Native Americans. In 1964 the MNR government was overthrown in a military coup. Guerilla leader Che GUEVARA was killed in 1967. From 1964 to 1982, Bolivia was ruled by a succession of repressive military

AREA: 1,098,580sq km (424,162sq mi)

POPULATION: 7,832,000

CAPITAL (POPULATION): La Paz (1,126,000),

Sucre (103,952)

GOVERNMENT: Multiparty republic

ETHNIC GROUPS: Mestizo 31%, Quechua 25%,

Aymará 17%, White 15%

LANGUAGES: Spanish, Aymará, Quechua (all

official)

RELIGIONS: Christianity (Roman Catholic 94%)

currency: Boliviano = 100 centavos

regimes, most prominently that of Colonel Hugo Banzer Suárez (1971–78). In 1982 civilian rule was restored. In 1997 Banzer became president, promising to maintain, with US support, the war against the growing of coca.

ECONOMY

Bolivia is the poorest nation in South America (1992 GDP per capita, US\$2,410). It is the world's sixth largest producer of tin, which accounts for nearly a third of all exports. The collapse in world tin prices led many into coca production, which experts believe may be its largest (unofficial) export. Agriculture employs 47% of the workforce. The introduction of a new currency in 1987 eased inflation.

Bolivia's coat of arms, shown on this 1972 stamp, contains a central image of a mountain where silver is mined, a breadfruit tree, and an alpaca, which is raised for its fine wool. At the top is the magnificent Andean condor, the world's heaviest bird of prey.

Boltzmann, Ludwig (1844–1906) Austrian physicist, acclaimed for his contribution to statistical mechanics and to the kinetic theory of gases. His research extended the ideas of James Maxwell. Boltzmann's general law asserts that a system will approach a state of thermodynamic equilibrium because that is the most probable state. He introduced the "Boltzmann equation" (1877) relating the kinetic energy of a gas atom or molecule to temperature. Symbol K in the formula, the gas constant per molecule, is called the "Boltzmann constant". In 1884 he derived a law, often termed the "Stefan-Boltzmann law", for BLACK BODY radiation discovered by his teacher, Josef Stefan (1835–93). Attacked for his belief in the atomic theory of matter, Boltzmann committed suicide.

Bombay Largest city in India, situated on an island off the w coast; capital of Maharashtra. In 1534 it passed out of the hands of the Indian maharajah's and was ceded to Portugal. In 1661 control of Bombay passed to England as part of Catherine of Braganza's dowry to Charles II. It was the headquarters for the British East India Company until 1858. Bombay's "Gateway to India" was the first sight many colonists had of India. After 1941 a population boom occurred as a result of immigration, rural migration and an increasing birth-rate. Bombay is notable for the Victorian architecture of its public buildings. It is a cultural, educational, trade and financial centre and the site of the world's largest film industry. It is India's second-largest port (after CALCUTTA). Educational establishments include the University of Bombay (1857) and the Indian Institute of Technology (1958). Industries: chemicals, textiles, oil refining, motor vehicles. Exports: cotton, manganese. Pop. (1991) 9,925,891.

Bonaparte, Joseph (1768–1844) King of Spain (1808–13), b. Corsica. He was the eldest brother of NAPOLEON I. He participated in the Italian campaign (1797) and later served as diplomat for the First Republic of France. Napoleon made him king of Naples (1806). After Napoleon's defeat at Waterloo, he resided in the USA (1815–32).

Bonaparte, Louis (1778–1846) King of Holland (1806–10), brother of NAPOLEON I and father of NAPOLEON III. He accompanied his brother in the Italian and Egyptian campaigns, became a general (1804) and governor of Paris (1805). Forced by Napoleon to assume the Dutch throne, he worked to restore its economy and welfare, but the French Continental System proved ruinous to Dutch trade. Napoleon felt he was too lenient and the conflict led Louis to abdicate.

Bonaparte, Napoleon See Napoleon I

Bonar Law, Andrew See Law, (Andrew) Bonar

Bond, Edward (1935–) English playwright. His early works, such as *Saved* (1965), were controversial in their use of violent imagery to express the cruelty of modern society. *Early Morning* (1968) was the last play to be banned in the UK by the lord chamberlain. His work has been performed regularly at the Royal Court Theatre, London. Other major plays include *Lear* (1971) and *War Plays* (1985). He has also written several film scripts, including *Blow Up* (1966).

bond Promissory note guaranteeing the repayment of a specific amount of money on a particular date at a particular fixed rate of interest. Bonds may be issued by corporations, states, cities or the federal government. The quality of the bond, and the interest rate paid on it, is determined by the period of the outstanding loan and the risk involved. Thus the US federal government normally pays a lower rate of interest than cities because US bonds are relatively risk-free. Bonds pay out fixed amounts of interest on a regular basis and appeal to investors seeking a regular income.

Bondfield, Margaret Grace (1873–1953) English Labour politician and trade unionist. In 1923 she became chairman of the Trades Union Congress (TUC) and entered parliament. As minister of labour (1923–31), she was the first British woman to hold cabinet office.

bone Connective TISSUE that forms the skeleton of the body, protects its internal organs, serves as a lever during locomotion and when lifting objects, and stores calcium and phosphorus. Bone is composed of a strong, compact layer of COLLAGEN and calcium phosphate and a lighter, porous inner spongy layer containing MARROW, in which ERYTHROCYTES and some LEUCOCYTES are produced.

bone china Hard-paste PORCELAIN, consisting of kaolin, china stone and bone ash. Josiah SPODE perfected the manufacture of bone china in the 19th century and was largely responsible for its popularity.

Bonhoeffer, Dietrich (1906–45) German theologian. A Lutheran pastor, he opposed the rise of fascism in Germany. Arrested by the Nazis in 1943, he was executed for treason after documents linked him with a failed conspiracy to assassinate Hitler in 1944. Among his works, most published posthumously, are Letters from Prison (1953) and Christology (1966). Bonhoeffer espoused a kind of "secular" Christianity. His theology is Christocentric and opposed to separation of church and world.

Boniface, Saint (675–754) English missionary. He left England in 716 to convert the pagan Germans. For his success he was rewarded with the Archbishopric of Mainz in 751. In 754 he was martyred by pagans in Friesland. He is buried in Fulda, Bavaria, and is venerated as the Apostle of Germany. His feast day is 5 June.

Boniface VIII (1235–1303) Pope (1294–1303), b. Benedetto Gaetani. To bring order to Rome and prevent schism, he imprisoned his predecessor Celestine V. He offered the first plenary indulgence (1300) for all who made a pilgrimage to Rome.

bonito Speedy, streamlined tuna-like fish found in all warm and temperate waters, usually in schools. Bonitos are blue, black and silver and highly valued as food and game fish. The ocean bonito (*Katsuwonus pelamis*) is also called skipjack tuna or bluefin. Family Scombridae.

Bonn City and capital of former West Germany, on the River Rhine, 26km (16mi) sse of Cologne. Founded in the 1st century AD as a Roman military establishment, it later became the seat of the electors of Cologne, and was awarded to Prussia by the Congress of Vienna (1815). It was capital of West Germany from 1949 until German reunification in 1990. There is some fine architecture, including a Romanesque cathedral and the Poppelsdorf Palace. Beethoven was born here. Industries: engineering, laboratory equipment. Pop. (1990) 297,400.

Bonnard, Pierre (1867–1947) French painter and graphic artist. Together with his friend, Jean-Edouard Vuillard, he adapted the traditions of IMPRESSIONISM to create a repertoire of sensuous domestic interiors. Known as *intimiste*, his paintings are drenched in gorgeous colours and generate an atmosphere of exuberant well-being. Examples include *The Terrasse Family*, Luncheon (1922) and Martha in a Red Blouse (1928).

Bonnie Prince Charlie See STUART, CHARLES EDWARD **bonsai** Japanese art of dwarfing woody plants and shrubs by pruning and restraining root growth; they are primarily outdoor plants and occur naturally in cliff areas. This art, which has been practised for centuries in the Far East, is most successful with plants that have a substantial tapering trunk, naturally twisted branches and small leaves. Bonsai can be 5–60cm (2–24in) tall, depending on the plant used.

Bonus Army (1932) Group of unemployed veterans who marched on Washington, D.C. and demanded cash payment of bonus certificates. The 17,000 veterans camped out during June and July until President HOOVER sent regular troops, led by Douglas MacArthur, to disperse them. In 1936 the veterans were given cashable bonds.

boogie-woogie Type of JAZZ popular in the 1930s. It has a rapid, driving beat, uses BLUES themes and is generally played on the piano. The melody is played over a consistently repeated bass motif played by the left hand.

book Primarily a bound volume of printed pages, it may also be a division within a book (as in the Bible) or a statement of accounts. The earliest books were Egyptian writings on papyrus, of which the BOOK OF THE DEAD is often considered the first. Roman books were mostly in the form of rolls, although the Roman period also saw the emergence of the codex, the forerunner of the paged book. In the Middle Ages, vellum, a fine parchment made from animal skin, became the standard material for books, but by the 15th century they were often written on paper. Modern printed books date to *c*.1454, when GUTENBERG conceived of using moveable type (developed earlier in China and Korea) in conjunction with

▼ bone A magnified crosssection of bone shows that it is composed of rod-like units (1) which have a central channel (2) containing blood vessels (3). These are surrounded by concentric layers or lamellae of collagen fibres, each arranged in a different direction from those in adjacent layers. Calcium salt crystals and bone cells (4) are embedded between the fibres.

early forms of the PRINTING press. The first printed book was a German Latin Bible (1455).

Booker Prize British literary prize. The Booker is the most prestigious award for new English-language novels published by UK, Commonwealth or Irish writers. The annual award generates much media attention, controversy and increased sales for short-listed writers. Recipients of the prize, first presented in 1969, have included Kazuo Ishiguro, Iris Murdoch, V.S. Naipaul and Pat Barker. In 1993 Salman Rushdie's Midnight's Children won the "Booker of Bookers". book-keeping Regular and systematic recording in ledgers of the amounts of money involved in business transactions. These records provide the basis for ACCOUNTANCY.

Book of Changes (I Ching) Ancient Chinese book of wisdom. Although the oldest parts of the text are thought to predate Confucius, he is credited with the commentaries that form a part of the collection.

Book of Common Prayer See COMMON PRAYER, BOOK OF **book of hours** Book containing the prescribed order of prayers, rites for the canonical hours and readings from the Bible. Such books, developed in the 1300s, were often lavishly decorated by miniaturists and served as status symbols. The most celebrated book of hours to survive is the *Très Riches Heures du Duc de Berry*, illustrated in part by the Limbourg brothers.

Book of Kells Illuminated manuscript of the four GOSPELS in Latin. Probably begun in the late 8th century at the Irish monastery of Iona, which later migrated to Kells, County Meath, Ireland, its intricate illumination and superb penmanship have earned it the title of "the most beautiful book in the world". After its collation in 1621 by James Usher, it was presented to Trinity College, Dublin, where it has remained.

Book of the Dead Collection of Old Egyptian texts probably dating from the 16th century BC. The papyrus texts, which exist in many different versions and incorporate mortuary texts from as early as 2350 BC, were placed in the tombs of the dead in order to help them combat the dangers of the afterlife. Boole, George (1815–64) English mathematician. Largely self-taught, he was appointed (1849) professor of mathematics of Cork University. He is best-known for his invention of Boolean algebra, a set of symbols which can be manipulated to represent logical operations. It is mostly used in COMPUTERS.

boomslang Venomous snake of the savannas of Africa. It is green or brown with a slender body and a small head. Commonly found in trees or bushes, it lies in wait for lizards and small birds, often with the front portion of its body extended motionless in mid-air. Length: to 1.5m (4.9ft). Species *Dispholidus typus*.

Boone, Daniel (1734–1820) US frontier pioneer. In 1775 he blazed the famous Wilderness Road from Virginia to Kentucky and founded the settlement of Boonesborough. During the American Revolution he was captured by the Shawnee, but escaped and reached Boonesborough in time to prevent it falling to the British and their Native American allies.

Booth, John Wilkes (1838–65) US actor and assassin of Abraham Lincoln. He was a Confederate sympathizer. On 14 April 1865, during a performance at Ford's Theater in Washington, D.C., he shot Lincoln, who died the next day. Booth escaped but was either shot, or killed himself, two weeks later. Booth, William (1829–1912) English religious leader, founder and first general of the Salvation Army. A Methodist revivalist, he preached regularly at the Methodist New Connection from 1852–61. He started his own revivalist movement, which undertook evangelistic and social work among the poor. It became known as the Salvation Army in 1878 and gradually spread to many countries. On his death Booth was succeeded by his son William Bramwell Booth.

bootlegging Illegal supply and sale of goods that are subject to government prohibition or taxation. Bootleg also refers to unlicensed copies of goods that are packaged to deceive the buyer into thinking they are the original. The name is said to derive from the practice of American frontiersmen who carried bottles of illicit liquor in the tops of their boots. In its original sense, bootlegging blossomed during the PROHIBITION era in the USA (1920–33), and helped create powerful gang bosses.

borage Hairy, annual plant native to s Europe. It has rough, oblong leaves and drooping clusters of pale blue flowers, and is cultivated as a food and flavouring. Height: up to 60cm (2ft). Family Boraginaceae; species *Borago officinalis*.

borax The most common borate mineral (hydrated sodium borate, Na₂B₄O₇·10H₂O), used to make heat-resistant glass, pottery glaze, water softeners in washing powders, fertilizers and pharmaceuticals. It is found in large deposits in dried-up alkaline lakes in arid regions as crusts or masses of crystals. It may be colourless or white, transparent or opaque.

Bordeaux City and port on the River Garonne; capital of Gironde département, sw France. There is an 11th-century Gothic cathedral, a university (1441) and many fine 18th-century buildings, from a period when the slave trade brought considerable prosperity. Bordeaux is a good, deepwater inland port and serves an area famous for its fine wines and brandies. Industries: shipbuilding, oil refining, pharmaceuticals, flour, textiles, glass. Pop. (1990) 210,336.

Borders Region of SE Scotland; its S boundary forms the border between Scotland and England. The administrative centre is Newtown St Boswells, other towns include Hawick and Jedburgh. The rivers Tweed and Teviot flow E through the region and meet near Kelso. The Cheviot Hills form most of its S border, and the Southern Uplands its E border with STRATHCLYDE and DUMFRIES AND GALLOWAY. Livestock farming and forestry are the major economic activities. Due to its strategic location it was the scene of many battles between the English and the Scots. Area: 4,714sq km (1,820sq mi). Pop. (1991) 103,881.

boreal forest Wooded zone of northern latitudes with a cold dry climate and a poor sandy soil. It consists primarily of conifers and stretches like a broad ribbon across the Northern Hemisphere. Its northern edge is bordered by frozen tundra.

Borg, Björn (1956–) Swedish tennis player. The dominant player in the late 1970s, Borg won five consecutive men's singles titles at Wimbledon (1976–80). He also won six French Open titles (1974–75, 1978–81) and helped Sweden win the 1975 Davis Cup. He retired in 1983.

Borges, Jorge Luis (1899–1986) Argentinian short-story writer, poet and critic. Borges is best known for his short-story collections *Dreamtigers* (1960), *The Book of Imaginary Beings* (1967) and *Dr Brodie's Report* (1970). Dream-like and poetic, they established Borges as one of the most significant figures in 20th-century fiction. Often using intellectual puzzles, they dramatize the extreme difficulty of achieving knowledge,

Borghese Italian princely family, originally of Siena, later Rome. Camillo Borghese (1552–1621) became pope as Paul V in 1605. Another Camillo (1775–1832) married Marie Pauline Bonaparte, the sister of Napoleon I, and was made governor of Piedmont.

Borgia, Cesare (1475–1507) Italian general and political figure, brother of Lucrezia Borgia. He was made a cardinal (1493) by his father, Pope Alexander VI, but forsook the church to embark on a military campaign (1498–1503) to establish his dominion in central Italy. His ruthless campaigns lend credence to the theory that he was the model for Machiavelli's *The Prince*. His political fortunes collapsed with Alexander's death (1503). Imprisoned by Pope Julius II, he escaped to Spain, where he was killed in battle.

Borgia, Lucrezia (1480–1519) Daughter of Pope Alexander VI and sister of Cesare Borgia. Her marriage to Giovanni Sforza (1493) was annulled by Alexander in 1497 when it failed to produce anticipated political advantages. Her marriage to Alfonso's murder (1500) by Cesare's henchman. After the collapse of Borgia aspirations in 1503, she forsook the political intrigue for which she was notorious and lived quietly, a patron of art, at Ferrara with her third husband, Alfonso d'Este.

Borglum, John Gutzon (1867–1941) US sculptor. From a six-ton marble block he fashioned a head of Abraham Lincoln, which now stands in the Capitol rotunda in Washington, D.C. His last and most exacting project was to carve the heads of George Washington, Thomas Jefferson, Abraham Lincoln and Theodore Roosevelt in a rock face at MOUNT RUSHMORE, South Dakota. The final details were completed by his son.

boric acid (boracic acid) Soft, white crystalline solid

▲ Borobudur One of the world's greatest Buddhist shrines, Borobudur was built in about the middle of the 9th century to a unique plan involving colossal resources: 570.000cu m (2 million cu ft) of stone were moved from a river bed, dressed, positioned and carved with countless spouts urns and other embellishments. The walls are covered with reliefs relating to Buddhist doctrine and there are altogether 504 shrines with seated Buddhas

(H₃BO₃) that occurs naturally in certain volcanic hot springs. It is used as a metallurgical flux, preservative, antiseptic, and an insecticide for ants and cockroaches.

Born, Max (1882–1970) German-British physicist. He was professor of physics at Göttingen University from 1921 but left Germany in 1933, teaching at the universities of Cambridge (1933–36) and Edinburgh (1936–53). He returned to Germany in 1954. For his work in QUANTUM MECHANICS, he shared the 1954 Nobel Prize for physics with Walther BOTHE. Borneo Island in the Malay Archipelago, 640km (400mi) E of Singapore, SE Asia. Mostly undeveloped, Borneo is the world's third largest island, and is divided into four political regions: SARAWAK (W) and SABAH (N) are states of Malaysia; BRUNEI (NW) is a former British protectorate; KALIMANTAN (E central and s) covers 70% of the island and forms part of Indonesia. Industries: timber, fishing, oil and coal extraction. Area: 743,330sq km (287,000sq mi).

Borobudur Ruins of a Buddhist monument in Central Java, built c.850, under the Sailendra dynasty. It comprises a stupa (relic mound), mandalas (ritual diagrams) and the temple mountain, all forms of Indian Gupta Dynasty religious art.

Borodin, Alexander Porfirevich (1833–87) Russian composer and chemist, one of the Russian Five group of composers. His most popular works include the tone poem *In the Steppes of Central Asia* (1880) and the *Polovtsian Dances* from his opera *Prince Igor* (completed after his death by Glazunov and Rimsky-Korsakov). He incorporated Russian folk song into his compositions.

boron (symbol B) Nonmetallic element of group III of the PERIODIC TABLE, first isolated in 1808 by Sir Humphry DAVY. It occurs in several minerals, notably kernite (its chief ore) and BORAX. It has two allotropes: **amorphous** boron is an impure brown powder; **metallic** boron is a black to silvergrey hard crystalline material. The element is used in semiconductor devices and the stable isotope B¹⁰ is a good neutron absorber, used in nuclear reactors and particle counters. Properties: at.no. 5; r.a.m. 10.81; r.d. 2.34 (cryst.), 2.37 (amorph.); m.p. 2,079°C (3,774°F); sublimes 2,550°C (4,622°F); most common isotope B¹¹ (80.22%).

Borromini, Francesco (1599–1667) Italian Baroque architect. He was the most inventive figure of the three masters (with BERNINI and Pietro da Cortona) of Roman Baroque. His hallmark was a dynamic hexagonal design based on intersecting equilateral triangles and circles, such as the spectacular Sant'Ivo della Sapienza (begun 1642). His masterpieces include San Carlo alle Quattro Fontane (1638–41) and Sant'Agnese in Piazza Navona (1653–55).

borzoi (Russian wolfhound) Keen-sighted speedy hunting DOG. It has a long, narrow head and powerful jaws. The body is deep and streamlined, with long legs and curved tail. The coat is long and silky, and is usually white with darker markings. Height: (at shoulder) up to 79cm (31in).

Bosch, Hieronymus (*c*.1450–1516) Flemish painter, b. Jerome van Aken in 's Hertogenbosch. His paintings of grotesque and fantastic visions based on religious themes led to accusations of heresy, but greatly influenced 20th-century

SURREALISM. The majority of his pictures explore the distressing consequences of human sin: innocent figures are besieged by horrifying physical torments. He had a superb painting technique and used vivid colours. About 40 examples of his work survive, but his most famous works are *The Temptation of St Anthony*, *The Garden of Earthly Delights* (often considered his masterpiece) and *Adoration of the Magi*.

Bose, Satyendranath (1894–1974) Indian physicist and mathematician. He significantly extended a theory of QUANTUM MECHANICS by Albert EINSTEIN concerning the gas-like properties of ELECTROMAGNETIC RADIATION. He developed a statistical model for the behaviour of a collection of subatomic particles.

Bosnia-Herzegovina Balkan republic in SE Europe. *See* country feature

boson ELEMENTARY PARTICLE which has an integer SPIN. Named after the physicist Satyendranath Bose, bosons are those particles not covered by the EXCLUSION PRINCIPLE. This means that the number of bosons occupying the same quantum state is not restricted. Bosons are force-transmitting particles, such as PHOTONS and gluons (the particles that hold QUARKS together). See also FERMION

Bosporus (Karadeniz Bogazi) Narrow strait joining the Sea of Marmara with the Black Sea, and separating European and Asiatic Turkey. It is an important strategic and commercial waterway, controlled by the Turks since 1452, and refortified after the Montreux Convention of 1936. Length: 30km (19mi). Boston State capital and seaport of Massachusetts, USA, at the mouth of the Charles River, on Massachusetts Bay. Founded in 1630, it became a Puritan stronghold and the scene of several incidents leading to the outbreak of the American Revolution. A religious and cultural centre, Boston is the home of many important educational establishments, including Boston University and Harvard Medical School. Harvard University and the Massachusetts Institute of Technology (MIT) are situated nearby. Industries: publishing, banking and insurance, shipbuilding, electronics, fishing, clothing manufacture. Pop. (1990) 574,283.

Boston Massacre (1770) Riot by American colonists, angered over the quartering of troops in private homes. Starting with some snowballing, it was put down by British soldiers and resulted in the death of five civilians, including Crispus Attucks. The riot was exploited for anti-British propaganda by Samuel Adams and the Boston radicals. The soldiers were tried for murder, defended by John Adams, and acquitted.

Boston Tea Party (1773) Protest by a group of Massachusetts colonists, disguised as Mohawks and led by Samuel Adams, against the Tea Act and, more generally, against "taxation without representation". The Tea Act (1773), passed by the British parliament, withdrew duty on tea exported to the colonies. It enabled the EAST INDIA COMPANY to sell tea directly to the colonies without first going to Britain and resulted in colonial merchants being undersold. The protesters boarded

▶ Bosch A detail of the "Hell" section of *The Garden of Earthly Delights*. The triptych by Hieronymous Bosch shows the surreal nature of his work. Among his patrons was the devout Catholic Philip II of Spain, and it is thought that Bosch's work was to serve as a warning against sin.

three British ships and threw their cargo of tea into Boston harbour. The British retaliated by closing the harbour.

Boswell, James (1740–95) Scottish biographer and author. As a young man, he travelled widely in Europe, meeting VOLTAIRE and Jean-Jacques ROUSSEAU. An inveterate hero-worshipper, Boswell found his vocation as the friend and biographer of Samuel JOHNSON. His monumental Life of Samuel Johnson (1791) is regarded not only as his masterpiece but also one of the greatest biographies in English. Boswell's other works include An Account of Corsica (1768) and The Journal of a Tour to the Hebrides (1785), an account of his travels with Johnson. His often disconcertingly frank journals paint a colourful picture of contemporary life. See also BIOGRAPHY

Bosworth Field English battleground, 19km (12mi) w of Leicester, England, where RICHARD III was defeated by Henry Tudor (1485). Henry, who claimed to represent the Lancastrian royal house, which had competed with the Yorkists during the Wars of the Roses, invaded England from France. Richard was killed, and Henry claimed the throne as HENRY VII.

botanical garden Large garden preserve for display, research and teaching purposes. Wild and cultivated plants

from all climates are maintained outdoors and in greenhouses. The first botanical gardens were established during the Middle Ages. In the 16th century, gardens existed in Pisa, Bologna, Padua and Leiden. Aromatic and medicinal herbs were arranged in rows and still exist in the Botanical Garden of Padua. The first US botanical garden was established by John Bartram in Philadelphia in 1728. Famous botanical gardens include the Royal Botanical Gardens in Kew, near London (1759); Botanical Gardens of Berlin-Dahlem (1646); and Botanical Gardens in Schönbrunn, Vienna (1753).

botany Study of PLANTS and ALGAE, including their classification, structure, physiology, reproduction and evolution. The discipline used to be studied in two halves: lower (nonflowering) plants, which included the algae (now in the kingdom Protoctista), MOSS and FERNS; and higher (seed-bearing) plants, including most flowers, trees and shrubs. Botany also studies the importance of plants to humans.

Botany Bay Large, shallow inlet immediately s of Port Jackson, Sydney Harbour, New South Wales, Australia. It was visited in 1700 by Captain James Cook, who named it because of its flora. It is fed by the Georges and Woronora rivers, and is *c*.1.6km (1mi) wide at its mouth.

BOSNIA-HERZEGOVINA

Bosnia-Herzegovina's flag was adopted when the country became independent in April 1992. The shield recalls the ancient Bosnian monarchy which existed before the Ottoman Turks conquered the area. The fleur-de-lis is thought to be derived from a Bosnian lily, Lilium bosniacum.

Bosnia-Herzegovina is one of the five republics that emerged from the break-up of the former Federal People's Republic of YUGOSLAVIA. It consists of two main regions — Bosnia in the N, with SARAJEVO as the capital; and Herzegovina in the s, with Mostar the main city. The E half of the nation is dominated by the DINARIC ALPS, which slope down gradually to the W. The River Sava, a tributary of the Danube, forms most of its N border with CROATIA. Bosnia-Herzegovina has a narrow, 20km (13mi), outlet to the Adriatic Sea at Neum.

CLIMATE AND VEGETATION

Coastal areas experience dry, sunny summers and mild, moist winters. Inland, the climate is

more extreme, with hot, dry summers and bitterly cold winters. Forests of beech, oak and pine grow in the N. The SW is an arid limestone plateau, interspersed with farmland.

HISTORY AND POLITICS

SLAVS settled in the region c.1,400 years ago. Bosnia was settled by Serbs in the 7th century and conquered by Ottoman Turks in 1463. The persistence of serfdom led to a peasant revolt (1875). The Congress of Berlin (1878) handed Bosnia-Herzegovina to the Austro-Hungarian EMPIRE, and it was annexed in 1908. Serbian nationalism intensified and in 1914 Archduke FRANZ FERDINAND was assassinated in Sarajevo, precipitating World War 1. In 1918 Bosnia-Herzegovina was annexed to SERBIA and incorporated into Yugoslavia in 1929. In World War 2 the region became part of the German puppet state of Croatia. In 1946 Bosnia-Herzegovina became a constituent republic of Tito's socialist federal republic. In 1991 the republic disintegrated with the secession of Croatia, SLOVENIA and MACEDONIA. Fearing the creation of a Greater Serbia, Croats and Muslims pushed for independence. In March 1992 a referendum, boycotted by Serbian parties, voted for independence. Alija IZETBEGOVIĆ became president of the new state. War broke out between Bosnian government forces and the Serb-dominated Federal Yugoslav Army (JNA). The JNA overran the republic and besieged the government in Sarajevo. International pressure forced the JNA to withdraw. The JNA handed its weapons to Bosnian Serbs, who established a separate Serb republic led by Radovan Karadžić (August 1992). Bosnian AREA: 51,129sq km (19,745 sq mi)

POPULATION: 4.366,000

CAPITAL (POPULATION): Sarajevo (526,000)
GOVERNMENT: Transitional

ETHNIC GROUPS: Muslim 49%, Serb 31%,

Croat 17%

LANGUAGES: Serbo-Croatian

RELIGIONS: Islam 40%, Christianity (Serbian

Orthodox 31%, Roman Catholic 15%,

Protestant 4%)

currency: Dinar = 100 paras

Serbs controlled 70% of the territory and Croats a further 20%. Muslims were forced from their villages in a deliberate act of "ethnic cleansing". In late 1992 the UN deployed peacekeeping forces to distribute humanitarian aid to the starved capital of Sarajevo. In 1993 the UN declared a number of "safe areas" - government-held enclaves where Muslims would not be shelled or persecuted. In February 1994 Bosnian Serbs attacked the enclaves of Sarajevo and Gorazde, prompting UN air-strikes. The governments of Bosnia and Bosnian Croats announced a cease-fire and the formation of a Muslim-Croat Federation. In 1995 the Federation launched a major offensive, forcing Bosnian Serbs to negotiate. The Dayton Peace Treaty (December 1995) agreed to preserve Bosnia-Herzegovina as a single state, but partitioned it between the Muslim-Croat Federation (51%) and Bosnian Serbs (Republika Srpska, 49%). The agreement deployed 60,000 NATO troops as part of a Peace Implementation Force (IFOR). KARADŽIĆ and the Bosnian Serb army leader Ratko MLADIĆ were indicted for war crimes and forced to resign. In 1996 elections Izetbegović was re-elected and Biljana Plavsic became president of Republika Srpska. NATO troops remained as a "stabilizing" force.

ECONOMY

Excluding Macedonia, Bosnia was the least developed of the former republics of Yugoslavia. Its economy has been shattered by the war. Before the war, manufactures were the main exports. Many foodstuffs have to be imported.

The families of botflies, Cuterebridae, Oestridae and Gaterophilidae, are parasitic on humans, sheep and horses respectively. The life cycle of the common horse botfly (Gasterophilus intestinalis) begins (1) as eggs are glued by the adult to the hairs, usually on the front legs of the horse. The stimulus of the moisture and friction provided by the horse's tongue when cleaning itself near the eggs causes the larvae to emerge and attach themselves to the animal's tongue and lips. The larvae pass to the stomach (2) where they attach themselves to the walls. The fully developed larvae release their hold on the walls and pass out with excrement (3). The larvae pupate in the ground and emerge as adults (4).

botfly Any of several families of stout, hairy, black-andwhite to grey fly. Its larvae are parasites of livestock, small animals and even humans. Usually eggs are laid on the host and the larvae cause damage to the host's skin or internal systems. The botfly that attacks deer is possibly the world's swiftest insect, flying at 80km/h (50mph). Order Diptera;

family Oestridae.

BOTSWANA

AREA: 581,730sq km (224.606sg mi) POPULATION: 1,373,000 CAPITAL (POPULATION): Gaborone (138,471) GOVERNMENT: Multiparty republic

ETHNIC GROUPS: Tswana 75%, Shona 12%, San (Bushmen) 3% LANGUAGES: English (official), Setswana (national

language) **RELIGIONS:** Traditional beliefs

49%, Christianity 50% **CURRENCY:** Pula = 100 thebe

Botha, P.W. (Pieter Willem) (1916-) South African statesman. The longest-serving member of the APARTHEID regime, he entered parliament in 1948. As defence minister (1966-78), he increased South Africa's armed forces and was responsible for the military involvement in Angola. He became prime minister (1978) and undertook limited reform of apartheid. The adoption of a new, racial constitution allowed the participation of non-whites in parliamentary government, but excluded the black majority. In 1980 he established the Southwest Africa Territorial Force, as part of a destabilization policy of South Africa's neighbours. He became the state's first president (1980) and was re-elected in 1987. In 1989 he suffered a stroke and, amid increasing National party factionalism, resigned and was replaced by the more reform-minded F.W. DE KLERK.

Botha, Louis (1862-1919) South African politician and military leader. During the South African War (1899-1902) he was an outstanding commander and led the Transvaal delegation at the peace conference. A moderate, he advocated reconciliation with the British, and in 1910 became first prime minister of the Union of SOUTH AFRICA.

Botham, lan Terence (1955-) English cricketer. In 1974 he made his county debut for Somerset and an auspicious test debut against Australia (1977). He was one of cricket's greatest all-rounders, with 14 test centuries (5,200 runs) and 373 test wickets. In 1979 he became the first player to score a century and take 10 wickets in a test. In 1981 he almost singlehandedly helped England regain The Ashes. In 1996 he was appointed England coach.

Bothe, Walther Wilhelm Georg Franz (1891-1957) German physicist. During World War 2 he worked on Germany's nuclear energy project and built Germany's first cyclotron. He shared the 1954 Nobel Prize for physics with Max Born for his development of the coincidence method, which can detect two particles emitted simultaneously from the same nucleus during radioactive decay.

Botswana Landlocked republic in the heart of s Africa; the capital is GABORONE. Land and climate Most of the land is flat or gently rolling, with an average height of c.1,000m (3,280ft) with more hilly country in the E. The KALAHARI Desert covers much of Botswana. Most of the s has no permanent streams, but large depressions form inland drainage basins in the N, such as the delta swamps of the River Okavango. Gaborone lies in the wetter and more populous E. Temperatures are high in the summer months (October-April), but winter months are much cooler, sometimes with night frost. The average annual rainfall varies from more than 400mm (16in) in E Botswana to less than 200mm (8in) in the sw. Economy At the time of independence, Botswana was one of Africa's poorest countries (depending on meat and live cattle for its exports). Many people migrated to work in the mines of South Africa. Today, Botswana is now one of the continent's wealthiest nation, its economy boosted by the discovery of diamonds. It is the world's third largest diamond producer. Diamonds account for 70% of its exports. Coal, copper and nickel are also valuable resources. Botswana is dependent on South African ports for the transshipment of its minerals. However, it remains essentially an agricultural economy. Agriculture employs over 40% of the workforce, mainly in pastoral farming. History The earliest inhabitants were the nomadic SAN. The cattle-owning Tswana, modern Botswana's majority population, first settled in E Botswana more than 1,000 years ago. The San were gradually displaced s to the Kalahari Desert, and now form a tiny minority. Incursion by Boers and the threat of German colonialism led Britain to form the Bechuanaland Protectorate (1885-1966). In 1966 it achieved independence as the Commonwealth republic of Botswana. One of the "front-line states", Botswana provided a haven for refugees from South Africa's apartheid government. Botswana is a stable multiparty democracy.

Botticelli, Sandro (1444-1510) (Alessandro di Mariano Filipepi) Florentine RENAISSANCE painter. Loved by the PRE-RAPHAELITE BROTHERHOOD and an important influence on ART NOUVEAU, he was part of a late 15th-century movement

which admired the ornamental, linear qualities of Gothic painting. He is best known for his mythological allegories, *Primavera* (c.1478), *The Birth of Venus* and *Pallas and the Centaur*. Botticelli was one of the privileged few to decorate the Sistine Chapel in Rome (1481) and, at the height of his career, was the most popular painter in Florence. He made a series of delicate pen drawings for a copy of Dante's *Divine Comedy*. From 1500, his style was superseded by the inspired naturalism of LEONARDO DA VINCI.

botulism Rare but potentially lethal form of food-poisoning caused by a toxin produced by the bacterium *Clostridium botulinum*. The toxin attacks the nervous system, causing paralysis and cessation of breathing. The most likely source of botulism is imperfectly canned meat. Botulinum toxin is used medicinally as a treatment for some neuromuscular disorders. Boucher, François (1703–70) French painter, decorator and engraver. His style was the epitome of ROCOCO frivolity and was distinctly risqué in tone. He was immensely successful and widely imitated. He produced over 11,000 historical, mythological, genre and landscape paintings. Boucher became director of the GOBELINS tapestry works (1755), and was also First Painter to LOUIS XV.

Boucicault, Dion (Dionysius Lardner) (c.1822–90) Transatlantic playwright and actor-manager. He was responsible for the development of the touring company. A prolific dramatist, he wrote and adapted nearly 300 plays. The most successful were his comedies and romantic melodramas, such as *London Assurance* (1841), *Grimaldi* (1855) and *The Octoroon* (1859). His ability to handle Irish, English and American theatrical traditions made him one of the greatest figures of Victorian theatre.

Bougainville, Louis Antoine de (1729-1811) French maritime explorer. A veteran of the French and Indian Wars, a diplomat, mathematician and soldier, he commanded the frigate La Boudeuse on the first French voyage around the world (1766-69). It included a long interlude in TAHITI, which, among other Pacific islands, he claimed for France. Important botanical and astronomical studies were made during the voyage, of which Bougainville published an account in 1771-72. Bougainville Volcanic island in the sw Pacific Ocean, E of New Guinea; a territory of Papua New Guinea. It was discovered in 1768 by Louis de BOUGAINVILLE. The island was under German control from 1884, and then under Australian administration after 1914 and again in 1945 (after the Japanese wartime occupation). It has been the scene of guerrilla warfare since the late 1980s. Kieta is the chief port. Industries: copper mining, copra, cocoa, timber. Area: 10,049sq km (3,880sq mi). Pop. (1990 est.) 128,000.

bougainvillea Tropical, flowering woody vine native to S America, often grown as a garden plant in warm climates. Its flowers have showy purple or red bracts. It was named after the French explorer Louis de BOUGAINVILLE. Family Nyctaginaceae; genus *Bougainvillea*.

Boulanger, Nadia (1887–1979) French music teacher. She was one of the foremost teachers of composition in the 20th century. Pupils included Aaron Copland, Darius Milhaud and Jean Françaix. In the 1930s she became the first woman to conduct the Boston Symphony Orchestra and the New York Philharmonic. Her sister Lili Boulanger (1893–1918) was an accomplished composer.

Boulez, Pierre (1925–) French conductor and composer. Influenced by Olivier Messiaen and Anton von Webern, he aimed to extend serialism into all aspects of a composition, including rhythm and dynamics. His works for voice and orchestra have received much attention, especially *Le Marteau sans maître* (1954) and *Pli selon pli* (1960). Renowned for conducting complex 20th-century works, Boulez became director of the French Institute for Acoustic and Musical Research (IRCAM) in 1975.

Boulle (Buhl), André Charles (1642–1732) French cabinet-maker, one of a number of skilled craftsmen maintained in the Louvre Palace by Louis XIV to design for the court. Boulle created a distinctive marquetry of tortoiseshell and gilded brass, to which he gave his name. There are examples of his output at Versailles and in the Louvre.

Boult, Sir Adrian (1889–1983) English conductor, widely known for his interpretation of early 20th-century English composers, such as Elgar, Holst and Vaughan Williams. He was musical director and principal conductor of the BBC Symphony Orchestra (1930–50) and principal conductor of the London Philharmonic Orchestra (1950–57).

Bourbons European dynastic family, descendants of the CAPETIANS. The ducal title was created in 1327 and continued until 1527. A cadet branch, the Bourbon-Vendôme line, won the kingdom of Navarre. The Bourbons ruled France from 1589 (when Henry of Navarre became HENRY IV) until the FRENCH REVOLUTION (1789). Two members of the family, LOUIS XVIII and CHARLES X, reigned after the restoration of the monarchy. In 1700 the Bourbons became the ruling family of Spain, when PHILIP V (grandson of LOUIS XIV of France) assumed the throne. His descendants mostly continued to rule Spain until the declaration of the Second Republic (1931). JUAN CARLOS I, a Bourbon, was restored to the Spanish throne in 1975.

bourgeoisie (middle class) Term originally applied to artisans and craftsmen who lived in medieval French towns. Up to the late 18th century it was a propertied but relatively unprivileged class, often of urban merchants and tradesmen, who helped speed the decline of the feudal system. The 19th-century advent of CAPITALISM led to the expansion of the bourgeoise and its division into the high (industrialists and financiers) and petty (tradesmen, clerical workers) bourgeoisie.

Bourguiba, Habib (1903–) First President of Tunisia. In 1934 Bourguiba founded the nationalist Neo-Destour Party. In 1954 he began negotiations that culminated in Tunisian independence (1956). He became prime minister and, after the abolition of the monarchy in 1957, was elected president. In 1975 he was proclaimed president-for-life. He maintained a pro-French, autocratic rule until, old and ill, he was removed from power in 1987.

Bourke-White, Margaret (1906–71) US photo-journalist She produced dramatic photo-essays for *Time*, *Life* and *Fortune* magazines on a variety of subjects, including the rural South of the 1930s, the Italian and Russian campaigns of World War 2, concentration camp victims, the Korean War, South Africa, India, modern industrial technology and world political leaders.

Boutros-Ghali, Boutros (1922–) Egyptian politician, sixth secretary-general (1992–96) of the UNITED NATIONS (UN). As Egypt's foreign affairs minister (1977–91), he was involved in many of the Middle East peace negotiations. He briefly served as Egypt's prime minister (1991–92), before becoming the first African secretary-general of the UN. Early in his term he had to face crises in the Balkans, Somalia and Rwanda. A fiercely independent secretary-general, he managed to alienate US opinion and was blamed for the failure of UN peacekeeping in Somalia and Bosnia

bovine spongiform encephalopathy (BSE) In cattle, degeneration of the brain caused by infectious particles or PRIONS, which may be transmitted by feeding infected meat. It is also known as "mad cow disease". *See also* CREUTZFELD-JAKOB DISEASE (CJD)

bowerbird Forest bird of New Guinea and Australia. The male builds a simple but brightly ornamented bower to attract the female. After mating, the female lays 1–3 eggs in a cupshaped nest. Adults, mainly terrestrial, have short wings and legs, and variously coloured plumage. Length: 25–38 cm (10–15in). Family Ptilonorhynchidae.

Bowie, Jim (James) (1796–1836) US frontiersman. He moved to Texas from Louisiana in 1828 and married the daughter of the Mexican vice-governor. By 1832 he had joined the US colonists who opposed the Mexican government. He was appointed a colonel in the Texas army (1835) and was killed at the Alamo (1836).

Bowie, **David** (1947–) British pop singer, b. David Jones. Fusing a bizarre theatricality to progressive pop, perhaps his greatest work is the album *Ziggy Stardust* (1972). His subsequent work has embraced many styles. Other albums include *Hunky Dory* (1972) and *Heroes* (1977). He made his film debut in *The Man Who Fell to Earth* (1976).

▲ bowerbird The tooth-billed bowerbird (*Scenopoeetes dentirostris*) is found in NE Australia. The male builds a nest as part of a courtship ritual.

bowling Indoor sport in which a ball is bowled at pins. An ancient game, it originated in Germany and was brought to the USA by Dutch immigrants in the 17th century. Known as ninepins, it soon became a popular gambling game and, when it was banned, a tenth pin was added to circumvent the law. Ten-pin bowling is now an extremely popular sport. Two players or teams bowl at pins set on a triangular base. Points are scored according to the number of pins knocked over and the pins are reset automatically. *See also* SKITILES

bowls Game popular in Britain and Commonwealth countries, in which a series of bowls (woods) are delivered underarm to stop as close as possible to a small white target ball (jack). A point is scored for each bowl closer to the jack than the best opposition bowl. Variations depend on the playing surface, such as lawn, crown green and indoor.

box Evergreen tree or shrub found in tropical and temperate regions in Europe, North America and w Asia. The shrub is popular for TOPIARY, and box wood is used for musical instruments. The 100 species include English or common *Buxus sempervirens* and larger *Buxus balearica* that grows to 24m (80ft). Family *Buxaceae*.

boxer Smooth-haired working DOG bred originally in Germany. It has a broad head with a deep, short, square muzzle, and its deep-chested body is set on strong, medium-length legs. The tail is commonly docked, and its coat is generally red or brown, with black and white markings. Height: to 61cm (24in) at the shoulder.

Boxer Rebellion (1900) European name for a Chinese revolt aimed at ousting foreigners from China. Forces led by the Society of Righteous and Harmonious Fists (hence the "Boxers"), with tacit support from the Dowager Empress, attacked Europeans and Chinese Christians and besieged Peking's foreign legations' enclave for two months. An international expeditionary force relieved the legations in August and suppressed the rising. China agreed to pay an indemnity. boxing Sport of fist fighting between two people wearing padded gloves within a roped-off ring. Boxers are classified in eight divisions according to weight: minimumweight (under 48kg/105lb), fly, bantam, feather, light, welter, middle and heavyweight (over 88kg/195lb). Professional bouts are scheduled for 4 to 15 rounds of three minutes' duration. A

The marine animal known as a brachiopod, or lampshell, lives in holes in mud flats. It comprises (A) a hinged shell and a stalk with which it grips the rocks. The cross-section (B) shows; lophophore (1) which bears ciliated tentacles for feeding; digestive gland (2); mouth (3) and stalks (4).

When feeding Lingula (C), which resembles fossil forms of 500 million years ago, rests at the surface of its burrow using feathery cilia to filter water for food particles. When disturbed, its stalk contracts, drawing the animal into the burrow (D), out of sight and reach of its potential predator.

fight is controlled by a referee in the ring and ends when there is a knock-down (a boxer is unable to get to his feet by a count of ten) or a technical knockout (one fighter is seriously injured). If both boxers finish the scheduled number of rounds, the winner is determined by a ringside referee or three judges. Boxing emerged from bareknuckle fighting when the Marquess of QUEENSBERRY's rules introduced timed rounds and padded gloves in 1866. Despite worldwide popularity, it is under increasing pressure to introduce further safety measures or be abolished, with brain damage, comas and deaths becoming worryingly regular. The international sport is now controlled by three major rival organizations: the World Boxing Association (WBA), the World Boxing Council (WBC), and the International Boxing Federation (IBF). **Boycott, Geoffrey** (1940–) English cricketer. Boycott was

captain of Yorkshire (1971–79). In 1971 he became the first batsman to average over 100 runs in an English first-class season. He played in 108 test matches. His 8,114 test runs for England is surpassed only by Graham Gooch and David Gower. In 1982 he was banned from test cricket for touring South Africa. Boycott is now a television sports commentator. **boycott** Refusal to deal with a person, organization or country, either in terms of trade or other activities, such as sport. The term originated in 1880 when Irish tenant farmers refused to work for, supply or speak with Captain Charles Boycott, an agent of their landlord. Boycotts can be powerful protest tools, if they have sufficient support. See also EMBARGO

Boyd, William (1952–) British novelist and short story writer, whose sometimes grimly comic works are often set in Africa, where he grew up. These include his first novel, A Good Man in Africa (1981), his second, An Ice-cream War (1982) and Brazzaville Beach (1990). The scene of Stars and Bars (1984) and The Blue Afternoon (1995) shifts to the USA, and his most ambitious novel, The New Confessions (1987), ranges across the whole history of the 20th century.

Boyle, Robert (1627–91) Anglo-Irish scientist, often regarded as the father of modern chemistry. In 1662 he invented an efficient vacuum pump, which enabled him to reduce pressures to levels never before achieved and to formulate Boyle's Law. He also formulated the chemical definitions of an element and a reaction. He was a founding Fellow of the ROYAL SOCIETY.

Boyle's law Volume of a gas at constant temperature is inversely proportional to the pressure. This means that as pressure increases, the volume of a gas at constant temperature decreases. First stated by Robert Boyle in 1662, Boyle's law is a special case of the ideal gas law (involving a hypothetical gas that perfectly obeys the gas laws).

Boyne, Battle of the (1690) Engagement near Drogheda, Ireland, which confirmed the Protestant succession to the English throne. The forces of the Protestant WILLIAM III of England defeated those of the Catholic JAMES II. The battle led to the restoration of English power in Ireland.

Boy Scouts Worldwide social organization for boys that encourages outdoor pursuits and good citizenship. It was founded (1908) in Britain by Lord BADEN-POWELL with the motto, "Be prepared". A companion organization, the GIRL GUIDES, was founded in 1910. In 1967 the movement was officially renamed the Scout Association. By the 1990s it had *c*.14 million members (including the Cubs and Brownies) in over 100 countries.

Brabant Province of central Belgium; the capital is BRUSSELS. ANTWERP is one of the world's largest ports. Mainly Flemish-speaking, it is a densely populated and fertile agricultural region. Industries: chemicals, metallurgy, food processing. Area: 3,372sq km (1,302sq mi). Pop. (1970 est.) 2,178,000.

brachiopoda (lampshells) Phylum of *c.*260 species of small, bottom-dwelling, marine invertebrates. They are similar in outward appearance to BIVALVE MOLLUSCS, having a shell composed of two valves; however, unlike bivalves, there is a line of symmetry running through the valves. They live attached to rocks by a pedicle (stalk), or buried in mud or sand. There are 75 genera including *Lingula*, the oldest known animal genus. Most modern brachiopods are less than 5cm (2in) across. More than 30,000 fossil species have been found and described.

bracken Persistent weedy FERN found worldwide. It has an underground stem that can travel 1.8m (6ft) and sends up fronds that may reach 4.6m (15ft) in some climates. The typica variety is widespread in Britain. Family Dennstaedtiaceae; species *Pteridium aquilinum*.

bracket fungus (shelf fungus) Any of a large family (Polyporaceae) of common arboreal fungi that have spore-bearing tubes under the cap. Bracket fungi are usually hard and leathery or wood-like and have no stems. They often cover old logs and their parasitic activity may kill living trees. Some are edible when young.

bract Modified leaf found on a flower stalk or the flower base. Bracts are usually small and scalelike. In some species they are large and brightly coloured, such as DOGWOOD and POINSETTIA. Bradbury, Ray Douglas (1920—) US novelist and short story writer. Best known for his imaginative science fiction, Bradbury's most celebrated work includes: The Martian Chronicles (1950), a collection of connected short stories; Fahrenheit 451 (1953), an unhappy vision of a book-burning future world; and the fantasy Something Wicked This Way Comes (1962). He has also written plays, poetry, children's stories, screenplays, and volumes of essays, such as Journey to Far Metaphor (1994).

Braddock, Edward (1695–1755) British general in the FRENCH AND INDIAN WARS. As commander in chief of the British forces in North America, Braddock led the attack on the French stronghold of Fort Dequesne (1755). Progress was slow and, on the advice of George WASHINGTON, Braddock led an advance party. Ambushed by Native Americans, the party was routed and Braddock killed.

Bradford, William (1590–1657) American colonial governor and signatory of the Mayflower Compact. He emigrated to America as one of the PILGRIMS on the *Mayflower* (1620), being one of the organizers of the voyage. He was elected governor of Plymouth Colony in 1621 and re-elected for 30 years thereafter. He helped draw up a body of laws for the colony in 1636, and wrote a *History of Plymouth Plantation*, 1620–46.

Bradford City in the Aire Valley, West Yorkshire, N England. Since the 14th century it has been a centre for woollen and worsted manufacturing, but industry has recently greatly diversified. The city is home to one of England's largest Asian communities. It has a university (established 1966). Industries: textiles, textile engineering, electrical engineering, micro-electronics. Pop. (1991) 457,344.

Bradley, Omar Nelson (1893–1981) US general. In World War 2 he commanded the 2nd Corps in N Africa and the invasion of Sicily (1943), and led the 1st Army in the Normandy invasion (1944). After the war he served as chief of staff of the US army (1948–49) and first chairman of the joint chiefs of staff (1949–53).

Bradman, Sir Don (Donald George) (1908–) Australian cricketer and sports administrator, probably the greatest batsmen the game has ever seen. He played for Australia from 1928 and was captain (1936–48). His test record was 6,996 runs in 52 games (an average of 99.94), including 29 centuries and a highest score of 334 (against England at Leeds in 1930). During his first-class career he made a total of 28,067 runs (averaging 95.14), including 117 centuries. He was knighted in 1949.

Brady, Mathew B. (1823–96) Pioneer US photographer After studying the daguerreotype process with Samuel F.B. Morse, he became the leading US portraitist of his day. President Lincoln was a frequent subject. Brady organized a staff of photographers to make a record of the Civil War. Much of this early war photography is in the Library of Congress.

Braganza Ruling dynasty of Portugal (1640–1910). The dynasty was founded by the Duke of Braganza, who ruled as John IV (1640–56). During the NAPOLEONIC WARS, the royal family fled to Brazil, then a Portuguese colony. A branch of the house ruled as emperors of Brazil from 1822–89.

Bragg, Sir (William) Lawrence (1890–1971) English physicist, b. Australia. He was director (1938–53) of the Cavendish Laboratory at Cambridge. With his father, Sir William Henry Bragg, he determined the mathematics involved in x-ray DIFFRACTION, showed how to compute x-ray

wavelengths and studied CRYSTAL structure by x-ray diffraction. For these advances, they were jointly awarded the 1915 Nobel Prize for physics.

Brahe, Tycho (1546–1601) Danish astronomer. Under the patronage of King Frederick II of Denmark he became the most skilled observer of the pre-telescope era, expert in making accurate naked-eye measurements of the stars and planets. He built an observatory on the island of Hven (1576) and calculated the orbit of the comet seen in 1577. This, together with his study of the supernova, showed that ARISTOTLE was wrong in picturing an unchanging heaven. Brahe could not, however, accept the world system put forward by COPERNICUS. In his own planetary theory (the Tychonian system), the planets move around the Sun, and the Sun itself, like the Moon, moves round the stationary Earth. In 1597 he settled in Prague, where Johann KEPLER became his assistant.

Brahma Creator god in HINDUISM, later identified as one of the three gods in the Trimurti. Brahma is usually thought equal to the gods VISHNU and SHIVA, but later myths tell of him being born from Vishnu's navel. There is only one major temple to Brahma, located at Pushkar, Rajasthan, NW India.

Brahman (Atman) In HINDUISM, the supreme soul of the universe. The omnipresent Brahman sustains the earth. According to the UPANISHADS, the individual soul is identified with Brahman. Brahman is not God, but rather is *neti neti* (not this, not that) or indescribable.

Brahman cattle (zebu) Many domestic varieties of a species of ox native to India. Tan, grey or black with a hump over the shoulders, brahmans have drooping ears and a large dewlap. Family Bovidae; species *Bos indicus*.

Brahmanism Term denoting an early phase of HINDUISM. It was characterized by acceptance of the VEDAS as divine revelation. The Brahmanas, the major text of Brahmanism, are the ritualistic books comprising the greater portion of Vedic literature. They were complemented by the UPANISHADS. In the course of time deities of post-Vedic origin began to be worshipped and the influence of Brahmanist priests declined. This led to a newer, popular form of Hinduism.

Brahmaputra River in s Asia. Rising in sw Tibet, it flows E into China, then s into India and wsw across India into Bangladesh (where it becomes the River YAMUNA). Before emptying into the Bay of BENGAL, it forms (with the GANGES and Meghna rivers) a vast delta. Length: c.2,900km (1,800mi). Brahmin (Brahman) Priestly CASTE that was the highestranking of the four varnas (social classes) in India during the late Vedic period, the era of BRAHMANISM. The term also denotes a member of that caste. Brahmin were believed to be ritually purer than other castes, and they alone could perform certain spiritual and ritual duties. The recitation of the VEDAS was their preserve, and for hundreds of years they were the only caste to receive an education and so controlled Indian scholarship. With the later development of HINDUISM as a popular religion, their priestly influence declined, but their secular influence grew, and their social supremacy and privileged status have changed little over the centuries. Brahmins maintain ritual cleanliness through strict dietary laws and tightly regulated contact with other castes.

Brahms, Johannes (1833–97) German composer. Encouraged by his friends Robert and Clara Schumann, he began to earn his living as a composer at the age of 30. He used classical forms rather than the less-strict programmatic style that was becoming popular, and was a master of contrapuntal HARMONY. He composed in all major musical genres except opera. Among his major works are the *German Requiem* (1868), the *Variations on the St Antony Chorale* (1863), the Violin Concerto in D (1878), four symphonies (1876–1885) and two piano concertos (1858 and 1881). He also wrote many songs. His best-known music includes the orchestral *Hungarian Dances* (1873).

Braille System of reading and writing for the blind. It was invented by Louis Braille (1809–52), who lost his sight at the age of three. Braille was a scholar, and later a teacher, at the National Institute of Blind Youth, Paris. He developed a system of embossed dots to enable blind people to read by touch. This was first published in 1829, and a more complete

form appeared in 1837. There are also Braille codes for music and mathematics.

brain Mass of nerve tissue which regulates all physical and mental activity; it is continuous with the spinal cord. Weighing about 1.5kg (3.3lb) in the adult (about 2% of body weight), the human brain has three parts: the hindbrain, where basic physiological processes such as breathing and the heartbeat are coordinated; the midbrain links the hindbrain and the forebrain, which is the seat of all higher functions and attributes (personality, intellect, memory, emotion), as well as being involved in sensation and initiating voluntary movement. See also CENTRAL NERVOUS SYSTEM; CEREBRUM

brain damage Result of any harm done to brain tissue causing the death of nerve cells. It may arise from a number of causes, such as oxygen deprivation, brain or other disease or head injury. The nature and extent of damage varies. Sudden failure of the oxygen supply to the brain may result in widespread (global) damage, whereas a blow to the head may affect only one part of the brain (local damage). Common effects of brain damage include weakness of one or more limbs, impaired balance, memory loss and personality change; epilepsy may develop. While brain cells do not regenerate, there is some hope of improvement following mild to moderate brain damage, especially with skilled rehabilitation. The

The vertebrate brain has three major structural and functional regions - the forebrain, the midbrain and the hindbrain. In primitive animals, such as amphibians, the forebrain is concerned with smell, the midbrain with vision and the hindbrain with balance and hearing. In higher animals, such as rats, cats, monkeys and humans, parts of the brain have adapted to meet the needs of the organism. Most notably, part of the forebrain, the cerebrum (1), developed into a complex, deeply fissured structure. It comprises large regions concerned with association. reasoning and judgement. Its outer layer, the cortex (2). contains areas that coordinate movement and sensory information. The limbic system (3) controls emotional responses, such as fear. The thalamus (4) coordinates sensory and motor signals, and relays them to the cerebrum: the hypothalamus (5) along with the pituitary glands control the body's hormonal system. Visual, tactile and auditory inputs are coordinated by the tectum (6). part of the midbrain. In the hindbrain, the cerebellum (7) controls the muscle activity needed for refined limb movements and maintaining posture. The medulla (8) contains reflex centres that are involved in respiration, heartbeat regulation and gastric function.

survivor of major brain injury is likely to remain severely disabled, possibly even permanently unconscious.

brain disorder Disturbances of physical or mental function due to abnormality or disease of the brain. Brain disorders should be distinguished from psychological (psychogenic) mental disturbances in which the functioning of the brain itself is not impaired. Brain disorders are associated with impairment of memory, orientation, comprehension and judgment, and also by shallowness of emotional expression. Secondary personality changes may occur, depending upon such factors as the strength and type of personality and the amount of psychological and social stress present. Brain disorders are divided into two types. Acute disorders are temporary, and are generally due to disruption of brain function rather than destruction of brain tissue. They may be caused by such things as infection, drug or alcohol intoxication, and brain trauma. Chronic brain disorders are irreversible, and include such things as congenital defects, hereditary diseases, senility, and brain damage. See also BRAIN DAMAGE, CONGENITAL DISORDER brain stem Stalk-like portion of the brain in vertebrates that includes everything except the CEREBELLUM and the CEREBRAL HEMISPHERES. It provides a channel for all signals passing between the spinal cord and the higher parts of the brain. It also controls automatic functions such as breathing and heartbeat.

Brain Trust (1933–35) Name given to the advisers of US president Franklin ROOSEVELT. It first described his closest advisers in the presidential campaign of 1932. Later the term was applied more widely to members of his administration who advised on the policies of the New DEAL.

brake Device for slowing the speed of a vehicle or machine. Braking can be accomplished by a mechanical, hydraulic (liquid) or pneumatic (air) system that presses a non-rotating part into contact with a rotating part, so that friction stops the motion. In a car, the non-rotating part is called a shoe or pad, and the rotating part is a disc or drum attached to a wheel. Some vehicles use electromagnetic effects to oppose the motion and cause braking. A "power" brake utilizes a vacuum system.

Bramante, Donato (1444–1514) Italian architect and painter. He is best known as the greatest exponent of High RENAISSANCE architecture. His first building, Santa Maria presso San Satiro in Milan (*c*.1481), uses perspective to give an illusion of deeply receding space in the choir. In 1506, he started rebuilding St Peter's in Rome. His influence was enormous and many Milanese painters took up his interest in perspective and *trompe l'oeil*.

bramble See BLACKBERRY

Branagh, Kenneth (1960-) Northern Irish actor and director. An immediate young acting success, he worked with the ROYAL SHAKESPEARE COMPANY (RSC) before leaving to form his own Renaissance Theatre Company. He moved into directing with the film Henry V (1989), receiving Academy Award nominations for Best Actor and Best Director. His success in popularizing Shakespeare was demonstrated further in Much Ado About Nothing (1993), Othello (1996) and Hamlet (1997). Branch Davidians Late 20th-century religious CULT. A breakaway branch of the SEVENTH-DAY ADVENTISTS, the cult had its headquarters in Waco, near Texas, and was led by the American David Koresh, who claimed to be the reincarnated Jesus Christ. Members collected weapons in the belief that they would need to defend themselves against nonbelievers when the end of the world came. On 28 February 1993, following the shooting of federal officers, the cult was besieged by FBI agents. On 19 April, a fire suddenly broke out and the corpses of more than 80 cult members, including Koresh, were found. Brancusi, Constantin (1876–1957) French sculptor. His primitive style is revealed in a series of wooden sculptures, including Prodigal Son (1914), Sorceress (1916), and Chimera (1918). In 1919, his Bird in Space was not permitted into the USA as a work of art, but was taxed on its value as raw metal. This decision was reversed in a suit filed by Brancusi, and the sculpture is now housed in the Museum of Modern Art, New York City. Other works include The Kiss (1908), Prometheus (1911), Sculpture for the Blind (1924), and Flying Turtle (1943).

Brandenburg State in NE Germany; the capital is POTSDAM. The region formed the nucleus of the kingdom of Prussia. The March of Brandenburg was founded in 1134 by Albert I (the Bear). It came under the rule of the Hohenzollerns in 1411, and in 1417 Frederick I became the first elector of Brandenburg. Frederick II became the first king of Prussia in 1701, Pop. (1993 est.) 2,543,000

Brando, Marlon (1924—) US actor. A brooding presence with an inimitable mumbling vocal style, he trained at the ACTORS' STUDIO. In 1951 a reprise of his Broadway role for the film A Streetcar Named Desire earned him the first of four consecutive Oscar nominations. He finally won his first Best Actor Oscar as the isolated docker in On the Waterfront (1954). By the end of the 1950s he was the first actor to command a million-dollar appearance fee. He was awarded a second Best Actor Oscar for his lead performance in The Godfather (1971), but refused the award in protest against the persecution of Native Americans. He received another Oscar nomination for The Last Tango in Paris (1972). Other supporting credits include Missouri Breaks (1976), Apocalypse Now (1979), and an Oscar-nominated performance in A Dry White Season (1989).

Brandt, Bill (1904–83) British photographer. He assisted Man RAY in Paris (1929–30), before returning to London where he developed a reputation as a social commentator, as shown in his collection of photographs *The English at Home* (1936). During the war he documented life during the Blitz in a series of atmospheric wartime landscapes. He is perhaps better known for his nudes, many of which can be found in his book *Perspective of Nudes* (1961).

Brandt, Willy (1913–92) German politician, chancellor of West Germany (1969–74), b. Karl Herbert Frahm. An active Social Democrat, he fled to Norway and then Sweden during the Nazi era. He returned to Germany after World War 2 and was elected mayor of West Berlin in 1957. In national politics he became foreign minister in 1966. As chancellor, he initiated a programme of cooperation with the Communist bloc states, for which he was awarded the Nobel Peace Prize in 1971. He resigned after a close aide was exposed as an East German spy. He chaired the Brandt Commission on international development issues, which published North-South: A Programme for Survival (1980) and Common Crisis (1983).

Brant, Joseph (1742–1807) Mohawk chief. He served in the French and Indian Wars (1754–63) and in Pontiac's Rebellion (1763–66). He attended an Anglican school and became an interpreter for missionaries. In return for securing an alliance between the Iroquois and the British he gained a commission in the British army in 1775. He fought with outstanding courage for the British during the American Revolution.

Braque, Georges (1882–1963) French painter who created CUBISM with PICASSO. Having tried FAUVISM without success, Braque's interest in analytical painting was sparked by the work he saw in CÉZANNE's 1907 memorial show. Head of a Woman (1909), Violin and Palette (1909–10) and The Portuguese (1911) show his transition through the early, analytical phases of cubism. Braque was badly wounded in World War 1, and afterwards evolved a gentler style of painting which earned him enormous prestige. He concentrated on still-life subjects but also produced book illustrations, stage sets and decorative ceramics.

Brasília Capital of Brazil, w central Brazil. Although the city was originally planned in 1891, building did not start until 1956. The city was laid out in the shape of an aircraft, and Oscar Niemeyer designed the modernist public buildings. It was inaugurated as the capital in 1960, in order to develop Brazil's interior. Pop. (1991) 1,596,274.

brass Alloy of mainly copper (55%–95%) and zinc (5%–45%). Brass is yellowish or reddish, malleable and ductile, and can be hammered, machined or cast. Its properties can be altered by varying the amounts of copper and zinc, or by adding other metals, such as tin, lead and nickel. Brass is widely used for pipe and electrical fittings, screws, musical instruments and ornamental metalwork.

brass Family of musical wind instruments made of metal and played by means of a cupped or funnel-shaped mouthpiece.

Simple brass instruments, such as the BUGLE, produce a limited range of notes, which are the harmonics corresponding to the length of the tube. In most other brass instruments the length of the air column can be altered by valves or slides to produce the full range of notes. The chief brass instruments of a symphony orchestra are the TRUMPET, FRENCH HORN, TROMBONE and TUBA. Other members of the family include the cornet.

Brassäi (1899–1984) French photographer and painter, b. Hungary as Guyla Halasz. Arriving in Paris in 1923, he worked as a journalist and painter, associating with Picasso and Dali. He turned to photography in 1930, concentrating on pictures of Paris nightlife and portraits, the latter being remarkable for their static quality.

brassica Genus of plants with edible roots or leaves. It includes cabbages, cauliflowers, Brussels sprouts (all subspecies of *Brassica oleracea*), turnip (*B.rapa*), swede (*B.napobrassica*). Some, such as broccoli, have edible flowerheads. Family Brassicaceae/Cruciferae.

Bratislava Capital of Slovakia, on the River Danube, w Slovakia. It became part of Hungary after the 13th century, and was the Hungarian capital from 1526–1784. Incorporated into Czechoslovakia in 1918, it become the capital of Slovakia in 1992. Industries: oil refining, textiles, chemicals, electrical goods. Pop. (1990) 440,421.

Brattain, Walter Houser (1902–87) US physicist. As research physicist with the Bell Telephone Laboratories he focused on solid-state physics. In 1956, he shared the Nobel Prize for physics with John Bardeen and William Shockley for their development of the Transistor and research into semiconductivity. In 1967 Brattain became professor at Whitman College in Walla Walla, Washington.

Braun, Eva (1912–45) Mistress of Adolf Hitler. She met Hitler in the early 1930s and they lived together for the rest of their lives. They married in Berlin the day before committing suicide.

Braun, Wernher von (1912–77) US röcket engineer, b. Germany. He perfected the V-2 rocket missiles in the early 1940s. In 1945 he went to the USA, becoming a US citizen in 1955. In 1958 von Braun was largely responsible for launching the first US satellite *Explorer 1*. He later worked on the development of the *Saturn* rocket (for the Apollo program) and was deputy associate administrator (1970–72) of NATIONAL AERONAUTICS AND SPACE ADMINISTRATION (NASA).

Brazil Republic in E South America. See country feature, p.104

Brazil nut Seed of an evergreen tree, which has leathery leaves and grows to 41m (135ft) tall. Its flowers produce a thick-walled fruit 10–30.5cm (4–12in) in diameter which contain 25–40 large seeds. Family Lecythidaceae; species *Bertholletia excelsa*.

Brazzaville Capital and largest city of the Congo, w Africa, on the River Congo, below Stanley Pool. Founded in 1880, it was capital of French Equatorial Africa (1910–58) and a base for Free French forces in World War 2. It has a university (1972) and a cathedral. It is a major port, connected by rail to the main Atlantic seaport of Pointe-Noire. Industries: foundries, chemicals, shipyards. Pop. (1992) 937,579.

bread Staple food made by mixing flour (containing a little yeast, salt and sugar) with water to make a dough, allowing the yeast to ferment carbohydrates in the mixture (thus providing carbon dioxide gas which leavens the bread), and

■ Brando Although considered one of America's greatest screen actors, Marlon Brando's personal-life has been interspersed with tragedy, culminating in the imprisonment of his son Christian for the murder of the boyfriend of his half-sister, Cheyenne.

▲ brazil Brazil nut trees (genus Bertholletia) are found along the banks of the Amazon and Orinoco rivers in Brazil. They grow in clumps and are a valuable source of natural oils.

The green symbolizes Brazil's rainforests, the yellow diamond its mineral wealth. The blue sphere bears the motto "Order and Progress". The 27 stars, arranged in the pattern of the night sky over Rio de Janeiro, represent the states and the federal district.

Pazzil is the world's fifth-largest country, accounting for nearly 50% of the total area of South America. In the N and W, the AMAZON basin covers more than half of Brazil and is drained by a river system that carries a fifth of the world's running water. The Amazon, the world's second-longest river, has a far greater volume than any other river. The only major city in this region is Manaus. The NE coast, from the mouth of the Amazon to N Bahia, was the heart of colonial Brazil's sugar plantations. Its major cities are RECIFE and SALVADOR. A narrow coastal strip is bordered by an escarpment, above which lies the vast Brazilian plateau. The capital Brasilla was moved here

in 1960. The SE is the most developed and heavily populated part of Brazil. It includes the port of RIO DE JANEIRO and the industrial sprawl of SÃO PAULO. BELO HORIZONTE is the centre of the mining region. The s is dominated by the River PARANÁ, which flows into Argentina.

CLIMATE

Brazil lies almost entirely within the tropics and average monthly temperatures are over 20°C (68°F), with little seasonal variation. The hottest regions are the semi-arid *sertão* (backlands) in the NE and the Amazon basin. Most areas have moderate rainfall with a dry season between May and September.

AREA: 8,511,970sq km (3,286,472sq mi)

POPULATION: 156,275,000

CAPITAL (POPULATION): Brasília (1,596,274)

GOVERNMENT: Federal republic

ETHNIC GROUPS: White 53%, Mulatto 22%, Mestizo 12%, African American 11%, Japanese

1%, Native American 0.1% LANGUAGES: Portuguese (official)

RELIGIONS: Christianity (Roman Catholic 88%,

Protestant 6%)

currency: Cruzeiro real

VEGETATION

The Amazon basin contains the world's largest rainforests (selvas). The forests are home to countless plants and animals, but many species are threatened by deforestation. The global environmental consequences are staggering. The rapid destruction of the forests is also ruining the lives of the last surviving Native Amazonians. The sertão is a region of thorny scrub. The SE contains fertile farmland and large ranches. Swamps are found along Brazil's borders with Bolivia and Paraguay, s of the MATO GROSSO.

BRAZIL

HISTORY AND POLITICS

Portuguese explorer Pedro Alvarez CABRAL claimed Brazil for Portugal in 1500 and colonial development began in 1530s. Brazil was more than 90 times larger than Portugal and development was achieved by the use of Native American and c.4 million African slaves to work on the sugar plantations and in the mines. The growth of mining saw the capital move from Salvador to Rio de Janeiro in 1763. Napoleon's defeat of Portugal led the Portuguese king JOHN VI to flee to Brazil. In 1822 he returned and his son PEDRO I declared Brazil an independent empire. In 1831 Pedro I was forced to abdicate in favour of his son PEDRO II. During his long reign (1831-89), Brazil's infrastructure developed. In 1888 slavery was finally abolished. In a bloodless revolution (1889), Brazil became a republic and Marshal Manuel Deodoro da Fonseca became the first president. The late 19th century saw an increase in European immigration, spurred by the boom in coffee and rubber prices. In 1930 Getúlio VARGAS seized power. His autocratic rule saw the beginnings of industrial development, diversification of agriculture and an emerging national consciousness. In 1945 Vargas was forced to resign, but rampant inflation led to his return to power (1950-54). As part of the development of the interior, the capital was transferred to Brasília (1960). In 1964 the military seized power and maintained control through the use of torture and death squads. Civilian government was finally restored in 1985 and a new constitution (1988) brought liberal reforms and the transfer of powers to Congress. Fernando Collor de Mello was elected president in 1990. In 1992 he was impeached for corruption and an interim government installed. In 1995 Fernando Henrique Cardoso was elected president.

ECONOMY

Brazil is a rapidly industrializing country. By the mid-1970s, it had also become the world's largest debtor. High rates of inflation (1995, 33%) and unemployment caused widespread poverty and political instability. By 1995 efforts to deal with inflation and public debt began to reap rewards. Its volume of production is one of the largest in the world, but most of the population, such as landless rural workers and residents of the favelas (city slums), are excluded from economic benefits. By 1993 industry had become the most valuable activity (37% of GNP), employing 25% of the workforce. Brazil is the world's second-largest producer of iron ore. Other vital resources include tin, manganese, aluminium and diamonds. Brazil's manufacturing base has expanded rapidly. It is now the world's third-largest producer of commerical vehicles. Other products include fertilizers and radio receivers. Brazil remains a major agricultural nation. It is the world's leading producer of oranges, coffee, sugar cane, cassava and sisal. Other major fruit and vegetable products include bananas, soya beans, pineapples, maize and tobacco. Brazil is the world's second largest producer of cattle and horses. Other meat products include beef, pigs and poultry. Forestry is a major industry. Despite international pressure and government promises, deforestation continues at the rate of 1.5% to 4% annually.

Education has long been regarded as an essential part of any development strategy in the under-developed world, because economic progress is impossible without a skilled workforce. Brazil has a good record in education, with adult literacy at about 80%. This stamp, issued in 1974, commemorates the bicentenary of a college.

finally baking in an oven. Yeast fermentation not only lightens the texture of the bread but also adds to its taste. Bicarbonate of soda (NaHCO₃) may be used instead of yeast. Unleavened bread, favoured in many Asian countries, is flat in shape and heavy in texture by comparison.

Breakspear, Nicholas See ADRIAN IV

Bream, Julian Alexander (1933–) English guitarist and lutenist. He studied at the Royal College of Music (1945–48). An outstanding classical guitarist, he has had pieces composed for him by, among others, Benjamin Britten and William Walton. He has transcribed lute music for the guitar. bream Freshwater fish of E and N Europe. Its stocky body is green-brown and silver, and anglers prize it for its tasty flesh. Length: 30–50cm (12–20in); weight: 4–6kg (9–13lb). Family Cyprinidae; species Abramis brama.

breast (mammary gland) Organ of a female mammal that secretes milk to nourish new-born young. In males, the glands are rudimentary and nonfunctional. A woman's breast, which develops during puberty, is made up of c.15–20 irregularly shaped lobes separated by connective and fat tissues. Lactiferous ducts lead from each lobe to the nipple, a small cone-shaped structure in the centre of the breast.

breathing Process by which air is taken into and expelled from the LUNGS for the purpose of GAS EXCHANGE. During inhalation, the intercostal muscles raise the ribs, increasing the volume of the THORAX and drawing air into the lungs. During exhalation, the ribs are lowered, and air is forced out through the nose, and sometimes also the mouth.

breccia Rock formed by the cementation of sharp-angled fragments in a finer matrix of the same or different material. It is formed either inside the Earth by movements of the crust, from scree slopes, or from volcanic material. *See also* CONGLOMERATE

Brecht, Bertolt (1898–1956) German playwright, poet and drama theorist. One of the most influential dramatists of the 20th century. Controversial early plays, such as *Baal* (1918), won praise for their radicalism. In the 1920s, Brecht developed his distinctive, politicized theory of EPIC THEATRE. An attempt to move away from Western theatrical realism, it encouraged audiences to see theatre as staged illusion via a range of "alienation" techniques. Music played an important part in this fore-

grounding of artifice. Brecht's major works were written in collaboration with composers: Kurt WellL, *The Threepenny Opera* (1928) and *The Rise and Fall of the City of Mahagonny*

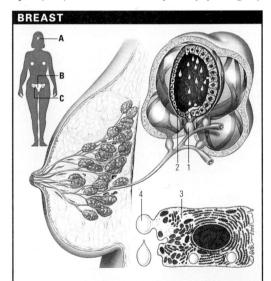

In humans, there is one pair of mammary glands, which are composed of a mass of epithelial ducts (1, shown magnified) surrounded by a fibrous tissue. In women, these ducts enlarge and spread, differentiating into milk-producing tissue. This process occurs under complex hormonal control from the anterior and posterior pituitary glands (A), the placenta during pregnancy (B), and from the

ovaries (C). Full development of the glands involves extensive growth of mammary ducts from which specialized lobules proliferate (2). Each lobule, lined by milk-producing cells (3), opens into the ducts leading to the gland nipple. Three to four days after childbirth, the hormone prolactin enables milk containing fat droplets (4) and protein to become available to the child.

(1927); Hanns Eisler, *The Mother* (1931); and Paul Dessau, *The Caucasian Chalk Circle* (1948). With the rise of Hitler in 1933, Brecht's Marxist views forced him into exile. While in the USA, he wrote *Mother Courage and Her Children* (1941) and *The Good Woman of Setzuan* (1943). In 1949 Brecht returned to East Germany to direct the Berliner Ensemble.

Breckinridge, John Cabell (1821–75) US vice president (1857–61). He was a major in the MEXICAN WAR and a congressman (1851), before being elected vice president under James Buchanan. Defeated as a pro-slavery presidential candidate in 1860 by Abraham Lincoln, he became a Confederate general and secretary of war in Jefferson Davis' cabinet (1865).

Breda City in Noord-Brabant province, s Netherlands. A historically important town, it is noted for the 1566 Compromise of Breda (a Dutch alliance against Spanish rule) and Charles II's Declaration of Breda (1660) before the Restoration. Industries: engineering, textiles. Pop. (1994) 129,125.

Breda, Treaty of (1667) Peace agreement that ended the Second DUTCH WARS with England. England gave up its claim to the Dutch East Indies but gained control of New York and New Jersey.

breeding Process of producing offspring, specifically the science of changing or promoting certain genetic characteristics in animals and plants. This is done through careful selection and combination of the parent stock. Breeding may involve cross-breeding or INBREEDING to produce the desired characteristics in the offspring. Scientific breeding has resulted in disease-resistant strains of crops, and in animals that give improved food yields. *See also* GENE; GENETIC ENGINEERING

Bremen City on the River Weser; capital of Bremen state, N Germany. Bremen suffered severe damage during World War 2, but many of its original buildings (including the Gothic city hall) survived. Industries: shipbuilding, electrical equipment, textiles. Pop. (1990) 553,200.

Brendel, Alfred (1931–) Austrian pianist. One of the world's most critically acclaimed and widely travelled concert artists, he is especially noted for his interpretations of Beethoven and Schubert.

Brest (formerly Brest-Litovsk) City and port at the confluence of the Bug and Muchavec rivers, near the Polish border, w Belarus. It was the site of the signing of the Treaty of Brest-Litovsk. Industries: food processing, sawmilling, textiles. Pop. (1991) 277,000.

Brest City and port on the Atlantic coast of Brittany, w France. An important naval base, the town was severely damaged in World War 2, when used as a German submarine base. Industries: shipbuilding and repair, chemical manufacture, electronic equipment, wine, fruit, coal and timber. Pop. (1990) 147,956.

Brest-Litovsk, Treaty of (March 1918) Peace treaty between Russia and the CENTRAL POWERS, confirming Russian withdrawal from World War 1. The Ukraine and Georgia became independent and Russian territory was surrendered to Germany and Austria-Hungary. The treaty was declared void when the war ended in November.

Breton, André (1896–1966) French poet and theorist. A founder and poet of the SURREALISM movement, he wrote *Manifeste du surréalisme* (1924) and *Le Surréalisme et la Peinture* (1928). His fictional works, an autobiographical novel *Nadja* (1928), *Les Vases Communicants* (1932), *L'Amour Fou* (1937) and *Poèmes* (1948) reflect surrealist theories.

Breton Celtic language spoken in Brittany, on the NW coast of France. It is a descendant of British, an old Celtic language, and is closely related to Welsh. Its approximately half a million users usually also speak French, which is rapidly replacing it. **Bretton Woods Conference** (officially the United Nations Monetary and Financial Conference) It met at Bretton Woods New Hampshire in July 1944. It was summoned

Nations Monetary and Financial Conference) It met at Bretton Woods, New Hampshire, in July 1944. It was summoned on the initiative of US president Franklin ROOSEVELT to establish a system of international monetary cooperation and prevent severe financial crises such as that of 1929, which had precipitated the GREAT DEPRESSION. Representatives of 44 countries agreed to establish the INTERNATIONAL MONETARY FUND (IMF), to provide cash reserves for member states faced by deficits in their balance of payments, and the Inter-

national Bank for Reconstruction and Development, or WORLD BANK, to provide credit to states requiring financial investment in major economic projects.

Breuer, Marcel (1902–81) US architect and designer, b. Hungary. One of the great innovators of modern furniture design, he studied and taught at the BAUHAUS (1920–28), where he created his famous tubular steel chair. In 1937, he settled in the USA and subsequently worked with Walter GROPIUS as a partner in architectural projects. He designed the Whitney Museum of American Art, New York City (1966). brewing Preparation of BEER and stout by using yeast as a

catalyst in the alcoholic fermentation of liquors containing malt and hops. In beer brewing, a malt liquor (wort) is made from crushed germinated barley grains. Hops are added to the boiling wort both to impart a bitter flavour, and also to help to clarify the beer and keep it free from spoilage by microbes. The clear, filtered wort is cooled and inoculated with brewer's yeast, which ferments part of the sugar from malt into alcohol. Brezhnev, Leonid Ilyich (1906-82) Soviet statesman. effective ruler from the mid-1960s until his death. He rose through party ranks to become secretary to the central committee of the Soviet Communist Party (1952) and a member of the presidium (later politburo) (1957). In 1964 he helped plan the downfall of Nikita Khrushchev and became party general secretary, at first sharing power with Aleksei Kosy-GIN. In 1977 he became president of the Soviet Union. He pursued a hard line against reforms at home and in Eastern Europe but also sought to reduce tensions with the West. After the Soviet invasion of CZECHOSLOVAKIA (1968), he promulgated the "Brezhnev Doctrine" confirming Soviet domination of satellite states, as seen in the 1979 invasion of Afghanistan.

Briand, Aristide (1862–1932) French political leader. A moderate, he was premier of 11 governments between 1909 and 1929. He advocated international cooperation and was one of the instigators of the Locarno Pact (1925), for which he shared the Nobel Peace Prize with Gustav Stresemann in 1926. He was also one of the authors of the Kellogg-Briand Pact (1928), and favoured a form of European union.

brick Hardened block of clay used for building and paving. Usually rectangular, bricks are made in standard sizes by machines that either mould bricks or cut off extruded sections of stiff clay which are conveyed into a continuously operating kiln where they are baked at temperatures of up to 1,300°C. The first, sun-dried, bricks were used in the Tigris-Euphrates basin *c.*5,000 years ago.

bridge Structure providing a continuous passage over a body of water, roadway or valley. Bridges are built for people, vehicles, pipelines or power transmission lines. Bridges are prehistoric in origin, the first probably being merely logs over rivers or chasms. Modern bridges take a great variety of forms including beams, arches, cantilevers, suspension bridges and cable-stayed bridges. They can also be movable or floating pontoons. They can be made from a variety of materials, including brick or stone (for arches), steel or concrete.

Bridgeport City on Long Island Sound, sw Connecticut, USA. Settled in 1639 as a fishing community, it is now a port of entry and the chief industrial city in Connecticut. Industries: electrical appliances, transport equipment, helicopters, machine tools. Pop. (1990) 141,686.

Bridgetown Capital and port of Barbados, in the West Indies. Founded in 1628, it is the seat of the parliament and has a college of the University of the West Indies. Industries: rum distilling, sugar processing, tourism. Pop. (1990 est.) 6,720.

Bright, John (1811–89) British parliamentary reformer. A Quaker and mill owner, he and his fellow radical, Richard COBDEN, were leaders of the ANTI-CORN LAW LEAGUE (founded 1839). First elected to Parliament in 1843, he subsequently represented Manchester, the home of FREE TRADE. He lost his seat in 1857 after opposing the Crimean War but was re-elected for Birmingham. After the repeal of the CORN LAWS (1846), Bright worked tirelessly in the cause of parliamentary reform. Brighton Resort town on the English Channel, East Sussex,

s England. Originally a fishing village, it was popularized as a resort by the Prince Regent (George IV), who had the Royal Pavilion rebuilt here in oriental style by John NASH. It is the

seat of the University of Sussex (1961) and the University of Brighton (1992). Industries: food processing, furniture, tourism. Pop. (1991) 143,582.

Brindley, James (1716–72) British engineer and pioneer canal-builder who constructed the first major canal in England, from Worsley, Lancashire to Manchester. He was responsible for a network of *c*.565km (350mi) of canals, an advancement that hastened the INDUSTRIAL REVOLUTION.

Brisbane City and seaport in E Australia, on the River Brisbane; capital of QUEENSLAND. First settled in 1824 as a penal colony, it became state capital in 1859. It is the location of Parliament House (1869) and the University of Queensland (1909) and is a major shipping and rail centre. Industries: oil refining, shipbuilding, car assembly, railway engineering, chemicals. Pop. (1993 est.) 1,421,600.

bristle tail See SILVERFISH

Bristol City and unitary authority at the confluence of the rivers Avon and Frome, sw England. An important seaport and trade centre since achieving city status in 1155, it was a major centre for the wool and cloth industry. From the 15th–18th century, it was England's second city and the base for many New World explorations. The 19th century witnessed a gradual decline in the city's economy due to competition from Liverpool. Bristol suffered intensive bombing during World War 2. Clifton Suspension Bridge (designed by BRUNEL) was completed in 1864. Other sites include a 12th-century cathedral and the 14th-century church of St Mary Redcliffe. Bristol has two universities, the University of Bristol (1909) and the University of the West of England (1992). The main port facilities are now at Avonmouth. Industries: aircraft engineering, chemicals, tobacco. Pop. (1991) 376,146.

Britain (Great Britain) Island kingdom in NW Europe, officially named the UNITED KINGDOM of Great Britain and NORTHERN IRELAND. It is made up of ENGLAND, SCOTLAND, WALES and NORTHERN IRELAND, the CHANNEL ISLANDS and the Isle of MAN.

Britain, ancient British history from PREHISTORY to ROMAN BRITAIN. During the NEOLITHIC age, hunter-gatherers gradually turned to sedentary farming. Old STONE AGE remains have been found at Cheddar Gorge, Somerset, s England. There are numerous examples of New Stone Age burial mounds. During the Bronze AGE (*c*.2300 BC) an advanced civilization, the Beaker culture, produced the stone circles at STONEHENGE and Avebury, s England. The IRON AGE was dominated by the CELTS. Julius Caesar invaded Britain in 54 BC, and the Roman conquest began in earnest from 43 BC.

Britain, Battle of (1940) Series of air battles fought over Britain. Early in World War 2 (as a prelude to invasion) the Germans hoped to destroy Britain's industrial and military infrastructure and civilian morale by a sustained series of bombing raids. Failure to eliminate the fighters of the Royal

Air Force in August–September resulted in the abandonment of the plans for invasion, though bombing raids continued.

British Antarctic Territory British colony in ANTARCTICA comprising the mainland and islands within a triangular area bounded by latitude 60°s and longitudes 20° and 80°w. It includes the South Sheetland Islands, South Orkney Islands and Graham Land. Formerly part of the FALKLAND ISLANDS, the territory became a British Crown colony in 1962, though today Argentina and Chile claim parts of it. There are no permanent settlements, but teams of scientists occupy meteorological stations and other establishments of the British Antarctic Survey. Area: 1,725,000sq km (666,000sq mi).

British Broadcasting Corporation (BBC) UK state-financed radio and television network. Its directors are appointed by the government but, in terms of policy and content, the BBC is largely independent. It receives its finances from a licence fee. The BBC was set up in 1927 to replace the British Broadcasting Company, which had been in operation since 1922. Its first director-general (1927–38) was Lord Reith, whose philosophy of the BBC as an instrument of education and civilization greatly shaped the corporation's policies. John Birt was appointed director-general in 1992. His controversial reforms have included rationalizing the BBC, exposing it to the influence of market forces and developing the use of independent production companies. He has also overseen a radical reshaping of radio programming.

British Columbia Province of w Canada, on the Pacific coast, bounded N by Alaska, s by Washington state. The Rocky Mountains run N to S through the province. The capital is VICTORIA, other major cities include VANCOUVER. The region was first sighted by Sir Francis Drake in 1578. Captain Cook landed here in 1778, and George Vancouver took possession of the island that bears his name for Britain in 1794. In 1846 the border with the USA was finally settled. Completion of the Canadian Pacific Railway in 1885 spurred the development of the province. The many rivers (principal of which is the Fraser) provide abundant hydroelectric power. Three-quarters of the land is forested, making timber an important industry. Mineral deposits include copper, silver, gold, lead, zinc and asbestos. Dairying and fruit-growing are the chief farming activities, practised mainly in the s. Industries: fishing, paper, tourism, transport equipment, chemicals. Area: 948,600sq km (366,255sq mi). Pop. (1991) 3,282,061. British empire Overseas territories ruled by Britain from the 16th to the 20th century. Historians distinguish two empires. The first, based mainly on commercial ventures (such as sugar and tobacco plantations), missionary activities and slave trading, resulted in the creation of British colonies in the Caribbean and North America in the 17th century. This "First Empire" was curtailed by the loss of 13 US colonies, at the end of the AMERICAN REVOLUTION (1775-81). The "Second

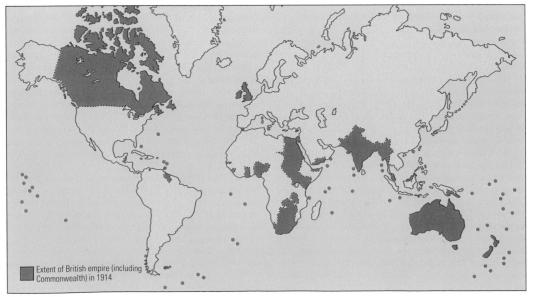

■ British empire Despite the loss of the USA (1783) and the strong anti-imperialist pressure of the free trade faction, the British empire continued to expand throughout the 19th century. By 1914 (shown here) the empire included all of India, Canada, Australia, most of the Cape to Nile "corridor," which ran up E Africa, and myriad small islands of strategic importance.

▶ bromeliad Many bromeliads, such as Aechmea fasciata, are epiphytes (air plants), plants that use other plants for support but are not parasitic. Its broad leaves catch water as it drips through the canopy of the tropical forest. Bromeliads are members of the pineapple family (Bromeliaceae).

Empire" was created in the 19th century, with Queen VICTO-RIA its empress. British colonial expansion was predominantly in the Far East, Australia (initially with the penal colonies), Africa and India (the "jewel" of the empire). By 1914 the empire comprised about 25% of the Earth's land surface and population. Virtually all the constituent members gained independence in the period after World War 2. Most subsequently became members of the COMMONWEALTH OF NATIONS.

British Empire, Order of the (OBE) Military and civil order or knighthood bestowed as a reward for public service to the Commonwealth of Nations. Created in 1917, it has five different classes for men and women: Knights (or Dames) Grand Cross, Knights (or Dames) Commanders, Officers and Members.

British Honduras See Belize

British Indian Ocean Territory British colony in the Indian Ocean comprising the islands of the Chagos Archipelago, 1,900km (1,200mi) NE of MAURITIUS. In 1814 France ceded the territory to Britain and it was administered by Mauritius. In 1965 Britain bought it from Mauritius in order to build a joint US/UK naval base on Diego Garcia island. In 1976 the islands of Aldabra, Farquhar, and Desroches reverted to SEYCHELLES administration. Industries: coconuts, fishing. Area: 80sq km (31sq mi). There is no permanent population.

British Isles Group of islands off the NW coast of Europe, made up of the UNITED KINGDOM of Great Britain and Northern Ireland, and the Republic of IRELAND. It also includes the Isle of MAN in the Irish Sea (a self-governing island but part of the United Kingdom); and the CHANNEL ISLANDS in the English Channel (a self-governing crown dependency).

British Legion Organization of ex-service men and women for helping disabled and unemployed war veterans, their widows and families. Each year during the week preceding Remembrance Day (the Sunday nearest to 11 November) millions of artificial red poppies are sold to commemorate the dead of two World Wars and raise funds for the Legion.

British Medical Association (BMA) UK professional body founded in 1832; 66% of all doctors in Britain are members. The BMA was set up to advance the medical sciences. Since the establishment of the NATIONAL HEALTH SERVICE (NHS) in 1948, it has also negotiated over pay and conditions for hospital doctors and general practitioners.

British Museum One of the world's greatest public collections of art, ethnography and archaeology (established 1753). Its first displays came from a private collection purchased from the naturalist, Sir Hans Sloane. Later additions included the ROSEITA STONE and the ELGIN MARBLES. The present building by Sir Robert SMIRKE was completed in 1847. The museum contains several separate departments including the Museum of Mankind and the Department of Prints and Drawings which houses works by Rembrandt, Rubens and Michelangelo, as well as many examples of Oriental art.

British North America Act (1867) Act of the British Parliament that created the Dominion of CANADA. It resulted from a series of conferences and provided a constitution similar to that of Britain. Residual British powers were surrendered in the Canada Act of 1982, when the act was renamed the Constitution Act.

British Summer Time (BST) See SUMMER TIME

Brittany (Bretagne) Former duchy and province in NW France, forming the peninsula between the Bay of Biscay and the English Channel. Under Roman rule from 56 BC to the 5th century AD, it was later inhabited by CELTS who provided its name, language (BRETON) and distinctive costume and culture. It was formally incorporated within France in 1532, and the years that followed saw the deliberate suppression of Breton culture, to the extent that the language was banned. In more recent times, the French government has improved the region's infrastructure. Pop. (1990) 2,795,600.

Britten, (Edward) Benjamin (1913–76) English composer. He is best known for his operas, which rank him among the foremost composers of the 20th century. He also wrote numerous songs, many especially for Peter PEARS. Britten's operas include Peter Grimes (1945), Billy Budd (1951), The Turn of the Screw (1954), A Midsummer Night's Dream (1960) and Death in Venice (1973). Other significant works include the popular Young Person's Guide to the Orchestra (1945) and the War Requiem (1962). In 1948 he established the music fustival held annually at his home town of Aldeburgh, on the E coast of England. He was made a peer in 1976.

brittle star (serpent star) Marine ECHINODERM with a small central disc body and up to twenty (though typically five) long, sinuous arms; these break off easily and are replaced by REGENERATION. Class Ophiuroidea; genera include the phosphorescent *Amphiopholis* and the small *Ophiactis*.

Brno (Brünn) Capital city of central Jihomoravský (Moravia) region, se Czech Republic. Founded in the 10th century, it has a 15th-century cathedral. The Bren Gun was designed here. Industries: armaments, engineering, textiles, chemicals. Pop. (1990 est.) 391,000.

broadcasting Transmission of sound or images to a widely dispersed audience through RADIO or TELEVISION receivers. The first US commercial radio company, KDKA, began broadcasting in Pittsburgh in 1920. By 1992 there were over 6,000 FM stations operating in the USA. In the UK, the BRITISH BROAD-CASTING CORPORATION (BBC), began radio transmission in 1927. There are five national BBC radio stations. Television is a huge market in the USA. By the early 1990s, there were 1,100 commercial television stations and 215 million TV sets. In 1962 Telstar delivered the first transatlantic, satellite television broadcast. By 1990, 60% of all US households had CABLE TELEVISION. Cable systems can deliver more than 100 channels. UK public television broadcasting began in 1936 from Alexandra Palace, London. The BBC transmitted on one channel. A second channel, ITV, run by Independent Television, was set up in 1955. BBC2 started broadcasting in 1964, and Channel 4 commenced transmission in 1982. Rupert Murdoch's Sky television satellite service began broadcasting in 1989, since when cable television as well as satellite television has become increasingly popular. Channel 5 was lauched in 1997. Further developments include the introduction of digital television.

Broads, Norfolk Region of shallow lakes and waterways in E England, connected by the rivers Waveney, Yare and Bure, between Norwich and the coast. It is a wildlife sanctuary and a popular sailing area, with 320km (200mi) of waterways.

Broadway Major thoroughfare of New York City that began as the principal N-S axis of the old town. It runs from the s tip of Manhattan to the northern city limit in the Bronx. Famous sites along the route include the Woolworth Building, the Lincoln Center for the Performing Arts and Columbia University. In the vicinity of Times Square, its theatres and cinemas have made it known worldwide as the "show centre" of the USA.

Brod, Max (1884–1968) Czech novelist, critic and philosopher. Although chiefly remembered for bringing to public attention the work of Franz KAFKA, of whom he also wrote a biography, Brod was also a novelist in his own right. He was a Zionist and settled in Palestine as a refugee in 1939, where he later became director of the Habina Theatre.

Brodsky, Joseph (1940–96) US-Russian poet, winner of the 1987 Nobel Prize for literature and US poet laureate (1991–92). Before his exile from the Soviet Union in 1972, he was accused of being a "social parasite" and sent to a Sovi-

et labour camp. His works include *Less than One*, which won the 1986 US National Book Critics award, and *History of the Twentieth Century*, cited by the Nobel committee as possessing an "amazing mastery of the English idiom".

Broglie, Prince Louis Victor de (1892–1987) French physicist who theorized that all ELEMENTARY PARTICLES have an associated wave. He devised the formula that predicts this wavelength, and its existence was proven in 1927. Broglie developed this form of QUANTUM MECHANICS, called WAVE MECHANICS, for which he was awarded the 1929 Nobel Prize for physics. Erwin Schrödinger advanced Broglie's ideas with his equation that describes the wave function of a particle. bromeliad Any of the 1,700 species of the PINEAPPLE family (Bromeliaceae). Most are native to the tropics and subtropics and, besides the pineapple, include many of the larger EPIPHYTES of trees of the rainforests.

bromide Salt of hydrobromic acid or certain organic compounds containing bromine. The bromides of ammonium, sodium, potassium and certain other metals were once extensively used medically as sedatives. Silver bromide is light-sensitive and is used in photography.

bromine (symbol Br) Volatile liquid element of the halogen group (elements in group VII of the PERIODIC TABLE), first isolated in 1826 by the French chemist A.J. Balard. Bromine is the only liquid form of a nonmetallic element. It is extracted by treating seawater or natural brines with CHLORINE. A reddish-brown fuming liquid having an unpleasant odour, it is used in commercial compounds, such as those used to manufacture photographic film and additives for petrol. Chemically it resembles chlorine but is less reactive. Properties: at.no. 35; r.a.m 79.904; r.d. 3.12; m.p. -7.2° C (19.04°F); b.p. 58.8°C (137.8°F); the most common isotope is Br⁷⁹ (50.54%).

bronchitis Inflammation of the bronchial tubes most often caused by a viral infection such as the common cold or influenza but exacerbated by environmental pollutants. Symptoms include coughing and the production of large quantities of mucus. It can be acute (sudden and short-lived) or chronic (persistent), especially in those who smoke.

bronchus (pl. bronchi) One of two branches into which the TRACHEA or windpipe divides, with one branch leading to each of the LUNGS. The bronchus divides into smaller and smaller branches, called bronchioles, which extend throughout the lung, opening into the air sacs or ALVEOLI. The bronchi are supported and kept open by rings of CARTILAGE.

Brontë, Anne (1820–49) English novelist and poet. The youngest of the Brontë sisters, she became a governess, an experience reflected in *Agnes Grey* (1847). All of her work was published under the male pseudonym Acton Bell and her best-known novel is *The Tenant of Wildfell Hall* (1848).

Brontë, Charlotte (1816–55) English novelist and poet. Her personal life was unhappy and she persistently suffered from ill health. Born into genteel poverty, her mother, four sisters, and dissolute brother Branwell died early. Her love for a married man was unrequited and she died in childbirth within a year of her marriage. Her four novels, *The Professor* (1846), *Jane Eyre* (1847), *Shirley* (1849), and *Villette* (1853) are works of remarkable passion and imagination. Her writings initially appeared under the male pseudonym Currer Bell.

Brontë, Emily (1818–48) English novelist and poet. Like her sisters she wrote under a male pseudonym, Ellis Bell. Her love for her native Yorkshire moors and insight into human passion are manifested in her poetry and her only novel, *Wuthering Heights* (1847).

brontosaurus Former name of apatosaurus, a DINOSAUR of the Jurassic and early Cretaceous periods. It had a long neck and tail, and a small head with the eyes and nostrils on the top so that it could remain presumably almost completely immersed in water. Length: 21m (70ft); weight: to 30 tonnes. bronze Traditionally an ALLOY of COPPER and no more than 33% tin. It is hard and resistant to corrosion, but easy to work. It has long been used in sculpture and bell-casting. Other metals are often added for specific properties and uses, such as aluminium in aircraft parts and tubing, silicon in marine hardware and chemical equipment, and phosphorus in springs, gunmetal and electrical parts.

Bronze Age Period in human cultural development between the NEOLITHIC period and the discovery of iron-working techniques (the IRON AGE). In Mesopotamia, BRONZE tools were used from *c*.3200 BC and the Bronze Age lasted until *c*.1100 BC. In Britain, bronze was used after 2000 BC, and iron technology did not become widespread until *c*.500 BC.

Brook, Peter Stephen Paul (1925–) British director of theatre, opera and film. He joined the ROYAL SHAKESPEARE COMPANY (RSC) as co-director in 1962. His most notable productions were *King Lear* (1962, filmed 1969), Peter Weiss' *Marat/Sade* (1964) and *Midsummer Night's Dream* (1970). He described his theories on modern theatre in *The Empty Space* (1969). In 1970 he established the experimental and collaborative International Centre for Theatre Research in Paris. Their productions include *The Conference of the Birds* (1973) and the epic cycle *The Mahabharata* (1985, filmed 1989). Brook's other film work includes *Lord of the Flies* (1963) and *Meetings with Remarkable Men* (1979).

Brooke, Rupert Chawner (1887–1915) English poet. Brooke wrote some of the most anthologized poems in the English language, including "The Soldier" and "The Old Vicarage, Grantchester", but the romantic image created by his early death during World War 1 has tended to distort his status as a fairly typical poet of the Georgian school. His collections include *Poems* (1911) and *1914 and Other Poems* (1915), the patriotism of the latter standing in stark contrast to the work of other war poets such as Wilfrid OWEN.

Brooklyn Borough of New York City, coextensive with Kings County in sw Long Island; it is connected to Manhattan and Staten Island by bridges, underground railways, and ferries. First settled in 1645, it became a borough in 1898. It is the home of Brooklyn College (1930), Prospect Park and Coney Island. Industries: shipbuilding, warehousing, brewing. Area: 184sq km (71sq mi). Pop. (1990) 2,291,664.

Brooks, Louise (1906–85) Legendary US film actress. Brooks achieved the majority of her success in Germany under the direction of G.W. Pabst in his *Diary of a Lost Girl* (1929), and as Lulu in *Pandora's Box* (1929). She was never able to recapture this early brilliance, and retired in 1938.

broom Any of various deciduous shrubs of the PEA family (Fabaceae/Leguminosae). They have yellow, purple or white flowers, usually in clusters. Many belong to the genus *Genista*, which gave its name to the Plantagenate kings of England (from the Latin *Planta genista*), who used the broom as their emblem.

Brown, "Capability" (Lancelot) (1715–83) English landscape gardener who revolutionized garden and parkland layout in the 1700s. He designed or remodelled nearly 150 estates, including gardens at Blenheim and Kew. He worked to achieve casual effects, with scattered groups of trees and gently rolling hills. He earned his nickname from a habit of saying that a place had "capabilities of improvement".

Brown, Ford Madox (1821–93) English painter, closely associated with (although not a member of) the PRE-

■ Brown The 18th century gardens of Stowe, Buckinghamshire, s England, were worked on successively by Bridgeman, Kent and "Capability" Brown. Bridgeman's layout moved some way from the formal geometric patterns of the French and Italian gardens, but was still characterized by a rigidity of outline. Kent's work (above) softened these outlines considerably, introducing the concept of naturalism, harmonizing house and temples with the landscape. It can be seen, however, that a certain formality persisted. The transformation of the gardens into their superbly landscaped state (below) is attributed to "Capability" Brown. The stilted outlines have gone, the whole setting has a deceptively natural breadth and ease as well as a generous fullness.

▲ bronchitis A common disease of industrialized areas with a cool damp climate. bronchitis involves inflammation of air passages and air sacs of the lungs. Mild attacks lasting only a few days are usually due to a cold, spreading to the chest. Chronic bronchitis is caused by heavily polluted air irritating the lining of the lungs. The lung air sacs become inflamed and lose their elasticity and air passages become constricted [normal air sac (A) diseased (B)]. Less oxygen (yellow dots) enters the blood stream and carbon dioxide (green dots) accumulate. Rapid shallow breathing arises to compensate.

RAPHAELITE BROTHERHOOD. A meticulous draughtsman he was in contact with the German Nazarenes before settling in England in 1845. The Pre-Raphaelite influence can be seen in *The Last of England* (1855) and *Work* (1852–63). Towards the end of his career he produced a cycle of paintings on the history of Manchester (1878–93). He was the grandfather of the writer Ford Madox FORD.

Brown, Gordon (1951–) British statesman, chancellor of the exchequer (1997–), b. Scotland. Brown entered parliament in 1983. He joined Neil Kinnock's shadow cabinet in 1987. Under the leadership of John SMITH, Brown became shadow chancellor and he maintained the post under Tony BLAIR. Brown's promise to freeze income tax rates for the lifetime of a parliament did much to secure Labour's victory in the 1997 general election. His first act as chancellor was to give the BANK OF ENGLAND independence in interest rate policy.

Brown, James (1933–) US singer and songwriter. An energetic performer, renowned for his dance routines, Brown is hailed as the "Godfather of Soul" and a pioneer of FUNK. His album *Live at the Apollo* (1962) is one of the best-selling pop albums of all time. Brown's hit singles include "Please, Please, Please, Please" (1956), "Papa's Got a Brand New Bag" (1965), and "Say it Loud, I'm Black and I'm Proud" (1968). His music is frequently sampled by rap and hip-hop artists.

Brown, John (1800–59) US anti-slavery agitator, hero of the song "John Brown's Body". Hoping to start a slave revolt, he led 21 men in the capture of the US arsenal at Harper's Ferry, Virginia, in 1859. They were driven out the next day by troops under General Robert E. Lee. Brown was captured, charged with treason and hanged. The trial aggravated North-South tensions on the eve of the American Civil War.

brown bear See BEAR

Brownian movement Random, zigzag movement of particles suspended in a fluid (liquid or gas). It is caused by the unequal bombardment of larger particles, from different sides, by the smaller molecules of the fluid. The movement is named after the Scottish botanist Robert Brown (1773-1858), who in 1827 observed the movement of plant spores floating in water. Browning, Elizabeth Barrett (1806–61) English poet. In 1846 she secretly married Robert Browning and, from 1847, the couple lived in Florence, Italy. She began to write verse early in life. Her first volume, The Battle of Marathon, was published privately in 1820. The Seraphim and Other Poems (1838) and Poems (1844) established her widespread popularity, later confirmed by her collection of 1850, which included Sonnets from the Portuguese, and Aurora Leigh (1857). She was regarded as the pre-eminent English woman poet of her age.

Browning, Robert (1812–89) English poet. *Pauline*, his first published poem, appeared anonymously in 1833. Later poems, such as "My Last Duchess" and "Soliloquy of the Spanish Cloister", both published in *Bells and Pomegranates* (1846), display his characteristic use of dramatic monologue. In 1846 he and Elizabeth Barrett (BROWNING) secretly married and moved to Florence, Italy, in 1847. He published the volumes *Christmas Eve and Easter Day* (1850) and *Men and Women* (1855) before returning to London after Elizabeth's death in 1861. His popularity increased with *Dramatis Personae* (1864) and *The Ring and the Book* (1868–69), a series of dramatic dialogues often considered to be his masterpiece. One of the foremost poets of the 19th century, Browning is also at times one of the most obscure.

Bruch, Max (1838–1920) German Romantic composer. He composed operas and was a prominent conductor, but he is remembered primarily for three orchestral works – the Violin Concerto No. 1, *Scottish Fantasy* for violin and orchestra, and the *Kol Nidrei* for cello and orchestra.

Brücke, Die (1905–13) (The Bridge) First group of German expressionist painters. Founded in Dresden by E.L. KIRCHNER, the group chose their name because they wanted their work to form a bridge with the art of the future. They produced paintings and drawings, but their greatest strength lay in the art of woodcut. Members of the group included Emil Nolde, Karl Schmidt-Rottluff, Max Pechstein and Erich Heckel. Inspired by Munch, Van Gogh and Gauguin, their work was charac-

terized by jagged edges, harshly distorted figures and a simplification of colour and form. See also EXPRESSIONISM

Bruckner, Anton (1824–96) Austrian romantic composer. An intensely pious man, he wrote a great deal of church music – cantatas, masses and a *Te Deum* (1881–84) – and nine symphonies. His symphonies are lengthy, monumental creations greatly influenced by ROMANTICISM. His use of complex musical form infuses his work, in which folk tunes are occasionally employed.

Bruegel, Pieter the Elder (1525–69) Netherlandish landscape painter and draughtsman. The greatest 16th-century Dutch artist. He travelled extensively in France and Italy. His return journey through the Alps influenced him profoundly and he produced a series of remarkably sensitive drawings of the region. In 1563, he moved to Brussels and for the rest of his life concentrated on painting. The characteristic rural scenes crowded with tiny peasant figures of his early years gave way during his last six years to paintings with larger figures which illustrated proverbs. His son, Pieter the Younger (1564–1637), sometimes copied his father's work. Another son, Jan (1568–1625), specialized in highly detailed flower paintings and earned the nickname "Velvet Bruegel" because of his skill in depicting delicate textures.

Bruges (Brugge) Capital of West Flanders province, NW Belgium. Built on a network of canals, it was a great trading centre in the 15th century. Its importance declined after 1500, but trade revived when the Zeebrugge ship canal was opened in 1907. It has many medieval buildings, including churches, a town hall and a market hall. Industries: engineering, brewing, lace, textiles, tourism. Pop. (1993 est.) 116,724.

Brunei Sultanate in N BORNEO, SE Asia; the capital is BANDAR SERI BEGAWAN. Land and climate Bounded in the NW by the South China Sea, Brunei consits of humid plains with forested mountains running along its s border with Malaysia. Brunei has a moist, tropical climate. Economy Oil and gas are the main source of income, accounting for 70% of GDP. Recently, attempts have been made to increase agricultural production. History and politics During the 16th century Brunei ruled over the whole of Borneo and parts of the Philippines, but gradually lost its influence in the region. It became a British protectorate in 1888. Brunei achieved independence in 1983. The sultan has executive authority. Area: 5,765sq km (2,225sq mi). Pop. (1993) 276,300.

Brunel, Isambard Kingdom (1806–59) British marine and railway engineer. A man of remarkable foresight, imagination and daring, he revolutionized British engineering. In 1829 he designed the Clifton Suspension Bridge (completed 1864). He is also famous for his ships: *Great Western* (designed 1837), the first trans-Atlantic wooden steamship; *Great Britain* (1843), the first iron-hulled, screw-driven steamship; and *Great Eastern* (1858), a steamship powered by screws and paddles, which was the largest vessel of its time.

Brunelleschi, Filippo (1377–1446) Florentine architect, first of the great Renaissance architects and a pioneer of Perspective. He influenced many later architects, including Michelangelo. In 1420 he began to design the dome of Florence Cathedral, the largest since the Hagia Sophia. Other works include the Ospedale degl'Innocenti (1419–26), the Basilica of San Lorenzo (begun 1421) and the Pazzi Chapel (c.1440), all in Florence.

Bruno, Frank (Franklin Roy) (1961–) English boxer. He turned professional in 1982, and in 1985 won the European heavyweight title and challenged Tim Witherspoon for the WBA crown. He retired after losing to Mike Tyson in 1989, but staged a comeback only to lose another world title challenge to Lennox Lewis in 1993. In 1995 he beat Oliver McCall on points to win the WBC title, but lost his defence against Tyson and retired again.

Brussels (Bruxelles) Capital of Belgium and of Brabant province, central Belgium. During the Middle Ages it achieved prosperity through the wool trade and became capital of the Spanish Netherlands. In 1830 it became capital of newly independent Belgium. Sites include a 13th-century cathedral, the town hall, splendid art nouveau period buildings and academies of fine arts. The main commercial, finan-

▲ bubble chamber Coloured image showing a collection of tracks left by subatomic particles in a bubble chamber. A charged particle leaves behind a trail of tiny bubbles as the liquid hydrogen boils in its wake. The tracks are curved due to an intense applied magnetic field. The tightly wound spiral tracks are due to electrons and positrons.

cial, cultural and administrative centre of Belgium, it is also the headquarters of the European Community (EC) and of the North Atlantic Treaty Organization (NATO). Industries: textiles, chemicals, electronic equipment, electrical goods, brewing. Pop. (1993 est.) 949,070.

Brussels, Treaty of (1948) Agreement signed by Britain, France and the Low Countries for cooperation in defence, politics, economics and cultural affairs for 50 years. The defence agreement was merged into the NORTH ATLANTIC TREATY ORGANIZATION (NATO) in 1950. In 1954 Italy and West Germany joined the original signatories, and the name was changed to the Western European Union. It was a forerunner of the European Community (EC).

brutalism Architectural movement of the 1950s and early 1960s. It took its inspiration from Le Corbusier's pilgrimage chapel at Ronchamp and his High Court building at Chandigarh, India. Corbusier designed both buildings as a reaction to the sterility of the INTERNATIONAL STYLE. A number of young architects, such as James STIRLING, tried to extend Le Corbusier's experiments into aggressive and chunky designs of their own. It should not be confused with the 1950s movement of new brutalism, in which Alison and Peter Smithson adopted the uncompromising simplicity of MIES VAN DER ROHE.

Bruton, John Gerard (1947–) Irish prime minister (1995–97). Bruton was elected to the Dáil in 1969. A member of Fine Gael, he rose steadily through the ministerial ranks, earning a reputation as a right-winger, notoriously after he tried to impose VAT on children's shoes in 1982. He became leader of Fine Gael in 1990 and succeeded Albert REYNOLDS as prime minister.

Brutus (85–42 BC) (Marcus Junius Brutus) Roman republican leader, one of the principal assassins of Julius CAESAR. He sided first with POMPEY against Caesar, but Caesar forgave him and made him governor of Cisalpine Gaul in 46 BC and city praetor in 44 BC. After taking part in Caesar's assassination, he raised an army in Greece but was defeated at Philippi by Mark Antony and Octavian. He committed suicide.

Bryant, William Cullen (1794–1878) US poet and editor. His debut volume, *Poems* (1821), contained some of his most famous verse including "Thanatopsis" and "To a Waterfowl". In 1825 he became co-editor of the *New York Review*. In 1826 he joined the *New York Evening Post*, soon rising to editor (1829) and part-owner. Under his editorship, the *Post* emerged as a powerful liberal voice. Later volumes include *The Fountain* (1842), *A Forest Hymn* (1860) and *Thirty Poems* (1864).

bryophyte Group of small, green, rootless non-VASCULAR PLANTS (phylum Bryophyta), including MOSS and LIVERWORT. Bryophytes grow on damp surfaces exposed to light, including rocks and tree bark, almost everywhere from the Arctic to the Antarctic. There are about 24,000 species. See also ALTERNATION OF GENERATIONS

BSE Acronym for BOVINE SPONGIFORM ENCEPHALOPATHY **bubble chamber** Device for detecting and identifying SUB-ATOMIC PARTICLES. It consists of a sealed chamber filled with a liquefied gas, usually liquid hydrogen, kept just below its boiling point by high pressure in the chamber. When the pressure is released, the boiling point is lowered and a charged particle passing through the superheated liquid leaves a trail of tiny gas bubbles that can be illuminated and photographed before the pressure is restored. If a magnetic field is applied to the chamber, the tracks are curved according to the charge, mass and velocity of the particles, which can thus be identified. The US physicist Donald GLASER received the 1960 Nobel Prize for physics for inventing the bubble chamber, and it was developed by Luis ALVAREZ.

Buber, Martin (1878–1965) Austrian Jewish philosopher, theologian and activist. He was a native of Vienna. An ardent early advocate of Zionism, he edited *Der Jude* (1916–24), the leading journal of German-speaking Jewish intellectuals. He defiantly opposed the Nazis in Germany until forced to move to Palestine in 1938. His most important published work is *I and Thou* (1922), on the directness of the relationship between man and God within the traditions of HASIDISM. He has also written on the ideals of the state of Israel.

bubonic plague See PLAGUE

Buchan, John, 1st Baron Tweedsmuir (1875–1940) British author and politician. Buchan is best-known for his adventure novels, such as *The Thirty-Nine Steps* (1915). He also wrote a four-volume history of World War 1 (1915–19) and biographies of Julius Caesar, Walter Scott (1932) and Oliver Cromwell (1934). He was governor-general of Canada (1935–40).

Buchanan, James (1791–1868) 15th US president (1857–1861). Buchanan entered Congress in 1821 and acted as Senator (1834–45). President POLK appointed him secretary of state (1845–49). Under President PIERCE, Buchanan served as minister to Great Britain (1853–56). After securing the DEMOCRATIC PARTY nomination, he defeated John C. FRÉMONT of the newly formed REPUBLICAN PARTY and Millard FILLMORE in the presidential election. Buchanan's administration was unpopular, his attempt to compromise between proand anti-SLAVERY factions floundered. His efforts to purchase Cuba and acceptance of a pro-slavery constitution in Kansas, contributed to his electoral defeat by Abraham LINCOLN. The Southern states seceded and, shortly after Buchanan left office, the American CIVIL WAR began.

Bucharest (Bucuresti) Capital and largest city of Romania, on the River Dimbovita, s Romania. Founded in the 14th century on an important trade route, it became capital in 1862 and was occupied by Germany in both World Wars. It is an industrial, commercial and cultural centre. The seat of the patriarch of the Romanian Orthodox Church, it has notable churches, museums and galleries. There are also two universities. Industries: oil refining, chemicals, textiles. Pop. (1992) 2,350,984.

Buchenwald Site of a Nazi concentration camp, near Weimar in Germany. Established in 1937, it became notorious for the medical experiments conducted on its inmates, of whom *c*.50,000 died. It was liberated by US forces in 1945.

Buck, Pearl S. (Sydenstricker) (1892–1973) US novelist. She was brought up in China, which she used as the setting for many of her novels, including *The Good Earth* (1931), which won the 1932 Pulitzer Prize. Her other works include *Sons* (1932), *The Mother* (1934), *A House Divided* (1935) and *Dragon Seed* (1942). She also wrote plays, screenplays, verse and children's fiction. She was awarded the 1938 Nobel Prize for literature.

Buckingham, George Villiers, 1st Duke of (1592–1628) English courtier. As favourite of James I from 1614, Buckingham became rich and influential. He also dominated the future Charles I. The missions he undertook abroad were failures, but Charles blocked parliament's attempts to impeach him in 1626 and a discontented naval officer murdered him.

Buckingham, George Villiers, 2nd Duke of (1628–87) English courtier and political figure. He was educated with Charles I's sons and supported the Royalists in the CIVIL WAR (1642–48). A dashing, rakish courtier in RESTORATION England, he was a member of the group of ministers known as the Cabal, but later joined the opposition to Charles II. He wrote several comedies, notably *The Rehearsal* (1671).

Buckingham Palace London residence of British sovereigns since 1837. Formerly owned by the dukes of Buckingham, it was purchased by George III in 1761 and remodelled into a 600-room palace by John NASH in 1825. Sir Aston Webb redesigned the east front in 1913. The changing of the guard ceremony takes place here daily.

Buckinghamshire County in SE central England; the county town is Aylesbury. In the Vale of Aylesbury to the N, cereal crops and beans are grown. Livestock and poultry are reared in the S. Industries: furniture, printing, building materials. Area: 1,877sq km (725sq mi). Pop. (1991) 632,487.

bud In plants, a small swelling or projection consisting of a short stem with overlapping, immature leaves covered by scales. Leaf buds develop into leafy twigs, and flower buds develop into blossoms. A bud at the tip of a twig is a terminal bud and contains the growing point; lateral buds develop in leaf axils along a twig.

Budapest Capital of Hungary, on the River Danube. It was created in 1873 by uniting the towns of Buda (capital of Hungary since the 14th century) and Pest on the opposite bank. It became one of the two capitals of the AUSTRO-HUNGARIAN

▶ Buddhism Founded in NE India in the 6th century, Buddhism has over 300 million followers in Japan, Sri Lanka, Nepal, Thailand and other regions of the Far East. Its disdain of material wealth is finding increasing support in parts of the West.

EMPIRE. It made rapid industrial and commercial progress in the early 20th century, and, was declared capital of an independent Hungary (1918). Budapest was the scene of a popular uprising against the Soviet Union in 1956. The old town contains a remarkable collection of buildings including: Buda Castle, the 13th-century Matthias Church, the Parliament Building, the National Museum and Roman remains. Industries: iron and steel, chemicals, textiles. Pop. (1993 est.) 2,009,000.

Buddha (Enlighted One) Title adopted by Gautama Siddhartha (c.563-c.483 BC), the founder of BUDDHISM. Born at Lumbini, Nepal, Siddhartha was son of the ruler of the Sakva tribe, and his early years were spent in luxury. At the age of 29, he realized that human life is little more than suffering. He gave up his wealth and comfort, deserted his wife and small son, and took to the road as a wandering ascetic. He travelled south and sought truth in a six-year regime of austerity and self-mortification. After abandoning asceticism as futile, he sought his own middle way towards enlightenment. The moment of truth came c.528 BC, as he sat beneath a banyan tree in the village of Buddha Gaya, Bihar, India. After this incident, he taught others about his way to truth. The title "buddha" applies to those who have achieved perfect enlightenment. Buddhists believe that there have been several buddhas before Siddhartha, and there will be many to come. The term also serves to describe a variety of Buddha images.

Buddhism Religion and philosophy founded in India c.528 BC by Gautama Siddhartha, the BUDDHA. Buddhism is based on Four Noble Truths: existence is suffering; the cause of suffering is desire; the end of suffering comes with the achievement of NIRVANA, and Nirvana is attained through the Eightfold Path: right views, right resolve, right speech, right action, right livelihood, right effort, right mindfulness and right concentration. There are no gods in Buddhism. Alongside the belief in the Four Noble Truths exists karma, one of Buddhism's most important concepts: good actions are rewarded and evil ones are punished, either in this life or throughout a long series of lives resulting from samsara, the cycle of death and rebirth produced by REINCARNATION. The achievement of nirvana breaks the cycle. Buddhism is a worldwide religion. Its main divisions are THERAVADA, or Hinayana, in SE Asia; MAHAYANA in N Asia; Lamaism or TIBETAN BUDDHISM in Tibet; and ZEN in Japan. The total number of Buddhists in the world in the mid-1990s was estimated at over 300 million.

budding Method of asexual reproduction that produces a new organism from an outgrowth of the parent. Hydras, for example, often bud in spring and summer. A small bulge appears on the parent and grows until it breaks away as a new individual.

Budge, (John) Don (Donald) (1915–) US tennis player. Regarded as one of the greatest players of all time, he was the first man to complete the Grand Slam of the four major singles (Wimbledon, USA, Australia, France) in one year (1938), after which he turned professional. He was Wimbledon and US Open twice (1937, 1938).

budgerigar (parakeet) Small, brightly coloured seed-eating PARROT native to Australia, and a popular pet. It can be taught to mimic speech. The sexes look alike but the coloration of the cere (a waxy membrane at the base of the beak) may vary seasonally. Size: 19cm (7.5in) long. Species *Melopsittacus undulatus*.

budget Plan for the financial expenditure of an individual, corporation or government, matching it against expected

income. National budgets determine the level of direct and indirect TAXATION against projected expenditure and economic growth. The complexity of modern trade and finance has sometimes forced governments to make two or more budgets in a single year.

Buenos Aires Capital of Argentina, on the estuary of the Río de la Plata, 240km (150mi) from the Atlantic Ocean. Originally founded by Spain in 1536, it was refounded in 1580 after being destroyed by the indigenous population. It became a separate federal district and capital of Argentina in 1880. Buenos Aires later developed as a commercial centre for beef, grain and dairy products. It is the seat of the National University (1821). Industries: meat processing, flour milling, textiles, metal works, car assembly, oil refining. Pop. (1992 est.) 11,662,050.

Buffalo Industrial city and port on the E shore of Lake Erie, NW New York State, USA. It was first settled in 1803 by the Holland Land Company. Its rapid industrial growth was encouraged by its position at the w terminus of the Erie Canal (opened 1825). President McKinley was assassinated at the Pan-American Exposition held here in 1901. It is home to the Albright-Knox art gallery and has two universities. Industries: flour milling, motor vehicles, chemicals and railway engineering. Pop. (1990) 328,123.

buffalo Any of several horned mammals and a misnomer for the North American BISON. The massive ox-like Indian, or water, buffalo (*Bubalus bubalis*) is often domesticated for milk and hides. Height: 1.5m (5ft). Family Boyidae.

buffer solution Solution to which a moderate quantity of a strong acid or a strong base can be added without making a significant change to its pH value (acidity or alkalinity). Buffer solutions usually consist of either a mixture of a weak acid and one of its salts, a mixture of an acid salt and its normal salt or a mixture of two acid salts.

bug Any member of the insect order Hemiptera, although in the USA any insect is commonly called a bug. True bugs are flattened insects that undergo gradual or incomplete metamorphosis, have two pairs of wings and use piercing and sucking mouthparts. Most feed on plant juices, such as the greenfly, although a number attack animals and are carriers of disease.

bugle Brass wind instrument resembling a small TRUMPET without valves, capable of playing notes of only one harmonic series. Because its penetrating tones carry great distances, it was often used for military signalling.

Buhl, André Charles See André Charles BOULLE

building society In the UK, a financial institution primarily for providing mortgage loans to house-buyers. The money lent by a building society comes from savings invested by the public in deposits and shares. Since the Building Societies Act (1986), they have been allowed to offer a wider range of financial services, putting them in direct competition with banks. They are comparable to SAVINGS AND LOAN ASSOCIATIONS in the USA.

Bujumbura (formerly Usumbura) Capital and chief port of Burundi, E central Africa, at the NE end of Lake TANGANYIKA. Founded in 1899 as part of German East Africa, it was the capital of the Belgian trust territory of Ruanda-Urundi after World War 1 and remained capital of Burundi when the country achieved independence in 1962. It is an administrative and commercial centre. Industries: textiles, cotton, coffee, cement. Pop. (1994 est.) 300,000.

Bukhara (Buchara) Ancient city in w Uzbekistan, capital of the Bukhara region. Founded c.1st century AD, it was ruled by Arabs (7th–9th century), by Turks and Mongols (12th–15th century) and annexed to Russia in 1868; it was included in Uzbekistan (1924). It is an important Asian trade and cultural centre. Monuments include the 10th-century mausoleum of Ismail Samani and the Ulugbek (1417–18). Industries: silk processing, rugs, handicrafts, textiles. Pop. (1990) 246,200.

Bukharin, Nikolai Ivanovich (1888–1938) Russian communist political theorist. After the 1917 Revolution he became a leading member of the COMMUNIST INTERNATIONAL (Comintern) and editor of *Pravda*. In 1924 he became a member of the politburo. He opposed agricultural collectivization and was executed for treason by STALIN in 1938.

▲ bulb As well as serving as underground storage organs, bulbs may also provide flowering plants with a means of vegetative reproduction. In spring, the flower bud (1) and young foliage leaves (2) will develop into a flowering plant using the food and water stored in the bulb's fleshy scale leaves (3). When the flower has died, the leaves live on, and continue to make food which is transported downwards to the leaf bases. These swell and develop into new bulbs. Axillary buds (4) may develop into daughter bulbs which break off to form new independent plants.

Bulawayo City in sw Zimbabwe, SE Africa; capital of Matabeleland North province. It was founded by the British in 1893 and was the site of the Matabele revolt in 1896. It is the second largest city in the country. Industries: textiles, motor vehicles, cement, electrical equipment. Pop. (1992) 620,936. **bulb** In botany, a food storage organ consisting of a short stem and swollen scale leaves. Food is stored in the scales, which are either layered in a series of rings, as in the onion, or loosely attached to the stem, as in some lilies. Small buds between the scale leaves give rise to new shoots each year. New bulbs are produced in the axils of the outer scale leaves. *See also* ASEXUAL REPRODUCTION

Bulfinch, Charles (1763–1844) US architect. He is particularly noted for his public buildings, such as the State House in Boston; University Hall at Harvard, Cambridge, Massachusetts; and Massachusetts General Hospital, Boston. In 1818–30 he completed the building of the Capitol in Washington, D.C. Bulganin, Nikolai (1895–1975) Soviet military and political leader. He was elected to the Communist Party Central Committee in 1934, and served in the army during the war. Defence minister in 1947–49 and 1953–55, he became prime minister after the fall of MALENKOV in 1955. He was dis-

missed in 1958, after disagreements with Nikita Khrushchev. **Bulgaria** Balkan republic in SE Europe. *See* country feature **Bulgars** Ancient Turkic people originating in the region N and E of the Black Sea. In c.AD 650 they split into two groups. The W group moved to Bulgaria, where they became assimilated into the Slavic population and adopted Christianity. The other group moved to the Volga region and set up a Bulgar state, eventually converting to Islam. The Volga Bulgars were conquered by the Kievan Rus in the 10th century.

Bulge, Battle of the Final German offensive of WORLD WAR 2. The Germans drove a wedge through the Allied lines in the Ardennes forest on the French–Belgian frontier in December 1944. Allied forces converged to extinguish the "bulge" in their lines in January 1945, and the advance into Germany was renewed.

bulimia nervosa EATING DISORDER that takes the form of compulsive eating, then purging by induced vomiting or the use of a LAXATIVE or DIURETIC. Confined predominantly to girls and women, the disorder most often results from an underlying psychological problem. An obsession with body image may be reinforced by Western media stereotypes of slim as beautiful. **bulldog** English bull-baiting breed of DOG with a distinctive

▲ bulldog The history of the bulldog goes back many centuries. It was initially bred in England for bear-baiting and dog-fighting, but these pursuits were banned in 1835. The French bulldog (shown here) is considerably smaller than the pure bulldog.

BULGARIA

This flag, first adopted in 1878, uses the colours associated with the Slav people. The national emblem incorporating a lion – a symbol of Bulgaria since the 14th century – was first added to the flag in 1947. It is now added only for official government occasions.

Northern Bulgaria consists of a plateau falling to the valley of the River DANUBE, which forms most of Bulgaria's N border with Romania. The heart of Bulgaria is mountainous and the main ranges include the BALKAN MOUNTAINS (Stara Planina) in the centre and the Rhodope Mountains in the s. The capital, SOFIA, lies close to Bulgaria's highest point, Mount Musala at 2,925m (9,600ft). Between these ranges lies the valley of the River Maritsa, which forms an E – W route between the Black Sea coast and the interior.

CLIMATE

Bulgaria has hot summers and cold winters. Rainfall is moderate. The E has drier and warmer summers than the W and the Black Sea coast is a popular resort area.

VEGETATION

More than half of Bulgaria is given over to crops

or pasture, while forests cover *c*.35% of the land. Trees swathe the mountain slopes, with meadows and Alpine plants above the tree line. In the Balkan Mountains are the rosefields of Kazanluk, from which attar of roses is exported.

HISTORY AND POLITICS

In the late 7th century, BULGAR tribes crossed the Danube and subjugated the SLAVS. The first Bulagarian empire (681-1018) quickly became a major Balkan power. In 870 Constantinople recognized the independence of the Bulgarian Christian Church. The empire was at its height in the early 10th century, but in 1018 it was annexed to the BYZANTINE EMPIRE by BASIL II. The second Bulgarian empire (1186-1396) conquered the whole of the Balkan peninsula, before it was subsumed into the OTTOMAN empire. The Turks' attempts to undermine Bulgarian religion and language created national resentment. The brutal crushing of a native rebellion (1876) brought Russian assistance, and Bulgaria gained autonomy in 1879. Prince FER-DINAND declared full independence in 1908. Bulgaria was victorious in the first of the BALKAN WARS (1912-13), but fell out with its allies in the second. Defeat in World War 1 led to the abdication of Ferdinand (1918). His successor, Boris III, established a dictatorship in 1935 and allied with Germany in World War 2. In 1944 Soviet troops invaded. Todor Zhivkov led a coup against the monarchy and declared war on Germany. In 1946 Bulgaria became a one-party republic. Industry was nationalized and agriculture collectivized. In 1949 Bulgaria joined the Council for Mutual Economic Assistance

AREA: 110,910sq km (42,822sq mi)

POPULATION: 8,963,000

CAPITAL (POPULATION): Sofia (1,141,142)
GOVERNMENT: Multiparty republic

ETHNIC GROUPS: Bulgarian 86%, Turkish 10%,

Gypsy 3%, Macedonian, Armenian,

Romanian, Greek

LANGUAGES: Bulgarian (official)

RELIGIONS: Christianity (Eastern Orthodox

87%), Islam 13%

currency: Lev = 100 stotinki

(COMECON) and was a founder member of the WARSAW PACT (1955). In the early 1950s, the Stalinist regime launched a series of purges of the Communist Party and deported large numbers of Turks. In the 1980s, the "Bulgarization" of Turks intensified. With the collapse of Soviet communism, Zhivkov's presidency (1971-89) came to an abrupt end. The Bulgarian Communist Party was renamed the Bulgarian Socialist Party (BSP). In 1990, the first non-communist president for 40 years, Zhelyu Zhelev, was elected. A new constitution (1991) saw the adoption of free-market reforms. The BSP won the 1994 general election, but virtual economic collapse and anti-government demonstrations prompted the government to resign (1996). Fresh elections (1997) were won by a centre-right coalition.

ECONOMY

Bulgaria is a lower-middle-income developing country, faced with a difficult transition to a market economy. Since 1989, Bulgaria's major trading partner has been the European Union (EU). Inflation (1994, 96%), unemployment (1993, 16%) and public debt are major economic and social obstacles. Manufacturing is the leading economic activity, but faces problems arising from outdated technology. The main products are chemicals, metals, machinery and textiles. Mineral reserves include molybdenum. Wheat and maize are the main crops. The warm valleys of the Maritsa are ideal for growing grapes for winemaking, plums and tobacco. Tourism is increasing rapidly (1995, 2 million visitors).

large head, a short upturned muzzle and a projecting lower jaw. The body is large, with muscular shoulders, a broad chest and short stout legs; the tail is short. The smooth coat may be white, tan or brindle. Height: (at shoulder) up to 38cm (15in). bullfighting National sport of Spain and also popular in Latin America and s France. Classically, there are six bulls and three matadors, who are assigned two bulls each. Each matador has five assistants - two picadors (mounted on armoured horses) and three peones or banderilleros. A bullfight starts when the picadors stab the bull to weaken it. The peones then plant banderillas (barbed sticks) on the withers of the bull. The matador makes several passes with his red cape (muleta) before attempting to kill the bull by thrusting a sword between its shoulder blades. In Spain, bullfighting is regarded as an art, to many others worldwide it is a cruel spectacle.

bullfinch Northern European and Asian finch, with a stout, rounded beak. Males have a crimson and grey body and a black head; females have duller colours. It grows to 14cm (5.5in) long; species Pyrrhula pyrrhula.

bullfrog FROG found in streams and ponds in the USA; it is green or brown and breeds in spring. The largest North American frog; it can jump ong distances and gests its name from its loud bass voice. Family Ranidae, genus Rana. Length: up to 20cm (8in).

bullhead Freshwater catfish, originally found throughout E USA. Now farmed as food, it has been introduced in Europe and Hawaii. It has four pairs of fleshy mouth whiskers and a square tail. Length: to 24in (61cm); weight: to 8lb (3.6kg). Family Ictaluridae.

Bull Run, First Battle of (21 July 1861) US CIVIL WAR engagement, fought near Manassas, Virginia. Under-trained Union troops commanded by General Irvin McDowell, at first successful, were eventually routed by Confederate troops under General P.G.T. BEAUREGARD, reinforced by General Thomas J. JACKSON, who earned his nickname "Stonewall" at the battle.

Bull Run, Second Battle of (28 August 1862) US Civil War battle. On the old battleground of 1861, 48,000 Confederates under General Robert E. LEE beat 75,000 Union soldiers under General John Pope, and once more, Lee threatened Washington D.C. Union losses were 16,000 to the Confederates' 9,000. Pope was dismissed as commander of the Union army, and General George McCLELLAN, the former commander, reassumed control.

BURKINA FASO

This flag was adopted in 1984, when Upper Volta was renamed Burkina Faso. The red, green and yellow colours symbolize the desire for African unity. This is because they are used on the flag of Ethiopia, Africa's oldest independent country.

Burkina Faso is a little larger than the United Kingdom, but has only one-sixth of the population. It consists of a plateau, c.200-700m (650-2,300ft) above sea level, which is cut by several rivers, most of which flow s into Ghana or E into the Niger River. During droughts, some of the rivers dry up and their valleys become marshes. The capital, OUAGADOUGOU, lies in the centre of the country.

CLIMATE

Burkina Faso is hot throughout the year, with most rain occurring between May and September, when it is often humid. Rainfall is erratic and droughts are common.

VEGETATION

Rainfall is heaviest in the sw, which is covered by savanna. The rest of Burkina Faso is the semi-desert region of the SAHEL, which merges

MAP SCALE NIGER Dori a Ouahigouya BURKINA FASO Quagadougou Tenkodogo Dioulasso IVORY COAST

into the Sahara. Overgrazing, deforestation and soil erosion are common problems in the Sahel, causing desertification in many areas of the country. Large areas of woodland border the rivers. The SE contains the "W" National Park, which Burkina Faso shares with both Benin and Niger, and the Arly Park. A third wildlife area, Po Park, lies s of Ouagadougou.

HISTORY AND POLITICS

The people of Burkina Faso are divided into two main groups. The Voltaic group includes the Mossi (the largest single group) and the Bobo. The other main group is the Mande. Some Fulani herders and Hausa traders also live in Burkina Faso. From c.1100 the Mossi invaded the region and established small, highly complex states. The powerful Ougadougou kingdom was ruled by an absolute monarch, the Moro Naba. These semi-autonomous states fiercely resisted domination by the larger Mali and Songhai empires. In the 1890s, as part of the "scramble for Africa", France gained control of the region. In 1919 it became the French protectorate of Upper Volta. In 1947 Upper Volta gained semi-autonomy within the French Union and in 1958 became an autonomous republic within the French Community. In 1960 it achieved full independence. A strong presidential form of government was adopted. Persistent drought and austerity measures led to a military coup in 1966. In 1970 civilian rule was partially restored but the military, led by Sangoulé Lamizana, regained power in 1974. Lamizana became president in 1978 elections, but was overthrown in 1980. Parliament and

AREA: 274,200sq km (105,869 sq mi)

POPULATION: 9,490,000

CAPITAL (POPULATION): Ouagadougou (442,223)

GOVERNMENT: Multiparty republic

ETHNIC GROUPS: Mossi 48%, Mande 9%, Fulani

8%, Bobo 7%

LANGUAGES: French (official)

RELIGIONS: Traditional beliefs 45%, Islam 43%,

Christianity 12%

CURRENCY: CFA franc = 100 centimes

the constitution were suspended and a series of military governments ensued. In 1983 Thomas Sankara seized power in a bloody coup. In 1984, as a symbolic break from the country's colonial past, Sankara changed the country's name to Burkina Faso ("land of the incorruptible"). Sankara was assassinated in 1987 and Captain Blaise Compaoré seized power. In 1991 Compaoré was elected president, after opposition parties boycotted the poll. He was re-elected in 1997.

ECONOMY

Burkina Faso is one of the world's poorest countries (1992 GDP per capita, \$US810). Since independence, recurrent drought has left it dependent on foreign (particularly French) aid. Nearly 90% of the workforce are engaged in agriculture, mainly at subsistence level. Less than 10% of the land is cultivable without irrigation and Burkina Faso remains reliant on food imports. The main industry is the rearing of cattle and sheep. The chief exports are livestock, groundnuts, cotton, maize, millet and sorghum. Burkina Faso has few resources. There are some deposits of gold, manganese, zinc, lead and nickel in the N, but the lack of an adequate transport network means that they remain largely unexploited. The country's manufactures are limited to basic consumer items, such as footwear and bicycles. Much of the male labour force is forced to migrate to the Ivory Coast and Ghana to work in factories and farms. A high rate of infant mortality means that each woman has on average 7 children.

bull terrier Strongly built sporting DOG, originating from England and once used for bear-baiting; it has a large oval head with small, erect ears. The broad-chested body is set on strong legs and the tail is short. The "coloured" variety can be any colour, but the "white" is pure white, often with darker head markings. Height (at shoulder): up to 56cm (22in).

Bülow, Bernhard von, Prince (1849–1929) Chancellor of the German empire (1900–09). He was cautious and conservative in domestic policy, but his aggressiveness in foreign policy left Germany isolated and heightened the tensions in Europe that preceded the outbreak of World War 1. He lost the favour of the emperor in 1908 and was forced to resign.

bulrush Grass-like plant of the SEDGE family, found in marshes or beside water in Europe, Africa and North America. The common British bulrush (reed mace), *Typha latifolia*, reaches 1.8–2.1m (6–7ft) and bears both male and female flowers. Family Cyperaceae.

bumblebee (humble bee) Robust hairy black BEE with broad yellow or orange stripes. The genus *Bombus* live in organized groups in ground or tree nests, where the fertile queen lays her first eggs after the winter hibernation. These become worker bees. Later, the queen lays eggs to produce drones (males) and new queens which develop before the colony dies. The cycle is then repeated. The genus *Psithyrus*, or cuckoo bee, lays its eggs in the nests of *Bombus*, which rear them. Length: up to 2.5cm (1in). Order Hymenoptera; family Apidae.

Bunche, Ralph Johnson (1904–71) US diplomat. He joined the staff of the UN in 1947 and helped negotiate a cease-fire in the Arab-Israeli conflict (1949), for which he won the Nobel Peace Prize (1950). He directed UN peace-keeping forces in Suez (1956), the Congo (1960) and Cyprus (1964) and was UN under-secretary-general (1967–71).

Bunin, Ivan Alekseyevich (1870–1953) Russian writer. He was opposed to the 1917 Revolution and emigrated to France. Influenced by Turgenev, his works lament the passing of the old Russian order. They include the novel *The Village* (1910) and the short story *The Gentleman from San Francisco* (1916). In 1933 he became the first Russian to be awarded the Nobel Prize for literature.

Bunker Hill, Battle of (June 1775) Battle in the American Revolution fought on Boston's Charlestown peninsula. The first large-scale battle of the war, it was actually fought s of Bunker Hill on Breed's Hill. Although the Americans were driven from their position, they inflicted heavy losses on the British.

Bunsen, Robert Wilhelm (1811–99) German chemist, professor at Heidelberg (1852–99). He did important work with organo-arsenic compounds and discovered an arsenic poisoning antidote and evolved a method of gas analysis. With Gustav Kirchhoff, he used Spectroscopy to discover two new elements (caesium and rubidium). He invented various kinds of laboratory equipment, including the bunsen burner.

Bunshaft, Gordon (1909–90) US architect, chief designer of the Skidmore, Owings and Merril Group. Influenced by MIES VAN DER ROHE, Bunshaft is best known for Lever House, New York (1952), a glass curtain-walled skyscraper that created an international style.

bunting FINCH found almost worldwide. Males of the genus *Passerina* are brightly coloured, whereas the females are smaller and duller. Members of the genus *Emberiza* are larger and dull coloured, although the snow bunting is almost white. Family Fringillidae.

Buñuel, Luis (1900–83) Spanish film director. Buñuel's films were harsh and ferociously critical of the church and social hypocrisy. Among his major works are *Un Chien Andalou* (1928), *Viridiana* (1961), *Belle de Jour* (1966) and *The Phantom of Liberty* (1974).

Bunyan, John (1628–88) English preacher and author. During the English Civil War (1642–52) he fought as a Parliamentarian. He set himself up as a puritan preacher in 1655, and was twice imprisoned for his nonconformist religious activities. His writings, which were popular and colloquial in style, include the Christian allegory *The Pilgrim's Progress* (1684). **buoyancy** Upward pressure exerted on an object by the

buoyancy Upward pressure exerted on an object by the fluid in which it is immersed. The object is subjected to pres-

sure from all sides. The result of all these pressures is a force acting upwards that is equal to the weight of the fluid displaced. See also ARCHIMEDES' PRINCIPLE

burdock Oil-yielding weed found throughout Europe, North Africa and North America. It has large basal leaves and thistle-like purple flower heads covered by stiff, hooked bracts. Common burdock, *Arctium pubens*, is biennial and grows to 0.9m (3ft). Family Asteraceae/Compositae.

Burger, Warren Earl (1907–95) Chief justice of the US Supreme Court (1969–86). He served as a judge of the US Court of Appeals in Washington, D.C. (1956–69), before his appointment as chief justice. A conservative, he led a court that reversed or limited liberal decisions. In *Gregg v. Georgia* (1976) capital punishment for murder was declared constitutional.

Burgess, Anthony (1917–93) English novelist. His early works are set in Malaya, where he lived and served as part of the Colonial Service (1954–60). In his subsequent novels, he demonstrated an interest in social trends, linguistic effects and religious symbolism. His best-known work is *A Clockwork Orange* (1962), a nightmare vision of a modern dystopia in which he deploys a macabre, invented language. *Earthly Powers* (1980) and *The Kingdom of the Wicked* (1985) are among his most ambitious later novels.

Burgess Shale Layer of siltstone in a quarry in Yoho National Park, E British Columbia, Canada. Discovered in 1909 by US scientist Charles Walcott, it contains a large number of animal fossils from the CAMBRIAN period. The silt has preserved traces of many of the soft bodies of sea creatures. The fossils include the oldest known chordate, a forerunner of all animals with backbones. They also include a number of kinds of animals that have completely vanished, and apparently do not belong to any of the 32 or so phyla of animals we know today. Burghley, William Cecil, 1st Baron (1520-98) English statesman and chief minister of ELIZABETH I of England. He was secretary of state (1550-53) under EDWARD VI but failed to win Mary I's favour on her accession to the throne. On Mary's death Elizabeth I made him secretary of state (1558-72) and then lord high treasurer (1572-98). An able administrator, he helped steer a moderate course between Catholicism and Protestantism. In 1587 he was responsible for ordering the execution of MARY, QUEEN OF SCOTS.

Burgos Capital city of Burgos province, N Spain. Founded in the 9th century, it was the capital of the former kingdom of CASTILE. During the Spanish CIVIL WAR it was General FRANCO's headquarters. Sites includes a fine Gothic cathedral (1221) and the burial place of El CID. It is an important trade and tourist centre. Pop. (1991) 160,381.

Burgundy Historical region and former duchy of E central France that now includes the départements of Yonne, Côted'Or, Saône et Loire, Ain and Nièvre. Dijon is the historical capital. Burgundy's golden age began in 1364 when John II of France made his son, Philip the Bold, duke of Burgundy. The succeeding dukes created a state that extended across the Rhine and included the Low Countries. The last duke, Charles the Bold (r.1467–77) failed to have himself crowned king by the Holy Roman emperor, and Burgundy was divided up after his death, France annexing the largest part. The region has many Romanesque churches. It is a rich agricultural region renowned for its wine. Pop. (1990) 1,609,400.

Burke, Edmund (1729–97) British statesman and writer, b. Ireland. He played a major part in the reduction of royal influence in the House of Commons and sought better treatment for Catholics and American colonists. He was involved in the impeachment of Warren HASTINGS in an attempt to reform India's government in 1788. Burke deplored the excesses of the FRENCH REVOLUTION in his most famous work, *Reflections on the Revolution in France* (1790).

Burke, Robert O'Hara (1820–61) Irish explorer. In 1860 he led the first expedition to cross Australia from s to N. Accompanied by W.J. Wills, the expedition began in Melbourne. At the Barcoo River, Burke left most of the party and continued with three companions. They reached N Australia in 1861. Only one of the group (King) survived the return journey.

Burkina Faso Republic in West Africa. See country feature

▲ bullfinch The stout-beaked bullfinch (*Pyrrhula pyrrhula*) is well adapted to its woodland habitats where it feeds on the buds and flowers found on trees.

▲ bunting The black-headed bunting (*Emberiza melanocephala*) is found in sE Europe and sw Asia. A type of finch this species grows to about 16cm (6in) long.

▲ bull terrier A sporting dog bred for dog-fighting and bearbaiting, the bull terrier was a cross between a bulldog and a type of terrier. No longer bred for their aggression, today's bull terriers are intelligent, loyal dogs, and make good family pets.

burlesque (It. ridicule) Form of literary or dramatic entertainment that achieves its effect by caricature, ridicule and distortion, often of celebrated literary genres or works. A later form, in the USA, became synonymous with strip shows.

Burlington, Richard Boyle, 3rd Earl of (1694–1753) English architect. He was an important exponent of PALLADIANISM in England. He promoted the style through his own buildings, such as his villa at Chiswick, London. He also published drawings by PALLADIO and Inigo JONES.

Burlington City on Lake Champlain, NW Vermont, USA. Settled in 1773, it was the scene of a British naval attack in the WAR OF 1812. The largest city in the state, it is the site of the University of Vermont and of Trinity College. Industries: missile parts, textiles, wood products. Pop. (1990) 39,127.

Burma Republic in SE Asia. See country feature

Burmese Official language of Burma, spoken by 75% of the population, or 25 million people. It belongs to the Tibeto-Burman branch of the Sino-Tibetan family of languages.

burn Injury caused by exposure to flames, scalding liquids, caustic chemicals, acids, electric current or ionizing radiation. Its severity depends on the extent of skin loss and the depth of tissue damage. A superficial burn, involving only the EPIDERMIS, causes redness, swelling and pain; it heals within a few days. A partial thickness burn (epidermis and DERMIS) causes intense pain, with mottling and blistering of the skin; it takes a couple of weeks to heal. In a full thickness burn, involving both the skin and the underlying flesh, there is charring, and the damaged flesh looks dry and leathery; there is no pain because the nerve endings have been destroyed. Such a burn, serious in itself, is associated with life-threatening complications, including dehydration and infection. Treatment includes fluid replacement and antibiotics; skin grafting may be necessary.

Burne-Jones, Sir Edward Coley (1833–98) English painter and designer. He was influenced by Dante Gabriel ROSSETTI and William MORRIS, and was associated with the PRE-RAPHAELITE BROTHERHOOD'S romanticism and escapism.

BURMA

The colours on Burma's flag were adopted in 1948 when the country became independent from Britain. The Socialist symbol, added in 1974, includes a ring of 14 stars for the country's states. The gearwheel represents industry and the rice plant agriculture.

Burma is officially called the Union of Myanmar. The most densely populated part of the country is the valley of the River Irrawaddy. Mandalay, Burma's second largest city, lies on the banks of the river. The capital, Rangoon, lies on the shores of the Andaman Sea. Burma's land borders are formed by a chain of Himalayan mountains, which rise in the N to 5,881m (19,294ft). In the E, lies the Shan Plateau, home to the Shan tribe. Burma is federated into tribal areas. Sittwe is the main port of the Arakan region, on the Bay of Bengal. In the se, lies the Tenassserim region, which includes the port of Moulmein.

CLIMATE AND VEGETATION

Burma has a tropical monsoon climate. The humid rainy season lasts from late May to mid-October. Rainfall generally decreases as you move inland. Mandalay is relatively dry, with an annual rainfall of 50–100cm (20–50in). The Irrawaddy delta is one of the world's largest rice-growing areas. About 50% of Burma is covered by forest.

HISTORY AND POLITICS

Burma's early history was dominated by conflict between the Burmans and Mons. In 1044 the Burman king Anawratha unified the Irrawaddy delta region. In 1287 Kublai Khan conquered the Burman capital, Pagan. Burma was divided: the Shan controlled N Burma, while the resurgent Mons held the s. In the 16th century the Burmans subjugated the Shan. In 1758 Alaungapaya reunified Burma by defeating the Mons kingdom based around Mandalay and established the Konbaung dynasty. The 19th century was marked by wars between the dynasty and British India. The first war (1824) resulted in the British gaining the coastal regions of Tenasserim

AREA: 676,577 sq km (261,228 sq mi)

POPULATION: 43,668,000

CAPITAL (POPULATION): Rangoon (Yangon,

2.458.712)

GOVERNMENT: Military regime

ETHNIC GROUPS: Burman 69%, Shan 9%, Karen

6%, Rakhine 5%, Mon 2%, Kachin 1% LANGUAGES: Burmese (official)

RELIGIONS: Buddhism 89%, Christianity 5%,

Islam 4%

CURRENCY: Kyat = 100 pyas

and Arakan. The second war (1852) saw the British gain control of the Irrawaddy delta, and in the third (1885) Burma was annexed to British India. In 1937 Burma gained limited self-government. Helped by the Burmese Independent Army, led by AUNG SAN, Japan conquered the country in 1942. The installation of a puppet regime, led Aung San to form a resistance movement. In 1947 Aung San was murdered. Burma achieved independence in 1948. The socialist AFPFL government, led by U Nu, was faced with secessionist revolts by communists and Karen tribesmen. In 1958 U Nu invited General NE WIN to re-establish order. Civilian government was restored in 1960, but in 1962 Ne Win mounted a successful coup. His military dictatorship was faced with mass insurgency. and by 1973 anti-government forces controlled a third of Burma. In 1974 Ne Win became president. Massive demonstrations forced Ne Win to resign (1988), but the military remained in control in the guise of the State Law and Order Restoration Council (SLORC) led by General Saw Muang. In 1989 the country's name was changed to Myanmar. Elections in 1990 were won by the National League for Democracy, led by AUNG SAN SUU KYI, but SLORC annulled the result. The country has an unenviable reputation for abuses of human rights.

ECONOMY

Burma is one of the world's poorest nations (1992 GDP per capita, \$751). Agriculture is the main activity, employing 64% of the workforce, mainly at subsistence level. Teak and rice constitute about two-thirds of exports. It has many mineral resources, mostly unexploited. Burma is famous for its precious stones, especially rubies.

He often depicted scenes from Arthurian and similar legends, and was considered an outstanding designer of stained glass.

Burnett, Frances (1849–1924) US author, b. England. She is chiefly remembered as the author of the children's classics *Little Lord Fauntleroy* (1886), *The Little Princess* (1905) and *The Secret Garden* (1911), although she also wrote adult novels and plays.

Burney, Fanny (1752–1840) English novelist, dramatist and diarist. The daughter of the musicologist Dr Charles Burney, she achieved fame with her debut novel, *Evelina* (1778), a semi-satirical, semi-sentimental look at polite society through the eyes of a young innocent. This was followed by similar works such as *Cecilia* (1782), *Camilla* (1796) and *The Wanderer* (1814). Her writings greatly influenced Jane Austen.

Burnham, Daniel Hudson (1846–1912) US architect and city planner. With his partner John W. Root, he pioneered the development of early steel-frame and modern commercial architecture. Designs include the Reliance Building (1890) and the Masonic Temple Building (1891), both in Chicago.

Burns, Robert (1759–96) Scottish poet. The success of *Poems, Chiefly in the Scottish Dialect* (1786), which includes "The Holy Fair" and "To a Mouse", enabled him to move to Edinburgh, where he was admired as "the heaven-taught ploughman". Although popular, he could not support himself from his poetry and so became an excise officer. Scotland's unofficial national poet, his works include "Tam o'Shanter" (1790) and the song "Auld Lang Syne". An annual Burns night is held on his birthday, 25 January.

Burnside, Ambrose Everett (1824–81) US Civil War general. He participated in the First Battle of BULL RUN (1861). He led the Army of the Potomac in the Union defeat at Fredericksburg (1862). He was relieved of command of the 9th Corps following Petersburg (1864). After the war, he was governor of Rhode Island and a senator (1875–81).

Burr, Aaron (1756-1836) US statesman, vice president (1801–05). A veteran of the American Revolution, Burr was senator for New York (1791-97). His contribution to the formation of a Republican legislature in New York (1800), ensured the election of a Republican president. Burr was meant to become vice president, but confusion in the ELEC-TORAL COLLEGE resulted in a tie for president between Burr and Thomas JEFFERSON. Jefferson was elected with the support of Alexander Hamilton. This mix-up led to the adoption of the 12th amendment to the US Constitution. Burr was an able vice president and was nominated for governor of New York. Hamilton led public attacks on Burr's suitability, which resulted in a duel (1804). Burr killed Hamilton and effectively ended his political career. Embittered, he embarked on an apparent conspiracy to establish an independent republic in sw USA. He was tried for treason but was acquitted (1807).

Burra, Edward John (1905–76) British painter. Fascinated with the urban life of Harlem, New York, and the Marseilles docks, some of his most famous paintings are the Harlem scenes (1933–34). In the mid-1930s he turned to fantastic imagery, akin to SURREALISM. His later paintings, such as *Soldiers* and *War in the Sun*, were provoked by the tragedies of the Spanish Civil War and World War 2.

Burroughs, Edgar Rice (1875–1950) US author of adventure novels. A prolific writer, he is best known as the creator of the apeman Tarzan, who featured in a series of books, beginning with *Tarzan of the Apes* (1912).

Burroughs, William S. (Seward) (1914–97) US novelist, regarded as one of the founders of the BEAT MOVEMENT. His most notable work, *Naked Lunch* (1959), deals in part with his herion addiction. Other works, experimental in style, include *The Ticket That Exploded* (1962), *The Wild Boys* (1971), and *The Western Lands* (1987).

bursitis Inflammation of the fluid-filled sac (bursa) surrounding a joint. It is characterized by pain, swelling and restricted movement. Treatment generally includes rest, heat and gentle exercise. "Housemaid's knee", "tennis elbow" and bunions are common forms of bursitis.

Burton, Richard (1925–84) Welsh stage and film actor, remembered for his deep, passionate and fiery voice. By the 1950s he had a reputation as a leading Shakespearian actor.

He made his film debut in *The Last Days of Dolwyn* (1948). From 1952 he concentrated on cinema, appearing in *The Robe* (1953), *Look Back in Anger* (1959) and *Becket* (1964). He made a number of films with Elizabeth Taylor, notably *Who's Afraid of Virginia Woolf?* (1966). The couple had a tempestuous relationship including two marriages.

Burton, Sir Richard Francis (1821–90) British explorer and scholar. In 1853 he travelled in disguise to Medina and Mecca, one of the first Europeans to visit the holy cities. On his second trip to E Africa, with John Speke in 1857, he discovered Lake Tanganyika. The author of many books, he was best known for his translation of the *Arabian Nights* (1885–88).

Burundi Republic in E central Africa. *See* country feature, p.118

Busby, Sir Matt (1909-94) Scottish football player and manager. Busby played for Manchester City, Liverpool and Scotland, before becoming manager (1945-69) of Manchester United. He survived the 1958 Munich air disaster (in which most of the famous "Busby Babes" died) to build his third great side, and the first English club to win the European Cup (1968). Bush, George Herbert Walker (1924-) 41st US president (1989-93). Bush served as a fighter pilot during World War 2. In 1966 he entered Congress as a representative of Texas. Under President Richard Nixon, he held several political offices, including ambassador (1971-73) to the United Nations. Under President Gerald Ford, Bush was head (1976–77) of the Central Intelligence Agency (CIA). In 1980, after failing to secure the presidential nomination, he became vice president (1981-88) to Ronald REAGAN. When Reagan retired, Bush gained the Republican nomination. In the 1988 presidential election he easily defeated the challenge of Michael Dukakis. For many Americans, the collapse of Soviet communism was a vindication of the hawkish policies of the Reagan-Bush years. In 1989 the US military invaded Panama and seized General Manuel Noriega. Iraq's invasion (1990) of Kuwait provided the first test of Bush's "new world order" and a threat to America's oil supplies. The Allied forces, led by General SCHWARZKOPF, won the GULF WAR (1991), but failed to remove Saddam HUSSEIN. At home, Bush was faced with a stagnant economy, high unemployment and a massive budget deficit. He was forced (1990) to break his election pledge and raise taxes. This factor, combined with a split in the conservative vote, led to a comfortable victory for his Democratic successor Bill CLINTON.

bushbaby (galago) Primitive, squirrel-like PRIMATE of African forests and bushlands. It is usually grey or brown with a white stripe between its large eyes. It is a gregarious nocturnal tree-dweller which can be domesticated. Length: (excluding tail) to 38cm (15in). Family Lorisidae; genus *Galago*.

bushido (Jap. way of the samurai) Moral discipline important in Japan between 1603 and 1868. It arose from a fusion of Confucian ethics and Japanese feudalism. Requiring loyalty, courage, honour, politeness and benevolence, Bushido paralleled European chivalry. Although not a religion, Bushido involved family worship and Shinto rites.

bushmaster Largest pit VIPER, found in central America and N South America. It has long fangs and large venom glands, and is pinkish and brown with a diamond pattern. Length: up to 3.7m (12ft). Family Viperidae; subfamily Crotalidae.

bustard Large bird found in arid areas of the Eastern Hemisphere. Its plumage is grey, black, brown and white and its neck and legs are long; in appearance it is quite ostrich-like. A swift runner and a strong, though reluctant flier, it feeds on small animals and lays up to five eggs. Family Otidae. Height: 1.3m (4.3ft).

butane Colourless flammable gas (C_4H_{10}) , the fourth member of the ALKANE series of HYDROCARBONS. It has two ISOMERS: n-butane is obtained from natural gas; isobutane is a byproduct of PETROLEUM refining. Butane can be liquefied under pressure at normal temperatures and is used in the manufacture of fuel gas and synthetic rubber. Properties: b.p. (n-butane) -0.3°C (31.5°F) and (isobutane) -10.3°C (13.46°F). **Buthelezi, Mangusuthu Gatsha** (1928–) ZULU chief and politician. Buthelezi was installed as chief of the Buthelezi tribe in 1953 and became chief minister of KwaZulu, a "ban-

tustan" within APARTHEID South Africa in 1970. In 1975 he founded INKATHA. Accusations of complicity in apartheid led to violence between Inkatha and the rival AFRICAN NATIONAL CONGRESS (ANC) in the early 1990s. Buthelezi acted as minister for home affairs (1994–) in the MANDELA government.

Butler, Samuel (1835–1902) British satirical writer. His famous novel *Erewhon* (1872) is a classic utopian criticism of contemporary social and economic injustice. He produced a sequel to his early masterpiece, *Erewhon Revisited* (1901), and the autobiographical *The Way of All Flesh* (1903), a biting attack on Victorian life and the values of his own upbringing. butter Edible fat made from milk. A churning process changes the milk from a water-in-oil emulsion to an oil-inwater emulsion. The fat (oil) globules of the milk collide and coalesce, losing their protective shield of protein and turning into butter, thus separating out from the more watery whey. Commercial butter contains about 80% fat, 1–3% added salt, 1% milk solids and 16% water.

buttercup Herbaceous flowering plant found worldwide; the many species vary considerably according to habitat, but usually have yellow or white flowers and deeply-cut leaves. Family Ranunculaceae; genus *Ranunculus*.

butterfly Day-flying INSECT of the order Lepidoptera. The adult has two pairs of scale-covered wings that are often brightly coloured. The female lays eggs on a selected food source and the (CATERPILLAR) larvae emerge within days or hours. The larvae have chewing mouthparts and often do great damage to crops until they reach the "resting phase" of the life cycle, the pupa (chrysalis). Within the pupa, the adult (imago) is formed with wings, wing muscles, antennae, a slender body and sucking mouthparts. The adults mate soon after emerging from the chrysalis, and the four-stage life cycle begins again. See also METAMORPHOSIS

butterwort Large group of carnivorous bog plants that trap and digest insects in a sticky secretion on their leaves. They bear single white, purple or yellow flowers on a leafless stalk. The sides of the leaves roll over to enclose the insect while it is digested. Family Lentibulariaceae; species *Pinguicula*. *See also* INSECTIVOROUS PLANT

buttress Mass of masonry built against a wall to add support or reinforcement. Used since ancient times, buttresses became increasingly complex and decorative in medieval architecture. Gothic Architecture often featured marvellously daring flying buttresses.

BURUNDI

This flag was adopted in 1966 when Burundi became a republic. It contains three red stars rimmed in green, symbolizing the nation's motto of "Unity, Work, Progress". The green represents hope for the future, the red the struggle for independence, and the white the desire for peace.

Burundi is the fifth smallest country on the mainland of Africa, and the second most densely populated (after its neighbour RWANDA). West Burundi is part of the Great RIFT VALLEY, which includes Lake TANGANYIKA. The capital, BUJUMBURA, lies on its shores. East of the Rift Valley are high mountains, reaching 2,760m (8,760ft). In central and E Burundi, the land descends in a series of step-like grassy plateaux, home to the majority of Burundi's population.

CLIMATE AND VEGETATION

Bujumbura has a warm climate. A dry season lasts from July to September. The mountains

R W A N D A

R W A N D A

Ngozi

Muyinga

A B U R U N D I

i Bujumbura

R E

Source of the Nile

Bururi

AMt Teza

Zobbo

TANZANIA

Lake

Tanganyika

MAP SCALE

JOO km

and plateaux are cooler and wetter. Rainfall generally decreases to the E. Grassland covers much of Burundi. The land used to be mainly forest, but farmers have cleared most of the trees.

HISTORY AND POLITICS

The Twa pygmies were the first known inhabitants of Burundi. About 1,000 years ago, Bantuspeaking Hutus gradually began to settle in the area, displacing the Twa. From the 15th century the Tutsi, a tall, cattle-owning people, gradually gained control of Burundi. The Hutu majority were forced into serfdom. Germany conquered the area that is now Burundi and Rwanda in the 1890s. The area, called Ruanda-Urundi, was occupied by Belgium in 1916 and became a trust terrritory. In 1962 Burundi became an independent monarchy, ruled by a Tutsi king. In 1965 an attempted Hutu coup against the monarchy was foiled and resulted in violent Tutsi reprisals. In 1966 the monarchy was overthrown and a republic was established. Another attempted coup led to the establishment of an authoritarian, oneparty state (1969). In the early 1970s, further Hutu rebellions were ruthlessly crushed. During the mid-1980s, the Tutsi government introduced limited reforms to quell ethnic divisons. In 1988 another Hutu coup led to massacres by the Tutsidominated army. A new constitution (1991) resulted in multi-party politics and the election (1993) of a Hutu president, Melchior Ndadaye. In 1993 Ndadaye was assassinated in a military coup. Two months of civil war left over 50,000 dead and created 500,000, mainly Hutu, refugees. Ndadaye was succeeded by another Hutu, Cyprien Ntaryamira. In April 1994 AREA: 27,830 sq km (10,745 sq mi)

POPULATION: 5,786,000

CAPITAL (POPULATION): Bujumbura (300,000)

GOVERNMENT: Republic

ETHNIC GROUPS: Hutu 85%, Tutsi 14%, Twa

(pygmy) 1%

LANGUAGES: French and Kirundi (both official) RELIGIONS: Christianity 85% (Roman Catholic

78%), traditional beliefs 13%

currency: Burundi franc = 100 centimes

Ntaryamira and Rwanda's president Habyarimana were killed in a rocket attack. A coalition government was unable to contain the genocide, which continued throughout 1995. In 1996 the Tutsi army, led by Pierre Buyoya, seized power. The international community imposed sanctions, but the instability and "ethnic cleansing" that has dominated the region in the 1990s continued.

ECONOMY

Burundi is one of the world's ten poorest countries (1992 GDP per capita, \$US720). Over 90% of the workforce are engaged in agriculture, mostly at subsistence level. The main food crops are beans, cassava, maize and sweet potatoes. Burundi is reliant on food imports. Coffee accounts for 80–90% of its export earnings. Manufacturing is on a small scale.

This 50-centime stamp, issued in 1964, shows impalas, among the most graceful of Africa's antelopes. In 1964, Burundi was a monarchy, as shown by the wording on the stamp – the French word Royaume means Kingdom. Two years later, Burundi's mwami (king) was overthrown and the country became a republic.

Buxtehude, Diderik (Dietrich) (1637–1707) Danish organist and composer known for his organ and church music. He was organist at Lübeck and became well-known for his evening concerts, *Abendmusik*, for which he composed many works. He wrote many sacred choral works, especially cantatas, a large number of organ compositions and much chamber music. J.S. BACH was greatly influenced by him.

buzzard Slow-flying bird with broad, rounded wings, fanshaped tail, sharp, hooked beak, and sharp talons. The name is used in reference to many BIRDS OF PREY, as in North America for hawks and vultures. Family Accipitridae; genus *Buteo*.

Byatt, A.S. (Antonia Susan) (1936–) British novelist and critic, sister of Margaret Drabble. Byatt was known as an acedmic literary scholar until the publication of her third novel, *The Virgin in the Garden* (1978). *Possession*, a literary mystery story and romance spanning two centuries, won the 1990 Booker Prize. She has written studies of Wordsworth, Coleridge and Iris Murdoch. Her recent work includes the novellas *Angels and Insects* (1993) and *The Djinn in the Nightingale's Eye* (1994). She was awarded the CBE in 1990. Byblos Ancient city of the Phoenicians, in Lebanon, 27km (17mi) N of BEIRUT. Byblos was a centre of Phoenician trade with Egypt from the 2nd millennium BC, and was particularly famous as a source of PAPYRUS. The Greek word for "book" derived from its name. Byblos was abandoned after its capture by the Crusaders in 1103.

Byrd, Richard Evelyn (1888–1957) US polar explorer. A naval officer and aviator, Byrd led five major expeditions to the Antarctic (1928–57), surveying more than 2,200,000sq km (845,000sq mi) of the continent. Among other feats, he claimed to be the first man to fly over both the North Pole (1926) and the South Pole (1929).

Byrd, William (1543–1623) English composer. He was appointed by Elizabeth I to be joint organist of the Chapel Royal with Thomas TALLIS, whom he succeeded in 1585. With Tallis, he was granted England's first monopoly to print music. Byrd was a master of all the musical forms of his day, but was especially celebrated for his madrigals and church music.

Byron, George Gordon Noel Byron, 6th Baron (1788–1824) British poet. After a childhood scarred by the handicap of a clubfoot and maltreatment by his mother, he went to Trinity College, Cambridge (1805). Although he achieved notice with the satire *English Bards and Scotch Reviewers* (1809), it was with the first two cantos of *Childe Harold's Pilgrimage* (1812) that he became famous. His romantic image and reputation for dissolute living and numerous sexual affairs vied with his poetic reputation. By 1816 he was a social outcast and went into permanent exile. Abroad, Byron wrote Cantos III and IV of *Childe Harold* (1816, 1818) and *Don Juan* (1819–24), an epic satire often regarded as his masterpiece. In 1823 he travelled to Greece to fight for Greek independence against the Turks and died of fever at Missolonghi.

byte Binary number used to represent the letters, numbers and other characters in a computer system. Each byte consists of the same number of BITS (binary digits). Each bit has two possible states, represented by the binary numbers 0 and 1. Byte is a contraction of "by eight", and originally meant an eight-bit byte, such as 01101010 (representing j). Some computers now use 16- or 32-bit bytes. A typical personal computer memory can store up to 4Mb (4 Megabytes, or 4 million bytes).

Byzantine art and architecture Art produced in the Roman empire E of the Balkans. Its greatest achievements fall within three periods. The first Golden Age coincided with the reign of JUSTINIAN I (527–65) and saw the construction of the

The life-cycle of the European swallowtail (*Papilio machoan*) is typical of most butterflies. The female adult (1) lays her eggs (2) on the underside of leaves in batches of 100 or more. The eggs hatch into the first stage larva or caterpillar (3). The caterpillar moults

several times before it is fully grown (4). After the final moult the caterpillar's skin hardens (4, 5) to form the case of the pupa or chrysalis (6). Within the case the tissues of the caterpillar reorganize before the adult butterfly emerges (1).

HAGIA SOPHIA. The second Golden Age refers to the artistic revival, which occurred during the time of the Macedonian emperors (867–1057) and which followed the terrible destruction caused by the Iconoclastic Controversy. Finally, the last years of the empire, under the rule of the Palaeologs (1261–1453), are often referred to as the Byzantine Renaissance. Most Byzantine art was religious in subject matter and combined Christian imagery with an oriental expressive style. The MOSAIC and ICON were the most common forms. Byzantine church architecture is typically central rather than longitudinal, and the central dome (surrounded by groupings of smaller or semi-domes) is supported by means of pendentives. Construction is of brick arranged in decorative patterns and mortar. Interiors are faced with marble slabs, coloured glass mosaics, gold leaf and fresco decoration.

Byzantine empire Christian, Greek-speaking, Eastern ROMAN EMPIRE, which outlasted the Roman empire in the West by nearly 1,000 years. Constantinople (Byzantium or ISTANBUL) was established by the Roman emperor Constan-TINE I in AD 330. The area of the Byzantine empire varied greatly and its history from c.600 was marked by continual military crisis and heroic recovery. At its height under JUSTIN-IAN I in the 6th century, it controlled, besides Asia Minor and the Balkans, much of the Near East and the Mediterranean coastal regions of Europe and North Africa. Of its many enemies, the most formidable were the Arabs, who overran the Near Eastern provinces in the 7th century; the Slavs and Bul-GARS, who captured most of the Balkans, and the Seljuk Turks. From 1204 to 1261 it was controlled by usurping Crusaders from w Europe and, although Constantinople was recovered, Byzantine territory shrank under pressure from the West and from the Ottoman Turks, who finally captured Constantinople in 1453, extinguishing the Byzantine empire.

C

C/c, third letter of the alphabet, derived from the Greek gamma and the Semitic gimel. It originally had a hard sound (like k), but before e, i or y took on a sibilant sound (like s), or had an h added to create the ch sound. Followed by a, o, u or any other consonant (except h), c normally has a hard sound.

▲ cabbage (1), broccoli (2), cauliflower (3), and brussels sprouts (4) all belong to the same Brassica species although they differ greatly in appearance. Like curly kale (5), they are all hardy and some varieties can stand quite cold winters.

Caballé, Montserrat (1933–) Spanish soprano. She made her debut as Mimì in Puccini's *La Bohème* (1957) and performed at the METROPOLITAN OPERA (1965). She specializes in Verdi and Donizetti.

cabbage Low, stout vegetable of the genus *Brassica*. Members include Brussels sprouts, cauliflowers, broccoli, kohlrabi, and turnips. They are all biennials that produce "heads" one year and flowers the next. The common cabbage (*Brassica oleracea capitata*) has an edible head and large, fleshy leaves. Its diverse varieties are classified by the shape of their heads, growth cycle or colour. They grow in temperate regions. Family Brassicaceae/Cruciferae.

cabbage white butterfly BUTTERFLY, the green caterpillar of which is a common pest on cabbage plants. The female adult is almost completely white except for black spots on its wings; the male has no forewing spots. Species *Pieris brassicae*.

cabbala (kabbala) Form of Jewish mysticism. It holds that every word, letter, number, even accent of the Bible contains mysteries to be interpreted, often in the form of codes for YAHWEH. The earliest extant cabbalist work is the 3rd century *Sefir Yezirah* (Book of Creation). Cabbalism spread throughout Europe in the 13th century, and is still practised by some Hasidic Jews.

Cabeza de Vaca, Álvar Núñez (1490–1557) Spanish explorer. In 1528 he was shipwrecked off the Texas coast. He and three fellow survivors became the first Europeans to explore the American Southwest, eventually settling in Mexico (1536). His *Comentarios* (1555) recount hardships endured in South America, where he served as governor (1542–45) of the province of Río de la Plata.

Cabinda Province of Angola, sw Africa, N of the River Congo, bounded w by the Atlantic Ocean and separated from the rest of Angola by Zaïre; the seaport and chief town is Cabinda. The Simulambuco Treaty (1885) politically unified Cabinda with Angola. Cabinda refuses to recognize the treaty and claims independence from Angola. There are important offshore oilfields. Industries: oil refining, palm, timber, cacao. Area: 7,270sq km (2,808sq mi). Pop. (1992 est.) 152,100.

cabinet Body of people collectively responsible to the legislature for government in a parliamentary system. Most cabinet ministers have individual responsibility for the management of a department of state. In the UK, cabinet ministers are chosen by the prime minister, but officially appointed by the crown. A cabinet minister need not sit in either House of Parliament, but usually sits in the House of Commons. In a presidential system, cabinets may be formed out of heads of major departments, but have only advisory status in relation to the president. Most present-day cabinets have about 20 members. cable Wire for mechanical support, for conducting electricity or carrying signals. In civil and mechanical engineering, a cable is made of twisted strands of steel wire. They range in size from small bowden cables to massive supporting cables on the decks of suspension bridges. In electrical engineering, a cable is a conductor consisting of one or more insulated wires, which may be either single or multi-stranded. They range greatly in size, from cables used for domestic wiring to the large, armoured underwater cables. These are used for telephone, radio, television and data signals. In a coaxial cable one conductor is cylindrical and surrounds the other. FIBRE OPTIC cables carry signals in the form of coded pulses of light. cable television Generally refers to community antenna television (CATV). CATV does not broadcast, but picks up signals at a central antenna and delivers them to individual subscribers via coaxial CABLES. Originally designed for areas with poor reception and no local station, cable television, run by private franchise, now serves to increase the variety of local viewing by transmitting channels brought by microwave relay.

Cabot, John (c.1450–98) Italian navigator and explorer in English service. Supported by Henry VII, he sailed in search of a western route to India, and reached Newfoundland (1497). His discovery served as the basis for English claims in North America. His account of the Newfoundland fisheries encouraged fishermen from European Atlantic ports to follow his route.

Cabral, Pedro Alvares (1467–1520) Portuguese navigator

who discovered Brazil. In 1500 he led an expedition to the East Indies on the route pioneered by Vasco da GAMA. To avoid contrary winds and currents, he took a westward course in the Atlantic and touched on the coast of Brazil, which he claimed for Portugal.

Cabrini, Saint Frances Xavier (1850–1917) US foundress of orphanages, hospitals, schools and convents, b. Italy; the first US citizen to be canonized (1946). She became a nun in 1877, founded the Institute of Missionary Sisters of the Sacred Heart (1880), and moved to the USA (1889). Her feast day is 22 December.

cacao See COCOA

Caccini, Giulio (1550–1618) Italian composer, one of the Florentine *camerata* group which pioneered OPERA. His opera *Euridice* was the first to be printed (probably 1601), and his *Le Nuove Musiche* (1602) was one of the most influential collections of vocal music in the new monodic style.

cactus Any of more than 2,000 species of succulent plants, found particularly in hot desert regions of the Western Hemisphere. Cactus' long roots enable it to absorb moisture from desert terrains and the fleshy green stem is adapted to water storage with a waxy coating to restrict evaporation. Stems are usually spiny, cylindrical and branched. Cactus flowers are usually borne singly in a wide range of colours. Their height ranges from less than 2.5cm (1in) to more than 15m (50ft). See also XEROPHYTE

caddis fly Any of several moth-like insects of the order Trichoptera. Adults have long, many-jointed antennae, hold their wings tent-like over the body and usually grow about 25mm (1in) long.

cadence In music, ending of a melodic phrase and/or its accompanying CHORD progression. In Western classical theory, the main kinds of chordal cadence are: **perfect** (dominant to tonic chords); **imperfect** (tonic or other chord to dominant); **plagal** (subdominant to tonic); and **interrupted** (dominant to chord other than tonic, often submediant).

Cádiz Port in sw Spain, on the Gulf of Cádiz; capital of Cádiz province (founded 1100 BC). It became an important port for shipping routes to the Americas, and in 1587 a Spanish fleet was burned here by Sir Francis Drake. It has a 13th-century cathedral, art and archaeological museums. Industries: shipbuilding, sherry, olives, salt, fishing. Pop. (1991) 153,550.

cadmium (symbol Cd) Silvery-white metallic element in group II of the periodic table, first isolated in 1817 by the German chemist Friedrich Stromeyer. Cadmium is mainly obtained as a by-product in the extraction of zinc and lead. Malleable and ductile, it is used in electroplating, as an absorber of neutrons in nuclear reactors, and in nickel-cadium batteries. Properties: at.no. 48; r.a.m. 112.4; r.d. 8.65; m.p. 320.9°C (609.6°F); b.p. 765°C (1,409°F); most common isotope Cd¹¹⁴ (28.86%).

caecilian Underground burrowing amphibian found in Central and South America, s Asia and Africa. Its worm-like body varies from $c.18-135\,\mathrm{cm}$ (7–53in) in length and its colour from black to pink. There are sensory tentacles between the eyes, which are tiny and often useless.

caecum Dilated pouch at the junction of the small and large intestines, terminating in the APPENDIX. It has no known function in humans. In rabbits and horses, the caecum contains microorganisms which help to break down the cellulose cell walls of the plants they eat.

Caedmon Earliest known English poet, dating from around the 7th century. According to Bede, he was an illiterate herdsman of Whitby Abbey, Yorkshire, who was commanded in a vision to turn the scriptures into poetry. His only surviving work is the fragmentary *Hymn on the Creation*.

Caernarvon (Caernarfon) Market town on the Menai Strait, Gwnedd, NW Wales. It has a 13th-century castle built by Edward I, whose son, Edward II, was crowned the first Prince of Wales (1301). The Princes of Wales are now invested here (most recently, in 1969, CHARLES). The principal industry is tourism. Pop. (1992 est.) 9,600.

Caesar Name of a powerful family of ancient Rome. The most illustrious representative was Julius CAESAR. The name became the title for the Roman emperor in 27 BC on the

accession of Octavius (later AUGUSTUS), adopted son of Julius Caesar. *Tsar* and *kaiser* are derived from it.

Caesar, (Gaius) Julius (100-44 BC) Roman general and statesman. A great military commander and brilliant politician, he defeated formidable rivals to become dictator of Rome. After the death of SULLA, Caesar became military tribune. As pontifex maximus, he directed reforms in 63 BC that resulted in the Julian CALENDAR. He formed the First Triumvirate in 60 BC with POMPEY and CRASSUS, instituted agrarian reforms and created a PATRICIAN-PLEBEIAN alliance. He conquered Gaul for Rome (58-49 BC) and invaded Britain (54 BC). Refusing Senate demands to disband his army, he provoked civil war with Pompey. Caesar defeated Pompey at Pharsalus in 48 BC and pursued him to Egypt, where he made CLEOPATRA queen. After further victories, he returned to Rome in 45 BC and was received with unprecedented honours, culminating in the title of dictator for life. He introduced popular reforms, but his growing power aroused resentment. He was assassinated in the Senate on 15 March by a conspiracy led by CASSIUS and BRUTUS. Caesar bequeathed his wealth and power to his grandnephew, Octavian (later Augustus) who, together with Mark ANTONY, avenged his murder.

Caesarean section See Caesarean BIRTH

caesium (symbol Cs) Rare silvery-white metallic element in group I of the PERIODIC TABLE; the most alkaline and electropositive element. Discovered in 1860 by Robert BUNSEN and Gustav KIRCHHOFF, caesium is ductile and used commercially in photoelectric cells. The isotope Cs¹³⁷ is used in cancer treatments. The decay rate of its most common isotope Cs¹³³ is the standard for measuring time. Properties: at.no. 55; r.a.m. 132.9055; r.d. 1.87; m.p. 28.4°C (83.1°F); b.p. 678°C (1.252.4°F). *See also* ALKALI METALS; ATOMIC CLOCK

caffeine $(C_8H_{10}N_4O_2)$ White, bitter substance that occurs in coffee, tea and other substances, such as cocoa and ilex plants. It acts as a mild, harmless stimulant and DIURETIC, although an excessive dose can cause insomnia and delirium. **Cage, John** (1912–92) US avant-garde composer. He experimented with new sound sources, believing that all sounds, including noise and silence, are valid compositional materials. He worked with percussion orchestras and invented the "prepared piano", modified by fixing objects to the strings. He used chance in his compositions: *Imaginary Landscape* (1951) is written for 12 randomly tuned radios; *Reunion* (1968) consists of electronic sounds created by chess moves on an electric board; 4'33'' (1952) has no sound, except for the environment in which it is performed.

Cain First-born son of Adam and Eve, brother of Abel. His story is recounted in Genesis 4. God accepted Abel's offering in preference to Cain's and Cain murdered Abel in anger. Marked by God to preserve him from being murdered, Cain was driven out from the Garden of Eden.

Cairngorms Range of mountains in NE central Scotland, in the Grampian region. A major British winter sports area, the highest peak, Ben Macdhui, 1,309m (4,296ft), is the second highest point in the British Isles.

Cairo (Al-Qahirah) Capital of Egypt and port on the River Nile. The largest city in Africa, Cairo was founded in AD 969 by the Fatimid dynasty and subsequently fortified by SAL-ADIN. Medieval Cairo became capital of the MAMELUKE empire, but declined under Turkish rule. During the 20th century it grew dramatically in population and area. Nearby are world-famous archaeological sites, the SPHINX and the PYRA-MIDS of GIZA; museums include the Museum of Egyptian Antiquities and Museum of Islamic Art. Old Cairo is a world heritage site containing over 400 mosques and other fine examples of ISLAMIC ART AND ARCHITECTURE. Its five universities include the world's oldest, housed in the mosque of Al Azhar (972) and the centre of SHITTE Koranic study. Industries: tourism, textiles, leather, iron and steel, sugar refining. Pop. (1992 est.) 6,663,000. See also Egyptian Architecture Cajun French-speaking settlers in Louisiana. They were driven from Nova Scotia (then Acadia) by the British in the 18th century. Cajun music is a popular style.

calabash gourd (bottle gourd) Tropical vine with oval leaves and white flowers. It grows to 9–12m (30–40ft). Its

smooth, hard fruit is bottle-shaped and grows to 180cm (6ft) long. Family Cucurbitaceae; species *Lagenaria vulgaris*.

Calabria Region in s Italy, including the provinces of Catanzaro, Cosenza and Reggio di Calabria. The capital is Reggio di Calabria. The local economy is almost exclusively agricultural. Area: 15,080sq km (5,822sq mi). Pop. (1992) 2,074,763. Calais City and seaport on the Strait of Dover, N France. A major commercial centre and port since the Middle Ages, it fell to the English in 1347, but returned to France (1558). Heavy fighting during World War 2 destroyed much of its fine architecture. Industries: lace making, chemicals, paper. Pop. (1990) 75,309.

calcium (symbol Ca) Common silvery-white metallic element of the ALKALINE-EARTH METALS; first isolated in 1808 by Sir Humphry DAVY. It occurs in many rocks and minerals, notably LIMESTONE and GYPSUM, and in bones. Calcium helps regulate the heartbeat and is essential for strong bones and teeth. The metal, which is soft and malleable, has few commercial applications but its compounds are widely used. It is a reactive element, combining readily with oxygen, nitrogen and other non-metals. Properties: at.no. 20; r.a.m. 40.08; r.d. 1.55; m.p. 839°C (1,542°F); b.p. 1,484°C (2,703°F); most common isotope Ca⁴⁰ (96.95%). See also HARDNESS OF WATER calcium carbide (calcium acetylide) Chemical (CaC₂) made commercially by heating coke and calcium oxide (CaO) in an ELECTRIC FURNACE. It reacts with water to yield ETHYNE. Calcium carbide is also used to manufacture ETHANOIC ACID and ETHANAL.

calcium carbonate (CaCO₃) White compound, insoluble in water, that occurs naturally as MARBLE, CHALK, LIMESTONE and calcite. Crystals are in the hexagonal system and vary in form. Calcium carbonate is used in the manufacture of cement, iron, steel and lime, to neutralize soil acidity and as a constituent of antacids. Properties: r.d. 2.7 (calcite).

calcium oxide (quicklime) White solid (CaO) made by heating CALCIUM CARBONATE (CaCO₃) at high temperatures. It is used industrially to treat acidic soil and to make porcelain and glass, bleaching powder, caustic soda, mortar and cement. Calcium oxide reacts with water to form calcium hydroxide (Ca(OH)₂). Calcium oxide was used in the 19th century for producing limelight illumination.

calcium sulphate Chemical compound (CaSO₄) that occurs naturally as the mineral anhydrite. The hydrated form is GYP-SUM, which loses water when heated to form plaster of Paris. **calculus** Branch of mathematics dealing with continuously changing quantities. DIFFERENTIAL CALCULUS is used to find slopes of curves and rates of change of a given quantity with respect to another. INTEGRAL CALCULUS is used to find the areas enclosed by curves. Gottfried Leibniz and Sir Issac Newton independently discovered the fundamental theorem of calculus. This is $\int_a^b f(x) dx = g(b) - g(a)$, where g is any FUNCTION whose DERIVATIVE is the function f.

Calcutta City on the River Hooghly, E India; capital of

▼ Caesar Successful campaigns were waged by Julius Caesar between 58 and 51 BC against the Helvetii, Belgae, Veneti and the Aquitani. He conquered the whole of Gaul and made it a new province, Transalpine Gaul. He twice landed in Britain, near Walmer or Deal in 54 BC. The second expedition was on quite a large scale and Caesar penetrated northward beyond St Albans.

West Bengal state. Founded *c*.1690 by the EAST INDIA COMPANY, it was the capital of India under British rule (1772–1912). It has a university (1857) and several important temples. The major port and industrial centre of E India, Calcutta has one of the world's largest jute-milling industries. Other industries: electrical equipment, chemicals, paper, cotton textiles. Pop. (1991) 4,309,819.

Calder, Alexander (1898–1976) US sculptor. Calder created the mobile, a type of delicate, colourful, kinetic sculpture with parts that move either by motors or air currents. He also developed non-moving scultpures called "stabiles".

caldera Large shallow crater formed when a VOLCANO collapses and the MAGMA migrates under the Earth's crust. The caldera of an extinct volcano, if fed by floodwater, rain or springs, can become a crater lake.

calendar Way of reckoning time for regulating religious, commercial and civil life, and for dating events in the past and future. Ancient Egyptians had a system based on the movement of the star SIRIUS and on the seasons. Calendars are based on natural and astronomical regularities: tides and seasons, movements of the Sun and Earth and phases of the Moon. The basic units are day, month and year. The Earth turns once a day on its axis; the Moon goes round the Earth once a lunar or synodic month (29.53059 days); the Earth takes one year to complete a revolution round the Sun - reckoned as a tropical year this is 365.242199 days. The main difficulty in compiling a calendar is that the month is not an exact number of days and the year not an exact number of months. For convenience, months and days are assigned a whole number of days, and extra days (intercalations) are added at intervals to compensate. In the modern Gregorian or New Style calendar, an extra day (29 February) is added every four years (leap year). The Gregorian calendar was based on the Julian or Old Style solar calendar. This was introduced by Julius Caesar in the 1st century BC and was developed from an earlier Moon-based calendar.

Calgary City at the confluence of the Bow and Elbow rivers, s Alberta, Canada. It was founded in 1875 as a post of the Royal Canadian Mounted Police. It is an industrial and commercial centre, and has a university (1945). Industries: flour milling, timber, brick, cement, oil refining. Pop. (1991) 710,677.

Calhoun, John Caldwell (1782–1850) US statesman and political philosopher, vice president (1825–32). After serving in the House of Representatives (1811–17), he was secretary of war (1817–25). He was vice president under John Quincy ADAMS and Andrew JACKSON, resigning over the NULLIFICATION issue. Calhoun was elected to the Senate and, except for a brief period as secretary of state (1844–45), served until 1850. A staunch advocate of SLAVERY and states' rights, he strongly influenced the South in the course that led to the CIVIL WAR.

California State in w USA, on the Pacific coast; the largest state by population and the third largest in area. The capital is SACRAMENTO. Other major cities include Los Angeles, San FRANCISCO, SAN DIEGO and Oakland. The Spanish explored the coast in 1542, but the first European settlement was in 1769, when Spaniards founded a Franciscan mission at San Diego. The area became part of Mexico and huge cattle ranches were established. Settlers came from the USA and, during the Mexican War, US forces occupied California (1846); it was ceded to the USA at the war's end. After gold was discovered (1848), the GOLD RUSH swelled the population from 15,000 to 250,000 in just four years. In 1850 California joined the Union. In the 20th century, the discovery of oil and development of service industries attracted further settlers. In the w, coast ranges run N to s, paralleled by the Sierra Nevada Mountains in the E; between them lies the fertile Central Valley, drained by the Sacramento and San Joaquin rivers. In the SE is a broad desert area. With a perennial growing season and vast irrigation projects, California is the leading producer of many crops, including a wide variety of fruit and vegetables. Poultry, fishing and dairy produce are also important. Forests cover c.40% of the land and support an important timber industry. Mineral deposits include oil, natural gas, and a variety of ores valuable in manufacturing (the largest economic sector). Industries: aircraft, aerospace equipment, electronic components, missiles, wine. Tourism is also a vital industry. Area: 403,971sq km (155,973sq mi). Pop. (1990) 29,760,021.

California, University of State university in California, USA (founded 1868). The university system comprises nine campuses located throughout the state. Undergraduate study is offered at eight campuses: Berkeley, Davis, Irvine, Los Angeles, Riverside, San Diego, Santa Barbara and Santa Cruz.

California redwood (Sequoia sempervirens) Conifer that grows to a height of more than 100m (330ft), and is one of the tallest trees. Its close relative (also from California) is the less common Big Tree or Wellingtonia (Sequoiadendron giganteum), the heaviest tree in the Western world. SequoiAs live to be more than 4,000 years old. Family Taxodiaceae.

californium (symbol Cf) Radioactive metallic element of the ACTINIDE SERIES, first made in 1950 at the University of California, Berkeley, by alpha-particle bombardment of the curium isotope Cm²⁴². Californium presents biological dangers because one microgram releases 170 million neutrons a minute. Properties: at.no. 98; most stable isotope Cf²⁵¹ (half-life 800 yr). *See also* TRANSURANIC ELEMENTS

Caligula (AD 12–41) (Gaius Caesar) Roman emperor (37–41). Son of Germanicus Caesar, he became emperor after the death of TIBERIUS. He was highly autocratic, made his horse a consul to mock the Senate, and was said to be insane. He was murdered by an officer of the Praetorian Guard and succeeded by his uncle, CLAUDIUS I.

caliph Leader of the Muslim community. After the death of MUHAMMAD, ABU BAKR was chosen to be his caliph (successor). The role was originally elective but later became hereditary. The caliphate was controlled by the dominant dynasty within Islam at the time. The title remained with the Ottoman sultans (1517–1924), after which it was abolished.

Callaghan, (Leonard) James, Baron (1912–) British statesman, prime minister (1976–79). Callaghan entered parliament in 1945 and succeeded Harold WILSON as LABOUR PARTY leader (1976). He is the only prime minister in British history to have held all three major offices of state: chancellor of the exchequer (1964–67), home secretary (1967–70) and foreign secretary (1974–76). Callaghan also has the distinction of being only the second post-war prime minister never to have won a general election. His tenure was marked by delicate negotiations with David STEEL in the Lib-Lab Pact, and strife with the trade unions which culminated in the "winter of discontent". He was defeated by Margaret THATCHER in the 1979 general election and became a life peer in 1987.

Callas, Maria (1923–77) Greek soprano. Her successes at LA SCALA, Milan and the ROYAL OPERA HOUSE, Covent Garden, established her reputation as a leading singing actress. She was particularly admired in the Italian repertoire, especially as PUCCINI's *Tosca*. She made her Metropolitan Opera debut in 1956 in BELLINI's *Norma*.

calligraphy Art of fine writing. Calligraphy is freehand, with components in proportion to each other. In Europe there was a marked difference between uncial hands used for literary works, which are rounded, easily inscribed letters, and cursive hands, used for documents and letters, which are more regularized. Fragments on papyrus from the 3rd century BC show a variety of cursive hands. Several different types of Greek uncials were used in Roman times. During the 8th century the minuscule superseded the uncial for ordinary, commercial purposes. Intentional complexity was developed to prevent forgeries. The 20th century has seen a revival of calligraphy.

Callisto Second-largest and outermost of Jupiter's GALILEAN SATELLITES, with a diameter of 4,800km (3,000mi). It is the most heavily cratered object known. As well as the dark dense craters, there are large, multi-ringed impact features, the largest of which is Valhalla, with a diameter of 4,000km (2,500mi).

callus In botany, a protective mass of undifferentiated plant cells formed at the site of a wound in a woody plant. Callus tissue is also formed at the base of cuttings as they start to take root. It is important as the starting point for TISSUE CULTURE in plants.

calorie Unit of heat. A calorie is the amount of heat required to raise one gram of water one degree Celsius between 14.5 –15.5°C (58.1–59.9°F). The SI system of units uses the JOULE

CALIFORNIA

Statehood: 9 September 1850 Nickname: The Golden State

State bird :

California valley quail State flower: Golden poppy

State tree : California redwood State motto :

Eureka!

(1 calorie = 4.184 joules) instead of the calorie. A dietition's "calorie" is the kilocalorie, 1,000 times larger than a calorie.

Calvin, John (1509–64) French theologian of the Reformation. He prepared for a career in the Roman Catholic Church but turned to the study of classics. In c.1533 he became a Protestant and began work on his *Institutes of the Christian Religion*. In this work he presented the basics of what came to be known as CALVINISM. To avoid persecution, he went to live in Geneva, Switzerland (1536), where he advanced the Reformation.

Calvin, Melvin (1911–) US chemist. He used radioactive carbon-14 as a trace to label carbon dioxide and track the process by which plants turned it into glucose by means of PHOTOSYNTHESIS. The series of reactions that take place during photosynthesis is known as the Calvin cycle. Calvin received the Nobel Prize for chemistry in 1961.

Calvinism Set of doctrines and attitudes derived from the Protestant theologian John CALVIN. The Reformed and Presbyterian churches were established in his tradition. Rejecting papal authority and relying on the Bible as the source of religious truth, Calvinism stresses the sovereignty of God and PREDESTINATION. Calvinism usually subordinates state to

church, and cultivates austere morality, family piety, business enterprise, education and science. The development of these doctrines, particularly predestination, and the rejection of consubstantiation in its eucharistic teaching, caused a split in PROTESTANTISM between LUTHERANISM and PRESBYTERIAN-ISM. The influence of Calvinism spread rapidly. Important Calvinist leaders include John KNOX and Jonathan EDWARDS. cambium In botany, layer of cells parallel to the surface of stems and roots of plants that divides to produce new cells to allow for growth in diameter of the stem and roots. There are two main types of cambium. Vascular cambium produces new PHLOEM on the outside and XYLEM on the inside, leaving narrow bands of thin-walled cells of nutrients and gases to diffuse to the centre of the plant. Cork cambium forms a cylinder just below the epidermis, and produces cork cells to replace the epidermis, which ruptures as the stem and root expand, forming the bark and corky outer layer of the older root. See also MERISTEM

Cambodia Kingdom in SE Asia, see country feature **Cambrian** Earliest period of the PALAEOZOIC era, lasting from c. 590 million to 505 million years ago. Cambrian rocks are the earliest to preserve the hard parts of animals as fossils.

CAMBODIA

Red is the traditional colour of Cambodia. Blue symbolizes the water resources that are so important to the people, 80% of whom depend on farming for a living. The silhouette is the historic temple at Angkor Wat.

AREA: 181,040sq km (69,900sq mi) **POPULATION:** 9,054,000

CAPITAL (POPULATION): Phnom Penh (920,000) GOVERNMENT: Constitutional monarchy ETHNIC GROUPS: Khmer 94%, Chinese 3%, Cham 2%, Thai, Lao, Kola, Vietnamese

LANGUAGES: Khmer (official)
RELIGIONS: Buddhism 88%, Islam 2%

currency: Riel = 100 sen

Cambodia is surrounded by low mountains, vast alluvial plain, drained by the River Mekong. The capital, Phnom Penh, lies on its banks. In the monsoon, the Mekong floods over 160,000ha (400,000 acres) of the plain, greatly aiding rice cultivation. The floods swell the size of Tonle Sap (Great Lake) almost threefold.

CLIMATE AND VEGETATION

Cambodia has a tropical monsoon climate, with constant high humidity and temperatures. Coastal regions have the highest rainfall. The dry season lasts from November to April. Forests cover *c.*75% of Cambodia. In the N mountains, on the border with Thailand, are dense tropical rainforests, while mangrove forests line the coast.

HISTORY AND POLITICS

In the 6th century the KHMER established an empire roughly corresponding to modern-day Cambodia and Laos. In 889 the empire was reunited, with its capital at ANGKOR. The Angkor period (889-1434) was the golden age of Khmer civilization, culminating in the 12th-century construction of Angkor Wat. In 1434 the Thai captured Angkor and the capital was transferred to Phnom Penh. In the 17th-18th centuries Cambodia was a battleground for the empires of Siam and Annam. In 1863 Cambodia became a French protectorate, and was subsumed into the Union of INDOCHINA in 1887. During World War 2 it was occupied by Japan. In 1953 Cambodia achieved full independence from France. Prince NORODOM SIHANOUK became king. In 1955 he abdicated to become prime minister. The VIET-NAM WAR (1954-75) dominated Cambodian politics. Initially, Cambodia received US aid, but in 1963 Sihanouk denounced US interference. The build-up of North Vietnamese troops persuaded Sihanouk to seek US help, and in 1969 the US conducted secret bombing raids on communist bases in Cambodia. In March 1970 Sihanouk was overthrown by Lon Nol, and US and South Vietnamese troops entered Cambodia to destroy North Vietnamese camps. Many innocent civilians were killed and public support rallied to the Cambodian communists (KHMER ROUGE). In October 1970 the Khmer Republic was declared, but the communists already controlled most of rural Cambodia. Civil War broke out. Despite US bombing and military aid, the government continued to lose ground. In 1973 the US Congress halted air attacks. In 1975 the Khmer

Rouge (led by Pol Pot) seized Phnom Penh. Cambodia was renamed **Kampuchea**. A brutal form of peasant politics ensued, and a series of purges left 1–4 million people dead. In 1979 Vietnamese and Cambodian troops overthrew Pol Pot, but fighting continued. Vietnam withdrew in 1989, and in 1992 UN forces began to disarm the various factions. In 1993 elections were held (without the Khmer Rouge) and a coalition government was formed. Sihanouk was restored as king. In 1994 the Khmer Rouge was banned. In 1997 Hun Sen ousted his co-premier, Norodom Ranariddh, claiming he had been negotiating with the depleted Khmer Rouge.

ECONOMY

Cambodia is a poor nation, wrecked by war. Until the 1970s it was agriculturally self-sufficient, but now depends on food imports and economic aid. Farming employs 80% of the workforce. Rice, rubber and maize are the major products. Corruption and instability persist.

The number of wild animals in Southeast Asia has been greatly reduced as land is cleared. The stamp, issued in 1964, shows a kouprey, a rare wild ox.

They contain a large variety of fossils, including all the animal phyla, with the exception of the vertebrates. The commonest animal forms were TRILOBITES, BRACHIOPODS, sponges and snails. Plant life consisted mainly of seaweeds. Cambridge City on the River Cam, county town of Cam-

bridgeshire, E England. The University of CAMBRIDGE is one of the world's leading institutions. Industries: precision engineering, electronics, printing and publishing. Pop. (1991) 91,933.

Cambridge, University of Founded in 1209 (with claims for an earlier origin), it is one of the oldest academic institutions in England. It has a collegiate system, the oldest college being Peterhouse (1284). A centre of Renaissance learning and theological debate in the Reformation, it now has faculties for studying almost every discipline. In the 20th century it excelled in scientific research. Its many buildings of historic and architectural interest include Kings College Chapel.

Cambridgeshire County in E central England; the county town is CAMBRIDGE. The area is mainly fenland with chalk hills to the s and is drained by the Ouse and Nene rivers. Ely and Peterborough both have cathedrals. Agriculture is the most important economic activity; crops include wheat, barley and oats. Area: 3,400sq km (1,312sq mi). Pop. (1990) 645,125.

camel Large, hump-backed, UNGULATE mammal of the family Camelidae. There are two species - the two-humped Bactrian of central Asia and the single-humped Arabian dromedary. Its broad, padded feet and ability to travel long periods without water make the camel a perfect desert animal. Genus Camelus. camellia Genus of evergreen trees or shrubs of the family Theaceae, native to E Asia. It has oval, dark green leaves and waxy, rose-like flowers which may be pink, red, white or variegated. Camellia japonica is the most common species.

Camelot In English mythology, the seat chosen by King ARTHUR for his court. Its site is not known, although many believe it was Cadbury Castle, Somerset, sw England.

cameo Relief carving, usually on striated gemstones, semiprecious stones or shell. The decoration, often a portrait head, is generally cut on the light-coloured vein, the dark vein being left as a background. Cameos originated from the carved stone seals bearing the mystic symbol of the scarab beetle used by Ancient Egyptians, Greeks and Etruscans.

camera Apparatus for taking photographs, consisting essentially of a light-proof box containing photographic film. When a shutter is opened, usually briefly, light from the scene is focused by a lens system onto the film. The amount of light

CAMEROON

Cameroon uses the colours that appear on the flag of Ethiopia, Africa's oldest independent nation. These colours symbolize African unity. The flag is based on the tricolour adopted in 1957. The design (with a yellow liberty star) dates from 1975.

ameroon gets its name from the early Portuguese explorers, who fished for camarões (prawns) along its coast.

Behind narrow coastal plains on the Gulf of Guinea, the land rises in a series of plateaux, home of the capital, YAOUNDÉ. In the N, the land slopes down towards the Lake CHAD basin. The mountainous sw region rises to the active volcano, Mount Cameroon at 4,070m (13,354ft).

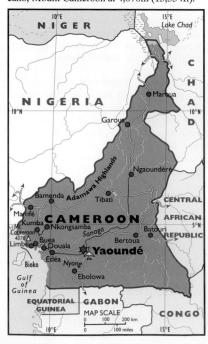

CLIMATE

Cameroon has one of the wettest climates on Earth. Rainfall is heaviest in the hot and humid sw between July and September. The inland plateaux are cooler. Rainfall decreases as you move N and the far N has a hot, dry climate.

VEGETATION

Rainforests flourish in the s. Inland, the forests give way to savanna. Here national parks (such as the Waza, N of Maroua) contain protected animal species. The far N is semi-desert.

HISTORY AND POLITICS

Cameroon is a diverse nation, with more than 160 ethnic groups. Bantu-speakers predominate in coastal areas, such as DOUALA. Islam is the dominant force in the N, where major tribal groupings include the FULANI. In 1472 Portuguese explorers (seeking a sea route to Asia) reached the Cameroon coast. From the 17th century, s Cameroon was a centre of the slave trade. In the early nineteenth century SLAVERY was abolished and replaced by the ivory trade, led by Britain.

In 1884 Cameroon became a German protectorate and the Germans developed the port facilities in Douala. In 1916 the country was captured by Allied troops. After World War 1 Cameroon was divided into two zones, ruled by Britain and France. In 1960, following civil unrest, French Cameroon became an independent republic. In 1961 N British Cameroon voted to join the Cameroon Republic (forming the Federal Republic of Cameroon), while s British Cameroon joined Nigeria.

AREA: 475,440sq km (183,567sq mi)

POPULATION: 12,198,000

CAPITAL (POPULATION): Yaoundé (750,000) GOVERNMENT: Multiparty republic ETHNIC GROUPS: Fang 20%, Bamileke and

Bamum 19%, Douala, Luanda and Basa 15%,

Fulani 10%

LANGUAGES: French and English (both

official)

RELIGIONS: Christianity (Roman Catholic 35%,

Protestant 18%),

traditional beliefs 25%, Islam 22% **CURRENCY:** CFA franc = 100 centimes

In 1966 a one-party state was created, and in 1972 the federation became a unitary state. From 1960 to 1982 Ahmadou Ahidjo was the country's president. His successor, Paul Biya, purged the party of Ahidjo's supporters. In 1984 a failed coup led to many executions, and Biya made Cameroon a republic. Biya was reelected in 1992, amidst charges of electoral malpractice. His autocratic rule was regularly accused of torture and the creation of a police state. In 1995, partly to satisfy its Englishspeaking community, it became the 52nd member of the COMMONWEALTH OF NATIONS.

ECONOMY

Cameroon is one of West Africa's most successful economies (1992 GDP per capita, \$US2,390). Its wealth, however, is extremely unevenly distributed. Northern Cameroon is impoverished and heavily dependent on cattleraising.

Agriculture dominates the economy, employing 79% of the workforce. Cameroon is self-sufficient in foodstuffs. Major crops include cassava, maize, millet and yams. It is the world's 7th largest producer of cocoa. Other commercial plantations grow coffee, bananas, groundnuts and tobacco. Fishing and forestry are other important activities.

Despite shrinking production, oil accounts for nearly 50% of Cameroon's exports. Other mineral resources include gold and bauxite.

Dogana (1730) by Giovanni Caneletto is one of his famous series of views of Venice. The incredible attention to detail is characteristic of his work

■ Canaletto The Punta della

Cameroon Republic in w Africa. See country feature

Campaign for Nuclear Disarmament (CND) Movement in Britain, founded by Bertrand RUSSELL and Canon John Collins (1958). Advocating unilateral nuclear disarmament, during the 1960s it organized an annual march between the atomic research centre at Aldermaston and Trafalgar Square, London. Membership and activities declined in the 1970s, but CND revived in the early 1980s in response to the escalation of the East-West nuclear arms race and the siting of cruise missiles at Greenham Common, s England. The end of the COLD WAR and disarmament treaties between the USA and the former Soviet Union, have lessened CND's political prominence. Campania Region of sw Italy on the Tyrrhenian Sea, including the provinces of Avellino, Benevento, Caserta, Napoli and Salerno. The capital is NAPLES. It is a mountainous area with fertile plains yielding agricultural products such as wheat, potatoes, fruit, tobacco, flowers and wine. Area: 13,595sq km (5,249sq mi). Pop. (1992) 5,668,895.

campanulaceae Bellflower family of herbaceous flowering plants. There are c. 300 species, including HAREBELL, Canterbury bell, Coventry bell, peach bellflower and clustered bellflower. They are cultivated extensively for their delicate blossoms, often a pale or purplish blue in colour.

Campbell, Donald Malcolm (1921–67) British world speed record holder. Son of Sir Malcolm CAMPBELL, he set seven new world records on water. In 1964 he broke the world water and speed records in Australia. On Lake Dumbleyung he achieved 444.7km/h (276.28mph), while on the salt flats of Lake Eyre he reached 648.72km/h (403mph). He died trying to set a new record. As with his father, all his vehicles were called *Bluebird*. In 1984 his daughter Gina set a new women's water speed record.

Campbell, Sir Malcolm (1885–1948) British world speed record holder. In 1935 he became the first man to reach a land speed of 300mph (483km/h), accomplished in *Bluebird* at Utah's Bonneville Salt Flats, USA. He also set a water record of 227km/h (141mph).

Camp David Agreement (September 1978) Significant step towards Arab-Israeli reconciliation. The agreement resulted from a meeting between Anwar SADAT of Egypt and Menachem Begin of Israel, mediated by US president Jimmy CARTER at his country residence. Condemned by other Arab leaders, the agreement formed the basis of a 1979 treaty between Egypt and Israel. Sadat and Begin shared the 1978 Nobel Peace Prize.

Campese, David lan (1962–) Australian rugby football player. A flamboyant player who played regularly in Italy as well as Australia, he holds the world record for the number of tries scored in international rugby (63). He retired from international rugby in 1996, after over 100 test appearances.

camphor Organic chemical compound ($C_{10}H_{16}O$). It has a strong odour, which also occurs in the wood and leaves of the camphor tree, *Cinammonum camphora*, native to Taiwan. Camphor is used in medicine for liniments, in the manufacture of celluloid, lacquers and explosives, and as an ingredient of motiballs.

Campion, Saint Edmund (1540–81) English Jesuit priest and martyr. He was ordained deacon in the Church of England (1569), but became a Roman Catholic (1571) and later a Jesuit missionary. In 1581 he published the pamphlet *Decem Rationes*, defending the Roman Catholic position against Protestantism. He was charged with treason and executed. His feast day is 1 December.

Campion, Jane (1955–) New Zealand film director and screenwriter. A sensitive and poetic film-maker, Campion's film *The Piano* (1993) shared the Palme d'Or and won her an Oscar for Best Screenplay. She also directed an adaptation of

Henry James' novel *Portrait of a Lady* (1997). This success was prefigured by her first feature film *Sweetie* (1989).

Camus, Albert (1913–60) French novelist, playwright and essayist. An active figure in the French Resistance he achieved recognition with his debut novel *The Outsider* (1942), a work permeated with the sense of individual alienation that underlies much of his writing. His later work include the novels *The Plague* (1947) and *The Fall* (1956), and the essay *The Rebel* (1951). He has been associated with EXISTENTIALISM and the Theatre of the ABSURD. He was awarded the 1957 Nobel Prize for literature.

Canaan Historical region occupying the land between the Mediterranean and the Dead Sea. The Canaanites were a Semitic people, identified with the Phoenicians from *c*.1200 BC. Canaan was the Promised Land of the Israelites, who settled here on their return from Egypt.

Canada Federation in N North America. See country feature, p.126

Canadian literature Literary work can be divided into two distinct (yet interrelated) traditions, reflecting Canada's dual French and English linguistic and cultural history. A French language tradition really began in opposition to English colonialism and cultural dominance. During the 1860s a Quebec group emerged, characterized by nationalist romanticism. In the early 20th century Quebec was again the focus for a parochial pastoralism. In Montreal a more innovative poetic SYMBOLISM developed. The first English-language works were accounts of the Canadian landscape by explorers, such as Alexander MACKENZIE. The first North American novel, The History of Emily Montague (1769), was an account of Quebec by Frances Moore Brooke. The Confederation of 1867 produced the first national literary movement, the Confederation school of poets. At the turn of the 19th century, prose tended to pastoral romanticism, such as L.M. Montgomery's classic Anne of Green Gables (1908). Literature in the 1920s was more critical of Canadian society and post-1945 literature reflected and nurtured a burgeoning national consciousness. Major poets of the period include Earle Birney, Dorothy Livesay and Jay Macpherson. Recent novelists include Margaret ATWOOD, Robertson Davies and Mordecai RICHLER. Canada also has a healthy tradition of literary criticism, major figures include Northrop Frye and Marshall McLuhan.

canal Artificial waterway for irrigation, drainage, navigation or in conjunction with hydroelectric dams. Canals were built 4,000 years ago in ancient Mesopotamia. Today, the longest canal able to accommodate large ships connects the Baltic and White seas in N Europe and is 227km (141mi) long. The heyday of canal building in England was in the late 18th—early 19th century.

Canaletto (1697–1768) (Giovanni Antonio Canal) Italian painter of the VENETIAN SCHOOL, famous for his perspectival views of Venice. His early work is more dramatic and free-flowing than his smoother, accurate mature style. He portrayed festivals and ceremonies in his Venetian views. In 1746 he travelled to England, where he painted views of London and country houses. He used a camera obscura to make his paintings more precise, sometimes making the finished work seem stiff and mannered. Canaletto managed to infuse his best work with energy, light and colour. He had an enormous influence in Italy, central Europe and England.

canary Popular cage-bird that lives wild in the Azores,

Canada's flag, with its simple 11-pointed maple leaf emblem, was adopted in 1964 after many attempts to find an acceptable design. The old flag, used from 1892, was the British Red Ensign. But this flag became unpopular with Canada's French community.

Canada, the world's second largest country (after Russia), is thinly populated. Much of the land is too cold or mountainous for human settlement, and most Canadians live within 300km (200mi) of the s border with the USA.

Western Canada has the most rugged terrain, including the Pacific ranges and the mighty ROCKY MOUNTAINS. Mount LOGAN is Canada's highest peak, at 6,050m (19,850ft). East of the Rockies are the fertile interior plains of Canada's Prairie Provinces (s Alberta, Manitoba and Saskatchewan). This vast farming region is the N extension of the prairies of the United States.

In the N are the bleak Arctic islands. The Canadian Shield, in E central Canada, is a vast region of ancient rocks, which covers almost half the country, enclosing the Hudson Bay low-lands. South of the Canadian Shield lie Canada's most populous regions: the lowlands N of Lakes Erie and Ontario and the St Lawrence River valley, including the capital, Ottawa, and Toronto. The northernmost part of the Appalachian Mountains are in the far se.

CLIMATE

Canada has a cold climate, with winter temperatures below freezing throughout most of the country. In the N, along the Arctic Circle, temperatures are below freezing for seven months every year. But VANCOUVER on the W coast has a mild climate, and average temperatures remain above freezing in winter.

Western Canada has plenty of rainfall but the prairies are dry with 250–500mm (10–20in) of rain annually. South-east Canada has a moist climate and Montreal has an annual average of c.1,040mm (41in) of rain.

VEGETATION

Forests of cedar and hemlock grow on the western mountains, with firs and spruces higher up. The interior plains were once grassy prairies, but today they are used mainly for farming and ranching. The far N is tundra. The SE lowlands contain forests of deciduous trees, such as beech, oak and walnut. The Appalachians include beautiful mixed coniferous and deciduous forests.

HISTORY

Canada's first people, ancestors of present-day Native Americans, arrived from Asia c.40,000 years ago. Later arrivals were the INUIT, also from Asia. John CABOT was the first European to reach the Canadian coast in 1497. A race began between France and Britain for the riches in this new land. France gained an initial advantage when Jacques CARTIER discovered the St Lawrence River in 1534 and claimed Canada for France.

The French established the first European settlement in 1605 and founded QUEBEC in 1608. The empire was extended by explorers such as LA SALLE. French settlement in the w was generally much slower than English development on the Atlantic coast. The French and Indian Wars (1689–1763) were a protracted battle for colonial domination of Canada. In 1713 the province of Nova Scotia was ceded in the Treaty of Utrecht. In 1759 Quebec was captured by Britain, and France surrendered all of its Canadian lands in the Treaty of Paris (1763). In 1774 the French-Canadian population of Quebec gained territory to the Ohio River, the Continental Congress responded by invading Canada. During the American Revolution, Canada remained loyal to the English crown,

AREA: 9,976,140sq km (3,851,788sq mi)

POPULATION: 27,562,000

CAPITAL (POPULATION): Ottawa (313,987)
GOVERNMENT: Federal multiparty constitution-

al monarchy

ETHNIC GROUPS: British 34%, French 26%, German 4%, Italian 3%, Ukrainian 2%, Native American (Amerindian/Inuit) 1.5%, Chinese, Dutch

LANGUAGES: English and French (both official)
RELIGIONS: Christianity (Roman Catholic 47%,
Protestant 41%, Eastern Orthodox 2%),
Judaism, Islam, Hinduism, Sikhism
CURRENCY: Canadian dollar = 100 cents

and American attempts to capture it failed. In 1784 the province of New Brunswick was created out of Nova Scotia. The Constitutional Act (1791) divided Canada along linguistic and religious lines: Upper Canada (now Ontario) was English and Protestant; Lower Canada (now Quebec) was French and Catholic.

C

Explorers such as Alexander MacKenzie, James Cook and George Vancouver enabled Britain to form the crown colony of British Columbia in 1858. Border disputes with the USA (see Aroostook War, War of 1812) continued into the 19th century.

Large-scale immigration from Ireland and Scotland increased tension and conflict between the English-speaking majority and the Frenchspeaking minority. In an attempt to reduce conflict, the British passed the British North America Act (1867). This constitutional act established the federation or Dominion of Canada, consisting of Quebec, Ontario, Nova Scotia and New Brunswick. In 1869 it acquired the lands of the Hudson's Bay Company and other provinces were added: Manitoba (1870), British Columbia (1871), PRINCE EDWARD ISLAND (1873), Alberta and Saskatchewan (1905) and NEWFOUNDLAND (1949). The Dominion's first prime minister, Sir John A. MACDONALD, established the Canadian Pacific Railway, which proved disastrous to his career but provided the means for 3 million Europeans to emigrate to Canada between 1894 and 1914. Canadians fought as part of Allied forces in both World Wars and in 1949 Canada was a founding member of NATO. Under the leadership of W.L. Mackenzie KING, national unity was strengthened and industry developed. In 1963 Lester PEARSON became prime minister and, as a sign of Canada's growing national confidence, adopted a new national flag. In 1967 Montreal hosted the influential Expo' 67. Pierre TRUDEAU's first administration (1968-79) was faced with violent separatist demands for Quebec's independence and martial law was imposed in 1970. In 1976 Montreal hosted the summer Olympic Games. In Trudeau's second administration (1980-84), Quebec voted to remain part of the federation (1980). The Canada Act (1981) amended the constitution, and Canada became a fully sovereign state with a Charter of Rights and Freedoms. It was approved by all the provinces except Quebec, who claimed power of constitutional veto. In 1985 Brian MULRONEY and provincial leaders signed the Meech Lake Accord, which provided for Quebec to be brought into the constitutional settlement as a "distinct society". Manitoba and Newfoundland failed to endorse the Accord, and Canada was plunged into constitutional crisis.

POLITICS

Jean Chrétien was elected in 1993 and reelected in 1997. A 1995 referendum on sovereignty for Quebec was narrowly defeated by 50.6% to 49.4%. Regional differences exist and experts argue that the reconciliation of the divisions between the E (Montreal-Toronto) axis and the w (Vancouver-Winnipeg) axis is essential for Canada's future prosperity.

Canada's new constitution has also enabled Native Americans to press for land claims. In 1999 NORTHWEST TERRITORIES will become the Inuit territory of Nunavut.

ECONOMY

Canada is a highly developed and prosperous nation (1992 GDP per capita, US\$20,520). Although farmland covers only 8% of the land, farms are highly mechanized and productive. Canada is the world's leading producer of linseed and the second largest producer of oats and rapeseed. Canada's vast conifer forests and the availability of cheap hydroelectric power has encouraged the development of huge wood pulp and paper industries. Fishing is important in both Atlantic and Pacific waters.

Canada is rich in mineral resources and is the world's leading producer of uranium, potash, and zinc ore. Other major resources include nickel, aluminium, cobalt ore and natural gas. Lesser resources include copper, gold, molybdenum and salt. Canada is also a major producer of petroleum. Manufacturing is highly developed, especially in the cities where 77% of the population live. Canada is a major manufacturer of commercial vehicles. Other products include chemicals, electronic goods, machinery and telecommunications equipment.

Canada has long been influenced, both culturally and economically, by the USA, and the two countries have the largest bilateral trade flow in the world. Since 1 January 1994, Canada, Mexico and the USA have been linked through the NORTH AMERICAN FREE TRADE AGREEMENT (NAFTA), the world's largest trading area, with the aim to eliminate cross-border tariffs within 20 years.

Issued in 1993, this stamp celebrates the bicentenary of Canada's largest metropolitan area, Toronto. The site was selected by John Graves Simcoe in 1793 and named York. But the settlement was renamed Toronto in 1834.

Toronto is a Huron word for "meeting place".

CANARY ISLANDS

AREA: 7,273 sq km (2,807 sq mi)
POPULATION: 1,493,784
CAPITAL (POPULATION): Santa
Cruz (189,317) / Las

Palmas (372,000)
GOVERNMENT: Spanish
autonomous region
ETHNIC GROUPS: Spanish
LANGUAGES: Spanish

RELIGIONS: Christianity (mainly Roman Catholic) CURRENCY: Spanish currency

Canary and Madeira islands. These yellowish FINCHES feed on fruit, seeds and insects, and lay spotted greenish-blue eggs. The pure yellow varieties have been domesticated since the 16th century, although they are difficult to breed in captivity. Family Fringillidae; species *Serinus canarius*.

Canary Islands Group of islands in the N Atlantic Ocean, c.110km (70mi) off the NW coast of Africa; they constitute two provinces of Spain, LAS PALMAS and SANTA CRUZ DE TENERIFE. Under Spanish rule since the 16th century, the islands are mountainous and the climate warm, with little rainfall. Industries: agriculture, fishing, tourism.

Canberra Capital of Australia on the River Molonglo, Australian Capital Territory, SE Australia. Settled in the early 1820s, it was chosen in 1908 as the new site for Australia's

capital (succeeding Melbourne). The transfer of all governmental agencies was not completed until after World War 2. Canberra has the Australian National University (1946), Royal Australian Mint (1965), Royal Military College and Stromlo Observatory. The new Parliament House was opened in 1988. Other important buildings include the National Library, National Museum and National Gallery. Pop. (1993 est.) 324,600.

Cancer Northern constellation between Gemini and Leo. It contains two open clusters: M44 the Praesene or Beehive

Cancer Northern constellation between Gemini and Leo. It contains two open clusters: M44, the Praesepe or Beehive Nebula (NGC 2632), and M67 (NGC 2692). The brightest star is Beta Cancri

cancer Group of diseases featuring the uncontrolled proliferation of cells (tumour formation). Malignant (cancerous) cells spread (metastasize) from their original site to other parts of the body. There are many different cancers. Known causative agents (carcinogens) include smoking, certain industrial chemicals, asbestos dust and radioactivity. Viruses are implicated in the causation of some cancers. Some people have a genetic tendency towards particular types of cancer. Treatments include surgery, chemotherapy with cell-destroying drugs and radiotherapy (or sometimes a combination of all three). Early diagnosis holds out the best chance of successful treatment.

Cancer, Tropic of Line of latitude, *c.*23.5° N of the Equator, which marks the N boundary of the tropics. It indicates the farthest N position at which the Sun appears directly overhead at noon. The Sun is vertical over the Tropic of Cancer on about 21 June, the summer SOLSTICE in the Northern Hemisphere.

candela (symbol cd) SI unit of luminous intensity. It is defined as 1/60 of the luminous intensity of a BLACK BODY at atmospheric pressure and the temperature of solidification of platinum, 1,772°C (3,222°F).

Canetti, Elias (1905–94) British writer, b. Bulgaria. His first-hand experience of violent anti-semitism in 1930s Europe inspired his masterpiece, *Crowds and Power* (1960). His fear of the destructive power of mass psychology also informed his only novel, *Auto da Fé* (1935). He won the Nobel Prize for literature (1981).

Canis Major (Great Dog) Southern constellation situated s of Monoceros. It contains the bright open cluster M41 (NGC 2287). The brightest star is Alpha Canis Majoris or Sirius (Dog Star), the brightest star in the sky

cannabis Common name for the Indian hemp plant, *Cannabis sativa* (family Cannabidaceae), and for the dried plant or extracted resin when used as a psychotropic drug. The drug produces NARCOTIC effect sometimes allied with a feeling of well-being. It is highly carcinogenic and can induce mild psychosis. It has been shown to relieve the symptoms of some illnesses, such as multiple sclerosis.

Cannes Resort on the French Riviera, SE France. The old part of the city has a 16th–17th century church. During the 19th century Cannes became fashionable with visiting British aristocracy. An international film festival is held here each spring. Industries: tourism, flowers, textiles. Pop. (1990) 68,676.

Canning, Charles John, Earl (1812–62) British imperial administrator. Son of George CANNING, he served in government before becoming governor general of India (1856–58). He repressed the INDIAN MUTINY and followed a policy of conciliation that earned him the nickname "Clemency Canning". With the transfer of the government of India to the British Crown, Canning became the first viceroy of India (1858–62).

Canning, George (1770–1827) British politician, prime minister (1827) He was Tory foreign minister (1807–10, 1822–24), favouring vigorous measures against Napoleon. He became prime minister, in coalition with the Whigs, but died four months later. His liberalism, such as support for South American independence, made him a maverick among Tories, some of whom refused to serve with him.

cannon ARTILLERY piece consisting of a metal tube, used to aim and fire missiles propelled by the explosion of gunpowder in the closed end of the cylinder. Cannon, first used in the 14th century, were originally made of bronze or iron.

canoe Light, shallow-draft boat propelled by one or more paddles. Primitive types are dug out of logs or made of skin or bark stretched over wooden frames. Modern types are

Cancer can spread in two ways. First, by direct growth into adjacent tissues, called "direct extension" (A), when cancer cells penetrate into bone, soft connective tissue and the walls of veins and lymphatic vessels. Alternatively, a cancer cell separates from its tumour and is transported to another part of the body. This spread of cancer is called "metastasis" (B). In metastasis after the

tumour has grown to some size, cancer cells or small groups of cells enter a blood or lymph vessel through the vessel wall (1). They travel through the vessel until they are stopped by a barrier, such as a lymph node, where additional tumours may develop, before releasing more cells which may develop on other lymph nodes. Such cancers, usually carcinomas, may also invade the blood

stream and establish more distant secondary growths. Another type of cancer, sarcomas, tend to spread via venous blood vessels frequently establishing tumours in the lungs, gastrointestinal tract or the genito-urinary tract (2). In abdominal cancers, metastases may also arise as a result of travel across body cavities, such as the peritoneal, oral or pleural cavities (3).

made of wood, metal or fibreglass. Canoeing became an Olympic sport in 1936.

canon In music, form of COUNTERPOINT using strict imitation. All the voices or parts have the same melody, but each voice starts at a different time, at the same or a different pitch. canon Term used in Christian religion with several meanings. The basic meaning is a rule or standard. In this sense, a canon is something accepted or decreed as a rule or regulation, such as the official list of saints or the list of books accepted as genuine parts of the BIBLE. This is the meaning embraced by the term canon law. Initially a canon was also a priest in a cathedral or collegiate church, whose life was regulated by the precepts of CANON LAW. They were distinct from secular canons, who lived outside the cathedral and, although ordained, played a largely administrative role.

canonization Official action by which a member of a Christian Church is created a cult figure or SAINT and added to the CANON. In the Orthodox Church, a person's sainthood may be proclaimed by a bishop after examining the candidate's case. In the Anglican Church, a commission determines whether someone is to be admitted into the list of saints. In the Roman Catholic Church, officials analyse the evidence of a candidate's reputation for sanctity or virtue and seek out evidence for any miracles done. The results are submitted to the Congregation for the Causes of Saints and, after their findings are ratified by the pope, the candidate is beatified. Further proof of additional miracles is required before full canonization.

canon law In the Roman Catholic, Anglican and Orthodox churches, a body of ecclesiastical laws relating to faith, morals and discipline. It is based on custom and regulations laid down by church councils, popes or bishops.

Canopus (Alpha Carinae) Second-brightest star in the sky. Its luminosity and distance are not accurately known, but one estimate classifies it as a bright giant, 800 times as luminous as the Sun, and 74 light years away.

Canova, Antonio (1757–1822) Italian sculptor. His work expresses the grave elegance and allusions to antique art which characterize NEO-CLASSICISM, but retains a high degree of individuality. Two important pieces of the 1780s, *Theseus and the Minotaur* and Pope Clement XIV's tomb, catapulted Canova into the limelight. He worked for many distinguished European patrons, notably the papal court.

cantata Musical work consisting of vocal solos and choruses, often alternating with passages of recitative, and accompanied by an orchestra. It was a popular form in the 17th and 18th centuries, when Alessandro Scarlatti and J.S. Bach wrote numerous cantatas, both secular and religious.

Canterbury City on the River Great Stour, Kent, se England. It is the seat of the archbishop and primate of the Anglican Church. The present cathedral (built in the 11th–15th centuries) replaced the original Abbey of St Augustine. Thomas à BECKET was murdered in the cathedral in 1170; after his canonization, Canterbury became a major pilgrimage centre. It contains the University of Kent (1965). Tourism is a major industry. Pop. (1991) 123,947.

Canterbury, Archbishop of Primate of All England and spiritual leader of the worldwide Anglican Communion. The archbishopric was established in 597, when Pope Gregory I sent a mission to England to convert the Anglo-Saxons. St Augustine of Canterbury, leader of the mission, became the first Archbishop. During the Reformation, Archbishop Thomas Cranmer accepted the decision of the English Crown to end papal jurisdiction in England (1534). The Archbishop of Canterbury traditionally crowns British monarchs and officiates at other religious ceremonies of national importance. He presides over the Lambeth Conference of worldwide Anglicanism, but exercises no jurisdiction outside his own ecclesiastical province.

cantilever bridge BRIDGE in which each half of the main span is rigidly supported at one end only. The other ends are joined in the middle of the bridge, where there is no supporting structure.

Canton See GUANGZHOU

canton Unit of government and administration that make up the Swiss Confederation (Switzerland). Each canton sends two members to the Council of State, which (with the National Council) forms the country's federal parliament.

Cantona, Eric (1966–) French football player. Cantona began his career with Auxerre (1980–88). In 1992 he moved to Leeds United and, after helping them win the league, transferred to Manchester United (1993). Two further championship medals followed. Cantona was banned during the 1994–95 season for kicking an abusive fan. In 1996 he became captain and his self-discipline helped Manchester United win their second consecutive Premiership title. Cantona retired in 1997.

Cantonese One of the major languages of China. Within the Chinese People's Republic it is spoken by *c.* 50 million people, mainly in the extreme southern provinces of GUANGDONG and GUANGXI. It is also the language spoken by most Chinese in Southeast Asia and the USA.

Canute II (*c*.994–1035) King of Denmark (1014–28), England (1017–35) and Norway (1028–29). He accompanied his father, Sweyn, on the Danish invasion of England (1013). After his father's death (1014), he was accepted as joint king of Denmark with his brother and later became sole king. He invaded England again (1015) and divided it (1016) with the English king Edmund Ironside. He was accepted as king after Edmund's death. His rule was a just and peaceful one. He restored the church and codified English law. His reign in Scandinavia was more turbulent. He conquered Norway (1028), made one son king of Denmark (1028) and another king of Norway (1029).

canyon Deep, narrow depression in the Earth's crust. Land canyons are the result of erosion by rivers flowing through arid terrain. Marine canyons may be formed when a river bed and the surrounding terrain is submerged, or by turbulence produced by deep water currents. *See* Grand Canyon

capacitance (symbol *C*) Property of an electrical circuit or component that describes its ability to store charge in its CAPACITOR. Capacitance is measured in farads: 1 farad is a capacitance needing a charge of 1 coulomb to raise its potential by 1 volt. Most capacitances are small enough to be measured in microfarads (one millionth of a farad).

capacitor (condenser) Electrical circuit component that stores charge. It has at least two metal plates and is used principally in alternating current (AC) circuits. The various types include parallel-plate condensers and electrolytic capacitors. *See also* ELECTRIC CURRENT

Cape Canaveral Low sandy promontory in E Florida, USA, extending E into the Atlantic Ocean. It is the site of the John F. Kennedy Space Center which, since 1950, has been NASA's main US launch site for space flights and long-range missiles. Cape Cod Hook-shaped sandy peninsula in SE Massachusetts, USA. The Pilgrim Fathers landed here in 1620. Of glacial origin, it extends into the Atlantic Ocean, forming Cape Cod Bay. It was originally a centre for fishing, whaling and salt extraction; tourism is now the major industry.

Cape Horn Southernmost point of South America in s Chile. It was sighted by Francis Drake in 1578, and first rounded in 1616 by Cornelis van Schouten.

Cape of Good Hope Peninsula, 50km (30mi) s of Cape Town, South Africa. The first European to sail around it was Bartholomeu Diaz in 1488. The Cape sea route between India and Europe was established by Vasco da Gama in 1497–99.

Cape Province Formerly the largest province in South Africa. In 1994 it was divided into the separate provinces of EASTERN CAPE, WESTERN CAPE and NORTHERN CAPE. The first colony was established by the Dutch EAST INDIA COMPANY in 1652 and slaves were imported to work the land. The BOER settlers' expansion led to territorial wars with indigenous tribes, such as the XHOSA (1779). In 1806 Britain established control and renamed the region, Cape of Good Hope Colony. The new British settlers clashed with the Boers, precipitating the GREAT TREK (1835). Diamonds were discovered near KIMBERLEY in 1867. The British attempt to incorporate TRANSVAAL and Orange FREE STATE into a single state with NATAL and Cape Colony, resulted in the SOUTH AFRICAN WARS (1899–1902). In 1910 the colony became a province of the Union of South Africa. During the 1960s, the apartheid government created the

▲ Capone Born in Naples, S Italy, AI Capone grew up in Brooklyn, New York. During the prohibition era, "Scarface" Capone established himself as the head of a organized crime syndicate in Chicago.

separate tribal areas (bantustans) of Transkei and Ciskei. In 1994 these were integrated to form Eastern Cape Province.

Capetians French royal family forming the third dynasty providing France with 15 kings. It began with Hugh Capet, Duke of Francia (987), and ended with Charles IV (1328). Hugh Capet was elected king after the death of Louis V, the last of the CAROLINGIANS. Capetians dominated the feudal forces, extending the king's rule over the country. It was succeeded by Philip VI of the House of Valois.

Cape Town City and seaport at the foot of Table Mountain, South Africa. It is South Africa's legislative capital and the capital of WESTERN CAPE province. Founded in 1652 by the Dutch EAST INDIA COMPANY, it came under British rule in 1795. Places of interest include the Union Parliament, a 17th-century castle, the National Historic Museum, and the University of Cape Town (founded 1829). It is an important industrial and commercial centre. Industries: clothing, engineering equipment, motor vehicles, wine. Pop. (1991) 2,350,157.

Cape Verde Republic in the E Atlantic Ocean. It is made up of 15 volcanic islands divided into two groups (Windward Islands and Leeward Islands). The capital is Praia on São Tiago. The economy is based on coffee, tobacco and sugar cane, and the mining of salt and coal. An overseas province of Portugal, the islands became independent in 1975. Area: 4,033sq km (1,557sq mi). Pop. (1993 est.) 350,000.

capillary Smallest of BLOOD VESSELS, connecting arteries and veins. Capillary walls consist of only a single layer of cells, so that water containing dissolved oxygen and other nutrients (as well as carbon dioxide and other wastes) can pass easily between the blood and surrounding tissues.

capital In architecture, the block of masonry at the top of a column, often elaborately carved. The design of the capital is characteristic of the ORDERS OF ARCHITECTURE.

capital In ECONOMICS, different forms of wealth. Fixed capital refers to such things as buildings, tools and equipment; working capital (variable or circulating capital) includes raw materials, stock and cash. In accounting, capital is the obligation a business enterprise has to its owners. Capital includes not only the owner's contribution but also the profits retained within the business for future use.

capitalism Economic system in which property and the means of production are privately owned. Capitalism is based on profit motive, free enterprise, efficiency through competition and a notion of freedom of choice. It was first articulated by Adam SMITH in his treatise *The Wealth of Nations* (1776). Its development dates from the INDUSTRIAL REVOLUTION and the rise of the BOURGEOISIE. In political practice, capitalist governments participate in economic regulation. The collapse of Soviet COMMUNISM removed capitalism's traditional opponent and created economic uncertainty. *See also* Milton FRIEDMAN; J.K. GALBRAITH; SOCIALISM

capital punishment Punishing a criminal offence by death. Usual methods of execution include hanging, electrocution, lethal injection, lethal gas or firing squad. The death penalty has been abolished in many Western countries. In the USA, capital punishment was effectively in abeyance during the 1970s after several rulings by the US Supreme Court, but by the mid-1990s, 37 states had the death penalty. Britain effectively abolished capital punishment in 1965. The use of capital punishment is the subject of much debate: supporters claim that such punishment can be deserved and has a deterrent effect, while opponents state that it is inhuman, does not deter and that miscarriages of justice cannot be rectified.

Capitol Building in Washington, D.C., in which the US Congress convenes. The original architect was William Thornton and the cornerstone was laid by George Washington in 1793. It was burned to the ground by the British in 1814. Benjamin Latrobe and Charles Bulfinch worked on the restoration, which was completed in 1830. The dome reaches a height of 88m (288ft).

Capone, Al (Alphonse) (1899–1947) US gangster of the PROHIBITION era, b. Italy. He inherited a vast crime empire from the gang leader Johnny Torio. Capone was suspected of involvement in many brutal crimes, but ironically was only ever convicted and imprisoned for income tax evasion (1931).

Capote, Truman (1924–84) US author. His works, typified by keen social observation and characters on the fringes of society, include the novella *Breakfast at Tiffany's* (1958), the novel *The Grass Harp* (1951) and volumes of shorter pieces such as *Music for Chameleons* (1980). Capote claimed that *In Cold Blood* (1966) was the first non-fiction novel.

Capra, Frank (1897–1991) US film director, b. Sicily. During the 1930s Depression, Capra made a string of successful screwball comedies. His central theme was the unlikely triumph of idealism and the common man over materialism and bureaucracy. He won three Academy Awards for Best Director for It Happened One Night (1934), Mr Deeds Goes to Town (1936) and You Can't Take It With You (1938). During World War 2 he directed propaganda films. Capra's best film It's a Wonderful Life (1947) was a commercial failure.

Capricorn, Tropic of Line of latitude, *c*.23.54° s of the Equator which marks the southern boundary of the tropics. It indicates the farthest southern position at which the Sun appears directly overhead at noon. The Sun is vertical over the Tropic of Capricorn on about 22 December, which is the summer SOLSTICE in the Southern Hemisphere.

Capricornus (Sea Goat) Southern constellation situated on the ecliptic between Sagittarius and Aquarius; the tenth sign of the zodiac, identified with the Greek god PAN. Usually referred to as Capricorn only for astrological purposes, this constellation contains the faint globular cluster M30 (NGC 7099).

capsicum See PEPPER

capuchin Small diurnal monkey found in South and Central America. It is generally brown or black and is a tree-dweller. Omnivorous, but preferring fruit, it may grow to 55cm (22in) with a furry, prehensile tail of similar length. Family Cebidae. Capuchins (officially Friars Minor of St Francis Capuchin, O.F.M.Cap.) Roman Catholic religious order, founded in 1525 as an offshoot of the Franciscans. Capuchins are so-called because of the pointed cowl (capuche), which forms part of their habit. They re-emphasized Franciscan ideals of poverty and austerity, and played an important role in the Counter-Reformation through their missionary activities.

capybara Largest living RODENT, native to Central and South America; it is semi-aquatic with webbed feet, a large, nearly hairless, body, short legs and a tiny tail. Length: 1.2m (4ft). Species *Hydrochoerus hydrochoeris*.

car See AUTOMOBILE

Caracalla (188–217) (Marcus Aurelius Antoninus) Roman emperor (211–17). He murdered his brother, Geta, along with many of his supporters (212). Excessive expenditure on war caused economic crisis. During his reign Roman citizenship was extended to all free men in the empire. Caracalla was assassinated by his successor, Macrinus.

Caracas Capital of Venezuela, on the River Guaire. Caracas was under Spanish rule until 1821. It was the birthplace of Simón BOLÍVAR. The city grew after 1930, encouraged by the exploitation of oil. It has the Central University of Venezuela (1725) and a cathedral (1614). Industries: motor vehicles, oil, brewing, chemicals, rubber. Pop. (1990) 1,824,892.

Caravaggio, Michelangelo Merisi da (1571-1610) Italian painter, the most influential and original painter of the 17th century. His work brought a new, formidable sense of reality at a time when a feeble MANNERISM prevailed. Caravaggio's early works were mainly experimental and include the erotic half-length figures of The Young Bacchus and Boy with a Fruit Basket (both c.1595). The majestic Supper at Emmaus (c.1598–1600) with its beautifully modelled images of Christ and his disciples shows Caravaggio gaining confidence. His mature phase (1599-1606) began with two large-scale religious paintings of St Matthew. The dramatic shadows in the pictures, and the use of a living model, show Caravaggio's revolutionary approach to religious themes. The Crucifixion of St Peter and The Conversion of St Paul (both 1600-01) are masterpieces of psychological realism.

caraway Biennial herb native to Eurasia and cultivated for its small, brown seed-like fruits that are used for flavouring foods. It has feathery leaves and white flowers. Family Apiaceae/Umbelliferae; species *Carum carvi*.

▲ capybara Found in central and South America, the capybara (*Hydrochoerus hydrochaeris*) is the largest rodent in the world. It grows to over 1m (3ft).

carbide Inorganic compound of carbon with metals or other more electropositive elements. Many transition metals form carbides, in which carbon atoms occupy spaces between adjacent atoms in the metal lattice. Some electropositive metals form ionic carbon compounds; the best known is CALCIUM CARBIDE. Carbides are commonly used as abrasives.

carbohydrate Organic compound of carbon, hydrogen and oxygen that is a constituent of many foodstuffs. The simplest carbohydrates are SUGARS. GLUCOSE and FRUCTOSE are monosaccharides, naturally occurring sugars; they have the same formula $(C_6H_{12}O_6)$ but different structures. One molecule of each combines with the loss of water to make sucrose $(C_{12}H_{22}O_{11})$, a disaccharide. Starch and cellulose are polysaccharides, carbohydrates consisting of hundreds of glucose molecules linked together. *See also* SACCHARIDE

carbon (symbol C) Common nonmetallic element of group IV of the periodic table. Carbon forms a vast number of compounds, which (with hydrogen—hydocarbons and other nonmetals) forms the basis of organic CHEMISTRY. Until recently, it was believed there were two crystalline ALLOTROPES: GRAPHITE and DIAMOND. In 1996 a third type, "bucky balls" (named after Richard Buckminster Fuller), which are shaped like geodesic domes, was discovered. Various amorphous (noncrystalline) forms of carbon also exist, such as coal, coke, and charcoal. A recently made synthetic form of carbon is CARBON FIBRE. The isotope C14 is used for CARBON DATING of archaeological specimens. Properties: at.no. 6; r.a.m. 12.011; r.d. 1.9–2.3 (graphite), 3.15–3.53 (diamond); m.p. c.3,550°C (6,422°F); sublimes at 3,367°C (6,093°F); b.p. c.4,200°C (7,592°F); most common isotope C12 (98.89%).

carbonate Salt of carbonic acid, formed when carbon dioxide (CO_2) dissolves in water. Carbonic acid is an extremely weak acid and both it and many of its salts are unstable, decomposing readily to release CO_2 . Nevertheless, large parts of the Earth's crust are made up of carbonates, such as CALCIUM CARBONATE and DOLOMITE.

carbon cycle Circulation of carbon in the biosphere. It is a complex chain of events. The most important elements are the taking up of carbon dioxide (CO_2) by green plants during PHOTOSYNTHESIS, and the return of CO_2 to the atmosphere by the respiration and eventual decomposition of animals which eat the plants. The burning of fossil fuels has also, over the years, released CO_2 back into the atmosphere.

carbon dating (radiocarbon dating) Method of determining the age of organic materials by measuring the amount of radioactive decay of an ISOTOPE of carbon, carbon-14 (C¹⁴). This radio-isotope decays to form nitrogen, with a half-life of 5,730 years. When a living organism dies, it ceases to take carbon dioxide into its body, so that the amount of C¹⁴ it contains is fixed relative to its total weight. Over the centuries, this quantity steadily diminishes. Refined chemical and physical analysis is used to determine the exact amount remaining, and from this the age of a specimen is deduced.

carbon dioxide (CO₂) Colourless, odourless gas that occurs in the atmosphere (0.03%) and as a product of the combustion of fossil fuels and respiration in plants and animals. In its solid form (dry ice) it is used in refrigeration; as a gas it is used in carbonated beverages and fire extinguishers. Research indicates that its increase in the atmosphere leads to the GREENHOUSE EFFECT and GLOBAL WARMING. Properties: m.p. -56.6° C (-69.9° F); sublimes -78.5° C (-109.3° F).

carbon fibre Form of carbon made by heating textile fibres to high temperatures. The result is fibres (typically 0.001cm in diameter) which are, weight-for-weight, some of the strongest of all fibres. They are too short to be woven into a super-strong yarn. Instead they are incorporated into plastics, ceramics and glass, which give the materials great strength.

Carboniferous Fifth geological division of the PALAEOZOIC era, lasting from 360 to 286 million years ago. It is often called the "Age of Coal" because of its extensive swampy forests of conifers and tree ferns that turned into most of today's coal deposits. Amphibians flourished, marine life abounded in warm inland seas, and the first reptiles appeared. carbon monoxide Colourless, odourless poisonous gas (CO) formed during the incomplete combustion of fossil fuels,

occurring for example in coal gas and the exhaust fumes of cars. Carbon monoxide poisons by combining with the HAEMO-GLOBIN in red blood cells and thus preventing them from carrying oxygen round the body. (This happens if the inhaled air contains only 0.1% of carbon monoxide by volume.) It is used as a reducing agent in metallurgy. Properties: density 0.968 (air = 1); m.p. -205°C (-337°F); b.p. -191.5°C (-312.7°F).

carcinogen External substance or agent that causes CANCER, including chemicals, such as the tar present in cigarette smoke, large doses of radiation and some viruses, such as polyoma.

carcinoma Form of CANCER arising from the epithelial cells present in skin and the membranes lining the internal organs. It is a malignant growth that tends to invade surrounding tissues, giving rise to metastases (secondary cancers).

cardamom Pungent spice made from seeds of a plant of the GINGER family (Zingiberaceae), often mixed with turmeric to make a type of curry. Species *Elettaria cardamomum*.

cardiac muscle See MUSCLE

Cardiff (Caerdydd) Capital of Wales and port on the River Severn estuary at the mouth of the rivers Taff, Rhymney and Ely, s Glamorgan. The construction of docks in 1839 led to the rapid growth of the city, and, until the early 20th century, it was a major coal exporting centre. It is the seat of the University College of South Wales and Monmouthshire (1893), and has an 11th-century castle. Other landmarks include Llandaff Cathedral and the Welsh National Folk Museum. Industries: steel manufacturing, engineering, chemicals, food processing. Pop. (1991) 279,055.

cardinal Priest of the highest rank in the hierarchy of the Roman Catholic Church after the pope. Some cardinals are heads of departments of the CURIA ROMANA, whereas others are PRIMATES of national churches or other senior bishops. They are nominated by the pope, whom they advise. On the death of a pope they meet in secret CONCLAVE to elect his successor.

cardinal (redbird) North American songbird with a pleasant, clear, whistle-like song. The male has bright red plumage and crest and a thick orange-red bill. They feed on seeds, fruits, and insects. A cup-shaped nest holds the pale blue, heavily

Elemental carbon is in constant flux. Gaseous carbon dioxide (CO_2) is first incorporated into simple sugars by photosynthesis in green plants. These may be broken down (respired) to provide energy, a process that

releases CO_2 back into the atmosphere. Alternatively, animals which eat the plants also metabolize the sugars and release CO_2 in the process. Geological processes also affect the Earth's carbon balance, with

carbon being removed from the cycle when it is accumulated within fossil fuels such as coal, oil and gas. Conversely, large amounts of carbon dioxide are released into the atmosphere when such fuels are burned.

▲ carnation Native to the Mediterranean region, carnations are a species of pink (*Dianthus caryophyllaceus*). A great number of hybrids have been developed to be grown in gardens and yards in many tempertate regions.

spotted eggs (4) incubated by the female. Length: to 9in (23cm). Family Fringillidae; species *Richmondena cardinalis*. **cardiology** Branch of medicine that deals with the diagnosis and treatment of the diseases and disorders of the HEART and vascular system.

Cardozo, Benjamin Nathan (1870–1938) US jurist. He was elected to the New York Supreme Court (1913). Appointed by Herbert Hoover to the US Supreme Court, he served as an associate justice (1932–38). He strove to simplify the law and create an intermediary department between the legislature and the courts. His decisions on New Deal legislation were extremely influential.

Carew, Thomas (1595–1639) English poet. His poetry was largely influenced by his friend Ben Jonson and John Donne, to whom he wrote an elegy. His work includes *A Rapture* and the MASQUE *Coelum Britannicum*.

Carey, George Leonard (1935–) Anglican Archbishop of Canterbury and primate of all England (1991–). After serving for four years as curate of St Mary's Church, Islington, he was made bishop of Bath and Wells (1988). Carey belongs to the evangelical wing of the Church of England. He favours the ordination of women priests and supports environmental conservation. His books include *I Believe in Men* (1975) and *The Great God Robbery* (1989). See also EVANGELICALISM

Carib Major language group and Native American tribe. They entered the Caribbean region from NE South America. About 500 Caribs still live on the island of Dominica; 5,000 migrated to the E coast of Central America, notably around Honduras, where their descendants still live.

Caribbean Community and Common Market (CARICOM) Caribbean economic union. CARICOM was formed in 1973 by the Treaty of Chaguaramas to coordinate economic and foreign policy in the WEST INDIES. Most members rely on the export of sugar and tropical fruits and are heavily dependent on imports, so competition for foreign markets is fierce. The headquarters are in Georgetown, Guyana.

Caribbean Sea Extension of the N Atlantic Ocean linked to the Gulf of Mexico by the Yucatán Channel and to the Pacific Ocean by the Panama Canal. The first European to discover the Caribbean was Columbus in 1492, who named it after the CARIB. It soon lay on the route of many Spanish expeditions and became notorious for piracy, particularly after other European powers established colonies in the West Indies. With the opening of the Panama Canal (1914) its strategic importance increased. Area: c.2,640,000sq km (1,020,000sq mi).

caribou See REINDEER

caricature (It. caricare, load or surcharge) Painting or drawing in which a person is presented in a comic, often ridiculous, light by the distortion of their features. Caricature may be used to interpret the character of a person, event or age. The genre first appeared in the late 16th century. HOGARTH attempted to distinguish between depicting character and comic likeness, but the two traditions merged. In the 20th century many popular graphic artists have combined caricature with social and political satire, and today most political CARTOONS are caricatures.

caries Decay and disintegration of teeth or BONE substance. Caries are caused by acids produced when bacteria present in the mouth break down sugars in food. Regular brushing, a reduced sugar intake and fluoride prevent decay.

Carina Part of the dismembered constellation Argo Navis, the ship Argo. It is the brightest and richest part of Argo, representing the ship's keel, and contains CANOPUS.

Carlists Reactionary Spanish political faction in the 19th century. They favoured the royal claims of Don Carlos and his successors, and figured in several rebellions, sometimes in alliance with Basques and Catalans. The remnants of the Carlists eventually merged with the fascist Falange in 1937. Carlos (1788–1855) Spanish prince and pretender to the throne. His elder brother, Ferdinand VII, changed Spanish law so that his daughter Isabella II succeeded him (1833). Carlos was proclaimed king by the Carlists, and civil war ensued. Isabella won (1840), and Carlos went into exile. In 1845 he resigned his claim in favour of his son Don Carlos II. Carlson, Chester (1906–68) US physicist, inventor of

XEROGRAPHY (1938). He patented it in 1940, but few were convinced of its commercial value. In 1947 he signed an agreement with the Haloid Company (now Rank Xerox). His royalties made him a multi-millionaire.

Carlyle, Thomas (1795–1881) Scottish philosopher, critic and historian. His most successful work, *Sartor Resartus* (1836), combined philosophy and autobiography. His histories include *The French Revolution* (1837). Influenced by Goethe and the German Romantics, he was a powerful advocate of the significance of great leaders in history. He was also an energetic social critic and a proponent of moral values.

Carmelites (officially Order of Our Lady of Mount Carmel) Order founded by St Berthold in Palestine *c*.1154. An order of Carmelite sisters was founded in 1452. The Carmelites devote themselves to contemplation and missionary work.

carnation Slender-stemmed herbaceous plant native to Europe. It has narrow leaves, characteristic swollen stem joints, and produces several dense blooms with serrated (pinked) petals which range from white to yellow, pink and red. Family Caryophyllaceae; species Dianthus caryophyllus. Carnegie, Andrew (1835-1919) US industrialist and philanthropist, b. Scotland. A telegraph operator with the Pennsylvania Railroad (1853-65), he foresaw the demand for iron and steel, and founded the Keystone Bridge Company. From 1873 he concentrated on steel manufacture, pioneering mass production techniques. By 1901 the Carnegie Steel Company was producing 25% of US steel. Carnegie endowed 2,800 libraries and donated more than \$350 million to charitable foundations. carnivore Any member of the order of flesh-eating mammals. Mustelids - weasels, martens, minks and the wolverine - make up the largest family. CATS are the most specialized killers among the carnivores; dogs, bears and raccoons are much less exclusively meat eaters; and civets, mongooses and their relatives also have a mixed diet. Related to the civets, but in a separate family, are the hyenas, large dog-like scavengers. More distantly related to living land carnivores are the seals, sea lions and walruses; they evolved from ancient land carnivores who gave rise to early weasel- or civet-like forms. Other extinct carnivores include the sabretooth cats, which died out during the Pliocene epoch, 2 million years ago.

carnivorous plant See INSECTIVOROUS PLANT

Carnot, Lazare Nicolas Marguerite (1753–1823) French general He was the outstanding commander of the French Revolutionary wars, his strategy being largely responsible for French victories. Ousted in 1797, he was recalled by Napoleon (1800), who made him minister of war. Carnot, Marie François Sadi (1837–94) French political leader, president of the Third Republic (1887–94). After quashing the anti-republican movement, he successfully defended the regime during the Panama Canal scandal (1892). He was stabbed to death by an Italian anarchist.

Carnot, Nicolas Léonard Sadi (1796-1832) French engineer and physicist whose work laid the foundation for the science of THERMODYNAMICS. His major work, Réflexions sur la puissance motrice du feu (1824), provided the first theoretical background for the STEAM ENGINE and introduced the concept of the second law of THERMODYNAMICS (involving ENTROPY), which was formulated later by Rudolf CLAUSIUS. Carnot's work was extended in 1834 by the railway engineer Emile Clapeyron and recognized in 1848 by William KELVIN. Carnot cycle In thermodynamics, cycle of events that demonstrates the impossibility of total efficiency in heat engines. Named after Sadi CARNOT, it shows how an engine can never convert all the heat energy supplied to it into mechanical energy. Some heat energy always remains unused in a "cold sink". In an internal combustion engine, this can be thought of as the engine itself.

Caro, Anthony (1924–) British sculptor. He is best known for distinctive "structures" made from "found" metal objects welded together in such a way that they keep their original identity but also create a definite mood. They go beyond CONSTRUCTIVISM in their expressiveness. He often places his work on the floor so as to involve the spectator on an intimate level. He worked as an assistant to Henry Moore.

carob Plant of the E Mediterranean. It belongs to the pea

family (Fabaceae/Leguminosae) and bears leguminous fruits. These long juicy pods are a foodstuff. Its seeds are used as a substitute for coffee beans. Species *Ceratonia siliqua*.

Carol I (1839–1914) Prince of Romania (1866–81); first king (1881–1914). He aided Russia in the first Russo-Turkish War (1877–78). Romanian independence and Carol's sovereignty were recognized by the Congress of Berlin (1878). By 1913 Romania had become the strongest Balkan power. He preserved the neutrality of Romania at the start of World War 1. but sympathized with Germany.

Carol II (1893–1953) King of Romania (1930–40), grandnephew of CAROL I. In 1925 he renounced the throne. He returned in 1930 and supplanted his son Michael as king, despite liberal opposition and economic crisis. Carol II supported Fascism. He aimed to become dictator, but German pressure forced him to abdicate in favour of his son Michael in 1940, leaving power in the hands of the Romanian fascist leader, Ion Antonescu.

carol Traditional song usually of religious joy and associated with Christmas. Earliest examples date from the 14th century. **Caroline Islands** Archipelago of *c.*600 volcanic islands, coral islets and reefs in the W Pacific Ocean, N of the Equator; part of the US Trust Territory of the Pacific Islands. Politically the islands exist as two entities. In 1979 all the islands except the Belau group became the Federated States of MICRONESIA. Area: 1,130sq km (450sq mi).

Carolingian renaissance Cultural revival in France and Italy under the encouragement of CHARLEMAGNE. Having enlarged and enriched the Frankish kingdom and organized an efficient government, the illiterate monarch gathered notable educators and artists from all over the world. He promoted Catholicism, art, and learning by founding abbeys and encouraging church building. As the first Roman emperor in the West for over 300 years, he imposed a new culture in Europe, combining Christian, Roman and Frankish elements. Carolingians Second Frankish dynasty of early medieval Europe. Founded in the 7th century by Pepin of Landen, it rose to power under the weak kingship of the MEROVINGIANS. In 732 Charles Martel defeated the Muslims at Poitiers; in 751 his son PEPIN III (THE SHORT) deposed the last Merovingian and became king of the Franks. The dynasty reached its peak under Pepin's son CHARLEMAGNE (after whom the dynasty is called), who united the Frankish dominions and much of w and central Europe, and was crowned Holy Roman emperor by the pope in 800. His empire was later subdivided and broken up by civil wars. Carolingian rule finally ended in 987.

Carothers, Wallace Hume (1896–1937) US chemist who discovered the synthetic polyamide fibre now called NYLON. carp Freshwater fish native to temperate waters of Asia. Introduced to the USA and Europe, it is an important food fish. It is brown or golden and has four fleshy mouth whiskers called barbels. Unlike other species of carp, the mirror carp has only a few scales and the leather carp has none. Length: to 1m (3.2ft). Family Cyprinidae; species Cyprinus carpio.

Carpaccio, Vittore (1460–1525) Venetian painter. His narrative paintings relate incidents against a background of an idealized Venice. His cycle of scenes from the legend of St Ursula has an exceptional vitality. Carpaccio's range of subjects varied from religious paintings, such as *The Presentation of Christ in the Temple*, to the enchanting *Two Venetian Ladies*.

Carpathian Mountains Mountain range in central and E Europe, extending NE from the central Czech Republic to the Polish-Czech border and into Romania and the Ukraine. The N Carpathians (Beskids and Tatra) run E along the border and SE through W Ukraine; the s Carpathians (Transylvanian Alps) extend sw to the River Danube. The highest peak is Gerlachovka, 2,655m (8,711ft). Industries: timber, mining, tourism. Length: 1,530km (950mi).

carpel Female reproductive part of a flowering plant. A carpel consists of a STIGMA, a STYLE and an OVARY. A group of carpels make up the **gynoecium**, the complete female reproductive structure within a flower.

carpetbaggers Term used after the US CIVIL WAR to refer to Northern whites who entered the South as Republicans. They were regarded by many white Southerners as oppor-

tunists, seeking political office with the aid of the votes of former slaves for the sake of economic gain. They were alleged to have arrived with nothing more than a small travelling bag. Carranza, Venustiano (1859-1920) Mexican political leader. As first chief of the constitutionalist army during the MEXICAN REVOLUTION, Carranza defeated Victoriano HUERTA (1914). Interim president in 1915, he allowed the Pershing expedition to pursue "Pancho" VILLA, resulting in the US occupation of Veracruz. Elected president in 1917, he was unable to impose a civilian successor. Carranza was murdered. Carreras, José Maria (1946–) Spanish tenor. He made his debut in Barcelona (1970), going on to sing in opera houses worldwide. At the height of his career he developed leukaemia. After treatment, he successfully returned to the stage in 1988, becoming a household name as one of the Three Tenors, with Placido Domingo and Luciano Pavarotti. Carroll, Lewis (1832–98) (Charles Lutwidge Dodgson) British mathematician, photographer and children's writer. An Oxford don, much of whose output consisted of mathematical textbooks, he is remembered for Alice's Adventures in Wonderland (1865) and its sequel, Through the Looking Glass (1872). Along with his nonsense poem The Hunting of the Snark (1876), they have attracted much serious scholarly criticism.

carrot Herbaceous, generally BIENNIAL, root vegetable, cultivated widely as a food crop. The edible orange taproot is the plant's store of food for the following year. The plant is topped by delicate fern-like leaves and white or pink flower clusters. Family UMBELLIFERAE; Species *Daucus carota*.

Carson, Edward Henry (1854–1935) Irish political leader. A famous barrister and powerful orator, he was the leader of resistance to Irish Home Rule. Organizing the paramilitary Ulster Volunteers (1912) and proclaiming "Ulster will fight, and Ulster will be right", he forced the British government to exclude the Protestant provinces from the Home Rule Agreement of 1914.

Carson, Kit (Christopher) (1809–68) US guide and soldier. He originally lived as a trapper and hunter but achieved fame for his work as a guide on FRÉMONT'S expeditions (1842–46). In 1854 he became an Indian agent in New Mexico and in 1861 became a colonel in the US army, fighting against Confederate forces. In 1868 he became superintendent of Indian affairs for the Colorado Territory.

Carson City State capital of Nevada, USA, 50km (30mi) s of Reno. The city grew rapidly after silver was discovered in the Comstock Lode in 1859. It was named after Kit Carson. Gambling is the main industry. Pop. (1990) 40,443.

Cartagena City and port in NW Colombia, on the Bay of Cartagena in the Caribbean Sea; capital of the department of Bolívar. It is the principal oil port of Colombia. There is a university (founded 1824). Industries: oil refining, sugar, tobacco, textiles, tourism. Pop. (1992) 688,306.

Cartagena Major seaport in SE Spain, on the Mediterranean Sea. Founded in *c*.255 BC by the Carthaginians, the settlement later fell to the Romans. Moors captured it in the 8th century, but it was retaken by Spaniards in the 13th century. In 1585, it was destroyed by Francis Drake. It is the site of the medieval Castillo de la Concepción and a modern naval base. Industries: shipbuilding, lead, zinc, iron. Pop. (1991) 166,736.

cartel Formal agreement among the producers of a particular product to fix the price and divide the market among themselves. It usually results in higher prices for con-

◀ carp Bony fish belonging to the order Cypriniformes, carps have large bodies usually covered evenly with scales, but these may be missing in cultivated types such as the mirror carp.

▲ cashew Grown in tropical regions, the cashew bears bean-shaped nuts that form beneath an apple-like fruit, and which have an inner and an outer shell which are removed before roasting.

▲ cassava Grown widely throughout the tropics, cassava (*Manihot utilissama*) is one of the world's most important tubers. A processed form of meal is produced from its roots and used as a cereal substitute.

sumers and extra profits for the producers. Cartels are illegal in many countries.

Carte, Richard D'Oyly (1844–1901) English impresario and producer of the operas of GILBERT and SULLIVAN. He founded the Savoy Theatre, London (1881).

Carter, Angela (1940–92) British novelist and short story writer. Renowned for her daring and innovative style, Carter is closely associated with MAGIC REALISM. Her writing draws on legend and myth, and mixes past and present, a technique apparent in Nights at the Circus (1984), whose central character is half-woman, half-bird. Other writings include the novels The Magic Toyshop (1967) and The Passion of New Eve (1977) and short-story collections such as The Bloody Chamber (1979) and Fireworks (1987).

Carter, Elliott Cook, Jr (1908–) US composer, widely regarded as the leading modern American composer. His works are notable for their elaborate COUNTERPOINT, complex structures and use of tempo as an aspect of form. His compositions include a piano (1946) and a cello (1948) sonata, *Variations* (1953–55) and *Concerto* (1970) for orchestra, and four string quartets (1951, 1959, 1971 and 1986). He received a Pulitzer Prize for his second string quartet (1960).

Carter, Jimmy (James Earl, Jr) (1924–) 39th US president (1977–81). Carter was a Democrat senator (1962–66) and governor (1971–74) for the state of Georgia. In 1976 he defeated the incumbent President Gerald FORD. Carter had a number of foreign policy successes, such as the negotiation of the CAMP DAVID AGREEMENT (1979). These were overshadowed, however, by the disastrous attempt to free US hostages in Iran (April 1980). Following the Soviet invasion of Afghanistan, Carter backed a US boycott of the 1980 Moscow Olympics. Events in Iran fuelled domestic problems. An oil price rise contributed to spiralling inflation, which was dampened only by a large increase in interest rates. In the 1980 general election Carter was easily defeated by Ronald Reagan. Since then he has sought to promote human rights and acted as a international peace broker.

Cartesian coordinate system System in which the position of a point is specified by its distances from intersecting lines (axes). In the simplest type – rectangular coordinates in two dimensions – two axes are used at right angles: x and y. The position of a point is then given by a pair of numbers (x, y). The abscissa, x, is the point's distance from the y axis, measured in the direction of the x axis, and the ordinate, y, is the distance from the x axis. The axes in such a system need not be at right angles but should not be parallel to each other. Three axes represent three dimensions.

Carthage Ancient port on a peninsula in the Bay of Tunis, N Africa. It was founded in the 9th century BC by Phoenician colonists. It became a great commercial city and imperial power controlling an empire in North Africa, s Spain and the w Mediterranean islands. The rise of ROME in the 3rd century resulted in the Punic Wars and, in spite of the victories of Hannibal, ended with the destruction of Carthage in the Third Punic War (149–146 BC). It was resettled as a Roman colony, and in the 5th century AD was the capital of the VANDALS.

Carthusian Monastic order founded by St Bruno in 1084. It is based at the Grande Chartreuse monastery near Grenoble, France. It is a mainly contemplative order, in which monks and nuns solemnly vow to live in silence and solitude.

Cartier, Jacques (1491–1557) French explorer who discovered the St Lawrence River (1535) and navigated it to Hochelaga, the site of Montreal. He laid the basis for French settlements in Canada.

cartilage Flexible supporting tissue made up of the tough protein COLLAGEN. In the vertebrate EMBRYO, the greater part of the SKELETON consists of cartilage, which is gradually replaced by BONE during development. In humans, cartilage is also present in the larynx, nose and external ear.

cartoon Originally a preparatory drawing. Italian Renaissance painters made very thorough cartoons, such as RAPHAEL for the Sistine Chapel. Its more common, modern usage in reference to a humorous drawing or satirical picture is derived from a 19th-century competition for fresco designs for Parliament parodied in *Punch* magazine. *See also* CARICATURE

Cartwright, Edmund (1743–1823) British inventor of the power loom. It was patented in 1785, but not used commercially until the early 19th century. He also invented a wool-combing machine (patented 1789) and an alcohol engine (1797).

Caruso, Enrico (1873–1921) Italian tenor, one of the most widely acclaimed opera singers of all time. He made his debut in Naples (1894), but settled in the USA. He appeared in leading European opera houses and made many recordings.

Carver, George Washington (1864–1943) US agricultural chemist. He is best known for his scientific research on the peanut, from which he derived more than 300 products. Born into an African-American slave family, his chief motive was to benefit the impoverished farmers of the South.

Carver, Raymond (1938–88) US short story writer and poet. Carver's fiction depicts, with uncompromising realism, the lives of US citizens. His short stories are collected in *Will You Please Be Quiet, Please?* (1976), *What We Talk About When We Talk About Love* (1981) and *Cathedral* (1983). He also wrote five books of poetry.

Cary, (Arthur) Joyce (Lunel) (1888–1957) British novelist. His experiences in colonial service in Nigeria (1914–20) are reflected in novels, such as *Mister Johnson* (1939). His best-known novel is *The Horse's Mouth* (1944).

Casablanca (Dar el-Beida) City on Africa's Atlantic coast, w Morocco. The site was resettled in 1515 by the Portuguese after their destruction of the old town. An earthquake damaged the city (1755). Today, Casablanca is a thriving commercial centre, exporting phosphates and importing petroleum products. Industries: tourism, textiles, fishing. Pop. (1992 est.) 2,700,000.

Casals, Pablo (Pau) (1876–1973) Spanish (Catalan) cellist and conductor. He organized his own orchestra in Barcelona in 1919 and organized the annual Casals Festival in Puerto Rico from 1957. His virtuoso playing influenced many cellists.

Casanova de Seingalt, Giovanni Giacomo (1725–98) Italian libertine and adventurer. From 1750 he travelled through Europe leading a dissolute existence. He amassed a fortune and mixed with high society. His exploits are recounted in his *Memoirs*, which were not published in unexpurgated form until 1960. His name is synonymous with the amorous adventurer.

Cascade Range Mountain range in w North America, extending from NE California across Oregon and Washington into Canada. The Cascade Tunnel, at 13km (8mi) the longest rail tunnel in the USA, passes through them. Crater Lake National Park is in the Cascades. The highest peak is Mount RAINIER, at 4,395m (14,410ft). The range also includes Mount ST HELENS, at 2,549m (8,363ft).

casein Principal protein in milk, containing about 15 amino acids. Obtained by the addition of either acid or the enzyme rennet, casein is used to make plastics, cosmetics, paper coatings, adhesives, paints, textile sizing, cheeses and animal feed. Casement, Sir Roger David (1864–1916) Irish humanitarian and revolutionary. While a British consul (1895–1912) he exposed the exploitation of rubber-gatherers in the Belgian Congo and similar iniquities in South America. During World War 1 he sought aid for an Irish nationalist uprising, and was executed for treason after the British secret service had tried to destroy his reputation by publishing the Casement diaries. cash crop Agricultural crop cultivated for its commercial value, as opposed to one grown for subsistence. The term is often encountered in development economics. Cash crops, such as coffee, sugar or cotton, were introduced into Africa, Asia and the Americas as part of the colonialist project and intensively farmed via plantation systems.

cashew Evergreen shrub or tree grown in the tropics, important for its nuts. The wood is used for boxes and boats and produces a gum similar to gum arabic. Height: to 12m (39ft). Family Anacardiaceae; species *Anacardium occidentale*.

cashmere Woolly hair of a goat native to Kashmir, India. The warm but lightweight wool is woven for clothing.

Caspian Sea Shallow salt lake, the world's largest inland body of water. The Caspian Sea is enclosed on three sides by Russia, Kazakstan, Turkmenistan and Azerbaijan. The s shore forms the N border of Iran. It has been an important

Metal alloys used to make turbine blades must withstand the huge temperatures and forces inside jet engines. The random crystalline structure formed when the alloy cools normally (as seen in the overflow ,1) can be a source of weakness. The strongest

structure is achieved by making a blade from a single crystal (2). This can be done by using heating elements (3). After the molten alloy is poured, the elements move up the sides of the mold (4) ensuring the alloy cools from the bottom and forms a single crystal.

trade route for centuries. It is fed mainly by the Volga River; there is no outlet. The chief ports are BAKU and ASTRAKHAN. It still has important fisheries and a seal trade. Area: *c*.371,000sq km (143,000sq mi).

Cassandra In Greek mythology, the daughter of PRIAM, skilled in the art of prophecy, but condemned by Apollo never to be taken seriously. Her warning that the Greeks would capture Troy went unheeded. She was raped by the Greek Ajax the lesser, and then carried off as a concubine by AGAMEMNON; they were both murdered by his wife CLYTEMNESTRA and her lover Aegisthus.

Cassatt, Mary (1845–1926) French painter and printmaker, b. USA. She was influenced by DEGAS and IMPRESSIONISM. Her finest paintings include *The Bath* (1892). She also made many fine DRYPOINT and AQUATINT studies of domestic life.

cassava (manioc) Tapioca plant native to Brazil. It is a tall woody shrub with small clustered flowers. A valuable cereal substitute is made from the tuberous roots. Height: up to 2.7m (9ft). Family Euphorbiaceae; species *Manihot esculenta*.

Cassini, Giovanni Domenico (1625–1712) French astronomer, who ran the Paris Observatory. He was the first to accurately measure the dimensions of the SOLAR SYSTEM, and discovered four satellites and also the division in the rings of SATURN that now bear his name. He measured Jupiter's rotation period, and also improved the tables of satellites.

Cassiopeia Distinctive northern constellation, representing in mythology the mother of ANDROMEDA. The five leading stars make up a "W" or "M" pattern.

Cassius Longinus (Gaius) (d.42 BC) Roman general who led the plot to assassinate Julius CAESAR. He sided with Pompey during the war against Caesar but was pardoned after Caesar defeated Pompey at Pharsalus (48 BC). After the assassination of Caesar in 44 BC he left for Sicily. Believing he had lost the battle against Mark Antony and Octavian (Augustus) at Philippi, Cassius committed suicide.

cassowary Flightless bird of rainforests in Australia and Malaysia. It has coarse black plumage, a horny crest on its brightly coloured head, large feet and sharp claws. The male incubates the eggs in a nest on the forest floor. Height: to 1.6m (65in). Family Casuariidae; species *Casuarius casuarius*.

caste Formal system of social stratification based on factors

such as race, gender or religious heritage, and sanctioned by tradition. An individual is born into and remains in a fixed social position. It is most prevalent in Hindu society.

Castile Region and former kingdom in central Spain, traditionally comprising Old Castile (N) and New Castile (s). Old Castile was part of the kingdom of León until 1230. The Castilian captured New Castile from the Moors. Queen ISABELLA I established the union with ARAGÓN in 1479, and in the 16th century Castile became the most influential power in Spain and the core of the Spanish monarchy.

Castile-La Mancha Region in central Spain; includes the provinces of Albacete, Ciudad Real, Cuenca, Guadalajara and Toledo; the capital is TOLEDO. It was captured from the Moors in 1212. Chief products are olive oil and grapes. Area: 79,226sq km (30,590sq mi). Pop. (1991) 1,658,446.

Castile-León Region in N Spain; includes the provinces of Ávila, Burgos, León, Palencia, Salamanca, Segovia, Soria, Valladolid and Zamora; the capital is Valladolid. Formerly part of the kingdom of León, Castile and Aragón were united in 1479. Extreme climate and poor soil allow limited grain growing and sheep raising. Area: 94,147sq km (36,350sq mi). Pop. (1991) 2,545,926.

casting Forming objects by pouring molten metal into moulds and allowing it to cool and solidify. Specialized processes, such as plastic moulding, composite moulding, CIRE PERDUE casting and die casting give greater dimensional accuracy, smoother surfaces and finer detail.

castle Fortified house or fortress, usually the medieval residences of European kings or nobles. Castles evolved from a need for strategic fortresses that could accommodate several households and provide shelter in times of war. Built of wood or masonry, castles were located on a raised site and sometimes surrounded by a water-filled moat. Walls were thick and high enough to withstand attack, with parapets to enable defenders to manoeuvre between the turrets. WINDSOR CASTLE in England is a modified but recognizably medieval castle.

Castlereagh, Robert Stewart, 2nd Viscount (1769–1822) British politician. Castlereagh was chief secretary of Ireland (1799–1801) and helped secure the passage of the Act of Union with Britain in 1800. As British war secretary (1805–06, 1807–09) he vigorously opposed Napoleon but resigned after a duel with George Canning. Castlereagh was a brilliant foreign secretary (1812–22), backing Wellington in war and helping to secure long-term peace in Europe at the Congress of Vienna (1814–15).

Castor and Pollux (Dioscuri) In Greek mythology, the twin sons of LEDA. They were invoked by sailors seeking favourable winds. Zeus, father of Pollux, transformed them into the Gemini constellation after Castor died and Pollux refused to be parted from him.

castration Removal of the sexual glands (testes or ovaries) from an animal or human. In human beings, removal of the testes has been used as a form of punishment, a way of sexually incapacitating slaves to produce EUNUCHS, a way of artificially creating soprano voices (CASTRATO) and as a method of stopping the spread of cancer. It can also make animals tamer. Castrato Male voice in the soprano or mezzo-soprano register, produced in adult males by CASTRATION during boyhood. Castratos were much used in operas in the 17th and 18th centuries and in music for the Roman Catholic Church. The most famous castrato was Farinelli. See also COUNTERTENOR

Castro, Fidel Ruz (1926–) Cuban revolutionary leader and politician, premier (1959–). In 1953 he was sentenced to 15 years' imprisonment after an unsuccessful coup against the BATISTA regime. Two years later, he was granted an amnesty and exiled to Mexico. In January 1959 his guerrilla forces overthrew the regime. He quickly instituted radical reforms, such as collectivizing agriculture and dispossessing foreign companies. In 1961, the USA organized the abortive BAY OF PIGS invasion, Castro responded by allying the revolutionary movement more closely with the Soviet Union and developing nations. In 1962 the CUBAN MISSILE CRISIS saw the USA and Soviet Union on the brink of nuclear war. Castro's attempt to export revolution to the rest of Latin America was largely crushed by the capture of his ally "Che" GUEVARA (1967). In

▲ cassowary The several species of large ground-dwelling birds — ostrich, rhea, emu and cassowary (*Casuarius* casuarius) — all resemble each other quite closely but are thought to have arisen independently and as such are examples of a phenomenon called convergent evolution.

▲ Castro Cuba's political leader since 1959, Fidel Castro has in the past enjoyed huge support from the Cuban people. However, US trade embargoes and lack of economic support from the former Soviet Union, has brought about public demand for economic and political reforms.

▲ catalytic converter A

catalytic converter is placed in the exhaust system (1) to reduce the pollution produced by combustion engines (2). It comprises a ceramic honeycomb structure (3), which maximizes the surface area of the converter, covered in catalysts - normally platinum and rhodium (4). As exhaust gases, primarily carbon monoxide, nitric oxide and hydrocarbons from the cylinder, pass through the converter they react with the catalysts. The platinum and rhodium accelerate oxidation and reduction in the hot gases. The pollutants are oxidized into water, carbon dioxide and nitrogen.

▲ caterpillar The lackey moth (Malacosoma neustria) is found throughout Europe. Its colourfully striped caterpillars live communally on hawthorn and similar bushes, which they may strip of their leaves. Eggs are laid in a collar around a twig.

1980 he lifted the ban on emigration and 125,000 people left for Florida. While Castro was able to maintain political independence from the Soviet Union, the Cuban economy was heavily dependent on Soviet economic aid. The combined effect of the collapse of European communism and the continuing US trade embargo dramatically worsened the Cuban economy, forcing Castro to introduce economic reforms.

cat Carnivorous, often solitary and nocturnal mammal of the family Felidae, ranging in size from the rare Siberian tiger to the domestic cat. It has specialized teeth and claws for hunting, a keen sense of smell, acute hearing, sensitive vision, and balances well with its long tail (only the Manx cat is tailless). Cats all have fully retractile claws, except for the cheetah which needs greater purchase on the ground to run at high speeds. One of the first animals to be domesticated, cats have appeared frequently in myth and religion. Order Carnivora.

catabolism See METABOLISM

Catalan Romance language spoken mainly in NE Spain, but also in the Balearic Islands, Andorra, and southern France. There are c.6 million speakers.

Catalonia (Sp. Cataluña) Region in NE Spain, extending from the French border to the Mediterranean Sea. The capital is BARCELONA. Catalonia includes the provinces of Barcelona, Gerona, Lérida and Tarragona. United with Aragón in 1137, it retained its own laws and language. During the Spanish Civil War it was a Loyalist stronghold, and recently has been a focus of separatist movements. The Costa Brava is an important tourist area. Products: grain, fruit, olive oil, wool, wine. Area: 31,932sq km (12,329sq mi). Pop. (1990) 6,059,454.

catalyst Substance that speeds up the rate of a chemical reaction without itself being consumed. Many industrial processes rely on catalysts such as the HABER PROCESS for manufacturing AMMONIA. Metals or their compounds catalyse by adsorbing gases to their surface, forming intermediates that then readily react to form the desired product while regenerating the original catalytic surface. The METABOLISM of all living organisms depends on biological catalysts called ENZYMES.

catalytic converter Anti-pollution device used in internal combustion engines. It consists of a bed of catalytic agents through which flow the gaseous exhaust of fuel combustion. Converters located in mufflers reduce harmful unburned hydrocarbons and carbon monoxide. These converters are adversely affected by tetraethyl lead found in some gasolines.

catalytic cracking See CRACKING

Catania Port near Mount Etna, E Sicily, Italy, capital of Catania province. Ancient Catania was founded by the Greeks in 729 BC. It was devastated by a volcanic eruption in 1669 and an earthquake in 1693. It has Greek and Roman ruins, a Norman cathedral (1091) and a university (1444). Industries: chemicals, cement, textiles. Pop. (1992) 329,898. cataract Opacity in the lens of an eye, causing blurring of vision. Most cases are due to degenerative changes in old age but it can also be congenital, the result of damage to the lens,

catastrophe theory Mathematical technique published in 1972 by the French mathematician René Thom. It is useful for describing situations in which gradually changing motivations or inputs cause a sudden discontinuous leap in a system's behaviour or output.

or some metabolic disorder such as diabetes. Treatment is by

removal of the cataract and implanting an artificial lens.

catechism Manual of instruction in Christian church teachings, for use by the young or by any candidate preparing for admission to membership of a church. In some sects, it provides a medium of instruction for baptized members. A catechism often takes the form of question and answer.

caterpillar Worm-like larva of a butterfly or moth; it has a segmented body, short antennae, simple eyes, three pairs of true legs and chewing mouthparts. Nearly all caterpillars feed voraciously on plants and are serious crop pests.

catfish Any member of a large family of slow-swimming scaleless fish found in tropical and subtropical waters; it has fleshy barbels on the upper jaw, sometimes with venomous spines. Most species live in freshwater and can be farmed. Length: up to 3.3m (10ft). Order Siluriformes.

cathedral (Gk. kathedra, throne or seat) Main church of a bishop's province, the church containing his throne. In the ROMANESQUE period, cathedrals started to become very large and many Gothic cathedrals are gigantic structures. The prototype of the true Gothic cathedral is the Abbey Church of St.-Denis near Paris. Suger, the abbot, enlarged the existing Romanesque building in the 12th century, adding a chapel and pointed groin VAULT. Bigger windows and slender arches gave it a sense of lightness very different from the static solidity of the Romanesque. Among the most remarkable of the great cathedrals of western Europe that followed are Notre-Dame, Paris (begun 1163), and CHARTRES (begun 1194) in France, COLOGNE cathedral in Germany, and MILAN cathedral (begun 1386) in Italy. Some of the finest English examples, such as Canterbury and York, combine Romanesque and Gothic features. St Mark's, VENICE, is a magnificent Byzantine example. Central and Eastern European cathedrals often amalgamate Byzantine and western features, while many Spanish cathedrals combine Romanesque, French, German and Moorish features. In Latin America, cathedrals are often of Portuguese or Spanish RENAISSANCE and BAROQUE origin. The Episcopal Cathedral of St John the Divine in New York is the world's largest Gothic cathedral. See also BYZANTINE ART AND ARCHITECTURE; GOTHIC ART AND ARCHITECTURE

Cather, Willa (1876-1947) US novelist and short story writer. She grew up among immigrant Nebraskan farmers who became the subject of her work. Her fiction explores the pioneer spirit: love of the land, loyalty to family and the struggle with nature. Her books, often featuring strong characters who lead life as a noble endeavour, include O Pioneers (1913), A Lost Lady (1923) and Death Comes for the Archbishop (1927). Catherine II (the Great) (1729-96) Empress of Russia (1762-96). A German princess, she married Peter III in 1745 and succeeded him after he was murdered. She began as an "enlightened despot", with ambitious plans for reform. Her economic improvements, patronage of the arts and vast extension of Russian territory (chiefly at the expense of the Ottoman Turks) raised national prestige, but did little for Russian peasants. After the revolt of 1773-74, led by the Cossack Pugachev, she became increasingly conservative.

Catherine de' Medici (1519-89) Oueen of France, wife of Henry II and daughter of Lorenzo de' MEDICI. She exerted considerable political influence after her husband's and first son's deaths in 1559. In 1560 she became regent for her second son, CHARLES IX, and remained principal adviser until his death (1574). Her initial tolerance of the HUGUENOTS turned to enmity at the beginning of the French Wars of RELIGION. Her concern for preserving the power of the monarchy led to a dependence on the Catholic House of GUISE, whose growing power she failed to control. Fearing the decline of her own power at court due to the rise of the Huguenot leader Gaspard de Coligny, she planned the SAINT BARTHOLOMEW'S DAY MASSACRE (1572). When her third son, HENRY III, acceded in 1574, her effectiveness in policy-making had been compromised.

Catherine of Aragon (1485–1536) Daughter of Ferdinand and Isabella, she was the first queen of Henry VIII (1509). Her only surviving child was a daughter (Mary I). The need to produce a male heir, combined with Henry's desire for Anne Boleyn, induced him to seek an annulment (1527), on the grounds of her previous marriage to his brother Arthur. The pope's procrastination led to the break with Rome and to the English Reformation. The annulment was granted by Thomas Cranmer in 1533.

cathode In chemistry, the negative electrode of an electrolytic cell or electron tube. It attracts positive ions (cations) during ELECTROLYSIS.

cathode ray Radiation emitted by the cathode of a thermionic electron valve containing a gas at low pressure. The rays were identified in 1897 by J.J. THOMSON as streams of charged, elementary particles having extremely low mass, later called ELECTRONS. Some electrons are emitted because the CATHODE is heated but most because of collisions between the cathode and positive ions formed in the valve.

cathode-ray tube Evacuated electron tube used for television picture tubes, oscilloscopes and display screens in radar sets and computers. An electron gun shoots a beam of electrons, focused by a grid. The electrons strike a fluorescent screen and produce a spot of light. In a television tube, an electrostatic or magnetic field deflects the beam so that it scans a number of lines on the screen, controlled by the incoming picture signals.

Catholic Church Term used in Christianity with one of several connotations: (1) It is the Universal Church, as distinct from local churches. (2) It means the church holding "orthodox" doctrines, defined by St Vincent of Lérins as doctrines held "everywhere, always, and by all" - in this sense the term is used to distinguish the church from heretical bodies. (3) It is the undivided church as it existed before the schism of East and West in 1054. Following this, the Western church called itself "Catholic", the Eastern church "Orthodox". (4) Since the REFORMATION, the term has usually been used to denote the ROMAN CATHOLIC CHURCH, although the ANGLICAN COMMU-NION and the OLD CATHOLICS use it to cover themselves as well. Catholic Emancipation, Act of (1829) Measure by which the statutes (dating back to the REFORMATION) barring Roman Catholics in Britain from holding civil office or sitting in Parliament were repealed. Emancipation was achieved through a series of acts. In 1778 restrictions against land purchase and inheritance were lifted. In 1791 further restrictions were removed, and by 1793 Catholics were allowed in the services, universities and judiciary. The final concession allowing them to sit in Parliament was wrung from the government of the Duke of WELLINGTON, who was concerned by civil unrest in Ireland, led by Daniel O'CONNELL.

cation Positive ION that is attracted to the CATHODE during electrolysis.

Catlin, George (1796–1872) US painter, who concentrated on pictures of Native American life. His paintings represent 45 tribal groups and include many portraits. He published books about his work, in particular *Notes on the Manners, Customs and Conditions of the North American Indians* (1841).

Cato the Elder (234–149 BC) (Marcus Porcius) Roman leader. As censor, from 184 BC, he worked to restore the old ideals of Rome – courage, honesty and simple living. His constant urging in the Senate that CARTHAGE should be destroyed helped initiate the Third Punic War.

Cato the Younger (95–46 BC) (Marcus Porcius Cato Uticensis) Roman politician, great-grandson of CATO THE ELDER. A firm supporter of the republic, he opposed Julius CAESAR

and forced the creation of the First Triumvirate. He favoured POMPEY in the civil war against Caesar (49 BC) and, when Caesar emerged victorious, committed suicide.

CAT scan (computerized axial tomography) X-ray technique for displaying images of cross-sections through the human body. X-ray sources and detectors slowly move around the patient's body on opposite sides, producing a changing "view" of an organ. The data from the detectors is processed through a computer to display only the details relating to a specific "slice" through the body.

cattle Large ruminant mammals of the family Bovidae, including all the varieties of modern domestic cattle (*Bos tau-rus*), the brahman (*Bos indicus*) and hybrids of these two. The family also includes the YAK, the wild GAUR, the wild banteng and the kouprey. Different terms are used to indicate the sex and age of domestic cattle. The male is born as a bull calf and becomes a bull if left intact; if castrated, it becomes a steer, bul-

▲ catfish The name "catfish" is applied to a very large family of freshwater fish of the order Siluriformes. They tend to be sluggish in their movements and have barbels (whiskers) growing from their mouths.

Television receivers are a type of cathode-ray tube. Three electron guns (1) receive colour signals from a colour decoder which splits the colour signal into red, green and blue. The guns fire three beams of electrons through vertical and

horizontal deflection coils (2) onto the screen of a "shadow mask tube" (3). This is made up of about a million dots (4), a third of which glow red who bombarded, a third blue and the remaining third, green. The dots compose the colour picture

received by the television. The beam of electrons scans hundreds of lines on the screen (525 in the USA, 625 in Europe) making up the moving pictures. The beam scans from left to right, starting top left and finishing at the bottom right (5).

C

lock or ox if used as a draught animal. The female is a heifer calf, growing to become a heifer and, after calving, a cow. In Hinduism, the cow is sacred. Horns, sometimes appearing only on the male, are permanent, hollow and unbranched. Domestic cattle are raised for meat, milk and other dairy products. Leather, glue, gelatin and fertilizer are made from the carcass.

Catullus (Gaius Valerius) (84–54 BC) Roman lyric poet. He is best known for his short love lyrics, the most famous of which refer to Lesbia, depicting the Roman woman, Clodia, with whom Catullus was in love. His longer works are the poems *Attis* and *The Marriage of Peleus and Thetis*.

Caucasus (Bol'šoj Kavkaz) Mountain region in SE Europe, Russia, Georgia, Armenia and Azerbaijan, extending SE from the mouth of the River Kuban on the Black Sea to the Apscheron Peninsula on the Caspian Sea. The system includes two major regions: N Caucasia (steppes) and TRANSCAUCASIA. It forms a natural barrier between Asia and Europe. There are deposits of oil, iron and manganese, and cotton, fruit and cereal crops are grown. The highest peak is Mount Elbrus, 5,637m (18,493ft). Length: 1,210km (750mi).

cauliflower Form of CABBAGE with a short thick stem, large lobed leaves and edible white or purplish flower clusters that form tightly compressed heads. Family Brassicaceae; species *Brassica oleracea botrytis*.

caustic soda (sodium hydroxide, NaOH) Strong ALKALI prepared industrially by the ELECTROLYSIS of salt (sodium chloride, NaCl). It is a white solid that burns the skin, with a slippery feel because it absorbs moisture from the air. It also absorbs atmospheric carbon dioxide, so forming a crust of sodium carbonate (Na₂CO₃). Caustic soda is used in many industries, such as soapmaking and in bauxite-processing to make ALUMINIUM.

Cavalier (Fr. *chevalier*) Name adopted by the Royalists during the English CIVIL WAR in opposition to the ROUNDHEADS (Parliamentarians). The court party retained the name after the RESTORATION until superseded by the name TORY.

cavalry Mounted troops. Cavalry were first employed by the ancient Egyptians; the first use of cavalry in Europe dates from the invasions of the Huns, Magyars and Mongols. The last prominent use of cavalry occurred in the American Civil. War, although it was used early in World War 1 to disastrous effect. cave Natural underground cavity. There are several kinds of caves, including coastal caves, formed by wave erosion, ice caves, formed in glaciers, and lava caves. By far the largest caves are formed in carbonate rocks such as limestone.

Cavendish, Henry (1731–1810) British chemist and physicist. He discovered hydrogen and the compositions of water and air, and estimated the Earth's mass and density by a method now known as the "Cavendish experiment". He also discovered nitric acid (HNO₃), the gravitational constant, measured the specific gravity of carbon dioxide (CO₂) and hydrogen, and stated the inverse square law for the interaction of charged particles.

▶ Ceauşescu The former president of Romania, Nicloae Ceauşescu, attempted massive social and political reforms while in power (1978—89), many of which were hugely unpopular. With the demise of communism in Eastern Europe, he was deposed, and executed along with his wife Elena.

caviar Roe (eggs) of a STURGEON and three less common fish (also occasionally a salmon) which, salted and seasoned, is a gastronomic delicacy, especially in Russia. The roe is extracted from the fish before it can spawn.

Cavour, Camillo Benso, Conte di (1810–61) Piedmontese politician, instrumental in uniting Italy under Savoy rule. From 1852 he was prime minister under Victor EMMANUEL II. He engineered Italian liberation from Austria with French aid, expelled the French with the help of Giuseppe GARIBALDI, and finally neutralized Garibaldi's influence. This led to the formation of the kingdom of Italy (1861).

cavy (wild guinea pig) Herbivorous South American rodent from which domestic GUINEA PIGS are descended. Small, with dark fur, cavies live in burrows and often form large colonies for protection. Family Caviidae; species *Cavia aperea*.

Caxton, William (1422–91) First English printer. Following a period in Cologne (1470–72), where he learned printing, he set up his own press in 1476 at Westminster. He published more than 100 items many of them his own translations from French, Latin and Dutch. Among his most influential publications were editions of CHAUCER, GOWER, and MALORY.

Cayley, Sir George (1773–1857) British inventor who founded the science of AERODYNAMICS. He built the first glider to carry a man successfully, developed the basic form of the early aeroplane and invented a caterpillar tractor.

Cayman Islands British dependency in the West Indies, comprising Grand Cayman, Little Cayman and Cayman Brac, c.325km (200mi) NW of Jamaica, in the Caribbean Sea. The capital is Georgetown. The islands were discovered by Columbus in 1503, and ceded to Britain in the 17th century. The islanders voted against independece in 1962. Industries: tourism, international finance, turtle and shark fishing, timber, coconuts, oil trans-shipment. Area: 259sq km (100sq mi). Pop. (1995) 33,600. See West Indies map

Cayuga Major branch of the Five Nations of the Iroquois Confederacy, originally living around Lake Cayuga, New York, and the Grand River in Ontario, Canada. The Cayuga fought with the British during the American Revolution and afterwards became widely scattered into Ohio, Wisconsin, and Oklahoma, where they joined the Seneca. Today, there are *c.*550 Cayuga in Oklahoma and 400 in New York.

CBI Abbreviation of the CONFEDERATION OF BRITISH INDUSTRY CD-ROM (compact disc read-only memory) Optical storage device for computer data and programs. A COMPACT DISC, a CD-ROM can store more data and allows much faster access than a MAGNETIC DISK. Computer games, encyclopedias and other software are now available in this form.

Ceauşescu, Nicolae (1918–89) Romanian statesman, the country's effective ruler from 1965 to 1989. He became a member of the politburo in 1955, general secretary of the Romanian Communist Party in 1965 and head of state in 1967. He promoted Romanian nationalism, pursued an independent foreign policy, but instituted repressive domestic policies. He was deposed and executed in the December 1989 revolution.

Cecil, Robert, 1st Earl of Salisbury (1563–1612) English statesman, son of Lord Burghley. He became secretary of state to Elizabeth I on his father's retirement in 1596. He was chiefly responsible for negotiating the accession of James I (1603).

cedar Evergreen tree native to the Mediterranean and Asia, but found in warm temperate regions worldwide; it has clustered needle-like leaves, long cones and fragrant, durable wood. It is a popular ornamental tree. Height: 30–55m (100–180ft). Family Pinaceae; genus *Cedrus*.

Celebes Former name of SULAWESI, Indonesia

celery Biennial plant, native to the Mediterranean and widely cultivated for its long stalks used as a vegetable. Its fruits are used as food flavouring and in medicine. Family Apiaceae/Umbelliferae; species *Apium graveolens*.

celesta (céleste) Percussion instrument with a range of four octaves. Like the GLOCKENSPIEL it consists of steel bars that are struck, producing a tinkling tone. Invented by Auguste Mustel in Paris (1886), it features on the "Dance of the Sugar Plum Fairy" in Tchaikovsky's *Nutcracker* ballet (1892).

celestial mechanics Branch of ASTRONOMY concerned

with the relative motions of stars and planets that are associated in systems (such as the Solar System or a binary star system) by gravitational fields. Introduced by Isaac NEWTON in the 17th century, celestial mechanics, rather than general RELATIVITY, is usually sufficient to calculate the various factors determining the motion of planets, satellites, comets, stars and galaxies around a centre of gravitational attraction.

celestial sphere Imaginary sphere of infinite radius used to define the positions of celestial bodies as seen from Earth, the centre of the sphere. The sphere rotates, once in 24 hours, about a line that is an extension of the Earth's axis. The position of a celestial body is the point at which a radial line through it meets the surface of the sphere. The position is defined in terms of coordinates, such as declination and right ascension or altitude and azimuth, which refer to great circles on the sphere, such as the celestial EQUATOR or the ecliptic.

celibacy Commitment to a lifelong abstention from sexual relations. The status of celibacy as a religious obligation is found in Christianity and Buddhism. From the 4th century, it gradually became compulsory for Roman Catholic priests, monks and nuns. In some Orthodox religions, married men may become priests, but bishops must be celibate.

cell Basic biological unit of which all plant and animal tissues are composed. The cell is the smallest unit of life that can exist independently, with its own self-regulating chemical system. Most cells consist of a MEMBRANE surrounding jelly-like CYTOPLASM with a central NUCLEUS. The nucleus is the main structure in which DNA is stored in CHROMOSOMES. Animal cells vary widely in shape. A red blood cell, for instance, is a biconcave disc, while a nerve cell has a long fibre. The cells of plants and algae are enclosed in a cell wall, which gives them a more rigid shape. Bacterial cells also have a cell wall, but do not have nuclei or chromosomes; instead, they have a loop of DNA floating in the cytoplasm. More advanced cells (those that have nuclei), often have other membrane-bounded structures inside the cell, such as MITOCHONDRIA and CHLOROPLASTS. See also EUKARYOTE: PROKARYOTAE

cell, electrochemical Device from which electricity is obtained due to a chemical reaction. A cell consists of two electrodes (a positive ANODE and a negative CATHODE) immersed in a solution (electrolyte). A chemical reaction takes place between the electrolyte and one of the electrodes. In a **primary** cell, current is produced from an irreversible chemical reaction, and the chemicals must be renewed at intervals. In a **secondary** cell (BATTERY), the chemical reaction is reversible, and the cell can be charged by passing a current through it.

cell division Process by which living cells reproduce and enable an organism to grow. In EUKARYOTE cells, a single cell splits in two, first by division of the NUCLEUS (occurring by MITOSIS Or MEIOSIS), then by fission of the CYTOPLASM. For growth and asexual reproduction, where the daughter cells are required to be genetically identical to their parents, mitosis is used. Meiosis results in daughter cells having half the number of chromosomes (HAPLOID). This type of division results in the production of GAMETES (sex cells), which allow genetic information from two parents to be combined at FERTILIZATION, when the DIPLOID number of chromosomes is restored. See also ALTERNATION OF GENERATIONS

cello (violoncello) Musical instrument, member of the violin family. It has a soft, mellow tone, one octave below the viola; its strings are tuned to C-G-D-A. It is played with a bow and supported by the knees of a seated player. It was developed in the 16th-century by the AMATI family. Among the most important players of the 20th century were Pablo CASALS and Jacqueline DU PRÉ.

cellophane Flexible, transparent film made of regenerated CELLULOSE and used mostly as a wrapping material. It is made by dissolving wood pulp or other plant material in an ALKALI, to which carbon disulphide is added to form viscose. This is forced through a narrow slit into a dilute acid where it precipitates (separates as solid particles) as a film of cellulose.

celluloid Hard plastic invented in the USA in 1869 by John Hyatt. Hyatt made the PLASTIC by mixing cellulose nitrate with pigments and fillers in a solution of camphor and alcohol. When heated, it can be moulded into a variety of shapes

and hardens on cooling. It was the first major plastic, and used for early motion pictures. It is highly flammable.

cellulose POLYSACCHARIDE, CARBOHYDRATE $(C_6H_{10}O_5)_n$ that is the structural constituent of the cell walls of plants and algae. Consisting of parallel unbranched chains of GLUCOSE units cross-linked together into a stable structure, it forms the basic material of the paper and textile industries.

Celsius Temperature scale, devised in 1742 by the Swedish astronomer Anders Celsius. On this scale the difference between the reference temperatures of the freezing and boiling points of water is divided into 100 degrees. The freezing point is 0°C and the boiling point is 100°C. The name Celsius officially replaced centigrade in 1948. Degrees Celsius are converted to degrees Fahrenheit by multiplying by 1.8 and then adding 32. See also Thermometer

Celt Someone who speaks one of the a CELTIC LANGUAGES or is descended from a Celtic language area. After 2000 BC, early Celts spread from E France and w Germany over much of w Europe, including Britain. They developed a village-based, heirarchical society headed by nobles and DRUIDs. Conquered by the Romans, the Celts were pushed into Ireland, Wales, Cornwall and Brittany by Germanic peoples. Their culture remained vigorous, and Celtic churches were important in the early spread of Christianity in N Europe.

Celtic art Artworks produced by Celts during the prehistoric La Tène period. For convenience, this period is normally subdivided into four periods: Early Style (after c.480 BC); Waldalgesheim Style (after c.350 BC); Plastic Style (after c.290 BC); and Hungarian Sword Style (after c.190 BC). Its chief characteristic was swirling, abstract design, which found its fullest expression in metalwork and jewellery. The term is sometimes also applied to the La Tène-influenced early Christian art of w Europe, such as The BOOK OF KELLS.

Celtic languages Group of languages spoken in parts of Britain, Ireland and France, forming a division within the Italo-Celtic subfamily of Indo-European languages. There are two branches of Celtic languages: Brittonic, which includes Welsh, Breton and Cornish; and Goidelic, including Irish and Scots Gaelic and Manx. The Brittonic or Celtic languages were dominant in the British Isles until the 5th century AD.

Celtic mythology Legends of local deities of the Celtic tribes. Each tribe had an omnipotent god, similar to Dagda, who possessed all-embracing power. The gods' world was seen as a reflection of the world of men, while female divinities were more closely identified with nature.

Cenozoic Most recent era of geological time, beginning about 65 million years ago and extending up to the present. It is subdivided into the TERTIARY and Quaternary periods. It is the period during which the modern world with its present geographical features and plants and animals developed.

censor Public official of ancient Rome (443–22 BC). Two censors were elected for 18-month terms. Besides taking the census, they supervised public works, finance and morals, and filled senatorial vacancies.

▲ cell Animal cells are made up of many different components called organelles. The most prominent is the nucleus (1), which contains all the information of the cell in the form of chromosomes. It is surrounded by the nuclear membrane (2), which contains many pores (3) that allow the nucleus to communicate with the rest of the cell. The centre of the nucleus, the nucleolus (4) generates ribosomes (5), which provide the cell with protein. They are found on the rough endonlasmic reticulum (6), a system of flattened sacs and tubes connected to the nuclear membrane. It brings the messenger RNA molecules, which control the creation of protein, to the ribosomes. The smooth endoplasmic reticulum (7) produces small spheres called vesicles (8) that provide the Golgi apparatus (9) with protein. The Golgi apparatus modifies, sorts and packs large molecules into other vesicles which bud off (10). They are sent to other organelles, or secreted from the cell. The fusion of such vesicles with the cell membrane allows particles to be transported out of the cell (exocytosis) (11-13) or brought in (endocytosis) (14-17). Lysosomes (18) break down the molecules entering the cell into enzymes. The mitochondria (19) power the cell, using oxygen and food to generate energy in the form of adenosine triphosphate (ATP). ATP is then used in many metabolic processes essential for the cell to function.

► centipede Despite its name the centipede rarely has 100 legs. They are placed in the class Chilopoda. The house centipede (Scutigera coleoptrata) is found in damp indoor places and measures up to 5cm (2in) long.

censorship System whereby a government-appointed body or official claims the right to protect the public interest by influencing the release of any item of mass communication. Censorship usually falls into four broad categories – politics, religion, pornography or violence. Material may be censored before dissemination or may be prevented or seized by the authorities. Censorship raises questions about the freedom of speech, and advanced communications technology (such as the Internet) have made policing more problematic.

centaur In Greek mythology, a creature half-human, half-horse. One of a warlike and lustful race of mountain-dwellers who roamed Mount Pelion in Thessaly, their debauched behaviour exacerbated by wine. *See also* Chiron

Centaurus (Centaur) Brilliant southern constellation representing a centaur. The brightest star in Centaurus is ALPHA CENTAURI.

centigrade See CELSIUS

centipede (lit. hundred-legged) Common name for many arthropods of the class Chilopoda. Found in warm and temperate regions, they have flattened, segmented bodies. Most centipedes have about 70 legs (one pair per segment). Many tropical species are 15–30cm (6–12in) long; temperate ones are about 2.5cm (1in). Fast-moving predators, they eat small insects and other invertebrates.

Central Administrative region of central Scotland; the capital is STIRLING. Major towns include Falkirk, Alloa, Grange-mouth and Dunblane. In the N lie the foothills of the Highlands, including the Trossachs. The s is drained chiefly by the River Forth and is the region's industrial base. Industries: brewing and distilling. The Firth of Forth cuts into the E of the region. Historic sites include BANNOCKBURN battleground and Stirling Castle. Area: 2,635sq km (913sq mi) Pop: 267,492.

Central African Republic Landlocked nation in central Africa; the capital is BANGUI. **Land and climate** It lies on a plateau, mostly 600–800m (1,970–2,620ft) above sea level, forming a watershed between the headwaters of two river systems. In the s, the rivers flow into the navigable River Ubangi (a tributary of the Congo). The Ubangi and the Bomu form much of its s border. In the N, most rivers are headwaters of the River Chari, which flows N into Lake CHAD. Bangui has a warm climate with a high average annual rainfall of 1,574mm (62in). The N is drier, with rainfall of c.800mm (31in). Wood-

ed savanna covers much of the country, with open grasslands in the N and rainforests in the sw. The country has many forest and savanna animals, such as buffaloes, elephants, lions, leopards, and many bird species. About 6% of the land is protected in national parks and reserves, but tourism is on a small scale because of the republic's remoteness. Economy Central African Republic is a low-income developing country, c.10% of the land is cultivated and over 80% of the workforce are engaged in subsistence agriculture. The main food crops are bananas, maize, manioc, millet and yams. Coffee, cotton, timber and tobacco are the main cash crops. Diamonds are the most valuable single export. Manufacturing is on a small scale. Development has been impeded by its poor transport system, untrained workforce and heavy dependence on foreign aid (especially from France). The country has no dominant tribe; most inhabitants migrated into the area during the past 200 years to escape the slave trade. History Little is known of the country's early history. Between the 16th and 19th centuries, the population was greatly reduced by slavery, and the country is still thinly populated. France first occupied the area in 1887, and in 1894 established the colony of Ubangi-Shari at Bangui. In 1906 the colony was united with CHAD, and in 1910 was subsumed into French Equatorial Africa (which included Chad, Congo and Gabon). Forced-labour rebellions occurred in 1928, 1935 and 1946. During World War 2 Ubangi-Shari supported the Free French. Post-1945 the colony received representation in the French parliament. In 1958 the colony voted to become a self-governing republic within the French community, and became the Central African Republic. In 1960 it declared independence, but the next six years saw a deterioration in the economy, and increasing government corruption and inefficiency under President David Dacko. In 1966 Colonel Jean Bedel Bokassa assumed power in a bloodless coup. He abrogated the constitution and dissolved the National Assembly. In 1976 Bokassa transformed the republic into an empire, and proclaimed himself Emperor Bokassa I. His rule became increasingly brutal, and in 1979 he was deposed in a French-backed coup led by Dacko. Dacko (faced with continuing unrest) was replaced by André Kolingba in 1981. The army quickly banned all political parties. Recent events The country adopted a new, multiparty constitution in 1991. Elections were held in 1993, none of the political parties won an overall majority. An army rebellion was put down in 1996 with the assistance of French troops.

Central America Geographical term for the narrow strip of land that connects North America to South America and divides the Caribbean Sea from the Pacific Ocean; it consists of GUATEMALA, EL SALVADOR, HONDURAS, NICARAGUA, COSTA RICA, BELIZE and PANAMA. Highly developed by the Mayas, the region (excluding Panama) was conquered and ruled by the Spanish from the 16th century until 1821. In 1823 the Central American Federation was formed, but broke up in 1838, the individual states (except Belize) declaring themselves independent. The terrain is mostly mountainous; the climate tropical. It enjoys an economic, ethnic and geological unity. Spanish is the main language. Area: 715,876sq km (276,400sq mi).

Central and South American mythology Traditional beliefs of the native peoples of Mexico and Central and South America. The AZTECS had a rich and complex mythology, much of it based on the earlier cultures of the TOLTECS and MAYAS. The Aztecs believed that there had been four eras (suns) before the one in which they were living, and that each sun had ended in universal destruction. They expected that their own era, the fifth, would end with an earthquake. The Aztec pantheon was headed by HUTTZILOPOCHTLI. Other important deities included QUETZALCÓATL, Tezcatlipoca (god of the night sky) and Tlaloc (rain-god). The underworld was ruled by Mictlantecuhtli, the god of death. Human sacrifice was a central feature of Aztec culture. They believed that the Sun would cease to rise unless constantly supplied with human blood. Religious festivals in which sacrificial victims were offered to the gods were held throughout the year. The Mayas of the Yucatán peninsula in Central America had a god of creation, Hunab Ku, remote from human affairs. His son, Itzamna, usually depicted as a toothless old man, was the inventor of draw-

CENTRAL AFRICAN REPUBLIC

AREA: 622,980sq km (240,533sq mi)
POPULATION: 3,173,000
CAPITAL (POPULATION):
Bangui (451,690)
GOVERNMENT: Multiparty republic

ETHNIC GROUPS: Banda 29%, Baya 25%, Ngbandi 11%, Azande 10% Sara 7%, Mbaka 4%, Mbum 4% LANGUAGES: French (official), Sango (most common) RELIGIONS: Traditional beliefs 57%, Christianity 35%, Islam 8% CURRENCY: CFA franc = 100 centimes ing and writing, and also offered help to the sick. Another important god was Cukulan, the bird snake – the Mayan equivalent of Quetzacóatl. In Guatemala there were creator divinities and also the ancient god Huracán who gave the Mayas fire. In South America the vast INCA empire of Peru worshipped, Inti, the sun god and ancestor of the ruling dynasty. Another important deity was Viracocha, the creator god. ANCESTOR WORSHIP played a central role in Inca religious observances. The dead were venerated and the mummies of previous emperors accorded special honours. Tribal peoples have evolved elaborate magical practices in order to control spirits. In these groups the shaman still enjoys considerable authority.

central bank Institution that regulates and sets policy for a nation's banking system. The US central bank is the Federal Reserve system, and in the UK it is the BANK OF ENGLAND. Central Criminal Court In the UK, the Crown Court of central London. Housed in the Old Balley, the Central

Criminal Court is responsible for trying all serious offences in the City of London and Greater London area.

Central Intelligence Agency (CIA) US government agency established to coordinate the intelligence activities of government departments and agencies responsible for US national security. Founded in 1947, it played a major role during the COLD WAR, supporting anti-communist movements. At times the CIA has come under attack for overstepping its mandate and interfering in the internal affairs of foreign nations. Having no domestic jurisdiction, it was severely criticized for its involvement in the WATERGATE SCANDAL. It advises and is directed by the NATIONAL SECURITY COUNCIL (NSC) and should report any action it proposes to take to Congress and gain presidential authorization.

central nervous system (CNS) (CNS) Term embracing the brain and spinal cord, as distinct from the PERIPHERAL NERVOUS SYSTEM. The CNS coordinates all nervous activity. *See also* NERVOUS SYSTEM

Central Powers Alliance of Germany and Austria-Hungary (with Bulgaria and Turkey) during World War 1. The name distinguished them from their opponents (Britain, France and Belgium) in the w, with Russia and others in the E.

central processing unit (CPU) Part of a digital computer circuit that controls all operations. In most modern computers, the CPU consists of one complex INTEGRATED CIRCUIT (IC), a chip called a MICROPROCESSOR. A CPU contains temporary storage circuits that hold data and instructions; an arithmetic and logic unit (ALU) that works out problems; and a control unit that organizes operations.

centre of gravity Point at which the weight of a body is considered to be concentrated and around which its weight is evenly balanced. An object in free flight spins around its centre of gravity (that is moving in a straight line). In a uniform gravitational field, the centre of gravity is the same as the CENTRE OF MASS.

centre of mass Point at which the whole mass of an object or group of objects is considered to be concentrated. A centre

of mass would therefore exist for colliding elementary particles. Isaac Newton first proved his inverse-square law of gravitation by assuming the respective masses of the Earth and Moon were located at their centres.

centrifugal force See CENTRIPETAL FORCE

centrifuge Rotating device used for separating substances. In laboratories, centrifuges separate particles from suspensions, and red blood cells from plasma. In the food industry, centrifuges separate cream from milk and sugar from syrup. In each case, the denser substance is forced to the outside of a rotating container. A spin dryer uses the same principle to remove water from clothes.

centripetal force In circular or curved motion, the force acting on an object that keeps it moving in a circular path. For example, if an object attached to a rope is swung in a circular motion above a person's head, the centripetal force acting on the object is the tension in the rope. Similarly, the centripetal force acting on the Earth as it orbits the Sun is gravity. In accordance with Newton's laws, the reaction to this, the (theoretical) centrifugal force, is equal in magnitude and opposite in direction.

Cephalopoda Advanced class of predatory marine molluscs, including SQUID, NAUTILUS, OCTOPUS and CUTTLEFISH. Each has eight or more arms surrounding the mouth, which has a parrot-like beak. The nervous system is well developed, permitting great speed and alertness; the large eyes have an image-forming ability equal to that of vertebrates. Most squirt an inky fluid to alarm attackers. Cephalopods move by squirting water from their mantle edge. Their heavily yolked eggs develop into larval young that resemble the adults. Members of this class vary dramatically in size from 4cm (1.5in) to the giant squid, which may reach 20m (65ft). There are more than 600 species.

cephalosporin Class of ANTIBIOTIC drugs derived from fungi of the genus *Cephalosporium*. Similar to PENICILLIN, they are effective against a wide spectrum of BACTERIA, including some which have become resistant to penicillin.

cepheid variable One of an important class of VARIABLE STARS that pulsate in a regular manner, accompanied by changes in luminosity. Cepheids can expand and contract up to 30% in each cycle. The average luminosity is 10,000 times that of the Sun. Cepheids became important in cosmology (1912) when US astronomer Henrietta Leavitt discovered a relationship between the period of light variation and the absolute magnitude of a cepheid. This period-luminosity law enables the distances of stars to be ascertained.

◀ Cephalopoda The squid (1), cuttlefish (2) and octopus (3) are all swimming molluscs of the Cephalopoda group. They have advanced, powerful eyes, tentacles lined with sucker pads which are used to catch fish and small crustaceans. The horny jawed mouth is powerful enough to break up their prey before it is digested in the gut.

➤ Cézanne The mountains at L'Estaque, were one of Cézanne's favourite landscape subjects. His use of interlocking flat planes of colour, representing land, water and buildings, greatly influenced abstract artists.

ceramics Objects made of moistened clay that are shaped and then baked. Earthenware, terracotta, brick, tile, faience, majolica, stoneware, and porcelain are all ceramics. Ceramic ware is ornamented by clay inlays, relief modelling on the surface, or by incised, stamped, or impressed designs. A creamy mixture of clay and water (slip) can be used to coat the ware. After drying, ceramic ware is baked in a kiln until it has hardened. Glaze, a silicate preparation applied to the clay surface

and fused to it during firing, is used to make the pottery non-porous and to give it a smooth, colourful, decorative surface. In ancient Egypt they developed a faience with a glaze. Mesopotamia and Persia used large architectural tiles with colourful glazes. In the 6th and 5th centuries BC the Greeks developed red, black, and white glazed pottery with figures and scenes, while the Romans used relief decoration. Persian, Syrian and Turkish pottery made further improvements. In Spain, lustreware, the first sophisticated ceramic of the modern era, was produced by 9th-century Moors. Italian majolica, Dutch delft, German Meissen, and English Wedgewood were further refinements. Chinese porcelain dates from the T'ang dynasty, and Chinese stoneware goes back to c.3000 BC.

cereal Any grain of the grass family (Gramineae) grown as a food crop. Wheat, corn, rye, oats and barley are grown in temperate regions. Rice, millet, sorghum and maize require more tropical climates. Cereal cultivation was the basis of early civilizations, and with the development of high-yielding strains, remains the world's most important food source.

cerebellum Part of the brain located at the base of the CERE-BRUM. It is involved in maintaining muscle tone, balance and finely coordinated movement.

CHAD

Chad's flag was adopted in 1959 as the country prepared for independence in 1960. The blue represents the sky, the streams in southern Chad and hope. The yellow symbolizes the sun and the Sahara in the north. The red represents national sacrifice.

AREA: 1,284,000sq km (495,752sq mi) **POPULATION:** 5,961,000

capital (population): Ndjamena (529,555)

GOVERNMENT: Transitional

ETHNIC GROUPS: Bagirmi, Kreish and Sara 31%, Sudanic Arab 26%, Teda 7%, Mbum 6% LANGUAGES: French and Arabic (both official) RELIGIONS: Islam 40%, Christianity 33%,

traditional beliefs 27%

CURRENCY: CFA franc = 100 centimes

Chad is Africa's fifth largest country. It is more than twice as big as France (the former colonial power). Southern Chad is crossed by rivers that flow into Lake CHAD, on the w border with Nigeria. The capital, NDJAMENA, lies on the banks of the River Chari. Beyond a large depres-

Sahara Desert

Bardai Aoo Sarh

Abèché

R

Map Scale

N

M

sion (NE of Lake Chad) are the Tibesti Mountains, which rise steeply from the sands of the SAHARA Desert. The mountains contain Chad's highest peak, Emi Koussi, at 3,415m (11,204ft).

CLIMATE

Central Chad has a hot tropical climate, with a marked dry season between November and April. The s is wetter, with an average yearly rainfall of c.1,000mm (39in). The hot N desert has an average annual rainfall of less than 130mm (5in).

VEGETATION

The far s contains forests, while central Chad is a region of savanna, merging into the dry grasslands of the SAHEL. Plants are rare in the N desert. Droughts are common in N central Chad. Long droughts, over-grazing and felling for firewood have exposed the Sahel's soil to the elements and wind erosion is increasing the rate of desertification.

HISTORY AND POLITICS

Chad straddles two, often conflicting worlds: the N, populated by nomadic or semi-nomadic Muslim peoples, such as Arabs and Tuaregs; and the dominant s, where a sedentary population practise Christianity or traditional religions, such as animism. Lake Chad was an important watering point for the trans-Saharan caravans. In c.AD 700 North African nomads founded the Kanem empire. In the 13th century the Islamic state of Bornu was established. In the late 19th century the region fell to Sudan.

The first major European explorations were

by the French in 1890. The French defeated the Sudanese in 1900, and in 1908 Chad became the largest province of French Equatorial Africa. In 1920 it became a separate colony.

In 1958 Chad was granted autonomous status within the French Community, and in 1960 it achieved full independence. Divisions between N and S rapidly surfaced. In 1965 President François Tombalbaye declared a oneparty state and the N Muslims, led by the Chad National Liberation Front (Frolinat), rebelled. By 1973 the revolt had been quashed with the aid of French troops. Libya (supporters of Frolinat) occupied N Chad. In 1981 two leaders of Frolinat came to power, Hissène Habré and Goukouni Oueddi. Splits soon emerged, and Libya's bombing of Chad in 1983 led to the deployment of 3,000 French troops. Libyan troops retreated, retaining only the uranium-rich Aozou Strip. A cease-fire took effect in 1987. In 1990 Habré was removed in a coup led by Idriss Déby. In 1994 the Aozou Strip was awarded to Chad. In 1996 a new democratic constitution was adopted and multiparty elections confirmed Déby as president.

ECONOMY

Hit by drought and civil war, Chad is one of the world's poorest countries (1992, GDP per capita, \$US760). Agriculture dominates the economy, over 80% of the workforce are engaged in farming, mainly at subsistence level. Groundnuts, millet, rice and sorghum are major crops in the wetter s. The most valuable crop is cotton, accounting for c.50% of Chad's exports.

cerebral cortex Deeply fissured outer layer of the CEREBRUM. The cortex (grey matter) is the most sophisticated part of the brain, responsible for the appreciation of sensation, initiating voluntary movement, emotions and intellect.

cerebral haemorrhage Form of stroke in which there is bleeding from a blood vessel in the BRAIN into the surrounding tissue. It is usually caused by ARTERIOSCLEROSIS and high blood pressure. Symptoms may vary from temporary numbness and weakness down one side of the body to deep coma. A major haemorrhage may be fatal. There is a high risk of repeated strokes.

cerebral hemispheres Lateral halves of the CEREBRUM, the largest parts of the BRAIN and the sites of higher thought. Due to the crossing over of nerve fibres from one cerebral hemisphere to the other, the right side controls most of the movements and sensation on the left side of the body, and vice-versa. Damage to cerebral hemispheres can produce personality changes.

cerebral palsy Disorder mainly of movement and coordination caused by damage to the BRAIN during or soon after birth. It may feature muscular spasm and weakness, lack of coordination and impaired movement or paralysis and deformities of the limbs. Intelligence is not necessarily affected. The condition may result from a number of causes, such as faulty development, oxygen deprivation, birth injury, haemorrhage or infection.

cerebrospinal fluid Clear fluid that cushions the brain and spinal cord, giving some protection against shock. It is found between the two innermost meninges (membranes), in the four ventricles of the brain and in the central canal of the spinal cord. A small quantity of the fluid can be withdrawn by lumbar puncture to aid diagnosis of some brain diseases.

cerebrum Largest and most highly developed part of the BRAIN, consisting of the CEREBRAL HEMISPHERES separated by a central fissure. It is covered by the CEREBRAL CORTEX. It coordinates all higher functions and voluntary activity.

Cerenkov, Pavel Alekseevich (1904–90) Russian physicist. Working at the Institute of Physics of the Soviet Academy of Science, he discovered that light (CERENKOV RADIATION) is emitted by charged particles travelling at very high speeds. He was awarded the 1958 Nobel Prize for physics with his co-workers, I.M. Frank and I.Y. Tamm.

Cerenkov radiation Light emitted when energetic particles travel through a transparent medium, such as water, at a speed higher than the velocity of light in that medium. This action is called the Cerenkov effect. It is analogous to a SONIC BOOM and a cone of light is emitted trailing the path of the particle. It is named after Pavel CERENKOV who discovered it in 1934. Cerenkov radiation is used in a Cerenkov counter (detector of energetic particles).

Ceres Largest ASTEROID and the first to be discovered (1 January 1801, by Guiseppe Piazzi). Ceres' diameter measures 913km (567mi). It orbits in the main asteroid belt, at an average distance from the Sun of 414 million km (257 million mi), the distance of the "missing" planet predicted by BODE'S LAW. cerium (symbol Ce) Soft, ductile, iron-grey metallic element, the most abundant of the LANTHANIDE SERIES, first isolated in 1803. The chief ore is monazite. It is used in alloys, catalysts, nuclear fuels, glass and as the core of carbon electrodes in arc lamps. Properties: at.no. 58; r.a.m. 140.12; r.d. 6.77; m.p. 798°C (1,468°F); b.p. 3,257°C (5,895°F). The most common isotope is Ce¹⁴⁰ (88.48%).

Cervantes, Miguel de (1547–1616) Spanish novelist, poet and dramatist. Cervantes published two volumes of his masterpiece *Don Quixote de la Mancha* (1605; 1615). Don Quixote is a great archetype of Western fiction; the picaresque hero who misapplies the logic of high Romance to the mundane situations of modern life. It established Cervantes as a towering figure in Spanish letters. Other works include two surviving plays and a collection of short stories, *Novelas Ejemplares* (1613).

cervical smear (pap test) Test for CANCER of the CERVIX, established by George Papanicolan. In this diagnostic procedure, a small sample of tissue is removed from the cervix and examined under a microscope for the presence of abnormal,

pre-cancerous cells. Treatment in the early stages of cervical cancer can prevent the disease from developing.

cervix Neck of the UTERUS, projecting downwards into the VAGINA. It dilates (expands) widely to allow the passage of the baby during childbirth.

Ceylon Former name of SRI LANKA

Cézanne, Paul (1839–1906) French painter. A friend of PISSARRO, Cézanne exhibited at the first impressionist show in 1874. House of the Hanged Man (1873–74) is characteristic of his impressionist period. He later shifted away from IMPRESSIONISM in favour of a deeper, more analytical approach, using colour to model and express form. Figure paintings, such as The Card Players (1890–92), Madame Cézanne (c.1885) and The Bathers (1895–1905), as well as landscapes, such as Mont Sainte Victoire (1904–06), were painted on this principle. Cézanne ranks as one of the great influences on modern art, especially CUBISM. See also POST-IMPRESSIONISM

Chad Landlocked republic in N central Africa. See country feature

Chad, Lake (Tchad) Lake in N central Africa, lying mainly in the Republic of Chad and partly in Nigeria, Cameroon and Niger. The chief tributary is the River Chari; the lake has no outlet. Depending on the season, the area of the surface varies from *c*.10,000 to 26,000sq km (3,850–10,000sq mi). Max. depth: 7.6m (25ft).

Chadwick, Sir James (1891–1974) British physicist who discovered and named the NEUTRON. Chadwick worked on radioactivity with Ernest RUTHERFORD at the Cavendish Laboratory, Cambridge. In 1920, Rutherford had predicted a particle without electric charge in the nucleus of an ATOM, and in 1932 Chadwick proved the neutron's existence and calculated its mass. For this, he received the 1935 Nobel Prize for physics. Chadwick also constructed Britain's first particle accelerator (1935). During World War 2, he moved to the USA to head British research on the Manhattan Project to develop the atomic bomb.

chaffinch Small songbird common throughout Europe. It generally perches on low trees, bushes and fences, feeding on plants and insects. The blue and buff colours and pink breast belong to the male only, although the drab female shares his white markings. In winter, flocks consisting solely of males can be seen. Family Fringillidae; species *Fringilla coelebs*.

Chagall, Marc (1887–1985) Russian-French painter. His paintings, with their dream-like imagery, considerably influenced SURREALISM. He worked using ceramics, mosaics and tapestry, and in theatre design. He designed stained-glass windows for Hadassah-Hebrew Medical Centre, Jerusalem (1962), murals for the Paris Opera and the Metropolitan Opera House, New York (1966), and mosaics and tapestries for the Knesset in Jerusalem (1969).

Chain, Sir Ernst Boris (1906–79) British biochemist, b. Germany. He shared the 1945 Nobel Prize for physiology or medicine with Howard Florey and Alexander Fleming for the isolation and development of penicillin as an antibiotic. He also studied spreading factor, an enzyme that aids the dispersal of fluids in tissue.

chain reaction Self-sustaining nuclear reaction in which one reaction is the cause of a second, the second of a third and so on. The initial conditions are critical, in that the quantity of fissionable material must exceed the CRITICAL MASS. The explosion of an atom bomb is an uncontrolled chain reaction. Chalcedon, Council of (451) Meeting of all the bishops of the Christian church in the city of Chalcedon, Asia Minor. It was convoked by the Emperor Marcian to settle controversial theological questions. It reaffirmed the doctrine of two natures (divine and human) in Christ and condemned NESTORIANISM. chalcedony Microscrystalline form of quartz. When cut and polished, it is used by gem engravers. It is waxy, lustrous and there are white, grey, blue and brown varieties. Often coloured by artificial methods, some varieties contain impurities giving a distinctive appearance, such as AGATE (coloured bands), ONYX (striped) and bloodstone (dark green with red flecks).

chalcopyrite (copper pyrites) Opaque, brass-coloured, copper iron sulphide (CuFeS₂); the most important copper ore. It is found in sulphide veins and in igneous and contact meta-

▲ Chagall The Russian-born artist Marc Chagall influenced many later "surrealist" painters. His paintings draw heavily from folklore and have a fairy tale or dreamlike appeal.

▲ Chamberlain Having been instrumental in the formation of the National Government (1931), British prime minister Neville Chamberlain's firm belief in appeasement resulted in Britain's slow preparation for war. The resulting initial victories for the Axis powers in the early stages of World War 2 forced Chamberlain to resign.

morphic rocks. The crystals are tetragonal but often occur in masses. Hardness 3.5–4; s.g. 4.2.

Chaliapin, Fyodor Ivanovich (1873–1938) Russian operatic bass. He made his debut at La Scala, Milan in 1901 and at the METROPOLITAN OPERA COMPANY, New York in 1907. His differences with the Soviet government caused him to leave Russia in 1921 and join the Metropolitan. He was particularly noted for the title role in Mussorgsky's Boris Godunov. chalk Mineral, mainly calcium carbonate (CaCO₃), formed from the shells of minute marine organisms. It varies in properties and appearance; pure forms, such as calcite, contain up to 99% calcium carbonate. It is used in making putty, plaster and cement, and harder forms are occasionally used for building. Blackboard chalk is now made from calcium sulphate (CaSO₄) or chemically produced calcium carbonate.

Challenger expedition (1872–76) British expedition in oceanographic research. The *Challenger* ship comprised a staff of six naturalists headed by Charles Wyville Thompson. She sailed c.128,000km (69,000 nautical mi) making studies of the life, water and seabed in the three main oceans.

Chamberlain, Joseph (1836–1914) British political leader, father of Neville Chamberlain. He entered parliament as a Liberal in 1876. In 1880 he became president of the board of trade. In 1886 he resigned over Gladstone's Home Rule Bill and was leader of the Liberal Unionists from 1889. In 1895 he returned to government as colonial secretary, where his aggressive, imperialist stance helped provoke the SOUTH AFRICAN WAR (1899). He resigned again in 1903 in order to argue freely for tariff reforms.

Chamberlain, (Arthur) Neville (1869–1940) British prime minister (1937–40). Son of Joseph Chamberlain, he was a successful businessman before entering parliament in 1918. During the 1920s, he served as chancellor of the exchequer (1923–24, 1931–37) and minister of health (1924–29). He succeeded Stanley Baldwin as Conservative prime minister. He confronted the threat to European peace posed by Hitler with a policy of APPEASEMENT and signed the MUNICH AGREEMENT (1938). After Hitler's invasion of Poland, Chamberlain declared war in September 1939. After the loss of Norway, he was replaced by Winston Churchill in May 1940.

Chamberlain, Wilt (Wilton Norman) (1936–) US basketball player. Perhaps the greatest offensive player in professional basketball history, he had a career total of 31,419 points. He played in the NBA for Philadelphia (1960–62, 1965–68), San Francisco (1963–65) and Los Angeles (1969–73). He was elected to the Basketball Hall of Fame in 1978.

chamber music Music intended for performance in intimate surroundings, rather than a concert hall. It is usually written for two to eight instruments (or voices). The string quartet (two violins, viola and cello) is the most common arrangement. The term dates from the 17th century, and was applied to music played privately in the homes of wealthy patrons. The form has been revived in the late 20th century.

chameleon Arboreal LIZARD, found chiefly in Madagascar, Africa and Asia, notable for its ability to change colour. The compressed body has a curled, prehensile tail and bulging eyes that move independently. Length: 17–60cm (7–24in). Family Chamaeleontidae; genus *Chamaeleo*; there are 80 species.

chamois Nimble, goat-like RUMINANT that lives in mountain ranges of Europe and w Asia. It has coarse, reddish-brown fur with a black tail and horns. Its skin is made into chamois leather. Length: up to 1.3m (50in); weight: 25–50kg (55–110lb). Family Bovidae; species *Rupicapra rupicapra*. **chamomile** (camomile) Low-growing, yellow- or white flowered both.

flowered herb. Several species are cultivated as ground cover. Flowers of the European chamomile (*Chamaemelum nobile*) are used to make herbal tea. Family Asteraceae; genus *Chamaemelum*.

Chamorro, Violeta Barrios de (1939–) Nicaraguan stateswoman, president (1990–96). She entered politics in 1978 when her husband, Pedro Joáin Chamorro, was assassinated. In 1989, supported by the USA, she became leader of the right-wing coalition, the National Opposition Union (UNO). She became president after defeating the SANDINISTA government in February 1990. Her early presidency was

marked by unemployment, strikes and skirmishes between CONTRA rebels and Sandinista militants. Many of Chamorro's policies were blocked by reactionary elements in the UNO and by members of the Sandinista Liberation Front.

Champagne District in NE France, made up of the Aube, Marne, Haute-Marne and Ardennes départements. The major city is REIMS. It was a centre for European trade and commerce in the 11th–13th centuries. During World War 2 there was heavy fighting along the River Marne. It is an arid region, renowned for its champagne, a sparkling white wine that can only be produced in the district. Area: 25,606sq km (9,886sq mi). Pop. (1990) 1,347,800.

Champaigne, Philippe de (1602–74) French painter, b. Flanders. He was the greatest French portraitist of the 17th century and a remarkable religious painter. In 1628 he became artist to Queen Marie de' Medici and Cardinal Richelieu. After 1643 his beliefs in JANSENISM produced religious paintings characterized by a serene realism. His best-known works include portraits and frescos at Vincennes and in the Tuileries. Champlain, Samuel de (1567–1635) French explorer, founder of New France (Canada). Following the discoveries of Jacques CARTIER, he made 12 visits to New France. Besides seeking a NORTHWEST PASSAGE, he encouraged settlement and the fur trade, established friendly relations with ALGONQUIN peoples (at the cost of antagonizing the Iroquois), and vastly increased geographical knowledge during his extensive travels. In 1608, he founded Quebec.

Champlain, Lake Lake that lies on the border of New York State and Vermont, USA, and extends into Quebec, Canada. It serves as a link in the Hudson–St Lawrence waterway. Explored by Samuel de Champlain (1609), it was the scene of many battles in the French and Indian wars, the American Revolution, and the defeat of the British in the War of 1812. Today the lake is a popular resort area. Area: 1,100sq km (435sq mi). chancellor of the exchequer British minister responsible for national finances. The office evolved from the 13th-century clerk of the court of exchequer, assistant to the chancellor. Until the mid-19th century the office was departmentally inferior to the first lord of the treasury. Since Gladstone's tenure of the office in 1850s, it has become probably the second most high-profile cabinet office (after the prime minister).

Chancellorsville, Battle of (2–4 May 1863) American Civil War battle. Union forces under General Joseph Hooker, advancing on Richmond, were opposed by General Robert E. Lee in N Virginia. Outflanked by General "Stonewall" JACKSON, the Union forces were decisively defeated, though Jackson, accidentally shot by his own men, died a week later.

Chancery In England, court developed in the 15th century for the lord chancellor to deal with petitions from aggrieved persons for redress when no remedy was available in the COMMON LAW courts. By the mid-17th century, Chancery had become a second system of law (equity) rather than a reforming agency. By the Supreme Court of Judicature Act (1925) the court of Chancery was merged into the HIGH COURT OF JUSTICE, of which it is now known as the Chancery Divison.

Chandings of City at the foot of the Sixvalit Hills, wy India.

Chandigarh City at the foot of the Siwalik Hills, NW India. The joint capital of Punjab and Haryana states, it is a planned city, designed by LE CORBUSIER and built in the 1950s. Pop. (1991) 511,000.

Chandler, Raymond Thornton (1888–1959) US crime writer. After a career in journalism and business, Chandler turned to writing DETECTIVE FICTION. Many of the novels featuring the tough private eye Philip Marlowe, such as *The Big Sleep* (1939), *Farewell, My Lovely* (1940) and *The Long Goodbye* (1953), have been made into successful films. His cracking dialogue and seedy plots are distinctive and much copied. Chandragupta Founder of the Maurya empire in India (r. c.321–297 BC) and grandfather of ASHOKA. He seized the throne of Magadha and defeated SELEUCUS, gaining dominion over most of N India and part of Afghanistan. His reign was characterized by religious tolerance. He established a vast bureaucracy and secret service based at Patna. He abdicated and, it is thought, become a Jain monk before dying.

Chandrasekhar, Subrahmanyan (1910–95) US astrophysicist, b. India. He formulated theories about the creation,

life and death of stars, and calculated the maximum mass of a white dwarf star before it becomes a neutron star; the Chandrasekhar limit. It equals 1.4 times the mass of the Sun. He shared the 1983 Nobel Prize for physics with William Fowler. Chanel, "Coco" (Gabrielle) (1883-1971) French fashion designer. She revolutionized women's fashion, borrowing many elements of her designs from men's clothing. She is associated with the Chanel suit, jersey dresses, bell-bottom trousers, trench coats and Chanel No.5 perfume.

Changchun (Ch'ang-ch'un) Capital of Jilin, NE China. As Hsinking it was the capital (1932-45) of the Japanese-occupied) state of Manchukuo. It is an industrial city. Industries: chemicals, textiles, motor vehicles. Pop. (1993 est.) 2,400,000. Channel Islands Group of islands at the sw end of the English Channel, c.16km (10mi) off the w coast of France. The main islands are JERSEY, GUERNSEY, Alderney and SARK; the chief towns are St. Helier on Jersey and St. Peter Port on Guernsey. A dependency of the British crown since the Norman Conquest, they were under German occupation during World War 2. They are divided into the administrative bailiwicks of Guernsey and Jersey, each with its own legislative assembly. The islands have a warm, sunny climate and fertile soil. The major industries are tourism and agriculture. Area: 194sq km (75sq mi). Pop. (1991) 142,949.

Channel Tunnel (Chunnel) Railway tunnel under the English Channel, 49km (30.6mi) long. The first Channel tunnel was proposed in 1802 by a French engineer. A start was made in 1882 but soon abandoned for defence reasons. Another false start was made in the 1970s. In 1985 Eurotunnel, a joint French-English private company, was granted a 55-year concession to finance and operate the tunnel. The French and English sections were linked in 1990, and the tunnel became operational in 1994. Consisting of two railway tunnels and one service tunnel, it links Folkestone, s England, with Calais, N France. A tunnel fire in November 1996 raised safety fears. chansons de geste Epic poems, written in Old French between the 11th and 14th centuries, generally dealing with the campaigns of CHARLEMAGNE. These anonymous narratives, of which some 80 survive, describe semi-fictional events in the lives of Guillaume d'Orange, Girart de Roussillon, Roland and others.

chant Unaccompanied liturgical singing, especially of PSALMS. Anglican chant developed from the earlier Gregorian tones, which were melody formulas defining pitch relationships only. Later, harmonies were added to the melodies and note values designated to English texts of the psalms. The chant is adjustable in length to fit the different verses by repeating one note for any number of words, a process known as pointing.

chaos theory Theory that attempts to describe and explain the highly complex behaviour of apparently chaotic or unpredictable systems which show an underlying order. The behaviour of some physical systems is impossible to describe using the standard laws of physics - the mathematics needed to describe these systems being too difficult for even the largest supercomputers. Such systems are sometimes known as "nonlinear" or "chaotic" systems, and they include complex machines, electrical circuits, and natural phenomena such as the weather. Non-chaotic systems can become chaotic, such as when smoothly flowing water hits a rock and becomes turbulent. Chaos theory provides mathematical methods needed to describe chaotic systems, and even allows some general prediction of a system's behaviour. However, chaos theory also shows that even the tiniest variation in a system's starting conditions can lead to enormous differences in the later state of the system. Because it is impossible to know the precise starting conditions of a system, accurate prediction is also impossible. chapel Place of worship, usually a separate area having its own altar within a church or cathedral. Side chapels are small rooms set into the wall of a cathedral apse, which often house the relics of saints. Many state and civic buildings, monasteries and convents have chapels for worship. A chapel also denotes a place of worship subordinate to a larger parish church, or a building used for services by nonconformists.

Chaplin, Charlie (Sir Charles Edward Spencer) (1889-1977) British actor and film-maker, often considered

▲ Chaplin Although he made several films with sound, Charlie Chaplin will always be remembered as one of the most notable figures of the silent movie era. His films, although comedies, were sophisticated enough to evoke sympathy and romance, unlike many of his contemporaries who relied solely on slapstick.

the greatest silent film comedian. In his short films, such as *The Immigrant* (1917) and *A Dog's Life* (1918), he developed his famous character; a jaunty, wistful figure of pathos in baggy trousers and bowler hat, with a cane and a moustache. His major films include *The Kid* (1920), *The Gold Rush* (1924), *City Lights* (1931), *Modern Times* (1936), *The Great Dictator* (1940), *Monsieur Verdoux* (1947) and *Limelight* (1952). He was attacked for his liberal politics and in 1952 left the USA to live in Switzerland.

Chapman, George (1560–1634) English poet, dramatist and translator. He completed Christopher Marlowe's unfinished poem *Hero and Leander* (1598), and worked with Ben JONSON and John Marston. His own works include the poem *The Shadow of Night* (1594), the plays *The Blind Beggar of Alexandria* (1598) and *Bussy D'Ambois* (1604), and translations of Homer's *Iliad* (1611) and *Odyssey* (1614–15).

charcoal Porous form of CARBON, made traditionally by heating wood in the absence of air, and used in western Europe until late medieval times for smelting iron ore. Today charcoal is chiefly used for its absorptive properties, to decolourize food liquids such as syrups, and to separate chemicals. Artists use charcoal sticks for sketching.

Charcot, Jean Martin (1825–93) French physician and founder of neurology. He made classical studies of HYPNOSIS and HYSTERIA, and taught Pierre Janet and Sigmund FREUD. His work centred on discovering how behavioural symptoms of patients relate to neurological disorders.

charge-coupled device (CCD) Type of silicon CHIP designed to capture images. The CCD is divided into a number of microscopic areas (pixels), arranged in rows. When a photon hits a pixel, it knocks off an electron from a silicon atom, which becomes charged. An opposite charge in a layer on the base of the CCD confines this charged silicon atom, and in this way a charge builds up in each pixel relative to the number of photons hitting it 50 times a second. The contents of each pixel are read off, a row at a time, forming an electrical signal that can be used to create television pictures. CCDs are found in video cameras, fax machines and digital cameras. Charge of the Light Brigade (25 October 1854) British cavalry charge in the CRIMEAN WAR, one of the most notorious mistakes in British military history. It stemmed from Lord Lucan's misreading of an ambiguous order by the British commander, Lord Raglan. As a result, Lord Cardigan led the unsupported Light Brigade straight at a battery of Russian guns. More than 600 men took part, nearly half of whom were casualties. The incident is commemorated in a famous poem by Lord TENNYSON.

charismatic movement Movement within the Christian

From Mary of Burgundy 1508
From Ferdinand and Isabella of Castile (1515)
From Maximilian of Austria (1519)

— boundary of Holy Roman Empire

Charolais

Charolais

FRANCE

Naveine

Castile

Cas

Church. It emphasizes the presence of the Holy Spirit in the life of an individual and in the work of the church. It is particularly associated with Pentecostal Churches.

Charlemagne (742–814) (lit. Charles the Great) King of the Franks (768-814) and Holy Roman emperor (800-14). The eldest son of PEPIN III (THE SHORT), he inherited half the Frankish kingdom (768), annexed the remainder on his brother Carloman's death (771), and built a large empire. He invaded Italy twice and took the Lombard throne (773). He embarked on a long and brutal conquest of Saxony (772-804), annexed Bavaria (788) and defeated the Avars of the middle Danube (791-96, 804). He undertook campaigns against the Moors in Spain. In 800 he was consecrated as emperor by Pope Leo II, thus reviving the concept of the Roman empire, and confirming the separation of the West from the Eastern BYZANTINE EMPIRE. Charlemagne encouraged the intellectual awakening of the CAROLINGIAN RENAISSANCE, set up a strong central authority and maintained provincial control through court officials. His central aim was Christian reform, both of church and laity, and he was convinced that God had made him emperor to undertake this holy work.

Charles II (the Bald) (823–77) King of the West Franks (843–77) and Holy Roman emperor (875–77). Younger son of Emperor Louis I, he was involved in the ambitious disputes of his elder brothers. The Treaty of Verdun (843) made him king of the West Franks, in effect the first king of France. Continuing family conflict, rebellion and Viking attacks resulted in territorial losses. Yet, after the death of the emperor Louis II, Charles was recognized as Holy Roman emperor. Charles III (the Fat) (839–88) Holy Roman emperor (881–87) and king of France (884–87) as Charles II. Through the death or incapacity of relatives, he inherited the kingdoms of the East and West Franks. He almost reunited the territories of Charlemagne in the 880s, but was deposed by his nephew, Arnulf.

Charles IV (1316–78) Holy Roman emperor (1355–78) and king of Bohemia (1347–78). Supported by Pope Clement VI, he was a rival of the Wittelsbach Emperor Louis IV, and when Louis died, was elected king of the Germans (emperorelect). A skilful diplomat, he blocked or appeased his Wittelsbach and Habsburg rivals and improved relations with the papacy. In 1356 he introduced a stable system of imperial government. He ruled from PRAGUE, his birthplace, where he founded Charles University (1348) and built the Charles Bridge. Czech culture reached a peak under his patronage. He was succeeded by his son, Wenceslas.

Charles V (1500–58) Holy Roman emperor (1519–56) and king of Spain, as Charles I (1516-56). He ruled the Spanish kingdoms, s Italy, the Netherlands and the Austrian Habsburg lands by inheritance and, when elected emperor in succession to his grandfather, MAXIMILIAN I, headed the largest European empire since CHARLEMAGNE. In addition, the Spanish CONQUIS-TADORES made him master of a New World empire. Charles' efforts to unify his possessions were unsuccessful, largely due to the hostility of Francis I of France, the Ottoman Turks in central Europe, and the conflicts arising from the advance of LUTHERANISM in Germany. The struggle with France was centred in Italy: Spanish control was largely confirmed by 1535, but French hostility was never overcome. The Turks were held in check but not defeated, and Charles' attempt to capture Algiers failed (1541). In Germany, Charles, who saw himself as the defender of the Catholic Church, nevertheless recognized the need for reform, but other commitments prevented him following a consistent policy, and LUTHERANISM expanded. Charles increasingly delegated power in Germany to his brother Ferdinand I, his successor, and in 1554-56 surrendered his other titles to his son, Philip II of Spain.

Charles VI (1685–1740) Holy Roman emperor (1711–40) and king of Hungary as Charles III. His claim to the Spanish throne against the grandson of Louis XIV, Philip V, supported by the powers opposed to Louis, caused the War of the SPANISH SUCCESSION. After his election as emperor (1711), he gave up his Spanish claim as international support for it fell away. He spent much of his reign trying to secure the succession of his daughter, MARIA THERESA, to his Austrian possessions.

▼ Charles V The map illustrates how Charles V gained his vast European empire. In 1506, he succeeded his father, Phillip, as duke of Burgundy. In 1516, Charles inherited much of s Europe from his grandparents, Ferdinand and Isabella and, in 1519, he became Holy Roman emperor.

Charles I (1887–1922) Austrian Emperor (1916–18) and king (as Charles IV) of Hungary (1916–18). When Hungary and Czechoslovakia declared their independence and Austria became a republic in 1918, Charles, the last Habsburg emperor, was forced into exile in Switzerland. In 1921 he unsuccessfully attempted to regain the Hungarian throne.

Charles I (1600-49) King of England, Scotland and Ireland (r.1625-49). Son of JAMES I, he was criticized by Parliament for his reliance on the Duke of BUCKINGHAM and for his Catholic marriage to Henrietta Maria. Although he accepted the PETITION OF RIGHT, Charles' insistence on the "divine right of kings" provoked further conflict with parliament, and led him to rule without it for 11 years (1629-40). With the support of the Archbishop of Canterbury, William LAUD, Charles imposed harsh penalties on nonconformists. When attempts to impose Anglican liturgy on Scotland led to the Bishops' War, Charles was forced to recall parliament to raise revenue. The LONG PARLIAMENT insisted on imposing conditions, and impeached Charles' chief advisers. Relations steadily worsened and Charles' attempt to arrest five leading opponents in the Commons precipitated the English CIVIL WARS. After the defeat of the Royalists, attempts by Oliver CROMWELL and other parliamentary and army leaders to reach a compromise with the king failed, and he was tried and executed.

Charles II (1630-85) King of England, Scotland and Ireland (1660-85). After the execution of his father, CHARLES I, he fled to France, but in 1650 was invited to Scotland by the COVENANTERS and crowned king in 1651. Charles' attempted invasion of England was repulsed by CROMWELL, and he was forced back into exile. In 1660 Charles issued the Declaration of Breda, in which he promised religious toleration and an amnesty for his enemies. Parliament agreed to the Declaration and Charles was crowned king in May 1660, ushering in the RESTORATION. He attempted to preserve royal power, accepting secret subsidies from Louis XIV in exchange for promoting Roman Catholicism. Charles' support of Louis led to a war with the Netherlands (1672-74). He clashed with parliament over both the war and his support of the Catholics. Conflict was further fuelled by strong anti-Catholic feeling, manifest in the "Popish Plot" rumour spread by Titus OATES and the Exclusion Crisis (1679-81), when attempts were made to exclude Charles' brother, the Catholic Duke of York (later JAMES II), from the succession. Unable to resolve his differences with parliament, Charles dissolved it and ruled with financial support from Louis XIV. Known as the Merry Monarch, Charles had many mistresses (including Nell Gwyn), but left no legitimate heir.

Charles V (the Wise) (1337–80) King of France (1364–80). He regained most of the territory previously lost to the English during the HUNDRED YEARS WAR, stabilized the coinage, and endeavoured to suppress anarchy and revolt in France. He strengthened royal authority further by introducing a regular taxation system, standing army, and powerful navy. He established a royal library, encouraged literature and art, and built the BASTILLE. He was succeeded by his son, CHARLES VI.

Charles VI (the Mad) (1368–1422) King of France (1380–1422). Until 1388 he was controlled by his uncle, Philip the Bold of Burgundy, whose policies drained the treasury and provoked uprisings. After ruling effectively for four years, Charles suffered recurrent bouts of insanity. Philip and Louis d'Orléans, the king's brother, fought over control of the kingdom. Louis was murdered in 1407, and Philip allied himself with Henry V of England. English victories at Agincourt (1415) and elsewhere forced Charles to sign the Treaty of Troyes (1420), acknowledging Henry as his successor.

Charles VII (1403–61) King of France (1422–61). The son of Charles VI, he was excluded from the throne by the Treaty of Troyes (1420). When his father died, Charles controlled French lands s of the River Loire, while the N remained in English hands. With the support of Joan of ARC, he checked the English at Orléans and was crowned king at Reims (1429). The Treaty of Arras (1435) ended the hostility of Burgundy, and by 1453 the English had been driven out of most of France. The king strengthened his authority by reestablishing regular taxation and creating a standing army.

Charles VIII (1470–98) King of France (1483–98). He succeeded his father Louis XI, and until 1491 was controlled by his sister Anne de Beaujeu and her husband. Obsessed with gaining the kingdom of NAPLES, he invaded Italy in 1494, beginning the long Italian Wars, and in 1495 he entered Naples. A league of Italian states, the Papacy and Spain forced him to retreat. One positive result was the introduction of Italian Renaissance culture into France. He was succeeded by his cousin Louis XII.

Charles IX (1550–74) King of France (1560–74). Charles succeeded his brother Francis II in 1560, and his mother Catherine de' Medici became regent. Her authority waned when, in 1571, the young king fell under the influence of Gaspard de Coligny, leader of the Huguenots. Coligny and thousands of his followers were slain in the Saint Bartholomew's Day Massacre (1572), ordered by Charles at the instigation of his mother. He was succeeded by his brother Henry III.

Charles X (1757–1836) King of France (1824–30). Brother of Louis XVI and Louis XVIII, he fled France at the outbreak of the French Revolution (1789). He remained in England until the Bourbon restoration (1814). He opposed the moderate policies of Louis XVIII. After the assassination of his son in 1820, his reactionary forces triumphed. In 1825 he signed a law indemnifying émigrés for land confiscated during the Revolution. In 1830 he issued the July Ordinance, which restricted suffrage and press freedom, and dissolved the newly elected chamber of deputies. The people rebelled and Charles was forced to abdicate. He designated his grandson Henry as successor, but the Duc d'Orléans, Louis Philippe, was selected.

Charles III (1716–88) King of Spain (1759–88) and of Naples and Sicily (1735–59), the son of Philip V and Elizabeth Farnese. He conquered Naples and Sicily in 1734, and inherited the Spanish crown from his half-brother Ferdinand VI. He handed Naples and Sicily to his son Ferdinand, who ruled as Ferdinand I of the Two Sicilies. Charles was a highly competent ruler. He encouraged commercial and agrarian reform, and brought the Spanish Catholic Church under state control, expelling the Jesuits in 1767. Allied with France in the Seven Years War, he received Louisiana in 1763. He was succeeded by his son Charles IV.

Charles IV (1748–1819) King of Spain (1788–1808), son and successor of Charles III. Unable to cope with the upheavals of Napoleon Bonaparte, Charles virtually turned over government to his wife María Luisa and her lover Manuel de Godoy. Godoy formed an alliance with France, but Spain was nevertheless occupied by French troops in the Peninsular War. Charles was forced to abdicate in favour of his son, Ferdinand VII, who in turn was forced from the throne by Napoleon.

Charles X (1622–60) King of Sweden (1654–60). He ascended the throne when his cousin Queen Christina abdicated in his favour. His efforts to complete Swedish dominination of the Baltic resulted in a reign of continuous military activity. He invaded Poland unsuccessfully and twice invaded Denmark. He established the natural frontiers in Scandinavia, recovering the s provinces of Sweden from Denmark. He was succeeded by his son, Charles XI.

Charles XII (1682–1718) King of Sweden (1697–1718). His father, Charles XI, trained him in all aspects of administration, and he became king when 14 years old. Charles XII was one of the greatest military leaders in European history. He defeated Denmark, Poland, Saxony and Russia in a series of brilliant campaigns. Leading the battle, he destroyed the army of Peter I (The Great) at Narva (1700). In 1708 he renewed his assault on Russia, but his army, depleted by the severe winter, was decisively defeated at Poltava (1709). He fled to the Ottomans and persuaded the sultan to attack Russia (1711). The sultan turned against him and, in disguise, he escaped back to Sweden and devoted his energy to the domestic economy. Weakened by war and opposed by numerous enemies, he was killed, while fighting in Norway, and succeeded by his sister, Ulrica Eleanora.

Charles XIV (1763–1844) (Jean Baptiste Bernadotte) King of Sweden (1810–44), b. France. He fought in the French Revolution and was chosen by the Swedish legislature in

► cheetah Also known as the hunting leopard, the cheetah (Acinonyx jubatus) is well adapted to catching its prey of antelope, hares and some species of birds, such as guinea fowl and young ostriches. It has long legs (height to shoulder, 1m/3ft), a supple but strong back (1.5m/5ft long) and welldeveloped eyesight; the cheetah hunts by sight not scent. It is distinguished by its pattern of solid black spots, a striped tail and a dark line running from the inner eye to the mouth.

1810 to succeed Charles XIII. In the Treaty of Kiel, he forced Denmark to cede Norway to Sweden, and became king of Norway as Charles III John (1818–44). He joined the Allies against Napoleon at the Battle of Leipzig (1814). His subsequent reign brought peace and prosperity to Sweden.

Charles Edward Stuart See STUART, CHARLES EDWARD Charles (Prince of Wales) (1948-) Eldest son of ELIZA-BETH II and heir to the British throne. He was invested as the Prince of Wales at Caernarvon (1969). He married Lady DIANA Spencer in 1981. A fairy-tale marriage rapidly and publicly disintegrated. Charles and Diana divorced in 1996. Their eldest son, Prince William (b. 1982), is second in line to the throne. Charles is well-known for his work with charities such as the Prince's Trust and his advocacy of COMMUNITY ARCHITECTURE. Charles' law Volume of a gas at constant pressure is directly proportional to its absolute temperature. As temperature increases, the volume of a gas also increases at a constant pressure. The relationship was discovered by a French scientist Jacques Charles in 1787. The law is a special case of the ideal gas law. It is sometimes called Gay-Lussac's law, because Joseph GAY-LUSSAC established it more accurately in 1802.

Charleston City and port in SE South Carolina, USA. Founded in the 1670s by William Sayle, it soon became the major SE seaport. The South Carolina Ordinance of Secession was signed here (1860), and the firing on FORT SUMTER was the first engagement of the American Civil War. It has many fine colonial buildings and the Fort Sumter National Monument. It is the site of an important naval base. Industries: paper, textiles, chemicals, steel. Pop. (1990) 80,414.

Charleston Capital of West Virginia, USA, in the w of the state, on the River Kanawha. The city grew around Fort Lee in the 1780s. It is an important trade and transport centre for the industrialized Kanawha Valley. Industries: chemicals, glass, metallurgy, timber, oil, gas, coal. Pop. (1990) 57,287.

Charlton, Sir Bobby (Robert) (1937–) English footballer. Charlton played for Manchester United and was voted European Footballer of the Year (1966). He was a member of England's World Cup winning team. He won 106 international caps, scoring an English record of 49 goals. On retiring, Bobby pursued a career in football administration and became a director of Manchester United. His elder brother, Jack (1935–), also a member of England's World Cup winning squad, went into club management and led the Republic of Ireland national team to remarkable success before retiring in 1996.

Charon In Greek mythology, boatman of the Lower World who ferried the souls of the dead across the STYX to HADES.

Charpentier, Gustave (1860–1956) French composer, taught by MASSENET. His best-known compositions are the operas *Louise* (1900) and *Julien* (1913) and the orchestral *Impressions d'Italie*.

Chartism (1838–48) British working-class movement for political reform. Combining the discontent of industrial workers with the demands of radical artisans, the movement adhered to the People's Charter (1838), which demanded electoral reform including universal male suffrage. As well as local riots and strikes, the Chartists organized mass petitions (1839, 1842, 1848). The movement faded away after a major demonstration in 1848.

Chartres Town on the River Eure, NW France; capital of Eure-et-Loire département. The stained glass and sculptures in the 12th–13th century gothic Cathedral of Notre Dame, make it one of Europe's finest cathedrals. It is a world heritage site. Industries: brewing, leather, agricultural equipment, radio and televison parts. Pop. (1990) 41,850.

Charybdis In Greek mythology, a female monster of the Straits of Messina, opposite SCYLLA. Daughter of Poseidon and Gaea, Zeus hurled her into the sea for stealing Heracles' cattle. A whirlpool formed where she lay under the water.

Chase, Salmon Portland (1808–73) Chief justice of the US Supreme Court (1864–73). Known as a defender of fugitive slaves, he was appointed chief justice by President LINCOLN. Chase reorganized the federal courts, and presided over the impeachment of President JOHNSON (1868). His decision in the Slaughterhouse Cases (1873) became a standard judgement on the restrictive clause of the 14th Amendment.

Chateaubriand, François René, Vicomte de (1768–1848) French writer and diplomat, whose works contributed to French ROMANTICISM. The Genius of Christianity (1802) was a reaction to ENLIGHTENMENT attacks on Catholicism and established his literary reputation. Atala (1801) and René (1805) are tragic love stories set in the American wilderness. After 1803 he held important diplomatic posts for both Napoleon and the Bourbons and was minister of foreign affairs (1823–24). In 1830 he resigned from politics and wrote his Memoirs from Beyond the Grave.

Chattanooga City on the Tennessee River, SE Tennessee, USA. Founded as a trading post in the early 19th century, it was an important strategic centre in the American Civil War. Since 1935 it has been the headquarters of the Tennessee Valley Authority (TVA). Industries: iron and steel, food processing, synthetic fibres, tourism. Pop. (1992) 152,888.

Chatterton, Thomas (1752–70) English poet and forger of antiquities. He achieved posthumous fame for poems such as "Bristowe Tragedie" and "Mynstrelles Songe", supposedly composed by Thomas Rowley, an imaginary 15th-century monk. An erratic talent, his early suicide established him as a hero of the Romantic movement. William Wordsworth described him as "the marvellous boy".

Chaucer, Geoffrey (1346–1400) English medieval poet. His writings are remarkable for their range, narrative sense, power of characterization and humour. They include *The Book of the Duchess* (1369), *The House of Fame* (c.1375), *The Parliament of Fowls* and *Troilus and Criseyde* (both c.1385). His most famous and popular work is *The Canterbury Tales* (c.1387–1400), an extraordinarily varied collection of narrative poems, each told by one of a group of pilgrims while travelling to the shrine of Thomas à Becket. Ranging from the courtly "Knight's Tale" to the bawdy "Miller's Tale", they provide a panoramic view of 14th-century English society and are a landmark in medieval fiction. Influenced by both French and Italian literary traditions, Chaucer's writings exercised a powerful influence on the future direction of English LITERATURE, not least in confirming SE English as its principal language.

Chávez, Cesar Estrada (1927–93) US labor leader. Born of Mexican-American parents, Chavez migrated to California as a field worker. In 1962 he founded the National Farm Workers Association (NFWA), which in 1966 merged with the Agricultural Workers Organizing Committee of the AFL-CIO, to become the United Farm Workers Organizing Committee. In 1968–70 he led a successful national boycott of California grapes, and later a lettuce boycott. Disputes over farm labourer representation continued into the 1980s.

Chechenya (formerly Chechen-Ingush Republic) Republic of the Russian Federation, in the N Caucasus; the capital is GROZNY. The region's chief rivers are the Terek and Sunzha, whose fertile valleys support farming. Chechens constitute 50% of the population and 40% live in urban areas. They are Sunni Muslims, Grozny oil field is a major source of Russian oil. The Chechen people fiercely resisted tsarist Russia's conquest of the Caucasus, even after absorption in 1859. In the 1920s separate autonomous regions were created by the Soviet Union for the Chechen and Ingush peoples, the Ingush living primarily in the lowlands. In 1934 the two were united to form a single region which, in 1936, became the Chechen-Ingush Autonomous Republic. The republic was dissolved in 1943-44 because of alleged collaboration with German occupying forces in World War 2. The region was reconstituted in 1957. In 1991 the Chechen-Ingush Republic split in two. A declaration of independence from the Russian Federation was not recognized by the Russian government. General Dudayev was elected president of Chechenya. In December 1994, following a period of bloody internal strife, Russia invaded but met fierce resistance. In February 1995, Russian troops completed the capture of Grozny after almost 25,000 civilian deaths. This led to a protracted guerrilla war. Industries: oil refining and equipment, chemicals. Area: 19,301sq km (7,452sq mi). Pop. (1992) 1,308,000.

cheese Food made by curdling milk and then processing the curd. The commonest source is cows' milk, Blue cheeses are pierced in order to channel air to a reactive fungus previously introduced. The simplest product is cottage cheese, formed when skimmed milk coagulates.

cheetah Spotted large CAT found in hot, arid areas of Africa, the Middle East and India. A long-legged animal with blunt, non-retractable claws, it has a tawny brown coat with round black spots. Capable of running at more than 95km/h (60mph), it hunts gazelles and antelopes by sight. Length: body: 140–150cm (55–60in); tail: 75–80cm (30–32in); weight: 60kg (132lb). Family Felidae; subfamily Acinonchinae; species *Acinonyx jubatus*.

Cheever, John (1912–82) US short story writer and novelist. His works satirize the morals of American suburban life, particularly 1940s Manhattan. His novel *The Wapshot Chronicle* (1957) won a National Book award and its sequel, *The Wapshot Scandal* (1964), was also popular. His short-story collection *The Stories of John Cheever* (1978) won a Pulitzer Prize.

Cheka First secret police force in the Soviet Union. Formed shortly after the Russian Revolution (1917), it had a wideranging role during the ensuing civil war. A ferocious reign of terror alienated many Bolshevik organizations and it was disbanded in 1922, replaced first by the GPU and then the KGB. Chekhov, Anton Pavlovich (1860–1904) Russian dramatist, who worked closely with Konstantin STANISLAVSKY at the Moscow ART THEATRE. His major plays, The Seagull (1896), Uncle Vanya (1897), The Three Sisters (1901) and The Cherry Orchard (1904), display a deep understanding of human nature and a fine blend of comedy and tragedy. They are detailed, realistic portraits of provincial life, and the main action usually takes place off-stage. Characters often reveal as much by what

chemical bond Mechanism that holds together atoms to form molecules. There are several types which arise either from the attraction of unlike charges, or from the formation of stable configurations through electron-sharing. The number of bonds an atom can form depends upon its valency. The main types are IONIC, COVALENT, metallic and HYDROGEN bonds.

they leave unsaid as the subtleties of the dialogue itself.

chemical engineering Application of engineering principles to the making of chemical products on an industrial scale. Unit processes of chemical engineering include oxidation and reduction, nitration and sulphonation, electrolysis, polymerization, ion exchange and fermentation.

chemical equation Set of symbols used to represent a CHEMICAL REACTION. Equations show how atoms are rearranged as a result of a reaction, with reactants on the left-hand side and products on the right-hand side. For example, the formation of magnesium oxide when magnesium burns in oxygen is represented by $2Mg + O_2 \rightarrow 2MgO$. The number of

atoms of an element on the left-hand side of an equation must equal the number on the right.

chemical equilibrium Balance in a REVERSIBLE REACTION, when two opposing reactions proceed at constant equal rates with no net change in the system. The initial rate of the reactions falls off as the concentrations of reactants decrease and the build-up of products causes the rate of the reverse reaction to increase.

chemical reaction Change or process in which chemical substances convert into other substances. This involves the breaking and formation of chemical bonds. Reaction mechanisms include endothermic, exothermic, replacement, combination, decomposition and oxidation reactions.

chemical warfare Use of chemical weapons such as poison and nerve gases, defoliants and herbicides. Saddam Hussein used gas to kill thousands of Kurds after the Iran-Iraq War. Allied troops were heavily protected against possible chemical warfare during the Gulf War. There are concerns about its terrorist uses, such as the nerve gas attack on the Tokyo underground system. See also BIOLOGICAL WARFARE

chemistry Branch of science concerned with the properties, structure and composition of substances and their reactions with one another. Today it is a vast body of knowledge with a number of subdivisions. The major division in chemistry is between organic and inorganic. Inorganic chemistry studies the preparation, properties and reactions of all chemical elements and their compounds, except those of CARBON. Organic chemistry studies the reactions of carbon compounds, which are c.100 times more numerous than nonorganic ones. It also studies an immense variety of molecules, including those of industrial compounds such as plastics, rubbers, dyes, drugs and solvents. Analytical chemistry deals with the composition of substances. PHYSICAL CHEMISTRY deals with the physical properties of substances, such as their boiling and melting points. Its subdivisions include ELECTROCHEMISTRY, thermochemistry and chemical KINETICS.

chemoreceptor Tiny region on the outer membrane of some biological cells that is sensitive to chemical stimuli. The chemoreceptor transforms a stimulus from an external molecule into a sensation, such as smell or taste.

Calorimeters measure the amount of heat absorbed or let out during a chemical reaction. In a high-pressure flow calorimeter, the apparatus is contained in a vacuum (1) for insulation. A constant flow of liquid or gas enters the calorimeter (2). A platinum resistance thermometer (3)

measures the temperature of the substance on entry. A heater (4) puts a known amount of energy into the liquid or gas inside a radiation shield (5) which further lessens any dispersion of energy. The change in temperature is measured by a second thermometer (6) again shielded (7).

▶ cherry Grown for their fruit in many parts of the world, the cherry forms a type of fruit known as a drupe. It takes the form of a single seed surrounded by fleshy fruit. Cherries date from Roman times and the one shown is the black Early Rivers variety. The Japanese have a annual national festival to celebrate the arrival of cherry blossom.

chemotherapy Treatment of a disease (usually cancer) by a combination of chemical substances, or DRUGS, that kill or impair disease-producing organisms in the body. Specific drug treatment was introduced in the early 1900s by Paul EHRLICH. Chernobyl (Ukrainian, Chornobyl) City on the River Pripyat River, N central Ukraine. It is 20km (12mi) from the Chernobyl power plant. On 26 April 1986, an explosion in one of the plant's reactors released 8 tonnes of radioactive material into the atmosphere. Within the first few hours 31 people died. Fallout spread across E and N Europe, contaminating much agricultural produce. Containment efforts began with the evacuation of more than 100,000 people from the vicinity of the plant. The reactor was encased in cement and boron. Data on the long-term effects of contamination are inconclusive, though 25,000 local inhabitants have died prematurely. Two of the three remaining reactors were reworking by the end of 1986. In 1991 Ukraine pledged to shut down the plant, but energy needs dictated its continued output. In 1994 the West pledged economic aid to ensure the plant's closure.

Chernomyrdin, Viktor Russian statesman, prime minister (1992–). A member of the Central Committee of the Communist Party (1986–90), he became prime minister despite the objections of Boris Yeltsin. Chernomyrdin broadly supported economic reform, but was critical of the pace of privatization. Yeltsin's ill-health meant that Chernomyrdin acted as caretaker-president throughout much of 1996.

Cherokee Largest tribe of Native Americans in the USA, members of the Iroquoian language family. The Cherokee migrated s into the Appalachian region of Tennessee, Georgia and the Carolinas. They sided with the British during the American Revolution. When gold was discovered on their land in Georgia in the 1830s, they were forced to move w. This tragic "Trail of Tears" (1838) reduced the population by 25%. One of the Five Civilized Tribes, c.47,000 Cherokee descendants now live in Oklahoma and c.3,000 in North Carolina.

cherry Widely grown fruit tree of temperate regions, probably native to W Asia and E Europe. Various types are grown for their fruit – round yellow, red or almost black with a round stone. The wood is used in furniture. Height: to 30m (100ft). Family Rosaceae; genus *Prunus*; there are about 50 species.

Chesapeake Bay Inlet of the Atlantic Ocean in Virginia (s) and Maryland (N), USA, at the mouth of the Susquehanna River. Linked to the Delaware River by the Chesapeake and Delaware Canal, the first permanent English settlement in North America was on Chesapeake Bay, at Jamestown, Virginia, (1607). In 1608 John Smith explored and charted the bay. Length: 311km (193mi). Width: 5–40km (3–25mi).

Cheshire County in NW England, bounded w by Wales and N by Greater Manchester and Merseyside. The county town is Chester. Cheshire is drained by the Mersey, Weaver and Dee rivers. It is an important industrial and dairy farming region, noted for its cheese. Industries: salt mining, chemicals, textiles, motor vehicles, oil refining. Area: 2,331sq km (900sq mi). Pop. (1991) 956,616.

chess Board game of strategic attack and defence, played on a 64-square chequered board. Two players start with 16 pieces each, white or black, set out along the outer two ranks (rows) of the board. With a black square in the left corner, white's pieces are set out: rook (castle), knight, bishop, queen, king, bishop, knight, rook. Black's pieces align directly opposite. Pawns stand on the second rank. White takes first move, and players move pieces alternately on either rank (horizontal), file (vertical), or diagonal as appropriate, until the king is captured (checkmate). Chess originated in ancient India. The earliest extant references date the game back to the

6th century AD. Modern chess is a high-profile, international game. Since 1950 all male world champion grandmasters (except Bobby Fisher from the USA) have come from Russia or the former Soviet Union.

Chester City and county district on the River Dee, NW England, Cheshire. A Roman garrison town, it has been of strategic importance throughout British history. It was a major port until the Dee became silted and Liverpool's port facilities were expanded. Notable buildings include the city wall, a Roman amphitheatre and a medieval cathedral. Industries: tourism, engineering. Area: 448sq km (173sq mi). Pop. (1991) 115,971. Chesterton, G.K. (Gilbert Keith) (1874–1936) British essayist, novelist, biographer and poet. Best known for his Father Brown stories, which began in 1911, he also wrote literary criticism and essays on social and political themes. His novels include The Napoleon of Notting Hill (1904) and The Man who was Thursday (1908). He became a Catholic (1922) and wrote St Francis of Assisi (1923) and St Thomas Aquinas (1933). His collected poems were published in 1933.

chestnut Deciduous tree native to temperate areas of the Northern Hemisphere. It has lance-shaped leaves and furrowed bark. Male flowers hang in long catkins, females are solitary or clustered at the base of catkins. The prickly husked fruits open to reveal two or three edible nuts. Family Fagaceae; genus *Castanea*; there are four species. *See also* HORSE CHESTNUT

Cheyenne Native North American tribe. Tribal competition forced them to migrate w from Minnesota along the Cheyenne River. During the 18th century, many abandoned sedentary farming for hunting buffalo. The tribe split in c.1830, with the Northern Cheyenne remaining near the Platte River, and the Southern Cheyenne settling near the Arkansas River. The Colorado Gold Rush (1858) brought rapid white migration and the Cheyenne were restricted to a reservation. War broke out following a US army massacre of Cheyenne (1864). General CUSTER crushed Southern Cheyenne resistance, but the Northern Cheyenne helped in his defeat at LITITE BIGHORN. They eventaully surrendered in 1877, and were forced to move to Oklahoma, then to Montana where c.2,000 Cheyenne remain.

Cheyenne State capital of Wyoming and county seat of Laramie County. Founded in 1867 as a centre for transporting goods and livestock by railway, it became famous for its law-lessness and connections with figures such as Buffalo Bill, Calamity Jane and Wild Bill Hickok. Industries: packing plants, oil refineries. Pop. (1990) 50,008.

Chiang Kai-shek (1887–1975) (Jiang Jieshi) Chinese nationalist leader. After taking part in resistance against the QING dynasty, he joined the KUOMINTANG, succeeding SUN YAT-SEN as leader (1925). From 1927 he purged the party of communists, and headed a Nationalist government in Nanking. The Japanese invasion (1937) forced a truce between nationalists and communists, and during World War 2, with US support, Chiang led the fight against Japan. Civil war resumed in 1945. Chiang was elected president of China (1948), but in 1949 the victorious communists led by MAO ZEDONG drove his government into exile in TAIWAN. Chiang established a dictatorship and maintained that the Kuomintang were the legitimate Chinese government. The United Nations finally accepted the Chinese Communist Party as the official government in 1972. Chiang Kai-shek remained president of Taiwan until his death.

Chiangmai City in NW Thailand. Founded in the 13th century, it is the commercial, cultural and religious centre of N Thailand. It has air, rail and road links with BANGKOK and is an export point for local produce. The city's own manufactures include pottery, silk and wooden articles. Pop. (1991 est.) 161,541.

chiaroscuro Term for the opposition of light and dark in painting and drawing. CARAVAGGIO and REMBRANDT were masters of the dramatic use of chiaroscuro.

Chiba City and port in Japan, on Tokyo Bay, central Honshü; capital of Chiba prefecture. It has an 8th-century Buddhist temple. Industries: textiles, paper. Pop. (1993 est.) 834,000.

Chibcha (Muisca) Late prehistoric culture in South America. Bogotá and Tunja were the main centres. The Chibcha

▲ chestnut Sweet chestnuts may be roasted, boiled or ground into flour or fed to livestock. The best quality chestnuts grow in Italy. Chestnut wood is extremely durable. The American chestnut *C. dentata* is almost extinct.

Chile's flag was adopted in 1817. It was designed by an American serving in the Chilean army, who was inspired by the US Stars and Stripes. The white represents the snow-capped Andes, the blue the sky, and the red the blood of the nation's patriots.

Chile stretches c.4,260km (2,650mi) from N to s, while the maximum E-W distance is only c.430km (270mi). The high Andes mountains form the country's E borders with Argentina and Bolivia. They include Ojos del Salado, at 6,863m (22,516km), the second-highest peak in South America. To the W are basins and valleys, with coastal uplands overlooking the shore. Easter Island lies 3,500km (2,200mi) off Chile's W coast. Western Chile contains three main land regions. In the N, is the sparsely populated Atacama Desert, stretching c.1,600km (1,000mi) s from the Peruvian border. The Central Valley, which contains the cap-

BOLIVIA

ARGENTINA

2

o

Santiago

PERUJ0

Antofagasta

Viña del Mar Valparaíso

Concepción

Tropic of Capricorn

PACIFIC

OCEAN

ital, Santiago, Valparaíso and Concepción, is by far the most densely populated region. In the s, the land has been heavily glaciated, the coastal uplands have been worn into islands, while the inland valleys are arms of the sea. In the far s, the Strait of Magellan separates the Chilean mainland from Tierra Del Fuego, a bleak group of islands divided between Chile and Argentina. Punta Arenas is the world's southernmost city.

CLIMATE

Chile's great N–S extent, ranging from the tropics in the N to 55°50's at Cape Horn, gives it a variety of climates. Santiago has a Mediterranean climate, with hot, dry summers from November to March and mild, moist winters from April to October. Northern Chile has a desert climate, with many places entirely without rain. Southern Chile, by contrast, has a cool temperate climate with frequent storms.

VEGETATION

The few plants that live in the Atacama Desert, include varieties of cactus and shrubs. Central Chile has mixed forests of beech and laurel, while the wet s is a region of thick forests, glaciers, scenic lakes and windswept, rocky slopes. Industrial growth has led to widespread deforestation.

HISTORY

ARAUCANICIANS reached the s tip of South America at least 8,000 years ago. In 1520 the Portuguese navigator Ferdinand MAGELLAN became the first European to sight Chile. In 1541 Pedro de Valdivia founded Santiago. Chile became a Spanish colony, ruled as part of the Viceroyalty of Peru. The Native Americans acted as bonded labour on colonial ranches. In 1817 an army, led by José de San Martín, surprised the Spanish by crossing the Andes. In 1818 Bernado O'HIGGINS proclaimed Chile's independence. His dictatorship was followed by democratic reforms. During the War of the Pacific (1879-84) Chile gained mineral-rich areas from Peru and Bolivia. In the late 19th century, Chile's economy rapidly industrialized but a succession of autocratic regimes and its dependence on nitrate exports hampered growth. In 1964 Eduardo Frei Montalvo of the Christian Democratic Party was elected. He embarked on a process of reform, such as assuming a majority share in the US-owned copper mines. In 1970 Salvador ALLENDE was elected president. He introduced many socialist policies, such as land reform and the nationalization of industries. In 1973 soaring inflation and public disturbances led to a military coup, with covert US backing. Allende and many of his supporters were executed. General Augusto PINOCHET assumed control and instigated a series of sweeping market reforms and proAREA: 756,950sq km (292,258sq mi)

POPULATION: 13,599,000

CAPITAL (POPULATION): Santiago (4,385,381) GOVERNMENT: Multiparty republic ETHNIC GROUPS: Mestizo 92%, Native

American 7%

LANGUAGES: Spanish (official)

RELIGIONS: Christianity (Roman Catholic 81%,

Protestant 6%)

currency: Peso = 100 centavos

Western foreign policy initiatives. Despite some success in education and health-care reform, unemployment and strikes increased, while production slumped. In 1977 Pinochet banned all political parties. His regime was characterized by repression and human rights violations. Many political opponents simply "disappeared". A new constitution was introduced in 1981 and free elections were held in 1989. Patricio Aylwyn was elected president, but Pinochet remained important as commander of the armed forces. In 1993 Eduardo Frei was re-elected president.

POLITICS

During the 1990s Chile's economy has improved and a process of social liberalisation continues. Pinochet remained commander-inchief until 1997, and tension between the government and the army continues.

ECONOMY

Chile is a lower-middle-income developing nation (1992 GDP per capita, \$US8,410). It is the world's largest producer of copper ore; accounting for 22% of total world production in 1993. The industry is based in N Chile, especially around Chaquicamata. Minerals dominate Chile's exports, but the most valuable activity is manufacturing, and the main products include iron and steel, wood products, transport equipment, cement and textiles.

Agriculture employs 18% of the workforce; the chief crop is wheat. Chile's major economic problem is its lack of an adequate domestic food supply. Climate and landscape combine to make Chile dependent on imports for over 50% of its food consumption. Yet, Chile's wine industry is expanding rapidly and its fishing industry is the world's fifth largest.

Chile's economy has become one of the strongest in Latin America. In 1995 it began negotiations to become the first South American member of the North American Free Trade Agreement (NAFTA), alongside Canada, Mexico and the USA.

Chile's shape and its inhospitable terrain have hampered the development of a good transport system. Air transport is important in linking Chilean cities.

China's flag was adopted in 1949, when the country became the Communist People's Republic. Red is the traditional colour of both China and communism. The large star represents the Communist Party programme. The smaller stars symbolize the four main social classes.

The People's Republic of China is the world's third largest country (after Russia and Canada). Most people live on the E coastal plains, in the highlands or the fertile valleys of the rivers HUANG HE and YANGTZE, Asia's longest river, at 6,380km (3,960mi).

Western China includes the bleak Tibetan plateau, bounded by the HIMALAYAS (the world's highest mountain range). EVEREST, the world's highest peak, lies on the Nepal-TIBET border. Other ranges include the TIAN SHAN and Kunlun Shan. China also has deserts, such as the GOBI on the Mongolian border.

CLIMATE

The capital, Beijing, in Ne China, has cold winters and warm summers, with moderate rainfall. Shanghai, in the E central region, has milder winters and more rain. The SE region has a wet, subtropical climate. In the w, the climate is more cold and severe.

VEGETATION

Large areas in the w are covered by sparse grasses or desert. The most luxuriant forests are in the SE, such as the bamboo forest habitat of the rare giant panda.

HISTORY AND POLITICS

The first documented dynasty was the Shang $(c.1523-c.1030~{\rm BC})$, when bronze casting was perfected. The Zhou dynasty $(c.1030-221~{\rm BC})$ was the age of Chinese classical literature, in particular Confucious and Lao Tzu. China was unified by Qin Shihuangdi, whose tomb near Xian contains the famous terracotta army. The Qin dynasty $(221-206~{\rm BC})$ also built the majority of the Great Wall. The Han dynasty $(202~{\rm BC-Ad}~220)$ developed the empire, a bureaucracy based on Confucianism, and also introduced Buddhism. China then split into three kingdoms (Wei, Shu and Wu) and the influence of Buddhism and Taoism grew. The

AREA: 9,596,960 sq km [3,705,386 sq mls]

POPULATION: 1,187,997,000

CAPITAL (POPULATION): Beijing (6,560,000) **GOVERNMENT:** Single-party Communist

republic

ETHNIC GROUPS: Han (Chinese) 92%, 55

minority groups

LANGUAGES: Mandarin Chinese (official)
RELIGIONS: The government encourages
atheism; though Confucianism, Buddhism,
Taoism, and Islam are practised

currency: Renminbi (yuan) = 10 jiao = 100 fen

T'ANG dynasty (618-907) was a golden era of artistic achievement, especially in poetry and fine art. GENGHIS KHAN conquered most of China in the 1210s and established the Mongol empire. KUBLAI KHAN founded the YÜAN dynasty (1271-1368), a period of dialogue with Europe. The Ming dynasty (1368–1644) reestablished Chinese rule and is famed for its fine porcelain. The Manchu QING dynasty (1644-1912) began by vastly extending the empire, but the 19th century was marked by foreign interventions, such as the OPIUM WAR (1839-42), when Britain occupied Hong Kong. Popular disaffection culminated in the BOXER REBELLION (1900). The last emperor (Henry Pu YI) was overthrown in a revolution led by SUN YAT-SEN and a republic established.

CHINA

China rapidly fragmented between a Beijing government supported by warlords, and Sun Yatsen's Kuomintang government in Guangzhou. The COMMUNIST PARTY OF CHINA initially allied with the nationalists. In 1926, CHIANG KAI-SHEK's nationalists emerged victorious and turned on their communist allies. In 1930 a rival communist government was established, but was uprooted by Kuomintang troops and began the LONG MARCH (1934). Japan, taking advantage of the turmoil, established the puppet state of MANCHUKUO (1932) under Henry Pu Yi. Chiang was forced to ally with the communists. Japan launched a full-scale invasion in 1937, and conquered much of N and E China. From 1941 Chinese forces, with Allied support, began to regain territory. At the end of World War 2, civil war

resumed: nationalists supported by the USA and communists by Russia. The communists, with greater popular support, triumphed and the Kuomintang fled to TAIWAN. MAO ZEDONG established the People's Republic of China on 1 October 1949. In 1950 China seized Tibet. Domestically, Mao began to collectivize agriculture and nationalize industry. In 1958 the GREAT LEAP FORWARD planned to revolutionize industrial production. The CULTURAL REVOLUTION (1966-76) mobilized Chinese youth against bourgeois culture. By 1971 China had a seat on the UN security council and its own nuclear capability. Following Mao's death (1976), a power struggle developed between the GANG OF Four and moderates led by DENG XIAOPING; the latter emerged victorious. Deng began a process

of modernization, forging closer links with the West. Despite China's economic reforms, political, cultural and intellectual pluralism were often suppressed by the party. In 1989 a prodemocracy demonstration was crushed in TIANANMEN SQUARE. In 1997 Jiang Zemin succeeded Deng as paramount leader.

ECONOMY

In 1979 special economic zones were created to encourage inward investment. China enjoys most-favoured nation status with the USA. In the mid-1980s, agreements were reached on the return of Hong Kong and Macau. China has one of the world's largest economies, agriculture employs c.70% of the population. It has vast mineral resources and a huge steel industry.

culture flourished between 1000 and 1541, and rivalled the INCA in political sophistication. The inhabitants, c.750,000, developed remarkable city-states. Their pottery, weaving and goldsmithing were inferior to Inca work. The Chibcha were conquered by the Spanish (1536–41). In modern times, Chibcha refers to a Native American language family, whose speakers inhabit s Panama and N Colombia.

Chicago City on the sw shore of Lake Michigan, NE Illinois, USA. In the late 18th century it was a trading post and became Fort Dearborn military post (1803). With the construction of the Erie Canal and railways, and the opening up of the prairies, Chicago attracted settlers and industry. Large areas of the city were destroyed by fire in 1871, but its expansion continued. It became a noted cultural centre in the late 19th century with the establishment of the Chicago Symphony Orchestra (1891) and several literary magazines. It is the major industrial, commercial, cultural and shipping centre of the Midwest. It has many colleges and universities, the largest rail terminal in the world and one of the world's busiest airports, O'Hare. Chicago is renowned for its architecture. The world's first SKYSCRAPER was built here in 1885 and, until 1996, the Sears Tower was the world's tallest building, 443m (1,454ft). Industries: steel, chemicals, machinery, food processing, metalworking. Pop. (1990) 2,783,726.

Chichester, Sir Francis (1901–72) English yachtsman and aviator. He embarked on a solo flight between England and Australia in a Gypsy Moth biplane (1929). He began ocean sailing in the 1950s, and won his first solo transatlantic race in 1960. In 1966–67 in *Gypsy Moth IV* he circumnavigated the globe single-handed.

Chickasaw Muskogean-speaking NATIVE AMERICANS, who originated in Mississippi—Tennessee (around present-day MEMPHIS and whose economy was based on intensive maize cultivation. One of the Five Civilized Tribes, they saw the US government establish the Ohio River as their boundary in the Hopewell Treaty (1786). In the 1830s the Chickasaw were resettled in Indian Territory (now Oklahoma) when their numbers were *c.*5,000. Pop. (1995) *c.*9,000.

chicken See POULTRY

chickenpox (varicella) Infectious disease of childhood caused by a virus of the HERPES group. After an incubation period of two to three weeks, a fever develops and red spots (which later develop into blisters) appear on the trunk, face and limbs. Recovery is usual within a week, although the possibility of contagion remains until the last scab has been shed. **chickpea** (dwarf pea, garbanzo, chich or gram) Bushy annual plant cultivated from antiquity in s Europe and Asia for its pea-like seeds. It is now also grown widely in the Western Hemisphere. The seeds are boiled or roasted before eating. Family Fabaceae/Leguminosae; species *Cicer arietinum*.

chicory Perennial weedy plant whose leaves are cooked and eaten, or served raw in salads. The fleshy roots are dried and ground for mixing with (or a substitute for) COFFEE. Chicory

has bright blue, daisy-like flowers. Height: 1.5m (5ft). Family Asteraceae/Compositae; species *Chichorium intybus*.

chigger (harvest mite or red bug) Tiny, red larva of some kinds of MITES found worldwide. Adults lay eggs on plants and hatched larvae find an animal host. On humans their bites cause a severe rash and itching. Length: 0.1–16mm (0.004–0.6in). Order Acarina; family Trombiculidae.

Chihuahua Largest state in Mexico, on the N Mexican plateau. The climate and terrain vary from cool mountains (w) to arid desert (E). The state capital Chihuahua has a Spanish colonial cathedral. Industries: mining, forestry, tourism, cotton. Area: 247,086sq km (95,400sq mi). Pop. (state, 1990) 2,441,873; (city, 1990) 530,783.

child abuse Emotional and/or physical (often sexual) maltreatment of a child. Neglect is considered a form of abuse. Physical abuse may be apparent in bruising and lacerations, burns or scars. Sexual abuse is often concealed by the abused either out of fear or guilt. Physical effects of sexual abuse may be apparent to a medical practitioner. Mental effects may result in remoteness or crudely violent outbursts. It is argued that victims of abuse are more likely to be abusers later in life. **childbirth** *See* LABOUR

child psychology See DEVELOPMENTAL PSYCHOLOGY

Children's Crusade Name given to two 13th-century CRUSADES by children. One group of French children were offered free transport from Marseilles to the Holy Land, but were sold as slaves in North Africa. Another group of German children bound for the Holy Land travelled to Italy, where the crusade floundered, many dying of starvation and disease.

Chile Republic in sw South America. *See* country feature, on p.151

chilli (chili) Hot red PEPPER. It is an annual with oval leaves and white or greenish-white flowers that produce red or green seedpods. When dried, the pods are ground to powder. Cayenne pepper comes from the same plant. Height: 2–2.5m (6–8ft). Family Solanaceae; species *Capsicum annuum*.

chimaera (ratfish or ghost shark) One of about 28 species of cartilaginous, deep-sea fish with a long poisonous dorsal spine and a slender tail. Some species have an elongated snout. An oil, derived from its liver, is used as a lubricant in precision equipment. Length: 60cm–2m (23–80in). Families Chimaeridae, Collorhinchidae and Rhinochimaeridae. The term also refers to an animal formed from several different embryos.

Chimera In Greek mythology, a monster with a lion's head, goat's body and dragon's tail. She was the the sister of Cerberus, HYDRA and the SPHINX, and slain by Bellerophon.

chimpanzee Gregarious, intelligent great APE of tropical Africa. Chimpanzees are mostly black and powerfully built. A smaller chimpanzee of the Congo region is sometimes classified as a separate species. Chimpanzees often nest in trees, but are mostly on the ground searching for fruit and nuts. They are communicative and, in controlled situations, have learned a limited human vocabulary in sign language. Height: *c.*1.3m

▲ chickpea A staple crop in certain regions of India, the chick pea (*Cicer arietinum*) is grown for its seed, which is then boiled.

▶ Chirac Becoming president of France in 1995, Jacques Chirac's major task was to try and ensure the French economy met the stringent criteria for European Monetary Union (planned for 1999). He received a major setback in 1997, when his right-wing RPR prime minister Alain Juppé was defeated by the socialist candidate Lionel Jospin.

(4.5ft); weight: c.68kg (150lb). Species Pan troglodytes, Congo Pan paniscus. Family Pongidae. See also PRIMATES Ch'in Alternative transliteration for the QIN dynasty China Republic in E Asia. See country feature, p.152 China Sea Western part of the Pacific Ocean, divided by Taiwan into the SOUTH CHINA SEA and the EAST CHINA SEA. chinchilla Genus of small, furry RODENTS native to South America. Chinchillas were hunted almost to extinction. They are now bred in captivity for their long, close-textured and soft fur, the most expensive of all animal furs. Length: 23–38cm (9–15in); weight; 450–900g (1–2lb). Family Chinchillidae.

Chinese Group of languages spoken by c.95% of the population of China and by millions more in Taiwan, Hong Kong, Southeast Asia, and other countries. There are six major languages, which are not mutually intelligible; the most numerous is Mandarin, spoken by c.66% of the Chinese population. All Chinese languages are written in a single common non-alphabetic script, whose characters number in the thousands and in some cases date back several thousand years. This single writing-system leads to the traditional classification of all Chinese languages as dialects of the same language. In this case, Chinese has twice as many users as any other language.

Chinese architecture Style that as early as the neolithic period, used columns to support roofs, faced houses s, and used bright colours. The characteristic Chinese roof with wide overhang and upturned eaves was probably developed in the Zhou period (1030–221 BC). A walled complex with a central axis for temples and palaces was established in the HAN (202 BC – AD 220), and the practice of building residential units around a central courtyard with elaborately planned garden became standard. The pagoda derives from Buddhist influences, notably the Indian stupa, and dates from the 6th century.

Chinese art Longest pedigree of any school in world art, its earliest artefacts (painted pottery) date back to the late Neolithic period. By the time of the SHANG dynasty (c.1523–1030 BC), native craftsmen were proficient at casting bronze and making jade carvings, many of which have survived as grave goods. The most elaborate of these early tombs belonged to the first emperor of the QIN dynasty, QIN SHI-HUANGDI (d.210 BC). It contains a fabulous Terracotta Army of c.7,500 life-sized figures and horses. Painting and sculpture were established during the HAN dynasty, though little survives. The T'ANG dynasty (618-907) marked China's artistic zenith. Sculpture reached a peak of refinement, and there were early attempts at landscape painting. The SUNG dynasty saw the introduction of the first true porcelain. Important technical advances, most notably in the application of coloured ENAM-ELS, took place during the MING period (1368–1644). Chinese porcelain became highly valuable in European markets, a trend which accelerated under the QING dynasty. The advent of communism created a rift in this long tradition, as artists adopted Soviet-inspired, SOCIALIST REALISM.

Chinese literature Earliest literary texts date from the Zhou dynasty (c.1030–221 BC). This period produced the canonical writings of CONFUCIANISM: the Five Classics, including the first poetry anthology Shih ching (Classic of Odes); and the Four Books, containing doctrinal writings, such as The Book of Mencius. Traditionally attributed to CONFUCIUS, the Shih ching is probably earlier still. In this era, LAO TZU is credited with founding TAOISM. During the HAN dynasty (202 BC–AD 220), elaborate fu prose poems which praised the dynasty flourished.

The T'ANG dynasty (618-907) marked the golden age of Chinese literature. Li Po, Tu Fu and Wang Wei were the outstanding poets of the period. In the SUNG dynasty (960-1279), the novel (often historical) and drama (stressing conflicts such as filial versus national loyalty) came into being. From the late-17th to early 19th century, much emphasis was placed on formal technique; no one form gained ascendancy and much literary in-fighting took place. Ts'ao Chan produced the most memorable work of the period, the novel Dream of the Red Chamber. The lyric poem has been the dominant form in Chinese literature. It is normally philosophical, with a quietness of tone and an emphasis on simple, routine experiences. In the first half of the 20th century, Chinese literature became greatly modernized, with the new Chinese republic striving to formulate a new, politicized literary language to reflect its doctrine. During the CULTURAL REVOLUTION, strict censorship was imposed. Recent years have seen a slight liberalization.

Chinese mythology During the SHANG dynasty, divination by means of animal bones was used to consult the spirits of royal ancestors on matters such as harvests, rainfall, and the prospects of success in battle. These ancestors were divine and provided a means of communication with the spirit world. A supreme god, Shang Ti, ruled in heaven as Chinese sovereigns did on earth. During the Zhou dynasty, Shang Ti was replaced by T'ien ("Heaven") as the supreme being. The emperor, the "Son of Heaven", was responsible for maintaining harmony on earth and assumed the role of both priest and monarch. Chinese creation myths are essentially the reduction of chaos to order. Later, in conjunction with popular mythology, there existed a formal Chinese pantheon ruled by a father-god, the August Personage of Jade. His heavenly court was an almost exact replica of the imperial court at Beijing. The Sun and the Moon were the objects of an official cult, and the Festival of the Moon was a major annual celebration. Another popular divinity was the Thunder God who punished those guilty of great crime.

Chinese theatre In its purest form, the traditions of Chinese theatre date back to the SUNG dynasty (960–1279). Traditional theatre is highly stylised and the symbolism of the various dramatic parts, the actors' costumes, make-up and gestures are considered of far greater importance than the dialogue (in earlier centuries it was often not recorded). Although much recent Chinese theatre has become Westernised, the old dramatic tradition remains enormously popular.

Ch'ing Alternative transliteration of the QING dynasty **Chinook** Native American tribe living along the Pacific coast from the Columbia River to The Dalles, Oregon. Although numbering fewer than 1,000, the Chinook travelled widely and the Chinook language was used by others, native and European, during the settlement of the West. The name is also given to a warm, dry wind on the E side of the Rocky Mountains.

chip Piece of SILICON etched to carry tiny electrical circuits Silicon chips are at the heart of most electronic equipment. A personal COMPUTER contains many different types of chip, most notably a MICROPROCESSOR. Chips are etched, layer by layer, onto slivers of extremely pure silicon. Each layer is "doped" to give it particular electrical properties, and the combination of different layers form components such as TRANSISTORS and DIODES. Most chips are made by photographic etching processes. This imposes a limit on the separation of components, and new ways of etching chips using much finer x-rays are being investigated. See also CHARGE-COUPLED DEVICE (CCD)

chipmunk Small, ground-dwelling SQUIRREL native to North America and Asia. It carries nuts, berries and seeds in cheek pouches, to store underground. Active tree-climbers in summer, they hibernate in winter. Most chipmunks are brown with one or more black-bordered, light stripes. Length: 13–15cm (5–6in) excluding the tail. Family Sciuridae; genera *Eutamias* and *Tamias*.

Chippendale, Thomas (1718–79) British furniture designer. One of the great English craftsmen, much of his fame rested upon the wide circulation of his *The Gentleman and Cabinet Maker's Directory* (1754–62), a trade catalogue illustrating the designs of his factory. Many of Chippendale's finest pieces were marquetry and inlaid items in neo-classical vein.

Chirac, Jacques (1932–) French statesman, president (1995–). Chirac was elected to the National Assembly in 1967 and held a number of ministerial posts. In 1974 he was appointed prime minister by President GISCARD D'ESTAING. In 1976 he resigned and formed a new Gaullist party, the Rally for the Republic (RPR). In 1977 he became mayor of Paris. He was again prime minister (1986–88), this time under President MITTERRAND. In 1995 Chirac succeeded Mitterand as president. Confronted by tough economic decisions in the lead-up to European economic and monetary union, Chirac called a surprise prime ministerial election (1997). Victory for the socialists, led by Lionel Jospin, was a personal setback for Chirac.

Chirico, Giorgio de (1888–1978) Italian painter, b. Greece. Chirico was founder of the quasi-surrealist "metaphysical painting" movement. He painted still lifes and empty, dream-like landscapes in exaggerated perspective. In the 1930s he repudiated all modern art in favour of paintings in the style of the Old Masters. *See also* SURREALISM

Chiron In Greek mythology, wisest and most famous CENTAUR. He taught many of the lesser gods and heroes, including ACHILLES, and was accidently killed by Hercules with a poisoned arrow. He was placed among the stars by ZEUS.

chiropractic Non-orthodox medical practice based on the theory that the nervous system integrates all of the body's functions, including defence against disease. Chiropractors aim to remove nerve interference by manipulations of the affected musculo-skeletal parts, particularly in the spinal region.

Chisinau (Kishinev) Capital of Moldova, in the centre of the country, on the River Byk. Founded in the early 15th century, it came under Turkish and then Russian rule. Romania held the city from 1918 to 1940 when it was annexed by the Soviet Union. In 1991 it became capital of independent Moldova. It has a 19th-century cathedral and a university (1945). Industries: plastics, rubber, textiles, tobacco. Pop. (1994) 700,000. chitin Hard, tough substance that occurs widely in nature, parcially in the shells (exoskeletons) of arthropods such as crabs, insects and spiders. The walls of hyphae (microscopic tubes of fungi) are composed of slightly different chitin. Chemically chitin is a polysaccharide, derived from glucose.

chiton (coat-of-mail shell) MOLLUSC that lives attached to, or creeping on, rocks along marine shores. Bilaterally symmetrical, its upper surface has eight overlapping shells. Underneath is a large fleshy foot and a degenerate head with mouth, gills and mantle. Length: to 33cm (13in). Class Amphineura; order Polyplacophora; family Chitonidae.

Chittagong Seaport on the River Karnaphuli, near the Bay of Bengal, SE Bangladesh. Under Mogul rule in the 17th century, it was ceded to the British EAST INDIA COMPANY in 1760. It is Bangladesh's chief port. Its facilities were badly damaged in the war between India and Pakistan (1971). Industries: jute, tea, oil, engineering, cotton, iron and steel. Pop. (1991) 1,363,998. chive Perennial herb whose long hollow leaves have an onion-like flavour used for seasoning. The flowers grow in rose-purple clusters. Family Liliaceae; species Allium schoenoprasum. chlamydia Small, virus-like BACTERIA that live as PARASITES in animals and cause disease. One strain, C. trachomatis, is responsible for TRACHOMA and is also a major cause of pelvic inflammatory disease (PID) in women. C. psittaci causes PSITTACOSIS. Chlamydial infection is the most common SEXUALLY TRANSMITTED DISEASE in many developed countries.

chloride Salt of HYDROCHLORIC ACID or some organic compounds containing CHLORINE, especially those with the negative ion Cl⁻. The best-known example is common salt, sodium chloride (NaCl). Most chlorides are soluble in water, except mercurous and silver chlorides.

chlorine (symbol Cl) Common nonmetallic element that is one of the HALOGENS, first discovered in 1774 by the Swedish chemist K.W. Scheele. It occurs in common salt (NaCl). It is a greenish-yellow poisonous gas extracted by the electrolysis of brine (salt water) and is widely used to disinfect drinking water and swimming pools, to bleach wood pulp and in the manufacture of plastics, chloroform and pesticide. Chemically it is a reactive element, and combines with most metals. Properties: at.no. 17; r.a.m. 35.453; m.p. 101°C (149.8°F); b.p. 34.6°C (30.28°F). The most common isotope is Cl35 (75.53%).

chlorofluorocarbon (CFC) Chemical compound in which hydrogen atoms of a HYDROCARBON, such as an alkane, are replaced by atoms of fluorine, chlorine, carbon and sometimes bromine. CFCs are inert, stable at high temperatures and are odourless, colourless, nontoxic, noncorrosive and nonflammable. Under the trade name of Freons, CFCs were widely used in aerosols, fire-extinguishers, refrigerators, and in the manufacture of foam plastics. The two most common are Freon 11 (trichlorofluoromethane, CFCl₃) and Freon 12 (dichlorodifluoromethane, CF2Cl2). CFCs slowly drift into the stratosphere and are broken down by the Sun's ultraviolet radiation into chlorine atoms that destroy the ozone layer. It often takes more than 100 years for CFCs to disappear from the atmosphere. Growing environmental concern led to a 1990 international agreement to reduce and eventually phase out the use of CFCs, and to develop safe substitutes.

chloroform (trichloromethane) Colourless, volatile, sweetsmelling liquid (CHCl₃) prepared by the chlorination of methane. Formerly a major anaesthetic, it is used in the manufacture of fluorocarbons, in cough medicines, for insect bites and as a solvent. Properties: r.d. 1.48; m.p. 63.5°C (82.3°F); b.p. 61.2°C (142.2°F).

chlorophyll Group of green pigments present in the CHLOROPLASTS of plants and ALGAE that absorb light for PHOTOSYNTHESIS. There are five types: chlorophyll a is present in all photosynthetic organisms except bacteria; chlorophyll b, in plants and GREEN ALGAE; and chlorophylls c, d and e, in some algae. It is similar in structure to HAEMOGLOBIN, with a magnesium atom replacing the iron atom.

chloroplast Microscopic green structure within a plant cell in which PHOTOSYNTHESIS takes place. The chloroplast is enclosed in an envelope formed from two membranes and contains internal membranes to increase the surface area for reactions. Molecules of the light-absorbing pigment CHLOROPHYLL are embedded in these internal membranes.

chocolate Like COCOA, chocolate was originally a drink (introduced to Europe in the 1500s) produced from the seeds of the tropical tree *Theobroma cacao*. The seeds are beans contained in an elliptical pod, and do not have the flavour or colour of chocolate until they have been fermented and roasted. The beans are then ground up to make chocolate powder. The first chocolate bar was produced in the late 1700s.

Choctaw One of the largest tribes of Muskogean-speaking Native North Americans, located in SE Mississippi and part of Alabama. An agricultural people closely related to the CHICK-ASAW, they were generally at peace with the settlers, and remained neutral during the Revolution. As large slave-owners, they supported the South during the Civil War. A majority of the Choctaw moved to Oklahoma in 1830, where some 40,000 of their descendents still reside.

choir Group of singers who perform together as a musical unit. The earliest choirs were ecclesiastical and sang the PLAINSONG in church services. From the 10th century onwards, polyphonic composition gradually replaced unharmonized plainsong in liturgical use. In the 16th and 17th centuries pieces were written for two or more contrasting choirs. The beginnings of OPERA marked the development of the secular choir, or CHORUS. Most modern choirs, apart from some all-male cathedral choirs, are mixed.

Choiseul, Etienne François, Duc de (1719–85) French statesman, chief minister of Louis XV (1758–1770). As ambassador to Vienna (1757–58), he negotiated the marriage of Marie Antoinette and the future Louis XVI. As minister of foreign affairs he negotiated the Family Compact (1761), allying the BOURBON rulers of France and Spain, and the Treaty of Paris (1763), in which France was forced to surrender French Canada and India to Britain. Choiseul supported the publication of the *Encyclopédie* (1759) and approved suppression of the Jesuits (1764).

Chola Dynasty of s India. Between 985 and 1024, they established an empire that included Sri Lanka, Bengal, parts of Sumatra and Malaya. The dynasty declined and ended in 1279. The Cholas marked a great era of Hindu culture in s India.

cholera Infectious disease caused by the bacterium *Vibrio cholerae*, transmitted in contaminated water. Cholera, preva-

A chloroplast Found mostly in the cells of plant leaves, chloroplasts absorb sunlight and use it to manufacture special types of sugar. They are able to move about in order to receive the maximum amount of light possible. A section through a leaf reveals that during the day (top). chloroplasts have moved to the outer and inner walls in the direct line of light. During the night (bottom) they move to the inner and side walls only.

► Chopin As well as a successful composer, Frédéric Chopin, was a virtuoso pianist. He left his native Poland due to political repression, and moved to Paris in 1831. Much of his music reflects traditional Polish folk songs. Chopin had a stormy relationship with the woman novelist George Sand.

▲ chromosome The 46 chromosomes in somatic (non-reproductive) cells contain a single sex-determining pair, which consists of an X and Y chromosome in males, or an XX pair in females. Ova contain only the X chromosome, while spermatazoa contain X or Y chromosomes in equal proportions. At fertilization, therefore, there is a 50% chance of an XX or XY pair being formed.

▲ chrysanthemum Native to E Asia, the chrysanthemum, along with the cherry blossom, is the national flower of Japan. Today there are some 200 species cultivated around the world.

lent in many tropical regions, produces almost continuous, watery diarrhoea often accompanied by vomiting and muscle cramps, and leads to severe dehydration. Untreated it can be fatal, but proper treatment, including fluid replacement and antibiotics, result in a high recovery rate. There is a vaccine. **cholesterol** White, fatty STEROID, occurring in large concentrations in the brain, spinal cord and liver. It is synthesized in the liver, intestines and skin and is an intermediate in the synthesis of vitamin D and many hormones. GALLSTONES are composed mainly of cholesterol. Meat-rich diets may produce high cholesterol in blood vessels, and can lead to atherosclerosis. See also ARTERIOSCLEROSIS

Chomsky, (Avram) Noam (1928–) US professor of LINGUISTICS. In *Syntactic Structures* (1957), he developed the concept of a transformational grammar, embodying his theories about the relationship between language and mind, and an underlying universal structure of language. Chomsky argues that the human capacity for language is partially innate, unlike supporters of BEHAVIOURISM. His ideas have greatly influenced psychologists concerned with language acquisition. Chomsky has been a consistent critic of US imperialism, especially during the Vietnam War. Political works include *American Power and the New Mandarins* (1969).

Chongjin City on the Sea of Japan, NE North Korea. From 1910to 1945 it was controlled by the Japanese, who developed the Musan iron mines. The city was severely damaged during the Korean War. Industries: iron, steel, shipbuilding, chemicals, textiles. Pop. (1984 est.) 754,128.

Chongqing See Chungking

Chopin, Frédéric François (1810–49) Polish-French composer for the piano. He studied in Warsaw moving to Paris in 1831. He wrote two piano concertos and three piano sonatas but is best known for his numerous short solo pieces, such as ballades, études, nocturnes, waltzes and preludes.

choral music Music written for several voices. Choral compositions were originally religious, CANTATA and ORATORIO being the most usual forms. The foremost composer of cantatas was J.C. BACH, and of oratorios HANDEL. Choral music varies greatly in size and style, from the small-scale, secular madrigals of the 16th century to the large-scale works of the 19th and 20th centuries, such as Verdi's *Requiem* (1874), Elgar's *Dream of Gerontius* (1900) and the choral symphonies of Mahler.

chordata Name of a large phylum of VERTEBRATES and some marine invertebrates, which, at some stage in their lives, have rod-like, cartilaginous supporting structures (noto-chords). Invertebrate chordates are divided into three subphyla: TUNICATES (seasquirts); Cephalochordata (amphioxus); and Hemichordata (acorn worms).

chord In music, the simultaneous occurrence of three or more musical tones of different pitch. Chords are categorized as anomalous, characteristic, common, inverted or transient. *See also* HARMONY

chorus In Greek tragedy, the *choros* danced and chanted commentary. Today, a chorus refers to a group of voices. Major works with chorus parts include CANTATAS, OPERAS and ORATORIOS. See also CHOIR

Chou Alternative name for the ZHOU dynasty

Chouteau, (Jean) Pierre (1758–1849) US fur trader and political figure. With René Auguste Chouteau, he controlled the important trade with the Osage Native Americans. In 1804 he became US agent for all Native American tribes w of the Mississippi. Chouteau founded the first permanent white settlement in Oklahoma.

Chrétien, Jean (Joseph-Jacques) (1934–) Canada's 20th prime minister (1993–). He became a member of Parliament in 1963 and held cabinet offices in Pierre TRUDEAU's government. In 1990 he became leader of the Liberal Party. His populist election campaign won the party a landslide victory. His main challenge has been to reduce unemployment.

Chrétien de Troyes (active1160–85) Romance writer of N France, noted for his tales of King Arthur and his knights. He influenced Geoffrey Chaucer and Thomas Malory, and wrote at least five romances, including *Lancelot*, *Yvain* and *Perceval*.

Christ (Gk. *christos*, "anointed one") Epithet for the Messiah in Old Testament prophecies. Later applied to Jesus, in recognition that he was the expected Messiah.

Christchurch City on South Island, New Zealand; main town of Canterbury. It was founded as a Church of England settlement (1850). The University of Canterbury (1873) is here. Industries: fertilizers, rubber, woollen goods, electrical goods, furniture. Pop. (1993) 312,600.

christening See BAPTISM

Christian Follower of Jesus Christ. The major Christian Churches regard belief in the divinity of Christ and the Holy Trinity as the minimum requirement for a Christian. This definition excludes religious bodies such as UNITARIANISM.

Christian IV (1577–1648) King of Denmark and Norway (1588–1648), the son of Frederick II. Despite a costly war with Sweden (1611–13) and his disastrous participation (1625–29) in the THIRTY YEARS WAR, he was a popular monarch who kept the nobility in check. His reign brought culture and economic prosperity, and he founded Oslo, Norway.

Christian X (1870–1947) King of Denmark (1912–47) and Iceland (1919–44), succeeding Frederick VIII. During his reign universal suffrage was established (1915) and social welfare policies were consolidated. He tried to remain neutral during World War 1 and defied the Germans during occupation (1940–45).

Christian Democrats Political group combining Christian conservative principles with progressive social responsibility. Christian Democrats have achieved power in many European countries, notably Germany and Italy. Its political principles include: individual responsibility allied with collective action; social equality within a welfare state; progress through evolutionary change; and a competitive society responsive to democratic debate and economic planning. Christian Democrats are also represented outside Europe.

Christianity Religion based on faith in Jesus Christs as the

Son of God. The orthodox Christian faith, summarized in the Apostles' and Nicene Creeds, affirms belief in the Trinity and Christ's incarnation, atoning death on the cross, resurrection and ascension. The moral teachings of Jesus are contained in the New Testament. The history of Christianity has been turbulent and often sectarian. The first major schism took place in 1054, when the eastern and western churches separated. The next occurred in the 16th-century Reformation, with the split of Protestantism and the Roman Catholic Church. In recent times the ecumenical movement, which aims at the reunion of all Christians, has gained strength. The number of Christians in the world is estimated at more than 1,000 million (1995).

Christian Science (officially Church of Christ Scientist) Religious sect founded in 1879 by Mary Baker Eddy, and based on her book *Science and Health With Key to the Scriptures*. Its followers believe that physical illness and moral problems can only be cured by spiritual and mental activity.

They refuse medical treatment. Divine Mind is used as a synonym for God. Each human being is regarded as a complete and flawless manifestation of God.

Christie, Dame Agatha Mary Clarissa (1891–1976) British author. A prolific and popular writer of detective stories. The Mysterious Affair at Styles (1920) introduced her most famous character, the Belgian detective Hercule Poirot. The Murder of Roger Ackroyd (1926) and Murder at the Vicarage (1930) featured the aged, busybody sleuth Miss Marple. Other novels include Murder on the Orient Express (1934) and And Then There Were None (1939). Curtain (1975) killed Poirot off. Her plays include The Mousetrap (1952), the longest-running play in London. Her novels are available in most major languages and many have been made into films.

Christie, Linford (1960–) British athlete, b. Jamaica. Christie captained the British men's team at the 1992 Olympic Games and won the 100m gold medal. He repeated this feat in the World Championships (1993). Christie also won gold medals in the European championships (1986, 1990) and the Commonwealth Games (1990, 1994). He retired in 1997.

Christina (1626–89) Queen of Sweden (1632–54). An intellectual of great energy, she brought foreign scholars, such as DESCARTES, to her court. Ruling a Lutheran country, she abdicated to become a Roman Catholic, and settled in Rome. She tried unsuccessfully to obtain the crown of Poland (1667).

Christmas Feast in celebration of the birth of JESUS CHRIST, common in Christendom since the 4th century. Although the exact date of Christ's birth is unknown, the feast takes place on 25 December within all Christian churches. Christmas is also a secular holiday, marked by the exchange of presents. **Christmas Island** *See* KIRITIMATI

Christmas Island Island in the E Indian Ocean, 320km (200mi) s of JAVA. Once under British domination, it was annexed to Australia in 1958. It has important lime phosphate deposits. Area: 135sq km (52sq mi). Pop. (1994 est.) 2,500.

Christophe, Henri (1767–1820) Haitian revolutionary leader, president (1806–11) and king (1811–20). Born a free black on the island of Grenada, he participated in the armed struggle against the French in Haiti and fought a civil war with the partisans of the mulatto Pétion. Christophe ordered the construction of the citadel of La Ferrière, a fort overlooking Cap Haitien, the building of which cost many Haitian lives.

Christopher, Saint Patron saint of ferrymen and travellers. His feast day, 25 July, was omitted from the Roman Catholic calendar of 1969 and is no longer officially recognized.

Christopher, Warren (1925–) US statesman, secretary of state (1993–97), appointed by Bill CLINTON. His early actions included initiating an assistance program for Russia, reopening peace negotiations between Arabs and Israelis, and attempting to clarify the US role in Bosnia.

chromatic Musical term used in melodic and harmonic analysis to refer to notes which do not occur in the scale of the KEY of a passage. Such notes are marked with accidentals; the chords in which they occur are termed chromatic. A chromatic scale is one containing all 12 notes of an octave rather than the seven notes of a diatonic scale.

chromatography Techniques of chemical analysis by which substances are separated from one another, identified and measured.

chromite Black mineral, ferrous chromic oxide (FeO.Cr₂O₃), separated from magma in the formation of igneous rock. It is weakly magnetic and opaque. Hardness 5.5; s.g. 4.6.

chromium (symbol Cr) Dull grey metal, one of the TRANSITION ELEMENTS, first isolated in 1797. Its chief ore is CHROMITE. It is extensively used as an electroplated coating. It is also an ingredient of many special steels. Chromium compounds are used in tanning and dyeing. Properties: at.no. 24; r.a.m. 51.996; r.d. 7.19; m.p. 1,890°C (3,434°F); b.p. 2,672°C (4,842°F); most common isotope Cr⁵² (83.76%).

chromosome Structure carrying the genetic information of an organism, found only in the cell nucleus of EUKARYOTES. Thread-like and composed of DNA, chromosomes carry a specific set of GENES. Each species usually has a characteristic number of chromosomes; these occur in pairs, members of which carry identical genes, so that most cells have a DIPLOID

number of chromosomes. Gametes carry a HAPLOID number of chromosomes. See also HEREDITY

chromosphere Layer of the Sun's atmosphere between the PHOTOSPHERE and the CORONA. The chromosphere is about 10,000km (6,000mi) thick and is normally invisible because of the glare of the photosphere. It is briefly visible near the beginning and end of a total solar eclipse as a spiky red rim around the Moon's disk, and at other times can be studied by SPECTROSCOPY. At its base the temperature of the chromosphere is c.4,000K, rising to 100,000K at the top. Powerful magnetic fields are believed to cause this rise in temperature. Chronicles Two historical books of the OLD TESTAMENT. They trace the history of Israel and Judah from the Creation to the return of the Jews from exile in Babylon (538 BC). See BABYLONIAN CAPITIVITY

chrysalis Intermediate or pupal stage in the life cycle of all insects that undergo complete METAMORPHOSIS. The chrysalis is usually covered with a hard case, but some pupae, such as the silk moth, spin a silk cocoon. Within the chrysalis, feeding and locomotion stop and the final stages of the development take place. See also LEPIDOPTERA

chrysanthemum Large genus of annual and perennial

◀ Christie Former Olympic and world 100m champion, Linford Christie, despite ruling out competing in the 1996 Olympic games, did eventually take part. Although he made the finals of the 100m event, he made three false starts and was automatically disqualified.

▼ chromatography Gas-liquid chromatographs can separate the components of tiny amounts of an unknown mixture. A sample of the mixture (1) is injected (2) into a stream of helium (3), or another inert gas. Heating ensures the vaporized gas mixes fully with the helium. After impurities are removed (4) the gas mixture passes into a tube (5) packed with coated granules of silicon (6). A liquid with a very high boiling point (7) covers the 4mm (0.15in) granules. The components of the vaporized mixture have different solubilities (8) and so pass through the liquid around the silicon, and the whole tube, at different speeds. The whole tube is kept at a high temperature to prevent the vaporized gas condensing. As the nowseparated parts of the mixture exit the tube (9) they enter a detector (10). Hydrogen (11) and oxygen (12) are added and the gas stream is then burnt (13). During burning, each compound produces ions that pass a charge between an anode (14) and a cathode (15). This charge is measured and can be compared to known results to determine the composition of the initial mixture.

▶ Churchill British prime minister Winston Churchill was an inspiring leader during World War 2. His charismatic public speeches and broadcasts encouraged a "bulldog" spirit of resistance to the German forces that had amassed in Europe. Even in the darkest days of the Blitz (1940–41), Churchill remained steadfast in his opposition to fascism and totalitarianism.

plants native to temperate Eurasia and now widely cultivated. Centuries of selective breeding have modified the original plain daisy-like flowers, and most species have large white, yellow, bronze, pink or red flower-heads. Family Asteraceae/Compositae.

chub Freshwater CARP found in flowing waters. It has a large head, wide mouth and is grey-brown. Length 10–60cm (4–25in). Family Cyprinidae. Chub is also the name of a marine fish of warm seas – oval-shaped with a small mouth and bright colours. Family Kyphosidae.

Chungking (Chongqing, Ch'ung-ch'ing) City on the River YANGTZE, S China. From the 14th century it was part of a unified China. It became a treaty port in 1891 and was the wartime capital of China (1937–45). It is a transport and shipping centre. Industries: chemicals, steel, iron, silk, cotton textiles, plastics. Pop. (1993 est.) 3,780,000.

church Community of believers. Although adopted by non-Christian movements such as SCIENTOLOGY, it is usually used in reference to CHRISTIANITY. The characteristics of the Christian Church as the whole body of Christ's followers are described in the NICENE CREED. The church is also the name of the building used for worship by Christians. Churches vary from the stark plainness of some Protestant CHAPELS to the grandeur of the world's major CATHEDRALS.

Churchill, Lord Randolph Henry Spencer (1849–95) British statesman, secretary of state for India (1885–86) and chancellor of the exchequer (1886). A gifted speaker and loyal member of the Tory Party, he nevertheless attempted widespread party reform, in particular encouraging mass participation in the Conservative Associations. His popularity ensured his appointment to government. His first budget as chancellor proposed deep cuts in military expenditure and was defeated. Churchill was forced to resign. He married Jennie Jerome, a US citizen, in 1874. Their son, Winston Churchill, was to achieve the success denied his father.

Churchill, Sir Winston Leonard Spencer (1874–1965) British statesman, prime minister (1940–45, 1951–55). Son of Lord Randolph Churchill, he was a reporter in the South AFRICAN WARS. Elected to parliament in 1900 as a Conservative, he crossed the floor to join the Liberals in 1904. As first lord of the admiralty under Herbert ASQUITH, Churchill expanded Britain's navy in preparation for World War 1. In LLOYD GEORGE's cabinet, he served as secretary of state for war (1918-21) and, as colonial secretary (1921-22), he oversaw the creation of the Irish Free State. He returned to power as chancellor of the exchequer (1924-29) in Stanley BALD-WIN's Conservative government. Out of office (1929–39), he spoke out against the rising threat of Nazi Germany. On the outbreak of WORLD WAR 2, he once more became first lord of the admiralty. In 1940 he replaced Neville Chamberlain as prime minister. He proved an inspiring war leader, resolute in his opposition to fascism. Cultivating close relations with President ROOSEVELT, Churchill was the principal architect of the grand alliance of Britain, the USA and Soviet Union, which eventually defeated the Axis Powers. In 1945 Churchill was succeeded by Clement ATTLEE, but he was reelected in 1950 and reversed some of Labour's nationalizations. He remained an MP until 1964. His extensive writings include a history of World War 2 and the History of the English-Speaking Peoples (1956-58). He was awarded the Nobel Prize for literature in 1953.

Church of England Christian Church in England, established by law in the 16th century. During the reign of King HENRY VIII, a process of separation from the Roman Catholic Church began. The initial impetus for this was the pope's refusal to grant Henry a divorce from CATHERINE OF ARAGON. By the Act of Supremacy (1534), the English monarch became head of the church. Henry wanted to retain the use of the Roman Catholic liturgy, but outside papal control. As the REFORMATION extended to England, the Church of England finally emerged independent of papal jurisdiction and adopted the Elizabethan Settlement. This agreement, while espousing PROTESTANTISM, aimed at preserving religious unity by shaping a national church acceptable to all persons of moderate theological views. This middle course found expression in the doctrinal formulae known as the 39 Articles (1571). The liturgy of the Church of England is contained in the Book of COMMON PRAYER (1662), but since the 1960s alternative forms of worship have come into use. The sovereign bears the title Supreme Governor of the Church of England, and formally nominates the bishops, but this does not confer any spiritual powers on the sovereign. The church is episcopally governed, but priests and laity share in all major decisions by virtue of their representation in the General Synod. Territorially, the church is divided into two provinces, Canterbury and York. The Archbishop of CANTERBURY is the Primate of All England: the Archbishop of YORK the Primate of England. The overseas expansion of the Church of England, in line with the growth of the British empire, resulted in the development of the worldwide ANGLICAN COMMUNION. The Church of England is the only part of the Anglican Communion still established by law as an official state church. In 1992 the General Synod voted in favour of the ordination of women as priests. The first women priests were ordained in 1994. The issue of gay priests remains divisive.

Church of Ireland Anglican Church in Ireland. It claims to be heir to the ancient Church of the island of Ireland. At the time of the REFORMATION, it ended papal jurisdiction and introduced doctrinal and disciplinary reforms similar to the Church of England. It is territorially divided into two provinces, Armagh and Dublin. The Archbishop of Armagh is Primate of All Ireland. The Church of Ireland was the legally established Church until 1869.

Church of Scotland National non-episcopal form of CHRISTIANITY in Scotland, adopting PRESBYTERIANISM by constitutional act in 1689. The church arose as a separate entity during the REFORMATION. Under the leadership of John KNOX, it abolished papal authority and accepted many of the teachings of John CALVIN. The doctrinal position of the Church is based on the Scottish Confession (1560) and the Westminster Confession of 1643. The highest authority of the Church of Scotland resides in the General Assembly, presided over by an annually elected moderator. The Disruption of 1843 led to about one-third of its ministers and members leaving to form the FREE CHURCH OF SCOTLAND. The spiritual independence of the Church was recognized by an act of parliament in 1921, although this did not affect its status as the established Church in Scotland. The Church has c.850,000 members.

CIA Abbreviation of CENTRAL INTELLIGENCE AGENCY

cicada Grasshopper-like insect found in most parts of the world. Males make a loud sound by the vibration of a pair of plates in their abdomen. Females lay eggs in tree branches. The dog-day cicada appears annually in summer. The larvae of the 17-year locust spends up to 17 years in the ground feeding on roots and lives only a week as a winged adult. Length: up to 5cm (2in).

Cicero (106–43 BC) (Marcus Tullius Cicero) Roman politician, philospher and orator. A leader of the Senate, he exposed Catiline's conspiracy (63 BC). He criticized Mark ANTONY in the Senate, and when Octavian came to power Antony persuaded him to have Cicero executed. Cicero's fame rests largely on his political philosophy and oratory. Among his greatest speeches were *Orations Against Catiline* and the *Phillipics*. His rhetorical and philosophical works include *De Amicitia* and *De Officiis*.

CID Abbreviation of CRIMINAL INVESTIGATION DEPARTMENT **Cid, El** (1043–99) (Rodrigo Díaz de Vivar) Spanish national hero. He was a knight in the service of the king of Castile, who spent his whole life fighting, often against the Moors. His greatest achievement was the conquest of Valencia (1094), which he ruled until his death. His exploits have been romanticized in Spanish legend.

cigarette Roll of shredded tobacco wrapped in thin paper for inhalation by smoking. Because of tar, nicotine (the addictive substance) and other chemicals in the smoke, cigarettes are highly carcinogenic. However, cigarettes continue to represent a huge industry and source of taxation for governments despite increasing controls, including clear warnings on packets and bans or limits on advertising.

cilia Small hair-like filaments on cell walls whose wafting motion is used for propulsion or moving matter along a surface. Cilia are present in great quantities on some lining cells of the body, such as those along the respiratory tract. Cilia are also found on single-celled PROTOZOA known as CILIATES.

ciliate One of a large class of PROTOZOA found in freshwater, characterized by hair-like CILIA used for locomotion and food collecting. Subclasses include the Holotrichs (*Paramecium*); Spirotrichs (*Stentor*); and Peritrichs (*Vorticella*).

Cimabue, Giovanni 13th-century Florentine painter, an important transitional link between the rigid Byzantine style of painting and the greater realism of the 14th-century School of Florence. His best-known work is *Madonna and Child Enthroned*. Cimabue is said to have taught Giotto.

Cimarosa, Domenico (1749–1801) Italian composer. He wrote more than 60 operas, his most famous being *Il matrimonio segreto*, which was first performed in Vienna in 1792. He also wrote seven cantatas and six oratorios. He was one of the most popular composers of his time.

cinchona Genus of evergreen trees native to the Andes and grown in South America, Indonesia and Zaïre. The dried bark of the trees is a source of QUININE and other medicinal products. Family Rubiaceae.

Cincinnati City on the Ohio River, sw Ohio, USA. Originally named Losantiville, it grew around Fort Washington (established 1789). The completion of the Miami and Eric Canal in 1832 made the city a shipping centre for farm produce. In order to compete with the growing cities of CHICAGO and ST LOUIS, Cincinnati built its own railway (1880). The city has a university (1819) and several other colleges. Industries: machine tools, soap products, brewing, meat packing, aircraft engines, metal goods. Pop. (1990) 364,040.

cine camera Apparatus that takes a number of consecutive still photographs or frames, on film. The illusion of motion is created when the developed film is projected on to a screen. Big-screen cine cameras use 70mm cine film, most professional cameras 35mm, and some smaller cameras 16 or 8mm. See also CINEMA; CINEMATOGRAPHY; VIDEO RECORDING

cinema Motion pictures as an industry and artistic pursuit. For much of its history, cinema has been commercially dominated by HOLLYWOOD. Public showings of silent moving pictures, with live musical accompaniment, began in the 1890s, but speech was not heard in a full-length film until The Jazz Singer (1927). By then cinema was big business with mass appeal. In Germany and Russia, startling technical innovations showed the creative possibilities of the medium. The 1930s saw the widespread introduction of colour. The growth of television in the USA during the 1940s profoundly altered film economics; the decline of Hollywood led to the rise of the independent producer and director. Fewer but more spectacular films were produced, with all-star casts, backed by international finance. In post-war Europe film-makers explored social and psychological themes with often disturbing candour and, although British cinema flourished in the 1950s and early 1960s, it has suffered since from a lack of finance and resources. See also ANIMATION, CINEMA; CINE CAMERA; CINEMATOGRAPHY; DOCUMENTARY

cinematography Technique of taking and projecting cine film, the basis of the CINEMA industry. Based on the experiments and inventions pioneered during the 1880s and 1890s by Thomas EDISON in the USA and the Lumière brothers in

France, cinematography was applied professionally to the taking and showing of films soon after the turn of the century. **cinéma vérité** Style of film-making, popular during the 1960s, but first practised by Dziga Vertov in the 1920s. It attempted to record truthful action, employing a documentary-like style, often using 16mm cameras. The style was also used in dramas, particularly by TRUFFAUT and GODARD.

cinnamon Light-brown SPICE made from the dried inner bark of the cinnamon tree. Its delicate aroma and sweet flavour make it a common ingredient in food, and it was once extremely expensive. It was also used for religious rites and witchcraft. The tree is a bushy evergreen native to India and Burma and cultivated in the West Indies and South America. Family Lauraceae; species *Cinnamomum zeylanicum*.

cipher See CRYPTOGRAPHY

circadian rhythm Internal "clock" mechanism found in most organisms that normally corresponds roughly with the 24-hour day. It relates most obviously to the cycle of waking and sleeping, but is also involved in other cyclic variations, such as body temperature, hormone levels, metabolism and mental performance.

Circe In Greek mythology, seductive but baleful enchantress whose spells could change men into animals. Mistress of the island of Aeaea, she kept Odysseus with her for a year, changing his men into pigs.

circle Plane geometric figure that is the locus of points equidistant from a fixed point (the centre). This distance is the radius (r). The area of a circle is πr^2 and its perimeter (circumference) is $2\pi r$.

circuit System of electric conductors, appliances or electronic components connected together so that they form a continuously conducting path. In modern electronics, circuits are often printed in copper on a plastic card (printed circuit). *See also* CAPACITOR; CHIP; INTEGRATED CIRCUIT (IC); TRANSISTOR

circulation, atmospheric Flow of the atmosphere around the Earth. The poleward circulation due to CONVECTION, produces large-scale eddies such as CYCLONES and ANTICYCLONES, low-pressure troughs and high-pressure ridges. The eddies are also caused by the Earth's rotation maintaining easterly winds towards the Equator and westerly winds towards the poles.

circulatory system Means by which oxygen and nutrients are carried to the body's tissues, and carbon dioxide and other waste products are removed. It consists of BLOOD VESSELS that carry the BLOOD, propelled by the pumping action of the HEART. In humans and other mammals, blood travels to the lungs, where it picks up OXYGEN and loses CARBON DIOXIDE. It then flows to the heart, from where it is pumped out into the AORTA, which branches into smaller arteries, arterioles and CAPILLAR-IES. Oxygen and other nutrients diffuse out of the blood, and carbon dioxide and other tissue wastes pass into the capillaries, which join to form veins leading back to the heart. Blood then returns to the lungs and the entire cycle is repeated. This is known as a double circulatory system, as the blood is pumped first to the lungs, and then to the rest of the body. In fish and

▲ cinchona The medicinal significance of the 40 or so species of the genus Cinchona lies in its bark which yields quinine and cinchona. Until relatively recently, quinine was the major drug used in the treatment and prevention of malaria, while cinchona eased coughs. However, with ever increasingly sophisticated ways of synthesizing natural products, cheaper man-made drugs are now available.

■ circuit This simple electric circuit (A) represents a torch. The power source is a battery (1). The on/off switch (2) breaks the circuit when it is in the off position.
When closed, in the on position, electrons flow to the resistor (3), the bulb, which emits light.

► citrus Most fruits belonging to the genus Citrus originated in China and SE Asia. The fruits are commercially important throughout the world, and some hybrids have been created to increase the number of varieties available. The orange (1) is probably the most economically important and popular citrus fruit. The largest producer is Brazil. It is sweet and contains a great amount of vitamin C. The grapefruit (2) is less sweet, and has been crossed with the tangerine to produce the sweet, juicy fruit known as the ugli (3). The lemon (4) is one of the few citrus fruits with a sour taste. The world's largest producer of grapefruits and lemons is the United States.

many other animals, there is a single circulatory system, with blood passing through the GILLS and on to the rest of the body without an extra boost from the heart. Both these circulatory systems are closed; the blood remains confined within the blood vessels. Insects and many other invertebrates have an open circulatory system, where the blood flows freely within the body cavity, but passes through a series of open blood vessels and heart(s), whose pumping maintains a directional flow. circumcision Operation of removing part or the whole of the foreskin of the penis or of removing the clitoris. Male circumcision is ritual in some groups, notably Jews and Muslims, and is said to have sanitary benefits. Female circumcision is intended to reduce sexual pleasure and has no medical benefit. circumference Distance round the boundary of a plane geometric figure, nearly always applied to a circle, for which it has the value $2\pi r$, where r is the radius.

cire perdue (Fr. lost wax) Method of casting metal objects (usually bronzes) used since classical antiquity. First the object is covered in wax then covered in a heat-proof mould. When heated, the wax melts away and the metal is poured into the space it occupied.

cirrhosis Degenerative disease in which there is excessive growth of fibrous tissue in an organ, most often the LIVER, causing inflammation and scarring. Cirrhosis of the liver may be caused by viral hepatitis, prolonged obstruction of the common bile duct, chronic abuse of alcohol or other drugs, blood disorder, heart failure or malnutrition.

Cistercian Religious order of monks founded by St Robert of Molesme (1098), based on ideals of strict Benedictinism. A community dedicated to contemplation, the Cistercians were noted agricultural pioneers. *See also* BENEDICTINE; TRAPPIST **citric acid** Colourless crystalline solid (C₆H₈O₇) with a sour taste. It is found in a free form in citrus fruits such as lemons and oranges, and is used for flavouring, in effervescent salts, and as a mordant (colour-fixer) in dyeing. Properties: r.d. 1.54; m.p. 153°C (307.4°F).

citron Evergreen shrub or small tree of the rue family, native to Asia. It has short spines and oval leaves. It bares large, oblong, lemon-yellow fruit. Height: up to 3.5m (11.5ft). Family Rutaceae; species *Citrus medica*.

citrus Important group of trees and shrubs of the genus Citrus in the rue family. They include GRAPEFRUIT, kumquat, LEMON, LIME, ORANGE, tangerine and ugli, and they are native to subtropical regions. The stems are usually thorny, the leaves bright green, shiny and pointed. The flowers are usually white, waxy and fragrant. The fruit (hesperidium) is usually ovoid with a thick, aromatic rind. The inside of the fruit is pulpy and juicy and is divided into segments that contain the seeds. Most citrus fruits contain large amounts of vitamin C. Family Rutaceae.

Ciudad Juárez City on the Rio Bravo del Norte (Río Grande), Chihuahua state, N Mexico. Lying on the US-Mexico border, it is connected by bridges to El Paso, Texas. It has processing industries for the surrounding cotton-growing region. Pop. (1990) 798,499.

civet Small, nocturnal, carnivorous mammal, related to the GENET and MONGOOSE, found in Africa, Asia and s Europe. It has a narrow body set on long legs, and its coat is grey-yellow with black markings. There are some 20 species. Length: (overall) 53–150cm (21–59in). Family Viverridae.

civil engineering Field of engineering dealing with large structures and systems. Civil engineers provide facilities for living, industry and transportation, such as roads, bridges, airports, dams, harbours and tunnels.

civil law Legal system derived from ROMAN LAW. It is different from COMMON LAW, the system generally adhered to in England and other English-speaking countries. Civil law is based on a system of codes, the most famous of which is the Code Napoléon (1804), and decisions are precisely worked out from general basic principles a priori. Thus the civil law judge follows the evidence and is bound by the conditions of the written law and not by previous judicial interpretation. Civil law influences common law in jurisprudence and in admiralty, testamentary and domestic relations; it is also the basis for the system of equity. It is prevalent in continental Europe, Louisiana (USA), Quebec (Canada) and Latin America.

civil liberties Basic rights that every citizen possesses and governments must respect in a democracy. In some countries, the courts ensure freedom from government control or restraint, except as the public good may require. See also CIVIL RIGHTS

civil list Annual grant of money voted by Parliament to supply the expenses of the royal establishment in Britain. The amounts are voted annually by Parliament. In February 1993 the number of royal family members on the civil list was reduced to the Queen, the Duke of Edinburgh and the Queen Mother.

civil rights Rights conferred legally upon the individual by the state. There is no universal conception of civil rights. The modern use of the phrase is most common in the USA, where it refers to relations between individuals as well as between individuals and the state. It is especially associated with the movement to achieve equal rights for African-Americans. Although that struggle dates back to the Civil War, the modern civil-rights movement may be said to have begun with the foundation of the NATIONAL ASSOCIATION FOR THE ADVANCE-MENT OF COLORED PEOPLE (NAACP) in 1910. It gathered pace after the 1954 Supreme Court decision against segregation in schools (enforced by federal troops in Little Rock, Arkansas in 1957), and the foundation of organizations such as the CONGRESS OF RACIAL EQUALITY (CORE), the Southern Christian Leadership Conference led by Martin Luther KING and the Student Non-violent Coordinating Committee (SNCC). Subsequently, a series of CIVIL RIGHTS ACTS protected individuals from discrimination.

Civil Rights Acts (1866, 1870, 1875, 1957, 1960, 1964, 1968) US legislation. The Civil Rights Act (1866) gave African-Americans citizenship and extended civil rights to all persons born in the USA (except Native Americans). The 1870 Act was passed to re-enact the previous measure, which was considered to be of dubious constitutionality. The 1870 law was declared unconstitutional by the US Supreme Court in 1883. The 1875 Act was passed to outlaw discrimination in public places because of race or previous servitude. The act was declared unconstitutional by the Supreme Court (1883-85), which stated that the 14th Amendment, the constitutional basis of the act, protected individual rights against infringement by the states, not by other individuals. The 1957 Act established the CIVIL RIGHTS COMMISSION to investigate violations of the 15th Amendment. The 1960 Act enabled court-appointed federal officials to protect black voting rights. An act of violence to obstruct a court order became a federal offence. The 1964 Act established as law equal rights for all citizens in voting, education, public accommodations and in federally assisted programmes. The 1968 Act guaranteed equal treatment in housing and real estate to all citizens. Civil Rights Commission US federal commission that investigates complaints alleging that citizens are being deprived of their right to vote because of their race, colour, religion, sex or national origin, or, in the case of federal elections, by fraudulent practices. It appraises the laws and policies of the federal government and submits reports of its activities, findings and recommendations to the president and Congress. civil service Administrative establishment for carrying on

the work of government. In Britain the modern service was developed between 1780 and 1870, as the weight of parliamentary business became too heavy for ministers to attend to both policy-making and departmental administration. The Treasury got its first permanent secretary in 1805, the Colonial Office a permanent official in 1825. The civil service has

grown from its centre in Whitehall, London and now has many regional offices. In the USA, the civil service evolved from the ineffective "spoils system" (1828) established during Andrew Jackson's presidency, whereby posts were given as rewards for political support. This system remained in place until the Pendleton Act (1883) created the Civil Service Commission. The commission implemented a merit system, and following the Hatch Acts (1939, 1940), federal employees were no longer allowed to take an active role in party politics. Civil War, American (1861-65) War fought in the USA between the northern states (the Union) and the forces of the 11 southern states that seceeded from the Union to form the CONFEDERATE STATES OF AMERICA (Confederacy). Its immediate cause was the determination of the southern states to withdraw from a Union that the northern states regarded as indivisible. The more general cause was the question of SLAV-ERY, a well-established institution in the South but one which the northern ABOLITIONISTS opposed. By the 1850s slavery, abolition and states' rights had created insurmountable divisions between North and South. There was political polarization with the abolitionists forming the new REPUBLICAN PARTY and those campaigning for the rights of southern states remaining in the DEMOCRATIC PARTY. The 1860 election of a Republican, Abraham LINCOLN, virtually assured southern withdrawal from the Union. The Unionists had superior numbers, greater economic power and command of the seas. The Confederates had passionate conviction and superior generals, such as Robert E. LEE and "Stonewall" JACKSON. The war began on 12 April 1861 when Confederate forces attacked FORT SUMTER, South Carolina. The Union's first objective was to take the Confederate capital at Richmond, Virginia, in the First Battle of BULL RUN (July 1861). This campaign was unsuccessful and the Confederates continued to be victorious with Lee winning the PENINSULAR CAMPAIGN (April-June 1862) and Jackson carrying off a brilliant campaign in the Shenandoah Valley (March-June 1862). The Confederates were also victorious at the SEVEN DAYS' BATTLES (June-July 1862) and the Second Battle of BULL RUN (August 1862). However, Lee's army was checked by the strengthening Union troops (led by General George McClellan), in the Battle of ANTIETAM (September 1862). The Union was defeated at the Battle of Fredericksburg (December 1862) under Ambrose Burnside and at Chancellorsville (May 1863) under Joseph Hooker. The Union victory in the Battle of GETTYSBURG (June-July 1863) was a turning point. The Union Navy had blocked southern ports, thereby denying the Confederacy essential trade with Europe. The Union strategy was to divide the South by taking control of the Mississippi, Tennessee and Cumberland rivers. The first big Union victory was at Fort Donelson on the Tennessee River (February 1862) under the command of Ulysses S. GRANT. Grant won a victory in the siege of VICKSBURG (November 1862-July 1863), which, with the fall of Memphis (June 1862), gave Union troops control of the Mississippi. In 1864 Grant became supreme commander. He confronted Lee's army in the WILDERNESS CAMPAIGN (May-June 1864) and began the long siege of Petersburg, Virginia - the defence of which was vital to the survival of RICHMOND. Meanwhile, the Unionist General SHERMAN cut a devastating swathe across Georgia, burning ATLANTA on the way. The Union victory at the battle of Five Forks blocked the retreat route for Confederate troops in Richmond. Petersburg fell two days later and Richmond was indefensible. The war ended with Lee's surrender to Grant at Appomattox in April 1865. The South was economically ruined by the war, and RECONSTRUCTION policies poisoned relations between North and South for a century.

Civil Wars, English (1642–45, 1648, 1651) Conflicts between crown and parliament. Following years of dispute between the king and state, essentially over the power of the crown, war began when the King Charles I raised his standard at Nottingham. Royalist forces were at first successful at Edgehill (1642) but there were no decisive engagements, and parliament's position was stronger, as it controlled the SE (including London), the navy, and formed an alliance with Scotland. Parliament's victory at Marston Moor (1644) was a

turning point, and in 1645 FAIRFAX and CROMWELL won a decisive victory at Naseby with their NEW MODEL ARMY. Charles surrendered in 1646. While negotiating with parliament, he secretly secured an agreement with the Scots that led to what is usually called the second civil war (1648). A few local Royalist risings came to nothing, and the Scots, invading England, were swiftly defeated. The execution of Charles I (1649) provoked further conflict in 1650, in which Scots and Irish Royalists supported the future CHARLES II. Cromwell suppressed the Irish and the Scots, the final battle being fought at Worcester (1651).

Civil War, Spanish (1936–39) Conflict developing from a military rising against the republican government in Spain. The revolt began in Spanish Morocco, led by General FRANco. It was supported by conservatives and reactionaries, collectively known as the Nationalists and including the fascist FALANGE. The leftist POPULAR FRONT government was supported by republicans, socialists and various ill-coordinated leftist groups, collectively known as Loyalists or Republicans. The Nationalists swiftly gained control of most of rural w Spain, but not the main industrial regions. The war, fought with great savagery, became a serious international issue, representing the first major clash between the forces of the extreme right and the extreme left in Europe. Franco received extensive military support, especially aircraft, from the fascist dictators Mussolini and Hitler. The Soviet Union provided more limited aid for the Republicans. Liberal and socialist sympathizers from countries such as Britain and France fought as volunteers for the Republicans, but their governments remained neutral. The Nationalists extended their control in 1937, while the Republicans were increasingly weakened by internal quarrels. In 1938, despite some Republican gains, the Nationalists reached the Mediterranean, splitting the Republican forces. The fall of Madrid, after a long siege, in March 1939 brought the war to an end, with Franco supreme. More than one million Spaniards were killed in the conflict.

clam Bivalve mollusc found mainly in marine waters. It is usually partly buried in sand or mud with the two parts of the shell slightly open for feeding. With a large foot for burrowing, its soft, flat body lies between two muscles for opening and closing the shells. A fleshy part called the mantle, lies next to the shells. Clams feed on PLANKTON. Class Pelecypoda.

Clapham Sect (c.1790-c.1830) Group of British evangelical reformers. Many of them, including William WILBERFORCE, lived in Clapham, s London, and several were MPs. Originally known as the "Saints", they were especially influential in the abolition of SLAVERY and in prison reform.

Clare, John (1793–1864) British poet. The son of an agricultural labourer, his verse is notable for its vivid descriptions of the countryside from the viewpoint of a class which seldom found a poetic voice. His works include *Poems Descriptive of Rural Life and Scenery* (1820), *The Village Minstrel* (1821), *The Shepherd's Calendar* (1827) and *The Rural Muse* (1835).

▼ Civil War Loyalties to South or North crossed state lines and divided families during the American Civil War. Three of Abraham Lincoln's brothers-in-law died fighting for the Confederates. The "border states", the slave states of Kentucky, Maryland and Missouri, were most divided. Their allegiance to the "Stars and Stripes" proved to be stronger than their purely regional interests. Often seen as the beginning of modern warfare, the Civil War claimed c.620,000 lives (360,000 Union troops, 260,000 Confederate), almost as many as the combined American dead in all other conflicts between 1775 and 1975. It cost billions of dollars and fuelled resentment and hostility towards the Northern states and central government.

Clare County between Galway Bay and the River Shannon estuary, Munster province, w Republic of Ireland. Ennis is the county town. The area is hilly and infertile. The chief crops are oats and potatoes. Sheep, cattle, pigs and poultry are raised, and fishing is important. Area: 3,188sq km (1,231sq mi). Pop. (1991) 90,918.

Clarendon, Edward Hyde, 1st Earl of (1609-74) English statesman and historian. A leading adviser to Charles I, he joined CHARLES II in exile, and negotiated the RESTORA-TION (1660). As chief minister to Charles II, he initiated (but disapproved of) four statutes collectively known as the Clarendon Code. The statutes restricted gatherings of Puri-TANS and Nonconformists, and the movement of their ministers. In addition, municipal and church officers were required to be professed Anglicans, and all ministers were forced to use the Anglican Book of COMMON PRAYER. Following disagreements with Charles II he was impeached and forced into exile in 1667, where he completed his History of the Rebellion and wrote an autobiography. See also Nonconformism Clarendon, Constitutions of (1164) Sixteen articles issued by HENRY II of England to limit the temporal and judicial powers of the church. The most controversial article required clergy who had been convicted in church courts to

clarinet Single-reed WOODWIND instrument. It is commonly pitched in B flat (also A) and has a range of over 3 octaves. Other members of the family include the alto clarinet in E flat, the bass in B flat and the high sopranino in E flat.

be punished by royal courts. They played a significant role in the dispute between Henry and Thomas à BECKET.

Clarke, Arthur C. (Charles) (1917–) British science-fiction writer. He is noted for the scientific realism of his works, such as *Childhood's End* (1953), *A Fall of Moondust* (1961) and *Voices from the Sky* (1965). Stanley Kubrick's film 2001: A Space Odyssey (1969) was based on his short story *The Sentinel* (1951). Clarke has since written two sequels, 2010: Odyssey Two (1982) and 2061: Odyssey Three (1987).

Clarke, Kenneth Harry (1940–) British statesman, chancellor of the exchequer (1993–97). Clarke became a Conservative MP in 1970 and joined Maragaret Thatcher's cabinet in 1985. He was secretary of state for health (1988–90). When John Major became prime minister, Clarke was appointed home secretary (1992). Clarke's first budget saw an increase in taxation, but the 1996 budget reduced the basic rate by a penny. An outspoken Europhile, following the Conservatives' landslide defeat in the 1997 general election, Clarke unsuccessfully challenged William Hague for the Conservative leadership.

classical Term used in many different and apparently conflicting ways. Literally, it refers to the period between the Archaic and the HELLENISTIC AGE phases of ancient Greek culture. It is used more generally, however, to mean the opposite of romantic or to refer to the artistic styles whose origins can be traced in ancient Greece or Rome. As the antithesis of ROMANTICISM, it is an art which follows recognized aesthetic formulae rather than a style which focuses on individual expression. The RENAISSANCE architect ALBERTI took his inspiration from ancient Greek and Roman buildings which he thought embodied "the harmony and concord of all the parts achieved by following well-founded rules". It is because of this that CLASSICISM often suggests descent from antique sources. A classical style of Greek and Roman architecture dominated Europe from 1500 to 1900.

classical economics Term applied to the work of British economists from the late-18th to the mid-19th century, figures range from Adam SMITH to John Stuart MILL. Classical economists were concerned with the nature of economic growth. They maintained that if left to their own devices, without the interference of government, markets would find a natural equilibrium. See also CAPITALISM; Thomas MALTHUS

Classical music Music composed between c.1750 and 1820, whose style is characterized by emotional restraint, the dominance of homophonic melodies (melodies with accompaniment), and clear structures and forms underlying the music. The Classical period saw the development of forms

such as the concerto, sonata, symphony and string quartet, and the piano replace the harpsichord as the most popular keyboard instrument. The greatest Classical composers were HAYDN, MOZART, BEETHOVEN and SCHUBERT.

classical revival Art and architecture in the style of the Ancient Greeks and Romans. The style reflects simplicity, harmony and balance. The Italian RENAISSANCE and the neoclassical style of the early 19th century are examples of classical revivals. See also CLASSICISM; NEO-CLASSICISM

classicism Art history term used to describe both an aesthetic attitude and an artistic tradition. The artistic tradition refers to the classical antiquity of Greece and Rome, its art, literature, and criticism, and the subsequent periods that looked back to Greece and Rome for their prototypes, such as the CAROLINGIAN RENAISSANCE, RENAISSANCE, and NEOCLASSICISM. Its aesthetic use suggests the classical characteristics of clarity, order, balance, unity, symmetry, and dignity. classification See TAXONOMY

Claude Lorrain (c.1604–82) (Claude Gellée) French landscape painter, the most influential ideal landscapist. After settling in Rome (1627), he developed a style that combined poetic idealism inspired by antique models and his own observations. His mature style evolved between 1640 and 1660, when he explored the natural play of light on different textures. Turner was among those to absorb his ideas, and he inspired the style known as picturesque.

Claudius I (10 BC-54 AD) (Tiberius Claudius Nero Germanicus) Roman emperor (AD 41-54). The nephew of TIBERIUS, he was the first emperor chosen by the army. He had military successes in Germany, conquered Britain in AD 43, and built both the harbour of Ostia at the mouth of the Tiber and the Claudian aqueduct. Agrippina (his fourth wife) poisoned him and made her son, NERO, emperor.

Clausius, Rudolf Julius Emanuel (1822–88) German physicist, regarded as the founder of THERMODYNAMICS. Using the work of Nicholas CARNOT, Clausius was the first to formulate the second law of thermodynamics that heat cannot pass from a colder to a hotter object. He also introduced the term ENTROPY.

clavichord Earliest stringed musical instrument with mechanical action controlled by a keyboard. Possibly originating in the 13th century, it was used extensively from the 16th to 18th centuries. The clavichord has a delicate, expressive tone; it was superseded by the HARPSICHORD and then by the PIANO. **clavicle** (collarbone) Thin, slightly curved bone attached by

ligaments to the top of the STERNUM (breast-bone). The clavicle and SHOULDER-blade make up the shoulder girdle, linking the arms to the axis of the body.

Clay, Cassius Marcellus Former name of Muhammad ALI Clay, Henry (1777-1852) US statesman He served in both the House of Representatives (1811-14, 1815-21, 1823-25), several times as speaker, and in the Senate (1831-42, 1849-52). He was one of the "war hawks" who favoured the WAR OF 1812. He ran for president (1824), and when the election went to the House of Representatives, he threw his support behind the eventual winner, John Quincy ADAMS. When Adams named Clay secretary of state (1825-29), charges of political corruption were levelled. One of the founders of the WHIGS, he ran against Andrew JACKSON (a bitter political enemy) in 1832. He ran for president again (1844) but was defeated by James Polk. Clay's last years in the Senate were spent trying to work out a compromise between the slaveowning states of the South and the free northern states. The COMPROMISE OF 1850 was one result of those efforts.

clay Group of hydrous silicates of aluminium and magnesium, including kaolinite and halloysite, usually mixed with some quartz, calcite or gypsum. It is formed by the weathering of surface granite or the chemical decomposition of feldspar. Soft when wet, it hardens on firing and is used to make ceramics, pipes and bricks. In developing countries it is used to clad the walls of simple buildings.

cleavage In embryology, progressive series of cell divisions that transform a fertilized egg into the earliest embryonic stage (BLASTULA). The egg is divided into blastomeres (smaller cells), each containing a DIPLOID number of chromosomes.

cleavage, rock Formation of definite planes through a rock. It is caused by compression associated with folding and metamorphism, and results in the rock splitting easily parallel to the cleavage. The line of cleavage follows the alignment of minerals within the rock.

cleft palate Congenital deformity in which there is an opening in the roof of the mouth, causing direct communication between the nasal and mouth cavities. It is often associated with HARELIP and makes normal speech difficult. Usual treatment includes surgical correction, followed by special dental care and speech therapy if necessary.

clematis Genus of perennial, mostly climbing shrubs found worldwide. Many have attractive deep blue, violet, white, pink or red flowers or flower clusters. The leaves are usually compound. Family Ranunculaceae.

Clemenceau, Georges (1841–1929) French statesman. A moderate republican, he served in the Chamber of Deputies (1876–1893), attempted compromise during the revolt of the Paris Commune (1871) and strongly supported Dreyfus. He returned to the Senate in 1902 and was twice premier (1906–09, 1917–20). He led the French delegation at the Versailles peace conference. See also Dreyfus Affair

Clement 1 (d. c.97) (Saint Clement of Rome) Pope (88–97) and saint. He was executed for refusing to pledge allegiance to the Roman emperor. His feast day is 23 November.

Clement VII (1478–1534) Pope (1523–34), b. Giulio de Medici. He sided with Francis I in the League of Cognac, thus opposing the Holy Roman Emperor Charles V. The imperial troops attacked Rome, and a compromise was won. He was unable to deal with the rise of Protestantism and his indecisiveness over the divorce of Catherine of Aragon and Henry VIII is thought to have hastened the REFORMATION.

Cleopatra (69–30 BC) Queen of Egypt (51–30 BC). In 48 BC she overthrew her husband, brother and co-ruler Ptolemy XIII with the aid of Julius CAESAR, who became her lover. She went to Rome with Caesar, but after his assassination in 44 BC she returned to Alexandria, once again becoming queen. Mark Antony followed her to Egypt, and they married (37 BC). The marriage infuriated Octavian (later Augustus), the brother of Mark Antony's former wife. Rome declared war on Egypt in 31 BC and defeated Antony and Cleopatra's forces at the Battle of ACTIUM. Mark Antony committed suicide, and Cleopatra surrendered to Octavian but failed to win his affections and she too killed herself.

clergy Collective organization of ordained or consecrated

priests and ministers, especially of the Christian church. In the Roman Catholic, Orthodox and Anglican churches, the clergy comprise the orders of bishop, priest and deacon, and may also include members of religious orders. In these churches, bishops exercise authority over priests and deacons. In non-episcopal Protestant churches, the clergy consist of pastors and ministers. Functions of the clergy include administration of the sacrament, preaching and the exercise of spiritual guidance. See also Ordination of Women

Cleveland, (Stephen) Grover (1837–1908) 22nd and 24th US president (1885–89, 1893–97). Cleveland rose to prominence as a reforming Democratic mayor of Buffalo (1881–82) and governor of New York (1883–84). With the help of Republican MUGWUMPS, he defeated James G. BLAINE to become the first Democratic president since the Civil War. Cleveland's reforms of the civil service had mixed success and his attempt to reduce the tariff contributed to Benjamin HARRISON's electoral victory in 1888. In his second term, he was faced with a monetary crisis (1893), and secured repeal of the Sherman Silver Purchase Act. He sent troops to crush the Pullman Strike (1894) called by Eugene V. Debs. His attempt to maintain the gold standard angered radical Democrats and tariff reform proposals were shelved. Cleveland was not renominated in 1896.

Cleveland City and port at the mouth of the Cuyahoga River, on Lake Erie, NE Ohio, USA. Founded in 1796 by Moses Cleaveland, it grew rapidly with the opening of the Ohio and Erie Canal and the arrival of the railway in 1851. John D. Rockefeller founded Standard Oil Company here in 1870. Cleveland has a symphony orchestra, three universities and an art institute. It is a major Great Lakes shipping port, and an important iron and steel centre. NASA maintains a research centre here. Industries: chemicals, oil refining, engineering, electronics. Pop. (1990) 505,616.

click language Any of several southern African languages belonging chiefly to the Khoisan group and characterized by the use of suction speech sounds called clicks. Several clicks can be distinguished, each being a distinct consonant. Clicks are also found in some Bantu languages.

client-server Type of relationship between computers in a COMPUTER NETWORK. A client computer makes requests of a designated server computer. The server performs the requested functions and delivers the results to the client.

cliff dwellers See PUEBLO

climate Weather conditions of a place or region prevailing over a long time. The major factors influencing climate are

▼ climate This map of the Eastern and Western Hemispheres shows the world's various major climatic regions. Latitude is a major factor in determining the amount of solar radiation, with the greatest in equatorial regions and the least in polar regions.

► Clinton Despite allegations of financial and personal impropriety, Clinton's charismatic style and the healthy state of the US economy helped to secure his re-election. Clinton called for a more bi-partisan approach to domestic politics. The priorities for his second term were education and welfare reforms, a balanced budget and the expansion of NATO.

temperatures, air movements, incoming and outgoing radiation and moisture movements. Climates are defined on different scales, ranging from macroclimates, which cover the broad climatic zones of the globe, down to microclimates, which refer to the conditions in a small area, such as a wood or a field.

climatology Scientific study of the Earth's climates. Physical climatology investigates relationships between temperature, pressure, winds, precipitation, and other weather phenomena. Regional climatology considers latitude and other geographical factors, such as the influence of large land masses in the climatic study of a particular place or region.

clinical psychology Field of psychology concerned with diagnosis and treatment of behavioural disorders. Clinical psychologists are engaged in diagnosis of disorders and in treatment including behaviour therapy and other forms of psychotherapy. Clinical psychologists may work with psychiatrists, but do not usually have medical training themselves.

Clinton, Bill (William Jefferson) (1946-) 42nd US president (1993-) Clinton became the youngest-ever US governor, when he was elected to represent Arkansas (1978-80, 1983-92). Economic recession and Clinton's reformist agenda led to an easy electoral victory over the incumbent President George BUSH (1992). Al GORE became vice president. As president, he made health-care an immediate priority, appointing his wife, Hillary CLINTON, to head a commission on reform. She was soon removed from the post, and many of the reforms were not realized. Clinton was a chief advocate of the North American Free Trade Agreement (NAFTA), which won congressional approval in 1993. His first term was dogged by the Whitewater investigation and the blocking of reforms and appointments by a Republican-dominated Congress. A buoyant domestic economy and Bob Dole's lacklustre campaign provided the base for Clinton's re-election in 1996, becoming the first Democratic president since Franklin D. ROOSEVELT to serve successive terms in office.

Clinton, De Witt (1769–1828) US politician. He was a successful mayor of New York City (1803–15) and in 1812 he ran for president but lost to James MADISON. He was governor of New York (1817–21, 1825–28) and was responsible for the construction of the Erie (1817–25) and Champlain-Hudson Canals.

Clinton, Hillary Rodham (1947–) US attorney and first lady. The wife of Bill CLINTON, she drafted a plan to provide health insurance for all US citizens in 1993, but it was not implemented. She has been involved with women's rights around the world. Along with her husband she has been implicated in the Whitewater land and banking scandal.

clitoris See VULVA

Clive, Robert, Baron Clive of Plassey (1725–74) British soldier and administrator. He went to India as an official of the British EAST INDIA COMPANY (1743), and successfully resisted growing French power with his capture of Arcot (1751). By taking Calcutta and defeating the pro-French Nawab of Bengal at Plassey (1757) he effectively assured British control of N India. He was governor of Bengal (1757–60, 1765–67). He returned to England in 1773 and was charged with but acquitted of embezzling state funds. He committed suicide.

cloaca Cavity into which intestinal, urinary, and genital tracts open in fish, reptiles, birds, and some primitive mammals.clock Instrument for measuring time. The earliest timekeeping instruments had no moving parts, being designed to measure the movements of the Sun, Moon and stars. Examples include neolithic stone columns, and ancient Egyptian sundials and water clocks. Candle clocks and sandglasses were later types of non-mechanical clocks. The central feature of all mechanical clocks is an escapement mechanism, which enables a clock to tick off time at discrete intervals. This movement is transmitted through a series of gears to the hands which are pushed forward a small distance with every escapement movement. Motive power for mechanical clocks has been provided variously by falling weights, pendulums and coiled springs. In some modern wristwatches, the coiled spring is rewound continually by natural wrist movements. Other modern clocks include those using an electrically oscillated quartz crystal as the basis of time-division. Even more accurate are ATOMIC CLOCKS, which rely upon the natural oscillations of atoms (usually those of the metal, caesium) and which measure time to an accuracy of thousandths of a second per year.

cloisonné Enamelling technique in which the design is constructed out of wires soldered to a plate, and the cells (cloisons) thus formed are filled with coloured ENAMEL paste and fired. The technique was developed in Mycenaean Greece, and was popular in Byzantine art of the 10th and 11th centuries. It flourished in China during the Ming and Qing dynasties and was also adopted in Japan.

clone Set of organisms obtained from a single original parent through some form of ASEXUAL REPRODUCTION or by ARTIFICIAL SELECTION. Clones are genetically identical and may arise naturally from PARTHENOGENESIS in animals. Cloning is often used in plant propagation (including TISSUE CULTURE) to produce new plants from parents with desirable qualities such as high yield, or from plants which have been genetically engineered. It is now possible to produce animal clones from tissue culture. See also GENETIC ENGINEERING

cloud Masses of water particles or ice crystals suspended in the lower atmosphere. Clouds are formed when water from the Earth's surface becomes vapour through EVAPORATION. As the water vapour rises, it cools and condenses around microscopic salt and dust particles, forming droplets. Where the atmosphere is below the freezing temperature of water the droplets turn to ice. There are ten different classifications of clouds: cirrus are high, white and thread-like; cirrocumulus are thin sheets; cirrostratus are white and almost transparent; altocumulus are greyish-white; altostratus are grey and streaky, and often cover the whole sky; nimbostratus are

Many modern clocks and watches use a quartz crystal (1) to tell the time accurately. When electricity is passed through the quartz, it oscillates exactly 32,768 times each second. The oscillations are counted and on every 32,768th, a pulse of electricity is sent to a motor (2) that moves the hands (3) via gears

(4). The need for a battery to power the motor can be removed if a swinging weight (5) is used to generate a current. As the watch moves the weight rotates (6) turning a generator (7). The current produced by the generator is stored in a capacitor (8) and is smoothed before reaching the quartz crystal.

thick and dark, and usually shed rain or snow; **stratocumulus** are masses of white, grey or dark cloud; **stratus** are low-lying and grey; **cumulus** are white and fluffy-looking; and **cumulonimbus** are towering, dark clouds which generally produce thunderstorms. By day, clouds reflect the rays of the Sun back into the atmosphere, keeping the ground cool. At night, clouds trap and re-radiate heat rising from the Earth, keeping surface temperatures warm. *See also* FOG; HYDROLOGICAL CYCLE

cloud chamber Instrument used to detect and identify charged particles, invented in the 1880s by C.T.R. WILSON to study atomic radiation. The principle is the same as the later BUBBLE CHAMBER, except liquefied gas is replaced by air supersaturated with water or alcohol vapour, and the tracks left are droplets which form around the ionizing particle. The tracks are deflected by a magnetic field and photographed for analysis. In a diffusion cloud chamber, a large temperature difference is maintained between the top and bottom of the chamber. clove Tall, aromatic, evergreen tree native to the Moluccan Islands. The small purple flowers appear in clusters; the dried flower buds are widely used in cookery. Oil of cloves is distilled from the stems. Height: to 12m (40ft). Family Myrtaceae; species Syzygium aromaticum.

clover Low-growing annual, biennial and perennial plants, native to temperate regions of Europe, but now found throughout warmer regions of the N Hemisphere. The leaves have three leaflets, rarely four (considered good luck), and the dense flower clusters are white, red, purple, pink or yellow. Some species are grown as food for cattle, others are grown by beekeepers as a good source of nectar. Most species are good nitrogen-fixers, due to the bacteria in their ROOT NODULES, which help to enrich soil. Family Fabaceae/Leguminosae; genus Trifolium. See also NITROGEN CYCLE; NITROGEN FIXATION Clovis I (465-511) Frankish king of the MEROVINGIAN dynasty. He overthrew the Romanized kingdom of Soissons and conquered the Alemmani near Cologne. He and his army later converted to Christianity in fulfilment of a promise made before the battle. In 507 he defeated the Visigoths under Alaric II near POITIERS. By the time Clovis died, he controlled most of GAUL and had firmly established Merovingian power. **club moss** Any of about 200 species of small evergreen spore-bearing plants which, unlike the more primitive true MOSSES, have specialized tissues for transporting water, food and minerals. They are related to FERNS and HORSETAILS. The small leaves are arranged in tight whorls around the aerial stems. Millions of years ago their ancestors formed the large trees that dominated CARBONIFEROUS coal forests. Phylum Lycopodophyta, Family Lycopodiaceae.

cluster, stellar See open cluster; globular cluster

clutch, electromagnetic Device that uses magnetic attraction to connect two rotating shafts. Forms include disc clutches with energized coils and magnetic clutch plates. Eddy current clutches induce rotational movement in the shaft to be engaged and rotated. Hysteresis clutches also transmit rotation without slip. Other electromagnetic clutches employ magnetic metal particles to induce TORQUE.

Clwyd County in N Wales, bordered by the Irish Sea, Cheshire, Shropshire, Powys and Gwynedd. The county town is Mold. The Vale of Clwyd is a rich agricultural region. Industries: iron and steel, tourism, chemicals, quarrying. Area: 2,426sq km (937sq mi). Pop. (1991) 408,090.

Clyde River in sw Scotland. It rises in the Southern Uplands, passing over the Falls of Clyde (which provide hydroelectric power) near Lanark and widening into the Firth of Clyde at Dumbarton. Clydebank, below GLASGOW, was Scotland's main shipbuilding region. Length: 170km (106mi).

Clytemnestra In Greek legend, the unfaithful wife of AGAMEMNON, King of Mycenae, and mother of his son ORESTES. On Agamemnon's return from TROY he was murdered by Clytemnestra and her lover Aegisthus.

CND Abbreviation of CAMPAIGN FOR NUCLEAR DISARMAMENT coal Blackish, solid fuel formed from the remains of fossil plants. In the carboniferous and tertiary periods, swamp vegetation subsided to form PEAT bogs. Sedimentary deposits buried the bogs, and the resultant increase in pressure and heat produced lignite (brown coal), then bituminous coal and

The process of making coal begins with plant debris (1). Dead vegetation lies in a swampy environment and forms peat (4), the first stage of coal formation. Underwater bacteria remove some oxygen, nitrogen and hydrogen from the organic material. Debris carried elsewhere and deposited by water forms a product called cannel coal (2).

Algal material collected underwater forms boghead coal (3). If the dead organic material is buried by sediment, the weight on top of the peat and the higher temperature will turn the peat into lignite (5). With more heat and pressure at increasing depths, lignite becomes bituminous coal (6) and then anthracite (7).

ANTHRACITE, if temperature increased sufficiently. Lignite, which has a low carbon content, is a poorer fuel than anthracite. Most coal seams are inter-stratified with shale, clay, sandstone and sometimes limestone.

coal tar By-product from the manufacture of coke. Coal tar comes from bituminous coal used in the distillation process. It is a volatile substance, important for its organic chemical constituents (coal-tar crudes), which are extracted by further distillation. These include xylene, toluene, naphthalene and phenanthrene, and are the basic ingredients for the synthesis of many products, such as explosives, drugs, dyes and perfumes. coati (coatimundi) Three species of raccoon-like rodents of the sw USA and South America. Most have long, slender reddish-brown to black bodies with tapering snouts and long ringed tails. Length: 67cm (26in); weight: 11.3kg (25lb). Family Procyonidae; genus Nasua.

coaxial cable Communications CABLE consisting of a central conductor with surrounding insulator and tubular shield. **cobalt** (symbol Co) Metallic element, a transition metal, discovered c.1735. It is found in cobaltite and smaltite, but mostly obtained as a by-product during the processing of other ores. Cobalt is a constituent of vitamin B¹². It is used in high-temperature steel, artists' colours (cobalt blue), jet engine manufacture, cutting tools and magnets. Co⁶⁰ (half-life 5.26yr) is an artificial isotope used as a source of gamma rays in radiotherapy and tracer studies. Properties: at.no. 27; r.a.m. 58.9332; r.d. 8.9; m.p. 1,495°C (2,723°F); b.p. 2,870°C (5,198°F); most common isotope Co⁵⁹ (100%).

Cobb, Ty (Tyrus) Raymond (1886–1961) US baseball player. The game's greatest hitter, the "Georgia Peach" played for the Detroit Tigers (1905–26) and the Philadelphia Athletics (1927–28), compiling records of 4,191 hits, 2,245 runs and 892 stolen bases. His career batting average (.367) was an all-time record, and 12 times he led the American League in batting. He was the first member of the Baseball Hall of Fame (1936).

Cobbett, William (1763–1835) British political essayist and reformer, who founded the influential *Cobbett's Weekly Political Register* (1802). His dislike of industrialization led to his tours, published as *Rural Rides* (1830), in which he champi-

▲ coca Native to regions of South America, the leaves of the coca tree (*Erythroxylon coca*) have been used for centuries as medicine and to relieve hunger. The leaves are harvested and used in the illegal manufacture of cocaine.

▲ cockle Bivalves, such as the cockle (*Cardium* sp.), have calcareous shells, the two halves of which are hinged, and can be closed by muscular action.

▲ coconut palm Their ability to survive in sandy, salty soil makes the coconut palm (*Cocus nucifera*) a common sight close to beaches. The nut is found within an outer skin and thick fibrous layer or husk. A hard shell covers the edible white "meat".

oned the yeoman society that was waning as a result of technology. He was a member in the Reformed Parliament of 1832. **Cobden, Richard** (1804–65) British Radical politician. With John Bright he led the campaign for the repeal of the Corn Laws and was the chief spokesman in Parliament (1841–57, 1859–65) for the "Manchester School" of free trade. He opposed Britain's participation in the CRIMEAN WAR, supported the Union in the US Civil War and negotiated a major trading agreement with France (1860).

COBOL (Common Business-Oriented Language) Widely used COMPUTER LANGUAGE developed in 1959 for processing business data.

cobra Any of several highly poisonous snakes in the family Elapidae, including the MAMBA, CORAL SNAKE, kraits and true cobras. It can expand its neck ribs to form a characteristic hood. Found primarily in Africa and Asia, they feed on snakes, rats, toads and small birds. It is the only snake to make a nest for its young. The king cobra (*Ophiophagus hannah*) reaches 5.5m (18ft) in length, and is the largest venomous snake in the world. The Indian cobra (*Naja naja*) has spectacle-like markings on its hood. Some African species have forward-facing fangs and can spit venom into a victim's eyes from more than 2m (7ft), causing temporary or permanent blindness.

coca Shrub native to Colombia and Peru which contains the ALKALOID drug COCAINE. Native Americans chew the leaves for pleasure, to quell hunger and to stimulate the nervous system. The plant has yellow-white flowers growing in clusters, and red berries. Height: c.2.4m (8ft). Family Erythroxylaceae; species *Erythroxylon coca*.

cocaine White crystalline ALKALOID extracted from the leaves of the COCA plant. Once used as a local anaesthetic, it is now primarily an illegal narcotic, with stimulant and hallucinatory effects. It is psychologically habit-forming, and the body does not develop tolerance. Habitual use of cocaine results in physical and nervous deterioration, and subsequent withdrawal results in severe depression. *See also* CRACK

coccus Small spherical or spheroid bacterium. Average diameter: 0.5–1.25 micrometres. Some, such as *Streptococcus* and *Staphylococcus*, are common causes of infection.

cochineal Crimson dye produced from the pulverized dried bodies of certain female scale insects, found in Central America. The dye is still used in cosmetics and foodstuffs, although now often replaced by aniline dyes.

Cochise (1815–1874) Chief of the Chiricahua APACHE. In 1861 the US Army falsely imprisoned him, killing five of his relatives. He escaped to lead his tribe in an 11-year war against the US army in Arizona. A war of extermination was raged against his people. Cochise concluded a treaty with General Oliver Otis Howard that created a reservation of tribal territory. He lived peacefully here until his death, after which the treaty was broken and his people forcibly moved. cochlea Fluid-filled structure in the inner EAR which is essential to hearing. It has a shape like a coiled shell, and is lined with hair cells which move in response to incoming sound waves, stimulating nerve cells to transmit impulses to the

pitches of sound, thus helping the brain to analyse the sound. **cockatoo** Large PARROT with a long, erectile crest. Cockatoos live mainly in Australia and sw Asia. Most are predominantly white, tinged with pink or yellow. They feed on fruit and seeds. Females lay 1–4 white eggs in a tree hole nest. Length: 38cm (15in). Family Psittacidae.

BRAIN. Different groups of hair cells are stimulated by different

Cockcroft, Sir John Douglas (1897–1967) British physicist who, with Ernest WALTON, was the first person to split the ATOM. He and Walton constructed a particle ACCELERATOR, and created the first man-made nuclear reaction by bombarding lithium atoms with protons (1932). They shared the 1951 Nobel Prize for physics for their use of particle accelerators to study atomic nuclei.

cockle Bivalve mollusc found in marine waters. Its varicoloured, heart-shaped shell has 20–24 strong, radiating ribs. There are *c*.200 recognized species, many of which are edible. Average length: 4–8cm (1.5–3in). Class Bivalvia; family Cardiidae; species include *Cardium aculeatum*.

cockroach (roach) Member of a group of insects with long

▲ cockroach The *Blaberus giganticus* species of cockroach is found in central America. Its wingspan measures 8cm (3in).

antennae and a flat, soft body found worldwide, but mostly in the tropics. Its head is hidden under a shield (pronotum) and it may be winged or wingless. Eggs are laid in considerable numbers in special egg cases. Some species are serious household pests. Length: 13–50mm (0.5–2in). Family Blattidae.

cocoa Drink obtained from the seeds of the tropical American evergreen tree *Theobroma cacao*. The seeds are crushed and some fatty substances are removed to produce cocoa powder. Cocoa is the basic ingredient of CHOCOLATE. The Ivory Coast is the world's largest producer. Family Sterculiaceae.

coconut palm (copra plant) Tall palm tree native to the shores of the Indo-Pacific region and the Pacific coast of South America; commercially the most important of all palms. Growing to 30m (100ft) tall, it has a leaning trunk and a crown of feather-shaped leaves. Copra, the dried kernel of the coconut fruit, is the valuable source of oil used in the manufacture of margarine and soap. The fibrous husk is used for matting as well as a peat substitute (coir) in horticultural composts. Family Arecacae/Palmae; species Cocos nucifera. cocoon Case or wrapping produced by larval forms of animals (such as some MOTHS, BUTTERFLIES and WASPS) for the resting or pupal stage in their life cycle. Some spiders spin a cocoon that protects their eggs. Most cocoons are made of SILK, and those of the domestic silkworm provide most of the world's commercial silk. See also CHRYSALIS; PUPA

Cocteau, Jean (1889–1963) French writer and film-maker, an experimental leader of the French avant-garde. He was associated with many leading artistic figures of the 1920s, such as APOLLINAIRE, PICASSO, DIAGHILEV and STRAVINSKY. His many successful works of surrealist fantasy include the novel Les enfants terribles (1929; filmed 1950); the plays Orphée (1926; filmed 1950) and La Machine Infernale (1934); and the films Le sang d'un poète (1930) and La belle et la bête (1946). cod Bottom-dwelling, marine fish found in cold to temperate waters of the Northern Hemisphere. It is grey, green, brown or red with darker speckled markings. Cod is one of the chief food fishes. Length: up to 1.8m (6ft). Family Gadidae.

code See CRYPTOGRAPHY

codeine White crystalline ALKALOID extracted from OPIUM by the methylation of MORPHINE, and with the properties of weak morphine. It is used in medicine as an analgesic to treat mild to moderate pain, as a cough suppressant and to treat diarrhoea.

Coe, Sebastian Newbold (1956–) English athlete. In the 1980 and 1984 Olympic Games, he won gold medals in the 1,500m and silver medals in the 800m. His 800m world record stood for 16 years. He retired in 1990 and became a Conservative MP (1992). Coe lost his seat in the 1997 general election.

▲ cod The characteristic configuration of the fins — three dorsal fins, two anal fins — reveal this to be a species of cod (*Gadus morhua*). A carnivorous fish, cod can grow up to 1.5m (5ft).

coefficient Term multiplying a specified unknown quantity in an algebraic expression. In the expression $1 + 5x + 2x^2$, 5 and 2 are the coefficients of x and x^2 respectively. In physics, it is a ratio that yields a pure number or a quantity with dimensions. **coelacanth** Bony fish of the genus *Latimeria*. Thought to have become extinct 60 million years ago, it was found in deep waters off the African coast in 1938. It is grey-brown with lobed fins that have fleshy bases. The scales and bony plates are unlike those of modern fish. Length: 1.5m (5ft). Order Crossopterygii; species *Latimeria chalumnae*.

automated, 200-250 coins per

minute can be produced.

thickness and the blanks cut out

with shears; today, coin-thick

coelenterate Alternative name for members of the phylum Cnidaria – aquatic animals which include the JELLYFISH, SEA ANEMONE, CORAL, and hydroids. Characterized by a digestive cavity that forms the main body, they may have been the first animal group to reach the tissue level of organization. Coelenterates are radially symmetrical, jelly-like, and have a nerve net and one body opening. Reproduction is sexual and asexual; regeneration also occurs. There are *c.*9,000 species.

Coetzee, J.M. (John Michael) (1940—) South African novelist and critic. His novels deal with life under forms of imperialism, including the South African apartheid system in *In the Heart of the Country* (1977) and *Age of Iron* (1990). He won the Booker Prize for *Life and Times of Michael K* (1983). His other novels include *Waiting for the Barbarians* (1980), *Foe* (1986) and *The Master of Petersburg* (1994).

coffee Plant and the popular CAFFEINE beverage produced from its seeds (coffee beans). The several plants of the genus *Coffea* are evergreen with white fragrant flowers. Originally native to Ethiopia, they are now cultivated in the tropics, especially Brazil (the world's biggest producer), Colombia and the Ivory Coast. Family Rubiaceae.

cognitive psychology Broad area of psychology con-

cerned with perceiving, thinking and knowing. It investigates such matters as the way in which people perceive by sight or hearing; how they organize, remember and use information; and the use they make of language.

cognitive therapy Form of PSYCHOTHERAPY that aims to treat psychological problems through changing patients' attitudes and beliefs. It is based on the theory that behaviour is learned, and beliefs and attitudes that lead to negative behaviour can be altered by relearning and CONDITIONING. It is used in the treatment of various behavioural problems, phobias, and sometimes for children with learning problems.

Cohen, William (1940–) US statesman, secretary of defence (1997–) Cohen was appointed by President CLINTON following his re-election in 1996. Cohen, a former Republican senator from Maine, was appointed partly as an attempt to ensure closer support for foreign policy initiatives from a Republican-dominated Senate. He is a strong advocate of a forward defence strategy.

cohesion Mutual attraction between the component atoms, ions or molecules of a substance. Weak cohesive forces permit the fluidity of liquids; those of solids are much stronger. Liquids form droplets because of surface tension caused by cohesion.

coin Stamped metal discs of standard sizes used as tokens of money in commercial transactions. The earliest coins are of Lydian origin, from the 7th century BC. Early coinage also appeared in China and India. Ancient coins usually contained a specific quantity of precious metal, often gold or silver, and were stamped with the symbol of the issuing authority. With the introduction of banknotes in the late 17th century and the gradual decline of the quantity of precious metal in each coin, the role of coins changed. They acquired only notional value, and became used for smaller money transactions.

Coke, Sir Edward (1552–1634) English jurist. As chief justice of the King's Bench (1613), he championed the COMMON LAW, and after 1620 developed it in parliament to oppose the king's assumption of "divine right". He helped to draft a declaration of civil liberties, PETITION OF RIGHT (1628), and wrote the influential *Institutes of the Laws of England* (1628). Colbert, Jean Baptiste (1619–83) French statesman, the principal exponent of MERCANTILISM. He came to prominence as an adviser to Cardinal MAZARIN. From 1661, when Louis XIV began his personal rule, Colbert controlled most aspects of government: reforming taxation and manufacturing, reducing tariffs, establishing commercial companies such as the French EAST INDIA COMPANY and strengthening the navy. He also enacted legal reforms and encouraged arts and sciences.

Colchester Town on the River Colne, Essex, SE England. The first Roman colony in Britain was settled here in AD 43 and was attacked by Boadicea in AD 61. It has a Roman wall and a fine Norman castle. It is a market centre for the surrounding agricultural and horticultural area. Pop. (1991) 142,515.

colchicine See COLCHICUM

colchicum Genus of about 30 species of flowering plants, including *C. autumnale*. Species grow throughout Eurasia, and have pink, white, or purple crocus-like flowers in bloom during the autumn. The CORM contains colchicine, an ALKALOID used to treat rheumatism and gout. Colchicine's ability to inhibit MITOSIS make it a valuable IMMUNOSUPPRESSIVE DRUG and aid to cancer research. Family Liliaceae.

cold, common Minor disease of the upper respiratory tract caused by viral infection. Symptoms include inflammation of the nose, headache, sore throat and a cough. A cold usually disappears within a few days. Fever-reducing and pain-

▲ cocoa The cacao tree (*Theobroma cacao*) sprouts pendulous pods 15–35cm (6–14in) long from its branches and trunk. Each pod contains 30–40 beans from which cocoa and chocolate are made.

▼ coffee The Arabian coffee plant (*Coffea arabia*) is the most common kind of coffee plant. It is a small evergreen tree which can grow to a height of 7.5m (25ft), but is pruned to 3m (10ft) on plantations. Its leaves are some 7.5–15cm (3–6in) long. The white blossoms are followed by tiny green berries, each holding two tough-skinned, greenish beans. The berries ripen to a deep red after six or seven months and are then ready for picking.

▲ Cold War The map shows the division of Europe in 1955, between the members of NATO and the Soviet-dominated Warsaw Pact.

▲ Cole Popular US singer and jazz pianist, Nat King Cole had a string of successful songs during the 1950s and 1960s.

▲ collie Bred in Scotland during the 17th and 18th centuries, the collie is still used on farms for rounding up livestock, most commonly sheep. Collies are highly intelligent dogs and one of the most popular breeds in the USA.

relieving drugs, as well as decongestants, may relieve symptoms; rest is recommended for heavy colds. Antibiotics may be prescribed where a bacterial infection is also present.

cold-blooded See POIKILOTHERMAL

Cold War Political, ideological and economic confrontation between the USA and the Soviet Union and their allies from the end of World War 2 until the late 1980s. Despite incidents such as the BERLIN AIRLIFT (1948–49) and the CUBAN MISSILE CRISIS (1962), plus many threats of retaliatory war by both sides, open warfare never occurred between the NORTH ATLANTIC TREATY ORGANIZATION (NATO) and the WARSAW PACT. It ended with the collapse of COMMUNISM in the late 1980s and the dissolution of the Warsaw Pact in 1990.

Cole, Nat King (Nathaniel Adams) (1917–65) US singer and pianist. He was a jazz pianist in the King Cole Trio from 1939, but achieved popularity as a singer with his velvety soft and rich voice. Cole's many hit songs include "Unforgettable", "Mona Lisa" and "Nature Boy".

Cole, Thomas (1801–48) US landscape painter, b. England. A founder of the HUDSON RIVER SCHOOL, his romantic landscapes depict the grandeur of the Hudson River valley and Catskill Mountains.

Coleridge, Samuel Taylor (1772–1834) British poet and critic. His literary output was mainly criticism, political journalism and philosophy, but he is chiefly remembered for poems, such as *The Rime of the Ancient Mariner, Kubla Khan, Christabel* and *Frost at Midnight*. In 1798, he and William Wordsworth published Lyrical Ballads, a fundamental work of the English Romantic movement. Coleridge's Shakespearean criticism, his work on cultural theory, such as *Biographia Literaria* (1817), and his writings on German metaphysics were influential during the 19th century.

Colette (1873–1954) French novelist. Her early works, including the first four *Claudine* novels (1900–03), were published under her first husband's pseudonym, Willy. Among her best-known works are *Chéri* (1920), *The Last of Chéri* (1926) and *Gigi* (1944).

colic Severe pain in the abdomen, usually becoming intense, subsiding and then recurring. Intestinal colic may be associated with obstruction of the intestine or constipation.

colitis Inflammation of the lining of the colon, or large intestine, that produces bowel changes, usually diarrhoea and cramp-like pains. In severe chronic ulcerative colitis, the colon lining ulcerates and bleeds.

collage Composition made up of various materials (such as cardboard, string and fabric), pasted on to a canvas or other background. Cubist artists, such as PICASSO, BRAQUE and GRIS developed it into a serious art form. Collage was also used by members of the DADA movement, such as SCHWITTERS.

collagen Protein substance that is the main constituent of bones, tendons, cartilage, connective tissue and skin. It is made up of inelastic fibres.

collective unconscious According to Jung's psychological theory, the inherited aspect of the unconscious that is common to all members of the human race. The collective unconscious has evolved over many centuries and contains images (archetypes), which are found in dreams and numerous religious and mystical symbols.

collectivism Political and economic theory, opposed to individualism. It emphasizes the need to replace competition with cooperation. Socialism and Communism are both expressions of the collectivist idea.

collectivization Agricultural policy enforced in the Soviet Union under Stalin in 1929, and adopted by China after the communist takeover in 1949. With the object of modernizing agriculture and making it more efficient, small peasant holdings were combined and agriculture brought under state control.

collie Smooth-coated or long-haired working dog. It has a lean, wedge-shaped head with small triangular ears. The long body is set on strong straight legs and the tail is long and curved. The coat, usually black-and-white or tan, may be rough or smooth. Height: to 66cm (26in) at the shoulder.

Collins, Michael (1890–1922) Irish revolutionary. He fought in the EASTER RISING in 1916, and helped to establish the Irish Assembly (Dáil) in 1918. He was one of the negotiators of the treaty which created the Irish Free State in 1921 and was killed in the ensuing civil war. His charm and early death contributed to his reputation as a revolutionary hero.

Collins, (William) Wilkie (1824–89) British novelist. He made important contributions to the development of DETECTIVE FICTION, especially in his two enduringly popular novels, *The Woman in White* (1860) and *The Moonstone* (1868). He collaborated with Charles DICKENS in writing plays and stories.

colloid Substance composed of fine particles which can be readily dispersed throughout a second substance. A sol is a solid dispersed in a liquid, an aerosol is a solid or liquid in a gas, an emulsion is a liquid in a liquid, and a foam is a gas in either a liquid or solid.

Cologne (Köln) City on the River Rhine, Nordrhein Westfalen, w Germany. The Romans established a fortress at Cologne in AD 50. It was made an archbishopric by Charlemagne in 785 and enjoyed great influence during the Middle Ages. It was heavily bombed during World War 2. Notable buildings include a cathedral (started 1248, completed 1880) and the Gürzenich (a Renaissance patrician's house). Its university was founded in 1388. Cologne is a commercial, industrial and transport centre. Industries: oil refining, petrochemicals, chemicals, engineering, textiles. Pop. (1990) 958,600.

Colombia Republic in NW South America. See country feature

Colombo Capital and chief seaport of Sri Lanka, on the sw coast. Settled in the 6th century BC, it was taken by Portugal in the 16th century and later by the Dutch. In 1796, it was captured by the British and gained its independence in 1948. Colombo has one of the world's largest artificial harbours. Sites include a town hall and Aqua de Lupo church. Apart from shipping, the city has light industries. Pop. (1992 est.) 684,000. Colombo Plan International organization with headquarters in COLOMBO, Sri Lanka, which seeks to promote the economic and social development in s and SE Asia. Initiated by the Commonwealth of Nations (1951), it now includes 26 states including Canada, Japan, UK and the USA. It fosters bilateral agreements providing various kinds of aid.

colon Part of the large INTESTINE, the digestive tract that extends from the small intestine to the RECTUM. The colon absorbs water from digested food and allows bacterial action for the formation of faeces. *See also* DIGESTIVE SYSTEM

colonialism Control by one country over a dependent area or people. Although associated with modern political history, the practice is ancient. In European colonial history, economic, political and strategic factors were involved in the colonial enterprise, which created the world empires of countries such as Britain and France, subjugating mainly African and Asian

states and often creating artificial boundaries. After World War 2, colonialist exploitation was widely recognized, and colonial powers conceded, willingly or not, independence to their colonies. See also IMPERIALISM

Colorado State in w USA; the state capital is DENVER. Other major cities include Colorado Springs and Pueblo. It is the highest state in the nation, with an average elevation of 2,073m (6,800ft). In the w half are the ranges of the ROCKY MOUNTAINS, and in the E the GREAT PLAINS. Major rivers are the Colorado, Rio Grande, Arkansas and South Platte. The USA acquired the E of the state from France in the LOUISIANA PURCHASE (1803). The remainder was ceded by Mexico after the MEXICAN WAR (1848). The discovery of gold and silver encouraged immigration and Colorado was made a territory in 1861. It achieved statehood in 1876. The most important agricultural activity is the raising of sheep and cattle on the Plains. Sugar beet, maize and hay are grown using extensive irrigation. Industries: tourism, transport and electrical equipment, mining, chemicals, timber. Area: 268,658sq km (103,729sq mi). Pop. (1990) 3,294,394.

Colorado River Major river in sw USA, which rises in the Rocky Mountains of N Colorado, and flows generally sw into

the Gulf of California, passing through the GRAND CANYON. There are many national parks, irrigation and hydroelectric power schemes along the river. Length: 2,333km (1,450mi). Colosseum Ampitheatre in Rome built AD 72-81 by the Emperor Vespasian. One of the most awe-inspiring examples of ancient Roman architecture, it measures 189×156m $(620 \times 513 \text{ft})$ by 45.7m (150ft) high, and seated c.50,000 people. Citizens of Rome came here to watch gladiatorial contests and, according to tradition, the martyrdom of Christians. Colossians, Epistle to the Book of the New Testament taking the form of a letter written by either St PAUL or a disciple to the Church at Colossae, a city in sw Phrygia (now central Turkey). The letter, written from prison in Rome (c.AD 61), is a warning to the Colossians not to adopt ideas from other faiths and philosophies that may undermine the supremacy of Jesus Christ.

Colossus of Rhodes One of the Seven Wonders of the WORLD, a bronze statue of the Sun god overlooking the harbour at Rhodes. It stood more than 30.5m (100ft) high. It was built, at least in part, by Chares of Lindos between c.292 BC and c.280 BC, and destroyed by an earthquake c.224 BC.

colostomy Operation to bring the COLON out through the

COLORADO

Statehood:

1 August 1876

Nickname:

The Centennial State State bird:

Lark bunting

State flower:

Rocky Mountain

columbine State tree :

Blue spruce

State motto :

Nothing without providence

COLOMBIA

The yellow on Colombia's flag depicts the land, separated from the tyranny of Spain by the blue of the Atlantic Ocean. The red symbolizes the blood of the people who fought for Colombia's independence. The flag has been used since 1806.

Cordillera contains the capital, BOGOTÁ, at c.2,800m (9,200ft). East of the Andes lie plains drained by headwaters of the AMAZON and Orinoco rivers. This region accounts for twothirds of the land, but only 2% of the population.

CLIMATE AND VEGETATION

Colombia's climate and vegetation vary greatly according to altitude. The Pacific lowlands have a tropical, rainy climate, but Bogotá has mild annual temperatures. The Caribbean lowlands and the Magdalena valley have dry seasons.

Colombia's vegetation varies from dense rainforest in the SE to the tundra of the snow-capped Andean peaks. Coffee plantations line the w slopes of the E Cordillera. Mangrove swamps lie along the Pacific coast. The original forests of the Caribbean lowlands have been largely cleared. The NE plains are covered by savanna (llanos).

HISTORY

The advanced, pre-Colombian CHIBCHA civilization lived undisturbed in the E cordillera for many thousands of years. In 1525 the Spanish established the first European settlement at Santa Marta. By 1538 the conquistador Gonzalo Jiménez de Quesada had conquered the Chibcha and established Bogotá. Colombia became part of the New Kingdom of Granada, whose territory also included Ecuador, Panama and Venezuela. Bogotá became the colonial capital. In 1819 Simón Bolívar defeated the Spanish at Boyacá and established Greater Colombia. Bolívar became president. In 1830 Ecuador and Venzuela gained independence. In 1885 the republic of Colombia was formed.

AREA: 1,138,910sq km (439,733sq mi)

POPULATION: 33,424,000

CAPITAL (POPULATION): Bogotá (4,921,000) GOVERNMENT: Multiparty republic

ETHNIC GROUPS: Mestizo 58%, White 20%, Mulatto 14%, Black 4%, mixed Black and Indian 3%, Native American 1%

LANGUAGES: Spanish (official) RELIGIONS: Christianity (Roman Catholic 93%)

currency: Peso = 100 centavos

Differences between republican and federalist factions proved irreconcilable and the first civil war (1899-1902) killed nearly 100,000 people. In 1903, aided by the USA, Panama achieved independence. The second civil war La Violencia (1949-57) was even more bloody. Political corruption, violence and repression became endemic. In 1957 Liberal and Conservative parties formed a National Front Coalition, which remained in power until 1974. Throughout the 1970s Colombia's illegal trade in cocaine grew steadily, creating wealthy drug barons. In the 1980s, armed cartels (such as the Cali) became a destabilizing force, and political and media assassinations were frequent. Guerilla groups fought for social and economic justice. In 1990 elections, a former guerilla movement, M19, gained 30% of the popular vote. A new constitution (1991) protected human rights. The Liberal leader Ernesto Samper was elected president in 1994. In 1996 the vice president resigned after corruption charges linked funding for the Samper campaign to the Cali. In 1997 the suspension of the coca crop-eradication programme further eroded US confidence.

ECONOMY

Colombia is a lower-middle-income developing country. It is the world's second-largest coffee producer. Other crops include bananas, cocoa and maize. Colombia also exports coal, oil, emeralds and gold. Manufacturing is based mainly in Bogotá, Cali and Medellín. In 1997 the collapse of the world coffee and banana market led to a massive budget deficit.

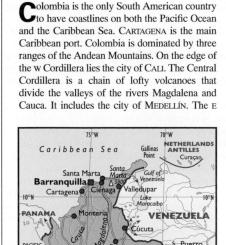

ECUADOR

wall of the abdomen in order to bypass the lower section of the bowel. An artificial opening is created so that faecal matter is passed into a bag, worn outside the body. The site of the colostomy varies according to the disease's location. See also DIGESTION

colour Sensation experienced when light of sufficient brightness and of a particular wavelength strikes the retina of the eye. Normal daylight (white light) is made up of a spectrum of colours, each a different wavelength. These colours can be placed in seven bands – red, orange, yellow, green, blue, indigo and violet – of decreasing wavelength. A pure spectral colour is called a **hue**. If the colour is not pure but contains some white, it is "desaturated" (**tint**). Saturation is the degree to which a colour departs from white and approaches a pure hue. A colour may also have luminosity (brightness) which determines its shade. Any colour is perceived as a mixture of three primary colours: red, green and blue.

colour blindness General term for various disorders of colour vision. The most common involves red-green vision, a hereditary defect almost exclusively affecting males. Total colour blindness (achromatic vision), an inherited disorder in which the person sees only black, white and grey, is exceedingly rare.

Coltrane, John William (1926–67) US jazz saxophonist, one of the leading innovators of the 1950s and 1960s. He played with Dizzy GILLESPIE (1949–51) and Miles DAVIS (1955–57) before forming his own seminal quartet in 1960. He established a reputation as an intense musician and technical virtuoso. He was a primary exponent of the "modal" improvisation technique. *A Love Supreme* (1964) is his masterpiece.

Colum, Padraic (1881–1972) Irish author. A key figure in the Irish literary renaissance, he was an associate of James JOYCE, of whom he wrote a memoir, and author of many poems. From 1914 he lived mainly in the USA, where he developed an interest in myth and folklore. His output includes many plays and a novel, *The Flying Swans* (1957).

Columba, Saint (521–97) Irish Christian missionary in Ireland and Scotland. He founded several monasteries throughout Ireland. In 563 he left Ireland and founded an important monastery on the island of Iona. As Abbot of Iona, he strove to convert the PICTS of N Scotland to Christianity. His feast day is 9 June.

Columbia, District of See WASHINGTON, D.C.

Columbia Capital of South Carolina, USA, in the centre of the state, at the junction of the Broad and Saluda rivers. Founded as state capital in 1786, it was nearly destroyed in the American Civil War. It is home to the University of South Carolina (1801), Columbia College (1854), Allen University (1870) and the Woodrow Wilson Museum. Industries: textiles, printing, electronic equipment. Pop. (1990) 98,052.

Columbia River River in sw Canada and Nw USA. It flows from Columbia Lake in British Columbia, Canada, through Washington and Oregon, USA, and enters the Pacific Ocean N of Portland. It has one of the largest drainage basins on the continent, *c*.668,220sq km (258,000sq mi). Length: Γ ,953km (1,214mi).

columbine Any of about 100 species of perennial herbaceous plant native to cool climates of the Northern Hemisphere. They have five-petalled, spurred flowers and notched leaflets. Height: to 90cm (3ft). Family Ranunculaceae; genus *Aquilegia*.

columbium See NIOBIUM

Columbus, Christopher (1451–1506) Italian explorer credited with the discovery of America. He believed he could establish a route to China and the East Indies by sailing across the Atlantic since, along with many learned contemporaries, he believed the circumference of the Earth to be much smaller than it actually is. After several disappointments, he secured Spanish patronage from Ferdinand and Isabella. He set out with three ships (Niña, Pinta and Santa Maria) in 1492 and made landfall in the Bahamas, the first European to reach the Americas since the Vikings, whose achievement was then unknown. Believing he had reached the East, he called the inhabitants "Indians". On a second, larger expedition (1493), a permanent colony was established in Hispaniola. He made

two more voyages (1498 and 1502), exploring the Caribbean region without reaching the North American mainland. He never surrendered his belief that he had reached Asia. His discoveries laid the basis for the Spanish empire in the Americas.

Columbus Capital of Ohio, USA, on the Scioto River. Founded in 1812, it grew rapidly with the arrival of the railway in 1850. It is a major transport, industrial and trading centre for a rich agricultural region. Columbus has numerous universities and colleges. The Battelle Memorial Institute (1929) conducts scientific, technological and economic research. Industries: machinery, aircraft, printing and publishing. Pop. (1990) 632,910.

column In architecture, a vertical post, supporting part of a building. A column may be free-standing, with a capital, base and shaft, or it may be partly attached to a wall. Triumphal columns such as the Roman Trajan's Column, had narrative reliefs to depict battle victories. Annulated columns, clustered together by rings or bands, were popular in medieval England. See also ORDERS OF ARCHITECTURE

coma State of unconsciousness brought about by a head injury, brain disease, drugs or lack of blood supply to the BRAIN. **Comanche** Shoshonean-speaking Native American nation. They separated from the parent SHOSHONE in the distant past and migrated from E Wyoming into Kansas. Numbering *c.*15,000, they were daring horsemen and introduced the horse to the Northern Plains tribes. Conflict with US forces resulted in their near extinction by 1874. Today *c.*4,500 Comanche live on reservations in sw Oklahoma.

Combination Acts British acts of Parliament of 1799 and 1800 making combinations (trade unions) of workers illegal. The government feared that such organizations were potentially subversive. Trade unions nevertheless multiplied after 1815, and in 1824 the acts were repealed. A later Combination Act (1825) restricted the right to strike and, as the TOLPUDDLE MARTYRS (1834) demonstrated, trade-union organizers could still be prosecuted.

combustion Burning, usually in oxygen. The combustion of fuels is used to produce heat and light. An example is a fire. Industrial techniques harness the energy produced using combustion chambers and furnaces.

COMECON Acronym for the Council for Mutual Economic Assistance

Comédie-Française French national theatre, founded in 1680. It is organized according to a charter granted by Louis XIV and revised by Napoleon I. There are two kinds of members: *pensionnaires*, chosen by audition and *sociétaires* to which the *pensionnaire* can be elevated only upon the death, retirement or resignation of a *sociétaires*.

comedy One of the two main types of DRAMA. It differs from TRAGEDY in its lightness of style and theme and its tendency to resolve happily. It originated in early Greek fertility rites and, in modern usage, refers not only to a humorous play or film, but also to the growing tradition of stand-up routines. As theatre has developed over the centuries, the once clear division between the two dramatic forms has been blurred, as fusions and a variety of sub-divisions of the two have been developed. *See also* ARISTOPHANES; GREEK DRAMA

comet Small, icy Solar System body in an independent orbit around the Sun. The solid nucleus of a comet is small, that of HALLEY'S COMET measures just $16 \times 8 \text{km} \ (10 \times 5 \text{mi})$, and comprises rock and dust particles embedded in ice. As the comet approaches the Sun and gets warmer, evaporation begins, and jets of gas and dust form the luminous, spherical coma. Later, radiation pressure from the Sun and the solar wind may send dust and gas streaming away as a tail, tens of millions of kilometres long. Comets are thought to originate outside the solar system, from where they may be displaced from their orbit and sent towards the Sun.

comfrey Any plant of the genus *Symphytum* of the BORAGE family (Boraginaceae), native to Eurasia. Comfreys have small yellow or purple flowers and hairy leaves. Boiled concoctions of *S. officinale* were once used to treat wounds.

comic Magazine consisting of stories told by means of strip cartoons with "balloons" containing the characters' speech. Comics evolved from the comic-strip in the 1930s and cover

▲ Columbus Although
Columbus was not the first
European to sail to the New
World (the Vikings had arrived in
c.1000), his voyages mark the
start of intensive European
exploration of the Americas. On
his final voyage (1502), he sailed
past Hispaniola and south along
the coast of Honduras. Attempting
to return to Hispaniola, he was
shipwrecked on Jamaica and
forced to return to Spain,
abandoning his travels.

many subjects, from war and science fiction to school and family life. A tradition of adult, politicized, subversive and often erotic comics, along with explicit graphic novels, has established itself during the latter part of the 20th century.

comic opera Musico-dramatic work with some spoken dialogue and a light or amusing plot. The term is used indiscriminately and includes musical comedy and OPERETTA. In operatic works, it approximates most closely to early 18th-century Italian OPERA BUFFA (notably the operas of PERGOLESI), but bears little relation to the French OPÉRA COMIQUE.

Comintern See Communist International

commedia dell'arte Style of Italian comedy, popular from the mid-16th to late-18th century, which spread throughout Europe. Professional players performed on street stages or at court functions. Plays were comic, often coarse, and crudely improvised on briefly outlined scenarios. Commedia produced several (now standard) masked characters: Harlequin (clown), Capitano (braggart soldier), Pantalone (deceived father or cuckolded husband), Colombina (maid) and Inamorato (lover). commensalism Situation in nature in which two species live in close association but only one partner benefits. One of the species (the commensal) may gain from increased food supply, or by procuring shelter, support or means of locomotion, but the other (the host) neither gains nor loses from the relationship. See also MUTUALISM; SYMBIOSIS

Commerce, US Department of US executive department which promotes economic development and technological advancement through activities that encourage and assist states, regions, communities, industries and firms. Its agencies include the Bureau of the Census, Office of Business Economics, Patent Office and National Bureau of Standards. It was founded in 1903 as the Department of Commerce and Labor, and became a separate department in 1913.

commodity market Market in which goods or services are bought and sold. Commodities are raw materials such as tea, rubber, tin or copper, which generally need processing to reach their final state. The actual commodities are seldom present, and what is traded is their ownership. The largest commodity exchange in the world is in Chicago, Illinois.

Common Agricultural Policy (CAP) System of support for agriculture within the EUROPEAN COMMUNITY (EC). The CAP was incorporated in the Treaty of ROME (1957). It was designed to increase food production within the EC, and to ensure a reasonable income for farmers. The EC sets target prices for commodities. If prices fall below target, to a level known as intervention prices, the EC buys up surplus product creating the so-called "beef mountains" and "wine lakes". In 1988, to prevent over-production, the EC introduced a policy of paying farmers to set aside part of their land as fallow. Prices for imports from outside the EC are kept above target by means of levies. By 1994 the CAP was absorbing 51% of the total EC budget, having soared to 75% in the 1970s. It is one of the most contentious issues in the Community, and demands for reform are frequent.

common law Legal system developed in England and adopted in most English-speaking countries. Distinguished from CIVIL LAW, its chief characteristics are judicial precedents, trial by jury and the doctrine of the supremacy of law. Based originally on the king's court, "common to the whole realm", rather than local or manorial courts, it dates back to the constitutions of CLARENDON (1164). It is the customary and traditional element in the law accumulating from court decisions. Swift changes in society and public opinion have resulted in a proliferation of statutes which have come to supersede common law. See also ROMAN LAW

Common Market See European Union (EU)

Common Prayer, Book of Official liturgy of the Church of England. It was prepared originally as a reformed version of the old Roman Catholic liturgy for Henry VIII by Thomas Cranmer in 1549. Three years later it underwent revision under the Protestant government of Edward VI. The final version (1559), a combination of the two, was produced by Elizabeth I's Archbishop of Canterbury, Matthew Parker. The Prayer Book was further revised in 1662 after the RESTORATION of Charles II.

Commons, House of Lower chamber of the UK PARLIA-

Commonwealth (1649–60) Official name of the republic established in England after the execution of Charles I in 1649. After a series of unsuccessful attempts to find a suitable constitution, the PROTECTORATE was set up in 1653, in which Oliver Cromwell was given almost regal powers. The Commonwealth ended with the RESTORATION of CHARLES II.

Commonwealth Games Sporting event originating as the British Empire Games (1930). Competitors are members of the COMMONWEALTH OF NATIONS. Based on the OLYMPIC GAMES, they are held every four years.

Commonwealth of Independent States (CIS) Alliance of 12 of the former republics of the Soviet Union. The CIS was formed in 1991 with Armenia, Azerbaijan, Belarus, Georgia, Kazakstan, Kyrgyzstan, Moldova, Russia, Tajikistan, Turkmenistan, Ukraine and Uzbekistan. The Baltic states (Estonia, Latvia and Lithuania) did not join. All members, except Ukraine, signed a treaty of economic union in 1993, creating a free trade zone. Russia is the dominant power, with an overall responsibility for defence and peacekeeping. It is also the main provider of oil and natural gas.

Commonwealth of Nations Voluntary association of 53 states, consisting of English-speaking countries formerly part of the British Empire. Headed by the British sovereign, it exists largely as a forum for discussion of issues of common concern. A Commonwealth secretariat is located in London. communications Processes for sharing information and ideas. Facial expressions, hand signals, writing and speech are examples. The 15th-century invention of the printing press revolutionized communications. The 20th century has witnessed a communications revolution, primarily in terms of increased access. Telecommunications inventions, such as the Telephone, Radio, Television and Computer Network, have facilitated rapid, global, mass communication. The Internet is the latest in a long line of technological innovations.

Communications Satellite (COMSAT) A private company that provides worldwide satellite communications systems. COMSAT, established by the US Congress, began with the launch of the Early Bird satellite in 1965. Many other nations now participate in COMSAT projects.

communism Political outlook based on the principle of communal ownership of property. The theory is derived from the interpretation placed by Karl MARX and Friedrich ENGELS on the course of human history. As outlined in the Communist Manifesto (1848), Capital (vol. 1, 1867) and other writings, Marx asserted that social and political relations depend ultimately upon relations of economic production. All value (and so wealth) is produced by labour (the labour theory of value), yet in a capitalist system, workers' salaries do not represent the full value of their labour, because some of it goes to the owners of the means of production and is appropriated by them in the form of profits. Thus, the working class (PROLE-TARIAT) and the class that is in control of capital and production (the BOURGEOISIE) have conflicting interests. CAPITALISM, it is asserted, is merely one stage in the progress of human institutions. As the forces of production (technology and capital stock) increase, the relations of production must change in order to accommodate them. Marx postulated that just as the feudal aristocracy of Europe had inevitably been supplanted as the ruling class by the capitalist bourgeoisie, so the bourgeoisie (by the nature of its operations) brought into being the urban proletariat. Conflicting interests within capitalism would inevitably lead to the overthrow of the bourgeoisie by the proletariat, and so the collapse of the system itself. This would be replaced, first by SOCIALISM and eventually by a communist society in which production and distribution would be democratically controlled, summarized in the slogan, "From each according to their ability, to each according to their need". A socialist experiment was attempted in Russia following the revolution (1917). STALIN turned communism into an ideology to justify the use of dictatorial state power to drive rapid economic development of a largely agricultural economy. This process was used as a model for other communist countries, such as China and Cuba.

COMPACT DISC

A compact disc player reads digital information from a compact disc (1) using a focused laser (2). Music or other information is written on the underside of the disc in a spiral track of pits (3), representing a digital code of zeros and ones. The disc spins and the laser, mounted on a

swing arm (4), moves as the disc plays. The laser passes through a semi-silvered mirror (5) and is focused on the disc (6). When the laser hits a flat area it is reflected back via the mirror to a sensor (7) and the information sent to a chip. When the laser hits a pit, it is scattered.

Communist International (Comintern, Third International) Communist organization founded by LENIN in 1919. He feared that the reformist Second International might remerge and wished to secure control of the world socialist movement. The Comintern was made up mainly of Russians, and failed to organize a successful revolution in Europe in the 1920s and 1930s. The Soviet Union abolished the Comintern in 1943 to placate its World War 2 allies.

Communist Party, Chinese Political organization established in July 1921 by Li Ta-chao and Ch'en Tu-hsiu. The party was strengthened by its alliance (1924) with CHIANG KAI-SHEK's nationalist KUOMINTANG, but virtually shattered when the communists were expelled from the alliance in 1927. MAO ZEDONG was the guiding force in revitalizing the party in the early 1930s. Under his leadership, solidified during the LONG MARCH (1934-35), the party revised the Soviet proletariatbased model to fit the peasant-oriented economy of China and, after another four years of civil war from 1945, the People's Republic was proclaimed in TIANANMEN SQUARE (October 1949). The party had achieved complete political and military power. Its structure and hierarchy was nearly destroyed during the CULTURAL REVOLUTION, but re-established after Mao's death (1976) by DENG XIAOPING. Following pro-democracy demonstrations (May 1989), the party swang away from political reform and hardline conservatives consolidated power. Yet, its flexible approach to economic reform enabled it to survive the collapse of Soviet COMMUNISM. Jiang ZEMIN became president in 1993. The National People's Congress is the supreme legislative body, and nominally elects the highest officers of state. The party has over 40 million members (1995).

Communist Party of America Radical Party organized in 1919 to represent the interest of workers, farmers and the lower middle class. Its programme evolved from open revolutionary objectives, to so-called "popular front" socialist goals. The party was strongest in 1932 when it polled 102,991 votes in the presidential election. In 1940, following the passage of the Voorhis Act, the party severed its connection with the COMMUNIST INTERNATIONAL and began to lose strength. Subsequently, the Smith Act (1940), the McCarran Act (1950), and the Communist Control Act (1954) drastically reduced its rights and possible influence.

Communist Party of the Soviet Union (CPSU) Former ruling party of the SOVIET UNION. It wielded all effective political power in the country and, via the COMMUNIST INTER-NATIONAL, had considerable influence over Communist parties in other countries. At its height the CPSU had c.15 million members, organized into c.400,000 local units (cells) throughout the Soviet Union. Party organization paralleled the hierarchy of local government administration, thus enabling party control of every level of government. There were party cells in almost all areas of Soviet life, such as the school system, armed forces, factories, collective farms and the media. After the break up of the Soviet Union in 1991, the party was dissolved, following a number of decrees by Boris YELTSIN. There remains a strong, traditional conservative power base of ex-party members who are politically active in Russia. The 1996 presidential elections revealed popular support for the communist leader, Gennady Zyuganov. See also COMMUNISM; LENIN; individual party leaders

community architecture Schemes, mainly for housing, that involve a study of the prevailing social conditions and consultation with the people who are going to use them. In Britain, the idea developed during the 1970s as a reaction to mass housing developments. Its most famous supporter is Prince CHARLES who, with his architectural advisor, Rod Hackney, created a new but traditional village based on the principles.

commutative law Rule of combination in mathematics; it requires that an operation on two terms is independent of the order of the terms. Addition and multiplication of numbers is commutative, since a + b = b + a and ab = ba. Vector crossmultiplication does not obey the commutative law.

Comoros (Comores) Independent republic off the E coast of Africa between Mozambique and Madagascar in the Indian Ocean, made up of a group of volcanic islands. The three major islands are Grande Comore (site of the capital, Moroni), Anjouan and Mohéli. The islands are mountainous, the climate tropical, and the soil fertile. Farming is the chief occupation. Coconuts, copra, vanilla, cocoa and sisal are the main crops and exports. France owned the islands between 1841 and 1909. They gained their independence in 1975. Area: 1,862sq km (719sq mi). Pop. (1994) 535,600.

compact disc (CD) Disc used for high-quality digital sound reproduction. It is a plastic disc with a shiny metal layer and a transparent protective plastic coating. The sound signal consists of millions of minute pits, pressed into one side of the metal. On replay, a narrow laser beam is reflected from the rotating disc's surface. A sensor detects changes in the beam, and forms an electrical signal of pulses. This is processed and decoded to form a sound signal that can be amplified for reproduction on loudspeakers. See also CD-ROM

company Group of people who agree to work together as a firm or business. The legal responsibility of running a company rests with its board of directors which, if the business has raised finance by selling shares in the company, has to account to its shareholders. In a **private** company, the directors sell shares to whomever they please (sometimes the only shareholders are the directors). The shares of a **public** company can be bought and sold by anyone through a STOCK EXCHANGE. In a **public limited company** (**plc**), the legal liability of its shareholders is limited to the value of their shares. *See also* CORPORATION

compass Direction-finding instrument also used to show direction of a magnetic field. It is a horizontal magnetic needle on a vertical pivot whose north-seeking end can turn to point towards magnetic N. Adjustments can be made to give true N. The compass has been used in Europe since the 12th century when the "needle" was a piece of lodestone. In navigation today, the magnetic compass is often replaced by the motor-driven GYROCOMPASS.

compiler Computer PROGRAM that translates the symbols of a programming language into instructions readable directly by a computer. Most programs are written in high-level languages, such as C or BASIC, which are made up of words and symbols easily comprehended by humans. A compiler takes these programs and renders them into a form that is readable by the circuits of the computer itself.

complex number Number of the form a+bi, where $i=\sqrt{-1}$, and a and b are REAL NUMBERS. In order to obtain a solution to the equation $x^2+1=0$, we need to introduce a new number i such that $i^2=-1$. The solutions to similar equations then give rise to a set of numbers of the general form a+bi. These are known as the complex numbers. Since b can be equal to zero, the set of complex numbers includes the real numbers.

Compositae Family of nearly 20,000 species of plants in which the "flower" is actually a composite flower-head consisting of a cluster of many, usually tiny, individual flowers (florets). In a typical composite, such as the DAISY, the flower-head has a central yellow disc, consisting of a cluster of tiny bisexual florets lacking visible petals. The outer ring of female ray florets has large white petals. In composites such as the DANDELION and ENDIVE, the flower-head consists entirely of ray florets. Others, such as THISTLES, consist entirely of disc florets. Composites make up by far the largest family of plants, and include food plants, such as ARTICHOKES, and many popular garden flowers. The Compositee are often known as the Asteraceae.

compound Substance formed by chemical combination of two or more elements that cannot be separated by physical means. Compounds are produced by the rearrangement of valency ELECTRONS (outer electrons of an atom) seeking to attain more stable configurations. They usually have properties quite different from those of their constituent elements. Ionic compounds have IONIC BONDS — they are collections of

Pressing a key (1) or pair of keys changes the current flowing through the key's circuit. A microprocessor (2) scans the circuits and detects when they change. A scan code is transmitted by the microprocessor to the memory buffer in the keyboard (3). The scan code then travels through the cable connecting the keyboard to its controller chip

(4), in the body of the computer. The controller chip informs the CPU (5) which finds the keyboard program in ROM (6) and cancels the scan code in the keyboard's memory buffer. The ROM converts the scan code into the PC's language, ASCII (7), and then instructs the monitor (8) to display the character, an uppercase E.

oppositely charged ions. They have high melting and boiling points, due to the strong electrostatic forces of attraction holding their crystal lattice together. COVALENT BONDS occur where non-metal atoms share electrons. Such compounds can be classified as simple molecular structures, such as carbon dioxide, with low melting and boiling points; or giant molecular structures, such as graphite and diamond. Their properties depend on the arrangement of the atoms in the macromolecule. See also MOLECULE

Compromise of 1850 Set of balanced resolutions by Senator Henry CLAY to prevent civil war. The US Congress agreed to admit California as a free state, organize New Mexico and Utah as territories without mention of slavery, provide for a tougher fugitive slave law, abolish the slave trade in Washington, D.C., and assume the Texas national debt. **Compton, Arthur Holly** (1892–1962) US physicist. He

discovered that wavelengths of x-rays increase when the rays collide with electrons (the Compton effect). This helped prove that x-rays could act as particles. He shared the 1927 Nobel Prize for physics with C.T.R. WILSON. Head of the early phase of the Manhattan Project to develop the atom bomb, Compton helped create the first sustained nuclear CHAIN REACTION. computer Device that processes data (information) by following a set of instructions called a PROGRAM. All digital computers work by manipulating data represented as numbers. The tallying principle of the ABACUS was mechanized in calculating machines, such as those devised by Charles BABBAGE, in which complicated calculations were processed by means of geared wheels. By the mid-1940s mechanical machines were replaced by electronic versions. Some used groups of electromagnetic switches, called relays, to register binary numbers. At any instant, each switch could be either on or off, corresponding to the digits 1 or 0 in the BINARY SYSTEM. Stages in the long term development of electronic digital computers are termed computer generations. A first generation computer was developed by engineers at the University of Pennsylvania in 1946. The 27-tonne machine called ENIAC (Electronic Numerical Indicator and Computer) used electronic VALVES instead of relays. Programming ENIAC to do a particular task was a lengthy process that consisted of changing wired connections. John von NEUMANN helped to develop techniques

► computer graphics Touchscreens detect physical contact with the screen (1). Most screens have two plastic layers with a thin transparent coating of a conducting material (2). The pressure of a finger brings the two sheets slightly closer together (3). The screen reads the position of the touch horizontally and vertically (4) to ascertain its position. In consumer touch-screens, such as automated teller machines, a small selection of options is presented to the user with each section of the screen relating to one of them.

for storing programs in code to avoid this problem. In 1951, UNIVAC 1 became the first computer offered for general sale. This second generation computer used a TRANSISTOR to perform the same role as valves. As a result, computers became smaller and more commonplace. In the 1960s, a third generation of computers appeared with the invention of INTEGRATED CIRCUITS, leading to a further reduction in size. Fourth generation computers, developed in the 1980s, are even smaller, utilizing powerful MICROPROCESSORS. Microprocessors contain a complete central processing unit (CPU) which controls operations. The latest microprocessors contain more than a million transistors and other components, all in a package little bigger than a postage stamp. Read-Only Memory (ROM) and Random Access Memory (RAM) chips act as permanent and temporary electronic memories for storing data. A typical desktop computer system consists of: a main unit, containing a central processor together with memory chips and storage devices (usually MAGNETIC DISKS); a monitor, containing a CATHODE-RAY TUBE; a keyboard; a mouse and printer. Computer programs are usually stored on disks and transferred to the machine's RAM when required. The keyboard and mouse are called input devices, since they allow the user to feed information into the computer. The keyboard enables the user to enter letters, numbers and other symbols. The mouse, a GRAPHICAL USER INTERFACE (GUI), is a small device moved by hand, which enables the user to control the computer by positioning a pointer on the monitor screen, to select functions from a list. Fifth generation computers using very large-scale integration (VLSI) chips will utilize the developments of ARTI-FICIAL INTELLIGENCE (AI) and may be controlled by spoken commands. A magnetic disk drive, such as a HARD DISK, acts as both an input and output device. It can supply programs and data to the computer, and store its output. Many computers have CD-ROM drives; these receive data from an optical storage disk. Many other peripherals are used, such as a scanner which converts images into a DIGITAL SIGNAL so that they can be stored and displayed by the computer, and other HARDWARE for storing and manipulating sounds. The modern computer market is dominated by PCs - the generic term used to refer to machines based on the original IBM personal computer produced in the early 1980s. All these machines use an operating system (such as DOS or Windows) produced by the giant SOFTWARE corporation, Microsoft. Other popular operating systems include Apple Macintosh and UNIX. computer-aided design (CAD) Use of COMPUTER GRAPH-

computer-aided design (CAD) Use of COMPUTER GRAPHICS to assist the design of, for example, fabrics, electronic circuits, buildings and vehicles. With CAD, designers can make alterations and analyse their effect. In fabric design, colours may be varied and the effect judged on the computer screen. In vehicle design, road conditions are varied before a prototype is actually built. See also VIRTUAL REALITY

computer graphics Illustrations produced on a COMPUTER. Simple diagrams and shapes may be produced by typing on the keyboard. Complex images require a mouse, painting or drawing SOFTWARE and often special graphics HARDWARE.

computerized axial tomography (CAT) Method of taking X-RAYS that provides images of "slices" through the body. Inside a CAT scanner is an x-ray source, which produces a narrow beam of radiation. This passes through a patient's body and is detected by an electronic sensor. The x-ray source and detector are rotated around the patient's body so that views are taken from all angles. A computer analyses the output of the sensor from each of these angles, and uses the information to build up a picture of the slice of the body.

computer language System of words and rules, based on normal language, in which a computer PROGRAM is written. The computer translates the language into binary coded instructions consisting of 0s and 1s (machine code) by which the computer actually works.

computer network Number of computers linked together for COMMUNICATIONS purposes. A typical local area network (LAN) links computers within the same building, enabling staff to exchange data and share printers. LANs may use low-power radio links or infrared radiation links. A wide area network (WAN) covers longer distances and may link LANs. The interconnections are made through public TELEPHONE services via electronic units called MODEMS, or through the INTEGRATED SERVICES DIGITAL NETWORK (ISDN), a dedicated high-speed line that carries digital signals. See also INTERNET computer program See PROGRAM

computer virus Part of a computer PROGRAM designed to disrupt the operation of a computer, such as the irretrievable loss or alteration of data. Viruses in widely circulated free software may infect computers worldwide. A virus may remain undetected for months and then suddenly activate.

COMSAT See Communications Satellite (COMSAT)

Comte, Auguste (1798-1857) French philosopher, the founder of Positivism. He proposed the law of the three stages (theological, metaphysical and positive) that represent the development of the human race. In the first two stages, the human mind finds religious or abstract causes to explain phenomena. While in the third, explanation of a phenomenon is found in a scientific law. He influenced John Stuart MILL and was the founder of SOCIOLOGY. His works include System of Positive Polity (1830-42) and Politique Positive (1851-54). Conakry Capital city of Guinea, w Africa, on Tombo Island, in the Atlantic Ocean. Founded in 1884, it is a major port and the administrative and commercial centre of Guinea. It has an airport. It exports alumina and bananas. Pop. (1983) 705,300. concentration camp Detention centre for military or political prisoners. The first were set up by the British for Afrikaner civilians during the SOUTH AFRICAN WARS (1899-1902). The most notorious were those established by the Nazi regime in Germany in the 1930s for political opponents, and people considered racially or socially undesirable. Some of these camps provided slave labour while others were the sites of mass execution. In Poland, more than 6 million people (mostly Jews) were murdered in the gas chambers. GULAGS were widely

► computer graphics A graphics pad is a method for inputting information to a computer. It allows the operator to "draw" on the computer with a pen or stylus (1) via the pad (2). Just below the surface of the pad are current-carrying filaments (shown blue and green). The pen has a magnet in the tip (3). As the pen moves across the pad, the magnet interferes with the magnetic fields (4) created by the filaments sending the location of the pen to the computer. The location of the interference is read hundreds of times a second by a chip, providing a constant stream of co-ordinates

employed during Stalin's purges, and reeducation camps were used in the Chinese CULTURAL REVOLUTION and by the KHMER ROUGE. See also Auschwitz; Belsen; Buchenwald; Dachau conceptualism Philosophical theory in which the universal is found in the particular, a position between NOMINALISM and REALISM. It asserts that the mind is the individual that universalizes by experiencing particulars, finding common factors in them, and conceptualizing these common factors as universals. concerto Musical work for instrumental soloists accompanied by orchestra. The earliest concertos are the 17th century Concerto grosso (a small section of soloists on various instruments, the concertino, is contrasted with the full orchestra, the ripieno) written by Corelli and Torelli. J.S. BACH's Brandenburg Concertos are fine examples of this form. VIVALDI composed most of his concertos for one soloist and orchestra and used the three-movement form (fast-slow-fast) which was to become standard in CLASSICAL MUSIC, such as the brilliant concertos of MOZART and BEETHOVEN. In the 19th century, concertos involved increasing virtuosity, particularly in the works of Liszt and RACHMANINOV. Concertos have also been written for two or three soloists (double and triple concertos). conclave Originally a place of private or secret assembly, then the assembly itself. More particularly, the term denotes the assembly of CARDINALS that meets to elect a new pope.

Concord Capital of New Hampshire, USA, on the Merrimack River. Founded as a trading post (1660), it was settled in 1727. It was the scene of New Hampshire's ratification of the Constitution as the ninth and deciding state on 21 June 1788, and designated state capital in 1808. Quarries N of the city produce the famous white granite used for the Library of Congress (Washington, D.C.) and the Museum of Modern Art (New York City). An industrial and financial centre, industries include electrical equipment and printing. Pop. (1992) 36,364. concordat Agreement between church and state, regulating relations between them on matters of common concern. The term is usually applied to treaties between individual states and the VATICAN.

Concorde Supersonic passenger aircraft. British Aircraft Corporation and Aerospatiale of France jointly developed and built Concorde. Test flights started in 1969, and passenger services started in 1976.

concrete Hard, strong building material made by mixing Portland CEMENT, sand, gravel and water. It is an important building material. It can be reinforced by embedded steel rods. Pre-stressed concrete contains piano wires instead of steel. Its modern use dates from the early 19th century, although the Romans made extensive use of concrete.

Condé (1530–1830) Junior branch of the French royal house of BOURBON. Notable members of the line included Louis I, Prince de Condé (1530–69), a HUGUENOT leader. The third prince was Henry II (1588–1646), a Catholic, who was arrested for blackmail and sedition (1616), but was reconciled to the crown under LOUIS XIII. Louis II, the Great Condé (1621–86), was a famous general. Victorious against Spain at Rocroi (1643), he was later involved in the civil conflict known as the FRONDES, opposing the Regent Anne and Cardinal MAZARIN. Louis Joseph de Bourbon-Condé (1736–1818) led the émigré nobility during the FRENCH REVOLUTION.

condensation Formation of a liquid from a gas or vapour, caused by cooling or an increase in pressure. More particularly, it is the changing of water vapour in the air into water droplets, forming mist, cloud, rain, or drops on cold surfaces. **condenser** *See* CAPACITOR

conditioning In experimental psychology, learning in which human or animal subjects learn to respond in a certain way to a stimulus. Most of the procedures and terminology of classical conditioning stem from the work of Ivan PAVLOV, while operant conditioning was first described by B.F. SKINNER.

condor Common name for two species of the American VULTURE: the black Andean condor (*Vultur gryphus*) and the rare grey-brown California condor (*Gymnogyps californianus*). They are two of the largest flying birds and feed on partly rotted carrion. Length: up to 127cm (50in). Wing-span: up to 3.5m (10ft).

conductance Ability of a material to conduct electricity. In

a direct current (DC) circuit, it is the reciprocal of electrical resistance. In an alternating current (AC) circuit, it is the resistance divided by the square of impedance (the opposition of a circuit to the passage of a current). SI units of conductance are siemens (symbol S). See also ELECTRIC CURRENT

conduction Transfer of heat within a body. If one end of a metal rod is placed in a flame, the heat energy received causes increased vibratory motion of the molecules in that end. These molecules bump into others farther along the rod, and the increased motion is passed along until finally the end not in the flame becomes hot.

conductivity Measure of the ease with which a material allows electricity or heat to pass through it. For a solid substance, the electrical conductivity is the CONDUCTANCE. See also ELECTRIC CURRENT

conductor In music, a person who coordinates the performance of a band, orchestra or choir and directs and inspires the interpretation of the music. Before the 19th century, a harpsichordist or first violinist "directed" orchestral playing. As the size of orchestras increased it became common practice for a musician to stand before the players and conduct with a baton. conductor Substance or object that allows easy passage of free electrons. Conductors have a low electrical RESISTANCE. Metals, the best conductors, have free electrons that become an ELECTRIC CURRENT when made to move. The resistance of a metallic conductor increases with temperature because the lattice vibrations of atoms increase and scatter the free conduction electrons.

cone Solid geometric figure swept out by a line (generator) that joins a point moving in a closed curve in a plane, to a fixed point (vertex) outside the plane. In a right circular cone, the vertex lies above the centre of a circle (base), and the cone's generators join the vertex to points on the circle. Such a cone has a volume $^1/_3\pi r^2h$ and a curved surface area πrs , where h is the vertical height, s the slant height, and r the radius of the base.

Confederate States of America (Confederacy) Southern states that seceded from the Union following the election of Abraham Lincoln. South Carolina left in December 1860, and was followed closely by Alabama, Florida, Georgia, Louisiana, Mississippi and Texas. In March 1861, Jefferson Davis was elected president and a new constitution protected STATES' RIGHTS and retained SLAVERY. A capital was established at Montgomery, Alabama. On 12 April, the US CIVIL WAR began and Arkansas, North Carolina, Tennessee and Virginia joined the Confederacy. The capital was moved to RICHMOND, Virginia. The Confederacy, despite its cotton trade, received little external support and internal division contributed to its defeat and dissolution in April 1965.

Confederation, Articles of See Articles of Confedera-

Confederation of British Industry (CBI) UK organization founded in 1965 to promote the prosperity and interests of British industry. Financed by *c*.250,000 companies, which

⋖ computer network The most common local area network (LAN) provides a communication link for all office computers and nrinters (A) From a single cable (1), spurs (2) lead to individual machines. A machine sends (3) an address code at the start of each message. Receiving machines (4) return a message, consisting of an address code and confirmation. When two machines send messages simultaneously they collide (5). The electronic shock wave (6), produced when the messages hit, are picked up by all the machines on the LAN. The machines suspend message-sending for a random length of time (7), before repeating the message (8).

▲ condor The Andean condor (Vultur gryphus) is a type of vulture. With a wing span of up to 3m (10ft), the Andean condor feeds mainly on carrion, but will take young lambs or deer.

are its members, the CBI advises the government on policy affecting the interests of industry.

confession Acknowledgement of sins. In the Jewish and Christian traditions, it may be made by a congregation in the course of worship, or by individual penitents.

confirmation Sacrament of the Christian Church by which the relationship between God and an individual, established by BAPTISM, is confirmed or strengthened in faith. Candidates for confirmation take the baptismal vows previously made on their behalf by godparents, and confirm the intention to keep them.

Confucianism Philosophy that dominated China until the early 20th century and still has many followers, mainly in Asia. It is based on the *Analects*, sayings attributed to Confucius. Strictly an ethical system to ensure a smooth-running society, it gradually acquired quasi-religious characteristics. Confucianism views man as potentially the most perfect form of *li*, the ultimate embodiment of good. It stresses the responsibility of sovereign to subject, of family members to one other, and of friend to friend. Politically, it helped to preserve the existing order, upholding the status of the Mandarins. When the monarchy was overthrown (1911–12), Confucian institutions were ended, but after the Communist Revolution (1949), many Confucian elements were incorporated into Maoism.

Confucius (551–479 BC) (K² ung-fu-tzu) Founder of Confucianism. Born in Lu, he was an excellent scholar and became an influential teacher of the sons of wealthy families. He is said to have been prime minister of Lu, but he resigned when he realized the post carried no real authority. In his later years he sought a return to the political morality of the early Zhou dynasty. *See also* Chinese Literature

congenital disorder Abnormal condition present from birth caused by faulty development, infection, or the mother's exposure to drugs or other toxic substances during pregnancy. SPINA BIFIDA is such a condition.

conglomerate In geology, a sedimentary rock made up of rounded pebbles embedded in a fine matrix of sand or silt, commonly formed along beaches or on river beds.

Congo Equatorial republic in w central Africa; the capital is BRAZZAVILLE. The main port is Pointe Noire, on the Gulf of

Guinea. Land and climate Congo generally has a hot, wet equatorial climate. Its narrow, treeless coastal plain is dry and cool due to the Benguela Current, which flows N along the coast. Inland, the River Niari has carved a fertile valley through the forested highlands. Central Congo consists of luxuriant savanna. Tree species include the valuable okoumé and mahogany. The N contains large swamps in the tributary valleys of the Congo and Ubangi rivers. History and Politics Between the 15th and 18th centuries, part of Congo probably belonged to the huge Kongo kingdom. The Congo coast became a centre of the European slave trade. European exploration of the interior took place in the late 19th century, and the area became a French protectorate in 1880. It was later governed as part of a larger region called French Equatorial Africa and remained under French control until 1960. In 1964 Congo adopted Marxism-Leninism as the state ideology. The military, led by Marien Ngouabi, seized power in 1968. Ngouabi created the Congolese Workers Party (PCT). In 1977 Ngouabi was assassinated, but the PCT retained power under Colonel Sassou-Nguesso. In 1990 the PCT renounced Marxism and Sassou-Nguesso was deposed. Multi-party elections in 1992 were won by the Pan-African Union for Social Democracy (UPADS), led by Pascal Lissouba. The 1997 election was postponed as Congo was riven by conflict between government forces and supporters of Sassou-Nguesso. Economy Congo is a lower-middle-income developing country. More than 60% of the workforce is engaged in subsistence agriculture. Major food crops include bananas, cassava, maize and rice, while cash crops are coffee and cocoa. Congo's main exports are oil (70% of the total) and timber.

Congo (Zaïre River) River in central and w Africa; the second-longest in the continent. It rises in s Zaïre and flows in a massive curve to the Atlantic Ocean for 4,670km (2,900mi). Its rate of flow and size of drainage basin make it Africa's largest untapped source of hydroelectric power. The chief ocean port is Matadi, the major river ports are KINSHASA and KISANGANI. The main headstream is the Lualaba, and the Kasai and Ubangi are among its many large tributaries.

congregationalism Christian church denomination in which local churches are autonomous; members have been called Brownists, Separatists and Independents. It is based on the belief that Christ is the head of the church and all members are God's priests. Modern Congregationalism began in England in c.1580. In the UK, the Congregational Church in England and Wales merged with others to form the United Reformed Church (1972). In the USA the Congregational Christian Churches united with others to form the United Church of Christ (1957).

Congress Legislative branch of the US federal government established by the US CONSTITUTION (1789). The first meeting of Congress took place in 1789 in New York City. Congress comprises the SENATE (the upper house) and the HOUSE OF REP-RESENTATIVES (the lower house). The main powers of Congress include the right to assess and collect taxes, introduce legislation, regulate commerce, propose constitutional amendments, mint money, raise and maintain armed forces, establish lower courts and declare war. Legislation must be passed by both houses and the president to become law. If the president uses his power of veto, Congress can still pass the bill with a twothirds majority in each house. A resident commissioner from Puerto Rico, and delegates from Guam, the Virgin Islands, and the District of Columbia complete the composition of Congress. The Senate can approve treaties and presidential appointments and tries the president if he is impeached. The House of Representatives initiates all tax bills and has the power to impeach the president. The Constitution requires that Congress meet at least once every year, and the president may call special sessions. The preparation and consideration of legislation is largely accomplished by the 17 standing committees in the Senate and the 21 in the House of Representatives. There are additional commissions and committees, some of which are composed of members from both Houses.

Congress of Industrial Organizations (CIO) See American Federation of Labor and Congress of Industrial Organizations (AFL-CIO)

CONGO

AREA: 342,000sq km (132,046sq mi)
POPULATION: 2,368,000
CAPITAL (POPULATION):
Brazzaville (937,579)
GOVERNMENT: Multiparty republic
ETHNIC GROUPS: Kongo
52%, Teke 17%, Mboshi
12%, Mbete 5%
LANGUAGES: French (official)
RELIGIONS: Christianity

(Roman Catholics 54%,

Protestants 25%, African

Christians 14%), traditional beliefs 5%

CURRENCY: CFA franc = 100 centimes

Congress of Racial Equality (CORE) US civil rights organization, founded in 1942 by James Farmer. It employed sit-ins, picketing and boycotting tactics to combat discrimination in employment.

Congress Party (officially Indian National Congress) Oldest political party in India, whose fortunes have often been intertwined with the Nehru dynasty. It was founded in 1885. but was not prominent until after World War 1, when Mahatma GANDHI transformed it into a mass independence movement, agitating by means of civil disobedience. Jawaharlal NEHRU became president of the Congress in 1929. In the 1937 provincial elections it gained power in many states. During World War 2 (after the British refused to grant selfgovernment) it remained neutral. At independence (1947), Nehru became prime minister. Nehru's daughter Indira GANDHI became prime minister in 1966, but in 1969 was challenged by a right wing faction (led by Moraji Desai) causing a split in the party. Indira's Congress (I) suffered a landslide defeat at the elections of 1977. They returned to power in 1979, and in 1984 (after Indira's assassination) her son Rajiv GANDHI became leader, securing the party's reelection in that year. Congress were defeated in 1989, and Rajiv was assassinated in 1991. He was succeeded by V.P. Singh, head of the breakaway Janata Dal. The Congress Party, led by Narasimha Rao, heavily lost the 1996 election. congress system Attempt during the early 19th century to conduct diplomacy through regular conferences between the European allies that had defeated Napoleonic France. It orig-

The reproductive cycle of the ponderosa pine is typical of many conifers. In summer, the mature tree bears both female cones (1) and male cones (2). A scale from the female cone (3) contains two ovules (4). Within each ovule, a spore cell (5) divides to develop into a female gametophyte (6). A scale from the male cone (7) contains many spores (8). Each of these develops into a male gametophyte within a winged pollen grain (9). This process lasts one year. Pollination occurs early the next summer, when female cones open so

that airborne pollen grains enter an ovule. Inside the ovule, the female gametophyte develops two ova (11). Fertilization occurs during the spring of the following year, after the male gametophyte has matured and grown a pollen tube, and the cone closes (13). Within the female gametophyte, the fertilized ova (zygote) develops into an embryo (14); and around it, a tough, winged seed case is formed (15). In the autumn of the second year, the female cone opens (16), and seeds are dispersed by wind, ready to germinate (17).

inated in the TREATY OF PARIS (1815). The four powers (Austria, Britain, Prussia and Russia) met in 1818, 1820 and 1821. Britain withdrew from the Congress of Verona (1822) after opposing proposals to intervene against revolutionary forces in South America and elsewhere. Differences between the three remaining powers at St Petersburg in 1825 caused the abandonment of the system.

Congreve, William (1670–1729) English dramatist who wrote comedies such as Love for Love (1695) and The Way of the World (1700). His elegant satire represents the peak of RESTORATION THEATRE. He also wrote a tragedy, The Mourning Bride (1697).

conic (conic section) Curve found by the intersection of a plane with a cone. Circles, ellipses, parabolas or hyperbolas are conic sections. Alternatively a conic is the locus of a point that moves so that the ratio of its distances from a fixed point (the focus) and a fixed line (the directrix) is constant. This ratio is called the eccentricity (e): e = 1 gives a parabola, e > 1a hyperbola, e<1 an ellipse, and e=0 a circle.

conifer Cone-bearing trees, generally evergreen, such as pines, firs and redwoods. Some are the Earth's largest plants, reaching heights of up to 99m (325ft). They are a major natural resource of the Northern Hemisphere. See also GYMNOSPERM Connecticut State in NE USA; its state capital and largest city is HARTFORD. One of the original 13 colonies, Connecticut was first settled by the English in the 1630s. Puritans flocked to the area, and in 1662 the colony received a charter from Charles II. Connecticut was one of the first states to ratify the US Constitution and was admitted to the union in 1788. The Connecticut River valley separates the w and E highlands. The state economy is based on manufacturing. Industries: transport equipment, machinery, chemicals, metallurgy. Hartford is one of the world's leading insurance centres. Dairy produce, eggs and tobacco are the main farm products. Fishing is also important. Area 12,549sq km (4,845sq mi). Pop. (1990) 3,287,116.

connective tissue Supporting and packing tissue that helps to maintain the body's shape and hold it together. Bones, ligaments, cartilage and skin are all types of connective tissue.

Connery, Sean (1930-) Scottish film actor. Connery starred in Dr No (1962), the first adaptation of Ian FLEMING's James Bond spy stories. He went on to make a further six Bond films, including Diamonds are Forever (1971) and Never Say Never Again (1983). Keen to escape typecasting, Connery established himself as a versatile character actor, in films such as The Name of the Rose (1986). He won an Academy Award as Best Supporting Actor for The Untouchables (1987).

Connolly, James (1870-1916) Irish nationalist leader. He went to the USA in 1903, and helped establish the INDUSTRI-AL WORKERS OF THE WORLD (IWW). Returning to Ireland, he united Belfast's dock workers and then helped organize the Dublin transport workers' strike (1913). He was a leader in the EASTER RISING of 1916 and was executed by the British. Connors, Jimmy (James Scott) (1952-) US tennis player. Connors won more Grand Prix singles titles (109) than any other player. In 1974, he won the US, Australian and Wimbledon singles titles. He went on to win the US Open four more times (1976, 1978, 1982-83) and Wimbledon in 1982. He also won doubles titles with Ilie Nastase. conquistador Leader of the Spanish conquest of the New

World in the 16th century. Conquistadores ("conquerors") were often ex-soldiers unemployed since the completion of

CONNECTICUT Statehood:

9 January 1788 Nickname:

Constitution state

State bird : Rohin

State flower:

Mountain laurel State tree :

White oak State motto :

He who transplanted still sustains

◄ Connery Sean Connery appeared in seven Bond films: Dr No (1962), From Russia with Love (1963), Goldfinger (1964), Thunderball (1965), You Only Live Twice (1967), Diamonds Are Forever (1971) and Never Say Never Again (1983). His performance in The Untouchables (1987) led to a succession of roles in Hollywood action films, such as Indiana Jones and the Last Crusade (1989).

the Christian reconquest of Spain. The most famous were Hernán Cortés and Francisco Pizarro.

Conrad IV (1228–54) German king (1237–54) and king of Sicily and Jerusalem (1250–54). Son of FREDERICK II, he was elected German king (emperor-elect, 1237). When Pope Innocent IV deposed Frederick in 1245 and named an anti-king to replace Conrad in 1246, Germany was plunged into war. Conrad inherited Sicily and Jerusalem upon Frederick's death, but was never crowned emperor. *See also* HOLY ROMAN EMPIRE

Conrad, Joseph (1857–1924) British novelist and shortstory writer, b. Poland. His eventful years as a ship's officer in Asian, African and Latin American waters informed the exotic settings of many of his novels. He was a central figure in the development of literary MODERNISM. His major works include The Nigger of the Narcissus (1898), Lord Jim (1900), Heart of Darkness (1902), Nostromo (1904), The Secret Agent (1907), Under Western Eyes (1911) and Victory (1915).

conscription Compulsory enlistment of people for service in the armed forces. In Britain, conscription was used in both World Wars and continued as National Service until 1962. In the USA, conscription was used during the Civil War, but dropped until 1940 when it was reintroducedand continued until 1973. In 1980 Congress reinstated the draft.

conservation Preservation of nature and natural resources. Conservation includes protecting the landscape from change due to natural erosion; using soil conditioners and artificial fertilizers to maintain soil fertility; replacing topsoil and landscaping spoiled land and protecting threatened species of animals and plants by law or in wildlife parks and reservations.

conservation, laws of Physical laws stating that some property of a closed system is unaltered by change in the system; it is conserved. The most important are the laws of conservation of matter and energy. Mass and energy are interconvertible according to the equation $E = mc^2$; what is conserved is the total mass and its equivalent in energy.

conservatism Political stance seeking to preserve the historic continuity of a society's laws, customs, social structure and institutions. Its modern expression derives from the response, first in Germany, to the liberal doctrines of the Enlightenment and the French Revolution. Rather than an abstract notion of human rights and the application of radical reform conservatives favour gradual piecemeal changes which address practical grievances. *See also* Christian Democrats; Conservative Party

Conservative Party (officially Conservative and Unionist Party) Oldest political party in Britain. Its origins lie in the transformation of the early 19th-century Tory Party into the Conservative Party under Sir Robert PEEL in the 1830s. Until late in the 19th century it was mainly a party of landed interests, and depended electorally on the county constituencies. After the Reform Act (1867) and the establishment of a central office in 1870, the urban and commercial element in the party increased. In 1886, the split in the LIBERAL PARTY over Irish home rule brought Liberal Unionists into the party. It was in power for 31 of the 71 years between 1834 and 1905 and for most of the 1920s and 30s, either alone or in coalition. It held office in 1951-64 and 1970-74. In 1979 the party swung to the right under the leadership (1975-90) of Margaret THATCHER. With the support of traditional Labour Party voters, it was able (under Thatcher and John MAJOR) to win four consecutive elections. Following electoral defeat in 1997, William Hague became the youngest leader of the party since William Pitt.

Constable, John (1776–1837) British painter, a leading western landscapist. He attended the Royal Academy (1795–1802) and studied the paintings of CLAUDE LORRAIN. He studied every effect of clouds and light on water, often using broken colour and a thick impasto texture. His first success came when *The Haywain* (1821) and *View on the Stour* (1817) were shown at the 1824 Paris Salon, although recognition in England only came after his death. He had a great impact on French romantic artists, notably DELACROIX.

Constance, Council of (1414–18) Ecumenical council that ended the GREAT SCHISM. It was convoked by the antipope John XXIII. Martin V was elected in 1417. The Council attempted to combat heresy, notably that of Jan Hus.

Constant (de Rebecque), (Henri) Benjamin (1761–1830) French political writer, b. Switzerland. A member of Napoleon's tribunate (1799–1802), he went into exile in 1803. After the BOURBON restoration he was leader of the liberal opposition (1819–22, 1824–30). His chief work was the psychological novel *Adolphe* (1816), a fictionalized account of his relationship with Madame de STAËL.

constant In mathematics, a quantity or factor that does not change. It may be universal, such as the ratio of the circumference of a circle to its diameter, or it may be particular, such as a symbol that has a fixed value in an algebraic equation.

Constanta City in E Romania, on the Black Sea. Founded in the 7th century BC as a Greek colony, it was taken by the Romans in 72 BC and named in the 4th century AD by the emperor Constantine. It is Romania's chief port and a major trade centre. It has Roman and Byzantine ruins, several mosques and a naval and air base. Industries: shipbuilding, oil refining, textiles. Pop. (1992) 350,476.

Constantine I (the Great) (285–337) Roman emperor (306–37) and founder of the Christian empire. A series of feuds for control of Italy ended when Constantine adopted Christianity and defeated Maxentius (312). Constantine and Licinius signed the Edict of Milan (313), which extended tolerance to Christians throughout the empire. In 324 Constantine defeated Licinius and became sole ruler of the empire. He presided over the first council of the Christian church at NICAEA (325), which condemned ARIANISM. Constantine rebuilt (330) Byzantium as his capital and renamed it Constantinople (modern-day ISTAN-BUL). Constantine centralized imperial power, but divided the empire on his death. Historians debate whether his Christianity was born of conviction or political expediency.

Constantinople Former name of ISTANBUL

constellation Grouping of stars, forming an imaginary figure traced on the sky. The groupings have no physical basis as each star is a different distance from Earth. There are 88 constellations that have been assigned boundaries on the CELES-TIAL SPHERE by the International Astronomical Union in 1930. constitution Code of laws or collection of customary practices delineating the powers and organization of the various organs of government within a nation, and some of the rights and obligations of its citizens. See also Constitutional Law Constitutional Convention (1787) Meeting of delegates, in Philadelphia, from 12 of the 13 US states (Rhode Island abstained), which resulted in the creation of the US Constitution. The Convention was called to revise the ARTICLES OF CONFEDERATION and to redress the lack of power wielded by the existing government structure. There was demand for a more stable and centralized federal government that had tighter monetary control. The major disagreement centred on how each state should determine its share of this centralized power. A bicameral system was agreed, whereby the House of Representatives was elected according to population, and the Senate was chosen by the states.

constitutional law Procedures and doctrines defining the operation of the constitution of a state. In states with a written constitution, courts often have specific powers relating to the constitution and likely points of conflict. In the USA, where there is a federal system of government, the SUPREME COURT often resolves conflict between the individual states and the central government. In countries without a written constitution, such as Britain, constitutional law is more imprecise and problems are addressed within the political process.

Constitution of the United States Fundamental laws and basis of government of the USA. Adopted by the Constitutional Convention in Philadelphia in September 1787 it was ratified by the 13 states in 1788–90. It replaced the Articles of Confederation (1781), which had proved inadequate, giving too much power to each state at the expense of central government. It was designed to create a system of "checks and balances", to prevent one branch of government gaining dominance over others. Opponents who feared that the federal government would be too powerful and the rights of the individual unprotected succeeded in having ten amendments, collectively known as the BILL of Rights, added to the Constitution. The US Constitution was designed not as a code of laws,

but as a statement of principles to which laws should adhere, thus allowing considerable flexibility in judicial interpretation. **constructivism** Russian ABSTRACT ART movement founded c.1913 by Vladimir TATLIN. Other leading members were the brothers Naum GABO and Antoine Pevsner. Influenced by CUBISM and FUTURISM, their sculptures were less purely abstract than Tatlin's geometric constructions and attempted to relate to contemporary technology. From 1921 the Soviet regime condemned the movement and Gabo and Pevsner left Russia. Through them, and other exiles, constructivism spread and influenced modern European architecture and sculpture.

consul One of the two chief magistrates of ancient Rome. The office was said to have been established in 510 BC. Consuls were elected each year to administer civil and military matters. After 367 BC, one consul was a PATRICIAN, the other a PLEBEIAN, each having the power to veto the other's decisions. **consumerism** Belief that consumers should influence the policies and practices regulating the standards and methods of manufacturers, advertisers and sellers. Interest in consumerism first arose in the 1960s, with Ralph Nader in the USA responsible for raising the issue in the public consciousness.

consumption See TUBERCULOSIS

contact lens Lenses worn on the CORNEA to aid defective vision. The earliest contact lenses were made of glass, but since 1938 plastic has generally been used.

contempt In law, disorderly conduct in a court or legislative body, or action performed elsewhere that tends to obstruct the work of a court or legislative body, or bring it into disrepute. continent Large land masses on the Earth's surface. The continents are Europe and Asia (or Eurasia), Africa, North AMERICA, SOUTH AMERICA, AUSTRALIA and ANTARCTICA. They cover about 30% of the Earth above sea level and extend below sea level forming continental shelves. All continents have four components which make up the continental crust. Shields are areas of relatively level land less than a few hundred metres above sea level, and consist of crystalline rocks. Stable platforms are areas that have a thin covering of sedimentary rock. Sedimentary basins are broad deep depressions filled with sedimentary rocks formed in shallow seas. Folded mountain belts are younger sedimentary rocks in long, linear zones of intensely folded and faulted rocks that have been metamorphosed and intruded by igneous and volcanic activity. The continental crust is composed of rocks that are less dense than the basaltic rocks in ocean basins, moving position over the surface of the Earth very slowly by CONTI-NENTAL DRIFT. Its thickness is mainly between 30 and 40km (20-25mi) except under large mountain chains where thickness can be 70km (45mi). See also PLATE TECTONICS

Continental Congress (1774–89) Federal legislature of the American colonies during the AMERICAN REVOLUTION and the period of Confederation. Its first meeting, at Philadelphia in September 1774, resulted in unified opposition to British rule and agreed on a boycott of trade with Britain. The Congress reconvened in May 1775 and appointed George WASHINGTON to command the American army. In July 1776 the Second Congress adopted the DECLARATION OF INDEPENDENCE and drafted the ARTICLES OF CONFEDERATION. The adoption of the US CONSTITUTION (1787) made it redundant, although it continued to meet until 1789.

continental drift Theory that the continents change position very slowly, moving over the Earth's surface at a rate of a only a few centimetres per year, adding up to thousands of kilometres over geological time. Early supporters of continental drift claimed that the jigsaw shapes of the present day continents could be pieced together to form an ancient land mass which,

at sometime in the past, split and drifted apart. Evidence for this theory included matching the outlines of continents, rock types, geological structures and fossils. Continental drift became accepted with the development of PLATE TECTONICS in the 1960s. In recent years, continental movement has been measured by global positioning satellites using laser beams.

continental margin Region of the ocean floor that lies between the shoreline and the abyssal ocean floor. It includes the continental shelf, the continental slope and the continental rise. The continental shelf slopes gently seawards, between the shoreline and the top of the continental slope. Between the continental shelf and the continental rise is the continental slope which leads into deep water. The continental rise, at the foot of the slope, is an area of thick deposits of sediments.

Contra Right-wing Nicaraguan revolutionary group active between 1979 and 1990. Supporters of the former dictator General Anastasio Somoza, ousted in 1979, the Contra aimed to overthrow the elected, left-wing Sandinista government. The Contra received financial and military assistance from the US government from mid-1986. Elections were subsequently held in Nicaragua in 1990, at which the US-funded Union of National Opposition (UNO), effectively the political wing of the Contra, was victorious. The Contra were officially disbanded, but social conditions within Nicaragua remained unstable. See also Iran-Contra AFFAIR

contraception (birth control) Use of devices or techniques to prevent pregnancy. The PILL is a hormone preparation that prevents the release of an egg (OVUM) and thickens the cervical mucus. The intra-uterine device (IUD) is a small spring made from plastic or metal inserted into the womb. It stops the fertilized egg embedding itself in the uterine lining. Barrier methods include the male and female condom and the diaphragm. The male condom is a latex sheath which covers the penis and collects the ejaculated semen; the female condom lines the inside of the vagina, preventing any sperm entering the womb. The use of condoms is widely advocated because they help protect against some sexually transmitted diseases, including ACQUIRED IMMUNE DEFICIENCY SYN-DROME (AIDS). Devices, such as diaphragms or caps, cover the cervix thus preventing sperm entering the womb. Less effective is the "rhythm method" which involves the avoidance of sex on days when conception is most likely (when the woman is ovulating). It is not a reliable method as ovulation cannot always be predicted accurately. Emergency contraception, known as the "morning-after pill", can be taken up to 72 hours after unprotected sexual intercourse; it prevents the fertilized ovum embedding itself in the womb. It is not suitable to be used regularly. See also SEXUAL REPRODUCTION

contract In law, an agreement between parties that can be legally enforced. A contract creates rights and obligations which can be enforced by law.

contralto Lowest range (below SOPRANO and MEZZO-SOPRANO) of the female singing voice. A male voice in this range is called a COUNTERTENOR. *See also* ALTO

convection Transfer of heat by flow of currents within fluids (gases or liquids). Warm fluids have a natural tendency to rise (because they are less dense), whereas cooler fluids tend to fall. This movement subsides when all areas of the fluid are at the same temperature. Convection in the form of winds is the main method of heat transfer from one part of the Earth to another. Liquid convection is used in a car's cooling system and some domestic central-heating systems.

convection current In geology, heat generated from radioactivity deep within the Earth's MANTLE causing rock to flow towards the CRUST. At the top of the mantle the rising

▼ continental drift About 200 million years ago, the original Pangaea land mass began to split into two continental groups, which further separated over time to produce the present-day configuration.

trench

new ocean floor
zones of slippage

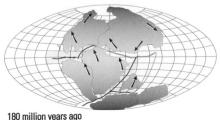

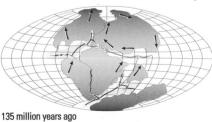

► Cook The map shows the three voyages of the British explorer Captain James Cook between 1768 and 1779. By sailing south into Antarctic waters and accurately charting the coastline of Australia and New Zealand, he won a new continent for the British crown. On his second voyage, Cook crossed Antarctica. On the third voyage, he set out to discover a western entrance to a possible Northwest Passage. After surveying the Bering Strait, he was killed by Hawaiian islanders.

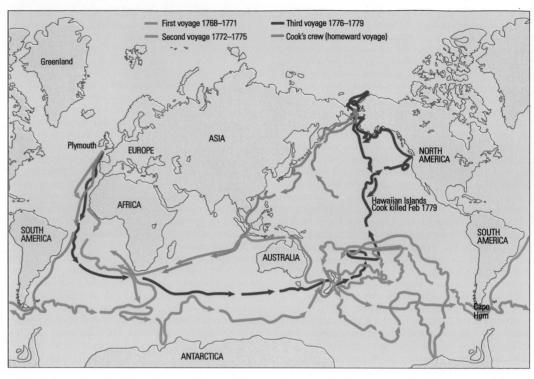

rock is deflected laterally below the crust before sinking. This mantle convection is thought to be the process driving PLATE TECTONICS.

convolvulus See BINDWEED

convulsion Intense, involuntary contraction of the muscles, sometimes accompanied by loss of consciousness. A seizure may indicate EPILEPSY although there are other causes, including intoxication, brain abscess or HYPOGLYCAEMIA.

Conway Cabal (1777) A US plot, supposedly led by Thomas Conway, to remove George WASHINGTON as commander and replace him with Horatio GATES.

Cook, James (1728–79) British naval officer and explorer. He demonstrated his remarkable navigational talent charting the approaches to Quebec during the Seven Years War. In 1768–71 he led an expedition to Tahiti to observe the transit of Venus and investigate the strategic and economic potential of the South Pacific. This accomplished, he conducted a survey of the unknown coasts of New Zealand and charted the E coast of Australia, naming it New South Wales and claiming it for Britain. On a second expedition to the S Pacific (1772–75), Cook charted much of the Southern Hemisphere and circumnavigated Antarctica. On his last voyage (1776–79), he discovered the Sandwich (Hawaiian) Islands, where he was killed in a dispute with the inhabitants. Cook is generally regarded as the greatest European explorer of the Pacific in the 18th century.

Cook, Robin British statesman, foreign secretary (1997–). Cook entered parliament in 1974. A skilful parliamentary speaker, he held various posts (1987–97) in Labour's shadow cabinet. As foreign secretary, Cook announced Labour's intention to pursue an ethics-based foreign policy.

Cook Islands Group of about 15 islands in the s Pacific Ocean, NE of New Zealand, consisting of the Northern (Manihiki) Cook Islands and the Southern (Lower) Cook Islands; a self-governing territory in free association with New Zealand. Discovered (1773) by Captain James Cook, the islands became a British protectorate in 1888 and were annexed to New Zealand in 1901. They achieved self-governing status in 1965. Products: copra, citrus fruits. Area: 293sq km (113sq mi). Pop. (1986) 17,463.

Coolidge, (John) Calvin (1872–1933) 30th US president (1923–29). Stern action in the Boston police strike of 1919 earned him the Republican nomination as vice president in 1920. He became president on the death of Warren HARDING in 1923 and was re-elected in 1924. A conservative with no

dramatic political programme, his administration was characterized by minimal government interference in business and commerce, summed up by his phrase, "the business of America is business". He declined to stand for re-election in 1928.

Cooper, James Fenimore (1789–1851) US novelist. One of the earliest American novelists and among the first to gain international recognition. His most successful works were the romantic "Leatherstocking Tales" about the frontier, of which the best known are The Pioneers (1823), The Last of the Mohicans (1826) and The Deerslayer (1841). He also wrote a number of novels about life at sea, including The Pilot (1823). cooperative movement Variety of worldwide organizations, founded to provide mutual assistance in economic enterprises for the benefit of their members. The first such movement was founded (1844) in England by the Rochdale Pioneers, who established a cooperative retail society to eliminate the middleman and share profits among its members. The cooperative movement has been extended to include cooperative agriculture, cooperative manufacturing (in which the workers own and manage their own plant) and cooperative banking and finance. See also Cooperative Party; COOPERATIVE WHOLESALE SOCIETY; Robert OWEN

► Coolidge His honesty and homespun philosophy made Calvin Coolidge a popular president. His term in office was distinguished by a "laissez-faire" approach to business. Many argue that his attitude towards commerce was partly responsible for the unsustainable bullishness of the US stock market in the 1920s.

Cooperative Party British political party, formed in 1917 as the political wing of the Cooperative Union. It is associated with the LABOUR PARTY and since 1946 all its parliamentary candidates have stood for election jointly as Labour cooperative candidates. Since 1959 it has limited the number of its candidates to 30.

Cooperative Wholesale Society Organization formed in the north of England in 1863 to provide for consumer cooperation. It was a development of the early cooperative experiments of Robert Owen and the Rochdale Pioneers, which encouraged consumers to form their own retail societies and share the profits among themselves, eliminating the middleman.

coordinate geometry (algebraic geometry) Branch of mathematics combining the methods of pure GEOMETRY with those of ALGEBRA. Any geometrical point can be given an algebraical value by relating it to coordinates, marked off from a frame of reference. Thus, if a point is marked on a square grid so that it is x_1 squares along the x axis and y_1 squares along the y axis, it has the coordinates (x_1, y_1) . Polar coordinates can also be used. It was first introduced in the 17th century by René Descartes. *See also* CARTESIAN COORDINATE SYSTEM

coot Aquatic bird of freshwater marshes. Related to the RAILS, it is a strong swimmer and diver. All coots have white bills and foreheads. The female lays 8–12 buff-coloured, brown-spotted eggs on a floating reed nest. Family Rallidae; genus *Fulica*.

Copenhagen (København) Capital and chief port of Denmark on E Sjaelland and N Amager Island, in the Øresund. A trading and fishing centre by the early 12th century, it became Denmark's capital in 1443. It has a 17th-century stock exchange, the Amalienborg palace (home of the royal family) and the Christianborgs Palace. Other sights include the Tivoli amusement park and the Little Mermaid sculpture. The commercial and cultural centre of the nation, it has shipbuilding, chemical and brewing industries. Pop. (1994) 620,970.

Copernicus, Nicolas (1473–1543) (Mikotay Kopernik) Polish astronomer. Through his study of planetary motions, Copernicus developed a heliocentric (Sun-centred) theory of the universe in opposition to the accepted geocentric (Earthcentred) theory conceived by PTOLEMY nearly 1,500 years before. In the Copernican system (as it is now called) the planets' motions in the sky were explained by their orbit of the Sun. The motion of the sky was simply a result of the Earth turning on its axis. An account of his work, *De revolutionibus orbium coelestium*, was published in 1543. Most astronomers considered the new system as merely a means of calculating planetary positions, and continued to believe in ARISTOTLE'S view of the world. *See also* GALILEO; KEPLER

Copland, Aaron (1900–90) US composer, especially known for combining folk and jazz elements with 20th-century symphonic techniques. His highly popular ballet music includes *Billy the Kid* (1938), *Rodeo* (1942) and *Appalachian Spring* (1944), which won a Pulitzer Prize. He wrote symphonies, chamber music and overtly patriotic pieces such as *A Lincoln Portrait* (1942). Less well known are Copland's experiments with serial techniques, as in *Piano Fantasy* (1957). He was also a conductor and an admired teacher.

Copley, John Singleton (1738–1815) US painter. An extraordinarily gifted draughtsman and colourist, he produced some ground-breaking historical paintings which introduced the notion of portraying subjects just because they were exciting. His notable paintings include *Colonel Epes Sargent* (c.1760), *The Boy with a Squirrel* (1765) and the history paintings *Brook Watson and the Shark* (1778) and *The Death of Major Peirson* (1783).

copper (symbol Cu) Metallic element, one of the transition metals. Reddish copper occurs native (free or uncombined) and in several ores including cuprite (an oxide) and chalcopyrite (a sulphide). The metal is extracted by smelting and is purified by ELECTROLYSIS. It is malleable, a good thermal and electrical conductor, second only to silver, and is extensively used in boilers, pipes, electrical equipment and alloys, such as brass and bronze. Copper tarnishes in air, oxidizes at high temperatures and is attacked only by oxidizing acids. Properties: at.no. 29; r.a.m. 63.546; r.d. 8.96; m.p. 1.083°C (1,981°F); b.p. 2,567°C (4,653°F); most common isotope Cu⁶³ (69.09%).

copperhead Any of various species of snakes, so-called because of their head colour. The N American copperhead is a pit viper, rarely over 1m (3ft) long. The Australian copperhead is a venomous snake of the cobra family, often reaching 1.5m (5ft) in length. The Indian copperhead is a rat snake.

Coppola, Francis Ford (1939–) US film director, producer and screenwriter. In 1969 Coppola established Zoetrope, an independent production company. He won an Academy Award for Best Picture for *The Godfather* (1972). Its sequel, *Godfather II* (1974), won him Oscars for Best Picture and Best Director. Coppola followed this success with *Apocalypse Now* (1975). During the 1980s, Coppola's output was less consistent. His credits included *Rumble Fish* (1983) and *Peggy Sue Got Married* (1986). In 1990 he made *Godfather*. *III*. Other films include *Dracula* (1992).

Coptic Church Ancient Christian church of Egypt and Ethiopia. Its members form 5–10% of Egypt's population. A few Copts are Catholics, but the majority adhere to the Monophysite creed, declared heretical in 451, which denies the humanity of Christ.

copyright Legal authority protecting an individual's or company's works of art, literature, music and computer programs from reproduction or publication without the consent of the owner of the copyright. Since the Universal Copyright Convention (1952) works must carry the copyright symbol (©) followed by the owner's name and the first year of publication. Computer software and programs are protected in the USA by the Copyright Act (1976) and Computer Software Act (1980), and in the UK by the Copyright (Computer Software) Amendment Act (1985). In the UK, the Copyright, Designs and Patents Act (1988) introduced the concept of "intellectual property" into law.

coral Small coelenterate marine animal of class Anthozoa, often found in colonies. The limestone skeletons secreted by each animal polyp accumulate to form a CORAL REEF. Reefbuilding corals are found only in waters with temperatures in excess of 20°C (68°F).

coral reef Rock formation found in shallow tropical seas. Such reefs are formed from the calcium carbonate secreted by living coral organisms as protection against predators and wave action. The way in which the coral, and therefore the reef, grows is strongly influenced by the prevailing currents and the temperature of the surrounding sea water.

Coral Sea Arm of the sw Pacific Ocean between the Great Barrier Reef off the E coast of Australia, Vanuatu (E) and New Guinea (NW). It was the scene of a US naval victory over the Japanese in 1942.

coral snake Poisonous burrowing snake of the Americas and SE Asia. It is shy and docile, but has fatal venom. Most species are brightly coloured, ringed with red, yellow and black. It feeds on lizards, frogs and other snakes. Family Elapidae.

cor anglais (English horn) Reed instrument of the OBOE family. Longer than the oboe, its range is a fifth lower. Its bell is pear-shaped and its double reed is inserted in a curved mouthpiece. A modern counterpart for the curved oboe da caccia in the music of J.S. Bach, parts have been scored for it in many 19th-century works, especially those of BERLIOZ and WAGNER. **Corbusier, Le** See LE CORBUSIER

Córdoba (Cordova) City on the River Guadalquivir, s Spain; capital of Córdoba province. A flourishing centre of learning under Abd ar-Rahman III (first caliph of Córdoba), it was captured (1236) by Ferdinand III of Castile, who imposed Christian culture on the city. There are many historic sites. Industries: tourism, coal and lead mining, engineering, textiles, olive oil. Pop. (1991) 300,229.

core Central area of the Earth from a depth of 2,885km (1,790mi). It accounts for 16% of the Earth's volume and 31% of its mass. Information about the core is obtained from the measurement of seismic waves. These indicate that the outer part of the core is liquid, because shear (S) waves will not travel through it, whereas the inner core from 5,150km (3,200mi) to the centre of the Earth is interpreted as solid because seismic velocities are lower. It is believed that the change from liquid to solid core occurs because of immense pressure conditions. The core is thought to be composed of iron-nickel alloy (90% iron,

▲ Coppola His Godfather trilogy on the history of the Corleone mafia family earned him a place in cinema history. Apocalypse Now (1975) was both a creative updating of the Joseph Conrad novel Heart of Darkness, and an expression of the horrors of the Vietnam War.

Corelli, Arcangelo (1653–1713) Italian Baroque composer. He achieved early distinction as a violinist under the guidance of Giovanni Benvenuti. He helped to develop the CONCERTO grosso, composed many sonatas and did much to consolidate the principles behind modern violin playing.

Corfu (Kérkyra) Island in NW Greece, second largest of the Ionian island group; the major town is Corfu. The island was allied with Athens in 433 BC against Corinth. The Romans held Corfu from 229 BC, and it was part of the Byzantine empire until the 11th century. It was occupied by the Venetians (1386–1797), and then fell under British protection (1809–64), when it passed to Greece. Products: olives, fruit, livestock, wine. Tourism and fishing are important industries. Area: 593sq km (229sq mi). Pop. (1991) 107,592.

coriander Strong-smelling herb of the CARROT family native to the Mediterranean and Near East. The leaves, the ground seeds and oil from the seeds are used as aromatic flavourings in foods, medicines and liqueurs. Family Apiaceae/Umbelliferae; species *Coriandrum sativum*.

Corinth (Kórinthos) Capital of Corinth department, NE Peloponnesos, at the sw tip of the Isthmus of Corinth, Greece. One of the largest and most powerful cities in ancient Greece, it was a rival of Athens and friend of Sparta, with which it was allied in the Peloponnesian War (431–404 BC). Destroyed by the Romans in 146 BC, it was rebuilt by Julius Caesar in 44 BC. Ruled by the Venetians (1687–1715), then by the Turks, it became part of Greece in 1822. The modern city is 5km (3mi) NE of ancient Corinth, which was destroyed by an earthquake in 1858. The ruins include a temple of Apollo and amphitheatre. It is a major transport centre and has chemical and winemaking industries. Pop. (1991 est.) 29,000.

Corinthian order One of the five Classical Orders of

Corinthians, Epistles to the Two books of the New Testament that are two letters of St PAUL addressed to the Christian Church in Corinth, Greece. The letters cover a number of issues but centre on the teething troubles of the newly founded Christian community at Corinth.

Coriolis effect (force) Apparent force on particles or objects due to the rotation of the Earth under them. The motion of particles or objects is deflected towards the right in the Northern Hemisphere and towards the left in the Southern Hemisphere, but their speed is unaffected. The direction of water swirling round in a drain or whirlpool demonstrates this force.

Cork County and county town in in Munster province, s Republic of Ireland. The largest of the Irish counties, it has a rugged terrain with fertile valleys. The chief occupations are farming and fishing along the rocky coastline. In the 9th century the Danes occupied Cork, but were driven out in 1172 by Dermot McCarthy who swore allegiance to the English throne.

A 3 1 2 2 4 B

10% nickel). Temperature estimates for the core vary from 4,000 to 7,000°C (7,200–12,600°F). Convection in the iron liquid outer core is thought to be responsible for producing the Earth's magnetic field.

Corelli Arcangelo (1653–1713) Italian BAROOUE compos-

Oliver Cromwell occupied Cork in 1649. Many public buildings were destroyed in nationalist uprisings in 1920. The city has both Catholic and Protestant cathedrals, the University College of Cork (1845) and a large harbour. The largest export is farm produce, but it is also renowned for its tweed and linen. Area: 7,462sq km (2,881sq mi). Pop. (1991) 410,369.

cork Outer dead, waterproof layer of the BARK of woody plants. The bark of the cork oak, native to Mediterranean countries, is the chief source of commercial cork. Family Fagaceae; species *Quercus ruber*

corm Fleshy underground stem that produces a plant such as the CROCUS. In most plants, new corms form on top of old ones, which last for one season. *See also* ASEXUAL REPRODUCTION

cormorant Bird found in coastal and inland waters throughout the world. It has a hooked bill, a black body and webbed feet. It dives well and, in some areas of SE Asia, it is trained to catch and retrieve fish. There are 30 species. Length: to 1m (3.3ft). Family Phalacrocoracidae; genus *Phalacrocorax*.

corncrake Bird of the RAIL family common in grain fields of N Europe. It has a brown body and a short bill, and its specific name describes its call. Family Rallidae; species *Crex crex.* **cornea** Transparent membrane at the front of the EYE. It is curved and acts as a fixed LENS, so that light entering the eye is to some extent focused before it reaches the lens.

Corneille, Pierre (1606–84) First of the great French classical dramatists. His plays include the tragedy *Médée* (1635), the epic *Le Cid* (1637) and a comedy *Le Menteur* (1643). He was elected to the French Academy in 1647.

cornet Brass musical instrument similar to a TRUMPET. It was one of the first brass instruments to have valves and, therefore, capable of playing a full range of notes. Hector Berlioz was one of the many 19th-century composers to take advantage of this ability. Its range is about the same as a trumpet's, but its tone is mellower. It is used in brass and military bands.

cornflower Annual of the composite family common in many parts of Europe. Family Asteraceae/Compositae; species *Centaurea cyanus*.

Corn Laws Series of acts regulating the import and export of grain in Britain. The act of 1815 prevented the import of wheat until the domestic price exceeded a certain figure. The result was to keep the price of bread high. Opposition led to repeal by the ANTI-CORN LAW LEAGUE (1846).

Cornwall County in sw England, on a peninsula bounded by the Atlantic Ocean, the English Channel and Devon; the county town is Bodmin. Major towns include Truro, St Austell and Penzance. A rocky coast with hills and moors inland, it is drained by the Camel, Fowey, Tamar and Fal rivers. It is a popular tourist region. Area: (including Scilly Isles) 3,512sq km (1,356sq mi). Pop. (1991) 468,425.

corona Outermost layer of the SUN's atmosphere, extending for many millions of kilometres into space. The corona emits strongly in the x-ray region, and has been studied by x-ray satellites. The corona has a temperature of 1–2 million K.

Coronado, Francisco Vásquez de (1510–54) Spanish explorer. He went to Mexico in 1535, and in 1540 headed an expedition to locate the seven cities of Cibola, reportedly the repositories of untold wealth. He explored the w coast of Mexico, found the Colorado River and the Grand Canyon, followed the route of the Rio Grande, and then headed N through the Texas Panhandle, Oklahoma and E Kansas.

coronary artery disease Disease of the coronary blood vessels, particularly the aorta and arteries supplying blood to the heart tissue. *See also* ANGINA; ARTERIOSCLEROSIS

coronary thrombosis Formation of a blood clot in one or other of the coronary arteries supplying the HEART, preventing blood (and with it oxygen and nutrients) from reaching the heart. It leads to death of part of the heart muscle – a HEART ATTACK. A major attack, marked by severe chest pain, sweating and sometimes collapse, may be fatal.

coronation Ceremony of crowning a monarch. The form of coronation used in Britain was first drafted by St Dunstan, who crowned King Edgar in 973. Since 1066, British sovereigns have been crowned in Westminster Abbey, London. The Merovingian kings of the Franks were probably the first to introduce Christian coronation to Europe *c*.5th century AD.

▶ cornea Focusing of light rays from distant objects (A) is mainly done by the cornea (1) with a little help from the lens (2). Ciliary muscles (3) encircling the lens relax and stretch ligaments (4), which pull the lens flat. Rays from a near object (B) are bent by a thick lens produced when the ligaments slacken as the ciliary muscles contract. This process, which is called accommodation, is essential for sharp focusing.

coroner Public official who inquires into deaths that have apparent unnatural causes by means of an inquest and/or post-mortem. The office dates to 12th-century England. Coroners in Britain also inquire into cases of "treasure trove" (coins, gold, silver or bullion with no known owner) which by law are the property of the crown. In the USA, coroners are usually elected by voters within the county. In both the USA and England, coroners are often assisted by a jury.

Corot, Jean-Baptiste Camille (1796–1875) French painter, a leading 19th-century landscapist. He had more sympathy for the French CLASSICAL tradition than for the attitudes of the BARBIZON SCHOOL, but was more natural than most classicists. After 1827 he gained success at the Paris Salon with more traditionally romantic paintings executed in a soft-edged style, unlike the precisely observed scenes of his earlier work. He was an important influence on CÉZANNE and POST-IMPRESSIONISM in general.

corporation Business organization that is legally a separate entity, which gives it limited liability, as compared to a proprietorship or partnership. The owners or shareholders are not individually responsible for the legal dealings of the corporation, except in the extent of their holdings. The corporation form is most usual in large organizations, especially in the US. In Britain the term COMPANY is often used.

Correggio (c.1490–1534) (Antonio Allegri) Italian painter from Correggio who worked mainly in Parma. His oil paintings and frescos produced daring (although anatomically exact) foreshortening effects inspired by those of MICHELANGELO and RAPHAEL. One of the first painters to experiment with the dramatic effects of artificial light, Corregio is the major link between the early illusionism of Mantegna and the great Baroque ceiling painters.

correlation In STATISTICS, a number that summarizes the direction and degree of relationship between two or more dimensions or variables. Correlations range between 0 (no relationship) and 1.00 (a perfect relationship), and may be positive (as one variable increases, so does the other) or negative (as one variable increases, the other decreases).

corrie See CIROUE

corrosion Gradual tarnishing of surface or major structural decomposition by chemical action on solids, especially metals and alloys. It commonly appears as a greenish deposit on copper and brass, RUST on iron, or a grey deposit on aluminium, zinc and magnesium. Rust is the most important form of corrosion because of the extensive use of iron and its susceptibility to attack. Some metals, such as aluminium and magnesium, corrode readily forming an oxide, which then protects the undersurface from further corrosion.

Corsica (Corse) Mountainous island in the Mediterranean Sea, *c*.160km (100mi) SE of the French coast. It is a region of France comprising two départements. The capital is Ajaccio. It was a Roman colony, before passing into the hands of a series of Italian rulers. In 1768 France purchased all rights to the island. Napoleon was born here in 1769. Products: grapes, olives, mutton, cheese, wool, fish. Area: 8,681sq km (3,352sq mi). Pop. (1990) 250,400.

Cortés, Hernán (1485–1547) Spanish CONQUISTADOR and conqueror of Mexico. In 1518 Cortés sailed from Cuba to Central America with 550 men. They marched inland toward the AZTEC capital, Tenochtitlán (Mexico City), gaining allies among the subject peoples of the Aztec king, Montezuma II. While he was absent, conflict broke out. Cortés recaptured the city after a three-month siege in 1521, gaining the Aztec empire for Spain.

cortex In animal and plant anatomy, outer layer of a gland or tissue. Examples are the cortex of the ADRENAL GLANDS; the cerebral cortex or outer layer of the brain; the cortical layers of tissue in plant roots and stems lying between the bark or EPIDERMIS and the hard wood or conducting tissues.

cortisone HORMONE produced by the cortex of the ADRENAL GLANDS and essential for carbohydrate, protein and fat metabolism, kidney function and disease resistance. Synthetic cortisone is used to treat adrenal insufficiency, rheumatoid arthritis and other inflammatory diseases and rheumatic fever.

corundum Translucent to transparent mineral in many

hues, aluminium oxide (Al_2O_3). It is found in igneous, pegmatitic and metamorphic rocks, occurring as pyramidal or prismatic crystals in the rhombohedral class and as granular masses. It is the hardest natural substance after DIAMOND. Gemstone varieties are sapphire and ruby. It is an important industrial abrasive. Hardness 9; s.g. 4.

Cosby, Bill (1937–) US comedian, actor and writer. The first leading black man in a television series (*I Spy*, 1965–68), he established one of the most successful situation comedies in television history, *The Cosby Show* (1984–92, 1996–), and appeared in several films. His best-selling books include *Fatherhood* (1986), *Time Flies* (1987) and *Love and Marriage* (1989).

cosecant In TRIGONOMETRY, ratio of the length of the hypotenuse to the length of the side opposite an acute angle in a right-angled triangle. The cosecant of angle *A* is usually abbreviated cosec *A* and is equal to the reciprocal of its sine. **cosine** In TRIGONOMETRY, ratio of the length of the side adjacent to an acute angle to the length of the hypotenuse in a right-angled triangle. The cosine of angle *A* is usually abbreviated cos *A*.

cosmology Branch of scientific study that brings together astronomy, mathematics and physics in an effort to understand the make-up and evolution of the Universe. Once considered the province of theologians and philosophers, it is now an allembracing science, which has made great strides in the 20th century. The discovery by Edwin Hubble in the 1920s that galaxies are receding from each other promoted the Big Bang theory. Associated with this is the OSCILLATING UNIVERSE THEORY. The other main theory is the STEADY-STATE THEORY.

Cosmos (Gk. order) Universe considered as an ordered whole. PLATO and ARISTOTLE conceived of the universe as ordered by an intelligent principle. The conviction of an ordered nature became the basis of modern natural science.

Cossacks Bands of Russian adventurers who undertook the conquest of Siberia in the 17th century. Of ethnically mixed origins, they were escaped serfs, renegades and vagabonds who formed independent, semi-military groups on the fringe of society. After the Russian Revolution (1917), the Cossacks opposed the BOLSHEVIKS and strongly resisted collectivization.

Costa Rica Republic in Central America; the capital is SAN José. Land and climate Central Costa Rica consists of mountain ranges and plateaux with many volcanoes. In the SE, the densely populated Meseta Central and Valle del General have

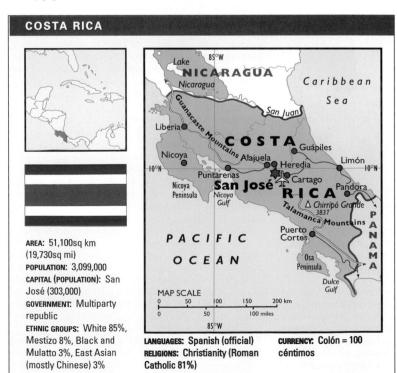

➤ Costner After the success of films such as Dances with Wolves (1990), Kevin Costner suffered a huge setback with the spectacular flop Waterworld (1995), the most expensive film made to date.

rich volcanic soils. The highlands descend to the Caribbean lowlands and the Pacific coast region. San José stands at c.1,170m (3,840ft) above sea level, and has a pleasant climate with an average annual temperature of 20°C (68°F), compared with more than 27°C (81°F) on the coast. The coolest months are December and January. The NE trade winds bring heavy rains to the Caribbean coast. Evergreen forests (including mahogany and tropical cedar) cover about 50% of Costa Rica. Oaks grow in the highlands, palm trees along the Caribbean coast, and mangrove swamps are common on the Pacific coast. History Christopher Columbus reached the Caribbean coast in 1502, and rumours of treasure soon attracted many Spanish settlers. Spain ruled the country until 1821; in 1822 Spain's Central American colonies broke away to join Mexico. In 1823 the Central American states broke from Mexico and set up the Central American Federation. This large union gradually disintegrated and Costa Rica achieved full independence in 1838. From the late 19th century, Costa Rica experienced a number of revolutions, with periods of dictatorship and democracy. In 1948 a revolt led to the abolition of the armed forces. Since then, Costa Rica has been a stable democracy. Economy Costa Rica is a lower-middle-income developing country. It is one of the most prosperous nations in Central America. The country has high education standards and life expectancy (an average of 73.5 years). Agriculture employs 24% of the workforce. Major crops include coffee, bananas and sugar (all of which are exported). Other crops include beans, citrus fruits, cocoa, maize, potatoes and vegetables. Cattle ranching is important. Costa Rica has rich timber resources, but lacks minerals (apart from bauxite and manganese). Developing industries include cement, clothing and fertilizers. Tourism is a fast-growing industry.

Costner, Kevin (1955–) US film actor and director. Costner's breakthrough film was *The Untouchables* (1987). Other leading roles followed, such as *Bull Durham* (1988). Costner won Academy Awards for Best Director and Best Actor in his directorial debut *Dances With Wolves* (1990), an epic Civil War-era Western. Other acting credits include *JFK* (1991) and *The Bodyguard* (1992).

cotangent Ratio of the length of the side adjacent to an acute angle, to the length of the side opposite the angle in a right-angled triangle. The cotangent of angle A is usually abbreviated $\cot A$ and is equal to the reciprocal of its TANGENT.

Cotman, John Sell (1782–1842) British landscape painter and etcher, co-founder (with John Crome) of the Norwich School. One of Britain's most important 19th-century water-colourists. He used broad, flat colour washes and built up his images in sharply defined planes and simple shapes. His paintings include *Greta Bridge* (c.1805) and *Chirk Aqueduct*. cotoneaster Genus of about 50 species of deciduous shrubs of the Rose family (Rosaceae), mostly native to China. They have small white flowers and small, red or black, round berry-like fruit, and are often cultivated as ornamental plants. Cotonou City in s Benin, w Africa. The former capital and largest city in Benin, it is an important port and distribution centre for the offshore oil industry. Industries: textiles, brewing. Pop. (1982) 487,020.

Cotopaxi Active volcano in N central Ecuador, 65km (40mi) s of Quito, in the Andes Mountains. It is the highest continually active volcano in the world and its frequent eruptions have caused severe damage. Height: 5,896m (19,344ft).

Cotswolds Range of limestone hills in w England, lying mainly in Gloucestershire and extending 80km (50mi) NE from Bath. The local stone is widely used as a building material and the region is also known for its breed of sheep.

cotton Annual shrub native to subtropical regions. Most cotton is grown for the fibres that envelop the seeds and are made into fabric. Family Malvaceae; genus *Gossypium*.

cotton gin Machine for separating cotton lint from seeds, a task previously done by hand. The gin, patented in 1794 by Eli Whitney, could clean over 20kg (50lb) per day. It contributed to the prosperity of US cotton plantations and to the industrialization of the textile industry.

cottonmouth See WATER MOCCASIN

cotyledon First leaf or pair of leaves produced by the embryo of a flowering plant. Its function is to store and digest food for the embryo plant, and, if it emerges above ground, to photosynthesize for seedling growth. *See also* DICOTYLEDON; MONOCOTYLEDON

cougar See PUMA

Coulomb, Charles Augustin de (1736–1806) French physicist. He invented the torsion balance which led to experiments in electrostatics and the discovery of Coulomb's law: the force between two charged particles (point charges) is proportional to the product of the charges, and inversely proportional to the square of the distance between them. The SI unit of electric charge is the coulomb.

Council for Mutual Economic Assistance (COME-CON) International organization (1949–91) aimed at the coordination of economic policy among communist states, especially in Eastern Europe. Led by the Soviet Union, its original members were Bulgaria, Czechoslovakia, East Germany, Hungary, Poland and Romania; later joined by Cuba, Mongolia and Vietnam. Cooperation took the form of bilateral trade agreements rather than the establishment of a single market or a uniform price system.

Council of Europe European organization that was founded in 1949 with the aim of strengthening pluralist democracy and human rights, and promoting European cultural identity. Originally a Western European organization, it admitted former communist countries in the 1990s. It has adopted around 150 conventions, the most important of which is the European Convention on Human Rights. The organization is based in Strasbourg, France.

council tax Tax levied on British households to pay for local services. Introduced in 1993, it was the successor to community charge (POLL TAX). The level of tax paid is assessed with reference to a range of eight price bands based on house value. counterfeiting Illegal manufacture of coins or printed "money". Although counterfeiting is a form of FORGERY, it is considered a more serious offence as it is perpetrated against the government rather than an individual or company.

counterpoint In music, technique in composition involving independent melodic lines that are sung or played simultaneously to produce HARMONY. The term derives from the medieval practice of adding an accompanying note to each note of a melody. Counterpoint (contrapuntal) writing reached its height in the 16th century in the work of William Byrd, Orlando di Lasso and Giovanni Palestrina, the organ compositions of J.S. Bach in the 18th century, and in the late works of Beethoven.

Counter Reformation Revival of the Roman Catholic Church in Europe during the 16th and early 17th centuries. It began as a reaction to the Protestant REFORMATION. The Counter Reformation strove to remove many of the abuses that had crept into the late medieval church and won new prestige for the papacy. A leading part was played in the movement by new monastic orders, particularly the Society of Jesus (JESUITS). The Council of TRENT (1545–63) clarified Roman Catholic teaching on the major theological controversies of the period and initiated internal reforms.

countertenor Male voice of the same register as the female CONTRALTO. It is most common in Britain, where some of the more traditional church choirs still prefer male altos.

country and western Popular music originally associated with rural areas of s USA. The music typically features senti-

▲ cotton The cotton plant (Gossypium sp.) is a shrub-like annual native to the world's subtropical regions. After rapid flowering, small green seedpods (bolls) develop. The cotton seeds within the bolls sprout a mass of fine fibre hairs. When mature, the bolls rupture and soft cloud of cotton erupts. The crop is either harvested by hand or machine and then taken to be ginned (separating the seed from the fibres), cleaned, carded and spun into yarn.

mental lyrics and instrumental music played with stringed instruments such as the guitar, banjo or fiddle. Its origins were in the folk music of British immigrants (although in Texas, the blues were also an influence). NASHVILLE, Tennessee, is the music's spiritual home.

county One of the main administrative divisions of LOCAL GOVERNMENT in the UK, the USA, and some Commonwealth countries. Counties are responsible for policing, local judicial administration, maintaining public roads, and other public facilities, such as a fire service and keeping record offices.

coup d'état Swift stroke of policy, either against the ruling power of a state or by the state against an element within it. Of the former, the most usual is a military takeover of civilian government, such as "the Colonels" in Greece (1967). An example of the latter is Hitler's murder of the *Sturm Abteilung* (SA) leaders in Germany (1934).

Couperin, François (1668–1733) French composer. He was organist and harpsichordist at the court of Louis XIV. "Le Grand", as he was known, is now principally remembered for his many harpsichord pieces.

Courbet, Gustave (1819–77) French painter, the leading exponent of REALISM. Largely self-taught, Courbet rejected traditional subject matter and instead painted peasant groups and scenes from life in Paris. His nudes, splendid in their richness of colour and textural contrast, shocked contemporary society. His controversial political activity forced him into exile in Switzerland in 1873. Courbet's rejection of both romantic and classical ideals prepared the way for IMPRESSIONISM.

Court, Margaret (1942–) Australian tennis player. Her singles titles include the US Open (1962, 1965, 1968–70, 1973), Wimbledon (1963, 1965, 1970), the Australian Open (1960–66 1969–71, 1973) and the French Open (1962, 1964, 1969–70, 1973). In 1970 she became only the second woman (after Maureen Connolly) to complete the Grand Slam. She won more Grand Slam titles (64) than any other player in the history of women's tennis.

Courtauld, Samuel (1793–1881) British industrialist. He founded the firm of Courtaulds in 1816. At first it specialized in the production of silks, but from 1904 it developed artificial fibres, such as viscose rayon and nylon. In 1931 he bequeathed his London house (Home House) and his collection of 19th-century French painting to the University of London, to form a department for the research and study of art (the Courtauld Institute).

court martial Court of the armed services for trial of service persons accused of breaking military law. Offences range from murder and robbery to those specific to the armed services, such as desertion. Court martials do not utilize the JURY system. Members of the court martial are serving officers, in certain cases advised by a judge advocate.

courts of law Judicial assemblies established to try legal cases and to impose punishment for wrongdoing or to remedy a damage. The history of the court system lies in the English assumption of COMMON LAW as its legal basis (which Britain introduced to its former colonies, including the USA and Canada) as opposed to ROMAN LAW, which is the judicial basis of many other countries around the world. In the UK and the USA, courts are hierarchically organized, and try suits of two different types, CIVIL or CRIMINAL. In the UK, civil law cases are heard by county courts and the HIGH COURT OF JUSTICE, while those of criminal law are heard by CROWN COURTS or MAGISTRATES' court. Serious criminal offences are referred from magistrates' courts to a crown court. The Court of Appeal is divided into civil and criminal divisions and hears appeals from crown courts, county courts and the High Court. Appeals from the High Court are heard by the House of Lords, the Supreme Court of Appeal. In the USA, there are two court systems. Federal courts administer cases involving the nation, federal laws, interstate disputes and non-US nationals. They include the SUPREME COURT, courts of appeal, district courts and specialist courts (that cover issues such as tax or patents). State courts are divided into superior and inferior courts. Superior courts include the state supreme court, county and municipal courts. Inferior courts include magistrates' courts, and tribunals such as traffic courts, juvenile and small claims courts.

Cousteau, Jacques Yves (1910–97) French oceanographer. Best known as the co-inventor (with Emile Gagnan) of the AQUALUNG, he also invented a process of underwater television and conducted a series of undersea living experiments (1962–65). Many of the expeditions made by his research ship *Calypso* were filmed for television.

covalent bond Chemical bond in which two atoms share a pair of electrons, one from each atom. Covalent bonds with one shared pair of electrons are called single bonds; double and triple bonds also exist. The molecules tend to have low melting and boiling points and to be soluble in nonpolar solvents. Covalent bonding is most common in organic compounds.

Covenanters Scottish Presbyterians pledged by the National Covenant (1638) to uphold their religion. They opposed CHARLES I's efforts to impose an Anglican episcopal system and supported parliament in the English CIVIL WAR, in exchange for a promise to introduce Presbyterianism in England and Ireland. The Scots changed sides when this promise was broken, but were defeated by Oliver CROMWELL. Covenanter revolts against Charles II were suppressed, but Presbyterianism was restored in Scotland in 1688.

Coventry City and county district in West Midlands, central England. An important weaving centre in the Middle Ages, it later became known for its clothing manufacture. The city was badly damaged by bombing during World War 2 and the 14th-century cathedral was destroyed. A new cathedral (designed by Sir Basil Spence) was completed in 1962. It is the home of the University of Warwick (1965) and Coventry University (1992). Industries: motor vehicles, telecommunications, mechanical and electrical engineering. Pop. (1991) 294,387. Coverdale, Miles (1488–1569) English cleric who issued the first printed English Bible (1535) and the "Great Bible" (1539). Influenced by the REFORMATION, he helped William Tyndale on his Bible translation.

cow Name for mature female CATTLE that have borne at least one calf. It is also applied to other female mammals, such as elephants and seals.

Coward, Sir Noel Pierce (1899–1973) British playwright, composer and performer. He first attracted notice as a playwright with his drama *The Vortex* (1924) and later with his urbane comedies such as *Hay Fever* (1925), *Bitter Sweet* (1929), *Private Lives* (1930) and *Blithe Spirit* (1941). His plays frequently lampooned drab high-society etiquette. Other works include the films *In Which We Serve* (1942) and *Brief Encounter* (1945). He also composed hundreds of songs, such as "Mad Dogs and Englishmen" and "Mad About the Boy".

cowboy (cowhand) US ranch hand. Traditionally living and working in the West, cowboys increased after the Civil War. They have been romanticized in books and films as a symbol of the rugged independence, colour and vigour of the old "Wild West". See also GAUCHO

Cowell, Henry Dixon (1887–1965) US composer, influenced by non-Western music. He created "tone clusters" (dissonances produced by striking piano keys with the fist or forearm), used in such pieces as *Advertisement* (1914). Other piano pieces are played directly on the strings by plucking or striking, for example *Aeolian Harp* (1923). His output includes over 20 symphonies, many concertos and operas.

Cowper, William (1731–1800) British poet and hymn writer. Despite bouts of near insanity, Cowper's poetry is lucid and direct, often drawing engagingly on the countryside or the details of domestic life, as in the long blank-verse poem *The Task* (1785). Some of his contributions to *Olney Hymns* have become standards of the Anglican church.

cowrie (cowry) Gastropod MOLLUSC identified by an ovoid, highly polished shell with a long toothed opening and varied markings. It is found on tropical coral shores. Length: 8.3–152mm (0.33–6in). Family Cypraeidae; more than 160 species, including the map cowry *Cypraea mappa*.

cowslip Herb of the PRIMROSE family (Primulaceae), with a hanging yellow flower head; species *Primula veris*. In the USA cowslip is a marsh marigold (*Caltha palustris*).

coyote Wild pog originally native to w North America. Coyotes have moved into many E areas of the USA formerly inhabited by wolves. Usually greyish-brown, they have

► coypu Native to swamps, lakes and streams of central and South America, the coypu (Myocastor coypus) is now found in the wetter regions of the USA and Europe, a number having escaped from fur farms.

pointed muzzles, big ears and bushy tails. Length: 90cm (35in); weight: c.12kg (26lb). Species Canis latrans.

coypu Large aquatic RODENT, native to South America. It now also lives in North America and parts of Europe, both wild and on fur farms. Coypus have brown outer fur and soft grey underfur, commercially known as nutria. Overall length: 1.06m (3.5ft); weight: 8kg (18lb). Species Myocastor coypus. crab Flattened, triangular, or oval ten-legged crustacean covered with a hard shell. Primarily marine, some crabs are found in freshwater and a few are terrestrial. Their short abdomen, often called a tail, is bent under. Most have a pair of large foreclaws, a pair of movable eyestalks and a segmented mouth. Crabs usually move sideways. Size: pea-sized to 3m (12ft). Order Decapoda.

Crabbe, George (1754–1832) British poet. His poetry is imbued with the atmosphere of his native Suffolk and is unflinchingly anti-sentimental, such as The Village (1783) and The Borough (1810), the basis for Benjamin Britten's opera Peter Grimes (1945).

crab nebula Nebula located about 6,500 light years away in Taurus. It is the remnant of a supernova noted by Chinese astronomers in July 1054, when it shone as brightly as Venus, visible even in daylight. The nebula was discovered in 1731 by the English astronomer John Bevis and independently by Charles Messier in 1758.

crack Street DRUG that is a COCAINE derivative. It is supplied in the form of hard, crystalline lumps, which are heated to produce smoke inhaled for its stimulant effects. It imposes considerable strain on the heart and blood vessels, and may result in heart failure or a stroke. Psychotic episodes may also occur. cracking Stage in oil-refining during which the products of the first distillation are treated to break up large hydrocarbons into smaller molecules by the controlled use of heat, catalysts and often pressure. The cracking of petroleum yields heavy oils, petrol, and gases such as ethane, ethylene and propene (propylene), which are used in the manufacture of plastics, textiles, detergents and agricultural chemicals. Cracking is, therefore, a means of yielding greater amounts of lighter hydrocarbons from heavier fractions such as lubricating oil. Craig, James (1871-1940) Northern Irish soldier and politician, first prime minister of Northern Ireland (1921-40).

He was an extreme Unionist and helped Sir Edward CARSON to keep the province in Britain.

Cranach, Lucas, the Elder (1472-1553) German painter and engraver, court artist to the Electors of Saxony. A friend and follower of Martin Luther, Cranach designed many propaganda woodcuts for the Protestant cause. He also produced some of the first full-length portraits and developed a style of painting female nudes in a unique, enamel-like finish.

cranberry Plant of the HEATH family, distributed widely in N temperate regions. It is a creeping or trailing shrub and bears red berries with an acid taste used to make sauce and juice. Family Ericaceae; Genus Vaccinium.

Crane, (Harold) Hart (1899–1932) US poet. Acclaimed as one of the most brilliant and creative 20th-century US poets, he published his first volume, White Buildings, in 1926. His major work, The Bridge (1930), is a series of related poems in which New York City's Brooklyn Bridge serves as a mystical symbol of the creative power of civilization.

Crane, Stephen (1871-1900) US writer, poet and war correspondent. His best-known work is The Red Badge of Courage (1895), a grimly realistic story of an American Civil War soldier. Other works include a novel, Maggie: A Girl of the Streets (1893), a collection of short stories, The Open Boat and Other Tales of Adventure (1898), and poems collected in The Black Riders (1895) and War is Kind (1900).

crane Any of several species of tall wading birds found in most parts of the world except s America. It has brownish, greyish or white plumage with a bright ornamental head and feeds on almost anything. After courtship dances, the female lays two eggs in a bulky nest. Height: to 150cm (60in). Family Gruidae.

crane fly True fly of the order Diptera. It has a slender body. long fragile legs and one pair of wings. The hindwings are reduced to special balancing organs called halteres. The larvae, leatherjackets, live in the soil where they feed on plant roots and stems, frequently becoming serious agricultural pests. Family Tipulidae; species Tipula simplex. Length: to 3cm (1.2in). The name is also given to the HARVESTMAN.

cranesbill Common name for certain species of wild GERANI-UM. Some species are cultivated for ornamental ground cover. cranium Dome-shaped part of the SKULL that protects the brain. It is composed of eight bones that are fused together.

Cranmer, Thomas (1489–1556) English prelate and religious reformer. He was appointed Archbishop of Canterbury by HENRY VIII in 1533. He secured the annulment of Henry's marriage to Catherine of Aragon, despite opposition from the pope. Cranmer, a friend of Thomas CROMWELL, promoted the introduction of Protestantism into England and compiled the first Book of COMMON PRAYER in 1549. Following the accession of the Roman Catholic MARY I in 1553, Cranmer's reforms were halted. He was burned at the stake.

Crassus, Marcus Licinius (115-53 BC) Roman political and military leader. He commanded an army for Sulla in 83 BC, amassed a vast personal fortune, and raised and led the troops who defeated the slave rebellion of Spartacus in 71. With POMPEY and Julius CAESAR he formed the First Triumvirate in 60 BC and was governor of Syria in 54 BC.

crater Roughly circular depression found in the surface of some planets, notably the Moon, usually with steep sides. It is formed either by meteoric impact, when shock waves blast out a hole in the ground, or at the vent of a volcano, when lava is expelled explosively. Space probes have revealed similar craters on Mars and Mercury.

crater lake Accumulation of water, usually by precipitation of rain or snow but sometimes groundwater, in a volcanic crater (caldera). Should an eruption occur, the resulting mud flow (lahar) is often more destructive than a lava flow, owing to its greater speed. Crater Lake in Crater Lake Park, Oregon, USA, was formed by precipitation and the waters are maintained solely by rain and snow. It is the second deepest lake in North America.

Crawford, Joan (1904–77) US film actress, b. Lucille Fay le Sueur. Determined and versatile, Crawford remained a star for almost 50 years. She started in musicals, such as Our Dancing Daughters (1928), before graduating to dramatic roles in films such as Grand Hotel (1932) and The Women (1939). She won a Best Actress Academy Award for Mildred Pierce (1945). Other films include Possessed (1947), Johnny Guitar (1954), and What Ever Happened to Baby Jane? (1962).

Crawford, Thomas (1814-57) US sculptor who studied in Rome and brought a neo-classical style to his art. His most famous works are the equestrian statue of George Washington, and the enormous Freedom statue on top of the US Capitol.

crayfish Edible, freshwater, ten-legged crustacean that lives in rivers and streams of temperate regions. Smaller than lobsters, crayfish burrow into the banks of streams and feed on animal and vegetable matter. Some cave-dwelling species are blind. Length: normally 8-10cm (3-4in). Families Astacidae (Northern Hemisphere), Parastacidae (Southern Hemisphere), Austroastacidae (Australia).

Crazy Horse (1842–77) Chief of the Oglala Sioux. He was a leader of Sioux resistance to the advance of white settlers in the Black Hills, and assisted SITTING BULL in the destruction of General Custer at the Battle of Little Bighorn in 1876. Persuaded to surrender, he was killed a few months later, allegedly while trying to escape.

creation myth In most mythologies and religions, an

▲ crane fly The hindwings of crane flies have evolved into small balancing organs known as halterers. In flight they vibrate with the wings, detecting and helping to correct any deviation from the stable flight path.

▲ crab Fiddler crabs (Uca sp.), like most crustaceans, recognize potential mates by sight. During courtship, the male waves his one enormous claw in a complex series of signals, while at the same time raising and lowering his body

account of the origin of the world, as well as of the human race and all the other creatures on Earth. There is a remarkable similarity in the creation stories as recounted in the holy books of major religions, and in the myths and legends of ethnic groups, such as Native Australians and Native Americans.

Crécy, Battle of (1346) First major battle of the HUNDRED YEARS WAR. The English led by EDWARD III and his son, the Black Prince, defeated the French of PHILIP VI. The English longbow, as well as superior tactics, accounted for their victory. Cree People belonging to the ALGONQUIN language family of Native Americans in Canada, who ranged from James Bay to the Saskatchewan River. Like the closely related Chippewa, the Cree served as guides and hunters for French and British fur traders. Many of the Plains Cree intermarried with the French. The current population is c.130,000.

creed (Lat. *credo*, I believe) In Christian churches, personal yet formal statement of commitment to doctrinal belief. *See also* Apostles' Creed; Athanasian Creed; Nicene Creed

Creek Confederation of NATIVE AMERICANS, part of the Muskogean-language group. One of the largest groups of SE USA, they ranged from Georgia to Alabama. They formed a settled, agricultural society, with land owned communally. Within the confederacy, individual settlements had a degree of autonomy. After the Creek Wars (1813–14), they were removed to Oklahoma, where c.60,000 remain today.

cremation Ritual disposal of a corpse by burning. It was a common custom in parts of the ancient civilized world, and is still the only funeral practice among Hindus and Buddhists. Early Christians rejected cremation because of their belief in the physical resurrection of the body. It was not until the 19th century that it was revived in the Western world. Its legitimacy is now recognized by all Christian churches.

Creole Person born in the West Indies, Latin America, or s USA but of foreign or mixed descent. Generally a Creole's ancestors were either African slaves or French, Spanish or English settlers. In the USA it also refers to someone of mixed European and African ancestry. Creole language is a PIDGIN, adopted as the native language of a community (English, French, Portuguese) and influenced by the native languages of the community's ancestors.

crescent Symbol of the Moon in its first quarter. The sym-

▲ crane The crowned crane (*Balearica pavonina*) is a tall, elegant bird of desert and grassland regions of Africa, s from the Nile Valley. It grows to a height of 95cm (3ft).

bol has been associated with Islam since the capture of Constantinople by the Ottoman Turks in 1453. It appears on the Turkish standard and other Islamic nation flags.

cress Any of several small, pungent-leaved plants of the mustard family (Brassicaceae/Cruciferae), generally used in salads and as garnishes. The best known is WATERCRESS. Species *Nasturtium officinale*.

Cretaceous Last period of the MESOZOIC era, lasting from 144 to 65 million years ago. DINOSAURS became extinct at the end of this period. The first true placental and MARSUPIAL mammals appeared and modern flowering plants were common.

Crete (Kreti, Kríti) Largest island of Greece, in the E Mediterranean Sea, SSE of the Greek mainland; the capital is IRÁKLION. MINOAN CIVILIZATION flourished on Crete from 2000 BC, and the palace of KNOSSOS was built c.1700 BC. Crete was conquered by Rome in c.68 BC and later came under Byzantine (395), Arab (826) and Venetian (1210) rule. In 1669, Crete fell to Turkey. Foreign intervention forced Turkey to evacuate Crete (1898) and it was eventually united with Greece (1908). It was occupied by German forces in World War 2. Crete has a mountainous terrain upon which sheep and goats are raised. The mild climate supports the cultivation of cereals, grapes, olives and oranges. Products: wool, hides, cheese, olive oil, wine. Tourism is important. Area: 8,336sq km (3,218sq mi). Pop. (1991) 540,054.

Creutzfeld-Jakob disease (CJD) Rare degenerative brain disease that results in dementia and death. It is believed to be caused by an infective agent, possibly a slow virus. Some scientists believe that CJD can be acquired by eating meat products from cattle infected with BOVINE SPONGIFORM ENCEPHALOPATHY (BSE).

Crick, Francis Harry Compton (1916—) British biophysicist. In the 1950s, with James WATSON and Maurice Wilkins, he established the double-helix molecular structure of deoxyribonucleic acid (DNA). The three were jointly awarded the Nobel Prize for physiology or medicine in 1962. cricket Brown to black insect with long antennae and hind legs adapted for jumping, found worldwide. Males produce a chirping sound by rubbing their wings together. Length: 3–50mm (0.8–2in). Family Gryllidae.

cricket Bat and ball game popular in Britain and other Commonwealth nations since c.1700. Two teams of 11 players compete on an oval or round pitch. The game revolves around two wickets, 20.1m (66ft, 22yd) apart. A wicket comprises three wooden stumps 71cm (28in) high, connected at the top with two small cross-pieces (bails). Leading nations compete against each other in a series of test matches, the most famous of which is probably The ASHES. A test match is held over a maximum of five days and two innings per side. In an innings all the players of one team bat once, while the other team fields, providing the bowlers and a wicket-keeper. A batsman stands within a marked area (crease) on the pitch, 1.2m (4ft) from the wicket. The bat is traditionally made of willow wood. Fielders are placed at strategic positions around the ground. A bowler is allowed to bowl six consecutive overarm deliveries (an over) at the wicket defended by a batsman, this is followed by another over from the opposite end of the pitch by a different bowler. Bowlers may be slow (relying mostly on spin), medium pace (relying on swinging the ball or moving it off the pitch), or fast (relying on speed to beat the batsman). The ball is made of stitched leather with a seam. A run is usually scored by a batsman making contact with the ball, and running between the wickets with his partner before the ball can be returned to either wicket. If the ball reaches the boundary of the pitch it scores four, or six runs if it does not bounce. A batsman can be given out in a number

of ways: by being bowled (when the ball delivered by a bowler hits the wicket); by being caught (the ball struck by the bat or glove is caught on the full by a player); by being run out or "stumped" (a player dislodges the bails with the ball when a batsman is outside the crease), by being "leg before wicket", or "lbw" for short (the ball pitches in line with the stumps and hits a batsman's padded leg and would, in the umpire's opinion, have hit the wicket); or by hitting his own wicket. The game is adjudicated by two umpires on the field. If they are uncertain of a dismissal, a third umpire (off the field) makes a definitive judgement based on television replays. Since the 1960s, one-day or "limited overs" cricket has become increasingly popular. Since 1975 cricketing nations have competed every four years in the World Cup, a one-day competition. The sport's administrative and historical headquarters is at Lord's Cricket Ground, London.

Crimea (Krym) Peninsula in s Ukraine that extends into the Black Sea, w of the Azov Sea and joined to the mainland by the Perekop Isthmus. Simferopol is the capital. The Crimea was inhabited from the 10th to 8th centuries BC by the Cimmerians. During the 5th century it was colonized by the Greeks and then by Romans, Ostrogoths, Huns, Mongols,

Byzantines and Turks, before being annexed to Russia in 1783. In 1921 it became an autonomous republic of Russia, and in 1954 was transferred to the Ukraine as the Krymskaya oblast. In 1991 it was made an autonomous republic of an independent Ukraine. The region has many mineral resources, notably iron and gypsum, and intensive agriculture. Area: *c*.27,000sq km (10,425sq mi). Pop. (1991 est.) 2,549,800.

Crimean War (1853–56) Fought by Britain, France and the Ottoman Turks against Russia. In 1853 Russia occupied Turkish territory and France and Britain, determined to preserve the Ottoman empire, invaded the Crimea (1854) to attack Sevastopol. The war was marked on both sides by incompetent leadership and organization. The CHARGE OF THE LIGHT BRIGADE is the best-known example. Sevastopol was eventually captured (1855). At the Treaty of Paris (1856) Russia surrendered its claims on the Ottoman empire.

Criminal Investigation Department (CID) Non-uniformed branch of the London Metropolitan Police (founded 1878) dealing with the prevention and investigation of crime, and with the preparation of information on criminal trends. There are *c.*1,600 CID officers, whose headquarters are at New Scotland Yard.

CROATIA

Croatia adopted a red, white and blue flag in 1848. Under communist rule, a red star appeared at the centre. In 1990 the red star was replaced by the present coat of arms, which symbolizes the various parts of the country.

AREA: 56,538sq km (21,824sq mi)
POPULATION: 4,764,000
CAPITAL (POPULATION): Zagreb (726,770)

GOVERNMENT: Multiparty republic ETHNIC GROUPS: Croat 78%, Serb 12%, Bosnian, Hungarian, Slovene LANGUAGES: Serbo-Croatian

RELIGIONS: Christianity (Roman Catholic 77%, Eastern Orthodox 11%), Islam 1%

currency: Kuna

Croatia was one of the six republics that made up the former federated state of YUGOSLAVIA. It achieved independence in 1991. The DALMATIA region borders the Adriatic Sea, and is dominated by the limestone mountains of the Dinaric Alps. The major port is SPLIT. Other highlands lie in the NE, but Croatia chiefly consists of the fertile Pannonian plain. The River Drava forms most of its border with Hungary. The capital, ZAGREB, lies on the River Sava.

CLIMATE

The coastal area has a typical Mediterranean climate, with hot, dry summers and mild, moist winters. Inland, the climate becomes more continental. Winters can be bitterly cold, while summer temperatures often soar to 38°C (100°).

VEGETATION

Farmland, including pasture, covers 70% of Croatia, with forest and woodland occupying only 15%. Sparse Mediterranean scrub (maquis) predominates in Dalmatia.

HISTORY AND POLITICS

SLAV peoples settled in the area around 1,400 years ago. In 803 Croatia became part of the Holy Roman Empire and the Croats soon adopted Christianity. Croatia was an independent kingdom in the 10th and 11th centuries. In 1102 an 800-year union of the Hungarian and Croatian crowns was formed.

In 1526 part of Croatia fell to the Ottoman empire, while the rest of Croatia came under the Austrian Habsburgs. In 1699 all of Croatia came under Habsburg rule. In 1867 the Habsburg empire became the Austro-Hungarian Empire. Following the defeat of Austria-Hungary in World War 1, Croatia became part of the new Kingdom of the Serbs, Croats and Slovenes, renamed Yugoslavia (1929). Germany occupied Yugoslavia during World War 2 and Croatia was proclaimed independent, though it was really a pro-Nazi puppet state (Ustashe).

After the war, communists took power, and Josip Broz Trro became the country's leader. Despite ethnic differences, Tito held Yugoslavia together until his death (1980). During the 1980s, economic and ethnic problems (including a deterioration in relations between Croatia and Serbia) threatened the country's stability. The Croatian Democratic Union (HDZ), led by Franjo TUDJMAN, won Croatia's first democratic elections (1990). A 1991 referendum voted

overwhelmingly in favour of Croatia becoming an independent republic. The Yugoslav National Army was deployed and Serb-dominated areas took up arms in favour of remaining in the federation. SERBIA supplied arms to Croatian Serbs and war broke out between Serbia and Croatia. In 1992 United Nations peacekeeping troops were deployed to maintain an uneasy cease-fire. Croatia had lost more than 30% of its territory. Tudjman was re-elected president. In 1992 war broke out in Bosnia-Herzegovina and Bosnian Croats occupied parts of Croatia. In 1993 Croatian Serbs in E Slavonia voted to establish the separate republic of Krajina. In 1994 the Bosnian, Bosnian Croat and Croatian governments formed a federation. In 1995 Croatian government forces seized the Krajina and 150,000 Serbs fled. Following the Dayton Peace Treaty (1995), Croatia and the rump Yugoslav state formally established diplomatic relations (August 1996). An agreement between the Croatian government and Croatian Serbs provided for the eventual reintegration of Krajina into Croatia. Postponed from 1997, this reintegration is due to take place in 1998.

ECONOMY

The wars have badly disrupted Croatia's relatively prosperous economy. Before the crisis, Dalmatia had been a major European tourist destination. Croatia has a wide range of manufacturing industries, such as steel, chemicals, oil refining and wood products. Agriculture remains the principal employer. Crops include maize, soya beans, sugar beet and wheat.

criminal law Body of law that defines crimes, lays down rules of procedure for dealing with them and establishes penalties for those convicted. Broadly, a crime is distinguished from a TORT by being deemed injurious to the state. In many countries the criminal law has been codified. Among the best-known modern codes are the *Constitutio Criminalis Carolina* (1532) promulgated by Charles II for the Holy Roman Empire, Joseph II's code for Austria (1786) and the Code Napoléon. Criminal law remains what it was originally, a part of COMMON LAW, although since the 18th century it has been greatly added to by statute law.

Cripps, Sir (Richard) Stafford (1889–1952) British statesman. He belonged to the left wing of the LABOUR PARTY and was ambassador to Russia (1940–42), later serving in Winston Churchill's war cabinet. As chancellor of the exchequer (1947–50) in the reforming government of ATTLEE, he played a significant role in the reconstruction of the post-war economy. critical angle Any angle at which a significant transition occurs. In optics, it is the angle of incidence with a medium at which total internal REFLECTION occurs. In telecommunications, it is the angle at which radio waves are reflected by the IONOSPHERE.

critical mass Minimum mass of fissionable material required in a fission bomb or nuclear reactor to sustain a CHAIN REACTION. The fissionable material of a fission bomb is divided into portions less than the critical mass; when brought together at the moment of detonation they exceed the critical mass. *See also* FISSION, NUCLEAR

Crittenden, John Jordan (1787–1863) US lawyer and statesman. He was a senator from Kentucky (1817–19, 1835–41, 1842–48, 1855–61). He served as attorney general under William Henry HARRISON (1841) and Millard FILL-MORE (1850–53). "Crittenden's Propositions" of 1860 sought to reach a compromise on slavery with the southern states and prevent war, but it was defeated.

Croatia Balkan republic in SE Europe. *See* country feature **Croce, Benedetto** (1866–1952) Italian idealist philosopher and politician. He was a senator (1910–20) and minister of education (1920–21). When Mussolini came to power, Croce retired from politics in protest against fascism, and wrote the idealistic *Philosophy of the Spirit* (1902–17). He rentered politics following the fall of Mussolini in 1943. As leader of the Liberal Party, he played a prominent role in resurrecting Italy's democratic institutions.

Crockett, Davy (David) (1786–1836) US politician and frontiersman. He served in the Tennessee legislature (1821–26) and the US Congress (1827–31, 1833–35). A Whig, he opposed the policies of Andrew Jackson and the Democrats. He died at the Alamo.

crocodile Carnivorous lizard-like REPTILE found in warm parts of every continent except Europe. Most crocodiles have a longer snout than ALLIGATORS. All lay hard-shelled eggs in nests. Length: up to 7m (23ft). There are about 12 species including two dwarf species in Africa. The Asian saltwater crocodile (*Crocodylus porosus*) sometimes attacks humans. Family Crocodylidae.

crocus Hardy PERENNIAL flowering plant. It is low growing with a single tubular flower and grass-like leaves rising from an underground corm. Family Iridaceae; genus *Crocus*.

Croesus King of Lydia in Asia Minor (r. c.560–546 BC). Renowned for his wealth, he was overthrown by CYRUS THE GREAT of Persia but served in his court.

Cro-Magnon Tall, Upper Paleolithic race of humans, possibly the earliest form of modern *Homo sapiens*. Cro-Magnon people settled in Europe *c*.35,000 years ago. They manufactured a variety of sophisticated flint tools, as well as bone, shell, and ivory jewellery and artifacts. Cro-Magnon artists produced the cave paintings of France and N Spain. Cro-Magnon remains were first found in 1868 in a rock shelter in Les Eyzies-de-Tayac, Dordogne, France.

Crompton, Richmal (1890–1969) British writer. She created one of the most popular characters in children's fiction, William, the scruffy, prankish schoolboy. The stories were first collected as *Just William* (1922), and more than 30 William novels followed. She also wrote adult fiction.

Crompton, Samuel (1753-1827) British inventor of a spinning machine. His "spinning mule" of 1779 proved a boon to the textile industry reducing the amount of threadbreakage and made possible the production of very fine yarn. Cromwell, Oliver (1599–1658) Lord protector of England (1653-58). A committed Puritan, Cromwell entered parliament in 1628 and was an active critic of CHARLES I in the LONG PARLIAMENT (1640). His tactical and organizational abilities became apparent in the first of the English CIVIL WARS, when his Ironsides helped defeat the Cavaliers at MARSTON MOOR (1644). In 1645 he was made second in command to Sir Thomas FAIRFAX, and helped form the NEW MODEL ARMY. After a decisive victory at NASEBY (1645), Cromwell emerged as the leading voice of the army faction. He favoured a compromise with CHARLES I, but Charles' duplicity convinced him of the need to execute the king. In the second civil war he defeated the Scottish Royalists at Preston (1648). Cromwell's political influence was strengthened in PRIDE'S PURGE (1648) of parliament. The RUMP PARLIAMENT pressed for Charles' execution and established the COMMONWEALTH republic (1649). Cromwell ruthlessly suppressed opposition in Ireland and defeated CHARLES II in the third civil war (1651). The failure of Barebone's Parliament (1653) led to the "Instrument of Government" that established the PROTECTORATE. Cromwell became a virtual military dictator as "lord protector". The Humble Petition and Advice (1657) offered Cromwell the throne, but he refused. Cromwell's expansionist foreign policy was both anti-Stuart and pro-Protestant. The DUTCH WARS (1652-54) and the war (1655-58) with Spain were financially exorbitant. He was succeeded by his son Richard Cromwell. Cromwell, Richard (1626-1712) Lord protector of England (1658-59). Son of Oliver Cromwell, Richard lacked his father's qualities of leadership. He was ousted from power after eight months and spent 20 years in exile before returning to England in 1680.

Cromwell, Thomas, Earl of Essex (1485–1540) English statesman. Cromwell was secretary to Cardinal Wolsey and succeeded him as Henry VIII's chief minister in 1531. He was responsible for the acts of the REFORMATION parliament that established the Church of England with the king as supreme head. Cromwell's ruthless management of the DISSOLUTION OF THE MONASTERIES (1536–40) was demonstrated by the Pilgrimage of Grace (1536). He made vital reforms of local government. Cromwell fell from power after the failure of Henry's marriage to Anne of Cleves, and was executed.

▲ crocus Native to Europe and Asia, the crocus is grown in temperate climates, usually appearing in spring months.

▶ crow The American crow (Corvus brachyrhynchas) is found throughout North America. A large crow, its wingspan can reach up to 90cm (3ft). It feeds on some eggs and nesting chicks as well as insects and small rodents.

Cronin, A.J. (Archibald Joseph) (1896–1981) Scottish novelist. He was a medical inspector of mines and physician until the success of his debut novel, *Hatter's Castle* (1931). Many of his works, such as *The Stars Look Down* (1935), *The Citadel* (1937), *The Keys of the Kingdom* (1942) and *The Green Years* (1944), were filmed soon after they were written. Crookes, Sir William (1832–1919) British chemist and physicist. He invented the radiometer (which measures ELECTROMAGNETIC RADIATION) and the Crookes tube, which led to the discovery of the electron by J.J. THOMSON. He was the first to suggest that CATHODE RAYS consist of negatively charged particles. He also discovered THALLIUM. *See also* X-RAY

crop rotation Practice of successively growing different crops on the same field. Rotated crops generally complement each other, each providing nutrients required by the others.

croquet Lawn game, popular in Britain and the USA, in which wooden balls are hit with wooden mallets through a series of six wire hoops towards a peg. The first player to complete all 12 hoops (each hoop in both directions) and reach the peg wins the game. On the way a player can "roquet" an opponent, by hitting the opponent's ball to a position of disadvantage on the lawn (usually the "wrong" side of a hoop). Croquet developed in France in the 17th century.

Crosby, "Bing" (Harry Lillis) (1904–77) US popular singer and actor. Following Crosby's film debut in *King of Jazz* (1930), he became one of the most successful "crooners". He worked with Bob Hope on the acclaimed *Road* series and won a Best Actor Academy Award for *Going My Way* (1944). His recording of the Irving Berlin song "White Christmas" (1942) was a huge bestseller.

cross Ancient symbol with different significance to many cultures. In Christianity, it is associated with Christ's sacrificial death by crucifixion for the redemption of mankind. An image of a cross is usually placed on, above, or near the altar in churches and is often carried in religious processions. Other crosses are used as religious or secular symbols. They include the crosses of St George, St Andrew, the Victoria Cross, the Red Cross, and the Maltese cross. As a religious symbol, the cross existed in ancient Egypt, Babylonia, and Assyria.

crossbill Parrot-like forest FINCH found mainly in the N of the Northern Hemisphere. It has a heavy, curved, scissor-like bill in which the upper and lower mandibles cross over, which it uses to prise seeds from cones of evergreens. Length: 15cm (6in). Family Fringillidae; genus *Loxia*.

crossbow See ARCHERY

croup Respiratory disorder of small children caused by inflammation of the LARYNX and airways. It is mostly triggered by viral infection. Symptoms are a harsh cough, difficult breathing, restlessness and fever.

Crow Large tribe of Siouan-speaking Native Americans who separated in the early 18th century from the HIDATSA. They migrated into the Rocky Mountains region from the upper Missouri River. Today, they occupy a large reservation area in Montana, where they were settled in 1868. They are noted for their fine costumes, artistic culture and complex social system. Crow Large, black bird found in many temperate woodlands and farm areas worldwide. Living in large flocks, crows prey on small animals and eat plants and carrion. They can be crop pests. They are intelligent birds and can sometimes be taught to repeat phrases. The female lays three to six greenish eggs. Family Corvidae. See also JAY; MAGPIE; RAVEN; ROOK

crown courts In England, courts established in 1971 to

replace the assize courts and courts of quarter session. They are superior courts with a general jurisdiction, presided over by High Court judges.

Cruelty, Theatre of French dramatic movement of the late 1920s. It developed under the influence of Antonin Artaud, who advocated a physical theatre expressing stark emotions rather than complex dialogue. Violence was used as a theatrical device to disturb audience perception. Artaud's theories emphasized the ritual and the surreal, and performance was considered more important than a specific text.

Cruikshank, George (1792–1878) British illustrator and cartoonist, well known for his political and theatrical illustrations. He first gained fame with his caricatures of the leading figures in George IV's divorce proceedings. He also illustrated over 800 books, of which the best-known are Dickens' *Sketches by Boz* (1836) and *Oliver Twist* (1839).

Cruise, Tom (1962–) US film star. His career began in teenage oriented films such as *Risky Business* (1983). More diverse roles followed, such as a navy pilot in *Top Gun* (1986) and a disabled Vietnam veteran in *Born on the Fourth of July* (1990). Other films include *The Color of Money* (1986), *The Firm* (1993) and *Mission Impossible* (1996).

cruise missile Self-propelled MISSILE that travels, generally at low altitudes, following the contours of the terrain. It has the advantage of being able to fly low enough to avoid conventional radar defences. The siting of American cruise missiles on European soil during the 1980s led to large-scale public demonstrations. In the 1991 GULF WAR, the US Navy used Tomahawk cruise missiles on ground targets in Iraq.

cruiser Warship smaller, lighter and faster than a BATTLE-SHIP, ranging in size from 7,500 to 21,000 tonnes. After World War 1, arms limitation treaties restricted its guns to 200mm (8in). Since World War 2, cruisers have replaced battleships as the major warships of a modern navy.

Crusades Military expeditions from Christian Europe to recapture the Holy Land (Palestine) from the Muslims in the 11th-14th centuries. Among the motives for the Crusades were rising religious fervour, protection of pilgrims to the Holy Land and aid for the BYZANTINE EMPIRE against the Seljuk Turks. Self-advancement of individual crusaders and commercial motives were also significant. The First Crusade (1096-99), initiated by Pope Urban II, captured Jerusalem and created several Christian states. Later crusades had the objective of supporting or regaining these states. The Third Crusade (1189-91) was a response to the victories of SALADIN. Its leaders included the Holy Roman emperor and the kings of France and England. It had some successes, but failed to reconquer JERUSALEM. Although crusader states survived for another century, later crusades were less successful. In the 13th century, the church sponsored crusades against other foes, such as the ALBI-GENSES in France. See also CHILDREN'S CRUSADES

crust In geology, the thin outermost solid layer of the Earth. The crust represents less than 1% of the Earth's volume and varies in thickness from *c.*5km (3mi) beneath the oceans to *c.*70km (45mi) beneath mountain chains, such as the Himalayas. Oceanic crust is generally thinner averaging 7km (4.5mi) thick and is basaltic in composition, whereas continental crust is mainly between 30–40km (20–25mi) thick and of granitic composition. The crust is defined by its seismicity. The lower boundary of the crust is defined by a marked increase in seismic velocity, known as the Mohorovičič discontinuity. *See also* MOHO

Crustacea Class of c.30,000 species of ARTHROPODS. The class includes the decapods (crabs, lobsters, shrimps and crayfish), isopods (pill millipedes and woodlice) and many varied forms, most of which have no common names. Most crustaceans are aquatic (marine or freshwater) and breathe through gills or the body surface. They are typically covered by a hard exoskeleton. They range in size from the Japanese spider crab up to 3m (12ft) across to the ocean plankton, as little as 1mm (0.04in) in diameter.

cryogenics Branch of physics that studies materials and effects at temperatures approaching ABSOLUTE ZERO. Some materials exhibit highly unusual properties such as SUPERCONDUCTIVITY or SUPERFLUIDITY at such temperatures. Cryogenics

(

has been used to freeze human bodies in the uncertain hope that future technology may be able to revive the subjects.

cryptography Form of written message in which the original text (plaintext) is replaced by a series of other signs according to a prearranged system, in order to keep the message confidential. Unlike a code, in which each letter of the plaintext is replaced by another sign, a cipher cannot be "cracked" without a key. Typically, a key is a complex pattern of letters or symbols forming the basis upon which the plaintext is enciphered. The receiver reverses this process to decipher the message. Ciphers were used by the ancient Greeks and were employed widely for military and diplomatic messages during the medieval and Renaissance periods. Mechanical devices for producing complex ciphers were developed between the two World Wars. The best-known cipher machine was the German Enigma device. Modern fast computers are today used by intelligence services for constructing and breaking constantly changing complex ciphers. The same system is used for keeping credit card information secret.

crystal Solid with a regular geometrical form and with characteristic angles between its faces, having limited chemical composition. The structure of a crystal, such as common salt,

is based upon a regular 3–D arrangement of atoms, ions or molecules (a crystal or ionic lattice). Crystals are produced when a substance passes from a gaseous or liquid phase to a solid state, or comes out of solution by evaporation or precipitation. The rate of crystallization determines the size of crystal formed. Slow cooling produces large crystals, whereas fast cooling produces small crystals.

crystallography Study of the formation and structure of crystalline substances. It includes the study of crystal formation, chemical bonding in crystals and the physical properties of solids. In particular, crystallography is concerned with the internal structure of crystals. *See also* X-RAY CRYSTALLOGRAPHY Crystal Palace First building of its size, 124 × 564m (408 × 1,850ft), to be made of glass and iron. Sir Joseph PAXTON designed it for the Great Exhibition held in Hyde Park, London (1851). It was the first building prefabricated in sections and assembled on site. Crystal Palace greatly influenced railway station design. After the exhibition it was dismantled and re-erected on Sydenham Hill, SE London, where it stood until accidentally destroyed by fire in 1936.

Cuba Caribbean island republic at the entrance to the Gulf of Mexico. *See* country feature

CUBA

Cuba's flag, the "Lone Star" banner, was designed in 1849, but not adopted as the national flag until 1901, after Spain had withdrawn from the country. The red triangle represents the Cuban people's bloody struggle for independence.

AREA: 110,860sq km (42,803sq mi)

POPULATION: 10,822,000

CAPITAL (POPULATION): Havana (2,096,054)

GOVERNMENT: Socialist republic

ETHNIC GROUPS: White 66%, Mulatto 22%,

Black 12%

LANGUAGES: Spanish (official)

RELIGIONS: Christianity (Roman Catholic 40%,

Protestant 3%)

currency: Cuban peso = 100 centavos

Cuba is the largest and most westerly of the WEST INDIES archipelago. It consists of one large island, Cuba, together with the *Isla de la Juventud* (Isle of Youth) and many small islets.

The highest mountain range, the Sierra Maestra in the SE, reaches 2,000m (6,562ft) at Pico Turquino. The rest of the land consists of gently rolling hills or coastal plains.

CLIMATE

Cuba has a semi-tropical climate. The dry season runs from November to April, while May to October is the rainy season. Fierce hurricanes may occur between August and October.

VEGETATION

Farmland covers about half of Cuba and 66% of this is given over to sugar cane. Pine forests still grow, especially in the SE. Mangrove swamps line some coastal areas.

HISTORY AND POLITICS

When Christopher Columbus discovered Cuba in 1492, it was inhabited by Native Americans. The first Spanish colony was established in 1511. The indigenous population was quickly killed, replaced by African slave labour. Cuba formed a base for Spanish exploration of the American mainland, and became a prime target for pirates. Discontent at Spanish rule erupted into war in 1868. Slavery was abolished in 1886. In 1895 a second war of independence was led by José MARTÍ. In 1898 the sinking of the US battleship Maine precipitated the SPANISH-AMERICAN WAR. From 1898 to 1902 Cuba was under US military occupation before becoming an independent republic. In order to protect US-owned plantations, the US occupied Cuba (1906-09, 1912).

During World War 1 Cuba's economy flourished as the price of sugar rose dramatically. From 1933 to 1959 Fulgencio BATISTA ruled Cuba, maintaining good relations with the US. In 1952 he imposed martial law. After an abortive coup attempt in 1953, Fidel CASTRO (supported by Che GUEVARA) launched a revolution in 1956. In 1959 Castro became premier. Castro's brand of revolutionary socialism included the nationalization of many US-owned industries. In 1961 the US broke off diplomatic ties and imposed a trade embargo. Castro turned to the Soviet Union. Cuban exiles, supported by the US government, launched the disastrous BAY OF PIGS invasion. In 1962 the potential siting of Soviet missiles fuelled the CUBAN MIS-SILE CRISIS. Castro's attempt to export revolution to the rest of Latin America ended in diplomatic alienation. Cuba turned to acting as a leader of developing nations and providing support for revolutionary movements. Between 1965 and 1973, over 250,000 Cubans went into voluntary exile. Emigration was legalized in 1980 and many disaffected Cubans chose to leave.

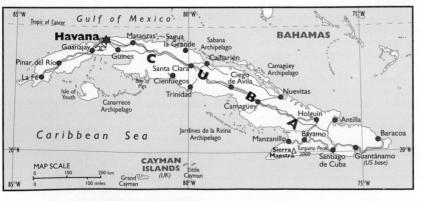

ECONOMY

Despite advances in health-care and education, Cuba's economy has been devastated (1992 GDP per capita, \$US3,412) by the dissolution of the Soviet Union. Restrictions on private ownership of industry were relaxed in 1993. The US trade embargo continues to bite, and the Helms-Burton Act (1996) imposed penalties on firms that invest in Cuba. Cuba is over-dependent on its sugar industry (75% of exports). It is the world's fourth-largest producer of sugar cane. Nickel ore is the second largest export. Other exports include cigars, fishing and rum.

▲ cuckoo The common
European cuckoo (*Cuculus*canorus) is famous for its parasitic
behaviour. The female lays its egg
in a smaller host's nest. The young
cuckoo ejects its smaller nest
mates and receives all the
attention of its foster parents.

Cuban Missile Crisis (October 1962) US and Soviet Union confrontation over the installation of Soviet nuclear rockets in Cuba, perhaps the closest the world has yet come to nuclear war. Photographs taken by US reconnaissance aircraft revealed the construction of ballistic missile bases in Cuba. President John Kennedy warned Premier Nikita Khrushchev that any missile launched from Cuba would be met by a full-scale nuclear strike on the Soviet Union. On 24 October, Cuba-bound Soviet ships bearing missiles turned back, and Khrushchev ordered the bases to be dismantled.

cube In mathematics, the result of multiplying a given number by itself twice. Thus, the cube of a is $a \times a \times a$, written a^3 . A cube is also described as the third power of a number. The cube root is the number that must be multiplied by itself twice over to give a specified number. A cube is a regular six-sided solid figure (all its edges are equal in length and all its faces are squares).

cubism Revolutionary, 20th-century art movement. It originated in c.1907 when Picasso and Braque began working together to develop ideas for changing the scope of painting. They wanted a new pictorial language able to represent ideas as well as objective reality. Abandoning traditional methods of creating pictures with one-point PERSPECTIVE, they built up three-dimensional images on the canvas using fragmented solids and volumes. In 1908 Braque held an exhibition of his new paintings, which provoked the critic Louis Vauxcelles to describe them as bizarre arrangements of "cubes". The initial experimental, "analytical", phase (1907-12), of which Picasso and Braque were the main exponents, was inspired mainly by African sculpture and the later works of CÉZANNE. They treated their subjects in muted grey and beige so as not to distract attention from the new concept. The "synthetic" phase (1912-14) introduced much more colour and decoration and the techniques of COLLAGE and papiers collés were very popular. Cubism attracted many painters as well as sculptors. These included Léger, Robert Delaunay and Sonia Delaunay-Terk and František KUPKA. The most important cubist sculptors (apart from Picasso) were ARCHIPENKO, LIPCHITZ and Ossip Zadkine. Although it was not an abstract idiom, cubism revolutionized artistic expression, and lent itself easily to adaptation and development. It is probably the most important single influence on 20th-century progressive art.

cuckoo Widely distributed forest bird. Related species are the ani, ROAD RUNNER and coucal. True Old World cuckoos are generally brownish, although a few species are brightly coloured and notable for parasitic behaviour. Their chief food is insects. Length: 15–75cm (6–30in). Family Cuculidae; genus *Cuculus*.

cuckoopint (wake robin or lords-and-ladies) Tuberous plant native to Europe. It has arrow-shaped leaves and sends up stout SPATHES, each of which unfurls to reveal a SPADIX that gives off a fetid carrion scent, attractive to insects, especially carrion-feeders. Later red poisonous berries form as the spathe dies off. Family Araceae; species *Arum maculatum*.

cucumber Trailing annual vine covered in coarse hairs; it has yellowish flowers and the immature fruit is eaten raw or pickled. Family Cucurbitaceae; species *Cucumis sativus*.

Culloden, Battle of (1746) Decisive battle of the Jacobite rising of 1745. The Jacobites, predominantly Highlanders, led by Charles Edward STUART were defeated near Inverness by government forces under the Duke of Cumberland, son of George II. Culloden ended Stuart attempts to regain the throne by force. The battle was followed by ruthless subjugation of the Highland clans.

cult System of religious beliefs, rites and observances connected with a divinity or group of divinities, or the sect devoted to such a system. Within a religion such as HINDUISM, many gods have their own cults, notably SHIVA. Animals are the focus of some cults, such as the INUIT whale cult. A deified human being may also be the object of worship, as in the emperor cults of ancient Rome. In the 20th century a cult often denotes a quasi-religious organization that controls its followers by means of psychological manipulation. Leaders of cults are usually forceful, charismatic personalities.

Cultural Revolution (1966–76) The Great Proletarian Cul-

tural Revolution was initiated by MAO ZEDONG and his wife, JIANG QING, to purge the Chinese COMMUNIST PARTY of his opponents and to instil correct revolutionary attitudes. Senior party officials were removed from their posts, intellectuals and others suspected of revisionism were victimized and humiliated. A new youth corps, the RED GUARDS, staged protests, held rallies and violently attacked reactionary ideas. By 1968 China was approaching civil war. The Red Guards were disbanded and the army restored order.

culture In ANTHROPOLOGY, all knowledge that is acquired by human beings by virtue of their membership of a society. A culture incorporates all the shared knowledge, expectations and beliefs of a group. Culture in general distinguishes human beings from animals, since only humans can pass on accumulated knowledge due to their mastery of language and other symbolic systems.

Cumbria County in NW England, bounded by the Solway Firth (N), and the Irish Sea (W); the county town is CARLISLE. The region includes the LAKE DISTRICT and the Cumbrian Mountains. Area: 6,808sq km (2,629sq mi). Pop. (1991) 483,163.

cummings, e.e. (Edward Estlin) (1894–1962) US poet. His first work was a novel, *The Enormous Room* (1922), which describes his imprisonment in a French detention centre. His reputation rests on his poetry, which usually exhibits sentimental emotion and/or cynical realism. It is famously characterized by unconventional spelling, punctuation and typography. His verse was collected in *Complete Poems* 1913–1962 (1972).

cuneiform System of writing developed in Mesopotamia $c.3000\,$ BC. The system consists of wedge-shaped strokes, derived from the practice of writing on soft clay with a triangular stylus as a "pen". Cuneiform developed from pictograms. The pictograms came to serve as an "alphabet", eventually consisting of more than 500 characters. Most stood for words, but there were also some that stood for syllables or speech-sounds.

Cunningham, Merce (1919–) US modern dancer and choreographer. In 1952 he formed the much-acclaimed Merce Cunningham Dance Company. His productions are highly experimental and controversial and include *Antic Meet* (1958) and *How to Pass, Kick, Fall and Run* (1965).

Cupid In Roman mythology, god of love, equivalent to the Greek god Eros.

cupola Small dome crowning a roof or turret, at the intersection of the arms of a building or on the corners of a square plan. **cuprite** Reddish-brown, brittle, translucent oxide mineral, cuprous oxide (Cu_2O). Formed by the oxidation of other ores, such as copper sulphide, it is an important source of copper.

Curação Largest island of the NETHERLANDS ANTILLES in the West Indies, in the s Caribbean Sea; the capital is Willemstad. Most inhabitants are descended from African slaves imported during the 17th and 18th centuries; the indigenous Arawak are now extinct. Curação derives most of its income from tourism and oil-refining. Products: groundnuts, tropical fruits, Curação liqueur, phosphates. Area: 444sq km (171sq mi). Pop. (1993 est.) 146,828.

curare Poisonous resinous extract obtained from various tropical South American plants of the genera *Chondodendron* and *Strychnos*. Most of its active elements are ALKALOIDS. Causing muscle paralysis, it is used on the poisoned arrows of Native South Americans when hunting. It is also used as a muscle relaxant in abdominal surgery and setting fractures.

curate (Lat. *cura*, charge) Clergyman who assists the incumbent priest of a parish in the performance of his duties. The term was originally used to denote a priest who had the charge of a parish.

Curia Romana Official administrative body of the Roman Catholic Church. It is based in the VATICAN and consists of a court of officials through which the pope governs the Church. It includes three groups – congregations, tribunals and curial offices – and is concerned with all aspects of the life of the Church and its members.

Curie, Marie (1867–1934) Polish scientist, who specialized in work on RADIATION. Marie and her husband Pierre Curie (who specialized in the electrical and magnetic properties of

▲ cucumber Large, watery fruits are a common feature of the cucumber (*Cucumis sativus*) and its relatives. The plants are generally large and covered in coarse hairs and many have tendrils that help them climb.

crystals, and formulated a law relating magnetism to temperature) worked together on a series of radiation experiments. In 1898 they discovered RADIUM and POLONIUM. In 1903 they shared the Nobel Prize for physics with A.H. BECQUEREL. In 1911 Marie became the first person to be awarded a second Nobel Prize (this time for chemistry), for her work on radium and its compounds. She died of leukaemia caused by laboratory radiation. Their daughter, Irène Joliot-Curie, and her husband, Frédéric Joliot-Curie, were awarded the 1935 Nobel Prize for chemistry for producing artificial radioactive substances by bombarding elements with alpha particles.

curie (symbol Ci) Unit formerly used to measure the activity of a radioactive substance. Named after Marie Curie, it is defined as that quantity of a radioactive isotope that decays at the rate of 3.7×10^{10} disintegrations per second. The curie has been replaced by an SI unit, the because (symbol Ba).

curium (symbol Cm) Synthetic radioactive metallic element of the ACTINIDE SERIES in the periodic table. It was first made in 1944 by the US nuclear chemist Glenn Seaborg and his colleagues by the alpha particle bombardment of plutonium-239 in a cyclotron. Silvery in colour, curium is chemically reactive, intensely radioactive and is toxic if absorbed by the body. It provides power for orbiting satellites. Properties: at.no. 96; r.d. (calculated) 13.51; m.p. 1,340°C (2,444°F); 14 isotopes, most stable Cm²⁴⁷ (half-life 1.6×10⁷ yr).

curlew Long-legged wading bird with a down-curved bill and mottled brown plumage. Often migrating long distances, it feeds on small animals, insects and seeds, and nests on the ground, laying two to four eggs. Length: to 48–62cm (19–25in). Species *Numenius arquata*.

curling Game resembling bowls on ice that is a major winter sport of Scotland, and popular in Canada, N USA and Nordic countries. The game is played by two teams of four players on an ice surface, 42m (138ft) \times 4.3m (14ft). Each player has two smooth circular stones — dished at the base and on top, and with a handle. Players are also provided with a crampit, a spiked metal footplate. At each end of the ice is a circular target with a central area known as the tee. One player sends his stone towards the tee, team-mates use brooms to sweep the surface in front of it to give it a smoother surface over which to glide. Each player delivers two stones. One point is scored for each stone lying nearer the tee than an opponent's stone.

currant Any of several mainly deciduous shrubs and their fruits, rich in vitamin C. Black, red and white currants are included in the genus *Ribes*: they are popular plants, cultivated widely. The fruits are used in pies, preserves and syrups. Family Grossulariaceae.

current See oceanic current

Curzon, George Nathaniel, 1st Marquess of Kedleston (1859–1925) British Conservative statesman. He entered parliament in 1886 and travelled widely in Asia before becoming Viceroy of India (1899–1905). There he carried out many reforms before he resigned as a result of an argument with Lord KITCHENER. He served in the war cabinet (1915–19) and as foreign secretary (1919–24).

Cushing, Harvey (1869–1939) US surgeon. His pioneering techniques for surgery on the brain and spinal cord helped advance neurosurgery. He first described the syndrome produced by over-secretion of adrenal hormones that is now known as Cushing's syndrome. It is characterized by weightgain in the face and trunk, high blood pressure, excessive growth of facial and body hair, and diabetes-like effects.

Custer, George Armstrong (1839–76) US military leader. A flamboyant, headstrong character, Custer served with the Union and became the youngest brigadier general in the US Civil War. Following the war, he was posted to the frontier, but was court-martialled for disobeying orders in 1867 and suspended. In 1868 he returned to service and led attacks on the CHEYENNE. In 1876, at the Battle of the LITTLE BIGHORN, his force was attacked by the SIOUX and every man killed.

cuticle Exposed outer layer of an animal. In humans this refers to the EPIDERMIS, especially the dead skin at the edge of fingers. In botany, it refers to the waxy layer on the outer surface of epidermal cells of leaves and stems of vascular plants. It helps to prevent excessive water loss.

cuttlefish Cephalopod MOLLUSC related to the SQUID and OCTOPUS. Like squid, cuttlefish swim rapidly by the propulsion of a jet of water forced out through a siphon. They have ten sucker-covered arms on the head, two much longer than the rest. Their flattened bodies contain the familiar chalky cuttle-bone. Capable of rapid colour changes, they can also eject blue-black "ink" as a means of protection. Family Sepidae; species *Sepia officinalis*.

Cuvier, Georges, Baron de (1769–1832) French geologist and zoologist, a founder of comparative anatomy and palaeontology. His scheme of classification stressed the form of organs and their correlation within the body. He applied this system of classification to fossils, and came to reject the theory of gradual evolution, favouring instead a theory of catastrophic changes.

Cuzco City in s central Peru; capital of Cuzco department. An ancient capital of the Inca empire from c.1200, it fell to the Spaniards in 1533. Cuzco was destroyed by earthquakes in 1650 and then rebuilt. It is a centre of archaeological research; nearby sites include the fortress of Sacsahuáman, Inca terraces at Pisac and MACHU PICCHU. Pop. (1993) 255,568.

cyanide Salt or ester of hydrocyanic acid (prussic acid, HCN). The most important cyanides are sodium cyanide (NaCN) and potassium cyanide (KCN), both of which are deadly poisonous. Cyanides have many industrial uses – in electroplating, for the heat treatment of metals, in the extraction of silver and gold, in photography, and in insecticides and pigments.

cyanobacteria (formerly blue-green algae) One of the major BACTERIA phyla, distinguished by the presence of the green pigment CHLOROPHYLL and the blue pigment phycocyanin. They perform PHOTOSYNTHESIS with the production of oxygen. Analysis of the genetic material of chloroplasts shows that they evolved from cyanobacteria, by ENDOSYMBIOSIS. Many cyanobacteria perform NITROGEN FIXATION. They occur in soil, mud and deserts; they are most abundant in lakes, rivers and oceans. Some produce toxic BLOOMS.

cybernetics Study of communication and control systems in animals, organizations and machines. It makes analogies between the BRAIN and nervous system, and COMPUTERS and other electronic systems, such as the analysis of the mechanisms of FEEDBACK and data processing. A household thermostat might be compared with the body's mechanisms for temperature control and respiration. Cybernetics combines aspects of mathematics, neurophysiology, computer technology, INFORMATION THEORY and psychology.

cyberspace Popular term for the perceived "virtual" space within computer memory or networks, especially if rendered graphically. The term is a product of science fiction, where it usually refers to a direct interace between brain and computer. During the mid-1990s, the term was commonly used in reference to the internet and the worldwide web.

cycad Phylum (Cycadophyta) of primitive palm-like shrubs and trees that grow in tropical and subtropical regions. Although they are GYMNOSPERMS, they have feathery palmor fern-like leaves (poisonous in most species) at the top of stout (usually unbranched) stems. In addition to their main roots, they also have special roots containing CYANOBACTERIA that carry out NITROGEN FIXATION. These plants first flourished *c*.225 million years ago. Most of the 100 or so surviving species are less than 6m (20ft) tall.

cyclamen Genus of 20 species of low-growing perennial herbs, native to central Europe and the Mediterranean region. They have swollen, tuberous corms, and heart- or kidney-shaped leaves. The drooping blooms are white, pink, lilac or crimson. Family Primulaceae.

cycle In physics, series of changes through which any system passes which brings it back to its original state. For example, alternating current starts from zero voltage, rises to a maximum, declines through zero to a minimum and rises again to zero. In the INTERNAL COMBUSTION ENGINE, the two-stroke engine completes one cycle each downward plunge and return; the four-stroke cycle takes two such movements. **cycling** Sport for individuals and teams competing on BICY-CLES. Now a regular event at the Olympic Games, cycle racing first became popular following the invention of the pneu-

▲ Custer The youngest Union general in the American Civil War, George Custer received the Confederate flag of truce. A controversial figure in US history, he was accused later of abandoning a detachment of his troops, who were massacred at Washita (1868). Custer's decision to divide his regiment and attack a superior force of Sioux at the Battle of Little Bighorn resulted in the killing of Custer and his entire regiment. Custer became a national hero.

▲ cyclamen Often cultivated for its pink or white flowers, the cyclamen (genus *Cyclamen*) has characteristic petals that are twisted at the base and bent back.

▲ cypress The Lawson cypress (Chamaecyparis lawsonia) can grow to a height of 60m (200ft), and live for up to 600 years. Also known as the Oregon cedar, this tree is native to Oregon and California, where it is grown for its timber and natural beauty.

matic tyre (1888). There is a diversity of formats and events, road racing being the best-known form. This takes place outdoors over various distances or time-trials. The most famous cycle race is the TOUR DE FRANCE (inaugurated 1903).

cyclone System of winds, or a storm, that rotates inwards around a centre of low atmospheric pressure (depression). The winds flow anti-clockwise in the Northern Hemisphere and clockwise in the Southern Hemisphere. Cyclones in middle latitudes are associated with cloudiness and high humidity, and the development of a FRONT. A strong tropical cyclone can give rise to a HURRICANE. See also TORNADO

Cyclopes In Greek mythology, three demons, each having one eye in the centre of its forehead, who forged the thunderbolts of Zeus. They were depicted by Homer as giant herdsmen living on an island. Odysseus escaped from the cannabalistic Cyclops Polyphemus by blinding him.

Cygnus One of the most distinctive constellations, often nicknamed the Northern Cross.

cylinder Solid figure or surface formed by rotating a rectangle using one side as an axis. If the vertical height is h and the radius of the base r, then the volume is $\pi r^2 h$ and the curved surface area $2\pi rh$.

Cymbeline (Cunobelinus) (d. *c.*AD 42) Ancient British king. An ally of the Romans, he was king of the Catuvellauni tribe. After conquering the Trinovantes, he became the strongest ruler of s Britain.

Cynewulf English poet of the early 8th century, presumed to be the author of *Elene*, *The Fates of the Apostles*, *The Ascension*, and *Juliana*. Little is known about him, but the poems suggest that he was a priest in Mercia or Northumbria.

Cynic Philosophical way of life begun by Antisthenes, a pupil of Socrates. This goal of life requires self-sufficiency, as exemplified in the life of Diogenes of Sinope (*c*.412–323 BC), a contemporary of Alexander the Great. With the succession of individuals who "lived" its precepts, great variation developed in its interpretation.

cypress Tall, evergreen tree native to North America and Eurasia, and growing best in warmer climates. It has scale-like leaves, roundish cones and a distinctive symmetrical shape. The wood is durable and fragrant and is of value commercially. Height: 6–24m (20–80ft). Family Cupressaceae; genus *Cupressus*. There are about 20 species.

Cyprus Island republic in the NE Mediterranean Sea; the capital is NICOSIA. **Land and climate** Cyprus has scenic mountain ranges, the Kyrenia and the Troodos, the latter rising to 1,951m (6,401ft), at Mount Olympus. The island contains fertile lowlands, used extensively for agriculture. It has a Mediterranean climate, with hot, dry summers and mild winters. Pine forests grow on the mountain slopes. **Economy**

Cyprus got its name from the Greek word Kypros, meaning copper, but little copper remains; the chief minerals today are asbestos and chromium. Industry employs 37% of the workforce, and manufactures include cement, footwear, tiles and wine. Farming employs 14% of the workforce and crops include barley, citrus fruits, grapes, olives, potatoes and wheat. The most valuable activity in Cyprus is tourism. Cyprus is classified as a developed country, but the economy of the Turkish Cypriot N lags behind that of the Greek Cypriot S. **History and Politics** Greeks settled on Cyprus c.3,200 years ago. From AD 330, the island was part of the Byzantine empire. In the 1570s, it became part of the Ottoman empire. Turkish rule continued until 1878, when Cyprus was leased to Britain. Britain annexed the island in 1914 and proclaimed it a colony in 1925. In the 1950s, Greek Cypriots, who made up 80% of the population, began a campaign for enosis (union) with Greece. Their leader was the Greek Orthodox Archbishop Makarios. A guerrilla force (EOKA) attacked the British, who exiled Makarios. In 1960, Cyprus became an independent country and Makarios was its first president. The constitution of independent Cyprus provided for power-sharing between the Greek and Turkish Cypriots. It proved unworkable, however, and fighting broke out between the two communities. In 1964, the UN sent in a peace-keeping force, but clashes recurred in 1967. In 1974, Greek-led Cypriot forces overthrew Makarios. This led Turkey to invade N Cyprus, occupying about 40% of the island. Many Greek Cypriots fled from the Turkish-occupied area, which, in 1979, was proclaimed a self-governing region. In 1983, the Turkish Cypriots declared the N to be an independent state, called the Turkish Republic of Northern Cyprus; the only country to recognize it is Turkey. The UN regards Cyprus as a single nation under the Greek Cypriot government in the s. The partition of Cyprus is a source of tension between Greece and Turkey. It is estimated that over 30,000 Turkish troops are deployed in N Cyprus. Depsite UN-brokered peace negotiations (1997), there are frequent border clashes between the two communities.

Cyrano de Bergerac, Savinien (1619–55) French writer. His novels and plays combine free thinking, humour and burlesque romance. As an author, he is best known for two posthumously published prose fantasies, *Journey to the Moon* (1656) and *The Comical Tale of the States and Empires of the Sun* (1662), which contain many scientific predictions. He is perhaps equally famous as the eponymous hero of the popular but historically inaccurate play by Edmond ROSTAND.

Cyril, Saint Greek Christian missionary. With his brother, Methodius, he is one of the two so-called "Apostles to the Slavs" who were sent to convert the Khazars and Moravians to Christianity. Cyril is said to have invented the CYRILLIC alphabet. His feast day is 14 February in the West and 11 May in the East.

Cyrillic ALPHABET based on Greek letter forms that is now used for writing several Slavic languages, most notably Russian and Serbian.

Cyrus the Great (600-529 BC) King of Persia, founder of the Achaemenid Persian empire. He overthrew the Medes, then rulers of Persia, in 549 BC, defeated King Croesus of Lydia (c.546 BC), captured Babylon (539 BC) and the Greek cities in Asia Minor. Though he failed to conquer Egypt, his empire stretched from the Mediterranean to India. He delivered the Jews from their Babylonian Captivity, sending them home to Palestine.

cystic fibrosis Hereditary glandular disease in which the body produces abnormally thick mucus that obstructs the breathing passages, causing chronic lung disease. There is a deficiency of pancreatic enzymes, an abnormally high salt concentration in the sweat and a general failure to gain weight. The disease is treated with antibiotics, pancreatic enzymes and a high-protein diet; sufferers must undergo vigorous physiotherapy to keep the chest as clear as possible.

cystitis Inflammation of the urinary bladder, usually caused by bacterial infection. It is more common in women. Symptoms include frequent and painful urination, low back pain and slight fever.

cytokinin (kinetin or kinin) Any of a group of plant hor-

AREA: 9,250 sq km (3,571 sq mi)
POPULATION: 725,000
CAPITAL (POPULATION):
Nicosia (177,451)

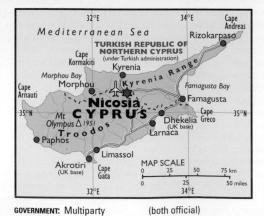

republic ETHNIC GROUPS: Greek Cypriot 81%, Turkish Cypriot 19% LANGUAGES: Greek and Turkish

RELIGIONS: Christianity
reek Cypriot (Greek Orthodox), Islam
oriot 19% currency: Cyprus pound =
k and Turkish 100 cents

mones that stimulate cell division. Cytokinins work in conjunction with AUXINS to promote swelling and division in the plant cells producing lateral buds. They can also slow down the aging process in plants, encourage seeds to germinate and plants to flower, and are involved in plant responses to drought and water-logging. They are used commercially to produce seedless grapes, to stimulate germination of barley in brewing, and to prolong the life of green-leaf vegetables.

cytology Study of living CELLS and their structure, behaviour and function. Cytology began with Robert Hooke's microscopic studies of cork in 1665, and the microscope is still the main tool. In the 19th century, a theory was developed which suggested that cells are the basic units of organisms. Recently cytochemistry has focused on the study of the chemistry of cell components.

cytoplasm Jelly-like matter inside a CELL and surrounding the NUCLEUS. Cytoplasm has a complex constituency and contains various bodies known as organelles, with specific metabolic functions. The proteins needed for cell growth and repair are produced in the cytoplasm.

Czech Language spoken in the Czech Republic (Bohemia and Moravia) by c.10 million people. A Slavic language, it is closely related to Slovak.

Czechoslovakia Former federal state in central Europe. Formed after World War 1 from parts of the old Austro-Hungarian Empire, Czechoslovakia was formally recognized as a new republic by the Treaty of St Germain (1918). A democratic constitution was established in 1920, and the nation was led first by Tomás Masaryk and then by Eduard Beneš. Nationalist tensions caused unrest: the Slovaks had

long wanted autonomy and the large German population in the N wanted to join with Germany. Hitler's rise to power and annexation of Austria led to the Munich Agreement (1938), which ceded Czech land to Germany. Poland and Hungary also acquired territory and Beneš resigned. Hitler occupied the country in 1939 and Beneš formed a government in exile in London. In 1945 the country was liberated by Soviet and US troops and Beneš was restored as president. A 1946 election gave the communists a majority in the coalition. By 1948 they had assumed complete control and Beneš resigned. Czechoslovakia became a Soviet-style state with greatly reduced political and cultural freedom. Unrest during the 1950s led to some liberalization, but it was not until the PRAGUE SPRING of 1968 with the reforms of Alexander DUBČEK that any great democratization occurred. Soviet troops crushed the revolution. There were mass arrests and all reforms were reversed. When democratic reforms were introduced in the Soviet Union in the late 1980s, Czechs also demanded reforms. In 1989, anti-government demonstrations and the democratization of Eastern Europe finally led to the resignation of Communist Party leaders. Non-communists came to power and the "Velvet Revolution" was completed with the election of Vaclav HAVEL. Free elections were held in 1990, but differences between the Czechs and Slovaks led to the partitioning of the country on 1 January 1993. The break was peaceful and the two new nations, the CZECH REPUBLIC and the SLOVAK REPUBLIC, have retained many ties. See also Bohemia: Moravia

Czech Republic Republic in central Europe. See country feature

CZECH REPUBLIC

After independence on 1 January 1993, the Czech Republic adopted the flag of the former Czechoslovakia. It features the red and white of Bohemia, together with the blue of Moravia and Slovakia. Red, white and blue are the colours of pan-Slavic liberation.

The Czech Republic is made up of two regions: the plateau of BOHEMIA in the W, and the lowland of MORAVIA in the E. The capital, PRAGUE, and PLZEN are Bohemia's largest cities; BRNO is the major Moravian city, Mountains form most of the N border. Rivers are vital to this landlocked republic. Some rivers, such as the ELBE, Oder and Vltava flow N into Germany, while others in the s flow into the DANUBE basin.

CLIMATE

The climate is continental. Moderate Atlantic air streams give Prague warm summers, while

easterly winds from Russia bring bitterly cold winters. The average annual rainfall is moderate, with 500mm-750mm (20in-30in) common in lowland areas.

VEGETATION

Many of the republic's forests have been cut down to create farmland, but oak and spruce remain. Acid rain is damaging trees in the N.

HISTORY AND POLITICS

The CZECHS people began to settle in the area c.1,500 years ago. Bohemia became important in the 10th century as a kingdom within the Holy Roman Empire. In 1526 the Austrian Habsburgs assumed control, but a Czech rebellion in 1618 led to the THIRTY YEARS' WAR. German culture dominated the area until the late 18th century. Although Austria continued to rule Bohemia and Moravia, Czech nationalism continued to grow throughout the 19th century.

After World War 1 CZECHOSLOVAKIA was created. Germany occupied the country in World War 2. In 1946 the communists emerged as the strongest party, but Eduard BENES became president. By 1948 communist leaders had assumed absolute control. Democratic reforms culminat-

AREA: 78,864sq km (30,449sq mi) **POPULATION:** 10,310,000

CAPITAL (POPULATION): Prague (1,216,005)
GOVERNMENT: Multiparty republic
ETHNIC GROUPS: Czech 81%, Moravian 13%,
Slovak 3%, Polish, German, Silesian, Gypsy,

Hungarian, Ukrainian LANGUAGES: Czech (official)

RELIGIONS: Christianity (Roman Catholic 39%,

Protestant 4%)

currency: Czech koruna = 100 halura

ed in the Prague Spring (1968). Warsaw Pact troops invaded to crush the liberals. In 1989, mass demonstrations resulted in the "Velvet Revolution", and the formation of a non-communist administration. Free elections were held in 1991, resulting in the re-election of Vaclav Havel. In 1992, the government agreed to the secession of the Slovak Republic, and on 1 January 1993 the Czech Republic was created. The break was peaceful and the two new nations retain many ties.

ECONOMY

Under communism, Czechoslovakia became one of the most industrialized parts of Eastern Europe. The country has deposits of coal, uranium, iron ore, magnesite, tin and zinc. Manufacturing employs 40% of the workforce. Industries include chemicals, beer, iron and steel and machinery. Light industries include glassware and textiles.

The Czech Republic is mainly self-sufficient in food. Private ownership of land is gradually being restored. Agriculture employs 12% of the workforce. Livestock raising is important. Crops include grains, fruit, and hops for brewing.

D/d, the fourth letter of the Roman-based w European alphabet, representing a voiced dental plosive consonant or stop. It is derived from the Semitic daleth and the Greek delta, receiving its present form from the Romans. In Roman numerals, D stands for 500.

▲ daffodil Originally native to Europe and N Africa, the daffodil (Narcissus genus) is grown worldwide for its attractive, yellow, trumpet-shaped flower. In many regions it heralds the beginning of spring.

▲ dahlia Numbering over 7,000 varieties, the dahlia (*Dahlia* genus) is named after the Swiss botanist Anders Dahl. Most varieties have been developed from the original s American species *D. pinnata*.

dace Any of several small freshwater fish of the carp family, Cyprinidae. The common European dace (*Leuciscus leuciscus*) is silvery and may grow 30cm (12in) long. The Moapa dace (*Moapa coriacea*) is an endangered species.

Dachau Town in Bavaria, sw Germany, site of the first Nazi CONCENTRATION CAMP established in March 1933. Up to 70,000 people died or were murdered here before liberation in 1945. The site is preserved as a memorial.

Dacia Ancient region of Europe (now in Romania). It was colonized (101–106) by TRAJAN. Dacia was later overrun by Goths, Huns and Avars. The language was retained and forms the basis of modern Romanian.

Dada (Dadaism) Movement in literature and the visual arts, started in Zürich (1915). Members included Jean ARP, Tristan Tzara and Marcel Janco. The group, repelled by war and bored with CUBISM, promulgated complete nihilism, espoused satire and ridiculed civilization. Dadaists participated in deliberately irreverent art events, designed to shock a complacent public. They stressed the absurd and the importance of the unconscious. In the early 1920s, conflicts of interest led to the demise of Dadaism. A number of its former disciples, particularly André BRETON, developed SURREALISM.

Dadd, Richard (1817–61) English painter. Dadd showed early promise as an artist, but murdered his father in 1843 and spent the rest of his life in asylums. He continued to paint, specializing in highly imaginative fairy and fantasy pictures. His finest work is *The Fairy Feller's Master-Stroke* (1855–64), a minutely detailed piece of whimsical invention. **daddy-longlegs** European name for the CRANE FLY

Daedalus In Greek mythology, a masterly architect and sculptor. He constructed the LABYRINTH for King MINOS of Crete. When denied permission to leave the island, he made wings of wax and feathers to escape with his son ICARUS.

daffodil Bulbous flowering plant, family Amaryllidaceae. Long leaves grow from the base and the single flowers are yellow or yellow and white, with a bell-like central cup and oval petals. Height: to 45cm (18in). Genus *Narcissus*.

Dagestan Republic in the Russian Federation, bounded on the E by the CASPIAN SEA, SE European Russia. The capital is Makhachkala. Islam was introduced in the 7th century, and the majority of the present population is Muslim. Annexed by Russia in the early 19th century, Dagestan's native population resisted Russian rule until autonomy was granted in 1921. In 1991 it claimed full republic status. The region is dominated by the CAUCASUS mountains. Lowlands to the N support wheat, maize and grapes. The rivers Samur and Sulak provide hydroelectric power. Difficulty of access has left mineral resources untapped. Industries: engineering, oil, chemicals. Area: 50,300sq km (19,416sq mi). Pop. (1994) 1,953,000.

Daguerre, Louis Jacques Mandé (1789–1851) French painter and inventor. In 1829 Daguerre and Niepce invented the daguerreotype, an early photographic process in which a unique image is produced on a copper plate without an intervening negative. Their process was announced in 1839, shortly before William Fox TALBOT developed the calotype.

Dahl, Roald (1913–90) British writer, chiefly of short stories. He is remembered for his witty, imaginative children's fiction. His books, such as *James and the Giant Peach* (1961) and *Charlie and the Chocolate Factory* (1964), are popular with all ages. He is also noted for his adult stories, which regularly feature a grotesque, moral twist, such as *Someone Like You* (1953) and *Kiss, Kiss* (1959). *Boy* (1984) and *Going Solo* (1986) are volumes of autobiography.

dahlia Genus of perennial plants with tuberous roots and large flowers. The common garden dahlia (*Dahlia pinnata*) has been developed into more than 2,000 varieties. Height: to 1.5m (5ft). Family Asteraceae/Compositae.

Dáil Éireann Lower house of the two-chamber Parliament of the Republic of Ireland (the upper house is the *Seanad Éireann*). It has 166 members elected for five-year terms by a system of proportional representation.

Daimler, Gottlieb (1834–1900) German engineer and automobile manufacturer. In 1883, with Wilhelm Maybach, Daimler developed an INTERNAL COMBUSTION ENGINE. He used this to power a motorcycle and then his first car (1886).

In 1890 he founded the Daimler Motor Company, which made Mercedes cars, and became Daimler-BENZ (1926).

daisy Any of several members of the family Asteraceae/Compositae, especially the common English garden daisy, *Bellis perennis*. It has basal leaves and long stalks bearing solitary flower heads, each of which has a large, yellow, central disc and small radiating white petal-like florets.

Dakar Capital and largest city of Senegal, w Africa. Founded in 1857 as a French fort, the city grew rapidly with the arrival of a railroad (1885). A major Atlantic port, it later became capital of French West Africa. There is a Roman Catholic cathedral and a presidential palace. Dakar has excellent educational and medical facilities, including the Pasteur Institute. Industries: textiles, oil refining, brewing. Pop. (1992 est.) 1,729,823.

Dakota See North Dakota and South Dakota

Daladier, Édouard (1884–1970) French statesman, prime minister (1933, 1934, 1938–40). In 1934 Daladier was forced to resign after failing to quell riots. As prime minister and minister of defence, he signed the MUNICH AGREEMENT (1938). Daladier again resigned after his failure to help Finland repel the Russian advance. In 1940 he was arrested by the new VICHY GOVERNMENT, and he was deported to Germany in 1942. He was released at the end of World War 2 and became a member of the National Assembly (1946–58).

Dalai Lama (Grand Lama) Supreme head of the Yellow Hat Buddhist monastery at LHASA, TIBET. The title was bestowed upon the third Grand Lama by the Mongol ruler Altan Khan (d.1583). In 1642 the Mongols installed Ngawang Lopsang Gyatso (1617-82), fifth Dalai Lama, as political and spiritual ruler of Tibet. Dalai Lamas thereafter retained political leadership, but spiritual supremacy was later shared with the PANCHEN LAMA. In 1950-51, Tenzin Gyatso (1935-), 14th Dalai Lama, temporarily fled Tibet after it was annexed by the People's Republic of China. Following a brutally suppressed Tibetan uprising (1959), he went into exile in India. In TIBETAN BUDDHISM, the Dalai Lama is revered as the BOD-HISATTVA Avalokitesvara. When a Dalai Lama dies, his soul is believed to pass into the body of an infant, born 49 days later. Dali, Salvador (1904–89) Spanish artist. His style, a blend of meticulous realism and hallucinatory transformations of form and space, made him an influential exponent of surrealism. His dream-like paintings exploit the human fear of distortion, as in The Persistence of Memory (1931). Dali also designed jewellery, fabrics and furniture.

Dallapiccola, Luigi (1904–75) Italian composer. He was

▲ Dali Soft Self Portrait (1941) by Salvador Dali. The Spanish painter Dali was influenced by the work of Sigmund Freud, and his surrealist images convey powerful dream and hallucinatory elements.

the first Italian composer to use ATONALITY, adopting the TWELVE-TONE system of SCHOENBERG in the 1930s. The opera *Volo di notte* (1940) is a fine example. Persecuted during World War 2, he wrote many pieces concerned with freedom, notably *Canti di Prigonia* (1941).

Dallas City in NE Texas, USA. First settled in the 1840s, Dallas expanded with the 20th-century development of its oilfields. President Kennedy was assassinated here on 22 November 1963. A leading commercial and transport centre of sw USA, it has many educational and cultural institutions. Industries: oil refining, electronic equipment, clothing, aircraft. Pop. (1990) 1,006,877.

Dalmatia Region of Croatia on the E coast of the Adriatic; the provincial capital is Split. From the 10th century it was divided N/s between Croatia and Serbia. By 1420, after centuries of fighting, most of Dalmatia was controlled by Venice. The Treaty of Campo Formio (1797) ceded the region to Austria. After World War 1 it became part of Yugoslavia. The coastline, a popular tourist destination since the 1960s, stretches along the Adriatic from Rijeka to the border with Montenegro. Most of the inland area is mountainous. In 1991, following Croatia's secession from the Yugoslav federation, Dalmatia was the scene of heavy fighting between Croats and Serbs. Other major cities in the region include Zadar (the historic capital) and Dubronnik.

dalmatian Dog, characterized by its white coat with black or liver spots. It has a long, flat head with long muzzle and highset ears. Its powerful body is set on strong legs and the tail is long and tapered. Height: to 58cm (23in) at the shoulder.

Dalton, John (1766–1844) British chemist, physicist and meteorologist. He researched TRADE WINDS, the cause of rain, and the AURORA borealis. He described COLOUR BLINDNESS based on personal experience. His study of gases led to Dalton's law of partial pressures: the total pressure of a gas mixture is equal to the sum of the partial pressures of the individual gases, provided no chemical reaction occurs. His atomic theory states that each element is made up of indestructible, small particles. He also constructed a table of relative atomic masses.

dam Barrier built to confine water (or check its flow) for irrigation, flood control or electricity generation. The first dams were probably constructed by the Egyptians 4,500 years ago. Gravity dams are anchored by their own weight. Single-arch dams are convex to the water they retain, supported at each end by river banks. Multiple-arch and buttress dams are supported by buttresses rooted in the bedrock. The cheapest commercial source of electricity comes from hydroelectric projects made possible by dams, such as the Aswan High Dam, Egypt.

Damascus Capital of Syria, on the River Barada, sw Syria. Thought to be the oldest continuously occupied city in the world, in ancient times it belonged to the Egyptians, Persians and Greeks, and under Roman rule was a prosperous commercial centre. It was held by the Ottoman Turks for 400 years, and after World War 1 came under French administration. It became capital of an independent Syria in 1941. Sites include the Great Mosque and the Citadel. It is Syria's administrative and financial centre. Industries: damask fabric, metalware, leather goods, refined sugar. Pop. (1993 est.) 1,497,000.

Damocles In Greek history, a courtier of Dionysius I of Syracuse (Sicily). Dionysius suspended a sword by a thread above Damocles' head to make him realize that wealth and power were transient and fragile.

damselfly Delicate insect resembling the DRAGONFLY. Almost all have a slender, elongated, blue abdomen and one pair of membranous wings that are held vertically over the body when at rest. Length: to 5cm (2in). Order Odonata.

damson Small tree and its edible fruit. The name is often applied to varieties of PLUM (*Prunus domestica*), especially *P.d. instititia*. The fleshy DRUPE is generally borne in clusters, has a tart flavour and is made into jam. Family Rosaceae. The damson-plum of tropical America is a separate species, *Chrysophyllum oliviforme*, Family Sapotaceae.

Danby, Thomas Osborne, Earl of (1632–1712) (subsequently Marquis of Carmarthen, Duke of Leeds) Leading minister of CHARLES II. He was impeached and imprisoned (1679–84) for trying to secure a secret subsidy from France.

Danby organized a group, later known as Tories, who supported the succession of the future James II, but he later changed sides and served William III (1690–95) until again impeached for bribery.

dance Ancient art of ordered, stylized body movements, normally performed to the accompaniment of music or voices. In its most primitive form, dance was probably part of courtship and religious ritual. In China, Japan, and India, graceful MIME is the distinctive feature, whereas the dances of Africa are characterized by rapid, athletic movements. In 18th-century Europe, Bach and Handel, among others, composed music for formal courtly dances, such as the gavotte and minuet. Ballroom dances, such as the waltz, foxtrot, tango and quickstep, became popular in the 19th and early 20th centuries. In the 1950s, dances such as the jive and the twist were introduced. Many different styles have emerged from MODERN DANCE. See also BALLET; FOLK DANCE

dandelion Widespread perennial weed, with leaves growing from the base and yellow composite flowers. It reproduces by means of parachute seeds. The leaves are used in salads; the flowers in winemaking. Family Asteraceae (Compositae); species *Taraxacum officinale*.

Danelaw Large region of NE England, occupied by Danes in the late 9th century. Its independent existence was formally confirmed by Alfred and Guthrum's Pact (886). Alfred's son, Edward the Elder, and grandson, Athelstan, restored it to English control in the early 10th century.

Daniel Legendary Jewish hero and visionary of the 6th century BC, who was at the court of the kings of Babylon, Nebuchadnezzar and Belshazzar. The Old Testament Book of Daniel, probably written *c*.165 BC, relates events in Daniel's life during the Babylonian Captivity. The book also gives an account of Belshazzar's Feast. The last six of its 12 chapters consist of visions and prophesies.

D'Annunzio, Gabriele (1863–1938) Italian poet, novelist, and playwright. His flamboyant rhetoric greatly influenced early 20th-century Italian poetry. His poems include *Alcyone* (1904), and novels *The Triumph of Death* (1896) and *The Child of Pleasure* (1898). Of his many plays, *La Figlia di Jorio* (1904) is considered the best. He became a national hero when he seized and ruled TRIESTE (1919–21).

Dante Alighieri (1265–1321) Italian poet. In his early years Dante wrote many *canzoni* to Beatrice Portinari, who remained the inspiration for much of his life's work. In 1300 he became one of the rulers of Florence, but was exiled in 1302 after a feud between the White and Black GUELPHS. He never returned to Florence, but wrote under the patronage of various nobles until he died impoverished in Ravenna. His writings include *The New Life* (c.1293), *Banquet* (c.1304–07), *On Monarchy* (c.1313) and *De Vulgari Eloquentia* (1304–07). His masterpiece, *The Divine Comedy*, a three-book epic in *terza rima*, represents one of the pinnacles of Western literature and places Dante among the greatest writers of all time.

Danton, Georges Jacques (1759–94) French politician and a leader of the French REVOLUTION. He played the role of moderate in the turbulent 1790s, seeking conciliation between the GIRONDINS and Montagnards. Briefly head of the JACOBINS in 1793 and a member of the Committee of Public Safety, he was arrested during the Reign of Terror and guillotined.

Danube (Donau) River in central and se Europe. Europe's second-longest river (after the Volga), it rises in sw Germany, flows NE then SE across Austria to form the border between Slovakia and Hungary. It then flows s into Serbia, forming part of Romania's borders with Serbia and Bulgaria. It continues N across SE Romania to the Black Sea. It is an international waterway, controlled by the Danube Commission. Length: *c.*2,859km (1,770mi).

Danzig See GDAŃSK

Daphne Nymph in Greek mythology. APOLLO, struck by a gold-tipped arrow of Eros, fell in love with Daphne. She had been shot with one of Eros' leaden points, and so scorned all men. To protect her from Apollo, the gods transformed her into a laurel tree.

Dardanelles (Çanakkale Bogazi) Narrow strait between the Sea of Marmara and the Aegean Sea, separating

▲ dalmatian Perhaps best known from the film 101 Dalmatians, dalmatians are thought to have been developed as carriage dogs in the Croatian region of Dalmatia.

▲ dandelion Found throughout the Northern Hemisphere, the leaves of the common dandelion (*Taraxacum officinale*) have teeth-shaped edges. It is from this shape that the dandelion derives its name (Fr. *dents de lion*, teeth of the lion.

Çanakkale (in Asian Turkey) from Gallipoli (in European Turkey). With the Bosporus Strait, the Dardanelles forms a waterway, whose strategic and commercial importance has been recognized since ancient times (then known as Hellespont). In the Byzantine and Ottoman empires and both World Wars, it was vital to the defence of Constantinople (ISTANBUL). Since the early 14th century it has been almost continuously controlled by Turkey. The strait was the scene of the Gallipoli Campaign in World War 1. The Treaty of Sévres (1920) demilitarized the straits, but by 1936 Turkey had remilitarized the zone. Some naval restrictions remain in force. Length: 61km (38 mi). Width: 1.2–6km (0.75–4mi).

Dar es Salaam Former capital of Tanzania, on the Indian Ocean, E Tanzania. Founded in the 1860s by the sultan of Zanzibar, it was capital of German East Africa (1891–1916) and of Tanganyika (1916–74). It is Tanzania's commercial centre, largest city and port. Industries: textiles, chemicals, oil products. Pop. (1988 est.) 1,360,850.

Darío, Rubén (1867–1916) (Félix Rubén García Sarmiento) Nicaraguan poet, father of the *modernismo* movement. He influenced both Latin American and Spanish writers. His earliest collections, *Blue* (1888) and *Profane Hymns and Other Poems* (1896), show the influence of Parnassian and symbolist poetry. His finest book of verse, *Songs of Life and Hope* (1905), is noted for its eloquence and universality of vision.

Darius I (*c*.558–486 BC) King of Persia (521–486 BC) of the ACHAEMENID dynasty. Troubled by revolts, particularly in BABYLON, he restored order by dividing the empire into provinces, allowing some local autonomy and tolerating religious diversity. He also fixed an annual taxation and developed commerce. He was defeated at Marathon in 490 BC.

Darjeeling City at the foot of the Himalayas, West Bengal, NE India. A former British hill station, it is noted for its teas and its views of Kanchenjunga and Everest. Pop. (1991) 73,090.

Dark Ages Period of European history from the fall of the Roman empire in the 5th century to the 9th or 10th century. The term appears to imply cultural and economic backwardness after the classical civilization of Greece and Rome, but indicates more an ignorance of the period due to the paucity of historical evidence.

Darmstadt City in Hesse state, w central Germany. The old town dates from the Middle Ages. The city was severely damaged during World War 2. It is a cultural centre, with a notable international music school. Industries: chemicals, aerospace engineering, steel. Pop. (1990) 140,900.

darts Indoor target game developed in 15th-century England. Three weighted, metal-pointed darts are thrown at a board 2.4m (8ft) away. The standard board is divided into 20 even wedges, with a triple scoring band in the middle and a double scoring band on the outside, fanning out from two small circles in the centre (the bull, worth 50 points, and around it the "25"). Starting with a certain number of points (usually 501), the object is to reach zero, finishing with a "double".

▲ ► date palm Today, grown as an ornament as well as for its fruit, the date palm (*Phoenix dactylifera*) has been cultivated for over 4,000 years. The tallest examples reach a height of 30m (100ft). The fruit is often dried.

Darwin, Charles Robert (1809–82) British naturalist, originator of a theory of EVOLUTION based on NATURAL SELECTION. In 1831, he joined a round-the-world expedition on HMS BEAGLE. Observations made of the flora and fauna of South America (especially the GALÁPAGOS ISLANDS) formed the basis of his work on animal variation. The development of a similar theory by A.R. WALLACE led Darwin to present his ideas to the Linean Society in 1858, and in 1859 he published *The Origin of Species*, one of the world's most influential science books.

Darwin Port in N Australia, on the Beagle Gulf, an inlet of the Timor Sea; capital of Northern Territory. Founded in the late 1860s as Palmerston it became Port Darwin in 1911. The Allied headquarters in N Australia during World War 2, it was bombed by the Japanese in 1942. In 1974 most of the city was destroyed by a cyclone. Darwin's harbour is the major shipping point for the sparsely populated and relatively undeveloped N region of Australia. Pop. (1993 est.) 77,900.

Darwinism See EVOLUTION

dasyurus Genus of mainly nocturnal, carnivorous marsupials found in Australia, New Guinea and Tasmania. They have large canine teeth, separate digits and long tails. The female's pouch is normally shallow. Family Dasyuridae.

data Information, such as lists of words, quantities or measurements. A computer PROGRAM works by processing data, which may be entered on the keyboard, or stored in code as a data file on a DATABASE, MAGNETIC DISK or tape.

database Collection of DATA produced and retrieved by computer. The data is usually stored on MAGNETIC DISK or tape. A database PROGRAM enables the computer to generate files of data and later search for and retrieve specific items or groups of items. For example, a library database system can list, on screen, all the books on a particular subject and can then display further details of any selected book.

data processing Systematic sequence of operations performed on DATA, especially by a COMPUTER, in order to calculate or revise information stored on MAGNETIC DISK or tape. The main processing operations performed by a computer are: arithmetical addition, subtraction, multiplication and division and logical operations that involve decision-making based on comparison of data.

data protection Computer technology now makes it easy to store large amounts of data, such as a person's financial details. Many governments have passed legislation ensuring that such databases are registered and that the information they contain is used only for the purpose for which it was originally given.

date palm Tree native to the Near East. It has feather-shaped leaves and large flower clusfers that produce the popular edible fruit. Height: up to 30m (100ft). Family Arecacae/Palmae. dating, radioactive (radiometric dating) Any of several methods using the laws of RADIOACTIVE DECAY to assess the ages of archaeological remains, fossils, rocks and of the Earth itself. The specimens must contain a long-lived radioisotope of known HALF-LIFE, which, with a measurement of the ratio of radioisotope to a stable ISOTOPE (usually the decay product), gives the age. In potassium-agon dating, the ratio of potassium-40 to its stable decay product argon-40, gives ages over ten million years. In radiocarbon dating, the proportion of carbon-14 (5,730 years) to stable carbon-12 absorbed into once-living matter, such as wood or bone, gives ages up to several thousand years.

Daumier, Honoré (1808–79) French painter, sculptor and caricaturist. He produced more than 4,000 lithographs in a vigorous style, lampooning French middle-class society.

David, Saint (d. c.600) Patron saint of Wales. He founded a monastery at what is now St Davids. Little is known of his life, but legends abound. His feast day is 1 March.

David (1000–c.962 BC) King of Israel. His career is related in the OLD TESTAMENT. He became a hero by defeating GOLIATH in a duel and was made king of Judah on SAUL'S death. He united Judah and Israel and made Jerusalem his capital. God is said to have promised that his dynasty would be eternal. *See also* MESSIAH

David, Gerard (1460–1523) Flemish painter. Influenced by van EYCK and van der WEYDEN, David has a distinctive austere grace. He was commissioned by the town of BRUGES to paint

L

several works: The Judgement of Cambyses and The Flaying of Sisamnes warned officials of the retribution for injustice. Other works include Madonna Enthroned and Annunciation.

David, Jacques Louis (1748–1825) French painter, a leader of NEO-CLASSICISM. Influenced by POUSSIN and Greek and Roman art, David's work was closely tied up with his Jacobin views and support for Napoleon during the FRENCH REVOLUTION. His most famous work is *Oath of the Horatii* (1784). Other masterpieces include *Death of Marat* (1793), and *Madame Recamier* (1799).

Davies, Sir Peter Maxwell (1934—) British composer. Prolific and varied in his compositions, he has written four operas, including *Taverner* (1972) and *Resurrection* (1988). Much of his work reflects the landscape and culture of his adopted home, the remote Orkney Islands, N Scotland, notably the opera *The Martyrdom of St Magnus* (1977).

Davies, Robertson (1913–95) Canadian novelist, dramatist and journalist. Davies is best known for *The Deptford Trilogy* (1970–75), which exhibits his characteristic mixture of myth, satire and psychological symbolism. Other works include *The Salterton Trilogy* (1951–58), and a number of plays, including *A Jig for the Gypsy* (1954). His non-fiction is collected in *The Mirror of Nature* (1983).

Da Vinci, Leonardo See LEONARDO DA VINCI

Davis, Angela (1944–) US political activist. Beginning in the 1960s, Davis was an eloquent advocate of both African-American and women's civil rights. Her communist views lost Davis her job as a philosophy lecturer at UCLA. In 1970, in a notorious incident, a judge was kidnapped and murdered with guns registered in her name. Charged with conspiracy, murder and kidnap, Davis was acquitted in a sensational trial.

Davis, Bette (1908–89) US film actress. She is remembered for her intense character portrayals and evocative screen presence in films such as *Of Human Bondage* (1934). She won two Best Actress Academy Awards for *Dangerous* (1935) and *Jezebel* (1938). Other films include *All About Eve* (1950) and *What Ever Happened to Baby Jane* (1962). In 1977 she became the first woman to receive a Life Achievement Award from the American Film Institute.

Davis, Sir Colin (1927–) English conductor. He was principal conductor of the BBC Symphony Orchestra (1967–71) and musical director at the Royal Opera House (1971–86). In 1983 he became chief conductor of the Bavarian Radio Symphony Orchestra.

Davis, Jefferson (1808–89) American statesman, president (1862–65) of the Confederate States during the US Civil War. Davis was elected to Congress in 1845, but resigned to fight in the Mexican War. He was a strong advocate of the extension of Slavery and acted as senator for Mississippi (1849–51). In 1853 Franklin Pierce made him secretary of war. In 1857 he rejoined the Senate and acted as leader of the Southern bloc. He resigned when Mississippi seceded from the Union (1861) and was soon elected leader of the Confederacy. Davis assumed authoritarian political power and also participated in military decision-making. Following Lee's surrender, Davis was captured and imprisoned (1865–67). He wrote The Rise and Fall of Confederate Government (1881).

Davis, Miles Dewey (1926–91) US jazz trumpeter, one of the most influential modern jazz musicians. During the 1940s he played BEBOP with Charlie PARKER. Eager to experiment with diverse musical forms, he changed the course of jazz with the sophisticated and reflective *Birth of the Cool* (1949), and played with the saxophonist John COLTRANE on the seminal *Kind of Blue* (1959). During the late 1960s, he switched to electric instrumentation, and was a pioneer of jazz-rock. In the 1970s and 1980s, he gained considerable commercial success. **Davis, Steve** (1957–) English snooker player. Davis made his professional debut in 1978. During the 1980s, he was the

championship six times (1981, 1983–84, 1987–89). **Davis, Stuart** (1894–1964) US painter, the leading American exponent of CUBISM. Although influenced by the ASHCAN SCHOOL, the greatest impact on his mature style was the ARMORY SHOW (1913). After a visit to Paris (1928–29), he turned towards cubism's synthetic phase, introducing natural

dominant figure in the game, winning the world professional

forms arranged in flat areas of pattern in bright, contrasting colours. His later abstract style used lettering that resembled advertising slogans, such as *Owh!* in *San Pao* (1951).

Davitt, Michael (1846–1906) Irish nationalist. Imprisoned in 1870 as a member of the FENIAN MOVEMENT. He and PARNELL established the Irish Land League (1879) to organize Irish tenant farmers against exploitive landlords. The League gained concessions of fair rents, fixed tenure and freedom of sale in the Land Act (1881).

Davy, Sir Humphry (1778–1829) British chemist who discovered that electrolytic cells produce electricity by chemical means. This led to his isolation of the elements sodium, potassium, barium, strontium, calcium and magnesium. He also proved that all acids contain hydrogen, which is responsible for their acidic properties. An investigation into the conditions under which firedamp (methane and other gases) and air explode, led to his invention of the miner's safety lamp.

Dawes, Charles Gates (1865–1951) US statesman, vice president (1925–29), comptroller of the currency (1897–1902). He headed the financial commission that drew up the Dawes Plan (1924) to restructure the German economy. He was awarded the Nobel Peace Prize (1925).

Day, Doris (1924–) US singer and film actress. Her recordings, such as "Sentimental Journey" (1945) and "Secret Love" (1954), sold millions during the 1940s and 1950s. Her wholesome, energetic performances in films such as *Calamity Jane* (1953), *Pajama Game* (1957) and *Send Me No Flowers* (1964) won her an even greater audience.

Dayan, Moshe (1915–81) Israeli army officer and politician. Dayan served with the British and led a Palestinian Jewish company against the Vichy French in World War 2. He led the invasion of the Sinai Peninsula in 1956 and, as minister of defence, became a hero of the Six Day War (1967). Active in Israeli policy-making, he served as foreign minister (1977–79). Day-Lewis, Cecil (1904–72) British poet and critic. He was associated with the leftist AUDEN circle. His concern for social justice is evident in *Transitional Poem* (1929), *Magnetic Mountain* (1933), *Overtures to Death* (1938) and *Collected Poems* (1954). He was poet laureate from 1968. He also wrote detective fiction under the pseudonym Nicholas Blake.

Day-Lewis, Daniel Michael (1957–) Irish actor, b. London. Day-Lewis first gained public recognition for his performance in *My Beautiful Laundrette* (1986). In 1989 he won a Best Actor Oscar for his extraordinary physical role in *My Left Foot*. Other films include *The Age of Innocence* (1993) and *In the Name of the Father* (1993).

Dayton City at the confluence of the Great Miami and Stillwater rivers, sw Ohio, USA. Settled in 1796, it is a commercial centre of an agricultural region. In 1995, the Dayton Peace Accord ended the Bosnian civil war. Pop. (1990) 182,044.

D-day (6 June 1944) Codename for the Allied invasion of Normandy during WORLD WAR 2. Commanded by General EISENHOWER, Allied forces landed on the French coast between Cherbourg and Le Havre. It was the largest amphibious operation in history, involving *c.*5,000 ships. Despite fierce resistance, bridgeheads were established by 9 June. It was the first step in the liberation of Europe.

DDT (dichlorodiphenyltrichloroethane) Organic compound used as an INSECTICIDE. It acts as a contact poison, disorganizing the nervous system. Effective against most insect pests, it proved to have long-lasting toxic effects and many species developed resistance. It is now banned in many countries.

deacon (Gk. *diakonas*, helper) Ordained minister who serves as a priest's assistant in Christian churches. The institution of the diaconate can be traced to the New Testament, which describes the ordination of seven deacons (Acts 6) to carry out the administrative work of the early Church.

deadly nightshade Poisonous perennial plant native to Europe and w Asia. It has large leaves, purple flowers, and black berries. Alkaloids, such as Atropine, are obtained from its roots and leaves. Eating the fruit can be fatal. Family Solanaceae; species *Atropa belladonna*.

Dead Sea (Al-Bahr-al-Mayyit) Salt lake in the Jordan valley, on the Jordan-Israel border. It is fed by the River JORDAN. The surface, 396m (1,302ft) below sea level, is the lowest point on

▲ Davis Trumpeter Miles Davis was among the first jazz musicians to experiment with other contemporary forms of music, such as funk and rap. Beginning in the 1940s be-bop era, his musical career spanned half a century.

▲ Davy Perhaps best known for the invention of the miner's safety lamp (Davy lamp), English chemist Sir Humphry Davy was a significant chemist who inspired Michael Faraday.

➤ Death Valley The desert region of SE California, known as Death Valley, is among the hottest places on Earth. It acquired its name from gold and silver prospectors, many of whom lost their lives trying to cross it.

Earth. It is situated in a hot, dry region, and much water is lost through evaporation. One of the world's saltiest waters, large amounts of its salts are extracted. It supports no life.

Dead Sea Scrolls Ancient manuscripts discovered from 1947 in caves at Qumran near the DEAD SEA. Written in Hebrew or Aramaic, they date from between the 1st century BC and the 1st century AD. They include versions of much of the OLD TESTAMENT and other types of religious literature. Some are a thousand years older than any other biblical manuscript. deafness Partial or total hearing loss. Conductive deafness, faulty transmission of sound to the sensory organs, is usually due to infection or inherited abnormalities of the middle ear. Perceptive deafness may be hereditary or due to injury or disease of the COCHLEA, auditory nerve or hearing centres in the brain. Treatment ranges from removal of impacted wax to delicate microsurgery. Hearing aids, sign language and lip-reading are techniques which help deaf people to communicate.

Dean, James (1931–55) US film actor. He played the restless son in the film of John Steinbeck's *East of Eden* (1954) and appeared as a misunderstood teenager in *Rebel Without a Cause* (1955). He was killed in a car crash, a year before the release of his final film *Giant*. He has become a cult hero.

dean Administrative official. In education, a head of administration in a university faculty or medical school. Such an official is also a teacher or lecturer and is responsible for maintaining discipline. In the Anglican Church, the leader of the chapter in a cathedral or collegiate church is a dean. In the Roman Catholic Church, the head of the College of Cardinals is a dean. death Cessation of life. In medicine, death has traditionally been pronounced on cessation of the heartbeat. However, modern resuscitation and life-support techniques have enabled the revival of patients whose hearts have stopped. In a tiny minority of cases, while breathing and heartbeat can be maintained artificially, the potential for life is extinct. In this context, death may be pronounced when it is clear that the brain no longer controls vital functions. The issue is highly controversial.

death cap (deadly amanita) Highly poisonous FUNGUS that grows in woodland. It has a yellowish-green cap and a white stem with a drooping ring and sheathed base. If eaten, the poison causes great pain, serious liver damage and, in most cases, death. Species *Amanita phalloides*.

death penalty See CAPITAL PUNISHMENT

Death Valley Desert basin in E California, USA. It has the lowest point in the western hemisphere, 86m (282ft) below sea level. Temperatures can reach 57°C (134°F), the highest in the USA. Gold and silver were mined in the 1850s, and borax in the late 19th century. It is surrounded by the Panamint mountains (w) and the Armagosa (E). Length: 225km (140mi).

deathwatch beetle Small beetle that tunnels through wood. It makes a faint ticking sound, once said to presage death. It is actually the mating signal of the female as it taps its head against the wood. Length: to 0.9cm (0.3in). Family Anobiidae; species *Xestobium rufovillosum*.

Debs, Eugene Victor (1855–1926) US labour organizer. President of the American Railway Union (1893–97), he was imprisoned during the Pullman Strike (1894). He organized the Social Democratic Party (1898), and was five times a presidential candidate (1900–20), even while imprisoned for violation of the Espionage Act (1918). He was a founder of the INDUSTRIAL WORKERS OF THE WORLD (IWW).

debt, national Public debt of a government. National debt

accumulates if governments spend more than they generate through taxation; it consists largely of borrowings from individuals and other governments. Many political groups demand that governments construct balanced budgets.

Debussy, Claude Achille (1862–1918) French composer, exponent of IMPRESSIONISM. Debussy wrote highly individual music that was delicate and suggestive. He explored new techniques of harmony and orchestral colour. Some critics cite his *Prélude à l'après-midi d'un faune* (1894) as the beginning of 20th-century music. Other orchestral works are *Nocturnes* (1899), *La Mer* (1905) and *Images* (1912). His piano works, such as *Suite Bergamasque* (1890) and *Etudes* (1915), are among the most important in the repertoire. His one completed opera was *Pelléas and Mélisande* (1902).

Debye, Peter Joseph Wilhelm (1884–1966) US chemist, b. Netherlands. He was best known for his work on molecular structure and ionization. He pioneered x-ray CRYSTALLOGRAPHY and was awarded the 1936 Nobel Prize for chemistry.

decathlon Sports event comprising ten different track and field activities: 100m, long jump, shot-put, high jump, 400m, 110m hurdles, discus, pole vault, javelin and 1,500m. It is an Olympic event.

Deccan Plateau in central India, s of the River Narmada. It has been a region of conflict since early times. In attempting to conquer it in the 17th century, Aurangzeb fatally weakened the Mogul dynasty. In the late 18th century, the British defeated the French here. On its E and W edges, the Deccan rises to the Ghats. The plateau is covered with rich volcanic soils. Cotton, cereal, coffee and tea are grown.

decibel (symbol dB) Logarithmic unit, one tenth of a bel, used for comparing two power levels and for expressing the loudness of a sound. The faintest audible sound $(2\times10^{-5} \text{ pascal})$ is given an arbitrary value of 0dB. The human pain threshold is c.120dB. Ordinary conversations occur at 50–60 dB.

deciduous Annual or seasonal loss of all leaves from a tree or shrub; it is the opposite of EVERGREEN.

decimal system Commonly used system of writing numbers using a base ten and the Arabic numerals 0 to 9. It is a positional number system, each position to the left representing an extra power of ten. Thus 6,741 is $(6\times10^3)+(7\times10^2)+(4\times10^1)+(1\times10^0)$. Note that $10^0=1$. Decimal fractions are represented by negative powers of ten placed to the right of a decimal point.

Declaration of Independence (4 July 1776) Statement of the principles with which the THIRTEEN COLONIES of North America justified the American Revolution and separation from Britain as the United States of America. Its blend of high idealism and practical statements have ensured its place as one of the world's most important political documents. The Declaration was drafted by a committee that included Thomas JEFFERSON and was based on the theory of NATURAL RIGHTS, propounded by John Locke to justify the Glorious REVOLUTION in England. It was approved by the Continental Congress on 4 July. The Declaration states the necessity of government having the consent of the governed, of government's responsibility to its people, and contains the famous paragraph: "We hold these truths to be self-evident, that all men are created equal, that they are endowed by their Creator with certain unalienable Rights, that among these are Life, Liberty, and the Pursuit of Happiness."

Declaration of Rights See BILL OF RIGHTS

Declaration of the Rights of Man and Citizen Statement of principles of the French Revolution, adopted by the National Assembly, accepted by Louis XVI and included in the 1791 constitution. Influenced by the American Declaration of Independence and the ideas of Jean Jacques Rousseau, it established the sovereignty of the people and the principles of "liberty, equality, and fraternity".

decomposition Natural degradation of organic matter into simpler substances, such as carbon dioxide and water. Organisms of decay are usually bacteria and fungi. Decomposition recycles nutrients by releasing them back into the ecosystem. **decompression sickness** See BENDS

deconstruction In architecture, a term used to describe work dating from the early 1980s that explored ways of rec-

onciling traditional oppositions in building design, such as structure–decoration and abstraction–figuration. Deconstruction is also a key term in literary criticism, pioneered by the work of the French philosopher Jacques Derrida (1930–). Patterns of opposition, which form a given text, are broken down and considered. Derrida's key writings include Writing and Difference (1967) and Dissemination (1972). The process of deconstruction is highly text-centred, and its critics claim that it excludes the role of history in literary work.

Decorated style Style of English Gothic architecture which flourished c.1250-1350. The most exuberant phase of English Gothic, it featured the double-curving ogee arch and intricate, curvilinear window tracery. Its French equivalent, the FLAMBOYANT STYLE, came much later. The windows of EXETER Cathedral are excellent examples of Decorated stone carving. See also GOTHIC ART AND ARCHITECTURE

deer Long-legged, hoofed, RUMINANT. There are 53 species in 17 genera distributed worldwide. In most species, the male (buck, hart or stag) bears antlers. Only in reindeer does the female (hind or doe) bear antlers. Deer often gather in herds. They are generally brown, with spotted young (fawns). They eat bark, shoots, twigs and grass. Humans exploit them for their meat (venison), hides and antlers (for hunting trophies). The deer family Cervidae has existed since the Oligocene epoch. The Chinese water deer is the smallest, measuring only 55cm (22in) tall at the shoulder; the ELK at 2m (6.5ft), is the largest.

Defence, Ministry of British department of state. First formed in 1940, in 1964 it was reorganized to combine the old War Office, Admiralty and Air Ministry. It is presided over by a secretary of state and two ministers of state.

Defender of the Faith (Lat. *Fidei Defensor*) Title adopted by the monarchs of England since 1521. The title was first given to HENRY VIII by Pope Leo X after the publication of a tract by Henry attacking the protestant Martin Luther.

Defense, US Department of (DOD) US government department. It consists of the secretary of defence, JOINT CHIEFS OF STAFF (JCS), service departments and operational military commands. The secretary of defence, with the president, is responsible for all operational military activities, providing civilian control for the ARMY, NAVY and AIR FORCE. First formed in 1789, it was reorganized in 1949.

deflation Falling prices, accompanied by falls in output and employment; the opposite of INFLATION. It normally occurs during a RECESSION or DEPRESSION and can be measured by the price index. Excess production capacity leads to an excess of supply, in which manufacturers supply more goods than consumers wish to buy, and usually causes deflation.

Defoe, Daniel (1660–1731) English journalist and novelist. He championed William III in his first notable poem, *The Trueborn Englishman* (1701). A politically controversial journalist, he was twice imprisoned, once for *The Shortest Way with the Dissenters* (1702). His reputation now rests on his fiction. His enduringly popular novels include *Robinson Crusoe* (1719), *Moll Flanders* (1722), *Colonel Jack* (1722) and *Roxana* (1724). A man of remarkably varied interests, Defoe is among the most prolific writers in the English language.

De Forest, Lee (1873–1961) US inventor of the audion triode valve (1907), one of the most important electronic inventions. It could amplify signals, and had numerous applications. Valves became essential in radio, television, radar and computer systems; they were replaced by the TRANSISTOR (1947). deforestation Clearing away of forests and their ECOSYSTEMS, usually on a large scale, by humans. It may be done to create open areas for farming or building, or for timber. There is an immediate danger that the vital topsoil will be eroded by wind (such as the DUST BOWL, USA) or, in hilly areas, by rain. Proposals to clear whole regions of the Amazonian RAINFORESTS, which play a key role in maintaining the oxygen balance of the Earth, could cause an environmental catastrophe.

Degas, (Hilaire Germain) Edgar (1834–1917) French painter and sculptor. Classically trained and an admirer of INGRES, Degas combined the discipline of classic art with the immediacy of the modern. After meeting Édouard MANET, he took part in exhibitions of IMPRESSIONISM and shared an inter-

est in scenes of everyday life, especially ballet and horse-racing. A brilliant draughtsman, he found inspiration in Japanese prints and photography. He made sculptures of dancers and horses to master the expression of movement. His subtle use of colour and light became concentrated in his later pastels.

De Gasperi, Ālcide (1881–1954) Italian statesman, prime minister (1945–53). De Gasperi was born in Trentino, then under Austrian rule. He struggled successfully for its reunification with Italy. A staunch anti-Fascist, De Gasperi was imprisoned twice in the 1920s. During World War 2 he founded the Italian Christian Democratic Party. De Gasperi is regarded as the chief architect of Italy's post-war recovery. He led Italy into NATO and championed closer relations with the US.

De Gaulle, Charles André Joseph Marie (1890–1970) French general and statesman, first president (1959-69) of the fifth republic. De Gaulle's experience of World War 1 (captured 1916), convinced him of the need to modernize the French army. In 1940 he became undersecretary of war, but fled to London after the German invasion. He organized French Resistance (Free French) forces, and in June 1944 was proclaimed president of the provisional French government. Following liberation he resigned, disenchanted with the political settlement. In 1958 he emerged from retirement to deal with the war in Algeria. In 1959 a new constitution was signed, creating the French Community. In 1962 De Gaulle was forced to cede Algerian independence. France gained an independent nuclear capability, but alienated the UK and USA by its temporary withdrawal from NATO and by blocking British entry into the EEC. De Gaulle's devaluation of the franc brought relative domestic prosperity. He was re-elected (1965), but resigned following defeat in a 1969 referendum.

degree In mathematics, unit of angular measure equal to 1/360 of a complete revolution. One degree is written 1°, and can be divided into 60 parts called minutes (e.g. 20'), which may in turn be divided into 60 parts called seconds (e.g. 25"). Three hundred and sixty degrees are equal to 2π radians. In physics and engineering, a degree is one unit on any of various scales, such as the Celsius temperature scale.

dehydration Removal or loss of water from a substance or tissue. Water molecules can be removed by heat, catalysts or a dehydrating agent such as concentrated sulphuric acid. Dehydration is used to preserve food. In medicine, excessive water loss is often a symptom or result of disease or injury.

deism System of natural religion, first developed in England in the late 17th century. It affirmed belief in one God, but held that He detached himself from the universe after its creation and made no revelation. Reason was man's only guide. The deists opposed revealed religion in general, and Christianity in particular. Deist writings include John Toland's *Christianity not Mysterious* (1696) and Matthew Tindal's *Christianity as Old as the Creation* (1730). VOLTAIRE, ROUSSEAU and DIDEROT were the main deists of the ENLIGHTENMENT period.

▼ Degas The French painter
Degas was an unusual
impressionist, because of the
emphasis he placed on drawing
and composition of indoor
scenes. Perhaps his most popular
theme was movement, in
particular dance, such as
Dancers on a Bench (1898).

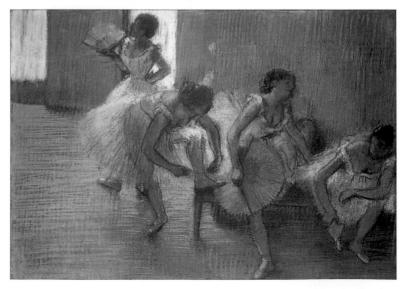

DELAWARE Statehood:

7 December 1787 **Nickname**:

The First State

State bird :

Blue hen chicken

State flower:

Peach blossom

State tree :

American holly

State motto:

Liberty and independence

deity God or goddess, or the condition, rank or quality of divinity. Deity is applied broadly to any divine being who is the object of worship, regardless of religious creed. In the 18th century, the deists used the term to signify a supreme being without having to refer to the God of Christianity.

de Klerk, F.W. (Frederik Willem) (1936—) South African statesman, president (1989—94). De Klerk entered parliament in 1972 and joined the cabinet in 1978. In 1989 De Klerk led a "palace coup" against P.W. BOTHA, and became president and National Party leader. Following a narrow electoral victory, De Klerk began the process of dismantling APARTHEID. In 1990 the ban on the AFRICAN NATIONAL CONGRESS (ANC) was lifted, and Nelson MANDELA was released. In 1991 the principal apartheid laws were repealed and victory in a 1992 whites-only referendum marked an end to white minority rule. In 1993 he shared the Nobel Peace Prize with Nelson Mandela. Following the 1994 elections, De Klerk became deputy president in Mandela's government of national unity. In 1996 he resigned and led the Nationalists out of the coalition. In 1997 he retired as leader of the National Party.

de Kooning, Willem (1904–97) US painter, b. Netherlands. De Kooning was greatly influenced by Picasso and Arshile Gorky. In 1948 he became one of the leaders of ABSTRACT EXPRESSIONISM. Unlike Pollock, he kept a figurative element in his work and shocked the public with violently distorted images, such as the *Women* series (1953). His emphasis on technique became known as ACTION PAINTING.

Delacroix, (Ferdinand Victor) Eugène (1798–1863) French painter, the greatest French artist of romanticism. Success came at his first Paris salon (1822), when he sold *The Barque of Dante* and, two years later, *The Massacre at Chios*. A visit to Morocco (1832) inspired a rich collection of sketches. His work underwent a major change in the 1830s when he began to exploit divisionism (placing complementary colours side by side to obtain greater vibrancy). He was one of France's best monumental history painters and influenced many late 19th-century progressive artists, especially Van Gogh.

De la Mare, Walter (1873–1956) British poet, short-story writer and anthologist. His technically accomplished collections of poems include *Songs of Childhood* (1902), *Peacock Pie* (1913), *Winged Chariot* (1951), and the anthology *Come Hither* (1923). His prose includes the novel *Memoirs of a Midget* (1921) and the collection of stories *On the Edge* (1930). **Delaunay, Robert** (1885–1941) French painter, co-founder (with his wife Sonia DeLAUNAY-TERK) of ORPHISM. Delaunay was a major influence on der BLAUE REITER. Many of his works are abstract cityscapes, principally of his native Paris. The Eiffel Tower series is his most famous.

Delaunay-Terk, Sonia (1885–1979) French painter, b. Russia. Co-founder (with her husband Robert Delaunay) of ORPHISM. Among her most notable works are the lyrical *Simultaneous Contrasts* (1912) and delightful abstract illustrations for the *Prose du Trans-Sibérien* by Blaise Cendrars.

Delaware Confederation of Algonquian-speaking NATIVE AMERICANS. The main members were the Unami, Munsee and Unalachtigo, who occupied territory from Long Island to Pennsylvania and Delaware. Under pressure from settlers and the IROQUOIS CONFEDERACY, they migrated to the Ohio region in the 18th century. They lost these lands by a treaty of 1795 and subsequently became widely scattered.

Delaware State in E USA, on the Atlantic coast, occupying a peninsula between Chesapeake and Delaware bays; the capital is DOVER, the largest city is WILMINGTON. Discovered by Henry Hudson in 1609, it was named after the British governor of Virginia, Baron De la Warr. Delaware was settled by Swedes in 1638. The Dutch, under Peter Stuyvesant, conquered the territory by 1655. Although the Dutch briefly recaptured Delaware in 1673, it was under effective English control from 1664 to 1776. One of the original THIRTEEN COLONIES, it was the first to ratify the Articles of Confederation (1789). Despite being a slave state, it maintained a fragile loyalty to the Union during the American Civil War. It is the second smallest US state (after Rhode Island) and most of its land is coastal plain. The Delaware River, an important shipping route, forms part of the E boundary. Industries: chemicals, rubber, plastics, metal-

lurgy. Agriculture: cereal crops, soya, dairy produce. Area: 5,328sq km (2,057sq mi). Pop. (1990) 666,168.

Delft City in South Holland province, sw Netherlands. Founded in the 11th century, it was an important commercial centre until the 17th century. It has a 13th-century Gothic church and a 15th-century church. Industries: Delftware pottery, ceramics, china, tiles, pharmaceuticals. Pop. (1994) 91,941.

Delhi Former capital of India, on the River Yamuna, union territory of Delhi, N central India. Delhi has held a key position throughout India's history, and is built on the site of at least 7 settlements, dating back more than 2,000 years. In the 17th century it was capital of the MOGUL EMPIRE. In 1912 it became capital of British India (replacing Calcutta) and remained so until independence in 1947, when the capital became NEW DELHI. Sites include the Red Fort, Qutb Minar, the Rajghat (a shrine where Gandhi was cremated), the Jamii Masjid and the Jai Singh observatory. Industries: cotton textiles, handicrafts, tourism. Pop. (1991) 7,206,704.

Delibes, (Clément Philibert) Léo (1836–91) French composer. He was famous for his ballet music, especially *Coppélia* (1870), and also wrote several operas (*Lakmé*, 1883), and sacred and secular choral works.

Delilah Philistine woman in the Old Testament (Judges 16).

The mistress of Samson, she betrayed him to the Philistines by cutting his hair, the source of his strength, while he slept. **delirium** State of confusion in which a person becomes agitated and incoherent and loses touch with reality; often associated with DELUSIONS OF HALLUCINATIONS. It may be seen in various disorders, brain disease, fever, and drug or alcohol intoxication. **Delius, Frederick** (1862–1934) English composer. He combined elements of ROMANTICISM with IMPRESSIONISM, most notably in orchestral pieces, such as *Brige Fair* (1907)

most notably in orchestral pieces, such as *Brigg Fair* (1907) and *On Hearing the First Cuckoo in Spring* (1912). His interest in nature is evident in the operas *A Village Romeo and Juliet* (1901) and *Fennimore and Gerda* (1910).

De Long, George Washington (1844–81) US naval officer and explorer. De Long set sail in 1879, but his ship was caught in polar ice and drifted until it was crushed in 1881. De Long was one of 14 survivors to reach Siberia, only to die of cold and starvation.

Delphi Ancient city state in Greece, near Mount Parnassus. The presence of the oracle of Apollo made it a sacred city. The Pythian Games, celebrating Apollo's destruction of the monster Python, were held at Delphi every four years. The Temple of Apollo was sacked in Roman times, and the oracle closed (AD 390) with the spread of Christianity.

delphinium (larkspur) Any of about 250 species of herbaceous plants native to temperate areas, with spirally arranged leaves and loose clusters of flowers. Petals form a tubular spur, which contains nectar. Garden delphiniums are varieties of *Delphinium elatum*. Family Ranunculaceae.

delta Fan-shaped body of ALLUVIUM deposited at the mouth of a river. A delta is formed when a river deposits sediment as its speed decreases while it enters the sea. Most deltas are extremely fertile areas, but are subject to frequent flooding.

delusion False or irrational belief based upon a misinterpretation of reality. False or irrational belief based upon a misinterpretation of reality. Mild delusions are quite common, but fixed delusions can be a symptom of PARANOIA.

dementia Deterioration of personality and intellect that can result from disease of or damage to the brain. It is characterized by memory loss, impaired mental processes, personality change, confusion, lack of inhibition and deterioration in personal hygiene. Dementia can occur at any age, although it is more common in the elderly. *See also* ALZHEIMER'S DISEASE **Demeter** In Greek mythology, the goddess of nature, sister

of Zeus and mother of Persephone.

De Mille, Agnes George (1906–93) US dancer and choreographer. Her choreography for the Broadway musical *Oklahoma* (1943) rendered dance integral to the plot and turned them into a serious art form. Other musicals include *Carousel* (1945), *Brigadoon* (1947), *Gentlemen Prefer Blondes* (1949), *Paint Your Wagon* (1951) and *Come Summer* (1969). She also created ballets that combined classical and modern elements, such as *Rodeo* (1942) and *Fall River Legend* (1948).

▲ Dempsey The first boxer to generate a \$1 million gate, Dempsey will always be remembered for his "Battle of the Long Count" fight with Gene Tunney (1927). After flouring Tunney, Dempsey failed to return to a neutral corner, and delayed the start of the referee's count. Tunney won the fight.

De Mille, Cecil B. (Blount) (1881–1959) US film producer and director, noted for his lavish dramatic presentations. His debut film, *The Squaw Man* (1913), established Hollywood as the world's film production capital. Much of his best-known work deals with biblical themes, such as *The Ten Commandments* (two versions, 1923 and 1956) and *King of Kings* (1927). Other major films include *Forbidden Fruit* (1921), *Union Pacific* (1939) and *The Greatest Show on Earth* (1952). Demirel, Süleyman (1924–) Turkish statesman, prime minister (1965–71, 1975–77, 1979–80, 1991–93) and president (1993–). He became leader of the centre-right Justice Party in 1964. He was twice ousted by military coups (1971, 1980). He led the Truth Path Party (1987–93).

democracy (Gk. demos kratia, people authority) Rule of the people, as opposed to rule by one (autocracy) or a few (oligarchy). Ancient GREECE is regarded as the birthplace of democracy, in particular ATHENS (5th century BC). Small Greek city-states enabled direct political participation, but only among its citizens (a small political elite). As societies grew, more refined systems of representative democracy were needed. In a FEUDAL SYSTEM, the king selected tenants-in-chief to provide counsel. In late 13th-century England, a PARLIA-MENT evolved, but remained answerable to the monarchy. Changes in land ownership and the growth of a mercantile class widened the representative base of parliament. The Roundheads' victory in the English CIVIL WARS was, in general terms, a victory for parliamentary sovereignty. A fundamental shift in emphasis was the transition from natural law to natural rights, as expounded by John Locke: in addition to responsibility (to crown or church), people possessed inalienable rights. ROUSSEAU developed these notions into the SOCIAL CONTRACT, which influenced the FRENCH and AMERICAN REV-OLUTIONS: government was limited by law from impinging on individual freedoms. During the 19th century, the FRANCHISE was extended. In the 20th century, democratic representation has been a matter of debate and sometimes bloody dispute. Common to modern liberal democracy is the principle of free multiparty elections with universal adult suffrage.

Democratic Party US political party, the descendant of the Anti-Federalist Party and the Democratic Republican Party. From the election of Thomas Jefferson (1801) until James Buchanan in 1857, the Democratic Party was the dominant force in US politics, gathering support from farmers and white-collar workers. The party was split by the Civil War (1861–65), with support mainly restricted to the South and West. It regained power in 1932 with Franklin D. Roosevell's "New Deal" policy. Democratic presidents were in office from 1961–69 (John F. Kennedy, Lyndon Johnson), a period marked by progressive economic and social policy, such as the passing of Civil Rights legislation. The 1970s and 1980s were more barren years, only Jimmy Carter (1977–81) held the presidency. The Republican Party dominated the political landscape until Bill Clinton recaptured the centre ground.

Democratic Republican Party Early US political party, and the precursor to the modern DEMOCRATIC PARTY. It was

formed in the late 1790s in opposition to the Federalist Party, and led by Thomas Jefferson and James Madison. It opposed strong central government and Alexander HAMIL-TON's economic policies, and advocated a liberal agrarian democracy, while also appealing to poor townsfolk. It became the Democratic Party in the era of Andrew JACKSON. democratic socialism Political movement that arose in late 19th- and early 20th-century Europe, out of the evolutionary wing of the Second Communist International. Broadly speaking, democratic SOCIALISM is committed to the principles of: equality and social justice, parliamentary government, redistribution of wealth (through progressive taxation), social protection and international cooperation. Democratic socialist parties have held power in most Western European countries, as well as Australasia, Canada and some Latin American countries. After the collapse of Soviet communism in the late 1980s, many communist parties reconstituted themselves as "democratic socialist" parties.

Democritus (460–370 BC) Greek philosopher and scientist. Only fragments of his work remain. He contributed to the theory of ATOMISM, propounded by his teacher Leucippus, by suggesting that all matter consisted of tiny, indivisible particles. **demography** Term introduced in 1855 by Achille Guillard for the scientific study of human populations: their changes, movements, size, distribution and structure. Demographic methods are used for gauging and anticipating public needs. **Demosthenes** (383–322 BC) Athenian orator and statesman. He devoted his life to speaking and fighting on behalf of the Greek states in their resistance to PHILIP II of Macedon.

Dempsey, Jack (1895–1983) US heavyweight boxer. Hugely popular with the public, Dempsey became the world heavyweight champion after knocking out Jess Willard (1919). He lost the title to Gene Tunney (1926) on points. Dempsey won 64 of his 79 professional fights.

dendrochronology Means of estimating time by examination of the growth rings in trees. Chronology based on the bristle-cone pine extends back over 7,000 years.

Deneb (Alpha Cygni) Remote and luminous white supergiant star in the constellation of Cygnus. It is 60,000 times more luminous than the Sun and located *c*.1,500 light years away.

dengue Infectious virus disease transmitted by the Aedes aegypti mosquito. Occurring in the tropics and some temperate areas, it produces fever, headache and fatigue, followed by severe joint pains, aching muscles, swollen glands and a reddish rash. Recovery usually follows, but relapses are common. Deng Xiaoping (1904–97) Chinese statesman. He took part in the Long March, served in the Red Army, and became a member of the central committee of the Chinese COMMUNIST PARTY in 1945. After the establishment of the People's Republic (1949) he held several important posts, becoming general secretary of the party in 1956. During the CULTURAL REVOLU-TION, Deng was denounced for capitalist tendencies and dismissed. He returned to government in 1973, was purged by the GANG OF FOUR in 1976, but reinstated in 1977 after the death of MAO ZEDONG. Within three years Deng had ousted HUA GUOFENG to become the dominant leader of party and government. He introduced rapid economic modernization, encouraging foreign investment, but without social and political liberalization. Deng officially retired in 1987, but was still essentially in control at the time of the TIANANMEN SQUARE massacre (1989). In 1993 JIANG ZEMIN became president.

De Niro, Robert (1943–) US film actor. An intense, powerful player, he first gained critical acclaim in Martin Scorsese's *Mean Streets* (1973). In 1974 he won an Oscar for Best Supporting Actor in *The Godfather, Part II*. Another critical triumph in *Taxi Driver* (1976) was followed by a nominated role in *The Deer Hunter* (1978). He finally won an Oscar for Best Actor in *Raging Bull* (1981). He made his directorial debut with *A Bronx Tale* (1993). Other films include *Goodfellas* (1990) and *Heat* (1995).

Denmark Kingdom in w Europe. *See* country feature, p.204 **density** Ratio of mass to volume for a given substance usually expressed in SI UNITS as (kg/m³). It is an indication of the concentration of particles within a material. The density of a solid or liquid changes little over a wide range of temperatures

▲ Deng Xiaoping Chinese political leader for much of the 1980s and paramount leader during the 1990s, Deng saw the advantage of introducing economic reforms to China, and encouraged a more open and free market. However, he was still deeply opposed to political reforms, and cracked down heavily on the pro-democracy movement.

▲ De Niro Academy Awardwinning actor Robert De Niro is famed for his method approach to acting. Many of his most complex performances have been as Italian-American gangsters in Martin Scorsese films, such as The Godfather Part II.

and pressures. Specific gravity (*sg*), or relative density, is the ratio of the density of one substance to that of a reference substance (usually water) at the same temperature and pressure. The density of a gas depends on both pressure and temperature. **dentistry** Profession concerned with the care and treatment of the mouth, particularly the teeth and their supporting tissues. As well as general practice, dentistry includes specialities such as oral surgery, periodontics and orthodontics.

dentition Type, number and arrangement of TEETH. An adult human has 32 teeth. In each jaw are four **incisors**, two **canines**, four **premolars**, four **molars** and, in most adults, up to four **wisdom** teeth. Children lack the premolars and four molars. The incisors are used for cutting; the canines for gripping and tearing; the molars and premolars for crushing and grinding food. A HERBIVORE has relatively unspecialized teeth that grow throughout life to compensate for wear, and are adapted for grinding. A CARNIVORE has a range of specialized teeth related to killing, gripping and crushing bones. In carnivores, unspecialized milk teeth are replaced by specialized adult teeth, which have to last a lifetime.

Denver Capital and largest city of Colorado state, USA, at the foot of the ROCKY MOUNTAINS. At an altitude of 1,608m

(5,280ft), it is nicknamed the "Mile High City". Founded in 1860, it became state capital in 1867. Its prosperity was boosted with the discovery of gold and silver and the building of the Denver Pacific Railroad (1870). Denver is the site of many government agencies, including a US Mint. Other places of note are the Denver Art Museum, the Boettcher Botanical Gardens and a university (1864). After World War 2, Denver's dramatic growth and high altitude led to serious pollution problems. During the 1970s, exploitation of oil deposits created further growth, but the worldwide slump in oil prices in the early 1980s temporarily stagnated its economy. It has the world's largest airport, Denver International. Its proximity to the Rockies and the ski resort of Aspen make it a major tourist centre. Denver is a processing, shipping and distribution centre and the location of many high-technology industries, especially aerospace and electronics. Pop. (1990) 467,610.

deoxyribonucleic acid See DNA

Depardieu, Gérard (1948–) French film actor. Burly and charismatic, he was France's principal actor in the 1980s. He has an extraordinary range, equally adroit at playing an historical figure such as *Danton* (1982), or a hunchback tax-collector, *Jean de Florette* (1986). *Green Card* (1990) was his first

DENMARK

Denmark's flag is the *Dannbrog*, "spirit of Denmark". It may be the oldest national flag in continuous use. It represents a vision thought to have been seen by King Waldemar II before the Battle of Lyndanisse (1219) in Estonia

AREA: 43,070sq km (16,629sq mi)

POPULATION: 5,170,000

CAPITAL (POPULATION): Copenhagen (620,970)

GOVERNMENT: Parliamentary monarchy

ETHNIC GROUPS: Danish 97% LANGUAGES: Danish (official)

RELIGIONS: Christianity (Lutheran 91%, Roman

Catholic 1%)

currency: Krone = 100 ore

Denmark is the smallest country in Scandinavia. It consists of a peninsula, Jutland (which is joined to Germany), and more than 400 islands, 89 of which are inhabited. The capital, COPENHAGEN, lies on Sjaelland (the largest island) facing Sweden across The Sound, a narrow strait, which leads from the Baltic Sea to the Kattegat and the North Sea. ODENSE lies on the island of Fyn. To the Nw of Denmark lie the self-governing Danish dependencies of GREENLAND and the FARÖE ISLANDS. The granite island of Bornholm, off the s tip of Sweden, is also a Danish possession and is a separate administrative region.

Denmark is flat and mostly covered by rocks deposited here by huge ice sheets during the last Ice Age. The highest point is only 171m (561ft) above sea level.

CLIMATE

Denmark has a cool but pleasant climate due to North Atlantic Drift. In cold winter spells, The Sound may freeze over. Summers are warm, and rainfall occurs throughout the year. The wettest seasons are summer and autumn.

VEGETATION

Much of Denmark is a patchwork of green fields, lakes and sandy beaches. Forests of oak and elm trees once covered the land, but most of the original forests have been felled. Today planted belts of beech, pine and spruce help to break the force of strong westerly winds.

HISTORY AND POLITICS

In c.2000 BC, the Danes developed an advanced Bronze Age culture. Between the 9th and 11th centuries, VIKINGS terrorized much of w Europe and Danes were among the invaders who conquered much of England. In the 11th century King CANUTE ruled over Denmark, Norway and England. Queen Margaret unified the crowns of Denmark, Sweden and Norway in 1397. Sweden broke away in 1523, while Norway was lost to 1814. Denmark in adopted LUTHERANISM as the national religion in the 1530s and Danish culture flourished in the 16th and early 17th centuries. CHRISTIAN IV led Denmark into costly wars with Sweden, and the Thirty Years War (1618-48) weakened the Danish aristocracy. Serfdom was abolished in 1788. In 1866 SCHLESWIG-HOLSTEIN was lost to Prussia.

In the late 19th century, Denmark developed its economy and education system. They set up cooperatives and improved farming techniques.

The Social Democratic Party dominated 20thcentury Danish politics. Denmark remained neutral in World War 1. In 1918 ICELAND gained independence. During the 1920s, Denmark adopted progressive social welfare policies. In 1940 Germany occupied Denmark. In 1943 CHRISTIAN X was arrested and martial law was declared. Many Jews escaped to Sweden. In 1945 Denmark was liberated by British forces. Denmark played an important part in European reconstruction. In 1949 it relinquished its neutrality and joined the North Atlantic Treaty Organization (NATO). In 1973 Denmark became the first Scandinavian member of the European Economic Community (EEC). In 1992 Denmark rejected the MAASTRICHT TREATY by a slender majority, but reversed the decision in a second referendum (1993).

ECONOMY

Danes enjoy a high standard of living (1992 GDP per capita, \$US19,080). During the 1980s and 1990s, the Danish economy suffered from high unemployment and foreign debt. Other problems include pollution and the high cost of welfare provision. Despite being self-sufficient in oil and natural gas, Denmark has few natural resources. The economy is highly developed, with manufacturing employing 27% of the workforce. Products include furniture, electrical goods and textiles. Services, including tourism, form the largest sector, accounting for 63% of GDP. Farms cover c.75% of the land. Farming employs only 4% of the workforce but is highly technological and productive. Meat and dairy farming predominate. Fishing is also important.

major English-speaking role. His performance as *Cyrano de Bergerac* (1990) was definitive. He made his directorial debut with *Tartuffe* (1984). Other films include *Germinal* (1993).

depression In economics, a term to describe a period of economic hardship, more severe than a RECESSION. It is commonly measured by a fall in output and a rise in unemployment. The most severe and widespread depression was the GREAT DEPRESSION of the 1930s.

depression In meteorology, a region of low atmospheric pressure with the lowest pressure at the centre. It usually brings unsettled or stormy weather. *See also* CYCLONE

depression Disorder characterized by feelings of guilt, failure, worthlessness or rejection. Frequently a response to a difficult life situation, depression leads to low self-esteem, self-recrimination and obsessive thoughts. Insomnia, loss of appetite and lethargy are often present, and in severe cases there is a risk of suicide. *See also* MANIC DEPRESSION

De Quincey, Thomas (1785–1859) English essayist and critic. An associate of Wordsworth and Coleridge, whom he memorialized in *Recollections of the Lakes* and *The Lake Poets* (1834–39). He is best known for his famous *Confessions of an English Opium Eater* (1822).

Derby, Edward George Geoffrey Smith Stanley, 14th Earl of (1799–1869) British statesman, three times prime minister (1852, 1858–59, 1866–68). He entered parliament as a Whig in 1827, and acted as chief secretary for Ireland (1830–33). He resigned shortly after becoming colonial secretary (1833), and joined the Conservative Party. He was colonial secretary under PEEL (1841–45), but resigned over the repeal of the Corn Laws. From 1846 to 1868, Derby led the Tory protectionists, briefly heading two administrations. In 1866 he became prime minister for the last time, introducing the Reform Act (1867). He was succeeded by DISRAELI.

Derby City and county district on the River Derwent, Derbyshire, central England. Industries: railway and aerospace engineering, textiles, ceramics. Rolls-Royce cars are made here. Pop. (1991) 218,802.

Derbyshire County in N central England; the county town is DERBY, other major towns are Chesterfield and Alfreton. Low-lying in the s, it rises to the PEAK DISTRICT in the N and is drained by the River Trent and its tributaries (the Dove, Derwent and Wye). Agriculture is important, such as dairy farming, livestock rearing, wheat, oats and market gardening. There are coal deposits in the E. Industries: steel, textiles, paper, pottery. Area: 2,631sq km (1,016sq mi). Pop. 887,600. derivative Rate of change of the value of a mathematical FUNCTION with respect to a change in the independent VARI-ABLE. The derivative is an expression of the instantaneous rate of change of the function's value: in general it is itself a FUNC-TION of the variable. An example is obtaining the velocity and acceleration of an object that moves distance x in time t according to the equation $x = at^n$. In such motion, the velocity increases with time. The expression dx/dt, called the first derivative of distance with respect to time, is equal to the velocity of the object; in this example it equals $nat^{(n-1)}$. The result is obtained by DIFFERENTIAL CALCULUS. In this example, the second derivative, written d²x/dt², is equal to the acceleration.

dermatitis Inflammation of the skin. In acute form it produces itching and blisters. In chronic form it causes thickening, scaling and darkening of the skin. *See also* ECZEMA

dermatology Branch of medicine that deals with the diagnosis and treatment of skin diseases.

dermis Thick inner layer of the SKIN, which lies beneath the EPIDERMIS. It consists mainly of loose CONNECTIVE TISSUE richly supplied with BLOOD and lymph vessels, nerve endings, sensory organs and sweat glands.

Derry City and administrative district on the River Foyle near Lough Foyle, NW Northern Ireland. In AD 546 St Columba founded a monastery here and a settlement grew up around it. In 1311 Derry was granted to the Earl of Ulster. In 1600 English forces seized the city, and in 1613 James I granted Derry to the citizens of London. It was renamed **Londonderry**, a new city was laid out and Protestant colonization began. In 1688–89 James II unsuccessfully besieged the city. In recent years, the city has been plagued by sectarian violence. In 1984

its name reverted to Derry. Industries: clothing manufacture. Area: 347sq km (149sq mi). Pop. (1991) 95,371.

dervish Member of a Muslim fraternity. Communities arose within Sufism, and by the 12th century had established themselves in the Middle East. The Bektashi order acted as companions to the Ottoman Janissaries, and were suppressed by Atatürk. The chief devotion of dervishes is *dhikr* (remembering of God). Its encouragement of emotional display and hypnotic trances has earned dervishes the epithet "whirling". desalination Extraction of pure water (for drinking, industrial and chemical uses, or for irrigation) from water containing dissolved salts, usually sea water. The commonest and oldest method is distribution; salt is excluded from the ice crystals which can then be melted. In reverse OSMOSIS, pure water only passes through a semipermeable membrane against which salt water is pressurized. Other methods include electrodialysis.

Descartes, René (1596–1650) French philosopher and mathematician. Descartes is often regarded as the father of modern philosophy. In 1619, he described an all-embracing science of the universe. He evolved his own philosophical principles during the 1630s and 1640s. His works include *Discourse on Method* (1637), *Meditations on the First Philosophy* (1641) and *Principles of Philosophy* (1644). His methods of deduction and intuition inform modern metaphysics. By doubting all his ideas, he reached one indubitable proposition: "I am thinking", and from this that he existed: *cogito ergo sum* (I think, therefore I am). Descartes also founded analytic geometry, introduced the CARTESIAN COORDINATE SYSTEM and helped establish the science of optics.

desert Arid region of the Earth, at any latitude, characterized by scant, intermittent rainfall of less than 25cm (10in) per year, and little or no vegetation. Regions with 25–50cm (10–20in) are semi-deserts. Cold deserts, areas almost permanently covered with snow or ice, extend over one-sixth of the Earth's surface; and hot deserts over one-fifth. Most desert regions lie between 20° and 30° N and s of the Equator, where mountains form a barrier to prevailing winds, or where high pressure prevents precipitation. The SAHARA in Africa is the world's largest desert.

desertification Process by which a desert gradually spreads into neighbouring areas of semi-desert. The change may result from a natural event, such as fire or climatic change, but occurs most frequently as a result of human activity. Once vegetation is removed (usually by over-grazing or for firewood), the soil is easily eroded and the land rendered infertile. Restoration is a long and slow process.

De Sica, Vittorio (1901–74) Italian film director and actor. He is noted for his use of amateur actors in realistic dramas. Working with Cesare Zavattini, he made a significant contribution to Italian NEO-REALISM with films such as *Shoeshine* (1946) and *Bicycle Thieves* (1948). Other films include *Umberto D* (1952), *Indiscretion of an American Wife* (1953), *Two Women* (1961) and *A Brief Vacation* (1974).

Des Moines Capital and largest city of Iowa state, USA,

▲ desertification The true causes of desertification are still not entirely understood, but it is generally accepted that recent desertification is directly attributable to increased human intervention. On a large scale, the burning of fossil fuels is likely to shift climatic belts and increase areas of desert. More localized problems have occured due to overgrazing of livestock and ill-planned irrigation projects.

near the confluence of the Des Moines and Raccoon rivers. Founded in 1843, it is now an industrial and transport centre for the Corn Belt. Severely flooded in 1954, the city is protected by a system of dams and reservoirs. Industries: mechanical and aerospace engineering, chemicals. Pop. (1990) 193,187.

Desmoulins, Camille (1760–94) French revolutionary. His pamphlets, such as *Révolutions de France et de Brabant* (1789), were widely read and he was responsible for provoking the mob that attacked the BASTILLE in 1789. Aligned with Georges DANTON, he played a part in bringing down the GIRONDINS, but was guillotined during the revolution.

De Soto, Hernando (1500–42) Spanish explorer. After taking part in the conquest of the Incas under Francisco Pizarro, he was appointed governor of Cuba (1537) with permission to conquer the North American mainland. His expedition landed in Florida (1539) and advanced as far N as the Carolinas and as w as the Mississippi. The search for treasure and the extreme brutality towards the native inhabitants led to a costly battle at Maubilia (1540). They returned to the Mississippi, where De Soto died; the survivors eventually reached Mexico (1543).

Des Prés, Josquin See Josquin Desprez

Dessalines, Jean Jacques (1758–1806) Haitian ruler. He succeeded Toussaint L'Ouverture as leader of the revolution in 1802. Having driven out the French, he declared independence in 1804, changing the country's name from St Domingue to Haiti. As Emperor Jacques, he ruled despotically and was assassinated after a two-year reign.

detective fiction Literary form in which a crime (almost always murder) is solved by a detective, usually amateur, who is the hero of the story. The greatest exponents of the genre include: Edgar Allan Poe; Wilkie Collins; Arthur Conan Doyle; G.K. Chesterton; Agatha Christie; Raymond Chandler and Dorothy L. Sayers.

detergent Synthetic chemical cleansing substance. The most common type is alkyl sulphonate. Detergents have molecules that possess a long hydrocarbon chain attached to an ionized group. This chain attaches to grease and other nonpolar substances, while the ionized group has an affinity for water (so the grease is washed away with the water).

determinism Philosophical thesis that every event is the necessary result of its causes. Nothing is accidental. It usually involves the denial of FREE WILL, though Thomas HOBBES and David HUME struggled to reconcile the two ideas. CALVIN'S concept of PREDESTINATION is a form of determinism.

Detroit City on the Detroit River, SE Michigan state, USA. Founded as a French trading post (1710), the British captured it in 1760 and used it as a base during the American Revolution. It was lost to Britain in the WAR OF 1812, but retaken by US forces in 1813. The largest city in Michigan, Detroit is a major GREAT LAKES centre and headquarters of General Motors, Chrysler and Ford. Industries: motor vehicles, steel, pharmaceuticals, machine tools, tyres, paint. Pop. (1990) 1,027,974.

deuterium Isotope (D or H^2) of hydrogen whose nuclei contain a neutron in addition to a proton. Deuterium occurs in water as D^2O (heavy water), from which it is obtained by ELECTROLYSIS. Heavy water is used as a moderator in some FISSION reactors. Properties: r.a.m. 2.0144.

deuteronomy Biblical book, fifth and last of the PENTA-TEUCH or TORAH. It contains three discourses ascribed to Moses, which frame a code of civil and religious laws. The book was probably written long after Moses.

De Valera, Eamon (1882–1975) Irish statesman, prime minister (1932–48, 1951–54, 1957–59). De Valera was active in the Irish independence movement and after the Easter Rising (1916) was elected president of SINN FÉIN while imprisoned in England. He opposed William Cosgrave's Irish Free State ministry and founded FIANNA FÁIL in 1924. He defeated Cosgrave in 1932. In 1959 De Valera became president of the republic. He retired in 1973.

devaluation Lowering the value of one nation's currency with respect to that of another or to gold. The decision to devalue is made by a central government usually when the nation is having BALANCE OF PAYMENTS problems. Devaluation stimulates the economy by reducing the foreign currency price of exports and raising the domestic price of imports.

developing countries *See* LESS DEVELOPED COUNTRIES (LDCs)

developmental psychology Study of behaviour as it changes through all life stages from the fetus to old age. Psychologists study normal growth, change, and self-actualization, as well as life-stage related problems. *See also* CHILD PSYCHOLOGY

devil Evil spirit considered in many religions to be the archenemy of the Supreme being. In Christianity, the Devil is the chief of the fallen angels cast out of heaven for their sins. The devil was named as SATAN, BEELZEBUB or the Prince of Darkness. The biblical account of Christ's temptation in the desert leads to the perception of the Devil as the tempter of men's souls. In Islam, Iblis is the name of the devil figure, the supreme tempter.

Devon County in sw England, bounded by the English Channel (s) and the Bristol Channel (n); the county town is EXETER. There are Bronze and Iron Age remains. During the Middle Ages, tin mining was a major industry. Devon is a hilly region that includes Dartmoor and Exmoor. The principal rivers are the Ex, Tamar, Dart and Teign. Cattle farming is important. Industries: tourism, fishing, dairy products, cider, textiles. Area: 6,711sq km (2,591sq mi). Pop. (1991) 1,009,950.

Devonian Fourth-oldest period of the PALAEOZOIC era, lasting from 408–360 million years ago. Numerous marine and freshwater remains include jawless fishes and forerunners of today's bony and cartilaginous fishes. The first known land vertebrate, the amphibian Ichthyostega, appeared at this time. Land animals included scorpions, mites, spiders and the first insects. Land plants included club moss, scouring rushes and ferns.

De Vries, Hugo (1848–1935) Dutch botanist. De Vries introduced the concept of MUTATION into the study of GENETICS. He wrote *The Mutation Theory* (1901–03), which influenced concepts of the role of mutation in evolution.

dew Water droplets formed, usually at night, by condensation on vegetation and other surfaces near the ground.

Dewar, Sir James (1842–1923) Scottish chemist and physicist who researched materials at extremely low temperatures. In 1872, he invented the Thermos flask. He also built a device that could produce liquid oxygen.

Dewey, John (1859–1952) US educator and philosopher. A founder of PRAGMATISM and FUNCTIONALISM, he had a profound impact on US educational practice and the development of applied psychology. His works include *The School and Society* (1899) and *Experience and Education* (1938).

Dewey decimal system Means of classifying books, created by US librarian Melvil Dewey in the 1870s. It is popular because of its subject currency and simplicity.

dew point Temperature at which a vapour begins to condense, for example when water vapour in the air condenses into cloud as the air becomes saturated with vapour.

Dhaka (Dacca) Capital of Bangladesh, a port on the Ganges delta, E Bangladesh. Its influence grew as the 17th century Mogul capital of Bengal. In 1765 it came under British control. At independence (1947) it was made capital of the province of East Pakistan. Severely damaged during the war of independence from Pakistan, it became capital of independent Bangladesh (1971). Sites include the Dakeshwari temple, Lal Bagh fort (1678), Bara Katra palace (1644) and a clutch of beautiful mosques. It is in the centre of the world's largest jute-producing area. Industries: engineering, textiles, printing, glass, chemicals. Pop. (1991) 3,397,187. **dharma** Religious concept relating to what is true or right,

found in the principal religions of India. In HINDUISM, it is the moral law or code governing an individual's conduct in life. In BUDDHISM, dharma is the doctrine of universal truth proclaimed by the BUDDHA. In JAINISM, dharma is moral virtue and is also the principle that gives beings the power of movement. **diabetes** Disease characterized by lack of INSULIN needed for sugar METABOLISM. This leads to HYPERGLYCAEMIA and an excess of SUGAR in the blood. Symptoms include abnormal thirst, over-production of urine and weight loss; degenerative changes occur in blood vessels. Untreated, the condition progresses to diabetic coma and death. There are two forms of the disease. **Type 1** usually begins in childhood and is an

autoimmune disease. Those affected owe their survival to insulin injections. Milder type 2 diabetes mostly begins in middle-age; there is some insulin output but not enough for the body's needs. The disease is managed with dietary restrictions and oral insulin. Susceptibility to diabetes mellitus is inherited and more common in males.

diagenesis Physical and chemical processes whereby sediments are transformed into solid rock, usually at low pressure and temperature. Pressure results in compaction, forcing grains together and eliminating air and water.

Diaghilev, Sergei Pavlovich (1872–1929) Russian ballet impressario. He was active in the Russian artistic avantgarde after 1898 and moved to Paris, where he formed the revolutionary BALLETS RUSSES (1909). He assembled many talented artists, dancers and musicians, including NIJINSKY, STRAVINSKY and FOKINE.

dialect Regional variety of a language, distinguished by features of pronunciation, grammar, and vocabulary. Dialectal differences may be relatively slight (as in the dialects of American English), or so great (Italian) that mutual comprehension becomes difficult or impossible.

dialectic Method of argument through conversation and dialogue; based on the philosophy of SOCRATES, in particular the *Dialogues*. Hegel went on to argue that ordinary LOGIC, governed by the law of contradiction, is static and lifeless. In the *Science of Logic* (1812–16) he claimed to satisfy the need for a dynamic method, whose two moments of thesis and antithesis are cancelled and reconciled in a higher synthesis. Logic was to be dialectical, or a process of resolution by means of conflict of categories. *See also* DIALECTICAL MATERIALISM

dialectical materialism Scientific theory and philosophical basis of MARXISM. It asserts that everything is material, and that change results from the struggle of opposites according to definite laws. Its main application was in the analysis of human history. Karl MARX agreed with HEGEL that the course of history is logically dialectical, so that true social change can only occur when two opposing views are resolved through a new synthesis, rather than one establishing itself as true. Marx believed that Hegel was wrong to define DIALECTICS as purely spiritual or logical. For Marx, the proper dialectical subject was material experience. According to his theory of historical materialism, history was derived from economic or social realities.

dialysis Process for separating particles from a solution by virtue of differing rates of diffusion through a semipermeable membrane. In an artificial KIDNEY, unwanted molecules of waste products are separated out to purify the blood. Electrodialysis employs a direct electric current to accelerate the process, especially useful for isolating proteins.

diamond Crystalline form of carbon (C). The hardest natural substance known, it is found in kimberlite pipes and alluvial deposits. Appearance varies according to its impurities. Bort, inferior in crystal and colour, carborondo, an opaque grey to black variety, and other non-gem varieties are used in industry. Industrial diamonds are used as abrasives, bearings in precision instruments such as watches, and in the cutting heads of drills for mining. Synthetic diamonds, made by subjecting GRAPHITE, with a catalyst, to high pressure and temperatures of c.3,000°C (5,400°F) are fit only for industry. Diamonds are weighed in carats (0.2gm) and points (1/100 carat). The largest producer is Australia. Hardness 10; s.g. 3.5.

Diana In Roman religion, the virgin huntress and patroness of domestic animals. She was identified with Artemis. A fertility deity, she was invoked to aid conception and childbirth. **Diana, Princess of Wales** (1961–97) Former wife of the heir to the British throne. The daughter of Earl Spencer, Diana married CHARLES, Prince of Wales in 1981, and they had two sons, William and Harry. A popular, glamorous figure, she worked for many public health and children's charities. Their marriage fell apart acrimoniously and publicly, and they divorced in 1996. She continued to campaign for humanitarian causes until her tragic death in a car crash.

diaphragm Sheet of muscle that separates the abdomen from the THORAX. During exhalation it relaxes and allows the chest to subside; on inhalation it contracts and flattens, causing the chest cavity to enlarge.

diarrhoea Frequent elimination of loose, watery stools, often accompanied by cramps and stomach pains. It arises from various causes, such as infection, intestinal irritants or food allergy. Mild attacks can be treated by replacement fluids.

Diaspora ("dispersion") Jewish communities outside Palestine. Although there were communities of Jews outside Palestine from the time of the Babylonian Captivity (6th century BC), the Diaspora essentially dates from the destruction of Jerusalem by the Romans (AD 70). *See also* ZIONISM

diatom Any of a group of tiny microscopic single-celled ALGAE (phylum Bacillariophyta) characterized by a shell-like cell wall made of silica. Diatoms live in nearly all bodies of salt and freshwater, and even soil and tree bark.

Diaz, Bartholomeu (1450–1500) Portuguese navigator, the first European to round the CAPE OF GOOD HOPE. In 1487, under the commission of King John II of Portugal, Diaz sailed three ships around the Cape, opening the long-sought route to India. He took part in the expedition of Cabral that discovered Brazil, but was drowned when his ship foundered. Díaz, Porfirio (1830–1915) Mexican statesman, president (1876–80, 1884–1911). After twice failing to unseat President JUÁREZ, he succeeded against Lerdo in 1876. Díaz provided stable leadership for 30 years. Growing opposition crystallized under Francisco MADERO in 1911 and Díaz resigned.

Dickens, Charles John Huffam (1812–70) British novelist. After a difficult early life, he began his writing career as a parliamentary reporter for the *Morning Chronicle*. His first success was the series of satirical pieces collected in 1836 as *Sketches by Boz*. They were followed by *The Posthumous Papers of the Pickwick Club* (1836–37), which launched his literary career. Most of his novels first appeared in serial form, such as *Oliver Twist* (1837–39), *Nicholas Nickleby* (1838–39), *The Old Curiosity Shop* (1840–41) and *Martin Chuzzlewit* (1843–44). His great mature novels include *David Copperfield* (1849–50), *Bleak House* (1852–53), *Hard Times* (1854) and *Great Expectations* (1860–61). Dickens' relentless energy also found outlet in journalism, short stories, comic plays, and demanding public reading tours.

Dickinson, Emily Elizabeth (1830–86) US poet. She led an active social life until the age of 23, when she became almost totally reclusive, writing more than 1,700 short, mystical poems in secrecy. Now considered one of the finest US poets, her rich verse explores the world of emotion and the beauty of simple things. Only seven of her poems were published during her lifetime. *Poems by Emily Dickinson* appeared in 1890 and her collected works were not published until 1955.

dicotyledon Larger of the two subgroups of flowering plants or ANGIOSPERMS, characterized by two seed leaves (COTYLE-

Diana's "fairy-tale" marriage to Charles (Prince of Wales) ended in a bitter divorce and left Diana without a clear public role. Her

■ Diana, Princess of Wales

a bitter divorce and left Diana without a clear public role. Her frankness about her personal difficulties struck an emotional chord. Diana's iconic beauty and glamour ensured the constant, often intrusive, presence of the media. Her self-appointed role as "Queen of Hearts" saw her campaign for a worldwide ban on landmines. An unprecedented outpouring of public emotion followed her tragic death with Dodi Fayed in a car crash in Paris.

DONS) in the seed embryo. Other general features of dicotyledons include broad leaves with branching veins; flower parts in whorls of fours or fives; vascular bundles in a ring in the stem and root; and a taproot. There are about 250 families of dicotyledons, such as the ROSE, DAISY and MAGNOLIA.

dictatorship Absolute rule without the consent of the governed. In many modern dictatorships, all power resides in the dictator, with representative DEMOCRACY abolished or existing as mere formality. Personal freedom is severely limited, censorship is generally enforced, education is tightly controlled, and legal restraints on governmental authority are abolished. **dictionary** Book that lists in alphabetical order, words and

dictionary Book that lists in alphabetical order, words and their definitions. A dictionary may be general or subject oriented. In the former category, Samuel JOHNSON'S A Dictionary of the English Language (1755) is the pioneering work in English; its two most comprehensive descendants are (in the UK) the Oxford English Dictionary, published from 1884, and (in the USA) Webster's Dictionary, published from 1828.

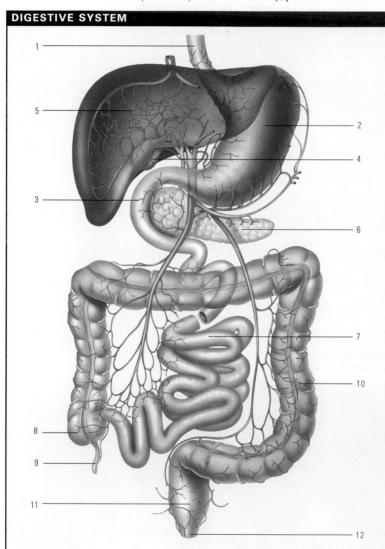

The digestion and absorption of food takes place within the digestive tract, a coiled tube some 10m (33ft) long which links mouth to anus. Food is passed down the oesophagus (1) to the stomach (2), where it is partially digested. Chyme is released into the duodenum (3), the first part of 7m (23ft) of

small intestine. The duodenum receives bile secreted by the gall bladder (4) in the liver (5), and enzymes secreted by the pancreas (6). Most absorption occurs in the jejunum and ileum, the remaining parts of the small intestine (7). Any residue passes into the caecum (8), the pouch at the start

of the large intestine. At one end of the caecum is the 10cm (4in) long vermiform appendix (9), which serves no useful purpose in man. Water is reabsorbed in the colon (10). Faeces form and collect in the rectum (11) before being expelled as waste through the anus (12).

Diderot, Denis (1713–84) French philosopher and writer. He was chief editor of the *Encyclopédie* (1751–72), an influential publication of the ENLIGHTENMENT. A friend of ROUSSEAU, he was imprisoned briefly (1749) for irreligious writings. He broadened the scope of the *Encyclopédie* and with d'Alembert recruited contributors, such as VOLTAIRE. As a philosopher, Diderot progressed gradually from Christianity through DEISM to atheism. His books *On the Interpretation of Nature* (1754) and *D'Alembert's Dream* (1769) reveal his scientific MATERIALISM. *Jacques the Fatalist* (1796) and *Rameau's Nephew* illustrate his DETERMINISM. He also wrote plays and art and literary criticism.

Dido In Greek and Roman legend, Phoenician princess and founder of CARTHAGE. Carthage prospered and Dido's hand was sought by the king of Libya. To escape him she stabbed herself. VIRGIL made Dido a lover of AENEAS, and attributes her suicide to his decision to abandon her.

Diem, Ngo Dinh (1901–63) Vietnamese statesman, prime minister of South Vietnam (1954–63). A nationalist opposed to both the communists and the French, he at first received strong US support, but corruption and setbacks in the war against communism led to growing discontent. With covert US help, army officers staged a coup in which Diem was murdered.

Dien Bien Phu Fortified village in N Vietnam. In a 1954 battle, the French stronghold was captured by the Vietnamese Viet Minh after a siege lasting 55 days. French casualties were *c*.15,000. The resultant cease-fire ended eight years of war.

diesel engine Internal combustion engine, invented by Rudolf Diesel (1897). Heat for igniting the light fuel oil is produced by compressing air.

diet Range of food and drink consumed by an animal. The human diet falls into five main groups of necessary nutrients: PROTEIN, CARBOHYDRATE, FAT, VITAMIN and MINERAL. An adult's daily requirement is about one gramme of protein for each kilogramme of body weight. Beans, fish, eggs, milk and meat are important protein sources. Carbohydrates (stored as GLYCOGEN) and fat, are the chief sources of energy and are found in cereals, root vegetables and sugars. Carbohydrates make up the bulk of most diets. Fats are a concentrated source of energy, and aid the absorption of fat-soluble vitamins (vitamins A, D, E and K). Water and minerals such as iron, calcium, potassium and sodium are also essential.

Dietrich, Marlene (1904–92) German film star and cabaret singer. Her glamorous, sultry image evolved in films directed by Josef von Sternberg, such as *The Blue Angel* (1930) and *Blonde Venus* (1932). Other films include *Destry Rides Again* (1939) and *Rancho Notorious* (1956).

differential In mathematics, small change occurring in the value of a mathematical expression due to a small change in a VARIABLE. If f(x) is a FUNCTION of x, the differential of the function, written df, is given by f'(x)dx, where f'(x) is the DERIVATIVE of f(x).

differential In mechanics, a set of circular gears that transmits power from an engine to the wheels. When a car is turning a corner, the differential allows the outside drive wheel to rotate faster than the inner one.

differential calculus (differentiation) Form of CALCULUS used to calculate the rate of change (DERIVATIVE) of one quantity with respect to another of which it is the FUNCTION.

diffraction Spreading of a wave, such as a light beam, on passing through a narrow opening or hitting the edge of an obstacle, such as sound being heard around corners. It is evidence for the wave nature of light. Diffraction provides information on the wavelength of light and the structure of CRYSTALS. All waves are diffracted by obstacles.

diffusion Movement of a substance in a mixture from regions of high concentration to regions of low concentration, due to the random motion of individual atoms or molecules. Diffusion ceases when there is no longer a concentration gradient. Its rate increases with temperature, since average molecular speed also increases with temperature.

digestion Process of the DIGESTIVE SYSTEM, in which food is broken down mechanically and chemically into smaller molecules that can be readily absorbed by an organism. Digestion occurs mainly by means of chemical agents called ENZYMES.

digestive system (alimentary system) Group of organs of the body concerned with the DIGESTION of foodstuffs. In humans, it begins with the mouth, and continues into the OESOPHAGUS, which carries food into the STOMACH. The stomach leads to the small intestine, which then opens into the COLON. After food is swallowed, it is pushed through the digestive tract by PERISTALSIS. On its journey, food is transformed into small molecules that can be absorbed into the bloodstream and carried to the tissues. CARBOHYDRATE is broken down to sugars, PROTEIN to AMINO ACIDS, and FAT to FATTY ACIDS and GLYCEROL. Indigestible matter, mainly cellulose, passes into the rectum, and is eventually eliminated from the body (as faeces) through the ANUS.

Diggers (1649–50) English millenarian social and religious sect in England, an extreme group of the LEVELLERS. They formed an egalitarian agrarian community at St George's Hill, Surrey. It was destroyed by local farmers. The main Digger theorist, Gertard Winstanley, proposed communalization of property to establish social equality in *Law of Freedom* (1652). **digital** Data or information expressed in terms of a few discrete quantities, often associated with a digital COMPUTER. Data is represented as a series of zeros and ones in a BINARY SYSTEM. Digital can also refer to displaying information in numbers, as opposed to continuously varying analogue.

digital audio tape (DAT) Technology for recording sound in DIGITAL form on magnetic TAPE. The original sound signal is encoded to form patterns of equal-strength pulses. These DIGITAL SIGNALS are recorded onto tape. On playback, the patterns are detected and decoded to produce an identical signal. digitalis Drug obtained from the leaves of the FOXGLOVE (Digitalis purpurea), used to treat HEART disease. It increases heart contractions and slows the heartbeat.

digital signal Group of electrical or other pulses in a COMPUTER OF COMMUNICATIONS system. They may represent data, sounds or pictures. Pulses in a stream of digital signals are represented by zeros and ones in the BINARY SYSTEM.

Dijon City in E France; capital of Côte-d'Or département. In the 11th century the dukes of Burgundy made it their capital. It was annexed to France (1477). Sites include Dijon University (1722), Cathedral of St Bénigne and the Church of Notre Dame. Exports: wine, mustard, cassis. Pop. (1990) 146,703. **dill** Aromatic annual herb native to Europe. Its small oval seeds and feathery leaves are used in cooking. Family Apiaceae/Umbelliferae; species *Anethum graveolens*.

DiMaggio, Joe (Joseph Paul) (1914–) US baseball player. DiMaggio played for the New York Yankees (1936–42, 1946–51), and holds the record for hitting safely in 56 consecutive games. He had a lifetime batting average of .325. DiMaggio married Marilyn Monroe (1954) and was elected to the Baseball Hall of Fame (1955).

dimensions In mathematics, numbers specifying the extent of an object in different directions. A figure with length only, is one-dimensional; a figure having area but not volume, two-dimensional; and a figure having volume, three-dimensional. diminishing returns, law of (law of increasing costs) In economics, if more of a variable input, such as labour, is added to the production process, while all other factors are held constant, the addition to total output per unit input begins to decline at some point.

Dinaric Alps (Dinara Planina) Mountain range running parallel to the E coast of the Adriatic Sea. Forming part of the E Alps, it extends from the Istrian peninsula (Croatia) to NW Albania, with peaks over 2,400m (7,900ft). Length: 640km (400mi).

D'Indy, Vincent (1851–1931) French composer and teacher. He co-founded the *Schola Cantorum* for the study of church music (1894), which became a general music school. D'Indy taught composition here until his death. *Cours de Composition* outlines his teaching methods. His pupils included SATIE. He composed several operas, orchestral, choral, chamber and piano music.

Dinesen, Isak (1885–1962) Danish writer. She described her life on a Kenyan coffee plantation in *Out of Africa* (1937). Her collections of short stories include *Seven Gothic Tales* (1934), *Winter's Tales* (1942) and *Shadows on the Grass* (1960).

dingo Yellowish-brown wild DOG found in Australia; it is

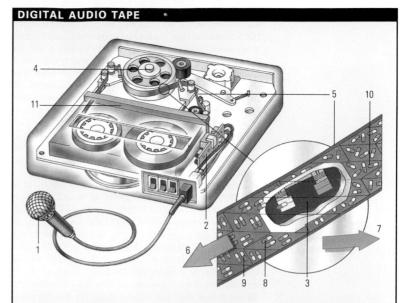

A digital audio tape (DAT) recorder records sound, an analogue signal, in digital form. The analogue signal enters via a microphone (1) and passes through a converter (2), which transcribes the sound wave into a series of zeros and ones. Two magnetic heads, tiny

electromagnets (3) in a rotating drum (4), receive the digital signal as electrical pulses which polarize diagonal strips of magnetic tape (5) (moving right to left) (6) as it is scanned diagonally (7). The heads align the magnetic elements of the tape representing a zero or a

one. Each head records one half of a stereo recording. One head records parallel to the tape (8), one perpendicular (9) to avoid interference. The units of an unrecorded tape are jumbled (10). When a tape (11) is played the head reads the polarization of the tape.

probably a descendant of early domestic dogs introduced by Native Australians. It feeds mainly on rabbits and other small mammals. Family Canidae; species *Canis dingo*.

dinosaur Any of a large number of REPTILES that lived during the MESOZOIC era, between 225 and 65 million years ago. They appeared during the Triassic period, survived the JURASSIC and became extinct at the end of the Cretaceous. There were two orders: Saurischia ("lizard hips"), included the bipedal carnivores and the giant herbivores; the Ornithiscia ("bird hips") were smaller herbivores. Their posture, with limbs vertically beneath the body, distinguish them from other reptiles. Many theories are advanced to account for their extinction. It is possible that, as the climate changed, they were incapable of swift adaptation. A more catastrophic theory is that they died because of the devastating atmospheric effects from the impact of a large METEOR. See also BRONTOSAURUS; DIPLODOCUS; TYRANNOSAURUS

Diocletian (245–313) Roman emperor (284–305). Of low birth, he was appointed by the army. He reorganized the empire to resist the Barbarians, dividing it into four divisions and sharing power with Maximilian, Constantius I and Galerius. He ordered the last great persecution of the Christians (303).

■ dinosaur The first dinosaurs roamed the Earth c.225 million years ago. They were the dominant land animals until they died out suddenly, c.65 million years ago. The stegosaurus (left) was a plant-eating dinosaur that lived c.140 million years ago. It grew to 20ft (6m) long and 8ft (2.4m) high at the hip. The bony plates along the spine and the spikes on the tail are thought to have offered protection against carnivorous dinosaurs, but may also have acted like radiators, regulating the animal's temperature.

diode Electronic component with two electrodes, used as a RECTIFIER to convert alternating current (AC) to direct current (DC). Semiconductor diodes have largely replaced electrontubes, and allow ELECTRIC CURRENT to flow freely in only one direction; only a small current flows in the reverse direction. A Zener diode blocks current until a critical voltage is reached.

Diogenes (active 4th century BC) Greek philosopher. He founded the CYNIC school of philosophy. He believed that by reducing personal needs to a minimum, one can have mastery over one's soul.

Dionysus Greek god of wine and fertility, identified with the Roman god BACCHUS. The son of ZEUS and Semele, he was reared by nymphs and taught men the secrets of cultivating grapes and making wine.

Dionysius the Elder (430–367 BC) Tyrant of Syracuse (405–367 BC). His ambitions were to spread Hellenism beyond Syracuse. He tried to form an empire in Lower Italy by seizing Rhegium (387), Caulonia and Croton (379). He then mixed the various populations. A supporter of the arts and an erstwhile playwright, he once sold Plato as a slave.

Dior, Christian (1905–57) French fashion designer. In the spring of 1947 he launched the New Look, whose wide shoulders and long shapely skirts signalled an end to war austerity. dioxin Any of various poisonous chemicals. The compound most commonly known as dioxin is 2,3,7,8-tetrachlorodibenzo-p-dioxin (TCDD), a by-product and impurity in the manufacture of various disinfectants and HERBICIDES. It is also produced in the burning of chlorinated chemicals and plastics. Dioxin causes skin disfigurement and is associated with birth defects, cancer and miscarriages. Accidental releases of dioxin from chemical plants have caused major disasters.

dip, magnetic Angle between the direction of the Earth's magnetic field and the horizontal. A freely suspended magnetic needle in London dips, with its north pole pointing down, at an angle of 71.5° to the horizontal.

diphtheria Acute infectious disease characterized by the formation of a membrane in the throat which can cause asphyxiation; there is also release of a toxin which can damage the nerves and heart. Caused by a bacterium, *Corynebacterium diphtheriae*, which often enters through the upper respiratory tract, it is treated with antitoxin and antibiotics

diplodocus DINOSAUR that lived in N USA during the Jurassic period. The longest land animal that has ever lived. It had a long slender neck and tail and was a swamp-dwelling herbivore. Length: 25m (82ft).

diploid Cell that has its CHROMOSOMES in pairs. Diploids are found in almost all animal cells, except GAMETES which are haploid. Cells of flowering plants and gymnosperms are also diploid. Algae and lower plants, such as ferns, have two generations in their life cycle, one diploid, the other haploid. In diploids, the chromosomes of each pair carry the same GENES. See also ALTERNATION OF GENERATIONS

dipole Separation of electric charge in a molecule. In a COVALENT BOND, the electron pair is not equally shared. In hydrogen chloride (HCl), electrons are attracted towards the more electronegative chlorine atom, giving it a partial negative charge and leaving an equal positive charge on the hydrogen atom. Dipoles contribute to the chemical properties of molecules.

dipper Bird found near fast-flowing mountain streams, where it dives for small fish and aquatic invertebrates. It has a thin, straight bill, short wings and greyish-brown plumage. Length: to 19cm (7.5in). Family Cinclidae; genus *Cinclus*.

dip pole Either of two imaginary points on the Earth's surface where the direction of the Earth's magnetic field is vertical (downwards at the North Pole, upwards at the South Pole). Dirac, Paul Adrien Maurice (1902–84) British physicist who devised a version of QUANTUM MECHANICS. He extended this to combine RELATIVITY and quantum-mechanical descriptions of ELECTRON properties. He also predicted the existence of the POSITRON, later discovered by Carl ANDERSON. Dirac shared the 1933 Nobel Prize for physics with Erwin SCHRÖDINGER.

direct current (DC) See ELECTRIC CURRENT

disarmament Refers principally to attempts post-1918 (and especially post-1945) to reach international agreements to reduce armaments. The United Nations established the Atom-

ic Energy Commission (1946), and the Commission for Conventional Armaments (1947). In 1952 these were combined into the Disarmament Commission. It produced no results and the Soviet Union withdrew in 1957. The USA and the Soviet Union signed the Nuclear Test Ban Treaty (1963) and the Nuclear Non-Proliferation Treaty (1968), which provided for an international inspectorate. This was followed by a series of STRATEGIC ARMS LIMITATION TALKS (SALT). Intensification of the COLD WAR in the early 1980s froze all disarmament efforts. In 1986 SALT was superseded by START (strategic arms reduction talks), resulting in the Intermediate Nuclear Forces (INF) Treaty (1987), which reduced the superpowers' arsenal of short-range, intermediate missiles by c.2,000 (4% of the total stockpile) and provided for on-site inspection. Following the break-up of the Soviet Union, the focus has shifted partly to non-nuclear disarmament. The Conventional Forces in Europe Treaty (1990) set limits on equipment and troop levels. Attempts to sign a comprehensive Test Ban Treaty have been thwarted by China, France, India and Pakistan.

disciple One of the followers of Jesus Christ during his life on earth, especially one of his 12 close personal associates. These 12 men were his first APOSTLES.

Disciples of Christ US Protestant church, claiming to derive all its beliefs from the Bible. It strives to return to the purity of the Scriptures. Beginning in the 19th century religious revival movements of frontier America, there is no single founder and no creed but Christ. There are *c.*1.2 million members.

discontinuity See Moho

discus Field athletics event, in which a wooden and metal disc is thrown by competitors. The thrower rotates in a circle (diameter 2.5m/8.2ft) several times before releasing the discus. Originally an ancient Greek sport, it was revived for the first modern Olympic Games (1896).

disease Any departure from health, with impaired functioning of the body. Disease may be acute, severe symptoms for a short time; chronic, lasting a long time; or recurrent, returning periodically. There are many types and causes of disease: infectious, caused by harmful BACTERIA or VIRUSES; hereditary and metabolic; growth and development; IMMUNE SYSTEM diseases; neoplastic (TUMOUR-producing); nutritional; deficiency; ENDOCRINE SYSTEM diseases; or diseases due to environmental agents, such as lead poisoning. Treatment depends on the cause and course of the disease. It may be symptomatic (relieving symptoms, but not necessarily combating a cause) or specific (attempting to cure an underlying cause). Disease prevention includes eradication of harmful organisms, VACCINES, public health measures and routine medical checks.

disk Form of computer data storage. Disks come in many different forms, some using magnetic methods to store data, such as the HARD DISK, while others use optical systems like the COMPACT DISC (CD) and CD-ROM.

disk operating system (DOS) Computer operating system, developed in the early 1980s by Bill GATES' Microsoft Corporation for use with early International Business Machines (IBM) personal computers. DOS is the SOFTWARE that governs a computer's data storage and PROGRAM execution. DOS remains the principal computer operating system, although Windows is a relatively DOS-free system.

Disney, Walt (Walter Elias) (1901–66) US film animator, producer and executive. Disney has become synonymous with family entertainment and a menagerie of cartoon characters, such as Mickey Mouse, Donald Duck and Pluto. Steamboat Willie (1928) was the first cartoon to use sound and featured Walt Disney's own voice as Mickey Mouse. Disney's first feature was Snow White and the Seven Dwarfs (1937). A series of popular classics followed: Pinocchio (1940), Fantasia (1940), Dumbo (1941) and Bambi (1942). In 1950 Disney diversified into live action features with Treasure Island (1950), and began a series of nature documentaries with The Living Desert (1953). In 1955 Disneyland amusement park opened in Anaheim, California. Disney collected a total of 29 Academy Awards. The Walt Disney Company (founded 1923) is one of the world's most powerful media corporations.

Disraeli, Benjamin, 1st Earl of Beaconsfield (1804–81) British statesman and novelist, prime minister (1868,

1874-80). Disraeli was elected to parliament in 1837. His brand of Toryism is expressed in the trilogy of novels Coningsby (1844), Sybil (1846), and Tancred (1847). Following the split in the Tory Party over the repeal of the CORN LAWS (1846), Disraeli became leader of the land-owning faction. His opposition to Robert PEEL was rewarded when he became chancellor of the exchequer (1852, 1858-59, 1866-68) under Lord DERBY. Disraeli succeeded Derby as prime minister, but was soon ousted by William GLADSTONE. His second term coincided with the greatest expansion of the second BRITISH EMPIRE. In 1876 Queen VICTORIA was proclaimed empress of India. Disraeli led Britain into the Zulu War (1879), the second Afghan War (1878–79), and sought to diminish the strength of Russia. In 1875 Britain purchased the Suez Canal from Egypt. In 1880 Disraeli was defeated for a second time by Gladstone. Dissolution of the Monasteries (1536-40) Abolition of English MONASTICISM in the reign of HENRY VIII. The operation, managed by Thomas CROMWELL, was a result of the break with Rome, but also provided additional revenue, since the monasteries owned c.25% of the land in England, all of which passed to the crown. The smaller religious houses were closed in 1536, larger ones in 1538-40. The Dissolution caused social hardship, resentment and revolt, while providing estates for upwardly mobile gentry.

distemper Contagious, often fatal, disease of young dogs, wild canines and weasels. Symptoms include fever, shivering, muscular spasms and loss of appetite. Death is caused by inflammation of the brain. Puppies can be immunized.

distillation Extraction of a liquid by boiling a solution in which it is contained and cooling the vapour so that it condenses and can be collected. Distillation is used to separate liquids in solution, or liquid solvents from dissolved solids, to yield drinking water from sea water, or to produce alcoholic spirit. Fractional distillation, which uses a vertical column for condensation, is used in OIL refining to separate the various fractions of crude oil.

distilling Production of liquor by DISTILLATION, especially of ethyl ALCOHOL. In wine, yeast FERMENTATION produces a maximum alcohol content of c.15%. Distillation concentrates alcohol to a much higher degree to produce spirit. Most spirits are c.40% proof.

distributive law Rule of combination in mathematics, in which an operation applied to a combination of terms is equal to the combination of the operation applied to each individual term. Thus, in arithmetic $3\times(2+1) = (3\times2)+(3\times1)$ and, in algebra a(x + y) = ax + ay.

District of Columbia US federal district, coextensive (since 1890) with the capital, WASHINGTON, D.C. It was created in 1790-91 from land taken from the states of Maryland and Virginia. The Virginia portion was returned in 1846. Area: 179sqkm (69sq mi)

diuretic Drug used to increase the output of urine. It is used to treat raised blood pressure and OEDEMA.

dividend Net earnings of a public company that is paid to its stockholders. The dividend is a percentage of the par value of the stock or is calculated on a per share basis. It is a share of the profits. In Britain, a dividend is paid in cash. In the USA, it may be paid in other forms, such as bonds or stock.

divination Foretelling the future by interpreting various signs. Divination is a form of magic with worldwide distribution. Omens are often thought to be found in cards, palms, or the entrails of sacrificed animals.

diving Water sport in which acrobatic manoeuvres are performed off a springboard or highboard, set at varying heights. Points are awarded for level of difficulty, technique and grace of flight, and cleanness of entry into the water. Techniques include tuck, pike, twist and somersault.

diving, deep-sea Underwater activity for commercial or leisure purposes. Underwater activity for commercial or leisure purposes. Deep-sea diving developed with the introduction of the diving-bell and diving-suit. It refers to descents to depths of more than c.11m (36ft). Divers need to ascend slowly from such depths to avoid the BENDS. Divers are widely employed in the oil industry. See also SCUBA DIVING

divorce Legal dissolution of marriage. The ease with which a

divorce may be obtained, if at all, varies greatly. In most Western countries, adultery was for many years the only ground for divorce. Desertion, insanity and mental cruelty were added over the years. More recently, irretrievable breakdown, which apportions blame on neither partner is cited. In many contemporary Western societies, over 1 in 3 marriages end in divorce. Diwali Festival of lights in HINDUISM. Homes are lit with numerous tiny clay lamps in commemoration of the defeat of Ravana by RAMA, and the festival marks the resumption of social activities, such as pilgrimages and marriages. The story is symbolic of the return of light after the monsoon.

Dix, Otto (1891-1969) German painter and engraver. He was a pitiless satirist of inhumanity, notably in a series of 50 etchings called The War (1924) and his portrayal of prostitutes. He attacked the corruption in Weimar Germany. The Nazis banned him from teaching (1933), and he was jailed for an alleged plot to kill Hitler (1939). After World War 2, he concentrated on religious themes.

Dixieland Style of JAZZ music originating in NEW ORLEANS in the 1900s. It consists of a steady beat with interweaving melodic lines played by a small group (typically, clarinet, trumpet, trombone and rhythm section). King Oliver and Louis Armstrong were two of its most famous exponents.

Djibouti (Jibouti) Republic on the NE coast of Africa; the capital is DIBOUTI. Land and Climate Diibouti occupies a strategic position around the Gulf of Tadjoura, where the RED SEA meets the Gulf of Aden. Behind the coastal plain lie the Mabla Mountains, rising to Moussa Ali at 2020m (6627ft). Djibouti contains the lowest point on the African continent, Lake Assal, at 155m (509ft) below sea level. Djibouti has one of the world's hottest and driest climates; summer temperatures regularly exceed 42°C (100°F) and average annual rainfall is only 130mm (5in). In the wooded Mabla Mountains, the average annual rainfall reaches c.500mm (20in). Nearly 90% of the land is semi-desert, and shortage of pasture and water make farming difficult. Economy Djibouti is a poor nation (1992 GDP per capita, US\$1,547), heavily reliant on food imports. Its economy is based mainly on revenue from the capital. A free trade zone, it has no major resources and manufacturing is on a very small scale. The only important activity is livestock raising, and 50% of the population are

▲ Disney Creator of the world's most famous cartoon characters, Walt Disney first introduced Mickey Mouse in a series of short cartoons in 1928. He went on to make full-length cartoons, the first of which, Snow White and the Seven Dwarfs (1937) became one of the most popular movies ever made. The Walt Disney Company. with theme parks in the USA, and Paris, France, and merchandizing, home-video, publishing and recording interests, is one of the most successful entertainment

AREA: 23,200sq km (8.958sg mi) **POPULATION: 695,000** CAPITAL (POPULATION): Djibouti (353,000) **GOVERNMENT:** Multiparty republic ETHNIC GROUPS: Issa 47%, Afar 37%, Arab 6% LANGUAGES: Arabic and French (both official) RELIGIONS: Islam 96%, Christianity 4%

YEMEN Red ERITREA Sea Bab el Mande Moussa Ali ETHIOPIA Daddato 12° DJIBOUTI Gulf of Tadjourd Lake Assal Djibout Garbes Ali Sabi MAP SCALE SOMALIA 42°E **CURRENCY:** Djibouti franc =100 centimes

▲ DNA molecules form a double helix, with two spiral backbones (1,2). These are made up of sugar and phosphate units. Linking the backbones, like rungs on a ladder, are the bases; adenine (3), thymine (4), guanine (5) and cytosine (6). Each backbone contributes one base to each rung, which are strictly paired; adenine with thymine, and cytosine with guanine.

pastoral nomads. History Islam was introduced in the 9th century. The subsequent conversion of the Afars led to conflict with Christian Ethiopians who lived in the interior. By the 19th century, Somalian Issas had moved N and occupied much of the Afars' traditional grazing land. France gained influence in the late 19th century, and set up French Somaliland (1888). In a referendum (1967), 60% of the electorate voted to retain links with France, though most Issas favoured independence. The country was renamed the French Territory of the Afars and Issas. Full independence as the Republic of Djibouti was achieved in 1977, and Hassan Gouled Aptidon of the Popular Rally for Progress (RPP) was elected president. He declared a one-party state in 1981. Continuing protests against the Issas-dominated regime forced the introduction of a multi-party constitution in 1992. Recent events The Front for the Restoration of Unity and Democracy (FUUD), supported primarily by Afars, boycotted 1993 elections, and Aptidon was re-elected for a fourth six-year term. FUUD rebels continued an armed campaign for political representation. In 1996 government and FUUD forces signed a peace agreement, recognizing FUUD as a political party.

Djibouti (Jibuti) Capital of DJIBOUTI, on the s shore of the Gulf of Tadjoura, NE Africa. Founded in 1888, it became capital in 1892, and a free port in 1949. Ethiopian emperor Menelik II built a railway from ADDIS ABABA, and Djibouti became the chief port for handling Ethiopian trade. While ERITREA was federated with Ethiopia (1952–93), it lost this status to the Red Sea port of Assab. Pop. (1993 est.) 353,000. **DNA** (deoxyribonucleic acid) Molecule found in all cells.

DNA (deoxyribonucleic acid) Molecule found in all cells, and in some viruses, which is responsible for storing the GENETIC CODE. It consists of two long chains of alternating SUGAR molecules and PHOSPHATE groups linked by nitrogenous bases. The whole molecule is shaped like a twisted rope ladder, with the nitrogenous bases forming the rungs. The sugar is deoxyribose and the four bases are adenine, cytosine, guanine and thymine. A base and its associated sugar are known as a nucleotide; the whole chain is a polynucleotide chain. The genetic code is stored in terms of the sequence of

nucleotides: three nucleotides code for one specific amino acid and a series of them constitute a GENE. In EUKARYOTE cells, DNA is stored in CHROMOSOMES inside the nucleus. Loops of DNA also occur inside chloroplasts and mitochondria. See also RECOMBINANT DNA RESEARCH; RNA

Dnieper (Dnepr) River in E Europe. Rising in the Valdai Hills, w of Moscow, it flows s through Belarus and Ukraine to the Black Sea. It is the third longest river in Europe. The Dneproges dam (completed 1932) made the river entirely navigable. It is linked by canal to the River Bug, and has several hydroelectric power stations. Length: 2,286km (1,420mi).

doberman Strong guard dog, bred in late 19th-century Germany. It has a long, wedge-shaped head and short erect ears. Its deep-chested body is set on straight legs. The smooth coat may be black, red or fawn. Height: to 71cm (28in) at the shoulder.

Dobzhansky, Theodosius (1900–75) US geneticist and authority on human evolution, b. Russia. He was influential in the development of population GENETICS as a separate study. His writings include *Genetics and the Origin of Species* (1937), *Mankind Evolving* (1962) and *Genetics of the Evolutionary Process* (1970).

dock Any of more than 200 species of flowering plants native to N USA and Europe. Curled dock (*Rumex crispus*) has scaly brown flowers and oblong leaves with curly margins. Dock leaves are a country remedy for nettle stings. Family Polygonaceae.

Doctorow, E.L. (Edgar Lawrence) (1931–) US writer. Doctrow's novels have a strong political edge and incisive concern for history. *Ragtime* (1975), his best known novel, deals with late 19th-century racism in the USA. Other works include *Welcome to Hard Times* (1960), *The Book of Daniel* (1971), *Loon Lake* (1980), *Billy Bathgate* (1988), and *The Waterworks* (1994).

documentary Factual film. The term was first applied to Robert Flaherty's *Nanook of the North* (1921), a first-hand account of life among the Inuit. Documentaries soon rivalled newspapers and became a major means of television news, current affairs and science presentation. Other ground-breaking documentaries include Donn Alan Pennebaker's *Don't Look Back* (1967) and Marcel Ophüls' *A Sense of Loss* (1972).

dodder Leafless, parasitic, twining plant with a thread-like stem and clusters of small yellow flowers. It feeds using haustoria, modified roots that enter the host plant. Family Convolvulaceae; species *Cuscuta europaea*.

Dodecanese (Dhodhekánisos) Group of about 20 islands forming a department of Greece, in the SE Aegean Sea, between Turkey and Crete. The capital and largest island is RHODES. The islands were under Ottoman control (1500–1912), before passing to Greece (1947). The main occupation is agriculture, such as fruit growing, livestock raising, and diving for sponges. Area: 2174sq km (839sq mi). Pop. (1991) 163,476.

dodo Extinct, flightless bird that lived on the Mascarene Islands in the Indian Ocean. The last dodo died in c.1790. The true dodo (*Raphus cucullatus*) of Mauritius and the similar Réunion solitaire (*Raphus solitarius*) were heavy-bodied birds with large heads and large hooked bills. Weight: to 23kg (50lb). **Dodoma** Capital of Tanzania, central Tanzania. In 1974 Dodoma replaced DAR ES SALAAM as capital, yet transfer of government offices is incomplete. It is in an agricultural region, crops include grain, seeds and nuts. Pop. (1988) 203,833.

dog Domesticated carnivorous mammal closely related to the jackal, wolf and fox. Typically it has a slender, muscular body; long head with slender snout; small paws, five toes on the forefeet, four on the hind; non-retractile claws; and well-developed teeth. Smell is the dog's keenest sense; its hearing is also acute. The gestation period is 49–70 days; one or more puppies are born. Dogs developed from the tree-dwelling *miacis*, which lived *c*.40 million years ago, through intermediate forms to tomarctus, which lived 15 million years ago. The dog was domesticated *c*.10–14,000 years ago. There are *c*.400 breeds, classified in various ways, such as TERRIER, sporting, hound, working and toy. Length: 34–135cm (13–53in); tail 11–54cm (4–21in); weight: 1kg–68kg (2–150lb). Family Canidae; species Canis familiaris. See also individual breeds

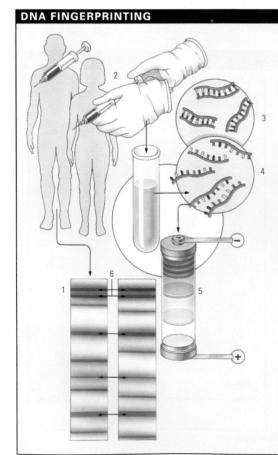

Using a technique known as DNA fingerprinting, a person can be accurately identified. The process allows a person's DNA to be represented in visual form (1). Each DNA pattern is unique (like a fingerprint) - with the exception of identical twins. In a case of disputed paternity, DNA fingerprinting allows the relationship to be settled beyond doubt. DNA is present in all cells, so a sample can be taken from blood (2), skin or even sweat. DNA is separated out (3) and an enzyme that divides DNA is added. The enzyme attacks the minisatellite region between the genes (4). The genes are then sorted by size by an electric field (5). Gel electrophoresis exploits the fact that snippets of DNA carry a charge to force them through a gel. The size of the snippets controls how far they travel, giving a pattern unique to each individual. A child combines DNA from both parents, so will have a partially similar pattern. Paternity is confirmed by the matching marks (6).

Doge's Palace Residence of the doge (chief magistrate of Venice, 697-1797), in ST MARK'S Square, VENICE, Italy. Begun in the 9th century and rebuilt several times. The present version (by Giovanni and Bartolomeo Buon) is a unique example of Venetian GOTHIC ARCHITECTURE. Its facades (1309-1424) are faced with white and rose-pink marble. It has delicately carved capitals and long lines of open tracery. dogfish SHARK found in marine waters worldwide. Generally greyish with white spots, it lacks a lower tail lobe. Eggs are laid in cases (mermaids' purses). Dogfish are divided into two groups: spiny, with a stout, sharp spine in front of each dorsal fin; and spineless, without a spine in front of the second dorsal fin. A food fish, they are sold as rock salmon. Length: spiny, 0.6-1.2m (2-4ft); spineless, 7.3m (24ft). Suborder Squalidae. **dogwood** Any of several small trees and shrubs in the genus Cornus of the dogwood family (Cornaceae). Wild flowering dogwoods are found in deciduous forests. They have small flowers, enclosed by four large, petal-like, white bracts.

Doha Capital of QATAR, on the E coast of the Qatar peninsula, in the Persian (Arabian) Gulf. Doha was a small fishing village until oil production began in 1949. It is now a modern city and trade centre. Industries: oil refining, shipping, engineering. Pop. (1992 est.) 313,639.

Dohnányi, Ernst (Ernö) von (1877–1960) Hungarian composer, conductor and pianist. Hungarian folk influences are evident, such as the piano suite *Ruralia Hungarica* (1926). He also composed operas, concertos and orchestral pieces.

Doisy, Edward Adelbert (1893–1986) US biochemist. He researched BLOOD buffers, VITAMINS and METABOLISM. He also isolated the female sex HORMONES, oestrone (1929) and oestradiol (1935). Doisy shared the 1943 Nobel Prize for physiology or medicine with Henrik Dam, for their analysis of vitamin K. doldrums Region of the ocean near the EQUATOR, characterized by calms, and light and variable winds. It corresponds approximately to a belt of low pressure around the equator.

Dole, Bob (Robert Joseph) (1923–) US politician. Dole served as a Republican representative from Kansas (1960–69), before joining the Senate. He was President Gerald FORD's running mate in the unsuccessful Republican campaign (1976). Dole served as leader of the Senate (1984–96). After twice failing to win the Republican presidential nomination (1980, 1988), he finally secured the vote in 1996. Dole ran a lacklustre campaign and lost the election to President Bill CLINTON.

dollar Standard monetary unit of the US since 1792. It was derived from the Spanish *dolar*, the most widely used coin in the American colonies. Divided into a hundred cents, the value of the US dollar was based on the gold price until 1934. Many other countries have adopted the dollar as their currency.

Dollfuss, Engelbert (1892–1934) Austrian statesman, chancellor (1932–34). Determined to preserve Austrian independence, he dissolved the National Socialist (Nazi) Party, which had demanded union with Germany (1933), crushed a socialist rising, and assumed authoritarian powers. He was assassinated by Austrian Nazis in an unsuccessful coup.

dolmen Megalithic monument comprising a stone lintel supported by upright stones. Dolmens were originally used as burial chambers and covered by mounds. They are most common in Cornwall, sw England, and Brittany, NW France.

dolomite Carbonate mineral, calcium-magnesium carbonate, CaMg(CO₃)₂, found in altered limestones. It is usually colourless or white. A rhombohedral class prismatic crystal, it is often found as a gangue mineral in hydrothermal veins. It is also a sedimentary rock, probably formed by the alteration of limestone by seawater, where calcite has been replaced by calcium magnesium carbonate. Hardness 3.5–4; s.g. 2.8.

Dolomites (Dolomiti or Dolomiten) Alpine range in NE Italy. The Dolomites are composed of dolomitic limestone, eroded to form a striking landscape popular with mountaineers and tourists. There are several hydroelectric power stations. The highest peak is Marmolada, 3,342m (10,964ft) high.

dolphin Family of small-toothed aquatic WHALES, there are salt and freshwater species. The best-known are the dark blue-backed common dolphin, the blue-grey bottle-nosed and the KILLER WHALE. Larger than a PORPOISE, a dolphin has a distinct beak and slender body, a tail fin for propulsion and a dorsal fin

for steering. A dolphin breathes through a single blowhole, and can remain underwater for 15 minutes. It is the fastest and most agile of the whales, achieving speeds up to 39km/h (24mph) and leaps of 9m (30ft). Dolphins swim in large, hierarchically organized schools, feeding on fish and crustacea. Their intelligence and playful behaviour have contributed to a wealth of maritime literature and mythology. They communicate through a complex language and map their environment by ECHOLOCATION. Dolphins have a gestation period of 12 months, and the mother nurtures her calf for the first two years of life. Length:

domain In mathematics, a set of values that can be assigned to the independent VARIABLE in a function or relation; the set of values of the dependent variable is called the **range**. For example, let the function be $y = x^2$, with x restricted to 0, 1, 2, 3 and -3. Then y takes the values 0, 1, 4, 9 and 9 respectively. The domain is $\{0, 1, 2, 3, -3\}$ and the range is $\{0, 1, 4, 9\}$. **domain** In TAXONOMY, some experts recognize the domain as a higher category than KINGDOM. In this scheme, the two subkingdoms of PROKARYOTAE (ARCHAEBACTERIA and EUBACTERIA) constitute two domains, called Archaea and Bacteria, while all other living organisms are included in a third domain, EUKARYOTES. *See also* PHYLOGENETICS; PLANT CLASSIFICATION **dome** In architecture, a hemispherical roof. One of the earliest

dome In architecture, a hemispherical roof. One of the earliest monumental domes is the PANTHEON, Rome. It was an important element in ISLAMIC ART AND ARCHITECTURE, especially MOSQUES. Eclipsed in importance in Gothic architecture, it was a significant element in Renaissance and Baroque styles.

Domenichino (1581–1641) Leading painter of the Italian BAROQUE. In 1602 he worked with Annibale Carracci on the FARNESE Palace. His landscape paintings, such as *The Hunt of Diana* and *Landscape with St John Baptizing*, influenced Nicolas Poussin and CLAUDE LORRAIN.

Dome of the Rock (Qubbat al-Sakhrah) Mosque and shrine built (685–692) by Abd al-Malik on a Jewish temple site in Jerusalem. The Dome covers the summit of Mount Moriah, where the prophet Muhammad is believed to have ascended to Heaven. According to the Old Testament, the Rock is also where Abraham was to have sacrificed Isaac. It is octagonal in plan, and the magnificent DOME is made entirely of wood.

Domesday Book (1085–86) Census of the English kingdom commissioned by WILLIAM I (THE CONQUERER). Its purpose was to ascertain potential crown revenue. The most complete survey in medieval Europe, it is an important primary historical source. It lists property and resources manor by manor.

Domingo, Placido (1941–) Spanish tenor, one of the leading opera singers of his generation. He made his debut at Monterrey, Mexico (1961), and has since toured extensively. He is an outstanding interpreter of the Italian romantic repertoire. In the 1990s, he achieved popularity as one of the Three Tenors. *See also* José Carreras; Luciano Pavarotti

Dominic, Saint (1170–1221) (Domingo de Guzmán) Spanish priest, founder of the DOMINICANS. In 1203 Pope Innocent

■ dome The dome of St Paul's Cathedral, London, was designed by Sir Christopher Wren. To make it as airy and as light as possible it has a triple construction: a brick inner dome (1), its "eye" rises 65m (213ft) above the floor; an intermediate, brick cone (2), reinforced with iron chains (3); and an outer dome (4), resting on the intermediate cone, and built out with timber framing (5) and

lead covering to obtain the desired silhouette.

▲ dock The curled dock (Rumex crispus) of Europe and Asia, is related to sorrel. It gets its name from the wavy margins of its leaves. Application of dock leaves is a country remedy for nettle stings.

DOMINICAN REPUBLIC

III sent him to s France to preach to the ALBIGENSES. He founded a monastery at Prouille. He developed an order based on scholastic and democratic principles, and rules derived from St AUGUSTINE. His feast day is 4 August.

Dominica Independent island nation in the E Caribbean Sea. West Indies; the capital and chief port is ROSEAU. The largest of the Windward Islands, it was named after dies dominica (Sunday), the day it was discovered by Christopher Columbus (1493). The original inhabitants were CARIB, but the present population are mainly the descendants of African slaves. Dominica is mountainous and heavily forested, and the climate is tropical. Possession of Dominica was disputed between Britain and France, until it was awarded to Britain in 1783. It became a British crown colony in 1805, and was a member of the Federation of the West Indies (1958-62). It achieved complete independence as a republic within the Commonwealth of Nations in 1978. Dominica is one of the poorest Caribbean countries. Agriculture is the dominant economic sector. Production was severely affected by hurricane damage in 1979 and 1980. Exports: copra, bananas, citrus fruit. Area: 750sq km (290sq mi). Pop. (1994 est.) 74,200. See WEST INDIES map

Dominican Republic Independent nation occupying the E two-thirds of the island of Hispaniola in the West Indies; the capital is SANTO DOMINGO. Dominican Republic is mountainous: the Cordillera Central range, running NW to SE, includes the highest point in the Caribbean, Duarte Peak, at 3,175m (10,417ft). The most fertile agricultural region is the Cibao Valley. Hispaniola was visited by Christopher Columbus in 1492, and a Spanish settlement was eventually established at Santo Domingo. In 1697 the w third of the island (now HAITI) was ceded to France. In 1795 the whole island came under French rule but the E part was returned to Spain in 1809. In 1821 the colony declared itself the independent Dominican Republic, but was annexed by Haiti. It won independence a second time in 1844. Its subsequent history was one of anarchy and civil war, punctuated by dictatorships and US military interventions. The most notorious dictator was Rafael Trujillo, who ruled from 1930 to 1961. A new constitution was introduced (1966). Mineral deposits are an increasingly important export, though agriculture is still the economic mainstay. Tourism is encouraged. Chief crops: sugar cane, coffee, fruit, cocoa and tobacco. Area: 48,442sq km (18,703sq mi). Pop. (1994 est.) 7,770,000. Dominicans (officially Ordo Praedicatorum, Order of Preachers, O.P.) Worldwide Roman Catholic religious order, founded (1215) by St DOMINIC in 1215 and sanctioned by Pope Honorius III. They are also known as Black Friars in England, and Jacobins in France. Dominicans are one of the four great mendicant orders of Roman Catholicism. Devoted to preaching and study, the order includes a contemplative order of nuns. domino theory Political doctrine that affected US foreign policy during the COLD WAR, especially in Southeast Asia. It held that if one country became communist, its neighbours would inevitably follow. The doctrine was widely used in support of US military involvement in VIETNAM.

Domitian (51–96) Roman emperor (81–96). A son of Ves-PASIAN, he succeeded his brother TITUS. His rule was at first orderly but became increasingly tyrannical and paranoid. After several failed attempts, he was assassinated. Domitian was partly responsible for building the COLOSSEUM.

Don River of sw Russia. Rising SE of Tula, it flows s, then sw to the Sea of Azov. Rostov is the major port. Annual floods are controlled by the Tsimlyansk Reservoir. The Don is navi-

gable for 1,370km (850mi), and is an important shipping route for grain, timber and coal. It is linked by canal to the River Volga. Length: 1,930km (1,200mi).

Donatello (1386–1466) Greatest European sculptor of the 15th century, joint creator of the RENAISSANCE style in Florence. His work is a turning point in European sculpture, moving from a formulaic GOTHIC style to a more vital means of expression. Inspired by HUMANISM, his initial innovations included standing figures of saints in the Church of Or San Michele. His reliefs and free-standing statues, have been likened to "drawing in stone". After a visit to Rome (1430–32), his work, such as the *Cantoria* for Florence Cathedral and the bronze *David*, adopted a more CLASSICAL feel. His late work, such as *Judith and Holofernes* and his wood carving of *Mary Magdalene* (1455), shows even greater emotional intensity. Donatello greatly influenced MICHELANGELO.

Donegal County in NW Republic of Ireland, bounded by Northern Ireland (E) and the Atlantic Ocean (N and W). The county town is Lifford. There is a rocky, indented coastline and much of the county is hilly. The chief rivers are the Finn, Foyle and Erne. Agriculture is the main activity, but only 33% of the land is fertile. Tourism and fishing are also important. Area: 4,830sq km (1,865sq mi). Pop. (1991) 128,117.

Donets Basin Industrial region in E Ukraine and S Russia; the capital is Donetsk. It is a major coal and steel producer, close to the mineral deposits in E Ukraine. Development of one of the world's most concentrated industrial areas began c.1870. By 1989, it was producing over 200 million tonnes of coal a year. In the 1990s there was a slump in production due to exhausted seams and antiquated technology. Area: c.25.900sq km (10,000sq mi).

Donizetti, Gaetano (1797–1848) Italian composer. He wrote 75 comic and serious operas. Initially influenced by Gioacchino Rossini, he formed his own melodic style with rich harmonies and orchestration. Operas include *L'Elisir d'Amore* (1832), *Lucia di Lammermoor* (1835), *Roberto Devereux* (1837), *La Fille du Régiment* (1840) and *Don Pasquale* (1843). Don Juan Legendary Spanish philanderer. A medieval folk tale, the earliest printed version is *The Rake of Seville* (1630) by Tirso de Molina. Notable versions of his amorous adventures are Molière's play *The Stone Feast* (1665), Mozart's opera *Don Giovanni* (1787), and Byron's poem *Don Juan* (1819–24).

donkey Domesticated Ass, used by humans since well before 3000 BC. Crossed with a horse it produces a MULE.

Donleavy, J.P. (James Patrick) (1926–) Irish author, b. USA. His first novel, *The Ginger Man* (1955), was not published in uncensored form in Britain and the USA until 1963. Other novels include *A Singular Man* (1963), *The Beastly Beatitudes of Balthazar B.* (1968), *The Onion Eaters* (1971) and *That Darcy, That Dancer, That Gentleman* (1991).

Donne, John (1572–1631) English poet and cleric. He converted to Anglicanism, was ordained in 1615, and became dean of ST PAUL'S Cathedral, London (1621). His poems fall broadly into two categories: early love poems and satires, such as *Songs and Sonnets*, have the characteristic wit, extravagant imagery and passion of the greatest METAPHYSICAL POETRY; and later religious poems, such as the powerful *Holy Sonnets*. Although he achieved recognition in his lifetime, the poems for which he is now famous were not published until 1633. His religious sermons and prose, including *Devotions Upon Emergent Occasions*, are memorably forceful.

Doolittle, Hilda (1886–1961) (H.D.) US poet associated with Ezra POUND and IMAGISM. Her published verse includes *Sea Garden* (1916) and *The Flowering of the Rod* (1946). Her *Collected Poems 1914–44* were published in 1983. She also wrote prose, such as *Hermione* (1981), a novel of lesbian love. **dopamine** Chemical normally found in the corpus striatum region of the brain. Insufficient levels are linked with PARKINSON'S DISEASE. Dopamine is a NEUROTRANSMITTER and a precursor in the production of ADRENALINE and NORADRENALINE.

Doppler, Christian Johann (1803–53) Austrian physicist and mathematician. Doppler is famous for his prediction of the DOPPLER EFFECT in a paper on DOUBLE STARS (1842).

DOPPLER EFFECT in a paper on DOUBLE STARS (1842). **Doppler effect** Change in frequency of a wave, when there is relative motion between the wave source and the observer.

▲ donkey Smaller than a horse, the donkey has a large head and long ears in proportion to its body. Its coarse hair is tight and matted giving the coat a very rough appearance. Male donkeys are crossed with female horses to breed mules.

The amount of change depends on the velocities of the wave, source and observer. With a sound wave, the effect is demonstrated by the drop in pitch of a vehicle's siren as it passes an observer. With light, the velocity of the source or observer must be large for an appreciable effect to occur, such as the red shift of a rapidly receding galaxy. See also NAVIGATION

Dordogne River in sw France. Rising in the AUVERGNE hills, it is formed by the convergence of the Dor and Dogne rivers. It flows sw then w to meet the River Garonne, and forms the Gironde estuary. It has famous vineyards along its 471km (293mi) course, and is a vital source of hydroelectric power.

Doré, Gustave (1832–83) French illustrator, painter and sculptor. He is best known for his engraved book illustrations, many of them grotesque fantasies, such as *Inferno* (1861), *Don Quixote* (1862) and the Bible (1866). His drawings of London slums (1869–71) inspired VAN GOGH.

Dorian Greek-speaking people, who settled N Greecc c.1200 BC, They displaced the culturally more advanced MYCENAEAN CIVILIZATION, seemingly because they had mastered the use of iron. Their arrival marks the beginning of the so-called "dark age" of ancient Greece, which lasted about 400 years.

Doric order One of the five ORDERS OF ARCHITECTURE

dormouse Squirrel-like RODENT of Eurasia and Africa that hibernates in temperate climates. Most dormice are active at night and sleep by day. They eat nuts, fruit, seeds, insects and other tiny animals. They were once bred for human food. Length: 10–20cm (4–8in), excluding tail. Family Gliridae.

Dorset County on the English Channel, sw England; the county town is Dorchester, other major towns include Bournemouth, Poole and Weymouth. Dorset's most famous prehistoric monument is the Iron Age hill fort, Maiden Castle. After the defeat of the Romans, Dorset became part of the West Saxon kingdom. It is traversed w to E by the North Dorset and South Dorset Downs, and drained by the rivers Frome and Stour. Cereal crop cultivation and livestock-raising is important. Industries: tourism, marble quarrying. Area: 2,654sq km (1,025sq mi). Pop. (1991) 361,919.

Dortmund City and port on the Dortmund-Ems Canal, Nordrhein-Westfalen state, NW Germany. In the 13th century Dortmund flourished as a member of the HANSEATIC LEAGUE. It declined in the late 17th century but grew as an industrial centre from the mid-19th century. Industries: iron and steel, brewing, engineering. Pop. (1990) 600,700.

dory (John Dory) Marine fish found worldwide. It is deepbodied with a large mouth. The species *Zeus faber* of the Mediterranean Sea and Atlantic Ocean is a valuable food fish. Length: to 1m (3.3ft). Family Zeidae.

DOS Acronym for DISK OPERATING SYSTEM

Dos Passos, John Roderigo (1896–1970) US novelist. The first novel to attract critical acclaim was *Manhattan Transfer* (1925). His best known work is the trilogy *United States* (1930–36), in which he deploys innovatory techniques (such as stream of consciousness, news headlines and biographies) to portray early 20th-century American life. Later fiction includes the trilogy *District of Columbia* (1939–43).

Dos Santos, José Eduardo (1942–) Angolan statesman, president (1979–). Dos Santos' succession to the presidency was marked by escalating violence between the Cuban-backed People's Movement for the Liberation of Angola (MPLA) government, and the South African-backed National Union for the Total Independence of Angola (UNITA). A peace agreement was negotiated (1991). UNITA leader Jonas SAVIMBI refused to recognize Dos Santos' re-election (1992) and fighting resumed. The Lusaka Protocol (1994) paved the way for a government of national unity, headed by Dos Santos.

Dostoevsky, Fyodor Mikhailovich (1821–81) Russian novelist, one of the greatest 19th century authors. After completing *Poor Folk* and *The Double* (both 1846), he joined a revolutionary group, was arrested, and sentenced to death (1849). He was reprieved at the eleventh hour, and his sentence was commuted to four years' hard labour. He returned to St Petersburg in 1859, where he wrote *Notes from the Underground* (1864). After his classic work on sin and redemption *Crime and Punishment* (1866), he left Russia, partly to escape creditors. While abroad, he wrote *The Idiot* (1868–69) and

The Devils (or The Possessed) (1872). His last major work was his masterpiece The Brothers Karamazov (1879–80).

Douai Bible English translation (from the Latin Vulgate) of the BIBLE, authorized by the Roman Catholic Church for use after the REFORMATION. Gregory Martin, living in exile at the English college at Douai, France, was the main translator. The New Testament was published at Reims (1582), the OLD TESTAMENT at Douai (1609–10). It was revised by Richard Challoner (1749–50).

Douala Chief port of Cameroon, on the Bight of Biafra, w Africa. As Kamerunstadt, it was capital of the German Kamerun Protectorate (1885–1901), became Douala (1907), and was capital of French Cameroon (1940–46). Industries: ship repairing, textiles and palm oil. Pop. (1991 est.) 810,000. **double bass** Largest stringed instrument. It has four strings tuned in fourths (E-A-D-G) and sounds one OCTAVE below the musical notation. It resembles a large violin but has sloping shoulders (it was originally a member of the VIOL family). The double bass is held vertically. A bow is generally used for classical music, but the strings are usually plucked in jazz. **double bassoon** (contrabassoon) *See* BASSOON

double star Two stars that appear close together in the sky. There are two types of double star: BINARY STARS and **optical doubles** (two stars that are quite distant from each other, but appear close together as a result of chance alignment).

Douglas, Gavin (1475–1522) Scottish medieval poet, important in the emergence of Scots as a distinct language. His rhymed couplet version of Virgil's *Aeneid* in Scots (1513) was the first translation of a classic into an English-based language. His other surviving work is *The Palace of Honour* (1553).

Douglas, Stephen Arnold (1813–61) US statesman. Douglas served in the House of Representatives (1843–47), before becoming senator for Illinois (1847–61). He tried to unite the Democratic Party on the issue of SLAVERY, and was instrumental in the COMPROMISE OF 1850. He sponsored the Kansas-Nebraska Act (1854), that promoted popular sovereignity. In the Lincoln-Douglas debates (1858), Douglas defeated the challenge of Abraham LINCOLN. In 1860 he gained the Democratic presidential nomination, but lost the election to Lincoln. He supported Lincoln at the start of the American CIVIL WAR.

Douglas-Home, Sir Alec (1903–95) British statesman, prime minister (1963–64). He entered parliament in 1931, and served as parliamentary private secretary (1937–39) to Neville Chamberlain. He joined the House of Lords as Lord Home of the Hirsel (1951), and had a succession of cabinet posts, including foreign secretary (1960–63). Douglas-Home renounced his peerage to succeed Harold Macmillan as Conservative prime minister. He was also foreign secretary under Edward Heath (1970–74).

Douglass, Frederick (1817–95) African-American abolitionist and social reformer. An escaped slave, he was a lecturer for the Massachusetts Anti-Slavery Society and managed to buy his freedom. He published an abolitionist paper, *North Star* (1847), and recruited African-American soldiers for the Union side in the American Civil War. He later held several government posts, such as minister to Haiti (1889–91).

Douro (Duero) River in Spain and Portugal. Rising in N central Spain, it flows w to form part of the Spain-Portugal border. It then turns w through N Portugal to empty into the Atlantic Ocean near Oporto. Length: 895km (556mi).

dove Cooing, plump-bodied bird found almost worldwide. Doves are related to PIGEONS, and have small heads, short legs and dense, varied plumage. They feed mostly on vegetable matter. Length: 15–83cm (6–33in). Family Columbidae.

Dover Seaport on the Strait of Dover, Kent, SE England. One of the cinque ports, Dover is a resort and cross-Channel ferry port. The nearest point to France on mainland Britain, it was

■ dormouse Found in Europe and Asia, the dormouse (Glis glis) usually lives in trees. The hands and feet of the dormouse are equipped with rough pads which assist in climbing. The diet is chiefly vegetarian, but may include insects and small birds. ▶ dragonfly An incomplete metamorphosis, such as occurs in dragonflies (order Odonata), may be an adaptation to take advantage of different habitats. The adult form (A) of *Anax imperator* is a fast-flying predator on other insects, while the nymph (B) is aquatic, preying on a variety of life in freshwater ponds.

fortified by the Romans. In World War 1 it was an important naval base, and suffered intensive bombing during World War 2. Its medieval castle contains the remains of a Roman lighthouse and Saxon stronghold. Pop. (1991) 34,322.

Dover Capital of Delaware state, USA, on the St Jones River. Founded in 1683, it was first laid out in 1717 and has been state capital since 1777. Dover contains fine examples of Georgian architecture. It is a shipping and canning centre for the surrounding agricultural region. It is also the site of Dover Air Force Base. Industries: gelatin food products, synthetic polymers, adhesives, chemicals. Pop. (1990) 27,630.

Dowell, Anthony (1943–) British ballet dancer. Noted for his agility and grace, he joined the Royal Ballet in 1961, and was principal dancer (1966–86). Many great choreographers created roles specifically for him, and he was principal dancer at the American Ballet Theater (1978–80). He was director of the Royal Ballet (1986–89).

Dowland, John (1563–1626) English composer of songs and lute music. His songs, written for voice and lute, are widely considered to be the finest of his generation, due to their great emotional range. He also composed much instrumental music, such as the famous set of variations. *Lachrimae*.

Down District on the Irish Sea coast, SE Northern Ireland; the administrative centre is Downpatrick. Anglo-Normans invaded (12th century), and 16th and 17th century English and Scottish settlers made their home here. A hilly region, the Mountains of Mourne lie in the s. Agriculture dominates, such as livestock and crop farming. Industries: agricultural machinery and textiles. Area: 650sq km (250sq mi). Pop. (1991) 58,008.

Downing Street Street in London, off Whitehall, named after the diplomat Sir George Downing (1623–84). It includes the official residence of the British prime minister at No. 10, chancellor of the exchequer at No. 11, chief whip at No. 12.

Downing Street Declaration (15 December 1993) Joint declaration issued by the UK prime minister John MAJOR and the Irish taoiseach Albert REYNOLDS. Continuing the momentum of the ANGLO-IRISH AGREEMENT, it set a framework for peace talks in Northern Ireland. It stated that all democratically mandated political parties (including SINN FÉIN) could be involved in an all-Ireland forum within three months, if they committed themselves to permanently ending paramilitary violence. The UK and Irish governments also agreed that the status of Northern Ireland could only change with majority consent of its people, and Ireland's future would be determined only by the peoples of the island of Ireland. On 31 August 1994, the IRISH REPUBLICAN ARMY (IRA) announced an immediate and "complete cessation of military operations". Loyalist paramilitaries followed on 13 October 1994. Disagreements over the timing of arms decommissions stalled the process. On 9 February 1996, the IRA declared an end to its cease-fire and a bomb devastated London's Docklands, killing two civilians. A further cease-fire was declared in 1997 and talks resumed.

Down's syndrome Human condition caused by a chromosomal abnormality. It gives rise to varying degrees of mental retardation, decreased life expectancy, and perhaps physical problems, such as heart and respiratory disorders. The syn-

drome was first described by a British physician, J.L.H. Down. It is caused by the presence of an extra copy of CHROMOSOME 21, and detected by counting chromosomes in the cells of the FETUS during pre-natal testing. There is evidence that the risk of having a Down's child increases with maternal age. Originally called "Mongolism" by Down, this term is now obsolete.

Doyle, Sir Arthur Conan (1859–1930) British novelist and physician. The novel *A Study in Scarlet* (1887) introduced his famous characters Sherlock Holmes and Dr Watson. A succession of hugely popular Sherlock Holmes stories followed, including *The Adventures of Sherlock Holmes* (1892), *The Memoirs of Sherlock Holmes* (1894) and *The Hound of the Baskervilles* (1902). Other works include a science fiction novel *The Lost World* (1912).

D'Oyly Carte, Richard See CARTE, RICHARD D'OYLY Drabble, Margaret (1939–) British novelist, sister of A.S. BYATT. Her debut novel was The Summer Birdcage (1963). The Millstone (1965) was filmed as A Touch of Love. Later work includes the trilogy The Radiant Way (1987), A Natural Curiosity (1989) and The Gates of Ivory (1991).

Draco (active 7th century BC) Athenian political leader and lawmaker. He drew up the first written code of laws in Athens. Famous for their severity, the death penalty was prescribed even for minor offences. They were repealed by Solon.

Draco (Dragon) Long, winding N constellation, representing the dragon slain by Hercules. It extends between URSA MAJOR and URSA MINOR, with the dragon's head near the star VEGA. **drag** (air resistance) Force opposing the motion of a body through a gas or liquid. Aircraft experience drag as the friction of air over external surfaces. To combat drag, aircraft and cars have streamlined designs.

dragon Mythical scaly lizard, snake or fire-breathing monster. Often depicted with wings, talons and a lashing tail. In some traditions it has many heads, or changes shape at will. Sometimes, such as the tale of St George and the dragon, it is used symbolically as the personification of evil. In China and Japan, the dragon is identified with a beneficent force of nature. It can also refer to certain lizards, such as the KOMODO DRAGON.

dragonfly Swift-flying insect of the order Odonata. It has a long, slender, often brightly coloured abdomen, and two pairs of large membranous wings. Like the DAMSELFLY, it mates while flying. The carnivorous nymphs, which hatch from eggs laid on water plants, are aquatic. Wingspan: to 17cm (7in).

Drake, Sir Francis (1540–96) English mariner. In 1577–80 he circumnavigated the world in the *Golden Hind*, looting Spanish ships and settlements in the Pacific, and claiming California for England. He was knighted by Elizabeth I on his return. His famous raid on CADIZ in 1587, postponed the Spanish ARMADA, which he helped to defeat in 1588. He died during a raid on the Spanish colonies.

Dravidian Family of languages spoken in s India by c.10 million people. The four major Dravidian languages are Tel-

▶ Drake This portrait of Sir Francis Drake by Samuel Lane, reflects Drake's life as an explorer, adventurer and mariner. He was the first Englisman to circumnavigate the world (1577–80) and to cross the Strait of Magellan. Along the way, Drake plundered a fortune in Spanish treasure. In 1587, he "singed the king of Spain's beard" by sinking 30 ships in Cadiz harbour, thus postponing the Spanish Armada.

ugu, Tamil, Kannada (Kanarese) and Malayalam. Tamil is also spoken in Sri Lanka. Brahui is spoken in Pakistan. Dravidian languages are unrelated to Indic languages, such as HINDI, which are a branch of INDO-EUROPEAN LANGUAGES.

dream Mental activity associated with the rapid-eye-movement (REM) period of sleep. It is usually a train of thoughts, scenes and desires expressed in visual images and symbols. On average, a person dreams for a total of 1.5–2 hours in eight hours of sleep. Dream content is often connected with body changes. For centuries, dreams have been regarded as a source of prophecy or visionary insight. In PSYCHOANALYSIS, patients' dreams are often examined to reveal a latent content. Dreiser, Theodore Herman Albert (1871–1945) US author, a leading exponent of American naturalism. His greatest work is An American Tragedy (1925), about a poor man driven to murder by his dreams of success. Other major works include Sister Carrie (1900) and Jennie Gerhardt (1911). He also wrote short stories, plays and essays.

Dresden City on the River Elbe, capital of Saxony state, SE Germany. First settled by Germans in the early 13th century. It suffered almost total destruction from Allied bombing during World War 2. Dresden china, famous since the 18th century, is in fact manufactured in Meissen. Industries: optical and precision instruments, glass, chemicals. Pop. (1990) 483,400.

Dreyfus Affair French political crisis arising from the conviction of Captain Alfred Dreyfus for treason in 1894. Dreyfus was a Jewish army officer, convicted on evidence later proved false. In 1898, publication of *J'accuse*, an open letter by Émile Zola in defence of Dreyfus, provoked a prolonged and bitter national controversy in which the opposing forces of republicanism and royalism almost resulted in civil war. Dreyfus, initially imprisoned, later received a presidential pardon.

drug In medicine, any substance used to diagnose, prevent or treat disease or aid recovery from injury. Although many drugs are still obtained from natural sources, scientists are continually developing synthetic drugs which work on target cells or microorganisms. Such drugs include ANTIBIOTICS. Some drugs interfere in physiological processes, such as anti-coagulants which render the blood less prone to clotting. Drugs also may be given to make good some deficiency, such as hormone preparations which compensate for an underactive gland.

drug addiction Psychological or physical dependence on a DRUG. Physical addiction is often manifested by symptoms of withdrawal. Long-term drug use often produces tolerance. Physical addiction has only been medically proven for NAR-COTICS (such as HEROIN), depressants (such as BARBITURATES or ALCOHOL) and some STIMULANTS (such as NICOTINE). Other drugs, such as hallucinogens or hashish, are not thought to be physically addictive, but can produce PSYCHOSIS or PARANOIA. Two of the most common addictions are alcohol and nicotine, since these are legal and easily available. Unlike narcotics, alcohol is physically harmful, especially to the brain and liver, and cigarette smoking (the commonest source of nicotine) annually accounts for more than 100,000 premature deaths in the United Kingdom alone. In comparison, addiction to "hard" drugs (such as HEROIN or COCAINE) is not common, but drug-related crime makes up a significant percentage of crime statistics in many countries.

druids Pre-Christian Celtic religious leaders in ancient Britain, Ireland and Gaul. Little is known of them, but they appear to have been judges and teachers as well as priests. In Britain and Gaul, druidism was suppressed by the Romans, but survived in Ireland until the 5th century.

drum Percussion instrument, generally a hollow cylinder or vessel with a skin stretched across the openings. It is struck with hands or a variety of sticks. Drums were among the earliest musical instruments; examples have been found dating from 6000 Bc. Much of African music is percussion-led. Drums first appeared in European CLASSICAL MUSIC in the 18th century, and TIMPANI were standard in 19th-century orchestras. In the 20th century, the role of drums in popular music has greatly expanded, especially in popular forms such as JAZZ. Since the 1980s, electronic drum machines have developed the sound of much contemporary dance music.

drupe (stone fruit) Any FRUIT with a thin skin, fleshy pulp

■ Dublin One of the world's most famous cultural centres, Dublin is the capital of the Republic of Ireland. It is closely associated with many literary figures, in particular George Bernard Shaw, W.B. Yeats, Oscar Wilde and James Joyce. Each year, hundreds of tourists visit the city to follow the route around Dublin taken by Leopold Bloom, the central character in Joyce's modernist masterpiece Ulysses (1922).

and hard stone or pip enclosing a single seed. Examples are plums, cherries, peaches, olives, almonds and coconuts.

Druse (Druzes) Members of a Middle Eastern religious sect. A breakaway group of the Ismails, the Druse originated in the reign of al-Hakim (996–1021), sixth Fatimid Caliph of Egypt, who claimed to be divine. They are named after al-Darazi, the first to proclaim the cult publicly. Stressing pure MONOTHEISM, they emphasize the possibility of direct communication with divinity as a living presence. They were persecuted in Egypt, fought against both Turks and local Christians, and against French rule in Syria in the 1920s. There are about 500,000 Druses living in Syria, LEBANON and Israel.

dryads In Greek mythology, nymphs of the woodlands and guardian spirits of trees.

Dryden, John (1631–1700) English poet and playwright. He became known for his *Heroic Stanzas* on Oliver Cromwell's death (1658); diplomatically followed by *Astraea Redux* (1660), praising Charles II. He was poet laureate (1668–88), when James II was ousted in the Glorious Revolution. Other poems include *Annus Mirabilis* (1667), the satires *Absalom and Achitophel* (1681), the allegory *The Hind and the Panther* (1687), and the ode *Alexander's Feast* (1693). Dryden also wrote numerous fine plays, his best-known are *All for Love* (1678) and *Marriage á la mode* (1673).

dry ice Popular term for frozen CARBON DIOXIDE

drypoint Quick ENGRAVING technique, probably originating in the 15th century, using a sharply pointed tool to draw lines in a metal plate. The drypoint steel can produce different qualities of line according to the amount of pressure.

dualism Doctrine in philosophy and metaphysics that recognizes two basic and mutually independent principles, such as mind and matter, body and soul, or good and evil. Dualism contrasts with MONISM. Both PLATO and DESCARTES were dualists, but more modern philosophers, influenced by the discoveries of science, have tended towards monism.

Dubai One of the seven federated states of the UNITED ARAB EMIRATES (UAE), on the Persian (Arabian) Gul, SE Arabia; the capital is Dubai. First settled in the late 18th century, it was a dependency of Abu Dhabi until 1833. At the end of the 19th century, it became a British protectorate. Dubai was at war with Abu Dhabi from 1945–48. In 1971 it became a founder member of the UAE. Oil was discovered in the early 1960s, and is the largest sector of Dubai's prosperous, export-driven economy. Area: c.3,890sq km (1,500sq mi). Pop. (1985) 419,104.

Dubček, Alexander (1921–92) Czechoslovak statesman, Communist Party secretary (1968–69). Dubček was elected party leader at the start of the Prague Spring. His liberal reforms led to a Soviet invasion in August 1968, and Dubček was forced to resign and expelled from the party. Following the collapse of Czech communism, he was publicly rehabilated and served as speaker of the federal parliament (1989–92).

Dublin (Baile Átha Cliath) Capital of the Republic of Ireland,

▲ duck Ducks were domesticated over 3,000 years ago. The picture shows Muscovy (A), buff Orpington (B), Aylesbury (C), khaki Campbell (D), Pekin (E), Rouen (F) and Indian runner white (G).

at the mouth of the River Liffey on Dublin Bay. In 1014 Brian Boru recaptured it from the Danish. In 1170 it was taken by the English and became the seat of colonial government. Dublin suffered much bloodshed in nationalist attempts to free Ireland from English rule. Strikes beginning in 1913 finally resulted in the EASTER RISING (1916). Dublin was the centre of the late 19th-century Irish literary renaissance. George Bernard Shaw, James Joyce and Oscar Wilde were born here. It is now the commercial and cultural centre of the Republic. Notable sites include Christ Church Cathedral (1053), St Patrick's Cathedral (1190), Trinity College (1591) and the ABBEY THEAIRE (1904). Industries: brewing, textiles, clothing. Pop. (1992) 915,516.

dubnium See ELEMENT 104 Du Bois, W.E.B. (William Edward Burghardt) (1868-1963) US civil rights leader, writer and educator. In 1905 he co-founded the Niagara movement that evolved into the NATIONAL ASSOCIATION FOR THE ADVANCEMENT OF COL-ORED PEOPLE (NAACP). A supporter of PAN-AFRICANISM, he helped organize the first Congress (1919) and was co-chairman of the fifth Pan-African Congress (1945). Works include The Souls of Black Folk (1903) and Color and Democracy (1945). Dubrovnik Adriatic seaport in Dalmatia, Croatia. As a free city, it was an important trading post between the Ottoman empire and Europe, and a traditional place of asylum for persecuted peoples. It was devastated by an earthquake (1979), and a 1991 Serbian siege. Sites include a 14th-century mint, Franciscan and Dominican monasteries. It is an important tourist centre. Products: grapes, cheese, olives. Pop. (1981) 66,131.

Dubuffet, Jean (1901–85) French painter and sculptor. Among his best-known works are assemblages of materials (such as glass, sand, rope) arranged into crude shapes, called *pâtes*. He collected the work of untrained artists, coining the phrase *art brut*.

Duccio di Buoninsegna (c.1265–1319) Italian painter, first great artist of the Sienese School. He infused the rigid Byzantine style of figure painting with humanity and lyricism. Notable for dramatic depiction of religious subjects, he is often compared unfavourably with Giotto. Surviving works include *Rucellai Madonna* (1285) and Maestà altarpiece (1308–11).

Duchamp, Marcel (1887–1968) French painter and theorist, one of the most radical art theorists of the 20th century. His *Nude Descending a Staircase* outraged visitors to the 1913 ARMORY SHOW. He produced relatively few paintings, concentrating on abolishing the concept of aesthetic beauty. He was a leading member of New York DADA, inventing the concept of the "ready-made". His *Fountain* consisted of nothing but a urinal. His main work, *The Bride Stripped Bare by her Bachelors, Even* (1915–23), is a "definitively unfinished" painting of metal collage elements on glass.

duck Worldwide waterfowl, related to the SWAN and GOOSE. Most nest in cool areas and migrate to warm areas in winter. All have large bills, short legs and webbed feet. Their colour is varied, and dense plumage is underlaid by down and waterproof feathers. There are two groups: **dabbling** ducks, which feed from the surface, and **diving** ducks. All eat seeds, insects, crustacea and molluscs. Most engage in complex courtship, and lay a large clutch of eggs. There are seven tribes: EIDERS, shelducks, dabbling ducks, perching ducks, pochards, sea ducks and stiff-tailed ducks. There are c.200 species. Length: 30–60cm (1–2ft); weight: to 7.2kg (16lb). Family Anatidae.

duck-billed platypus See PLATYPUS

duckweed Family (Lemnaceae) of four genera including 25 species of tiny, floating, aquatic flowering plants. The disc-like leaflets have a single 15cm (6in) trailing root.

due process of law Formal legal procedure to ensure that no one is deprived of life, freedom or property before proper legal authority has been obtained. It is enshrined in England's Magna Carta and the 5th and 14th amendments of the US Constitution. A major element of the process is a TRIAL.

Dufay, Guillaume (1400–74) Burgundian composer. He composed many motets and settings of the liturgy. His motets were grand, complex compositions written for specific events. He wrote some outstanding masses and secular songs. **Dufy, Raoul** (1877–1953) French painter. He was associated with IMPRESSIONISM and FAUVISM, and is famous for his

decorative racing and boating scenes. His work has great appeal because of its exuberant simplicity.

dugong (sea cow) Large plant-eating aquatic mammal found in shallow coastal waters of Africa, Asia and Australia. Grey and hairless, the dugong has no hind legs, and its forelegs are weak flippers. Length: 2.5–4m (8–13ft); weight: 270kg (600lb). Family Dugongidae.

duiker (duikerbok) Small sub-Saharan African ANTELOPE usually found in scrubland. The female is larger than the male and occasionally carries stunted horns; the horns of the male are short and spiky. Duikers are grey to reddish-yellow. Height: up to 66cm (26in) at the shoulder; weight: up to 17kg (37lb). Family Bovidae; species *Sylvicapra grimmia*.

Duisburg City at the confluence of the Rhine and Ruhr rivers, Nordrhein-Westfalen, NW Germany. Chartered in 1129, it remained a free imperial city until the late 13th century. During World War 2, it was the centre of the German armaments industry, and suffered extensive bombing damage. Industries: iron, steel, textiles, chemicals. Pop. (1990) 538,300.

Dukas, Paul (1865–1935) French composer. His best-known work, the orchestral scherzo *The Sorcerer's Apprentice* (1897), shows his skilful orchestration and individual style. He also wrote the opera *Ariane et Barbe-Bleue* (1907). **dulcimer** Medieval stringed instrument, originally Persian, with a flat, triangular sounding board and ten or more strings struck with hand-held hammers.

Dulles, John Foster (1888–1959) US statesman, secretary of state (1953–59) under Dwight D. EISENHOWER. A powerful opponent of communism, he became a back-room influence on the Republican Party in the 1940s, and served briefly in the Senate. He was a member of the US delegation at the San Francisco Conference that founded the United Nations (1945). Dumas, Alexandre (1802–70) (père) French novelist and dramatist. He achieved success with romantic historical plays, such as *La Tour de Nesle* (1832). He is better known today for his swashbuckling novels, such as *The Count of Monte Cristo*,

The Three Musketeers (1844–45) and The Black Tulip (1850). **Dumas, Alexandre** (1824–95) (fils) French dramatist and novelist, illegitimate son of Alexandre Dumas (père). His work stands in stark contrast to his father's exuberant historical romances. His first great success was La Dame aux Camélias (1852), which forms the basis of Verdi's opera La Traviata. His didactic later plays, such as Les idées de Madame Aubray (1867), helped to provoke French social reform.

Du Maurier, Daphne (1907–89) British novelist. Her romantic novels include *The Loving Spirit* (1931), *Jamaica Inn* (1936), *The Glass Blowers* (1936), *Rebecca* (1938), *Frenchman's Creek* (1941) and *My Cousin Rachel* (1951). She also wrote plays, short stories (including *The Birds*), and a biography of Branwell Brontë.

Dumfries and Galloway Region in sw Scotland, bounded SE by England and S by the Solway Firth; the capital is Dumfries. Major towns include Castle Douglas, Lockerbie and Stranraer. An agricultural region, with forestry and livestock raising, sites include the Galloway Hills and the runic Ruthwell Cross. Area: 6,396sq km (2,470sq mi). Pop. (1991) 147,805.

dump In computing, information copied from computer memory to an output or storage device. It may be the entire contents of a file copied to another disk, or a print-out of the screen (screen dump).

Dunbar, Paul Laurence (1872–1906) US author. His poetry, written in African-American dialect, is a bitter-sweet mixture of sadness and humour. His *Lyrics of Lowly Life* (1896) concerns Southern black life before the Civil War. His novels include *The Love of Landry* (1900).

Duncan, Isadora (1877–1927) US dancer, pioneer of MODERN DANCE. She achieved fame in Europe for her emotional, expressive style. She died tragically when her scarf caught in the wheel of her car and strangled her. She wrote an autobiography, *My Life* (1926–27).

Dundee City on the N shore of the Firth of Tay, Tayside, E Scotland. A centre of the Reformation in Scotland, Dundee is an important port and has a university (founded 1881). Industries: textiles, confectionery, engineering. Pop. (1991) 165,873. **dune** Ridge of wind-blown particles, most often sand. They

occur in deserts in many shapes: **barchans** (crescent-shaped) are formed by a constant wind; **seifs** are narrow ridges.

Dunedin City in SE South Island, New Zealand. Founded in 1848 by Scottish Free Church settlers, Dunedin grew after the discovery of gold in the 1860s. It is home to the University of Otago (1871). Industries: agricultural machinery and engineering. Pop. (1993) 111,200.

dung beetle Small to medium-sized SCARAB BEETLE. Some species form balls of dung as food for their larvae, and may roll the balls some distance before burying them. Family Scarabaeidae; species *Geotrupus stercorarius*.

Dunkirk (Dunkerque) City in Nord département, Nw France. It came under French rule in 1662. In World War 2, more than 300,000 Allied troops were evacuated from its beaches between 29 May and 3 June 1940, when the German army broke through to the English Channel. Now it is a leading port, and one of the principal iron and steel producers in w Europe. Industries: oil refining, shipbuilding. Pop. (1990) 70,331.

Duns Scotus, John (1265–1308) Scottish theologian and scholastic philosopher. His main works were commentaries on the writings of the Italian theologian Peter Lombard. He founded a school of SCHOLASTICISM called Scotism.

Dunstable, John (c.1390–1453) Important 15th-century English composer. Little is known about him, but masses, motets and a few secular works have survived. He gained recognition for his experiments in COUNTERPOINT and influenced Guillaume DUFAY and Gilles de BINCHOIS.

duodenum First section of the small INTESTINE, shaped like a horseshoe. The pyloric sphincter, a circular muscle, separates it from the STOMACH. Alkaline BILE and pancreatic juices are released into the duodenum to aid the DIGESTION of food.

Du Pont de Nemours, Eleuthère Irénée (1771–1834) US industrialist, b. France. Founder of a huge chemical company and family empire. He came to the USA in 1799 with his father, Pierre Samuel Du Pont de Nemours (1739–1817). They started a business producing high-quality gunpowder, and prospered from the War of 1812. The company, E.I. Du Pont de Nemours and Co., continues to trade.

Du Pré, Jacqueline (1945–87) English cellist. Soon after her London debut (1961), she became widely acknowledged as a remarkable talent. Her interpretation of Elgar, Beethoven and Brahms drew special acclaim. Multiple sclerosis cut short her career in 1973, but she continued to teach.

Duras, Marguérite (1914–96) French novelist and playwright, b. Indochina. Novels include *The Sea Wall* (1950), *The Sailor from Gibraltar* (1952), *Destroy, She Said* (1969), *The Lover* (1984) and *Summer Rain* (1990). Her best-known screenplay is *Hiroshima Mon Amour* (1959).

Durban Seaport on the N shore of Durban Bay, South Africa. Founded in 1835, the national convention initiating the Union of South Africa was held here. It has the University of Natal (1949) and Natal University College (1960). Industries: shipbuilding, oil refining, and chemicals. Pop. (1991) 1,137,378. **Dürer, Albrecht** (1471–1528) German painter, engraver and designer of woodcuts; the greatest artist of the northern RENAISSANCE. During his visits to Italy, Dürer was influenced by artists such as LEONARDO DA VINCI. His personal synthesis of N and S European traditions deeply affected European art. His album of woodcuts, *The Apocalypse* (1498), established him as a supreme graphic artist. His paintings include *The Feast of the Rose Garlands* (1506) and *Four Apostles* (1526), which reveal his preoccupation with LUTHERANISM. He is often credited as the founder of ETCHING.

Durga In the Hindu pantheon, one of the names of the wife of SHIVA. Depicted as a 10-armed goddess, she is both destructive and beneficent but is worshipped today as a warrior against evil. Her festival, the Durga-puja, which occurs in September or October, is an occasion for family reunions.

Durham, John George Lambton, 1st Earl of (1792–1840) British statesman. One of the drafters of the Great REFORM ACT of 1832, he led the radical wing of the Whig Party. Governor-general of Canada (1838), he produced a report which became the basis of British colonial policy.

Durham City and administrative district on the River Wear, NE England; the county town of Co. Durham. Founded by

■ Dürer German artist, Albrecht Dürer's Self-portrait (1500), depicts the artist resembling Christ. The greatest artist of the northern Renaissance, he is perhaps best known for his albums of woodcuts, such as The Apocalypse (1498). These have a remarkably dense and subtle texture, creating paint-like tones. The Emperor Maximilian was a patron, and commissioned his famous Rhinoceros woodcut.

monks in the 10th century, it became a defensive outpost against the Scots and the seat of prince-bishops. Its cathedral (1093) contains the tomb of the Venerable Bede, and an 11th-century castle is now part of the university (founded 1832). Durham is is home to the Gulbenkian Museum of Oriental Art and Archaeology (1960). Industries: textiles, carpetweaving, engineering. Pop. (1991) 85,800.

Durkheim, Emile (1858–1917) French sociologist. Influenced by the POSITIVISM of Auguste COMTE, Durkheim used the methods of natural science to study human society, and is considered (along with Max Weber) a founder of sociology. In *The Division of Labour in Society* (1893) and the *Elementary Forms of Religious Life* (1912), Durkheim argued that religion and labour were basic organizing principles of society. *The Rules of the Sociological Method* (1895) set out his methodology. *Suicide* (1897) outlines his theory of alienation (*anomie*).

Durrell, Gerald Malcolm (1925–95) British naturalist and author, b. India. Brother of Lawrence Durrell, his humorous and stylish novels include *My Family and Other Animals* (1956) and *A Zoo in My Luggage* (1960). Other works include *Beasts in the Belfry* (1973) and *The Aye-Aye and I* (1992).

Durrell, Lawrence George (1912–90) British novelist and poet, b. India. Brother of Gerald DURRELL, his life in Greece and Egypt provided inspiration for most of his writing. His major work is the inventive tetralogy, *The Alexandria Quartet: Justine* (1957), *Balthazar* (1958), *Mountolive* (1958) and *Clea* (1960). Other novels include *Avignon Quintet* (1992). His *Collected Poems* 1931–74 appeared in 1980.

Dürrenmatt, Friedrich (1921–90) Swiss dramatist, novelist and essayist. Influential in the post-1945 revival of German theatre, his works are ironic and display a nihilistic, black humour. His first play was *It is Written* (1947). *Woyzeck* (1972) is his most frequently performed play

Dushanbe (Dušanbe) Capital of Tajikistan, at the foot of the Gissar Mountains, Central Asia. Founded in the 1920s, it was known as Stalinabad from 1929–61. An industrial, trade and transport centre, it is the site of Tadzhik University and Academy of Sciences. Industries: cotton milling, engineering, leather goods, food processing. Pop. (1991 est.) 592,000.

Düsseldorf Capital of North Rhine-Westphalia, at the confluence of the rivers RHINE and Düssel, NW Germany. Founded in the 13th century, it was the residence of the dukes of Berg in the 14th–16th centuries. It became part of Prussia in 1815 and was under French occupation 1921–25. It is a cultural centre, with an Academy of Art and an opera house. Industries: chemicals, textiles, iron, steel. Pop. (1990) 577,400.

dust bowl Area of c.40 million ha (100 million acres) of the Great Plains, USA that suffered extensively from wind erosion. Due to drought, overplanting and mismanagement, much of the topsoil was blown away in the 1930s. Subsequent soil conservation programmes have helped restore productivity.

Dutch Official language of the Netherlands, spoken by almost all of the country's 13 million inhabitants, and also in

▲ Dvořák Czech composer
Antonín Dvořák drew heavily on
folk music, both Czech (for the
polka rhythms) and American.
While he was director (1892–95)
of the National Conservatory,
New York, he wrote his famous
Ninth Symphony ("From the New
World"). Although he was
intrigued with opera, it is
generally accepted that his stage
works are of less significance
than his orchestral pieces.

Netherlands Antilles and Surinam. Dutch is a Germanic language, belonging to the Indo-European family.

Dutch art Before the 16th century, most Netherlandish art was commissioned by the church. Artists, such as LUCAS VAN LEYDEN, produced elaborate altarpieces. After independence from Spain, the chief patrons were the merchant class. The 17th century was a golden age in portraiture, landscape and genre painting, producing artists of the calibre of REMBRANDT, Jan VERMEER, Frans HALS and Jacob van RUISDAEL. The 19th-century Hague School rekindled the Dutch landscape tradition. VAN GOGH, though Dutch-born, had closer links with 19th-century French art. In the 20th century, the main artistic contributions have come from Piet Mondrian and the De Still group.

Dutch East India Company See EAST INDIA COMPANY **Dutch East Indies** Until 1949 the part of Southeast Asia that is now Indonesia. An overseas territory of the Netherlands, it comprised the Malay Archipelago, SUMATRA, JAVA, BORNEO (except North Borneo), SULAWESI, MOLUCCAS and the Lesser Sunda Islands (except Portuguese TIMOR). The islands were first colonized by the Dutch in the early 17th century.

Dutch elm disease Highly infective fungus infection that attacks the bark of ELM trees and spreads inwards until it kills the tree. It is spread by beetles whose grubs make a series of linked tunnels in the wood below the bark.

Dutch Wars Three 17th-century naval conflicts between Holland and England arising from commercial rivalry. The first war (1652–54) ended inconclusively, but with England holding the advantage. The second war (1665–67) followed England's seizure of New Amsterdam (New York). The Dutch inflicted heavy losses, and destroyed Chatham naval base, England; England modified its trade laws. The third war (1672–74) arose from English support of a French invasion of the Netherlands. The Dutch naval victory forced England to make peace.

Duvalier, "Baby Doc" (Jean-Claude) (1951–) President of Haiti (1971–86). He succeeded his father, "Papa Doc" DUVALIER as president-for-life. Though he introduced reforms and disbanded the *Tonton Macoutes*, he retained his father's brutal methods. Civil unrest forced his exile to France in 1986. **Duvalier, "Papa Doc" (François)** (1907–71) President of

Haiti (1957–71). He declared himself president-for-life and relied on the feared *Tonton Macoutes*, a vigilante group, to consolidate his rule. Under his ruthless regime, the longest in Haiti's history, the country's economy severely declined. He was succeeded by his son "Baby Doc" DUVALIER.

Dvořák, Antonín (1841–1904) Czech composer. He adapted Czech FOLK MUSIC to a classical style. Best known for his orchestral works, which include nine symphonies, two sets of *Slavonic Dances* and several symphonic poems, his Cello Concerto (1895) is one of the supreme achievements of the form. His stay in the USA (1892–95) inspired his most popular work, the Symphony in E minor ("From the New World"). dye Substance, natural or synthetic, used to impart colour to various substances. Natural dyes have mostly been replaced by synthetic dyes, many derived from coal tar. Dyes are classified according to their application: direct dyes, such as sulphur and vat dyes, can be applied directly to fabric because they bind to the fibres. Indirect dyes, such as ingrain and mordant dyes, require a secondary process to fix the dye.

Dyfed County in sw Wales; the administrative centre is Carmarthen. The Cambrian Mountains extend to the coast. Agriculture is based on livestock rearing, and the cultivation of crops. Industries: fishing, timber, woollen textiles and tourism. Area: 5,765sq km (2,226sq mi). Pop. (1990) 343,543.

Dyke, Sir Anthony van See Van Dyck, Sir Anthony dyke In engineering, a barrier or embankment designed to confine or regulate the flow of water. Dykes are used in reclaiming land from the sea by sedimentation (as practised in The Netherlands), and also as controls against river flooding. In geology, a dyke (dike) is an intrusion of igneous rock whose surface is different from that of the adjoining material. Dylan, Bob (1941–) US popular singer and composer, b. Robert Allen Zimmerman. During the 1960s, Dylan successfully combined social protest poetry and Folk Music on albums such as The Times They Are A-Changin' (1963). His switch to Rock music and electric instrumentation, initially alienated many fans. Classic albums from this period include Highway 61 Revisited (1965) and Blood on the Tracks (1975). Dylan's tunes include "All Along the Watchtower".

dynamics Branch of MECHANICS that deals with objects in motion. Its two main branches are: kinematics, which examines motion without regard to cause; and KINETICS, which also studies the causes of motion. *See also* INERTIA; MOMENTUM

dynamite Solid, blasting explosive. It contains NITROGLYC-ERINE incorporated in an absorbent base, such as charcoal or wood-pulp. Dynamite is used in mining, quarrying and engineering. Its properties are varied by adding ammonium nitrate or sodium nitrate. It was invented by Alfred NOBEL in 1866.

dynamo (generator) Device that converts mechanical energy into electrical energy by the principle of ELECTROMAGNETIC INDUCTION. In a simple dynamo, a CONDUCTOR, usually an open coil of wire (armature), is placed between the poles of a permanent magnet. This armature is rotated within the magnetic field, inducing an ELECTRIC CURRENT. *See also* ALTERNATOR

dysentery Infectious disease characterized by DIARRHOEA, bleeding and abdominal cramps. It is spread in contaminated food and water, especially in the tropics. There are two types: **bacillary** dysentery, caused by BACTERIA of the genus *Shigella*; and **amoebic** dysentery, caused by a type of PROTOZOA. Both forms are treated with antibacterials and fluid replacement.

dyslexia Impairment in reading ability. Dyslexia is usually diagnosed when difficulty in learning to read is clearly not due to inadequate intelligence, brain damage or emotional problems. Its specific causes are disputed, but is probably due to a neurological disorder. Symptoms may include difficulty with writing, especially in spelling correctly.

dyspepsia (indigestion) Pain or discomfort in the stomach or abdomen arising from digestive upset.

dysprosium (symbol Dy) Silvery-white metallic element of the LANTHANIDE SERIES, first identified by Lecoq de Boisbaudran (1886). Its chief ores are monazite and bastnaesite. Its capacity to absorb neutrons makes it important in nuclear technology. Its compounds are also used in lasers. Properties: at.no. 66; r.a.m. 162.5; r.d. 8.54; m.p. 1,409°C (2,568°F); b.p. 2,335°C (4,235°F); most common isotope Dy¹⁶⁴ (28.18%).

Amoebic dysentery is a widespread disease caused by a microscopic organism (*Entamoeba histolytica*), found in contaminated water and food. *Entamoeba* is a natural inhabitant of the gut, however, unhabitant of the gut, however, of the gut wall occurs. Ingested *Entamoeba* cysts undergo division and multiplication in the

large intestine (1). After division, eight trophozoites (feeding protozoa) are produced (2), non-infective trophozoites remain in the intestine (3) feeding on bacteria and food particles. Infective trophozoites invade the gut wall (4), multiply and dissolve away tissues by producing protein-digesting enzymes. If organisms enter the

blood stream (5) they can be carried to the lungs (6), liver and brain where abscesses develop. Those released from gut abscesses reinvade tissues or form cysts (7) and are passed in the faeces. The disease is transmitted if flies carry cysts from faeces to food or, more commonly, by drinking contaminated water (8).

▲ Earth Formed c.4,600 million years ago, the first humans (*Homo habilis*) appeared only 2 million years ago. The Earth consists of concentric rings, from the uppermost crust to a solid inner core of nickel and iron.

eagle Strong, carnivorous diurnal BIRD OF PREY. Sea and fishing eagles, such as the American bald eagle, are large birds found on sea coasts and inland bodies of water, where they feed on fish, small animals and carrion. Serpent eagles are stocky reptile-eating birds. Large harpy eagles inhabit tropical forests. Some eagles indigenous to Asia and Africa are open-country predators. True (booted) eagles (Aquila) have long hooked bills, broad wings, powerful toes with long curved talons and fully feathered legs. They are usually brownish, black or grey with light or white markings. They nest high on sea coasts or island mountains, building massive stick nests (eyries) lined with grass and leaves. One or two light-brown or spotted eggs are laid. Length: 40–100cm (16–40in). Family Accipitridae. See also FALCON

Eakins, Thomas (1844–1916) US painter and photographer. Regarded as one of the finest US portrait painters of his era. His paintings include *The Gross Clinic* (1875), *The Chess Players* (1876) and *The Swimming Hole* (1883).

Ealing Studios British film studios founded in 1929. Ealing produced a series of classic British comedies, such as *Passport to Pimlico* (1949), *The Lavender Hill Mob* (1951) and *The Ladykillers* (1955). Original screenplays and a nucleus of actors led by Alec Guinness, assured their success. The studios were sold in 1952 and went into receivership in 1994. They were bought by the BBC and now belong to the National Film and Television School.

ear Organ of hearing and balance. It converts sound waves to nerve impulses which are carried to the BRAIN. In most mammals, it consists of the outer, middle and inner ear. The outer ear carries sound to the eardrum. The middle ear is air-filled, and has three tiny bones (ossicles) that pass on and amplify sound vibrations to the fluid-filled inner ear. The inner ear contains the COCHLEA and semi-circular canals. Vibrations stimulate tiny hairs in these organs which cause impulses to be sent via the auditory nerve to the brain. The inner ear also contains semi-circular canals that maintain orientation and balance.

Earhart, Amelia (1898–1937) US aviator, first woman to fly solo across the Atlantic (1932). In 1937, she attempted to fly around the world, but disappeared in the Pacific Ocean.

Early, Jubal (1816–94) Confederate general in the US CIVIL WAR. A Virginian lawyer with military training, he opposed secession. He led a daring raid on Washington, D.C. (1864), but later suffered defeats and was relieved of his command after being crushed by superior forces at Waynesboro (March 1865).

Early English First phase of English GOTHIC ARCHITECTURE (13th century). It followed NORMAN ARCHITECTURE. In c.1250 French-inspired English stonemasons developed a native Gothic idiom: CANTERBURY Cathedral is a very early example. Later works emphasized appearance rather than

structure: builders ornamented and enhanced visible walls, such as Rievaulx Abbey, or made prominent use of VAULT ribbing, such as Lincoln Cathedral. *See also* DECORATED STYLE; PERPENDICULAR STYLE

Early English (Anglo-Saxon, or Old English) ENGLISH language from c.450 to 1100. It constitutes the earliest form of English, directly descended from the Germanic languages of the early ANGLO-SAXONS. It had a vocabulary of c.50,000 words. It comprised four main dialects: Northumbrian, Mercian, Kentish, and West Saxon. The best of Early English literature, such as the epic poem Beowulf, was written in Northumbrian. West Saxon became the chief dialect as a result of Alfred The Great's unification of England.

Earp, Wyatt Berry Stapp (1848–1929) US law officer. In 1879 he became deputy sheriff of Tombstone, Arizona. The Earp brothers and Doc Holliday fought the Clanton gang in the famous gunfight at the O.K. Corral in 1881.

Earth Third major planet from the Sun, and the largest of the four inner, or terrestrial planets. Some 70% of the surface is covered by water. This fact and the Earth's average surface temperature of 13°C (55°F), makes it suitable for life. Continental land masses make up the other 30%. Our planet has one natural satellite, the Moon. Like all the terrestrial planets, there is a dense CORE, rich in iron and nickel, surrounded by a MANTLE of silicate rocks. The thin, outermost layer of lighter rock is the CRUST, which can vary in depth from between 50km (30mi) - the thickest continental crust - to 5km (3mi) – the thinnest oceanic crust. The boundary between the crust and the mantle is called the Moho (Mohorovičić) discontinuity. The solid inner core rotates at a different rate from the molten outer layers, and this, together with currents in the outer core, gives rise to the Earth's MAGNETIC FIELD. The crust and the uppermost mantle together form the lithosphere, which consists of tightly fitting slabs called plates. The plates, which float on a semi-molten layer of mantle called the asthenosphere, move with respect to one another in interactions known as PLATE TECTONICS. See also ATMOSPHERE earthquake Tremor below the surface of the Earth which causes shaking to occur in the crust. Shaking lasts for only a few seconds, but widespread devastation can result. According to PLATE TECTONICS, earthquakes are caused by the movement of crustal plates, which produces FAULT lines. The main earthquake regions are found along plate margins, especially on the edges of the Pacific, such as the SAN ANDREAS FAULT. When the shock takes place, three different waves are created: primary/push (P), secondary/shake (S), and longitudinal/sur-

E/e, the fifth letter of the alphabet. E is a vowel, and the most frequently used letter in written English. It has various pronunciations depending on its position in a word. It may be long as in me (although this sound is much more frequently denoted by a double e, as in feed), or short as in

EARTH: DATA

Diameter (equatorial): 12,756km Mass: 5,378 billion billion tons Volume: 1,083 billion cubic km Density (water =1): 5.52g/cm³ Orbital period: 365.3 days Rotation period: 23h 56m 04s Surface temperature: 290K

The ear is divided into three parts – the outer, middle and inner ear. The outer consists of the pinna and the auditory canal. The pinna funnels sound waves via the canal to the ear drum,

tympanic membrane, of the middle ear. The sound waves are amplified and transmitted by tiny bones, the ossicles, which cause the oval window to vibrate. This sets the fluids of the inner ear in

motion. Hair cells in structures of the inner ear, the cochlea and semicircular canals, are stimulated and generate impulses interpreted by the brain as sound.

▲ Eastwood Charismatic leading actor and director, Clint Eastwood has enjoyed a career spanning 40 years. He is best known for his tough, tight-lipped action roles, in films such as Dirty Harry (1971). His love of jazz music is revealed in his direction of the film biography of Charlie Parker, Bird (1988). Other films include White Hunter Black Heart (1990) and In the Line of Fire (1993).

face (L). P and S waves originate from the seismic focus (point of origin), up to 690km (430mi) deep. They travel to the surface and cause shaking. On the Earth's surface, they travel as L waves. The surface point directly above the seismic focus is the epicentre, around which most damage is concentrated. A large earthquake is usually followed by smaller "aftershocks". An earthquake beneath the sea is known as a TSUNAMI. Earthquake prediction is a branch of SEISMOLOGY. Present methods indicate only a probability of earthquake activity, and cannot be used to predict actual events. The world's largest recorded earthquake (1976) at Tangshan, China, killed over 250,000 people and measured 8.2 on the RICHTER SCALE.

Earth sciences General term used to describe all the sciences concerned with the structure, age, composition and atmosphere of the EARTH. It includes the basic subject of GEOLOGY, with its sub-classifications of GEOCHEMISTRY, GEOMORPHOLOGY, GEO-PHYSICS; MINERALOGY and PETROLOGY; SEISMOLOGY and VOL-CANISM; OCEANOGRAPHY; METEOROLOGY; and PALAEONTOLOGY. Earth Summit (June 1992) United Nations Conference on Environment and Development, held in Rio de Janeiro, Brazil. The first serious global acknowledgement of the problems created by the impact of industrial society on the ENVI-RONMENT. The Rio Declaration laid down principles of environmentally sound development, a "blueprint for action", and imposed limits on the emission of gases, responsible for the GREENHOUSE EFFECT. A second Earth Summit (June 1997) called for practical progress in the reduction of carbon dioxide emissions and strict enforcement of the Convention on Biodiversity. The European Union (EU) pledged to cut ${\rm CO_2}$ emissions to 15% below 1990 levels. The US only agreed to maintain its level of emissions.

earthworm Annelid with a cylindrical, segmented body and tiny bristles. Most worms are red, pink or brown, and live in moist soil. Their burrowing loosens and aerates the soil, helping to make it fertile. Length: 5cm-33m (2in-11ft). There are several hundred species. Class Oligochaeta; genus Lumbricus. earwig Slender, flattened, brownish-black insect found in crevices and under tree bark. There are some 900 winged and wingless species worldwide. All have a pair of forceps at the hind end of the abdomen. Order Dermaptera; genus Forficula. East Anglia Region of E England, made up of the counties of NORFOLK and SUFFOLK, and parts of CAMBRIDGESHIRE and ESSEX. The protection afforded by the fenlands made it one of the most powerful Anglo-Saxon kingdoms of the late 6th century. A fertile agricultural land, farming includes grain, vegetables and livestock-raising. Industries: market gardening, tourism and fishing.

East China Sea Northern branch of the China Sea, bordered by Korea and Japan (N), China (W), Taiwan (s) and the Ryukyu Islands (E). Area: c.1,249,160sq km (482,300sq mi). **Easter** Feast in celebration of the resurrection of JESUS CHRIST on the third day after his crucifixion. It is the oldest and greatest Christian feast, celebrated on the Sunday following the first full moon between 21 March and 25 April. The exchange of Easter eggs is a pre-Christian rite.

Easter Island (Isla de Pascua) Volcanic island in the SE Pacific; the chief town is Hanga Roa. The most isolated island in Polynesia, it was discovered by a Dutch navigator on Easter Day, 1722, and has been under Chilean administration since 1888. It is famous for the curious hieroglyphs (*rongorongo*) and formidable statues carved in stone, standing up to 12m (40ft) high. It is mainly hilly grassland. The subtropical climate allows a variety of crops, such as sugarcane and bananas. Industries: farming, tourism. Area: 163sq km (63sq mi). Pop. (1982) 1,867.

Eastern Cape Province in SE South Africa; the capital is East London. Eastern Cape was created in 1994 from the E part of the former CAPE PROVINCE. It incorporates the former, apartheid-created homelands of Transkei and Ciskei. Area: 169,600sq km (65,466sq mi). Pop. (1994 est.) 6,436,790

Eastern Orthodox Church (Orthodox Church) Community of c.130 million Christians living mainly in E and SE Europe, parts of Asia and a significant minority in the USA. The Church is a federation of groups that share forms of worship and episcopal organization, but each group has its own

national head. Although there is no central authority, member churches recognize the patriarch of Istanbul as titular head. Eastern Orthodox Christians reject the jurisdiction of the Roman pope. When Constantine moved his capital to Byzantium (ISTANBUL) in 330, a separate non-Roman culture developed. The Eastern Orthodox Christians accepted the Nicene Creed, as modified in 381. Conflicts grew between the Eastern patriarchs and Rome. In the schism (1054), Western and Eastern arms of Christendom excommunicated each other's followers, and the split became irreparable when Crusaders invaded Constantinople (1204). Attempts at reconciliation in 1274 and 1439 failed. In 1962 Orthodox observers attended the Second Vatican Council. In 1963 the Eastern Orthodox Churches agreed to begin dialogue with Rome.

Easter Rising (24 April 1916) Rebellion by Irish nationalists against British rule. Led by Patrick Pearse, James Con-NOLLY, Joseph Plunkett, c.1,200 men, mainly from the Irish Citizen Army, seized the General Post Office and other buildings in Dublin and proclaimed Ireland a republic. The British crushed the rising within a week and executed 15 of the ringleaders. A wave of nationalist sentiment produced an electoral victory for SINN FÉIN in 1917.

East India Company Name of several organizations set up by European countries in the 17th century to trade E of Africa. The British company was set up in 1600 to compete for the East Indian spice trade, but competition with the Dutch led it to concentrate on India, where it gradually won a monopoly. Although the British government assumed political responsibility (1773), the company continued to administer the British colony in India until the mutiny (1857). The Dutch Company was founded (1602), with headquarters in Jakarta from 1619. The company was dissolved in 1799, and its possessions incorporated into the Dutch empire. The French company was founded by Louis XIV (1664) and set up colonies on several islands in the Indian Ocean. Established as a trading company in India in the early 18th century, it was defeated by the English company and abolished in 1789.

Eastman, George (1854–1932) US photographic inventor and manufacturer, who created the basic materials for still and motion picture PHOTOGRAPHY. He introduced innovations in photographic technology during the late 1800s and founded the Eastman Kodak Company (1892).

East Sussex County of SE England. The county town is Lewes, other major towns include Brighton, Hastings and Eastbourne. Its s border is the English Channel. The chalky South Downs run parallel to the coast. In the N, the Weald plains are drained by the River Ouse. Most of the region was included in the kingdom of Wessex. In 1066 William the Conqueror met the forces of Harold II in the Battle of HASTINGS. The local economy is dominated by agriculture, services and tourism. Area: 1,795sq km (693sq mi) Pop. (1991) 670,600. **East Timor** See TIMOR

Eastwood, Clint (1930–) US film actor and director. Following the long-running television series *Rawhide*, Eastwood revitalized his career playing the no-nonsense drifter in the "spaghetti WESTERNS" *A Fistful of Dollars* (1964), *For a Few Dollars More* (1965) and *The Good, the Bad and the Ugly* (1967). *Dirty Harry* (1971) and its four sequels were tough and uncompromising. As a director, he earned praise for *The Outlaw Josey Wales* (1976) and *Bird* (1988). Eastwood won Academy Awards for Best Director, Best Actor and Best Picture for *Unforgiven* (1992).

eating disorders Range of disorders involving eating habits and appetites. The most common are ANOREXIA NER-VOSA and BULIMIA NERVOSA.

ebola Virus that causes haemorrhagic fever. Thought to have been long present in animals, the ebola virus was first identified in humans during an outbreak in Zaïre in 1976. It is acquired through contact with contaminated body fluids. Death rate can be as high as 90%.

ebony Hard, fine-grained dark heartwood of various Asian and African trees of the genus *Diospyros* in the ebony family (Ebenaceae). Its major commercial tree is the macassar ebony (*D. ebenum*) of s India and Malaysia. It is valued for woodcarving, cabinetwork and parts of musical instruments.

Ebro River in N Spain. Rising at Fontibre in the Catabrian Mountains, it flows ESE and then SE through Logrono and ZARAGOZA, and into the Mediterranean below Tortosa. It is the longest river whose entire course is in Spain. Length: 910km (565mi).

eccentricity (symbol e) One of the elements of an ORBIT. It indicates how much an elliptical orbit departs from a circle. It is found by dividing the distance between the two foci of the ellipse by the length of the major axis. A circle has an eccentricity of 0, a parabola an eccentricity of 1.

Ecclesiastes OLD TESTAMENT book of aphorisms, compiled under the pseudonym "the Preacher, the son of David". Evidence suggests that the book dates from after the BABYLONIAN CAPTIVITY. Its theme is the vanity and emptiness of human life and aspirations, relieved only by faith in God.

ecclesiastical courts Tribunal system set up by European church authorities during the later Middle Ages for matters involving the church and the clergy, religious offences and secular matters. They had wide social jurisdiction. The best known was the INOUISITION. The highest penalty available to the courts was excommunication. In England, ecclesiastical courts were introduced after the Norman Conquest. In the 16th century, these courts were compelled to become Anglican and the PRIVY COUNCIL became the highest ecclesiastical court.

Ecclesiasticus Book of the APOCRYPHA, an example of Jewish WISDOM LITERATURE. The work of a Jewish scribe, Jesus ben Sirach, written in c.180 BC. Although originally in Hebrew, it found its way into the SEPTUAGINT and not the Jewish canon. A handbook of practical and moral advice, the central theme is the relationship between wisdom and God.

echidna (spiny anteater) MONOTREME related to the PLATYPUS, found in Australia, Tasmania and New Guinea. It is a primitive egg-laying mammal with a CLOACA, spines on the upper body, and an elongated snout. Length: 30–77cm (12–30in).

echinoderm Phylum of spiny-skinned marine invertebrate animals. Radially symmetrical with five axes, their skin consists of calcareous plates. Their hollow body cavity includes a complex, internal fluid-pumping system and tube feet. They reproduce sexually, and produce a bilaterally symmetrical larva resembling that of chordates; regeneration also occurs. Species include SEA URCHIN, SEA CUCUMBER and STARFISH.

Echo In Greek mythology, a mountain nymph condemned to speak only in echoes, because her chattering distracted the goddess HERA from the infidelity of ZEUS. Unable to declare her love for NARCISSUS, Echo pined away in solitude until her bones turned to stone and only her voice remained.

echo Reflected portion of a wave, such as SOUND or radar, from a surface so that it returns to the source and is heard after a short interval. High notes provide a better sound echo than low notes. Echoes are useful in NAVIGATION.

echolocation In animals, system of orientation used principally by WHALES and BATS. The animal emits a series of short, high-frequency sounds, and from the returning ECHO it gauges its environment. Bats also use the system for hunting. Eckhart, Johannes (1260–1327) (Meister Eckhart) German Dominican theologian and mystic. His speculations on the union of the soul with God were condemned as herectical and influenced later Protestant thinkers.

eclipse Celestial body completely or partially obscuring another, as seen from the Earth. Eclipses are transitory, the most familiar are solar and lunar eclipses. A solar eclipse occurs when the Moon passes between the EARTH and the Sun, so that the Sun's light is blocked from the part of the Earth on which the Moon's shadow (umbra) falls. It provides a unique research opportunity for astronomers, such as checking Einstein's theory of RELATIVITY. A lunar eclipse is caused by the Earth when it moves between Sun and Moon, so that the Moon passes into the Earth's umbra, and cannot shine by reflected sunlight. If a solar eclipse happens when the Moon is at its apogee (furthest point from Earth), its apparent size is less than the Sun's, and an annular or ring eclipse results, with the Sun appearing as a bright ring around the dark Moon. If Earth and Moon's orbits were in the same plane, solar and lunar eclipses would be monthly, occurring at new and full moons. Because the Moon's orbit is at an angle to Earth's,

eclipses can occur only when the Moon crosses Earth's orbital plane and is in line with the Earth and Sun. This happens, at most, seven times a year.

Eco, Umberto (1932–) Italian writer and academic. He lectures on aesthetics, architecture, visual communications and SEMIOTICS. His writing is based on these themes. His best-known work is the erudite philosophical thriller *The Name of the Rose* (1981). Other novels include *Foucault's Pendulum* (1989) and *The Island Before Time* (1994).

ecology Biological study of relationships between organisms, groups of organisms and their ENVIRONMENT.

economics Social science studying the allocation of RESOURCES in a society. Methods of PRODUCTION are studied to obtain maximum efficiency in the use of resources and deciding how material wealth is to be distributed. Developments in economic understanding should help societies plan for the satisfaction of their future needs.

ecosystem Interacting community of organisms and their physical ENVIRONMENT. It includes all organic life in a given area along with the soil, water and other inorganic components of their HABITAT, and all the ecological interactions that take place within and between the organic and inorganic. It is a complete ecosystem only if it can incorporate energy into organic compounds and pass it from organism to organism, and if it recycles elements for re-use.

ecstasy (MDMA) (3,4—methylnedioxymethylamphetamine) An AMPHETAMINE-based drug, which raises body temperature and blood pressure by inducing the release of adrenaline and targeting the neurotransmitter SEROTONIN. Users experience short-term feelings of euphoria, rushes of energy and increased tactility. Withdrawal can involve bouts of DEPRESSION and INSOMNIA. In the 1980s, taking of ecstasy in tablet form was widespread in club culture in Europe and North America. It is estimated that there are up to 500,000 weekly users in the UK. Some deaths have resulted from use of ecstasy.

ECT Abbreviation of ELECTROCONVULSIVE THERAPY

ectopic Occurrence of a pregnancy outside the UTERUS, such as in the FALLOPIAN TUBE. The EMBRYO cannot develop normally and spontaneous ABORTION often occurs. If not, urgent surgery is necessary to save the mother from serious haemorrhage.

Ecuador Republic in NW South America. *See* country feature, p.224

ecumenical council (general council) Ecclesiastical convention of worldwide church representatives. Pronouncements are considered binding on all church members. All Christians recognize the first seven councils, the last of which was held in Nicaea in 787. Since then, the Roman Catholic Church has recognized 21 ecumenical councils convened by various popes. Since the Reformation, the councils have been restricted to Roman Catholics. The most recent was the Second Vatican Council (1962–65).

ecumenical movement Movement to restore the lost unity of Christendom. In its modern sense, the movement began with the Edinburgh Missionary Conference of 1910 and led to the foundation of the WORLD COUNCIL OF CHURCHES in 1948. eczema Inflammatory condition of the skin, a form of DERMATTIS characterized by dryness, itching, rashes and blister formation. It can be caused by contact with a substance, such as a detergent, to which the skin has been sensitized, or a general ALLERGY. Treatment is usually with a corticosteroid ointment.

▲ echidna An example of a primitive mammal, the echidna (spiny anteater) is classified as a monotreme. Instead of giving birth to live young like other mammals, it lays a tiny egg. The egg (1) is soft-shelled and resembles a reptile's egg. Once the egg is laid, the echidna uses its hind limbs to roll it to a special incubation groove (2). The minute hatchling is about 1.25cm (0.5in) long.

▼ eclipse When the Moon passes between the Sun and the Earth, it causes a partial eclipse of the Sun (1) if the Earth passes through the Moon's outer shadow (P), or a total eclipse (2) if the inner cone shadow crosses the Earth's surface. In a lunar eclipse, the Earth's shadow crosses the Moon and, again, provides either a partial or total eclipse. Eclipses of the Sun and the Moon do not occur every month because of the 5° difference between the plane of the Moon's orbit and the plane in which the Earth moves.

Eddington, Sir Arthur Stanley (1882–1944) British scientist who contributed to mathematics, relativity, cosmology and astronomy. While professor of astronomy at Cambridge University, he researched the structure of stars. He also made significant contributions to the general theory of RELATIVITY. A great popularizer of science, the Eddington medal is awarded by the Royal Astronomical Society for outstanding work in theoretical astronomy.

Eddy, Mary Baker (1821–1910) US founder of Christian Science (1879). She claimed to have rediscovered the secret of primitive Christian healing after an instantaneous recovery from serious injury. She expounded her system in *Science and Health With Key to the Scriptures* (1875).

edelweiss Small perennial plant native to the Alps and other high Eurasian mountains. It has white, downy leaves and small yellow flower heads enclosed in whitish-yellow bracts. Family Asteraceae (COMPOSITAE); species *Leontopodium alpinum*.

Eden, Sir Anthony, 1st Earl of Avon (1897–1977) British statesman, prime minister (1955–57). He entered parliament in 1923 and was Britain's youngest foreign secretary (1935). He resigned (1938) in protest against the APPEASEMENT

policy of Neville Chamberlain. He served again as foreign secretary (1940–45, 1951–55), and succeeded Winston Churchill as Conservative prime minister. Ill health and his mishandling of the Suez Canal Crisis forced him to resign. He was succeeded by Harold Macmillan.

Eden, Garden of In GENESIS 2, garden created by God as the home of ADAM and EVE. Adam and Eve lived in the garden and enjoyed its fruits without toil, until they were banished for eating the forbidden fruit from the tree of knowledge. The Garden of Eden is also mentioned in the KORAN and is popularly equated with paradise.

edentate (Lat. "with all the teeth removed") Any of a small order of North and South American mammals found from Kansas to Patagonia. There are c.30 species, including ARMADILLO, SLOTH and ANTEATER. Only anteaters are truly toothless.

Edgehill, Battle of (23 October 1642) First encounter of Parliamentarians and Royalists in the English CIVIL WARS, near Banbury, Oxfordshire. The Royalists were outnumbered (11,000 men to the Parliamentarians' 13,000), but the result was to their advantage.

Edinburgh, Duke of See Philip, Prince

ECUADOR

Ecuador's flag was created by a patriot, Francisco de Miranda, in 1806. The armies of Simón Bolívar, who liberated much of South America, fought under this flag. At the centre is Ecuador's coat of arms, showing a condor over Mount Chimborazo, Ecuador's highest peak at 6,267m (20,561ft).

AREA: 283,560sq km (109,483sq mi)

POPULATION: 10,980,972

CAPITAL (POPULATION): Quito (1,100,847)
GOVERNMENT: Multiparty republic
ETHNIC GROUPS: Mestizo 40%, Amerindian

40%, White 15%, Black 5% LANGUAGES: Spanish (official)

RELIGIONS: Christianity (Roman Catholic 92%)

currency: Sucre = 100 centavos

cuador straddles the Equator. Three ranges of the high Andes mountains form its backbone. The snowcapped Andean peaks include Mount Chimborazo and the world's highest active volcano, Cotopaxi, at 5,896m (19,344ft). Earthquakes are frequent and often devastating. Ecuador's capital, Quito, lies in the high Andean plateaux, which are home to nearly half of the nation's population. West of the Andes lie flat coastal lowlands, which include Ecuador's largest city and port, GUAYAQUIL. The E lowlands (Oriente) are drained by headwaters of the River AMAZON. The GALÁPAGOS ISLANDS, a province of Ecuador in the Pacific Ocean, lie c.1,050km (650mi) off the w coast.

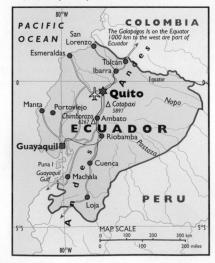

CLIMATE

Ecuador's climate varies greatly according to altitude. Though the coast is cooled by the Peruvian current, temperatures remain between 23° and 25°C (73°F and 77°F) throughout the year. Quito, just s of the Equator at 2,500m (8,200ft), experiences temperatures of 14°C to 15°C (57°F to 59°F). Rainfall is low in the sw, but the Oriente region is hot and wet.

VEGETATION

Vegetation in the Andes varies from high snowfields to grassy meadows in the foothills. Beans, maize and wheat are grown in the highlands; citrus fruits, rice and sugar cane on the coastal lowlands. These lowlands also include deciduous woodland and large tropical forests in N coastal areas. Palm trees are common. Balsa trees grow in the Guayas valley. The s border with Peru is desert. Dense rainforest covers the Oriente.

HISTORY AND POLITICS

The INCA conquered the kingdom of Quito in the late 15th century, and their language, QUECHUA, remains widely spoken. In 1532 Spanish forces, under Francisco PIZARRO, defeated the Incas at Cajamarca and established the Spanish viceroyalty of Quito. A revolutionary war culminated in Antonio José de SUCRE's defeat of the Spanish at the battle of Mount Pichincha (1822). Simón BOLÍVAR negotiated the admittance of Quito to the federation of Gran Colombia, along with Colombia and Venezuela. Ecuador seceded in 1830. The 19th century was characterized by internal instability, with Conservatives and the Roman Catholic Church attempting to preserve

the status quo against the Liberals desire for socio-economic reform, and wars with Peru.

For the first half of the 20th century, the army dominated the political scene. In the Treaty of Rio (1942), Ecuador was forced to cede over 50% of its Amazonian territory to Peru. Post-1945 politics was dominated by José María Velasco Ibarro. During the 1950s, his authoritarian regime improved Ecuador's infrastructure. In 1970, faced with student riots and economic recession, Velasco established a dictatorship. In 1972 he was deposed by an army coup. Ecuador returned to democracy in 1979. Failure to implement land reforms and lack of recognition for minorities saw continual unrest during the 1980s. Durán Ballen's presidency (1992-96) saw the start of privatization. Austerity measures provoked civil unrest. A border war with Peru (1995) led to the establishment of a demilitarized zone. Ballen was defeated by Abdala Bucaram in 1996 elections. In 1997 Bucaram was declared mentally incompetent and removed from office. Fresh elections are due to be held in 1998.

ECONOMY

Ecuador is a lower-middle-income developing nation (1992 GDP per capita, US\$4,350). Agriculture employs 33% of the workforce. Ecuador is the world's third largest producer of bananas. Cocoa and coffee are also vital crops. Fishing is important, but periodically disrupted by EL Niño. Forestry is a vital industry, and mining is increasingly important. The economy was transformed by the discovery (1972) of oil in the Oriente. Energy crises are a recurrent feature.

Edinburgh Capital of Scotland, in Lothian region. The city grew steadily after Malcolm III made Edinburgh Castle his residence (11th century), and became the capital of Scotland in the early 15th century. It flourished as a cultural centre in the 18th and 19th centuries, with figures such as David HUME, Adam SMITH, Robert BURNS and Sir Walter Scott. Sites include: Palace of Holyrood House (official residence of the monarch in Scotland); Chapel of St Margaret (part of Edinburgh Castle and the city's oldest building); the Royal Mile (linking the Castle with Holyrood House); St Giles Cathedral; the home of John KNOX; and Princes Street. The University of Edinburgh was founded in 1583. It has two other universities, Heriot-Watt (1966) and Napier (1992). Museums and art galleries include the National Gallery of Scotland and the Royal Museum of Scotland. Edinburgh has held an international arts festival since 1947. Industries: brewing, tourism, chemicals, printing and publishing, electrical engineering. Pop. (1991) 418,914.

Edirne (Adrianople) Fortified city at the confluence of the Meric and Tundzha rivers. Rebuilt by Emperor Hadrian (*c*.AD 125) as Adrianopolis, it was the scene of a Roman defeat by the Visigoths in 378. Edirne was capital of Ottoman Turkey (1361–1453). Held by the Russians in 1829–79 and the Bulgarians in 1913, Edirne was ceded to Greece in 1920. It was returned to Turkey in 1923. It is an agricultural trading centre. Industries: textiles, tanning. Pop. (1990) 102,300.

Edison, Thomas Alva (1847–1931) US inventor. With little formal education, he made many important inventions, such as the telegraph, phonograph (1877), the first commercially successful electric light (1879), and many improvements to the electricity distribution system. By the time of his death, he had patented over 1,000 inventions. During World War 1, he worked for the US government on anti-submarine weapons. Most of his companies were merged into the General Electric Company (GEC) in 1892.

Edmonton Capital of Alberta province, on the North Saskatchewan River, sw Canada. Founded in 1795, it developed with the arrival of the railway in 1891 and became capital in 1905. Edmonton enjoyed a boom with the discovery of oil after World War 2. Industries: coal mining, natural gas, petrochemicals, oil refining. Pop. (1991) 616,741.

Edo Japanese city, renamed Tokyo when it became the official capital and imperial residence in 1868. Edo was the seat of government under the Tokugawa shogunate (1603–1868), when the emperor lived at Kyōto. The Edo period was an era of unparalleled peace, economic advance and culture.

education Process of acquiring knowledge and skills, leading to the development of understanding, attitudes and values. Individuals learn survival skills in their early years from those in their immediate environment. In later years, education is influenced by wider culture and society. The individual experiences a variety of educational activities and opportunities in school. Educational approaches usually reflect predominant social attitudes. States and private institutions provide a variety of forms of education. *See also* LEARNING; UNIVERSITY

Education, UK Department of (DES) British government department responsible for the promotion of EDUCATION and the fostering of civil science in England. Headed by the secretary of state for education, its specific function is the broad allocation of capital resources for education, provision and training of teachers, and the setting of basic educational standards. The department works in cooperation with local education authorities (LEAs), which administer the day-to-day running of schools, and with the University Grants Committee which administers the universities. The department derives from the Board of Education and was set up as the Ministry of Education by the Education Act (1944).

Education, US Department of US government department, formed from part of the Department of Health, Education and Welfare (HEW). It was created in 1979 and establishes policy and administers and coordinates federal assistance to EDUCATION.

educational psychology Branch of PSYCHOLOGY that deals with the process and context of learning. It includes attempts to measure intelligence and ability and theories of teacher training.

Edward I (1239–1307) King of England (1272–1307), son and successor of HENRY III. Edward's suppression of the baronial revolt (1263-65), led by Simon de Montfort, made him king in all but name. Edward joined the Ninth Crusade (1270), and was crowned on his return (1274). His foreign policy was aggressive. Edward conquered Wales and incorporated it into England (1272-84). In 1296 he captured the Scottish coronation stone from Scone, but William WALLACE and ROBERT I led Scottish resistance. Edward's domestic reforms are central to Britain's legal and constitutional history. The Statutes of WEST-MINSTER codified common law. Edward's foreign ambitions led to the formation of the MODEL PARLIAMENT (1295). His son, EDWARD II, inherited high taxation and the enmity of Scotland. Edward II (1284-1327) King of England (1307-27), son and successor of EDWARD I. Edward reliance on his friend and advisor Piers Gaveston alienated his barons. The barons drafted the Ordinances of 1311, which restricted royal power and banished Gaveston. In 1312 they killed Gaveston. Renewing his father's campaign against the Scots, Edward was routed at BANNOCK-BURN (1314). In 1321, Thomas, earl of Lancaster, led an unsuccessful revolt against the king and his new favourite, Hugh le Despenser. In 1325, Edward's estranged queen, Isabella, went as envoy to France. In 1326, she formed an army with her lover, Roger Mortimer, which invaded England and forced Edward to abdicate in favour of his son, EDWARD III. Edward II was murdered in Berkeley Castle, Gloucestershire, England.

Edward III (1312–77) King of England (1327–77), son and successor of EDWARD II. For the first three years of his reign, Edward was king in name only: his mother, Isabella, and Roger Mortimer wielded all political power. In 1330 Edward mounted a successful coup. He conducted inconclusive wars with Scotland, but his reign was dominated by the outbreak of the HUNDRED YEARS WAR (1337). Edward led several campaigns to France, won a famous victory at Crécy (1346), and claimed the title king of France, although only conquering Calais. The BLACK DEATH accelerated the abolition of serfdom. PARLIAMENT was divided into two houses, and permanently sited at Westminster. In old age, his sons, EDWARD THE BLACK PRINCE and JOHN OF GAUNT, took over government. He was succeeded by his grandson, Richard II.

Edward IV (1442–83) King of England (1461–70, 1471–83). On the death (1460) of his father, Richard, Duke of York, in the Wars of the Roses, Edward became the Yorkist candidate for the throne. He became king after the defeat of the Lancastrians at Towton. When the powerful Earl of Warwick changed sides, Edward was forced into exile, but returned to defeat Warwick at Barnet (1471). Edward accepted a subsidy to withdraw from a French campaign, encouraged trade, restored order and enforced royal absolutism. He died leaving two young sons, "the Princes in the Tower", but the throne was usurped by his brother, RICHARD III.

Edward V (1470–83) King of England for 77 days in 1483. He succeeded his father, EDWARD IV. His uncle, duke of Gloucester, imprisoned Edward and his younger brother, Richard, in the Tower of London, and assumed the throne as RICHARD III. The disappearance of "the Princes in the Tower" was attributed to Richard, although some suspect HENRY VII. Edward VI (1537–53) King of England (1547–53), only legitimate son of HENRY VIII. Edward reigned under two regents, the dukes of Somerset (1547–49) and Northumberland (1549–53). During his reign, the REFORMATION was consolidated by the introduction of Protestant liturgy. Clever, highly educated, but frail, Edward died at 16 after willing the crown to Northumberland's daughter-in-law, Lady Jane GREY, in an attempt to exclude his Catholic sister, MARY I.

Edward VII (1841–1910) King of Great Britain and Ireland (1901–10), son of Queen VICTORIA. As Prince of Wales, his liberal views and lifestyle led to his exclusion from government by his mother. As king, he restored court pageantry and contributed to the ENTENTE CORDIALE with France. He reluctantly cooperated with Herbert Asquith's reform of the House of Lords and was succeeded by his son, George V.

Edward VIII (1894–1972) King of Great Britain and Ireland (1936), subsequently Duke of Windsor. Edward's proposed marriage to an American divorcee, Wallis Simpson, was

▲ egg A duck embryo grows from a patch of cells on the surface of the egg yolk. The yolk is its food store. First, a network of tiny blood vessels spreads over the volk and a simple heart develops. The developing embryo (enlarged here for clarity) begins to elongate and develops a vertebral column (1). A head and bulging eye start to form, and the heart folds around into its final position (2). The gut forms, the brain begins to enlarge and the embryo starts to curl (3-4). The limbs appear as tiny buds; and the tail and mouth form (5). By 13 days (6) it is possible to identify the bird from its bill. Some species of hird hatch shortly after this stage, others, such as the mallard duck (7) continue to develop in the egg. Feathers grow, limbs become stronger and the bird hatches with its eyes open and able to see.

▲ Egyptian art and architecture Examples of the work of ancient Egyptian jewellers survive as evidence of their craftsmanship. Gold was the major material. Silver, the alloy electrum, and semi-precious stones, such as carnelians, turquoise and lapiz lazuli, were also used.

opposed by Stanley BALDWIN's government. Edward refused to back down, and was forced to abdicate after a 325-day reign. Controversy surrounds his relations with Nazi Germany.

Edward the Black Prince (1330–76) Son and heir of King EDWARD III of England. An outstanding military commander, he distinguished himself at the Battle of CRÉCY (1346) and won a famous victory at Poitiers (1356), where he captured the French king. As ruler (1362–71) of Aquitaine, Edward was responsible for the massacre at Limoges (1371). He insured the accession of his son as RICHARD II.

Edward the Confessor (1002–66) King of England (1042–66), son of ETHELRED II (THE UNREADY). Before succeeding Hardecanute, Edward was resident in Normandy. Edward's perceived favouritism of Normans resulted in a rebellion, led by his father-in-law, Godwin. His reign is noted for the rebuilding of Westminster Abbey. Edward's name resulted from his piety and, having taken a vow of chastity, he produced no heir. Though said to have promised the crown to WILLIAM I (THE CONQUEROR) in 1051, before he died he acknowledged Harold I, son of Godwin, as his heir.

Edward the Elder (d.925) King of Wessex (899–925), son and successor of Alfred the Great. Edward completed the reconquest of the s Danelaw (918), and was considered overlord by the rulers of Northumbria and Wales (920).

Edward the Martyr (d.978) King of England (975–78). He was murdered, perhaps by his stepmother, and succeeded by his step-brother ETHELRED II (THE UNREADY). Miracles were reported at his grave and he was popularly regarded as a saint. Edwards, Jonathan (1703–58) US revivalist minister and theologian. A powerful preacher in Northampton, Massachusetts (1729–50), he gained a wide following. With his Calvinist themes of PREDESTINATION and man's dependence on God, he brought about the GREAT AWAKENING, which he chronicled in A Faithful Narrative of the Surprising Work of God (1737). His fierce sermons, like "Sinners in the Hands of an Angry God", argued against any change in the strict Calvinist creed. EEC See EUROPEAN COMMUNITY (EC)

eel Marine and freshwater fish found worldwide in shallow temperate and tropical waters. Eels have snake-like bodies, dorsal and anal fins continuous with the tail, and an air bladder connected to the throat. Length: up to 3m (10ft). Types include freshwater, moray and conger. Order Anguilliformes. eelworm Tiny, thread-like nematode found worldwide. Most species are parasitic, and can cause extensive damage to crops. They have been used to control other pests. See ROUNDWORM efficiency Work a MACHINE does (output) divided by the amount of work put in (input). It is usually expressed as a percentage. In mechanical systems there are energy losses, such as those caused by FRICTION. Output never equals input, and the efficiency is always less than 100%. A simple machine with an efficiency of 100% would be capable of PERPETUAL MOTION. For very simple machines, efficiency can be defined as the force ratio (mechanical advantage) divided by the distance ratio (velocity ratio).

EFTA Acronym for the EUROPEAN FREE TRADE ASSOCIATION **egg** (OVUM) Reproductive cell of female organism. Its nucleus supplies half the chromosome complement of a future ZYGOTE, and almost all the CYTOPLASM, upon union with the male gamete (SPERM). Once fertilized, an animal egg is surrounded as it develops by ALBUMIN, shell, egg case or MEMBRANE, depending on the species. The egg provides a reserve

of food for the EMBRYO in the form of yolk. Bird and insect eggs have a large yolk, mammalian eggs a much smaller one. **eggplant** *See* AUBERGINE

ego Self or "I" which the individual consciously experiences. According to Sigmund FREUD, it is the conscious level of personality that deals with the external world, and also mediates the internal demands made by the impulses of the ID and the prohibitions of the SUPEREGO.

egret White HERON of temperate and tropical marshy regions. It is known for its plumes. Egrets are long-legged, longnecked, slender-bodied wading birds with dagger-like bills. They feed on small animals and nest in colonies. Height: 50–100cm (20–40in). Family Ardeidae; genus *Egretta*.

Egypt Republic in NE Africa. See country feature

Egypt, ancient Civilization that flourished along the River Nile in NW Africa from c.3400 BC-30 BC, when Egypt was annexed to Rome. The dynasties are numbered from 1 to 30, and the kingdoms of Upper and Lower Egypt were united c.3100 BC by the legendary MENES. Ancient Egyptian history is separated into a number of periods. The highlight of the Old Kingdom was the building of the pyramids of GIZA during the 4th dynasty. The Great Pyramid was Khufu's; the other two pyramids were those of his son Khafre and grandson Menkaure. After the death of Pepy II in the 6th dynasty, central government disintegrated and Egypt was in general chaos. This was the First Intermediate Period. Central authority was restored in the 11th dynasty and the capital was moved to Thebes (now LUXOR). The Middle Kingdom (c.2040–1640 BC) saw Egypt develop into a great power. Amenemhet I, founder of the 12th dynasty (c.1991 BC), crushed provincial opposition, secured Egypt's borders, and created a new capital. Art, architecture, and literature flourished. At the end of this Kingdom, Egypt once again fell into disarray (Second Intermediate Period) and control was seized by the HYKSOS. The New Kingdom began c.1550 BC and the 18th dynasty was founded by Ahmose I. The New Kingdom (18th, 19th, and 20th dynasties) brought great wealth. Massive temples and tombs, such as TUTANKHAMUN's, were built. Wars with the Hittites under RAMSES II weakened Egypt and subsequent ineffectual rulers led to the decline of the New Kingdom. The 21st to 25th dynasties (Third Intermediate Period) culminated in Assyrian domination. The Persians ruled from 525 until 404 BC, when the Egyptians revolted, and the last native dynasties appeared. In 332 BC, Egypt fell to the armies of ALEXANDER THE GREAT, who moved the capital to ALEXANDRIA. After Alexander's death, his general became ruler of Egypt, as PTOLEMY I. The Ptolemies maintained a powerful empire for three centuries, and Alexandria became a centre of learning. Roman power was on the ascendancy, and when Ptolemy XII asked POMPEY for aid in 58 BC, it marked the end of Egyptian independence. CLEOPATRA tried to assert independence through associations with Julius CAESAR and Mark ANTONY, but she was defeated at ACTIUM. Her son, Ptolemy XV (whose father was probably Julius Caesar), was the last Ptolemy; he was killed by OCTA-VIAN (Augustus), and Egypt became a province of Rome.

Egyptian architecture Architecture developed since 3000 BC and characterized by post and lintel construction, massive walls covered with hieroglyphic and pictorial carving, flat roofs, and structures such as the mastaba, obelisk, pylon and the Pyramids. Houses were built of clay or baked bricks. Tombs and temples reproduced features of domestic architecture, but on a massive scale using permanent materials. Perhaps the great architects of the period was Imhotep.

▲ eel Moray eels (*Gymnothorax undulatus* and *G. favagineus*) are found in all tropical seas. They can inflict severe bites if disturbed.

Egyptian art (2686–2181 BC) Works were chiefly relief sculpture and painting, characterized by front and side views of the human figure, flat colour tones, symmetry in sculpture, and static figures. Relief-decorated private tombs and temples portrayed the daily life of subjects. With the decline of Egyptian power, distinctive national art declined, supplanted by Greek and Roman forms.

Egyptian mythology Polytheistic mythology that developed in small agricultural communities, each with its own local deities, united under the pharaohs. A vast pantheon of gods and a multiplicity of myths emerged. Each religious centre had its own creation myth justifying itself as the centre of existence. Although there is an account of the Flood, there is no EDEN, no past Golden Age or prediction of the end of the world.

Egyptology Study of ancient EGYPT, its people and its antiquities. Mystery still surrounds ancient EGYPTIAN ART AND ARCHITECTURE (such as the significance of the PYRAMIDS) and the primitive religion of its ancient peoples. Important landmarks include the discovery of the ROSETTA STONE, the temple of AMUN and tomb of TUTANKHAMUN at LUXOR, and the moving of the temples at ABU SIMBEL.

Ehrlich, Paul (1854-1915) German bacteriologist. He

shared with Ilya Metchnikoff the 1908 Nobel Prize for physiology or medicine for his work on immunization, which included the development of basic standards and methods for studying toxins and antitoxins, especially DIPHTHERIA antitoxins. His subsequent search for a "magic bullet" against disease, and his discovery of salvarsan (a chemical effective against syphilis microorganisms) introduced CHEMOTHERAPY. Eichmann, (Karl) Adolf (1906–62) Austrian Nazi, head of subsection IV-B-4 of the Reich Central Security Office in World War 2. He supervised fulfilment of the Nazi policies of deportation, slave labour, and mass murder in the CONCENTRATION CAMPS, which led to the death of some 6 million Jews. He escaped to Argentina in 1945, but was abducted by Israelis in 1960, and tried and executed in Israel.

eider Large sea DUCK found in N Europe and North America. Its down is used as a filling for pillows and quilts. In the breeding season the male grows striking black and white plumage. Family Anatidae; genus *Somateria*.

Eiffel Tower Landmark built for the Paris *Exposition* (1889). Designed by Alexandre Gustave Eiffel, the iron tower rises 300m (984ft). Lifts and stairs lead to observation platforms.

Einstein, Albert (1879–1955) US physicist, b. Germany,

▲ Einstein The great physicist, Albert Einstein, was forced to flee Nazi persecution (1933), and worked at Princeton, USA. He formulated the special theory of relativity and advanced quantum theory (1905). Most of his work was on unified field theory.

EGYPT

A flag consisting of three bands of red, white and black, the colours of the Pan-Arab movement, was adopted in 1958. The design includes a gold eagle in the centre: symbolizing Saladin, the warrior who led the Arabs in the 12th century.

AREA: 1,001,450sq km (386,660 sq mi)

POPULATION: 55,163,000

CAPITAL (POPULATION): Cairo (6,663,000)

GOVERNMENT: Republic

ETHNIC GROUPS: Egyptian 99%

LANGUAGES: Arabic (official), French, English RELIGIONS: Islam (Sunni Muslim 94%), Christianity (mainly Coptic Christian 6%) CURRENCY: Pound = 100 piastres

gypt is Africa's second most populous country (after Nigeria), and its capital, CAIRO, is Africa's largest city. ALEXANDRIA is Egypt's largest port. Most of Egypt is desert and almost all the people live either in the NILE valley and its fertile delta, or along the SUEZ CANAL, a vital artificial waterway between the Mediterranean and Red seas. The region N of Cairo is often called Lower Egypt; s of Cairo, Upper Egypt. On the Sudanese border, s of the ASWAN High Dam, lies Lake Nasser.

Egypt has three other, largely uninhabited, regions: the Western (Libyan) and Eastern (Arabian) deserts (parts of the Sahara), and the Sinal Peninsula, which contains Egypt's highest peak, Gebel Katherina, at 2,637m (8,650ft).

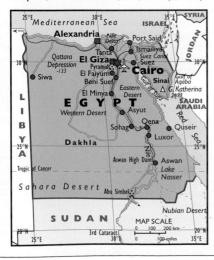

CLIMATE

Egypt is a dry country, and sparse rainfall occurs in winter. It has mild winters and hot summers.

VEGETATION

The Nile valley forms a long, green ribbon of fertile farmland. Dry landscape covers 90% of Egypt; the Western Desert alone covers c.75%.

HISTORY AND POLITICS

The Egyptian state was formed (c.3100 BC). The Old Kingdom saw the building of the PYRAMIDS at GIZA. The ruins of the Middle Kingdom's capital at Luxor bear testament to Egypt's imperial power (see EGYPT, ANCIENT). In 332 BC, it was conquered by Alexander the Great and the capital moved to ALEXANDRIA. After CLEOPATRA, the Roman empire was dominant. In AD 642, Egypt was conquered by the UMAYYAD dynasty, who were supplanted by the ABBASIDS. ARABIC became the official language and ISLAM the dominant religion. Under the FATIMIDS, Cairo became a centre of SHITTE culture. SALADIN'S rule (1169-93) was notable for the defeat of the Cru-SADES. His dynasty was overthrown (1250) by MAMELUKE soldier slaves. In 1517 Egypt was conquered by the OTTOMANS, who ruled for nearly three centuries. Egypt was occupied (1798-1801) by Napoleon I. France was expelled by MUHAMMAD ALI, who established the modern Egyptian state. The construction of the Suez Canal (1867) encouraged British imperial ambitions. Britain subdued Cairo (1882) and the British army remained even after Egypt became an independent monarchy under FUAD I (1922). Fuad was succeeded by FAROUK

(1936-52). The creation of Israel (1948) saw the involvement of Egypt in the first of the ARAB-ISRAELI WARS. In 1953 the monarchy fell, and Gamal Abdal NASSER led (1954-70) the new republic. Nasser's nationalization of the Suez Canal (1956) was briefly contested by Israel, Britain and France. In 1958 Egypt, Syria and Yemen formed the short-lived United Arab Republic. Nasser promoted Egypt as leader of the Arab world. Egypt was defeated by Israel in the Six Day War (1967). Nasser was succeeded by Anwar SADAT. After defeat in the Yom Kippur War (1973), Sadat signed the CAMP DAVID AGREEMENT (1979) with Israel. Israel withdrew from Sinai (1982). Egypt was expelled from the Arab League and Sadat was assassinated by Islamic extremists. Hosni MUBARAK became president (1981-). A state of emergency has been in force since 1981. Mubarak led Egypt back into the Arab League (1989) and improved relations with the West. In 1992 Muslim fundamentalists re-launched an armed struggle. Terrorist attacks included the massacre of 58 tourists in Luxor (1997), damaging the vital tourist industry.

ECONOMY

Egypt is Africa's second most industrialized country (after South Africa), but it remains a poor developing country (1992 GDP per capita, US\$3,540). In return for rescheduling its foreign debt, Egypt has undertaken privitizations. Farming employs 34% of the workforce. Egypt is the world's second-largest producer of dates. Buffalo and cotton are also important. Textiles are the second most valuable export (after oil).

ELECTRICITY SOURCES 12 13 10 11 17

A combined cycle power station burns gas to generate electricity. It is considerably more efficient than traditional fossil fuel power stations. The first turbine (1) sucks in air (2) compressing it before mixing it with the fuel (3) and burning the mixture (4). Exhaust gases spin a second turbine, connected to the first turbine and a generator (5). The energy of the gases is harnessed to power a second multiple turbine (6) connected to another generator (7). Gases are used to superheat water (8) looping through a special vessel (9). To maximize power generation, superheated steam (10) turns a high-pressure turbine (11), before passing (at a slightly lower temperature) into a lower-pressure turbine (12). Steam is fed into the turbine directly from the heating loops (13), and is cooled (14) before going back into the circuit.

who devised the famous theories of RELATIVITY. Einstein published many important theoretical papers: his explanation of Brownian Movement confirmed the reality of atoms, his application of Quantum theory to photoelectricity won him the 1921 Nobel Prize for physics. In 1905 he devised the special theory of relativity, which completely revolutionized physics and led, through its equivalence of Mass and Energy ($E=mc^2$), to the invention of the atomic bomb. In 1916 Einstein produced the general theory of relativity. He also made other fundamental contributions to quantum theory.

einsteinium (symbol Es) Radioactive, synthetic metallic element of the ACTINIDE SERIES. The isotope, Es²⁵³, was first identified in 1952 at the University of California at Berkeley; this was after it was found as a decay product of U²³⁸ produced by the first large hydrogen bomb explosion. Eleven isotopes have been identified. Properties: at.no. 99; most stable isotope Es²⁵⁴ (half-life 276 days). *See also* TRANSURANIC ELEMENTS

Eire See IRELAND, REPUBLIC OF Eisenhower, Dwight David ("Ike") (1890-1969) 34th US president (1953-61). Eisenhower served as aide (1935-40) to General MACARTHUR. As supreme commander of the Allied Expeditionary Force from 1943, he was largely responsible for the integration of Allied forces in the liberation of Europe. In 1950 he became Supreme Allied Commander (Europe) and helped establish the NORTH ATLANTIC TREATY ORGANIZATION (NATO). In 1952 Eisenhower gained the Republican Party nomination, and secured an easy victory over Adlai STEVEN-SON in the presidential election. Eisenhower enforced a prompt end to the KOREAN WAR and, with John Foster DULLES, established a staunchly anti-communist foreign policy. The domestic economy suffered under austerity budgets, but Eisenhower was resoundingly re-elected in 1956. In 1957 he ordered Federal troops into Little Rock, Arkansas, to end segregation in schools. His second term was marked by the escalation of the COLD WAR. Eisenhower was succeeded by John F. KENNEDY. Eisenstein, Sergei (1898-1948) Soviet film director. Although he completed just six films in 25 years, he is one of the most influential artists in the history of cinema. He developed a strong political and aesthetic style, enhanced by the use of creative editing for narrative and expressive effect. His

films include The Battleship Potemkin (1925) and October

(or Ten Days That Shook the World, 1928). See also MONTAGE

El Alamein Village in N Egypt. In October 1942, the British

8th Army (under General Montgomery) launched a successful attack on Axis forces here, and eventually drove them back to Tunisia. The battle was a turning point in the North Africa campaign of World War 2.

Elam Ancient country of Mesopotamia; the capital was Susa. Elamite civilization became dominant *c*.2000 BC, with the capture of Babylon. It continued to flourish until the Muslim conquest in the 7th century. Susa was an important centre under the Achaemenid kings of Persia and contained a palace of Darius I; archaeological finds include the stele of Hammurabi, inscribed with his code of law.

eland Largest living ANTELOPE, native to central and s Africa. Gregarious and slow-moving, elands have heavy, spiralled horns. Height: up to 1.8m (5.8ft) at the shoulder; weight: up to 900kg (1,984lb). Family Bovidae.

elasticity Capability of a material to recover its size and shape after deformation by STRESS and Strain. When an external force is applied, a material develops stress, which results in strain (a change in dimensions). If a material passes its elastic limit, it will not return to its original shape. See also HOOKE'S LAW

Elat (Eilat) Seaport town in s Israel, on the Gulf of AQABA. A popular holiday resort, it is also the site of an oil pipeline terminal. Its location close to the SINAI PENINSULA and its deep, manmade harbour make it a vital gateway for Israel's trade with Africa. Industries: fishing, tourism. Pop. (1990 est.) 26,000.

Elba Italian island in the Tyrrhenian Sea; largest of the Tuscan Archipelago; the chief port and town is Portoferraio. The island is mountainous, and a major supplier of iron ore. Napoleon I was exiled here (1814–15). Industries: fisheries, wine, tourism. Area: 223sq km (86sq mi). Pop. (1984 est.) 28,907.

Elbe River in central Europe. It rises as the Labe on the s slopes of the Riesengebirge in the Czech Republic, flows N and NW through Germany and enters the North Sea at Cuxhaven. Length: 1,167km (725mi).

Elbert, Mount Mountain in the Sawatch Range of the Rocky Mountain system, central Colorado, USA. It is the highest peak in the ROCKY MOUNTAINS, at 4,402m (14,433ft). **Elbrus, Mount** (Gora El'Brus) Two peaks in s European Russia, in the Caucasus range, on the border with Georgia. Extinct volcanoes, the w peak, rising to 5,633m (18,481ft), is the highest in Europe. The E peak is 5,595m (18,356ft) high. **elder** Shrub or small tree found in temperate and subtropical areas. It has divided leaves and clusters of small white flowers. Its small, shiny black berries are used for making wine, jelly and in medicine. There are 40 species. Family Caprifoliaceae, genus *Sambucus*.

El Dorado (Sp. The Golden One) Mythical city of fabulous wealth, supposedly located in the interior of South America, the focus of many Spanish expeditions in the 16th century.

electoral college Body, elected by the states, which casts the votes to elect the US president and vice president. The number of electors from each state equals the number of its representatives in both houses of Congress. In each state, people vote for a list of electors, each list representing a particular party. Therefore, a party wins all or none of a state's electoral votes.

Electra In Greek Mythology, the daughter of Agamemnon and Clytemnestra. She helped her brother Orestes avenge their father's death by plotting to kill Clytemnestra and their step-father Aegisthus.

Electra complex See OEDIPUS COMPLEX

electric charge Quantity of ELECTRICITY. Electric charges (measured in coulombs) are either positive or negative. They can be stored on insulated metal spheres (VAN DE GRAAFF GENERATOR), insulated plates (CAPACITOR) or in chemical solutions (electric BATTERY).

electric current Movement of ELECTRIC CHARGES, usually the flow of ELECTRONS along a CONDUCTOR or the movement of ions through an ELECTROLYTE. Current (symbol *I*) flows from a positive to a negative terminal, although electrons actually flow along a wire in the opposite direction. It is measured in AMPERES. Direct current (DC) flows continuously in one direction, whereas alternating current (AC) regularly reverses direction. The frequency of AC current is measured in HERTZ (Hz). See also ELECTRICITY

electric field (electrostatic field) Region around an ELECTRIC

▲ elder Native to Europe, the elder (family Caprifoliaceae, commonly honeysuckle) grows to a height of 12m (40ft). In early summer, the tree bears clusters of white flowers. The species shown here is Sambucus nigra.

CHARGE in which any charged particle experiences a force. The strength of the field (E) upon unit charge at a distance r from a charge Q is equal to $Q/4\pi r^2$ E, where E is the permittivity (degree to which molecules polarize). A changing MAGNETIC FIELD can also create an electric field.

electric furnace Enclosure heated to a very high temperature by an ELECTRIC CURRENT. Electric furnaces are used in industry for melting metals and other materials. Three main methods of heating are used: striking an ARC between electrodes in the furnace; producing currents in the material by ELECTROMAGNETIC INDUCTION; and passing a high current through the material, heat being produced because of its RESISTANCE.

electricity Form of energy associated with static or moving charges. Charge has two forms - positive and negative. Like charges repel, and unlike attract; as described by Charles COULOMB in Coulomb's law. ELECTRIC CHARGES are acted upon by forces when they move in a MAGNETIC FIELD, this movement generates an opposing magnetic field (FARADAY'S LAWS). Electricity and MAGNETISM are different aspects of ELEC-TROMAGNETISM. The flow of charges constitutes a current, which in a CONDUCTOR consists of negatively charged ELEC-TRONS. For an ELECTRIC CURRENT to exist in a conductor there must be an ELECTROMOTIVE FORCE (EMF) or POTENTIAL DIFFER-ENCE between the ends of the conductor. If the source of potential difference is a BATTERY, the current flows in one direction as a direct current (DC). If the source is the mains, the current reverses direction twice every cycle, as alternating current (AC). The AMPERE is the unit of current, the coulomb is the unit of charge, the OHM the unit of RESISTANCE and the VOLT is the unit of ELECTROMOTIVE FORCE. OHM'S LAW and the laws of KIRCHHOFF are the basic means of calculating circuit values.

electricity sources Devices that convert other forms of energy into ELECTRICITY. Most of the world's electricity is produced in power stations from the chemical energy of fossil fuels. The heat from burning coal, oil or natural gas turns water into steam. The steam drives a TURBINE, linked to an electricity GENERATOR. In a nuclear power station, heat comes from the FISSION of nuclei in a NUCLEAR REACTOR. A BATTERY and fuel cell converts chemical energy directly into electricity. SOLAR CELLS convert SOLAR ENERGY into electricity. Wind generators and water turbines produce electricity from the

ELECTRIC MOTOR

Electric motors work using the interaction of a magnet (1) and a wire with a current passing through it (2). With the current flowing, the magnetic field produced by the loop interacts with the field of the magnet. A downward force acts on the right side, an upward force on the left side. When the loop reaches the

vertical the split ring (through which the current reaches the loop) (3) reverses the current and so the magnetic field. Electric motors use multiple coils (4) to ensure constant torque. In an electric drill, the turning shaft (5) emerges from the magnetic coils and is then geared (6) through to a chuck (7) to the drill bit (8).

energy of movement in wind and water. *See also* ENERGY SOURCES; HYDROELECTRICITY; RENEWABLE ENERGY **electric light** Artificial light produced by a flow of electric-

ity in a wire or gas. In an ordinary light bulb, light is produced

by INCANDESCENCE when a filament, such as tungsten-alloy wire, is heated by an electric current. In a fluorescent tube, the ELECTRIC CURRENT passes through a gas. The gas atoms give off invisible ultraviolet rays. These strike a coating on the inside of the tube, causing it to emit light by FLUORESCENCE. electric motor Machine that converts electrical energy into mechanical energy. In a simple form of electric motor, an ELECTRIC CURRENT powers a set of ELECTROMAGNETS on a rotor in the MAGNETIC FIELD of a permanent MAGNET. Magnetic forces between the permanent magnet and the electromagnet cause the rotor to turn. Electric motors are convenient and relatively quiet, and have replaced many other forms of motive power. They may use alternating current (AC) or direct current (DC). electrocardiogram (ECG) Recording of the electrical activity of the heart traced on a moving strip of paper by an

electrochemistry Branch of chemistry concerned with the relationship between ELECTRICITY and chemical changes. It includes the properties and reactions of IONS in solution, the CONDUCTIVITY of ELECTROLYTES and the study of the processes occurring in electrochemical cells and in ELECTROLYSIS.

electrocardiograph. It is used to diagnose heart disease.

electroconvulsive therapy (ECT) Treatment of mental disturbance by means of an electric current passed via ELECTRODES to one or both sides of the brain to induce convulsions. Given under anaesthesia, it is recommended mainly for severe DEPRESSION that has failed to respond to other forms of treatment. It can produce unpleasant side-effects, such as confusion, memory loss and headache. There is continuing controversy about its use and effectiveness.

electrocution Death caused by the passage of an ELECTRIC CURRENT through the body. The current may come from a low- or (more often) a high-voltage source, or from lightning. A major shock either causes chaotic disruption of the heartbeat (fibrillation) or stops the heart completely, in which case breathing also ceases. Severe burns may be visible where the current has entered the body and also at its point of exit.

electrode Conductor, usually a wire or rod, through which an ELECTRIC CURRENT flows into or leaves a medium. In ELECTROLYSIS, two electrodes – a positive (ANODE) and a negative (CATHODE) – are immersed in an ELECTROLYTE.

electroencephalogram (EEG) Recording of electrical activity of the brain. Electrodes are attached to the scalp to pick up the tiny oscillating currents produced by brain activity. It is used mainly in the diagnosis and monitoring of EPILEPSY. electrolysis Chemical reaction caused by passing a direct current (DC) through an ELECTROLYTE. This results in positive IONS migrating to the negative ELECTRODE (CATHODE) and negative ions migrating to the positive electrode (ANODE). Electrolysis is an important method of obtaining chemicals, particularly reactive elements such as sodium, magnesium, aluminium and chlorine. A commercial use is in ELECTROPLATING.

electrolyte Solution or molten salt that can conduct ELECTRICITY, as in ELECTROLYSIS. In electrolytes, current is carried by IONS, rather than by ELECTRONS. In a lead-acid car battery, the electrolyte is dilute sulphuric acid, which contains negative sulphate ions and positive hydrogen ions.

electromagnet Magnet constructed from a soft iron core around which is wound a coil of wire. A MAGNETIC FIELD is set up when an ELECTRIC CURRENT is passed through the wire. electromagnetic force One of the four FUNDAMENTAL FORCES. Within an atom, the electromagnetic force binds the negatively charged electrons to the positively charged nucleus. See also GRAND UNIFIED THEORY (GUT); UNIFIED FIELD THEORY electromagnetic induction Use of MAGNETISM to produce an ELECTROMOTIVE FORCE (EMF). If a bar magnet is pushed through a wire coil, an ELECTRIC CURRENT is induced, in the coil, as long as the magnet is moving. By the same principle, an electric current is induced in the the coil if it is rotated around the magnet, as in a DYNAMO, ELECTRIC MOTOR or transformer. See also INDUCTANCE; INDUCTION

electromagnetic radiation Energy in the form of waves.

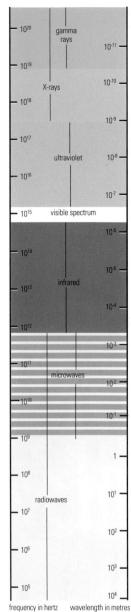

▲ electromagnetic radiation

can be ordered by either frequency or wavelength, to make up the electromagnetic spectrum. It ranges from low-frequency (high-wavelength) radio waves, through microwaves, infrared waves, light (the visible spectrum – red, orange, yellow, green, blue, indigo and violet), continues through ultraviolet waves and x-rays, to very high-frequency (short wavelength) gamma rays.

It travels through empty space at the speed of light, nearly 300,000km (186,000mi) per second. In general, electromagnetic waves are set up by electrical and magnetic vibrations that occur universally in ATOMS. These waves, which make up the **electromagentic spectrum**, range from low-frequency radio waves, through the visible spectrum to very high-frequency gamma rays. They can undergo REFLECTION, REFRACTION, INTERFERENCE, DIFFRACTION and polarization. Other phenomena, such as the absorption or emission of light, can be explained only by assuming the radiation to be composed of PHOTONS rather than waves.

electromagnetism Branch of physics dealing with the laws and phenomena that involve the interaction or interdependence of ELECTRICITY and MAGNETISM. The region in which the effect of an electromagnetic system can be detected is known as an electromagnetic field. When a magnetic field changes, an ELECTRIC FIELD can always be detected. When an electric field varies, a magnetic field can always be detected. Either type of energy field can be regarded as an electromagnetic field. A particle with an ELECTRIC CHARGE is in a magnetic field if it experiences a force only while moving; it is in an electric field if the force is experienced when stationary.

electromotive force (emf) Potential difference between the terminals in a source of ELECTRIC CURRENT, measured in

volts. It is equal to the energy liberated when this voltage drives the current round an electric circuit. See also ELECTRICITY electron (symbol e) Stable elementary particle with a negative charge and a rest mass of 9.1×10^{-31} kg. Identified in 1879 by J.J. Thomson, electrons are constituents of matter, moving around the NUCLEUS of an atom in complex orbits. In a neutral atom, the electrons' total negative charge balances the positive charge of the PROTONS in the nucleus. Removal or addition of an atomic electron produces a charged Ion. CHEMICAL BONDS are formed by the transfer or sharing of electrons between atoms. When not bound to an atom, electrons are responsible for electrical conduction. Beams of electrons are used in electronic devices, such as TELEVISION tubes, OSCILLOSCOPES and ELECTRON MICROSCOPES. An electron is classified as a LEPTON. Its antiparticle is the POSITRON.

electronic mail (e-mail) Correspondence sent via a COMPUTER NETWORK. In a simple system, messages produced using word-processing programs are transmitted over a network (such as a local-area network or the INTERNET) and stored in a computer called a mail server. People connected to the network can contact the mail server to collect their mail and transfer it to their own computer.

electronic music Music in which electronic methods are used to generate or modulate sounds. The first pieces, produced on tape recorders, were composed in the 1920s. The post-1945 development of tapes, stimulated more complex electronic music. In Paris, Pierre Schaeffer and Pierre Henry experimented with the manipulation of recorded sounds, producing one of the first major works, *Symphonie pour un homme seul* (1950). In Germany, electronic sound sources were explored by composers such as Karel Goeyvaerts. The invention of the Synthesizer, capable of generating required sounds and modulating other sounds, inspired many composers, particularly Karlheinz Stockhausen. In the 1960s, it became possible to use computers in the manipulation of complex electronic sounds; Yannis Xenakis and Pierre Boulez are two of the many composers to have used computers in the compositional process.

electronic publishing Production of publications by electronic means, generally using a COMPUTER. During production, word-processing and graphics PROGRAMS are used to assemble "pages" on a computer screen. The publication may be printed on paper or produced as a CD-ROM.

electronics Study and use of CIRCUITS based on the conduction of electricity through valves and semiconducting devices. The DIODE valve, invented by John FLEMING, and the triode valve, invented by Lee DE FOREST, provided the basic components for all the electronics of radio, television and radar until the end of World War 2. A major revolution occurred in 1948, when a team led by William SHOCKLEY produced the first semiconducting TRANSISTOR. SEMICONDUCTOR devices do not require the high operating voltages of valves and can be miniaturized as an INTEGRATED CIRCUIT (IC). This has led to the production of electronic COMPUTERS and automatic control devices, which have changed the face of both industry and scientific research. See also MICROELECTRONICS; PRINTED CIRCUIT electron microscope MICROSCOPE used for producing an image of a minute object. It "illuminates" the object with a stream of electrons, and the "lenses" consist of magnets that focus the electron beam. Smaller objects can be seen, because electrons have shorter wavelengths than light and thus provide greater resolution. The image is obtained by converting the pattern (made by electrons passing through the object) into a video display, which may be photographed. These microscopes can magnify from 2,000 to a million times.

electrophoresis Movement of electrically charged colloidal particles through a fluid from one ELECTRODE to another when a voltage is applied across the electrodes. It is used in the analysis and separation of colloidal suspensions, especially colloidal proteins. *See also* COLLOID

electroplating Deposition of a coating of metal on another by making the object to be coated the CATHODE in ELECTROLY-SIS. Positive ions in the ELECTROLYTE are discharged at the cathode and deposited as metal. Electroplating is used to produce a decorative or corrosion-resistant layer, as in silver-plated tableware and chromium-plated motor-car parts.

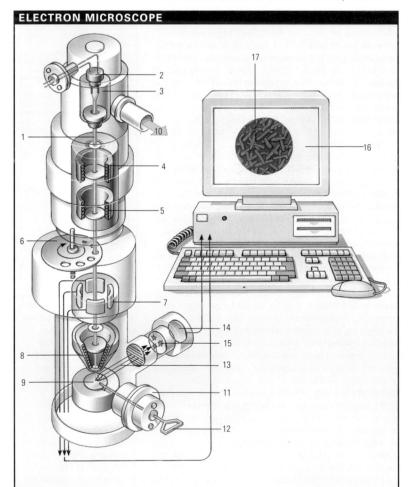

In an electron microscope, a beam of electrons (1) streams from the heated tungsten cathode (2) of an electron gun (3, and is focused by upper (4) and lower (5) electromagnetic lenses. It then passes through an aperture ring (6) and a scan coil (7) before being focused by a projector lens (8) onto the

sample (9). The process takes place in a vacuum with air evacuated (10) by a pump. A computer controls the scan coil, which directs the beam across the sample. The sample is placed in an airlock (11) and manipulated into position (12). An image of the sample is created by detecting electrons

dislodged (13) from the sample. These electrons correlate to the topography of the sample and are measured by a flash detector (14) when they hit a fluorescent target (15). The image is displayed on a computer monitor (16): here Lactobacillus bulgaricus magnified 1,000 times (17).

■ elephant Over many

thousands of years, the

numerous front teeth of the

elephant have been reduced to

two upper incisors which form

has extended to form the trunk.

africana) was once found over

much of the continent, but it is

now relatively rare due to

destruction of its habitat

and hunting for its ivory.

two long tusks, and the nose too

The African elephant (Loxodonta

electroscope Instrument for detecting the presence of an ELECTRIC CHARGE or radiation. The commonest type is the gold-leaf electroscope, in which two gold leaves hang from a conducting rod held in an insulated container. A charge applied to the rod causes the leaves to separate, and the amount of separation indicates the amount of charge.

electrostatics See STATIC ELECTRICITY

element Substance that cannot be split into simpler substances by chemical means. All atoms of a given element have the same ATOMIC NUMBER (at.no.) and thus the same number of PROTONS and ELECTRONS. The atoms can have different ATOMIC MASS NUMBERS and a natural sample of an element is generally a mixture of ISOTOPES. The known elements range from hydrogen (at.no. 1) to unnilenium (at.no. 109); elements of the first 95 atomic numbers exist in nature, the higher numbers have been synthesized. See also PERIODIC TABLE

element 104 (dubnium, symbol db) Radioactive synthetic element with ATOMIC NUMBER 104, the first of the transactinide series. The longest-lived of its ten ISOTOPES has a half-life of 70 seconds. Previously named "unnilquadium", "dubnium" was adopted in 1995 over the proposed US name of "Rutherfordium" (symbol Rf) and Russia's proposal of "Kurchatovium" (symbol Ku).

element 105 Radioactive synthetic element with ATOMIC NUMBER 105; six isotopes have been synthesized. It was first reported by a Soviet team at the Joint Institute for Nuclear Research at Dubna. They claimed the isotopes of mass numbers 260 and 261, as a result of bombarding americium with neon ions. In 1970 a team at the University of California at Berkeley claimed the isotope 260, obtained by bombarding californium with nitrogen nuclei. The names hahnium and unnilpentium (symbol Unp) have been suggested.

elementary particle In physics, a SUBATOMIC PARTICLE that cannot be subdivided. Such particles are the basic constituents of matter. There are three groups of elementary particles: QUARKS, LEPTONS (light particles) and gauge BOSONS (messenger particles). All elementary particles have an associated antiparticle.

elephant Largest land animal, the only living member of the mammal family Proboscidea. It is native to Africa (*Loxodonta africana*) and India (*Elephas maximus* or *E. indicus*). A bull elephant may weigh as much as 7,000kg (15,400lb). They are herbivores, and browse in herds, each elephant eating about 225kg (100lb) of forage daily. The tusks, the source of ivory, are elongated upper incisors. The trunk is an elongated nose and upper lip; at its tip are nostrils and finger-like projections. **elephantiasis** Condition in which there is gross swelling of the tissues due to blockage of lymph vessels. It is usually caused by parasitic worms, as in FILARIASIS.

Eleusinian Mysteries Religious rites performed in ancient Greece at Eleusis, Attica, to honour Demeter and Persephone. The rites probably arose out of a rural fertility festival. Elgar, Sir Edward (1857–1934) English composer. Elgar wrote two symphonies, a violin concerto, a cello concerto and several orchestral and choral works, the grandest of which is the *Dream of Gerontius* (1900). His most popular works include "Land of Hope and Glory", one of the five *Pomp and Circumstance* marches (1901–30), and *Variations* on an Original Theme (1899), popularly known as *Enigma Variations*.

Elgin Marbles Group of sculptures from the Acropolis of Athens, including sculptures of the Parthenon. They were collected by the 7th Earl of Elgin, sold to the British Government in 1816, and are now on display in the British Museum, London. The Greek government has campaigned for their return.

Elijah Old Testament prophet who appeared in Israel in the 9th century BC and attacked the Phoenician cult of Baal (1 Kings 17, 2 Kings 2). The rites associated with Baal were being promoted at the expense of the native cult of YAHWEH. Elijah, aided by ELISHA, set out to prove that there was no God but Yahweh.

Eliot, Charles William (1834–1926) US educator. President (1869–1909) of Harvard University, he began editing the 50-volume *Harvard Classics*, an anthology of world literature. Eliot, George (1819–80) British novelist, b. Mary Ann Evans. Influenced by her relationship with G.H. LEWES, her

first fiction publication was the collected stories, *Scenes of Clerical Life* (1858). Her novels, all intensely moral, depict the provincial middle classes; examples are *Adam Bede* (1859), *The Mill on the Floss* (1860), *Silas Marner* (1861), the masterpiece *Middlemarch* (1871–72) and *Daniel Deronda* (1876).

Eliot, John (1604–90) American missionary, b. England. He travelled to Massachusetts (1631) as the first Christian missionary in New England. He became known as the "Apostle of the Indians" for his evangelistic work.

Eliot, T.S. (Thomas Stearns) (1888–1965) British poet, playwright and critic, b. USA. His poem *The Waste Land* (1922), with its complex language and bleak view of contemporary life, is one of the keystones of literary MODERNISM. Later poems, notably *Ash Wednesday* (1930) and the *Four Quartets* (1935–43), held out hope through religious faith. An influential literary critic, Eliot also wrote verse plays, including *Murder in the Cathedral* (1935) and *The Cocktail Party* (1950). His children's poems, *Old Possum's Book of Practical Cats* (1939), formed the basis for the musical *Cats*. He was awarded the 1948 Nobel Prize for literature.

Elisha Old Testament prophet of Israel, disciple and successor of ELIJAH (2 Kings 2–13). He appeared in the 9th century BC and accomplished the destruction of the Phoenician cult of Baal. Elisha is portrayed as a miracle-worker, healer and fulfiller of God's commissions to his master Elijah.

Elizabeth (1709–62) Empress of Russia (1741–62). The daughter of Peter I (THE Great), she came to the throne after overthrowing her nephew, Ivan VI. She reduced German influence in Russia, waged war against Sweden (1741–43) and annexed the southern portion of Finland (1743). A great patron of the arts, she was succeeded by her nephew, Peter III. Elizabeth I (1533–1603) Queen of England (1558–1603), daughter of Henry VIII and Anne Boleyn. During the reigns of EDWARD VI and MARY I, her half-brother and half-sister, she avoided political disputes. Once crowned, she reestablished

■ Elizabeth I Her rule was a "Golden Age" of increasing prosperity and a flowering of the arts. Elizabeth I became known as "Good Queen Bess" or the "Virgin Queen". Throughout her reign friction with Spain grew, culminating in the Armada, and there were attempts to place the Catholic Mary, Queen of Scots on the throne.

After three weeks a human embryo bears a primitive heart and head (A). By the fourth week, the heart is pumping blood around the body and into the placenta and 25 pairs of tissue blocks (somites) appear, which later give rise to bone and muscle tissue (B). After five weeks. limb buds and rudimentary eyes are visible (C). The limbs become well developed and the tail region recedes by the sixth week (D). The head grows rapidly, eyes, ears and teeth buds appear by the seventh week (E). The tail portion vanishes and almost all the organs and tissues have developed by the eighth week (F). It is now known as a fetus.

Protestantism. The Elizabethan Settlement saw the Church of ENGLAND adopt the 39 Articles (1571). Various plots to murder Elizabeth and place the Catholic MARY, QUEEN OF SCOTS on the throne resulted in Mary's imprisonment and execution (1587), and increasing discrimation against Catholics. Elizabeth adhered to a small group of advisers, such as Lord BURGHLEY and Sir Francis WALSINGHAM. For most of her reign, England was at peace and commerce and industry prospered. ELIZA-BETHAN DRAMA, and the arts in general, reflected this "golden age". The expansion of the navy saw the development of the first British Empire. The hostility of Catholic Spain eventually resulted in war and the defeat of the Spanish ARMADA (1588). Despite pressure to marry, Elizabeth remained single. The end of her reign was marred by an uprising led by the 2nd Earl of ESSEX. Elizabeth was the last of the TUDORS, and the throne passed to the JAMES I, a STUART.

Elizabeth II (1926—) Queen of Great Britain and Northern Ireland (1952—), daughter and successor of George VI. Elizabeth married Phillip Mountbatten in 1947, and the couple had four children, Charles (Prince of Wales), Anne, Andrew and Edward. Her coronation (June 2, 1953) was the first to be televised. Elizabeth travels extensively, especially in the Commonwealth. Her Silver Jubilee year (1977) was marked by mass popular celebration. Expanded media coverage demystified the monarchy and encouraged criticism of her personal wealth (1994 est. £5 billion), and the behaviour of the younger royals. In 1993 she voluntarily agreed to pay income tax. The marriage failures of her children, particular that of Charles and DIANA, PRINCESS OF WALES, intensified public criticism.

Elizabeth (1900–) (Queen Mother) British queen consort of GEORGE VI, b. Lady Bowes-Lyon. Elizabeth married George in 1923. They had two children, Elizabeth (later ELIZABETH II) and Margaret (later Princess Royal). In 1936 she unexpectedly became queen when George's elder brother, EDWARD VIII, abdicated. A popular figure, she continued to perform public duties into her nineties.

Elizabethan drama Drama staged in England during the reign of ELIZABETH I (1558–1603). Drawing on classical and medieval thought, as well as folk drama, Elizabethan drama is characterized by a spiritual vitality and creativity. Masters of the period include SHAKESPEARE, MARLOWE and JONSON.

elk Name of two different species of DEER: the European elk (*Alces alces*), known in North America as the moose; and the American elk, or WAPITI. The elk, found in N Eurasia, is the largest of all deer. Height at the shoulder: to 1.9m (6ft); weight: 820kg (1,800lb). Family Cervidae.

Ellesmere Island Mountainous island in the Arctic Ocean, NW of Greenland, forming part of the Northwest Territories of Canada. It is the second largest and northernmost island of the Arctic Archipelago. Area: 196,236sq km (75,767sq mi).

Ellice Islands Former name of TUVALU

Ellington, "Duke" (Edward Kennedy) (1899-1974) US jazz composer, pianist and bandleader. Ellington's early pieces, performed (1927-32) at the Cotton Club, Harlem, New York, include "Black and Tan Fantasy" (1927) and "Mood Indigo" (1930). His extended compositions include Creole Rhapsody (1932). The "jungle" style gave way to the elegance of the Blanton-Webster years (1939-42), and standards such as "Take the A Train" and "I Got It Bad". Black, Brown and Beige (1943) was written for a concert at Carneige Hall, Ellington also wrote the score for the film Anatomy of a Murder (1959). ellipse Conic section formed by cutting a right circular cone with a plane inclined at such an angle that the plane does not intersect the base of the cone. When the intersecting plane is parallel to the base, the conic section is a circle. In rectangular Cartesian coordinates its standard equation is $x^2/a^2 + v^2/b^2$ = 1. Most planetary orbits are ellipses.

Ellis Island Island in Upper New York Bay, near Manhattan, SE New York, USA. It acted as the main US immigration centre (1892–1943); at the height of immigration it was handling one million applicants annually. From 1943 to 1954 it was a detention centre for aliens and deportees. It is estimated that over 20 million immigrants entered via Ellis Island. The Ellis Island Immigration Musuem was opened in 1990. Area: 11ha (27 acres).

Ellison, Ralph Waldo (1914—) US novelist, short story writer and essayist. He won international fame for his semi-autobiographical first novel, *Invisible Man* (1952). The book deals with the prejudice faced by a young African-American. elm Hardy, DECIDUOUS tree of N temperate zones. The simple leaves are arranged alternately along the stem, and the flowers are greenish and inconspicuous. Species include the American (*Ulmus americana*), English (*U. procera*) and Scotch elm (*U. glabra*). Height: over 30m (100ft). Family Ulmaceae.

El Niño (Sp. Christ Child) Warm surface current that sometimes flows in the equatorial Pacific Ocean towards the South American coast. It occurs approximately every 7–11 years around Christmas time. The flow of warm water prevents plankton-rich cold water from the Antarctic rising to the surface off the coasts of Peru and Chile. As a result, fish do not come to feed and local fishermen make no catches. The current is associated with short-term changes in worldwide climate patterns, and may cause drought in places such as Australia, India, Central America, and s Africa; flooding and severe winters in Central and North America; and violent tropical cyclones in the Pacific and Indian oceans

El Salvador Republic in Central America. *See* country feature **Elysium** In Greek mythology, the Elysian fields. The abode of blessed mortals after their removal from the Earth, it is the realm to which heroes departed to live a life of happiness.

Emancipation Proclamation Declaration of Abraham LINCOLN freeing slaves in the CONFEDERATE STATES of America, 1 January 1863. Lincoln's primary aim was to preserve the union. The Proclamation, which he announced in September 1862, had little immediate effect, but did establish the abolition of SLAVERY as a Union war aim. Slavery was abolished totally by the 13th Amendment to the Constitution (December 1865). embargo Obstruction of the movement of cargo to prevent its delivery. In modern terms, it refers to complete suspension of trade with a country or withholding crucial goods.

Embargo Act (1807) Act passed under President JEFFERSON to force England and France to remove restrictions on US trade. It forbade international trade to and from US ports.

embolism Blocking of a blood vessel by an obstruction called an embolus, usually a blood clot, air bubble or particle of fat. The effects depend on where the embolus lodges; a cerebral embolism causes a STROKE. Treatment is with anticoagulants or surgery. *See also* ARTERIOSCLEROSIS

embroidery Decorative needlework (specifically stitching) on cloth. An ancient art, sometimes used to depict historic events, such as the BAYEUX TAPESTRY. During the Renaissance, embroidery was an important art of many royal courts. There was also a tradition of rural and folk embroidery, particularly in E Europe and in the quilting of early English settlers in N America. Most of today's fabrics are embroidered using machines.

embryo Early developing stage of an animal or plant. In animals, the embryo stage starts at FERTILIZATION, and ends when the organism emerges from the egg or from its mother's UTERUS. In plants, the embryo is found in the seed and the embryo stage ends on GERMINATION. An embryo results when the nuclei of an EGG and a SPERM fuse to form a single cell, called a ZYGOTE (fertilized egg). The zygote then divides into a ball of cells called an embryo. The embryo undergoes rapid changes in which the cells differentiate themselves to form features, such as limbs and organs. *See also* MEIOSIS; MITOSIS **embryology** Biological study of the origin, development and activities of an EMBRYO.

emerald Variety of BERYL, highly valued as a gemstone. The colour varies from light to dark green due to the presence of small amounts of chromium.

Emerson, Ralph Waldo (1803–82) US essayist and poet. He was an exponent of TRANSCENDENTALISM, the principles of which are expressed in his book *Nature* (1836). His belief in the soul, the unity of God with man and nature, self-reliance and hope is articulated in his *Essays* (1841, 1844), *Poems* (1847), *The Conduct of Life* (1860), *Society and Solitude* (1870) and many other influential works.

Emilia-Romagna Region in N central Italy, bordering the Adriatic Sea; the capital is BOLOGNA. It was incorporated in the kingdom of Italy in 1860. The N part of Emilia-Romagna forms a vast plain. In the s lies the central part of the APEN-NINES, from which flow its main rivers. Agriculture is important, products include cereals, rice, vegetables and dairying. Industries: tourism, motor vehicles, refined petroleum, chemicals. Area: 22,124sq km (8,542sq mi). Pop. (1991) 3,909,512. Empedocles (490–430 BC) Greek scientist and philosopher. He taught the doctrine of the four elements (earth, water, air and fire) and, anticipating modern physics, he explained change as alterations in the proportions of these four elements. emphysema Accumulation of air in tissues, most often occurring in the lungs (pulmonary emphysema). Pulmonary emphysema, characterized by marked breathlessness, is the result of damage to and enlargement of the ALVEOLUS. It is associated with chronic bronchitis and smoking.

Empire State Building Skyscraper in New York. Completed in 1931, it was the highest building in the world until 1972. It is 381m (1,250ft) tall, or 449m (1,472ft) to the top of its television mast. Its name derives from the nickname of New York State, USA.

EL SALVADOR

This flag was adopted in 1912, replacing the earlier "Stars and Stripes". The blue and white stripes are featured on the flags of several Central American countries which gained their independence from Spain at the same time in 1821.

AREA: 21,040sq km (8,124sq mi)

POPULATION: 5,047,925

CAPITAL (POPULATION): San Salvador (422,570)

GOVERNMENT: Republic

ETHNIC GROUPS: Mestizo 89%, Native American 10%, White 1%

LANGUAGES: Spanish (official)

RELIGIONS: Christianity (Roman Catholic 94%)
CURRENCY: Colón = 100 centavos

El Salvador is the smallest and most densely populated country in Central America. It has a narrow coastal plain along the Pacific Ocean. The majority of the interior is mountainous with many extinct volcanic peaks, overlooking a heavily populated central plateau. Earthquakes are common; in 1854 an earthquake destroyed the capital, SAN SALVADOR, and another in October 1986 killed 400 people and caused widespread damage.

CLIMATE

The coast has a hot tropical climate. Inland, the climate is moderated by altitude. There is a wet season between May and October.

VEGETATION

Grassland and some virgin forests of original oak and pine are found in the highlands. The central plateau and valleys have areas of grass and deciduous woodland, while coastal regions are covered by tropical savanna or forest.

HISTORY AND POLITICS

In 1524–26, the Spanish explorer Pedro de Alvarado conquered Native American tribes such as the Pipil, and the region became part of the Spanish viceroyalty of Guatemala. Independence was achieved (1821), and in 1823 El Salvador joined the Central American Federation. The federation was dissolved in 1839. El Salvador declared its independence in 1841, but was continually subject to foreign interference (especially from Guatemala and Nicaragua). El Salvador's coffee plantations were developed.

Following a collapse in the world coffee market, Maximiliano Hernández Martínez seized power in a palace coup (1931). His brutal dictatorship was overthrown by a general strike (1944). A period of progressive government was followed by a military junta headed by Julio Adalberto Rivera (1962-67) and Fidel Sánchez Hernández (1967-72). Border tension with Honduras was exacerbated by Honduras' discriminatory immigration laws. The "Soccer War" (1969) broke out following an ill-tempered World Cup qualifying match between the two countries. Within four days, El Salvador had captured much of Honduras. A ceasefire was announced and the troops withdrew. In the 1970s El Salvador's problems of overpopulation, unequal distribution of wealth and social unrest were compounded by the repressive National Republican Alliance (ARENA) regime. Civil war broke out in 1979 between US-backed government forces and the Farabundo Marti National Liberation Front (FMLN). The 12-year war claimed 75,000 lives and caused mass homelessness. A cease-fire came

into effect in 1992, and the FMLN became a recognized political party. In 1993 a UN Truth Commission led to the removal of senior army officers for human rights abuses, and FMLN arms were decommissioned. In 1994 Armando Calderón Sol of the ruling ARENA party was elected president.

ECONOMY

El Salvador is a lower-middle-income developing country (1992 GDP per capita, US\$2,250). Farmland and pasture account for c.60% of land use. El Salvador is the world's 10th largest producer of coffee. Its reliance on the crop has caused profound economic structural imbalance. The Salvadorean Coffee Company is being privatized. Sugar and cotton are grown on the coastal lowlands. Fishing is important, but manufacturing is small scale. The civil war has devastated the economy. Between 1993 and 1995 El Salvador received over US\$100 million of credit from the IMF.

Francisco Antonio Gavidia, the El Salvadorean philosopher and humanist, was celebrated by a set of six stamps issued in 1965.

▲ Engels A founder of 19th century communism, Friedrich Engels' success in the textile industry helped finance the work of Karl Marx, and they collaborated on the *Communist Manifesto* (1848). Engels work on dialectical materialism informed much subsequent Marxist philosophy. *The Origin of the Family, Private Property and the State* (1884) is a seminal work.

Empire style Neo-classical style in interior decoration, associated with the reign of NAPOLEON I. It made affected use of Egyptian decorative motifs and corresponded to the REGENCY STYLE in England.

empiricism Philosophical doctrine that all knowledge is derived from experience. It was developed mainly by a school of British philosophers, Locke, Berkeley and Hume, in reaction to the RATIONALISM of DESCARTES, SPINOZA and LEIBNIZ, who claimed the existence of *a priori* knowledge (innate ideas). See also LOGICAL POSITIVISM

Empson, William (1906–84) British poet and critic. He expanded the ideas of I.A. RICHARDS in the *Seven Types of Ambiguity* (1930). He wrote detailed analyses of specific texts, a technique that became known as the New Criticism. Empson's other critical works include *The Structure of Complex Words* (1951) and *Milton's God* (1961).

emu Large, dark-plumed, flightless Australian bird. It is a strong runner with powerful legs. Large greenish eggs (8–10) are hatched by the male in a ground nest. Height: 1.5m (5ft); weight: to 54kg (120lb). Species *Dromaius novaehollandiae*. emulator Computer configured in such a way that it acts like another type of computer. Emulators are often used in the development of new microprocessors, allowing a designer to assess a new design without building an expensive prototype. enamel Decorative or protective glazed coating produced on metal surfaces, or a type of paint. Ceramic enamels are made from powdered glass and calx, with metal oxides to add colour. Enamel paints consist of zinc oxide, lithopone and high-grade varnish. The finish is hard, glossy and highly durable.

encephalitis Inflammation of the brain, usually associated with a viral infection; often there is an associated MENINGITIS. Symptoms include fever, headache, lassitude and intolerance of light; in severe cases there may be sensory and behavioural disturbances, paralysis, convulsions and coma. The disease is diagnosed by tests on CEREBROSPINAL FLUID.

enclosure In European history, the fencing-in by landlords of common land. Complaints against this practice date from the 13th century. Enclosure usually led to increased agricultural productivity at the cost of depriving people of free grazing and firewood. It was a cause of popular rebellions, especially in the 16th century. The AGRICULTURAL REVOLUTION of the 18th century produced another spurt of enclosure.

encyclical Letter addressed by the Pope to all members of the Roman Catholic Church. Recent encyclicals have condemned contraception (Paul VI, 1968) and ecumenism (John Paul II, 1995).

endangered species Animals or plants threatened with extinction as a result of such activities as habitat destruction and overhunting. Nearly 1,000 animals and 20,000 plants are considered endangered.

endive Leafy annual or biennial plant widely cultivated for its sharp-flavoured leaves. There are two main types: curly endive (escarole), with slender, wavy-edged leaves and a variety with broad, flat leaves. Family Asteraceae/Compositae; species *Cichorium endivia*.

endocrine system Body system made up of all the endocrine (ductless) glands that secrete HORMONES directly into the bloodstream to control body functions. The endocrine system (together with the nervous system) controls and regulates all body functions. The chief endocrine glands are the PITU-ITARY GLAND, the THYROID GLAND, the ADRENAL GLAND, and the sex gland or GONAD (TESTIS in males and OVARY in females).

endometriosis Common gynaecological disorder in which tissue similar to the ENDOMETRIUM is found in other parts of the pelvic cavity. It is treated with analgesics, hormone preparations or surgery

endometrium Mucous membrane, well supplied with blood vessels, that lines the UTERUS. It is shed each month during menstruation.

endoplasmic reticulum Network of membranes and channels in the CYTOPLASM of EUKARYOTE cells. It helps to transport material inside the CELL. Parts of the endoplasmic reticulum are covered with minute granules called RIBOSOMES, which consist of protein and a form of ribonucleic acid (RNA).

endorphin Neurotransmitter that occurs naturally in the

HYPOTHALAMUS and PITUITARY GLAND connected to the brain. Endorphins are PEPTIDES that reduce pain by affecting communication between nerve cells. See also ANALGESIC

endoscope Instrument used to examine the interior of the body. Generally a light source and lenses are included in a flexible tube. "Keyhole" surgery can be performed using fine instruments passed through the endoscope.

endosperm Tissue that surrounds the developing embryo of a seed and provides food for growth. It is triploid (each cell has three sets of chromosomes), being derived from the fusion of one of the male gametes from the germinated pollen grain and two of the haploid nuclei in the embryo sac. *See also* ALTERNATION OF GENERATIONS

endosymbiosis Mutually beneficial relationship in which one organism lives inside another. For example, bacteria were engulfed by EUKARYOTE cells and formed symbiotic relationships with them, eventually becoming so interdependent that the cells behaved as a single organism; the bacteria became MITOCHONDRIA and CHLOROPLASTS. Mitochondria and chloroplasts have their own small RIBOSOMES, which resemble those of bacteria, and also their own DNA distinct from that of the host cell. See also SYMBIOSIS

endothermic reaction Chemical reaction in which heat is absorbed from the surroundings, causing a fall in temperature – as in the manufacture of water-gas from coal and steam.

energy In physics, capacity for doing work. It is measured in JOULES. The many forms of energy include POTENTIAL, KINETIC, electrical, nuclear, thermal, light and chemical. Energy undergoes limitless transformations by a vast variety of mechanisms. The law of conservation of energy states that energy cannot be created or destroyed. The concept of energy began with GALILEO and Sir Isaac Newton. The idea that MASS is a form of energy was established (1905) by Albert EINSTEIN, who recognized that energy (E) and mass (m) could be transformed into each other according to the relation $E = mc^2$, where c is the velocity of light.

Energy, US Department of US government department. Established in 1977, it is responsible for administering a comprehensive national energy plan, including research and development, regulatory functions, and promoting energy conservation and the nuclear energy programme.

energy sources Naturally occurring substances, processes and phenomena from which we obtain ENERGY. The very great majority of energy is derived from the Sun. Fossil FUELs are the remains of life that was dependent for growth on SOLAR ENERGY. HYDROELECTRICITY also derives from solar energy, which maintains the Earth's HYDROLOGICAL CYCLE, while wind is generated by uneven heating of the atmosphere and its energy harnessed by wind farms. The movements of the oceans, namely waves and tides, controlled by wind and the pull of the Sun and Moon, have been used successfully in some regions to create energy. Increasingly, solar energy is being used to heat some domestic water supplies directly, and for providing electricity from PHOTOELECTRIC CELLS. GEOT-HERMAL ENERGY is energy obtained from underground hot rocks. Other major energy sources are radioactive metals, such as URANIUM and PLUTONIUM, which provide NUCLEAR ENERGY. Engels, Friedrich (1820-95) German political writer. Engels and MARX formulated the theory of DIALECTICAL

Engels and MARX formulated the theory of DIALECTICAL MATERIALISM, and co-wrote the *Communist Manifesto* (1848). From 1870 until Marx's death in 1883, Engels helped financially with Marx's research and continued to help him with his writings, particularly *Das Kapital* which he subsequently edited. His materialist reorientation of the dialectics of HEGEL is most evident in his *Socialism, Utopian and Scientific* (1882) and *Anti-Dühring* (1878).

engine Machine that produces useful energy of motion from some other form of energy. The term is usually restricted to combustion engines, which burn fuel. These machines include the STEAM ENGINE, DIESEL ENGINE, JET ENGINE and ROCKET engine. Such engines are distinguished from electric motors which, in providing their power, do not directly alter the chemical or physical composition of a substance. Combustion engines are of two main kinds: an external combustion engine burns its fuel outside the chamber in which motion is pro-

duced. In a steam LOCOMOTIVE, for example, the fire box is separate from the cylinders. An INTERNAL COMBUSTION ENGINE burns its fuel and develops motion in the same place.

engineering Application of scientific principles for practical purposes, such as construction and developing power sources. There are many different fields in engineering including MECHANICAL, CIVIL, CHEMICAL, electrical and nuclear. Academic training starts with a grounding in the fundamentals of science and general engineering. See also ELECTRONICS

England Largest nation within the United Kingdom, bounded by the North Sea (E), the English Channel (s), Wales and the Irish Sea (w), and Scotland (N); the capital is LONDON. Land and economy The landscape is complex. In general, the N and w are higher and geologically older than the s and E. The chief rivers are the SEVERN, THAMES, TRENT, Ouse, Humber, and Mersey. The principal lakes include WINDERMERE and Derwentwater in the Lake District. The s of the country has low hills and downs, while much of E England is flat fenland. The N is predominantly upland and includes the PENNINES, Cheviot Hills, and Cumbrian Mountains. History There are traces of PALAEOLITHIC settlements in England. Occupied by the CELTS from c.400 BC, England was later conquered by the Romans, whose rule lasted until the 5th century. Germanic tribes began arriving in the 3rd century AD and gradually established independent kingdoms. Christianity was introduced into the country in the 6th century. In the 9th century ALFRED THE GREAT led a united England against the Danes. The NORMAN CONQUEST (1066) brought strong central government and inaugurated the FEUDAL SYSTEM. IRELAND was conquered in the late 12th century, and WALES became a principality of England in 1284. The 13th century saw the foundations of parliamentary government and the development of statute law. During the Middle Ages, England's fortunes continued to be linked with France, as English kings laid claim to French territory. The Wars of the ROSES curbed the power of the nobility. Under the TUDORS, Wales was united politically with England and became a strong Protestant monarchy. The reign of ELIZABETH I was one of colonial expansion and growing naval power. In 1603 JAMES I merged the English and Scottish crowns. For the subsequent history of England, see United Kingdom. Area: 130,362sq km (50,333sq mi). Pop. (1991) 47,055,204.

English Language belonging to the Germanic branch of the INDO-EUROPEAN family. It may be said to have come into existence with the arrival of the ANGLO-SAXONS in England in the 5th century AD. During more than 1,500 years of development, it has been transformed from an inflected language with grammatical gender to one with very few inflections and employing a sex-correlated gender system (he, she and it). Its vocabulary has been massively expanded by the inclusion of numerous foreign, technical and slang words. It is the mother tongue of c.300 million people, and a second language for hundreds of millions more worldwide.

English architecture Between the 6th and the 17th centuries, there were at least five distinctive styles of English architecture: SAXON, NORMAN, GOTHIC, RENAISSANCE and BAROQUE. England was influenced by European trends in architecture towards the end of their development. For example, Inigo Jones brought his revolutionary Renaissance ideas relatively late to the 17th-century STUART court, and Christopher WREN introduced Baroque forms to England at the end of his career. The GEORGIAN period (1702-1830) is subdivided into English Baroque, PALLADIANISM and NEO-CLASSICISM. In the 19th century, the Victorian age was marked by earnestness and solidity, while the Great Exhibition (1851) paved the way for MODERNISM. William MORRIS and the ARTS AND CRAFTS MOVEMENT encouraged purity of design in the late 19th century, a concept which was maintained in the early 20th-century work of LUTYENS and VOYSEY. In the late 20th century, the movements of MODERNISM and POST-MODERNISM, in particular the work of Richard Rogers and Norman Foster, has been challenged by proponents of more classical styles.

English art England's earliest artistic traditions were shaped by invading forces. The ANGLO-SAXONS had an enduring influence. Its most notable achievement came with the BAYEUX TAPESTRY. In succeeding centuries, the preference for foreign

talent hampered the development of a native tradition, which eventually emerged in the 18th century, with William Hogarth, Thomas Gainsborough and Joshua Reynolds. In the 19th century, England's two most influential artists were J.M.W. Turner and John Constable. The work of the Preraphaelite Brotherhood bridged the movements of romanicism and symbolism, while William Morris was a seminal influence on the Arts and Crafts Movement. The major 20th-century figures were Stanley Spencer and Francis Bacon. Modern English sculptors, including Henry Moore and Barbara Hepworth have exerted a widespread influence.

English Channel Arm of the Atlantic Ocean between France and Britain, joining the North Sea at the Strait of Dover. A cross-channel train-ferry service was started in 1936 and the CHANNEL TUNNEL was completed in 1994. Width: 30–160km (20–100mi); length: 564km (350mi).

English Horn See COR ANGLAIS

English literature Body of written works produced in the British Isles in the English language. The earliest surviving works are from the Old English period (475-1000). Mainly poems in the heroic mould, epics such as BEOWULF belong to an oral tradition but were written down in the 7th century. King Alfred translated a number of Latin works into the vernacular and initiated the Anglo Saxon Chronicle. Norman French replaced Old English as the language of the ruling classes after 1066, and the influence of French literature was reflected in the numerous romances centred around the stories of Charlemagne and the legends of King Arthur. The native tradition of alliterative poetry re-emerged in the 14th century in the works of LANGLAND, MALORY and Geoffrey CHAUCER, whose talent was not surpassed until the 16th century. Humanism and the Renaissance influenced English writing in the 16th century. William SHAKESPEARE and Christopher MAR-LOWE were the leading figures in ELIZABETHAN DRAMA. Shakespeare's late works formed a bridge with the JACOBEAN era. Edmund Spenser and Philip Sidney ensured the period was

In an in-line, four cylinder petrol engine, air is sucked through a filter (1) into the carburettor (2), where it mixes with the petrol. This mixture then enters the cylinders through the dual inlet valves (3) on each cylinder (4).

The spark plug (5) then ignites the mixture forcing the piston rapidly down. The burnt gases are expelled through the outlet valves (6). The reciprocating motion of the pistons is converted into rotation by the

crankshaft (7). The crankshaft also turns the timing belt (8) which controls the opening of the valves, through the cams (9) located on the camshaft (10) and also the firing of the spark plugs.

also a golden age for poetry. John Donne and the METAPHYSI-CAL poets continued this tradition, but the poetry of MILTON was unsurpassed in the 17th century. English prose flourished with the production of the Authorised Version of the Bible in 1611. After the RESTORATION, drama was revived in the comedies of CONGREVE; the classical ideals of the Augustan age (c.1690-1740) are typified by the satiric prose of SWIFT, the poetry of POPE, the drama of GOLDSMITH, and the criticism of Samuel JOHNSON. The NOVEL emerged during the early 18th century, with works by Defoe, Richardson, Fielding, STERNE and SMOLLETT, and was developed further in the 19th century by Jane Austen, Walter Scott, Thackeray, the Brontës, Eliot and Dickens. The Romantic movement, presaged by BLAKE's visionary poetry, gained full expression with Wordsworth and Coleridge, and was developed by KEATS, BYRON, and SHELLEY. The major Victorian poets were TENNYSON and Robert and Elizabeth Browning. The wit of SHAW and WILDE, and the bleak novels of HARDY, gave way to the cynicism of war poets such as Sigfried SASSOON. The formal inventions of Modernism were best realised in the novels of James JOYCE, Virginia WOOLF and D.H. LAWRENCE, and the poetic dramas of T.S. ELIOT. W.B. YEATS looked back to the visions of Blake. The novel diversified with the writings of Aldous HUXLEY, Evelyn WAUGH and Graham GREENE. In the 1930s, W.H. AUDEN produced explicitly political poems and Noel Coward lampooned the British class system. The 1950s saw the emergence of the "ANGRY YOUNG MEN", including John OSBORNE and Kingsley Amis, and the absurdist plays of Samuel Beckett. Post-war novelists include Anthony BURGESS, William GOLDING, Iris MURDOCH, Angela CARTER and Salman RUSHDIE; dramatists include Harold PINTER, Tom STOPPARD, Joe ORTON and David HARE; poets include Dylan THOMAS, Philip LARKIN, Ted HUGHES and Seamus HEANEY.

English National Opera (ENO) English opera company with a policy of performing all operas in English. The ENO moved from Sadler's Wells to its present location at the London Coliseum in 1968. They have given the first British performance of numerous operas, such as GLASS' Akhnaten, and many premières, such as BIRTWISTLE'S The Mask of Orpheus. engraving INTAGLIO printing process; it describes various methods of making prints by cutting lines into metal or wood. Variations include ETCHING and AQUATINT. In modern engraving, different processes are frequently combined in a single plate. See also WOODCUT

Enlightenment Intellectual temper of Western Europe in the 18th century. It developed from the spirit of rational enquiry of the Scientific Revolution and from political theorists of the late 17th-century Age of Reason, such as LOCKE. Its leaders thought that all things could be understood or explained by reason. Their emphasis on human reason and perfectibility often brought conflict with the church.

Ennius, Quintus (239–169 BC) Roman poet, sometimes known as the father of Latin poetry. He is best known for his epic history of Rome, *Annales*.

Enoch Name of several Old Testament figures. One was the father of METHUSELAH, and writer of PSEUDEPIGRAPHA, such as the Books of Enoch. Another was the eldest son of CAIN.

Entebbe City on the NW shore of Lake Victoria, s central Uganda, E Africa. Founded in 1893, it was capital of the British protectorate of Uganda (1894–1962). Pop. (1991) 41,638.

Entente Cordiale Anglo-French alliance, formalized in April 1904. Outstanding differences, especially over colonies, were solved and the basis laid for future cooperation. The Entente was the first step leading to the TRIPLE ENTENTE.

enthalpy (symbol H) Amount of thermodynamic heat energy possessed by a substance. The enthalpy of a system equals the sum of its internal energy and the product of the pressure and volume. It can be measured in terms of the change of heat that accompanies a CHEMICAL REACTION at a constant pressure. entomology (Gk. entomon, insect) Term for the scientific study of INSECTS, coined by ARISTOTLE. The ancient Greeks were the first serious entomologists (4th century BC).

entropy Quantity that specifies the disorder of a physical system; the greater the disorder, the greater the entropy. In THERMODYNAMICS, it expresses the degree to which thermal

energy is available for work – the less available it is, the greater the entropy. According to the second law of thermodynamics, a system's change in entropy is either zero or positive in any process.

Enver Pasha (1881–1922) Turkish general and political leader. Involved in the Young Turk revolution (1908), he became virtual dictator after a coup (1913). He was instrumental in bringing Turkey into World War 1 as an ally of Germany. He was killed leading an anti-Soviet expedition in Bukhara.

environment Physical and biological surroundings of an organism. The environment covers non-living (**abiotic**) factors such as temperature, soil, atmosphere and radiation, and also living (**biotic**) organisms such as plants, microorganisms and animals.

Environmental Protection Agency (EPA) US federal government agency. It was created (1970) to reduce and control pollution by a variety of research, monitoring and enforcement activities.

enzyme Protein that functions as a catalyst in biochemical reactions. Enzymes are not altered in these reactions so are effective in tiny quantities. Enzymes only operate within narrow temperature and pH ranges and many require the presence of accessory substances (coenzymes) in order to function effectively. The names of most enzymes end in "-ase".

Eocene Second of the five epochs of the TERTIARY period, c.55–38 million years ago. The fossil record shows members of modern plant genera, including beeches, walnuts and elms, and indicates the apparent dominance of mammals, including the ancestors of camels, horses, rodents, bats and monkeys.

Eos In Greek mythology, the goddess of dawn, identified with the Roman goddess Aurora. Daughter of HYPERION, and of HELIOS and SELENE, she drove through the sky in a horsedrawn chariot.

Ephesus (Efes) Ancient Ionian city of w Asia Minor (modern Turkey). A prosperous port under the Greeks and Romans, it was a centre of the cult of Artemis (Diana). The Temple of Artemis was the largest Greek temple ever built and was one of the Seven Wonders of the World. Ephesus was captured by Croesus (c.550 BC), Cyrus the Great (c.546 BC) and by Alexander the Great (334 BC), falling eventually into Roman control (133 BC). Today, it is one of the world's principal archaeological sites.

epic Long narrative poem in grandiose style. The earliest known form of Greek literature, epics were originally used to transmit history orally. Using highly formalized language, epics tend to involve gods, men and legendary battles. Homer is the author of two of the most famous epics, the *Iliad* and the *Odyssey*, which effectively established the scope and conventions of the form. Later examples include the *Aeneid* by VIRGIL, *Paradise Lost* (1667) by MILTON and *The Faerie Queene* (1589–96) by SPENSER.

epic theatre Theory of dramatic presentation formulated in the late 1920s by Bertolt BRECHT and Erwin PISCATOR. Attempting to undermine theatrical illusion by distancing effects in the use of costume, sets, songs, argument and self-concious soliloquies, the audience is meant to view events objectively and critically.

Epicureanism School of Greek philosophy founded by EPICURUS. He proposed that the sensations of pleasure and pain were the ultimate measures of good and evil, and that pleasure should be actively pursued. He also embraced a theory of physics derived from the ATOMISM of DEMOCRITUS, and a theology denying the existence of an afterlife.

Epicurus (341–270 BC) Greek philosopher, founder of EPICUREANISM. Born on the island of Samos, he began teaching philosophy at the age of 32. He settled in Athens in 306 BC and taught students in his garden. He wrote many books and letters, only fragments remain.

epidemic Outbreak of an infectious disease rapidly spreading to many people. The study of epidemics, which includes the causes, patterns of contagion and methods of containment of disease, is known as **epidemiology**. An epidemic sweeping across many countries, such as the BLACK DEATH, is termed a pandemic.

epidermis In animals, outer layer that contains no blood

vessels. In many invertebrates it is only one cell thick, in vertebrates it may comprise several layers, and forms part of the SKIN. In plants, it is the outermost layer of a leaf or of an unthickened stem or root; it is usually coated in a waxy layer, the CUTICLE, which reduces water loss.

epiglottis Small flap of CARTILAGE projecting upwards behind the root of the tongue. It closes off the LARYNX during swallowing to prevent food entering the airway.

epilepsy Disorder characterized by abnormal electrical discharges in the brain which provoke seizures. It is seen both in generalized forms, involving the whole of the CEREBRAL CORTEX, or in partial (focal) attacks arising in one small part of the brain. Attacks are often presaged by warning symptoms, the "aura". Seizure types vary from the momentary loss of awareness seen in petit mal attacks ("absences") to the major convulsions of grand mal epilepsy. They may be triggered by a number of factors, including sleep deprivation, flashing lights or excessive noise. All forms of epilepsy are controlled with anti-convulsant drugs.

Epiphany Christian feast celebrated on 6 January. It originated in the Eastern Church as an observance of the baptism of Jesus. In the West, it became associated with the manifestation of Christ to the Gentiles and more particularly it has come to celebrate the coming of the Magi (Three Wise Men). **epiphyte** (air plant) Plant that grows on another plant, but is not a PARASITE. Epiphytes usually have aerial roots and produce their own food by PHOTOSYNTHESIS. They are common in tropical forests. Examples are some FERNS, ORCHIDS, Spanish moss, and many BROMELIADS.

Episcopal Church US Anglican Church. CHURCH OF ENG-LAND services were held in the first American colonies. With the AMERICAN REVOLUTION, the Church of England was disestablished and a national church organized in its place. Known as the Protestant Episcopal Church, its constitution and version of the Book of COMMON PRAYER were established in 1789. It is active in the ecumenical movement and carries out missionary work. In 1989 it appointed the first woman bishop in the ANGLICAN COMMUNION. The Reformed Episcopal Church was established in 1873 by a breakaway group of clergy and laity. epistemology Branch of philosophy that critically examines the nature, limits and validity of knowledge and the difference between knowledge and belief. DESCARTES showed that many previously "philosophical" questions would be better studied scientifically, and that what remained of metaphysics should be absorbed into epistemology.

epistles Collection of 20 letters forming most of the middle section of the New Testament. More than half of them are attributed to the apostle St PAUL – the so-called Pauline Epistles – while the rest are by various writers: two by Peter, three by John, one by James and one by Jude. The author of the Epistle to the Hebrews is unknown. Among the Pauline Epistles, the Epistle to the Romans contains the single most complete formulation of Paul's teachings.

epithelium Layer of cells, closely packed to form a surface for a body tube or cavity. Epithelium covers the SKIN, and various internal organs and surfaces such as the intestines, nasal passages and mouth. Epithelial cells may also produce protective modifications such as hair and nails, or secrete substances such as ENZYMES and mucus.

epoxy resin Group of thermosetting polymers with outstandingly good mechanical and electrical properties, stability, heat and chemical resistance, and adhesion. Epoxy resins are used as adhesives, in casting and protective coatings. Popular epoxy resins are sold in two separate components, a viscous resin and a hardener, which are mixed just before use.

Epstein, Sir Jacob (1880–1959) British sculptor, b. USA. He made his most audacious sculptural statements before 1920, starting with a series of 18 nude figures (1907–08), whose explicit representation caused a public outcry. He scandalized Paris with the angel carved for Oscar Wilde's tomb (1912). His most revolutionary sculpture was *The Rock Drill* (1913–14), an ape that has mutated into a robot. He also produced some extraordinary religious works including the bronze *Visitation* (1926), the stone *Ecce Homo* (1934–35) and the alabaster *Adam* (1939).

equation Mathematical statement of VARIABLES, equal to some subset of all possible variables. The equation $x^2 = 8$ 2x is true only for certain values (solutions) of x (x = 2 and x-4). This type of equation is contrasted with an identity, such as $(x+2)^2 = x^2 + 4x + 4$, which is true for all values of x. Equations are said to be linear, quadratic, cubic, quartic, etc., according to whether their degree (the highest power of the variable) is 1, 2, 3, 4, etc. See also SIMULTANEOUS EQUATIONS equator Name given to two imaginary circles. The terrestrial equator lies midway between the North Pole and South Pole and is the zero line from which LATITUDE is measured. It divides the Earth into the Southern and Northern Hemispheres. The celestial equator lies directly above the Earth's equator and is used as a reference to determine the position of a star using the astronomical co-ordinate system of right ascension and declination.

Equatorial Guinea (formerly Spanish Guinea) Republic in w central Africa, consisting of a mainland territory between Cameroon and Gabon, Mbini (Río Muni), and five islands in the Gulf of Guinea, the largest of which is Bioko (Fernando Póo). The capital is MALABO (Bioko). Land and climate Bioko is a volcanic island with fertile soils, and Malabo's harbour is part of a submerged volcano. Bioko is mountainous, rising to 3,008m (9,869ft), and has heavy rainfall. It has varied vegetation, with grasslands at higher levels. There is a marked dry season from December to February. Mainland Mbini (90% of Equatorial Guinea's land area) consists mainly of hills and plateaux behind the coastal plains. Its main river, the Lolo, rises in Gabon. Mbini has a similar climate to Bioko, though rainfall diminishes inland. Dense rainforest covers most of Mbini, including valuable trees such as mahogany, okoumé and African walnut. Mangrove forests line the coast. Economy Agriculture employs 66% of the workforce. The main food crops are bananas, cassava and sweet potatoes. The most valuable export crop is cocoa, grown on Bioko. Forestry is important in Mbini. Timber and coffee are also exported, but the country has few manufacturing industries. History Portuguese navigators reached the area in early 1471. In 1778 Portugal ceded the islands and commercial mainland rights to Spain. Spanish settlers on Bioko were hit by yellow fever, and withdrew in 1781: nobody settled on mainland Mbini. In 1827 Spain leased bases on Bioko to Britain, and the British settled some freed slaves. Descendants of these former slaves (Fernandinos) remain on the island. Spain returned to the area in the mid-19th century and began to develop plantations on Bioko. Bioko and Mbini were made provinces of overseas Spain (1959). They attained a degree of self-government (1963) and finally achieved independence (1968). In 1979 the nation's

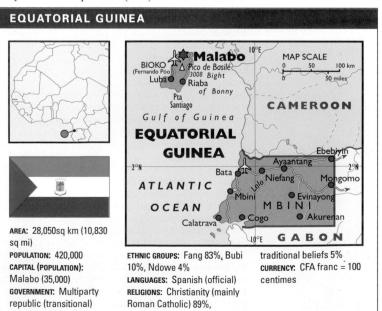

▲ Erasmus The artist Hans
Holbein the Younger was often
commissioned by the great
Dutch humanist Erasmus.
Erasmus' scholarly attempts at
internal reform of the Roman
Catholic Church were
denounced by Martin Luther.
Erasmus was critical of clerical
abuse, and church involvement
in material matters. The
Education of a Christian Prince
(1515) is his greatest work.

first president, Francisco Macias Nguema, was deposed by a Supreme Military Council, led by Colonel Teodoro Obiang Nguema Mbasogo. **Politics** A 1991 referendum voted to set up a multiparty democracy, consisting of the ruling Equatorial Guinea Democratic Party (PDGE) and ten opposition parties. Elections (1993) were boycotted by the main parties and most of the electorate. The PDGE formed a government. In 1996 elections, again boycotted by most opposition parties, President Mbasogo claimed 99% of the vote. His regime has been accused of routine arrests and torture of opponents.

equestrian sports Three Olympic equestrian disciplines of dressage, showjumping and trials (or eventing). This tests a horse's training, development and ability to execute defined movements; showjumping tests speed and jumping ability over obstacles set in a confined area; trials, held over 1-3 days, test ability at dressage, and jumping in the ring and cross-country. equilibrium In physics, a stable state in which any variety of forces acting on a particle or object negate each other, resulting in no net force. While thought of as a state of balance or rest, an object with constant velocity is also said to be in equilibrium. The term can also be ascribed to a body with a constant temperature; this is known as thermic equilibrium. equinox Either of the two days each year when day and night are of equal duration. They occur on the two occasions when the Sun crosses the celestial EQUATOR, moving in either a northerly or southerly direction.

equity In law, a field of jurisdiction that enables the judiciary to apply principles or morals. It applies to individual cases where a strict adherence to the law would result in unjust sentencing. In a number of legal systems, equity (as well as the rules of law) must be considered before the judiciary makes its decision.

Erasmus, Desiderius (1466-1536) Combined Greek and Latin name adopted by Gerhard Gerhards, Dutch scholar and teacher, considered the greatest of the RENAISSANCE humanists. His Latin translation of the Greek New Testament revealed flaws in the VULGATE text. He also edited the writings of Saint JEROME and other patristic literature. Among his original works, his Enchiridion militis (Manual of the Christian Knight, 1503) emphasized simple piety as an ideal of CHRISTIANITY and called for reform of the church. His works had an early influence on Martin LUTHER and other Protestant reformers, although he sought change from within the Catholic Church and disagreed with the course of the REFORMATION. In On Free Will (1524) he openly clashed with Luther. See also HUMANISM **Erastianism** Complete control of church affairs by the state. It is named after Thomas Erastus (1524-85), a Swiss physician and theologian, who denied that the church alone had disciplinary powers, especially of excommunication. Hence, Erastianism is a distortion of his position, which assumed cooperation between church and state.

Eratosthenes (276–194 BC) Greek scholar who first measured the Earth's circumference by geometry. Eratosthenes administered the library of ALEXANDRIA and was renowned for his work in mathematics, geography, philosophy and literature. **erbium** (symbol Er) Silvery metallic element of the LANTHANIDE SERIES. There are six isotopes naturally occurring, and the chief ores are monazite and bastnaesite. Nine radioactive isotopes have been identified. Soft and malleable, erbium is used in some specialized alloys, and erbium oxide is used as a pink colourant for glass. Properties: at.no. 68; r.a.m. 167.26; m.p. 1,522°C (2,772°F); r.d. 9.045; b.p. 2,863°C (5,185°F); most common isotope Er¹⁶⁶ (33.41%).

erica Genus of more than 500 species of mostly low, evergreen shrubs comprising true heaths and heathers. Most species are native to Africa, but many grow on moors in Britain and other parts of Europe. Blossoms are colourful and tube-shaped or bell-shaped. Family Ericaceae.

Eric the Red (active late 10th century) Discoverer of Greenland. Born in Norway, he settled in Iceland, from which he was banished after a murder. He set off to the west and discovered the land he named Greenland in *c*.981. Returning to Iceland, he organized a party of colonists who set out in *c*.985.

Erie, Lake Great Lake in North America, bordered by Ontario (w), New York (E), Ohio and Pennsylvania (S), and

Michigan (sw); part of the Great Lakes—St Lawrence Seaway. It was the site of a British defeat by the USA in the War of 1812. The second smallest of the lakes, it has been polluted by the cities on its shores. Government regulations are now aiding its recovery. Area: 25,667sq km (9,910sq mi). Max. depth: 64m (210ft).

Erie Canal Waterway in New York State, between Buffalo and Albany, USA. It was built in 1817–25 and was originally 584km (363mi) long. A commercial success, it contributed to the rapid growth of the Midwest. Largely superseded by the railroads, it was revitalized by the expansion of the canal system in the early 20th century.

Eritrea Independent state in NE Africa, on the Red Sea; the capital is ASMARA. The chief ports are Aseb and Massawa. Land Much of Eritrea is a continuation of the high Ethiopian plateau, sloping down to plains to the E and W. Climatic conditions vary greatly and unreliable rainfall is a frequent cause of drought. History Eritrea was a dependency of Ethiopia until the 16th century when it became annexed to the Ottoman empire. During the 19th century, control of the region was disputed between Ethiopia, Egypt and Italy. In 1890 it became an Italian colony. From 1941-52 it was under British military administration. In 1952 it was federated with Ethiopia. becoming a province in 1962. Eritrean separatists began a 30year campaign of guerrilla warfare, and 700,000 refugees fled to Somalia. In 1991 the Eritrean People's Liberation Front (EPLF) helped topple Mengistu's Ethiopian government, and won a referendum on independence. Eritrea formally gained independence in 1993. In 1994 the EPLF became a political party, the People's Front for Democracy and Justice (PFDJ). The war-devastated economy is mainly agricultural. Industries: textiles, leather goods, salt. Area: 117,599sq km (45,405sq mi). Pop. (1994 est.) 3,530,000. See Етнюріа тар ermine Known as a STOAT in Eurasia, or short-tailed WEASEL in North America.

Ernst, Max (1891–1976) German painter and sculptor, founder of Cologne DADA (1919), later influential in SURREALISM. Ernst was a prolific innnovator and developed ways of adapting COLLAGE, photomontage and other radical pictorial techniques. His most important works include *L'Eléphant Célèbes* (1921) and *Two Children Threatened by a Nightingale* (1924). Ernst left the surrealist movement in 1938 and lived in New York (1941–48), where he collaborated on the periodical *VVV* with André BRETON and Marcel DUCHAMP.

Eros Elongated asteroid with an irregular-shaped orbit. In 1931 and 1975 it approached to within 24 million km (15 million mi) of Earth. Longer diameter, 27km (17mi); mean distance from the Sun, 232 million km (144 million mi); mean sidereal period 1.76 yr.

Eros In Greek MYTHOLOGY, god of love, equivalent to the Roman god Cupid. Depicted as a winged boy carrying a bow and arrows, and often blindfold, he was the youngest and most mischievous of the gods. He married PSYCHE.

erosion In geology, alteration of landforms by the wearing away of rock and soil, and the removal of any debris (as opposed to WEATHERING). Erosion is carried out by the actions of wind, water, glaciers and living organisms. In chemical erosion, minerals in the rock react to other substances, such as weak acids found in rainwater, and are broken down. In physical erosion, powerful forces such as rivers and glaciers physically wear rock down and transport it. Erosion can have disastrous economic results, such as the removal of topsoil, the gradual destruction of buildings, and the alteration of water systems. Inland, erosion occurs most drastically by the action of rivers, and in coastal regions, by the action of waves. See also GEOMORPHOLOGY

erratic In geology, a rock that has been transported some distance from its source by glacial action, and is therefore of a different type to the surrounding rocks. The tracing of erratics can give important information about the movement of ice.

erythrocyte Red blood cell, usually disc-shaped and without a nucleus. It contains HAEMOGLOBIN, which combines with oxygen and gives blood its red colour. Normal human blood contains an average of five million such cells per cu mm of blood.

Esaki, Leo (1925–) Japanese physicist, who developed the tunnel DIODE, a SEMICONDUCTOR that allows electrons to cross normally impassable electronic barriers. US physicist Ivar Giaever extended Esaki's research to the field of SUPERCONDUCTIVITY. For this work, they shared the 1973 Nobel Prize for physics with Brian JOSEPHSON. The Esaki diode is used in computer data storage.

Esau Old Testament figure who, after a hard day's work, sold his future inheritance for refreshment to his scheming brother JACOB. The story probably derives from an attempt to give an ancient background to the enmity between the Israelites and the Edomites.

escape velocity Minimum velocity required to free a body from the gravitational field of a celestial body or stellar system. Escape velocities are, for the Earth 11.2km/sec (7mi/s) and Moon 2.4km/sec (1.5mi/s). They can be calculated from the formula: $v = (2GM/R)^{1/2}$ where G is the gravitational constant, M the mass of the planet or system and R the distance of the rocket from the centre of mass of the system.

Escher, Maurits Cornelis (1898–1972) Dutch graphic artist. He is best known for his prints based on mathematical premises. These contain bizarre metamorphoses, illusions and paradoxical structures as in *Ascending and Descending* (1960). **Escorial** Spanish monastery and palace near Madrid. Built 1563–84 for PHILIP II, it comprises a massive group of buildings arranged in a square plan, dominated by church towers, and houses a notable art collection.

Esfahan See ISFAHAN

Eshkol, Levi (1895–1969) Israeli statesman, prime minister (1963–69), b. Ukraine. Eshkol established one of the first *kibbutzim* (cooperative farms), became minister of finance (1952–53), created the Israel Labour Party, and succeeded David Ben-Gurion as prime minister.

Eskimo (Algonquian, eaters of raw flesh) Aboriginal inhabitants of Arctic and sub-Arctic regions of North America, Greenland and Asia. Eskimos originally migrated from Asia c.2,000 years ago. Sharing the common language family of Eskimo-Aleut, Eskimos have adapted well to harsh climates and are proficient hunters. In some areas, a nomadic existence has been replaced by village settlements and work in the oil and mining industries. *See also* Inuit

ESP Abbreviation of Extrasensory Perception

Esperanto Language devised in 1887 by Ludwik Zamenhof (1859–1917), as a language of international communication. Its spelling and grammar are regular and consistent, and its vocabulary mostly derived from w European languages.

essay (Fr. essai, attempt) Usually short, non-fictional prose composition, written expressing a personal point of view. The essay form originated with the 16th-century French writer Montaigne. Famous British essayists include Francis Bacon, Henry Fielding, Dr Samuel Johnson, Oliver Goldsmith, Matthew Arnold, Charles Lamb and William Morris. Noted US essayists include Ralph Waldo Emerson, Henry David Thoreau, Oliver Wendell Holmes Jr, James Thurber, George Santayana, and Dorothy Parker.

Essen City on the River Ruhr, Nordrhein-Westfalen, NW Germany. Essen developed around a 9th-century Benedictine convent and was annexed to Prussia in 1802. Lying at the centre of a major coalfield, it underwent a huge industrial expansion during the 19th century and is home to the Krupp steelworks. Essen was heavily bombed in World War 2. It has a cathedral (begun 11th century). Industries: mining, iron and steel, glass, textiles, chemicals. Pop. (1990) 627,800.

Essenes Jewish religious sect that existed in Palestine from the 2nd century BC to the end of the 2nd century AD. Members of the sect, adult men, lived in communal groups isolated from society. A secrecy developed about the sect, and they shunned public life and temple worship. The DEAD SEA SCROLLS are said to contain their sacred books.

essential oil Oil found in flowers, fruits or plants. It is the source of their characteristic odour and is widely used in aromatherapy, potpourri and perfumed toiletries. Many are obtained from plants that originate in dry, Mediterranean climates. These oils are usually produced by special GLANDS.

Essex, Robert Devereux, 2nd Earl of (1566–1601) Eng-

lish courtier and soldier. A favourite of ELIZABETH I, he attacked Cadiz in 1596. Following a quarrel with Elizabeth, he was made the reluctant lord lieutenant of a rebellious Ireland. He returned in disgrace six months later, attempted a coup d'état, and was executed for treason.

Essex, Robert Devereux, 3rd Earl of (1591–1646) Parliamentary commander in the English CIVIL WAR from July 1642. A poor strategist, his failures perhaps prolonged the war. He was effectively superseded by Oliver CROMWELL when the NEW MODEL ARMY was formed in 1645.

Essex County in SE England; the county town is Chelmsford. Colonized by the Romans at COLCHESTER, it was invaded by Anglo-Saxons in the 5th century and later came under Danish control. Low lying on the E coast, the land rises to the NW, providing pasture for dairy and sheep farming. Wheat, barley and sugar beet are important crops. Industries: machinery, electrical goods. Area: 3,674sq km (1,419sq mi). Pop. (1991) 1,528,577. **ester** Any of a class of organic compounds formed by reaction between an ALCOHOL and an ACID.

Esther Old Testament book narrating how the legendary queen Esther averted the killing of her people, the Jews, by the Persians in Babylon. She persuaded the Persian king (Xerses I) to ignore his grand vizier Haman (Aman), who advocated their extermination. Haman's overthrow is celebrated at the Jewish feast of Purim.

EROSION 2 2 7

Erosion is the breakdown and transportation of rock due to the action of an outside agent. There are three main forms: river, glacial and wind. Rivers (1) erode their channels through the flow of water and the abrasion of the load they are carrying against the banks and riverbed. Erosion is most forceful at the outside of bends (2), where the banks are undercut (3) often creating cliffs or bluffs (4) down which

material moves. Flood surges dramatically increase the power of the river and correspondingly magnify the erosive force.On a smaller scale, rainwater will move material down a hillside (5). Particles of soil are carried by rivulets and the impact of raindrops throws soil down slope. Vegetation reduces such erosion by binding the soil together. Where vegetation is removed, as on tracks (6).

▼ coastal erosion The powerful action of the waves produces recognizable features. Horse-shoe bays (below), for example, are formed when rock layers of different hardness lie parallel to the coast. The erosive power of the sea exploits areas of weakness in a hard rock deposit (1). Waves will then cutaway any softer rock behind (2), eroding back until they reach another strata of harder rock (3). When bays join (4) islands of hard rock can be left across the mouth (5).

erosion is accentuated. In arid conditions wind erosion can carve distinctive features. Sand and stones blown by the wind (7) have the same effect as shot-blasting. Mushroomshaped formations, pedestals, (8) are often the result. This is due to the maximum height at which the erosive sand is carried by the wind as it bounces across the surface (9), above which the rock is untouched.

ESTONIA

AREA: 44,700sq km (17.300sg mi) POPULATION: 1,491,583 CAPITAL (POPULATION): Tallinn (490,000)

GOVERNMENT: Multiparty republic

ETHNIC GROUPS: Estonian 62%. Russian 30%, Ukrainian 3%, Belorussian 2%, Finnish 1% LANGUAGES: Estonian (official)

RELIGIONS: Christianity

and Baptist minorities) **CURRENCY:** Kroon = 100 senti

(Lutheran, with Orthodox

Estonia Republic on the E coast of the Baltic Sea, Estonia is the smallest of the three Baltic states, which gained independence from the Soviet Union in 1991. Land and Climate Estonia is mostly flat, rising in the SE to a maximum height of only 318m (1,043ft), at Munamagi. The area was covered by ice sheets during the Ice Age and is strewn with MORAINE. Estonia is dotted with more than 1,500 small lakes. Lake Peipus (Chudskoye Ozero) and the River Narva make up much of Estonia's Russian border. Estonia has more than 800 islands, which together make up c.10% of total area; the largest is Saaremaa. Despite its northerly position, Estonia has a fairly mild climate; sea winds warm the land in winter and cool it in summer. Average temperatures fall below freezing in winter, but summers are warm. Rainfall averages from 480 to 580mm (19-23in). Farmland and pasture use over 33% of the land, with swamps and lakes taking up about 15% and forests of aspen, birch, fir and pine, another 31%. Economy Under Soviet rule, Estonia was the most prosperous of the Baltic states. Chief natural resources are oil shale deposits and forests. Oil shale is used in the petrochemical industry and to fuel power plants. Manufactures include petrochemicals, fertilizers, machinery, processed food and textiles. Agriculture and fishing are important. Barley, potatoes and oats are major crops. Since 1988, the nationalized economy has begun a process of privatization, and Estonia has strengthened its European ties. History and Politics The original settlers were related to the Finns. The TEUTONIC KNIGHTS introduced Christianity in the 13th century, and by the 16th century German noblemen owned much of the land. In 1561 Sweden seized N Estonia, and Poland the s. In 1625 Sweden assumed complete control, before passing to Russia in 1721. Estonia became independent in 1918. In 1940 Soviet forces occupied Estonia, but were driven out by Germany in 1941. Soviet troops returned in 1944, and Estonia became one of the 15 socialist republics of the Soviet Union. Estonians strongly opposed Soviet rule and many were deported to Siberia. Gorbachev's political reforms in the late 1980s led to renewed demands for freedom. In 1990 Estonia declared independence, which the Soviet Union recognized in September 1991. Estonia adopted a new constitution in 1992 and multiparty elections were held. President Meri was elected and a right-wing coalition government was formed. Russian troops completed their withdrawal in 1993. In 1995 a centreleft government was elected.

estuary Coastal region where a river mouth opens into the ocean and freshwater from the land mixes with salt water from the sea. Estuaries usually provide good harbours and breeding grounds for many kinds of marine life.

etching Method of INTAGLIO (incised) printing used for black-and-white designs. A metal plate, usually copper, is coated with an acid-proof ground. A design is etched with a needle so that the lines penetrate the ground. The plate is then placed in an acid that eats away the exposed line so that it will hold ink. When the plate is finished, it is rolled with ink and placed in an etching press to be printed.

ethanal (acetaldehyde) Colourless volatile flammable liquid (CH2CHO) manufactured by catalytic oxidation of ethene or ethanol, or catalytic hydration of acetylene. It is used in the breathalyser test and to silver mirrors. Properties: r.d. 0.788; m.p. -123.5°C (-190.3°F); b.p. 20.8°C (69.4°F).

ethane Colourless odourless gas (CH₂CH₂), the second member of the ALKANE series of HYDROCARBONS. It is a minor constituent of natural gas. See also SATURATED COMPOUND

ethanoic acid (acetic acid) Colourless corrosive liquid (CH3COOH) made by the oxidation of ethanol, either by catalysis or by the action of bacteria. It is the active ingredient in VINEGAR, and has many uses in the organic chemicals industry. Properties: r.d 1.049; m.p. 16.6°C (61.9°F); b.p. 117.9°C (244.4°F).

ethanol (ethyl alcohol) Colorless flammable and volatile ALCOHOL (C₂H₅OH), produced by the fermentation of sugars, molasses and grains, or by the catalytic hydration of ethylene. Also known as grain alcohol, its many uses include alcoholic beverages (such as wine, beer, cider and spirits), cleaning solutions, antifreeze, rocket fuels, cosmetics, and pharmaceuticals. Properties: r.d. 0.789; b.p. 78.5°C (173.3°F).

Ethelbert (d.616) King of Kent (560-616). He was the strongest ruler in England's of the River Humber, and was the first Christian king in Anglo-Saxon England. He allowed AUGUSTINE and his monks to settle and preach in Canterbury. Ethelred II (the Unready) (968–1016) (Old English, evil rede or counsel) King of England (978-1013; 1014-16). Following continuous Danish attacks, he paid off the raiders with money raised by the Danegeld (994). The Danes returned nevertheless in 997 and again in 1002 when they were massacred by Ethelred's forces. The Danish King Swevn retaliated and conquered England (1013). Ethelred was made king again on Sweyn's death, but was succeeded by Sweyn's son CANUTE II. ethene (ethylene) Colourless gas (CH₂H₄) derived from the cracking of propane and other compounds. Vast quantities are used in polyethylene production. Ethene is also used for many other chemical syntheses.

ether In physics, hypothetical medium that was supposed to fill all space and offer no resistance to motion. It was postulated as a medium to support the propagation of electromagnetic radiations, but was disproved.

ether (diethyl ether) Colourless volatile inflammable liquid (C₂H₅OC₂H₅) prepared by the action of sulphuric acid on ethanol followed by distillation. It is used as an industrial solvent, fuel additive and decreasingly as an anaesthetic. Diethyl ether is a typical member of the ethers with the general formula ROR', where R,R' are hydrocarbon radicals. Properties: m.p. -116.2°C (-117.2°F); b.p. 34.5°C (94.1°F).

Ethiopia Landlocked republic in E Africa. See country feature ethnic group In sociology, any social group that shares a complex of characteristics distinguishing it from larger society. Such groups are usually based on national origins, religion, language, culture or race.

ethnography Study of the culture of an ethnic group or society. Ethnographers gather anthropological data by direct observation of a group's economic and social life. See also ANTHROPOLOGY; ETHNOLOGY

ethnology Comparative study of cultures. Historical ethnology was developed in the late 19th century in an attempt to trace cultural diffusion.

ethology Study of animal behaviour especially in the natural environment, first outlined in the 1920s by Konrad LORENZ. Ethologists study natural processes, such as courtship, mating and self-defence.

ethylene See ETHENE

ethyne (acetylene) Colourless flammable gas (C2H2), manufactured by cracking of petroleum fractions. The simplest ALKYNE, it is explosive if mixed with air. When burned with oxygen, it produces extremely high temperatures up to $3,480^{\circ}\text{C}$ ($6,300^{\circ}\text{F}$) and is used in oxyacetylene torches. It is polymerized to manufacture plastics, synthetic fibres, resins and neoprene. It is also used to produce ethanal and ethanoic acid. Properties: r.d. 0.625; m.p. -80.8°C (-113.4°F); b.p. -84°C (-119.2°F).

Etna Volcanic mountain on the E coast of Sicily, Italy. The first known eruption was in 475 BC, others occurring in 1169, 1669 and 1971. It is the highest active volcano in Europe and the highest mountain in Italy, s of the Alps. The fertile lower slopes are used for agriculture. Height: c.3,340m (10,958ft).

Etruscan Inhabitant of ancient Etruria, central Italy. Etruscan civilization flourished in the first millennium BC. Their sophisticated society was influenced by Greece and organized in city states. From the 5th to the 3rd century BC they were gradually overrun by neighbouring peoples, particularly the Romans.

etymology Branch of PHILOLOGY dealing with the origin and history of words. The word telephone, for example, is a combination of two elements derived from Greek, *tele* (distant) and *phone* (sound or voice).

eubacteria Subkingdom of the kingdom PROKARYOTAE, sometimes considered a separate DOMAIN. Eubacteria include

all multicellular BACTERIA, including those that photosynthesize, deriving their carbon from the air. They do not have the unique types of cell walls, RIBOSOMES and RNA of the other subkingdom, ARCHAEBACTERIA. See also PHOTOSYNTHESIS

Euboea (Évvoia) Island in the w Aegean Sea, SE central Greece; the administrative centre is Khalkís. Under Athenian domination (506–411 BC), it was taken by Philip II of Macedon in 338 BC, then held successively by the Romans, Byzantines, the Venetians and the Turks, before being incorporated into independent Greece in 1830. Industries: livestock, grapes, timber, grain, marble quarrying, lignite and magnesite mining. Area: 3,654sq km (1,411sq mi). Pop. (1991) 208,408.

eucalyptus (gum tree) Genus of evergreen shrubs and slender trees, native to Australia and cultivated in warm and temperate regions. They are valuable sources of hardwood and oils. Leaves are blue/white, and they bear woody fruits and flowers without petals. Height: to 122m (400ft). There are *c*.600 species. Family Myrtaceae.

Eucharist Central act of Christian worship, in which the priest and congregation partake in Holy Communion – one of the principal SACRAMENTS. The Eucharist is a commemorative re-enactment of the LAST SUPPER. Among Roman

ETHIOPIA

The tricolour flag of Ethiopia was first flown as three separate pennants, one above the other. The red, yellow and green combination dates from the late 19th century. It appeared in flag form in 1897. The present sequence was adopted in 1914.

Thiopia is dominated by the Ethiopian Plateau, a block of volcanic mountains. Its average height is 1,800m to 2,450m (6,000ft to 8,000ft), rising in the N to 4,620m (15,157ft), at Ras Dashen. The plateau is bisected by the Great RIFT VALLEY. The Eastern Highlands include the Somali Plateau and the desert of the Ogaden Plateau. The Western Highlands include the capital, ADDIS ABABA, the Blue NILE (Abbay) and its source, Lake Tana (Ethiopia's largest lake). The Danakil Desert forms Ethiopia's border with ERITREA.

CLIMATE

Ethiopia's climate is greatly affected by altitude. Addis Ababa, at 2,450m (8,000ft), has an

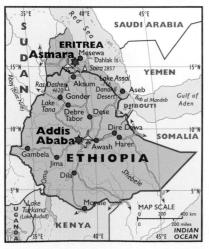

average annual temperature of 20°C (68°F). Rainfall is generally more than 1,000mm (39in), with a rainy season from April to September. The NE and SW lowlands are extremely hot and arid with less than 500mm (20in) rainfall, and frequent droughts.

VEGETATION

Grass, farmland and trees cover most of the highlands. Semi-desert and tropical savanna cover parts of the lowlands. Dense rainforest grows in the sw.

HISTORY AND POLITICS

According to tradition, the Ethiopian kingdom was founded (c.1000 BC) by Solomon's son, Menelik I. Coptic Christianity was introduced to the N kingdom of Axum in the 4th century. In the 6th century, Judaism flourished. The expansion of Islam led to the isolation of Axum. The kingdom fragmented in the 16th century. In 1855 Kasa reestablished unity, and proclaimed himself negus (Emperor) Theodore, and founded the modern state. The late 19th century was marked by European intervention, and Menelik II became emperor with Italian support. He expanded the empire, made Addis Ababa his capital (1889), and defeated an Italian invasion (1895). In 1930 Menelik II's grandnephew, Ras Tafari Makonnen, was crowned Emperor HAILE SELASSIE I. In 1935 Italian troops invaded Ethiopia (Abyssinia). In 1936 Italy combined Ethiopia with Somalia and Eritrea to form Italian East Africa. During World War 2, British and South African forces recaptured Ethiopia, and Haile Selassie was restored as emperor.

AREA: 1,128,000sq km (435,521sq mi)

POPULATION: 55,500,000

CAPITAL (POPULATION): Addis Ababa (1,700,000)
GOVERNMENT: Federation of nine provinces
ETHNIC GROUPS: Oromo (Galla) 40%, Semitic
(Amhara and Tigreans) 33%, Shangalla 5%,
Somalis 5%. Others 17%

LANGUAGES: Amharic (de facto official)
RELIGIONS: Christianity 53%, Islam 36%, traditional beliefs 11%

CURRENCY: Birr = 100 cents

In 1952, Eritrea was federated with Ethiopia. The 1960s witnessed violent demands for Eritrean secession and economic equality. Following famine in N Ethiopia, Selassie was deposed by a military coup in 1974. The Provisional Military Administrative Council (PMAC) abolished the monarchy. Military rule was repressive and civil war broke out. In 1977 Somalia seized land in the Ogaden Desert. The new PMAC leader, Mengistu Mariam, recaptured territory in Eritrea and the Ogaden with Soviet military assistance. In 1984-85 widespread famine received global news coverage, and 10,000 FALASHAS were airlifted to Israel. In 1987 Mengistu established the People's Democratic Republic of Ethiopia. In 1991 the Tigrean-based Ethiopian People's Revolutionary Democratic Front (EPRDF) and the Eritrean People's Liberation Front (EPLF) brought down Mengistu's regime. In 1993 Eritrea achieved independence. In 1994 a federal constitution was adopted. In 1995 multiparty elections were won by the EPRDF. Negasso Gidada was elected president.

ECONOMY

Ethiopia is the world's poorest country (1992 GDP per capita, US\$330), 88% of the workforce are engaged in agriculture (mostly subsistence) and 67% of exports are food products. Coffee is the main cash crop, shipped through the port of DIBOUTI. During the 1970s and 1980s, it was plagued by civil war and famine (partly caused by long droughts). Ethiopia remains heavily dependent on food and financial aid.

▼ Europe Earth's second smallest continent is, strictly speaking, a peninsula of the vast Eurasian land mass. Traditionally, it is separated from Asia by the Urals (E), the Caucasus and the Caspian Sea (SE) and the Black Sea (s). Europe is home to over 500 million people. The ancient civilizations of Greece and Rome were the cradle of democracy. European languages, culture and religion were disseminated by migration, imperialism and colonialism. Throughout human history, Europe has witnessed many destructive wars. In the 19th century, vast European empires crumbled with the rise of nationalism. The antagonism of these new nation states led to both world wars. Europe lay at the heart of the Cold War between capitalism and communism. The collapse of Soviet communism saw the emergence of new nations. The European Union (EU) was formed to promote pan-European cooperation and development.

Catholics, the rite is also called Mass; among Protestants, it is the Lord's Supper. See also TRANSUBSTANTIATION

Euclid (c.330–c.260 BC) Ancient Greek mathematician, who taught at Alexandria, Egypt. He is remembered for his text books on geometry, such as *The Elements* (Lat. pub. 1482) and *Data*. Other works include *Phaenomena* (on astronomy). Several books have been lost.

Eugène of Savoy (1663-1736) French-born prince and Austrian general. Rejected by Louis XIV, he displayed extraordinary courage and leadership for Austria against the Ottoman Turks at Vienna (1683) and Zenta (1697). In the War of the Spanish Succession (1702–13), he cooperated with the Duke of MARLBOROUGH in victories over the French at BLENHEIM (1704), Oudenarde (1708) and Malplaquet (1709). eugenics Study of human improvement by selective breeding, founded in the 19th century by Sir Francis GALTON. It proposed the genetic "improvement" of the human species through the application of social controls on parenthood, encouraging parents who are above average in certain traits to have more children, while ensuring those who are below average have fewer. As a social movement, eugenics was discredited in the early 20th century, owing to its ethical implications and its racist and class-based assumptions. Advances in GENETICS have given rise to the modern field of genetic counselling, through which people known to have defective genes that could cause physical or mental disorders in offspring are warned of the risks.

euglenophyta Phylum of single-celled ALGAE which includes the genus *Euglena*. Members of this group have both animal and plant characteristics. They swim by means of flagella. Many species contain CHLOROPLASTS and employ

PHOTOSYNTHESIS, but some are colourless and feed on BACTE-RIA and DIATOMS. Photosynthetic euglenoids can temporarily "close" their chloroplasts and feed like colourless forms.

eukaryote Organism whose CELLS have a membrane-bound NUCLEUS, with DNA contained in CHROMOSOMES. Making up one of the three DOMAINS, eukaryotes include all ANIMALS, PLANTS, FUNGUS and PROTOCTISTA. They have a complex CYTOPLASM with an ENDOPLASMIC RETICULUM, and most of them possess MITOCHONDRIA. Most plants and algae also possess CHLOROPLASTS. Other structures specific to eukaryotic cells include microtubules, GOLGI BODIES, and membrane-bound flagella. *See also* KINGDOM; PROKARYOTAE

Euler, Leonhard (1707–83) Swiss mathematician. He is best known for his geometric theorem, which states that for any polyhedron (many-sided figure), V - E + F = 2, where V is the number of vertices, E the number of edges, and F the number of faces. He published on subjects as diverse as mechanics, algebra, optics and astronomy.

eunuch Castrated man, originally used as keeper of a HAREM. Employed as servants in royal and wealthy households, especially in the Byzantine and Ottoman empires, eunuchs were often obtained through the African slave trade. See also CASTRATO

Euphrates (Firat) River of sw Asia. Formed by the confluence of the rivers Murat and Karasu, it flows from E Turkey across Syria into central Iraq, where it joins the River Tigris NW of BASRA to form the SHATT AL-ARAB, and eventually flows into the Persian Gulf. The ancient civilizations of BABYLONIA and ASSYRIA developed along the lower Euphrates, including the cities of BABYLON and Ur. Length: 2,800km (1,740mi).

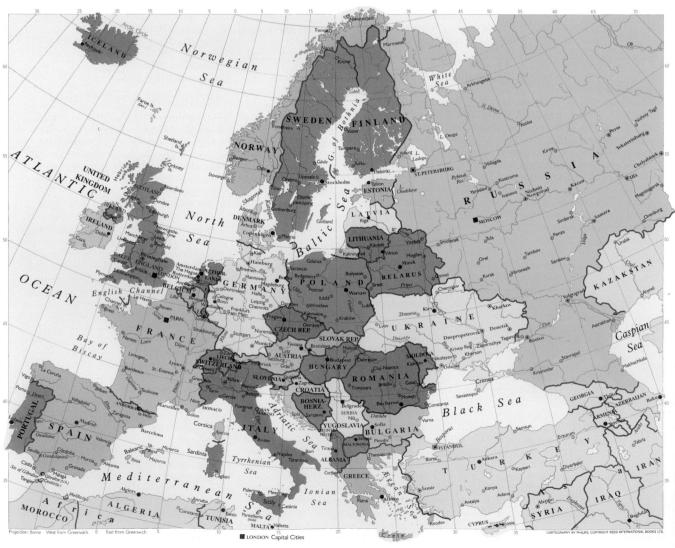

Eureka Stockade (1854) Armed rebellion of gold diggers at Ballarat, Victoria, Australia. Resentment at exploitative administration of the goldfields culminated in some 150 diggers forming a stockade and firing on a contingent of 280 police and troops. They were quickly overcome and 30 men killed. None of the rebels were subsequently convicted.

eurhythmics System of musical and dance training which has influenced ballet and acting. Developed in Switzerland and Germany by Emile Jaques-Dalcroze during the early 20th century, and also applied by Rudolf STEINER, it evolved from a series of interpretive gymnastic exercises in response to music. Euripides (480–450 BC) Greek playwright. With AESCHY-LUS and SOPHOCLES, one of the three great writers of Greek tragedy. Euripides' plays caused contemporary controversy, with their cynical depiction of human motivation. The significance of the CHORUS is reduced in favour of a more complex examination of individual behaviour, especially women in love. His works, such as Medea, Electra, Hecuba and the anti-war satire Trojan Women have been radically reassessed. Provacative and iconoclastic, they achieved great posthumous popularity. Only 18 plays are extant.

Europa Smallest of Jupiter's Galilean Satellites, with a diameter of 3,138km (1,950mi). Mainly rock, Europa's smooth water-ice crust is criss-crossed by a network of light and dark linear markings. A form of ice tectonics might be operating on the planet, since there are very few craters.

Europe Earth's second smallest continent, comprising the western fifth of the Eurasian land mass. It is separated from Asia by the Urals (E), Caspian Sea and the Caucasus (SE), Black Sea and Dardanelles (s), and from Africa by the Mediterranean Sea. Land Europe is dominated by the Alpine mountain chain, the principal links of which are the PYRENEES, ALPS, CARPATHIAN MOUNTAINS, BALKAN STATES and the CAU-CASUS, traversing the continent from W to E. Between the Scandinavian peninsula and the Alpine chain is the great European plain, which extends from the Atlantic coast in France to the Urals. Much of the plain is fertile farmland, but also includes areas of forest, steppe, lakes and tundra. To the s of the Alpine chain are the Iberian, Italian and Balkan peninsulas. Major islands include the British Isles, Sicily, Sardinia, Corsica and Iceland. Europe's longest river is the Volga, other major rivers are (from w to E) the TAGUS, Garonne, LOIRE, RHÔNE, RHINE, ELBE, DANUBE and the Oder. The CASPIAN SEA is the world's largest lake. Structure and geology Much of N Europe is made up of large sedimentary plains overlying an ancient PRECAM-BRIAN shield, outcrops of which remain in N Scandinavia, Scotland and the Urals. There are also worn-down PALAEOZOIC highlands. Many upland areas N of the Alps were formed during the CARBONIFEROUS period, including Ireland, the moorlands of Devon and Cornwall and the PENNINES, England. Southern Europe is geologically younger. Alpine folding began in the OLIGOCENE period. Climate and vegetation Europe's climate varies from sub-tropical to polar. The Mediterranean climate of the s is dry and warm. Much of the land is scrub (maquis), with some hardwood forests. Further N, the climate is mild and quite humid, moderated by prevailing westerly winds and the GULF STREAM. The natural vegetation is mixed forest, but this has been extensively depleted and less than 25% of Europe is forested. Almost half of European land is unproductive because of climate, relief, soil or urbanization. In central Europe, there is a much greater range of temperature. Mixed forest merges into boreal forests of conifers. In SE European Russia, wooded and grass steppe merge into semidesert to the N of the Caspian Sea. In the far N lies the tundra. People The racial origin of European peoples is unclear. They are usually characterized by ETHNIC GROUP. Most European languages fall into three groups, Germanic, Latin (Romance) and Slavic, all of which are INDO-EUROPEAN in origin. Other languages include Finno-Ugric, spoken in Finland, Hungary and parts of European Russia, Altaic in Turkey, Maltese (Semitic) and Basque. Christianity is dominant among religious faiths. In general, s and central Europe is Roman Catholic, while N Europe is predominantly Protestant and the SE (Greece, Romania and Bulgaria) is Orthodox. Ukraine and European Russia are also mainly Orthodox. Islam is practised in Bosnia-Herzegovina, Albania, Bulgaria and Turkey. There are also substantial Muslim minorities in several w European countries.

Economy Timber and associated industries are particularly important in Scandinavia and the mountainous areas of E Europe. Fishing is a major industry in countries with Atlantic or North Sea coastlines and moderately important in the Mediterranean. Two-thirds of cultivated land is arable. Cereals are the principal crop: wheat is the most important, replaced by oats in the N and sometimes by maize in the S. Rice is grown with the aid of irrigation. Sheep are grazed on many upland areas, but dairy farming is by far the most important form of animal husbandry. In Mediterranean areas, many fruits, early vegetables and vines (mainly for wine) are cultivated. Europe produces over a third of the world's coal. Germany, Poland, the Czech Republic and European Russia are the leading producers. Other mineral deposits include bauxite, mercury, lead, zinc and potash. Romania was the largest producer of oil in Europe until North Sea states, especially Britain, began to exploit their resources. Several countries in central Europe also have oil fields. Europe is highly industrialized and manufacturing employs a high proportion of the workforce. The largest industrial areas are in w central Europe, in particular N and NE France, the RUHR and around the North Sea ports of ANTWERP. AMSTERDAM, ROTTERDAM and HAMBURG. There are other major industrial regions in Britain, N Italy and central European Russia.

History The Mediterranean region was the cradle of the ancient Greek and Roman civilizations. The collapse of the Western Roman empire and the barbarian invasions brought chaos to much of Europe, although BYZANTIUM remained intact until the 15th century. During the Middle Ages, Christianity was a unifying force throughout the continent. The post-medieval period witnessed a fundamental split in the CATHOLIC CHURCH, and the emergence of the nation state. European powers began to found vast empires in other parts of the globe (See COLONIALISM; IMPERIALISM), and the FRENCH REVOLUTION ushered in an era of momentous political changes. During the 20th century, a period overshadowed by two World Wars and the rise of COMMUNISM, Europe began to lose some of its preeminence in world affairs. After World War 2, the countries of Europe became divided into two ideological blocs: Eastern Europe, dominated by the Soviet Union, and Western Europe, closely aligned with the USA. The resulting rivalry was known as the COLD WAR. The NORTH ATLANTIC TREATY ORGANIZATION (NATO) was established to act as a deterrent to the spread of communism; the WARSAW PACT was its E European counterpart. Several economic organizations, in particular the EUROPEAN COMMUNITY (EC), worked for closer intra-national cooperation. In 1991, the collapse of European communism added to the momentum for a kind of supranational union in the form of the EUROPEAN UNION (EU). Area c.10.4 million sq km (4 million sq mi) Highest mountain Mount Elbrus (Russia) 5,633m (18,481ft) Longest river Volga 3,750km (2,330mi) Population (1990 est.) 785,700,000 Largest cities Moscow (8,881,000); Lon-DON (6,966,800); ST PETERSBURG (4,883,000); BERLIN (3,466,000). See also articles on individual countries

European Atomic Energy Commission (Euratom) Organization that was formed following the second of the Treaties of Rome (1958). Euratom was founded to coordinate non-military nuclear research and production, and provide capital for investment, specialists and equipment. It is administered by the European Commission.

European Community (EC) Economic and political body dedicated to European development. The history of the Community lies in the establishment of the European Coal and Steel Community (ECSC), following the Treaty of Paris (1951). The purpose of the ECSC was to integrate the coal and steel industries, primarily of France and West Germany, to create a more unified Europe. The success of the ECSC led to the formation of the European Economic Community (EEC), or Common Market, and the EUROPEAN ATOMIC ENERGY COMMUNITY (EURATOM). Established by the Treaties of Rome (1958), the aim was to create a common economic approach to agriculture, employment, trade and social development, and to give West-

ern Europe more influence in world affairs. Original members included France, West Germany, Italy, Belgium, The Netherlands and Luxembourg; the United Kingdom, Ireland and Denmark joined (1973), Greece (1981), Spain and Portugal (1986), and Austria, Finland and Sweden (1995). The Community's institutional structure comprises the European Commission (responsible for implementing EC legislation), the Council of Ministers (which votes on Commission proposals), the Economic and Social Committee (which advises on draft EC legislation), the European Investment Bank (responsible for all the EC's financial operations), the European Parliament and the European Court of Justice. See also European Union (EU) **European Convention on Human Rights** Agreement to protect the rights and freedoms of the individual, signed by the members of the Council of Europe in 1950. The

to protect the rights and freedoms of the individual, signed by the members of the COUNCIL OF EUROPE in 1950. The Convention listed 12 basic rights, including the right to life, to a fair trial, to peaceful assembly and association, and to freedom of expression and from slavery and torture. An additional protocol provides for the abolition of the death penalty. See also HUMAN RIGHTS

European Court of Human Rights Created in 1959, the court is presided over by one judge from member states that are signatories of the 1950 EUROPEAN CONVENTION ON HUMAN RIGHTS. It decides whether or not an individual's rights have been disregarded by a member state in cases when the two parties have already failed to reach a settlement through the European Commission of Human Rights. The court is located in Strasbourg, E France.

European Court of Justice (officially Court of Justice of the European Communities) Court responsible for the interpretation and implementation of European Community laws. The court will also rule in cases where member states are alleged to have broken EC laws.

European Currency Unit (ECU) Theoretical unit against which the currencies of all European Community countries are valued. Part of the European Monetary System (EMS), the ECU is intended to lead to a single currency for the European Community.

European Free Trade Association (EFTA) Organization seeking to promote free trade among its European members. Established in 1960, it originally comprised Austria, Denmark, Ireland, Norway, Portugal, Sweden, Switzerland and the UK. By 1995 all but Norway and Switzerland had joined the European Union (EU), while Iceland and Liechtenstein joined EFTA in 1970 and 1991 respectively. Iceland, Liechtenstein and Norway are also members of the European Economic Area (EEA), the single market with the EU states.

European Monetary System (EMS) System set up in 1979 to bring about monetary stability among members of the European Community (EC). There are three parts to the system: the European Currency Unit (ECU); the Exchange Rate Mechanism (ERM); and the credit mechanisms. From the start, the ECU had no coins or notes, but was a symbolic unit based on a weighted average of a number of currencies. In practice, the German currency (the Deutsche Mark), serves as the standard. As part of the original vision, there were plans to make the ECU an actual pan-European currency. The ERM sets a central rate of exchange for the currency of each country, which is required to keep within a certain percentage (originally 2% or 6%) above or below the rate. The central banks of each country use the credit mechanisms to borrow money from each other to keep currencies stable.

European Monetary Union (EMU) Proposed union of EU member states who will share common economic policies and a common currency. Member states who meet certain economic criteria will relinquish control of their own money supplies to a European Central Bank, which would take increasing responsibility for the regulation of the money supply. Exchange rates would become fixed and a single European currency, the Euro, created. The "first wave" of the Union is planned for 1999, when international financial transactions will be calculated in Euros. The "second wave", in 2002, will involve the introduction of Euros to the public and its use as an alternative to national currencies. Not all EU member states will join the EMU. Some will be unable to

meet the strict economic criteria; for others, such as the UK, the choice to enter or not is a political issue.

European Parliament Institution of the EUROPEAN COMMUNITY. The Parliament forms part of the permanent structure of the European Community, along with the Council of Ministers, the Commission, the Court of Justice and the Court of Auditors. It meets in Strasbourg, Brussels and Luxembourg. It has 626 members, representing the 15 member states, elected for five-year terms. It has limited legislative powers.

European Space Agency (ESA) Organization founded by several European nations in 1962 as the European Space Research Agency (ESRO) to promote international cooperation in space research. Australia was admitted in 1965.

European Union (EU) Political entity that was established following ratification of the Maastricht Treaty (1993). The EU aims to use the existing framework and institutions of the European Community (EC) to implement greater integration of member states; particularly in areas such as foreign and security policies, and internal and judicial policies. Some member states, particularly the UK and Denmark, have resisted moves towards closer integration, particularly in the areas of a single European currency and a common social policy. Arguments persist over loss of national sovereignity and many argue that the union will create a federalist Europe. See also European Monetary System (EMS); European Parliament

europium (symbol Eu) Silvery-white metallic element of the LANTHANIDE SERIES. Its chief ores are monazite and bastnaesite. The metal is used in the manufacture of colour television screens, lasers, and in control rods in nuclear reactors. Properties: at.no. 63; r.a.m. 151.96; r.d. 5.25; m.p. 822°C (1,512°F); b.p. 1,597°C (2,907°F); most common isotope Eu¹⁵³ (52.18%). Eurydice In Greek mythology, nymph married to ORPHEUS. Eustachian tube Small channel that connects the middle EAR to the back of the throat. It opens when swallowing, to allow the pressure in the middle ear to remain the same as the pressure of air outside the body.

Euston Road School School of painting and drawing founded in London in 1937. Its return to a more straightforward naturalism was inspired by SICKERT and CÉZANNE, and was a response to the prevalent abstract or surrealist styles.

euthanasia Inducing the painless death of a person (usually someone with a terminal illness), often through the administration of a drug. It is illegal in most countries. An associated practice is the withholding of treatment which would prolong life.

eutrophication Process by which a stream or lake becomes rich in inorganic nutrients, such as compounds of nitrogen, phosphorus, iron, sulphur and potassium, by agricultural runoff or other artificial means. These compounds overstimulate the growth of surface ALGAE and microorganisms, which consume all the available dissolved oxygen, killing off most higher organisms.

evangelicalism (Gk. euangelos, good news or gospel) Term applied to several, generally Protestant, tendencies within the Christian Church. In a broad sense it has been applied to PROTESTANTISM as a whole because of its claim to base its doctrines strictly on the gospel. Evangelicalism denotes the school which stresses personal conversion and witness of salvation by faith in the atoning death of Jesus Christ.

Evangelical United Brethren Church Christian denomination formed in the USA in 1946 by the union of the Evangelical Church and the United Brethren in Christ. Both these Protestant churches had existed since the early 19th century. The Evangelical United Brethren Church emphasized the importance of prayer and the authority of scripture. In 1968 it merged with the Methodist Church to form the United Methodist Church.

evangelist Person who preaches the gospel, announcing the good news of redemption through Jesus Christ and the hope of everlasting life. The word also applies by extension to the authors of the four gospels of the New Testament: Saints MATTHEW, MARK, LUKE and JOHN.

Evans, Dame Edith (1888–1976) British stage and screen actress. While with the OLD VIC (1925–26, 1936) she played a variety of roles, including the Nurse in *Romeo and Juliet*. Her

best-remembered roles include Lady Bracknell in *The Importance of Being Earnest*. She was awarded the New York Film Critic's Award for her performance in *The Whisperers* (1967). **Evans, Walker** (1903–75) US photographer. He is famed for his portrait images of the poverty-stricken South of the 1930s, many published in *Let Us Now Praise Famous Men* (coauthored by James AGEE, 1941). His works also include stark studies of Victorian architecture and building interiors. **evaporation** Process by which a liquid or solid becomes a vapour. The reverse process is CONDENSATION. Solids and liquids cool when they evaporate because they give up energy (LATENT HEAT) to the escaping molecules.

Eve In the Bible (GENESIS 2), the first woman, created by God from Adam's rib to be his companion and wife in the Garden of EDEN. She succumbed to temptation and disobeyed God by eating the fruit of the tree of the knowledge of good and evil and sharing it with Adam. For this act, the couple became mortal and were banished from the garden. She was the mother of CAIN, ABEL and Seth.

evening primrose Any of various plants of the genus *Oenothera*, many of which are native to w North America. They have yellow, pink or white flowers that open in the evening. Height: 1.8m (5.3ft). Family Onagraceae.

Everest, Mount (Nepalese *Sagarmatha*; Tibetan *Chomo-Langma*, Mother Goddess of the World) Highest mountain in the world, in the central Himalayas on the borders of Tibet and Nepal. It is named after George Everest, first surveyor-general of India. Everest was conquered on 29 May 1953, by Sir Edmund HILLARY and Tenzing Norgay. Height: 8,848m (29,029ft).

Everglades Large tract of marshland in s Florida, USA, extending from Lake Okeechobee to Florida Bay; it includes the Everglades National Park. The region is made up of mangrove forests, saw grass and hummocks (island masses of vegetation). It supports tropical animal life, including alligators, snakes, turtles, egrets and bald eagles. Area: *c*.10,000sq km (4,000sq mi).

evergreen Plant that retains its green foliage for a year or more, unlike DECIDUOUS plants. Evergreens are divided into two groups: narrow-leaved, or CONIFERS, and broad-leaved. Conifers include fir, spruce, pine and juniper. Among the broad-leaved evergreens are holly and rhododendron. Not all conifers are evergreens; exceptions include the larch (*Larix*).

Evert, Chris (Christine Marie) (1954–) US tennis player. Evert was the first woman player to win over \$1 million in prize money. Her 18 grand slam singles titles include seven French Opens (1974–75, 1979–80, 1983, 1985–86); six US Opens (1975–78, 1980, 1982); Wimbledon (1974, 1976, 1981) and the Australian Open (1982, 1984).

evolution Theory that a species undergoes gradual changes to survive and reproduce in a competitive, and often changing, environment, and that a new species is the result of development and change from the ancestral forms. Early work on evolutionary theory was initiated by Jean LAMARCK, but it was not until Charles DARWIN wrote The Origin of Species (1859) that the theory was considered worthy of argument. Present-day evolutionary theory is largely derived from the work of Darwin and MENDEL and maintains that in any population or gene pool, there is VARIATION, including random MUTATION, in genetic forms and characteristics. Most species produce greater quantities of offspring than their environment can support, so only those members best adapted to the environment survive. When new characteristics provide survival advantages, those individuals that possess them pass on these characteristics to their offspring. Since more of their offspring are likely to survive, the proportion of the population containing these new characteristics increases down the generations. See also ADAPTATION; ADAPTIVE RADIATION; NATURAL SELECTION; PUNCTUATED EQUILIBRIUM

exchange rate In economics, the rate at which one nation's currency can be converted to that of another. It varies according to the fluctuations registered on the world's FOREIGN EXCHANGE markets. See also EXCHANGE RATE MECHANISM (ERM)

Exchange Rate Mechanism (ERM) System for keeping the currencies of member states of the EUROPEAN UNION (EU)

stable, as part of the EUROPEAN MONETARY SYSTEM (EMS). The ERM worked well for a time, but currency speculation forced two currencies, the UK pound sterling and the Italian lira, to leave it in 1992, because they were unable to keep the value of their currencies above the minimum limit. The ERM was near collapse, and to save it several currencies were allowed to fluctuate by as much as 15% above or below their central rate. See also FOREIGN EXCHANGE

exclusion principle Basic law of QUANTUM MECHANICS, proposed by Wolfgang PAULI in 1925, stating that no two ELECTRONS in an atom can possess the same energy and SPIN. More precisely, the set of four QUANTUM NUMBERS characterizing certain ELEMENTARY PARTICLES called FERMIONS must be unique.

excommunication Formal expulsion from the communion of the faithful, from sacraments and from rites of a religious body. Largely abandoned by Protestants, excommunication has been retained by Jewish congregations and by the Roman Catholic Church. In the days when the church held great temporal (as well as spiritual) authority, excommunication was a severe punishment for HERESY OF BLASPHEMY.

excretion Elimination of materials from the body that have been involved in METABOLISM. Such waste materials, particularly nitrogenous wastes, would be toxic if allowed to accumulate. In mammals these wastes are excreted mainly as URINE, and to some extent also by sweating. Carbon dioxide is excreted through the lungs during breathing. Defaecation is not excretion, as faeces consist mostly of material that has never been part of the body.

Exeter City on the River Exe; county town of Devon, sw England. Many ancient buildings remain, notably the Norman cathedral (c.1275), the 12th-century Guildhall and the remains of Roman walls. Exeter University was established in 1955. Industries: tourism, textiles, leather goods, metal products, pharmaceuticals. Pop. (1991) 98,125.

existentialism Philosophical movement concerned with individuals and their relationship with a seemingly meaningless universe or with God. Most adherents believe that people are free to create their own destinies and are not constrained by forces outside their control. The beginnings of the modern existentialist movement can be seen in the theological writings of Søren Kierkegaard, later developed by Karl Jaspers. The writings of Martin Heidegger, Jean-Paul Sartre and Albert Camus are linked with existentialism.

exobiology Search for life on other planets. Exobiology is concerned with attempts to detect environmental conditions and possible biochemical and evolutionary pathways to life beyond Earth.

Exodus Old Testament book of the Bible, the second book of the PENTATEUCH or TORAH. The first part details the flight of the Israelites from Egypt; the second part contains a catalogue of religious instructions that formed the basis of Mosaic law. **exoskeleton** Protective skeleton or hard supporting structure forming the outside of the soft bodies of certain animals, notably ARTHROPODS and MOLLUSCS. In arthropods, it consists of a thick horny covering attached to the outside of the body and may be jointed and flexible. The exoskeleton does not

grow as the animal grows; instead it is shed periodically and the animal generates a new one. **exothermic reaction** CHEMICAL REACTION in which heat is evolved. A common example is COMBUSTION. See also

■ Everest The world's highest peak, at 8,848m (29,028ft). Since Everest was first climbed in 1953, mountain-climbing technology has greatly improved and the Himalayan summit is now reached without the need for oxygen tanks. The mountain is imbued with local religious significance.

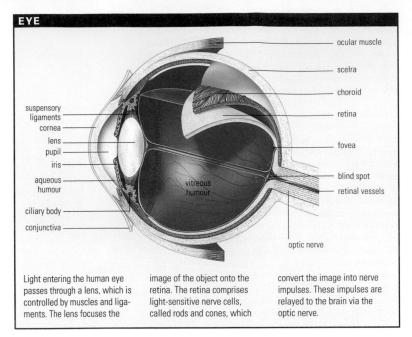

expansion Change in the size of an object with change in temperature. Most substances expand on heating, although there are exceptions (ice expands on cooling). The expansivity (coefficient of expansion) of a substance is its increase in length, area or volume per unit temperature rise. For a gas, the coefficient of expansion is the ratio of the rates of change of volume to temperature (at constant pressure), or of volume to pressure (at constant temperature).

explosive Substances that react rapidly and violently, emitting heat, light, sound and shock waves. Chemical explosives are mostly highly nitrated compounds or mixtures that are unstable and decompose violently with the evolution of much gas. Nuclear explosives are radioactive metals, the atoms of which can undergo nuclear FISSION or FUSION to release radiant energy and devastating shock waves.

exponent Superscript number placed to the right of a symbol indicating its power, e.g. in a^4 (= $a \times a \times a \times a$), 4 is the exponent. Certain laws of exponents apply in mathematical operations. For example, $3^2 \times 3^3 = 3^{(2+3)} = 3^5$; $3^4/3^3 = 3^{(4-3)} = 3^1$; $(3^2)^3 = 3^{(2\times3)} = 3^6$; $3^{-5} = 1/3^5$.

exponential In general, a function of x of the form ax, where a is a constant. The exponential function ex where e is the base of natural logarithms, 2.7182818..., can be represented by a power series 1 + x + x2/2! + x3/3! + ...

expressionism Style of art in which conventional methods of NATURALISM are replaced by distorted and exaggerated images to express intense, subjective emotion. The term is often used in relation to a radical German art movement between the 1880s and c.1905. The inspiration for this new focus came from many different sources, including the work of Van Gogh, Gauguin, Munch and those within symbolism, as well as from folk art. German expressionism reached its apogee in the work of the Blaue Reiter group. The term also applies to performance arts, such as the works of Strindberg and Wedekind.

extensor See MUSCLE

extinction Dying out of a species or population. Extinction is part of the process of EVOLUTION in which certain species of plants and animals die out, often to be replaced by others. Extinctions brought about by human impact on the environment do not necessarily involve the replacement of extinct species by others.

extrasensory perception (ESP) Perception that takes place outside the known sensory systems. The term covers alleged parapsychological phenomena such as clairvoyance, telepathy and precognition. Although not explainable by the traditional methods of physical science, ESP has been the subject of serious investigation, beginning with the establishment in 1882 in London of the Society for Psychical Research.

extroversion Personality type characterized by outgoing behaviour; the opposite of INTROVERSION. The term was popularized by Carl Jung, according to whose theory of PERSONALITY, extroverts are sociable, impulsive, and more interested in the outside world than in their own emotions.

extrusion In geology, the breaking-out of IGNEOUS ROCK from below the Earth's surface. Any volcanic product reaching the surface becomes extrusive material whether it is ejected through a VOLCANO'S cone or through pipe-like channels or fissures in its crust. In industry, extrusion is the forcing of metals or plastics at optimum temperature through a die to make rods, tubes and various hollow or solid sections.

Eyck, Jan van (c.1390-d.1441) Flemish painter. His bestknown work is the altarpiece for the Church of St Bavon, Ghent, which includes the Adoration of the Lamb (1432) and the Arnolfini Wedding (1434), both of which display intricate detail. He is said to have perfected the manufacture and technique of oil paint. His brother, Hubert van Eyck (c.1370–1426) is thought to have worked in Ghent and assisted Jan on the St Bayon alterpiece. No other works are definitely ascribed to him and some art historians think he never existed. eye Organ of vision. It converts light energy to nerve impulses that are transmitted to the visual centre of the brain. Most of the mass of a human eye lies in a bony protective socket, called the orbital cavity, which also contains muscles and other tissues to hold and move the eye. The eyeball is spherical and composed of three layers: the sclera (white of the eye), which contains the transparent CORNEA; the choroid, which connects with the IRIS, PUPIL and LENS and contains blood vessels to provide nutrients and oxygen; and the RETI-NA, which contains rods and cones for converting the image into nerve impulses. The aqueous humour (a watery liquid between the cornea and iris) and the vitreous humour (a jellylike substance behind the lens) both help to maintain the shape of the eye. See also SIGHT

eyebright Any of several small annual and perennial plants found in temperate and subarctic regions. They have terminal spikes of white, yellow or purple flowers. Some are hemiparasites, whose roots form attachments to those of other plants. European eyebright (*Euphrasia officinalis*) was formerly used to treat eye diseases. Family Scrophulariaceae.

Eyre, Lake Salt lake in NE South Australia. It is the lowest point on the continent, c.15m (50ft) below sea level, and the largest salt lake in Australia. Area: 9,324sq km (3,600sq mi). Max. depth: 1.2m (4ft).

Eysenck, Hans Jurgen (1916–97) British psychologist and pioneer of behaviour therapy, b. Germany. Much of Eysenck's work focused on developing a scientific definition of personality, based on experimental and psychometric methods. Eysenck founded (1955) the psychological department of the Institute of Psychiatry, Maudsley Hospital, London. Many of his works, such as *Uses and Abuses of Psychology* and *Know Your Own IQ*, were bestsellers. His research methodology and views on genetic determination often courted controversy.

Ezekiel Old Testament prophet who was among the Jews deported during the BABYLONIAN CAPTIVITY. He is traditionally considered the author of the Old Testament Book of Ezekiel. He was the third and last of the "greater" Old Testament prophets, the successor of ISAIAH and JEREMIAH.

Ezra In the Old Testament, a continuation of Chronicles I and II. It records the priest Ezra's journey from Babylon to Jerusalem to spread the law of Moses.

Fabergé, Peter Carl (1846–1920) Russian jeweller. He took over his father's business in 1870, making decorative objects in gold and precious stones. Famed for his designs of flowers and animals, he made many jewelled Easter eggs for European royalty, the first for Tsar Alexander III in 1884. Fabergé left Russia after the revolution of 1917.

Fabian Society British society of non-Marxists founded in 1883, who believed that SOCIALISM could be attained through gradual political change. With George Bernard Shaw and Sidney and Beatrice Webb as leaders, the society gained widespread recognition and helped found the Labour Representation Committee in 1900, which became the Labour Party in 1906. The Fabian Society is affiliated to the Labour Party and publishes a journal and pamphlets.

fable Literary genre which takes the form of a short allegorical tale, intended to convey a moral. The oldest extant fables are the Greek tales of AESOP and the Indian stories of the *Panchatantra*. Other notable collections of fables were made by Jean de LA FONTAINE, John GAY and Ivan Krylov.

facies In geology, all the features of a rock or that show the history of its formation. Geologists often distinguish age by facies. The term is also applied to gradations of IGNEOUS ROCK. **factor** In mathematics, any number that divides exactly into a given number. For example, the factors of 72 are 1, 2, 3, 4, 6, 8, 9, 12, 18, 24 and 36.

factory farming Intensive rearing of livestock, such as pigs, poultry and calves, in large, densely populated enclosures. Feeding is usually automatically dispensed, and the emphasis is on "mass-production" of the food products rather than the well-being of the animals involved. ANIMAL RIGHTS campaigns have encouraged less intensive rearing, such as free-range chickens.

Fahrenheit, Gabriel Daniel (1686–1736) German physicist and instrument-maker. He invented the alcohol THER-MOMETER (1709), the first mercury thermometer (1714) and devised the FAHRENHEIT TEMPERATURE SCALE. He also showed that the boiling points of liquids vary with changes in pressure and that water can remain liquid below its freezing point. Fahrenheit temperature scale System for measuring temperature based on the freezing point of water (32°F) and the boiling point of water (212°F). The interval between them is divided into 180 equal parts. Although replaced in Britain by CELSIUS, Fahrenheit is still used in the USA for nonscientific measurements. Fahrenheit is converted to Celsius by subtracting 32 and then dividing by 1.8. See also THERMOMETER fainting (syncope) Temporary loss of consciousness accompanied by general weakness of the muscles. A faint may be preceded by giddiness, nausea and sweating. Its causes include insufficient flow of blood to the brain and shock.

Fairbanks, Douglas Father and son US film actors. Douglas, Sr (1883–1939) founded United Artists films (1919) with his wife, Mary Pickford, Charlie Chaplin and D.W. Griffith. His swashbuckling acrobatics made him a screen idol in adventures such as *The Mark of Zorro* (1920), *Robin Hood* (1922) and *The Thief of Baghdad* (1924). His son, Douglas, Jr (1909–), had a successful career in films such as *The Dawn Patrol* (1930), *Catherine the Great* (1934), and *The Prisoner of Zenda* (1937).

Fairfax of Cameron, Thomas, 3rd Baron (1612–71) Parliamentary commander in the English CIVIL WAR. He succeeded ESSEX as commander-in-chief (1645), but in 1650 he refused to march against the Scots, and was replaced by Oliver CROMWELL. He later headed the commission to the Hague to arrange the RESTORATION of Charles II (1660).

Falange Spanish political party founded in 1933 by José Antonio Primo de Rivera. Modelled on other European followers of FASCISM, it was merged with other groups under the FRANCO regime and became the sole legal political party. It was heavily defeated in free elections in 1977.

Falashas Ethnic group of black Jews in Ethiopia, probably descended from early converts to JUDAISM. Their form of religion relies solely on observance of the OLD TESTAMENT. Israel acknowledged them as Jews in 1975, and, suffering discrimination at home, many migrated to Israel. During the early 1980s, there were about 30,000 Falashas living in

Ethiopia, but amid the war and famine that ensued, thousands were airlifted to Israel.

falcon Widely distributed, hawk-like bird of prey, sometimes trained by man to hunt game. Falcons have keen eyesight, short hooked bills, long pointed wings, streamlined bodies, strong legs with hooked claws, and grey or brownish plumage with lighter markings. The females are much larger than the males. Falcons feed on insects, smaller birds, and small ground animals. They can kill on the wing, using their talons. They lay two to five brown-spotted white eggs, often in abandoned nests. Length: 15–64cm (6–25in). Family Falconidae.

Faldo, Nick (Nicholas Alexander) (1957–) English golfer. A dedicated and methodical player, Faldo's first success was the English Amateur championship (1975). He has won the British Open (1987, 1990, 1992), and the US Masters (1989, 1990, 1996); the only player apart from Jack Nicklaus to win in successive years. In 1995, his dramatic, last-hole victory enabled Europe to regain the Ryder Cup. He was also a member of the victorious 1997 European Ryder Cup team.

Falkland Islands (Islas Malvinas) British crown colony in the s Atlantic Ocean, SE of Argentina; the capital is STANLEY (on East Falkland). It includes two large islands (East and West Falkland) and 200 smaller ones. First explored by Europeans in the late 16th century, the Falklands were at various times under Spanish, French and British control. Argentinian denials of British sovereignty led to the FALKLANDS WAR (1982). The main activity is sheep farming; wool and hides are exported. Area: c.12,200sq km (4,620sq mi). Pop. (1991) 2,121.

Falklands War (April–June 1982) Military conflict fought between Great Britain and Argentina on the question of sovereignty over the Falkland (Malvinas) Islands, located c.400km (250mi) off the Argentine coast. On 2 April, after the breakdown of negotiations, Argentine forces invaded and occupied the Falklands, South Georgia, and South Sandwich Islands, which had been administered and occupied by Great Britain since the 19th century. Despite attempts by the UN to negotiate a settlement, the Argentine government refused to withdraw. The British established a blockade of the islands and staged an amphibious landing at Port San Carlos. They surrounded the Argentine troops at the capital, Port Stanley, and forced them to surrender on 14 June. Losses on both sides of the conflict were heavy. Although the British resumed their administration of the islands, the basic issue of sovereignty remains unresolved.

Falla, Manuel de (1876–1946) Spanish composer. He developed a Spanish style by using folksongs combined with rich modern harmonies. Among his works are the opera *La Vida Breve* (1905), *Nights in the Gardens of Spain* (1916) for piano and orchestra, and the music for the ballets *Love the Magician* (1915) and *The Three-Cornered Hat* (1919).

Fallopian tube (oviduct) In mammals, either of two narrow ducts leading from the upper part of the UTERUS into the pelvic cavity and ending near each OVARY. After ovulation, the OVUM enters and travels through the Fallopian tube where FERTILIZATION can occur. The fertilized ovum, or EMBRYO, continues into the uterus where it becomes implanted.

family planning Alternative term for CONTRACEPTION famine Extreme prolonged shortage of food, produced by both natural and man-made causes. If it persists, famine results

F/f Sixth letter of the Roman-based w European alphabet, A fricative consonant, it is derived from the hook-shaped Semitic letter waw. In earlier stages of English, f between vowels sounded as v. and it is pronounced like a v in of. In some English words ending in f (such as hoof) the f changes to a v in the plural (hooves). In Welsh a single f is regularly pronounced as v, while the doubled consonant is pronounced f.

■ Faldo Famed for his powers of concentration and attention to detail, Faldo was the first home player to win the British Open three times (1987, 1990, 1992) for over 50 years. His success in the US has seen him play less golf on the European circuit.

The Earth's crust is subjected to enormous forces, and the stress creates faults. In a tear fault (1), the stresses cause horizontal movement. The forces build up until they are released in a

sudden movement (2), often causing earthquakes. In a normal fault (3), the rocks are pulled apart, causing one side to slip down along the plane of the fault. In a reverse fault (4), the

rocks on either side of the fault are forced together. One side rises above the other along the fault plane. In a horst fault (5), the central section is left protruding due to compression

from both sides or the sinking of the bracketing rock. A rift valley (6), has a sunken central section, formed either by compression or the outward movement of the two valley sides.

in widespread starvation and death. Famine is often associated with drought, or alterations in weather patterns, which leads to crop failure and the destruction of livestock. However, warfare and complex political situations resulting in the mismanagement of food resources are equally likely causes.

Fangio, Juan Manuel (1911–95) Argentine racing driver. One of the best drivers of all time, he was Formula One world champion five times (1951, 1954–57), and on his retirement (1958) had won a total of 24 Grands Prix.

FAO See FOOD AND AGRICULTURE ORGANIZATION

Faraday, Michael (1791–1867) British physicist and chemist. A student of Sir Humphry Davy, in 1825 he became director of the laboratories at the Royal Institution in London. He liquefied chlorine, discovered benzene and enunciated the laws of electrolysis (Faraday's Laws). He also discovered electromagnetic induction, made the first DYNAMO, built a primitive electric motor, and studied nonconducting materials (dielectrics). The unit of capacitance (the farad) is named after him.

Faraday's laws Two laws of ELECTROLYSIS and three of ELECTROMAGNETIC INDUCTION, formulated by Michael FARADAY. The electrolysis laws state that (1) the amount of chemical change during electrolysis is proportional to the charge passed, and (2) the amount of chemical change produced in a substance by a certain amount of electricity is proportional to the electrochemical equivalent of that substance. Faraday's laws of induction state that (1) an electromagnetic force is induced in a conductor if the magnetic field surrounding it changes, (2) the electromagnetic force is proportional to the rate of change of the field, and (3) the direction of the induced electromagnetic force depends on the field's orientation.

farce Comic drama typified by its stereotypical characterizations, its improbable plot lines and its emphasis on physical humour. Modern farce was developed by Arthur Pinero and Ben Travers in England, and Eugène Labiche and Georges FEYDEAU in France.

Fargo, William George (1818–81) US businessman. He organized, with Henry Wells, a carrier service between Buffalo and the West in 1844. Wells, Fargo and Company then set up an express service between New York and San Francisco to cater for the gold rush. The company merged with two others to form the American Express Company in 1850.

farming See AGRICULTURE

Farnese Italian family of the Roman aristocracy. The military skill of Ranuccio Farnese (d. c.1460) won the gratitude of Pope Eugenius IV, and his son Alessandro became Pope PAUL III (1534).

Faröe Islands Group of 22 mountainous, volcanic islands (17 inhabited) in the N Atlantic between Iceland and the Shet-

land Islands. The largest are Streymoy and Esturoy. Settled in the 7th century, it was part of Norway from the 11th century to 1380, when it was ceded to Denmark. In 1852 parliament was restored, and since 1948 they have enjoyed a degree of autonomy. Capital and chief port: Tórshavn (Streymoy), pop. (1993) 14,192; Language: Faroese; Industries: fishery, sheep-rearing. Area: 1,339sq km (540sq mi). Total pop. (1993) 45,349.

Farouk (1920–65) King of Egypt (1936–52). Son of King FUAD I, he alienated many Egyptians by his personal extravagance and corruption. His ambitious foreign policy ended in defeat in the first Arab-Israell War (1948), and he was overthrown in a military coup, led by Gamal Abdel Nasser. Farquhar, George (1678–1707) Irish dramatist associated

with RESTORATION THEATRE. His comedies were distinguished by their combination of humour and depth of character. Among his plays are *The Constant Couple* (1699), *The Recruiting Officer* (1706) and *The Beaux Stratagem* (1707). **Farrakhan, Louis** (1933–) US leader of the Nation of Islam, a black separatist organization. A controversial figure,

Islam, a black separatist organization. A controversial figure, he was recruited into the BLACK MUSLIMS in the 1950s by MALCOLM X. Farrakhan was a charismatic advocate of its racial exclusivity. In 1976 he formed the Nation of Islam, claiming greater adherence to the teachings of Elijah MUHAMMAD. His powerful oratory stresses the importance of self-discipline, family values and community regeneration. His speeches often contain inflammatory anti-white, anti-Semitic and anti-homosexual remarks. In 1995 he organized the USA's largest political demonstration, assembling 400,000 men in a "Million Man March" on Washington.

Farrell, James Thomas (1904–79) US author. He is bestknown for his trilogy about Studs Lonigan (1932–35). Set in a poor Irish community in Chicago, it is typical of his harshly realistic treatment of modern city life. Later fiction includes a five-volume series of novels which revolves around Danny O'Neill, a character from the earlier trilogy, and 10 novels of a projected 25-volume series called *A Universe of Time*.

Farrell, Terry (1938–) British post-modern architect known for his witty imagery and anthropomorphism. His best-known projects include the Edinburgh International Conference Centre, Scotland, and the redevelopment of Charing Cross station, London. His hallmarks include strategies for breaking down the verticality of buildings by introducing variations in colour and banding. See also POST-MODERNISM

fascism Political movement founded in Italy by Benito MUSSOLINI (1919), characterized by NATIONALISM, TOTALITARIANISM and anti-COMMUNISM. The term also applied to the regimes of Adolf HITLER in Germany (1933) and Francisco Franco in Spain (1936). A reaction to the Russian Revolution (1917) and the spread of communist influence, the movement based

its appeal on the fear of financial instability among the middleclasses and on a wider social discontent. Basic to fascist ideas were glorification of the state and total subordination to its authority; suppression of all political opposition; preservation of a rigid class structure; stern enforcement of law and order; the supremacy of the leader as the embodiment of high ideals; and an aggressive militarism aimed at achieving national greatness. It also typically encouraged racist and xenophobic attitudes and policies. Unlike communism, it lacked a consistent philosophy, and the character of fascist regimes varied. Discredited by defeat in World War 2, fascism was insignificant in the politics of Western Europe for many years. In the 1990s, however, far-right nationalist groups have re-emerged. See also NATIONAL SOCIALISM

Fassbinder, Rainer Werner (1946–82) German film director, a leading figure in modern German cinema. He directed his first feature in 1969, and became known for his radical, low-budget, hypnotic style. Fiercely political, his films include *The Bitter Tears of Petra von Kant* (1972), *The Marriage of Eva Braun* (1979) and *Veronika Voss* (1982).

fat Semi-solid organic substance made and used by plants and animals to store energy. In animals, fats also serve to insulate the body and protect internal organs. Fats are soluble in organic solvents such as ether, carbon tetrachloride, chloroform and benzene. They are triglycerides: ESTERS, in which one molecule of glycerol is connected to three molecules of FATTY ACIDS (such as palmitic, lauric and stearic acid), each having 12 to 18 carbon atoms. Research indicates that the consumption of high levels of animal fats can increase the risk of heart disease. Vegetable oils are similar to fats, but are viscous liquids rather than semi-solids and have a higher proportion of molecules with double carbon—carbon bonds in the chain – that is, they are unsaturated. See also LIPID; SOAP

Fates In Greek mythology, the three goddesses of human destiny. Called the *Moirae* by the Greeks, they correspond to the Roman *Parcae* and the Germanic Norns. Clotho spun the thread of life; Lachesis, the element of chance, measured it; and Atropos, the inevitable, cut it.

Fatima (606–32) Daughter of the prophet MUHAMMAD, and wife of ALI. She is revered by the SHITTE sect of ISLAM, believe that Ali was usurped by ABU BAKR. See also FATIMID Fatimid SHITTE dynasty who claimed the caliphate on the basis of their descent from FATIMA. The dynasty was founded by Said ibn Husayn. The Fatimids quickly overthrew the SUNNI rulers in most of NW Africa. By ibn Husayn's death (934), the Fatimid empire had expanded into s Europe, and in 969 they captured Egypt and established the Mosque and University of Al-Azhar, one of the most influential educational establishments in contemporary Islam. By the end of the 11th century, Egypt was all that remained of the Fatimid empire.

fatty acids Organic compounds, present widely in nature as constituents of FAT. They contain a single carboxyl acid group (—COOH). Examples of saturated fatty acids (those which lack double bonds in their hydrocarbon chain), are acetic acid and palmitic acid, the latter being a common fat constituent; unsaturated fatty acids (having one or more double carbon—carbon bonds) include oleic acid — both types have molecules shaped like a long, straight chain. See also LIPID

Faulkner, William Cuthbert (1897–1962) US novelist. Faulkner's debut novel was Soldier's Pay (1925). Sartoris (1929) was the first in a series of novels set in the fictional Mississippi county of Yoknapatawpha. The Sound and the Fury (1929) and As I Lay Dying (1930) utilise a STREAM OF CONSCIOUSNESS style to explore the relationship of past to present. Light in August (1932) and Absalom, Absalom! examine the effects of racism in the Deep South. Faulkner was awarded the 1949 Nobel Prize for literature. He won Pulitzer Prizes for A Fable (1951), and his final novel The Reivers (1962).

fault In geology, a fracture in the Earth's crust along which movement has occurred. The result of PLATE TECTONICS, faults are classified according to the type of movement. Vertical movements in the crust cause normal and reverse faults, while horizontal movements result in tear faults. Faults can occur in groups creating horsts, or block mountains, or grabens, or rift valleys.

Fauré, Gabriel Urbain (1845-1924) French Romantic composer renowned for his intimate, restrained compositions. They include many songs, such as Clair de lune (1889); chamber music, such as his Elégie (1883); and the Requiem (1887). He was director of the Paris Conservatoire (1805–22). fauvism Expressionist style based on extremely vivid nonnaturalistic colours. MATISSE was the leading figure and, with SIGNAC and Derain, exhibited at the Salon d'Automne (1905). A critic described their work as something produced by wild animals (fauves). Other members included Albert Marquet, George Rouault, VLAMINCK and BRAQUE. Although fauvism was short-lived, its influence on EXPRESSIONISM was profound. Fawcett, Dame Millicent Garrett (1847–1929) British leader of the women's suffrage movement. President of the National Union of Women's Suffrage Societies (1897–1919), she also founded Newnham College, Cambridge, one of the first women's colleges of higher education in Britain.

Fawkes, Guy (1570–1606) English conspirator in the GUN-POWDER PLOT of 1605. He was enlisted by Roman Catholic conspirators in a plot against JAMES I and Parliament. The plot was betrayed, and Fawkes, surrounded by barrels of gunpowder, was arrested in a building adjacent to the House of Lords. He was later executed with other conspirators. Traditionally, an effigy called a "guy", is burned on 5 November, the anniversary of the intended explosion.

fax (facsimile transmission) Equipment by which text, photographs and drawings can be transmitted and received through a TELEPHONE system. The image, on paper, is scanned to translate it into a series of electrical pulses. Inside the fax machine, a MODEM converts the pulses into a form that can be transmitted through the telephone system. At the receiving end, the fax machine's modem converts the signals back into pulses, and prints these as dots to build up a copy of the original document. See also SCANNING

FBI Abreviation of the FEDERAL BUREAU OF INVESTIGATION

▲ Faulkner Much of William Faulkner's work describes the effects of social disintegration on family life in s USA. He also wrote the screenplays for the noir films *To Have and Have Not* (1945) and *The Big Sleep* (1946).

A fax machine converts text or images fed into the machine (1) into a digital code (2). The code is created by shining light on tiny strips of the document in turn (3). Sensors (4) detect the amount of light that bounces back. Where ink is present little light is reflected creating an

electrical pulse of low voltage. A high voltage results when light is reflected from white paper. The digital code is converted by a modem in the fax into an analogue signal (5) and transmitted to the receiving fax machine (6) via the telephone network. A modem in

the second machine converts the analogue code back into a digital code (7), a printer (8) interprets the digital code and produces the hard facsimile copy (9). Each machine has its own number which is dialled in via a keyboard (10) on the sending machine.

FEATHER

The structure of a bird's feather (A) shows how barbs (2) extend from the central midrib (1) Barbules (3) project from both sides of the barb, one side of which has tiny hooks (hamuli) (4) which catch on the next barbule. The interlocking construction adds strength and helps the feather to retain its shape. Types of feather include flight (B), bristle (C), down (D), contour feathers (E), which insulate, filoplumes (F), hair-like feathers that are either sensory or decorative, and body contour feathers (G), which have a smaller feather (aftershaft) growing from the base.

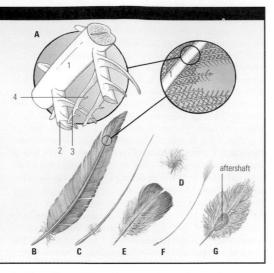

feather One of the skin appendages that makes up the plumage of BIRDS. Feathers are composed of the fibrous protein KERATIN, and provide insulation and enable flight. They are usually replaced at least once a year.

February Revolution (1848) French insurrection that overthrew the government of Louis Philippe. The revolution began in Paris following the economic crisis of 1847–48 and agitation for parliamentary reform. Led by bourgeois radicals and working-class revolutionaries, it created the short-lived Second Republic in France, and set off popular uprisings and unrest throughout Europe. See also REVOLUTIONS OF 1848

Federal Bureau of Investigation (FBI) US federal government agency that investigates all violations of federal law, especially those concerning internal security. Its findings are reported to the ATTORNEY GENERAL and various nationwide attorneys for decisions on prosecution. Established in 1908, its autonomy was strengthened under the directorship (1924–72) of J. Edgar HOOVER. Its headquarters are in Washington, D.C., and its director is appointed by the president, subject to Senate approval.

Federal Courts US judicial system consisting of the US Supreme Court, the US courts of appeals and the US district courts. There are also many specialized courts for areas of law including tax, patents and military law.

federalism Political system that allows states united under a central government to maintain a measure of independence. Examples include the USA, Australia, Canada, Germany, India and Switzerland. Central government has supreme authority, but the component states have a considerable amount of autonomy in such matters as education and health. Federalist Party US political party led by George WASHING-TON, Alexander HAMILTON, John ADAMS and John JAY. Formed (1787) to promote ratification of the Constitution, it represented planters, merchants, bankers and manufacturers. The "Federalist Papers" were essays written by Hamilton, James MADI-SON (who later became an Anti-Federalist) and Jay, expressing support for sound financial management, government banking and strong federal powers. The Federalists were opposed to the STATES' RIGHTS, agrarian philosophy of the REPUBLICAN PARTY. Federal Reserve System US central banking authority, established in 1913 to maintain sound monetary and credit conditions. Twelve regional banks are supervised by a Federal Reserve Board of Governors appointed by the president. All national banks are members, as are many state and commercial banks. The Federal Reserve System regulates money flow and credit by varying its discount rate on loans to member banks and by varying the percentage of total deposits

feedback In technology, process by which an electronic or mechanical control system monitors and regulates itself. Feedback works by returning part of the "output" of the system to its "input". *See also* BIOFEEDBACK

member banks must keep in reserve.

Feininger, Lyonel (1871–1956) US painter. He left the USA

for Europe in 1887 and became involved with CUBISM in 1912. He evolved a distinctive style of figurative scenes in straightedged patterns of interconnecting planes, coloured to resemble prisms. He exhibited with the BLAUE REITER (1913) and taught at the BAUHAUS (1919–33). In 1937 he returned to the USA and produced some of his best work, such as *Dawn* (1938).

Feldman, Morton (1926–87) US composer. In the 1950s he worked with John CAGE and was influenced by contemporary New York painters. Some of his works explore chance, with decisions left for the performers to make. Works include *Rothko Chapel* (1971) and *The Viola in my Life* (1970–71).

feldspar Group of common rock-forming minerals that all contain aluminium, silicon and oxygen, but with varying proportions of potassium, sodium and calcium. They are essential constituents of IGNEOUS ROCKS. Hardness 6–6.5; s.g. 2.5–2.8.

Fellini, Federico (1920–93) Italian film director. Fellini's full directorial debut was *The White Sheik* (1952). His next film, *I Vitelloni* (1953), was a critical triumph and established the elements of satire, autobiography and humanism common to many of his films. *La Strada* (1954) won an Academy Award for best foreign film. Fellini won a second Oscar for *Le notti di Cabiria* (1957). *La Dolce Vita* (1960) was a controversial success. Fellini won two more Oscars for 8½ (1963) and *Amarcord* (1974). His last film was *Voices of the Moon* (1990). He won a Lifetime Achievement Oscar (1992).

felony Indictable criminal offence. In British law, until 1967, felonies were distinguished from misdemeanours (crimes of a less serious nature). In US federal law, the distiction remains, with a felony being defined as any crime punishable by more than one year's imprisonment.

feminism Movement that promotes equal rights for women. In both the USA and the UK, the feminist movement became focused during the late 19th century, particularly over the question of women's right to vote (the SUFFRAGETTE MOVEMENT). It gained further impetus during the two World Wars, as women assumed manufacturing and administrative roles previously filled by men, and won the right to vote (in the UK in 1918, and in the USA in 1920). Post-war exponents of feminism, such as Simone de BEAUVOIR and Germaine GREER, argued that gender differences are socially conditioned and do not justify different treatment or the withholding of equal rights. In an attempt to end discrimination, the Equal Employment Opportunity Commission was created in the USA (1964), while in Britain the Equal Opportunities Commission was set up (1978).

femur Thigh bone, extending from the hip to the knee. It is the longest and strongest bone of the human skeleton.

fencing Sport of swordsmanship, using blunt weapons: the foil, épée and sabre. Fencers wear protective jackets and breeches (generally made of canvas), gloves and wire-mesh masks. In competitions, electronic sensors register hits, which score 1 point each. It has been an Olympic sport since 1896.

Fenian movement (Irish Republican Brotherhood) Irish nationalist organization set up in 1858, which sought independence from Britain by revolution. After several abortive plots, the leaders were arrested in 1867 and the focus of Fenian activity moved to the USA, where there were many Irish immigrants. The movement was superseded by SINN FÉIN.

fennel Tall, perennial herb of the PARSLEY family, native to S Europe. The seeds and extracted oil are used to add a liquorice flavour to medicines, liqueurs and foods. It grows to 1m (3.2ft). Family Apiaceae/Umbelliferae; species *Foeniculum vulgare*.

Fens Lowland region of E England, including parts of Lincolnshire, Cambridgeshire and Norfolk. About 117km (73mi) long and 56km (35mi) wide, this marshy area was first drained in the 17th century and is now intensively cultivated for fruit and vegetables.

Fenton, Roger (1819–69) British photographer whose carefully composed portraits and landscape studies earned him enduring acclaim. In 1855 he became one of the first war photographers, with a series of plates of the Crimean War.

Ferdinand II (1578–1637) Holy Roman emperor (1619–37) and HABSBURG king of Bohemia (1617–37) and Hungary (1621–37). Educated by Jesuits, he opposed the REFORMATION. The Bohemian revolt against him in 1618 precipitated the THIRTY YEARS WAR. Albrecht WALLENSTEIN'S victories

made him master of Germany, but Ferdinand later arranged his assassination (1634). Although the hostile German princes agreed to the Peace of Prague (1635), Ferdinand's son, FERDINAND III, inherited a dangerous situation.

Ferdinand III (1608–57) Holy Roman emperor (1637–57), son of Ferdinand II. In 1634, he succeeded Albrecht Wallenstein as commander of the imperial armies in the Thirty Years War. His victory at the battle of Nordlingen (1634) was followed by a series of defeats. As emperor, Ferdinand was forced to negotiate, and the Peace of Westphalia (1648) marked the end of Habsburg dominance in Germany.

Ferdinand (1861–1948) Prince (1887–1908) and tsar (1908–18) of Bulgaria. In 1908 he declared Bulgaria independent of the Ottoman empire and himself tsar. He allied Bulgaria with Serbia, Greece and Montenegro in the first BALKAN WAR (1912–13), but Bulgaria's territorial gains were largely lost to its former allies in the second war (1913). This led Ferdinand to join the CENTRAL POWERS in World War 1. After the defeat, Ferdinand abdicated in favour of his son, Boris III.

Ferdinand V (1452–1516) (Ferdinand the Catholic) King of Castile and León (1474-1504), of Aragon (as Ferdinand II) (1479-1516), of Sicily (1468-1516), and of Naples (as Ferdinand III) (1504-16). He became joint king of Castile and León after marrying ISABELLA I in 1469, and inherited Aragon from his father, John II, in 1479. After he and Isabella conquered the Moorish kingdom of Granada in 1492, they ruled over a united Spain. In 1492 they sponsored the voyage of Christopher COLUMBUS to the New World, expelled the Jews from Spain, and initiated the Spanish INQUISITION. Under Ferdinand, Spain became involved in the Italian wars against France. After Isabella's death (1504), Ferdinand acted as regent in Castile for their insane daughter, Joanna, and later for her son, Charles I (who succeeded Ferdinand and ruled as Emperor CHARLES V). Ferlinghetti, Lawrence (1919-) US author. A BEAT MOVEMENT poet, he opened the City Lights bookstore in San Francisco (1953) and began publishing beat authors, such as Allen GINSBERG. His works include A Coney Island of the Mind (1958) and Starting from San Francisco (1961).

Fermanagh District in sw Northern Ireland; the county town is Enniskillen. During the 17th century, English people settled here as part of the Plantation of Ulster. The district is hilly in the NE and Sw. Cattle raising is important. Area: 1,876sq km (724sq mi). Pop. (1991) 54,033.

Fermat, Pierre de (1601–65) French mathematician. With Blaise PASCAL, Fermat formulated the theory of probability and, by showing that light travels along the shortest path (Fermat's principle), founded the science of geometric optics.

Fermat's last theorem Theory that, for all integers n > 2, there are no non-zero integers x, y and z that satisfy the equation $x^n + y^n = z^n$. Fermat wrote that he had found a proof, but he died without revealing it. Subsequent attempts at a valid proof, although largely unsuccessful, have enriched the area of algebraic number theory. In 1993 Andrew Wiles of Princeton University announced a proof, but it was soon found to contain a gap. Further work repaired this, and the complete proof was widely accepted in 1995.

fermentation Energy-yielding metabolic process by which sugar and starch molecules are broken down to carbon dioxide and ethanol in the absence of air (ANAEROBIC respiration). Catalysed by ENZYMES, it is used for bread-making, wine- and beer-brewing and cheese maturation. The intoxicating effect of fermented fruits has been known as since 4000 BC.

Fermi, Enrico (1901–54) US physicist, b. Italy. He worked mainly in the fields of atomic behaviour and structure, and QUANTUM THEORY. He discovered NEPTUNIUM and produced the first self-sustaining CHAIN REACTION in uranium. In 1942 he built the world's first nuclear reactor. He worked on the MANHATTAN PROJECT and on developing the hydrogen bomb. For his work with RADIOACTIVITY, Fermi won the 1938 Nobel Prize for physics; the element FERMIUM was named after him. fermion Subatomic particle that has a half-integer SPIN. Fermions are particles that obey the EXCLUSION PRINCIPLE. Nuclear structures tend to be made up of fermions; LEPTONS (such as ELECTRONS and NEUTRINOS) and QUARKS are all fermions. See also BOSON

fermium (symbol Fm) Radioactive metallic TRANSURANIC ELEMENT of the ACTINIDE SERIES. Identified in 1952 as a decay product of U²⁵⁵ from the first large hydrogen bomb explosion. Ten isotopes have subsequently been identified. Properties: at.no. 100; most stable isotope Fm²⁵⁷ (half-life 80 days).

fern Non-flowering plant. Ferns grow mainly in warm, moist areas; there are *c*.10,000 species. The best-known genus *Pteridium* (BRACKEN) grows on moorland and in open woodland. Ferns are characterized by two generations: the conspicuous sporophyte that possesses leafy fronds, stems, RHIZOMES and roots and reproduces by minute spores usually clustered on the leaves; and the inconspicuous GAMETOPHYTE that resembles moss and produces sperm and ova. Fronds unroll from curled "fiddle-heads" and may be divided into leaflets. Phylum Filicinophyta. *See also* ALTERNATION OF GENERATIONS **Ferneyhough, Brian** (1943–) English composer. His avant-garde style compositions are highly complex with detailed notations. His works include *Transit* (1975) and *Time and Motion Studies I–III* (1974–77).

Ferrari, Enzo (1898–1988) Italian racing and sports car designer and manufacturer. He began racing with Alfa Romeo in 1920. In 1939 he founded his own company, and the first Ferrari racing car was produced in 1947. Ferrari have won more Formula One championships than any other team. They also make production sports cars.

ferret Semi-domesticated albino form of the POLECAT. WEASEL-like animals, ferrets have long necks, slender bodies, long tails, short legs and white fur. They are agile killers, used to hunt rats and rabbits. Body length: 36cm (14in); weight: 700g (1.5lb). Family Mustelidae; species *Mustela putorius*.

Ferrier, Kathleen (1912–53) English contralto. She sang the title role in the first performance of Benjamin BRITTEN'S *The Rape of Lucretia* (1946) at GLYNDEBOURNE, England, and was also acclaimed as Orpheus in Christoph GLUCK'S *Orfeo*. She died of cancer.

fertility drugs Drugs taken to increase a woman's chances of conception and pregnancy. One of the many causes of female sterility results from insufficient secretion of pituitary hormones, and this can be treated with either human chorionic gonadotropin or clomiphene citrate, although use of the latter has resulted in multiple births. In cases where fertilization occurs, but where the uterine lining is unable to support the developing fetus, the hormone progesterone may be used. Infertility cannot always be corrected with drugs.

fertilization Impregnation of an EGG nucleus by a SPERM

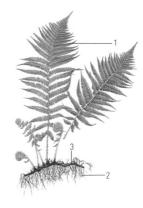

▲ fern A typical fern, such as the lady fern shown here, has upright leaves called fronds (1) which uncurl as they grow, and roots (2) that grow from the underground stem (3). The first ferns grew in the Devonian

FERTILIZATION

Mammalian fertilization begins with ovulation, in which an ovum or egg (1) develops in an ovary (2) into a follicle (3). The follicle consists of the ovum, a sac of liquid and follicle cells. The pressure in the follicle increases until it bursts, releasing the ovum into the Fallopian tube (4). During ovulation, oestrogen is produced by the collapsed follicle, which causes the lining of the uterus to thicken and extend its network of blood vessels, from which the ovum will be nourished. Fertilization occurs when sperm (5) are ejaculated from the penis during copulation. The sperm use their tail-like flagella (6), powered by mitochondria (7), to swim up the uterus. The first to reach the ovum penetrates the ovum membrane with enzymes secreted by the acrosomal vesicle (8). This triggers the formation of a

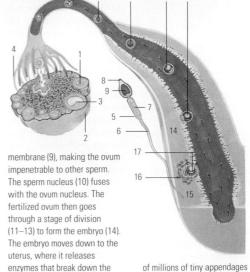

lining (15), creating a hole in

which the embryo sits (16). The

embryo (17) develops an organ,

the placenta, that is comprised

12 13

called villi. The oxygen and food are absorbed from the mother's blood, via capillaries in the villi, into the embryo's blood.

- tissue factor
- plasma factor
- fibringgen
- platelet
- red blood cell
- fibrin

▲ fibrin An essential component of blood clotting, fibrin prevents excessive blood loss from a wound. Normally, circulating blood contains red cells, platelets, plasma, clotting factors and fibrinogen. Tissue-clotting factors lie trapped within cells surrounding each blood vessel (A). When damage occurs, blood escapes from the broken vessel. Platelets congregate at the site and help plug the wound. Tissueclotting factors are released (B). The reaction of the platelets with plasma and tissue-clotting factors converts the soluble fibrinogen into insoluble threads of fibrin. The fibrin forms a mesh across the break (C). Platelets and blood cells become trapped in the mesh. The jelly-like mass shrinks and serum oozes out, leaving a clot (D).

(male sex cell) nucleus, forming a ZYGOTE. Fertilization is the key process in the SEXUAL REPRODUCTION of plants, animals, fungi and protoctista, and includes the penetration of the egg by the sperm, and the fusion of the egg and sperm nuclei. Fertilization can be external (fish, amphibians and plants) or internal (reptiles, birds, mammals). See also EMBRYO; GAMETE

fertilizer Substance added to soil to improve plant growth by increasing fertility. Manure and compost were the first fertilizers. Other natural fertilizers include bone meal, ashes, guano and fish. Modern chemical fertilizers, composed of nitrogen, phosphorus, and potassium in powdered, liquid, or gaseous forms, are now widely used.

Fessenden, Reginald Aubrey (1866-1932) US engineer, physicist and inventor, a pioneer in radio and echo-sounding. He is thought to have broadcast the first radio programme (using speech signals, not Morse code) in 1906. Among his more than 500 patents were AMPLITUDE MODULATION (AM), the high-frequency alternator, the electrolytic detector, the heterodyne system of radio reception and the fathometer.

fetus (foetus) EMBRYO in a mammal after the main adult features are recognizable. In humans it dates from about eight weeks after conception.

feudal system Social system that prevailed in most of Europe from the 9th century to the late MIDDLE AGES, based on the tenure of land. The system originated from the need to provide for a permanent group of knights to assist the king in his wars. All land was theoretically owned by the monarch and leased out to tenants-in-chief in return for their attendance at court and military assistance; and they in turn let out fiefs to knights in return for military service and other obligations. The church too was sometimes required to render military service for its land. Feudalism collapsed in 16th-century England, but persisted into the 18th century in other parts of Europe.

fever Elevation of the body temperature above normal -37°C (98.6°F). It is mostly caused by bacterial or viral infection and can accompany virtually any infectious disease.

Feydeau, Georges (1862-1921) French playwright. He wrote many extremely popular plays, with absurd plots and sparkling dialogue, in which he pioneered 19th-century French FARCE. Among these plays were La Dame de chez Maxim (1899) and L'Hôtel du Libre Échange (1894).

Feynman, Richard Phillips (1918-88) US physicist who is considered one of the most important theoretical physicists of modern times. He worked on the atom bomb during World War 2, then at Cornell University with Hans BETHE on QUAN-TUM ELECTRODYNAMICS (QED). Feynman diagrams greatly facilitated the solution of electromagnetic interactions between ELEMENTARY PARTICLES. He was professor of physics (1950-88) at the California Institute of Technology. He shared the 1965 Nobel Prize for physics. With Murray GELL-MANN, Feynman developed a theory of weak interactions, which occurs in the emission of electrons from radioactive nuclei. He also did research on the structure of protons and the properties of liquid helium. In 1986, he was a key member of the committee which investigated the Challenger space shuttle disaster. Fez (Fès) City in N central Morocco. Founded c.790, it is a former capital of Morocco and a sacred city of Islam containing many mosques. Industries: leather goods, pottery, traditional crafts, metal-working. Pop. (1982) 448,823.

Fianna Fáil (Gaelic, Soldiers of Destiny) Irish political party. It was formed in 1926 by those opposed to Irish partition. The party came to power in 1932 under Eamon DE VALERA and has formed the government alone or in coalition for most years since then. It seeks the reunification of Ireland by peaceful means, believes that the government should take an active role in economic development, and has traditionally been the most conservative of the main parties.

Fibonacci, Leonardo (c.1170-c.1240) Italian mathematician. He wrote Liber abaci (c.1200), the first Western work to propose the adoption of the Arabic numerical system. He produced the mathematical sequence named after him, in which each term is formed by the addition of the two terms preceding it. The sequence begins 0, 1, 1, 2, 3, 5, 8, 13, 21.... and so on. Many natural forms, such as spiral shells and leaf systems, are delimited by the Fibonacci series.

fibre Any of various materials consisting of thread-like strands. Natural fibres can be made into yarn, textiles and other products, including carpets, rope and felt. The fibres consist of long narrow cells. Animal fibres are based on protein molecules and include wool, SILK, mohair, angora and horsehair. Vegetable fibres are based mainly on CELLULOSE and include COTTON, LINEN, FLAX, JUTE, SISAL and KAPOK. The mineral ASBESTOS is a natural, inorganic fibre. Regenerated fibres are manufactured from natural products, modified chemically. For example, RAYON is made from cellulose fibre obtained from cotton or wood. Synthetic fibres are made from a molten or dissolved plastic resin by forcing it through fine nozzles (spinnerets). The result is a group of filaments that are wound onto bobbins. These fibres can be used as single-strand yarn, or spun to form multi-strand yarn and woven into textiles. Synthetic fibres include NYLON and other polyamides, polyesters and ACRYLICS. Other synthetic fibres, such as carbon, can be used to reinforce resins to produce extremely strong materials.

fibreglass Spun glass used as a continuous filament in textiles and electrical insulation, and in a fibrous form to reinforce plastics or for sound or heat insulation. Molten glass is drawn through spinnerets or spun through holes in a revolving dish. Combined with layers of resin, fibreglass is a popular medium for car bodies, boats, aircraft parts and containers. fibre optics Branch of OPTICS concerned with the transmission of data and images by reflecting light through very fine glass OPTICAL FIBRES.

fibrin Insoluble, fibrous protein that is essential to BLOOD CLOTTING. Developed in the blood from a soluble protein, fibrinogen, fibrin is laid down at the site of a wound in the form of a mesh, which then dries and hardens so the bleeding stops. fibula Long thin outer bone of the lower leg of four- and two-legged VERTEBRATES, including humans. It articulates with the other lower leg bone, the TIBIA, just below the knee.

Fidei Defensor See Defender of the Faith

Fielding, Henry (1707–54) British novelist and playwright. During the 1730s, Fielding wrote a number of successful, satirical plays, such as Pasquin (1736). His first work of fiction, An Apology for the Life of Mrs Shamela Andrews (1741), was a parody of Samuel RICHARDSON'S Pamela (1740). Joseph Andrews (1742) was his first NOVEL. Other works include The Life of Mr Jonathan Wild the Great (1743). Fielding strengthened the novel genre through his depiction of character and narrative sophistication. His masterpiece is the picaresque novel Tom Jones (1749). Fielding was also responsible for the foundation of Britain's first organized police force, the Bow Street Runners.

field marshal Senior rank in most European armies and the equivalent of a US general. Symbolized by the award of a decorated baton, the modern rank dates from the early 19th century, when NAPOLEON I named some of his generals maréchal de l'Empire (Fr. Marshal of the Empire).

Fields, W.C. (William Claud) (1880-1946) US musichall, film and radio comedian. He was famous for his portrayal of hard-drinking, misanthropic braggarts in such films as Tillie's Punctured Romance (1928), My Little Chickadee (1940) and Never Give a Sucker an Even Break (1941).

Fife Region in E central Scotland between the firths of Tay and Forth; the capital is Glenrothes, other towns include Cowdenbeath and Dunfermerline. The central part is mostly low-lying farmland. Coalfields are situated in the w and E. Along the North Sea coast there are many fishing villages. The Rosyth naval base lies on the N shore of the Firth of Forth. ST ANDREWS is the seat of Scotland's oldest university (1410), and the home of the Royal and Ancient Golf Club. Area: 1,305sq km (504sq mi). Pop. (1991) 341,199.

fig Tree, shrub or climber of the mulberry family, growing in warm regions, especially from the E Mediterranean to India and Malaysia. The common fig (Ficus carica) has tiny flowers without petals that grow inside fleshy flask-like receptacles; these become the thick outer covering holding the seeds, the true, edible fruit of the fig tree. Height: to 11.8m (39ft). Family Moraceae, genus Ficus.

Fiji Independent nation in the s Pacific Ocean, consisting of more than 800 islands and islets; the capital is Suva on Viti Levu island. The two largest islands, Viti Levu and Vanua Levu, rise sharply from the fertile, heavily populated coastal region to a mountainous and rugged interior. They (and the smaller islands) are generally volcanic in origin. On the wet, E side, the islands are covered in dense tropical forest. The w side is mainly dry grassland with some scrub. Settlement on Fiji dates back to the second millennium BC. Discovered by Abel TASMAN in 1643, the islands were visited by British explorers in the 18th century and became a British crown colony in 1874. Indians were subsequently imported to work on the sugar plantations, and by the 1950s outnumbered the native Fijian population. In 1970 Fiji achieved independence as a member of the Commonwealth. The election in 1987 of a government with an Indian majority led to a military coup by native Fijians and the proclamation of a republic. Agriculture is the most important sector of the economy: the main products are copra, sugar and rice. Gold and silver are mined and tourism is important. Area: 18,272sq km (7,055sq mi). Pop. (1995 est.) 783,800.

filariasis Group of tropical diseases caused by infection with a nematode worm, *filaria*. The parasites, which are transmitted by insects, infiltrate the lymph glands, causing swelling and impaired drainage. Drug treatment reduces the symptoms. *See also* ELEPHANTIASIS

filibuster Method of frustrating the action of a legislative assembly by making long speeches. It has particular reference to debates in the US senate, which did not have any method for voting to end debate until 1917. Since then a two-thirds majority is required to close a debate, thereby allowing a minority to prevent a vote on legislation that they oppose. **Fillmore, Millard** (1800–74) 13th US president (1850–53). Fillmore served (1833–43) in the House of Representatives,

Fillmore, Millard (1800–74) 13th US president (1850–53). Fillmore served (1833–43) in the House of Representatives, and in 1834 joined the newly formed WHIGS. In 1848 he was elected vice president to Zachary TAYLOR, and succeeded as president when Taylor died. In an attempt to mediate between pro- and antislavery factions, Fillmore agreed to the COMPROMISE OF 1850. His attempt to enforce the Fugitive Slave Law embittered abolitionists and split the party. Fillmore failed to win renomination in 1852 and was succeeded by Franklin PIERCE. In the 1856 elections Fillmore stood for the KNOWNOTHING MOVEMENT, but was defeated by Abraham LINCOLN. film noir Genre of cynical, bleak films, originating in Hollywood during the 1940s and 1950s. Often bathed in gloomy shadows, the ominous mood of the films mirrored the corrup-

film noir Genre of cynical, bleak films, originating in Hollywood during the 1940s and 1950s. Often bathed in gloomy shadows, the ominous mood of the films mirrored the corruption and paralysis of the underworld characters they presented. Influenced by the effects of World War 2, it depicted an uneasy world, lacking ideals or moral absolutes. John Huston's *The*

FINLAND

The flag of Finland was adopted in 1918, after the country had become an independent republic, following a century of Russian rule. The blue represents Finland's many lakes. The white symbolizes the blanket of snow which masks the land in winter.

AREA: 338,130sq km (130,552sq mi)
POPULATION: 5.042.000

POPULATION: 5,042,000

CAPITAL (POPULATION): Helsinki (508,588) GOVERNMENT: Multiparty republic ETHNIC GROUPS: Finnish 93%, Swedish 6% LANGUAGES: Finnish and Swedish (both

official)

RELIGIONS: Evangelical Lutheran 88% CURRENCY: Markka= 100 penniä

Finland (*Suomi*) has four geographical regions. In the s and w, on the Gulfs of Bothnia and Finland, is a low, narrow coastal strip, where

most Finns live. The capital and largest city, HELSINKI, is here. The ÅLAND ISLANDS lie in the entrance to the Gulf of Bothnia. Most of the interior is a beautiful wooded plateau, with over 60,000 lakes. The Saimaa area is Europe's largest inland water system. A third of Finland lies within the Arctic Circle; this "land of the midnight sun" is called *Lappi* (LAPLAND).

CLIMATE

Finland has short, warm summers; Helsinki's July average is 17°C (63°F). In Lapland the temperatures are lower, and in June the sun never sets. Winters are long and cold; Helsinki's January average is –6°C (21°F). The North Atlantic Drift keeps the Arctic coasts free of ice.

VEGETATION

Forests (birch, pine and spruce) cover 60% of Finland. The vegetation becomes more and more sparse to the N, until it merges into Arctic tundra.

HISTORY

In the 8th century, the LAPPS were forced N by Finnish-speaking settlers. In the 13th century Sweden conquered the country. Lutheranism was established in the 16th century. Finland was devastated by wars between Sweden and Russia. Following the Northern War (1700–21), Russia gained much Finnish land. In the NaPOLEONIC Wars, Russia conquered Finland and it became a grand duchy (1809). Despite considerable autonomy, Finnish nationalism gained strength, fuelled by important Finnish language works. Tsar Nicholas II's programme of Russification (1899–1905) met fierce resistance.

Following the Russian Revolution, Finland declared independence. Civil (January-May 1918) broke out between the Russian-backed Red Guard and the Germanbacked White Guard, led by MANNERHEIM. The conservative White Guard triumphed, and a republic was established (1919). Territorial disputes with the Soviet Union focused on KARE-LIA. Finland declared its neutrality at the start of World War 2, but Soviet troops invaded in November 1939, and in March 1940 Finland ceded part of Karelia and Lake LADOGA. In 1941 Finland allied itself with Germany, and in 1944 Soviet troops invaded and forced Finland to sign an armistice. Much of N Finland was destroyed in the ensuing war with Germany. The 1947 Paris Treaty confirmed the 1944 armistice terms. In 1955 Finland joined the UN and the Nordic Council, and maintained a policy of neutrality during the Cold War. Urho Kaleva Kekkonen led Finland (1956-81) through reconstruction. Finland became a full member of EFTA in 1986 and joined the European Union (EU) in 1995.

Есопому

Forests are Finland's most valuable resource. Forestry accounts for c.35% of exports. The chief manufactures are wood and paper products. Post-1945 the economy has diversified. Engineering, shipbuilding and textile industries have grown. Farming employs only 9% of workforce. Livestock and dairy farming are the chief activities. The collapse of the Soviet bloc led to economic decline and unemployment, and Finland's economy is slowly recovering.

▲ fir The largest Douglas firs, named after the botanical explorer David Douglas, grow to some 90m (300ft) and can live for over 400 years. In damp conditions, a Douglas fir will grow 1m (3ft) a year for the first 30 years of its life.

Maltese Falcon (1941) was the blueprint for other genre classics, such as The Big Sleep (1946) and Touch of Evil (1958).

filter Porous device for separating solid particles from a liquid or gas. The process is known as filtration. Many complex forms of filter have been devised for various uses. Most cars have a number of filters, for air, petrol and oil. These operate either by trapping solid particles in porous materials such as paper or meshes, or by circulating the material to be filtered through a maze, the pockets of which trap particles, as in the air filter.

finch Any of a family (Fringillidae) of small or medium-sized birds, including the SPARROW, CARDINAL, CANARY, BUNTING and GROSBEAK. They are found in most parts of the world, except for Australia, New Zealand and the Pacific islands. Most have a cone-shaped bill and feed on seeds, although some eat fruit or insects. Some British "finches", such as the bullfinch and goldfinch, belong to another family, Ploceidae.

Fine Gael Irish political party. It was founded in 1933, as a successor to the party under William Cosgrave that had held power since the inception of the Irish Free State. Overshadowed by FIANNA FAIL, Fine Gael has held office only four times, always in coalition with the Labour Party (1948–51, 1954–57, 1973–77, 1994–97).

fingerprint Pattern of ridges in the dermis or deeper skin on the end of the fingers and thumbs. Fingerprints are specific to an individual and remain unchanged in pattern throughout life; for this reason they are useful as a means of identification. **Finland** Republic in N Europe. *See* country feature, p.253

Finnish One of the two official languages of Finland and a member of the Finno-UGRIC group of languages. It is spoken by over 4.5 million people in Finland and by nearly a million people in Sweden, Russia and the USA. Swedish is the other official language of Finland, spoken by c.300,000 inhabitants. Finn Mac Cumhail (Finn MacCool) (active 2nd or 3rd century AD) Semi-mythical Irish leader of a group of soldiers known as the Fenians. Their exploits were recorded in many ballads and poems, including those in the 12th-century Book of Leinster and others said to have been written by Ossian.

Finno-Ugric Group of related languages spoken by more than 22 million people in Finland and N Norway, in Estonia and Karelia, in various areas at the N end of the River Volga and each side of the Ural Mountains, and in Hungary. The languages are totally unrelated to the INDO-EUROPEAN family. The Finnic branch includes FINNISH, Estonian, Lappish, Mordvinian, Mari, Komi, Votyak, Cheremiss and Zyrian; the Ugric branch comprises HUNGARIAN, Ostyak and Mansi (Vogul). Together with the Samoyed languages, Finno-Ugric makes up the Uralic family.

fir Any of a number of evergreen trees of the PINE family, native to cooler, temperate regions of the world. They are

counteracting the tendency to

sink or float to the surface.

pyramid-shaped and have flat needles and erect cones. Species include the silver and balsam firs. Height: 15–90m (50–300ft). Family Pinaceae; genus *Abies*.

Firdausi (935-1020) Persian poet. He wrote the Shah Nama, an epic poem of more than 50,000 couplets about the history of Persia. The work, which created the traditions of Persian poetry, was presented to Mahmud of Ghazni in 1010. firearm Term used usually to describe a small arm - a weapon carried and fired by one person or a small group of people. Firearms were used in Europe in the 14th century. They were, however, ineffective in close combat until c.1425. when a primitive trigger to bring a lighted match into contact with the gunpowder charge was invented. Such firearms, called matchlocks, were heavy and cumbersome, and needed a constantly lit match. The lighter flintlock (which used the spark produced by flint striking steel to ignite the powder) superseded the matchlock in the mid-17th century. During the 19th century there were great changes. In 1805 the explosive properties of mercury fulminate were discovered and, together with the percussion cap invented in 1815, it provided a surer, more efficient means of detonation. It permitted the development by 1865 of both the centre-fire cartridge (which has been the basic type of ammunition used in firearms ever since) and breech loading, not previously practicable. Another major 19th-century advance was rifling - the cutting of spiral grooves along the inside of a barrel in order to make the bullet spin in flight. During the 1830s Samuel Colt perfected the revolver, a PISTOL which could fire several shots without the need to reload. By the 1880s magazine RIFLES were also in use, and were made more effective when a bolt action was incorporated after 1889. Development of a weapon that could fire a continuous stream of bullets began with the manually operated GATLING GUN, but the first modern MACHINE GUN was the maxim gun, invented in the 1880s, which used the recoil energy of the fired bullet to push the next round into the breech and recock the weapon. Guns of this type dominated the trench warfare of World War 1. By World War 2 more portable automatic weapons, such as the Bren gun and sub-machine gun, were in use. Newer developments include gas-operated rifles, firearms with several rotating barrels and extremely high rates of fire, and small firearms that use explosive bullets.

fireball (bollide) Exceptionally bright METEOR. Fireballs have been loosely defined as meteors brighter than the planets; with the modern estimate of the maximum brightness of Venus, this would mean that all meteors brighter than magnitude –4.7 should be classified as fireballs.

firefly Light-emitting beetle found in moist places of temperate and tropical regions. Organs underneath the abdomen usually give off rhythmic flashes of light that are typical of the species. The luminous larvae and wingless females of some species are called GLOW-WORMS. Length: to 25mm (1in). There are 1,000 species. Family Lampyridae.

Fire of London (2–6 September 1666) Accidental fire that destroyed most of the City of London, England. It started in a baker's shop in Pudding Lane, a site now marked by the Monument, and a strong wind spread it quickly through the closely packed wooden houses. The fire provided an opportunity for rebuilding London on a more spacious plan, but, for the most part, only the famous churches of Christopher WREN (including ST PAUL'S Cathedral) were built.

first aid Action taken by anyone encountering sudden illness or injury in order to save life, mitigate harm or assist subsequent treatment.

First World War See WORLD WAR 1

Fischer-Dieskau, Dietrich (1925–) German baritone. One of the foremost operatic singers of the 20th century, and an outstanding interpreter of Lieder. He was an extremely versatile singer, appearing in recitals, as soloist with orchestras, in operatic roles and on numerous recordings.

Fischer, Hans (1881–1945) German biochemist who received the 1930 Nobel Prize for chemistry for his structural studies of CHLOROPHYLL and of the red blood pigment haemin. His research indicated the close relationship between the two substances. He was able to synthesize haemin, and he almost completely synthesized one of the chlorophylls.

density using the swim bladder.

The fish can expand or contract

common features. All have a

tail with equal upper and lower

fish Cold-blooded, aquatic vertebrate animal characterized by fins, gills for breathing, a streamlined body almost always covered by scales or bony plates on to which a layer of mucus is secreted, and a two-chambered heart. Fish are the most ancient form of vertebrate life, with a history of about 450 million years. They reproduce sexually, and fertilization may be external or internal. The eggs develop in water or inside the female, according to species. Fish have lateral line organs, which are fluid-filled pits and channels that run under the skin of the body. Sensitive fibres link these channels to the central nervous system and detect changes of pressure in the water and changes of strength and direction in currents. About 75% of all fish live in the sea; the remainder are freshwater species that live in lakes, rivers and streams. A few fish, such as the SALMON and EEL, divide their lives between salt and freshwater habitats. The classification of fish varies. They are usually divided into three classes: Agnatha, which are jawless fish, including the HAGFISH and LAMPREY; Chondrichthyes (CARTI-LAGINOUS FISH), which includes SHARK, SKATE, RAY and CHIMERA; and the much more numerous Osteichthyes (bony fish), including subclasses of soft-rayed fish (LUNGFISH and lobefin), and the very successful teleost fish, such as salmon and COD. There are more than 22,000 species of bony fish, and they represent about 40% of all living vertebrates. They are divided into 34 orders and 48 families.

Fisher, Saint John (1469–1535) English Roman Catholic prelate. Fisher opposed Henry VIII's proposed divorce from Catherine of Aragon in 1529. He was tried and executed for denying that Henry was supreme head of the church under the Act of Supremacy. He was canonized in 1935. His feast day is 9 July.

fishing and fisheries Harvesting fish from the seas, large inland lakes, and rivers for food and other commercial uses. Commercial fishing boats and fleets employ several methods for catching fish, including pole and line, purse seine, gill netting, trawling and stunning. About 70% of the commercial fish catch is taken in the Northern Hemisphere, with the greatest catches taken between the Philippines and Japan. Other fishing areas include the North Atlantic, the North Pacific and the North Sea. The most significant Southern Hemisphere areas are the Pacific coast of Peru and the South African coast. Herrings, sardines and anchovies make up the largest percentage of the total catch. Other species caught in large commercial quantities include cod, haddock, hake, redfish, sea bream, mackerel, tuna, salmon and flatfish. The major fishing nations (by catch) are China, Japan, Peru, Chile, Russia and the United States. By the late 1970s fish stocks were severely depleted, due to increasingly sophisticated and efficient methods of locating and catching fish. While attempts have been made to allow fish stocks to return to previous levels, such as the 1983 United Nations' "Law of the Sea" resolution that allowed countries to enforce an exclusive 320km (200mi) limit around their coastlines, fish stocks remain low. See also ANGLING

fission Form of ASEXUAL REPRODUCTION in unicellular organisms. The parent cell divides into two or more identical daughter cells. Binary fission produces two daughter cells (as in bacteria). Multiple fission produces 4, 8, or, in the case of some protozoa, more than 1,000 daughter cells, each developing into a new organism.

fission, nuclear Form of nuclear reaction in which a heavy atomic NUCLEUS splits into two, with the release of two or three NEUTRONS and large amounts of energy. It may occur spontaneously or be made to occur by bombarding certain nuclei with low-energy (slow) neutrons. The neutrons released by the initial splitting may go on to produce further fission in a nuclear CHAIN REACTION. The process is employed in atom bombs and nuclear reactors. *See also* FUSION, NUCLEAR; NUCLEAR ENERGY

Fitzgerald, Ella (1917–96) US jazz singer. The "First Lady of Song" was discovered by Chick Webb at Harlem's Apollo Theatre (1934). Her first hit was "A-Tisket A-Tasket" (1938). Her "Songbook" series of renditions of popular "standards" by George Gershwin, Jerome Kern and Cole Porter have become definitive. She worked with most of the jazz greats of her era, including Duke Ellington, Count Basie and Louis Armstrong.

FISSION

Most nuclear power stations use uranium-235 as fuel. When a uranium-235 nucleus is struck by a slow-moving neutron (1), it absorbs the neutron to form uranium-236. This is unstable and splits violently (2) forming two smaller nuclei, generating radiant energy (some in the form of heat), and releasing several neutrons (3). These neutrons can then start the process again (4), splitting further nuclei, which in turn release yet more neutrons (5). Such a process is known as a chain reaction and can spread at lightning speed. In a nuclear reactor, many of the neutrons are absorbed to prevent the chain reaction from running out of control and causing an excessive release of energy. Atomic bombs are designed to encourage the chain reaction to spread extremely rapidly.

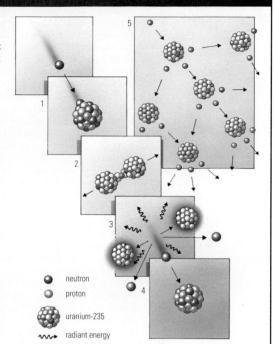

Fitzgerald, F. Scott (Francis Scott Key) (1896–1940) US author. He began his debut novel, *This Side of Paradise* (1920), while in the US army. Along with *The Beautiful and Damned* (1922), this established him as a chronicler of what he christened the "Jazz Age". He spent much of the 1920s in Europe, mingling with wealthy and sophisticated expatriates. Fitzgerald's masterpiece, *The Great Gatsby*, was published in 1925. His last novels were *Tender is the Night* (1934) and the unfinished *The Last Tycoon* (1941).

Fitzgerald, Penelope (Mary) (1916–) British novelist and biographer. Her first novel, *The Golden Child*, did not appear until 1977. *Offshore* (1979), a portrait of a houseboat community, won the Booker Prize. Her later works, including *At Freddie's* (1982), *Innocence* (1986) and *The Gate of Angels* (1990), show a similarly deft handling of character and detail. fjord (fiord) Narrow, steep-sided inlet on a sea coast. They were formed by GLACIERS moving towards the sea, and were flooded when the ice melted and sea levels rose.

flagellant Religious zealot who uses flagellation, or flogging, for disciplinary or devotional purposes. Now almost obsolete, the practice of flagellation has been part of many religions, including those of ancient Greece and Rome, some Native American cultures and Christianity. In most cases, flagellants have used beatings as a form of penance or purification.

flagellate Any of numerous single-celled organisms that possess, at some stage of their development, one or several whip-like structures (flagella) for locomotion and sensation. They are divided into two major groups; the phytoflagellates resemble plants, the zooflagellates resemble animals. Most have a single nucleus. Reproduction may be asexual (FISSION) or sexual.

Flaherty, Robert Joseph (1884–1951) Pioneer US director of DOCUMENTARY films. In Canada he made *Nanook of the North* (1922) about Inuit life, followed by *Moana* (1926), an idyllic treatment of Samoa. Other major films include *Industrial Britain* (1932) and *Louisiana Story* (1948).

flamboyant style Final phase of French GOTHIC ARCHITECTURE (14th–16th century). The name comes from the flamelike forms of the elaborate tracery used in cathedrals, as on the west façade of Rouen Cathedral (1370). The English DECORATED STYLE is a close equivalent.

flamenco Traditional song, dance and instrumental music, thought to have developed from an amalgam of Romany, Jewish and Arab cultures in Andalusia, s Spain. Flamenco consists of improvisation within strict rules. There are three types of song, of which the most demanding is the *cante hondo*. The

▲ Fitzgerald US jazz singer Ella Fitzgerald's smooth, effortless, "scat" vocalizing is best heard on her interpretations of standards by Cole Porter, Jerome Kern and George Gershwin.

▲ flax Cultivated in moist, temperate climates, only one of several species of flax (*Linum* sp.) is cultivated for its fibre and rich oil seeds. After harvesting, flax stems are retted (soaked in water) to soften the fibres which are then spun into yarn.

dances epitomize pride, poise and sensuality. Songs and dances are accompanied by handclaps, finger-snapping and rhythmic rolls on the guitar.

flamingo Long-necked, long-legged wading bird of tropical and subtropical lagoons and lakes. They have webbed feet and a plumage that varies in colour from pale to deep pink. Their bills have fine hair-like filters which strain food from the muddy water. Height: to 1.5m (5ft). Family Phoenicopteridae. Flanders Historic region now divided between Belgium and France. In the 13th–15th centuries, Flanders grew prosperous on trade, and the old nobility lost authority to the towns. By 1400 it was part of Burgundy, passing to the Habsburgs in 1482, before becoming part of the Spanish Netherlands. It was frequently fought over by France, Spain and later Austria. It was the scene of devastating trench warfare in World War 1.

flare, solar See SOLAR FLARE

flat (symbol) In musical notation, an accidental sign placed before a note or immediately after the clef to indicate that the note it refers to should be sounded a semitone lower.

flatfish Any of more than 500 species of bottom-dwelling, mainly marine fish found worldwide. Most have oval flattened bodies. Both eyes are on the upper side; the lower side is generally white. Examples include the halibut, flounder, plaice, dab, turbot and sole. Order Pleuronectiformes.

Flathead Indians Term applied to many Native American tribes, from their custom of deforming the heads of infants so that they developed a socially desirable, elongated skull. The term most commonly refers to the Chinook. The Salish of the Flathead Reservation, Montana were called "flatheads" by neighbouring tribes that shaped their heads in a pointed style. flatworm Simple, carnivorous, ribbon-like creature which,

having no circulatory system and sometimes no mouth or gut, feeds by absorption through its body wall. The FLUKE and TAPEWORM are both parasites of animals. Order Platyhelminthes.

Flaubert, Gustave (1821–80) French novelist of the 19th-century realist school. An extremely craftsmanlike and elegant writer, he remains one of the most highly respected of European novelists. *Madame Bovary* (1857), his masterpiece, represents the transition from ROMANTICISM to REALISM in the development of the NOVEL. Other fiction includes *The Temptation of St Anthony* (1847), *Salammbô* (1862), *A Sentimental Education* (1869) and the short stories *Three Tales* (1877).

flax Slender, erect, flowering plant cultivated for its fibres and seeds. After harvesting, the stems are retted (soaked in water) to soften the fibres and wash away other tissues. The fibres are spun into yarn to make linen. The seeds yield linseed oil. Family Linaceae; species *Linum usitatissium*.

flea Any of 1,000 species of wingless, leaping insects found worldwide. They are external parasites on warm-blooded animals. In moving from one host to another, they can carry disease. Length: to 1cm (0.4in). Order Siphonaptera.

Fleming, Sir Alexander (1881–1955) Scottish bacteriolo-

FLAMINGO

3

Flamingos feed by lowering their heads into the water so that their bills are upside down (1). Its crooked shape allows the front half of the bill to lie horizontally in the water (2). Tiny hook-like lamellae (3) strain food as the

water is pumped through them by a backward and forward motion of the tongue. Protuberances on the tongue (4) scrape the particles of food off the lamellae for ingestion as the tongue moves back and forth.

gist, discoverer of PENICILLIN. In 1922 Fleming discovered lysozyme, a natural antibacterial substance found in saliva and tears. During research on staphylococci in 1928, Fleming noticed that a mould, identified as Penicillium notatum, liberated a substance that inhibited the growth of some bacteria. He named it penicillin; it was the first antibiotic. Howard FLOREY and Ernst CHAIN refined the drug's production, and in 1941 it was produced commercially. In 1945 Fleming, Florey and Chain shared the Nobel Prize for physiology or medicine. Fleming, lan Lancaster (1908–64) British novelist. After a career as a journalist and banker, he wrote 13 escapist spy thrillers about James Bond, secret agent "007", which won great popularity for their realistic detail and sexual and violent fantasy. They include Casino Royale (1952) (in which Bond makes his first appearance), From Russia with Love (1957) and Goldfinger (1959). The subsequent films based on, or inspired by, his novels have become a cinematic institution.

Fleming, Sir John Ambrose (1849–1945) British electrical engineer, inventor of the thermionic valve. Fleming's valve was a RECTIFIER, or DIODE, consisting of two electrodes in an evacuated glass envelope. The diode permitted current to flow in one direction only. It could detect radio signals but could not amplify them.

Fleming's rules In physics, ways of remembering the relationships between the directions of the current, field and mechanical rotation in electric motors and generators. In the left-hand rule (for motors), the forefinger represents field, the second finger current, and the thumb, motion; when the digits are extended at right-angles to each other, the appropriate directions are indicated. The right-hand rule applies the same principles to generators. John FLEMING devised the rules.

Flemish One of the two official languages of Belgium (the other being French). It is spoken mainly in the N half of the country, by c.50% of the population. Flemish is virtually the same language as DUTCH, but for historical and cultural reasons it is called Flemish in Belgium and Dutch in The Netherlands. Flemish art (Netherlandish art) Loose art history term used to describe artists working in what roughly corresponds to modern-day Netherlands, Belgium and Luxembourg. In the 14th and early 15th centuries, Flemish artists were masters of the International Gothic style, brilliantly characterized by the illuminated manuscripts of the Limbourg brothers. Naturalism became a hallmark of Flemish art, such as the portraits and altarpieces of van EYCK and van der WEYDEN and the LAND-SCAPE PAINTINGS of BRUEGEL. The greatest figures of the next era were Anthony Van Dyck, who spent much of his career in England, and Peter Paul RUBENS, the chief exponent of BAROQUE art in N Europe. After 1650, Flemish art went into a

▶ Florence Located among the

Florence is one of Italy's oldest

intellectual and cultural centres.

Tuscan foothills of N Italy,

long decline. In the 19th century, the leading Belgian artist was James Ensor, a precursor of EXPRESSIONISM. In the 20th century, MAGRITTE and Paul Delvaux both made significant contributions to the SURREALISM movement. See also DUTCH ART

Fletcher, John (1579–1625) English dramatist and poet. From c.1607 to 1616, he collaborated with Francis Beaumont on romantic tragicomedies, such as *Philaster*, *The Maid's Tragedy* and *A King and No King*. He may have collaborated with Shakespeare on *Henry VIII* and *The Two Noble Kinsmen*. His own work includes *The Faithful Shepherdess* (1608) and *The Chancer* (1623).

flight See AERODYNAMICS; AEROFOIL; AERONAUTICS; AIRCRAFT flight recorder (black box) Device for automatically recording data during the operation of an aircraft. Investigators analyse the data after a crash or malfunction. A small aircraft may have a simple cockpit voice recorder (CVR), which records all cockpit sounds and all radio contact with air traffic control. Larger aircraft carry a separate flight data recorder (FDR). Control settings, instrument readings and other data are recorded on magnetic wire. The FDR is usually coloured orange for ease of location at a crash site.

flint Granular variety of QUARTZ (SiO₂) of a fine crystalline structure. It is usually brown or dark grey, although the variety known as chert is a paler grey. It occurs in rounded nodules and is found in chalk or other sedimentary rocks containing calcium carbonate. Of great importance to early humans during the STONE AGE, when struck a glancing blow, flint is flaked, leaving sharp edges appropriate for tools and weapons; two flints struck together produce a spark which can be used to make fire. Flood, the Primeval deluge, sent by God to devastate the Earth as a punishment for wickedness. As related in the Old Testament (Genesis 6-9), God sent rain upon the Earth for 40 days and nights, destroying everything he had created. Only NoAH, his family, and a pair of every living creature, contained in the floating Ark that he had built, were spared to start creation afresh. Similar myths occur in many cultures, from Native American tribes to the Native Australians. The Genesis account bears some resemblance to a section of the Mesopotamian Epic of GILGAMESH. The Flood is also mentioned in the Koran.

Flora In Roman mythology, personification and goddess of springtime and of budding fruits, flowers and crops. She was honoured as a fertility goddess.

Florence (Firenze) Capital of Tuscany and Firenze province, on the River Arno, Italy. It is one of the world's greatest historic cities and tourist attractions. Initially an Etruscan town, it was a Roman colony from the 1st century BC to 5th century AD. In the 12th century it became an independent commune and major trading centre. The site of many factional power struggles, especially the 13th-century war between the GUELPHS and GHI-BELLINES, it nevertheless became the cultural and intellectual centre of Italy. Florence's period of dominance coincided with the rule of the MEDICI family. It became a city-state and one of the leading centres of the RENAISSANCE. Artists who contributed to the flourishing city included MICHELANGELO, LEONARDO DA VINCI, RAPHAEL and DONATELLO. In 1569 Florence became the capital of the Grand Duchy of Tuscany. In the late 16th century, it witnessed the development of opera and the establishment of the literary Accademia della Crusca (1582). From 1865 to 1871 Florence was the capital of the kingdom of Italy. Its many notable churches include: the Duomo gothic cathedral (1296); San Lorenzo, Florence's first cathedral rebuilt in 1425 by Brunelleschi, including a New Sacristy built by Michelangelo; and the monastery San Marco which holds FRA ANGELICO masterpieces. Major art collections include the Uffizi Museum and the Bargello Palace. Industries: tourism, craft, fashion. Pop. (1992) 397,434.

Florence, school of Painters and sculptors who flourished in Florence during the Renaissance. Major figures include Giotto, Fra Angelico, Leonardo da Vinci, Michelangelo, Botticelli and Raphael. The finest achievements of the school were in the early 15th and early 16th centuries.

Florey, Sir Howard Walter (Baron Florey of Adelaide) (1898–1968) British pathologist, b. Australia. He shared, with Alexander Fleming and Ernst Chain, the 1945 Nobel Prize for

physiology or medicine for his part in the development of PENI-CILLIN. Florey isolated the antibacterial agent from the mould, thus making possible the large-scale preparation of penicillin.

Florida State in the extreme SE USA, occupying a peninsula between the Atlantic Ocean and the Gulf of Mexico; the capital is TALLAHASSEE. Florida forms a long peninsula with thousands of lakes, many rivers and vast areas of swampland. At the s tip there is a chain of small islands, the FLORIDA KEYS, stretching w. The subtropical climate has encouraged tourism; the biggest attractions are the EVERGLADES, Florida Keys and Disney World. Discovered in 1513, the first permanent settlement in Florida was at St Augustine. Originally Spanish, the land passed to the English (1763), and returned to the Spanish (1783). America purchased Florida in 1819 and, although the state seceded from the Union in 1861, it was little affected by the US Civil War. It developed rapidly after 1880 when forest clearing and drainage schemes were begun. Florida's historic ties with Cuba are particularly evident in MIAMI, Florida's second largest city (after JACK-SONVILLE). Industries focus on the John F. Kennedy Space Center at CAPE CANAVERAL. Chief agricultural products are citrus fruits, sugar cane and vegetables. Area: 151,670sq km (58,560sq mi). Pop. (1990) 12,938,000.

flour Finely ground edible part of cereal grains, seeds of leguminous plants, or various nuts. Flour used for baking bread comes from cereals. The degree of whiteness varies according to the bran content. Self-raising flour contains added SODIUM BICARBONATE (baking powder).

flower Reproductive structure of a FLOWERING PLANT. It has four sets of organs set in whorls on a short apex (receptacle). The leaf-like sepals protect the bud and form the calyx. The brightly coloured petals form the corolla. The stamens are stalks (filaments) tipped by anthers (pollen sacs). The carpels form the pistil, with an ovary, style and stigma. Flowers are bisexual if they contain stamens and carpels, and unisexual if only one of these is present. Reproduction occurs when POLLEN is transferred from the anthers to the stigma. A pollen tube grows down into the ovary where FERTILIZATION occurs and a seed is produced. The ovary bearing the seed ripens into a FRUIT and the other parts of the flower wilt and fall.

flowering plant Any of *c*.250,000 species of plants that produce FLOWERS, FRUITS and SEEDS. Such plants include most herbs, shrubs, and many trees, fruits, vegetables and cereals. Their seeds are protected by an outer covering and are classified as ANGIOSPERMS. Angiosperms are further subdivided into two main groups, MONOCOTYLEDONS and DICOTYLEDONS. Many flowering plants are used for food, timber and in medicine. Phylum Angiospermophyta.

flu Abbreviation of INFLUENZA

fluid Any substance that is able to flow. Of the three common states of matter, GAS and LIQUID are considered fluid, while a SOLID is not.

fluid mechanics Study of the behaviour of liquids and gases. Fluid statics is the study of fluids at rest and includes the study of pressure, density and the principles of PASCAL and ARCHIMEDES. Fluid dynamics is the study of moving fluids and includes the study of streamline flow, BERNOULLI'S LAW and the propagation of waves. Engineers use fluid mechanics in the design of bridges, dams and ships. AERODYNAMICS is a branch of fluid mechanics.

fluke FLATWORM, an external or internal parasite of animals. Flukes have suckers for attachment to the host. Human infection can result from eating uncooked food containing encysted larvae, or from penetration of the skin by larvae in infected waters. The worms enter various body organs, such as the liver, lungs and intestines, causing oedema (swelling) and decreased function. Phylum Platyhelminthes, class Trematoda.

fluorescence Emission of radiation, usually light, from a substance when its atoms have acquired excess energy from a bombarding source of radiation, usually ultraviolet light or electrons. When the source of energy is removed, the fluorescence ceases. Mercury vapour is a fluorescent substance used in motorway lights; television tubes use fluorescent screens. fluoride Any salt of hydrogen fluoride (HF); more particularly, fluoride compounds added to drinking water or tooth-

FLORIDA
Statehood:
3 March 1845
Nickname:
Sunshine State
State bird:
Mockingbird
State flower:
Orange blossom
State tree:
Sabal palm
State motto:

In God we trust

▲ flower A typical flower has four main parts: sepals, petals, stamens and carpels. The sepals (1) form a protective covering (the calyx) over the developing flower bud, and lie outside the showy petals (2) which collectively are called the corolla. Each male stamen is made up of an anther (3), which contains the pollen grains, borne on a filament (4). The female carpels, which together form the pistil, are found at the centre of the flower, each containing ovaries (5) that bear ovules, and a style (6) which supports the stigma (7) - the structure on which pollen is deposited.

▲ flute Flutes, although called woodwind instruments, are metallic and covered in silver or gold plate. The illustration shows three members of the flute family; piccolo (1), flute (2) and bass flute (3).

▲ flycatcher The paradise flycatcher (*Terpsiphone viridis*), like all flycatchers, catches its prey of small insects on the wing. It sits on its perch waiting to dart out after insects, rather than trying to catch them in continual flight.

paste in order to build up resistance to tooth decay. Fluoride protection appears to result from the formation of a fluorophosphate complex in the outer tooth layers, making them resistant to penetration by acids made by mouth bacteria.

fluorine (symbol F) Gaseous toxic element of the halogen group (elements in group VII of the periodic table), isolated in 1886 by Henri Moissan. Chief sources are fluorspar and cryolite. The pale yellow element, obtained by ELECTROLYSIS, is the most electronegative element and the most reactive nonmetallic element. It is in FLUORIDE in drinking water and is used in making FLUOROCARBONS and in extracting URANI-UM. Properties: at.no. 9; r.a.m. 19; m.p. $-219.6~^{\circ}\text{C}$ ($-363.3~^{\circ}\text{F}$); b.p. $-188.1~^{\circ}\text{C}$ ($-366.6~^{\circ}\text{F}$); single isotope F¹⁹. **fluorite** (fluorspar) Mineral, calcium fluoride (CaF $_2$). It has cubic system crystals with granular and fibrous masses. Brittle and glassy, it can be yellow, purple or green. It is used as a flux in steel production and in ceramics and chemical industries. Hardness 4; s.g. 3.1.

fluorocarbon (technically chlorofluoromethanes) Used as propellants in some AEROSOL spray cans and as refrigerants (freons). They are inert gases, yet in the STRATOSPHERE they are broken down by sunlight to release chlorine atoms. These can react with ozone, so reducing the protective OZONE LAYER. Because of this effect, new propellants have been developed for aerosols. *See also* CHLOROFLUOROCARBON (CFC)

flute WOODWIND musical instrument. Air is blown across a mouth-hole near one end of a horizontally held tube. It has a range of three octaves, with a mellow tone in the lower register and a brighter tone in the higher.

flux In ceramics, any substance that promotes vitrification when mixed with clay. When the ware is fired, the flux melts, filling the porous clay form. As the piece cools, it hardens, becoming glossy and non-porous. Fluxes include felspathic rock, silica and borax. In METALLURGY, a flux is added to the charge of a smelting furnace to purge impurities from the ore and to lower the melting point of the slag.

flycatcher Any of several small birds of the order Passeriformes, found worldwide, that catch insects in midflight.

fly Any of a large order (Diptera) of two-winged insects. They range in size from midges, 1.6mm (0.06in) long, to robber flies more than 76mm (3in) in length. There are between 60,000 and 100,000 species worldwide. Adult flies have compound eyes and sucking mouthparts. Many are pests and spreaders of disease, especially horseflies, mosquitoes and tsetse flies. The common housefly is species *Musca domestica*.

 $\label{eq:conditional} \textbf{Flying bomb} \ \ Popular \ name \ for the \ V1, V2 \ \ \ \ ROCKETS \ used \ by the \ Germans \ in \ \ World \ \ War \ 2.$

flying fish Tropical marine fish found worldwide. It is dark blue and silver and uses its enlarged pectoral and pelvic fins to glide above the water surface for several metres. Length: to 45.7cm (18in). Family Exocoetidae; species *Cypselurus opisthopus*.

flying fox Fruit-eating bat with a fox-like head that lives in SE Asia. The largest of all bats, it does substantial damage to fruit crops. Length: to 40cm (16in); wingspan: to 1.5m (5ft). Genus *Pteropus*.

flying squirrel Small gliding rodent that lives in forests of Eurasia and the USA. It glides by means of furry flaps of skin that stretch out flat and taut on both sides of the body when the limbs are extended. Genus *Pteromys*. The African flying squirrel is of a separate genus (*Anomalurus*).

Flynn, Errol (1909–59) US film actor, b. Tasmania. He made his name with *Captain Blood* (1935), and won worldwide fame playing romantic, swashbuckling heroes, as in *The Adventures of Robin Hood* (1938). He had a scandalous offscreen reputation, and published an autobiography, *My Wicked, Wicked Ways* (1959).

FM Abbreviation of FREQUENCY MODULATION

focal length Distance from the midpoint of a curved mirror or the centre of a thin lens to the focal point of the system. For converging systems, it is given a positive value; for diverging systems, a negative value.

Fo, Dario (1926—) Italian playwright and director. Inspired by the traditions of the COMMEDIA DELL' ARTE and the "alienation" techniques of Bertolt BRECHT, Fo's drama includes elements of farce and the carnivalesque. His best-known works are Accidental Death of an Anarchist (1970) and Can't Pay? Won't Pay! (1975). He won the Nobel Prize for literature in 1997.

fog (mist) Water vapour in the atmosphere that has condensed around particles of dust at or near the ground, as opposed to water vapour condensed as clouds. Fog forms when moist air is cooled below its DEW POINT.

Fokine, Michel (1880–1942) Russian choreographer. In his ballets, he aimed for unity of music, drama, dancing and décor, an approach that was revolutionary in the early 1900s. He was chief choreographer for DIAGHILEV and his BALLETS RUSSES in Paris (1909). He became a naturalized American in 1932. His best-known works include *Les Sylphides* (1909), *Firebird* (1910) and *Petrushka* (1916).

fold In geology, a bend in a layer of rock. An upfold is an ANTICLINE; a downfold a SYNCLINE. The line around which the rock is folded is termed the fold axis. The fold system may be symmetrical, asymmetrical, overturned or recumbent (with the axis of the fold horizontal). A single folding is a monocline.

folic acid Yellow crystalline derivative of glutamic acid, it forms part of the vitamin B complex. Found in liver and green vegetables, it is crucial for growth and is used in the treatment of ANAEMIA.

folk art Term used to describe the art of folk cultures, especially those of rural and ethnic minority communities. It is usually practised by people who have not had formal training and who use local craft processes. The decoration of everyday objects features strongly in folk art, often with motifs that have been handed down from generation to generation.

folklore Traditions, customs and beliefs of the people. The most prevalent form of folklore is the folk tale. In contrast to LITERATURE, which is transmitted through written texts, the folk tale has an oral basis and is transmitted primarily through memory and tradition. Often the tales take the form of myths, fables and fairy tales. The best-known study of folklore is Sir James Frazer's anthropological study *The Golden Bough* (1890).

folk music Music deriving from, and expressive of, a particular national, ethnic or regional culture; it is nearly always vocal. Its main theme tends to be the history of a people, so that folk songs are usually narrative. Their origin is almost always peasant. The musical structure is the simple repetition of a tune (with or without chorus), sometimes with a freedom of rhythm that adheres more to the natural metre of the word than to the more formal requirements of composition. Some modern writers of popular music, such as Bob DYLAN, have applied the folk idiom to their compositions.

follicle-stimulating hormone (FSH) HORMONE produced by the anterior PITUITARY GLAND found in the brain of mammals. In females, it regulates OVULATION by stimulating the Graafian follicles found in the OVARY to produce eggs (ova). In males, FSH promotes SPERMATOGENESIS. FSH is an ingredient in most fertility drugs.

Fonda, Henry (1905–82) US actor. Fonda made his film debut in a reprise of his Broadway role in *The Farmer takes a Wife* (1935). His natural style led to a series of roles as the model of American decency and homespun wisdom in John Ford films, such as *Young Mr Lincoln* (1939), *The Grapes of Wrath* (1940), and *Twelve Angry Men* (1957). For his performance opposite his daughter, Jane Fonda, in *On Golden Pond* (1981), he won his first Best Actor Academy Award. Other films include *The Lady Eve* (1941), *My Darling Clementine* (1946) and *Mister Roberts* (1955).

Fonda, Jane (1937–) US film actress, daughter of Henry Fonda. Following a lauded performance in *They Shoot Horses, Don't They?* (1969), Fonda won a Best Actress Academy Award for *Klute* (1971). A second award followed for *Coming Home* (1978). She starred opposite her father in *On Golden Pond* (1981). Other films include *Julia* (1977) and *The China Syndrome* (1979). Her personal fitness programme, *Jane Fonda's Workout Book* (1981), was a worldwide best-seller and spawned a series of imitations.

Fontainebleau Town in the Forest of Fontainebleau, N France, famed for its royal palace. The 16th-century palace was commissioned by Francis I. Built on the site of a previous

royal residence, it is a world heritage site and a masterpiece of French Renaissance architecture. Napoleon's imperial head-quarters, it was also the location for the signing of his first abdication (1814). It is now a museum and the presidential summer residence. The town was headquarters of the military branch of NATO from 1945 to 1965. Pop. (1982) 18,750.

Fontainebleau School Style of painting associated with a group of artists working at the French court in the 16th century. In a bid to match the magnificence of the Italian courts, Francis I gathered international artists to decorate his palace at Fontainebleau. Led by the Florentine artists Fiorentino Rosso and Francesco Primaticcio, the group evolved a unique style of MANNERISM, blending sensuality and elegance.

Fonteyn, Dame Margot (1919–91) British ballerina. She was a member of the Royal Ballet (1934–59) and a guest artist with every major US and European ballet company. She continued to dazzle audiences late in her career, especially in her appearances with Rudolf Nureyev. She was acclaimed as one of the most exquisite classical dancers of the 20th century.

food Material taken into an organism to maintain life and growth. Important substances in food include PROTEINS, FATS, CARBOHYDRATES, MINERALS and VITAMINS. See also FOOD CHAIN food additive Substance introduced into food to enhance flavour, to act as a preservative, to effect a better external coloration or more appetizing appearance, or to restore or increase nutritional value. Other additives include thickeners, stabilizers and anti-caking agents. The use of food additives is strictly regulated by law and requires prominent labelling. Food and Agriculture Organization (FAO) Specialized agency of the United Nations (UN), established in 1946. It aims to eliminate hunger and improve world nutrition. Its headquarters are in Rome.

Food and Drug Administration (FDA) US federal agency within the Department of Health and Human Services, established in 1979. Its purpose is to protect against impure and unsafe foods, drugs and cosmetics, and other potential hazards. The FDA is divided into several bureaux. food chain Transfer of energy through a series of organisms, each organism consuming the previous member of the chain the main sequences in from green plants (produces) to

food chain Transfer of energy through a series of organisms, each organism consuming the previous member of the chain. Its main sequence is from green plants (producers) to HERBIVORES (primary consumers) and then to CARNIVORES (secondary consumers). Decomposers, such as bacteria and fungi, act at each stage, breaking down waste and dead matter into forms that can be absorbed by plants, thus perpetuating the chain. *See also* DECOMPOSITION; PHOTOSYNTHESIS

food poisoning Acute illness caused by consumption of food which is itself poisonous or which has become poisoned or contaminated with bacteria. Frequently implicated are SALMONELLA bacteria, found in cattle, pigs, poultry and eggs, and listeria, sometimes found in certain types of cheese. Symptoms include abdominal pain, DIARRHOEA, nausea and vomiting. Treatment includes rest, fluids to prevent dehydration and, possibly, medication to curb vomiting. See also BOTULISM; GASTROENTERITIS

food preservation Treatment of foodstuffs to prolong the time for which they can be kept before spoiling. Salting, pickling and FERMENTATION preserve food chemically. Chemical preservatives, such as sodium benzoate, can also be added to foods. In canning, meats and vegetables are sterilized by heat after being sealed into airtight cans. Cold storage at 5°C (41°F) prolongs the life of foods temporarily, while deepfreezing at -5° C (23°F) or below greatly extends the acceptable storage period. In the technique of freeze-drying, frozen foods are placed in a vacuum chamber and the water in them is removed as vapour; the foods can be fully reconstituted at a later date. Since the early 1990s, irradiation (the preservation of food, by subjecting them to low levels of radiation in order to kill micro-organisms) has been increasingly used.

food technology Application of scientific techniques to the generation, mass production, packaging and preservation of all types of food. Generating new and better forms of food often involves GENETIC ENGINEERING. The genetic material in edible plants is improved in order to achieve greater yield and resistance to disease. Improving genetic strains is also important in the mass production of all forms of meat farming. The

scientific provision of an idealized environment can increase the size and quality of vegetables and animals. Animals can be further scientifically bioengineered through the careful introduction of hormones intended to cause effects beneficial to the eventual consumer. Mechanical and electronic machinery for the mass-production of both plant and animal food-stuffs evolves year by year. See also FOOD PRESERVATION

food web See FOOD CHAIN

Foot, Michael (1913—) British politician, writer and leader of the Labour Party (1980–83). He was editor of the *Evening Standard* (1942–44) and *Tribune* (1955–60) and a prominent supporter of the Campaign for Nuclear Disarmament (CND). First elected to parliament in 1945, he joined Harold Wilson's cabinet as secretary of state for employment (1974), later becoming leader of the House of Commons. In 1980 he succeeded James CALLAGHAN as leader of the party, but resigned after Labour's disastrous defeat in the 1983 general election. foot In poetry, unit of verse metre. Each foot is composed of a group of two or more syllables, some of which are stressed. Most commonly used feet are anapest, dactyl, iamb and trochee.

football, American Contact sport played mainly in the USA. It is second in popularity only to baseball. It is played by 2 teams of 11 people on a field 100×53yd (91.5×49m). The field is marked off by latitudinal stripes every 5yd (4.6m) and is flanked on each end by an end zone, 10yd (9.1m) long. At each end of the end zone are H-shaped goal posts. An inflated leather, spheroid ball is used, with the object of moving the ball - by the ground or air - across the opponent's goal line. A game consists of two halves, each having two 15-minute quarters. Each half starts with a kickoff, and after the receiving team has run back the ball, it must advance 10yd in 4 attempts (downs) or turn the ball over to the opponents. The defending team must stop the ball carrier by pushing him out of bounds or by bringing him to the ground (tackling). The ball is usually turned over by punting (kicking) on the last down or attempting a field goal. If a player fumbles and loses possession of the ball during the series of downs, the opposition takes over the ball. Scoring can occur in four ways: a touchdown (crossing the opponent's goal line) scores six points; a conversion (kicking the ball through the uprights of the goal post after a touchdown) scores one; a field goal (kicking the ball through the uprights in normal play) scores three; and a safety (downing the ball carrier behind his own goal line) scores two points. Except for certain instances in professional football, games can end in a tie. Substitutions are freely allowed. Football has its roots in England and has similarities to rugby and soccer. Professional football began in the 19th century. The winners of the two US professional leagues, the American Football Conference (AFL) and the National Football Conference (NFL), play off each January for the Super Bowl.

football, association (soccer) Arguably the most popular worldwide sport. It involves two teams of 11 players who attempt to force a round ball into their opponents' goal. It is played on a rectangular pitch of maximum size 120×90m (390×300ft), minimum 90×45m (300×150ft). The goals, two uprights surmounted by a crossbar, are 7.32m×2.44m (8ft×24ft) wide. Only the goalkeeper may handle the ball, and then only in the penalty area of the goal he is defending. The

▲ flying fox The grey-headed flying fox (*Pteropus poliocephalus*) of Australia grows to 40cm (16in) and has a wingspan of more than 1m (3.3ft). They feed in groups on various wild and cultivated fruits.

■ Fonda Her political activities included a campaign for the return of US troops from Vietnam. Jane Fonda starred in her first husband, Roger Vadim's cult classic *Barbarella* (1968).

other players may play the ball in any direction with any other part of the body, essentially it is kicked or headed. A game is played over two 45-minute periods and controlled by a referee. Modern football rules were formulated in 19th-century England, and the Football Association (FA) was founded in 1863. The FA Cup, established in 1872, is the world's oldest knockout football competition. The introduction of professionalism in 1885 led to the foundation (1888) of the Football League Championship. Football soon spread beyond Britain and, in 1904, Fédération internationale de football association (FIFA) was formed to control the sport at world level. Football has been played at the Olympic Games since 1908. The first of the four-yearly World Cup competitions was held in 1930. In Europe, the winners of each national league annually compete for the European Champions Cup (established 1955) Recent years have seen a significant increase in commercial sponsorship and television coverage. In 1992 the English FA changed the "four-divisions" structure of the Football League, primarily to raise the commercial profile of leading clubs. This structure consisted of a "Premier" league of the top 20 clubs as a separate entity within the FA, and the First, Second and Third Divisions of the Football League.

football, Australian rules Type of football popular in Australia and Papua New Guinea. It is played over four 25-minute quarters between two teams of 18 players using an oval-shaped ball on an oval pitch 135–185m (440–600ft) long and 110–155m (345–504ft) wide. The ball may be kicked or punched, and although players can run with the ball, they must bounce it on the ground every 10m (33ft). The object of the game is to score points by kicking the ball between goalposts 6.4m (21ft) apart (6 points). There are two other posts farther apart, one 6.4m (21ft) each side of the goalposts; a ball passing between one of these and a goal post scores a behind (1 point). football, Canadian Game similar to American FOOTBALL. The main differences are that teams have 12 players, are allowed only three downs and play on a larger field, 100×59m (330×195 ft). The Grey Cup is the principal trophy.

football, Gaelic Sport popular in Ireland and dating from the 16th century. Each side has 15 players who may kick, punch or pass the ball, but not throw it. Players may not pick the ball up from the ground; it may be carried for four paces and then has to be bounced, kicked or punched away. The pitch is 128m (420ft) and 146m (480ft) long and between 77m (252ft) and 91m (300ft) wide with goalposts at each end. One point is scored for putting the ball over the bar and three for driving it under the bar. The game lasts 60 minutes (except in the All-Ireland semi-finals and final when it lasts 80 minutes) with two halves, and is controlled by a referee and four goal umpires.

foraminifera Amoeboid protozoan animals that live among plankton in the sea. They have multi-chambered chalky shells (tests) which may be spiral, straight or clustered and vary in size from microscopic to 5cm (2in) across, according to species. Many remain as fossils and are useful in geological dating. When they die, their shells sink to the oceanfloor to form large deposits, the source of chalk and limestone. Order Foraminiferida.

force Push, pull or turn. A force acting on an object may (1) balance an equal but opposite force or a combination of forces so that it does not move, (2) change the state of motion of the object (in magnitude or direction), or (3) change the shape or state of the object. There are four FUNDAMENTAL FORCES.

Ford, Ford Madox (1873–1939) British novelist, poet and critic, b. Ford Madox Hueffer. He provided influential support to such writers as Ezra POUND, while editing the *Transatlantic Review* in Paris, and Joseph CONRAD and D.H. LAWRENCE during his editorship of the *English Review*. He was also a prolific writer; his most remembered works are the novels *The Good Soldier* (1915) and the tetralogy *Parade's End* (1924–28).

Ford, Gerald Rudolph (1913—) 38th US president (1974—77). Elected to the House of Representatives in 1948, he gained a reputation as an honest and hard-working Republican. He was nominated by President NIXON to replace the disgraced Spiro AGNEW as vice president (1973). When Nixon resigned, Ford became president – the only person to hold the office without winning an election. One of his first

acts was to pardon Nixon. His attempts to counter economic recession with cuts in social welfare and taxes were hindered by a Democrat-dominated Congress. Renominated in 1976, he narrowly lost the election to Jimmy Carter.

Ford, Henry (1863–1947) US industrialist. He developed a petrol-engined car in 1892 and founded Ford Motors in 1903. It achieved huge success with the economical and inexpensive Model T (1908), which from 1913 was produced on an assembly line, lowering production costs enormously. Almost as startling was Ford's introduction of an eight-hour working day and a relatively high basic wage.

Ford, John (1586–1639) English playwright who, with Cyril Tourneur, pioneered post-JACOBEAN drama. His major plays include *The Broken Heart* (c.1630), *Love's Sacrifice* (c.1630), *Tis Pity She's a Whore* (c.1633) and *Perkin Warbeck* (1634). Incest and thwarted passion are common themes, and plays emphasize the difference between public and private morality. Ford, John (1895–1973) US film director. Ford won four Academy Awards for Best Director: *The Informer* (1935), *The Grapes of Wrath* (1940), *How Green Was My Valley* (1941) and *The Quiet Man* (1952). A prolific film-maker, he made a significant contribution to the development of the WESTERN. His genre classics include *Stagecoach* (1939), *My Darling Clementine* (1946), *The Horse Soldiers* (1959) and *The Searchers* (1956).

foreign exchange Buying and selling national currencies. All currencies have an underlying value relative to the value of gold, registered with the INTERNATIONAL MONETARY FUND (IMF). This value may deviate and governments can control the amount of deviation by tactical trading on foreign exchange markets. Speculators may trade on foreign exchange markets in the hope of profiting from short-term fluctuations in the value, an activity known as arbitrage. International commercial companies may also trade on these markets, in order to obtain favourable currency rates. Financial institutions buy and sell foreign currencies to individuals and businesses at rates determined by their values on national foreign exchange markets.

Foreign Legion Professional military group, created in 1831 to serve in French colonies. In 1962, after fighting in two World Wars and later French colonial struggles, the Legion moved its headquarters from Algeria to s France.

forensic science (medical jurisprudence) Application of medical, scientific or technological knowledge to the investigation of crimes. Forensic medicine involves examination of living victims and suspects, as well as the pathology of the dead. The cause of death, if there is doubt, is established at an autopsy. Forensic science developed in the early 1900s in England as a collaboration between police work and medicine. Modern developments include DNA fingerprinting.

Forester, C.S. (Cecil Scott) (1899–1966) British author. He is most famous for his 12-novel saga about Horatio Hornblower, a naval officer during the Napoleonic Wars; the series began with *The Happy Return* (1937). His other works include *The African Queen* (1935) and *The Gun* (1933).

forestry Managing areas of forest and their waters and clearings. Forestry aims to produce timber, but conservation of soil, water and wildlife is also a consideration. Natural forests once covered nearly two-thirds of the world's land surface, but clearances have reduced this figure to less than one-third today.

forgery Imitation of a document or artefact. In Britain, forgery is a serious crime punishable by imprisonment, and the forgery of a deed, will or banknote may be punishable with imprisonment for life.

forget-me-not Any of about 50 species of hardy perennial and annual herbs of the genus *Myosotis*, found in temperate parts of Europe, Asia, Australasia and North America. The typical five-petalled flowers are sky blue but may change colour with age. Family Boraganaceae (BORAGE).

forging Shaping of metal by hammering, or by applying pressure against a shaped die. Blacksmiths forge horseshoes and other iron items by hammering the red-hot metal on an anvil. In mass-manufacturing processes, pressure from an hydraulic forging press or blows from a forging hammer shape metal parts by forcing them against hard-metal die. Most metals are forged hot, but cold forging is also practised.

formaldehyde Alternative name for METHANAL

Forman, Milos (1932–) Czech film director. Forman made several films in Czechoslovakia, including Fireman's Ball (1967), before moving to the USA in 1968. One Flew Over the Cuckoo's Nest (1975) is one of only three films (It Happened One Night and Silence of the Lambs) to gain Academy Awards for Best Film, Best Director, Best Actor and Best Actress. He also won a further Oscar as Best Director for Amadeus (1984). formic acid Alternative name for METHANOIC ACID

Formosa See TAIWAN

Forster, E.M. (Edward Morgan) (1879–1970) British novelist. He wrote six novels before giving up fiction at the age of 45: Where Angels Fear to Tread (1905), The Longest Journey (1907), A Room with a View (1908), Howards End (1910), A Passage to India (1924) – widely seen as his masterpiece – and the posthumously published homosexual love story, Maurice (1971). He made a significant contribution to the development of the realist novel, and Aspects of the Novel (1927) is a collection of lectures in literary criticism. Abinger Harvest (1936) and Two Cheers for Democracy (1951) comprise essays on literature, society and politics.

forsythia Genus of hardy deciduous shrubs of the OLIVE family Oleaceae, named after the British botanist William Forsyth. They are commonly cultivated in temperate regions. The masses of small vellow flowers look like golden bells and appear in early spring before the leaves. Height: to 3m (10ft). Fort-de-France Capital of the French overseas department of Martinique, on Fort-de-France Bay. First settled in the 17th century, it remained undeveloped until the beginning of the 20th century, when a volcanic eruption destroyed St. Pierre, Martinique's commercial centre. It is now a popular tourist resort. Exports: sugar cane, rum, cacao. Pop. (1990) 101,540. Fort Lauderdale City on the Atlantic coast of SE Florida, USA; seat of Broward county. It was established as a military post in 1838 by Major William Lauderdale during the wars with the SEMINOLE. There are over 435km (270mi) of waterways. Port Everglades is one of the world's largest passenger ports. In the late 20th century, it became a popular holiday resort. Industries: tourism, computing. Pop. (1990) 149,377. Fort Sumter Fort in South Carolina, scene of the first hostilities of the American CIVIL WAR. In 1861 it was held by Federal forces. The Confederate authorities, having failed to negotiate a peaceful evacuation, felt compelled to take it by force. The Confederate General BEAUREGARD opened fire on 12 April and the fort surrendered the following day.

Fort Wayne City in NE Indiana, USA, at the confluence of the St Joseph and St Mary rivers. It was captured by the British during the French and Indian War (1755–63) and held by Native Americans (1763) during Pontiac's Rebellion. Development was spurred in the 1850s by the Wabash and Erie

Animal fossils are not only made from their bones or shells, often their tracks can also be fossilized. Typically, a footprint (1) is left behind in soft mud, which partially hardens to form a cast. If the mud becomes flooded (2), sediment is laid over the mud especially quickly (3) helping to preserve the shape of the footprint. Over the course of time, the mud and sediment become compressed and turn to rock (4). The original mudbased rock forms a mould of the footprint (5) and the sediment-based rock forms a cast (6).

canals and the railroad . It is home to the Indiana Institute of Technology (1930). Industries: heavy vehicles, copper wire, stainless steel, mining machinery, pumps. Pop. (1990) 173,072. Fort Worth City in N central Texas, USA, c.50km (30mi) w of Dallas. It was settled in 1843 and the US army established a post here in 1847. In the 1870s, Fort Worth was a supply centre on the cattle route from Texas to Kansas. It is famous for its oil and cattle. Industries: aerospace, electronic equipment. Pop. (1990) 447,619.

fossil Direct evidence of the existence of an organism more than 10,000 years old. Fossils document evolutionary change and enable geologic dating. They are original structures, such as bones, shells, or wood (often altered through mineralization or preserved as moulds and casts), or imprints, such as tracks and footprints. Leaves are often preserved as a carbonized film outlining their form. Occasionally organisms (such as mammoths) are totally preserved in frozen soil, peat bogs and asphalt lakes, or trapped in hardened resin (such as insects in amber). Fossil excrement (coprolite) frequently contains undigested and recognizable hard parts.

fossil fuels Term to describe COAL, OIL, and NATURAL GAS – FUELS that were formed millions of years ago from the fossilized remains of plants or animals. By their very nature, fossil fuels are a non-renewable energy source.

Foster, Jodie (1962–) US film actress and director. Foster was a precocious talent. In 1976, aged 13, she received an Academy nomination for her role in *Taxi Driver*. She has won two Best Actress Oscars, one for a controversial and demanding performance as a gang-rape victim in *The Accused* (1988) and another for *The Silence of the Lambs* (1991). She made her directorial debut with the personal *Little Man Tate* (1991). Other films include *Sommersby* (1993) and *Nell* (1994).

Foster, Sir Norman (1935–) English architect, one of the prime exponents of high-tech architecture. Foster is a late modernist whose huge glass and steel exoskeletons seem to exemplify modernist ideals of efficiency. His works include Hong Kong Bank building (1986), Stansted airport terminal, Essex (1991) and the Millenium Dome, Greenwich (2000).

■ Foster When only 13 years old, Foster starred in *Taxi Driver* and *Bugsy Malone* (1975). A deranged fan, John Hinckley, Jr, tried to assassinate Ronald Reagan in a bid to impress her.

▲ fowl Commercial hybrid poultry are bred for eggs and meat from pure breeding birds. The most productive egg-laying strains are derived from leghorns (1) and Rhode Island reds (2), while the Dorking (3) and Cornwall (4) are popular British meat breeds.

▲ foxglove Native to Old World countries, particularly those of Europe, N Africa, and Asia, foxgloves are hardy plants that bear purple and white, or less commonly, golden flowers.

Foster, Stephen Collins (1826–64) US songwriter. Influenced by the Negro spiritual, his popular songs include "Camptown Races" (1850), "Old Folks at Home" (1851), "My Old Kentucky Home (1853) and "Jeanie with the Light Brown Hair" (1854).

Foster, William Zebulon (1881–1961) US labour leader and politician. He was affiliated with the Socialist Party, the Industrial Workers of the World (IWW) and the American Federation of Labor (AFL). He led a steel strike (1919), and was the Communist Party presidential candidate (1924, 1928 and 1932). He became national party chairman (1945–61).

Foucault, Jean Bernard Léon (1819–68) French physician and physicist who invented the GYROSCOPE. He used a PENDULUM (Foucault's pendulum) to prove that the Earth spins on its axis and devised a method to measure the absolute velocity of light (1850), showing it to be slower in water than in air. With Armand Fizeau, he took the first clear photograph of the Sun. He also noted the occurrence of eddy currents, which became known as Foucault currents.

Foucault, Michel (1926–84) French philosopher, academic and social historian. Foucault was professor of the history of systems of thought at the *Collège de France* (1970–84). He examined the social and historical contexts of ideas and institutions, such as school, prison, police force and asylum. For Foucault (like Nietzsche), social scientific knowledge and power are inextricably linked. His main theme was how Western systems of knowledge (such as psychiatry) have changed humans into subjects. His works include *Madness and Civilization* (1961), *Discipline and Punish* (1975) and *The Order of Things* (1966).

Fouquet, Jean (1420–80) French court painter. His work is monumental and sculptural, with figures modelled in broad planes. Notable works include a portrait of Charles VII (c.1447), Books of Hours (1450–60), and the *Pietá* at Nouans. **Four Freedoms** Expression of war aims in World War 2 enunciated by US president Franklin ROOSEVELT in his State of the Union address (January 1941). They were: freedom of speech and worship, and freedom from want and fear. These aims were echoed in the ATLANTIC CHARTER (1941).

Fourier, (François Marie) Charles (1772–1837) French utopian socialist. He supported cooperativism and set forth detailed plans for the organization of the communities (called phalanxes). Fourier suggested that capital for the enterprise come from the capitalist, and he provided for payment to capital in his division of output. See also UTOPIANISM

four-stroke engine Engine in which the operation of each piston is in four stages, each stage corresponding to one movement of a piston along a cylinder. The stages are: induction, in which the fuel-air mixture enters the cylinder; compression; expansion, in which the exploding mixture forces the piston along the cylinder; and exhaust. This system is called the four-stroke cycle, or the Otto cycle, after its inventor, Nickolaus Otto (1832–91), and is used by many INTERNAL COMBUSTION ENGINES, including DIESEL ENGINES.

Fourteen Points Programme presented (January 1918) by US president Woodrow WILSON for a just peace settlement of World War 1. In general, the programme required greater liberalism in international affairs and supported the principle of national self-determination. It made useful propaganda for the Allies and was the basis on which Germany sued for peace in 1918. Some points found expression in the Treaty of VER-SAILLES, others were modified or rejected at the peace conference. The 14th Point laid the basis for the LEAGUE OF NATIONS. **fourth estate** Name sometimes given to the press – people who gather, write and edit news. The phrase was first used by Thomas Babington MACAULAY when he wrote (1828) of the House of Commons that: "The gallery in which the reporters sit has become a fourth estate of the realm." This was an expansion of the concept of the three estates - the lords spiritual, lords temporal and commons.

Fourth of July US national holiday. It celebrates the signing of the DECLARATION OF INDEPENDENCE, 4 July 1776, and has been a national holiday since then.

fowl Term applied to domestic birds, such as chicken or turkey, and game such as pheasant and duck. See also POULTRY

Fowler, Henry Watson (1858–1933) British lexicographer and grammarian. He is best known for *A Dictionary of Modern English Usage* (1926), which continues to be published with revisions. He also produced other writings in the same vein, such as *The King's English* (1906).

Fowler, William A. (Alfred) (1911–95) US physicist and astrophysicist best known for his explanation of how chemical elements are built up (from heavier to lighter) within stars as they evolve. He developed these ideas (published 1957) while working with three British astronomers: Fred HOYLE, and Geoffrey and Margaret Burbidge. In 1983 he shared the Nobel Prize for physics with Subrahmanyan CHANDRASEKHAR.

Fowles, John Robert (1926-) British novelist. His debut

novel, The Collector (1963), about an obsessive who kidnaps a young woman, was made into a feature film. The Magus (1966) and The French Lieutenant's Woman (1969) were also filmed. Later novels include A Maggot (1985) and works on natural history, such as A Short History of Lyme Regis (1982). Fox, Charles James (1749-1806) British statesman and orator, the main parliamentary proponent of liberal reform in the late 18th century. Fox entered parliament in 1768 and served as lord of the Admiralty (1770-72) and as lord of the Treasury (1773-74) under Lord NORTH. He was dismissed by GEORGE III for his opposition to government policy on North America. He became foreign secretary (1782) in Rockingham's government and formed a short-lived coalition government (1783) with Lord North. Thereafter, he led Whig opposition to the government of William Pitt, urging the abolition of slavery and the extension of the franchise. On Pitt's death (1806), Fox briefly returned as foreign secretary.

Fox, George (1624–91) English religious leader, founder of the QUAKERS. He embarked upon his evangelical calling in 1646 in response to an "inner light". Imprisoned eight times between 1649 and 1673, his missionary work included visits to Quaker colonies in Caribbean and America (1671–72). His *Journal* (1694) is a record of the early Quaker movement.

fox Any of several carnivores of the DOG family. The red fox (*Vulpes vulpes*) is typical. Height: 38cm (15in); weight: *c*.9kg (20lb). Distinguished by its sharp features, large ears and long, bushy tail, foxes feed on insects, fruit, small birds and mammals and carrion. They are solitary animals, living in dens only for the mating season. Family Canidae. *See also* FOX-HUNTING Foxe, John (1516–87) English Anglican clergyman and historian, whose writings promoted Protestantism and influenced policy towards Roman Catholics. He returned from exile in France during Elizabeth 1's reign and wrote *Actes and Monuments of these latter and perillous Dayes*, better known as *Foxe's Book of Martyrs* (1563).

foxglove Hardy Eurasian BIENNIAL and PERENNIAL plants of the genus *Digitalis*. They have long, spiky clusters of drooping tubular flowers. The common biennial foxglove (*D. purpurea*), source of the heart stimulant DIGITALIS, is grown for its showy purple or white flowers. Family Scrophulariaceae. foxhound Medium-sized dog (sporting group) used in FOX-

TOXHOUNG Medium-sized dog (sporting group) used in FOX-HUNTING. The coat is short and smooth, the ears droop and the tail is carried erect. They are black, tan and white and are noted for their speed and stamina. The American foxhound, recognized as a separate breed, is slighter than the English variety. Height: 53.3–63.5cm (21–25in) at the shoulder.

fox-hunting Field sport, in which a fox is pursued across country by horse riders with FOXHOUNDS. The hunting season lasts from November to April. In Britain, calls for the abolition of fox-hunting have widespread public support.

fractal Geometrical figure in which an identical motif is repeated on a reducing scale; the figure is "self-similar". Coined by Benoit MANDELBROT, fractal geometry is closely associated with CHAOS THEORY. Fractal objects in nature include shells, cauliflowers, mountains and clouds. Fractals are also produced mathematically in computer graphics.

fraction Quotient written in the form of one number divided by another. A fraction is a/b, where a is the numerator and b the denominator. If a and b are whole numbers, the quotient is a simple fraction. If a is smaller than b, it is a **proper** fraction; if b is smaller than a, it is an **improper** fraction. In an **algebraic** fraction the denominator, or the numerator and denominator,

are algebraic expressions, e.g. $x/(x^2+2)$. In **composite** fractions, both the numerator and denominator are themselves fractions. **Fragonard, Jean-Honoré** (1732–1806) French painter. He was a student of Jean Chardin and François BOUCHER. He is best known for the lighthearted spontaneity of his amorous scenes, rustic landscapes and decorative panels.

Frame, Janet (1924–) New Zealand short story writer and novelist. Her works explore the position of women in contemporary New Zealand. Her harrowing autobiography, *An Angel at My Table* (1984), was made into a feature film.

franc Monetary unit of France, Belgium, Switzerland and Luxembourg as well as of the African Financial Community (CFA) and the French Pacific Community. It is divided into 100 centimes.

France, Anatole (1844–1924) (Jacques Anatole François Thibault) French author. He achieved recognition with the novels *The Crime of Sylvester Bonnard* (1881) and *Thaïs* (1890). He supported Emile Zola during the Dreyfus Affair, and his writing grew more political, such as the four-volume novel series *Contemporary History* (1897–1901) and *Penguin Island* (1908). He was awarded the 1921 Nobel Prize for literature.

France Republic in W Europe. See country feature, p.264
Francesca, Piero della See PIERO DELLA FRANCESCA

Franche-Comté Historic region of E France; its capital was Dôle until 1674 and Besançon thereafter. Founded in the 12th century as the "free county" of the Burgundians, it was disputed throughout the Middle Ages between the Holy Roman Empire, France, Burgundy, Spain and Switzerland. After Louis XIV's conquest of 1674, it was finally recognized as part of France in 1678. Area:16,202sq km. Pop. (1991) 1,097,300.

franchise Right or privilege of an individual to vote in public political elections, granted by government. Franchise is conferred according to a set of criteria which may include age, sex, race or class. In contemporary democracies, the intention is that anyone over a specific age has the right to vote. In Britain, the modern basis of the franchise dates from the 1832 Reform Act and subsequent acts which, by 1918, ensured all men over the age of 21 and women over 30 were entitled to vote (the first country to give women the vote was New Zealand, 1893). By 1928, women aged over 21 were enfranchised and in 1969 the voting age in Britain was lowered to 18. In the USA, the franchise is granted by each state, and this is overseen by the Constitution. The 14th and 15th Amendments (1868 and 1870 respectively) forbid any state to deny voting rights to resident adult men aged over 21 on the grounds of race, colour or previous servitude. The 19th Amendment (1920) gave women the vote. In US political practice, voting rights were restricted until the 1960s. In particular, grandfather clauses were added to the constitutions of seven Southern States to deprive black people of their voting rights. Other methods of restricting the franchise included literacy tests and poll taxes. The 24th Amendment (1964) banned poll taxes. The Voting Rights Act (1965) outlawed literacy tests and installed poll observers to prevent voter intimidation. The 26th Amendment (1971) lowered the voting age to 18.

Franciscans Friars belonging to an itinerant religious order founded by St Francis of Assisi. The first order, known as the Friars Minor now comprises three subdivisions: the Observants; the Capuchin; and the Conventual, who are allowed to own property corporately. The second order, Poor Clares, an order of nuns founded by St Francis and St Clare, came into being in 1212. Originally called Greyfriars, Franciscans now wear brown robes.

Francis I (1708–65) Holy Roman emperor (1745–65), duke of Lorraine (1729–35) and Tuscany (1737–65). In 1736 he married the Habsburg heiress MARIA THERESA. Her accession (1740) precipitated the War of the Austrian Succession. In 1745 Francis succeeded Charles VIII as emperor, but Maria Theresa effectively wielded all political power.

Francis II (1768–1835) Last Holy Roman emperor (1792–1806) and first emperor of Austria, as Francis I (1804–35). Repeatedly defeated by France, he was forced to accept steady diminution of his territories, culminating in the abolition of the HOLY ROMAN EMPIRE (1806). He preserved

Austria by alliance with Napoleon and in 1813 joined the coalition that defeated him. At the Congress of VIENNA, where he was the host, his minister, Prince METTERNICH, succeeded in restoring Austrian predominance in central Europe. Francis I (1494–1547) King of France (1515–47). A leader of the Renaissance, he is best remembered for his contributions to the humanities and support of the arts. Repression of religious reform, centralization of monarchical power and foolish financial policies earned the dissatisfaction of his people. A long and costly struggle with the Emperor CHARLES V over the imperial crown led to a severe defeat at Pavia in 1525. Francis was imprisoned and forced to give up Burgundy as a condition of the Treaty of Madrid (1526). An ensuing war with Charles (1527–29) led to the loss of Italy, but campaigns in the 1540s were more successful.

Francis II (1544–60) King of France (1559–60). Eldest son of Henry II and Catherine de' Medici, he was king for less than two years and ruled only in name. Married to Mary Queen of Scots at the age of 14, he was a sickly youth and his kingdom was controlled by two uncles – Charles, cardinal of Lorraine, and Francis, duke of Guise.

Francis of Assisi, Saint (1182–1226) Italian founder of the itinerant religious order of friars known as the Franciscans. Born the son of a wealthy merchant, he renounced his worldly life for one of poverty and prayer in 1205. In 1209 he received permission from Pope Innocent III to begin a monastic order. The Franciscans were vowed to humility, poverty and devotion to the task of helping people. In 1212, with St Clare, he established an order for women, popularly called the Poor Clares, and in 1221 a lay fraternity. In 1224 he received the STIGMATA while at prayer on Mount Alverna, near Florence. He was canonized in 1228. His feast day is 4 October.

Francis Xavier, Saint (1506–52) Early JESUIT missionary, often called the Apostle to the Indies. He was an associate of St IGNATIUS OF LOYOLA, with whom he took the vow founding the Society of Jesus. From 1541 he travelled through India, Japan, and the East Indies, making many converts. He died while on a journey to China. His feast day is 3 December.

Franck, César Auguste (1822–90) French Romantic composer, b. Belgium. He wrote major works for the organ and is best remembered for the *Symphonic Variations* for piano and orchestra (1885), the popular *Symphony in D Minor* (1888) and significant chamber works.

Franck, James (1882–1964) US physicist, b. Germany. With Gustav Hertz, he experimented with electron bombardment of gases, providing support for the theory of atomic structure proposed by Niels BOHR and information for the quantum theory of Max Planck. Franck and Hertz shared the 1925 Nobel Prize for physics for their studies on the changes of energy occurring when atoms collide with electrons. He worked on the MANHAITAN PROJECT to develop the atom bomb, and presented the "Franck petition" which opposed the use of the bomb against Japanese civilians.

Franco, Francisco (1892–1975) Spanish general and dictator of Spain (1939–75). He joined the 1936 military uprising that led to the Spanish CIVIL WAR and assumed leadership of the fascist FALANGE. By 1939, with the aid of Nazi Germany and fascist Italy, he had won the war and become Spain's dictator. He kept Spain neutral in World War 2, after which he presided over accelerating economic development, while

▲ foxhound Foxhounds are

▲ foxhound Foxhounds are medium-sized dogs that have been bred for their speed and stamina. They are used in foxhunting to track and chase down the fox.

◄ Franco The Spanish dictator Francisco Franco ruled Spain for 36 years. Although he allied himself with Nazi Germany and fascist Italy, he kept Spain neutral during World War 2. Towards the end of his dictatorship his regime became increasingly liberal.

The colours of this flag originated during the French Revolution of 1789. The red and blue are said to represent Paris, while the white represented the monarchy. The present design was adopted in 1794. It is meant to symbolize republican principles.

rance is Europe's second-largest country (after Ukraine). Almost half of its 5,500km (3,440mi) of frontier is sea. The Pyrenees form its sw border with Spain. The JURA MOUNTAINS and the ALPS form the E and SE borders with Switzerland and Italy. MONT BLANC is w Europe's highest peak, 4,807m (15,771ft). The RHINE forms part of the border with Germany. The Massif Central, between the Rhône-Saône valley and the Aquitaine basin, covers 15% of France. Lyon and MARSEILLES are connected to the Rhône. The ÎLE-DE-FRANCE province, w of the River LOIRE, includes the capital, PARIS, See individual gazetteer articles

CLIMATE

The climate in w France is mild, moderated by the effects of the Atlantic Ocean. The E experiences greater seasonal variation. The Mediterranean Sea coast has hot, dry summers and mild, moist winters. The Alps, Jura and Pyrenees have good snowfall and are popular for winter sports.

VEGETATION

A patchwork of fields and meadows covers c.60% of the land. Forests occupy about 27%; beech and oak are common in the N, birch, pine and poplar in the centre, and olive trees in the Mediterranean regions.

Julius Caesar completed the Roman conquest of Gaul in 51 BC. The Roman empire began to decline in the 3rd century AD. In 486, the Franks led by CLOVIS I established the MEROVINGIAN dynasty. Following his death, the kingdom fragmented. In 687 the CAROLINGIANS reunited Gaul, and PEPIN III (THE SHORT) overthrew the Merovingians (757). His son, CHARLEMAGNE, was crowned emperor of the West (800). He expanded the empire and provided sound administration. His empire soon disintegrated, and in 843, his grandson, CHARLES II (THE BALD) became ruler of the area of present-day France. Hugh Capet is often seen as the first king of France (987), and the CAPETIANS gradually subdued the nobility. The Norman Con-QUEST (1066) marked the start of a long history of Anglo-French rivalry. PHILIP II regained land lost through dowry to the English. In 1328 the first Valois king, PHILIP VI, acceded to the throne. The HUNDRED YEARS WAR (1337-1453) was a series of battles for the French succession. By 1422, England controlled most of France. JOAN OF ARC helped to crush the siege of Orléans (1428) and by 1453 England had been expelled from France. Louis XI restored royal authority and crushed the ANGEVINS. FRANCIS I's reign marked the beginning of the Renaissance

HISTORY

POPULATION: 57,372,000 CAPITAL (POPULATION): Paris (2,152,423) GOVERNMENT: Multiparty republic ETHNIC GROUPS: French 93%, Arab 3%, German 2%, Breton 1%, Catalan LANGUAGES: French (official) RELIGIONS: Christianity (Roman Catholic 86%. other Christian 4%), Islam 3% **CURRENCY:** Franc = 100 centimes

AREA: 551,500sg km (212,934sg mi)

in France and the struggle with the Habsburgs.

The rise of the HUGUENOTS led to the Wars of RELIGION (1562-98). The Guise faction lost, and HENRY IV became the first BOURBON king (1589). Cardinals RICHELIEU and MAZARIN led France to victory in the THIRTY YEARS WAR (1618-48). Louis XIV's court at VERSAILLES was the richest in Europe. Yet, the ancien régime of Louis XV and Louis XVI was bankrupted by war and incapable of reform. The FRENCH REVOLUTION (1789-99) saw the execution of the king, and ROBESPIERRE's brutal REIGN OF TERROR. The Directory ended when NAPOLEON I proclaimed himself emperor (1799). The success of the NAPOLEONIC WARS was wiped out at WATERLOO (1815). Napoleon was forced into exile, and the Bourbons restored to the throne. The FEBRUARY REVOLUTION (1848) established a Second Republic. Napoleon I's nephew seized power as NAPOLEON III (1852). His defeat in the FRANCO-PRUSSIAN WAR (1870-71) led to the formation of the Third Republic (1870-1940). The PARIS COMMUNE (1871) was violently suppressed. The DREYFUS Affair polarized France. France was the battleground for most of WORLD WAR 1. CLEMENCEAU and BRIAND led France to peace. Léon Blum and Édouard Daladier failed to tackle Germany's increasing power. In June 1940, German troops completed the conquest of France and established the VICHY GOVERNMENT. Charles DE GAULLE became head of a government-in-exile. Paris was liberated in August 1944 and a Fourth Republic was founded (1946). Political instability and colonial war, especially in ALGERIA, slowed the post-war recovery. In 1958, Charles de Gaulle was elected president and established a Fifth Republic. Gaullist foreign policy alienated the USA and UK. De Gaulle resigned in 1969, replaced first by Georges POMPIDOU, then Valéry GISCARD D'ESTAING. François MITTERRAND's presidency was marked by nationalization, civic rebuilding, decentralization and advocacy of the European Union. Following Mitterand's death (1995), his rival Jacques CHIRAC was elected president. His welfare reforms and attempts to meet the criteria for European Monetary Union (EMU) brought strikes and unemployment and led to the election of a socialist prime minister, Lionel JOSPIN.

UNITED KINGDOM BELGIUM GERMAN Bo English Channel Cherbourg PICARD Versailles Paris Brest ATLANTIC OCEAN La Rochelle 45°N Biscay Marseilles Ajaccio Cors MAPSCALE Mediterranean Sea Sardinia

ECONOMY

France is a leading industrialized nation (1992 GDP per capita, US\$19,510). It is the world's fourth-largest manufacturer of cars. Industries include chemicals and steel. It is the leading producer of farm products in w Europe. Livestock and dairy farming are vital sectors. It is the world's second-largest producer of cheese and wine. Wheat is the principal crop. Tourism is a major industry (1992 receipts, US\$25 million).

maintaining rigid control over its politics. In 1947 he declared Spain a monarchy with himself as regent, and in 1969 he designated JUAN CARLOS as heir to the throne.

Franco-Prussian War (1870–71) Conflict engineered by the Prussian chancellor, Otto von BISMARCK. The nominal cause was a dispute over the Spanish succession. Bismarck's aim was to use the prospect of French invasion to frighten the s German states into joining the North German Confederation dominated by Prussia. The French were defeated at Sedan, NAPOLEON III abdicated, and Paris was besieged. An armistice was agreed in January 1871, and Alsace and Lorraine were ceded to the new German empire.

Frank, Anne (1929–45) German Jew who became a symbol of suffering under the Nazis. Born in Frankfurt am Main, she fled with her family to the Netherlands in 1933. The Franks were living in Amsterdam at the time of the German invasion in 1940, and went into hiding from 1942 until they were betrayed in August 1944. Anne died in Bergen-Belsen concentration camp. The diary she kept during her years in hiding was published in 1947 and attracted worldwide readership.

Frankenthaler, Helen (1928–) US painter, sculptor and graphic artist who provides the link between ABSTRACT EXPRESSIONISM and colour field painting. Her early work betrays the influence of Jackson POLLOCK. She evolved a modified drip technique, staining her unprimed canvases with thinned-down paint. Her seminal work is *Mountains and Sea* (1952). She was married (1958–71) to Robert MOTHERWELL.

Frankfort State capital of Kentucky, USA, on the Kentucky River, N central Kentucky. First settled in 1779, it was made the state capital in 1792. Notable buildings include Kentucky State College (1886), "Liberty Hall" (1796), reportedly designed by Thomas Jefferson, and the Old Capitol (1827–30). Industries: tobacco, whisky distilling, textiles, electronic parts, furniture. Pop. (1990) 25,535.

Frankfurt am Main City and port, on the River Main, Hesse state, w Germany. One of the royal residences of Charlemagne, Holy Roman emperors were elected here and the first German National Assembly met at Franfurt in 1848. Notable buildings include a Gothic cathedral, an art museum and a university. Goethe was born in the city. Frankfurt is Germany's banking centre and a venue for international fairs. It has a busy international airport. Industries: chemicals, electrical equipment, telecommunications, publishing. Pop. (1993 est.) 660,800.

Frankfurter, Felix (1882–1965) US jurist and educator. An assistant US attorney (1906–11) and law officer in the War Department (1911–14), he helped found the American Civil Liberties Union (1920). He was an advisor to President Franklin D. Roosevelt, who appointed him associate justice of the Supreme Court (1939–62).

Franklin, Aretha (1942–) US gospel and soul singer, the "Queen of Soul". Since her first hit, "I Never Loved a Man, (The Way I Love You)" (1967), she has had more millionselling singles than any other female artist. Other classics include "Respect" (1967) and "Chain of Fools" (1968).

Franklin, Benjamin (1706–90) US statesman, scientist and inventor. A successful printer in Philadelphia, where he published Poor Richard's Almanac (1732-57), he gave the business up to devote his life to scientific research. His experiments in electricity, which he identified in lightning, were influential. Franklin was deputy paymaster general (1753-74) of the colonies. At the ALBANY CONGRESS (1754), he proposed a union of the colonies. Franklin argued for moderate opposition to the STAMP ACT (1768). A leading delegate to the CONTINENTAL CONGRESS, he became an architect of the new republic. When war broke out, Franklin went to Paris and negotiated a treaty of alliance (1778). His peace proposals formed the basis of the final Treaty of Paris (1783) with Great Britain. Franklin was president of Pennsylvania's executive council (1785-88) and, as a member of the Constitu-TIONAL CONVENTION (1787), helped form the US constitution. Franklin, Sir John (1786–1847) British Arctic explorer. Franklin served as a naval officer in the Battle of Trafalgar (1805). His first overland exploration of N Canada (1819–22) crossed from Great Slave Lake to the Arctic coast. Franklin's second expedition (1825-27) descended the Mackenzie River. He served as governor of Tasmania (1836–43). In 1845 he embarked on a fated search for the Northwest Passage. The first of 40 search parties was launched in 1848. These expeditions greatly advanced knowledge of the Arctic and eventually established (1859) that Franklin had died with his entire 129-man crew after they became caught in the ice in Victoria Strait. Franks Germanic people who settled in the region of the River Rhine in the 3rd century. In the late 5th century, under CLOVIS I, they overthrew the remnant of Roman rule in Gaul and established the MEROVINGIAN empire. This was divided into the kingdoms of Austrasia, Neustria and Burgundy, but was reunited by the CAROLINGIANS, notably by CHARLEMAGNE. The partition of his empire into the East and West Frankish kingdoms is the origin of Germany and France.

Franz Ferdinand (1863–1914) Archduke of Austria. Nephew of Franz Joseph, he became heir apparent in 1889 but, having made a morganatic marriage, had to renounce his children's claim to the throne. On an official visit to Bosnia-Herzegovina in 1914, he and his wife were assassinated by a Serb nationalist, Gavrilo Princip, in Sarajevo (28 June). The incident led directly to the outbreak of WORLD WAR 1.

Franz Joseph (1830–1916) (Francis Joseph) Emperor of Austria (1848–1916), and king of Hungary (1867–1916). He succeeded his uncle Ferdinand, who abdicated during the revolutions of 1848, and quickly brought the revolutions under control, defeating the Hungarians under Louis Kossuth in 1849. With the formation (1867) of the Austro-Hungarians under Louis Kossuth in the Empire, Franz Joseph was forced to grant Hungary co-equal status. He died in the midst of World War 1, two years before the final collapse of the Habsburg empire.

Franz Josef Land (Zemlya Frantsa Iosifa) Russian archipelago in the Arctic Ocean, forming part of Archangel'sk oblast. A group of *c*.187 islands, it includes Alexandra Land, George Land and Graham Bell Island. It was discovered in 1873 by an Austrian expedition and was incorporated into the Soviet Union in 1926. Area: *c*.20,700sq km (8,000sq mi).

Fraser, John Malcolm (1930–) Australian statesman, prime minister (1975–83). Fraser entered parliament in 1955, becoming the youngest-ever Liberal MP. He served in the cabinet (1966–71) before becoming Liberal Party leader (1975) and forming a coalition government. An uncomprising politician, he was defeated in 1983 elections by Bob HAWKE and resigned from parliament.

fraud In law, deception or misrepresentation of facts in order to obtain an advantage by unfair means. It is commonly an element of specific crimes such as impersonation, misrepresentation or obtaining money by false pretences. Withholding or concealing facts injurious to another person may also constitute criminal fraud.

Fraunhofer, Joseph von (1787–1826) German physicist and optician, founder of astronomical spectroscopy. By studying the DIFFRACTION of light through narrow slits, he developed the earliest form of diffraction grating. He observed and began to map the dark lines in the Sun's spectrum (1814), now called Fraunhofer lines. Fraunhofer solved many of the scientific and technical problems of astronomical telescope-making.

Frazier, Joe (1944–) US heavyweight boxer. An Olympic heavyweight champion (1964), Frazier won a version of the world's heavyweight title when he beat Buster Mathis (1968) and was undisputed champion after he defeated Jimmy Ellis (1970). He lost the title to George Foreman (1973). His bouts with Muhammad ALI, whom he defeated in 1971, were his most notable. After losing again to Foreman and twice to Ali, he retired in 1976.

Frederick I (Barbarossa) (1123–90) Holy Roman emperor (1152–90), who succeeded his uncle, Conrad III. Pope Alexander III encouraged the formation of the LOMBARD LEAGUE against Frederick. Fredrick set up an antipope, but after his defeat at Legnano (1176) was reconciled with Alexander and made peace (1183) with the Lombards. He asserted his authority in Germany, at first conciliating but later (1180) overthrowing the Guelph, Henry the Lion.

Frederick II (1194–1250) Holy Roman emperor (1215–50) and king of Sicily (1198–1250). Son of Emperor Henry VI,

he devoted himself to Italian affairs. He was elected German king (1215), and although he promised to make his son Henry king of Sicily, he gave him Germany (1220) instead. Frederick deposed Henry (1235) and made another son, Conrad IV, German king. In Sicily, Frederick set up a centralized royal administration. Attempting to extend his rule to Lombardy, he was confronted by a revived Lombard League and papal opposition. He went on a crusade and was crowned king of Jerusalem (1229), although this failed to appease the pope. In 1245 Innocent IV deposed him, and civil war ensued in Germany and Italy.

Frederick III (1415–93) Holy Roman emperor (1440–93). He attempted to win the thrones of Bohemia and Hungary after the death of his ward, Ladislas V (1458). Instead he lost Austria, Carinthia, Carniola and Styria to Matthias Corvinus of Hungary, recovering them only on Matthias' death (1490). By marrying his son Maximilian to Mary, heiress of Burgundy, in 1477, he acquired an enormous inheritance for the Habsburgs. Frederick III (1831–88) Emperor of Germany (1888). Son of William I, he married (1858) Victoria, eldest daughter of the British Queen VICTORIA. Liberal and popular, he died 90 days after his accession and was succeeded by his son, William II. Frederick II (the Great) (1712-86) King of Prussia (1740-86). Succeeding his father, FREDERICK WILLIAM I, he made PRUSSIA a major European power. In the War of the AUSTRIAN SUCCESSION (1740-48), Fredreick took the valuable province of Silesia from Austria. During the SEVEN YEARS WAR (1756-63), his brilliant generalship preserved the kingdom from a superior hostile alliance. Austro-Russian forces reached Berlin (1760), but Russia's subsequent withdrawal from the war enabled Frederick to emerge triumphant at the peace and he directed Prussia's remarkable recovery from the devastation of war. Gaining further territory in the first partition of Poland (1772), he renewed the contest against Austria in the War of the Bavarian Succession (1778-79). Artistic and intellectual, he was a friend and patron of Voltaire. He wrote extensively in French, built the palace of Sans Souci, and was a gifted musician.

Frederick V (1596–1623) (Winter King) Elector Palatine (1610–20), King of Bohemia (1619–20). A Calvinist prince belonging to a branch of the Wittelsbach family, he married the daughter of James I of England (1613). In 1619 he was chosen as king by the Protestant rebels of Bohemia in preference to the Holy Roman emperor FERDINAND II, provoking the outbreak of the THIRTY YEARS WAR. Defeat at the Battle of the White Mountain (1620) resulted in the loss of Frederick's titles.

Fredericksburg US historic city, on the Rappahannock River, N Virginia. Planned in 1727, the many historic landmarks make it a major tourist attraction. It is particularly associated with the American Revolution and Civil War. From 1760 the Rising Sun Tavern was a meeting place for American patriots. Many sites are connected to George WASHINGTON, including the site of the signing of a 1775 resolution of American Independence. The US Civil War battle of Fredericksburg (1862) was a one-sided victory for the 72,500-strong Confederate army of Northern Virginia, led by General Robert E. LEE, over the 114,000-strong Union Army of the Potomac, led by Major General Ambrose Burnside. Nearly 13,000 Union troops were killed or wounded in 14 futile assaults on Marye's Heights. In comparison, the Confederate troops of Stonewall JACKSON and James Longstreet lost about 5,300. There is a memorial military park outside the city. Industries: tourism, clothing, shoes, cement, cinder blocks. Pop. (1990) 19,030.

Frederick William I (1688–1740) King of Prussia (1713–40). Succeeding his father, Frederick I, he strengthened the army and economy and centralized the government, laying the basis for the rise of Prussia as a great power. He treated his son, the future FREDERICK II (THE GREAT), with brutality, but bequeathed him a full treasury and the finest army in Europe.

Frederick William II (1744–97) King of Prussia (1786–97). He succeeded his uncle, FREDERICK II (THE GREAT). He joined (1792) the alliance against France, but made peace in 1795 in order to consolidate his acquisitions in the E as a result of the second (1793) and third (1795) partitions of Poland. He kept an extravagant court and left the country virtually bankrupt.

Frederick William III (1770–1840) King of Prussia (1797–1840). Son and successor of Frederick William II, he declared war on France (1806), suffered a disastrous defeat at Jena and was forced to sign the Treaty of Tilsit (1807). In Prussia, some progressive reforms were made, but a constitution, though promised, was never produced, and the king became increasingly reactionary. The reorganized Prussian army re-entered the war against Napoleon in 1813 and played a major part in his eventual defeat.

Frederick William IV (1795–1861) King of Prussia (1840–61). Son and successor of Frederick William III, he granted a constitution in response to revolutionary demands in 1848, but later amended it to eliminate popular influence. He refused the crown of Germany (1849) because it was offered by the Frankfurt parliament, a democratic assembly. From 1858 the future Emperor William I ruled as regent.

Frederick William (1620–88) (Great Elector) Elector of Brandenburg (1640–88). He inherited a collection of small, disparate and impoverished territories ravaged by the THIRTY YEARS WAR. By the end of his reign his organizational powers had created a unified state with a sound, centralized tax system and a formidable standing army. The powers of the provincial estates (assemblies) were reduced, and the noble class of Junkers provided loyal officers for the army. The Elector encouraged commerce and industry and attracted talented refugees such as Jews and Huguenots. He acquired Eastern Pomerania at the Peace of WESTPHALIA and, by his interventions in the war between Poland and Sweden (1655–60), gained sovereignty over Prussia, formerly a Polish fief.

Free Church Any of a number of Protestant churches which are independent of the established church of a country. In England Congregationalism, Methodism, Presbyterianism and the Baptist movements formed a National Council of Evangelical Free Churches.

Free Church of Scotland Grouping of Scottish Presbyterians formed as a result of the secession of nearly one-third of the membership of the established Church of Scotland in the Disruption of 1843. In 1900 all but a small minority of this Free Church joined the United Presbyterian Church to become the United Free Church of Scotland. In 1929, following the acceptance of the Church of Scotland's spiritual independence, the United Free Church of Scotland reunited with it. The tiny Presbyterian minority who had opposed the initial union retained their independence and kept the name United Free Church.

Freedmen's Bureau US government agency established in 1865, at the end of the American Civil War, to aid newly freed African-Americans. Administered by the War Department, the agency provided relief work and educational services, as well as legal protection for African-Americans in the South. The bureau also acted as a political machine, recruiting voters for the Republican Party.

Freedom of Information Act (1967) US law giving greater public access to government records. It permits government agencies to exercise full discretion about disclosure of information only in such areas as national defence, confidential financial information and law enforcement. The effect of the act was weakened by agency reclassification of information under permitted exemptions.

Freedom Rides Civil rights trips to the South in 1961 sponsored by the Congress of Racial Equality (CORE). They led to the desegregation of interstate terminals and subsequently to the Interstate Commerce Commission's ruling providing "non-racial" seating in buses.

Free French Group formed by Charles DE GAULLE on the creation of the VICHY GOVERNMENT in 1940. Its purpose was to continue French opposition to Germany. Operating outside France, the group was soon aligned with internal resistance groups. The Free French aided the Allies throughout the war, forming a provisional government after the D-DAY invasion. freemasonry Customs and teachings of the secret fraternal order of Free and Accepted Masons, an all-male secret society with national organizations all over the world. Freemasonry is most popular in the UK and some countries in the Commonwealth of Nations. It evolved from the medieval guilds of stonemasons and cathedral builders. The first Grand Lodge

(meeting place) was founded in England (1717). Historically associated with liberalism, freemasonry teaches morality, charity and law-abiding behaviour. Freemasons believe in God and the immortality of the soul. In recent times, they have incurred criticism because of their strict secrecy, male exclusivity and alleged use of influence within organizations, such as the police or local government, to benefit members. It is estimated that there are c.6 million masons worldwide.

free port Area in which goods may be landed and reshipped without customs intervention. Free ports aid in quicker movement of ships and goods. When the goods are moved to the consumer, they then become subject to customs duties. Free ports include Copenhagen, Singapore, Stockholm and New York City.

freesia Genus of PERENNIAL herbs of the IRIS family, native to South Africa. Species of freesia are widely cultivated for their fragrant yellow, white or pink tubular flowers. They are grown in cool greenhouses for winter blooming.

Free State (formerly Orange Free State) Province in E central South Africa; the capital is BLOEMFONTEIN. The region consists principally of fertile high plains, with the Drakensberg Range as part of its E border with Lesotho. The River Orange forms its S border with Northern Cape. Boers began to settle in large numbers after the Great Trek (1836). In 1848 the British annexed the region as the Orange River Sovereignity and, in 1854, it achieved independence as Orange Free State. After its involvement in the South African Wars (1899–1902), it was again annexed by Britain. Regaining independence in 1907, the Orange Free State joined the Union of South Africa in 1910. The economy is dominated by agriculture and gold. Pop. (1995 est.) 2,782,500.

freethinkers People whose opinions and ideas, especially on matters of religion, are not influenced by CANON law or dogma. The original freethinkers were part of a post-Reformation movement that sought to assert reason over religious authority. DEISM emerged as the chief expression of freethought during the 17th and 18th centuries. *See also* ATHEISM; HUMANISM

Freetown Capital and chief port of Sierra Leone, w Africa. First explored by the Portuguese in the 15th century and visited by Sir John Hawkins in 1562. Freetown was founded by the British in 1787 as a settlement for freed slaves from England, Nova Scotia and Jamaica. It was the capital of British West Africa (1808–74). West Africa's oldest university, Fourah Bay, was founded here in 1827. Freetown was made capital of independent Sierra Leone in 1961. Industries: platinum, gold, diamonds, oil refining, palm oil. Pop. (1985 est.) 469,776.

free trade Commerce conducted between nations without restrictions on imports and exports. In modern history, its origins lie in the 19th-century attack (especially in Britain) on the traditional mercantile control of trade. The repeal of the Corn Laws (1846) and the Anglo-French free trade treaty (1860) were the hallmarks of the mid-Victorian faith in free trade. Twentieth-century free-trade agreements include the European Free Trade Agreement (EFTA) (1959) and the 1994 North American Free Trade Agreement (NAFTA). Protectionists oppose free trade, advocating import duties and restrictive quotas to safeguard domestic industry.

free verse Verse with no regular metre and no apparent form, relying primarily on cadence. The unsystematized rhythm is close to that of prose. WHITMAN and RIMBAUD were early users of free verse, which has become common in the 20th century. **freezing** See FOOD PRESERVATION

freezing point Temperature at which a substance changes state from liquid to solid. The freezing point for most substances increases with pressure. Melting point is the change from solid to liquid and is the same as freezing point.

Frege, Gottlob (1848–1925) German philosopher. He was professor of mathematics at the University of Jena (1879–1918). With George BOOLE, Frege was one of the founders of modern symbolic LOGIC. In his *Foundations of Arithmetic* (1884), Frege attempted to derive all mathematics from logical axioms.

Frémont, John Charles (1813–90) US explorer and general. Following his exploration and mapping of the Oregon Trail (1842), Frémont crossed the Sierra Nevada in the win-

ter of 1843–44. A second expedition (1845) led to the BEAR FLAG REVOLT by American settlers, and Frémont became civil governor. He resigned his commission in 1848 and made a fortune in the goldrush. He served briefly (1850–51) as one of California's first two senators and was the first REPUBLICAN PARTY presidential candidate losing to James Buchanan. He was removed from office during the Civil War and became governor of Arizona (1878–83).

French Major language, spoken in France and parts of Belgium, Switzerland, Canada, Haiti, Africa and other areas. There are some 80–100 million French speakers worldwide. Descended from Latin, it is one of the Romance languages and part of the Indo-European family. It is one of the six official languages of the United Nations.

French and Indian Wars (1754–63) Colonial wars in North America forming part of the SEVEN YEARS WAR. British and American colonial forces fought French Canadians with Native American nations fighting on both sides. The term is sometimes applied to conflicts in North America during the larger European and colonial wars fought between 1689 and 1763. British efforts to capture the French forts in the west in 1754–55 were unsuccessful. After 1756, British resources improved and forts at Louisburg and Duquesne (1758) were captured. Ticonderoga fell in 1759. The British capture of Quebec was decisive in the conquest of Canada, which passed to Britain in the Treaty of Paris (1763).

French architecture From the 8th to early 19th centuries, French architects were dependent on royal patronage, although the 10th-century Benedictine abbey at Cluny had an influence on church architecture. During the 11th and 12th centuries, CATHEDRALS in the ROMANESQUE style were constructed. In the 13th century, Gothic cathedrals, such as CHARTRES and NOTRE-DAME, were built. In 1494, the influence of Italian RENAISSANCE ARCHITECTURE grew and inspired kings, such as Francis I and Henry IV, to commission magnificent palaces, including FONTAINEBLEAU, the LOUVRE and Chambord. Royal influence climaxed in the 17th century with Louis XIV's palace at VERSAILLES. After 1685, a lighter note prevailed, but in the mid-18th century, official architecture turned to NEO-CLASSICISM, introducing designs based on the Doric order. In the 19th century, patronage shifted from the court to the bourgeoisie. Baron George-Eugène Haussman designed the wide boulevards of Paris, and between 1850 and 1870, mansard roofs and pavilions marked a Renaissance revival. The skeletal frame of the EIFFEL TOWER (1889) heralded MODERNISM and ART NOUVEAU faded quickly. In the 1920s and 1930s, BAUHAUS had a large influence, and the Domino frame buildings of LE CORBUSIER spearheaded the INTERNATIONAL STYLE. French architects took an active role in the Congrès Internationaux d'Architecture Moderne (CIAM), which created a forum for serious discussions from 1928.

French art Studies of French art usually begin with the 12th century, when the kingdom was starting to take a recognizable shape. There were several important centres of manuscript illumination in Cistercian abbeys, but for many centuries FRENCH ARCHITECTURE was more prominent than the visual arts. During the RENAISSANCE, the art of the court was heavily influenced by Italian trends, as is evident from the output of Jean FOUQUET and the FONTAINEBLEAU SCHOOL. It was not until the 17th century that artists of international stature emerged. Dominant figures were CLAUDE LORRAIN and Nicolas Poussin, both masterful exponents of classical landscape painting. The latter was particularly important, and his rigorous draughtsmanship was used as a benchmark for academic standards until well into the 19th century. The twilight years of the ancien régime were celebrated in the light-hearted ROCOCO fantasies of François BOUCHER and Jean-Honoré FRAGONARD. As the revolution drew near, however, these gave way to the stern moralizing of neo-classical painters such as Jacques Louis DAVID. He remained influential into the romantic period, when the leading French artist was Eugène DELACROIX. In the second half of the 19th century, there were a succession of movements which increased artistic freedom. These began with the REALISM of Gustave Courbet and culminated in IMPRESSIONISM, POST-IMPRESSIONISM and SYMBOLISM. This cre-

▲ freesia Now cultivated commercially worldwide, freesias are native to South Africa. They grow to a height of 75cm (30in).

FRENCH GUIANA

AREA: 90,000sq km (37,749 sq mi)
POPULATION: 104,000

CAPITAL (POPULATION):
Cayenne (41,600)
GOVERNMENT: Overseas
department of France
ETHNIC GROUPS: Creole 42%,
Chinese 14%, French 10%,
Haitian 7%

LANGUAGES: French (official)
RELIGIONS: Catholic 80%,
Protestant 4%)

currency: French franc = 100 centimes

ativity continued into the 20th century, when the School of Paris fostered many new developments. France remained the leading force in avant-garde art until after World War 2, when its mantle passed to the USA.

French Guiana French overseas département in South America. Land and Climate The coastal plain includes cultivated areas, particularly near the capital, CAYENNE. Inland, lies a plateau, with low mountains (Sierra Tumucumaque) in the s. The River Maroni forms the border with SURINAM, and the River Oyapock its E border with Brazil. The climate is hot and equatorial, with high annual temperatures. Rainfall is heavy, although August to October is dry. Rainforest covers c.90% of the land and contains valuable hardwood species. Mangrove swamps line parts of the coast, while other areas are covered by tropical savanna. History The original inhabitants of the area were Native Americans, but today only a few remain in the interior. Europeans first explored the coast in 1500, and they were followed by adventurers seeking EL DORADO. The French were the first settlers (1604), and Cayenne was founded in 1637 by French merchants. First attempts at colonization failed, and the area changed hands several times before becom-

► French Revolution Shortly before the Revolution, Paris' city limits had been extended by the building of the "tax-farmers" wall (1785), authorized by the finance minister, Calonne, to facilitate the collection of tolls from those entering the city. The wall, 3m (7ft) high, ran concentrically with the old city boundaries and took in several of the surrounding districts (faubourgs). Access was gained through 54 gates, (barrières), which were largely destroyed by the crowds during the Revolution. The city's population in 1789 was approximately 600,000.

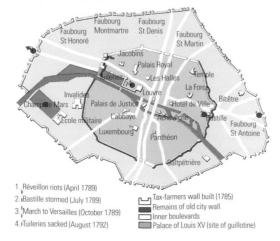

ing a French colony in the late 17th century. The colony, whose plantation economy depended on African slaves, remained French except for a brief period in the early 19th century. Slavery was abolished in 1848, and Asian labourers were introduced to work the land. From the time of the French Revolution, France used the colony as a penal settlement, and between 1852 and 1945 the country was notorious for the harsh treatment of prisoners; many died, unable to survive in the tropical conditions. Alfred Dreyfus was imprisoned on Île du Diable (Devil's Island). In 1946, French Guiana became an overseas départment of France and, in 1974, also became an administrative region. Politics An independence movement developed in the 1980s, but most people wanted to retain links with France and receive development aid. Economy Despite rich forest and mineral resources, it is a developing country with high unemployment. It depends on France to finance services, and the government is the main employer. Since 1968, Kourou has been the European Space Agency's rocket-launching site. Industries: fishing, forestry, gold mining and agriculture, Crops include bananas, cassava, rice and sugar cane; though food imports are essential. Exports include shrimps, timber, rum and rosewood essence.

French horn Brass musical instrument. It has a flared bell, long coiled conical tube, three or four valves, and a funnelshaped mouthpiece. Its romantic, mellow tones were favoured by Richard Wagner, Johannes Brahms and Richard Strauss. French literature Although the earliest surviving works of French literature, written in the langue d'oil, date from the 10th century, major works date from the 12th century when the CHANSONS DE GESTE ("songs of deeds") celebrated the military exploits of the nobility. Allegorical romances by Chrétien de Troyes and others gave way to more intimate poetry in the 15th century by writers such as François VILLON. The poems of the 16th century poet Pierre de RONSARD (leader of La PLÉI-ADE) rivalled that of Renaissance Italy, and in prose, the comic genius of RABELAIS contrasted with the pithy originality of the essayist Montaigne. The great dramatists CORNEILLE, RACINE and Molière, and the writings of philosophers Descartes and PASCAL ensured that the 17th century was a golden age of French literature. They were succeeded in the 18th century by the writers of the ENLIGHTENMENT, the rationalists ROUSSEAU, DIDEROT and VOLTAIRE; and BEAUMARCHAIS, who wrote social farces. The romantic movement of the early 19th century produced novels and poems by the prolific Victor Hugo, Lamartine and Dumas (père and fils). Writers such as STEND-HAL, BALZAC, FLAUBERT, MAUPASSANT and ZOLA reacted against ROMANTICISM, producing works of NATURALISM and REALISM. Poets BAUDELAIRE and RIMBAUD paved the way for SYMBOLISM and modern poetry, typified by the works of VER-LAINE, and of VALÉRY and APOLLINAIRE in the 20th century. PROUST and GIDE dominated French fiction until 1940, backed up by Mauriac and Duhamel, with Sartre, Beauvoir, CAMUS, MALRAUX and SAINT-EXUPÉRY producing the finest post-war work. The most original dramatists of the post-war period are GENET, IONESCO and BECKETT, with their abstract, poetic and unconventional works.

French Polynesia French overseas territory in the s central Pacific Ocean, consisting of over 130 islands, divided into five scattered archipelagos: Society Islands, Marouesas ISLANDS, Tuamotu Archipelago, Gambier Islands and the Tubuai Islands; the capital is Papeete on TAHITI (Society Islands). The larger islands are volcanic with fertile soil and dense vegetation. The more numerous coral islands are low lying. The climate is tropical and humidity is high. Missionaries arrived in Tahiti at the end of the 18th century, and in the 1840s France began establishing protectorates. In 1880-82 the islands were annexed by France and became part of the colony of Oceania. In 1958 they were granted the status of an overseas territory. In recent years, there have been increasing demands for autonomy in Tahiti – the largest and most populous island. In the 1960s the French government began nuclear testing on Mururoa atoll, leading to worldwide protests. In 1995 the French government put forward proposals to grant Polynesia the status of an autonomous overseas territory. Copra and vanilla are the leading agricultural products, and cultured pearls are exported. Animal husbandry is important and tourism has grown considerably in recent years. Area: 3,265sq km (1,260sq mi). Pop. (1994 est.) 216,600.

French Revolution (1789-99) Series of events that removed the French monarchy, transformed government and society, and established the First Republic. Suggested causes include economic pressures, an antiquated social structure, weakness of the - theoretically absolute - royal government and the influence of the ENLIGHTENMENT. Beginning in June 1789, when the STATES GENERAL met at VERSAILLES during a political crisis caused by attempts to tax the nobility, representatives of the bourgeoisie demanded reform and proclaimed themselves a National Assembly. Popular resistance, epitomized by the storming of the BASTILLE, forced the government to accede to demands which included the abolition of the aristocracy, reform of the clergy and a Declaration of the Rights of Man. The Legislative Assembly was installed (October 1791) and, faced with growing internal and external pressure, declared war on Austria (April 1792). It was soon in conflict with most other European states, whose governments viewed events in France with fear. The war hastened political change: Louis XVI was deposed (August 1792) and the National Convention met to proclaim a republic (September 1792). After a period of rivalry between JACOBINS and GIRONDINS (November 1792-June 1793), strong central government, marked by fanaticism and violence, was imposed during the REIGN OF TERROR, and Louis was executed. Social anarchy and runaway inflation characterized the Thermidorean Reaction (July 1794-October1795), which followed the fall of ROBESPIERRE. Another new constitution imposed a five-man executive called the "Directory" (1795). It lasted until 1799, when the Consulate (1799-1804), dominated by NAPOLEON, put an end to the decade of revolution.

French Revolutionary Wars (1792–1802) Series of campaigns in which the popular armies of revolutionary France fought combinations of their European enemies. Fear and hatred of the French Revolution fuelled the hostility of Austria in particular. The French declared war on Austria and Prussia in 1792, and their success at Valmy and Jemappes provoked other states, including Britain, the Netherlands and Spain, to form the First Coalition (1793). It was no more successful against France's conscript army and soon fell apart, Austria making peace at Campo-Formio. Britain remained at war and Nelson won significant naval victories, but a Second Coalition was again unsuccessful on land in 1799–1800, NAPOLEON winning a notable victory at Marengo. Britain made peace at Amiens in 1802, but it marked only an interval before the NAPOLEONIC WARS.

frequency Rate of occurrence. In statistics, the number of times a numerical value, event, or special property occurs in a population in a given time. In physics, the number of oscillations occurring in a given time (measured in HERTZ), such as sound, light and radio waves, or a swinging PENDULUM, or vibrating springs. Frequency is the reciprocal of period.

frequency modulation (FM) Form of RADIO transmission. It is the variation of the FREQUENCY of a transmitted radio carrier wave by the signal being broadcast. The technique makes radio reception fairly free from static interference and, although restricted in range to receivers in line-of-sight of the transmitter, has become the most favoured transmission method. See also AMPLITUDE MODULATION (AM) fresco Method of painting on freshly spread plaster while it is still damp. In true fresco (buon fresco) paint combines chemically with moist plaster so that, when dry, the painted surface does not peel. Dry fresco, fresco secco, involves the application of paint in a water and glue medium to a dry plaster wall. It does not last as well as true fresco. The palace at Knossos, Crete (c.1700 BC), was decorated with frescos. GIOTTO and MICHELANGELO are considered to be masters of the form.

Fresnel, Augustin Jean (1788–1827) French physicist and engineer. His pioneer work in optics was instrumental in establishing the wave theory of light. He researched the conditions governing interference phenomena in POLARIZED LIGHT, studied double refraction and devised a way of producing circularly polarized light.

Freud, Anna (1895–1982) British psychotherapist, b. Austria, youngest of Sigmund Freud's children. She applied PSYCHOANALYSIS to the development of children, was an early user of play therapy and wrote a number of books, including Normality and Pathology in Childhood (1968).

Freud, Lucian (1922–) British painter, b. Germany, grandson of Sigmund Freud. He is regarded as one of the strongest contemporary British figure painters. His most characteristic subjects are portraits and nudes, often painted in strikingly realistic close-up.

Freud, Sigmund (1856-1939) Austrian physician and founder of PSYCHOANALYSIS. With Josef Breuer he developed new methods of treating mental disorders by free association and the interpretation of dreams. These methods derived from his theories of the ID, EGO and SUPEREGO, and emphasized the unconscious and subconscious as agents of human behaviour. He developed theories of neuroses involving childhood relationships to one's parents and stressed the importance of sexuality in behaviour. He believed that each personality had a tripartite structure: the id, the unconscious emotions, desires and fears which may surface in dreams or madness; the ego, the conscious rationalizing section of the mind; and the superego, which may be compared to the conscience. As he saw it, a very young baby is largely id, full of unchecked desires; the ego develops from the id, enabling the child to negotiate realistically with the world; and the superego evolves as the child internalizes the moral values of society. The ego comes to mediate the selfish needs of the id and the idealistic demands of the superego. The adoption of a satisfactory superego is dependent on the resolution of the OEDI-PUS COMPLEX. His works include The Interpretation of Dreams (1900), The Psychopathology of Everyday Life (1904) and The Ego and the Id (1923).

friar Member of certain religious orders. The four main orders – the DOMINICANS, FRANCISCANS, CARMELITES, and AUGUSTINIANS – were founded in the 13th century. Friars differ from cloistered monks in that they are involved in widespread outside activity and are more centrally organized.

friction Resistance encountered when surfaces in contact slide or roll against each other, or when a fluid flows along a surface. Friction is directly proportional to the force pressing the surfaces together and the surface roughness. When the movement begins, it is opposed by a static friction up to a maximum "limiting friction" and then slipping occurs. Aircraft reduce air (fluid) friction by having a streamlined design. **Friedan, Betty** (1921–) US feminist author. Through her best-selling book, *The Feminine Mystique* (1963), she prompted women to examine their roles in society. She was a founder and first president (1966–70) of the National Organization for Women (NOW). *The Second Stage* (1981) called for new directions in the women's movement.

Friedman, Milton (1912–) US economist. An influential member of the Chicago School of Economics, he supported MONETARISM as the best means of controlling the economy. His works include: A Monetary History of the United States 1867–1960 (1963), written with Anna Schwartz and a key book in monetary economics; A Theory of the Consumption Function (1957); Essays in Positive Economics (1953); and Capitalism and Freedom (1962). He was awarded the 1976 Nobel Prize for economic science.

Friedrich, Caspar David (1774–1840) German painter. One of the greatest German romantic painters, he created eerie, symbolic landscapes, such as *Shipwreck on the Ice* (1822) and *Man and Woman Gazing at the Moon* (1824).

friendly societies Associations established in Britain to provide insurance against sickness, old age and funeral expenses. Started in the 17th century, they became a conventional alternative to parish relief and charitable assistance. They spread quickly and, in the Victorian age, were the most important form of insurance for the working-class. In the USA, benefit societies filled a similar role.

Friends, The Religious Society of See QUAKERS
Frisch, Karl von (1886–1982) Austrian zoologist. He shared the 1973 Nobel Prize for physiology or medicine with K. LORENZ and N. TINBERGEN for his pioneering work in

▲ Freud The Austrian doctor Sigmund Freud is considered the founder of psychoanalysis. His methods of dream interpretation and employing free association were considered highly revolutionary.

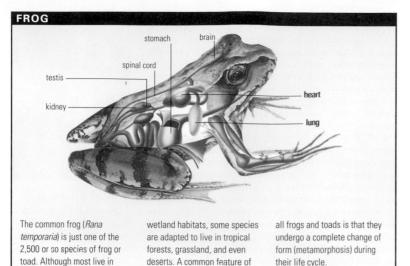

ETHOLOGY. He deciphered the "language of bees" by studying their dance patterns in which one bee tells others in the hive the direction and distance of a food source. In his earlier work he showed that fish and bees see colours, fish can hear and that bees can distinguish various flower scents.

Frisch, Max (1911–91) Swiss novelist and dramatist. His early plays, greatly influenced by BRECHT, are experimental in form and often satirical. They include: *The Chinese Wall* (1946), *The Fire Raisers* (1953) and *Andorra* (1961). His later plays, including *Biography* (1968) and *Triptych* (1979), and the novels *Stiller* (1954) and *A Wilderness of Mirrors* (1964), are concerned with man's quest for identity.

fritillary Common name for several genera of butterflies including large fritillaries (silverspots) of the genus *Speyeria* and small fritillaries of the genus *Boloria*. The larvae (caterpillars) are largely nocturnal. Family Nymphalidae.

Froebel, Friedrich Wilhelm August (1782–1852) German educator and influential educational theorist. His main interest was in pre-school age children, and in 1841 he opened the first kindergarten. He stressed the importance of pleasant surroundings, self-directed activity, physical training and play in the development of the child.

frog Tailless AMPHIBIAN, found worldwide. Frogs have long hind limbs, webbed feet and external eardrums behind the eyes. Most begin life as TADPOLES after hatching from gelatinous eggs, usually laid in water. Some frogs remain aquatic, some terrestrial, living in trees or underground. Most have teeth in the upper jaw and all have long sticky tongues attached at the front of the mouth to capture live food, usually insects. Length: 2.5–30cm (1–12in). Subclass Salientia (or Anura), divided into 17 families; the most typical genus is *Rana. See also* TOAD

Froissart, Jean (1335–1401) French poet and chronicler. He travelled widely in Europe, visiting several famous courts. He is best known for his *Chronicles*, a lively if not always reliable account of events in Europe (1325–1400.

Fromm, Erich (1900–80) US psychoanalyst and writer, b. Germany. Fromm applied PSYCHOANALYSIS to the study of peoples and cultures, stressing the importance of interpersonal relationships in an impersonal, industrialized society. His books include *Escape from Freedom* (1941) and *The Art of Loving* (1956).

Frondes (1648–53) Series of rebellions against oppressive government in France. The Fronde of the Parlement (1648–49) began when Anne of Austria tried to reduce the salaries of court officials. It gained some concessions from the regent, Louis XIV. The Fronde of the Princes (1650–53) was a rebellion of the aristocratic followers of Condé, and forced the unpopular Cardinal Mazarin into temporary exile. Condé briefly held Paris, but the rebellion soon collapsed, and promised reforms were withdrawn. The Fronde succeeded in moderating the financial excesses of royal government, but under Louis XIV royal absolutism triumphed.

front In meteorology, the boundary between two air masses of different temperatures or of different densities. Cold fronts occur as a relatively cold and dense air mass moves under warmer air. With a warm front, warmer air is pushing over colder air and replacing it. An occluded front is composed of two fronts: a cold front overtakes a warm or stationary front. In a stationary front, air masses remain in the same areas and the weather is mostly unchanged.

frontier In US history, the westernmost region of white settle-

ment. In the 17th century the frontier began at the foothills of the APPALACHIAN Mountains and gradually moved westwards until the late 19th century, when no new land remained for pioneer homesteaders. The existence of a frontier region, where a dominant group was able to expand (usually at the expense of native inhabitants), has been an important factor in the history of other countries, such as South Africa. In the USA the frontier notions of rugged individualism and free enterprise as central to US society was promoted by Frederick Jackson Turner in The Significance of the Frontier in American History (1893). Frost, Robert Lee (1874–1963) US poet. His work is shaped by the landscape of his native New England and by the fusion of colloquial idioms and traditional rhythms. His first two volumes of lyric poems, A Boy's Will (1913) and North of Boston (1914), established his reputation. His best known poems include: "Stopping by Woods on a Snowy Evening", "The Road Not Taken" and "Mending Wall". He received the Pulitzer Prize for poetry (1924, 1931, 1937, 1943).

frost In meteorology, atmospheric temperatures at Earth's surface below 0° C (32° F). The visible result of a frost is usually a deposit of minute ice crystals formed on exposed surfaces from DEW and water vapour. In freezing weather, the "degree of frost" indicates the number of degrees below freezing point.

frostbite Freezing of living body-tissue in sub-zero temperatures. Frostbite is an effect of the body's defensive response to intense cold, which is to shut down blood vessels at the extremities in order to preserve warmth at the core of the body. Consequently, it mostly occurs in the face, ears, hands and feet. In superficial frostbite, the affected part turns white and cold; it can be treated by gentle thawing. In deep frostbite, ice crystals form in the tissues. The flesh hardens and sensation is lost. It requires urgent medical treatment. No attempt should be made at rewarming if there is a risk of refreezing, as this results in the death of body tissue (gangrene).

fructose (fruit sugar) Simple white monosaccharide $C^6H^{12}0^6$, found in honey, sweet fruits and flower nectar. Sweeter than SUCROSE, it is made commercially by the HYDROLYSIS of beet or cane sugar, and is used in foods as a sweetener. Its derivatives play a crucial role in providing energy for organisms.

fruit Seed-containing mature OVARY of a flowering plant. Fruits serve to disperse plants and are an important food source (they provide vitamins, acids, salts, calcium, iron and phosphates). They can be classified as simple, aggregate or multiple. Simple fruits, dry or fleshy, are produced by one ripened ovary of a single pistil (unit comprising a stigma, style and ovary) and include legumes (peas and beans) and nuts. Aggregate fruits develop from several simple pistils; examples are raspberry and blackberry. Multiple fruits develop from a flower cluster; each flower produces a fruit which merges into a single mass at maturity; examples are pineapples and figs. Although considered fruits in culinary terms, apples and pears are regarded botanically as "false" fruits, as the edible parts are created by the RECEPTACLE and not the carpel walls.

Frunze Former name for BISHKEK

Fry, Christopher (1907–) British dramatist, real name Christopher Harris. His witty blank-verse plays are often set in ancient or medieval times. They include *A Phoenix Too Frequent* (1946), *The Lady's Not for Burning* (1948) and *Venus Observed* (1950).

Fry, Elizabeth (1780–1845) British social worker and prison reformer. She agitated for more humane treatment of women prisoners and convicts transported to Australia. She was also involved in attempts to improve working conditions for nurses and facilities for women's education.

Fuad I (1868–1936) Sultan (1917–22), first king (1922–36) of

▲ front Fronts form in temperate latitudes where a cold air mass meets a warm air mass (A). The air masses spiral round a bulge causing cold and warm fronts to develop (B). The warm air rises above the cold front and the cold air slides underneath the warm (C). Eventually, the cold air areas merge, and the warm air is lifted up or occluded (D).

modern Egypt, son of ISMAIL PASHA. During Fuad's reign, Egypt remained under strong British influence and conflict with the nationalist Wafd Party led him to suspend (1928–35) the constitution. His grandson reigned briefly (1952–53) as Fuad II, before FAROUK assumed the throne.

Fuchs, Klaus (1912–88) German physicist. He worked on the atom bomb in the USA (1943) and returned to Britain (1946) to head the theoretical physics division of the atomic research centre at Harwell. Imprisoned (1950) for passing secrets to the Soviet Union, his British citizenship was revoked. After release (1959), he went to Germany to work at a nuclear research centre.

fuchsia Genus of shrubby plants found wild in tropical and subtropical America and parts of New Zealand. They are widely cultivated. Named after the German herbalist, Leonard Fuchs (1501–66), they have oval leaves and pink, red or purple trumpet-shaped, waxy flowers. The 100 or so species include the crimson-purple *Fuchsia procumbens* and *F. speciosa*. Family Onagraceae.

fuel Substance that is burned or otherwise modified to produce energy, usually in the form of heat. Apart from fossil hydrocarbons (coal, oil and gas) and firewood and charcoal, the term also applies to radioactive materials used in nuclear power stations. *See also* FOSSIL FUELS

Fuentes, Carlos (1928–) Mexican novelist and short story writer. His first two novels, Where the Air is Clean (1958), and The Death of Artemio Cruz (1962), share a critical view of Mexican society and helped establish his international reputation. Other fiction includes Change of Skin (1967), The Hydra Head (1978) and Distant Relations (1980), The Campaign (1991) and the novella El Naranjo (1993). Other works include a volume of criticism, The Buried Mirror (1992), and the essays Geography of the Novel (1993).

Fugard, Athol (1932–) South African playwright, director and actor. He achieved international acclaim for his plays *The Blood Knot* (1961), *Sizwe Bandi is Dead* (1972) and *My Children! My Africa* (1990). His work often explores the effects of apartheid on South Africa's black population and the country's rapidly changing modern politics.

fugue In music, a composition of several parts or voices where the same melodic line or theme is stated and developed in each voice so that interest in its overall development becomes cumulative. Generally the theme begins in one part and others are added in sequence. Popular in the BAROQUE period, fugue writing reached its peak in the music of J.S. BACH and has been revived by composers of the 20th century. **Fujiyama** (Mount Fuji) Highest mountain in Japan, in the Fuji-Hakone National Park. An extinct volcano, it is seen as the most sacred mountain in Japan. It is a summer and winter sports area. Height: 3,776m (12,389ft).

Fukuoka City on the SE shore of Hakata Bay, N Kyūshū, S Japan. In medieval times, Hakata was one of Japan's major ports. There is a rich agricultural region to the N. Industries: textiles, machinery, chemicals, fishing. Pop. (1993) 1,214,000. Fulani (Fulah or Fulbe) West African people, numbering c.6 million. Their language belongs to the W Atlantic group of the NIGER-CONGO. Originally a pastoral people, they helped the spread of Islam throughout w Africa from the 16th century, establishing an empire lasting until British colonialism in the 19th century.

Fuller, Melville Weston (1833–1910) US lawyer, chief justice of the Supreme Court (1888–1910). Appointed by Grover Cleveland, Fuller was a strict constructionist. Important cases include *Plessy* v. *Ferguson* (1896), which upheld "separate but equal" laws of segregation and *Lochner* v. *New York* (1905). He helped settle a boundary dispute between Venezuela and Great Britain (1899) and was a member of the Hague Tribunal (1900–10).

Fuller, Richard Buckminster (1895–1983) US architect and engineer. Believing that only technology can solve modern world problems, he invented several revolutionary designs. The most widely used is the GEODESIC DOME. His books include *Operating Manual for Spaceship Earth* (1969) and *Earth Inc.* (1973).

Fuller, Roy Broadbent (1912–91) British poet and novel-

ist. The progress of Fuller's verse from Audenesque works to a more individual voice can be traced in *Collected Poems* 1936–61 (1962) and *New and Collected Poems* (1985). Novels include: *Image of a Society* (1956), *My Child, My Sister* (1965) and *Stares* (1990). He also wrote an autobiography, *Spanner and Pen* (1991).

fuller's earth Clay-like substance containing over 50% SILICA. Once used for fulling (removing oil and grease from wool), it is now used to bleach petroleum and refine vegetable oils.

Fulton, Robert (1765–1815) US inventor and engineer. Designing torpedoes and other naval weapons, his main interest was in navigation and, as early as 1796, he was urging the USA to build canals. In 1807, he pioneered the use of steamboats for carrying passengers and freight, when his craft, *Clermont*, travelled between New York City and Albany.

Funchal Capital and chief port of Madeira. Founded in 1421, it was ruled by Spain from 1580 to 1640 and was briefly under British administration in the early 19th century. It is now an industrial and resort centre for the Madeira archipelago. Industries: sugar-milling, distilling, wine. Pop. (1981) 44,111. function In mathematics, rule that assigns a unique value to each element of a given set. The given set is the domain of the function, and the set of values is the range. Two or more elements of the domain may be assigned the same value, but a function must assign only one value to each element of the domain. A function f maps each element x of the domain to a corresponding element (or value) y in the range. Here x and y are variables, with y dependent on x through the functional relationship f. The dependent variable y is said to be a function of the independent variable x. For example, the squareroot is a function, its domain and range being the non-negative real numbers. See also TRIGONOMETRIC FUNCTION

functionalism In art and architecture, an early 20th-century style based on UTILITARIANISM. Functionalism rejected ornamentation and stressed the basic structure of the work and of the materials used. Major proponents of functionalism included Gropius, Bauhaus and Le Corbusier.

functionalism Sociological and anthropological theory outlined by Emile DURKHEIM. The theory attempts to understand the function of each part of society (customs, institutions, objects, roles, religion) in relation to each other and to the whole society. It attempts to explain how each separate cultural phenomenon corresponds to the "needs" of the whole society.

fundamental forces Four basic forces that exist in physics. The most familiar, and the weakest, is GRAVITATION. The gravitational force between the Earth and an object accounts for the object's WEIGHT. Much stronger is the ELECTROMAGNETIC FORCE, which "binds" particles together. The two other forces operate only on the subatomic level: the WEAK NUCLEAR FORCE, associated with the decay of particles, is intermediate in strength between the gravitational and electromagnetic force; the STRONG NUCLEAR FORCE, associated with the "glue" that holds nuclei together, is the strongest natural force.

fundamentalism Movement within some Protestant denominations, particularly in the USA, which originated in the late 19th and early 20th centuries as a reaction against biblical criticism and contemporary theories of evolution. The name is derived from *The Fundamentals*, a series of 12 tracts published in 1909–15 by eminent US evangelical leaders. The doctrines most emphasized are the inspiration and infallible truth of the BIBLE, the divinity of Christ, the VIRGIN BIRTH,

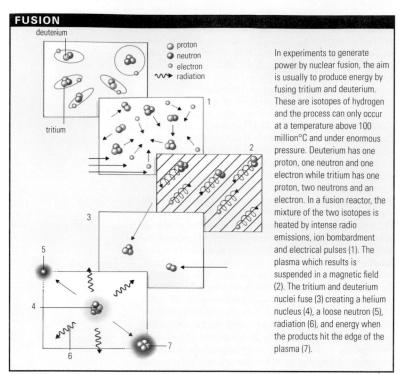

ATONEMENT by Christ bringing expiation and salvation for all, the physical RESURRECTION and the SECOND COMING. Fundamentalism has been loosely used to refer to any extreme orthodox element within a religion, such as Islamic fundamentalists. **Fundamental Orders** Code of laws adopted by representatives of the settlements in Connecticut in 1639 to govern the Connecticut colony. It was similar to a system in Massachusetts, but did not demand church membership from voters. Sometimes called the first written constitution, it remained in force until superseded by the Connecticut Charter (1662).

fungicide Chemical that kills fungi. For example, creosote used on wood to prevent dry rot.

fungus Any of a wide variety of organisms of the KINGDOM Fungi, which are unable to photosynthesise and which reproduce by means of spores and never produce cells with flagella. They include MUSHROOMS, MOULDS and YEASTS. There are c.100,000 species. Fungi have relatively simple structures, with no roots, stems or leaves. Their cell walls contain the polysaccharide CHITIN. The main body of a typical multicellular fungus consists of an inconspicuous network (mycelium) of fine filaments (hyphae), which contain many nuclei and may or may not be divided into segments by cross-walls. The hypha nuclei are HAPLOID. The mycelia may develop sporeproducing, often conspicuous, fruiting bodies, mushrooms and TOADSTOOLS. Fungal PARASITES depend on living animals or plants: SAPROPHYTES utilize the materials of dead plants and animals, and symbionts obtain food in a mutually beneficial relationship with plants. Fungi feed by secreting digestive ENZYMES onto their food, then absorbing the soluble products of digestion. All three groups are of great importance to man. Many cause diseases in crops, livestock and humans (athlete's foot). Moulds and yeasts are used in the production of BEER AND CHEESE; some fungi, such as Penicillium, are sources of ANTIBIOTICS.

funk Style or energy of popular music. It was originally

employed in the 1950s to summarize a form of modern JAZZ which, although influenced by BE-BOP harmonies, emphasized modern melodies. Funk developed into an independent form with artists such as James BROWN and George Clinton. **fur** Soft, dense hair covering the skin of certain mammals. Such mammals include mink, fox, ermine, musquash, wolf, bear, squirrel and rabbit. Most are hunted and killed for their pelts which, when manufactured into clothing, may command high prices. Some fur-bearing animals are now protected by law because overhunting has threatened extinction.

Furies (Erthyes and Eumenides) In Greek mythology, three hideous goddesses of vengeance whose main task was to torment those guilty of social crimes.

furnace Enclosed space raised to a high temperature by the combustion of fuels or by electric heating. Most furnaces are used in the extraction of metals or the making of alloys. An arc furnace relies on the heat generated by an electric arc (spark), often between two large carbon electrodes, which are slowly consumed. A resistance furnace is heated by passing an electric current through a heating element, or directly through metallic material. An induction furnace uses ELECTROMAGNETIC INDUCTION to cause a current to flow in a metallic charge. The resulting heat is sufficient to melt the metal.

Furtwängler, Wilhelm (1886–1954) German conductor. He became conductor of the Berlin Philharmonic Orchestra in 1922 (life appointment in 1952), and of the Vienna Philharmonic Orchestra in 1930. He appeared frequently at the Bayreuth and Salzburg festivals and was a specialist in the works of Beethoven and Wagner. His ambiguous relationship with the Nazi regime aroused controversy and censure.

furze See GORSE

fuse In electrical engineering, a safety device to protect against overloading. Fuses are commonly strips of easily melted metal placed in series in an electrical circuit such that when overloaded, the fuse melts, breaking the circuit and preventing systemic damage.

fusel oil Poisonous, clear, colourless liquid with a disagreeable smell. It consists of a mixture of amyl alcohols, obtained as a by-product of the fermentation of plant materials containing sugar and starch. It is used as a solvent for waxes, resins, fats and oils, and in the manufacture of explosives.

fusion, nuclear Form of nuclear reaction in which nuclei of light atoms (such as hydrogen) combine to form one or more heavier nuclei with the release of large amounts of energy. The process takes place in the Sun and other stars, and has been reproduced on Earth in the HYDROGEN BOMB. In a self-sustaining fusion reaction, the combining nuclei are in the form of a PLASMA. It is the maintenance of this state of matter that has proved difficult in harnessing fusion reaction as a controlled source of NUCLEAR ENERGY. *See also* FISSION, NUCLEAR

futurism Art movement that originated in Italy (1909) with the publication of the first futurist manifesto. It aimed to glorify machines and to depict speed and motion by means of an adapted version of CUBISM. It was violently opposed to the study of art of the past and embraced the values of modernity. Leading futurists include the poet MARINETTI. Its ideas were absorbed by the DADA movement and by SURREALISM.

Fuzhou (Fuzhou or Fu-chou) City and port on the River Min Chiang, capital of Fukien province, SE China. Fuzhou was founded in the T'ang dynasty (618–907). It was one of the first treaty ports to be opened to foreign trade (1842) and flourished as China's largest tea-exporting centre. It declined in the early 20th century. In 1949, after the communist takeover, Fuzhou was blockaded by the nationalists. Industries: engineering, chemicals, textiles. Pop. (1993 est.) 1,290,000.

G Symbol for the universal constant of GRAVITATION. g is also the symbol for acceleration of free fall due to Earth's gravity. One g is c.9.8m/s² (32ft/s²).

G8 Abbreviation of GROUP OF EIGHT

Gable, Clark (1901–60) US film actor. His virile magnetism made him "king" of 1930s Hollywood. Gable won his only Academy Award for best actor in *It Happened One Night* (1934). His performance as Rhett Butler in *Gone With the Wind* (1939) is one of cinema's most enduring. His best post-war acting was in the posthumously released *The Misfits* (1961).

Gabo, Naum (1890–1977) US sculptor and architect, b. Russia as Naum Pevsner. A founder of CONSTRUCTIVISM, he published the *Realist Manifesto* (1920) with his brother Antoine PEVSNER.

Gabon The Gabonese Republic lies on the Equator in w central Africa; the capital is LIBREVILLE. Land and Climate Behind the coastline, which is 800km (500mi) long, is a narrow coastal plain. The land then rises to hills, plateaux and mountains divided by deep valleys carved by the River Ogooué and its tributaries. Gabon has high temperatures and humidity most of the year. Libreville experiences a dry season between June and August. Dense rainforest covers c.75% of Gabon, with tropical savanna in the E and S. The forests teem with wildlife, and Gabon has several national parks and wildlife reserves. History Portuguese explorers reached the Gabon coast in the 1470s and the area later became a source of slaves. France established a settlement in 1839, later named Libreville. Gabon became a French colony in the 1880s. In 1960 it achieved full independence. In 1968, after the death of Gabon's first president, Leon Mba, it became a one-party state. Free elections took place in 1990. The Gabonese Democratic Party (PDG), formerly the only party, won a majority in the National Assembly. President Bongo, of the PDG, won the presidential elections in 1993, although accusations of fraud and corruption led to riots in Libreville. Under the Paris Agreement (1994), parliamentary elections were scheduled for 1996 but were not held until 1997, when the PDG was resoundingly re-elected. Economy Gabon's abundant natural resources, including forests, oil and gas deposits, manganese and uranium, make it one of Africa's richer nations (1992 GDP per capita, US\$3,913). However, agriculture still employs c.75% of the workforce. Crops include bananas, cassava, maize and sugar cane, while cocoa and coffee are grown for export. Other exports: oil, manganese, timber and wood products, uranium.

Gaborone Capital of Botswana, s Africa. First settled in the 1890s, it served as the administrative headquarters of the former Bechuanaland Protectorate, becoming the capital when the Protectorate gained its independence as Botswana in 1966. Gabriel Archangel, mentioned in the Old and New Testaments and in the Koran. In the Old Testament, Gabriel helps DANIEL to interpret his visions. In the New Testament he foretells the birth of St JOHN THE BAPTIST to his father, ZACHARIAS, and that of JESUS CHRIST to his mother, MARY. In the Koran, he is the angel who appears to MUHAMMAD. The Christian Church celebrates Gabriel's feast day on 24 March. Gabrieli Two Italian composers, uncle and nephew. Andrea Gabrieli (c.1533-86) was organist at St Mark's, Venice. He wrote vocal and organ music, developing the antiphonal use of several choirs. His nephew, Giovanni Gabrieli (c.1553-1612), succeeded him as organist at St Mark's. His output included large works for voices and orchestra. He developed the new CONCERTO style and was a major influence on the early BAROQUE.

Gaddafi See Qaddafi, Muammar al-

Gaddi, Taddeo (*c*.1300–*c*.1366) Leading member in a family of Florentine artists. Taddeo's father, **Gaddo** di Zanobi (*c*.1259–*c*.1330), was a noted painter and mosaicist. Taddeo served as an apprentice to Giotto. His best-known work is the fresco series *Life of the Virgin* (completed in 1338). Taddeo's son, **Agnolo** (d.1396), also painted frescos; the most famous is the *Legend of the True Cross* (*c*.1380).

gadolinium (symbol Gd) Silvery-white metallic element of the LANTHANIDE SERIES. Chief ores are gadolinite, monazite and bastnaesite. Its uses include neutron absorption and the manufacture of certain alloys. Properties: at.no. 64; r.a.m. 157.25; r.d. 7.898; m.p. 1,311°C (2,392°F); b.p. 3,233°C (5,851°F); most common isotope Gd^{158} (24.87%).

Gadsden Purchase Land purchased by the USA from Mexico in 1853. It was a narrow strip, 77,000sq km (30,000sq mi) in area, now forming s Arizona and New Mexico. The deal was negotiated by James Gadsden.

Gaelic Language spoken in parts of Ireland and Scotland. The two branches diverged in the 15th century and are mutually unintelligible. The Irish variety is one of the official languages of the Republic of Ireland, but the number of speakers is diminishing. In Scotland, Gaelic has no official status and is gradually dying out.

Gagarin, Yuri Alekseyevich (1934–68) Russian cosmonaut, the first man to orbit Earth (12 April 1961). Gagarin made the single orbit in 1 hour 29 minutes. He died in a plane crash. gag rules Series of rules adopted by US Congress in the 1830s to prevent discussion of slavery. John Quincy ADAMS led the fight against the rules, and in 1844 they were repealed. Gaia (Gaea) In Greek mythology, mother goddess of the Earth. Wife (and in some legends, mother) of URANUS, she bore the TITANS and the CYCLOPES.

Gaia hypotheses Scientific theory interrelating the Earth's many and varied processes – chemical, physical and biological. Popular in the 1970s, when it was proposed by James Lovelock, it showed the Earth as one single living organism.

Gainsborough, Thomas (1727–88) British portrait and landscape painter. Influenced by the Dutch landscape painters, he developed a personal style that is remarkable for its characterization and use of colour. His portraits, such as *Viscount Kilmorey* (1768), rivalled those of Sir Joshua REYNOLDS. Among his best landscapes is *The Watering Place* (1777).

Gaitskell, Hugh Todd Naylor (1906–63) British statesman, Labour Party leader (1955–63). Gaitskell became an MP in 1945, entering the cabinet in 1947. In 1950 he became minister of state for economic affairs and then chancellor of the exchequer (1950–51). In the 1950 leadership elections he led Labour's right to victory over Aneurin BEVAN's challenge. A period of consensus between the two main parties, known as "Butskellism", ensued in British politics. In 1960 Gaitskell refused to accept conference's decision to adopt a policy of unilateral disarmament and defeated a leadership challenge from his eventual successor Harold Wilson.

Galápagos Islands (Sp. Archipiélago de Colón) Pacific

G/g, the seventh letter of the alphabet, derived from the Greek gamma. In English a g may be hard, as in game, or soft as in page. A following h gives it a variety of sounds (like a w in bough, an f in rough or silent as in high); g is also silent as in sign.

▲ Gable The epitome of the rugged male, Clark Gable will perhaps be best remembered for his role as Rhett Butler in *Gone with the Wind*.

AREA: 267,670sq km (103,347sq mi) POPULATION: 1,237,000 CAPITAL (POPULATION): Libreville (418,000) GOVERNMENT: : Multiparty republic

ETHNIC GROUPS: Fang 36%, Mpongwe 15%, Mbete 14%, Punu 12% LANGUAGES: French (official)

RELIGIONS: Christianity (Roman Catholic 65%, Protestant 19%, African churches 12%), tradi-

tional beliefs 3%, Islam 2% **CURRENCY:** CFA franc = 100 centimes archipelago on the equator; a province of Ecuador; c.1,050km (650mi) w of mainland South America. The capital is Baquerizo Moreno, on San Cristóbal. Other main islands include Santa Cruz, San Salvador, and Isabela. There are numerous smaller islands. The islands are volcanic with sparse vegetation, except for dense forests on the high lava craters, which rise to 1,707m (5,633ft) at Volcán Wolf (Isabela). Mangrove swamps and lagoons teem with wildlife. Many animal species are unique to the islands, such as the giant land tortoises. Other native creatures include marine and land iguanas and flightless cormorants. The Galápagos National Park is a world heritage site, established in 1935 to protect the wildlife. In 1832 Ecuador annexed the archipelago and established a settlement. In 1835 Charles DARWIN spent six weeks studying the fauna. His evidence provided much support for the theory of natural selection. Area: 7,845sq km (3,029sq mi) Pop. (1990) 9,785.

galaxy Huge assembly of stars, dust and gas. There are three main types, as classified by Edwin Hubble in 1925. Elliptical galaxies are round or elliptical systems, showing a gradual decrease in brightness from the centre outwards. Spiral galaxies are flattened disk-shaped systems in which young stars, dust and gas are concentrated in spiral arms coiling out from a central bulge, the nucleus. Barred spiral galaxies have a bright central bar from which the spiral arms emerge. Irregular galaxies are systems with no symmetry. Current theories suggest that all galaxies were formed from immense clouds of gas soon after the Big Bang. Galaxies can exist singly or in clusters. Our Galaxy is spiral and c.100,000 light years in diameter. The Solar System is located at the edge of one of the spiral arms, about 30,000 light years from the centre. The stars of the spiral arms form the MILKY WAY. The whole Galaxy is rotating, but the rotational rate varies with distance from the centre. galaxy cluster Group of associated galaxies, consisting of several separate systems moving together through space. Our Galaxy belongs to the Local Group of galaxies, which includes the Andromeda Galaxy and the Magellanic Clouds. A concentration of galaxy clusters is a galaxy supercluster.

galena Grey metallic mineral, lead sulphide (PbS); an ore of lead. It is found in hydrothermal veins and as a replacement in limestone and dolomite rocks. Hardness 2.5–2.7; s.g. 7.5.

Galicia Region of SE Poland (Western Galicia) and w Ukraine (Eastern Galicia), on the slopes of the Carpathian Mountains (N) and bordering the Czech Republic (s). After passing to Austria in 1772, Galicia became the centre of HASIDISM. After World War 1, Poland seized Western Galicia and was awarded Eastern Galicia at the 1919 Paris Peace Conference. The 1939 partition of Poland between Nazi Germany and the Soviet

Union gave most of Eastern Galicia to the Ukraine, a position ratified by the 1945 Polish-Soviet Treaty. During World War 2 almost the entire Galician Jewish population perished in the Holocaust. The region is predominantly agricultural, but there are also oilfields. The major cities are Kraków (Poland) and Lvov (Ukraine). Area: 78,500sq km (30,309sq mi).

Galicia Autonomous region in NW Spain, comprising the provinces of La Coruña, Lugo, Orense and Pontevedra; the capital is Santiago de Compostela. It was a centre of resistance to the Moorish invasions in the 8th century and passed to Castile in the 13th century. Galicia has a mountainous interior. Its economy is based on the raising of livestock; fishing and mining are also important. Area: 29,434sq km (11,361sq mi). Pop. (1991) 2,731,669.

Galilean satellites Four chief SATELLITES OF JUPITER: GANYMEDE, CALLISTO, IO and EUROPA, named after GALILEO. Galilee, Sea of (Lake Tiberius or Yam Kinneret) Freshwater lake in N Israel, fed by the River JORDAN. Israel's major reservoir, it is an important fishing ground and the source of water for irrigation of the Negev Desert. The surface is c.215m (705ft) below sea level. Area: 166sq km (64sq mi).

Galileo (1564–1642) (Galileo Galilei) Italian scientist. He studied falling bodies and disproved Aristotle's view that they fall at different rates according to weight. In 1610 he used one of the first astronomical telescopes to discover sunspots, lunar craters, Jupiter's major satellites and the phases of Venus. In *Sidereus Muncius* (1610) he supported the Copernican view of the Universe, with the Earth orbiting the Sun. This was declared a heresy, and in 1633 he was brought before the INQUISITION and forced to recant.

Galileo Space probe to Jupiter, launched in October 1989. The probe passed the asteroids Gaspra and Ida in October 1991 and August 1993 respectively, photographing both. Galileo went into orbit around Jupiter in 1995.

gall Abnormal swelling of plant tissue stimulated by an invasion of any of a wide variety of parasitic or symbiotic organisms, including bacteria, fungi, insects and nematodes. Most gall organisms stunt but do not kill the affected plants.

Galla Hamitic people who make up 40% of the population of Ethiopia, living mainly in the south. Characteristically tall and dark-skinned, they are predominantly nomadic pastoralists. Their religions include Christianity, Islam and animism. gall bladder Muscular sac, found in most vertebrates, which stores BILE. In humans it lies beneath the right lobe of the LIVER and releases bile into the DUODENUM by way of the bile duct. Its release is signalled by a hormone that is secreted when food is present in the duodenum.

Gallic Wars (58–51 BC) Campaigns in which the Romans, led by CAESAR, conquered GAUL. By 57 BC Caesar had subdued sw and N Gaul. In 56 BC he conquered the Veneti, leaders of an anti-Roman confederation, and in 55–54 BC invaded Germany and Britain. He defeated a united Gallic revolt in 52 BC.

Gallipoli (Gelibolu) Peninsula and port in w Turkey, on the European side of the DARDANELLES. Colonized by the Ancient Greeks, it has been of strategic importance in the defence of Istanbul (Constantinople). It was the first European city to be conquered by the Ottoman Turks (1354). In 1915–16 it was the scene of the GALLIPOLI CAMPAIGN. Pop. (1985) 16,715.

Gallipoli Campaign (1915–16) Allied operation against the Turks during WORLD WAR 1. Some 45,000 British and French and 30,000 ANZAC troops were involved. After eight months of inconclusive fighting and more than 145,000 casualties on both sides, the Allies withdrew.

gallium (symbol Ga) Grey metallic element of group III of the periodic table. It was discovered in 1875. Chief sources are bauxite and some zinc ores. The metal, liquid at room temperature, is used in lasers, semiconductors and high-temperature thermometers. Properties: at.no. 31; r.a.m. 69.72; r.d. 5.9; m.p. 29.78°C (85.60°F); b.p. 2,403°C (4,357°F); most common isotope Ga⁶⁹ (60.4%).

gallstone (cholelithiasis) Hard mass, usually composed of cholesterol and calcium salts, which forms in the gall bladder. Gallstones may cause severe pain (biliary colic) or become lodged in the common bile duct, causing obstructive JAUNDICE or cholecystitis. Treatment is by removal of the stones themselves or of the gall bladder.

Gallup, George Horace (1901–84) US statistician. He sampled public opinion on social, political and business matters, and correctly forecast the outcome of the 1936 presidential election. Since then, Gallup polls have acquired a reputation for accuracy.

Galsworthy, John (1867–1933) British novelist and playwright. His novels deal with contemporary English upper-middle-class life. The most noted are *The Forsyte Saga* (1906–21), *A Modern Comedy* (1924–28) and *End of the Chapter* (1931–33); plays include *The Silver Box* (1906) and *Justice* (1910). He was awarded the 1932 Nobel Prize for literature.

Galvani, Luigi (1737–98) Italian physician and physicist. His experiments with frogs' legs indicated a connection between muscular contraction and electricity. He believed a new type of electricity was created in the muscle and nerve.

galvanizing Coating of iron or steel articles with zinc in order to protect from CORROSION. The coating can be applied directly in a bath of molten zinc, electroplated from cold zinc sulphate solutions, or dusted on and baked.

Galway County in the province of Connaught, w Republic of Ireland; the county town is Galway. Bounded by the Atlantic (w), it has an indented coastline with many islands. It is mountainous in the w, low-lying in the E and drained by the River Shannon. It is an agricultural region. Industries: tourism, agriculture, cotton-spinning, sugar-refining, handicrafts. Area: 5,939sq km (2,293sq mi). Pop. (1991) 129,511.

Gama, Vasco da (1469–1524) Portuguese naval commander. He led an expedition around the Cape of Good Hope (1497), which opened up the sea route to India. In 1502 he led a heavily armed expedition of 20 ships and, employing brutal tactics, secured Portuguese supremacy in the Eastern spice trade.

Gambetta, Léon Michel (1838–82) French politician. A parliamentary opponent of NAPOLEON III, he organized French resistance in the Franco-Prussian War (1870–71) and helped form the Third Republic. He was prime minister (1881–82).

Gambia The Republic of The Gambia is the smallest country in mainland Africa; the capital is BANJUL. **Land and Climate** The Gambia consists of a narrow strip of land bordering the River Gambia, and is entirely enclosed by Senegal, except for a short Atlantic coastline. Near the sea, the land is flat and the soils are salty. The middle part of the River Gambia is bordered by terraces (*banto faros*), which are flooded after heavy rains. The upper river flows through a deep valley that the river has cut into a sandstone plateau. Gambia has hot, humid summers. In winter (November to May), temperatures drop to c.16°C

(61°F). Mangrove swamps line the river banks. Tropical savanna used to cover most of the land, but much has been cleared for farming. Gambia is rich in wildlife. History Portuguese mariners reached Gambia's coast in 1455 when the area was part of the Mali empire. In the 16th century, Portuguese and English slave traders operated in the area. In 1664 the British established a settlement and later founded a colony, Senegambia (1765), which included parts of present-day Gambia and Senegal. In 1783 this was handed over to France. In 1816 Britain founded Bathurst (now Banjul) as a base for its antislavery operations. The Gambia became a British colony in 1888 and remained under British rule until it achieved full independence in 1965. Politics In 1970 The Gambia became a republic. In 1981 an attempted coup was defeated with the help of Senegalese troops. In 1982 The Gambia and Senegal set up a defence alliance, the Confederation of Senegambia, but this ended in 1989. In July 1994 a military group led by Yahyah Jammeh overthrew the president, Sir Dawda Jawara. In 1996 Jammeh was elected president, and in 1997 legislative elections his Patriotic Alliance for Reorientation and Construction (PARC) was victorious. Economy Agriculture employs more than 80% of the workforce. The main food crops are cassava, millet and sorghum; groundnuts are the leading export. Tourism is becoming increasingly important.

gamelan Traditional Indonesian orchestra using xylophones, marimbas, gongs and drums. Used to accompany ceremonies, the rhythmically complex music has inspired Western composers, such as Claude Debussy and Philip Glass.

gamete Reproductive sex cell that joins with another sex cell to form a new organism. Female gametes (ova) are usually motionless; male gametes (sperm) often have a tail (flagellum) enabling them to swim to the ova. All gametes are HAPLOID.

game theory In mathematics, the analysis of problems involving conflict. Its application includes problems in business management, sociology, economics and military strategy. The theory was introduced by Émile Borel and developed by John von Neumann in 1928.

gametophyte Generation of plants and algae that bears the female and male GAMETES. In flowering plants these are the germinated pollen grains (male) and the embryo sac (female) inside the ovule. See also ALTERNATION OF GENERATIONS; FERN gamma radiation Form of very short wavelength ELECTROMAGNETIC RADIATION emitted from the nuclei of some radioactive atoms. High-energy gamma rays have even greater powers of penetration than X-RAYS They are used in medicine to treat cancer and in the food industry to kill microorganisms. See also RADIOACTIVITY

Gamow, George (1904-68) US nuclear physicist, b. Russia. He developed the Big Bang theory, helped decipher the genetic code, developed the quantum theory of radioactivity and proposed the liquid-drop model of atomic nuclei. With Edward TELLER, he established the Gamow-Teller theory of beta decay. Gandhi, Indira (1917-84) Indian politician, prime minister (1966-77, 1980-84). The daughter of Jawaharlal Nehru, she served as president of the Indian National Congress Party (1959-60), becoming prime minister in 1966. In 1975, amid growing social disturbance, she was found guilty of breaking electoral rules in her 1971 re-election. She refused to resign, invoked emergency powers and imprisoned many of her opponents. When elections finally took place in 1977, the Congress Party suffered a heavy defeat, which split the party. In 1980, leading a faction of the Congress Party, she returned to power. In 1984, after authorizing the use of force against Sikh dissidents in the Golden Temple at Amritsar, she was assassinated by a Sikh bodyguard.

Gandhi, "Mahatma" (Mohandas Karamchand) (1869–1948) Indian political and spiritual leader who led the nationalist movement (1919–47). A lawyer, he practised in South Africa (1893–1914), where he led equal-rights campaigns, before returning to his native India. Following the massacre at AMRITSAR (1919), he launched a policy of non-violent non-cooperation with the British. Resistance methods included strikes, refusal to pay taxes, and refusal to respect colonial law, such as the famous 388km (241mi) protest march against a salt tax (1930). He also strove to raise the status of lower castes.

▲ Gandhi After years of nonviolent campaigns against the British, Gandhi finally realized his dream of witnessing the creation of an independent India in May 1947. Having won this great victory for democracy, he was pained to see growing division between the Hindu and Muslim populations of India.

▲ Ganges The River Ganges holds great religious significance for the world's Hindu population. Certain points along the river, known as *tirath*, are holy places where bathing festivals (*mela*) occur annually. The best-known *tirath* are at Varanasi, Allahabad, and Hardwar.

After frequent imprisonments, he saw India gain independence in 1947. A figure of immense international and moral stature, he was assassinated by a religious fanatic in Delhi.

Gandhi, Rajiv (1944–91) Indian politician, prime minister (1984–89). The elder son of Indira Gandhi, Rajiv Gandhi was a pilot before reluctantly entering politics. He became prime minister after his mother's assassination. He worked to placate India's Sikh extremists, but his reputation was tarnished by a bribery scandal. Defeated in the 1989 election, Gandhi was assassinated while campaigning for re-election in 1991.

Ganesh Elephant-headed Hindu god, son of SHIVA and PAR-VATI. He is the patron of learning and is said to have written down the MAHABHARATA. His birth festival is in the lunar month Bhadrapada.

Ganges (Ganga) River of N India. It rises in the Himalayas, then flows SE and empties into the Bay of Bengal through the Brahmaputra—Ganges delta. The plains of the Ganges are extremely fertile and support one of the world's most densely populated areas. In Hinduism, it is the earthly form of the Goddess Ganga, and pilgrims purify themselves in its waters. Length: 2,512km (1,560mi).

ganglion Cluster of nervous tissue containing cell bodies and SYNAPSES, usually enclosed in a fibrous sheath. In VERTEBRATES, most ganglia occur outside the CENTRAL NERVOUS SYSTEM.

Gang of Four Radical faction that tried to seize power in China after the death of MAO ZEDONG. In 1976 both Chairman Mao and Prime Minister ZHOU ENLAI died, leaving a power vacuum. The Gang of Four, Zhang Chunjao, Wang Hungwen, Yao Wenyuan, and their leader JIANG QING (Mao's widow), tried to launch a military coup but were arrested for treason by HUA GUOFENG. They were sentenced to life imprisonment.

gannet Diving seabird related to the tropical booby. Gannets are heavy-bodied with tapering bills, long pointed wings, short legs and webbed feet. Their plumage is white with black wing tips. They feed on fish and nest in huge colonies on rocky islands. Length: 63–100cm (25–40in). Family Sulidae. Gansu (Kansu) Province in Nw central China, bordered E by Inner Mongolia; the capital is Lanzhou. The region became Chinese territory in the 3rd century BC. Wheat, cotton, rice, maize and tobacco are grown under irrigation, particularly in the Huang He valley. Livestock graze on the mountain slopes. Mineral deposits include iron ore, oil and coal. Area: 366,625sq km (141,550sq mi). Pop. (1990) 22,930,000.

Ganymede Largest of Jupiter's GALILEAN SATELLITES, with a diameter of 5,262km (3,270mi). Its cratered terrain is covered with grooves suggesting recent geological activity.

gar Primitive freshwater bony fish found in shallow waters of North America. Its long cylindrical body is covered with bony diamond-shaped plates. Its snout is studded with teeth. Length: to 3m (10ft); weight: to 135kg (300lb). Family Lepisosteidae. **Garbo, Greta** (1905–90) Swedish film actress. Garbo's aura of mystery and enigmatic beauty made her an adored

screen idol. Her first lead role was in *Torrent* (1926). Her first "talkie" was *Anna Christie* (1930). She played the leads in the classics *Anna Karenina* (1935) and *Camille* (1937), and the comedy *Ninotchka* (1939). She retired in 1941.

García Lorca, Federico See Lorca, Federico García García Márquez, Gabriel (1928–) Colombian novelist. His popular novel One Hundred Years of Solitude (1967) achieves a unique combination of realism, lyricism and mythical fantasy, making it a central text of MAGIC REALISM. Later works include The Autumn of the Patriarch (1975), Love in the Time of Cholera (1985) and The General in his Labyrinth (1989). He was awarded the 1982 Nobel Prize for literature.

Garda, Lake Largest lake in Italy, forming the border between Lombardy and Venetia. It has many popular tourist resorts along its shoreline. Area: 370sq km (143sq mi)

gardenia Genus of more than 60 species of evergreen shrubs and small trees, native to tropical and sub-tropical Asia and Africa. They have white or yellow, fragrant, waxy flowers. Height: to 5.5m (18ft). Family Rubiaceae.

Gardner, Erle Stanley (1889–1970) US writer, creator of the detective lawyer Perry Mason. He wrote 80 novels featuring Perry Mason, the first of which was *The Case of the Velvet Claws* (1933).

Garfield, James Abram (1831–81) 20th US president (1881). He served in the Civil War until 1863, when he was elected to the House of Representatives. He became the Republican leader of the house in 1876. The 1880 Republican convention was deadlocked and, on the 36th ballot, he became the compromise presidential candidate. His four-month administration was characterized by party squabbles over federal jobs and political patronage. He was assassinated on 2 July 1881.

Garibaldi, Giuseppe (1807–82) Italian patriot and guerrilla leader who helped to bring about Italian unification. Influenced by MAZZINI, he participated in a republican rising in 1834, subsequently fleeing to South America. Returning in 1848, he defended the Roman Republic against the French. In 1860 he led his 1,000-strong band of "Red Shirts" against the Kingdom of the Two Sicilies, a dramatic episode in the RISORGIMENTO. He handed his conquests over to King VICTOR EMMANUEL II and they were incorporated into the new kingdom of Italy.

Garland, Judy (1922–69) US singer and film actress, b. Frances Gumm. Her performance as Dorothy in *The Wizard of Oz* (1939) made her a worldwide star. Her other films include *Meet Me in St Louis* (1944), *Easter Parade* (1948) and *A Star is Born* (1954). Her daughter is the actress Liza Minnelli.

garlic Bulbous herb native to s Europe and central Asia. It has onion-like foliage and a bulb made up of sections called cloves, which are used for flavouring. It is also claimed to have medicinal properties. Family Liliaceae; species *Allium sativum*.

garnet Two series of orthosilicate minerals found in metamorphic rocks and pegmatites. Some varieties are important as gemstones. Hardness 6.5–7.5; s.g. 4.

Garrick, David (1717–79) English actor, theatre manager and dramatist. He is credited with replacing the formal declamatory style of acting with easy, natural speech. After playing Shakespeare's *Richard III* in 1741, he stayed at the Drury Lane Theatre from 1742 until his retirement in 1776.

Garrison, William Lloyd (1805–79) US ABOLITIONIST. In 1831 he started the *Liberator* in Boston, an influential journal in the anti-slavery movement. After the Civil War, he concentrated on other reforms, including temperance and women's suffrage.

Garter, Order of the Most ancient of chivalric orders in Britain. It was created by Edward III in 1348 and held its first meeting the same year. The monarch is the Grand Master and there are usually 25 knights of the order.

garter snake Non-venomous SNAKE native to North and Central America. They are usually olive-brown with yellow, orange, red or blue stripes often spotted with black. Length: to 60cm (24in). Family Colubridae; genus *Thamnophis*.

Garvey, Marcus (1887–1940) US black nationalist leader, b. Jamaica. In 1914 he founded the Universal Negro Improvement Association (UNIA) to "promote the spirit of race pride". Garvey believed that black people could not achieve equality within white-dominated, Western countries. He created a

▲ gannet The Atlantic gannet (Sula bassana) is found in some coastal regions of N Europe and E North America. It grows to a length of 100cm (40in). Gannets spot their prey of surface-swimming fish from the air, before dropping in a near-vertical dive to catch the fish. They snatch and swallow the prey before re-emerging.

"back-to-Africa" movement, establishing the Black Star Line shipping company as a means of transport. By the 1920s, via his *Negro World* newspaper, Garvey was the most influential US black leader. In 1922 the Black Star Line and the UNIA collapsed. Garvey was convicted of fraud and jailed (1925). He was pardoned by President Coolidge and deported to Jamaica (1927). RASTAFARIANISM is influenced by his philosophy.

gas State of MATTER in which molecules are free to move in any direction; a gas spreads by DIFFUSION to fill a container of any size. Because of their low densities, most gases are poor conductors of heat and electricity (although at high voltages a gas may be ionized and become electrically conductive). When cooled, gases become liquids. Some, such as carbon dioxide, can be liquefied by pressure alone. All gases follow certain laws, such as Avogadro's law, Boyle's law CHARLES' LAW, GRAHAM's law and the IDEAL GAS LAWS. See also SOLID: LIQUID: PLASMA

Gascoigne, Paul John ("Gazza") (1967–) English footballer. In 1988 he transferred from Newcastle United to Tottenham Hotspur and his goalscoring abilities took them to the 1991 FA Cup final. The following year Gascoigne joined the Italian team, Lazio. Returning to the UK in 1995 with Glasgow Rangers, he revived skills that had helped England to the semi-finals of the 1990 World Cup.

Gascony Former province in sw France, bounded to the s by the Pyrenees and to the w by the Bay of Biscay. Part of Roman Gaul, it was later overrun by the Visigoths and the Franks. In the 6th century it was conquered by the Vascones. It passed to Aquitaine in the 11th century. From 1154 to 1453 it was ruled by England. It was finally united to the French crown in the 16th century by Henry IV.

gas exchange In biology, the uptake and output of gases, especially oxygen and carbon dioxide, by living organisms. In animals and other organisms that obtain their energy by AERO-BIC respiration, gas exchange involves the uptake of oxygen and the output of carbon dioxide. In plants, algae and bacteria that carry out PHOTOSYNTHESIS, the opposite may occur, with a carbon dioxide uptake and oxygen output. At the cellular level, gas exchange takes place by DIFFUSION across cell MEMBRANES in solution. See also BREATHING; CIRCULATORY SYSTEM; RESPIRATION; RESPIRATORY SYSTEM; VENTILATION

Gaskell, Elizabeth Cleghorn (1810–65) British writer. She explored the problems of the industrial poor in her novels *Mary Barton* (1848) and *North and South* (1855). Other works include *Cranford* (1853), *Wives and Daughters* (1866) and an acclaimed biography of her friend Charlotte BRONTË (1857).

gasoline See PETROLEUM

Gasperi, Alcide de (1881–1954) Italian statesman, prime minister (1945–53). He was elected to the Austro-Hungarian parliament in 1911, and in 1921 entered the Italian parliament as a founder of the Italian People's Party. A strong opponent of fascism, he was imprisoned during Mussolini's regime. During World War 2 he was active in the resistance and helped to create the Christian Democratic Party. As prime minister, he contributed greatly to his country's postwar recovery.

gastric juice Fluid comprising a mixture of substances, including PEPSIN and hydrochloric acid, secreted by GLANDS of the stomach. Its principal function is to break down proteins into polypeptides during DIGESTION.

gastroenteritis Inflammation of the stomach and intestines causing abdominal pain, diarrhoea and vomiting. It may be caused by infection, food poisoning, or allergy. Severe cases can cause dehydration. Treatment includes fluid replacement. gastropod Class of MOLLUSCS, which includes the SNAIL, SLUG, WHELK, LIMPET, ABALONE and SEA SLUG. Many possess a single spiral shell produced by chemical precipitation from the mantle. Many types of gastropod live immersed in seawater, breathing through gills. Some freshwater snails, however, breathe through lungs and surface periodically for air. Sea slugs are entirely without shells and are often brilliantly coloured. gas warfare See CHEMICAL WARFARE

Gates, Bill (William Henry) (1955–) US businessman, often cited as the richest man in the world. In 1975 he cofounded Microsoft Corporation, which in the 1980s became the dominant COMPUTER software producer. He was noted for

his innovative thinking and for his aggressive marketing and business tactics.

Gates, Horatio (1727–1806) US general, b. England. He served in the British army under General Braddock in the French and Indian War before emigrating to Virginia in 1772 and joining the colonists' cause in the AMERICAN REVOLUTION. In 1776 he became commander of the army in the north and defeated the British at Saratoga (1777). He lost his command after his defeat at Camden, South Carolina (1780).

gatling gun Early MACHINE GUN invented in 1862 by Richard Gatling. It had several barrels mounted in a cylinder that was rotated manually by a crank so that each barrel fired in turn.

GATT Acronym for the General Agreement on Tariffs and Trade

gaucho Colourful COWBOY of the Argentine and Uruguayan grasslands. Originally nomadic, the mixed-blood gauchos became farmhands and superb horse soldiers. They were an important political force in the 18th and 19th centuries and are part of the region's history and legend.

Gaudí, Antonio (1852–1926) Spanish architect. Gaudí's work employs bizarre sculptural and sinuous forms, and is often associated with ART NOUVEAU. Examples include the Palau Guell (1885–89), the Caso Battlo (1905–07) and the unfinished church of the Sagrada Familia, all in Barcelona.

Gaudier-Brzeska, Henri (1891–1915) French sculptor, who lived in England from 1911. A friend of Ezra POUND, he was part of the VORTICISM movement. Two of his best-known works are *The Dancer* and *Bird swallowing Fish*.

Gauguin, Eugène Henri Paul (1848–1903) French painter. He reacted against the realism of IMPRESSIONISM. His belief that form and pattern should represent mental images influenced SYMBOLISM. In 1891 he left France for Tahiti, where he was inspired by the art of many different cultures. He developed his own "synthetist" style, which was characterized by bold contours and large areas of unmodulated colour. His paintings, often of South Sea islanders, convey a sense of mystery and myth. His masterpiece is Where do we come from? What are we? Where are we going? (1897).

Gaul Ancient Roman name for the region roughly equivalent to modern France, Belgium, N Italy and Germany w of the Rhine. Most of Gaul, which was inhabited by Celts, was conquered (58–51 BC) in the GALLIC WARS. From the 3rd century, it was under attack by Germanic tribes who settled in N Gaul. **Gaultier, Jean-Paul** (1952–) French fashion designer. He joined Pierre Cardin at 18, before launching his own collections in 1977. His designs reveal a sense of humour, mixing textures and cuts with unconventional features and accessories. **gaur** Species of wild cattle found in forested hilly country in India and Malaysia. Gaurs, also called seladangs, are dark brown in colour with a white "sock" on each leg. Length: up to 3.8m (12.4ft). Family Bovidae; species *Bos gaurus*.

Gauss, Karl Friedrich (1777–1855) German mathematician and physicist. He studied electricity and magnetism and areas of mathematics such as number theory and series. The unit of magnetic flux density is named after him.

Gauteng Province in N central South Africa; the capital is JOHANNESBURG. Formed in 1994 from the TRANSVAAL as PWV (PRETORIA - WITWATERSRAND - Vereeniging), the province was renamed Gauteng in 1995. It is South Africa's smallest but most populous province. Area: 18,810sq km (7,260sq mi). Pop. (1995 est.) 7,048,300.

Gautier, Théophile (1811–72) French poet, novelist and critic. His poems, such as *Albertus* (1833), *España* (1845) and *Enamels and Cameos* (1852), exhibit the formalist aesthetic theory of art that influenced SYMBOLISM.

gavial Crocodilian native to N India. It has a long, narrow snout, an olive or brownish back, and a lighter belly. It feeds almost exclusively on fish. Length: to 5m (15.4ft). Family Gavialidae; species *Gavialis gangeticus*.

Gay, John (1685–1732) English poet and dramatist. His best-known work is the ballad-opera *The Beggar's Opera* (1728), a political satire and burlesque of Italian opera. Other works include the poem *Trivia*.

Gaya City on the Phalgu River, Bihar state, NE India. It is a pilgrimage centre sacred to both Hindus and Buddhists. Bud-

▲ Gaudi The Sagrada Familia (Holy Family) cathedral in Barcelona is a fine example of the Spanish architect Antonio Gaudi's extraordinary style. The cathedral, although started in 1883, remains unfinished. Gaudi's plans reveal a vast central spire, surrounded by 12 smaller spires (four are visible here). The building represents Christ surrounded by his 12 disciples. Funding for the church is still uncertain, and there is no definite completion date.

▲ gazelle The Thomson's gazelle (Gazella thomsoni) inhabits the savanna of East Africa. Its relatively small size and unremarkable colouring make it less attractive to poachers and hunters than other African herbivores, and for this reason there exist large populations. The males' long, elegant horns are more often used for stylized, display fighting, but serious disputes do occur, often resulting in significant injury.

dha received enlightenment nearby, and the God Vishnu is said to have sacrificed the demon of Gaya. It is the seat of Magadha University (1962). Pop. (1991) 292,000.

Gaye, Marvin (1939–84) US singer-songwriter. Gaye was an influential singer throughout his recording life, from the number one gold single *I Heard It Through The Grapevine* (1968), through his work with Tammi Terrell, to his Grammy award-winning *Sexual Healing* (1982). He was shot dead by his father during an argument.

Gay-Lussac, Joseph Louis (1778–1850) French chemist and physicist. He discovered the law of combining gas volumes (Gay-Lussac's Law) and the law of gas expansion, often attributed to J.A.C. CHARLES.

Gaza Strip Strip of territory in sw Israel, bordering on the SE Mediterranean Sea. The settlement following the Arab-Israel War (1948–49) made it an Egyptian possession. It subsequently served as a Palestinian Arab refugee centre. Occupied by Israel from 1967, it was the scene of the Intifada against Israel in 1988. In 1994, under a peace agreement, its administration was taken over by the Palestinian National Authority. Area: 363sq km (140sq mi). Pop. (1994) 724,500. gazelle Any of several species of graceful, small-to-medium antelopes native to Africa and Asia, often inhabiting plains. Most are light brown with a white rump and horns. Some can run at up to 80km/h (50mph). Family Bovidae; genus Gazella. GCSE Abbreviation of GENERAL CERTIFICATE OF SECONDARY EDUCATION

Gdańsk (Danzig) City and seaport on the Gulf of Gdańsk, N Poland; capital of Gdańsk county. Settled by Slavs in the 10th century, it was a member of the HANSEATIC LEAGUE. It was taken by Poland in the 15th century but passed to Prussia in 1793. The Treaty of VERSAILLES (1919) established Gdańsk as a free city, and annexation by Germany in 1939 precipitated World War 2. In the 1980s its shipyards became a focus of opposition to Poland's communist rulers. Industries: metallurgy, chemicals, machinery, timber. Pop. (1993) 466,500.

gear Wheel, usually toothed, attached to a rotating shaft. The teeth of one gear engage those of another in order to transmit and modify speed of rotation and TORQUE.

gecko Any of about 650 species of LIZARDS, native to warm regions of the world. They owe their remarkable climbing ability to minute hooks on their feet. They make chirping calls. Length: 3–15cm (1–6in). Family Gekkonidae.

Gehrig, (Henry) Lou (Louis) (1903–41) US baseball player. Gehrig played for the New York Yankees (1925–39) and notched up a record 2,130 consecutive appearances. He had a lifetime batting average of .340 and hit 493 home runs. His career was cut short by amyotrophic lateral sclerosis, a degenerative muscular disease that became known as "Gehrig's disease". He was elected to the Baseball Hall of Fame in 1939.

Geiger, Hans Wilhelm (1882–1945) German physicist who, with Ernest RUTHERFORD, devised the GEIGER COUNTER (1908). In 1909 Geiger and Ernest Marsden studied the deflection of alpha particles by thin metal foil, providing the basis of Rutherford's discovery of the atomic nucleus.

Geiger counter (Geiger-Müller counter) Instrument used to detect and measure the strength of radiation by counting the number of ionized particles produced.

gel Homogeneous mass consisting of minute particles dispersed in a liquid to form a fine network throughout the mass. A gel's appearance can be elastic or jellylike, as in GELATIN, or quite rigid and solid, as in silica gel.

gelatin Colourless or yellowish protein obtained from COL-LAGEN in animal cartilage and bones. It is used in photograph-

ic film emulsions, capsules for medicines, as a culture medium for bacteria, and in foodstuffs such as jellies.

Gell-Mann, Murray (1929–) US physicist. He was awarded the 1969 Nobel Prize for physics for his application of group theory to ELEMENTARY PARTICLES, which led to the prediction of the QUARK as the basic constituent of the BARYON and MESON. His theory also predicted the existence of a baryon called the omega-minus particle, subsequently discovered in 1964.

gem Any of about 100 minerals valued for their beauty, rarity and durability. Transparent stones, such as DIAMOND, RUBY, EMERALD and SAPPHIRE, are the most highly valued. PEARL, AMBER and CORAL are gems of organic origin.

Gemeinschaft In sociology, concept formulated by Ferdinand Toennies in 1887, denoting social systems based on spontaneous, small-group, face-to-face relationships.

Gemini (the Twins) Northern constellation situated on the ecliptic between Taurus and Cancer; the third sign of the zodiac. The brightest star is Beta Geminorum (Pollux).

gemma In botany and zoology, a bud that will give rise to a new individual. The term also refers to a multicellular reproductive structure found in algae, liver worts and mosses.

gender Any of several categories into which nouns and pronouns can be divided for grammatical purposes. In some languages, adjectives or verbs may take different forms to agree with the different genders. A three-gender system, with categories labelled masculine, feminine and neuter, exists in such languages as German, Latin and Russian, while a two-gender system, with masculine and feminine, operates in such languages as French and Welsh.

gene Unit by which hereditary characteristics are passed on from one generation to another in plants and animals. A gene is a length of DNA that codes for a particular protein or peptide. Genes are found along the CHROMOSOMES. In most cell nuclei, genes occur in pairs, one located on each of a chromosome pair. Where different forms of a gene (ALLELES) are present in a population, some forms may be recessive to others and will not be expressed unless present on both members of a chromosome pair. See also GENETIC CODE; GENETIC ENGINEERING

gene bank Genetic material kept for future possible use. Material stored includes cultures of bacteria and moulds; seeds, spores and tubers; frozen sperm, eggs and embryos; and even live plants and animals. The material can be used in plant and animal BREEDING, GENETIC ENGINEERING and in medicine. Live specimens are used for restocking natural habitats in which species are in danger of EXTINCTION.

General Agreement on Tariffs and Trade (GATT)
United Nations agency of international trade, subsumed into
the new WORLD TRADE ORGANIZATION in 1995. Founded in
1948, GATT was designed to prevent "tariff wars" (the retaliatory escalation of tariffs) and to work towards the reduction of
tariff levels. Most non-communist states were party to GATT.
General Certificate of Education (GCE) Secondary education qualification gained through public examination in the
UK, except Scotland. Until 1988, pupils took GCE Ordinary
level examinations around the age of 16; they were replaced
by the GENERAL CERTIFICATE OF SECONDARY EDUCATION. GCE
Advanced level (A-level) examinations are taken by many
students at 18 and are used for higher-education entrance.

General Certificate of Secondary Education (GCSE) Secondary education qualification gained through public examination in UK, except Scotland. It replaced GCE Ordinary level and the Certificate of Secondary Education in 1988. general strike Stoppage of work by all or most workers simultaneously. In Britain a nationwide general strike, involving about 3 million workers, was called in May 1926 in support of the coal miners, who had struck in protest against reduced pay. General strikes played a part in undermining communist regimes in Europe in 1989.

generator Device for producing electrical energy. The most common is a machine that converts the mechanical energy of a turbine or internal combustion engine into electricity by employing ELECTROMAGNETIC INDUCTION. There are two types of generators: alternating current (an alternator) and direct current (a dynamo). Each has an armature (or ring) that rotates within a magnetic field creating an induced ELECTRIC CURRENT.

▶ gecko The banded gecko (Coleonyx variegatus) is one of a great many species of gecko inhabiting desert regions. It is nocturnal, hiding under rocks during the day and foraging for insects at night.

gene replacement therapy (GRT) Method of treating hereditary disorders using GENETIC ENGINEERING. Affected cells are removed from the patient and their faulty DNA repaired. The repaired cells are then reintroduced into the patient's body. GRT shows most promise with inherited blood disorders (such as SICKLE-CELL ANAEMIA), and has been successfully carried out on animals. See also GENE; GENETICS Genesis First book of the OLD TESTAMENT and of the PENTATEUCH or TORAH. It probably achieved its final form in the 5th century BC, but parts may be much older. It relates the creation of the universe, from ADAM and EVE to ABRAHAM, and from Abraham to JOSEPH, and the descent into Egypt.

Genet, Jean (1910–86) French dramatist and novelist. In works such as *Notre Dame des Fleurs* (1944) and *Journal du Voleur* (1949) he records his experiences as a homosexual in brothels and prisons. A leading exponent of the dramatic theories of the Theatre of the ABSURD, he employed elements of the fantastical and the bizarre in his work.

genet Cat-like carnivore of the CIVET family, native to W Europe and S and E Africa. Solitary and nocturnal, genets have slender bodies, short legs, grey to brown spotted fur and banded tails. Length: body – to 58cm (22in), tail – to 53cm (21in); weight: to 2kg (4.4lb). Family Viverridae; genus *Genetta*.

genetic code Arrangement of information stored in GENES. It is the ultimate basis of HEREDITY and forms a blueprint for the entire organism. The genetic code is based on the genes that are present, which, in molecular terms, depends on the arrangement of nucleotides in the long molecules of DNA in the cell CHROMOSOMES. Each group of three nucleotides specifies, or codes, for an amino acid, or for an action such as start or stop. By specifying which PROTEINS to make and in what quantities, the genetic code directly controls production of structural materials. It also codes for ENZYMES, which regulate all the chemical reactions in the cell, thus indirectly coding for the production of other cell materials as well.

genetic engineering Construction of a DNA molecule containing a desired gene. The gene is then introduced into a bacterial, fungal, plant, or mammalian cell, so that this cell produces the desired protein. It has been used to produce substances such as human growth hormone, insulin and enzymes for biological washing powder. There are concerns about the ethics of genetic engineering, given that scientists may be able to alter human genetic structure.

genetic fingerprinting Forensic technique pioneered by Alec Jeffreys in 1950. It uses genetic material, specifically the DNA within sample body cells, to identify individuals. It is used in paternity suits to detect the true father of a child, and sometimes in rape cases. The technique's first use in a court of law was in the late 1980s.

genetics Study of HEREDITY. Geneticists study how the characteristics of an individual organism depend on its GENES; how the characteristics are passed down to the next generation; and how changes may occur through MUTATION. A person's behaviour, learning ability and physiology may be explained partly by genetics, although the environment in which an individual lives has a considerable influence too. See also GENETIC CODES; GENETIC ENGINEERING

Geneva City at the s end of Lake Geneva, Sw Switzerland. A Roman town, it was taken by the Franks in the 6th century and passed to the HOLY ROMAN EMPIRE in the 12th century. During the REFORMATION, it became the centre of PROTESTANTISM under John CALVIN. It joined the Swiss Confederation in 1814 and was the scene of the GENEVA CONVENTION in 1864. It was the seat of the LEAGUE OF NATIONS (1919–46) and is the head-quarters of the Red Cross and the World Health Organization. It has a university, founded by Calvin, and a Gothic cathedral. Industries: banking, watch-making and jewellery, precision instruments, tourism, enamelware. Pop. (1992) 169,600.

Geneva, Lake (Lac de Genéve, Lac Léman) Lake in sw Switzerland and E France. Crescent-shaped, it lies between the ALPS and the JURA MOUNTAINS. Its s shore forms part of the French–Swiss border. It is drained to the w by the River Rhône. Length: 72km (45mi). Width: up to 14km (9mi). Area: 580sq km (224sq mi).

Geneva convention Series of agreements, beginning

1864, on the treatment of wounded soldiers and prisoners during war, and on the neutrality of the medical services.

Genghis Khan (1167–1227) Conqueror and founder of the Mongol empire. He united the Mongol tribes in 1206 and demonstrated his military genius by capturing Peking (1215), annexing Iran, and invading Russia as far as Moscow. His empire was divided and expanded by his sons and grandsons. Genoa (Genova) Seaport on the Gulf of Genoa, NW Italy; capital of Liguria region. An influential trading power during the Middle Ages, its fortunes declined in the 15th century and it came under foreign control. It has a university (1471) and an Academy of Fine Arts (1751). Industries: oil refining, motor vehicles, textiles, chemicals, paper, shipbuilding. Pop. (1992) 667,563.

genocide Policy aimed at destroying a racial, religious or ethnic group. The Nazi extermination of Jews during World War 2 is an example of genocide.

genome Entire complement of genetic material carried within the CHROMOSOMES of a single cell. In effect, a genome carries all the genetic information about an individual; it is coded in sequence by the DNA that makes up the chromosomes. The term has also been applied to the whole range of GENES in a particular species. *See also* GENETICS

genotype Genetic makeup of an individual. The particular set of GENES present in each cell of an organism is distinct from the PHENOTYPE, the observable characteristics of the organism. **genre painting** Art term used to define paintings that portray scenes of everyday life. It appeared in the late 18th century to define the small paintings of household interiors popularized by 17th-century Dutch artists.

Gentile da Fabriano (1370–1427) Italian painter. A leader of the International Gothic style, he greatly influenced Florentine art with frescos and the *Adoration of the Magi* (1423) for the Church of Santa Trinita, Florence.

genus Group of closely related biological SPECIES with common characteristics. The genus name is usually a Latin or Greek noun. *See also* TAXONOMY

geochemistry Study of the chemical composition of the Earth and the changes that have resulted in it from chemical and physical processes.

geodesic dome Architectural structure of plastic, metal or cardboard, based, in shape, upon triangular or polygonal facets. They were originated (1947) by R. Buckminster FULLER.

geodesic surveying Method of surveying that covers areas large enough to involve consideration of the Earth's curvature. Geodesic surveying is used to establish features, such as national boundaries, and for mapping whole states or countries. **Geoffrey of Monmouth** (1100–54) Welsh priest and

GENE REPLACEMENT THERAPY (GRT)

GRT is used to treat severe combined immunodeficiency (SCID), where the gene responsible for production of the enzyme adenosine deaminase (ADA) is missing. As ADA is essential for white blood cell production, this renders the body open to infection. Two retroviruses (1) are introduced into the bone marrow. These have the ability to produce RNA from their DNA (2) using a reverse transcriptase enzyme (3) This DNA is then incorporated into the human chromosomes (4). When these chromosomes multiply, new viral RNA and viral proteins as well as ADA are produced (5). The first two produce more new viruses, while the ADA is used by the body to produce vital white blood cells. The process then repeats and spreads throughout the bone marrow.

▶ geological time The 4,600 million years since the formation of the Earth are divided into four great eras, which are further solit into periods and, in the case of the most recent era, epochs. The present era is the Cenozoic ("new life"), extending backwards through "middle life" and "ancient life" to the Pre-Cambrian. Although traces of ancient life have since been found, it was largely the proliferation of fossils from the beginning of the Paleozoic era onwards some 570 million years ago, which first allowed precise sub-divisions to be made

▲ geomagnetism A magnetic survey from a research ship (1) sailing back and forth over a midoceanic ridge gives readings (2, 3, 4) that indicate that the magnetism of the rocks of the seafloor points alternately north and south in a series of hands parallel to the ridge (6). The pattern of bands is identical at each side of the axis and corresponds to the pattern of reversals in the Earth's magnetic field for the last few million years (5). The rocks moving away from the axis carry a record of the Earth's magnetic field.

chronicler, best known for his *History of the Kings of Britain*. Though accepted as reliable until the 17th century, Geoffrey essentially told folk tales. His book was the chief source for the legend of King ARTHUR and his knights, and it was Shakespeare's source for *King Lear* and *Cymbeline*.

geography Science studying the physical nature of the Earth and people's relationship to it. It includes land masses and features, seas, resources, climate and population.

geological time Time scale of the history of Earth. Until recently, only methods of relative dating were possible, by studying the correlation of rock formations and fossils. The largest divisions of geologic time are called eras, each of which is broken down into periods, which, in turn, are subdivided into series or epochs.

geology Study of the materials of the Earth, their origin, arrangement, classification, change and history. Geology is divided into several categories, the major ones being mineralogy (arrangement of minerals), petrology (rocks and their combination of minerals), stratigraphy (succession of rocks in layers), palaeontology (study of fossilized remains), geomorphology (study of landforms), structural geology (classification of rocks and the forces that produced them), and environmental geology (study of use of the environment).

geomagnetism Physical properties of the Earth's magnetic field. Geomagnetism is thought to be caused by the metallic composition of the Earth's core. The gradual movements of magnetic north result from currents within the MANTLE.

geometric mean The geometric mean of *n* numbers is the *n* th root of their product. For example, the geometric mean of 8 and 2 is $\sqrt{(8 \times 2)} = 4$.

geometry Branch of mathematics concerned with shapes. Euclidean geometry deals with simple plane and solid figures. Analytic geometry (coordinate geometry), introduced by DESCARTES (1637), applies algebra to geometry and allows the study of more complex curves. Projective geometry, introduced by Jean-Victor Poncelet (1822), is concerned with projection of shapes and with properties that are independent of such changes. More abstraction occurred in the early 19th century with formulations of non-Euclidean geometry by Janos Bolyai and N. I. Lobachevsky, and differential geometry, based on the application of calculus. See also TOPOLOGY geomorphology Scientific study of features of the Earth's surface and the processes that have formed them.

geophysics Study of the characteristic physical properties of the Earth as a whole system. It uses parts of CHEMISTRY, GEOLOGY, ASTRONOMY, SEISMOLOGY, METEOROLOGY and many other disciplines. From the study of seismic waves, geophysicists have deduced the Earth's interior structure.

George, Saint (active 3rd–4th century) Early Christian martyr who became patron saint of England in the late Middle Ages. According to tradition he was born in Palestine and martyred probably at Lydda some time before 323. Many stories grew up about him, including the 12th-century tale of his killing a dragon to save a maiden. His feast day is 23 April.

George I (1660–1727) King of Great Britain and Ireland (1714–27), and Elector of Hanover (1698–1727). A Protestant, he succeeded Queen Anne as the first Hanoverian monarch. He favoured the Whios over the Tories, suspecting the latter of Jacobite sympathies. As king of England, he preferred his native Hanover and spoke little English. As a result, power passed increasingly to ministers, especially Sir Robert Walpole, and Parliament.

George II (1683–1760) King of Great Britain and Ireland and Elector of Hanover (1727–1760). Son of George I, he too was more German than English. Sir Robert WALPOLE dominated politics early in the reign. George survived a JACOBITE revolt (1745) and was the last British king to lead his army in battle, at Dettingen (1746). British prosperity was growing fast, and George witnessed great victories overseas in the SEVEN YEARS WAR.

George III (1738–1820) King of Great Britain and Ireland (1760–1820), and King of Hanover (1760–1820). Grandson of George II, he was the first thoroughly English monarch of his line. His reign saw the loss of the American colonies, wars with France, and the first stages of the Industrial Revolution. In 1765 he suffered his first attack of apparent insanity, now known to be symptoms of porphyria. They grew worse and in 1811 his son, the future George IV, was made prince regent. **George IV** (1762–1830) King of Great Britain and Ireland (1820–30). He served as regent for his father, George III, from 1811, ascending the throne in 1820. Self-indulgent and extravagant, he was bored by government but was a strong

patron of the arts. His marriage to Caroline of Brunswick

(1795) became a source of scandal and he contracted a legal-

ly invalid marriage with Mrs Fitzherbert in 1785.

George V (1865–1936) King of Great Britain and Northern Ireland and Emperor of India (1910-36). The second son of EDWARD VII, he married Princess Mary of Teck in 1893. In 1917 he changed the name of the royal house from the German SAXE-COBURG-GOTHA to Windsor. Honourable and devoted to duty, he maintained the popularity of the monarchy. George VI (1895–1952) King of Great Britain and Northern Ireland (1936-52) and Emperor of India (1936-47). He became king when his brother, EDWARD VIII, abdicated. In 1923 he married Lady Elizabeth Bowes-Lyon. He refused to move his family away from London during the BLITZ. In 1949 he became head of the newly formed COMMONWEALTH. **George I** (1845–1913) King of the Hellenes (1863–1913). Made king by Great Britain, France and Russia, with the approval of the Greek national assembly, he backed the constitution of 1864 giving power to an elected parliament. He gained territory through the Balkan Wars. He was assassinated in 1913 and was succeeded by his son Constantine I.

Georgetown Capital and largest city of Guyana, at the mouth of the River Demerara. Founded in 1781 by the British, it was the capital of the united colonies of Essequibo and Demerara and was known as Stabroek during the brief Dutch occupation from 1784. Renamed Georgetown in 1812 by the British, it is the country's major port. Industries: shipbuilding, brewing and rum-distilling. Pop. (1985 est.) 200,000.

Georgetown See PENANG

Georgia Republic in central Europe. *See* country feature **Georgia** State in SE USA, on the Atlantic Ocean, N of Florida; the capital is ATLANTA. Other major cities are Columbus, Macon and Savannah. First settled in 1732, it was one of the original six states of the Confederacy in the American CIVIL WAR. Ravaged by the armies of General Sherman in 1864, Georgia was readmitted to the Union in 1870. In the s and E of the state is a broad coastal plain. The central area consists of the Piedmont plateau beyond which, in the N, are the Blue Ridge Mountains and the Appalachian plateau. The area is drained by the Savannah, Ogeechee and Altamaha rivers. Cotton, once the chief crop, has declined in favour of tobacco, peanuts, livestock and poultry. Textiles have been a major industry, but chemicals,

paper and timber, and the manufacture of ships, aircraft and truck bodies are becoming increasingly significant. Area: 152,488sq km (58,876sq mi). Pop. (1996 est.) 7,193,700.

Georgian architecture Building styles in Britain and its colonies (1714-1830). The name derives from the Hanoverian kings who reigned during this period (George I-IV). The various Georgian styles include ROCOCO, Greek revival, NEO-CLASSICISM, GOTHIC REVIVAL and REGENCY STYLE.

Georgian language Language of GEORGIA. The most important member of the South Caucasian (Kartvelian) language family, it is used by nearly 4 million people.

geostationary orbit Location of an artificial satellite so that it remains above the same point on a planet's surface. Communications and remote-sensing satellites are often placed in geostationary orbits.

geothermal energy Heat contained in the Earth's crust. It is produced by RADIOACTIVITY within the Earth's core and by the movement of tectonic plates. It is released naturally by GEYSERS and VOLCANOES, and can be used as a power source for generating electricity. See also PLATE TECTONICS

geranium (Pelargonium) Genus of 400 perennial plants. They bear pink, purple or white flowers. Family Geraniaceae. gerbil Nocturnal rodent native to arid areas of Asia and Africa; a popular pet. It has large eyes and ears, and long hind legs and tail. Its fur may be fawn, grey, brown or red. It is a subterranean herbivore and often hoards food. Family Cricetidae. geriatrics Branch of medicine that deals with the problems of the elderly.

Géricault, (Jean Louis André) Théodore (1791–1824) French painter. A forerunner of the romantic movement, he began by painting battles. His most famous work, Raft of the Medusa (1817), depicts the survivors of a shipwreck.

germ Popular term for any infectious agent. Germs can be bacteria, fungi or viruses. In biology, it denotes a rudimentary stage in plant growth.

German Indo-European language spoken by about 120 million people in Germany, Austria and Switzerland, and by German communities in other countries, including the Czech Republic, France, Italy, Poland and Russia. High German (Hochdeutsch), of s Germany and Austria, is now the standard dialect. Low German (Plattdeutsch) was spoken widely in the N but is now declining.

German architecture Architecture of Germany including, in its early days, that of Austria. The earliest surviving buildings date from CHARLEMAGNE. They are in the ROMANESOUE style, at its best in Worms cathedral (built c.1180).

GEORGIA Statehood:

2 January 1788

Nickname:

Empire state of the South

State bird: Brown thrasher

State flower:

Cherokee rose

State tree :

Live oak

State motto:

Wisdom, justice and moderation

GEORGIA

Georgia's flag was first used between 1917 and 1921. It was readopted when Georgia became independent. The wine-red colour represents the good times of the past and the future. The black symbolizes Russian rule and the white represents hope for peace.

he Transcaucasian republic of Georgia contains two autonomous republics of ABK-HAZIA and Ajaria, and the province of Tskhinvali (South Ossetia). It has four geographical areas: the CAUCASUS Mountains form its N border with Russia, and include its highest peak, Mount Kazbek, at 5,042m (16,541ft); the fertile Black Sea coastal plain in the w: the E end of the Pontine Mountains form its s borders with Turkey and Armenia; and a low plateau to the E extends into Azerbaijan. Between the mountains lies the Kura valley and the capital TBILISI.

CLIMATE

The climate varies from subtropical in the Black Sea lowlands to the permanent snowcovered, alpine Caucasus. Tbilisi has moderate rainfall, hot summers and cold winters.

VEGETATION

Forest and shrub cover c.50% of Georgia. Alpine meadows lie above the tree line. The coastal plain has apple orchards and orange groves.

HISTORY

The land of the legendary Golden Fleece, Georgia has a strong national culture and a long literary tradition based on their own language and alphabet. Georgia was an independent kingdom from c.4th century BC, and the Georgians formed the two Black Sea states of Colchis and Iberia in c.1000 BC. The Persian SASSANIDS ruled during the 3rd and 4th centuries AD. Christianity was introduced in AD 330, and the established church is independent Eastern Orthodox. In the 11th century, independence was won from the Turkish SELJUK empire. The 12th century was Georgia's greatest period of cultural, economic and military expansion. Thereafter it was divided and in the centre of a power struggle between the rival Persian and Turkish empires. In 1555 Georgia was divided between Persia (w) and Turkey (E). In the early 19th century, Georgia was absorbed into the Russian empire.

Despite a brief period of independence after the Russian Revolution, in 1921 Georgia became a constituent republic of the SOVIET UNION. Russia combined Georgia, Armenia and Azerbaijan into a single republic of TRANSCAU-CASIA. This federation was broken up in 1936, and Georgia became a separate Soviet republic. Joseph STALIN, the Soviet Union's second leader, was born in Gori, Georgia.

Following violent demonstrations in 1989, Georgia declared its independence (May 1991). By the end of 1991, President Gamsakhurdia's authoritarian regime had led to civil war in the streets of Tbilisi. In 1992 Eduard SHEVARD-

AREA: 69,700sg km (26,910sg mi)

POPULATION: 5,456,000

CAPITAL (POPULATION): Tbilisi (1,279,000) GOVERNMENT: Multiparty republic

ETHNIC GROUPS: Georgian 70%, Armenian 8%, Russian 6%, Azerbaijani 6%, Ossetes 3%, Greek 2%, Abkhazian 2%, others 3% LANGUAGES; Georgian (official)

RELIGIONS: Christianity (Georgian Orthodox 65%, Russian Orthodox 10%, Armenian

Orthodox 8%), Islam 11%

CURRENCY: Lary

NADZE was elected president. Faced by conflict from Gamsakhurdia's supporters and secessionist movements in Abkhazia and South Ossetia, Shevardnadze called in Russian troops to defeat the rebellion.

POLITICS

In return for Russian support, Georgia joined the COMMONWEALTH OF INDEPENDENT STATES (CIS) and allowed Russia ultimate economic power. Minority demands for secession continued, and in 1995 South Ossetia was renamed Tskhinvali and Abkhazia granted autonomous status. Conflict continues in the region and CIS peacekeeping forces are deployed in Abkhazia.

ECONOMY

Georgia is a developing country (1992 GDP per capita, US\$2,300), its economy devastated by civil war and the break-up of the Soviet Union. Agriculture engages 58% of the workforce, though the rugged terrain makes farming difficult. The E region is famous for its grapes, used to make wine. The coastal lowlands produce large amounts of tea and tropical fruit, and are a tourist destination. Georgia is rich in minerals, such as barite, coal and copper. These remain relatively unexploited, though manganese is mined relatively extensively. Georgia has huge potential for generating hydroelectric power, but is desperately short of energy and dependent on Ukraine, Azerbaijan and Russia for oil.

This flag, adopted by the Federal Republic of Germany (West Germany) in 1949, became the flag of the reunified Germany in 1990. The red, black and gold colours date back to the Holy Roman Empire. They are associated with the struggle for a united Germany from the 1830s.

The Federal Republic of Germany lies in the heart of Europe. It is the fifth-largest country in Europe (after Ukraine, France, Spain and Sweden), but the world's 12th most populous country. Germany can be divided into three geographical regions: the N German plain, central highlands and the S Central Alps.

The fertile N plain is drained by the rivers ELBE, Weser and Oder. It includes the industrial centres of HAMBURG, BREMEN, HANOVER and KIEL. In the E, lies the capital, Berlin, and the former East German cities of LEIPZIG, DRESDEN and MAGDEBURG. NW Germany (especially the

RHINE, RUHR and Saar valleys) is Germany's industrial heartland. It includes the cities of COLOGNE, ESSEN, DORTMUND, DÜSSELDORF and DUISBURG. The central highlands include the HARZ MOUNTAINS and the cities of MUNICH, FRANKFURT AM MAIN, STUTTGART, NUREMBERG and AUGSBURG. Southern Germany rises to the Bavarian ALPS on the border with Switzerland and Germany's highest peak, Zugspitze, at 2,963m (9,721ft). The BLACK FOREST, overlooking the Rhine valley, is a major tourist attraction. The region is drained by the DANUBE (Europe's second-largest river).

DENMARK MAP SCALE Baltic Sea North Puttgard Sacchitz HLEWIG-Kiel Stralsund North Sea 540 Rostoc Cuxhaver East Frisian Islands Lübec MECKLENBURG Wilhelmshav Neubrand Hamburg WEST POMERANIA P Ö Wittstock Luneburg Heath BRANDENBUR NETHER-A Berlin LANDS & N Wolfsburg D Brunswie Osnabrück Oder Hildeshein Bielefeld? Salzgitte Dessau RHINE. Harz Paderhorn Leipzig A X O Chemr THURINGIA Jena Bonn Zwickau Suhl Thuringian For BELGEUM CZECH 50°N Bayreuth RHEINLAND-Darmstadt Würzburg REPUBLIC PFALZ Heidelberg Nuremberg Ludwigshafen Heilbron В A Stuttgart Ingolstadt Ulm FRANCE Reutlin EMBERG Augsbur Munich S TZERLAND

AREA: 356,910sq km (137,803sq mi) POPULATION: 80,569,000

CAPITAL (POPULATION): Berlin (3,446,000) GOVERNMENT: Federal multiparty republic ETHNIC GROUPS: German 93%, Turkish 2%, Yugoslav 1%, Italian 1%, Greek, Polish.

Spanish
LANGUAGES: German (official)

RELIGIONS: Christianity (Protestant, mainly Lutheran 45%, Roman Catholic 37%), Islam

currency: Deutschmark = 100 Pfennige

CLIMATE

Germany has a temperate climate. The Nw is warmed by the North Sea. The Baltic lowlands in the NE are cooler. In the s, the climate becomes more continental.

VEGETATION

The North German plain contains large areas of heath. The forests of central and s Germany include pine, beech and oak.

HISTORY

In c.2000 BC, German tribes began to displace the Celts. In the 5th century AD, they conquered much of the western Roman empire. In 486 CLOVIS I conquered s and w Germany and THURINGIA. His son CHARLEMAGNE expanded the territory to the Elbe and was crowned emperor (800). His empire rapidly fragmented, and the FEUDAL SYSTEM created powerful local duchies. In 918 HENRY I (THE FOWLER) began a century of SAXON rule, and his son OTTO I (THE GREAT) established the HOLY ROMAN EMPIRE (first Reich) (962).

In 1152 FREDERICK I founded the HOHEN-STAUFEN dynasty. FREDERICK II's conflict with the papacy created civil war. In 1273 Rudolf I founded the HABSBURG dynasty. City states formed alliances, such as the HANSEATIC LEAGUE. CHARLES V's reign (1519-58) brought religious and civil unrest, such as the REFORMA-TION and the PEASANTS' WAR. Catholic and Protestant conflict culminated in the devastating THIRTY YEARS WAR (1618-48). The reign of FREDERICK II (THE GREAT) (1740-86) saw the emergence of the state of PRUSSIA. The NAPOLEONIC WARS (1803-15) were a humiliating defeat. The Congress of VIENNA (1815) created the German Confederation. The 19th century brought growing nationalism, fuelled by German ROMANTICISM. The REVOLUTIONS OF 1848 led to the election of BISMARCK as chancellor (1862-90). Prussian victories in the Austro-PRUSSIAN WAR (1866) and the FRANCO-PRUSS-IAN WAR (1870-71) created the second German reich under the HOHENZOLLERN king, WILLIAM I.

Prince von Bülow's imperial ambitions were a cause of World War 1 (1914–18). The Treaty of Versailles (1919) placed a heavy price on German defeat. William II was forced to abdicate, and the Weimar Republic (1919–33) was created. Mass unemployment, crippling inflation, war reparations, and world depression created the conditions for FASCISM. The leader of the National Socialist Party, Adolf Hitler, was elected (1933) to build a Third Reich.

NATIONAL SOCIALISM pervaded all areas of society, dissent was crushed by the GESTAPO,

GERMANY

opposition parties and elections banned. Hitler, as Führer, became the father of the nation through GOEBBELS' propagandizing. CONCEN-TRATION CAMPS were set up and armaments stockpiled. Hitler remilitarized the RHINELAND (1936), aided Franco in the Spanish CIVIL WAR (1936-39), and annexed Austria (1938). The MUNICH AGREEMENT (1938) marked the failure of appeasement, Germany invaded Czechoslovakia (March 1939) and Poland (September 1939), precipitating WORLD WAR 2. Initial success was halted by failure in the Battle of BRITAIN, and Hitler's disastrous Soviet offensive (June 1941). The blanket bombing of German cities devastated German industry and morale. Faced with defeat, Hitler committed suicide (April 1945). Germany surrendered (8 May 1945), and leading Nazis faced the NUREMBERG TRIALS. Germany was divided into four military zones. COLD WAR tension increased. Following the BERLIN AIRLIFT (1949), American, British and French zones were joined to make the Federal Republic of Germany (West Germany); the Soviet zone formed the German Democratic Republic (East Germany). Berlin was also divided: East Berlin became capital of East German, BONN de facto capital of West Germany.

Walter ULBRICHT became leader of East Germany (1950-71). Economic deprivation led to a revolt in 1953, which Soviet troops subdued. In 1955 East Germany joined the Warsaw Pact. From 1945-61, 4 million people crossed to the west. The BERLIN WALL was built to halt the exodus. Ulbricht was replaced by Erich HONECKER (1971-89). Relations with West Germany thawed, and travel was permitted between the two. Honecker's refusal to adopt reforms led to civil unrest. In November 1989, a rally of 500,000 people demanded reunification, the Wall was opened, and the regime collapsed. Christian Democrats won the first free elections (March 1990). In July 1990, East and West Germany were formally unified.

Konrad ADENAUER was elected as the first chancellor (1949–63) of **West Germany**. He was committed to German reunification. In 1955 West Germany became a member of NATO. The economy continued to grow dramatically under KIESINGER (1963–69). Willy BRANDT's chancellorship (1969–74) was noted for his *Ostpolitik* (establishing better relations with the Soviet bloc). His successor was Helmut SCHMIDT (1974–82). Helmut KOHL's chancellorship (1982–) was more conservative. In Decem-

ber 1990, Kohl was elected in the first all-German elections since 1933.

POLITICS

Reunification has meant massive investment to restructure the former East German economy, which has strained federal resources and entailed tax increases. High unemployment, unequal distribution of wealth, crime and the rise of neo-Nazi groups are all serious political problems. Germany is a major advocate of greater European cooperation.

ECONOMY

Germany is one of the world's greatest economic powers (1992 GDP per capita, US\$21,120). Services form the largest economic sector. Machinery and transport equipment account for 50% of exports. It is the world's third-largest car producer. Other major products: ships, iron, steel, petroleum, tyres. It has the world's second-largest lignite mining industry. Other minerals: copper, potash, lead, salt, zinc, aluminium. Germany has a large agricultural sector. It is the world's second-largest producer of hops and beer, and fifthlargest wine-producer. Other products: cheese and milk, raspberries, barley, rye, pigmeat.

Romanesque was superseded by GOTHIC, seen in ecclesiastical architecture and provincial buildings, such as the Rathaus (town hall) typical of NE German towns. There is little RENAIS-SANCE architecture in Germany, an exception being the rebuilt facade of the Rathaus in Bremen. The BAROQUE period extended into the ROCOCO, examples including the elaborate Church of the Vierzehnheiligen (Fourteen Saints) (1772) by Balthasar Neuman and masterpieces by Fischer von Erlach and Matthaeus Pöppelmann. Vienna has several examples of such work. In the late 1700s NEO-CLASSICISM inspired buildings in Berlin and Munich by Friedrich Schinkel, Leo von Klenze and others. New materials such as cast iron were exploited, as in Vienna's Dianabad (baths) by Karl Etzel (1843). Walter GROPIUS and the BAUHAUS dominated the beginning of the 20th century. In the 1930s, MIES VAN DER ROHE exemplified the INTERNATIONAL STYLE, which was replaced by the re-adoption of neo-classicism under HITLER, with "official" Nazi architect Albert Speer. After the destruction of World War 2, most new buildings adopted principles of EXPRESSIONISM or MODERNISM. German art Dates back to the illuminated manuscripts of

the 9th and 10th centuries. By the end of the Middle Ages, a flourishing tradition in wood-carving had grown up in the s with the work of Veit Stoss and Tilman Riemenschneider. In the 16th century, Germany was at the forefront of the Northern Renaissance, led by Albrecht Dürer and Hans Holbein the Younger. This was a golden age for German painting and, although Caspar Friedrich made an important contribution to ROMANTICISM, it was only in the 20th century that EXPRESSIONISM and BAUHAUS achieved comparable status.

Germanic languages Group of languages, a sub-division of the INDO-EUROPEAN family. One branch (West Germanic) includes English, German, Yiddish, Dutch, Flemish, Frisian and Afrikaans; another (North Germanic) includes Swedish, Danish, Norwegian, Icelandic and Faroese.

germanium (symbol Ge) Grey-white metalloid element of group IV of the PERIODIC TABLE, discovered in 1886. A byproduct of zinc ores or the combustion of certain coals, it is important in semiconductor devices. Properties: at.no. 32; r.a.m. 72.59; r.d. 5.35; m.p. 937°C; (1,719 °F); b.p. 2,830°C (5,126°F); most common isotope Ge⁷⁴ (36.54%).

German measles (rubella) Viral disease usually contracted in childhood. Symptoms include a sore throat, slight fever and pinkish rash. Women developing rubella during the first three months of pregnancy risk damage to the fetus. Immunization is recommended for girls who have not had the disease.

German shepherd (Alsatian) Working dog bred in Germany by about 1900. It has woolly underhair and is black, grey or black and tan. Height: *c*.64cm (25in) at the shoulder; weight: 27–38kg (60–85lb).

Germany Republic in central Europe. *See* country feature **germination** Growth of the embryo in the seed of a new plant. To germinate, a seed or spore needs favourable conditions of temperature, light, moisture and oxygen. *See also* DICOTYLEDON

Geronimo (1829–1908) Chief of the Chiricahua Apaches. He led his tribe against white settlers in Arizona for over ten years. In 1886 he surrendered his tribe to General Miles, and they were taken to Fort Sill, Oklahoma. He became a farmer and national celebrity.

Gerry, Elbridge (1744–1814) US vice president (1813–14). Elected to the Massachusetts General Court (1772), he signed the Declaration of Independence but refused to sign the Constitution until the Bill of Rights was added. Elected vice president under James MADISON, he died in office. *See also* GERRYMANDER

gerrymander Practice of redrawing electoral boundaries to favour a particular party. It is named after Elbridge GERRY, governor of Massachusetts (1810–12), whose party employed the practice. One of his redefined districts was said to resemble a salamander, hence gerrymander.

Gershwin, George (1898–1937) US popular composer. His brother Ira Gershwin (1896–1983) mostly wrote the lyrics. He wrote scores for several musicals, such as *Lady Be Good* (1924), a jazz opera *Porgy and Bess* (1935), and some serious orchestral works, such as *Rhapsody in Blue* (1924).

gestalt psychology School of psychology holding that phenomena are perceived as relating to a whole, rather than the sum of their parts. It was developed from the end of the 19th century in Germany by Max Wertheimer, Wilhelm WUNDT, Wolfgang KÖHLER and Kurt KOFFKA.

Gestapo (Geheime Staatspolizei) State secret police of Nazi Germany. Founded in 1933 by GOERING, it became a powerful, national organization under HIMMLER from 1934, as an arm of the SS. With up to 50,000 members by 1945, it had virtually unlimited powers in suppressing opposition.

gestation (PREGNANCY) Period that a developing EMBRYO is

▲ Getty As well as being one of the world's richest men, John Paul Getty was considered an important patron of the arts.

A

▲ geyser A plume of hot water and steam, a geyser is the result of the boiling of water at depth in a series of interconnecting chambers by volcanic heat (A). The expansion of steam produced drives the water and steam above it out at the surface (B), and this is followed by a period of refilling and heating making it a periodic phenomenon (C).

carried in the UTERUS. Gestation periods are specific to each mammalian species.

Getty, Jean Paul (1892–1976) US businessman and art collector. He inherited his father's oil business, becoming its president in 1930. After 1959 he lived in England. He was one of the world's richest men, with a fortune estimated at more than \$1,000 million.

Gettysburg, Battle of Decisive campaign of the American CIVIL WAR, fought over three days in July 1863 near Gettysburg, Pennsylvania. The Union army of George Gordon Meade checked the invasion of Pennsylvania by the Confederate forces of Robert E. Lee. The battle was a turning point. The heavy casualties (*c*.20,000 each side) prompted Abraham Lincoln's GETTYSBURG ADDRESS.

Gettysburg Address Speech by US President Abraham LINCOLN on 19 November 1863 at the dedication of the national cemetery on the battlefield of GETTYSBURG. It ended by describing democracy as "government of the people, by the people and for the people".

Getz, Stan (1927–91) US jazz saxophonist. He played with Woody Herman in the 1940s, going on to lead his own groups and develop his soft, breathy sound. Popular and widely respected, he was influenced by Lester Young.

geyser Hot spring that erupts intermittently, throwing up jets of superheated water and steam to a height of c.60m (200ft), followed by a shaft of steam with a thunderous roar. Geysers occur in Iceland, New Zealand and the USA.

Ghana Republic in w Africa. See country feature

Ghats Two mountain systems in India running parallel to the coast on both sides of the Deccan Plateau. The Western Ghats extend from the Tapti River to Cape Comorin. The Eastern Ghats extend from the Mahānadi River to the Nilgiri Hills. Height: (Western) 900–1,500m (2,950–4,920ft); (Eastern) 600m (1,970ft). Length: (Western) 1,600km (1,000mi); (Eastern) 1,400km (875mi).

Ghazali, al- (1058–1111) Muslim scholar and mystic. He wrote on law, philosophy, theology and mysticism. He has been called the renewer of Islam. *See also* SUFISM

Ghent (Gent, Gand) City in NW central Belgium. A major cloth centre in the 13th century, it came under Austrian control from 1714 and was captured by the French in 1792, becoming part of independent Belgium in 1830. Textile factories revived its prosperity in the 19th century, and it was occupied by Germany in both World Wars. Notable buildings include the 12th-century Cathedral of St Bavon and the 16th-century Town Hall. Industries: plastics, chemicals, steel, electrical engineering and motor vehicles. Pop. (1993 est.) 228,490.

Ghent, Treaty of (1814) Agreement ending the WAR OF 1812 between Britain and the USA. It appointed a commission to settle the dispute over the USA—Canada boundary.

Ghibelline Political faction in 13th-century Italy that supported the HOHENSTAUFEN dynasty of the HOLY ROMAN EMPIRE and opposed the pro-papal GUELPHS. During the struggles between FREDERICK II and the popes in the mid-13th century, Ghibellines came to designate those on the imperial side. Defeated by the Guelphs in 1268, the family went into decline.

Ghiberti, Lorenzo (1378–1455) Italian sculptor, goldsmith, architect, painter and writer; a major transitional figure between the late GOTHIC and RENAISSANCE worlds. He made two pairs of bronze doors for the Baptistery in Florence. One pair, the "Doors of Paradise", is considered his masterpiece.

Ghirlandaio, Domenico (1449–94) Florentine painter, best known for his frescos. He worked on the Sistine Chapel with BOTTICELLI and others, his major contribution being *Christ Calling the First Apostles* (1482).

Ghose, Aurobindo (1872–1950) (Sri Aurobindo) Indian mystic and philosopher. After his imprisonment and acquittal by the British in 1909 on charges of sedition, he renounced nationalist politics for Hindu philosophy.

Giacometti, Alberto (1901–66) Swiss sculptor and painter, influenced by SURREALISM. During the 1940s and 1950s he produced his most characteristic works: emaciated, dream-like figures built of plaster on a wire base. His paintings have the same agitated, visionary quality.

Giant's Causeway Promontory on the N coast of Northern

Ireland in County Antrim. It extends 5km (3mi) along the coast and consists of thousands of basalt columns of varying height. **gibberellin** Any of a group of plant HORMONES that stimulate cell division, stem elongation and response to light and temperature. They have been used to increase crop yields.

gibbon Ape, native to forests in SE Asia. It has a shaggy brown, black or silvery coat and is very agile. It has long, powerful arms for swinging from branch to branch. Height: 41–66cm (16–26in). Family Pongidae, genus *Hyloblates*.

Gibbon, Edward (1737–94) British historian. He conceived the idea of his great work, *The Decline and Fall of the Roman Empire* (1776–88), while among the ruins of ancient Rome.

Gibbons, Grinling (1648–1721) English wood carver, best known for his carved fruit and flowers. There are examples of his work at St Paul's Cathedral, London, and in many country houses. His patrons included Charles II and George I.

Gibbons, Orlando (1583–1625) English composer. He wrote viol fantasies and madrigals, such as *The Silver Swanne*. A master of POLYPHONY, he composed mostly church music.

Gibbs, James (1682–1754) British architect who was inspired by Sir Christopher WREN. Gibbs was an individualist, fitting neither into the BAROQUE style, which preceded him, nor the later Palladian. His best-known work is the church of St Martin in the Fields, London (1722–26).

Gibbs, Josiah Willard (1839–1903) US theoretical physicist and chemist. His application of thermodynamics to physical processes led to statistical mechanics. He devised the phase rule and developed vector analysis.

Gibraltar British crown colony, a rocky peninsula on the s coast of Spain. The MUSLIM conquest of Spain began in 711, and Gibraltar remained under Moorish control until 1462. In 1704 it was captured by an Anglo-Dutch fleet and was ceded to Britain by the Treaty of UTRECHT (1713). In 1964 it was granted extensive self-government. In a 1967 referendum the islanders voted against independence. Industries: tourism, reexportation of petroleum and petroleum products. Area: 6.5sq km (2.5sq mi). Pop. (1993 est.) 28,051.

Gibson, Mel (1956–) Australian film actor and director, b. USA. International recognition followed his starring roles in Mad Max (1979) and Gallipoli (1981). He showed his versatility in the Zeffirell production of Hamlet (1990). In 1995 he won Best Director and Best Picture Oscars for Braveheart. Gide, André Paul Guillaume (1869–1951) French novelist, playwright and critic. His novels and Journals (1885–1950) show the constant struggle between his puritan and pagan elements. Mature works, such as Les Faux-monnayeurs (1926), dramatize a search for spiritual truth. He was awarded the 1947 Nobel Prize for literature.

Gideon International Worldwide organization that seeks to spread Christianity by distributing Bibles to hotel rooms, hospitals, military barracks, prisons and other public places. It was founded in the USA (1899) by three commercial travellers.

Gielgud, Sir Arthur John (1904–) British stage and film actor and director. His excellent performances in both modern and classical roles established him as one of the century's finest actors. He played almost every major Shakespearian role and appeared in *The Importance of Being Earnest* (1930, 1939) and *The Cherry Orchard* (1961). He achieved popular success in many films, such as *Arthur* (1981), *Gandhi* (1982), *The Shooting Party* (1985) and *Prospero's Books* (1991).

gila monster Poisonous nocturnal LIZARD that lives in deserts of sw USA and N Mexico. It has a stout body, massive head, flat tail and scales of orange, yellow and black. It eats small mammals and eggs. Length: 50cm (20in). Family Helodermatidae; species *Heloderma suspectum*.

Gilbert, Cass (1859–1934) US architect, inspired by NEO-CLASSICISM. He designed the US Supreme Court Building in Washington, D.C. and the Woolworth Building in New York, which influenced the development of skyscrapers.

Gilbert, William (1544–1603) English physicist and physician to Queen Elizabeth I. He was the first to recognize terrestrial MAGNETISM and coined the terms magnetic pole, electric attraction and electric force.

Gilbert, Sir W.S. (William Schwenck) (1836–1911) English librettist and playwright. He collaborated with Sir Arthur SULLIVAN on an immensely successful series of 14 comic operettas, nearly all first performed by the D'Oyly CARTE company. Their works include *The Mikado* (1855), *HMS Pinafore* (1878) and *The Pirates of Penzance* (1879). **Gilbert and Ellice Islands** Two groups of coral islands in the w Pacific Ocean, 4,000km (2,500mi) Ne of Australia. In 1915 the islands became a British colony. Separated from the Ellice Islands in 1975, the Gilbert Islands are now part of KIRIBATI. The Ellice Islands are now called TUVALU.

Gilgamesh Hero of the great Assyro-Babylonian myth, the Epic of Gilgamesh. He went in search of the secret of immortality. Having overcome monsters and gods, he found the flower of life, only to have it snatched from him by a serpent. Gill, (Arthur) Eric (Rowton) (1882–1940) British engraver and sculptor. He designed many typefaces, including Gill sans serif (1927), and produced marvellous carved sculptures. His carvings include the Stations of the Cross (1914–18) in Westminster Cathedral, London.

Gillespie, "Dizzy" (John Birks) (1917–93) US jazz trumpeter and bandleader. One of the central figures in the history of jazz, with Charlie (Bird) PARKER he helped found BEBOP. After 1950 he led his own groups and made many recordings.

Gillray, James (1757–1815) English caricaturist, whose witty cartoons were famous throughout Europe. His political and social satire was wider in scope than that of HOGARTH. His caricatures include "Farmer George" (George III) and "Temperance Enjoying a Frugal Meal".

gills Organs through which most fish, some larval amphibians, such as tadpoles, and many aquatic invertebrates obtain oxygen from water. When a fish breathes it opens its mouth, draws in water and shuts its mouth again. Water is forced through the gill slits, over the gills, and out into the surrounding water. Oxygen is absorbed into small capillary blood vessels, and at the same time, waste carbon dioxide carried by the blood diffuses into the water.

ginger Herbaceous PERENNIAL plant native to tropical E Asia and Indonesia and grown commercially in Jamaica and elsewhere. It has fat, tuberous roots and yellow-green flowers. The kitchen spice is made from the tubers of *Zingiber officinale*. Family Zingiberaceae.

Gingrich, Newt (Newton Leroy) (1943—) US politician. In the 1994 Congressional elections, he persuaded Republicans to subscribe to his "Contract with America", a commitment to cut wasteful government spending. As speaker in the House of

GHANA

Ghana's flag has red, green and yellow bands like the flag of Ethiopia, Africa's oldest independent nation. These colours symbolize African unity. The black star is a symbol of African freedom. Ghana's flag was adopted when the country became independent in 1957.

The Republic of Ghana (formerly Gold Coast) faces the Gulf of Guinea in West Africa. The densely populated s coastal plains are lined by lagoons and include the capital, ACCRA. In the sw plateau lies the ASHANTI region and its capital KUMASI. Ghana's major river is the VOLTA. The Aksombo Dam (built 1964) created one of the

world's largest artificial lakes, Lake Volta. The dam is used to generate hydroelectricity.

CLIMATE

Accra has a tropical climate, yet is cooler than many equatorial areas. Rain falls throughout the year, especially heavily in the sw. The N is warmer than the s. The winter months (November–March) have a low average rainfall.

VEGETATION

Tropical savanna dominates the coastal region and the far N. Rainforest covers most of the central region.

HISTORY

Various African kingdoms existed in the region before the arrival of Portuguese explorers in 1471, who named it the Gold Coast after its precious mineral resource. The Dutch gained control (1642), and the Gold Coast was a centre of the 17th-century slave trade. Following the abolition of slavery (1860s), the European powers withdrew under the advance of Ashanti. In 1874 Britain colonized the region, excluding Ashanti. In 1901 Ashanti was also subdued. The British developed cacao plantations.

After World War 2, nationalist demands intensified, and in 1951 elections were held. Kwame Nkrumah became prime minister. Ghana became the first African colony to gain full independence, in 1957. British Togoland was incorporated into the new state. The country was renamed Ghana after a powerful, medieval West African kingdom. In 1960 Ghana became a republic, with Nkrumah as president. In 1964

AREA: 238,540sq km (92,100sq mi)

POPULATION: 16,944,000

CAPITAL (POPULATION): Accra (949,013)

GOVERNMENT: Republic

ETHNIC GROUPS: Akan 54%, Mossi 16%, Ewe

12%, Ga-Adangame 8%, Gurma 3%

LANGUAGES; English (official)

RELIGIONS: Christianity 62% (Protestant 28%, Roman Catholic 19%), traditional beliefs

21%, Islam 16%

currency: Cedi = 100 pesewas

Ghana became a one-party state. The economy slumped, burdened by debt, corruption, and the falling cacao price. Nkrumah was deposed in a military coup (1966). Ghana briefly returned to civilian rule (1969–72). The National Redemptive Council (NRC), led by Colonel Acheampong (1972–78), continued to nationalize industry. In 1979 Flight-Lieutenant Jerry Rawlings overthrew the government, and executed opposition leaders. A civilian government was formed. In 1981 this was toppled by Rawlings.

POLITICS

In 1992 a new constitution paved the way for multiparty elections. Opposition parties and voters boycotted the elections, and The National Democratic Council (NDC), led by Rawlings, secured a victory. Rawlings became president in November 1992 and started a second term in 1997.

ECONOMY

Ghana is a low-income developing country (1992 GDP per capita, US\$2,110). Agriculture employs 59% of the workforce and accounts for over 66% of exports. Ghana is the world's fifth-largest producer of cocoa beans. Other cash crops: coffee, coconuts, palm kernels. Minerals are the second-largest export. Ghana is the world's tenth-largest producer of manganese. The Ashanti Goldfields Corporation is one of the world's largest producers. Timber is also an important export. The economy has grown significantly since 1983.

▼ glacier In spite of a return to warmer conditions, some regions of the world (namely those nearer the poles) are still covered by ice and are being greatly altered by its action. Glaciated regions have been subjected to erosion and deposition, the erosion mainly taking place in the highland areas, leaving features such as pyramidal peaks, corries, roches moutonnées, truncated spurs and hanging valleys. Most deposition has occurred on lowlands, where, after the retreat of the ice, moraines, drumlins, eskers, erratio boulders and alluvial fans remain.

Key:

- 1 pyramidal peak
- 2 firn (granular snow)
- 3 corrie
- 4 tarn (corrie lake)
- 5 arête
- 6 marginal crevasse
- 7 lateral moraine
- 8 medial moraine 9 terminal moraine
- 10 sérac
- 11 subplacial moraine
- 12 glacial table

- 17 finger lake

ginkgo (maidenhair tree) Oldest living species of GYM-NOSPERM, native to temperate regions of China, occurring only rarely in the wild. It dates from the late Permian period. It has fan-shaped leaves, small, foul-smelling fruits and edible, nut-like seeds. Height: to 30m (100ft). Phylum Ginkgophyta; species Ginkgo biloba.

Ginsberg, Allen (1926–97) US poet. Ginsberg's work was influenced by ZEN, meditation and the use of drugs. His most famous poems are Howl (1956), a condemnation of American society, which established him as the leading poet of the BEAT MOVEMENT, and Kaddish for Naomi Ginsberg (1894-1956) (1961), a lament for his mother.

ginseng Either of two perennial plants found in the USA (Panax quinquefolius) and E Asia (P. ginseng). It has yellowgreen flowers and compound leaves. The dried tuberous roots are used in Chinese traditional medicine. Height: to 51cm (20in). Family Araliaceae.

Giolitti, Giovanni (1842-1928) Italian statesman, five times prime minister (1892-1921). He introduced measures of social welfare and broadened the franchise. Although he instigated the Italo-Turkish War of 1911, he opposed Italy's entry into World War 1. He initially backed MUSSOLINI, withdrawing support in 1924.

Giorgione, **II** (c.1478–1510) Italian painter. He was a pupil of BELLINI, becoming one of the major painters of the Venetian High RENAISSANCE. He had a mysterious romantic style, exemplified by Tempest (c.1505). Some paintings that he began were finished by others, including TITIAN.

Giotto di Bondone (1266–1337) (Giotto) Italian painter and architect, and an important figure of the early RENAISSANCE. His best work is the *Lives of the Virgin and Christ* (c.1305–08) in the Arena Chapel, Padua. Giotto's frescos in the Church of Santa Chiara, Assisi, were destroyed in a 1997 earthquake.

giraffe Hoofed, ruminant mammal found in the African savannas; the tallest living mammal. It has a very long neck, a short tufted mane, and two to four skin-covered horns on the head. The legs are long, slender and bony. Their coats are pale brown with red-brown blotches. Height: to 5.5m (18ft). Family Giraffidae; species Giraffa camelopardalis.

Giraudoux, Jean (1882-1944) French novelist and dramatist. His international successes include Amphitryon '38 (1929), La Guerre de Troie n'aura pas lieu (1935; trans. as Tiger at the Gates by Christopher FRY, 1955) and La Folle de Chaillot (The Madwoman of Chaillot) (1946).

Girl Guides Organization for girls founded in England in 1910 by Agnes Baden-Powell, sister of Lord BADEN-POWELL, founder of the Boy Scouts. There are about 871,000 guides in Britain, divided into three groups, Brownie Guides, Guides and Ranger Guides, according to age.

Girondins Political group in the French Revolution named after deputies from Gironde, sw France. From 1792 the relatively moderate and middle-class Girondins tried to prevent the execution of Louis XVI and reduce the power of Paris. They were expelled from the National Congress by the JACOBINS in 1793, and their leaders executed.

Giscard d'Estaing, Valéry (1926-) French politician. He was elected to the National Assembly (1956). In 1974, as the candidate of the right, he defeated François Mitterrand to become president, but narrowly lost to him in 1981. In 1988 he was elected leader of the Union for French Democracy (UDF), a centre-right alliance that includes his own Republican Party.

Giulio Romano (1492–1546) Italian painter and architect. One of the founders of MANNERISM, he was the chief assistant to RAPHAEL in his youth. His later work was considered pornographic and he had to flee from Rome to Mantua, where in 1526 he began his famous Palazzo del Tè.

Giza (Al-Jīzah) City in N Egypt, a suburb of Cairo. It is the site of the Great SPHINX, the pyramid of Khufu (Cheops), the University of Cairo (relocated in 1924), and Egypt's film industry. It is a resort and agricultural centre. Industries: cotton textiles, footwear, cigarette-manufacturing. Pop. (1990 est.) 2,156,000. glacier Large mass of ice, mainly recrystallized snow, which moves slowly by creep downslope or outward in all directions due to the stress of its own weight. The flow terminates where the rate of melting is equal to the advance of the glacier. There are three main types: the mountain or valley glacier, originating above the snow line in mountain regions; the piedmont, which develops when valley glaciers spread out over lowland; and the ice-sheet and ICE-CAP.

Glacier National Park Park in NW Montana, USA, along the continental divide in the Rocky Mountains (est. 1910). It is characterized by many glaciers, glacier-fed lakes, mountains, forests and waterfalls. Area: 4,103sq km (1,584sq mi). gladiator In ancient Rome, prisoner of war, slave or condemned convict trained to fight fellow humans or wild animals in public arenas. A gladiator's fate was often decided by the spectators. Gladiatorial contests were officially abolished by Constantine I in AD 325, but persisted into the 5th century. gladiolus Genus of 250 species of PERENNIAL flowering plants native to Europe and Africa but cultivated widely. A gladiolus passes the dry season as a CORM, which sprouts in spring to produce a spike of funnel-shaped flowers and tall, lance-shaped leaves. Height: to 0.91m (3ft). Family Iridaceae. Gladstone, William Ewart (1809-98) British statesman, prime minister (1868-74, 1880-85, 1886, 1892-94). He entered Parliament as a Tory (1832), but joined the Whigs and then, under his leadership, the Liberals (1859). He was a social reformer and Christian moralist. His adoption of a policy of Home Rule for Ireland in 1886 split his party and dominated his fourth ministry.

Glamorganshire (Morganwg) Former county in s Wales, divided into West, Mid and South Glamorgan. The Romans invaded in the 1st century AD and constructed roads to link their fortified settlements, which included Caerlon-upon-Usk. Christianity spread through the region in the 6th century. In Norman times Glamorgan became a border territory owing allegiance to the English crown. In the early 15th century it suffered during the rebellion of Owain GLYN DWR. It was created as a county in 1536, and underwent rapid industrialization owing to its coal industry. Area: 2,119sq km (818sq mi). gland Cell or tissue that manufactures and secretes special substances. There are two basic types. Exocrine glands make such substances as hydrochloric acid, mucus, sweat, sebaceous fluids and ENZYMES, and secrete these usually through

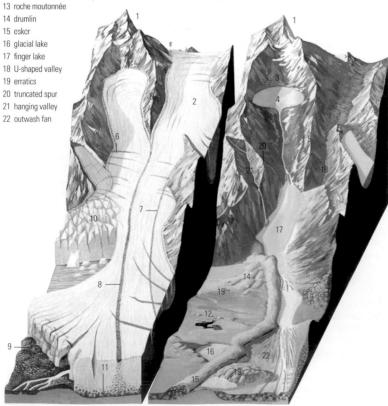

ducts to an external or internal body surface. Endocrine glands contain cells that secrete HORMONES directly into the bloodstream. See also ENDOCRINE SYSTEM

glandular fever (infectious mononucleosis) Acute disease, usually of young people, caused by the Epstein-Barr virus. There are an increased number of white cells (monocytes) in the blood and symptoms include fever, painful enlargement of the LYMPH nodes and pronounced lassitude. There may be a sore throat, skin rash and digestive disorder.

Glaser, Donald Arthur (1926–) US physicist who invented the BUBBLE CHAMBER, using it to study ELEMENTARY PARTICLES. He won the 1960 Nobel Prize for physics. Since 1964, he has conducted research applying physics to molecular biology.

Glasgow Largest city and port on the River Clyde, Strathclyde Region, sw central Scotland. Founded in the 6th century, it developed commercially with the American tobacco trade in the 18th century and the cotton trade in the 19th century. Nearby coalfields and the Clyde estuary promoted the growth of heavy industry, chiefly iron, steel and shipbuilding, although this is now in decline. Notable buildings include the 12th-century cathedral and the Provands Lordship (1471). Glasgow is a cultural centre, with three universities, the Glasgow School of Art and the Kelvingrove Art Gallery. Industries: shipbuilding, heavy engineering, flour milling, brewing, textiles, tobacco, chemicals, textiles, printing, Pop (1991, city) 662,853.

glasnost (Rus. *openness*) Term adopted by Mikhail Gorbachev in 1986 to express his more liberal social policy. One result was widespread popular criticism of the Soviet system and the Communist Party, leading to the break-up of the Soviet Union and the fall of Gorbachev. *See also* Perestroika

Glass, Philip (1937–) US composer. He studied with Vincent Persichetti at Juilliard and with Nadia BOULANGER in Paris, where he met Ravi SHANKAR and became interested in non-Western music. The hypnotic repetition of short motifs within a simple harmonic idiom characterizes him as a "minimalist" composer. In addition to 15 operas, he has written instrumental and chamber works.

glass Brittle, transparent material. It behaves like a solid but is actually a liquid that is cooled to prevent particles organizing themselves into a regular pattern. It is made by melting together silica (sand), sodium carbonate (soda) and calcium carbonate (limestone). It can only be worked while hot and pliable. There are many types of glass. Soda-lime glass is used in the manufacture of bottles and drinking vessels. Flint glass refracts light well and is used in lenses and prisms. Toughened Glass (laminated with plastic) is used in car windscreens. Glass is also used in fibre optic cables.

glass fibre Glass in the form of fine filaments. It is made by forcing molten glass through fine metal nozzles (spinnerets). The resulting continuous filaments are usually bundled together to form strands. These may then be chopped, twisted, or woven. It is used for heat insulation (as glass wool), fabrics, and with a plastic resin to make GRP (glass-reinforced plastic). glass snake (glass lizard) Legless LIZARD found in North America, Eurasia and Africa. The cylindrical body has a groove along each side and is mostly brown or green, although some species are striped. Length: 60–120cm (24–48in). Family Anguidae; genus *Ophisaurus*.

glaucoma Condition in which the pressure within the eye is increased due to an excess of aqueous humour, the fluid within the chamber. It occurs when the normal drainage of fluid is interrupted, posing a threat to vision. Most frequently found in the over 40s, the disease cannot be cured but is managed with drugs and surgery.

Glazunov, Alexander Constantinovich (1865–1936) Russian composer, who wrote in the Romantic tradition of TCHAIKOVSKY. His works include eight symphonies, chamber music, two violin concertos and the ballets *Raymonda* (1897) and *The Seasons* (1898).

Glendower, Owen See GLYN DWR, OWAIN

Glenn, John Herschel, Jr (1921–) First US astronaut to orbit the Earth (20 February 1962). He made three orbits of the Earth in the spacecraft *Friendship 7*. Glenn later became a Democrat Senator for Ohio.

gliding Leisure activity involving flight in a glider. The

unpowered glider is launched off the ground by a sling mechanism or towed by a small aircraft and then released. Once airborne, gliders descend relative to the surrounding air. If this air is a rising updraft, a glider may gain altitude for a while, thus prolonging its flight. See also HANG GLIDING

Glinka, Mikhail (1804–57) Russian composer, the first Russian composer to receive international acclaim. His two operas, *A Life for the Czar* (1836) and *Ruslan and Ludmila* (1841), inspired the RUSSIAN FIVE. Later in his life he lived in Italy and Spain, writing songs and orchestral music.

global warming Trend towards higher average temperatures on Earth's surface. During the last few million years, there have been several periods when surface temperatures have been significantly higher or lower than at present. During cold periods (ice ages) much of the land area has been covered by glaciers. The Earth is currently in the middle of a warm period (inter-glacial), which began about 10,000 years ago. Since the 1960s, some scientists have called attention to signs that the Earth is becoming unnaturally warmer as the result of an increased GREENHOUSE EFFECT caused by human activity.

Globe Theatre Elizabethan public theatre associated with William SHAKESPEARE. Built in 1599, it had polygonal walls with a roof over the stage and galleries. Destroyed by fire in 1613 and rebuilt in 1614, it was closed down by the Puritans in 1642 and demolished in 1644. The theatre was recently rebuilt and reopened in 1995, staging period performances.

globular cluster Near-spherical cluster of very old stars in the halo of our GALAXY and others. Globular clusters contain anything from 100,000 to several million stars, concentrated so tightly near the centre that they cannot be separately distinguished by ground-based telescopes.

glockenspiel (Ger. *Glocken*, bells, and *spielen*, to play) Percussion instrument with a bell-like sound. Its tuned metal bars are struck with a hammer, either freehand or from a miniature keyboard.

glomerulonephritis Group of kidney disorders featuring damage to the glomeruli (clusters of blood vessels that are found in the kidney nephrons). Chronic forms may progress to kidney failure.

Glorious Revolution (1688–89) Abdication of James II of England and his replacement with WILLIAM III (OF ORANGE) and Mary II. After James had antagonized powerful subjects by his favour towards Roman Catholics, political leaders invited William to take the throne. William landed in November and James fled to France. It was called "glorious" because it occurred virtually without violence.

Gloucester County town of GLOUCESTERSHIRE on the River SEVERN, W England. It was the Roman city of Glevum and capital of Mercia in Saxon times. There is an 11th-century

▲ giraffe The world's tallest mammal, the giraffe (*Giraffa camelopardalis*) reaches a height of 5.5m (18ft). The giraffe's long neck makes up about half its height, and enables it to browse from the higher branches of trees of the African savanna.

◄ global warming Short-wave solar radiation enters the Earth's atmosphere warming the planet (1). Cloud cover and the surface of the Earth reflect energy at a longer wavelength. Most of the energy then radiates out into space (2). When, however, the products of the burning of fossil fuels have polluted the atmosphere (3), the radiation is trapped and bounces back to the surface a second time (4). increasing the energy input into the Earth. This is known as the greenhouse effect, because the same principle warms the interior of greenhouses. The incoming short-wave rays can enter the greenhouse through the glass panels but the reflected longwave rays are blocked by the same glass trapping the energy. On a global scale scientists believe the greenhouse effect could raise the temperature of the Earth, resulting in the melting of the polar ice-caps and subsequent sea-level rise and flooding of lowlying areas (5).

cathedral where Edward II is buried. A market town, it has agricultural machinery, aircraft components, railway equipment and fishing industries. Pop. (1991) 101,608.

Gloucestershire County in sw England; the county town is Gloucester. Other important towns include Cheltenham and Stroud. There was a strong Roman presence in the county and in later periods it became important for coalmining and as the centre of a wool industry. The Cotswold Hills, to the E, sustain dairy and arable farming. The fertile Severn River valley is also devoted to dairying. Sheep are raised in the Forest of Dean and the Wye valley. Industries: engineering, scientific instruments, plastics. Area: 2,642sq km (1,020sq mi). Pop. (1991) 528,370. glow-worm Small European BEETLE closely related to the FIREFLY. The male is winged with tiny light-producing organs. The wingless female flashes her luminous hindquarters to attract a mate. Adults die shortly after mating. Family Lampyridae, genus Lampyris.

Gluck, Christoph Willibald von (1714–87) German operatic composer. His early operas were composed in the Italian tradition. In *Orfeo ed Euridice* (1762) he attempted to reform opera by unifying musical and dramatic components. He turned to the French tradition in *Iphigénie en Tauride* (1779). His reforms influenced Mozart.

glucose (dextrose) Colourless crystalline sugar ($C_6H_{12}O_6$) occurring in fruit and honey. It requires no digestion before absorption. A monosaccharide sugar, it is prepared commercially by the hydrolysis of starch using hydrochloric acid. It is used in food and pharmaceuticals. *See also* GLYCOGEN

glue Adhesive made by boiling animal skin, bones, horns and hooves. It consists of a jelly of hydrolyzed collagen (fibrous protein) and other substances. It forms a tough skin when dry. Vegetable glues are made from starch (flour and water), rubber, soybeans and other sources. Synthetic adhesives include epoxy resins, a group of POLYMERS with additional properties of heat and chemical resistance.

gluten Main protein substance in wheat flour. Not present in barley, oats or maize, gluten contributes the elasticity to dough. It is then used to make gluten bread for diabetics, and as an additive to chocolate and coffee.

glycerol (glycerine) Thick, syrupy, sweet liquid (1,2,3–tri-hydroxypropane, CH₂OHCH(OH)CH₂OH) obtained from animal and vegetable fats and oils, or propene (propylene). It is used in the manufacture of various products, including plastics, explosives and foods.

glycogen Carbohydrate stored in the body, principally by the liver and muscles. Glycogen is a polymer of GLUCOSE. When the body needs energy, glycogen is broken down to glucose. *See also* RESPIRATION

Glyndebourne Estate in East Sussex, England, site of an annual opera festival. John Christie built an opera theatre here in 1931. A bigger theatre was built, which opened in 1994.

Glyn Dwyr, Owain (*c*.1359–1416) (Glendower, Owen) Welsh leader. He was a member of the house of Powys, and led a revolt against English rule (1400). Proclaimed Prince of Wales, he won temporary alliances with the Mortimer and Percy families in England, and captured Harlech and Aberystwyth castles. He lost both castles by 1409, retreating to the hills to maintain guerrilla warfare against the English until 1412.

GMT Abbreviation of Greenwich Mean Time

gnat Common name for several small flies, mainly of the family Culicidae, the female of which bites human beings.

gneiss METAMORPHIC ROCK with a distinctive layering or banding. The darker minerals are likely to be hornblende, augite, mica or dark feldspar. Before metamorphism, gneiss was an IGNEOUS ROCK, possibly a granite.

Gnosticism Religious movement, embracing numerous sects, based on *gnosis*. This was occult knowledge that released the spiritual part of human beings from the evil bondage of the material world. Gnosticism became widespread by the 2nd century AD and competed with Christianity. **gnu** (wildebeest) Large, ox-like African ANTELOPE. The white-tailed gnu (*Connochaetes gnou*) is almost extinct. The brindled gnu (*Connochaetes taurinus*) lives in E and S Africa, where large herds migrate annually. It has a massive, buffalo-like head and a slender body. Both sexes are horned.

Length: up to 2.4m (7.8ft); height: 1.3m (4ft); weight: up to 275kg (600lb). Family Bovidae.

Goa State in sw India, on the Arabian Sea; the capital is Panaji. It was ruled by Hindu dynasties until it came under Muslim domination in the 15th century. Captured by the Portuguese in 1510, it became a flourishing trade centre and the hub of Portugal's Asian empire. It was annexed by India in 1962 and made a Union territory of India. In 1987 Goa was created a separate state. The state's products include rice, cashews, spices, pharmaceutical products, footwear and pesticides. Area: 3,702sq km (1,429sq mi). Pop. (1991) 1,169,793

goat Horned RUMINANT raised for milk, meat, leather and hair. They are brown or grey in colour. The male is a ram or billy, the female a doe or nanny, and the young a kid. Wild species are nomadic, living in rugged mountains. The five species include the ibex (*Capra ibex*), markhor (*Capra falconeri*) and the pasang (*Capra aegagrus*). Length: to 1.4m (4.5ft); height: to 0.85m (2.8ft). Family Bovidae; genus *Capra*.

goatsucker Common name for various large-mouthed, nocturnal birds of the order Caprimulgiformes. Widely distributed in warm areas, they include the frogmouth, nighthawk, nightjar, potoo and whippoorwill. Length: 15–30cm (6–12in). Family Caprimulgidae.

Gobbi, Tito (1915–84) Italian baritone. Following his debut in Rome in 1938, in Verdi's *La traviata*, he sang in most of the great opera houses. He was highly acclaimed for his powerful acting ability.

Gobelins, Manufacture nationale des State-controlled TAPESTRY factory in Paris, founded *c*.1440 by Jean Gobelin. The factory converted from a dyeworks to making tapestry in 1601. Louis XIV bought the premises in 1662 to create a royal tapestry and furniture works.

Gobi (Sha-moh) Desert area in central Asia, extending over much of s Mongolia and \mathbb{N} China. One of the world's largest deserts, it is on a plateau, 900–1,500m (3,000–5,000ft) high. The fringes are grassy and inhabited by nomadic Mongolian tribes who rear sheep and goats. The Gobi has cold winters, hot summers, and fierce winds and sandstorms. Area: c.1,300,000sq km (500,000sq mi).

Gobind Singh (1666–1708) Tenth and last Sikh guru, who laid the foundations of Sikh militarism. In 1699 he created the *Khalsa*, a military fraternity of devout Sikhs, which became the basis of the Sikh army he led against the MOGUL EMPIRE. The wearing of the turban and the common attachment of Singh ("lion") to Sikh names date from his reign.

God Supernatural, divine and usually immortal beings worshiped by followers of a polytheistic religion such as those of ancient Greece and Rome. Also the single supreme being, creator and mover of the universe, as worshiped by the followers of monotheistic religions such as JUDAISM or ISLAM. ALLAH is God of Islam and YAHWEH is God of Judaism. CHRISTIANITY, a monotheistic religion, conceives of one God with three elements – Father, Son and Holy Spirit. In HINDUISM, BRAHMA is considered the soul of the world, but there are lesser gods. *See also* POLYTHEISM; MONOTHEISM; AGNOSTICISM; ATHEISM; BUDDHISM; DEISM; ZEUS

Godard, Jean-Luc (1930–) French film director whose imaginative flair revolutionized film-making. He produced the respected science-fiction film *Alphaville* (1965), and his political sketches, such as *Weekend* (1968) and *Tout va bien* (1972), transformed film as propaganda. *Breathless* (1959) and *Made in USA* (1966) also received praise.

Goddard, Robert Hutchings (1882–1945) US physicist and pioneer in ROCKET development. He developed and launched (1926) the first liquid-fuelled rocket, and developed the first smokeless powder rocket and the first automatic steering for rockets.

Gödel, Kurt (1906–78) US logician, b. Czechoslovakia. In 1931 he published the theorem named after him. By uniquely numbering each statement in his Consistency Theorem, he proved that in any formal system that can be dealt with using NUMBER THEORY there exist true propositions that cannot be proved within the system. The implication is that the whole of human knowledge can never be systematized within one axiomatic system.

▲ goat Bred mainly in countries where the pasture is too poor for sheep, goats are an important source of milk and meat in many desert and mountain regions worldwide. Angora goats (A) originated in Turkey, near Ankara. They have now spread to other parts of the world and are bred for their fleece, known as mohair. The quality of mohair is important and animals are carefully bred to produce long, fine-haired fleece. The Granada (B) is a black, hornless Spanish breed, kept for its milk. Although still popular in Spain, it has not spread further afield. The Toggenburg (C) is a hardy, hornless breed. It originated in Switzerland, but is now used in many countries for cross-breeding.

Godiva, Lady (d. c.1080) English benefactress, wife of Leofric, Earl of Mercia. According to tradition, she rode naked through the streets of Coventry in 1040 to persuade her husband to reduce the burden of taxation.

Godthab Danish name for NUUK, capital of Greenland.

Godunov, Boris (1551–1605) Tsar of Russia (1598–1605). The chief minister (and brother-in-law) of IVAN IV, he became regent to Ivan's son Fyodor after Ivan's death and was popularly supposed to have murdered Fyodor's brother and heir, Dmitri, in 1591. On Fyodor's death in 1598, Boris was elected tsar. He gained recognition for the Russian Orthodox Church as an independent patriarchate.

Goebbels, Joseph (1897–1945) German Nazi leader. He joined the Nazi Party in 1924 and in 1926 founded the newspaper *Der Angriff.* When the Nazis came to power in 1933, he became minister of propaganda. He took total control of the media, which he exploited to support Nazi policy. He committed suicide with his entire family in April 1945.

Goering, Hermann Wilhelm (1893–1946) German Nazi leader. As commander of the Luftwaffe (air force) from 1933, and overall director of economic affairs from 1936, he was second to HITLER. His reputation declined during World War 2 with the failure of the Luftwaffe to subdue the British or the Russians. Captured in 1945, he was sentenced to death at the NUREMBERG TRIALS but committed suicide.

Goes, Hugo van der (c.1440–82) Flemish painter, one of the greatest artists of the 15th century. In 1474 he was elected dean of the painter's guild in Ghent and in the following year entered a monastery. His triptych known as the *Portinari Altarpiece* (the only work definitely ascribed to him) is a masterpiece of emotional intensity.

Goethe, Johann Wolfgang von (1749–1832) German poet. He wrote simple love lyrics, profound philosophical poems and scientific theories. He was lawyer, botanist, politician and civil servant, physicist, zoologist, painter and theatre manager. Johann Gottfried von Herder taught him to appreciate Shakespeare, and this influenced his *Götz von Berlichingen* (1773), which, together with his novel *Die Leiden des Jungen Werthers* (1774), is a seminal work of ROMANTICISM. His most famous work, the tragic and wide-reaching drama *Faust*, is in two parts: *Part 1* (1808), *Part 2* (1832).

Gogol, Nikolai (1809–52) Russian novelist and dramatist who marks the transition from ROMANTICISM to early realism. He made his reputation with stories, such as *The Nose* (1835), and the drama *The Government Inspector* (1836). He turned to religion and lived mostly in Rome from 1836–48. Here he wrote the first part of his major work, *Dead Souls* (1842), and the story *The Overcoat* (1842).

Goh Chok Tong (1941–) Prime minister of Singapore (1990–). An economist, Goh became a member of parliament for the People's Action Party in 1976. He rose steadily through the ministerial ranks and was Lee Kuan Yew's successor.

Golan Heights (Ramat Ha Golan) Range of hills in sw Syria on the border with Israel. During the Arab-Israell War of 1967, Israel occupied the area and later annexed it. Of great strategic importance to Israel, it has remained a source of conflict between the two countries. Area: 1,150sq km (444sq mi). Pop. (1983 est.) 19,700.

gold Naturally occurring metallic element, symbol Au. It is also obtained as a by-product in the refining of copper. Gold is used in jewellery, in connectors for electronic equipment, and as a form of money. Gold in the form of a COLLOID is sometimes used in colouring glass. The isotope Au-198 (half-life 2.7 days) is used in RADIOTHERAPY. The metal is unreactive but dissolves in aqua regia, a mixture of nitric and hydrochloric acids. Properties: at. no. 97; r.a.m. 196.9665; r.d. 19.30; m.p. 1,063°C (1,945°F); b.p. 2,800°C (5,072°F); most common isotope Au-197 (100%).

goldcrest Smallest British bird. Its head is capped with bright orange and a black stripe. Its body is green and its wings are black with a white stripe. Length: about 8.4cm (3.3in). Family Muscicapidae; species *Regulus regulus*.

Golden Fleece In Greek mythology, fleece of the ram that saved Helle and Phrixus from their stepmother Ino. On arrival in Colchis, Phrixus sacrificed the ram and hung the

fleece in a wood guarded by a dragon. The fleece was seized by JASON and the ARGONAUTS.

Golden Gate Strait on the coast of California, USA, linking the Pacific Ocean with San Francisco Bay. The first landing was made (1769) by Francisco de Ortega. It is spanned by the Golden Gate Bridge, completed in 1937.

Golden Horde Name given to the Mongol state established in s Russia in the early 13th century. The state derived from the conquests of GENGHIS KHAN. It was extended by his successors, who took over the whole of the Russian state, centred on Kiev. It was conquered by TAMERLANE in the late 14th century and subsequently split up.

goldfinch Small, seed-eating, sparrow-like bird native to Bermuda and Europe. Found in flocks, it lays bluish-white eggs (3–6) in a cup-shaped nest. The red-faced European goldfinch (*Carduelis carduelis*) has a brownish body with yellow and black wings. Family fringillidae.

goldfish Freshwater CARP originally found in China. The most popular aquarium fish, it was domesticated in China *c.*1,000 years ago. The wild form is plain and brownish, but selective breeding has produced a variety of colours. Family Cyprinidae; species *Carassius auratus*.

Golding, Sir William Gerald (1911–93) British novelist. He achieved fame with his first novel, *Lord of the Flies* (1954). Other novels include *The Spire* (1964) and the trilogy *The Ends of the Earth* (1991), which incorporates the Booker Prize-winning *Rites of Passage* (1980). He was awarded the 1983 Nobel Prize for literature.

gold rush Rapid influx of population in response to reports of the discovery of gold. The largest gold rush brought *c*.100,000 prospectors to California (1849–50). Some of the miners, known as Forty-Niners, went on to Australia (1851–53). There were also gold rushes to WITWATERSRAND, South Africa (1886), to Klondike in the Yukon, Canada (1896), and to Alaska (1898).

Goldsmith, Oliver (1730-74) Irish poet, novelist, essayist and dramatist. After a colourful but penurious early life, he embarked on a career of literary hackwork in London. His work includes the essay The Citizen of the World (1762), the poem The Deserted Village (1770), the novel The Vicar of Wakefield (1766) and the play She Stoops to Conquer (1773). gold standard Monetary system in which the gold value of currency is set at a fixed rate and currency is convertible into gold on demand. It was adopted by Britain in 1821, by France, Germany and the USA in the 1870s, and by most of the rest of the world by the 1890s. Internationally it produced nearly fixed exchange rates and was intended to foster monetary stability. The Great Depression forced many countries to depreciate their exchange rates in an attempt to foster trade, and by the mid-1930s all countries had abandoned the gold standard. Goldwyn, Samuel (1882–1974) US film producer, b. Poland. He was noted for his commercially successful films, including Wuthering Heights (1939), The Best Years of Our Lives (1946), Guys and Dolls (1955) and Porgy and Bess (1959). He formed Goldwyn Pictures in 1917 and later merged with Louis B. Mayer to form Metro-Goldwyn-Mayer (1924).

golf Game in which a small, hard ball is struck by a club. The object of the game is to hit the ball into a sequence of holes (usually 18), in the least possible number of shots. The length of each hole varies from c.100-500yd (90-450m). Each hole consists of a tee, from where the player hits the first shot; a fairway of mown grass bordered by trees and longer grass, known as the rough; and a green, a putting area of smooth, short grass and the site of the hole. A player may have to circumvent course hazards, such as ponds or bunkers. Each hole is given a par, the number of shots it should take to complete the hole. Competition is usually over 18, 36 or 72 holes; the winner decided by the lowest total of strokes (stroke play) or the most holes won (match play). A player may use a maximum of 14 clubs. In 1754 the Royal and Ancient Golf Club, ST ANDREWS, Scotland, was formed and the basic rules of the game codified. The Club is the highest authority in the sport. The major tournaments are the US Open, British Open, US Professional Golfer's Association (PGA), and the US Masters. Golgi body Collection of microscopic vesicles or packets

▲ goose Unlike most species of birds, geese mate for life. Found in freshwater habitats all over the world, geese have been domesticated for their eggs and down. The species shown here are the Roman (A), the Egyptian (B), the Chinese (C), the greylag (D) and the embden (E).

▲ gooseberry The green, hairy fruit of the gooseberry (*Ribes grossularia*) is excellent for bottling, jam and pies.

observed near the nucleus of many living cells. It is a part of a cell's ENDOPLASMIC RETICULUM, specialized for the purpose of packaging and dispatching proteins made by the cell.

Goliath In the OLD TESTAMENT, the PHILISTINE giant slain by DAVID when he was still a shepherd boy (1 Samuel 17). David killed Goliath with a slingshot, hitting him between the eyes with a stone.

Gómez, Juan Vicente (1857–1935) Venezuelan leader (1908–35). Vice president under Cipriano Castro, he seized power during Castro's absence abroad and controlled the country, either as elected president (1908–15, 1922–29, 1931–35) or through puppets, until his death. His rule was autocratic and intolerant of opposition, but it provided the stability for Venezuela to pay off its international debts.

Gompers, Samuel (1850–1924) US labour leader, b. England. As a cigarmaker in New York, he served as president of a local union (1877–81). He helped to found the Federation of Organized Trades and Labor Unions. When it was reorganized as the American Federation of Labor (1886), Gompers became its first president, serving until his death, except for the year 1895. During World War 1, he organized and headed the War Commission on Labor and served on the Advisory Commission to the Council of National Defense.

Gomulka, Wladyslaw (1905–82) Polish communist leader. He rose through party ranks to become first secretary and deputy prime minister (1945), but was dismissed during a Stalinist purge (1948). Reinstated as party leader (1956), he adopted liberal policies that made him popular at home and were accepted by Moscow. As economic problems grew, Gomulka's regime became more oppressive and anti–Semitic. Steep rises in food prices (1970) led to his resignation.

gonad Primary reproductive organ of male and female animals, in which develop the GAMETES or sex cells. Thus, the gonad in the male is a testis and in the female an ovary. Hermaphrodite animals possess both types.

Goncourt, Huot de, Edmond Louis Antoine and Jules Alfred French novelists and social historians, Edmond (1822–96) and Jules (1830–70). They wrote in collaboration until Jules died of syphilis. They are famous for *The Journal of the Goncourts* (1836–40). Edmond wrote the novels *La Fille Elisa* (1877) and *Les Frères Zemganno* (1879). In his will, he provided for the *prix goncourt*, France's top literary award.

Gondwanaland Southern supercontinent which began to break away from the single land mass Pangaea about 200 million years ago. It became South America, Africa, India, Australia and Antarctica. The northern supercontinent, which eventually became North America and Eurasia without India, was Laurasia.

gonorrhoea SEXUALLY TRANSMITTED DISEASE caused by the bacterium *Neisseria gonorrhoeae*, giving rise to inflammation of the genital tract. Symptoms include pain on urination and the passing of pus. Some infected women experience no symptoms. The condition is treated with antibiotics. If not treated, it may spread, causing sterility and ultimately threatening other organs in the body; there is a risk of blindness in a baby born to an infected mother.

Gooch, Graham Alan (1953–) English cricketer. He played for Essex (1973) and appeared in his first of 118 Test matches in 1975. He captained the "rebel" side that toured South Africa (1982) and was banned from the England team for three years. He exceeded David Gower's England record (1993), his final total being 8,900 Test runs. He was England captain (1989–93).

Good Friday Friday before EASTER Day. It is observed by all Christians as marking the day of the crucifixion of Jesus. For many Christians it is a day of fasting and abstinence.

goose Widely distributed waterfowl, related to the DUCK and SWAN. Geese have blunt bills, long thick necks, shortish legs, webbed feet and, in the wild, a combination of grey, brown, black and white dense plumage underlaid by down. They live near fresh or brackish water and spend time on land, grazing on meadow grasses. Wild geese breed in colonies, mate for life, and build grass-and-twig, down-lined nests for 3–12 eggs. There are 14 species. Weight: 1.4–5.9kg (3–13lb). Family Anatidae.

gooseberry Hardy, deciduous, spiny shrub and its edible fruit. It is generally green and hairy and fairly acidic. Family Grossulariaceae; species *Ribes grossularia*.

gopher Small, stout, burrowing rodent of North and Central America. It has fur-lined external cheek pouches and long incisor teeth outside the lips. It lives underground, digging tunnels to find roots and tubers and for shelter and food storage. Length: 13–46cm (5–18in). Family Geomyidae.

Gorbachev, Mikhail Sergeyevich (1931–) Soviet statesman, president of the Soviet Union (1985–91). Secretary of the Communist Party from 1985, he embarked on a programme of reform based on two principles: PERESTROIKA and GLASNOST. The benefits of radical socio-economic change were slow to take effect, and Gorbachev became extremely unpopular as prices rose. He agreed major arms limitation treaties with the USA and acquiesced to the demolition of the communist regimes in Eastern Europe (1989–90), effectively ending the COLD WAR. Having strengthened his presidential powers in 1990, he was forced to resign in 1991 by opponents eager to grant independence to the constituent republics of the Soviet Union. He won the Nobel Peace Prize in 1990.

Gordimer, Nadine (1923–) South African author. Her works, critical of apartheid, are concerned with contemporary politics and social morality. Among her collections of short stories are *Face to Face* (1949) and *Jump* (1991). Her novels include *The Lying Days* (1953) and *My Son's Story* (1990). She won the 1991 Nobel Prize for literature.

Gordon, Charles George (1833–85) British soldier and administrator. He fought in the CRIMEAN WAR and OPIUM WAR and was employed by the Chinese government in the TAIPING REBELLION. He was governor-general of the Sudan (1877–80) and returned to Khartoum in 1884 to evacuate Egyptian forces threatened by the MAHDI. He was killed two days before the arrival of a relieving force.

Gordon Riots (1780) Violent demonstrations against Roman Catholics in London, England. Protestant extremists led by Lord George Gordon (1751–93) marched on Parliament to protest against the Catholic Relief Act (1778), which lifted some restrictions on Catholics. The march degenerated into a week-long riot; *c.*450 people were killed or injured.

Gore, Al (Albert Arnold) (1948–) US statesman, vice president (1993–). Gore became known for his commitment to environmental concerns as the Democratic representative for Tennessee in the House of Representatives (1977–85) and Senate (1985–93). His vice-presidency is characterized by a close working relationship with Bill CLINTON. He began a second term as vice president following Clinton's re-election in November 1996.

Górecki, Henryk (1933–) Polish composer. His early works were influenced by Webern and serialism, but his later output is inspired more by medieval Polish chants, Renaissance polyphony and the richness of the Wagnerian orchestra. His third symphony is extremely popular.

Gorgon In Greek mythology, three monsters named Stheno, Euryale and the mortal MEDUSA. They had gold wings, snakes for hair, and turned anyone who looked directly at them to stone. PERSEUS killed Medusa using his shield as a mirror.

gorilla Powerfully built great ape native to the forests of equatorial Africa. The largest primate, it is brown or black, with long arms and short legs. It walks on all fours and is herbivorous. Height: to 175cm (70in); weight: 140–180kg (308–396lb). Family Pongidae; species *Gorilla gorilla*.

Gorky, Arshile (1905–48) US painter, b. Armenia. His work bridged SURREALISM and ABSTRACT EXPRESSIONISM. In 1920 he emigrated to the USA, where he joined a group of European surrealists in New York in the 1940s. He became fascinated by the work of MIRÓ, who inspired some of his paintings, such as the different versions of *Garden in Sochi* (1940) and *Mojave* (1941–42).

Gorky, Maxim (1868–1936) Russian dramatist and writer, b. Aleksei Madsimovich Peshkov. He championed the worker in *Sketches and Stories* (1898), in the play *The Lower Depths* (1902) and in the novel *Mother* (1907). He wrote autobiographical volumes (1913–23) and plays, including *Yegor Bulychov* (1931). He lived in intermittent exile after 1907.

gorse (furze) Any of several dense thorny shrubs found mainly in Europe; genus *Ulex*; family Fabaceae/Leguminosae. The common European species, *U. europaea*, bears yellow flowers and thrives in open hilly regions.

gospel Central content of the Christian faith, the good news (*god spell* in Old English) that human sins are forgiven and that all sinners are redeemed. The first four books of the New Testament, ascribed to the Evangelists Matthew, Mark, Luke and John, are known as the four Gospels.

gospel music African-American vocal church music. It first arose in the depression years of the 1930s from the fusion of Protestant hymn harmony with African rhythmic and melodic features. Gospel music emphasizes the "good news" aspect of revivalist Christianity. Powerfully expressive, it often uses a call-and-response form, with a choir answering a soloist/preacher.

Gothenburg (Göteborg) City in sw Sweden, at the confluence of the Göta and Kattegat rivers; the country's chief seaport and second-largest city. Founded by Gustavus II (1619), it quickly flourished as a commercial centre. Industries: shipbuilding, vehicles, food processing, chemicals, textiles. Pop. (1993) 437,313.

Gothic art and architecture Architecture of medieval Europe from the 12th–16th centuries. It is characterized by the pointed arch and ribbed vault. The style is religious in inspiration and ecclesiastical in nature. Its greatest and most characteristic expression is the cathedral. The introduction of flying buttresses was a technical advance that made the large windows possible. An early prototype is the Abbey Church of St Denis (1140–44). Ever higher and lighter structures followed, with increasingly intricate vaulting and tracery.

Gothic novel Genre of English fiction popular in the late 18th and early 19th centuries; part of the romantic movement. Gothic novels often rely on eerie medieval externals, such as old castles, monasteries and hidden trapdoors, for their symbolism. Horace WALPOLE wrote an important protoype, *The Castle of Otranto* (1764). Later examples include *The Mysteries of Udolpho* (1794) by Ann Radcliffe and *Frankenstein* (1818) by Mary SHELLEY.

Gothic revival (neo-Gothic) Architecture based on the Gothic style of the Middle Ages. Beginning in the late 18th century, it peaked in 19th-century Britain and the USA, also appearing in many European countries. British exponents, notably the critic John Ruskin and the writer and architect A.W.N. Pugin, insisted on the need for authentic, structural recreation of medieval styles. Notable examples are the Houses of Parliament in London by Pugin and Sir Charles Barry, and Trinity Church in New York City by Richard Upjohn. See also Gothic art and architecture

Goths Ancient Germanic people, groups of whom settled near the Black Sea in the 2nd–3rd centuries AD. The **Visigoths** were driven westwards into Roman territory by the Huns in 376, culminating in their sacking Rome under Alaric in 410. They settled in sw France, then, driven out by the Franks in the early 6th century, in Spain. Some groups united to create the **Ostrogoths**, who conquered Italy under Theodoric the Great (489). The Ostrogoths held Italy until conquered by the Byzantines under Belisarius and Narses (536–553).

Gottlieb, **Adolph** (1903–74) US painter, leading exponent of ABSTRACT EXPRESSIONISM. His early work shows the influence of EXPRESSIONISM and SURREALISM. Best known for a series of *Pictographs* (1941–51), he portrayed Freudian or mythological concepts compartmentalized in different areas of the canvas.

gouache Watercolour paint made opaque by the addition of white. It lightens in colour when dry and cracks if used thickly. Popular among manuscript illuminators in the Middle Ages, gouache has been used by 20th-century painters and commercial artists.

Gould, Glenn (1932–82) Canadian pianist and composer. A soloist with the Toronto Symphony Orchestra at the age of 14, he is famous for interpretations of the romantic composers and J.S. BACH. His first string quartet was premiered in 1956. In later years he concentrated on recording. His writings on music are admired.

Gould, Jay (1836–92) US financial speculator. With his partner, James Fisk, he typified the capitalist "robber barons" who made large fortunes from corrupt dealings in stocks and shares. He and Fisk nearly cornered the gold market, forcing the Treasury to release gold stocks and leading to the panic of Black Friday (24 September 1869).

Gounod, Charles François (1818–93) French composer and organist. He composed church and choral music and is best known for his operas, which include *Faust* (1859), *Mireille* (1863) and *Roméo et Juliette* (1864).

gourd Annual vine and its ornamental, hard-shelled fruit. These range from almost spherical, as in *Cucurbita pepo*, to irregular or bottle-shaped, as in *Lagenaria siceraria*. The rind may be smooth or warty. Family Cucurbitaceae.

gout Form of arthritis, featuring an excess of uric acid crystals in the tissues. More common in men, it causes attacks of pain and inflammation in the joints, most often those of the feet or hands. It is treated with anti-inflammatories.

Gower, David (1957–) English cricketer. A left-handed batsman, he played for Leicestershire from 1975, playing his first Test match in 1978. He captained both Leicestershire and England (1984–86, 1989), regaining the "Ashes" from Australia (1985), making 8,231 test runs in 117 matches. He played for Hampshire from 1990, retiring in 1993 to focus on commentating and journalism.

Gower, John (1330–1408) English poet. Ranked in his time with Lydgate and CHAUCER, his work includes *Vox Clamantis* (1379–82), an attack on social injustice, and his most famous work, *Confessio Amantis* (1386–93), a collection of allegorical tales on the subject of Christian and courtly love.

Goya y Lucientes, Francisco José de (1746–1828) Spanish painter and engraver. A severe illness (1791) provoked a vein of fantastic works, one of the most vicious and sinister of which is *Los Caprichos*, a series of 82 engravings published in 1799. Goya enjoyed the royal patronage of Charles IV despite mercilessly realistic paintings such as *The family of Charles IV* (1800). His bloody scenes *The Second of May, 1808* and *The*

▲ Gorbachev The former president (1985–91) of the Soviet Union, Mikhail Gorbachev was responsible for the two radical socio-economic reforms of glasnost ("openness") and perestroika ("restructuring"). Although initially he enjoyed huge popular support, his economic reforms resulted in massive price rises and he was eventually forced to resign in 1991.

■ Gothic art and architecture Cologne Cathedral, Germany, was begun in 1248, but the present building was completed between 1842 and 1880. The largest Gothic church in N Europe, the illustration shows the w facade. The cathedral's grandeur lies predominantly in its highly decorated, spiny twin towers, which rise to 152m (502ft).

► Graf German tennis star Steffi Graf is among the greatest women tennis players of all time. She has dominated the game since she first became world number one in 1987. The next ten years saw her retain the top spot every year apart from 1990 and 1991 when she was surpassed by Monica Seles. By early 1997, Graf had won a remarkable total of 105 titles.

▲ grain The fruits of various cereal plants, the various grains together are the most important food. Wheat (A), corn or maize (C) and barley (D) are grown in the world's temperate regions. Rice (B) needs a tropical climate to grow successfully. Millet (E) is one of the oldest cultivated grains in the world and along with sorghum (F) is grown extensively in Africa. Oats (G) and rye (H) are grown extensively in Europe, and rye especially is well suited to poorer soils than those required for most cereal grains.

Third of May, 1808 portray the Spanish resistance to the French invasion. The Disasters of War (1810–14) is a savage suite of 65 etchings. Still obsessed with the dark side of the human psyche, his last works are the so-called Black paintings, 14 murals in sombre colours in which Goya unleashed yet more horrors from his tortured imagination.

Gozzoli, Benozzo (1421–97) Italian painter. He is famous for his numerous frescos, such as that of the Medici family as the Magi, in the chapel of the Medici Palace, Florence.

Gracchus (153–121 BC) (Gaius Sempronius) Roman statesman. As tribune (123–112 BC) he organized the social reforms of his brother Tiberius (d.133 BC). He sought to check the power of the Senate by uniting the plebeians and the equites and by reforming agrarian laws to benefit the poor. These reforms were short-lived; he was defeated in the election of 121 and killed during the riots that followed.

Grace, W.G. (William Gilbert) (1848–1915) English cricketer. He played for England, Gloucestershire and London County. He scored a total of 54,896 runs (including 126 centuries), took 2,876 wickets and held 877 catches in first-class matches. He led England in 13 of his 22 Test matches (1880–99).

Graces In Greek mythology, three goddesses who represented intellectual pleasures: beauty, grace and charm. Associated especially with poetry, Aglaia, Euphrosyne and Thalia were often linked with the MUSES. They were also described as daughters or granddaughters of ZEUS.

grackle Several species of stout-billed, New World blackbirds within the genera *Quiscalus* and *Cassidix* of the family Icteridae. Sometimes called crow blackbirds, they have blackish, iridescent plumage. The common grackle, *Q. quiscula*, of the USA, may reach 30cm (12in) in length. Species of Asian mina birds of the genus *Gracula* are also called grackles.

Graf, Steffi (1969–) German tennis player. Graf succeeded Martina NAVRATILOVA as the world's No. 1 woman tennis player in 1987. In 1988 she completed a Grand Slam of the major tournaments. Graf's powerful serve and forehand play dominated the women's game, despite her injury problems. She has won the Australian Open (1988, 1989, 1990, 1994), the French Open (1987, 1988, 1993, 1995, 1996) Wimbledon (1988, 1989, 1991, 1992, 1993, 1995, 1996) and the US Open (1988, 1989, 1993, 1995, 1996). In 1997 her father was found guilty of tax evasion on income earned as her manager. grafting In horticulture, method of plant propagation. A twig of one variety, called the scion, is established on the roots of a related variety, called the stock. Most fruit trees are propagated by a similar process called budding, in which the scion is a single bud.

Graham, Billy (William Franklin) (1918–) US evangelist.

A charismatic preacher, he led Christian revivalist crusades all over the world, including communist countries. He was consulted by several US presidents, especially Richard Nixon.

Graham, Martha (1894–1991) US choreographer and dancer, a leading figure in MODERN DANCE. In the early 1920s, she began to break with traditional BALLET, employing highly individual forms based on natural movement.

Graham, Thomas (1805–69) British chemist, best remembered for Graham's law. This states that the diffusion rate of a gas is inversely proportional to the square root of its density. This law is used in separating isotopes by the diffusion method and has important industrial applications. He also discovered DIALYSIS.

Grahame, Kenneth (1859–1932) British author of children's books. He created Mole, Rat, Badger and Mr Toad in the classic *Wind in the Willows* (1908), which formed the basis for the A.A. MILNE play *Toad of Toad Hall* (1929).

grain Fruits of various CEREAL plants, or the plants themselves. The main kinds of grain are WHEAT, MAIZE and RICE. It is an important food, rich in carbohydrates and containing proteins and vitamins too.

Grainger, Percy Aldridge (1882–1961) Australian composer and pianist. He was a pupil of Ferruccio Busoni and a protégé of Edvard Grieg. His arrangements of *Country Gardens* and *Shepherd's Hey* were both published in 1908. He produced other pieces in the same folk tradition and also wrote highly experimental music.

grammar Nature and structure of language, including the form, sound and meaning of words and the construction of sentences. Traditional rules of grammar were developed in the Middle Ages and were based on Latin. They were later applied to other languages such as English, German and Russian. In the mid-20th century, linguists such as Noam Chomsky developed a more scientific approach to analysing language, which did not depend on structural similarities with Latin.

grammar school State-maintained secondary school in the UK, except Scotland, catering for academically able pupils. Since comprehensive education has become almost universal in Britain, fewer than 4% of pupils in England and Wales are educated in grammar schools, though in Northern Ireland about 33% of pupils attend them.

Grampian Region in NE Scotland, bordered by the North Sea, the Grampian Highlands and the CAIRNGORMS; the capital is ABERDEEN. The w of the region is mountainous, rising to 1,311m (4,301ft) at Ben Macdhui. The E is drained by the Spey, Dee and Don rivers. Along the banks of the Spey lie many whisky distilleries. Industries: beef farming, fishing and tourism. Area: 8,707sq km (3,361sq mi). Pop. (1991) 503,900. **Grampians** Mountain range in N central Scotland. It is the highest mountain system in Britain, running Sw – NE between Glen More and the Scottish Lowlands. Rivers rising in the Grampians include the Spey and Findhorn (flowing N), the Don and Dee (flowing E), and the Tay and Forth (flowing s). Highest peak: Ben Nevis, 1,343m (4,406ft).

Granada City in Andalusia, s Spain; capital of Granada province. Founded in the 8th century as a Moorish fortress, it became the capital of the independent Muslim kingdom of Granada in 1238. The last Moorish stronghold in Spain, it surrendered to the Christian armies of Ferdinand and Isabella in 1492. The central splendour of Granada is the ALHAMBRA. Industries: tourism and textiles. Pop. (1991) 254,034.

Gran Chaco Lowland plain of central South America, stretching across the borders of Argentina, Bolivia and Paraguay. Arid and largely unpopulated, the region is famous for its quebracho trees, a major source of TANNIN. The discovery of oil in the Chaco Borea, and Bolivia's subsequent need for a route to the sea, led to the Chaco War (1932–35) between Bolivia and Paraguay. The war killed more than 100,000 soldiers before an agreement gave 75% of Gran Chaco to Paraguay, and allowed Bolivia use of the Paraguay River.

Grand Canal Ancient inland waterway in NE China, between Beijing and Hangzhou. The first part, between the Yangtze and Huai Ho rivers, was built in the 6th century BC. It was extended to Hangzhou in the 6th century AD and to Beijing by Kublai Khan in the 13th century. Total length: $c.1,600 \mathrm{km}$ (1,000mi).

Grand Canyon Deep gorge in NW Arizona, USA, carved by the Colorado River. It is 450km (280mi) long and varies from 6km (4mi) to 18km (11mi) in width. With its magnificent multicoloured rock formations revealing hundreds of millions of years of geological history, the Grand Canyon is considered one of the great natural wonders of the world. It was made a National Park in 1919.

grand jury In US law, a group appointed by the law to investigate a crime within its jurisdiction. It hears evidence, then decides whether a person should stand trial. It is so-called because it is usually larger than a petit trial, or JURY.

Grand Remonstrance Statement of grievances by the English Parliament presented to King Charles I in November 1641. It listed numerous objections to the royal government and demanded parliamentary approval of ministers and fundamental changes in the church. It was passed in the House of Commons by only 11 votes, and Charles rejected it. It hardened the division between the crown and Parliament, which culminated in the CIVIL WAR.

grand unified theory (GUT) Theory that would demonstrate that three of the four FUNDAMENTAL FORCES are actually different aspects of the same fundamental force. The WEAK NUCLEAR FORCE and ELECTROMAGNETIC FORCE have been incorporated as the electroweak force, as demonstrated by particle accelerator experiments. In order to prove the GUT, the electroweak force must be unified with the STRONG NUCLEAR FORCE. If the gravitational force could be incorporated, then a UNIFIED FIELD THEORY would be produced.

Granger Movement US agrarian movement. The National Grange, or Order of the Patrons of Husbandry, was founded in 1867. Individual granges, organized on a local basis, established cooperative grain elevators, mills and stores. Together, grangers brought pressure on state legislatures to regulate railroads and other costs. In the 1990s there were over 5,000 local granges in the USA.

granite Coarse-grained, light-grey, durable IGNEOUS ROCK, composed chiefly of feldspar and quartz, with some mica or hornblende. It is thought to have solidified from magma (molten rock). It is a valuable construction material.

Grant, Cary (1904–86) US film star, b. Britain. A handsome and charming actor, he specialized in playing romantic leads. His many films include sophisticated comedies such as *Topper* (1937) and *Bringing Up Baby* (1938), and stylish thrillers such as *North by Northwest* (1959) and *Charade* (1963).

Grant, Duncan (1885–1978) British landscape painter, portraitist and designer, one of the first British artists to be influenced by POST-IMPRESSIONISM. He was a member of the BLOOMSBURY GROUP.

Grant, Ulysses S. (Simpson) (1822–85) US Civil War general and 18th US president (1869–77). He served in the MEXICAN WAR (1846–48) and the CIVIL WAR. He masterminded the Vicksburg Campaign (1862–63). In 1864 Abraham LINCOLN gave him overall command of the Union forces. He coordinated the final campaigns and accepted the surrender of Robert E. LEE (1865). As president, he achieved foreign policy successess, but failed to prevent the growth of domestic corruption. He was comfortably re-elected in 1872, but members of his own administration were implicated in the corruption charges and he retired at the end of his second term.

grant maintained schools Schools in the UK that, dependent on a majority vote by parents, "opt out" of Local Education Authority Control, become self-governing and receive finance directly from the Department of Education. Such schools have existed since the 1988 Education Act.

grape Vines that grow in temperate and subtropical climates, producing fruit which is eaten raw, dried or used for making WINE. The classical European vine (Vitis vinifera) had its origins in Asia. The climate, soil, topography and methods of cultivation all determine the quality of the crop. Family Vitaceae. grapefruit Evergreen citrus fruit tree and its yellow edible fruit, which is a valuable source of vitamin C. The tree may reach 6m (20ft), and is grown mainly in subtropical climates in the USA, Israel, South Africa and Argentina. Family Rutaceae. graph Diagram representing a relationship between numbers or quantities. Many graphs use the CARTESIAN COORDINATE SYS-

TEM. Other forms include bar charts, in which a series of figures is represented by lines of various lengths, and pie charts, in which quantities are represented by sectors of a circle.

graphical user interface (GUI) Computer PROGRAM enabling a user to operate a COMPUTER using simple symbols. Early personal computers used operating systems that were text based. Commands were often obscure combinations of letters and numbers, which made using the systems difficult for the uninitiated. A GUI replaces these commands with a screen containing symbols called icons. The user manipulates these using a "mouse".

graphite (plumbago) Dark-grey, soft crystalline form of CARBON. It occurs naturally in deposits of varying purity and is made synthetically by heating petroleum coke. It is used in pencils, lubricants, electrodes, brushes of electrical machines, rocket nozzles and as a moderator that slows down neutrons in nuclear reactors. Graphite is a good conductor of heat and electricity. Hardness 1–2; s.g. 2.1–2.3.

Grass, Günter Wilhelm (1927–) German novelist, poet and playwright. His prose combines evocative description with historical documentation in the mannerist style. He used powerful techniques to grotesque comic effect in *The Tin Drum* (1959) and *Cat and Mouse* (1961), and he satirized the Nazi era in *Dog Years* (1963). Later works include *The Flounder* (1977) and *The Call of the Toad* (1992).

grass Non-woody plants with fibrous roots that have long, narrow leaves enclosing hollow, jointed stems. The stems may be upright or bent, lie on the ground, or grow underground. The flowers are small, without PETALS and SEPALS. The leaves grow from the base, and so removal of the tips does not inhibit growth, making grass suitable for lawns and pastures. CEREAL grasses, such as rice, millet, maize and wheat, are cultivated for their seeds. Others are grown as food for animals and for erosion control and ornament. There are c.8,000 species. Family Poaceae/Gramineae. See also MONOCOTYLEDON

grasshopper Plant-eating insect. Its enlarged hind legs make it a powerful jumper. The forewings are leathery and the hind wings are membranous and fan-shaped; when the insect is at rest, the wings are folded over its back. Length: 8–11cm (0.3–4.3in). Order Orthoptera; families Acrididae and Tettingoniidae. *See also* CRICKET; LOCUST.

Grattan, Henry (1746–1820) Irish political leader. A compelling orator, he led the movement to free the Irish Parliament from British control, which was finally achieved in 1782. He failed to prevent the merger of the Irish and British Parliaments in the Act of Union (1801). As a member (1805–20), Grattan fought for CATHOLIC EMANCIPATION.

Graves, Robert von Ranke (1895–1985) British poet, novelist and critic. After publishing his classic World War 1 autobiography, *Goodbye To All That* (1929), he emigrated to Majorca. Other works include *I, Claudius* (1934) and *The Crowning Privilege* (1955).

gravitation One of the four FUNDAMENTAL FORCES in nature. Gravitation is weak compared with the others, but it is apparent because of the great mass of the Earth. The gravitational force F between two masses m_1 and m_2 a distance d apart was found by Isaac Newton to be $F = Gm_1m_2/d^2$, where G is a constant of proportionality called the universal constant of gravitation. A more complete treatment of gravitation was developed by Albert Einstein, who showed in his general theory of RELATIVITY that gravitation is a manifestation of space-time.

Gray, Elisha (1835–1901) US inventor. He received his first patent for a self-adjusting telegraph relay in 1867. He also patented the telegraphic repeater and the type-printing telegraph. He claimed priority as the inventor of the telephone, but Alexander Graham Bell's patent rights were upheld by the US Supreme Court.

Gray, Thomas (1716–71) English poet. His masterpiece was *Elegy Written in a Country Churchyard* (1751). Other poems include *Ode on the Death of a Favourite Cat* (1748) and *The Descent of Odin* (1768).

gray (symbol Gy) SI unit of absorbed radiation dose. One gray is equivalent to supplying 1 joule of energy per kilogram of irradiated material. It superseded the rad (1 gray = 100 rad). **Graz** City at the foot of the Schlossberg mountain peak, on

▲ Grant US general and president, Ulysses S. Grant enjoyed little success in the army (1839–54) or in business until the outbreak of the Civil War. A Union hero, he was twice Republican president. His foreign policy successes while in office, however, were overshadowed by financial scandal and charges of corruption.

▲ grass Meadow grass (Poa pratensis) is an important hay and green pasture grass in North America and Europe, and as such it is an economically valuable member of the large and widespread grass family (Gramineae). The flower of the grass is a minute spikelet, usually arranged in open branching clusters known as panicles. The flowers are cross-fertilized by the wind and the single ovule then develops into a seed or grain. Grassland will evolve readily wherever forest or scrub cover is sparse and where there is sufficient moisture and nutrients in the soil. Vast areas of the world are natural grasslands, such as the steppes of Asia and the North American prairies.

▶ grasshopper Because they have problems visually attracting mates in long grass, grasshoppers (order Orthoptera) seek partners using sound signals. By scraping a row of protruding pegs on the inside of each back leg against hardened ridges on their forewings, they make high-frequency mating calls. The calls, known as stridulation, vary from species to species depending on the number of pegs on each leg.

the River Mur, SE Austria; capital of Styria. Graz's many historic buildings include a 15th-century Gothic cathedral, the famous *Uhrturm* clock tower (1561) and the Renaissance Landhaus (provincial parliament). Johannes Kepler taught at the state university (founded 1586) and Emperor Frederick II is buried here. Industries: iron and steel, paper, leather, glass, chemicals, textiles. Pop. (1991) 237,810.

Great Awakening Series of 18th-century religious revivals in the American colonies. They began with the preaching of Jonathan EDWARDS in New England (1734), William Tennent in New Jersey, and Samuel Davies in Virginia, and were united by George Whitefield (1739–41). Baptist revivals occurred in 1760, and METHODISM evolved in the pre-Revolutionary period.

Great Barrier Reef World's largest CORAL REEF, in the Coral Sea off the NE coast of Queensland, Australia. It was first explored by James COOK in 1770. It forms a natural breakwater and is up to 800m (2,600ft) wide. The reef is separated from the mainland by a shallow lagoon, 11–24km (7–15mi) wide. It is a major tourist site. Length: 2,000km (1,250mi). Area: *c*.207,000sq km (80,000sq mi).

Great Basin Desert area in w USA, comprising most of Nevada and parts of Utah, Idaho, California, Wyoming and Oregon. It includes the DEATH VALLEY, Mojave Desert and Carson Sink. There are mountain ranges running N – S, and the region is sparsely populated. The few streams drain into saline lakes, the biggest is GREAT SALT LAKE. Mineral deposits include gold, magnesite, mercury and beryllium ore. Area: c.492,000sq km (190,000sq mi)

Great Bear Lake Lake in Northwest Territories, NW Canada; the largest lake in Canada and fourth largest in North America. It was first explored in 1825 by John Franklin. It is drained in the w by the Great Bear River. Though the lake is one of North America's deepest, it is icebound for eight months of the year. Area: c.31,800sq km (12,300sq mi).

Great Britain Name for the island of Britain, comprising ENGLAND, SCOTLAND and WALES. Wales was united with England in 1536. The Act of UNION (1707) united Scotland with England, and the Act of Union (1801) established the UNITED KINGDOM of Great Britain and Ireland.

great circle Circle on a spherical surface, whose centre is coincident with the centre of the sphere. On the celestial sphere, the EQUATOR is a great circle, as are all MERIDIANS. The shortest distance between any two points on a sphere, great circles are used for mapping aircraft routes.

Great Dane (German mastiff) Large hunting dog, originally bred in Germany more than 400 years ago. One of the largest dog breeds, it has a narrow head and blunt muzzle. Its deep-chested body is set on long, strong legs. The smooth coat may be various colours. Height: up to 92cm (36in) at the shoulder.

Great Depression Severe economic DEPRESSION that afflicted the USA throughout the 1930s. At the close of the 1920s, economic factors such as over production, unrealistic credit levels, stock market speculation, lack of external markets, and unequal distribution of wealth all contributed to the prolonged economic crisis. The dramatic collapse of the stock market in October 1929 saw \$30,000 million wiped off stock values in the first week. Bank failures became commonplace. At the depth of the Depression (1932–33), unemployment stood at 16 million, almost 33% of the total workforce. The gross national product fell by almost 50%. The Hawley-Smoot Tariff Act increased US tariffs and effectively spread the depression worldwide. Franklin D. ROOSEVELT, sensing the national emer-

gency, instituted the New Deal, which helped to mitigate the worst effects of the crisis. The economy only really started to pick up with increased defence spending in the 1940s.

Great Dividing Range (Eastern Highlands) Series of mountain ranges along the E coast of Australia. They extend s from the Atherton Tableland in Queensland to the Grampian Mountains in Victoria. The highest peak is Mount Kosciusko, 2,230m (7,316ft). Length: 3,703km (2,300 mi).

Greater Antilles Largest of three major island groups in the WEST INDIES, between the Atlantic Ocean and the Caribbean Sea. The group includes CUBA, HISPANIOLA, JAMAICA, PUERTO RICO and the CAYMAN ISLANDS.

Great Exhibition (1851) See CRYSTAL PALACE

Great Lakes Five lakes in central North America, between Canada and the USA; the world's largest expanse of freshwater. They are, from w to E, lakes SUPERIOR, MICHIGAN, HURON, ERIE and ONTARIO. They are connected by straits, rivers and canals, providing a continuous waterway. They are drained by the ST LAWRENCE River, the deepening of which opened up the lakes to world shipping. The growth in industry and commerce has brought people and pollution to the lakes' shores. Major cities include CHICAGO, TORONTO, DETROIT, BUFFALO, CLEVELAND and MILWAUKEE. Total surface area: c.245,300sq km (94,700sq mi).

Great Leap Forward Five-year economic plan begun by MAO ZEDONG in China in 1958. It aimed to double industrial production and boost agricultural output in record time. Tens of millions of workers were mobilized to smelt steel in primitive furnaces, but much of the steel proved useless. Collective farms were merged into communes, but progress was dashed by a succession of poor harvests. After four years the government was forced to admit failure.

Great Plains High, extensive region of grassland in central North America. The Great Plains extend from the Canadian provinces of Alberta, Saskatchewan and Manitoba through w central USA to Texas. The plateau slopes down and E from the Rocky Mountains. It is a sparsely populated region with a semi-arid climate, prone to high winds. The chinook wind warms the otherwise bitter winter. Most of the land is prairie, and cattle-ranching and sheep-rearing are the main economic activities. The soil is often fertile, and wheat is the principal crop. The Great Plains were roamed by Native Americans until Europeans destroyed the herds of BISON. The railroads brought settlers in the late 19th century, but drought and soil mismanagement resulted in the 1930s DUST BOWL.

Great Red Spot See JUPITER

Great Salt Lake Large, shallow saltwater lake in NW Utah, USA. It is fed by the Bear, Weber and Jordan rivers, and its depth and area vary with climatic changes. The heavy brine supports only shrimp and algae. It is the remnant of the prehistoric Lake Bonneville, which covered much of the Great Basin of North America. Bonneville Salt Flats, famous for land speed records, lies in the Great Salt Desert. Area: varies from c.2,500sq km (960sq mi) to c.6,200sq km (2,400sq mi). Great Schism Division within the Roman Catholic Church resulting in the election of rival popes (1378–1417). An Italian line of popes continued in Rome, and a rival "antipope" line in AVIGNON, France. The SCHISM ended with the Council of CONSTANCE (1414–18), which established MARTIN V as the only pope.

Great Slave Lake Second-largest lake in Canada, w Northwest Territories; the deepest lake in North America. It is named after the Slave tribe of Native Americans. The first European discovery was in 1771. Gold is mined on its N shore. It is drained by the Mackenzie River. Area: *c*.28,400sq km (10,980sq mi). Max. depth: 615m (2,015ft).

Great Smoky Mountains Part of the APPALACHIANS, on the North Carolina–Tennessee border, USA. One of the oldest ranges on Earth, it includes the largest virgin forest of red spruce. The region is renowned for its flora and fauna. Early 20th-century exploitation of the region was restricted by the establishment of a national park. The highest point is Clingmans Dome, 2,026m (6,643ft). Area: 2,090sq km (806sq mi). **Great Trek** (1835–40) Migration of *c*.12,000 Boers from Cape Colony into the South African interior. Their motives

were to escape British control and to acquire cheap land. The majority settled in what became Orange Free State, Transvaal and Natal.

Great Wall of China Defensive frontier and world heritage site, *c*.2,400km (1,500mi) long, extending from the Huang Hai (Yellow Sea) to the central Asian desert, N China. It is an amalgamation of fortifications constructed by various dynasties. Sections of the wall were first built by the Warring States. QIN SHIHUANGDI ordered that they should be joined to form a unified boundary (214 BC). The present wall was mostly built 600 years ago by the MING dynasty. It averages 7.6m (25ft) high and up to 9m (30ft) thick.

Great Zimbabwe Ruined city and world heritage site, SE Zimbabwe. It was the capital of a Bantu-speaking kingdom (12th–15th century). At the height of its power, the city's population probably numbered more than 15,000. The city's 9m (30ft) tower is a national symbol.

grebe Brown, grey and black freshwater diving bird found worldwide. It flies laboriously and has legs set so far back that it cannot walk. There are five common species of grebes in Britain and w Europe. Length: to 48cm (19in). Family Podicepididae; genus *Podiceps*.

Greco, El (1541–1614) Spanish painter, b. Crete. His early style was influenced by TITIAN. By 1577 he had settled in Toledo. His earliest work here, *The Assumption of the Virgin*, combines Spanish influences with Italian. His characteristically elongated and distorted figures disregard normal rules of perspective. His later paintings, such as *Burial of Count Orgasz* (1586), *Agony in the Garden* (1610) and *Assumption* (1613), express his profound religious conviction.

Greece Republic in SE Europe. See country feature

Greece, **ancient** Period beginning with the defeat of the second Persian invasion in 479 BC and ending with the establishment of Macedonian power in 338 BC. Warring city-states flourished as centres of trade. ATHENS, the most wealthy and powerful, developed a democratic system under the guidance of PERICLES. Its main rival was the military state of SPARTA. Classical Greece was the birthplace of many ideas in art, literature, philosophy and science – among them those of PLATO and ARISTOTLE. It is traditionally regarded as the birthplace of Western civilization.

Greek INDO-EUROPEAN LANGUAGE spoken in Greece since c.2000 BC. In ancient Greece there were several dialects: Attic, spoken in Athens, is the most common in literary records.

GREECE

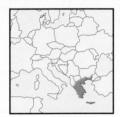

Blue and white became Greece's national colours during the war of independence (1821–29). The nine horizontal stripes on the flag, which was finally adopted in 1970, represent the nine syllables of the battle cry Eleutheria i thanatos ("Freedom or Death").

The mountainous, maritime Hellenic Republic can be divided into four geographical regions: Northern Greece includes the historic regions of Thrace and Macedonia, and its second-largest city Thessaloniki. Central Greece, N of the Gulf of Corinth, includes the capital and largest city, Athens, and its highest peak, Mount Olympus at 2,917m (9,570ft). Southern Greece is the Peloponnesos peninsula, and includes the city of Corinth. The fourth region is the Greek islands, which constitute c.20% of Greece. The largest island, Crette, lies in the Mediterranean Sea, while the Dodecanese group (including Rhodes, Euboea and Lesbos) all

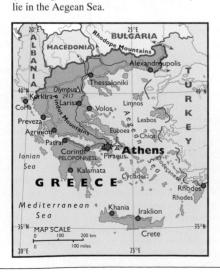

CLIMATE

Low-lying areas have mild, moist winters and hot, dry summers. The E coast has c.50% of the rainfall of the W. The mountains have a much more severe climate.

VEGETATION

Much of Greece's original vegetation has been destroyed. Some areas are covered by maquis.

HISTORY AND POLITICS

Crete was the centre of Minoan civilization, between c.3000 and 1450 BC. The Minoans were followed by the Mycenaean civilization, which prospered until the Dorians settled $(c.1200 \, \text{BC})$. Powerful city-states emerged, such as Sparta and Athens. Solon established Democracy in Athens (5th century BC). The revolt of the Ionians started the Persian Wars (499–79 BC). See Greece, ancient

Athens was defeated in the PELOPONNESIAN WAR (431-04 BC), and Corinth and THEBES gained control. In 338 BC MACEDON, led by PHILIP II, became the dominant power. His son, ALEXANDER THE GREAT, ushered in the HEL-LENISTIC AGE. Greece became a Roman province in 146 BC. Greece formed part of the BYZANTINE EMPIRE from AD 330-1453. In 1456 the Ottomans conquered Greece. The Greek War of Independence (1821-27) was supported by the European powers, and an independent monarchy was established (1832). As king of the Hellenes (1863-1913), GEORGE I recovered much Greek territory. In 1913 Greece gained Crete. Greece finally entered World War 1 on the Allied side (1917). In 1923 1.5 million Greeks from Asia AREA: 131,990sg km (50,961sg mi)

POPULATION: 10,300,000

CAPITAL (POPULATION): Athens (3,072,922) **GOVERNMENT:** Multiparty republic

ETHNIC GROUPS: Greek 96%, Macedonian 2%,

Turkish 1%, Albanian, Slav LANGUAGES; Greek (official)

RELIGIONS: Christianity (Eastern Orthodox

97%), Islam 2%

currency: Drachma = 100 lepta

Minor were resettled in Greece. In 1936 Joannis METAXAS became premier. His dictatorial regime remained neutral at the start of World War 2. By May 1941 Germany had occupied Greece. Resistance movements recaptured most territory by 1944, and the Germans withdrew. From 1946-49 a civil war raged between communist and royalist forces. In 1951 Greece was admitted to NATO. In 1955 KARAMANLIS became prime minister, the economy improved, but tension with Turkey over CYPRUS surfaced. In 1964 a republican, George Papandreou, became prime minister. In 1967 a military dictatorship seized power. The "Greek Colonels" imposed harsh controls on dissent. In 1973 the monarchy was abolished and Greece became a presidential republic. Civil unrest led to the 1974 restoration of civilian government, headed by Karamanlis. In 1981 Greece joined the European Community, and Andreas PAPANDREOU became president. A series of scandals saw the re-election of Karamanlis (1990). In 1995 Constantine Stephanopoulos became president.

ECONOMY

Despite improvements in infrastructure and industry, Greece is one of the poorest members of the European Community (1992 GDP per capita, US\$8,310). Manufacturing is important. Products: textiles, cement, chemicals, metallurgy. Minerals: lignite, bauxite and chromite. Farmland covers c.33% of Greece, grazing land 40%. Major crops: tobacco, fruit (olives, grapes), cotton and wheat. Livestock are raised. Shipping and tourism are also major sectors.

Greek was widely spoken in the Middle East during the HEL-LENISTIC AGE. It was the official language of the Byzantine Empire, and it began to evolve into its modern form in c.1000 AD. After the fall of Byzantium, it developed two forms: "demotiki", the spoken language also used in most literary forms, and "katharevousa", used in official documents.

Greek art and architecture Greek architecture came into its own in the 6th century BC when stone replaced wood as the building material for civic and temple buildings. Distinct ORDERS OF ARCHITECTURE began to emerge. The earliest remaining Doric temple is the Temple of Hera at Olympia (late 7th century BC), and the most outstanding example is the PARTHENON. Among Ionic temples, the Erectheum is considered the most perfect. The Corinthian mausoleum at Halicarnassus (350 BC) was one of the SEVEN WONDERS OF THE WORLD. Greek art may be divided into four chronological periods: Geometric (late 11th-late 8th century BC), Archaic (late 8th century-480 BC), Classical (480-323 BC) and Hellenistic (323–27 BC). Only a few small bronze horses survive from the Geometric period. During the Archaic period, stone sculpture appeared, vase painting proliferated, and the human figure became a common subject. Civic wealth and pride was a feature of the Classical period, and sculpture reached its peak of serene perfection. The Hellenistic period is noted for increasingly dramatic works.

Greek drama First form of DRAMA in Western civilization. It took three forms – TRAGEDY, COMEDY and satyr plays. Tragedy and comedy were the two main forms. Tragedy developed from religious festivals, at which a CHORUS sang responses to a leader. AESCHYLUS introduced a second actor, and SOPHOCLES added a third. The other major tragedian was EURIPIDES. Greek tragedy usually dealt with mythical subjects, but sometimes (as in Aeschylus' *The Persians*) used recent history for its setting. A tradition of Greek comedy arose in the 5th century BC. It was often highly topical and lampooned politics and the conventions of tragedy; its best-known exponent was ARISTOPHANES. Comedy flourished in the Hellenistic Age (323–27 BC), especially in the work of MENANDER. Satyr plays were bawdy works written to accompany tragedies.

Greek literature One of the longest surviving traditions in world literature. The earliest Greek literature took the form of EPIC songs, collected by HOMER in the *Iliad* and the *Odyssey*; and the didactic poetry of Hesiod, such as Theogony. It also saw the development of lyric poetry, exemplified by the choric lyrics and odes of PINDAR. Throughout the Classical period (c.480-c.323 BC) there was a tradition of fine literature in poetry and prose writing. During the Hellenistic Age (323–27 BC), epic, epigrammatic and didactic poetry flourished in the works of Apollonius of Rhodes, Aratus and Callimachus. Herodus revitalized the art of MIME. During the Roman period (c.27 BC - c. AD 330) important figures included PLUTARCH, MARCUS AURELIUS and PTOLEMY. Writing in Greek died out after the Turkish invasions of the 15th century and was only revived after their overthrow in 1828. Prominent among the new generation ware Dionysios Solomos and Andreas Kalvos. Modern Greek writers of international stature include Nikos KAZANTZAKIS.

Greek mythology Collection of stories mainly concerning the adventures of gods and heroes. In the myths, the gods are not wholly admirable figures: they have similar weaknesses to humans and are capable of great vindictiveness, revenge and favouritism. Greek myths were often explanatory, offering answers to questions of human nature and the universe, clarifying abstract ideas, or explaining religious matters in a more rational manner.

Greeley, Horace (1811–72) US journalist and political leader. Greeley founded and edited the *New York Tribune* (1841). He advocated progressive social reforms and opposed slavery. His advocacy of Western settlement was encapsulated in his advice, "Go West, young man, go West". A supporter of LINCOLN, he served briefly in Congress (1848–49). His bid for the presidency for the Liberal Republican Party (1872) was defeated by Ulysses S. GRANT.

green algae Large group of marine and freshwater ALGAE (phylum Chlorophyta). They are distinct from other algae by

virtue of possessing cup-shaped CHLOROPLASTS that contain chlorophyll b, and by producing cells with flagella at some stage in their lives. Green algae range in size from microscopic single-cell types to large, complex SEAWEEDS. See also LICHEN Greenaway, Peter (1942–) Welsh film director and screenwriter. An innovative and painterly director, his breakthrough film was The Draughtsman's Contract (1983). Other films include The Cook, the Thief, His Wife and Her Lover (1989), Prospero's Books (1991) and The Pillow Book (1996).

greenback Paper money issued by the US government during the Civil War. They were authorized by Congress as legal tender but could not be redeemed in gold or coins. A total of \$450 million was issued. They became convertible to gold in 1878.

Greenback Party US political party (1875–84). Deriving its main support from Western farmers, it favoured the issue of more GREENBACKS to stimulate prices. It nominated Peter Cooper for president (1876) and elected 14 Congressmen in 1878. It declined in the 1880s.

green belt Area of open land maintained as a barrier between adjoining built-up areas. The concept of green belts was first put forward by Ebenezer Howard in Britain in his plans for garden cities. Howard used them to distinguish residential from industrial sections. Green belts provide protection from factories and intensive commercial areas.

Greene, (Henry) Graham (1904–91) British novelist and dramatist. Greene converted to Catholicism in 1926; religion, guilt and the search for redemption are consistent themes in his novels. His psychological thrillers are among the most popular and critically acclaimed works of 20th-century fiction. His first novel was *The Man Within* (1929). Important works include *Brighton Rock* (1938), *The Power and the Glory* (1940), *The Heart of the Matter* (1948), *The Quiet American* (1955), the "entertainment" *Our Man in Havana* (1958), *The Honorary Consul* (1973) and *Travels with My Aunt* (1978).

Greene, Nathanael (1743–86) US general. Greene was an outstanding general in the AMERICAN REVOLUTION, and fought with George WASHINGTON. In 1776 he skilfully led the left wing of the American forces at Trenton, Princeton and Brandywine. Greene assumed command of the Southern army in 1780. His reorganization and strategy ensured the success of the Carolina Campaign (1780–82), which resulted in numerous British defeats.

greenhouse effect Raised temperature at a planet's surface as a result of heat energy being trapped by gases in the ATMOSPHERE. As the Sun's rays pass through Earth's atmosphere, some heat is absorbed but most of the short-wave SOLAR ENERGY passes through. This energy is re-emitted by the Earth as long-wave radiation, which cannot pass easily through the atmosphere. More heat is retained if there is a CLOUD layer. In recent centuries, more heat has been retained due to the increased levels of carbon dioxide (CO₂) from the burning of FOSSIL FUELS. Tiny particles of CO₂ form an extra layer, which acts like the glass in a greenhouse. Scientists argue that the greenhouse effect is contributing to GLOBAL WARMING.

Greenland World's largest island, in the NW Atlantic Ocean, lying mostly within the Arctic Circle. It is a self-governing province of Denmark; the capital is Nuuk (Godthåb). More than 85% of Greenland is covered by PERMAFROST, with an average depth of 1,500m (5,000ft). Settlement is confined to the sw coast, which is warmed by Atlantic currents. Most of Greenland's inhabitants are INUIT. Its European discovery is credited to ERIC THE RED, who settled in 982, founding a colony that lasted over 500 years. Greenland became a Danish possession in 1380, and was incorporated into the kingdom in 1953. Following a referendum, Greenland achieved home rule (1979) and self-government (1981). In 1985 it withdrew from the European Union. Greenland's economy is heavily dependent on subsidies from Denmark. Fish forms the basis of the economy. Lead and zinc are mined in the NW, and the s has untapped reserves of uranium. Tourism is increasing. Area: 2,175,000sq km (840,000sq mi). Pop. (1993) 55,117.

green movement Campaign to preserve the environment and to minimize pollution or destruction of the Earth's natural habitat. The green movement formed its own active pressure

▲ Greek art A collection of Classical Greek jewellery dating from the 4th century BC. The items include a bracelet (A) showing lions' heads in chased gold with filigree collars; a central element of diadem (B) decorated with gold filigree work; a golden earring (C) shaped in a spiral tube, ending in a lion's head; a second earring (D) in the form of a gold filigree rosette with delicately chased female head suspended from the disc; and two gold rings, one carved in intaglio with a female figure (E), the other is carved with a woman's profile (F).

groups Greenpeace and Friends of the Earth in the 1970s. It gained political representation shortly afterwards in the form of various European Green Parties. In affluent Western societies, effects of the movement have included the production of environmentally safe products and a concern with the recycling of waste products such as glass, paper and plastics.

Green Party Any of a number of European political parties embodying the principles of the GREEN MOVEMENT. Green parties promote sustainable exploitation of natural resources and the use of RENEWABLE ENERGY sources. Major European Green parties were founded in the early 1970s. By the late 1980s, traditional political parties had adopted many Green policies and the Green vote declined.

Greenpeace International pressure group founded in 1971, initially to oppose US nuclear testing in Alaska. Greenpeace promotes environmental awareness and campaigns against environmental abuse. It gains wide media coverage for its active, non-violent demonstrations against whaling, toxic-waste dumping and nuclear testing.

Green Revolution Intensive plan of the 1960s to increase crop yields in developing countries by introducing higher-yielding strains of plant and new fertilizers. The scheme began in Mexico in the 1940s and was successfully introduced in parts of India, SE Asia, the Middle East and Latin America.

Greenwich Borough in SE London, England. In Greenwich Park stands the former Royal Observatory (founded 1675). The prime meridian forms the basis of Greenwich Mean Time (GMT). Greenwich has a rich maritime history and is home to the Royal Naval College, which stands on the site of a royal palace. The last tea clipper, *The Cutty Sark*, and Sir Francis Chichester's round-the-world yacht, *Gipsy Moth IV*, lie in dry dock. Pop. (1991) 207,650.

Greenwich Mean Time (GMT) Local time at GREENWICH, London, situated on the prime meridian. It has been used as the basis for calculating standard time in various parts of the world since 1884. GMT corresponds with civil time in Britain during the winter months; British SUMMER TIME (BST) is one hour ahead of GMT.

Greer, Germaine (1939–) Australian feminist author. Her controversial book *The Female Eunuch* (1970) portrayed marriage as a legalized form of female slavery and questioned a number of gender-oriented stereotypes. Other works include *Sex and Destiny: the Politics of Human Fertility* (1984) and *The Change: Women, Ageing and the Menopause* (1991).

Gregory I, Saint (540–604) (Gregory the Great) Pope (590–604). He devoted himself to alleviating poverty and hunger among the Romans. His reforms included changes in the Mass, and he initiated the conversion of the Lombards. He sent Saint AUGUSTINE OF CANTERBURY to convert the ANGLO-SAXONS. He is considered a saint and is regarded as one of the Fathers of the Church. His feast day is 12 March.

Gregory VII (1020–85) Pope (1073–85), b. Hildebrand. He brought about various reforms to counteract abuses in the church and twice excommunicated the Holy Roman Emperor Henry IV. He increased the papacy's temporal power.

Gregory XIII (1502–85) Pope (1572–85), b. Ugo Buoncompagni. He supported education, training for the clergy, and missionary activity, especially the JESUITS. He promoted church reform and sought to carry out the decrees of the Council of TRENT. He is best known for his reform of the Julian CALENDAR (1582).

Grenada Independent island nation in the SE Caribbean Sea, the most southerly of the WINDWARD ISLANDS, *c.*160km (100mi) N of Venezuela. It consists of Grenada and the smaller islands of the Southern Grenadines dependency; the capital is St George's. First sighted in 1498 by Christopher COLUMBUS, the islands were then inhabited by the Carib. In the mid-17th century Grenada was settled by the French. It became a permanent British possession in 1783 and a crown colony in 1877. It was a member of the West Indian Federation (1958–62). In 1974 it became an independent Commonwealth state. In 1979 the New Jewel movement seized power and in 1983, following a military coup, US forces invaded the island. They were withdrawn in 1985 after the re-establishment of a democratic government. Elections in 1995 were won by the

New National Party, led by Dr Keith Mitchell. The country is volcanic in origin, with a ridge of mountains running N – s. It has a tropical climate with occasional hurricanes. The economy is largely agricultural, based on cocoa, bananas, sugar, spices and citrus fruits. It is heavily dependent on tourism. Area: 344sq km (133sq mi). Pop. (1995 est.) 96,000.

Grenadines Group of *c.*600 small islands in the s Windward Islands, Caribbean Sea, West Indies. The s Grenadines are included in Grenada. The N Grenadines form part of ST VINCENT AND THE GRENADINES. Industries: cotton, limes, livestock, tourism.

Grenville, Sir Richard (1541–91) English naval commander and hero. He commanded the fleet that carried Sir Walter Raleigh's colonists to Roanoke, Virginia, in 1585. His adventurous career ended when he was fatally wounded and his ship, *Revenge*, captured in a 15-hour battle off the Azores (1591).

Gretzky, Wayne (1961–) ("the Great Gretzky") Canadian ice hockey player. He led the Edmonton Oilers to a series of National Hockey League (NHL) titles before being traded to the Los Angeles Kings in 1988. In 1981–82 he became the first player to achieve more than 200 points (212). In 1994 he established a new NHL record for most career points (goals and assists).

Grey, Charles, 2nd Earl (1764–1845) British Prime Minister (1830–34). During his administration the First Reform ACT was passed (1832) and slavery was abolished throughout the British empire (1833). Grey supported limited parliamentary reform, though as a Whig aristocrat he was no radical.

Grey, Lady Jane (1537–54) (Nine-Day Queen) Queen of England (1553). Great-granddaughter of Henry VII, she was married to the son of the Duke of NORTHUMBERLAND, regent for the ailing EDWARD VI. On Edward VI's death she was proclaimed queen, but the rightful heir, MARY I, was almost universally preferred. Lady Jane and her husband were executed. greyhound Coursing dog traditionally used to hunt hares and also used for racing. It has a long tapered head and muzzle with small ears set at the back. Its muscular back and well-arched loins are set on long, lean legs. The tail is long and tapered and the smooth coat may be almost any colour. Height: 66cm (26in) at the shoulder; weight 29kg (65lb).

Grieg, Edvard Hagerup (1843–1907) Norwegian composer. He used Norwegian folk themes in his compositions, many of which are for piano or voice. Among his best-known works are the song *I Love Thee* (1864), the two *Peer Gynt* suites for orchestra (1876), and the Piano Concerto (1868).

Griffith, Arthur (1872-1922) Irish statesman, founder of SINN FÉIN. From 1899 he edited the republican newspaper United Irishman. Griffith regarded armed resistance as impractical and took no part in the EASTER RISING (1916). He was elected vice president of the Dáil Éireann (1918), and led the negotiations that created the Irish Free State (1921). When DE VALERA rejected the settlement, Griffith became president. Griffith, D.W. (David Wark) (1875–1948) US film director, the most influential figure in the development of the cinema in the USA. His directorial debut was The Adventures of Dollie (1908). His expressive use of the camera, lighting and dramatic editing established film as an independent art form. In 1915 he released the Civil War epic The Birth of a Nation, often cited as the most important document in cinematic history, but also condemned as racist. Intolerance (1916) was his response, examining the persistence of prejudice. In 1919 he cofounded United Artists, and in 1935 he won an honorary Oscar.

griffon (griffon vulture) Carrion-eating bird of prey of Eurasia and N Africa, with gold or sandy-brown plumage. It is gregarious and nests in large flocks. Length: 1m (3.3ft). Family Accipitridae; species *Gyps fulvus*.

Grimm brothers German philologists and folklorists. Jakob Ludwig Karl (1785–1863) formulated **Grimm's law** relating to the regular shifting of consonants in INDO-EUROPEAN LANGUAGES. He and his brother Wilhelm Karl (1786–1859) are popularly known for their collection of folk tales, *Grimm's Fairy Tales* (1812–15). It was a major text of ROMANTICISM.

Grimond, Jo (Joseph), Baron (1913–93) British politician, Liberal Party leader (1956–67). Grimond became a member of Parliament in 1950. He modernized the Liberal

▲ Gretzky Canadian ice hockey star Wayne Gretzky was the first player ever to exceed 200 points (goals and assists) in a single season (1981–82). He was voted Most Valuable Player in the National Hockey League from 1980 to 1987

Party and proposed a political realignment, which captured new supporters. He opposed nuclear weapons and favoured Britain's entry into the EUROPEAN COMMUNITY (EC). After the forced resignation of Jeremy Thorpe (1976), Grimond became caretaker leader of the Party until David STEEL took over.

Gris, Juan (1887–1927) Spanish painter. He settled in Paris in 1906 and, with Picasso and Braque, became a leading exponent of synthetic CUBISM. Later works include collages, architectonic paintings, stage sets and costumes for Diaghillev. grizzly bear Large Bear, generally considered to be a variety of brown bear (*Ursus arctos*) although sometimes classified as a separate species (*Ursus horribilis*). Once widespread in w North America, the grizzly is now rare except in w Canada, Alaska and some US national parks. Length: to 2.5m (7ft); weight: 410kg (900lb).

Gromyko, Andrei (1909-89) Soviet statesman, foreign minister (1957-85), president (1985-88). Soviet ambassador to the USA (1943-46), Gromyko took part in the Yalta and Potsdam peace conferences (1945). He acted as the permanent Soviet delegate to the United Nations (1946-48). As foreign minister, he was influential in establishing the round of summits between the US and Soviet presidents. GORBACHEV promoted Gromyko to the presidency, but he was forced to retire in 1988. **Groningen** City at the confluence of the Hoornse Diep and the Winschoter Diep, NE Netherlands; capital of Groningen province. A member of the HANSEATIC LEAGUE from 1284, it controlled most of Friesland. Groningen remained loyal to the Habsburgs, but was forced to surrender to the Dutch in 1594. It has 15th- and 17th-century churches and a university (1614). The surrounding fertile agricultural land makes it one of the country's biggest markets. Industries: shipbuilding, electrical equipment. Pop. (1994) 170,535.

Gropius, Walter (1883–1969) German-American architect, founder of the BAUHAUS (1919–28). Gropius transformed the Weimar School of Art into the Bauhaus, which was relocated to his newly designed buildings in Dessau (1926). He fled Germany (1934) and headed the Harvard school of architecture (1937–52). Gropius pioneered functional design and the INTERNATIONAL STYLE in particular. The results of his cooperative, group-work design methods can be seen in the Harvard graduate centre and the US embassy, Athens.

grosbeak Any of several birds of the FINCH family (fringillidae). They have short, thick, seed-cracking beaks. Found in woodlands of the Americas, Europe and Asia, species include the rose-breasted grosbeak (*Pheucticus ludovicianus*) of North and South America, and the pine grosbeak (*Pinicolor enucleator*) of Canada and N Europe. Length: 18–25cm (7–10in).

gross domestic product (GDP) Total amount of goods and services produced by a country annually. It does not include income from investments or overseas possessions. GDP gives an indication of the strength of national industry. See also GROSS NATIONAL PRODUCT (GNP)

gross national product (GNP) Total market value of all goods and services produced by a country annually, plus net income from abroad. GNP is a universal indicator of economic performance and provides an assessment of different economic sectors. GNP is the sum of four types of spending: private consumption (goods and services bought by the community); government expenditure; balance of trade; and business investment. See also GROSS DOMESTIC PRODUCT (GDP)

Gros Ventre (Fr. big belly) Name applied by French settlers to two distinct tribes of Native North Americans: the HIDATSA and the Atsina.

Grosz, George (1893–1959) German illustrator and painter. A founder of the DADA movement in Berlin, he satirized capitalist and military corruption in drawings and caricatures, such as *Ecce Homo* (1923). He settled in the USA in 1932. His later works showed some affinity with SURREALISM. **groundnut** *See* PEANUT

ground squirrel (gopher) Small terrestrial SQUIRREL native to Eurasia and North America. Ground squirrels eat plants, seeds, insects, small animals and sometimes eggs. Most have greyish-red to brown fur and some are striped or spotted. Length: to 40.5cm (16in); weight: 85–1,000g (0.1–2.2lb). Family Sciuridae; genus *Citellus* (and others).

groundwater Water that lies beneath the surface of the Earth. It comes chiefly from rain, although some is of volcanic or sedimentary origin. It moves through porous rocks and soil and can be collected in wells. Ground water can dissolve minerals and leave deposits, creating structures such as CAVES, STALAGMITES and STALACTITES. See also WATER TABLE

grouper Tropical marine fish found from the coast of Florida to South America, and in the Indian and Pacific oceans. It has a large mouth, sharp teeth, a mottled body and the ability to change colour. Length: to 3.7m (12ft); weight: to 450kg (1,000lb). Family Serranidae; species: giant, *Epinephelus itajara*; Australian, *Epinephelus lanceolatus*.

Group of Eight (G8) (formerly Group of Seven, G7) Group of eight nations whose heads of government meet annually to discuss the world's economy. In 1975 the heads of government of the world's seven wealthiest nations – the USA, Japan, Germany, Britain, France, Canada and Italy – met for the first summit. In 1997 Russia was formally admitted to the group.

grouse Plump game bird of N areas of the Northern Hemisphere. Grouse are fowl-like, but have feathered ankles and toes and brightly coloured air sacs on the neck. Family Tetraonidae. *See also* PRAIRIE CHICKEN

Grozny City in the Caucasus Mountains, sw Russia, the capital of CHECHENYA. Founded in 1818, it has been an oil-producing centre since 1893 and has a pipeline to the Black Sea and the Donets Basin. Grozny was severely damaged in fighting between Russian forces and Chechen rebels from 1994–96. Industries: oil, petrochemicals. Pop. (1992) 388,000.

Grünewald, Mathias (1470–1528) German painter. He was Dürer's greatest contemporary, and one of the earliest exponents of expressionism. Grünewald focused on religious themes, especially crucifixions.

Guadalajara City in sw Mexico; capital of Jalisco state and second-largest city in Mexico. Founded in 1531, it has become a major industrial centre. It has some fine Spanish colonial architecture, such as the cathedral and governor's palace. Noted for its mountain scenery and mild climate, it is a popular health resort. Industries: engineering, textiles, food processing, pottery, glassware. Pop. (1990) 1,650,205.

Guadalcanal Largest of the Solomon Islands, c.970km (600mi) E of New Guinea, w central Pacific Ocean; the capital is Honiara. Guadalcanal was the scene of heavy fighting between Japanese and US troops in World War 2. The chief products are coconuts, fish, fruit and timber. Area: 5,302sq km (2,047sq mi). Pop. (1991 est.) 60,692.

Guadalupe-Hidalgo, Treaty of (1848) Peace settlement ending the MEXICAN WAR. Mexico ceded the present states of Texas, New Mexico, Arizona, California, Nevada, Utah, and parts of Colorado and Wyoming. The USA paid \$15 million in compensation.

Guadalupe Mountains National Park Park in w Texas, USA. The region was established as a national park in 1966. The mountains contain portions of an extensive Permian limestone fossil reef. The park features unusual flora and fauna. Area: 328sq km (127sq mi).

Guadeloupe French overseas département (since 1946), consisting of the islands of Basse-Terre (w), Grande-Terre (E), and several smaller islands in the Leeward Islands, E WEST INDIES. Discovered in 1493 by Columbus, Guadeloupe was settled by the French (1635), briefly held by Britain and Sweden, and reverted to French rule in 1816. The chief crops are sugar cane and bananas. Industries: distilling, tourism. Area: 1,780sq km (687sq mi). Pop. (1990) 378,178.

Guam Southernmost and largest of the MARIANA ISLANDS in the W Pacific Ocean; the capital is Agaña. An unincorporated US territory, Guam was discovered by Ferdinand Magellan (1521) and ceded to the USA (1898). Guam was the first US territory to be occupied by the Japanese during World War 2. Industries: oil refining, palm oil, fish products. Area: 541sq km (209sq mi). Pop (1992 est.) 140,200.

Guangxi (Kwangsi) Autonomous region in s China, on the border with Vietnam; the capital is Nanning. It was created as an autonomous region in 1958 for the Zhuang, China's largest minority nationality. Cultivation is limited by the mountainous terrain. Minerals include manganese, zinc, tin,

tungsten and antimony. Industries: oil refining, fertilizers. Area: 220,495sq km (85,133sq mi). Pop. (1990) 21,000,000. **Guangzhou** (Canton) Largest city in s China, on the Pearl River; capital of Guangdong province. Since 300 BC it has been an important trading port. The birthplace of SUN YATSEN, it was the focal point of the nationalist revolution (1911). It is s China's leading industrial and commercial city. Industries: textiles, rubber products, shipbuilding, sugar refining, iron, steel. Pop. (1993 est.) 3,560,000.

guano Dried excrement of sea birds and bats. It contains phosphorous, nitrogen and potassium and is a natural fertilizer. It is found mainly on certain coastal islands off South America and Africa, and on some Paficic islands.

Guaraní Native South American tribe and language. The tribe's population has decreased greatly, although most Paraguayans are descended from Guaraní. Their language has survived as Paraguay's second national language.

Guardi, Francesco (1712–93) Venetian painter. He produced vivid and fluidly painted views of Venice, appreciated after the Impressionists "discovered" them in the 19th century. His work is much freer than that of CANALETTO.

Guatemala Republic in Central America. *See* country feature **Guatemala City** (Ciudad Guatemala) Capital of Guatemala, on a plateau in the Sierra Madre; largest city in Central Amer-

ica. Founded in 1776, the city was the capital of the Central American Federation from 1823–39. It was badly damaged by earthquakes in 1917–18 and in 1976. Industries: mining, furniture, textiles, handicrafts. Pop. (1989 est.) 2,000,000.

guava Any of 100 species of fruit-bearing trees or shrubs native to tropical America and the West Indies. The large white flowers produce a berry-like fruit, usually yellow with white, pink or yellow flesh. Family Myrtaceae.

Guayaquil City on the River Guayas, near the Gulf of Guayaquil, w Ecuador; chief port and largest city of Ecuador. Founded by the Spanish in the 1530s, Guayaquil was frequently attacked by buccaneers in the 17th and 18th centuries. Industries: textiles, pharmaceuticals, leather goods, cement, iron products, oil refining, fruit. Pop. (1990) 1,508,444.

gudgeon Freshwater CARP found in rivers from Britain to China. It has a small mouth with barbels, an elongated body and variable colour. Length: 20cm (8in). Species *Gobio gobio*. **guelder rose** Plant of the HONEYSUCKLE family (Caprifoliaceae). It has globular clusters of white or pink flowers. Species *Viburnum opulus*.

Guelph Political faction in medieval Italy, opposed to the GHIBELLINE. The two factions were linked to rival families contending for the HOLY ROMAN EMPIRE in the 12th century. In 1198 Otto IV (a Guelph) became Holy Roman emperor.

▲ guava The fruit of the tropical American tree (*Psidium guajava*) is high in vitamin C. It is most commonly made into guava jelly, but it can also be stewed and canned.

GUATEMALA

Guatemala's flag was adopted in 1871, but its origins go back to the days of the Central American Federation (1823–39), which was set up after the break from Spain in 1821. The Federation included Costa Rica, El Salvador, Guatemala, Honduras and Nicaragua.

The Central American republic of Guatemala contains a densely populated fertile mountain region. The capital, GUATEMALA CITY, is situated here. The highlands run in an E–W direction and contain many volcanoes. Guatemala is subject to frequent earthquakes and volcanic eruptions. Tajmulco, an inactive volcano, is the highest peak in Central America, at 4,211m (13,816ft).

South of the highlands lie the Pacific coastal lowlands. North of the highlands is the thinly populated Caribbean plain and the vast Petén

MAP SCALE

O 50 100 km

O Sornles

Uaxactuno

Like

Peten Izza

Flores

Peten Izza

Peten Izza

Puerto

Barrios

Puerto

Barrios

Puerto

Barrios

Coban

Loke

Izaba

Coban

Loke

Izaba

Puerto

Barrios

Coban

Chigumula U

Mazatenango

San José

tropical forest. Guatemala's largest lake, Izabal, drains into the Caribbean Sea.

CLIMATE

Guatemala lies in the tropics and the lowlands are hot and rainy. The central mountain region is more temperate. Guatemala City, at c.1,500m (5,000ft) above sea level, has a pleasant, warm climate, with a marked dry season between November and April.

VEGETATION

Hardwoods, such as mahogany, rubber, palm and chicozapote (from which chicle, used in chewing gum, is obtained), grow in the tropical forests in the N, with mangrove swamps on the coast. Oak and willow grow in the highlands, with fir and pine at higher levels. Much of the land on the Pacific plains is farmed.

HISTORY AND POLITICS

Between AD 300 and 900, the QUICHÉ branch of the MAYA ruled much of Guatemala, but inexplicably abandoned their cities on the N plains. The Quiché ruins at Tikal are the tallest temple pyramids in the Americas. In 1523–24 the Spanish conquistador Pedro de Alvarado defeated the native tribes. In 1821 Guatemala became independent. From 1823–39 it formed part of the Central American Federation. Various dictatorial regimes interfered in the affairs of other Central American states, arousing much resentment and leading to the establishment of the Central American Court of Justice.

AREA: 108,890sq km (42,042sq mi)

POPULATION: 9.745.000

CAPITAL (POPULATION): Guatemala City

(2,000,000)

GOVERNMENT: Republic

ETHNIC GROUPS: Native American 45%, Ladino (mixed Hispanic and Native American) 45%, White 5%, Black 2%, others including

Chinese 3%

LANGUAGES; Spanish (official)

RELIGIONS: Christianity (Roman Catholic 75%,

Protestant 25%)

currency: Guatemalan quetzal = 100 centavos

In 1941 Guatemala nationalized the Germanowned coffee plantations. After World War 2 Guatemala embarked on further nationalization of plantations. In 1960 the mainly Quiché Guatemalan Revolutionary National Unity Movement (URNG) began a guerrilla war, which has killed over 100,000 people. During the 1960s and 1970s, Guatemala was beset by terrorism and political assassinations. In 1976 Guatemala City was devastated by an earthquake, which killed over 22,000 people.

In 1983 Guatemala reduced its claims to BELIZE. Civilian rule was restored in 1984, after the USA withdrew backing for the Guatemalan military. In 1995 an accord was signed recognizing the rights of the indigenous population. Support for the URNG has dwindled. In 1996 Alvaro Arzú was elected president.

ECONOMY

Guatemala is a lower-middle-income developing nation (1992 GDP per capita, US\$3,330). Agriculture employs 50% of the workforce. Coffee, sugar, bananas and beef are leading exports. Other important crops are cardamom and cotton. Maize is the chief food crop, but Guatemala has to import food. Forestry is a major activity. Tourism and manufacturing are growing in importance. Manufactures: processed farm products, textiles, wood products, handicrafts.

In the battle for control of Italy, the Guelphs took the side of the papacy, while the Ghibellines backed the emperor FRED-ERICK II. The Ghibellines were defeated by the Guelphs at Tagliacozzo in 1268, but the feud lived on.

guenon Any of 10-20 species of long-tailed, slender, medium-sized African MONKEYS found s of the Sahara Desert. Guenons are omnivorous tree-dwellers, living in small troops dominated by an old male. Genus Cercopithecus.

Guernica Town in Vizcaya province, N Spain. It is a centre of BASQUE nationalism. The bombing of Guernica by German aircraft during the Spanish CIVIL WAR inspired Picasso's masterpiece Guernica (1937).

Guernsey Second-largest island in the CHANNEL ISLANDS; the capital is St Peter Port. It constitutes a bailiwick with several smaller islands, including Alderney and SARK. Its mild, sunny climate is ideal for dairy farming and horticulture. Tourism is also important. Area: 78sq km (30sq mi). Pop. (1991) 58,867. guerrilla warfare Small-scale ground combat operations usually designed to harass, rather than destroy, the enemy. Such tactics are often employed by insurgents or irregular soldiers. They are especially suited to difficult terrain and rely on lightning attacks and aid from civilian sympathizers. In the 20th century, guerrilla tactics have been used by many nationalist and communist movements, such as TITO's Yugoslavian partisans in World War 2.

Guevara, "Che" (Ernesto) (1928-67) Argentine-Cuban revolutionary leader. He became associated with Fidel CASTRO in Mexico, and returned with him to Cuba in 1956 to conduct guerrilla activities against the BATISTA regime. He disappeared from public view in 1965. Two years later he was captured and killed while trying to establish a communist guerrilla base in Bolivia. His remains were returned to Cuba in 1997.

Guggenheim US family of industrialists and philanthropists. Meyer Guggenheim (1828–1905), b. Switzerland. immigrated to Philadelphia (1847) and prospered in the lace import business. He bought silver and lead mines in Colorado. He retired leaving control of his enterprises to his seven living sons. Daniel Guggenheim (1856–1930) took the leading role in expanding the family businesses. A prominent philanthropist, he established the Daniel and Florence Guggenheim Foundation. Solomon R. Guggenheim (1861–1949) endowed a foundation to foster nonobjective art: the Guggenheim Museum opened in New York City in 1959. Simon Guggenheim (1867-1941) was a US senator. In memory of

GUINEA

Guinea's flag was adopted when the country became independent from France in 1958. It uses the colours of the flag of Ethiopia, Africa's oldest nation, which symbolize African unity. The red represents work, the yellow justice and the green solidarity.

he Republic of Guinea, which faces the Atlantic Ocean in West Africa, can be divided into four regions: an alluvial coastal plain, which includes the capital, CONAKRY; the highland region of the Fouta Djallon, the source of one of Africa's longest rivers, the NIGER; the NE savanna; and the SE Guinea Highlands, which rise to 1,752m (5,748ft) at Mount Nimba.

CLIMATE

Guinea has a tropical climate. Conakry has heavy rains between May and November. During the dry season, hot, harmattan winds blow from the SAHARA.

VEGETATION

Mangrove swamps grow along parts of the coast. Inland, the Fouta Djallon is largely open grassland. Northeastern Guinea is tropical

savanna, with acacia and shea scattered across the grassland. Rainforests of ebony, mahogany and teak grow in the Guinea Highlands.

HISTORY

The NE Guinea plains formed part of the medieval empire of Ghana. The Malinke formed the Mali empire, which dominated the region in the 12th century. It was replaced by the Songhai empire. Portuguese explorers arrived in the mid-15th century, and the slave trade began soon afterwards. From the 17th century, other European slave traders became active in Guinea. In the early 18th century, the FULANI gained control of the Fouta Djallon. Following a series of wars, France gained control and made Guinea the colony of French Guinea (1891). France exploited Guinea's bauxite deposits and mining unions developed.

In 1958 Guinea voted to become an independent republic. France severed all aid. Its first president, Sékou Touré (1958-84), adopted a marxist programme of reform and embraced Pan-Africanism. Opposition parties were banned and dissent was brutally suppressed. In 1970 Guinea was invaded by Portuguese Guinea (GUINEA-BISSAU). Conakry acted as the headquarters for independence movements in Guinea-Bissau. A military coup followed Touré's death and established the Military Committee for National Recovery (CMRN) led by Colonel Lansana Conté (1984).

POLITICS

Conté improved relations with the West and introduced free enterprise policies. Civil unrest

AREA: 245,860sq km (94,927sq mi) POPULATION: 6,116,000

CAPITAL (POPULATION): Conakry (705,000) GOVERNMENT: Multiparty republic

ETHNIC GROUPS: Fulani 40%.

Malinke 26%, Susu 11%, Kissi 7%, Kpelle 5%

LANGUAGES; French (official)

RELIGIONS: Islam 85%, traditional beliefs 5%,

Christianity 2%

CURRENCY: Guinean franc = 100 cauris

forced the introduction of a multiparty system in 1992. Conté was elected president amid claims of electoral fraud. A military coup in February 1996 proved unsuccessful.

ECONOMY

Guinea is a low-income developing country (1992 GDP per capita, US\$592). It is the world's second-largest producer of bauxite (after Australia), which accounts for 90% of its exports. Guinea has 25% of the world's known reserves of bauxite. Other natural resources include diamonds, gold, iron ore and uranium. Due to the mining industry, the rail and road infrastructure is improving. Agriculture (mainly at subsistence level) employs 78% of the workforce. Major crops include bananas, cassava, coffee, palm kernels, pineapples, rice and sweet potatoes. Cattle and other livestock are raised in highland areas.

Africa's wildlife, though seriously threatened in many areas, remains one of its chief tourist attractions. This stamp is one of a set of nine issued by Guinea in 1968.

his son, he established the John Simon Guggenheim Memorial Foundation. **Harry Frank Guggenheim** (1890–1971) was US ambassador to Cuba (1929–33). **Peggy Guggenheim** (1898–1979) was a patron and collector of modern art.

guided missile Missile controlled throughout its flight by exterior or interior control systems. There are four types: (1) surface-to-surface, (2) surface-to-air, (3) air-to-air, (4) air-to-surface. The first guided missiles were built in Germany during World War 2. Post-war developments ranged from the huge intercontinental ballistic missiles (ICBMs), with ranges of 10,000km (6,000mi) and nuclear warheads, to small handlaunched antitank missiles. The multiple independently targeted re-entry vehicles (MIRVs) – ICBMs with many independently targetable sub-missiles – were developed in the late 1960s. The USA has built the CRUISE MISSILE which, like the MIRV, threatens the balance of power.

guild Association of craftsmen or merchants in medieval Europe. Merchant guilds probably developed from earlier religious associations and sometimes became more or less synonymous with municipal government. Guilds existed to control economic conditions in the interest of their members, but were eventually eclipsed by the emergence of nation states. They survived in a predominantly ceremonial role into the 19th century.

Guildford Four Three men and a woman of Irish extraction convicted in an English court of terrorist bombings in Guildford and Woolwich, s England, in 1975. The life sentences were quashed on appeal in 1989. The Court of Appeal ruled that confessions recorded in 1974 had been made under duress. *See also* BIRMINGHAM SIX

guillemot Small, usually black-and-white seabird of the AUK family (Alcidae). It lives on cold Northern Hemisphere coastlines and dives for food. Nesting in colonies, it lays two eggs. Length: *c.* 43cm (17in). Genera *Cepphus* and *Uria*.

guillotine Mechanized device for execution by beheading adopted during the FRENCH REVOLUTION. First used in 1792, c.1,400 died under it during the REIGN OF TERROR. It remained in use in France until the abolition of CAPITAL PUNISHMENT in 1981. The term also describes a British parliamentary procedure (first used in 1887) by which a set time is allotted to various stages of a bill in order to speed its passage into law.

Guinea Republic in West Africa. See country feature

Guinea-Bissau Small republic in West Africa; the capital and chief port is BISSAU. Land and Climate Guinea-Bissau is mostly low-lying, with a swampy coastal plain and broad river estuaries. The land rises to low plateaux in the E. Guinea-Bissau has a tropical climate, with a dry season and a rainy season. Mangrove forests line the coasts, and dense rainforest covers much of the coastal plain. Inland, forests merge into tropical savanna, with open grassland on the high ground. History It was first visited by Portuguese navigators in 1446. Between the 17th and early 19th centuries, Portugal used the coast as a slave trade base. In 1836 Portugal appointed a governor to administer Guinea-Bissau and the CAPE VERDE Islands. In 1879 the two territories were separated and Guinea-Bissau became the colony of Portuguese Guinea. In 1956 African nationalists founded the African Party for the Independence of Guinea and Cape Verde (PAIGC). Portugal's determination to keep its overseas territories forced the the PAIGC to begin a guerrilla war (1963), and by 1968 it held 66% of the country. In 1972 a rebel National Assembly in the PAIGC-controlled area voted to form the independent republic of Guinea-Bissau. In 1974 it formally achieved independence (followed by Cape Verde in 1975). In 1980 an army coup led by Major João Vieira overthrew the government. The new Revolutionary Council was against unification with Cape Verde; it concentrated on national policies and socialist reforms. In 1991 the PAIGC voted to introduce a multiparty system. The PAIGC won the 1994 elections, and Vieira was re-elected president. Economy Guinea-Bissau is a poor country (1992 GDP per capita, US\$820), with agriculture employing over 80% of the workforce. Major crops: rice, coconuts, groundnuts, the last two making up 40% of Guinea-Bissau's exports. Fishing is also important.

guinea fowl Pheasant-like game bird of Africa and Mada-

gascar. The common domestic guinea hen (*Numida melea-gris*) is blue, grey or black with white spots and an ornamental crest. Length: to 50cm (20in). Family Phasianidae.

guinea pig Type of CAVY found in South America. The domestic *Cavia porcellus* is a popular pet. It has a large head, soft fur, short legs and no tail. It eats grass and other green plants. *Cavia aperea* is a wild species. Family Caviidae.

Guinevere In Arthurian legend, King Arthur's queen who was loved by Lancelot of the Lake. In Thomas Malory's Morte d'Arthur she betrayed the king and was sentenced to die. She was rescued by Lancelot and later restored to Arthur. Guinness, Sir Alec (1914—) British stage and film actor. Guinness won fame for his performances in the Ealing Studios comedies, such as The Lavender Hill Mob (1951) and The Ladykillers (1955). He won a Best Actor Oscar for Bridge on the River Kwai (1957). Other films include Lawrence of Arabia (1962), Doctor Zhivago (1965), Star Wars (1977), A Passage to India (1984) and Little Dorrit (1988).

Guise, House of Ducal house of Lorraine, the most powerful family in 16th-century France. Claude, duke of Lorraine (1496-1550), founded the house in 1528. His son François (1519-63) supervised the massacre of HUGUENOTS at Vassy in 1562, precipitating the French Wars of RELIGION. His brother Charles (1524-74), cardinal of Guise, played an important role at the Council of TRENT. Their sister, Marie of Scotland, married JAMES V, and their daughter, Mary (later MARY, QUEEN OF SCOTS), married the future François II of France. François' son, Henri (1550-88), helped to organize the SAINT BARTHOLOMEW'S DAY MASSACRE (1572) and led the Holy League, which vehemently opposed Protestantism. Guise power declined when HENRY IV acceded to the throne. guitar Plucked stringed musical instrument. The early guitar had four double strings and was similar to the LUTE. The modern guitar has six strings. The virtuoso playing of Andrés SEGOVIA inspired compositions by Manuel de FALLA and VILLA-LOBOS. In the 1940s Les Paul invented the electric guitar, now a standard instrument in blues, pop and rock music. Acoustic and semi-acoustic guitars are used in folk and jazz. Guizhou (Kweichow) Province in s China; the capital is

Guizhou (Kweichow) Province in s China; the capital is Guiyang. Guizhou became a Chinese province in the Ming dynasty. There were frequent rebellions against Chinese rule in the 19th and 20th centuries. During World War 2, it served as a military base for Allied forces. It was taken by Chinese communists in 1950. Industries: coal mining, iron ore, mercury. Area: 174,060sq km (67,204sq mi). Pop. (1990) 32,370,000.

▲ Guevara The revolutionary leader "Che" Guevara was closely associated with Castro's seizure of power in Cuba, where Guevara held several government posts. A committed Marxist, he was eventually killed by Bolivian government forces while attempting to forment a peasant's revolution in that country. His actions and violent death made him an heroic figure for many revolutionaries.

AREA: 36,120sq km (13,946sq mi)
POPULATION: 1,006,000
CAPITAL (POPULATION):
Bissau (126,900)
GOVERNMENT: Multiparty republic
ETHNIC GROUPS: Balante

27%, Fulani (or Peul) 23%,

Malinke (Mandingo or Mandinka) 12%, Mandyako 11%, Pepel 10% LANGUAGES: Portuguese (official) RELIGIONS: Traditional beliefs 54%, Islam 38%, Christianity 8% CURRENCY: Guinea-Bissau peso = 100 centavos

Gujarat State in w India, on the Arabian Sea; the capital is Gandhinagar. Absorbed into the MAURYAN EMPIRE in the 3rd century BC, it was a centre of JAINISM under the Maitraka dynasty (5th-8th centuries AD). In the early 15th century it was an autonomous Muslim sultanate. Under British rule it became a province (1857). After independence, it was established as a separate state. It is highly industrialized, with substantial reserves of oil and gas. Industries: cotton textiles, salt mining, electrical engineering, petrochemicals. Area: 195,984sq km (75,669sq mi). Pop. (1994 est.) 44,235,000.

Gujarati (Gujerati) Modern language of N India, the official language of GUJARAT. Belonging to the Indic branch of INDO-EUROPEAN LANGUAGES, it began to evolve in c. AD 1000. Gujarati is spoken by more than 30 million inhabitants of Gujarat and other Asian communities worldwide.

gulag Network of detention centres and forced-labour prisons within the former Soviet Union. The term is an acronym in Russian for Chief Administration of Corrective Labour Camps. Established in 1918, gulags were secret CONCENTRA-TION CAMPS used to silence political and religious dissenters. The regime was forcefully described by Alexander Solzhenitsyn in The Gulag Archipelago (1973).

Gulf States Countries around the Persian (Arabian) Gulf, including Iran, Iraq, Kuwait, Saudi Arabia, Qatar, Trucial OMAN and the BAHRAIN islands. Since the 1960s, the political and economic importance of the states has been bolstered by the extensive exploitation of oil reserves.

Gulf Stream Relatively fast-moving current of the N Atlantic Ocean. It flows from the straits of Florida, USA, along the E coast of North America, then E across the Atlantic (as the North Atlantic Drift) to the NW European coast. The current warms coastal climates along its course.

Gulf War (16 January 1991–28 February 1991) Military action by a US-led coalition of 32 states to expel Iraqi forces from Kuwart. Iraqi forces invaded Kuwait (2 August 1990) and claimed it as an Iraqi province. On 7 August 1990, Operation Desert Shield began a mass deployment of coalition forces to protect Saudi oil reserves. Economic sanctions failed to secure Iraqi withdrawal, and the UN Security Council set a deadline of 15 January 1991 for the peaceful removal of Iraqi forces. Iraqi president Saddam Hussein ignored the ultimatum, and General Norman SCHWARZKOPF launched Operation Desert Storm. Within a week, extensive coalition air attacks had secured control of the skies and weakened Iraq's military command. Iraqi ground forces were defenceless against the coalition's technologically advanced weaponry. Iraq launched Scud missile attacks on Saudi Arabia and Israel, in the hope of weakening Arab support for the coalition. On 24 February, the ground war was launched. Iraqi troops burned Kuwaiti oil wells as they fled. Kuwait was liberated two days later, and a cease-fire was declared on 28 February. Saddam Hussein remained in power. An estimated 100,000 Iraqi troops were killed, 600,000 wounded, captured or deserted; 300 coalition forces were killed.

gull (seagull) Any of various ground-nesting birds found along coastlines. They eat carrion, refuse, fish, shellfish, eggs and young birds. The herring gull (Larus argentatus) is grey and white with black markings, hooked bill, pointed wings and webbed feet. It grows to 56-66cm (22-26in). The blackheaded gull (Larus ridibundus) is smaller, with black feathers on its head in summer. Family Laridae.

gum Secretions of plants. Gums are chemically complex, consisting mainly of various saccharides bound to organic acids. Common examples are gum arabic, agar and tragacanth. See also EUCALYPTUS; RESINS

gun Tubular weapon firing a projectile, usually by force of explosion. The term is now restricted to ARTILLERY pieces with a relatively high muzzle velocity and a flat trajectory. PISTOLS, RIFLES and MACHINE GUNS are usually described as guns; mortars and howitzers are not.

Gunnell, Sally Janet Jane (1966-) English athlete. In the 1992 Olympic Games, she captained the British women's team, and won a gold medal in the 400m hurdles. She repeated this success in the 1993 world championships, breaking the world record. A foot injury prevented her defence of the world title in 1995 and forced her retirement from the 1996 Olympic Games.

gunpowder Mixture of saltpetre (potassium nitrate), charcoal and sulphur. When ignited, it expands violently due to the almost instantaneous conversion of solid ingredients into gases. It was used extensively in firearms until c. 1900, when it was replaced by smokeless powders such as DYNAMITE.

Gunpowder Plot (November 1605) Failed Roman Catholic conspiracy to blow up JAMES I of England and his Parliament. The leader of the plot was Robert Catesby, and its chief perpetrator Guy FAWKES. The plotters were arrested on 5 November, a date now celebrated in Britain as Bonfire Night.

Gupta dynasty (c.320-c.550) Ruling house whose kingdom covered most of N India. It was founded by Chandragupta I. The Gupta dynasty embraced Buddhism, and is seen as a golden age. It reached its greatest extent at the end of the 4th century, but declined at the end of the 5th century under concerted attack from the Huns.

Gurdwara (Sanskrit, Guru's doorway) Sikh temple housing a copy of the Adi Granth, the holy scripture of SIKHISM. There are several historically important gurdwaras, such as the Golden Temple of Amritsan, Punjab.

Gurkha Hindu ruling caste of Nepal since 1768. They speak a SANSKRIT language. The name also denotes a Nepalese soldier in the British or Indian army.

gurnard Tropical, marine, bottom-dwelling fish. It has a large spiny head and enlarged pectoral fins. Length: to 50cm (20in). Family Triglidae.

guru Personal teacher and spiritual master. In traditional Hindu education, boys lived in the home of a guru, who guided their studies of the VEDAS and saw to their physical health and ethical training. In SIKHISM, the title guru was assumed by the first ten leaders. Guruship was terminated in 1708.

Gustavus I (Vasa) (1496–1560) King of Sweden (1\\$23–60) and founder of the Vasa dynasty. He led a victorious rebellion

GUYANA

AREA: 214,970sq km (83,000sq mi) **POPULATION: 808,000** CAPITAL (POPULATION): Georgetown (188,000) GOVERNMENT: : Multiparty republic

ETHNIC GROUPS: Indian 49%. Black 36%, Mixed 7%, Native American 7%, Portuguese, Chinese LANGUAGES: English (official)

RELIGIONS: Christianity (Protestant 34%, Roman Catholic 18%), Hinduism currency: Guyana dollar =

34%, Islam 9% 100 cents

against the invading Danes in 1520. In 1523 he was elected king and the Kalmar Union was destroyed. During his reign, Sweden gained independence, the Protestant church was established, and the Bible was translated into Swedish.

Gustavus II (Adolphus) (1594–1632) King of Sweden (1611–32). He succeeded his father Charles IX during a constitutional crisis. Gustav's reign was distinguished by constitutional, legal and educational reforms. He ended war with Denmark (1613) and Russia (1617). Hoping to increase Sweden's control of the Baltic and to support Protestantism, he entered the THIRTY YEARS WAR (1618–48) and died in battle. **Gutenberg, Johann** (1400–68) German goldsmith and printer, credited with the invention of PRINTING from movable metallic type. He experimented with printing in Mainz, Germany, in the 1430s. He made the first printed Bible, known as the *Gutenberg Bible* or *Mazarin Bible* (c.1455).

Guthrie, "Woody" (Woodrow Wilson) (1912–67) US folk singer, guitarist and songwriter. His social-protest poetry captured the spirit of the Great Depression and championed workers' rights. His most famous tunes, such as *This Land Is Your Land* and *So Long, It's Been Good to Know You*, greatly influenced later artists.

Guyana (formerly British Guiana) Republic on the Atlantic Ocean, NE South America; the capital is GEORGETOWN. Land and Climate Over 80% of Guyana is forested. Its interior includes rainforests, savannas, valleys of the Essequibo River, and the Pakaraima Mountains, which rise to 2,772m (9,094ft) at Mount Roraima. The narrow, alluvial coastal plain is largely reclaimed marshland and mangrove swamp. Guyana has a hot and humid climate, but temperatures are lower in the s and w highlands. Rainfall is heavy. There are two dry seasons: February to April, and August to November. History The Dutch settled here in 1581, and the Treaty of Breda (1667) awarded them the area. Land reclamation for plantations began in the 18th century, under the control of the Dutch West India Company. Britain gained control in the early 19th century and set up the colony of British Guiana (1831). Slavery was abolished in 1838. After World War 2, progress towards selfgovernment was achieved with a new constitution (1952), and the election of Dr Cheddi Jagan. British Guiana became independent in 1966, and Forbes Burnham of the socialist People's National Congress (PNC) became the first prime minister. Ethnic conflict between the majority East Indian and African minority marred much of the late 1960s. In 1970 Guyana became a republic. In 1980 Burnham became president, and a new constitution increased his power. After Burnham's death (1985), Desmond Hoyte introduced liberal reforms. Hoyte was defeated in 1992 presidential elections by Jagan. Jagan's People's Progressive Party (PPP) formed the first non-PNC government since independence. On the death of Jagan in 1997, Samuel Hinds became president. Economy Guyana is a poor, developing country (1992 GDP per capita, US\$1,800), its economy dominated by mining and agriculture. Principal exports: Demerara sugar, rice, bauxite. Diamond and gold mining are important. Fishing and forestry industries are expanding, as is ecotourism.

Gwent County in SE Wales, bounded E by the English border, s by the Severn estuary; the county town is Cwmbran. Other major towns include Newport and Tredegar. It is drained by the Usk and Wye rivers. Dairying is important in the Usk valley. Sheep are reared in upland areas. Industries: aluminium, tinplate, chemicals, textiles, electronics. Area: 1,376sq km (531sq mi). Pop. (1991) 442,212.

Gwyn, Nell (1650–87) English actress. She made her first appearance in John Dryden's *The Indian Emperor* (1665), after being discovered selling oranges. She attracted the attention of Charles II and became his mistress.

Gwynedd County in NW Wales, on the Irish Sea coast; the administrative centre is CAERNARVON, other towns include Llandudno, Bangor and Holyhead. It is the site of a medieval principality. Gwynedd is rugged and mountainous, and includes most of the Snowdonia National Park. To the N of the

mountains lie the Lleyn peninsula and the island of Anglesey. Industries: slate quarrying, hydroelectric power, tourism. Area: 3,866sq km (1,493sq mi). Pop. (1990) 235,452.

gymnastics Multidisciplined sport requiring suppleness, strength and poise in a variety of regulated athletic exercises. Men and women compete separately in individual and team events. Men perform in six events: vault, parallel bars, horizontal bars, pommel horse, rings and floor exercises. Women perform in four events: vault, balance beam, asymmetrical bars and floor exercises. Exercises are rated in terms of difficulty, and points are awarded for technical skills and artistry. World championships were inaugurated in 1950, and women's gymnastics became an Olympic sport in 1952.

gymnosperm Seed plant with naked seeds borne on scales, usually cones. Most EVERGREENS are gymnosperms. However, LARCH and some other CONIFERS are DECIDUOUS. All living seed-bearing plants are divided into two main groups: gymnosperms and ANGIOSPERMS. In the Five KINGDOMS classification system, gymnosperms comprise three distinct phyla: Coniferophyta (such as PINE, SPRUCE and CEDAR); Ginkgophyta (a single species, the GINKGO); and Gnetophyta (strange plants such as Welwitschia, Ephedra and Gnetum).

gynaecology Area of medicine concerned with the female reproductive organs. Its study and practice is often paired with OBSTETRICS.

gypsum Most common sulphate mineral, hydrated calcium sulphate ($CaSO_4.2H_2O$). Huge beds of gypsum occur in sedimentary rocks, where it is associated with HALITE. It crystallizes in the monoclinic system. Varieties are ALABASTER, selenite (transparent and foliated) and satinspar (silky and fibrous). It is a source of plaster of Paris. Hardness 2; s.g. 2.3. **gypsy** See ROMANY

gypsy moth Small tussock MOTH with black zigzag markings; the larger female is lighter in colour. The caterpillar feeds on forest and fruit trees, and can be a serious pest. Length: 5cm (2in). Family Lepidoptera; species *Lymantria dispar*.

gyrocompass Navigational aid incorporating a continuously driven GYROSCOPE. The spinning axis of the gyroscope is horizontal and its direction indicates true N, irrespective of the course or attitude of the craft. *See also* COMPASS

gyroscope Symmetrical spinning disc that can adapt to any orientation, being mounted in gimbals (a pair of rings with one swinging freely in the other). When a gyroscope is spinning, a change in the orientation of the gimbals does not change the orientation of the spinning wheel. This means that changes in direction of an aircraft or ship can be determined without external references. A gyrostabilizer is used to stabilize the roll of a ship or aircraft. *See also* AUTOPILOT

GYROCOMPASS

A laser gyrocompass measures rotation by comparing the wavelength of lasers (1). A current is passed from a cathode (2) to two anodes (3) creating two lasers in a gasfilled triangular chamber (4) drilled in a solid glass block (5). Part of the lasers are bled out at one end of the gyrocompass (6) and the wavelength measured. If the gyrocompass rotates to the left the path of the laser travelling to the left is reduced fractionally reducing its wavelength. The opposite occurs to the other laser. A sensor (7) compares the two lasers to measure the rotation.

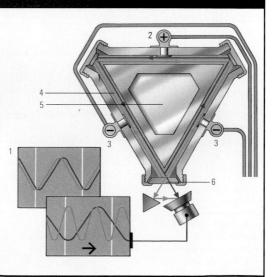

H/h, the eighth letter of the alphabet. It is derived from the Semitic letter cheth, which was pronounced like the ch sound in loch, but with a more "throaty" articulation. It was taken into the Greek alphabet as eta. In its earlier form, it passed into the Roman alphabet. In English, an initial h may be silent (as in hour and heir). It is used with other letters to stand for sounds that may be hard to symbolize with just one letter, such as ch, gh, ph, sh and th. It also serves to mark long vowel sounds in such words as bah and mah-jong. It is silent, especially in British English south of Scotland, after w (such as what, where and which).

Haakon IV (1204–63) King of Norway (1247–63). He secured the submission of Iceland and Greenland to his rule. A patron of learning and the arts, he reigned at the beginning of medieval Norway's "golden age" (1217–1319). He died in the Orkneys after a campaign against the Scots.

Haarlem City on the River Spaarne, w Netherlands; capital of North Holland province. By the 12th century Haarlem was a fortified town. A centre of Dutch painting in the 16th and 17th centuries, it is famous for its tulip bulbs. Industries: electronic equipment, publishing and printing. Pop. (1994) 150,213.

habeas corpus (Lat. you have the body) Writ in English law for the protection of the liberty of the individual. Of the several kinds of writs of *habeas corpus*, the most important is the *habeas corpus ad subjiciendum*, which commands a person who holds another in custody to bring the captive before the court and to state the cause of detention.

Haber process Industrial process (invented by Fritz Haber and Carl Bosch) in which nitrogen from the atmosphere is "fixed" by synthesizing ammonia. A mixture of nitrogen and hydrogen is passed over a heated catalyst at a pressure of c.1,000 atmospheres. The chemical reaction $N_2+3H_2\rightarrow 2NH_3$ occurs. See also NITROGEN FIXATION

habitat Place in which an organism normally lives. A habitat is defined by characteristic physical conditions and the presence of other organisms.

Habsburg (Hapsburg) Austrian royal dynasty, a leading ruling house in Europe from the 13th to 19th century. It became a major force when Count Rudolph was elected king of the Germans (1273). He established the core of the Habsburg dominions in Austria. From 1438 to 1806 the Habsburgs ruled the Holy Roman Empire. Under Charles V their dominions included the Low Countries, Spain and its empire, and parts of Italy. From 1556 the house was divided into Austrian and Spanish branches. The Spanish branch ended in 1700, and the male line of the Austrian branch ended in 1740. MARIA THERESA, though losing Silesia, re-established the house as Habsburg-Lorraine. By 1867 the Habsburg empire was reduced to the AUSTRO-HUNGARIAN EMPIRE. It finally broke up in 1918, when CHARLES I was deposed.

hacker In computing, a person who obtains unauthorized access to a computer DATABASE. A hacker, who usually gains access through the public telephone system using a MODEM, may read or even alter the information in the database.

haddock Marine fish found in cold and temperate waters, primarily in the Northern Hemisphere. Dark grey and silver, it has a large, dark blotch near the pectoral fins. Length: to c.90cm (36in); weight: to 11kg (24.5lb). Family Gadidae; species *Melanogrammus aeglefinus*.

Hades In Greek mythology, the world of the dead, ruled by PLUTO and PERSEPHONE; also another name for Pluto. The dead were ferried to Hades by CHARON across the river STYX. In Hades, the virtuous went to ELYSIUM, while the wicked were condemned to Tartarus – the bottomless pit.

Hadlee, Sir Richard John (1951–) New Zealand cricketer. Hadlee's fast bowling brought 431 wickets in 86 test matches between 1973 and 1990. He is the second highest wicket-taker in test match history (after Kapil Dev). He also scored 3,124 test runs. He was knighted in 1990.

Hadrian, Publius Aelius (76–138) Roman emperor (117–138). Nephew and protegé of Emperor Trajan, he adopted a policy of imperial retrenchment, discouraging new conquests, relinquishing territory hard to defend, and ordering the construction of Hadrian's Wall in Britain. He erected many fine buildings, notably the vast Hadrian's Villa at Tivoli, and also rebuilt the Pantheon. The erection of a shrine to Jupiter on the site of the Temple in Jerusalem provoked a Jewish revolt (132–35), which was ruthlessly suppressed.

Hadrian's Wall Defensive fortification in N England, Erected (AD 122–36) on the orders of the Roman Emperor HADRIAN. It extended 118.3km (73.5mi) and was about 2.3m (7.5ft) thick and 1.8–4.6m (6–15ft) high. Forts were built along its length. Extensive stretches of the wall survive.

hadron Group of SUBATOMIC PARTICLES that are influenced by STRONG NUCLEAR FORCE. Made up of QUARKS, the group can be divided into BARYONS, such as the NEUTRON and PROTON, and MESONS. Over 150 hadrons have been discovered, and, with the exception of the proton and antiproton, they are all unstable. Unlike LEPTONS, they have a measurable size.

haemoglobin Protein present in the ERYTHROCYTES of vertebrates. It carries oxygen to all cells in the body by combining with it to form oxyhaemoglobin. Oxygen attaches to the haem part of the protein, which contains iron; the globin part is a globular PROTEIN.

haemophilia Hereditary blood clotting disorder causing prolonged external or internal bleeding, often without apparent cause. Haemophilia A is caused by inability to synthesize blood factor VIII, a substance essential to clotting. This can be managed with injections of factor VIII. The rarer haemophilia B is caused by a deficiency of blood factor IX. The gene for both types is passed on almost exclusively from mother to son. haemorrhage Loss of blood from a damaged vessel. It may be external, flowing from a wound, or internal, as from internal injury or a bleeding ulcer. Blood loss from an artery is most serious, causing shock and death if untreated. Chronic bleeding can lead to ANAEMIA. Internal bleeding is signalled by the appearance of blood in the urine or sputum.

haemostasis Process by which bleeding stops. Blood vessels constrict, platelets aggregate, and plasma coagulates to form filaments of fibrin.

Hafiz (c.1325–c.1390) (Shams ed-Din Muhammad) Persian poet, one of the finest lyricists in the Persian language. His verse, in rhyming couplets, deals powerfully with sensual pleasures, most famously in the *Divan*. He was a devout Sufi and DERVISH and much of his poetry is religious in content.

hafnium (symbol Hf) Silvery metallic element, one of the TRANSITION ELEMENTS. It was discovered in 1923 by Dirk Coster and Georg von Hevesy. Hafnium's chief source is as a by-product in obtaining the element ZIRCONIUM. It is used as a neutron absorber in reactor control rods. Properties: at.no. 72; r.a.m. 178.49; r.d. 13.31; m.p. 2,227°C (4,041°F); b.p. 4,602°C (8,316°F); most common isotope Hf¹⁸⁰ (35.24%).

Haganah Semi-underground Zionist army formed in the 1920s to protect Jewish interests in Palestine. Allied with the extreme Irgun group in 1945, it attempted to change British policy on Jewish immigration, receiving financial and military aid from US Zionists. *See also* ZIONISM

Haggadah Story of the Exodus and redemption of the people of Israel by God, read during PASSOVER services. Developed over centuries, it includes excerpts from the Bible, rabbinical writings, psalms, stories and prayers.

Haggai (active 6th century BC) Old Testament prophet. He is probably not the author of the Book of Haggai, the tenth of the 12 books of the Minor Prophets. The book records four prophesies made by Haggai in 521 BC, in which he urged the Jews to make haste in the rebuilding of the TEMPLE.

Haggard, Sir (Henry) Rider (1856–1925) British novelist. He wrote hugely successful romantic adventure novels, such as King Solomon's Mines (1885), She (1887) and Allan Quatermain (1887). Other books include Rural England (1902).

Hagia Sophia (Aya Sofia) Byzantine church in Istanbul. It was built (532–37) for the Emperor JUSTINIAN I. A supreme masterpiece of Byzantine architecture, it was the first building to use pendentives to support a central dome. A series of domes extends the lofty interior space. The interior contains columns of marble and porphyry. The church was converted into a mosque in 1453. The Hagia Sophia now acts as a museum.

Hague, William Jefferson (1961–) British politician, Conservative Party leader (1997–). Hague entered parliament in 1989. In 1995 he joined John Major's cabinet as secretary of state for Wales. After the Conservatives' landslide defeat in the 1997 general election, Hague emerged as the youngest Tory leader since William Pitt in 1783. His anti-

▶ haddock One of the mainstay species of the world's commercial fish catch, the haddock (Melanogrammus aegelfinus) is found in cold and temperate waters of the Northern Hemisphere. One of the main fishing areas for this member of the cod family lies off the coast of New England, USA.

European single currency platform seemed destined to push the party toward the Thatcherite right.

Hague, The ('s-Gravenhage, Den Haag) City in the w Netherlands; capital of South Holland province. It is the seat of the Dutch government. Founded in the 15th century, the Hague has been an intellectual and political centre since the 17th century. Notable buildings include the medieval Hall of Knights and the Mauritshuis. The Hague has been the seat of the International Court of Justice since 1945. Much of the city's economy depends on its diplomatic activities. Industries: textiles, pottery, furniture, chemicals. Pop. (1994) 445,279.

Hahn, Otto (1879–1968) German chemist. With Fritz Strassmann in 1939, he discovered nuclear fission, for which he won the 1944 Nobel Prize for chemistry. With Lise Meitner, he discovered protactinium and several isomers.

hahnium See ELEMENT 105

Haifa (Hefa) City on Mount Carmel, NW Israel. It is the centre of the BAHA'ı religion and is the seat of Haifa University (1963). It is one of Israel's largest ports. Industries: textiles, chemicals, shipbuilding, oil refining. Pop. (1992) 251,000.

Haig, Alexander Meigs (1924–) US statesman and general. He served in the army during the Korean War. During the 1960s, he held appointments as military assistant to the secretary of the army and deputy secretary of defence. After duty in Vietnam, he served as White House chief of staff for President NIXON. He was NATO commander (1974–79) and served as secretary of state (1981–82) under President REAGAN.

Haig, Douglas, 1st Earl (1861–1928) British general. Soon after the beginning of World War 1, he became commander in chief of the British forces (1915). His policy of attrition produced enormous casualties but he cooperated effectively with Marshal Foch in the last stages of the war.

haiku Japanese poetry form consisting of 17 syllables in five-seven-five pattern, originally evoking a moment in nature. Matsuo Bashō (1644–94) is considered to be the finest exponent of the form, which remains popular in Japan.

hail Precipitation from clouds in the form of balls of ice. Hailstorms are associated with atmospheric turbulence extending to great heights together with warm, moist air nearer the ground.

Haile Selassie I (1892–1975) (Ras Tafari Makonnen) Emperor of Ethiopia (1930–74). When Italy invaded Ethiopia in 1935, he was forced into exile (1936), despite his appeal to the League of Nations for help. He drove out the Italians with British aid in 1941. Subsequently he became a leader among independent African nations, helping to found the Organization of African Unity (OAU) in 1963. Unrest at lack of reforms led to his being deposed by a military coup in 1974. He died while under arrest. See also RASTAFARIANISM

Hainan Island off s China, separated from the mainland by the Hainan Strait; the capital is Haikou. It has been under Chinese authority from the 2nd century BC. In 1988 it was designated a special economic zone. Its products include rubber, coffee, rice, timber, tin, copper, iron, steel and bauxite. Area: 33,991sq km (13,124sq mi). Pop. (1990) 6,420,000.

Haiphong Port on the Red River delta, N Vietnam. Founded in 1874, Haiphong became the chief naval base of French Indochina. It was occupied by the Japanese during World War 2 and bombed by the French in 1946. During the Vietnam War it was heavily bombed by the USA, and its harbour was mined. Industries: cement, glass, chemicals. Pop. (1989) 456,049.

hair Outgrowth of mammalian skin, with insulating, protective and sensory functions. It grows in a follicle, a tubular structure extending down through the EPIDERMIS to the DERMIS. New cells are continually added to the base of the hair; older hair cells become impregnated with KERATIN and die. Hair colour depends on the presence of MELANIN in the hair cells. A small muscle attached to the base of the hair allows it to be erected in response to nerve signals sent to the follicle. Erecting the hairs traps a thicker layer of air close to the skin, which acts as INSULATION. See also FUR

hairstreak Any of a group of butterflies in the family Lycaenidae. They are grey and brown and found in open areas on every continent, especially in the tropics. Hairstreaks have a quick, erratic flight. Genus *Strymon*.

Haiti Independent nation occupying the w third of the Caribbean island of Hispaniola and including the islands of Tortuga and Gonâve; the capital is PORT-AU-PRINCE. Much of Haiti is mountainous, with a humid tropical climate. Discovered by Columbus in 1492, Spanish settlements were established at the E end of the island and within a century most native Arawaks had died out. In the 17th century, French colonists set up plantations in the w of the island, and in 1697 Spain ceded Haiti (then called Saint Dominque) to France. In the 18th century, the region prospered with the development of sugar and coffee plantations by African slaves, who soon formed the majority of the population. In 1790 Toussaint L'OUVERTURE led a slave revolt against the colonial rulers. In 1801, as governor general, he abolished slavery, but he was killed by the French in 1803. In 1804, Haiti declared independence, under Emperor Jean Jacques DESSALINES. During the 19th century, Haiti experienced much political instability, plagued by assassinations, revolutions and dictatorships. From 1915 to 1934 it was virtually governed by the USA. The election of "Papa Doc" DUVALIER as president in 1957 inaugurated a period of brutality and corruption. Attempts to establish a democratic government in the 1980s and 1990s, after the deposition of the Duvalier family, were frustrated by the army. The democratically-elected president, Jean-Bertrand Aristide, was removed from office by a military coup (1991), but was restored in 1994 with US backing. In 1995 René Préval was elected president. Haiti is the poorest country in the Western Hemisphere (1992 GDP per capita, US\$1,046) and is reliant on food imports. There is some light manufacturing industry. Area: 27,750sq km (10,714sq mi). Pop. (1992 est.) 6,763,746. Haitink, Sir Bernard (1929-) Dutch conductor, principal conductor of the Amsterdam Concertgebouw Orchestra (1961-88) and the London Philharmonic (1967-79). In 1987 he became musical director of the London ROYAL OPERA HOUSE, where he was noted for superb WAGNER performances. Hajj (Arabic, migration) Pilgrimage to MECCA, made in the 12th month of the Muslim year. All Muslims are required to undertake the Hajj. It is the last of the Five Pillars of ISLAM, the religious duties defined by the KORAN.

hake Marine fish found in cold and temperate waters. Its streamlined body is silver and brown. Length: to 1m (40in); weight: to 14kg (30lb). Family Gadidae or Merluccidae; species Atlantic *Merluccius bilinearis*; Pacific *M. productus*. Halcyon Greek mythological figure. The daughter of Aeolus, best known as the wife of Ceyx, king of Thessaly. When Ceyx was drowned in a shipwreck, Halcyon ran to the seashore to find his body and drowned herself. The gods, feeling sorry for the couple, changed them into kingfishers.

Hale, George Ellery (1868–1938) US astronomer who organized a number of observatories, including the YERKES OBSERVATORY, completed in 1897, the Mount Wilson Observatory, completed in 1917, and the PALOMAR Observatory, which entered regular service in 1949. Each observatory featured in turn the largest telescope of its day. Hale was an able solar observer; he invented the spectroheliograph.

half-life Time taken for one-half of the nuclei in a given amount of radioactive ISOTOPE to decay (change into another element or isotope). Only the half-life is measured because the decay is never considered to be total. Half-lives remain constant under any temperature or pressure, but there is a great variety among different isotopes. Oxygen-20 has a half-life of 14 seconds and Uranium-234 of 250,000 years. A

▲ Hagia Sophia One of the finest examples of Byzantine architecture in the world, the Hagia Sophia (Gk. holy wisdom), has been, in its lifetime, an Eastern Orthodox church, a Catholic cathedral and a mosque. Now a museum and World Heritage site, the building is undergoing intensive restoration, which is revealing previously hidden Christian mosaics and decorations.

▲ Handel Although born in Germany, George Frideric Handel spent most of his working life in England under the patronage of George I, king of England and elector of Hanover. Among Handel's best-known works are the oratorios, including the Messiah (1742), and orchestral pieces such as the Water Music (1717), which was written for George I. He was the first director of the Royal Academy of Music, London.

radioactive isotope disintegrates by giving off alpha or beta particles, and a measurement of this rate of emission is the normal way of recording decay. The term "half-life" also refers to particles that spontaneously decay into new particles, such as a free neutron being transformed into an electron. *See also* DATING, RADIOACTIVE; RADIOACTIVITY

halibut Flatfish found worldwide in deep, cold to temperate seas. Important commercially, it is brownish on the eye side and white below. Family Pleuronectidae; species, Atlantic *Hippoglossus hippoglossus*, giant Pacific *H. stenolepis*.

Halicarnassus Ancient Greek city in sw Asia Minor. Under Persian rule from the 6th century BC, its advantageous trading position made it rich. In the 4th century BC it was a semi-independent state under the Persian governor, Mausolus, whose tomb was one of the SEVEN WONDERS OF THE WORLD.

halide Salt of one of the HALOGENS (elements in group VII of the periodic table), or a compound containing a halogen and one other element; examples are sodium fluoride and potassium chloride. The alkyl halides (haloalkanes) are organic compounds, such as methyl chloride (chloromethane, CH₃Cl).

Halifax City and seaport in E Canada, on the Atlantic Ocean; capital of Nova Scotia. Founded in 1749, it developed as an important naval base. In 1912 many of the victims from the *Titanic* were buried here. In 1917 it was the scene of a huge explosion on a munitions ship, which killed more than 2,000 people. Industries: commercial fishing, shipbuilding, oil refining. Pop. (1992) 114,455.

halite Sodium chloride (NaCl), or common (rock) salt. It is found in evaporite sedimentary rocks, and in salt domes and dried lakes. It is colourless, white or grey with a glassy lustre. It has a cubic system of interlocking cubic crystals, granules and masses. It is important as table salt and as a source of CHLORINE. Hardness 2.5; s.g. 2.2.

Hall, Granville Stanley (1846–1924) US psychologist. He is credited with founding one of the first US psychology laboratories, the first US psychology journal (1887), and the American Psychological Association (1892). His books *The Contents of Children's Minds* (1883) and *Adolescence* (1904) contributed powerfully to the development of the child-study movement. In 1909 his invitation to FREUD and JUNG introduced psychoanalysis to the USA.

Hall, Sir Peter Reginald Frederick (1930–) British theatrical director. He was director of the ROYAL SHAKESPEARE COMPANY (1961–73). He directed opera at Glyndebourne and the Royal Opera House. His films include *Akenfield* (1974). He was director of the National Theatre of Great Britain (1973–88) and formed his own Peter Hall Company in 1987.

Hallé, Sir Charles (1819–95) British conductor and pianist. In 1857 he formed a symphony orchestra in Manchester, England, which subsequently became the Hallé Orchestra. In 1893 he was a founder of the Royal Manchester College of Music.

Haller, Albrecht von (1708–77) Swiss biologist, physician and poet. As a botanist he was celebrated for his descriptions of alpine flora, and as a poet for *The Alps* (1729), with its glorification of the mountains. During 1736 he researched the contractile properties of muscle tissue, and his resulting treatise (1757–66) laid the foundations of modern neurology.

Halley, Edmond (1656–1742) British astronomer and mathematician. His most famous achievement was to realize that comets could be periodic, following his observation of HALLEY'S COMET. It was Halley who financed Isaac NEWTON to write the *Principia*. He also founded modern geophysics, charting variations in the Earth's magnetic field, and establishing the magnetic origin of the AURORA borealis. He showed that atmospheric pressure decreases with altitude, and studied monsoons and trade winds.

Halley's comet Bright periodic COMET. It takes 76 years to complete an orbit that takes it from within Venus' orbit to outside Neptune's. It was observed by Edmond HALLEY in 1682; later he deduced that it was the same comet that had been seen in 1531 and 1607, and predicted its return in 1758. There are records of every return since 240 BC. In 1986 the Giotto space probe showed the nucleus to be an irregular object measuring 15×8km (9×5mi) and consisting of ice. It is coated with a dark deposit.

hallmark Official stamp used by British government ASSAY offices to mark the standard of gold and silver articles. The mark has four elements: the standard mark, showing the purity of the metal; the office mark, bearing the assay office's cipher; the date mark; and the maker's mark.

Hallowe'en (hallowed or holy evening) In medieval times, a holy festival observed on 31 October, the eve of All Saints' Day. It was merged with the ancient Celtic festival of Samhain, which marked the beginning of the Celtic year. This was the occasion when fires were lit to frighten away evil spirits and to guide the souls of the dead who were supposed to revisit their homes on this day. Today, Hallowe'en is observed as a social festival.

Hallstatt Small town in w central Austria, believed to be the site of the earliest Iron AGE culture in w Europe. Iron was worked here from $c.700~\rm BC$. The site contains a large Celtic cemetery and a deep salt mine. Fine bronze and pottery objects have also been discovered.

hallucination Apparent perception of something that is not present. Although they may occur in any of the five senses, auditory hallucinations and visual hallucinations are the commonest. While they are usually symptomatic of psychotic disorders, hallucinations may result from fatigue or emotional upsets and can also be a side effect of certain drugs.

hallucinogen Drug that causes HALLUCINATIONS. Hallucinogenic drugs, such as MESCALINE, were used in primitive religious ceremonies. Today, drugs such as LSD are illicitly taken. halogen Elements (FLUORINE, CHLORINE, BROMINE, IODINE and ASTATINE) belonging to group VII of the periodic table. They react with most other elements and with organic compounds. The halogens are highly electronegative; they react strongly because they require only one electron to achieve the "stable 8" inert gas configuration. They produce crystalline salts (HALIDES) containing negative ions of the type F⁻ and Cl⁻.

halon Any of several organic gases used in fire extinguishers. Chemically halons can be considered as simple HYDRO-CARBONS that have had some or all of their hydrogen atoms replaced by a HALOGEN. Similar to CHLOROFLUOROCARBONS (CFCs), they are even more destructive to the OZONE LAYER. **halophyte** Any plant, usually a seed plant, that is able to live in salty conditions.

Hals, Frans (*c*.1580–1666) Dutch painter. He is best known for his paintings of robust, vital figures, such as the *Laughing Cavalier* (1624), and his group portraits. His more subdued later works have a dignity and strength approaching those of

Cavalier (1624), and his group portraits. His more subdued later works have a dignity and strength approaching those of his contemporary, REMBRANDT.

Hamburg City, state and port on the River Elbe, N Germany. Founded in the 9th century by Charlemagne, it became one of

the original members of the HANSEATIC LEAGUE. Severely bombed during World War 2, it is now Germany's second largest city. It is a notable cultural centre, with an opera house, art gallery and university (1919). Industries: electronic equipment, brewing, publishing, chemicals. Pop. (1990) 1,675,200. Hamilcar Barca (d.228 BC) Carthaginian commander. Initially successful in the first of the PUNIC WARS, he was defeated in 241 BC. He suppressed a revolt of Carthaginian mercenaries in 238 BC and the following year conquered much of

Spain. He was the father of HANNIBAL and Hasdrubal Barca. **Hamilton, Alexander** (1755–1804) US politician. During the AMERICAN REVOLUTION, he became an assistant to George WASHINGTON. An architect of the US CONSTITUTION, he was one of its strongest advocates. He served as secretary of the treasury during Washington's first administration (1789–93), setting up the BANK OF THE UNITED STATES.

Hamilton, James Hamilton, 1st Duke of (1606–49) Scottish political and military leader. He fought in the Thirty Years War. Later, as Charles Γ's commissioner in Scotland (1638–39), he failed to achieve a compromise with the COVENANTERS and led an army against them in 1639. He fought for Charles in the English CIVIL WAR, though his contant plotting resulted in his imprisonment (1644–45). In 1648 he led Scottish forces in support of the king. He was defeated by CROMWELL at Preston and executed.

Hamilton, Richard (1922–) British artist, a leader of the POP ART movement. He produced collages using images taken

from commercial art. His best-known work is *Just what is it that makes today's homes so different, so appealing?* (1956).

Hamilton Capital and chief seaport of Bermuda, on Great Bermuda, at the head of Great Sound. Founded in 1790, it became the capital in 1815 and was made a free port in 1956. Tourism is the major industry. Pop. (1994) 1,100.

Hamilton City in SE Ontario, Canada, 65km (40mi) sw of Toronto. Founded in 1813, it is an important communication and manufacturing centre. Industries: iron, steel, vehicles, electrical equipment, textiles. Pop. (1991) 318,499.

Hamito-Semitic languages See AFRO-ASIATIC LANGUAGES Hammarskjöld, Dag (1905–61) Swedish diplomat and second secretary-general of the United Nations (1953–61), an office to which he brought great moral force. In 1956 he played a leading part in resolving the Suez Crisis. He sent a UN peacekeeping force to the Congo (Zaïre) and later died there in an air crash. He was posthumously awarded the 1961 Nobel Peace Prize.

hammer In athletics, men's field event in which a spherical, metallic weight attached to a steel wire is thrown. The "hammer" weighs 7.26kg (16lb) and the wire is 1.2m (3.8ft) long. The thrower stands within a circle 2.13m (7ft) in diameter. An Olympic event since 1900, the world record stands at 86.74m (284ft 7in).

hammerhead Aggressive SHARK found in tropical marine waters and warmer temperate zones. It can be recognized by its head, which has extended sideways into two hammer-like lobes, with one eye and one nostril located at the tip of each. It is grey above and white below. Length: to 6.1m (20ft); weight: to 906kg (2,000lb). Family Sphyrnidae.

Hammerstein, Oscar, II (1895–1960) US lyricist and librettist. He collaborated with Jerome KERN on *Show Boat* (1927) and with Richard RODGERS on *Oklahoma!* (1943), *Carousel* (1945), *South Pacific* (1949), *The King and I* (1951) and *The Sound of Music* (1959).

Hammett, Dashiell (1894–1961) US author, the originator of realistic, hard-boiled detective fiction. Hammett drew on his own experience as a Pinkerton detective to create the investigators Sam Spade and Nick Charles. His books include *Red Harvest* (1929), *The Maltese Falcon* (1930) and *The Thin Man* (1934), all of which were made into successful films.

Hammurabi King of BABYLONIA (r. c.1792–c.1750 BC). By conquering neighbours, such as SUMERIA, he extended his rule in Mesopotamia and reorganized the empire under the Code of HAMMURABI. He was also a good administrator, improving productivity by building canals and granaries.

Hammurabi, Code of Ancient laws compiled under HAM-MURABI. A copy of the code is in the Louvre, Paris. It is composed of 282 provisions with harsh penalties for offenders and includes the maxim, "An eye for an eye, a tooth for a tooth". Covering family life, property and trade, it provides information on social and economic conditions in ancient Babylonia.

Hampden, John (1594–1643) English parliamentarian, a leader of the opposition to Charles I. As a result of his criticism and his part in drawing up the Grand Remonstrance, Hampden was one of the five members whom the king tried to arrest in the House of Commons in 1642, an act that precipitated the English Civil War.

Hampshire County in s England, bordering the English Channel; the county town is Winchester. There are traces of Iron Age hill forts. The area was settled in Roman times, the most notable remains being at Silchester. Predominantly agricultural, Hampshire contains the major port of Southampton and the naval base at Portsmouth. Its coastal resorts and the New Forest woodlands are tourist attractions. Industries: agriculture, oil refining, chemicals, brewing, electronics. Area: 3,782sq km (1,460sq mi). Pop. (1991) 1,541,547.

Hampton Seaport in SE Virginia, USA, on the James River. First settled in 1610, it is reputedly the oldest continuous English settlement in the USA. Industries: defence, tourism, seafood packing, fertilizers. Pop. (1990) 133,793.

Hampton Court Palace Palace situated beside the River Thames, 23km (14mi) from Westminster, London. It was begun in 1515 by Cardinal Wolsey, who gave it to Henry VIII in 1526, hoping to regain his favour. The splendour of its

architecture was matched by the garden, famous both for its maze and for the discreet towers which Henry added for liaisons with his mistresses. Christopher WREN rebuilt and extended parts of the palace between 1696 and 1704.

Hampton Roads Peace Conference (February 1865) Abortive peace conference during the American CIVIL WAR. Abraham LINCOLN and Confederate vice president Alexander H. Stephens met in Hampton Roads, Virginia. The talks failed with the Confederate states declining to rejoin the Union.

hamster Small, mainly nocturnal, burrowing RODENT native to Eurasia and Africa. It has internal cheek pouches for carrying food. Golden hamsters, popular as pets, are descendants of a single family discovered in Syria in 1930. Length: up to 18cm (7in). Family Cricetidae; species *Cricetus mesocricetus*. Hamsun, Knut (1859–1952) Norwegian novelist, playwright and poet. A proponent of individualism, his work reflected his suspicion of modern Western culture. In 1920 he won the Nobel Prize for literature for *The Growth of the Soil* (1917). Other important novels include *Hunger* (1890), *Victoria* (1898) and *Vagabonds* (1927).

Han Imperial Chinese dynasty (202 BC-AD 220). It was founded by a rebellious peasant, Liu Pang, who established the capital at Chang'an. Under the Han, CONFUCIANISM became the state philosophy and China achieved unprecedented power, prosperity, technological invention (paper, porcelain) and cultural growth, especially under the rule of Han Wu Ti in the 2nd century BC. A usurper, Wang Mang, interrupted the dynasty between AD 8 and 25; the dynasty is divided by that period into the Former Han and Later Han.

Hancock, Winfield Scott (1824–86) US general. A veteran of the MEXICAN WAR, he was a Union commander in the CIVIL WAR, fighting in the Peninsular and Antietam campaigns and at Fredericksburg, Chancellorsville and Gettysburg (1863), where he was badly wounded. In 1880, he was the unsuccessful Democratic candidate for president.

handball Name given to two games played mostly in Ireland and the USA. One is played indoors or outdoors with a hard, small ball by two or four gloved players on courts of one, three or four walls. A variant of this game that additionally utilizes wooden rackets is called paddleball. The other game, sometimes called team handball, is played on a court where, between two goals and two goalkeepers, players catch, pass and throw a ball with the object of hurling the ball past the opposing goalkeeper.

Handel, George Frideric (1685–1759) German composer, who became a British citizen in 1726. One of the greatest composers of the BAROQUE period, his many works include operas (such as *Berenice*, *Serse* and *Semele*), oratorios (including *Samson* and *Judas Maccabaeus*), organ music and chamber works. His most popular pieces include the *Water Music* (c.1717), *Music for the Royal Fireworks* (1749) and the oratorio *Messiah* (1742). Haydn, Mozart and Beethoven all professed great admiration for his music.

Handy, W.C. (William Christopher) (1873–1958) US composer and musician, known as the "father of the BLUES". Handy published the first blues piece, "Memphis Blues" (1912). He led his own band from 1903 and composed many hits, including "St Louis Blues" (1914).

hang gliding GLIDING using a lightweight craft, usually with a triangular wing, which is stabilized by the weight of the pilot's body underneath. The wing may be rigid, but is usually made of fabric. Take-off is made by running down a slope, assisted by a steady updraught. The pilot hangs from a harness and by using a control bar to shift body weight steers the glider. Hanging Gardens of Babylon One of the Seven Wonders of The World. The gardens are thought to have been spectacular, rising in a series of terraces (rather than hanging) and ingeniously irrigated by water pumped up from the Euphrates. They were probably built by Nebuchadnezzar c.600 Bc. Nothing remains of them.

hanging valley Valley that ends high up the face of a larger valley, possibly with a stream running through it and ending in a waterfall. Most hanging valleys result from glacial deepening of the main valley.

Hanks, Tom (1956-) US film actor. Initially typecast in

▲ Hanks US actor and director
Tom Hanks enjoyed huge success
in Hollywood films of the 1980s
and 1990s. He is one of only two
actors (the other is Spencer Tracy)
to win Best Actor Oscars in
consecutive years, with
Philadelphia (1993) and Forrest
Gump (1994). He made his
directorial debut in 1996 with That
Thing You Do!

comedy roles, early films included *Splash* (1984) and *Big* (1988). His performance as a gay AIDS victim in *Philadelphia* (1993) demonstrated his versatility and gained him an Academy Award for Best Actor. A second Oscar followed for *Forrest Gunp* (1994). Other films include *Sleepless in Seattle* (1993). **Hanna, Marcus Alonzo** (1837–1904) US Republican politician. A wealthy businessman, his campaign management and financial support helped William McKinley win the 1896 presidential election. His use of advertising is wide-

ly seen as the beginning of modern campaign politics. **Hannibal** (247–183 BC) Carthaginian general in the second of the Punic Wars, son of Hamilcar Barca. One of the greatest generals of ancient times, he fought against the Romans in Spain (221 BC). In 218 BC he invaded N Italy after crossing the Alps with a force of elephants and 40,000 troops. He won a series of victories in Italy, but was unable to capture Rome. In 203 BC he was recalled to Carthage to confront the invasion of SCIPIO AFRICANUS. Lacking cavalry, he was defeated at Zama (202 BC). After the war, as chief magistrate of Carthage, he alienated the nobility by reducing their power. They sought Roman intervention and Hannibal fled to the Seleucid kingdom of Antiochus III. He fought under Antiochus against the Romans, was defeated and committed suicide.

Hanoi Capital of Vietnam and its second largest city, on the River Red. In the 7th century the Chinese ruled Vietnam from Hanoi; it later became capital of the Vietnamese empire. Taken by the French in 1883, the city became the capital of French Indochina (1887–1945). In 1946–54 it was the scene of fierce fighting between the French and the Viet Minh. It was heavily bombed during the VIETNAM WAR. Industries: engineering, vehicles, textiles, rice milling, food processing. Pop. (1989) 1,088,862.

Hanover (Hannover) City on the River Leine, N Germany; capital of Lower Saxony. Chartered in 1241, the city joined the HANSEATIC LEAGUE in 1386. In 1636 it became the residence of the dukes of Brunswick-Lüneberg (predecessors of the House of Hanover); GEORGE I was elector of Hanover. Hanover was badly damaged during World War 2, but many old buildings were later reconstructed. Industries: machinery, steel, textiles, rubber, chemicals. Pop. (1990) 520,900.

Hanover (Hannover) Former kingdom and province of Germany. In 1692 Duke Ernest Augustus, a duke of Brunswick-Lüneberg, was created elector of Hanover; his lands were known thereafter as Hanover. His son succeeded to the British throne as GEORGE I in 1714. Divided during the Napoleonic era, Hanover was reconstituted as a kingdom in 1815. Allied with Austria in the Austro-Prussian War (1866), it was annexed by Prussia after Austria's defeat. After World War 2 it was incorporated into the state of Lower Saxony.

HARD DISK

5 TO DITO TO DO TO

A computer hard disk is made up of multiple rotating platters (1) each one of which has circular magnetic tracks (2) that are read and written on by a magnetic head (3) held by an arm (4). The disks spin at 100 times per second. The magnetic heads, tiny electromagnets, align magnetic particles on the surface of the platters to represent a digital code of zeros and ones (5). The magnetic tracks on the platters are divided into sectors (6) and when information is written on the hard disk files are split into different sectors on the platters (7). A file-allocation table tells the chip (8) controlling the hard disk where information is held on the platters.

Hanover, House of German royal family and rulers of Britain from 1714 to 1901. The electors of Hanover succeeded to the English throne in 1714 under the terms of the Act of Settlement (1701) and the Act of Union (1707). GEORGE I, the first elector also to be king of England, was succeeded in both England and Hanover by GEORGE II, GEORGE III, GEORGE IV and WILLIAM IV. Salic law forbade Queen Victoria's accession in Hanover; the Hanoverian title was inherited by her uncle, the Duke of Cumberland, and the crowns of Britain and Germany were separated.

Hansard Colloquial name for the daily record of the proceedings of the British Houses of Parliament. Named after Luke Hansard (1752–1828), printer to the Commons, who compiled unofficial reports, these verbatim records have continued to be referred to as "Hansard", even though the family sold their publishing interest in 1889. The responsibility now rests with The Stationery Office.

Hanseatic League Commercial union of c.160 German, Dutch and Flemish towns established in the 13th century. The League protected its merchants by controlling the trade routes from the Baltic region to the Atlantic. It began to decline in the late 15th century with the opening up of the New World and aggressive trading by the British and Dutch.

Hanukkah (Chanukah or Feast of Lights) Eight-day festival celebrated in JUDAISM. It commemorates the re-dedication of the Jerusalem TEMPLE in 165 BC and the miracle of a one-day supply of oil lasting for eight days.

Hanuman In Hindu mythology, the monkey general who helped RAMA to find and rescue his wife, Sita. His attributes include great strength, agility and wisdom. He remains a favourite deity in rural India.

haploid Term describing a cell which has only one member of each CHROMOSOME pair. All human cells except GAMETES are DIPLOID, having 46 chromosomes. Gametes are haploid, having 23 chromosomes. The body cells of many lower organisms, including many algae and single-celled organisms, are haploid. *See also* ALTERNATION OF GENERATIONS; MEIOSIS

Harare (formerly Salisbury) Capital of Zimbabwe, in the NE part of the country. Settled by Europeans in 1890 as Fort Salisbury, it became capital of Southern Rhodesia in 1902. The city served as capital of the Federation of Rhodesia and Nyasaland (1953–63) and of Rhodesia (1965–79). It has a university (1957) and two cathedrals. Industries: gold mining, textiles, steel, tobacco, chemicals, furniture. Pop. (1992) 1,184,169.

Harbin (Haerbin) City on the River Sungari, NE China; capital of Heilungkiang province. It was a place of refuge for White Russians after the Revolution of 1917. Under Japanese rule 1932–45, it was then briefly occupied by Soviet forces before falling to the Chinese Communists in 1946. Industries: oil, coal, turbines and generators, mining equipment, sugar refining, food processing, paper. Pop. (1993) 3,100,000.

hard disk Rigid MAGNETIC DISK for storing computer PROGRAMS and DATA. The built-in hard disk drive in a typical personal COMPUTER consists of a number of hard platters coated with a magnetic material set on a common spindle. They are housed inside a sealed container, with a motor to spin the stack of platters, a head to write (record) and read (replay) each side of each platter, and associated electronic circuits. Hard disk capacity is continually being increased: most computers are now sold with a disk of at least 500Mb (500 megabytes, or 500 million bytes) capacity.

Hardie, (James) Keir (1856–1915) British politician, a founder of the British LABOUR PARTY. He founded the newspaper *Labour Leader* and was chairman of the Independent Labour Party (1893–1900, 1913–14). He was the first Labour MP, and for three years (1892–95) the only Labour member. Harding, Warren G. (Gamaliel) (1865–1923) 29th US president (1921–23). A senator (1915–21), he was a compromise Republican presidential candidate. His campaign for a return to "normalcy" easily won the election. He left government to his cabinet, and his administration, known as the "Ohio Gang", was one of the most corrupt in US history. The TEAPOT DOME SCANDAL forced a Congessional investigation. Harding died before the worst excesses became public knowledge, and he was succeeded by his vice president, Calvin COOLIDGE.

hardness Resistance of a material to abrasion, cutting or indentation. The Mohs' scale is a means of expressing the comparative hardness of materials, particularly minerals, by testing them against ten standard materials. These range from (1) talc to (10) diamond (the hardest). A mineral hard enough to scratch material 3, but soft enough to be scratched by material 5, would be rated as having hardness 4 on the Mohs scale. hardness of water Reluctance of water to produce a lather with soap, due to various dissolved salts, mainly those of calcium and magnesium. These salts give rise to an insoluble precipitate, which causes "fur" or "scale" in boilers, pipes and kettles. Lather is inhibited until all the dissolved salts are precipitated as scum, which floats on the surface. Hardness may be temporary (removed by boiling), caused by calcium bicarbonate; or permanent (not affected by boiling), caused by calcium sulphate.

Hardouin-Mansart, Jules (1646–1708) Royal architect to Louis XIV. His bold Baroque style made him an ideal person to carry out the king's vast building works. His major achievements include the Hall of Mirrors (1678–84), the Orangerie (1681–86) and the Grand Trianon (1687–88), all at Versailles, and the dome of the Hôtel des Invalides, Paris (1680–91).

hardware In computing, equipment as opposed to the programs, or software, with which a computer functions. The computer, keyboard, printer and electronic circuit boards are examples of hardware.

Hardy, Thomas (1840–1928) British novelist and poet. Hardy's birthplace of Dorset, sw England, forms the background to most of his writing. His debut novel was *Desperate Remedies* (1871). Far from the Madding Crowd (1874) was the first critical success. Hardy's major novles are The Return of the Native (1878), The Mayor of Casterbridge (1886), Tess of the d'Urbervilles (1891) and Jude the Obscure (1895). The latter was attacked for its immoral tone, and thereafter Hardy devoted himself to poetry, including Wessex Poems (1898) and the verse drama The Dynasts (1903–08).

Hare, David (1947–) British playwright and director. Hare founded the Portable Theatre in 1968. He has worked as a dramatist and director for the National Theatre, as well as for film and television. His most popular plays include *Slag* (1970), *Licking Hitler* (1978), *Pravda* (1985), *Strapless* (1989) and *The Absence of War* (1993).

hare Large member of the RABBIT family (Leporidae). Unlike rabbits, true hares (genus *Lepus*) have ears that are longer than their heads, and their young are born with open eyes and a full coat of fur. Length: to 76cm (30in); weight: to 4.5kg (10lb). Hares include the JACK RABBIT and snowshoe rabbit.

harebell Flowering plant of the bell flower family (CAMPAN-ULACEAE) widespread as a wild flower of pastures and also cultivated in gardens. It has drooping, bell-shaped, mid-blue flowers. Species *Campanula rotundifolia*.

Hare Krishna (officially International Society for Krishna Consciousness) Hindu religious movement, founded in New York in 1965 by Swami Prabhupada (A.C. Bhaktivedanta). The movement is based on the philosophy that Krishna is the supreme God and stresses the importance of asceticism. Public perception of the movement has been enhanced by the proselytizing of its shaven-headed, saffron-robed devotees, who practise self-denial, meditation and chanting.

harelip Congenital cleft in the upper lip caused by the failure of the two parts of the palate to unite. It is a congenital condition, often associated with CLEFT PALATE.

harem Women's quarters in a Muslim household. It contained a man's wives, concubines and female servants. The most famous harems were those of the Turkish sultans in ISTANBUL, which often had several hundred women and were guarded by EUNUCHS.

Hargreaves, James (1722–1778) British inventor and industrialist. In 1764 he invented the spinning jenny. This machine greatly speeded the spinning process of cotton by producing eight threads at the same time. In 1768 local spinners destroyed his equipment, fearing that it threatened their jobs. Hargreaves moved to Nottingham and, with Thomas James, built a spinning mill and became one of the first great factory owners.

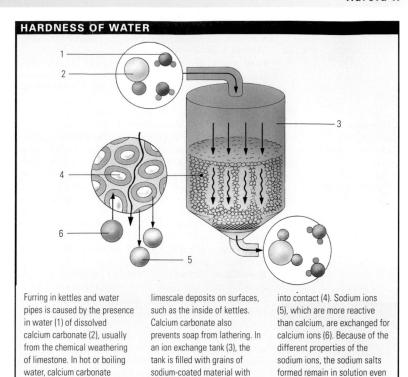

which the water has to come

Harlem Residential area of New York City, USA, a political and cultural focus for African-Americans. The Center for Research in Black Culture is located here, next to the Countee Cullen library, which has been a meeting place for black writers since the 1920s.

precipitates forming solid

Harlem Renaissance Period of creativity, particularly in literature, among African-Americans in the 1920s. Centered in HARLEM, New York, the Renaissance produced many fine writers, such as Countee Cullen, Langston HUGHES and Claude McKay.

harlequin English name derived from the character Arlecchino of the COMMEDIA DELL'ARTE, who was a quick-witted, unscrupulous serving man. A harlequin nowadays appears in pantomine and comedy as a mute jester, dressed in diamond-patterned, multi-coloured tights.

harmonica (mouth organ) Musical instrument consisting of a metal cassette containing metal reeds. The reeds are vibrated as the player blows or inhales through slots along one edge of the cassette.

harmonics In acoustics, additional notes whose frequencies are multiples of a basic (fundamental) note. When a violin string is plucked, the sounds correspond to vibrations of the string. The loudest sound (note) corresponds to the fundamental mode of vibration. But other, weaker notes, corresponding to subsidiary vibrations, also sound at the same time. Together these notes make up a harmonic series.

harmony In music, structure of chords and the relationships between them. The diatonic scale (from one C to the next on a piano, for example) is the basis of chord construction, and a harmonic progression from one chord to the next is defined by the KEY. The tonic, dominant and subdominant chords are the primary chords of a key (C, G and F chords in the key of C). Composers, especially of the 18th and 19th centuries, follow specific rules of harmony.

Harold I (d.1040) (Harold Harefoot) Danish king and ruler of England (1035–40). An illegitimate son of Canute II, he claimed the crown, ruling as regent (1035–37). Elected king at Oxford, he disposed of his rival, Alfred the Aethling, and displaced the heir, his half-brother, Hardecanute.

Harold II (1022–66) Last Anglo-Saxon king of England (1066). He was elected king following the death of EDWARD THE CONFESSOR, despite having pledged to support William of Normandy's (WILLIAM I) claim to the throne. He immediately

when boiled.

▲ hare The wide range of the various species of hare, from cold polar climates to warmer, temperate regions, has brought about physical adaptations. To conserve as much heat as possible the arctic hare (*Lepus timidus*) (top) has shorter ears and a more spherical body than its relative the Mediterranean brown hare (*L. capensis*). The arctic also has thicker fur which turns white in winter for camouflage.

▲ harvestman The North African harvestman (*Phalangium africanum*) has many relatives throughout the world, including North America where it is known as the daddy-long-legs. This minute scavenger measures up to 12mm (0.5in).

▲ Havel President of the Czech Republic, Vaclav Havel was imprisoned under the former communist regime, and his plays, which are centred about the lives of political dissidents, were banned. By the late 1990s, he was suffering from cancer.

▲ hawthorn An ideal tree for hedge-planting because of its hardiness and its display of thorns, the hawthorn (family Rosaceae) can grow to 11.5m (35ft) if left untrimmed. Its heavily scented blossom is conspicuous in late spring and early summer in the hedgerows of Europe.

ately had to contend with the invasion of Harold III of Norway, whom he defeated. Three days later he was defeated and killed by William at the Battle of Hastings.

harp Ancient musical instrument consisting of a frame over which strings are stretched. Variations have been found in civilizations as diverse as Egyptian, Greek and Celtic. A modern orchestral harp has a large triangular frame that carries 47 strings. Seven pedals ensure the whole chromatic range is covered by altering the pitch of the strings.

harpsichord Keyboard musical instrument. Its metal strings are mechanically plucked by quill plectrums. Its volume can barely be regulated, although stops may be used to bring extra strings into use. Historic instruments may have had two or, rarely, three keyboards. The harpsichord was the principal keyboard instrument from 1500 to 1750 but was later replaced by the piano.

harrier Bird of prey. Active by day, it frequents grasslands where it swoops on small animals. It has a small bill and long wings, legs and tail. Length: 38–50cm (15–20in). Family Accipitridae; genus *Circus*.

Harris, Joel Chandler (1848–1908) US author. A journalist in the American South for much of his career, Harris is best known for the *Uncle Remus* stories, retellings of African-American folk-tales. The character of Brer Rabbit is perhaps his most memorable.

Harrisburg Capital of Pennsylvania, USA, in the SE of the state, on the Susquehanna River. Established as a trading post in *c*.1718, by 1785 a town was established, which was the scene of the Harrisburg Convention (1788). It became the state capital in 1812. Industries: textiles, machinery, electronic equipment. Pop. (1992 est.) 53,430.

Harrison, Benjamin (1833–1901) 23rd US president (1889–93). He was a grandson of William Henry Harrison. After one term in the US Senate, he was selected (1888) as the Republican presidential nominee against President CLEVELAND. He won with a majority of the electoral votes, although Cleveland had the most popular votes. As president, Harrison signed the Sherman Antitrust Act and the McKinley Tariff Act. He was defeated by Cleveland in 1892.

Harrison, William Henry (1773–1841) Ninth US president (1841). Harrison is chiefly remembered for his military career, especially his victory against Native Americans at Tippecanoe (1811). He was elected president in 1840, with John Tyler as vice president, under the slogan "Tippecanoe and Tyler too." Harrison died only a month after taking office. Hart, Moss (1904–61) US dramatist. He collaborated with George S. KAUFMAN on many comedies, including You Can't Take It With You (1936). His most successful musical was Lady in the Dark (1941), written with Kurt WEILL and Ira Gershwin. In 1956 he directed My Fair Lady.

hartebeest Large ANTELOPE native to African grasslands S of the Sahara Desert. They have sharply rising horns united at the base. Length: up to 200cm (80in); height: to 150cm (60in); weight: up to 180kg (400lb). Family Bovidae.

Hartford State capital of Connecticut, USA, on the Connecticut River. More than 25 insurance companies have their headquarters here. Manufactures include precision instruments and electrical equipment. Pop. (1990) 139,739.

Hartford Convention (1814–15) Secret meeting of leaders from five New England states opposed to the WAR OF 1812 because it disrupted trade. Convention resolutions sought to strengthen states' rights over conscription and taxation; some delegates favoured withdrawal from the Union.

Hartley, L.P. (Lesley Poles) (1895–1972) British novelist, short-story writer and critic. Hartley first won acclaim with his trilogy of novels *The Shrimp and the Anemone* (1944), *The Sixth Heaven* (1946) and *Eustace and Hilda* (1947). *The Go-Between* (1953) presents a picture of the sexual desires beneath the surface of aristocratic Edwardian society.

Hartmann, Nicolai (1882–1950) German realist philosopher. Although influenced by PLATO and Immanuel KANT, he proposed, in *Outlines of a Metaphysics of Knowledge* (1921), that existence is an essential prerequisite for knowledge, a reversal of Kant's idea. He finally rejected Kantian ideas in his book *New Ways of Ontology* (1942). *See also* REALISM

Harun al-Rashid (764–809) Most famous of the Abbasid caliphs of Baghdad (786–809). His reign has gained romantic lustre from the stories of the *Thousand and One Nights*. He engaged in successful war with the BYZANTINE EMPIRE, but his effort to reconcile competing interests by dividing the empire between his sons led to civil war.

Harvard University Oldest US college, founded in 1636 by John Harvard at Cambridge, Massachusetts. It was originally intended for the instruction of Puritan ministers.

harvestman Arachnid with legs that may be several times its body length. It feeds on insects and plant juices. Body length: 2.5–13mm (0.1–0.5in). Family Phalangidae.

Harvey, William (1578–1657) English physician and anatomist who discovered the circulation of the blood. His findings, published in *De Motu Cordis et Sanguinis* (1628), were ridiculed at first. He also studied EMBRYOLOGY.

Haryana State in N central India; the capital is Chandigarh. It was formed in 1966 from part of the state of Punjab. The land has been improved by irrigation and fertilization. Industries: machine tools, farming implements, cement, paper, bicycles. Area: 44,222sq km (17,074sq mi). Pop. (1991) 16,403,648.

Harz Mountains Mountain range in central Germany, extending 96km (60mi) between the Weser and Elbe rivers. The highest peak is the Brocken, 1,142m (3,747ft).

Hašek, **Jaroslav** (1883–1923) Czech novelist and short story writer. He wrote the best-selling satirical novel *The Good Soldier Schweik* (1920–23).

hashish Resin obtained from the flowering tops of the hemp plant *Cannabis sativa* and used as a psychotropic drug. When smoked or eaten it generally induces heady sensations and often a feeling of detachment. It is not considered addictive. Possession of the drug is illegal in the UK and the USA. *See also* MARIHUANA

Hasidism Popular pietist movement within JUDAISM founded by Israel ben Eliezer (c.1699-c.1761), known as the Baal Shem Tov (Master of the Good Name). The movement, centred in E Europe until World War 2, strongly supports Orthodox Judaism. Its main centres are now in Israel and the USA. **Hassan II** (1929–) King of Morocco (1961–), son and successor of Muhammad V. He dissolved the National Assembly in 1965 and introduced a new constitution, approved by referendum (1971), which left his authority supreme. He eliminated foreign ownership of business in 1973, and in 1975 made claims to much of Western Sahara.

Hastings, Warren (1732–1818) First British governor general of India (1774–85). He successfully defended British territory against several Indian opponents. He made many enemies and returned to England in 1785 to face a variety of charges. Though eventually acquitted, his career was ruined. Hastings, Battle of (14 October 1066) Fought near Hastings, SE England, by King HAROLD II of England against an

man victory and death of Harold marked the end of the Anglo-Saxon monarchy and produced a social revolution. hatchet fish Marine fish found in deep temperate and tropical seas. There are light-emitting organs along the underside

invading army led by WILLIAM, duke of Normandy. The Nor-

ical seas. There are light-emitting organs along the underside of its deep, muscular abdomen. Length: to 10cm (4in). Family Sternoptychidae (or Characidae).

Hathor Ancient Egyptian goddess of love and happiness, music and dance. She was depicted as a cow or with the horns of a cow.

Hatshepsut (d.1482 BC) Queen of Egypt (c.1494–1482 BC). Daughter of THUTMOSE I, she married Thutmose II and after his death (c.1504 BC) ruled, first as regent for her nephew, then in her own right, the only woman to rule as pharaoh.

Haughey, Charles (1925–) Irish statesman, prime minister (1979–81, 1982, 1986–92). A member of Fianna Fáil, Haughey entered parliament in 1957. Dismissed from the cabinet in 1970 for alleged conspiracy in Irish Republican Army (IRA) gun-running, he was later acquitted. He retired in 1992. Hauptmann, Gerhart (1862–1946) German dramatist, poet and novelist. His play *Vor Sonnenaufgang* (1889) marked the birth of German naturalist drama. He was awarded the 1912 Nobel Prize for literature. He is chiefly remembered for his early naturalistic works.

I

Hausa Predominantly Muslim people, inhabiting NW Nigeria and s Niger. Hausa society is feudal and based on patrilineal descent. Its language is the official language of N Nigeria and a major trading language of W Africa. Hausa crafts include weaving, leatherwork and silversmithing.

Havana (La Habana) Capital of CUBA, on the NW coast; largest city and port in the West Indies. It was founded by the Spanish explorer Diego Velázquez in 1515 and moved to its present site in 1519. Havana became Cuba's capital at the end of the 16th century. Industries: oil refining, textiles, sugar and cigars. Pop. (1990 est.) 2,096,054.

Havel, Vaclav (1936-) Czech playwright and statesman, president (1989-). Havel was imprisoned several times by the communist regime during the 1970s and 1980s, both for his satirical plays and for his work as a human rights activist. He was the first democratically elected president in 1989 and tried to preserve a united republic. Havel resigned in 1992 when break-up became inevitable. In 1993 he became president of the newly formed Czech Republic and was re-elected in 1998. Hawaii State of the USA in the N Pacific Ocean, 3,363km (2,090mi) wsw of San Francisco, California; the capital is HONOLULU. It consists of eight large and 124 small volcanic islands, many of which are uninhabited. Polynesians established settlements in the 9th century AD. Annexed by the USA in 1898, it became the last state to be admitted to the Union in 1959. There is an important US naval base at PEARL HARBOR. The economy is based on agriculture and tourism. Exports include bananas, pineapples, sugar, nuts and coffee. Area: 16,705sq km (6,450sq mi). Pop. (1993 est.) 1,171,592. hawfinch Largest European FINCH, nesting in temperate regions. Its large bill cracks nuts and fruit stones. It has mostly chestnut plumage, with black and white patches. Length: 18cm (7in). Species Coccothraustes coccothraustes.

hawk Any of several species of day-active BIRDS OF PREY found in temperate and tropical climates. They have short, hooked bills for tearing meat and strong claws for killing and carrying prey. Hawks have red, brown, grey or white plumage with streaks on the wings. Length: 28–66 cm (11–26in). Order Falconiformes; genera *Accipiter* and *Buteo*. Hawke, Bob (Robert) (1929–) Australian statesman and labour leader, prime minister (1983–91). Elected to parliament in 1980, he became leader of the Australian Labor Party (ALP) in 1983 and led the party to victory in the ensuing general election. His administration was returned to office for an unprecedented three further terms. With the economy in recession, he was replaced by Paul Keating in 1991.

Hawking, Stephen William (1942–) British theoretical physicist. Hawking supported the BIG BANG theory of the origin of the Universe and did much pioneering work on the theory of BLACK HOLES. He published a popular account of his work in *A Brief History of Time* (1988).

Hawkins, Coleman (1904–69) US jazz saxophonist. His definitive recording of "Body and Soul" was one of the first recordings of an extended jazz solo. From 1934 to 1939 he lived in Europe, where he recorded with "Django" REINHARDT. Hawkins, Sir John (1532–95) English naval commander. With the support of Queen Elizabeth I, he led two lucrative expeditions to Africa and the West Indies (1562–63, 1564–65), but on his third expedition (1567–69) the Spanish destroyed most of his ships. He played an important role in the defeat of the Spanish Armada in 1588

Hawksmoor, Nicholas (1661–1736) English Baroque architect who started his career as an assistant to Wren. He also assisted Vanbrugh at Castle Howard and Blenheim Palace. His own buildings are bold and highly original, and include Queen's College, Oxford, and several outstanding London churches, notably St Mary Woolnoth.

hawthorn Any of more than 200 species of thorny DECIDU-OUS shrubs and trees of the genus *Crataegus*, growing in N temperate parts of the world. Their flowers are white or pink, and small berries are borne in clusters. Family Rosaceae.

Hawthorne, Nathaniel (1804–64) US novelist and short-story writer. Hawthorne's debut novel was *Fanshawe* (1829). His short-story collections include *Twice-Told Tales* (1837) and *Mosses from an Old Manse* (1846). His masterpiece is

the psychological novel *The Scarlet Letter* (1850). Other works include *The House of the Seven Gables* (1851), *The Blithedale Romance* (1852), and the children's books *A Wonder Book* (1852) and *Tanglewood Tales* (1853).

Hay, John Milton (1838–1905) US statesman, secretary of state (1898–1905) under presidents McKinley and Theodore Roosevelt . His "open-door policy" was a demand for equal trading status for foreign powers in China, and he negotiated treaties ensuring US control of the Panama Canal.

Haydn, Franz Joseph (1732–1809) Austrian composer. One of the greatest classical composers, he brought the SONATA form to masterful fruition in more than 100 symphonies, notably the *Military*, the *Clock* and the *London* (all 1793–95). He also wrote many string quartets, chamber works, concertos, masses and choral works. His most famous choral works are the oratorios *The Creation* (1798) and *The Seasons* (1801). He influenced, and was in turn influenced by, his friend MOZART. Hayek, Friedrich August von (1899–1992) British econ-

Hayek, Friedrich August von (1899–1992) British economist, b. Vienna. He was professor at London (1931–50), Chicago (1950–62) and Freiburg (1962–69). He has written many books on law, economics and philosophy, and won the 1974 Nobel Prize for economics.

Hayes, Rutherford Birchard (1822–93) 19th US president (1877–81). As governor of Ohio, he won the Republican nomination for president in 1876. Some of the electoral votes were disputed, but an electoral commission awarded all of them to Hayes, giving him victory over Samuel J. Tilden. As president, Hayes ended RECONSTRUCTION by removing all federal troops from the South and tried to promote civil service reform. He retired after one term.

hay fever Seasonal ALLERGY induced by grass POLLENS. Symptoms include ASTHMA, itching of the nose and eyes, and sneezing. Symptoms are controlled with an ANTIHISTAMINE.

Hay-Pauncefote Treaty (1901) Agreement promising equal rates through the Panama Canal to all nations and all vessels, commercial or military. It was negotiated by John HAY and Lord Pauncefote, British ambassador to the USA.

Haywood, William Dudley (1869–1928) US labour leader. He helped organize the INDUSTRIAL WORKERS OF THE WORLD (IWW) and advocated violence in pursuit of workers' rights. During World War 1 he was convicted of sedition. Released on bail in 1921, he fled to the Soviet Union.

Hayworth, Rita (1918–87) US film actress. Her sultry, temptress image was established in *Blood and Sand* (1941). She was the dancing partner of both Gene Kelly in *Cover Girl* (1944), and Fred ASTAIRE in *You Were Never Lovelier* (1941). Orson Welles (one of her four husbands) directed her in *The Lady From Shanghai* (1948).

hazel Any of about 15 bushes or small trees of the genus *Corylus*, native to temperate regions of Europe, Asia and America. There are separate male and female flowers. The fruit is a hazelnut, also called cobnut or filbert. Family Betulaceae.

Hazlitt, William (1778–1830) British writer and critic. A friend to many of the leading talents of the romantic movement, his works include *Characters of Shakespeare's Plays* (1817), and *Table Talk* (1821–22).

headache Pain felt in the skull. Most frequently caused by stress or tension, it may also signal other diseases, especially if associated with fever. *See also* MIGRAINE

Health, UK Department of UK government department responsible for the administration of the NATIONAL HEALTH

▲ Hawking The author of the best-selling A Brief History of Time (1988), Professor Stephen Hawking's work has concentrated on the nature of black holes. He was the first scientist to hypothesize that the immensely powerful gravitational field around super dense black holes can radiate matter. Since the 1960s he has suffered from a motor neuron disease, which has confined him to a wheelchair.

HAWAII Statehood :

21 August 1959 Nickname : Aloha state

State bird :

Nene (Hawaiian goose)

State flower:

Yellow hibiscus

State tree :

Kukui State motto :

The life of the land is perpetuated in righteousness

■ Hayworth A cousin of Ginger Rogers, the US actress and dancer Rita Hayworth came from a show-business family. Known as the "Love Goddess", she was best known for her roles as the sultry temptress, in films such as Blood and Sand (1941) and Gilda (1946), and as the fun-loving female lead in musicals, the most popular of which is Cover Girl (1944).

▲ Heaney Nobel Prize-winning poet Seamus Heaney was deeply affected by the violence in his native Northern Ireland. Much of his poetry examines the violence and its effect on the community. He left Northern Ireland because of the troubles, and taught in Dublin, later becoming professor of rhetoric and oratory at Harvard. USA, in 1985 and professor of poetry at Oxford, UK, in 1989.

SERVICE and local authority social services. It also provides information on public and environmental health, and is responsible for public ambulance services. The head of the Department is the secretary of state for health.

Health and Human Services, US Department of US cabinet department, formed in 1980 from parts of the Department of Health, Education and Welfare (HEW). It consolidated the services of programmes including Medicare and Medicaid, Social Security and the Federal Drug Administration.

Health and Safety Commission British Government body set up in 1974 to instigate and monitor measures to protect people in working environments. It employs officers to inspect working premises in order to prevent accidents.

Heaney, Seamus (1939-) Irish poet and critic, influenced by the history of sectarian violence in Northern Ireland. His volumes include Eleven Poems (1965), Death of a Naturalist (1966), Door to the Dark (1969), North (1975) and The Spirit Level, which won the 1996 Whitbread Prize. His essays are collected in Preoccupations (1980) and The Government of the Tongue (1988). He is Oxford Professor of Poetry (1989–) and won the 1995 Nobel Prize for literature.

hearing Process by which sound WAVES are experienced. Sound waves enter the EAR canal and vibrate the eardrum. The vibrations are transmitted by three small bones to the COCHLEA. In the cochlea, receptors generate nerve impulses that pass via the auditory nerve to the brain to be interpreted. Hearst, William Randolph (1863-1951) US publisher. He built a nationwide empire that included newspapers, magazines, news services, radio stations and film studios. With his rival, Joseph PULITZER, he practised sensational journalism and promoted American imperialism.

heart Muscular ORGAN that pumps BLOOD throughout the body. In humans, the heart is located behind the breastbone between the lower parts of the lungs. Divided longitudinally by a muscular wall, the right side contains only deoxygenated blood, the left side only oxygenated blood. Each side is divided into two chambers, an atrium and a ventricle, both separated by valves. The average heart-beat rate for a healthy adult at rest is 70-80 beats per minute.

heart attack (myocardial infarction) Death of part of the heart muscle due to the blockage of a coronary artery by a blood clot (thrombosis). It is accompanied by chest pain, sweating and vomiting. Modern drugs treat abnormal heart rhythms and dissolve clots in the coronary arteries. Heart failure occurs when the heart is unable to pump blood at the rate necessary to supply body tissues; it may be due to high BLOOD PRESSURE or heart disease. Symptoms include shortness of breath, oedema and fatigue. Treatment is with a DIURETIC and heart drugs. See also ANGINA

heart-lung machine Apparatus used during some surgery

to take over the function of the heart and lungs. It consists of a pump to circulate blood around the body and special equipment to add oxygen to the blood and remove carbon dioxide. heat Form of energy associated with the constant vibration of atoms and molecules. Currently accepted KINETIC THEORY holds that the hotness of a body depends on the extent of vibration of its atoms. Heat is distributed in three forms: CON-VECTION through fluids, CONDUCTION through solids and RADI-ATION mainly through space. See also TEMPERATURE heat capacity (thermal capacity) The ratio of the heat supplied to an object to the rise in its temperature. It is measured

in joules/kelvin. See also SPECIFIC HEAT CAPACITY

Heath, Sir Edward Richard George (1916-) British statesman, prime minister (1970-74). Heath entered parliament in 1950, and acted as lord privy seal (1960-63). In 1965 he became leader of the Conservative Party. He succeeded Harold WILSON as prime minister. Heath secured Britain's membership of the European Community (1973), but poor industrial relations led to a bitter miners' strike and the introduction of a "three-day week" (1974). The Conservatives were defeated in two elections in 1974, and Heath was replaced as party leader by Margaret THATCHER (1975). Heath was a staunch critic of "Thatcherism" and an outspoken advocate of European integration during John MAJOR's terms in office.

Erica, found in Europe, Africa and North America. They generally have bell-shaped blue or purple flowers. Family Ericaceae. The term also applies to land that supports heath. heather (ling) Evergreen shrub native to Europe and Asia Minor. It has small bell-shaped flowers of pink, lavender or white. Family Ericaceae; species Calluna vulgaris. See

heath Any of various woody evergreen shrubs of the genus

heatstroke Condition in which the body temperature rises above 41°C (106°F). It is brought on by exposure to extreme heat. In mild cases there may be lassitude and fainting; in severe cases, collapse, coma and death may ensue.

heaven Abode of divine beings or a world of bliss beyond death. In the later Jewish tradition (after the 3rd or 2nd century BC), it was the dwelling place of God and the angels, and of those human beings who had died after leading a virtuous life. Christian theology adopted this conception but modified it as the destination after death of the true followers of Jesus Christ. See also HADES; HELL; LIMBO; PURGATORY

heavy metal Metal of high density, such as platinum or lead. The term may also refer to metallic pollutants in soil that restrict plant growth.

heavy water See DEUTERIUM

also ERICA

Hebrew Language of the SEMITIC branch of the AFRO-ASIAT-IC family. Spoken in Palestine from ancient times, it is the language of the OLD TESTAMENT. It declined during the BABYLON-IAN CAPTIVITY and was overtaken by ARAMAIC. Hebrew persisted as a literary and liturgical language among Jews. It was revived as a spoken language in the 19th century and became the official language of Israel (1948). See also YIDDISH Hebrews, Epistle to the Part of the New TESTAMENT. It contains a letter of encouragement to a group of Jewish Christians and a review of Israel's history and Jesus' place in it. Its author is unknown.

Hebrides (Western Isles) Group of more than 500 islands in the Atlantic Ocean off the w coast of Scotland. They are divided into the Inner Hebrides (principal islands: Skye, Rhum, Eigg, Islay, Mull), which are part of the Strathclyde and Highland regions, and the Outer Hebrides (principal islands: Lewis with Harris, North and South Uist), part of the Western Isles administrative area. First inhabited in the 4th millennium BC, from the 3rd century AD the islands were settled by Picts and later by Scots. In the 8th century they were invaded by Vikings and became a Norwegian dependency. In the 13th century they were ceded to Scotland by Norway. Few of the islands are inhabited and agriculture is limited. There is abundant wildlife. The main occupations are fishing, farming and the manufacture of woollens.

Hebron (El Khalil) City in the Israeli-occupied WEST BANK, almost entirely controlled by the Palestinian National Authority. An ancient city, it came under Arab control in the 7th cen-

The human heart contains four chambers - two atria and two ventricles - and four sets of valves. Blood from the body passes into the right atrium, via the vena cavae. Flow of blood into the right ventricle is controlled by the tricuspid valve. Pulmonary arteries carry blood from the right ventricle to the lungs, while the pulmonary veins carry oxygenated blood back from the lungs to the left atrium. In a similar way, the mitral valve controls the flow of blood between the left atrium and the left ventricle. The aorta conducts the oxygenated blood from the left ventricle to all parts of the body.

tury AD and was occupied by the Crusaders (12th–13th centuries) before reverting to Arab rule. In 1948 it was annexed to Jordan, but was occupied by Israel during the SIX DAY WAR (1967). It has witnessed much Israeli-Arab tension, especially during the INTIFADA. The ISRAELI-PALESTINIAN ACCORD (1993) granted Palestinian self-rule to 85% of the city. An Israeli withdrawal finally took place in January 1997. Hebron is sacred to both Jews and Muslims. The Tomb of the Patriarchs (Cave of Machpelah) is the traditional burial place of Abraham, Sarah, Isaac, Rebecca, Jacob and Leah. Hebron is surrounded by vineyards and vegetable farms. Industries: tanning, glassmaking, food processing. Pop. (1995 est.) 117,000.

Hecate Goddess in Greek mythology. Assiciated with Artemis, she bestowed wealth and blessings, and presided over witchcraft, graveyards and cross-roads.

Hector In Greek legend, the greatest of the Trojan heroes, eldest son of PRIAM. He was slain by ACHILLES.

hedgehog Small, nocturnal Eurasian mammal of the family Erinaceidae. It has short, sharp spines above, lighter-coloured fur below, and a pointed snout. It feeds on insects and other small animals and defends itself by rolling into a ball with the spines outermost. Species *Erinaceus europaeus*.

hedonism Pursuit of pleasure, or any of several philosophical or ethical doctrines associated with it. Aristippus (c.435–c.356 BC) taught that pleasure was the highest good. EPICURUS advocated discrimination in the seeking of pleasure. Locke believed that the idea of "good" can be defined in terms of pleasure. Jeremy BENTHAM and J.S. MILL adapted a psychological view of hedonism in formulating UTILITARIANISM.

Hegel, Georg Wilhelm Friedrich (1770–1831) German philosopher, whose method of dialectical reasoning had a strong influence on his successors, notably Karl Marx. He was professor of philosophy at Heidelberg and subsequently at Berlin, where he developed a metaphysical system that traced the self-realization of spirit by dialectical movements towards perfection. These progressions took the form of battles between a thesis (proposition) and an antithesis (its opposite), eventually resolved in a synthesis at a higher level of truth. Hegel wrote two major works, *Phenomenology of Spirit* (1807) and *Science of Logic* (1812–16). *See also DIALECTICAL MATERIALISM*

hegemony Leadership or dominance of one state over others. The term originated in ancient Greece where the cities of Athens, Sparta and Thebes held hegemony over Greece in the 5th and 4th centuries BC. Britain was a hegemonic power in the 19th century and the USA has been since 1945. The term was also employed by the Italian Marxist theorist Antonio Gramsci to refer to the phenomenon of one social class monopolizing the creation and transmission of values.

Heidegger, Martin (1889–1976) German philosopher. A founder of EXISTENTIALISM and a major influence on modern philosophy, Heidegger's most important work was *Being and Time* (1927). Influenced by hermeneutics, PHENOMENOLOGY and Christian ONTOLOGY, his central concern was how human self-awareness is dependent on the concepts of time and death. For him, Western science and philosophy have led to NIHILISM, and prevent people from rediscovering their true selves. His later work focused more on the role of language. His support for the Nazi Party has damaged his reputation.

Heidelberg City on the River Neckar, Baden-Württemberg, sw Germany. Founded in the 12th century, it has the oldest university in Germany (1386) and a medieval castle. Industries: printing machinery, precision instruments, publishing, textiles, leather goods. Pop. (1990) 139,900.

Heimlich manoeuvre First-aid technique, developed by Dr Henry J. Heimlich for relieving blockage in the windpipe. The rescuer uses his or her arms to encircle the choking person's chest from behind, positioning one fist in the space just beneath the breastbone and covering it with the other hand. The rescuer then thumps the fist into the person's midriff.

Heine, Heinrich (1797–1856) German poet and prose writer. The *Book of Songs* (1827), a collection of verse, is his best-known work. It was followed by the four-volume satirical *Pictures of Travel* (1826–31). SCHUMANN and SCHUBERT both set his lyrics to music.

◀ hedgehog The spines of the European hedgehog (Erinaceus europus) are actually hairs, modified into hollow tubes with reinforcing ridges on the inside walls, making for a strong but light structure. The spines are raised when the animal is threatened

Heisenberg, Werner Karl (1901–76) German physicist and philosopher, best known for discovering the UNCERTAINTY PRINCIPLE (1927). He won the 1932 Nobel Prize for physics for his contribution to QUANTUM MECHANICS.

Hejaz Region in NW Saudi Arabia, on the Red Sea coast. The centre of Islam, it contains the Muslim holy cities of Mecca and Medina. It has been part of Saudi Arabia since 1932. Area: 388,500sg km (150,000sg mi).

Hejira (Arab. *Hegira*, breaking off of relations) Flight of MUHAMMAD from MECCA to MEDINA in AD 622 in order to escape persecution. The Islamic calendar begins in 622.

Helen In Greek legend, the beautiful daughter of Leda and Zeus. She married Menelaus, King of Sparta, but was carried off by Paris, Prince of Troy, thus provoking the Troian War. Helena Capital of Montana, USA, in the w central part. It was settled by prospectors in 1864. By 1868 the population was 7,500 and US\$16 million worth of gold had been mined. In 1875 it was made the capital of Montana territory, becoming state capital in 1889. Industries: mineral smelting, bakery equipment, ceramics, paints. Pop. (1990) 24,569.

helicopter Aircraft that gains lift from power-driven rotor(s). The helicopter is capable of vertical take-off and landing (VTOL), hovering, and forward, backward and lateral flight. Helios In Greek mythology, god of the Sun, identified with the Roman god Apollo. Helios appears driving a four-horse chariot through the sky.

helium (symbol He) Nonmetallic element, a NOBLE GAS, discovered in 1868 by Jules Janssen. First obtained in 1895 from the mineral clevite, the chief source today is from natural gas. It is also found in some radioactive minerals and in the Earth's atmosphere (0.0005% by volume). It has the lowest melting and boiling points of any element. It is colourless, odourless

A helicopter rotor head transfers the power of the engines to the rotor blades via gears (1) and the rotor shaft (2). The swish plate controls the tilt of the rotor (3) and also the pitch of the blades (4). The upper (5) and lower (6) swish plates are controlled by hydraulic cylinders (7) attached to the lower plate. The upper plate is connected to the rotor blades by control rods (8). The pitch of the blades controls the amount of lift

generated while the attitude of the whole rotor controls how the helicopter moves horizontally. If the rear of the swish plate is raised (9) the rotor dips towards the nose of the helicopter causing it to travel forward.

▲ Hemingway US novelist Ernest Hemingway was constantly seeking adventure, and was a correspondent in the Spanish Civil War and World War 1. Between the wars, Hemingway would spend time big-game hunting or deep-sea fishing. During his later life he suffered increasingly from severe bouts of depression, and it is thought that this illness. combined with a fear of old age, drove him to shoot himself in 1961. He won the Pulitzer Prize in 1953, and was awarded the Nobel Prize for literature in 1954.

and nonflammable, and is used in light-air balloons, to make artificial "air" (with oxygen) for deep-sea divers and in welding, semiconductors and lasers. Liquid helium is used in cryogenics (physics dealing with low temperatures). Properties: at.no. 2; r.a.m. 4.0026; r.d. 0.178; m.p. -272.2°C (-458°F); b.p. -268.9°C (-452.02°F); single isotope He⁴.

helix Curve generated when a point moves over the surface of a cylinder so that it traces a path inclined at a constant angle to the cylinder's axis, as in a coil spring.

hell Abode of evil spirits, and the place or state of eternal punishment after death for the wicked. In modern Christian theology, hell is conceived as eternal separation from God. Hell is parallelled in other religions and mythologies, for example, the Hebrew *sheol* or the Greek HADES. *See also* HEAVEN; LIMBO; PURGATORY

hellebore Any of about 20 species of poisonous herbaceous plants of the genus *Helleborus*, native to Eurasia. Best known is the Christmas rose, *H. niger*, which bears white flowers from mid-winter to early spring. Family Ranunculaceae.

Hellenistic Age (323–30 BC) Period of Classical Mediterranean history from ALEXANDER THE GREAT to the reign of AUGUSTUS. Alexander's conquests helped to spread Greek civilization over a wide area east of the Mediterranean. The age was distinguished by remarkable scientific and technological advances, especially in ALEXANDRIA, and by more elaborate and naturalistic styles in the visual arts.

Heller, Joseph (1923–) US author. His first novel, *Catch*–22 (1961), is one of the satirical masterpieces of the 20th century. Other works include the play *We Bombed in New Haven* (1968) and the novels *Something Happened* (1974), *God Knows* (1984) and *Closing Time* (1994).

Hellespont See DARDANELLES

Hellman, Lillian (1905–84) US playwright and author. Her debut play, *The Children's Hour* (1934), set the tone for her enduring interest in Marxist theory. She received acclaim for her memoirs, beginning with *An Unfinished Woman* (1969) and concluding with *Maybe* (1980).

Helmholtz, Hermann Ludwig Ferdinand von (1821–94) German anatomist, physicist and physiologist. He made contributions in ACOUSTICS and OPTICS, expanding Thomas YOUNG's three-colour theory of vision. His experiments on the speed of nerve impulses led him to formulate a principle of conservation of energy.

Helsinki (Helsingfors) Capital of Finland, in the s of the country, on the Gulf of Finland. Founded in 1550 by GUSTAVUS I VASA, it became the capital in 1812. It has two universities (1849, 1908), a cathedral (1852), museums and art galleries. The commercial and administrative centre of the country, it is Finland's largest port. Industries: shipbuilding, engineering, food processing, ceramics, textiles. Pop. (1993) 508,588.

Helvétius, Claude Adrien (1715–71) French philosopher and educator. His best-known work, *De L'Esprit (On the*

Mind, 1758), attacked the religious basis of morality, arousing great opposition. He claimed that everybody is intellectually equal but some have less desire to learn than others. This led him to claim, in *De l'homme* (1772), that all human problems could be solved by education.

Hemingway, Ernest Miller (1899–1961) US author. After serving as an ambulance driver in World War 1, Hemingway became a journalist, first in Paris and later as a war correspondent in the Spanish Civil War and World War 2. The novel *The Sun Also Rises* (1926), published in the UK as *Fiesta* (1927), chronicled the Lost Generation and established his reputation. Later works include a non-fiction work about bullfighting, *Death in the Afternoon* (1932), *A Farewell to Arms* (1929), *For Whom the Bell Tolls* (1940) and the novella *The Old Man and the Sea* (1952). Hemingway was also an acclaimed short-story writer. He won the 1954 Nobel Prize for literature.

hemlock Poisonous herbaceous plant found in Eurasia. It has a long taproot and flat clusters of white flowers. The leaf stalks have purple spots. Family Apiaceae/Umbelliferae; species *Conium maculatum*. Hemlock also refers to species of conifers of the genus *Tsuga*, family Pinaceae.

hemp Herb native to Asia and cultivated throughout Eurasia, North America and parts of South America. It has hollow stems with fibrous inner bark, also called hemp, which is used to make ropes and cloth. Oil from the seeds is used in soap and paint. The flowers, leaves and resinous juice are used to produce MARIHUANA and HASHISH. Height: to 5m (16ft). Family Cannabinaceae; species *Cannabis sativa*.

Hendrix, Jimi (James Marshall) (1942–70) US rock guitarist, songwriter and singer. Hendrix's improvised guitar solos have influenced generations of rock and jazz musicians. His debut album was *Are You Experienced?* (1967). His band, The Jimi Hendrix Experience, played live at Woodstock (1970). Other albums include *Band of Gypsies* (1970).

Hendry, Stephen Gordon (1969–) Scottish snooker player. In 1987 he became the youngest player to win a major title. In 1988 he became British Open champion. The youngest–ever world champion in 1990, he took the world title six times in the next seven years.

Henley Royal Regatta Oldest rowing regatta in the world, begun (1839) in Henley-on-Thames, Oxfordshire, England. Held every July, it is also a social event. Trophies include the Grand Challenge Cup and Diamond Challenge Sculls.

henna (Egyptian privet) Small shrub native to the Middle East and N Africa. Since ancient times, people have extracted a red-brown dye from the leaves to colour hair and skin. Family Lythraceae; species *Lawsonia inerma*.

Hennepin, Louis (1640–1701) French explorer. A Franciscan missionary, he sailed to Canada in 1675 and became chaplain to LA SALLE. He accompanied him on the 1679 expedition, writing the first description of Niagara Falls and being held prisoner by the Sioux. His exaggerated account, Description de la Louisiane (1683), was very popular.

Henri, Robert (1865–1929) US painter, a member of the ASHCAN SCHOOL. One of the most influential artists of his time, he is best known for his realistic urban scenes.

Henrietta Maria (1609–69) Queen consort of CHARLES I of England. Daughter of Henry IV of France, her Catholicism and her support for Charles' absolutist tendencies incurred Parliament's hostility. After 1644 she lived in France, except for a brief return to England after the RESTORATION in 1660.

Henry I (the Fowler) (*c*.876–936) King of the Germans (918–36). Duke of Saxony, he was elected to succeed Conrad I as king. He asserted his authority over the German princes and reconquered Lotharingia (Lorraine, 925). In 933 he defeated the Magyar raiders. He was succeeded by his son, OTTO I, first Holy Roman emperor.

Henry III (1017–56) German king (1039–56) and Holy Roman emperor (1046–56). He succeeded his father, Conrad II. Imperial power reached its zenith in his reign as he subdued rebellious vassals in Saxony and Lorraine, and compelled the rulers of Poland, Bohemia and Hungary, as well as the s Italian princes, to pay him homage.

Henry IV (1050–1106) German king (1056–1106) and Holy Roman emperor (1084–1106). Embroiled in controversy with

▶ Hendrix Considered by many to be the most influential rock guitarist of all time, Jimi Hendrix enjoyed greater initial success in the UK than his native USA. Although left handed, he played a right-handed guitar turned upside down. He died, aged 28, following a drug overdose.

the popes over the lay investiture of clerics, he deposed Pope GREGORY VII and was in turn deposed by the pope (1076). Rebellion in Germany weakened Henry's position. After seeking papal absolution in 1077, he continued the struggle, setting up the antipope Clement III. In 1105 he was deposed by his son, HENRY V.

Henry V (1081-1125) German king (1105-25) and Holy Roman emperor (1111-25). Having deposed his father, HENRY IV, he resumed the quarrel with the papacy over investiture, while antagonizing German princes by the ruthless assertion of his power. He was defeated in Germany and compelled to compromise with the papacy. The Concordat of WORMS (1122) ended the investiture conflict.

Henry VI (1165-97) German king (1190-97) and Holy Roman emperor (1191-97). The son of Frederick I, he married (1186) Constance, heiress of the kingdom of Sicily, and much of his reign was devoted to securing that inheritance. After 1194, the empire was at the height of its power. Although he failed to make the empire hereditary in the HOHENSTAUFEN line, his infant son, Frederick II, was accepted as his successor.

Henry I (1068–1135) King of England (1100–35). When his brother, WILLIAM II, was killed, Henry seized the throne. He rescinded unpopular taxes, married a Scottish princess and recalled ANSELM from exile. He thus won the support that helped him defeat his brother, ROBERT II, duke of Normandy, and regain Normandy for the English crown (1106).

Henry II (1133-89) King of England (1154-89). Son of Geoffrey of Anjou and Matilda (daughter of HENRY I). He inherited the ANGEVIN lands and obtained Aquitaine by marrying ELEANOR in 1152. Intelligent and practical, he re-established stable royal government in England and instituted reforms in finance, local government and justice. His efforts to impose the Constitutions of CLARENDON led to his guarrel with Thomas à BECKET. His later years were troubled by the rebellions of his sons, including two future kings, RICHARD I and JOHN.

Henry III (1207-72) King of England (1216-72). The influence of foreigners on Henry's administration antagonized the nobles. He was forced to accept the Provisions of Westminster (1259), giving more power to his councillors, but renounced them in 1261, provoking the Barons' War. The leader of the barons, Simon de Montfort, was defeated at Lewes (1264) by Henry's son, the future EDWARD I, who thereafter ruled on his father's behalf.

Henry IV (1367-1413) King of England (1399-1413). Son of JOHN OF GAUNT, Henry was one of the five "lords apellant" who ruled England in 1388-89. He betrayed his fellow lords, but was exiled by RICHARD II in 1398. Henry mounted a successful invasion and usurped the throne. He was faced with revolts, notably by Owen GLYN DŵR and the PERCYS of Northumberland. He was succeeded by his son, HENRY V.

Henry V (1387–1422) King of England (1413–22). Son of HENRY IV, he helped defeat Owen GLYN DŵR and the PER-CYS. As king, he reopened the HUNDRED YEARS WAR and won a decisive victory at AGINCOURT in 1415. Further conquests in 1417-19 resulted in the Treaty of Troyes (1420), when CHARLES VI of France recognised him as his heir. He died on his third invasion of France. His military success and popular appeal made him a national hero.

Henry VI (1421–71) King of England (1422–61, 1470–71). He succeeded his father, HENRY V, as a baby. Henry BEAU-FORT dominated government until Henry came of age. His reign was characterized by military disasters in France and by the start of the Wars of the Roses. In 1453 Henry was pronounced insane and Richard, duke of York, became protector. Deposed by Richard's son, EDWARD IV, in 1461, Henry was briefly restored to the throne when the earl of WARWICK (Richard Neville) switched allegiances. He was murdered in captivity and succeeded by Edward IV.

Henry VII (1457–1509) King of England (1485–1509), founder of the TUDOR dynasty. Henry assumed the throne after defeating RICHARD III at Bosworth (1485). He united the houses of LANCASTER and YORK by marrying (1486) the Yorkist heiress, Elizabeth. Henry's financial acumen restored England's fortunes after the devastation of civil war. He ruthlessly suppressed Yorkist plots with the use of the STAR

CHAMBER and foreign treaties secured the dynasty. He was succeeded by HENRY VIII.

Henry VIII (1491-1547) King of England (1509-47). Second son of HENRY VII, he became heir on the death of his elder brother, Arthur, in 1502. His aggressive foreign policy, administered by Cardinal Wolsey, depleted the royal treasury. Henry, supported by Thomas CROMWELL, presided over the first stages of the English REFORMATION. He managed to obtain a divorce from his first wife, CATHERINE OF ARAGON, and married Anne BOLEYN (1533), mother of the future ELIZ-ABETH I. In 1535 Anne was executed for adultery. Thomas More, Henry's former chancellor, was also executed for refusing to accept Henry as head of the church. Henry then married Jane Seymour, who died shortly after the birth of the future EDWARD VI. His next marriage, to ANNE OF CLEVES, ended in divorce (1540) and with the execution of Cromwell. Shortly after, he married Catherine Howard (executed 1542) and finally Catherine Parr in 1543 who survived him. Henry's reign will also be remembered for the DISSOLUTION OF THE Monasteries (1536-40), which brought temporary relief from financial problems, but at the cost of great social unrest. Henry II (1519–59) King of France (1547–59). Son and successor of Francis I, he married Catherine De' Medici but was dominated by his mistress, Diane de Poitiers, and the rival families of Guise and Montmorency. After bankrupting the royal government, the war with Spain ended with the

peace of Cateau-Cambrésis (1559).

Henry III (1551-89) King of France (1574-89). As duke of Anjou, he fought against the HUGUENOTS in the Wars of RELI-GION. By making peace with the Huguenots (1576), he antagonized extremist Roman Catholics, who formed the Catholic League led by the House of GUISE. After the League provoked a revolt in 1588, Henry had the Guise leaders killed and made an alliance with the Huguenot, Henry of Navarre (later HENRY IV). The king was assassinated by a member of the league.

Henry IV (1553-1610) King of France (1589-1610), first of the Bourbon dynasty. From a Protestant upbringing, Henry was recognized as leader of the HUGUENOTS. Henry's marriage Margaret of Valois was marred by the SAINT BARTHOLOMEW'S DAY MASSACRE (1572). Henry survived, but was forced to convert to Catholicism. In 1584 he became legal heir to HENRY III. On Henry's death, the Guise family refused to recognize his claim, but were subdued. In 1593, Henry willingly converted to Roman Catholicism - allegedly remarking

■ Henry VIII Portrait by Hans Holbein. Henry's reign was most notable as the time during which England no longer acknowledged the pope as the head of the church. As the new head of the Church of England, Henry was able to grant himself a divorce from his first wife. Catherine of Aragon. who was unable to provide him with an heir

▲ herbivore Mammalian herbivores may conveniently share a habitat without competing for resources. On the African plains. giraffes (1) browse in branches up to 6m (20ft) above the ground. Elephants (2) too can browse tree canopies, using their trunks to pluck off vegetation. Eland (3) attack the middle branches with their horns, twisting twigs to break them off, while gerenuk (4) stand on their hind legs to reach higher branches. The black rhino (5) uses its hook-like upper lip to feed on bark, twigs and leaves (white rhinos have lengthened skulls and broad lips for grazing the short grasses that they favour). The wart hog (6) and dik-dik (7) eat buds and flowers, and will also dig up roots and tubers. Such sharing of a single resource also occurs among grazers. Migrating zebra (8) crop the taller, coarse grasses; wildebeest (9) feed on the leafy centre layer, allowing small gazelles (10) to reach the tender new shoots.

"Paris is well worth a Mass". He ended the Wars of RELIGION by the Edict of NANTES (1598), but remained sympathetic to Protestantism, secretly supporting the revolt of the Protestant Netherlands against Spain. A popular king, with a keen sense of social justice, he was assassinated by François Ravaillac.

Henry, Joseph (1797–1878) US physicist, whose work on ELECTROMAGNETISM was essential for the development of the telegraph. His work on INDUCTION led to the production of the TRANSFORMER. The unit of inductance is named after him.

Henry, O. (1862–1910) US short-story writer, b. William Sydney Porter. Supposedly taking his pseudonym from a contraction of Ohio Penitentiary, where he served a sentence for embezzlement, he produced popular short stories.

Henry, Patrick (1736–99) US statesman. As a member of the CONTINENTAL CONGRESS, he called the colonists to arms in March 1775 with his memorable demand, "Give me liberty or give me death". He served as governor of Virginia (1776–79, 1784–86). A strong believer in states' rights, he opposed ratification of the CONSTITUTION in 1787, but was later reconciled with the Federalists.

Henry the Lion (1129–95) Duke of Saxony (1142–80) and of Bavaria (1156–80). A GUELPH, he recovered the lands lost by his father, Henry the Proud, to the Emperor Conrad III. As duke of Saxony he promoted German expansion beyond the River Elbe. In 1180, after refusing to support the Italian campaign of Emperor FREDERICK I (Barbarossa), he was deprived of most of his lands.

Henry the Navigator (1394–1460) Portuguese prince. A son of JOHN I, he sponsored Portuguese voyages of discovery to the Atlantic coast of Africa, which later led to the discovery of the route to India via the Cape of Good Hope.

Henze, Hans Werner (1926–) German composer. Influenced by TWELVE-TONE MUSIC, he is best-known for his operas, such as *Elegy for Young Lovers* (1961).

hepatitis Inflammation of the liver, usually due to a generalized infection. Early symptoms include lethargy, nausea, fever and muscle and joint pains. Five hepatitis viruses are known: A, B, C, D and E. The most common single cause is the hepatitis A virus (HAV). More serious is infection with the hepatitis B virus (HBV), which can lead to chronic inflammation or complete failure of the liver and, in some cases, to liver cancer. Hepburn, Audrey (1929-93) US actress, b. Belgium. Her ingénue performance in Roman Holiday (1953) won her an Academy Award for Best Actress. A succession of similiar roles in films such as Sabrina (1954) and Funny Face (1957) earned her further popular success. Other credits include Breakfast at Tiffany's (1961) and My Fair Lady (1964). She later became involved in charitable and humanitarian work. Hepburn, Katharine (1909-) US stage and film actress. She made her film debut in 1932 and won her first Best Actress

Academy Award for Morning Glory (1933). She made nine films with Spencer Tracy, beginning with Woman of the Year (1952) and ending with an Oscar-winning performance in Guess Who's Coming to Dinner (1967). In 1968 she won a third Best Actress Oscar for The Lion in Winter. Her performance in On Golden Pond (1981) gained her a fourth award. Other films include Bringing Up Baby (1938), The Philadelphia Story (1940), The African Queen (1951), Suddenly Last Summer (1959) and Long Day's Journey Into Night (1962).

Hephaestus Ancient Greek god of fire and crafts. Son of Zeus and Hera, he is equivalent to the Roman Vulcan. Blacksmith and armourer to the Olympian gods, with a forge under Etna, he is depicted as crippled and uncouth.

Hepplewhite, George (d.1786) British furniture designer and cabinet-maker. His chairs often have tapered legs with shield backs, and his furniture combines pale woods with mahogany, often in the form of inlay.

heptathlon Athletics discipline for women consisting of seven events contested over two days. *See also* DECATHLON

Hepworth, Dame Barbara (1903–76) English sculptor. One of Britain's leading modernist artists, Hepworth's abstract works, such as *Pelagos* (1946), are noted for their simplicity and elegance. She was married (1932–51) to Ben Nicholson. **Hera** In Greek mythology, queen of the Olympian gods, sister

Hera In Greek mythology, queen of the Olympian gods, sister and wife of Zeus. She appears as a jealous scold who persecuted her rivals but helped heroes such as JASON and ACHILLES.

Heracles (Roman, Hercules) In Greek mythology, greatest of the Greek heroes. Condemned to serve King Eurystheus, he performed 12 labours: he killed the Nemean lion and the Hydra; caught the Erymanthian boar and the Cerynean hind; drove away the Stymphalian birds; cleaned the Augean stables; caught the Cretan bull and Diomedes' horses; stole the girdle of Hippolyte; killed Geryon; captured Cerberus and stole the golden apples of Hesperides. After death, he was allowed to ascend as a god to Olympus.

Heraclitus (536–470 BC) Greek philosopher. Heraclitus believed that the outward, unchanging face of the universe masked a dynamic equilibrium in which all things were constantly changing, but with opposites remaining in balance. The elemental substance connecting everything was fire. Heraclitus is credited with two sayings that sum up his world view: "All things change" and "You cannot step into the same river twice". Only fragments of his one book survive.

Heraclius (575–641) Byzantine emperor (610–41). An outstanding military leader, he came to power at a time of economic, political and military crisis. He re-established government and army, defeated the Persians and took the Byzantine empire to unrivalled power. By the time of his death, however, the Arabs had conquered much of the empire.

herb Seed-bearing plant, usually with a soft stem that withers away after one growing season. Most herbs are ANGIOSPERMS. The term is also applied to any plant used as a flavouring, seasoning or medicine, such as thyme, sage and mint.

Herbert, George (1593–1633) English poet and churchman. His verse, some of the finest METAPHYSICAL POETRY, was published after his death as *The Temple*. It is remarkable for its devotional tone and formal complexity.

herbicide Chemical substance used to kill weeds and other unwanted plants. There are two kinds: selective herbicides kill the weeds growing with crops, leaving the crops unharmed; non-selective herbicides kill all the vegetation.

herbivore Animal that feeds solely on plants. The term is most often applied to mammals, especially ungulates (hooved mammals). Herbivores are characterized by broad molars and blunt-edged teeth. Their digestive systems are adapted to the assimilation of cellulose.

Herculaneum Ancient city on the Bay of Naples, Italy, the site of modern Resina. Devastated in AD 62 by an earthquake, it was buried in AD 79 by the eruption of VESUVIUS. Archaeological excavations unearthed the Villa of the Papyri, which contained a library, furniture, and the bodies of victims.

Herder, Johann Gottfried von (1744–1803) Prussian philosopher and historian. He believed human society to be an organic, secular totality that develops as the result of an historical process. Herder was a founder of German ROMANTICISM

and an opponent of Kant. *Ideas on the Philosophy of History of Humanity* (1784–91) is regarded as his masterpiece.

heredity Transmission of characteristics from one generation of plants or animals to another. Characteristics, such as red hair, may be specific to individuals within a group; others, such as the possession of external ears, may be typical of a group as a whole. The combination of characteristics that makes up an organism and makes it different from others is set out in the organism's GENETIC CODE, passed on from its parents. The first studies of heredity were conducted by Gregor MENDEL.

Hereford and Worcester County in w central England, bounded w and sw by Wales; the county town is WORCESTER. It is drained by the Severn, Wye and Teme rivers. The Malvern Hills divide the county into two lowland plains. The Vale of Evesham in the s provides rich soil for market gardening. Agriculture and dairy farming are important activities. Industries: agricultural machinery, fruit canning and processing. Area 3,926sq km (1,516sq mi). Pop. (1991) 676,747. heresy Denial of, or deviation from, orthodox religious belief. The concept is found in most organized religions with a rigid, dogmatic system. The early Christian church fought against heresies such as ARIANISM and NESTORIANISM. In the Middle Ages, the Catholic Church set up the INQUISITION to fight heresy. After the REFORMATION, the Catholic Church described Protestants as heretics because of their denial of many papally defined dogmas, while Protestants applied the term to those who denied their interpretation of the major scriptural doctrines. Persecutions for heresy were common in most parts of Christendom until relatively recently.

hermaphrodite Organism that has both male and female sexual organs. Most hermaphrodite animals are invertebrates, such as the EARTHWORM and SNAIL. They reproduce by the mating of two individuals, each of which receives SPERM from the other. Some hermaphrodites are self-fertilizing.

Hermes In Greek mythology, god identified with the Roman Mercury. Represented with winged hat and sandals and carrying a golden wand, Hermes was the messenger of the gods and patron of travellers and commerce.

hermit crab Small, crab-like CRUSTACEAN found in tidal pools and shallow water worldwide. It uses sea-snail shells to protect its soft abdomen, changing shells as it grows. Some are terrestrial and do not use shells as adults. Family Paguridae.

hernia Protrusion of an organ, or part of an organ, through its enclosing wall or connective tissue. Common hernias are a protrusion of an intestinal loop through the umbilicus (umbilical hernia), or protrusion of part of the stomach or oesophagus into the chest cavity (hiatus hernia).

Herod Agrippa I (10–44) King of Judaea (41–44). Grandson of Herod the Great, he attracted the favour of Caliguda, who confirmed him as ruler of most of Palestine. He was a zealous opponent of Christianity.

Herod Agrippa II (27–93) King of Chalcis (50–93) and of Judaea (53–70). Son of HEROD AGRIPPA I and last of the Herodian dynasty, he tried to prevent the Jewish revolt (66) and afterwards sided with Rome.

Herodotus (*c*.485–*c*.425 BC) Greek historian. Regarded as the first true historian, his *Histories* are the first great prose work in European literature. His main theme was the struggle of Greece against the mighty Persian empire in the Persian Wars, but he also provides an insight into the contemporary Mediterranean world.

Herod the Great (73–04 BC) King of Judaea (37–04 BC). Supported by Mark Antony and Augustus, he endeavoured to reconcile Jews and Romans and was responsible for many public works, including the rebuilding of the temple in Jerusalem. He later became cruel and tyrannical, executing three of his sons and his wife. According to the New Testament, Herod was king of Judaea when Jesus was born.

heroin Drug derived from MORPHINE. It produces similar effects to morphine, but acts more quickly and is effective in smaller doses. It is prescribed to relieve pain in terminal illness and severe injuries. Widely used illegally, it is more addictive than morphine.

heron Any of several species of wading bird that live near rivers. Herons have white, grey or brown plumage, long neck and legs, and a sharp bill. They feed mainly on fish, and nest in large groups. Height: to 1.8m (6ft). Family Ardeidae.

herpes Infectious disease caused by one of the herpes viruses. Herpes simplex 1 infects the skin and causes cold sores. Herpes zoster attacks nerve ganglia, causing SHINGLES. The same virus is responsible for CHICKENPOX.

Herrick, Robert (1591–1674) English poet, disciple of Ben JONSON. He was ordained in 1623, but was ejected from his post (1647) for royalist sympathies. He regained the position after the RESTORATION. His poems, notably the collection *Hesperides* (1648), have great lyrical freshness.

herring Marine fish found worldwide. One of the most important food fish, various species are canned as PILCHARD or SARDINE or sold fresh, pickled or smoked (as kippers and bloaters). Herrings have a laterally compressed body and a deeply forked tail fin. Length: 8–46cm (3–18in). Family Clupeidae; the 190 species include *Clupea harengus*.

Herschel, Sir John Frederick William (1792–1871) English astronomer, son of Sir William HERSCHEL. Herschel extended his father's work on double stars and nebulae. In 1834, at the Cape of Good Hope, he undertook a systematic survey of the southern sky, discovering more than 1,200 doubles and 1,700 nebulae and clusters. He combined these and his father's observations into a *General Catalogue of Nebulae and Clusters*. He made the first good direct measurement of solar radiation, and inferred the connection between solar and auroral activity. His *Outlines of Astronomy* (1849) was a standard textbook for many decades.

Herschel, Sir William (1738–1822) English astronomer, b. Germany. He discovered URANUS (1781) and the following year was appointed the king's private astronomer. He discovered two SATELLITES of Uranus (1787) and two of SATURN (1789). He observed many double stars and more than 2,000 nebulae and clusters, and published catalogues of them. Herschel realized that the Milky Way is the plane of a disk-

◆ hermit crab Unlike most other species of crab, the hermit crab (Eupagurus sp.) has a soft body. To protect itself, the hermit crab uses empty whelk or sea snail shells as a home. It has a modified abdomen with a twisted shape to fit the spiral snail shell, and its last two legs and hind appendages (uropods) are specialized for gripping the shell. When the hermit crab has grown too large for its shell, it waits until it has found a suitable larger shell before risking the change-over.

◆ heron The purple heron (Ardea purpurea) is found in reed-grown waters in open country of southern Europe and Asia, and Africa. It grows to length of 80cm (2.5ft), and like many other species of heron feeds on fish. shaped universe, whose form he calculated by counting the numbers of stars visible in different directions. In 1800 he discovered and investigated infrared radiation.

Hertfordshire County in London's "commuter belt", SE England; the county town is Hertford. Other major towns include St Albans (built on the site of a Roman settlement), Watford, Hatfield and Letchworth (Britain's first garden city). The terrain is flat, apart from an extension of the Chiltern Hills in the NW. The main rivers are the Lea, Stort and Colne. Agriculture is important. Industries: engineering, electrical equipment, printing. Area 1,636 sq km (631sq mi). Pop. (1994) 1,005,400. Hertz, Heinrich Rudolf (1857–94) German physicist. He discovered, broadcasted and received radio waves, as predicted by James Clerk MAXWELL. Hertz also demonstrated that heat and light are kinds of ELECTROMAGNETIC RADIATION. The unit of frequency, the HERTZ (Hz), is named after him.

hertz (symbol Hz) SI unit of FREQUENCY named after Heinrich HERTZ. A periodic phenomenon with a period of one second (such as one oscillation per second) is equivalent to 1Hz. Hertzog, James Barry Munnik (1866–1942) Afrikaner political leader. He was a general in the Boer forces during the SOUTH AFRICAN WARS (1899–1902). A member of the Union government under BOTHA (1910), he founded the National Party in 1914 and became prime minister in 1924. He later formed an alliance with SMUTS in the United Party, but resigned in 1939 in protest against South Africa's support for Britain in World War 2.

Hertzsprung-Russell diagram (HR diagram) Plot of the absolute MAGNITUDE of stars against their spectral type; this is equivalent to plotting their LUMINOSITY against their surface temperature or colour index. Brightness increases from bottom to top, and temperature increases from right to left. The diagram was devised by Henry Norris Russell in 1913, independently of Ejnar Hertzsprung, who had had the same idea some years before. The HR diagram reveals a pattern in which most stars lie on a diagonal band, the main sequence. Herzegovina See BOSNIA-HERZEGOVINA

Herzl, Theodor (1860–1904) Founder of modern ZIONISM, b. Hungary. As a journalist reporting on the Dreyfus Affair, Herzl became convinced of the need for a Jewish national state. In 1897 he published *Der Judenstaat*, and organized the first Zionist World Congress. Herzl acted as its president (1897–1904). In 1949 his body was moved from Vienna to Jerusalem, where he was reburied with Israeli state honours.

Heseltine, Michael Ray Dibdin (1933–) British statesman, deputy prime minister (1995–97). Heseltine entered parliament in 1966. In Margaret Thatcher's cabinet, he was secretary of state for the environment (1979–83) and defence secretary (1983–86), resigning over the Westland Affair. Heseltine rejoined the cabinet as secretary of state for the environment (1990–92) under John Major's leadership. As secretary of state for trade and industry (1992–95), he announced a drastic programme of pit closures. Despite a heart attack, Heseltine continued as a combative deputy prime minister. Following electoral defeat (1997), he took a less active role in Conservative Party politics.

Hess, Rudolf (1894–1987) German Nazi leader. He joined the Nazi Party (1921) and took part in the abortive MUNICH PUTSCH. Hess was the nominal deputy leader under Hitler from 1933. In 1941 he flew to Scotland in a mysterious solo effort to make peace with the British. He was sentenced (1945) to life imprisonment at the NUREMBERG TRIALS, and spent the rest of his life in Spandau jail, Berlin, for many years its sole inmate. Hess, Victor Francis (1883–1964) US physicist, b. Austria. As a result of his investigations into the ionization of air, he suggested that radiation similar to x-rays, later named cos-

mic RADIATION, comes from space. He shared the 1936 Nobel Prize for physics with Carl Anderson.

Hesse, Hermann (1877–1962) German novelist. Hesse studied Indian mysticism and Jungian psychology, subjects that find expression in novels such as *Demian* (1919), *Siddhartha* (1922) and *Steppenwolf* (1927). Other novels include *Narcissus and Goldmund* (1930) and *The Glass Bead Game* (1943). He was awarded the 1946 Nobel Prize for literature. **Hessen** Region of central Germany. It was divided by a strip

of Prussian territory until 1945. Industries: chemicals, manufacturing, electrical engineering, cereal cropping. Area 21,114sq km (8,150sq mi). Pop. (1993) 5,967,305.

Hestia In Greek mythology, goddess of the burning hearth. The daughter of Cronus and Rhea, she scorned the attentions of Apollo and Poseidon and was installed in Olympus by Zeus. In Rome, she was worshipped as Vesta. *See also* VESTAL VIRGINS **heterosexuality** Attraction of a male or female to members of the opposite sex. The word is used to distinguish such attraction from HOMOSEXUALITY.

heterozygote Organism possessing two contrasting forms (ALLELES) of a GENE in a CHROMOSOME pair. In cases where one form is dominant and the other RECESSIVE, only the dominant form is expressed in the PHENOTYPE. *See also* HOMOZYGOTE

Hewish, Antony (1924–) British astronomer He shared the 1974 Nobel Prize for physics for his work on PULSARS.

hexagon Six-sided plane figure. Its interior angles add up to 720°. In a regular hexagon, whose sides and interior angles are all equal, each interior angle is 120°.

Heyerdahl, Thor (1914–) Norwegian ethnologist who, with five companions, drifted on the balsa raft *Kon Tiki c.*8,000km (5,000mi) across the Pacific Ocean from Peru to Polynesia (1947) in an attempt to prove that the Polynesians came from South America and not from Southeast Asia. He also sailed (1970) from Africa to the West Indies in a papyrus boat *Ra II*, and travelled (1977) from Iraq to Djibouti in a reed boat, *Tigris*. Hiawatha Native American leader. As chief of the Onondaga, he founded (*c.*1575) the five-nation Iroquois Confederacy to halt intertribal wars. His semi-mythic reputation is partly the result of association with the fictional hero of the Longfellow poem, *The Song of Hiawatha* (1855).

hibernation Dormant (sleep-like) condition adopted by some animals to survive harsh winters. Adaptive mechanisms to avoid starvation and extreme temperatures include reduced body temperature, and slower heartbeat, breathing rate and metabolism.

hibiscus Genus of plants, shrubs and small trees native to tropical and temperate regions and cultivated worlwide. Their large white, pink, yellow, blue or red bell-shaped flowers have darker or variegated centres. Family Malvaceae.

Hickok, "Wild Bill" (James Butler) (1837–76) US frontiersman. A renowned marksman, he was a scout first with the Union Army during the American Civil War, and then with George Custer. He served as US marshal in Kansas (1869–71) and later toured with the Wild West show of "Buffalo Bill". He was shot dead while playing poker.

hickory Deciduous tree of the WALNUT family native to E North America. Hickories are grown for ornament, timber and for their nuts. Height: 25m (80ft). Family Juglandaceae; genus *Carya*. *See also* PECAN

Hidalgo y Costilla, Miguel (1753–1811) Mexican priest and revolutionary. Of Creole birth, he was a priest in Dolores, Guanajuato, where he plotted a revolt against Spain. With an untrained army of 80,000, he captured Guanajuato and Valladolid, but failed to generate support among the ruling class. Defeated by government forces at Calderón Bridge, Hidalgo fled, but was captured and executed.

hieroglyphics Writing system used in ancient Egypt and, by extension, those of ancient Crete, Asia Minor, Central America and Mexico. The Egyptian system of hieroglyphs (pictorial characters or symbols) arose sometime before 3100 BC. At first they were purely picture symbols: the word "sun", for instance, was represented by a circle or disc with a dot inside. In due course, they also came to be used conceptually, with symbols such as that for "sun" also standing for "day". Eventually, many symbols were used phonetically. The "sun" symbol, for instance, stood for a syllable that contained the same combination of consonants but had a different meaning. By the 7th century, hieroglyphics came into use for business and literary purposes. As the ancient Egyptian language was gradually supplanted by Greek, hieroglyphics died out. Most Egyptian hieroglyphic texts have been deciphered, thanks to the discovery of the ROSETTA STONE (1799).

Higginson, Thomas Wentworth Storrow (1823–1911) US social reformer. A Unitarian minister, he

worked for abolition of slavery and for women's rights. He was colonel of the first black regiment during the Civil War, an experience recorded in *Army Life in a Black Regiment* (1870). He was a close friend of many writers, notably Emily DICKINSON, and the biographer of other poets.

High Court of Justice In English law, court established primarily to hear civil cases. It also hears appeals from the magistrates' courts. It consists of three divisions: the Queen's Bench, the Chancery and the Family division.

high-definition television (HDTV) Form of television on which the picture is made up of 1,250 or 1,125 scanning lines instead of 625 or 525. The increased number of scanning lines makes the TV image sharper. It relies on digital transmission down OPTICAL FIBRES, rather than the transmission of electronic signals by radio waves. The use of cables increases the total number of available channels.

high jump Track and field event in which a competitor attempts to jump over a bar supported between two uprights. An Olympic sport since 1896, a competitor may have a maximum of three attempts to clear each height to which the bar is raised. The record for men's high jump was set at 2.45m (8ft ½in) in 1993 and women's at 2.09m (6ft 10½in) in 1987.

Highland Games Series of athletics competitions featuring traditional Scottish events. The term specifically refers to the autumn Royal Braemar Games or Braemar Gathering, held annually since 1819. The programme includes highland dancing, bagpipe playing and the tossing of the caber.

Highlands Scottish mountain and moorland region, lying N of a line running roughly SW to NE from Dumbarton to Stonehaven; the administrative centre is Inverness. The area is split into the Northwest Highlands and the Grampian Highlands (separated by Glen More). Hydroelectric power and forestry schemes have been introduced in an effort to halt the decline in population through emigration. Industries: tourism, forestry, fishing. Area: 25,396sq km (9,804sq mi) Pop: (1991) 204,000 **high-level language** COMPUTER LANGUAGE that is reasonably close to spoken English. The higher the level, the further the language is removed from the BINARY SYSTEM of many other computer languages.

Hill, Ambrose Powell (1825–65) Confederate commander in the American Civil War. He fought in the Second Battle of Bull Run (1862) and led his troops through the GETTYSBURG and WILDERNESS campaigns. He was killed at Petersburg while trying to restore the Confederate defence.

Hill, Geoffrey (1932–) British poet. He usually writes on historical and religious themes. His volumes of poetry include For the Unfallen (1959), King Log (1968), Mercian Hymns (1971), Tenebrae (1978) and The Mystery of the Charity of Charles Péguy (1983).

Hill, Graham (1929–75) English motor racing driver. Hill's long Formula 1 career included 14 wins in 176 starts. In 1962, racing for BRM, he won his first Grand Prix and the world driver's championship. In 1968 he won his second title, racing for Lotus. In 1972 he became the first Formula 1 world champion to win the Le Mans 24-hour race. His son, Damon (1960–), is also a successful Formula 1 driver, becoming world champion in 1996.

Hillary, Sir Edmund Percival (1919–) New Zealand explorer and mountaineer. On 29 May 1953, Hillary and the Sherpa guide, Tenzing Norgay, were the first climbers to reach the summit of Mount EVEREST.

Hill, James Jerome (1838–1916) US railroad magnate, b. Canada. Seeing the importance of transportation to the West, Hill put together the Great Northern Railroad Company and gained control of its rival, the Northern Pacific.

Hill, Sir Rowland (1795–1879) British administrator and postal reformer. He invented the nationwide "penny post", adopting the first adhesive, pre-paid postage stamp.

Hilliard, Nicholas (1547–1619) English miniaturist and goldsmith. He portrayed many of the leading figures of the time in an exquisitely graceful style.

Hillman, Sidney (1887–1946) US labour leader. He was first president of the Amalgamated Clothing Workers (1915) and helped found the Congress of Industrial Organizations (CIO) in 1935. He rallied support for President Franklin

Roosevelt's New Deal, established the American Labor Party, and helped form the World Federation of Trade Unions (1945). **Himachal Pradesh** State in the w Himalayas, Nw India; the capital is Simla. It suffered numerous invasions before coming under British rule in the 19th century. The state is mountainous and heavily forested, with highly cultivated valleys. Timber provides the main source of income. Area: 55,673sq km (21,495sq mi). Pop. (1991) 5,170,877.

Himalayas System of mountains in s Asia, extending c.2,400km (1,500mi) N-s in an arc between Tibet and India-Pakistan. The mountains are divided into three ranges: the Greater Himalayas (N), which include Mount EVEREST, the Lesser Himalayas and the Outer Himalayas (s).

Himmler, Heinrich (1900–45) German Nazi leader. In 1929 he became head of the SS. After the Nazis came to power in 1933, he assumed control of the German police system and of the CONCENTRATION CAMPS. He was captured by the British in 1945 and committed suicide.

Hincks, Sir Francis (1807–85) Canadian statesman, joint premier with Augustin Morin (1851–54), b. Ireland. An advocate of reform and cooperation between English and French speakers, Hincks was also finance minister (1869–73) under Sir John A. MACDONALD.

Hindemith, Paul (1895–1963) German composer, who emigrated to the USA in 1939. In the 1930s he developed, with Kurt Weill, *Gebrauchsmusik* (Ger. utility music) written for amateur performance. His best-known work is the symphony he derived (1934) from his opera *Mathis der Maler*.

Hindi Most widespread language in India, spoken in the north-central area by 154 million people. Hindi and English are the official languages of India. It derives from SANSKRIT and belongs to the Indo-European family.

Hinduism Traditional religion of India, characterized by a philosophy and a way of life rather than by a dogmatic structure. It was not founded by an individual and has been developing gradually since $c.3000~\rm BC$, absorbing external influences. There are several schools within Hinduism, but all Hindus recognize the VEDAS as sacred, believe that all living creatures have souls, follow the doctrine of Transmigration of Souls and consider moksha – liberation from the cycle of suffering and rebirth represented by REINCARNATION — as the chief aim in life. One of the features of Hindu society is the CASTE system, but modern Hindu scholars maintain that it is not part of the religion. In the mid-1990s, Hindus numbered $c.800~\rm million$.

Hindu Kush Mountain range in central Asia, a continuation of the Himalayas extending wsw for 800–960km

■ Hinduism Hindus practice a complex set of rites, ceremonies and festivals based around a pantheon of gods. The religion first appeared in N India c.4,000 years ago. The three chief gods (the Trimurti) are Brahma, Vishnu and Siva, creator, preserver and destroyer respectively. Central to Hinduism is the belief in reincarnation, which is seen as the cycle of rebirth and suffering. To escape this cycle is the chief aim for all Hinduis

▲ hippopotamus Hoofed mammals with an even number of toes, such as the hippopotamus (Hippopotamus amphibius shown here) are grouped together in the order Artiodactyla. The hippopotamus has a family of its own, the Hippopotamidae. It is a waterloving mammal that was once common in deep water habitats all over Africa, but is now severely restricted in range.

(500–600mi) from N Pakistan and NE Afghanistan. The highest peak is Tirich Mir, at 7,700m (25,260ft).

Hindustani Member of the Indo-Iranian branch of INDO-EUROPEAN LANGUAGES, closely related to HINDI and URDU. More than 300 million people are thought to speak or understand Hindustani in India and Pakistan.

hip Joint on each side of the lower trunk, into which the head of the femur fits; the hip bones form part of the PELVIS.

hip-hop RAP music and its associated culture, originating in New York in the early 1980s. The music is characterized by a strong drumbeat, percussive "scratching" of vinyl records, and rap vocals.

Hipparchus (146–127 BC) Greek astronomer. He estimated the distance of the Moon from the Earth and drew the first accurate star map. He developed an organization of the Universe which, although it had the Earth at the centre, provided for accurate prediction of the positions of the planets.

Hippocrates (460–377 BC) Greek physician, often called "the father of medicine". He emphasized clinical observation and provided guidelines for surgery. He is credited with the **Hippocratic oath**, a code of professional conduct still followed by doctors.

Hippolytus In Greek mythology, son of Theseus and Hippolyta. When he spurned the advances of his stepmother, Phaedra, she turned his father against him. He was put to death, but came back to life when his innocence was proved. **hippopotamus** Bulky, herbivorous mammal, native to Africa. *Hippopotamus amphibius* has a massive grey or brown body with a large head, short legs and short tail and spends much time in water. Males weigh up to 4.5 tonnes. Pygmy hippopotamuses, *Choeropsis liberiensis*, are much smaller and spend more time on land. Family Hippopotamidae.

hire-purchase (HP) Method of acquiring goods by making a deposit, then paying the rest, with interest, in regular instalments. The vendor usually has an agreement with a financer who pay the full price of the goods. The buyer becomes full owner of the goods only after repaying the financer.

Hirohito (1901–89) Emperor of Japan (1926–89). Hirohito was the first crown prince to travel abroad (1921). Although he exercised little political power during his reign, he persuaded the Japanese government to surrender to the Allies in 1945. Under the new constitution of 1946, he lost all power and renounced the traditional claim of the Japanese emperors to be divine. He was succeeded by his son, AKIHITO.

Hiroshige, Ando (1797–1858) Japanese master of UKIYO-E (coloured WOODCUT). With HOKUSAI and UTAMARO, he was one of the leading Japanese printmakers of his day. He is best known for his landscapes, which influenced IMPRESSIONISM.

Hiroshima City on the delta of the River Ota, sw Honshū Island, Japan; the river divides the city into six islands connected by 81 bridges. Founded in 1594, it was a military headquarters in the SINO-JAPANESE and RUSSO-JAPANESE wars. In August 1945 it was the target of the first atomic bomb dropped on a populated area. The city centre was obliterated and more than 70,000 people were killed. The event is commemorated in the Peace Memorial Park. Industries: brewing, shipbuilding, motor vehicles, chemicals, engineering. Pop. (1993) 1,072,000.

Hirst, Damien (1965–) British sculptor. Hirst made his name by exhibiting sculptures of animals preserved in formaldehyde. One of these pieces, *Mother and Child Divided* (1993), con-

sisting of the severed halves of a cow and calf displayed in four tanks, helped to win him the Turner Prize in 1995.

Hispaniola Island in the West Indies, in the N central Caribbean Sea, between Cuba (w) and Puerto Rico (E). The second-largest island in the West Indies, it was discovered in 1492 by Christopher Columbus. Hatti occupies the w third of the island and the Dominican Republic the remaining portion. It is a mountainous, agricultural region with a subtropical climate. Industries: coffee, cacao, tobacco, rice, sugar cane, mining. Area: 76,480sq km (29,521sq mi). See West Indies map histamine Substance derived from the amino acid histidine.

histamine Substance derived from the amino acid histidine, occurring naturally in many plants and in animal tissues, and released on tissue injury. It is implicated in allergic reactions that can be treated with ANTIHISTAMINE drugs.

histology Biological, especially microscopic, study of TISSUES and structures in living organisms.

historical novel Type of novel in which the main characters, plot and setting are based on historical persons, events or places. Walter Scott's *Ivanhoe* (1819) and Charles DICKENS' *A Tale of Two Cities* (1859) are major examples.

history Written record of the human past, often used to mean the events themselves rather than the record of them. The Western historical tradition began with the Greek historians HERODOTUS and THUCYDIDES. China, and countries influenced by it, had a different, even older historical tradition in which the past was seen as the source of wisdom and historians strove to distinguish comprehensible patterns in it.

Hitchcock, Sir Alfred (1899–1980) British film director. Hitchcock's full debut was *The Pleasure Garden* (1925). Blackmail (1929) was the first British film with synchronous sound. Hitchcock's appearances as an extra, the thrilling chases, sinister mood and sudden shocks, greatly influenced the French New Wave. *The Man Who Knew Too Much* (1934) was an international success. After the *39 Steps* (1935) and *The Lady Vanishes* (1938), Hitchcock left for Hollywood. *Rebecca* (1940) won an Academy Award for Best Picture. Though less consistent in the 1940s, his credits included *Suspicion* (1941) and *Spellbound* (1945). An extraordinary sequence began with *Strangers on a Train* (1951). Hitchcock's art was at its peak with classic thrillers such as *Rear Window* (1954), *Vertigo* (1958), *North by Northwest* (1959) and *Psycho* (1960).

Hitler, Adolf (1889-1945) German fascist dictator (1933-45), b. Austria. He served in the German army during World War 1 and was decorated for bravery. In 1921 he became leader of the small National Socialist Workers' Party (Nazi Party). While imprisoned for his role in the failed MUNICH PUTSCH, he set out his extreme racist and nationalist views in Mein Kampf. Economic distress and dissatisfaction with the WEIMAR government led to electoral gains for NATIONAL SOCIALISM and, by forming an alliance with orthodox Nationalists, Hitler became chancellor in January 1933. He made himself dictator of a one-party state in which all opposition was ruthlessly suppressed by the SS and GESTAPO. The racial hatred he incited led to a policy of extermination of Jews and others in the HOLOCAUST. Hitler pursued an aggressive foreign policy aimed at territorial expansion in E Europe. The invasion of Poland finally goaded Britain and France into declaring war on Germany in September 1939. Hitler himself played a large part in determining strategy during WORLD WAR 2. In April 1945, with Gemany in ruins, he committed suicide. Hittites People of Asia Minor who controlled a powerful empire in the 14th-13th centuries BC. They founded a kingdom in Anatolia (Turkey) in the 18th century BC; their capital was Hattusas (Boğazköy). They expanded E and s in the 15th century BC, and conquered N Syria before being checked by

hives (urticaria or nettle rash) Transient, itchy reddish or pale raised skin patches. Hives may be caused by an ALLER-GY, by irritants such as sunlight, or by stress.

the Hittite empire disintegrated c.1200 BC.

the Egyptians under RAMSES II. Under attack from ASSYRIA,

Hizbollah (Hezbollah) Iranian-backed, Islamic fundamentalist group. It was formed in the early 1980s to encourage the integration of Shirte religious militants into Middle Eastern politics. Hizbollah has been responsible for terrorist activities, including missile attacks on Israel from within Lebanon.

► Hitchcock Known as the "master of suspense", Alfred Hitchcock is widely accepted as one of the greatest directors of all time. His films were often visually spectacular and contained brooding, threatening undertones. Criticized for remaining faithful to the melodramatic genre, Hitchcock never received an Academy Award for Best Director.

Hobart Port and state capital of TASMANIA, SE Australia. Founded as a penal colony in the early 1800s, it became capital in 1812. It has one of the world's best natural harbours. Industries: fruit processing, textiles, zinc. Pop. (1994 est.) 52,900.

Hobbema, Meindert (1638–1709) Dutch painter. His serene landscapes, especially his masterpiece *The Avenue of Middelharnis* (1689), were highly influential on 18th and early 19th-century English landscape artists.

Hobbes, Thomas (1588–1679) English social and political philosopher. In *De Corpore* (1655), *De Homine* (1658) and *De Cive* (1642), he argued that matter and its motion comprise the only valid subjects for philosophy. His greatest work, *Leviathan* (1651), argued that man is not naturally social but obeys moral rules in order to maintain civilized society.

Hobbs, Sir Jack (John Berry) (1882-1963) English cricketer. Hobb's record of 61,237 runs (including 197 centuries) remains unbeaten. He played cricket for Surrey (1904-30) and England (1908-30). He scored 5,410 runs (3,636 against Australia) in 61 tests. He was knighted in 1953. Hochhuth, Rolf (1931-) Controversial German dramatist. The Representative (1963) attacked the non-intervention of the Pope in World War 2. Soldiers (1967) implied that Winston Churchill was inhumane for blanket-bombing Dresden. Ho Chi Minh (1890-1969) (Nguyen That Thanh) Vietnamese statesman, president of North Vietnam (1954-69). An agent of the COMMUNIST INTERNATIONAL, he founded the Communist Party of INDOCHINA in 1930. Forced into exile, he returned in 1941 to lead the VIET MINH against the Japanese. In 1945, he declared Vietnamese independence, and led resistance to French colonialism. After the French defeat at DIEN BIEN PHU, Vietnam was divided and Ho Chi Minh became president of North Vietnam. South Vietnamese elections were shelved, and Ho Chi Minh formed a guerilla movement (VIET CONG) to forcibly reunite Vietnam. The US-sponsored government in South Vietnam resisted, initiating the VIETNAM WAR.

Ho Chi Minh City (Saigon) City at the mouth of the River Saigon in the Mekong delta, s Vietnam; the largest city in Vietnam. An ancient Khmer settlement, Saigon was seized by the French in 1859 and made capital of Cochin China, then French INDOCHINA (1887–1902). In 1954 it became capital of independent South Vietnam. During the VIETNAM WAR it served as the military headquarters for US and South Vietnamese forces. Taken by the North Vietnamese in 1975, it was later renamed Ho Chi Minh City. It is the commercial, industrial and transport centre of Vietnam. Industries: shipbuilding, textiles, pharmaceuticals. Pop. (1989) 3,169,135.

hockey (field hockey) Game played by two teams of 11 players, in which a hooked stick is used to strike a small, solid ball into the opponents' goal. The field of play usually measures 91.47×54.9 m (300×180 ft). There are two 35-minute halves. The modern game dates from the formation of the English Hockey Association in 1875 and has been an Olympic sport since 1908. Recent developments in the UK include the introduction of a national club league system. See also ICE HOCKEY Hockney, David (1937-) British painter, the most acclaimed British artist of his generation. He first attracted attention with witty POP ART paintings, such as Flight into Italy-Swiss Landscape (1962). The swimming-pool was a common theme, such as A Bigger Splash (1967). His portraits in spacious interiors, such as Mr and Mrs Clark and Percy (1970), are almost period pieces. His graphic work is often regarded as being more innovative than his painting.

Hoddle, Glenn (1957–) English football player and coach. A creative midfield player, he made 377 appearances for Tottenham and earned 53 international caps. After a brief spell at Monaco, Hoddle became player-manager at Swindon Town and then Chelsea. He succeeded Terry VEN-ABLES as England's national coach (1996). He led England to the 1998 World Cup finals.

Hodgkin's disease Rare type of cancer causing painless enlargement of the LYMPH GLANDS, lymphatic tissue and spleen, with subsequent spread to other areas. Named after the pathologist Thomas Hodgkin (1798–1866), its treatment consists of RADIOTHERAPY, surgery, drug therapy or a combination of these. It is curable if caught early.

Hoffa, James Riddle (1913–75) US labour leader. President of the International Brotherhood of Teamsters (1957–71), he was imprisoned in 1967 for jury tampering, mail fraud and mishandling of union funds. His sentence was commuted in 1971, but he disappeared in 1975 and is presumed dead.

Hoffman, Dustin (1937–) US film actor. Hoffman's debut performance in *The Graduate* (1967), earned him an Academy nomination for Best Actor. A dedicated character actor, he won further nominations for his roles as a derelict in *Midnight Cowboy* (1969) and as comedian Lenny Bruce in *Lenny* (1974). He finally won a Best Actor Oscar for *Kramer vs Kramer* (1979). After a startling performance in *Tootsie* (1982), he won a second Best Actor award for *Rain Man* (1988).

Hoffmann, E.T.A. (Ernst Theodor Amadeus) (1776–1822) German romantic author, musician and music critic. He wrote many fantastic gothic stories, several of which later formed the basis for the opera *The Tales of Hoffmann* (1881) by OFFENBACH. Tchaikovsky's *Nutcracker Suite* was also based on one of his stories. His two novels are *The Devil's Elixir* (1815–16) and *The Educated Cat* (1820–22).

Hofstadter, Robert (1915—) US physicist who shared the 1961 Nobel Prize for physics with Rudolf Mössbauer. He proposed that PROTONS and NEUTRONS have a positively charged central core surrounded by a cloud of elementary particles (pions).

hoa See PIG

Hogan, (William) Ben (Benjamin) (1912–97) US golfer. After winning the US PGA (1946, 1948) and the US Open (1948), Hogan was seriously injured in a car accident. He made a remarkable recovery and went on to win three further US Opens (1950–51, 1953), two US Masters' (1951, 1953) and the British Open (1953).

Hogarth, William (1697–1764) English painter and engraver. He is best known for his dark portrayals of contemporary English society, expressed most famously in his narrative paintings (later released as engravings), *The Harlot's Progress, The Rake's Progress* and *Marriage à la Mode*.

Hogmanay In Scotland, New Year's Eve. Traditionally more festive than Christmas, the Hogmanay celebrations date back to Celtic times.

Hohenstaufen German dynasty that exercised great power in Germany and the HOLY ROMAN EMPIRE from 1138 to 1254. It is named after the castle of Staufen, built by Frederick, Count of Swabia, whose son became Conrad III of Germany and Holy Roman emperor in 1138. From Conrad III to Conrad IV, the family occupied the Imperial throne, except for the years 1209–15 (when Otto IV, the representative of their great rivals, the GUELPHS, was emperor). The greatest of the dynasty was FREDERICK II.

Hohenzollern German dynasty that ruled BRANDENBURG, Prussia, and Germany. The family acquired Brandenburg in 1415, and Prussia was added in 1618. FREDERICK WILLIAM (the Great Elector) further expanded their territories, and his son, Frederick I, adopted the title "king in Prussia". FREDERICK WILLIAM I built up the Prussian army, and FREDERICK II used it to great effect against the Habsburgs. Germany was finally united in 1871 under the Hohenzollern emperor, WILLIAM I. His grandson, WILLIAM II, abdicated at the end of World War 1. Hokkaidō (formerly Yezo) Most northerly and second largest of the main islands of Japan, bounded w by the Sea of Japan and E by the Pacific Ocean; the capital is Sapporo. Until the late 19th century it was the homeland of the Ainu aboriginals. It is mountainous and forested, with some active volcanoes. Linked to Honshū by the Seikan Tunnel, it is Japan's chief farming region and coal-producer, and a winter sports resort. Crops: rice, maize, wheat, soya beans, potatoes, sugar beet. Industries: fishing, forestry, coal mining, natural gas. Area: 83,451sq km (32,212sq mi). Pop. (1992 est.) 5,659,000. Hokusai, Katsushika (1760-1849) Japanese master of UKIYO-E (coloured WOODCUT), especially famous for his landscapes. He had enormous influence on late 19th-century European painters. His most famous print is The Wave.

Holbein, Hans, the Younger (1497–1543) German painter. Holbein gained international recognition with three portraits of his friend, Erasmus (1523). He settled in London

▲ Holbein Portrait of Thomas Cromwell wearing the Order of St George, by Hans Holbein the Younger. Best known for his woodcuts and portraits, Hans Holbein the Younger painted many influential people of both German and English society, including Thomas More and Thomas Cromwell. He was also court painter to Henry VIII .

► Hollywood One of the most famous signs in the world, Hollywood, Los Angeles, is home to legendary film studios including MGM, Paramount, 20th Century Fox and Colombia Pictures. Once the world centre of cinema, an increasing number of films are being made outside Hollywood as film production facilities become more dispersed.

(1532) and was court painter to Henry VIII. Holbein's masterpieces include *The Ambassadors* (1533) and superb portraits of *Christina of Denmark, Duchess of Milan* (1538) and *Anne of Cleves* (1540).

Holguín City in SE Cuba, its port on the Atlantic Ocean. Founded c.1720, it was the focus for rebellions against Spanish rule (1868–78, 1895–98). Located on a fertile plateau, it exports tobacco and cattle products. Industries: sugar cane, coffee, timber, furniture. Pop. (1990 est.) 228,052.

Holiday, Billie (1915-59) US blues and jazz singer, nick-

named Lady Day. She became famous in the 1930s with the bands of Count Basie and Artie Shaw. Her melancholic renditions of *My Man, Mean to Me* (1937) and *God Bless the Child* (1941) are legendary in the history of jazz.

Holland Popular name for the NETHERLANDS, but properly referring only to a historic region, now divided into two provinces. A fief of the Holy Roman Empire in the 12th century, Holland was united with the county of Hainaut in 1299. It passed to Burgundy in 1433 and to the Habsburgs in 1482. In the 16th century, Holland led the Netherlands in their long struggle for independence from Spain.

Holly, Buddy (1936–59) US singer and songwriter, b. Charles Hardin Holley. Holly and his group, the Crickets, achieved success in 1957 with "That'll be the Day", "Oh Boy" and "Peggy Sue". He was a pioneer of double-tracking and the standard rock grouping of drums, bass, rhythm and lead guitar. He was killed in a plane crash.

Hollywood Suburb of Los Angeles, California, USA. After 1911 it became the primary centre for film-making in the USA and by the 1930s its studios dominated world cinema. From the 1950s, television became increasingly important.

Holmes, Oliver Wendell (1809–94) US author and physician, father of Oliver Wendell Holmes, Jr. His best literary work takes the form of humorous table talk, such as The Autocrat of the Breakfast Table (1857–58), The Profes-

HONDURAS

The flag of Honduras was officially adopted in 1949. It is based on the flag of the Central American Federation, which was set up in 1823 and included Costa Rica, El Salvador, Guatemala, Honduras and Nicaragua. Honduras left the federation in 1838.

onduras is the second largest country in Central America (after Nicaragua). It has two coastlines: the N Caribbean coast extends for c.600km (375mi), its deep offshore waters prompted the Spanish to name the country Honduras (Sp. depths); and a narrow, 80km (50mi) long, Pacific outlet to the Gulf of Fonseca. Along the N coast are vast banana plantations. To the E lies the Mosquito Coast. The Cordilleras highlands form 80% of Honduras, and include the capital, Tegucigalpa.

CLIMATE

Honduras has a tropical climate. The rainy season is from May to October. The N coast is sometimes hit by fierce hurricanes.

VEGETATION

Pine forests cover 75% of Honduras. The N coastal plains contain rainforest and tropical

savanna. The Mosquito Coast contains mangrove swamps and dense forests. Forests of mahogany and rosewood grow on the lower mountain slopes.

HISTORY

From AD 400 to 900 the MAYA civilization flourished. The magnificent ruins at Copán in W Honduras were discovered by the Spaniards in 1576, but became covered in dense forest and were only rediscovered in 1839. Christopher Columbus sighted the coast in 1502. Pedro de Alvarado founded the first Spanish settlements (1524). The native population were gradually subdued and gold and silver mines were established. In 1821 Honduras gained independence, forming part of the Mexican empire. In 1823-38 Honduras was a member of the Central American Federation. Throughout the rest of the 19th century, Honduras was subject to continuous political interference, especially from Guatemala. Britain controlled the Mosquito Coast. In the 1890s, US companies developed the banana plantations and exerted great political influence. Honduras became known as a "banana republic". After World War 2, demands grew for greater national autonomy and workers' rights. The Liberal government was overthrown by a military coup in 1963. Honduras' expulsion of Salvadorean immigrants led to the brief "Soccer War" (1969) with El Salvador; following an ill-tempered World Cup qualifying match between the two coun**AREA:** 112,090sq km (43,278 sq mi) **POPULATION:** 5,462,000

CAPITAL (POPULATION): Tegucigalpa (670,100)

GOVERNMENT: Republic

ETHNIC GROUPS: Mestizo 90%, Native American 7%, Garifunas (West Indian) 2%,

LANGUAGES: Spanish (official)

RELIGIONS: Roman Catholic 85%, Protestant

OUDDENIG

CURRENCY: Honduran lempira = 100 centavos

tries. In 1974 a hurricane devastated the Caribbean coast. Civilian government was restored in 1982. During the 1980s, Honduras acted as a base for the US-backed Contra rebels from Nicaragua. Honduras was heavily dependent on US aid. Massive popular demonstrations against the presence of the Contras, led to the declaration of a state of emergency (1988). In 1990 the war in Nicaragua ended. In 1992 Honduras signed a treaty with El Salvador, settling the disputed border.

POLITICS

The Liberal Party won the 1993 and 1997 elections. The current president is Carlos Flores.

ECONOMY

Honduras is the least industrialized country in Central America, and the poorest developing nation in the Americas. It has very few mineral resources, other than silver, lead and zinc. Agriculture dominates the economy, forming 78% of all exports and employing 38% of the population. Bananas and coffee are the leading exports, and maize is the principal food crop. Cattle are raised in the mountain valleys and on the s Pacific plains. Fishing and forestry are also important activities. Honduras has vast timber resources. Overall development of the country is hampered by the lack of an adequate transport infrastructure. The only railroads link plantations to the ports.

sor at the Breakfast Table (1860) and The Poet at the Breakfast Table (1872).

Holmes, Oliver Wendell, Jr (1841–1935) US jurist and legal scholar, son of Oliver Wendell Holmes. He co-edited the *American Law Review* (1870–73) and *Kent's Commentaries* (1873), and wrote *The Common Law* (1881). A justice (1882–99) and then chief justice (1899–1902) of the Massachusetts Supreme Court, he became an associate justice of the US Supreme Court (1902–32). He supported laws protecting child labour and was a champion of civil liberties.

Holocaust Great massacre, in particular the extermination of European Jews and others by the Nazi regime in Germany (1933–45). The Nazi persecution reached its peak in the "Final Solution", a programme of mass extermination adopted in 1941. Jews, as well as others considered racially inferior by the Nazis, were killed in CONCENTRATION CAMPS such as AUSCHWITZ, BELSEN, DACHAU, Majdanek and Treblinka. Total Jewish deaths are estimated at more than 6 million.

Holocene (Recent epoch) Division of geological time extending from c.10,000 years ago to the present. It includes the emergence of humans as settled members of communities; the first known villages date from c.8,000 years ago.

holography Process of making a hologram. One or more photographs are formed on a single film or plate by interference between two parts of a split LASER beam. The photograph appears as a flat pattern until light hits the plate in the correct position; it then becomes a 3-D image.

Holst, Gustav (Gustavus Theodore von) (1874–1934) British composer. His early works were often influenced by Hinduism, as in the opera *Sita* (1906), and folksong, as in *Somerset Rhapsody* (1907). Among his works are several operas, including *The Perfect Fool* (1922), songs, chamber music and the popular orchestral suite *The Planets* (1914–16). Holy Alliance Agreement signed by the crowned heads of Russia, Prussia and Austria in 1815. Its purpose was to reestablish the principle of hereditary rule and to suppress democratic and nationalist movements, which had sprung up in the wake of the FRENCH REVOLUTION. The agreement, signed later by every European dynasty except the king of England and the Ottoman sultan, came to be seen as an instrument of reaction and oppression.

Holy Communion See Eucharist

Holy Grail In medieval legend, the cup supposedly used by Jesus at the LAST SUPPER and by JOSEPH OF ARIMATHEA at the crucifixion to catch the blood from Jesus' wounds. The quest for the grail, especially by the knights of Arthurian legend, became a search for mystical union with God.

Holy Roman Empire European empire centred on Germany (10th–19th centuries), which echoed the empire of ancient ROME. It was founded in 962 when the German king Otto I (THE GREAT) was crowned in Rome, although some historians date it from the coronation of CHARLEMAGNE in 800. The emperor, elected by the German princes, claimed to be the temporal sovereign of Christendom, ruling in cooperation with the spiritual sovereign, the pope. However, the empire never encompassed all of western Christendom and relations with the papacy were often stormy. From 1438 the title was virtually hereditary in the HABSBURG dynasty. After 1648, the empire became little more than a loose confederation, containing hundreds of virtually independent states. It was abolished by NAPOLEON I in 1806.

Holy Spirit (Holy Ghost) Third Person of the Trinity in Christian theology. The Holy Spirit represents the spiritual agent through whom God's grace is given. The New Testament contains many references to the Holy Spirit, firstly as the agent by whom Mary conceived Jesus Christ and later as the divine power imparted to the church.

Holy Week Seven-day period preceding EASTER. It begins with Palm Sunday, commemorating Christ's entry into Jerusalem; Maundy Thursday marks his institution of the EUCHARIST; Good Friday marks his betrayal and crucifixion.

Home, Sir Alec Douglas- See Sir Alec Douglas-Home Home Office British department of state, dating from 1782. The Home Office's present duties cover all matters of national administration not entrusted to another minister. The head of the department, the Home Secretary, is a cabinet position; there are separate secretaries of state for Scotland and Wales. There is also a separate Northern Ireland Office.

homeopathy Unorthodox medical treatment that involves administering minute doses of a drug or remedy which causes effects or symptoms similar to those that are being treated. It was popularized in the 18th century by the German physician Christian Hahnemann.

homeostasis In biology, processes that maintain constant conditions within a cell or organism in response to either internal or external changes.

homeothermal (endothermic or warm-blooded) Describes an animal whose body temperature does not fluctuate with the changing temperature of its surroundings. Mammals and birds are warm-blooded. They maintain their body temperature through metabolism. *See also* POIKILOTHERMAL

Homer Greek epic poet of the 8th century BC. He is traditionally considered to be the author of the great epics of the Trojan wars, the *Iliad* and the *Odyssey*. Nothing factual is known about Homer, but the works attributed to him represent the foundations of Greek and European literature.

Homer, Winslow (1836–1910) US painter and illustrator. He won international acclaim for his coverage of the American Civil War in *Harper's Weekly* and particular recognition as a painter with *Prisoners from the Front* (1866). He is best known for haunting oil and watercolour paintings, such as *The Country School* (1871) and *Northeaster* (1895).

homicide In law, killing of a person by another. The various legal definitions depend on the circumstances of the killing. A distinction is made between premeditated murder, murder with some mitigating circumstances (such as when the balance of the killer's mind is temporarily disturbed), justifiable homicide (which may include mercy-killing or the killing of a suspect by a police officer in a shoot-out), and killing by negligence.

homo Genus to which humans belong. For *Homo habilis*, *Homo erectus* and *Homo sapiens*, *See* HUMAN EVOLUTION.

homology In biology, similarity in essential structure of organisms based on a common genetic heritage. It often refers to organs that now have a different superficial appearance and function in different organisms. For example, a human arm and a seal's flipper are homologues, having evolved from a common origin. *See also* EVOLUTION

homophony In music, the sounding in unison of voices or instruments. It also refers to a musical texture with a predominant melody part and an accompaniment, as opposed to monophony (music in a single part) or POLYPHONY.

homosexuality Emotional or sexual attraction to members of one's own sex. Male and female homosexuals are popularly known as gays and lesbians. Historically, homosexuality was seen as a pathological condition and many psychoanalytic and psychiatric theories served to reinforce this impression. Doctors now agree that homosexuality is a normal aspect of sexuality. Gays and lesbians have long sought to obtain equal rights. In the USA, public policy towards homosexuality varies from state to state. In most states, private, unharmful sexual acts between consenting adults are considered to be outside the remit of legislation. In 1986, however, the Supreme Court upheld the rights of those states who have prohibitive legislative on homosexuality. In the UK, gay liberation groups, such as Stonewall, have struggled for an end to discrimination. The pressure group Outrage has created controversy in its policy to "out" public figures. The threat of AIDS (ACQUIRED IMMUNE DEFICIENCY SYNDROME) has unified much of the gay community into promoting the importance of safe sex, emphasizing the need for greater public awareness and increased funding for AIDS research.

homozygote Organism possessing identical forms of a gene on a CHROMOSOME pair. It is a purebred organism and always produces the same kind of GAMETE. *See also* HETEROZYGOTE

Honduras Republic in Central America. *See* country feature **Honecker, Erich** (1912–94) East German communist leader (1971–89). Imprisoned by the Nazis (1935–45), he rose rapidly in the East German Communist Party after World War 2, and succeeded Walter Ulbricht as party leader, pursuing policies approved by Moscow. With the

reforms under Mikhail GORBACHEV and the collapse of European communism, the ailing Honecker resigned.

Honegger, Arthur (1892–1955) French composer. One of a group of Parisian composers known as *Les Six*, he caused a sensation with *Pacific 231* (1923), an orchestral description of a steam locomotive. His other compositions include five symphonies, two operas, and the dramatic psalm *Le Roi David* (1921).

honey Sweet, viscous liquid manufactured by honeybees from nectar. It consists of the sugars laevulose and dextrose, traces of minerals, and c.17% water.

honeyeater (honey sucker) Any of a group of Australian songbirds. They have long tongues for feeding on nectar and fruit, and pollinate the flowers they feed on. Family Meliphagidae

honeysuckle Woody twining or shrubby plant that grows in temperate regions worldwide. It has oval leaves and tubular flowers. A common species in Eurasia, *Lonicera periclymenum*, climbs to 6m (20ft). Family Caprifoliaceae.

Hong Kong (Xianggang Special Administrative Region) Former British crown colony off the coast of SE China; the capital is Victoria, on Hong Kong Island. The colony comprises Hong Kong Island, ceded to Britain by China in 1842; the mainland peninsula of Kowloon, acquired in 1860; the New Territories on the mainland, leased for 99 years in 1898; and some 230 islets in the South China Sea. In 1984 Britain agreed to transfer sovereignty of the whole colony to China in 1997. The Joint Declaration of the British and Chinese governments (1985) provided that Hong Kong would become a special administrative region. It would remain a free port with its own existing commercial and financial policies. Under the governorship of Chris Patten (1992–97), limited democratic reforms were introduced which China promised to reverse. The climate is subtropical, with hot, dry summers. Hong Kong is an important international financial centre with a strong manufacturing base. Industries: textiles, electronic goods, cameras, toys, plastic goods, printing.

Honolulu Capital and chief port of Hawaii, on SE Oahu Island. It became the capital of the kingdom of Hawaii in 1845 and remained the capital after the annexation of the islands by the USA in 1898. Landmarks include the Iolani Palace, Waikiki Beach and the Diamond Head Crater. There are two universities and several colleges. Tourism is of major importance. Industries: sugar refining, pineapple canning. Pop. (1990) 365,272. *See also* PEARL HARBOR

Honshū Largest of Japan's four main islands, lying between

the Sea of Japan (w) and the Pacific Ocean (E). It includes FUJIYAMA and BIWA-KO. It is highly industrial and has six of Japan's largest cities, including TOKYO. The majority of the population inhabit the coastal lowlands. Industries: shipbuilding, oil refining, chemicals, textiles, rice, tea, fruit. Area: 230,782sq km (89,105sq mi). Pop. (1990) 82,569,581.

Honthorst, Gerard (1590–1656) Dutch painter. He was influenced by Caravaggio and was skilful in depicting dramatic candle-lit interiors, notably *Samson and Delilah* (c.1620). He made his name, however, after abandoning the Caravaggesque style, becoming a successful portrait painter.

Hooch, Pieter de (1629–84) Dutch genre painter. He is best known for his paintings of serene, domestic interiors and courtyards. His best works, such as *The Courtyard of a House in Delft* and *The Pantry*, date from the 1650s.

Hood, John Bell (1831–79) Confederate general in the American Civil. War. He fought in the Second Battle of Bull Run and distinguished himself at Antietam, Fredericksburg, Gettysburg and Chickamauga. He became commander in Georgia (1864), but was unable to stem William Sherman's march. After a series of defeats, he resigned (1865).

Hooke, Robert (1635–1703) English philosopher, physicist and inventor. Interested in astronomy, he claimed to have stated the laws of planetary motion before Isaac Newton. He studied elasticity of solids, which led to HOOKE'S LAW. Among his inventions were a practical telegraph system and the Gregorian (reflecting) microscope.

Hooke's law Law applying to an elastic material when it is stretched. The law states that the stress (internal tension) is proportional to the strain (a change in dimensions). It was discovered in 1676 by Robert HOOKE. *See also* ELASTICITY

hookworm Two species of human parasite. Larvae usually enter the host through the skin of the feet and legs, and attach to the wall of the small intestine. Symptoms can include anaemia, constipation and weakness. Phylum Nematoda; species *Necator americanus* and *Ancyclostoma duodenale*.

hoopoe Striped, fawn-coloured bird that lives in open areas throughout warmer parts of Eurasia. It has a fan-like crest, a long, curved bill, and feeds on small invertebrates. Length: 30cm (12in). Family Upupidae; species *Upupa epops*.

Hoover, Herbert Clark (1874-1964) 31st US president (1929–33). Acclaimed for his work with victims of war, he was secretary of commerce under presidents HARDING and COOLIDGE and, after winning the Republican nomination for president in 1928, easily defeated Alfred E. Smith. During his first year in office, the economy was shattered by the Wall Street crash and the ensuing GREAT DEPRESSION. With his belief in individual enterprise and distrust of government interference, Hoover failed to mobilize sufficient government resources to deal with the Depression. In 1932 Hoover mobilized troops to disperse the Bonus Army and was resoundingly defeated by Franklin ROOSEVELT's promise of a NEW DEAL. Hoover, J. (John) Edgar (1895-1972) US administrator, director (1924-72) of the US FEDERAL BUREAU OF INVESTIGA-TION (FBI). Hoover reorganized the Bureau, compiling a vast file of fingerprints and building a crime laboratory. During the 1930s he fought organized crime. After World War 2, he concentrated on what he saw as the threat of communist subversion, harassing public figures, such as Martin Luther King, Jr. Hoover Dam One of the world's largest dams, on the Colorado River between Arizona and Nevada, USA. Opened in 1935, its waters irrigate land in s California, Arizona and Mexico. Height: 221m (726ft). Length: 379m (1244ft).

hop Twining vine native to Eurasia and the Americas. It has rough stems, heart-shaped leaves and small male and female flowers on separate plants. The female flowers of *Humulus lupulus* are used to flavour BEER. Family Cannabiaceae.

Hope, Bob (1903–) US comedian, b. England. After appearing on radio and in vaudeville, Hope made his film debut in *The Big Broadcast of 1938* (1939). *Road to Singapore* (1940) was the first of seven "Road" pictures he made with Bing Crosby and Dorothy Lamour. Other films include *The Paleface* (1947). Hope's work for charity and humanitarian causes earned him a Presidential Medal of Freedom.

Hopi Shoshonean-speaking tribe of Native Americans. They

HONG KONG

AREA: 1,071 sq km (413 sq mi)
POPULATION: 6,000,000
CAPITAL (POPULATION):
Victoria (part of Hong
Kong Island, 1,251,000)
GOVERNMENT: Chinese/Hong
Kong provisional
legislature
ETHNIC GROUPS: Chinese

98%, others 2% (including European) LANGUAGES: English and Chinese (official) RELIGIONS: Buddhism majority.

Confucism, Taoism, Christianity, Islam, Hinduism, Sikhism, Judaism currency: Hong Kong dollar = 100 cents are famous for having retained the purest form of pre-Columbian life to have survived in the USA today. Today, c.6,000 Hopi live in Arizona.

Hopkins, Sir Anthony (1937–) Welsh film and stage actor. His film career experienced several false starts before a dramatic resurgence in the 1990s. His hypnotic performance in *The Silence of the Lambs* (1991) won an Academy Award for Best Actor. He also starred in *Shadowlands* (1993) and *Nixon* (1995). *August* (1995) was his directorial debut.

Hopkins, Gerard Manley (1844–89) British poet and Jesuit priest. He contributed the principle of "sprung rhythm" to English poetry. Hopkins' writing is most concerned with problems of faith. The sinking of a German ship carrying five nuns inspired "The Wreck of the *Deutschland*".

Hopper, Edward (1882–1967) US realist painter. A pupil of Robert HENRI, he was greatly influenced by the ASHCAN SCHOOL. His paintings of scenes in New England and New York City, such as *Early Sunday Morning* (1930), convey a unique sense of melancholic romanticism.

Horace (65–08 BC) Roman poet. His first *Satires* appeared in c.35 BC, and were followed by *Epodes* (c.30 BC), *Odes* (c.23 BC), *Epistles* (c.20 BC) and *Ars Poetica* (c.19 BC). His simple Latin lyrics provided a vivid picture of the Augustan age.

horizon, celestial Great Circle on the Celestial Sphere. It lies midway between the observer's Zenith and Nadir.

hormone Chemical substance secreted by living cells. Hormones affect the metabolic activities of cells in other parts of the body. In MAMMALS, hormones are secreted by glands of the ENDOCRINE SYSTEM and are released directly into the bloodstream. They exercise chemical control of physiological functions, regulating growth, development, sexual functioning, METABOLISM and (in part) emotional balance. The secretion and activity of the various hormones are closely interdependent. They maintain a delicate equilibrium that is vital to health. The HYPOTHALAMUS is responsible for overall coordination of the secretion of hormones. Hormones include THYROXINE, ADRENALINE, INSULIN, OESTROGEN, PROGESTERONE and TESTOSTERONE. In plants, hormones control many aspects of metabolism, including cell elongation and division, direction of growth, initiation of flowering, development of fruits, leaf fall, and responses to environmental factors. The most important plant hormones include AUXIN, GIBBERELLIN and CYTOKININ. See also HOMEOSTASIS

hormone replacement therapy (HRT) Use of the female HORMONES progestogen and OESTROGEN in women who are either menopausal or who have had both ovaries removed. HRT relieves symptoms of the MENOPAUSE; it also gives some protection against heart disease and OSTEOPOROSIS. The oestrogen causes a thickening of the lining of the uterus, which may increase risk of cancer of the ENDOMETRI-UM. The progestogen causes a regular shedding of the lining, similar to menstruation, which may lessen this risk.

horn Brass musical instrument traditionally used in hunting and ceremonies. They appeared in the opera orchestras of 17th-century Europe and in the 19th century with Wagner and Strauss. The modern instrument (French horn) consists of a coiled tube of conical bore that widens to a flared bell; most have three valves. It has a mellow tone.

hornbill Brownish or black-and-white bird, native to tropical Africa and SE Asia. It has a large, brightly coloured bill. The female lays one to six eggs in a hole high up in a tree trunk and then sometimes erects a barricade, imprisoning herself and her eggs there for 4 to 11 weeks. The male feeds her through a slit in the wall. There are several species. Length: 38–152cm (15–60in). Family Bucerotidae.

hornblende Black or green mineral found in IGNEOUS and METAMORPHIC ROCKS. It is the commonest form of AMPHIBOLE, and contains iron and silicates of calcium, aluminium and magnesium. Hardness 5.5; s.g. 3.2.

Horne, Marilyn (1934–) US mezzo-soprano. She studied with Lotte Lehmann and made her debut in *The Bartered Bride*, Los Angeles (1954). Her career included a cycle of Rossini and Bellini operas with Joan Sutherland.

hornet Large, orange and brown wasp native to Europe. They build egg-shaped paper nests with one queen and many

■ hornbill The great hornbill (Buceros bicomis) is just one of the 45 species of hornbill, all of which are found in tropical Asia and Africa. The enormously developed bill seen in the great hornbill is used for display and nesting purposes rather than for feeding.

nectar-gathering workers. They have a powerful sting, but are less aggressive than the common wasp. Family Vespidae.

horoscope Map of the stars and planets at the time of a person's birth. It shows the position of the celestial bodies in relation to the 12 signs of the ZODIAC and is the basis of ASTROLOGY.

Horowitz, Vladimir (1904–89) US concert pianist, b. Russia. He first performed in public in 1921 and was world-famous by the age of 20 for his virtuoso technique and great sensitivity. From 1950 he was an infrequent concert performer, but continued to make recordings.

horse Hoofed mammal that evolved in North America but became extinct there during the late Pleistocene epoch. Early horse forms crossed the land bridge across the Bering Strait, dispersed throughout Asia, Europe and Africa and produced the modern horse family. The only surviving true wild horse is Przewalski's horse. The horse was first domesticated about 5,000 years ago in central Asia and played a crucial role in agricultural and military development. Horses returned to the New World with the Spanish conquistadores in the 1500s. Horses are characterized by one large functional toe, molars with crowns joined by ridges for grazing, an elongated skull and a simple stomach. Fast runners, they usually live in herds. All species in the family can interbreed. Family Equideae; species *Equus caballus*.

horse chestnut Any of 25 species of deciduous trees that grow in temperate regions, especially the common horse chestnut, *Aesculus hippocastanum*. It has large leaves, long flower spikes and round prickly fruits containing one or two inedible nuts. Family Hippocastanaceae. Height: to 30m (100ft).

horsefly Any of several species of flies in the family Tabanidae, especially *Tabanus lineola*. The female inflicts a painful bite and sucks blood. Length: to 3cm (1.2in).

horsepower (hp) Unit indicating the rate at which work is done, adopted by James Watt in the 18th century. He defined it as the weight, 250kg (550lb), a horse could raise 0.3m (1ft) in one second. The electrical equivalent of 1 hp is 746 watts. horse racing Sport in which horses guided by jockeys race over a course. Most popular is thoroughbred racing, although harness racing (in which horses draw a light two-wheeled vehicle) is popular in some countries. Thoroughbred racing includes flat races and steeplechases, in which the course has obstacles such as hurdles, fences and water jumps. Horse racing began in Assyria in c.1500 BC. The oldest current race is the English Derby, first held in 1780. One of the most famous is the Grand National Steeplechase, held annually at Aintree, Liverpool, England, since 1839. In the USA, the most popular races constitute the Triple Crown: the Kentucky Derby, Preakness and Belmont Stakes.

horseradish Perennial plant native to Eastern Europe. It is cultivated for its pungent, fleshy root, which is a useful seasoning. It has lance-shaped, toothed leaves, white flower clusters and egg-shaped seed-pods. Height: 1.2m (4ft). Family Brassicaceae/Cruciferae; species *Armoracia rusticana*.

▲ horse Domesticated for over 5,000 years, the horse has played a significant role in the development of both agriculture and war. The species shown here are the Percheron (A) a medium-weight draught horse, bred for agricultural and industrial work. It was first bred in France, but is now found worldwide. The Holstein (B) is a saddle and harness horse, bred in Germany by crossing local strains with Spanish horses. The Hanover (C) originated in Germany and is a cross between German harness breeds and the English thoroughbred.

▲ horsetail Considered in the same group as ferns, horsetails have cylindrical "leaves", borne in whorls, and jointed stems. The spores are produced in cone-like structures at the tips of the fertile stems. They are "living fossil" relatives of giant Carboniferous trees.

horsetail Any of about 30 species of flowerless, rush-like plants that are allied to ferns and grow in all continents except Australasia. The hollow jointed stems have a whorl of tiny leaves at each joint. Spores are produced in a cone-like structure at the top of a stem. Horsetails date from the Carboniferous period. Phylum Sphenophyta, genus *Equisetum*.

Horthy, Miklós Nagybánai (1868–1957) Hungarian political leader, regent (1920-44). He commanded the Austro-Hungarian fleet in World War 1. He took part in the counter-revolution that overthrew Béla Kun, becoming regent and effective head of state. His highly conservative regime suppressed political opposition and resisted the return of CHARLES I. Allied with the Axis Powers in 1941, he tried to arrange a separate peace with the Allies in 1944 but was arrested by the Germans. After the war he settled in Portugal. horticulture Growing of vegetables, fruits, seeds, herbs, shrubs and flowers on a commercial scale. Techniques employed include propagation by leaf, stem and root cuttings, and by stem and bud grafting. Fruit trees, shrubs and vines are usually propagated by grafting the fruiting stock on to a hardier rootstock. SEED is a major horticultural crop. Close scientific control of POLLINATION is essential for producing crops of specific quality.

Horus In Egyptian mythology, falcon-headed god, son of Isis and Osiris. He came to be closely identified with all the pharaohs, who used his name as the first of their titles and were thought to rule as him on Earth.

Hosea (Osee) OLD TESTAMENT prophet active in the 8th century BC. The Book of Hosea is the first of the 12 books of the Minor Prophets.

Hospitaller See Knights Hospitallers

Hottentot (Khoikhoi) Khoisan-speaking people of s Africa, now almost extinct. Traditionally nomadic, many were displaced or exterminated by Dutch settlers. Descendants have mostly been absorbed into the South African population.

Houdini, (Harry) (1874–1926) US escapologist, b. Erich Weiss in Hungary. He escaped from packing cases, handcuffs and straitjackets, often while underwater in a tank. He also specialized in exposing fraudulent mediums. Author of *The Unmasking of Robert-Houdin* (1908), his extensive library on magic resides in the Library of Congress, Washington, D.C.

Houphouët-Boigny, Félix (1905–93) Ivory Coast stateman, first president (1960–93). He served in the French colonial government, becoming president on independence. His control remained almost absolute. Maintaining close relations with France, the Ivory Coast became one of the more affluent West African countries. In the 1980s, a recession, exacerbated by expenditure on grandiose projects, caused mounting unrest and he was forced to legalize opposition parties (1990).

House, Edward Mandell (1858–1938) US politician and diplomat. He helped Woodrow WILSON obtain the 1912 Democratic presidential nomination and became his closest adviser. He was twice sent to Europe in attempts to prevent World War 1 (1914) and mediate peace (1915). A member of the US peace commission, he helped draft the Treaty of Versallles and the Covenant of the League of Nations.

house music Form of dance music popular in the USA and Britain from the late-1980s. Using drum machines and sampled sound effects, often put into repetitive loops, house music increased the creative role of the disc jockey (DJ). It has produced a number of other forms of dance music.

House of Commons Lower house of the British Parliament (the upper house being the unelected House of Lords), dating from the 13th century. It is the major forum for voting on intended legislation and questioning of ministers. Its 659 members are elected by their constituents in a secret ballot, usually in general elections which must be held at least every five years. The PRIME MINISTER is the leader of the majority party in the Commons, and most members of the CABINET are drawn from the Commons, although some may be from the Lords. Debates and proceedings are controlled by the speaker of the House. Select committees scrutinise legislation.

House of Lords Upper house of the British Parliament. In its legislative capacity, the Lords is completely subordinated to the HOUSE OF COMMONS. The Parliament Acts of 1911 and

1949 checked virtually all its power, except the right to delay passage of a bill for 13 months. Life peers, whose titles may not be inherited, and hereditary peers sit in the House. Hereditary peers may resign their titles to run for election to the Commons. There are special "law lords" who sit in judgement when the House acts as Britain's final court of appeal.

House of Representatives Lower house of the US legislature, which together with the SENATE forms the CONGRESS. It has 435 members. Each state has at least one representative; the larger the population of a state the more representatives are allowed. Representatives must be over 25 years old, US residents for no less than seven years and resident in the state they represent. They are directly elected and serve two-year terms. The House considers bills and has exclusive authority to originate revenue bills, initiate impeachment proceedings and elect the president if the electoral college is deadlocked.

Houses of Parliament (Palace of Westminster) First largescale public building of the GOTHIC REVIVAL in Britain. After a fire destroyed the old Palace of Westminster, Charles BARRY won a competition for its replacement. Together with PUGIN, a passionate Gothic specialist, he created a building that combined a functional plan and modern technology with Gothic detail. The Palace was finished in 1868.

Housman, A.E. (Alfred Edward) (1859–1936) British poet and classical scholar. He is best known for three volumes of poetry, *A Shropshire Lad* (1896), *Last Poems* (1922) and *More Poems* (1936), in which he treats universal themes, such as the brevity of life, in short, subtle lyrics.

Houston, Sam (Samuel) (1793–1863) US military and political leader. Governor of Tennessee (1827–29) before moving to Texas, he became commander in chief of the army when Texas rebelled against Mexican rule (1835). He was the first president of the Republic of Texas (1836–38, re-elected 1841–44). When Texas was annexed by the USA, he served in the Senate and as governor in 1859. Isolated by his support for the Union and for Native Americans, he was forced out of office when Texas voted to secede (1861).

Houston City and port in SE Texas, USA, connected to the Gulf of Mexico by the Houston Ship Canal. Founded in 1836, it was capital of the Republic of Texas (1837-39, 1842-45). Its greatest growth came after the building of the canal (1912-14), as the coastal oil fields provided a rich source of income and Houston developed as a deep-water port. The largest city in the state, it is a major cultural centre with five universities, a symphony orchestra and many art galleries and museums. It is also a leading industrial, commercial and financial centre, with vast oil refineries and a massive petrochemical complex. Industries: space research (the Johnson Space Center is nearby), shipbuilding, meat-packing, electronics, chemicals, brewing, sugar and rice processing, synthetic rubber, printing and publishing. Pop. (1990) 1,630,553. hovercraft (AIR-CUSHION VEHICLE) Fast, usually amphibious craft, invented by Sir Christopher Cockerell (1910-). A horizontal fan produces a cushion of air supporting the craft just above the ground or water. Vertical fans propel the craft. Most hovercraft are powered by gas turbine engines, similar to those used in aircraft, or by diesel engines. Hovercraft travel at speeds up to about 160km/h (100mph). They are used as marine ferries and as military vehicles.

Hovhaness, Alan (1911–) US composer. Influenced by Far Eastern music, he gained recognition as an original and exotic composer. His works, some of which reflect his Armenian ancestry, include *Mysterious Mountain* (1955), *Magnificat* (1957) and *And God Created Great Whales* (1970). He wrote over 60 symphonies.

Howard, Catherine (1520–42) Fifth queen of HENRY VIII. She was brought to Henry's attention by opponents of Thomas Cromwell. Henry married her in July 1540, but evidence of her premarital indiscretions led to her execution.

Howard, Henry *See* Surrey, Henry Howard, Earl of **Howard, John Winston** (1939–) Australian statesman, prime minister (1996–). Howard was elected to the House of Representatives in 1974. He served in Malcolm Fraser's government, before becoming Liberal Party leader in 1985. In 1995 he was appointed leader of the opposition. In 1996,

▲ Horus One of the principal deities of ancient Egypt, Horus is depicted as a hawk or falcon, or a man's body with a falcon's head. Horus was identified with Ra, and was the son of Isis and Osiris, who avenged his father's death and rightfully took the throne. For this reason, the Egyptian pharaohs were all considered Horus incarnate.

Howard led the Liberal-National coalition to victory against Paul Keating's ruling Labour Party.

Howard, Oliver Otis (1830–1909) US general. He fought in the American Civil War and, commanding the Army of the Tennessee, accompanied General William T. SHERMAN on his march through Georgia. After the war, he headed the FREEDMEN'S BUREAU that aided former slaves and was a founder and president (1869–73) of Howard University.

Howard, Trevor (1916–88) British actor. Howard made his film debut in *The Way Ahead* (1944). His first major role was in David Lean's *Brief Encounter* (1945). Other films include *Sons and Lovers* (1960), *Ryan's Daughter* (1970), *Kidnapped* (1971), *The Missionary* (1982) and *Gandhi* (1982).

Howe, Sir Geoffrey (1926—) British statesman, chancellor of the exchequer (1979–83), foreign secretary (1983–89), deupty prime minister and leader of the House of Commons (1989–90). A leading figure in the Conservative government of Margaret THATCHER, he made a dramatic resignation speech after she voiced her hostility to European monetary union.

Howe, Sir William (1729–1814) British general during the AMERICAN REVOLUTION. He fought at Bunker Hill and became commander in chief of British forces in North America in 1775. He captured New York (1776) and occupied Philadelphia (September 1777). After defeat at Saratoga (1777), he resigned and returned to England (1778).

Howells, William Dean (1837–1920) US novelist and critic. Editor (1871–81) of the literary journal *Atlantic Monthly*, his socialist sympathies are reflected in *The Rise of Silas Lapham* (1885), *A Traveler from Altruria* (1894) and *Through the Eye of the Needle* (1907).

Hoxha, Enver (1908–85) Albanian statesman, prime minister (1946–54), first secretary of the Communist Party (1954–85). Hoxha was a founder (1941) of the Albanian Communist Party and led the resistance to Italian occupation during World War 2. In 1946 the republic of Albania was established and Hoxha became prime minister. His dictatorial control of party, army and state led to accusations of Stalinism. Hoxha withdrew from the Warsaw Pact when rifts between the Soviet Union and China emerged in 1961. The later break with Peking led to the isolation and economic impoverishment of Albania.

Hoyle, Sir Fred (Frederick) (1915–) English astrophysicist and cosmologist. He developed the STEADY-STATE THEORY, which, although superseded by the Big Bang theory, sparked important research into NUCLEOSYNTHESIS in stars. Hoyle has often attracted controversy with unorthodox ideas. Hua Guofeng (1918–) (Hua Kuofeng) Chinese statesman, premier (1976–80), chairman (1976–81) of the Chinese Communist Party. After the death (1976) of Mao Zedong and Zhou Enlai, Hua was responsible for the arrest of the Gang of Four. His pragmatic approach to domestic and foreign policy led to his isolation within the party. The rising power of Deng Xiaoping led to Hua being replaced by Zhao Ziyang as premier and Hu Yaobang as party chairman.

Huang Hai (Yellow Sea) Shallow branch of the Pacific Ocean, N of the East China Sea between the Chinese mainland and the Korean peninsula. It is connected to the Chihli and Liaodong gulfs by the Strait of Chihli. The HUANG HE, Liao and Yalu rivers drain into it; the yellow loess (fine-grained silt) from these rivers give the sea its popular name. Such deposits, along with shifting sandbanks and notorious fogs, make navigation perilous. Area: *c.*466,200sq km (180,000sq mi).

Huang He (Huang Ho or Yellow) River in N central China; China's second longest (after the YANGTZE). It rises in the Kunlun mountains, QINGHAI province, and flows E to LANZHOU. It then takes a "great northern bend" around the Ordos Desert. Near Baotau, it turns s through Shanxi province. It then flows E through Henan province and NE through Shandong to enter the Bo Hai Gulf, an arm of the HUANG HAI. The river gets its popular name from the huge amounts of yellow silt it collects in its middle course. The silting of the riverbed makes it prone to serious flooding, but the threat has been greatly reduced by dykes and dams. Length: c.5.500km (3.400mi).

Hubbard, L. Ron (Lafayette Ronald) (1911–86) US science fiction writer and the guiding spirit of the Church of SCIENTOLOGY. His works *Dianetics: The Modern Science of*

Mental Health (1950) and Science and Survival (1951) formed the basis of scientology. Hubbard was executive director of the church (1955–66). He returned to science fiction with Battlefield Earth (1982).

Hubble, Edwin Powell (1889–1953) US astronomer. Hubble discovered that NEBULAE were resolvable as independent star systems. He attributed the RED SHIFT of spectral lines of galaxies to their recession and hence to the expansion of the Universe, upon which modern COSMOLOGY is based. *See also* HUBBLE'S LAW

Hubble's law Proposed by Edwin Hubble (1929), it claimed a linear relation between the distance of galaxies from us and their velocity of recession, deduced from the RED SHIFT in their spectra. The **Hubble constant** (symbol H_0) is the rate at which the velocity of recession of galaxies increases with distance from us. The inverse of the Hubble constant is the **Hubble time**, which gives a maximum age for the Universe on the assumption that there has been no slowing of the expansion.

Hubble Space Telescope (HST) Optical telescope that was placed in Earth orbit by the SPACE SHUTTLE in 1990. Images transmitted back to Earth revealed that the telescope's main mirror was incorrectly shaped. A repair team corrected the fault in 1993, and it was again repaired in 1997. Hubble now produces acurate images of bodies that cannot be observed clearly by terrestrial telescopes due to atmospheric distortion.

Hudson, Henry (d.1611) English maritime explorer. He made several efforts to find a NORTHEAST PASSAGE. Employed by the Dutch EAST INDIA COMPANY (1609), he was blocked by ice and crossed the Atlantic to search for a NORTHWEST PASSAGE. He was the first European to sail up the HUDSON river, reaching as far as ALBANY. In 1610 he embarked on another voyage to discover the Northwest Passage and reached HUDSON BAY. Forced by ice to winter in the Bay, his mutinous crew set him adrift to die in an open boat. Hudson River in E New York state. It rises in the ADIRON-DACK MOUNTAINS and flows s to New York Bay, NEW YORK CITY. First explored in 1609 by Henry HUDSON, it has become one of the world's most important waterways. The New York State Barge Canal connects the Hudson with Lake Champlain, the Great Lakes and the St Lawrence River. Length: c.493km (306mi).

Hudson Bay World's largest inland sea, in E Northwest Territories, Canada, also bounded by Quebec (E), Ontario (s) and Manitoba (sw). It is connected to the Atlantic by the Hudson Strait (NE) and to the Arctic Ocean by the Foxe Channel (N). Explored in 1610 by Henry Hudson, the bay contains Southampton, Mansel and Coats Islands. The Churchill and Nelson rivers drain into the bay, which is ice-free from July to October. Area: *c.*1,243,000sq km (480,000sq mi).

Hudson River School (c.1825–75) Group of US landscape painters influenced by European ROMANTICISM. They were so named because of their idealized scenes of the HUD-

◄ Hubble Space Telescope

One of the most ambitious and expensive pieces of astronomical equipment ever to be made, the Hubble Space Telescope initially was unable to relay useable images back to Earth due to an optical aberration of its main mirror. A shuttle mission in 1993 corrected this fault. A further mission in 1997 corrected problems with the telescope's power supply. Images now received on Earth have provided astronomers with the clearestever images of distant objects.

▲ Hughes The son of a wealthy industrialist, Howard Hughes' passion was for film making. Between 1926 and 1932, Hughes made six films, including Hell's Angels (1930) and Scarface (1932). He left Hollywood to pursue his other passion for flying and designing aircrafts, building the largest ever wooden aircraft. By this time he had returned to film making, directing his most notorious film The Outlaw (1943). The last 10 years of his life he spent as a total recluse.

▼ human evolution Although the fossil record is not complete, we know that humans evolved from ape-like creatures. Our earliest ancestor. Austrolpithecus afarensis (A), lived in NE Africa some 5 million years ago. Over the next 3-4 million years A. africanus (B) evolved. Homo Habilis (C), who used primitive stone tools, appeared c.500,000 years later. H. erectus (D) is believed to have spread from Africa to regions all over the world 750,000 years ago. Records indicate that from H erectus evolved two species, Neanderthal man (E), who died out 40,000 years ago, and who could have been made extinct by the other species, the earliest modern man H. sapiens sapiens (F).

SON River Valley. The group included Thomas COLE, Frederick E. Church, Henry Inman and Asher B. Durand.

Hudson's Bay Company English company chartered in 1670 to promote trade in the Hupson Bay region of North America and to seek a Northwest Passage. The Company had a fur trading monopoly and was virtually a sovereign power in the region. Throughout the 18th century, it fought with France for control of the bay. In 1763 France ceded control of CANADA to England, and the North West Company was formed. Intense rivalry forced the Hudson's Bay Company into a more active role in w exploration, and in 1771 Samuel Hearne proved the lack of a short Northwest Passage out of the Bay. The companies merged in 1821, with the new company controlling a territory from the Atlantic to the Pacific. After the Confederation of Canada (1867), challenges to its monopoly power increased, and in 1869 it was forced to cede all its territory to Canada for £300,000. As the fur trade declined in the early 20th century, the company diversified, and in 1930 was divided up.

Huerta, Victoriano (1854-1916) Mexican general and president (1913-14). Instructed by President Francisco MADERO to suppress the revolt led by Félix Díaz, Huerta instead joined forces with the rebels. Madero was arrested and killed, and Huerta became president. Defeated by the Constitutionalists led by CARRANZA, Huerta fled to the USA. Hughes, Charles Evans (1862-1948) US statesman and jurist, associate justice of the Supreme Court (1910-16), secretary of state (1921-25), eleventh US chief justice (1930-41). He was a Republican presidential candidate (1916), but narrowly lost the election to Woodrow WILSON. He served as secretary of state under presidents HARDING and COOLIDGE and negotiated the naval disarmament treaties emanating from the Washington Conference. He was a member of the Permanent Court of Arbitration (1926-30) and judge of the Permanent Court of International Justice (1928-30). Appointed chief justice by President HOOVER, he was a moderating influence. He retired in 1941.

Hughes, Howard Robard (1905–76) US industrialist, aviator and film producer. He inherited an industrial corporation (1923) and became a billionaire as head of the Hughes Aircraft Company. In 1935 he set the world speed record of 567km/h (352mph) in an aircraft of his own design. He occasionally produced films, including *Hell's Angels* (1930), starring Jean Harlow, and *The Outlaw* (1941), starring Jane Russell. He was famed for his reclusive lifestyle.

Hughes, Langston (1902–67) US poet and leading figure of the HARLEM RENAISSANCE. His debut volume was *The Weary Blues* (1926). His distinctive musical style combined African-American dialect with the rhythms of jazz and blues. Ohter works include *Shakespeare in Harlem* (1942) and *One-Way Ticket* (1949).

Hughes, Ted (Edward James) (1930–) British poet. One of the most distinctive voices in contemporary English verse, Hughes' work concerns itself with raw nature. Collections

include *Hawk in the Rain* (1957), *Lupercal* (1960), *Wodwo* (1967), *Crow* (1970), *Moortown* (1979) and *Wolfwatching* (1989). He was married to Sylvia PLATH (1956–62) and became poet laureate in 1984. Tales from Ovid (1997) was a creative translation of the Greek master. He has also written children's books, critical essays and plays.

Hughes, Thomas (1822–96) British novelist and political writer. An active member of the Christian Socialist Movement, he is best known for the novel *Tom Brown's Schooldays* (1857). Other works include *The Scouring of the White Horse* (1859) and *The Manliness of Christ* (1879).

Hugo, Victor Marie (1802–85) French poet, dramatist and novelist. A major force in 19th-century French literature, he received a pension from Louis XVIII for his first collection of Odes (1822) and presented his manifesto of ROMANTICISM in the preface to his play Cromwell (1827). Later works include the plays Hernani (1830) and Ruy Blas (1838), and the novels The Hunchback of Notre Dame (1831) and Les Misérables (1862). Some of his most important works were written whilst in exile, such as the satirical poems The Punishments (1853). On the fall of the Second Republic he returned to Paris, where he became a senator.

Huguenots French Protestants who arose in Roman Catholic France during the REFORMATION and suffered persecution. In 1559 a national synod of Huguenot congregations met in Paris and adopted a confession of faith and an ecclesiastical structure highly influenced by CALVIN. During the Wars of RELIGION (1562–98), Huguenots continued to face persecution and thousands died. King Henry IV, a Huguenot, came to the throne in 1589 and, despite adopting the Roman faith in 1593, promulgated the Edict of NANTES (1598) which recognized Catholicism as the official religion, but gave Huguenots certain rights. It was revoked by LOUIS XIV in 1685, and thousands of Huguenots fled France. In 1789 their civil rights were restored, and the Code Napoléon (1804) guaranteed religious equality.

Huitzilopochtli Chief deity of the AZTEC, revered as a Sun god, god of war and protector of the fifth era. He is usually shown in armour decorated with humming-bird feathers. His cult required a daily nourishment of human blood. *See also* CENTRAL AND SOUTH AMERICAN MYTHOLOGY

Hull, Cordell (1871–1955) US statesman, secretary of state (1933–44) under Franklin D. ROOSEVELT. A member of the House of Representatives (1907–21, 1923–31), he was the author of the first federal income tax law (1913). He developed relations with Latin American states, was an important diplomatic figure in World War 2, and played a key role in gaining US acceptance of the United Nations. He was awarded the 1945 Nobel Peace Prize.

Hull (officially Kingston upon Hull) City and unitary authority on the N bank of the Humber estuary, NE England. Britain's third largest port, it was founded in the late 13th century and grew around its fishing industry. Hull gained city status in 1897. The decline of the fishing industry has been part-

ly offset by the construction of the Humber Bridge (1981), one of the world's longest single-span suspension bridges. The city is home to the University of Hull (1954) and the University of Humberside (1992). Pop. (1991) 254,117

human Primate MAMMAL of the genus *Homo*, the only living species of which is *Homo sapiens*. When compared with near relatives, the CHIMPANZEE, GORILLA and ORANG-UTAN, humans are distinguishable by a number of features. They walk upright, their body is only patchily hairy, their big toes are not opposable to the other toes, their backbone is more S-shaped than straight, and their forehead is higher than that of any ape. Microscopically, humans are distinguishable from great apes by the size, number and shape of their chromosomes. Another distinction is the human capacity for language. Socially, humans are similar to lesser primates, preferring a family or other small group. Humans have always actively made great changes to both their immediate environment and to ecosystems.

human body Physical structure of a HUMAN. It is composed of water, PROTEIN and other organic compounds, and some minerals. The SKELETON consists of more than 200 bones, sheathed in voluntary MUSCLE to enable movement. A SKULL surrounds the large BRAIN. The body is fuelled by nutrients absorbed from the DIGESTIVE SYSTEM and oxygen from the LUNGS, which are pumped around the body by the CIRCULATORY SYSTEM. Metabolic wastes are eliminated mainly by EXCRETION. Continuation of the species is enabled by the reproductive system. Overall control is exerted by the NERVOUS SYSTEM, working closely with the ENDOCRINE SYSTEM. The body surface is covered by a protective layer of SKIN.

human evolution Process by which humans developed from pre-human ancestors. The FOSSIL record of human ancestors is patchy and unclear. Some scientists believe that our ancestry can be traced back to one or more species of Australopithicenes that flourished in s and E Africa c.4-1 million years ago. Other scientists believe that we are descended from some as yet undiscovered ancestor. The earliest fossils that can be identified as human are those of Homo habilis (handy people) which date from 2 million years ago. The next evolutionary stage was Homo erectus (upright people), who first appeared c.1.5 million years ago. The earliest fossils of our own species, Homo sapiens (wise people), date from c.250,000 years ago. An apparent side-branch, the NEANDERTHALS, Homo sapiens neanderthalensis, existed in Europe and w Asia c.130,000-40,000 years ago. Modern humans, Homo sapiens sapiens, first appeared c.100,000 years ago. All human species apart from Homo sapiens sapiens are now extinct.

human immunodeficiency virus (HIV) Organism that causes Acquired Immune Deficiency Syndrome (AIDS). A retrrovirus identified in 1983, HIV attacks the immune system, leaving the person unable to fight off infection. There are two distinct viruses: HIV-1, which has now spread worldwide; and HIV-2, which is concentrated almost entirely in West Africa. Both cause AIDS. There are three main means of transmission: from person to person by sexual contact; from mother to baby during birth; and by contact with contaminated blood or blood products (for instance, during transfusions or when drug-users share needles). People can carry the virus for many years before developing symptoms.

humanism Philosophy based on a belief in the supreme importance of human beings and human values. The greatest flowering of humanism came during the RENAISSANCE, spreading from Italy to other parts of Europe. Early adherents included PETRARCH and ERASMUS. From the 15th to the 18th centuries, humanism represented the revival of classical values in philosophy and art. Modern humanism developed as an alternative to traditional Christian beliefs. This movement, which has been associated with social reform, was championed by Bertrand RUSSELL.

human rights Entitlements that an individual may arguably possess by virtue of being human and in accordance with what is natural. The concept of the inalienable rights of the human being has traditionally been linked to the idea of natural law, on which important commentaries were written by several Greek and Roman writers. John LOCKE helped to shape ideas of fun-

■ hummingbird The sword-billed hummingbird (Ensifera ensifera) is one of the 300 or so species of hummingbird found in the Americas. Hummingbirds live largely on nectar; and their long bills are perfectly suited to extracting the nectar from deep within the flowers.

damental human rights and liberal DEMOCRACY in *Two Treatises on Government* (1690). The concept of human rights has been most notably formulated in a number of historic declarations, such as the American DECLARATION OF INDEPENDENCE (1776), the American Constitution (1789) – particularly its first amendments in the BILL OF RIGHTS (1791), and the French DECLARATION OF THE RIGHTS OF MAN AND CITIZEN (1789). These documents owed much to the English PETITION OF RIGHT (1628) and BILL OF RIGHTS (1689), which extended the concept of individual freedom proclaimed earlier in the MAGNA CARTA (1215). The responsibility of the international community for the protection of human rights is proclaimed in the Charter of the United Nations (1945) and the Universal Declaration of Human Rights (1948). *See also* CIVIL RIGHTS

Humboldt, Baron Friedrich Heinrich Alexander von (1769–1859) German scientist and explorer. On scientific trips in Europe and Latin America, he studied volcanoes, ropical storms, and the increase in magnetic intensity from the equator towards the poles. His five-volume *Kosmos* (1845–62) comprehensively describes the physical universe. Hume, David (1711–76) Scottish philosopher, historian and man of letters. Hume's publications include *A Treatise of Human Nature* (1739–40), *History of England* (1754–63), and various essays and philosophical "enquiries". Widely known for his humanitarianism and philosophical SCEPTICISM, Hume's philosophy was a form of EMPIRICISM that affirmed the contingency of all phenomenal events. He argued that there was nothing beyond subjective experiences of impressions and ideas.

Hume, John (1937–) Northern Irish politician, leader of the SOCIAL DEMOCRATIC LABOUR PARTY (SDLP). Hume was a founder member and president of the Credit Union League (1964–68), the precursor of the SDLP. He entered parliament in 1983. Hume's nationalist politics and commitment to peace in Northern Ireland saw him enter into negotiations with Gerry ADAMS and SINN FÉIN, which led to an IRA cease-fire.

humerus Bone in the human upper arm, extending from the scapula to the elbow. A depression on the posterior, roughened lower end of the humerus provides the point of articulation for the ULNA.

humidity (relative humidity) Measure of the amount of water vapour in air. It is the ratio of the actual vapour pressure to the saturation vapour pressure at which water normally condenses, and is usually expressed as a percentage. Humidity is measured by a HYGROMETER.

hummingbird Popular name for small, brilliantly coloured birds of the family *Trochilidae*, found in s and N America. They feed in flight on insects and nectar, usually by hovering in front of flowers. Their speed can reach 100km/h (60mph) and their wings, which beat 50–75 times a second, make a humming sound. Length: 6–22cm (2.2–8.6in).

Humperdinck, Engelbert (1854–1921) German music teacher and composer. His works include incidental music, songs and seven operas, of which the first, *Hansel and Gretel* (1893), is his most popular work. He worked with WAGNER in the preparation of *Parsifal* (1880–81).

Humphrey, Hubert Horatio (1911–78) US statesman, vice president (1965–69). As Lyndon Johnson's deputy, Humphrey's support of the VIETNAM WAR incurred much hostility. He won the Democratic nomination in 1968, but

▲ Hussein Despite a costly war with neighbouring Iran (1980–88), a crushing defeat by an Allied force following his invasion of Kuwait (1990) and an oil embargo which has crippled Iraq's economy, Saddam Hussein has managed to retain power. He maintains an aggressive stance towards the West and Israel, and has been accused of stockpilling chemical weapons and developing a nuclear capability.

▲ Huston US actor and director John Huston was one of the most colourful of Hollywood characters. His directorial debut was The Maltese Falcon (1941). His father, Walter Huston, won an Academy Award for Best Supporting Actor in The Treasure of the Sierra Madre (1946). The early 1950s were a golden period, with films such as The Asphalt Jungle (1950). African Queen (1951) and Moulin Rouge (1952). His daughter, Anjelica Huston, won an Oscar as Best Supporting Actress in Prizzi's Honor (1985). Huston also appeared in front of the camera, and gained an Academy nomination for Chinatown (1974).

lost the ensuing election to Richard NIXON and returned to the Senate.

humus Dark brown, organic substance resulting from partial decay of plant and animal matter. It improves soil by retaining moisture, aerating and increasing mineral nutrient content and bacterial activity. Types include peat moss, leaf mould and soil from woods.

Hunan Province in SE central China, s of Tung-t'ng Lake; the capital is Changsha. The region is largely forested, but agriculture is important; rice, tea, rapeseed and tobacco are produced. The province has valuable mineral resources. Area: 210,570sq km (81,301sq mi). Pop. (1990) 60,600,000. **hundred days** Period between the escape of Napoleon I from Elba and his second abdication (1815). The term has since been applied to the early months os a new administration, notably that of Franklin D. ROOSEVELT (1933).

Hundred Years War Conflict between France and England pursued sporadically between 1337 and 1453. EDWARD III's claim to the French crown sparked the war. Early English successes brought territorial gains in the Peace of Brétigny (1360). The French gradually regained their lost territory and a revival stimulated by JOAN OF ARC led eventually to the expulsion of the English from all of France except Calais.

Hungarian (Magyar) Official language of Hungary, spoken by the country's 10.3 million inhabitants and by about 3 million more in parts of Romania, Slovakia and other countries bordering Hungary. It belongs to the Ugric branch of the FINNO-UGRIC languages.

Hungary Republic in central Europe. *See* country feature **Huns** Nomadic people of Mongol or Turkic origin who expanded from central Asia into E Europe. Under Attila, they overran large parts of the Roman empire in 434–53, exacting tribute, but after his death they disintegrated.

Hunt, (James Henry) Leigh (1784–1859) British critic, journalist and poet. He was instrumental in introducing the work of SHELLEY and KEATS to the public. He founded the literary periodical *The Examiner* and also contributed to *The Indicator* and *The Liberal*. He published a two-volume memoir of BYRON (1828) and *Poetical Works* (1832).

Hunt, Richard Morris (1827–95) US architect. Influenced by French Gothic and Italian Renaissance style, he is best known for the large town and country houses he built for the wealthy. Examples are "Biltmore" in North Carolina and "The Breakers" in Newport, Rhode Island.

Hunt, William Holman (1827–1910) British painter, who was one of the founders of the PRE-RAPHAELITE BROTHER-HOOD in 1848. His works, such as *The Light of the World* (1854) and *The Scapegoat* (1856), combine meticulous precision with heavy, didactic symbolism.

hunting and gathering Practice of small societies in which members subsist by hunting and by collecting plants rather than by agriculture. The groups are always small bands and have sophisticated kinship and ritualistic systems. Today, hunting-gathering societies are most numerous in lowland South America and parts of Africa.

Huntington's disease (formerly Huntington's chorea) Acute degenerative disorder. It is genetically transmitted and usually occurs in early middle life. It is caused by the presence of abnormally large amounts of glutamate and aspartate. Physical symptoms include loss of motor coordination. Mental deterioration can take various forms.

hurling (hurley) One of the national sports of Ireland. It is played by two teams of 15 on a field $137 \times 82 \text{m}$ ($450 \times 270 \text{ft}$), at each end of which are goalposts. The object is to score points by propelling the ball between the goal uprights, either above (1 point) or below (3 points) the crossbar. Every player carries a hurley (hooked stick), on which the ball may be balanced as the player runs, or with which it may be batted upfield towards a team-mate; the ball also may be kicked.

Huron Small confederation of Iroquoian-speaking tribes of Native North Americans who once occupied the St Lawrence Valley, E of Lake Huron. In wars (1648–50), fought for control of the fur trade with the Iroquois Confederacy, their population was reduced from 15,000 to c.500. After a period of wandering, they settled in Ohio, the Great Lakes area and

Kansas. Today, some 1,250 live on reservations in Ohio and Oklahoma and in Ontario.

Huron, Lake Second largest of the Great Lakes of North America, forming part of the boundary between the USA and Canada. It drains Lake Superior and feeds Lake Erie as part of the Great Lakes—St Lawrence Seaway system and is navigable by ocean-going vessels. Area: 59,596sq km (23,010sq mi). Max. depth: 230m (750ft).

hurricane Wind of Force 12 or greater on the BEAUFORT WIND SCALE; intense tropical cyclone with winds ranging from 120 to 320km/h (75 to 200mph), known also as a typhoon in the Pacific. Originating over oceans around the Equator, hurricanes have a calm central hole, or eye, surrounded by inward spiralling winds and cumulonimbus clouds.

Hus, Jan (1369–1415) Bohemian (Czech) religious reformer. Born at Husinec in s Bohemia, he studied and later taught at Prague, where he was ordained priest. Influenced by the beliefs of the English reformer John Wycliffe, he became leader of a reform movement, for which he was excommunicated in 1411. In *De Ecclesia (Concerning the Church)* (1412), Hus outlined his case for reform. In 1415 he was burned at the stake as a heretic. His followers were known as Hussites.

Hussein I (1935–) King of Jordan (1953–). King Hussein sought to maintain good relations with the West, while supporting the cause of the Palestinians in the Arab-Israeli Wars. In 1967 he led his country into the Six Day War and lost the West Bank and East Jerusalem to Israel. In 1970 he ordered his army to suppress the activities of the Palestine Liberation Organization (PLO) in Jordan. In 1974 he relinquished Jordan's claim to the West Bank to the PLO. He supported efforts to secure peace in the Middle East in the 1990s, signing a peace treaty with Israel in 1994.

Hussein, Saddam (1937-) Iraqi statesman, president of Iraq (1979-). In 1957 he joined the Ba'ATH PARTY. In 1959 Hussein was forced into exile for his part in an attempt to assassinate the Iraqi prime minister. He returned in 1963 and was soon imprisoned. Following Hussein's release, he played a prominent role in the 1968 Ba'athist coup, which replaced the civilian government with the Revolutionary Command Council (RCC). In 1979 he became chairman of the RCC and state president. His invasion of Iran marked the beginning of the IRAN-IRAQ WAR (1980-88). Domestically, he ruthlessly suppressed all opposition, including the gassing of Kurdish villagers. His 1990 invasion of Kuwait provoked worldwide condemnation and, in the ensuing GULF WAR (1991), a multinational force expelled Iraqi forces from Kuwait. Further uprisings by KURDS and Iraqi SHIITES were ruthlessly suppressed, and Saddam survived punitive economic sanctions.

Husserl, Edmund (1859–1938) German philosopher, founder of PHENOMENOLOGY. He studied man's consciousness as it related to objects and the structure of experience. His works include *Ideas: General Introduction to Pure Phenomenology* (1913) and *Cartesian Meditations* (1931).

Hussites Followers of the religious reformer Jan Hus in Bohemia and Moravia in the 15th century. The execution of Hus in 1415 provoked the Hussite wars against the emperor Sigismund. Peace was agreed at the Council of Basel (1431), but it was rejected by the radical wing of the Hussites, the Taborites, who were defeated at the Battle of Lipany in 1434. Huston, John (1906–87) US film director, writer and actor. His debut feature was The Maltese Falcon (1941). In 1946 he won a Best Director Academy Award for The Treasure of the Sierra Madre. Other classics followed, such as Key Largo (1948), The Asphalt Jungle (1950) and The African Queen (1951). After a series of critical failures, Huston returned to form with The Man Who Would Be King (1975) and Prizzi's Honor (1985). His last film was The Dead (1987).

Hutchinson, Anne Marbury (1591–1643) Massachusetts colonist and religious leader. Her disagreement with the orthodox Puritanism of Boston led to her trial for sedition (1637) and expulsion. She moved to Pelham Bay, New York, where she was murdered by Native Americans.

Hutton, James (1726–97) Scottish geologist. He sought to formulate theories of the origin of the Earth and of atmospheric changes. Concluding that the Earth's history could be

explained only by observing forces currently at work within it, he laid the foundations of modern geological science.

Hutton, Sir Len (Leonard) (1916–90) English cricketer who was England's first professional captain (1952). An opening batsman for Yorkshire, he captained England for 23 of his 79 Test matches (1937–1955). In 1938 he scored 364 against Australia, a world record until Gary Sobers innings (1958). Huxley, Aldous Leonard (1894–1963) British novelist, grandson of Thomas Huxley. Huxley began his career as a journalist and published several volumes of poetry before his debut novel, *Crome Yellow* (1921). *Point Counter Point* (1928)

satirized the hedonism of the 1920s. Huxley's best-known work, *Brave New World* (1932), presents a nightmarish vision of a future society. *Island* (1962) invokes a Utopian community. *Eyeless in Gaza* (1936) and *The Doors of Perception* (1954) explore his interest in mysticism and states of consciousness. Among his finest works are the *Collected Short Stories* (1957). **Huxley, Sir Julian Sorell** (1887–1975) British biologist, grandson of Thomas Huxley, his researches were chiefly on the behaviour of birds and other animals in relation to evolution. His books include *The Individual in the Animal Kingdom* (1911) and *Evolutionary Ethics* (1943).

Huxley, Thomas Henry (1825–95) British biologist. Huxley was a champion of Charles Darwin's theory of evolution. His works include *Zoological Evidences as to Man's Place in Nature* (1863), *Manual of Comparative Anatomy of Vertebrated Animals* (1871) and *Evolution and Ethics* (1893).

Hu Yaobang (1915–89) Chinese statesman, general secretary of the Chinese Communist Party (1980–87). Hu joined the Communist Party in 1933 and took part in the LONG MARCH. He was closely associated with DENG XIAOPING in the war against Japan (1937–45), during which he served as political commissar. In 1952 Hu became head of the Young Communist League, but lost his post in the CULTURAL REVOLUTION (1966). Rehabilitated by Deng in 1977, he was appointed general secretary and chairman of the party. Accused of symapathizing with student demostrations for democracy, Hu was dismissed. The TIANANMEN SQUARE protests followed his death.

Huygens, Christiaan (1629–95) Dutch physicist and astronomer. In 1655 he discovered Saturn's largest satellite, Titan, and explained that the planet's appearance was due to a broad ring surrounding it. He introduced the convergent eyepiece for telescopes and constructed the first pendulum clock. Huygens' contributions also include the wave notion of light.

HUNGARY

Hungary's flag was adopted in 1919. A state emblem was added in 1949 and removed in 1957. The colours of red, white and green had been used in the Hungarian arms since the 15th century. The tricolour design became popular during the 1848 rebellion against Habsburg rule.

AREA: 93,030sq km (35,919sq mi) **POPULATION:** 10,313,000

CAPITAL (POPULATION): Budapest (2,009,000)
GOVERNMENT: Multiparty republic

ETHNIC GROUPS: Magyar (Hungarian) 98%, Gypsy, German, Croat, Romanian, Slovak LANGUAGES: Hungarian (official)

RELIGIONS: Christianity (Roman Catholic 64%, Protestant 23%, Orthodox 1%), Judaism 1%

CURRENCY: Forint = 100 filler

ungary is a mostly low-lying, landlocked country in central Europe. The River Danube forms much of its N border with the Slovak Republic. The capital, BUDAPEST, lies on the banks of the river. To the E of the Danube is the Great Hungarian Plain (Nagyalföld), drained by the River Tisza and including Hungary's second-largest city, Debrecen. To the w lies the Little Plain (Kisalföld) and the region of Transdanubia, which includes central Europe's largest lake, Lake BALATON. In the NE, the Mátra Mountains rise to the Kékes peak, at 1,015m (3,330ft).

CLIMATE

Hungary has a continental climate, with hot summers and cold winters. Autumn and spring are short seasons.

VEGETATION

Much of Hungary's original vegetation has been cleared. Large forests remain in the scenic NE highlands.

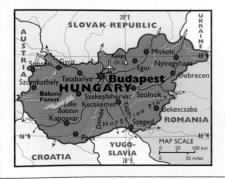

HISTORY AND POLITICS

MAGYARS first arrived in the 9th century. In the 11th century Hungary's first king, Saint STEPHEN, made Roman Catholicism the official religion. In 1222 the Golden Bull established a parliament. In the 14th century, the ANGEVIN dynasty extended the empire. In the Battle of Mohács (1526), Hungary was defeated by the Ottomans. In 1699 LEOPOLD I expelled the Turks and established HABSBURG control. The accession of FRANZ JOSEPH led to war with Austria (1848). Austrian defeat in the AUSTRO-PRUSSIAN WAR (1866) led to the compromise solution of the "dual monarchv" AUSTRO-HUNGARIAN or EMPIRE. (1867-1918). As defeat loomed in World War 1, nationalist demands intensified. In 1918 independence was declared. In 1919 communists, led by Béla Kun, briefly held power. In 1920 Miklós HORTHY became regent. World War 1 peace terms saw the loss of all non-Magyar territory (66% of Hungarian land).

In 1941 Hungary allied with Nazi Germany, gaining much of its lost territory. Virulent antisemitism saw the extermination of many Hungarian Jews. Hungary's withdrawal from the war, led to German occupation (March 1944). The Soviet expulsion of German troops (October 1944–May 1945) devastated much of Hungary. Hungary became a republic, headed by Imre NAGY (1946). In 1948 the Communist Party gained control, forcing Nagy's resignation, and declaring Hungary a People's Republic (1949). Hungary became a Stalinist state. Industry was nationalized, and agriculture collectivized. Economic crisis forced the brief reinstatement (1953–55) of Nagy. In 1955 Hungary

joined the Warsaw Pact. In 1956 a nationwide revolution led to Nagy forming a government. János KÁDÁR formed a rival government and called for Soviet military assistance. Soviet troops brutally suppressed the uprising. Nagy was executed and 200,000 people fled. Kádár's regime adopted a more liberal social policy. Relations with the Catholic Church were restored and a new economic policy (1968) relaxed the command economy. During the 1980s, Hungary began to seek Western aid to modernize its economy. In 1989 Kádár forced to resign and the Communist Party was disbanded. Subsequent multiparty elections (1990) were won by the conservative Democratic Forum. The Hungarian Socialist Party (HSP), composed of ex-communists, won the 1994 elections, and set up a coalition government with the liberal Alliance of Free Democrats. Gyula Horn of the HSP became prime minister.

ECONOMY

Since the early 1990s, Hungary has adopted market reforms and privatization programmes. The economy (1992 GDP per capita, US\$6,580) has suffered from the collapse of its exports to the former Soviet Union and Yugoslavia. Transitional costs have resulted in an increase in national debt, unemployment and inflation. The manufacture of machinery and transport is the most valuable sector. Hungary's resources include bauxite, coal and natural gas. Agriculture remains important (14% of GDP). Major crops include grapes for wine-making, maize, potatoes, sugar beet and wheat. Tourism is a growing sector.

hyacinth Bulbous plant native to the Mediterranean region and Africa. It has long, thin leaves and spikes of bell-shaped flowers, which may be white, yellow, red, blue or purple. Family Liliaceae; genus *Hyacinthus*.

hyaena See HYENA

hybrid Offspring of two parents of different GENE composition. It often refers to the offspring of different varieties of a species or of the cross between two separate species. Most inter-species hybrids are unable to produce fertile offspring. hybridization Cross-breeding of plants or animals between different species to produce offspring that differ in genetically determined traits. Changes in climate or in the environment of an organism may give rise to natural hybridization, but most hybrids are produced by human intervention to produce plants or animals that may be hardier or more economical than the original forms.

Hyderabad City in the River Mūsi valley, s India; capital of Andhra Pradesh state. Founded in 1589, it has a number of notable buildings dating from that time, including the Char Minar (1591). Industries: tobacco, textiles, handicrafts, vehicle parts. Pop. (1991) 3,145,939.

Hyderabad City on the River INDUS, Sind province, SE Pakistan. Founded in 1768, it was the capital of Sind until captured by the British in 1843. Industries: chemicals, pottery, shoes, furniture, handicrafts. Pop. (1981) 795,000.

Hydra Largest constellation in the sky. It represents the water snake killed by HERACLES in classical mythology.

hydra Popular name for a group of small, freshwater organisms including the JELLYFISH, CORAL and SEA ANEMONE.

hydrangea Genus of 80 deciduous woody shrubs, small trees and vines, native to the w Hemisphere and Asia. They are grown for their showy clusters of flowers, which may be white, pink or blue. Family Hydrangeaceae.

hydraulics Physical science and technology of the behaviour of fluids in both static and dynamic states. *See also* FLUID MECHANICS

hydrocarbon Organic compound containing only CARBON and HYDROGEN. There are thousands of different hydrocarbons, including open-chain compounds, such as the alkanes (paraffins), alkenes (olefins) and acetylenes. Petroleum, natural gas and coal tar are sources of hydrocarbons.

hydrocephalus Increase in volume of cerebrospinal fluid (CSF) in the brain. A condition that exerts dangerous pressure on brain tissue, it can be due to obstruction or a failure of natural reabsorption. In babies it is congenital; in adults it may arise from injury or disease. It is treated by insertion of a shunting system to drain the CSF into the abdominal cavity.

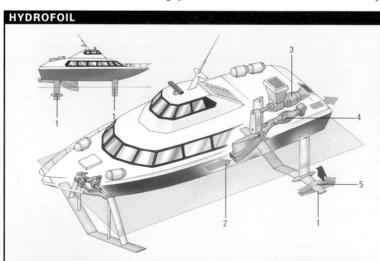

Hydrofoils use the lift of underwater wings (1) to push the body of the boat out of the water. This lessens the drag allowing the boat to travel faster. The Boeing Jetfoil (shown) scoops up water (2) and uses gas turbines (3) to drive high-pressure pumps (4) that throw the water from the rear, creating thrust. The jetfoil can reach speeds of up to 75km/h

(45 mph). The hydrofoil works in water the same way an aerofoil does in air. A low-pressure zone is created above the top surface of the hydrofoil, sucking and pushing the wing upwards (5).

hydrochloric acid Solution of hydrogen chloride (HCl) gas in water. It is obtained by the action of sulphuric acid on common salt, as a byproduct of the chlorination of hydrocarbons, or by combination of HYDROGEN and CHLORINE. Hydrochloric acid is used in industry and is produced by humans cells in the stomach lining to allow the enzyme PEPSIN to digest proteins.

hydroelectricity Electricity generated from the motion of water. In all installations this energy of movement, or kinetic energy, is first converted into mechanical energy in the spinning blades of a water turbine, and then into electricity by the spinning rotor of an electric GENERATOR.

hydrofoil Boat or ship whose hull is lifted clear of the water, when moving at speed, by submerged wings. They usually have gas-turbine or diesel engines that power propellers or water jets. Speeds range from 30 to 60 knots.

hydrogen (symbol H) Gaseous nonmetallic element, first identified as a separate element in 1766 by Henry CAVENDISH. Colourless and odourless, hydrogen is the lightest and most abundant element in the universe (76% by mass), mostly found combined with oxygen in water. It is used to manufacture AMMONIA, to harden fats and oils, and in rocket fuels. Properties: at.no. 1; r.a.m. 1.00797; r.d. 0.0899; m.p. -259.1° C (-434.4° F); b.p. -252.9° C (-423.2° F); most common isotope H¹ (99.985%).

hydrogen bomb (H-bomb) NUCLEAR WEAPON developed by the USA in the late 1940s and first exploded in 1952 in the Pacific. The explosion results from nuclear FUSION when hydrogen nuclei are joined to form helium nuclei, releasing great destructive energy and radioactive fallout.

hydrogen peroxide Liquid compound of hydrogen and oxygen (H₂O₂). It is prepared by electrolytic oxidation of sulphuric acid and by methods involving reduction of oxygen. Hydrogen peroxide is used as a bleach, a disinfectant and an oxidizer for rocket fuel and submarine propellant. Properties: r.d. 1.44; m.p. -0.9° C (30.4°F); b.p. 150°C (302°F).

hydrogen sulphide Colourless, poisonous gas (H₂S) with the smell of bad eggs. It is produced by decaying matter, found in crude oil and prepared by the action of sulphuric acid on metal sulphides. Properties: m.p. -85.5°C (-121.9°F), b.p. -60.7°C (-77.3°F).

hydrological cycle (water cycle) Circulation of water around the Earth. Water is evaporated from the sea; most falls back into the oceans, but some is carried over land. There it falls as precipitation, and (by surface runoff or infiltration and seepage) gradually finds its way back to the sea. Less than 1% of the world's water is involved in this cycle.

hydrology Study of the Earth's waters, their sources, circulation, distribution, uses and chemical and physical composition. The HYDROLOGICAL CYCLE is the Earth's natural water circulation system. Hydrologists are concerned with the provision of freshwater, building dams and irrigation systems, and controlling floods and water pollution.

hydrolysis Chemical reaction in which molecules are split into smaller molecules by reaction with water; often assisted by a CATALYST. For example, in digestion, ENZYMES catalyse the hydrolysis of CARBOHYDRATES, PROTEINS and FATS into smaller, soluble molecules that the body can assimilate.

hydrophyte (aquatic plant) Plant that grows only in water or in damp places. Examples include WATER LILIES, WATER HYACINTH, DUCKWEED and various PONDWEEDS.

hydroponics (soil-less culture or tank farming) Plants are grown with their roots in a mineral solution or a moist inert medium (such as gravel) containing the necessary nutrients, instead of soil.

hydrotherapy Use of water within the body or on its surface to treat disease. It is often used in conjunction with PHYSIOTHERAPY.

hydroxide Inorganic chemical compound containing the group –OH, which acts as a BASE. The strong inorganic bases such as potassium hydroxide (KOH) dissociate (break down) in water almost completely to provide many hydroxyl ions.

hydrozoa Class of animals without backbones, all living in water, belonging to the phylum Coelenterata. They vary in shape and size from the large PORTUGUESE MAN-OF-WAR to the simple HYDRA.

hyena Predatory and scavenging carnivore native to Africa and s Asia. The spotted or laughing hyena (*Crocuta crocuta*) of the sub-Sahara is the largest. Other species include the brown hyena (*Hyaena brunnea*) of s Africa. Weight: 27–80kg (60–176lb). Family Hyaenidae.

hygrometer Instrument used to measure the HUMIDITY of the atmosphere. One type, the psychrometer, compares the wet and dry bulb temperatures of the air; other types measure absorption or condensation of moisture from the air, or chemical or electrical changes caused by that moisture.

Hyksos Invaders of Egypt in the 17th century BC. They probably came from Palestine and attacked Egypt at a time of weakness, perhaps possessing a military advantage in the use of chariots. They ruled Egypt from 1674 to 1567 BC as the 15th and 16th dynasties. A native revolt ended in their overthrow.

hymen In ANATOMY, MEMBRANE that covers the entrance to the VAGINA. Intact at birth, it normally opens spontaneously before PUBERTY or at first penetration during sexual intercourse. **Hymen** In Greek mythology, god of marriage. Son of APOLLO, he is represented as a youth attending APHRODITE.

hymn Song of praise or gratitude to a god or hero. The oldest forms are found in ancient Egyptian and Greek writings and in the Old Testament psalms of rejoicing. In strict Christian church usage, hymns are religious songs sung by the choir and congregation in a church, distinct from a psalm or a canticle. Hymns, both old and new, are now regular features of church services.

hyperbola Plane curve traced out by a point that moves so that its distance from a fixed point bears a constant ratio, greater than one, to its distance from a fixed straight line. The fixed point is the focus, the ratio is the eccentricity, and the fixed line is the directrix. The curve has two branches and is a CONIC section. Its standard equation in Cartesian coordinates x and y is $x^2/a^2-y^2/b^2=1$.

hyperbole Rhetorical device in which an obvious exaggeration is used to create an effect without being meant literally, such as "the music is loud enough to wake the dead".

hyperglycaemia Condition in which blood-sugar level is abnormally high. It can occur in a number of diseases, most notably DIABETES. *See also* HYPOGLYCAEMIA

Hyperion In Greek mythology, sometimes said to be the original Sun god. He was one of the TITANS, the son of URANUS and Gaea and the father of HELIOS (the Sun), SELENE (the Moon), and EoS (the dawn). He is the subject of an incomplete epic poem (1818–19) of the same name by John KEATS.

hypersensitivity Condition in which a person reacts excessively to a stimulus. Most hypersensitive reactions are synonymous with ALLERGIES, the commonest being HAY FEVER.

hypertension Persistent high BLOOD PRESSURE. It can damage blood vessels and may increase the risk of strokes or heart disease. *See also* HYPOTENSION

hyperthermia Abnormally high body temperature, usually defined as being 41°C or more. It is usually due to over-heating (as in HEATSTROKE) or FEVER.

hyperthyroidism Excessive production of thyroid hormone, with enlargement of the thyroid gland. Symptoms include protrusion of the eyeballs, rapid heart rate, high blood pressure, accelerated metabolism and weight loss. *See also* HYPOTHYROIDISM

hyperventilation Rapid breathing that is not brought about by physical exertion. It reduces the carbon dioxide level in the blood, producing dizziness, tingling and tightness in the chest; it may cause loss of consciousness.

hypnosis Artificially induced, sleep-like state during which suggestions are readily obeyed. It was first described more than two centuries ago. It is physiologically different from sleep and closer to a state of relaxed wakefulness. There is increased suggestibility, a reduction of critical faculties, and effects on memory.

hypochondria (hypochondriasis) Neurotic condition characterized by an exaggerated concern with ill health. Hypochondriacs imagine they have serious diseases and often consult several doctors in the hope of a "cure".

hypodermic syringe Surgical instrument for injecting flu-

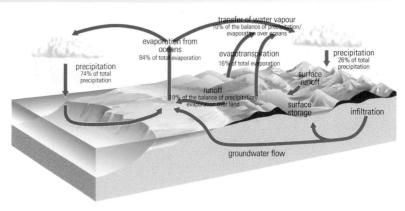

ids beneath the skin into a muscle or blood vessel. It comprises a graduated tube containing a piston plunger, connected to a hollow needle. *See also* INJECTION

hypoglycaemia Abnormally low level of sugar in the blood. It may result from fasting, excess INSULIN in the blood, or various metabolic and glandular diseases, notably DIABETES. Symptoms include dizziness, headache, sweating and mental confusion. See also HYPERGLYCAEMIA

hypotension Condition in which the blood pressure is abnormally low. It is commonly seen after heavy blood loss or excessive fluid loss due to prolonged vomiting or diarrhoea. It also occurs in many kinds of serious illness. Temporary hypotension may cause sweating, dizziness and fainting. *See also* HYPERTENSION

hypotenuse Side opposite the right angle in a right-angled triangle. It is the longest side of the triangle.

hypothalamus Region at the base of the brain containing centres that regulate body temperature, fluid balance, hunger, thirst and sexual activity. It is also involved in emotions, sleep and the integration of HORMONE and nervous activity.

hypothermia Fall in body temperature to below 35°C. Most at risk are newborns and the elderly. Insidious in onset, it can progress to coma and death. Hypothermia is sometimes induced during surgery to lower the body's oxygen demand. It occurs naturally in animals during HIBERNATION.

hypothesis Assumption or proposal made in order to account for or correlate known facts. Consequences inferred from a hypothesis are put to further inquiry, thus enabling the assumption to be tested in a particular situation. A set of hypotheses, logically connected and leading to the prediction of a wide range of naturally occurring events or states, is called a theory.

hypothyroidism Deficient functioning of the THYROID GLAND. Congenital hypothyroidism can lead to cretinism in children. In adults the condition is called myxoedema. More common in women, it causes physical and mental slowness, weight gain, sensitivity to cold and susceptibility to infection. It can be due to a defect of the gland or a lack of iodine in the diet. It is treated with the hormone thyroxine.

hyrax Small, rodent-like, herbivorous, hoofed mammal of Africa and sw Asia, with a squat, furry body and short ears, legs and tail. Rock hyraxes (genus *Procavia*) living in deserts and hills are larger than the solitary, nocturnal, treedwelling hyraxes (genus *Dendrohyrax*). Length: to 50cm (20in). Family Procaviidae.

hysterectomy Removal of the UTERUS, possibly with surrounding structures. It is performed to treat fibroids or cancer or to put an end to heavy menstrual bleeding.

hysteresis Phenomenon occurring in the magnetic and elastic behaviour of substances in which the strain is greater when the stress is decreasing than when it is increasing because of a lag in the effect. When the stress is removed, a residual strain remains.

hysteria In psychology, a group of disorders characterized by emotional instability, dissociation, hallucinations and the presence of physical symptoms of illness with no physiological cause. Hysteria is no longer used as a diagnostic term. Leading researchers in this field have included Jean Martin Charcot, Pierre Janet and Sigmund Freud.

▲ hydrological cycle The Earth's water balance is regulated by the constant recycling of water between the oceans, the atmosphere and the land. The movement of water between these three

"reservoirs" is called the hydrological cycle. The oceans play a vital role in this cycle: 74% of the total precipitation falls over the oceans and 84% of the total evaporation comes from the oceans. Water vapour in the atmosphere circulates around the planet, transporting energy as well as water itself. When the vapour cools it falls as rain or other precipitation.

I/i, the ninth letter of the alphabet, derived from the Semitic letter vod, meaning hand. It passed through Phoenician unchanged to the Greeks, who called it iota. In the Roman alphabet it was pronounced ee. In English i has two main sounds, short, as in bit, and long, as in wide. The long i has a different sound in some words (e.g. police and first) and is pronounced like a y in words such as union.

▲ ibis The scarlet ibis (Eudocimus ruber) is found in marsh regions of tropical South America. It grows to a height of some 60cm (24in). It has distinctive scarlet plumage with black wing tips.

▲ Ibsen Norwegian playwright Henrik Ibsen is often considered the father of modern drama. He was among the first dramatists to tackle contemporary social issues in his plays.

lasi City in NE Romania, 16km (10mi) from the frontier with Moldova. It was the capital of Moldavia from 1562–1861. Notable buildings include the 15th-century Church of St Nicholas. It remains an important commercial and administrative centre. Industries: textiles, machinery, pharmaceuticals, food products. Pop. (1992) 342,994.

Ibadan City in sw Nigeria, c.145km (90mi) NNE of Lagos; capital of Oyo state. It was established in the 1830s as a Yoruba military base. Ibadan handles the regional cacao and cotton trades. Industries: plastics, cigarettes, brewing, chemicals, food processing. Pop. (1992 est.) 1,295,000.

Ibañez, Vicente Blasco See BLASCO IBÁÑEZ, VICENTE **Iberian Peninsula** Part of sw Europe occupied by Spain and Portugal, separated from Africa by the Strait of Gibraltar and from the rest of Europe by the Pyrenees Mountains. The early Iberian inhabitants were colonized by Phoenicians and then Carthaginians until the 2nd century Bc when Rome dominated. Fourth-century Visigothic incursions were followed by the Moorish invasions from North Africa. By the 13th century, the Christian reconquest of the peninsula was virtually complete. Area: 596,384sq km (230,264sq mi).

ibex Any of several species of wild GOAT. The long, backward-curving horns grow up to 1.5m (5ft) long on the male, and both sexes have long, yellow-brown hair. Ibexes are renowned for their agility. Height: 85cm (3ft) at shoulder. Family Bovidae.

ibis Tropical lagoon and marsh wading bird with long, down-curved bill, long neck and lanky legs. Closely related to the SPOONBILL, it may be black, whitish or brightly coloured. It feeds on small animals, and nests in colonies. Length: 60–90cm (2–3ft). Subfamily: Threskiornithidae.

Ibiza Island of Spain, 130km (80mi) off the E coast, in the w Mediterranean; part of the Balearic group. The mild climate and beautiful scenery have made Ibiza a major tourist resort. Other activities: fishing, salt mining, cultivating figs and olives. Area: 572sq km (221sq mi). Pop. (1981) 60,937.

Ibn Battutah (1304–68) Arab traveller and writer. Born in Tangier, Morocco, he began his adventures in 1325 with a pilgrimage to Mecca by way of Egypt and Syria. Travel was to occupy the next 30 years of his life, with visits to Africa, Asia and Europe. He finally returned to Morocco in 1349.

Ibsen, Henrik Johan (1828–1906) Norwegian playwright. Ibsen's first published play was *Catilina* (1850), but he first gained international attention for the poetic drama *Peer Gynt* (1867). The NATURALISM of his presentation of social issues in tragedies such as *A Doll's House* (1879), *Ghosts* (1881), *An Enemy of the People* (1882) and *Hedda Gabler* (1890) earned him a controversial reputation. His later works, such as *The Master Builder* (1892), are more symbolic.

Icarus In Greek mythology, the son of DAEDALUS, architect of the LABYRINTH for MINOS of Crete. Daedalus made wings of feathers and wax in order to escape to the mainland, and was successful. Icarus, however, flew too near the Sun, which melted his wings, and he fell into the sea and drowned.

ice Water frozen to 0°C (32°F) or below, when it forms complex six-sided crystals. It is less dense than water and floats. When water vapour condenses below freezing point, ice crystals are formed. Clusters of crystals form snowflakes.

Ice Ages Periods in the Earth's history when ice sheets and GLACIERS advance to cover areas previously not affected by ice. There is evidence of at least six ice ages having occurred throughout the Earth's history, the earliest dating back to 2,300 million years ago. The best known is the most recent ice age, which began about 2 million years ago and lasted until the retreat of the ice to its present extent some 10,000 years ago. The present time may be a warmer period known as an interglacial. The last ice age produced many of the landforms seen in northern continents and affected sea level on a global scale. iceberg Large drifting piece of ice, broken off from a GLAC-IER or polar ice cap. In the Northern Hemisphere the main source of icebergs is the sw coast of Greenland. In the south, the glacial flow from Antarctica releases huge tabular icebergs. Icebergs can be dangerous to shipping, since only a small portion is visible above the surface of the water.

ice-cap Small ice-sheet, often in the shape of a flattened dome, which spreads over the mountains and valleys of polar

islands. The floating ice fields surrounding the North Pole are sometimes incorrectly called an ice-cap.

ice hockey Fast-action sport on an oval ice rink in which two teams of six players wearing ice skates (and protective clothing) use special hockey sticks to try to propel a vulcanized rubber disc ("puck") into the opponents' goal. The rink is usually 61m (200ft) long by 26m (85ft) wide and surrounded by walls c.1.2m (4ft) high. It is evenly divided into three zones - attacking, neutral and defending - each 18.3m (60ft) long. The goals are within the playing area, 3-4m (10-15ft) from each back line. Regulation games consist of three 20minute periods of actual timed play. Substitutions are allowed at any time and the game is controlled by a referee and two linesmen. A penalized player may be banished to the penalty box for two or more minutes, and the team remains a player short unless the opponents score. Popular in Canada and the USA, Scandinavia, Britain, and central and eastern Europe, it has been included in the winter Olympics since 1920, and there are world and European championships.

Iceland Small Scandinavian republic in the North Atlantic Ocean, N Europe; the capital is REYKJAVÍK. Land and climate Iceland sits astride the Mid-Atlantic Ridge, which is slowly widening as the ocean is stretched apart by continental drift. Molten lava wells up to fill the gap in the centre of Iceland. Iceland has around 200 volcanoes and eruptions are frequent. Geysers and hot springs are common features. Ice-caps and glaciers cover c.12% of the land; the largest is Vatnajökull in the SE. The only habitable regions are the coastal lowlands. Vegetation is sparse or non-existent on 75% of the land. Treeless grassland or bogs cover some areas. Deep fjords fringe the coast. Economy Iceland has few resources besides its fishing grounds. Fishing and fish processing are major industries, accounting for 80% of Iceland's exports. Barely 1% of the land is used to grow crops, and 23% is used for grazing sheep and cattle. Iceland is self-sufficient in meat and dairy products. Vegetables and fruits are grown in greenhouses. Manufacturing is important. Products: aluminium, cement, electrical equipment and fertilizers. Geothermal power is an important energy source and heats Reykjavík. Overfishing is a major economic problem. History and politics Norwegian Vikings colonized Iceland in AD 874, and in 930 the settlers founded the world's oldest parliament (Althing). Iceland united with Norway in 1262, and when Norway united with Denmark in 1380, Iceland came under Danish rule. During the colonial period Iceland lost much of its population due to migration, disease and natural disaster. In 1918 Iceland became a selfgoverning kingdom, united with Denmark. During World War 2 Iceland escaped German occupation, largely due to the presence of US forces. In 1944 a referendum decisively voted to sever links with Denmark, and Iceland became a fully independent republic. In 1946 it joined the North Atlantic Treaty Organization (NATO). The USA maintained military bases on Iceland. In 1970 Iceland joined the European Free Trade Association. The extension of Iceland's fishing limits in 1958 and 1972 precipitated the "Cod War" with the United Kingdom. In 1977 the UK agreed not to fish within Iceland's 370km (200 nautical mi) fishing limits. The continuing US military presence remains a political issue. Vigdis Finnbogadottir has been president since 1980. In 1995 David Oddson was re-elected prime minister, heading a centre right coalition. Icelandic Official language of Iceland, spoken by virtually all of the island's 268,000 inhabitants. It belongs to the Germanic family of Indo-European languages. It is descended from Old Norse, which was taken to Iceland by Norwegian Vikings in the 9th and 10th centuries AD. By the time the earliest works of Icelandic were written, many dialectal characteristics had arisen to distinguish it from Norwegian. Icelandic has undergone little linguistic change since the 12th century apart from pronunciation, which has altered greatly. The language has three grammatical genders, a system of noun declensions involving case forms, and complex verb conjugations.

Icelandic literature Early Icelandic literature emerged in the 13th century from the oral tradition of Eadic and skaldic poetry, both of which were based on ancient Icelandic mythology. Other early writings (14th–16th centuries)

include the sagas of Norse monarchs, translations of foreign romances and religious works. From the 14th-19th centuries the rímur, a narrative verse poem, was popular. The 19th century was probably the most important period in the development of Icelandic literature, with the rise of Icelandic realism late in the period. Important 20th-century writers include Gunnar Gunnarsson (1889-1975) and Halldór LAXNESS.

Iceni Ancient British tribe that occupied the area now known as Norfolk and Suffolk. The territory had been ruled by Prasutagus, a client-king, but on his death (AD 60) the Romans attempted to annex it. This led to a widespread revolt led by Prasutagus' queen, BOADICEA. The Iceni sacked Colchester, London and St Albans before they were crushed by the Roman governor, Suetonius Paulinus.

ice skating Winter leisure activity and all-year-round indoor competitive sport in which participants use steel skates to glide on ice. The three disciplines of competition ice skating are solo skating, pairs skating and (pairs) ice dancing. Solo and pairs skating comprise compulsory figure-skating, a short programme of compulsory elements, and free skating. The ice dancing competition is basically the same but based on set styles of dancing. Speed-skating has two disciplines: international-track and short-track. In international-track speed-skating, competitors generally enter four races over different distances and aggregate times are calculated for individual placings. Short-track speed-skaters race either as individuals or in relay teams, or in pursuit races in which two start on opposite sides of the track and race against each other and the clock for a maximum 10 laps of the track.

I Ching See Book of Changes

ichneumon fly Parasitic insect that attacks other insects and spiders. Found worldwide, they are characterized by an ovipositor that is often longer than the body. They are usually 1cm (0.4in) long. Family Ichneumonidae.

icon Type of religious painting or sculpture, often of Christ, the Virgin and Child or individual saints. The term is particularly used of Byzantine pictures and later Russian imitations. Icons were being produced as early as the 5th century; they have been used as an aid to prayer since the 6th century.

iconography Study and interpretation of themes and symbols in the figurative arts. In the 18th century the term referred to the classification of ancient monuments by motifs and subjects, but by the 19th it was more specifically concerned with symbolism in Christian art. Modern iconographers also study secular art and that of religions other than Christianity.

id In psychoanalytic theory, the deepest level of the personality. It includes primitive drives (hunger, anger, sex) demanding instant gratification. Even after the EGO and the SUPEREGO develop and limit these instinctual impulses, the id is a source of motivation and often of unconscious conflicts.

Idaho State in NW USA, on the border with Canada; the capital and largest city is BOISE. Idaho remained unexplored until 1805. The discovery of gold in 1860 brought many immigrants, although the Native-American population was not subdued until 1877. The state was admitted to the Union in 1890 and soon began to develop its resources. The terrain is dominated by the Rocky Mountains and is drained chiefly by the Snake River, whose waters are used to generate hydroelectricity and for irrigation. The principal crops are potatoes, hay, wheat and sugar beet, and cattle are reared. Silver, lead, antimony and zinc are mined. Industries: food processing, timber. Area: 216,412sq km (83,557sq mi). Pop. (1993 est.) 1,099,096. ideal gas law Law relating pressure, temperature and volume of an ideal (perfect) gas: pV = N k T, where N is the number of molecules of the gas and k is a constant of proportionality. This law implies that at constant temperature (T), the product of pressure and volume (pV) is constant (BOYLE'S LAW); and at constant pressure, the volume is proportional to the temperature (CHARLES' LAW).

idealism Philosophical doctrine that assigns metaphysical priority to the mental over the material. It denies the claim within REALISM that material things exist independently of the mind. Idealism in the West dates from the teachings of PLATO. The term is also applied to artistic pursuits to denote a rendering of something "as it ought to be" rather than as it actually is.

ARCTIC OCEAN Arctic Circle Straumnes Siglufjördu Isafjördur Breidafjördur AND Seydisfjördur Reykjavik Keflavik All MAP SCALE

AREA: 103,000 sq km (39,768 sq mi) POPULATION: 260,000

ICELAND

CAPITAL (POPULATION): Revkiavík (101.824) **GOVERNMENT:** Multiparty republic ETHNIC GROUPS: Icelandic 94%, Danish 1% LANGUAGES: Icelandic

ATLANTIC OCEAN 20°W

(official) **RELIGIONS:** Christianity (Evangelical Lutheran 92%, other Lutheran 3%, Roman Catholic 1%) currency: Króna = 100

aurar

ideology Collection of beliefs or ideas reflecting the interests and aspirations of a country or its political system. In the 20th century the term has been applied to various political theories, including FASCISM, MARXISM and COMMUNISM. Ides Day in the Roman Republican calendar. They fell on the

eighth day after the nones of each month, that is on the 15th of March, May, July and October and on the 13th of the other months. Julius CAESAR was assassinated on the Ides of March. Igbo (Ibo) Kwa-speaking people of E NIGERIA. Originally, their patrilineal society consisted of politically and socially autonomous village units, but in the 20th century political unity developed in reaction to British colonial rule. In 1967 the Igbo attempted to secede from Nigeria as the Republic of BIAFRA.

Ignatius of Antioch, Saint (active 1st century AD) Bishop of Antioch, and influential theologian of the early Christian Church. On his way to Rome, where he died for his faith, he wrote his seven Epistles, which are valuable sources for an assessment of the doctrine of the early Church.

Ignatius of Loyola, Saint (1491–1556) Spanish soldier, churchman and founder of the JESUITS. In 1534, with FRANCIS XAVIER and other young men, he made vows of poverty, chastity and obedience. He was ordained to the priesthood in 1537 and moved to Rome where, in 1540, Pope Paul III formally approved his request to found a religious order: the Society of Jesus, or Jesuits. He spent the rest of his life in Rome supervising the rapid growth of the order, which was to become the leading force in the Counter Reformation.

igneous rock Broad class of rocks produced by the cooling and solidifying of the molten magmas deep within the Earth. Intrusive rocks, such as GRANITE, are those formed beneath the Earth's surface by the gradual cooling of molten material; extrusive rocks, such as BASALT, are formed by the rapid cooling of molten material upon the Earth's surface.

iguana Any of numerous species of terrestrial, arboreal (treedwelling), burrowing or aquatic LIZARDS that live in tropical America and the Galápagos Islands. The common iguana (Iguana iguana) is greenish-brown, with a serrated dewlap and a crest along its back. Length: to 2m (6.5ft). Family Iguanidae. ljsselmeer Large lake in the NW Netherlands. It was formed in 1932 by the completion of a dyke that divided the Zuider Zee into the saline Wadden Zee and the freshwater Ijsselmeer. Length of dyke: 32km (20mi).

ileum Major part of the small INTESTINE, c.4m (13ft) long. Its inner wall is lined with finger-like villi, which increase the area for the absorption of nutrients.

lliescu, lon (1930-) Romanian statesman, president (1990-96). He became propaganda secretary in Nicolae

IDAHO Statehood: 3 July 1890 Nickname: Gem state State bird:

Mountain bluebird State flower: Mock orange State tree:

Western white pine State motto:

It is forever

▲ iguana The common iguana (Iguana iguana) is one of the world's largest lizards, growing up to 2m (6.5ft) or more in length. It lives near rivers in tropical America. The young feed mainly on insects, whereas adults eat leaves and fruit.

CEAUŞESCU's government in 1971. He was banished to Timişoara for his opposition to Ceauşescu's growing personality cult and the "cultural revolution". Iliescu emerged to succeed Ceauşescu in the "Christmas Revolution" (1989). He was elected president in May 1990 and re-elected in 1992.

Illinois State in N central USA, on the E bank of the Mississippi River; the capital is Springfield. Illinois was explored first by the French in 1673. Ceded to the British in 1763, it was occupied by American troops during the American Revolution. Illinois became a state of the Union in 1818. The land is generally flat and is drained by many rivers flowing sw to the Mississippi. The state has fertile soil that supports crops such as hay, oats and barley; livestock farming is also important. Mineral deposits are found in the s. CHICAGO (the largest city) is a transport centre and port on Lake MICHIGAN. Area: 146,075sq km (56,400sq mi). Pop. (1993 est.) 11,697,336.

illiteracy Inability to read and write. The eradication of illiteracy is one aim of public and compulsory education around the world, and yet the problem remains huge. It is estimated that about one billion adults in the world (about 1 in 5 of the world's population) are unable to read.

illumination Coloured decorations serving to beautify manuscripts of religious books, the earliest dating from about the 5th century. The style ranges from decoration of initial letters and borders to miniatures and full-page illustrations. Glowing colours and the use of gold leaf are common features. Early medieval illuminations were produced by monks. During the Gothic period, illumination was used for both religious and secular book illustrations. Illumination was at its height during the 14th and 15th centuries when the International Gothic style was in use by such Flemish and French artists as the LIMBOURG brothers and Jean FOUQUET.

Illyria Historic region on the N and E shores of the Adriatic Sea, now mainly in Albania. The tribes of Illyria were conquered by the Romans after 168 BC, and the region was later divided into the provinces of Dalmatia and Pannonia. Several late Roman emperors were of Illyrian origin.

image, optical Representation of an object produced by an optical instrument. A real image can be projected onto a screen and recorded in a photograph; a virtual image, such as that produced by a plane mirror, cannot. *See also* LENS

imaginary number In mathematics, square roots of negative quantities. The simplest, $\sqrt{-1}$, is usually represented by i. Imaginary numbers are necessary for the solution of many quadratic equations, the roots of which can be expressed only as COMPLEX NUMBERS, which are composed of a real part and an imaginary part.

imagism Movement in poetry that flourished in the USA and England from 1912 to 1917. The imagists believed that poetry should use the language and flexible rhythms of common speech. Amy Lowell, their principal exponent, produced three anthologies called *Some Imagist Poets* (1915–17). Among its most distinguished contributors was Ezra Pound. imago Adult, reproductive stage of an insect that has undergone full METAMORPHOSIS. Imagos are the winged insects,

gone full METAMORPHOSIS. Imagos are the winged insects, such as butterflies and dragonflies, that emerge from PUPAS or develop from NYMPHS.

Imam Leader of a Muslim community invested with various forms of spiritual or temporal authority. It may describe a man who leads public prayers at a mosque. The word *Imam* is also a title of honour for Islamic theologians and religious leaders, such as the AGA KHAN. Finally, it is the title borne by any of a succession of spiritual guides and intercessors for the SHITTE Muslims.

IMF Abbreviation of International Monetary Fund

Immaculate Conception Roman Catholic belief that the Blessed Virgin Mary was free of all Original Sin from the moment of her conception. It was defined as a dogma by Pope Pius IX in 1854.

immune system System by which the body defends itself against disease. It involves many kinds of LEUCOCYTES in the blood, lymph and bone marrow. Some of the cells make ANTIBODIES against invading microbes, or neutralize TOXINS produced by PATHOGENS, while others (PHAGOCYTES) attack and digest invaders. See also MACROPHAGE

immunity Resistance to attack by disease-causing microorganisms. It can be acquired naturally, as from an infection that stimulates the body to produce protective ANTIBODIES. Alternatively, it can be conferred by IMMUNIZATION.

immunization Practice of conferring IMMUNITY against disease by artificial means. Passive immunity may be conferred by the injection of an antiserum containing antibodies. Active immunity involves vaccination with dead or attenuated (weakened) organisms to stimulate production of specific antibodies and so provide lasting immunity.

immunoglobulin Protein found in the bloodstream that plays a role in the body's immune defences. Immunoglobulins act as ANTIBODIES for specific ANTIGENS. They can be obtained from donor plasma and injected into people at risk of particular diseases.

immunology Study of IMMUNITY and ALLERGY. It is concerned with preventing disease by vaccination – active immunity; or by injections of antibodies – passive immunity. Allergic reactions result from an overactive response to harmless foreign substances rather than to infective organisms.

immunosuppressive drug Any drug that suppresses the body's immune responses to infection or "foreign" tissue. Such drugs are used to prevent rejection of transplanted organs and to treat autoimmune disease and some cancers.

impala (or pala) Long-legged, medium-sized African antelope. Long, lyrate horns are found only on the males. Both sexes have sleek, glossy brown fur with black markings on the rump. Length: to 1.5m (5ft); height: to 1m (3.3ft) at the shoulder. Family Bovidae; species *Aepyceros melampus*.

impatiens (Busy Lizzies) Genus of 450 species of succulent annual plants, mostly native to the tropics of Asia and Africa. They have white, red or yellow flowers and seedpods which, when ripe, pop and scatter their seeds. Some species are known as touch-me-not. Family Balsaminaceae.

impeachment Prosecution of a public official by the legislature of a state. In Britain it is conducted by the House of Commons with the House of Lords as judge, and in the USA by the House of Representatives with the Senate as judge.

imperialism Domination of one people or state by another. Imperialism can be economic, cultural, political or religious. With the age of exploration came the setting up, from the 16th century, of trading empires by major European powers such as the British, Spanish, French, Portuguese and Dutch. They penetrated Africa, Asia and North America, their colonies serving as a source of raw materials and providing a market for manufactured goods. With few exceptions, imperialism imposed alien cultures on native societies. In the 20th century, although Japan, Germany and Italy exercised imperialist ambitions for a time, all but the smallest former colonies gained independence. imperial system System of WEIGHTS AND MEASURES based on the foot, pound and the second. It has largely been replaced by the METRIC SYSTEM of SI UNITS

impetigo Contagious skin condition caused by streptococcal or staphylococcal infection. It causes multiple, spreading lesions with yellowish-brown crusts and primarily affects the face, hands and feet. It is most common in children.

impotence Inability to perform sexual intercourse. It may be temporary or permanent, brought about by illness, injury, the effects of certain drugs, fatigue or psychological factors.

impressionism Major French anti-academic art movement of the late 19th century, gaining its name from a painting by MONET entitled Impression, Sunrise (1874). In the words of Monet, the movement's leading painter, impressionists aimed to create "a spontaneous work rather than a calculated one". In the 1860s, Monet, RENOIR, Sisley and Frédéric Bazille formed a close-knit group exploring the possibilities of painting outdoors and closely analysing and interpreting the effects of light on nature. The first impressionist exhibition took place in 1874. Although not accepted at first, impressionism became widely influential from the late 1880s and spread throughout Europe. DEGAS and PISSARRO were prominent impressionists and CÉZANNE exhibited with them twice. MANET was influenced by, and in turn influenced, impressionism. Other impressionists include Berthe Morisot and Mary Cassatt. Rodin has been called impressionist because of his interest in the effects of

ILLINOIS

Statehood :

3 December 1818

Nickname :

Prairie state

State bird :

Cardinal

State flower:

Native violet State tree :

Oak

State motto :

State sovereignty, national union

light on his sculpture. In music, the term impressionism refers to a period lasting from roughly 1890 to 1930 and is usually applied to the work of Claude DEBUSSY. Music composed in this style tends to be subtle and atmospheric rather than overtly emotional. Many composers were influenced by Debussy's style and methods, including Maurice Ravel, Frederick Delius and Manuel de Falla. See also ROMANTICISM

imprinting Form of learning that occurs within a critical period in very young animals. A complex relationship develops between the newborn infant and the first animate object it encounters; this is usually a parent. The future emotional development of the infant depends upon this relationship. Imprinting in birds has been studied by Konrad LORENZ, who believed that it is an irreversible process.

inbreeding Mating of two closely blood-related organisms. It is the opposite of outbreeding and over successive generations causes much less variation in GENOTYPE and PHENOTYPE than is normal in a wild population. A form of genetic engineering, it can be used to improve breeds in domestic plants and animals. In humans, it can have harmful results, such as the persistence of HAEMOPHILIA in some European royal families.

Inca South American ruler and people who migrated from the Peruvian highlands into the Cuzco area in about AD 1250. The Incas expanded and consolidated their empire slowly and steadily until the reigns of Pachacuti (c.1438-71) and his son Topa (c.1471–93), when Inca dominance extended over most of the continent w of the Andes. Though highly organized on bureaucratic lines, the Inca empire collapsed when the Spanish invasion, led by Pizarro in 1532, coincided with a civil war.

incandescence Emission of light by a substance at a high temperature. An incandescent object is never at a temperature below about 400°C (750°F). An object such as a fluorescent lamp can emit bright light without being incandescent.

incarnation Act of appearing in or assuming bodily form, especially the assumption of human form by a divine being. All orthodox Christians believe that the eternal Son of God, the creator and sole deity, took on bodily form and lived on Earth as a mortal human being, Jesus of Nazareth. The doctrine of the Incarnation was confirmed amid controversy by the first general council of the Church at Nicaea in 325. Heresies emphasizing only the godlike or manlike aspects of Christ were condemned by the Council of Chalcedon (451), which affirmed that Christ is "truly God and truly man".

incendiary bomb Bomb designed to burn, rather than destroy by explosion, its target. Incendiary bombs were first used in World War 1. In World War 2 they had phosphorus or thermite as the charge. They were also widely used by the USA in the VIETNAM WAR, in the form of napalm.

incest Sexual relations within a family or kinship group, the taboo on which varies between societies. In many countries incest is a crime that carries a prison sentence. It is likely that the rules of many primitive communities prohibited marriage between close relatives, long before the possible adverse genetic effects of such relationships were realized.

inch Imperial unit of measurement equal to 2.54cm. There are 12 inches to 1 foot.

Inchon City and port on the Yellow Sea, NW South Korea. It was first opened for foreign trade in the 1880s. It was the scene of a Russo-Japanese naval battle in 1904, and US forces landed there at the beginning of the Korean War in 1950. It is one of South Korea's major commercial centres. Industries: iron and steel, textiles and chemicals. Pop. (1990) 1,818,293.

income tax Federal or state annual assessment of tax on income, profits and financial gains of any type. It is a direct tax on money earned or acquired, as distinct from a tax levied on goods or services. Tax rates are usually graduated, increasing as levels of income climb from one bracket to another. Governments can use tax rates as a means of regulating consumer demand: if tax rates rise, consumers have less disposable income and thus less money to buy goods. Income tax can also be used to redistribute wealth, using funds raised from income tax to fund social programmes. In Britain, income tax is administered by the Board of Inland Revenue and in the USA by the Internal Revenue Service.

incubation In biology, process of maintaining stable, warm

conditions to ensure that eggs develop and hatch. Incubation is carried out naturally by birds, and by some reptiles. It is accomplished by sitting on the eggs, by making use of volcanic or solar heat or the warmth of decaying vegetation, or by covering the eggs with an insulating layer of soil or sand. incubation period In medicine, time-lag between becoming infected with a disease and the appearance of the first symptoms. In many infectious diseases, the incubation period is quite short - anything from a few hours to a few days -

although it may also be very variable. Independence Day See FOURTH OF JULY

Index Abbreviation for Index librorum prohibitorum (Index of Prohibited Books), a list of books banned by the Roman Catholic Church as being dangerous to the faith or morals of its members. It was first issued in 1559 and revised at intervals until it was finally discontinued in 1966.

India Republic in s Asia. See country feature, page 338-39 Indiana State in N central USA, s of Lake Michigan; the capital is INDIANAPOLIS. Indiana was explored by the French in the early 18th century and ceded to the British in 1763. It passed to the USA after the American Revolution. The Native American population was not subdued until 1811. The state remained a rural area until late 19th-century industrialization. Access to Lake Michigan and to the Ohio River in the s ensures efficient distribution of the state's agricultural and manufacturing products. The area is a rich farming region. The development of heavy industry in the NW has made Indiana a leading producer of machinery. Industries: grain, soya beans, livestock, coal, limestone, steel, electrical machinery, motor vehicles. Area: 93,993sq km (36,291sq mi). Pop. (1993 est.) 5,713,000.

Indianapolis Capital of Indiana, USA, at the centre of the state, on the White River. Built on a specially selected site, it became the state capital in 1825. It is home to the Motor Speedway, where the Indianapolis 500 motor race takes place. The city is the major cereal and livestock market in a fertile agricultural area. Industries: electronic equipment, vehicle parts, pharmaceuticals, meat packing. Pop. (1990) 741,952.

Indian art and architecture Earliest examples of Indian art date from the ancient civilization of the Indus Valley (c.2300-1750 BC). Excavations at Harappa (Punjab) and Mohenjo-daro (Sind) show fortified cities with a variety of buildings and sophisticated sanitation. Art in the MAURYA EMPIRE (321-185 BC) was intensely Buddhist in motivation. It can be seen in the chaitya (shrines) and vihara (monastic halls hollowed out of solid rock) at Ajanta. The GUPTA DYNASTY (AD 320-550) was the golden age of Buddhist art. The Buddhist temple, with a porch and cella (main sanctuary), originated at this time. From the 6th century AD, a typical Hindu temple plan developed. In s India in the 7th and 8th centuries AD, a Dravidian style of Hindu temple emerged. ISLAMIC ART AND ARCHITECTURE were introduced after the Muslim conquest (1192). Between the 16th and 18th centuries, during the MOGUL EMPIRE, an Indo-Islamic style evolved, influenced by Persian prototypes. The TAJ MAHAL stands as the most perfect example of Mogul architecture. Persian influence was initially strong in drawing, but by the late 16th century Indian taste was emerging in bright colouring and in detailed backgrounds. Under British rule, most Indian art declined to mere craftsmanship until the early 20th century. Major modern painters include Rabindranath TAGORE, Jamini Roy, Amrita Shir Gil and Francis Souza.

Indian Mutiny (1857-58) Indian rebellion against the British originating among Indian troops (sepoys) in the Bengal army. It is known in India as the first war of independence. The immediate cause was the introduction of cartridges lubricated with the fat of cows and pigs, a practice offensive to both Hindus and Muslims. A more general cause was resentment at modernization and Westernization. Delhi was captured, and atrocities were perpetrated by both sides. The revolt resulted in the British government taking over control of India from the EAST INDIA COMPANY in 1858.

Indian National Congress See Congress Party

Indian Ocean Third-largest ocean in the world, bounded by Asia (N), Antarctica (S), Africa (W) and Southeast Asia and Australia (E). Known in ancient times as the Erythraean Sea,

INDIANA Statehood:

11 December 1816

Nickname:

Hoosier state

State bird :

Cardinal

State flower:

Peony

State tree: Tulip tree

State motto: Crossroads of America

India's flag developed during the struggle for freedom against British rule. The orange symbolizes the Hindus, who form the majority of the population. The green symbolizes the Muslims, and the white peace. The blue Buddhist wheel symbol was added at independence in 1947.

The Republic of India is the world's seventh-largest country, but the second most populous (after China). India can be divided into three geographical regions: N India is dominated by the HIMALAYAS. The rivers BRAHMAPUTRA, INDUS and GANGES rise in the Himalayas and form the fertile, alluvial central plains. A densely populated area, the plains include the capital, NEW DELHI. CALCUTTA lies in the Ganges delta. In the w is the THAR DESERT and India's largest state, RAJASTHAN. Southern India consists of the large DECCAN plateau, bordered by the Western and Eastern GHATS. India's largest city is BOMBAY. See individual state and city articles

CLIMATE

India has three main seasons: a cool season, from October to February; a hot season, between March and June; and the monsoon season, from mid-June to September. There are wide regional variations in temperature and rainfall.

VEGETATION

The KARAKORAM RANGE in the far N has permanently snow-covered peaks. The E Ganges delta has mangrove swamps. Between the gulfs of Kutch and Cambay are the deciduous forest habitats of the last of India's wild lions. The Ghats are clad in heavy rainforest.

AREA: 3,287,590sq km (1,269,338sq mi) POPULATION: 879,548,000

CAPITAL (POPULATION): New Delhi (301,800) GOVERNMENT: Multiparty federal republic ETHNIC GROUPS: Indo-Aryan 72%, Dravidian

(Aboriginal) 25%, Other 3%

LANGUAGES: Hindi 30% and English (both official), Telugu 8%, Bengali 8%, Marati 8%, Urdu 5%, and many others

RELIGIONS: Hinduism 83%, Islam (Sunni) 11%, Christianity 2%, Sikhism 2%, Buddhism 1% CURRENCY: Rupee = 100 paisa

HISTORY

One of the world's oldest civilizations flourished in the lower Indus valley, *c.*2500–1700 BC. In *c.*1500 BC, Aryans conquered India and established an early form of HINDUISM. In 327–25 BC, Alexander the Great conquered part of NW India. CHANDRAGUPTA founded the MAURYA EMPIRE. His grandson, ASHOKA, unified India and established BUDDHISM in the 3rd century BC. The CHOLA established a s trading kingdom in the 2nd century AD. In the 4th and 5th centuries AD, N India flourished under the

INDIA

GUPTA DYNASTY. The 7th century is seen as the classical period of India's history. In 1192 the DELHI Sultanate became India's first Muslim kingdom and dominated the region. In 1526 BABUR founded the MOGUL EMPIRE (1526–1857). In the 17th century India became a centre of ISLAMIC ART AND ARCHITECTURE under SHAH JAHAN (who built the TAJ MAHAL) and AURANGZEB.

In the 17th century, the MARATHA successfully resisted European imperial ambitions in the guise of the East India Company. In 1757 Robert Clive established the British Empire (1757–1947). Growing civil unrest culminated in the Indian Mutiny (1857–58). Reforms failed to dampen Indian nationalism, and the Congress Party was formed (1885). The Muslim League was founded (1906) to protect Muslim minority rights. Following World War 1, Mahatma Gandhi began his passive resistance campaigns. The Amritsar Massacre (1919)

intensified Indian nationalism. In August 1947 British India was partitioned into India and the Muslim state of PAKISTAN. The ensuing mass migration killed over 500,000 people. India became the world's largest democratic republic. Jawaharlal NEHRU of the Congress Party was India's first prime minister. Conflict began (1948) with Pakistan over the status of JAMMU AND KASHMIR. In 1965 Nehru's daughter, Indira GANDHI, became prime minister. In 1971 India provided military support to create an independent BANGLADESH. In 1974 India became the world's sixth nuclear power. In 1984, faced with demands for an independent Sikh state, troops stormed the Golden Temple in Amritsar. Indira Gandhi was murdered by her Sikh bodyguards (October 1984) and was succeeded by her son, Rajiv GANDHI. In 1984 India was devastated by the world's worst industrial accident, at BHOPAL. Rajiv Gandhi was assassinated by TAMILS during the 1990 elections.

POLITICS

In the period 1947–96, India was ruled by the Congress Party (I) for all but four years. In 1996 the United Front formed a coalition government, first under H.D. Deve Gowda (1996) and then under Kumar Gujral (1997–). The withdrawal of Congress (I)'s support for Gujral's government led to fresh elections in 1998.

ECONOMY

India has rapidly industrialized; manufacturing is its largest export sector. India is rich in mineral resources; it is the world's third-largest producer of bituminous coal. Agriculture employs 62% of the workforce, and food crops account for 75% of cultivated areas. India is the world's second-greatest producer of rice and third-largest producer of wheat. It is the world's largest exporter of tea. In 1991 India abandoned command economics and introduced free market reforms. Poverty and urban overcrowding are problems.

the Indian Ocean was the first to be extensively navigated. Branches of the ocean include the ARABIAN SEA, the Bay of BENGAL and the Andaman Sea. Its largest islands are MADA-GASCAR and SRI LANKA. The average depth is 4,000m (13,000ft) although there is a Mid-Oceanic Ridge, extending from Asia to Antarctica; several of its peaks emerge as islands. The deepest part is the Java Trench, reaching 7,725m (25,344ft). The climate of the nearby land masses is strongly influenced by the ocean's winds and currents. There are three wind belts: the monsoons, which pick up moisture from the ocean, bringing heavy rainfall to w India and Southeast Asia; the SE TRADE WINDS; and the prevailing westerly winds, bringing tropical storms. The currents are governed by these winds, the seasonal shift of the MONSOON dictating the flow of water N of the equator. Area: c.73,600,000sq km (28,400,000sq mi). Indians, American See Native Americans

Indian Territory Area set aside for Native Americans by the US government. The Indian Removal Act of 1830 gave the president authority to designate specific Western lands for settlement by Indians removed from their native lands. In 1834 the Indian Intercourse Act set aside Kansas, Nebraska, and Oklahoma N and E of the Red River as the Indian Territory. In 1854 Kansas and Nebraska were redesignated territo-

ry. In 1854 Kansas and Nebraska were redesignated territories open to white settlement. West Oklahoma was opened to white settlement in 1889. In 1907 the last of the Indian Territory was dissolved when Oklahoma became a state.

Indian theatre Classical and modern dramatic traditions of the Indian subcontinent, including Sanskrit, Kutiyattam and Kathakali. Sanskrit (Hindu) classical drama, the two great epics of which are the Mahabharata and the Ramayana, can be traced back as far as the 3rd century BC and survived into the 11th century AD, dying out probably as a result of Muslim disapproval. Sanskrit was followed by a more eclectic tradition that emphasized music, poetry and dance in its performance. This developed in tandem with the endemic Indian Folk Drama. Largely as a result of Western influence, modern drama appeared during the latter half of the 20th century. There is also a strong tradition of puppetry in Indian theatre.

India-Pakistan Wars Three conflicts between India and Pakistan after they became separate and independent states in 1947. The first (1947–49) arose from a dispute over Kashmir. Inconclusive fighting continued until January 1949, when the United Nations arranged a truce, leaving Kashmir partitioned. It remained a source of friction and was the chief cause of the second war (1965), when fighting began over another territorial dispute. Both sides invaded the other's territory, but military stalemate resulted in a cease-fire after a few weeks. The third Indo-Pakistan war arose out of the civil war between East and West Pakistan in 1971. India inter-

vened in support of East Pakistan (Bangladesh); (West) Pakistan suffered a decisive defeat.

indicator In chemistry, substance used to indicate acidity or alkalinity. It does this usually by a change of colour. Indicators, such as the dye LITMUS, can detect a change of PH, which measures a solution's acidity (litmus turns red) or alkalinity (turns blue). Universal indicator (liquid or paper) undergoes a spectral range of colour changes from pH 1 to 13.

indigestion See DYSPEPSIA

indium (symbol In) Silvery-white metallic element of group III of the PERIODIC TABLE. Its chief source is as a by-product of zinc ores. Malleable and ductile, indium is used in semiconductors and as a mirror surface. Properties: at.no. 49; r.a.m. 114.82; r.d. 7.31; m.p. 156.6°C (313.9°F); b.p. 2,080°C (3,776°F); most common isotope In¹¹⁵ (95.77%).

Indochina Peninsula of SE Asia, including BURMA, THAI-LAND, CAMBODIA, VIETNAM, West MALAYSIA and LAOS. The name refers more specifically to the former federation of states of Vietnam, Laos and Cambodia, associated with France within the French Union (1945-54). European penetration of the area began in the 16th century. By the 19th century France controlled Cochin China, Cambodia, Annam and Tonkin, which together formed the union of Indochina in 1887; Laos was added in 1893. By the end of World War 1 France had announced plans for a federation within the French Union. Cambodia and Laos accepted the federation, but fighting broke out between French troops and Annamese nationalists, who wanted independence for Annam, Tonkin and Cochin China as Vietnam. The war ended with the French defeat at DIEN BIEN PHU. French control of Indochina was officially ended by the Geneva Conference of 1954.

Indo-European languages Family of languages spoken throughout all of Europe and sw and s Asia, and used in all the areas of European colonial settlement, such as Australia and New Zealand, South Africa, Canada, the USA, and Latin America. The family consists of the following subgroups: the GERMANIC LANGUAGES, the CELTIC LANGUAGES and the Indo-Iranian (including Persian, Avestan, and the Indo-Aryan or Indic languages Sanskrit, Pali, and modern Hindi). Other languages and groups in the family are Armenian, Albanian, Greek, the Italic Languages (including Latin and its descendants, the ROMANCE LANGUAGES), the Baltic group (including Latvian and Lithuanian), and the Slavic group (including Old Church Slavonic, Russian, Polish, Czech, Serbian, Croatian, and others). About half the world's population speaks one or other of these Indo-European languages.

Indonesia Republic in the Malay archipelago, se Asia. See country feature, page 340

Indra In Vedic mythology, the ruler of heaven, great god of storms, thunder and lightning, worshipped as rain-maker and

bringer of fertility. In the creation myth, he slew Vritra, dragon of drought, to produce the Sun and water on the Earth.

inductance Property of an electric circuit or component that produces an ELECTROMOTIVE FORCE (EMF) following a change in the current. The SI unit of inductance is the henry. Self-inductance (symbol L) occurs when the current flows through the circuit or component, and mutual inductance (symbol M) when current flows through two circuits or components that are linked magnetically. See also ELECTROMAG-NETIC INDUCTION; INDUCTION

induction In medicine, initiation of LABOUR before it starts of its own accord. It involves perforating the fetal membranes and administering the hormone oxytocin to stimulate contractions of the UTERUS.

induction In physics, process by which an ELECTROMOTIVE FORCE (EMF) is created in a circuit by a change in the magnetic field around the circuit. The magnitude of the current is proportional to the rate of change of magnetic flux. In a transformer, the alternating current in the primary coil creates a changing magnetic field that induces a current in the secondary coil. See also ELECTROMAGNETIC INDUCTION; FARA-DAY'S LAWS; INDUCTANCE

indulgence In Roman Catholic theology, remission by the Church of temporal punishment for sin. An indulgence, once granted, obviates the need for the sinner to do penance, although it does not necessarily remove guilt, and may itself be only a partial rather than a full (plenary) indulgence. Previously available from bishops, indulgences are today granted only by the pope. Abuses connected with the sale of indulgences in the later Middle Ages were among the principal causes of the REFORMATION.

Indus River of s Asia. It rises in the Kailas mountain range in Tibet and flows wnw through the Jammu and Kashmir region of India, then sw through Pakistan and into the Arabian Sea. Semi-navigable along its shallow lower part, the river is used chiefly for irrigation and hydroelectric power. In its lower valley there are traces of an urban civilization that flourished in the 3rd millennium BC. Length: c.3,060km (1,900mi).

Industrial Revolution Term applied to the profound economic changes that took place in w Europe and the USA in the late 18th and 19th centuries. It was preceded by a rapid increase in population, which was both a cause and result of the AGRICULTURAL REVOLUTION. The STEAM ENGINE was the main driving force, leading to huge advances in manufactur-

INDONESIA

This flag was adopted in 1945, when Indonesia proclaimed itself independent from the Netherlands. The colours, which date back to the Middle Ages, were adopted in the 1920s by political groups in their struggle against Dutch rule.

he southeast Asian republic of Indonesia is the world's most populous Muslim nation and fourth most populous nation on Earth. It is also the world's largest archipelago, with 13,677 islands (less than 6,000 of which are inhabited). Three-quarters of its area and population is included in five main islands: the Greater Sunda Islands of SUMATRA, JAVA, SULAWESI and KALI-MANTAN; and IRIAN JAYA (w New Guinea). Over 50% of the total population live on Java, home of Indonesia's capital, JAKARTA. The Lesser Sunda Islands include BALI, TIMOR and Lombok. Indonesia is mountainous and prone to earthquakes. It has more active volcanoes (over

CLIMATE

Indonesia lies on the equator and is hot and humid throughout the year. Rainfall is generally heavy; only the Sunda Islands have a dry season.

100) than any other country.

VEGETATION

Mangrove swamps line the coast. Tropical rainforests remain the major vegetation on less populated islands. Much of the larger islands have been cleared by logging and shifting cultivation.

HISTORY AND POLITICS

In the 7th and 8th centuries, the Indian GUPTA DYNASTY was the dominant force, and was responsible for the introduction of Buddhism and the building of BOROBUDUR, Java. In the 13th century Buddhism was gradually replaced by Hinduism. By the end of the 16th century Islam had become the principal religion. In 1511 the Portuguese seized MALACCA. By 1610 the Dutch had acquired all of Portugal's holdings, except East Timor. During the 18th century, the Dutch EAST INDIA COMPANY controlled the region. In 1799 Indonesia became a Dutch colony. In 1883 KRAKATOA erupted, claiming c.50,000 lives. In AREA: 1,904,570sq km (735,354sq mi) POPULATION: 191,170,000

CAPITAL (POPULATION): Jakarta (7,885,519) GOVERNMENT: Multiparty republic ETHNIC GROUPS: Javanese 39%, Sundanese

16%, Indonesian (Malay) 12%, Madurese 4%, more than 300 others

LANGUAGES: Bahasa Indonesian (official) RELIGIONS: Islam 87%, Christianity 10% (Roman Catholic 6%), Hinduism 2%, Buddhism 1%

currency: Indonesian rupiah = 100 sen

1927 SUKARNO formed the Indonesian Nationalist Party (PNI). During World War 2, the Japanese expelled the Dutch (1942) and occupied Indonesia. In August 1945 Sukarno proclaimed its independence; the Dutch forcibly resisted. In November 1949 Indonesia became a republic, with Sukarno as its first president. During the 1950s economic hardship and secessionist demands were met with authoritarian measures. In 1962 paratroopers seized Netherlands New Guinea and, in 1969, Netherlands New Guinea formally became part of Indonesia as Irian Jaya. In 1966 General SUHARTO assumed control. The Communist Party was banned and alleged communists executed. In escalating violence up to 750,000 people were killed. In 1968 Suharto was elected president. In 1975 Indonesian forces seized East Timor, and declared it a province of Indonesia. Resistance to Indonesian rule has killed over 200,000 East Timorese. The UN does not recognize the annexation. In 1997 Indonesia suffered from dangerously high levels of smog caused by forest fires exacerbated by drought.

ECONOMY

Indonesia is a developing country, whose economic problems led, in late 1997, to economic collapse, threatening to destabilize Suharto's government. Agriculture employs 56% of the workforce. Oil is its most valuable resource. Indonesia is the world's second-largest exporter of natural gas and second-largest exporter of rubber. Coffee and rice production are important.

ing and transport. The Industrial Revolution produced huge social changes, in particular the creation of an industrial working class, and introduced rapid economic change, which has been maintained in varying forms ever since.

industrial tribunal Form of judicial panel established to resolve disputes between employers and employees over terms and conditions of employment as laid down by industrial law. Both employers and employees may be represented before the panel by legal counsel or, in the case of employees, by a trade union official.

Industrial Workers of the World (IWW) US labor union; also known as the "Wobblies". The IWW was formed in Chicago by Daniel DeLeon, Eugene V. Debs and William D. Haywood in 1905. It was designed to combine both skilled and unskilled labour in one organization. The group, which advocated a socialist society and employed militant tactics, supported strikes by textile workers (1912) and silk weavers (1919) in E USA. The IWW split up after World War 1.

industry In economic terms, all businesses that produce goods or services. The term is also used to define a group of firms producing a similar kind of product, such as the computer industry. Industries are often classified into three groups: **manufacturing** industries process commodities; **agriculture** provides food; and **service** industries provide largely intangible services, such as entertainment.

inequality Mathematical statement that one expression is less, or greater, than another. The symbols >, for "is greater than," and <, for "is less than," are used. The symbols ≥ and ≤ are also used, for "greater than or equal to" or "less than or equal to" respectively.

inert gases See NOBLE GAS

inertia Property possessed by all matter that is a measure of the way an object resists changes to its state of motion. Isaac NEWTON formulated the first law of motion, sometimes called the law of inertia, stating that a body will remain at rest or in uniform motion unless acted upon by external forces.

infantry Foot soldiers carrying portable firearms and equipment. Modern infantry forces are organized into platoons, companies and battalions, and are equipped with rifles, machine guns, mortars, grenades, rocket-launchers and other lightweight weapons.

infarction Death of part of an organ caused by a sudden obstruction in an artery supplying it. In a myocardial infarction (HEART ATTACK), a section of heart muscle dies.

infection Invasion of the body by disease-causing organisms that become established, multiply and give rise to symptoms. **infertility** Inability to reproduce. In a woman it may be due to a failure to ovulate (release an egg for FERTILIZATION), obstruction of the FALLOPIAN TUBE, or disease of the ENDOMETRIUM; in a man it is due to inadequate sperm production. In plants, the term refers to inability to reproduce sexually. Infertility occurs in a HYBRID between different species, which are unable to produce viable GAMETES (eggs and male sex cells).

infinity Abstract quantity that represents the magnitude of an object without limit or end. In geometry, the "point at infinity" is where parallel lines can be considered as meeting. In algebra, 1/x approaches infinity as x approaches zero. In set theory, the set of all integers is an example of an infinite set.

inflammation Reaction of body tissue to infection or injury, with resulting pain, heat, swelling and redness. It occurs when damaged cells release a substance called histamine, which causes blood vessels at the damaged site to dilate. White blood cells invade the area to engulf bacteria and remove dead tissue, sometimes with the formation of pus.

inflation In economics, continual upward movement of prices. Although normally associated with periods of prosperity, inflation may also occur during recessions. It usually occurs when there is relatively full employment. Under "costpush" inflation, prices rise because the producers' costs increase. Under "demand-pull" inflation, prices increase because of excessive consumer demand for goods.

inflection Variation in the form of a lexical item (word) that distinguishes its grammatical relationship to other words in a sentence without altering its part of speech. In a common type of inflection, affixes are added to a stem or root form in order to

distinguish tense, person, number, gender, voice or case. In English, this is usually achieved by adding different endings to the word stem – singular noun "house" gives plural "houses". Another type uses internal vowel differences within the word stem – the verb "sing" gives simple past tense "sang". Even closely related languages may differ widely in inflection.

inflorescence FLOWER or flower cluster. Inflorescences are classified into two main types according to branching characteristics. A racemose inflorescence has a main axis and lateral flowering branches, with flowers opening from the bottom up or from the outer edge in; types include panicle, raceme, spike and umbel. A cymose inflorescence has a composite axis with the main stem ending in a flower and lateral branches bearing additional, later-flowering branches.

influenza Viral infection mainly affecting the airways, with chesty symptoms, headache, joint pains, fever and general malaise. It is treated by bed-rest and pain-killers. Vaccines are available to confer immunity to some strains.

information technology (IT) Computer and TELECOMMUNICATIONS technologies used in processing information of any kind. Word processing, the use of a DATABASE, and the sending of messages over a COMPUTER NETWORK all involve the use of information technology. Television stations use information technology to provide viewers with TELETEXT Services.

information theory Mathematical study of the laws governing communication channels. It is primarily concerned with the measurement of information and the methods of coding, transmitting, storing and processing this information. infrared wave Electromagnetic radiation that produces a sensation of heat emitted by hot objects. Intermediate in energy between visible light and microwaves, its wavelength range is about 750nm to 1mm. It has applications in astronomy, medicine and warfare.

Ingres, Jean Auguste Dominique (1780–1867) French neo-classical painter. One of the great figures of early 19th-century French art, he was an outstanding portraitist, especially of women in high society such as *Madame d'Haussonville* (1845). He also produced sensual nudes, such as *Bather of Valpinçon* (1808), and, much later, *The Turkish Bath* (1863). In 1824 Ingres found himself hailed as the leader of the anti-Romantic movement, with DELACROIX as his arch rival.

Ingushetia Autonomous Russian republic; the capital is Nazran. Ingushetia lies on the N side of the Caucasus Mountains. The majority population (85%) are Ingush with a Chechen minority. The economy is based on oil and cattle raising. For much of the 20th century, Ingushetia's history has been tied to CHECHENYA. In 1991 the Chechen-Ingush Republic declared its independence from Russia. The Ingush desire to distance itself from the Chechen-dominated decision led to the deployment of Russian troops and formal separation from Chechenya (1992). In 1993 Ingushetia became a member of the Russian Federation.

injection In medicine, use of a syringe and needle to introduce drugs or other fluids into the body to diagnose, treat or prevent disease. Most injections are either intravenous (into a vein), intramuscular (into a muscle), or intradermal (into the skin).

injunction A court order enjoining a specified party to refrain from a specified action.

ink Coloured liquid used for writing, drawing or printing. It may be coloured by a suspended pigment or a soluble dye. Some inks dry by evaporation of a volatile solvent.

Inkatha South African political organization, founded in 1975 by Chief BUTHELEZI. Its initial aim was to work towards a democratic, non-racial political system. In the early 1990s, it was involved in violent conflict with the AFRICAN NATIONAL CONGRESS (ANC). In terms of representation in the National Assembly, it ranks third among political parties, and its strongest base is in KwaZulu-Natal.

Innocent III (1161–1216) Pope (1198–1216), b. Lotario di Segni. He stressed moderation; increased papal control over civil matters; and established the courts of Inquisition. During his papacy, the term TRANSUBSTANTIATION became part of Communion dogma. He allowed the Franciscan and Dominican orders to form and backed the crusade against the ALBIGENSES.

Innsbruck City in w Austria, on the River Inn, 135km (84mi) sw of Salzburg; capital of Tirol state. Founded in the 12th century, the city grew rapidly because of its strategic position on a historic transalpine route. Innsbruck is a commercial and industrial centre, and an important winter sports resort. Industries: manufacturing, metalworking, textiles, food processing. Pop. (1991) 118,112.

Inns of Court Four legal societies in London: Lincoln's Inn, Inner Temple, Middle Temple, and Gray's Inn. They date from the 13th century, and have the exclusive right to admit persons to practise as barristers in English courts.

Inönü, Ismet (1884–1973) Turkish statesman, president (1938–50) and prime minister (1923–24, 1925–37, 1961–65). Inönü was a leading figure in the Turkish nationalist movement and a formative influence on the development of the Turkish republic. He served as prime minister for most of ATATÜRK's presidency (1923–37) and succeeded him as president. Inönü's Republican People's Party lost the republic's first free elections (1950). Following a military coup in 1960, Turkey's constitution was reformed and Inönü returned as prime minister.

inorganic chemistry See CHEMISTRY

inquest Inquiry into the manner of death of a person who has been killed, died in prison, died unexpectedly or under suspicious circumstances.

Inquisition Court set up by the Roman Catholic Church in the Middle Ages to seek out and punish heresy. The accused were sometimes interrogated under torture. Punishments for the guilty ranged from penances to banishment and death. Kings and nobles supported the organized persecution of Jews, Protestants, and others considered enemies of church and state. The medieval Inquisition was active in Europe from the 12th to the 15th centuries. A later tribunal, the Spanish Inquisition, was instituted in 1483 at the request of the rulers of Spain and was not formally abolished until 1834. In 1542 a Roman Inquisition was set up to check the growth of Protestantism.

insect Any of more than a million species of small, invertebrate animals, including the BEETLE, BUG, BUTTERFLY, ANT and BEE. There are more species of insects than all other species combined. Adult insects have three pairs of jointed legs, usually two pairs of wings, and a segmented body with a horny outer covering or EXOSKELETON. The head has three pairs of mouthparts, a pair of compound eyes, three pairs of simple eyes and a pair of antennae. Most insects can detect a wide range of sounds through ultra-sensitive hairs on various parts of their bodies. Some can "sing" or make sounds by rubbing together parts of their bodies. Most insects are plant-eaters, many being serious farm and garden pests. Some prey on small animals, especially other insects, and a few are scavengers. There are two main kinds of mouthparts - chewing and sucking. Reproduction is usually sexual. Most insects go through four distinct life stages, in which complete METAMORPHOSIS is said to take place. The four stages are OVUM (egg), LARVA (caterpillar or grub), PUPA (chrysalis) and adult (IMAGO). Young grasshoppers and some other insects, called NYMPHS, resemble wingless miniatures of their parents. The nymphs develop during a series of moults (incomplete metamorphosis). SILVERFISH and a few other primitive, wingless insects do not undergo metamorphosis. Phylum Arthropoda, class Insecta. See also ARTHROPOD insectivore Small order of carnivorous MAMMALS (Insectivora), many of which eat insects. Almost worldwide in distribution, some species live underground, some on the ground and some in streams and ponds. Most insectivores have narrow snouts, long skulls and five-clawed feet. Three families are always placed in the order: Erinaceidae (moon rats, gymures, HEDGEHOGS); Talpidae (MOLES, shrew moles, desmans); and Soricidae (SHREWS). Six other families – including tree shrews, tenrecs and solenodons – are also often included in the order.

insectivorous plant (carnivorous plant) Any of several plants that have poorly developed root systems and are often found in nitrogen-deficient sandy or boggy soils. They obtain the missing nutrients by trapping, "digesting" and absorbing insects. Some, such as the Venus's fly-trap (Dionaea muscipula), are active insect trappers. The sundews (Drosera) snare insects with a sticky substance and then enclose them in their leaves. Bladderworts (Utricularia) suck insects into their underwater bladders. Other plants have vase-shaped leaves, such as the pitcher plant (Sarracenia flava).

insemination, artificial Introduction of donor semen into a female's reproductive tract to bring about fertilization. First developed for livestock breeding, it is now routinely used to help infertile couples. *See also* IN VITRO FERTILIZATION (IVF) **insomnia** Inability to sleep. It may be caused by anxiety, pain or stimulants such as drugs.

instinct Behaviours that are innately determined, as opposed to behaviours that are learned. In the 19th century instincts were often cited to explain behaviour, but the term fell into disrepute with the advent of BEHAVIOURISM. The term has been revived in the work of such ethologists as Konrad LORENZ.

insulation Technique for reducing or preventing the transfer of heat, electricity, sound or other vibrations. Wool, fibre-glass and foam plastic are good heat insulating materials because they contain air. This trapped air reduces the transfer of heat by CONDUCTION. Water is also a good heat insulator. A diver's wet suit keeps the wearer warm by trapping a layer of water around the body. Electrical insulation materials include rubber, PVC, polythene, glass and porcelain. Sound insulating materials absorb sound and change it to heat by FRICTION.

insulin HORMONE secreted by the islets of Langherhans in the PANCREAS and concerned with the control of blood-glucose levels. Insulin lowers the blood-glucose level by helping the uptake of glucose into cells, and by causing the liver to convert glucose to glycogen. In the absence of insulin, glucose accumulates in the blood and urine, resulting in DIABETES.

insurance Procedure whereby one party (the insured) transfers the financial consequences of risk of loss to another (the insurer) for a consideration (the premium). Each insured contributes to a common fund, and the losses of the unfortunate few are reimbursed from the fund. Modern practices date back to the 16th and 17th centuries. It covers such things as life, fire, accident and theft.

intaglio Incised carving on gemstones, hardstones or glass, in which the design is sunk below the surface. In printing, the term is used to describe processes in which ink is applied to incisions and hollows in a printing plate, as in ETCHING.

integer Any negative or positive whole number or zero, e.g. ... -3, -2, -1, 0, 1, 2, 3 ... There are a limitless (infinite) number of integers. The positive integers are the natural numbers. The existence of negative integers and zero allow any integer to be subtracted from any other integer to give an integer result. **integral calculus** In mathematics, branch of CALCULUS that deals with integration: the finding of a function, one or more derivatives of which are given. There are many applications of integral calculus. It is used to find the areas and volumes of curved shapes. In engineering calculations, differential equations are solved by integral calculus. Its principles are also incorporated in many measuring and control instruments.

integrated circuit (IC) Complete miniature electronic CIR-

The internal anatomy of all insects, such as the honey bee, is contained and protected within the confines of the tough, flexible exoskeleton. The typical insect body contains organs of digestion, respiration, circulation, excretion and reproduction. There are muscles through which movement is effected and a nervous system that coordinates and controls insect actions on the basis of information received by the sense organs, most important of which are the large compound eyes and the feelers and antennae. All insect bodies comprise three parts: the head, thorax and abdomen.

CUIT, incorporating semiconductor devices such as the TRANSISTOR and RESISTOR. Monolithic integrated circuits have all the components manufactured into or on top of a single crystal of silicon (commonly called a silicon CHIP). Hybrid integrated circuits have separate components attached to a ceramic base. Components in both types are joined by conducting film. See also PRINTED CIRCUIT

Integrated Services Digital Network (ISDN) Highspeed telephone lines designed to carry digital information. The various grades of ISDN can carry information more than a thousand times faster than conventional analogue voice lines. ISDN lines connect directly to a computer and do not need a MODEM.

integration See integral calculus

intelligence General ability to learn and to deal with problems, new situations and abstract concepts. It can be manifest in many different ways, including skills in adaptability, memory and reasoning. Fierce debate has raged over the roles of hereditary and environmental factors in developing intelligence. Intelligence tests measure abstract reasoning and problem-solving abilities.

intelligence quotient See IQ

intelligence service Government organization maintained in most countries to obtain information concerning activities that might endanger the state. In Britain MI5 (Military Intelligence 5) is responsible for domestic counterespionage; MI6 is responsible for overseas intelligence. See also CENTRAL INTELLIGENCE AGENCY (CIA); FEDERAL BUREAU OF INVESTIGATION (FBI); KGB

interdict Instrument of punishment in the Roman Catholic Church whereby sacraments and clerical offices are withdrawn from a place. Bishops have this power over individual parishes, but the pope has much wider powers. Medieval popes sometimes placed an entire country under an interdict. **interest** In economics, price paid to the lender by the borrower for the "use" of money over a specified period of time, usually calculated as a percentage of the principal (sum lent). Simple interest is paid regularly and calculated as a percentage of the original principal. In compound interest, the interest calculated for one period (such as a year) is added to the original principal, and the interest for the next period is calculated as a percentage of this total.

interface Way that a computer PROGRAM or system interacts with its user. The simplest form of computer interface is the keyboard, through which the user controls the computer by typing in commands. The most common type for personal computers is the GRAPHICAL USER INTERFACE (GUI).

interference In optics, interaction of two or more wave motions, such as those of light and sound, creating a disturbance pattern. Constructive interference is the reinforcement of the wave motion, occurring when the component motions are in phase. Destructive interference occurs when two waves are out of phase and cancel each other.

interferometer Instrument in which a wave, especially a light wave, is split into component waves that are made to travel unequal distances to recombine as INTERFERENCE patterns. The patterns have such uses as quality control of lenses and prisms, and the measurement of wavelengths.

interferon Protein produced by body cells when infected with a virus. Interferons can help uninfected cells to resist infection by the virus, and may also impede virus replication and protein synthesis. In some circumstances they can inhibit cell growth; human interferon is now produced by GENETIC ENGINEERING to treat some cancers, HEPATITIS and MULTIPLE SCLEROSIS.

interlude Short theatrical piece, prominent in the late 15th and early 16th centuries, which provided entertainment during royal and noble banquets. Performed by a small travelling company, it combined moral messages with clowning, and is sometimes seen as the starting point for English drama. It was the immediate precursor of Elizabethan comedy.

intermezzo Light theatrical entertainment performed to music between the acts of a drama or OPERA. The earliest intermezzi date from the late 15th century. The 18th-century intermezzi of operas were the basis for the development of

Computer operators use a variety of means to interact with the computer. A hand-held mouse, for example, moves a cursor on a monitor screen. The central ball (1) rotates as the mouse moves. As the ball moves, spoked wheels (2) turn according to sideways and up-and-down movement. An LED (3) shines through the spokes (4). The rate of rotation of both wheels is detected by sensors (5), which send information to the computer via a cable (6) moving the cursor appropriately. Buttons at the front of the mouse (7) can be used to click on areas of the monitor screen or call up menus.

OPERA BUFFA. Today the term most commonly refers to an instrumental interlude during the course of an opera.

internal combustion engine Engine, widely used in automobiles, in which fuel is burned inside, so that the gases formed can produce motion. An internal combustion engine may be a TWO-STROKE ENGINE or a FOUR-STROKE ENGINE. In the most common type of engine, a mixture of petrol vapour and air is ignited by a spark. The gases produced in the resulting explosion usually drive a piston along a cylinder. A crankshaft changes the reciprocating movement of the pistons into rotary motion. In the WANKEL ENGINE, the gases produced in the explosions drive a triangular rotor. *See also* DIESEL ENGINE

International Atomic Energy Agency (IAEA) Intergovernmental agency of the UNITED NATIONS (UN). It was founded in 1956 to promote peaceful uses of nuclear energy and to establish international control of nuclear weapons. The organization's headquarters are in Vienna, Austria.

International Labour Organization (ILO) Specialized, intergovernmental agency of the UNITED NATIONS (UN). Its aim is to facilitate improved industrial relations and conditions of work. It was formed as an agency of the LEAGUE OF NATIONS in 1919 by the Treaty of VERSAILLES, and has a membership comprising government, employer and worker representatives. Its headquarters are in Geneva, Switzerland. international law Body of rules deemed legally binding that have resulted from treaties, agreements and customs between states. Its sources are also decisions by agencies, conferences or commissions of international organizations such as the United Nations, as well as decisions of international tribunals such as those of the International Court of Justice.

International Monetary Fund (IMF) Specialized, intergovernmental agency of the UNITED NATIONS, and administrative body of the international monetary system. Its main function is to provide assistance to member states troubled by BALANCE OF PAYMENTS problems and other financial difficulties. The IMF does not actually lend money to member states; rather, it exchanges the member state's currency with its own Special Drawing Rates (SDR) (a "basket" of other currencies) in the hope that this will alleviate balance of payment difficulties. These loans are usually conditional upon the recipient country agreeing to pursue prescribed policy reforms. The organization is based in Washington, D.C., USA.

International style (International modern style) Name for the architectural style developed in Europe in the 1920s and 1930s that stresses function and abhors superfluous decoration in design. It characteristically features austere white walls, asymmetrical cubic shapes and large expanses of glass. LE CORBUSIER and Walter GROPIUS were early exponents.

Internet Worldwide communications system consisting of hundreds of small COMPUTER NETWORKS, interconnected by telephone systems. It is a network of networks, in which messages and data are sent using short local links from place to place around the world. This enables users to send a message

to the other side of the world by ELECTRONIC MAIL (E-MAIL) for the cost of a local phone call.

interplanetary matter Material in the space between the planets. It is made up of atomic particles (mainly protons and electrons) ejected from the Sun via the solar wind, and dust particles (mainly from COMETS, but some possibly of cosmic origin) in the plane of the ecliptic.

Interpol (International Criminal Police Organization) Intergovernmental organization. Established in 1923, its main function is to provide member states with information about international criminals and to assist in their arrest. Its head-quarters are in Lyon, France.

intersection Point, or LOCUS of points, common to two or more geometrical figures. Two non-parallel lines in the same plane meet in a point; two non-parallel planes meet in a line. **intestine** Lower part of the ALIMENTARY CANAL, beyond the STOMACH. Food is moved through the intestine by the wavelike action known as PERISTALSIS. It undergoes the final stages of digestion and is absorbed into the bloodstream in the small intestine, which extends from the stomach to the large intestine. In the large intestine (caecum, colon and rectum) water is absorbed from undigested material, which is then passed out of the body through the anus.

Intifada (Arabic, uprising) Campaign of violent civil disobedience by Palestinians in the Israeli-occupied territories of the WEST BANK of the River JORDAN and the GAZA STRIP. The Intifada began in 1987 and was a sustained attempt to disrupt Israel's heavy-handed policing tactics. By early 1995 the Intifada had claimed over 1,400 Palestinian and 230 Jewish lives. It lost momentum following the ISRAELI-PALESTINIAN ACCORD.

Intolerable Acts (1774) British legislation designed to punish the American colonists after the BOSTON TEA PARTY. Also known as the Coercive Acts, they closed the Boston port and moved the customs house to Salem. British officials accused of capital offences would be tried in England (Administration of Justice Act); another law (the Massachusetts Government Act) annulled the Massachusetts Charter, giving the governor power to control town meetings and making the council and judiciary appointed bodies. The colonists' opposition resulted in the calling of the First Continental Congress.

intoxication Condition arising when the body is poisoned by any toxic (harmful) substance, whether liquid, solid or gas. Symptoms vary according to the ingested substance. The term is most commonly used in connection with excessive alcohol consumption.

intravenous drip Apparatus for delivering drugs, blood and blood products, nutrients and other fluids directly into the bloodstream. A hollow needle is inserted into an appropriate vein and then attached to a length of tubing leading from a bag containing the solution.

introversion Preoccupation with one's own responses and impressions, coupled with a preference for reflection over action and a dislike of social activity. The term was coined by C. G. Jung as a polar opposite to EXTROVERSION. Extreme introverts can be passive and withdrawn.

intrusion In geology, process in which rock material is forced or flows into spaces among other rocks to form intrusive rocks. An igneous intrusion, sometimes called a pluton, consists of magma that never reached the Earth's surface but filled cracks and faults, then cooled and hardened.

Inuit Collective name for the Eskimo people of Alaska, Greenland, and the Northwest Territories, Arctic Quebec and N Labrador areas of Canada. Many Inuit still live by the traditional skills of fishing, trapping and hunting in their remote communities. In 1980 an Inuit Circumpolar Conference was held to promote the rights, interests, cultural unity and civilization of the inhabitants of the Arctic polar region.

invertebrate Without a backbone; in zoology, the term for an animal without a backbone. There are more than a million species of invertebrates, divided into 30 major groups. One of these is Arthropoda (joint-legged animals), the largest of all animal phyla in numbers of species. MOLLUSCS make up the second-largest group of invertebrates. *See also* ARTHROPODS; CRUSTACEA; PHYLUM

investment Employment of money with the object of providing profit or income. An element of risk accompanies investment; generally, the higher the risk the greater the potential profit. Forms of investment include personal savings placed in a bank; factory plants and machinery; insurance; and stocks and shares.

in vitro fertilization (IVF) Use of artificial techniques that join an egg with sperm outside a woman's body to help infertile couples to have children of their own. The basic technique of IVF involves removing eggs from a woman's OVARIES, fertilizing them in the laboratory and then inserting them into the woman's UTERUS. In ZYGOTE intrafallopian transfer (ZIFT), a fertilized egg (zygote) is returned to the FALLOPIAN TUBE, from where it makes its own way to the uterus. In gamete intrafallopian transfer (GIFT), the eggs are removed, mixed with sperm, then both eggs and sperm are inserted into a Fallopian tube to be fertilized in the natural setting.

involuntary muscle One of three types of MUSCLE in the body, so called because, unlike SKELETAL MUSCLE, it is not under the conscious control of the brain but is stimulated by the AUTONOMIC NERVOUS SYSTEM and by HORMONES in the bloodstream. It is of two kinds. Smooth muscle is the muscle of the alimentary canal, blood vessels and bladder. Cardiac muscle powers the HEART.

lo Large innermost satellite of JUPITER. It was discovered by GALILEO in 1609–10 and is larger than the Moon. It is more than 3,600km (2,200mi) in diameter and is 422,000km (262,000mi) above the surface of the planet.

iodine (symbol I) Nonmetallic element, the least reactive of the HALOGEN group. The black volatile solid gives a violet vapour and has an unpleasant odour that resembles CHLORINE. Iodine was discovered in 1811. Found in seawater, seaweeds and other plants, it is also extracted from Chile saltpetre and oil-well brine. Iodine is essential for the functioning of the THYROID GLAND. In medicine, it is used as an antiseptic. Properties: at.no. 53; r.a.m. 126.9; r.d. 4.93; m.p. 113.5°C (236.3°F); b.p. 184.4°C (363.9°F); most stable isotope I¹²⁷ (100%).

ion Atom or group of atoms with an electric (positive or negative) charge resulting from the loss or gain of one or more electrons. Positive ions are called cations and move towards the CATHODE in ELECTROLYSIS; negative ions are called anions and move towards the ANODE. The process of forming ions is called ionization.

lona Island off the coast of w Scotland in the Inner HEBRIDES. The island has an abbey, founded in AD 563 by St Columba. Tourism is the main source of income. Area: 13sq km (5sq mi). **lonesco, Eugène** (1912–94) French dramatist. A major force behind the Theatre of the ABSURD, Ionesco had his first success with *The Bald Prima Donna* (1950), a satire on the futility of verbal communication.

lonia Historic region on the w coast of Asia Minor (Turkey), including the neighbouring Aegean islands. The area was settled by people from Mycenae in Greece in the 11th and 10th centuries BC. Miletus and EPHESUS became the most important of the prosperous Ionian cities. Ionia was conquered by the Persians in the 6th century BC, then fell under Athenian domination until the Persians regained control in the 4th century BC. After the conquests of ALEXANDER THE GREAT, Ionia was ruled by Hellenistic kings and from the 2nd century BC was part of the Roman empire.

lonians In ancient Greece, inhabitants of Attica, Boeotia and

Iran's flag was adopted in 1980 by the country's Islamic government. The white strip contains the national emblem, which is the word for Allah in formal Arabic script. The words Allah Akbar (God is Great) is repeated 11 times on both the green and red stripes.

he Islamic Republic of Iran contains a barren central plateau, which covers c.50% of the country. It includes the Dasht-e-Kavir (Great Salt Desert) and the Dasht-e-Lut (Great Sand Desert). The Elburz Mountains, N of the plateau, contains Iran's highest point, Damavand, at 5,604m (18,368ft), and the capital, TEHRAN. To the NE lies Iran's second city, MASHHAD. On the NW edge of the plateau lies the city of Qom. The w of the plateau is bounded by the Zagros Mountains, including the cities of ISFAHAN and SHIRAZ. In the far NW lies its largest lake, Lake Urmia, and the city of TABRIZ. The SHATT AL ARAB forms part of its border with Iraq. Iran is susceptible to earthquakes.

CLIMATE

Iran has hot summers and cold winters. There are wide regional variations in temperature and precipitation. Precipitation is highest in the N, often in the form of winter snow.

VEGETATION

Forest covers c.10% of Iran, mainly in the Elburz and Zagros mountains. Semi-desert and desert cover most of the country.

~ 355°E AZERBAIJAN UZBEKISTAN TURKMENISTAN Caspian Sea Mas Sabzevar 35°N Tehran Dasht-e-Kavir Kashan Tabas AFGHANISTAN Biriand Esfahan Nountains IRAQ Khorramshah KUWAIT Saidabad Bushehr Bam Khasl Bandar Abbas SAUDI 6411 N ARABIA 25°N 250N QATAR Gavat MAP SCALE Gulf of Oman Tropic of Cancer UNITED ARAB OMAN EMIRATES 50°E

HISTORY

Until 1935 Iran was known as PERSIA. Aryans settled in Persia c.2000 BC. The Persian king CYRUS THE GREAT founded the ACHAEMENID dynasty in 550 BC. The Persian empire fell to Alexander the Great in 331 BC. Persian rule was restored by the SASSANIDS in AD 224. Arabs conquered Persia in AD 641 and introduced ISLAM. For the next two centuries Persia was a centre of Islamic art and architecture. SELJUK Turks conquered Persia in the 11th century, but in 1220 the land was overrun by the MONGOLS. The SAFAVID dynasty (1501-1722) was founded by Shah ISMAIL, who established the SHITE theocratic principles of modern Iran. NADIR SHAH expelled Afghan invaders. His despotic rule (1736-47) was noted for imperial ambition. The Qajar dynasty (1794-1925) witnessed the gradual decline of the Persian empire in the face of European expansion. Britain and Russia competed for influence in the area. The discovery of oil in sw Iran led to the Russian and British division of Iran (1907). In a 1919 treaty Iran effectively became a British protectorate. In 1921 Reza Khan seized power in a military coup, established the Pahlavi dynasty, and was elected shah (1925). He annulled the AREA: 1,648,000sq km (636,293 sq mi)
POPULATION: 59,964,000
CAPITAL (POPULATION): Tehran (6,475,527)
GOVERNMENT: Islamic republic
ETHNIC GROUPS: Persian 46%, Azerbaijani
17%, Kurdish 9%, Gilaki 5%, Luri,
Mazandarani, Baluchi, Arab
LANGUAGES: Farsi (or Persian, official)
RELIGIONS: Islam 99%
CURRENCY: Rial = 100 dinars

British treaty and began a process of modernization. In 1941 British and Soviet forces occupied Iran. Reza Shah abdicated in favour of his son Muhammad Reza Shah PAHLAVI. The 1943 Tehran Declaration guaranteed Iran's independence. In 1951 the oil industry was nationalized. The shah fled Iran, but soon returned with US backing and restored Western oil rights (1953). During the 1960s the shah undertook large-scale reforms, such as land ownership and extending the franchise to women (1963). Discontent surfaced over increasing westernization and economic inequality. The secret police crushed all dissent. Iranian clerics, led by Ayatollah KHOMEINI, openly voiced their disapproval of the secularization of society. In 1971 Britain withdrew its troops from the Persian Gulf. Iran increased its defence spending to become the largest military power in the region. Following his expulsion, Khomeini called for the abdication of the shah (1978).

In January 1979 the shah fled and Khomeini established an Islamic republic. The theocracy was profoundly conservative and anti-western. In July 1979 the oil industry was renationalized. In November 1979 militants seized the US embassy in Tehran, taking 52 American hostages. In September 1980 the Iraqi invasion marked the start of the Iran-Iran War (1980–88). The war claimed over 500,000 lives. In 1986 the US covertly agreed to supply Iran with arms, in return for influence over the return of hostages (see Iran-Contra Affair). In June 1989 Khomeini died and was succeeded by Rafsanjani.

POLITICS

Rafsanjani's regime began to ease relations with the West. Free market reforms were adopted and Iran supported international sanctions against Iraq in 1991. Allegations of support for international terrorism and development of a nuclear capability led the USA to impose trade sanctions in 1995. In 1997 elections Rafsanjani was defeated by Muhammad Khatami.

ECONOMY

Iran's prosperity is based on oil production. Oil accounts for 95% of its exports, and it is the world's fourth-largest producer of crude oil. The Iran-Iraq War devastated Iran's industrial base. Oil revenue has been used to diversify the economy and develop manufacturing. Industry now employs 26% of the workforce. Attempts have been made to reduce Iran's dependence on food imports. Agriculture employs 30% of the workforce. Iran is the world's largest producer of dates. Other major crops include wheat and barley. Iran is famous for its fine carpets. Tourism has great potential, but the political situation discourages many visitors.

IONIA. They spoke a dialect distinct from that of the DORIANS and Aeolians. The hostility between Ionians and Dorians, neither regarding the other as fully Greek, appears in the contest between Athens and Sparta in the PELOPONNESIAN WARS. The term is also applied to the inhabitants of Ionia alone.

ionic bond (electrovalent bond) Type of chemical bond in which ions of opposite charge are held together by electrostatic attraction.

ionic compound Substance formed by ionic bonding, a chemical bond of positively and negatively charged IONS. Salts, bases and some acids are ionic compounds. As crystalline solids, they have high melting points and boiling points. As solids, they are nonconductors of electricity, and are usually soluble in water but insoluble in organic solvents. In the liquid and molten states, ionic compounds are good conductors.

lonic order One of the five ORDERS OF ARCHITECTURE ionosphere Wide region of IONS in the ATMOSPHERE. It extends from about 60km (37mi) above the Earth's surface to the limits of the atmosphere in the VAN ALLEN RADIATION BELTS. Radio waves are deflected in the ionosphere, which makes possible long-distance radio communication.

lowa State in N central USA, lying between the Missouri and

Mississippi rivers; the capital is DES MOINES. First discovered in 1673, the land was claimed for France in 1682. The region was sold to the USA in the LOUISIANA PURCHASE of 1803. Iowa was admitted to the Union in 1846. Industrial development was encouraged after World War 2. Originally prairie that was ploughed to create farmland, the region is known for its fertile soil. Maize and other cereals are produced and Iowa stands second only to Texas in the raising of prime cattle. Industries: food processing, farm machinery. Area: 145,790sq km (56,290sq mi). Pop. (1995 est.) 2,842,000.

Iphigenia In Greek legend, daughter of AGAMEMNON and CLYTEMNESTRA and sister of ELECTRA and ORESTES. She was sacrificed by her father to the goddess Artemis in exchange for her giving him favourable winds for his journey to Troy.

Ipswich City and port in E England, on the Orwell estuary; the county town of SUFFOLK. The wool trade brought it prosperity in the Middle Ages. After a decline, its fortunes were revived in the 19th century with the introduction of light industry. Industries: milling, brewing, printing, agricultural machinery. Pop. (1991) 116,956.

IQ (Intelligence Quotient) Classification of the supposed intelligence of a person. It is computed by dividing the per-

IRAQ

Irag's flag was adopted in 1963, when the country was planning to federate with Egypt and Syria. It uses the four Pan-Arab colours. The three green stars symbolize the three countries. Iraq retained these stars even though the union failed to come into being.

AREA: 438,320sq km (169,235sq mi) POPULATION: 19,290,000

CAPITAL (POPULATION): Baghdad (3,850,000)

GOVERNMENT: Republic

ETHNIC GROUPS: Arab 77%, Kurdish 19%,

Turkmen, Persian, Assyrian

LANGUAGES: Arabic (official), Kurdish (official

in Kurdish areas)

RELIGIONS: Islam 96%, Christianity 4% currency: Iraqi dinar = 20 dirhams = 1,000 fils

he Republic of Iraq has only a narrow outlet, via the SHATT AL ARAB delta, to the PERSIAN GULF. Its main port, BASRA, is located here. Part of the Syrian Desert forms most of w Iraq and there are mountains in the NE. Central Iraq is dominated by the valleys of the EUPHRATES and TIGRIS rivers, including the capital, BAGHDAD.

CLIMATE

Iraq's climate varies from temperate in the N to subtropical in the s and E. The central feature is the lack of adequate rainfall, except in the NE.

VEGETATION

Forests account for 3% of the land. Dry grass-

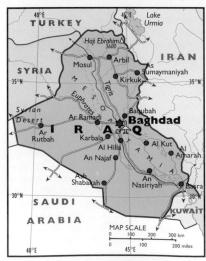

land and low shrubs grow in the N. The desert provides winter grazing land. The s is mainly marshland. Dates are grown in the sandy SE.

HISTORY

The ancient region of MESOPOTAMIA roughly corresponds with modern Iraq. SUMERIA was the first great civilization, c.3000 BC. In c.2340 BC SARGON I conquered Sumeria. In the 18th century BC, HAMMURABI established the first empire of BABYLONIA In the 8th century BC, Babylonia fell to Assyria. In the 1st century BC, the Assyrian kings Sargon II, SennacheriB and AshurBani-PAL added to the splendour of NINEVEH. NEB-UCHADNEZZAR extended the New Babylonian empire, and was responsible for the BABYLONIAN CAPTIVITY. In 539 BC Babylon fell to CYRUS THE GREAT, who founded the ACHAEMENID dynasty. Mesopotamia became part of the Persian empire. ISLAM was introduced via the Arab conquest in AD 637. In the 8th century Baghdad became capital of the ABBASID caliphate (750-1258). Mongols captured Baghdad in 1258. From 1534 Mesopotamia was part of the Ottoman empire. Britain invaded Mesopotamia in 1916. In 1920 it became a British mandated territory. Britain renamed the country Iraq and set up an Arab monarchy. Iraq finally became independent in 1932 and oil was first exported in 1934.

As a member of the Arab League, Iraq participated in the 1948 ARAB-ISRAELI WAR. By the 1950s, oil dominated Iraq's economy and funded national development programmes. In 1958 a proposal to form an Arab Union with Jordan precipitated a military coup. A republic was established and the king executed. In 1962 the KURDS of N Iraq demanded autonomy, beginning a protracted war of secession. In 1968 the BA'ATH PARTY emerged as the dominant power. Iraq participated in the 1973 Arab-Israeli War. In 1979 Saddam Hussein became president and purged the Ba'ath Party. Iraq invaded Iran, starting the IRAN-IRAQ WAR (1980-88). The Kurdish rebellion continued and poison gas was used against villagers. On 2 August 1990, Iraqi troops invaded Kuwait (see GULF WAR).

POLITICS

Following Iraq's forced withdrawal from Kuwait (1991), rebellion broke out in the Kurdish N highlands and Shiite s marshlands. The revolt was brutally suppressed. The UN formed air exclusion zones to protect the civilian population. In 1994 an autonomous Kurdish administration collapsed amid bitter in-fighting. In 1995 weapons inspectors discovered evidence of Iraq's attempts to gain a nuclear capability.

ECONOMY

Wars, sanctions and financial mismanagement have created economic chaos. Oil traditionally accounts for 98% of revenue and 45% of GNP. Since 1990 a UN embargo has halted oil exports. In 1996 concern about severe hardship suffered by the civilian population led to a UN "oil-forfood" deal, which allowed the annual sale of a certain amount of oil to provide funds for buying humanitarian goods. Farmland covers c.20% of Iraq. Products are barley, cotton, dates and fruits, but Iraq is dependent on food imports. Manufacturing is dominated by petroleum products.

son's assessed "mental age" by their real age, then multiplying by 100. The "mental age" is determined by comparison to the average performance of people of various ages on a standard intelligence test. See also APTITUDE TEST

IRA Abbreviation of IRISH REPUBLICAN ARMY

Iráklion (Heraklion or Candia) Seaport and largest city on the island of Crete, s Greece; capital of Iráklion prefecture. Founded in the 9th century by the Saracens, it was conquered by the Byzantines in 961, the Venetians in 1204, and the Ottoman Turks in 1669. It became part of Greece in 1913. The ruins of KNossos are nearby. Tourism is important. Exports: wine, olive oil, almonds and raisins. Pop. (1991) 115,124.

Iran Islamic republic in sw Asia. See country feature, page 345 Iran-Contra affair (Irangate) US political scandal (1987–88). It involved a secret agreement to sell weapons to Iran via Israel, in order to secure the release of US hostages held in the Middle East. The profits were diverted to support the Nicaraguan Contra, who were attempting to overthrow the Sandinista government. The affair, negotiated by Colonel Oliver North with the support of national security advisers to the White House, was revealed by a congressional investigative committee in 1987. North and his superiors, plus several other officials, were later convicted of various charges, including obstructing Congress. In 1992 they were controversially pardoned by President Bush.

Iranian languages Group of languages forming a subdivision of the Indo-Iranian family of INDO-EUROPEAN LANGUAGES. The major Iranian languages are Persian, Pashto, Kurdish, Mazanderani and Gilaki (of Iran), Baluchi (of Iran and Pakistan) and Tajik and Ossetic, spoken in the republic of Tajikistan and in South Ossetia (a part of Georgia) and North Ossetia (an autonomous region of the Russian Federation).

Iran-Iraq War (1980–88) Contest for supremacy in the Persian Gulf. The war began when Iraq, partly in response to Iranian encouragement of revolt among the Shiites of s Iraq, invaded Iran, which was disorganized after the Islamic fundamentalist revolution of 1979. Iraq's objective was the Shatt Alara waterway, but stiff Iranian resistance checked its advance and forced its withdrawal (1982). The conflict bogged down in stalemate, with sporadic Iranian offensives. US-led intervention in 1987 was seen as tacit support for Iraq. A UN cease-fire resolution (1987) was accepted by Iraq and, after several Iraqi successes, by Iran also. Estimated total casualties were more than 1 million.

Iraq Republic in sw Asia. See country feature

Ireland, John Nicholson (1879–1962) British composer, influenced by Brahms, Dvořák and Ravel. His works, firmly grounded in ROMANTICISM and often inspired by places and landscape, include *The Forgotten Rite* (1913), *Mai-Dun* (1921), *These Things Shall Be* (1937), the overture *Satyricon* (1946) and many songs and piano pieces.

Ireland Second-largest island of the British Isles. Ireland is w of Great Britain. The Irish Sea and St Georges Channel run between the two islands. At present, Ireland is divided into two separate countries, the Republic of IRELAND and NORTH-ERN IRELAND. Land and climate The central area of Ireland is lowland with a mild, wet climate. This area is covered with peat bogs (an important source of fuel) and sections of fertile limestone (the location of dairy farming). Most coastal regions are barren highlands. The interior of Ireland has many lakes and wide rivers (loughs). It boasts the longest river in the British Isles, the SHANNON. History From c.3rd century BC to the late 8th century, Ireland was divided into five kingdoms inhabited by Celtic and pre-Celtic tribes. The Danes invaded in the 8th century BC establishing trading towns such as DUBLIN and creating new kingdoms. In 1014 Brian Boru defeated the Danes, and for the next 150 years Ireland was free from invasion but subject to clan warfare. In 1171 Henry II of England invaded Ireland and established English control. In the late 13th century an Irish parliament was formed. English dominance was threatened by the Scottish invasion of 1315. In the late 15th century HENRY VII restored English hegemony and began the plantation of Ireland by English settlers. Edward Poynings forced the Irish Parliament to pass Poynings Law (1495), stating that future

Council. Under JAMES I the plantation of ULSTER was intensified. An Irish rebellion (1641-49) was eventually thwarted by Oliver Cromwell. During the GLORIOUS REVOLUTION Irish Catholics supported JAMES II, while Ulster Protestants supported WILLIAM III. After James' defeat, the English-controlled Irish Parliament passed a series of punitive laws against Catholics. In 1782 Henry Grattan forced trade concessions and the repeal of Poynings Law. William PITT's government passed the Act of UNION (1801), which abolished the separate Irish assembly and created the United Kingdom of Great Britain and Ireland. In 1829, largely due to the efforts of Daniel O'CONNELL, the Act of CATHOLIC EMANCIPATION was passed, which secured Irish representation in the British Parliament. A blight ruined the Irish potato crop and caused the Great Potato Famine (1845-49). Nationalist demands intensified. Gladstone failed to secure Home Rule, amid mounting pressure from fearful Ulster Protestants. Arthur GRIFFITH founded SINN FÉIN (1905). In 1914 Home Rule was agreed, but implementation was suspended during World War 1. In the EASTER RISING (April 1916) Irish Nationalists announced the creation of the Republic of Ireland. The British Army's brutal crushing of the rebellion was a propaganda victory for Sinn Féin and led to a landslide victory in Irish elections (1918). During 1918–21 the IRISH REPUBLICAN ARMY (IRA), founded by Michael COLLINS, fought a guerrilla war against British forces. In 1920 a new Home Rule bill established separate parliaments for Ulster and Catholic Ireland. Sinn Féin initially opposed the bill, but the Anglo-Irish Treaty (1921) led to the creation of an Irish Free State in January 1922 and de facto acceptance of partition. (For history post-1922, see Ireland, Northern; Ireland, Republic of) Ireland, Northern Part of the UNITED KINGDOM, 26 districts occupying the NE of IRELAND, traditionally divided into the six counties of Antrim, Armagh, Derry, Down, Fermanagh and Tyrone; the capital is BELFAST. Other major towns include DERRY, Coleraine, Ballymena, Lisburn, Newry, Armagh and Enniskillen (for land and climate and pre-1922 history, see IRELAND). Economy Over 80% of the land is farmed (chief crops are potatoes and barley). Heavy industry is concentrated around the port of Belfast. Industries include shipbuilding, vehicle manufacture and textiles (especially linen). The majority population is Protestant; Catholics form a significant minority of 38%. Northern Ireland's economic prosperity is not equally shared: the Catholic community has a much higher rate of unemployment. The economy has been devastated by civil war. History In 1920 the six counties of Ulster province became the self-governing province of Northern Ireland with a separate, Protestant-dominated parliament. The British government affirmed the inclusion of Northern Ireland within the UK under the principle of self-determination. The Irish Free State (now Republic of IRELAND) constitution upheld the unity of the island of Ireland. In 1955 the IRISH REPUBLICAN ARMY (IRA) began a campaign of violence for the creation of an independent, unified Ireland. In 1962 the Republic of Ireland condemned the use of terrorism. Northern Catholics felt aggrieved at discrimination in employment, housing and political representation. In 1967 the Civil Rights Association was established to campaign for equal rights. In 1968 civil rights marches resulted in violent clashes, especially in Derry. Catholic fear of the increasing Protestant-domination of local security forces was compounded when the Royal Ulster Constabulary (RUC) was supplemented by the sectarian Ulster Defence Regiment (UDR). The British Army was brought in to protect the Catholic populations in Belfast and Derry. The IRA and Protestant LOYALIST paramilitary organizations, such as the Ulster Defence Association (UDA), increased their campaigns of sectarian violence. In 1972 the Northern Ireland parliament (Stormont) was suspended and replaced by direct rule from Westminster. Also in 1972 the British Army killed 13 demonstrators in what became known as "Bloody Sunday". In 1974 the Council of Ireland, formed by the British and Irish governments to promote cooperation between Ulster and the Irish Republic, quickly collapsed under pressure from a Unionist-led general strike. The IRA campaign widened to

Irish legislation must be sanctioned by the English Privy

IOWA Statehood :

28 December 1846

Nickname : Hawkeye state

State bird: Eastern goldfinch

State flower: Wild rose

State tree :

State motto :

Our liberties we prize and our rights we will maintain

include terrorist attacks on the British mainland and British military bases in w Europe. Hunger strikes by IRA prisoners in 1981 were more successful in gaining worldwide sympathy. In 1985 the Anglo-Irish Agreement gave the Republic of Ireland a consultative role in the government of Northern Ireland. In 1986 a Northern Ireland Assembly was reestablished, but quickly failed under the Unionists' boycott. In 1993 (following secret talks between the British government and Sinn Féin) the DOWNING STREET DECLARATION offered all-party negotiations following a cessation of violence. A cease-fire in 1994 raised hopes of an end to a sectarian conflict that had claimed over 2,700 lives. Disputes over arms decommissions stalled the process and the IRA resumed its terrorist campaign in Great Britain. In July 1997 another cease-fire was agreed, and in October Sinn Féin and Unionists took part in joint peace talks for the first time since partition. Area: 14,121sq km (5,452sq mi). Pop. (1991) 1,573,836.

Ireland, Republic of Country occupying most of the island of Ireland, NW Europe. *See* country feature

Irian Jaya (West Irian, or Irian Barat) Province of E Indonesia, comprising the w half of New Guinea and adjacent islands; the capital is Djajapura. First explored by Europeans in the 16th

century, it was formally claimed by the Netherlands in 1828 and became known as Dutch New Guinea. It achieved independence in 1962 and was incorporated into Indonesia the following year. In the central part of the province, a mountain range rising to more than 5,000m (16,500ft) runs c.640km (400mi) from E to w. Much of the region N of the mountain range is covered by tropical rainforest. Irian Jaya is noted for the richness of its flora and fauna. The economy is predominantly agricultural, the chief products being copra, groundnuts, rice and timber. Copper and crude oil are exported. Area: 422,170sq km (162,900sq mi). Pop. (1990) 1,648,708.

iridium (symbol Ir) Silver-white metallic element discovered in 1804 by the English chemist Smithson Tennant. A platinum-type metal, iridium is hard and brittle and the most corrosion-resistant metal. It is used in making surgical tools, scientific instruments, pen tips and electrical contacts. Properties: at.no. 77; r.a.m. 192.22; r.d. 22.42; m.p. 2,410°C (4,370°F); b.p. 4,130°C (7,466°F); most common isotope Ir¹⁹³ (62.6%). iris Coloured part of the EYE. It controls the amount of light that enters the PUPIL in the centre of the eye by increasing or decreasing the size of the pupil. These changes are brought about by muscles in the iris contracting or relaxing.

IRELAND, REPUBLIC OF

Ireland's flag was adopted in 1922 after the country had become independent from Britain, though nationalists had used it as early as 1848. Green represents Ireland's Roman Catholics, orange the Protestants, and the white a desire for peace between the two.

AREA: 70,280sq km (27,135sq mi)

POPULATION: 3,547,000

capital (population): Dublin (915,516) government: Multiparty republic

ETHNIC GROUPS: Irish 94%

LANGUAGES: Irish and English (both official)
RELIGIONS: Christianity (Roman Catholic 93%,

Protestant 3%)

currency: Irish pound = 100 new pence

The Republic of Ireland occupies over 80% of the island of Ireland. It is divided into 4 provinces of 26 counties (see individual articles). The capital is DUBLIN (Gaelic, Baile Atha Cliath). Other major cities include CORK and LIMERICK. (For land, climate and pre-1922 history and politics, see IRELAND)

HISTORY

In January 1922 the Irish Free State was created as a Dominion within the British empire. Civil war ensued between supporters of the settlement, and those who refused to countenance the partition of Ireland and the creation of Northern IRELAND. The anti-settlement party SINN FÉIN (led by Eamon DE VALERA) and the IRISH REPUBLICAN ARMY (IRA) (led by Michael COLLINS) was defeated. Collins died in the conflict. In 1926 De Valera formed a separate party, FIANNA FÁIL, and became prime minister (1932). In 1937 a new constitution declared the sovereign nation of Ireland (Eire) to be the whole island of Ireland and abolished the oath of loyalty to the English crown. During World War 2 Eire remained neutral. It opposed Allied operations in Northern Ireland and the IRA pursued a pro-German line. In 1949 Ireland became a republic outside of the Commonwealth. Its claim to the six counties of Northern Ireland was reiterated. In 1955 Ireland was admitted to the UN. During the 1950s, the IRA was banned by both Irish governments and, as a secret organization, it conducted bombing campaigns in Northern Ireland and England. Relations with Northern Ireland improved. In 1973 Ireland joined the European Community (EC). During the 1980s a series of short-lived coalition government caused political uncertainty. The Anglo-Irish Agreement (1985) gave Ireland a consultative role in the affairs of Northern Ireland. In 1990 Mary ROBINSON was elected as Ireland's first female president. The DOWNING STREET DECLARATION (1993), signed by John Major and Albert REYNOLDS, continued the momentum for a peaceful settlement in Northern Ireland. The Republic agreed to relinquish its claim to Northern Ireland, if a majority of the peoples of the North voted to remain in the United Kingdom.

POLITICS

In 1995 Reynolds' administration fell and John Bruton's Fine Gael party formed a coalition with the Labour Party. Following a 1995 referendum divorce was legalized. Abortion remains a contentious political issue. In 1997 elections Fianna Fáil returned to office, led by Bertie Ahern. Ireland is a strong supporter of greater European cooperation.

ECONOMY

Ireland's economy has benefited greatly from its membership of the European Community. Com-MON AGRICULTURAL POLICY (CAP) grants have enabled the modernization of farming. Agriculture employs 14% of the workforce. Food and live animals account for over 20% of exports. Major products include cereals, cattle and dairy products, sheep, sugar beet and potatoes. Fishing is also an important economic activity. Industry has greatly expanded and accounts for 35% of GNP. Traditional sectors such as brewing, distilling and textiles have been supplemented by high-tech industries such as electronics. The service sector employs 57% of the workforce and accounts for over 50% of GNP. Tourism is the most important component, receipts from tourism totalled US\$1,620 million (1992). Unemployment remains high and economic migration, though decreasing, is common.

iris Genus of about 300 species of monocotyledonous flowering plants widely distributed, mostly in temperate areas. They may have BULBS or RHIZOMES. Height: up to 90cm (3ft). Family Iridaceae. *See also* CROCUS; GLADIOLUS

Iris In Greek mythology, goddess of the rainbow and messenger of the gods. Depicted as swift-footed, golden-winged and robed in bright colours, she appears in numerous classical writings, including Euripides' *Herakles*.

Irish See GAELIC

Irish literature Body of work produced by inhabitants of Ireland The earliest written works, mainly heroic sagas, date from the 7th to the 12th centuries and were composed in GAELIC. A number of lyric poets were also active during this period, writing on historical or religious subjects. Between the 13th and the 17th centuries, professional poets, commissioned by noble families, produced long poems in honour of their wealthy patrons. After a quiet period in the 17th and 18th centuries, the late 19th and early 20th centuries saw a renaissance in Irish literature. Inspired by the movement for self-government, literature and drama prospered. Among those involved were W.B. YEATS, Lady Gregory, J.M. SYNGE and Sean O'CASEY. It is often remarked that many of the leading figures in 20th-century ENGLISH LITERATURE have been Irish.

Irish Republican Army (IRA) Guerrilla organization dedicated to the reunification of Ireland. Formed in 1919, the IRA waged guerrilla warfare against British rule. Some members ("irregulars") rejected the Anglo-Irish settlement of 1921, fighting a civil war until 1923. In 1970 the organization split into an "official" wing (which emphasized political activities), and a "provisional" wing (committed to armed struggle). Thereafter, the provisional IRA became committed to terrorist acts in Northern Ireland and mainland Britain. It declared a cease-fire in 1994, but in 1996 resumed its campaign. It declared another cease-fire in 1997.

Irish Sea Part of the Atlantic Ocean, lying between Ireland and Britain. It is connected to the Atlantic by the North Channel (N) and by St George's Channel (s). Scotland, Wales and England are on its E shore and Ireland on the W shore. Area: 103,600sq km (40,000sq mi).

Irkutsk City on the River Angara, E Siberia, Russia; capital of Irkutsk oblast. It began as a camp and trading centre in the mid-17th century. It grew as a result of trade with China and the completion of the Trans-Siberian Railway. Irkutsk is an important industrial and educational centre. Gold from the Lena goldfields is transshipped here, and there is also trade in furs. Industries: ship-repairing, timber, machine tools, heavy machinery, oil refining, hydroelectricity. Pop. (1992) 639,000. iron (symbol Fe) Common metallic element of the first transition series, known from the earliest times. Its chief ores are hematite (Fe₂O₃), magnetite (Fe₃O₄) and iron pyrites (FeS₂). It is obtained in a blast furnace by reducing the oxide with carbon monoxide from coke (carbon), using limestone to form a slag. The pure metal - a reactive soft element - is rarely used; most iron is alloyed with carbon and other elements in various forms of STEEL. Properties: at.no. 26; r.a.m. 55.847; r.d. 7.86; m.p. 1,535°C (2,795°F); b.p. 2,750°C $(4,982^{\circ}F)$; most common isotope Fe^{56} (91.66%).

Iron Age Period succeeding the Bronze Age, dating from about 1100 BC in the Near East, later in W Europe. During this period people learned to smelt iron, although the HITTITES had probably developed the first significant iron industry in Armenia soon after 2000 BC.

Iron Curtain Term describing the barrier between communist East Europe and the capitalist West during the COLD WAR. The term passed into common use after it was used by Winston Churchill in a speech at Fulton, Missouri, in March 1946. irony Use of words to convey, often satirically, the opposite of their literal meaning. It was first developed by Plato in his Socratic dialogues, in which Socrates often feigned ignorance to evoke admissions from other people. Dramatic irony refers to situations in which the audience possesses information that the protagonist does not.

Iroquois Confederacy League of Native North Americans occupying the Mohawk Valley and the Lakes area of New York state. They called themselves Oñgwanósioñi (Hodinonh-

sioni), "people of the long house", after the distinctive shape of their bark dwellings. The original tribes were the MOHAWK, SENECA, ONONDAGA, CAYUGA and Oneida. The Tuscarora joined later. The Iroquois had a highly developed political system and were renowned warriors. Their total number has halved since 1600; in the mid-1990s they numbered c.10,000, living in New York, Wisconsin, Oklahoma and Canada.

irrational number In mathematics, any number that cannot be expressed as the ratio of two integers. An example is $\sqrt{2}$: like other irrational numbers, its expression as a decimal is infinite and non-repeating. Irrational numbers, together with the RATIONAL NUMBERS, make up the set of REAL NUMBERS.

Irrawaddy (Irawadi) River in central Burma (Myanmar), formed by the union of the Mali and Nmai rivers. A vast delta extends 290km (180mi) from Henzada to the Andaman Sea. One of Asia's major rivers, it lies at the centre of an important rice-producing region. Length: *c*.2,100km (1,300mi).

irrigation Artificial watering of land for growing crops. Irrigation enables crops to grow in regions with inadequate precipitation. The first irrigation systems date from before 3000 BC in Egypt, Asia and the Middle East. Today, most water for irrigation is surface water (from streams, rivers and lakes) or ground water (obtained from wells). In some regions, freshwater for irrigation is obtained by DESALINATION. Canals, ditches, pumps and pipes are used to convey water to fields.

Irving, Sir Henry (1838–1905) British actor-manager, real name John Henry Brodribb. He made his first stage appearance in 1856. In 1878 he took over as manager of the Lyceum Theatre, London, and engaged Ellen Terry as his leading lady. Irving last appeared as an actor in a production of *Becket* in 1905. Irving, Washington (1783–1859) US essayist and shortstory writer. He wrote the burlesque *History of New York* (1809) under the pseudonym Dietrich Knickerbocker. He is most famous for the stories *Rip Van Winkle* and *The Legend of Sleepy Hollow*, which were written during his 17 years in Europe. He returned to the USA in 1832, where his continuing literary output included *Astoria* (1836).

Isaac Biblical character of the Old Testament, and one of the Patriarchs. He was the only son of ABRAHAM and Sarah. As a test of faith in God, Abraham was prepared to sacrifice Isaac as commanded, but at the last minute, Isaac was told to sacrifice a lamb instead. Isaac took as his wife Rebecca and became the father of JACOB and ESAU.

Isabella I (1451–1504) Queen of Castile (1474–1504), whose marriage to Ferdinand II of Aragon (FERDINAND V of Castile and León) led to the unification of Spain and its emergence as a dominant European power. Daughter of John II, she won a dispute over the succession by 1468 and married Ferdinand (1469). With his support she reformed royal administration in Castile and encouraged humanist scholarship in Spain, although she was also responsible for the Spanish Inquisition (1487) and the expulsion of the Jews (1492). Her popularity was enhanced by the conquest of Granada (1492). She supported the voyages of COLUMBUS, which led to the establishment of the Spanish empire in the New World. Isabella II (1830-1904) Queen of Spain (1833-68). The daughter of Ferdinand VII, she was challenged by her uncle, Don Carlos, which resulted in the first CARLIST civil war. A liberal revolt led by army officers forced her into exile (1868), and in 1870 she abdicated in favour of her son, ALFONSO XII.

Isaiah (Isaias) (active c.8th century BC) Old Testament prophet who was active in Jerusalem from the 740s until the end of the century and gave his name to the Old Testament Book of Isaiah. Isaiah's career coincided with the westward expansion of the Assyrian empire. The Book of Isaiah was written in both verse and prose. Only part of it is attributed to Isaiah. The rest is thought to be the work of one or even two authors from a later period. The book contrasts Judah's perilous present-day state with glimpses into the future, when God shall send a king to rule over his people.

ISDN Abbreviation of INTEGRATED SERVICES DIGITAL NET-WORK

Isfahan (Esfahan) City in central Iran, on the Zaindeh River. The ancient city of Aspadana, it was occupied successively by Arabs, Seljuk Turks and Mongols. In the late 16th century

▲ iris Grown mainly in temperate regions for displays, the many plants of the genus iris usually feature narrow, pointed leaves. The flowers are either purple, white or yellow.

▶ Islamic architecture Much of Islamic architecture, such as this mosque in Tehran, Iran, is decorated with complex and colourful geometric shapes, often inscribing the name of the prophet Muhammad. Domes and minarets are common architectural forms.

the SAFAVID dynasty made it their capital and transformed it into one of the most beautiful cities of the age. After its capture by the Afghans in 1722, the city declined. It has steel and textile industries as well as the traditional crafts of carpets and rugs, metalwork and silverware. Pop. (1986) 986,753.

Isherwood, Christopher William Bradshaw (1904–86) British writer. His novels, characteristically dealing with the sensibility of the homosexual artist, include *All the Conspirators* (1928) and *Mr Norris Changes Trains* (1935), set in pre-war Germany. The musical *Cabaret* (1966) was based on a short story from *Goodbye to Berlin* (1939). He collaborated on three plays with W.H. AUDEN, including *The Ascent of F6* (1936). He emigrated to the USA in 1939 and became interested in Hinduism.

Ishiguro, Kazuo (1954–) Japanese novelist, resident in the UK since 1960. His first novels, *A Pale View of Hills* (1982) and *An Artist of the Floating World* (1986), are set in Japan. *The Remains of the Day* (1989) won the Booker Prize. *The Unconsoled* (1995) marked a sharp departure from the elegantly crafted economy of his early style.

Ishmael Any of several biblical figures, most notably Abraham's son by Hagar and half brother to Isaac. He married an Egyptian and fathered 12 sons and one daughter, who married Esau, Isaac's son.

Ishtar Principal goddess of Assyro-Babylonian mythology. She is the daughter of Anu, the sky god, and Sin, the moon god. Through the centuries, she came to exhibit diverse attributes, those of a compassionate mother goddess and of a lustful goddess of sex and war. Ishtar is identified with the Sumerian Inanna, Phoenician Astarte and the biblical Ashtoreth.

Isidore of Seville (560–636) Archbishop of Seville from *c*.600 and a distinguished administrator, teacher and author. His works include *Etymologies*, which was an encyclopedia, and books on history, natural science, linguistic studies and theology. He was canonized by Pope Clement VIII in 1598.

isinglass Clear, almost pure gelatin that is prepared from the air bladders of sturgeon and other sources. It is used primarily to clarify wines and beers. The name also refers to an abundant silicate material, also called muscovite, used as an insulator.

Isis In Egyptian mythology, wife and sister of OSIRIS, and mother of Horus. After Osiris was murdered, Isis put together the dismembered parts of Osiris's body and magically revived him. The epitome of fidelity and maternal devotion, she was worshipped throughout the ancient world.

Islam (Arabic, submission to God) Monotheistic religion founded by MUHAMMAD in Arabia in the early 7th century. At

the heart of Islam stands the KORAN, considered the divine revelation in Arabic of God to Muhammad. Members of the faith (MUSLIMS) date the beginning of Islam from AD 622, the year of the HEJIRA. Muslims submit to the will of Allah by five basic precepts (pillars). First, the shahadah, "there is no God but Allah, and Muhammad is his prophet". Second, salah, five daily ritual prayers. At the MOSQUE a Muslim performs ritual ablutions before praying to God in a attitude of submission, kneeling on a prayer mat facing MECCA with head bowed, then rising with hands cupped behind the ears to hear God's message. Third, zakat or alms-giving. Fourth, sawm, fasting during RAMADAN. Fifth, HAJJ, the pilgrimage to MECCA. The rapid growth in Islam during the 8th century can be attributed to the unification of the temporal and spiritual. The community leader (CALIPH) is both religious and social leader. The Koran was soon supplemented by the informal, scriptural elaborations of the Sunna (Muhammad's sayings and deeds), collated as the Hadith. A Muslim must also abide by the Sharia or religious law. While Islam stresses the importance of the unity of the summa (nation) of Islam, several distinctive branches have developed, such as SUNNI, SHI-ITE and SUFISM. In 1990 it was estimated that there were 935 million Muslims worldwide.

Islamabad Capital of Pakistan, in the N of the country. Construction of a new capital to replace KARACHI began in 1960, and in 1967 Islamabad became the official capital. It lies at the heart of an agricultural region, but administrative and governmental activities predominate. Pop. (1981) 201,000.

Islamic art and architecture Lacking a strong, independent tradition, Islamic art began to develop as a unique synthesis of the diverse cultures of conquered countries from the 7th century. Early Islamic art and craft is perhaps best illustrated in the architecture of the MOSQUE. Two of the most impressive surviving examples of early Islamic architecture are the DOME OF THE ROCK (685-92) in Jerusalem and the UMAYYAD Mosque in Damascus (c.705). Common architectural forms, such as the DOME, MINARET, sahn (courtyard), and the often highly-decorated mihrab (prayer niche) and mimbar (prayer pulpit) developed in the 9th century. Mosques also acquired rich surface decorations of mosaic, carved stone and paint. In Spain, Moorish architecture developed independently after the Umayyads were forced to flee there by the ABBASID dynasty. It is characterized by its use of the horseshoe arch, faience and stone lattice screens, as seen in the ALHAMBRA. Islamic CAIRO is a world heritage site of Muslim architecture, often derived from Persian innovation. The Ibn Tulun Mosque (879) is a fine example of early brick and stucco form. The Al-Azhar mosque displays 10th-century developments. The masterwork of Persian mosques, with their distinctive onion-shaped domes and slender pencil minarets, is the ISFAHAN Imperial Mosque (1585-1612). The Persians influenced the Islamic architecture of India and Turkey. Because of a religious stricture on the representation of nature, Islamic art developed stylized figures, geometrical designs and floral-like decorations (arabesques). The KORAN was the focus for much of the development of calligraphy and illumination. Many of the cursive scripts were developed in the 10th century, and the most commonly used script, Nastaliq, was perfected in the 15th century. Muslim secular art included highly ornamented metalwork (often inlaid with red copper), which developed in the 13th century around Mosul, N MESOPOTAMIA. The art of pottery and ceramics was extremely advanced, with excellent glazes and decoration. The Islamic minai (enamel) technique reached its zenith in the 16th century in Isfahan, where entire walls were decorated in faience. Perhaps the best-known art of the Islamic world is that of rug-making.

Isle of Man See Man, ISLE OF **Isle of Wight** See WIGHT, ISLE OF

Ismail (1486–1524) Shah of Persia (Iran) (1501–24), founder of the SAFAVID dynasty. A national and religious hero in Iran, he re-established Persian independence and established SHITTE Islam as the state religion. He warred successfully against the UZBEKS in 1510 but was defeated by the Ottoman sultan, Selim I, at the battle of Chaldiran in 1514.

Ismaili (Seveners) Member of the smaller of the two Shiite

Israel's flag was adopted when the Jewish state declared itself independent in 1948. The blue and white stripes are based on the *tallit*, a Hebrew prayer shawl. The ancient, sixpointed Star of David is in the centre. The flag was designed in America in 1891.

The State of Israel, a small nation in the E Mediterranean, can be divided into four geographical regions: a narrow, fertile coastal plain, site of Israel's main industrial cities, HAIFA and TEL AVIV; the Judaeo-Galilean highlands; the NEGEV Desert, which occupies the shalf of Israel, extending to ELAT on the Gulf of AQABA, and includes the city of BEERSHEBA; in the E lies part of the Great RIFT VALLEY, including the Sea of GALILEE, the River JORDAN, and the DEAD SEA, the world's lowest point, at 396m (1,302ft). Israeli-occupied territories are the GAZA STRIP, the WEST BANK (including East JERUSALEM) and the GOLAN HEIGHTS.

LEBANON Mediterranean Sea Nahariyya 33°N Tel Aviv-laffa Bat Yam erusalem 0 R D A Negev Desert N E SAUDI ARABIA

CLIMATE

Israel has a Mediterranean climate with hot, dry, summers and mild, rainy winters. Temperature and rainfall vary with elevation and proximity to the sea. The Dead Sea region has only 70mm (2.5in) of rainfall a year, and temperatures rise to 49°C (120°F).

VEGETATION

Despite reforestation schemes, forests account for only 6% of land use. Farmland covers c.20% of the land, with pasture making up another 40%. The arid Negev Desert is partly irrigated with water pumped from the Sea of Galilee.

HISTORY

Israel is part of a historic region which makes up most of the Biblical Holy Lands (for history pre-1947, see PALESTINE). In the late 19th century ZIONISM began to agitate for a Jewish homeland. In 1947 the United Nations (UN) agreed to partition Palestine into an Arab and a Jewish state, but the plan was rejected by the Arabs. On 18 May 1948 the State of Israel was proclaimed. Hundreds of thousands of Palestinians fled. In the first of the Arab-Israeli Wars Egypt, Iraq, Jordan, Lebanon and Syria invaded. The HAGANAH successfully defended the state. An Israeli government was formed with Chaim WEIZMANN as president and David BEN-GURION as prime minister. In 1949 Israel was admitted to the UN, and the capital transferred from Tel-Aviv to Jerusalem. In 1950 the Law of Return provided free citizenship for all immigrant Jews. Following Egypt's nationalization of the SUEZ CANAL, Israel captured Gaza and the SINAI PENINSULA. In 1957 Israel withdrew. In 1963 Ben-Gurion resigned and Levi ESHKOL became prime minister (1963-69). In 1967 NASSER blockaded Elat. Israel's defence minister Moshe DAYAN launched a pre-emptive attack against Egypt and Syria. Within six days Israel had occupied the Gaza Strip, the Sinai peninsula, the Golan Heights, the West Bank and East Jerusalem. Eshkol died in 1969 and Golda MEIR became prime minister (1969-74). On 6 October 1973 (YOM KIPPUR), Egypt and Syria attacked Israeli positions in Sinai and the Golan Heights. Recovering from the initial surprise, Israeli troops launched a counter-offensive and retained its 1967 gains. Yitzhak RABIN's government (1974-77) is chiefly remembered for the daring rescue of Israeli hostages at ENTEBBE. Rabin was succeeded by Menachem BEGIN (1977-83). Begin's hard-line government encouraged Jewish settlement on the West Bank and suppressed Palestinian uprisings. Following the CAMP DAVID AGREEMENT, Egypt and Israel signed a peace treaty (1979) in which Egypt recognized the Israeli state and regained Sinai. In 1982 Begin launched a strike against nuclear installations in Iraq and a full-scale invasion of LEBANON (1982-85) to counter the PALESTINE LIBERATION

AREA: 26,650sq km (10,290sq mi)

POPULATION: 4,946,000

CAPITAL (POPULATION): Jerusalem (544,200)
GOVERNMENT: Multiparty republic

ETHNIC GROUPS: Jewish 82%, Arab and others

LANGUAGES: Hebrew and Arabic

(both official)

RELIGIONS: Judaism 82%, Islam 14%, Christianity 2%, Druse and others 2% CURRENCY: New Israeli sheqel = 100 agorat

ORGANIZATION (PLO). In 1987 the INTIFADA began in Israeli-occupied territory. From 1989-92 Israel's population expanded by 10%, due to the immigration of FALASHAS and Soviet Jews. Increasing Jewish settlement inflamed the popular uprising. During the GULF WAR (1991) Israel was the target for Iraqi Scud missiles, but under US pressure did not respond. In 1992 Rabin was re-elected and began "peace-for-land" negotiations with the PLO. In 1993 Rabin and Yasir Arafat signed the Israeli-Palestinian ACCORD. In 1994 the Palestinian National Authority (PNA) assumed limited autonomy over the West Bank town of JERICHO and the Gaza Strip. On 4 November 1995 Rabin was assassinated by a Jewish extremist. His successor, Shimon PERES continued the peace process.

POLITICS

Peres was narrowly defeated in the 1996 general election by the Likud leader Benjamin NETANYAHU who, while vowing to maintain the peace process, favoured a more hardline policy. Jewish settlement on the West Bank intensified, despite US and UN disapproval. In January 1997 Israeli troops withdrew from HEBRON and the process crept forward. Further Jewish settlement on the West Bank threatened to stall the process.

Есопому

Israel is a prosperous nation (1992 GDP per capita, US\$14,700). In 1948 Israel was heavily reliant on food imports, and hit by Arab boycotts during the 1950s. Now it is self-sufficient and a major exporter of fruits and vegetables. Agriculture, which employs 4% of the workforce, is highly scientific. Manufactured goods are the leading export; products include chemicals, electronic and military equipment, jewellery, plastics and scientific instruments. About 66% of the workforce are employed in the service sector. Tourism is a major source of foreign earnings.

Israelis have used modern technology and science to raise production levels. They have turned a poor country into a prosperous one. This 1968 stamp illustrates some of Israel's major food exports; the melon, avocado and strawberry.

branches of Islam. Ismailis believe that Muhammad, the son of Ismail, was the seventh and last Imam. They are based mainly in India and Pakistan. Their leader is the AGA KHAN. **Ismail Pasha** (1830–95) Viceroy and Khedive of Egypt (1863–79). He received the title of khedive from the Ottoman sultan in 1867. Profits from cotton enabled him to build extensively in Alexandria and Cairo, but later financial difficulties forced him to sell Egypt's share in the Suez Canal Company to Britain and led to his forced resignation in favour of his son, Tewfik Pasha.

isobar Line on a weather map connecting points of equal pressure, either at the Earth's surface or at a constant height above it. The patterns of isobars depict the variation in atmospheric pressure, showing areas of high and low pressure on the map. isolationism Avoidance by a state of foreign commitments and alliances. It is connected in particular with the foreign policy of the USA. US isolationism was not applied to the Americas, considered an exclusively US area of interest under the MONROE DOCTRINE, nor did it prevent US involvement in China and elsewhere in pursuit of commercial gains. With respect to Europe, it was interrupted when the USA entered World War 1 in 1917 and permanently abandoned in 1941, although it continues to have some advocates.

isomers Chemical compounds having the same molecular formula but different properties due to the different arrangement of atoms within the molecules. Structural isomers have atoms connected in different ways. Geometric isomers, also called cis-trans isomers, differ in their symmetry about a double bond. Optical isomers are mirror images of each other.

isotope One of two or more atoms with the same ATOMIC NUMBER but a different number of neutrons. Both mass number and mass of the nucleus are different for different isotopes. The atomic mass of an element is an average of the isotope masses. The isotopes of an element have similar chemical properties, but physical properties vary slightly. Most elements have two or more naturally occurring isotopes, some of which are radioactive (radioisotopes). Radioisotopes are used in medicine, research and industry. Isotopes are also used in radioactive DATING

Israel Name given in the Old Testament to Jacob and to the nation that the Hebrews founded in Canaan. Jacob was renamed Israel after he had wrestled with the mysterious "man" who was either an angel or God Himself (Genesis 32: 28). As a geographical name, Israel at first applied to the whole territory of Canaan captured or occupied by the Hebrews after the Exodus from Egypt. This territory was united as a kingdom under David in the early 10th century BC, with its capital at Jerusalem. Following the death of David's son Solomon, the ten northern tribes seceded, and the name Israel thereafter applied to the kingdom they founded in N Palestine; the remaining two tribes held the southern kingdom of Judah.

Israel Republic in sw Asia. See country feature, page 351 Israeli-Palestinian Accord Agreement that aimed to end hostilities between Palestinians and Israelis, especially in the WEST BANK and GAZA STRIP. Secret talks began in the mid-1980s. On 13 September 1993, a "Declaration of Principles" was signed by Yitzhak RABIN and Yasir ARAFAT. The PLO recognized Israel's right to exist and renounced terrorism. In return, Israel recognized the PLO as the legitimate representative of the Palestinians and agreed to a staged withdrawal of troops from parts of the occupied territories. On 18 May 1994, the Israeli army completed its redeployment in the Gaza Strip and withdrew from JERICHO. The Palestinian National Authority (headed by Arafat) assumed limited autonomy. In September 1995 Rabin agreed to withdraw Israeli troops from six more towns and 85% of HEBRON. In October 1995, 1,100 Palestinian prisoners were released. The assassination of Rabin and the election of Benjamin NETANYAHU slowed the process, and Jewish settlement on the West Bank accelerated. See also INTIFADA

Istanbul City and seaport in Nw Turkey, on both sides of the Bosporus, partly in Europe and partly in Asia, at the entrance to the Sea of Marmara. The city was founded by Greek colonists in the 7th century BC. It was known as Byzantium

until ad 330 when Constantine I chose it as the capital of the Eastern Roman Empire and renamed it Constantinople. Captured by the Ottoman Turks in 1453, the city was largely destroyed by an earthquake in 1509 and rebuilt by Sultan Beyazid II. When the new Turkish Republic was established after World War 1, the capital was moved to Ankara and Constantinople was renamed Istanbul. Today it is the commercial and financial centre of Turkey. Industries: shipbuilding, cement, textiles, glass, pottery, leather goods. It also derives a valuable income from tourism. Pop. (1990) 6,293,397.

Italian Language of Italy, where it is spoken by that country's 58 million inhabitants, and of the canton of Ticino, Switzerland. It is one of the ROMANCE LANGUAGES descended from spoken Latin and so belongs ultimately to the Italic group of INDO-EUROPEAN LANGUAGES. There are many Italian dialects, and the official language is based on those of central Italy, particularly Tuscan. During the 20th century, broadcasting and the cinema standardized the language greatly, but most Italians continue to use a regional dialect for everyday communication. Italian art and architecture Painting, sculpture and other art produced in Italy following the Roman period. By the 6th century, trade with the Byzantine empire had brought a Byzantine influence to Italian art, which lasted through the 11th century. The chief centres of the Italo-Byzantine style were Venice, Tuscany, Rome and the deep south. Mosaics and stylized, geometric forms became standard. Icon panels were the main type of paintings during the 11th through the 13th centuries, with major schools in SIENA, Lucca and PISA. By the time of the Renaissance, the emphasis was on balance and harmony, with such masters as LEONARDO DA VINCI, GHIBERTI, DONATELLO, BOTTICELLI and MICHELANGELO. MANNERISM developed in Florence late in the Renaissance but faded by the end of the 16th century, giving way to the BAROQUE style of the 17th century. This was typified by artists such as the painter Caravaggio and the architect Bernini. In the 18th and 19th centuries, NEO-CLASSICISM was inspired by Classical Roman art, the subject of PIRANESI's engravings. The 20th century saw the birth of FUTURISM, as well as the more tranquil works of Modigliani and de Chirico. Since the 1960s, Italian designers have been highly influential internationally.

Italian literature Body of work produced in Italy from the 13th century on. Italian vernacular literature emerged in the 13th century with the work of the Sicilian poets at the court of Frederick II; they extensively employed the SONNET. Religious poetry also flourished. Major figures of the 14th century were DANTE, PETRARCH and BOCCACCIO, who influenced the works of CHAUCER. The RENAISSANCE produced outstanding poetry and philosophy, especially in the work of Torquato Tasso, Lodovico Ariosto (1474–1533), and the politician Machiavel-LI. During the Age of Enlightenment in the 18th century, a new literary language was required to reflect modern experience. The poet Carlo Porta (1775-1821) employed regional dialects, while Guiseppe Parini (1729-99) wrote in a more conventional style. The lyrical works of Giacomo Leopardi (1798–1837) and the novels of Alessandro Manzoni helped to take Italian literature into its Romantic period. The 19th-century political movement for Italian unification and independence inspired a literary flowering. The major figure to emerge was Gabriele D'Annunzio. Important 20th-century writers include Alberto MORAVIA, Cesare PAVESE and Eugenio MONTALE, and more recently Umberto Eco and Italo Calvino (1923-85).

italics Style of handwriting developed by the Florentine humanist Niccolò Niccoli in the 15th century. By the 16th century it had replaced Gothic script in most European countries. The 20th century has seen its revival. It is now used in printed works to indicate emphasis or foreign words.

Italy Republic in s Europe. See country feature

Ito, Prince Hirobumi (1841–1909) Japanese statesman. The leading figure in the modernization of Japan after the MEIJI RESTORATION (1868), he served in several government posts and took part in the Iwakura Mission (1871–73) to study Western governments. After the RUSSO-JAPANESE WAR, he headed the Japanese administration in what was then the protectorate of Korea. He was assassinated by a Korean nationalist.

lturbide, Agustín de (1783–1824) Mexican general and

The Italian flag is based on the military standard carried by the French Republican National Guard when Napoleon invaded Italy in 1796, causing great changes in Italy's map. It was finally adopted as the national flag after Italy was unified in 1861.

taly is bordered in the N by the ALPS, which include it's highest peak, Gran Paradiso, at 4,061m (13,323ft). In the NE lies Italy's largest lake, Lake GARDA, framed by the DOLOMITES. The Alps drop down to a vast, fertile plain, drained by Italy's largest river, the Po. This is Italy's richest industrial and agricultural region. The APENNINES form Central Italy's backbone. Either side of the range are narrow coastal lowlands. On the Tyrrhenian side lies Italy's capital, ROME. SICILY is the largest Mediterranean island and includes Mount ETNA. See individual gazetteer articles

CLIMATE

Italy has a Mediterranean climate, except for Sicily, which is subtropical. Alpine winters are long and the frequent snow is ideal for winter sports.

HISTORY

By tradition ROMULUS AND REMUS founded ancient ROME in 753 BC. The ETRUSCANS were overthrown by the Romans, who established a republic (509 BC). In the PUNIC WARS Rome gained a Mediterranean empire. Pompey was defeated by Julius CAESAR, whose assassination led to the formation (27 BC) of the ROMAN EMPIRE under Augustus. Diocletian divided the empire into Eastern (BYZANTINE EMPIRE) and Western sections. The PAPACY ensured the continuation of Rome's influence. PEPIN III (THE SHORT) expelled the LOMBARDS and enabled the creation of the PAPAL STATES. His son Charlemagne was crowned emperor of the West (800). In 962 OTTO I conquered Italy and established the HOLY ROMAN EMPIRE. Central and N Italy were controlled by powerful citystates, while the s established a FEUDAL SYSTEM

POPULATION: 57,782,000
CAPITAL (POPULATION): Rome (2,775,250)
GOVERNMENT: Multiparty republic
ETHNIC GROUPS: Italian 94%, German, French,
Greek, Albanian, Slovenian, Ladino
LANGUAGES: Italian 94% (official), Sardinian
3%
RELIGIONS: Christianity (Roman Catholic) 83%
CURRENCY: Lira = 100 centesimi

AREA: 301,270sq km (116,320sq mi)

under the HOHENSTAUFEN and Angevin dynasties. The 13th-century battle between imperial and papal power divided the cities and nobles into the GUELPH and GHIBELLINE factions. The RENAISSANCE profoundly affected western civilization. ITALIAN ART AND ARCHITECTURE was an informing force across Europe. In the 16th century Spain gained Sicily, Naples and Milan. The FRENCH REVOLUTIONARY WARS failed to bring reunification. Nationalist groups, such as the RISORGIMENTO, emerged. MAZZINI'S republicans were defeated by monarchists led by GARIBALDI and the kingdom of Italy was unified under VICTOR EMMANUEL II (1861). The papacy refused to concede the loss of Rome and VATICAN CITY was set up as a sovereign state (1929). The late-19th century was marked by industrialization and empire-building. VICTOR EMMANUEL III's reign (1900-46) saw Italy enter World War 1 on the Allied side (1915). Italian discontent at the post-war settlement culminated in D'ANNUNZIO's seizure of TRIESTE and the emergence of FASCISM. In 1922 Benito MUSSOLINI assumed dictatorial powers. Aggressive foreign policy included the seizure of ETHIOPIA and Albania. In 1936 Mussolini entered an alliance with Hitler. During World War 2, Italy fought on the Axis side, but after losing its North African empire, Mussolini was dismissed and Italy surrendered (1943). Germany invaded and Italy declared war. Rome fell to the Allies in 1944.

The Christian Democrat Party emerged as the dominant post-war political force, with DE GASPERI as prime minister (1945–53). In 1948 Italy became a republic and was a founder member of NATO (1949) and the European Economic Community (1958). Italy has been riven by political instability (50 governments since 1947), endemic corruption (often linked to the MAFIA), social unrest and the wealth gap between N and S.

POLITICS

Popular discontent with traditional political parties and structure led to the 1993 adoption of a "first-past-the-post" system and the emergence of the Northern League and anti-corruption parties. The 1996 election was won by the left-wing Olive Tree alliance. Romano Prodi became prime minister.

ECONOMY

Italy's main industrial region is the NW triangle of MILAN, TURIN and GENOA. It is the world's eighth-largest car and steel producer. Machinery and transport equipment account for 37% of exports. Italy has few mineral resources. Agricultural production is important. Italy is the world's largest producer of wine. Tourism is a vital economic sector, with receipts over US\$21,577 million.

politician, who helped Mexico achieve independence (1821) and was emperor (1822–23). Dissent crystallized when Santa Anna and Guadalupe Victoria called for the creation of a republic. Iturbide abdicated and was exiled. Early in 1824 he returned to Mexico and was promptly arrested and shot.

Ivan III (the Great) (1440–1505) Grand Duke of Moscow (1462–1505). He laid the foundations of the future empire of Russia. By 1480 Moscow's northern rivals, including Novgorod, were absorbed by conquest or persuasion, domestic rebellion was crushed, and the Tatar threat was ended permanently. His later years were troubled by conspiracies over the succession. He began to use the title *tsar* ("caesar") and employed Italian artists in the buildings of the KREMLIN.

Ivan IV (the Terrible) (1530-84) Grand Duke of Moscow (1533-84) and tsar of Russia. Ivan was crowned as tsar in 1547 and married Anastasia, a ROMANOV. At first, he was an able and progressive ruler, reforming law and government. By annexing the Tatar states of Kazan and Astrakhan, he gained control of the Volga river. He established trade with w European states and began Russian expansion into Siberia. After his wife's death in 1560, he became increasingly unbalanced, killing his own son in a rage. He established a personal dominion, the oprichnina, inside Russia. He also created a military force, the oprichniki, which he set against the boyars. Ives, Charles (1874-1954) US composer. He often used American folk music as his thematic basis, as in Variations on America for organ (1891) and the Symphony No. 2 (1902). His works vary greatly in style, some are atonal, some quote from hymns or band music and some are quite conventional. He wrote four symphonies, chamber music and many songs. He was awarded the 1947 Pulitzer Prize for music.

IVF Abbreviation of IN VITRO FERTILIZATION

ivory Hard, yellowish-white dentine of some mammals. The most highly prized variety is obtained from elephant tusks. The term also refers to the teeth of hippopotamuses, walruses, sperm whales and several other mammals.

Ivory Coast (officially Côte d'Ivoire) Republic in w Africa; the capital is YAMOUSSOUKRO. Land and climate The SE coast features lagoons enclosed by sandbars, on one of which the former capital and chief port of ABIDJAN is situated. Rocky cliffs line the SW coast. Coastal lowlands give way to a plateau. The NW highland borders with Liberia and Guinea

are an extension of the Guinea Highlands. Ivory Coast has a hot and humid tropical climate. The s has two distinct rainy seasons, May to July and October to November. Inland, rainfall decreases. The N has a dry season and only one rainy season. Rainforests of valuable trees, such as mahogany and African teak, once covered the s lowlands, but much of the land has been cleared for farming. Tropical savanna covers the plateau, and forests cover much of the Guinea Highlands. Economy Agriculture employs about 66% of the workforce. and agriculture makes up c.50% of Ivory Coast's exports. Ivory Coast is the world's largest producer of cocoa beans and fourth-largest producer of coffee. Other exports include cotton, bananas, palm oil, pineapples and hardwoods. Food crops include cassava, rice, vegetables and yams. Manufacturing products include fertilizers, refined oil, textiles and timber. History and politics European contact with the region dates back to the late 15th century, and trade in ivory and slaves soon became important. French trading posts were founded in the late 17th century, and Ivory Coast became a French colony in 1893. From 1895 Ivory Coast was governed as part of French West Africa, a massive union that also included modern-day Benin, Burkina Faso, Guinea, Mali, Mauritania, Niger and Senegal. In 1958 Ivory Coast voted to remain within the French Community, but achieved full independence in 1960. Its first president, Félix Houphouër-BOIGNY, was the longest-serving African head of state, with an uninterrupted 33-year presidency until his death in 1993. He was a paternalistic, pro-Western leader. His dialogue with South Africa's apartheid government enraged many fellow African states. In 1983 the National Assembly agreed to move the capital from Abidjan to Yamoussoukro, the president's birthplace, but economic setbacks delayed the completion of the transfer, and government offices remained in Abidjan until 1990. Civil unrest continued throughout the 1980s and led to the adoption of a new constitution (1990), which legalized opposition parties. Houphouët-Boigny was succeeded by Henri Konan Bédié. Bédié was re-elected in 1995 elections, following an opposition boycott.

ivy Woody, EVERGREEN vine, native to Europe and Asia. Its long, climbing stems cling to upright surfaces, such as trees or walls, by aerial roots. The common English ivy (*Hedera helix*) is propagated by cuttings and grows outdoors in moist shady or sunny areas. Family Araliaceae.

Ivy League Group of eight long-established colleges and universities in NE USA. Members are HARVARD, YALE, PRINCETON, Pennsylvania, Brown, Columbia, Dartmouth and Cornell. They are organized as an intercollegiate track and field league. Iwo Jima (formerly Sulphur Island) Largest of the Japanese Volcano Islands in the w Pacific Ocean. During World War 2, it was captured by US forces at great human cost (1945). A photograph of the US flag being planted on its highest peak, Mount Suribachi, became a US symbol of the Pacific conflict and the basis for a sculpture in Arlington National Cemetery, Washington, D.C.. Iwo Jima was returned to Japan in 1968. Industries: sugar refining and sulphur mining. Area: 21sq km (8sq mi).

Izetbegović, Alija (1925–) Bosnian politician, president of Bosnia-Herzegovina (1992–). A Muslim, Izetbegović was imprisoned by the Yugoslavian government for pan-Islamic activities (from 1945–48) and for his Islamic Declaration of 1970 (from 1983–88). Elected leader of the Party of Democratic Action (PDA) in 1990, Izetbegović advocated a multi-faith republic. He led Bosnia-Herzegovina's coalition government from 1990 until its declaration of independence in 1992, when he became president. He retained his position throughout the civil war, and signed the Treaty of Paris (1995), which ended the Bosnian War. He was re-elected in 1996.

Izmir (formerly Smyrna) City and seaport on the Gulf of Izmir, w Turkey. It was settled by Greeks at the beginning of the 1st millennium BC. Izmir was part of the Ottoman empire from 1424–1919, when it was assigned to Greece. It passed to Turkey under the Treaty of Lausanne (1923). Industries: tourism, tobacco, silk, carpets, cotton and woollen textiles, petrochemicals, foodstuffs, cement. Pop. (1990) 2,319,188.

IVORY COAST

AREA: 322,460 sq km (124,502 sq mi)
POPULATION: 12,910,000
CAPITAL (POPULATION):
Yamoussoukro (106,786)
GOVERNMENT: Multiparty republic
ETHNIC GROUPS: Akan
41%, Kru 17%, Voltaic
16%, Malinke 15%,

Southern Mande 10%

LANGUAGES: French (official)
RELIGIONS: Islam 38%,
Christianity 28%, traditional

currency: CFA franc = 100 centimes

jabiru Stork of the New World, found in tropical swamps from Mexico to Argentina. Length: 1.5m (5ft); wingspan: 2m (7ft). Family Ciconiidae, species *Jabiru mycteria*.

jaçana (lily trotter) Long-toed water bird of tropical lakes with a slender body, narrow bill and tapered claws. It is black or reddish-brown. It feeds on aquatic plants and small animals. Length: to 50.8cm (20in). Family Jacanidae.

jacaranda Genus of trees native to tropical America. The ornamental *Jacaranda mimosifolia* and *J. cuspidifolia* have showy blue flowers amd fern-like leaves. There are 50 species. Family Bignoniaceae.

jackal Wild dog, found throughout Asia and Africa, that resembles a COYOTE. It eats small animals, fruit and seeds. Length: to 74cm (29.1in). Family Canidae; genus *Canis*.

jackdaw Gregarious black-and-grey bird that frequents open country near buildings or cliffs. Smaller than its relative, the CROW, it has a grey head and white-rimmed eyes. It lives in colonies. Family Corvidae; species *Corvus monedula*.

jack rabbit Any of several large, slender, long-eared HARES of w North America. Jack rabbits rely on their great speed, powerful leaps and agility to escape from predators. Most are grey with white underparts. Family Leporidae; genus Lepus. Jackson, Andrew (1767-1845) Seventh US president (1829-37). Jackson became a national hero in the WAR OF 1812 when he defeated the British at New Orleans (1815). Jackson's popular appeal narrowly failed to defeat John Quincy ADAMS in the 1824 presidential election. His supporters built the basis of the new DEMOCRATIC PARTY and Jackson was elected with John C. CALHOUN as his vice president in 1828. Jackson faced staunch opposition from the establishment and set up a SPOILS SYSTEM of political appointments. Calhoun resigned over the NULLIFICATION issue and Jackson faced further conflict over states' rights, the expansion of the FRONTIER, and the tariff. His second term (1832-37) was marked by his trenchant opposition to the BANK OF THE UNIT-ED STATES. He was succeeded by Martin Van Buren.

Jackson, Glenda (1936–) British actress and politician. Jackson reprised her stage role in her film debut *Marat/Sade* (1967). Her performance in Ken Russell's *Women in Love* (1969) earned her an Academy Award for Best Actress. She won a second Best Actress Oscar for *A Touch of Class* (1973). Other films include *Sunday Bloody Sunday* (1971) and *Hedda* (1975). She was elected to parliament in 1992.

Jackson, Jesse (1941–) US political leader and CIVIL RIGHTS activist. He worked with Martin Luther KING in the Southern Christian Leadership Conference. In 1971 he formed Operation PUSH (People United to Save Humanity) to combat racism. He mounted unsuccessful campaigns for the Democratic presidential nomination in 1984 and 1988. In 1986 he became president of the National Rainbow Coalition. Jackson, Michael (1958–) US pop singer and songwriter. At age five, he was the youngest member of his brothers' singing group, The Jackson Five. His albums, *Got to Be There* (1971) and *Off the Wall* (1979), launched a major solo career that peaked in the 1980s with elaborate worldwide concert tours and top-selling albums, such as *Thriller* (1982), *Bad* (1987), and *Dangerous* (1991).

Jackson, "Stonewall" (Thomas Jonathan) (1824–63) Confederate general in the American Civil War. His stand against overwhelming odds at the first battle of Bull Run (1861) gained him the nickname "Stonewall". He fought, again greatly outnumbered, in the Shenandoah Valley (1862) and played an important part in the Confederate victories after the second battle of Bull Run. Jackson was accidentally shot and killed by his own men at Chancellorsville.

Jackson State capital and largest city of Mississippi, USA, on the Pearl River, sw Mississippi. Established as a trading post in the 1790s, it was chosen as state capital in 1821. Industries: natural gas, glass, textiles. Pop. (1990) 196,637. Jacksonville Seaport on the St John's River, NE Florida, USA. The largest city in the state, it served as a Confederate base during the Civil War, developed as a port in the 19th

century, and was devastated by fire in 1901. Industries: cigars, fruit canning, wood products. Pop. (1994 est.) 676,718. **Jacob** Old Testament figure, grandson of ABRAHAM and, by tradition, ancestor of the nation of Israel. He was the secondborn son of Israel and Rebecca and younger twin brother of Esau. Stories about him and his family form the last part of Genesis (25:19–50:13). Jacob had 12 sons and one daughter by his two wives, Rachel and Leah, and their respective maids. The descendants of his 12 sons became the 12 tribes of Israel.

Jacobean (Lat. *Jacobus*, James) Artistic styles during the reign (1603–25) of JAMES I. The major literary form was drama, such as the works of Webster and the late plays of SHAKESPEARE. METAPHYSICAL POETRY, such as the work of John Donne, was also a feature of the age. In architecture, the major achievement was the work of Inigo Jones.

Jacobins French political radicals belonging to a club that played an important role during the FRENCH REVOLUTION. Established in 1789, the club split in 1791 when the moderates left. In 1793–94, the club acted as an instrument of ROBESPIERRE's government. It closed soon after Robespierre's downfall in 1794.

Jacobites Supporters of James II of England and his STUART descendants, who attempted to regain the English throne after the GLORIOUS REVOLUTION of 1688. Jacobitism was strong in the Scottish Highlands and parts of Ireland. Several Jacobite rebellions took place, most notably the rising of 1745, in which Prince Charles Edward STUART regained Scotland. His Highlanders were decisively defeated at CULLODEN in 1746, and the English government embarked upon a policy of suppression of the Highland clans that ended the Jacobite threat.

Jacob's ladder Any of 50 species of wild and cultivated plants of temperate areas. It has clusters of delicate blue, violet or white flowers and alternate compound leaves. Height: up to 90cm (3ft). Family Polemoniaceae.

Jacopone da Todi (1230–1306) Italian poet. After the death of his wife in the 1260s, he became a monk and wrote numerous fervid, intensely personal hymns. The Latin canticle *Stabat mater dolorosa* is attributed to him.

jade Semiprecious silicate mineral of two major types: **jadeite**, which is often translucent; and **nephrite**, which has a waxy quality. Both types are extremely hard. Jade is found mainly in Burma and comes in many colours, most commonly green and white. Hardness 5–6; s.g. 3–3.4.

Jade, August Personage of In Chinese mythology, the supreme god of heaven and, according to some traditions, the creator of human beings. He concerned himself exclusively with the affairs of the emperor, leaving his heavenly ministers to deal with lesser mortals.

jaeger (skua) Gull-like, predatory, fast-flying seabird that breeds in the Arctic and winters in the subtropics. It has a dark, stocky body with pointed wings and long tail feathers. It feeds on small land animals and seabirds. Length: 33–51cm (13–20in). Genus: *Stercorarius*.

Jaffa City and port in w Israel, a suburb of Tel Aviv. Mentioned in the Bible, it was captured by Alexander the Great in 332 BC. It was taken back by the Jews during the Hasmonean revolt, but was destroyed by the Roman emperor Vespasian in AD 68. It changed hands many times in the Middle Ages. In the 20th century it became a focus of Palestinian resistance to Jewish settlement. In 1948 Jaffa was settled by Israelis and united with Tel Aviv in 1950.

Jagiello (Jagello) Medieval Polish dynasty. It began with the marriage of Grand Duke Jagiello of Lithuania to Queen Jadwiga of Poland (1386), uniting Poland and Lithuania. Members of the dynasty reigned also in Hungary and Bohemia in the 15th–16th centuries.

jaguar Spotted big CAT found in wooded or grassy areas from

J/j, the tenth letter of the Roman-based w European alphabet, It evolved from the letter i and was the last to be incorporated into the modern alphabet; its early history is the same as that of i. The j developed from the tailed form of the i, often written at the beginnings of words. Today, it represents a consonant sound in modern English, nearly always pronounced as a voiced affricate, as in jug; in some words (such as hallelujah) it is pronounced like a y.

▲ Jackson Raised in modest circumstances, Jesse Jackson became the first African-American to contend seriously for president in 1984 and 1988. A charismatic preacher and civil rights advocate, he later formed the National Rainbow Coalition, a political organization made up of a collection of minority groups, environmentalists and peace activists.

■ jaguar Largest cat in the Americas, the jaguar (*Panthera onca*) is now extinct in most of N America. It is a solitary and agile hunter, and an excellent swimmer and tree climber.

jaguarundi Small, ground-dwelling CAT found in Central and South America. It is black, brown, grey, or fox red. Length: to 67cm (26.4in), excluding the tail; weight: to 9kg (19.8lb). Family Felidae; species *Felis yagouaroundi*.

Jahangir (1569–1627) Mogul emperor of India (1605–27). He succeeded his father, AKBAR I, and continued the expansion of the empire. He granted trading privileges to the Portuguese and the British, and was a patron of poetry and painting.

Jainism Ancient religion of India originating in the 6th century BC as a reaction against conservative Brahmanism. It was founded by Mahavira (599–527 BC). Jains do not accept Hindu scriptures, rituals, or priesthood, but they do accept the Hindu doctrine of Transmigration of Souls. Jainism lays special stress on *ahimsa* – non-injury to all living creatures. Today, the number of Jains is estimated at *c*.4 million.

Jaipur State capital of Rajasthan. Founded in 1727, it was enclosed by a wall (still extant), and there is a system of wide, regular streets. A transport and commercial centre, it is famous for its carpets, jewellery, enamels and printed cloth. Pop. (1991) 1,458,000.

Jakarta Capital of Indonesia, on the NW coast of Java. It was founded (as Batavia) by the Dutch c.1619 as a fort and trading post, and it became the headquarters of the Dutch EAST INDIA COMPANY. It became the capital after Indonesia gained its independence in 1949. Industries: ironworking, printing, timber. Exports: rubber, tea, quinine. Pop. (1994 est.) 7,885,519. Jamaica Independent island nation in the Caribbean, 145km (90mi) s of Cuba; the capital is KINGSTON. Jamaica was discovered by Christopher Columbus in 1494 and remained a Spanish possession until captured by the British in 1655. Its sugar plantations brought prosperity, but the economy declined after the abolition of slavery in 1834. British rule was threatened by a black rebellion in 1865. The colony was granted internal selfgovernment within the Commonwealth in 1944, and in 1958 joined the newly formed Federation of the West Indies. After the collapse of the Federation, Jamaica achieved full independence in 1962. Many social reforms were introduced, but it continues to suffer from severe economic problems. Jamaica is a largely mountainous country with a tropical maritime climate. The chief crops are sugar cane, bananas and other fruits. The economy is based on light engineering, construction and mining. Tourism is also important. Area: 10,962sq km (4,232sq mi). Pop. (1993 est.) 2,471,600. See WEST INDIES map James I (1566-1625) King of England (1603-25) and, as James VI, king of Scotland (1567-1625). Son of MARY, QUEEN OF SCOTS, he acceded to the Scottish throne as an infant on his mother's abdication. After inheriting the English throne, he confined his attention to England. He supported the Anglican Church at the cost of antagonizing the PURITANS, and sponsored the Authorized (King James) Version of the Bible (1611). The GUNPOWDER PLOT (1605) resulted in further restrictions on Catholicism. James' assumption of "divine right" saw him rule often without Parliament or regard for common law, as defended by Sir Edward Coke. The death (1612) of Robert CECIL and the impeachment of Francis BACON widened the gulf between Crown and Parliament, and James' son, CHARLES I, inherited a volatile state.

James II (1633–1701) King of England (1685–88), second son of Charles I, brother and successor of Charles II. Following the English CIVIL War, James fought for the French and Spanish, before returning as lord high admiral after the RESTORATION (1660). He converted to Roman Catholicism (1669) and was forced to resign all his offices. As king, James was confronted immediately by MONMOUTH'S Rebellion (1685). His pro-Catholic policies inflamed popular opinion and the birth of a son, James STUART, precipitated the GLORI-OUS REVOLUTION. His daughter, MARY II, and her husband, WILLIAM III OF ORANGE, acceded to the throne, and James was forced to flee to France. With French aid, James invaded Ireland but was defeated by William at the Battle of the BOYNE (1690). See also JACOBITES

James I (1394–1437) King of Scotland (1406–37). His father, Robert III, sent him to France for safety but he was intercepted by the English (1406). He was not ransomed until 1424. James then restored royal authority by ruthless methods. He carried out reforms of the financial and judicial systems and encouraged trade. His campaign against the nobility made him many enemies, and he was assassinated at Perth.

James II (1430–60) King of Scotland (1437–60), son and successor of JAMES I. His minority was dominated by aristocratic factions, particularly the Douglases. In 1452 he killed the earl of Douglas and seized control. During the Wars of the Roses, James supported the Lancastrians against the Yorkists, and was killed by an exploding cannon at Roxburgh.

James III (1451–88) King of Scotland (1460–88), son of JAMES II. James was challenged by his brother, Albany, whom EDWARD IV of England recognized as king in 1482. Peace was arranged, but a new rebellion resulted in James' defeat and his subsequent murder.

James IV (1473–1513) King of Scotland (1488–1513). He succeeded his father, James III, capturing and killing those nobles responsible for his death. He defended royal authority against the nobility and the church and endeavoured to promote peace with England, marrying Henry VIII's sister, Margaret Tudor. Henry's attack on Scotland's old ally, France, drew him into war (1513), and he was killed at Flodden.

James V (1512–42) King of Scotland (1513–42). He made a French alliance through marriage as a safeguard against his uncle, HENRY VIII. Lack of support from the nobility contributed to his defeat by the English at Solway Moss (1542). He was succeeded by his daughter, MARY, QUEEN OF SCOTS.

James Edward Stuart See Stuart, James Edward James, Henry (1843–1916) US novelist, brother of William James, Henry (1843–1916) in England and became a British subject in 1915. His early masterpiece The Portrait of a Lady (1881) contrasts the values of American and European society. The novels of his middle period, such as The Bostonians (1886), deal with political themes. His final novels, The Wings of the Dove (1902), The Ambassadors (1903) and The Golden Bowl (1904) show his mastery of the psychological novel.

Other works include *The Turn of the Screw* (1898). **James, Jesse Woodson** (1847–82) US outlaw. With his brother, Frank, he fought for the Confederacy during the Civil War. In 1867 they formed an outlaw band and terrorized the frontier. He was shot dead by Robert Ford, a member of his own gang, for a large reward.

James, William (1842–1910) US philosopher and psychologist, elder brother of Henry James. He held that the feeling of emotion is based on the sensation of a state of the body; the bodily state comes first and the emotion follows. As a philosopher, he influenced PRAGMATISM. His most famous works are *The Principles of Psychology* (1890) and *Varieties of Religious Experience* (1902).

James, the Epistle of Book of the New Testament consisting of a letter traditionally attributed to St James, the brother of Jesus. Its authorship is, however, far from certain. It exhorts Christians to live righteous lives, warning that profession of Christian faith should not take the place of good works.

Jameson, Sir Leander Starr (1853–1917) British political leader in South Africa. A physician, he emigrated to South Africa (1878). In 1895, with the connivance of Cecil Rhodes, he led a failed raid on the Afrikaner republic of Transvaal and was imprisoned. After his release, he served as prime minister (1904–08) of Cape Colony.

Jamestown First successful English settlement in America. It was established in 1607 on the James River, Virginia. On the verge of collapse from disease and starvation, it was saved by the leadership of Captain John SMITH (1608) and the timely arrival of new supplies and colonists (1610). From 1614 survival was assured thanks to tobacco planting.

Jammu and Kashmir State in NW India, bounded N by Pakistan-controlled Kashmir, w by Pakistan and E by China. The capitals are Srinagar (summer) and Jammu (winter). The state is largely mountainous, and the Himalayas tower above the heavily populated valleys of the Indus and Jhelum rivers. Industries: rice cultivation, animal husbandry, silk

factories, rice and flour mills, tourism. Area: 100,569sq km (38,845sq mi). Pop. (1994 est.) 8,435,000.

Janáček, Leoš (1854–1928) Czech composer. His compositions include orchestral works, such as *Taras Bulba* (1918) and the *Sinfonietta* (1926), two string quartets (1923, 1928), and the cantata *The Eternal Gospel* (1914). He also wrote several operas, including *Jenûfa* (1904), *The Cunning Little Vixen* (1924) and *The Makropoulos Case* (1926).

Janissaries Elite corps of the Ottoman army, founded in the 14th century. The Janissaries were a highly effective fighting force until the 17th century, when discipline and military prestige declined. They were abolished by MAHMUD II in 1826.

Jansen, Cornelis (1585–1638) Dutch theologian. He studied problems raised for Catholics by Lutheran and Calvinist doctrine. He argued for a return to the views of St Augustine OF Hippo on grace and salvation. *See also* Jansenism

Jansenism Theological school that grew up in the Roman Catholic Church in the 17th and 18th centuries. It was named after Cornelis JANSEN, but the movement was strongest in France. The Jansenists believed that man is incapable of carrying out the commandments of God without divine "grace", which is bestowed only on a favoured few. French Jansenists incurred the hostility of the JESUITS and of the French crown, and they were condemned by the pope (1713).

Jansky, Karl (1905–50) US engineer, who discovered (1931) unidentifiable radio signals from space. He concluded that they were stellar in origin and that the source lay in the direction of SAGITTARIUS. Jansky's discovery is considered to be the beginning of radio ASTRONOMY. The unit measuring radio emission is named after him.

Japan Archipelago state in E Asia. See country feature, p.358 Japanese Official language of Japan and the native tongue of more than 120 million people in Japan, and the Ryukyu and Bonin islands. Some scholars classify Japanese as a member of the Ural-Altaic family, which also includes Finnish, Hungarian and Turkish. Japanese uses a pitch accent. There are at least four different forms of spoken Japanese, and a modern literary style. Japanese writing uses a combination of some 1,850 Chinese characters and tables of syllabic symbols called kana.

Japanese art and architecture Earliest surviving examples of **Japanese art** are Jomon pottery figurines (c.1000 BC). In the 6th century AD Chinese influence was strong. LACQUER work, sculpture and ink-painting developed during the Nara period (AD 674-794). The Yamato-e tradition was based on national, rather than Chinese, aesthetic standards. It flowered during the Kamakura military rule (1185-1333). The profound influence of ZEN Buddhism on Japanese art is particularly apparent in the Muromachi period (1333-1573). Many of the best-known examples of Japanese art were produced in the Edo (Tokugawa) period (c.1600-1868). The ukiyo-E prints of UTAMARO, HOKUSAI, HIROSHIGE and others date from this period. Modern Japanese artists have made important contributions to 20th-century art and design. Japanese architecture derives from 6th century Chinese Buddhist structures. Temples have curved wooden columns, overhanging roofs and thin exterior wood and plaster walls. A gateway, drum tower, and pagoda are also built, usually on a picturesque wooded hillside. Domestic structures are traditionally built with interior wooden

posts supporting the roof. The outer walls are movable panels of wood or rice paper that slide in grooves. The interior is subdivided by screens and decorated with simplicity and delicacy. Japanese literature Earliest extant works are the Kojiki (712) and the Nihongi (720), which are histories written in Chinese characters used phonetically. The earliest recorded Japanese poetry is in the Manyoshu (760), which contains poems dating to the 4th century. The Heian Period (794-1185) is noted for the Kokinshu (905), an anthology of poetry commissioned by the emperor, which provided a pattern for tanka (short poems). Classical prose developed during this period and accounts of court life flourished. The most significant work was Murasaki Shikibu's Genji Monogatari (c.1010), the first true novel. During the Middle Ages (1185-1603) No DRAMA was refined, and "war tales", such as Heike Monogatari, were developed. In the Tokugawa Period (1603-1868) literature, once the preserve of the aristocracy, became the field of the commoners. HAIKU became popular; Matsuo Bashō (1644-94) was the greatest poet of this form. In the Modern Period, foreign contacts and Western literature had a major influence. Poetry flourished, and major figures, such as Yosano Akiko (1878–1942), Ishikawa Takuboku (1885–1912) and Hagiwara Sakutaro (1886-1942) found new means of expression. Writers of modern fiction, such as MISHIMA Yukio, Abe Kobo and KAWABATA Yasunari have earned an international reputation.

Japanese theatre Various dramatic forms, including No DRAMA, PUPPET THEATRE and KABUKI THEATRE. Japanese theatre descended from ritual dances, and involves music, song and dance in addition to dialogue. More modern styles of drama, known as *shinpa* and *shingeki* (new theatre), which were influenced by Western theatre, developed out of the desire to portray modern events and ideas in a more realistic style.

Jarman, Derek (1942–94) English film director. A candid and confrontational figure in the vanguard of the "queer film" movement, Jarman's style was politicized, experimental and erotic. His films include *Caravaggio* (1986), *War Requiem* (1989) and *Wittgenstein* (1993). Jarman died of AIDS.

Jarrow March (1936) British protest march of unemployed workers from Jarrow, County Durham, to London. Unemployment was especially high in Jarrow, a small shipbuilding town dependent on one company, which closed down in 1933. About 200 people took part in the march.

Jarry, Alfred (1873–1907) French playwright, poet and satirist. He is chiefly remembered for his avant-garde farce *Ubu Roi* (1896). His work foreshadowed SURREALISM.

jasmine Any evergreen or deciduous shrub or vine of the genus *Jasminum*, common in the Mediterranean. It produces fragrant yellow, pink, or white flowers, and an oil that is used in perfumes. Height: to 6.5m (20ft). Family Oleaceae.

Jason In Greek mythology, hero and leader of the Argonauts. Sent on a quest for the Golden Fleece, Jason sailed aboard the *Argo*. After surviving many perils, he found the fleece in Colchis and stole it, with the help of the sorceress Medea, whom he married.

Jatakas (birth stories) Buddhist writings that drew moral conclusions from stories of the BUDDHA in a previous existence. The main character usually appears as an animal whose present circumstances are the result of past acts.

jaundice Yellowing of the skin and the whites of the eyes, caused by excess of BILE pigment in the blood. Mild jaundice is common in newborn babies. In adults, jaundice may occur when the flow of bile from the liver to the intestine is blocked by an obstruction such as a GALLSTONE, or in diseases such as CIRRHOSIS, HEPATITIS OF ANAEMIA.

Jaspers, Karl (1883–1969) German philiosopher and psychopathologist. Jaspers was professor of psychology (1921–48) at the University of Heidelberg. His major work, *Philosophy* (1932), presents an individual interpretation of EXISTENTIALISM. Jaspers argued that the deepest insights into human nature are revealed in "limit situations", such as death. Java Indonesian island, between the Java Sea and the Indian Ocean, se of SUMATRA; its largest city is JAKARTA. In the early centuries AD, the island was ruled by Hindu kingdoms. Islam began to spread in the 16th century. By the 18th century the island was mainly under Dutch control. It was occupied by

■ Japanese architecture The Shonkintei garden pavilion (1641) at the palace of Katsura in Kyōto is typical of Japanese period architecture. It is comprised of two large rooms (1) and (2) divided by *shoji* (translucent screens), a tea room (3), lobby (4), and pantry section (5). The *tokonoma* (6) is an alcove for the display of flowers and objects of art.

▲ Japanese art The decorative arts in Japan were well developed by the end of the 8th cenury. Colour printing was particularly advanced, along with woodcuts, and ceramic glazes. *Kakemono* are hanging scrolls executed on thin silk or paper with Chinese ink, then mounted on silk brocade and rolled on a rod.

Japan's flag was officially adopted in 1870, though Japanese emperors had used this simple design for many centuries. The flag shows a red sun on a white background. The geographical position of Japan is expressed in its name *Nippon* or *Nihon*, (source of the Sun).

Japan is an archipelago nation in the N Pacific Ocean. Its four largest islands are (in decreasing order of size) Honshū, Hokkaidō, Kyūshū and Shikoku. These constitute 98% of the total land area and enclose the Inland Sea (Sea of Japan). Japan has thousands of other small islands, including the Ryukyu Islands. Okinawa forms part of the Ryukyu archipelago.

The four main islands are mostly mountainous. The highest peak is the sacred FUJIYAMA, at 3,776m (12,389ft). Japan has more than 150 volcanoes, about 60 of which are active. Many of the small islands are the tips of volcanoes. Volcanic eruptions, earthquakes and TSUNAMI occur frequently. Around the coast are small, densely populated fertile plains covered by alluvium deposited by the short rivers that rise in the mountains. The Kanto plain stretches from the s coast of Honshū to N Kyūshū, and is Japan's industrial heartland. The plain includes

the capital and world's sixth largest city, TOKYO. If you include YOKOHAMA, this is the world's most densely populated area. Other major cities in the region include NAGOYA, KYŌTO, OSAKA, KŌBE and FUKUOKA.

CLIMATE

The climate of Japan varies greatly from cool temperate in the N to subtropical in the S. Sapporo on Hokkaidō has cold, snowy winters with temperatures below -20°C (4°F). Summer temperatures sometimes exceed 30°C (86°F). Tokyo has higher rainfall and temperatures.

VEGETATION

Forests and woodland cover c.66% of the land. The N forests include fir and spruce. Central Japan has mixed forests of beech, maple and oak. Deciduous trees dominate in the s. The cherry tree is found throughout Japan.

135°E 140°E MAP SCALE Sea of Othotsk RUSSIA Rumoi Otaru Sapporo Obihiro Tomakoma Muroran Cape Erimo Hakodate Matsuma NORTH Aom KOREA Hirosa S e o f Hachinohe a 40°N Noshiro Akita a Þ a **Ich**inoseki Ishinomaki Sado A Yama Sendai Fukushima Cape Suzu ivama SOUTH KOREA Hitachi 145°E Fukui Kawasaki 35°N okohama 35°N Kagoshima Hamada Hiroshima 1 Tanega oyohashi Kitakyushu Shingu Fukuoka! OCEAN Cape Shione PACIFI Okinawa MAP SCALE Sakishima Islands TAIWAN 130°E 130°E

AREA: 377,800sq km (145,869sq mi)

POPULATION: 124,336,000

CAPITAL (POPULATION): Tokyo (7,894,000) GOVERNMENT: Constitutional monarchy ETHNIC GROUPS: Japanese 99%, Chinese.

Korean, Ainu

LANGUAGES: Japanese (official)

RELIGIONS: Shintoism 93%, Buddhism 74%, Christianity 1% (most Japanese consider themselves to be both Shinto and Buddhist)

currency: Yen = 100 sen

HISTORY

Most Japanese people are descendants of migrants from mainland Asia. One of the earliest groups are the AINU, c.15,000 of whom still live on Hokkaido. According to legend, Japan's first emperor, Jimmu, ascended the throne in 660 BC. The native religion was SHIN-To. The Yamato established the Japanese state in the 5th century and made Kyōto the imperial capital. In the 6th century BUDDHISM was introduced. Confucianism was part of the profound cultural influence that China has had on JAPANESE ART AND ARCHITECTURE and JAPANESE LITERATURE. In the 12th century, civil war gave way to the power of the shogun, who ruled in the emperor's name. For the next 700 years Japan was ruled by these warrior-kings. European contact began when Portuguese sailors reached Japan in 1543. Following unsuccessful invasions of Korea and China, the Tokugawa shōgunate (1603-1867) unified Japan and established their capital at Edo (Tokyo). Through the codes of BUSHIDO, the Tokugawa ensured total loyalty. Japan pursued an isolationalist path. In 1854 Matthew C. Perry forced the Tokugawa shogunate to open its ports to Western trade. Western powers plotted the overthrow of the shogunate and the reestablishment of imperial power (MEIJI RESTORATION, 1868). The Emperor Meiji's reign (1868-1912) was characterized by social and economic modernization, headed by the ZAIBATSU. Japanese nationalism created the desire for empire-building. The first of the SINO-JAPANESE WARS (1894-95) saw Japan acquire Formosa (Taiwan). Japan's decisive victory in the Russo-Japanese War (1904-05) marked its emergence as the dominant regional power. In 1910 Japan annexed Korea, During the 1920s Japan concentrated on building its economy, interrupted only by an earthquake (1923) that claimed 143,000 lives and devastated Tokyo and Yokohama. Militarists began to dominate Japanese politics. In 1930 Japan invaded Manchuria, and set up the puppet state of MANCHUKUO. In 1937 Japan invaded China and precipitated the second Sino-Japanese War. At the start of WORLD WAR 2, Japan signed a pact with Germany and Italy. In 1941 Japan launched an attack on the US naval base at PEARL HARBOR. Japan conquered a huge swathe of Pacific territory, but gradually the Allies regained ground. In 1945 the United States dropped atomic bombs on the cities of HIROSHIMA and NAGASAKI and forced Japan's unconditional surrender (14 August 1945). The US occupation of Japan under Douglas MACARTHUR (1945-52) undertook the demilitarization of industry and the adoption of a democratic constitution. Emperor HIROHITO

JAPAN

declaimed his divinity and became a constitutional monarch. The Liberal Democratic Party (LDP) governed Japan almost continuously from 1948 to 1993. In 1951 Japan concluded a security treaty with the United States that allowed US bases to be stationed on Japan in return for securing its defences. During the 1960s and early 1970s Japan witnessed popular demonstrations against US interference. Under the prime ministership of Eisaku SATO, the US completed the return of the Ryukyu Islands to Japan (1972). In 1989 Hirohito died and was succeeded by his son, AKIHITO.

POLITICS

In the early 1990s, Japan was rocked by a series of political corruption scandals. In 1993 the LDP split: the three splinter parties formed a short-lived coalition government. In 1994 a new electoral system was introduced with an element of proportional representation. In 1996 the LDP leader Ryutaro Hashimoto became prime minister. In 1997 there were fears that economic turmoil in Southeast Asia would spread to Japan.

ECONOMY

Japan is the world's second largest (1993 GDP, US\$4,190,399 million) economic power (after the USA). Its success is based on the latest industrial technology, a skilled and committed labour force, vigorous export policies, and comparatively small defence expenditure. But economic success has brought problems: the rapid growth of industrial cities has led to high land prices, housing shortages and pollution. Its aging workforce also presents problems.

Services form the largest sector of Japan's economy. Japan has seven of the world's 10 largest banks. Despite having to import most of its raw materials and fuels, manufacturing is a vital sector of the Japanese economy. Machinery and transport equipment account for over 70% of exports. Japan is the world's leading car, ship and steel producer. It is also the world's second largest iron and cement producer. Other important manufactures include electrical and electronic equipment, chemicals and textiles.

Japan has the second largest fish catch (after China). Attempts have been made to reduce its

whaling. Because Japan is so mountainous only 15% of land is farmed and Japan has to import 30% of its food. Rice is the chief crop, taking up c.50% of total farmland. Other products include fruits, cereals, tea and vegetables. Japan is under increasing pressure to lift its protectionist policies of import restrictions and high tariffs.

The kimono is a traditional Japanese garment, worn by both women and men. It is now worn on special occasions. For everyday use, most city dwellers wear Western-style clothes.

the Japanese during World War 2. Java is a mountainous country, with a volcanic belt in the s and an alluvial plain to the N. It is thickly forested and has many rivers. It produces rice, tea, coffee, sugar cane, textiles, tobacco and rubber. Silver, gold and phosphate is mined in the N. Area: 126,501sq km (48,842sq mi). Pop. (1990) 107,581,306.

javelin Lightweight tapered, tubular spear thrown in a field event: the longest throw wins, provided the javelin lands point-first. The modern javelin is made of a metal alloy, is up to 2.7m (8.9ft) long, and weighs a minimum of 800g (28.2oz) for men and 600g (21oz) for women.

Jay, John (1745–1829) US statesman, first chief justice of the Supreme Court (1789–95). Jay was president of the Continental Congress (1778–79) and negotiated the peace treaty with Great Britain. He was secretary of foreign affairs (1784–89) and contributed to *The Federalist* (1787–88). In 1794 he concluded Jay's Treaty, which settled outstanding disputes with Britain and restored trade relations. It also served to sharpen divisions between the FEDERALIST PARTY and the DEMOCRATIC REPUBLICAN PARTY.

jay Any of several species of harsh-voiced birds related to the MAGPIE and JACKDAW. It has blue wing markings. Length: 34.2cm (13.5in). Family Corvidae.

jazz Style of music that evolved in the USA in the late 19th century out of African and European folk music, and spiritual and popular songs. It is traditionally characterized by improvization, steady rhythm, and prominence of melody, often with elements derived from the BLUES. Early jazz developed in New Orleans, becoming known as DIXIELAND music. In the 1920s it spread to Chicago and New York City. In the 1930s swing enjoyed great popularity, as did the BEBOP style of the 1940s. Modern jazz incorporates many musical forms. Jeans, Sir James Hopwood (1877–1946) British astrophysicist and writer who popularized astronomy. He investigated stellar dynamics and proposed the tidal theory of planetary origin, in which the matter of the planets was drawn out of the Sun by the attraction of a passing star.

Jedda See Jiddah

Jefferson, Thomas (1743–1826) Third US president (1801–09), vice president (1797–81). Jefferson was a leading member of the Continental Congress and the primary author of the Declaration of Independence (1776). His governorship of Virginia (1779–81) was ended by the American Revolution. Jefferson returned to Congress (1783–84), before succeeding Benjamin Franklin as minister to France (1785–89). He was persuaded by George Washington to serve as his first

secretary of state (1789–93). Disagreements with Alexander Hamilton saw the formation of the Democratic Republican Party led by Jefferson. Narrowly defeated by John Adams in the 1796 presidential election, Jefferson became vice president. He led opposition to the Alien and Sedition Acts (1798). The landmarks of Jefferson's first administration (1801–05) were the Louisiana Purchase (1803) and the Lewis and Clark Expedition (1804–06). His second administration (1805–09) overcame the Aaron Burr conspiracy. He managed to avoid war with Britain, instead passing an Embargo Act (1807). Jefferson retired from office and was succeeded by James Madison. He was a slave owner, although in principle opposed to slavery. He founded the University of Virginia (1825).

Jefferson City State capital of Missouri, on the Missouri River. It was chosen as state capital in 1821. The Capitol building (1911–18) contains some fine murals. Industries: shoes, clothes, electrical appliances. Pop. (1990) 35,480.

Jeffreys, George, 1st Baron (1648–89) English judge. He became lord chief justice in 1683 and lord chancellor in 1685. He presided over the BLOODY ASSIZES for JAMES II. After the GLORIOUS REVOLUTION (1688), he was caught trying to flee the country and was imprisoned in the Tower of London, where he died. See also MONMOUTH, JAMES SCOTT, DUKE OF Jehovah Latinized representation of the name of the God of the Israelites. The name Jehovah developed during the Mid-

Jehovan Latinized representation of the name of the God of the Israelites. The name *Jehovah* developed during the Middle Ages from the Latin framework of the sacred name YAH-WEH (JHVH) and the vowels from *Adonai* (a, o, and a).

Jehovah's Witnesses Religious sect founded in the

Jehovah's Witnesses Religious sect founded in the 1870s by Charles Taze Russell (1852–1916) of Pittsburgh. The sect believes in the imminent end of the world for all except its own members. They hold to the theory of a theocratic kingdom, membership of which cannot be reconciled with allegiance to any country. They deny most of the fundamental Christian doctrines. No member of the sect may give or receive blood transfusions. The sect is active worldwide.

jellyfish Marine COELENTERATE found in coastal waters and characterized by tentacles with stinging cells. The adult form is the medusa. It has a bell-shaped body with a thick layer of jelly-like substance between two body cell layers, many tentacles and four mouth lobes surrounding the gut opening. Diameter: 7.5–30.5cm (3in–12in). Class Scyphozoa.

Jenner, Edward (1749–1823) British physician who pioneered VACCINATION. Aware that cowpox, a minor disease, seemed to protect people from smallpox, Jenner, in 1796, inoculated a healthy boy with cowpox from the sores of an infected dairymaid. The boy was later found to be immune to smallpox.

jerboa Nocturnal, herbivorous, burrowing RODENT of Eurasian and African deserts, with long hind legs developed for jumping. It has a satiny, sand-coloured body and a long tail. Length: to 15cm (6in), excluding the tail. Family Dipodidae.

Jeremiah (active c.626–c.586 BC) Old Testament prophet who gave his name to the Old Testament Book of Jeremiah. He preached that the sinful behaviour of his countrymen would be punished by God. When Babylon invaded Judah (587 BC), Jeremiah saw this as divine retribution.

Jericho Ancient city of Palestine, on the WEST BANK of the River Jordan, N of the Dead Sea. It is one of the earliest known sites of continuous settlement, dating from c.9000 BC. According to the Old Testament, Joshua captured Jericho from the Canaanites (c.300 BC). The city was destroyed and HEROD THE GREAT built a new city to the south. In 1993, following the Israel-PLO peace agreement, Jericho was selected as the centre for Palestinian self-rule. It lies in an agricultural area, producing citrus fruit and dates.

Jeroboam Name of two kings of Israel (northern Palestine). Jeroboam I (active late 10th century BC) led an unsuccessful revolt against King Solomon and was forced to flee to Egypt. After Solomon's death, he returned to lead the secessionist kingdom of Israel in Palestine's northern hill country. Jer**oboam II** (r. c.783-c.741 BC) ruled Israel during a period of relative peace. Although Israel made economic progress and saw a revival in its political power, corruption was widespread. Jerome, Saint (347–420) Scholar and translator of the Bible into Latin, b. Eusebius Hieronymous. After a literary education at Rome, he spent two years of intense study as a hermit in the Syrian desert before being ordained a priest at Antioch. Later he returned to Rome. Pope Damasus I commissioned Jerome to prepare a standard text of the gospels for use by Latin-speaking Christians. His work was the basis for what later became the authorized Latin text of the Bible. In 384, Jerome left Rome and set up a monastic community in Bethlehem.

Jerome, Jerome K. (Klapka) (1859–1927) British humorist, actor and dramatist. His most successful works include the play *The Passing of the Third Floor Back* (1907) and the novel *Three Men in a Boat* (1889).

Jersey Largest of the CHANNEL ISLANDS, lying *c*.16km (10 mi) off the NW coast of Normandy in France; the capital is St Helier. It is administered as a bailiwick. Fruit and dairy farming (Jersey cattle) form the basis of the economy. Area: 117sq km (45sq mi). Pop. (1991) 84,082.

Jerusalem Capital of Israel, a sacred site for Christians, Jews and Muslims. Originally a Jebusite stronghold (2000–1500 BC), the city was captured by King DAVID after 1000 BC. Destroyed (c.587 BC) by NEBUCHADNEZZAR, it was rebuilt (c.35 BC) by HEROD THE GREAT, but was again destroyed (AD 70) by TITUS. The Roman colony of Aelia Capitolina was established, and Jews were forbidden within city limits until the 5th century. Christian control was ended by the Persians in AD 614. It was conquered in 1071 by the SELIUKS, whose maltreatment of Christians precipitated the CRUSADES. It was held by the OTTOMAN Turks from 1244 to 1917, before

▼ Jerusalem Dating from the 7th century, the Dome of the Rock was the first domed mosque. By tradition, it encloses the rock where Muhammad ascended to Heaven. The mosque stands within the Haram esh-Sharif. The wall of the Haram includes the Western (Wailing) Wall. The only extant piece of the Temple of Solomon, the site is sacred for Jews.

becoming the capital of the British-mandated territory of Palestine. In 1948 it was divided between Jordan (the east) and Israel (the west). In 1967 the Israeli army captured the Old City of East Jerusalem. In 1980 the united city was declared the capital of Israel, although this status is not recognized by the UN. Notable monuments within the old city include the DOME OF THE ROCK, the El Aqsa Mosque, and the WESTERN WALL. Jerusalem is an administrative and cultural centre. Industries: tourism, diamond-cutting. Pop. (1992) 544,200.

Jesuits (officially Society of Jesus) Members of a Roman Catholic religious order for men, founded by St IGNATIUS OF LOYOLA in 1534. They played a significant role in the COUNTER-REFORMATION. The Jesuits were active missionaries. They antagonized many European rulers because they gave allegiance only to their general in Rome and to the pope. In 1773 Pope Clement XIV abolished the order, under pressure from the kings of France, Spain and Portugal, but it continued to exist in Russia. The order was reestablished in 1814 and remains an influential international religious organization.

Jesus Christ (active 1st century AD) Hebrew preacher who founded the religion of CHRISTIANITY, hailed and worshipped by his followers as the Son of God. Knowledge of Jesus' life is based mostly on the biblical gospels of St MATTHEW, St MARK and St Luke. Mary gave birth (c.4 BC) to Jesus near the end of the reign of HEROD THE GREAT in Bethlehem, Judaea. Some Christians believe in the Virgin Birth and the appearance of a bright star and other portents. Jesus grew up in Nazareth, and may have followed his father, JOSEPH, in becoming a carpenter. In c.AD 26, Jesus was baptized in the River Jordan by JOHN THE BAPTIST. Thereafter, Jesus began his own ministry, preaching to large numbers as he wandered throughout the country. He also taught a special group of 12 of his closest disciples, who were later sent out as his APOSTLES to bring his teachings to the Jews. Jesus' basic teaching, summarized in the SERMON ON THE MOUNT, was to "love God and love one's neighbour". He also taught that salvation depended on doing God's will rather than adhering to the letter and the contemporary interpretation of the Jewish Law. Such a precept angered the hierarchy of the Jewish religion. In c.AD 29 Jesus and his disciples went to Jerusalem. His reputation as preacher and miracle-worker went before him, and he was acclaimed by the people as the MESSI-AH. A few days later, Jesus gathered his disciples to partake in the Last Supper. At this meal, he instituted the Eucharist. Before dawn the next day, Jesus was arrested by agents of the Hebrew authorities accompanied by JUDAS ISCARIOT, a disaffected disciple, and summarily tried for sedition by the SAN-HEDRIN, who handed him over to the Roman procurator, Pon-TIUS PILATE. Roman soldiers crucified Jesus at Golgotha. After his death, his body was buried in a sealed rock tomb. Two days later, according to the gospel, he rose from the dead. Forty days after his resurrection, he is said to have ascended into heaven. jet engine Engine that derives forward motion by reaction

to the rapid discharge of a jet of fluid (gas or liquid) in the opposite direction. In a jet engine, fuel burns in oxygen from the air to produce a fast-moving stream of exhaust gases. These are ejected from the back of the jet engine and produce a forward thrust in accordance with Newton's third law of motion. See also NEWTON'S LAWS

jet lag Phenomenon experienced when the body clock is disrupted by the sudden change in time zones, causing adverse effects on physiological and psychological rhythms. Symptoms include fatigue, confusion, mood alterations, irritability, sleep disturbance and other signs of stress.

Jet Propulsion Laboratory (JPL) Space centre in Pasadena, California, for the development and control of unmanned spacecraft. The California Institute of Technology runs JPL for the NATIONAL AERONAUTICS AND SPACE ADMINISTRATION (NASA). JPL scientists sent the Surveyor probes to the Moon in the 1960s. Other notable achievements include the MARINER PROGRAM, VIKING SPACE MISSION and VOYAGER PROGRAM.

jet stream Narrow, swiftly moving winds between slower currents at altitudes of 10–16km (6–10mi) in the upper troposphere or lower stratosphere, principally in the zone of prevailing westerlies.

Jews Followers of the religion of JUDAISM, especially those

J

who claim descent from the ancient Hebrews, a Semitic people who settled in Palestine toward the end of the 2nd millennium BC. The word Jew arose in medieval times, derived from the Latin word Judaea (Judea), the Romanized name of the region of PALESTINE. From c.600 BC, the people of Judah suffered domination by a number of foreign powers, among them the Assyrians, Babylonians, Seleucid rulers, and finally the Romans. The destruction of Jerusalem by the Romans (AD 70) led to the DIASPORA. The Jews were driven out of England in 1290 and were expelled from Spain in the 15th century. During World War 2 (1939-45), six million Jews were killed in the HOLOCAUST. In 1948, having struggled against British rule in modern Palestine, a group of Jews finally established the nation state of ISRAEL there, despite opposition from Arab and other Islamic states. About five million Jews live in Israel. Many millions more live in other countries.

Jezebel (d. c.843 BC) Phoenician princess who became the wife of Ahab, king of Israel. She introduced into Israel the worship of the Phoenician deity Baal and came into conflict with the priests of Yahweh. She clashed most severely with the prophet Elijah, who foretold her brutal death.

Jiang Qing (1914–92) Chinese actress and politician, the third wife of MAO ZEDONG. She became a high-ranking party official and the leader of the CULTURAL REVOLUTION. One of the radical GANG OF FOUR that sought power after Mao's death in 1976, she was arrested in 1977, convicted of treason and imprisoned for life.

Jiangsu (Kiangsu) Province in E China; the capital is NANKING. Under the rule of the Ming dynasty (1368–1644), it became a separate province in the 18th century. Taken by Japan in 1937, the province was freed by Chinese nationalists in 1945 but fell to the Chinese communists in 1949. One of China's smallest and most densely populated provinces, it is an extremely fertile region that includes the delta of the River YANGTZE. It is highly industrialized. SHANGHAI (the largest city) is the chief manufacturing centre of China. Products: rice, cotton, wheat, barley, sova beans, peanuts, tea. Industries: silk, oil refining, textiles, food processing, cement. Area: 102,240sq km (39,474sq mi). Pop. (1990) 68,170,000. Jiang Zemin (1926-) Chinese statesman, general secretary of the CHINESE COMMUNIST PARTY (1989-). A cautious proponent of reform, Jiang was elected to the central committee in 1982 and served as mayor of Shanghai (1985-88). He succeeded ZHAO ZIYANG as general secretary. Jiang was designated by DENG XIAOPING as China's paramount leader.

Jiddah (Jedda) Administrative capital and largest port of Saudi Arabia, on the Red Sea, 75km (45mi) w of Mecca. Under Turkish rule until 1916, it was taken in 1925 by IBN SAUD. It acts as a port of entry for the HAJJ. Oil wealth has also expanded the city and port. Industries: steel rolling, oil refining, cement and pottery manufacture. Pop. (1986 est.) 1,400,000.

jihad (jehad) Religious obligation imposed upon Muslims through the Koran to spread ISLAM and protect its followers by waging war on non-believers. There are four ways in which Muslims may fulfil their jihad duty: by the heart, by the tongue, by the hand, and by the sword.

Jim Crow Laws Laws enacted in southern US states after RECONSTRUCTION, enforcing racial segregation in public places and on public transport. They were progressively overturned by the CIVIL RIGHTS legislation of the 1950s and 1960s. Jinnah, Muhammad Ali (1876–1948) Founder of PAKISTAN. A British-trained lawyer, he joined the Indian National Congress in 1906, but left it in 1920 when his demand for a separate Muslim electorate was rejected. He led the MUSLIM LEAGUE in campaigning for political equality for Indian Muslims, while continuing to seek agreement with Hindus. By 1940 he had adopted the aim of a separate Muslim state. This was realized when India was partitioned in 1947.

Joan of Arc (1412–31) (Jeanne d'Arc, Joan of Lorraine or the Maid of Orléans) National heroine of France. A peasant girl, she claimed to hear heavenly voices urging her to save France during the Hundred Years War. In early 1429, she led French troops in breaking the English siege of Orléans. She drove the English from the Loire towns and persuaded the indecisive dauphin to have himself crowned at Reims as

A turbofan engine is the most commonly used jet engine on civil aircraft. Fuel entering the engine (1) mixes with compressed air and burns in the combustion chamber (2). The

expanding gases rotate highspeed (3) and low-speed (4) turbines. These, in turn, drive a compressor (5), which forces air into the combustion chamber, and fans (6), which push air round the combustion chamber and into the tail pipe, providing extra thrust by means of displacement. An engine of this type is able to generate up to 30.000lbs of thrust.

CHARLES VII. In 1430 she was captured and handed over to the English. Condemned as a heretic, she was burned at the stake. **Job** Old Testament book describing the crises in the life of Job, a well-to-do man from a town E of Palestine. The main theme is that suffering comes to good and bad people alike.

Jodhpur (Marwar) Walled city on the edge of the THAR DESERT, Rajasthan, NW India. Founded in 1459, it was the capital of the former princely state of Jodhpur. It is now an important road and rail junction. Industries: textiles, lacquerware, bicycles. Pop. (1991) 668,000

Jodrell Bank Experimental station, part of the University of Manchester, England, and the location of one of the world's largest steerable radio telescopes.

Joffre, Joseph Jacques Césaire (1852–1931) French general. He was commander in chief of the French army at the outbreak of World War 1 (1914). Determined to take the offensive, he was forced to retreat but recouped his forces, and his reputation, in the First Battle of the MARNE. After heavy losses at VERDUN and on the SOMME in 1916, he resigned.

Johannesburg City in NE Republic of South Africa; capital of GAUTENG province. It was founded in 1886. Today, it is South Africa's leading industrial and commercial city, and the administrative headquarters for gold-mining companies. Industries: pharmaceuticals, metal, machinery, textiles, engineering, diamond-cutting. Pop. (1991) 1,916,063.

John, Saint (active 1st century AD) APOSTLE of JESUS CHRIST, one of the original 12 disciples. Known also as St John the Apostle and St John the Evangelist, he is widely believed to be the author of the fourth GOSPEL and the three New Testament epistles of John. He is also identified with St John the Divine, the author of the Book of REVELATION. John was the brother of another apostle, St James the Greater. Together with his brother and St PETER, St John belonged to the inner group of disciples. His feast day is 27 December.

John XXIII (1881–1963) Pope (1958–63), b. Angelo Giuseppe Roncalli. He served in the papal diplomatic service before his election as pope. A compromise choice, he convened the Second Vatican Council to promote reform and renewal within the Church and encourage ecumenicalism.

John (1167–1216) King of England (1199–1216), youngest son of HENRY II. John ruled during RICHARD I's absence on the Third Crusade. Disgraced for intriguing against Richard, John nevertheless succeeded him as king. The loss of vast territories in France (1204–05) and heavy taxation made him unpopular. In 1215 he was compelled to sign the MAGNA CARTA, and his subsequent disregard of the terms led to the first BARONS' WAR.

John II (the Good) (1319–64) King of France (1350–64), son of Philip VI. In the HUNDRED YEARS WAR, he was captured (1356) at Poitiers and held in captivity in England. He

▲ Jordan Nicknamed "Air Jordan", Michael Jordan began his professional basketball career in 1984, as guard for the Chicago Bulls. He went on to become one of the most successful players of all time, averaging a record 32.3 points per game. His sponsorship deals, including a famous series of adverts with director Spike Lee, made him one of the world's richest sportsmen.

was released on the promise of a large ransom, but failure to meet the terms forced his return to England, where he died.

John II (1609–72) King of Poland (1648–68). His reign was beset by wars against Sweden, Russia and the Ottoman Turks. Territory was lost, Poland devastated, the royal government bankrupted, and John was forced to abdicate.

John III Sobieski (1624–96) King of Poland (1674–96). His ambition led him to conspire with the French against Polish interests, but his successful generalship against the Ottoman Turks gained him the throne. His greatest triumph was ending the siege of Vienna (1683) and liberating Hungary by defeating the Ottoman Turks. In Poland, his rule was frustrated by opposition and revolt.

John I (1357–1433) King of Portugal (1385–1433). After the death of his half-brother, Ferdinand I, he resisted the proposed regency of Ferdinand's daughter, and was elected king. His reign marked the start of Portuguese maritime expansion. **John III** (1502–57) King of Portugal (1521–57). John's reign marked the climax of Portuguese expansion, including the colonization of Brazil, but the empire began to decline by its end. He introduced (1536) the Inouisitron into Portugal and generally favoured clerical, particularly Jesuit, interests.

John IV (1605–56) King of Portugal (1640–56). As duke of Braganza he was a leader of the Portuguese revolt against Spanish rule (1640) and became king. Portuguese independence was confirmed by victory at Montijo (1644).

John VI (1767–1826) King of Portugal (1816–26). Owing to the insanity of his mother, Queen Maria, he was effectively sovereign from 1792 and officially regent from 1799. In 1807 he fled to Brazil to escape the invading French and did not return to claim the throne until 1822, when he accepted the constitutional government proclaimed in 1820.

John, Augustus Edwin (1878–1961) British portrait and landscape painter. He was an ardent opponent of academicism. Although influenced by the Old Masters and by POST-IMPRESSIONISM, his high-toned colour and solidity of drawing were very much his own. His works include *Galway* (1916) and the portraits *Dorelia* and *Bernard Shaw* (c.1914).

John, Gospel according to Saint Fourth and last gospel of the New Testament, recounting the life and death of JESUS CHRIST and believed to be the work of the Apostle JOHN. It is more concerned with the spiritual meaning of events than with historical facts or even historical sequence.

John, Gwen (Gwendolen Mary) (1876–1939) British painter. The antithesis of her brother, Augustus John, she created restrained, grey-toned portraits of single figures. Her subtlety of characterization and tonal relationships is demonstrated in *Self Portrait* (c.1900) and *Portrait of a Nun* (c.1920–30). John Bull Symbolic representation of the typical Englishman and, by extension, of England itself. The name was popularized by Dr John Arbuthnot's History of John Bull (1712).

John of Gaunt (1340–99) English nobleman, duke of Lancaster (1362–99). Fourth son of EDWARD III, he acquired the Lancastrian estates through marriage. He spent much of his life campaigning abroad in the HUNDRED YEARS WAR and attempted to enforce (1386–88) a claim to the crown of Castile. Protector of John WYCLIFFE and patron of CHAUCER, he was the father of HENRY IV, first king of the Lancastrian dynasty.

John of the Cross, Saint (1542–91) Spanish poet and monk in the Carmelite order. He tried to reform the order to make it more austere, and became co-founder of the contemplative order of the Discalced Carmelites. He is best known for his spiritual poems, which are among the finest verses in Spanish literature. His feast day is 14 December or 24 November.

John Paul I (1912–78) Pope (1978), b. Albino Luciani. He became the 263rd pope of the Roman Catholic Church. A modest but gregarious man, his reign lasted only 34 days.

John Paul II (1920–) Pope (1978–) b. Poland as Karol Wojtyla. He was ordained in 1946 and became auxiliary bishop of Kraków (1958), archbishop (1964) and then cardinal (1967). He was the first non-Italian pope to be elected for over 450 years and he travelled widely. Theologically conservative, John Paul II upheld papal infallibility and condemned artificial methods of birth control and the ordination of women priests. John the Baptist, Saint (active 1st century AD) Prophet

who heralded the appearance of JESUS CHRIST and the kingdom of God. The son of ZECHARIAH and Elizabeth, he was born in Judaea six months before Jesus. Jesus was one of those who accepted his baptism, an action that marked the beginning of his ministry and was the true start of the New Testament.

Johns, Jasper (1930–) US painter, sculptor and printmaker. Together with Robert RAUSCHENBERG, he led the movement away from ABSTRACT EXPRESSIONISM towards POP ART and MINIMAL ART. His characteristic style features canvases covered with banal, everyday images, such as *Three Flags* (1958) and *Target With Four Faces* (1955).

Johnson, Amy (1903–41) British pilot, the first woman to fly solo from England to Australia (1930). In 1932 she broke the record held by her husband, James Mollinson, for a solo flight to the Cape of Good Hope, South Africa. In World War 2 she was a pilot in the Air Transport Auxillary.

Johnson, Andrew (1808–75) 17th US president (1865–69), vice president (1864–65). Jonhson was a Democrat governor (1853–57) and senator (1857–62) for Tennessee. He was the only Southerner to remain in the Senate after the outbreak of civil war. Johnson was elected with the incumbent Republican president Abraham LINCOLN on a National Union ticket, and became president when Lincoln was assassinated. His policy of RECONSTRUCTION saw the restoration of civil government to the South. His opposition to civil rights for blacks, conciliation of Confederate leaders and attempt to remove Edwin M. STANTON led to his impeachment for "crimes and misdemeanours". He was acquitted by one vote.

Johnson, Jack (John Arthur) (1878–1946) US boxer. He was the first African-American to win the world heavyweight title, defeating Tommy Burns (1908).

Johnson, Lyndon Baines (1908–73) 36th US president (1963–69), vice president (1960–63). Johnson represented Texas as a Democrat in the House of Representatives (1937–48) and the Senate (1948–60). He served as vice president to John F. KENNEDY, and became president after Kennedy's assassination (1963). He showed considerable skill in securing passage of the CIVIL RIGHTS Act (1964) and was overwhelmingly re-elected in 1964. He carried out an ambitous domestic reform programme, but its success was overshadowed by the escalation of the VIETNAM WAR, which, together with severe race riots in 1965–68, dissuaded him from seeking re-election in 1968. His vice president, Hubert HUMPHREY, lost the ensuing election to Richard NIXON.

Johnson, "Magic" (Earvin) (1959–) US professional basketball player. He won five National Basketball Association (NBA) championships (1980, 1982, 1985, 1987–88) with the Los Angeles Lakers and was named Most Valuable Player three times (1987, 1989, 1990). In 1991, Johnson announced he was HIV+ and retired, but he returned to win an Olympic gold medal (1992) in the US "Dream Team".

Johnson, Michael (1967–) US track athlete. Johnson became 200m world champion (1991), but was forced to retire from the 1992 Olympics. He was 200m and 400m world champion (1995). At the 1996 Olympics, he became the first man in Olympic history to win 200m and 400m gold medals.

Johnson, Philip Cortelyou (1906–) US architect. A leader of the International Style, he later radically changed his style towards Post-Modernism. In 1988 Johnson declared modern architecture to be dead and organized an exhibition of deconstructionist architecture. See also DECONSTRUCTION

Johnson, Dr Samuel (1709–84) British lexicographer, poet and critic. Most notable among his prolific array of works is the *Dictionary of the English Language* (1755), which established his reputation. He also produced a collection of essays, *The Idler* (1758–61), and an edition (1765) of the plays of SHAKESPEARE. A discerning critic and trenchant conversationalist, he was co-founder with Joshua REYNOLDS of "The Club" (1764), later known as "The Literary Club". James BOSWELL's life of Johnson contains invaluable biographical detail.

joint In anatomy, place where one BONE meets another. In movable joints, such as those of the knee, elbow and spine, the bones are separated and cushioned from one another by pads of CARTILAGE. In fixed joints, cartilage may be present in infancy but disappear later as the bones fuse together, as in the SKULL.

In the movable joints of bony VERTEBRATES, the bones are held together by LIGAMENTS. SYNOVIAL FLUID lubricates the joint.

Joint Chiefs of Staff (JCS) US military body, the princi-

pal advisors on military strategy to the president. **Joliot-Curie**, **Irene** See Marie Curie

Jolson, Al (1886–1950) US music hall singer, remembered for his sentimental renditions of "Swanee" and "Mammy". He starred in the first "talkie", *The Jazz Singer* (1927).

Jonah Fifth of the 12 minor prophets and central character in the Old Testament Book of Jonah. This book is an account of Jonah's adventures, showing God's mercy to non-Jews.

Jones, Inigo (1573–1652) English architect, stage designer and painter. He introduced a pure CLASSICAL style based on the work of Andrea PALLADIO. His knowledge of Italian architecture gained him enormous prestige in JACOBEAN and Carolingian England. Buildings include Queen's House, Greenwich (1616–35) and Banqueting House, Whitehall (1619–21).

Jones, John Paul (1747–92) American naval commander, b. Scotland. He joined (1775) the Continental navy and raided British merchant shipping during the AMERICAN REVOLUTION. Jongkind, Johan Barthold (1819–91) Dutch painter and etcher, whose work had close affinities with IMPRESSIONISM.

Many of his oil paintings were based on landscape watercolours and drawings executed outside his studios.

Jonson, Ben (1572–1637) English dramatist, lyric poet and actor. A friend of Shakespeare, he was popular and influential in ELIZABETHAN and Stuart drama. His comedies of humours include *Volpone* (1606), *The Alchemist* (1610) and *Bartholomew Fair* (1614). He also wrote the neoclassical tragedies *Sejanus* and *Catiline*, and several court masques.

Joplin, Scott (1868–1917) US composer. He wrote ragtime piano music, such as *Maple Leaf Rag* (1900) and *The Entertainer* (1902), and the opera *Treemonisha* (1911).

Jordaens, Jacob (1593–1678) Flemish painter. He is known for his allegorical and mythological works and for his naturalistic depictions of peasant life.

Jordan, Michael Jeffrey (1963–) US professional basketball player. He led the Chicago Bulls to four National Basketball Association (NBA) championships (1991–93, 1996). and was named Most Valuable Player four times (1988, 1991, 1992, 1996). He played in both the 1984 and 1992 US Olympic gold medal teams. In 1993 he switched to baseball, but returned to the Bulls in 1995.

Jordan Hashemite kingdom in sw Asia. See country feature

JORDAN

The green, white and black on this flag are the colours of the three tribes who led the Arab Revolt against the Turks in 1917. Red is the colour of the Hussein dynasty. The star was added in 1928. Its seven points represent the first seven verses of the Holy Koran.

AREA: 89,210sq km (34,444sq mi)

POPULATION: 4,291,000

CAPITAL (POPULATION): Amman (1,300,042)
GOVERNMENT: Constitutional monarchy
ETHNIC GROUPS: Arab 99%, of which
Palestinians make up roughly half

LANGUAGES: Arabic (official)
RELIGIONS: Islam 93%, Christianity 5%
CURRENCY: Jordan dinar = 1,000 fils

Jordan can be divided into three geographical areas: the Transjordan plateau in the E constitutes 90% of total land area and is the most populous region. It includes the capital, AMMAN. Central Jordan forms part of the Great RIFT VALLEY, and contains the River JORDAN and the DEAD SEA. West Jordan (now the WEST BANK) is part of historic PALESTINE, and includes the region of SAMARIA; this area is now occupied by ISRAEL. Jordan has a coastline on the Gulf of AOABA. The ancient city of PETRA lies close to Jordan's highest peak, Jebel Ram, at 1,754m (5,755ft).

CLIMATE

The Transjordan plateau is a transition zone between a Mediterranean climate to the w and a desert climate to the E.

VEGETATION

Most of Jordan is desert or semi-desert. Parts of the w plateau have scrub vegetation and there are some areas of dry grassland.

HISTORY

The region was conquered by the SELEUCIDS in the 4th century BC. In the 1st century BC the Nabatean empire developed a capital at Petra. The Romans led by Pompey captured the region in the 1st century AD. In AD 636 Arab armies conquered the territory and introduced Islam. After the First CRUSADE the region was incorporated into the Latin kingdom of Jerusalem (1099). In 1517 it became part of the Ottoman empire. After the defeat of the Ottomans in World War 1, the area E of the River Jordan was included in the British League of Nations mandated territory of Palestine. In 1921 the E region was administered separately as Transjordan. In 1928 it became a constitutional monarchy ruled by the Hashemite dynasty. In 1946 Transjordan achieved independence. The creation of the state of Israel (1948) led to the first of the ARAB-ISRAELI WARS (1948-49). Hundreds of thousands of Palestinians fled to Jordan. Under the peace terms, Transjordan annexed the remaining Arab parts of Palestine (West Bank and EAST JERUSALEM). This incensed the Palestinians and King ABDULLAH was assassinated in 1951. Hus-SEIN I acceded in 1953. In 1958 Jordan formed

the short-lived Arab Federation with Iraq. The SIX DAY WAR (1967) ended in the Israeli occupation of East Jerusalem and the West Bank: more than one million Palestinian refugees now lived in E Jordan. Jordan became embroiled in a bloody civil war with Palestinian independence movements (1970). By 1971 Jordan had ejected all guerrillas operating from its soil. In 1974 King Hussein recognized the Palestinian LIBERATION AUTHORITY (PLO) as the legitimate representative of the Palestinians. In 1988 Jordan gave up its claim to the West Bank and approved the creation of an independent Palestine. Jordan sided with Iraq in the Iran-Iraq War and the Gulf War.

POLITICS

Opposition parties were legalized in 1991 and the first multiparty elections were held in 1993. In October 1994, Jordan and Israel signed a peace treaty which ended the state of war existing since 1948. The border between Elat and Aqaba was opened and King Hussein was granted custodial rights of Islamic sites in Jerusalem. Elections in 1997 were boycotted by opposition parties, including the Islamic Action Front (IAF).

ECONOMY

Jordan is a developing country. It is the world's 7th largest producer of phosphates and potash. Just over half of the land is farm or pasture land. Major crops include barley, citrus fruits, grapes, olives, vegetables and wheat. It is depdendent on aid. Jordan has an oil refinery and produces natural gas. Tourism is developing rapidly and reforms are helping to expand the economy.

▲ Joyce Born in Dublin and educated first by Jesuits then at University College, Dublin, James Joyce was a voracious reader and an accomplished linguist. He was afflicted by glaucoma from a relatively early age, and was deeply troubled by his daughter's mental illness. His seminal novel, *Ulysses* (1922), was highly controversial at the time of its publication, but is now regarded as a ground breaking work of modernism.

Jordan River in the Middle East, rising in the Anti-Lebanon Mountains at the confluence of the Hasbani, Dan and Baniyas rivers. It flows s through Israel and the Sea of Galilee and empties into the Dead Sea. Since 1967, the s part of the river has formed a section of the Israel-Jordan border. Length: 320km (200mi).

Joseph, Saint In the New Testament, husband of Mary and the legal father of Jesus Christ. He was a carpenter from Nazareth, N Palestine. His feast day is 19 March or 1 May. **Joseph I** (1678–1711) Holy Roman emperor (1705–11).

His reign was dominated by revolt in Hungary, where he was king from 1687, and by the War of the SPANISH SUCCESSION. He was succeeded by his brother, CHARLES VI.

Joseph II (1741–90) Holy Roman emperor (1765–90). Coruler with his mother, MARIA THERESA, until 1780, he introduced sweeping liberal and humanitarian reforms while retaining autocratic powers. Some of his reforms were reversed by his successor, Leopold II.

Joseph In the Old Testament book of Genesis, 11th of the 12 sons of JACOB. Given a richly woven, multi-coloured coat by his father, Joseph was sold into slavery by his jealous elder brothers. He was taken to Egypt, where he gained the pharaoh's favour by predicting the seven-year famine, thus allowing stores to be laid by from the previous seven good years. He was later reconciled with his brothers.

Joseph of Arimathea, Saint Prosperous Jew who was a secret follower of Jesus Christ. He claimed Christ's body from Pontius Pilate after the crucifixion and attended to its burial. His feast day is 17 March in the West, 31 July in the East.

Joséphine (1763–1814) Consort of NAPOLEON I and empress of the French (1804–09). Her first marriage, to Vicomte Alexandre de Beauharnais, ended (1794) with his death in the REIGN OF TERROR. She married Napoleon in 1796. Her inability to bear him a son caused Napoleon to seek and obtain annulment of their marriage in 1809.

Josephson, Brian David (1940–95) British physicist. In 1962 he predicted that an electric current would flow between two superconductors separated by a thin layer of insulator. Known as the Josephson effect, he shared the 1973 Nobel Prize for physics with Leo ESAKI and Ivar Giaever for its discovery. It has helped in the understanding of SUPERCONDUCTIVITY.

Josephus, Flavius (37–100) Jewish leader and historian. A Pharisee, he took part reluctantly in the revolt against Rome (66–70) and was captured. He found favour with VESPASIAN and settled in Rome in AD 70.

Joshua Heroic figure among the Israelites, who became their commander after the death of Moses and led them into Canaan following their exodus from Egypt. His subsequent exploits and campaigns are recorded in the Book of Joshua, the sixth book of the Old Testament.

Jospin, Lionel (1937–) French statesman, prime minister (1997–). Jospin joined the French Socialist Party (PS) in 1971. In 1981 he became first secretary of the PS. In 1995 he succeeded François MITTERRAND as leader of the PS, but lost the ensuing presidential election to Jacques CHIRAC. In the 1997 prime ministerial elections Jospin won a surprise victory against the incumbent RPR prime minister, Alain Juppé.

Josquin Desprez (1445–1521) (Josquin Des Prés) Flemish composer. He wrote three books of masses, more than 100 motets and many secular songs. The expressiveness and inventiveness of his music mark him as the most prominent composer of Renaissance Europe.

Joule, James Prescott (1818–89) British physicist. Joule's law (1841) relates the current flowing through a wire to its heat loss. It laid the foundation for the law of conservation of energy. The JOULE is named after him.

joule (symbol J) SI unit of energy. One joule is the work done by a force of one NEWTON acting over a distance of one metre. It was named after James P. JOULE and replaced the erg.

Joyce, James (1882–1941) Irish novelist. Joyce renounced Catholicism and left Ireland in 1904 to live and work in Europe. Joyce's experiments with narrative form place him at the centre of literary MODERNISM. His debut was the short-story collection *Dubliners* (1914). A Portrait of the Artist as a Young Man (1916) was a fictionalized autobiography of Stephen

Daedalus. His masterpiece, the novel *Ulysses* (1922), presents a day (June 16, 1904) in the life of Leopold Bloom. *Finnegan's Wake* (1939) is an allusive mix of Irish history and myth.

Juan Carlos (1938–) King of Spain (1975–), grandson of Alfonso XIII. In 1975 Juan Carlos succeeded General Franco and set about the democratization of Spanish society. Juan survived an attempted military coup (1981). He married (1962) Princess Sophia of Greece.

Juárez, Benito Pablo (1806–72) President of Mexico (1858–62, 1867–72). Juárez was exiled (1853–55) by SANTA ANNA. As president, he defeated the conservatives in the "War of Reform" and headed resistance to the French invasion (1862) until the fall of MAXIMILIAN (1867).

Judah Fourth son of JACOB and his first wife Leah, and forefather of the most important of the 12 tribes of ancient ISRAEL. After the exodus and Joshua's conquest of CANAAN, the tribe of Judah received the region south of JERUSALEM. This territory later became known as Judaea. The tribe of Judah eventually became the dominant one. Israel's greatest kings, DAVID and SOLOMON, belonged to it, and prophets foretold that the MESSIAH would arise from among its members.

Judaism Monotheistic religion developed by the ancient HEBREWS in the Near East during the third millennium BC and practised by modern Jews. Tradition holds that Judaism was founded by ABRAHAM, who (c.20th century BC) was chosen by God to receive favourable treatment in return for obedience and worship. Having entered into this covenant with God, Abraham moved to CANAAN, from where centuries later his descendants migrated to Egypt and became enslaved. God accomplished the Hebrews' escape from Egypt and renewed the covenant with their leader, MosEs. Through Moses, God gave the Hebrews a set of strict laws. These laws are revealed in the TORAH, the core of Judaistic scripture. Apart from the PENTATEUCH, the other holy books are the TALMUD and several commentaries. Local worship takes place in a SYNAGOGUE, a building where the Torah is read in public and preserved in a replica of the ARK OF THE COVENANT. A RABBI undertakes the spiritual leadership and pastoral care of a community. Modern Judaism is split into four large groups: Orthodox, Reform, Conservative and Liberal Judaism. Orthodox Judaism, followed by most of the world's 18 million Jews, asserts the supreme authority of the Torah and adheres most closely to traditions, such as the segregation of men and women in the synagogue. Reform Judaism denies the Jews' claim to be God's chosen people, and is more liberal in its interpretation of certain laws and the Torah. Conservative Judaism is a compromise between Orthodox and Reform Judaism, adhering to many Orthodox traditions, but seeking to apply modern scholarship in interpreting the Torah. Liberal Judaism, also known as Reconstructionism, is a more extreme form of Reform Judaism, seeking to adapt Judaism to the needs of society.

Judas Iscariot (d. c.AD 30) Disciple who betrayed JESUS CHRIST to the Jewish hierarchy. In the New Testament, he was named as one of the 12 apostles originally chosen by Jesus, and served as the group's treasurer. In return for 30 pieces of silver, Judas agreed to assist the chief priests in arresting Jesus. Jude, Epistle of New Testament book of the Bible. It consists of a letter exhorting all Christians to keep the faith and live righteously. The author calls himself the brother of James, probably the one mentioned in Mark 6:3.

judge Any officer appointed to administer the law. Judges are raised from the bar to preside over courts. Their chief duties are to conduct court cases fairly, to arrive at a conclusion (or to direct a jury to a conclusion) and to pass sentence. **Judges** Seventh book of the Old Testament. It covers a 200-year period in the history of ancient Israelt, from the death of JOSHUA to the establishment of the first Israelite kingdom (c.11th century BC). The judges are leaders inspired by God to fight battles on behalf of the fledgling nation. The Book of Judges contains some of the oldest material in the Bible.

judicial review In England and Wales, the re-examination in the High Court (acting as the supreme court of appeal) of a previous verdict. The review may decide on various courses of action, such as overturning a verdict, changing the sentence on a conviction, or issuing an INJUNCTION.

Judith Heroine of an Old Testament book that is considered apocryphal by Protestants and Jews. She is described as a beautiful young widow who heroically rescued the Israelite city of Bethulia from siege by the Assyrians.

judo Form of JUJITSU, and one of the most popular of the Japanese martial arts. It places great emphasis on physical fitness and mental discipline. A system of belt colours displays a practioner's standard. Manoeuvres include holds, trips and falls. Scoring is according to the finality of a throw or hold.

jujitsu Method of unarmed self-defence used in hand-to-hand combat. It involves such techniques as striking, holding, throwing, choking and joint locking. There are c.50 systematized variants (including JUDO, KARATE and AIKIDO) that have been refined over a period of 2,000 years in Japan, China and Tibet. In the early 19th century, when the SAMURAI were forbidden to carry weapons, jujitsu became a form of self-defence.

jujube Either of two species of small thorny trees and their fruit of the genus *Zizyphus*. *Z. jujuba*, native to China, has elliptical leaves and reddish brown, plum-sized fruits, which have a crisp, white, sweet flesh. *Z. mauritanica* of India has smaller fruit. Family Rhamnaceae.

Julian (the Apostate) (331–63) Roman Emperor (361–63). He achieved power on the death of Constantine II. He tried to restore paganism, without persecuting Christians. Julius Caesar See CAESAR. (GAIUS) JULIUS

July Revolution (1830) Insurrection in France. The immediate cause was the July Ordinances, which dissolved the chamber of deputies, reduced the electorate and imposed rigid press censorship. CHARLES X was forced to abdicate and LOUIS PHILIPPE was proclaimed king with a more liberal constitution. Juneau State capital of Alaska, USA; a seaport on the Gastineau Channel, bordering British Columbia. It grew rapidly after the discovery of gold in 1880, was made capital of Alaska territory in 1900 and state capital in 1959. Industries: mining, timber, salmen, (1975, 1961). Suring greathers in the

Jung, Carl Gustav (1875–1961) Swiss psychiatrist. Jung worked closely (1907–13) with Sigmund Freud, but disagreed that sexuality was the primary cause of NEUROSIS. Jung founded analytical psychology, based on psychic "individuation". He argued that the unconscious had two dimensions – the personal and archetypes of a collective unconscious. He believed introversion and extraversion to be basic personality types. His writings on myth, religion and folklore have proved influential.

Jungfrau Mountain peak in the Swiss Alps, first climbed in 1811. Height: 4,158m (13,642ft).

juniper Any evergreen shrub or tree of the genus *Juniperus*, native to temperate regions of the Northern Hemisphere. Junipers have needle-like or scale-like leaves. The aromatic timber is used for making pencils, and the berry-like cones of common juniper for flavouring gin. Family Cupressaceae.

Junkers Landed aristocracy of Prussia. Descendants of knights who conquered large areas of E Germany in the Middle Ages, they came to dominate the government and army in Prussia and, after 1871, the German Empire. Intensely conservative, their hostility to the WEIMAR REPUBLIC contributed to the success of the Nazis.

Juno Asteroid discovered by Karl Harding in 1804. It is the tenth-largest asteroid, with a diameter of 244km (152mi).

Juno In Roman mythology, the principal female deity and consort of Jupiter, depicted as a statuesque, matronly figure. Jupiter Fifth major planet from the Sun and the largest of the giant planets. It is one of the brightest objects in the sky. Through a telescope, Jupiter's yellowish elliptical disk is seen to be crossed by brownish-red bands, known as belts and zones. The most distinctive feature is the Great Red Spot (GRS), first observed (1664) by Robert HOOKE. Spots, streaks and bands are caused by Jupiter's rapid rotation and turbulent atmosphere. Eddies give rise to the spots, which are cyclones or (like the GRS) anticyclones. Hydrogen accounts for nearly 90% of Jupiter's atmosphere and helium for most of the rest. The pressure at the cloud tops is c.0.5 bar. At 1,000km (600mi) below the cloud tops there is an ocean of liquid molecular hydrogen. At a depth of 20,000-25,000km (12,500-15,000mi), under a pressure of 3 million bars, the hydrogen becomes so compressed that it behaves as a metal. At the centre of Jupiter there is probably a massive iron–silicate core surrounded by an ice mantle. The core temperature is estimated to be 30,000K. The deep, metallic hydrogen "mantle" gives Jupiter a powerful magnetic field. It traps a large quantity of plasma (charged particles); high-energy plasma is funnelled into radiation belts. Its magnetosphere is huge, several times the size of the Sun, and is the source of the planet's powerful radio emissions. Jupiter has 16 known SATELLITES, the four major ones being the Galilean SATELLITES. Knowledge of the planet owes much to visits by space probes: Pioneers 10 and 11, Voyagers 1 and 2, Ulysses and Galileo.

Jupiter King of the Roman gods, identified with the Greek god Zeus. He could take on various forms: the light-bringer (Lucetius), god of lightning and thunderbolts (Fulgur) and god of rain (Jupiter Elicius).

Jura Mountains Mountain range in E France and NW Switzerland. Forming part of the Alpine system, it extends from the River Rhine at Basel to the River Rhône, sw of Geneva. It has several hydroelectric schemes.

Jurassic Central period of the MESOZOIC era, lasting from 213 to 144 million years ago. In this period there were saurischian and ornithischian DINOSAURS, such as *Allosaurus* and *Stegosaurus*, plesiosaurs, pterosaurs and ARCHAEOPTERYX. Primitive mammals had begun to evolve.

jurisprudence Philosophy and science of the law, which dates back to the ancient Greeks. PLATO and ARISTOTLE attempted to answer the question "What is law?". Jurisprudence seeks to discover the source and justification of the law and its scope and function in a particular society.

jury Group of people summoned to pass judgment under oath. The 12-member jury in criminal trials dates from the mid-12th century, but it was only in the 17th century that jury members ceased to give evidence and simply passed judgment on the basis of evidence heard in court. The basics of the British jury system have been adopted by most Commonwealth and European countries, and the USA.

Justice, US Department of Legal office of the US federal government. Directed by the attorney general, it is responsible for the enforcement of federal laws and represents the government in legal matters. It includes a number of associated agencies, such as the FEDERAL BUREAU OF INVESTIGATION (FBI).

Justinian I (482–565) Byzantine Emperor (527–565), sometimes called the Great. His troops, commanded by Belisarius, regained much of the old Roman empire, including Italy, North Africa and part of Spain. Longer-lasting achievements were the Justinian Code, a revision of the whole body of Roman law, and his buildings in Constantinople. Heavy taxation to pay for wars, including defence against Sassanid Persia, drained the strength of the empire.

Justin Martyr, Saint (100–165) Greek philosopher. He was one of the first Christian apologists in the early church. Raised as a Jew, he was converted to Christianity, probably while studying Platonic and Stoic philosophy at Ephesus. He strongly defended Christian doctrine and was put to death in Rome for his faith. His feast day is 1 June.

jute Natural plant fibre obtained from *Corchorus capsularis* and *C. olitorius*, both native to India. The plants grow up to 4.6m (15ft) tall. The fibre is obtained from the bark by soaking (retting) and beating. Jute is used to make sacking, twine and rope. Family Tileaceae.

Jutes Germanic people who invaded Britain in the 5th century along with Angles, Saxons and others. They settled mainly in Kent and the Isle of Wight.

Jutland, Battle of (1916) Naval battle in the North Sea between the British and Germans in World War 1. The only full-scale engagement of the war involving both main fleets, it ended indecisively. Although British losses were greater, the German fleet remained in harbour for the rest of the war.

Juvarra, Filippo (1678–1736) Italian architect, one of the finest exponents of the BAROQUE style. His greatest achievements are the Superga (1717–31), just outside Turin, and the Church of the Carmine (1732).

Juvenal, Decimus Junius (55–140) Roman poet. His satirical poems denounced the immorality of his time. He contrasted decadence in imperial Rome with the virtues of the republic.

JUPITER: DATA

Diameter (equatorial):

142,800km (88,700mi)

Mass (Earth = 1): 317.9

Volume (Earth = 1): 1319

Density (Earth = 1): 1.33

Orbital period: 11.86 years

Rotation period: 9hr 50m 30s

Average surface temperature:

—150° C (—238°F)

▲ jute This tall, annual plant yields a fine bast fibre that is cheap, easy to bleach and dye, and can be readily woven into coarse fabrics such as hessian, scrim and burlap for sacking and furnishing uses.

K/k, the eleventh letter of the English alphabet, derived from the Semitic letter kaph, possibly from an earlier Egyptian hieroglyph for a hand. In Greek it became kappa, and in that form passed into the Roman alphabet. In English it generally has the same sound as the "hard" form of c, as in kitten. However, in front of an n, as in such native English words as knot or know, it is no longer pronounced.

K2 (Godwin Austen) Mountain in NE Pakistan, on the border with China. It is the world's second-highest peak, and the highest in the Karakoram range. It was first climbed in 1954 by Ardito Desio. Height: 8,611m (28,251ft).

Kaaba (Ka'abah or Ka'ba) Central shrine of ISLAM, located in the Great Mosque in MECCA. In prayer, Muslims face the meridian that passes through the Kaaba. Each pilgrim who undertakes the HAJJ circles the shrine seven times, touching the Black Stone for forgiveness. The Black Stone is said to have been given to the patriarch Abraham by the Archangel Gabriel. kabbala Variant spelling of CABBALA

kabuki theatre Stylized mixture of dance and music, mime and vocal performance; a major form of moralizing entertainment in Japan since the mid-17th century. In contrast to No DRAMA, which originated with the nobility, Kabuki was the theatre of the common people. See also JAPANESE THEATRE

Kabul Capital of Afghanistan, on the River Kabul, in the E part of the country. It is strategically located in a high mountain valley in the HINDU KUSH. It was taken by Genghis Khan in the 13th century. Later it became part of the Mogul empire (1526-1738). The capital of Afghanistan since 1776, it was occupied by the British during the Afghan Wars in the 19th century. Following the Soviet invasion in 1979, Kabul was the scene of bitter fighting. Unrest continued into the mid-1990s as rival Muslim groups fought for control. Industries: textiles, leather goods, furniture, glass. Pop. (1993 est.) 700,000.

Kádár, János (1912–89) Hungarian statesman, premier (1956-58, 1961-65). Active in the Communist Party, he fought in the resistance movement during World War 2. From 1948–50 he served as Minister of the Interior and was deputy premier in NAGY's government during the 1956 Hungarian revolution. He succeeded Nagy as premier.

Kaddish Ancient Jewish prayer used particularly at services of mourning for the dead. It is a formal statement of praise and faith in the coming of God's Kingdom.

Kafka, Franz (1883–1924) German novelist, b. Czechoslovakia. Kafka suffered from intense self-doubt and guilt and published little during his lifetime. He requested that his friend Max Brod destroy his works after his death. Brod overrode his wishes and published the trilogy of unfinished novels for which Kafka is best known today: The Trial (1925), The Castle (1926) and Amerika (1927) are disturbing studies of the alienation of the individual in a bureaucratic society.

Kahn, Louis Isadore (1901–74) US modernist architect. He followed the lead given by LE CORBUSIER, GROPIUS and MIES VAN DER ROHE, using bare concrete to create his severely beautiful designs. His greatest statement is undoubtedly the Jonas Salk Institute of Biological Studies in La Jolla, California (1959-65). See also MODERNISM

Kaifeng City in Henan province, E central China. First settled in the 4th century BC, it served as capital of China during the Five Dynasty period (907–60) and the Northern Sung dynasty (960-1126). It is the site of a Jewish settlement that flourished from 1163 until the 15th century. Industries: electrical goods, agricultural machinery, chemicals, silk. Pop. (1990) 690,000.

Kaiser German title equal to emperor. It derives from the Roman title "Caesar" and was first connected with Germany when Otto I became Holy Roman Emperor in 962. The last Kaiser was Wilhelm II (r. 1888-1918), whose father had adopted the title after the Franco-Prussian War (1870-71).

Kalahari Desert region in s Africa, covering parts of BOTSWANA, NAMIBIA and SOUTH AFRICA, between the ORANGE and ZAMBEZI rivers. Thorn scrub and forest grow in some parts of the desert, and it is possible to graze animals during the rainy season. The Kalahari is inhabited by the SAN, as well as by Africans and Europeans primarily engaged in rearing cattle. Area: c.260,000sq km (100,000sq mi).

kale Hardy crop plant related to the CABBAGE. It is shortstemmed and has large, bluish-green, curly-edged leaves. It may reach a height of 61cm (24in). Family Brassicaceae; (sub)species Brassica oleracea acephala.

Kali Hindu goddess of destruction, consort of SHIVA. She is also known as Chandi, Durga, Parvati, Sakti, Uma and Mata. She represents the all-devouring aspect of Devi, the mothergoddess of India, who in other forms is calm and peaceful.

Kalimantan Region of Indonesia, forming the s part of the island of BORNEO. In the 16th century, Muslim states were created. In the 17th century, the Dutch gradually established colonial rule over what became part of the Netherlands East Indies. Kalimantan came under Indonésian control in 1950. Products: rice, copra, pepper, oil, coal, industrial diamonds, timber. Area: 539,460sq km (208,232sq mi). Pop. (1990) 9,099,874.

Kalinin, Mikhail Ivanovich (1875-1946) Soviet statesman, first formal head of state of the Soviet Union (1919-46). Prominent in the 1917 Russian Revolution and founder of the newspaper Pravda, he was elected chairman of the Communist Party Central Committee in 1919 and joined the Politburo in 1925.

Kaliningrad (Königsberg) City and seaport in Russia, on the Baltic coast; capital of Kaliningrad oblast. Founded in 1255 as Königsberg, the city was a member of the Hanseatic League. It became the residence of the dukes of Prussia in 1525. In 1946 it was incorporated into the Soviet Union. Following the break-up of the Soviet Union, Kaliningrad oblast is now separated from Russia proper. It shares a border with Poland and Lithuania. Industries: shipbuilding, fishing, motor vehicle parts. Pop. (1993) 411,000.

Kalmykia Republic of the Russian Federation on the Caspian Sea, SE European Russia; the capital is Elista. The region was made an autonomous republic in 1936. In World War 2 its inhabitants were deported to Soviet Central Asia for alleged collaboration with the Germans. They returned in 1957. After the break-up of the Soviet Union, it became a republic within the Russian Federation, acquiring its present name in 1992. Industries: fishing, animal farming. Area: c.75,900sq km (29,300sq mi). Pop. (1994) 320,600.

Kamchatka Peninsula Peninsula in E Siberia, Russia, separating the Sea of Okhotsk (w) from the Bering Sea and the Pacific Ocean (E). The region has several active volcanoes. Mineral resources include oil, coal, gold and peat. Area: 270,034sq km (104,260sq mi).

Kamehameha Name of five kings of Hawaii. Kamehameha I (r. c.1758–1819) united all the Hawaiian islands. He instituted harsh laws, but abolished human sacrifice. His son, Kamehameha II, or Liholiho (r. 1819-25), admitted the first US missionaries. Kamehameha III, or Kauikeaouli (r. 1825-54), introduced a liberal constitution and land reform. Kamehameha IV, or Alexander Liholiho (r. 1854-63), made social and economic reforms and resisted US influence. His brother, Kamehameha V (r. 1863-72), abandoned the constitution and strengthened royal authority. The dynasty ended with his death.

Kamerlingh-Onnes, Heike (1853-1926) Dutch physicist. In 1908, using a liquid HYDROGEN cooling system, he liquefied HELIUM and found its temperature to be four degrees above absolute zero. He discovered that at this temperature some metals, such as MERCURY and LEAD, become superconductors. He was awarded the 1913 Nobel Prize for physics.

kamikaze (Jap. divine wind) Name given to crews or their explosive-laden aircraft used by the Japanese during World War 2. Their suicidal method of attack was to dive into ships of the enemy fleet. Serious losses were inflicted on the US Navy. Kampala Capital and largest city in UGANDA, on the N shore of Lake Victoria. Founded in the late 19th century on the remains of a royal palace of the kings of Buganda, it replaced Entebbe as capital when Uganda attained independence in 1962. It is the trading centre for the agricultural goods and livestock produced in Uganda. Industries: textiles, food processing, tea blending, coffee, brewing. Pop. (1991) 773,463. Kampuchea See Cambodia

Kanawa, Kiri Te See TE KANAWA, DAME KIRI

Kanchenjunga (Kinchinjunga or Kanchanjanga) Thirdhighest mountain in the world, in the E Himalayas. It was first climbed in 1955 by a British expedition led by Charles Evans. The highest of its five peaks reaches 8,586m (28,169ft).

Kandahar (Qandahar) City and provincial capital in s Afghanistan, c.480km (300mi) sw of Kabul. Because of its location on important trade routes, it was occupied by many foreign conquerors before becoming the capital of the independent Afghani kingdom (1747-73). It was the scene of fighting after the Soviet invasion of Afghanistan in 1979 and became

the headquarters of the Taliban in the 1990s. It is a commercial centre for the surrounding region. Pop. (1988 est.) 225,500. **Kandinsky, Wassily** (1866–1944) Russian painter and theorist. His experiments with abstraction were revolutionary. His early abstract paintings, including the many numbered *Compositions*, express great lyricism. From 1911 he was an active member of the BLAUE REITER. His writings, especially *Concerning the Spiritual in Art* (1914), show the influence of Oriental art philosophy. After World War 1, his work became more controlled. *White Line* (1920) and *In the Black Circle* (1921) show the beginnings of a refinement of geometrical form that developed during his years at the BAUHAUS (1922–33).

Kandy City in Sri Lanka. Former capital of the ancient kings of Ceylon, it was occupied by the Portuguese and the Dutch before being captured by the British in 1815. The city is a market centre for a region producing tea, rice, rubber and cacao. The chief industry is tourism. Pop. (1981) 97,872.

kangaroo Marsupial found only in Australia, New Guinea and adjacent islands. The three main types are the grey kangaroo, the red kangaroo and the wallaroo, or euro. The thick, coarse fur is red, brown, grey or black. The front legs are small, the hind legs long and used in leaping. Height: to 1.8m (6ft) at the shoulder; weight: to 70kg (154lb). Family Macropodidae, genus *Macropus*.

kangaroo rat Tiny, desert-dwelling RODENT of w North America. It has long hind legs and a long tail, and hops. It stores seeds in its cheek pouches. Length: to 41cm (16in), including the tail. Family Heteromyidae; genus *Dipodomys*. **Kano** City in N central Nigeria; capital of Kano state. The city dates from before the 12th century and became a Muslim possession in the 16th century. It was conquered by the FULANI in the early 19th century. Today Kano is a trading centre for a region producing cotton and nuts. Industries: textiles, leather

Kanpur (Cawnpore) City on the River Ganges, Uttar Pradesh, N India. Kanpur was ceded to the British in 1801 and became a frontier post. During the INDIAN MUTINY the entire British garrison in Kanpur was massacred. The city is now a major industrial and commercial centre. Industries: chemicals, leather goods, textiles. Pop. (1991) 1,879,420.

goods, brewing, chemicals. Pop. (1992 est.) 699,900.

Kansa Small Native American tribe that in 1854 gave its name to the state of Kansas. Linguistically part of the Siouan language group, the people now live in diverse clusters, mostly in Nebraska and Oklahoma.

Kansas State in central USA; the capital is TOPEKA. Other major cities are Wichita and KANSAS CITY. First visited by Spanish explorers in the 16th century, the area passed from France to the new United States under the LOUISIANA PURCHASE of 1803. It was Native American territory until 1854, when the Territory of Kansas was created and the area opened up for settlement. It was admitted to the Union as a free state in 1861. Part of the Great Plains, the land rises from the prairies of the E to the semi-arid high plains of the w. The area is drained by the Kansas and Arkansas rivers. Kansas is the leading US producer of wheat. Corn, hay and sorghum are also grown and cattle raising is important. Manufacturing is economically significant. Industries: transport equipment, chemicals, petroleum products, machinery. Area: 213,094sq km (82,276sq mi). Pop. (1993 est.) 2,530,746.

Kansas City City in w Missouri, USA, on the Missouri River, adjacent to Kansas City, Kansas. Established in 1821 as a trading post, it developed in the 1860s with the introduction of the railroad and the growth in cattle trade. Industries: aerospace equipment, vehicles, chemicals, petroleum products, livestock, grain. Pop. (1990) 435,146.

Kansas City City in NE Kansas, USA, at the confluence of the Kansas and Missouri rivers, adjacent to KANSAS CITY, Missouri. Part of a Native American reservation, it was acquired by Wyandotte Native Americans in 1843 and sold to the US government in 1855. The modern city was established in 1886. Industries: livestock, motor vehicles, metal products, chemicals. Pop. (1990) 149,767.

Kant, Immanuel (1724–1804) German metaphysical philosopher. He was a teacher and professor of logic and metaphysics. The order and modesty of Kant's life was undis-

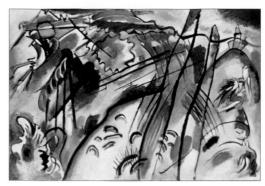

turbed by the notoriety caused by his publications. Kant's philosophy, outlined in *Critique of Pure Reason* (1781), sought to discover the nature and boundaries of human knowledge. It was much influenced by Isaac Newton and David Hume. Kant's system of ethics, described in the *Critique of Practical Reason* (1790), places moral duty above happiness. His views on aesthetics are embodied in his *Critique of Judgment* (1790). Kant also produced several essays in support of religious liberalism and the Enlightenment.

kaolin (china clay) Fine clay composed chiefly of KAOLINITE, a hydrous silicate of aluminium. It is used in the manufacture of coated paper, ceramics and fine porcelain.

kaolinite Sheet silicate mineral of the kaolinite group, hydrous aluminium silicate [Al₂Si₂O₅(OH)₄]. It is a product of the weathering of feldspar and has triclinic system tabular crystals. It is white with a dull lustre. Hardness 2-2.5; s.g. 2.6. kapok Tropical tree with compound leaves and white or pink flowers. Its seed pods burst to release silky fibres, which are commonly used for stuffing and insulation. Height: to 50m (165ft). Family Bombacaceae; species Ceiba pentandra. Karachi City and seaport on the Arabian Sea, se Pakistan; capital of Sind province. Settled in the early 18th century, in 1843 it passed to the British, who developed it as a major port. It was the first capital of Pakistan in 1947 and remains the country's largest city. Karachi is an important trading centre for agricultural produce. Industries: steel, engineering, oil refining, motor vehicle assembly, textiles, chemicals, printing and publishing. Pop. (1981) 5,103,000.

Karadžić, Radovan (1945–) Bosnian Serb politician. As leader of the Bosnian Serbian Democratic Party from 1990, Karadžić agitated for an exclusively Serb state. On Bosnia-Herzegovina's independence in 1992, he pronounced a "Serbian Republic of Bosnia and Herzegovina", thus prompting civil war. Serb military aggression, along with its policy of "ethnic cleansing", led to Karadžić being formally charged with war crimes in 1996.

Karajan, Herbert von (1908–89) German conductor. He conducted the Berlin State Opera (1938–45) and was director of the Vienna State Opera (1945–64). As musical director of the Berlin Philharmonic Orchestra (1955–89) and artistic director of the Salzburg festival (1956–60), he dominated the European classical music scene.

Kara-Kalpak Autonomous republic in w Uzbekistan; the capital is Nukus. Under Russian control at the end of the 19th century, it was made an autonomous region of Kazakstan (1925) and an autonomous republic (1933). In 1936 it became part of the Uzbek Soviet Republic and retained its autonomous status within independent Uzbekistan. Crops include alfalfa, rice, cotton and maize. Livestock raising and the breeding of muskrats and silkworms are important, and there is some light industry. Area: 165,600sq km (63,940sq mi). Pop. (1990) 1,244,700

Karakoram Range Mountain range in central Asia, extending sE from E Afghanistan to Jammu and Kashmir in India. It includes some of the world's highest mountains, among them K2. Length: *c*.480km (300mi).

Karamanlis, Koństantinos (1907–) Greek statesman, prime minister (1955–63, 1974–80), president (1980–85, 1990–95). He was elected to parliament in 1935. On becoming prime minister, he formed his own party, the National Radical Union (ERE). He resigned in 1963 after an election defeat.

■ Kandinsky Improvisation 28 (Second Version) (1912).
Throughout his life, the influential Russian painter
Wassily Kandinsky explored what he saw as the deeply spiritual relationship between visual art and music. He is widely accepted as the founder of abstract art.

KANSAS Statehood :

29 January 1861

Nickname : Sunflower state

State bird : Western meadowlark

State flower: Sunflower

State tree :

Cottonwood State motto:

To the stars through difficulties

During 11 years of self-imposed exile he was an opponent of the Greek military junta, and when it fell in 1974 he returned as prime minister at the head of the new Democratic Party (ND). **karate** Martial art popularized in Japan in the 1920s. The technique, which involves a formal method of physical and mental training, includes a variety of blows using the hand, legs, elbows and head. In competition, scoring depends on the finality of the blow.

Karelia Republic of the Russian Federation in NW European RUSSIA, bounded by the White Sea to the E and FINLAND to the W; the capital is Petrozavodsk. In the Middle Ages the region was an independent Finnish state. Split in the 12th century between Sweden and NovGOROD, it was unified under Swedish rule in the 17th century. The E was returned to Russia in 1721, while the w was part of Finland until 1940. After the 1939–40 Soviet-Finnish War the E sector absorbed 36,000sq km (14,000sq mi) of Finnish land and became a constituent republic (Karelo-Finnish SSR). During World War 2 the Finns occupied most of Karelia but it was returned to the Soviet Union in 1944. Declaring itself the Republic of Karelia, it became a constituent republic of the Russian Federation in 1992. Climate restricts farming to the S, where vegetables and cereal crops are

grown and livestock are raised. Fishing and timber are the chief industries. The region has valuable mineral deposits. Area: 172,400sq km (66,564sq mi). Pop. (1994) 794,200.

Karloff, Boris (1887–1969) British character actor. He is noted for his performances in horror films, including the portrayal of the monster in *Frankenstein* (1931).

karma Concept in Indian philosophy that relates one's actions in a past life to one's present and future life experiences. The Vedic principle of Karma is directly related to belief in REINCARNATION. Salvation involves cancelling the effects of past evil deeds by virtuous actions in one's present life. See also HINDUISM; VEDAS.

Karnak See Luxor

Kashmir Region in N India and NE Pakistan; former Indian princely state. When the Indian subcontinent was partitioned in 1947, the maharaja of Kashmir acceded to India, precipitating war between India and Pakistan. A cease-fire agreement left it divided between the Indian-controlled state of JAMMU AND KASHMIR and the Pakistan-controlled areas in the N and W of the region. The N area of Kashmir is ruled directly by the Pakistan government; the W area, Azad Kashmir, is partly autonomous. The Aksai Chin area of Kashmir, on the border

KAZAKSTAN

Kazakstan's flag was adopted on 4 June 1992, about six months after it had become independent. The blue represents cloudless skies, while the golden sun and the soaring eagle represent love of freedom. A vertical strip of gold ornamentation is on the left.

Asia. It stretches over 3,000km (2,000mi) from the Volga and Caspian Sea lowlands in the w to the Altai and Tian Shan mountains in the E. The Caspian Sea lowlands extend E through the Aral Sea region and include the Karagiye depression at 132m (433ft) below sea level. Eastern Kazakstan contains several freshwater lakes, the largest of which is Lake Balkhash. Kazakstan's rivers have been used extensively for irrigation, causing ecological problems: the Aral Sea has shrunk from 66,900sq km (25,830sq mi) in 1960 to 33,642sq km (12,989sq mi) in 1993. Whole fishing villages are now barren desert.

CLIMATE

Kazakstan has a continental dry climate. Winters are cold. At ALMATY, snow covers the ground for an average of 100 days each year.

VEGETATION

Kazakstan has very little woodland. Grassy

steppe covers much of the N, while the s is desert or semidesert. Large dry areas between the Aral Sea and Lake Balkhash are irrigated farmland.

HISTORY

Little is known of the early history of Kazakstan, except that it was the home of nomadic peoples. In 1218 the Mongol emperor GENGHIS KHAN conquered the region. Following his death the empire was divided into khanates. Feudal trading towns emerged beside the oases. In the late 15th century the towns formed a Kazak state, which fought for its independence from the neighbouring khanates. In 1731 Kazakstan appealed to Russia for protection and voluntarily acceded to the Russian empire. In the early 19th century, Russia abolished the khanates and encouraged Russian settlement throughout Kazakstan.

The conscription of Kazaks during World War 1 aroused much resentment, and after the Russian Revolution (1917) demands for independence grew. In 1920 Kazakstan became an autonomous Soviet republic, and in 1936 a full constituent republic. During the 1920s and 1930s the process of Russification increased. Stalin's forced collectivization of agriculture and rapid industrialization led to great famine. Soviet minorities were transported to Kazakstan. In the 1950s, the "Virgin Lands" project sought to turn vast areas of grassland into cultivated land to feed the Soviet Union. The Soviets placed many of their nuclear missile sites in Kazakstan and also built their first fast-breeder nuclear reactor at Mangyshlak. In 1986 nationalist riots were AREA: 2,717,300sq km (1,049,150sq mi)

POPULATION: 17,038,000

CAPITAL (POPULATION): Almaty (1,515,300)
GOVERNMENT: Multiparty republic

ETHNIC GROUPS: Kazak 40%, Russian 38%, German 6%, Ukrainian 5%, Uzbek, Tatar

LANGUAGES; Kazak (official);

Russian, the former official language, is

widely spoken

RELIGIONS: Mainly Islam, with a Christian

minority **CURRENCY:** Tenge

prompted by the imposition of a Russian to lead the republic. Following the dissolution of the Soviet Union, Kazakstan declared independence (December 1991) and joined the COMMON-WEALTH OF INDEPENDENT STATES (CIS).

POLITICS

A former Communist Party leader, Nursultan Nazarbayev, was Kazakstan's first elected president. He introduced free market reforms and a multiparty constitution. Multiparty elections were held in 1994. In a 1995 referendum Nazarbayev was confirmed as president until 2000. In 1996 the government announced plans to move the capital to AOMOLA by 2000. Aqmola is nearer to the main industrial areas and mineral resources in the N.

ECONOMY

Kazakstan is a developing country (1992 GDP per capita, US\$4,270). The break-up of the Soviet Union hit Kazak exports. In 1994 it entered into a single market agreement with other Central Asian states. Its post-independence free market reforms have encouraged much inward investment. Industry accounts for 41% of earnings. Kazakstan is rich in mineral resources. It is the world's ninth-largest producer of bituminous coal. Its gas, oil and gold reserves are being increasingly exploited. In 1996 construction started on a pipeline to Russia. Agriculture is highly developed. Grain is the principal crop. Cotton and wool are also produced.

K

with Tibet, is occupied by China. Indian Jammu and Kashmir has remained in a state of unrest. Kashmir includes parts of the Himalayas and the KARAKORAM RANGE. The Vale of Kashmir, in the River Jhelum valley, is the most populated area; wheat and rice are grown. Total area: 222,236sq km (85,806sq mi).

Kasparov, Gary (1963–) Russian chess champion. Winner of the Soviet title (1981), he beat Anatoly Karpov for the world title in 1985, becoming the youngest world champion. In 1987, after disagreements with FIDE, the international chess organization, Kasparov formed the Grandmasters' Association.

Katmandu (Kathmandu) Capital of Nepal, situated c.1,370m (4,500ft) above sea level in a valley of the HIMALAYAS. It was founded in AD 723. It was an independent city from the 15th century until 1768, when it was captured by Gurkhas. Katmandu is Nepal's administrative, commercial and religious centre. Pop. (1991) 419,073.

Katowice City in s Poland. Founded in the 16th century and chartered in 1865, it was occupied by Germany throughout World War 2. It is one of Poland's foremost industrial centres, producing coal, iron and steel, heavy machinery and chemicals. Pop. (1993) 366,900.

Katz, Sir Bernard (1911–) British biophysicist. He shared the 1970 Nobel Prize for physiology or medicine with Ulf von Euler and Julius Axelrod for work on the chemistry of nerve transmission. Katz discovered how the NEUROTRANS-MITTER acetylcholine is released by neural impulses, causing muscles to contract.

Kaufman, George Simon (1889–1961) US playwright. He collaborated with other writers, such as Edna Ferber on *Stage Door* (1936) and Moss HART on *You Can't Take It With You* (1936) and *The Man Who Came To Dinner* (1939). He also contributed to *Guys and Dolls* (1950).

Kaunas City and port in s Lithuania. Founded in the 11th century, it became part of Russia in 1795. From 1918–40, it was capital of independent Lithuania. Industries: iron and steel, electrical machinery, chemicals, textiles. Pop. (1990) 592,500. Kaunda, Kenneth (1924–) Zambian political leader. He became leader of the United National Independence Party (UNIP) in colonial Northern Rhodesia (1960) and first president of independent Zambia (1964–91). His government imposed single-party rule in 1972. Kaunda was a strong supporter of African independence and a respected figure among Commonwealth leaders. Severe economic problems and political unrest forced him to allow multiparty elections in 1991, when he and his party were defeated.

Kawabata, Yasunari (1899–1972) Japanese novelist. His best-known works are *Snow Country* (1948), *Thousand Cranes* (1952) and *The Sound of the Mountain* (1952). He was awarded the 1968 Nobel Prize for literature.

Kawasaki City in SE Honshū Island, on Tokyo Bay, Japan. The city suffered extensive damage from bombing during World War 2. Industries: iron and steel mills, machinery, motor vehicles, petrochemicals, shipbuilding. Pop. (1993) 1,168,000. Kazak Turkic-speaking Muslim people who inhabit the Republic of KAZAKSTAN and the adjacent Sinkiang province of China. Traditionally nomadic, in the 20th century they settled within the collective farm system of the former Soviet Union.

Kazakstan Republic in central Asia. See country feature Kazan, Elia (1909–) US author and director, b. Turkey. He was one of the founders of the ACTORS' STUDIO. His work in the cinema includes A Tree Grows in Brooklyn (1945), Gentleman's Agreement (1947) and On the Waterfront (1954). He wrote two best-selling novels, America, America (1962) and The Arrangement (1967).

Kazan City and port on the River Volga, E European Russia; capital of TATAR REPUBLIC. Founded in the 13th century, Kazan became the capital of the Tatar khanate (1438). Conquered by Ivan IV, it served as the E outpost of Russian colonization. Industries: electrical equipment, engineering, oil refining, chemicals, fur. Pop. (1992) 1,104,000.

Kazantzakis, Nikos (1885–1957) Greek politician and writer. He wrote in a wide variety of genres, including lyric and epic poetry, literary criticism and translations from DANTE and GOETHE. He is best known outside Greece for his novel *Zorba the Greek* (1946).

Kearny, Stephen Watts (1794–1848) US general. He participated in the War of 1812 and in numerous wars on the Western frontier. In 1846 he took possession of New Mexico, promising full citizenship to the Native Americans. He also led a successful march to California, taking San Diego (1846) and Los Angeles (1847).

Keaton, Buster (1895–1966) US comic silent-film actor and director. *Our Hospitality* (1923), *Seven Chances* (1925) and *The General* (1926) are pre-eminent among the ten full-length features he released before 1928.

Keats, John (1795–1821) British poet. He produced a huge body of verse, the best of which stands among the finest in the English language. In 1819 alone he wrote, among other pieces, "The Eve of St Agnes"; "La Belle Dame Sans Merci"; the magnificent odes "On a Grecian Urn", "To a Nightingale", "On Melancholy" and "To Autumn"; the long poem "Lamia"; and the second version of his fragmentary epic "Hyperion".

Keelung (Chilung) City on the East China Sea, N Taiwan. Occupied by the Spanish in the early 17th century, it was later briefly in Dutch hands. Under Japanese occupation (1895–1945) the city developed rapidly. An important commercial centre, it is the country's principal naval base. Industries: fishing, chemicals, shipbuilding. Pop. (1992) 355,894.

Keillor, Garrison Edward (1942–) US author and humorist. His bittersweet stories about the engaging fictional community of Lake Wobegon feature in *Happy To Be Here* (1981), *Leaving Home* (1987) and *We Are Still Married* (1989). Keller, Helen Adams (1880–1968) US social worker, writer and lecturer. With the help of her teacher Anne Sullivan, she overcame the loss of sight, hearing and speech, caused by an early illness, to master several languages and lecture throughout the world. Her books include *The Story of My Life* (1902), *The World I Live In* (1908) and *The Open Door* (1957).

Kellogg-Briand Pact (1928) International peace agreement negotiated by US secretary of state, Frank B. Kellogg, and French foreign minister, Aristide Briand. It renounced war as a means of settling international disputes and was subsequently signed by most of the world's governments.

Kelly, Gene (1912–96) US dancer, choreographer, film star and director. His greatest films, co-directed with Stanley Donen, were *On the Town* (1949), *An American in Paris* (1951) and the hugely popular *Singin' in the Rain* (1951).

Kelly, Grace Patricia (1929–82) US film actress. She appeared in *High Noon* (1952) and *Mogambo* (1953), and won an Academy Award for her leading role in *The Country Girl* (1954). She retired from the screen after marrying Prince Rainier of Monaco in 1956.

kelp Any of several brown SEAWEEDS commonly found on Atlantic and Pacific coasts, a type of brown ALGAE. A source of iodine and potassium compounds, kelps are now used in a number of industrial processes. Giant kelp (*Macrocystis*) exceeds 46m (150ft) in length. Phylum Phaeophyta.

Kelvin, William Thomson, 1st Baron (1824–1907) British physicist and mathematician after whom the absolute scale of temperature is named. The Kelvin temperature scale has its zero point at absolute zero and degree intervals the same size as the degree Celsius. The freezing point of water occurs at 273K (0°C or 32°F) and the boiling point at 373K (100°C or 212°F). In THERMODYNAMICS he resolved conflicting interpretations of the first and second laws.

Kemal Atatürk See ATATÜRK, KEMAL

Kempis, Thomas à (1380–1471) German Augustinian monk and spiritual writer. Ordained in 1413, he remained in the monastery of the Brethren of the Common Life, near Zwolle, for most of his life. He wrote or edited numerous treatises on the life of the soul. The most famous work often attributed to him is *Imitation of Christ*. Other works include *Soliloquium Animae* and *De Tribus Tabernaculis*.

Kendall, Edward Calvin (1886–1972) US chemist. He worked on the biological effects of the HORMONES of the ADRENAL GLANDS, in particular CORTISONE, which he isolated. He shared the 1950 Nobel Prize for physiology or medicine. Keneally, Thomas Michael (1935–) Australian novelist. He drew on his experience of training for the Catholic priesthood in early novels, including *The Place at Whitton* (1964).

▲ Keaton A family music-hall background provided the US comic actor and director Buster Keaton with many of the ideas for his sophisticated and completely visual slapstick style. Many of his films, including *The Navigator* (1924) and *The General* (1926) are becoming increasingly recognized for their comic inventiveness.

► Kennedy US president John F. Kennedy's youth, charm and good looks helped him to become one of the most popular US presidents. His liberal policies and support of civil rights, while making him many friends within minority groups, alienated more conservative elements. There has been much mystery surrounding his assassination in Dallas in 1963, ranging from the inconclusive Warren report. which upheld the official theory that it was the work of a lone gunman, Lee Harvey Oswald, to theories that the assassination was the work of many co-conspirators.

With *Bring Larks and Heroes* (1967) he turned to historical fiction. His best-known work, *Schindler's Ark* (1982), won the Booker Prize, and formed the basis of Steven Spielberg's film *Schindler's List* (1993).

Kennedy, John F. (Fitzgerald) (1917–63) 35th US president (1961–63). He was elected to Congress as a Democrat from Massachusetts in 1946, serving in the Senate (1953–60). He gained the presidential nomination in 1960 and narrowly defeated Richard Nixon. He adopted an ambitious and liberal programme, under the title of the "New Frontier", and embraced the cause of CIVIL RIGHTIS, but his planned legislation was frequently blocked by Congress. In foreign policy he founded the "Alliance for Progress", the aim of which was to improve the image of the USA abroad. Adopting a strong anticommunist line, he was behind the BAY OF PIGS disaster (1961) and outfaced Khrushchev in the ensuing Cuban Missile Crisis, which was followed by a US-Soviet treaty banning nuclear tests. He increased military aid to South Vietnam. He was assassinated in Dallas, Texas, on 22 November 1963.

Kennedy, Joseph Patrick (1888–1969) US businessman and statesman. He was chairman of the Securities and Exchange Commission (1934–35) and later ambassador to Great Britain (1937–40). He was involved in many philanthropic endeavours, especially the Joseph P. Kennedy Memorial Foundation. He was determined that his sons, Joseph P. Kennedy Jr., John F. Kennedy, Robert Kennedy and Edward Kennedy, should enter politics.

Kennedy, Nigel (1956–) English violinist. In addition to performances with leading orchestras worldwide, he is known for his improvisational concerts with the jazz violinist Stephane Grappelli.

Kennedy, Robert Francis (1925–68) US lawyer and statesman. He served on the Senate Select Committee on Improper Activities (1957–59), where he clashed with the Teamsters' Union president Jimmy HOFFA. In 1960 he managed the successful presidential campaign of his brother John F. KENNEDY. He became US attorney general (1961–64), vigorously enforcing civil rights laws and promoting the Civil Rights Act of 1964. After his brother's assassination, he left the cabinet and was elected senator for New York in 1964. While a candidate for the Democratic presidential nomination, he was assassinated in Los Angeles in June 1968.

Kennedy Space Center See CAPE CANAVERAL

Kent, Rockwell (1882–1971) US painter, author and illustrator whose pictorial works won great popularity for their vivid portrayal of the wilderness. He wrote and illustrated several books, notably *Wilderness* (1920), *Voyaging Southward* (1924) and *Greenland Journal* (1962).

Kent County in SE England, S of the Thames estuary and NW of the Strait of Dover; the county town is Maidstone. Roman settlement began in AD 43. It later became an Anglo-Saxon kingdom, and remained a separate kingdom until the 9th century. Apart from the North Downs, the area is mainly lowlying. It is drained by the rivers Medway and Stour. Cereals, hops, fruit and vegetables are grown, and sheep and cattle are reared. Dover, Folkestone and Ramsgate are ports. There are Norman cathedrals at Canterbury and Rochester. Industries: paper making, shipbuilding, chemicals, brewing. Area: 3,732sq km (1,441sq mi). Pop. (1991) 1,508,873.

Kentucky State in SE central USA; the capital is FRANKFORT. Other major cities include Lexington and Louisville. Ceded to

Britain by France in 1763, the territory was admitted to the Union in 1792. Its loyalties were divided at the outbreak of the CIVIL WAR, and the state was invaded by both sides. Most of the area is rolling plain. In the SE the Cumberland Mountains dominate a rugged plateau region. The state is drained chiefly by the Ohio and Tennessee rivers. Tobacco is the chief crop, followed by hay, maize and soya beans. Cattle are reared and Kentucky is noted for breeding thoroughbred racehorses. Industries: electrical equipment, machinery, chemicals, metals. Kentucky is one of the country's major coal producers. Area: 104,623sq km (40,395sq mi). Pop. (1990) 3,685,296.

Kentucky and Virginia Resolutions (1798 and 1799) Declarations of states' rights. Drafted by Thomas Jefferson (Kentucky Resolutions) and James Madison (Virginia), they expressed opposition to the ALIEN AND SEDITION ACTS. They denied the right of the federal government to exercise powers not granted it by the constitution and declared that states had the right to judge the constitutionality of federal acts.

Kenya Republic on the E coast of Africa. *See* country feature **Kenya**, **Mount** Extinct volcanic mountain in central Kenya. The second-highest mountain in Africa, it was first climbed in 1899. It consists of three peaks, the highest of which is Batian, rising to 5,199m (17,057ft).

Kenyatta, Jomo (1893–1978) Kenyan statesman, first president of Kenya (1964–78). A KIKUYU, he led the struggle for Kenyan independence from 1946. He was imprisoned by the British colonial authorities in 1953 for MAU MAU terrorism after a dubious trial. As leader of the Kenya African National Union, he became president on Kenya's independence in 1964. Though he suppressed domestic opposition, he presided over a prosperous economy and generally followed pro-Western policies.

Kepler, Johannes (1571–1630) German mathematician and astronomer. He supported the Sun-centred Solar System put forward by COPERNICUS. He succeeded Tycho BRAHE as Imperial Mathematician to the Holy Roman Emperor, Rudolf II. From Brahe's observations, he concluded that Mars moves in an elliptical orbit and went on to establish the first of his three laws of planetary motion. The *Rudolphine Tables*, based on Brahe's observations and Kepler's laws, appeared in 1627 and remained the most accurate until the 18th century.

Kerala State on the Arabian Sea, sw India; the capital is Trivandrum. One of India's smallest states, it is the most densely populated. Fishing is important. Chief products include rubber, tea, coffee, coconuts, cashew nuts, ivory, textiles, teak, chemicals and minerals. Area: 38,864sq km (15,005sq mi). Pop. (1991) 29,098,518.

keratin Fibrous PROTEIN present in large amounts in SKIN cells, where it serves as a protective layer. Hair and fingernails are made up of cells filled with keratin, which is also the basis of claws, horns and feathers.

Kerensky, Alexander Feodorovich (1881–1970) Russian moderate political leader. He became prime minister of the provisional government in July 1917, shortly after the overthrow of the Tsar. Deposed by the BOLSHEVIKS, he fled to France. *See also* RUSSIAN REVOLUTION

Kern, Jerome David (1885–1945) US songwriter of film and show music. His best-known musical, *Showboat* (staged 1927; filmed 1936, 1959), contains the song "Ol' Man River". He influenced Richard RODGERS and George GERSHWIN.

kerosene (paraffin) Distilled petroleum product heavier than petrol but lighter than diesel fuel. Kerosene is used in camping stoves, tractor fuels and fuels for jet and turboprop aircraft.

Kerouac, Jack (1922–69) US poet and novelist. He published his first novel, *The Town and the City*, in 1950, but it was *On the Road* (1957) that established him as the leading novelist of the BEAT MOVEMENT. Later works include *The Dharma Bums* (1958), *Desolation Angels* (1965) and the posthumously published *Visions of Cody* (1972).

Kerry County in Munster province, sw Republic of Ireland; the county town is Tralee. It is a mountainous region with an indented coastline and many lakes. Oats and potatoes are grown, and sheep and cattle raised. Industries: tourism, fishing, footwear, woollen goods. Area: 4,701sq km (1,815sq mi). Pop. (1991) 121,894.

KENTUCKY

Statehood: 1 June 1792

Nickname:

Bluegrass state

State bird :

Kentucky cardinal

State flower:

Goldenrod State tree :

Kentucky coffee tree

State motto :

United we stand, divided we fall

Kesselring, Albert (1885–1960) German general. During World War 2, he commanded the Luftwaffe, later becoming commander-in-chief in Italy (1943) and then supreme commander on the Western front (1945). Implicated in a 1943 massacre of Italian hostages, in 1947 he was sentenced to death, later commuted to imprisonment, by a British court.

kestrel (windhover) Small FALCON that lives mainly in Europe, and hovers over its prey before attacking. It feeds mainly on rodents, insects and small birds. Length: 30cm (12in). Species *Falco tinnunculus*.

kettledrum See TIMPANI

Kew Gardens (Royal Botanic Gardens) Collection of plants and trees in sw London, UK. Founded in 1760 by George III's mother, they were given to the nation by Queen Victoria in 1840. Much plant research is carried out here.

key In music, term used to indicate TONALITY in a composition, based on one of the major or minor scales. The key of a piece of music is indicated by the key signature at the left hand end of the stave. The key of a passage may, however, change by the addition of accidentals before prescribed notes; a change of key is known as a modulation.

keyboard instrument Large group of musical instruments

played by pressing keys on a keyboard. Notes are sounded by hitting or plucking a string (as in the PIANO OF HARPSICHORD), passing air through a pipe or reed (as in the ORGAN OF ACCORDION), or electronically (as in the SYNTHESIZER).

Keynes, John Maynard (1883–1946) British economist. In *The General Theory of Employment, Interest and Money* (1936), which was strongly influenced by the Great Depression, Keynes established the foundation of modern MACROECONOMICS. He advocated the active intervention of government in the economy to stimulate employment and prosperity. He was highly influential as an economic advisor in World War 2, and took a leading role in the Bretton Woods Conference of 1944.

KGB (Komitet Gosudarstvennoye Bezhopaznosti, Rus. Committee for State Security) Soviet secret police. In the 1980s, it employed an estimated 500,000 people and controlled all police, security and intelligence operations in the Soviet Union. It also gathered military and political information about other countries. Opposing liberalization under Gorbachev, its chief was a leader of the attempted coup against him in 1991. After the collapse of communism and the breakup of the Soviet Union, it underwent extensive reform.

KENYA

Kenya's flag dates from 1963, when the country became independent. It is based on the flag of KANU (Kenya African National Union), the political party that led the nationalist struggle. The Masai warrior's shield and crossed spears represent the defence of freedom.

The Republic of Kenya straddles the Equator in East Africa. Mombasa lies on the narrow coastal plain. Most of Kenya comprises high plains. In the NW is an area of high scrubland around Lake Turkana. In the SW are the Kenyan highlands, including Mount Kenya, the country's highest peak at 5,199m (17,057ft), and the capital, NAIROBI. The Great RIFT VALLEY cuts through w Kenya.

CLIMATE

Mombasa is hot and humid. Inland the climate is

SUDAN

SON

Lake Turkana
(Lake Turkana
(Lake Turkana
(Lake Rudolf)

A

N

Great
Ret
Voiley

Kitsumu

Eldoret

A

Kisumu

Lake Turkana
(Lake Rudolf)

A

Marsabit

O

Ret
Voiley

Kitsumu

A

Kisumu

Figuatis

Nakuru

Tinka

Nairobi

Victoria

Tsavo

Wajir

A

L

Kisumu

Tinka

Nairobi

Victoria

Tsavo

Wajir

A

L

Kisumu

Mi Kenya

Tinka

Voi

Tinka

Voi

Tinka

Voi

Tinka

Voi

Tinka

O CEAN

Pemba

Sos

Janebbas

Janebbas

Zanebbas

Janebbas

moderated by elevation: Nairobi has summer temperatures 10°C (18°F) lower than Mombasa.

VEGETATION

The coast is lined with mangrove swamps. The inland plains are bushlands. Much of the N is semi-desert. Forests and grasslands are found in the densely populated sw highlands.

HISTORY AND POLITICS

Some of the earliest hominid fossils have been found in s Kenya. Kenya's coast has been a trading centre for more than 2,000 years. In the 8th century, the Arabs founded settlements. In the 16th century, Portuguese traders controlled the area. In 1729 Arab dynasties regained control. Britain gained rights to the coast in 1895. Colonization began in 1903, and land was acquired from the Kikuyu for plantations and farms. The territory was divided into the inland Kenya Colony and the coastal Protectorate of Kenya. European settlement intensified. The employment of Africans as plantation and farm labourers led to social unrest. MAU MAU waged an armed struggle (1952-56) for land rights and independence. Britain declared a state of emergency and imprisoned its leader, Jomo KENYAT-TA. In 1963 Kenya achieved independence, becoming a republic in 1964. Jomo Kenyatta was the first president. His authoritarian regime tried to establish unity. Territorial disputes with Uganda and Tanzania and drought created civil unrest. In 1978 Kenyatta died and was succeeded by Daniel Arap Moi. Moi rejected calls for democracy and cracked down on dissent. In 1982 the Kenya African National Union became **AREA:** 580,370sq km (224,081sq mi) **POPULATION:** 26,985,000

CAPITAL (POPULATION): Nairobi (1,346,000)
GOVERNMENT: Multiparty republic

ETHNIC GROUPS: Kikuyu 21%, Luhya 14%, Luo 13%, Kamba 11%, Kalenjin 11%

LANGUAGES; Swahili and English (both official)

RELIGIONS: Christianity (Roman Catholic 27%, Protestant 19%, others 27%), traditional

beliefs 19%, Islam 6% currency: Kenya shilling = 100 cents

the sole legal political party. Following nationwide riots in 1988, the government agreed to electoral reform. In 1992 multiparty elections Moi was re-elected, but independent observers claimed the elections were rigged. Prior to 1997 elections, demonstrators again called for democratic reform. Moi was re-elected.

ECONOMY

Kenya is a developing country (1992 GDP per capita, US\$1,400). Agriculture employs c.80% of the workforce. Kenya is the world's fourth-largest tea producer. Coffee is an important cash crop. The chief food crop is maize. Kenya's wildlife parks and reserves attract many tourists.

The Citrus Swallowtail is an example of the fascinating wildlife found in Kenya.

▲ kidney The human kidney is enclosed in a fibrous capsule, and consists of an outer cortex region (1), a medulla region (2) with pyramidal-shaped areas, and an inner pelvis region (3), which leads into the ureter (4). The renal artery (5) conducts blood into the kidney to be filtered; it is then carried away by the renal vein (6).

Khachaturian, Aram llyich (1903–78) Armenian composer. He wrote a piano concerto (1936) and a violin concerto (1940), but his best-known works are probably the ballet scores *Gayane* (1942) and *Spartacus* (1953).

Khafre, Great Sphinx of Monumental statue of the SPHINX at GIZA, Egypt. Its name derives from the pharaoh whose pyramid complex it may be part of and whose portrait is said to be represented by the sphinx's face. The strange and compelling symbolism of its part human, part animal body continues to baffle archaeologists.

Khan, (Niazi) Imran (1952–) Pakistani cricketer and politician. He made his Test debut for Pakistan in 1971. He played English county cricket for Worcestershire (1975–77) and Sussex (1978–88). He captained Pakistan for most of the decade 1982–92, leading them to victory in the 1992 World Cup. An outstanding all-rounder, he took 325 wickets in Test matches and became only the second player to score a century and take ten wickets in a test (1983). In the 1997 Pakistan elections his political aspirations received a setback.

Kharkov (Kharkiv) City in NE Ukraine. It was founded in the 17th century to serve as a stronghold for the Ukrainian Cossacks defending Russia's s border. During the 19th century it developed industrially, stimulated by nearby coalfields. From 1919–34 it was capital of the Ukrainian Soviet Socialist Republic. Industries: mining machinery, ball-bearings, chemicals, electrical goods. Pop. (1991) 1,623,000.

Khartoum Capital of Sudan, at the junction of the Blue NILE and White Nile rivers. Khartoum was founded in the 1820s by MUHAMMAD ALI and was besieged by the Mahdists in 1885, when General GORDON was killed. In 1898 it became the seat of government of the Anglo-Egyptian Sudan, and from 1956 the capital of independent Sudan. Industries: cement, gum arabic, chemicals, glass, cotton textiles. Pop. (1983) 476,218.

Khayyám, Omar See Omar Khayyám

Khazars Turkic people who first appeared in the lower Volga region c.2nd century AD. Between the 8th and 10th centuries their empire prospered and extended from N of the Black Sea to the River Volga and from W of the Caspian Sea to the River Dnieper. They conquered the Volga Bulgars and fought the Arabs, Russians and Pechenegs. In the 8th century, their ruling class was converted to JUDAISM. Their empire was destroyed in 965 by the army of Sviatoslav, Duke of Kiev.

Khmer Language of up to 85% of the inhabitants of Cambodia. It belongs to a group of the Mon-Khmer languages. A Khmer empire was set up between the 9th and 15th centuries AD. Cambodia was renamed the Khmer Republic in 1970. When the Republic fell to the Khmer ROUGE in April 1975, the country was renamed Kampuchea; the name Cambodia was restored in 1989.

Khmer Rouge Cambodian communist guerrilla organization. It gained control of Cambodia in 1975. Led by POL POT and Khieu Samphan, it embarked on a forced wholesale communist transformation of Cambodian society, during which an estimated 2 to 3 million people died. The regime lost power to the Vietnamese after a period of intense conflict in 1977-78. The Kampuchean National United Front for National Salvation, supported by the Vietnamese, founded a People's Republic in 1979. In 1982 the Khmer Rouge joined a coalition with Prince SIHANOUK (the former Cambodian leader) and the Khmer Peoples National Liberation Front. From 1988 attempts were made to settle the political situation by peaceful means. In 1991 each faction signed a cease-fire agreement, which was to be monitored by United Nations (UN) troops. After an election in 1993, in which the Khmer Rouge refused to take part, Prince Sihanouk's parliamentary monarchy was re-established. The Khmer Rouge continued hostilities and have been officially banned since 1994.

Khoisan Group of South African languages. The Khoikhoi and SAN are the two largest groups of native speakers of these languages. The Khoisan languages also include Sandawe and Hadza, spoken by small tribal groups in Tanzania. *See also* CLICK LANGUAGE

Khomeini, Ayatollah Ruhollah (1900–89) Iranian religious leader. An Islamic scholar with great influence over his Shiite students, he published an outspoken attack on Riza

Shah Pahlavi in 1941 and remained an active opponent of his son, Muhammad Reza Shah Pahlavi. Exiled in 1964, he returned to Iran in triumph after the fall of the Shah in 1979. His rule was characterized by strict religious orthodoxy, elimination of political opposition, and economic turmoil. In 1988 he issued a *fatwa* (death order) against Salman Rushde.

Khrushchev, Nikita Sergeyevich (1894–1971) Soviet politician, first secretary of the Communist Party (1953–64) and Soviet prime minister (1958–64). Noted for economic success and ruthless suppression of opposition in the Ukraine, he was elected to the Politburo in 1939. After Stalin died, he made a speech denouncing him and expelled his backers from the central committee. Favouring detente with the West, he yielded to the USA in the CUBAN MISSILE CRISIS. Economic setbacks and trouble with China led to his replacement by Leonid Brezhnev and Aleksei Kosygin in 1964.

Khyber Pass Mountain pass in the Safid Kuh range, on the frontier between Afghanistan and Pakistan, linking the Kabul valley in Afghanistan (w) with Peshawar in Pakistan (E). Height: 1,073m (3,520ft). Length: 50km (30mi).

kibbutz Collective settlement in Israel that is owned by its members. The idea developed from the pioneering settlements established by Jewish settlers in a part of ancient Palestine that became Israel in 1948.

Kickapoo Major tribe of Algonquian-speaking Native North Americans, originally occupying south-central Wisconsin. In 1852 part of the tribe went to Texas, and then to Mexico, where many of their descendants still inhabit a reservation area in Chihuahua. Eventually most of the Kickapoo moved to Oklahoma, where some 1,500 now live.

Kidd, William (1645–1701) Scottish-born pirate, commonly known as Captain Kidd. After a successful career as a privateer, he turned pirate on an expedition to East Africa in 1696. In 1699 he was arrested in Boston, Massachusetts, and sent to England where he was tried and hanged for piracy.

Kiddush Blessing recited before a meal on the eve of the Jewish Sabbath or of a festival. The head of the household says the prayer over a cup of wine, which is then passed round to each member to sip.

kidney In vertebrates, one of a pair of organs responsible for regulating blood composition and the EXCRETION of waste products. The kidneys are at the back of the abdomen, one on each side of the backbone. The human kidney consists of an outer cortex and an inner medulla with about one million tubules (NEPHRONS). Nephrons contain numerous CAPILLARIES, which filter the blood entering from the renal ARTERY. Some substances, including water, are reabsorbed into the blood. URINE remains, which is passed to the URETER and on to the BLADDER. See also HOMEOSTASIS

kidney machine (artificial kidney) Equipment designed to remove toxic wastes from the blood in kidney failure. Plastic tubing is used to pipe blood from the body into the machine, where waste products are filtered out by DIALYSIS.

Kiel City and seaport in N Germany, at the head of the Kiel Canal linking the North Sea and the Baltic Sea; capital of SCHLESWIG-HOLSTEIN state. Today Kiel is a yachting centre. Industries: shipbuilding, textiles, precision instruments, printed matter. Pop. (1990) 248,000.

Kierkegaard, Søren (1813–55) Danish philosopher and theologian, regarded as the founder of modern EXISTENTIALISM. He believed that the individual must exercise free will, making deliberate decisions about the direction of his/her life. Critical of Hegel's speculative philosophy, he considered that religious faith was, at its best, blind obedience to an irrational God. His books include *Either/Or* (1843) and *Philosophical Fragments* (1844).

Kiesinger, Kurt Georg (1904–88) Chancellor of West GERMANY (1966–69). First elected to the Bundestag as a Christian Democrat in 1949, he became federal chancellor in 1966, maintaining the conservative policy of his predecessors ADENAUER and Ludwig Erhard.

Kieslowski, Krzysztof (1941–96) Polish film director. He gained international praise for the ten-part epic *Dekalog* (1988), which drew on the commandments to reflect the pessimism and humanism in modern Poland. He received great

critical acclaim for his final work, the *Three Colours* film trilogy *Blue* (1993), *White* (1993) and *Red* (1994).

Kiev (Kiyev) Capital of Ukraine and a seaport on the Dnieper River. Founded in the 6th or 7th century, Kiev was the capital of Kievan Russia. It later came under Lithuanian, then Polish rule before being absorbed into Russia. It became the capital of the Ukrainian Soviet Socialist Republic in 1934, and of independent Ukraine in 1991. Industries: shipbuilding, machine tools, footwear, furniture. Pop. (1993) 2,600,000.

Kigali Capital of Rwanda, central Africa. It was a trade centre during the period of German and Belgian colonial administration, becoming the capital when Rwanda achieved independence in 1962. Industries: tin mining, cotton, tanning, textiles, coffee. Pop. (1993) 234,500.

Kikuyu Bantu-speaking people of the highlands of Kenya, E Africa. British conquest strained their political and agricultural system; the result was an outbreak of terrorism during the 1950s by a group known as MAU MAU. After Kenya gained independence in 1963, the Kikuyu were the country's most important tribe, forming 20% of the population.

Kilauea Volcanic crater in Hawaii, on SE Hawaii Island. It last erupted in 1968 and is the largest active crater in the world. Height: 1,247m (4,090ft). Depth: 152m (500ft).

Kildare County in Leinster province, E Republic of Ireland; the county town is Naas. It is a low-lying region, and its chief rivers are the Liffey, Boyne and Barrow. Primarily agricultural, Kildare is noted for its breeding of racehorses. Area: 1,694sq km (654sq mi). Pop. (1991) 122,656.

Kilimanjaro Mountain in NE Tanzania, near the border with Kenya. The highest mountain in Africa, it is an extinct volcano with twin peaks joined by a broad saddle. Coffee is grown on the intensely cultivated s slopes. Height: Kibo 5,895m (19,340ft); Mawenzi 5,150m (16,896ft).

Kilkenny County in Leinster province, E Republic of Ireland; the county town is Kilkenny. Part of the central plain of Ireland, it is drained by the Suir, Barrow and Nore rivers. Farmers grow cereal crops and vegetables, and cattle are reared. Industries: brewing and coal mining. Area: 2,062sq km (796sq mi). Pop. (1991) 73,635.

killdeer Noisy bird of North American meadows, known for its alarm call and distraction displays. Its plumage is white with a double black breast ring and chestnut rump and tail. Family Charadriidae; species *Charadrius vociferus*.

killer whale Toothed marine mammal of the DOLPHIN family that lives in all the world's oceans, especially colder regions. A fierce predator, it is black above and white below, with a white patch above each eye and a long, erect, dorsal fin. Length: 9m (30ft). Species: *Orcinus orca*.

kilogram (symbol kg) SI unit of mass, defined as the mass of the international prototype cylinder of platinum-iridium kept at the International Bureau of Weights and Measures near Paris. 1 kilogram is equal to 1000g (2.2lb).

Kimberley City in South Africa; capital of Northern Cape province. It was founded in 1871 after the discovery of diamonds nearby. Today it is one of the world's largest diamond centres. Other industries are the processing of gypsum, iron and manganese. Pop. (1991) 167,060.

Kim II Sung (1912–94) Korean statesman, president of North Korea (1948–94). He joined the Korean Communist Party in 1931 and led a Korean unit in the Soviet army during World War 2. In 1950 he led a North Korean invasion of South Korea, precipitating the Korean War (1950–53). Chairman of the Korean Workers' Party from 1948, his government suppressed all opposition and pursued strictly orthodox communist policies.

Kim Jong II (1941–) North Korean politician, head of state since the death of his father, KIM IL SUNG, in 1994. In 1980 he was officially named as his father's successor, assuming a more important role in government and being included in the personality cult that surrounded his father.

Kim Young Sam (1927–) South Korean politician and president (1992–). He was a founder-member of the Democratic Party in 1955 and president of the New Democratic Party (NDP) from 1974. In 1979 he was banned from politics for his opposition to President Park. The ban was lifted in

1985. In 1992, as leader of the Democratic Liberal Party (DLP), Kim Young Sam became president of South Korea. **kinetic energy** Energy that an object possesses because it is in motion. It is the energy (symbol K) given to an object to set it in motion; it depends on the mass (m) of the object and its velocity (v), according to the equation $K = 1/2 mv^2$. On impact, it is converted into other forms of energy such as heat, sound and light. *See also* POTENTIAL ENERGY

kinetics In physics, one of the branches of DYNAMICS. In chemistry, a branch of physical chemistry that deals with the rates of chemical reactions.

kinetic theory Theory in physics dealing with matter in terms of the forces between particles and the energies they possess. There are five principles to the kinetic theory: matter is composed of tiny particles; these are in constant motion; they do not lose energy in collision with each other or the walls of their container; there are no attractive forces between the particles or their container; and at any time the particles in a sample may not all have the same energy.

King, B.B. (Riley B.) (1925–) US rhythm-and-blues guitarist and singer-songwriter. Among his most notable recordings are *There Must be a Better World Somewhere* (1981) and *Six Silver Strings* (1985).

King, Billie Jean (1943–) US tennis player. A powerful singles player, King won the US Open (1967, 1971–72, 1974); Wimbledon (1966–68, 1972–73, 1975); Australia (1968); and France (1972). She also dominated women's doubles and advocated parity in the prize money for men's and women's competitions.

King, Martin Luther, Jr (1929–68) US Baptist minister and CIVIL RIGHTS leader. He led the boycott of segregated public transport in Montgomery, Alabama, in 1956. As founder (1960) and president of the Southern Christian Leadership Council, he became a national figure. He opposed the Vietnam War and demanded measures to relieve poverty, organizing a huge march on Washington (1963) where he made his most famous ("I have a dream...") speech. In 1964 he became the youngest person to be awarded the Nobel Peace Prize. He was assassinated in Memphis, Tennessee, where he had gone to support striking workers.

King, Stephen (1947–) US novelist and short-story writer. King is a master of the modern horror novel. Many of his books, such as *The Shining* (1977) and *Misery* (1987), have been made into successful films.

King, William Lyon Mackenzie (1874–1950) Canadian politician, prime minister (1921–30, 1935–48). His career was marked by the drive for national unity, culminating in the Statute of Westminster (1931). He made concessions to the Progressives, and he was conciliatory towards French-Canadian demands. In foreign policy his basic sympathies were isolationist and anti-British, but he cooperated closely with Britain and the USA during World War 2.

kingbird (tyrant flycatcher) New World flycatcher, whose habitat is mainly in tropical America. It dives at intruders and snaps up insects. It grows to 17cm (6.8in).

kingdom The most widely adopted TAXONOMY for living organisms is the Five Kingdoms system, in which the kingdom is the topmost level (taxon). The Five Kingdoms are Animalia (ANIMAL), Plantae (PLANT), Fungi (FUNGUS), PROKARYOTAE and PROTOCTISTA. Two subkingdoms are often recognized within Prokaryotae, ARCHAEBACTERIA and EUBACTERIA, but the bacteria are so diverse that many taxonomists think they comprise more than one kingdom. Some

▲ killer whale The large triangular dorsal fin and the black and white body are the two obvious features of the killer whale (*Orcinus orca*). It is found mostly in polar seas and is generally considered to be the most ferocious of whales.

Almost any creature in the sea is considered as food by the 9m (30ft) killers.

▲ King US civil rights leader Martin Luther King was an inspiring orator of impressive moral impact. Often criticized by more militant activists, his policy of passive resistance was based on Gandhi's activities in India. During the latter part of his life he became increasingly concerned with economics as well as racial discrimination.

▲ kingfisher The kingfisher (Alcedo atthis) is widespread throughout Europe, Asia, N Africa and eastward to the Solomon Islands. The birds live on the banks of freshwater streams and lakes, feeding on small minnows and sometimes reptiles and crustaceans.

believe that they merit the status of a new, even higher category, DOMAINS. See also EUKARYOTE; PLANT CLASSIFICATION **kingfish** Name applied to several varieties of fish valued for food or sport. They include Scomberomorus cavalla, a type of large mackerel, and Menticirrhus saxitalis, a member of the drum family, also known as whiting.

kingfisher Compact, brightly coloured bird with a straight, sharp bill. It dives for fish along rivers, streams and lakes. It nests in a horizontal hole in an earth bank. Length: 12.7–43.2cm (5–17in). Family Alcedinidae.

King Philip's War (1675–76) War between English settlers and Native Americans in New England. The Wampanoags, under their chief Philip (Metacomet), rebelled against increasing white aggression. Colonial forces eventually gained the upper hand and wreaked still greater destruction on native settlements. King Philip was killed in 1676.

Kings I and II Two books in the OLD TESTAMENT, called Third and Fourth Kingdoms in the Greek SEPTUAGINT. These books recount the history of the kingdom of ISRAEL from the end of the reign of DAVID (*c*.970 BC) to the fall of Judah and the destruction of Jerusalem by the Babylonians in 586 BC.

Kingsley, Charles (1819–75) British author. He was one of the first clergymen to support Charles DARWIN, whose ideas he partly incorporated into *The Water Babies* (1863). His immensely popular historical novels include *Hypatia* (1843) and *Hereward the Wake* (1866).

king snake Nonpoisonous SNAKE that lives in the USA. It is generally black with white or yellow markings. Length: to 1.3m (4.2ft). Family Colubridae, genus *Lampropeltis*.

Kingston Capital and largest city of Jamaica. It was founded in 1693. It rapidly developed into Jamaica's commercial centre, based on the export of raw cane sugar, bananas and rum. In 1872 it became the island's capital. Kingston is the cultural heart of Jamaica, the home of calypso and reggae music. In recent years Kingston has been plagued by urban disturbances and armed drug gangs. Pop. (1991) 643,800.

Kingston upon Hull Official name of HULL, NE England **Kingstown** Capital and chief port of St Vincent and the Grenadines, on the sw coast. Exports: cotton, sugar cane, molasses, cacao, fruit. Pop. (1991) 26,223.

kinkajou Nocturnal mammal of the RACOON family that lives in forests of Central and South America. Primarily a fruit and insect eater, it lives almost entirely in trees. Length: to 57.5cm (22.7in); weight: to 2.7kg (6lb). Family Procyonidae; species *Potos flavus*.

Kinsey, Alfred Charles (1894–1956) US zoologist, noted for his studies on human sexual behaviour. He was a director of the Institute for Sex Research, Indiana University, and is best known for Sexual Behavior in the Human Male (1948) and Sexual Behavior in the Human Female (1953).

Kinshasa (formerly Léopoldville) Capital of Zaïre, a port on the River Zaïre, on the Zaïre-Congo border. Founded in 1881, it replaced Boma as the capital of the Belgian Congo in 1923. When Zaïre gained independence in 1960 it continued as the capital, changing its name in 1966. Industries: tanning, chemicals, brewing, textiles. Pop. (1991 est.) 3,804,000.

kinship Relationship by blood or marriage, sometimes extended to cover relations of affinity. It also refers to a complex of rules in society governing descent, succession, inheritance, residence, marriage and sexual relations. See also INCEST

Kiowa Major tribe of Tanoan-speaking Native North Americans who moved from their earlier Yellowstone–Missouri River homeland into the southern Plains region, where they eventually allied with the Comanche and Arapaho. Today the descendants of the Kiowa live mostly in Oklahoma.

Kipling, Joseph Rudyard (1865–1936) British author, b. India. His *Barrack Room Ballads and Other Verses* (1892), which includes the poem "If", established his reputation. His novels include *The Light That Failed* (1890) and *Kim* (1901). He also wrote children's stories, including *The Jungle Book* (1894) and *Just So Stories* (1902). Kipling was the first English writer to be awarded the Nobel Prize for literature (1907).

Kirchhoff, Gustav Robert (1824–87) German physicist. With Robert Bunsen, he developed the spectroscope, with which they discovered Caesium and Rubidium in 1860. He is famous for two laws that apply to multiple-loop electric circuits. Kirchhoff's laws state that (1) at any junction the sum of the currents flowing is zero, and (2) the sum of the ELECTROMOTIVE FORCES (EMF) around any closed path equals the sum of the products of the currents and impedances (resistances).

Kirchner, Ernst Ludwig (1880–1938) German painter and printmaker, a leader of the expressionist artists known as Die BRÜCKE. Kirchner characteristically portrayed urban scenes. His art was condemned by the Nazis as degenerate and he committed suicide. See also EXPRESSIONISM

Kiribati (formerly Gilbert Islands) Independent nation in the w Pacific Ocean, comprising about 33 islands, including the Gilbert, Phoenix and Line Islands, and straddling the Equator over a vast area; the capital is Bairiki (on Tarawa). British navigators first visited the islands during the late 18th century. They became a British protectorate in 1892. Full independence within the Commonwealth of Nations was granted in 1979. The mining of phosphates dominated the economy until 1980, when production ended because of diminishing resources. Agriculture is now the major economic activity. Land area: 717sq km (277sq mi). Pop. (1995 est.) 80,000

Kiritimati (Christmas Island) Largest atoll in the world, one of the Pacific Line Islands, forming part of KIRIBATI. It was the site of nuclear tests by Britain (1956–62) and the USA (1962). Area: 575sq km (222sq mi). Pop. (1990) 2,537.

Kirov, Sergei Mironovich (1888–1934) Soviet politician. An effective speaker, he was elected to the Communist Party Politburo in 1930. His murder, probably on Stalin's orders, served as a pretext for the Stalin purges (1934–38).

Kirov Former name (1934–92) of VYATKA

Kirov Ballet Ballet company, founded in 1735 at St Petersburg. Under the direction of Petipa (1862–1903), the Kirov Ballet was the world's top company, with principal dancers such as Pavlova and Nijinsky. The Kirov Opera has also made a distinguished contribution to Russian culture.

Kisangani (formerly Stanleyville) City and port on the River Congo, N central Zaïre. Kisangani was founded in 1883 by the English explorer Henry M. STANLEY. During the 1950s it was the headquarters of the Congolese National Movement led by Patrice LUMUMBA. During the 1960s it was the focus for a series of unsuccessful rebellions. In 1996 it was at the centre of the Hutu refugee crisis in Zaïre. Pop. (1984) 282,650.

Kissinger, Henry Alfred (1923–) US political scientist and statesman, b. Germany. He became President Nixon's assistant for national security in 1969 and the chief adviser on foreign policy. Nixon named him secretary of state in 1973, and he continued in that post under President FORD. In 1973 he shared the Nobel Peace Prize with Le Duc Tho for his part in negotiating a cease-fire in the Vietnam War. He acted as mediator in the Middle East crisis of 1973–74.

Kitaj, R.B. (Ronald Brooks) (1932–) English painter, b. USA. An individualist, he has loose links with the POP ART movement. He paints in flat, soft-edged areas of bright colour, often on very large canvasses.

Kitchener, Horatio Herbert, Earl (1850–1916) British soldier and statesman. He took part in the relief of Khartoum (1883–85) and achieved the pacification of the Sudan (1898). After service in the South African (Boer) Wars (1899–1902) and then in India and Egypt, he was appointed Secretary of State for War in 1914. He was lost at sea when his cruiser sank.

the many ballets that ensured the enduring reputation of the Kirov Ballet. In recent years, however, the company has been accused of falling standards. Some believe that the increased commercial profile of the company has been to the detriment of their art.

► Kirov Ballet The Nutcracker

by Tchaikovsky was just one of

Klimt Hygieia (1900–07) clear-

kite Common name for several diurnal birds of prey, especially the red kite, *Milvus milvus*, which frequents wooded slopes in Europe. It has a hooked bill, long wings and a long forked tail. Length: 60cm (24in). Family Accipitridae.

kiwi Any of three species of flightless, fast-running, forest and scrubland birds of New Zealand; especially the common brown kiwi, *Apteryx australis*. It has a long, flexible bill with which it probes for food in the ground. Family Apterygidae.

Klee, Paul (1879–1940) Swiss painter and graphic artist. Klee evolved his own pictorial language based on correspondences between line, colour and plane. Some of his images are entirely ABSTRACT ART, but some are recognizable figures. He taught at the BAUHAUS (1920–31) and at Düsseldorf Academy (1931–33) but returned to Switzerland in 1933 after the Nazis had condemned his work as degenerate. Characteristic works include *Graduated Shades of Red-Green* (1921) and *Revolutions of the Viaducts* (1937).

Klein, Melanie (1882–1960) Austrian psychoanalyst who developed therapy for young children. In *The Psychoanalysis of Children* (1932) she presented her methods and ideas of child analysis; she believed play was a symbolic way of controlling anxiety and analysed it to gain insight into the psychological processes of early life.

Klein, Yves (1928–62) French painter and experimental artist, one of the forerunners of conceptual art. He is best known for hand and body prints in his characteristic colour scheme of bright blue ("Klein blue") on white.

Kleist, Bernd Heinrich Wilhelm von (1777–1811) German dramatist. He left the Prussian Army as a young officer to write what are considered to be some of Germany's best romantic dramas: *Amphitryon* (1807) and *Der Zerbrochene Krug* (1808). He shot himself at the age of 34.

Klemperer, Otto (1885–1973) German conductor. He was celebrated for his interpretations of Beethoven, Brahms and Mahler. In 1933, with the rise of Nazism in Germany, he went to the USA and became conductor of the Los Angeles Philharmonic. In 1946 he returned to Europe as director of the Budapest Opera (1947–50).

Klimt, Gustav (1862–1918) Austrian painter and designer, a founder of the Vienna Sezession group and the foremost ART NOUVEAU painter in Vienna. His style considerably influenced the decorative arts in Austria and the work of the painters Egon Schiele and Oskar Kokoschka.

Kline, Franz (1910–62) US abstract expressionist painter. In the 1950s he began to paint large, stark, grid-like compositions, generally in black and white. He re-introduced colour in his late works.

Klondike Gold Rush (1896–1904) Mass migration of gold prospectors to the Klondike region, YUKON TERRITORY, NW Canada. The rich gold deposits discovered in the River Klondike in 1896 brought more than 30,000 prospectors to the territory. Within a decade more than \$100 million worth of gold had been extracted. The easily accessible lodes were exhausted, c.1910, but mining continues.

Klopstock, Friedrich Gottlieb (1724–1803) German poet. He anticipated the STURM UND DRANG movement and influenced other poets, notably GOETHE, RILKE and Hölderlin. While a student he began writing the epic poem *The Messiah*. Kneller, Sir Godfrey (1646–1723) Painter, b. Germany, who settled in London (1674), where he became the foremost portrait painter. His best-known works include 42 portraits, known as the *Kit Cat Series*. He founded the first English Academy of Painting (1711).

knight In medieval Europe, a mounted warrior of intermediate rank. The knight began as a squire and was knighted with a sword touch on the shoulder after a period of trial. Knights were often landholders, owing military service to their overlord. Honorary orders of knighthood, such as the Knights of the Garter (1349), were founded towards the end of the Middle Ages, a tradition that continued into the modern era.

Knights Hospitallers (Order of the Hospital of St John of Jerusalem) Military Christian order recognized in 1113 by Pope Paschal II. In the early 11th century a hospital was established in Jerusalem for Christian pilgrims. They adopted a military role in the 12th century to defend Jerusalem. After

ly shows the influence of the pre–Raphaelites on the Austrian painter Gustav Klimt. Much of his art, often erotic, features a bejewelled effect reminiscent of mosaics, a format in which he worked later in his life.

the fall of Jerusalem (1187), they moved to Acre, then Cyprus, then Rhodes (1310), from where they were expelled by the Ottoman Turks (1522). The pope then gave them Malta, where they remained until driven out by Napoleon in 1798. The order still exists as an international, humanitarian charity. **Knights Templar** Military religious order established in 1118, with headquarters in the supposed Temple of Solomon in Jerusalem. With the KNIGHTS HOSPITALLERS, the Templars protected routes to Jerusalem for Christians during the CRUSADES. The possessions of the Templars in France attracted the envious attention of King PHILIP IV, who urged Pope Clement V to abolish the order in 1312.

knitting Hand-weaving of a textile by using rod-like needles to interlace loops of spun yarn. Knitting was apparently unknown in Europe before the 15th century, when the practice began in Spain and Italy, having arrived there probably from the Arab world. The first knitting machine was invented in England in 1589.

Knossos Ancient palace complex in N central Crete, 6.4km (4mi) se of modern Iráklion. In 1900 Sir Arthur Evans began excavations that revealed that the site had been inhabited before 3000 BC. His main discovery was a palace from the MINOAN CIVILIZATION (built c.2000 BC and rebuilt c.1700 BC). Close to the palace were the houses of Cretan nobles. The complex also contains many frescos. Knossos dominated Crete c.1500 BC but the palace was occupied c.1400 BC by invaders from MYCENAE.

knot Unit of measurement equal to one nautical mile per hour -1 knot equals 1.852km/h (1.15mph). The speeds of ships and aircraft are generally expressed in knots, as are those of winds and currents.

Know-Nothing movement US political party active in the 1850s. Officially the American Party, it arose from secret, anti-immigrant societies and derived its nickname from its members' standard answer to inquiries. Its presidential candidate, Millard Fillmore, gained 20% of the popular vote in 1856 but, split over slavery, the party then disintegrated.

Knox, John (1514–72) Leader of the Protestant REFORMATION in Scotland. Ordained a Catholic priest, he later converted to Protestantism and took up the cause of the Reformation. Captured by French soldiers in Scotland, he was imprisoned in France (1547), then lived in exile in England and Switzerland. In 1559 Knox returned to Scotland, where he continued to promote the Protestant cause. In 1560 the Scotlish Parliament, under Knox's leadership, made PRESBYTERIANISM the state religion. In 1563 he was tried for treason but acquitted.

koala Small marsupial that lives in eucalyptus trees of Australia, eating the leaves. A single immature young is born, nurtured in its mother's pouch until fully formed, then carried on her back for a further six months. Length: 85cm (33in). Species *Phascolarctos cinereus*,

Kōbe City and seaport on sw Honshū Island, Japan, on the N shore of Osaka Bay. It is Japan's leading port and a major industrial centre. In January 1995 more than 5,000 people were killed and 27,000 injured in an earthquake. Industries: shipbuilding, iron and steel, electronics, chemicals. Pop. (1993) 1,468,000.

Kodály, Zoltán (1882–1967) Hungarian composer. With BARTÓK he collected and systematized Hungarian folk music, which was the principal influence on his work. Among his best-known compositions are the *Psalmus Hungaricus* (1923) and the comic opera *Háry János* (1927).

Koestler, Arthur (1905–83) British novelist and philosopher, b. Hungary. After living in many European capitals during the 1920s and 1930s, he went to Spain as a journalist to cover the Spanish CIVIL WAR. *Darkness at Noon* (1940), his best-known novel, is a biting indictment of Stalinist totalitarianism. His other novels also embody political themes. He died in a suicide pact with his wife.

Koffka, Kurt (1886–1941) US psychologist, b. Germany. With Wolfgang Köhler and Max Wertheimer, he was a founder of GESTALT PSYCHOLOGY. He wrote *The Growth of the Mind* (1921) and *Principles of Gestalt Psychology* (1935).

Kohl, Helmut (1930–) German statesman. He was elected to the legislature of Rhineland-Palatinate in 1959 and rose through the ranks of the Christian Democratic Union party. In 1982 he succeeded Helmut SCHMIDT as chancellor of West Germany. His conservative approach advocated strong sup-

port for the Western military alliance and a return to the traditional values of the West German state. He remained in the position until 1990, when he was elected as the first leader of the new unified Germany. He was re-elected in 1994.

Köhler, Wolfgang (1887–1967) US psychologist, b. Estonia. With Kurt KOFFKA and Max Wertheimer, he was a key figure in GESTALT PSYCHOLOGY. His work on animal learning and problem solving is summarized in *The Mentality of Apes* (1917).

Kokoschka, Oskar (1886–1980) Austrian painter. He was influenced by the elegance of KLIMT but soon developed his own type of EXPRESSIONISM. His work is characterized by forceful, energetic draughtsmanship and restless brushwork. kolanut (colanut) Fruit of an African tree that bears the same name, from which is extracted an ingredient of cola soft

drinks. Family Sterculiaceae; species *Cola acuminata*. **Kollwitz, Käthe** (1867–1945) German graphic artist and sculptor. Influenced by her experiences of the poverty-stricken districts of N Berlin, her best-known works depict suffering, especially of women and children. Her economical style conveyed the essence of tragedy in the best traditions of German EXPRESSIONISM. She made her name by the series of etchings, *The Weavers' Revolt* (1897–98) and *Peasants' War* (1902–28). She also produced lithographs and woodcuts such as *War* (1922–23) and *Death* (1934–35).

Köln See Cologne

Kommunizma Pik (Communism Peak) Mountain in central Asia, in SE Tajikistan, in the Pamirs region. Known as Mount Garmo until 1933 and Stalin Peak until 1962, it was the highest peak in the former Soviet Union. Height: 7,495m (24,590ft).

komodo dragon Giant monitor lizard that lives on four islands to the E of Java, Indonesia; it is the largest lizard in

KOREA, NORTH

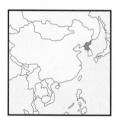

The flag of the Democratic People's Republic of Korea (North Korea) has been flown since Korea was split into two states in 1948. The colours are traditional ones in Korea. The design, with the red star, indicates that North Korea is a communist country.

The Democratic People's Republic of Korea occupies the N part of the Korean peninsula. North Korea is largely mountainous. The capital, Pyongyang, lies on the w coastal plain.

MAP, SCALE

O SO miles

C H I N A Tumen of Tumen

North Korea's border with South Korea is based on the 38th parallel. (For land, climate and pre-1953 history, see KOREA and KOREAN WAR.)

HISTORY

In 1948 North Korea established a communist government led (1948–94) by KIM IL SUNG. Kim Il Sung's Stalinist regime exploited North Korea's rich mineral resources. Industry was nationalized. Heavy industry and arms production greatly increased. Agriculture was collectivized and mechanized.

After the Korean War several million Koreans fled Kim II Sung's dictatorial regime. North Korea remained largely closed to outside interests. Alliances were formed with China and the Soviet Union, but the collapse of the latter had adverse effects on North Korea's economy. Its emphasis on military industry had a destabilizing effect on regional politics and internal economic planning. Since 1991 Korea's economy has slumped. In 1991 North and South Korea signed a non-aggression pact and agreed on a series of meetings on reunification. The process was halted in 1994 with the death of Kim II Sung. He was succeeded by his son, KIM JONG IL.

AREA: 120,540sq km (46,540sq mi) **POPULATION:** 22,618,000

capital (Population): Pyongyang (2,639,448) government: Single-party people's republic

ETHNIC GROUPS: Korean 99% LANGUAGES; Korean (official) RELIGIONS: Traditional beliefs 16%,

Chondogyo 14%, Buddhism 2%, Christianity 1%

currency: North Korean won = 100 chon

POLITICS

During the early 1990s North Korea's nuclear weapons building programme gathered momentum. In 1994 North Korea briefly withdrew from the Nuclear Non-Proliferation Treaty. They rejoined after agreeing to halt the reprocessing of plutonium, in return for guarantees on energy supplies and the establishment of economic and diplomatic relations with the USA. In 1995 severe flooding caused over US\$15 billion of damage and devastated agricultural production. In 1996 the UN sent emergency food aid to relieve famine. Many analysts see North Korea in imminent danger of collapse.

ECONOMY

North Korea has considerable mineral resources, including coal, copper, iron ore, lead, tin, tungsten and zinc. Despite these resources, it is a net consumer of energy and is reliant on oil imports. Its 1992 GDP per capita was US\$3,026. Agriculture employs over 40% of the workforce. Rice is the leading crop. Industries: chemicals, iron and steel, machinery, processed food and textiles.

the world. Length: 3m (10ft). Family Varanidae; species Varanus komodoensis.

Königsberg See KALININGRAD

Konya City in s central Turkey. Known in ancient times as Iconium, it was first settled in the 8th century BC. The capital of the SELJUK sultanate of Rum from 1099, it was annexed by the Ottoman sultan in 1472. It is the religious centre of the whirling DERVISHES. Manufactures include cotton and leather goods, and carpets. Pop. (1990) 543,460.

kookaburra (laughing jackass) Large KINGFISHER of Australia, known for its call, which resembles fiendish laughter. Groups often scream in unison at dawn, midday and dusk. They feed on animals. Species *Dacelo gigas*.

Koons, Jeff (1955–) US sculptor. He burst onto the art scene in the 1980s with a series of sexually explicit pieces. Other exhibits, such as his vacuum cleaners in perspex cases, were intended as a comment on modern consumer society and have their roots in the POP ART movement of the 1960s.

Koran (Quran) Sacred book of ISLAM. According to Muslim belief, the Koran contains the actual word of God (Allah) as revealed by the angel GABRIEL to the Prophet MUHAMMAD. Muhammad is said to have received these revelations over two decades beginning c. AD 610 and ending in 632, the year of his death. The 114 suras (chapters) of the Koran are the source of Islamic belief and a guide for the whole life of the community. The central teachings of the Koran are that there is no God but Allah and all must submit to Him, that Muhammad is the last of His many messengers (which have included Abraham, Moses and Jesus), and that there will come a day of judgment. In addition to these teachings, the Koran contains rules that a Muslim must follow in everyday life.

Korda, Sir Alexander (1893–1956) British film director, b. Hungary, who was noted for his lavish productions. His films include *The Scarlet Pimpernel* (1935), *Lady Hamilton* (1941) and *Anna Karenina* (1948).

Korea Peninsula in E Asia, separating the Yellow Sea from the Sea of Japan. The Yalu and Tumen rivers form most of its N border with China. Land and climate The E seaboard is mountainous, rising in the NE to 2,744m (9,003ft) at Mount Paektu. The mountains descend in the w to coastal lowlands. The traditional capital, SEOUL, lies close to the 38th parallel border between North Korea and South Korea. The Korean Archipelago lies off the s coast, and includes the province of Cheju-do. North Korea experiences long and severe winters; lakes and rivers can remain frozen for up to 4 months a year. Summers are warm. South Korea has a more tropical climate with occasional typhoons in the rainy months (July-August). History Korea's calendar starts in 2333 BC. China was a dominant influence. The first native Korean state was established in the 1st century AD, and Korea was unified under the Silla dynasty in the 7th century. Korea was invaded by Mongols in 1231 and eventually surrendered. The Yi dynasty ruled Korea from 1392-1910. Early in the Yi period, Seoul was made the new capital and Confucianism became the official religion. In the 17th century Korea was a semi-independent state, dominated by the Qing dynasty. A long period of isolationism followed. In the late 19th century Korea became more active in foreign affairs, due to the growing power of Japan. After the Russo-Japanese War (1904-05) Korea was effectively a Japanese protectorate and was formally annexed in 1910. Japan's enforced industrialization of Korea caused widespread resentment. Following Japan's defeat in World War 2, Korea was divided into two zones of occupation: Soviet forces N of the 38th parallel, and US forces s of the line. Attempts at reunification failed, and in 1948 two separate regimes were established: the Republic of Korea in the s and the Democratic People's Republic in the N. In June 1950 North Korea invaded South Korea. The ensuing KOREAN WAR (1950-53) resulted in millions of deaths and devastated the peninsula. An uneasy truce has prevailed ever since. Attempts at reunification continue.

Korea, North Republic in E Asia. *See* country feature **Korea, South** Republic in E Asia. *See* country feature, page 378

Korean National language of North and South Korea. Some

scholars classify it as one of the ALTAIC LANGUAGES. It is spoken by over 50 million people. The Korean alphabet developed in the 15th century.

Korean War (1950–53) Conflict between North Korea, supported by China, and South Korea, supported by UN forces dominated by the USA. South Korea was invaded by forces of the North in June 1950. The UNITED NATIONS Security Council, during a boycott by the Soviet Union, voted to aid South Korea. Major US forces, plus token forces from its allies, landed under the overall command of General Douglas MACARTHUR. The invaders were driven out, but when the UN forces advanced into North Korea, China intervened and drove them back, recapturing Seoul. After more heavy fighting, UN forces slowly advanced until virtual stalemate ensued near the 38th parallel, the border between North and South Korea. Negotiations continued for two years before a truce was agreed in July 1953. Total casualties were estimated at four million.

Kornberg, Arthur (1918–) US biochemist. In 1959 he shared (with Severo Ochoa) the Nobel Prize for physiology or medicine for work on the synthesis of RNA and DNA, an important contribution to the study of genetics.

Kosciusko, Mount Mountain in SE Australia, in the Great Dividing Range, in SE New South Wales. The highest mountain in Australia, it lies inside a national park and is a winter sports resort. Height: 2,228m (7,310ft).

Kościuszko, Thadeus (1746–1817) Polish soldier and statesman. After the second partition of Poland in 1793, he led a revolutionary movement to regain Polish independence. It was initially successful, but the invading armies of Russia and Prussia proved too strong, and Kościuszko was imprisoned (1794–96) and then exiled.

kosher Ritually correct or acceptable for Jews. A word of Hebrew origin, it is applied by Orthodox Jews to food that conforms to Jewish dietary laws and customs.

Kossuth, Louis (1802–94) Hungarian nationalist leader. Emerging as leader of the Revolution of 1848, he declared Hungarian independence (1849), but Russian intervention led to his defeat. He fled to rouse support for Hungarian independence in Europe and the USA. The compromise of 1867, which created the Dual Monarchy of the Austro-Hungarian AN EMPIRE, put an end to his hopes.

Kosygin, Aleksei Nikolayevich (1904–80) Soviet statesman, prime minister (1964–80). He was elected to the Communist Party Central Committee in 1939 and the Politburo in 1948. He was removed in 1953 but regained his seat in 1960. After Khrushchev's fall in 1964, he became prime minister, a position he held until his retirement.

Koussevitzky, Sergei Aleksandrovich (1874–1951) US musician, b. Russia. A virtuoso double-bass player, he became even more famous as conductor of the Boston Symphony Orchestra (1924–49).

Kowloon Peninsula on the SE coast of China, part of Hong Kong. One of the most densely populated areas of the world, it was ceded to Britain by China in 1860. Industries: shipbuilding. Area: 9sq km (3.5sq mi). Pop. (1986) 2,301,691.

Krakatoa Small volcanic island in w Indonesia, in the Sunda Strait between Java and Sumatra. In 1883 one of the world's largest volcanic eruptions destroyed most of the island. The resulting tidal waves caused 50,000 deaths and great destruction. Height: 813m (2,667ft).

Kraków (Cracow) City in s Poland. Founded in the 8th century, it became a residence of the Polish kings in the 12th century and subsequently capital of Poland. In 1795 it was ceded to Austria. After a period of independence (from 1815) it was restored to Austria in 1846. The city became part of Poland after World War 1. Historic buildings include the Wawel Cathedral. The Jagiellonian University (1364) is one of the oldest in Europe. Today Kraków is a manufacturing centre. Industries: chemicals, metals, machinery, clothing, printing. Pop. (1993) 751,300.

Krasnodar City and port on the E bank of Kuban River, SW European Russia; capital of Krasnodar Kray. Founded in 1794 by CATHERINE II as a frontier outpost, it was known as Yekaterinodar until 1920. Industries: oil refining, machine tools, textiles, metalworking. Pop. (1992) 635,000.

Krasnoyarsk City and port on the w bank of the upper Yenisei River, w Siberian Russia; capital of Krasnoyarsk Kray. Founded in 1628 by the COSSACKS, it was attacked in the later 17th century by Tatars and other tribes. It underwent rapid development after the discovery of gold in the area. Industries: shipbuilding, heavy machinery, electrical goods, cement, timber, flour milling. Pop. (1992) 925,000.

Krebs, Sir Hans Adolf (1900–81) British biochemist, b. Germany. In 1953 he shared (with F.A. Lipmann) the Nobel Prize for physiology or medicine for his discovery of the KREBS (or citric acid) CYCLE, the process that results in the production of energy in living organisms (RESPIRATION).

Kremlin (Rus. citadel) Historic centre of Moscow. It is a roughly triangular fortress covering c.37ha (90 acres). The Kremlin walls were built of timber in the 12th century and its first stone walls were built in 1367. Within the walls several cathedrals face on to a central square; the Great Kremlin Palace was the tsar's Moscow residence until the revolution. In March 1918 the Supreme Soviet established the Kremlin complex as the location of all government offices. Today, the Kremlin is the home of the Russian presidential offices.

Křenek, **Ernst** (1900–91) US composer, b. Austria, who emigrated to the USA in 1938. From 1920 in Berlin he experimented with atonal music. After 1930 in Vienna, he adopted the TWELVE-TONE MUSIC technique of Schoenberg. He created a sensation with the jazz opera *Jonny spielt auf* (1925–26).

krill Collective term for the large variety of marine crustaceans found in all oceans. They are strained and used as food by the various species of baleen whale.

Krishna Most celebrated hero of Hindu mythology. He was the eighth AVATAR (incarnation) of VISHNU and primarily a god of joyfulness and fertility. Many devotional cults grew up around him, as well as legends and poems.

Krishnamurti, Jiddu (1895–1986) Hindu religious leader. He founded the World Order of Star with Annie BESANT, the theosophist leader, and in 1969 founded the Krishnamurti Foundation in Ojai, California. *See also* THEOSOPHY

Kroeber, Alfred Louis (1876–1960) US anthropologist, one of the most important cultural anthropologists of the early 20th century. He helped to advance the study of Native North American ethnology, linguistics and folklore.

Kropotkin, Peter Alexeievich (1842-1921) Russian

KOREA, SOUTH

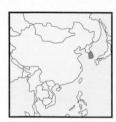

South Korea's flag, adopted in 1950, is white, the traditional symbol for peace. The central yin-yang symbol signifies the opposing forces of nature. The four black symbols stand for the four seasons, the points of the compass, and the Sun, Moon, Earth and Heaven.

AREA: 99,020sq km (38,232sq mi)

capital (Population): Seoul (10,799,000)
GOVERNMENT: Multiparty republic

ETHNIC GROUPS: Korean 99% LANGUAGES: Korean (official)

RELIGIONS: Buddhism 28%, Christianity (Protestant 19%, Roman Catholic 6%) CURRENCY: South Korean won = 100 chon

The Republic of Korea occupies the s part of the Korean peninsula. South Korea is largely mountainous. The capital, Seoul, lies on the w coastal lowlands. Other major cities include Inchon, Taegu and the main port of Pusan, on the se coast. Cheju-do, the largest island, includes Mount Halla, South Korea's highest peak, at 1,950m (6,398ft). (For land, climate and pre-1953 history, see Korea and Korean War.)

HISTORY

South Korea's first government, led (1948-60) by Syngman RHEE, was beset by economic problems. South Korea was a predominantly agricultural economy, heavily dependent on the N for energy and resources. South Korea's infrastructure was devastated by the Korean War. Rhee's corrupt and repressive regime became increasingly unpopular. The massacre of student protesters in 1960 sparked nationwide disturbances and a military junta, led by General PARK, seized power in 1961. Park's presidency (1963-79) brought rapid economic growth. Helped by US aid, South Korea became a major manufacturer and exporter. In 1972 Park introduced martial law and passed a new constitution that gave him almost unlimited powers. In the social and political sphere, his regime pursued increasingly authoritarian policies. Park was assassinated in 1979, but the military still dominated the government. Opposition to the political climate continued to grow. In 1987 a new constitution ensured the popular election of the president and reduced the presidential term to five years. In 1988 Seoul hosted the summer Olympic Games. Relations with North Korea continued to improve, and in 1991 the two

countries signed a non-aggression pact and established a series of summit meetings on reunification. In 1992 the long-standing opposition leader, KIM YOUNG SAM, became president. His administration was South Korea's first full civilian government in 32 years.

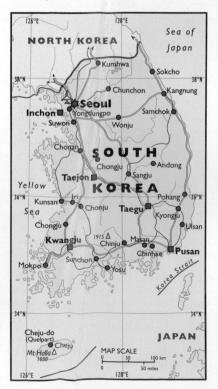

POLITICS

The death of North Korean president Kim Il Sung stalled reunification talks, but the momentum had been established. In 1997 preliminary talks were held to discuss the possibility of four-party peace talks involving North and South Korea, China and the USA.

ECONOMY

South Korea is an upper-middle-income developing country (1992 GDP per capita, US\$9,250). During the late 20th century it was one of the world's fastest growing industrial economies. US aid of over US\$6,000 million (1945-78) played a large part in the success story. South Korea's industrial conglomerates (chaebols) benefited from a highly educated workforce and import controls. From the mid-1980s growth slowed, and increasing labour costs led to unpopular changes in the labour market. South Korea's protectionist policies are slowly giving way to free market reforms. The largest sector of the economy is services, employing 50% of the workforce. The manufacturing sector is South Korea's greatest asset. Manufactured goods, machinery and transport equipment make up 66% of South Korea's exports. South Korea is the world's fifthlargest car producer and is a major producer of iron and steel, cement, electrical and electronic products. Agriculture employs 17% of the workforce. South Korea is self-sufficient in grain, and is the world's eighth-largest producer of rice. Fishing is another vital sector. In late 1997 the financial crisis spreading through Southeast Asia reached South Korea. The dramatic fall of the currency and the virtual collapse of several chaebols led to a request for assistance from the IMF.

anarchist leader. He was jailed for seditious propaganda in 1874, but escaped into exile in 1876. Living mostly in Britain, he became one of the most important theorists of anarchist socialism, criticizing the centralizing tendencies of Marxism. He argued in *Mutual Aid* (1902) that cooperation rather than competition is the natural order of things.

Kruger, Paul (Stephanus Johannes Paulus) (1825–1904) South African statesman. After Transvaal was annexed by the British in 1877, he worked for its independence. In 1883 he was elected the first president of the South African Republic, and won re-election in 1888, 1893 and 1898. He fought in the first of the SOUTH AFRICAN WARS and, during the second, he sought further European support for the BOER cause. Following the British victory, Kruger died in exile.

Kruger National Park Game reserve in Northern Province, South Africa, on the Mozambique border. Founded in 1898 by Paul Kruger as the Sabi Game Reserve, it became a national park in 1926. Area: *c*.20,700sq km (8,000sq mi).

krypton (symbol Kr) Gaseous nonmetallic element that is a NOBLE GAS. Discovered in 1898, krypton makes up about 0.0001% of the Earth's atmosphere by volume and is obtained by the fractional distillation of liquid air. It is used in fluorescent lamps, lasers and in electronic heart valves. Properties: at.no. 36; r.a.m. 83.80; density 3.73; m.p. -156.6°C; (-249.9°F); b.p. -152.3°C (-242.1°F); most common isotope Kr⁸⁴ (56.9%).

Kuala Lumpur (Malay, estuary mud) Capital of Malaysia, in the s MALAY PENINSULA. Founded in 1857, it was made the capital of the Federated Malay States in 1895, of the Federation of Malaya in 1957 and of Malaysia in 1963. A modern commercial centre, it has much striking modern architecture, including one of the world's tallest buildings, the twin Petronas Towers, at 452m (1,483ft). Industries: tin, rubber. Pop. (1990) 1,231,500.

Kubelík Name of two Czech musicians. **Jan** (1880–1940) was a violinist and composer, highly regarded for his technical mastery. **Rafael** (1914–), his son, was an eminent conductor as well as a composer. He was musical director of the METROPOLITAN OPERA COMPANY in New York (1973–74).

Kublai Khan (1215–94) Mongol Emperor (1260–94). Grandson of GENGHIS KHAN, he completed the conquest of China in 1279, establishing the YÜAN dynasty, which ruled until 1368. He conquered the Southern SUNG dynasty and extended operations into SE Asia, although his attempt to invade Japan was thwarted by storms. He conducted correspondence with European rulers and apparently employed Marco POLO.

Kubrick, Stanley (1928–) US film director. An ambitious and sometimes bleak film-maker, his films include *Dr Strangelove* (1963), 2001: A Space Odyssey (1968), A Clockwork Orange (1971), The Shining (1980) and Full Metal Jacket (1987).

kudu Large African ANTELOPE found s of the Sahara. The body is grey-brown with vertical white stripes and the male bears long, spiral horns. Genus *Tragelaphus*.

Kuiper, Gerard Peter (1905–73) US astronomer, b. Netherlands. He discovered the satellites Miranda (of Uranus) in 1948 and Nereid (of Neptune) in 1949. He found methane in the atmospheres of Uranus, Neptune and Titan, and carbon dioxide in the atmosphere of Mars.

Ku Klux Klan (KKK) Name of two secret, white, racist groups in the USA. The first Ku Klux Klan was organized in the South in 1866. Opposed to RECONSTRUCTION, it attempted to enforce labour discipline in plantation districts and to maintain white supremacy by preventing blacks from voting. Klansmen dressed in white robes and hoods terrorized black communities. By 1872 the Klan had been suppressed by Federal authorities. A second Ku Klux Klan was founded in 1915, embracing broader-based racism directed also against Catholics, Jews and communists. By the mid-1920s its membership was estimated at four million. It declined thereafter, but there was a minor resurgence in the 1960s and in some Southern states in the 1990s.

Kumasi City in central Ghana; capital of ASHANTI region. The second-largest city in Ghana, it was the capital of the Ashanti kingdom in the 17th and 18th centuries, before being

annexed by the British in 1901. It is a commercial centre for a cocoa-growing region. Industries: food processing, handicrafts, timber. Pop. (1984) 376,246.

Kun, Béla (1886–1937) Hungarian political leader. With the support of Lenin, Kun led communist agitation against the new republic of Hungary and led a communist regime for a few months in 1919. His attempt to turn Hungary into a Soviet-style republic was defeated by Romanian troops.

Küng, Hans (1928–) Swiss Roman Catholic theologian. He became the first important Roman Catholic theologian to question the doctrine of papal infallibility and the dogma of the Virgin Mary. He was censured by the Vatican (1979) and forbidden to teach Catholic theology.

kung fu Ancient Chinese martial art based on the idea that the best form of defence against violence utilizes actions that combine attack and defence.

Kuniyoshi, Yasuo (1893–1953) Japanese painter. His work, which has been described as Oriental in spirit but Western in technique, includes *Child* (1923), *Landscape* (1924) and *Upside Down Table and Mask* (1940).

Kuomintang Nationalist Party in China, the major political force during and after the creation of a republic in 1911. It was first led by SUN YAT-SEN. It cooperated with the Communist Party until 1927, when Sun's successor, CHIANG KAI-SHEK, turned against the communists, initiating a civil war. Cooperation was renewed in order to repel the Japanese (1937–45), after which the civil war was resumed. With the communists victorious, Chiang set up a rump state on the island of Taiwan, where the Kuomintang survives.

Kupka, František (1871–1957) Czech painter, etcher and illustrator active mainly in Paris. He was among the first painters to develop purely abstract painting. His works include *Fugue in Red and Blue* (1912). *See also* ABSTRACT ART

Kurdistan Extensive mountainous and plateau region in sw Asia, inhabited by the Kurds and including parts of E Turkey, NE Iran, N Iraq, NE Syria, S Armenia and E Azerbaijan. Plans for the creation of a separate Kurdish state were put forward after World War 1 but subsequently abandoned. Area: *c*.192,000sq km (74,000sq mi).

Kurds Predominantly rural Islamic population numbering some 18 million, who live in a disputed frontier area of sw Asia that they call KURDISTAN. Traditionally nomadic herdsmen, they are mainly SUNNI Muslims who speak an Iranian dialect. For 3,000 years they have maintained a unique cultural tradition, although internal division and constant external invasion have prevented them from uniting into one nation. In recent times, their main conflicts have been with Iran and Iraq. After the Iran-Iraq War (1988), Iraq destroyed many Kurdish villages and their inhabitants. The Iraqi response to a Kurdish revolt after the Gulf War caused 1.5 million Kurds to flee to Iran and Turkey. In 1996 Iraqi troops invaded the region and captured the Kurdish city of Irbil. The USA responded by launching cruise missiles at Iraqi military installations. Currently about 8 million Kurds live in E Turkey, 4 million in N Iraq, 500,000 in Syria and 100,000 in Azerbaijan and Armenia.

Kuril Islands (Kurilskiye Ostrova) Chain of 30 large and 26 smaller islands in Sakhalin region, Russia; extending 1,200km (750mi) from the s Kamchatka Peninsula to NE Hokkaido, Japan, and separating the Sea of Okhotsk from the Pacific Ocean. The N islands were settled by Russians, the s islands by Japanese. In 1875 Russia gave the islands to Japan in exchange for full control of Sakhalin island. After World War 2 the islands were ceded to the Soviet Union. The chief economic activities are sulphur mining and whaling. Area: 15,600sq km (6,023sq mi).

Kurosawa, Akira (1910–) Japanese film director. In *Rashomon* (1950) he introduced the world of the Samurai warriors to Western audiences. The popularity of this genre was confirmed by *The Seven Samurai* (1954). *Dursu Uzala* (1975) won an Academy Award for Best Foreign Language Film. Other classics include *Kagemusha* (1980) and *Ran* (1985).

Kursk City in w Russia, at the confluence of the Tuskoc and Seim rivers. Founded in 1095, it was destroyed by the TATARS in 1240 and rebuilt as a frontier post in 1586. Industries: iron

▲ krill The shrimp-like krill, some of the most important animals of the plankton, are about 5cm (2in) long when fully grown. They belong to a group of crustaceans (found in all oceans) characterized by luminescent organs along their sides, on their undersides and heads. Euphausia superba (shown) is the most important species of the Antarctic seas, for it supports much of the warm-blooded life of the southern oceans.

and steel, chemicals, synthetic fibres, shoes, electrical equipment. Pop. (1992) 435,000.

Kush Kingdom and former state in Nubia. Lasting from $c.1000~{\rm BC}$ to $c.~{\rm AD}~350$, it conquered Egypt in the 7th–8th centuries BC. It was later defeated by the Assyrians and moved its capital to Meroë in the Sudan. After Roman and Arab attacks in the N, Meroë was captured by the Axumites around AD 350. The Kushites are thought to have fled w.

Kuti, Fela (Anikulapo) (1938–97) Nigerian singer-song-writer and saxophonist. Known for protesting against oppression and respected for his intricate Afro-beat music, his albums include *Coffin for Head of State* (1978) and *Underground System* (1992).

Kutusov, Mikhail Illarionovich (1745–1813) Russian general. He was the supreme commander during the Napoleonic Wars. After the French abandoned Moscow in 1812, he forced them to retreat in winter, harrying them by guerrilla attack.

Kuwait (Al Kuwayt) Independent state in the NE Arabian Peninsula, N of the Persian Gulf. Kuwait was founded in the early 18th century. In 1899 it became a British protectorate, becoming fully independent in 1961. It was invaded in 1990 by Iraqi forces, precipitating the GULF WAR. In 1991 the Iraqis were ejected by an international coalition led by the USA. Huge oil reserves have made it one of the world's richest countries. Industries: shipbuilding, petrochemicals, fertilizers. Agriculture is being developed.

Kuznetsov, Anatoly (1929–79) Soviet novelist and shortstory writer, who changed his name to A. Anatoli after defecting to England in 1969. His writings include the novel *Sequel* to a Legend (1957) and the poem *Babi Yar*.

Kwakiutl Tribe of Native Americans on the Nw coast speaking the Wakashan language, and closely related to the Bella Bella. They number c.2,000 and occupy N Vancouver Island in British Columbia, Canada.

Kwa languages Group of languages making up a branch of the Niger-Congo family of African languages. Kwa languages include Yoruba and Ibo of s Nigeria; Ewe of Ghana, Togo and Benin; Akan of Ivory Coast and Ghana; Gã of Accra city; and Bini of Benin.

KwaZulu-Natal Province in E South Africa, bordered by the Indian Ocean and the Drakensberg Mountains; the capital is Pietermaritzburg. It was created in 1994 from the Zulu homeland, KwaZulu, and the former province of Natal. The main industry is sugar refining. Other industries: textiles, tanning and oil refining. Area: 92,180sq km (33,578sq mi). Pop. (1995 est.) 8,713,100.

Kyd, Thomas (1558–94) English dramatist who achieved popular success with *The Spanish Tragedy* (c.1589). Kyd was a member of the literary circles of his day, associating with MARLOWE. In 1593 he was arrested for treasonable activities. Kyōto City on w central Honshū Island, Japan; capital of Kyōto prefecture. Founded in the 6th century, it was the capital of Japan for more than 1,000 years. Industries: porcelain, lacquerware, textiles, precision tools. Pop. (1993) 1,395,000. Kyrgyz Turko-Mongolian people who inhabit the Republic of Kyrgyzstan in central Asia. Of the Muslim faith, they are Turkic-speaking nomadic pastoralists who began to settle in the TIAN SHAN region of Kyrgyzstan in the 7th century. They were colonized by the Russians during the 19th century. After fighting the BOLSHEVIKS in the Russian Civil War (1917–21), many Kyrgyz perished in the ensuing famine.

Kyrgyzstan (Kirghizia) Landlocked republic between China, Tajikistan, Uzbekistan and Kazakstan; the capital is BISHKEK Land and climate The country is mountainous and less than a sixth of the land is below 900m (2,950ft). The highest mountain, Pik Pobedy, reaches 7,439m (24,406ft) above sea level. The largest of Kyrgyzstan's many lakes is Ozero (Lake) Issyk-Kul in the NE. The lowlands of Kyrgyzstan have warm summers and cold winters, but in the mountains, January temperatures plummet to -28°C (-18°F). Much of Kyrgyzstan has a low annual rainfall. Mountain grassland is the dominant vegetation, with woodland covering only a small area, mainly in the lower valleys. Less than a tenth of the land is used for crops. History The area that is now Kyrgyzstan was populated in ancient times by nomadic herders. Mongol armies conquered the region in the early 13th century. Islam was introduced in the 17th century. China gained control of the area in the mid-18th century, but in 1876 Kyrgyzstan became a province of Russia. In 1916 Russia put down a rebellion and many local people fled to China. In 1922, when the Soviet Union was formed, Kyrgyzstan became an autonomous region. In 1936 it became a Soviet Socialist Republic. Under communism, nomads were forced to live on government-run farms. Politics In 1991, following the breakup of the Soviet Union, Kyrgyzstan became an independent country. The Communist Party was dissolved and the government introduced reforms aimed at increasing free enterprise. A new constitution was adopted in 1994 and parliamentary and presidential elections were held in 1995. Economy Agriculture, especially livestock rearing, is the chief activity. The chief products include cotton, eggs, fruits, grain, tobacco, vegetables and wool. Industries are concentrated around Bishkek, and manufactures include machinery, processed food, metals and textiles. Exports include wool, chemicals, cotton and metals.

Kyūshū Island in s Japan; the third-largest and southernmost of the four principal Japanese islands. The terrain is mountainous, and the irregular coastline provides many natural harbours. It is the most densely populated of the Japanese islands. The chief port is NAGASAKI. Products: rice, tea, tobacco, fruit, soya beans. Industries: mining, fishing, timber, textiles, porcelain, metals, machinery. Area: 42,149sq km (16,274sq mi). Pop. (1992 est.) 13,314,000.

Kyzyl Kum (Kizil Kum) Desert of central Asia, in Uzbekistan and s Kazakstan, between the Amudarya and Syrdarya rivers. Cotton and rice are grown in the irrigated river valleys and karakul sheep are raised by tribespeople. Area: *c*.230,000sq km (89,000sq mi).

KYRGYZSTAN

AREA: 198,500sq km (76,640sq mi) POPULATION: 4,568,000 CAPITAL (POPULATION): Bishkek (641,400)

GOVERNMENT: Multiparty republic ETHNIC GROUPS: Kirghiz 52%, Russian 22%, Uzbek 13%, Ukrainian 3%, German 2%, Tatar 2%
LANGUAGES: Kirghiz
RELIGIONS: Islam
CURRENCY: Som

Labor, US Department of US government department. It administers and enforces statutes benefiting wage earners, improving working conditions and providing opportunities for employment. In 1903 it was part of the Department of Commerce and Labor, becoming a separate department in 1913.

labour In childbirth, stage in the delivery of the FETUS at the end of pregnancy. In the first stage, contractions of the UTERUS begin and the CERVIX dilates in readiness; the sac containing the amniotic fluid ruptures. In the second stage, the contractions strengthen and the baby is propelled through the birth canal. The third stage is the expulsion of the PLACENTA and fetal membranes, together known as the afterbirth.

Labour Party Social democratic political party, traditionally closely linked with the trade union movement. There are Labour Parties in many countries, including Australia, Britain, Canada, Israel and New Zealand. The first British socialist parties, founded in the 1880s, united in the Independent Labour Party (ILP) in 1893, whose president was Keir HARDIE, the first socialist member of Parliament. The ILP created the Labour Representation Committee in 1900, which was renamed the Labour Party in 1906. In 1922 the party became the second largest in Parliament. Labour formed a brief minority government in 1924 under Ramsay MACDON-ALD and again in 1929-31, but following a coalition with the Liberals in 1931, the party was split and defeated at the polls. Labour joined the wartime coalition of World War 2 and its leader, Clement ATTLEE, was deputy prime minister from 1942. After a landslide Labour victory in 1945, the Attlee government introduced a series of social reforms. Labour won the general election of 1964 under Harold WILSON and continued in power until 1970. From 1974-79 it was in office, mostly as a minority administration. Following Wilson's resignation, James Callaghan became prime minister. During the 1980s, led by Michael Foot and Neil Kinnock (1983-92), Labour remained in opposition. After the death of John Smith (1994), Tony Blair stepped up the party's process of "modernization" under the slogan "New Labour". In 1997, after 18 years in opposition, Labour regained power. Labrador Mainland part of NewFoundland province, E Canada, bordered w and s by Quebec and E by the Atlantic Ocean. The coast was visited by John Cabot in 1498. It passed to Britain under the Treaty of Paris (1736). In 1949 Labrador became part of Canada. It is mountainous with an indented coastline. The inland granite plateau is forested, with many lakes and rivers. Industries: timber, fishing, iron ore mining, hydroelectric power. Area: 292,220sq km (112,830sq mi).

La Bruyère, Jean de (1645–96) French satirist. He ridiculed the injustice and hypocrisy in French life in his best-known work, *The Characters of Theophrastus, Translated from the Greek, with the Characters and Mores of This Age* (1688).

laburnum Any of several Eurasian shrubs and small trees of the genus *Laburnum*, especially the common Laburnum, *L.anagyroides*, which has drooping clusters of bright yellow flowers. It bears pods, each of which contains round, black, poisonous seeds. Family Fabaceae/Leguminosae.

labyrinth In architecture, an intricate structure of chambers and passages, generally constructed with the object of confusing anyone within it. In Greek mythology, MINOS had a labyrinth built by DAEDALUS to confine the MINOTAUR.

lac Name of an insect and the sticky substance it secretes and deposits onto twigs; the deposit is harvested in Asia for use in shellac and red lac dye. Species *Laccifer lacca*.

lacemaking Manufacture of lace, an openwork ornamental fabric made from fine threads of linen, cotton, silk, wool or artificial fibres. The two chief styles are needlepoint lace and bobbin lace. Most lace is now made by machine.

lacewing Any of numerous species of neuropteran insects, especially members of the families Chrysopidae and Hemerobiidae, which are found worldwide. Common green lacewings have a slender greenish body, long antennae and two pairs of delicate, lacy, veined wings.

lachrymal gland Organ in the eye that produces tears. It is located in the orbital cavity and is controlled by autonomic nerves. It produces slightly germicidal tears, which flow through ducts to the surface of the eye to lubricate it.

▲ lacewing The European lacewing (Eurolean europaeus), also known as the ant lion, grows to 2cm (0.8in). A member of the Neuroptera order, lacewings are found worldwide. The larva of the lacewing is a fierce predator of certain small insects, particularly aphids.

Laclos, Pierre (Ambroise François) Choderlos de (1741–1803) French general and novelist. His one important work, *Les Liaisons Dangereuses* (1782), caused a sensation and was only belatedly recognized as a great work.

lacquer Varnish used for ornamental or protective coatings, forming a film by loss of solvent through evaporation. Lacquer is usually composed of a cellulose derivative, such as cellulose nitrate, in combination with a resin.

lacrosse Ball game that originated among the Iroquois in Canada and the USA. It is played on a grass or artificial pitch by teams of 10 male or 12 female players. They carry sticks that have a thonged meshwork head like a flexible scoop. The ball may be conveyed, passed or hit with the stick, or kicked, but only the goalkeepers are allowed to handle it. Players can be sent off the field for up to three minutes for infractions of the rules. Lacrosse became Canada's national game in 1867. lactation Secretion of milk to feed the young. In pregnant

lactation Secretion of milk to feed the young. In pregnant women, HORMONES induce the breasts to enlarge, and prolactin (a pituitary hormone) stimulates breast cells to begin secreting milk. The milk appears in the breast immediately after the birth of the baby. The hormone oxytocin controls the propulsion of milk out of the breast.

lactic acid Colourless organic acid (2-hydroxypropanoic acid, CH₃CHOHCOOH) formed from LACTOSE by the action of bacteria. It is also produced in muscles, where it causes muscle fatigue, when ANAEROBIC respiration occurs due to insufficient oxygen. Lactic acid is used in foods and beverages, in tanning, dyeing, and adhesive manufacture. Properties: r.d. 1.206; m.p.18°C (64.4°F); b.p. 122°C (252°F).

lactose (milk sugar) Disaccharide present in milk, made up of a molecule of GLUCOSE linked to a molecule of galactose. It is important in cheesemaking, when lactic bacteria turn it into LACTIC ACID. This sours the milk and results in the production of cheese curd.

Ladoga (Rus. *Ladozhskoye Ozero*, Finnish *Laatokka*) Europe's largest lake, in NW Russia (near the Finnish border). It is drained by the River Neva. Formerly divided between Finland and the Soviet Union, it has been entirely within the Russian border since the Soviet invasion of Finland in 1940. Area: 17,678sq km (6,826sq mi).

ladybird (ladybug) Any of a large number of small, brightly coloured beetles; the most common are red with conspicuous black spots and a black and white head. Ladybirds and their larvae are regarded as useful by farmers because their diet consists primarily of aphids. Family Coccinellidae.

Lady Day (Annunciation) Christian feast marking Gabriel's Annunciation to the Virgin Mary (often referred to as "Our Lady"), traditionally celebrated on 25 March. Before 1753, Lady Day was the beginning of the legal year in England and Wales; it is still one of the financial year's QUARTER DAYS.

lady's smock (cuckooflower) North American and Eurasian perennial flowering plant, common in moist meadows. It has a stout stem, fine leaves and clusters of pink or purplish flowers. Family Brassicaceae/Cruciferae; species *Cardamine pratensis*. Lafayette, Marie Joseph Gilbert de Motier, Marquis de (1757–1834) French general who fought for the colonists in the AMERICAN REVOLUTION. He distinguished himself in the Yorktown campaign (1781).- Returning to France, he became a member of the National Assembly during the FRENCH REVOLUTION. In 1791 he lost popular support by ordering his troops to fire on a riotous crowd; he deserted to

L/l, the 12th letter of the alphabet. It can be traced to the Semitic letter lamedh, which passed into Greek as lambda. It became slightly modified in the Roman alphabet and in this form has passed into English. It is nearly always pronounced as in love, although it is silent in such words as could and calf.

▲ ladybird The seven-spot ladybird (or ladybug) (Coccinealla septempunctata) is found throughout Europe. It is the largest of the European ladybirds, growing to 8mm (0.4in). Both the adults and larvae feed on aphids, making them popular with gardeners. During the winter large numbers hibernate together.

▲ Lamarck French naturalist
Jean-Baptiste Lamarck's theories
of evolution were highly
influential in the 19th century,
but were proved false by the
work of Charles Darwin. Lamarck
believed that adaptations were
caused by behaviour and were
then passed on to offspring; for
example the giraffe developed a
long neck over generations
because its ancestors were
always reaching to feed on
higher branches.

the Austrians in 1792. He played a symbolic role in the JULY REVOLUTION (1830) in support of Louis Philippe.

La Follette, Robert Marion (1855–1925) US statesman. He was a Republican congressman (1885–91) and governor of Wisconsin (1900–06). His progressive administration carried out wide-ranging social reforms. As a US senator (1906–25), he fought for workers and farmers against Republican-supported business. He was chosen as Progressive presidential candidate before being replaced by Theodore Roosevelt in 1912. He ran again in 1924.

La Fontaine, Jean de (1621–95) French poet noted for his fables, which are considered among the masterpieces of French literature. His *Fables choisies, mises en vers* (1668–94) consists of 12 books featuring some 240 fables. He was elected to the Académie Française in 1683.

Lagerkvist, Pär Fabian (1891–1974) Swedish author. One of the major 20th-century Scandinavian writers, his key works include *Anguish* (1916) and *The Hangman* (1933). International recognition came with *The Dwarf* (1944) and *Barabbas* (1950). In 1951 he was awarded the Nobel Prize for literature. Lagerlöf, Selma (1858–1940) Swedish novelist. Her lyrical work *Story of Gösta Berling* (1891) became immensely popular. Her greatest novel, *Jerusalem* (1901), was inspired by a visit to Palestine. In 1909 she became the first Swedish writer to be awarded the Nobel Prize for literature.

lagoon Shallow stretch of seawater protected from waves and tides by a strip of land or coral.

Lagos Largest city and chief port of Nigeria, in the s of the country, on the Gulf of Guinea. From the 17th–19th centuries, Lagos grew as a YORUBA settlement. It came under British control in 1861, after years of Portuguese exploitation through the slave trade. It became the capital of independent Nigeria in 1960, but was replaced by ABUJA in 1982. Industries: brewing, ship repairing, textiles, crafts. Pop. (1992) 1,347,000.

Lagrange, Joseph Louis (1736–1813) French mathematician. He created the calculus of variations, devised a mathematical analysis of perturbations in gravity, and made contributions in many other areas, including the mathematics of sound and mechanics. He wrote *Analytical Mechanics* (1788). Lagrangian points One of the five points at which a celestial body can remain in a position of equilibrium with respect to two much more massive bodies orbiting each other.

Lahore City on the River Ravi, NE Pakistan, capital of Punjab province and Pakistan's second-largest city. An important city during the Ghazni and Ghuri sultanates of the 12th–13th centuries, it was used as a royal residence under the Mogul empire. It was part of the Sikh kingdom from 1767 and passed to the British in 1849. From 1955–70 it was capital of West Pakistan. It is an important commercial and industrial centre. Industries: iron, steel, textiles, chemicals, rubber, leather, carpets, gold and silver jewellery. Pop. 2,953,000.

Laing, R.D. (Ronald David) (1927–1989) Scottish psychiatrist. He was an exponent of existential psychology and produced radical work on the nature of SCHIZOPHRENIA. He believed that the mentally ill are not necessarily maladapted: a psychotic disorder may be a reasonable reaction to the stresses of the world and of difficult family relationships.

laissez-faire Nineteenth-century economic doctrine. In reaction to MERCANTILISM, the proponents of laissez-faire adopted Adam SMITH's argument that trade and industry would best serve the interests of all if government interference was reduced to a minimum, so that market forces would be allowed to determine production, prices and wages.

lake Inland body of water, generally of considerable size and too deep to have rooted vegetation completely covering the surface. The expanded part of a river and a reservoir behind a dam are also termed lakes.

Lake District Region of Cumbria, NW England, containing the principal English lakes. Its spectacular mountain and lakeland scenery and its literary associations make it a major tourist attraction. Among its 15 lakes are Derwent Water, Grasmere, Buttermere and WINDERMERE. The highest point is SCAFELL PIKE at 978m (3,210ft). The Lake District National Park was established in 1951. Area: 2,243sq km (866sq mi). lake dwelling Prehistoric settlement built on piles within

the margins of lakes. Cattle and sheep were raised on lakeside pasture. Lake dwellings in Europe have been found in Germany, Switzerland, Italy and Britain. Some date back to Neolithic times, but most are from the BRONZE AGE.

Lake poets Three English poets (William Wordsworth, Samuel Taylor Coleridge and Robert Southey) who lived in the Lake District c.1800.

Lakshmi (Padma or Sita) In Hindu mythology, the lotus goddess, wife of VISHNU, who existed at the beginning of creation, rising from the ocean borne by a lotus. Lakshmi is the goddess of beauty and youth, worshipped as goddess of wealth and good fortune. She is often depicted with (or as) a lotus.

Lalique, René (1860–1945) French jewellery designer. His work significantly contributed to the art nouveau movement. In 1920 he began to produce the popular Lalique glass.

Lamaism See TIBETAN BUDDHISM

Lamarck, Jean Baptiste Pierre Antoine de Monet, Chevalier de (1744–1829) French biologist. His theories of EVOLUTION, according to which acquired characteristics are inherited by offspring, influenced evolutionary thought throughout the 19th century, until they were disproved by DARWIN. One of his major works is *Philosophie zoologique* (1809). Lamb, Charles (1775–1834) British writer. He is best known for his essays, most famously collected as *The Essays of Elia* (1820–23; 1833). He is also remembered for his children's books, which include *Tales from Shakespeare* (1807), on which he collaborated with his sister, Mary (1764–1847).

Lamb, Willis Eugene, Jr (1913–) US physicist who applied new techniques to measure the lines of the hydrogen SPECTRUM. He found that the actual positions (wavelengths) varied from the positions predicted by DIRAC's theory. For this research, he shared the 1955 Nobel Prize for physics.

Lamentations Old Testament book bewailing the destruction of Jerusalem and the Temple in 587 or 586 BC; it is commonly attributed to the author of the Book of Jeremiah. All five chapters of Lamentations are written in Hebrew verse.

Lammas Christian festival of thanksgiving for the harvest, celebrated on 1 August in medieval England. It was originally one of the QUARTER DAYS.

Lamming, George (1927–) Caribbean novelist and poet. His native Barbados forms the background to his first novel, *In The Castle of My Skin* (1953). *The Emigrants* (1954) describes the problems facing West Indians in England, where he settled in the 1950s. Later novels include *Water with Berries* (1971) and *Natives of My Person* (1972).

lamp Form of artificial lighting. Early lamps burned fuels such as animal fat, wax and oil. Lamps fuelled by coal gas were used from the early 1800s. The ELECTRIC LIGHT became popular in the early 1900s. Most modern lamps are electrically powered and are of three main types: INCANDESCENT, discharge (or vapour) and fluorescent. The common light bulb produces light by incandescence. Discharge lamps contain gas that glows brightly when an electric current is passed through it. Fluorescent lamps are discharge devices that produce invisible ultraviolet radiation. This causes a chemical coating to give off visible light by FLUORESCENCE.

lamprey Eel-like, jawless vertebrate found in marine and fresh waters on both sides of the Atlantic. It feeds by attaching its mouth to fish and sucking their blood. Length: to 91cm (3ft). Family Petromyzondiae.

Lancashire County in NW England, bordered by Cumbria (N), North and West Yorkshire (E), Greater Manchester and Merseyside (s), and the Irish Sea (W); the county town is Preston. Other major towns include Lancaster (the administrative centre) and Blackburn. Occupied in Roman times, it later formed part of an Anglo-Saxon kingdom. From the 16th century, textile manufacturing became important, and by the 19th century, cotton goods were vital to Lancashire's economy. In the 20th century, cotton and its other traditional industry, coal, sharply declined. It is drained by the rivers Lune and Ribble. Lowland regions are predominantly agricultural. Major attractions include the seaside resort of Blackpool and the Pennines. Area: 3,064sq km (1,183sq mi). Pop. (1994) 1,424,000. Lancaster, Burt (1913–94) US film actor and producer. A former circus acrobat, he made his film debut in *The Killers*

(1946). He won a Best Actor Oscar for Elmer Gantry (1960). Other films include From Here to Eternity (1953), Bird Man of Alcatraz (1962), The Leopard (1963) and Atlantic City (1981). Lancaster, Duchy of English estate first given by HENRY III to his son Edmund in 1265. The revenues from the duchy passed permanently to the crown in 1399, with the accession of the Lancastrian king HENRY IV.

Lancaster, House of English royal dynasty. The first earl of Lancaster was Edmund "Crouchback" (1245–96), son of HENRY III. In 1361 the Lancastrian title and lands passed to JOHN OF GAUNT via his wife. Their son became HENRY IV in 1399. During the Wars of the Roses in the 15th century, the rival royal houses of Lancaster and York, both PLANTAGENETS, contended for the crown.

Lancelot of the Lake In Arthurian legend, the father of Galahad and one of the most famous knights; he is portrayed as the lover of Guinevere, wife of King ARTHUR.

Lanchow See Lanzhou

Landau, Lev Davidovich (1908–68) Soviet physicist. In 1927 he proposed a concept for energy called the density matrix, later used extensively in QUANTUM MECHANICS. He originated the theory that underlies the superfluid behaviour of liquid helium. In 1962 he received the Nobel Prize for physics for his research into condensed matter, especially helium.

Landis, Kenesaw Mountain (1866–1944) US jurist and sports administrator. He became baseball's first commissioner (1920–44), following the 1919 "Black Sox" scandal. He restored the game's integrity through his disciplinarian leadership. He was elected to the Baseball Hall of Fame in 1944. Landor, Walter Savage (1775–1864) British poet and writer. His works include Gebir: a Poem in Seven Books (1798) and Heroic Idylls (1863). He is chiefly remembered for his prose dialogues, Imaginary Conversations of Literary Men and Statesmen (1824–29).

Landowska, Wanda (1877–1959) Polish harpsichordist and pianist who lived in Paris from 1919 and in the USA from 1941. An authority on early music, she founded the École de Musique Ancienne (1925) in Paris. In her teaching and performances she did much to promote interest in the HARPSICHORD. landscape gardening Arranging gardens to produce certain effects. Broadly, there are two main traditions: the Sino-English, with its retention of the informality of nature; and the Franco-Italian, with its geometric patterns in which nature is trimmed to art. The second tradition arose in Italy during the Renaissance. It is best exemplified in the *parterres* of VER-SAILLES, designed by André Le Nôtre. In England the naturalist style developed in the 18th century, with the work of William Kent, "Capability" Brown and Humphrey Repton.

landscape painting Art of portraying natural scenery. While landscape painting was central to the art of the East, especially China, the West did not recognize it as a separate genre until the 16th century. Landscape painting came into full flower in 17th-century Holland; Jacob van RUISDAEL is still regarded as the greatest Dutch landscape painter. A different tradition developed in Italy after Annibale Carracci invented the so-called "ideal landscape". CLAUDE LORRAIN and Nicolas Poussin arranged natural elements into artificial compositions. In the 19th century, mystical and awe-inspired romantic landscapes were created by painters such as FRIEDRICH in Germany and TURNER in Britain, as well as a number of North American artists. COROT and CONSTABLE introduced a more naturalistic approach, which led in turn to the enormous popularity that landscape achieved through IMPRESSIONISM. The 20th-century abstract and surrealist painters have reinvented the genre.

Landseer, Sir Edwin Henry (1802–73) British painter and sculptor. He achieved immense popularity with his sentimental paintings of animals, such as the stag in *Monarch of the Glen* (1851) and the dogs in *Dignity and Impudence* (1839). His best-known sculptures are the lions in Trafalgar Square.

Landsteiner, Karl (1868–1943) US pathologist, b. Vienna. He discovered the four different blood groups (A, B, AB and O) and demonstrated that certain blood groups are incompatible with others; clots form if blood of such groups are mixed. His findings explained why some blood transfusions

in the past had been beneficial, whereas others had been fatal. He won the 1930 Nobel Prize for physiology or medicine. In 1940 he identified the rhesus (Rh) factor in collaboration with A. S. Wiener.

Lanfranc (c.1005–89) Italian-born theologian, Archbishop of Canterbury (1070–89). A BENEDICTINE monk, his priory at Bec in Normandy became a centre for European scholars in the 1040s. As a counsellor of William of Normandy, he was put in charge of the English church. A powerful reformer, he brought the previously autonomous, vernacular-speaking Anglo-Saxon church into line with continental norms. He established church courts, installed Normans as bishops and moved their seats to major towns, strengthened the monasteries and reformed moral standards among the clergy.

Lang, Fritz (1890–1976) Austrian director of silent and early sound films. His debut feature was *Halbblut* (1919). Lang's first major success was the two-part crime thriller *Dr Mabuse* (1922). His best-known film, *Metropolis* (1926), has become a science-fiction classic. Perhaps his greatest film was his first sound feature, *M* (1931), an expressionist, psychological thriller. Fleeing Nazism, Lang moved to the USA. His first film in Hollywood was *Fury* (1936). Later films include *The Big Heat* (1953) and *While the City Sleeps* (1956).

Lange, Dorothea (1895–1965) US photographer. Her portraits of urban poor and migrant labourers in California during the Great Depression, and her images of rural America taken for the Farm Security Administration (1935–42), have an eloquence and strength that make them classics of documentary photography.

Langland, William (1331–99) English poet. His poem *Piers Plowman*, a late flowering of the alliterative tradition in English verse, is considered one of the most important works of medieval literature. It is remarkable for its sustained, complex but profoundly Christian allegorical style.

Langley, Samuel Pierpont (1834–1906) US astronomer. He showed that mechanical flight was possible by building large steam-powered model aircraft (1896), which achieved the most successful flights up to that time. In 1880 he developed the bolometer, which could measure infrared emissions. Langmuir, Irving (1881–1957) US physical chemist who invented a gas-filled tungsten lamp. He increased the life of the lamp by introducing nitrogen into the bulb instead of a high vacuum. He also devised the atomic hydrogen welding process and techniques to produce rain by cloud seeding. He received the 1932 Nobel Prize for chemistry for his work in surface chemistry.

Langton, Stephen (*c*.1150–1228) English cardinal and scholar, one of England's most politically controversial and anti-royalist archbishops of Canterbury. His appointment to the see of Canterbury by Pope Innocent III (1207) was bitterly opposed by King John, and he was prevented from entering England and occupying his post until 1213. Langton supported the barons over the issue of Magna Carta (1215). **language** System of human communication. Although

■ Lang The work of Austrian film director Fritz Lang has been widely acclaimed for its dramatic composition and exacting detail. Metropolis (1926) is a powerful, futuristic vision of an urban dystopia. Lang used his expressionist style in a variety of genres, including crime melodramas and westerns. His last film was The 1000 Eyes of Dr Mabuse (1960).

there are more than 4,000 different languages, they have many characteristics in common. Almost every human language uses a fundamentally similar grammatical structure, or syntax, even though the languages may not be linked in vocabulary or origin. Families of languages have been constructed, such as the INDO-EUROPEAN family, but their composition and origins are the subject of continuing debate. Historical studies of language are undertaken by the disciplines of ETYMOLOGY and PHILOLOGY. LINGUISTICS as a discipline usually addresses itself to contemporary language.

Languedoc-Roussillon Region of s France, extending from the RHÔNE valley to the foothills of the PYRENEES; the capital is MONTPELLIER. Languedoc was part of the Carolingian empire, before passing to the French crown in 1271. Languedoc-Roussillon is one of the world's major wine-producing regions. The industry is based on the fertile soils along the River Garonne and the alluvial Mediterranean coastal plain. Area: 27,736sq km (10,706sq mi). Pop. (1990) 1,926,514.

langur Any of about 15 species of medium to large MONKEYS of SE Asia and the East Indies. They are slender, with long hands and tails. Gregarious tree dwellers, they are active by day and are found from sea level to snowy Himalayan slopes up to an elevation of 4,000m (13,000ft). Length: 43–78cm (17–31in). Family Cercopithecidae; genus *Presbytis*.

Lansing State capital of MICHIGAN, USA, on the Grand River, s Michigan. First settled in the 1840s, it became the state capital in 1847. Industries: motor vehicles, trucks, tractors, metal goods, machinery. Pop. (1991) 127,321.

lantern fish Any of numerous species of marine fish found in Atlantic and Mediterranean waters, especially *Diaphus rafinesquiei*. It is identified by light organs along its sides, and is found in deep water during the day and near the surface at night. Length: 7.5cm (3in). Family Myctophidae.

lanthanide series (lanthanide elements, rare-earth metals) Series of 15 rare metallic elements with atomic numbers from 57–71. They are, in order of increasing atomic numbers: LANTHANUM (sometimes not considered a member), cerium, praseodymium, neodymium, promethium, samarium, europium, gadolinium, terbium, dysprosium, holmium, erbium, thulium, ytterbium and lutetium. Their properties are similar and resemble those of lanthanum, from which the series takes

its name. The shiny metals occur in monazite and other rare minerals and are placed in group III of the periodic table.

lanthanum (symbol La) Silvery-white metallic element of the LANTHANIDE SERIES, first identified in 1839. Its chief ores are monazite and bastnasite. Soft, malleable and ductile, lanthanum is used as a catalyst in cracking crude oil, in alloys and to manufacture optical glasses. Properties: at.no. 57; r.a.m. 138.9055; r.d. 6.17; m.p. 920°C (1,688°F); b.p. 3,454°C (6,249°F); most common isotope La¹³⁹ (99.91%).

Lanzhou City on the Huang He river, w China; capital of Gansu province. An old walled city dating from the 6th century BC, Lanzhou retained its importance under successive rulers. The principal industry is oil refining. Since 1960 it has been the base for the Chinese nuclear industry. Pop. (1993) 1,340,000.

Laos Landlocked republic in Southeast Asia; the capital is VIENTIANE. Land and climate Mountains and high plateaux cover most of Laos. The highest point is Mount Bia, at 2,817m (9,242ft), in central Laos. Most people live on the plains bordering the MEKONG River and its tributaries. The Mekong is one of Asia's longest rivers and forms much of Laos's NW and SW borders. The Annam Cordillera mountains form the E border with Vietnam. Laos has a tropical monsoon climate, with dry, sunny winters. Temperatures rise until April, when moist sw winds herald the monsoon season. Forests cover c.60% of the land, **History** In 1353 Fa Ngoun founded the kingdom of Lan Xang ("land of a million elephants"). Theravada Buddhism was adopted as the official religion. In 1707 the kingdom divided into the N kingdom of Luang Prabang and the s kingdom of Vientiane. In the early 19th century the kingdoms were controlled by Siam. From 1893 Laos was ruled as part of French Indochi-NA. In 1945 Laos was occupied by Japan. In the aftermath of World War 2, Laos gained increasing self-rule and in 1947 became a semi-autonomous constitutional monarchy. In 1953 Laos achieved independence, but was immediately plunged into civil war. The communist Patriotic Front (Pathet Lao) controlled most of N Laos, and royalist forces controlled Vientiane. For most of the next 22 years Laos was riven by sectarian conflict. The North Vietnamese use of the Ho Chi Minh Trail through Laos as a military supply line saw US bombardment of E Laos, and US military and financial support to the Laotian government against the Pathet Lao. By 1974 the Pathet Lao had secured most of Laos. The victory of the Viet Cong in the VIETNAM WAR enabled the final victory of Pathet Lao. The king abdicated and a democratic republic was proclaimed. Vietnam remained a powerful influence on Laos. Politics The 1991 constitution confirmed the Lao People's Revolutionary Party (LPRP) as the only legal political party. President Nouhak Phoumsavan was elected in 1992. Economy Laos is one of the world's poorest countries (1992 GDP per capita, US\$1,760). Agriculture employs c.76% of the workforce and accounts for 60% of GDP. Rice is the main crop; timber and coffee are exported. Hydroelectricity is produced at power stations along the Mekong and exported to Thailand. The "Golden Triangle", on the border with Cambodia and Burma, is the centre for the illegal production of OPIUM. Laos is thought to be the world's third-largest producer of opium. In 1986 Laos began to introduce liberal economic reforms, including the encouragement of private enterprise. Inflation has rapidly reduced and in 1995 the economy grew by 8%.

Lao Tzu (604–531 BC) (Laozi) Chinese philosopher, credited as the founder of TAOISM. Tradition says that he lived in the 6th century BC and developed Taoism as a mystical reaction to the moral-political concerns of CONFUCIANISM. He is said to have been the author of *Tao Te Ching*, the sacred book of Taoism.

La Paz Administrative capital and largest city of Bolivia, in the w part of the country. Founded by the Spanish in 1548 on the site of an Inca village, it was one of the centres of revolt in the War of Independence (1809–24). Located at 3,600m (12,000ft) in the ANDES, it is the world's highest capital city. Industries: chemicals, tanning, flour-milling, electrical equipment, textiles, brewing and distilling. Pop. (1992) 1,126,000. Laplace, Pierre Simon, Marquis de (1749–1827) French astronomer and mathematician. Laplace used proba-

LAOS

AREA: 236,800sq km

(91,428sq mi)

POPULATION: 4,469,000
CAPITAL (POPULATION):
Vientiane (449,000)
GOVERNMENT: Single-party
republic
ETHNIC GROUPS: Lao 67%,
Mon-Khmer 17%, Tai 8%
LANGUAGES: Lao (official)
RELIGIONS: Buddhism 58%,
traditional beliefs 34%,
Christianity 2%, Islam 1%
CURRENCY: Kip = 100 at

bility theory to apply Newton's gravitational theory to the entire Solar System; this work was summarized in his book *Celestial Mechanics* (1798–1827). He also did fundamental work in the study of heat, magnetism and electricity.

Lapland Region in N Europe, lying almost entirely within the Arctic Circle and including N Norway, the northernmost parts of Sweden and Finland, and the w part of the Kola Peninsula of Russia. The land is mountainous in Norway and Sweden, but tundra predominates in the NE. The s regions are forested. The harsh climate has restricted settlement and vegetation. Industries: hydroelectricity, fishing, tourism, mining for iron ore, copper and nickel. Area: c.388,500sq km (150,000sq mi).

La Plata City in E Argentina, 55km (35mi) ESE of Buenos Aires. Founded in 1882, the city was called Eva Perón from 1946–55. La Plata is Argentina's largest oil refining centre. Its port, Ensenada, is a major exporter of oil, cereals and frozen meat. Pop. (1991) 640,000.

La Plata, Rio de See Plata, Río de la

Lapps People inhabiting LAPLAND. The mountain Lapps are nomadic herders of reindeer, while those of the forest and coast are semi-nomadic and live by hunting, trapping and fishing. Their racial origins are uncertain.

lapwing (peewit) Any of several species of birds, especially the Eurasian lapwing, *Vanellus vanellus*, a wading bird with a conspicuous crest. It commonly nests in open agricultural land and defends its young by luring predators away, feigning a broken wing. Length: 30cm (12in). Family Charadriidae.

Lara, Brian Charles (1969–) Trinidadian cricketer, West Indies captain (1997–). Lara became captain of Trinidad in 1989 and got his first cap for the West Indies in 1990. In 1994, against England at Antigua, he made 375 runs, beating Gary Sobers' world record of runs in a single test-match innings. Playing for Warwickshire, he achieved a world record first-class score of 501 (not out) against Durham.

larch Any CONIFER tree of the genus *Larix*, native to cool and temperate regions of the Northern Hemisphere. Larches bear cones and needle-like leaves that, unusually for a conifer, are shed annually. Family Pinaceae.

lark Any of several small birds, known for their melodious songs. Most common in Europe are the woodlark (*Lullula arborea*), skylark (*Alauda arvensis*) and shorelark (*Eremophila alpestris*). All are mottled brown. Depending on where they live, they feed on insects, larvae, crustaceans or berries. Length: to 18cm (7in). Family Alaudidae.

Larkin, Philip Arthur (1922–85) English poet. His first collection of verse was *The North Ship* (1945), but he found

his characteristic voice with *The Less Deceived* (1955). Other works include *The Whitsun Weddings* (1964) and *High Windows* (1974). Larkin edited the *Oxford Book of Twentieth Century Verse* (1973). His *Collected Poems* were published in 1988 and his controversial letters in 1992.

larkspur See DELPHINIUM

La Rochefoucauld, François, Duc de (1613–80) French writer, renowned for his literary maxims and epigrams. In 1635 he was involved in an intrigue against Cardinal RICHELIEU and took part in the FRONDES revolts (1648–53). His best-known work is *Réflexions ou Sentences et Maximes Morales* (1665).

La Rochelle Seaport on the Bay of Biscay, w France; capital of Charente-Maritime département. An English possession during the 12th–13th centuries, it changed hands several times during the Hundred Years War (1337–1453). In the 16th century it became a Huguenot stronghold, but capitulated to the forces of Cardinal Richelieu in 1628. Industries: shipbuilding, oil refining, sawmilling, fish-canning, cement, fertilizers, plastics. Pop. (1990) 71,094.

Larousse, Pierre (1817–75) French lexicographer. He founded the publishing firm Larousse, which produced *The Great Universal Dictionary of the 19th Century* (1866–76), the first of a famous series of dictionaries and encyclopedias. larva Developmental stage in the life cycle of many invertebrates and some other animals. A common life cycle, typified by the BUTTERFLY, is egg, larva, PUPA, adult. The larva fends for itself and is mobile, but is distinctly different in form from the sexually mature adult. It metamorphoses (or pupates) to become an adult. Names for the larval stage in different organisms include MAGGOT, CATERPILLAR and TADPOLE.

laryngitis Inflammation of the LARYNX and vocal cords. Symptoms include a sore throat, hoarseness, coughing and breathing difficulties. It is usually due to a respiratory tract infection but may also be caused by exposure to irritant gases or chemicals.

larynx (voice-box) Triangular cavity located between the trachea and the root of the tongue. Inside it are the vocal cords, which are thin bands of elastic tissue. The vocal cords vibrate when outgoing air passes over them, setting up resonant waves that are changed into sound by the action of throat muscles and the shape of the mouth.

La Salle, René Robert Cavelier, Sieur de (1643–87) French explorer of North America. He explored the Great ■ Lara West Indian cricketer
Brian Lara is a prodigious lefthanded batsman. In 1994 he beat
Gary Sober's world record of runs
made in a single test-match
innings, when he scored 375
against England in Antigua. His
total of 501 against Durham,
England, is the highest number of
runs scored in a first-class match.

▲ lark Found in many regions of Africa, Europe and Asia, and some parts of North America and Australasia, larks (family Alaudidae) are notable for their songs. The crested lark (Galerida cristata) (shown) has a sandy coloration suited for camouflage in the dry, dusty grassland habitats in which it is found.

The larynx, together with the epiglottis, tongue, mouth and lips are the principal organs of speech. A side view (A) and back view (B) of these organs are shown. Air pushed out from the lungs through the larynx causes. the vocal cords to vibrate,

producing a continuous singing tone, the "voice". This tone can be altered in "pitch" by varying the arrangement of the cartilages of the larynx (thyroid and cricoid) by action of the associated muscles. As air passes through the mouth, the voice is modulated

and broken up by changing the position and shape of the other organs to produce speech. The different vowels are produced by altering the shape of the mouth. Consonants (four shown) are formed when the stream of air is suddenly emitted or cut off.

▶ laser surgery Used for a number of surgical operations today, lasers were initially used in surgery for operations involving the eye, notably to correct detached retinas. The ultra-fine beam of light is a much more delicate instrument than a scalpel, and the energy of the laser cauterizes an incision as soon as it is made.

Lakes area and was governor of Fort Frontenac on Lake Ontario (1675). On his greatest journey, he followed the Mississippi to its mouth (1682), naming the land Louisiana and claiming it for France.

La Scala (Teatro alla Scala) One of the world's great opera houses, Milan, Italy. Designed by Giuseppe Piermarini, it opened in 1776 and has been the scene of many famous premieres, among them Bellini's *Norma*, Verdi's *Otello* and Puccini's *Madame Butterfly*.

Las Casas, Bartolomé de (1474–1566) Spanish missionary and historian of early Spanish America, known as the Apostle of the Indies. He went to Hispaniola in 1502 and spent his life trying to alleviate the conditions of the Native Americans; his *History of the Indies* documents their persecution by Spanish colonists.

Lascaux Complex of caves in the French Pyrenees, discovered in 1940. They contain examples of 13 different styles of palaeolithic wall paintings, depicting horses, ibex, stags and a reindeer. The caves, some of which may have been used for ritual ceremonies, were closed in 1963 in order to halt the deterioration of the paintings. *See also* CAVE PAINTING

laser (acronym for light amplification by stimulated emission of radiation) Optical MASER, source of a narrow beam of intense monochromatic light in the ultraviolet, visible or infrared region in which all the waves are in step with one another. It was first developed in 1960 by the US physicist Theodore H. Maiman. The source can be a solid, liquid or gas. It has applications in medicine, research, engineering, telecommunications, holography and other fields.

laser surgery Surgical treatment carried out using a LASER beam. The high energy in an extremely narrow laser beam can burn through body tissues to make a fine "cut". The heat also seals blood vessels, so there is much less bleeding than when a knife is used. A less powerful laser beam can remove coloured marks, such as tattoos, from the skin. Some forms of skin cancer are treated in this way.

Laski, Harold Joseph (1893–1950) British political scientist and teacher. A prominent member of the Fabian Society, he served on the national executive of the Labour Party (1937–49) and as party chairman (1945–46). As a teacher, he influenced a number of the first wave of post-colonial leaders. Las Palmas (Las Palmas de Gran Canaria) Spanish city in NE Grand Canary Island; capital of Las Palmas province. Founded in 1478, the city expanded considerably after the building of the port in 1883. It is now a tourist resort. Its port, Puerto de la Luz, is the chief port in the Canary Islands, exporting bananas, sugar, tomatoes and almonds. Pop. (1994) 372,000.

Lassa fever Acute viral disease, classified as a haemorrhagic fever. The virus, first detected in 1969, is spread by a species of rat found only in w Africa. It is characterized by internal bleeding, with fever, headache and muscle pain.

Lasso, Orlando di (1532–94) Flemish composer of madrigals, masses and motets. He was famous throughout Europe and is ranked with PALESTRINA as one of the greatest composers of the late 16th century. He was a prolific composer and wrote over 2,000 pieces in all current genres.

Last Supper (Lord's Supper) Final meal shared by JESUS CHRIST and his disciples in Jerusalem during or just before PASSOVER, in the course of which Jesus instituted the Chris-

tian EUCHARIST. According to the gospels of St Matthew, St Mark and St Luke, Jesus warned the disciples of his imminent betrayal and blessed and shared bread and wine among them, telling them that these were his body and blood of the Covenant.

Las Vegas Largest city in Nevada, USA, in the s of the state. It is a world-famous gambling and entertainment centre. With over 13 million visitors per year, it is one of the USA's major tourist destinations. The Mormons established a colony on the site in 1855–57. The modern city began with the construction of a railway in 1905. Nevada legalized gambling in 1931 and the city grew rapidly. Its first big gambling casino opened in 1946 and by the 1970s gambling was earning the city over \$1 million a day. Las Vegas is also the commercial centre for a mining and ranching area. Pop. (1990) 258,295.

latent heat Heat absorbed or given out by a substance as it changes its phase at constant temperature. When ice melts, its temperature remains the same until it has been completely transformed into water; the heat necessary to do this is called the latent heat of fusion. The heat necessary to transform water into steam at constant temperature is called the latent heat of vaporization.

Lateran Councils Five Ecumenical Councils of the Western Church, held in the Lateran Palace in Rome. The first, held in 1123, confirmed the Concordat of Worms of 1122. The second, in 1139, promulgated 30 decrees that, among other things, condemned simony and the marriage of the clergy. The third, in 1179, decreed that the pope was to be elected by a two-thirds majority of the College of Cardinals. The fourth council, in 1215, gave a definition of the doctrine of the EUCHARIST, officially using the term "TRANSUBSTANTIATION" for the first time. The fifth, in 1512–17, introduced some minor reforms in the wake of the Protestant Reformation.

Lateran Treaty (1929) Agreement between Italy and the VATICAN. The Italian government recognized the Vatican as an independent sovereign state with the pope as its temporal head, and the Vatican surrendered the Papal States and Rome. Roman Catholicism was affirmed as Italy's state religion.

latex Milky fluid produced by certain plants, the most important being that produced by the RUBBER TREE. Rubber latex is a combination of gum resins and fats in a watery medium. It is used in paints, special papers and adhesives, and to make sponge rubbers. Synthetic rubber latexes are also produced.

Latimer, Hugh (1485–1555) English clergyman and Protestant martyr. He defended King Henry VIII's divorce from Catherine of Aragon. In 1535 he was made bishop of Worcester, but resigned his see in 1539 as a protest against the temporary reaction in favour of Catholicism. With the accession of EDWARD VI (1547), he resumed preaching. When the Roman Catholic Mary I came to the throne (1553), he was charged with heresy and, refusing to recant, was burned at the stake.

Latin Language of ancient Rome, the Roman Empire and of educated medieval European society. It belongs to the family of INDO-EUROPEAN LANGUAGES. Its earliest written records are inscriptions and legal formulas dating from the late 6th century BC. As Rome extended its rule throughout Italy, Latin gained supremacy over other Italic languages as well as over Etruscan. By the 3rd century BC, a literary form of Latin was evolving, which achieved its richest form between 70 BC and AD 18. The prose of CICERO, Julius CAESAR and LIVY and the poetry of CATULLUS, VIRGIL, HORACE and OVID are among the greatest works in the language. Spoken Latin was used throughout the Roman empire. It eventually broke up into numerous dialects, which formed the basis of the Romance languages. Latin remained the language of the church, science, medicine and law, and of education and most written transactions in Europe throughout the Middle Ages. It was still used in some scholarly and diplomatic circles in the 19th century, and the Roman Catholic mass was celebrated in Latin until the 1960s.

Latin America Parts of the Western Hemisphere (excluding French-speaking Canada) where the official or chief language is a ROMANCE LANGUAGE. Commonly it refers to the 18 Spanish-speaking republics and Brazil (Portuguese) and Haiti (French). Occasionally it includes those islands of the West Indies where Romance languages are the mother tongue.

Latin literature Literature of ancient Rome. The earliest works of Latin literature date from the 3rd century BC, and were imitations of Greek plays and epic poetry by Livius Andronicus and Naevius. One of Rome's greatest dramatists, PLAUTUS wrote in a similar style in the early 2nd century BC. Latin literature reached its stylistic peak in the 1st century BC. This so-called Golden Age ended soon after the death of AUGUSTUS in AD 14. The following century was noted for the writings of Seneca the Elder, TACITUS, PLINY THE ELDER and PETRONIUS. After c.100 AD, Latin literature went into a decline from which it was revived during the 4th century by the writings of Christian authors such as AUGUSTINE OF HIPPO.

latitude Distance N or s of the Equator measured at an angle from the Earth's centre. All lines of latitude are parallel to the Equator, which is the zero line of latitude. The tropics of Cancer and Capricorn are 23.5° away from the Equator, and the Arctic and Antarctic circles are at 66.5°, which is 23.5° away from the poles.

La Tour, Georges de (1593–1652) French painter of religious and genre scenes. An inspired follower of CARAVAGGIO, he is famous for nocturnal scenes lit by a single candle. Many art historians consider him to be one of the most important representatives of 17th-century French CLASSICISM. Examples of his work include *Christ and St Joseph in the Carpenter's Shop* (c.1645) and the *Lamentation over St Sebastian* (1645).

Latrobe, Benjamin Henry (1766–1820) US architect, b. England. He emigrated to the USA in 1796. He designed the neo-classical cathedral in Baltimore (1806–18) and worked on rebuilding the Capitol in Washington, D.C. (1815–17).

Latter Day Saints, Church of See MORMONS

Latter Day Saints, Reorganized Church of Jesus Christ of See Mormons

Latvia Baltic republic in NW Europe; the capital is RIGA. Land and climate Latvia consists mainly of flat plains separated by low hills. Small lakes and peat bogs are common and its highest point is only 311m (1020ft) above sea level. Latvia's main river is the Daugava (Western Dvina). Riga has warm summers, but the winter months (December to March) are subzero and the sea often freezes. Moderate rainfall occurs throughout the year, with snow in winter. Forests cover c.40% of the county. About 27% of the land is crop farmed, while 13% is used for grazing livestock. History The ancestors of most modern Latvians settled in the area c.2,000 years ago, but the area has always been vulnerable to attack by powerful neighbours. Between the 9th and 11th centuries, the region was attacked by Vikings from the w and Russians from the E. In the 13th century, German invaders took over, naming the country Livland (Lat. Livonia). From 1561 the area was partitioned between various groups, including Poles, Lithuanians and Swedes. In 1710 Peter the Great took Riga and, by the end of the 18th century, Latvia was under Russian rule. Nationalist movements developed in the 19th century and, just after the end of World War 1, Latvia declared itself independent. In 1939 Germany and the Soviet Union made a secret agreement to divide up parts of E Europe and, in 1940, Soviet troops invaded Latvia, which became part of the Soviet Union. German forces seized Latvia in 1941, but Soviet troops returned in 1944. Under Soviet rule, many Russian immigrants settled in Latvia and the Latvians feared that Russians would become the dominant ethnic group. In the late 1980s, when reforms were being introduced in the Soviet Union, Latvia's government relaxed communist laws, allowed press and religious freedom and made Latvian the official language. In 1990 it unilaterally declared independence, an act that was finally recognized by the Soviet Union in September 1991. Latvia held its first free elections in 1993. Voting was limited to those who had been citizens of Latvia on 17 June 1940 and their descendants. This meant that about 34% of Latvian residents were unable to vote. In 1994 Latvia adopted a law restricting the naturalization of non-Latvians, including many Russian settlers. Politics Latvia has been seeking to increase its contacts with the West and, in 1995, it joined the Council of Europe and formally applied to join the European Union. In 1997 the ruling coalition collapsed amid corruption allegations and a new government was appointed.

Economy Latvia is a lower-middle-income country (1992 GDP per capita, US\$6,060). It faced many problems in transforming from a command to a free-market economy. The country lacks natural resources and has to import many of the materials needed for its most valuable activity, manufacturing. Its industries are varied, with products including electronic goods, farm machinery, fertilizers, plastics, radios, vehicles and washing machines. Latvia produces only c.10% of the electricity it needs and the rest is imported from Belarus, Russia and Ukraine. Farm products include barley, dairy products, beef, oats, potatoes and rye.

Laud, William (1573–1645) English cleric, Archbishop of Canterbury (1633–45). As religious advisor to King Charles I, whom he supported during his period of non-parliamentary rule (1629–40), he imposed press censorship, enforced a policy regulating wages and prices, and sought to remove PURITANS from important positions in the church. His attempt to impose the English prayer book upon the Scots was one of the immediate causes of the English Civil War. Laud was impeached (1640) by the LONG PARLIAMENT.

Lauda, Niki (Nikolas) (1949–) Austrian motor racing driver who, driving for Ferrari, won the world drivers' championship in 1975, 1977 and 1984. In 1976 he suffered near-fatal injuries in an accident at the German Grand Prix.

Laue, Max Theodor Felix von (1879–1960) German physicist. Using IONS in a crystal as a grating, he produced X-RAY interference patterns, thus showing that x-rays are waves and providing a method of investigating crystal structure. For this discovery, he received the 1914 Nobel Prize for physics. *See also* X-RAY CRYSTALLOGRAPHY

Lauraceae Large family of flowering plants, mostly evergreen shrubs and trees, including BAY, cherry laurel and SASSAFRAS; it is represented in warm and temperate regions worldwide. The flowers are generally green and followed by berries. laurel Evergreen shrubs and trees native to s Europe and cultivated in the USA. Included is the noble or BAY laurel (Laurus nobilis) with leathery, oval leaves, tiny yellowish flowers and purple berries. Height: 18–21m (60–70ft). Family LAURACEAE. Laurel and Hardy US comedy team who starred in more than 200 films. Stan Laurel (1890–1965), b. Britain, played the thin, bumbling oaf. His US partner, Oliver Hardy (1892–1957), played the fat, pompous womanizer. Their best films include Leave 'em Laughing (1928), The Music Box (1932) and Way Out West (1937).

Laurier, Sir Wilfrid (1841–1919) Canadian statesman, prime minister (1896–1911). Laurier was the first French-Canadian to lead a federal party (the Liberals, 1887–1919). He created a separate Canadian navy in 1909 and signed a

LATVIA Baltic Sea EST 58°N Valmiera Gulf o Ventspils Riga Liepaja LITHUANIA AREA: 64,589sq km (24,938sq mi) 50 mi RUSSIA 27 F 28 E POPULATION: 2,632,000 CAPITAL (POPULATION): Riga 53%, Russian 34%, **RELIGIONS:** Christianity (910,200)Belorussian 4%, Ukrainian (including Lutheran, GOVERNMENT: Multiparty 3%, Polish 2%, Lithuanian, Russian Orthodox and republic Jewish Roman Catholic) **ETHNIC GROUPS:** Latvian LANGUAGES: Latvian (official) **CURRENCY:** Lats = 10 santimi

▲ leaf Leaves exhibit a wide variety of shapes. The pendunculate oak (Quercus rober) (A) and the Scots pine (Pinus sylvestris) (B) have simple leaves, with a single leaf blade, while the horse chestnut (Aesculus hippocastrum) (C) and ferns, such as Polypodium (D) have compound leaves. The leaflets of compound leaves either radiate from one point (palmate) as in the case of the horse chestnut, or are arranged in opposite pairs down the main stalk (pinnate) as is the case with ferns. The primary function of leaves is photosynthesis, but in addition leaflets may be modified into climbing tendrils (E), or protective spines, as in the cactus Mammillaria zeilmannia (F).

reciprocal tariff agreement with the USA in 1911. In opposition, he supported Canadian entry into World War 1 but, in deference to French-Canadian opinion, opposed conscription and declined to join the coalition government in 1917.

Lausanne City on the N shore of Lake Geneva, sw Switzerland; capital of Vaud canton. Originally a Celtic settlement, it became an episcopal see in the 6th century. It was ruled by prince-bishops until 1536, when it was conquered by Bern and accepted the Reformation. Industries: leather, brewing, chemicals, printing, confectionery. Pop. (1991) 265,000.

Lautrec, Henri Toulouse See Toulouse-Lautrec, Henri Marie Raymond de

lava Molten rock or MAGMA that reaches the Earth's surface and flows out through a volcanic vent in streams or sheets. There are three main types of lava: vesicular, such as pumice; glassy, such as obsidian; and even-grained. Chemically, lavas range from acidic to ultrabasic. Basic lavas have a low viscosity and flow easily, covering large areas. Acidic lavas are highly viscous and rarely spread far.

Laval, Pierre (1883–1945) French statesman, prime minister (1931–32, 1935–36). His government fell as a result of the unpopularity of the Hoare-Laval Pact, which approved the Italian conquest of Ethiopia. In 1940 he joined the VICHY GOVERNMENT, becoming its head under Marshal PÉTAIN. His capitulation to German demands was seen as treason by the FREE FRENCH and he was executed after the war.

Laver, Rod (Rodney George) (1938–) Australian tennis player. Laver's major singles titles included the US (1962, 1969), French (1962, 1969) and Australian (1960, 1962, 1969) opens, and Wimbledon (1961, 1962, 1968, 1969). He was the first man to win the "Grand Slam" twice (1962, 1969). Lavoisier, Antoine Laurent (1743–94) French chemist who founded modern chemistry. He demolished the PHLOGISTON theory (which said that phlogiston was lost during combustion) by demonstrating the function of oxygen in combustion. He named oxygen and hydrogen and showed how they combined to form water. In collaboration with Claude Berthollet, he published *Methods of Chemical Nomenclature* (1787), which laid down the modern method of naming substances.

Law, (Andrew) Bonar (1858–1923) British statesman, prime minister (1922–23), b. Canada. He entered Parliament in 1900 and in 1911 became the first leader of the Conservative Party to come from a manufacturing background. He was chancellor of the exchequer (1916–19) before becoming prime minister.

Law, John (1671–1729) French financier, b. Scotland. His banking and stock-market schemes created a boom in France, where he founded a state bank, later named the Banque Générale, in 1716. His "Mississippi Scheme" (1717) attracted huge investment in French Louisiana. Appointed controller-general of finance (1720), he merged all his interests into one organization. Within months a dip in public confidence caused heavy selling and the whole scheme collapsed. Law died in exile, a bankrupt.

law System of rules governing human society, enforced by punishments specified by society itself. The major systems of law are COMMON LAW, ROMAN LAW and EQUITY.

Law and the Prophets Two major divisions of the OLD TESTAMENT. The Law, or Law of Moses, consists of the first five books of the Old Testament, known as the TORAH in Hebrew and the PENTATEUCH in Greek. The Prophets consists of several books grouped into different arrangements according to Jewish or Christian tradition. The groupings include: (a) Joshua, Judges, I and II Samuel and I and II Kings; (b) Isaiah, Jeremiah and Ezekiel; and (c) Hosea, Joel, Amos, Obadiah, Jonah, Micah, Nahum, Habakkuk, Zephaniah, Haggai, Zechariah and Malachi.

Lawrence, D.H. (David Herbert) (1885–1930) British novelist, short-story writer and poet. His first poems were published by Ford Madox Ford in the English Review (1909) and were followed in 1911 by his first novel, *The White Peacock*. His other novels include *Sons and Lovers* (1913), *Women in Love* (1920) and *Lady Chatterley's Lover* (privately published 1928). He also wrote numerous short stories, plays, poems and miscellaneous non-fiction.

Lawrence, Ernest Orlando (1901–58) US physicist. In 1930, as professor at the University of California at Berkeley, he built the first cyclotron, a subatomic particle ACCELERATOR. He developed larger cyclotrons and received the 1939 Nobel Prize for physics. Lawrencium was named after him.

Lawrence, T.E. (Thomas Edward) (1888–1935) (Lawrence of Arabia) British soldier. He joined the army in World War 1 and in 1916 became a leader of the Arab revolt against the Turks. He proved a successful guerrilla commander, leading Arab forces into Damascus, Syria, in October 1918. He published his remarkable account of the Arab revolt, *The Seven Pillars of Wisdom*, privately in 1926.

Lawrence of Arabia See Lawrence, T.E. (Thomas Edward)

lawrencium (symbol Lr) Radioactive metallic element, one of the ACTINIDE SERIES. It was first made in 1961 at the University of California at Berkeley by bombarding CALIFORNI-UM with boron nuclei. Properties: at.no. 103; r.a.m. 262; most stable isotope Lr²⁵⁶ (half-life 27 seconds).

Law Society Either of two inclusive organizations of solicitors in Britain – the Law Society in England and Wales, and the Law Society of Scotland – as incorporated in 1831 by Act of Parliament. Each Law Society regulates and enforces the standards by which solicitors operate. It administers legal aid to those entitled to it and retains a fund from which compensation may be made in the case of a solicitor's fraud or negligence.

laxative Any agent used to counteract constipation. There are various kinds available, including bulk-forming drugs, stimulant laxatives, fecal softeners and saline purgatives.

Laxness, Halldór Kiljan (1902–98) Icelandic novelist. He was awarded the 1955 Nobel Prize for literature for his novels about the fishing villages and farms of Iceland. His fiction includes *Independent People* (1934–35), *The Atom Station* (1948) and *Paradise Reclaimed* (1960). The trilogy *Iceland's Bell* (1943–46) was influenced by traditional Icelandic sagas. Lazarus Either of two men mentioned in the New Testament. In John 11 Lazarus was the brother of Mary and Martha of Bethany. Four days after his death, Jesus miraculously restored him to life. In Luke 16 Lazarus is the poor man in Christ's parable about a beggar and a rich man.

L-dopa (levodopa) Naturally occurring amino acid used to relieve some symptoms of PARKINSON'S DISEASE. It sometimes suppresses the trembling, unsteadiness and slowness of movement that characterize the condition.

Leacock, Stephen Butler (1869–1944) Canadian humorist, b. Britain. His *Literary Lapses* (1910) proved popular for their gentle satire and love of the absurd. He also wrote *Sunshine Sketches of a Little Town* (1912) and an incomplete autobiography, *The Boy I Left Behind Me*, published in 1946. **Leadbelly** Popular name of blues singer Huddie LEDBETTER

lead (symbol Pb) Metallic element of group IV of the periodic table, known from ancient times. Its chief ore is GALENA (lead sulphide), from which lead is obtained by roasting. Exposure to lead from paints, pipes, petrol and other sources can lead to lead poisoning. Soft and malleable, it is used as a shield for x-rays and nuclear radiation, and in plumbing, batteries, cable sheaths and alloys such as pewter and solder. Chemically, lead is unreactive and a poor conductor of electricity. Properties: at.no. 82; r.a.m. 207.19; r.d. 11.35; m.p. 327.5°C (621.5°F); b.p. 1,740°C (3,164°F); most common isotope Pb²⁰⁸ (52.3%). leaf Part of a plant, an organ that contains the green pigment

ICHLOROPHYLL and is involved in PHOTOSYNTHESIS and TRAN-SPIRATION. It usually consists of a blade and a stalk (petiole), which attaches it to a stem or twig. Most leaves are simple (undivided), but some are compound (divided into leaflets). **leaf hopper** Any of numerous species of small, slender

leaf hopper Any of numerous species of small, slender insects of the family Cicadellidae. Leaf hoppers feed by sucking the sap of plants and may, in large numbers, do a great deal of damage. Many species are brightly coloured.

leaf insect Any of several species of flat, green insects that bear a resemblance to leaves and are found throughout tropical Asia. The female has large leathery forewings with markings resembling a pattern of leaf veins. Order Phasmida; family Phylliidae. *See also* STICK INSECT

League of Nations International organization (1920–46),

forerunner of the UNITED NATIONS (UN). Created as part of the Treaty of VERSAILLES (1919) ending World War 1, it was impaired by the refusal of the USA to participate. The threats to world peace from Germany, Italy and Japan caused the League to collapse in 1939. It was dissolved in 1946.

League of Women Voters US political organization. It was founded in 1920 "to promote political responsibility through informed and active participation of citizens in government". A non-partisan organization, it is comprised of women citizens who distribute information on issues and candidates and campaign to encourage registration and voting.

Leakey, Louis Seymour Bazett (1903–72) English archaeologist and anthropologist, who discovered fossils in East Africa that proved man to be older than had been thought. In 1931 he began to research Olduvai Gorge in Tanzania. Working with his wife Mary (1913–96), he found animal fossils and tools. Mary Leakey continued working in East Africa, often with her son Richard (1944–), who became director of the National Museums of Kenva.

Lean, Sir David (1908–91) British film director. Lean's early films, such as *In Which We Serve* (1942) and *Brief Encounter* (1945), were collaborative projects with Noel COWARD. These were followed by the Dickens' adaptations, *Great Expectations* (1946) and *Oliver Twist* (1948). He is best known for meticulously crafted, visual spectaculars, such as *The Bridge on the River Kwai* (1957) and *Lawrence of Arabia* (1962), for which he won Best Director Academy Awards. Other films include *Doctor Zhivago* (1965) and *Ryan's Daughter* (1970). In 1984 he made his final film, *A Passage to India*, and was knighted.

Lear, Edward (1812–88) British poet, painter and draughtsman. He is famous for his tragi-comic nonsense verse for children. He invented such characters as the "Pobble Which Had No Nose" and "The Owl and the Pussycat". Books include *The Book of Nonsense* (1846) and *Laughable Lyrics* (1877). learning Acquisition of skills and concepts by a variety of processes. There have been many different theories of how learning takes place. The oldest theories held learning to be an associative process by which ideas, images and events become linked in the mind. Behaviourists believed that learning was related to conditioning. GESTALT PSYCHOLOGY dealt with such learning potentials as problem solving; modern COGNITIVE PSYCHOLOGY concentrates on mental processes such as concept formation. Modern researchers tend to investigate particular problems rather than formulating universal theories.

leather Animal hide, treated to make it hard-wearing and resistant to decay. Most leather is made from cattle hide, but many other kinds of skin are used too. The skin is first cured, via a drying process or the application of salt. It is then washed and prepared for tanning, a process that usually con-

sists of treating the skin with a solution of chromium salts or plant extract (TANNIN). Other processes include dyeing, oiling and the application of various finishes, such as VARNISH.

Leavis, FR. (Frank Raymond) (1895–1978) British literary critic. His works of criticism include *The Great Tradition* (1948), *The Common Pursuit* (1952) and *D.H. Lawrence, Novelist* (1955). His views on society and education are expounded in *Mass Civilization and Minority Culture* (1933) and *Education and the University* (1943).

Lebanon Republic in sw Asia. *See* country feature, page 391 **Lebed, Aleksander Ivanovich** (1950–) Russian general and politician. As commander of the Tula Airborne Troops Division, he stood guard at the Supreme Soviet building during the attempted coup of August 1991. In 1995 Lebed moved into politics, becoming a member of the National Council, Congress of Russian Communities, and the State Duma. Standing against Yeltsin in the 1996 presidential elections, Lebed's level of support was such that YELTSIN offered him a government position in order to win his votes. He was appointed national security adviser but dismissed later that year.

Leblanc, Nicolas (1742–1806) French chemist. In 1790 he devised a process for producing soda ash (sodium carbonate, Na₂CO₃) from salt (sodium chloride, NaCl) by treating it with sulphuric acid.

LeBrun, Charles (1619–90) French painter. He painted religious, mythological and historical subjects. As chief painter to Louis XIV, he created the Galerie d'Apollon at the Louvre (1661) and designed much of the interior of Versallles, including the extraordinary Hall of Mirrors (1679–84). He became director of the Académie Française and the GOBELINS tapestry factory in 1663.

Le Carré, **John** (1931–) British writer of espionage thrillers, b. David John Moore Cornwell. His first novel, *Call for the Dead* (1961), introduced his best-known character, George Smiley. Le Carré's stories are intricately plotted studies of history and character. His works include *The Spy Who Came in from the Cold* (1963), *Tinker, Tailor, Soldier, Spy* (1974), *Smiley's People* (1980), *The Little Drummer Girl* (1983), *A Perfect Spy* (1986) and *The Russia House* (1989).

Leclanché cell Electric cell invented by French engineer Georges Leclanché, c.1865. Its ANODE was a zinc rod and its cathode a carbon plate surrounded by packed manganese dioxide. These electrodes were dipped into a solution of ammonium and zinc chlorides. It is the basis of the dry cell or battery.

Leconte de Lisle, Charles Marie René (1818–94) French poet. He was the leader of the anti-romantic Parnassian school, and his work, which he collected as *Poèmes antiques* (1852), *Poèmes barbares* (1862) and *Poèmes tragiques*, is disciplined and pessimistic. He was elected to the Académie Française in 1866.

▲ leaf insect Masters of disguise, leaf insects such as Phyllium crurufolium (shown here), have legs and wings adapted to resemble leaves. In their tropical Asian habitats their predators find them difficult to spot. Some species have taken this adaptation a stage further, by laying eggs that resemble the seeds of various plants.

■ League of Nations Set up following World War 1 to arbitrate over international disputes, the original members of the League of Nations were the 32 states that signed the Covenant and ratified it (although the USA did not ratify), and those states that joined by invitation. Other states were admitted at later dates by a two-thirds vote of the Assembly. The lack of US support weakened the League to the point at which it was largely ineffectual as a forum for world peace.

▶ Le Corbusier The pilgrimage chapel of Notre-Dame-du-Haut, Ronchamp, France, was built by Le Corbusier in 1955. The flowing, highly sculptural concrete structure deliberately resembles a nun's headdress in both form and coloration. A combination of the southern wall of the chapel, which contains numerous stained glass windows, and structures of the northern wall, which break through the roof, suffuse the interior with light.

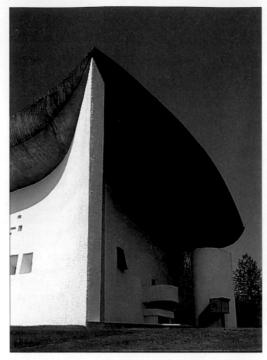

Le Corbusier (1887–1963) French architect, b. Switzerland as Charles Édouard Jeanneret. Perhaps the most influential of modernist architects, Le Corbusier set out his design principles in *Five Points of a New Architecture* (1925). His use of reinforced concrete in modular, cube-like forms came to be known as BRUTALISM. His extension of functionalism was illustrated in the Unité d'Habitation, Marseilles (1946–52). Its design was widely adopted for modern mass housing. Le Corbusier then began a shift to a more poetic style, realized in the highly sculptural chapel of Notre-Dame-du-Haut, Ronchamp, France (1955). His most ambitious project was the planning of Chandigarh, India. His last major work was the Visual Arts Center at Harvard (Massachusetts, USA, 1961–62).

Leda In Greek mythology, Queen of Sparta, the wife of Tyndareus and mother of CLYTEMNESTRA. She was also the mother of CASTOR AND POLLUX and HELEN by ZEUS. The myth reveals that Zeus came to her in the form of a swan.

Ledbetter, Huddie (1888–1949) US composer and blues singer, better known as Leadbelly. Folklorist John A. Lomax discovered him in prison and used his songs in the book *Negro Folk Songs as Sung by Lead Belly* (1936). He is known as the composer of many classic blues songs including "Goodnight Irene", "The Midnight Special" and "Rock Island Line".

Lee, Ann (1736–84) British mystic, member of the United Society of Believers in Christ's Second Appearing, popularly called the SHAKERS. The Shaker sect was persecuted in Britain, and in 1774 Lee and eight others fled to the American colonies. In 1776 she founded a colony near Albany, New York State, and gained many converts.

Lee, Laurie (1914–97) British writer. Lee's collections of poetry include *The Sun My Monument* (1944) and *My Many-Coated Man* (1955). He is best known for his autobiography *Cider with Rosie* (USA: The Edge of Day) (1959), and his accounts of travels in Spain during the Spanish Civil War, *As I Walked Out One Midsummer Morning* (1969) and *A Moment of War* (1991). He also wrote short stories.

Lee, Richard Henry (1732–94) US political leader. He was a leading spokesman for colonial rights in Virginia. As a delegate to the CONTINENTAL CONGRESS, he proposed the resolution on which the Declaration of Independence was based (1776). He opposed the Constitution on the grounds that it diminished the power of the states, but he supported the Bill of Rights. He was president of Congress (1784–86) and one of the first US senators from Virginia (1789–92).

Lee, Robert E. (Edward) (1807–70) Commander of the Confederate forces in the American CIVIL WAR and military

adviser to Jefferson DAVIS. In 1862 Lee was appointed commander of the main Confederate force, the Army of Virginia. He successfully defended Richmond and won the Second Battle of BULL RUN. Though checked at Antietam (1862), he defeated the Union forces at Fredericksburg (1862) and Chancellorsville (1863). His invasion of the North ended in defeat at Gettysburg in July 1863. He was finally trapped by Ulysses S. GRANT and surrendered in April 1865.

Lee, Spike (1957–) US film director, screenwriter and actor. His first feature, the stylish comedy *She's Gotta Have It* (1986), was a commercial success. *Do the Right Thing* (1989) was a bleak meditation on urban racism in the USA. Following the jazz film *Mo' Better Blues* (1990), Lee made the controversial *Jungle Fever* (1991), another meditation on racial integration. Other films include *Malcolm X* (1992) and *Crooklyn* (1994).

leech Any of numerous species of freshwater, marine and terrestrial annelids found in tropical and temperate regions. Its tapered, ringed body is equipped with a sucking disc at each end. Many species live on the blood of animals. Length: 13–51mm (0.5–2in). Class Hirudinea.

Leeds City and county district on the River Aire, West Yorkshire, N England. Founded in Roman times, it forms part of one of England's major industrial regions. In the 18th–19th centuries the city became famous for its cloth manufacture. It remains the centre of England's wholesale clothing trade. Leeds has two universities (1904 and 1992) and is host to an international piano competition. Industries: aircraft components, textile machinery, engineering, chemicals, plastics, furniture, paper and printing. Pop. (1994) 529,000.

leek Biennial plant related to the onion; it originated in the Mediterranean region and is cultivated widely for culinary purposes. Family Liliaceae, species *Allium porrum*.

Lee Teng-hui (1923–) Chinese politician, president of Taiwan (1988–). A member of the ruling Nationalist Party (Kuomintang), he became mayor of Tapei in 1979, and vice president of the party (and of Taiwan) in 1984. On the death of Chiang Ching-kuo in 1988, Lee Teng-hui became president and was subsequently elected. Recognized as a technocrat, he was largely responsible for the rapid liberalization of Taiwan. Leeuwenhoek, Anton van (1632–1723) Dutch scientist. A scientific amateur, he built simple microscopes with a single lens, made so accurately that they had better magnifying powers than the compound microscopes of his day. He investigated many microorganisms and their life histories, and described various microscopic structures, such as spermatozoa.

Leeward Islands Group of islands in the West Indies, the N section of the Lesser Antilles; it includes the US and British VIRGIN ISLANDS, GUADELOUPE, ANGUILLA, ANTIGUA AND BARBUDA, MONTSERRAT, ST KITTS-NEVIS and St Martin. The islands are volcanic with a warm climate and tropical vegetation. The economy is based on agriculture and tourism. Crops include fruits, sugar, cotton and coffee. See West Indies map legal aid System by which those below a certain income can receive free or subsidized legal representation or advice. In criminal cases it is paid for mainly from public funds. In civil cases costs will usually be met from the costs awarded by the court. It was introduced in Britain in 1949 and is now covered in Scotland by the Legal Aid (Scotland) Act (1986), and in England and Wales by the Legal Aid Act (1988). The high cost of legal advice is placing strain on the scheme.

Léger, Fernand (1881–1955) French painter. He evolved a form of CUBISM jokingly called "tubism" because of its emphasis on cylindrical, mechanical forms. He designed stage sets for theatre and ballet and produced ceramics and stained glass.

legion Basic organizational unit of the Roman army from the early Republic to the fall of the empire in the West in the 5th century AD. During the great period of Rome's expansion, a legion was about 6,000 men strong, consisting mainly of heavy infantrymen (legionaries), with some light troops and cavalry in support. The legion was subdivided into cohorts (420 men each), maniples (120 men each), and centuries (100 men each). legionnaire's disease Lung disease caused by infection with the bacterium Legionella pneumophila. It takes its name from the serious outbreak that occurred during a convention of the American Legion held in Philadelphia in 1976. The

bacterium thrives in water and may be found in defective heating, ventilation and air-conditioning systems. It is inhaled in fine water droplets present in the air.

legion of honour (Légion d'Honneur) French award, created by Napoleon in 1802 to reward civil and military service. The highest class of award is the great cross (*grand-croix*). The most common level at which it is awarded is that of Knight of the Legion (*Chevalier de la Légion*).

legislation See LAW

legislature Representative assembly whose primary function is the enactment of laws. Legislatures can be either unicameral or bicameral (composed of one or two chambers). In most democracies, including Britain, the "lower" or more directly elected chamber is the more powerful, and the "upper" chamber is filled by either government appointees or hereditary members. In the USA, however, the upper house, Senate, is constitutionally more powerful than the HOUSE OF REPRESENTATIVES, and both houses are elected. *See also* PARLIAMENT

legume Member of the PEA family of flowering plants, including many trees, shrubs, vines and herbs whose roots bear nodules that contain nitrogen-fixing bacteria. The fruit is typically a pod (legume) containing a row of seeds. Important

food species include the pea, runner BEAN, SOYA BEAN, LENTIL, broad bean, kidney bean and haricot bean. *See also* NITROGEN CYCLE; NITROGEN FIXATION; ROOT NODULE

Lehár, Franz (1870–1948) Austrian composer, b. Hungary. His first operetta, *Kukuschka*, was written in 1896. He composed more than 30 operettas, of which *The Merry Widow* (1905) is the most popular today.

Le Havre City and seaport in N France, at the mouth of the River Seine, on the English Channel. Founded in the 16th century on the site of a fishing village, it is now France's second-largest port. It was briefly the base of the Belgian government in World War 2. The city was rebuilt after being almost completely destroyed during the war. It is the principal export point for Paris and a transatlantic and cross-Channel passenger port. Industries: chemicals, fertilizers, timber, food processing, oil-refining, shipbuilding. Pop. (1990) 195,854.

Lehmann, Lotte (1888–1976) US soprano, b. Germany. She was the most illustrious singer of her time. She sang with the Vienna State Opera (1914–38) and the Metropolitan Opera Company, New York, from 1934 until her retirement in 1961.

Leibniz, Gottfried Wilhelm (1646–1716) German philosopher and mathematician. Leibniz made many practical inven-

LEBANON

Lebanon's flag was adopted in 1943. It uses the colours of Lebanese nationalists in World War 1 (1914–18). The cedar tree on the white stripe has been a Lebanese symbol since Biblical times. Because of deforestation, only a few of Lebanon's giant cedars survive.

The Republic of Lebanon lies on the E shores of the Mediterranean Sea. A narrow coastal plain contains the capital, BEIRUT, and the second-largest city of TRIPOLI. Behind the plain are the rugged Lebanese Mountains, which rise to 3,088m (10,131ft). The Anti-Lebanon Mountains form the E border with Syria. Between the two ranges is the Bekaa Valley, a fertile farming area and site of the ancient city of BAALBEK.

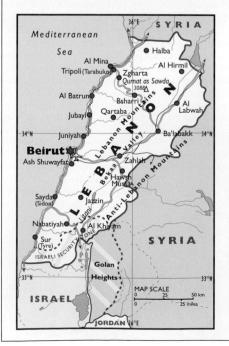

CLIMATE

Coastal regions have a typical Mediterranean climate, with hot, dry summers and mild, wet winters. Onshore winds bring heavy winter rain to the w slopes of the mountains.

VEGETATION

Lebanon was famous in ancient times for its cedar forests, but these have largely disappeared. Forests now cover only 8% of the land.

HISTORY

In c.3000 BC Canaanites founded the city of TYRE and established what became known as PHOENICIA. In 332 Alexander the Great conquered the territory. In 64 BC the region fell to the Romans. Christianity was introduced in AD 325. Arab conquest in the 7th century saw the introduction of Islam, but Christian MARONITES predominated. Lebanon was one of the principal battlefields of the CRUSADES (1100-1300). In 1516, Lebanon became part of the Ottoman empire, and Turkish rule continued until World War 1. After the war Lebanon and Syria were mandated to France. In 1926 Lebanon gained a republican constitution. In 1945 Lebanon became fully independent. During the 1950s Lebanon's economy grew rapidly and it pursued a pro-Western foreign policy. This infuriated the Arab population and US troops were called in to crush a 1958 rebellion. Lebanon did not participate in the 1967 or 1973 ARAB-ISRAELI WARS. In the late-1960s Lebanon came under increasing military pressure from Israel to act against Palestinian guerrillas operating in s Lebanon. In 1975 civil war broke out between Maronite, SUNNI,

AREA: 10,400sq km (4,015sq mi)

POPULATION: 2,838,000

CAPITAL (POPULATION): Beirut (1,500,000) GOVERNMENT: Multiparty republic ETHNIC GROUPS: Arab (Lebanese 80%, Palestinian 12%), Armenian 5%, Syrian,

Kurdish

LANGUAGES: Arabic (official)

RELIGIONS: Islam 58%, Christianity 27%,

Druse

CURRENCY: Lebanese pound = 100 piastres

SHITTE and DRUSE militias. About 50,000 Lebanese died and the economy was devastated. In 1976 Syrian troops imposed a fragile ceasefire. In 1978 Israel invaded s Lebanon to destroy Palestinian bases. UN peacekeeping forces were called in to separate the factions. In 1982 Israel launched a full-scale attack on Lebanon. The 1983 deployment of US and European troops in Beirut was met by a terrorist bombing campaign. Multinational forces left in 1984, and Israeli troops withdrew to a buffer zone in s Lebanon. In 1987 Syrian troops moved into Beirut to quell disturbances. In 1990 an uneasy truce was called and the government began to disarm the militias. Syria maintained troops in West Beirut and the Bekaa Valley. The Syrian-backed HEZBOLLAH and the Israeli-backed South Lebanon Army (SLA) continued to operate in s Lebanon.

POLITICS

In 1995 President Elias Hrawi's term in office was extended for three years. In 1996 Israel launched attacks on Hezbollah guerrilla bases in s Lebanon, in retaliation for terrorist strikes in Israel. Hostilities continued into 1998.

ECONOMY

Lebanon is an historically important commerce and trading centre for the Middle East. The civil war devastated its valuable tourism, trade and financial sectors. Manufacturing was also badly damaged. Manufactures include chemicals, electrical goods, and textiles. Farm products include fruits, vegetables and sugar beet.

▶ Leigh Although she epitomized in looks and manner an English lady, the English actress Vivien Leigh in fact will be most remembered for her two Academy-Award winning roles as American heroines, Scarlet O'Hara in *Gone with the Wind*, and Blanche du Bois in *A Streetcar Named Desire*. Suffering from tuberculosis for much of her career, she was often exhausted while working on set.

tions, including a calculating machine (1671). His discovery of differential and integral CALCULUS was made independently of Sir Isaac Newton. He created a rationalist form of metaphysics, according to which the universe comprises a hierarchy of constituents (monads) with God at the top asserting a divine plan. This belief led him to argue that evil is divinely motivated. His major works include *New Essays Concerning Human Understanding* (1765) and *Monadology* (1898).

Leicester, Robert Dudley, Earl of (1532–88) English courtier. He was a favourite of Queen ELIZABETH I, who ennobled him and gave him the castle of Kenilworth, Warwickshire, England. Marriage to Elizabeth seemed possible, but instead, Elizabeth proposed his marriage to MARY, QUEEN OF SCOTS, who rejected him. Leicester unsuccessfully led (1585–87) an English force in the Revolt of the Netherlands against Spain.

Leicester City in central England; county town of Leicestershire. It was founded in the 1st century AD as a Roman town (Ratae Coritanorum). Leicester was conquered by the Danes in the 9th century. The city is famous for the manufacture of hosiery and footwear. Pop. (1994) 297,000.

Leicestershire County in E central England; the county town is LEICESTER. The area is drained chiefly by the Soar and Wreak rivers. The uplands of the E are devoted to farming; the w has more industry. Wheat, barley, sheep and dairy cattle are important, and the region is famous for its hosiery, Stilton cheese and Melton Mowbray meat pies. Area: 2,553sq km (986sq mi). Pop. (1994) 916,900.

Leiden (Leyden) City on the River Oude Rijn, w Netherlands, 15km (9mi) NE of The Hague. Leiden received its city charter in the 13th century and soon developed a flourishing textile industry. The Pilgrim Fathers lived in the city before setting out for America in 1620. Industries: textiles, printing and publishing, food processing, metalworking. Pop. (1993) 192,000.

Leif Ericsson (*c*.970–1020) Norse adventurer and explorer. Son of ERIC THE RED, he sailed from Greenland in 1003 to investigate land in the west. He visited Helluland (probably Baffin Island), Markland (Labrador) and Vinland.

Leigh, Mike (1943–) English film director, playwright and screenwriter. His debut feature, Bleak Moments (1971), established his reputation for innovative social realism. After a long break, he made the acclaimed High Hopes (1988) and the similarly satirical Life is Sweet (1990). Naked (1993) and Secrets and Lies (1995) have gained Leigh international recognition. Leigh, Vivien (1913–67) British film and stage actress. She received an Academy Award for her performance as Scarlett O'Hara in Gone With The Wind (1939). She also received an Oscar for her moving portrayal of Blanche du Bois in A

Streetcar Named Desire (1951). She was married to Laurence OLIVIER from 1937 to 1960.

Leinster Province in E Republic of Ireland, comprising the counties of Carlow, Dublin, Kildare, Kilkenny, Laoighis, Longford, Louth, Meath, Offaly, Westmeath, Wexford and Wicklow. It is the most populous of Ireland's four provinces, and includes the most fertile farmland in the country. The major city is DUBLIN. Area: 19,635sq km (7,581sq mi). Pop. (1991) 1,860,949.

Leipzig City in E central Germany, at the confluence of the Pleisse, White Elster and Parthe rivers. It was founded as a Slavic settlement in the 10th century. In 1813 it was the scene of the Battle of the Nations. It was home to J.S. Bach for 27 years and is the birthplace of Richard Wagner. It was East Germany's second-biggest city (after Berlin). The printing industry (founded in 1480) is still important. Industries: textiles, machinery, chemicals. Pop. (1993 est.) 494,200.

leitmotiv German word for a guiding theme in musical compositions. It is a theme that recurs throughout a work, usually an opera or a piece of programme music, and is evocative of an idea or a character on each occasion.

Leitrim County in Connacht province, N Republic of Ireland, narrowly bounded on the Nw by Donegal Bay; the capital is Carrick-on-Shannon. Hilly in the N, undulating in the s, it is drained by the River Shannon and its tributaries. Although farming is the main occupation, the soil is not highly productive. Area 1,525sq km (589sq mi). Pop. (1991) 25,301.

Lely, Sir Peter van der Faes (1618–80) Dutch portrait painter, active in England. Principal Painter to CHARLES II, he is associated with the Restoration court. He established the tradition of the society portrait, which survived unchallenged until the advent of HOGARTH in the mid-18th century. His best-known paintings include two series, *The Windsor Beauties* and the famous *Admirals*.

Lemaître, Abbé Georges Édouard (1894–1966) Belgian astrophysicist and mathematician who formulated the Big Bang theory for the origin of the universe. His book *The Primeval Atom: An Essay on Cosmogony* (1950) outlines his ideas.

Le Mans City in NW France; capital of Sarthe département. It is world-famous as the venue of the Le Mans 24-hour race for sports cars. A feature of the race was the "Le Mans start", in which drivers ran across the track to their cars, but this was discontinued after 1969. Pop. (1990) 145,502.

lemming Any of several species of herbivorous RODENTS, native to Arctic regions. They have brown fur, small ears and a short tail. They occasionally migrate in large numbers when numbers are high, and some species have been known to suffer great losses by drowning while doing so. Family Cricetidae.

lemon Evergreen tree and its familiar, sour, yellow citrus fruit. Grown primarily in the USA and in subtropical regions, it is rarely eaten raw, but is used in cooking and in drinks. Height of tree: to 6m (20ft). Family Rutaceae; species *Citrus limon*.

lemur Any of several small primitive, mainly arboreal (tree-dwelling) and nocturnal, herbivorous PRIMATES that live in Madagascar. It resembles a squirrel, but has grasping monkey-like hands with which it climbs easily. Lemurs have changed little in 50 million years, closely resembling the ancestors of man and other primates. Family Lemuridae.

Lena River in E central Russia. Rising in the Baikal Mountains, it flows N through the central Siberian uplands and empties through a wide delta into the Laptev Sea (part of the Arctic Ocean). Yakutsk is the only major town on its course. Though navigable for 3,437km (2,135mi) of its 4,400km (2,730mi) route, it is frozen from early autumn to late spring.

▶ lemur The ring-tailed lemur (Lemur catta), like the 16 or so other species of lemur, is found only in Madagascar and small neighbouring islands. The various species range in size, the smallest being no larger than a rat, while the largest reaches a similar size to a cat. All species are arboreal and omnivorous, feeding on fruit, insects and small mammals.

■ Lenin "Lenin Lived, Lenin

Lives, Lenin will always Live!".

Founder of the Bolsheviks and

the first leader of the Soviet

Union, Vladimir Ilyich Lenin

November 1917 to 1922. His

worked unceasingly for a

worldwide revolution. His

interpretation of Marxism

retained absolute authority from

desire for a workers' revolution

did not stop with Russia, and he

(Marxism-Leninism) stressed the

Party in establishing communism.

leading role of the Communist

Lenard, Philipp Eduard Anton (1862–1947) German physicist, b. Hungary. He was awarded the 1905 Nobel Prize for physics for his studies of cathode rays. His work was important in the development of electronics and nuclear physics. He researched ultraviolet light and phosphorescence.

Lendl, Ivan (1960–) Czech tennis player. He led the world rankings list for a record 270 weeks, winning a total of seven Grand Slam singles titles. He is one of the greatest players never to have won Wimbledon.

lend-lease US programme of assistance during World War 2. The Lend-Lease Act was passed in March 1941, before the USA became a combatant. It empowered President Franklin ROOSEVELT to transfer military equipment to other countries in the US national interest. The first beneficiaries were Britain and China. The programme was later extended to other allies, notably the Soviet Union.

Lenin, Vladimir llyich (1870–1924) Russian revolutionary. He evolved a revolutionary doctrine, based principally on MARXISM, in which he emphasized the need for a vanguard party to lead the revolution. In 1900 he went abroad, and founded what became the BOLSHEVIKS (1903). After the first part of the RUSSIAN REVOLUTION of 1917, he returned to Russia. He denounced the liberal republican government of KERENSKY and demanded armed revolt. After the Bolshevik revolution (November 1917), he became leader of the first and totally reorganized government and economy. He founded the third COMMUNIST INTERNATIONAL in 1919. His authority was unquestioned until he was crippled by a stroke in 1922.

Leningrad Former name for ST PETERSBURG

Lennon, John (1940–80) British singer and songwriter, a member of the Beatles. He co-wrote the majority of the Beatles' songs with Paul McCartney. In 1969 the Beatles split up and Lennon formed the Plastic Ono Band with his wife Yoko Ono (1933–). Their hit single "Give Peace a Chance" became an anthem of the peace movement. In 1971 Lennon moved to the USA and released *Imagine*. Shortly after the release of *Double Fantasy* (1980), Lennon was shot dead by a fan.

Le Nôtre, André (1613–1700) French landscape gardener. His grandiose, architectural style established the French garden as the leading style in contemporary Europe. Le Nôtre became royal gardener in 1637 and, from the 1650s, created formal gardens for some of France's grandest châteaux and palaces, such as VERSAILLES, Chantilly, and Les Tuileries in Paris.

lens Piece of transparent glass, plastic, quartz or organic matter, bounded by two surfaces, usually both spherical, that changes the direction of a light beam by REFRACTION and can produce an image. A convex lens bends light rays towards the lens axis. A concave lens bends rays away from the axis. The

and magnified or reduced in size.

Lent Period in the Christian liturgical year that precedes EASTER. In the Western Churches it begins on Ash Wednesday and is 40 days long (Sundays are not included in the count of days); in the Eastern Church it lasts 80 days (neither Saturdays nor Sundays are counted). Lent is meant to be a time of fasting, abstinence and penitence in preparation for the remembrance of the crucifixion and resurrection of Jesus Christ.

optical image may be right-side-up or inverted, real or virtual,

lentil Annual plant of the PEA family that grows in the Mediterranean region, sw Asia and N Africa. It has feather-like leaves and is cultivated for its nutritious seeds. Height: to 51cm (20in). Family Fabaceae/Leguminosae; species *Lens cultinaris*. **Lenya**, **Lotte** (c.1898–1981) Austrian singer and actress. She became famous in two notable BRECHT plays with musical scores by her husband Kurt WEILL, namely *The Threepenny Opera* (1928) and *The Rise and Fall of the City of Mahagonny* (1930). She emigrated to the USA in 1935.

Leo I, Saint (390–461) (Leo the Great) Pope (440–61). He established important points of doctrine, including the dual nature of Christ, which he propounded at the Council of Chalcedon (449). By personal meetings, he saved Rome from Attila (452) and the Vandal leader Gaiseric (455).

Leo III (c.750–816) Pope (795–816). With the help of CHARLEMAGNE, Leo imposed his rule on Rome, and crowned Charlemagne emperor on Christmas Day, 800. This historically important act strengthened papal authority in Rome and led to recognition of the pope and emperor as religious and secular leaders of Western Christendom.

Leo X (1475–1521) Pope (1513–21), b. Giovanni de' Medici, son of Lorenzo de' Medici. He continued the artistic schemes of his predecessor, Julius II, and presided over the Fifth LATERAN COUNCIL. In 1517 Martin LUTHER published his theses at Wittenberg. Leo's excommunication of Luther in 1521 marks the beginning of the REFORMATION.

León City in NW Spain; capital of León province. A military camp in Roman times, it was occupied by the Moors in the 8th century. Recaptured in 882 by Alfonso III of Asturias, it was capital of the medieval kingdom of Asturias and León until 1230. Industries: leather, cotton, textiles, iron, glass, pottery, tourism. Pop. (1991) 144,137.

León City in w Nicaragua, its second-largest city. It was

▲ leopard The leopard (Panthera pardus) and the "black panther", a member of the same species but with different coloration, are found in tropical rainforests of Africa and Asia. Powerful, agile hunters, they feed on any animal they can overpower. If they are unable to consume their prey at one sitting, leopards will drag the carcass into a tree out of reach of scavengers.

founded near Lake Managua in 1524. In 1610 a severe earthquake forced the city's reconstruction on its present site. It served as the nation's capital until 1858. In 1821, when Nicaragua gained independence from Spain, a bitter rivalry between León and Granada led to civil war. León was the scene of bitter fighting between Sandinista guerrillas and government forces in the late 1970s. Industries: food processing, leather goods, cigars, cotton. Pop. (1994 est.) 158,577.

Leonardo da Vinci (1452–1519) Florentine painter, sculptor, architect, engineer and scientist. He was the founder of the High RENAISSANCE style. By the 1470s he had developed his characteristic style of painting figures who seem rapt in a mood of sweet melancholy. In c.1482 he moved to Milan where he worked mainly for Duke Ludovico Sforza. While in Milan he worked on an altarpiece, *Madonna of the Rocks*, and the portrait of Sforza's mistress, *Lady with an Ermine*. He painted the *Last Supper* (1495–98) using a new MURAL technique, which proved unstable. When the French invaded Milan in 1499, he left for Florence. From 1500 to 1506 he created his finest paintings, including the *Mona Lisa* and the *Battle of Anghiari*. One of his last paintings is *St John the Baptist* (c.1515).

Leoncavallo, Ruggiero (1858–1919) Italian composer, mainly of operas. He travelled all over Europe working as an accompanist and composer of music-hall songs. Of his operas, *I Pagliacci* (1892) alone has withstood the test of time.

Leone, Sergio (1921–89) Italian film director, creator of the "spaghetti western". The "Man With No Name" trilogy of *A Fistful of Dollars* (1964), *For a Few Dollars More* (1965) and *The Good The Bad and The Ugly* (1966) revived Clint EASTWOOD's career. The epics *Once Upon a Time in the West* (1968) and *Once Upon a Time in America* (1984) were commercially unsuccessful but later reappraised as his masterworks.

leopard Solitary big CAT found throughout Africa and s Asia, sometimes called a panther. The coat may be yellow and white with dark spots, or almost completely black, as in the black panther. A good climber and swimmer, it feeds on birds, monkeys, antelopes and cattle. Length: to 2.5m (8ft) including the tail; weight: to 90kg (200lb). Family Felidae; species *Panthera pardus*.

Leopold I (1640–1705) Holy Roman emperor (1658–1705). Throughout his long reign, he was compelled to defend the extensive HABSBURG dominions against foreign aggression. Leopold joined the European defensive alliances against the France of Louis XIV in 1686, 1689 and 1701, but died before the end of the War of the SPANISH SUCCESSION.

Leopold I (1790–1865) First king of independent Belgium (1831–65). Son of the duke of Saxe-Coburg-Saalfield, he became a British subject after marrying the daughter of the future King George IV (1816). He refused the throne of Greece in 1830, but accepted that of Belgium after it declared its independence from the Netherlands. He was an important influence on the young Queen VICTORIA, his niece, and was largely responsible for her marriage to Prince Albert.

Leopold II (1835–1909) King of Belgium (1865–1909). He initiated colonial expansion and sponsored the expedition (1879–84) of Henry Stanley to the Congo. In 1885 he established the Congo Free State (ZAÏRE), under his own personal

rule. Following reports of appaling exploitation, he was forced to cede the Congo to the Belgian state (1908).

Leopold III (1901–83) King of Belgium (1934–51). When the Germans invaded Belgium (1940) during World War 2, he declined to accompany the government into exile and surrendered. He remained in Belgium during the war, until removed to Germany in 1944. On his return, he encountered such fierce opposition that he abdicated in favour of his son, Baudouin.

Lepanto, Battle of (1571) Naval engagement in the Gulf of Patras, off Lepanto, Greece, between Christian and Ottoman fleets. The last great battle between fleets of war galleys, it was the first major victory of the Christians over the Turks.

lepidoptera Order of insects which includes MOTHS and BUTTERFLIES found in every continent except Antarctica. Wingspan: 4–300mm (0.16–12in).

leprosy (Hansen's disease) Chronic, progressive condition affecting the skin and nerves, caused by infection with the microorganism *Mycobacterium leprae*. There are two main forms. Lepromatous leprosy is a contagious form in which raised nodules appear on the skin and there is thickening of the skin and peripheral nerves. In tuberculoid leprosy there is loss of sensation in parts of the skin, sometimes with loss of pigmentation and hair. Now confined almost entirely to the tropics, leprosy can be treated with a combination of drugs, but the nerve damage is irreversible.

lepton One of a class of ELEMENTARY PARTICLES. There are 12 types, including the ELECTRON and electron-NEUTRINO, muon and muon-neutrino, tau and tau-neutrino, together with their antiparticles (antileptons). Leptons are governed by the WEAK NUCLEAR FORCE, the force involved in radioactive decay. They have no QUARK substructure.

Le Sage, Alain René (1668–1747) French novelist and dramatist. The best known of his 100 or so comedies is *Crispin, Rival of his Master* (1707). His novel *Histoire de Gil Blas de Santillane* (1715–35) is the first masterpiece of PICARESQUE fiction.

lesbianism Term that describes female HOMOSEXUALITY Lesbos (Lesvos or Mylini) Third-largest Greek island, 10km (6mi) off the NW coast of Turkey, in the Aegean Sea; the capital is Mitilíni. Lesbos was settled by the Aeolians c.1000 BC. In the 7th and 6th centuries BC it was a cultural centre. It was held at various times by Persia, the Greek city-states, Macedonia, Rome and Byzantium. The Ottoman Turks occupied the island from 1462-1913, when it passed to Greece. Products include olives, wheat, grapes and citrus fruits. Industries: fishing and tourism. Area: c.1630sq km (630sq mi). Pop. (1991) 103,700. Lesotho (formerly Basutoland) Enclave kingdom within the Republic of South Africa; the capital is MASERU. Land and climate The scenic Drakensberg Range forms Lesotho's NE border with KwaZulu-Natal, and includes its highest peak, Thabana Ntlenyana, at 3,482m (11,424ft). Most people live in the w lowlands, site of Maseru, or in the s valley of the River ORANGE. All land in Lesotho is held by the king in trust for the SOTHO nation. Lesotho's climate is greatly affected by altitude; 66% of the land lies above 1,500m (4,921ft). Maseru has warm summers and cold winters. Rainfall averages c.700mm (28in). Grassland covers much of Lesotho. Trees and shrubs grow in sheltered valleys. History and Politics The early 19th-century tribal wars dispersed the Sotho. In the 1820s a Sotho kingdom was formed by Moshoeshoe I in present-day Lesotho. Moshoeshoe I resisted Boer and British attempts at colonization, but was finally forced to yield to the British, and in 1868 the area became a protectorate. In 1871 it became part of the British Cape Colony, but after British failure to disarm the Sotho, the area fell under direct rule. Sotho opposition to incorporation into the Union of South Africa saw the creation of the independent kingdom of Lesotho in 1966. Moshoeshoe II, great-grandson of Moshoeshoe I, became king. In 1970 Leabua Jonathan suspended the constitution and banned opposition parties. The next 16 years were characterized by civil conflict between government and Basuto Congress Party (BCP) forces. In 1986 a military coup led to the reinstatement of Moshoeshoe II. In 1990 Moshoeshoe II was deposed and replaced by his son, Letsie III. The BCP won the 1992 multiparty elections and the military council was dissolved. In 1994 Letsie III attempted to overthrow the government. In January 1995 Moshoeshoe II was restored to the throne. His death in 1996 saw the restoration of Letsie III. In 1997 the prime minister and former BCP leader, Ntsu Mokhehle, established a new political party, the Lesotho Congress for Democracy (LCD). A majority of BCP politicians joined the LCD, thus turning the BCP into the official opposition. **Economy** Lesotho is a low-income, less-developed country (1992 GDP per capita, US\$1,060). It lacks natural resources. Agriculture is the main activity. Major products include beans, cattle, hides and skins, maize, wool and wheat. Light manufacturing and expatriates' remittances from working abroad (mainly in South African mines) are the other main sources of income. Manufactures include processed food, handicrafts and textiles. Tourism is developing.

less developed countries (LDCs) Those countries (primarily of Africa, Asia and Latin America) that have little or no industrial base. Characteristically, they have high rates of population growth, high infant mortality, short life expectancy, low levels of literacy, and poor distribution of wealth. Since the late 1980s, some countries, especially in Asia and Latin America, have experienced rapid economic development, resulting in greater differences between the less developed countries.

Lesseps, Ferdinand Marie, Vicomte de (1805–94) French diplomat and engineer. He conceived the idea of a canal through the isthmus of Suez, linking the Red Sea with the Mediterranean. He formed the SUEZ CANAL Company, securing finance from the French government. Digging was begun in 1859 and the canal was opened in November 1869. His scheme to construct the PANAMA CANAL without using a system of locks began in 1879, but was abandoned seven years later with the failure of De Lesseps' company.

Lesser Antilles See Antilles

Lessing, Doris May (1919–) British novelist, b. Persia (Iran), who was brought up in Rhodesia (Zimbabwe). Lessing's debut novel, *The Grass Is Singing* (1950), is a story of racial hatred. Her *Children of Violence* quintet explores the social position of women; *The Golden Notebook* (1962) is a key feminist text. She also wrote the science fiction quintet *Canopus in Argos*, of which *The Making of the Representative for Planet 8* (1982) is best known. Her novel *The Good Terrorist* (1985) was shortlisted for the Booker Prize.

Lessing, Gotthold Ephraim (1729–81) German philosopher, writer and critic. He revealed his commitment to the German enlightenment in the verse play *Nathan the Wise* (1779). His other plays include *Miss Sara Sampson* (1755) and *Emilia Galotti* (1772).

Lethe In Greek mythology, the river of forgetfulness in HADES. All who drank from it lost their memories of past lives. **lettuce** Edible annual plant that is widely cultivated for use in salads. Most varieties of *Lactuca sativa* are cool-weather crops. The large leaves form a compact head or loose rosette. **leucite** Grey or white feldspar mineral, a potassium aluminium silicate, KAl(SiO₃)₂. Unstable at high pressures, it can be found in potassium-rich lava flows and volcanic plugs. Hardness 5.5–6: s.g. 2.5.

leucocyte White blood cell, a colourless structure containing a NUCLEUS and CYTOPLASM. There are two types of leucocytes – LYMPHOCYTES and PHAGOCYTES. Normal blood contains 5,000–10,000 leucocytes per cu mm of blood. Excessive numbers of leucocytes are seen in such diseases as LEUKAEMIA.

leukaemia Any of a group of cancers in which the bone marrow and other blood-forming tissues produce abnormal numbers of immature or defective LEUCOCYTES. This over-production suppresses output of normal blood cells and PLATELETS, leaving the person vulnerable to infection, anaemia and bleeding. Acute lymphoblastic leukaemia (ALL) is predominantly a disease of childhood; acute myelogenous leukaemia (AML) is mainly seen in older adults. Both are potentially curable.

Le Vau, Louis (1612–70) French architect. Inspired by contemporary Italian Baroque buildings, he evolved a classic 17th-century French style, seen most spectacularly in his designs for the Palace of Versallles (1669–85).

levée Natural embankment formed alongside a river by the deposition of silt when the river is in flood. Levées can help

to prevent flooding, and are sometimes built up and strengthened artificially. On some large rivers, such as the Mississippi, they may reach heights of more than 15m (50ft).

Levellers (1645–49) Members of a radical movement in England in the Commonwealth period (c.1645–57). They wanted sweeping parliamentary reform, religious toleration and a fairer, more egalitarian society. Their leaders, including John Lilburne, presented a constitution to Oliver Cromwell in 1647. When their demands were not met, several mutinies broke out in the army, resulting in their suppression.

lever Simple machine used to multiply the force applied to an object, usually to raise a heavy load. A lever consists of a rod and a point (fulcrum) about which the rod pivots. In a crowbar, for example, the applied force (effort) and the object to be moved (load) are on opposite sides of the fulcrum, with the point of application of the effort farther from the fulcrum. Leverrier, Urbain Jean Joseph (1811–77) French astronomer. In 1845 he predicted that a planet (which he prematurely named Vulcan) lay within the orbit of Mercury, but it was never found. More successful was his prediction, independently of John Couch Adams, that an unknown planet (Neptune) was responsible for discrepancies between the calculated and observed orbital motion of Uranus.

Levi, Primo (1919–87) Italian writer. A Jew, Levi joined a guerrilla movement in World War 2. He was captured and sent to Auschwitz. He survived, but was haunted by the HOLOCAUST. His books, such as *If This is a Man* (1947), *The Truce* (1963) and *The Periodic Table* (1984), are attempts to deal with his experiences. He committed suicide.

■ Lessing British novelist
Doris Lessing drew heavily on
her childhood experiences in
Rhodesia (now Zimbabwe) to
create her best-known work,
The Grass is Singing (1950).
The novel's exploration of racial
and sexual themes made her
unpopular with the Rhodesian
authorities

Levine, James (1943–) US pianist and conductor. He was principal conductor (1973) and then musical director (1975) of the New York METROPOLITAN OPERA. In 1982 he made his debut at Bayreuth and is a leading interpreter of Wagner.

Lévi-Strauss, Claude (1908–90) French anthropologist, founder of structural anthropology, which explores the underlying structures of social organization. Lévi-Strauss became professor of anthropology at the College of France in 1959 and was elected to the Académie Française in 1973. His books include *The Elementary Structures of Kinship* (1949) and *Structural Anthropology* (1958).

Levites Clan of religious officials in ancient Israel. It is possible that they once constituted one of the 12 tribes of Israel mentioned in the Old Testament, descended in this case from Levi, the third son of JACOB by his first wife Leah. After the building of the Temple of Jerusalem, Levites performed the lesser religious services. By the time of Jesus Christ, the Levites ran the entire Temple organization with the sole exception of the actual priesthood.

Leviticus Third book of the PENTATEUCH or TORAH. It is primarily a manual for the instruction of priests on ritual technicalities.

Lewes, George Henry (1817–78) English journalist and critic. He wrote dramatic criticism as well as philosophical works, including *A Biographical History of Philosophy* (1845) and the hugely successful *The Life and Works of Goethe* (1855). Separated from his wife, he lived with George ELIOT, whose work he encouraged and influenced.

Lewis, Carl (Frederick Carlton) (1961–) US track and field athlete. In a glittering career, Lewis won nine Olympic gold medals: 100m, 200m, 4×100m relay and long jump (1984, Los Angeles), equalling Jesse Owens' feat; 100m and long jump (Seoul, 1988); long jump and 4×100m relay (Barcelona, 1992); and long jump (Atlanta, 1996). Lewis set 100m world records at the Seoul Olympics (9.97sec) and the 1991 World Championships (9.86sec).

Lewis, C.S. (Clive Staples) (1898–1963) British scholar, critic and author. His scholarly works include *The Allegory of Love* (1936) and *The Discarded Image* (1964). He is best known, however, for the books on religious and moral themes written after his conversion to Christianity, particularly *The Screwtape Letters* (1942) and his autobiography *Surprised by Joy* (1955). He wrote a number of highly acclaimed children's books, including the seven "Narnia" stories, beginning with *The Lion, the Witch and the Wardrobe* (1950).

Lewis, John Llewellyn (1880–1969) US trade union leader. He served as president (1920–60) of the United Mine Workers of America (UMW). After splitting with the AMERICAN FEDERATION OF LABOR (AFL) over the unionization of mass-production industries, he formed the Congress of Industrial Organizations (CIO) and was its president (1935–40) His strikes during World War 2 led to the restrictive legislation of the Smith-Connally Act (1943) and Taft-Hartley Act (1947). Lewis, Meriwether (1774–1809) US explorer. An army

officer, he was secretary to Thomas Jefferson, who chose him to lead the Lewis and Clark Expedition (1804). In 1808 he was appointed governor of Louisiana Territory. He died of a gunshot wound, either by suicide or murder.

Lewis, (Harry) Sinclair (1885–1951) US author. Lewis' debut novel Main Street (1920) introduced his central theme, the hypocrisy and parochialism of small town, Midwestern society. Babbitt (1922), often cited as his greatest work, is the story of a businessman who is forced to conform. Lewis refused the Pulitzer Prize for Arrowsmith (1925). In 1930 he became the first US author to win the Nobel Prize for literature. Lewis, (Percy) Wyndham (1884–1957) British novelist, painter and critic. Lewis was a central figure in the VORTICISM movement; he and Ezra POUND founded its periodical Blast. Often criticized for his savage imagery and extremist politics, his work was influenced by FUTURISM and NIETZSCHE. Lewis' debut novel was Tarr (1918). Other novels include The Apes of God (1930) and The Human Age trilogy.

Lewis and Clark Expedition (1804–06) US expedition to seek a route by water from the Mississippi to the Pacific Ocean. Instigated by President JEFFERSON, it was led by army

officers Meriwether Lewis and William Clark, with the assistance of a Shoshone woman, Sacajawea. It reached the Pacific at the mouth of the Columbia River and produced valuable information about the country and peoples of the Northwest. **Lexington** City in the bluegrass region of NE central Kentucky. It was named after the Battle of Lexington (1775).

tucky. It was named after the Battle of LEXINGTON (1775). The city is a famous breeding ground for thoroughbred horses. It also has the world's largest tobacco market. Industries: automobile parts, electrical machinery, distilling, bluegrass seed, oil, coal. Pop. (1992) 232,252.

Lexington and Concord, Battles of (April 1775) First battles of the American Revolution. British troops marching from Boston to Concord, Massachusetts, were intercepted by MINUTEMEN at Lexington Green. Several minutemen were killed, and the British advanced to Concord and destroyed some military supplies. During their return to Boston the British were involved in several skirmishes and suffered nearly 300 casualties.

Leyden jar Earliest and simplest device for storing static electricity, developed c.1745 in Leyden, Holland. The original electrical condenser (capacitor), it consists of a foil-lined glass jar partly filled with water and closed with a cork through which protrudes a brass rod wired to the foil. To charge the jar, friction is applied to the tip of the rod.

Lhasa Capital of Tibet (Xizang Zizhiqu) Autonomous Region, sw China, on a tributary of the Brahmaputra, at 3,600m (11,800ft) in the N Himalayas. An ancient religious centre, it was occupied by the Chinese in 1951. After the Tibetan revolt against the occupation (1959–60), many of Lhasa's temples and monasteries were closed. The 17th-century Potala Palace was the home of the DALAI LAMA. Today the city is an important trading centre, also manufacturing chemicals and processing gold and copper. Pop. (1992) 124,000.

liana Any ground-rooting woody vine that twines and creeps extensively over other plants for support; it is common in tropical forests. Some species may reach a diameter of 60cm (24in) and a length of 100m (330ft).

Liaoning Coastal province in NE China, bordering North Korea; the capital is SHENYANG. Japan conquered the Liaotung peninsula during the RUSSO-JAPANESE WAR (1904-05) and developed the province's industries and railways. It later formed part of the Japanese puppet state MANCHUKUO (1932-45). After World War 2 it fell under the joint control of Russia and China. Since 1955 it has been a Chinese province. Liaoning is the chief site of China's heavy industry. The province has rich coal and iron ore reserves and supplies 20% of China's electrical power. It includes the cities of Anshan (China's steel capital), Fushun (coal-mining centre) and Dalian (China's major port). The principal river is the Liao. Area: 151,000sq km (58,300sq mi). Pop. (1990) 39,980,000. Libby, Willard Frank (1908-80) US chemist who developed the radiocarbon dating technique. From 1941-45 he worked on the separation of isotopes for the atomic bomb. This led to his development of radioactive carbon-14 dating, for which he was awarded the 1960 Nobel Prize for chemistry. He is the author of Radiocarbon Dating (1955).

libel Permanent, false statement to a third person containing an untrue imputation against the reputation of another. Publications of any defamatory matter in permanent form (such as an article, picture, film or broadcast statement) are treated as libel. Although usually a civil offence, libel may be considered criminal in certain circumstances. In the USA, libel against public figures must be proven to have been factually incorrect and made with malicious intent.

Liberal Democrats (officially Social and Liberal Democrats) British political party, formed in Mar ch 1988 by the merger of the LIBERAL PARTY and the SOCIAL DEMOCRATIC PARTY (SDP). Since 1988 it has been led by Paddy ASHDOWN. The smallest of the main political parties, it has vigorously campaigned for PROPORTIONAL REPRESENTATION (PR). In the 1997 general elections, the Liberal Democrats more than doubled their representation in Parliament.

liberalism Political and intellectual belief that advocates the right of the individual to make decisions, usually political or religious, according to the dictates of conscience. Its modern

origins lie in the 18th-century ENLIGHTENMENT. In politics it opposes arbitrary power and discrimination against minorities. In British history its greatest influence was exercised in the 19th century. In the USA, liberalism has, since the 1930s, referred to a belief in government action to manage the economy and (from the 1960s on) to improve the position of women and racial minorities. See also LIBERAL PARTY

Liberal Party British political party. It grew out of the early 19th-century WHIG PARTY. The first official use of the name was the National Liberal Federation (1877), founded by Joseph CHAMBERLAIN. The 19th-century party drew its strength from religious dissent and the urban electorate. Its predominant interests were free trade, religious and individual liberty, financial retrenchment and constitutional reform. Its greatest leader was William GLADSTONE, who led four governments (1868-74, 1880-85, 1885-86 and 1892-94). The 1906 government of Campbell-Bannerman legalized TRADE UNIONS, reformed the House of Lords and introduced progressive SOCIAL SECURITY measures. In 1908 Herbert ASOUTH became leader and prime minister. In 1916 LLOYD GEORGE formed a coalition government with the CONSERVA-TIVE PARTY. Since the fall of that administration, it has never formed a government. It was nevertheless instrumental in keeping the LABOUR PARTY in office during two periods of minority government: in the mid-1920s by tacit support, and in 1977 by a formal arrangement (Lib-Lab Pact) to support Labour bills in Parliament. After the formation of the Social DEMOCRATIC PARTY (SDP) in 1980, the Liberal Party entered into an alliance, and then merged with it in 1987. In 1988 the Liberal members and most of the SDP formed the LIBERAL DEMOCRATS. A small, independent Liberal Party still exists. Liberal Party Canadian political party. Holding principles similar to the British LIBERAL PARTY, it was formed in 1854 by a union of the more radical elements of the Reformers. Their first administration (1873-78), under Alexander Mackenzie,

was anti-railway and advocated free trade. Under the leader-

ship of Wilfrid LAURIER (1896-1911), the Liberals supported

ethnic conciliation, independence and immigration. The party

opposed conscription in World War 2, finding support among

the French and the western Progressives. Later, it held power

under Lester Pearson (1963-68), Pierre Trudeau (1968-79,

1980-84), John Turner (1984) and Jean CHRÉTIEN (1993-). Liberia Republic in w Africa. Land and climate Liberia's Atlantic coast stretches over 500km (300mi) and is the site of the capital and chief port, MONROVIA. A narrow coastal plain rises to a plateau region. The most important rivers are the St Paul and the Cavally. Liberia has a tropical climate with high annual temperatures and humidity. Rainfall generally increases from E to W. There are two rainy seasons: May to July and October to November. Mangrove swamps and lagoons line the coast, while inland, forests cover c.40% of the land. Only 5% of the land is cultivated. History Liberia was founded in 1821 by the American Colonization Society. In 1822 the Society landed African-American former slaves at a coastal settlement, which they named Monrovia. In 1847 Liberia became a fully independent republic. For many years Americo-Liberians controlled Liberia's government. Under the leadership (1944-71) of William Tubman, Liberia's economy grew and social reforms were adopted. Tubman's successor, William R. Tolbert, was assassinated in a military coup in 1980, and Master-Sergeant Samuel Doe led the new military government. Doe's brutal and corrupt regime won a fraudulent election in 1985. In 1990 civil war broke out, and the Economic Community of West African States (ECOWAS) sent a five-nation peacekeeping force. Doe was assassinated and an interim government, led by Amos Sawyer, was formed. Recent events Civil war raged on, and by mid-1993, an estimated 150,000 people had died and hundreds of thousands were homeless. In 1995 a cease-fire was agreed and a council of state, composed of formerly warring leaders, was established. Conflict resumed when one faction's leader, Roosevelt Johnson, was dismissed from the council. A further cease-fire was agreed in July 1996. In 1997 elections, former warlord Charles Taylor and his National Patriotic Party (NPP) secured a resounding victory. Economy Civil war has devastated Liberia's economy (1992 GDP per capita, US\$1,045). Agriculture employs 75% of the workforce, mainly at subsistence level. Chief food crops include cassava, rice and sugar cane. Rubber, cocoa and coffee are grown for export. Timber is also exported. Crude materials, principally iron ore, account for over 90% of Liberia's exports. Liberia obtains revenue from its "flag of convenience", used by c.15% of the world's commercial shipping.

Liberty Bell Historic US monument housed in Independence Hall, Philadelphia. According to legend, it was rung in July 1776 to celebrate the signing of the American Declaration of Independence.

libido In PSYCHOANALYSIS, term used by Sigmund FREUD to describe instinctive sexual energy. Freud later enlarged its meaning to include all mental energy (or life energy) that accompanies strong desires.

Libreville Capital and largest city of Gabon, w central Africa, at the mouth of the River Gabon, on the Gulf of Guinea. Founded by the French in 1843 and named Libreville (Fr. Freetown) in 1849, it was initially a refuge for escaped slaves. The city has expanded with the development of the country's minerals and is now also an administrative centre. Other industries: timber (hardwoods), palm oil and rubber. Pop. (1993) 418,000. **Libya** Republic of N Africa. *See* country feature, page 398 **lice** *See* LOUSE

lichen Plant consisting of a FUNGUS in which microscopic (usually single-celled) ALGAE are embedded. The fungus and its algae form a symbiotic association in which the fungus contributes support, water and minerals, while the algae contribute food produced by PHOTOSYNTHESIS. *See also* SYMBIOSIS **Lichtenstein, Roy** (1923–97) US painter, sculptor and graphic artist. He experimented with ABSTRACT EXPRESSIONISM, but is now regarded as a leading exponent of POP ART. Among his best-known paintings are *Whaam!* (1963) and *Good Morning, Darling* (1964).

licorice See LIQUORICE

Lie, Trygve Halvdan (1896–1968) Norwegian statesman, first secretary-general of the United Nations (1946–52). He blamed both sides for the COLD WAR, but antagonized the Soviet Union by his support for UN intervention in the Korean War (1950). He was replaced by Dag HAMMARSKJÖLD.

Liebig, Baron Justus von (1803–73) German chemist. He was the first to realize that animals use oxygen to get energy from food, although he incorrectly thought that muscular power is a result of protein oxidation. Liebig also showed that plants derive their minerals from the soil, and introduced synthetic fertilizers into agriculture.

Liebknecht, Karl (1871–1919) German Communist revolutionary, son of Wilhelm LIEBKNECHT. He vigorously opposed Germany's participation in World War 1 and was imprisoned (1916–18). With Rosa LUXEMBURG, he was a leader of the communist group known as the Spartacists. After the failure of the Spartacist rising (1919), they were murdered while in police custody.

Liebknecht, Wilhelm (1826–1900) German revolutionary. After taking part in the REVOLUTION OF 1848, he was exiled to England where he became an associate of Karl Marx. In 1863 he was a founder of the Marxist German Socialist Party. His opposition to the Franco-Prussian War resulted in a spell in prison. He was elected to the Reichstag (parliament) in 1874. Liechtenstein Independent principality in w central Europe at the E end of the Alps, between Austria (E) and Switzerland (w); the capital is Vaduz. The principality was formed in 1719 through the merging of Vaduz and Schellenberg. It remained

part of the Holy Roman Empire until 1806. A member of the German Confederation from 1815, it gained independent status in 1866. In 1921 Liechtenstein entered into a currency union with Switzerland and, in 1923, a customs union. Until 1990 Switzerland also handled Liechtenstein's foreign policy. In 1990 the principality joined the United Nations. Liechtenstein has a constitutional and hereditary monarchy, the ruling family is the Austrian house of Liechtenstein. Women were not granted the right to vote until 1984. Liechtenstein is the fourth-smallest country in the world and one of the richest (1992 GDP per capita, US\$34,000). Traditionally an agricultural region, since 1945 it has rapidly developed a specialized manufacturing base. The major part of state revenue is derived from international companies, who are attracted by the low taxation rates. Tourism is increasingly important. Area: 157sq km (61sq mi). Pop. (1990) 28,777.

lie detector (polygraph) Electronic device that may be capable of detecting lies when used by a trained examiner. The lie detector monitors such factors as heart rate, breathing rate and perspiration, all of which may be affected when a person lies. Liège (Flemish, Luik) City and river port in E Belgium, at the confluence of the Meuse and Ourthe rivers; capital of Liège province. It was known in Roman times as Leodium. In 1465

LIBYA

Libya's flag was adopted in 1977. It replaced the flag of the Federation of Arab Republics, which Libya left in that year. Libya's flag is the simplest of all world flags. It represents the country's quest for a green revolution in agriculture.

AREA: 1,759,540sq km (679,358sq mi)

POPULATION: 4,875,000

CAPITAL (POPULATION): Tripoli (990,697)
GOVERNMENT: Single-party socialist state
ETHNIC GROUPS: Libyan Arab and Berber 89%,

others 11%

LANGUAGES: Arabic (official)

RELIGIONS: Islam

CURRENCY: Libyan dinar = 1,000 dirhams

The North African state of Libya consists of three geographical areas: the NW and NE Mediterranean coastal plains are home to the majority of Libya's population. The NE plain includes Libya's capital, TRIPOLI; the NW plain its second-largest city, BENGHAZI. The SAHARA occupies 95% of Libya, inhabited only at scattered oases. The desert rises to 2,286m (7,500ft) at Bette Peak, on the s border with Chad.

CLIMATE

The coastal plains have a Mediterranean climate, with hot, dry summers and mild, moist winters. Inland, the average annual rainfall drops to 100mm (4in) or less.

VEGETATION

Shrubs and grasses grow on the N coasts, with some trees in wetter areas. At the desert oases date palms provide shade from the sun.

HISTORY

The earliest known inhabitants of Libya were the BERBERS. Between the 7th century BC and the 5th century AD, the region came under the rule of Greeks, Carthaginians, Romans and Vandals. Magnificent Roman ruins survive. Arabs invaded Libya in AD 642 and Islam remains the dominant religion. From 1551 Libya was part of the Turkish Ottoman empire; power resided with local rulers or JANISSARIES. During the 17th century Barbary pirates used bases on the Libyan coast to attack shipping. In the 19th century US, British and French forces attempted to curb their power. Italy invaded Libya in 1911, and by 1914 had conquered the whole territory. Attempts at colonization were made in the 1930s and in 1939 Libya was formally incorporated into Italy. During World War 2 the country was a battleground for many of the North Africa Campaigns. Following the Allied victory Libya was placed under UN mandate until 1951, when it became an independent monarchy. In 1953 Libya joined the Arab League, and in 1955 became a member of the UN. In 1969 the king was overthrown in a military coup led by Colonel Muammar al-QADDAFI. A Revolutionary Command Council set about the nationalization of industry, the establishment of an Islamic state, and the reduction of foreign interference. In 1970 the British closed all their military bases. In 1971 Libya entered a Federation with Egypt and Syria. Libya

maintained an anti-Israel foreign policy and Qaddafi aided Palestinian guerrilla movements. During the 1980s Libyan and US relations deteriorated further. Following an attack on US forces, the USA placed an oil embargo on Libya. In 1986, following evidence of Libyan support of international terrorism, the USA bombed Tripoli and Benghazi. In 1992 Libya was accused of sheltering the terrorists responsible for the bombing of a domestic airliner over Lockerbie, UK, and has subsequently refused to extradite them to the USA or the UK. Libya has a long-standing territorial dispute with Chad, and sent troops to intervene in the civil war. In 1994 the International Court of Justice dismissed Libya's claim to the Aozou Strip in N Chad.

POLITICS

Qaddafi has attracted worldwide criticism for his support for revolutionary movements. In 1995 all Palestinians were deported from Libya in protest against the PLO-Israeli peace agreement.

ECONOMY

The discovery of oil in 1958 transformed Libya's economy. Oil revenue was used to finance welfare services and development projects. Formerly one of the world's poorest countries, it has become Africa's richest in terms of its GDP per capita (1992, US\$9,782). Oil accounts for over 95% of exports, and Libya remains a developing country because of this structural imbalance. It has oil refineries and petrochemical plants. Agriculture is important, but Libya is dependent on food imports.

the town became a protectorate of Burgundy. In 1792 it fell to the French, but was ceded to the Netherlands at the Congress of Vienna (1815). It became part of Belgium in 1830. During the 19th century it was a steel-making and coal-mining centres. Occupied by Germany in both World Wars, it was severely damaged in the Battle of the Bulge (1944–45). After World War 2, Liège's steel industry drastically declined. The modern city is a commercial centre. Industries: chemicals, electronics, armaments, textiles. Pop. (1991) 195,201.

life Feature of organisms that sets them apart from inorganic matter. Life can be regarded as the ability to obtain energy from the Sun or from food and to use this for growth and reproduction. The current theory on life's origin is that giant molecules, similar to proteins and nucleic acids, reacted together in the watery surface environment of the young Earth that is now commonly called the primordial soup. The evolution and development of cellular life out of this molecular pre-life has yet to be explained fully.

lift In AERODYNAMICS, force that acts upwards on the undersurface of an AEROFOIL, or wing. As it travels forwards, the leading edge of an aerofoil splits the airstream. Because the upper part of the airstream is forced to travel farther, its pressure falls. The lift force is a result of the upward pressure underneath the aerofoil being greater than the downward pressure on the top.

ligament Bands of tough fibrous CONNECTIVE TISSUE that join bone to bone at the joints. Ligaments, which contain COLLAGEN, form part of the supporting tissues of the body. In the wrist and ankle joints, for example, they surround the bones like firm inelastic bandages.

Ligeti, György (1923-) Hungarian composer whose avantgarde works involve shifting patterns of tone colours. After 1956, Ligeti's work on electronic sound influenced his compositions, especially Atmosphères (1961) and Lux Aeterna (1966). Since 1966, most of his work has been instrumental. light Part of the total electromagnetic spectrum that can be detected by the human eye. Visible light is in the wavelength range from c.400nm (violet) to 770nm (red). Light exhibits typical phenomena of wave motion, such as REFLECTION, REFRACTION, DIFFRACTION, light polarization and INTERFER-ENCE. The properties of light were investigated in the 17th century by Sir Isaac NEWTON, who believed in a particle theory of light. The wave theory was well-established by the second decade of the 19th century after the work of Thomas Young. At the beginning of the 20th century, experiments on the PHOTOELECTRIC EFFECT and the work of Max PLANCK revived the idea that light can behave like a stream of particles. This dilemma was resolved by the QUANTUM THEORY, according to which light consists of elementary particles called PHOTONS. When light interacts with matter, as in the photoelectric effect, energy is exchanged in the form of photons and so light seems to be particles. Otherwise, it behaves as a wave. See also ELECTROMAGNETIC RADIATION

lightning Visible flash of light accompanying an electrical discharge between clouds or between clouds and the surface, most commonly produced in a THUNDERSTORM.

light-year Unit of astronomical distance equal to the distance travelled in free space or a VACUUM by light in one tropical year. One light-year is equal to 9.4607×10^{12} km $(5.88 \times 10^{12}$ mi) **lignin** Complex non-carbohydrate substance that occurs in woody tissues (especially XYLEM of plants), often in combination with CELLULOSE. It is lignin that gives wood its strength. To obtain pure cellulose for the paper and rayon industries, the lignin has to be removed from wood.

lilac Any of 20 species of evergreen ornamental shrubs and small trees of the genus *Syringa*, which bear panicles (pointed clusters) of tiny fragrant white to purple flowers. Height: to 6m (20ft).

Lilburne, John (1614–57) English republican, leader of the Levellers. Imprisoned (1638–40) under Charles I, he fought for Parliament during the Civil War (1642–45). Captured, he escaped execution by the Royalists when Parliament arranged an exchange of prisoners. He left the army in 1645, refusing to sign the SOLEMN LEAGUE AND COVENANT. Demanding greater equality and religious freedom, he led

protests against the government of Oliver Cromwell. Often imprisoned, he spent his last years among Quakers.

Lilienthal, Otto (1849–96) German engineer and pioneer of glider design. In 1853 a glider designed by Sir George CAYLEY had carried a passenger, but this aircraft had had no controls. In 1891 Lilienthal became the first person to control a glider in flight. He made c.2500 more flights before his death in a crash. Lille (Flemish, Lisle) City in NW France, near the Belgian border; capital of Nord département. It flourished in the 16th century under the dukes of Burgundy. In the late 17th century Lille became capital of French Flanders; the building of its stock exchange established its commercial reputation. It is a major industrial, commercial and cultural city. Industries: textiles, engineering, chemicals, brewing. Pop. (1990) 172,142. Lilongwe Capital of Malawi, SE Africa, in the centre of the

Lilongwe Capital of Malawi, SE Africa, in the centre of the country, c.80km (50mi) w of Lake Malawi. Lilongwe was originally an agricultural trade centre, handling tobacco, maize and peanuts. It replaced Zomba as the capital of Malawi in 1975. It has grown rapidly to become Malawi's second-largest city. Pop. (1993) 268,000.

lily Any of numerous species of perennial, BULB-producing plants of the genus *Lilium*, from temperate and subtropical regions. They have erect stems and various leaf arrangements. The showy flowers may be almost any colour.

lily of the valley Perennial woodland plant native to Europe, Asia and E USA. It has broad, elongated leaves and bears stalks of tiny, white, bell-shaped fragrant flowers. Family Liliaceae; species *Convallaria majalis*.

Lima Capital and largest city of Peru, on the River Rímac at the foot of the Cerro San Cristóbal. Lima was founded in 1535 by Francisco Pizarro. It functioned as the capital of Spain's New World colonies until the 19th century. During the War of the Pacific, Lima was occupied by Chilean forces (1881–83). It is the commercial and cultural centre of Peru. With the oilrefining port of Callao, the Lima metropolitan area forms the third-largest city of South America, and handles over 75% of all Peru's manufacturing. Pop. (1993) 6,386,308.

limbic system Collection of structures in the middle of the brain. Looped around the HYPOTHALAMUS, the limbic system is thought to be involved in emotional responses, such as fear and aggression, mood changes, and the laying down of memories. limbo In Roman Catholic theology, abode of souls excluded from HEAVEN but not condemned to any other punishment. According to this concept, which never became doctrine, unbaptized infants go to limbo after death, as did the Old Testament prophets who died before Christ came to redeem the world.

Limbourg, Pol de (active 1380–1416) Franco-Flemish manuscript illustrator. Pol and his brothers, Jan and Hermann, became court painters to Jean, duc de Berry in 1411. Their masterpiece is a Book of Hours known as *Les Très Riches Heures du Duc de Berry* (1413–15). *See also* ILLUMINATION **lime** Name for any of the deciduous linden trees that grow throughout the N temperate zone. It has serrated, heart-shaped leaves with small, fragrant, yellowish flowers borne in clusters. The common British linden, *Tilia vulgaris*, is one of the three British species. The American lime, *T. americana*, is also called basswood. Family Tiliaceae.

lime Small tropical tree (*Citrus aurantifolia*) of the rue family (Rutaceae). The trees grow to 2.4–4.6m (8–15ft) tall and yield small green acid fruits. The juice was a valuable commodity in the 18th and 19th centuries for consumption on long sea voyages; the vitamin C helped to ward off scurvy.

Limerick City on the Shannon estuary, sw Republic of Ireland; capital of Limerick county, Munster province. In the 9th century it was sacked by Norse invaders. At the beginning of the 11th century, Brian Boru made Limerick the capital of Munster. During the 17th century the city was besieged by both the armies of Oliver Cromwell and William III. Industries: lacemaking, salmon fishing. Pop. (1993 est.) 75,436.

limestone SEDIMENTARY ROCK composed primarily of carbonates, such as calcite CaCO₃. Generally formed from deposits of the skeletons of marine invertebrates, it is used to make cement and lime and as a building material.

Limoges City on the River Vienne; capital of Haute-Vienne

▲ lily Grown mainly in temperate and tropical regions, the showy displays of colour make lilies a common sight in gardens in many regions of the world. Most lilies thrive in well-drained, moist soil and a sunny location.

▲ lime The American lime or linden (*Tilia americana*), also known as American basswood, has some of the largest leaves found on deciduous trees, with examples reaching 30cm (12in) long. In the past the wood was commonly used in carving, as it has pliability and strength.

▲ limpet The conical shell of limpets (Patella sp shown) differs from most other gastropods, which have coiled shells. Found in rocky, coastal regions of the Pacific and Atlantic, limpets remain attached to the rock by a muscular "foot", occasionally leaving their position to feed on seaweed.

▲ Lincoln US president Abraham Lincoln was born into a

Adranam Lincoin was born into a frontier family and received little formal education as a boy. After reading law, he was elected to the US House of Representatives in 1847. The highly publicized Lincoln-Douglas debates over the pro-slavery Kansas-Nebraska Act won Lincoln national fame. He went on to win the presidential election of 1860, and his dogged determination to retain the Union and refuse Southern secession brought about the start of the Civil War.

▶ ling A member of the cod family, the various species of ling (*Molva molva* shown) are commercially important fish. They are long-bodied fish, growing to 2m (7ft) and weighing up to 20kg (45lb).

département, w central France. A Roman settlement, it was later a tribal capital of the Gauls. In 1199 Richard I (the Lionheart) was killed in battle on the city outskirts. In 1370 Edward the Black Prince sacked the city. Its enamel industry culminated in the 16th-century craftsmanship of Léonard Limousin, but was devastated by the Thirty Years War. In the late 18th century, porcelain manufacturing flourished once more. Since 1945 economic expansion has been led by the exploitation of uranium mines. Pop. (1990) 133,464.

limpet Primitive gastropod MOLLUSC commonly found fixed to rocks along marine shores. It has a cap-like, rather than coiled, shell and a large muscular foot. Length: to 13cm (5in). Families: Patellacea, Acmaeidae and Fissurellidae.

Limpopo (Crocodile) River in s Africa. It rises in NE South Africa, in the former Transvaal province. It then flows in a great curve N, forming part of the border between South Africa and Botswana, then E as the border of South Africa and Zimbabwe, before crossing Mozambique to enter the Indian Ocean NE of Maputo, Length: *c*.1,770km (1,100mi).

Lin Biao (1907–71) Chinese communist general and political leader. He defeated Chiang Kai-shek in Manchuria (1948), thus helping to secure the victory of the communists in 1949. Lin was a leader of the Cultural Revolution (1966–69) and compiled the book of quotations from Mao Zedong known as the *Little Red Book*. He was designated Mao's heir in 1969 but, after disagreements with Mao, was said to have died accidentally while fleeing to the Soviet Union.

Lincoln, Abraham (1809-65) 16th US president (1861-65). He was elected to the Illinois legislature for the WHIG PARTY in 1834. He served in the US House of Representatives (1847-49) and unsuccessfully ran for the Senate for the new REPUBLICAN PARTY against Stephen A. DOUGLAS in 1858. He was nominated as Republican candidate for president in 1860. Lincoln's victory made the secession of the Southern, slave-owning states inevitable, and his determination to defend FORT SUMTER began the American CIVIL WAR. A strong commander-in-chief, he played a leading role in military planning until he found a sufficiently determined general in Ulysses S. Grant, whom he appointed overall commander in 1864. In September 1862 he issued the EMANCIPATION PROCLAMATION, and in November 1863 delivered his famous GETTYSBURG ADDRESS. Lincoln was re-elected in 1864 and saw the war to a successful conclusion. On 14 April 1865, five days after the surrender of Robert E. LEE, he was shot by John Wilkes BOOTH, a Southern sympathizer. He died the next day. Lincoln State capital and second-largest city of NEBRASKA, USA. Founded in 1856 as Lancaster, its name was changed in honour of Abraham Lincoln. The city was made state capital when Nebraska was admitted to the Union in 1867. Lincoln is a centre for livestock and grain, and more recently for insurance. Industries: rubber products, pharmaceuticals, agricultural equipment. Pop. (1990) 191,972.

Lincoln City in E England; the county town of Lincolnshire. Founded by the Romans as Lindum Colonia, it thrived on its wool trade until the 14th century. The castle was begun in the reign of William I. Lincoln Cathedral (begun *c.*1073) has one of the original copies of the Magna Carta. Industries: agricultural and automobile parts. Pop. (1991) 81,900.

Lincolnshire County in E England, bordering the North Sea; the county town is Lincoln. The area was settled by the Romans and an Anglo-Saxon kingdom was later established in Lindsey. In the Middle Ages it was a prosperous farming region. In 1974 part of N Lincolnshire was incorporated into the authority of Humberside. Apart from the undulating Wolds, the region is flat, drained by the Trent, Welland and Witham rivers. Agriculture, mainly cereals, sugar beet and sheep, is the mainstay of the economy, and local industries are closely allied to it. Area: 5,886sq km (2,273sq mi). Pop. (1994) 605,800.

Lind, Jenny (Johanna Maria) (1820–87) ("The Swedish nightingale") Sweden's most famous operatic soprano. She made her debut in 1838, and after world success in coloratura roles she settled in London (c.1852), where she sang in oratorio and taught at the Royal College of Music.

Lindbergh, Charles Augustus (1902–74) US aviator. He became an international hero when, in *The Spirit of St Louis*,

he made the first nonstop transatlantic solo flight, from New York to Paris (1927) in 33 hours 30 minutes. In 1932 his baby son was kidnapped and murdered.

Lindisfarne Gospels Manuscript illuminated in the Hiberno-Saxon style in the late 7th or 8th century. It may have been executed for Eadfrith, Bishop of Lindisfarne (698–721). It is now held in the British Museum, London.

linear script Early form of writing, found on clay tablets in Crete and Greece. **Linear A** was in extensive use during the middle period of the MINOAN CIVILIZATION (c.2100–c.1550 BC). **Linear B** was an adaptation of Linear A, used by the MYCENAEAN CIVILIZATION of mainland Greece to write their early form of Greek. Linear B was used from c.1450 BC to the end of the Mycenaean period (c.1120 BC). In 1952 Michael Ventris deciphered Linear B; Linear A still defies analysis.

Lineker, Gary Winston (1960–) English footballer. Lineker was the leading scorer in the 1986 World Cup finals in Mexico. He then moved to Barcelona before following manager Terry Venables to Tottenham Hotspur (1989). He scored 48 goals in 80 internationals, failing by one goal to equal Bobby Charlton's scoring record for England. He retired from football in 1995 and took up sports journalism.

linen Yarn and fabric made of fibres from the FLAX plant. The fibres are released from the substance that binds them by retting (soaking) the long stems in water. After sorting, the fibres are spun to form yarn, which is then woven.

ling See HEATHER

ling Food fish related to the COD found in the Atlantic Ocean. It is brown and silver and has long dorsal and ventral fins. Length: to 2m (7ft); weight: 3.6kg (8lb). Family Gadidae; species *Molva molva*.

lingua franca Language that serves as a medium of communication between people who otherwise lack a common tongue. A lingua franca may be a simplified form of the language of the dominant power, such as PIDGIN English, or it may be a hybrid, such as SWAHILI, which consists of words of both Arabic and Bantu origins.

linguistics Systematic study of LANGUAGE, its nature, its structure, its constituent elements, and the changes it may undergo. As a discipline, linguistics embraces PHONETICS, phonology (the study of sound systems within languages), GRAMMAR (including SYNTAX), SEMANTICS and pragmatics (the study of language use).

Linnaeus, Carolus (1707–78) (Carl von Linné) Swedish botanist and taxonomist. His *Systema Naturae* (1735) laid the foundation of the modern science of TAXONOMY by including all known organisms in a single classification system. He was one of the first scientists to define clearly the differences between species, and he devised the system of BINOMIAL NOMENCLATURE, which gave standardized Latin names to every organism.

linnet Small songbird of the family Carduelidae. *Carduelis cannabina* of Europe inhabits hedgerows and thickets, moving to open country in colder seasons. Both sexes are brown and grey, but the male has a red breast and crown in the summer. Length: to 13cm (5in).

linseed See FLAX

linseed oil Oil pressed from seeds of cultivated FLAX (*Linum usitatissimum*). Because of its drying qualities, it is an important ingredient of oil paints and printing inks and is used to make VARNISH and linoleum.

Linz City and major port on the Danube River; capital of Upper Austria, NW Austria. Founded in Roman times as Lentia, it became a provincial capital of the Holy Roman Empire in the late 15th century. Austria's third-largest city, Linz is a commercial and industrial centre. Manufactures include iron and steel, chemicals and fertilizers. Pop. (1991) 203,044.

lion Large CAT that lives on African savannas s of the Sahara and in Sw Asia. It is golden yellow with light spots under the

eyes. The male is instantly recognizable by its deep neck mane, which darkens with age. The female does most of the hunting and preys on antelopes, zebras and bush pigs. Length: to 2.5m (8.5ft) overall. Family Felidae; species *Panthera leo*. **Lipchitz, Jacques** (1891–1973) French sculptor, b. Lithuania. He created one of the first cubist sculptures, *Man with Guitar* (1914), exploring the concept of faceted planes and multiple viewpoints. After moving to the USA in 1941 his work became more spiritual and more solid in structure. Among his most representative works are *Sailor with a Guitar* (1914), *Harpist* (1928) and *Prayer* (1943). *See also* CUBISM

Li Peng (1928–) Chinese political leader. A protégé of Zhou Enlai, he studied electrical engineering in Moscow, returning to China in 1955. He rose rapidly in the political hierarchy, becoming deputy premier (1983) and a member of the politburo in 1985. Though seen as a moderate reformer, he was careful not to alienate the powerful conservative elements in government. He became premier in 1987. During the prodemocracy demonstrations of 1989 he declared martial law, leading to the military intervention against students demonstrating in TIANANMEN SQUARE, Beijing.

lipid One of a large group of fatty organic compounds in living organisms. They include animal fats, vegetable oils and natural waxes. Lipids form an important food store and energy source in plant and animal cells.

Li Po (701–62) Chinese poet of the T'ANG dynasty, regarded as one of the two greatest poets in CHINESE LITERATURE. Unlike his contemporary and rival, Tu Fu (a Confucian), Li Po was a Taoist and the influence of TAOISM can be seen in the sensual and spiritual aspects of his work. His poetry is characterized by its vivid imagery, spontaneity and emotion. **Lippi, Filippino** (1457–1504) Florentine painter, son of Fra

Lippi, Filippino (1457–1504) Florentine painter, son of Fra Filippo LIPPI. He studied with BOTTICELLI. He completed the frescos of MASACCIO in *Santa Maria del Carmine* (1484). His work is shown to full effect in his fresco cycles in the Caraffa Chapel, Santa Maria sopra Minerva, Rome (1488–93) and the Strozzi Chapel, Santa Maria Novella, Florence. He also painted altarpieces, notably *The Vision of St Bernard* (c.1480, Badia, Florence).

Lippi, Fra Filippo (1406–69) Florentine painter. His early work shows the influence of MASACCIO, but from c.1440 he developed his own style. His most characteristic subject was the Virgin and Child, which he sometimes painted in an innovative circular format. His finest fresco cycle depicts the lives of St Stephen and St John in Prato Cathedral. Lippi was a major influence on the 19th-century PRE-RAPHAELITE BROTHERHOOD. **liquid** State of MATTER intermediate between a GAS and a SOLID. A liquid substance has a relatively fixed volume but flows to take the shape of its container. The state that a substance assumes depends on the temperature and the pressure at which it is kept; a substance that is liquid at room temperature, such as water, can be changed into a vapour (its gaseous state, steam) by heating, or into a solid (ice) by cooling.

liquid crystal Substance that can exist half-way between the liquid and solid states with its molecules partly ordered. By applying a carefully controlled electric current, liquid crystals turn dark. They are used in liquid crystal displays (LCDs) to show numbers and letters, as in pocket calculators. liquorice (licorice) Perennial plant of the PEA family, native to the Mediterranean region and cultivated in temperate and subtropical areas. It bears spikes of blue flowers. The dried

roots are used to flavour confectionery, tobacco, beverages and medicines. Height: to 90cm (3ft). Family Fabaceae/Leguminosae; species *Glycyrrhiza glabra*.

Lisbon (Lisboa) Capital, largest city and chief port of Portugal, at the mouth of the River TAGUS, on the Atlantic Ocean. An ancient Phoenician settlement, the city was conquered by the Romans in 205 BC and fell to the Moors in 716. In 1147 the Portuguese reclaimed the city, and in 1260 it became the nation's capital. It declined under Spanish occupation from 1580–1640. Lisbon was devastated by an earthquake in 1755. Modern Lisbon is a busy international port and tourist centre. Industries: steel, shipbuilding, chemicals, oil, sugar refining. Pop. (1991) 2,561,000.

Lissitzky, El (Eliezor Markovich) (1890–1941) Innovative Russian painter. MALEVICH inspired him to create a series of paintings that simulate 3-D architectonic constructs. In 1921 he arranged an important exhibition in Berlin of contemporary Russian ABSTRACT ART. He also contributed designs to constructivist periodicals and had his ideas promoted at the BAUHAUS. See also CONSTRUCTIVISM

Lister, Joseph, 1st Baron (1827–1912) British surgeon who introduced the principle of antisepsis, which complemented PASTEUR's theory that bacteria cause infection. Using carbolic acid (phenol) as the ANTISEPTIC agent, and employing it in conjunction with heat sterilization of instruments, he brought about a dramatic decrease in post-operative fatalities. Liszt, Franz (1811–86) Hungarian composer and pianist. He was patron to many great artists of his day, notably Frédéric Chopin and Edvard Grieg. His music influenced subsequent composers including Wagner (who married Liszt's daughter Cosima), Richard Strauss and Maurice Ravel. Among his compositions are two piano concertos, Hungarian rhapsodies and a plethora of piano, orchestral and choral pieces.

literary criticism Discipline concerned with literary theory and the evaluation of literary works. The long Western tradition of literary criticism effectively began with PLATO's comments on the role of poets in his *Republic*; ARISTOTLE's response to this, the *Poetics*, represents the first systematic attempt to establish principles of literary procedure. Notable

Liquid-crystal displays use the property of liquid crystals to twist the polarization of light to produce numbers or symbols. Incoming light (1) is first regimented in one plane by a polarizer (2) before it passes through the first of two plates of glass (3) on which are fixed electrodes (4). Seven electrodes are needed to represent Arabic numerals. The liquid crystal is

between the two plates of glass and twists light (5) passing through uncharged electrodes (6). This light can pass through the second polarizer (7) and can be seen. The light passing through the charged electrodes (8) is not twisted (9), is blocked by the polarizer, and cannot be seen forming the components of the number (10).

■ lion Prides of lions (Panthera leo) are commonly seen lazing in the shade of a tree. Lionesses, which lack manes, do most of the killing, often working as a team to stalk prey. Lions themselves have no natural enemies except humans.

later contributions to the debate include Sir Philip Sidney's The Defence of Poesie (1595); D'RYDEN'S Of Dramatick Poesie (1668); WORDSWORTH'S preface to Lyrical Ballads (1798); SHELLEY'S A Defence of Poetry (1820); and Matthew Arnold'S Culture and Anarchy (1869). The 20th century has seen an explosion of literary critical effort, both concerning literary theory and evaluating past and present works, notably among which are the writings of T.S ELIOT, I.A. RICHARDS, William EMPSON and F.R. LEAVIS; also important are the writings of STRUCTURALISM and post-structuralism, notably Roland Barthes, Michel Foucault and Jacques Derrida. The late 20th century saw the emergence of critical approaches such as DECONSTRUCTION and FEMINISM.

literature Collections of writings, usually grouped according to language, period and country of origin. Within such groupings, literature may be further divided into forms, such as POETRY and PROSE, and within these again into categories, such as verse drama, non-fiction prose, novels, epic poems, tragedies, satires and so on. *See also* LITERARY CRITICISM

lithium (symbol Li) Common silvery metallic element, one of the ALKALI METALS, first isolated in 1817. Ores include lepidolite and spodumene. Chemically it is similar to sodium. The element, which is the lightest of all metals, is used in alloys, and in glasses and glazes; its salts are used in medicine. Properties at.no. 3; r.a.m. 6.941; r.d. 0.534; m.p. 180.5°C (356.9°F); b.p. 1,347°C (2,456.6°F); most stable isotope Li⁷ (92.58%).

lithography In art, method of printing from a flat inked surface. In traditional lithography, invented in the 1790s, the design is made on a prepared plate or stone with a greasy pencil, crayon or liquid. Water applied to the surface is absorbed where there is no design. Oil-based printing ink, rolled over the surface, sticks to the design, but not to the moist areas. Pressing paper onto the surface produces a print. Today, many magazines, books and newspapers are produced by OFFSET printing. **lithosphere** Upper layer of the solid EARTH which includes the CRUST and the uppermost MANTLE. Its thickness varies, but is *c.*60km (40mi); it extends down to a depth of *c.*200km (125mi). It is rigid, solid and brittle, and is made up of a number of tectonic plates that move independently, giving rise to PLATE TECTONICS.

Lithuania Baltic republic in NW Europe; the capital is VILNIUS. **Land and climate** Lithuania is a mostly lowland country, with SE highlands. Ice Age moraine covers most of Lithuania and includes over 2,800 lakes. The longest river is the Neman, which rises in Belarus and flows through Lithuania to the Baltic Sea. Winters are cold: average January temperature -5° C (23°F). Summers are warm: average July

temperature 17°C (63°F). Average rainfall is c.630mm (25in). Farmland covers c.75% of Lithuania, and forests only 16%. History The first independent, unified Lithuanian state emerged in 1251, and by the 14th century had expanded E as far as Moscow. In 1386 Lithuania entered into a dynastic union with Poland. The two countries were unified as a Commonwealth in 1569. The final partition of Poland saw Lithuania become part of the Russian empire (1795). Enforced Russification strengthened Lithuanian nationalist resolve. In February 1918 Lithuania declared its independence. In 1920 it signed a peace treaty with the SOVIET UNION, and Poland captured Vilnius. In 1926 a military coup established a dictatorial government. In 1940 the Soviet Union annexed Lithuania as a Soviet republic. In 1941 German troops occupied Lithuania and many Lithuanian Jews were murdered. Soviet troops recaptured the territory in 1944. Nationalist demands forced the Lithuanian Communist Party to agree to multiparty elections in 1989. The 1990 elections were won by the nationalists, and Lithuania proclaimed its independence. In January 1991 Soviet troops and nationalist forces fought on the streets of Vilnius. A referendum voted overwhelmingly in favour of independence, and the Soviet Union recognized Lithuania as an independent republic in September 1991. Politics The Democratic Labour Party, containing many excommunists, won 1992 elections. In 1993 Algirdas Brazauskas, a former Communist Party chairman, became president and Soviet troops completed their withdrawal. In 1996 Lithuania signed a treaty of association with the European Union (EU). In 1997 Valdas Adamkus was elected president. Economy As a Russian republic, Lithuania rapidly industrialized. Since independence it has experienced many problems of transition from a command economy into a more market-oriented one. Lithuania is a developing country (1992) GDP per capita, US\$3,700). It lacks natural resources and is dependent on Russian raw materials. Manufacturing is the most valuable export sector: major products include chemicals, electronic goods and machine tools. Dairy and meat farming and fishing are also important activities.

litmus Dye that is purple in neutral aqueous solutions; it is used to indicate acidity (turning red) or alkalinity (turning blue). It is most familiar in the form of litmus paper used as an acid-base indicator. The dye is extracted from lichens. *See also* PH

litre (symbol 1 or L) Metric unit equal to a cubic decimetre, one thousandth of a cubic metre. Another definition, used from 1901 to 1968, was that 1 litre equalled the volume of 1kg of pure water at 4°C (39°F). A litre is equivalent to 0.22 imperial gallons or 0.264 US gallons.

Little Bighorn, Battle of (June 1876) Victory of SIOUX and CHEYENNE Native Americans against the US cavalry led by Colonel George CUSTER. Sometimes known as "Custer's Last Stand", it was the last major victory of Native Americans against the US army. The cavalry regiment of 225 men was annihilated by the Sioux, led by SITTING BULL and CRAZY HORSE, near the Little Bighorn River in Montana.

Little Richard (1935–) US singer-songwriter and pianist, b.

Richard Penniman. He achieved fame in the late 1950s with songs such as "Tutti Frutti" (1956) and "Good Golly Miss Molly" (1958). After a near-fatal plane accident, he was ordained a minister in the Church of the Seventh Day Adventists and has oscillated between music and ministry ever since. Little Rock State capital and largest city of Arkansas, on the Arkansas River, USA. Founded in 1814, it became the state capital in 1821. It was strongly anti-Union during the CIVIL WAR. In 1957 federal troops had to be used to enforce a US Supreme Court ruling against racial segregation in schools. Industries: electronics, textiles, foodstuffs, bauxite, timber. Pop. (1992) 176,870.

liturgy Established order of the rituals of public ceremonies and worship, as laid down by the authorities of an organized religion. In Christianity, the term also refers to the Divine Office or to the rites proper to specific days, such as GOOD FRIDAY, or to particular sacraments, such as BAPTISM. In the Eastern Orthodox Church, the Divine Liturgy refers specifically to the celebration of the EUCHARIST.

LITHUANIA

AREA: 65,200sq km (25,200sq mi)
POPULATION: 3,759,000
CAPITAL (POPULATION):
Vilnius (578,000)
GOVERNMENT: Multiparty republic

ETHNIC GROUPS: Lithuanian 80%, Russian 9%, Polish 7%, Belarussian 2% LANGUAGES: Lithuanian (official)
RELIGIONS: Christianity
(mainly Roman Catholic)
CURRENCY: Litas = 100 centai

agamid (Leiolepis belliana) is

a lizard of SE Asia. Its body is

flattened from top to bottom, an

adaptation suited to its habit of

burrowing up to 1m (39in) into

the soil

Liu Shao-ch'i (1898–1974) Chinese communist leader. Trained in Moscow (1920–22), he became one of the chief theorists of the Chinese COMMUNIST PARTY, ranking second to MAO ZEDONG. He was author of the influential manual, How to Be a Good Communist (1939). Liu was made official head of state in 1959, but was purged in 1968 during the CULTURAL REVOLUTION and died in prison.

Lively, Penelope (1933–) British novelist, b. Egypt. Lively has written numerous children's books, including the award-winning *The Ghost of Thomas Kempe* (1973) and *A Stitch in Time* (1976). Her first work for adults was *The Road to Lichfield* (1977). *Moon Tiger* (1987) won the Booker Prize. Other novels include *According to Mark* (1984), *City of the Mind* (1991) and *Cleopatra's Sister* (1993).

liver Large organ located in the upper right abdomen of VERTEBRATES. Weighing up to 4.5lbs (2kg) in an adult human, it is divided into four lobes and has many functions. It is extremely important in the control of the body's internal environment (HOMEOSTASIS). It receives nutrients from the intestine and is a site of metabolism of proteins, carbohydrates and fats. It synthesizes BILE and some vitamins, regulates the blood-glucose level, produces blood-clotting factors, breaks down worn-out ERYTHROCYTES and removes toxins from the blood. The many metabolic reactions that go on in the liver are the body's main source of heat, which is distributed around the body by the blood. *See also* INSULIN

Liverpool City and seaport in Merseyside, NW England, on the N bank of the River Mersey estuary. Liverpool was founded in the 10th century and became a free borough in 1207. The first wet dock was completed in 1715, and the city expanded rapidly to become Britain's largest port. In the early 20th century it was the major embarkation port for emigration to the New World. Liverpool suffered severe bomb damage during World War 2. The 1972 construction of a container terminal and the completion of a rail tunnel link with Birkenhead improved the city's transport and trade links. In the 1980s inner-city regeneration schemes included the Albert Dock refurbishment. Liverpool Free Port (Britain's largest) was opened in 1984. The sixth-largest city in England and the principal Atlantic port, Liverpool has over 800ha (2,000 acres) of dockland. Pop. (1991) 452,450.

liverwort Any of about 9,000 species of tiny non-flowering green plants, which, like the related mosses, lack specialized tissues for transporting water, food and minerals within the plant body. Liverworts belong to the plant phylum Bryophyta. **Livingstone, David** (1813–73) British explorer of Africa. He went to South Africa as a missionary in 1841 and became famous through his account of his journey, accompanied by Africans, across the continent from Angola to Mozambique (1853–56). He led a major expedition (1858–64) to the Zambezi and Lake Nyasa and set off again in 1866 to find the source of the Nile. He disappeared and was found in 1871 by Henry Morton STANLEY on Lake Tanganyika.

Livy (59–17 BC) (Titus Livius) Roman historian. One of the greatest Roman historians, he began his *History of Rome c.*28 BC. Of the original 142 books, 35 have survived in full.

lizard Reptile found on every continent; there are 20 families, comprised of c.3,000 species. A typical lizard has a scaly cylindrical body with four legs, a long tail and moveable eyelids. Most lizards are terrestrial, and many live in deserts. There are also semi-aquatic and arboreal (tree-dwelling) forms, including the flying dragon. Burrowing species frequently have shortened limbs or are legless. Length: 5cm–3m (2in–10ft). Order Squamata; suborder Sauria.

Ljubljana (Ger. *Laibach*) Capital and largest city of Slovenia, at the confluence of the Sava and Ljubljanica rivers. Ljubljana was founded as Emona by the Roman emperor Augustus in 34 BC. From 1244 it was the capital of Carniola, an Austrian province within the Habsburg empire. During the 19th century it was the centre of the Slovene nationalist movement. The city remained under Austrian rule until it became part of the kingdom of Serbs, Croats and Slovenes in 1918. When Slovenia became independent (1991), Ljubljana became capital. Industries: textiles, paper and printing, electronics, chemicals. Pop. (1991) 268,000.

llama Domesticated, South American, even-toed, ruminant mammal. The llama has been used as a beast of burden by Native Americans for more than 1,000 years. It has a long, woolly coat and slender limbs and neck. The smaller alpaca is bred for its superb wool. Family Camelidae; genus *Lama*.

Llewelyn ap Gruffydd (c.1225–82) (Llewelyn the Last) Prince of Wales. Allied with the rebellious English barons, he gained control of as much territory as his grandfather, LLEWELYN AP IORWERTH. He was recognized as prince of Wales by the Treaty of Montgomery (1267). The accession of EDWARD I brought his ruin. He renewed his rebellion in 1282 and was killed in battle.

Llewelyn ap lorwerth (1173–1240) (Llewelyn the Great) Prince of Gwynedd, Wales. He overcame dynastic rivals and captured Mold from the English (1199). He established his suzerainty in Gwynedd, subsequently gaining control of Powys also. He allied himself with the English barons against John and was recognized as suzerain by all the Welsh princes. Lloyd, Harold (1893-1971) US film actor. Lloyd was hired by Hal ROACH in 1914 to star in comedy shorts. Lloyd modelled himself on Charlie CHAPLIN, but added cliff-hanging, death-defying stunts, such as hanging from the a skyscraper clockface in Safety Last (1923). His success waned in the sound era and he made his final film, Mad Wednesday, in 1947. Lloyd George, David (1863-1945) British statesman, prime minister (1916-22). A Welsh Liberal, he sat in the House of Commons from 1890. As chancellor of the exchequer (1908-15), he increased taxation to pay for social measures such as old-age pensions. His "People's Budget" (1909) provoked a constitutional crisis, which led to a reduction of the powers of the House of Lords. He was an effective minister of munitions (1915). In 1916 he joined with Conservatives to dislodge the prime minister, ASQUITH, whom he replaced. He won an easy victory for his coalition government in 1918 and was a leading figure at the peace conference at VER-SAILLES. He ended the Irish crisis by the treaty creating the Irish Free State (1921), but then fell from power.

Lloyd's Insurance market in London, dealing especially in marine insurance. Lloyd's began in the 17th century as a coffee house, where businessmen willing to insure shipping gathered. Lloyd's as an institution does not insure anything; it is merely the market where the individual underwriters (known

■ Llama Domesticated for over a thousand years, Ilama (Lama peruana, shown) are used primarily as pack animals in s and w South America, from sealevel to elevations of 5,000m (16,500ft). They thrive in a semi-desert habitat feeding on mountain grass. They grow to 1.2m (4ft) long and to a height at the shoulder of 1.2m (4ft).

as "names") can meet. Between 1988 and 1993 some syndicates sustained substantial losses, leading to a change in the regulations of names, allowing some to have limited liability. **Lloyd Webber, Andrew** (1948–) British composer. He composed *Joseph and the Amazing Technicolour Dreamcoat* (1967) while still a student. The lyricist, Tim Rice, was also his collaborator on the rock opera *Jesus Christ Superstar* (1971) and on the musical *Evita* (1978). *Cats* (1981), using verse by T.S. Eliot, was a long-running hit, as were *The Phantom of the Opera* (1986) and *Sunset Boulevard* (1993). His brother **Julian** (1951–) is a highly respected cellist.

loach Small freshwater fish that lives in mountain streams of central and s Asia and Europe; there are more than 200 species. British loaches are the stone loach (*Nemachilus barbatula*) and the spined loach (*Cobitis taenia*).

lobelia Genus of 365 species of flowering plants found worldwide, mainly known as trailing or bedding plants. The flowers may be blue, red or white and are irregularly shaped. The leaves are simple. Family Lobeliaceae.

lobster Large, long-tailed, marine decapod crustacean. Some species are prized edible shellfish. True lobsters possess enlarged bulbous chelae (claws) and a segmented body. local government System of regional administration differing in each country. The systems that developed in France, the former Soviet Union and England have served as models for much of the rest of the world. The French system is relatively centralized with clear lines of authority running from central government to the regional authorities. Local government in England developed from the Municipal Reform Act (1835), which first established elected councils in cities; the Local Government Act (1888) set up county councils elsewhere. In 1974 a two-tier system was established in England, Scotland and Wales, with counties subdivided into districts, each with an elected council. Some metropolitan counties were abolished in 1986 and replaced by a single tier of smaller local borough councils. The system in the USA follows the general principles of the British system, although supervisory committees are less common. The COUNTY is the usual political subdivision, but there is considerable variation between the organizations in different states, and the relationships between the states themselves and central government are complex, often involving shared responsibilities.

Locarno Pact (1925) Group of international agreements that attempted to solve problems of European security outstanding since the Treaty of Versailles of 1919. The pact established Germany's w borders and enabled Germany to enter the League of Nations. The general peace established at Locarno was soon disturbed by German violations of the Treaty of Versailles under Hitter.

loch (Scot. lake) See individual gazetteer articles

Lochner, Stefan (1410–51) German painter. His most important surviving work is *The Adoration of the Magi*, which is now in Cologne Cathedral. Dürer gazed "with wonder and astonishment" at the delicate naturalism of his style. **lock** Structure built into a stretch of inland waterway to raise or lower water levels to correspond with the surrounding

8 6 1 3 4 5 9 7

countryside. Each lock consists of two sets of lock gates. A vessel enters the lock, the gates are closed, and sluices are opened to admit or release enough water to bring the vessel to the same level as the water beyond the second pair of gates.

Locke, John (1632–1704) English philosopher and expo-

Locke, John (1632–1704) English philosopher and exponent of EMPIRICISM. In 1679 his friendship with the Earl of Shaftesbury, accused of conspiracy against Charles II, made him a target of suspicion and he went into exile in the Netherlands (1683–89). He returned to England only after the Glorious Revolution. Locke rejected the concept of "innate ideas" and held that all ideas are placed in the mind by experience. In 1690 he published *Two Treatises on Civil Government*, in which he advocated the SOCIAL CONTRACT, the right to freedom of conscience and the right to property.

lockjaw See TETANUS

locomotive Engine that moves under its own power, usually on rails. In 1804 Richard Trevithick built the first locomotive, which was steam powered. The first locomotive on a passenger RAILWAY was George Stephenson's *Locomotion*, built in 1825. Electric locomotives arrived in the late 19th century. Diesel, diesel-electric and gas-turbine locomotives were introduced during the 20th century.

locus In geometry, the path traced by a specified point when it moves to satisfy certain conditions. For example, a circle is the locus of a point in a plane moving in such a way that its distance from a fixed point (the centre) is constant.

locust Insect (type of large GRASSHOPPER) that migrates in huge swarms. Initially, the nymphs move in vast numbers on foot. As they feed, they develop into flying adults. Swarms may contain up to 40,000 million insects, and cover an area of c.1,000sq km (386sq mi). Length: 12.5–100mm (0.5–4in). Order Orthoptera; species *Schistocerca gregaria*.

Lodge, Henry Cabot (1850–1924) US political leader and historian. He represented Massachusetts in the House of Representatives (1887–93) and the Senate (1893–1924). A friend of Theodore ROOSEVELT and a conservative Republican, he supported the establishment of a powerful army and navy. As Senate majority leader and chairman of the Foreign Relations Committee (1918–24), he led the successful opposition to US membership of the LEAGUE OF NATIONS.

loess Light-coloured fine silt or clay deposited by the wind, generally unstratified and sometimes exposed in bluffs. The loess in the Mississippi River Valley is believed to have been produced by glacial action and then transported by wind.

Logan, Mount Peak in the St Elias Mountains, Yukon, Canada. At 6,050m (19,849ft), it is the highest in Canada and the second-highest in North America. It was first climbed in 1925. **loganberry** Biennial, hybrid, red-berried bramble. It is a cross between the blackberry and raspberry. Family Rosaceae; species *Rubus ursinus loganbaccus*.

logarithm Aid to calculation devised by John Napier in 1614 and developed by the English mathematician Henry Briggs. A number's logarithm is the power to which a base must be raised to equal the number, i.e. if $b^x = n$, then $\log_b n = x$, where n is the number, b the base and x the logarithm. Common logarithms have base 10, and so-called natural logarithms have base e (2.71828...). Logarithms to the base 2 are used in computer science and information theory.

logic Branch of philosophy that deals with the processes of valid reasoning and argument. Logic defines the way in which one thing may be said to follow from, or be consequent upon, another. This is known as deductive logic. Inductive logic is when a general conclusion is drawn from a particular fact or facts. Although logical systems were devised in China and India, the history of logic in the West began in the 4th century BC with the Greek philosopher ARISTOTLE. In the Middle Ages, Arab scholars rediscovered logic and in Europe Pierre ABÉLARD used logic in the synthesis of ideas that was the goal of SCHOLASTICISM. Various post-Renaissance scholars, including Leibniz, developed the foundations of modern logic. Symbolic, or mathematical, logic was outlined in the 19th century by George BOOLE and developed by Gottlob FREGE. Modern formal logic or symbolic logic utilizes symbols to represent precisely defined classes of proposition connected to each other by such operators as "and", "or", "if... then".

able to swim short distances). The legs are borne in pairs (1–5), the first of which is enlarged to form nipping claws (chelae) (6). Of the two pairs of antennae (7, 8), the second may be far longer than the body. With the eyes (9), the antennae are the principal sense organs. The body segments are visible only on the abdomen (10) for the thorax is covered by a hard shell (the

carapace) (11). The tail (12) is a

characteristic fan shape

▶ lobster The Norway lobster

(Nephrops norvegicus), a small

burrowing form up to 20cm (8in) long found off NE Atlantic coasts,

is a typical crustacean. With the

shrimps, it is classified in a sub-

group of the order Decapoda ("10

crabs, crayfish, prawns and

legs") called the Reptantia

("walking"; although they are

logical positivism School of philosophy whose adherents consider that only empirically verifiable scientific propositions are meaningful. Its roots were in the logic of Gottlob FREGE and Bertrand RUSSELL, the positivism of Ernst Mach and, above all, the claim of Ludwig WITTGENSTEIN that philosophy was the clarification of thought.

Loire Longest river in France. The Loire rises in the Cévennes range, on the sE edge of the MASSIF CENTRAL, and flows N and NW to Orléans. It then turns sW into a wide, fertile basin. The cities of Tours and Angers lie on its banks. It then flows through the Pays de la Loire to NANTES, emptying into the Bay of Biscay at St-Nazaire. It is connected by canals to the Rhône and SEINE rivers. Length: 1,020km (635mi).

Lollards Followers of the 14th-century English religious reformer John WYCLIFFE. They helped to pave the way for the REFORMATION, and challenged many doctrines and practices of the medieval church, including TRANSUBSTANTIATION, pilgrimages and clerical celibacy. They rejected the authority of the PAPACY and denounced the wealth of the church. The first Lollards appeared at Oxford University, where Wycliffe was a teacher (c.1377). They went out among the people as "poor preachers", teaching that the Bible was the sole authority in religion. After 1401 many Lollards were burned as heretics, and in 1414 they mounted an unsuccessful uprising in London and then went underground.

Lombard League Defensive alliance of the cities of Lombardy in N Italy (1167). Its purpose was to resist the re-establishment of imperial authority by the emperor FREDERICK I. Led by Pope ALEXANDER III, the league defeated the emperor at Legnano (1176). By the Peace of Constance in 1183 the Italian cities retained independence while paying lip service to Frederick's authority. The league was active again in 1226 against FREDERICK II.

Lombards Germanic peoples who inhabited the area E of the lower River Elbe until driven w by the Romans in AD 9. In 568 they invaded N Italy under Alboin and conquered much of the country, adopting Catholicism and Latin customs. The Lombard kingdom reached its peak under Liutprand (d.744). It went into decline after defeat by the Franks under CHARLEMAGNE (775).

Lombardy (Lombardia) Region in N Italy, bordering Switzerland in the N; the capital is MILAN. Lombardy is Italy's most populous and industrial region. It is divided into the provinces of Bergamo, Brescia, Como, Cremona, Mantova, Milano, Pavia, Sondrio and Varese. North Lombardy is an Alpine region with many lakes. South Lombardy is dominated by the fertile plain of the River Po. The plains have been a major European battleground, from the Roman occupation of the 3rd century BC to the Italian take-over of 1859. Area: 23,834sq km (9,202sq mi). Pop. (1991) 8,856,074.

Lomé Capital and largest city of the Republic of Togo, w Africa, on the Gulf of Guinea. Made capital of German Togoland in 1897, it later became an important commercial centre. It was the site of conferences in 1975 and 1979 that produced a trade agreement (known as the Lomé Convention) between the EC and 46 African, Caribbean and Pacific states. Its main exports are coffee, cocoa, palm nuts, copra and phosphates. Pop. (1991) 590,000.

Lomond, Loch Long, narrow lake in Strathclyde and Central regions, w central Scotland. It is drained by the River Leven into the Firth of Clyde. The largest of the Scottish lochs, it is 37km (21mi) long and 190m (625ft) deep at its deepest part. It is dominated at the N end by Ben Lomond (height: 973m/3,192ft). Area: 70sq km (27.5sq mi).

London, Jack (1876–1916) US novelist and short story writer. He is best known for his Alaskan novels, such as *Call of the Wild* (1903) and *White Fang* (1906). *The Iron Heel* (1907) is a dystopian novel inspired by his socialist beliefs.

London Capital of the United Kingdom, and (after Moscow) the second-largest city in Europe, located on both banks of the River Thames, 65km (40 mi) from its mouth in the North Sea, SE England. Since 1965 it has been officially called Greater London, comprising the square mile of the City of London and 13 inner and 19 outer boroughs, covering a total of 1,580sq km (610sq mi). Little is known of London before the

Romans set up camp in the 1st century AD. Called Londinium, it was their most important town in Britain. By the 3rd century the population numbered c.40,000 and the town covered an area of 120ha (300 acres). After the Romans left Britain, London declined until the 9th century, when ALFRED THE GREAT made it the seat of government. The settlement of Westminster, to the w of the city walls, grew in the 10th century. Edward the Confessor built WESTMINSTER ABBEY and made Westminster his capital in 1042. The prosperity of England during the Tudor period firmly established London's wealth and importance. In the reign of Elizabeth I the population increased from fewer than 100,000 to almost 250,000. During the 17th century the area between Westminster and the City was built up. The plague of 1665 killed 75,000 Londoners and the Fire of London the next year destroyed many buildings. Sir Christopher WREN played an important role in the reconstruction of the city, designing many churches, including ST PAUL'S. During the 19th century the population reached 4 million. By the end of the 19th century London was the world's biggest city. Further growth between the wars was accompanied by extensions to the transport system. Much of E London was rebuilt after bomb damage during World War 2, and in the late 1980s the largely derelict docklands were developed. Despite the problems of inner-city decay, experienced by most large Western cities since the 1960s, London remains one of the world's most important administrative, financial, commercial and industrial cities. Industries: tourism, entertainment, engineering, chemicals, paper, printing and publishing, clothing, brewing. Pop. (1994) 6,966,800.

London, University of University founded in 1836, originally comprising King's College and University College. The university now comprises 14 colleges, 6 medical schools and 11 postgraduate medical institutions, as well as various other academic institutes.

Londonderry See Derry

Long, Huey Pierce (1893–1935) US political leader. A formidable populist and opponent of big business, he was Democratic governor of Louisiana (1928–32). As a senator (1932–35), he was highly critical of Franklin ROOSEVELT and attracted wide support with an ambitious plan for redistribution of wealth. He was manoeuvring for the Democratic presidential candidacy when he was assassinated.

Longfellow, Henry Wadsworth (1807–82) US poet. Longfellow's escapist poetry was extremely successful in his lifetime. He is best known for his long narrative poems, such as Evangeline (1847), The Song of Hiawatha (1855), The Courtship of Miles Standish (1858) and Tales of a Wayside Inn (1863), which includes "Paul Revere's Ride". Influenced by European romanticism, Longfellow combined archaic rhythms to enliven American mythology. Ballads and Other Poems (1842) contains two of his most popular shorter poems, "The Wreck of the Hesperus" and "The Village Blacksmith". longhorn Almost extinct breed of beef cattle, originally from Mexico, descended from European cattle introduced by Spanish conquistadors. Once the mainstay of Western US herds, they are now used only as rodeo and show animals.

Long Island Island in SE New York State, USA, bounded on the s by the Atlantic Ocean and separated from Manhattan by the East River and from Connecticut by Long Island Sound. Originally inhabited by the Delaware Native Americans, it was settled by the Dutch West India Company and the Massachusetts Bay Colony in the 17th century. About 190km (120mi) long, it is used for commuter towns, light industry, market gardening, fishing and holiday resorts. Area: 4,463sq km (1,723sq mi). Pop. (1990) 6,861,454.

longitude Angular measurement around the Earth, usually

◀ locust Types of grasshoppers that respond to overcrowding by migrating in huge swarms, locusts occur in two forms. The solitary form (shown) is relatively inactive. The gregarious form is distinguished by the darker colour of the immature insects, or nymphs.

▲ Lorenz Austrian scientist
Konrad Lorenz studied the
behaviour of animals for much
of his life. Unlike animal
psychologists, who studied
animal behaviour in laboratories,
Lorenz studied animals in their
natural environments and arrived
at radically different conclusions
as to why animals behave in
certain ways.

in degrees E or W of an imaginary N-S line through the prime MERIDIAN. All N-S lines are called either meridians or lines of LONGITUDE.

long jump Field event in which competitors run up to a take-off board and try to leap the farthest. The length of the jump is measured from the forward edge of the board to the rear imprint the jumper leaves in the cushioning sandpit.

Long March (1934–35) Enforced march of the Chinese Red Army during the war against the nationalist (KUOMINTANG) forces. Led by Chu Teh and MAO ZEDONG, 90,000 communist troops, accompanied by c.15,000 civilians, broke through a Nationalist encirclement of their headquarters and marched some 10,000km (6,000mi) from JIANGSU province, SE China, to Shanxi province in the NW. Under frequent attack, the communists suffered 45,000 casualties. The march prevented the extermination of the COMMUNIST PARTY by the Nationalists.

Long Parliament English Parliament initially summoned by Charles I in November 1640 to raise revenue to combat Scotland in the "Bishop's wars". It followed the Short Parliament, which lasted only weeks. Antagonism between Charles and Parliament resulted in the outbreak of the English Civil. War. The Long Parliament sat, with intervals, for 20 years. Oliver Cromwell expelled hostile members in Pride's Purge (1648), and thereafter it was known as the Rump Parliament. long-sightedness (hyperopia) Defect of vision that causes distant objects to be seen more clearly than nearby ones. In a long-sighted person, the focusing distance of the eyeball is too short and, as a result, light rays entering the eye strike the retina before they can be properly focused. Long-sightedness is corrected by convex lenses. See also MYOPIA

loon (diver) Diving bird of the Northern Hemisphere, known for its harsh call. It has black, white and grey plumage. An excellent swimmer, it often stays submerged while fishing. Length: 88cm (35in). Family Gaviidae.

Loos, Adolf (1870–1933) Czech architect who pioneered modern building design. He hated ART NOUVEAU, the prevailing style of the time, publishing his views in *Ornament and crime* (1908). His most important projects were houses built between 1904–10; Steiner House (Vienna, 1910) was one of the first to use concrete. *See also* MODERNISM

loran (long range navigation) Radio navigational system for guiding ships and aircraft. Pairs of transmitters emit signal pulses that are picked up by a receiver. By measuring the difference in time between the signals reaching the receiver, the vessel's position can be plotted.

Lorca, Federico García (1898–1936) Spanish poet and dramatist. His poetry, from *Gypsy Ballads* (1928) to *The Poet in New York* (1940), was internationally acclaimed. In the theatre, his early balletic farces gave way to tragedies of frustrated womanhood, such as the trilogy *Blood Wedding* (1933), *Yerma* (1935) and *The House of Bernarda Alba* (1936). He was killed by Nationalist soldiers at the outbreak of the Spanish CIVIL WAR.

Lord Chancellor Head of the British legal system, an office of CABINET rank. The Lord Chancellor's duties include acting as head of the judiciary and as speaker of the House of Lords. Lord's CRICKET ground in London, UK. Founded by Thomas Lord in 1787, it has been at its present location in St John's Wood since 1814. It is the home of the Marylebone Cricket Club and the Middlesex County Cricket Club. Since 1884 every Test series in England has included a match at Lord's. Lord's Prayer Prayer JESUS CHRIST taught his disciples. It is found in Matthew 6:9–13, and slightly differently in Luke 11:2–4. It is also called *Pater Noster* (Lat. Our Father).

Lorelei Large rock in the River Rhine near Sankt Goarshausen, w Germany. According to legend, a beautiful maiden called Lorelei drowned herself in despair over her faithless lover, only to rise as a siren to lure fishermen to their doom on the rock.

Loren, Sophia (1934–) Italian film actress. Her sensuous performance in *The Black Orchid* (1959) set Hollywood alight. She won a Best Actress Academy Award for *Two Women* (1961). Other films include *Marriage Italian Style* (1964).

Lorentz, Hendrik Antoon (1853–1928) Dutch physicist and professor at Leiden. His early work was concerned with

the theory of ELECTROMAGNETIC RADIATION devised by James Clerk MAXWELL. This led him to the Lorentz transformation and the prediction of the Lorentz-Fitzgerald contraction, both of which helped Albert EINSTEIN to develop his special theory of RELATIVITY. Lorentz also worked on the ZEEMAN EFFECT, for which he and Pieter ZEEMAN were awarded the 1902 Nobel Prize for physics.

Lorenz, Konrad (1903–89) Austrian pioneer ethologist. He observed that instinct played a major role in animal behaviour, as for example in IMPRINTING. Some of his views are expressed in *On Aggression* (1966). In 1973 he shared, with N. TINBERGEN and K. von FRISCH, the Nobel Prize for physiology or medicine. *See also* ETHOLOGY

loris Any of several species of primitive, tailless, treedwelling, nocturnal PRIMATES of s Asia and the East Indies. They have soft, thick fur and large eyes, and feed mainly on insects. Length: 18–38cm (7–15in). Family Lorisidae; genera *Loris* and *Nycticebus*.

Lorrain, Claude See CLAUDE LORRAIN

Lorraine (Ger. Lothringen) Region of NE France, bounded N by Belgium, Germany and Luxembourg, E by Alsace, s by Franche-Comté and E by CHAMPAGNE. The capital is Nancy. Lorraine is divided into four départements: Meurthe-et-Moselle, Meuse, Moselle and Vosges. In the 10th century it was divided into two duchies, Upper and Lower Lorraine. In 1766 it became a French province. In 1871, following the Franco-Prussian War, the E part of Lorraine was joined to form the German territory of Alsace-Lorraine, which lay at the heart of Franco-German conflict in World Wars 1 and 2. Industries: brewing, winemaking. It also has rich deposits of iron-ore. Area: 23,547sq km (9,089sq mi). Pop. (1990) 2,305,700.

Los Alamos Town in New Mexico, USA, site of a large scientific laboratory. During World War 2 the laboratory was one of the centres for the MANHATTAN PROJECT, which produced the atomic bomb. After the war, the laboratory developed the HYDROGEN BOMB.

Los Angeles, Victoria de (1923–) Spanish soprano. She gave her first public concert in Barcelona (1945). Los Angeles made her debut at the Paris Opéra and La Scala, Milan, in 1949. In 1950 she made her American debut at Carnegie Hall and joined New York's Metropolitan Opera Company.

Los Angeles (Sp. City of Angels) City in sw California, USA, on the Pacific coast; the second-largest US city (after New York) and the nation's leading manufacturing base. Los Angeles was founded in 1781 by Mexican settlers. At the conclusion of the MEXICAN WAR (1848) the USA acquired Los Angeles. The city grew with the completion of the Southern Pacific (1876) and Santa Fe (1885) railways. The discovery of oil (1894), the completion of San Pedro harbour (1914) and the development of the HOLLYWOOD film and television industry encouraged further growth. During World War 2 the city's industry boomed with the need for aircraft and munitions, and many African-Americans migrated to the city to work in the factories. Los Angeles' rapid growth has brought major social problems. In 1965 five days of riots in the Watts district left 34 dead and US\$200 million damages. In 1992 the acquittal of four policemen on a charge of beating an African-American suspect sparked off further race riots, which left 58 dead and US\$1 billion damages. Air pollution is a major problem. A subway system is under construction to ease the city's traffic jams. A 1994 earthquake killed 57 people and caused US\$15-30 billion of damage. Greater Los Angeles sprawls over 1,204sq km (465sq mi). Over 600,000 Mexican-Americans live here, more than in any other US city, the majority in the overcrowded barrio of E Los Angeles. The city also has one of the largest black communities in the USA (over 500,000 African-Americans), concentrated in the s central district of Watts. Central Los Angeles consists mainly of Hollywood, the heart of the US film industry. To the w of Hollywood lies Beverly Hills, home of many film stars. Greater Los Angeles includes Anaheim (home of Disneyland) and Santa Monica (headquarters of the aircraft manufacturers, McDonnell Douglas). Aerospace is the city's principal industry. Industries: tourism, film and television, oil refining, electronic equipment, chemicals, fish canning. Pop. (1990) 3,489,779.

Lot Biblical character who was living in SODOM when God decided to destroy it (Genesis 11:31–14:16. 19). Lot survived, but his wife disobeyed instructions and looked back at the destruction of the city; she was turned into a pillar of salt.

Lothair I (795–855) Frankish emperor (840–55). Eldest son of Louis I, he was co-emperor with his father from 817. On the death of Louis (840), war broke out between Lothair and his two brothers. Lothair was defeated at Fontenoy (841) and in 843 the Frankish empire was divided in three by the Treaty of Verdun. Lothair retained the title of emperor and ruled the Middle Kingdom, consisting of the Low Countries, N France, Switzerland and N Italy

Lothair II (1070–1137) (Sometimes called Lothair III, "the Saxon") King of the Germans and Holy Roman emperor (1125–37). He secured the throne by successful war against the HOHENSTAUFEN (1125–35). He encouraged German eastward expansion and supported Pope Innocent II against his opponents, invading Italy in 1136–37. On his death, the German princes chose the Hohenstaufen Conrad III rather than Lothair's intended successor, Henry of Bavaria.

Lothian Region in E central Scotland, bounded N by the Firth of Forth, E by the North Sea and S by the Lammermuir, Moorfoot and Pentland Hills; the capital is EDINBURGH. Industries: coal-mining, engineering, whisky distilling. Area: 1,755sq km (677sq mi). Pop. (1991) 726,000.

lottery Form of gambling whereby participants pay to enter and winners are picked by a method based on chance. This method often involves participants choosing numbers. They win if their numbers correspond to numbers picked randomly by the lottery organizer during a subsequent draw.

lotus Common name for any water lilies of the genus *Nelumbo* and several tropical species of the genus *Nymphaea*. The circular leaves and flowers of some species may be 60cm (2ft) across. *Nymphaea* is sacred to the Chinese, Egyptians and Indians. Family Nymphaeaceae. The genus *Lotus* is made up of the trefoils that belong to the unrelated Fabaceae/Leguminosae family.

loudspeaker Device for converting changing electric currents into sound. The most common type has a moving coil attached to a stiff paper cone suspended in a strong magnetic field. By ELECTROMAGNETIC INDUCTION, the changing currents in the coil cause the cone to vibrate at the frequency of the currents, thus creating sound waves.

Louis, Joe (1914–81) (Joseph Louis Barrow) US heavyweight boxer. He won the world heavyweight title from James J. Braddock in Chicago in 1937 and retired undefeated in 1949. He fought 25 successful defences and scored 21 knockouts. He made a comeback in 1950, but lost on points to Ezzard Charles (1950) and was knocked out by Rocky Marciano (1951). Louis held the title for longer than any other heavyweight.

Louis I (778–840) Emperor of the Franks (814–840), called "the Pious". He was Charlemagne's only surviving son. He struggled to maintain his father's empire, cooperating closely with the church. The Franks had no law of primogeniture, and Louis's attempts to provide an inheritance for his four sons provoked civil war.

Louis VI (1081–1137) King of France (1108–37). He was the effective ruler for several years before he succeeded his father, Philip I. He re-established control of the royal domain, increasing the authority of the royal courts and enjoying the strong support of the church. In 1137 he secured the marriage of his heir, LOUIS VII, to Eleanor of Aquitaine.

Louis VII (c.1120–80) King of France (1137–80). His marriage to Eleanor of Aquitaine extended the French crown's lands to the Pyrenees. As king, he consolidated royal power by cultivating the church and the growing towns. Returning from the Second Crusade, he divorced Eleanor for alleged infidelity. She married HENRY II of England, whose French territories then became greater than those of Louis. Louis retaliated by supporting the rebellions of Henry's sons.

Louis VIII (1187–1226) King of France (1223–26). He invaded England (1216) at the invitation of barons opposing King JOHN but was defeated at Lincoln (1217) and returned to France. He successfully concluded the crusade against the heretical Albigenses in the south of France.

Louis IX (1214–70) King of France (1226–70), later known as St Louis. His mother, Blanche of Castile, was regent from 1226–36. Louis defeated the English at Taillebourg (1242) and was a leader of the Sixth Crusade in 1248. He was taken prisoner and did not return to France until 1254. He tried to form a permanent peace with England and to reform the French system of justice.

Louis XI (1423–83) King of France (1461–83). A rebel against his father, CHARLES VII, he was driven out of his province of the Dauphiné in 1456 and sought refuge at the court of Burgundy. As king, he suppressed rebellious nobles, largely by exploiting divisions between them. His greatest rival was Charles the Bold of Burgundy, but after Charles' death (1477), Louis gained Burgundy, and also, after another convenient death, Anjou. He strengthened the French monarchy.

Louis XII (1462–1515) King of France (1498–1515). On becoming king, he had his first marriage annulled in order to wed Anne of Britanny, resulting in the incorporation of Britanny into France. He succeeded his cousin, Charles VIII, and was involved throughout his reign in the dynastic wars arising from Charles's invasion of Italy in 1494. Louis continued this policy, invading Italy in 1499. In spite of some military successes, he was defeated by the HOLY LEAGUE and forced to surrender all his Italian acquisitions (1513).

Louis XIII (1601–43) King of France (1610–43). Son of Henry IV and MARIE DE MÉDICIS, he forcibly ended his mother's regency in 1617 and exiled her. During the course of his reign, he increasingly relied on Cardinal RICHELIEU, who exercised total authority from 1624. Louis approved the policy of crushing the HUGUENOTS at home while making alliances with Protestant powers abroad, in opposition to the Habsburgs, during the THIRTY YEARS WAR.

Louis XIV (1638–1715) King of France (1643–1715). The first part of his reign was dominated by Cardinal MAZARIN. From 1661 Louis ruled personally as the epitome of absolute monarchy and became known as the "Sun King" for the luxury of his court. He chose men of the junior nobility as ministers, such as the able COLBERT, and he reduced the power of the aristocracy in the provinces. After Colbert's death (1683), decline set in. Louis' wars of aggrandisement in the Low Countries and elsewhere drained the royal treasury. His revocation of the Edict of NANTES drove many Huguenots abroad, weakening the economy. In the War of the SPANISH SUCCESSION, the French armies were at last defeated.

Louis XV (1710–74) King of France (1715–74). Grandson and successor of LOUIS XIV, he failed to arrest the slow decline. Disastrous wars, especially the War of the AUSTRIAN SUCCESSION and the SEVEN YEARS WAR, resulted in financial crisis and the loss of most of the French empire. Louis encountered opposition from *parlements* (the supreme courts) and conflict with the followers of JANSENISM and court factions. The monarchy became deeply unpopular.

Louis XVI (1754–93) King of France (1774–92). Grandson and successor of Louis XV, he married the Austrian archduchess Marie Antoinette in 1770. Louis' lack of leadership qualities allowed the parlements (supreme courts) and aristocracy to defeat the efforts of government ministers, such as Jacques Necker, to carry out vital economic reforms. The massive public debt forced Louis to convoke the STATES GEN-ERAL in order to raise taxation. His indecisiveness on the composition of the States General led the third (popular) estate to proclaim itself a National Assembly, signalling the start of the French Revolution. The dismissal of Necker and rumours that Louis intended to forcibly suppress the assembly led to the storming of the BASTILLE (14 July 1789). Louis was forced to reinstate Necker, but continued to allow the queen and court to conspire against the revolution. In October 1789 the royal family were confined to the Tuileries palace. In June 1791 their attempt to flee France failed and Louis was forced to recognize the new constitution. Louis sought support from foreign powers. Early French defeats in the war against Austria and Prussia led to the declaration of a republic. Louis was tried for treason by the Convention and found guilty. He was guillotined on 21 January 1793.

Louis XVIII (1755–1824) King of France (1814–24). Brother

▲ loris The slow loris (Nycticebus coucang) is found in the forests of sɛ Asia. Their tailless bodies grow to 30cm (12in). A nocturnal primate, the slow loris clings so closely to the branches of its arboreal habitat that it is able to climb upside down.

LOUISIANA Statehood:

30 April 1812

30 April 181

Nickname: Pelican State

State bird :

Brown pelican

State flower:

Magnolia

State tree :

Bald cypress State motto:

Union, Justice and

Confidence

of Louis XVI, he fled from the French Revolution to England and was recognized by the *emigrés* as king from 1795. Louis was restored to the throne in 1814, but was forced to flee again during the Hundred Days until Napoleon's final defeat at Waterloo (1815). He agreed to a constitution providing for parliamentary government and a relatively free society, but came increasingly under the influence of extremists.

Louisiana State on the Gulf of Mexico, s central USA; the capital is BATON ROUGE. In 1699 the French colony of Louisiana was founded. It was later ceded to Spain but regained by France in 1800. In the LOUISIANA PURCHASE (1803) Napoleon sold the state to the USA. In 1861 it joined the Confederacy, being readmitted to the Union in 1868. The discovery of oil and natural gas in the early 20th century provided a great boost to the economy. Racial discrimination left the large African-American community (30% of the population) politically powerless until the 1960s. Louisiana consists of two main regions: the MISSISSIPPI alluvial plain and the Gulf coastal plain. The Mississippi Delta in the SE covers c.33,700sq km (13,000sq mi), about 25% of the state's total area. The tidal shoreline is 12,426km (7,721mi) long. Nearly 15% of the state is marshland. North of the marshes, prairies stretch to the Texas border. Almost half the state is forested. Louisiana has a subtropical climate. Low-lying land and heavy rainfall make it prone to flooding. It is a leading producer of soya beans, sweet potatoes, rice and sugar cane. Fishing is a major industry, particularly shrimps and crayfish. Louisiana is second only to Texas in US mineral production. Petroleum and coal account for more than 95% of mining income. Area: 125,674sq km (48,523sq mi). Pop. (1992) 4,278,889.

Louisiana Purchase (1803) Transaction between the USA and France, in which the USA bought, for 60 million francs (\$15 million), 2,144,500sq km (828,000sq mi) of land between the Mississippi River and the Rocky Mountains. With national security and the control of the Mississippi in mind, President Thomas JEFFERSON sent James MONROE to France to join US minister Robert Livingston. The two men negotiated the purchase from Napoleon, who had lost interest in a colonial empire in the New World. The Louisiana Purchase doubled the area of the USA, and 13 states were admitted from the territory. Louis Philippe (1773–1850) King of France (1830–48). He returned to France from exile in 1814 and acquired a reputation as a liberal. He gained the throne after the JULY REVOLU-TION. Although known as the "Citizen King", he retained much personal power. He abdicated when revolution broke out again and the Second Republic was declared in February

1848. He died in exile in England. **Louisville** City in NW Kentucky, USA, a port on the Ohio River; largest city in Kentucky. Established as a military base in 1778 by George Rogers Clark, it was named after LOUIS XVI of France. Host to the famous Kentucky Derby, the city has many stud stables. Industries: bourbon whiskey, tobacco, domestic appliances, synthetic rubber. Pop. (1990) 269,063.

Lourdes Town in sw France, in Hautes-Pyrénées département; a centre of religious pilgrimage. In 1858 a 14-year-old peasant girl called Bernadette Soubirous claimed to have had visions of the Virgin Mary in the nearby grotto of Massabielle, where there is an underground spring. In 1862 the Roman Catholic Church declared the visions to be authentic. The waters of the spring, believed to have healing powers, are the focus of pilgrimages by up to 5 million visitors a year.

louse Common name for various small, wingless insects, parasitic on birds and mammals. There are two main groups, classified in different sub-orders of Phthiraptera. The chewing lice (Mallophaga) feed mainly on the feathers of birds. The biting or sucking lice (Anoplura) feed only on the blood of mammals. Both kinds are small, pale and flattened, with leathery or hairy skins.

Louth County in the NE Republic of Ireland, in Leinster province, bordering Northern Ireland (N) and the Irish Sea (E); the capital is Dundalk. It is a low-lying region, except in the hilly NW and the mountainous N, drained by the rivers Fane, Dee and Castletown. Industries: textiles, footwear, processed food. Area: 821sq km (317sq mi). Pop. (1991) 90,724.

Louvre France's national museum and art gallery in Paris. It

holds a collection of more than 100,000 works, including paintings, drawings, prints and sculpture from all over the world, from the prehistoric period to the late 19th century. Originally a royal palace, the Louvre became a fully fledged museum in the 18th century and opened as the first national public gallery during the Revolution in 1793.

Lovelace, Richard (1618–58) English CAVALIER poet. A flamboyant and ardent royalist, he was imprisoned in 1642 and 1648, during which time he wrote *To Althea, from Prison* and *To Lucasta, Going to the Wars*. Another collection, *Lucasta: Posthume Poems*, appeared in 1659.

Lovell, Sir Alfred Charles Bernard (1913–) British astronomer. From 1951–81 he was director of the JODRELL BANK experimental station for radio astronomy near Manchester, England, and oversaw the construction of the world's first large steerable radio telescope.

Low Countries Name given to the region of NW Europe now occupied by the Netherlands, Belgium and Luxembourg. It was the most advanced and prosperous region of N Europe during the Middle Ages and Renaissance, under the dukes of BURGUNDY from 1384 and the HABSBURGS from 1477. The Dutch gained independence as the United Provinces in 1609. The southern Netherlands (Belgium), after a period united with the Dutch (1815–30), became an independent kingdom in 1830. Luxembourg was ruled by the Dutch house of Orange until 1890, when it passed to another branch.

Lowell, Amy (1874–1925) US poet and critic, sister of Percival Lowell. Her first volume was the sensuous *A Dome of Many-Coloured Glass* (1912). Following the exit of Ezra Pound, Lowell became the leader of the IMAGISM movement. *Sword Blades and Poppy Seed* (1914) was an experiment with "polyphonic prose", or free-verse.

Lowell, Percival (1855–1916) US astronomer, brother of Amy Lowell. In 1894 he built an observatory at Flagstaff, Arizona. Lowell studied the orbits of Uranus and Neptune and calculated that their orbital irregularities were caused by an undiscovered Planet X. His predictions led to the discovery of Pluto in 1930. He also observed Mars, producing intricate maps of the "canals", which he ascribed to the activities of intelligent beings.

Lowell, Robert (1917–77) US poet. Lowell was perhaps the most important voice in American poetry to emerge after World War 2. His early work, such as the Pulitzer Prize-winning *Lord Weary's Castle* (1946) is rich in Catholic symbolism. He is best known for his later, more intimate "confessional" style, best represented by the autobiographical *Life Studies* (1959). Lowell and other "confessional" poets, such as Sylvia PLATH, reappraised the gap between the private and the public. He won a second Pulitzer Prize for *The Dolphin* (1973).

Lower Saxony Region of N Germany, formed in 1946 by the merging of the provinces of Hanover, Brunswick, Oldenberg and Schaumberg–Lippe. Agriculture focuses on cereal crops. Industries: machine construction, electrical engineering. Area: 47,606sq km (18,376sq mi). Pop. (1993 est.) 7,648,004.

Lowry, L.S. (Lawrence Stephen) (1887–1976) British painter. He is best known for the highly personal way in which he portrayed cityscapes of his native Salford.

Loyalist In Northern Ireland, a person who wishes that province to remain part of the United Kingdom of Great Britain and Northern Ireland. In contrast, a Republican is a person who wishes the province to unite with the neighbouring Republic of Ireland. In US history, the term referred to North American colonists who refused to renounce loyalty to the British crown after the DECLARATION OF INDEPENDENCE (July 1776).

LSD (lysergic acid diethylamide) Hallucinogenic drug, causing changes in mental state, sensory confusion and behavioural changes, resulting from the drug blocking the action of serotonin in the brain. First synthesized in the 1940s, LSD was made illegal in the UK and USA in the mid-1960s.

Luanda Capital, chief port and largest city of Angola, on the Atlantic coast of sw Africa. First settled by the Portuguese in 1575, its economy was based on the shipment of more than 3 million slaves to Brazil until the abolition of slavery in the 19th century. Today it exports crops from the province of

Luanda. Industries: oil refining, metalworking, building materials, textiles, paper, oil products. Pop. (1990) 1,544,000. Lübeck Baltic port at the mouth of the Trave River, Schleswig-Holstein, NE Germany. A Slavonic city in the 11th century, in 1138 it was destroyed by fire. In 1143 it was refounded as part of Holstein. In the 13th century it held a preeminent position in the Hanseatic League. During the 16th century the city declined as the importance of trade with Scandinavia decreased. In 1937 it was incorporated into Schleswig-Holstein. The city was badly damaged by Allied bombing during World War 2. The port is the principal employer. Industries: shipbuilding, aeronautical equipment, steel, ceramics, fish canning, timber products. Pop. (1990) 216,500.

Lublin City in sE Poland. Founded in the late 9th century, Lublin developed as a trade centre along the SE route to the Ukraine. The city has twice produced national governments: Poland's first Council of Workers' Delegates (a temporary authority) was formed in 1918; and in 1944, following the retreat of the German army, the provisional government was convened in Lublin. Today it is the focus for a fertile farming region and a transport and industrial centre, producing heavy machinery, textiles and electrical goods. Pop. (1991) 352,000. Lucas, George (1944-) US film director and producer. Lucas began his career as an assistant to Francis Ford Coppo-LA. American Graffiti (1973) was his breakthrough film. Lucas is best known for his science fiction classic Star Wars (1977). It was revolutionary in its use of special effects and became one of the biggest grossing films of all time. Lucas was executive producer of the Star Wars sequels The Empire Strikes Back (1980) and Return of the Jedi (1983). He worked with Steven Spielberg on the "Indiana Jones" trilogy.

Lucas van Leyden (1494-1533) Dutch painter and celebrated engraver. His engravings (which are regarded as second only to those of Dürer) include Ecco Homo and Dance of the Magdalene (1519). Among his paintings are Moses Striking Water from the Rock (1527) and Last Judgement (1526). Lucerne City on Lake Lucerne, central Switzerland. It joined the Swiss Confederation in 1332. Lucerne became the capital of the French-inspired Helvetic Republic in 1803, but rejoined the Confederation in 1848. It is a summer resort and the centre of the cereal-growing canton of Lucerne. Industries: engineering, metal goods, chemicals, printing, textiles. It is host to a summer music festival. Pop. (1994 est.) 61,656. Lucifer Name given in ancient Roman times to the planet Venus as seen at dawn. In classical mythology, Lucifer's Greek counterpart was Phosphorus, and both were personified as male torch-bearers. In Christian mythology, Lucifer was an epithet of SATAN.

Lucknow City in N India, on the River Gomati; capital and largest city of Uttar Pradesh. The first Mogul emperor of India conquered the city in 1528. It was the capital of the kingdom of Oudh (1775–1856), then of Oudh province (1856–77) and of the United Provinces (1887). Lucknow was the centre of the Muslim League in its campaign (1942–47) for an independent Pakistan. Industries: papermaking, distilling, chemicals, printing, handicrafts. Pop. (1991) 1,642,000. **Lucretius** (*c*.95–55 BC) (Titus Lucretius Carus) Latin poet and philosopher. His long poem *De rerum natura* (On the Nature of Things) is based on the philosophy of EPICURUS.

Luddites Unemployed workers in early 19th-century England who vandalized the machines that had put them out of work. They were chiefly hand-loom weavers who were replaced by mechanical looms. The riots started in the Nottingham area in 1811 and spread to Lancashire and Yorkshire before dying out after 1815.

Ludendorff, Erich (1865–1937) German general. He played a major part in revising the SCHLIEFFEN PLAN before World War 1. In 1914 he masterminded the victory over the Russians at Tannenberg. In 1916 he and Hindenburg were given supreme control of Germany's war effort. In the 1920s he was a member of the Nazi Party.

Ludlow, Roger (1590–1664) English colonist in North America. He helped found Dorchester, Massachusetts, and became deputy governor of Massachusetts in 1634. He presided over the first Connecticut court at Windsor in 1636

and evolved the state's first codified laws, known as Ludlow's Code. He returned to England in 1654.

Luftwaffe German air force. In English-speaking countries, the term refers specifically to the air force of Nazi Germany. Built up rapidly in the 1930s, it was designed primarily as part of German *Blitzkrieg* tactics and was highly effective in the early stages of WORLD WAR 2 and during the invasion of the Soviet Union (1941). It was less successful as a high-explosive bombing force in the Battle of BRITAIN (1940).

lugworm Marine WORM that lives in the sand of the seabed. With the aid of bristles along its middle portion, it burrows a U-shaped tunnel in sand or mud, from which it rarely emerges. Length: up to 30cm (12in). Genus *Arenicola*.

Lukacs, György (1885–1971) Hungarian literary critic and philosopher. He joined the Communist Party in 1918 and was exiled after the abortive 1919 revolution. He returned to Budapest in 1945. His writings include *History and Class Consciousness* (1923) and *The Historical Novel* (1955).

Luke, Saint Author according to Christian tradition of the gospel that bears his name and of the ACTS OF THE APOSTLES in the New Testament. He is said to have been a physician, to have been able to speak and write Greek, and may have been a non-Jew born in Antioch, Syria (modern-day Antakiyah, Turkey). He was a co-worker of the apostle St PAUL. Luke is the patron saint of painters. His feast day is 18 October.

Luke, Gospel according to Saint Third book of the New Testament and one of the three Synoptic Gospels. It is traditionally attributed to St Luke. One of its sources is the Gospel according to St Mark, but it also seems to have relied on another source (now lost), which scholars refer to as "Q".

Lully, Jean Baptiste (1632–87) French composer, b. Italy. Lully was an early influence on the development of French opera. He joined the court musicians to Louis XIV in 1652. After a series of comedy-ballets (1658–64) came *Cadmus and Hermione* (1673), which has been termed the first French lyrical tragedy. Other operas include *Alceste* (1674), *Proserpine* (1680) and *Acis et Galatée* (1686).

lumbago Pain in the lower (lumbar) region of the back. It is usually due to strain or poor posture. When associated with sciatica, it may be due to a slipped disc. *See also* RHEUMATISM **lumen** (symbol lm) SI unit measuring the amount of light in a certain area for one second. The light is emitted in a unit solid angle (one steradian) from a source of unit intensity (one CANDELA).

Lumière, Louis Jean and Auguste Two brothers, Louis Jean (1864–1948) and Auguste (1862–1954), pioneers of CINEMATOGRAPHY. Together they invented an early combination of motion-picture camera and projector called the *Cinématographe*. Their film *Lunch Break at the Lumière Factory* (1895) is generally considered to be the first motion picture. They made numerous short films, each only 30 seconds or a minute in length. By 1895 the brothers had made improvements in colour photography. *See also* CINEMA

luminescence See PHOSPHORESCENCE

luminism Art style followed by a group of 19th-century US painters. The Luminists were principally concerned with the depiction of light and atmospheric effects. They used careful gradations of tone to achieve these, so that no brushwork was apparent. The leading figures were George Caleb BINGHAM, Asher Durand and members of the HUDSON RIVER SCHOOL.

luminosity Absolute brightness of a star, given by the amount of energy radiated from its entire surface per second. It is expressed in watts (joules per second), or in terms of the Sun's luminosity. Bolometric luminosity is a measure of the star's total energy output, at all wavelengths. Absolute magnitude is an indication of luminosity at visual wavelengths.

lumpfish (lumpsucker) Marine fish of the North Atlantic coasts. A bottom-dwelling fish, it has a roughly spherical body and a modified sucking disk formed by pelvic fins, with which it attaches itself to rocks. Length: up to 61cm (2ft); weight: 6lkg (13lb). Family Cyclopteridae

Lumumba, Patrice Emergy (1925–61) African political leader, first prime minister of the Republic of the Congo (ZAÏRE). He was a leader of the independence movement against Belgian rule and became prime minister in 1960.

▲ Lumière On 22 March 1895
Louis Lumière (pictured) and his
brother, Auguste, projected their
first film. On 28 December 1895
they projected several short
films to a paying audience for
the first time. This date is now
considered by many to be the
birthday of cinema. Lumière
initially shot his films himself,
but later employed
photographers, who were sent
all over the world to record
important events.

Refusing to accept dismissal after three months, he was captured by government troops and subsequently killed.

lungfish Elongated fish from which the first amphibians developed, found in shallow freshwater and swamps in Africa, South America and Australia. It has primitive lungs, and during a dry season the various species can breath air or survive total dehydration by burrowing into the mud and enveloping themselves in a mucous cocoon. Order Dipnoi

lungs Organs of the RESPIRATORY SYSTEM of vertebrates, in which the exchange of gases between air and blood takes place. They are located in the pleural cavity within the ribcage. This cavity is lined by two sheets of tissue (the pleura), one coating the lungs and the other lining the walls of the thorax. Between the pleura is a fluid that cushions the lungs and prevents friction. Light and spongy, lung tissue is composed of tiny air sacs, called ALVEOLI, which are served by networks of fine capillaries. *See also* GAS EXCHANGE; VENTILATION

lupin Any ANNUAL and PERENNIAL plants of the genus *Lupinus*, in the PEA family. They have star-shaped compound leaves and tall showy spikes of flowers. Height: to 2.4m (8ft). Family Fabaceae/Leguminosae.

lupus erythematosus Autoimmune disease affecting the skin and connective tissue. The discoid form causes red patches covered with scales, often on the cheeks and nose. The systemic or disseminated form varies in severity. Nine times more common in women than in men, the disease is treated mainly with corticosteroids.

lupus vulgaris Tuberculous infection of the skin. Often starting in childhood, it is characterized by the formation of brownish nodules, leading to ulceration and extensive scarring. Treatment is with antituberculous drugs.

The mechanism of breathing introduces air into the lungs for the exchange of oxygen and carbon dioxide. Air is funnelled into the trachea, the flexible windpipe ringed with cartilage. The trachea forks into the left and right bronchi, which enter their respective lungs. Each bronchus

branches into several small segments, or bronchi, terminating ultimately in more than 250,000 respiratory bronchioles, each about 0.5 mm (0.02in) in diameter. Beyond lie the alveolar ducts leading into hollow alveoli. Here in the alveoli, networked with capillaries only one cell in width,

diffusion occurs across a fine membrane. Stale blood is reoxygenated and makes its way back to the heart to be pumped to each living cell in the body.
Carbon dioxide is eliminated from the lungs in expired air. The inset diagram shows the position of the diaphragm during breathing.

Lusaka Capital and largest city of Zambia, in the s central part of the country, at an altitude of 1,280m (4,200ft). Founded by Europeans in 1905 to service the local lead mining, it replaced Livingstone as the capital of Northern Rhodesia (later Zambia) in 1935. A vital road and rail junction, Lusaka is also the centre of a fertile agricultural region and is a major financial and commercial city. Industries: textiles, shoe manufacture, cement, food processing, car assembly, brewing. Pop. (1990) 982,000 lute Plucked stringed instrument most popular in 16th— and 17th—century Europe. It has an almond-shaped body and fretted neck and originally had 11 gut strings. It was often played to accompany songs and stylized dances and has been revived in recent years as a concert instrument.

Luther, Martin (1483–1546) German Christian reformer who was a founder of Protestantism and leader of the Reformation. He was deeply concerned about the problem of salvation, finally deciding that it could not be attained by good works but was a free gift of God's grace. In 1517 he affixed his 95 Theses to the door of the Schlosskirche in Wittenberg. This was a document that included, among other things, statements challenging the sale of INDULGENCES. This action led to a quarrel between Luther and church leaders, including the pope. Luther decided that the Bible was the true source of authority and renounced obedience to Rome. He was excommunicated, but gained followers among churchmen as well as the laity. After the publication of the Augsburg Confession (1530) he gradually retired from the leadership of the Protestant movement. See also Lutheranism

Lutheranism Doctrines and Church structure that grew out of the teaching of Martin LUTHER. The principal Lutheran doctrine is that of justification by faith alone (*sola fide*). Luther held that grace cannot be conferred by the Church but is the free gift of God's love. He objected to the Catholic doctrine of TRANSUBSTANTIATION. Instead, Luther believed in the real presence of Christ "in, with, and under" the bread and wine (consubstantiation). The essentials of Lutheran doctrine were set down by Philip MELANCHTHON in 1530 in the AUGSBURG CONFESSION, which has been the basic document of the Lutherans ever since. In 1947 the Lutheran World Federation was formed as a coordinating body for Lutheranism on a global scale.

Luthuli, Albert John Mvumbi (1898–1967) South African civil rights leader. Elected chief of a ZULU community, he became president of the AFRICAN NATIONAL CONGRESS (ANC) in 1952. A period of increasing militancy culminated in the banning of the ANC in 1960. Luthuli was constantly harassed by the government for his non-violent protests against APARTHEID and demands for a non-racial democracy. He was the first African to be awarded the Nobel Peace Prize (1960). Thereafter, his movements were closely restricted and his publications banned.

Lutoslawski, Witold (1913–94) Polish composer. He gained international recognition with his *Concerto for Orchestra* (1954). He later experimented with serialism, notably in *Funeral Music* (1958), and aleatory techniques, as in *Venetian Games* (1961).

Lutyens, Sir Edwin Landseer (1869–1944) British architect. He built a reputation on original designs for houses. He developed a talent for more majestic commissions in his World War 1 memorials, notably The Cenotaph (1922) in Whitehall, London. His most ambitious project was his plan for the imperial capital of New Delhi (1913–30).

Lutyens, (Agnes) Elisabeth (1906–83) British composer, daughter of Sir Edwin LUTYENS. She worked mainly within the TWELVE-TONE MUSIC system. Her works include various symphonies as well as *Quincunx for Orchestra* (1959–60) and the operas *The Numbered* and *Isis and Osiris* (both 1973) lux (symbol lx) SI unit of illumination, equal to one LUMEN per square metre.

Luxembourg Independent grand duchy in w Europe, bordered by Belgium, France and Germany; the capital is Luxembourg. **Land and climate** Luxembourg is divided geographically into the forested Ardennes plateau and the fertile Bon Pays in the s. In the e, the Moselle and Sauer river valleys provide fertile farmland. Luxembourg has a temperate climate. Forests cover *c.*20% of Luxembourg, farms 25%, and pasture

another 20%. History In the 11th century the county of Luxembourg formed one of the largest fiefs of the Holy Roman Empire. In 1354 Luxembourg became a duchy. In 1482 it passed to the HABSBURG dynasty, and in the 16th century it was incorporated in the Spanish Netherlands. In 1714 it passed to Austria. It was occupied by France during the Napoleonic Wars and was made a Grand Duchy at the Congress of VIENNA (1815). In 1839 Belgium acquired a large part of the duchy. In 1867 Luxembourg was recognized as an independent state and its neutrality was guaranteed by the European powers. Luxembourg was occupied by Germany in World War 1 and in 1940 Germany invaded again. A neutral government-in-exile was formed in London. In 1948 it joined NATO. In 1960 Belgium, Netherlands and Luxembourg formed the economic union of Benelux. Luxembourg was one of the six founders of the European Community (EC). In 1964 Prince Jean became Grand Duke. Politics Following 1994 elections, the Christian Social People's Party (CD) and the Luxembourg Socialist Workers' Party (SOC) formed a coalition government. Jean-Claude Juncker (CD) became prime minister. Economy There are rich deposits of iron ore, and Luxembourg is a major producer of iron and steel. Other industries: chemicals, textiles, tourism, banking, electronics. Farmers raise cattle and pigs. Major crops: cereals, fruits, grapes for winemaking. The city of Luxembourg is a centre of European administration and finance.

Luxembourg Capital of the Grand Duchy of Luxembourg, at the confluence of the Alzette and Pétrusse rivers. Luxembourg was a stronghold in Roman times. The walled town developed around a 10th-century fortress. The Treaty of London (1867) dismantled the fortress and demilitarized the city. It is the seat of the European Court of Justice, the Secretariat of the Parliament of the European Union, the European Monetary Fund, the European Investment Bank and the European Coal and Steel Union. Industries: iron and steel, chemicals, textiles, tourism. Pop. (1995) 76,446.

Luxemburg, Rosa (1871–1919) German socialist leader, b. Poland. She was an active revolutionary and anti-nationalist in Russian Poland before acquiring German citizenship by marriage. She founded the radical left-wing Spartacist League in 1916 with Karl LIEBKNECHT. Both she and Liebknecht are thought to have been murdered while under arrest in 1919.

Luxor (Arabic, El Uqsur) City in E central Egypt, on the E bank of the River Nile; known to the ancient Egyptians as Weset and to the ancient Greeks as Thebes. After the PYRA-MIDS, Luxor's temples and tombs constitute Egypt's greatest pharaonic monuments. There are remains of many temples and tombs, dating back c.4,000 years. Luxor Temple lies on the banks of the Nile in the heart of the city. It was linked to the Karnak temple, 2.5km (1mi) N of Luxor, by an avenue of sphinxes. Karnak's temple complex covers 40ha (100 acres) and was built over 1,300 years. The site comprises three separate temples, the greatest of which is the Temple of Amun. The Valley of the Kings, on the Nile's w bank, contains the tombs of many pharaohs. The 1922 discovery of Tutankhamun's tomb revealed the lavish treasure buried with kings. Luxor is a winter resort town, but in 1997 58 tourists were massacred by Muslim fundamentalists. The tourist industry was badly damaged. Pop. (1992) 146,000.

Luzon Largest island of the Philippines, occupying the N part of the group; the main cities are QUEZON CITY and the nation's capital, Manila. Luzon accounts for about one-third of the land mass of the Philippines and over 50% of its population. The coastal areas are generally mountainous, the highest peak being Mount Pulog at 2,928m (9,606ft). The fertile central plain is a major rice-producing region. The indigenous Igorots also farm rice on the steep mountain terraces. The Bicol peninsula in the SE has many coconut plantations. Luzon has important mineral deposits, such as gold, chromite and copper. Manila Bay is one of the world's finest natural harbours and has been the landing point for countless invasions. Luzon has been at the epicentre of Philippine nationalism, leading revolts first against Spanish rule in 1896 and then against US rule in 1899. In 1941 the island was invaded by the Japanese. US forces staged a last desperate stand on BATAAN peninsula in 1942. In 1945 the Japanese were finally expelled. Several US

bases have remained on the island since World War 2. Area: 104,688sq km (40,420sq mi). Pop. (1992 est.) 30,500,000.

Lvov (Ger. Lemberg) City in w Ukraine, on a tributary of the River Bug, close to the Polish border. Founded in 1256 by a Ukrainian prince, it was captured by Poland in 1340. Lvov became part of Austria in 1772, and in 1918 was briefly the capital of the independent Ukrainian Republic, before reverting to Poland. It was annexed by the Soviet Union (1945–91). Industries: heavy machinery, chemicals, oil refining, food processing. Pop. (1992) 807,000.

Lyceum School in Classical Athens where ARISTOTLE taught. In later times the name was adopted by many educational institutions, including a group devoted to adult education in the USA, founded in 1826, in which such scholars as EMERSON and THOREAU took part.

Lycopodophyta Taxonomic group (phylum) of about 1,000 species of VASCULAR PLANTS related to ferns, which includes the CLUB MOSSES, spike mosses and quillworts. They have branching underground stems (RHIZOMES) and upright shoots supported by roots. Some species are EPIPHYTES.

Lycurgus (active *c*.625 BC) Semi-mythical lawgiver of ancient Sparta. He has been cited as the author of the political and social system in Sparta. Many scholars now doubt that one individual was responsible for the Spartan social system. **Lydia** Ancient kingdom of w Asia Minor. Under the Mermnad dynasty (c.700–547 BC), it was a powerful and prosperous state, the first to issue a coinage, with its capital at Sardis. Its last king was CROESUS, famous for his wealth, who was defeated by the Persians under CYRUS THE GREAT in 547 BC.

Lyell, Sir Charles (1797–1875) British geologist. He was influential in shaping 19th-century ideas about science and wrote the popular three-volume *Principles of Geology* (1830–33). Other works include *Elements of Geology* (1838), and *The Geological Evidence of the Antiquity of Man* (1863). Lyly, John (1553–1606) English poet, dramatist and writer of prose romances. His prose comedies and pastoral romances include *Sappho and Phao* (1584), *Endymion: the Man in the*

▲ lute Capable of great expressiveness, the lute requires a high degree of skill on the part of the player, or lutenist. The instrument was once played throughout w Europe, particularly in Middle Eastern countries, from where, it is assumed, it originated.

AREA: 2,590sq km (1,000sq mi)
POPULATION: 390,000
CAPITAL (POPULATION):
LUXEMBOURG (76,446)
GOVERNMENT:
Constitutional monarchy
(Grand Duchy)
ETHNIC GROUPS:
LUXEMBOURGE 71%,
Portuguese 10%, Italian
5%, French 3%, Belgian
3%, German 2%
LANGUAGES: Letzeburgish

(Luxembourgian-official),

French, German

RELIGIONS: Christianity

Troisy B GERMANY E singen 50°N 50°N Wiltz Diekirch LUXEMBOURG Mersch macher Steinfort embourg Hespérange Bettembourg MAP SCALE FRAN 20 km 10 mile

(Roman Catholic 95%, Protestant 1%) currency: Luxembourg franc = 100 centimes

▲ Iynx The s European lynx (Felis lynx) is found only in inaccessible mountain sierras in s Spain and Portugal. It is the same species as the common lynx, which is found in North America and Asia as well as Europe, but has more clearly defined markings. The red lynx, or bobcat (Felix rufus), ranges throughout North America as far s as Mexico. It has adapted to living in a variety of habitats, and is among the most common wild cats in the USA.

Moon (1591) and *Midas* (1592), but he is best known for the elaborate prose style that he evolved in *Euphues* (1578).

lyme disease Condition caused by a spirochete (spiral-shaped bacterium) transmitted by the bite of a TICK that lives on deer. It usually begins with a red rash, often accompanied by fever, headache and pain in the muscles and joints. Untreated, the disease can lead to chronic arthritis, and there may also be involvement of the nervous system, heart, liver, or kidneys. It is treated with ANTIBIOTICS.

lymph Clear, slightly yellowish fluid derived from the BLOOD and similar in composition to plasma. Circulating in the LYMPHATIC SYSTEM, it conveys LEUCOCYTES (white blood cells) and some nutrients to the tissues.

lymphatic system System of connecting vessels and organs in vertebrates that transport LYMPH through the body. Lymph flows into lymph capillaries and from them into lymph vessels, or lymphatics. These extend throughout the body, leading to lymph glands that collect lymph, storing some of the LEUCOCYTES. Lymph nodes empty into large vessels, linking up into lymph ducts that empty back into the CIRCULATORY SYSTEM. The lymphatic system plays a major role in the body's defence against disease. At the lymph nodes, MACROPHAGES trapped in a network of fibres remove foreign particles, including bacteria, from the lymph.

lymph glands (lymph nodes) Masses of tissue occurring along the major vessels of the LYMPHATIC SYSTEM. They are filters and reservoirs that collect harmful material, notably bacteria and other disease organisms, and often become swollen when the body is infected.

lymphocyte Type of white blood cell found in vertebrates. Produced in the bone marrow, they are mostly found in the lymph and blood and around infected sites. In human beings lymphocytes form about 25% of LEUCOCYTES (white blood cells) and play an important role in combating disease. There are two main kinds: B-lymphocytes, responsible for producing antibodies; and T-lymphocytes, which maintain immunity. lynx Any of several small CATS found in forests of central and N Europe, along the French-Spanish border, and in the USA. It may be yellow-grey or reddish-brown. It has long legs, large feet, tufted ears, and characteristic beard-like hair on its cheeks. Length: to 116cm (46in). Family Felidae.

lymph nodules valves

network of lymphatic vessels which collects tissue fluid (the lymph) and conducts it back to the bloodstream. In the process it transports nutrients from blood to cells and cell wastes back into capillaries. Lymph drains through the system but the lymphatics possess valves

The lymphatic system is a

to prevent backflow. Lymphatic nodes are scattered along the lymph vessels but particularly in the neck, ampits and groin. In the tissue around the nodes micro-organisms are destroyed by macrophage cells, while antibody-synthesizing white blood cells, the lymphocytes, are produced by the lymph nodules.

Lyon (Eng. Lyons) City and river port in SE France, at the confluence of the Rhône and Saône rivers; capital of Rhône département. Lyon was founded by the Romans as Lugdunum in 43 BC and became the capital of Roman Gaul. Its historic association with silk began in the 15th century. It was also one of the first printing centres. In 1793 Lyon was devastated by French Revolutionary troops. During World War 2 it was a stronghold of the French resistance. Lyon is the third-largest city in France, a major industrial area, and Europe's biggest producer of silk and rayon fabrics. Pop. (1990) 415,487.

lyre Ancient stringed musical instrument. Used originally by the Sumerians, it was introduced into Egypt and Assyria in the second millennium BC. In classical Greek times it had seven strings supported by a wooden frame and attached to a sound box at the base; the strings were plucked using a bulky plectrum. In Europe since the Middle Ages they have more commonly been played with a bow. Today the lyre also exists in various forms in E Africa and in Ethiopia.

lyrebird Either of two shy Australian songbirds; the superb lyrebird (*Menura superba*) and Albert's lyrebird (*M. alberti*). These large, perching birds have lyre-shaped tails displayed during courtship performances.

Lysander (d.395 BC) Spartan general. He was responsible for the victory over Athens during the PELOPONNESIAN WAR (429–404 BC), defeating the Athenian fleet in 406 and 405 BC and obtaining Persian support for Sparta. He forfeited his popularity by establishing oligarchies under a Spartan governor in cities he liberated from Athens, and lost influence in Sparta after the accession of King Agesilaus II in 399 BC.

Maastricht City on the River Maas; capital of Limburg province, SE Netherlands. Maastricht's strategic location close to the Belgian and German borders has meant frequent occupation by foreign armies. In 1992 the MAASTRICHT TREATY was signed here. It is the commercial, industrial and transport centre for a wide region. Industries: dairy products, paper, leather goods, glass. Pop. (1994) 118,102.

Maastricht Treaty (7 February 1992) Agreement signed by the leaders of 12 European nations at MAASTRICHT, Netherlands. It turned the EUROPEAN COMMUNITY (EC) into the EUROPEAN UNION (EU), with a view to eventually becoming an integrated federation. The Treaty included a timetable for a single currency; an end to all internal immigration/emigration, customs and excise operations; the full empowerment of the EUROPEAN PARLIAMENT and its Commissions; an agreed social welfare policy (the social chapter); and measures to set up a common defence policy. The British prime minister, John MAJOR, retained an opt-out clause in relation to the social chapter. Under Tony BLAIR, Britain signed the social chapter. Maazel, Lorin (1930–) US conductor, b. France. Maazel made his debut as a conductor in 1953. He was director of Deutsche Opera (1965–71) and Vienna State Opera

burgh Symphony Orchestra (1986–). **Mabuse** (1478–1536) (Jan Gossaert) Netherlandish painter. He began his career in the tradition of Gerard DAVID and Hugo van der GOES, but changed his style dramatically after a visit to Italy as an assistant to Philip of Burgundy in 1508–09. Italianate features appeared within his Netherlandish style, as seen in *Neptune and Amphitrite* (1516).

(1982-84). A methodical, lively performer he was music

director of the Cleveland Orchestra (1971-82), and the Pitts-

McAdam, John Loudon (1756–1836) Scottish engineer who invented the macadam road surface. He proposed that roads should be raised above the surrounding ground, with a base of large stones covered with smaller stones and bound together with fine gravel. He was made surveyor general of roads in Britain in 1827.

macadamia Genus of Australian trees of the family Proteaceae. Most species have stiff, oblong, lance-like leaves. The edible seeds are round, hard-shelled nuts, covered by thick husks that split when ripe. Height: to 18m (60ft).

macaque Diverse group of omnivorous, medium-sized to large Old World MONKEYS found from NW Africa to Japan and Korea. Most are yellowish brown and are forest dwellers and good swimmers. Weight: to 13kg (29lb). Genus *Macaca*. See also BARBARY APE: RHESUS

MacArthur, Douglas (1880–1964) US general. A divisional commander in World War 1, he became army chief of staff in 1930 and military adviser to the Philippines in 1935, retiring from the US army in 1937. He was recalled in 1941 and conducted the defence of the Philippines until ordered out to Australia. As supreme Allied commander in the sw Pacific (1942), he directed the campaigns that led to Japanese defeat. He was appointed commander of UN forces on the outbreak of the KOREAN WAR in 1950. Autocratic and controversial, he was relieved of his command by President TRUMAN in April 1951. Macau (Macao) Portuguese overseas province in SE China, 64km (40mi) w of Hong Kong, on the River Pearl estuary; it consists of the 6sq km (2sq mi) Macau Peninsula and the nearby islands of Taina and Colôgne. The city of Santa Nome de

consists of the osq kin (2sq ini) Macau remissia and the hearby islands of Taipa and Colôane. The city of Santa Nome de Deus de Macau (coextensive with the peninsula) is connected by a narrow isthmus to the Chinese province of GUANGZHOU. The first European discovery was by Vasco da Gama in 1497. The Portuguese colonized the island in 1557. In 1849 Portugal declared it a free port. In 1887 the Chinese government recognized Portugal's right of "perpetual occupation". Competition from Hong Kong and the increased silting of Macau's harbour led to the port's decline towards the end of the 19th century. In 1974 Macau became a Chinese province under Portuguese administration. It is scheduled to be returned to China in 1999. Macau's economy is based on gambling and tourism. Other industries: textiles, electronics, plastics. Pop. (1991) 339,464.

Macaulay, Thomas Babington (1800–59) English historian and statesman. He upheld liberal causes in Parliament (1830–38) and served on the British governor's council in

India (1834–38), where he introduced a Western education system. He re-entered Parliament but spent his later years mainly in writing his *History of England* (1849–61).

Macbeth (d.1057) King of Scotland (1040–57). In 1040 he killed Duncan I, his cousin, in battle and seized the throne. English intervention on behalf of Duncan's son (later Malcolm III Canmore) resulted in his defeat by Siward, earl of Northumbria, at Dunsinane Hill, near Scone (1054). Macbeth fled north, and was eventually killed by Malcolm at Lumphanan. Shakespeare based his tragedy on a 16th-century history of the king. Maccabees, Books of Four historical books, two of which are included in the Roman Catholic Deuterocanonical books of the Bible and the Protestant APOCRYPHA. These two are modelled on the Old Testament books of Chronicles and are a valuable historical source for the period they describe. The other two books of Maccabees are PSEUDEPIGRAPHA.

McCarthy, Joseph Raymond (1908–57) US senator from Wisconsin, leader of a crusade against alleged communists in US government. McCarthy took advantage of Cold War anti-communist hysteria and widened his attack to the rest of society, especially the entertainment industry. In 1954 his investigations committee turned its attention to the army. The hearings were televised and McCarthy's accusations were shown to be baseless.

McCarthy, Mary (1912–89) US writer and drama critic. She wrote several novels, including *The Groves of Academe* (1952) and *The Group* (1963). Among her other works are *Venice Observed* (1956), and the autobiography *Memories of a Catholic Girlhood* (1957).

McCartney, Sir Paul (1942–) British pop singer and songwriter. McCartney was the bass player in The BEATLES and co-wrote most of their hit songs with John LENNON. The release of his solo album, McCartney (1970), marked the break-up of The Beatles. In 1971 he formed a new band, Wings, with his wife Linda (1942–). "Mull of Kintyre" (1977) became the bestselling (2.5 million) UK single. In 1995 McCartney was involved in a brief reformation of The Beatles. During the 1990s he turned to more classically inspired work, such as Liverpool Oratorio (1991) and Standing Stone (1997). He was knighted in 1997.

McClellan, George Brinton (1826–85) US general and political leader. He served in the MEXICAN WAR and was appointed commander of Union forces early in the CIVIL WAR (November 1861). He directed major campaigns in 1862, but his conservative tactics irked President LINCOLN and he was replaced. He ran unsuccessfully as Democratic candidate for president against Lincoln in 1864 and was governor of New Jersey (1878–81).

McCullers, Carson (1917–67) US writer. Her remarkable debut novel, *The Heart is a Lonely Hunter* (1940), showed her to be a sensitive exponent of the "southern gothic" style, epitomized by Tennessee WILLIAMS and William FAULKNER. Other poetic stories include *Reflections in a Golden Eye* (1941), and *The Ballad of the Sad Cafe* (1951).

McCullin, Donald (1935–) British photographer, best known for his war photo-journalism for *The Observer* and *The Sunday Times*. McCullin produced haunting images of the horrors of conflict in Vietnam (1968) and Cambodia (1970).

MacDiarmid, Hugh (1892–1978) Scottish poet and critic, b. Christopher Murray Grieve. A nationalist and communist, MacDiarmid was the dominant poetic voice in Scotland from the early 1920s. His revival of Scots as a medium for poetry was influential in the 20th-century Scottish renaissance, of which *A Drunk Man Looks at the Thistle* (1926) is regarded as the poetic masterpiece.

Macdonald, Sir John Alexander (1815–91) Canadian statesman, first prime minister of the Dominion of Canada (1867–73, 1878–91). He strengthened the Dominion by the introduction of protective tariffs, encouragement of western settlement and the acquisition of HUDSON'S BAY COMPANY lands (1869). His efforts to organize a transcontinental railway led to the Pacific Scandal and electoral defeat (1873).

MacDonald, (James) Ramsay (1866–1937) British statesman, prime minister (1924, 1929–31, 1931–35), b. Scotland. MacDonald became an MP in 1906, and leader of

M/m, the 13th letter of the alphabet, derived from the Semitic letter mem (meaning water). The corresponding Greek letter was mu, which went via the Etruscan alphabet to Latin as m. In English it always has the same pronunciation, but has the effect of silencing a following b that ends a word, such as in numb. the Labour Party in 1911. His opposition to Britain's participation in World War 1 lost him the party leadership (1914), and his seat (1918). MacDonald was re-elected to parliament and as Labour leader in 1922. In 1924 he became prime minister and foreign secretary in Britain's first Labour government. His administration was short-lived as the Liberal Party withdrew its support, and Stanley Baldown succeeded him. Labour's second spell in office was also cut short, this time by the Great Depression. MacDonald, however, remained in office at the head of a Conservative-dominated "National" government. MacDonald lost his seat in the 1935 general election and Baldwin returned to power.

MacDowell, Edward Alexander (1861–1908) US composer. He is remembered chiefly for his piano works, including four sonatas, 12 studies, some lyrical suites and, above all, his two piano concertos.

Macedon Ancient country in se Europe, roughly corresponding to present-day MACEDONIA, Greek Macedonia and Bulgarian Macedonia. The Macedonian king Alexander I (d.420 BC) initiated a process of Hellenization. Philip II founded the city of Thessaloniki (348 BC), and was acknowledged as king of Greece in 338 BC. His son, ALEXANDER THE GREAT, built a world empire, but this rapidly fragmented after his death (323 BC). Macedon was eventually defeated by the Romans in the Macedonian Wars, and the empire was restricted to Macedonia proper. In 146 BC Thessaloniki became capital of the first Roman province. In AD 395 Macedonia became part of the

Eastern Roman (Byzantine) empire. Slavs settled in the 6th century, and from the 9th to the 14th century control of the territory was contested mainly by Bulgaria and the Byzantine empire. A brief period of Serbian hegemony was followed by Ottoman rule from the 14th to 19th century. In the late 19th century Macedonia was claimed by Greece, Serbia and Bulgaria. In the first of the BALKAN WARS, Bulgaria gained much of historic Macedonia, but was decisively defeated in the Second Balkan War and the present-day boundaries were established. **Macedonia** Balkan republic, SE Europe. See country feature

McEnroe, John Patrick, Jr (1959–) US tennis player, b. Germany. McEnroe was an exquisite stroke-maker, whose fiery temperament often brought him into conflict with referees. He won the US Open singles four times (1979–81, 1984), and Wimbledon three times (1981, 1983–84). McEnroe and Peter Fleming also captured 10 Grand Slam doubles titles.

Machaut, Guillaume de (1300–77) French poet, musician and diplomat. His best-known poetry, which influenced CHAUCER and anticipated the ballade and the rondeau, is to be found in *Le livre de Voir-dit*. A leading figure of the *ars nova*, he was among the first to compose polyphonic settings of poetry and the Mass.

Machiavelli, Niccolò (1469–1527) Florentine statesman and political theorist. He served from 1498 to 1512 as an official in the republican government of Florence, but lost his post when the Medici family returned to power. His most famous work, *The Prince* (1513), offered advice on how the

MACEDONIA

At the centre of Macedonia's flag, introduced in August 1992, was an emblem found on the war-chest of Philip II of Macedon. The Greeks claimed this symbol as their own, and, in 1995, Macedonia agreed to redesign its flag, as shown here.

The landlocked Former Yugoslav Republic of Macedonia is a largely mountainous country in SE Europe. The land rises to Mount Korab, at 2,764m (9,068ft), on the border with Albania. Most of Macedonia is drained by the River Vardar, and the capital, SKOPJE, lies on its banks. In the sw, Macedonia shares the large lakes of Ohrid and Prespa with Albania and Greece.

CLIMATE

Macedonia's climate is mainly continental, with hot summers, cold winters and often heavy snowfall. Rainfall is slightly heavier in early summer and autumn.

VEGETATION

Mountain forests of beech and oak are common, but farmland covers c.30% of Macedonia.

HISTORY AND POLITICS

(for history pre-1913, see MACEDON) The BALKAN WARS (1912-13) ended with the flight of thousands of Macedonians into Bulgaria, and the division of Macedonia into Greek Macedonia, Bulgarian Macedonia and Serbian Macedonia (the largest portion, in the N and centre). At the end of World War 1, Serbian Macedonia became part of the Kingdom of the Serbs, Croats and Slovenes (later YUGOSLAVIA). Macedonian nationalists waged an armed struggle against Serbian domination. Between 1941 and 1944, Bulgaria occupied all Macedonia, but a peace treaty restored the 1913 settlement. In 1946 President Tito created a federal Yugoslavia, and Macedonia became one of its constituent republics. Regional tension between Greece, Bulgaria and Yugoslavia remained strong. Multiparty elections in 1990 produced the first post-war, non-communist regional government. The break-up of the Yugoslav Federation led to Macedonia's declaration of independence in September 1991. It renounced all territorial claims to Greek and Bulgarian Macedonia, but (under pressure from Greece) the EC refused to recognize its sovereignty, on the grounds that AREA: 24,900sq km (9,600sq mi)

POPULATION: 2,174,000

CAPITAL (POPULATION): Skopje (440,577)
GOVERNMENT: Multiparty republic
ETHNIC GROUPS: Macedonian 65%, Albanian
21%, Turkish 5%, Romanian 3%, Serb 2%

LANGUAGES: Macedonian

RELIGIONS: Christianity (mainly Eastern Orthodox, with Macedonian Orthodox and Roman Catholic communities), Islam CURRENCY: Denar = 100 paras

its name, flag and currency were signs of its territorial intentions. A compromise was reached, and the country temporarily became known as the Former Yugoslav Republic of Macedonia (FYRM). In 1993 the UN accepted the new republic as a member and all the EU members, except Greece, established diplomatic relations with the FYRM. In 1994 Greece banned Macedonian trade through Greece. The ban was lifted in 1995, when Macedonia agreed to redesign its flag and remove any claims to Greek Macedonia from its constitution. Internal tensions exist between Macedonians and the Albanian minority.

ECONOMY

Macedonia is a developing country. The poorest of the six former republics of Yugoslavia, its economy was devastated by UN trade sanctions against the rump Yugoslav federation and by the Greek embargo. In 1995 unemployment was running at 45%, and inflation at 57%. The extent of national debt is also a major obstacle. Manufactures, especially metals, dominate exports. Macedonia mines coal, but imports oil and natural gas. Agriculture employs nearly 17% of the workforce, and Macedonia is nearly self-sufficient in food. Major crops include cotton, fruits, maize, tobacco and wheat.

ruler of a small state might best preserve his power, including judicious use of force. The term Machiavellian, to describe immoral and deceitful political behaviour, arose from a simplification of Machiavelli's ideas.

machine Device that modifies or transmits a force in order to do useful work. In a basic (simple) machine, a force (effort) overcomes a larger force (load). The ratio of the load (output force) to the effort (input force) is the machine's force ratio, formerly called mechanical advantage. The ratio of the distance moved by the load to the distance moved by the effort is the distance ratio (formerly velocity ratio). The ratio of the work done by the machine to that put in it is the EFFICIENCY, usually expressed as a percentage. The three primary machines are the inclined plane (which includes the screw and the wedge), the LEVER, and the wheel (which includes the PULLEY and the WHEEL AND AXLE).

machine gun Weapon that loads and fires automatically and is capable of sustained rapid fire. The firing mechanism is operated by recoil (backward thrust) or by gas from fired ammunition. The gun may be water- or air-cooled. The first widely used machine gun, the maxim gun, was invented by Hiram MAXIM in 1883. See also GATLING GUN

machine tools Power-driven machines for cutting and shaping metal and other materials. Shaping may be accomplished in several ways, including shearing, pressing, rolling, and cutting away excess material using lathes, shapers, planers, drills, milling machines, grinders and saws. Other techniques include the use of machines that use electrical or chemical processes to shape the material. Advanced machine-tool processes include cutting by means of LASER beams, high-pressure water jets, streams of PLASMA (ionized gas), and ULTRASONICS. Today, computers control many cutting and shaping processes carried out by machine tools and ROBOTS.

Mach number Ratio of the speed of a body or fluid to the local speed of sound. Mach 1 therefore refers to the local speed of sound. An aircraft flying below Mach 1 is said to be subsonic. Supersonic flight means flying at speeds above Mach 1. Mach numbers are named after the Austrian physicist Ernst Mach (1838–1916).

Machu Picchu Ancient fortified town, 80km (50mi) Nw of Cuzco, Peru. The best-preserved of the INCA settlements, it is situated on an Andean mountain saddle, 2,057m (6,750ft) above sea-level. A complex of terraces extends over 13sq km (5sq mi), linked by over 3,000 steps. Machu Picchu was discovered in 1911 by the American explorer Hiram Bingham, who dubbed it the "lost city of the Incas".

Macke, August (1887–1914) German painter. He was a prominent member of the BLAUE REITER group and specialized in sensitive watercolours. During visits to Paris (1907–12), he was influenced by Robert DELAUNAY and by experimental groups, notably FAUVISM and ORPHISM. His own work remained basically in the style of EXPRESSIONISM.

Mackenzie, Sir Alexander (1764?–1820) Canadian fur trader and explorer, b. Scotland. Mackenzie moved to Montreal in 1778, and became a partner (1787) in the fur-trading North West Company. In 1789, searching for a route to the Pacific, he followed the river now named after him to the Arctic Ocean. On his second expedition (1793), Mackenzie became the first man to cross the American continent N of Mexico. He travelled up the River Peace, discovered the River Fraser, and reached the Pacific coast at Bella Coola.

Mackenzie River in Nw Canada. The longest river in Canada, it flows c.1,800km (1,120mi) Nw from the Great Slave Lake to the Arctic Ocean. Between the Great Slave and Athabasca lakes, the Mackenzie is called the Slave River. The Mackenzie River basin in Northwest Territories is heavily forested. During the 20th century, minerals have replaced fur as the principal economic resource of the basin.

mackerel Fast-swimming, agile, marine food fish related to the TUNNY, found in N Atlantic, N Pacific and Indian oceans. They have streamlined bodies and powerful tails. The body colour is silvery blue with dark side bars. It feeds on smaller fish and plankton. Length: 61cm (2ft). Family Scombridae.

Mackerras, Sir (Alan) Charles (1925–) Australian conductor, b. USA. He was musical director of English National

Opera (1970–79). In 1986 he became music director of Welsh National Opera. His most distinctive contribution has been as an interpreter of Czech music, notably Leoš Janáček.

McKinley, William (1843–1901) 25th US president (1897–1901). McKinley sat in the House of Representatives as a Republican (1876–90) and was elected governor of Ohio in 1891. He defeated William Jennings Bryan in the presidential election of 1896. A strong and effective president, he was largely preoccupied by foreign affairs. McKinley gained the support of Congress for the Spanish-American War (1898) and sanctioned US participation in suppression of the BOXER REBELLION in China (1900). McKinley declared that ISOLATIONISM was "no longer possible or desirable". Re-elected in 1900, he was shot by an anarchist on 6 September 1901. McKinley was succeeded by Theodore ROOSEVELT.

McKinley, Mount Peak in s central Alaska state, USA, in the Alaska Range, and the highest peak in North America. Permanent snowfields cover more than half the mountain. Wildlife is abundant on the lower slopes, in particular the caribou and white Alaskan mountain sheep. It is included in Mount McKinley National Park (since 1980 known by the Aleutian name of Denali). Height: 6.194m (20,321ft).

Mackintosh, Charles Rennie (1868–1928) Scottish architect, artist and designer. He was one of the most successful and gifted exponents of ART NOUVEAU. His buildings, such as the Glasgow School of Art (1898–1909), were notable for their simplicity of line and skilful use of materials. Mackintosh's ideas, some of which came from traditional Scottish buildings, had an enormous influence on early 20th-century European architecture, especially in Germany and Austria.

MacLeish, **Archibald** (1892–1982) US poet and playwright. One of the US expatriates in Paris during the 1920s, he was strongly influenced by Ezra Pound and T.S. Eliot. The epic poem *Conquistador* (1932) and *Collected Poems* (1952) both won Pulitzer Prizes, as did the verse play *J.B.* (1958).

McLuhan, (Herbert) Marshall (1911–80) Canadian academic and expert on communications. His view that the forms in which people receive information (such as television, radio and computers) are more important than the messages themselves was presented in *The Mechanical Bride: Folklore of Industrial Man* (1951), *Understanding Media* (1964), and *The Medium is the Message* (1967).

McMillan, Edwin Mattison (1907–91) US physicist. In 1951 he shared the Nobel Prize for chemistry with Glenn Seaborg for the discovery of neptunium and other TRANSURANIC ELEMENTS. McMillan worked on the atomic bomb at Los Alamos, New Mexico, then on the cyclotron with Ernest Lawrence at the University of California at Berkeley. McMillan developed the synchrocyclotron that led to modern nuclear accelerations, for which he shared the 1973 Atoms for Peace Prize with the Russian physicist V.I. Veksler.

▲ Mackintosh Glasgow School of Art (1909). Scottish architect Charles Rennie Mackintosh based his work upon the tradition of Scottish baronial architecture, arriving at a simplified style stripped of all formal ornamentation. The clarity of line of the Glasgow School of Art shows art nouveau influences.

Macmillan, Sir (Maurice) Harold (1894-1986) British statesman, prime minister (1957-63). Macmillan became a Conservative MP in 1924. He held a succession of cabinet posts, including minister of defence (1954-55) and chancellor of the exchequer (1955-57), before succeeding Anthony EDEN as prime minister. Macmillan improved Anglo-American relations and sought a rapprochement between Moscow and Washington. His attempt to lead Britain into the European Economic Community (EEC) faltered in the face of DE GAULLE'S opposition. Macmillan's campaign on the theme of domestic prosperity ("you've never had it so good") won him a landslide victory in the 1959 general election. His government was quickly beset by recession and the Profumo scandal. Macmillan resigned on grounds of ill health, and was succeeded by Alec Douglas-Home. He became Earl of Stockton in 1984.

MacNeice, Louis (1907-63) Northern Irish poet. MacNeice was a leading member of a left-wing group of writers of the 1930s, later dubbed the "Auden circle". MacNeice and W.H. AUDEN collaborated on Letters from Iceland (1937). Other volumes include Autumn Journal (1939) and Solstices (1961). Other works include the verse play The Dark Tower (1947).

McPherson, Aimee Semple (1890-1944) US evangelist

who founded the International Church of the Foursquare Gospel (1927). McPherson's controversial brand of EVAN-GELICISM incorporated faith healing and glossolalia (speaking in tongues). In 1923 she opened the Angelus Temple in Los Angeles, California. McPherson also used the radio to broadcast her message of personal salvation. In 1926 she claimed to have been kidnapped and was unsuccessfully tried for fraud. See also PENTECOSTAL CHURCHES

Macready, William Charles (1793-1873) British actor and theatrical manager. Distinguished as a Shakespearean actor, he achieved fame in the leading role of Richard III in 1819. His productions were noted for their meticulous attention to detail. macroeconomics Study of the economic system as a whole, rather than the study of individual markets as in MICROECONOMICS. It involves the determination of items such as GROSS NATIONAL PRODUCT (GNP) and the analysis of unemployment, INFLATION, growth and the balance of payments. See also Economics; Keynes, John Maynard

macromolecule Molecule up to 1,000 times greater in diameter than the molecules of most substances. Many proteins, nucleic acids, plastics, resins, rubbers and natural and synthetic fibres are made up of such giant units.

MADAGASCAR

The colours on this flag are those used on historic flags in Southeast Asia, because it was from there that the ancestors of many Madagascans came around 2,000 years ago. The flag was adopted in 1958, when Madagascar became a self-governing republic under French rule.

adagascar, the world's fourth-largest Misland, lies 390km (240mi) off the SE coast of Africa. In the w, a wide coastal plain gives way to a central highland region, mostly

Cape d'Ambre COMOROS Antsiranana @ Mozambique Channel Mahajanga Antananarivo (Tananarive) INDIAN Tropic of Capricorn Toliara OCEAN Taolagnaro Cape St Marie 50°E

between 600m and 1,220m (2,000ft to 4,000ft). This is Madagascar's most densely populated region and home of the capital, ANTANANARIVO. The land rises in the N to the volcanic peak of Tsaratanana, at 2,876m (9,436ft). The land slopes off in the E to a narrow coastal strip.

CLIMATE

Antananarivo lies in the tropics, but temperatures are moderated by altitude. Winters (April to September) are dry, but heavy rain falls in summer. The E coastlands are warm and humid, while the w is drier.

VEGETATION

Grass and scrub grow in the s. Forest and tropical savanna once covered much of the country, but large areas have been cleared for farming, destroying natural habitats and seriously threatening Madagascar's unique and diverse wildlife.

HISTORY

Africans and Indonesians arrived over 1,400 years ago, and Muslims arrived in the 9th century. In the early 17th century Portuguese missionaries vainly sought to convert the native population. The 17th century saw the creation of small kingdoms. In the early 19th century the Merina began to subdue smaller tribes, and by the 1880s they controlled nearly all the island. In 1896 the French defeated the Merina, the monarchy was abolished, and Malagasy became a French colony. In 1942 Vichy colonial rule was overthrown by the British, and the Free French reasserted control. In 1946-48 a rebellion against French power was brutally dispatched, perhaps

AREA: 587,040sq km (226,656sq mi)

POPULATION: 12,827,000

CAPITAL (POPULATION): Antananarivo (802,000) GOVERNMENT: Republic

ETHNIC GROUPS: Merina 27%, Betsimisaraka 15%, Betsileo 11%, Tsimihety 7%, Sakalava

LANGUAGES: Malagasy (official), French,

English

RELIGIONS: Christianity 51%, traditional beliefs 47%, Islam 2% **CURRENCY:** Malagasy franc = 100 centimes

as many as 80,000 islanders died. Republican status was adopted in 1958, and full independence achieved in 1960. President Tsiranana's autocratic government adopted many unpopular policies, such as the advocacy of economic relationships with South Africa's apartheid regime. In 1972 the military took control of government. In 1975 Malagasy was renamed Madagascar, and Lieutenant Commander Didier Ratsiraka proclaimed martial law and banned opposition parties. During the 1980s Madagascar was beset by civil strife and numerous failed coups. In 1991 the opposition formed a rival government, led by Albert Zafy. In 1993 multiparty elections, Zafy became president. In 1995 he was granted the right of prime ministerial appointment. Zafy was impeached in 1996. In the ensuing elections (1997), Ratsiraka regained the presidency.

ECONOMY

Madagascar is one of the world's poorest countries (1992 GDP per capita, US\$710). The land has been badly eroded by deforestation and overgrazing. Farming, fishing and forestry employ about 80% of the workforce. Food and live animals form 66% of all exports. The major cash crop is coffee. Madagascar produces about 66% of the world's natural vanilla. Other exports include cloves, sisal and sugar. Madagascar's food crops include bananas, cassava, rice and sweet potatoes. It is hoped that Madasgacar's 150,000 unique species of plants and animals will encourage eco-tourism.

macrophage Large white blood cell (LEUCOCYTE) found mainly in the liver, spleen and lymph nodes. It engulfs foreign particles and microorganisms by phagocytosis. Working together with other LYMPHOCYTES, it forms part of the body's defence system.

Madagascar Island republic in the Indian Ocean, off the E coast of Mozambique. *See* country feature

mad cow disease Popular name for BOVINE SPONGIFORM ENCEPHALOPATHY

Madeira Islands Archipelago and autonomous Portuguese region, off the NW African coast, *c*.420km (260mi) N of the Canary Islands, in the Atlantic Ocean; the capital and chief port is FUNCHAL (on Madeira). Madeira, the largest, and Porto Santo are the only inhabited islands. The region's warm and stable climate makes it a popular European tourist destination. Industries: production of Madeira (a fortified wine), sugar cane, fruit, embroidery. Area: 794sq km (307sq mi). Pop. (1991) 253,400.

Maderna, Bruno (1920–73) Italian composer, conductor and leader of the Italian avant-garde. In 1955 he founded, with BERIO, the electronic music studio of Italian Radio. His use of electronic media was often combined with live performance.

Madero, Francisco Indalecio (1873–1913) Mexican statesman, president (1911–13). Madero was imprisoned (1910) for his opposition to the dictatorship of Porfirio Díaz and was forced to flee to Texas, where he called for a Mexican Revolution. With the aid of "Pancho" VILLA and Emiliano Zapata, Madero overthrew Díaz. Madero was a weak president and the revolutionary movement rapidly and violently fragmented. He was murdered during a military coup led by his former general Victoriano Huerta.

Madhya Pradesh State in central India; the capital is BHOPAL. Other major cities include Gwalior and Indore. In the 16th–17th centuries the region was ruled by the indigenous Gonds. In the 18th century the MARATHAS assumed control. In 1820 it was occupied by the British, and from 1903 to 1950 was known as Central Provinces and Berar. In 1956 Madhya Bharat, Vindhya Pradesh and Bhopal were incorporated into the new state of Madhya Pradesh. Lying between the Deccan and Gangetic plains, it is the largest state in India. The economy is dominated by agriculture. Major crops include wheat, rice and cotton. Madhya Pradesh is also rich in mineral resources, such as bauxite, iron ore and manganese. Bhopal has many chemical and electrical industries. Area: 443,446sq km (171,261sq mi). Pop. (1991) 66,181,170.

Madison, James (1751–1836) Fourth US president (1809–17). He was a close adviser to George WASHINGTON until, dismayed by the growing power of the executive, he broke with the FEDERALIST PARTY, his former allies. He became associated with Thomas JEFFERSON and the DEMOCRATIC REPUBLICAN PARTY. Jefferson made him secretary of state in 1801, and he succeeded Jefferson in the presidency, winning the election easily in spite of his association with the unsuccessful EMBARGO ACT (1807). As president, he was unable to avoid the WAR OF 1812 with Britain, which provoked threats of secession in New England. The successful conclusion of the war restored national prosperity, and Madison, the "Father of the Constitution", retired to his Virginia plantation as an admired elder statesman.

Madison State capital and second-largest city of Wisconsin, USA; on an isthmus between lakes Mendota and Monona. Founded as the state capital in 1836, it was incorporated as a city in 1856. It is an educational and manufacturing centre in a dairy-farming region. Industries: agricultural machinery, meat and dairy products, medical equipment. Pop. (1990) 191,262. Madison River in Nw Wyoming, USA. It rises in Yellowstone National Park, flows w then N through sw Montana and joins the Jefferson and Gallatin rivers to form the Missouri River. Length: 295km (183mi).

Madonna (1958–) (Madonna Louise Veronica Ciccone) US popular singer and actress. Madonna's first hit was "Like A Virgin" (1984). After a promising debut in *Desperately Seeking Susan* (1985), Madonna's film career was less consistent and she turned to other media. The documentary *In Bed With Madonna* (1991) was followed by the dance

album Erotica (1992), and the book Sex (1992). Other films include Evita (1996)

Madonna Representation in painting or sculpture of the Virgin MARY, usually with the infant Jesus. The early Christians painted the Madonna in their catacombs, and she was a notable feature of many outstanding Byzantine ICONS. The advent of the Renaissance brought less stylized representations, and portraits of her during that period were produced by almost every great painter and sculptor.

Madras City on the Bay of Bengal; capital of Tamil Nadu, SE India. India's second-largest port and fourth-largest city, Madras was founded in 1639 as a British trading post. As Fort St George, it became the seat of the EAST INDIA COMPANY, and developed rapidly as a commercial centre. Madras was occupied (1746–48) briefly by the French, but returned to Britain. The harbour was constructed in the second half of the 19th century. Industries: textiles, Tamil films, railway stock, transport equipment. Pop. (1991) 3,841,396.

Madrid Capital and largest city of Spain, lying on a high plain in the centre of Spain on the River Manzanares. It is Europe's highest capital city, at an altitude of 655m (2,149ft). Madrid was founded in the 10th century as a Moorish fortress. It was captured by Alfonso VI of Castile in 1083. In 1561 Philip II moved the capital from Valladolid to Madrid. The French occupied the city during the Peninsular War (1808–14). Madrid expanded considerably in the 19th century. During the Spanish Civil War, it remained loyal to the Republican cause and was under siege for almost three years. Its capitulation in March 1939 brought the war to an end. Modern Madrid is a thriving cosmopolitan centre of commerce and industry. Industries: tourism, banking, publishing. Pop. (1991) 2,909,792.

madrigal Form of unaccompanied vocal music originating in Italy in the 14th century. Early madrigals feature two or three parts and a highly ornamented upper part. During the 16th and early 17th centuries the number of voices increased and the style became more contrapuntal. The middle period of madrigal composition (c.1540–80) was dominated by Italian masters (Andrea Gabriel; Palestrina) and Flemish composers such as Orlando di Lasso. The late period (c.1580–1620) was dominated by Monteverdi and English composers such as William Byrd, Orlando Gibbons and Thomas Weelkes.

Madurai City on the River Vaigai, Tamil Nadu, s India. Madurai was the capital of the Pandya dynasty (5th century BC–11th century AD) and the Nayaka kingdom (*c*.1550–1736) before passing to the British in 1801. Industries: crafts, brassware, coffee, tea, tourism. Pop. (1991) 1,094,000.

Maeterlinck, Maurice (1862–1949) Belgian playwright. His plays include *The Princess Maleine* (1889), *Pelléas and Mélisande* (1892) and *The Blue Bird* (1908), first produced in Moscow by STANISLAVSKY. Maeterlinck won the 1911 Nobel Prize for literature.

Mafia Name given to organized groups of Sicilian bandits.

■ Madonna US singer and actress Madonna trained briefly with the Alvin Ailey dance company before turning to pop music. She is one of the most successful recording artists of all time. Pop hits like "Material Girl" (1985) were backed by music videos and spectacular concerts. Her acting career was less consistent, though her performance as Eva Perón in Evita (1996) was widely acclaimed.

A magnolia The flowers of the magnolia tree or shrub reveal it to be a relatively primitive plant. Like the earliest known flowering plants, its sepals resemble its petals. Native to ε Asia and North America, they are popular in temperate gardens for their early white/pink flowers.

Originating in feudal times, the Mafia spread to the USA in the early 20th century, and became involved in organized crime.

Magdalene, Mary See MARY MAGDALENE, SAINT

Magdeburg City-port on the River Elbe; capital of Saxony-Anhalt, central Germany. In the 13th century Magdeburg was granted a charter, and prospered as a leading member of the HANSEATIC LEAGUE. During the 16th century it was one of the centres of the Protestant REFORMATION. In 1631, during the THIRTY YEARS WAR, Magdeburg was sacked and destroyed by fire. The city also suffered heavy bomb damage in World War 2. A major inland port, it is linked to the Rhine and the Ruhr by the Mittelland Canal. Industries: iron and steel, scientific instruments, chemicals. Pop. (1990) 274,000.

Magellan, Ferdinand (1480–1521) Portuguese explorer, leader of the first expedition to circumnavigate the globe. He sailed to the East Indies and may have visited the Spice Islands (Moluccas) in 1511. Subsequently he took service with Spain, promising to find a route to the Moluccas via the New World and the Pacific. He set out with five ships and nearly 300 men in 1519. He found the waterway near the s tip of South America that is now named Magellan's Strait. After severe hardships, the expedition reached the Philippines, where Magellan was killed in a local conflict. Only one ship, the Victoria, completed the round-the-world voyage.

Magellanic Clouds Two small satellite galaxies of the MILKY WAY GALAXY, visible in skies around the South Pole as misty stellar concentrations. The Small Cloud (Nubecula Minor), located in the constellation of Tucana, is irregular; the Large Cloud (Nubecula Major), mostly in the constellation of Dorado, is vaguely spiral. Distance: *c*.150,000 light years.

maggot Name commonly given to the legless LARVA of a fly. It is primarily used to describe those larvae that infest food and waste material; others are generally called grubs or caterpillars. Maghreb Arabic term for NW Africa, generally applied to Morocco, Algeria, Tunisia and sometimes Libya.

Magi (sing. Magus) Members of a hereditary priestly class of ancient Persia (Iran), responsible for certain religious ceremonies and cultic observances. By the time of Christ, the term Magi applied to astrologers, soothsayers and practitioners of the occult. The coming of the Magi to Jesus is marked in the Western Church by the feast of Epiphany. In the East, it is celebrated at Christmas.

magic Use (or apparent use) of natural or spirit forces to produce results that are logically impossible. Belief in magic is associated mainly with primitive societies, although traces can still be found (such as superstitions) in highly developed countries. There are two main types of magic: black magic (which

makes use of evil spirits) and white magic (used to good purpose and to counteract black magic). See also WITCHCRAFT

magic realism Twentieth-century literary form, particularly associated with post-1945 Latin American novelists. Magic realism is characterized by the interweaving of realistic and fantastical elements. Gabriel GARCÍA MÁRQUEZ'S One Hundred Years of Solitude (1967) is a classic example of the genre. magistrate In England, anyone invested by the state with authority to administer the law. A magistrate is a judicial officer, inferior to a judge, who presides over a magistrate's court. There are two kinds, the unpaid justice of the peace and, in larger towns, the stipendiary (paid) magistrate.

magma Molten material that is the source of all IGNEOUS ROCKS. The term refers to this material while it is still under the Earth's crust. In addition to its complex silicate composition, magma contains gases and water vapour.

Magna Carta (1215) "Great Charter" issued by King John of England. He was forced to sign the charter by his rebellious barons at Runnymede, an island in the River Thames. The 63 clauses of the Magna Carta were mainly concerned with defining, and therefore limiting, the feudal rights of the king and protecting the privileges of the church.

magnesia Magnesium oxide (MgO), a white, neutral, stable powder formed when magnesium is burned in oxygen. It is used industrially in firebrick and medicinally in stomach powders. Magnesium carbonate, found as magnesite and also used as an antacid, is often called magnesia.

magnesium (symbol Mg) Silvery-white metallic element, one of the ALKALINE-EARTH METALS. Magnesium's chief sources are magnesite and DOLOMITE. Magnesium burns in air with an intense white flame and is used in flashbulbs, fireworks, flares and incendiaries. Magnesium alloys are light, and are used in aircraft fuselages, jet engines, missiles and rockets. Chemically, the element is similar to CALCIUM. Hydrated magnesium sulphate is called Epsom salts. Properties: at.no. 12; r.a.m. 24.312; r.d. 1.738; m.p. 648.8°C (1,200°F); b.p. 1,090°C (1,994°F); most common isotope Mg²⁴ (78.7%).

magnet Object that produces a MAGNETIC FIELD. Lodestones, which are naturally magnetic, were used as early magnets, and strong magnetic materials were later recognized as containing either iron, cobalt, nickel or their mixtures. A typical permanent magnet is a straight or horseshoe-shaped magnetized iron bar. The Earth is a giant magnet; its magnetic lines of force being detectable at all latitudes. An ELECTROMAGNET is much stronger than a permanent one and is used for raising heavy steel weights and scrap. A superconducting magnet, the strongest of all, has special alloys cooled to very low temperatures. See also MAGNETISM

magnetic disk Plastic disk coated with magnetic material and used for storing computer PROGRAMS and DATA as a series of magnetic spots. Most computers contain a HARD DISK unit for general storage. There is also a unit for inserting lower-capacity floppy disks. Hard magnetic disks can store larger amounts of data and come in cartridges that slot into a special drive unit. See also CD-ROM

magnetic field Region surrounding a MAGNET, or a conductor through which a current is flowing, in which magnetic effects, such as the deflection of a compass needle, can be detected. A magnetic field can be represented by a set of lines of force (flux lines) spreading out from the poles of a magnet or running around a current-carrying conductor. The direction of a magnetic field is the direction a tiny magnet takes when placed in the field. Magnetic poles are the field regions in which MAG-NETISM appears to be concentrated. If a bar magnet is suspended to swing freely in the horizontal plane, one pole will point north; this is called the north-seeking or north pole. The other pole, the south-seeking or south pole, will point south. Unlike poles attract each other; like poles repel each other. The Earth's magnetic poles are the ends of the huge "magnet" that is Earth. magnetic flux Lines of force or of magnetic induction in a MAGNETIC FIELD. These lines can be seen as the closed curves followed by iron filings placed near a MAGNET. The direction of the flux at any point is the direction of the magnetic field, and the closeness of the flux (number of flux lines in a given area) is a measure of the magnetic field strength.

a magnetic hoppy disk (1) uses a magnetic head, a tiny electromagnet (2), to polarize magnetic particles in the surface of the disk (3). The polarization represents zeros and ones. A screw (4) moves the head across the disk which is spun by a motor (5). When the disk is inserted, a lever moves aside the protective window over the disk (6). An

LED (7) checks whether the disk is write-protected. If the light can pass through a window on the disk (8) it is protected, and no new data can be stored on the disk or old data removed.

magnetic recording Formation of a record of electrical signals on a wire or tape by means of a pattern of magnetization. In an audio tape recorder, plastic tape coated with iron oxide is fed past an electromagnet that is energized by the amplified currents produced by a MICROPHONE. By ELECTROMAGNETIC INDUCTION, variations in magnetization (from the oscillating current produced by the sound) are induced in the particles of iron oxide on the tape. When played back, the tape is fed past a similar electromagnet, which converts the patterns into sound, which is in turn fed to an AMPLIFIER and LOUDSPEAKER. magnetic resonance Absorption or emission of electromagnetic radiation by atoms placed in a magnetic field. Spectrometers for nuclear magnetic resonance (NMR) use radio frequencies for chemical analysis and research in nuclear physics, and medically to analyse body tissues. Magnetic resonance imaging (MRI) is a medical scanning system for the brain, spinal cord and other tissues of the body.

magnetism Properties of matter and of electric currents associated with a MAGNETIC FIELD and with a north-south polarity (magnetic poles). All substances possess these properties to some degree because orbiting electrons in their atoms produce a magnetic field; similarly, an external magnetic field will affect the electron orbits. All substances possess weak magnetic (diamagnetic) properties and will tend to align themselves with the field, but in some cases this diamagnetism is masked by the stronger forms of magnetism: paramagnetism and ferromagnetism. Paramagnetism is caused by electron spin, and occurs in substances having unpaired electrons in their atoms or molecules. The most important form of magnetism, ferromagnetism, is shown by substances such as iron and nickel, which can be magnetized by even a weak field due to the formation of tiny regions, called domains, that behave like miniature magnets and align themselves with an external field. magnetite Iron oxide mineral (Fe₃O₄). It is a valuable iron ore, found in igneous and metamorphic rocks. It is black, metallic and brittle. Permanently magnetized deposits are called lodestone. Hardness 6; s.g. 5.2.

magnification Measure of the enlarging power of a MICRO-SCOPE or TELESCOPE. It is the size of an object's image produced by the instrument compared with the size of the object viewed with the unaided eye. In an astronomical telescope, magnification is equal to the ratio of the FOCAL LENGTH of the objective (the lens or lenses nearest the object) to the focal length of the eyepiece.

magnitude In astronomy, numerical value expressing the brightness of a celestial object on a logarithmic scale. Apparent magnitude is the magnitude as seen from Earth, determined by either eye, photographically or photometrically. It ranges from positive through zero to negative values, the brightness increasing rapidly as the magnitude decreases. Absolute magnitude indicates intrinsic luminosity and is defined as the apparent magnitude of an object at a distance of 10 parsecs (32.6 light-years) from the object.

magnolia Any of about 40 species of trees and shrubs of the genus *Magnolia*, native to North and Central America and E Asia. They are valued for their white, yellow, purple or pink flowers. Height: to 30m (100ft). Family Magnoliaceae.

magpie Bird of the CROW family, closely related to the JAY, found mostly in the Northern Hemisphere. The common magpie (*Pica pica*) has a chattering cry, a long greenish-black tail and short wings. It has a clearly defined white underside with black above. Length: 46cm (18in). Family Corvidae.

Magritte, René (1898–1967) Belgian painter. Influenced by DADA, Magritte's *The Menaced Assassin* (1926) is a landmark in the development of SURREALISM. He concentrated on the analysis of pictorial language, placing familiar objects in incongruous surroundings, and disturbing the link between word and image. Other works which explore paradox and ambiguity include *The Key of Dreams* (1930).

Magyars People who founded the kingdom of Hungary in the late 9th century. From their homeland in NE Europe, they moved gradually south over the centuries and occupied the Carpathian basin in 895. Excellent horsemen, they raided the German lands to the west until checked by Otto I in 955. They adopted Christianity and established a powerful state that

included much of the N Balkans, but lost territory to the Ottoman Turks after the battle of Mohács (1526). The remainder of the kingdom subsequently fell to the Habsburg empire. **Mahabharata** (Sanskrit, Great Epic of the Bharata Dynasty) Poem of almost 100,000 couplets, written *c*.400 BC-*c*.AD 200. One of India's two major Sanskrit epics (the other is the Ramayana), the verse incorporates the Bhagavad GITA (Song of the Lord). It is important both as literature and as Hindu religious instruction.

Maharashtra State in w India, bordering on the Arabian Sea; the capital is Bombay. India's third-largest state in both area and population, it was formed in 1960 and is composed of five sub-regions: Konkan, Deccan, Khandesh, Marathwada and Vidarbha. In the 14th—17th centuries the area was under Muslim rule. In the 17th century it came under the control of the local Maratha tribe. Britain incorporated Maharashtra into its Indian empire in the early 19th century. Most of the land lies on the dry, w Deccan plateau where farming is poor. Rice is grown along the coast. The area has rich mineral deposits, including manganese and coal. Industries, such as textiles and chemicals, are concentrated in the major cities, especially Bombay. Area: 307,762sq km (118,827sq mi). Pop. (1991) 78,707,000.

Mahatma (Sanskrit, Great Soul) Person of special holiness. The term is used by Hindus, but has no specific place in organized Hindu religion. The most famous Mahatma of modern times was Mohandas K. GANDHI.

Mahayana (greater vehicle) One of the two main schools of BUDDHISM, the other being the THERAVADA, also known as *Hinayana*. *Mahayana* Buddhism was dominant in India from the 1st to the 12th century and is now prevalent in Tibet, China, Korea, and Japan. Unlike the *Hinayana* (smaller vehicle) school, it conceives of BUDDHA as divine, the embodiment of the absolute and eternal truth.

Mahdi (Arabic, Rightly Guided One) Messianic Islamic leader. The title is usually used to refer to Muhammad Ahmad (1844–85) of the Sudan, who declared himself the Mahdi in 1881 and led the attack on Khartoum (1885) during which the British general Charles George Gordon was killed. The Mahdi set up a great Islamic empire with its capital at Omdurman. His reign lasted only about six months. His followers were eventually defeated at Omdurman (1898).

Mahler, Gustav (1860–1911) Austrian composer and conductor. Mahler conducted the Vienna State Opera (1897–1907) and Metropolitan Opera (1908-10). He completed nine symphonies (the unfinished tenth was left as a full-length sketch) that incorporated folk elements and expanded the size and emotional range of the orchestra. His second, fourth and eighth symphonies feature choral parts. Other works include the song cycles Das Lied von der Erde (The Song of the Earth, 1908) and Kindertotenlieder (Songs on the Death of Children, 1902). Mahmud II (1785–1839) Sultan of the Ottoman Empire (1808-39). Mahmud's reign saw conflict with Greece, Russia and Egypt. He was initially successful against Greece in the Greek War of Independence, but Russian and British intervention forced him to capitulate (1829) and started the Russo-Turkish war (1828-29). Mahmud then lost the support of the viceroy of Egypt, Muhammad ALI, which led to the invasion of Turkey, precipitating Egyptian independence.

mahogany Any of numerous species of tropical American deciduous trees and their wood, valued for furniture making. Mahogany has composite leaves, large clusters of flowers, and winged seeds. Height: to 18m (60ft). Family Meliaceae. Mailer, Norman (1923–) US novelist. Mailer's debut novel, The Naked and the Dead (1948), was one of the major works on World War 2. His combative political journalism, such as Why are we in Vietnam? (1967) and The Prisoner of Sex (1971), have courted controversy. Armies of the Night (1968) and The Executioner's Song (1979) both won Pulitzer Prizes. Mailer has experimented with a variety of genres, from thrillers such as Tough Guy's Don't Dance (1984), to historical novels such as Ancient Evenings (1983). The Gospel According to the Son (1997) was a political reworking of the life of Jesus.

Maillol, Aristide (1861–1944) French sculptor. Initially a painter and tapestry designer, after 1900 Maillol concentrated on sculpture and in particular the female nude. He rejected the

A magpie Found in temperate regions of Europe, Asia, North Africa and NW North America, magpies are members of the crow family. The common magpie (*Pica pica*) of Europe and North America, which grows to 46cm (18in), has gained an unfavourable reputation primarily due to its aggressive behaviour towards other birds, and its tendency to kill distressed lambs or sickly calves.

▲ Mailer Norman Mailer's debut novel, *The Naked and the Dead* (1948), is both an uncompromising account of the brutality of war, and a critique of American society. His characteristically rough and direct style often created controversy, most infamously in his attack on feminism in *The Prisoner of Sex* (1971). His works of journalism include *Marilyn: A Biography* (1973), and *Executioner's Song* (1979) on the state execution of the murderer Gary Gilmore.

MAINE
Statehood:
15 March 1820
Nickname:
Pine Tree State
State bird:
Chickadee
State flower:
White pine cone and

State tree : White pine State motto :

I direct

flower

▲ Major In 1990, John Major succeeded Margaret Thatcher as prime minister and leader of the Conservative Party. His consensual approach to government contrasted strongly with Mrs Thatcher's more autocratic style. In 1992, Major helped the Conservative Party secure a fourth consecutive election victory. Recession soon forced him to increase taxation. Major's second term was dominated by internal wrangling over European policy. His "backto-basics" campaign floundered amidst accusations of sleaze and, despite an improving economy, the Conservative Party suffered a landslide defeat in the 1997 general election.

fluid forms and romanticism of Rodin in favour of classical ideals. Works include *Mediterranean* (1901) and *Night* (1902). **Maimonides, Moses** (1135–1204) Jewish philosopher, Hebrew scholar and physician, b. Spain. As a youth he was attracted to Aristotelian philosophy, which influenced his well-known *Guide of the Perplexed*, a plea for a more rational philosophy of Judaism. He emigrated to Egypt in 1159 after a tyrannical Muslim sect took over his native Córdoba. In Cairo he became court physician to SALADIN and was the recognized leader of Egyptian Jewry. His *Mishneh Torah* is a systematic compilation of Jewish oral law. Other works on Jewish law and philosophy and on medicine confirmed him as one of the most influential thinkers of the Middle Ages.

Maine State in New England, extreme NE USA; the capital is AUGUSTA. The largest city is PORTLAND. The land is generally rolling country with mountains in the w and more than 2,000 lakes. The chief rivers are the St John, Penobscot, Kennebec and St Croix. Inhabited by Abnaki Native Americans, Maine was explored by John Cabot in 1498. The first British settlement, Fort St George, was established in 1607 but quickly abandoned. Firm colonization began in the 1620s. Further British settlements were hindered by French and Native American resistance. In 1652 it fell under the administration of the MASSACHUSETTS BAY COMPANY, and then of MASSACHUSETTS proper in 1691. In 1820 Maine became the 23rd state of the Union. Economic development was rapid, based on the trading ports and its timber resources for shipbuilding. Three-quarters of Maine is forested. The major economic sector is the manufacture of paper and wood products. Economic development has been hampered by poor soil, a short growing season, geographic remoteness and a lack of coal and steel. Broiler chickens and blueberries are the major agricultural products. Lobsters are the mainstay of the modern fishing industry. Tourism is increasingly important. Area: 86,026sq km (33,215sq mi). Pop. (1990) 1,127,928. Mainz City at the confluence of the Rhine and Main rivers;

capital of Rhineland-Palatinate, w Germany, Mainz was founded as a Roman camp in 1 BC. In AD 1118 it became a free city. In the 15th century, Mainz flourished as a major European centre of learning. In 1792 it fell to the French. Restored to Germany in 1815, Mainz was rapidly fortified. Today, it is a vital transport and commercial centre. Pop. (1990) 183,300. maize (corn or sweet corn) CEREAL plant of the grass family. Originally from Central America, it is the key cereal in subtropical zones. Edible seeds grow in rows upon a cob, protected by a leafy sheath. Height: to 5m (16 ft). Species Zea mays. Major, John (1943-) British statesman, prime minister (1990-97). Major entered parliament in 1979. In 1989, Margaret THATCHER unexpectedly made him foreign secretary, then chancellor of the exchequer. Following Mrs Thatcher's resignation, Major emerged as the compromise successor. He moderated the excesses of Thatcherism; such as scrapping the unpopular POLL TAX. Major lent full military support to the US in the GULF WAR (1991). Major led the CONSERVATIVE PARTY to a surprise victory in the 1992 general election. The catastrophic events of "Black Wednesday" (16 September 1992) forced Britain to withdraw from the European Mone-TARY SYSTEM (EMS) and devalue its currency. The issue of Europe dogged the rest of his term and divided the party. Political scandals and sleaze contributed to Tony BLAIR's landslide victory at the 1997 general election. Major resigned as party leader and was succeeded by William HAGUE.

Majorca (Mallorca) Largest of the BALEARIC ISLANDS, in the w Mediterranean, c.233km (145mi) off the Spanish coast; the capital is PALMA. The island is administered by Spain as part of the Baleares autonomous region. In 1229 James I of Aragon captured the island from the Moors and founded the kingdom of Majorca. During the Spanish Civil War it served as a base for Italian forces supporting General Franco. Excluding the mountainous NW, the island has a mild climate, with fertile, rolling hills. Agricultural products include olives, figs and citrus fruits. The major industry is tourism. Area: 3,639sq km (1,405sq mi). Pop. (1987 est.) 605,512.

Makarios III (1913–77) Greek-Cypriot leader. Appointed Greek Orthodox archbishop of Cyprus in 1950, he led the

The life cycle of the malaria parasite *Plasmodium* requires two hosts, the *Anopheles* mosquito and a human host, with adverse effects of infection only appearing in the human host. An infected mosquito injects thousands of *Plasmodium* organisms into the bloodstream when it bites a human (1). These penetrate liver cells, multiply and cause cell rupture (2). Released organisms may re-infect liver cells (3), but usually progress to infect red

blood cells (4, 5). Male and female parasites shortly appear in the red blood cells (6). At this stage, another mosquito bites the human and takes infected blood from him (7). Fertilization occurs within the mosquito, the "embryo" penetrating the stomach wall (8). Within the cyst formed (9) thousands or organisms develop. The cyst ruptures, organisms released travel to the salivary glands, and from here they are injected into a second human host (10).

movement for ENOSIS (union with Greece), and was deported by the British in 1956. He was elected president when Cyprus became independent in 1959, but was briefly overthrown (1974) by Greek Cypriots still demanding *enosis*. The coup provoked unrest among Turkish Cypriots and led to a Turkish invasion and the subsequent partition of Cyprus into Greek and Turkish sections, which Makarios was unable to prevent. **Malabo** Seaport capital of Equatorial Guinea, on BIOKO island, in the Gulf of Guinea, w central Africa. Founded in 1827 as a British base to suppress the slave trade, it was known as Santa Isabel until 1973. Malabo stands on the edge of a volcanic crater that acts as a natural harbour. Industries: fish processing, hardwoods, cocoa, coffee. Pop. (1992) 35,000.

Malacca (Melaka) Malaysian state on the Strait of Malacca, sw Malay Peninsula; the capital is Malacca. The city was founded in 1403 and prospered as the leading trade centre for E Asia. The Muslim sultanate of Malacca became the region's most powerful empire, and the centre for the spread of Islam throughout Malaya. In 1511 Malacca was conquered by the Portuguese. In 1641 the Dutch seized the region and fortified the city. In 1824 it was ceded to Britain. In 1957 it became a state of independent Malaya and, in 1963, of Malaysia. Area: 1,658sq km (640sq mi). Pop. (1993 est.) 583,400.

Malachi Last of the books of the 12 minor prophets and last

book of all of the Old Testament in the Authorized Version. Probably written *c*.460 BC, it addresses the Jews who had returned to Judaea after the Babylonian Captivity but were disillusioned by the continuing harshness of their existence. **Málaga** City and seaport at the mouth of the River Guadalmedina; capital of Málaga province, Andalusia, S Spain. It was founded in the 12th century BC by the Phoenicians. In 711 it was captured by the Moors and prospered as a major trading port. Málaga was reconquered in 1487. During the Spanish Civil War it was captured from the Loyalists by Franco. Tourism has swelled Málaga's population and spilled over into the resorts of Torremolinos, Marbella and Fuengirola. Industries: wine, beer, textiles. Pop. (1991) 512,136.

Malagasy See MADAGASCAR

Malamud, Bernard (1914–86) US short-story writer and novelist. Malamud's novels include *The Assistant* (1957), *A New Life* (1961) and *The Fixer* (1966). His short story collections include *Rembrandt's Hat* (1973).

malaria Parasitic disease resulting from infection with one of four species of *Plasmodium* PROTOZOA. Transmitted by the *Anopheles* mosquito, it is characterized by fever and enlargement of the spleen. Attacks of fever, chills and sweating typify the disease, and recur as new generations of parasites develop in the blood. The original antimalarial drug, QUININE, has given way to synthetics such as chloroquine. With 270 million people infected, malaria is one of the most widespread diseases, claiming two million lives a year.

Malawi Landlocked republic in SE Africa. See country feature

Malawi, Lake (formerly Lake Nyasa) Lake in the Great RIFT VALLEY of E central Africa, bordered by Tanzania (N), Mozambique (E) and Malawi (s and w). First sighted by the explorer Caspar Boccaro in 1616, the lake was visited by David Livingstone in 1859. The third-largest lake in Africa, it is fed chiefly by the River Ruhuhu and drained by the Shire. Malayalam Language spoken on the w coast of extreme s India, principally in the state of Kerala. It belongs to the Dravidian family of languages and there are about 20 million speakers. It is one of the 15 constitutional languages of India. Malayo-Polynesian language Alternative name for the Austronesian Languages

Malay Peninsula Promontory of SE Asia, stretching for c.1,100km (700mi) between the Strait of MALACCA and the South China Sea. The N part of the peninsula is now s Thailand

MALAWI

The colours in Malawi's flag come from the flag of the Malawi Congress Party, which was adopted in 1953. The symbol of the rising sun was added when Malawi became independent from Britain in 1964. It represents the beginning of a new era for Malawi and Africa.

alawi is dominated by Lake MALAWI, which constitutes 50% of the nation's area. The lake forms most of its E border with Tanzania and Mozambique, and is drained in the s by the River Shire (a tributary of the ZAMBEZI). The capital, LILONGWE, lies in a valley of the central plateau. Mountains fringe the w edge of Lake Malawi, rising in the s to 3,000m (9,843ft) at Mlange.

CLIMATE

The lowlands are hot and humid throughout the year, but the uplands have a pleasant climate. Lilongwe has a warm, sunny climate, with occasional frosts in July and August.

VEGETATION

Grassland and tropical savanna cover much of Malawi. Woodland grows in wetter regions.

HISTORY AND POLITICS

The SAN were gradually displaced by Bantuspeakers, who formed the Maravi kingdom (15th-18th century). In the early 19th century, the area was a centre of the slave trade. In 1891 it became a British protectorate: slavery was abolished and coffee plantations established. In 1907 it became known as Nyasaland. In 1915 a rebellion against British domination was suppressed. In 1953 Nyasaland became part of the Federation of Rhodesia (modern Zimbabwe) and Nyasaland (the Federation also included present-day Zambia). The Congress Party, led by Dr Hastings BANDA, strongly opposed the Federation. In 1959 a state of emergency was declared. The Federation was dissolved in 1963 and in 1964 Nyasaland achieved independence as Malawi. Banda was the first post-colonial prime minister, and when Malawi became a republic (1966) he was made president. Malawi became a one-party state, and Banda's autocratic government established diplomatic relations with South Africa's apartheid government in

AREA: 118,480sq km (45,745sq mi)

POPULATION: 8,823,000
CAPITAL (POPULATION): Lilongwe (268,000)

GOVERNMENT: Multiparty republic ETHNIC GROUPS: Maravi (Chewa, Nyanja, Tonga, Tumbuka) 58%, Lomwe 18%, Yao

13%, Ngoni 7%

LANGUAGES: Chichewa and English (both

official)

RELIGIONS: Christianity (Protestant 34%, Roman Catholic 28%), traditional beliefs

21%, Islam 16%

currency: Kwacha = 100 tambala

1967. In 1971, as the newly appointed presidentfor-life, Banda became the first post-colonial,
black African head of state to visit South Africa.
Malawi became a shelter for rebels and refugees
from the civil war in Mozambique – more than
600,000 were accommodated in the late 1980s.
Banda's repression of opposition became more
brutal. International aid for the 1992 famine was
tied to improvements in human rights and the
establishment of multiparty democracy. Elections were held in 1994, and Banda and his
Malawi Congress Party were defeated. Bakili
Muluzi of the United Democratic Front became
president. In 1995 Banda and his close associates were acquitted of murder charges.

ECONOMY

Malawi is one of the world's poorest countries (1992 GDP per capita, US\$820). Agriculture employs more than 80% of the workforce, mostly at subsistence level. Food crops include cassava, maize and rice. Chief export crops include tobacco, tea, sugar and cotton. Malawi lacks mineral resources and has few manufacturing industries. Lake fishing is an important activity.

Malawi's rich flora is revealed in this 1987 stamp showing wild flowers (*Ochna macrocalyx*).

and the s part is Malaya (w MALAYSIA): SINGAPORE lies off its s tip. A mountain range forms the backbone of the peninsula, rising to 2,190m (7,186ft) at Mount Gunong Tahang. Most of the vegetation is dense tropical rainforest. Malay peninsula is one of the world's largest producers of tin and rubber. Today, it is populated equally by Malays and Chinese. The region was controlled almost continuously from the 8th to the 13th centuries by the Buddhist Sailendra dynasty from SUMATRA. In the 15th century the Malaccan empire held sway. For the next three centuries the region came under the control of various European imperial powers. In 1909 Britain assumed control of a majority of the states and reached a border agreement with Siam (Thailand). Area: c.180,000sq km (70,000sq mi).

Malaysia Federation of SE Asian states. See country feature **Malcolm III** (*c*.1031–93) King of Scotland (1058–93), called Ceann mor or Canmore. Son of Duncan I, he overthrew MAC-BETH to regain the throne. He spent much of his youth in England, and his second wife was an English princess, St Margaret (d.1093). As a result, English influence in Scotland was strengthened. In 1072 Malcolm was forced to swear allegiance to WILLIAM I of England. He continued to make incursions, however, and was killed at Alnwick, N England.

Malcolm X (1925-65) African-American nationalist leader, b. Malcolm Little. While in prison, Malcolm joined the BLACK MUSLIMS and, after his release (1953), became their leading spokesman. Following an ideological split with its leader, Elijah MUHAMMAD, he made a pilgrimage to MECCA, became an orthodox Muslim and formed a rival group. His assassination may have been authorized by the Black Muslims.

Maldives Republic in the Indian Ocean, c.640km (400mi) sw of Sri Lanka, consisting of c.1,200 low-lying coral islands grouped into 26 atolls; the largest island and capital is MALE. The islands (200 of which are inhabited) are prone to flooding. The climate is tropical, and the monsoon season lasts from April to October. Coconuts and copra are the primary crop. Fishing is traditionally the major industry, and the leading export-earner is the bonito (Maldives tuna). Since 1972 tourism has been encouraged to boost foreign reserves. The chief religion is Sunni Muslim. From the 14th century the Maldives were ruled by the ad-Din dynasty. In 1518 they were claimed by the Portuguese. From 1665 to 1886 they were a dependency of Ceylon (Sri Lanka). In 1887 Maldives became a British protectorate. In 1965 they achieved independence as a sultanate. In 1968 the sultan was deposed and a republic was

MALAYSIA

This flag was adopted when the Federation of Malaysia was set up in 1963. The red and white bands date back to a revolt in the 13th century. The star and crescent are symbols of Islam. The blue represents Malaysia's place in the Commonwealth.

he Federation of Malaysia consists of two The Federation of Malaysia is on the MALAY PENINSULA between the Strait of Malacca and the SOUTH CHINA SEA. It is home to c.80% of the population and includes the capital, Kuala Lumpur. East Malaysia consists of the states of SABAH and SARAWAK, in N BORNEO. Within Sarawak is the independent nation of Brunei. East and West Malaysia consist of coastal lowlands with mountainous interiors. The highest peak is Kinabalu (in Sabah), at 4,101m (13,455ft).

CLIMATE

Malaysia has a hot and rainy climate. There are monsoon seasons in the sw and Nw. Kuala Lumpur averages 200 days of rain per year.

only 13% of the land is farmed.

VEGETATION Dense rainforest covers c.60% of Malaysia;

PHILIPPINES MAP SCALE China Sea S uala Terengannu BRUNE PENINSULAR EASTERN MALAYSIA MALAYSIA uantan a Lumpur Islands Bintulu Sea Islands ohor Baharu. Sumatra Borneo INDONESIA Equator INDONESIA 100°E

HISTORY AND POLITICS

(for early history, see Malay Peninsula, SABAH and SARAWAK) In 1641 the Dutch captured MALACCA and controlled much of the trade through the narrow strait. In 1795 Britain conquered Malacca. In 1819 Britain founded SINGAPORE, and in 1826 formed the Straits Settlement, consisting of Penang, Malacca and Singapore. In 1867 the Straits Settlement became a British colony. Sabah and Sarawak became a British protectorate in 1888. In 1896 the states of Perak, Selangor, Pahang, and Negeri Semblian were federated. In 1909 the states of Johor, Kedah, Kelantan, Perlis and Terengganu formed the Unfederated Malay States. Japan occupied Malaysia throughout World War 2. After Japan's defeat, the British expanded the Federation of Malaya (1948) to include the unfederated states, and Malacca and Pinang. Communists (largely from the Chinese population) began a protracted guerrilla war,

AREA: 329,750sg km (127,316sg mi) POPULATION: 18,181,000

CAPITAL (POPULATION): Kuala Lumpur

(1,231,500)

GOVERNMENT: Federal constitutional monarchy ETHNIC GROUPS: Malay and other indigenous

groups 62%, Chinese 30%, Indian 8% LANGUAGES: Malay (official)

RELIGIONS: Islam 53%, Buddhism 17%, Chinese folk religions 12%, Hinduism 7%,

Christianity 6% **CURRENCY:** Ringgit (Malaysian dollar) = 100

cents

and many Chinese were forcibly resettled. In 1957 the Federation of Malaya became an independent state within the Commonwealth of Nations. In 1963 Singapore, Sabah and Sarawak joined the Federation, which became known as Malaysia. Tension over Chinese representation led to the secession of Singapore in 1965. The New Economic Policy (1970-90) was largely successful in reducing ethnic tension, caused by economic inequality. The United Malays National Organization (UMNO) has held power, either alone or in coalition, since independence. A regional economic crisis and smog problems (1997) led to criticism of Dr Mahathir Muhammad's premiership (1979–).

ECONOMY

Malaysia is an upper-middle-income developing country (1992 GDP per capita, US\$7,790). The National Development Policy (1990–2000) was the second stage in its rapid industrialization. In the early 1990s, economic growth averaged 8% per annum. In 1997 Thailand's devaluation of its currency triggered a regional economic crisis. Malaysia's stock market fell by 40%, and the currency 20% lost of its value against the US dollar. Manufactured goods account for 78% of exports. Malaysia is the world's largest producer of palm oil, secondlargest producer of tin and third-largest producer of natural rubber. Agriculture is an important activity. Rice is the chief food crop.

declared. In 1982 Maldives joined the Commonwealth. In 1988 an attempted coup was suppressed with the aid of Indian troops. Area: 298sq km (115sq mi). Pop. (1990) 213,215.

Male Largest of the Maldive Islands, in the Indian Ocean. The island atoll forms the only urban area in the group. The extension of the airport has boosted tourism. Industries: bonito, breadfruit, copra. Pop. (1990) 55,000.

Malenkov, Georgi Maksimilianovich (1902–88) Soviet statesman, prime minister (1953–55). Malenkov succeeded STALIN as prime minister and leader of the Communist Party. He was soon superseded by Nikita Khrushchev as party leader and, in 1955, lost the premiership also. Implicated in an unsuccessful coup against Khrushchev in 1957, he was dispatched to manage a power station in Siberia. In 1961 he was expelled from the party.

Malevich, Kasimir (1878–1935) Russian painter, an important pioneer of geometric ABSTRACT ART. Malevich absorbed ideas from CUBISM (LÉGER in particular), FUTURISM. His experiments with the fragmentation and multiplication of images include *The Knife Grinder* (1912). Malevich founded (1913) the SUPREMATISM movement, and later concentrated on the development of CONSTRUCTIVISM.

Mali Landlocked republic in w Africa. See country feature Malinowski, Bronislaw (1884–1942) English anthropologist, b. Poland. Considered by many to be one of the pioneers of social ANTHROPOLOGY, Malinowski's work with primitive societies led him to believe that every aspect or norm of a society is a function vital to its existence.

mallard Large, common, freshwater duck. The male is black, white, brown and grey with a green head, whereas the female is mottled brown with blue wing markings. It feeds from the surface. Length: 63cm (28in). Species *Anas platyrhyncho*.

Mallarmé, Stephane (1842–98) French poet, leading exponent of SYMBOLISM and precursor of MODERNISM. Mallarmé's allusive poetic style defies definitive statement in favour of sound associations. His best-known poems are *Hérodiade* (1869) and *L'Après-Midi d'un faune* (1876). Mallarmé's work was a defining influence on Paul VALÉRY.

Malle, Louis (1932–95) French film director. Malle's debut feature, Ascenseur pour l'Echafaud (1957), was a landmark in the French nouvelle vague. Other films from this period include Les Amants (1958) and Le Feu Follet (1963). Malle first English language film was Pretty Baby (1978). Other US films include Atlantic City (1980) and My Dinner with Andre

MALI

The colours on Mali's flag are those used on the flag of Ethiopia, Africa's oldest independent nation. They symbolize African unity. This flag was used by Mali's African Democratic Rally prior to the country becoming independent from France in 1960.

Ali, the largest country in w Africa, is generally flat. Northern Mali forms part of the SAHARA, which rises to the border with Algeria. This region contains many wadis (dry river valleys). The old trading city of TIMBUKTU lies on the edge of the desert. The main rivers, the Sénégal and the Niger, are both in s Mali. The capital, BAMAKO, lies on the banks of the Niger.

CLIMATE

Northern Mali has a hot, arid climate. The s has enough rain for cultivation. Dry and dusty harmattan winds blow from the Sahara.

VEGETATION

Over 70% of Mali is desert or semi-desert with

sparse vegetation. Central and SE Mali is a dry grassland region known as the SAHEL. In prolonged droughts, the N Sahel dries up and becomes part of the Sahara. Southern Mali, the most densely populated region, is covered by fertile farmland and tropical savanna.

HISTORY AND POLITICS

Mali has lain at the heart of many of Africa's historic empires. From the 4th to the 11th centuries, the region was part of the ancient Ghana empire. The medieval empire of Mali was one of the world's most powerful and prosperous powers; its gold riches were legendary. The 14th-century reign of Emperor Mansa Musa saw the introduction of Islam, and the development of Timbuktu as a great centre of learning and the trans-Saharan trade. The SONGHAI empire dominated the region during the 15th century. In the 19th century France gradually gained control. In 1893 the region became known as French Sudan, and in 1898 was incorporated into the Federation of West Africa. Nationalist movements grew more vocal in their opposition to colonialism. In 1958 French Sudan voted to join the French Community as an autonomous republic. In 1959 it joined with SENEGAL to form the Federation of Mali. Shortly after gaining independence, Senegal seceded and in 1960 Mali became a one-party republic. Its first president, Modibo Keita, was committed to nationalization and pan-Africanism. In 1962 Mali adopted its own currency. In 1963 Mali joined the ORGANIZATION OF AFRICAN STATES (OAS). Economic crisis forced Keita to revert to the franc zone, and permit France

AREA: 1,240,190sq km (478,837sq mi)

POPULATION: 9,818,000

capital (POPULATION): Bamako (646,000)
GOVERNMENT: Multiparty republic

ETHNIC GROUPS: Bambara 32%, Fulani (or Peul) 14%, Senufo 12%, Soninke 9%, Tuareg 7%, Songhai 7%, Malinke (Mandingo or

Mandinke) 7%

LANGUAGES: French (official)

RELIGIONS: Islam 90%, traditional beliefs 9%,

Christianity 1%

CURRENCY: CFA franc = 100 centimes

greater economic influence. Opposition led to Keita's overthrow in a military coup in 1968. The army group formed a National Liberation Committee, and appointed Moussa Traoré as prime minister. During the 1970s the Sahel suffered a series of droughts, which contributed to a devastating famine that claimed thousands of lives. In 1979 a new constitution was adopted, and Traoré was elected president. In 1991 Traoré was overthrown in a military coup, and a new constitution (1992) saw the establishment of a multiparty democracy. Alpha Oumar Konaré, leader of the Alliance for Democracy in Mali (ADEMA), won the ensuing presidential election. A political settlement provided a special administration for TUAREGS in N Mali. ADEMA won 1997 elections, and Ibrahim Keita became prime minister.

ECONOMY

Mali is one of the world's poorest countries (1992 GDP per capita, US\$550). Agriculture, including nomadic pastoralism, employs 85% of the workforce. Farming is hampered by water shortages, and only 2% of the land is cultivated. Another 25% is used for grazing animals. Food crops include millet, rice and sorghum. The chief cash crops are cotton, groundnuts and sugar cane. Fishing is an important economic activity. Mali has vital mineral deposits of gold and salt. In 1984 Mali rejoined the franc zone, and is a major recipient of international aid to support its free market reforms.

republic

ETHNIC GROUPS: Maltese

English (both official)

RELIGIONS: Christianity

(1981). His best-known film is *Au Revoir Les Enfants* (1987). Malle's final film was *Uncle Vanya on 42nd Street* (1995).

100 cents

mallow Annual and perennial plants occurring in tropical and temperate regions of the world. The flowers are pink and white. The mallow family includes more than 900 species of plants, of which cotton, okra, hollyhock and hibiscus are among the best known. Family Malvaceae; especially genus *Malva*.

malnutrition Condition resulting from a diet that is deficient in necessary components such as proteins, fats or carbohydrates. It can lead to deficiency diseases, increased vulnerability to infection and death.

Malory, Sir Thomas (active 1460–70) English author. He wrote *Le Morte d'Arthur*, which recounts the legends associat-

▲ mammoth The mammoth was a hairy, elephant-like mammal that inhabited the steppes and tundra of North America, Europe and Asia during the ice ages of the Pleistocene period. Complete specimens have been found preserved in ice formations in Russia, and are reddish brown in colour. The mammoth was a herbivore and, while its body was of a similar size to modern elephants, it possessed a larger head and tusks and a thick coat of hair to protect it from the cold.

The feet of mammals have evolved in many different ways from the basic mammalian foot (A), possessed by the earliest shrew-like mammal. Scals (B) have developed evenly graduated toes for a webbed paddle. Moles (C) have truncated toes for leverage when digging. The camel's two

toes (D) are padded for walking on sand. Horses have a hoof (E) in stead of claws, and elongated feet for speed, as has the cheetah (F). Bats (G) have enormously elongated digits to support wings. Kangaroos' toes (H) are designed for hopping. Lemurs (I) and sloths (J) have forelimbs for grasping trees.

ed with King Arthur. The book was apparently written in prison and completed in 1469, but Malory's identity is obscure. **Malraux, André** (1901–76) French novelist and politician. Malraux won the Prix Goncourt for *Man's Fate* (1933). His work for the Republican cause in the Spanish Civil War inspired *Man's Hope* (1938). Malraux was active in the French resistance during World War 2, and was minister of cultural affairs (1960–69) in De Gaulle's government.

malt Germinated grain, usually BARLEY, used in beverages, beer and foods. The grain is softened in water and allowed to germinate. This activates ENZYMES, which convert the starch to malt sugar (maltose). The grain is then kiln-dried.

Malta Archipelago republic in the Mediterranean Sea, c.100km (60mi) s of Sicily; the capital is VALLETTA (on Malta). Land and climate Malta consists of two main islands, Malta (area: 246sq km/95sq mi) and Gozo (67sq km/26sq mi); the small island of Comino, located between the two large islands; and two tiny islets. The islands are low-lying. Malta island is composed mostly of limestone. Gozo is largely covered by clay, and as a result, its landscapes are less arid. The climate is typically Mediterranean, with hot, dry summers and mild, wet winters. In spring, the SIROCCO may raise temperatures and damage crops. Malta has no forests, and 38% of the land is arable. History Malta has evidence of Stone Age settlement dating back c.4,000 years. The Phoenicians colonized Malta c.850 BC. They were followed by the Carthaginians, Greeks and Romans. In AD 395 Malta became part of the Byzantine empire. Islam was introduced via Arab invasion in 870, but Christian rule was restored in 1091 by Roger I, Norman king of Sicily. A succession of feudal lords ruled Malta until the early 16th century. In 1530 the Holy Roman Emperor gave Malta to the KNIGHTS HOSPITALLERS. The Knights, who had fought in the CRUSADES, held Malta against a Turkish siege in 1565. NAPOLEON I seized Malta in 1798 but, with help from Britain, the French were driven out in 1800. In 1814 Malta became a British colony and strategic base. In World War 2, Italian and German aircraft bombed the islands. In recognition of the bravery of Maltese resistance, the British king George VI awarded the George Cross to Malta in 1942. In 1953 Malta became a NATO base. Malta gained independence in 1964, and in 1974 it became a republic. In 1979 Britain's military agreement with Malta expired, and all British forces withdrew. In the 1980s Malta declared itself a neutral country. Politics In 1990 Malta applied to join the European Community. Elections in 1997 were won by the Malta Labour Party (MLP), who pledged to rescind the application.

Malthus, Thomas Robert (1766–1834) British economist and minister, famous for his *Essay on Population* (1798). According to Malthusian theory, population increases geometrically but the food supply can increase only arithmetically so that population must eventually overtake it, resulting in famine, war and disease.

maltose (malt sugar) Disaccharide $(C_{12}H_{22}O_{11})$ that contains two molecules of the simple sugar GLUCOSE. It is produced by the hydrolysis of STARCH by the enzyme AMYLASE and by the breakdown of starches and GLYCOGEN during digestion.

mamba Any of several large, poisonous African tree snakes of the cobra family, Elapidae. The deadly black mamba (*Dendroaspis polylepsis*) is the largest species. It is grey, greenishbrown or black and is notoriously aggressive; its bite is almost always fatal. Length: to 4.3m (14ft).

Mameluke Military elite in Egypt and other Arab countries. In 1250 the Mamelukes of Egypt overthrew the Ayyubid dynasty. They halted the Mongols, defeated the Crusaders and crushed the Assassins. Though conquered by the Ottoman Turks in 1517, they continued to control Egypt until suppressed by Muhammad All in 1811.

Mamet, David (1947–) US playwright and film director. Mamet is noted for his sharp, perceptive dialogue. His play Glengarry Glen Ross (1983) won a Pulitzer Prize. Screenplays include The Postman Always Rings Twice (1981). His directorial debut was House of Games (1987). Other plays include Oleanna (1992), a controversial play about sexual harassment. mammal Class (Mammalia) of VERTEBRATE animals characterized by mammary glands in the female and full, partial or

vestigial hair covering. Mammals are warm-blooded. They have a four-chambered heart with circulation to the lungs separate from the rest of the body. As a group, mammals are active, alert and intelligent. They usually bear fewer young than other animals, and give them longer and better parental care. Most mammals before birth grow inside the mother's body and are nourished from her by means of a placenta. When born, they continue to feed on milk from the mother's mammary glands. There is a wide range of features, shapes and sizes among mammals. Mammals include 17 orders of placentals, one MARSUPIAL order – all live-bearing – and an order of egg-laying MONOTREMES. They probably evolved c.180 million years ago from a group of warm-blooded reptiles. Today, mammals range in size from shrews weighing a few grams to the blue whale, which can weigh up to 150 tonnes.

mammary glands See BREAST

mammoth Extinct PLEISTOCENE ancestor of the elephant. Many were covered with long red or brown hair. The prominent tusks were long and curved, sometimes crossing in adult males. In summer months, the permafrost of Siberia has been known to yield whole specimens that have been frozen for as long as 30,000 years. Genus *Mammuthus*.

man Zoological term for a HUMAN BEING

Man, Isle of Island off the NW coast of England, in the Irish Sea; the capital is Douglas. In the Middle Ages it was a Norwegian dependency, subsequently coming under Scottish then English rule. It has been a British crown possession since 1828 and has its own government (the Tynwald). The basis of the economy is tourism although agriculture is important, the chief products being oats, fruit and vegetables. Area: 572sq km (221sq mi). Pop. (1991) 69,788.

Managua Capital of Nicaragua, on the s shore of Lake Managua, w central Nicaragua. It became the capital in 1855. Managua suffered damage from earthquakes in 1931 and 1962. It is the economic, industrial and commercial hub of Nicaragua. Industries: textiles, tobacco, cement. Pop. (1985) 682,111.

Manama (Al-Manamah) Capital of Bahrain, on the N coast of Bahrain Island, in the Persian Gulf. It was made a free port in 1958, and a deepwater harbour was built in 1962. It is the country's principal port and commercial centre. Industries: oil refining, banking, boatbuilding. Pop. (1988) 151,500.

manatee Any of three species of large, plant-eating, subungulate, aquatic mammals found primarily in shallow coastal waters of the Atlantic Ocean. It has a tapered body ending in a large rounded flipper; there are no hind limbs. Length: to 4.5m (14.7ft); weight: 680kg (1,500lb). Family Trichechidae; genus *Trichechus*. *See also* DUGONG

Manchester City on the River Irwell, forming a metropolitan district in the Greater Manchester urban area, NW England. In AD 79 the Celtic town was occupied by the Romans, who named it Mancunium. The textile industry (now in decline) dates back to the 14th century. In 1830 the world's first passenger railway was constructed between LIVERPOOL and Manchester. In 1894 the Manchester Ship Canal opened, providing the city with its own access to the sea. In 1838 Manchester was incorporated as a borough. Modern Manchester has a diverse manufacturing base, including chemicals, pharmaceuticals, printing and publishing. It is the major financial centre of N England. Pop. (1991) 404,861.

Manchu Nomadic peoples of MANCHURIA. They established the QING dynasty.

Manchukuo Japanese puppet state in MANCHURIA (1932–45). It was under the nominal rule of the pretender to the Qing throne, Henry Pu Yi. The state of Manchukuo was not recognized by most foreign governments and, after the defeat of Japan in 1945, Manchuria was returned to China.

Manchuria Region of NE China, now included in the provinces of Heilongjiang, Jilin and Liaoning. Manchuria is rich in mineral deposits and has become one of China's leading sites for heavy industry. It is a major agricultural area, whose chief product is soya beans. Dalian is the principal port. The Manchus conquered China in the 17th century, and at the end of the 19th century the Chinese constructed the railways and the Russians developed the naval facilities at Port Arthur. In the Russo—Japanese War (1904—05) Japan seized

control of s Manchuria and Port Arthur. In 1931 Japan occupied the whole of Manchuria and established the puppet state of Manchukuo. During World War 2 the region's industry supplied the Japanese war effort. In 1945 Manchuria was occupied by Soviet forces, who destroyed many factories. In 1948 the Chinese communists defeated the Manchurian nationalists and reconstruction began. From 1960 to 1990 the

Manchurian Incident (1931) Japanese seizure of MANCHURIA. The Japanese captured Mukden in September and rapidly overran the province, setting up the puppet state of MANCHUKUO. The ensuing Sino–Japanese War later merged into World War 2. After the defeat of Japan (1945), Manchuria was returned to China.

region was at the forefront of Sino-Soviet hostilities. Area:

c.1,500,000sq km (600,000sq mi).

Mandalay City on the River Irrawaddy, capital of Mandalay division, central Burma (Myanmar). Founded in 1857, Mandalay was the last capital (1860–85) of the Burmese kingdom before it was annexed to Britain. The city was occupied by the Japanese during World War 2 and suffered severe damage. Pop. (1983) 532,985.

Mandan Dakota name for a Siouan tribe of Native North Americans inhabiting the upper Missouri River between the Heart and Missouri rivers. From an early population of 3,600, epidemics introduced by Europeans decimated the tribe. Today, c.350 live on Fort Berthold Reservation, North Dakota. **Mandarin** Major dialect of CHINESE, the spoken language of about 70% of the population of China. It was originally the language of the imperial court. Mandarin is the basis of modern standard Chinese.

mandarin (mandarine) Type of orange popular because of its sweet flavour. The tangerine is a flattish, loose-skinned species of mandarin. Family Rutaceae; species *Citrus reticulata*.

Mandela, Nelson Rolihlahla (1918-) South African statesman, president (1994-). Mandela joined the AFRICAN NATIONAL CONGRESS (ANC) in 1944, and for the next 20 years led a campaign of civil disobedience against South Africa's APARTHEID government. Following the SHARPEVILLE Massacre (1960), Mandela formed Umkhonte We Sizwe (Spear of the Nation), a paramilitary wing of the ANC. The ANC was banned. In 1962 he was acquitted on charges of treason, but in 1964 Mandela was sentenced to life imprisonment for political offences. He spent the next 27 years in prison, becoming a symbol of resistance to apartheid. International sanctions forced F.W. DE KLERK to begin the process of dismantling apartheid. In February 1990 Mandela was released to resume his leadership of the newly-legalized ANC. In 1993 Mandela and de Klerk shared the Nobel Peace Prize. Mandela gained 66% of the popular vote in South Africa's first democratic general election (1994). A strong advocate of the need for reconciliation, Mandela made de Klerk deputy president (1994-96) in his government of national unity. In 1991 he separated from his wife Winnie (1934-). Winnie was convicted of kidnapping and of being an accessory to assault.

Mandelbrot, Benoit B. (1942–) US mathematician, b. Poland. He has made major contributions to CHAOS THEORY, and is best known for coining the term FRACTAL. His book *The*

■ manatee The Florida manatee
(Trichechus manatus) like all
manatees is related to the
elephant. Manatees live in fresh or
brackish estuarine waters in family
groups consisting of parents and
offspring. Peaceful, herbivorous
animals, they feed on plants
growing on the seafloor or river
bed. It is supposed that they are
the source of the mermaid legends.

▲ Mandela South African president Nelson Mandela struggled for a democratic South Africa for much of his life, and spent 27 years in prison charged with attempting to overthrow the government. He was primarily responsible for the immense and peaceful revolution that turned South Africa into a "rainbow republic". Mandela's charismatic personality and benevolence made him a national and international figure of great moral stature.

➤ mandrill A species of baboon, the mandrill (Mandrillus sphinx) is found in Equatorial West Africa. The extraordinary colours of the mandrill's face intensify if the animal becomes annoyed or excited. Zoologists believe that this visual display has replaced the baring of teeth to express anger common to most other baboons.

Fractal Geometry of Nature (1982) contains many examples of natural fractals, such as ferns, trees and rivers. The Mandelbrot set, a well-known fractal object, is named after him.

mandolin Stringed musical instrument related to the LUTE and associated with 18th-century Italy. It has four or six paired wire strings, which are played with a plectrum. It is most often used today as an accompaniment to folk songs and dances.

mandrake Plant of the potato family, native to the Mediterranean region and used since ancient times as a medicine. It contains the ALKALOIDS: hyoscyamine, scopolamin and mandragorine. Leaves are borne at the base of the stem, and the large greenish-yellow or purple flowers produce a many-seeded berry. Height: 40cm (16in); family Solanaceae; species Mandragora officinarum.

mandrill Large BABOON that lives in dense rainforests of central w Africa. Mandrills roam in small troops and forage for their food on the forest floor. The male has a red-tipped, pale blue nose, yellow-bearded cheeks and a reddish rump. Height: 75cm (30in) at the shoulder; weight: to 54kg (119lb). Species Mandrillus sphinx.

Manet, Édouard (1832–83) French painter. Although Manet is often linked with IMPRESSIONISM, he did not consider himself part of the movement. The famed *Le Déjeuner sur l'Herbe* (1863) was violently attacked by contemporary critics for its realistic depiction of the female nude. *Olympia* (1863), a portrait of a well-known courtesan, was similarly received. Manet finally achieved recognition with later works, such as *Le Bar aux Folies-Bergères* (1881).

manganese (symbol Mn) Grey-white metallic element that resembles iron and was first isolated in 1774. Its chief ores are pyrolusite, manganite and hausmannite. The metal is used in alloy steels, ferromagnetic alloys, fertilizers and paints, and as a petrol additive. Properties: at.no. 25; r.a.m. 54.938; r.d. 7.20; m.p. 1,244°C (2,271°F); b.p. 1,962 °C (3,564°F); most common isotope Mn⁵⁵ (100%). See also TRANSITION ELEMENTS

mango Evergreen tree native to SE Asia and grown widely in the tropics for its fruit. It has lanceolate leaves, pinkish-white clustered flowers, and yellow-red fruit, which is eaten ripe or preserved when green. Height: to 18m (60ft). Family Anacardiaceae; species *Mangifera indica*.

mangrove Common name for any one of 120 species of tropical trees or shrubs found in marine swampy areas. Its stilt-like aerial roots, which arise from the branches and hang down into the water, produce a thick undergrowth, useful in the reclaiming of land along tropical coasts. Some species also have roots that rise up out of the water. Height: to 20m (70ft). Chief family: Rhizophoraceae.

Manhattan Borough of New York City, in SE New York state, USA; lying mainly on Manhattan Island and bounded w by the Hudson River. In 1625 the Manhattan Indians sold the island to the Dutch West India Company and the town of New Amsterdam was built. The British captured the Dutch colony in 1664 and renamed it New York. In 1898 Manhattan became one of five boroughs established by the Greater New

York Charter. Industries: electrical goods, chemicals, fabricated metals, finance, tourism, entertainment, broadcasting, publishing. Pop. (1990) 1,487,536.

Manhattan Project Code name given to the development of the US atomic bomb during WORLD WAR 2. Work on the bomb was carried out in great secrecy by a team including Enrico FERMI and J. Robert OPPENHEIMER. The first test took place on 16 July 1945, near Alamogordo, New Mexico, and the following month bombs were dropped on Japan.

mania Mental illness marked by feelings of intense elation and excitement. Speech is rapid and physical activity frenetic. In extreme cases mania is accompanied by violent behaviour. manic depression (bipolar disorder) Mental illness featuring recurrent bouts of DEPRESSION, possibly alternating with periods of MANIA. Depressive and manic symptoms may alternate in a cyclical pattern, be mixed or be separated by periods of remission and disturbances of thought and judgement.

Manichaeism Religious teaching of the Persian prophet Mani (c.216–c.276) based on a supposed primeval conflict between light and darkness. The Manichaean sect, which was influenced by ZOROASTRIANISM and CHRISTIANITY, spread rapidly to Egypt and Rome, where it was considered a Christian heresy, and eastward to Chinese Turkestan, where it survived probably until the 13th century.

Manila Capital of the Philippines, on Manila Bay, sw Luzon island. Manila is the industrial, commercial and administrative heart of the Philippines. The River Pasig bisects the city. On the s bank stands the old walled city (Intramuros), built by the Spanish in the 16th century on the site of a Muslim settlement. It became a trading centre for the Pacific area. On the N bank lies Ermita, the administrative and tourist centre. In 1942 it was occupied by the Japanese. In 1945 a battle between Japanese and Allied forces destroyed the old city. Pop. (1990) 1,587,000. Manitoba Province in s central Canada, the easternmost of the prairie provinces, bordered by Hudson Bay (NE) and the USA (s); the capital and largest city is WINNIPEG. In 1670 Charles II granted the land to the HUDSON'S BAY COMPANY. In 1869 the company sold it to the newly created confederation of Canada. Manitoba became a province in 1870. The terrain varies from the prairie country and lake district of the s, to the rugged upland of the Canadian Shield of the NE, and the tundra of the far N. Manitoba is famous for its wheat fields. Dairy farming and the rearing of poultry are also important. Manufacturing includes food products, clothing, electrical products, machinery, metals and transport equipment. Mineral deposits include nickel, copper and zinc. There are large oilfields in the sw of the province and extensive timber reserves. Area: 649,947sq km (250,946sq mi). Pop. (1994 est.) 1,131,100.

Mann, Thomas (1875–1955) German novelist and essayist. Perhaps the outstanding figure of 20th-century German literature, Mann linked individual psychological problems to the great decline in European culture. His first novel, Buddenbrooks (1901), is an epic family saga. Shorter works include the novella Death in Venice (1912), and the autobiographical essay Reflections of a Non-political man (1918). The Magic Mountain (1924) is widely acclaimed as his masterpiece. Mario and the Magician (1930) was an allegorical critique of fascism. In 1933 Mann left Germany, first for Switzerland, then the United States. Other works include the tetralogy Joseph and His Brothers (1933–43), and Confessions of Felix Krull, Confidence Man (1955). Mann won the 1929 Nobel Prize for literature.

Mannerheim, Carl Gustav Emil von (1867–1951) Finnish statesman and general, president (1944–46). He served in the Russian army and was a general in World War 1. After the Russian Revolution (1917), he returned to Finland and led the anti-Bolshevik forces in the civil war. In 1918–19 he obtained international recognition of Finnish independence. He lost the 1919 presidential election but, later, as head of the Defence Council, planned the fortified Mannerheim Line across Karelia.

mannerism Term generally applied to the art and architecture of Italy between the High RENAISSANCE and the BAROQUE. The style is typified by PARMIGIANO, PONTORMO and Giovanni Lanfranco. Theorists are still debating the scope of mannerism:

it has been extended to include El GRECO, the FONTAINEBLEAU SCHOOL and the Romanist painters of the Netherlands. The term still implies a courtly, self-conscious style.

Mannheim City and river port on the E bank of the River Rhine, at the mouth of the River Neckar, Baden-Wüttemberg, central Germany. Originally a fishing village, Mannheim was fortified in 1606 and destroyed by the French in 1689. It was rebuilt in 1697, became the seat of the Rhine Palatinate (1719–77), and passed to Baden in 1803. Industries: chemicals, oil refining, engineering, paper, textiles. Pop. (1990) 316,900.

Manning, Olivia (1912–80) British novelist. Manning's debut novel was *The Wind Changes* (1937). Her attention to characterization and historical detail is best represented by the popular Balkan Trilogy: *The Great Fortune* (1960), *The Spoilt City* (1962), and *Friends and Heroes* (1965). Its sequel was the Levant Trilogy (1977–78): *Danger Tree*, *Battle Lost and Won*, and *Sum of Things*.

manor Name for a type of unit, or estate, characteristic of medieval Europe. Typically, a manor was divided into the lord's demesne (on which peasants were bound to labour), an area assigned to peasants for their own use, and an area of common land. The lord, or his steward, occupied the manor house. Mansell, Nigel (1953–) English racing car driver. Mansell made his Formula 1 debut for Lotus (1980). In 1985 he joined Williams and won his first race, the European Grand Prix. Mansell won the world driver's championship in 1992. He then left Formula 1 to compete in the US IndyCar championships, becoming World Series champion (1993).

Mansfield, Katherine (1888–1923) British writer, b. New Zealand. A master of the short story, her debut volume was *In a German Pension* (1911). Her delicate humour and deceptively simple style are best represented by *The Garden Party* (1922) and *The Dove's Nest* (1923). Mansfield had a troubled life and died of tuberculosis.

manslaughter Crime of killing another person either accidentally or for humane motives. Manslaughter merits less punishment than MURDER.

Mantegna, Andrea (1431–1506) Italian painter and engraver. In 1460 he became court painter to the Gonzaga family in Mantua, and decorated the Camera degli Sposi in the Duke's Palace. This room contains the first example of illusionistic architecture to have been created since antiquity. Mantegna's other great work for the Gonzagas was his series of oil paintings, *The Triumph of Caesar* (c.1480–95).

mantis (praying mantis) Any of several species of mantids, insects found throughout the world. They have powerful front legs used to catch and hold their insect prey. Colours range from brown and green to bright pinks. Length: 25–150mm (1–6in). Family Mantidae.

mantissa Decimal part of a LOGARITHM

mantle Layer of the Earth between the CRUST and the CORE, which extends to a depth of 2,890km (1,795mi). The mantle forms the greatest bulk of the Earth: 82% of its volume and 68% of its mass. The uppermost part is rigid, solid and brittle and together with the Earth's crust forms the lithosphere. From a depth of about 60km (40mi) down to 200km (125mi) the mantle has a soft zone, which is called the asthenosphere. Temperature and pressure are in balance so that much of the mantle material is near melting point or partly melted and capable of flowing. The remainder of the mantle is thought to be more solid but still capable of creeping flow. In the lower mantle several changes in seismic velocity can be detected. The chemical constitution of the mantle is uncertain, but it is thought to be made up of iron-magnesian silicates.

mantra Sacred word, verse or formula recited during prayers or meditation in HINDUISM and BUDDHISM. Mantras include such chantings as the symbolic sound *Aum* (or *Om*). Manx Language formerly spoken in the Isle of Man. Closely related to Scottish GAELIC, it was spoken by most of the native inhabitants until *c*.1700, when English was introduced. By 1900 there were only a few thousand speakers left.

Manzoni, Alessandro (1785–1873) Italian novelist and poet. His poetry expressed his religious faith, but his masterpiece is an historical novel, *The Betrothed* (1827), regarded as one of the most outstanding works of Italian literature.

Maori Polynesian population, the original inhabitants of New Zealand. Traditionally, Maoris lived by agriculture, hunting and fishing. They retain strong attachments to the Maori language, culture and customs. In Maori society, tattooing, carving and weaving were developed arts, and their war chants (*haka*) are still kept alive. Since the 1970s, Maori political activity has increased, and some of their land has been restored to them. *See also* MAORI WARS

Maori Wars (1845–48, 1860–72) Two wars between British settlers and indigenous MAORI tribes in New Zealand. They arose when the settlers broke the terms of the Treaty of WAITANGI (1840) that guaranteed the Maoris possession of their lands. As a result of the wars, a Native Land Court was established (1865), a Maori school system formed (1867) and the admission of four elected Maoris to the national legislature.

Mao Zedong (1893–1976) Chinese statesman, founder and chairman (1949-76) of the People's Republic of China. Mao was a founder member of the Chinese COMMUNIST PARTY in 1921. After the nationalist Kuomintang, led by Chiang Kai-SHEK, dissolved the alliance with the communists in 1927, Mao helped established rural soviets. In 1931 he was elected chairman of the Soviet Republic of China, based in JIANGSU. The advance of nationalist forces forced Mao to lead the Red Army on the LONG MARCH (1934-35) NW to Shanxi. In 1937 the civil war was suspended as communists and nationalists combined to fight the second SINO-JAPANESE WAR. The communists' brand of guerrilla warfare gained hold of much of rural China. Civil war restarted in 1945, and by 1949 the nationalists had been driven out of mainland China. Mao became chairman of the People's Republic and was re-elected in 1954. ZHOU ENLAI acted as prime minister. In 1958 Mao attempted to distinguish Chinese COMMUNISM from its Soviet counterpart by launching the Great Leap Forward. The programme ended in mass starvation, and the withdrawal of Soviet aid. Mao's leadership was challenged. The CULTURAL REVOLUTION was an attempt by Mao and his wife, JIANG QING, to reassert Maoist ideology. The cult of the personality was encouraged, political rivals were dismissed, and Mao became supreme commander of the nation and army (1970). Mao and Zhou Enlai's death created a power vacuum. A struggle developed between the GANG OF FOUR, HUA GUOFENG, and DENG XIAOPING. Quotations from Chairman Mao Zedong (popularly known as "The Little Red Book", 1967) is a worldwide bestseller.

map Graphic representation of part or all of the Earth's surface. Maps are usually printed on a flat surface using various kinds of projections based on land surveys, aerial photographs and other sources.

maple Genus of deciduous trees native to temperate and cool regions of Europe, Asia and North America. They have yellowish or greenish flowers and winged seeds. They are grown for ornament, shade or timber, depending on the species; the sugar maple is also tapped for maple syrup. A common British example is the sycamore tree. Height: 4.6–36m (15–120ft). Family Aceraceae; genus *Acer*.

Maputo (Lourenço Marques) Capital and chief port of Mozambique, on Maputo Bay, s Mozambique. It was visited by the Portuguese in 1502 and was made the capital of Portuguese East Africa in 1907, being known as Lourenço Marques until 1976. It is linked by rail to South Africa, Swaziland and Zimbabwe, and is a popular resort area. Industries: footwear, textiles, rubber. Pop. (1992 est.) 2,000,000.

Maracaibo City and port in NW Venezuela, between Lake Maracaibo and the Gulf of Venezuela. Founded in 1529, it was sacked in 1669. It expanded after the discovery of oil in 1917, and is now Venezuela's second-largest city. Industries: oil processing, coffee, cacao, sugar. Pop. (1990) 1,207,513.

Marat, **Jean Paul** (1743–93) French revolutionary. A physician, he founded *L'Ami du Peuple* (Friend of the People), a vitriolic journal that supported the JACOBINS. His murder by Charlotte Corday, a member of the GIRONDINS, was exploited for propaganda by the Jacobins and contributed to the ensuing REIGN OF TERROR.

Maratha (Mahratta) Hindu warrior people of w central India, who rose to power in the 17th century. They extended their rule throughout w India by defeating the MOGUL EMPIRE

▲ mango The fruit of the mango tree has a delicate fragrance. Its juicy flesh surrounds a single flat seed. The tree itself is grown as a garden plant throughout the tropical region.

and successfully resisting British supremacy in India during the 18th century. They were finally defeated in 1818.

marathon Long-distance race. The standard marathon is 42.2km (26.2mi) long, which was the distance run by the ancient Greek soldier who brought news to Athens of the victory over the Persians at the Battle of MARATHON (490 BC).

Marathon, Battle of (490 BC) Victory of the Greeks, mainly Athenians, during the Persian Wars. The defeat of a much larger Persian army on the Marathon plain, NE of Athens, secured Attica from the invasion of Cyrus the Great.

marble Metamorphic rock composed largely of recrystallized limestones and dolomites. The colour is normally white, but when tinted by serpentine, iron oxide, or carbon can vary to shades of yellow, green, red, brown or black. It has long been a favourite building and sculpting material.

Marceau, Marcel (1923–) French mime artist. His best-known creation was Bip, a sad, white-faced clown with a tall, battered hat. Marceau made several films, including *Un Jardin Public* (1955), and appeared in *Silent Movie* (1976).

Marche Region in E central Italy, between the Apennines and the Adriatic Sea; the capital is Ancona. The region acquired its present name in the 10th century, when it was divided into border provinces of the Holy Roman Empire. In the 13th-17th centuries the papacy gradually won control of the region. It was under French occupation from 1797 to 1815. In 1860 it was united with the kingdom of Italy. Except for a narrow coastal plain, Marche is mountainous. Farming is the principal economic activity; major crops include cereals, olives and grapes. Area: 9,692sq km (3,743sq mi). Pop. (1990) 1,435,570. Marconi, Guglielmo (1874-1937) Italian physicist who developed RADIO. By 1897 Marconi was able to demonstrate radio telegraphy over a distance of 19km (12mi) and established radio communication between France and England in 1899. By 1901 radio transmissions were being received across the Atlantic Ocean. Marconi was awarded the Nobel Prize for physics in 1909.

Marco Polo See Polo, Marco

Marcos, Ferdinand Edralin (1917-89) Philippine statesman, president (1965-86). Marcos was elected to the Philippine Congress in 1949. As president, he received support from the US for his military campaigns (1969) against communist guerrillas on Panay and Moro secessionists on MINDANAO. Continued civil unrest led to the imposition of martial law in 1972. A new constitution (1973) gave Marcos authoritarian powers. His regime acquired a reputation for corruption and repression, symbolized by the extravagance of his wife, Imelda (1930-). In 1983 his main rival, Benigno Aquino, was assassinated and political opposition coalesced behind Benigno's widow, Cory AQUINO. Marcos appeared to win the 1986 general election, but allegations of vote-rigging forced him into exile. In 1988 US authorities indicted both him and Imelda for fraud. Ferdinand was too ill to stand trial and died in Hawaii. Imelda was subsequently acquitted, but on her return to Manila in 1991 she was indicted for embezzlement. In 1992 Imelda unsuccessfully ran for president. In 1993 she was sentenced to 18 years imprisonment, but appealed the judgement.

Marcus Aurelius (121–180) (Antoninus) Roman emperor (161–180) and philosopher of the STOIC school, b. Marcus Annius Verus. From 161 to 169, he ruled as co-emperor with his adoptive younger brother, Lucius Aurelius Verus (d.169). His much-admired *Meditations*, his one surviving work, is a collection of philosophical thoughts and ideas that occurred to him during his campaigns, on the last of which he died.

Marcuse, Herbert (1898–1979) US radical political philosopher, b. Germany. Marcuse is noted for his critical reinterpretations of MARXISM, and for his Freudian analysis of 20th-century industrial society. In the 1920s he was a founder member of the Frankfurt Institute for Social Research. Fleeing Nazi Germany in 1933, he settled in the USA and worked for the US government (1941–50). Marcuse's advocacy of civil resistance found favour with left-wing students of the 1960s. His works include *Eros and Civilization* (1955) and *One-Dimensional Man* (1964). See also ALIENATION

Mardi gras Community festival or carnival held on Shrove Tuesday, the day before the beginning of Lent, in many Roman

Catholic countries, particularly France. In the USA, most notably New Orleans, it includes parades, concerts and dances.

Mare, Walter de la See De la Mare, Walter

Margaret of Anjou (1430–82) Wife of HENRY VI of England from 1445. During the Wars of the Roses she, rather than Henry, led the cause of Lancaster, raising troops in France. After her only son, Edward, was killed at Tewkesbury (1471) she was taken prisoner. Ransomed by Louis XI of France in 1476, she spent her last years in exile.

margarine Butter-like substance made from vegetable fats blended with aqueous milk products, salt, flavouring, food colouring, emulsifier, and vitamins A and D. It is used for cooking and as a spread.

Margrethe II (1940–) Queen of Denmark, daughter of Frederick IX. In 1972, she became the first queen regent since the Middle Ages, and the first democratically appointed sovereign in Denmark's history. In 1967 she married the French Count Henri Laborde Monpezat.

marguerite Perennial plant of the daisy family native to the Canary Islands. It has white-rayed, yellow-centred flower heads c.5cm (2in) across. Height: to 91cm (3ft). Family Asteraceae/ Compositae; species Argyranthemum frutescens. Mariana Islands Volcanic island chain in the w Pacific Ocean, stretching over 800km (500mi) of the Marianas Trench, c.2,400km (1,500mi) E of the Philippines. The group comprises GUAM and the islands of the Northern Marianas: Saipan, Tinian, Rota, Pagan and 11 smaller islands. Discovered by Ferdinand MAGELLAN in 1521 and named Islands of Thieves, the islands were renamed the Marianas in 1668. The Northern Marianas came under German control in 1898, subsequently passing to Japan. They were taken by US forces in 1944, and in 1947 became part of the US Trust Territory of the Pacific Islands. In 1978 the Commonwealth of the Northern Mariana Islands was formed in association with the USA, and in 1986 the islanders acquired US citizenship. Trusteeship status was ended in 1990. Exports include sugar cane, coconuts and coffee. Tourism is important. Area (excluding Guam): 464sq km (179sq mi). Pop. (1990) 43,345.

Maria Theresa (1717–80) Archduchess of Austria, ruler (1740–80) of the Austrian Habsburg empire. She succeeded her father, Emperor Charles VI, but was challenged by neighbouring powers in the War of the Austrian Succession (1741–48), losing Silesia to Prussia but securing the imperial title for her husband, Francis I. She switched allegiances, but failed to regain Silesia in the Seven Years War (1756–63).

Marie Antoinette (1755–93) Queen of France. Daughter of

Emperor Francis I and Maria Theresa of Austria, she married the future Louis XVI in 1770. Her life of pleasure and extravagance contributed to the outbreak of the French Revolution in 1789. She initiated the royal family's attempt to escape in 1791, was held prisoner and was finally guillotined. **Marie de Médicis** (1573–1642) Queen of France. A member of the Medici family, daughter of the Grand Duke of Tuscany, she married Henry IV of France (1600). He was assassinated the day after she was crowned queen in 1610, possibly with her connivance. As regent for her son, Louis XIII, she relied on Italian advisers and reversed Henry's anti-Habsburg policy. She was constantly at odds with Louis after 1614 and antagonized Cardinal Richelieu. Failing to have him dismissed in 1630, she was forced into exile in Brussels (1631).

Marie Louise (1791–1847) French Empress. Daughter of Emperor Francis II, she married Napoleon I in 1810. A son, the future Napoleon II, was born in 1811, and she acted briefly as regent during Napoleon's absences on campaign. Alienated from him by 1814, she was made duchess of Parma.

marigold Any of several mostly golden-flowered plants, mainly of the genera *Chrysanthemum Tagetes* and *Calendula*, all of the daisy family (Asteraceae/ Compositae). Those most commonly cultivated are the French marigold (*Tagetes patula*) and the African marigold (*T. erecta*).

marijuana Narcotic drug prepared from the dried leaves of the Indian hemp plant (*Cannabis sativa*); it is different from HASHISH, which is prepared from resin obtained from the flowering tops of the plant. Possession of the drug is illegal in many countries. *See also* ADDICTION

Marine Corps, US Branch of the armed forces that is a service within the department of the Navy. It consists of c.196,000 personnel and conducts land operations connected with naval manoeuvres. *See also* Joint Chiefs of Staff (JCS): Navy, US

Mariner program Series of US space probes to the planets. Mariner 2 flew past Venus in 1962, and Mariner 4 flew past Mars in July 1965, photographing craters on its surface. Mariner 5 passed Venus in October 1967, making measurements of the planet's atmosphere. Mariners 6 and 7 obtained further photographs of Mars in 1969. Mariner 9 went into orbit around Mars in November 1971. It made a year-long photographic reconnaissance of the planet's surface and obtained close views of the two moons, Phobos and Deimos. Mariner 10, the last of the series, was the first two-planet mission, passing Venus in February 1974 and then encountering Mercury three times, in March and September 1974 and March 1975.

marines See Marine Corps, US; Royal Marines

Marineti, Filippo Tommaso (1876–1944) Italian poet, novelist, dramatist and founder of FUTURISM. In such works as Futurismo e Fascismo (1924), he embraced fascism and advocated the glorification of machinery, speed and war. One of his earliest collections of poetry was entitled simply Destruction; another was called War: the Only Hygiene of the World (1915). Maris, Roger Eugene (1934–85) US baseball player. Playing for the New York Yankees, Maris set a season homerun record (61) in 1961, eclipsing Babe RUTH's record from 1927. Maris hit a total of 275 home runs during his majorleague career (1957–68).

maritime law Branch of the law concerned with the sea and those who use it. It is quite distinct in its function and practice from domestic law.

Marius, Gaius (157–86 BC) Roman political and military leader. His policy of recruiting poor men without property contributed to the bond between Roman troops and their commanders. He also revised standard army training and equipment. His rivalry with SULLA forced him out of Rome, but he raised an army and recaptured the city (87 BC).

marjoram Perennial herb of the mint family (Lamiaceae/Labiatae) c.60cm (24in) tall with purplish flowers. It is native to the Mediterranean region and w Asia and is cultivated as an annual in northern climates. Species *Origanum vulgare*.

Mark, Saint (active 1st century AD) Apostle and possibly one of the four evangelists of the New Testament. He is identified with John Mark (Acts 12:12. 15:37), the cousin of the apostle St Barnabas. He accompanied both Barnabas and St PAUL on several missionary journeys until a disagreement with Paul caused him to detach himself. Christian tradition says that he went off to become secretary to St Peter and to write the first gospel. His feast day is 25 April.

Mark, Gospel according to Saint Second GOSPEL in the New Testament, but the earliest in composition. It was written c.AD 55–65 and is believed to be one of two reference works (the other being "Q") used by St MAITHEW and St LUKE in compiling their gospels. It is traditionally attributed to St MARK and is one of the three SYNOPTIC GOSPELS – those presenting a common view of Jesus Christ's life.

Mark Antony See Antony, Mark

market economy Economy in which resources are controlled by the operation of free markets (in which the forces of supply and demand operate without interference). The opposite is a command economy, in which market forces are under governmental control; in a mixed economy, there is partial governmental control.

marketing Study and practice of enhancing the sales of goods or services. It includes product development, design, packaging, pricing, MARKET RESEARCH and advertising.

market research Study of consumer preferences and demand, for the purpose of increasing the sales of commercial products. It involves the collection, recording and analysis of data derived from testing a product on a representative sample of likely consumers. Interviewing to ascertain popular preferences for products is another method.

Markova, Dame Alicia (1910–) British ballerina, real name Lilian Alicia Marks. She joined the Vic-Wells Ballet in 1931 and was its first prima ballerina. Classical ballets in which she excelled include *Giselle*, *Les Sylphides* and *Swan Lake*. She was made a Dame of the British Empire in 1963.

Marlborough, John Churchill, 1st Duke of (1650–1722) English general. Churchill helped James II defeat Monmouth (1685), but switched allegiance in support of the Protestant Glorious Revolution (1688). Partly due to his wife's friendship with Queen Anne, he was appointed Captain-General of Allied armies in the War of the Spanish Succession. His strategic skill gained great victories at Blenheim (1704), Ramillies (1706), Oudenaarde (1708) and Malplaquet (1709). Churchill was rewarded with a dukedom and Blenheim Palace. When his wife lost the Queen's favour and the Tories regained power, Malborough was dismissed (1711) and went into exile.

Marley, Bob (Robert Nesta) (1945–81) Jamaican singer-songwriter. Marley and his band, The Wailers, transformed REGGAE into an internationally popular music form with hit singles such as "Get Up, Stand Up" (1973) and "No Woman No Cry" (1974). He combined faith in RASTAFARIANISM with political statement. Marley's albums include *Natty Dread* (1975), *Exodus* (1977), and *Uprising* (1980).

Marlowe, Christopher (1564–93) English playwright and poet. Marlowe helped make BLANK VERSE the vehicle of ELIZ-ABETHAN DRAMA. Much of his success derives from his ability to humanize his overreaching heroes, such as *Tamburlaine the Great* (1590), *The Tragical History of Doctor Faustus* (1604), and *The Jew of Malta* (1633). His masterpiece is the tragedy *Edward II* (1592). His greatest poems are *Hero and Leander* (1598) and *The Passionate Shepherd* (1599). Marlowe served as a spy in Francis WALSINGHAM's intelligence service.

marmoset Small diurnal, arboreal MONKEY of tropical America. Among the smallest of the monkeys, marmosets are the size of small squirrels. They have soft, dense fur and sickle-shaped nails. Family Callitrichidae; typical genus *Callithrix*.

marmot Stocky, terrestrial rodent of the SQUIRREL family, native to North America, Europe and Asia. Most marmots have brown to grey fur, short, powerful legs and furry tails. Length, excluding tail: 30–60cm (12–24in); weight: 3–8kg (6.6–16.5lb). Family Sciuridae.

Marne, Battles of Two battles on the River Marne, N France, during WORLD WAR 1. The first, in September 1914, was a counterattack directed by General JOFFRE, which checked the German drive on Paris. The second, in July 1918, was another Allied counter-stroke, which stopped the last German advance and preceded the final Allied offensive.

Maronites Christian community of Arabs in Lebanon and Syria, who have spread (by emigration) to Egypt, Cyprus, southern Europe, and North and South America. The Maronite Church claims origins from St Maron (d.407), a Syrian hermit. The Maronites were condemned as Monotheletic heretics by the Third Council of Constantinople (680). They returned to communion with the pope in 1182. They have the status of a uniate Church – an Eastern Church in union with Rome but retaining its own rite and canon law. The 19th-century massacre of Maronites by the DRUSE led to French intervention in Lebanon and Syria. Today, Maronites number over 1 million

Marquesas Islands Volcanic archipelago in the Pacific Ocean, s of the Equator. The islands, part of French Polynesia, include Fatu Hiva, Hiva Oa and Nuku Hiva; the capital is Taiohae (on Nuku Hiva). They were first discovered by a Spanish navigator in 1595. The French took possession in 1842. During the 19th century European diseases killed many of the native Polynesians. The islands are mountainous, with fertile valleys and several good harbours. Exports: tobacco, vanilla and copra. Area: 1,049sq km (405sq mi). Pop. (1988) 7,538.

Márquez, Gabriel García See García Márquez, Gabriel **Marrakech** (Marrakesh) City in w central Morocco, at the Nw foot of the Atlas Mountains. Founded in 1062 by the Almoravids, it was Morocco's capital until 1147 and subsequently served as the sultan's residence. Industries: tourism, leather goods. Pop. (1983) 439,728.

marriage In the modern Western sense, the legal status of a man and a woman joined by ceremony as husband and wife. This is known as MONOGAMY, but some societies practise polyandry and POLYGAMY.

▲ marjoram Wild marjoram (*Origanum vulgare*) is a pungent-flavoured herb much used in Mediterranean cooking to season meat, poultry, soups and omelettes. It is known in its dried form as oregano.

marrow Soft tissue containing blood vessels, found in the hollow cavities of BONE. The marrow found in many adult bones is somewhat yellowish and functions as a store of fat. The marrow in the flattish bones is reddish and contains cells that give rise eventually to ERYTHROCYTES (red blood cells) as well as to most of the LEUCOCYTES (white blood cells), but not LYMPHOCYTES and platelets.

Marsalis, Wynton (1961–) US jazz musician. Marsalis was a member (1980–82) of Art Blakey's Jazz Messengers, before forming his own group. Marsalis is one of the few jazz players to successfully crossover into classical music. His albums include *Black Codes (From the Underground)* (1984) and *Blood on the Fields* (1996).

Marseilles (Marseille) City and seaport on the Gulf of Lyon, and connected to the River Rhône by an underground canal; capital of Bouches-du-Rhône département, SE France. The oldest city in France, it was founded in 600 BC by Phocaean Greeks. During the CRUSADES, Marseilles was a commercial centre and shipping port for the Holy Land. The 19th-century French conquest of Algeria and the opening of the Suez Canal (1869) brought great prosperity to the city. Industries: flour milling, soap, vegetable oil, cement, sugar refining, chemicals, engineering. Pop. (1990) 800,550.

marsh Flat wetland area, devoid of peat, saturated by moisture during one or more seasons. Typical vegetation includes grasses, sedges, reeds and rushes. Marshes are valuable wetlands and maintain water tables in adjacent ecosystems. Unlike BOGS, they have alkaline not acidic soil. See also SWAMP

Marshall, George Catlett (1880–1959) US general and statesman. He served as a staff officer during World War 1 and, after various commissions including service in China (1924–27), became chief of staff during World War 2. After the war he was secretary of state (1947–49) and defense secretary (1950–51). He inspired the MARSHALL PLAN.

Marshall, Thurgood (1908–93) US lawyer and Supreme Court justice (1967–91). As counsel (1938–62) for the National Association for the Advancement of Colored People (NAACP), he played a key role in obtaining Supreme Court judgments against racial segregation in schools. He was appointed solicitor general (1965) and became the first African-American associate justice of the US Supreme Court. Marshall Islands Republic in the w Pacific Ocean, E of the Caroline Islands, consisting of a group of atolls and coral reefs; the capital is Dalap-Uliga-Darrit (on Majuro Atoll). The islands were first explored by Spain in the early 16th century. Annexed to Germany in 1885, the group was occupied by

Japan in 1914, and by US forces in World War 2. In 1947 the islands became part of the US-administered Trust Territory of the Pacific Islands. The Trusteeship ended in 1990 and in 1991 the islands became a full member state of the UN. They consist of two great chains, the Ralik (w) and the Ratak (E), which run almost parallel Nw to SE, covering an ocean area of 11,650sq km (4,500sq mi). Products: copra, coconuts, tropical fruits, fish. Area: c.180sq km (70sq mi). Pop. (1994 est.) 54,000.

Marshall Plan US programme of economic aid to European countries after World War 2. Promoted by the secretary of state, General MARSHALL, its purpose was to repair war damage and promote trade within Europe, while securing political stability. The Soviet Union and E European countries declined to participate. Between 1948 and 1951, 16 countries received a total of \$US12,000 million under the plan.

Mars Fourth major planet from the Sun. Mars appears red to the naked eye because of the high iron content of its surface crust, and is also known as the Red Planet. The atmosphere consists mainly of 95% carbon dioxide, 2.5% nitrogen, and 1.5% argon, with smaller quantities of oxygen, carbon monoxide and water vapour. Its axial tilt is similar to the Earth's, so it passes through a similar cycle of SEASONS. The surface temperature on Mars varies between extremes of 130K and 290K. Its surface reveals a long and complex history of geological activity. The major difference in terrain is between the largely smooth, lowland volcanic plains of the northern hemisphere and the heavily cratered uplands of the south. The biggest volcanic structure on Mars is Olympus Mons, which is hundreds of kilometres across and 27km (17mi) high. Other geographical features, such as giant canyons, are channels in which rivers once flowed. The variable polar ice caps appear to be composed of solid carbon dioxide with underlying caps of water ice. Mars has two tiny SATELLITES in very close orbits, Phobos and Deimos. In 1996 scientists investigating a meteorite, thought to have originated on Mars, found fossilized microorganisms that some believe indicate the presence of primitive life on the planet.

Mars Ancient Roman god of war, often depicted as an armed warrior; one of the three protector-deities of the city of Rome itself (with JUPITER and Quirinus). He was originally associated with agriculture but later took on his dominant military aspects; the wolf and woodpecker were sacred to him.

Marston Moor Site of a decisive battle in the English CIVIL WAR, 11km (7mi) w of York. Royalist forces under Prince RUPERT were defeated by the Parliamentarians under Thomas FAIRFAX, with Scots allies, on 2 July 1664.

marsupial Mammal of which the female usually has a pouch (marsupium), within which the young are suckled and protected. At birth, the young are not fully formed. Most marsupials are Australasian, and include such varied types as the KANGAROO, KOALA, WOMBAT, TASMANIAN DEVIL, BANDICOOT, and marsupial MOLE. The only marsupials to live outside Australasia are the OPOSSUMS and similar species found in the Americas. See also MONOTREME

marten Any of several species of carnivorous mammals of the WEASEL family that live in forested areas of Europe, Asia and North and South America. Martens have a long body and short legs and are hunted for their fur. The dark brown skins of the SABLE, *Martes zibellina*, are the most valuable. Family Mustelidae.

Martí, José (1853–95) Cuban poet and essayist. His verse reflected his belief that poetry and politics were inseparable. He was forced into exile and lived in New York before returning to Cuba, where he died fighting the Spanish. Many Latin Americans writers have been strongly influenced by his works. *Ismaelillo* (1882), *Versos libres* (published posthumously), and *Versos sencillos* (1891) contain his best poems. martial law Maintenance of civic order by using military personnel. Martial law may be declared on a local short-term basis by a government in an emergency, as when sending in the army to deal with pockets of civil unrest. It may also be declared on a nationwide, long-term basis following a military coup.

Martin, Saint (315–97) Bishop of Tours. Born a heathen, he became a Christian in his youth. As a Roman soldier he is reputed to have torn his cloak to share it with a beggar. From

MARS: DATA

Diameter (equatorial):
6,787km (4,217mi)
Mass (Earth = 1): 0.11
Volume (Earth = 1): 0.15
Density (water = 1): 3.94
Orbital period: 687.0 days
Rotation period: 24h 37m 23s
Average surface temperature:
-23°C (-9°F)

360 he lived as a monk and was acclaimed bishop in 371, against his will. His feast day is known as Martinmas.

Martin V (1368–1431) Pope (1417–31), b. Oddone Colonna. After 39 years of schism, he tried to restore papal prestige and church unity through political means. He reorganized the Curia and sought unsuccessfully to reopen diplomatic links with the Eastern Orthodox Church in Constantinople.

martin Fast-flying bird closely related to the SWALLOW and native to Europe and North America. It has long, pointed wings and short legs. Species include the house martin (*Delichon urbica*), purple martin (*Progne subis*) and sand martin (*Riparia riparia*). Family Hirundinidae.

Martin du Gard, Roger (1881–1958) French novelist. His major works, such as *Jean Barois* (1913) and the eight-novel series *Les Thibault* (1922–40), are treatments of moral and intellectual preoccupations. He was awarded the 1937 Nobel Prize for literature.

Martineau, Harriet (1802–76) British writer and reformer. Her works include collections of stories that propound her social theories, among them *Illustrations of Political Economy* (9 vols, 1832–34) and *Poor Laws and Paupers Illustrated* (1833–34). She visited the USA in 1834, voicing outspoken opposition to slavery, and wrote *Society in America* (1837).

Martini, Simone (1284–1344) Italian painter. His imposing fresco, the *Maestà* (1315), combines elements of BYZANTINE ART and GOTHIC ART and presages the RENAISSANCE. The *Annunciation* (1333) is his most accomplished work.

Martinique Island in the Caribbean, in the Windward group of the Lesser Antilles, forming an overseas département of France; the capital is Fort-de-France. Discovered in 1502 by Christopher Columbus, Martinique was inhabited by Carib Indians until they were displaced by French settlers after 1635. Attacked in the 17th century by the Dutch and the British, the island became a permanent French possession after the Napoleonic Wars. Of volcanic origin, it is the largest of the Lesser Antilles. The original capital, St Pierre, was completely destroyed by a volcanic eruption in 1902. Industries: tourism, sugar, rum, fruits, cocoa, tobacco, vanilla, vegetables. Area: 1,079sq km (417sq mi). Pop. (1990) 359,579. See WEST INDIES map

Martins, Peter (1946–) Danish dancer, choreographer and ballet director. Martins' partnership with Suzanne Farrell was one of the greatest in the history of ballet. Their performance of Balanchine's *Jewels* (1967) was definitive. He was principal dancer with the New York City Ballet (1969–83), before becoming its joint ballet master (with Jerome Robbins) then director (1990–). His choreographed works include *Les Gentilhommes* (1987) and *A Musical Offering* (1991).

Martinů, Bohuslav (1890–1959) Czech composer. From 1923 he studied with Albert Roussel in Paris, where he remained until 1940. Much of his music is based on Bohemian folk rhythms and Czech dances. He composed many operas and ballets, including *The Butterfly that Stamped* (1929) and *Comedy on a Bridge* (c.1950), as well as orchestral and chamber works.

Marvell, Andrew (1621–78) English poet and satirist. He is chiefly remembered today for his lyric poetry, first collected in 1681 in a volume that included "The Garden", "Bermudas" and his best-known poem, "To His Coy Mistress".

Marx, Karl Heinrich (1818-83) German social philosopher, political theorist and founder (with Friedrich ENGELS) of international COMMUNISM. He produced his own philosophical approach of DIALECTICAL MATERIALISM. He proclaimed that religion was "the opium of the people" and in The German Ideology (1845-46), written with Engels, described the inevitable laws of history. In Brussels he joined the Communist League and wrote with Engels the epoch-making Communist Manifesto (1848). Marx took part in the revolutionary movements in France and Germany, then went to London (1849), where he lived until his death. His work at the British Museum produced a stream of writings, including Das Kapital (3 vols, 1867, 1885, 1894; the last two edited by Engels), which became the "Bible of the working class". In 1864 the International Workingmen's Association (the First International) was formed, and Marx became its leading spirit. His expulsion of BAKUNIN from the Association in 1872 led to its collapse. Marx was one of the most important political theorists of modern times. See also MARXISM

Marx Brothers US team of vaudeville and film comedians. The Marx Brothers consisted of Chico (Leonard, 1891–1961), Harpo (Arthur, 1893–1964), Groucho (Julius, 1895–1977) and Zeppo (Herbert, 1901–79), the latter withdrew from the group in 1935. Marx Brothers' riotous, wisecracking comedies include *Animal Crackers* (1930), *Duck Soup* (1933) and *A Night at the Opera* (1935).

Marxism School of SOCIALISM, based on the writings of Karl Marx, that arose in 19th-century Europe as a response to the growth of industrial CAPITALISM. According to Marxism, a communist society was historically inevitable. Capitalism, because of its emphasis on profits, would eventually so reduce the condition of workers that they would rebel, overthrow the capitalists and establish a classless society in which the means of production were collectively owned. The Communist Manifesto (1848) and Das Kapital (1867, 1885, 1894) both contain ideas central to Marxism, which forms the basis of COMMUNISM and Strongly influenced the related ideology, socialism. See also DIALECTICAL MATERIALISM

Mary (Blessed Virgin Mary) (active 1st century AD) Mother of Jesus Christ. She figures prominently in the first two chapters of the Gospels according to St Matthew and St Luke, which record Christ's birth. Mary has always been held in high regard in Christendom. In the early church, the principal Marian feast was called the Commemoration of St Mary, from which developed the feast of the Assumption (15 August). Other Marian feasts are: the Nativity (8 September), the Annunciation or Lady Day (25 March), the Purification or Candlemas (2 February), the Visitation (2 July), and (for Roman Catholics) the Immaculate Conception (8 December).

Mary I (Mary Tudor) (1516–58) Queen of England (1553–58). Daughter of Henry VIII and Catherine of Aragon. During the reign of her half-brother, Edward VI, Mary remained a devout Catholic. On Edward's death, the Duke of Nothumberland's arranged the brief usurpation of Lady Jane Grey but Mary acceded with popular support. A Spanish alliance was secured by her marriage (1554) to the future King Phillip II of Spain. The marriage provoked a rebellion, led by Sir Thomas Wyatt, and hostility intensified after England lost Calais to France (1558). Mary's determination to re-establish papal authority saw the restoration of heresy laws. The resultant execution of c.300 Protestants, including Thomas Cranmer, Hugh Latimer and Nicholas Ridley, earned her the epithet "Bloody Mary". She was succeeded by Elizabeth I.

Mary II (1662–94) Queen of England, Scotland and Ireland, eldest daughter of James II. Despite her father's conversion to Catholicism, Mary was brought up a Protestant. In 1677 she married her cousin, William of Orange, and moved to Holland. The Glorious Revolution (1688–89) resulted in the exile of James II, and she and her husband were invited to assume the English throne as Mary II and William III (OF Orange).

Mary, Queen of Scots (1542–87) Daughter of JAMES V, she succeeded him as queen when one week old. She was sent to France aged six and married the future Francis II of France in 1558. On his death in 1560 she returned to Scotland, where, as a Catholic, she came into conflict with Protestant reformers. Her marriage to Henry Stuart (Lord Darnley) was also resented and soon broke down. After Darnley's murder (1567), she married Lord Bothwell, possibly her husband's murderer, which alienated her remaining supporters. Following a rebellion of Scottish nobles, she was imprisoned and forced to England). Although she escaped and raised an army, it was defeated at Langside (1568) and Mary fled to England. She was kept in captivity, but became involved in Spanish plots against ELIZABETH I and was eventually executed.

Maryland State in E USA, on the Atlantic Ocean; the capital is Annapolis. The largest city is Baltimore. The first settlements were founded in 1634. Maryland (one of the 13 original states) was active in the drive towards American independence. In 1791 it ceded an area of land on the Potomac River to create the District of Columbia, the site of the national cap-

▲ Marx Brothers From top, Chico, Harpo, Groucho and Zeppo, the Marx Brothers, were born in New York City. They were encouraged towards vaudeville by their ambitious mother, Minna. After many unsuccessful years, they finally made it to Broadway with I'll Say She Is (1924). Zeppo left the team early but the remaining brothers each developed a distinctive style: Chico was the piano player with the broad Italian accent; Harpo was the harp player who never spoke a word; and Groucho was the moustached wisecracker. Their humour is seen at its best in Duck Soup (1933).

MARYLAND Statehood: 28 April 1788 Nickname:

Old Line State, Free State

State bird : Baltimore oriole

State flower: Black-eyed Susan

State tree : White oak State motto :

Manly deeds, womanly words

ital. During the American CIVIL WAR, Maryland was one of the border states that did not secede from the Union, but its citizens served in both armies. The w half of the state is part of the Piedmont plateau region. Maryland is dominated by Chesapeake Bay and its coastal marshlands. The rearing of cattle and chickens is the most important farming activity. Maize, hay, tobacco and soya beans are the chief crops. Industries: iron and steel, shipbuilding, primary metals, transport equipment, chemicals, electrical machinery, fishing. Area: 25,316sq km (9,775sq mi). Pop. (1990) 4,781,468.

Mary Magdalene, Saint (active 1st century AD) Early follower of Jesus Christ, from the village of Magdala on the w shore of the Sea of Galilee. According to the gospels, Christ freed her of seven demons. She accompanied him on his preaching tours in Galilee, witnessed his crucifixion and burial and was the first to see him after his resurrection. She is often identified as a repentant prostitute. Her feast day is 22 July.

Masaccio (Tommaso Giovanni di Mone) (1401-28) Italian painter. The first of his three most important surviving works is a polyptych (1426) for the Carmelite Church, Pisa (now in London, Berlin and Naples). The second is a fresco cycle that he created with Masolino portraying the life of St Peter, in the Brancacci Chapel, Santa Maria del Carmine, Florence (c.1425-28). The third is his Trinity fresco in Santa Maria Novella, Florence (probably 1428).

Masada Fortified hill near the Dead Sea, SE Israel. It was the scene of the final defence of the Jewish ZEALOTS against the Romans during the Jewish revolt that began in AD 66. The defenders, c.1,000 in number, committed mass suicide rather than surrender (AD 73).

Masai African people of Kenya and Tanzania, consisting of several subgroups who speak a Nilotic language. They are characteristically tall and slender. Their patrilineal, egalitarian society is based on nomadic pastoralism, cattle being equated with wealth. The traditional Masai kraal is a group of mud houses surrounded by a thorn fence.

Masaryk, Tomás (1850–1937) Czechoslovak statesman and philosopher, first president of CZECHOSLOVAKIA (1918–35). In 1900 Masaryk founded the Czech Peoples Party to represent Czech interests in the Austro-Hungarian EMPIRE. Masaryk fled at the outbreak of World War 1 and (with Eduard BENEŠ) formed the Czechoslovak national council. In 1918 he returned as president. Revered as the "father" of the nation, Masaryk enacted land reforms and pursued a liberal path on minority rights. He was succeeded by Beneš.

Masefield, John (1878–1967) British poet and novelist. Masefield's early seafaring experiences inform much of his work. His debut volume Salt-Water Ballads (1902) includes "Sea Fever". He was poet laureate from 1930. Masefield is best-known for his long narrative poems, such as The Everlasting Mercy (1911) and Reynard the Fox (1919).

maser (acronym for microwave amplification by stimulated emission of radiation) Device using atoms artificially kept in states of higher energy than normal to provide amplification of high-frequency radio signals. The principle was discovered by the US physicist Charles Townes, for which he shared the 1964 Nobel Prize for physics with the Soviet physicists Nikolai Basov and Alexander Prokhorov. The first maser used electrostatic (charged) plates to separate high-energy ammonia atoms from low-energy ones. Radiation of a certain frequency stimulated the high-energy ammonium atoms to emit similar radiation and strengthen the signal. See also LASER

Maseru Capital of Lesotho, on the River Caledon, near the w border with South Africa. Originally a small trading town, it became capital of British Basutoland protectorate (1869-71, 1884-1966). It remained the capital when the kingdom of Lesotho achieved independence (1966). It is a commercial, transport and administrative centre. Pop. (1992 est.) 367,000.

Mashhad (Arabic, shrine of martyrdom) City in NE Iran, close to the border with Turkmenistan; capital of Khorasan province. It is an Islamic holy city and a place of pilgrimage for Shirte Muslims. In 809 the Abbasid Caliph Harun AL-RASHID was buried here and in 818 the Imam Ali Riza died while visiting Harun's grave. An ornate shrine was built over both their tombs. In the 18th-century Mashhad became the capital of Persia. Today, Mashhad is Iran's second-largest city and a major trade centre. It is famous for its carpet and textile manufacture. Pop. (1986) 1,463,508.

Mason-Dixon Line Border of Pennsylvania with Maryland and West Virginia, USA. It is named after the men who surveyed it in the 1760s. It was regarded as the dividing line between slave and free states at the time of the MISSOURI COMPROMISE (1820-21), and became the popular name for the boundary between North and South in the USA.

masque Dramatic presentation that originated in Italy but became popular in the English court and the great houses of the nobility during the late 16th and early 17th centuries. The masque consisted of verse, comedy and, as an essential feature, a dance for a group of masked revellers. The earliest masque text is Proteus and the Adamantine Rock, performed at Gray's Inn in 1594 in honour of Elizabeth I.

mass Celebration of the EUCHARIST in the Roman Catholic Church and among some High Church Anglicans. The Catholic rite comprises the Liturgy of the Word and the Liturgy of the Eucharist, which includes the Offertory, the sacrifice of Christ's body and blood under the guise of bread and wine. In the late 20th century, the mass underwent a number of changes following the Second Vatican Council (1962–65).

mass In music, a setting of the Roman Catholic religious service in Latin. Composers from all eras have written masses. One of the most famous is J.S. Bach's Mass in B minor. In the 19th century mass settings increased in scale until they were more likely to be performed in concert halls than in church.

mass Measure of the quantity of matter in an object. Scientists recognize two types of mass. The gravitational mass of a body is determined by its mutual attraction to another reference body, such as the Earth, as expressed in Newton's law of gravitation. Spring balances and platform balances proved a measure of gravitational mass. The inertial mass of a body is determined by its resistance to a change in state of motion, as expressed in the second law of motion. INERTIA balances provide a measure of inertial mass. According to Einstein's principle of equivalence, upon which his general theory of RELA-TIVITY is based, the inertial mass and the gravitational mass of a given body are equivalent. See also WEIGHT

Massachusetts State in New England, on the Atlantic Ocean, NE USA; the capital and largest city is Boston. Other major cities are Worcester, Springfield, Cambridge and New Bedford. The first settlement, PLYMOUTH COLONY, was made in 1620 on Massachusetts Bay by the Pilgrim Fathers. Boston was founded by English Puritans in 1630, and it became the centre of the Massachusetts Bay Colony. The state played a leading role in events leading up to the American Revolution and was the scene of the first battle. After achieving statehood in 1788, Massachusetts prospered. In the E of the state is a low-lying coastal plain. The uplands of the interior are divided by the Connecticut River valley and the Berkshire valley. The principal rivers are the Housatonic, Merrimack and Connecticut. A highly industrialized region, Massachusetts is one of the most densely populated states in the nation. Agricultural produce includes cranberries, tobacco, hay, vegetables and market garden and dairy products. Industries: electronic equipment, plastics, footwear, paper, machinery, metal and rubber goods, printing and publishing, fishing. Area: 20,300sq km (7,838sq mi). Pop. (1990) 6,016,425.

Massachusetts Bay Company English company chartered in 1629. Its purpose was trade and colonization of the land between the Charles and Merrimack rivers in North America. A group of Puritans, led by John Winthrop, gained control of the company and founded the Massachusetts Bay Colony in 1630. They took the company's charter with them to Massachussetts and thus enjoyed considerable autonomy. Within a decade, c.20,000 people, mainly English Puritans, had settled in the colony.

Massenet, Jules Émile-Frédéric (1842-1912) French Romantic composer who dominated 19th-century French lyric opera. He composed many operas, including Le Cid (1885), Werther (1892) and Thérèse (1909). His two masterpieces are considered to be Manon (1884) and Thaïs (1894). Massif Central Extensive mountainous plateau in SE cen-

MASSACHUSETTS

Statehood:

6 February 1788 Nickname:

Bay State

State bird :

Chickadee

State flower:

Mayflower

State tree :

American elm

State motto:

By the sword we seek peace, but peace only under liberty

tral France. The volcanic AUVERGNE Mountains form the core of the region, which also includes the Cévennes (SE) and the Causses (SW). Sheep and goats are grazed on the slopes. Hydroelectric power is generated and coal and kaolin are mined. The highest peak is Puy de Sancy, at 1,886m (6,186ft). Area: c.85,000sq km (32,800sq mi).

Massine, Léonide (1896–1979) US choreographer and ballet dancer, b. Russia. His choreography includes *Le Soleil de Nuit* (1915), *La Boutique Fantasque* (1919) and *Three Cornered Hat* (1919). He influenced the development of choreography when he created his first symphonic ballet, *Les Présages* (1933). He also performed in the films *The Red Shoes* (1948) and *Tales of Hoffmann* (1951).

Massinger, Philip (1583–1640) English dramatist. He wrote more than 40 plays, often in collaboration, many of which are now lost. He is best known for his realistic yet highly symbolic satires of domestic life, such as *A New Way to Pay Old Debts* (1621–22) and *The City Madam* (*c*.1632).

mass production Manufacture of goods in large quantities by standardizing parts, techniques and machinery. American inventor Eli WHITNEY introduced mass production in 1798 to produce weapons. The assembly line, a conveyor belt carrying the work through a series of assembly areas, was introduced in 1913 by car manufacturer Henry FORD. Many mass-production processes depend on computer control of machines, including ROBOTS.

mass spectrograph (mass spectrometer) Instrument for separating ions according to their masses (or more precisely, according to their charge-to-mass ratio), used in chemical analysis. In the simplest types, the ions are first accelerated by an electric field and then deflected by a strong magnetic field; the lighter the ions the greater the deflection. By varying the field, ions of different masses can be focused in sequence onto a photographic plate or detector and a record of charge-to-mass ratios obtained.

mastectomy In surgery, removal of all or part of the female breast. It is performed to treat CANCER. Simple mastectomy involves the breast alone; or, when the cancer has spread, radical mastectomy may be undertaken, removing also the lymphatic tissue from the armpit.

Masters, Edgar Lee (1868–1950) US poet and novelist. Although he published a number of volumes, he never repeated the early success of his *Spoon River Anthology* (1915), a series of free verse monologues spoken by the dead of a small Midwest town.

Masters, William Howell (1915–) US physician who, with his psychologist wife Virginia (née Johnson) (1925–), became noted for studies of the physiology and anatomy of human sexual activity. Their works include *Human Sexual Response* (1966) and *Human Sexual Inadequacy* (1970).

mastiff (Old English mastiff) Large fighting dog that was first bred in England more than 2,000 years ago. It has a broad, rounded head with a dark-coloured, square muzzle and small V-shaped ears. The wide deep-chested body is set on strong legs with large feet. The short, coarse coat may be brown, grey or brindle. Height: to 84cm (33in) at shoulder; weight: to 95kg (210lb).

mastodon Any of several species of extinct elephantine mammals, all of which existed mainly in the PLEISTOCENE epoch. Mastodons had a long coat of red hair; the grinding teeth were notably smaller and less complex than those of modern ELEPHANTS, and the males had small tusks on the lower as well as the upper jaw. Genus *Mastodon*.

masturbation Self-stimulation by manipulation of the genital organs for pleasure, usually to ORGASM. Once regarded as taboo, sinful or physically harmful, moderate masturbation is no longer considered abnormal.

Mata Hari (1876–1917) Dutch courtesan. Her real name was Margaretha Geertruida Zelle. In 1917 she was arrested in Paris as a German agent and subsequently executed. Although her conduct was suspicious, few people now believe she was the mysterious secret agent that the French authorities alleged.

materialism System of philosophical thought that explains the nature of the world as dependent on matter. The doctrine was formulated as early as the 4th century BC by DEMOCRI-

TUS. The early followers of BUDDHISM were also materialists. Dialectical materialism as preached by Karl MARX is a modern development of the older theory.

mathematical induction Method of proving that a mathematical statement is true for any positive integer n by proving: (1) that it is true for a base value, for example 1; and (2) that if it is true for a value k then it is also true for k+1. If (1) and (2) hold, then it follows in a finite number of steps that the statement is true for any positive integer n.

mathematics Study concerned originally with the properties of numbers and space; now more generally concerned with deductions made from assumptions about abstract entities. Mathematics is often divided into pure mathematics, which is purely abstract reasoning based on axioms, and applied mathematics, which involves the use of mathematical reasoning in other fields, such as engineering, physics, chemistry and economics. The main divisions of pure mathematics are GEOMETRY, ALGEBRA and analysis. The latter deals with the concept of limits and includes differential and integral CALCULUS. See also ARITHMETIC; TRIGONOMETRY

Mather, Cotton (1663–1728) Puritan minister in colonial Massachusetts. Son of Increase MATHER, to whose Boston ministry he succeeded (1723), he was a prolific author. He supported the Salem witch trials, though not the subsequent executions, yet was sympathetic to scientific and philosophical ideas. He was one of the founders of Yale University and a member of the Royal Society in London.

Mather, Increase (1639–1723) Puritan minister in colonial Massachusetts. A powerful influence on political and religious life in the colonies, he went to England (1688–91) to renegotiate the charter of Massachusetts. He doubted the reliability of testimony at the Salem witch trials, and his *Cases of Conscience* (1693) helped to stop the executions.

Matisse, Henri Emile Benoît (1869–1954) French painter, sculptor, graphic artist and designer. Having experimented with NEO-IMPRESSIONISM in paintings such as Luxe, calme et volupte (1905), he developed the style of painting that became known as FAUVISM. After a relatively brief fliration with CUBISM, Matisse turned back to the luminous and sensual calmness that typified his art. He became ill in later life, but produced one of his greatest works, the design of the Chapel of the Rosary at Vence (1949–51). He also started making coloured paper cutouts, such as L'Escargot (1953). Matisse's most famous sculptures include a series of four bronzes The Back (1909–29).

Mato Grosso State in w central Brazil, bordered s by MATO GROSSO DO SUL, and w and sw by Bolivia; the capital is Cuiabà. First settled in the early 18th century by miners seeking gold and diamonds, it became a state in 1889. Much of the area lies on the central plateau of Brazil and there is rainforest in the N and marshland in the sw. The w has good grazing land and cattle rearing is the chief occupation. Rice, maize and sugar-cane are grown. There are extensive mineral deposits but most of them are unexploited. Area: 881,000sq km (340,156sq mi). Pop. (1991) 2,020,581.

Mato Grosso do Sul State in sw Brazil, bordered N by MATO GROSSO, w by Bolivia, and w and s by Paraguay; the capital is Campo Grande. Early pioneers exploited the area's gold and diamonds but there was little permanent settlement until the late 20th century. In 1979 it was created a separate state from the s part of Mato Grosso. Most of Mato Grosso do Sul lies on an extension of the central plateau of Brazil. There is marshland to the Nw and the state has extensive grazing land. There are vast mineral resources, including iron ore and manganese. Agriculture and livestock are important, and the main crops are groundnuts, rice, beans, maize and cotton. Area: 350,548sq km (135,347sq mi). Pop. (1991) 1,778,494. matriarchy Any society or group that is ruled by women. Matriarchal societies exist among some primitive peoples in South America. See also PATRIARCHY

matrix Rectangular array of numbers in rows and columns. The number of rows need not equal the number of columns. Matrices can be combined (added and multiplied) according to certain rules. They are useful in the study of transformations of coordinate systems and in solving sets of simultaneous equations.

▲ Matisse One of the most influential artists of the 20th century, Matisse originally studied law, before quitting his studies to enter the studio of Moreau in Paris in 1892. His work culminates in the decorations for the Chapel of the Rosary at Vence, France. He designed the windows, ceramic tiles and vestments as a gift to the nuns of the adjacent convent, who had looked after him during an illness.

matter Any material that takes up space. Ordinary matter is made up of ATOMS, which are combinations of ELECTRONS, PROTONS and NEUTRONS. Atoms, in turn, make up ELEMENTS, an ordered series of substances that have atoms with from one proton in their nuclei (hydrogen) to a hundred or more. All matter exerts an attractive force on other matter, called GRAVITATION. Charged particles exert an attractive or repulsive ELECTROMAGNETIC FORCE that accounts for nearly all everyday phenomena. The strong interaction force is responsible for binding the protons and neutrons in an atomic NUCLEUS, and the weak interaction is responsible for beta decay. See also ANTIMATTER; FUNDAMENTAL FORCES; MATTER, STATES OF; MOLECULE

matter, states of Classification of MATTER according to its structural characteristics. Four states of matter are generally recognized: solid, liquid, gas and plasma. Any one ELEMENT or compound may exist sequentially or simultaneously in two or more of these states. Solids may be crystalline, as in salt and metals; or amorphous, as in tar or glass. Liquids have molecules that can flow past one another but that remain almost as close as in a solid. In a GAS, molecules are so far from one another that they travel in relatively straight lines until they collide. In a PLASMA, atoms are torn apart into electrons and nuclei by the high temperatures, such as those in stars.

Matterhorn (Monte Cervino) Mountain peak in Switzerland, in the Pennine Alps, on the Swiss-Italian border. It has a distinctive pyramidal peak formed from several cirques and was first climbed in 1865 by the British mountaineer Edward Whymper. Height: 4,478m (14,691ft).

Matthew, Saint (active 1st century AD) Apostle and probably one of the four evangelists of the New Testament. In the lists of the disciples given in the Synoptic Gospels, Matthew is sometimes called Levi. Before his calling, he was a tax collector for King Herod Antipas. Feast day: 21 September in the West, 16 November in the East.

Matthew, Gospel according to Saint Gospel traditionally placed first in the New Testament but probably written after those of St MARK and St LUKE. Written *c*.AD 70–75, it is traditionally ascribed to St MATTHEW, the tax gatherer who became one of the 12 disciples. The Gospel of St Matthew contains more of the teachings, parables and sayings of Jesus than any other gospel. It is also the only Synoptic Gospel written in a Jewish, rather than a Hellenistic, style.

Matthews, Sir Stanley (1915–) English footballer who played for Stoke City and Blackpool. Matthews made 786

appearances, including 54 caps for England, in a professional career that spanned from 1932 to 1965. He was the first European Footballer of the Year (1956).

Maugham, (William) Somerset (1874–1965) British novelist, dramatist and essayist. He achieved fame initially as a playwright, and his successes include *Lady Frederick* (1912) and *The Circle* (1921). Among his novels are the semi-autobiographical *Of Human Bondage* (1915), *Ashenden* (1928) and *Cakes and Ale* (1930).

Mau Mau Anti-colonial terrorist group of the KIKUYU of Kenya. Following repeated attacks on Europeans, a state of emergency was declared in 1952 and troops brought in. Within four years about 100 Europeans and 2,000 anti-Mau Mau Kikuyu were killed. More than 11,000 Mau Mau died before the state of emergency ended in 1960. Kenya achieved independence in 1963, and the former Mau Mau leader Jomo KENYATTA was elected its first prime minister.

Mauna Kea (White Mountain) Dormant shield volcano in central Hawaii, USA. At 4,205m (13,796ft), Mauna Kea is the highest island mountain in the world. On the snow-capped peak of the volcano stands Mauna Kea Observatory, the world's biggest astronomical site with many large telescopes, such as the W.M. Keck 10-m (33-ft) telescope.

Mauna Loa Active volcano in central Hawaii, USA, s of MAUNA KEA. The second highest active volcano in the world, Mauna Loa has many craters. Kilauea is the largest. Mokuaweoweo is the summit crater. The greatest eruption was in 1881. Major eruptions also took place in 1942, 1949, 1975 and 1984. Height: 4,169m (13,678ft).

Maundy Thursday In the Christian liturgical calendar, the day before Good Friday, commemorating the institution of the Eucharist and the washing of the disciples' feet by Jesus, described in St John's Gospel. In the UK, the day is marked by a ceremony in which the reigning monarch distributes specially minted silver coins to selected pensioners.

Maupassant, Guy de (1850–93) French short-story writer and novelist. He produced one of his greatest short stories, "Boule de suif (Ball of Fat)", for the collection Les Soirées de Médan (1880). He wrote more than 300 short stories; a number are collected in La Maison Tellier (1881), Contes de la Bécasse (1883) and L'Inutile Beauté (1890). Pierre et Jean (1887) is regarded as the best of his six novels.

Mauriac, François (1885–1970) French novelist and playwright. His novels, *A Kiss for the Leper* (1922), *Genitrix* (1923) and *The Desert of Love* (1925), portray the futility of pursuing fulfilment through material comfort and secular love. He also wrote poetry and volumes of memoirs and autobiography. He was awarded the 1952 Nobel Prize for literature.

Mauritania Republic in NW Africa; the capital is NOUAK-CHOTT. Land and climate The low-lying Sahara Desert covers most of Mauritania. A sandstone plateau runs N to S through the centre of the country. In the SE lies the Hodh basin. The majority of Mauritanians live in the semi-arid sw region of SAHEL. Tropical savanna covers much of the rainier s. Economy Mauritania is a low-income developing country (1992 GDP per capita, US\$1,650). The chief resource and leading export is iron ore. Agriculture employs 69% of the workforce. Recent droughts have forced many nomadic herdsmen to migrate to urban areas. Farmers in the SE grow crops such as beans, dates, millet, rice and sorghum. History Berbers migrated to the region in the first millennium AD. The Hodh basin lay at the heart of the ancient Ghana empire (700-1200), and towns grew up along the trans-Saharan caravan routes. In the 14th and 15th century the region formed part of the ancient Mali empire. Portuguese mariners explored the coast in the 1440s, but European colonialism did not begin until the 17th century, when trade in gum arabic became important. Britain, France and the Netherlands were all interested in this trade, and France set up a protectorate in 1903. In 1920 the region became a separate colony within French West Africa. In 1958 Mauritania became a selfgoverning territory in the French Union, before achieving full independence in 1960. Mokhtar Ould Daddah was elected president, and re-elected in 1966 and 1971. Mauritania became a one-party state. Devastating drought increased dissatisfaction with Ould Daddah's regime. In 1973 Mauritania withdrew

MAURITANIA

AREA: 1,025,520sq km (395,953sq mi)
POPULATION: 2,143,000
CAPITAL (POPULATION):
NOUAKCHOTT (393,325)
GOVERNMENT: Multiparty
Islamic republic
ETHNIC GROUPS: Moor
(Arab-Berber) 70%, Wolof
7%, Tukulor 5%, Soninke

3%, Fulani 1%
LANGUAGES: Arabic (official)

RELIGIONS: Islam 99%
CURRENCY: Ouguiya = 5 khoums

from the franc zone and joined the Arab League. In 1976 Spain withdrew from Spanish Sahara: Morocco occupied the N twothirds, while Mauritania took the rest. Nationalists, led by the guerrillas of the Popular Front for the Liberation of Saharan Territories (POLISARIO) began an armed struggle for independence, which drained Mauritania's resources. In 1978 Ould Daddah was overthrown in a military coup, and a military committee assumed control. In 1979 Mauritania withdrew from Western Sahara, and Morocco assumed sole authority (for political developments, see WESTERN SAHARA). In 1984 recognition of Western Sahara's independence provoked civil unrest, and Ould Taya came to power. Recent events In 1991 Mauritania adopted a new constitution. In 1992 multiparty elections Ould Taya was elected president. Tension continues between the black African minority in s Mauritania and Arabs and Berbers in the N.

Mauritius Republic in the sw Indian Ocean, c.800km (500mi) E of Madagascar; the capital is Port Louis (on Mauritius). Mauritius consists of the main island of Mauritius, 20 nearby islets and the dependency islands of Rodrigues, Agalega and Cargados Carajos. The climate is sub-tropical, with up to 5,000mm (200in) of rain a year. Its vast plantations produce sugar cane; sugar and molasses are the major exports. The increase in tourism and textile production have partly compensated for the decline in the sugar market. Ethnic and class divisions, combined with economic austerity, created a divided society in the 1980s. The Dutch began to colonize the island in 1598, and named it after Prince Maurice of Nassau. In 1715 it came under the control of France. The French established sugar cane plantations and imported African slave labour. In 1810 Britain seized Mauritius, and it was formally recognized as a British colony in 1814. In 1833 slavery was abolished and Indian forced labour was used. In 1968 Mauritius achieved independence within the Commmonwealth of Nations. It became a republic in 1992. Area: 2,046sq km (790sq mi). Pop. (1990) 1,058,942.

Maurya empire (321–185 BC) Ancient Indian dynasty and state founded by CHANDRAGUPTA (r. c.321–c.291 BC). His son, Bindusara (r. c.291–c.268 BC), conquered the Deccan, and all N India was united under ASHOKA (r. c.264–c.238 BC), Chandragupta's grandson. After Ashoka's death the empire broke up, the last emperor being assassinated c.185 BC.

mausoleum Impressive tomb. The widow of Mausolus (from whom the term derives), ruler of Caria, raised a great tomb to his memory at HALICARNASSUS (c.350 BC). It became one of the SEVEN WONDERS OF THE WORLD. The best-known mausoleum is the TAJ MAHAL in India.

Mawson, Sir Douglas (1882–1958) British geographer and Antarctic explorer. He accompanied Sir Ernest SHACKLE-TON on the first expedition (1907–09) to the South Pole, and led the Australasian Antarctic expedition (1911–14). In 1929–31 he led a joint British, Australian and New Zealand Antarctic expedition.

Maxim, Sir Hiram Stevens (1840–1916) US inventor of the Maxim machine gun (1883). His other inventions include a smokeless powder and a delayed-action fuse. He settled in England (1881) and was knighted in 1901.

Maximilian I (1459–1519) Holy Roman emperor (1493–1519), son and successor of Frederick III. Maximilian was one of the most successful members of the Habsburg dynasty. He gained Burgundy and the Netherlands by marriage, and defended them against France. He was less successful in asserting control over the German princes and involvement in the Italian Wars led to his defeat by the Swiss (1499). Maximilian strengthened the Habsburg heartland in Austria and through marriage diplomacy ensured that his grandson and successor, Charles V, inherited a vast European empire.

Maximilian, Ferdinand Joseph (1832–67) Emperor of Mexico (1864–67). An Austrian archduke, brother of the Emperor Francis Joseph, he was offered the throne of Mexico after the French invasion (1862). When the French withdrew in 1867, Maximilian was overthrown by the liberal forces of Benito Juárez and executed.

Maxwell, James Clerk (1831–79) Scottish mathematician and physicist who did outstanding theoretical work in ELEC-

TROMAGNETIC RADIATION. He used the theory of the electromagnetic field for Maxwell's equations, which linked light with electromagnetic waves, established the nature of Saturn's rings, and did further work in thermodynamics and statistical mechanics. The former unit of magnetic flux, the maxwell (symbol Mx), was named after him (but is now replaced by the SI unit, the weber).

Maya Outstanding culture of classic American civilization. Occupying s Mexico and N Central America, it was at its height from the 3rd to 9th centuries. They built great templecities, with buildings surmounting stepped PYRAMIDS. They were skilful potters and weavers, and productive farmers. They worshipped gods and ancestors, and blood sacrifice was an important element of religion. Maya civilization declined in the 10th century, and much was destroyed after the Spanish conquest in the 16th century. The modern Maya, numbering c.4 million, live in the same area and speak a variety of languages related to that of their ancestors.

Mayakovsky, Vladimir (1893–1930) Russian poet and dramatist. Mayakovsky was the leader of the Russian FUTURISM movement, and founded the journal *Left Arts Front*. He is often referred to as the voice of the RUSSIAN REVOLUTION. His poem 150,000,000 (1920) and the play *Mystery Bouffe* (1918) were propaganda pieces for the new Soviet Union. Mayakovsky's late work, such as the plays *Bedbug* (1928) and *Bath-House* (1930), display his disillusionment with the bureaucracy of the regime. He committed suicide.

Mayan Family of languages spoken on the Yucatán Peninsula of Mexico, and in Guatemala and part of Belize by the Maya. There are several dozen of these languages, the most important being Yucatec (in Mexico), and Quiché, Cakchiquel, Mam, and Kekchi (in Guatemala).

May beetle (June bug) Medium-sized, stout, brownish SCARAB BEETLE that feeds on tree foliage. The white grubs that eat roots of various crops are one of the most destructive soil pests facing farmers. Genus *Phyllophaga*.

May Day First day of May, traditionally celebrated as a festival, the origin of which may lie in the spring fertility rites of pagan times. The Roman festival of Flora, goddess of spring, was held from 28 April to 3 May. In England, the festivities have centred on the dance round the Maypole. In some countries May Day is a holiday in honour of workers, and may be accompanied by a military display.

Mayer, Louis B. (Burt) (1885–1957) US film executive. Mayer founded a film production company in 1917, and became vice president of Metro-Goldwyn-Mayer (MGM) in 1924. During the 1930s and 1940s, he was the most powerful magnate in Hollywood.

Mayflower Ship that carried the PILGRIMS from Plymouth, England to Massachusetts in September, 1620. It carried 120 English Puritans (some from a congregation that had settled in the Netherlands) who established the PLYMOUTH COLONY in December 1620.

mayfly Soft-bodied insect found worldwide. The adult does not eat and lives only a few days, but the aquatic larvae (NYMPH) may live several years. Adults have triangular front wings, characteristic thread-like tails and vestigial mouthparts; they often emerge from streams and rivers in swarms. Length; 10–25mm (0.4–lin). Order Ephemeroptera.

Mayo County in Connaught province, NW Republic of Ireland, bounded to the N and W by the Atlantic Ocean; the county town is Castlebar. A largely mountainous region, it has numerous lakes and is drained by the rivers Errif and Moy. Oats and potatoes are the chief crops. Cattle, sheep, pigs and poultry are reared. Industries: woollen milling, toy manufacturing. Area: 5,397sq km (2,084sq mi). Pop. (1991) 110,713.

Mayotte (Mahore) French-administered archipelago in the Indian Ocean, E of the COMOROS. The two major islands are Grande Terre and Petite Terre (Pamanzi). Grande Terre includes the new capital, Mamoudzou. Pamanzi is the site of the old capital, Dzaoudzi. Mayotte was a French colony from 1843 to 1914, when it was attached to the Comoro group and collectively achieved administrative autonomy as a French Overseas Territory. In 1974 the rest of the Comoros became independent, while Mayotte voted to remain a

French dependency. In 1976 it became an overseas collectivity of France. The economy is primarily agricultural; the chief products are bananas and mangoes. Area: 373sq km (144sq mi). Pop. (1991) 94,410.

Mazarin, Jules, Cardinal (1602–61) French statesman, b. Italy. He was the protégé of Cardinal RICHELIEU and chief minister under Anne of Austria from 1643. During the civil wars of the Frondes, he played off one faction against another and although twice forced out of France, emerged in full control. As a former papal diplomat, he was a skilful negotiator of the treaties ending the THIRTY YEARS WAR.

Mazzini, Giuseppe (1805–72) Italian patriot and theorist of the RISORGIMENTO. A member of the *Carbonari* (Italian republican underground) from 1830, he founded the "Young Italy" movement in 1831, dedicated to the unification of Italy. He fought in the REVOLUTIONS OF 1848 and ruled in Rome in 1849, but was then exiled. Unlike Garibaldi or Cavour, Mazzini remained committed to popular republicanism.

Mbabane Capital of Swaziland, in the NW of the country, in the high veld region of s Africa. It is both an administrative and commercial centre, serving the surrounding agricultural region. Tin and iron ore are mined nearby. Pop. (1986) 38,290. Mboya, Thomas Joseph (1930–69) Kenyan political leader. Mboya rejected Kenya's 1954 constitution and campaigned for independence. When Jomo Kenyatta established the African National Union (KANU), Mboya became general secretary. He served as minister for economic development and planning (1964–69) in Kenya's first post-colonial government. His assassination provoked rioting against the Kikuyu.

ME (abbreviation for myalgic encephalomyelitis) Condition defined as extreme fatigue that persists for six months or more, and is not relieved by rest. Also known as chronic fatigue syndrome or post-viral fatigue syndrome, it may be accompanied by other non-specific symptoms, such as fever, headache, muscle and joint pains, gastric upset, dizziness and mood changes. Often occurring after a VIRUS infection, it ranges in severity from chronic weariness to total physical collapse. The cause of the condition is unknown. There is no specific treatment, and full recovery may take months or even years.

Mead, George Herbert (1863–1931) US philosopher and social psychologist. A founder of PRAGMATISM, influenced by John Dewey, Mead studied the mind, the self and society. His studies of the behaviour of individuals and small groups led to the sociological theories of symbolic interactionism.

Mead, Margaret (1901–78) US cultural anthropologist, curator of ethnology (1926–69) at the American Museum of Natural History. Mead's fieldwork was done in the sw Pacific, particularly Samoa, the subject of her first and most famous work, *Coming of Age in Samoa* (1928). She was primarily interested in sexuality and adolescence and helped develop the national-character approach to anthropology. Some of her early conclusions about Samoan society have been criticized for shortcomings in perspective and sampling technique.

mean (arithmetic mean) Mathematical average. It is found by adding a group of numbers and dividing by the number of items in the group. Thus, for numbers a, b, c and d, the mean is (a + b + c + d)/4.

meander Naturally occurring looplike bend of a river or stream channel. Meanders form on a flood plain where there is little resistance in the alluvium. They lengthen the river, thus reducing its gradient and velocity. Meanders migrate slowly downstream, depositing sediment on one bank while eroding the opposite. Sometimes meanders make complete loops that, when cut off, form OXBOW LAKES. The name comes from the winding River Maeander in Asian Turkey.

measles (rubeola) Extremely infectious viral disease of children. The symptoms (fever, catarrh, skin rash and spots inside the mouth) appear about two weeks after exposure. Hypersensitivity to light is characteristic. Complications such as pneumonia occasionally occur, and middle-ear infection is also a hazard. Vaccination produces life-long IMMUNITY.

Mecca (Makkah) City in w Saudi Arabia and the holiest city of ISLAM. The birthplace of the prophet MUHAMMAD, only Muslims are allowed in the city. Mecca was originally home to an Arab population of merchants. When Muhammad began

his ministry here the Meccans rejected him. The flight or Heirra of Muhammad from Mecca to Medina in 622 marked the beginning of the Muslim era. In 630 Muhammad's followers captured Mecca, and made it the centre of the first Islamic empire. The city was controlled by Egypt during the 13th century. The Ottoman Turks held it from 1517 to 1916, when Hussein Ibn Ali secured Arabian independence. Mecca fell in 1924 to the forces of Ibn Saud, who later founded the Saudi Arabian kingdom. Much of Mecca's commerce depends on Muslim pilgrims undertaking the Haji to the Great Mosque enclosing the Kaaba. Since World War 2 the city's wealth has been increased by oil revenues. Pop. (1991 est.) 630,000.

mechanical advantage (force ratio) Factor by which any machine multiplies an applied force. It may be calculated from the ratio of the forces involved or from the ratio of the distances through which they move, as with simple machines such as the LEVER and PULLEY. See also EFFICIENCY

mechanical engineering Field of ENGINEERING concerned with the design, construction and operation of machinery. Mechanical engineers work in many branches of industry, including transportation, power generation and tool manufacture. Achievements in mechanical engineering include the development of wind and water TURBINES, STEAM ENGINES and INTERNAL COMBUSTION ENGINES.

mechanics Branch of physics concerned with the behaviour of MATTER under the influence of forces. It may be divided into solid mechanics and fluid mechanics. Another classification is as STATICS – the study of matter at rest – and DYNAMICS – the study of matter in motion. Relativistic mechanics deals with the behaviour of matter at very high speeds, whereas QUANTUM MECHANICS deals with the behaviour of matter at the atomic level. *See also* FORCE; NEWTON'S LAWS; QUANTUM THEORY; RELATIVITY

Mecklenburg-West Pomerania State in NE Germany, on the Baltic coast; the capital is Schwerin. In 1621 the region was divided into the duchies of Mecklenburg-Schwerin and Mecklenburg-Güstrow. In 1871 they were among the founding members of the German empire. In 1918 the dukes were deposed, and the sectors became free states of the Weimar Republic. In 1934 the two states were unified. In 1946 they were joined with Pomerania to form a region of East Germany. In 1952 this region was split into various districts. In 1990, as part of German reunification, Mecklenburg-West Pomerania was reconstituted as one of the five new states of the Federal Republic. It is mainly a low-lying agricultural state. On the coast are the Baltic ports of Rostock, Wismar and Straslund. Area: 23,170sq km (8,944sq mi). Pop. (1993) 1,843,455.

Medawar, Sir Peter Brian (1915–87) British biologist. He shared the 1960 Nobel Prize for physiology or medicine with Sir Frank Macfarlane Burnet for the discovery of acquired immune tolerance. *See also* IMMUNE SYSTEM

Medea Daughter of Aeëtes, King of Colchis, whom she defied to help JASON retrieve the Golden Fleece. Renowned as a sorceress, she lived with Jason for many years in Corinth but fled to Athens after his desertion of her caused her to murder their children, and his new wife, in a jealous rage.

Medellín City in Nw central Colombia; capital of Antioquia department and the second-largest city in Colombia. It was founded in the early 17th century by refugees from Spain. In recent years it has become the focal point of Colombia's illegal cocaine trade. Gold and silver are mined in the surrounding region. Industries: food processing, coffee, chemicals, steel. Pop. (1992) 1,581,364.

media General term for the modern channels of public information. Traditionally, they are radio, television, newspapers and films, but the Internet is increasingly accepted as a form of media. These media disseminate information and entertainment on a wide scale and their powers of manipulating people are the subject of much discussion and research.

median In statistics, the middle item in a group found by ranking the items from smallest to largest. In the series, 2, 3, 7, 9, 10, for example, the median is 7. With an even number of items the MEAN of the two middle items is taken as the median. Thus in the series 2, 3, 7, 9, the median is 5.

Medici, Catherine de' See Catherine de' Medici

Medici, Cosimo de' (the Elder) (1389–1464) Ruler of Florence (1434–64). With the Medici banking fortune he led the oligarchy that was expelled from Florence in 1433 but returned to rule permanently the next year. He increased the Medici fortune, strengthened Florence by alliance with Milan and Naples, and was a great patron of the artists of the early Renaissance.

Medici, Cosimo I de' (the Great) (1519–74) Duke of Florence (1537–74), grand duke of Tuscany (1569–74). Under Cosimo's authoritarian rule, Florence flourished and its territory swelled with the acquisition of Siena. He was given the title of grand duke by the pope.

Medici, Lorenzo de' (1449–92) Ruler of Florence, grandson of Cosimo (the Elder). Lorenzo succeeded his father, Piero, in 1469. Lacking a formal title, his grip on power worried Pope Sixtus IV who instigated a coup led by the rival Pazzi family. Lorenzo survived an assassination attempt, and ruthlessly clamped down on his enemies. His enlightened patronage of RENAISSANCE artists, such as Botticelli, Michelangelo and Leonardo da Vinci, drained the Medici coffers and Lorenzo gained control of public funds. A notable poet, Lorenzo also encouraged Italian literature. His autocratic rule was attacked by Girolamo SAVONAROLA.

medicine Practice of the prevention, diagnosis and treatment of disease or injury; the term is also applied to any agent used in the treatment of disease. Medicine has been practised since ancient times, but the dawn of modern Western medicine coincided with accurate anatomical and physiological observations first made in the 17th century. By the 19th century practical diagnostic procedures had been developed for many diseases; BACTERIA had been discovered and research undertaken for the production of immunizing serums in attempts to eradicate disease. The great developments of the 20th century include the discovery of PENICILLIN and INSULIN, CHEMOTHERAPY (the treatment of various diseases with specific chemical agents), new surgical procedures including organ transplants, and sophisticated diagnostic devices such as radioactive TRACERS and various scanners. Alternative medicine, such as osteopathy, homeopathy or acupuncture, some of which have existed for hundreds of years, is becoming increasingly popular, and some therapies are being accepted within alternative medicine.

medieval music Music produced in Europe during the later Middle Ages, c.1100–1400. It was dominated by Christian liturgical vocal choruses (chants), which were sung in polyphonic style. Secular songs were transmitted orally by travelling TROUBADOURS or MINNESINGERS. In the 14th and 15th centuries, guilds of professional musicians were formed, and musical notation began to become more sophisticated, enabling composers to transmit whole works to later generations. See also MOTET; MUSICAL NOTATION; POLYPHONY

Medina City in Saudi Arabia, N of MECCA. Originally called Yathrib, it was renamed Medinat an-Nabi ("Prophet's city") after MUHAMMAD fled Mecca and settled here in 622. Medina became his capital. In 661 the UMAYYAD caliphs moved their capital to DAMASCUS, and Medina's importance declined. It came under Turkish rule (1517–1916), before briefly forming part of the independent Arab kingdom of the Hejaz. In 1932 it became part of Saudi Arabia. Pop. (1991 est.) 400,000.

Mediterranean Sea Largest inland sea in the world, lying between Europe and Africa and extending from the Strait of Gibraltar in the w to the coast of sw Asia in the E. The Mediterranean was once a trade route for Phoenicians and Greeks, later controlled by Rome and Byzantium. In the Middle Ages Venice and Genoa were the dominant maritime powers until the rise of the Ottoman Turks. The opening of the Suez Canal in 1869 made the Mediterranean one of the world's busiest shipping routes and the development of the Middle Eastern oilfields further increased its importance. The Mediterranean is connected to the Black Sea via the Dardanelles, the Sea of Marmara and the Bosporus, and to the Red Sea by the Suez Canal. It includes the Tyrrhenian, Adriatic, Ionian and Aegean seas. It receives the waters of several major rivers, including the Nile, Rhône, Ebro, Tiber and Po. There are c.400 species of fish in the Mediterranean, and tuna, sardines and anchovies are among those caught commercially. In recent years, pollution has become a major issue. Area: 2,509,972km (969,100sq mi).

Medusa In Greek mythology one of the three gorgons, until Athena sent Perseus to decapitate her. From the wound sprang Pegasus and Chrysaor, children of Poseidon.

Meegeren, Hans van (1889–1947) Dutch painter and celebrated forger, especially of VERMEER paintings, such as *Christ at Emmaus* (1937). He deceived art experts for years and was discovered only after his own confession in 1945.

meerkat (suricate) Any of a number of small carnivorous mammals closely related to the MONGOOSE, native to the bush country of southern Africa. It is similar in appearance to the mongoose but without the bushy tail. Length: 47cm (19in). Typical species *Suricata suricatta*.

megalith (lit. huge stone) Prehistoric stone monument. Historians usually apply the term to the gigantic slabs that form stone circles, half circles and rows in N Europe. These constructions date from the NEOLITHIC and early BRONZE AGE. One of the best-known and complex examples is STONEHENGE (c.2100–2000 BC). Megaliths existed long before the first stone buildings of Mycenean Crete. See also DOLMEN; MENHIR

Megiddo Ancient city of CANAAN. Strategically located on the route from Egypt to Mesopotamia, it was the scene of many battles, notably between the Egyptians and the Syrians in 1486 BC. It was often rebuilt, notably under the kings of ancient Israel in the 10th–9th centuries BC and after the Assyrian conquest of *c*.734 BC.

Mehta, Zubin (1936–) Indian conductor. A flamboyant figure, Mehta was director of the Los Angeles Philharmonic Orchestra (1961–77), the New York Philharmonic (1978–91) and Israel Philharmonic (1977–).

Meiji, Mutsohito (1852–1912) Emperor of Japan (1867–1912). His reign saw the transformation of Japan into a modern industrial state. Mutsuhito introduced sweeping reforms, including the abolition of the feudal system, a western-style constitution, the establishment of state education and the encouragement of industrial growth.

Meiji Restoration Constitutional revolution in Japan (1868). Opposition to the shōgunate built up after Japan's policy of isolation was ended by US Commodore PERRY in 1854. Pressure for modernization resulted in a new imperial government, at first dominated by former samurai, with the young Emperor Meiji as its symbolic leader.

meiosis In biology, the process of cell division that reduces the CHROMOSOME number from DIPLOID to HAPLOID. The first division halves the chromosome number in the cells; the second division then forms four haploid "daughter" cells, each containing a unique configuration of the parent cells' chromosomes. In most higher organisms, the resulting haploid cells are the GAMETES, or sex cells, the OVA and SPERM. In this way meiosis enables the genes from both parents to combine in a single cell without increasing the overall number of chromosomes. See also MITOSIS

Meir, Golda (1898–1978) Israeli stateswoman, prime minister (1969–74), b. Ukraine as Golda Mabovitch. Her family emigrated to the US in 1906, and Meir became active in ZIONISM. In 1921 she emigrated to Palestine. In 1936 she became head of the Jewish labour movement. After Israeli

■ Medici Detail from The Journey of the Magi (1459-61) in Palazzo Medici-Riccardo by Benozzo Gozzoli, portraying Lorenzo de' Medici as one of the three Magi. Lorenzo the Magnificent, as he was also known, was a great patron of the Renaissance. A fine humanist poet and an astute politician, he was a generous supporter of many notable artists, among them Ghirlandaio, Botticelli, Leonardo da Vinci and Michelangelo. His main collecting interest, however, was in antique coins and gems.

independence, Meir became minister of labour (1949–56) and foreign minister (1956–66). She succeeded Levi ESHKOL as prime minister. Meir managed to maintain a fragile domestic coalition, while negotiating with Israel's Arab neighbours. She was forced to resign following criticism of the government's lack of preparedness for the 1973 ARAB—ISRAELI WAR. meistersingers German poet-musicians of the 15th–16th centuries. They were organized in guilds, which held competitions and awarded prizes. Generally, the songs were religious and followed strict conventions. Some guilds continued into the 18th century. A famous meistersinger, the cobbler Hans Sachs (1494–1576), was immortalized in *Die Meistersinger von Nürnberg* by Richard Wagner.

Mekong River in SE Asia. It rises in Tibet as the Lancang Jiang and flows s through Yünnan province, China. It forms the Burma-Laos border and part of the Laos-Thailand border and then flows s through Cambodia and Vietnam, creating a vast river delta that is one of the most important rice-producing regions in Asia. Length: c.4,180km (2,600mi).

Melaka See MALACCA

Melanchthon, Philip (1497–1560) German theologian and educator, considered with Martin LUTHER as a founder of PROTESTANTISM. Melanchthon wrote the *Confessions of Augsburg* (1530), a statement of Protestant beliefs. He also helped Luther with his German translation of the New Testament.

Melanesia Collective term for a number of island groups in the w Pacific Ocean, generally s of the Equator, w of the International Date Line, N and E of Australia. It includes the Bismarck Archipelago, SOLOMON ISLANDS, New Hebrides and the TONGA group. Melanesia is one of the subdivisions of OCEANIA. The others are POLYNESIA and MICRONESIA.

melanin Dark pigment found in the skin, hair and parts of the eye. The amount of melanin determines skin colour. Absence of melanin results in an ALBINO.

Melba, Dame Nellie (1861–1931) Australian soprano, real name Helen Porter Mitchell. Initially a high coloratura soprano, she was famous in the roles of Lucia (Donizetti's *Lucia di Lammermoor*) and Gilda (Verdi's *Rigoletto*) and later for such lyric roles as Mimì (Puccini's *La Bohème*) and Marguerite (Gounod's *Faust*).

Melbourne, William Lamb, 2nd Viscount (1779-1848) British statesman, prime minister (1834, 1835-41). Melbourne entered Parliament as a Whig in 1805. He joined the House of Lords in 1828. As home secretary (1830-34) in Earl GREY's administration, Melbourne was responsible for the suppression of the Tolpuddle Martyrs. As prime minister, he oversaw reform of the Poor Law (1834), but resisted changes to the CORN LAWS. Melbourne gave Lord PALMERSTON control of foreign affairs and tutored Queen VICTORIA in statecraft. He was succeeded by Sir Robert PEEL. Melbourne's wife, Lady Caroline Lamb, is chiefly remembered for her affair with Lord Byron.

Melbourne City and port on the River Yarra at the N end of Port Phillip Bay; capital of Victoria state, SE Australia. Founded in 1835 by settlers from Tasmania, it became the state capital in 1851 and served (1901–27) as the seat of the Australian federal government. A major centre of finance, commerce, communications and transport, and Australia's largest cargohandling port, it exports wool, flour, meat, fruit and dairy pro-

▶ melon Melons belong to the cucumber and marrow family, and many different types have been cultivated. Cantaloupe melons (right) are true melons while watermelons (left) belong to the same family but a different genus. Melons grow successfully only in warm climates or under glass if temperatures are cooler.

duce. Manufacturing is also important. Industries: aircraft, motor vehicles, heavy engineering, shipbuilding, textiles, chemicals, agricultural machinery. Pop. (1993 est.) 3,189,200. **Mellon, Andrew William** (1855–1937) US financier. He inherited a fortune which he increased through industrial investment and banking, and was secretary of the treasury under three presidents (1921–32). A generous patron of the arts, he was ambassador to Britain (1932–33).

melodrama Theatrical form originating in late 18th-century France, and achieving its greatest popularity during the following century. It relied on simple, violent plots in which virtue was finally rewarded.

melody In music, a sequence of notes that makes a recognizable musical pattern. The term is most commonly used of the dominant part or voice (the "tune") in Romantic and light music, in which harmonic accompaniment is nearly always subordinate. Music featuring several melodies simultaneously and harmoniously is termed "contrapuntal" or POLYPHONY, and is characteristic of the late BAROQUE period.

melon Annual vine and its large fleshy edible fruit. Melons grow in warm temperate and subtropical climates. The cantaloupe melon, with its rough skin, probably originated in Armenia; the smoother yellow rind honeydew, in SE Asia. The large, dark green watermelon, with its red watery flesh, is believed to have come from Africa. Family Cucurbitaceae.

melting point Temperature at which a substance changes from solid to liquid. The melting point of the solid has the same value as the freezing point of the liquid, thus the melting point of ice, 0°C (32°F), is the same as the freezing point of water.

Melville, Herman (1819–91) US novelist. Melville became a sailor in 1839, and joined a whaling ship in 1841. His debut novel, *Typee* (1846), recounts his experiences among remote island natives. *Moby Dick*, an allegorical story of the search for a great whale, was written in 1851. His short story *Billy Budd* (1924) was the inspiration for BRITTEN's eponymous opera. Melville's work was relatively neglected during his lifetime, but *Moby Dick* is now regarded as a classic of US literature.

membrane In biology, boundary layer or layers inside or around a living CELL or TISSUE. Cell membranes include the plasma membrane surrounding the cell, the network of membranes inside the cell (endoplasmic reticulum), and the double membrane surrounding the NUCLEUS. The multicellular membranes of the body comprise mucous membranes of the respiratory, digestive and urinogenital passages, synovial membranes of the joints, and the membranes that coat the inner walls of the abdomen, thorax and the surfaces of organs. See also EPITHELIUM

Memling, Hans (1440–94) (Hans Memlinc) Flemish painter, b. Germany. Memling had a flourishing workshop from which he produced a large number of portraits and religious works. His patrons included the Italians, Tommaso Portinari and his wife, whom he painted in *c*.1468.

memory Capacity to retain information and experience and to recall or reconstruct them in the future. Modern psychologists often divide memory into two types, short-term and long-term. An item in short-term memory lasts for about 10–15 seconds after an experience, but is lost if not used again. An item enters long-term memory if the item is of sufficient importance or if the information is required frequently. Memphis Ancient city of Egypt, s of Cairo, part of which is now occupied by the village of Mit Ra-hina. Founded in c.3100 BC by Menes, Memphis was formerly the royal residence and capital of Egypt. Material from its ruins was used by the Arabs for building Cairo.

Memphis City and river port on the Mississippi River, sw Tennessee, USA; largest city in Tennessee. Strategically located on Chickasaw Bluff above the Mississippi, Memphis was a French (1682), Spanish (1794) and US (1797) fort before the first permanent settlement was made in 1819. Today, it is a major transport centre and livestock market. Industries: timber, farm machinery, cotton, food processing, pharmaceuticals. Pop. (1990) 610,337.

Menander (342–292 BC) Greek playwright. Menander wrote more than 100 comedies, of which only one, *The Curmudgeon*, survives in full. As the outstanding exponent of the

New Comedy of Hellenistic times, he is regarded as the founder of the domestic comedy of manners.

Mencius (c.372–289 BC) (Mengzi) Chinese philosopher of the Confucian school. He held that human beings are basically good but require cultivation to bring out the goodness. His teachings were recorded in the *Book of Mencius*, one of the Four Books in the canonical writings of CONFUCIANISM.

Mendel, Gregor Johann (1822–84) Austrian naturalist. He discovered the laws of HEREDITY, and in so doing laid the foundation for the science of GENETICS. His study of the inheritance of characteristics such as flower colour, height of plants and texture of the seeds of garden peas was published in *Experiments with Plant Hybrids* (1866). It was rediscovered in 1900. mendelevium (symbol Md) Radioactive metallic element that is the ninth of the TRANSURANIC ELEMENTS in the ACTINIDE SERIES. A. Ghiorso and colleagues at the University of California first synthesized it in 1955 by the alpha-particle bombardment of einsteinium-253. Properties: at.no. 101; r.a.m. 258; most stable isotope Md²⁵⁸ (half-life 2 months).

Mendeleyev, Dmitri Ivanovich (1834–1907) Russian chemist who devised the PERIODIC TABLE. Mendeleyev demonstrated that chemically similar elements appear at regular intervals if the elements are arranged in order by atomic weights. He classified the 60 known elements and left gaps in the table, predicting the existence and properties of several unknown elements later discovered. The radioactive element MENDELEVIUM is named after him.

Mendelsohn, Eric (1887–1953) German architect, who designed the Einstein Observatory at Potsdam (1920), perhaps the most famous example of EXPRESSIONISM in architecture. He later adopted FUNCTIONALISM, designing offices and other commercial buildings. During the 1930s he practised in England, and in 1941 he settled in the USA, where his work includes the Maimonides Hospital, San Francisco (1946).

Mendelssohn (-Bartholdy), (Jakob Ludwig) Felix (1809–47) German composer and conductor. A child prodigy, at 16 he composed an octet and at 17 he wrote his overture to *A Midsummer Night's Dream*. His orchestral works include the violin concerto (1844) and five symphonies. He also wrote much piano and chamber music. His two oratorios, *St Paul* (1836) and *Elijah* (1846), are considered to be among the greatest works of the 19th century.

Mendès-France, Pierre (1907-82) French statesman, prime minister (1955-56). Mendès-France was imprisoned by the Vichy regime but escaped to London in 1941. There he enlisted in the Free French air force, later joining DE GAULLE's government-in-exile. Mendès-France rejoined parliament in 1946. After the defeat of the French army at DIEN BIEN PHU (1954) he became prime minister and oversaw France's withdrawal from Indochina. He also prepared the way for Tunisian independence. His austere economic plans led to his downfall. Menem, Carlos Saul (1935-) Argentinian statesman, president (1989-). Menem was governor (1973-76, 1983-89) of La Rioja. He was imprisoned (1976-81) by the military government. Menem invoked the name of Juan Perón in his campaign for president. He introduced privatization, released hundreds of political prisoners and improved relations with the UK over the fate of the Falkland Islands. He was re-elected in 1995. Menes Egyptian king (c.3100 BC), regarded as the first king of the First Dynasty. He unified upper and lower Egypt, establishing the Old Kingdom with its capital at Memphis.

menhir Archaeological term given to single standing stones found in W Europe. Probably of NEOLITHIC origin, they are usually tall and square in section, tapering towards the top. They are thought to mark places of religious or ritual significance.

Menière's disease Chronic condition of the inner EAR affecting hearing and balance. Symptoms are deafness, vertigo and ringing in the ears (tinnitus). Caused by excessive fluid in the inner ear, it occurs in middle age or later. It is generally treated with ANTIHISTAMINE drugs.

meningitis Inflammation of the meninges (membranes) covering the brain and spinal cord, resulting from infection. Bacterial meningitis is more serious than the viral form. Symptoms include headache, fever, nausea and stiffness of the neck. The disease can vary from mild to lethal.

Mennonites Christian sect founded by the Dutch reformer Menno Simons (1496–1561) and influenced by ANABAPTIST doctrines. They believe in the BAPTISM of adult believers and reject infant baptism as well as the doctrine of the real presence in the EUCHARIST.

menopause Stage in a woman's life marking the end of the reproductive years, when the MENSTRUAL CYCLE becomes irregular and finally ceases, generally around the age of 50. Popularly known as the "change of life", it may be accompanied by unpleasant effects such as hot flushes, excessive bleeding and emotional upset. HORMONE replacement therapy (HRT) is designed to relieve menopausal symptoms.

menorah Sacred seven-branched candelabra that has become a worldwide symbol of JUDAISM. It is rich in symbolic meaning: some interpret it in terms of the seven planets, the tree of life, or the six-day creation of the universe with the centre shaft representing the Sabbath. An eight-branched menorah is used during the HANUKKAH festival.

Menotti, Gian Carlo (1911–) US composer, b. Italy. His operas in modern opera buffa style have been most successful and include *The Telephone* (1947). Menotti has also composed operas specifically for television such as *Amahl and the Night Visitors* (1951) and *Labyrinth* (1963).

Menshevik Moderate faction of the Russian Social Democratic Labour Party. The Mensheviks ("the minority") split from the more radical BOLSHEVIKS ("the majority") in 1903. They believed in "scientific socialism" and favoured a gradual transformation of society, whereas the Bolsheviks wanted total revolution organized by a small, central group of disciplined revolutionaries. The Mensheviks were suppressed in 1922.

menstrual cycle In humans and some higher primates of

The changes occuring during the menstrual cycle are controlled by the balance of the follicle stimulating hormone (FSH) and luteinizing hormone (LH) secreted by the pituitary. The diagram shows the changing levels of these, and of oestrogen and progesterone induction from the ovarian follicle, together with changes in the structure of the uterine wall (A) and development of the follicle (B), in a circular form through a normal 28-day cycle. The sharp increase in LH at about midcycle causes ovulation (C) and, if fertilization does not occur,

the corpus luteum (D) formed degenerates around day 26 as pituitary hormone levels fall. The consequent withdrawal of oestrogen and progesterone causes the uterine wall to shed itself in the menstrual flow. This then proliferates again under the influence of oestrogen from a new follicle. If fetilization and egg implantation do occur the placenta produces chorionic gonadotrophin, possibly as early as day 21, that allows the corpus luteum to continue to produce oestrogen and progesterone until the placenta takes over.

▲ Mendelssohn A highly respected conductor. Felix Mendelssohn's concert tours took him all over Europe. His performance (1829) of the St Matthew Passion revived 19thcentury interest in Bach. Mendelssohn's visit to Scotland inspired his popular orchestral overture, The Hebrides (1832; also known as "Fingal's Cave"), and the Scottish Symphony (1845). Typical of German romanticism, his compositions often have extra-musical associations, inspired by literature, historical events or beautiful scenery.

► Messerschmitt Founder of a successful aircraft manufacturing company, Messerschmitt designed the aircraft used by the Luftwaffe in World War 2, and joined Hitler's War Council in 1937. His Me-262, a swept-wing jet fighter, was used by the Russians as a model for their MiG fighter aircraft.

reproductive age, the stage during which the body prepares for pregnancy. In humans, the average cycle is 28 days. At the beginning of the cycle, HORMONES from the PITUITARY GLAND stimulate the growth of an ovum (egg cell) contained in a follicle in one of the two OVARIES. At approximately mid-cycle, the follicle bursts, the egg is released (ovulation) and travels down the FALLOPIAN TUBE to the UTERUS. The follicle (now called the corpus luteum) secretes two hormones, PROGES-TERONE and OESTROGEN, during this secretory phase of the cycle, and the ENDOMETRIUM thickens, ready to receive the fertilized egg. If fertilization (conception) does not occur, the corpus luteum degenerates, hormone secretion ceases, the endometrium breaks down, and menstruation occurs in the form of a loss of blood. In the event of conception, the corpus luteum remains and maintains the endometrium with hormones until the PLACENTA is formed. In humans, the onset of the menstrual cycle (menarche) occurs at PUBERTY; it ceases with the MENOPAUSE (around 50 years of age).

mental handicap Intellectual functioning that is below the average, irrespective of cause. It is usually related to congenital conditions but can arise later in life through brain damage. Assuming a normal intelligence quotient (IQ) of 90 to 110, impairment is often described as borderline (IQ 68–85), mild (IQ 52–67), moderate (IQ 36–51), severe (IQ 20–35) and profound (IQ under 20).

mental illness Any failure of mental health that is severe enough for psychiatric treatment to be appropriate. The term "mental disorder" is now often preferred. Some mental disorders can be attributed to injury or organic disease of the BRAIN. Mental disorder may also be the result of a hereditary predisposition. Other disorders are psychogenic, without any clear evidence of any physiological cause. SCHIZOPHRENIA, severe DEPRESSION, and manic-depressive psychoses are the most widespread of mental disorders. Neurotic disorders, which can be severe but do not often warrant prolonged stays in hospital, include persistent anxiety, PHOBIAS, obsessions and HYSTERIA. menthol (C₁₀H₁₉OH) White, waxy crystalline compound having a strong odour of peppermint. Its main source is oil of peppermint from the plant Mentha arvensis. It is an ingredient of decongestant ointments and nasal sprays, and is used to flavour toothpaste and cigarettes.

Menuhin Name of a family of musicians. **Yehudi** (Lord Menuhin, 1916–), a violinist, b. USA, is one of the world's most gifted musicians. He gave his first concert aged seven. During his many world tours, a standard repertoire was interspersed with unfamiliar works. He is also responsible for introducing Indian music to Western audiences. **Hephzibah** Menuhin (1920–81), his sister, was a pianist who gave many recitals, most often as accompanist to Yehudi. Yaltah, another sister, and Jeremy, a son, are also pianists.

Menzies, Sir Robert Gordon (1894–1978) Australian statesman, longest-serving prime minister (1939–41, 1949–66). He encouraged British and US commitment to the security of Southeast Asia, and supported the ANZUS PACT and the SOUTHEAST ASIA TREATY ORGANIZATION (SEATO).

mercantilism Sixteenth- to 18th-century trade policy advocating state intervention in economic affairs, primarily to maximize exports. Foreign trade was publicly controlled to produce the maximum possible surplus in the nation's trade balance, thus increasing the country's store of silver and gold, which constitute the "nation's wealth". **Mercator, Gerardus** (1512–94) Flemish cartographer. His huge world map of 1569 employed the system of projection now named after him, in which lines of longitude, as well as latitude, appear as straight, parallel lines.

merchant bank One of a number of UK specialist banks that offer financial services, primarily to corporate customers. They rose to prominence in the 18th and 19th centuries, involved in overseas trade. Today, they provide a range of services including: operating as issuing houses; sponsoring capital issues; offering corporate advisory work, such as advising on mergers and acquisitions; asset management; and foreign exchange.

Mercury Smallest of the four inner planets, and the planet closest to the Sun. It has no known satellite. Very little was known about Mercury's surface until the Mariner 10 probe made three close approaches to the planet in 1974 and 1975, and returned pictures of nearly half the surface. These showed a heavily cratered, lunar-like world marked by valleys and ridges. Radar mapping of Mercury's polar regions in 1991 and 1992 revealed what may be water-ice on the floors of craters permanently in shadow. There is a very tenuous atmosphere, mainly of helium and sodium and a weak magnetic field.

mercury (quicksilver, symbol Hg) Liquid metallic element, known from earliest times. The chief ore is cinnabar (a sulphide), from which it is extracted by roasting. The silvery element is poisonous and the only metal that is liquid at normal temperatures. Mercury is used in barometers, thermometers, laboratory apparatus, mercury-vapour lamps and mercury cells. Mercury compounds are used in pharmaceuticals. Properties: at.no. 80; r.a.m. 200.59: r.d. 13.6; m.p. -38.87°C; (-37.97°F); b.p. 356.58°C (673.84°F); most common isotope Hg²⁰² (29.8%).

Meredith, George (1828–1909) British novelist and poet. Most modern critics regard *The Egoist* (1879) as his masterpiece, followed by *Diana of the Crossways* (1885). In his last years, he wrote mainly poetry.

merganser Any of several species of slender freshwater or marine ducks that dive for food, especially the red-breasted merganser (*Mergus serrator*), which has a hooked bill. The goosander (*M. merganser*) differs mainly in coloration. Family: Anatidae.

meridian Circle that runs through the North and South Poles, at right angles to the Equator. See also LONGITUDE

Mérimée, Prosper (1803–70) French dramatist and shortstory writer. He wrote a large body of dramatic work in the 1820s, but is best remembered for his historical novellas and short stories. These include the collection of short stories *Mosaïque* (1833) and the novellas *Colomba* (1841) and *Carmen* (1845), on which Georges Bizet based his opera.

meristem In plants, a layer of cells that divides repeatedly to generate new tissues. It is present at the growing tips of shoots and roots, and at certain sites in leaves. In monocotyledons, the leaf meristem is at the base, explaining why grasses continue to grow when the leaf tips are removed by grazing or mowing. See also CAMBIUM

Merlin Legendary magician. His origins may be traced to early Celtic folklore, although his name is usually associated with the Arthurian legends as the mentor of King ARTHUR.

Merovingian Frankish dynasty (476–750). It was named after Merovech, a leader of the Salian Franks, whose grandson, CLOVIS I (r. c.481–511), ruled over most of France and, converting to Christianity, established the common interests of the Frankish rulers and the already Christian population of his new kingdom. The last Merovingian king was overthrown by PEPIN III, founder of the Carolingian dynasty.

Merseyside Metropolitan county in NW England, formed in 1974. It lies on both banks of the estuary of the River Mersey, and is divided into five administrative districts. The major town is LIVERPOOL. In the 19th century shipbuilding and ship repair grew in importance, and Liverpool became one of Britain's leading ports. Industries: motor vehicles, chemicals, electrical goods. Area: 655sq km (253sq mi). Pop. (1991) 1,403,642.

mesa Large, broad, flat-topped hill or mountain of moderate height and with steep, cliff-like sides. A mesa is capped with layers of resistant horizontal rocks which may then erode to form narrower buttes.

MERCURY: DATA

Diameter (equatorial):
4,878km (3,031mi)
Mass (Earth=1): 0.055
Volume (Earth=1): 0.056
Density (water=1): 5.44
Orbital period: 89.97 days
Rotation period: 68.646 days
Average surface temperature:
427°C (800°F)

mescaline Psychedelic drug obtained from the dried tops of the peyote cactus, *Lophophora williamsii*. In North America, mescaline is used in some Native American religious rites.

Mesmer, Franz (Friedrich Anton) (1734–1815) Austrian physician. Mesmer's interest in "animal magnetism" led to his development of mesmerism (HYPNOSIS) as a therapeutic treatment. Ridiculed by fellow scientists, Mesmer died in obscurity. Mesolithic (Middle Stone Age) In NW Europe the period in human cultural development following the PALAEOLITHIC and preceding the NEOLITHIC. It followed an ice age (c.8000 BC). As the environment changed, scrub gave way to forest and small game proliferated. A nomadic form of life became unnecessary and human settlement was a feature of this period, as were flint tools.

meson Subatomic particle, member of a subgroup of HADRONS, all of which have either zero or integral SPIN. They include the pions, kaons and eta mesons.

mesophyll Soft tissue located between the two layers of epidermis in a plant leaf. In most plants, mesophyll cells contain chlorophyll-producing structures called CHLOROPLASTS, which are essential to PHOTOSYNTHESIS.

Mesopotamia Ancient region between the rivers TIGRIS and EUPHRATES in SW Asia, roughly corresponding to modern Iraq. It was the site of one of the earliest human civilizations, resulting from the development of irrigation in the 6th millennium BC and the extreme fertility of the irrigated land. The first cities were established by the Sumerians c.2500 BC. The first empire builders on a large scale were the people of Akkadia under SARGON I, who conquered (c.2300 BC) the Sumerian cities. BABYLONIA gained supremacy in the 18th century BC and was followed by others, notably the Assyrians. Later ruled by the Persians, Greeks and Romans, Mesopotamia gradually lost its distinctive cultural traditions. See also SUMERIA

Mesozoic Third era of GEOLOGICAL TIME, extending from c.248–65 million years ago. It is divided into three periods: the TRIASSIC, JURASSIC, and CRETACEOUS. For most of the era, the continents are believed to have been joined into one huge landmass called Pangaea. The period was also characterized by the variety and size of its reptiles.

Messerschmitt, Willy (Wilhelm) (1898–1978) German aircraft designer, famous for the Messerschmitt Bf-109 fighter used by the LUFTWAFFE during World War 2. Messerschmitt also designed the ME-262, the first jet-propelled aircraft to be used in combat (1944).

Messiaen, Olivier (1908–92) French composer and organist. His organ works, including *L'Ascension* (1933) and *La Nativité du Seigneur* (1935), are important contributions to the repertoire of that instrument. Among other compositions is the monumental ten-movement *Turangalîla-symphonie* (1949) and an opera on the life of Francis of Assisi (1983).

Messiah Saviour or redeemer. Specifically, the Messiah was the descendant of King David expected by the Jews of ancient times to become their king, free them from foreign bondage, and rule over them in a golden age of glory, peace, and right-eousness. The word is Hebrew in origin, meaning "anointed",

and refers to the "idealized" king as having been anointed by God or his representative in the way that David and his successors were. The title "Christ", derived from the Greek version of the term Messiah, was applied to JESUS by his followers.

Messina Seaport city on the Strait of Messina, in Italy; capital of Messina province, NE Sicily, Italy. Messina was founded by the Greeks in c.730 BC. The city was conquered by mercenaries, whose backing from Rome led directly to the first of the Punic Wars. From 241 BC Messina was a free city of Rome. In the 9th century it was conquered by the Muslim Saracen army and then by the Normans in 1061. In 1190 Messina was taken by the Crusaders and was ruled by Spain from 1282 to 1714. In 1860 it was liberated by Giuseppe Garibaldi. In 1908 an earthquake killed over 80,000 people, and destroyed most of the city. Exports: wine, citrus fruit, olive oil, chemicals. Industries: chemicals, pharmaceuticals, processed foods. Pop. (1991) 231,693.

metabolism Chemical and physical processes and changes continuously occurring in a living organism. They include the breakdown of organic matter (catabolism), resulting in energy release, and the synthesis of organic components (anabolism) to store energy and build and repair TISSUES.

metal Element that is a good conductor of heat and electricity - the atoms of which are bonded together within crystals in a unique way. Mixtures of such elements (alloys) are also metals. About three-quarters of the known elements are metals: most are hard, shiny materials that form oxides. Malleability and ductility are further characteristics of all metals. Some metals have very high melting points and various high-temperature applications: TUNGSTEN, with the highest melting point of all, at 3,410°C (6,170°F), is used for incandescent-lamp filaments. ALUMINIUM, followed by IRON, are the two most abundant and useful of metals. TITANIUM, although rarely seen as a metal, is more commonly distributed than the more familiar COPPER, ZINC and LEAD. Other metals of economic importance, because they can undergo nuclear FISSION, are URANIUM and PLUTONIUM. metalloid ELEMENT having some properties typical of metals, and some normally associated with non-metals. Metalloids are sometimes called semi-metals or semi-metallic elements. Examples are silicon, germanium and arsenic. Some metalloids are SEMICONDUCTORS.

metallurgy Science and technology concerned with metals. Metallurgy includes the study of: methods of extraction of metals from their ores; physical and chemical properties of metals; ALLOY production, and the hardening, strengthening, corrosion-proofing and ELECTROPLATING of metals. *See also* ANODIZING; GALVANIZING

metamorphic rock Broad class of rocks that have been changed by heat or pressure from their original nature – SEDI-MENTARY, IGNEOUS, or older metamorphic. The changes characteristically involve new crystalline structure, the creation of new minerals, or a radical change of texture. For example, the metamorphic rock slate is made from sedimentary shale.

metamorphosis Change of form during the development of various organisms, such as the changing of a caterpillar

▼ metamorphosis When common frogs mate, fertilization and egg laying occur in water (1). Within an hour, the jelly around the egg swells to produce frogspawn (2). The eggs develop (3) and produce embryos (4) that hatch as long-tailed tadpoles with external feathery gills six days after fertilization (5). Mouths and eyes develop later and the tails become powerful means of propulsion. Hind legs are well formed by week eight (6); meanwhile, the tadpole has changed from a herbivore to a carnivore. Via an intermediary gill and lung stage, the tadpole changes from gill- to lungbreathing, its internal lungs growing as its external gills are absorbed; the process is complete when the gills fully disappear at month three, by which time the forelegs are well developed (7). Metamorphosis is complete when the young frog (8) loses its tail.

into a moth, or a tadpole into a frog. Sometimes the change is gradual, as with a grasshopper, and is known as incomplete metamorphosis. Complete metamorphosis usually involves the more distinct stages of LARVA, PUPA and adult stages.

metaphor Figure of speech that draws a comparison. It differs from ordinary comparisons in its inventiveness, and from a **simile** in the complexity of the idea expressed. "Fleece as white as snow", is a simile, whereas "His political life was a constant swimming against the tide", is a metaphor.

metaphysical poetry English literary form of the 17th century, characterized by the combination of unlike ideas or images to create new representations of experience, and a reliance on wit and subtle argument. Although this method was by no means new, in the hands of such writers as George HERBERT, Andrew MARVELL and John DONNE it infused new life into English poetry.

metaphysics Branch of philosophy that deals with the first principles of reality and with the nature of the universe. Metaphysics is divided into ONTOLOGY, the study of the essence of being, and COSMOLOGY, the study of the structure and laws of the universe. Leading metaphysical thinkers have included Plato, Aristotle, Descartes, Leibniz, Kant and A.N. Whitehead.

Metaxas, Joannis (1871–1941) Greek general and statesman, prime minister (1936–41). Metaxas fought in the BALKAN WARS (1912–13), but was dismissed for pro-German leanings during World War 1. As prime minister, Metaxas dissolved parliament and ruled as a virtual dictator. Despite fascist trappings, he led resistance to Mussolini's imperialism.

meteor (shooting star) Brief streak of light in the night sky caused by a meteoroid entering the Earth's upper atmosphere at high speed from space. A typical meteor lasts from a few tenths of a second to a few seconds, depending on the meteoroid's impact speed, which can vary from *c*.11–70km/s (7–45mi/s). At certain times of the year there are meteor showers, when meteors are more numerous than usual.

meteorite Part of a large meteoroid (a small particle or body following an Earth-crossing orbit) that survives passage through the Earth's atmosphere and reaches the ground. Most of a meteoroid burns up in the atmosphere to produce meteors, but c.10% reaches the surface as meteorites and micrometeorites. Meteorites generally have a pitted surface and a fused charred crust. There are three main types: iron meteorites (siderites); stony meteorites (aerolites) and mixed iron and stone meteorites. Some are tiny particles, but others weigh up to 200 tonnes.

meteorology Study of weather conditions, a branch of CLIMATOLOGY. Meteorologists study and analyse data from a network of weather ships, aircraft and satellites in order to compile maps showing the state of the high- and low-pressure regions in the Earth's atmosphere. They also anticipate changes in the distribution of the regions and forecast the future weather.

meter Instrument that measures a particular quantity. For example, a gas meter measures the amount of gas that has flowed in a certain time, and a voltmeter measures the voltage between two points in an electrical circuit.

methanal (formaldehyde) Colourless, inflammable, poisonous gas, HCHO, with a penetrating odour. It is the simplest aldehyde and is produced by the oxidation of METHANOL by air. It was discovered by August von HOFMANN in 1867. Most methanal is in the form of formalin. Methanal is used in the manufacture of dyes and plastics. Chief properties: r.d. 0.82; m.p. $-92^{\circ}\text{C}(-133.6^{\circ}\text{F})$, b.p. $-19^{\circ}\text{C}(-2.2^{\circ}\text{F})$.

methane Colourless, odourless HYDROCARBON (CH₄), the simplest ALKANE (paraffin). It is the chief constituent of NAT-URAL GAS, from which it is obtained. It is produced by decomposing organic matter, such as in marshes, which led to its original name of marsh gas. In the air, it contributes to the GREENHOUSE EFFECT and an increase in global temperature. Methane is used in the form of natural gas as a fuel. Properties: m.p. -182.5°C (-296.5°F); b.p. -164°C (-263.2°F). methanoic acid (formic acid) Colourless, corrosive, pungent, liquid carboxylic acid, HCOOH. It is used to produce insecticides and for dyeing, tanning and electroplating. It

occurs naturally in a variety of sources – stinging ants, nettles, pine needles and sweat. The simplest of the carboxylic acids, it can be produced by the action of concentrated sulphuric acid on sodium methanoate. Properties: r.d. 1.22; m.p. 8.3°C (46.9°F); b.p. 100.8°C (213.4°F).

methanol (methyl alcohol) Colourless, poisonous, flammable liquid (CH₃OH), the simplest of the ALCOHOLS. It is obtained synthetically either from carbon monoxide and hydrogen, by the oxidation of natural gas, or by the destructive distillation of wood, giving it the informal name of wood alcohol. It is used as a solvent and a petrol additive and to produce rocket fuel and petrol. Properties: m.p. -93.9°C (-137°F); b.p. 64.9°C (148.8°F).

Methodism Worldwide religious movement that began in England in the 18th century. It was originally an evangelical movement within the CHURCH OF ENGLAND, started in 1729 by John and Charles WESLEY. John Wesley stayed within the Anglican Church until his death in 1791. In 1795 the Wesleyan Methodists became a separate body and divided into other sects, such as the Methodist New Connection (1797) and the Primitive Methodists (1811). The United Methodist Church reunited the New Connection with the smaller Bible Christians and the United Methodist Free Churches in 1907; in 1932 these united with the Wesleyans and Primitives. In the USA, the Methodist Episcopal Church was founded in 1784. In the 1990s there were more than 50 million Methodists worldwide. **Methuselah** In the Old Testament (Genesis 5:25–27), the longest-lived of all human beings; son of ENOCH and eighth in descent from ADAM and EVE. He is said to have died at the age of 969 and was the father of many children, including Lamech, the father of NOAH.

methylated spirit Industrial form of ETHANOL (ethyl alcohol). It contains 5% METHANOL (methyl alcohol), which is extremely poisonous, and enough pyridine to give it a foul taste. It is dyed purple and used as a solvent and fuel.

metre (symbol m) SI unit of distance. Conceived as being one ten millionth of the surface distance between the North Pole and the Equator, it was formerly defined by two marks on a platinum bar kept in Paris. It is now defined as the length of the path travelled by light in a vacuum during 1/299,792,458 of a second. One metre equals 39.3701 inches. metre In poetry, a regular rhythmic pattern. It imposes a regular recurrence of stresses, typically dividing a line into equal units called metrical feet. The most commonly used metrical feet are anapaest, dactyl, iamb and trochee. The metre of a poem is described according to the kind and number of metrical feet per line: for example, iambic pentameters have five iambs per line.

metric system Decimal system of WEIGHTS AND MEASURES based on the METRE (m) and the KILOGRAM (kg). Larger and smaller metric units are related by powers of 10. Devised in 1791, the metric system is used internationally by scientists (particularly as SI UNITS) and has been adopted for general use by most Western countries, although the IMPERIAL SYSTEM is still commonly used in the USA and for certain measurements in Britain.

Metropolitan Museum of Art US art museum, New York City. Founded in 1870, the museum has a large and diverse permanent art collection, including numerous Egyptian, Greek, and Roman works. Much of the medieval collection is housed in a separate complex, The Cloisters. In addition to European sculpture, there are more than 4,600 European paintings ranging from the 15th century to the present, as well as many US paintings and sculptures. The Oriental art collection numbers 30,000 pieces.

Metropolitan Opera Company New York City company famous for the high standard of its productions. Operas premiered at "the Met" include *Gianni Schicchi* (1918) and *The Girl of the Golden West* (1910), both by Puccini. The Metropolitan Opera House was opened in 1883; it moved to the new house in the Lincoln Center for the Performing Arts, New York, in 1966.

Metternich, Klemens Wenzel Lothar, Prince von (1773–1859) Austrian statesman, foreign minister (1809–48) and chancellor (1821–48). Metternich was the leading Euro-

pean statesman of the post-Napoleonic era. Following Austria's defeat in the Napoleonic Wars (1809), he adopted a conciliatory policy towards France. After Napoleon's retreat from Moscow (1812), he formed the QUADRUPLE ALLIANCE (1813), which led to Napoleon's defeat. He was the dominant figure at the Congress of Vienna (1814–15), and at subsequent conferences held under the Congress System. After securing peace in Europe, he became increasingly autocratic, pressing for the intervention of the great powers against any revolutionary outbreak. He was deposed by the Revolutions of 1848.

Metz City on the River Moselle; capital of Moselle département, NE France. One of Roman Gaul's chief cities, it was burned by Vandals (406) and by Huns (451). After the 8th century the bishops of Metz ruled a vast empire. As a free imperial city in 12th century, Metz enjoyed considerable prosperity. It was taken by France in 1552 but became part of Germany in 1871 after the Franco-Prussian War. The Treaty of Versailles (1919) restored it to France. Industries: metals, machinery, tobacco, wine, tanning, clothing. Pop. (1990) 119,594.

Mexican Revolution (1910-40) Extended political revolution that improved the welfare of the Mexican underpriviliged. The Mexican Revolution was prompted by the dictatorial, elitist presidency of Porfirio Díaz. In 1910 Díaz, who had agreed not to stand for re-election following the threat of armed revolt led by Francisco MADERO, reneged on his agreement and was re-elected. He was forced to resign in 1911 by Madero, who was subsequently elected. Madero intended to make landownership more egalitarian, to strengthen labour organizations, and to lessen the influence of the Catholic Church. He was assassinated in 1913, however, by his former general Victoriano HUERTA. The repressive regime of Huerta caused massive unrest in the peasant community, who found leaders in Venustiano Carranza, Francisco "Pancho" VILLA and Emiliano ZAPATA. Huerta resigned and Carranza became president (1914). Although some agrarian, educational and political reforms continued, it was Lázaro Cárdenas (1934-40) who finally began the process of land distribution, support of the labour movement, and improvements in health and education. Mexican War (1846-48) Conflict between Mexico and the USA. It broke out following US annexation of TEXAS (1845). The Mexicans were swiftly overwhelmed, and a series of US expeditions effected the conquest of the sw. The war ended when General Winfield Scott, having landed at Vera Cruz in March 1847, defeated the army of SANTA ANNA and entered Mexico City on 8 September. In the Treaty of GUADALUPE-HIDALGO (1848), Mexico ceded sovereignty over California and New Mexico, as well as Texas north of the Rio Grande. Mexico Republic in s North America. See country feature,

p.444 Mexico City Capital of Mexico, largest city in the world, situated in a volcanic basin at an altitude of 2,380m (7,800ft), in the centre of the country. Mexico City is the nation's political, economic and cultural centre. It suffers from overcrowding, high levels of pollution and is vulnerable to earthquakes. The former AZTEC capital, known as Tenochtitlán, was destroyed by Hernán Cortés in 1521. A new city was constructed, which acted as the capital of Spain's New World colonies for the next 300 years. During the MEXICAN WAR, the city was occupied by US troops (1847). In 1863 French troops conquered the city and established MAXIMILIAN as emperor. It was recaptured in 1867 by Benito Juárez's republican forces. In 1914–15, the city was captured and lost three times by the revolutionary forces of Emiliano ZAPATA and Francisco VILLA. It is a major tourist centre. Pop. (1990) 15,047,685.

Meyerbeer, Giacomo (1791–1864) German composer, b. Jakob Liebmann Beer. His early operas, in the Italian tradition, were influenced by Gioacchino Rossini. His greatest acclaim, however, came in Paris where his works laid the foundations of French grand opera. With libretti by Eugene Scribe, these operas included *Robert le Diable* (1831), *Les Huguenots* (1836) and *Le Prophète* (1849).

mezzo-soprano (middle soprano) Range of the human voice falling between SOPRANO and CONTRALTO. It grew popular with opera composers in the 19th century, when the CASTRATO voice (which had a similar range) became less usual.

Miami City and port on Biscayne Bay in SE Florida, USA. Originally a small agricultural community, it developed quickly after 1895 when the railroad was extended and the harbour dredged. Modern Miami is a popular tourist resort, with luxury hotels and many sporting facilities. Industries: clothing, concrete, metal products, fishing, printing and publishing. Pop. (1990) 358,548.

mica Group of common rock-forming minerals characterized by a platy or flaky appearance. All contain aluminium, potassium and water; other metals, such as iron and magnesium, may be present. Micas have perfect basal cleavage. Common micas are muscovite and the biotite group. Muscovite is commonly found in coarse-grained acidic rocks, schists and gneisses, and in sedimentary rocks. The biotite micas are found in a wide range of igneous and metamorphic rocks, but more rarely in sedimentary rocks.

Michael, Saint One of the four archangels mentioned in the Bible, the others being Gabriel, Raphael and Uriel. In the Old Testament, Michael is the guardian of Israel and the highest of the archangels. In the New Testament book of Revelation, he is said to have thrown down the Dragon (Satan). His feast day is 29 September (Michaelmas). He is given prominence also in Islam.

Michael (1921–) King of Romania (1927–30, 1940–47). He succeeded his grandfather as a child, surrendered the throne to his father in 1930, and regained it when his father abdicated (1940). He backed the overthrow of the fascist rule of Ion Antonescu in 1944, whereupon Romania joined the Allies in World War 2. Michael was forced to abdicate when the communists gained power (1947).

Michaelmas Christian feast day of St Michael and All Angels, celebrated on 29 September. Since the Middle Ages, Michaelmas has been one of the four QUARTER DAYS of the financial year.

Michelangelo Buonarroti (1475–1564) Florentine sculptor, painter, architect and poet. He was one of the outstanding figures of the High RENAISSANCE and a creator of MANNERISM. He spent five years in Rome where he made his name with a statue of *Bacchus* and the *Pietà* (now in St Peter's). In 1501 he returned to Florence, where he carved the gigantic *David*, a symbol of the new-found confidence of the Florentine Republic. Pope Julius II called him to Rome in 1505 to carry out two substantial commissions. The first, a magnificent tomb for Julius I, ended in disaster due to lack of funds from the Pope's heirs. The other, a vast painting for the Sistine Chapel ceiling, was Michelangelo's most sublime achievement. He added *The Last Judgment* later, starting in 1536. Among Michelangelo's other great (unfinished) works are the Medici Chapel and the Biblioteca Laurenziana, both for the church of San Lorenzo in

▼ Michelangelo Detail of the Sistine Chapel ceiling, Vatican Palace, Rome, showing Creation of Adam (1510) by Michelangelo. Although he preferred sculpture to painting, Michelangelo worked almost single-handedly on the ceiling between 1508 and 1512. He learned the fresco technique from Ghirlandaio in Florence, although his most important lessons came from copying figures by Giotto and Masaccio.

Mexico's flag dates from 1821. The stripes were inspired by the French tricolour. The emblem in the centre contains an eagle, a snake and a cactus. It is based on an ancient Aztec legend about the founding of the capital, Tenochtitlán (now Mexico City).

he North American republic of Mexico is The North American republic the world's largest Spanish-speaking countries. try. It is largely mountainous. The SIERRA MADRE Occidental begins in the NW state of CHIHUAHUA, and runs parallel to Mexico's w coast and the Sierra Madre Oriental. MONTER-REY lies in the foothills of the latter. Between the two ranges lies the Mexican Plateau. The s part of the plateau contains a series of extinct volcanoes, rising to Citlaltépetl, at 5,700m (18,701ft). This region includes many of Mexico's largest cities, including the capital (and world's largest city), MEXICO CITY, and GUADALAJARA. The s highlands of the Sierra Madre del Sur include the archaeological sites in OAXACA. Mexico contains two large peninsulas: the mountainous and arid BAJA CALIFOR-NIA in the NW; and the lowland YUCATÁN peninsula in the SE. CIUDAD JUÁREZ and NUEVO LAREDO are important cities on the border with the United States.

CLIMATE

Mexico's climate varies greatly according to altitude. Most rain occurs between June and September, and rainfall decreases N of Mexico City. Over 70% of Mexico has a desert or semi-desert climate. Irrigation is essential for agriculture.

VEGETATION

The N deserts are abundant in plants such as cactus, mesquite and yucca. Luxuriant rainforests exist in the s, and Mexico also has areas of tropical grassland.

1876 an armed revolt gave Porfirio Díaz the presidency. Beside the period 1880-84, Díaz dic-STATES TED Gulf Mexico Tropic of Cancer Tropic of Cancer Mazatlán Cape San Lucas Mérida Valladolio Poza Rica Gulf of Guadalajara Nucatan 20 Campech PACIFIC OCEAN Acapulco 110°W 100°W 90°W

HISTORY AND POLITICS

One of the earliest NATIVE AMERICAN civilizations was the OLMEC (800-400 BC). The MAYA flourished between AD 300 and 900. The TOLTEC empire was dominant between 900 and c.1200. But it was the AZTEC who dominated the central plateau from their capital at Tenochtitlán (modern-day Mexico City). Many splendid PYRAMIDS and temples remain from these civilizations. Fernández de Córdoba was the first European to explore Mexico in 1517. In 1519-21 Spanish conquistadors, led by Hernán Cortés, captured the capital and the Aztec emperor MONTEZUMA. In 1535 the territory became the viceroyalty of New Spain. Christianity was introduced. Spanish colonial rule was harsh, divisive and unpopular. HIDALGO Y COSTILLO's revolt (1810) failed to win the support of creoles. In 1821 Mexico gained independence, and General Augustín de ITURBIDE became emperor. In 1823 republicans seized power and, in 1824, Mexico became a republic. In 1832 SANTA ANNA became president. War with Texas escalated into the MEXICAN WAR (1846-48) with the United States. Under the terms of the Treaty of GUADALUPE-HIDALGO (1848), Mexico lost 50% of its territory. A revolution led to the overthrow of Santa Anna in 1855, and civil war broke out. Liberal forces, led by Benito Juárez, triumphed in the War of Reform (1858-61), but conservatives with support from France installed MAXIMILIAN of Austria as emperor in 1864. In 1867 republican rule was restored, and Juárez became president. In AREA: 1,958,200sq km (756,061sq mi)

POPULATION: 89,538,000

CAPITAL (POPULATION): Mexico City (15,047,685)

GOVERNMENT: Federal republic ETHNIC GROUPS: Mestizo 60%, Native American 30%, European 9% LANGUAGES: Spanish (official)

RELIGIONS: Christianity (Roman Catholic 90%,

Protestant 5%)

currency: New peso = 100 centavosm.

tatorship lasted until 1910. Following an armed insurrection, Francisco Madero became president in 1911. A weak leader, Madero was toppled by General Huerta in 1913. Huerta's dictatorship prolonged the Mexican Revolution (1910–40) and led to US intervention. The USbacked forces of Carranza battled with the peasant armies of VILLa and Zapata. During the 1920s and 1930s Mexico introduced land and social reforms. After World War 2, Mexico's economy developed with the introduction of liberal reforms. Relations with the US improved greatly, though problems remain over Mexican economic migration and drug trafficking.

The Institutional Revolutionary Party (PRI) has ruled Mexico continuously since its formation (1929). In 1994 the Zapatista National Liberation Army (ZNLA) staged an armed revolt in the s state of Chiapas, principally calling for land reforms and recognition of Native American rights. Despite concessions on indigenous rights, guerrilla activity continues. In 1994 Ernesto Zedilo of the PRI was elected president. In 1997 congressional elections, the PRI lost its majority for the first time since 1929.

ECONOMY

Mexico is an upper-middle-income developing country (1992 GDP per capita US\$7,300), faced with problems of unemployment, inflation, inequality, and illegal emigration to the United States. Mexico's heavy borrowing on the strength of its oil reserves in the 1970s, led to economic depression in the 1980s with the drop in oil prices. In June 1993 Mexico joined the Organization for Economic Co-operation and Development (OECD). In 1994 Mexico, the USA, and Canada formed the NORTH AMERICAN FREE TRADE ASSOCIATION (NAFTA), the world's single largest trading bloc. In late 1994 Mexico was plunged into economic crisis. Only a US\$50,000 million loan from the USA prevented Mexico defaulting on its foreign debts. An austerity package of wage freezes, interest rate rises and tax increases was introduced. Remarkably, the loan was repaid in 1997.

Mexico is the world's fifth largest producer of crude oil. Machinery and transport equipment account for 32% of exports, minerals and fuels 30%. Other manufactures include chemicals, clothing, steel and textiles. Many factories near the US border assemble goods (such as car parts and electrical products) for US companies. Agriculture is important, contributing c.8% of GDP and employing 28% of the workforce. Mexico is the world's fifth largest producer of coffee. Food crops include beans, maize, rice and wheat. Beef and dairy cattle and other livestock are raised. Fishing is also an important activity. The largest sector of the economy is services. Growing industries include forestry and tourism.

Florence. For the last 30 years of his life, Michelangelo concentrated on architecture. He created the magnificent cathedral of ST PETER'S, Rome, but died before completing it.

Michelson, Albert Abraham (1852–1931) US physicist, b. Germany. In 1887 he conducted an experiment with Edward Morley to determine the velocity of the Earth through the ETHER, using an INTERFEROMETER of his own design. The negative result prompted the development of the theory of RELATIVITY. In 1907 Michelson became the first US scientist to win a Nobel Prize.

Michigan State in N central USA, bordered by four of the GREAT LAKES; the capital is LANSING. The largest city is DETROIT. First settled by the French in the 17th century, the region was ceded to Britain after the SEVEN YEARS WAR. The British finally left the area in 1796 and Michigan became a US territory in 1805, achieving full statehood in 1837. The opening of the Erie Canal in 1825 aided its growth, but the real industrial boom came with the development of the motor vehicle industry in the early 20th century. Michigan is made up of two peninsulas separated by the Straits of Mackinac, which connect lakes Michigan and Huron. The Upper Peninsula has swampland on the NE lake shore and mountains in the w. Copper and iron ore are mined and timber is a valuable resource. The Lower Peninsula is also forested and mineral deposits include oil, gypsum, sandstone and limestone. In the s cereal crops are cultivated and livestock rearing is important. The Lower Peninsula has most of Michigan's population. Industries: motor vehicles, primary and fabricated metals, chemicals, food products. Area: 150,544sq km (58,110sq mi). Pop. (1990) 9,295,297.

Michigan, Lake Third-largest of the five Great Lakes of North America, and the only one entirely within the USA. Discovered by the French in 1634, it is connected to Lake Huron by the Straits of Mackinac. The ST LAWRENCE SEAWAY opened up the lake to international trade. CHICAGO is on the sw shore. Area: 57,757sq km (22,300sq mi).

Micmac Algonquian-speaking tribe of Native North Americans, once inhabiting Nova Scotia, Cape Breton Island, Prince Edward Island and Newfoundland. They were probably the first Native Americans to meet the early European explorers. Today, c.4,000 remain in NE Canada.

microbiology Study of microorganisms, their structure, function and significance. Mainly concerned with single-cell forms such as VIRUSES, BACTERIA, PROTOZOA and FUNGI, it has immense applications in medicine and the food industry.

microcomputer Small computer that has its central processing unit (CPU) on an integrated circuit (chip) called a MICROPROCESSOR.

microeconomics Study of individual components of the economic system. It analyses individual consumers and producers, the market conditions and the law of SUPPLY AND DEMAND. It is one of the two major subdivisions of ECONOMICS; the other is MACROECONOMICS.

microelectronics In ELECTRONICS, systems designed and produced without wiring or other bulky components. They allow a high packing density, greatly reducing the size of component assemblies. Following World War 2, the application of such newly developed devices as the TRANSISTOR saw the beginnings of the microelectronics industry. This accelerated with the development of the PRINTED CIRCUIT. Even further reduction in size, or microminiaturization, was achieved with INTEGRATED CIRCUITS. Molecular electronics is a new development that promises to be the ultimate in size reduction.

Micronesia Archipelago in the w Pacific Ocean, N of Polynesia. Micronesia includes Belau, Kiribati, Mariana Islands, the Federated States of Micronesia, Nauru and Tuvalu.

Micronesia, Federated States of Republic in the w Pacific Ocean, consisting of all the CAROLINE ISLANDS except BELAU. The 607 islands of the republic are divided into four states: Kosrae, Pohnpei, Truk and Yap. The capital, Palikir, is on the main island of Pohnpei. The islands are widely dispersed. The economy is heavily dependent on US aid. Land use is limited to subsistence agriculture. The islands were formally annexed by Spain in 1874. In 1899 they were sold to Germany. In 1914, Japan occupied the archipelago and was given a mandate to govern by the League of Nations in 1920.

In 1944 US naval forces captured the islands, and in 1947 they came under formal US administration as part of the UN Trust Territory of the Pacific Islands. In 1979 the Federated States of Micronesia came into being, with Belau remaining a US trust territory. In 1986 a compact of free association with the USA was signed. In 1990 UN trust status was annulled, and in 1991 Micronesia became a full member of the UN. Area: 705sq km (272sq mi). Pop. (1991) 107,662.

microphone Device for converting sound into varying electric currents of the same frequency. Live music performers often use a moving coil microphone, in which a coil attached to a diaphragm vibrates in a stationary magnetic field. The recording industry prefers the condenser microphone, which employs a CAPACITOR. Crystal microphones use the PIEZOELECTRIC EFFECT.

microprocessor Complex INTEGRATED CIRCUIT (chip) used to control the operation of a computer or other equipment.

microscope Optical device for producing an enlarged image of a minute object. The first simple microscope was made in 1668 by Anton van Leeuwenhoek. The modern compound microscope has two converging lens systems, the objective and the eyepiece, both of short focal length. The objective produces a magnified image, which is further magnified by the eyepiece to give the image seen by the observer. Because of the nature of the visible spectrum of light, an optical microscope can magnify objects only up to 2,000 times. For extremely small objects, an Electron Microscope is used.

microsurgery Delicate surgery performed under a binocular microscope using specialized instruments, such as microneedles as small as 2mm long, sutures 20 micrometers in diameter, ENDOSCOPES and LASERS. It is used in a number of specialized areas, including the repair of nerves and blood vessels, eye, ear and brain surgery, and the reattachment of severed parts.

An optical microscope magnifies a sample (1) held on a slide (2). Light from below (3) illuminates the sample which is magnified by a lens (4) which can be changed. Complicated lenses (5) direct the image onto an eyepiece (6). The position of the sample can be altered physically by turning knobs (7) that bring the image into position and focus.

MICHIGAN Statehood: 26 January 1837

Nickname : Wolverine State

State bird : Robin

State flower: Apple blossom

State tree : White pine

State motto :

If you seek a pleasant peninsula, look around

▲ migration Remarkable annual migrations are made by birds of northern temperate regions flying south in autumn to new breeding grounds, and returning north in spring to breed. The arctic tern nests in polar regions and flies south along one of the various routes shown to the islands of Antarctica, the round trip often totalling 32,000km (20,000mi).

microwave Form of ELECTROMAGNETIC RADIATION having a wavelength between 1mm (0.04in) and 1m (3.3ft) and a frequency range of about 255 to 300,000MHz. Microwaves are used for RADAR, RADIO and TELEVISION broadcasting, high-speed microwave heating and cellular telephones.

Midas Name of several historical Phrygian rulers and one legendary foolish king in classical mythology. As a reward for rendering a service to a god, King Midas asked that everything he touched should become gold. Midas found he was unable to eat or drink because his food, too, was transformed. His story was told by Ovid.

Mid-Atlantic Ridge Underwater topographic feature along the margin between the diverging American crustal plate on one side and the European and African plates on the other. It runs for 14,000km (8,700mi) along the middle of the Atlantic Ocean. Iceland is located on the ridge itself, and was formed by the outpourings of volcanic lava.

Middle Ages Period in European history covering roughly 1,000 years between the disintegration of the Roman empire in the 5th century and the RENAISSANCE. The Middle Ages are sometimes divided into Early (up to the 10th century), High (10th-14th centuries), and Late Middle Ages. The Middle Ages were, above all, the age of the Christian church, whose doctrine was universally accepted, and of the social-political system known as the FEUDAL SYSTEM. In the arts the Middle Ages encompassed the GOTHIC period (from the 11th century), and in science and learning, the predominance of ISLAM. Middle East Geographical term loosely applied to the predominantly Islamic countries of the E Mediterranean, NE Africa and sw Asia. It usually includes: Bahrain, Cyprus, Egypt, Iran, Iraq, Israel, Jordan, Kuwait, Lebanon, Libya, Oman, Qatar, Saudi Arabia, Sudan, Syria, United Arab Emirates and Yemen. Middle English Form of the English language in use from c.1100 until c.1450. This period saw the borrowing of many words from NORMAN FRENCH. Grammatical gender was superseded by natural gender, and the use of an Anglo-Norman writing system caused radical changes in spellings.

Middlesbrough Port and unitary authority on the River Tees estuary, NE England; former county town of Cleveland. During the 19th century Middlesbrough developed around its iron industry. Industries: steel, shipbuilding. Pop. (1991) 140,849.

MICROWAVE

6

7

7

5

A microwave oven exploits the presence of water in food to cook things from the inside. An oven generates microwaves in a magnatron (1) and when the microwaves penetrate the food they cause water molecules (2),

which have a positive side and a negative side, to rotate (3) generating heat through friction with the food. The oven is heavily insulated (4) to prevent leakage of microwaves. A rotating plate (5) and paddles (6),

which ensure an even distribution of microwaves, make sure the food cooks evenly. To dissipate the hot air, generated by cooking and by the magnatron, a fan (7) pushes cold air around the oven.

Middlesex Former county of SE England, adjoining London. The area was settled by Saxon tribes in the 5th century. Throughout its history it was overshadowed by London. In 1888 it became an administrative county, losing much of its area to the county of London. In 1965 most of the county was absorbed into Greater London, the remainder going to SURREY and HERTFORDSHIRE.

Middleton, Thomas (1570–1627) English playwright. Among his many comedies are *The Honest Whore* (1604), in collaboration with Thomas Dekker, and the political satire *A Game at Chesse* (1624). Perhaps his best-known play is the tragicomedy, *The Changeling* (1621).

Mid Glamorgan County on the Bristol Channel in s Wales; the administrative centre is Cardiff, in South Glamorgan. Other towns include Merthyr Tydfil, Pontypridd and Bridgend. The region is drained by the Taff, Rhymney and Ogmore rivers. The economy was formerly dominated by the coal mines in the N, particularly the Rhondda Valley. Longterm decline in coal production and in the associated iron and steel industries has caused economic and social problems. The s part of the county is a mainly agricultural area. Area: 1,019sq km (393sq mi). Pop. (1991) 526,500.

Midway Islands Coral atoll in the central Pacific Ocean, c.2,000km (1,250mi) wnw of Honolulu, consisting of two small islands, Easter and Sand. The islands were annexed to the USA in 1867 and were made an air base in 1935. They were the scene of the World War 2 Battle of Midway (1942). The islands are now administered by the US Department of the Interior. Area: 5sq km (2sq mi). Pop. (1995 est.) 2,000.

Midwest (Middle West) Imprecise term referring to the interior plains of the USA around the w Great Lakes and the upper Mississippi River valley. It usually refers to the states of Indiana, Illinois, Iowa, Kansas, Missouri, Minnesota, Michigan, Nebraska, Ohio and Wisconsin. Traditionally, the Midwest has been the manufacturing heartland of the USA. The national shift to the service sector has led to the decline of its heavy industrial base. The Midwest is also one of the world's richest agricultural regions; the major crop is wheat.

Mies van der Rohe, Ludwig (1886–1969) US architect and designer, b. Germany. A leading exponent of MODERNISM and the INTERNATIONAL STYLE, Mies was the last director (1930–33) of the BAUHAUS, moving the school to Berlin before it was closed by the Nazis. In 1938 he emigrated to the US, becoming director of the Illinois Institute of Technology, Chicago. Principally using glass and steel, Mies developed the most coherent plastic system of pure modernism. His technological, rationalist aesthetic exerted a profound influence on a new generation of architects, such as Gordon Bunshaft, Eero Saarinen and Philip Johnson. Buildings include Alumni Memorial Hall, Chicago (1944–46) and Seagram Building, New York (1954–58).

migraine Recurrent attacks of throbbing headache, mostly on one side only, often accompanied by nausea, vomiting and visual disturbances. It results from changes in diameter of the arteries serving the brain. More common in women, it is seen usually in young adults and often runs in families. Attacks, which may last anything from two to 72 hours, are often associated with trigger factors, such as certain foods (especially chocolate), missed meals, consumption of alcohol, fatigue, exposure to glare or use of the contraceptive pill. It can be treated, or in some cases prevented, with various drugs.

migration Periodic movement of animals or humans, usually in groups, from one area to another, in order to find food, breeding areas or better conditions. Animal migration involves the eventual return of the migrant to its place of departure. Fish migrate between fresh and salt water or from one part of an ocean to another. Birds usually migrate along established routes. Mammals migrate usually in search of food. For thousands of years the deserts of central Asia widened inexorably and this phenomenon resulted in the human migration of pre-historic tribes to China, the Middle East and Europe. Another type of migration occurred in the 14th century when the Maoris left their overpopulated homes in the islands of central Polynesia to settle in New Zealand.

Milan (Milano) City in NW Italy; capital of Lombardy region.

It was conquered by Rome in 222 BC. It was a free commune by the 12th century and was a powerful Italian state under the Sforza family from , when it was taken by the Spanish. It was ruled by Napoleon (1796–1814) and subsequently by the Austrian Habsburgs, before becoming part of Italy in 1860. It is the country's leading commercial, financial and industrial centre. Industries: motor vehicles, machinery, electrical goods, textiles, clothing, publishing and printing. Pop. (1991) 1,369,231. mildew External filaments and fruiting structures of numerous mould-like FUNGI. Mildews are PARASITES of plants and cause substantial damage to growing crops.

Milhaud, Darius (1892–1974) French composer. In the incidental music to Claudel's translation of Aeschylus' *Orestes*, (1913–22), Milhaud experimented with polytonality. He also included jazz elements in his compositions, notably *La Création du Monde* (1923). His most ambitious work was the opera *Christophe Colombe* (1930).

milk Liquid secreted from mammary glands by the females of nearly all mammals to feed their young. The milk of domesticated cattle, sheep, goats, horses, camels and reindeer has been used as food by humans since prehistoric times, both directly and to make BUTTER, CHEESE and yogurt. Milk is a suspension of fat and protein in water, sweetened with lactose sugar.

Milky Way Faint band of light visible on clear dark nights encircling the sky along the line of the galactic equator. It is the combined light of an enormous number of stars, in places obscured by clouds of interstellar gas and dust. It is in fact the disc of our GALAXY, viewed from our vantage point within it. Mill, James (1773–1836) Scottish philosopher, father of John Stuart MILL. Mill became a friend of Jeremy BENTHAM, and together they evolved the doctrine of UTILITARIANISM. He wrote an Analysis of the Phenomena of the Human Mind (1829) and, among other works, a multi-volume history of the East India Company, for which he worked.

Mill, John Stuart (1806–73) British philosopher who advocated UTILITARIANISM. His book *On Liberty* (1859) made him famous as a defender of human rights. *System of Logic* (1843) attempted to provide an account of inductive reason.

Millais, Sir John Everett (1829–96) English painter and illustrator, founder of the Pre-Raphaelite Brotherhood. His Pre-Raphaelite works, such as *Christ in the House of his Parents* (1850), show the Brotherhood's liking for righteous subjects. His later, more sentimental style, included *Bubbles* (1886), which Pears Soap Company used as an advertisement. Millay, Edna St Vincent (1892–1950) US poet. She wrote *Renascence* (1917), *A Few Figs from Thistles* (1920) and *Second April* (1921). *The Harp Weaver and Other Poems* (1923) won a Pulitzer Prize.

millennium In religion, the supposed second coming of Christ, when he will reign for 1,000 years. This belief, known as millenarianism, was popular until the 4th century. It then fell dormant until the REFORMATION, when it was revived and embraced by the ANABAPTISTS, the MORAVIAN CHURCH, and the Fifth Monarchy Men of 17th-century England. Since the 19th century, MORMONS and ADVENTISTS have professed millenarian beliefs. Some sects, such as JEHOVAH'S WITNESSES, have forecast the imminence of the millennium. Any period of one thousand years is also known as a millennium.

Miller, Arthur (1915–) US dramatist. Miller's Pulitzer Prizewinning play *Death of a Salesman* (1949) is a masterpiece of 20th-century theatre: an egocentric salesman, Willy Loman, has unrealistic aspirations, which he struggles to articulate. *The Crucible* (1953) is both a dramatic reconstruction of the SALEM witch trials and a parable of the MCCARTHY era. Miller won a second Pulitzer Prize for *A View From the Bridge* (1955). He was married (1955–61) to Marilyn MONROE, and wrote the screenplay for her film *The Misfits* (1961). *After the Fall* (1964) is a fictionalized account of their relationship. Other plays include *All My Sons* (1947) and *Playing for Time* (1981).

Miller, (Alton) Glenn (1904–44) US jazz trombonist And bandleader. During World War 2, Miller's dance band played to servicemen all over the world. He composed such classic tunes as "Moonlight Serenade" and "In the Mood" (both 1939). Miller died as a result of "friendly fire" while flying from England to France.

Miller, Henry (1891–1980) US author. Miller's sexually explicit novels, such as *Tropic of Cancer* (1934) and *Tropic of Capricorn* (1939), were considered obscene, and many were banned in the USA and Britain until the 1960s. Other works include *The Rosy Crucifixion* trilogy: *Sexus*, *Plexus*, and *Nexus* (1949–60).

Miller, Jonathan Wolfe (1934-) British stage director. Miller wrote parts for, and appeared in, Beyond the Fringe (1961). His first production for the British National Theatre was The Merchant of Venice (1970). Miller has also directed definitive opera productions, notably Verdi's Rigoletto for English National Opera (1984). He was artistic director of the OLD VIC (1988–90). Miller also writes on neuropsychology. Millet, Jean François (1814-75) French painter. He is best known for solemn, gritty scenes of rural life and labour. Millet's strengths as an artist show clearly in his drawings, which stress the dignity of his figures without any trivializing detail. millet CEREAL grass that produces small, edible seeds. The stalks have flower spikes and the hulled seeds are white. In Russia, w Africa and Asia, it is a staple food. In w Europe, it is used mainly for pasture or hay. Pearl millet (Pennisetum glaucum) grows in poor soils, and is used as food in India and Africa. Height: 1m (39in). Family Poaceae/Gramineae.

millipede Any of numerous species of elongated, invertebrate, arthropod animals with large numbers of legs. Found throughout the world, it has a segmented body, one pair of antennae, two pairs of legs per segment and can be orange, brown or black. All species avoid light and feed on plant tissues. Length: 2–280mm (0.2–11in). Class Diplopoda.

Mills, C. (Charles) Wright (1916–62) US sociologist. His research was in the areas of social psychology and political sociology. Among his many books are *From Max Weber* (1946), edited with Hans Gerth, *The Power Elite* (1956), *The Sociological Imagination* (1959), and *Listen Yankee* (1960).

Milne, A.A. (Alan Alexander) (1882–1956) British essayist, dramatist and author of children's books. He wrote the verses in *When We Were Very Young* (1924) and *Now We Are Six* (1927), and the stories in *Winnie-the-Pooh* (1926) and *The House at Pooh Corner* (1928).

Milošević, Slobodan (1941—) Serbian statesman, president of Serbia (1989—). He became head of the Serbian Communist Party in 1986. As president, he was confronted with the break-up of the federation of Yugoslavia. After his re-election in 1992, Milošević gave moral, financial and technical support to the Serb populations in Croatia and Bosnia-Herzegovina, who fought for a Greater Serbia. He gradually distanced himself from the brutal activities of the Bosnian Serb leaders, MLADIĆ and KARADZIĆ. In November 1995 Milošević, Alija IZETBEGOVIĆ and Franjo TUDIMAN signed the Dayton Peace Accord that ended the civil war in former Yugoslavia.

Milosz, Czeslaw (1911–) Polish poet and novelist, b. Lithuania. His novels, *The Valley of the Issa* (1955) and *The Usurpers* (1955), demonstrate an acute critical self-awareness. His celebrated volume of essays, *The Captive Mind* (1953), analyses the effects of communism on writers. His poetry is collected in *Selected Poems* (1973). He was awarded the 1980 Nobel Prize for literature.

Milstein, César (1927-) British molecular biologist and immunologist, b. Argentina. He shared the 1984 Nobel Prize for physiology or medicine for helping to develop antibodies that can be commercially produced for drugs and diagnostic tests. In 1975 he and the German immunochemist Georges Köhler developed a technique for cloning monoclonal antibodies (MABs) that combat diseases by targeting their sites. Milton, John (1608-74) English poet. Milton first major pieces are the masque Comus (1634), and the pastoral elergy Lycidas (1637). He was committed to reform of the Church of England, and his pamphlet Of Reformation in England (1641) attacked episcopacy. Milton was the champion of the revolutionary forces in the English CIVIL WAR (1642-51). His Areopagitica (1644) is a classic argument for freedom of the press. Milton's defence of regicides in The Tenure of Kings and Magistrates (1649) earned him a position in CROMWELL's Commonwealth government. Blind from 1652, Milton was forced into hiding immediately after the RESTORATION (1660).

▲ millipede The pill millipede (Glomeris marginata) have the peculiar ability to roll up when disturbed tucking their heads in. The shell-like cuticle covering the segments of a millipede's body provides excellent protection against prying predators.

▲ mimosa Native to tropical and subtropical regions of Brazil, the leaves of the mimosa (*Mimosa pudica*) are sensitive. The plant will shrink when touched.

Paradise Lost, perhaps the greatest epic poem in English, was first published in 10 books (1667). In 1674 he produced a revised edition in 12 books. Written in blank-verse, it relates the theological stories of Satan's rebellion against God, and Adam and Eve in the Garden of Eden. Its sequel, Paradise Regained (1671), was published in four books, and describes Christ's temptation. Milton's poetic drama Samson Agonistes (1671) became the libretto of Handel's oratorio.

Milwaukee City and port of entry on the w shore of Lake Michigan, SE Wisconsin, USA. It was founded in 1836, and during the second half of the 19th century received many German settlers. Industries: brewing, diesel and petrol engines, construction, electrical equipment. Pop. (1990) 628,088.

mime In drama, the communication of mood, story and idea through the use of gestures, movements and facial expressions, with no verbal interaction. It derives from Greek and Roman theatrical traditions. Modern mime artists include Jean-Louis Barrault and Marcel Marceau.

mimosa Genus of plants, shrubs and small trees native to tropical North and South America. They have showy, feather-like leaves and heads or spikes of white, pink or yellow flowers. Family Mimosaceae.

mina (myna or mynah) Any of several species of tropical birds of SE Asia, s Africa, Australasia and the Pacific Islands; it is related to the STARLING. A natural mimic, especially the species *Gracula religiosa*, it imitates other birds. It feeds mainly on fruit. Length: to 33 cm (13in). Family Sturnidae.

minaret Tower of a MOSQUE from which the MUEZZIN calls a Muslim to prayer. A mosque may have several minarets, and they vary enormously in shape and height. The earliest minarets (*c*.673) were built in Egypt as low square towers; later Persian developments included covered balconies and tiling.

mind Hypothetical faculty postulated to account for the ability of conscious beings to think, feel, will or behave. The mind is considered to control, or consist of, so-called mental processes. Dualist philosophers, such as René Descartes, have distinguished between mind and matter as two totally independent entities. IDEALISM suggests that the world is a product of the mind and dependent on experience. Materialism begins with a concept of a material world independent of experience; the mind is not separate from the physical but derives from it.

Mindanao Second-largest island of the Philippines, in the s of the archipelago; Davao is the major port and city. The island is forested and mountainous, rising to the active volcano of Mount Apo, at 2,954m (9,690ft), the highest peak in the Philippines. The jagged coastline features deep bays and islets. There are numerous inland waterways and lakes. Islam arrived in the 14th century, and the disparate Muslim groups united to resist intervention by foreign countries, such as Spain in the 16th century, and the USA in the 20th century. In the 1960s the central government encouraged Philippine colonization of Mindanao, and the dispossessed Moros sought secession from the Philippines. In 1969 the national army began a military campaign that resulted in thousands of deaths. The economy is primarily agricultural. Tin mining takes place around Mindanas. Area: 94,631sq km (36,537sq mi). Pop. (1990) 14,297,000.

mine Excavation from which minerals (mainly coal and metal ores) are extracted. Underground mines are of two main types: shaft mines and drift mines. Shafts are sunk vertically in the Earth's crust until they reach the depth of the seams to be exploited, which are then reached by tunnels or galleries. Drift mines are generally shallower, the seams being reached by a drift, or gradually sloping shaft, which leads on to a gallery system. In opencast mining, the seams are near or on the surface and are exposed by giant dragline machines that dig away the topsoil; this is also called strip mining.

mine Concealed or buried explosive device detonated through contact with individuals or vehicles. Underwater mines are used either to protect or to blockade coastal areas. mineral Natural, homogeneous and, with a few exceptions, solid and crystalline material that form the Earth and make up its ROCKS. Most are formed through inorganic processes, and more than 3,000 minerals have been identified. They are classified on the basis of chemical make-up, crystal structure and physical properties such as hardness, specific gravity, cleavage,

colour and lustre. Some minerals are economically important as ORES from which metals are extracted. *See* individual articles **mineralogy** Investigation of naturally occurring inorganic substances found on Earth and elsewhere in the Solar System. *See* GEOCHEMISTRY; MINERAL; PETROLOGY

Minerva Roman goddess of the arts, professions and handicrafts, whose cult is believed to have originated in Etruria. She was identified with the Greek goddess ATHENA, and so became goddess of wisdom and later of war.

Ming Imperial Chinese dynasty (1368–1644). It was founded by a Buddhist monk and peasant leader, Chu Yüan-chang (r.1328–98), who expelled the Mongol YūAN dynasty and unified China by 1382. Under the despotic rule of the early Ming emperors, China experienced a period of great artistic and intellectual distinction and economic expansion. Decline began in the late 16th century, and in 1644 a rebel leader took Beijing. A Ming general summoned aid from the QING, who overthrew the dynasty and established their own.

Mingus, Charles (1922–79) US jazz bass player, composer and bandleader. His large-scale compositions and use of overdubbing inspired a generation of modern jazz musicians. *The Black Saint and the Sinner Lady* (1963) is his masterpiece.

miniature painting Term that originally meant the art of manuscript ILLUMINATION, but was later applied to very small paintings, usually portraits. In Europe, the earliest miniatures were produced in the late 15th century and executed in the same materials as illuminated manuscripts. During the 18th century, miniaturists usually painted in watercolour on ivory and sometimes worked in oils on metal. After the mid-19th century, the art of miniature painting declined in the West because of competition from PHOTOGRAPHY, but the tradition remained strong in several Islamic countries and in India.

minimal access surgery Term used to encompass operations that do not involve cutting open the body in the traditional way. Minimal access (keyhole) procedures are performed either by means of an ENDOSCOPE, or by passing miniature instruments through a fine catheter into a large blood vessel. The surgical LASER is also used.

minimal art Movement in 20th-century painting and sculpture that used only the most fundamental geometric forms. It originated in the 1950s as a reaction against the chaotic emotions provoked by ABSTRACT EXPRESSIONISM.

minimalism Trend in musical composition, beginning in the 1960s, in which short melodic or rhythmic fragments are repeated in gradually shifting patterns, usually in a simple harmonic context. Many minimalist composers, such as Steve REICH and Philip GLASS, were influenced by the repetitive patterns of Indian and other non-Western music.

mink Small, semi-aquatic mammal of the WEASEL family, with soft, durable, water-repellent hair of high commercial value. They have slender bodies, short legs, and bushy tails. Wild mink have dark brown fur with long black outer hair. Ranch mink have been bred to produce fur of various colours. They eat fish, rodents and birds. Escaped ranch mink can be a serious threat to indigenous wildlife. Length to: 73cm (29in) including the tail; weight: 1.6kg (3.5lb). Family Mustelidae.

Minneapolis City and port on the Mississippi River, next to SAINT PAUL, SE Minnesota, USA; the largest city in Minnesota. First settled in the 1840s, it developed timber and flour milling industries and is now an important processing and distribution centre for grain and cattle. Industries: farm machinery, food processing, electronic equipment, computers, printing and publishing. Pop. (1990) 368,383.

minnesingers Medieval German poets or singers of courtly love (or *minne*), similar in style to the Provençal TROUBADOURS whom they originally copied. An individual German style developed in the 14th century, and several of the poems are considered among the best of Middle High German lyric verse. Minnesota State in N central USA, on the Canadian border; the capital is ST PAUL. Other major cities include MINNEAPOLIS and Duluth. French fur traders arrived in the 17th century. The area E of the Mississippi passed to Britain after the SEVEN YEARS WAR, then to the USA after the AMERICAN REVOLUTION. The lands w of the Mississippi were acquired from France in the LOUISIANA PURCHASE (1803). Minnesota was organized as

MINNESOTA Statehood:

Statehood: 11 May 1858

Nickname : Gopher State

State bird : Common loon

State flower:

Pink and white ladyslipper

State tree :

Norway pine State motto:

Star of the North

a territory in 1849, acquiring statehood in 1858. Europeans settled the area during the 1880s. The terrain varies from the prairies of the s to the forests of the N. There are mountains in the E. The state is drained chiefly by the Minnesota, St Croix, and Mississippi rivers. Wheat and maize are the major crops, and many farms raise dairy cattle. There are rich deposits of iron ore in the Mesabi Range in the E. Since the 1950s manufacturing has replaced agriculture as the main economic activity. Industries: food processing, electronic equipment, machinery, paper products, chemicals, printing and publishing. Area: 206,207sq km (79,617sq mi). Pop. (1990) 4,375,099.

minnow Subfamily of freshwater fish found in temperate and tropical regions. It includes shiners, dace, chub, tench and bream. More specifically, the term includes small fish of the genera *Phoxinus* and *Leuciscus*. Length: 4–46cm (1.5–18in). Family Cyprinidae.

Minoan civilization Ancient Aegean civilization that flourished $c.3000-c.1100~{\rm BC}$ on the island of Crete, named after the legendary King Minos. The Minoan period is divided into three eras: **Early** $(c.3000-c.2100~{\rm BC})$, **Middle** $(c.2100-c.1550~{\rm BC})$, and **Late** $(c.1550-c.1100~{\rm BC})$. In terms of artistic achievement, and perhaps power, Minoan civilization reached its height in the Late period. The prosperity of Bronze Age Crete is evident from the works of art and palaces excavated at Knossos, Phaistos and other sites. Its empire was based on trade and seafaring.

minor In English law, a person under 18 years of age. Minors cannot vote at elections, nor hold freehold or leasehold property, nor be made bankrupt. They cannot make a valid will nor a valid marriage without the consent of their parents or guardian. In the USA, the age of majority varies from state to state, but is 18 for voting purposes throughout the country.

Minos In Greek mythology, the son of Europa and Zeus, king of Crete. He was consigned at his death to HADES to judge human souls. He angered POSEIDON who, in revenge, caused his wife, Pasiphaë, to give birth to the monstrous MINOTAUR.

Minotaur In Greek mythology, beast with the head of a bull and the body of a man, the issue of Pasiphaë, wife of Minos, and a bull. He was confined by Minos in the LABYRINTH built by DAEDALUS. The Minotaur was killed by THESEUS.

Minsk Capital of Belarus, on the River Svisloc. Founded c.1060, it was under Lithuanian and Polish rule before becoming part of Russia in 1793. During World War 2 the city's large Jewish population was exterminated by the occupying Germans. In 1991 it became the capital of the newly independent Belarus. Industries: textiles, machinery, motor vehicles, electronic goods. Pop. (1991) 1,633,600.

minstrel Itinerant musician and professional entertainer; more specifically, a secular musician, usually an instrumentalist. Minstrels were popular from the 12th to 17th centuries, and some were attached to courts. In the 14th and 15th centuries, their social importance was reflected in the number of minstrel guilds that were formed throughout Europe.

mint In botany, any species of aromatic herbs, with a characteristic flavour, of the genus *Mentha*. It is commonly used as a flavouring in cooking, confectionery and medicines. Most species have oval leaves and spikes of purple or pink flowers. Family Lamiaceae/Labiatae. *See also* PEPPERMINT

minuet French dance fashionable at the court of Louis XIV from 1650. Graceful and precise, it is danced by couples and played in triple time. It became popular as a dance in the 18th century and was a familiar movement in the SUITES of composers such as HANDEL and MOZART.

minutemen Local militia units in the AMERICAN REVOLUTION. The first such units were formed in Massachusetts in 1774, and minutemen took part in the opening battles of LEXINGTON AND CONCORD in 1775. The name was adopted by certain extreme right-wing groups in the USA in the 1960s, and was given to a class of ballistic missiles.

Miocene Geological epoch beginning about 25 million and ending about 5 million years ago. It falls in the middle of the TERTIARY period and is marked by an increase in grasslands over the globe at the expense of forests, and the development of most of the modern mammal groups.

Mirabeau, Honoré (1749-91) French revolutionary. One

of the most capable early leaders of the FRENCH REVOLUTION, he was instrumental in establishing the National Assembly and became its leader. His goal was a parliamentary monarchy, but his plans were frustrated by the obstinacy of the king on the one hand and the assembly on the other.

miracle Event or occurrence that is contrary to the laws of nature and is assumed to be the result of supernatural or divine intervention. Most religions include a belief in miracles. The mythologies of ancient India, the Middle East, Greece and Rome abound with amazing wonders brought about by the gods, but in both Christianity and Judaism, a human agent is generally involved.

miracle play See MYSTERY PLAY

mirage Type of optical illusion sometimes seen near the Earth's surface when light is refracted (bent) as it passes between cool dense air to warmer, less dense air. Mirages are most commonly seen shimmering on hot, dry roads; the shimmer is a refracted image of the sky.

Miró, Joan (1893–1983) Spanish painter and graphic artist, one of the most versatile and original of 20th-century artists. Early works reveal experimentation with FAUVISM, CUBISM and DADA. Miró's Catalan Landscape (1923) heralds his more mature phase and a close affinity with ABSTRACT ART and PRIMITIVISM. In 1924 he became a member of the SURRE-ALISM movement. His work is often playful, but the Spanish Civil War provoked him into creating darker, more savage images. He also worked with murals, ceramics, stained glass and explored the techniques of etching and lithography.

miscarriage Popular term for a spontaneous ABORTION, the loss of a FETUS from the UTERUS before it is sufficiently developed to survive.

misdemeanour Criminal offence that is too slight to be considered a FELONY. In the USA, misdemeanors incur such punishments on conviction as fines, community service or short custodial sentences in local jails. In Britain and elsewhere in the English-speaking world, the difference between misdemeanours and felonies is a historical technicality only.

Mishima, Yukio (1925–70) Japanese novelist. Mishima's early novel, *Confessions of a Mask* (1949), is a semi-autobiographical study of homosexuality. His final work, the four-volume *The Sea of Fertility* (1965), is an modern Japanese epic. He committed ritual suicide at Tokyo's military head-quarters, which he had occupied with a small private army.

Mishna Collection of Jewish legal traditions and moral precepts that form the basis of the TALMUD. The Mishna was compiled (*c*.AD 200) under Rabbi Judah ha-Nasi. It is divided into six parts: laws pertaining to agriculture; laws concerning the sabbath, fasts, and festivals; family laws; civil and criminal laws; laws regarding sacrifices; and laws concerning ceremonial regulations.

missile Unmanned and self-propelled flying weapon. Ballistic missiles travel in the outer atmosphere and can be powered only by rockets. Cruise missiles travel in the lower atmosphere and can be powered by jet engines. GUIDED MISSILES carry self-contained guidance systems or can be controlled by radio from the ground.

Missionary Societies Organizations for the promotion of Christianity among non-Christians. The first such society was established in New England in 1649. In the 18th century, both the Baptists and Methodists established societies and the 19th century saw the emergence of interdenominational and geographically specialized societies. The International Missionary Council was formed in 1921. Today, governments or agencies, such as Christian Aid, have taken over much of the Missionary Societies' educational and medical work, and local ministries have been encouraged to further their religious and social aims. Mississippi State in s central USA, on the Gulf of Mexico; the capital and largest city is JACKSON. Other major cities are Meridian, Biloxi, Vicksburg and Laurel. The French claimed the region in 1682, but it passed to Britain after the SEVEN YEARS WAR. The Territory of Mississippi was organized in 1798. The state seceded from the Union in 1861. It was a battleground during the American CIVIL WAR. Racial segregation remained in force until the 1960s when the state became a focus of the civil rights movement. The land slopes w from the

▲ minnow Found in freshwater habitats all over the world, the minnow (*Phoxinus* sp.) will swim in shoals to reduce the chance of individuals being preyed upon.

▲ mint Long used as a food flavouring, many species of mint (Mentha sp.) are known, and they show subtle differences in the aroma they discharge. Crosses between water mint (Mentha aquatica) and spearmint (Mentha spicata) are the basis of cultivated peppermint (Mentha x piperita), which is commercially grown on a wide scale in the USA, and used to flavour gums, toothpaste and a variety of drugs.

MISSISSIPPI Statehood:

10 December 1817

Nickname : Magnolia State

State bird :

Mockingbird State flower:

Magnolia State tree : Magnolia

State motto:
By valour and arms

MISSOURI Statehood :

10 August 1821

Nickname :

"Show me" State

State bird :

Eastern bluebird

State flower:

Hawthorn

State tree : Flowering dogwood

State motto:

The welfare of the people shall be the supreme law

hills of the NE to the Delta, a fertile plain between the Mississippi and Yazoo rivers. Pine forests cover most of the s of the state as far as the coastal plain. Primarily an agricultural state, Mississippi is the leading producer of cotton in the USA; hay and soya beans are also grown. Dairy farming is of great importance. There are valuable reserves of oil and natural gas. Other industries: clothing, wood products, chemicals. Area: 123,515sq km (47,689sq mi). Pop. (1990) 2,573,216.

Mississippi Principal river of the USA, second-longest national river (after the MISSOURI), c.3,780km (2,350mi) long. It rises in NW Minnesota, and flows SE (forming many state boundaries along its course), emptying into the Gulf of Mexico via its huge marshland delta in SE Louisiana. Its chief tributaries include the Missouri, Ohio, Arkansas and Tennessee rivers. A major transport route, it is connected to the GREAT LAKES and the ST LAWRENCE SEAWAY (N) and the Intracoastal Waterway (E). Major ports on the river include MINNEAPOLIS, ST LOUIS, MEMPHIS and NEW ORLEANS. In 1541 Hernando DE Soto became the first European to discover the river. In 1682 La Salle sailed down the Mississippi to the Gulf of Mexico and gained control of the region. In 1803 it was acquired by the USA as part of the LOUISIANA PURCHASE. The Mississippi was used as a major transport route by Union forces during the Civil War. Since the 1950s improvements have been made to the river's channels, enabling bulkier freight to be transported. Mississippi Period In the USA, name given to the earlier part of the CARBONIFEROUS period

Missouri Compromise Effort to end the dispute between slave and free states in the USA in 1820–21. Pushed through Congress by Henry CLAY, it permitted Missouri to join the union as a slave state at the same time as Maine was admitted as a free state, preserving an equal balance between slave and free.

Missouri State in central USA, w of the Mississippi River; the capital is JEFFERSON CITY. The largest cities are ST LOUIS, KANSAS CITY and SPRINGFIELD. The French were the first to settle the area in the mid-18th century. The USA acquired the

region as part of the LOUISIANA PURCHASE of 1803. The Missouri Territory was organized in 1812, and became a major corridor for westward migration. Missouri was admitted to the Union in 1821 without restrictions on slavery, but when the American CIVIL WAR began sympathies were bitterly divided and there was much violence. The state remained in the Union. Geographically it is divided into two parts: to the N of the Missouri River is prairie country, where farmers grow maize and raise livestock. South of the river are the foothills and plateaux of the Ozark Mountains. In the sw, is a small wheat-growing area and in the SE are the cotton fields of the Mississippi floodplain. The chief mineral resources are coal, lead, zinc and iron ore. Missouri's economy is based on manufacturing. Industries: transport equipment, food processing, chemicals, printing and publishing, fabricated metals, electrical machinery. Area: 178,446sq km (68,898sq mi). Pop. (1990) 5,117,073.

Missouri ("Big Muddy") Longest river of the USA at c.4,120km (2,560mi) long; the major tributary of the Missis-SIPPI. It rises at the confluence of the Jefferson, Madison and Gallatin rivers in the Rocky Mountains, Montana. It then flows E through Great Falls cataracts and Fort Peck reservoir. In North Dakota it turns SE across the Great Plains, passing through Sioux City, OMAHA and KANSAS CITY. It joins the Mississippi River 27km (17mi) N of St Louis, Missouri. Sioux City, Iowa, is the head of navigation. Seasonal fluctuation in flow is a major problem, and the Missouri has seven major dams along its route. Its major tributaries are the Yellowstone and Platte rivers. The river was used as a trade route by the Native Americans for centuries before its discovery by the French explorers Marquette and Jolliet in 1683. Mapped by the Lewis and Clark Expedition (1804-06), the river was used by traders, gold seekers and pioneers as a route to the NW. mistletoe Any of numerous species of evergreen plants that are semi-parasitic on tree branches. It has small, spatulashaped, yellowish-green leaves and generally forms a large dense ball of foliage. The mistletoe taps into the branch of its host to sap its food supply, avoiding the necessity of growing

Mobile phone networks use a system of cells (1). By having a transmitter (2) in each cell, the same frequencies can be used in each cell allowing an enormous capacity for calls. Where there are many users, such as the heart of a city (3), the cells are much smaller - further multiplying the number of frequencies available. A digital

mobile phone (4) sends digital information (5) to a transmitter tower (6). Digital phones are better than analogue versions because they reduce background noise and interference, and are more difficult to bug. The transmitter passes the message to the systems' central exchange (7). If the call is for another mobile phone, the exchange

sends a message (8) to the other transmitters, which in turn send out a message to locate the receiving phone. The transmitter locating the required phone (9) sends a confirmation message to the exchange (10), which then connects the conversation (11 - dotted line). When a phone moves out of range of a transmitter (12) a complicated

procedure ensures the conversation can continue seamlessly. When the phone's signal to the transmitter becomes weaker the exchange sends a message (13) to the transmitters in the surrounding cells to see which is receiving the strongest signal. It then transfers the conversation to that transmitter (14 - dotted line).

roots itself. It also carries out photosynthesis, so is not entirely parasitic. Families: Loranthaceae and Viscaceae.

mistral Wind prevalent in the NW Mediterranean during the winter. It sweeps from the MASSIF CENTRAL, down the Rhône valley, reaching the Rhône delta as a strong, dry wind.

mite Minute ARACHNID found worldwide, many as parasites on plants and animals. The adult has four pairs of legs with claws at the tip, and a fused head and abdomen. Length: 0.5–3mm (0.02–0.1in). Class Arachnida; order Acarina. *See also* CHIGGER; TICK

Mitford Name of six British sisters, the daughters of Lord and Lady Redesdale (family name Mitford). The most famous, Nancy Freeman Mitford (1904–73), was a novelist and biographer. Her first successful novel was *The Pursuit of Love* (1945), which was followed by *Love in a Cold Climate* (1949) and *The Blessing* (1951). Her sister Jessica Mitford (1917–96) also wrote, protesting about snobbery, in *The American Way of Death* (1963) and *Kind and Usual Punishment* (1973). The other two notable sisters, Unity Valkyrie (1914–48) and Diana (1910–96), turned to fascism, the former travelling to Germany and becoming a disciple of Adolf Hitler, and the latter marrying Sir Oswald Mosley.

Mithridates VI (132–63 BC). King of Pontus (120–63 BC). He attempted to extend his rule southwards but was repeatedly defeated by the Romans. He was overwhelmed by the forces of SULLA in the war of 88–85 BC and lost his kingdom in a second campaign in 83–82. He reconquered it in 74 but was defeated by POMPEY in 66 and fled to the Bosporus. He was planning an invasion of Italy when his troops mutinied, and he committed suicide.

mitochondrion Structure (organelle) inside a CELL containing ENZYMES necessary for energy production. Mitochondria are found in the cytoplasm of most types of cell (but not in bacteria). *See also* RESPIRATION

mitosis Nuclear division of a CELL resulting in two genetically identical "daughter" cells with the same number of chromosomes as the parent cell. Mitosis is the normal process of TISSUE growth, and is also involved in ASEXUAL REPRODUCTION. See also MEIOSIS

Mitra (Mithra or Mithras) God who in different forms was worshipped in India, Persia and then the Roman empire, and whose cult was the basis of Mithraism. In Vedic mythology, Mitra was the spirit of the day, of the rain and of the sun, linked closely with VARUNA. The Persian Mitra was a popular deity of the ACHAEMENID empire, revered as the god of light and power. Mitterrand, François Maurice Marie (1916–96) French statesman, president (1981-96). Mitterand was active in the French Resistance during World War 2, and served in the government of the Fourth Republic. In 1965 he united the parties of the left, and narrowly lost the presidential election in 1974. Mitterand defeated the incumbent president GISCARD D'Es-TAING in 1981, and was re-elected in 1988. He introduced reforms, including the abolition of CAPITAL PUNISHMENT, and favoured state intervention in economic management. In the 1980s Mitterand gradually changed course. Nationalization ceased and some state-owned industries returned to private hands. He was forced further to the right after 1986, when he had to cooperate with the Gaullist prime minister Jacques CHIRAC. Mitterrand was a strong supporter of the European Union and of close Franco-German relations.

mixture In chemistry, two or more substances that retain their specific identities when mixed (such as air containing oxygen, nitrogen and other gases). The identities remain separate no matter in what proportion or how closely the components are mixed. *See also* COMPOUND; SOLUTION

Mladić, Ratko (1943–) Bosnian Serb general. Mladić came to international attention in 1992, after war broke out in Bosnia-Herzegovina. As the aggressive commander of the Bosnian Serb army, he earned the sobriquet "Butcher of the Balkans" and was formally indicted in 1996 as a war criminal. mobile telephone Portable radio that connects users to the public TELEPHONE system. They are also called cellular phones, because they operate within a network of radio cells. The first generation operated with analogue signals, the second generation with digital signals.

Mobutu Sese Seko (1930–97) Zairean political leader, b. Joseph-Désiré Mobutu. Mobutu was defence minister under Patrice LUMUMBA. With the support of the army, he deposed Lumumba in 1960. In 1965 he led a coup against Joseph Kasavubu, becoming prime minister in 1966, and president in 1967. His calls for Africanization and nationalization of industries were largely publicity stunts. The stark reality of his autocratic rule was a state founded on corruption. Mobutu amassed a huge personal fortune, while Zaireans became increasingly impoverished. With the support of the CIA and the criminal activites of his security forces. Mobutu maintained a dictatorship for over 30 years. In May 1997 he was deposed by a Tutsi-dominated revolt, led by Laurent Kabila, and forced into exile. He died three months later in Morocco. mockingbird Any of a group of New World birds, known for imitating other birds. The common mockingbird (Mimus polyglottos) of the USA is typical; it is c.27cm (11in) long, ashy above with brownish wings and tail marked with white. Family Mimidae.

mock orange (Philadelphus or sweet syringa) Ornamental deciduous shrub native to the Western Hemisphere and Asia. It has solitary, white or yellowish, fragrant flowers. Family Hydrangeaceae; genus *Philadelphus*.

mode Classified scheme developed during the 4th to 16th centuries AD to systematize music. From the scale worked out scientifically by PYTHAGORAS, St Ambrose is thought to have devised (4th century) four "authentic" modes: Dorian, Phrygian, Lydian and Mixolydian. All the modes comprised eight notes within the compass of an octave. Pope Gregory (6th century) added four "plagal" modes, which were essentially new forms of the Ambrosian modes (Hypodorian, Hypophrygian etc.). Glareanus (16th century) added the Aeolian and Ionian modes, the basis of the minor and major diatonic scales respectively. See also HARMONY

mode In statistics, a measure of central tendency. It is computed by determining the item that occurs most frequently in a data set. It is a quick measure of central tendency, but is not as commonly used as the MEDIAN OF MEAN.

Model Parliament English parliament summoned by EDWARD I in 1295. For the first time, knights of the shire and burgesses (representatives of the Commons) dealt with the affairs of the nation with the king and magnates. This enlargement of the Commons' function was held to be the model for the future. They had previously merely agreed to what the king and the magnates had already decided.

modem (modulator-demodulator) Electronic device for sending and receiving COMPUTER signals through a telephone

▶ Modigliani Girl with Pigtails (1901) The Italian painter and sculptor Modigliani spent most of his life in Paris, but his studies of Renaissance masters in Italy had a strong influence on his work. Influenced by Brancusi, Modigliani's achievements may have been limited, but his legendary bohemian lifestyle, passion for work, and his tragic early death from tuberculosis have ensured him a lasting reputation.

system. The electrical pulses produced by a computer are fed into a modem, which uses the pulses to modulate a continuous tone (carrier) by a process called FREQUENCY MODULATION (FM). At the other end, another modem extracts the pulses (demodulation), so that they can be fed into a receiving computer. See also COMPUTER NETWORK; INTERNET

modern dance Dance style that began to develop during the late 19th century as a protest against classical BALLET. It is often said to have been pioneered by Isadora DUNCAN. In Europe and the USA, such innovators as Rudolph von Laban, Ruth St. Denis and Ted Shawn attempted to make dance a viable contemporary art form.

modernism 20th-century movement in art, architecture, design and literature that, in general, concentrates on space and form, rather than content or ornamentation. In architecture and design, early influences were BAUHAUS (1919-33) and individuals such as Walter Gropius and Mies van Der ROHE. Modernist architects developed the use of new building materials, such as glass, steel and concrete. While difficult to define and date precisely, the echoes of literary modernism can still be heard in late-20th-century fiction. The most recognizably distinct form is the STREAM OF CONSCIOUS-NESS narrative, as evidenced in the work of Virginia WOOLF and James JOYCE's seminal novel, Ulysses (1922). The outstanding example of modernist poetry is the fragmentary The Wasteland (1922) by T.S. ELIOT. Literary modernism exhibits an increasing concern with psychological states and the subconscious. Artists such as PICASSO and Marcel DUCHAMP adopted new techniques of representation and worked in previously unexploited media. The movements of DADA and SURREALISM were vital to this new experimentation. In music, composers such as STRAVINSKY challenged previously held notions of tonality. See also POST-MODERNISM

Modigliani, Amedeo (1884–1920) Italian painter, sculptor and draughtsman. Many of his sculptures portray elongated heads, inspired by the primitive strength of African masks and caryatids. During World War 1 he returned to painting, focusing mainly on erotic female nudes and portraits.

modulation In physics, the process of varying the characteristics of one wave system in accordance with those of another. It is basic to RADIO broadcasting. In AMPLITUDE MODULATION (AM), the amplitude of a high-frequency radio carrier wave is varied in accordance with the frequency of a current generated by a sound wave. For static-free, short-range broadcasting FREQUENCY MODULATION (FM) is used, in which the frequency of the carrier wave is modulated.

Mogadishu Capital and chief port of Somalia, on the Indian Ocean. Mogadishu was founded by Arabs in the 10th century. In the 16th century it was captured by the Portuguese and became a cornerstone of their trade with Africa. In 1871 control passed to the sultan of Zanzibar, who first leased (1892) and then sold (1905) the port to the Italians. Mogadishu was made the capital of Italian Somaliland. During World War 2 the city was occupied by the British from 1941. In 1960 Mogadishu became the capital of independent Somalia. During the 1980s and early 1990s, the city was devastated by civil war, its population swollen by refugees escaping famine and drought in the outlying regions. In 1992 UN troops were flown into Mogadishu to control aid distribution but withdrew in 1995 after little success. Pop. (1990 est.) 1,200,000.

Mogul empire (1526–1857) Muslim empire in India. It was founded by BABUR, who conquered Delhi and Agra (1526). The Mogul empire reached its height under AKBAR I (THE GREAT) (r.1556–1605), Babur's grandson, when it extended from Afghanistan to the Bay of Bengal and as far s as the Deccan. Religious tolerance encouraged by Akbar was reduced under his successors, Janhangir (r.1605–27), SHAH JAHAN (1627–58) and AURANGZEB (1658–1707). Mogul art and architecture reached a peak under Shah Jahan, builder of the TAJ MAHAL. By the death of Aurangzeb, the Mogul dynasty was in decline. The last Mogul emperor was deposed by the British in 1858 after the rising known as the Indian Mutiny.

Mohammed Alternative spelling of MUHAMMAD

Mohawk Iroquoian-speaking Native North American tribe of the Iroquois confederacy, formerly inhabiting central New York State. Today, there are *c.*2,000 Mohawks. Most are farmers on two reservations in Ontario, Canada.

Mohican (Mahican) Algonquian-speaking tribe of Native North Americans, formerly inhabiting the upper Hudson valley in New York, and the area E of the Housatonic River in Connecticut, USA. They once numbered about 3,000. Today the surviving 525 Mohicans occupy the Stockbridge-Munsee Reservation in Wisconsin.

Moho (Mohorovičič discontinuity) Boundary between the

MOLDOVA

AREA: 33,700 sq km (13,010

sq mi)
POPULATION: 4,458,000
CAPITAL (POPULATION):
Chisinau (700,000)
GOVERNMENT: Multiparty
republic
ETHNIC GROUPS: Moldovan
65%, Ukrainian 14%,
Russian 13%, Gagauz 4%,
Jewish 2%, Bulgarian
LANGUAGES: Moldovan
(Romanian) (official)
RELIGIONS: Christianity
(Eastern Orthodox)
CURRENCY: Leu

Earth's CRUST and MANTLE. It is identified by a sharp increase in the velocity of seismic waves passing through the Earth, and is named after the Croatian geophysicist Andrija Mohorovičič, who first recognised it in 1909. The velocity increase is explained by a change to more dense rocks in the mantle. The depth of the Moho varies from $c.5 \mathrm{km}$ (3mi) to $60 \mathrm{km}$ (37mi) below the Earth's surface.

Moholy-Nagy, László (1895–1946) Hungarian designer, painter and sculptor. He was one of the most influential founders of CONSTRUCTIVISM. He taught at the BAUHAUS (1923–28), before working in Berlin as a stage designer and film-maker. He then moved to Paris, Amsterdam and London. In 1937 he emigrated to the USA and became director of the short-lived New Bauhaus.

Moi, Daniel (Torotich) Arap (1924—) Kenyan statesman, president (1978—). He was the British-appointed representative to the Kenya Legislative Council from 1958 until independence (1964). He was elected president in 1978, succeeding Jomo Kenyatta. He maintained Kenyatta's liberal economic policies but came under increasing international criticism for his repressive rule. He was re-elected in 1992 and 1997.

Mojave Desert Arid region with low, barren mountains in S California, USA, surrounded by mountain ranges on the N and W, and the Colorado Desert on the SE. It was formed by volcanic eruptions and deposits from the Colorado River. Area: c.38,850sq km (15,000sq mi).

Moldavia Historic Balkan region, between the CARPATHIAN MOUNTAINS in Romania and the DNIEPER River in MOLDOVA. Major cities in the Romanian portion include Galat and Suceava. Moldavia is primarily an agricultural region. Under Roman rule it formed the major part of the province of DACIA and today's population is Romanian-speaking. In the 14th century it became an independent principality ruled by the Vlachs; its lands included Bessarabia and Bukovina. In 1504 Moldavia was conquered by the Turks and remained part of the Ottoman empire until the 19th century. In 1775 Bukovina was lost to the Austrians, and in 1815 Bessarabia was taken by Russia. After the Russo-Turkish War (1828-29) Russia became the dominant power. In 1856 the twin principalities of Moldavia and WALLACHIA were given considerable autonomy. Three years later they were united under one crown to form Romania, but Russia re-occupied s Bessarabia in 1878. In 1920 Bessarabia and Bukovina were incorporated into the Romanian state. In 1924 the Soviet republic of Moldavia was formed, which in 1947 was enlarged to include Bessarabia and N Bukovina. In 1989 the Moldovans asserted their independence by making Romanian the official language, and in 1991, following the dissolution of the Soviet Union, Moldavia became the independent republic of Moldova.

Moldova Republic in E Europe; the capital is CHISINAU. Land and climate Moldova is a mostly hilly country. A large plain covers the s. The main river is the Dniester, which flows through E Moldova. The climate is moderately continental, with warm summers and fairly cold winters, when temperatures dip below freezing. Most rainfall occurs during the warmer months. Forests of hornbeam and oak grow in N and central Moldova. The drier s is a farming region, with rich pasture along the rivers. Economy Moldova is a lower-middle-income developing economy (1992 GDP per capita, US\$3,670). Agriculture is important and major products include fruits, grapes for wine-making, maize, sugar beet, sunflower seeds, tobacco, vegetables and wheat. Farmers also raise livestock, including dairy cattle and pigs. Moldova has no major natural resources, and has to import materials and fuels for its industries. Major manufactures include agricultural machinery and consumer appliances. Leading exports include food, wine, tobacco, textiles and footwear. History In the 14th century, the Moldovans formed the state of Moldavia (for history pre-1991, see MOLDAVIA). Following independence in 1991, the majority Moldovan population wished to rejoin Romania, but this alienated the Ukrainian and Russian populations E of the Dniester, who declared their independence from Moldova as the Transdniester republic. War raged between the two, with Transdniester supported by the Russian 14th Army. A cease-fire was declared in August 1992. The former communists of the Agrarian Democratic Party won the 1994 multiparty elections, and a referendum rejected reunification with Romania. Parliament voted to join the Commonwealth of Independent States (CIS). **Politics** Under the new 1994 constitution Moldova is a presidential parliamentary republic. In 1995 President Snegur resigned from the Agrarian Democratic Party and, despite promises of greater autonomy, Transdniester voted in favour of independence in a referendum. Russian troops began to withdraw in 1996.

molecular biology Biological study of the make-up and function of molecules found in living organisms. Major areas of study include the chemical and physical properties of proteins and of nucleic acids such as DNA. See also BIOCHEMISTRY molecule Smallest particle of a substance (such as a compound) that exhibits the properties of that substance. Molecules consist of two or more atoms held together by chemical bonds. For example, water molecules consist of two atoms of hydrogen bonded to one atom of oxygen (H₂O). A molecule (unlike an ION) has no electrical charge. See also MACROMOLECULE

mole (symbol mol) SI unit of amount of substance. This is the amount of substance that contains as many elementary units, such as atoms and molecules, as there are atoms in 0.012kg of carbon-12. A mass of one mole of a compound is its relative molecular mass (molecular weight) in grams.

mole Any of several species of small, burrowing, mainly insectivorous mammals that live in various habitats worldwide. The European mole, *Talpa europaea*, has short brown or black fur, a short tail and wide clawed forefeet for digging tunnels. Its eyes are sensitive only to bright light. Length: to 18cm (7in). Family Talpidae.

Molière (1622–73) French playwright, b. Jean-Baptiste Poquelin. An accurate observer of contemporary modern manners, Moli is regarded as the founder of modern French comedy. His best-known comedies include *Tartuffe* (1661), *The Misanthrope* (1667) and *The Miser* (1669). His work found favour with Louis XIV but was unpopular with church leaders. His last play was *The Imaginary Invalid*, during a performance of which he collapsed and died.

molluse Any of more than 80,000 species of invertebrate animals in the phylum Mollusca. They include the SNAILS,

Molecules are groups of bonded atoms. They can be groups of the same atoms as in oxygen (0_2) or combinations of different elements, such as water (H_20) and benzene (C_6H_6) . Molecules can be illustrated in four ways. Line one (A), the chemical formula, lists the type and number of atoms in a molecule but does not show their structure. Line two (B) is

the closest representation of the actual shape of the molecule but does not detail the bonds between the atoms. Line three (C) is less realistic but does show the bonding. Line four (D) combines the chemical formula, using the abbreviations of the periodic table, and symbolic representation of the bonding structure.

▲ mole Grant's desert mole (Eremitalpa granti) is found in South Africa. It is a golden mole, and although it resembles true moles, it is not closely related.

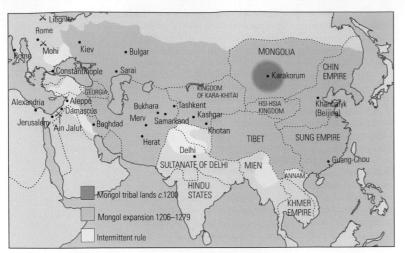

▲ Mongol In 1206, under the leadership of Genghis Khan, the Mongols extended the territory under their rule, until by 1279 it stretched from the Black Sea to the Pacific Ocean.

CLAMS and SQUIDS, and a host of less well-known forms. Originally marine, members of the group are now found in the oceans, in freshwater and on land. There are six classes: the GASTROPODS, CHITONS, univalves (SLUGS and snails), BIVALVES, tusk shells and CEPHALOPODA. The mollusc body is divided into three: the head, the foot and the visceral mass. Associated with the body is a fold of skin (the mantle) that secretes the limy shell typical of most molluses. The head is well developed only in snails and in the cephalopods. The visceral mass contains the internal organs. The sexes are usually separate but there are many hermaphroditic species.

Molotov, Vyacheslav Mikhailovich (1890–1986) Soviet statesman, premier (1930–41) and foreign minister (1939–49, 1953–56). A loyal ally of STALIN, Molotov became a full member of the Politburo in 1926. As foreign minister, one of his first acts was to sign the Nazi-Soviet Pact (1939). He lost favour under KHRUSHCHEV, was demoted and expelled from the Communist Party in 1962. He was readmitted in 1984.

Moluccas (Maluku) Island group and province in E Indonesia, between Sulawesi (w) and New Guinea (E); the capital is Ambon. The fabled Spice Islands were originally explored by Magellan in the early 16th century, and later settled by the Portuguese. The Dutch took the islands in the 17th century and monopolized the spice trade. After Indonesian independence, the s Moluccas became the focus of a movement for secession. The group includes the larger islands of Halmahera, Ceram, and Buru, and the island groups of Sula, Batjan, Obi, Kai, Aru, Tanimbar, Banda, Babar and Leti. Products: spices, copra, timber, sago. Area: 74,505sq km (28,759sq mi). Pop. (1990) 1,857,790.

(28,759sq mi). Pop. (1990) 1,857,790.

MONGOLIA

100°E

R
100°E

Lake Baikat

AREA: 1,566,500sq km (604,826sq mi) POPULATION: 2,130,000 CAPITAL (POPULATION): Ulan Bator (601,000)

GOVERNMENT: Multiparty republic ETHNIC GROUPS: Khalkha Mongol 79%, Kazakh 6% LANGUAGES: Khalkha Mongolian (official) RELIGIONS: Tibetan Buddhism was once the main religion; reliable recent information is unavailable CURRENCY: Tugrik = 100 möngö

molybdenum (symbol Mo) Silvery-white metallic element; one of the TRANSITION ELEMENTS. It was first isolated in 1782. Its chief ore is molybdenite. Hard but malleable and ductile, it is used in alloy steels, x-ray tubes and missile parts; molybdenum compounds are used as catalysts and lubricants. It is one of the essential TRACE ELEMENTS for plant growth. Properties: at.no. 42; r.a.m. 95.94; r.d. 10.22; m.p. 2,610°C (4,730°F); b.p. 5,560°C (10,040°F); most stable isotope Mo⁹⁸ (23,78%).

Mombasa City and seaport on the Indian Ocean, sw Kenya, partly on Mombasa Island and partly on the mainland (to which it is connected by causeway). From the 11th–16th centuries Mombasa was a centre of the Arab slave and ivory trades. From 1529 to 1648 it was held by the Portuguese. Taken by Zanzibar in the mid-19th century, the city passed to Britain in 1887, when it was made capital of the British East Africa Protectorate. Kenya's chief port, Mombasa exports coffee, fruit and grain. Industries: tourism, food processing, glass, oil refining, aluminium products. Pop. (1989) 465,000. moment of force See TOROUE

moment of inertia For a rotating object, the sum of the products formed by multiplying the point masses of the rotating object by the squares of their distances from the axis of the rotation.

momentum Product of the mass and linear velocity of an object. One of the fundamental laws of physics is the principle that the total momentum of any system of objects is conserved at all times, even during and after collisions.

Monaco Principality in s Europe, on the Mediterranean coast, forming an enclave in French territory near the border with Italy; the capital is Monaco-Ville. Ruled by the Grimal-di family from the end of the 13th century, it came under French protection in 1860. The chief source of income is tourism, attracted by the casinos of Monte Carlo. There is some light industry, including printing, textiles and postage stamps. Area: 1.9sq km (0.7sq mi). Pop. (1990) 29,972.

Monaghan County in Ulster province, NE Republic of Ireland, on the boundary with Northern Ireland; the county town is Monaghan. The s and E are hilly, but the rest of the county is a fertile plain. The Blackwater and the Finn are the chief rivers. It is primarily an agricultural county and the main crops are potatoes, oats and flax. Beef and dairy cattle are raised. Industries: linen-milling, footwear, furniture. Area: 1,290sq km (498sq mi). Pop. (1991) 51,293.

monasticism Ascetic mode of life followed by men and women who have taken religious vows and belong to a recognized Roman Catholic or Orthodox religious order. Christian monasticism is said to have its origins in the late-3rd-century asceticism of the desert hermits of Egypt, St Anthony and St Pachomius. In time, this solitary life was replaced by a communal approach, in which community members followed a strict rule. The earliest such rule in Europe was that laid down by St Benedict (of Nursia) in the 6th century. Monasticism still embraces community life of enclosed Christian orders, such as the CISTERCIANS and the reformed CARMELITES. There are, however, many more orders that combine asceticism with social welfare work and spiritual guidance to society at large. Spiritual leadership provided through monasticism is also found in Hinduism, Buddhism, Jainism, and Taoism.

Monck, George, 1st Duke of Albemarle (1608–70) English soldier and diplomat. In the English Civil War, Monck fought for Charles I (1643–44). After his capture and imprisonment (1644–46), Monck changed sides and helped Oliver Cromwell quell an Irish rebellion. He was rewarded with command of the forces in Scotland (1651). Monck was a general in the DUTCH Wars. After the collapse of the Protectorate, he supported the return of the Rump Parliament. Monck led the campaign for the Restoration of Charles II. His troops became the Coldstream Guards—the first permanent regiment of the British army.

Mondrian, Piet (1872–1944) Dutch painter, co-founder (with Theo van Doesburg) of De STIJL and a pioneer of ABSTRACT ART. Influenced by CUBISM, Mondrian developed a distinctive, geometric style, which he dubbed neoplasticism. He founded the art magazine *De Stijl* in 1917. Mondrian's art, such as *Composition in Yellow and Blue* (1925), informed the

BAUHAUS movement and the INTERNATIONAL STYLE in architecture. In 1940 he moved to the USA where his pieces, such as *Broadway Boogie-Woogie* (1942–43), became more colourful, reflecting his interest in jazz and dance rhythms.

Monera See Prokaryotae

Monet, Claude (1840-1926) French painter. A founder of IMPRESSIONISM, Monet's piece Impression, Sunrise (1872) gave the movement its name. During the 1860s he studied in Paris with RENOIR, Sisley and Bazille. The group painted directly from nature, recording the transient effects of light. Monet often painted the same scene several times, such as the Gare St-Lazare (1876–78) and Rouen Cathedral (1892–94). In 1870 he stayed with PISSARRO in London, and made studies of the River Thames. In 1883 he settled in Giverny. Despite failing sight, Monet's last series, Water Lillies (1906-26) is his most vibrant. monetarism Economic and monetary theory that argues changes in monetary stability are the principal causes of changes in the economy. It asserts the importance of controlling the money supply as the means of achieving a non-inflationary, stable economy capable of supporting high employment and economic growth. This theory is associated particularly with the theories advanced by Milton FRIEDMAN in the 1950s and 1960s. Monetarism exerted great influence on government policy in the UK and the USA during the 1980s.

money Any type of payment that is generally accepted within an economy as a medium of exchange for goods and services. It may take many forms besides currency or cash (coins and banknotes). A large portion of the money supply may be in the form of deposits within a banking system, accessed by the use of cheques.

Mongol Nomadic people of E central Asia who overran a vast region in the 13th–14th centuries. The different tribes in the area were united by GENGHIS KHAN in the early 13th century and conquered an empire that stretched from the Black Sea to the Pacific Ocean and from Siberia to Tibet. Genghis Khan's possessions were divided among his sons and developed into four khanates, one of which was the empire of the Great Khan (KUBLAI KHAN), which included China. In the 14th century TAMERLANE, allegedly a descendant of Genghis, conquered the Persian and Turkish khanates, and broke up the GOLDEN HORDE. By the 15th century, the true Mongol khanates had practically disappeared.

Mongolia Republic in central Asia; the capital is ULAN BATOR. Land and climate Sandwiched between China and Russia, Mongolia is the world's largest landlocked country. High plateaux cover most of the republic. In the w, the ALTAI mountains contain Mongolia's highest peak, at 4,362m (14,311ft). The land descends towards the E and S, where part of the Gobi Desert is situated. Ulan Bator lies on the N edge of a desert plateau in the heart of Asia. It has bitterly cold winters, dropping to -50° C (-58° F). Summer temperatures are moderated by altitude. Mountain forests contain birch, cedar, larch, pine and spruce. Mongolia has large areas of steppe grassland. Plants become increasingly sparse to the s. Economy Mongolia is a lower-middle-income developing country (1992 GDP per capita, US\$2,389). Traditional nomadic life was disrupted by communism. Forced collectivization placed many people in permanent settlements, but nomads still remain (especially in the Gobi Desert). In the mid-20th century, Mongolia rapidly industrialized, especially the mining of coal, copper, gold and molybdenum. Minerals and fuels now account for c.50% of Mongolia's exports. Livestock and animal products remain important. Economic development is hampered by lack of labour and poor infrastructure. History In the 13th century, GENGHIS KHAN united the Mongolian peoples and built up a great empire. Under his grandson, KUBLAI KHAN, the Mongol empire extended from Korea and China to E Europe and Mesopotamia. The empire broke up in the late 14th century. In the early 17th century, Inner Mongolia came under Chinese control. By the late 17th century, Outer Mongolia also became a Chinese province. In 1911 Mongolians drove the Chinese out of Outer Mongolia, and established a short-lived Buddhist kingdom. In 1919 China re-established control. In 1924 the Mongolian People's Republic was established (Inner Mongolia remained a Chinese province). The

Mongolian Peoples' Revolutionary Party (MPRP) became the sole political party. A revolution in land ownership prompted the Lama Rebellion (1932), which saw the migration of thousands of peoples and millions of livestock into Inner Mongolia. From the 1950s, Mongolia supported Soviet policies, especially in relation to Sino-Soviet disputes. In 1961 Mongolia was accepted into the United Nations. Popular demonstrations led to multiparty elections in 1990, which were won by the MPRP. Politics In 1992 a new constitution confirmed the process of liberalization, enshrining democratic principles and establishing a mixed economy. In 1993 President Ochirbat was re-elected, despite the MPRP refusing to endorse him as a candidate. In 1996 the Democratic Union Coalition formed the first non-communist government for more than 70 years. mongolism See Down's Syndrome

mongoose Small, agile, carnivorous mammal of the CIVET family, native to Africa, s Europe and Asia. It has a slender, thickly furred body and a long, bushy tail. Mongooses eat rodents, insects, eggs, birds and snakes. Some may be domesticated, but most are highly destructive. Length: 46–115cm (18–45in). Family Viverridae.

monism In METAPHYSICS, doctrine that reality consists of a single unifying substance, or that the mental and physical are indivisible. SPINOZA saw this substance as God, while HEGEL believed it was the Spirit. The term was coined by the German philosopher Christian Wolf (1679–1734). Monism contrasts with DUALISM. See also PLURALISM

monitor Any of several species of powerful lizards that live in Africa, s Asia, Indonesia and Australia, including the KOMODO DRAGON (*Varanus komodoensis*). Most species are dull-coloured with yellow markings; many are semi-aquatic. Length: to 3m (10ft). Family Varanidae.

Moniuszko, Stanislaw (1819–72) Polish composer. Moniusko is best-known for composing the first Polish national opera, *Halka* (1848).

Monk, Thelonious Sphere (1917–82) US jazz pianist. Along with "Dizzy" GILLESPIE and Charlie PARKER, Monk was a key figure in the development of BEBOP. In the early 1950s he formed his own band, featuring John COLTRANE. His distinctive, idiosyncratic chord structures and dissonances brought humour to the idiom. His greatest compositions, such as "Round Midnight", "Straight No Chaser", "Epistrophy" and "Crepuscule with Nellie" have become jazz standards.

monk Member of a monastic community living under vows of religious observance such as poverty, chastity and obedience. *See also* MONASTICISM

monkey Any of a wide variety of mostly tree-dwelling, diurnal, omnivorous PRIMATES that live in the tropics and subtropics. Most monkeys have flat, human-like faces, relatively large brains and grasping hands. They fall into two broad groups – Old World monkeys (family Cercopithecidae) and New World monkeys (Cebidae). The 60 Old World species include MACAQUES, BABOONS, BARBARY APES and LANGUR monkeys. They all have non-prehensile (unable to grasp) tails. They range in distribution from Japan and N China through s Asia and Africa. The 70 species of New World monkeys include CAPUCHIN monkeys, SPIDER MONKEYS and MARMOSETS. They are all tree dwellers, and most have grasping (prehensile) tails. They live in tropical forests of Central and South America.

▲ monkey The howler monkey (Allouata caraya) is named after its very loud and persistent roaring calls. It inhabits the forests of tropical South America, feeding mainly on fruit and nuts, but also eating a variety of small animals. It can grow to 1m (3ff) in length, with its tail reaching a similar length.

Monroe US actress Marilyn Monroe has attained legendary status. A talented comedy actress, she will always be remembered as a vivacious sex symbol. Her career and private life were a constant source of public interest, particularly her marriages to such high profile men as Joe DiMaggio and Arthur Miller, and her alleged relationships with President John F. Kennedy and his brother, Bobby Kennedy.

monkey puzzle (Chilean pine) Evergreen tree native to the Andes mountains of South America. It has tangled branches, with spirally arranged, sharp, flat leaves. The female seeds are edible. Height to 45m (150ft). Family Araucariaceae; species *Araucaria araucana*.

Monmouth, James Scott, Duke of (1649–85) English nobleman, illegitimate son of Charles II. As captain general, Monmouth defeated the Scots at Bothwell Bridge (1679). Allied with the Earl of Shaftesbury, he became leader of the Protestant opposition to the succession of the Duke of York (later James II). The discovery of a plot (1683) forced Monmouth into exile in Holland. Upon James' accession (1685), he launched a rebellion. Despite initial success, Monmouth lacked the support of the nobility and was defeated by the Duke of MARLBOROUGH at the Battle of Sedgemoor. He was executed. monocotyledon Subclass of flowering plants (ANGIOSPERMS) characterized by one seed leaf (COTYLEDON)

monocotyledon Subclass of flowering plants (ANGIOSPERMS) characterized by one seed leaf (COTYLEDON) in the seed embryo; the leaves are usually parallel-veined. Examples include lilies, onions, orchids, palms and grasses. The larger subclass of plants is DICOTYLEDON.

monogamy Principle in which it accepted that a relationship or MARRIAGE is an exclusive union between two people. It is commonly supported by legal institutions. *See also* POLYGAMY monomer Chemical compound composed of single molecules, as opposed to a POLYMER, which is built up from repeated monomer units. For example, propene (propylene) is the monomer from which polypropene (polypropylene) is made. mononucleosis, infectious *See* GLANDULAR FEVER

monopoly Sole supplier or producer of a product or service. A monopolistic industry has complete power over the market for its product and is able to determine levels of output and prices. In many countries there are regulations to limit or prevent monopolies.

monotheism Belief in the existence of a single God. JUDAISM, CHRISTIANITY and ISLAM are the three major monotheistic religions.

monotreme One of an order of primitive mammals that lay eggs. The only monotremes are the PLATYPUS and two species of ECHIDNA, all native to Australasia. The eggs are temporarily transferred to a pouch beneath the female's abdomen where they eventually hatch and are nourished by rudimentary mammary glands. *See also* MARSUPIAL

Monroe, James (1758–1831) Fifth US President (1817–25). Monroe fought in the American Revolution and was wounded at the Battle of Trenton (December 1776). He was a personal friend of Thomas Jefferson and served him loyally in the Senate (1790–94). Monroe was governor of Virginia (1799–1802), before helping to negotiate the LOUISIANA PURCHASE (1803). He was secretary of state (1811–16) under James Madison, before becoming president. His first term was marred by disputes over SLAVERY and resulted in the MISSOURI COMPROMISE. His foreign policy successes included the RUSH-BAGOT CONVENTION (1817), and the acquisition of Florida. He is chiefly remembered for the MONROE DOCTRINE.

Jean Baker. Her films include Gentlemen Prefer Blondes (1953), The Seven Year Itch (1955), Bus Stop (1956), Some Like It Hot (1959) and The Misfits (1961). She attended Lee STRASBERG'S ACTORS' STUDIO and married playwright Arthur MILLER in 1956. She has lived on as an icon of beauty and has consistently inspired both analysis of and tributes to her life. Monroe Doctrine Foreign policy statement made by US President James Monroe to Congress in 1823. It asserted US authority over the American continent and declared that European interference in the Western Hemisphere would be regarded as "dangerous to peace and safety"; also, that the USA would not become involved in the internal conflicts of Europe.

Monroe, Marilyn (1926-62) US film actress, b. Norma

Monrovia Capital and chief port of Liberia, West Africa, on the estuary of the River St Paul. It was settled in 1822 by freed US slaves on a site chosen by the American Colonization Society. Monrovia exports latex and iron ore. Industries: bricks and cement. Pop. (1984) 425,000.

monsoon Seasonal reversal of winds, and their associated abrupt weather changes, that blow inshore in summer and offshore over nearby oceans in winter. The monsoon occurs annually in s Africa and E Asia and is centred on the Indian subcontinent where it occurs as a distinct rainy season.

monstera Genus of tropical American, climbing or trailing plants with large glossy leaves that are commonly holed or deeply incised. *Monstera deliciosa* is a popular houseplant; it is often called a Swiss-cheese plant. Family Araceae.

montage (Fr. *monter*, to mount) Cinematic film-editing and artistic technique. Images are cut and spliced in a particular way in order to obtain a desired narrative, structural or purely aesthetic effect. The Odessa Steps sequence in Sergei EISENSTEIN'S *The Battleship Potemkin* (1925) is a classic example of film montage.

Montale, Eugenio (1896–1981) Italian poet, journalist, critic and translator. In 1922 Montale helped to found the literary magazine *Primo Tempo* and from 1948 was the literary editor of *Corriere della Sera*. His poetry is characteristically pessimistic in tone, especially in *Cuttlefish Bones* (1925). Montale was awarded the 1975 Nobel Prize for literature.

Montana State in NW USA, on the Canadian border; the capital is HELENA. Other major cities include Billings and Great Falls. Until the USA acquired the area in the LOUISIANA PURCHASE (1803), it was relatively unexplored. The discovery of gold in 1852 brought a rush of immigrants and the Territory of Montana was organized in 1864. The opening of the Northern Pacific Railroad in 1883 provided a stimulus to growth and development. The w section of Montana is dominated by the ROCKY MOUNTAINS. The E is part of the GREAT PLAINS, drained by the Missouri and Yellowstone rivers. Sheep and cattle are raised on the plains. The principal crops (grown by means of irrigation) are wheat, hay, barley and sugar beet. The Rockies have large mineral deposits including copper, silver, gold, zinc, lead and manganese. Oil, natural gas and coal are found in the SE. Industries: timber, food processing, petroleum products; tourism is also important. Area: 381,086sq km (147,137sq mi). Pop. (1990) 799,065.

Mont Blanc Highest peak in the Alps and the second-highest peak in Europe, lying on the border between France and Italy. It was first climbed in 1786. The 11-km (7-mi) tunnel through the base of Mont Blanc (1958–62) is the longest road tunnel in the world. Height: 4,810m (15,781ft).

Montcalm, Louis Joseph, Marquis de (1712–59) French general in North America. Commander in chief of the French army in Canada (1756–59), Montcalm won several victories against the British, including the Battle of Fort Ticonderoga (1758). In 1759 he held Quebec against a British siege for several months, but when the British, under James Wolfe, climbed the cliffs from the St Lawrence River to the Plains of Abraham, he was taken by surprise. Both he and Wolfe were killed in the battle.

Monte Carlo Town on the Mediterranean coast. N Monaco. It was founded (1858) by Prince Charles III of Monaco. Today, it is a popular resort noted for its scenery and mild climate. The Casino is a great tourist attraction. Pop. (1982) 13,154.

Montenegro (Crna Gora) Constituent republic of

MONTANA Statehood:

8 November 1889

Nickname:

Treasure State

State bird :

Western meadowlark

State flower:

Bitterroot

State tree :

Ponderosa pine State motto :

Gold and silver

YUGOSLAVIA; the capital is Podgorica (formerly Titograd). The region was part of the Serbian empire until the Turkish invasion of 1355. SERBIA was decisively defeated by Turkey in 1389, while Montenegro successfully resisted the sultan's rule. By 1500 most of the territory had been surrendered to the Ottomans. In 1799 Turkey recognized Montenegro's independence. In 1851 a monarchy was established, and in 1878 the sovereignty of the state was formally recognized. In 1910 Nicholas I assumed the title of king and sought to expel the Turks. In 1914 he declared war on Austria, and Montenegro was quickly overrun by the Austro-German armies. He was deposed in 1918 and Montenegro was united with Serbia. In 1946 Montenegro became a republic of Yugoslavia. In 1989, the local communist leadership resigned, but were returned to power in 1990 elections. Montenegro supported Serbia in the establishment of a new, Serb-dominated federation, but four of the six Yugoslav republics voted to secede from the union. In a 1992 referendum Montenegro voted to remain part of the rump Yugoslav federation with Serbia. It is a mountainous region that remains industrially underdeveloped. Much of the land is barren, and agriculture is mainly centred on the Zeta Valley. Industries: tobacco, grain, stock raising, bauxite mining. Area: 13,812sq km (5,331sq mi). Pop. (1991) 615,035.

Montessori, Maria (1870–1952) Italian educator who believed that preschool children, given an environment rich in manipulative materials and free from restraint, would develop their creative and academic potential. Her method was adapted for use in many of the school systems in Britain and the USA. Monteverdi, Claudio. (1567–1643) Italian composer, the first great OPERA composer. Many of his operas are lost; the surviving ones include L'Orfeo (1607) and L'Incoronazione di Poppea (1642). He wrote much religious music and was the last and greatest master of the MADRIGAL.

Montevideo Capital of Uruguay, in the s part of the country, on the River Plate. Originally a Portuguese fort (1717), it was captured by the Spanish in 1726 and became the capital of Uruguay in 1828. One of South America's major ports, it is the base of a large fishing fleet and handles most of the country's exports. Products include textiles, dairy goods, wine and packaged meat. Pop. (1992 est.) 1,383,660.

Montezuma Name of two AZTEC emperors. **Montezuma I** (r.1440–69) increased the empire by conquest. **Montezuma II** (r.1502–20) allowed the Spaniards under CORTÉS to enter his capital, Tenochtitlán, unopposed, in 1519, and subsequently became their captive.

Montfort, Simon de, Earl of Leicester (1208–65) French-born leader of a revolt against HENRY III of England. Montfort distinguished himself on crusade. Resentful at being forced to cede power in Gascony to the future EDWARD I, Montfort led the rebel barons in the Barons' War (1263). He won the Battle of Lewes (1264) and formed a parliament. Montfort was defeated and killed by Edward at Evesham.

Montgolfier, Joseph Michel (1740-1810) and Jacques Étienne (1745–99) French inventors of the hot-air balloon. In 1782 the brothers experimented with paper and linen balloons filled with hot gases collected over a fire. In November 1783, the brothers launched the first balloon to carry humans. Montgomery, Bernard Law, 1st Viscount Montgomery of Alamein (1887-1976) British general. As commander of the British Eighth Army in World War 2, Montgomery defeated ROMMEL and the AFRIKA KORPS at EL ALAMEIN (1942), and pursued them across North Africa. He led the invasion of Sicily and Italy. "Monty" helped to plan the Normandy landings (1944), and, under the overall command of General EISENHOWER, led the Allies in the initial stages. He was Deputy Supreme Allied Commander, Europe (1951–58). Montgomery State capital of Alabama, USA, in SE central Alabama. Made state capital in 1847, in 1861 it became the first capital of the Confederate States of America. It subsequently grew in importance. In the 1950s it was the scene of the beginnings of the civil rights movement. Industries: tex-

month Time taken for the Moon to travel completely around the Earth. The sidereal month is the time of one revolution with respect to the stars and is equal to 27.32 days. As the Earth is in

tiles, fertilizers, machinery. Pop. (1990) 187,106.

motion around the Sun, the synodic month – from full moon to full moon – is longer (29.53 days) than the sidereal month.

Montpelier State capital of Vermont, USA, at the confluence of Winooski and North Branch rivers, N central Vermont. First settled in the 1780s, it became state capital in 1805. Industries: tourism, machinery, granite quarrying, timber products, maple sugar and syrup, plastics. Pop. (1990) 8,247.

Montpellier City in s France, 10km (6mi) N of the Mediterranean coast; capital of Hérault département. Founded in the 8th century, it was a possession of the counts of Toulouse until the 13th century. In the 1960s the population grew rapidly with an influx of refugees from Algeria. Industries: textiles, metal goods, wine, printing, chemicals. Pop. (1990) 207,996. Montreal City on Montreal Island and the N bank of the St Lawrence River, Québec province, NE Canada; Canada's second-largest city and the country's chief port. The site was settled by the French in 1642. It remained under French control until 1760 when it was taken by the British. Montreal's growth accelerated with the opening of the Lachine Canal in 1825, connecting it to the Great Lakes. Montreal served (1844-49) as the seat of the Canadian government. Industries: aircraft, electrical equipment, rolling-stock, textiles, oil refining, metallurgy, chemicals. Pop. (1990) 1,017,666.

Montserrat British overseas territory in the West Indies; a volcanic island in the Leeward Islands, Lesser Antilles; the capital and chief port is Plymouth. The island is dominated by an active volcano in the Soufrière Hills that has threatened to make most of the island uninhabitable. The first European discovery was in 1493 by Christopher COLUMBUS. Montserrat was colonized by the British in 1632. It formed part of the Leeward Island colony from 1871 until 1956, when it became a separate dependent territory of the UK. Increased volcanic activity in 1997 prompted the British government to offer aid to the remaining islanders for rehousing in the N or relocation to neighbouring islands. Industries: tourism, light industry and construction, offshore finance, cotton. Area: 102sq km (40sq mi). Pop. (1996) 9,000. See WEST INDIES map

moon Natural satellite of a planet; in particular the natural satellite of Earth. Apart from the Sun, the Moon is the brightest object in the sky as seen from the Earth because of its proximity, at a mean distance of 384,000km (239,000mi). Its diameter is 3,476km (2,160mi). The Earth and Moon revolve around a common centre of gravity. As the Moon orbits the Earth, it is seen to go through a sequence of PHASES as the proportion of the illuminated hemisphere visible to us changes. An observer on Earth always sees the same side of the Moon because its orbital period around the Earth is the same as its axial rotation period. The surface features may be divided into the darker maria, which are low-lying volcanic plains, and the brighter highland regions (terrae), which are found predominantly in the southern part of the Moon's near side and over the entire far side. The origin of the Moon is uncertain. A current theory is that a Mars-sized body collided with the newly formed Earth, and debris from the impact formed the Moon. Lunar rocks are IGNEOUS ROCKS. The Moon has only the most tenuous of atmospheres. The surface temperature variation is extreme, from 100 to 400K. In 1998 it was confirmed that there was water-ice near the Moon's poles. See also APOLLO PROGRAM

Moore, Bobby (Robert Frederick) (1941–93) English footballer who captained England to victory in the 1966 World Cup and won a record 108 caps (1962–70). A masterly defender, Moore played for West Ham (1968–74), captaining the team to victory in the FA Cup (1964) and European Cup-Winners' Cup (1965). He ended his career at Fulham (1974–77).

Moore, Brian (1921–) Canadian novelist, b. Northern Ireland. His works examine the nature of religions and sexual guilt, and the plight of the individual when transplanted from a familiar environment. Novels include *The Lonely Passion of Miss Judith Hearne* (1955), *Lies of Silence* (1990) and *The Statement* (1995).

Moore, Henry (1898–1986) British sculptor and graphic artist. Moore is one of the greatest sculptors of the 20th century. The most characteristic features of his art are hollowedout or pierced spaces, such as *Reclining Figure* (1938). Moore based most of his work on natural forms and one of

▲ Moore British sculptor Henry Moore was influenced more by ancient Mexican and Sumerian carving than the classical ideals of the Renaissance. He rejected academic techniques in favour of a method called "truth to materials", which allowed the shape and texture of stone or wood to be an integral part of the work.

Morocco has flown a red flag since the 16th century. The green pentagram (five-pointed star), called the Seal of Solomon, was added in 1915. This design was retained when Morocco gained its independence from French and Spanish rule in 1956.

AREA: 446,550sq km (172,413sq mi) **POPULATION:** 26,318,000

CAPITAL (POPULATION): Rabat (518,616) GOVERNMENT: Constitutional monarchy ETHNIC GROUPS: Arab 70%, Berber 30% LANGUAGES: Arabic (official)

RELIGIONS: Islam 99%, Christianity 1% currency: Moroccan dirham = 100 centimes

orocco is separated from Europe by the narrow Strait of Gibraltar. The majority of the population live on the narrow w coastal plain, which includes the capital, RABAT, the largest city and port, CASABLANCA, and the cities of TANGIER and AGADIR. The ATLAS mountains dominate central Morocco, and Djebel Toubkal (in the Haut Atlas) is the highest peak in North Africa, at 4,165m (13,665ft). The Rif Atlas lie in the far N. Between the Atlas mountains and the coastal plain lies a broad plateau, which includes the cities of FEZ and MARRAKECH. Southern Morocco forms part of the SAHARA Desert, which continues into the disputed territory of WESTERN SAHARA.

CLIMATE

The Atlantic coast of Morocco is cooled by the Canaries Current. Inland, summers are hot and dry. During the mild winters (October to April) sw winds from the Atlantic bring moderate rainfall, and snow on the Haut Atlas.

VEGETATION

The Sahara is barren. Forests of cedar, fir and juniper swathe the mountain slopes. The coastal plain is a fertile region.

HISTORY

Berbers settled in the area c.3,000 years ago. Jewish colonies were established under Roman rule. In c.AD 685 Morocco was invaded by Arab armies, who introduced Islam and Arabic. In 711 Moroccan Muslims (Moors)

invaded Spain. In 788 Berbers and Arabs were united in an independent Moroccan state. Fez became a major religious and cultural centre. In the mid-11th century the ALMORAVIDS conquered Morocco, and established a vast Muslim empire. They were succeeded by the ALMOHAD dynasty. In the 15th century the Moors were expelled from Spain, and Spain and Portugal made advances into Morocco. In 1660 the present ruling dynasty, the Alawite, came to power. Most of the European-held territory was reclaimed.

In the mid-19th century Morocco's strategic and economic potential began to attract European imperial interest, especially France and Spain. In 1912 Morocco was divided into French Morocco, and the smaller protectorate of Spanish Morocco. Nationalist resistance was strong. Abd al-Krim led a revolt (1921-26) against European rule. In 1942 Allied forces invaded Morocco and removed the pro-Vichy colonial government. In 1947 the sultan, Sidi Muhammad, called for the reunification of the French and Spanish Morocco, but France refused and exiled the Sultan in 1953. Continuing civil unrest forced the French to accede to the return of the sultan in 1955.

In 1956 Morocco gained independence, although Spain retained control of two small enclaves, Ceuta and Melilla. In 1957 Morocco became an independent monarchy when Sidi Muhammad changed his title to King Muhammad V. In 1961 Muhammad was succeeded by

his son, King HASSAN II. During the 1960s Morocco was faced with external territorial disputes (especially with Algeria), and internal political dissent. In 1965 Hassan II declared a state of emergency and assumed extraordinary powers. While the 1972 constitution reduced royal influence, Morocco remains only nominally a constitutional monarchy, and effectively the king wields all political power.

In 1976 Spain finally relinquished its claim to Spanish Sahara, and the region became known as Western Sahara. Western Sahara was divided between Morocco and Mauritania. In 1979 Mauritania withdrew, and Morocco assumed full control of the phosphate-rich region, but met with fierce resistance from independence movements.

POLITICS

The collapse of several coalition governments in 1993 led to King Hassan's appointment of an administration. In 1994 Morocco restored diplomatic links with Israel. In 1995 Hassan formed a new government of technocrats and members of the Entente National. A referendum (1996) approved the establishment of a bicameral legislature, with a directly elected lower chamber. The ensuing general election (1997) led to the formation of a new coalition government.

ECONOMY

Morocco is a lower-middle-income developing country (1992 GDP per capita, US\$3,370). The post-independence exodus of Europeans and Jews from Morocco created an economic vacuum. The cost of war in Western Sahara further strained Morocco's scant resources. Its main resource is phosphate rock, which is used to make fertilizers. Morocco is the world's fourth-largest phosphate producer, and processes 75% of the world's reserves. The principal mines are located near Khouribga.

Agriculture employs 46% of the workforce. In the mountains, most agriculture is undertaken by peasant farmers or nomadic pastoralists. The chief commercial farming areas are the Atlantic coastal plains and the inland plateaux, where farming is made possible by extensive irrigation. The main crops include barley, beans, citrus fruits, grapes, maize, olives, sugar beet and wheat. Fishing is another important activity.

Casablanca, the chief manufacturing city and largest port, is also a thriving tourist centre. Morocco is an important tourist destination; the annual number of visitors exceeds three million and contributes over US\$1,360 million annual receipts. Tourism is centred on the Atlantic Coast resorts, the Atlas Mountains, and the historic cities of Marrakech, Fez, and Rabat. In 1996, as part of a rapidly improving infrastructure, Morocco and Spain agreed to build a tunnel linking the two countries.

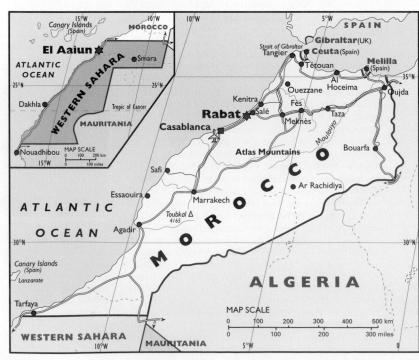

his favourite themes was the mother and child. Many of his sculptures are placed in parks rather than galleries.

Moore, Marianne (1887–1972) US poet. Her poetry is considered among the most distinguished US verse of the 20th century, with its wit, irony, and wide-ranging subject matter and its highly accomplished technical discipline. *Collected Poems* (1951) was awarded a Pulitzer Prize.

moorhen (waterhen) Common Old World aquatic bird of the RAIL family, so named because of its liking for rivers and ponds. It has black plumage and a yellow bill, and its long toes lack the webs or lobes typical of other water birds. Length: to 32.5cm (13in). Species *Gallinula chloropus*.

Moors (Latin *Maures*) Name given to the predominantly Berber people of Nw Africa. In Europe, the name is applied particularly to the North African Muslims who invaded Spain in 711 and established a distinctive civilization that lasted nearly 800 years. It was at its height under the Gordoba CALIPHS in the 10th–11th centuries, and the finest surviving example of Hispan-Moorish art is the ALHAMBRA, in Granada. The Christian rulers of N Spain gradually reconquered the country, and after the ALMOHAD empire broke up in the 13th century, Granada alone survived, until it fell to the Christians in 1492.

moose See ELK

moraine General term indicating a mound, ridge or other visible accumulation of unsorted glacial drift, predominantly TILL. End moraines are formed when a GLACIER is either advancing or retreating, and the rock material is dumped at the glacier's edge. Ground moraines are sheets of debris left after a steady retreat of the glacier.

morality play See MYSTERY PLAY

Moravia Region of the CZECH REPUBLIC, bordered N by the Sudetes Mountains, E by the Carpathian Mountains and W by Bohemia. Major cities include BRNO and Ostrava. A fertile agricultural region, Moravia also has abundant mineral resources, especially coal and iron. These helped the region's rapid industrialization in the 20th century. In the 9th century Moravia established a large empire and adopted Christianity. In the 10th century, the empire fell and Moravia was conquered, first by the MAGYARS then subsumed into the HOLY ROMAN EMPIRE. From the 11th to the 16th centuries it was part of the kingdom of BOHEMIA. In 1526 it became Austrian HABSBURG territory and a process of Germanification was begun. A failed revolution in 1849 led to Moravia becoming Austrian crown land. In 1918 the Habsburgs were deposed and Moravia was incorporated into the new republic of Czechoslovakia. In 1938, s Moravia was annexed by Germany, and in 1939 Moravia became a German protectorate. Following World War 2, Moravia was restored to Czechoslovakia, and the German population expelled. In 1960 Moravia was divided into s Moravia and N Moravia.

Moravia, Alberto (1907–90) Italian novelist. His early novels, including *The Time of Indifference* (1929) and *The Fancy Dress Party* (1940), were critical of fascism, and he was forced into hiding until 1944. Later works include *The Woman of Rome* (1947), *The Conformist* (1951) and *Two Women* (1957). Moravian Church Protestant church that originated in Bohemia and Moravia in the 15th century among followers of Jan Hus. In the 18th century, Moravians began extensive missionary work. Several groups migrated to North America, where they founded settlements in Bethlehem, Pennsylvania, and Winston-Salem, North Carolina. Today, there are Moravian communities in Europe, North and South America, Africa, and N India.

More, Sir Thomas (1478–1535) English statesman, humanist scholar, and author of *Utopia* (1516). More was knighted by Henry VIII in 1521. Despite his opposition to Henry's divorce from Catherine of Aragon, More succeeded Cardinal Wolsey as lord chancellor in 1529. He resigned in 1532, following policy disagreements with Henry. More's principled refusal to sign the Act of Supremacy (1534), which made Henry head of the English church, led to his imprisonment and execution for treason. *Utopia* portrays an ideal state founded on reason.

Moreau, Gustave (1826–98) French painter and a leading practitioner of SYMBOLISM. His pictures are sensuous and

notable for his use of jewel-like colours. Although he spent much of his life in seclusion, he was professor at the École des Beaux-Arts, Paris.

Morgan, J.P. (John Pierpont) (1837–1913) US financier. Son of a rich banker, he formed what became the influential banking house of J.P. Morgan in 1871. He built a vast financial and industrial empire, financing and consolidating US industries, including the giant US Steel Corporation (1901).

Morgan, Sir Henry (1635–88) Welsh adventurer in the Caribbean. He led a band of buccaneers against Spanish colonies and ships, capturing and looting Panama (1671). In 1672 he was sent back to England charged with piracy, but was greeted as a hero and returned to the West Indies with a knighthood as lieutenant governor of Jamaica.

Morgan, Thomas Hunt (1866–1945) US biologist who was awarded the 1933 Nobel Prize for physiology or medicine for the establishment of the CHROMOSOME theory of HEREDITY. His discovery of the function of chromosomes through experiments with the fruit-fly (*Drosophila*) is related in his book *The Theory of the Gene* (1926).

Mörike, Eduard Friedrich (1804–75) German poet. He published several volumes of subtle lyric poetry, including *Gedichte* (1938), a collection he added to in 1848, 1856 and 1867. It ranks among the finest examples of late German ROMANTICISM. His small but influential output also includes the novel *Maler Nolten* (1832).

Mormons ADVENTIST sect, the full name of which is the Church of Jesus Christ of Latter-day Saints. It was established (1830) in Manchester, New York, USA, by Joseph SMITH. Believing that they were to found Zion, or a New Jerusalem, Smith and his followers moved west. They tried to settle in Ohio, Missouri, and Illinois, but were driven out. Joseph Smith was murdered in Illinois in 1844. Brigham Young then rose to leadership, and in 1846–47 took the Mormons to UTAH.

Morocco Kingdom in NW Africa. See country feature

Moroni Capital of the COMOROS Islands, on sw Grande Comore. Founded by Arab settlers, it replaced Mayotte as capital in 1958. Chief exports are coffee, vanilla, cacao, and timber and metal products. Pop. (1988 est.) 22,000.

morphine White crystalline ALKALOID derived from OPIUM. It depresses the CENTRAL NERVOUS SYSTEM and is used as an ANALGESIC for severe pain. An addictive drug, its use is associated with a number of side-effects, including nausea. Morphine was first isolated in 1806. See also HEROIN

morphology Biological study of the form and structure of living things. It often focuses on the relation between similar features in different organisms.

Morricone, Ennio (1928–) Italian film composer who scored over 400 films. He is best known for his work with director Sergio Leone. He wrote the scores for Leone's "spaghetti westerns" *A Fistful of Dollars* (1964), *The Good, the Bad and the Ugly* (1966) and *Once Upon a Time in the West* (1968). Other works include the classic scores for *The Untouchables* (1987) and *The Mission* (1986).

Morris, William (1834–96) British artist, craftsman, writer, social reformer and printer. In 1861 he founded the ARTS AND CRAFTS MOVEMENT, a collection of decorators and designers

■ Morris The Red House. Bexley Heath, near London, was designed in 1859-60 by the architect Philip Webb for (and in collaboration with) William Morris. The illustration shows the north and east of the house. It became one of the basic buildings of modern architecture. Morris and Webb created a simple brick building with echoes of traditional architecture in its high-pitched roof, Gothic arches and Queen Anne windows. Among the house's more revolutionary features is the raising of the kitchen to the ground floor from its customary position in the basement, and the provision of windows to allow servants to overlook the gardens.

▲ moss Mosses vary in growth and colour according to species. Fontinalis anti pyretica (A) is an aquatic moss, whose boat-shaped leaves have a sharp keel (1); the capsules are oblong or cylindrical (2, 3) and there is a pointed cap (4). Polytrichum commune (B) is extremely common and has a capsule (5) that looks like a foursided box. It bears a long, golden brown cap (6) which is released before the spores are dispersed. Atrichum undulatum (C) is common on heaths and in woods, and has a capsule (7) with a long, pointed cap. Schistostega pennata (D), has flattened, translucent leaves.

influenced by medieval craftsmanship. Morris is perhaps best remembered for his wallpaper designs, which anticipated ART NOUVEAU in their use of the S-curve. In the 1880s he became interested in socialism, writing *The Dream of John Ball* (1886–87) and *News from Nowhere* (1890).

Morrison, Toni (1931–) US writer, b. Chloe Anthony Wofford. Morrison's debut novel, *The Bluest Eye* (1970), established her as a major voice in AMERICAN LITERATURE. Her chronicles of African-American experience in the rural South, include *Song of Solomon* (1977) and *Tar Baby* (1981). *Beloved* (1987), a powerful indictment of slavery, won a Pulitzer Prize. Other works include *Jazz* (1992). She was awarded the 1993 Nobel Prize for Literature.

Morse, Samuel Finley Breese (1791–1872) US inventor of the Morse code. A successful artist, he became interested in developing a practical electric telegraph c.1832. His receiver was based on an electromagnet. Using a simple system of dots and dashes, he set up the first US telegraph from Washington to Baltimore in 1844.

Morton, "Jelly Roll" (1885–1941) US jazz pianist, bandleader and composer, b. Ferdinand Joseph La Menthe. Morton played in the brothels of Storyville in New Orleans, before making some of the first jazz recordings (1923). Morton and his band, the Red Hot Peppers, combined blues, ragtime and "stomp" music on classics such as "Wolverine Blues" (1923). mosaic Technique of surface decoration using small pieces of coloured material set tightly together in an adhesive to form patterns or pictures. The technique was employed for floor and wall decorations in ancient Mesopotamia and Greece. Roman mosaics commonly featured a central design or a portrait, surrounded by a decorative geometric border. The art developed rapidly in early Christian times especially during the 4th–6th centuries and continues to be used for floors, church interiors and wall decorations.

Moscow (Moskva) Capital of Russia and largest city in Europe, on the River Moskva. The site has been inhabited since Neolithic times, but Russian records do not mention it until 1147. It had become a principality by the end of the 13th century, and in 1367 the first stone walls of the Kremlin were constructed. By the end of the 14th century, Moscow had emerged as the focus of Russian opposition to the Mongols. Polish troops occupied the city in 1610, but were driven out two years later. Moscow was the capital of the Grand Duchy of Russia from 1547 to 1712, when the capital was moved to ST PETERSBURG. In 1812 Napoleon and his army occupied Moscow, but were forced to flee when the city burned to the ground. In 1918, following the RUSSIAN REVOLUTION, it became the capital of the SOVIET UNION. The failure of the German army to seize the city in 1941 was the Nazis' first major setback in World War 2. The Kremlin is the centre of the city, and the administrative heart of the country. Adjoining it are Red Square, the Lenin Mausoleum and the 16thcentury cathedral of Basil the Beatified. Industries: metalworking, oil-refining, motor vehicles, film-making, precision instruments, chemicals, publishing, wood and paper products, tourism. Pop. (1993) 8,881,000.

Moscow Art Theatre Russian theatre, famous for its contribution to naturalistic theatre. It was founded in 1898 by STANISLAVSKY and Nemirovich-Danchenko. The original company was composed of amateur actors from the Society of Art and Literature, who were committed to adopting a more rigorous and professional approach to staging and acting. It was at the Moscow Art Theatre that Stanislavsky developed his influential method principle.

Moscow (Muscovy), Grand Duchy of Historic Russian state. Centred on the trading centre of Moscow, it emerged from Mongol and Tatar rule in the late 15th century as the centre of a unified Russian state, defeating the principality of Novgorod and absorbing part of Lithuania.

Moses (active c.13th century BC) Biblical hero who, as a prophet and leader of the ancient Hebrews, was the central figure in their liberation from bondage in Egypt and a formative influence in the founding of their nation-state, Israel. His story is recounted in the Old Testament books of Exodus and Numbers. An abandoned Hebrew child, Moses was brought

up in the pharaoh's court. As a man, Moses sought to lead the Hebrews out of Egypt, and eventually was permitted to lead the exodus. God revealed himself to Moses on Mount Sinai, but made the Israelites wander in the desert for a further 40 years before they entered the promised land of CANAAN.

Moses, Grandma (Anna Mary Robertson) (1860–1961) US primitive painter. She only began painting when she was in her late seventies. Her scenes of country life, based on recollections from her youth, became world-famous through prints and greeting cards. Well-known examples are Out for the Christmas Tree and Thanksgiving Turkey.

Moslem See Muslim

Mosley, Sir Oswald Ernald (1896–1980) British fascist leader. Mosley became a Conservative MP in 1918, but defected to Labour (1924). He resigned as junior minister in 1929, and formed the leftist New Party (1931). In 1932 he founded the British Union of Fascists. Modelled on German and Italian fascist parties, its rhetoric was virulently anti-Semitic. Mosley's blackshirts engaged in confrontational marches, especially in the East End of London. His support for Hitler led to his internment (1940–43). Following the defeat of fascism in World War 2, Mosley's pernicious influence declined.

mosque Islamic place of worship. Mosques are usually decorated with abstract and geometric designs, because ISLAM prohibits the imitation of God's creation. The building's parts include a DOME; a mihrab (prayer niche), which shows the direction of MECCA; a MINARET, from which the MUEZZIN calls the faithful to prayer; and a sahn (courtyard) often with a central fountain for ritual ablution. The complex often includes a madressa (school). See also ISLAMIC ART AND ARCHITECTURE mosquito Long-legged, slender-winged insect, found throughout the world. The female sucks blood from warmblooded animals. Some species carry the parasites of diseases, including MALARIA, YELLOW FEVER, DENGUE, viral ENCEPHALITIS and FILARIASIS. The larvae are aquatic. Adult length: 3–9mm (0.12–0.36in) Family Culicidae.

Mosquito Coast (Mosquitia) Coastal region bordering on the Caribbean Sea, *c*.65km (40mi) wide, now divided between Nicaragua and Honduras. A British protectorate from 1740, it was returned to its original inhabitants (the Miskito) in 1860. In 1894 it became part of Nicaragua. International arbitration awarded the N part to Honduras in 1960. The region, which consists mainly of tropical forest, swamp and lagoons, is only thinly populated.

Moss, Stirling (1929–) British racing driver who won 16 Grand Prix events and finished second four times in the world driver's championship. He retired after a serious crash in 1962. moss Any of about 14,000 species of small, simple nonflowering green plants that typically grow in colonies, often forming dense carpets. They reproduce by means of SPORES produced in a capsule on a long stalk. The spores germinate into branching filaments, from which buds arise that grow into moss plants. Mosses grow on soil, rocks and tree trunks in a wide variety of habitats, especially in shady, damp places. See also ALTERNATION OF GENERATIONS; BRYOPHYTE

▲ Moscow The Lenin Mausoleum is situated on the w side of Red Square, Moscow. Since the collapse of the Soviet Union, Moscow has witnessed a growth in foreign business and tourism. There are plans to bury Lenin, rather than continue to preserve his body.

Mossi People inhabiting Burkina Faso and who are found in small numbers elsewhere in West Africa. Their traditional livelihood involves growing staple crops, including millet and sorghum.

motet Musical form prominent in all choral church music from c.1200–1600. In the 13th and 14th centuries it consisted of three unaccompanied voice parts. The Renaissance motet of the 15th century, usually in four or five parts, was contrapuntal in style. Palestrina composed some of the purest examples of the form. After 1600 there were new developments in the form, including occasional instrumental parts and texts in vernacular languages.

moth Insect of the order LEPIDOPTERA, found in almost all parts of the world. It is distinguished from a BUTTERFLY mainly by its non-clubbed antennae, although there are a few exceptions. Most moths are nocturnal. Like a butterfly, a moth undergoes METAMORPHOSIS. It has a long coiled proboscis for sipping liquid food, particularly the nectar of flowers.

Motherwell, Robert (1915–91) US painter and writer. Motherwell was a pioneer of ABSTRACT EXPRESSIONISM. Perhaps his best-known work is the series *Elegies to the Spanish Republic*. He was the editor of the influential *The Documents of Modern Art* series (1944–57).

motor Mechanism that converts energy (such as heat or electricity) into useful work. The term is sometimes applied to the internal combustion ENGINE but is more often applied to the ELECTRIC MOTOR. ROCKET engines are motors that can leave the Earth's atmosphere because they carry both fuel and oxidizer. Ion motors are in development, intended for spacecraft propulsion: a stream of ions, possibly from a nuclear reactor, is accelerated in a strong electrostatic field to produce a reaction that drives the spacecraft.

motorcycle Powered vehicle, usually with two wheels. Gottlieb DAIMLER is credited with building the first practical motorcycle (1885). Motorcycles are classified in terms of engine capacity, usually 50cc to 1200cc. Transmission of power to the rear wheel is by chain, shaft or belt. The clutch, accelerator and front brake controls are on the handlebars. Foot pedals control the gear change and rear brake.

motor racing Competitive racing of automobiles. The first organized race took place in 1894, from Paris to Rouen. The first Formula One Grand Prix was held in 1906. The world driver's championship started in 1950, and the constructors' trophy in 1956. The season (March–November) involves 16 Grands Prix. Formula One cars are purpose-built to strict specifications. With average speeds in excess of 240kph (150mph), Formula One circuits have rigorous safety procedures. Formula One is a worldwide sport which attracts major commercial sponsorship. The LE MANS 24-hour endurance race has been held annually since 1923. Other forms of motor racing include rallying and Indy car racing in the USA. Famous road races include the Monte Carlo Rally, the Paris-Dakar Rally and the Lombard-RAC Rally (first held 1927). The Indianapolis 500 was first held in 1911.

motorcycle racing Sport in which motorcyclists compete on road circuits, cross country (scrambling and trials), on grass tracks, and on cinder tracks (speedway). The first organized race took place in 1906, from Paris to Nantes. The world championship started in 1949. The championship is organized by engine capacity: the 500cc is the premier title. The Isle of Man TT road race has been held annually since 1907.

motor neuron Nerve carrying messages to the muscles from the Brain via the Spinal Cord. The cell bodies of some motor Nerves form part of the spinal cord. Motor nerves are involved in both reflex action and voluntary muscular control. Motown Highly successful record company, whose artists made a major contribution to popular music of the 1960s. Founded in Detroit ("Motor town") in 1959 by Berry Gordy Jr, the company's original roster included Marvin Gaye, Stevie Wonder, Diana Ross and Smokey Robinson. Berry sold Motown to the MCA company in 1988.

mould Mass composed of the spore-bearing mycelia (vegetative filaments) and fruiting bodies produced by numerous fungi. Many moulds live off fruits, vegetables, cheese, butter, jelly, silage and almost any dead organic material. Roquefort,

camembert and stilton cheeses involve the use of mould. Although many species are pathogenic (disease-causing), PENICILLIN and a few other ANTIBIOTICS are obtained from moulds. See also FUNGICIDE; FUNGUS; SLIME MOULD

mountain Part of the Earth's surface that rises to more than 2,000ft (510m) above sea level. They are identified geologically by their most characteristic features, and are classified as FOLD, volcanic, or fault-block mountains. Mountains may occur as single isolated masses, as ranges or in systems or chains.

mountain climbing Sport and leisure activity that gained popularity in Europe in the 18th and 19th centuries. By the mid-1990s even the world's highest mountain, EVEREST, had been scaled by thousands of people.

mountain lion See PUMA

Mountbatten, Louis, 1st Earl Mountbatten of Burma (1900–79) British admiral, great-grandson of Queen Victoria, uncle of Prince Philip. During World War 2, Mountbatten directed (1942–43) commando raids upon Norway and France. In 1943 he was appointed Allied commander-in-chief in SE Asia, and led operations against the Japanese in Burma. He accepted the Japanese surrender. Mountbatten was last viceroy (1947–48) of British India, overseeing the transition to independence. He was murdered by an IRA bomb.

Mount Rushmore Mountain in the Black Hills, sw South Dakota, USA. The colossal busts of US presidents Washington, Jefferson, Lincoln and Theodore Roosevelt were carved out of the granite face of Mount Rushmore by Gutzon Borglum from 1927. After his death in 1941, the work was completed by his son. Area: 5sq km (2sq mi).

mouse Any of numerous species of small, common RODENTS found in a variety of habitats worldwide; especially the omnivorous, brown-grey house mouse (*Mus musculus*) of the family Muridae. This prolific nest-builder, often associated with human habitation, is considered a destructive pest and is believed to carry disease-producing organisms. It may grow as long as 20cm (8in) overall, and has been bred for use in laboratories and as a pet. Many species within the family Cricetidae are also called mice, as are pocket mice (Heteromydiae), jumping mice (Zapodidae) and marsupial mice (Dasyuridae). mouth In animals, the anterior (front) end of the ALIMENTARY CANAL, where it opens to the outside. In humans and other higher animals, it is the cavity within the jaws, containing the teeth and tongue.

Mozambique Republic in SE Africa. *See* country feature, p.462

Mozart, Wolfgang Amadeus (1756-91) Austrian composer. A child prodigy on the piano, Mozart was taken by his father, Leopold, on performing tours in Europe (1762-65), during which he composed his first symphonies. In the 1770s he worked at the prince archbishop's court in Salzburg. Masses, symphonies and his first major piano concerto date from this time. Opera was his primary concern, and in 1780 he composed Idomeneo, which is impressive for its rich orchestral writing and depth of expression. In the 1780s he moved to Vienna, where he was to spend most of the rest of his life, becoming court composer to the Austrian emperor in 1787. In this decade, he composed and performed his greatest piano concertos, the last eight of his 41 symphonies and the brilliant comic operas Le Nozze di Figaro (1786), Don Giovanni (1787) and Così fan tutti (1790). In the last year of his life, Mozart wrote the operas Die Zauberflöte and La Clemenza di Tito, the clarinet concerto and the Requiem (completed by a pupil). In all, he composed more than 600 works, perfecting the CLASSICAL style and foreshadowing ROMANTICISM.

Mubarak, Hosni (1928–) Egyptian statesman, president (1981–). He was vice president (1975–81) under Anwar SADAT, and became president on his assassination. He continued Sadat's moderate policies, improving relations with Israel and the West. He gained Egypt's readmission to the Arab League (1989). He has struggled to stem the rise of Islamic fundamentalism.

Muckrakers Name given to US journalists and others who exposed political and business corruption in the early 20th century. The term was first used by Theodore ROOSEVELT (1906).

▲ moth The male Madagascan moon moth (*Argema mittrei*) has a wingspan of 10cm (4in). It has feather antennae that are able to detect the scent given off by a female when she is ready to mate. The pheremone scent can be detected many miles away.

▲ mouse The house mouse (Mus musculus) is found throughout the world. Due to its close association with people, the house mouse can be a transmitter of diseases. On average it has a body length of up to 10cm (4in) and a similar length tail.

mucous membrane Sheet of TISSUE (or EPITHELIUM) lining all body channels that communicate with the air, such as the mouth and respiratory tract, the digestive and urogenital tracts, and the various glands that secrete mucus, which lubricates and protects tissues.

muezzin Person who calls Muslims to prayer. In small Mosoues, the call is given by the IMAM. In larger mosques, a muezzin is specially appointed for that purpose.

Mugabe, Robert Gabriel (1925–) Zimbabwean statesman, prime minister (1980–), president (1987–). In 1961 Mugabe became deputy secretary-general of Joshua Nkomo's Zimbabwe African People's Union (ZAPU). In 1963 Mugabe was forced into exile and co-founded the Zimbabwe African National Union (ZANU). He was imprisoned by Ian SMITH's white minority Rhodesian regime, and spent the next decade (1964–74) in detention. After his release, Mugabe continued to agitate for majority rule from Mozambique. In 1976 ZAPU and ZANU merged to form the Patriotic Front, which became the first black majority government. During the 1980s Mugabe shifted away from communism. He succeeded Canaan Banana as president. Mugabe won Zimbabwe's first multi-party elections (1990). He was a leading opponent of APARTHEID.

Mugwumps US political faction. A group of independent, or liberal, Republicans, they deserted their party's candidate, James G. Blaine, in the 1884 presidential election. They considered him corrupt, and supported the victorious Democratic candidate, Grover CLEVELAND.

Muhammad (c.570-632) Arab prophet and inspirational religious leader who founded ISLAM. He was born in the Arabian city of MECCA. He was orphaned at the age of six and went to live first with his grandfather, and then with his uncle. At the age of 25, he began working as a trading agent for Khadijah, a wealthy widow of 40, whom he married. For 25 years, she was his closest companion and gave birth to several children. Only one brought him descendants - his daughter FATIMA, who became the wife of his cousin, ALI. In c.610, Muhammad had a vision while meditating alone in a cave on Mount Hira, outside Mecca. A voice three times commanded him to "recite", and he felt his body compressed until he could hardly breathe. Then he heard the words of the first of many revelations that came to him in several similar visions over the next two decades. The revelations came from Allah, or God, and Muhammad's followers believe that they were passed to Muhammad through the angel GABRIEL. At the core of his new religion was the doc-

MOZAMBIQUE

Mozambique's flag was adopted when the country became independent from Portugal in 1975. The green stripe represents fertile land, the black stands for Africa and the yellow for mineral wealth. The badge on the red triangle contains a rifle, a hoe, a cogwheel and a book.

ozambique faces the Indian Ocean. The coastline is dotted with the mouths of many rivers, including the LIMPOPO and the ZAMBEZI. The coast is fringed by swamps and offshore coral reefs. The only natural harbour is

TANZANIA

JOSE

TANZANIA

JOSE

TANZANIA

JOSE

Lugendo

Pemba

Lugendo

Nampula

O Chinde

Mozambique

Fodic of Capricore

In D I A N

SWAEL

Lourenço Marques

MAP SCALE

Q 100 200 300 400 km

Q 100 200 miles

APRICA

JOSE

MAP SCALE

Q 100 200 miles

APRICA

JOSE

JOSE

APRICA

JOSE

J

the capital, Maputo. The coastal plains make up 50% of Mozambique's land area. To the N of the Zambezi, the plain is narrow, while to the s it is much broader. Inland, a savanna plateau rises to highlands at the frontiers with Zimbabwe, Zambia, Malawi and Tanzania.

CLIMATE

Mozambique has a tropical climate. The warm, south-flowing Mozambique Current gives Maputo hot and humid summers, though winters are mild and fairly dry.

VEGETATION

Tropical savanna is the most widespread vegetation. Palm trees are found along the coast, and there are rainforests of ebony and ironwood.

HISTORY AND POLITICS

Bantu-speakers arrived in the first century AD. Arab traders in gold and ivory settled in coastal regions from the 10th century AD. Vasco da GAMA was the first European to discover Mozambique in 1498, and in 1505 Portugal established its first settlement. During the 16th century Portuguese adventurers built huge, semi-autonomous plantations. In the 18th and 19th centuries, Mozambique was a major centre of the slave trade. In 1910 Mozambique formally became a Portuguese colony. Nationalist opposition increased with unfair land rights, forced labour, and social inequity. The Front for the Liberation of Mozambique (FRE-LIMO) was founded (1961) to oppose Portuguese rule. In 1964, FRELIMO launched a guerrilla war. In 1975 Mozambique gained AREA: 801,590sq km (309,494sq mi)

POPULATION: 14,872,000

CAPITAL (POPULATION): Maputo (2,000,000) GOVERNMENT: Multiparty republic ETHNIC GROUPS: Makua 47%, Tsonga 23%, Malawi 12%, Shona 11%, Yao 4%, Swahili

1%, Makonde 1%

LANGUAGES: Portuguese (official)
RELIGIONS: Traditional beliefs 48%,
Christianity (Roman Catholic 31%, others

9%), Islam 13%

currency: Metical = 100 centavos

independence, and Samora Machel became president. Many Europeans fled the country, taking vital capital and resources. The new FRELIMO government established a one-party Marxist state. FRELIMO's assistance to liberation movements in Rhodesia (now Zimbabwe) and South Africa was countered by these white-minority regimes' support for the-Mozambique National Resistance Movement (RENAMO) opposition. Civil war raged for 16 years, claiming tens of thousands of lives. In 1986 Samora Machel died, and was succeeded by Joachim Chissano. In 1989 FRELIMO dropped its communist policies and agreed to end one-party rule. In 1992, faced with severe drought and famine, a peace agreement was signed between FRELIMO and RENAMO. In 1994 Chissano was elected president. In 1995 Mozambique became the 53rd member of the Commonwealth of Nations.

ECONOMY

Mozambique is one of the world's poorest countries (1992 GDP per capita, US\$380). Agriculture employs 85% of the workforce, mainly at subsistence level. Crops include cassava, cotton, cashew nuts, fruits, maize, rice, sugar cane and tea. Fishing is also important. Shrimps, sugar and copra are exported. Despite its large hydroelectric plant at Cahora Bassa dam on the River Zambezi, manufacturing is on a comparatively small scale. Electricity is exported to South Africa.

trine that there is no God but Allah and His followers must submit to Him - the word *islam* means "submission". Muhammad gained followers but also many enemies among the Meccans. In 622 he fled to MEDINA. Muslims, followers of Islam, later took this HEJIRA as initiating the first year in their calendar. Thereafter, Muhammad won more followers. He organized rules for the proper worship of Allah and for Islamic society. Muhammad also made war against his enemies. He conquered Mecca in 630. Most of the Arab tribes allied with him. In Medina, he married the woman who became his favourite wife, Aishah, the daughter of ABU BAKR, one of his strongest supporters. Muhammad is considered an ideal man, but he never claimed supernatural powers, and is not held to be divine. His tomb is in the Holy Mosque of the Prophet, MEDINA.

Muhammad II (1429–81) Ottoman sultan (1451–81), considered to be the true founder of the OTTOMAN EMPIRE. Muhammad captured Constantinople (1453) and made it the capital of the Ottoman empire.

Muhammad, Elijah (1897–1975) Leader (1934–75) of the BLACK MUSLIMS, b. Elijah Poole. He became leader following the disappearance of the Black Muslims founder, Wallace D. Fard. During World War 2 he was imprisoned for encouraging draft-dodging. The rhetorical skills of MALCOLM X gained the movement national attention, and tensions grew until Malcolm was suspended. Under Muhammad's leadership, the Muslim doctrines were codified and membership increased.

Muhammad Ali (1769–1849) Albanian soldier who founded an Egyptian dynasty. In 1798 Muhammad took part in an Ottoman expeditionary force sent to Egypt to drive out the French. He was unsuccessful, but (after the departure of the French) quickly rose to power. In 1805 Muhammad was proclaimed the Ottoman sultan's viceroy. In 1811 he defeated the Mamelukes, who had ruled Egypt since the 13th century. Muhammad put down a rebellion in Greece in 1821, but his fleet was later destroyed by the European powers at the Battle of Navarino (1827). He challenged the sultan and began the conquest of Syria in 1831. The European powers again intervened, and Muhammad was compelled to withdraw.

Muhammad Reza Pahlavi *See* Pahlavi, Muhammad Reza Shah

Mujaheddin Muslim militants dedicated to waging a holy war. The term is most often applied to the guerrilla fighters of Iran in the 1970s–80s, and of Afghanistan in the 1980s–90s. **mulberry** Any member of the genus *Morus*, trees and shrubs that grow in tropical and temperate regions. They have simple leaves, and the male flowers are catkins, while the female flowers are borne in spikes. Several species are cultivated for their fleshy, edible fruits.

mule HYBRID offspring of a female horse and a male ass; it is different from the smaller hinny, which is the result of a cross between a male horse and a female ass. Brown or grey, it has a uniform coat and a body similar to a horse, but has the long ears, heavy head and thin limbs of an ass. Known since ancient times, the hardy mule is commonly used as a draught or pack animal. It is usually sterile. Height: 1.8m (5.8ft).

mule deer Game animal that inhabits w USA from Alaska to Mexico. It is red-brown with a blacktipped white tail; the male bears antlers. It is generally solitary, but often gathers in herds in winter. Height: to 1.1m (3.5ft) at the shoulder. Family Cervidae; species *Odocoileus hemionus*.

mullah Muslim cleric well-versed in the SHARIA (Islamic law). There are no formal qualifications that a man must gain to become a mullah, but he will usually have attended a *madressa*, or religious school.

Muller, Hermann Joseph (1890–1967) US geneticist. He found that he could artifically increase the rate of MUTATIONS in the fruit fly (Drosophila) by the use of x-rays. He thus highlighted the human risk in exposure to radioactive material. He was awarded the 1946 Nobel Prize for physiology or medicine. mullet (grey mullet) Marine food fish found in shoals in shallow tropical and temperate waters throughout the world. Its torpedo-shaped body is green or blue and silver. Size: to about 90cm (3ft); weight: 6.8kg (15lb). Family Mugilidae.

Mulroney, Brian (1939–) Canadian statesman, prime minister (1984–93). In 1983 Mulroney became an MP and leader

of the Progressive Conservative Party. In his first term, he signed the Meech Lake Accord (1985), which constitutionally made QUEBEC a "distinct society". In 1987 he negotiated a free trade treaty with the US, which led to the 1992 NORTH AMER-ICAN FREE TRADE AGREEMENT (NAFTA). The status of Quebec continued to vex his administration and, following defeat in a national referendum, Mulroney resigned. He was succeeded as party leader and prime minister by Kim Campbell. multiple sclerosis (MS) Incurable disorder of unknown cause in which there is degeneration of the myelin sheath that surrounds nerves in the brain and spinal cord. Striking mostly young adults (more women than men), it is mainly a disease of the world's temperate zones. Symptoms may include unsteadiness, loss of coordination and speech and visual disturbances. MS sufferers typically have relapses and remissions over many years.

Mumford, Lewis (1895–1990) US writer and critic, best known for his essays on town planning and architecture, which include *The City in History* (1961) and *Roots of Contemporary Architecture* (1972). He also published works on a variety of subjects, including *Herman Melville* (1929) and *Renewal of Life* (1934, 1938, 1944, 1951).

mummy Human body embalmed and usually wrapped in bandages before burial. The practice was common in ancient Egypt, where religion decreed that the dead would require the use of their bodies in the afterlife. Certain other peoples, including the Incas of South America, had similar practices. **mumps** Viral disease, most common in children, characterized by fever, pain and swelling of one or both parotid sali-

ratings viral disease, most common in children, characterized by fever, pain and swelling of one or both parotid salivary glands (located just in front of the ears). The symptoms are more serious in adults, and in men inflammation of the testes (orchitis) may occur, with the risk of sterility. Children over 18 months of age can be vaccinated against the disease. One attack of mumps generally confers lifelong immunity.

Munch, Edvard (1863–1944) Norwegian painter and printmaker. Munch was one of the most influential of modern artists, inspiring EXPRESSIONISM. Munch's tortured, isolated figures and violent colouring caused a scandal when he exhibited his work in Berlin in 1892, but his paintings inspired progressive artists to form the SEZESSION. Munch compiled a series of studies of love and death entitled a *Frieze of Life*, which included *The Scream* (1893). Other important works are *Ashes* (1894), and *Virginia Creeper* (1898).

Munich (München) City in s Germany, on the River Isar; capital of BAVARIA. Founded in 1158, Munich became the residence of the dukes of Bavaria in 1255. Occupied by the Swedes in 1632, and the French in 1800, it developed rapidly in the 19th century, when its population grew to more than 100,000. From the early 1920s Munich was the centre of the Nazi Party. It sustained heavy bomb damage in World War 2. Industries: chemicals, brewing, pharmaceuticals, motor vehicles, precision instruments, tourism. Pop. (1990) 1,241,300.

▲ mule Traditionally common in regions where there is low mechanization, mules have been used as pack animals for many thousands of years. They need very little food, though they are strong and can endure hard conditions. Normally they cannot breed, but occasionally a female will produce a foal; the male is always sterile.

■ Munch Girls on the Bridge (1901). Norwegian painter Edvard Munch is famous for his portrayals of mental anguish, which expressed his own deep sense of disillusionment with contemporary life. In 1908 Munch suffered a severe mental breakdown; his gradual recovery is reflected in the more optimistic tone of his later work.

Munich Agreement (September 1938) Pact agreed by Britain, France, Italy and Germany to settle German claims on Czechoslovakia. Hoping to preserve European peace, Britain and France compelled Czechoslovakia (not represented at Munich) to surrender the predominantly German-speaking SUDETENLAND to Nazi Germany on certain conditions. HITLER ignored the conditions and, six months later, his troops took over the rest of the country, an action that finally ended the Anglo-French policy of APPEASEMENT.

Munich Putsch (Beer hall Putsch) Attempted coup in 1923 by Adolf Hitler and the Nazi Party to overthrow the republican government of Bavaria, which began in a beer-hall. The coup proved abortive and Hitler was arrested and sentenced to five years in the Landsberg fortress. He served nine months.

Munro, H.H. (Hector Hugh) See SAKI

Munster Largest of the Republic of Ireland's four provinces, on the Atlantic coast; . It includes the counties of CLARE, CORK, KERRY, LIMERICK, N and S TIPPERARY, and WATERFORD. Area: 24,126sq km (9,315sq mi). Pop. (1991) 1,009,533.

muntjac Small primitive Asian DEER. It is brown with cream markings and has tusk-like canine teeth and short, two-pronged antlers. There are two well known species, the Indian muntjac or barking deer (*Muntiacus muntjak*) and the Chinese muntjac (*M. reevesi*). Height: to 60cm (24in) at the shoulder; weight: to 18kg (40lb). Family Cervidae.

Muscles are contractile tissue, which can initiate or maintain movement in the body. Muscles comprise 35–40% of the total body weight and there are over 650 human skeletal muscles

(some of those directly under the skin are shown) controlled by the nervous system. Skeletal muscles may be massive, like the gluteus maximus in the buttock, or minute, like the stapedius

muscle inside the middle ear.

Most skeletal muscles join one
bone to another, and have their
"origin" on one immobile bone,
and their "insertion" on the more
mobile bone.

mural Painting or other design medium applied directly to a wall; a FRESCO is a type of mural. The Egyptians, Greeks and Romans produced murals in TEMPERA as well as fresco. In the Renaissance, mural painting was allied with architecture in efforts to create illusions of space. The 20th century has accorded more significance to the exterior mural, as exemplified by the works of the Mexicans José Clemente Orozco and Diego Rivera. Porcelain and liquid silicate enamels are among the media used in modern murals.

Murasaki, Shikibu (978–1014) Japanese diarist and novelist. She is best known for her novel, *The Tale of Genji*, which she is thought to have written c.1000. It is one of the first works of fiction written in Japanese. *See also* JAPANESE LITERATURE

Murcia Autonomous region in SE Spain; the capital is Murcia. It was settled in c.225 BC by the Carthaginians, who founded the port of Cartagena and the city of Murcia. The Moors captured the region in the 8th century. In the 11th century Murcia became an independent kingdom, but in the 13th century it fell under the control of Castile. Murcia is an arid, rugged province with desert vegetation. Historically, the region has been associated with the production of silk, concentrated around the city of Murcia. Area: 11,317sq km (4,368sq mi). Pop. (1991) 1,045,601.

murder Unlawful killing of a person, performed with malice or forethought. Committed accidentally, under sufficient provocation or in self-defence, a killing may not constitute murder. See also MANSLAUGHTER

Murdoch, (Jean) Iris (1919–) British novelist and moral philosopher, b. Ireland. Murdoch created her own genre, the philosophical love story. Her early novels, culminating in *The Bell* (1958), are short and concise. Her later novels, such as *The Black Prince* (1973), the Booker Prize-winning *The Sea*, the Sea (1978), *The Good Apprentice* (1985) and *The Book and the Brotherhood* (1987), are longer and more elaborate. Recurrent themes include the difference between sacred and profane love and the nature of chance.

Murdoch, (Keith) Rupert (1931–) US media tycoon, b. Australia. In 1952 Murdoch assumed control of his late father's newspaper, *The Adelaide News*. He transferred his successful recipe of sensationalist journalism to the British newspapers *News of the World* (1969) and *The Sun* (1970). In 1973 he moved into the US newspaper market, acquiring the *Boston Herald* and *The Star*. In Britain, he bought *The Times* and the *Sunday Times*. In 1985 Murdoch became a US citizen. He began to diversify into other media industries, acquiring 50% of 20th Century Fox. In 1989 Murdoch launched the first satellite broadcasting network in the UK, Sky Television. He has also monopolized the development of digital cable television.

Murillo, Bartolomé Estebán (1617–82) Spanish painter. Murillo made his name with a series of 11 pictures showing the lives of the Franciscan saints (1645–46). His mature style is characterized by soft, idealized figures.

Murray Longest river in Australia. It flows 2,590km (1,610mi) from the Australian Alps in SE New South Wales through Lake Alexandrina, and empties into the Indian Ocean at Encounter Bay, SE of Adelaide. It forms a large part of the border between New South Wales and Victoria. Its main tributary is the Darling. The Murray valley contains almost all the irrigated land in Australia.

Murrow, Ed (Edward Roscoe) (1908–65) US broadcasting journalist. Murrow joined Columbia Broadcasting System (CBS) in 1935 and, during World War 2, gained fame for his vivid descriptions of the Battle of Britain.

Muscat (Masqat, Maskat) Capital of Oman, on the Gulf of Oman, in the SE Arabian Peninsula. Muscat was held by the Portuguese from 1508 to 1650, when it passed to Persia. After 1741 it became capital of Oman. In the 20th century Muscat's rulers developed treaty relations with Britain. Industries: fish, dates, natural gas, chemicals. Pop. (1990 est.) 380,000.

muscle Tissue that has the ability to contract, enabling movement. There are three basic types: SKELETAL MUSCLE, smooth muscle and cardiac muscle. Skeletal muscle, or striped muscle, is the largest tissue component of the human body, comprising about 40% by weight. It is attached by TENDONS to the BONES of the SKELETON and is characterized by cross-markings known as

striations. Smooth muscle lines the digestive tract, blood vessels and many other organs. It is not striated. Cardiac muscle is found only in the heart and differs from the other types of muscle in that it beats rhythmically and does not need stimulation by a nerve impulse to contract. See also INVOLUNTARY MUSCLE muscular dystrophy Any of a group of hereditary disorders in which the characteristic feature is progressive weakening and ATROPHY of the muscles. The commonest type, Duchenne muscular dystrophy, affects boys, usually before the age of four. Muscle fibres degenerate, to be replaced by fatty tissue. muses In classical mythology, nine daughters of the Titan Mnemosyne (memory) and ZEUS. Calliope was the muse of epic poetry, Clio of history, Erato of love poetry, Euterpe of lyric poetry, Polyhymnia of song, Melpomene of tragedy, Terpsichore of dance, Thalia of comedy and Urania of astronomy. **mushroom** Any of numerous relatively large fleshy fungi, many of which are gathered for food. A typical mushroom consists of two parts: an extensive underground cobwebby network of fine filaments (hyphae), called the mycelium, which is the main body of the FUNGUS, and a short-lived fruiting body (the visible mushroom).

Musial, Stan (Stanley Frank) (1920–) US baseball player. "Stan the Man" played for the St Louis Cardinals (1941–44, 1946–63) and complied a record 3,630 hits (broken in 1981 by Pete Rose). He hit 475 home runs and had a .331 batting average. He was three times Most Valuable Player (1943, 1946, 1948) and was elected to the Baseball Hall of Fame in 1969.

music Sound arranged for instruments or voices, for many purposes, exhibiting a great variety of forms and styles. It can be split into categories, including ROCK, JAZZ, BLUES, FOLK MUSIC, SOUL MUSIC, RAP, HOUSE MUSIC and COUNTRY AND WESTERN. Within classical music, there are distinct historical periods – MEDIEVAL MUSIC (1100–1400), RENAISSANCE MUSIC (1400–1600), BAROQUE (1600–1750), CLASSICAL MUSIC (1750–c.1800) and Romantic (c.1800–1900) (see ROMANTICISM). In the 20th century, various techniques developed, notably SERIAL MUSIC, TWELVE-TONE MUSIC and IMPRESSIONISM. Composers also experimented with ELECTRONIC MUSIC.

musical Genre of popular dramatic light entertainment exemplified by firm plot, strong songs and vivacious dance numbers. It developed at the end of the 19th century from elements of light opera, revue and burlesque. The most popular musicals originated in the USA with the work of George GERSHWIN, Jerome KERN, Richard RODGERS, Oscar HAMMERSTEIN and Stephen SONDHEIM. Audiences in the 1970s responded to the works of Andrew LLOYD WEBBER and Tim Rice, such as Jesus Christ Superstar (1971) and Evita (1978). Lloyd Webber was extremely successful in the 1980s with Cats (1981) and The Phantom of the Opera (1986). Successful film musicals, such as West Side Story (1961), My Fair Lady (1964) and The Sound of Music (1965), are generally based on stage originals. Original film musicals include Forty-Second Street (1933), Meet Me in St Louis (1944), and Singin' in the Rain (1952).

musical form Structural scheme that gives shape and artistic unity to a composition. The standard forms are binary, ternary, rondo and sonata. Each consists of a number of musical sections or subsections. Binary form consists of two sections, which may be contrasted in idea, key or tempo but which complement each other within the musical entity. Ternary form consists of a restatement of the first section after a middle section of contrasted material; an example is the MINUET and trio. In rondo form, the number of sections varies, but there is at least one restatement of the first section. Sonata form, as its name suggests, evolved with the sonata and is used most often for the first movement of a sonata or SYMPHONY. The exposition states two subjects, which are developed musically in the middle section, before being reworked in the recapitulation.

musical notation Method of writing down music – the language of music. Staff notation defines the absolute and relative pitches of notes; crotchets, quavers and so on indicate their time values.

music hall Stage for popular variety shows, originally tavern annexes, devoted to comic song, acrobatics, magic shows, juggling and dancing. The popularity of the music hall was at its height in late Victorian and Edwardian England, but

declined with the advent of radio and motion pictures in the 1930s. In the USA, it was often known as VAUDEVILLE.

musicology Academic study of music. The term embraces various disciplines, including the study of music history, the analysis of compositions, acoustics and ethnomusicology. The study of music history began in the 18th century. Musicological research in the 20th century is responsible for the increased interest in and performance of early music.

muskellunge Freshwater fish found in the Great Lakes. A type of PIKE, it has a shovel-like bill, sharp teeth, and elongated body. It eats fish, amphibians, birds, and small mammals. Length: to 167.6cm (5.5ft); weight: 49.9kg(110lb). Family Esocidae; species *Esox masquinongy*.

musk ox Large, wild, shaggy RUMINANT, related to oxen and GOATS, native to N Canada and Greenland. Its brown fur reaches almost to the ground, and its down-pointing, recurved horns form a helmet over the forehead. When threatened, the herd forms a defensive circle round the calves. Length: to 2.3m (7.5ft); weight: to 410kg (903lb). Family Bovidae; species *Ovibos moschatus. See also* ox

muskrat Large, aquatic RODENT (a type of VOLE) native to North America. It is a good swimmer, with partly webbed hind feet and a long, scaly tail. Its commercially valuable fur (musquash) is glossy brown and durable. Length, including tail: to 53.5cm (21in); weight: to 1.8kg (4lb). Family Cricetidae; species *Ondatra obscura* and *O. zibethica*.

Muslim (Arabic, one who submits) Follower or believer in Islam. A Muslim is one who worships Allah alone and holds Muhammad to be the only true prophet. In 1990 it was estimated there were 935 million Muslims worldwide.

Muslim League Political organization (founded 1906) to protect the rights of Muslims in British India. The League cooperated with the predominantly Hindu National Congress until the 1930s when, fearing Hindu domination, it turned to independent action under the leadership of Muhammad Ali Jinnah. Although pro-British, in 1940 it called for a separate Muslim state, which was achieved when the country was partitioned at independence (1947). At first, the League dominated politics in Pakistan but subsequently split into rival factions.

mussel Any of several species of bivalve MOLLUSCS with thin oval shells. Marine species of the family Mytilidae are found throughout the world in dense colonies on sea walls and rocky shores, where they attach themselves by means of strands called byssus threads. The edible mussel, *Mytilus edulis*, is sometimes cultivated on ropes hanging from rafts. Freshwater mussels of the family Unionidae, found in N continents only, produce PEARLS.

Musset, Alfred de (1810–57) French poet and playwright. He is best remembered for his poems which, after 1834, appeared in the periodical Revue des Deux Mondes. His four lyrics Les Nuits (1835-37) are the most famous of his poems. Mussolini, Benito (1883–1945) Italian fascist dictator, prime minister (1922-43). Mussolini turned to revolutionary nationalism in World War 1, and in 1919 founded the Italian Fascist movement. The fascists' march on Rome in 1922 secured his appointment as prime minister. Mussolini imposed one-party government with himself as Il Duce (lit. the leader), or dictator. His movement was a model for HITLER's Nazi Party, with whom Mussolini formed an alliance in 1936. Imperial ambitions led to the conquest of Ethiopia (1935–36), and the invasion of Albania (1939). Mussolini delayed entering World War 2 until a German victory seemed probable in 1940. A succession of defeats led to his fall from power. He

▲ mussel The common mussel (Mytilis edulis) is edible and cultivated on ropes hanging from stakes or similar structures driven into seabeds, or on ropes suspended from floating rafts. Both methods involve the collection by settlement of mussel "seed" or "spat". The seed may then be transferred to farming areas free from predators or pollution.

was briefly restored as head of a puppet government in N Italy by the Germans, but in April 1945, fleeing Allied forces, he was captured and killed by Italian partisans.

Mussorgsky, Modest Petrovich (1839–81) Russian composer, one of the "Russian Five" who promoted nationalism in Russian music. Mussorgsky's finest work is the opera Boris Godunov (1868–69). Other important works include the piano work Pictures from an Exhibition (1874, later orchestrated by several composers) and A Night on the Bare Mountain (1867). After his death, much of Mussorgsky's work was edited and revised, notably by Nikolai RIMSKY-KORSAKOV.

Mustafa Kemal See Kemal ATATÜRK

mustang Feral HORSE of the Great Plains of the USA, descended from horses that were imported from Spain. The mustang has short ears, a low-set tail and round leg bones. During the 17th century, there were 2-4 million mustangs. Today, only c.20,000 survive in sw USA.

mustard Any of various species of annual and perennial plants, native to the temperate zone. These plants have pungent-flavoured leaves, cross-shaped, four-petalled flowers and carry pods. The seeds of some species are ground to produce the condiment, mustard. Height: 1.8–4m (6–13ft). Family Brassicaceae/Cruciferae.

mutation Sudden change in an inherited characteristic of an organism. This change occurs in the DNA of the GENES. Natural mutations during reproduction are rare, occur randomly, and usually produce an organism unable to survive in its environment. Occasionally, the change results in an organism being better adapted to its environment and, through NATURAL SELECTION, the altered gene may pass on to the next generation. Natural mutation is therefore one of the key means by which organisms evolve. The mutation rate can be increased by exposing genetic material to ionizing radiation, such as xrays or UV light, or mutagenic chemicals. See also EVOLUTION Muti, Riccardo (1941-) Italian conductor. He made his début in 1968 with the Italian Radio Symphony Orchestra. In 1973 he became chief conductor of the Philharmonia Orchestra. He was principal conductor of the Philadelphia Orchestra (1981–92), and musical director of La Scala (1986–).

Mutter, Anne-Sophie (1963–) German violinist. She made her concerto début with the Berlin Philharmonic in 1977, having come to the notice of Herbert von KARAJAN, with whom she later recorded all the major violin concertos. mutualism Relationship with mutual benefits for the two or more organisms involved. An alternative term for SYMBIOSIS, it usually refers to two organisms of different species.

Muybridge, Eadweard (1830–1904) US photographer, b. Britain. After emigrating to the USA in 1852, he became a pioneer of motion photography. From 1878, he recorded the movements of animals and people by using a series of still cameras. In 1881 he invented the Zoopraxiscope, a forerunner of motion pictures, which projected animated pictures on a screen.

Myanmar Official name of BURMA since 1989

Mycenae Ancient city in Greece, 11km (7mi) N of modern Argos, which gave its name to the MYCENAEAN CIVILIZATION. Dating from the third millennium BC, Mycenae was at its cultural peak c.1580–1120 BC. It was destroyed in the 5th century BC. Later restored, by the 2nd century AD it was once more in ruins. The ruins of Mycenae were discovered (1874–76) by Heinrich SCHLIEMANN.

Mycenaean civilization Ancient Bronze Age civilization (c.1580–1120 BC) centred around Mycenae, s Greece. The Mycenaeans entered Greece from the N, bringing with them advanced techniques particularly in architecture and metallurgy. By 1400 BC, having invaded Crete and incorporated

much of MINOAN CIVILIZATION, the Mycenaeans became the dominant power in the Aegean, trading as far as Syria, Palestine and Egypt, and importing luxurious goods for their wealthy and cultured citadel palaces. The reasons for the collapse of the Mycenaean civilization are uncertain, but it was most likely due to invasion by the Dorians.

Mycenean art Greek art of the late Helladic period (c.1500-1100~BC) of the Bronze Age, centred around the fortress-city of Mycenae . Its greatest achievements came in the fields of architecture, which included both grand fortifications and beehive tombs, and in pottery, precious metalwork and fresco.

mycology Science and study of FUNGUS.

mynah See MINA

myopia (short-sightedness) Common disorder of vision in which near objects are seen sharply, but distant objects are hazy. It is caused either by the eyeball being too long or the eye's lens being too powerful, so that light rays entering the eye focus in front of the RETINA. It is easily corrected with concave lenses in spectacles or contact lenses.

myrrh Aromatic, resinous, oily gum obtained from thorny, flowering trees such as *Commiphora myrrha* (family Burseraceae). Known and prized since ancient times, it has commonly been used as an ingredient in incense, perfumes and medicines.

myrtle Any of numerous species of evergreen shrubs and trees that grow in tropical and subtropical regions, especially the aromatic shrub, *Myrtus communis*, of the Mediterranean region. Its leaves are simple and glossy; the purple-black berries, which follow the white flowers, were once dried and used like pepper. Family Myrtaceae.

mystery play (miracle play) Medieval English drama based on a religious theme. Mystery plays were originally used by the clergy to teach their illiterate congregation the principal stories of the Bible. By the 14th century, they had become a popular entertainment. Each year, the plays were performed by the various craft guilds in a town. In England, mystery plays from four towns have survived: Chester, York, Wakefield and Coventry.

mysticism Belief in, or experience of, a perception of reality that is elevated above normal human understanding. It may involve some form of spiritual search for unity of self with God or the universe. It is found in most major religions, and exponents of mysticism (mystics) may experience trances, dreams or visions. In India, mysticism has long been important in HINDUISM, and is based on Yoga. Mysticism in Judaism is apparent in HASIDISM and the CABBALA. Mystics in the Far East have mostly been followers of TAOISM or BUDDHISM.

mythology Literally, telling of stories, but usually collectively defined as the myths of a particular culture. A myth occurs in a timeless past, contains supernatural elements and seeks to dramatize or explain such issues as the creation of the world (CREATION MYTH) and human beings, the institutions of political power, the cycle of seasons, birth, death and fate. Most mythologies have an established pantheon, or hierarchy, of gods who are more or less anthropomorphic. See also African Mythology; Celtic Mythology; Central And South American Mythology; Creek Mythology; Chinese Mythology; Egyptian Mythology; Greek Mythology; North American Mythology; Oceanic Mythology; Persian Mythology, Ancient; Teutonic Mythology

myxoedema Disease caused by deficient function of the THYROID GLAND, resulting in fatigue, constipation, dry skin, a tendency towards weight-gain and, in the later stages, mental dullness. It mostly affects middle-aged women. Treatment involves administration of the thyroid hormone, thyroxine.

Nabokov, Vladimir (1899–1977) US novelist, b. Russia. His family emigrated in 1919 and he settled in Germany. His debut novel was *Mary* (1926). The rise of fascism forced Nabokov to flee first to France then the USA (1940). His first novel in English was *The Real Life of Sebastian Knight* (1938). Nabokov composed some of the greatest imaginative novels of the 20th century. *Bend Sinister* (1947) is a political novel on authoritarianism. His best-selling work, *Lolita* (1955), is a controversial, lyrical novel about an old man's desire for a 12-year old "nymphette". Other works include *Pnin* (1957), *Pale Fire* (1962) and *Ada* (1969).

nadir Point on the CELESTIAL SPHERE vertically below the observer. It is diametrically opposite the ZENITH.

Nadir Shah (1688–1747) Ruler of Persia (1736–47), who created a vast empire in central Asia. After seizing the throne he embarked upon a series of wars against neighbouring states. He invaded India, sacking Delhi, and conducted campaigns against Russia and Turkey. He failed in his attempt to impose the Sunnite form of Islam on Persia. His ceaseless warring ruined the country's economy and his cruelty aroused hostility from his subjects. He was assassinated by his own soldiers.

Nagaland State in NE India; the capital is Kohima. Briefly ruled by Burma in the early 19th century, it gradually came under British control, then became a separate state in 1963. The Nagas live in an underdeveloped tribal society with a strong separatist movement. Crops: rice, potatoes, sugar cane. Area: 16,579sq km (6,399sq mi). Pop. (1991) 1,209,546.

Nagasaki Seaport on w Kyūshū island, sw Japan. In the 16th century it was the first Japanese port to receive Western ships and became a centre of Christian influence. During Japanese isolation (1639–1859) it was the only port open to foreign trade. In August 1945 the inner city was destroyed by the second US atomic bomb dropped on Japan and more than 70,000 people were killed. Industries: shipbuilding, heavy engineering, fishing, mining. Pop. (1993) 439,000.

Nagorno-Karabakh Autonomous region of Azerbaijan, between the Caucasus and Karabakh Mountains. The capital is Stepanakert. During the 19th century the region was absorbed into the Russian empire. In 1921 it was annexed to the Azerbaijan republic. In 1991 the region declared its independence and Azerbaijan responded by imposing direct rule. The ensuing civil war claimed thousands of lives. In 1993 Armenian troops occupied the enclave and a peace agreement was reached in 1994. The main activities are farming and silk production. Area: 4,400sq km (1,700sq mi). Pop. (1990) 192,400 Nagoya City and Pacific port on Honshū island, central Japan. Nagoya grew up around the 17th-century Castle. Industries: iron and steel, textiles, motor vehicles, aircraft. Pop. (1993) 2,095,000.

Nagpur City in Maharashtra state, w central India. Founded in the 18th century as the capital of the kingdom of Nagpur, it became the capital of Berar state (from 1903) and of Madhya Pradesh state (1947–56). Industries: metal goods, transport equipment, cigarettes, textiles, pottery, glass, leather, pharmaceuticals, brassware. Pop. (1991) 1,624,572.

Nagy, Imre (1896–1958) Hungarian communist statesman, premier (1953–55). As premier, Nagy enacted liberal reforms of the Hungarian economy and society. Under pressure from the Soviet Union, Nagy was dismissed from the Hungarian Communist Party. The Hungarian Revolution (1956) led to Nagy's reinstatement as premier. Soviet tanks crushed the uprising and handed power to János KÁDÁR. Nagy was tried and executed for treason.

Nahuatl Native American language of the Uto-AZTECAN linguistic family of the s USA and Central America. It is spoken today by about a million people, mostly in Mexico.

nail In anatomy, tough KERATIN outgrowth from the fingers and toes of primates.

Naipaul, V.S. (Vidiadhar Surajprasad) (1932–) West Indian novelist and short-story writer. He was educated in his native Trinidad and at Oxford, but later settled in London. His novels include A House for Mr Biswas (1961), the Booker Prize-winning In a Free State (1971), and A Bend in the River (1979). His travelogues include Among the Believers: An Islamic Journey (1981) and A Turn in the South (1989).

Nairobi Capital and largest city of Kenya, in the s central part of the country, Founded in 1899, Nairobi replaced Mombasa as the capital of the British East Africa Protectorate in 1905. Nairobi has a national park (1946), a university (1970) and several institutions of higher education. It is an administrative and commercial centre. Industries: cigarettes, textiles, chemicals, food processing, furniture, glass. Pop. (1989) 1,346,000. Naismith, James (1861–1939) US sportsman and inventor of basketball, b. Canada. Many of his rules are still in use today. Nakhichevan Autonomous republic of Azerbaijan, bounded N and E by Armenia, S and W by Iran, and W by Turkey; the capital is Nakhichevan. Under Persian domination from the 13th to the 19th century, it became part of Russia in 1828. In 1924 it was made an autonomous republic within the Soviet Union. In 1991 it became part of the independent republic of Azerbaijan, but was subsequently disputed between Armenia and Azerbaijan. Nakhichevan is mountainous and subject to earthquakes. Crops: grains, cotton, tobacco, fruit, grapes. Industries: mining, silk textile production, food processing. Area: 5,500sq km (2,120sq mi). Pop. (1994) 315,000.

Namath, Joe (Joseph William) (1943–) ("Broadway Joe") US football player. Joining New York in 1965 as quarterback, he had a phenomenally successful career over 13 seasons. In 1967 he passed for a record 4,007 yards.

Namib Desert Coastal desert region of Namibia, between the Atlantic Ocean and the interior plateau. It has less than 1cm (0.4in) of rain a year and is almost completely barren. Diamonds are mined. Length: *c*.1,900km (1,200mi).

Namibia (formerly South West Africa) Republic in sw Africa. Land and climate Namibia can be divided into four geographical regions. The arid NAMIB DESERT runs along the Atlantic coast. Inland, a central plateau, mostly between 900 and 2,000m (2,950-6,560ft), includes the capital, WINDHOEK. The highest point is Brandberg Mountain, at 2,606m (8,550ft). In the N lies an alluvial plain, which includes the marshlands of the Caprivi Strip. To the E is the w fringe of the KALAHARI. The ORANGE River forms Namibia's s border. Namibia is a warm, arid country. Grassland and shrub cover much of the interior. The Etosha National Park is a magnificent wildlife reserve. History The nomadic SAN inhabited the region c.2,000 years ago. They were gradually displaced by Bantuspeakers, such as the Ovambo, Kavango and Herero. Portuguese navigators arrived in the early 15th century. Colonization began in earnest in the 19th century. In 1884 Germany

N/n, the 14th letter of the modern Roman alphabet used for English and most other w European languages. It is derived from the Semitic letter nun, which was the pictorial representation of a fish. It was adopted by the Greeks as the letter nu and subsequently by the Romans. N is unpronounced after m in a few words such as condemn and hymn.

NAMIBIA

AREA: 825,414sq km (318,694 sq mi)
POPULATION: 1,562,000
CAPITAL (POPULATION):
Windhoek (126,000)
GOVERNMENT: Multiparty
republic

ETHNIC GROUPS: Ovambo 50%, Kavango 9%, Herero 7%, Damara 7%, whites

6%, Nama 5% LANGUAGES: English (official) RELIGIONS: Christianity 90% (Lutheran 51%)
currency: Namibian dollar
= 100 cents

▲ Napoleon I Emperor of the French, Napoleon Bonaparte was a military and organizational genius. After various military victories, he established order at home with his Napoleonic Code. He achieved his greatest military victory at Austerlitz over Russia and Austria in 1805. He soon controlled much of continental Europe but his invasion of Russia (1812) was a disaster. He was eventually defeated at the Battle of Waterloo in 1815.

claimed the region as a protectorate and subsumed it into the territory of South West Africa. Local rebellions were brutally suppressed. The discovery of diamonds in 1908 increased European settlement. During World War 1 it was occupied (1915) by South African troops. In 1920 South Africa was granted a mandate. After World War 2 South Africa refused to relinquish control. In 1966 the SOUTH WEST AFRICA PEOPLE'S ORGANIZATION (SWAPO) began a guerrilla war against South Africa. In 1968 the United Nations called on South Africa to withdraw. In 1971 the International Court of Justice declared that South African rule over Namibia was illegal. South Africa refused to comply. International pressure forced South Africa to promise Namibia independence, but then qualified the terms. Civil war raged from 1977. A UN security council peace settlement was finally implemented in 1989. SWAPO won multiparty elections in November 1989. In March 1990 Namibia became an independent republic within the Commonwealth of Nations. Sam NUJOMA became its first president and was re-elected in 1994. Economy Namibia is the world's seventh-largest producer of diamonds and ninth-largest producer of uranium. Minerals make up 90% of exports. Farming employs c.40% of the workforce. The main activity is cattle and sheep farming. The chief food products are maize, millet and vegetables. Atlantic fishing is also important.

Nanak (1469–1539) Indian spiritual teacher, founder and first guru of SIKHISM. Nanak preached a monotheistic religion that combined elements from both HINDUISM and ISLAM. In 1519 he founded the town of Kartarpur in Punjab, where he attracted many followers.

Nan-ch'ang (Nan-ch'ang-hsien) City in SE China; capital of Jiangxi province. It was founded as a walled city in the 3rd century BC. Army Day (August 1) commemorates the failed communist coup here in 1927. Industries: rice, tea, cotton textiles, machinery. Pop. (1993) 1,420,000.

Nanking (Nanjing) City on the River Yangtze, E China; capital of Jiangsu province. Founded in the 8th century BC, it served as the capital of China at various times. The Treaty of Nanking (1842) ended the Optum War and opened five Chinese ports to foreign trade. It was the seat of Sun Yat-sen's provisional presidency in 1912. In 1937, during the Sino-Japanese War, the city was captured by the Japanese, who massacred over 100,000 of the population. Notable landmarks include the city wall and the tombs of the Ming emperors. Industries: iron and steel, oil refining, chemicals. Pop. (1993) 2,430,000.

nanotechnology Micromechanics used to develop working devices the size of a few nanometres. (A nanometre is one billionth of a metre.) US scientists have etched an electric motor from silicon that is smaller than 0.1 mm wide and have made workable gears with a diameter less than a human hair. Nansen, Fridtjof (1861–1930) Norwegian explorer and statesman. After a pioneering crossing of Greenland in 1888, he designed a ship that would withstand being frozen into the ice in the hope that currents would carry her to the North Pole. She did not reach the Pole, but crossed the Arctic Ocean in the ice undamaged (1893–96). Nansen and one companion attempted to reach the Pole with skis and kayaks. They failed but set a record for farthest north. After 1918 Nansen was involved in international humanitarian work. He was awarded the Nobel Peace Prize in 1922.

Nantes City in w France, at the mouth of the River Loire; capital of Loire-Atlantique département. France's seventh-largest city, it has been a trading centre since Roman times. In the 10th century it was captured from Norse invaders by the duke of Brittany. Nantes remained a residence of the dukes until 1524. The city developed around its port and the trade in sugar and ebony. By the 18th century it had become France's largest port. During World War 2 it was a centre of the French resistance movement. Industries: shipbuilding, sugar refining, food products. Pop. (1990) 244,995.

Nantes, Edict of (1598) French royal decree establishing toleration for HUGUENOTS (Protestants). It granted freedom of worship and legal equality for Huguenots within limits, and ended the Wars of Religion. The Edict was revoked by LOUIS XIV in 1685, causing many Huguenots to emigrate.

naphtha Any of several volatile liquid-hydrocarbon mix-

tures. In the 1st century AD, "naphtha" was mentioned by Pliny the Elder. Alchemists used the word for various liquids of low boiling point. Several types of products are now called naphtha, including coal-tar naphtha and petroleum naphtha.

naphthalene Important hydrocarbon (C₁₀H₉) composed of

naphthalene Important hydrocarbon ($C_{10}H_8$) composed of two benzene rings sharing two adjacent carbon atoms. A white, waxy solid, naphthalene is soluble in ether and hot alcohol and is highly volatile. It is used in mothballs, dyes and synthetic resins, and in the high-temperature cracking process of petroleum. Properties: m.p. $80^{\circ}C$ ($176^{\circ}F$); b.p. $218^{\circ}C$; ($424^{\circ}F$).

Napier, John (1550–1617) Scottish mathematician. He developed "Napier bones", a calculating apparatus that he used to invent logarithms (1614) and the present form of decimal notation.

Naples (Napoli) City on the Bay of Naples, s central Italy; capital of the province of CAMPANIA. Founded c.600 BC as a Greek colony, Naples was conquered by Rome in the 4th century BC. Successively ruled by the Byzantines, Normans, Spanish and Austrians, it became the capital of the Kingdom of the Two Sicilies in 1734, eventually joining the Kingdom of Italy in 1860. Notable buildings include the 13th-century Gothic cathedral, the Church of the Holy Apostles, the University (1224) and the Music Conservatory (1537). The city contains areas of great economic deprivation. Industries: textiles, leather, steel, shipbuilding, aircraft, telecommunications, tourism. Pop. (1991) 1,067,365.

Napoleon I (1769–1821) (Napoléon Bonaparte) Emperor of the French (1804-15), b. Corsica. The greatest military leader of modern times, he became a brigadier (1793) after driving the British out of Toulon. He was given command in Italy (1796) where he defeated the Austrians and Sardinians. In 1798 he launched an invasion of Egypt. French defeats in Europe prompted his return to Paris (1799), where his coup of 18 Brumaire (9 November) overthrew the Directory and set up the Consulate, headed by himself. He enacted sweeping administrative and legal reforms with the Code Napoléon, while defeating the Austrians at Marengo (1800) and making peace with the British at Amiens (1802). In 1804 he crowned himself emperor. Efforts to extend French power provoked the Napoleonic Wars (1803-15). Napoleon's Grand Army shattered his continental opponents but, after TRAFALGAR (1805), Britain controlled the seas. Napoleon tried to defeat Britain by a commercial blockade, which led indirectly to the PENINSULAR WAR in Portugal and Spain. By 1812 he controlled most of continental Europe. His invasion of Russia (1812) ended in the destruction of the Grand Army, encouraging a new coalition against France, which captured Paris in March 1814. Napoleon was exiled to ELBA, but in March 1815 he returned triumphantly to France. The HUNDRED Days of his renewed reign ended with defeat at WATERLOO in June. Napoleon was exiled to ST HELENA, where he died.

Napoleon III (1808–73) (Louis Napoleon) Emperor of the French (1852–70). The nephew of Napoleon I, he twice attempted a coup in France (1836, 1840). Returning from exile after the February Revolution (1848), he was elected president of the Second Republic. In 1851 he assumed autocratic powers and established the Second Empire (1852), taking the title Napoleon III. His attempt to establish a Mexican empire under the Archduke Maximillan ended in disaster, and in 1870 he was provoked by Bismarck into declaring war on Prussia. Defeat at Sedan was followed by a republican rising that ended his reign.

Napoleonic Wars (1803–15) Campaigns by a series of European coalitions against the expansion of France under Napoleon I. Britain declared war in 1803 and formed the Third Coalition with Austria, Russia and Sweden in 1804. Napoleon defeated the Austrians at UIm and the Russians and Austrians at Austrenziz (1806), but the British won a decisive naval victory at Trafalgar (1805). Prussia joined the Fourth Coalition (1806) but was defeated at Jena. Resistance to the French occupation of Portugal (1807) began the Peninsullar War. The Fifth Coalition (1809) collapsed with the defeat of Austria at Wagram. In 1812 Napoleon invaded Russia. He lost most of his army when compelled to retreat during bitter weather. Against the Sixth Coalition, Napoleon was

eventually defeated at Leipzig. Allied forces entered Paris in 1814. War was renewed during the HUNDRED DAYS, but ended in the final defeat of Napoleon by WELLINGTON and Blücher at WATERLOO (1815).

Nara City on s Honshū island; capital of Nara prefecture, Japan. A centre of Japanese Buddhism, Nara was founded in 706. From 710–784 it was Japan's first imperial capital. Todai-ji (East Great Temple) houses a 22m (72ft) tall bronze statue of Buddha. The 7th-century Horyuji temple is reputedly Japan's oldest building. Industries: textiles. Pop. (1993) 353,000.

Narcissus In Greek mythology, a beautiful youth who rejected the love of the nymph Echo and was punished by being made to fall in love with his own reflection in a pond. He pined away and was turned into a flower.

narcissus Genus of Old World, bulb-forming, garden flowers, including daffodils and jonguils. The long, pointed leaves surround yellow, orange or white trumpet-like flowers. Family Amaryllidaceae.

narcotic Any drug that induces sleep and/or relieves pain. The term is used especially in relation to opium and its derivatives. These drugs have largely been replaced as sedatives because of their addictive properties, but they are still used for severe pain, notably in terminal illness. Other narcotics include alcohols and BARBITURATES.

Narragansett Algonquian-speaking tribe of Native North Americans, who occupied part of Rhode Island. Once the most powerful New England group, they were almost entirely wiped out during King Philip's War (1675–76).

narwhal Small, toothed Arctic whale. The male has a twisted horn, half as long as its body, which develops from a tooth and protrudes horizontally through one side of the upper lip. Length: up to 5m (16ft). Species *Monodon monoceros*.

NASA See NATIONAL AERONAUTICS AND SPACE ADMINISTRA-TION (NASA)

Naseby, Battle of Final battle of the first English CIVIL WAR, fought in June 1645. Royalist troops under Prince RUPERT were defeated by the Parliamentarians under CROMWELL and FAIRFAX.

Nash, John (1752–1835) British architect and town planner, an important figure in the REGENCY STYLE. He designed Regent's Park and Regent Street, London, and rebuilt the Royal Pavilion, Brighton (1815–23).

Nash, Ogden (1902–71) US poet. Among his many volumes of humorous and satirical poetry are *Free Wheeling* (1931), *I'm a Stranger Here Myself* (1938) and *Everyone But Me and Thee* (1962).

Nash, Paul (1889–1946) British painter and graphic artist. Devoted to the English countryside, he was also closely in touch with European modernism. SURREALISM helped to stimulate the poetic, dream-like style of his landscapes, as in *The Menin Road* (1918) and *Landscape from a Dream* (1938).

Nash, Sir Walter (1882–1968) New Zealand statesman, prime minister (1957–60), b. England. Nash emigrated to New Zealand in 1909 and became a member of Parliament in 1929. As finance minister (1935–49), he helped to introduce the Labour Party's wide-ranging social security scheme.

Nashville Capital of Tennessee, USA, a port on the Cumberland River. Settled in 1779, it became state capital in 1843. During the Civil War, it was the scene of a decisive Union victory. The city merged with Davidson County in 1963. It is a country music centre and the home of the Country Music Hall of Fame (Grand Old Opry). The city has many neo-classical buildings. Industries in unsic, publishing. Pop. (1990) 510,784.

Nassau Capital of the Bahama Islands, West Indies, a port on the NE coast of New Providence Island. Founded in the 1660s by the British and named Charles Towne, it was renamed in 1695. It is a commercial centre and popular winter tourist resort. Pop. (1990) 172,000.

Nasser, Gamal Abdel (1918–70) Egyptian soldier and statesman, prime minister (1954–56) and first president of the republic of Egypt (1956–70). In 1942 Nasser founded the Society of Free Officers, which secretly campaigned against British imperialism and domestic corruption. He led the 1952 army coup against King FAROUK. He quickly ousted the nominal prime minister General Muhammad Neguib and assumed pres-

idential powers. Nasser's nationalization of the SUEZ CANAL (1956) prompted an abortive Anglo-French and Israeli invasion. Nasser emerged as champion of the Arab world. Nasser formed the short-lived United Arab Republic (1958–61) with Syria. He briefly resigned after Israel won the SIX DAY WAR (1967). The crowning achievement of his brand of Arab socialism was the completion of the ASWAN dam (1970).

Natal Former name (1910–94) of KwaZulu-Natal

Natchez Tribe of Muskogean-speaking Native Americans of the s Mississippi region. Today only a handful of Natchez people survive in Oklahoma.

National Aeronautics and Space Administration (NASA) US government agency that organizes civilian aeronautical and space research programmes. It has departments throughout the USA. The Lyndon B. Johnson Space Center in Houston, Texas, is responsible for manned space flights. Space rockets, both manned and unmanned, are launched from the John F. Kennedy Space Center at CAPE CANAVERAL, Florida.

National Association for the Advancement of Colored People (NAACP) US CIVIL RIGHTS organization. Founded in 1909, its objectives are "to achieve through peaceful and lawful means, equal citizenship rights for all American citizens by eliminating segregation and discrimination in housing, employment, voting, schools, the courts, transportation and recreation". Early leaders included W.E.B. Du Bois. It set up the successful Legal Defense and Educational Fund to finance court battles over discriminatory practices.

national curriculum Curriculum that is compulsory for all of a nation's schools. In the UK a national curriculum for state primary and secondary schools was introduced in 1989. Mathematics, English and science are core subjects to be studied by all pupils from 5 to 16.

national debt See DEBT, NATIONAL

National Front (NF) Extreme right-wing British political party founded in the 1960s. It has a racist doctrine advocating the repatriation of ethnic minorities irrespective of their place of birth and strongly opposing immigration. Although tainted by a neo-Nazi image, the National Front gained some support in the late 1970s, particularly in inner-city areas.

National Guard Volunteer citizen militia in the USA. Units are under state jurisdiction in peacetime and in times of national emergency may be activated for federal duty. Units are also activated during disasters and civil unrest.

National Health Service (NHS) In Britain, system of state provision of health care established in 1948. The NHS undertook to provide comprehensive coverage for most health services including hospitals, general medical practice and public health facilities. It is administered by the Department of Health. General practitioners have registered patients; they may also have private patients and may contract out of the state scheme altogether. They refer patients, when necessary, to specialist consultants in hospitals. Health visitors such as midwives and district nurses are the third arm of the service. Hospitals are administered by regional boards, which include governors of teaching hospitals.

national insurance In Britain, state scheme, founded in 1911, to provide sickness and unemployment benefits and old-age pensions. The scheme is funded by compulsory contributions from employers and employees, and is administered by the Department of Social Security.

nationalism Ideology according to which all people owe a supreme loyalty to their nation and which holds that each nation should be embodied in a separate state. Nationalist sentiment, drawing upon and extolling a common culture, language and history, can be a powerful unifying force. With the exception of national independence movements, nationalism is essentially conservative and dwells on a nation's past.

▲ narwhal Generally found only in the male, the distinctive tusk of the narwhal (Monodon monoceros) develops from the left tooth of a pair in the upper jaw. The function of the tusk remains unknown. Narwhals feed on fish and squid.

▲ Nasser First president of the republic of Egypt, Gamal Abdel Nasser was a British-trained soldier. In 1952 he led the army coup that ousted King Farouk. Becoming president in 1956, he provoked an international crisis by nationalizing the Suez Canal. Having fought in the 1948 Arablsraeli War, he brought on the 1967 Arab-Israeli War by blocking the Israeli port of Elat.

▲ Native American A map of the main language groups of North America including the Caribbean area and Mexico.

nationalization Policy of acquiring for public ownership business enterprises that were formerly owned privately. Nationalization was an economic principle of early SOCIALISM. Proponents of nationalization maintain that bringing essential industries under government control enhances social and economic equality. In the UK, the Labour government (1945–51) nationalized industries such as coal, steel and transport. In the 1980s, however, the trend was towards PRIVATIZATION, and several industries were returned to private ownership.

national parks Protected areas where restraint on the killing of wildlife is enforced, and forests, waters and other natural environments are preserved from commercial use. The USA was the first country to set aside reserves for preservation and recreation. YELLOWSTONE NATIONAL PARK was the first national park (1872). In Africa, the main purpose of national parks is game preservation. See also CONSERVATION; NATURE RESERVE

National Republican Party US political party, formed after the election of Andrew Jackson as president (1828). Staunchly opposed to Jackson, the party supported the Bank of the United States, a protective tariff and internal improvements. Daniel Webster and Henry Clay were dedicated leaders of the party. By 1836 it had become the Whigs.

National Security Council (NSC) US federal agency within the executive branch of government. Founded in 1947, it considers policies on matters concerning national security and makes recommendations to the president. The leading members are the US president, vice president, secretary of state and secretary of defense.

national service See CONSCRIPTION

national socialism (Nazism) Doctrine of the National Socialist German Workers' (Nazi) Party, 1921–45. It was biologically racist (believing that the so-called Aryan race was superior to others), anti-Semitic, nationalistic, anti-communist, anti-democratic and anti-intellectual. It placed power before justice and the interests of the state before the individual. These beliefs were stated by the party's leader, Adolf HITLER, in his book *Mein Kampf* (1925). *See also* FASCISM

National Theatre Permanent theatre company usually sub-

sidized by the state and housed in one venue, where national classics of drama are performed in repertory. Unlike establishments in many other European countries, some more than 200 years old, the National Theatre of Great Britain only became a reality in 1963. With Laurence OLIVIER as artistic director, the first production, *Hamlet*, took place on 22 October 1963, at the OLD VIC theatre. In 1973 Sir Peter HALL succeeded Olivier. New buildings designed by Sir Denys Lasdun were officially opened in October 1976, and comprise the Lyttelton Theatre, Olivier Theatre and Cottesloe Theatre. Following the departure of Richard Eyre, who succeeded Sir Peter Hall, Trevor NUNN was announced as the new artistic director in 1996.

National Trust British organization formed in 1895 in order to acquire and own buildings and land for permanent preservation. In 1907 the trust was given the power to declare its land inalienable. Today it protects about 471,000 acres.

Native Americans Indigenous peoples of the American continent. North America Native North Americans are

believed to be descended from Asian peoples who crossed via the Bering Strait or the Aleutian Islands about 20,000 BC or earlier. They may be divided into eight distinct cultural and geographic groups: the Arctic area; the Northeastern-Mackenzie area; the Northwest Coast area; the Southwestern area; the Plains area; the California-Intermountain area; the Southwestern area; and the Mesoamerican area. See separate articles for individual tribes. South America Native South Americans derived from North American groups who migrated s. Three main culture groups inhabiting distinct geographic areas are recognized: (1) Native Americans of the Andean area developed the highest cultures of the continent. After AD 1300 the QUECHUA culture dominated almost the entire region. (2) Native Americans of the Amazon Basin are mainly isolated, primitive, agricultural communities of many localized tribes. (3) Native Americans of the pampas successfully resisted Inca and Spaniard alike. In the southernmost portion of the continent live the Tierra del Fuegans, who are now few in number. Native Australians Indigenous peoples of Australia. Originally from SE Asia, Native Australians are thought to have colonized Australia 40,000-45,000 years ago. Before the arrival of Europeans (c.1788) they probably numbered more than 400,000, but many thousands died from European diseases when they were placed in reserves. All the 500 tribal groups led a nomadic life, hunting and gathering. They believe that the land is a religious phenomenon, inhabited by spirits of their ancestors, and these beliefs are celebrated in legends, song, mime, carving and painting. They were granted the right to full Australian citizenship in 1967, and were first included in the census in 1971, when their estimated numbers were 140,000. The Aboriginal Land Rights Act (1976) and the Aboriginal and Torres Islander Heritage Protect Act (1984) have resulted in an increased population approaching 300,000 by the mid-1990s.

Native North American art Traditional art produced by the indigenous peoples of North America. The INUIT of the Arctic area have been producing ivory carvings since prehistoric times and are also noted for their ceremonial masks (made from driftwood or whalebone). The Nw region is best known for its TOTEM POLES, while in California, basket-weaving and pottery were specialities. Similar crafts were practised by the PUEBLO people of the sw, who also created remarkable prehistoric wall paintings. The painted decoration of animal hides was popular in the Great Plains, while in the Eastern Woodlands, there was a preference for copper ornaments and stone carvings.

Native North American languages Any of more than 100 languages spoken in N and Central America by descendants of the various indigenous peoples. The languages fall into many different families. In the USA and Canada, languages include Algonquian (as spoken by the ALGONQUIN), ATHABASCAN and SIOUX. In the USA and Mexico, UTO-MATECAN is the most common. In Mexico itself, Oto-Manguean is common, and in Mexico and Guatemala MAYAN. NAHUATL (the language of the Aztecs) is the most widely spoken of this group.

Native South American languages Any of more than 1,000 languages spoken in South America by between 10–12

million people. Among the more important linguistic families are Chibcha, Arawak and Tupian. Widely spoken languages are Quechua (the language of the Incas) and Aymará, found in Peru and Bolivia. Guaraní is spoken in Paraguay.

nativity Birth of a New Testament figure as marked by a Christian feast. In general, the term refers to the birth of JESUS CHRIST, as described in the GOSPELS. These accounts relate that Jesus' birth in a stable in Bethlehem was attended by wonders – the sudden appearance of a bright star, angels rejoicing, and the arrival of shepherds and the MAGI to pay homage to the infant. Christians celebrate Jesus' Nativity at the festival of CHRISTMAS on 25 December. Other Nativity festivals are held during the Church year.

NATO Acronym for North Atlantic Treaty Organization **Nat Turner Insurrection** (1831) Slave revolt in Virginia. It was led by Nat Turner, a carpenter and preacher who believed he was inspired by God to seek vengeance for blacks. With c.70 men, he killed 57 or more whites in four days before the revolt was crushed. Many blacks died in revenge killings, while Turner and 19 others were hanged.

natural In musical notation, an accidental sign placed before a note; it cancels a SHARP or FLAT.

natural gas Fossil fuel associated geologically with PETROLE-UM. The fossil history of the two fuels is the same, since they are both formed by the decomposition of ancient marine plankton. The main constituent of natural gas is methane, CH₄.

naturalism Late 19th-century literary movement that began in France and was led by Emile Zola. An extension of Realism, it emphasized the importance of documentation. Writers sought to represent unselective reality with all its emotional and social ramifications. A major exponent of naturalistic drama was August Strindberg. The movement declined by the beginning of the 20th century but influenced the development of the modern US novel and social realist art.

natural rights Concept that human beings possess certain fundamental and inalienable rights, as described by John LOCKE. Among these rights were life, property ownership and political equality. *See* HUMAN RIGHTS

natural selection In EVOLUTION, theory that advantageous change in an organism tends to be passed on to successive generations. Changes arise out of natural genetic VARIATION, especially MUTATION. Those that give an individual organism a greater capacity for survival and reproduction in a particular environment help it to produce more offspring bearing the same beneficial characteristic or trait. This theory was proposed by Charles DARWIN in his book The Origin of Species (1859). It is still regarded as the key mechanism of evolution. nature-nurture controversy Debate over whether people's INTELLIGENCE, behaviour and other characteristics are influenced more by heredity or environment. The controversy has raised strong feelings, particularly over the question of whether intelligence is genetically fixed or the result of the way children are brought up and educated. Most psychologists now believe that behavioural and intellectual traits result from a complex mix of many factors.

nature reserve Area of land, sometimes including inland waters and estuaries, set aside for the study and conservation of wildlife, habitat or geological features.

naturopathy System of medical therapy that relies exclusively on the use of natural treatments, such as exposure to sunlight, fresh air and a healthy diet of organically grown foods. Herbal remedies are preferred to manufactured drugs. Nauru Island republic in the w Pacific Ocean, a coral atoll located halfway between Australia and Hawaii, and the world's smallest independent state. Nauru was explored by a British navigator, John Hunter, in 1798. In 1888 the atoll was annexed to Germany. During World War 1 Nauru was occupied by Australian forces. During World War 2 the Japanese occupied Nauru. In 1968 the island became an independent republic within the Commonwealth. Nauru has rich deposits of highgrade phosphate rock, the sale of which accounts for 98% of its exports. Area: 21sq km (8sq mi). Pop. (1990) 8,100.

nautilus (chambered nautilus) Cephalopod MOLLUSC found in w Pacific and E Indian oceans at depths down to 200m (660ft). Its large coiled shell is divided into numerous, gas-

filled chambers, which give it buoyancy. The body is located in the foremost chamber. Its head has 60–90 retractable, thin tentacles without suckers, and it moves by squirting water from a funnel. Shell size c.25cm (10in). Family Nautilidae; genus Nautilus. See also CEPHALOPODA

Navajo Athabascan-speaking tribe, the largest group of NATIVE AMERICANS in the USA. Their reservation in Arizona and New Mexico is the biggest in the country. In the early 1990s the growing population numbered *c*.150,000.

Navarino, Battle of (1827) Naval battle off the port of Navarino (Pylos), Greece. The combined British, French and Russian fleets destroyed the Turkish-Egyptian fleet of Ibrahim Pasha. The battle helped to ensure Greek independence (1829). Navarre Autonomous region and ancient kingdom in N Spain, stretching from the River Ebro to the w Pyrenees border; the capital is PAMPLONA. For 400 years the kingdom of Navarre fended off successive invasions by the Visigoths, Arabs and Franks. In 1512 s Navarre was annexed by Ferdinand II of Aragon. The N part was incorporated as French crown land in 1589. The Spanish region has historically maintained semi-autonomous status. It is a mountainous, agricultural region producing cattle, grapes, timber, cereals, vegetables and sugar beet. Area: 10,421sq km (4,023sq mi). Pop. (1991) 519,227.

nave (Lat. *navis*, ship) Central, main area of a church or cathedral. It extends from the main entrance to the transepts and includes the main aisle. It is the congregation's seating area.

navigation Determining the position of a vehicle and its course. Five main techniques are used: dead reckoning, piloting, celestial navigation, inertial guidance and radio navigation. The last includes the use of radio beacons, LORAN, radar navigation and satellite navigation systems. Instruments and charts enable the navigator to determine position, expressed in terms of LATITUDE and LONGITUDE, direction in degrees of arc from true north, speed, and distance travelled.

Navigation Acts English 17th-century statutes placing restrictions on foreign trade and shipping. The first Navigation Act (1651) declared that English trade should be carried only in English ships; it was the main cause of the first Anglo—Dutch War. Later acts placed restrictions on the trade of the colonies. Navratilova, Martina (1956–) US tennis player, b. Czechoslovakia. Navratilova dominated women's tennis during the 1980s. She won a total of 55 Grand Slam events, second only to Margaret COURT. She won nine Wimbledon singles titles (1978–79, 1982–87, 1990). Other singles titles include: the US Open (1983–84, 1986–87); French Open (1982, 1984); and Australian Open (1981, 1983, 1985). She became a US citizen in 1981 and retired in 1994.

▲ nautilus The shell is divided into about 30 compartments, but the body of the nautilus only occupies the first, and largest, chamber (1). All other chambers are self-contained buoyancy tanks filled with gas. The nautilus nevertheless is a poor shape for swimming. Water passes into the mantle (2) around its whole edge. It is expelled from the funnel (3) by the funnel muscles themselves, and by the animal expanding its body in the shell. Unlike its relatives squids, octopuses and cuttlefish, the nautilus cannot contract its mantle, which is attached to its shell.

The world is ringed by 24 global positioning satellites (1) launched by the USA. At any time four are above the horizon wherever you are on Earth (A). With a handheld receiver (2) that compares the time signals (3) from the satellite, your position can be fixed to a remarkable degree of accuracy. The receivers are now small enough to fit in the hand, and display either longitude and latitude (B) or a grid reference. Each satellite carries an atomic clock and transmits time signals to Earth. The receiver knows exactly where each satellite should be at any given time, and by simultaneously analysing the time the signals from three satellites take to reach the receiver, it can compute its own position to within 10m (33ft). Aircraft and military users use a fourth satellite signal for even greater accuracy.

NEBRASKA Statehood: 1 March 1867

Nickname:

The Cornhusker State State bird :

Western meadowlark

State flower:

Goldenrod
State tree:

Cottonwood

Cottonwood

State motto :

Equality before the law

Navy, US Naval service of the US armed forces. It consists of over 500,000 personnel under the president, who is commander in chief of the armed forces. The navy is under the general supervision of the secretary of the Navy and his adviser, the chief of naval operations (CNO), who is the Navy's highest ranking officer. Currently, the Navy operates cruisers, destroyers, patrol ships, aircraft carriers, amphibious warfare ships, conventional and missile submarines, and aircraft. The Navy was established by Congress in 1798, although naval activities had begun during the Revolutionary War. The Navy plays an active part in US military operations. See also DEFENSE, DEPARIMENT OF; JOINT CHIEFS OF STAFF; MARINE CORPS, US

Nazism See National Socialism

Ndjamena Capital of Chad, N central Africa, a port on the River Chari. Founded by the French in 1900, it was known as Fort Lamy until 1973. It grew rapidly after independence in 1960. It is an important market for the surrounding region, which produces livestock, dates and cereals. The main industry is meat processing. Pop. (1993) 529,555.

Neagh, Lough Lake in Northern Ireland, the largest freshwater lake in the British Isles. It has many feeder channels, the largest of which is the River Bann. The lake is noted for its fishing (especially trout and eels). Area: 396sq km (153sq mi). Neanderthal Middle PALAEOLITHIC variety of human, known from fossils in Europe and Asia. Neanderthals were discovered when a skeleton was unearthed in the Neander Valley in w Germany in 1856. The bones were thick and powerfully built and the skull had a pronounced brow ridge. Neanderthals are now considered to be a separate species of human, possibly a local adaptation during the ice ages, and are not thought to be ancestral to modern humans. Neanderthals predated modern humans in Europe, but were superseded by them about 35,000 years ago.

Nebraska State in w central USA, in the Great Plains; the capital is LINCOLN. OMAHA is the largest city. The region was acquired under the LOUISIANA PURCHASE of 1803 and was unexplored until the LEWIS AND CLARK EXPEDITION (1804). The territory of Nebraska was created in 1854. Nebraska was admitted to the union in 1867. The land rises gradually from the E to the foothills of the Rocky Mountains in the w, and is drained chiefly by the Platte River, a tributary of the MISSOURI. The E half of the state is farmland where farmers grow grain and raise cattle and pigs. Nebraska's economy is overwhelmingly agricultural. Industries: food processing, oil, and sand, gravel and stone quarrying. Area: 199,113sq km (76,878sq mi). Pop. (1990) 1,578,385.

Nebuchadnezzar (c.630–562 BC) Second and greatest king of the Chaldaean (New Babylonian) empire (605-562 BC) who changed the political map of the ancient Middle East. He subjugated Syria and Palestine but was himself defeated by Egyptian forces in 601 BC. He occupied JUDAH, capturing JERUSALEM in 597 BC and installing the puppet king Zedekiah on the throne of Judah. Following Zedekiah's rebellion, Nebuchadnezzar destroyed the city and TEMPLE of Jerusalem and deported its population into exile in BABYLON. A brilliant military leader, Nebuchadnezzar continued to follow an expansionist strategy. He was responsible for many buildings in Babylon, and (according to legend) built for his Median wife the famous hanging gardens, which became one of the SEVEN WONDERS OF THE WORLD. Biblical accounts of Nebuchadnezzar's involvement with Judah and the Jews appear principally in II Kings, Jeremiah and Daniel.

nebula (Lat. cloud) Region of interstellar gas and dust. There are three main types of nebula. Emission nebulae are bright diffuse nebulae that emit light and other radiation as a result of ionization and excitation of the gas atoms by ultraviolet radiation. In contrast, the brightness of reflection nebulae results from the scattering by dust particles of light from nearby stars. Dark nebulae are not luminous: interstellar gas and dust absorb light from background stars, producing apparently dark patches in the sky.

Necker, Jacques (1732–1804) French financier and statesman, b. Switzerland. A wealthy Protestant banker, he was

finance minister under LOUIS XVI (1776–81). Dismissed, he was recalled to deal with a financial crisis in 1788 and advised calling the STATES GENERAL. The political demands of the Third Estate caused Necker's second dismissal, but the consequent riots, leading to the storming of the BASTILLE, forced Louis to reappoint him. Unable to stem the tide of revolution, he resigned in September 1790.

necrosis Death of plant or animal tissue. It can be caused by disease, injury or interference with the blood supply.

nectarine Variety of PEACH tree and its sweet, smooth-skinned, fleshy fruit. The tree and stone are identical to those of the peach. Family Rosaceae; species *Prunus persica nectarina*. **Nefertiti** (active 14th century BC) Queen of Egypt as wife of AKHNATEN. She supported her husband's innovative religious ideas and was exceptionally beautiful. Her best surviving representation is a bust now in the Berlin Museum.

Negev (Hebrew, dry) Desert region in s Israel that extends from Beersheba to the border with Egypt at Elat, and accounts for over 50% of Israeli land. An irrigation network has increased cultivation in the region. The area has good mineral resources, including copper, phosphates, natural gas, gypsum and magnesium ore. Area: c.13,300sq km (5,130sq mi).

negligence In law, failure to exercise reasonable care towards material goods, other people or oneself, resulting in unintentional harm. Most negligence cases are decided by jury. Nehru, Jawaharlal (1889–1964) Indian statesman, first prime minister of independent India. Son of a prominent Indian nationalist, he belonged to the more radical wing of the Indian National Congress and was its president in 1929 and later. Conflicts with the British resulted in frequent spells in prison, but he took a leading part in the negotiations leading to the independence of India and Pakistan and headed the Indian government from 1947 until his death. Internationally he followed a policy of nonalignment and became a respected leader of the Third World. See Congress Party

Nelson, Horatio, Viscount (1758–1805) Britain's most famous naval commander. Joining the navy aged 12, he was a captain at 20. He lost an eye in action in 1794 and his right arm in 1797. Having played a notable part in the victory at Cape St Vincent (1797), he again used unorthodox tactics in the Battle of the Nile (Abukir Bay) in 1798. He was killed at the moment of his greatest victory, when he destroyed the combined French and Spanish fleets at Trafalgar (1805). Nelson is remembered for his courage and tactical ability and for his enduring love affair with Emma Hamilton.

nematode See ROUNDWORM

Nemesis In Greek mythology, personification of the gods' disapproval, jealousy and retribution.

neo-classicism Movement in late 18th- and early 19th-century European art and architecture. Neo-classicism grew out of the Age of ENLIGHTENMENT, whose exponents admired the order and clarity of ancient Greek and Roman art. The archaeological discoveries at Herculaneum and Pompeii, Italy, in the 1740s helped to stimulate interest in these ancient civilizations. Many of the movement's pioneers congregated in Rome, notably Johann Winckelmann, Canova, John Flaxman, Gavin Hamilton and Bertel Thorvaldsen. The most powerful neo-classical painter was Jacques Louis David, whose work expressed great severity and grandeur. The concurrent Greek Revival involved, in architecture, imitating the simplicity of ancient Greek buildings.

neo-Darwinism Development of Darwinism that incorporates the modern ideas of genetic heredity, with DARWIN's ideas of EVOLUTION through NATURAL SELECTION.

neodymium (symbol Nd) Silver-yellow metallic element of the LANTHANIDE SERIES. Discovered in 1885, it is used to manufacture lasers, and its salts are used to colour glass. Properties: at.no. 60; r.a.m. 144.24; r.d. 7.004; m.p. 1,010°C (1,850°F); b.p. 3,068°C (5,554°F); most common isotope Nd¹⁴² (27.11%). **neo-fascism** Revival of the principles of FASCISM. Neo-fascism surfaced in Germany in the 1980s, feeding on social discontent and the presence of many foreign workers. In France Jewish graves were desecrated, and in Italy neo-fascism has had moderate electoral success. In Britain and the USA neo-fascist elements are found in certain white supremacist groups.

▲ Nelson English naval commander, Nelson was one of the greatest of all naval heroes. At the outbreak of war with France (1793), he served with distinction under Admiral Hood, losing his right eye and right arm. He blockaded Toulon for two years until the French fleet finally eluded him. He was killed at the ensuing Battle of Trafalgar, in which the French fleet was destroyed.

neo-impressionism Late 19th-century painting style, originating in France and involving the use of POINTILLISM. The style is seen at its purest in the works of SEURAT.

Neolithic (New Stone Age) Period in human cultural development following the PALAEOLITHIC. The Neolithic began *c*.8000 BC in w Asia and *c*.4000 BC in Britain. It was during this period that people first lived in settled villages, domesticated and bred animals, cultivated cereal crops and practised stone-grinding and flint mining.

neon (symbol Ne) Gaseous nonmetallic element, a NOBLE GAS. Colourless and odourless, it is present in the atmosphere (0.0018% by volume) and is obtained by the fractional distillation of liquid air. Discovered in 1898, its main use is in discharge tubes for advertising signs (emitting a red glow while conducting electricity) and in gas lasers, geiger counters and particle detectors. It forms no compounds. Properties: at.no. 10; r.a.m. 20.179; m.p. -248.67°C (415.6°F); b.p. -246.05°C (-410.89°F); most common isotope Ne²⁰ (90.92%).

Neoplatonism School of philosophy that dominated intellectual thought between about AD 250 and 550. It combined the ideas of PYTHAGORAS, the STOICS, PLATO and ARISTOTLE, with strains from JUDAISM, oriental religions and Christianity. Fundamental to Neoplatonism was the concept of the One, something that transcends knowledge or existence but from which are derived intelligence and the Soul. Neoplatonism's influence persisted through the Middle Ages and the Renaissance.

neo-realism Italian film movement (1945–50) that dealt with the harshness of life and death. Roberto ROSSELLINI directed the first such film, called *Open City* (1945), using non-professionals and real locations.

Nepal Independent kingdom in central Asia, between India (s) and China (N); the capital is KATMANDU. Land and climate Nepal comprises three distinct regions. As lowland area (terai) of grassland, forests and national park is the location of Nepal's agriculture and timber industry. The central Siwalik mountains and valleys are divided between the basins of the Ghaghara, Gandak and Kosi rivers. Between the Gandak and Kosi lies Katmandu valley, Nepal's most populous area and centre for its greatest source of foreign currency - tourism. The last region is the main section of the Himalayas and includes Mount Everest. History In 1768 Nepal was united under Gurkha rule. Gurkha expansion into N India ended in conflict with Britain. British victory led Nepal to ratify its present boundaries and accept permanent British representation in Katmandu. From 1846-1951 Nepal was ruled by hereditary prime ministers from the Rana family. In 1923 Britain recognized Nepal as a sovereign state. During both world wars Gurkha soldiers fought in the British army. In 1951 the Rana government was overthrown and a monarchy re-established. The first national constitution was adopted in 1959 and free elections were held. In 1960 King Mahendra dissolved parliament and introduced a political system based on village councils (panchayat). In 1972 Mahendra was succeeded by his son, Birendra. Mass demonstrations in 1990 led to the introduction of a new democratic constitution, with the king retaining joint executive power. Politics In 1991 multiparty elections were won by the Nepali Congress Party. In 1994 the United Marxist-Leninist Party formed a minority government. In 1995 a new coalition government was formed, but in 1997 the prime minister was forced to resign, after losing a vote of confidence. A new coalition government was formed, again dominated by the United Marxist-Leninist Party. Economy Nepal is an undeveloped rural country (1992 GDP per capita, US\$1,170). It is heavily reliant on Indian trade. The most important economic activity is livestock farming (especially yaks) and the growing of medicinal herbs. nephritis (Bright's disease) Inflammation of the KIDNEY. It is a general term used to describe a condition rather than any specific disease. It may be acute or chronic, often progressing to kidney failure.

nephron Basic functional unit of the mammalian KIDNEY. There are more than one million nephrons in a human kidney. Each consists of a cluster of tiny blood capillaries, cupped in a structure with an attached long, narrow tubule. Blood enters the kidney under pressure, and water and wastes are forced into the tubule. Some water and essential molecules are reab-

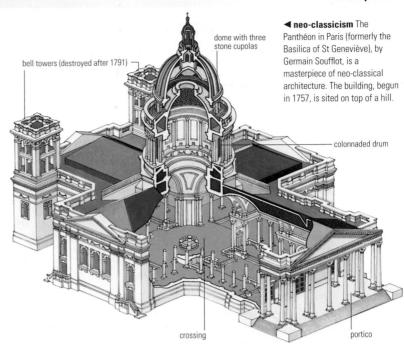

sorbed into the bloodstream; the remaining filtrate, URINE, is passed to the BLADDER for voiding.

Neptune Eighth planet from the Sun. The mass, orbit and position of an unseen planet had been calculated by LEVERRI-ER and, independently, by British astronomer John Couch Adams (1819-92). Neptune was first observed in 1846 and is invisible to the naked eye. Through a telescope it appears as a small, greenish-blue disc with very few details. The upper atmosphere is about 85% molecular hydrogen and 15% helium. Its predominant blue colour is due to a trace of methane, which strongly absorbs red light. Several different atmospheric features were visible at the time of the fly-by of the Voyager 2 probe in 1989. There were faint bands parallel to the equator, and spots, the most prominent of which was the oval Great Dark Spot (GDS), about 12,500km (8,000mi) long and 7,500km (4,500mi) wide, which is a giant anticyclone. White, cirrus-type clouds of methane crystals cast shadows on the main cloud deck some 50km (30mi) below. There are also the highest wind speeds recorded on any planet at over 2,000km/h (1,250mi/h) in places.

Neptune Roman god, originally associated with freshwater but later identified with the Greek god Poseidon and hence the sea. He was often depicted carrying a trident and riding a dolphin. His festival was in July.

NEPTUNE: DATA

Diameter (equatorial):
49,528km (30,707mi)
Mass (Earth=1): 17.2
Volume (Earth=1): 57
Density (water=1): 2.06
Orbital period: 164.8 years
Rotation period: 16 7 m 0s
Average surface temperature:
-220°F (-364°F)
Surface gravity (Earth=1): 0.98

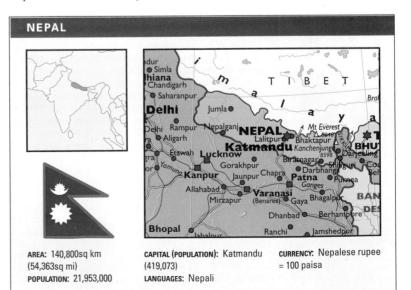

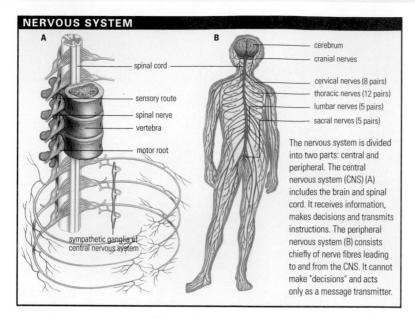

neptunium (symbol Np) Radioactive metallic element, the first of the TRANSURANIC ELEMENTS of the ACTINIDE SERIES. Discovered in 1940, this silvery element is found in small amounts in uranium ores, and is obtained as a by-product in nuclear reactors. Properties: at.no. 93; r.a.m. 237.0482; r.d. 20.25; m.p. 640°C (1,184°F); b.p. 3,902°C (7,056°F); most stable isotope Np²³⁷ (half-life 2.2 million years).

Nero (37–68) Roman emperor (54–68). One of the most notorious of rulers, he was responsible for the murders of his half-brother, his mother and his first wife. Rome was burned (64), according to rumour, at Nero's instigation. He blamed the Christians and began their persecution. Faced with widespread rebellion, Nero committed suicide.

Neruda, Pablo (1904–73) Chilean poet, b. Neftalí Ricardo Reyes. He identified with the impoverished masses and was active in politics. His poetry presents the tragedy of the human condition through surreal imagery. His best-known work is the epic *Canto General* (1950). He was awarded the 1971 Nobel Prize for literature.

nerve Collection of NEURONS providing a communications link between the vertebrate NERVOUS SYSTEM and other parts of the body. Afferent or sensory nerves transmit nervous impulses to the CENTRAL NERVOUS SYSTEM; efferent or MOTOR NERVES carry impulses away from the central nervous system to muscles.

nerve cell See NEURON

Nervi, Pier Luigi (1891–1979) Italian architect who is noted for his innovative use of concrete. He established himself as a major creative force with his designs for the Giovanni Berta stadium, Florence (1932). He co-designed the UNESCO building, Paris (1954–58) and the Pirelli skyscraper, Milan (1958). nervous breakdown Popular term for a mental and emotional crisis in which the person either is unable or feels unable to function normally. It is an imprecise term and may refer to any of a range of conditions. See also MENTAL ILLNESS nervous system Communications system consisting of interconnecting nerve cells or NEURONS that coordinate all life, growth and physical and mental activity. The mammalian nervous system consists of the CENTRAL NERVOUS SYSTEM (CNS) and the PERIPHERAL NERVOUS SYSTEM.

Ness, Loch Freshwater lake in N Scotland, running SW to NE along the geological fault of Glen More. It is 38km (24mi) long and 230m (754ft) deep and forms part of the Caledonian Canal. Accounts of a Loch Ness monster date back to the 15th century, but the veracity of the legend has never been established. **Nestorianism** Christian heresy according to which Jesus

CHRIST, the incarnate God, possesses two separate natures, one divine and the other human, as opposed to the orthodox belief that Christ is one person who is at once both God and man. The heresy was associated with Nestorius, Bishop of Constan-

tinople, who died c.451. It was condemned by the Councils of EPHESUS (431) and CHALCEDON (451). Nestorius was deposed and banished. His supporters gradually organized themselves into a separate Church, which had its centre in Persia (Iran). Nestorians have survived as a small community.

Netanyahu, Benjamin (1949–) Israeli statesman, prime minister (1996–). Netanyahu served as permanent representative to the United Nations (1984–88), before becoming deputy minister of foreign affairs. In 1993 he became leader of the right-wing Likud Party. Netanyahu defeated Shimon Peres in the elections that followed the assassination of Yitzhak RABIN. His uncompromising stance over Israeli settlement on the West Bank and Likud's opposition to the Israeli-Palestinian Accord threatened to disrupt the peace process.

netball Seven-a-side ball game played by women. Invented in 1891, it is a variant of BASKETBALL. Only two players of each team are allowed in the shooting circle at goal, which is the same size and height as in basketball but without a backboard. The game dates from the 1980s and is played chiefly in the English-speaking countries and the Commonwealth.

Netherlands Kingdom in NW Europe. See country feature Netherlands Antilles Group of five main islands (and part of a sixth) in the West Indies, forming an autonomous region of the Netherlands; the capital is Willemstadt (on CURAÇAO). The islands were settled by the Spanish in 1527 and captured by the Dutch in 1634. They were granted internal self-government in 1954. The group includes Aruba, Bonaire, Curaçao, Saba, Saint Eustatius and the s half of Saint Maarten. Industries: oil refining, petrochemicals, phosphates, tourism. Area: 993sq km (383sq mi). Pop. (1992) 189,474. nettle Any of numerous species of flowering plants of the

nettle Any of numerous species of flowering plants of the genus *Urtica*, especially the stinging nettle (*U. dioica*), which is typical of the genus in that it has stinging hairs along the leaves and stem. It has heart-shaped serrated leaves, small green flowers and is sometimes used for medicinal or culinary purposes. The stinging agent is formic acid. Family Urticaceae. **network** *See* COMPUTER NETWORK

neuralgia Intense pain from a damaged nerve, possibly tracking along its course. Forms include trigeminal neuralgia, which features attacks of stabbing pain in the mouth area, and post-herpetic neuralgia following an attack of SHINGLES.

neurology Branch of medicine dealing with the diagnosis and treatment of diseases of the NERVOUS SYSTEM.

neuron (nerve cell) Basic structural unit of the NERVOUS SYSTEM, which enables rapid transmission of impulses between different parts of the body. It is composed of a cell body, containing a nucleus, and a number of trailing processes. The largest of these is the axon, which carries outgoing impulses; the rest are dendrites, which receive incoming impulses.

neurosis Emotional disorder such as anxiety, depression or various phobias. It is a form of mental illness in which the main disorder is of mood, but the person does not lose contact with reality as happens in PSYCHOSIS.

neurotransmitter Any one of several dozen chemicals involved in communication between nerve cells or between a nerve and muscle cells. When an electrical impulse arrives at a nerve ending, a neurotransmitter is released to carry the signal across the specialized junction (synapse) between the nerve cell and its neighbour. Some drugs work by disrupting neurotransmission. *See also* NERVOUS SYSTEM

neutrality Policy of non-involvement in hostilities between states. It is recognized by international law, mainly in the Declaration of Paris of 1856 and the Hague Conventions V and XIII of 1907. A state proclaiming its neutrality must be wholly impartial and refrain from helping or hindering any side.

neutralization In chemistry, the mixing, or TITRATION, of equivalent amounts of an acid and a base in an aqueous medium until the mixture is neither acidic nor basic (PH of 7).

neutrino (symbol v) Uncharged ELEMENTARY PARTICLE with no mass or a very low mass, SPIN 1/2 and travelling at the speed of light. Classified as a LEPTON, it has little reaction with matter and is difficult to detect. There are three known species. The ELECTRON neutrino is closely associated with the electron and is produced when protons and electrons react to form NEUTRONS, as in the Sun. The muon neutrino is associat-

▲ nettle Bearing both male and female flowers, the stinging nettle (*Urtica dioica*) has bristle-like stinging hairs, which are long, hollow cells. The tips of these are toughened with silica and they are easily broken off. When the plant is touched, the hairs penetrate the skin like surgical needles, the tips are lost, and the poison contained in the cells is released.

ed with the muon and occurs in high-energy reactions. The tau neutrino is associated with the tau particle.

neutron (symbol n) Uncharged ELEMENTARY PARTICLE that occurs in the atomic nuclei of all chemical elements except the lightest isotope of HYDROGEN. Outside the nucleus, it is unstable, decaying with a half-life of 11.6 minutes into a PRO-TON, ELECTRON and antineutrino. Its neutrality allows it to penetrate and be absorbed in nuclei and thus to induce nuclear transmutation and fission.

neutron bomb Small hydrogen bomb, also called an enhanced radiation weapon, that produces a small blast but a very intense burst of high-speed neutrons. The lack of blast means that buildings are not heavily damaged. The neutrons, however, produce intense RADIATION SICKNESS in people located within a certain range of the explosion.

neutron star Extremely small, dense star that consists mostly of neutrons. Neutron stars are formed when a massive star explodes as a SUPERNOVA, blasting off its outer layers and compressing the core so that its component protons and electrons merge into neutrons. They are observed as PULSARS. They have masses comparable to that of the Sun, but diameters of only about 20km (12mi) and average densities of $c.10^{15}$ g/cm³.

he kingdom of the Netherlands is popularly

known as Holland, and with Belgium and

Luxembourg forms the Low Countries. Except

in the far SE, the Netherlands is flat and c.40%

lies below sea level. Large areas (polders) have

been reclaimed from the sea. Dykes prevent

flooding and have created IJSSELMEER. The mar-

itime provinces contain the constitutional capital

AMSTERDAM, the administrative capital THE

HAGUE, and the cities of ROTTERDAM, DELFT,

Nevada State in w USA; the capital is CARSON CITY. The USA acquired the region in 1848 at the end of the MEXICAN WAR. When gold and silver were found in 1859, settlers flocked to Nevada. Much of the state lies in the Great Basin, but the SIERRA NEVADA rise steeply from its w edge. Nevada's dry climate and steep slopes have hindered the development of an agricultural economy. Hay and lucerne (alfalfa) are the chief crops; sheep and cattle grazing is important. Most of Nevada's economic wealth comes from its mineral deposits, which include copper, lead, silver, gold, zinc and tungsten. Industries: chemicals, timber, electrical machinery, glass products. It is a tourist area and, in cities such as LAS VEGAS and Reno, gambling provides an important source of state revenue. Area: 286,297sq km (110,539sq mi). Pop. (1990) 1,201,833. New Age System of philosophy and religion that came to prominence during the late 1980s and traces its origins to a variety of sources, including oriental mysticism and new scientific ideas. The New Age movement embraces diverse issues, including feminism, astrology, ecology, spiritualism and pagan ritual, and takes a holistic approach to healing.

Newark City in NE New Jersey, USA, on the Passaic River and Newark Bay, connected to nearby New York City by tun-

NEVADA

Statehood:

31 October 1864

Nickname: The Silver State

State hird :

Mountain bluebird

State flower: Sagebrush

State tree :

Pine nut

State motto:

All for our country

NETHERLANDS

The flag of the Netherlands, one of Europe's oldest, dates from 1630, during the long struggle for independence from Spain, which began in 1568. The tricolour became a symbol of liberty, inspiring many other revolutionary flags around the world.

CLIMATE

The Netherlands has a temperate maritime climate, with mild winters and abundant rainfall.

VEGETATION

The Netherlands is very densely populated. About 66% of the land is arable or grazing land. The country is irrigated by a series of canals.

HISTORY AND POLITICS

From the 4th-8th century the region was ruled by the Franks, and in the 10th century became part of the Holy Roman Empire. In the 14th and 15th centuries trade flourished through the HANSEATIC LEAGUE. In 1477 the region passed to the Habsburgs. PHILIP II's attempt to impose the Inquisition met with fierce resistance. The N Protestant provinces, led by WILLIAM I (THE SILENT), declared independence in 1581. The foundation of the Dutch EAST INDIA COMPANY in 1602 marked the beginnings of empire. The mercantile class became the patrons of DUTCH ART. Following the THIRTY YEARS WAR, the Peace of WESTPHALIA (1648) recognized the independence of the N and s provinces as the United Provinces. In 1652 Jan de Witt established a republic. Trading rivalry with England led to the DUTCH WARS. The Treaty of BREDA (1667) confirmed Dutch imperial possessions. In 1672 France invaded and De Witt was murdered. The House of Orange re-established control under WILLIAM III (OF ORANGE). France controlled the Netherlands from 1795-1813. In 1815 the former United Provinces, Belgium and Luxembourg united to form the kingdom of the Netherlands under WILLIAM I. Belgium broke away in AREA: 41,526sg km (16,033sg mi) POPULATION: 15,178,000

CAPITAL (POPULATION): Amsterdam (724.096)

GOVERNMENT: Constitutional monarchy ETHNIC GROUPS: Netherlander 95%. Indonesian, Turkish, Moroccan, German

LANGUAGES: Dutch (official)

RELIGIONS: Christianity (Roman Catholic 34%. Dutch Reformed Church 17%, Calvinist 8%),

Islam 3%

currency: Guilder = 100 cents

1830. In 1890 Luxembourg seceded, and WIL-HELMINA began her long reign. The Netherlands was neutral in World War 1. Germany invaded in May 1940; most Dutch Jews were deported to Poland and murdered. Queen Wilhelmina was exiled during World War 2. ARNHEM was a vital bridgehead in the Allied liberation of Europe. In 1948 Wilhelmina abdicated in favour of her daughter, Juliana. In 1949 the Netherlands joined NATO, and Indonesia gained its independence. In 1957 it was a founder member of the European Community, and in 1958 formed the Benelux customs union. It gave Netherlands New Guinea and Surinam independence in 1962 and 1975 respectively. It retains the islands of the NETHERLANDS ANTILLES. In 1980 Queen Juliana abdicated in favour of her daughter, Beatrix. Post-1945, the Netherlands has been ruled by a succession of coalition governments. In 1994 Wim Kok was elected prime minister.

ECONOMY

The Netherlands has prospered through its close European ties (1992 GDP per capita, US\$17,780). Private enterprise has successfully combined with progressive social policies. Services account for 65% of GDP and industry 30%. It is highly industrialized. Products: aircraft, chemicals, electronics, machinery. Natural resources include natural gas, but it imports raw materials. Agriculture is intensive and mechanized, employing only 5% of the workforce. Dairy farming is the leading agricultural activity. Major products: cheese, barley, flowers, bulbs.

NEW HAMPSHIRE

Statehood:

21 June 1788 Nickname:

The Granite State

State bird:

Purple finch

State flower:

Purple lilac

State tree :

White birch

State motto:

Live free or die

trical equipment, paints, chemicals. Pop. (1990) 275,221. New Brunswick Maritime province on the US-Canadian border, E CANADA; the capital is Fredericton. The largest towns are St John and Moncton. The region was first explored by Jacques Cartier in 1534. It was ceded to Britain in 1713, but settlement was slow. Many loyalists entered the region from the American colonies during the AMERICAN REVOLUTION. The province of New Brunswick was established in 1784. In 1867

nel. Founded in 1666 by the Puritans, Newark began its

industrial growth after the American Revolution. It is an

important commercial and financial centre. Industries: elec-

it joined Nova Scotia, Quebec and Ontario to form the Dominion of Canada. The land rises gradually from E to W and is drained by the St John and Miramichi rivers. More than 75% of the province is forested. The chief crops are hay, clover, oats, potatoes and fruit. Industries: timber, leather goods, pharmaceuticals, machinery. There are valuable mineral deposits. Area: 73.437sq km (28.354sq mi). Pop. (1991) 723.900.

New Caledonia (Nouvelle Calédonie) French overseas territory in the sw Pacific Ocean, c.1,200km (750mi) E of Australia, consisting of New Caledonia, Loyalty Islands, Isle des Pins, Isle Bélep, and Chesterfield and Huon Islands; the capital is Nouméa (on New Caledonia). Discovered in 1774 by Captain Cook, the islands were annexed by France in 1853. The group became a French overseas territory in 1946. In the 1980s there was a growing separatist movement. Direct French rule was imposed in 1988. Products: copra, coffee, cotton, nickel, iron, manganese, cobalt, chromium. Area: 18,575sq km (7,170sq mi). Pop. (1989) 164,182.

Newcastle upon Tyne City and major port on the River Tyne, NE England; administrative centre of Tyne and Wear. The site of a fort in Roman times, Newcastle acquired a Norman castle in the 11th century. It was a major wool-exporting port in the 13th century and later a coal-shipping centre. Its shipbuilding industry is in decline, but heavy engineering is still important. Industries: pharmaceuticals, engineering, aircraft. Pop. (1991) 259,541.

New Deal (1933-39) Programme for social and economic reconstruction in the USA following the GREAT DEPRESSION, launched by President Franklin D. ROOSEVELT. It was based on massive and unprecedented federal intervention in the economy. Early measures, including extensive public works, were mainly concerned with relief. The New Deal encountered bitter resistance from conservatives and did not avert further recession in 1937-38. Industrial expansion, full employment and agricultural prosperity were achieved less by the New Deal than by the advent of World War 2. However, the programme laid the basis for future federal management of the economy and provision of social welfare.

New Delhi Capital of India, in the N of the country, on the River Yamuna in Delhi Union Territory. Planned by the British architects Sir Edwin LUTYENS and Herbert Baker, it was constructed during 1912-29 to replace Calcutta as the capital of British India. Whereas the old city of DELHI (to the sw) is primarily a commercial centre, New Delhi has an administrative function. Industries: textile production, chemicals, machine tools, plastics, food processing, electrical appliances, traditional crafts. Pop. (1991) 301,800.

New England Region in NE USA, made up of the states of Maine, New Hampshire, Vermont, Connecticut, Massa-CHUSETTS and RHODE ISLAND. In 1643 the New England Confederation was set up by some of the colonies for the purposes of defence and to establish a common policy towards the Native Americans. New England was the centre of events leading up to the AMERICAN REVOLUTION. The region became highly industrialized after the War of 1812 and developed as a centre of literature and learning. It was home to writers such as EMERSON, HAWTHORNE and THOREAU and the literary movement Transcendentalism.

New Forest Region of forest and heathland in s Hampshire, s England. It was established (1079) as a royal hunting ground by William I. The forest includes many species of trees. Pigs, cattle and ponies are reared. Area: c.383sq km (148sq mi). Newfoundland Province in E Canada, on the Atlantic

Ocean, consisting of the mainland region of LABRADOR and

the island of Newfoundland plus adjacent islands; the capital is ST JOHN'S. Norsemen are believed to have landed on the coast of Labrador c. AD 1000. John CABOT reached the island in 1497. The region became a British colony in 1824. It remained apart from the rest of Canada until 1949, when it became the country's tenth province. The island of Newfoundland is a plateau with many lakes and marshes. Labrador has tundra in the N; the cold climate and lack of transport facilities have hindered economic development. There are valuable mineral resources. Timber is an important industry, and the Grand Banks is one of the world's best cod-fishing areas. Area 404,420sq km (156,185sq mi). Pop. (1991) 568,474.

Newfoundland Rescue and working dog originally bred by fisherman in Newfoundland. It has a massive head with a square, short muzzle. The full-chested, broad-backed body is set on short, strong legs and the tail is broad and long. Height: 71cm (28in) at the shoulder; weight: 68kg (150lb).

New France Area of North America claimed by France in the 16th-18th centuries. It included the St Lawrence valley, the Great Lakes region and the Mississippi valley. Parts were lost during the Anglo-French wars of the 18th century, and the whole of New France passed to Britain in 1763.

New Frontier (1961–63) Term describing the legislative programme of US president John F. KENNEDY. The programme included massive expenditure on social reforms and welfare, as well as ambitious new projects such as the PEACE CORPS and SPACE EXPLORATION. Kennedy's assassination led to many of the proposals being implemented by his successor, Lyndon Johnson.

New Guinea World's second-largest island, part of the E Malay archipelago, in the w Pacific Ocean. Discovered in the early 16th century, New Guinea was colonized by the Dutch, the Germans and the British during the next two centuries. In 1904 the British-administered part was transferred to Australia and during World War 1 Australian forces seized German New Guinea. The E half eventually achieved independence as PAPUA New Guinea in 1975. The w half, Irian Jaya, became a province of Indonesia in 1969. The island has a tropical climate and is mountainous. Products: copra, cocoa, coffee, rubber, coconuts, tobacco. Area: 885,780sq km (342,000sq mi).

New Hampshire State in NE USA, on the Canadian border; the capital is CONCORD. The first settlement was made in 1623. Much of the land is mountainous and forested. The principal rivers are the Connecticut and the Merrimack, and there are more than 1,000 lakes. Farming is restricted by poor, stony soil and is mostly concentrated in the Connecticut valley. Dairy and market garden produce, hay, apples and potatoes are the chief products. New Hampshire is highly industrialized. There is abundant hydroelectricity. Industries: electrical machinery, paper and wood products, printing and publishing, leather goods, textiles. Area: 24,097sq km (9,304sq mi). Pop. (1990) 1,109,253.

New Haven City and port in s Connecticut, USA, on Long Island Sound. Founded by Puritans in 1638, it shared the role of capital of Connecticut with HARTFORD from 1701 to 1875. The presence of YALE UNIVERSITY (founded 1701) has made the city a cultural centre. Industries: firearms and ammunition, rubber products, locks, tools. Pop. (1990) 130,474.

Ne Win, U (1911-) Burmese soldier and statesman, prime minister (1958-60, 1962-74) and head of the state council (1974-88). In 1943 Ne Win became commander of the Burmese army. After Burma gained independence (1948), Ne Win became home and defence minister. In 1958 he overthrew U Nu and became prime minister. U Nu returned to office in 1960 but was again overthrown (1962) by a military coup led by Ne Win. Ne Win established a Revolutionary Council and banned all political opposition to the Burma Socialist Program Party. Ne Win was faced with mass insurgency. In 1974 he introduced a new constitution, establishing a state council, which he headed. In 1988 continuing economic and political crises forced Ne Win to resign. An army coup, led by Ne Win supporters, established a military government, and Burma became Myanmar.

New Jersey State in E USA, on the Atlantic coast, s of New York; the capital is TRENTON. Other major cities include

NEW JERSEY Statehood:

18 December 1787

Nickname:

The Garden State

State bird:

Eastern goldfinch

State flower:

Purple violet

State tree :

Red oak

State motto:

Liberty and prosperity

N

NEWARK, ATLANTIC CTTY and Paterson. Settlement began in the 1620s, when the Dutch founded the colony of New Netherland (later New York). When the British took the colony in 1664 the land between the Hudson and Delaware rivers was separated and named New Jersey. The N of the state is in the Appalachian highland region; SE of this area are the piedmont plains, and more than half the state is coastal plain. A variety of crops are grown, and cattle and poultry are important. New Jersey is overwhelmingly industrial and densely populated. Industries: chemicals, pharmaceuticals, rubber goods, textiles, electronic equipment, missile components, copper smelting, oil refining. Area: 20,295sq km (7,836sq mi). Pop. (1990) 7,730,188.

Newlands, John Alexander Reina (1837–98) British chemist. In 1864 he announced his law of octaves, which arranged the chemical elements in a table of eight columns according to atomic weight. MENDELEYEV included the law in his own PERIODIC TABLE five years later.

Newman, Barnett (1905–70) US painter, associated with ABSTRACT EXPRESSIONISM. He developed a distinctive kind of mystical abstraction, expressed in its earliest form in *Onement* (1948). This painting consists of a single tone of dark red with one, narrow stripe of lighter red running vertically across the middle. With Mark ROTHKO, Newman pioneered monochromatic colour field painting and the use of huge canvases.

Newman, Cardinal John Henry (1801–90) British theologian. As leader of the OXFORD MOVEMENT (1833–45), he had a powerful effect on the Church of England, only equalled by the shock of his conversion to Roman Catholicism (1845). A great literary stylist, he is remembered especially for his autobiography. *Apologia pro vita sua* (1864).

Newman, Paul (1925–) US film actor, director and producer. Newman made his big breakthrough in 1958 with *The Left-Handed Gun, The Long Hot Summer* and *Cat on a Hot Tin Roof.* He was nominated for Academy Awards for *The Hustler* (1961), *Hud* (1963) and *Cool Hand Luke* (1967). In 1968 Newman made his directorial debut, *Rachel, Rachel.* He won a Best Actor Oscar for *The Color of Money* (1986). Other films include *Butch Cassidy and the Sundance Kid* (1969), *The Sting* (1973) and *The Hudsucker Proxy* (1994).

New Mexico State in sw USA, on the Mexican border; the capital is Santa Fe. The largest city is Albuquerque. The first permanent Spanish settlement was established at Santa Fe in 1610. The USA acquired the region in 1848 at the end of the Mexican War. It entered the Union in 1912 as the 47th state. The first atomic bomb was exploded at Alamogordo in 1945. The Sangre de Cristo Mountains in the N flank the Rio Grander, which runs N to S through the state. The terrain includes desert, forested mountains and stark mesa. In the S and Sw are semi-arid plains. The S Pecos and Rio Grande rivers irrigate cotton crops; hay, wheat, dairy produce and chilli peppers are also important. A large proportion of the state's wealth comes from mineral deposits, including uranium, manganese, copper, silver, turquoise, oil, coal and natural gas. Area: 314,334sq km (121,335sq mi). Pop. (1990) 1,515,069.

New Model Army Reformed Parliamentary army in the English CIVIL WAR. Formed in 1645 largely by Oliver CROMWELL, it was better organized, trained and disciplined than any comparable Royalist force, and it ensured final victory for Parliament.

New Orleans City and river port in SE Louisiana, USA, between Lake Pontchartrain and the Mississippi River. Founded by the French in 1718, it was ceded to Spain in 1763 and acquired by the USA under the LOUISIANA PURCHASE of 1803. Its industries expanded rapidly in the 20th century after the discovery of oil and natural gas. New Orleans made an important contribution to the development of JAZZ. It is also the home of the annual MARDI GRAS festival. Industries: food processing, petroleum, natural gas, oil and sugar refining, shipbuilding, tourism, aluminium, petrochemicals. Pop. (1990) 496,938.

Newport City and port in Narragansett Bay, SE Rhode Island, USA. Founded in 1639, it served as joint state capital with Providence until 1900. It is home to music festivals and for many years hosted the AMERICA'S CUP yachting races. Tourism is the chief industry. Other industries: shipbuilding and electronic instruments. Pop. (1990) 28,227.

Newport News City on the James River, part of the port of Hampton Roads, SE Virginia, USA. First settled in 1621 by Irish colonists, it was the scene of the CIVIL WAR naval battle of Hampton Roads between the warships Monttor and Merrimack (1862). It later grew in importance as a coal-shipping port. Newport News is one of world's largest shipbuilding and repair centres. Other industries: food processing, metal products, building materials, oil refining. Pop. (1990) 170,045.

New South Wales State in SE Australia, on the Tasman Sea; the capital is SYDNEY. Captain James COOK first visited the area in 1770, landing at Botany Bay. He claimed the E coast of Australia for Britain, naming it New South Wales. The colony developed in the 19th century with the growth of the wool industry. It originally included all the known area of the continent. New South Wales achieved responsible government in 1855, becoming a state of the Commonwealth of Australia in 1901. The Great Dividing Range separates the narrow coastal lowlands from the w plains that occupy two-thirds of the state. The MURRAY River and its tributaries are used extensively for irrigation. Wheat, wool, dairy produce and beef are the principal agricultural products. The state has valuable mineral deposits. New South Wales is the most populous and most industrialized state in Australia. Steel is the chief product. Area: 801,430sq km (309,180sq mi). Pop. (1991) 5,730,947. newspaper Periodical publication, usually daily or weekly, conveying news and comment on current events. Handwritten news-sheets were posted in public places in ancient Rome under such titles as Acta Diurna (Daily Events). In Europe, the invention and spread of printing in the 15th century facilitated the growth of newspapers. The earliest examples were printed in German cities, soon followed by Venice, the Low Countries and other states in the sixteenth century.

newt Any of numerous species of tailed AMPHIBIANS of Europe, Asia and North America. The common European newt, *Triturus vulgaris*, is terrestrial, except during the breeding season, when it is aquatic and the male develops ornamental fins. Its body is long and slender and the tail is laterally flattened. Length: to 17cm (7in). Family Salamandridae.

New Testament Second part of the Bible, consisting of 27 books all originally written in Greek after AD 45 and concerning the life and teachings of JESUS CHRIST. It begins with the three SYNOPTIC GOSPELS (MAITHEW, MARK and LUKE), which present a common narrative of Christ's life and ministry, and a fourth gospel (JOHN), which is more of a theological meditation. The ACTS OF THE APOSTLES follows, which records the early development and spread of Christianity. Next are 21 letters (the EPISTLES) addressed to specific early Church communities. The New Testament ends with the REVELATION of St John the Divine (otherwise known as the Apocalypse), which is an interpretation of history designed to demonstrate the sovereignty of God.

Newton, Sir Isaac (1642–1727) English scientist. He studied at CAMBRIDGE and became professor of mathematics (1669–1701). His main works were *Philosophiae Naturalis Principia Mathematica* (1687) and *Opticks* (1704). In the former, he outlined his laws of motion and proposed the principle of universal GRAVITATION; in the latter he showed that white light is made up of colours of the SPECTRUM and put forward his particle theory of light. He also created the first system of CALCULUS in the 1660s, but did not publish it until the German mathematician Gottfried Leibniz had published his own system in 1684. He built a reflecting telescope in *c*.1671. **newton** (symbol N) SI unit of FORCE. One newton is the force that gives a mass of one kilogram an acceleration of one metre per second.

Newton's Laws Three physical laws of motion, formulated by Isaac Newton. The first law states that an object remains at rest or moves in a straight line at constant speed unless acted

NEW MEXICO

Statehood: 16 January 1912

Nickname:

The Land of Enchantment

State bird : Roadrunner

State flower:

Yucca flower

State tree :

Pine nut

State motto : It grows as it goes

■ newt An amphibian from mountainous regions of central Europe, the alpine newt (*Triturus* alpestris) feeds on worms and insects. Normally dull brown or black, the male develops bright colours in the breeding season.

NEW YORK Statehood: 26 July 1788 Nickname:

Nickname : The Empire State State bird :

Bluebird
State flower:

Rose

State tree : Sugar maple

State motto : Ever upward ated with it an equal and opposite force. See also MECHANICS **new town** Satellite town in the UK designed to re-house residents from a nearby large city and to create local employment. The construction of some 37 new towns began in 1946 and continued until 1975. **New York** State in NE USA, bounded by the Canadian border, the Great Lakes, the Atlantic Ocean and three New England states; the capital is ALBANY. NEW YORK CITY is by far the

upon by a force. The second law, which enables force to be

calculated, states that force is proportional to the rate of change

of MOMENTUM. The third law states that every force has associ-

New York State in NE USA, bounded by the Canadian border, the Great Lakes, the Atlantic Ocean and three New England states; the capital is Albany. New York City is by far the largest city in the state. Henry Hudson discovered New York Bay in 1609 and sailed up the river that bears his name. The New Netherland colony was established in the Hudson valley. In 1664 it was seized by the British and renamed New York. It was one of the 13 original states of the Union. The opening of the Erie Canal in 1825 was an enormous stimulus to New York's growth. Throughout US history its economic strength and large population have given it great influence in national affairs. Much of the state is mountainous, the ADIRONDACK MOUNTAINS (NE) and Catskills (SE) being the principal ranges. The w consists of a rolling plateau sloping down to Lake

Ontario and the St Lawrence valley. The HUDSON and its tributary, the Mohawk, are the chief rivers. Agricultural produce is varied. New York is the leading manufacturing and commercial state in the USA. Industries: clothing, machinery, chemicals, electrical equipment, paper, optical instruments. Area: 127,190sq km (49,108sq mi). Pop. (1993 est.) 18,197,154.

New York City City and port in SE New York State, USA, at the mouth of the Hudson River; largest city (by population) in the USA. MANHATTAN Island was settled in 1624 and was bought (1626) from Native Americans by the Dutch West India Company. New Amsterdam was founded at the s end of the island. In 1664 the British took the colony and renamed it New York. The founding of the Bank of New York by Alexander Hamilton and the opening of the Erie Canal in 1825 made New York the principal US commercial and financial centre. After the American CIVIL WAR and in the early 20th century, the city received a great influx of immigrants. It is made up of five boroughs: Manhattan, the Bronx, BROOKLYN, QUEENS and Staten Island. Monuments and buildings of interest include the STATUE OF LIBERTY, the EMPIRE STATE BUILDING, Rockefeller Center, the METROPOLITAN MUSEUM OF ART, the Museum of Modern Art, the Guggen-

NEW ZEALAND

New Zealand's flag was designed in 1869 and adopted as the national flag in 1907, when New Zealand became an independent dominion. The flag includes the British Blue Ensign and four of the five stars in the Southern Cross constellation.

Mew Zealand consists of two mountainous main islands and several smaller ones, c.1,600km (1,000mi) SE of Australia. Much of NORTH ISLAND is volcanic; Ngauruhoe and Ruapehu are active volcanoes. It is noted for its hot springs and geysers. New Zealand's largest river (Waikato) and largest lake (Taupo) are

170°E 175°F PACIFIC OCEAN 35°5 3505 Whangarei NORTH ISLAND Mt Egmont Hawke Bay Hastings 40° 40°5 Tasma Palmerston North Sea Wellington SOUTH ISLAND NEW ZEALAND 170°E 175°E

both on North Island. North Island cities include the capital, Wellington, and the largest port, Auckland. The Southern Alps extend for almost the entire length of South Island, rising to Mount Cook at 3,753m (12,313ft). South Island is famed for its glaciers and fjords. The major South Island cities are Christichurch and Dunedin. Territories include the Ross Dependency in Antarctica. Cook Islands and Niue are associated states.

CLIMATE

The climate varies from N to s. Auckland has a warm, humid climate throughout the year. Wellington has cooler summers, while in Dunedin, temperatures can dip below freezing in winter. Rainfall is heaviest on the W highlands.

VEGETATION

Only small areas of original *kauri* forests survive, mainly in the N and S extremities of South Island. Beech forests grow in the highlands, and large plantations are grown for timber. Abundant sunshine is ideal for E coast vineyards.

HISTORY AND POLITICS

MAORI settlers arrived in New Zealand more than 1,000 years ago. The first European discovery was by the Dutch navigator Abel TASMAN in 1642. The British explorer James Cooκ landed in 1769. Trade in fur and whaling brought British settlers in the early 19th century. A series of intertribal wars (1815–40) killed tens of thousands of Maoris. In 1840 the first British settlement at Wellington was established. The Treaty of WAITANGI (1840) promised to honour Maori

AREA: 270,990sq km (104,629sq mi)
POPULATION: 3,414,000
CAPITAL (POPULATION): Wellington (329,000)
GOVERNMENT: Constitutional monarchy
ETHNIC GROUPS: New Zealand European 74%,
New Zealand Maori 10%, Polynesian 4%
LANGUAGES: English and Maori (both official)
RELIGIONS: Christianity (Anglican 21%.

Presbyterian 16%, Roman Catholic 15%, Methodist 4%)

currency: New Zealand dollar = 100 cents

land rights in return for recognition of British sovereignty. In 1841 New Zealand became a separate colony. Increasing colonization led to the MAORI WARS. In 1893 New Zealand was the first country to extend the franchise to women. In 1907 New Zealand became a self-governing dominion in the British Commonwealth. New Zealand troops fought on the side of the Allies in both World Wars. In 1973 Britain joined the European Community, and New Zealand's exports to Britain shrank. Since the 1980s, it has pursued a more independent economic and foreign policy. In 1985 the Greenpeace ship Rainbow Warrior was blown up in Auckland harbour, prompting the adoption of anti-nuclear policies. Maori rights and the preservation of Maori culture remain a political issue. A 1992 referendum voted in favour of the introduction of proportional representation. Jim Bolger was re-elected prime minister in 1996. In 1997 he was replaced by Jenny Shipley, who became New Zealand's first woman prime minister.

ECONOMY

During the 1980s New Zealand gradually shifted from a state-controlled economy, with a large welfare state, to a more market-oriented economy, encouraging private sector finance. It has traditionally depended on agriculture, particularly sheep- and cattle-rearing. New Zealand is the world's third-largest producer of sheep. Manufacturing now employs twice as many people as agriculture. Tourism is the fastest growing economic sector (1992 receipts, US\$1,032 million).

heim Museum, Lincoln Center and Carnegie Hall. It is one of the world's leading ports and an important financial centre. Industries: clothing, chemicals, metal products, scientific instruments, shipbuilding, food processing, broadcasting, entertainment, tourism, publishing. Pop. (1990) 7,322,564.

New Zealand Archipelago state in the s Pacific. *See* country feature

Ney, Michel (1769–1815) French general, one of the most brilliant of Napoleon's commanders. He fought in the French Revolutionary and Napoleonic Wars, notably at Friedland (1807) and in the retreat from Moscow (1812). He urged Napoleon to abdicate in 1814 and accepted the Bourbon restoration, but rejoined Napoleon during the Hundred Days and fought gallantly in the Waterloo campaign. He was subsequently executed as a traitor.

Nez Percé (Fr. pierced nose) Tribe of Native North Americans living in central Idaho, sw Washington and NE Oregon.

Ngo Dinh Diem See DIEM, NGO DINH
Niagara Falls Waterfalls on the Niagara River on the border
of the USA (w New York state) and Canada (se Ontario);
divided into the Horseshoe, or Canadian, Falls, and the
American Falls. The Canadian Falls are 48m (158ft) high and

American Falls. The Canadian Falls are 48m (158ft) high and 792m (2,600ft), wide; the American Falls are 51m (167ft) high and 305m (1,000ft) wide.

Niamey Capital of Niger, West Africa, in the sw part of the country, on the River Niger. It became capital of the French colony of Niger in 1926. It grew rapidly after World War 2 and is now the country's largest city and its commercial and administrative centre. Manufactures include textiles, ceramics, plastics and chemicals. Pop. (1988) 392,169.

Nicaea, Councils of Two important ecumenical councils of the Christian church held in Nicaea (modern Iznik, Turkey). The first was convoked in AD 325 to resolve the problems caused by the emergence of ARIANISM. It promulgated a creed, affirming belief in the divinity of Christ. The Second Council of Nicaea, held in 787, was summoned by the patriarch Tarasius to deal with the problem of the worship of icons.

Nicaragua Republic in Central America. See country feature, page 480

Nice City on the Mediterranean coast, SE France; capital of Alpes-Maritimes département. Founded by Phocaean Greeks in the 4th century BC, it was conquered by Rome in the 1st century AD. In the 10th century it passed to the counts of Provence. In 1388 it became a possession of the House of Savoy. It became permanently part of France in 1860. It is a major centre of the French Riviera. Industries: tourism, olive oil, perfumes, textiles, electronics. Pop. (1990) 342,349.

Nicene Creed Statement of Christian faith named after the First Council of NICAEA (325). Its exact origin is uncertain. The Nicene Creed defends the orthodox Christian doctrine of the TRINITY against the ARIAN heresy. It is subscribed to by all the major Christian Churches and is used by them in their celebrations of the EUCHARIST. *See also* APOSTLES' CREED; ATHANASIAN CREED

Nicholas, Saint Patron saint of children and sailors. Traditionally, he was Bishop of Myra in the 4th century. He is the subject of many legends. In one he secretly gave gold to three poor girls as their dowries. From this came the custom of giving presents on his feast day, 6 December, a habit later transferred to Christmas in most countries. His name in one Dutch dialect, *Sinter Claes*, became anglicized as Santa Claus.

Nicholas I (1796–1855) Tsar of Russia (1825–55). Ascending the throne in 1825, he was immediately confronted by the Decembrist revolt, during which a secret society of officers and aristocrats assembled some 3,000 troops in St Petersburg, demanding a representative democracy. Having crushed the rebels, he ruthlessly suppressed rebellion in Poland and assisted Austria against the Hungarian revolution of 1848. His pressure on Turkey led to the CRIMEAN WAR (1853–56). Nicholas II (1868–1918) Last Tsar of Russia (1894–1917).

Nicholas II (1868–1918) Last Tsar of Russia (1894–1917). Torn between the autocracy of his father, ALEXANDER III, and the reformist policies of ministers such as Count Sergei Witte, he lacked the capacity for firm leadership. Defeat in the RUSSO–JAPANESE WAR was followed by the RUSSIAN REVOLUTION OF 1905. Nicholas agreed to constitutional govern-

■ New York City The famous skyline of New York City is that of the island of Manhattan, one of the five boroughs of the city. The tallest buildings in the photograph are the World Trade Center. Its two skyscrapers were the tallest in the world on their completion in 1973.

ment but, as danger receded, removed most of the powers of the Duma (parliament). In World War 1 he took military command (1915), but defeat in war again provoked revolution (1917). Nicholas was forced to abdicate, and in July 1918 he and his family were executed by BOLSHEVIKS.

Nicholson, Ben (1894–1982) British painter, one of the champions of British ABSTRACT ART. Influenced by CUBISM and Piet Mondrian, Nicholson developed a geometric abstract style, which he expressed in austere carved and painted reliefs, such as *White Relief* (1935). He later produced a series of freely abstracted still-lifes and landscapes, before returning to reliefs in the 1960s.

Nicholson, Jack (1937–) US film actor. Charismatic and versatile, Nicholson won an Oscar-nomination for his supporting role in *Easy Rider* (1969). Other nominations followed for *Five Easy Pieces* (1970) and *Chinatown* (1974). He won a Best Actor Oscar for *One Flew Over The Cuckoo's Nest* (1975) and a Best Supporting Actor award for *Terms of Endearment* (1983). His directorial credits include *The Two Jakes* (1990).

nickel (symbol Ni) Silvery-white metallic element, one of the TRANSITION ELEMENTS. Its chief ores are pentlandite and niccolite. Hard, malleable and ductile, nickel is used in stainless steels, other special alloys, coinage, cutlery, storage batteries and as a hydrogenation catalyst. Properties: at.no. 28; r.a.m. 58.71; r.d. 8.90 (25°C); m.p. 1,453°C (2,647°F); b.p. 2,732°C (4,950°F); most common isotope Ni⁵⁸ (67.84%).

Nicklaus, Jack William (1940–) US golfer. He won a record 18 professional majors between 1962 and 1986, including: the US Open (1962, 1967, 1972, 1980); British Open (1966, 1970,1978); US PGA (1963, 1971, 1973, 1975, 1980); and the US Masters (1963, 1965–66, 1972, 1975, 1986). He captained the irrepressible US Ryder Cup team (1969–81). In 1988 Nicklaus was voted "Golfer of the Century".

Nicosia (Levkosía) Capital of Cyprus, in the central part of

▲ Nicholson One of the most versatile film actors, Jack Nicholson's films include *The Shining* (1980), *Reds* (1981), *The Postman Always Rings Twice* (1981), *Prizzi's Honor* (1985) and *Batman* (1989). His roles are often that of an outsider.

■ Niagara Falls Two spectacular waterfalls on the Niagara River are known as the Niagara Falls. They lie on the border between the USA and Canada, with Goat Island separating the Canadian Falls from the American (shown here). They provide hydroelectric power as well as attracting vast numbers of tourists.

▲ Nietzsche The influential German philosopher Friedrich Nietzsche's work was distorted by the Nazis and used to defend their idea of an Aryan super-race.

the island. Known to the ancient world as Ledra, the city was later successively held by the Byzantines, French crusaders and Venetians. The Ottoman Turks occupied the city from 1571 to 1878, when it passed to Britain. It is now divided into Greek and Turkish sectors. Manufactures include cigarettes, textiles and footwear. Pop. (1992 est.) 177,451.

nicotine Poisonous ALKALOID obtained from the leaves of TOBACCO, used in agriculture as a pesticide and in veterinary medicine to kill external parasites. Nicotine is the principal addictive agent in smoking tobacco. See also CIGARETTE

Nielsen, Carl (1865-1931) Danish composer, known internationally for his six symphonies. He also composed concertos for violin, flute and clarinet, two operas, a woodwind quintet and four string quartets. His originality lies in the use of established procedures in novel contexts.

Niemeyer, Oscar (1907-) Brazilian architect. An early advocate of modern architecture, he worked with LE Cor-BUSIER on the Ministry of Education and Health Building in Rio (1936-45). He subsequently developed an original approach: elegant, sub-tropical luxury expressed through curving, sculptural forms. In the late 1950s Niemeyer began designing the main public buildings at Brasília.

Niemöller, Martin (1892–1984) German Protestant minister and theologian. He opposed Hitler's creation of a "German Christian Church" and was arrested in 1938 because of his opposition to the Nazi Party. In 1961 he became a President of the World Council of Churches.

Nietzsche, Friedrich Wilhelm (1844-1900) German philosopher who rejected Christianity and the prevailing morality of his time and emphasized people's freedom to create their own values. In 1879 he abandoned classical philology for philosophy. Over the next decade, he worked out his view of the freedom of the individual. He presented his notion of the Übermensch, the idealized man, strong, positive, and able to impose his wishes upon the weak and worthless, in Thus Spake Zarathustra (1883-85). Other works include Beyond Good and Evil (1886) and On the Genealogy of Morals (1887).

Niger Republic in N central Africa. See country feature Niger Major river of w Africa. It rises in the Fouta Djallon plateau in the sw Republic of Guinea and flows NE through Guinea into the Mali Republic, where it forms an extensive inland delta. It then flows in a great curve across the border into Nigeria and s into another vast delta before emptying into the Gulf of Guinea. Length: 4,180km (2,600mi).

NICARAGUA

Nicaragua's flag was adopted in 1908. It was the flag of the Central American Federation (1823-39), which included Costa Rica, El Salvador, Guatemala, Honduras and Nicaragua. It resembles the flag of El Salvador except for the shading of the blue and the central motif.

he Republic of Nicaragua is the largest country in Central America. The Central Highlands rise in the NW Cordillera Isabella to over 2,400m (8,000 ft) and are the source for many of the rivers that drain the E plain. The Caribbean coast forms part of the Mosquito Coast. Lakes Managua and Nicaragua lie on the edge of a narrow volcanic region, which contains Nicaragua's major urban areas, including the capital, MAN-AGUA, and the second-largest city, LEÓN. This region is highly unstable, with many active volcanoes, and is prone to earthquakes.

CLIMATE

Nicaragua has a tropical climate, with a rainy season from June to October. The Central Highlands are cooler, and the wettest part is

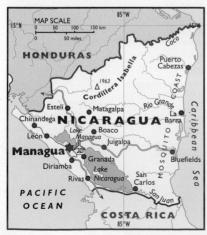

the Mosquito Coast, with c.4,200mm (165in) of annual rain.

VEGETATION

Rainforests cover large areas in the E, with trees such as cedar, mahogany and walnut. Tropical savanna is common in the drier w.

HISTORY AND POLITICS

Christopher Columbus reached Nicaragua in 1502 and claimed the land for Spain. By 1518 Spanish forces had subdued the indigenous population, and Nicaragua was ruled as part of the Spanish Captaincy-General of Guatemala. In the 17th century Britain secured control of the Caribbean coast. In 1821 Nicaragua gained independence and formed part of the Central American Federation (1825-38). In the mid-19th century Nicaragua was ravaged by civil war, and US and British interference. The USA was interested in the construction of a trans-isthmian canal through Nicaragua. In 1855 William WALKER invaded and established himself as the shortlived president of Nicaragua. José Santos Zemalya's dictatorial regime gained control of Mosquito Coast, and formed close links with the British. Following his downfall, civil war raged once more. In 1912 US marines landed to protect a pro-US regime, and in 1916 the USA gained exclusive rights to the canal. Liberal opposition to US occupation resulted in guerrilla war, led by Augusto César Sandino. In 1933 the US marines withdrew, but set up the National Guard to help defeat the rebels. In 1934 Sandino was assassinated by Anastasio Somoza, director of the National Guard and official president from 1937.

AREA: 130,000sq km (50,193sq mi) POPULATION: 4,130,000 CAPITAL (POPULATION): Managua (682,111) **GOVERNMENT:** Multiparty republic ETHNIC GROUPS: Mestizo 77%, White 10%,

Black 9%, Native American 4% LANGUAGES: Spanish (official)

RELIGIONS: Christianity (Roman Catholic 91%,

others 9%)

CURRENCY: Córdoba oro (gold córdoba) = 100

centavos

Somoza's dictatorial regime led to political isolation. He was succeeded by his sons Luis (1956) and Anastasio (1967). Anastasio's diversion of international relief aid following the devastating 1972 Managua earthquake cemented opposition. In 1979 the SANDINISTA National Liberation Front (FSLN) overthrew the Somoza regime. The Sandinista government, led by Daniel Ortega, instigated wide-ranging socialist reforms. The USA, concerned over the Sandinista's relations with Cuba and the Soviet Union, sought to destabilize the government by organizing and funding the CONTRA rebels. A ten-year civil war destroyed the economy and created dissatisfaction with the Sandinistas.

In 1990 elections, the Sandinistas lost power to the National Opposition Union coalition of opposition parties. Violeta CHAMORRO became president. Many of Chamorro's reforms were blocked by her coalition partners and the Sandinista-controlled trade unions. In 1996 elections, Chamorro was defeated by the Liberal leader, Arnoldo Aleman.

ECONOMY

Nicaragua faces many problems in rebuilding its shattered economy and introducing free-market reforms. Agriculture is the main activity, employing c.50% of the workforce and accounting for 70% of exports. Major cash crops include coffee, cotton, sugar and bananas. Rice is the main food crop. It has some copper, gold and silver, but mining is underdeveloped. Most manufacturing is based in and around Managua.

Niger-Congo languages Group of nearly a thousand languages spoken by more than 300 million people who live in Africa s of the Sahara. The main ones are Bantu (spoken in s Africa), Fulani (Guinea, Senegal and other w African countries), Malinke (Mali), Swahill (E coast) and Yoruba (Nigeria).

Nigeria Republic in w Africa. See country feature, page 482 Nightingale, Florence (1820–1910) British nurse, b. Italy. She founded modern NURSING and is best known for her activities in the CRIMEAN WAR. In 1854 she took a unit of 38 nurses to care for wounded British soldiers. In 1860 she founded the Nightingale School and Home for nurse training at St Thomas's Hospital, London.

nightingale Migratory Old World songbird of the THRUSH family (Turdidae). The common nightingale of England and Western Europe (*Luscinia megarhynchos*) is ruddy-brown with light grey underparts. Length: *c.* 16.5cm (6.5in).

nightjar Insect-eating, nocturnal bird found worldwide. It has a whirring cry. Length: 27cm (10.5in). Family Caprimulgidae. **nightshade** Name given to various species of poisonous flowering plants, but especially to the DEADLY NIGHTSHADE (Atropa belladonna) and its close relatives.

nihilism Doctrine of certain Russian revolutionaries in the late 19th century. It condemned contemporary society as hostile to nature and rejected non-rational beliefs. Nihilists demanded radical reform of government and society by violent means.

Nijinsky, Vaslav (1890–1950) Russian dancer, often regarded as the greatest male ballet dancer of the 20th century. Dancing with the BALLETS RUSSES, his most noted roles were in *Petrushka*, *Les Sylphides* and *Scheherazade*. From 1912 he choreographed such ballets as *L'Après-midi d'un faune*, *Jeux* and *Le Sacre du printemps* for DIAGHILEV.

Nile Longest river in the world, flowing c.6,700km (4,160mi) from the Kagera headstream, E Burundi, to its Mediterranean delta in NE Egypt. The Kagera flows generally N before emptying into Lake VICTORIA. The Victoria Nile flows from Lake Victoria to Lake Albert in Uganda. From Lake Albert to the Sudanese border, it is called the Albert Nile. It continues to flow N through the S Sudanese swamps as the Bahr el Jebel. From Malakâl to Khartoum the river is called the White Nile. At Khartoum it converges with the Blue Nile. As simply the Nile, the river continues to flow N to the Egyptian border. It then flows into the man-made Lake Nasser, created by the damming of the river at ASWAN. From

NIGER

This flag was adopted shortly before Niger became independent from France in 1960. The orange stripe represents the Sahara in the north, and the green the grasslands in the south. Between them, the white stripe represents the River Niger, with a circle for the sun.

AREA: 1,267,000sq km (489,189sq mi)

POPULATION: 8,252,000

CAPITAL POPULATION: Niamey (392,169) GOVERNMENT: Multiparty republic ETHNIC GROUPS: Hausa 53%, Zerma-Songhai 21%, Tuareg 11%, Fulani (or Peul) 10%

LANGUAGES: French (official)
RELIGIONS: Islam 98%

currency: CFA franc = 100 centimes

The Republic of Niger is a landlocked nation in N central Africa. The N plateaux lie in the SAHARA. Central Niger contains the rugged, partly volcanic Aïr Mountains, which reach a height of 2,022m (6,634ft) near Agadez. The s consists of broad plains, including the Lake CHAD basin in SE Niger, on the borders with Chad and Nigeria. The only major river is the NIGER in the SW. The narrow Niger valley is the country's most fertile and densely populated region, and includes the capital, NIAMEY.

CLIMATE

Niger is one of the world's hottest countries. The hottest months are March to May, when the HARMATTAN wind blows from the Sahara. Niamey

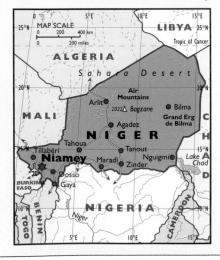

has a tropical climate, with a rainy season from June to September. Rainfall decreases from s to N. Northern Niger is practically rainless.

VEGETATION

The far s consists of tropical savanna. Buffaloes, elephants, giraffes and lions are found in the "W" National Park, which Niger shares with Benin and Burkina Faso. Most of s Niger lies in the SAHEL region of dry grassland. The Aïr Mountains support grass and scrub. The N deserts are generally barren.

HISTORY AND POLITICS

Neolithic remains have been found in the N desert. Nomadic TUAREG settled in the Aïr Mountains in the 11th century AD, and by the 13th century had established a state based on Agadez and the trans-Saharan trade. In the 14th century the HAUSA settled in s Niger. In the early 16th century the Songhai empire controlled much of Niger, but were defeated by the Moroccans at the end of the century. In the early 19th century the Fulani gained control of much of s Niger. The first French expedition arrived in 1891, but Tuareg resistance prevented full occupation until 1914. In 1922 Niger became a colony within French West Africa. In 1958 Niger voted to remain an autonomous republic within the French Community. Full independence was achieved in 1960. Hamani Diori became Niger's first president, and he maintained close ties with France. Drought in the Sahel began in 1968 and killed many livestock and destroyed crops. In 1974 a group of army officers, led by Lieutenant Colonel Seyni

Kountché, overthrew Hamani Diori and suspended the constitution. Kountché died in 1987 and was succeeded by his cousin General Ali Saibou. In 1991 the Tuareg in N Niger began an armed campaign for greater autonomy. A national conference removed Saibou and established a transitional government. In 1993 multiparty elections, Mahamane Ousmane of the Alliance of Forces for Change (AFC) coalition became president. The collapse of the coalition led to further elections in 1995, which were won by the National Movement for a Development Society (MNSD), but a military coup, led by Colonel Ibrahim Bare Mainassara, seized power. A peace accord was signed between the government and the Tuaregs. In 1996 elections, Brigadier General Mainassara became president.

ECONOMY

Niger has been badly hit by droughts, which have caused great suffering and food shortages, and the destruction of the traditional nomadic lifestyle. Niger's chief resource is uranium, and it is the world's second-largest producer. Uranium accounts for over 80% of exports, most of which is exploited by the French Atomic Energy Authority. Some tin and tungsten are also mined. Other mineral resources are largely unexploited. Despite its resources, Niger is one of the world's poorest countries (1992 GDP per capita, US\$820). Farming employs 85% of the workforce, though only 3% of the land is arable and 7% is used for grazing. Food crops include beans, cassava, millet, rice and sorghum. Cotton and groundnuts are leading cash crops.

Nigeria's flag was adopted in 1960 when Nigeria became independent from Britain It was selected after a competition to find a suitable design. The green represents Nigeria's forests. The white in the centre stands for peace.

he Federal Republic of Nigeria is the most populous nation in Africa. It has a sandy coastline, fringed by a belt of mangrove swamps and lagoons, which includes the former capital, LAGOS. The NIGER and Benue rivers meet in central Nigeria, and run s into the Niger Delta, where Benin City is situated. North of the coastal lowlands is a hilly region of rainforest and savanna. At the foot of the great plateau of Nigeria lies the city of IBADAN. The plateau is a region of high wooded and savanna plains, and includes the capital, ABUJA. In the extreme NE lies the Lake CHAD basin. In the NW lies the Sokoto plains. The Adamawa Highlands extend along the SE border with Cameroon, and contain Nigeria's highest point, at 2,042m (6,699ft).

CLIMATE

Lagos has a tropical climate, with high temperatures and rain throughout the year. The N is drier and often hotter than the s, though the highlands are cooler. KANO in N central Nigeria has a marked dry season from October to April.

VEGETATION

Behind the coastal swamps are rainforests, though large areas have been cleared by farmers. The plateau contains large areas of tropical savanna with forested river valleys. Open grassland and semi-arid scrub occur in drier areas. To the N lie the dry grasslands of the SAHEL.

HISTORY AND POLITICS

Excavations around the Nigerian village of Nok have uncovered some of the oldest and most beautiful examples of African sculpture. The Nok civilization flourished between 500 BC and AD 200. In the 11th century, the Kanem-Bornu kingdom extended s from Lake Chad into Nigeria, and the HAUSA established several citystates. In sw Nigeria, the state of BENIN and the YORUBA kingdom of Oyo flourished in the 15th century. They were renowned for their brass, bronze and ivory sculptures. The SONGHAI empire dominated N Nigeria in the early 16th century. The Portuguese were the first Europeans to reach the Nigerian coast, and they established trading links with Benin in the late 15th century. Nigeria became a centre of the slave trade, with major European powers competing for control. The IGBO established citystates built on the wealth of the trade. In the early 19th century, the FULANI captured many of the Hausa city-states. Sokoto retained its independence. The sw began a protracted civil war. In 1807 Britain renounced the slave trade, but other countries continued the practice. In 1861 Britain seized Lagos, ostensibly to stop the trade. By 1885 Britain controlled all of s Nigeria and gradually extended northwards. By 1906 Britain had conquered all of Nigeria, and divided the country into the Colony (Lagos) and Protectorate of Southern Nigeria and the Protectorate of Northern Nigeria. In 1914 the two were

AREA: 923,770sg km (356,668sg mi) POPULATION: 88.515.000

CAPITAL (POPULATION): Abuja (305,900) **GOVERNMENT:** Federal republic

ETHNIC GROUPS: Hausa 21%, Yoruba 21%, Ibo (or Igbo) 19%, Fulani 11%, Ibibio 6%

LANGUAGES: English (official) RELIGIONS: Christianity (Protestant 26%, Roman Catholic 12%, others 11%), Islam

currency: Naira = 100 kobo

combined. Britain ruled indirectly through colonial officials and local rulers. Cities, infrastructure and industries developed. In 1954 Nigeria was federated into three regions (N, E and W) plus the territory of Lagos. In 1960 Nigeria gained independence; it became a republic in 1963. In 1966 Igbo army officers staged a successful coup, but the regime was rapidly topped by a Hausa-led coup. In 1967 the Igbo, increasingly concerned for their safety within the federation, formed the independent republic of BIAFRA. For the next three years civil war raged in Nigeria, until Biafra capitulated.

The division of Nigeria into 30 states reflects the fact that it contains more than 250 ethnic and language groups, and several religious ones. The early 1970s were more peaceful, as Nigeria expanded its oil industry. Nigeria joined OPEC in 1971. Oil revenue created widespread government corruption and widened the wealth gap. Drought in the SAHEL killed much livestock and led to mass migration to the s. After several military coups, civilian rule was briefly restored in 1979. Following 1983 elections, the military seized power again. Between 1960 and 1996 Nigeria enjoyed only nine years of civilian government. The 1993 presidential elections, won by Chief Moshood Abiola, were declared invalid by the military government. The army commander-in-chief, General Sanni Abacha. gained power. In 1994 nationwide demonstrations prompted Abiola to form a rival government, but he was swiftly arrested. In 1995 General Abacha was given an open-ended term in office, vowing to restore civilian rule by 1998. His regime has been severely criticized for human rights abuses and the suppression of opposition. In November 1995, after the execution of nine activists, Nigeria was suspended from the Commonwealth of Nations.

ECONOMY

Nigeria is a low income developing country, with great economic potential (1992 GDP per capita, US\$1,560). It is the world's eleventh-largest producer of crude oil, which accounts for 95% of its exports. The major oilfields are in the Niger delta and the bights of Benin and Biafra. The drop in the price and production of oil, and mounting foreign debt caused economic recession in the 1980s. Agriculture employs 43% of the workforce. Nigeria is the world's third-largest producer of palm oil and palm kernels, fourth-largest producer of groundnuts, sixth-largest producer of cocoa, and seventh-largest producer of rubber. Cattle rearing is important in the N grasslands, while fishing is a major activity in the s. Manufacturing is diversifying. Products include chemicals and clothing. Nigeria has petroleum refineries, vehicle assembly plants and steel mills.

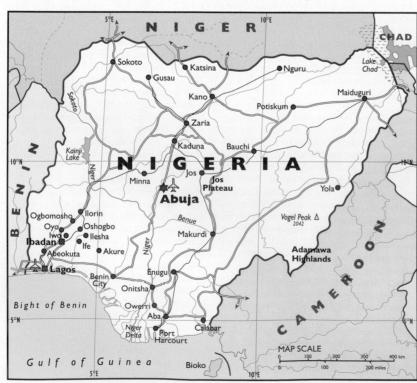

Aswan the river flows through Luxor to Cairo. N of Cairo is the Nile Delta, Egypt's largest agricultural area. The Nile empties into the Mediterranean at Damietta and Rosetta. As well as supporting the agriculture of Egypt and Sudan, the Nile is used for transport, hydroelectricity and tourism.

Nimitz, Chester William (1885–1966) US admiral. He served in submarines during World War 1 and commanded the Pacific fleet during World War 2, directing operations against the Japanese at Midway and subsequent battles.

Nineveh Capital of ancient Assyria, on the River Tigris (opposite modern Mosul, Iraq). The site was first occupied in the 6th millennium BC. It became the Assyrian capital under SENNACHERIB (r.704–681 BC). The city walls were more than 12km (7.5mi) long and contained gardens irrigated by canals. Nineveh was sacked by the Medes in 612 BC, but continued to be occupied until the Middle Ages.

niobium (symbol Nb) Shiny grey-white metallic element of the second transition series. Its chief ore is pyrochlore. Soft and ductile, niobium is used in special stainless steels and in alloys for rockets and jet engines. Properties: at.no. 41; r.a.m. 92.9064; r.d. 8.57; m.p. 2,468°C (4,474°F); b.p. 4,742°C (8,568°F); most common isotope Nb⁹³ (100%).

nirvana Conception of salvation and liberation from rebirth in the religions of ancient India – HINDUISM, BUDDHISM and JAINISM. To Hindus, nirvana is extinction in the supreme being, brought about by internal happiness, internal satisfaction and internal illumination. To Buddhists, it is the attainment of a transcendent state of enlightenment through the extinction of all desires. To Jains, nirvana is a state of eternal blissful repose. **nitrate** Salt of NITRIC ACID (HNO₃). Nitrate salts contain the nitrate ion (NO₃⁻) and some are important naturally occurring compounds, such as saltpetre (potassium nitrate, KNO₃) and Chile saltpetre (sodium nitrate, NaNO₃). Nitrates are used as food preservers, fertilizers, explosives and as a source of nitric acid. They can be an environmental hazard.

nitric acid Colourless liquid (HNO₃) that is one of the strongest mineral acids. Nitric acid attacks most metals, resulting in the formation of NTRATES, and is a strong oxidizing agent. It is used in the manufacture of agricultural chemicals, explosives, plastics, dyes and rocket propellants.

nitrogen (symbol N) Common gaseous nonmetallic element of group V of the periodic table. Colourless and odourless, it is the major component of the atmosphere (78% by volume), from which it is extracted by fractional distillation of liquid air. It is necessary for life, being present in all plants and animals. The main industrial use is in the HABER PROCESS. Nitrogen compounds are used in fertilizers, explosives, dyes, foods and drugs. The element is chemically inert. Properties: at.no. 7; r.a.m. 14.0067; r.d. 1.2506; m.p. -209.86°C (-345.75°F); b.p. -195.8°C (-320.4°F); most common isotope N¹⁴ (99.76%).

nitrogen cycle Circulation of nitrogen through plants and animals in the BIOSPHERE. Plants obtain nitrogen compounds for producing essential proteins through assimilation. Nitrogen-fixing bacteria in the soil or plant root nodules take free nitrogen from the soil and air to form the nitrogen compounds used by plants to grow. The nitrogen is returned to the soil and air by decay or denitrification.

nitrogen fixation Incorporation of atmospheric NITROGEN into chemicals for use by organisms. Nitrogen-fixing microorganisms (mainly BACTERIA and CYANOBACTERIA) absorb nitrogen gas from the air, from air spaces in the soil, or from water, and build it up into compounds of ammonia. Other bacteria can then change these compounds into nitrates, which can be taken up by plants. *See also* NITROGEN CYCLE

nitroglycerine Oily liquid used in the manufacture of explosives. It is used in medicine (as glyceryl trinitrate) to relieve the symptoms of ANGINA.

nitrous oxide (dinitrogen oxide) Colourless gas (N₂O) that is used as an anaesthetic or analgesic during surgical or dental operations. It is known as "laughing gas" since it produces exhilaration. It is also used in making pressurized foods.

Niue Island territory in the s Pacific Ocean, 2,160km (1,340mi) NE of New Zealand; the capital is Alofi. The largest coral island in the world, Niue was first visited by Europeans

in 1774. In 1901 it was annexed to New Zealand. In 1974 it achieved self-government in free association with New Zealand. The island is prone to hurricanes and tropical rainstorms. Its economy is mainly agricultural. The major export is coconut. Area: 260sq km (100sq mi). Pop. (1991) 2,239.

Nixon, Richard Milhous (1913-94) 37th US president (1969-74). Nixon was elected as a Republican to the House of Representatives in 1946 and the Senate in 1950. He came to prominence during the Alger Hiss hearings of the House Un-American Activities Committee (HUAC). He was vice president (1953-61) under EISENHOWER, but lost the presidential election to John F. KENNEDY. In 1968 he again received the Republican nomination for president and defeated Hubert HUMPHREY. Spiro AGNEW became his vice president. As president, Nixon persevered with Lyndon JOHNSON'S STRATEGIC ARMS LIMITATIONS TALKS (SALT) with the Soviet Union. In 1969 Nixon began a phased withdrawal of US troops from the VIETNAM WAR, but the USA invaded Cambodia (1970) and Laos (1971). In 1972 Nixon became the first US president to visit communist China. Despite domestic recession and the imposition of wage and price controls, Nixon won re-election in 1972. Following the blanket bombing of North Vietnam, Nixon withdrew US troops from Vietnam (1973). In 1973 members of Nixon's re-election committee were convicted of the burglary of Democratic Party headquarters in the WATER-GATE building. The scandal sunk his administration. Nixon was forced to submit tape recordings of conversations, which revealed that he had tried to cover-up the burglary. On 9 August 1974, Nixon resigned to avoid impeachment. His successor, Gerald FORD, granted him a pardon.

Nkrumah, Kwame (1909–72) Ghanaian statesman, prime minister (1957–60), first president of Ghana (1960–66). Nkrumah was the leading post-colonial proponent of PAN-AFRICANISM. In 1949 he formed the Convention People's Party in the Gold Coast. He was imprisoned (1950) by the British, but released when his party won the general election. He led the Gold Coast to independence (1957) and became prime minister. In 1960 Gold Coast became the Republic of Ghana and Nkrumah was made president. Nkrumah formed a loose union with Guinea and Mali and promoted the Charter of African States (1961). Nkrumah gradually assumed absolute power and, following a series of assassination attempts, Ghana became a one-party state (1964). While on a visit to China, he was deposed in a military coup (1966).

Noah Old Testament patriarch, the only person righteous enough to be chosen by God to survive the destruction of the FLOOD. In Genesis 6–9, Noah built an ARK, in accordance with God's instructions, to carry and shelter himself, all his family, and selected animals and birds. Noah and his sons and their wives were the ancestors of the human race after the Flood.

Nobel, Alfred Bernhard (1833–96) Swedish chemist, engineer and industrialist. He invented DYNAMITE in 1866 and patented a more powerful explosive, gelignite, in 1876. With the fortune he made from the manufacture of explosives, he founded the NOBEL PRIZES.

nobelium (symbol No) Radioactive metallic element, one of the ACTINIDE SERIES of elements. Seven isotopes are known. Properties: at.no. 102, most stable isotope No²⁵⁵ (half-life 3 minutes). *See also* TRANSURANIC ELEMENTS

Nobel Prize Awards given each year for outstanding contributions in the fields of physics, chemistry, physiology or medicine, literature and economics and to world peace. Established in 1901 by the will of Swedish scientist Alfred Nobel, the prizes are awarded annually on 10 December. The winners are selected by committees based in Sweden and Norway.

Nobili, Leopoldo (1784–1835) Italian physicist who was a pioneer in electrochemistry. He generated electricity using platinum ELECTRODES in an alkaline nitrate ELECTROLYTE and devised the astatic galvanometer to measure the current.

noble gas (inert gas) Helium, neon, argon, krypton, xenon and radon – the elements (in order of increasing atomic number) forming group 0 of the PERIODIC TABLE. They are colourless, odourless and very unreactive. Their low reactivity is due to their complete outer electron shells (two electrons for helium and eight each for the rest), which offer no VALENCE "hooks".

nocturne In music, a quiet piece endeavouring to reflect the atmosphere and mood of night-time. First used by John Field for some of his piano pieces, the title was later used by CHOPIN. DEBUSSY composed three orchestral nocturnes.

No drama Form of Japanese symbolic drama that developed between the 12th or 13th and the 15th centuries. It was influenced by Zen, and the actors were originally Buddhist priests. The plots were taken chiefly from Japanese mythology and poetry. With little character or plot development, the No play seeks to convey a moment of experience or insight. It is highly stylized and uses masks, music, dance and song. No was central to the development of KABUKI THEATRE.

Nolan, Sidney (1917–92) Australian painter. He is famed for a series of paintings (begun in 1946) based on the life of the notorious outlaw, Ned Kelly. He continued painting subjects that portrayed events from Australian history, notably the *Eureka Stockade* series (1949). His almost surreal land-scapes express the hard, scorched majesty of the outback.

Nolde, Emil (1867–1956) German painter and graphic artist who exemplified EXPRESSIONISM. He trained as a wood-carver before turning to painting relatively late. He painted his subjects (often flowers or landscapes) with deep, glowing colours and simplified outlines, bringing the works to the borders of ABSTRACT ART. Although he was a member of Die BRÜCKE (1905–07), he was essentially a solitary figure.

nomad Member of a wandering group of people who live mainly by hunting or herding. Nomadism is regarded as an intermediate state between hunter-gatherer and farming societies. Today, nomadic groups survive only in the more remote parts of Africa, Asia and the Arctic. See also Bedouin; Eskimo **nominalism** Philosophical theory, opposed to Realism, that denies the reality of universal concepts. Whereas realists claim that there are universal concepts, such as roundness or dog, that are referred to by the use of these terms, nominalists argue that such generalized concepts cannot be known, and that the terms refer only to specific qualities common to particular circles or dogs that have been encountered up to now. Nominalism was much discussed by the scholastic philosophers of the Middle Ages.

nonalignment See NEUTRALITY

Nonconformism Dissent from or lack of conformity with the religious doctrines or discipline of an established church, especially the Church of England. The term Nonconformist applies to all the sects of British Protestantism that do not subscribe to the principles of the established Anglican Church or the established Church of Scotland. It arose in England in reaction to the Act of Uniformity (1662). Movements such as Congregationalism and Presbyterianism, Baptists and Quakers proliferated. Nonconformist Churches were eventually granted freedom of worship in 1689 and civil and political rights in 1828. Methodism and Unitarianism were added to their ranks during the 18th century.

non-figurative (non-objective) Art that makes no attempt to represent objects from the physical world. The term comprises all ABSTRACT ART that does not rely on the appearance of the visual world for the source of its ideas.

Nonjurors Clergy in England and Scotland who refused to

take the oath of allegiance to WILLIAM III and MARY II in 1689. Anglo-Catholic in sympathy, they included several bishops and about 400 priests in England and most of the Scottish episcopal clergy.

Nono, Luigi (1924–90) Italian composer. An early follower of Anton Webern, he gained international recognition with the *Canonic Variations* (1950), an orchestral work based on a note series of Arnold Schoenberg. He composed several political works, including the anti-fascist opera *Intolerance* (1960).

Nootka Tribe of Native Americans living along the w coast of Vancouver Island, British Columbia. They were expert fishermen and were the only Native Americans on Canada's Pacific coast to hunt whales.

noradrenaline Hormone secreted by nerves in the autonomic nervous system and by the ADRENAL GLANDS. It slows the heart rate and constricts small arteries, thus raising the blood pressure. It is used therapeutically to combat the fall in blood pressure that accompanies shock.

Nordenskjöld, Nils Adolf Erik, Baron (1832–1901) Swedish explorer and scientist. A geologist by training, he explored the Greenland ice cap and the Arctic Ocean. In 1878 he led the Swedish expedition in the *Vega*, which was the first ship to sail through the NORTHEAST PASSAGE.

Norfolk County of E England; the county town is Norwich. The region was home to the ICENI tribe in the 3rd century BC. After the departure of the Romans it became part of the ANGLO-SAXON kingdom of East Anglia. In the Middle Ages Norfolk was a centre of the wool industry. The land is generally low-lying and is used mainly for agriculture. The region is drained by the rivers Waveney, Yare, Bure and Ouse, and by the BROADS. Today Norfolk produces cereals and root vegetables; poultry farming and fishing are also important. Area: 5,372sq km (2,073sq mi). Pop. (1991) 745,613.

Norfolk City and port on Elizabeth River, SE Virginia, USA. Norfolk was founded in 1682; it forms the port of Hampton Roads, together with NEWPORT NEWS and PORTSMOUTH. Norfolk was almost completely destroyed by fire during the American Revolution (1776). In the Civil War it acted as a Confederate naval base. It is now the largest US naval complex. Exports: coal, grain, tobacco. Industries: shipbuilding, motor vehicles, chemicals, textiles. Pop. (1990) 261,229.

Norfolk Broads See Broads, Norfolk

Norfolk Island Territory of Australia in the sw Pacific Ocean, c.1,450km (900mi) E of Australia. Visited in 1774 by Captain James Cook, it was a British penal colony (1788–1814, 1825–55). Many people living on Pitcairn Island, descendants of the *Bounty* mutineers, were resettled here in 1856. The chief economic activities are agriculture and tourism. Area: 34sq km (13sq mi). Pop. (1991) 1,912.

Noriega, Manuel (Antonio Morena) (1934–) Panamanian general. In 1963 Noriega became head of Panama's National Defence Forces and was made chief of military intelligence in 1969. Recruited as a CIA operative by the USA, Noriega became an important backstage power-broker. During 1983–89 he was effectively Panama's paramount leader, ruling behind puppet presidents. In 1987 evidence emerged of Noriega's criminal activities, and the USA withdrew its support. In 1988 he was indicted by a US court on drug-connected charges and accused of murder. In December 1989 US roops invaded Panama and installed a civilian government. Noriega surrendered to US forces and was taken to the USA for trial on corruption, drug trafficking and money laundering. In April 1992 he was sentenced to 40 years in prison.

Norman architecture ROMANESQUE architectural style of the Normans in England, N France and S Italy. Characteristic buildings include the cathedrals at St Étienne and Caen in France, and Durham in England (begun 1093). The style was marked by massive proportions, square towers, round arches and little decoration.

Norman Conquest (1066) Invasion of England by WILLIAM I (THE CONQUEROR), duke of Normandy. William claimed that EDWARD THE CONFESSOR (d.1066) had recognized him as heir to the throne of England, and he disputed the right of HAROLD II to be Edward's successor. William's army defeated and killed Harold at the battle of HASTINGS, then

► Nolde Flowers in a Garden.
Flowers were a favourite subject
of the expressionist painter,
Nolde, who was fascinated by
the expressive potential of
colour. Declared degenerate by
the Nazis and forbidden to paint,
his later works were small
watercolours that he painted
in secret.

advanced on London, where William was accepted as king. The ruling class, lay and ecclesiastical, was gradually replaced by Normans, and Norman institutions were imposed.

Normandy Region and former province of Nw France, coextensive with the départements of Manche, Calvados, Orne, Eure and Seine-Maritime. Part of the Roman province of Gaul, it was absorbed into the Frankish kingdom of Neustria in the 6th century. It was the seat of William, Duke of Normandy (later WILLIAM I), who invaded England in 1066. Normandy was recovered by the French in 1204. It was the site of the NORMANDY CAMPAIGN. It is characterized by forests, flat farmlands and rolling hills. The economy is based on livestock rearing, dairy products, fruit, cider and fishing.

Normandy Campaign Allied invasion of German-occupied France, launched on 6 June 1944 (D-Day). Commanded by EISENHOWER, the invasion was the largest amphibious operation in history. The successful landings were the start of the final campaign of WORLD WAR 2 in w Europe.

Norman French Dialect of Old French spoken by the Normans at the time of the conquest of England (1066). In Normans at the time of the conquest of England (1066).

mandy, it was the general language, but it was also used by the Normans in England, where it coexisted with contemporary MIDDLE ENGLISH for about three centuries.

Normans Descendants of Vikings who settled in NW France in the 9th–10th centuries. They created a powerful state, with a strongly centralized feudal society and warlike aristocracy. In the 11th century, under Robert Guiscard and ROBERT II, they defeated the Muslims to create an independent kingdom in Sicily. In 1066 Duke William of Normandy conquered England and became WILLIAM I.

Norns In Germanic mythology, three maidens who spun or wove the fate of both mortals and gods. Their names were Urth (Past), Verthandi (Present) and Skuld (Future).

Norodom Sihanouk (1922–) Cambodian king and statesman. He became king in 1941 but in 1955, after establishing a socialist government, abdicated to become prime minister. In 1960 he became head of state. In 1965 he broke off diplomatic relations with the USA because of US military involvement in Indochina. In 1970 he was deposed by Lon Nol in a right-wing military coup. He returned from exile when the KHMER ROUGE

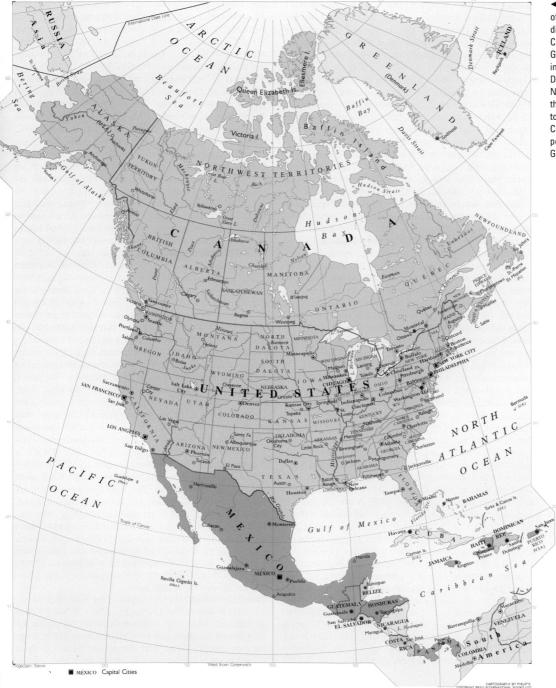

■ North America The N part of the American continent is divided fairly evenly between Canada and the USA. Greenland, the largest island in the world, is a part of Denmark. The climate of North America ranges from the tropical Caribbean islands to the tundra landscape of N Canada, Alaska and the permanent icesheet covering Greenland.

took over in 1975, first supporting then opposing their regime. Sihanouk formed a government-in-exile after the Vietnamese invasion in 1979. He returned to Cambodia in 1991 and, in 1993. became constitutional monarch. Sihanouk's son, Prince Ranariddh, was ousted by his co-premier, Hun Sen, in 1997.

Norris, Frank (1870-1902) US novelist, one of the most striking naturalistic writers. He first attracted attention with McTeague (1899). He is also noted for his trilogy about wheat: The Octopus (1901), The Pit (1903) and The Wolf (unfinished). Norse literature Literature of the Scandinavian Norsemen, written between the 9th and the 12th century. It consists mainly of mythological poetry and SAGAS. The works were set down in stone and wood, and survived orally to be recorded in the 12th-14th centuries.

North, Frederick, Lord (1732-92) British statesman. He entered Parliament at 22 and served in several governments, becoming prime minister in 1770. North's repressive measures against unrest in the North American colonies, particularly the INTOLERABLE ACTS, have been blamed for their rebellion. He was forced out of office in 1783.

North, Oliver Laurence (1943-) US marine lieutenant colonel. He was recruited as an aide to the National Security Council and was involved in several covert operations. The Congressional committee that investigated the notorious IRAN-CONTRA AFFAIR in 1987 revealed him as the central figure, and he was subsequently convicted of three criminal charges. He was pardoned in 1992.

North America Continent, including the mainland and offshore islands N of and including Panama. Land North America extends N of the Arctic Circle and s almost to the Equator. To the w it is bordered by the Bering Sea and the Pacific Ocean, and to the E by the Atlantic Ocean. There are many islands off both coasts, particularly to the N in the Arctic Ocean, and to the SE in the Caribbean Sea. There are two major mountain ranges: the APPALACHIANS in the E and the ROCKY MOUNTAINS in the w. Between these two ranges lie the fertile GREAT PLAINS and the Central Lowlands. In the E. a long coastal plain extends from New England to Mexico. The w coast is more mountainous. Structure and Geology Much of Canada is an old Precambrian shield area forming a saucershaped depression centred in the HUDSON BAY. The Appalachians also have their origins in the Precambrian era. In the w, the complex fold mountains of the Rockies and the Pacific Margin are younger and continue into South America as the ANDES. Lakes and rivers Lakes Superior, Huron, ERIE and ONTARIO make up the GREAT LAKES. The ST LAWRENCE River forms a navigable link between the Great Lakes and the Atlantic Ocean. The longest river is the combined Mississippi-Missouri system. Other important rivers include the YUKON, MACKENZIE, COLORADO, COLUMBIA, DELAWARE and RIO GRANDE. Climate and vegetation The geographical range of the continent means that every climatic zone is represented. In the far N, there are areas of tundra and arctic conditions. In the interior, in areas sheltered by high mountains, there are desert areas. Tropical rainforest is found in the lower areas of Central America. On much of the continent, however, the climate is temperate. The natural vegetation on the Great Plains is grass, bordered by mixed and coniferous forests in the mountains to the E, W and N. People North America's first settlers probably arrived about 45,000 years ago from Asia by way of Alaska. By the time the Vikings arrived from Europe, around AD 1000, NATIVE AMERICANS occupied the entire continent. European settlement accelerated after Christopher Columbus's famous voyage in 1492. The Spaniards settled in Mexico and the WEST INDIES, whereas the English and French settled farther N. Swedes, Germans and the Dutch also made early settlements. Europe's political and economic problems later drove larger numbers to the New World. Descendants of the Spanish settlers are predominant in Mexico, Central America and some Caribbean islands, and French concentrations exist in Quebec province, Canada, and parts of the West Indies. In the Central American countries and the Caribbean, people of European descent are in the minority. Economy Much of North America benefits from a combination of fertile soil and climatic conditions favourable

to agriculture. The plains region of North America is one of the world's major grain and livestock-producing areas. The s produces mainly cotton, tobacco, coffee and sugar cane. There is also substantial industrial development. Mining is important, particularly in Canada and Mexico. Recent events The early 20th century saw mass emigration to the USA and Canada. The USA has been the dominant economic force on the continent throughout the 20th century. The USA emerged from the Spanish American War (1898) as a world power. In 1903 Theodore ROOSEVELT enforced the construction of the PANAMA CANAL, control of which is due to return to Panama in 1999. The USA and Russia emerged from World War 2 as global superpowers. The ideological battle between CAPITAL-ISM and COMMUNISM created the COLD WAR, and led to US involvement in the KOREAN WAR and the VIETNAM WAR. Since January 1994, Canada, the USA and Mexico have been linked through the NORTH AMERICAN FREE TRADE AGREE-MENT (NAFTA). Economic inequality and instability remain major issues in Mexico. Since World War 2 many Caribbean islands have gained independence. The US trade embargo, since Castro's revolution in 1959, has crippled Cuba's economy. Central America has also been dominated by US interests and by repressive regimes and economic inequality. Total area: 24,454,000sq km (9,442,000sq mi) Highest mountain MT McKinley (Denali) 6,194m (20,321ft) Longest river MISSISSIPPI-MISSOURI 6,050km (3,760mi) Population 395,000,000 Largest cities MEXICO CITY (15,047,685); NEW YORK CITY (7,322,564); Los Angeles (3,489,779) See also INDIVIDUAL COUNTRY ARTICLES

North American Free Trade Agreement (NAFTA) Treaty designed to eliminate trade barriers between Canada, Mexico and the USA. The agreement was signed in 1992, and NAFTA came into effect on 1 January 1994. Some Latin American countries have also applied to join.

North American mythology Traditional beliefs of Native North Americans. The Native North Americans displayed a great diversity of languages and cultures, but their mythologies had many common features. Among these was the concept of heroes in the form of animal deities, such as Raven or Coyote, believed to have been the original inhabitants of the country. They brought order into the world by gaining possession of fire, wind and rain and by establishing laws and institutions. They also created mountains and rivers and other natural features. Native Americans had numerous gods, including the Great Spirit and the Earth Mother of the Algonquins, and the gods of thunder and wind of the Iroquois. Belief in protective or harmful spirits remains universal, and the SHAMAN plays a central part in religious life, acting as an intermediary between man and the spirit world.

Northamptonshire County in central England; the county town is Northampton. There are traces of pre-Celtic habitations as well as Roman and Anglo-Saxon settlement. The land is undulating and is drained by the Welland and Nene rivers. Much of the region is devoted to pasture, wheat growing and forestry. Products include cereals, potatoes and sugar beet. There are extensive iron ore deposits, and iron and steel industries are important. Industries: footwear, engineering, food processing. Area: 2,367sq km (914sq mi). Pop. (1991) 578,807.

North Atlantic Treaty Organization (NATO) Intergovernmental organization, military alliance of the USA, Canada and 14 European countries. The original treaty was signed in Washington in 1949 by Belgium, Britain, Canada, Denmark, France, Iceland, Italy, Luxembourg, Norway, Portugal, Netherlands and the USA. Since then, Greece, Turkey, Spain and Germany have joined. In July 1997, despite Russian opposition, the Czech Republic, Hungary and Poland were invited to join. NATO's headquarters is in Brussels. During the COLD WAR, NATO was the main focus of the West's defence against the Soviet Union.

North Carolina State in E USA, on the Atlantic coast; the capital is RALEIGH. The first English colony in North America was founded in 1585 on Roanoke Island. Permanent settlers moved into the region from Virginia in the 1650s. It was the last state to secede from the Union. North Carolina's coastal plain is swampy and low-lying. Its w edge rises to

NORTH CAROLINA Statehood:

21 November 1789

Nickname:

The Tar Heel State

State bird:

Cardinal State flower:

Flowering dogwood

State tree:

Pine

To be, rather than to seem

rolling hills; further w are the Blue Ridge and Great Smoky Mountains. It is the leading producer of tobacco in the USA. Important agricultural products are corn, soya beans, peanuts, pigs, chickens and dairy produce. Industries: textiles, timber, fishing, tourism, electrical machinery, chemicals. Mineral resources include phosphate, feldspar, mica and kaolin. Area: 136.523sg km (52,712sg mi). Pop. (1990) 6,628,637.

Northcliffe, Alfred Charles William Harmsworth, Viscount (1865–1922) British newspaper publisher, b. Ireland. He began his career as a freelance journalist but, with the help of his brother Harold, was soon publishing his own popular periodicals. In 1896 he launched the *Daily Mail*, whose concise, readable style of news presentation proved very successful. In 1905 he founded the *Daily Mirror*, the first picture paper, and in 1908 gained control of *The Times*.

North Dakota State in N central USA, on the Canadian border; the capital is BISMARCK. French explorers first visited the region in 1738. The USA acquired the w half of the area from France in the LOUISIANA PURCHASE (1803), and the rest from Britain in 1818 when the boundary with Canada was fixed. Dakota was divided into North and South Dakota in 1889. The region is low-lying and drained by the Missouri and Red rivers. Wheat, barley, rye, oats, sunflowers and flaxseed are the chief crops. Cattle rearing is the most important economic activity. Area: 183,022sq km (70,665sq mi). Pop. (1990) 638,800.

Northeast Passage Route from the Atlantic to the Pacific via the Arctic Ocean. Unsuccessful attempts were made to find the passage by Dutch and English mariners from the 16th century. The complete voyage was first made by Baron Nordenskjöld in 1878–80.

Northern Cape Province in sw South Africa; the capital is Kimberley. Northern Cape was created in 1994 from the N part of the former Cape Province. Area: 361,800sq km (139,650sq mi). Pop. (1994) 737,360.

Northern Ireland See IRELAND, NORTHERN

northern lights Popular name for the AURORA borealis

Northern Province Province in N South Africa; the capital is Pietersburg. In 1994 Northern Transvaal was formed from the N part of the former province of Transvaal. In 1995 it was renamed Northern Province. Area: 123,280sq km (46,970sq mi). Pop. (1994 est.) 5,201,630.

Northern Territory Territory in N central Australia bounded by the Timor and Arafura seas (N), and the states of Western Australia (W), South Australia (S) and Queensland (E); the capital is DARWIN. In 1863 it was annexed to South Australia but in 1911 was brought under the control of the federal government. In 1978 it achieved internal self-government. The territory lies mostly within the tropics. The coastal areas are flat with many offshore islands, and the region rises inland to a high plateau, the Barkly Tableland. In the mainly arid south are the Macdonnell Ranges and AYERS ROCK. Today there is little farming but some government-aided stock-breeding. Manganese ore, bauxite and iron are mined. Area: 1,347,525sq km (520,280sq mi). Pop. (1993) 169,298.

Northern War (1700–21) Conflict in N Europe between Sweden and its neighbours. It began with an attack on Sweden by Denmark, Saxony, Poland and Russia. CHARLES XII of Sweden defeated all his opponents (1700–06), but war was renewed in 1707 when Charles invaded Russia. The Swedes were decisively defeated at Poltava (1709). He took refuge with the Ottoman Turks, encouraging their attack on Russia in 1710–11. At the ensuing peace treaties (1719–21), Sweden lost virtually all its northern empire.

North Island Smaller but more densely populated of the two main islands of New Zealand; separated from SOUTH ISLAND by Cook Strait. The chief cities are WELLINGTON, AUCKLAND and Hamilton. The island contains several mountain ranges, Lake Taupu (New Zealand's largest lake), fertile coastal plains and numerous hot springs. Most of New Zealand's dairy produce comes from North Island. Industries: wood pulp and paper, mining, fishing. Area: 114,729sq km (44,297sq mi). Pop. (1991) 2,553,413.

North Korea See Korea, North

North Pole Most northerly point on Earth; the n end of the Earth's axis of rotation, 725km (450mi) n of Greenland. Geo-

graphic north lies at 90° latitude, 0° longitude. The Arctic Ocean covers the entire area.

North Sea Arm of the Atlantic Ocean, lying between the E coast of Britain and the European mainland and connected to the English Channel by the Straits of Dover. Generally shallow, it is *c.*960km (600mi) long, with a maximum width of 640km (400mi). It is a major fishing ground, shipping route, and (since 1970) an important source of oil and natural gas. Area: *c.*580,000sq km (220,000sq mi).

Northumberland, John Dudley, Duke of (1502–53) Effectively ruler of England (1549–53). He was one of the councillors named by HENRY VIII to govern during the minority of EDWARD VI. In 1553 he attempted to usurp the succession through his daughter-in-law, Lady Jane GREY, but was thwarted by popular support for the rightful queen, MARY I. He was subsequently executed for treason.

Northumberland County in NE England, on the border with Scotland; the county town is Morpeth. In the 2nd century AD HADRIAN'S WALL was built to defend Roman Britain from the northern tribes. In the 7th century the region became part of the Saxon kingdom of Northumbria. The land slopes down from the Cheviot Hills in the NW, and the region is drained by the Tyne, Tweed, Blythe and Coquet rivers. The county is largely rural, the chief farming activities being cattle and sheep rearing. Barley and oats are grown and forestry is important. Coal is mined. Area: 5,033sq km (1,943sq mi). Pop. (1991) 304,694. Northumbria, Kingdom of Largest kingdom in Anglo-Saxon England. Formed in the early 7th century, it included NE England and SE Scotland up to the Firth of Forth. In the age of the historian BEDE and the LINDISFARNE GOSPELS, Northumbria experienced a blossoming of scholarship and monastic culture. Its power declined in the 8th century.

North-West Frontier Province Province in NW Pakistan; the capital is PESHAWAR. It is a region of high mountains divided by fertile valleys of the River INDUS. It is linked by a series of passes, including the KHYBER PASS, with India and Afghanistan. Since the 7th century, the PATHANS have fiercely defended the region. Islam was introduced in the 10th century. In 1849 Britain assumed control. For the next 50 years the Pathans resisted British rule. In 1901 Britain divided the Pun-JAB province and created a separate North-West Frontier Province. In 1947 it joined the new state of Pakistan. The economy is based on agriculture and the principal crop is wheat. Area: 74,521sq km (28,765sq mi). Pop. (1985 est.) 12,287,000. Northwest Ordinance (1787) Decree of the US CONTINEN-TAL CONGRESS, establishing the Northwest Territory. Based on plans proposed by a committee chaired by JEFFERSON, it created a government for the Territory, between the Ohio and Mississippi rivers, and laid down the policy for federal land sales. Northwest Passage Western route from the Atlantic to

Northwest Passage Western route from the Atlantic to the Pacific via N Canada. Many European explorers in the 16th–17th centuries tried to find a passage through North America to the Pacific. The effort was renewed in the 19th century. The expedition of Sir John Franklin, which set out in 1845, was lost with all hands, but during the search for survivors, the route was established. First to make the passage in one ship was Roald Amundsen in 1903–06.

North-West Province Province in Nw South Africa; the capital is Mmabatho. North-West Province was created from the Nw part of the former province of TRANSVAAL. Area: 116,190sq km (44,489sq mi). Pop. (1994 est.) 3,252,991.

Northwest Territories Region in N Canada, covering more than 33% of the country and consisting of mainland Canada N of latitude 60°N, and hundreds of islands in the Arctic Archipelago. The capital is Yellowknife. Much of the N and E of the province is tundra, inhabited by INUIT and other native peoples. The HUDSON's BAY COMPANY acquired the area under a charter from CHARLES II in 1670. In 1869 the Canadian government bought the land from the company. The present boundaries were set in 1912. In 1999 part of the Northwest Territories will become the Inuit land of Nunavut. Most economic development has occurred in Mackenzie district, which has large tracts of softwoods and rich mineral deposits. Area: 3,426,000sq km (1,320,000sq mi). Pop. (1992) 57,649.

North Yorkshire County in N England; the administrative

NORTH DAKOTA Statehood:

2 November 1889 Nickname :

The Flickertail State

State bird :

Western meadowlark

State flower: Wild prairie rose

State tree :

American elm State motto :

Liberty and union, now and forever, one and inseparable

centre is YORK. Other major towns include Scarborough, Whitby and Harrogate. The Roman administration of the region was based at York. In the 9th century a thriving culture was destroyed by the Scandinavian invasions. In the Middle Ages the region became noted for its many monastic foundations. In the w of the county are the PENNINES. In the E are the North Yorkshire Moors. North Yorkshire is predominantly agricultural, with dairy farming, cereals and hill sheep farming. There is some manufacturing industry. Area: 8,309sq km (3,208sq mi). Pop. (1991) 702,161.

Norway Scandinavian kingdom in NW Europe. See country feature

Norwegian Official language of Norway, spoken by nearly all the country's four million inhabitants. The major dialect, bokmål, spoken mainly in the cities, is very similar to Danish; nynorsk ("New Norse"), spoken in the countryside, more closely reflects the language as it was spoken before Danish influence. Norwegian belongs to the N branch of the Germanic family of INDO-EUROPEAN LANGUAGES.

Norwich City and county town of NORFOLK, E England. It was already an important market town in the 11th century. There are many fine churches dating from the medieval period, including the Norman cathedral (1096). Industries: textiles, machinery, chemicals, electrical goods, foodstuffs, footwear. Pop. (1991) 120,895.

nose In human beings, other primates and some vertebrates. the prominent structure between the eyes. It contains receptors sensitive to various chemicals (sense of smell) and serves as the opening to the respiratory tract, warming and moistening the air and trapping dust particles on the MUCOUS MEM-BRANES. It has two cavities separated by a wall of CARTILAGE; the external openings are the nostrils.

Nostradamus (1503–66) (Michel de Nostredame) French seer and astrologer. After practising as a doctor, he began making astrological predictions in 1547. These were published in rhyming quatrains in Centuries (1555) and represented one verse for every year from then till the end of the world (in the 1990s). To avoid prosecution as a magician, he changed the order of the verses so that no time sequence was discernible.

notary (notary public) Public official who authenticates documents such as deeds and contracts by witnessing them.

notochord In chordates and the early embryonic stages of

NORWAY

This flag became the national flag of Norway in 1898, although merchant ships had used it since 1821. The design is based on the Dannebrog, the flag of Denmark, the country that ruled Norway from the 14th century until the early 19th century.

AREA: 323,900sq km (125,050sq mi)

POPULATION: 4,286,000

CAPITAL (POPULATION): Oslo (459,292) GOVERNMENT: Constitutional monarchy

ETHNIC GROUPS: Norwegian 97% LANGUAGES: Norwegian (official), Lappish,

Finnish

RELIGIONS: Christianity (Lutheran 88%)

currency: Krone = 100 ore

he Kingdom of Norway forms the w part of the Scandinavian peninsula. Its coast is fringed by many islands and FJORDS. Many of Norway's cities lie on or near the fjords, including the capital, OSLO, and BERGEN and TROND-HEIM. The land rises steeply from the coastal lowlands to a 1,500m (5,000ft) central plateau. Europe's largest glacier field, Josdtedalsbreen, lies w of Galdhøppigen, Norway's highest point, at 2,469m (8,100ft). The plateau contains many deep valleys with lakes and rivers, such as the Glåma. The distant Arctic islands of SVALBARD and Jan Mayen are Norwegian possessions.

CLIMATE

North Atlantic Drift gives Norway a mild climate. Most of Norway's seaports remain ice-free throughout the year. Snow covers the land for over three months every year. In Trømso, the sun does not set between November and January.

VEGETATION

Large areas of the rugged mountains are bare rock. Forest and woods cover c.27% of Norway.

HISTORY AND POLITICS

Norway's seafaring tradition dates back to the VIKINGS, who raided w Europe between the 9th and 11th centuries. OLAF II introduced Christianity in the early 11th century, but was deposed by CANUTE II of Denmark. HAAKON IV re-established unity in the 13th century. In 1319 Sweden and Norway were joined. In 1397 Norway, Sweden and Denmark were united in the Kalmar Union. For the next four centuries Norway was subject to Danish rule. Lutheranism became the state religion in the mid-16th century. In 1814

20°E 65°N Bothnia 9 Z of 93

Denmark ceded Norway to Sweden. Norway declared its independence, but Swedish troops forced Norway to accept union under the Swedish crown. An independent monarchy was established in 1905. Norway was neutral in World War 1. In the 1920s Norway industrialized. In the 1930s Norway adopted progressive social welfare provisions. In April 1940 German troops invaded. Over 50% of Norway's merchant fleet was destroyed in the resistance. Liberation was achieved in May 1945. Norway joined NATO in 1949 and was a co-founder (1960) of the European Free Trade Association (EFTA). In 1972 and 1994 referenda, Norway voted against joining the European Community. In 1977 Gro Harlem Brundtland became Norway's first woman prime minister. In 1991 Olav V was succeeded by his son, Harald V. In 1996 Brundtland was replaced as prime minister by Thorbjoern Jagland. The 1997 general elections produced a disappointing result for Jagland's Labour Party, and it was replaced by a centrist government under Kjell Magne Bondevik.

ECONOMY

Norway has one of the world's highest standards of living (1992 GDP per capita, US\$18,580). Its chief exports are oil and natural gas. Oil was discovered in 1969. Norway is the world's eighthlargest producer of crude oil. Per capita, Norway is the world's largest producer of hydroelectricity. Major manufactures include petroleum products, chemicals, aluminium, wood pulp and paper. Farmland covers c.3% of the land. Dairy farming and meat production are the chief activities, but Norway has to import food. Norway has the largest fish catch in Europe (after Russia).

vertebrates, the flexible, primitive backbone; in mature vertebrates it is replaced by the SPINE.

Notre-Dame Early Gothic cathedral in Paris (1163–1250). One of the most daring constructions of its time, it has a wide nave and double ambulatory, and the w façade was imitated in many French churches.

Nottingham City and county town of NOTTINGHAMSHIRE, on the River Trent, N central England. Originally a 6th-century Anglo-Saxon settlement, it is the traditional birthplace of ROBIN HOOD. The city grew rapidly in the 19th century, becoming famous for the manufacture of fine lace, cotton and hosiery. Industries: textiles, engineering, bicycles, electronic equipment, pharmaceuticals. Pop. (1991) 263,522.

Nottinghamshire County in central England; the county town is NOTTINGHAM. The land slopes down from the E ridges of the PENNINES in the W to the lowlands of the E. The principal river is the TRENT. Wheat, barley and sugar beet are the chief crops; beef and dairy cattle are important. There are rich deposits of coal in the county. Nottinghamshire has long been noted for its textile industries. Area: 2,164sq km (836sq mi). Pop. (1991) 993,872.

Nouakchott Capital of Mauritania, NW Africa, in the SW part of the country, c.8km (5mi) from the Atlantic Ocean. Originally a small fishing village, it was chosen as capital when Mauritania became independent in 1960. Nouakchott now has an international airport and is the site of modern storage facilities for petroleum. Light industries have been developed and handicrafts are important. Pop. (1988) 393,325.

Nouméa City and seaport in sw New Caledonia island, s Pacific Ocean; the capital of New CALEDONIA. Originally called Port-de-France, it was made capital of New Caledonia in 1854. Nouméa was used as a French penal colony during the late 19th century. Local mining products include nickel, chrome and manganese. Pop. (1989) 65,110.

noun Member of a linguistic class or category consisting of words that serve to name a person, place, thing or concept. In traditional grammar, nouns form one of the so-called parts of speech. Modern linguistics experts, however, tend to define them in terms of their grammatical function.

nouveau roman (Fr. new novel) Experimental fictional form. Pioneered by Alain ROBBE-GRILLET, Samuel BECKETT and Nathalie Sarraute during the 1950s, it was influenced by the work of Franz KAFKA and James JOYCE and also by film technique. It is characterized by meticulously detailed description, the avoidance of value judgments, and a consciousness of the artificiality of time sequences.

nova (plural novae) Faint star that undergoes unpredictable increases in brightness by several magnitudes, apparently due to explosions in its outer regions, and then slowly fades back to normal. See also VARIABLE STAR

Novalis (1772–1801) German romantic poet and novelist, b. Friedrich Leopold, Baron von Hardenberg. He began his major work, the mythical romance Heinrich von Ofterdingen, in 1799, but had not completed it by the time of his death. His work influenced the development of German ROMANTICISM.

Nova Scotia Maritime province in SE Canada, consisting of a mainland peninsula, the adjacent Cape Breton Island and a few smaller islands; the capital is HALIFAX. The first settlement of Nova Scotia was made by the French in 1605. The mainland was awarded to Britain in 1713, and Cape Breton Island was seized from the French in 1758. Nova Scotia joined NEW BRUNSWICK, QUEBEC and ONTARIO to form the Dominion of CANADA in 1867. The land is generally low-lying, rolling country and there are extensive forests. The principal crops are hay, apples, grain and vegetables. There are coal deposits on Cape Breton Island. Fishing is very important. Industries: shipbuilding, pulp and paper, steelmaking, food processing. Area: 55,490sq km (21,425sq mi). Pop. (1991) 899,942.

novel Narrative fiction, usually in prose form, that is longer and more detailed than a short story. The word is derived from the Latin word novus (new) and the Italian NOVELLA (a short tale with an element of surprise). The roots of the modern novel are generally traced to CERVANTES' Don Quixote (1605-15). Its development as a major literary form can be seen in 18th-century Britain in Daniel DeFoe's Robinson Crusoe (1719) and

Samuel RICHARDSON's Pamela (1740). The 20th century has seen considerable formal experimentation, notably the STREAM

OF CONSCIOUSNESS technique and the NOUVEAU ROMAN. novella Short, highly structured prose narrative. The form was developed by Giovanni Boccaccio in the Decameron (1348–53), and has proved popular since the 18th century. In modern usage, the term broadly denotes a work of prose fiction that is longer than a short story but shorter than a NOVEL. Noverre, Jean-Georges (1727-1810) French choreographer and ballet reformer. He abolished the conventional, meaningless gestures of ballet and initiated the ballet d'action in which dance and story were united.

Novgorod City in NW Russia, on the River Volchov. One of Russia's oldest cities, it was supposedly founded by the Varangian prince RURIK in the 9th century. Its inhabitants were forcibly converted to Christianity in 989. It subsequently became capital of a vast territory. After a long fight for supremacy, the city was forced to submit to Moscow in 1478. In 1570 IVAN IV (THE TERRIBLE) massacred the inhabitants. It declined in importance after the founding of ST PETERSBURG. During World War 2 it suffered great destruction. Industries: distilling, foodstuffs, electrical engineering, furniture, chinaware. Pop. (1992) 235,000.

Novi Sad City in NE Serbia, a port on the River Danube; capital of the autonomous province of Vojvodina. Industries: machinery, electrical goods, chemicals, textiles, tobacco. Pop. (1991) 179,626

Novosibirsk City on the River Ob, s Siberia, Russia. Founded in 1896 after the construction of the Trans-Siberian Railway, it grew quickly. During World War 2 it received complete industrial plants moved from war areas of the w Soviet Union. It is now a centre for scientific research. Industries: agricultural and mining machinery, metallurgy, machine tools, chemicals, textiles, furniture, foodstuffs. Pop. (1992) 1,442,000.

Nu, U (1907-95) Burmese statesman, prime minister (1948-56, 1957-58, 1960-62). Active in the struggle for independence, Nu became BURMA's first prime minister. Ousted by the military in 1958, he returned to power in 1960. In 1962 he was again deposed by a military coup led by U NE WIN. After years of exile, he returned to Burma in 1980 and was later placed under house arrest.

Nuba Name for a group of several unrelated peoples inhabiting a region of s Sudan. Most Nuba peoples are farmers and many tribes cultivate terraces on rugged granite hillsides. Animal husbandry is also practised. The predominant religious rituals are closely linked to agricultural fertility rites.

Nubia Ancient state on the upper Nile, NE Africa. At its height, Nubia extended from Egypt to the Sudan. At first ruled by Egypt, it later controlled Egypt in the 8th and 7th centuries BC. It converted to Christianity in the 6th century AD and became part of Ethiopia in the 14th century.

nuclear disarmament See DISARMAMENT; STRATEGIC ARMS LIMITATION TALKS (SALT)

■ Notre-Dame The Early Gothic cathedral of Notre-Dame is situated on the lle de la Cité in Paris France seen here from the Seine River. A fine example of Gothic architecture, it is noted for its flying buttresses, which were a technical advance providing support, and for the rose window in the west façade.

nuclear energy ENERGY released during a nuclear reaction as a result of the conversion of mass into energy according to Einstein's equation $E=mc^2$. Nuclear energy is released in two ways: by FISSION and by FUSION. Fission is the process responsible for the atomic bomb and for the fission reactors now contributing to energy requirements worldwide. Fusion provides the energy for the Sun and the stars and for the HYDROGEN BOMB. It also offers the prospect of cheap energy once a method has been perfected for controlling fusion reactions.

nuclear fission See FISSION, NUCLEAR nuclear fusion See FUSION, NUCLEAR

nuclear physics Branch of physics concerned with the structure and properties of the atomic NUCLEUS. The principal means of investigating the nucleus is the SCATTERING experiment, carried out in particle ACCELERATORS, in which a nucleus is bombarded with a beam of high-energy ELEMENTARY PARTICLES and the resultant particles analysed. Study of the nucleus has led to an understanding of the processes occurring inside stars and has enabled the building of NUCLEAR REACTORS and NUCLEAR WEAPONS.

nuclear reactor Device in which nuclear FISSION reactions are used for power generation or for the production of radioactive materials. In nuclear power stations, NUCLEAR ENERGY is released as heat for use in electricity generation. In the reactor, the fuel is a radioactive heavy metal: uranium-235, uranium-233 or plutonium-239. In these metals, atoms break down spontaneously, undergoing a process called RADIOACTIVE DECAY. Some NEUTRONS released in this process strike the nuclei of fuel atoms, causing them to undergo fission and emit more neutrons. These cause more fission to occur. In this way a CHAIN REACTION is set up, and heat is produced in the process. The heat is absorbed by a circulating coolant, often liquid sodium, and transferred to a boiler to raise steam to drive an electricity GENERATOR. Experiments are being undertaken with FUSION reactors.

nuclear waste Residues, generally from nuclear reactors, containing radioactive substances. After URANIUM, PLUTONIUM and other useful fission products have been removed, some long-lived radioactive elements remain, such as caesium-137 and strontium-90.

nuclear weapon Device whose enormous explosive force derives from nuclear FISSION or FUSION reactions. The first atomic bombs were dropped by the USA on the Japanese cities of HIROSHIMA and NAGASAKI in August 1945. The

bombs consisted of two stable sub-critical masses of URANI-UM OR PLUTONIUM which, when brought forcefully together, caused the CRITICAL MASS to be exceeded, thus initiating an uncontrolled nuclear fission reaction. In such detonations, huge amounts of energy and harmful radiation are released: the explosive force can be equivalent to 200,000 tonnes of TNT. The HYDROGEN BOMB (H-bomb or thermonuclear bomb), first tested in 1952, consists of an atomic bomb that on explosion provides a temperature high enough to cause nuclear fusion in a surrounding solid layer, usually lithium deuteride. The explosive power can be that of several million tonnes (megatons) of TNT.

nucleic acid Chemical molecules present in all living cells and in viruses. They are of two types, DNA (deoxyribonucleic acid) and RNA (ribonucleic acid), both of which play fundamental roles in heredity. *See also* GENE; CHROMOSOME

nucleon Any of the particles found within the NUCLEUS of an atom: a NEUTRON or a PROTON.

nucleus Membrane-bound structure that contains the CHRO-MOSOMES in most cells. Exceptions include BACTERIA, which, instead of chromosomes, have a naked, circular molecule of DNA in the CYTOPLASM, and mature red blood cells. As well as holding the genetic material, the nucleus is essential for the maintenance of cell processes. The term nucleus also refers to the central part of an ATOM.

Nuevo Laredo City on the Rio Grande, NE Mexico. Founded in 1755, it was separated from Laredo, Texas, during the Mexican War (1848). It lies at the N end of the Inter-American Highway, and is a rail terminus and international trade centre. Industries: trade (cotton and livestock), natural gas, tourism. Pop. (1990) 218,413.

Nuffield, William Richard Morris, 1st Viscount (1877–1963) British automobile manufacturer and philanthropist. He developed low-price, mass-produced cars and revolutionized the British car industry. In 1952 he became chairman of the British Motor Corporation (BMC), which was an amalgamation of the Morris and Austin companies.

Nujoma, Sam (1929–) Namibian statesman, president (1990–). A founder and leader of the SOUTH WEST AFRICA PEOPLE'S ORGANIZATION (SWAPO) from 1959, Nujoma was exiled by the South African government to Tanzania in 1960. Forced to resort to armed conflict from 1966, Nujoma controlled an army of highly effective SWAPO guerrillas. After negotiating Namibian independence through the auspices of the United Nations, he returned in 1989 to contest successfully its first free elections. He was re-elected in 1994.

Nukualofa Capital of Tonga, in the sw Pacific Ocean, on the N coast of Tongatabu Island. The chief industry is copra processing. Pop. (1986) 29,018.

nullification In US history, the idea that a state may choose not to enforce a law passed by the federal government. First advanced in the Kentucky and Virginia Resolutions (1798), it influenced Southern thinking on states' rights before the Civil War. It was tested in 1832, when the South Carolina legislature nullified the Tariff Law of 1828, declaring it unconstitutional. The crisis was defused when South Carolina accepted a compromise Tariff Act (1833).

numbat (banded anteater) Squirrel-like Australian marsupial that feeds on TERMITES. The female, unlike most marsupials, has no pouch. The numbat has a long snout and lateral white bands on its red-brown coat. Length: 46cm (18in). Species *Myrmecobius fasciatus*.

number Symbol representing a quantity used in counting or calculation. All ancient cultures devised their own number systems for the practical purposes of counting and measuring. From the basic process of counting we get the natural numbers. This concept can be extended to define an INTEGER, a RATIONAL NUMBER, a REAL NUMBER and a COMPLEX NUMBER. See also BINARY SYSTEM; IRRATIONAL NUMBER

Numbers Fourth book of the Bible and of the PENTATEUCH. Its describes the Israelites' 40 years of wandering in the desert of the Sinai Peninsula, in search of the Promised Land of CANAAN. Interwoven with their story is a collection of religious material, including laws concerning purification rituals and procedures for sacrificing to God.

A pressurized water reactor (PWR) is so named because the primary coolant (1) that passes through the reactor core (2) is pressurized to prevent it from boiling. The uranium-235 fuel is loaded into the reactor in pellets (3) contained by the fuel rods (4). To prevent an uncontrolled chain reaction the fuel rods are separated by control rods of graphite (5). All the rods are loaded into the reactor from above (6). The primary coolant is heated by the fission reaction in the fuel rods and circulates into a steam generator (7) where it superheats the secondary coolant (8). The secondary coolant leaves the protective containment vessel (9) and drives turbines (10), which produce electricity through a generator (11). A third coolant loop (12) cools the secondary coolant transferring the heat to a sea, river or lake. Reducing the temperature of the secondary coolant increases the efficiency of the transfer from the primary to the secondary coolant.

number theory Branch of mathematics concerned with the properties of natural numbers (whole numbers) or special classes of natural numbers such as PRIME NUMBERS and perfect numbers. The 4th-century BC Greek mathematician EUCLID proved that the number of primes was infinite. One of the unresolved problems in number theory is to find formulae for the generation of the primes. FERMAT in the 17th century and EULER in the 18th century both explored number theory.

numeral Symbol used alone or in a group to denote a number. Arabic numerals are the 10 digits from 0 to 9. ROMAN NUMERALS consist of seven letters or marks.

nun Woman belonging to a female religious order who has taken monastic vows (*see* MONASTICISM). Nuns may belong to either an enclosed order or one that encourages its members to work in the world for the welfare of society at large. BUDDHISM, CHRISTIANITY and TAOISM all have monastic orders of nuns. Nuns serve a preparatory period called a novitiate, after which they take their final vows. For centuries, Christian nuns lived in closed orders. But in 1633 St VINCENT DE PAUL founded the Sisters of Charity, an order of nuns who work outside the convent serving the community. Today nuns often live in small groups outside convents.

Nunn, Trevor (1940–) British stage director He became artistic director of the ROYAL SHAKESPEARE COMPANY (RSC) in 1968. He also directed the hit West End musicals *Cats* (1981) and *Starlight Express* (1984). In 1996 he was appointed artistic director of the National Theatre of Great Britain.

Nur-ad-Din (1118–74) (Nureddin) Ruler of Syria. He united Muslim forces in Syria to resist the Christians of the CRUSADES. He recaptured Edessa from the Christians in 1146 and in 1154 took Damascus from the Seljuk Turks.

Nuremberg (Nürnburg) City in Bavaria, s Germany. It began as a settlement around an 11th-century castle, later becoming a free imperial city. It was a centre of learning and artistic achievement during the 15th and 16th centuries. During the 1930s it was the location of the annual congress of the Nazi Party, and after World War 2 was the scene of the trials of Nazi war criminals. Today Nuremberg is an important commercial and industrial centre. Industries: textiles, pharmaceuticals, electrical equipment, machinery, publishing and printing, motor vehicles, toys, brewing. Pop. (1990) 498,500.

Nuremberg Trials (1945–46) Trials of Germans accused of war crimes during World War 2, held before a military tribunal. The tribunal was established by the USA, Britain, France and the Soviet Union. Several Nazi leaders were sentenced to death and others to terms of imprisonment.

Nureyev, Rudolf (1938–93) Russian ballet dancer and choreographer. While on tour in Paris in 1961 he defected from the Soviet Union. He was noted for his spectacular technical virtuosity and dramatic character portrayal. Major ballets in which he had leading roles included *Sleeping Beauty*, *Giselle* and *Swan Lake*, and he regularly partnered Margot Fonteyn.

Nurhachi (1559–1626) Organizer and creator of the QING state, which later ruled China. He welded related tribes into a powerful unit, creating the Manchu military banner organization for control and mobilization. Among other innovations, he introduced a writing system for administrative purposes.

nursing Profession that has as its general function the care of people who, through ill-health, disability, immaturity or advanced age, are unable to care for themselves. Caring for the sick was particularly emphasized by the early Christian Church; many religious orders and, later, chivalric orders, performed such "acts of mercy". In the 19th century, Florence NIGHTINGALE revealed the need for reforms in nursing; by the end of the 19th century certain of her principles had been adopted in England and the USA. Modern nursing is continually broadening its range of services, with standards laid down by relevant professional bodies.

nut Dry, one-seeded fruit with a hard, woody or stony wall. It develops from a flower that has petals attached above the OVARY. Examples include ACORNS and hazelnuts. **nutation** Oscillating movement (period 18.6 years) superimposed on the steady precessional movement of the Earth's axis so that the precessional path of each celestial pole on the CELESTIAL SPHERE follows an irregular rather than a true cir-

cle. It results from the varying gravitational attraction of the Sun and Moon on the Earth. See also PRECESSION

nutcracker Crow-like bird of evergreen forests of the Northern Hemisphere. A projection inside the bill turns it into a highly efficient seed cracker or nutcracker. The European thick-billed nutcracker (*Nucifraga caryocatactes*) is a typical species. Family Corvidae. Length: 30cm (12in).

nuthatch Bird found in the Northern Hemisphere and occasionally in Africa and Australia. It is bluish-grey above and white, grey or chestnut underneath. It eats nuts, opening them with its sharp bill. It also feeds on insects, spiders and seeds. Length: 9–19cm (3.5–7.5in). Family Sittidae.

nutmeg Evergreen tree native to tropical Asia, Africa and America. Its seeds yield the spice nutmeg; the spice mace comes from the seed covering. Height: up to 18m (60ft). Family Myristicaceae.

nutrition Processes by which plants and animals take in and make use of food substances. The science of nutrition involves identifying the kinds and amounts of nutrients necessary for growth and health. Nutrients are generally divided into PROTEINS, CARBOHYDRATES, FATS, MINERALS and VITAMINS.

Nuuk (Danish, Godthåb) Capital and largest town of GREEN-LAND, at the mouth of a group of fjords on the sw coast. Founded in 1721, it is the oldest Danish settlement in Greenland. Industries: fishing and fish processing, scientific research. Pop. (1993) 12,181.

Nyerere, Julius Kambarage (1922—) Tanzanian statesman, first president of Tanzania (1964–85). In 1954 Nyerere founded the Tanganyika African National Union. Following the 1960 election victory, he became chief minister and led Tanganyika to independence (1961). Nyerere negotiated the union between Tanganyika and Zanzibar, creating the state of Tanzania (1964). He established a one-party state. His Arusha Declaration (1967) is an important statement of African Socialism. In 1979 Nyerere sent troops into Uganda to help topple the regime of Idi Amin. Under his autocratic but generally benign socialist government, Tanzania made striking progress in social welfare and education, but in the 1980s economic setbacks encouraged demands for greater democracy. Nyerere retired as president in 1985.

nylon Any of numerous synthetic materials consisting of polyamides (with protein-like structures). Developed in the USA in the 1930s, nylon can be formed into fibres, filaments, bristles or sheets. It is characterized by elasticity and strength and is used chiefly in yarn, cordage and moulded products.

Nyman, Michael (1944–) English composer. In his early career, influenced by John CAGE, he explored experimental music. His works include operas, notably *The Man who Mistook his Wife for a Hat* (1986), but he is best known for his film scores. These include *The Draughtsman's Contract* (1982), *Prospero's Books* (1991) and *The Piano* (1993). His accessible musical style is characterized by the repetition and variation of harmonic, melodic and rhythmic patterns.

nymph In Greek mythology, a female nature spirit who was said to be a guardian of natural objects. Nymphs were identified with specific locations, often with trees and water.

nymph Young insect of primitive orders that do not undergo complete METAMORPHOSIS. The term designates all immature stages after the egg. The nymph resembles the adult and does so more closely with each moulting. Examples are the aquatic nymphs of dragonflies, mayflies and damsel flies.

■ nuclear weapon The detonation of a large nuclear weapon above ground creates a huge mushroom cloud of radioactive dust and debris above the explosion that can reach several kilometres in height. The hazardous airborne dust is then free to be carried in any direction by the prevailing winds. The devastation covers a wide area: a 15 megaton hydrogen bomb will cause all flammable material within 20km (12mi) to burst into flame.

O/o, the 15th letter of the English alphabet and a letter employed in the alphabets of all other w European languages. It is derived originally from the Phoenician alphabet. It entered the Greek alphabet as omicron, "short o", and passed unchanged through the Roman alphabet into the various languages in which it is used today. In English o is a vowel and may be pronounced with a "short" sound, as in not, or a "long" sound, as in note. A different long sound is represented by a double o (as in boot). Combined with a, the long o sound is preserved (coat); with other vowels diphthongs are represented (hoist and rout). In the word people the o is silent.

oak Common name of almost 600 species of the genus *Quercus*, which are found in temperate areas of the Northern Hemisphere and at high elevations in the tropics. Most species are hardwood trees that grow 18–30m (60–100ft) tall. Leaves are simple, often lobed and sometimes serrated. The flowers are greenish and inconspicuous; male flowers hang in catkins. The fruit is an acorn, surrounded by a cup.

Oakley, Annie (1860–1926) US entertainer. She was an expert shot, eventually beating a noted marksman, Frank E. Butler, whom she married. She was the star of Buffalo Bill's Wild West Show for 17 years.

oarfish Any of several deep water, marine, ribbon fish. Its long, thin body has a dorsal fin extending along its entire length. Two long oar-like pelvic fins protrude from beneath the head. Length: to 6m (20ft). Genus *Regalecus*.

OAS Abbreviation of the Organization of American States OAS (Organisation de l'Armée Secrète) French terrorist group opposed to Algerian independence. It was set up in 1961 by disaffected army officers and French settlers in Algeria when it became clear that President DE GAULLE was preparing to come to an agreement with Algerian nationalists. Acts of terrorism in France and Algeria failed to prevent Algeria becoming independent in 1962.

oasis Fertile location that has water in an arid landscape. Usually, groundwater is brought to the surface in a well, but an oasis may occur where a river flowing from a wetter region crosses the desert on its way to the sea, such as the NILE.

oat Cereal plant native to w Europe, and cultivated worldwide. The flower comprises numerous florets that produce one-seeded fruits. Mainly fed to livestock, oats are also eaten by humans. Family Poaceae/Gramineae; species Avena sativa. Oates, Joyce Carol (1938—) US novelist, short-story writer and poet. Oates' debut book of short stories was By the North Gate (1963). Her works, such as the trilogy of novels A Garden of Earthly Delights (1967), Expensive People (1968) and Them (1969), are grim chronicles of violence and deprivation in modern America. Other novels include The Assassins (1975), You Must Remember This (1987) and We Were the Mulvaneys (1996).

Oates, Titus (1649–1705) English author of the anti-Catholic Popish Plot (1678). He invented the story of a Jesuit plot to depose King Charles II. It provoked a hysterical reaction and encouraged efforts to exclude Charles' Catholic brother, the future James II, from the succession.

oath Promise or pledge, especially a solemn one involving an appeal to God to witness the truth of the pledge. In a corporal oath, usually taken by a person before giving evidence in a court of law, a witness swears to the truth of a statement. Giving false evidence under oath is perjury.

OAU Abbreviation of the Organization of African Unity **Oaxaca** (officially Oaxaca de Juárez) City in s Mexico; capital of Oaxaca state. Oaxaca is an agricultural state, and coffee is the principal crop. Tourists use the city as a base for exploring archaeological sites, such as Monte Albán. The city is renowned for its jewellery and hand-woven textiles. Oaxaca was founded by the Aztecs. In 1521 it was captured by Spain. It played a significant role in Mexico's struggle for independence. Pop. (1990) 213,985.

Ob River in W Siberia, central Russia. It flows NW then NE through the lowlands of W Siberia, before continuing N and then E to enter the Gulf of Ob, an arm of the Kara Sea within the Arctic Ocean. Length: 3,680km (2,300mi). With its principal tributary, the Irtysh, it is the seventh-longest river in the world: 5,410km (3,360mi).

obelisk Stone monolith, which usually has a tapering, square-based column with a pyramid-shaped point. Pairs of obelisks stood at the entrance to ancient Egyptian temples, such as Karnak (LUXOR). The two Cleopatra's needles in New York's Central Park and on London's Thames Embankment, date from 1500 BC long before CLEOPATRA's reign.

Oberammergau Village in upper Bavaria, s Germany, famous for its PASSION PLAY. The performance takes place once every 10 years, in fulfilment of a vow made by the inhabitants in 1634 during an outbreak of the plague.

Oberon, Merle (1911-79) Australian film actress. Her per-

formance in *The Dark Angel* (1935) earned her an Oscar nomination. In 1939 she married Alexander Korda, with whom she made *The Scarlet Pimpernel* (1934) and *The Divorce of Lady X* (1938).

Oberon In medieval folklore, the king of the fairies and husband of TITANIA. Perhaps the most familiar use of the character is in SHAKESPEARE's *A Midsummer Night's Dream*.

obesity Condition of being overweight, generally defined as weighing 20% or more above the recommended norm for the person's sex, height and build. People who are overweight are at increased risk of disease and have a shorter life expectancy than those of normal weight.

oboe WOODWIND musical instrument. It has a slightly flared bell and, like the BASSOON, is a double-reed instrument. The earliest true oboes were used in the mid-17th century and have been widely used since the 18th century.

Obote, (Apollo) Milton (1924–) Ugandan political leader. He created the Uganda People's Congress in 1960, and became the first prime minister of independent Uganda (1962–66). In 1966 he drove out the king of the old kingdom of Buganda, and became president of a more centralized state. He was ousted by his army chief, Idi AMIN, in 1971, but returned to power after Amin was overthrown in 1979. Obote was again overthrown by an army coup in 1985.

O'Brien, Flann (1911–66) Irish novelist, b. Brian O'Nolan. His first and most ambitious novel was At Swim-Two-Birds (1939). He wrote three other novels in English – The Hard Life (1961), The Dalkey Archive (1964) and The Third Policeman (1967) – and one in Gaelic, An Béal Bocht (1941). O'Brien, William Smith (1803–64) Irish nationalist leader. He entered Parliament as an Irish member in 1828 and supported Roman Catholic emancipation. In 1843 he joined Daniel O'CONNELL's Repeal Association against the Act of UNION (1800), but left in 1846 to set up the more militant Repeal League. He was arrested after leading an ineffective insurrection in 1848 and sentenced to death, but his sentence was commuted to transportation.

observatory Location of TELESCOPES and other equipment for astronomical observations. Large optical telescopes are housed in domed buildings, usually sited well away from the smoke of cities. Radio observatories are open sites containing one or more large radio telescopes. The largest radio-telescope dishes have been built in natural mountain hollows: the Arecibo Observatory in Puerto Rico is 300m (975ft) across.

obsidian Rare, grey to black, glassy volcanic rock. It is the uncrystallized equivalent of rhyolite and GRANITE. It makes an attractive semi-precious stone. Hardness 5.5; s.g. 2.4.

obstetrics Branch of medicine that deals with pregnancy, childbirth and the care of women following delivery.

O'Casey, Sean (1880–1964) Irish playwright. His first play, *The Shadow of a Gunman* (1923), immediately made him famous. *Juno and the Paycock* (1924) was followed by *The Plough and the Stars* (1926). His later works, such as *The Silver Tassie* (1929), are in an expressionistic style, very different from the realism of his early plays.

Occam's razor See WILLIAM OF OCCAM

occupational therapy Development of practical skills to assist patients recovering from illness or injury. Therapists oversee a variety of pursuits, from the activities of daily living (ADLs), such as washing and dressing, to hobbies and crafts. ocean Continuous body of saltwater that surrounds the continents and fills the Earth's great depressions. There are five main oceans, the ATLANTIC, PACIFIC, INDIAN, ARCTIC and Antarctic and they cover 71% of the Earth's surface. The oceans may be divided by region (littoral, pelagic and abyssal) or by depth (CONTINENTAL MARGIN, deep sea plain and deep trenches). The SEAFLOOR has a varied topography, with vast mountain chains, valleys, and plains. Ocean water consists of about 3.5% dissolved minerals.

Oceania Collective term applied to the islands in the central and s Pacific Ocean. It includes the islands of Melanesia, Micronesia and Polynesia and, sometimes, Australasia (Australia and New Zealand) and the Malay Archipelago.

Oceanic art Much art from OCEANIA involves objects used in religious rites. Among the most notable examples are the giant, stone, ancestor-cult figures of EASTER ISLAND, MAORI wood carvings and the carved drums, masks, stools and shields of New Guinea.

oceanic current Movement of sea water between layers of varying temperature and density. Ocean circulation is produced by CONVECTION, with warm currents travelling away from the equator, cooler water moving from the poles. In the Southern Hemisphere the oceanic currents move in an anticlockwise system, whereas in the Northern the system is clockwise, an effect caused by the Earth's rotation. There are about 50 major currents, including the GULF STREAM of the N Atlantic and the Humboldt (Peru) current off the w coast of South America. See also CORIOLIS EFFECT; EL NIÑO

Oceanic mythology Traditional beliefs of the native inhabitants of OCEANIA. The mythological traditions are varied and complex. Among the Polynesians, there are various accounts of the creation of the world by the celestial deity Tangaroa (Ta'aroa). Maui, the most famous of the Polynesian mythic heroes, often thought of as half god and half human, is known for his cunning deeds. In Melanesian creation myths, the beginning of the world is seen as a movement that brings order out of chaos. In the daily life of the Melanesians there are a vast number of unseen forces - benevolent spirits, demons, ghosts, and the souls of the departed - to be dealt with by means of elaborate rituals. In Micronesian creation myths, female deities play a prominent part. The worship of ancestors is also an important part of social life. In most Oceanic mythology, the concept of mana plays a fundamental role. Mana is seen as an impersonal, supernatural force that resides in a person, a natural object, or a place.

oceanography Science of the marine environment. It studies oceans and seas past and present, the shorelines, sediments, rocks, muds, plants, animals, temperatures, tides, winds, currents, formation and erosion of abyssal depths and heights, and the effect of neighbouring land masses.

ocelot Small cat that lives in s USA, Central and South America. Its valuable fur is yellowish with elongated dark spots. It feeds on small birds, mammals and reptiles. Length: to 1.5m (4.9ft). Family Felidae; species *Felis pardalis*.

O'Connell, Daniel (1775–1847) (the Liberator) Irish nationalist leader. He led resistance to Britain's remaining anti-Catholic laws and founded the Catholic Association (1823) to unite Irish Catholics. In 1828 he was elected to the British parliament; the Act of CATHOLIC EMANCIPATION (1829) was passed to enable him to take his seat. He tried unsuccessfully to extract reforms from government.

O'Connor, Sandra Day (1930–) US Supreme Court justice (1981–), the first woman appointee. A Republican, she won election to two full terms in the Arizona Senate and was elected majority leader in 1973. She served on the Superior Court in Phoenix (1974–79).

octane number Indication of the antiknock properties of a liquid motor fuel. The higher the number, the less likely the possibility of the fuel detonating.

octave In music, the interval between any given note and another one that is exactly twice (or half) the frequency of the first and thus, acoustically, a perfect consonance. In Western music it encompasses the eight notes of the diatonic SCALE.

Octavian See Augustus

October Revolution See Russian Revolution

octopus Predatory cephalopod mollusc with no external shell. Its sac-like body has eight powerful suckered tentacles. Many of the 150 species are small, but the common octopus (Octopus vulgaris) grows to 9m (30ft). Family Octopodidae. ode Lyric poem of unspecific form but typically of heightened emotion or public address. The first great writer of odes was PINDAR, but more simple were the lyrical odes of HORACE and CATULLUS. In 17th-century England it was taken up by JONSON, HERRICK and MARVELL. Representative of the more personal type are the 19th-century odes of WORDSWORTH, SHELLEY and KEATS.

Odense City and port in s central Denmark. Founded in the 10th century, Odense has a 13th-century Gothic cathedral and an 18th-century palace. Industries: shipbuilding, metalworking, engineering. Pop. (1994) 181,824.

Oder Second-longest river in the catchment basin of the Baltic Sea. It rises in the NE Czech Republic, flows N and W through sw Poland, before turning N, forming the Polish-German border and reaching the Baltic Sea. The Oder has many navigable tributaries, notably the rivers Neisse and Warta. Length: 886km (550mi).

Odessa City and port on the Black Sea, s Ukraine. A Tatar fortress was established here in the 14th century. It later passed to Poland-Lithuania and then to Turkey (1764). Brought under Russian control in 1791, it was made a naval base. Odessa was the scene of the mutiny on the battleship *Potemkin* during the revolution of 1905. Industries: fishing, whaling, shipbuilding and repairing, oil refining, metalworking, chemicals, heavy machinery. Pop. (1991) 1,101,000.

Odets, Clifford (1906–63) US social protest dramatist. He helped to organize the Group Theatre in 1931. His plays include Awake and Sing (1935), Waiting for Lefty (1935) and Golden Boy (1937). He later moved to Hollywood, where he wrote and directed films, including The Country Girl (1950). Odin Principal god in Norse mythology. Identified with the Teutonic god Woden, he is considered to be the god of wisdom, culture, war and death. He lived with the Valkyries in VALHALLA, where he received the souls of dead warriors.

Odoacer (c.433–93) (Odovacar) Chief of the Germanic Heruli people and conqueror of the West ROMAN EMPIRE. The Heruli were Roman mercenaries until 476, when they declared Odoacer king of Italy. After the Ostrogoths invaded in 489, Odoacer fled to Ravenna. King Theodoric of the Ostrogoths invited Odoacer to a banquet, where he was murdered.

odontology Study of the structure, development and diseases of the teeth. It is closely allied with DENTISTRY.

Odysseus (Ulysses) Greek hero of HOMER's epic poem, the ODYSSEY. King of the city-state of Ithaca, husband of the faithful PENELOPE, he was an astute and brave warrior. It was Odysseus who devised the stratagem of the wooden TROJAN HORSE in order to enter Troy.

Odyssey, The Epic poem of 24 books attributed to HOMER. The story of ODYSSEUS tells of his journey home from the Trojan Wars after 10 years of wandering. He wins back his wife PENELOPE and his kingdom, after killing her suitors.

oedema Abnormal accumulation of fluid in the tissues; it may be generalized or confined to one part, such as the

■ ocelot A member of the flesheating mammal order (Carnivora), the ocelot (*Felis pardalis*) is found in Central and South America, and sometimes as far N as Texas. It measures from 80 to 47cm (31–58in) long and is grouped with all other cats in the family Felidae.

▲ oceanography One of the most important scientific voyages ever made, the map shows the route of the Challenger expedition of 1872-76. The expedition lasted four years and laid the foundations for the modern science of oceanography. The Challenger covered a distance of 68,900 nautical miles and established 362 observation stations, where depth, temperature, surface currents were measured and samples of water, fauna, fishes were taken. The ship held a cramped but very well-equipped laboratory.

OHIO

Statehood: 1 March 1803

Nickname:

The Buckeye State

State bird :

Cardinal

State flower:

Scarlet carnation

State tree : Buckeye

State motto:

With God, all things are possible

ankles. It may be due to heart failure, obstruction of one or more veins, or increased permeability of the capillary walls.

Oedipus In Greek mythology and literature, son of Laius (king of Thebes) and Jocasta; father of Antigone, Ismene, Eteocles and Polynices by his own mother. SOPHOCLES told how Oedipus was saved from death as an infant and raised in Corinth. He inadvertently killed his father, solved the riddle of the SPHINX, and became king of Thebes. There he married Queen Jocasta, unaware that she was his own widowed mother. On discovering the truth he made himself blind.

Oedipus complex In psychoanalytic theory, a collection of unconscious wishes involving sexual desire for the parent of the opposite sex and jealous rivalry with the parent of the same sex. Sigmund FREUD held that children pass through this stage between the ages of three and five. The complex in females is sometimes known as the Electra complex, a term coined by C.G. JUNG. The theory has been considerably modified, if not totally rejected, by most modern practitioners.

Oersted, Hans Christian (1777–1851) Danish physicist and professor at Copenhagen University. He took the first steps in explaining the relationship between electricity and magnetism, thus founding the science of ELECTROMAGNETISM. The oersted unit of magnetic field strength is named after him. oesophagus (gullet) Muscular tube, part of the ALIMENTARY CANAL (or gut), which carries swallowed food from the throat to the STOMACH. Food is moved down the lubricated channel by the wave-like movement known as PERISTALSIS.

oestrogen Female SEX HORMONE. First produced by a girl at PUBERTY, oestrogen leads to the development of the secondary sexual characteristics: breasts, body hair and redistributed fat. It regulates the MENSTRUAL CYCLE and prepares the UTERUS for pregnancy. It is also a constituent of the contraceptive PILL.

Offenbach, Jacques Levy (1819–80) French composer. His reputation was founded on the brilliance of his numerous operettas, notably *Orpheus in the Underworld* (1858).

Official Secrets Act (1989) Law passed by the British parliament forbidding government employees to disclose information formally classified as secret. The act, which replaced one passed in 1911, is aimed particularly at members of the national security and intelligence services but also applies to many other civil servants, politicians and police officers.

offset Method of PRINTING widely used for high-volume publications. In the printing machine, a roller applies ink to the printing plate, which is mounted on a rotating cylinder. The image is then transferred (offset) to a cylinder with a rubber covering, called the blanket. This transfers the image to the paper. Usually, the plates are made by LITHOGRAPHY, and the process is called offset lithography. Separate plates are used for each colour of ink. This book was printed using a four-colour, offset-litho process.

O'Flaherty, Liam (1897–1984) Irish novelist and short story writer. His novels, which often reflect contemporary Irish social conditions, include *The Informer* (1925), *The Puritan* (1931), *Famine* (1937) and *Insurrection* (1950). He also wrote three autobiographical works.

Ogdon, John (1937–89) British pianist and composer. He established his strong international reputation in 1962 when he was joint winner of the Tchaikovsky Competition in Moscow with Vladimir ASHKENAZY.

O'Higgins, Bernardo (1778–1842) South American revolutionary leader and ruler of Chile. A member of the revolutionary junta in colonial Chile, O'Higgins commanded the army against the Spanish. Defeated in 1814, he joined José de SAN MARTÍN in Argentina to defeat the Spanish at Chacabuco (1817). Appointed "supreme director" of Chile, he declared independence in 1818 but resigned in 1823.

Ohio State in E central USA, bounded by Lake Erie in the N; the capital is COLUMBUS. Other cities include Toledo and CLEVELAND. Britain acquired the land in 1763, at the end of the Seven Years' War. It was ceded to the USA after the American Revolution and in 1787 it became part of the Northwest Territory. Ohio was accepted into the Union in 1803. Mostly lowlying, the state is drained chiefly by the Ohio, Scioto, Miami and Muskingum rivers. Ohio's large farms produce hay, maize, wheat, soya beans and dairy foods, and cattle and pigs are

raised. The state is highly industrialized. Ohio produces sandstone, oil, natural gas, clay, salt, lime and gravel. Its lake ports handle large amounts of iron and copper ore, coal and oil. Industries: vehicle and aircraft manufacture, transport equipment, primary and fabricated metals. Area: 106,764sq km (41,222sq mi). Pop. (1990) 10,847,115.

Ohio River in E central USA, formed at the confluence of the Allegheny and Monongahela rivers at Pittsburgh in w Pennsylvania. It flows w and then sw to join the Mississippi River at Cairo, Illinois. The Ohio River valley is a highly industrialized region. Length: 1,571km (976mi).

ohm (symbol W) SI unit of electrical resistance, equal to the resistance between two points on a conductor when a constant potential difference of one volt between them produces a current of one ampere.

Ohm's law Statement that the amount of steady current through a material is proportional to the voltage across the material. Proposed in 1827 by the German physicist Georg Ohm (1787–1854), Ohm's law is expressed mathematically as V = IR (where V is the voltage in volts, I is the current in amperes and R is the resistance in ohms).

oil General term to describe a variety of substances, whose chief shared properties are viscosity at ordinary temperatures, a density less than that of water, inflammability, insolubility in water, and solubility in ether and alcohol. Mineral oils, most notably crude oil or petroleum oil, are used as fuels. Animal and vegetable oils (fatty oils or fats) are used as food, lubricants, and in soap.

oil painting Method of painting that uses pigments saturated in a drying oil medium. Widely used in Europe since the 16th century, oil is still the most versatile paint medium because of its range of textures and colours.

oil palm Tree grown in humid tropical regions of w Africa and Madagascar, source of oil for margarine and soap. The long, feather-shaped fronds rise from a short trunk. Height: 9–15m (30–50ft). Family Arecaceae/Palmae.

Oistrakh, David (1908–74) Russian violinist. His interpretation of the violin repertoire earned him the reputation of being the greatest violinist of his day. His son and pupil, Igor (1931–), is also a virtuoso violinist.

Ojibwa (Chippewa) Group of Algonquian-speaking Native North Americans. In the 17th century they were constantly at war with the Sioux, eventually driving them across the Mississippi River. Since then, they have lived on reservations in Michigan, Wisconsin, Minnesota and North Dakota. Today, *c*.90,000 live in the USA and Canada.

O'Keeffe, Georgia (1887–1986) US painter. O'Keeffe's first exhibition was in 1916, and in 1924 she married Alfred STIEGLITZ. Her early works were stylized, betraying the influence of ABSTRACT ART. She is, however, best known for her microscopically detailed paintings of flowers, such as *Black Iris* (1926). Her use of vibrant colour was combined with strong overtones of sexual symbolism.

Okhotsk, Sea of Arm of the N Pacific Ocean off the E coast of Russia, bounded E by the Kamchatka Peninsula and SE by the Kuril Islands. The chief ports are Magadan and Korsakov in Russia. Area: 1,528,000sq km (590,000sq mi).

Okinawa Largest island of the Okinawa archipelago, sw of mainland Japan, part of the Ryukyu Islands group in the w Pacific Ocean; the major settlement is Naha. The N is mountainous, densely forested and sparsely populated. Economic activity, such as agriculture and fishing, is concentrated in the s. In April 1945 US troops landed, and met fierce Japanese resistance. Okinawa surrendered in June 1945 after many casualties. Area: 1,176sq km (454sq mi). Pop. (1990) 1,222,458.

Oklahoma State in central s USA; the capital is OKLAHOMA CITY. Other important cities are TULSA and Lawton. Much of the area was acquired by the USA from France in the LOUISIANA PURCHASE (1803). The Territory of Oklahoma was merged with the Indian Territory to form the state of Oklahoma in 1907. The w of the state is part of the Great PLAINS. The E is mountainous. Oklahoma is drained chiefly by the Arkansas and Red rivers. Wheat and cotton are the leading crops, but livestock is more important. There are many minerals, but oil and natural gas form the basis of Oklahoma's

OKLAHOMA

Statehood :

16 November 1907

Nickname:

The Sooner State

State bird :

Scissor-tailed flycatcher

State flower:

Mistletoe

State tree :

Redbud

State motto : Labour conquers all

things

economic wealth. Area: 181,089sq km (69,918sq mi). Pop. (1990) 3,189,456.

Oklahoma City Capital and largest city of Oklahoma, USA, in the centre of the state on the North Canadian River. The area was settled in 1889. The city was made the state capital in 1910, and prospered with the discovery of rich oil deposits in 1928. It was the site of a terrorist bomb in April 1995, which killed 168 people and injured 400 others. Industries: oil refining, grain milling, cotton processing, steel products, electronic equipment, aircraft. Pop. (1990) 404,014.

okra (gumbo) Annual tropical plant with red-centred yellow flowers. The green fruit pods are edible. Height: 0.6–1.8m (2–6ft). Family Malvaceae; species *Hibiscus esculentus*

Okri, Ben (1959–) Nigerian novelist. His first two novels, Flowers and Shadows (1980) and The Landscapes Within (1981), established his reputation. The Famished Road won the Booker Prize in 1991; its sequel is Songs of Enchantment (1993). Other novels include Astonishing the Gods (1995) and Dangerous Love (1996).

Olaf II (995–1030) Norwegian king and patron saint of Norway. Olaf became king in 1015. He introduced Christianity, but this proved unpopular with a number of chiefs who rebelled against him, backed by CANUTE II of Denmark. Olaf was exiled in 1029 and killed in battle the following year.

Old Bailey (Central Criminal Court) Court on Old Bailey Street, London. It became a CROWN COURT in 1971. The judges entitled to sit in the court include the lord mayor of London and the aldermen, as well as the recorder of London and the common serjeant.

Oldcastle, Sir John (1377–1417) English leader of the LOLLARDS. He fought in the army under HENRY IV and earned the respect and liking of the future Henry V. A fervent supporter of the teachings of John WYCLIFFE, he was a leader of the Lollards and was condemned as a heretic in 1413. He escaped to lead an unsuccessful Lollard rising but was eventually captured and executed.

Old Catholics Religious movement rejecting the dogma of PAPAL INFALLIBILITY, which had been announced by the First Vatican Council of 1870. The Old Catholics set up churches in German- and Dutch-speaking Europe, which later united in the Union of Utrecht in 1889. Since then the Archbishop of Utrecht has been head of the International Old Catholic Congress. Old Catholics have much affinity with Anglicans.

Oldenbarneveldt, Johan van (1547–1619) Dutch political leader in the Revolt of the Netherlands. With WILLIAM I (THE SILENT), he was the founder of the Dutch republic. He played an important part in arranging the union of the provinces at Utrecht (1579), and supported Maurice of Nassau as stadtholder when William was assassinated (1584). From 1586 he was the dominant figure in Holland and, with Maurice, practically the ruler of the United Provinces. He was instrumental in securing the truce with Spain (1609), which implied Dutch independence. He fell out with Maurice, largely over religious differences and after an unjust trial was executed.

Oldenburg, Claes (1929–) US sculptor, a leading member of the POP ART movement. He is famous for his gigantic sculptures based on everyday objects, such as *Lipstick* (1969), and for his "soft sculptures" and pieces representing food.

old red sandstone Geological term for freshwater deposits of the DEVONIAN PERIOD found in Britain. These strata are noted for their fish fossils among which are jawless fishes (ostracoderms), the first jawed fishes (placoderms), and the first true bony fishes (osteichthyes).

Old Testament First and older section of the BIBLE, originally written in Hebrew or Aramaic, and accepted as religiously inspired and sacred by both Jews and Christians. Among Jews it is known as the Hebrew Bible. It begins with the creation, but the main theme of the Old Testament is the history of the Hebrews. In addition, there are many examples of prophetic writing, poetry and short narrative tales. It comprises the Pentateuch or Torah (Genesis to Deuteronomy); the Historical Books (Joshua to I and II Kings); the Wisdom Books (Job, Proverbs and Ecclesiastes); the Major Prophets (Isaiah, Jeremiah and Ezekiel); the 12 Minor Prophets (Hosea to Malachi); and the miscellaneous collection of books

known as the Writings (including Psalms and the Song of Songs). Sometimes included is a collection of books written in the final three centuries BC, known as the APOCRYPHA. The number, order and names of the books of the Old Testament vary between the Jewish and Christian traditions; texts for both are based mainly on the SEPTUAGINT. Parts of the ancient Hebrew text were found among the DEAD SEA SCROLLS. See also LAW AND THE PROPHETS

Olduvai Gorge Site in N Tanzania where remains of primitive humans have been found. Louis Leakey uncovered four layers of remains dating from c.2 million years ago to c.15,000 years ago. In 1964 he announced the discovery of Homo habilis, whom he believed to have been a direct ancestor of modern humans. The gorge, which is 40km (25mi) long and 100m (320ft) deep, runs through the Serengeti Plain. Old Vic London theatre. Built in 1818 as the Royal Coburg Theatre, it was renamed the Royal Victoria in 1833, and soon became known as the Old Vic. Under the management of Lilian Baylis from 1898 it became well known for its Shakespearean productions. From 1963 to 1976 it was the home of the National Theatre of Great Britain. The Young Vic was opened in 1970.

oleander Evergreen shrubs of the genus *Nerium*, native to the Mediterranean region. They have milky poisonous sap, clusters of white, pink or purple flowers and smooth leaves. The best-known is the rosebay (*N. oleander*). Family Apocynaceae. **oligarchy** System of government in which power is concentrated in the hands of a few, who rule without the requirement of popular support and without external check on their authority. Oligarchs rule in their own interests.

Oligocene Extent of geological time from about 38 to 25 million years ago. It is the third of five epochs of the TERTIARY period. In the Oligocene period, the climate cooled, and many modern mammals evolved, including elephants and an ancestor of the modern horse.

olive Tree, shrub or vine and its fruit, especially the common olive tree, *Olea europaea*, native to the Mediterranean region. It has leathery, lance-shaped leaves, a gnarled and twisted trunk and may live for more than 1,000 years. The fruit is bitter and inedible before processing. Height: to 9m (30ft). Family Oleaceae. *See also* OLIVE OIL

olive oil Yellowish liquid oil, containing oleic acid, obtained by pressing OLIVES. It is used for cooking, as a salad oil, in the manufacture of soap and in medicine. It contains an extremely low proportion of fatty acids.

Olivier, Laurence Kerr, Baron Olivier of Brighton (1907-89) British actor and director. Olivier was the outstanding Shakespearean interpreter of his generation. He made his film debut in 1930, and established himself as a romantic lead in films such as Wuthering Heights (1939) and Pride and Prejudice (1940). In 1944 Olivier and Ralph Richardson became directors of the OLD VIC. He won a Special Academy Award for his directorial debut, Henry V (1944). Olivier's second film, Hamlet (1948), earned him Oscars for best actor and best picture. He was director (1963-73) of the NATIONAL THEATRE of Great Britain. Olivier became the first actor to be created a life peer (1970). The London Theatre awards are named after him. olivine Ferromagnesian mineral, (MgFe)2 SiO4, found in basic and ultrabasic IGNEOUS ROCKS. Olivine has orthorhombic system crystals and is usually olive-green. It is glassy and brittle with no cleavage. Hardness 6.5-7; s.g. 3.3.

Olmec Early civilization of Central America, which flourished between the 12th and 4th centuries BC. Its heartland was the s coast of the Gulf of Mexico, but its influence spread more widely. From the 9th century BC the main Olmec centre was La Venta. Olmec art included high-quality carving of jade and stone, notably giant human heads in basalt. The Olmec heritage can be traced through later civilizations, including the MAYA.

Olympia Area in S Greece, the site of an ancient sanctuary and of the original Olympic Games. Buried by earthquakes in the 6th century AD, Olympia was not rediscovered until the 18th century. It contained some of the finest works of Classical art and architecture, including the huge temple of Zeus, which contained a giant statue of the god that was numbered among the Seven Wonders of the World.

▲ okra Originating in Africa and now widely cultivated throughout the tropics, the okra plant (Hibiscus esculentus) is related to the cotton plant. Its sticky green pods are picked ten weeks after planting, and are eaten as a vegetable.

▲ Olivier Perhaps the greatest classical actor of his generation, Laurence Olivier played all the great Shakespearean roles on stage and successfully transferred several of them to screen. He played a number of romantic leads, including that of Max de Winter in Rebecca (1940). Olivier produced, directed and starred in Henry V (1944) and Hamlet (1948). In 1955 he directed and co-starred with Marilyn Monroe in The Prince and the Showgirl. Olivier's private life attracted a great deal of press attention, particularly his second marriage to actress Vivien Leigh

Olympia State capital and port of entry in sw Washington, on s tip of Puget Sound. Settled c.1845 as Smithfield, its name changed to Olympia when it was made capital of Washington Territory in 1853. Development was spurred with the coming of the railroad in the 1880s and its port was expanded during both World Wars. Industries: agriculture, food canning, beer, oysters, lumber. Pop. (1990) 27,447.

Olympic Games World's major international athletic competition, held in two segments - the Summer Games and the Winter Games - from 1992 alternating so that there are two years between segments, but four years before a segment is repeated. The games were first celebrated in 776 BC in OLYMPIA, Greece and were held every four years until AD 393, when they were abolished by the Roman emperor. The modern summer games were initiated by Baron Pierre de Coubertin, and were first held in Athens, Greece, in 1896. Women did not compete until 1912. The games were cancelled during World War 1 and World War 2. Summer events include archery, athletics (a full programme of track and field events), basketball, boxing, canoeing, cycling, diving, equestrian sports, fencing, gymnastics, handball, (field) hockey, judo, rowing, shooting, soccer, swimming, volleyball, water polo, weightlifting, wrestling and yachting. Winter events include the biathlon, bobsledding and luge, ice hockey, skating, and skiing (including ski jumping and freestyle skiing). The control of the games is vested in the International Olympic Committee, which lays down the rules and chooses venues.

Olympus Mountain range in N Greece, on the border of Thessaly and Macedonia, c.40km (25mi) long. Its peak, Mount Olympus, is the highest point in Greece, at 2,917m (9,570ft). It was first climbed in 1913. In ancient Greek mythology it was considered to be the home of the gods, closed to mortal eyes.

Om (Aum) Sacred mystical symbol representing a sound considered to have divine power by Hindus, Buddhists and other religious groups. The sound is chanted at the beginning and end of prayers, and is used as a mantra in meditation.

Omaha Siouan-speaking tribe of Native North Americans. In the 1880s they participated in a major political action against the US government concerning ownership of Native American lands. Today, some 2,000 Omaha people reside in Nebraska and Oklahoma.

Omaha Port on the Missouri River, in E Nebraska, USA.

The area was ceded to the US government in 1854. It was the capital of Nebraska Territory from 1854 to 1867. It is a leading livestock market and meat processing centre, and a major insurance centre. Pop. (1990) 335,795.

Oman Sultanate on the SE corner of the Arabian peninsula, sw Asia; the capital is MUSCAT. Land and climate Oman is 95% desert. On the Gulf of Oman coast lies the fertile plain of Al Batinah, and the city of Muscat. The plain is backed by the Al Hajar mountains, which rise, at Jebel Sham, to 3,019m (9,905ft). In the s, lies part of the barren and rocky Rub' al Khali desert ("Empty Quarter"). The sultanate also includes the tip of the Musandam Peninsula, overlooking the strategic Strait of Hormuz, and separated from the rest of Oman by the UNIT-ED ARAB EMIRATES. Oman has a hot tropical climate. In Muscat, summer temperatures rise to 47°C (117°F). Parts of the N mountains have an average annual rainfall of 400mm (16in), but most of Oman has less than 125mm (5in). Date palms grow on the coastal plain and around desert oases. Grassy pasture occurs on the Al Hajar mountains and on the s coast. Economy Oman is an upper-middle-income developing country (1992 GDP per capita, US\$11,710). Its economy is based on oil production. Oil was first discovered in 1964, and now accounts for more than 90% of exports. The industry attracts many migrant workers. Oil refining and the processing of copper are among Oman's few manufacturing industries. Agriculture supports 50% of the workforce. Major crops include alfalfa, bananas, coconuts, dates, limes, tobacco, vegetables and wheat. Some farmers raise camels and cattle. Fishing, especially for sardines, is also important, but Oman is reliant on food imports. History and Politics In ancient times, Oman was an important trading area on the main route between The Gulf and the Indian Ocean. Islam was introduced in the 7th century AD, and Muslim culture remains a unifying force. In 1507 the Portuguese captured several seaports in Oman, including Muscat. Portugal controlled maritime trade until expelled by the Ottomans in 1659. Oman set up trading posts in East Africa, including Zanzibar in 1698 and, until the 1860s, was the dominant Arabian power. The Al Said family have ruled Oman since taking power in 1741. During the 20th century, the sultanate often has been in conflict with religious leaders (imams) of the Ibahdi sect, pressing for the establishment of a more theocratic society. British colonial interference and economic inequality led to popular rebellions in the 1950s and 1960s. Insurrectionist forces continued to control much of s Oman. In 1970 Sultan Said bin Taimur was deposed by his son, Qaboos bin Said. In 1971 Oman joined the UN and the Arab League. Qaboos bin Said initiated the modernization of health, education and social welfare services. Despite the extension of free education, 65% of the population remained illiterate by 1992. In 1981 Oman was a founder member of the Gulf Cooperation Council (GCC). Ties with the UK and the USA remain strong. In 1991 Oman allowed coalition forces to use its military bases during the Gulf War.

Omar (581-644) (Umar) Second CALIPH, or ruler of ISLAM. He was converted to Islam in 618 and became a counsellor of MUHAMMAD. He chose the first caliph, ABU BAKR, in 632 and succeeded him two years later. Under his rule, Islam spread by conquest into Syria, Egypt and Persia, and the foundations of an administrative empire were laid.

Omar Khayyám (1048–1131) Persian poet, mathematician and astronomer. He so impressed the Sultan that he was asked to reform the calendar. His fame in the West is due to a collection of verses freely translated by Edward Fitzgerald as The Rubáiyát of Omar Khayyám (1859).

Omayyads See UMAYYADS

ombudsman Official appointed to safeguard citizens' rights by investigating complaints of injustice made against the government or its employees. The office was created in Sweden in 1809. In 1967 Britain appointed a parliamentary commissioner for administration. The first US state to appoint an ombudsman was Hawaii, in 1967.

omen Observed phenomenon that can be interpreted as a prediction of future events, either good or bad. Common omens in folk beliefs include weather changes and astronomical events, especially the sudden appearance of a comet.

OMAN

AREA: 212,460sq km (82,278sq mi) POPULATION: 1,631,000 CAPITAL (POPULATION): Muscat (250,000) **GOVERNMENT:** Monarchy with a consultative council ETHNIC GROUPS: Omani Arab 74%, Pakistani 21% LANGUAGES: Arabic (official) RELIGIONS: Islam 86%, Hinduism 13%

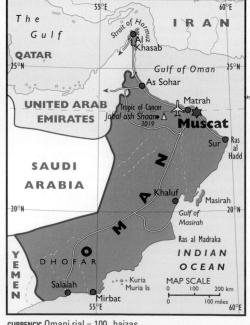

currency: Omani rial = 100 baizas

omnivore Any creature, such as humans and pigs, that eat both animal and vegetable foods. Omnivorous animals have teeth adapted for cutting, tearing and pulping food.

Omsk City on the Irtysh and Om rivers, w Siberia, Russia. Founded as a fortress town in 1716, it was made the administrative centre of w Siberia in 1824. From 1918–19 it was the headquarters of the anti-Bolshevik Kolchak government. It is now a major port. Industries: oil refining, chemicals, engineering, agricultural machinery, textiles. Pop. (1992) 1,169,000.

onager Fast-running animal related to the ASS, found in semi-desert areas of Iran and India. The onager is duncoloured with a dorsal stripe that reaches the tip of the tail. Height at the shoulder: 0.9–1.5m (2.9–4.9ft). Family Equidae; species *Equus hemionus onager*.

onchocerciasis (river blindness) Tropical disease of the skin and connective tissue, caused by infection with filarial worms; it may also affect the eyes, causing blindness. It is transmitted by blood-sucking blackflies found in Central and South America and Africa.

oncogene Gene that, by inducing a cell to divide abnormally, contributes to the development of CANCER. Oncogenes arise from gene mutations (proto-oncogenes), which are present in all normal cells and in some viruses. The oncogene concept led to the development of the onco-mouse, a laboratory animal that has one of these rogue genes implanted into its cells; it is used in testing anti-cancer treatments. *See also* GENETICS **oncology** In medicine, specialty concerned with the diagnosis and treatment of CANCER.

Onega, Lake (Onezhskoye Ozero) Lake in Nw Russia, near the border with Finland; second-largest lake in Europe. It drains sw through the River Svir to Lake Ladoga, and has numerous inlets and islands along its N shore. The chief port is Petrozavodsk. Area: 9,610sq km (3,710sq mi).

O'Neill, Eugene Gladstone (1888–1953) US playwright. O'Neill's first full-length play, *Beyond the Horizon* (1920), won the Pulitzer Prize, as did *Anna Christie* (1921) and *Long Day's Journey into Night* (1956). In 1936 he won the Nobel Prize for literature. He sometimes made use of themes from classical Greek drama, as in *Mourning Becomes Electra* (1931). Other plays include *The Emperor Jones* (1920), *Desire Under the Elms* (1924) and *The Iceman Cometh* (1946).

onion Hardy, bulb-forming, biennial plant of the lily family, native to central Asia, and cultivated worldwide for its strongsmelling, edible bulb. It has hollow leaves, white or lilac flowers. Height: to 130cm (50in). Family Alliaceae/Liliaceae.

Ontario Province in SE Canada, bounded to the s by four of the Great Lakes (Superior, Huron, Erie and Ontario) and the USA; the capital is TORONTO. Other major cities include OTTAWA, HAMILTON, Windsor and London. Ontario is Canada's most populous province. Trading posts were established in the region during the 17th century by French explorers. The area became part of New France, but was ceded to Britain in 1763. Ontario was known as Upper Canada until 1841, when it joined with QUEBEC to form the province of Canada. In 1867 the Dominion of Canada was created, and the province of Ontario was established. In the N is the forested Canadian Shield, with its lowlands bordering on Hudson and James bays. To the E and S are the lowlands of the ST LAWRENCE River and the Great Lakes, where agriculture and industry are concentrated. Cattle, dairy produce and pigs are important. The chief crops are tobacco, maize, wheat and vegetables. The Canadian Shield has many mineral deposits. Industries: motor vehicles, transport equipment, metallurgy, chemicals, paper, machinery, electrical goods. Area: 1,068,587sq km (412,582sq mi). Pop. (1994 est.) 10,900,000. Ontario, Lake Smallest of the GREAT LAKES, bounded by New York state (s and E) and Ontario province, Canada (s, w and N). Fed chiefly by the Niagara River, the lake is drained to the NE by the St Lawrence River. Forming part of the St Lawrence Seaway, it is a busy shipping route. The chief Canadian cities on Lake Ontario are TORONTO, HAMILTON and Kingston; on the US shore are Rochester and Oswego. Area: 19,684sq km (7,600sq mi).

ontogeny Total biological development of an organism. It includes the embryonic stage, birth, growth and death.

ontology Branch of METAPHYSICS that studies the basic nature of things; the essence of "being" itself.

onyx Semi-precious variety of the mineral CHALCEDONY, a form of AGATE. It has straight parallel bands. White and red forms are called carnelian onyx; white and brown, sardonyx. It is found mostly in India and South America.

ooze Fine-grained, deep-ocean deposit containing materials of more than 30% organic origin. Oozes are divided into two main types: **calcareous** ooze, at depths of 2,000–3,900m (6,600–12,800ft), contains the skeletons of animals such as foraminifera and pteropods. **Siliceous** ooze, at depths of more than 3,900m (12,800ft), contains skeletons of radiolarians and diatoms.

opal Non-crystalline variety of QUARTZ, found in recent volcanoes, deposits from hot springs and sediments. Usually colourless or white with a rainbow play of colour in gem forms, it is the most valuable of quartz gems. Hardness 5.5–6.5; s.g. 2.0.

op art (optical art) US ABSTRACT ART movement, popular in the mid-1960s. It relies on optical phenomena to confuse the viewers' eye and to create a sense of movement on the surface of the picture. Leading exponents include Victor Vasarély, Kenneth Noland and Bridget RILEY.

OPEC Acronym for Organization of Petroleum Exporting Countries

opencast mining Stripping surface layers from the Earth's crust to obtain coal, ores or other valuable minerals. Dragline excavators strip away surface layers and mechanical shovels distribute minerals and spoil. The minerals are carried away for grading and processing. Owners of opencast mines in some countries are required to restore the environmental quality of the land after MINING has ceased.

open cluster (galactic cluster) Group of young stars in the spiral arms of our GALAXY, containing from a few tens of stars to a few thousand. They are usually several light-years across. One example is the PLEIADES.

open door policy US policy designed to preserve its commercial interests in China in the early 20th century. It originated (1899) in a pronouncement by the US secretary of state, John M. Hay. At that time, China was divided into spheres of interest among European powers and Japan. The open door policy demanded that trade and traders from other countries should receive equal rights with other foreigners in China.

open-hearth process Method of producing STEEL in a furnace heated by overhead flames. The flames come from gas or oil burners, and oxygen may be blown through the furnace to increase its temperature. Pig iron, scrap steel and limestone are heated together. Various impurities form slag, which is removed from the surface of the molten metal. Other materials are added to the metal to produce steel of the required type.

Open University (OU) Form of British higher education chartered in 1969 as a nonresidential alternative to conventional university training, with open access. Teaching is carried out through television and radio broadcasts, as well as personal tuition and summer schools. It gives full undergraduate degrees in all its faculties.

opera Stage drama that is sung. It combines acting, singing, orchestral music, set and costume design, making spectacular entertainment. The best-known opera houses include LA SCALA (Milan), the Opéra (Paris), the ROYAL OPERA (London), the State Opera (Vienna), the Festspiele (Bayreuth) and the METROPOLITAN OPERA (New York). Opera began in Italy in c.1600. The classical style evolved in c.1750; its greatest exponent was MOZART. The 19th century was dominated by VERDI and WAGNER. Twentieth-century opera has been marked by a profusion of styles by composers as diverse as PUCCINI, STRAUSS, BERG and BRITTEN. See also OPERA BUFFA; OPÉRA COMIQUE; OPERA SERIA; OPERETTA

opera buffa Style of Italian comic opera that developed in mid-18th-century Naples. Light and simple in style, it introduced the elaborate finale which influenced the subsequent development of opera. An early example of the style is *La Serva Padrona* (1733) by Giovanni Pergolesi.

opéra comique Style of French opera that began in the late 18th century. Its hallmarks are a witty plot involving some spoken dialogue, romantic subject matter, and simple engag-

Optical fibres carry information as signals of light. The glass core (1) of a fibre optic cable is clad in glass of a different refractive index which contains the light pulses in the core. The light signal cannot leave the core because it always hits the edge of the core at too shallow an angle to escape. A sheath (2) provides physical protection and bundles of the sheathed cores are given strength by a central steel wire (3). Narrow cores (4) are now used because they allow signals to be sent over greater distances without blurring. In a wider cable (5) more reflections can occur, causing the pulse to spread out and merge with adjacent pulses. To prevent this more space must be left between pulses in wider cables and that limits the volume of data that can he transmitted.

ing music. The genre can also include tragic works, such as Bizet's *Carmen* and Offenbach's *Tales of Hoffmann*.

opera seria Style of Italian opera in the 17th and early 18th centuries. The plots were usually heroic or tragic. Priority was given to virtuoso vocal display in elaborate arias. The formalism and stylization of such operas prompted a reaction that gave rise to the development of OPERA BUFFA.

operetta Type of light opera involving songs, dialogue, dancing and an engaging story. Operettas developed from attempts by composers to reach wider audiences. Among these composers were Johann Strauss, Arthur Sullivan (in association with W.S. GILBERT) and Jacques Offenbach.

ophthalmology Branch of medicine that specializes in the diagnosis and treatment of diseases of the eye.

ophthalmoscope Instrument for examining the interior of the eye, invented by Hermann von HELMHOLTZ in 1851.

Ophüls, Max (1902–57) German film director. His *miseen-scène* style was superbly realized in two masterpieces, *Letter from an Unknown Woman* (1948) and *Reckless Moment* (1949). His son, **Marcel** (1927–), is a DOCUMENTARY film-maker. He often presents controversial issues, such as the Nuremberg trials in *The Memory of Justice* (1975) and reactions to the Bosnian war in *Veillées d'Armes* (1994).

opium Drug derived from the unripe seed-pods of the opium POPPY. Its components and derivatives have been used as NARCOTICS and ANALGESICS for many centuries. It produces drowsiness and euphoria and reduces pain. MORPHINE and CODEINE are opium derivatives.

Opium Wars (1839–42) Conflict between Britain and China. It arose because Chinese officials prevented the importation of opium. After a British victory, the Treaty of Nanking gave Britain trading rights in certain ports and the grant of Hong Kong. A second, similar war (1856–60) was fought by the British and French. When China refused to ratify the Treaty of Tientsin (1858), Anglo-French forces occupied Peking (Beijing).

Oporto City and port on the River Douro, NW Portugal. A Roman settlement, it was occupied by the Visigoths (540–716) and the Moors (716–997) before being brought under Portuguese control in 1092. By the 17th century it was a famous wine centre and its PORT is still exported. Portugal's second-largest city, it lies in an industrialized region. Industries: textiles, fishing, fruit, olive oil. Pop. (1991) 310,640.

opossum (possum) New World MARSUPIAL animal. The only marsupial found outside Australasia. Omnivorous treedwellers, they have silky grey fur (except on the long prehen-

sile tail), and feign death when in danger. The common opossum, *Didelphis marsupialis*, grows up to 50cm (20in) long, plus a 30cm (12in) tail. Family Didelphidae.

Oppenheimer, (Julius) Robert (1904–67) US theoretical physicist. Oppenheimer was appointed director (1943–45) of the Los Alamos laboratory in New Mexico, where he headed the MANHATTAN PROJECT to develop the atomic bomb. In 1949 he opposed the construction of the HYDROGEN BOMB and in 1953 was suspended by the Atomic Energy Commission. Oppenheimer was subsequently reinstated.

opposition, leader of the In parliamentary systems, the leader of the party that is runner-up in a general election and so does not form the government. Official recognition was given to the leader of the opposition in 1937, when the holder was granted a salary higher than that of an ordinary MP.

optical fibre Fine strand of glass, less than 1mm (0.04in) thick, that is able to transmit digital information in the form of pulses of light. Such transmission is possible because light entering an optical fibre is conducted, by reflection, from one end of the fibre to the other with very little loss of intensity. Initially used in ENDOSCOPES, their application is spreading to many forms of mass communication.

optics Branch of physics concerned with the study of LIGHT and its behaviour. Fundamental aspects are the physical nature of light, both as a wave phenomenon and as particles (PHOTONS), and the REFLECTION, REFRACTION and polarization of light. Optics also involves the study of mirrors and LENS systems and of optically active chemicals and crystals that polarize light. *See also* POLARIZED LIGHT

optometry Testing of vision in order to prescribe corrective eyewear, such as spectacles or contact lenses. It is distinct from OPHTHALMOLOGY.

Opus Dei International Roman Catholic organization of laymen and a few priests, known for its highly conservative political and religious influence. It was founded in Spain in 1928. Its members seek to put into practice traditional Christian values through their chosen professions. Opus Dei supported the Nationalists during the Spanish Civil War (1936–39). General FRANCO appointed some members to ministerial posts to further his economic policies. After Franco's death, Opus Dei's influence in Spain began to decline, but internationally it maintains its sponsorship of educational and charitable projects.

oracle In ancient Greece, a priest or priestess who gave the answer of a god to questions put by individuals. The most famous was the oracle of Apollo at DELPHI. The god spoke through a priestess (Pythia), whose words were, in turn, interpreted by priests. Answers tended to be ambiguous, so that the oracle could never be said to be wrong.

Oran City and seaport on the Gulf of Oran, Nw Algeria. Founded in the 10th century, it was taken by Spain from its Arab rulers in 1509. Captured by Ottoman Turks in 1708, it was retaken by Spain in 1732. Under French rule from 1831 to 1962, it developed as a naval base. It is Algeria's second-largest city. Industries: iron ore, textiles, chemicals, cereals, wine, fruit. Pop. (1987) 609,823.

Orange Longest river of South Africa. It rises in the Drakensberg Mountains in N Lesotho and flows generally w, forming the boundary between FREE STATE and CAPE PROVINCE. It continues w through the Kalahari and Namib deserts, forming South Africa's border with Namibia. It empties into the Atlantic Ocean at Oranjemund. Length: c.1,300mi (2,100km). **orange** Evergreen citrus tree and its fruit. There are two basic types. The sweet orange (*Citrus sinensis*) is native to Asia and widely grown in the USA and Israel. The fruit develops without flower pollination and is often seedless. The sour orange (*C.aurantium*) is widely grown in Spain for the manufacture of marmalade. Related fruits include the mandarin, tangerine and satsuma, all varieties of *C. reticulata*. Height: to 9m (30ft). Family Rutaceae; genus *Citrus*.

Orange, House of Royal dynasty of the Netherlands. Orange was a principality in s France, which was inherited by WILLIAM I (THE SILENT) in 1544. He led the successful Dutch revolt against Spain in the late 16th century. WILLIAM III became king of England in 1689. The son of William V became king of the Netherlands in 1815 as WILLIAM I.

▲ orchid The bee orchid (Ophrys apifera) of Europe tempts its pollinators with sex rather than nectar. Its elaborate flowers imitate the colour, shape, texture and scent of female bees of the genus Eucera. Male bees, which emerge before the females, alight on the flower's broad platform or labellum and attempt to mate with it. Structures containing thousands of pollen grains adhere to the bee's body, anchored by the sticky ends of their stalks. The bee transfers the pollen to other flowers, and cross fertilization is followed by the formation of thousands of tiny seeds.

Orange Free State Former name (1854–1995) of the Free STATE province, South Africa

Orangemen Members of the Orange Society (Orange Order). It was founded in Ulster in 1795 in response to the mainly Roman Catholic, nationalist United Irishmen, and was named after the Protestant hero, WILLIAM III, prince of Orange. His victory over the Catholic JAMES II at the Battle of the BOYNE (1690) is celebrated on its anniversary, 12 July.

orang-utan Stout-bodied great APE native to forests of Sumatra and Borneo. It has a bulging belly and a shaggy, reddish-brown coat. It swings by its arms when travelling through trees, but proceeds on all fours on the ground. Height: 1.5m (5ft); weight: to 100kg (220lb). Species Pongo pygmaeus. See also PRIMATES

oratorio Form of sacred musical composition for solo voices, chorus and orchestra. The first of these compositions were presented in oratories (chapels) in 17th-century Italy. Outstanding examples are Handel's Messiah (1742) and Elgar's Dream of Gerontius (1900).

orbit Path of a celestial body in a gravitational field. The path is usually a closed one about the focus of the system to which it belongs, as with those of the planets around the Sun. Most celestial orbits are elliptical, although the ECCENTRICITY can vary greatly. It is rare for an orbit to be parabolic or hyperbolic. Orcagna, Andrea (1308-68) (Andrea di Cione) Florentine painter, sculptor and architect. His single surviving altarpiece, The Redeemer with the Madonna and Saints (begun 1354), shows a return to the style of BYZANTINE ART. He was head architect of Orvieto Cathedral.

orchestra Group of musicians who play together. During the 17th century string orchestras developed out of viol consorts; in the 18th century some wind instruments were added. The woodwind section was soon established, and by the end of the 19th century the brass section was too. Modern orchestras consist of between 80 and 120 players divided into sections: STRINGS (violin, viola, cello, double bass and harp); WOODWIND (flute, oboe, clarinet and bassoon); BRASS (trumpet, trombone, French horn and tuba) and PERCUSSION.

orchid Any plant of the family Orchidaceae, common in the tropics. There are c.35,000 species. All are perennials and grow in soil or as EPIPHYTES on other plants. Parasitic and saprophytic species are also known. All orchids have bilaterally symmetrical flower structures, each with three sepals. They range in diameter from c.2mm (0.1in) to 38cm (15in). orders, holy In the Roman Catholic, Orthodox, and Anglican churches, the duties of the clergy, and the grades of hierarchical rank as outlined in the office of ORDINATION. A person is ordained as a subdeacon, deacon, priest or bishop. These ranks are known as the major orders. The minor orders are those of porter, lector, exorcist, and acolyte.

orders of architecture In classical architecture, style and decoration of a column, its base, capital and entablature. Of the five orders, the Greeks developed the Doric, Ionic and Corinthian. The Tuscan and Composite orders were Roman adaptations. A typical Doric column has no base, a relatively short shaft with surface fluting meeting in a sharp edge and an unornamented capital. The Ionic order is characterized by slender columns with 24 flutes and prominent spiral scrolls on the capitals. The Corinthian is the most ornate of the Classical orders of architecture. A typical Corinthian column has a high base, sometimes with a pedestal, a slim, fluted column and a bell-shaped capital with acanthus-leaf ornament.

ordination Process of consecrating a person as a minister of religion. In Christian Churches organized along episcopal lines, ordination confirms the ordinand (the individual undergoing the process) as a priest or minister in holy ORDERS. In Roman Catholic and Orthodox Churches, the rite of ordination is a SACRAMENT. In Protestant Churches without episcopal organization, ordination is carried out by ministers, ruling elders, or specially selected lay persons.

ordination of women Official recognition of women as priests or ministers by a church. In Christianity, the ban on women as full members of the clergy has persisted in some churches, notably the Roman Catholic Church. During the 20th century, however, many Protestant churches began to

admit women first as deacons and later as priests. The General Synod of the Church of England agreed that there was no theological objection to women priests in 1975; but because of opposition, the necessary church legislation was not passed until 1992. The first women priests were ordained in 1994.

Ordovician Second-oldest period of the PALAEOZOIC era, 505 to 438 million years ago. All animal life was restricted to the sea. Numerous invertebrates flourished and included trilobites, brachiopods, corals, graptolites, molluscs, and echinoderms. Remains of jawless fish from this period are the first record of the vertebrates.

ore Mineral or combination of minerals from which metals and non-metals can be extracted. It occurs in veins, beds or seams parallel to the enclosing rock or in irregular masses.

oregano (marjoram) Dried leaves and flowers of several perennial herbs of the genus Oreganum, native to Mediterranean lands and w Asia. It is a popular culinary herb. Family Lamiaceae/Labiatae; genus Origanum.

Oregon State of NW USA, on the Pacific coast; the capital is SALEM. Other major cities include PORTLAND and Eugene. Trading posts were set up in the 1790s, mainly by the HuD-SON'S BAY COMPANY. From 1842 the OREGON TRAIL brought more settlers. Oregon Territory was formed in 1848 and was admitted to the Union in 1859. It is dominated by the forested slopes of the CASCADE RANGE and the Coast ranges. Between the two lies the fertile Willamette Valley. The COLUMBIA RIVER and the Willamette are the major rivers. Agriculture includes cattle, dairy produce, wheat and market garden products. Oregon produces more than 20% of the nation's softwood timber. Area: 251,180sq km (96,981sq mi). Pop. (1993 est.) 3,038,000. Oregon Trail Main route of US pioneers to the West in the 1840s and 1850s. It ran 3,200km (2,000mi) from Independence, Missouri, to Fort Vancouver on the Columbia River in Oregon, and crossed the Rocky Mountains via South Pass. The journey took about six months. It was heavily used from 1843, when "Oregon fever" attracted thousands of settlers. After 1848, when gold was discovered in California, the numbers began to decline.

Orestes In Greek legend, the son of AGAMEMNON and CLYTEMNESTRA, and brother of ELECTRA. He killed his mother and her lover Aegisthus to avenge their murder of his father.

Orff, Carl (1895-1982) German composer. He used deliberately primitive rhythms in his best-known works, Carmina Burana (1937) and Catulli Carmina (1943), and the opera Trionfo di Afrodite (1953).

organ In biology, group of TISSUES that form a functional and structural unit in a living organism. The major organs of the body include the brain, heart, lungs, skin, liver and kidneys. Leaves, flowers and roots are examples of plant organs. organ KEYBOARD INSTRUMENT. The player sits at a console and regulates a flow of air to ranks of pipes, producing rich tones. The organ was in use in Christian churches in the 8th century. The modern organ dates from the BAROQUE period. organic chemistry See CHEMISTRY

Organization for Economic Cooperation and Development (OECD) International consultative body set up in 1961 by the major Western trading nations. Its aims are to stimulate economic growth and world trade by raising the standard of living in member countries and by coordinating aid to less developed countries. Its headquarters are in Paris and it has 26 member nations including all the worlds major powers.

Organization of African Unity (OAU) Intergovernmental organization. Founded in 1963, the OAU brings together all African states. It aims to safeguard African interests and independence, encourage the continent's development, and settle disputes among member states. Its headquarters are in Addis Ababa, Ethiopia.

Organization of American States (OAS) Organization of 35 member states of the Americas that promotes peaceful settlements to disputes, regional cooperation in the limitation of weapons, and economic and cultural development. The successor to the Pan American Union, the OAS was created (1948) at an international conference in Colombia. It is affiliated to the UNITED NATIONS (UN). Its headquarters are in Washington D.C.

▲ orders of architecture The five main orders of architecture

were first presented by Sebastiano Serlio (1475-1554) in Book IV of his treatise on architecture (1537).

OREGON

Statehood: 14 February 1859

Nickname:

The Beaver State

State bird:

Western meadowlark

State flower:

Oregon grape State tree:

Douglas fir

State motto: She flies with her own

OSCILLOSCOPE

An oscilloscope displays an electronic signal on a display in analogue form. Usually time is represented on the x axis (horizontal), with the y axis (vertical) recording the incoming voltage - here a heartbeat (1). The signal from the object being monitored is converted into an electrical voltage (2). That voltage is shown in visible form on the screen of a cathode ray tube (3) similar to a black and white television. Deflector magnets (4) direct the stream of electrons from the electron gun (5). The magnets sweep the electron beam from left to right over a set period, while variations in the voltage of the external signal cause the wave pattern. The control box (6) allows the period of the x axis and the strength of the signal displayed to be changed.

Organization of Petroleum Exporting Countries (OPEC) Intergovernmental organization established in 1960 by many of the world's major oil producing states to safeguard their interests. Its primary purpose is to set production quotas and coordinate prices among the 12 members. It was able to control oil prices in the 1970s, but its influence has waned since then, largely because of internal differences and the emergence of major oil-producing countries outside OPEC. Its headquarters are in Vienna, Austria.

orgasm Physiological culmination of sexual stimulation, marked by general release of muscular tension and waves of contractions causing climactic spasms of vaginal muscles in the female and ejaculation (the release of SEMEN) in the male. orienteering Sport similar to cross-country running but requiring both athletic and navigational skills. Runners, leaving at timed intervals, carry a map and compass with which to locate control points around the usually 10km (6.2mi) course. The fastest to complete the course wins.

original sin Sin committed by ADAM and EVE for which they were expelled from the Garden of EDEN and were made mortal (Genesis 3). The sin was their eating from the tree of the knowledge of good and evil against God's strict instructions. Adam and Eve's guilt was deemed to have been passed down to their descendants through all the generations.

Orinoco River in Venezuela. Rising in the Sierra Parima in s Venezuela, it flows Nw to Colombia, then N, forming part of the Venezuela-Colombia border, and finally E into the Atlantic Ocean by a vast delta. Length: c.2,062km (1,281mi). **oriole** Two unrelated types of songbirds. The Old World oriole (family Oriolidae) is brightly coloured and lays eggs in a cup-shaped nest. The New World oriole (family Icteridae) has similar colouring and builds hanging nests in trees.

Orion Prominent constellation, representing a hunter. Four young stars form a conspicuous quadrilateral containing a row of three other stars representing his belt.

Orion nebula Emission nebula visible to the naked eye in the constellation Orion. It is a mass of gas surrounding a quadrilateral grouping of four hot O-type stars (the trapezium).

Orissa State in NE India, on the Bay of Bengal; the capital is Bhubaneswar. After being ruled by Hindus, Afghans and Moguls, it was ceded to the Mahrattas in 1751. Occupied by the British in 1803, it was proclaimed a constituent state of India in 1950. Industries: mining, fishing, rice, wheat, sugar

cane, oilseeds, forestry. Area: 155,782sq km (60,147sq mi). Pop. (1991) 31,659,736.

Orkney Islands Archipelago of over 70 islands off the N coast of Scotland. Mainland (Pomona) is the largest island, and is the seat of the regional capital (Kirkwall). Other principal islands include Hoy and South Ronaldsay. The land is a low-lying, fertile plain and the climate is mild and wet. The islands were conquered in 875 by the Viking king Harald I. They remained Norwegian territory until 1231. In 1472 the islands were annexed by Scotland. Scapa Flow (between Mainland and Hoy) was the major British naval base in both World Wars. The local economy remains predominantly agricultural. Area: 974sq km (376sq mi). Pop. (1991) 19,612.

Orlando, Vittorio Emanuele (1860–1952) Italian statesman, prime minister (1917–19). Orlando became prime minister after a series of Italian defeats in World War 1. He represented Italy at the Treaty of VERSAILLES. His early support for Benito Mussolini turned to opposition in 1925. After World War 2 he rejoined the Senate and ran for president (1948).

Orlando City in central Florida, USA. Orlando is one of the world's most popular tourist destinations, with the Disney World and Magic Kingdom theme park. Established in 1827 as a trading post, Orlando was incorporated as a city in 1875 and expanded with the arrival of the railroad. Industries: citrus-growing, aerospace, electronics. Pop. (1990) 164,693.

Orléans, Louis-Philippe, Duc d' (1747–93) French Bourbon prince. A liberal, he was elected to the National Convention (1782) and voted for the king's execution. When his son, the future King Louis Philippe, defected (1793), he was arrested and subsequently executed during the REIGN OF TERROR.

Orléans City on the River Loire, N central France; capital of Loiret département. Besieged by the English during the HUNDRED YEARS WAR, it was relieved by JOAN OF ARC in 1429. During the 16th-century Wars of Religion, the city was besieged by Catholic forces and held by them until the Edict of NANTES. Industries: tobacco, textiles, fruit and vegetables, chemicals. Pop. (1991) 105,111.

Ormuzd See Ahura Mazdah

ornithology Study of birds. Included in general ornithological studies are classification, structure, function, evolution, distribution, migration, reproduction, ecology and behaviour. **orogenesis** Mountain building, especially where the Earth's crust is compressed to produce large-scale FOLDS and FAULTS.

Orozco, José Clemente (1883–1949) Mexican painter. In his wash drawings, *Mexico in Revolution* (1911–16), Orozco aimed to demonstrate the futility of war. His MURALS are grand in both scale and mood, none more so than *Katharsis* (1934). Orozco's final paintings became increasingly violent. Orpheus In Greek mythology, the son of Calliope by APOLLO, and the finest of all poets and musicians. Orpheus married Eurydice, who died after being bitten by a snake. He descended into the Underworld to rescue her and was allowed to regain her if he did not look back at her until they emerged into the sunlight. He could not resist, and Eurydice vanished forever.

orphism (orphic cubism) Term invented in 1912 by APOLLI-NAIRE to describe a new art form combining elements of CUBISM, FUTURISM and FAUVISM. The style was first associated with the work of DELAUNAY and its other exponents exerted considerable influence in Germany through the works of KLEE and Kandinsky. See also BLAUE REITER

orthoclase Essential mineral in acidic IGNEOUS rocks and common in METAMORPHIC rocks. It is a potassium aluminium silicate, KAlSi₃O₈ with monoclinic system crystals. It is usually white but can be pink. Hardness 6–6.5; s.g. 2.5–2.6.

orthodontics See DENTISTRY

Orthodox Church (Eastern Orthodox Church) Family of Christian national churches mostly of E Europe. The churches are independent but acknowledge the primacy of the Patriarch of Constantinople. They developed from the Church of the BYZANTINE EMPIRE, which separated from that of Rome in 1054. The Russian Orthodox Church is by far the largest in the number of its adherents. *See also* SCHISM

orthopaedics Branch of medicine that deals with the diagnosis and treatment of diseases, disorders and injuries of bones, muscles, tendons and ligaments.

ortolan Small European BUNTING. It has an olive-green head and chest, a black back streaked with brown, a yellow throat, and pinkish underparts. It lays 3–6 eggs in a cup-shaped nest. Length: 16.4cm (6.5in). Species *Emberiza hortulana*.

Orton, Joe (John Kingsley) (1933–67) British playwright who specialized in black satirical comedies. *Entertaining Mr Sloane* and *Loot* were staged in London in 1964 and 1965 respectively. *What the Butler Saw* was produced posthumously (1969) after Orton's murder by his lover, Kenneth Halliwell.

Orwell, George (1903–50) British novelist and essayist, b. Eric Arthur Blair in India. Orwell's service (1922–27) with the Indian imperial police in Burma formed the basis of *Burmese Days* (1934). Other early autobiographical works include *Down and Out in Paris and London* (1933), *The Road to Wigan Pier* (1937), and *Homage to Catalonia* (1938), the latter on his experiences in the Spanish Civil War. Orwell, however, is best-known for his fictions on totalitarianism: the satirical fable *Animal Farm* (1945) and the dystopic novel *1984* (1949). Oryx (gemsbok) Any of four species of ANTELOPES. The male has a tuft of hair at the throat and both sexes carry long horns ringed at the base. Two species are almost extinct, but the other two survive in considerable numbers in Africa. Height: 1.2m (4ft). Family Bovidae.

Osage Tribe of Native North Americans. Hunters with a strong religious tradition, they settled in Kansas, Missouri and Oklahoma. Numbering *c.*7,000 today, they have prospered since the discovery of oil on their Oklahoma reservation.

Osaka City on Osaka Bay, s Honshū island, Japan; capital of Osaka prefecture. Japan's third-largest city and its principal industrial port, Osaka was intensively bombed during World War 2. It is a major transport hub. It was the imperial capital in the 4th–8th centuries. During the Edo Period, Osaka became the commercial centre of Hideyoshi. Pop. (1993) 2,495,000.

Osborne, John James (1929–95) British dramatist whose play *Look Back in Anger* (1956) established his reputation as the "ANGRY YOUNG MAN" of the English theatre. His other successes included *The Entertainer* (1957) and *Luther* (1961) but later works such as *The Hotel in Amsterdam* (1968) and *Watch It Come Down* (1976) provoked critical hostility.

Oscar (officially Academy Award) Prize awarded annually for services to the cinema by the US Academy of Motion Picture Arts and Sciences. The gold-plated bronze statuettes stand 25cm (10in) high and are reputed to have been nicknamed after the Academy librarian's uncle Oscar.

oscillating Universe theory Variant of the Big Bang theory in which it is suggested that the Universe passes through successive cycles of expansion and contraction (or collapse). At the end of the collapse phase, with the Universe packed into a small volume of great density, it is possible that a "bounce" would occur. The Universe would thus oscillate between Big Bang and "Big Crunch" episodes, and so be infinite in age. For this to happen, however, the density of the Universe would have to be above a certain value (the critical density), which is not thought to be the case.

oscillator In physics, a device for producing sound waves, as in a SONAR or an ultrasonic generator. In electronics, an oscillator circuit converts direct current (DC) electricity into high-frequency alternating current (AC).

oscilloscope (cathode-ray oscilloscope) Electronic instrument in which a CATHODE-RAY TUBE (CRT) system displays how quantities, such as voltage or current, vary over a period of time. The electron beam that traces the pattern on the screen is moved by a time-base generator within the oscilloscope. The result is generally a curve or graph on the screen. **osier** Any of various willows, especially *Salix viminalis* and *S. purpurea*, the flexible branches and stems of which are used for wickerwork.

Osiris In EGYPTIAN MYTHOLOGY, the god of the dead. He is generally depicted wearing a feathered crown and bearing the crook and flail of a king. In the myths, Osiris was killed by his brother SETH. His sister and wife, ISIS, retrieved the corpse, and Osiris' son HORUS avenged his death.

Oslo Capital of Norway, at the head of Oslo Fjord, se Norway. The city was founded in the mid-11th century. Largely destroyed by fire in 1624, it was rebuilt by Christian IV,

who named it Christiania. In 1905 it became the capital of independent Norway and was renamed Oslo in 1925. Industries: machinery, wood products, food processing, textiles, chemicals, shipbuilding. Pop. (1990) 459,292.

osmium (symbol Os) Bluish-white metallic element, one of the TRANSITION ELEMENTS. The densest of the elements, osmium is associated with platinum; the chief source is as a byproduct from smelting nickel. Like IRIDIUM, osmium is used in producing hard alloys. It is also used to make electrical contacts and pen points. Properties: at.no.76; r.a.m. 190.2; r.d. 22.57; m.p. 3,045°C (5,513°F); b.p. 5,027°C (9,081°F); most common isotope Os¹⁹² (41.0%).

osmosis Diffusion of a solvent (such as water) through a selectively permeable MEMBRANE (one which only allows the passage of certain dissolved substances) into a more concentrated solution. Because the more concentrated solution contains a lower concentration of solvent molecules, the solvent flows by diffusion to dilute it until concentrations of solvent are equal on both sides of the membrane. Osmosis is a vital cellular process. *See also* TURGOR PRESSURE

Osnabrück City on the River Haase, Lower Saxony, NW Germany. It obtained a city charter in 1171. It was the scene of the negotiations for the Peace of WESTPHALIA in 1648. Industries: iron and steel, textiles, papermaking, chemicals, motor vehicles, machinery. Pop. (1990) 165,400.

osprey Hawk that lives beside lakes and in coastal regions of all continents except Antarctica. It has a short hooked bill, broad ragged wings and a white head; it has brownish-black plumage on its back and a cream breast. Length: 51–61cm (20–24in). Family Pandionidae, species *Pandion haliaetus*.

Ossetia Region of the central Caucasus. The region is divided along the Terek River. North Ossetia is an autonomous republic within the Russian Federation, whose capital is Vladikavkaz. South Ossetia is an autonomous region of GEORGIA, whose capital is Tshkinvali. Ossetia is a mountainous agricultural region, producing fruit, wine and grain. North Ossetia has rich mineral deposits. Ossetia became part of the Russian empire in the early 19th century. In 1861 it was annexed to Russia as the Terek region. In 1918 Ossetia became a republic of the Soviet Union and two years later was incorporated into a greater Mountain Autonomous Republic. In 1922 South Ossetia was made a region within the Republic of Georgia. In 1924 North Ossetia became part of the Russian republic, and in 1936 achieved the status of an autonomous republic. In 1990 Georgia abolished South Ossetia's autonomous status, but it was restored in 1995. Area: North Ossetia, 8,000sq km (3,090sq mi); South Ossetia, 3,900sq km (1,505sq mi). Pop. North Ossetia (1990), 638,000; South Ossetia (1990), 99,800. ossification (osteogenesis) Process of BONE formation in

vertebrates. Bone is formed through the action of special cells called osteoblasts, which secrete bone-forming minerals that combine with a network of COLLAGEN fibres.

osteomyelitis Infection of the Bone, sometimes spreading along the marrow cavity. Rare except in diabetics, it can arise from a compound fracture, where the bone breaks through the skin, or from infection elsewhere in the body. It is accompanied by fever, swelling and pain. The condition may be treated with immobilization, ANTIBIOTICS and surgical drainage.

osteopathy System of alternative medical treatment based on the use of physical manipulation to rectify damage caused by mechanical stresses. The concept was formulated by US physician Andrew Still in 1874.

osteoporosis Condition where there is loss of bone substance, resulting in brittle bones. It is common in older people, especially in women following the MENOPAUSE; it may also occur in Cushing's syndrome and as a side-effect of prolonged treatment with corticosteroid drugs. There is no cure, but it may be treated with calcium supplements and a drug called disodium etidronate. HORMONE REPLACEMENT THERAPY (HRT) may help to prevent its occurence in post-menopausal women.

Ostrava City in NE Czech Republic, near the confluence of the rivers Oder and Opava. Founded in the 13th century, it is an industrial centre. Industries: coal, iron and steel, chemicals, machinery. Pop. (1990) 331,000.

ostrich Largest living bird, found in central Africa. It is flight-

▲ ostrich Africa is the home of the ostrich, the largest living bird. It is the only member of the order Struthioniformes. Several large ground-dwelling birds, the ostrich, rhea, emu and cassowary, all resemble each other quite closely, but are thought to have arisen independently, and as such are examples of a phenomenon called convergent evolution.

▲ Oswald Although he vehemently asserted his innocence, claiming that he had been framed, Lee Harvey Oswald was widely believed to be the assassin of US president John F. Kennedy in 1963. Oswald was shot and killed while in police custody before he came to trial. Rumours that Oswald was a double agent, and conspiracy theories that suggest more than one gunman carried out the assassination, persist.

less and has a small head and long neck. Plumage is black and white in males, brown and white in females. Eggs are laid in holes in the sand. Height: to 2.5m (8ft); weight: to 155kg (345lb). Family Struthionidae; species *Struthio camelus*.

Ostrogoths See GOTH

Ostrovsky, Alexsandr Nikolayevich (1823–86) Russian dramatist. He is an important figure in 20th-century Russian theatrical realism. Many of his plays deal with the life of the Russian merchant class. His plays include *Poverty is no Crime* (1854) and *The Thunderstorm* (1859).

Oswald, Lee Harvey (1939–63) Alleged assassin of US president John F. KENNEDY, on 22 November 1963, in Dallas. Before he could stand trial he was murdered in police custody by Jack Ruby. *See also* WARREN COMMISSION

Oswald, Saint (*c*.605–42) King of Northumbria (633–42). He became a Christian and converted his people with the help of St AIDAN. Oswald became King of Northumbria in 633 and was eventually killed in battle. His feast day is 5 August. **Othman** (Uthman) (574–656) Third CALIPH (644–56) A son-in-law of MUHAMMAD, he was a member of the UMAYYAD family of Mecca. He was blamed for widespread revolts and intrigues, culminating in his assassination.

O'Toole, Peter (1932–) Irish stage and film actor. O'Toole's stage performances (1955) as Shylock and Hamlet were exhilarating. He gained an Academy nomination for Best Actor in his film debut in Lawrence of Arabia (1962). Other Oscar nominations include Becket (1964), The Lion in Winter (1968), Goodbye Mr Chips (1969) and The Ruling Class (1972). O'Toole's career was revived with further nominated performances in The Stunt Man (1980) and My Favorite Year (1982). Otosclerosis Inherited condition in which overgrowth of bone in the middle ear causes deafness. It is gradual in onset and twice as common in women as in men. Surgery can rebuild the sound conduction mechanism.

Ottawa Group of Algonquian-speaking Native North Americans. Hunter-farmers, they originally lived north of the Great Lakes. They allied with the French and Hurons, but were broken into five groups by the Iroquois and Anglo-Americans and now live in the Great Lakes area, Kansas, and Oklahoma. Ottawa Capital of Canada, in SE Ontario, on the Ottawa River and the Rideau Canal. Founded in 1826 as Bytown, it acquired its present name in 1854. Queen Victoria chose it as capital of the United Provinces in 1858, and in 1867 it became the national capital of the Dominion of Canada. Industries: glass-making, printing, publishing, sawmilling, pulp-making, clocks and watches. Pop. (1991) 313,987.

otter Semi-aquatic carnivore found worldwide except Australia. Otters have narrow, pointed heads with bristly whiskers, sleek furry bodies, short legs with webbed hind feet and long tails. The river otter (genus *Lutra*) is small to medium-sized and spends considerable time on land. Family Mustelidae.

Otto I (the Great) (912-73) King of the Germans (936-73)

and Holy Roman emperor (962–73). Otto succeeded his father, HENRY I, in Germany and defeated the rebellious princes and their ally, Louis IV of France. Royal power was further augmented by his close control of the church. In 955 he crushed the MAGYARS at Lechfeld. He invaded Italy to aid Queen Adelaide of Lombardy, married Adelaide and became king of Lombardy. In 962 he was crowned as Roman emperor (the "Holy", meaning "Christian", was added later).

Otto IV (1174–1218) (Otto of Brunswick) Holy Roman emperor (1198–1215). A member of the Guelph family, Otto antagonized the powerful Pope INNOCENT III by his invasion of Italy against the Hohenstaufen King Frederick I (later Emperor Frederick II). With Innocent's support, Frederick was elected king (1212) by the German princes, and supported by Phillip II of France. Otto was defeated by Philip at Bouvines (1214) and forced to retire.

Ottoman empire Former Turkish state that controlled much of SE Europe, the Middle East and North Africa between the 14th and 20th centuries. It was founded by Osman I (r.1290-1326). He ruled a small principality in Anatolia, which he greatly enlarged at the expense of the BYZANTINE EMPIRE. The contest with the Byzantines ended with the capture of Constantinople (now ISTANBUL), which became the Ottoman capital in 1453. Under Suleiman I (THE MAGNIFICENT) (r.1520-66), the Ottoman empire included the Arab lands of the Middle East and North Africa, SE Europe and the E Mediterranean. The decline of Ottoman power began before 1600, and thereafter, Ottoman territory was reduced in wars with its European neighbours, Austria and Russia. After World War 1, when Ottoman territory was reduced to roughly the present Turkish borders, nationalists led by ATATÜRK deposed the last sultan and created the modern Turkish republic (1923).

Ouagadougou Capital of Burkina Faso, West Africa. Founded in the late 11th century as capital of the Mossi empire, it remained the centre of Mossi power until captured by the French in 1896. Industries: handicrafts, textiles, food processing, groundnuts, vegetable oil. Pop. (1985) 442,223. **ouzel** (ousel) Heavy-bodied bird found in the mountains of Asia, Europe and the Western Hemisphere. The ring ouzel

Asia, Europe and the Western Hemisphere. The ring ouzel (*Turdus torquatus*) has black plumage, with a white chest collar. Family Turdidae.

ovary In biology, part of a multicellular animal or a flowering plant that produces egg cells (ova), the female reproductive cells; in vertebrates it also produces female sex hormones. In women there is an ovary on each side of the UTERUS. Controlled by the PITUITARY GLAND, each ovary produces OESTROGEN and PROGESTERONE, which control the functioning of the female reproductive system. In flowering plants, the female sex cells are contained within structures called ovules inside the ovary. After fertilization the ovules develop into seeds, and the ovary develops into fruit. *See also* HORMONES; MENSTRUAL CYCLE

overfishing Practice of catching too many marine creatures for an ecological balance to be maintained. It remains an international problem largely because of the inability of marine law to regulate the fish catch and WHALING.

Overseas Development Administration (ODA)
Department of the British Foreign and Commonwealth
Office that assigns development aid to other countries and
contributes to the European Development Fund and other aid
agencies including charities. It is also responsible for the
training and dispatch of technical specialists.

overture Instrumental prelude to an opera or operetta; the term now also includes an orchestral composition in its own right, usually lively in character. Famous operatic overtures were composed by Mozart, Rossini and Wagner.

Ovid (43 BC-AD 18) (Publius Ovidius Naso) Roman poet. He was a great success in Rome until, aged 50, he was exiled by AUGUSTUS. His works include *Amores*, short love poems; *Ars Amatoria*, amusing instructions on how to seduce women; and *Metamorphoses*, a retelling of Greek myths.

ovule In seed-bearing plants, part of the reproductive organ that contains an egg cell or OVUM and develops into a seed after fertilization. In ANGIOSPERMS, ovules develop inside an

fertilized ovum to pass down the Fallopian tube and implant itself in the uterine lining, the endometrium. Within hours of conception, mitosis begins with the development of a sphere of an increasing number of cells; the sphere starts as the blastomere (1), develops into the morula (2) of about 64 cells At this stage, it changes into a hollow, fluid-containing ball blastocyst (3) - with the inner cell mass at one end. It can now begin implantation (4). By the ninth day after conception the blastocyst has sunk deep into the endometrium (5) and is already receiving nutrition from the mother.

It takes about a week for the

OVARY. In GYMNOSPERMS, ovules are borne on the inner surface of the cone without any covering.

ovum (egg cell) Female GAMETE produced in an OVARY. After FERTILIZATION by SPERM it becomes a ZYGOTE, which is capable of developing into a new individual.

Owen, Robert (1771–1858) Welsh industrialist and social reformer. He believed that better conditions for workers would lead to greater productivity. He put these beliefs into practice at his textile mills in Scotland. He also attempted to establish a self-contained cooperative community in New Harmony, Indiana (1825–27). His ideas provided the basis for the COOPERATIVE MOVEMENT.

Owen, Wilfred (1893–1918) British war poet. His World War 1 poems, which include "Strange Meeting", "Anthem for Doomed Youth" and "Dulce et Decorum Est", are a searing indictment of war. After Owen's death in action, Siegfried SASSOON arranged for their publication.

Owens, Jesse (1913–80) US black athlete. Owens broke several world records for jumping, hurdling and running (1935–36). At the 1936 Olympics in Berlin he won four gold medals, angering Adolf Hitler, who was keen to use the Games as a political demonstration of Aryan superiority.

owl Bird that is found worldwide, except at extreme latitudes. Owls have round heads, hooked bills, large eyes and long, curved talons. Most are nocturnal, and feed on s.mall birds and mammals. Order Strigiformes.

ox Domesticated cattle of the genus *Bos*. The term is specifically applied to castrated males used as draught animals. Many varieties of wild cattle are sometimes called wild oxen. **oxalic acid** Poisonous, colourless crystalline organic acid (C₂H₂O₄) whose salts occur naturally in some plants, such as sorrel and rhubarb. It is used for metal and textile cleaning and in tanning. Properties: m.p. 101.5°C (214.7°F).

oxbow lake Crescent-shaped section of a river channel that no longer carries the main discharge of water. It is formed by contact at the neck of a meander loop, leaving the loop abandoned as stagnant water and silty marsh.

Oxfam British charity formed in 1948. It attempts to alleviate suffering due to poverty or natural disaster in all parts of the world. Nearly 75% of Oxfam's overseas budget is devoted to long-term projects, including agriculture, family planning and medicine.

Oxford City and county district in s central England, on the River Thames; the county town of Oxfordshire. Established as a trading centre and fort, it was raided by the Danes in the 10th and 11th centuries. During the English Civil War the city was a Royalist stronghold. Industries: motor vehicles, steel products, electrical goods, printing and publishing. Pop. (1991) 110,113. Oxford, University of Oldest university in Britain. It developed from a group of teachers and students who gathered in Oxford in the 12th century. The first colleges, University, Balliol and Merton, were founded between 1249 and

▲ Oxford Dating from the mid-12th century, Oxford University is one of the most venerable institutions of higher learning in Europe. It is organized as a collection of self-contained, autonomous residential colleges, each employing its own teachers and enrolling its own students. The first three colleges were founded in the mid-13th century; Christ Church College, shown here, was established in 1546.

1264. The colleges quickly increased in number and became almost autonomous. Women were not admitted until 1878.

Oxford Movement Attempt by some members of the CHURCH OF ENGLAND to restore the ideals of the pre-REFORMATION Church. It lasted from c.1833 to the first decades of the 20th century. The main proponents were John Keble, Edward Pusey and John NEWMAN. The aims and ideals of the movement live on in Anglo-Catholicism.

Oxfordshire County in s central England, bounded in the NW by the COTSWOLDS and in the SE by the Chilterns, and drained by the River THAMES. The county town is OXFORD. The county was the scene of fighting during the Civil War period. It lies mostly within the Thames basin. Its economy is based on agriculture, with sheep and arable farming, dairying and beef production. Industries: motor vehicles, pressed steel, light engineering. Area: 2,611sq km (1,008sq mi). Pop. (1991) 547,584. Oxidation-reduction (redox) Chemical reaction involving simultaneous oxidation (a loss of one or more electrons by an atom or molecule) and reduction (a gain of those electrons by another atom or molecule). Oxidation-reduction reactions are important in many biochemical systems.

oxide Any inorganic chemical compound in which OXYGEN is combined with another element. Oxides are often formed by burning the element in air or oxygen.

oxygen (symbol O) Common gaseous element that is necessary for the RESPIRATION of plants and animals and for combustion. Oxygen, colourless and odourless, is the most abundant element in the Earth's crust (49.2% by weight) and is a constituent of water and many rocks. It is also present in the atmosphere (23.14% by weight). It can be obtained by the ELECTROLYSIS of water or fractional distillation of liquid air. It is used in apparatus for breathing (oxygen masks) and resuscitation (oxygen tents); liquid oxygen is used in rocket fuels. It is chemically reactive, and forms compounds with nearly all other elements (especially by oxidation). Properties: at.no. 8; r.a.m. 15.9994; r.d. 1.429; m.p. -218.4°C; (-361.1°F); b.p. -182.96 °C; (-297.3°F); most common isotope O¹⁶ (99.759%). See also OXIDATION-REDUCTION; OZONE

oxygen debt Insufficient supply of oxygen in the muscles following vigorous exercise. This reduces the breakdown of food molecules that generate energy, causing the muscles to overproduce lactic acid creating a sensation of fatigue and sometimes muscular cramp. Automatic rapid breathing after exercise creates extra oxygen.

oxytocin Hormone produced by the posterior PITUITARY GLAND in women during the final stage of pregnancy. It stimulates the muscles of the UTERUS, initiating the onset of labour and maintaining contractions during childbirth. It also stimulates lactation.

oyster Edible BIVALVE mollusc found worldwide in temperate and warm seas. The European flat, or edible, oyster *Ostrea edulis* occurs throughout coastal waters. The pearl oyster (*Pinctada fucats*) is used to produce cultured pearls.

oystercatcher Seashore bird with a strikingly marked black-and-white stocky body and bright orange legs and beak. Oystercatchers feed on molluses, prying them open with their long beaks. Length: 43cm (17in). Family Haematopodidae; typical genus *Haematopus*.

ozone Unstable, pale-blue, gaseous allotrope of OXYGEN, formula (O³). It has a characteristic pungent odour and decomposes into molecular oxygen. It is present in the atmosphere, mainly in the OZONE LAYER. Prepared commercially by passing a high-voltage discharge through oxygen, ozone is used as an oxidizing agent in bleaching, air-conditioning and purifying water. See also ALLOTROPY

ozone layer Region of Earth's atmosphere in which ozone (O₃) is concentrated. It is densest at altitudes of 21–26km (13–16mi). Produced by ultraviolet radiation in incoming sunlight, the ozone layer absorbs much of the ultraviolet, thereby shielding the Earth's surface. Aircraft, nuclear weapons and some aerosol sprays and refrigerants yield chemical agents that can break down high-altitude ozone, which could lead to an increase in the amount of harmful ultraviolet radiation reaching the Earth's surface. *See also* CHLOROFLUOROCARBON (CFC)

▲ ozone A naturally occurring substance, ozone acts as a sunscreen for the Earth because its molecules absorb the Sun's ultraviolet radiation (1). The presence of chlorofluorocarbon pollution (2) causes the layer to break down allowing ultraviolet rays through. Ozone is created when ultraviolet rays split oxygen molecules. The lone oxygen atoms (3) bond with oxygen molecules (4) to make ozone (5). When, however, chlorofluorocarbons are present, they are split by the ultraviolet rays. The released chlorine atom (6) in turn splits ozone molecules to form a chlorine monoxide molecule (7) and oxygen. The process is continued as the chlorine monoxide absorbs the lone oxygen atoms that previously formed ozone. This frees the chlorine atom which splits another ozone molecule (8) creating another chlorine monoxide molecule and oxygen.

P/p, the 16th letter of the English alphabet and a letter employed in the alphabets of other W European languages. It is a consonant and descends from the Semitic letter pe, a word meaning "mouth". The letter was modified in shape by the Greeks and taken into their alphabet as pi. The letter is nearly always sounded, as in pig and top, although it is "silent" in a few words, such as psychology or pneumatic. Combined with h it is pronounced like an f, as in phase and epitaph.

paca (spotted cavy) Shy, nocturnal, tail-less RODENT of South America; it is brown with rows of white spots and has a relatively large head. A burrow-dweller, it feeds mainly on leaves, roots and fruit. Length: to 76cm (30in). Family Dasyproctidae; species *Cuniculus paca*.

pacemaker (sino-atrial node) Specialized group of cells in the vertebrate heart that contract spontaneously, setting the pace for the heartbeat itself. If it fails it can be replaced by an artificial pacemaker, an electronic unit that stimulates the heart by means of tiny electrical impulses.

Pacific Ocean Largest and deepest ocean in the world, covering c.33% of the Earth's surface and containing more than 50%of the Earth's seawater. The Pacific extends from the Arctic Circle to Antarctica, and from North and South America in the E to Asia and Australia in the w. The E Pacific region is connected with the Cordilleran mountain chain, and there is a narrow CONTINENTAL MARGIN. The ocean is ringed by numerous volcanoes, known as the Pacific Ring of Fire. There are a number of large islands in the Pacific, most of which are in the s and w. The major ones are New Zealand, and the Japan and Malay archipelagos. The principal rivers that drain into the ocean are the COLUMBIA in North America and the HUANG HE and YANGTZE in Asia. The average depth of the Pacific is 4,300m (14,000ft). The greatest-known depth is that of the Challenger Deep (sw of Guam in the Mariana Trench), which has a depth of 11,033m (36,198ft). The current pattern of the Pacific is made up of two gyres: N of the equator are the North Equatorial Current, the Kuroshio Current, the North Pacific Drift and the California Current; s of the equator are the South Equatorial Current, the East Australian Current and the Humboldt Current. The Equatorial Counter Current separates the two gyres. Most fishing in the Pacific Ocean is done on the continental margins. Crab, herring, cod, sardine and tuna are the principal catch. Area: c.166,000,000sq km (64,000,000sq mi).

Pacino, Al (Alberto) (1940–) US film actor. He studied method acting at Lee STRASBERG's Actors' Studio, and made his film debut in *Me*, *Natalie* (1969). He appeared three times (1972, 1974 and 1990) in his famed role as Michael Corleone (in *The Godfather* and its two sequels), for which he received two of his several Academy Award nominations. He finally won a Best Actor Academy Award for *Scent of a Woman* (1992). Other films include *Serpico* (1973), *Dog Day Afternoon* (1975), *Scarface* (1983) and *Donnie Brasco* (1996). His directorial debut was *Looking for Richard* (1996).

paddlefish Primitive bony fish related to the sturgeon and found in the basins of the Mississippi and Yangtze rivers. Blue, green or grey, it has a cartilaginous skeleton and a long paddle-like snout. Length: 1.8m (6ft). Family Polyodontidae. Paderewski, Ignacy Jan (1860–1941) Polish pianist, composer and statesman. He wrote a piano concerto (1888) and a symphony (1907), and his opera *Manru* was first produced in Dresden in 1901. He became prime minister and minister of foreign affairs of the newly created Polish state in 1919.

Padua (Padova) City in Veneto region, NE Italy. The city is first mentioned (as Patavium) early in the 4th century BC. In the Middle Ages it was a flourishing artistic centre. It came under Venetian control in 1405. In 1815 it passed to Austria, and took a leading part in the movement for Italian independence. The city is renowned for its art treasures. Industries: motor vehicles, textiles, machinery, electrical goods. Pop. (1991) 215,137.

paediatrics Medical speciality devoted to the diagnosis and treatment of disease and injury in children. Specialists in this

field require a thorough knowledge not only of a wide range of conditions peculiar to children, but also of normal childhood development and the ways in which it may affect treatment and recovery.

Paganini, Niccolò (1782–1840) Italian violinist, the most famous virtuoso of his day. He enlarged the range of the violin by exploiting harmonics and mastered the art of playing double and triple stops (two or three notes at a time).

Pagnol, Marcel (1894–1974) French author, playwright and film director. He wrote *Topaze* (1928), and the trilogy *Marius* (1929), *Fanny* (1931) and *César* (1937). Most of his films were comedies or screen versions of his own plays. His popularity was revived with the films *Jean de Florette*, *Manon des Sources* (both 1986) and *My Father's Glory* (1990).

pagoda Eastern temple in the form of a multi-storeyed, tapering tower. The basic design is either square or polygonal, and each storey is a smaller replica of the one beneath. The storeys often have wide, overhanging roofs, and the buildings are usually made of wood, brick or stone. Pagodas originated in India and spread with the diffusion of BUDDHISM to China, Korea and Japan.

Pahlavi, Muhammad Reza Shah (1919–80) Shah of Iran (1941–79). He encouraged rapid economic development and social reforms. The westernization of Iran, combined with a repressive regime and worsening social inequalities, aroused strong discontent among religious fundamentalists and others. In 1979 a theocratic revolution, led by Ayatollah Khomeini, forced him into exile. He died in Egypt.

pain Unpleasant sensation signalling actual or threatened tissue damage as a result of illness or injury; it can be acute (severe but short-lived) or chronic (persisting for a long time). Pain is felt when specific nerve endings are stimulated. According to the "gate theory", pain signals must pass through a gating mechanism in the SPINAL CORD in order to be transmitted onwards to the brain; this "gate" can be shut by the use of other stimuli that block entry of the pain messages. First advanced in 1965, the gate theory has influenced the study and management of pain ever since. Pain is treated in a number of ways, most commonly by drugs known as ANALGESICS.

Paine, Thomas (1737–1809) Anglo-American revolutionary political writer. He emigrated from England to Pennsylvania in 1754. His pamphlet *Common Sense* (1776) demanded independence for the North American colonies. He returned to England in 1787 and published *The Rights of Man* (1791–92), a defence of the French Revolution. Accused of treason, he fled to France in 1792. He became a French citizen and was elected to the National Convention, but later imprisoned (1793–94). He returned to the USA in 1802.

paint Coating applied to a surface for protective, decorative or artistic purposes. Paint is composed of PIGMENT (colour) and a liquid vehicle (binder or medium) that suspends the pigment, adheres to a surface and hardens when dry. Pigments are made of metallic compounds, usually oxides, or synthetic materials. Vehicles may be oils, water mixed with a binding agent, organic compounds or synthetic RESINS, which may be soluble in water or oil.

Painted Desert Barren high plateau region in N central Arizona, USA, E of the Colorado and Little Colorado rivers. Erosion and heat have exposed bands of red and yellow sediment and bentonite clay. Area: c.19,400sq km (7,500sq mi).

painting Art of using one or more colours, generally mixed with a medium (such as oil or water) and applied to a surface with a brush, finger or other tool to create pictures. Paintings are among the earliest of historical records. Painting in early civilizations, such as Egypt, was largely a matter of filling in with colour areas outlined by drawing. Little Greek painting survives (apart from that on pottery). The Romans were greatly influenced by Greek art, as the fine FRESCO paintings at Pompeii and Herculaneum demonstrate. In the early Christian and Byzantine periods, traditions in mural painting and manuscript ILLUMINATION were established that were to last throughout the Middle Ages. When the humanist ideals of the RENAISSANCE took root in S Europe, the range of subjects and techniques available to the artist widened enormously. The period also saw the first use of oil paint on canvas, the begin-

▶ paca Found in tropical America, the paca (Cuniculus paca) is a shy rodent that lives in forests near water. It can reach a length of up to 76cm (30in) and an adult can weigh up to 10kg (20lb).

nings of GENRE PAINTING and pure portraiture. It was also the age of PERSPECTIVE and of a more natural approach to form and composition. To this creative legacy the great painters of the BAROQUE period added an unrivalled bravura brushwork and drama of vision. North of the Alps the Renaissance had spread more gradually than in Italy. The 17th-century Dutch painters' choice of intimate, everyday subjects was the antithesis of the grand manner characteristic of the Italian masters. By the 18th century British painters had become established in portraiture, animal and landscape painting, although overshadowed by the great Venetian masters. The 19th century opened with the supremacy of NEO-CLASSICISM challenged by the new ROMANTICISM. Both schools were superseded, first by IMPRESSIONISM and then by a succession of new movements in the late 19th and early 20th centuries. Most of these movements - impressionism, POST-IMPRESSION-ISM, SYMBOLISM, FAUVISM, CUBISM, DADA and SURREALISM originated in Paris. Germany was the cradle of EXPRESSIONISM and Russia contributed SUPREMATISM. In the latter half of the 20th century, the USA has produced many original movements, such as ABSTRACT EXPRESSIONISM, POP ART and OP ART. Paiute Shoshonean-speaking tribe of Native North Americans. They are divided into two major groups: the Southern Paiute (or "Digger Indians" during the Gold Rush days) who occupied w Utah, N Arizona, SE Nevada and California; and the Northern Paiute (or "Snake Indians", Mono-Paviotso) who inhabited w Nevada, s Oregon and E California. Today the Paiute number some 4,000.

Pakistan Republic in s Asia. *See* country feature, page 506 **palaeobotany** Study of ancient plants and pollen that have been preserved by carbonization, waterlogging or freezing. Some plants have been preserved almost intact in frozen soils and in AMBER.

Palaeocene Geological epoch that extended from about 65 to 55 million years ago. It is the first epoch of the TERTIARY period, when the majority of the DINOSAURS had disappeared and the small early mammals were flourishing.

Palaeolithic (Old Stone Age) Earliest stage of human history, from *c*.2 million years ago until between 40,000 and 10,000 years ago. It was marked by the use of stone tools. It covers the evolution of humans from *Homo habilis* to *Homo sapiens*.

Palaeolithic art Art from the PALAEOLITHIC period. Typical works are realistic cave paintings of bison, deer and hunting scenes. The best-known surviving examples are at ALTAMIRA and LASCAUX. Other forms include portable art, such as carved animals and figurines made from stone, bone and antler.

palaeomagnetism Study of changes in the direction and intensity of Earth's MAGNETIC FIELD through GEOLOGICAL TIME. This is important in the investigation of the theory of CONTINENTAL DRIFT. Since the "magnetic memory" of rocks is measurable, this determines their orientation in relation to magnetic north at the time they solidified. The EARTH's polarity has reversed at least 20 times in the past 4–5 million years; earlier changes cannot at present be determined.

palaeontology Study of the fossil remains of plants and animals. Evidence from fossils is used in the reconstruction of ancient environments and in tracing the evolution of life.

Palaeozoic Second era of geological time, after the PRE-CAMBRIAN era, lasting from 590 million to 248 million years ago. It is sub-divided into six periods: Cambrian, Ordovician, Silurian, Devonian, Carboniferous and Permian. Invertebrate animals evolved hard skeletons capable of being preserved as fossils in the Cambrian; fish-like vertebrates appeared in the Ordovician; amphibians emerged in the Devonian; and reptiles in the Carboniferous.

palate Roof of the mouth, comprising the bony front part known as the hard palate, and the softer fleshy part at the back, known as the soft palate.

Palatinate Historic state of the Holy Roman Empire, including the present German state of Rhineland-Palatinate and parts of adjacent states. It was ruled from 1156 by the counts palatine. It was a centre of the German Reformation and was a major battleground in the 17th century.

Palermo City and seaport on the Tyrrhenian Sea, NW Sicily, Italy; capital of Sicily. Palermo was founded by the Phoeni-

cians in the 8th century BC. It passed to the Romans in 254 BC, and came under Byzantine control in the 6th century AD. From the 9th to 11th centuries it prospered under Arab rule. Captured by the Normans in 1072, it was briefly capital of the Kingdom of Sicily. Palermo subsequently came under Spanish, then Austrian rule. It was the scene of the outbreak of the 1848 revolution in Italy and was captured by Giuseppe GARIBALDI in 1860. Industries: shipbuilding, textiles, food processing, chemicals, tourism. Pop. (1991) 698,556.

Palestine Territory in the Middle East, on the E shore of the Mediterranean Sea; considered a Holy Land by Jews, Christians and Muslims. Palestine has been settled continuously since 4000 BC. The Jews moved into Palestine from Egypt c.2000 BC but were subjects of the Philistines until 1020 BC, when SAUL, DAVID and SOLOMON established Hebrew kingdoms. The region was then under Assyrian and, later, Persian control before coming under Roman rule in 63 BC. In succeeding centuries Palestine became a focus of Christian pilgrimage. It was conquered by the Muslim Arabs in 640. In 1099 Palestine fell to the Crusaders, but in 1291 they in turn were routed by the MAMELUKES. The area was part of the OTTOMAN EMPIRE from 1516 to 1918, when British forces defeated the Turks at Megiddo. Jewish immigration was encouraged by the BALFOUR DECLARATION. After World War 1 the British held a League of Nations mandate over the land w of the River Jor-DAN (now once again called Palestine). Tension between Jews and the Arab majority led to an uprising in 1936. World War 2 and Nazi persecution brought many Jews to Palestine, and in 1947 Britain, unable to satisfy both Jewish and Arab aspirations, consigned the problem to the United Nations. The UN proposed a plan for separate Jewish and Arab states. This was rejected by the Arabs, and in 1948 (after the first of several ARAB-ISRAELI WARS) most of ancient Palestine became part of the new state of ISRAEL; the GAZA STRIP was controlled by Egypt and the WEST BANK of the River Jordan by JORDAN. These two areas were subsequently occupied by Israel in 1967. From the 1960s, the PALESTINE LIBERATION ORGANIZA-TION (PLO) led Palestinian opposition to Israeli rule, which included acts of terrorism and an uprising in the occupied territories. In 1993 Israel reached an agreement with the PLO, and in 1994 the Palestine National Authority took over nominal administration of the Gaza Strip and West Bank.

Palestine Liberation Organization (PLO) Organization of Palestinian parties and groups, widely recognized as the representative of the Palestinian people. It was founded in 1964 with the aim of dissolving the state of Israel and establishing a Palestinian state to enable Palestinian refugees to return to their ancestral land. Many of its component guerrila groups were involved in political violence against Israel and, in the 1970s, in acts of international terrorism to further their cause. Dominated by the al-Fatah group led by Yasir ARAFAT, in 1974 the PLO was recognized as a government in exile by the Arab League and the United Nations. In the early 1990s, PLO representatives conducted secret negotiations with Israel, culminating in a peace agreement signed in 1993. See also GAZA STRIP; PALESTINE; WEST BANK

Palestrina, Giovanni Pierluigi da (1525-94) Italian

■ pagoda A typical Chinese pagoda is built on a stone podium (1). The wooden hall has a twostorey elevation covered by a single hipped roof (2). The first storey is overhung by shallow eaves (3), which are supported by bracketing, as is the balcony (4). Divided into five bays, doors occupy the centre three bays (5) which are left open on the upper storey (6). The fabric of the roof is wood; it is insulated with mud and tiled. The interior has a gallery (7) on each storey around the central wall which is the full height of the temple.

Pakistan's flag was adopted in 1947, when the country became independent from Britain. The colour green, the crescent Moon and the five-pointed star are all traditional symbols of Islam. The white stripe represents the other religions in Pakistan.

HISTORY AND POLITICS

The Indus Valley civilization developed c.4,500 years ago. Waves of invaders later entered the area. The Kushans conquered the entire region in the 2nd century AD. Arabs conquered Sind in 712 and introduced Islam. In 1206 Pakistan became part of the Delhi Sultanate. In 1526 the Sultanate was replaced by the MOGUL EMPIRE, which introduced URDU. In the late 18th century Ranjit Singh conquered the Punjab and introduced Sikhism. The early 19th century saw the emergence of the British East India Company as a dominant force. The British conquered Sind (1843) and Punjab (1849). Much of Baluchistan was conquered in the 1850s. Pathans in the NW resisted subjection, and the British created a separate province in 1901. The dominance of Hindus in British India led to the formation of the MUSLIM LEAGUE (1906). In the 1940s the League's leader, Muhammad Ali JIN-NAH, gained popular support for the idea of a separate state of Pakistan (Urdu, "land of the pure") in Muslim-majority areas. British India achieved independence in 1947 and was partitioned into India and Pakistan. The resulting mass migration and communal violence claimed over 500,000 lives. In 1947 the longstanding war with India over Kashmir began.

AREA: 796,100sq km (307,374sq mi) POPULATION: 115,520,000

CAPITAL (POPULATION): Islamabad (201,000)
GOVERNMENT: Federal republic

ETHNIC GROUPS: Punjabi 60%, Sindhi 12%, Pushtun 13%, Baluch, Muhajir LANGUAGES: Urdu (official)

RELIGIONS: Islam 97%, Christianity, Hinduism CURRENCY: Pakistan rupee = 100 paisa

he Islamic Republic of Pakistan is divided into the four provinces of BALUCHISTAN, NORTH-WEST FRONTIER PROVINCE, PUNJAB and SIND. The mountains of the HINDU KUSH extend along the NW border with Afghanistan. In N Pakistan lies the disputed territory of KASHMIR. This mountainous region is occupied by Pakistan but claimed by India. It contains the world's second highest-peak, K2, at 8,611m (28,251ft), in the KARAKORAM range. At the foot of the mountains lies Pakistan's capital, ISLAMABAD, and the city of RAWALPINDI. The Punjab plains ("land of the five rivers") are drained by the River INDUS and its four main tributaries (Jhelum, Beas, Ravi and Sutlei). LAHORE lies on the border with India. The alluvial plain continues into Sind, which includes HYDERABAD and KARACHI (Pakistan's major port). Baluchistan is an arid plateau region.

CLIMATE

Most of Pakistan has hot summers and cool winters. Rainfall is sparse, except in the monsoon season (June-October).

VEGETATION

Forests grow on mountain slopes, but most of Pakistan is covered by dry grassland.

Gilgit E CHINA

Gilgit E CHINA

Gilgit E CHINA

AFGHANISTAN

Peshawar AISHAMADAI

AND SAHMIR

AND SAHMIR

Salvot

Salvot

Garpanwala

Rawaland

Jhelum

Salvot

Salvot

Charle

Salvot

Jinnah became Pakistan's first governor-general. Muslim Pakistan was divided into two parts: East Bengal and West Pakistan, more than 1,600km (1,000mi) apart. Pakistan was faced with enormous political and administrative problems. In 1955 East Bengal became East Pakistan, and in 1956 Pakistan became a republic within the Commonwealth of Nations. General Muhammad Ayub Khan led a military coup in 1958, and in 1960 established presidential rule. His dictatorship brought constitutional changes, but failed to satisfy East Pakistan's claim for greater autonomy. The pro-independence Awami League won a landslide victory in 1970 East Pakistan elections. In 1971 East Pakistan declared independence BANGLADESH. West Pakistani troops invaded. The ensuing civil war killed hundreds of thousands of people, and millions fled to India. India sent troops to support Bangladesh. West Pakistan was forced to surrender and Zulfikar Ali BHUTTO assumed control. In 1977 a military coup, led by General Zia-ul-Haq, deposed Bhutto. In 1978 General Zia proclaimed himself president and Bhutto was hanged for murder. During the 1980s Pakistan received US aid for providing a safe haven for Mujaheddin fighters in the war in Afghanistan. In 1985 Zia ended martial law. In 1988 Zia dismissed parliament, but died shortly after in a mysterious plane crash. The Pakistan People's Party (PPP) won the ensuing elections and Benazir BHUTTO, daughter of Zulfikar, became president. Charged with nepotism and corruption, she was removed from office in 1990. The ensuing election was won by the Islamic Democratic Alliance, led by Nawaz Sharif. In 1991 Islamic law was given precedence over civil law. Sharif also faced charges of corruption and lost the 1993 elections to Benazir Bhutto. In 1994 civil disorder flared in Sind, inspired by a militant campaign for an autonomous Karachi province. Bhutto was again dismissed on corruption charges in 1996. Political disenchantment saw a low turnout in 1997 elections and a landslide victory for Nawaz Sharif.

ECONOMY

Pakistan is a low-income developing country (1992 GDP per capita, US\$2,890). The economy is based on agriculture, which employs c.47% of the workforce. Pakistan has one of the world's largest irrigation systems. It is the world's third-largest producer of wheat. Other crops include cotton, fruits, rice and sugar cane. Electricity is produced at massive hydroelectricity plants. Pakistan produces natural gas and coal, as well as iron ore, chromite and stone. Manufacturing has developed post-independence. Major products include clothing and textiles. Small-scale craft industries, such as carpets, are also important.

composer who spent most of his life in the service of the church. He wrote masses, magnificats, litanies and about 600 motets in four to eight or twelve parts. The six-part mass Assumpta est Maria and the eight-part setting of the motet Stabat Mater are examples of polyphonic and rhythmic mastery, melodic balance and proportion.

Palladianism Architectural style especially popular in England, derived from the work of Andrea Palladio. Based on Roman Classicism, it emphasized symmetrical planning and harmonic proportions. Inigo Jones introduced Palladianism to England after visiting Italy (1613–14). There was a revival of interest in Palladianism in the early 18th century.

Palladio, Andrea (1508–80) Italian RENAISSANCE architect. He studied Roman architecture and published his own designs and drawings of Roman ruins in *Four Books of Architecture* (1570). *See also* PALLADIANISM

palladium (symbol Pd) Shiny silver-white metallic element of the TRANSITION ELEMENTS. It was discovered in 1803 by the English chemist William Wollaston. Malleable and ductile, palladium is found in nickel ores associated with platinum, to which it is chemically similar. It does not tarnish or corrode and is used for electroplating, surgical instruments, dentistry, jewellery and for catalytic converters for cars. Properties: at.no. 46; r.a.m. 106.4; r.d. 12.02; m.p. 1,552°C (2,826°F); b.p. 3,140°C (5,684°F); most common isotope Pd¹⁰⁶ (27.3%). palm Member of a family of trees found in tropical and subtropical regions. Palms have a woody, unbranched, trunk with a crown of large, stiff leaves. The leaves may be palmate (fan-like) or pinnate (feather-like). Instead of having true bark, palm trunks are covered with fibres that are often derived from the leaf stems. Palms are the source of wax, oil, fibres, sugar and other foods. Height: 60m (200ft). Family Arecacae/Palmae.

Palma (Palma de Mallorca) City and seaport in Spain, in W Majorca (Mallorca) Island; capital of the BALEARIC ISLANDS. Under Roman rule from the 2nd century BC, Palma later became part of Byzantium before falling to the Arabs in the 8th century. Conquered by James I of Aragon in the 13th century, it was finally united with Spain in 1469. Industries: tourism, pottery, glasswork, leather goods, jewellery, wine, food processing. Pop. (1991) 296,754.

Palmer, Arnold Daniel (1929–) US golfer. He won the US Open Championship in 1960, the British Open in 1961 and 1962, and the Masters tournament in 1958, 1960, 1962 and 1964. He continued playing top golf well into the 1980s. Palmer, Samuel (1805–81) British Romantic landscape painter and graphic artist, the most important follower of William Blake. He enjoyed his most productive period at Shoreham, Kent (1826–35), where he was the focal point for a group of artists called the Ancients.

Palmerston, Henry John Temple, 3rd Viscount (1784–1865) British statesman. He was a dominant influence on foreign affairs, 1830–65. He vigorously upheld British interests abroad, initiating the OPIUM WAR to help British merchants. At the same time he supported liberal and nationalist causes in Europe, such as the RISORGIMENTO in Italy. At home, he was an opponent of political reform.

Palm Sunday In the Christian year, the Sunday before Easter. Palm Sunday commemorates JESUS CHRIST'S triumphal entry into Jerusalem, when the people spread palm branches before him. It also marks the beginning of Holy Week, the period of days commemorating his betrayal, trial and crucifixion.

Palmyra (Tadmur, City of Palms) Ancient oasis city, in the Syrian Desert. By the 1st century BC it had become a city-state by virtue of its control of the trade routes between Mesopotamia and the Mediterranean. In *c*. AD 30 the city-state became a Roman dependency under local rule. By the 2nd century AD Palmyra's influence had spread to Armenia. In 267 ZENOBIA became queen, the empire expanded and she severed the state's links with Rome. In AD 273 the Roman emperor Aurelian laid waste to the city, which was afterwards largely forgotten. Today tourists visit its extensive ruins.

Palo Alto, Battle of (May 1846) First battle of the Mexican War, fought near Brownsville, Texas. US General Zachary Taylor defeated a Mexican force under Mariano

Arista. US casualties were minimal, though the Mexicans lost several hundred men.

Palomar, Mount Peak in s California, USA, 72km (45mi) NNE of San Diego. It is the site of the Palomar Observatory, which houses the 122-cm (48-in) Schmidt telescope and a 508-cm (200-in) reflecting telescope. Palomar is administered jointly with Mount Wilson Observatory as the Hale Observatories. Pamirs Mountainous region in central Asia, lying mostly in Tajikistan and partly in Pakistan, Afghanistan and China. The region forms a geological structural knot from which the TIAN SHAN, KARAKORAM, Kunlun and HINDU KUSH mountain ranges radiate. The climate is cold during winter and cool in summer; the terrain includes grasslands and sparse trees. The main activity is sheep herding, and some coal is mined. The highest peak is KOMMUNIZMA PIK, at 7,495m (24,590ft).

pampas grass Species of tall, reed-like GRASS native to South America and widely cultivated in warm parts of the world as a lawn ornamental. Female plants bear flower clusters, 91cm (3ft) tall, which are silvery and plume-like. Family Poaceae/Gramineae; species *Cortaderia selloana*.

Pamplona Ancient city in N Spain; capital of Navarre province. In 68 BC it was rebuilt by POMPEY, and in AD 778 the city was conquered by CHARLEMAGNE. In the 11th century it was made capital of the kingdom of Navarre. In 1512 control of Pamplona passed to Ferdinand of Aragon, who united Navarre with Castile. During the PENINSULAR WAR, Pamplona was captured from the French by the Duke of Wellington (1813). The festival of San Fermin is celebrated with bull-running in the streets. Industries: rope and pottery manufacture, papermaking, flour and sugar milling. Pop. (1991) 179,251.

Pan In Greek mythology, the god of woods and fields, shepherds and their flocks. He is depicted with the horns, legs and hooves of a goat. A forest dweller, he pursued and loved the DRYADS and led their dances while playing the syrinx, the reed pipes that were his invention.

Pan-Africanism Historical political movement for the unification and independence of African nations. It began officially at the Pan-African Congress of 1900 in London, organized by western black leaders. It met five times between 1900 and 1927 and worked to bring gradual self-government to African colonial states. In 1945 the Pan-African Federation convened the sixth congress, attended by many future leaders of post-colonial Africa. It demanded autonomy and independence for African states. As independence was gained, the movement broke up and was eventually replaced by the Organization of African Unity (OAU), formed in 1963.

▲ Palladio The Redentore, Venice (1577–92), is a superb example of Italian architect Andrea Palladio's work. The whole church is raised on a podium, has a choir separated from the chancel (Palladio's innovation), an absolute minimum of non-architectural ornament, and a light, spacious interior. It was financed by the Venetian state, in fulfilment of a vow on deliverance of the city from the plague of 1575–76.

▲ pampas grass Native to Argentina, pampas grass (Cortaderia argentea) was originally grown to provide food for grazing animals. More recently, it has been grown extensively as an ornamental plant in gardens.

PANAMA

AREA: 77,080sq km (29,761sq mi)
POPULATION: 2,515,000
CAPITAL (POPULATION):

Panama City (584,803)
GOVERNMENT: Multiparty
republic
ETHNIC GROUPS: Mestizo 60%,
Black and Mulatto 20%, White

10%, Native American 8%,

Asian 2%
LANGUAGES: Spanish (official)
RELIGIONS: Christianity
(Roman Catholic 84%,
Protestant 5%), Islam 5%
CURRENCY: Balboa = 100 cents

Panama Republic on the Isthmus of Panama, connecting Central and South America; the capital is PANAMA CITY. Land and climate The narrowest part of Panama is less than 60km (37mi) wide. The PANAMA CANAL cuts across the isthmus. The Canal has given Panama great international importance, and most Panamanians live within 20km (12mi) of it. Most of the land between the Pacific and Caribbean coastal plains is mountainous, rising to 3,475m (11,400ft) at the volcano Barú. Panama has a tropical climate, though the mountains are much cooler than the coastal plains. The rainy season is between May and December. The Caribbean side of Panama has about twice as much rain as the Pacific side. Tropical forests cover c.50% of Panama. Mangrove swamps line the coast. Subtropical woodland grows on the mountains, while tropical savanna occurs along the Pacific coast. Economy The Panama Canal is a major source of revenue, generating jobs in commerce, trade, manufacturing and transport. After the Canal, the main activity is agriculture, which employs 27% of the workforce. Rice is the main food crop. Bananas, shrimps, sugar and coffee are exported. Tourism is also important. Many ships are registered under Panama's flag, due to its low taxes. History Christopher COLUMBUS landed in Panama in 1502. In 1510 Vasco Núñez de BALBOA became the first European to cross Panama and see the Pacific Ocean. The indigenous population was soon wiped out and Spain established control. In 1821 Panama became a province of Colombia. The USA exerted great influence from the mid-19th century. After a revolt in 1903, Panama declared independence from Colombia. In 1904 the USA began construction of the Panama Canal and established the Panama Canal Zone. Since it was opened in 1914, the status of the Canal has been a feature of Panamanian politics. US forces intervened in 1908, 1912 and 1918 to protect US interests. Panama has been politically unstable throughout the 20th century, with a series of dictatorial regimes and military coups. Civil strife during the 1950s and 1960s led to negotiations with the USA for the transfer of the Canal Zone. In 1977 a treaty confirmed Panama's sovereignty over the Canal, while providing for US bases in the Canal Zone. The USA agreed to hand over control of the Canal on 31 December 1999. In 1979 the Canal Zone was disestablished. In 1983 General Noriega took control of the National Guard and ruled Panama through a succession of puppet governments. In 1987 the USA withdrew its support for Noriega after he was accused of murder, electoral fraud and aiding drug smuggling. In 1988 the USA imposed sanctions. In May 1989 Noriega annulled elections. In December 1989 he made himself president and declared war on the USA. On 20 December 1989 25,000 US troops invaded Panama. Noriega was captured in January 1990 and taken to the USA for trial. Pérez Balladares was elected president in 1994.

Panama Canal Waterway connecting the Atlantic and Pacific oceans across the Isthmus of Panama. A canal, begun in 1882 by Ferdinand de Lesseps, was subsequently abandoned because of bankruptcy. The US government decided to finance the project to provide a convenient route for its warships. The main construction took about ten years to complete, and the first ship passed through in 1914. The 82-km (51-mi) waterway reduces the sea voyage between San Francisco and New York by about 12,500km (7,800mi). Control of the canal passes from the USA to Panama at the end of 1999.

Panama City Capital of Panama, on the shore of the Gulf of Panama, near the Pacific end of the Panama Canal. It was founded by Pedro Arias de Avila in 1519, and was destroyed and rebuilt in the 17th century. It became the capital of Panama in 1903. It developed rapidly after the construction of the Panama Canal in 1914. Industries: brewing, shoes, textile, oil-refining, plastics. Pop. (1990) 584,803.

Pan-American Highway Road system linking s USA, Mexico, Central America and South America. The system includes the Inter-American Highway, which connects Panama and Texas. Work on the Pan-American Highway started in the late 1920s, and the system is still being extended. By 1990, it included more than 47,000km (29,000mi) of roads.

Pan-American Union See Organization of American States (OAS)

Panchen Lama Tibetan Buddhist religious leader who is second in importance to the DALAI LAMA. In 1923 the ninth Panchen Lama fled to China because of disagreements with the Dalai Lama. In 1938 Bskal-bzang Tshe-brtan, a boy of Tibetan parentage, was born in China and later hailed by the Chinese government as the 10th Panchen Lama. When the Dalai Lama fled to India in 1959, the Chinese government officially recognized this Panchen Lama as the true leader of Tibet. In 1964, however, he was stripped of his power. He died in 1989. In May 1995 the Dalai Lama announced from exile that his representatives in Tibet had found the six-yearold successor of the 10th Panchen Lama. The Tibetan boy in question, his family, and a number of monks immediately disappeared, reportedly detained by the Chinese authorities. In December 1995 another Tibetan boy, Gyaincain Norbu, was selected by the Chinese government and enthroned in Beijing as the 11th Panchen Lama. He is not recognized as such by the Tibetan government-in-exile, nor by the majority of the international community. See also TIBETAN BUDDHISM pancreas Elongated gland lying behind the stomach, to the left of the mid-line. It secretes pancreatic juice into the SMALL INTESTINE to aid digestion. Pancreatic juice contains the enzymes AMYLASE, TRYPSIN and lipase. The pancreas also contains a group of cells known as the islets of Langerhans, which secrete the hormones INSULIN and glucagon, concerned with the regulation of blood-sugar level. See also DIABETES panda Two mainly nocturnal mammals of the racoon family.

panda Two mainly nocturnal mammals of the racoon family. The lesser panda, *Ailurus fulgens*, ranges from the Himalayas to w China. It has soft, thick, reddish brown fur, a white face and a bushy tail. It feeds mainly on fruit and leaves, but is also a carnivore. Length: 115cm (46in) overall. The rare giant

▶ panda The giant panda (Ailuropoda melanoleuca) is found in mountain forests in parts of Sichuan, central China, and on the slopes of the Tibetan plateau. It is a rare, solitary animal, which usually lives on the ground, but will climb trees if pursued. They spend about 12 hours a day feeding, mainly on bamboo stems and shoots. It is an endangered species, and pairs have been encouraged to breed in captivity.

panda, *Ailuropoda melanoleuca*, inhabits bamboo forests in China (mainly Tibet). It has a short tail and a dense white coat with characteristic black fur on shoulders, limbs, ears and around the eyes. It eats mainly plant material, particularly bamboo shoots. Length: 1.5m (5ft); weight: 160kg (350lb).

Pandora In Greek mythology, the first woman. She was created on Zeus' orders as his revenge on Prometheus, who had created men and stolen fire from heaven for them. When she opened a great jar she had been ordered by Zeus not to look into, all the evils of the human race flew out. Hope alone remained inside the jar. In later tradition the jar became a box. Pangaea Name for the single supercontinent that formed about 240 million years ago, and which began to break up at the end of the Triassic period. Geologists have reconstructed existing land masses with continental shelves to form models of this supercontinent. See also GONDWANALAND

pangolin (scaly anteater) Any of several species of toothless insectivorous mammals, covered with horny overlapping plates, that live in Asia and Africa. It has short, powerful forelegs with which it climbs trees and tears open the nests of tree ants, on which it feeds. Length: to 175cm (70in). Family Manidae; genus *Manis*.

Pankhurst, Emily (Emmeline Goulden) (1858–1928) British leader of the militant movement for women's suffrage, the SUFFRAGETTE MOVEMENT. She set up the Women's Social and Political Union in 1903, supported by her daughters, Christabel (1880–1958) and Sylvia (1882–1960). Their militant tactics courted prosecution, and they gained further publicity in prison by hunger strikes.

panpipes (syrinx) Primitive musical wind instrument, probably from Asia. Several tubes of cane, reed, bamboo or clay, of different lengths, are joined together side by side. Blown across one end, each pipe produces one note of a scale. Panpipes are associated with the pastoral Greek god of fertility.

pansy Common name for a cultivated hybrid VIOLET. An annual or short-lived perennial, it has velvety flowers, usually in combinations of blue, yellow and white, with five petals. Height: to about 15–30cm (6–12in). Family Violaceae; species *Viola tricolor*:

pantheism Religious system, contrasted with certain forms of DEISM, that is based on the belief that God (or gods) and the universe are identical. According to this philosophy, all life is infused with divinity. No distinction is recognized between the creator and creatures.

pantheon Ancient Greek and Roman temple for the worship of all the gods. The most famous example is the Pantheon in Rome, originally built by Agrippa (27 BC), rebuilt by Hadrian (c. AD 120), and converted into the church of Santa Maria Rotonda in the 7th century. The term was later extended to apply to a building honouring illustrious public figures. **panther** See LEOPARD

pantomime Theatrical spectacle with its modern origins in early 18th-century France. It has come to mean a Christmas extravaganza, with music and comic actors. Popular in England by the 19th century, the "dame" figure was traditionally played by a male actor and the principal boy by a female. The once-central HARLEQUIN character now appears infrequently. Paolozzi, Sir Eduardo (1924—) Scottish sculptor and graphic artist. He created box-like, chromium-plated sculptures evocative of jazz-age amusement arcades and picture palaces. Since the 1950s he has worked mainly on large-scale ABSTRACT sculptures.

papacy Office, status or authority of the pope as head of both the ROMAN CATHOLIC CHURCH and the VATICAN CITY. The pope is nominated Bishop of Rome and Christ's spiritual representative on Earth. He is elected by the College of Cardinals. There have been more than 260 holders of the office of pope. Until the REFORMATION the papacy claimed authority over all Western Christendom. Today papal authority extends only over the members of the Roman Catholic Church. *See also* PAPAL INFALLIBILITY

Papago Piman-speaking tribe of Native North Americans who inhabited the Gila and Santa Cruz river valleys of s Arizona, and N Sonora, Mexico. Today c.11,000 Papago people live s of Tucson, Arizona.

papal bull Official letter from the pope, written in solemn style and consisting of a formal announcement. Such a document usually contains a decree relating to doctrine, CANON-IZATION, ecclesiastical discipline, promulgation of INDUL-

GENCES, or some other matter of general importance. **papal infallibility** Roman Catholic doctrine according to which the pope, under certain conditions, cannot make a mistake in formal statements on issues of faith or morals. It was defined in its present form, amid great controversy, at the First Vatican Council (1869–70). An essential requirement of the doctrine is that all Roman Catholics must accept any papal statement on faith or morals without question.

Papal States Territories of central Italy under the rule of the popes (756–1870). In the 15th century the papal government displaced the feudal magnates who had ruled the Papal States in the Middle Ages and imposed direct control from Rome. The territory was temporarily lost during the Napoleonic period, restored to the papacy in 1815, and annexed by the Italian nationalists during the RISORGIMENTO. The LATERAN TREATY of 1929 restored the small area comprising the VATICAN in Rome to papal rule.

Papandreou, Andreas (1919–96) Greek statesman, prime minister (1981–89, 1993–96). Papandreou founded the Pan-Hellenic Socialist Movement (PASOK) in the mid-1970s, becoming leader of the opposition in 1977. In 1981 he was elected as Greece's first socialist prime minister and was re-elected in 1985. Implicated in a financial fraud, he was unable to form a government following the election of 1989 and resigned. Cleared of fraud, Papandreou was re-elected in 1993.

■ Pankhurst The pioneers of the fight for women's suffrage in Britain, Emily Pankhurst and her daughter Christabel were frequently arrested because of their use of militant protest tactics. They interrupted meetings of the cabinet, political parties, and even the House of Commons. Later they turned to even more violent methods of protest, including arson. The law granting British women full voting rights was passed a few weeks after Emily's death.

▼ papacy Innocent III (1198–1216) extended the power of the medieval papacy at the expense of kings and princes by intervening throughout Europe to combat any challenge, temporal or spiritual, to the authority of the Roman Catholic Church.

Papal States from 1213

Vassals of papacy

Intervention by papacy

New relations

Sphere of papal influence

Byzantine states

Under Muslim rule

Holy Roman Empire

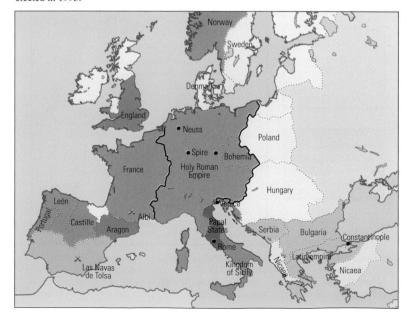

▲ papaya The skin of the papaya, or pawpaw, ripens from green to yellow or orange. Its succulent pulp encloses small, black/brown seeds in its centre. Papain, an enzyme contained in the leaves and unripe fruit, is used to tenderize meat.

papaya (pawpaw) Palm-like tree widely cultivated in tropical America for its fleshy, melon-like, edible fruit. It also produces the ENZYME papain, which breaks down proteins, and is used commercially for a variety of purposes. Height: to 6m (20ft). Family Caricaceae; species *Carica papaya*.

Papeete Capital and chief port of French Polynesia, in the S Pacific Ocean, on the Nw coast of Tahiti. It is a trade centre for the islands and a tourist resort. Its exports include copra, mother-of-pearl and vanilla. Pop. (1988) 78,814.

paper Sheet or roll of compacted cellulose fibres with a wide range of uses. The word "paper" derives from PAPYRUS, the plant that the Egyptians used over 5,500 years ago to make sheets of writing material. The modern process of manufacture originated c.2,000 years ago in China and consists of reducing wood fibre, straw, rags or grasses to a pulp by the action of an ALKALI, such as CAUSTIC SODA. The non-cellulose material is then extracted and the residue is bleached. After washing and the addition of a filler to provide a smooth and flat surface, the pulp is made into thin sheets and dried.

Papineau, Louis Joseph (1786–1871) French-Canadian political leader. He opposed the union of Upper and Lower Canada, fearing that French-Canadian society would be submerged. His quarrels with Britain, which rejected his plan for greater French-Canadian autonomy, incited his followers to rebellion (1837). He escaped arrest by fleeing to the USA, then to France. Granted an amnesty (1847), he returned to Canada and was a member of the unified legislature (1848–54).

paprika Popular, spicy condiment, a red powder ground from the fruit of a sweet PEPPER (capsicum) native to central Europe. Family Solanaceae.

pap smear test Sample of cells from the female genital tract, specially stained to detect malignant or premalignant disease. It is named after its discoverer, George Papanicolaou. Papua New Guinea Independent Commonwealth island group in Melanesia, sw Pacific, 160km (100mi) NE of Australia; the capital is PORT MORESBY. Land and climate Papua New Guinea includes the E part of New Guinea, the Bismarck Archipelago, the N SOLOMON ISLANDS, the Trobriand and D'Entrecasteaux Islands and the Louisiade Archipelago. The land is largely mountainous, rising to Mount Wilhelm, at 4,508m (14,790ft), E New Guinea. In 1995 two volcanoes erupted in Esstern New Britain. East New Guinea also has extensive coastal lowlands. Papua New Guinea has a tropical climate. The monsoon season runs from December to April. Forests cover over 70% of the land. The dominant vegetation is rainforest. Mangrove swamps line the coast. "Cloud" forest and tussock grass are found on the higher peaks. Economy

Agriculture employs 75% of the workforce, many at subsistence level. Minerals, notably copper and gold, are the most valuable exports. Papua New Guinea is the world's ninthlargest producer of gold. Other exports include yams, coffee, timber, palm oil, cocoa and lobster. Manufacturing industries process farm, fish and forest products. History and politics The first European sighting of the island was made by the Portuguese in 1526, though no settlements were established until the late 19th century. In 1828 the Dutch took w New Guinea (now IRIAN JAYA in Indonesia). In 1884 Germany took NE New Guinea as German New Guinea, and Britain formed the protectorate of British New Guinea in SE New Guinea. In 1906 British New Guinea passed to Australia as the Territory of Papua. When World War 1 broke out, Australia occupied German New Guinea. In 1921 German New Guinea became the League of Nations mandate Territory of New Guinea under Australian administration. Japan captured the islands in 1942, and the Allies reconquered them in 1944. In 1949 Papua and New Guinea were combined to form the Territory of Papua and New Guinea. In 1973 the Territory achieved self-government as a prelude to full independence as Papua New Guinea in 1975. Post-independence, the government of Papua New Guinea has worked to develop its mineral reserves. One of the most valuable reserves was a copper mine at Panguna on BOUGAINVILLE. Conflict developed when the people of Bougainville demanded a larger share in mining profits. Following an insurrection, the Bougainville Revolutionary Army proclaimed independence in 1990. Bougainville's secession was not recognized internationally. In 1992 and 1996 Papua New Guinea launched offensives against the rebels. The use of highly paid mercenaries created unrest in the army. In March 1997 troops and civilians surrounded parliament, forcing the resignation of the prime minister, Sir Julius Chan. In the ensuing elections, Bill Skate became prime minister.

papyrus Stout, perennial water plant, native to s Europe, N Africa and the Middle East, and used by the ancient Egyptians to make a PAPER-like writing material. Strips of the stem were arranged in layers, crushed and hammered to form a loosely textured, porous kind of paper. Height: to 4.5m (15ft). Family Cyperaceae; species *Cyperus papyrus*.

parable Short, simple story intended to convey a moral or religious message. The best-known parables are those attributed to Jesus Christ in the New Testament, including the Good Samaritan, the Prodigal Son, the Sower and the Seed, and the Pearl of Great Price.

parabola Mathematical curve, a CONIC section traced by a point that moves so that its distance from a fixed point, the focus, is equal to its distance from a fixed straight line, the directrix. It may be formed by cutting a cone parallel to one side. The general equation of a parabola is $y = ax^2 + bx + c$ where a, b and c are constants.

Paracelsus (1493–1541) Swiss physician and alchemist, real name Philippus Aureolus Theophrastus Bombast von Hohenheim. According to Paracelsus, the human body is primarily composed of salt, sulphur and mercury, and it is the separation of these elements that causes illness. He introduced mineral baths and made opium, mercury, lead and various minerals part of the pharmacopoeia.

paracetamol ANALGESIC drug that lessens pain and is also effective in reducing fever. It is used to treat mild to moderate pain, such as headaches, toothaches and rheumatic conditions, and is particularly effective against musculoskeletal pain. The drug is called acetaminophen in the USA.

parachute Lightweight fabric device for slowing movement through the air. Parachutes allow people to descend safely from aircraft and are used to drop cargo and supplies. The most common use is for the sport of SKYDIVING.

paradox Self-contradictory or absurd statement that conflicts with preconceived notions of what is reasonable or possible, but which is significant when considered from the appropriate viewpoint. A well-known paradox is that of Zeno of Elea, who reasoned that motion is impossible.

paraffin (kerosene) Common domestic fuel that is mainly a mixture of ALKANE hydrocarbons. It is a product of the distillation of petroleum. Less volatile than petrol, paraffin is also

PAPUA NEW GUINEA

AREA: 462,840sq km (178,073 sq mi)
POPULATION: 4,056,000
CAPITAL (POPULATION): Port
Moresby (193,242)
GOVERNMENT:
Constitutional monarchy

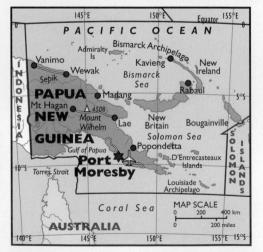

ETHNIC GROUPS: Papuan 84%, Melanesian 1% LANGUAGES: English (official) RELIGIONS: Christianity (Protestant 58%, Roman Catholic 33%, Anglican 5%), traditional beliefs 3% CURRENCY: Kina = 100 toea used as a fuel for jet aircraft. Paraffin wax is a white, translucent, waxy substance consisting of a mixture of solid alkanes obtained by solvent extraction; it is used to make candles, waxed paper, polishes and cosmetics.

Paraguay Landlocked republic in central South America: the capital is ASUNCIÓN. Land and climate Paraguay is bisected by the River Paraguay. The majority of the population live between the E bank of the River Paraguay and the River PARANÁ, which forms the s border with Argentina. The s has extensive marshes. West of the River Paraguay is part of the Gran Chaco, a flat grassy plain that extends into Bolivia and Argentina. The s is subtropical. Rainfall is heaviest in the SE Paraná plateau. The Chaco is the driest and hottest part of Paraguay. Paraguay is a country of coarse grass, shrub and scrub forest, with some hardwood forests. Economy Agriculture and forestry are the leading activities, employing 48% of the workforce. Paraguay has large cattle ranches, and many crops are grown in the fertile soils of E Paraguay. Paraguay is the world's seventh-largest producer of soya beans. Other crops include cassava, cotton and coffee. Raw materials account for 79% of exports. Major exports include timber, coffee, tannin and meat products. Paraguay has abundant hydroelectricity. In 1973 construction started on the Itaipú Dam on the River Paraná; it is the world's largest dam by volume. Paraguay has no major mineral or fossil fuel resources. History The earliest known inhabitants of Paraguay were the GUARANÍ. Spanish and Portuguese explorers reached the area in the early 16th century. In 1537 a Spanish expedition built a fort at Asunción, which became the capital of Spain's colonies in SE South America. From the late 16th century, Jesuit missionaries worked to protect the Guaraní from colonial exploitation and to convert them to Christianity. In 1767 the Spanish king expelled the Jesuits. In 1776 Paraguay was subsumed into the colony of the viceroyalty of Río de la Plata. Paraguayan opposition intensified, and Paraguay declared independence in 1811. Paraguay's post-colonial history has been dominated by dictatorships. The disastrous War of the Triple Alliance (1865-70) against Brazil, Argentina and Uruguay killed over 50% of Paraguay's population and resulted in great loss of territory. Border disputes with Bolivia led to the Chaco War (1932-35) in which Paraguay regained some land. In 1954 General Alfredo Stroessner led a successful military coup. His dictatorial regime suppressed all political opposition. In 1989, shortly after re-election for an eighth successive term, Stroessner was overthrown by General Andrés Rodríguez. In 1993 multiparty elections, Juan Carlos Wasmosy was elected as Paraguay's first civilian president since 1954. An attempted military coup, led by retired General Lino Oviedo, was foiled in 1996.

parakeet Name given to several different small, brightly coloured PARROTS that are popular pets. The most common pet parakeet is the Australian budgerigar (*Melopsittacus undulatus*), which can often be taught to mimic speech. The males have bluish nostrils, females brownish.

parallax Angular distance by which a celestial object appears to be displaced with respect to more distant objects, when viewed from opposite ends of a baseline. The parallax of a star (annual parallax) is the angle subtended at the star by the mean radius of the Earth's orbit (one astronomical unit); the smaller the angle, the more distant the star. *See also* PARSEC

parallelogram Quadrilateral (four-sided plane figure) having each pair of opposite sides parallel and equal. Both the opposite angles of a parallelogram are also equal. Its area is the product of one side and its perpendicular distance from the opposite side. A parallelogram with all four sides equal is a RHOMBUS.

Paralympic Games Sports meeting run every four years in conjunction with the Olympic Games and in which all competitors are physically handicapped. Much of the full Olympic programme of events is staged. Prosthetic limbs and other devices may be worn; many events are undertaken by competitors in wheelchairs.

paralysis Weakness or loss of muscle power; it can vary from a mild condition to complete loss of function and sensation in the affected part. It can be associated with almost any disorder of the NERVOUS SYSTEM, including brain or spinal

PARAGUAY BOLIVIA BRAZIL 0 25°5 Asunción AREA: 406,750sg km (157,046sq mi) ARGENTINA POPULATION: 4,579,000 CAPITAL (POPULATION): Asunción (637,737) **GOVERNMENT:** Multiparty MAP SCALE republic BRAZH 300 miles ETHNIC GROUPS: Mestizo 90%, Native American 3% LANGUAGES: Spanish and RELIGIONS: Christianity (Roman **CURRENCY:** Guaraní = 100 Guaraní (both official) Catholic 96%, Protestant 2%) céntimos

cord injury, infection, stroke, poisoning, or progressive conditions such as a tumour or motor neurone disease. Paralysis is very rarely total.

Paramaribo Capital of Surinam, a port on the River Surinam. It was founded in the early 17th century by the French and became a British colony in 1651. It was held intermittently by the British and the Dutch until 1816, when the latter finally took control until independence. Industries: bauxite, timber, sugar cane, rice, rum, coffee, cacao. Pop. (1993 est.) 200,970.

Paraná River in SE central South America. It rises in SE Brazil, flows s into Argentina, forming the SE and s border with Paraguay, and joins the River Uruguay to form the Río de la PLATA. It is an important route for inland communications. Combined length: Paraná/Plata c.4,000km (2,400mi).

paranoia Term in psychology for a psychotic disorder characterized by a systematically held, persistent delusion, usually of persecution or irrational jealousy. Typically, those experiencing paranoia do not believe themselves to be ill, and their behaviour is rational within the context of the particular delusion that they have. Paranoia can accompany SCHIZOPHRENIA, manicdepressive disorder, drug or alcohol abuse, or brain damage.

paraplegia Paralysis of both legs. It is usually due to spinal cord injury, and often accompanied by loss of sensation below the site of the damage.

parapsychology Branch of psychology concerned with research into phenomena that appear inexplicable by traditional science. It involves research into EXTRASENSORY PERCEPTION (ESP), such as TELEPATHY, and precognition (perceiving future events). Parapsychology is also concerned with physical phenomena such as psychokinesis, in which objects can apparently be willed to change shape or move, and the POLITERGEIST phenomenon.

parasite Organism that lives on or in another organism (the host) upon which it depends for its survival; this arrangement may be harmful to the host. Parasites occur in many groups of plants and in virtually all major animal groups. A parasite that lives in the host is called an endoparasite; a parasite that survives on the host's exterior is an ectoparasite. Many parasites, such as PROTOZOA, FLEAS and WORMS, carry disease or cause sores or lesions, which may become infected. The European CUCKOO and cowbird rely on other birds to rear their young, and are therefore considered "brood parasites". In parasitoidism, the relationship results in the death of the host. For example, various flying insects, such as the ichneumon flies, lay their eggs on or in a host that becomes the food

A parasite Some external parasites live either on, or nearby, humans. The crab louse (A) lives on areas of the body with widely spaced coarse hair. The acarus mite (B) is just about visible to the human eye, and is responsible for causing scabies. The body louse (C) is one of the more dangerous parasites. It is a carrier of epidemic typhus. The common bedbug (D) is found all over the world. During the day it is inactive, but at night it finds humans and sucks their blood.

for the insect larvae. A hyperparasite is one that parasitizes another parasite.

parathyroid glands Four small endocrine glands, usually embedded in the back of the THYROID GLAND, that secrete a HORMONE to control the level of calcium and phosphorus in the blood. Overproduction of parathyroid hormone causes loss of calcium from the bones to the blood; a deficiency causes tetany (involuntary muscle spasm). See also ENDOCRINE SYSTEM

Paré, Ambroise (1517–90) French physician regarded by some as the founder of modern surgery. In 1537 he was employed as an army surgeon and in 1552 became surgeon to HENRY II. He introduced new methods of treating wounds, described in his book *The Method of Treating Wounds Made by Harquebuses and Other Guns* (1545), and revived the practice of tying arteries during surgery instead of cauterizing them.

Paris Capital of France, on the River Seine. When the Romans took Paris in 52 BC, it was a small village on the Ile de la Cité on the Seine. Under their rule it became an important administrative centre. Paris was the capital of the Merovingian Franks in the 5th century but subsequently declined. It was re-established as the French capital by the Capetian kings in the 10th century. The city expanded rapidly in the 11th and 12th centuries. During the 14th century Paris rebelled against the Crown and declared itself an independent commune. It suffered further civil disorder during the Hundred Years War. In the 16th century it underwent fresh expansion, its architecture strongly influenced by the Italian Renaissance. In the reign of Louis XIII, Cardinal RICHELIEU established Paris as the cultural and political centre of Europe. The French Revolution began in Paris when the BASTILLE was stormed by crowds in 1789. Under the emperor NAPOLEON I the city began to assume its present-day form. The work of modernization was continued during the reign of NAPOLEON III, when Baron Haussmann was commissioned to plan the boulevards, bridges and parks that now characterize the city. Although occupied during the Franco-Prussian War (1870-71) and again in World War 2, Paris was not badly damaged. The city proper consists of the Paris département, Ville de Paris. Its suburbs lie in the départements of the Ilede-France region. Paris remains the hub of France despite attempts at decentralization, and retains its importance as a European cultural, commercial and communications centre. Paris is noted for its fashion industry and for the manufacture of luxury articles. Industries: motor vehicles, chemicals, textiles, clothing, printing, publishing. Pop. (1990, city) 2,152,423; (conurbation) 9,318,821.

Paris In Greek legend, the son of PRIAM and Hecuba. Paris chose APHRODITE as the victor in a competition among goddesses. Aphrodite helped Paris to abduct HELEN, wife of Menelaus, King of Sparta. This kidnapping sparked the TROJAN WAR, in which Paris slew ACHILLES.

Paris, Treaties of Name given to several international agreements made in Paris. The most notable include: the treaty of 1763, which ended the SEVEN YEARS WAR; the treaty of 1783, in which Britain recognized the independence of the USA; the treaty of 1814, which settled the affairs of France after the first abdication of Napoleon; the treaty of 1815, after Napoleon's final defeat; the treaty of 1856, ending the CRIMEAN WAR; the treaty of 1898, ending the SPANISH-AMERICAN WAR and giving the Philippines to the USA; and the main international settlement (1919) after World War 1, more often called the Treaty of VERSAILLES. Certain territorial adjustments after World War 2 were signed in Paris in 1946–47, as was the truce in the VIETNAM WAR (1973), in which the USA agreed to withdraw its forces.

Paris Commune (18 March—28 May 1871) Revolutionary government in Paris. Anger with the national government provoked Parisians into establishing an independent city government. Socialists and other radicals played an important part in the Commune. Besieged by the forces of the national government, the city fell and the Commune was violently suppressed. The slaughter of an estimated 30,000 people alienated many French workers and encouraged revolutionary doctrines.

parity In physics, term used to denote space-reflection symmetry. The principle of conservation of parity states that physi-

cal laws are the same in a left- and right-handed co-ordinate system. This was regarded as inviolable until 1956, when Chen Ning Yang and Tsung-Dao Lee showed that it was transgressed by certain interactions between elementary atomic particles. Parity is also used in information theory to denote a coding method employed in message transmission to detect errors. Park, Chung Hee (1917–) President of South Korea (1963–79). He seized power in a military coup in 1961, ruled for two years as a general, then resigned from the army. He was elected President in 1963, 1967 and 1971.

Park, Mungo (1771–1806) British explorer. He was asked by the African Association (forerunner of the Royal Geographical Society) to investigate the course of the River Niger (1795). Approaching from the Gambia, he explored *c*.450 km (280mi) of the Upper Niger, a journey described in his *Travels...* (1799). On a second, government-sponsored, expedition (1805) he and his companions were ambushed and killed.

Parker, Alan (1944–) English film director. His debut feature, *Bugsy Malone* (1976), was followed by *Midnight Express* (1978), for which he received an Oscar nomination. *Mississippi Burning* (1988) earned him a second nomination. Other films include *Birdy* (1985), *The Commitments* (1991) and *Evita* (1997).

Parker, Charlie (Charles Christopher) (1920–55) ("Bird") US JAZZ alto saxophonist. In the 1940s Parker, Dizzy GILLESPIE, Thelonious MONK and Bud POWELL were the founders of BEBOP, a revolutionary departure in jazz. Parker's powerful improvisations inspired a new generation of jazz musicians, such as Miles DAVIS.

Parker, Dorothy (1893–1967) US poet, short-story writer and critic. She wrote three volumes of poetry, the first of which, *Enough Rope* (1926), was a best-seller. A large body of her short stories were collected in *Here Lies* (1939). Her gift for witty epigrams is evident throughout her work.

Parkinson's disease Degenerative BRAIN DISEASE characterized by tremor, muscular rigidity and poverty of movement and facial expression. It arises from a lack of the NEUROTRANSMITTER DOPAMINE. Slightly more common in men, it is rare before the age of 50. Foremost among the drugs used to control the disease is L-DOPA.

Parkman, Francis (1823–93) US historian. His masterpiece is *France and England in North America* (8 vol. 1865–84), one of the greatest works on North American history. He carried out extensive research in the field, one result of which was his classic *The Oregon Trail* (1849).

parliament Legislative assembly that includes elected members and acts as a debating forum for political affairs. Many parliamentary systems are based on the British Parliament. It emerged in the late 13th century as an extension of the king's council, and has been housed at Westminster since that time. It is the supreme power in the country. Parliament comprises the monarch, in whose name members of the government act, and two Houses: the House of Lords, an upper chamber of hereditary and life peers, bishops and law lords, and the House of Commons. There are 659 members of the Commons (known as "members of Parliament" or MPs), elected in single-member constituencies by universal adult suffrage. The PRIME MINISTER and CABINET members are almost always members of the Commons. There is a maximum of five years between elections.

Parma City in N Italy, capital of Parma province. Parma is famed for its food products, such as Parma ham and Parmesan cheese. It was founded by the Romans in 183 BC. In the 9th century AD it became a bishopric, and in 1513 was incorporated into the Papal States. In 1545 Pope Paul III established the duchy of Parma, and until 1731 it was controlled by the Farnese family. Despite suffering severe bombing in World War 2, the city retains many historic buildings. Pop. (1991) 170,520.

Parmigiano (1503–40) (Francesco Mazzola) Northern Italian painter and graphic artist, a master of MANNERISM. Among his best-known works are *Madonna with St Zachary* (c.1530), Vision of St Jerome (c.1527) and Madonna with the Long Neck (c.1535).

Parnassus Mountain peak in central Greece. In ancient times it was considered sacred to APOLLO, DIONYSUS and the

MUSES, and was the site of the equally sacred Castalian spring, which lies just above DELPHI, at the s foot of the mountain. Height: 2,457m (8,061ft).

Parnell, Charles Stewart (1846–91) Irish political leader. He entered the British Parliament in 1875, vigorously supporting home rule for Ireland and rapidly taking over leadership of the Irish group in the Commons. He was imprisoned from 1881–82. His power reached its peak in 1886, when the government introduced the Home Rule Bill. The bill was eventually defeated. His career collapsed when he was cited as co-respondent in the divorce of William O'Shea, whose wife, Kitty, he subsequently married.

parody Work in which the characteristics of artists or their works are imitated and exaggerated for comic effect. While parody exists in music and the arts, it is most commonly associated with literature and has its roots in ancient Greece. The tendency of parody to follow hard on the heels of distinctive work means that it has often served to question, consolidate and extend original advances in form, style or subject. Among 20th-century writers who have made effective use of parody are Max Beerbohm, James Joyce and Stephen Leacock.

parrot Common name for many tropical and subtropical birds. Parrots are brightly coloured and have thick, hooked bills. They include BUDGERIGARS, macaws, lories, lorikeets, parakeets, keas, kakapos and others. In the wild they nest in tree holes, rock cracks or on the ground. Length: 7.5–90cm (3in–3ft). Family Psittacidae.

Parry, Sir (Charles) Hubert (Hastings) (1848–1918) British composer. His mastery of choral music is best shown in *Blest Pair of Sirens* (1887). He is well known for *Jerusalem* (1916). He also wrote many songs, five symphonies and an opera.

parsec (pc) Distance at which a star would have a PARALLAX of one second of arc; equivalent to 3.2616 light years, 206,265 astronomical units, or 3.0857×10^{13} km.

Parsi (Parsee) Modern descendant of a small number of ancient Persian Zoroastrians who emigrated to Gujarat in India from the 10th century onwards. Modern Parsis, concentrated in Bombay, follow a mixture of ZOROASTRIANISM and some Indian beliefs and practices.

parsley Branching biennial herb, native to the Mediterranean region and widely cultivated for its aromatic leaves used for flavouring and as a garnish. It has heads of small, greenish-yellow flowers. Height: to 0.9m (3ft). Family Apiaceae/Umbelliferae; species *Petroselinum crispum*.

parsnip Biennial vegetable native to Eurasia, widely cultivated for its edible white taproot. The plant has many leaves, deeply and finely lobed. The roots develop slowly until cool weather sets in, and then they mature quickly. Family Apiaceae/Umbelliferae; species *Pastinaca sativa*.

Pärt, Arvo (1935–) Estonian composer. His early works were written in a traditional "Soviet" style. In the 1970s, he adopted a minimalist style of gradually shifting chords and note-patterns that he called "tintinnabula". Among his bestknown works are *Tabula Rasa* (1977), *Cantus in memoriam Benjamin Britten* (1980) and the *St John Passion* (1981).

parthenogenesis Development of a female sex cell or GAMETE without fertilization. Since there is no involvement of a male gamete, it leads to the production of offspring that are genetically identical to the mother. This process occurs naturally among some plants and invertebrates, such as APHIDS.

Parthenon Temple to the goddess Athena erected (447–432 BC) by Pericles on the Acropolis in Athens. The finest example of a Doric order temple, it was badly damaged by an explosion in 1687. Most of the surviving sculptures were removed by Lord Elgin in 1801–03. See Elgin Marbles

Parthia Region in ancient Persia, corresponding approximately to the modern Iranian province of Khurāsān, with part of s Turkmenistan. It was the seat of the Parthian empire, founded after a successful revolt against the Seleucids (238 BC). Under the Arsacid dynasty, the Parthian empire extended, at its peak, from Armenia to Afghanistan. In Ad 224 the Parthians were defeated by the rising power of the Sassanids and the empire rapidly crumbled.

particle accelerator See ACCELERATOR, PARTICLE

particle physics Branch of physics that studies SUBATOMIC PARTICLES and interactions between them. Physicists now recognize more than 300 different subatomic particles, which can be grouped in various ways, although they are all composed of a few basic building blocks. The indivisible, fundamental units of matter are known as ELEMENTARY PARTICLES. They are termed the gauge BOSON, LEPTON and QUARK. Other subatomic particles, termed HADRONS, are made up of two or more elementary particles. For example, PROTONS and NEUTRONS are made up of three quarks, and MESONS are made up of two quarks. Most subatomic particles are unstable and decay into other particles.

partridge Any of several species of gamebirds found worldwide. True partridges of Europe belong to the pheasant family (Phasianidae), and include the common partridge Perdix perdix, which has been introduced to N America. It lives on heathland, scrub and farmland and feeds on plants and insects. Parvati In Hindu mythology, the wife of the god SHIVA in one of her more benevolent aspects as a mountain goddess. Parvati is also the mother of the elephant-headed god GANESH and his brother Skanda. She is generally depicted as a young woman. Pascal, Blaise (1623-62) French scientist and mystic. With Pierre de FERMAT, he laid the foundations of the mathematical theory of probability. He also contributed to calculus and hydrodynamics, devising Pascal's law in 1647. It states that the pressure applied to an enclosed fluid (liquid or gas) is transmitted equally in all directions and to all parts of the enclosing vessel. The SI unit of pressure is named after him. Pashto (Pushto) One of the two major languages of

Pashto (Pushto) One of the two major languages of Afghanistan, the other being Persian. Pashto is spoken by about 12 million people in E Afghanistan and N Pakistan. It is historically the language of the PATHAN tribes and is written in an adapted Arabic alphabet. One of the Iranian languages, it forms part of the Indo-European family of languages.

Pasolini, Pier Paolo (1922–75) Italian poet, novelist and film director. A Marxist, he wrote about urban poverty with great realism in novels such as *A Violent Life* (1959). Films he directed include *The Gospel According to St Matthew* (1964), *Oedipus Rex* (1967) and *The Decameron* (1970). His last film was *Salo* (1975).

passion In Christian theology, the suffering of JESUS CHRIST from the time of his praying in the garden of Gethsemane until his death on the cross. Passion Sunday is the fifth Sunday in Lent; PALM SUNDAY and EASTER follow.

passion flower Any plant of the genus *Passiflora*, climbing tropical plants that probably originated in tropical America, especially the blue passion flower, *P. caerulea*. The flowers can be various colours; the outer petals ring a fringed centre. The leaves are lobed and some species produce edible fruits, such as granadilla and calabash. Family Passifloraceae. passion play Dramatic presentation of Christ's PASSION, death and resurrection, originally developed in medieval Europe. The best-known example of this tradition is still held every ten years in OBERAMMERGAU, Germany.

Passover (Pesach) Jewish festival of eight days, commemorating the Exodus from Egypt and the redemption of the Israelites. Symbolic dishes are prepared, including bitter herbs (maror) and unleavened bread (matzot), to remind the Jews of the haste with which they fled Egypt and, by extension, of their heritage. It is a family celebration, at which the HAGGADAH is read. Christ's Last Supper, at which he instituted the Eucharist, was a Passover meal.

■ Parthenon The ceremonial centrepiece of the Acropolis, Athens' hilltop temple complex, the Parthenon was constructed in the fifth century ac in honour of Athena, the city's patron goddess. It was designed by Athens' foremost architects and ornamented by its most gifted sculptors. A carved frieze, a section of which is shown here, ran around the top of the inner wall. It depicted the Panathenaia, the annual festival in honour of Athena.

▲ passion flower A climbing woody plant, the passion flower, makes its way by means of twining tendrils. Some species produce large, edible fruits.

pasta Food, high in carbohydrate, made from semolina, which is derived from durum wheat. Traditionally associated with Italian cooking, it comes in a variety of shapes and sizes. Pasternak, Boris (1890–1960) Soviet poet, novelist and translator. Before the Stalinist purges of the 1930s, he published works such as the poetry collection My Sister, Life (1922) and the autobiographical Safe Conduct (1931). After the death of Stalin he began work on Dr Zhivago (1957). Its themes offended officials, and he was expelled from the Soviet Writers Union; the book was not published in the Soviet Union until the 1980s. He was also compelled by official pressure to retract his acceptance of the 1958 Nobel Prize for literature.

Pasteur, Louis (1822–95) French chemist and one of the founders of microbiology. He discovered that microorganisms can be destroyed by heat, a technique now known as PASTEURIZATION. Pasteur also discovered that he could weaken certain disease-causing microorganisms – specifically those causing anthrax in animals and rabies in man – and then use the weakened culture to vaccinate against the disease.

pasteurization Controlled heat treatment of food to kill bacteria and other microorganisms, discovered by Louis Pasteur in the 1860s. Milk is pasteurized by heating it to 72°C (161.6°F) and holding it at that temperature for 16 seconds. Ultrapasteurization is now used to produce UHT (ultra-heattreated) milk; it is heated to 132°C (270°F) for one second to provide a shelf-life of several months.

pastoral In literature, work portraying rural life in an idealized manner, especially to contrast its supposed innocence with the corruption of the city or royal court. In classical times Theocritus and Virgil wrote pastoral poems. The form was revived during the Renaissance by such poets as Dante, Petrarch, Boccaccio and Spenser. Militon and Shelley were noted for their pastoral elegies, and poets such as Wordsworth and Frost have been referred to as pastoral poets because their work has a characteristically rural setting. pastoralism Form of subsistence agriculture that involves the herding of domesticated livestock. Societies practising this are small, restricted by the large amount of grazing land needed for each animal. Indigenous pastoralism is widespread in N Africa and central Asia, but in the Americas it is confined to the Andes. See also NOMAD

Patagonia Region in Argentina, E of the Andes Mountains, extending to the Strait of Magellan; the term is sometimes used to include part of s Chile. The area was first visited by MAGELLAN in the early 16th century. It was colonized in the 1880s, many of the settlers being Welsh or Scottish. The present boundaries were set in 1902. Most of Patagonia is arid, windswept plateau. Until recently sheep rearing was the main source of income. Oil production is now important, and coal and iron ore are mined. Area: 805,490sq km (311,000sq mi). patella (kneecap) Large, flattened, roughly triangular bone just in front of the joint where the FEMUR and TIBIA are linked. It is surrounded by bursae (sacs of fluid) that cushion the joint. patent (letters patent) Privilege granted to the inventor of a new product or process. A patent excludes others from producing or making use of the invention for a limited period, unless under license from the holder of the patent.

Pathans (Pashtuns) MUSLIM tribes of SE Afghanistan and NW Pakistan. They speak various dialects of an E Iranian language, PASHTO, and are composed of about 60 tribes, numbering in total perhaps 10 million. Formerly, they were pastoralists inhabiting the mountainous border regions, but they are now mainly farmers and are more widely spread. In their clashes with the British in the 19th century, they gained a reputation as formidable warriors. Their way of life was disrupted during the Soviet occupation (1979–89) and the subsequent civil wars in Afghanistan.

Pathé, Charles (1863–1957) Pioneer French film producer. He produced many short films and is credited with having made one of the first long films, *Les Misérables* (1909). Through the Pathé newsreels, he can be closely identified with the development of the film DOCUMENTARY.

pathogen Microorganism that causes disease in plants or animals. Animal pathogens are most commonly BACTERIA and VIRUSES, while common plant pathogens also include FUNGI.

pathology Study of diseases, their causes and the changes they produce in the cells, tissues and organs of the body.

Paton, Alan Stewart (1903–88) South African novelist and reformer. Strongly opposed to APARTHEID, he helped to found the South African Liberal Party, of which he was president (1958–68). His two best-known novels, *Cry, the Beloved Country* (1948) and *Too Late the Phalarope* (1953), raised awareness of injustices in South African society.

patriarch Head of a family or tribe, invested in certain circumstances with the status or authority of a religious leader. In the Old Testament, the term referred either to the ancestors of the human race who lived on Earth before the Flood (as recorded in Genesis 1–11) or more commonly to the ancestors of the ancient Israelites, namely: ABRAHAM, ISAAC, JACOB and Jacob's 12 sons (Genesis 12–50). Since about the 4th century AD, the word has also been used as an ecclesiastic title for a few exalted bishops in the Eastern Christian Church, who rule over large dioceses known as patriarchates. patriarchy Social organization based on the authority of a senior male, usually the father, over a family.

patrician Aristocratic class in the ancient Roman Republic, members of the SENATE. In the early years of the republic, the patricians controlled all aspects of government and society. Over the centuries, the PLEBEIANS (ordinary citizens) achieved a greater share of power, and under the empire the division between the two classes disappeared.

Patrick, Saint (active 5th century AD) Patron saint of Ireland. Facts about his life are confused by legend. What is known of him comes almost entirely from his autobiography, Confessio. He was born in Britain into a Romanized Christian family. Abducted by marauders at the age of 16, he was carried off to Ireland and sold to a local chief. After six years, he escaped back to Britain. He was sent to Ireland as a missionary by Pope Celestine I (432) and established an episcopal see at Armagh. His missionary work was so successful that Christianity was firmly established in Ireland before he died. His feast day is 17 March.

Patten, Christopher Francis (1944–) British politician and last British governor of Hong Kong (1992–97). He held many ministerial portfolios during the 1980s and, as chairman of the Conservative Party (1990–92), he helped engineer a Conservative victory in the 1992 election, but lost his own seat. As governor of Hong Kong, Patten sought to preserve its political and economic institutions in the handover to China.

Patton, George Smith, Jr (1885–1945) US general. In World War 1 he served with the American Expeditionary Force (AEF) in France. He commanded a tank corps in North Africa and the 7th Army in Sicily in World War 2. After the Normandy invasion in 1944, he commanded the 3rd Army in its dash across France and into Germany. As military governor of Bavaria after the war, he was criticized for leniency to Nazis and was removed to command the US 15th Army.

Paul, Saint (active 1st century AD) Apostle of JESUS CHRIST, missionary, and early Christian theologian. His missionary journeys among the Gentiles form a large part of the ACTS OF THE APOSTLES. His many letters (epistles) to early Christian communities, recorded in the New Testament, represent the most important early formulations of Christian theology following the death of Jesus Christ. Named Saul at birth, he was both a Jew and a Roman citizen, brought up in the Roman colony of Tarsus. He saw the teachings of Jesus as a major threat to JUDAISM, and became a leading persecutor of early Christians. Travelling to Damascus to continue his persecution activities, he saw a bright light and heard the voice of Jesus addressing him. Having thus undergone his religious conversion, he adopted the name Paul and became an energetic evangelist and teacher of Christianity. In c.60 he was arrested and taken to Rome, where he died sometime between 62 and 68, probably suffering a martyr's execution.

Paul III (1468–1549) Pope (1534–49), b. Alessandro Farnese. As pope, he largely initiated the Counter Reformation. He sponsored reform, approved the Jesuits, and summoned the Council of Trent (1545).

Paul VI (1897–1978) Pope (1963–78), b. Giovanni Battista Montini. He earned a reputation as a reformer in the Vatican

▲ Pavlov During his study of the digestive process in dogs, the Russian physiologist Ivan Pavlov worked out his theory of conditioned reflexes. He established that dogs salivated when they were presented with food. This was a reflex action that the dog could not control. He then "conditioned" a dog by ringing a bell every time he gave it food. Eventually the dog would salivate whenever it heard the bell. His work helped to establish the physiological basis of behaviour.

secretariat (1937–54) and as archbishop of Milan (1954–63). He continued the Second VATICAN COUNCIL, begun by John XXIII, but disappointed liberals by upholding the celibacy of priests, papal primacy, and condemning contraception.

Pauli, Wolfgang (1900–58) US physicist, b. Austria. His work on QUANTUM THEORY led him to formulate (1925) the EXCLUSION PRINCIPLE, which explains the behaviour of electrons in atoms. He received the 1945 Nobel Prize for physics for the work. In 1931 he had predicted the existence of the NEUTRINO, and lived to see his prediction verified in 1956.

Pauling, Linus Carl (1901–94) US chemist. His work on the application of WAVE MECHANICS to molecular structure is detailed in *The Nature of the Chemical Bond* (1939). For this work he won the Nobel Prize for chemistry in 1954. He also worked on the structure of PROTEINS. His work on DNA nearly anticipated the findings of Francis CRICK and James WATSON, when he suggested, in the 1950s, that its molecules were arranged in a helical structure. A keen advocate of nuclear disarmament, he was awarded the 1962 Nobel Peace Prize.

Pavarotti, Luciano (1935–) Italian tenor. He made his operatic debut, as Rodolfo in Puccini's *La Bohème*, in 1961. He made his US debut in 1968. His rich voice is well suited to the Italian repertoire and Mozart. Internationally famous, he later formed part of the popular concert in Rome called *The Three Tenors*, along with José CARRERAS and Placido DOMINGO.

Pavese, Cesare (1908–50) Italian poet, novelist and translator. His translations of English and American novels had considerable influence on Italian literature of the time. His work with the Resistance during World War 2 influenced his own creative writing, which includes the poem *The Political Prisoner* (1949), the novel *The Moon and the Bonfire* (1950) and collections of poetry and essays.

Pavlov, Ivan Petrovich (1849–1936) Russian neurophysiologist. His early work centred on the PHYSIOLOGY and NEUROLOGY of digestion, for which he received the 1904 Nobel Prize for physiology or medicine. He is best known for his studies of conditioning of behaviour in dogs. His major works are Conditioned Reflexes (1927) and Lectures on Conditioned Reflexes (1928).

Pavlova, Anna (1881–1931) Russian ballerina who made her debut in 1899. She toured in Europe and the USA and left Russia in 1913 to tour with her own company. She excelled in *Giselle, The Dragonfly, Autumn Leaves* and the *Dying Swan*, choreographed for her by Michel FOKINE in 1905.

pawnee Caddoan-speaking tribe of Native North Americans. They are related to the Arikara, who once occupied the Central Platte and Republican River areas in Nebraska. In the mid-1990s, some 1,500 lived on reservations in Oklahoma. **pawpaw** See PAPAYA

Paxton, Sir Joseph (1803–65) British architect and landscape gardener. Noted for his greenhouses, he designed the CRYSTAL PALACE for the Great Exhibition of 1851.

Paz, Octavio (1914–) Mexican poet and essayist. His work has gone through many phases, from Marxism to SURREALISM and oriental philosophies. His poetry was collected in translation as *The Collected Poems of Octavio Paz*, 1957–1987 (1987). He has also written essays and literary criticism, including *The Labyrinth of Solitude* (1950). He was awarded the 1990 Nobel Prize for literature.

pea Climbing annual plant (*Pisum sativum*), probably native to w Asia. It has small oval leaves and white flowers that give rise to pods containing wrinkled or smooth seeds. The seeds are a popular vegetable. It grows to 1.8m (6ft). Family Fabaceae/Leguminosae.

Peace Corps US government agency, organizing work by volunteers in developing countries. The corps was established in 1961 by President John F. KENNEDY with the aim of providing trained manpower in developing countries. Peace corps volunteers usually spend two years overseas and are paid only a basic local wage.

peach Small fruit tree (*Prunus persica*) native to China and grown throughout temperate areas. The lance-shaped leaves appear after the pink flowers in spring. The fruit has a thin, downy skin, white or yellow flesh, with a hard "stone" in the middle. Height: to 6.5m (20ft). Family Rosaceae.

Peacock, Thomas Love (1785–1866) British writer of satirical poetry and romances. Peacock is remembered for his idiosyncratic satirical novels, which include *Headlong Hall* (1816), *Melincourt* (1817), *Nightmare Abbey* (1818), *Crotchet Castle* (1831) and *Gryll Grange* (1860–61). He also wrote poetry and literary criticism.

peacock (peafowl) Any of several species of birds of Asia and Africa. The male is called a peacock and the female a peahen, but peacock has become the common name for both sexes. The male has a 150cm (60in) tail, which it can spread vertically as a semicircular fan with a pattern of eye-like shapes. The body of the male may be metallic blue, green or bronze, depending on the species. Hens are almost as big as the males; they lack the tail and head ornaments and are brown, red or green. In the wild, peafowl inhabit open, low-land forests, roosting in trees. Length of body: 75cm (30in). Family Phasianidae; genera *Pavo* and *Afropavo*.

Peak District Plateau area at the s end of the Pennines, Derbyshire, N central England. The Peak District National Park was established here in 1951. The highest point is Kinder Scout, at 636m (2,088ft). Area: 1,404sq km (542sq mi).

Peale, Charles Willson (1741–1827) US painter, inventor, naturalist and father of a family of artists. In 1782 he opened the USA's first art gallery, in Philadelphia, where he exhibited his own portraits. He later expanded the gallery into the country's first natural history museum. In 1795 he painted his most celebrated picture, *The Staircase Group*, a portrait of two of his sons.

peanut (groundnut) Annual leguminous plant *Arachis hypogaea* of the PEA family. Native to South America, it is now grown in many temperate regions of the world. A versatile plant, in the 19th century, US scientist George Washington CARVER researched more than 300 uses for it. The seeds (peanuts) are a valuable source of protein and yield an oil used both in food and in industry. The body of the plant can be used as animal feed. Family: Fabaceae/Leguminosae.

pear Tree and its edible fruit, native to N Asia and S Europe and grown in temperate regions. The tree has white flowers and glossy, green leaves. The greenish-yellow, brownish or reddish fruit, picked unripe and allowed to mature, is eaten fresh or preserved. Height: 15–23m (50–75ft). Family Rosaceae; species *Pyrus communis*.

pearl Hard, smooth, iridescent concretion of calcium carbonate produced by certain marine and freshwater bivalve MOLLUSCS. It is composed of nacre, or mother-of-pearl, which forms the inner layer of mollusc shells. A pearl results from an abnormal growth of nacre around minute particles of foreign matter, such as a grain of sand.

Pearl Harbor US naval base in Hawaii. On 7 December 1941, the base (headquarters of the US Pacific fleet) was attacked by aircraft from a Japanese naval task force, which had approached unobserved. About 2,400 people were killed and 300 aircraft and 18 ships were destroyed or severely damaged. The attack provoked US entry into World War 2.

Pears, Sir Peter (1910–86) British tenor. A lifelong friend of Benjamin BRITTEN, he created many roles in Britten's operas, including the title roles of *Peter Grimes* (1945) and *Albert Herring* (1949), the Male Chorus in *The Rape of Lucretia* (1946) and Aschenbach in *Death in Venice* (1973).

Pearse, Patrick Henry (1879–1916) Irish author and political figure. He headed the revival of interest in Gaelic culture, writing poems, short stories and plays. He led the insurgents in the EASTER RISING (1916) and was court-martialled and executed by British authorities.

Pearson, Lester Bowles (1897–1972) Canadian statesman and diplomat, prime minister (1963–68). A distinguished diplomatic career culminated in his appointment (1945) as head of Canada's delegation to the United Nations (UN). He acted as president of the general assembly (1952–53). In 1948 he entered the Canadian parliament as a Liberal and was secretary of state for external affairs (1948–63). Pearson's efforts in resolving the Suez Crisis earned him the 1957 Nobel Peace Prize. In 1958 he became leader of the LIBERAL PARTY. He succeeded Diefenbaker as prime minister. His term was marked by health and social welfare reforms.

▲ peanut The groundnut, or peanut (*Arachis hypogaea*), is the second most important source of vegetable oil after soya beans.

▲ pear A fruit from a plant of the rose family, pears thrive in warmer temperate regions. In Canada, Australia and South Africa a large proportion of the crop is canned, whereas in Europe and the USA, canning is less significant.

▲ pecan Mottled brown shells of the pecan burst apart to release the ripe nut. The pecan, a relative of the walnut, grows on large trees, which are found in temperate parts of North America. Pecans make excellent dessert nuts.

Peary, Robert Edwin (1856–1920) US Arctic explorer. He made several expeditions to Greenland (1886–92) and in 1893 led the first of five expeditions towards the North Pole. He claimed to have reached the pole in April 1909.

Peasants' Revolt (1381) Rebellion in England. The immediate provocation was a POLL TAX (1380). Fundamental causes were resentment at feudal restrictions and statutory control of wages, which were held down artificially despite the shortage of labour after the BLACK DEATH. Roused by a rebel priest, John Ball, and led by Wat Tyler, the men of Kent marched into London, where they were pacified by RICHARD II. Promises to grant their demands were broken after they dispersed.

Peasants' War (1524–25) Rebellion of German peasants, probably the largest popular uprising in European history. Sparked by anger over ever-increasing dues demanded by the princes, there was widespread pillaging in the countryside of s Germany. The peasants hoped for and needed the support of Martin Luther, but he rejected their charter of liberties and their rebellion was savagely suppressed.

peat Dark brown or black mass of partly decomposed plant material. It forms in bogs and areas of high rainfall, and contains a high proportion of water. It is thought to be similar to the first stage in the formation of coal, and its high carbon content makes it suitable for use as a fuel.

peat moss Decomposed organic matter (HUMUS) obtained from disintegrated sphagnum MOSS (bog moss). The most widely obtainable source of humus, it is dug into soil and added to compost to retain moisture. Its continuing use poses an ecological threat to peat bogs.

pecan North American nut tree whose nut, resembling a small, smooth-shelled WALNUT, is 70% fat. Family Juglandaceae; species *Carya illinoinensis*.

peccary Omnivorous, pig-like mammal native to sw USA and Central and South America. It has coarse, bristly hair, and scent glands on its back. Collared peccaries, or javelinas (*Tayassu taja*), have dark-grey hair with a whitish collar. White-lipped peccaries (*Tayassu pecari*) have brown hair. Weight: 23–30kg (50–66lb). Family Tayassuidae.

Peck, (Eldred) Gregory (1916—) US film actor. Peck made his debut in Days of Glory (1943). He received Academy Award nominations for The Keys of the Kingdom (1945), The Yearling (1946), Gentleman's Agreement (1947), and Twelve O'Clock High (1950). In 1956 Peck won a Best Actor Oscar for his powerful performance in To Kill a Mockingbird (1962). Other films include Spellbound (1945), The Gunfighter (1950), Moby Dick (1956), McKenna's Gold (1968) and The Omen (1976). He starred in two versions of Cape Fear (1962, 1991). Pectin Water-soluble POLYSACCHARIDE found in the cell walls and intercellular tissue of certain ripe fruits or vegetables. When fruit is cooked, it yields a gel that is the basis of jellies and jams.

pediment Low-pitched gable formed by the sloping eaves of a pitched roof and a horizontal cornice. The classic triangular pediment appeared in Greek temples such as the PARTHENON. Later architects developed more extravagant forms, featuring curved, broken and inverted styles over doors and windows.

Pedro I (1798–1834) Emperor of Brazil (1822–31). Son of the future JOHN VI of Portugal, he fled with the rest of the royal family to Brazil in 1807. When his father reclaimed the Portuguese Crown (1821), he became prince regent of Brazil and declared it an independent monarchy (1822). His reign was marked by opposition from right and left, military failure against Argentina (1825–28) and revolt in Rio de Janeiro (1831). He abdicated and returned to Portugal, where he secured the succession of his daughter, Maria II, to the Portuguese throne.

Pedro II (1825–91) Emperor of Brazil (1831–89). He reigned under a regency until 1840. His reign was marked by internal unrest and external threats from Argentina and Paraguay. Slavery was abolished in 1888, and Pedro's policy was generally reformist, antagonizing the military and the rich planters. He was forced to resign in 1889, retiring to Europe, while Brazil became a republic.

Peel, Sir Robert (1788–1850) British statesman, one of the founders of the Conservative Party. As Tory Party home

secretary, he created the first modern police force, the Metropolitan (London) Police, in 1829. He was chiefly responsible for passage of the CATHOLIC EMANCIPATION Act (1829) and was prime minister in 1834–35 and 1841–46. His Tamworth manifesto (1934) was a statement of emergent conservatism. Peel became converted to the doctrine of FREE TRADE, and the Irish FAMINE convinced him of the need to repeal the CORN LAWS. The proposal split the Party, and he resigned (1845). He returned to power and carried through the repeal, before being finally forced from office.

peerage British nobility holding any of the following titles: baron, viscount, earl, marquess or duke. Although all titles were originally hereditary, these are now rare, and non-hereditary life peerages are more usually granted. Peers constitute the Lords Temporal section of the HOUSE OF LORDS, having the right to sit in the House and vote.

Pegasus Northern constellation between Andromeda and Cygnus. Three of its bright stars form the Giant Square in Pegasus with Alpha Andromedae; the brightest is Epsilon, with a magnitude of 2.30.

Pegasus In Greek mythology, winged horse. Born out of the blood of MEDUSA, it was tamed by Bellerophon and helped him in his battles. Later, it carried the thunderbolts of ZEUS.

Pei, leoh Ming (1917–) US architect, b. China. Some of his most important buildings include Mile High Center, Denver (1957), the National Airlines Terminal at Kennedy International Airport, New York (1971), the East Building to the National Gallery of Art, Washington, D.C. (1978), and the John F. Kennedy Library, Boston (1979). He designed the pyramid in front of the Louvre, Paris (1989).

Peirce, Charles Sanders (1839–1914) US scientist, philosopher and logician, a leading exponent of PRAGMATISM. He explained pragmatism in a series of six articles published between 1877 and 1878. He also helped to develop SEMIOTICS, the study of the use of signs and symbols. Most of his work was published posthumously in eight volumes as *The Peirce Papers: Collected Papers* (1931–58).

Peking See Beijing

Pelagius (c.360–c.420) Monk and theologian, probably born in Britain, who preached the heresy of Pelagianism. In c.380 he went to Rome and became the spiritual guide of many clerics and lay persons. After 410 he preached in Africa, where his ideas were denounced by St AUGUSTINE OF HIPPO, and later in Palestine. He maintained that man is master of his own salvation and rejected the idea of original sin. He countered criticisms from Augustine and St JEROME in his book *De Libero Arbitrio* in 416. He was excommunicated by Pope Innocent I in 417.

Pelé (1940–) (Edson Arantes do Nascimento) Brazilian soccer player. He led Brazil to three World Cup victories (1958, 1962 and 1970). He made his last international appearance in 1971. Apart from 1975–77, when he played for the New York Cosmos, all his club games were played for Santos. He scored a total of 1,281 goals. In 1997 he became Brazil's minister for sport.

pelican Any of several species of inland water birds, with a characteristic distensible pouch under its bill for scooping up fish from shallow water. It is usually white or brown and has a long hooked bill, long wings, short thick legs and webbed feet. Length: to 1.8m (6ft). Family Pelecanidae; genus *Pelecanus*.

pellagra Disease caused by a deficiency of nicotinic acid, one of the B group of vitamins. Its symptoms are lesions of the skin and mucous membranes, diarrhoea and mental disturbance.

Peloponnesian Wars (431–404 BC) Conflict in ancient Greece between Athens and Sparta. The underlying cause was Sparta's fear of Athenian hegemony. Athenian hostility towards Corinth, Sparta's chief ally, provoked the Spartan declaration of war. Having a stronger army, Sparta regularly invaded Attica, while Athens, under Pericles, avoided land battles and relied on its navy. The early stages were inconclusive. The Peace of Nicias (420 BC) proved temporary. In 415 BC Athens launched a disastrous attack on Syracuse, which encouraged Sparta to renew the war. With Persian help, Sparta built up a navy which, under Lysander, defeated Athens in 405 BC. Besieged and blockaded, Athens surrendered.

▲ Peel The Conservative politician Sir Robert Peel was known for his opposition to the Reform Act and the Corn Laws. He is perhaps best known for the establishment of the London police force (1828), hence the nickname Peelers or Bobbies.

Peloponnesos (Pelopónnisos) Peninsula in s Greece, connected to the mainland by the Isthmus of Corinth. The chief cities are Patras, Corinth, Pirgos and Sparta. A mountainous region, it included the ancient cities of Sparta, Corinth, Argos and Megalopolis. The peninsula was involved in the Persian Wars (500–449 BC), and it was the site of many battles during the Peloponnesian Wars (431–404 BC). In 146 BC the region fell to the Romans, who reduced it to the status of a province. Held by the Venetians from 1699 to 1718, then by the Ottoman Turks, it passed to Greece after independence. Industries: silk, fish, manganese, chromium, fruits, tobacco, wheat, tourism. Area: 21,756sq km (8,400sq mi). Pop. (1991) 1,077,002.

Peltier effect Phenomenon in the temperature changes at a junction where an electric current passes from one kind of metal to another. When a current passes through a THERMOCOUPLE, the temperature at one junction increases while that at the other decreases. The effect was discovered in 1834 by the French physicist Jean Charles Peltier. See also SEEBECK EFFECT pelvis Dish-shaped bony structure that supports the internal organs of the lower abdomen in vertebrates. It serves as a point of attachment for muscles that move the limbs or fins.

penance Carrying out of a specified act as a mark of sincere regret following the commission of a sin or sins. The most common penance, prescribed by a priest after ABSOLUTION, is to say a prayer at a special time.

Penang (Pinang) Island of MALAYSIA, off the Nw coast of the Malay Peninsula, which (together with a coastal strip on the mainland) comprises a state of Malaysia; the capital is Penang. The island was Britain's first possession in Malaya (1786). In 1826 it united with Singapore and MALACCA, and in 1867 the group became the Straits Settlements colony. Penang joined the Federation of Malaya in 1948. Its products include rice, rubber and tin. The city of Penang is Malaysia's principal port. Area: 1,040sq km (400sq mi). Pop. (1993 est.) 1,141,500.

penates Ancient Roman gods of the household, worshipped at home in association with the lares (spirits of ancestors). Originally the penates were the spirits of the store room.

Penderecki, Krzysztof (1933–) Polish composer. His reputation was established in 1960 with his *Threnody for the Victims of Hiroshima* for string orchestra. Other pieces include a *Passion According to St Luke* (1963–65), several operas, and two symphonies (1973 and 1980).

pendulum Any object suspended at a point so it swings in an arc. A simple pendulum consists of a small heavy mass attached to a string or light rigid rod. A compound pendulum has a supporting rod whose mass is not negligible. The pendulum was first used to regulate clocks in 1673 by the Dutch physicist Christiaan HUYGENS. Foucault's pendulum, devised by the French physicist Léon FOUCAULT, swings in all directions and was used to demonstrate the Earth's rotation.

Penelope In Greek mythology, wife of ODYSSEUS. As described in HOMER's *Odyssey*, she had been married for only a year when her husband left for ten years of war and ten of wandering. She remained faithful, putting off her many suitors with the promise that she would choose one when her weaving was done. By day she wove and by night she undid her work.

penguin Flightless sea bird that lives in the Southern Hemisphere and ranges from the Antarctic northwards to the Galápagos Islands. Their wings have been adapted to flippers and their webbed feet help to propel their sleek bodies through the water. Although they are awkward on land, they are fast and powerful swimmers, easily able to catch the fish and squid that they feed on. Height: to 1.22m (4ft). Family Spheniscidae.

penicillin ANTIBIOTIC agent derived from moulds of the genus *Penicillium*. The first antibiotic to be discovered (by Sir Alexander Fleming in 1928), it can now be produced synthetically. It can produce allergic reactions, and some microorganisms have become resistant to its action.

Peninsular Campaign (April–July 1862) Series of battles in the American Civil War resulting from the attempt by Union forces under George McClellan to take Richmond, Virginia, by advancing up the peninsula between the York and James rivers. The Confederates, under Joseph Johnston and later Robert E. Lee, checked the advance and after the Battle of Malvern Hill, McClellan was ordered to withdraw.

Peninsular War (1808–14) Campaign of the NAPOLEONIC WARS in Portugal and Spain. A British force commanded by the future Duke of WELLINGTON supported Portuguese and Spanish rebels against the French. Initially on the defensive, Wellington's forces gradually drove the French out of the Iberian peninsula and, after the victory of Vitoria (1813), invaded s France. Napoleon's abdication (1814) brought the campaign to an end.

penis Male reproductive organ. It contains the URETHRA, the channel through which URINE and SEMEN pass to the exterior, and erectile tissue that, when engorged with blood, causes the penis to become erect. *See also* SEXUAL INTERCOURSE

Penn, William (1644–1718) English Quaker leader and chief founder of what later became the US state of PENNSYL-VANIA. Because of his advocacy of religious freedom, he was imprisoned four times. While in the Tower of London, he wrote *No Cross – No Crown* (1669), explaining Quaker-Puritan morality. He persuaded King CHARLES II to honour an unpaid debt by granting him wilderness land in America to be settled by the Quakers and others seeking refuge from religious persecution. The colony was named the Commonwealth of Pennsylvania in his honour.

Pennines Range of hills in N England, extending from the Tyne Gap and Eden Valley on the border with Scotland to the valley of the River Trent. The hills are a series of highland blocks dissected by rivers such as the Tees, Aire and Ribble. The rearing of sheep is the chief occupation. Tourism and limestone quarrying are also important. The highest peak is Cross Fell, rising to 893m (2,930ft). Length: *c*.260km (160mi).

Pennsylvania State in E USA; one of the Middle Atlantic states; the capital is HARRISBURG. The chief cities are PHILADELPHIA, PITTSBURGH, Scranton, Bethlehem, Wilkes-Barre and Erie. Swedish and Dutch settlements were made along the DELAWARE River in the mid-17th century. By 1664 the area was controlled by the English, and William PENN received a charter from Charles II in 1681 for what is now Pennsylvania. It was one of the 13 original states of the Union. The DECLARATION OF INDEPENDENCE was signed and the US Constitution was ratified in Philadelphia, which was also the national capital from 1790 to 1800. The Union victory at the Battle of GETTYSBURG in July 1863 was a turning point in the American CIVIL WAR. Apart from small lowlying areas in the NW and SE, the state is composed of mountain ridges and rolling hills with narrow valleys. Farming is concentrated in the SE; the principal crops are cereals, tobacco, potatoes and fruit, and dairy products are important. Pennsylvania has rich deposits of coal and iron ore. The state has long been a leading producer of steel, which today accounts for about 25% of the nation's output. Industries: chemicals, cement, electrical machinery, metal goods. Area: 117,412sq km (45,333sq mi). Pop. (1990) 11,881,643.

Pennsylvanian period In the USA, name given to the later part of the CARBONIFEROUS period.

Pentagon Headquarters of the US Department of Defense in Arlington, Virginia. The complex is made up of five concentric buildings in pentagonal form and covers 14ha (34 acres). It was completed in 1943. The Pentagon has come to signify the US military establishment.

Pentateuch (Gk. Five scrolls) First five books of the Bible, traditionally attributed to Moses and in Judalsm referred to collectively as the *Torah*, or Law. The Pentateuch comprises the five Old Testament books of Genesis, Exodus, Leviticus, Numbers and Deuteronomy. Composed over a very long period (possibly 1,000 years or more), they were probably collected in their present form during the Babylonian Captivity of the Jews during the 6th century BC.

pentathlon Athletic competition originating in ancient Greece. It consisted of five events — running, jumping, wrestling, discus-throwing and javelin-throwing — all undertaken on the same day. It was made an Olympic event in 1912. **Pentecost** Important religious festival celebrated in May or June. In Judaism, it is a festival held seven weeks after the second day of the Passover, commemorating the giving of the Law to Moses. In the Christian calendar it is also known as Whit Sunday, falling seven weeks after Easter.

▲ pelican The brown pelican (Pelecanus occidentalis) has a large bill with a distensible pouch that it uses to catch the fish on which it feeds. It lives on the coasts of tropical America.

PENNSYLVANIA Statehood :

12 December 1787 Nickname :

The Keystone State

State bird : Ruffed grouse

State flower: Mountain laurel

State tree :

Hemlock
State motto:

Virtue, liberty and independence

▲ penguin The royal penguin (Eudyptes schlegeli), like many other species of penguin, is a highly social bird. During the breeding season colonies of up to 2 million royal penguins amass on Macquarie Island, sw of New Zealand.

▲ pepper Green peppers are used to flavour food. The strong flavour of some varieties of pepper is due to the presence of capsaicin, which is found in the walls of the fruit.

Pentecostal Churches Fellowship of revivalist Christian sects, inspired by the belief that all Christians should seek to be baptized with the Holy Spirit, as Jesus' disciples were, and to experience events such as speaking in tongues. Pentecostalists believe in the literal truth of the Bible, and many abstain from alcohol and tobacco and disapprove of dancing, theatre and other pleasures. The Pentecostal movement began in the USA at Topeka, Kansas, in 1901. It became an organized movement in Los Angeles in 1906 and spread rapidly to other countries. The numerous Pentecostal Churches now have a collective world membership of c.10 million.

Penzias, Arno Allan (1933-) US astrophysicist, b. Germany, who together with Robert Wilson discovered the cosmic background radiation emanating from outer space, which scientists agree supports the Big Bang theory. In the early 1960s, the two men studied radio noise coming from all directions in space. They detected a non-varying signal that is considered to be thermal energy left over from the Big Bang. For their pioneering work, they shared the 1978 Nobel Prize for physics with the Russian physicist Peter Kapitza.

peony Perennial plant native to Eurasia and North America. It has glossy, divided leaves and large white, pink or red flowers. Height: to 0.9m (3ft). Tree peonies grow in hot, dry areas and have brilliant blossoms of many colours. Height: to 1.8m (6ft). Family Paeoniaceae; genus Paeonia.

Pepin III (the Short) (714–768) First CaroLingian king of the Franks (750-768). He and his brother Carloman inherited the office of "mayor of the palace" (de facto ruler) in 741. They suppressed a series of revolts by 747, when Carloman entered a monastery. In 750 Pepin deposed the last MEROVIN-GIAN king, Childeric III, and was anointed king of the Franks. He promised to change Carolingian policy by supporting the papacy against the LOMBARDS, and he defeated the Lombards in 754 and 756. He ceded the conquered territories (the future PAPAL STATES) to the papacy in what was known as the Donation of Pepin. Pepin was the father of CHARLEMAGNE.

pepper (capsicum) Perennial woody shrub native to tropical America. The fruit is a many-seeded, pungent berry whose size depends on the species. Included are bell, red, cayenne and CHILLI peppers. They all belong to the NIGHTSHADE family, Solanaceae; genus Capsicum.

peppermint Common name for Mentha piperita, a perennial herb of the MINT family (Lamiaceae/Labiatae) cultivated for its ESSENTIAL OIL, which is distilled and used in medicine and as a flavouring.

pepsin Digestive ENZYME secreted by GLANDS of the STOM-ACH wall as part of the GASTRIC JUICE. In the presence of hydrochloric acid it catalyzes the splitting of PROTEINS in food into polypentides

peptide Compound consisting of two or more linked AMINO ACID molecules. Peptides containing several amino acids are called polypeptides. PROTEINS consist of polypeptide chains with up to several hundred amino acids cross-linked to each other in various ways.

Pepys, Samuel (1633-1703) English diarist. His Diary (1660-69) describes his private life and the English society of his time. It includes a vivid account of the RESTORATION, the 1661 coronation ceremony, the PLAGUE and the Great FIRE OF LONDON of 1666. Written in shorthand, it was not published until 1815, and not in complete form until 1983.

percentage Quantity expressed as the number of parts in 100 (considered to be a whole). Fractions can be expressed as a percentage by multiplying by 100, i.e. 3/4 becomes 75%.

perception Process by which the brain acquires and organizes incoming stimuli from the sensory nerves, translating them into meaningful information.

perch Freshwater food fish found in Europe and the USA E of the Rocky Mountains. The North American yellow perch (Perca flavescens) is gold-coloured with black side-bars. Weight: 1.0-2.7kg (2.2-6lb). Family Percidae.

percussion Term for any of several musical instruments that produce sound when struck with a beater or the hand. They are divided into two groups: ideophones, in which the whole object vibrates when struck (such as CYMBALS, gongs and XYLOPHONES); and membranophones, in which a stretched skin or membrane vibrates a column of air (this group includes all DRUMS).

Percy, Sir Henry (1364-1403) English nobleman, known as "Hotspur" for his zeal in guarding the Scottish-English border. Son of the Earl of Northumberland, he supported the deposition of Richard II in 1299, but later guarrelled with the new king, Henry IV. In 1403 he and his father, in alliance with Owain GLYN DWR, launched a rebellion. They were defeated at Shrewsbury, where Percy was killed.

peregrine falcon Crow-sized, grey, black and white BIRD OF PREY. It inhabits craggy open country or rocky coastlines and marshes or estuaries. The largest breeding FALCON in Britain, it flies swiftly with prolonged glides. Length: to 48cm (19in). Family Falconidae; species Falco peregrinus.

perennial Plant with a life cycle of more than two years. It is a common term for flowering herbaceous and woody plants. They include the LILY, DAISY and IRIS, and all trees. See also ANNUAL: BIENNIAL

Peres, Shimon (1923-) Israeli statesman, prime minister (1986-88, 1995-96), b. Poland. Elected to the Knesset in 1959, he was a founder of the Labour Party (1968), becoming its leader (1977). He held ministerial posts under Golda MEIR and Yitzhak RABIN. In 1992, losing the party leadership to Rabin, he played a vital role in the Palestine peace process. On Rabin's assassination (1995), he returned as prime minister but was defeated in 1996 elections by Benjamin NETANYAHU. perestroika (Rus. reconstruction) Adopted by Soviet prime minister, Mikhail GORBACHEV in 1986, perestroika was linked with GLASNOST. The restructuring included reform of government and the bureaucracy, decentralization and abolition of the Communist Party monopoly. Liberalization of the economic system included the introduction of limited private enterprise and freer movement of prices.

Pérez de Cuéllar, Javier (1920-) Peruvian diplomat, fifth secretary-general of the UNITED NATIONS (UN) (1982-91). He emerged as a successful compromise candidate in 1981, following opposition to the re-election of Kurt WALDHEIM. The initial crisis of the Falklands War (1982) was soon forgotten, and his two terms as secretary-general are considered

performance art Events that take place before an audience, but which defy the traditional definitions of DRAMA and MUSIC. Arguably originating in the USA in the 1960s, performance art is often visually oriented. It tends to be multi-disciplinary, and sometimes improvised or spontaneous.

perfume Substance that produces a pleasing fragrance. The scents of such plants as rose, citrus, lavender and sandalwood

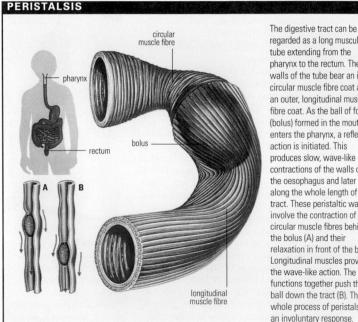

regarded as a long muscular tube extending from the pharynx to the rectum. The walls of the tube bear an inner. circular muscle fibre coat and an outer, longitudinal muscle fibre coat. As the ball of food (bolus) formed in the mouth enters the pharvnx, a reflex action is initiated. This produces slow wave-like contractions of the walls of the oesophagus and later along the whole length of the tract. These peristaltic waves involve the contraction of the circular muscle fibres behind the bolus (A) and their relaxation in front of the bolus. Longitudinal muscles provide the wave-like action. The two functions together push the ball down the tract (B). The whole process of peristalsis is an involuntary response.

are obtained from their essential oils. These are blended with a fixative of animal origin, such as musk, ambergris or civet. Liquid perfumes are usually alcoholic solutions containing 10–25% of the perfume concentrate; colognes and toilet waters contain about 2–6% of the concentrate.

Pergamum Ancient city state on the site of modern BERGA-MA, w Turkey. It was founded by Greek colonists under licence from the Persian emperors in the 4th century BC. At its peak in the 3rd–2nd centuries BC, it controlled much of w Asia Minor. In 133 BC it was bequeathed to Rome by Attalus III.

Pergolesi, Giovanni Battista (1710–36) Italian composer. His intermezzo, *La Serva Padrona* (1733), became a model for Italian OPERA BUFFA. His *Stabat Mater* (1730) is one of the finest examples of religious music of the Baroque period.

Peri, Jacopo (1561–1633) Italian composer. His musical drama *Dafne* (1597) is generally regarded as the first opera. His next opera, *Euridice* (1600), remains the earliest opera to have been preserved in its entirety.

perianth Outer region of a flower. The perianth includes all the structures surrounding the reproductive organs and usually consists of an outer whorl of sepals (calyx) and an inner whorl of petals (corolla).

pericarp In seed plants, the wall of a ripened fruit that is derived from the ovary wall. The tissues of the pericarp may be fibrous, stony or fleshy.

Pericles (490–429 BC) Athenian statesman. He dominated Athens from *c*.460 BC to his death, overseeing its golden age. He is associated with achievements in art and literature, including the building of the Parthenon, while strengthening the Athenian empire and government. Believing war with Sparta to be inevitable, he initiated the Peloponnesian Wars (431–404 BC) but died of plague at the outset.

peridot Gem variety of transparent green OLIVINE, a silicate mineral. Large crystals are found on St John's Island in the Red Sea and in Burma.

peridotite Term derived from PERIDOT. It is a heavy IGNEOUS ROCK of coarse texture composed of olivine and pyroxene with small flecks of mica or hornblende. It alters readily into SERPENTINE.

perigee Point in the orbit about the Earth of the Moon or of an artificial satellite, at which the body is nearest to the Earth. **perihelion** Point in the orbit of a planet, asteroid, comet or other body (such as a spacecraft) moving around the Sun at which the body is nearest the Sun.

periodic table Arrangement of the chemical elements in order of their ATOMIC NUMBERS in accordance with the periodic law first stated by Dmitri Mendeleyev in 1869. In the modern form of the table, the elements are arranged into 18 vertical columns and seven horizontal periods. The vertical columns containing groups are numbered I to VII (sometimes called IA to VIIA) with a final column numbered 0. The metallic TRANSITION ELEMENTS are arranged in the middle of the table between groups II and III. ALKALI METALS are in group I and ALKALINE-EARTH METALS in group II. Metalloids and nonmetals are found from groups III to VII, with the halogens in group VII and the NOBLE GASES (inert gases) collected into group 0. The elements in each group have the same number of VALENCE electrons and accordingly have similar chemical properties. Elements in the same horizontal period have the same number of electron shells.

peripheral nervous system All parts of the nervous system that lie outside the CENTRAL NERVOUS SYSTEM (brain and spinal cord). It comprises the 12 pairs of cranial nerves, which principally serve the head and neck region, and 31 pairs of spinal nerves with their fibres extending to the farthermost parts of the body.

periscope Optical instrument consisting of a series of mirrors or prisms that allows a person to view the surroundings from a concealed position by changing the direction of the observer's line of sight. Since World War 1, the periscope has been most commonly associated with SUBMARINES.

peristalsis Series of wave-like movements that propel food through the gut or digestive tract. It is caused by contractions of the smooth INVOLUNTARY MUSCLE of the gut wall. The reverse process, antiperistalsis, produces vomiting.

peritoneum Strong membrane of CONNECTIVE TISSUE that lines the body's abdominal wall and covers the abdominal organs. *See also* PERITONITIS

peritonitis Inflammation of the PERITONEUM. It may be caused by bacterial infection or chemical irritation or it may arise spontaneously in certain diseases. Symptoms include fever, abdominal pain and distension and shock. Treatment is directed at the underlying cause.

periwinkle Any of several species of trailing or erect evergreen plants that are cultivated as ground cover and for hanging baskets. Family Apocynaceae.

periwinkle (winkle) Any of several marine snails, gastropod molluses that live in clusters along marine shores. A her-

▲ Peres One of the founders of the Israeli Labour Party and prime minister of Israel (1986–88), Shimon Peres left his post as foreign minister to become prime minister after the assassination of Yitzhak Rabin in 1995.

▼ periodic table The periodic table arranges chemical elements according to their atomic number. The vertical columns, called groups, contain elements with similar chemical properties. The horizontal rows, called periods, are arranged in order of increasing atomic number and all elements in a row have the same number of electron shells. Elements coloured green in the table are non-metals; those coloured orange are metals; those coloured vellow are metalloid: those coloured blue, purple or pink are transition metals, the purple ones are the rare-earth elements, and the pink ones the transactinide elements.

GROUP I	ODIC T		Dente Salari				(A) (A) (A) (A) (A)						l IV	V	V	l VII	
Hydrogen	1				KEV								IV	V	V	l VII	2 He Helium 4.0026
3 Li ithium 5.941	Beryllium 9.0122				KEY r (most stable	atomic name of e elative atom	ic mass	- 43 Tc Technetium - [97]					6 C Carbon 12.011	7 N Nitrogen 14.0067	8 O Oxygen 15.9994	9 F Fluorine 18.998	10 Ne Neon 20.179
11 Na Sodium 22.9898	Mg Magnesium 24.305				(most stable	isotope in b	dckets)					13 Al Aluminium 26.9815	14 Si Silicon 28.086	15 P Phosphorus 30.9738	16 S Sulphur 32.06	17 CI Chlorine 35.453	18 Ar Argon 39.948
19 K Potassium 39.098	20 Ca Calcium 40.06	21 Sc Scandium 44.956	22 Ti Titanium 47.90	23 V Vanadium 50.941	24 Cr Chromium 51.996	25 Mn Manganese 54.9380	26 Fe Iron 55.847	27 Co Cobalt 58.9332	28 Ni Nickel 58.70	29 Cu Copper 63.546	30 Zn Zinc 65.38	31 Ga Gallium 69.72	32 Ge Germanium 72.59	33 As Arsenic 74.9216	34 Se Selenium 78.96	35 Br Bromine 79.904	36 Kr Krypton 83.80
37 Rb Rubidium 85.4678	38 Sr Strontium 87.62	39 Y Yttrium 88.906	40 Zr Zirconium 91.22	41 Nb Niobium 92.906	Mo Molybdenum 95.94	43 Tc Technetium [97]	44 Ru Ruthenium 101.07	45 Rh Rhodium 102.905	46 Pd Palladium 106.4	47 Ag Silver 107.868	48 Cd Cadmium 112.40	49 In Indium 114.82	50 Sn Tin 118.69	51 Sb Antimony 121.75	52 Te Tellurium 127.75	53 I lodine 126.9045	54 Xe Xenon 131.30
55 Cs Caesium 132.905	56 Ba Barium 137.34	57–71 Lanthanide Series	72 Hf Hafnium 178.49	73 Ta Tantalum 180.948	74 W Tungsten 183.85	75 Re Rhenium 186.207	76 Os 0smium 190.2	77 Ir Iridium 192.22	78 Pt Platinum 195.09	79 Au Gold 196.9665	80 Hg Mercury 200.59	81 TI Thallium 204.37	82 Pb Lead 207.2	83 Bi Bismuth 208.98	84 Po Polonium [209]	85 At Astatine [210]	86 Rn Radon [222]
87 Fr Francium [223]	88 Ra Radium [226]	89–103 Actinide Series	104 Db Dubnium [261]	105 Hn § Hahnium [262]	106 Rf Rutherfordium [263]	107 Uns Unnilseptium [262]	108 Uno Unniloctium [265]	109 Une Unnilenium [266]									
LANTHANIDE SERIES (rare earth elements)		57 La Lanthanum 138.9055	58 Ce Cerium 140.12	59 Pr Praeseodymium 140.9077		61 Pm Promethium [145]	62 Sm Samarium 150.36	63 Eu Europium 151.96	64 Gd Gadolinium 157.25	65 Tb Terbium 158.9254	66 Dy Dysprosium 162.50	67 Ho Holmium 164.9308	68 Er Erbium 167.26	69 Tm Thulium 168.9342	70 Yb Ytterbium 173.04	71 Lu Lutetium 174.97	
ACTINIDE SERIES (radioactive rare earth elements)		89 Ac Actinium [227]	90 Th Thorium 232.0381	91 Pa Protactinium 231.0359		93 Np Neptunium 237.0482	94 Pu Plutonium	95 Am Americium [243]	96 Cm Curium [247]	97 Bk Berkelium [247]	98 Cf	99 Es Einsteinium [254]	100 Fm	101 Md Mendelevium [256]	102 No	103 Lr Lawrencium [256]	

bivore, it nestles in cracks among rocks. Many are edible. Length: to 2.5cm (1in). Family Littorinidea; genus *Littorina*. **permafrost** Land that is permanently frozen, often to a considerable depth. The top few centimetres generally thaw in the summer, but the meltwater is not able to sink into the ground because of the frozen subsoil. If the landscape is fairly flat, surface water lies on the ground throughout the summer. Construction work is very difficult, and many methods have been employed in Russia, Canada and Alaska to overcome the problems. *See also* TUNDRA

Permian Geological period of the PALAEOZOIC era lasting from 286 to 248 million years ago. There was widespread geologic uplift and mostly cool, dry climates with periods of glaciation in the southern continents. Many groups of marine invertebrate animals became extinct during the period.

Perón, Eva Duarte de (1919–52) Argentine political leader known as "Evita", first wife of President Juan Perón. She administered the country's social welfare agencies and was Argentina's chief labour mediator. Her popularity contributed to the longevity of the Peronist regime.

Perón, Juan Domingo (1895–1974) President of Argentina (1946–55, 1973–74). He was an army officer who took part in the coup of 1943 and became the leading figure in the military junta (1943–46). He cultivated the trade unions and earned support from the poor by social reforms, greatly assisted by his wife, "Evita" PERÓN. Though briefly ousted in 1945, he won the presidential election (1946) and was reelected in 1952. Perón's populist programme was basically nationalistic and totalitarian. Changing economic circumstances and the death of his wife reduced Perón's popularity after 1951, and he was overthrown in 1955. He retired to Spain, but returned to regain the presidency in 1973. His rule, marked by violence, was cut short by his death.

perpendicular style Final period of English Gothic architecture, from *c*.1330 to the mid-16th century. Named after the strong vertical lines of its window tracery and panelling, it is characterized by fan vaulting and flattened arches.

perpetual motion Hypothetical machine that continues to work without any energy being supplied. Such a machine would require either the complete elimination of FRICTION, or would have to violate the laws of THERMODYNAMICS.

Perrault, Charles (1628–1703) French poet and prose writer. A leading member of the Académie Française from 1671, he is best remembered for *Tales of Mother Goose* (1697). Perry, Fred (Frederick John) (1909–95) British table tennis and tennis player. World table tennis champion in 1929, he won three successive Wimbledon tennis singles titles (1934–36). He also won the US, French and Australian titles. (1937) Matthew Calbraith (1794–1858) US naval officer. In 1837 he commanded the first steam vessel in the US Navy, the *Fulton*. He also established the Navy's apprentice system in 1837 and organized the first naval engineer corps. He was responsible for opening up Japan to the West (1853–54).

Persephone In Greek mythology, goddess of spring. She was the daughter of Zeus and the Earth goddess Demeter. When Persephone was abducted by Hades, king of the underworld, to be his wife, famine spread over the Earth. To prevent catastrophe, Zeus commanded Hades to release her. He did so, and thus, each year, spring returns to the Earth. Persephone was known as Proserpine to the Romans.

Persepolis City of ancient Persia (Iran), c. 60km (37mi) NE of SHIRAZ. As the capital (539–330 BC) of the ACHAEMENID empire, it was renowned for its splendour. It was destroyed by the forces of ALEXANDER THE GREAT in 330 BC.

Perseus In astronomy, a prominent northern constellation. Perseus is a rich constellation, crossed by the Milky Way.

Perseus In Greek mythology, son of Danaë and Zeus. Perseus beheaded the snake-haired gorgon MEDUSA, turned ATLAS to stone and rescued the princess ANDROMEDA from being sacrificed to a sea monster.

Pershing, John Joseph (1860–1948) US general. He led a punitive expedition against Pancho VILLA in Mexico (1916) before being appointed to command the American Expeditionary Force (AEF) in World War 1 (1917–19). Returning a hero, he later served as army chief of staff (1921–24).

Persia Former name of Iran, in Sw Asia. The earliest empire in the region was that of Media (c.700–549 BC). It was overthrown by the Persian king, Cyrus the Great, who established the much larger Achaemenid dynasty (549–330 BC), destroyed by Alexander the Great. Alexander's successors, the Seleucids, were replaced by people from Parthia in the 3rd century BC. The Persian Sassanid dynasty was established by Ardashir I in Ad 224. Weakened by defeat by the Byzantines under Heraclius, it was overrun by the Arabs in the 7th century.

Persian (Farsi) Official language of Iran. It is spoken by nearly all of Iran's population as a first or second language. It is also widely used in Afghanistan. Persian belongs to the Indo-Iranian family of Indo-European Languages. Since the spread of Islam to Iran during the Middle Ages, Persian has incorporated many borrowings from Arabic. It is written in the Arabic script.

Persian art Earliest manifestations of art in Persia (Iran), prior to the 7th-century development of ISLAMIC ART AND ARCHITECTURE. The oldest pottery and engraved seals date back to c.3500 BC. However, the greatest achievements of Persian art occurred during the rule of the ACHAEMENID and SASSANID dynasties. The former is best represented by the low relief carvings and massive gateway figures executed for the palace of Darius at Persepolis. The Sassanians excelled at metalwork and sculpture.

Persian Gulf (Arabian Gulf) Arm of the Arabian Sea between Arabia and the Asian mainland, and connected to it by the Strait of Hormuz and the Gulf of Oman. European powers began to move into the region in the 17th century. Britain had achieved supremacy in the Gulf by the mid-19th century. The discovery of oil in the 1930s increased its importance, and (after the British withdrawal in the 1960s) both the USA and the Soviet Union sought to increase their influence. Tension in the region was heightened by the IRAN-IRAO WAR in the 1980s, and the Gulf WAR against Iraq in 1991. The Gulf remains a major shipping and oil supply route. Area: c.240,000sq km (93,000sq mi).

Persian mythology, ancient Beliefs of the Persian people c.500 BC. The oldest Persian deity was Mithra, who was identified with the sun. He was a god of courage and enlightenment, and led the chariot of the sun across the sky on its daily journey. He was associated with Anahita, the goddess of water and of fertility. In the Zoroastrian period Mithra became subordinate to Ahura Mazdah, who was worshipped by the ACHAEMENID kings of Persia as the creator and ruler of the world. Ahura Mazdah was engaged in an eternal conflict with Ahriman, the principle of evil. At a later period both Ahura Mazdah and Ahriman (or Angra Mainyu) were regarded as the twin offspring of Zurvan (Time). Their cosmic struggle would end ultimately with the victory of Ahura Mazdah.

Persian Wars (499–479 BC) Conflict between the ancient Greeks and Persians. In 499 BC the Ionian cities of Asia Minor rebelled against Persian rule. Athens sent a fleet to aid them. Having crushed the rebellion, the Persian emperor, Darius I, invaded Greece but was defeated at Marathon (490 BC). In 480 BC his successor, Xerxes, burned Athens but withdrew after defeats at Salamis and Plataea (479 BC). Under Athenian leadership, the Greeks fought on, regaining territory in Thrace and Anatolia, until the outbreak of the Peloponnesian Wars (431 BC).

persimmon Any of several types of tree of the genus *Diospyros*. It produces reddish-orange fruit, which is sour and astringent until ripe. Species include the North American persimmon (*D. virginiana*) and the Japanese persimmon (*D. kaki*). Family Ebenaceae.

personality Emotional, attitudinal and behavioural characteristics that distinguish an individual. Psychologists use the term to refer to enduring, long-term characteristics of a person. Personality traits are assessed by a variety of methods, including personality tests and projective techniques. Influential theories of personality in psychology include Sigmund FREUD's PSYCHOANALYSIS, JUNG's theories of personality types, and social theories, which examine the influence of the environment on personality.

perspective Method of showing three-dimensional objects and spatial relationships in a two-dimensional image. The linear perspective system is based on the idea that parallel lines converge at a vanishing point as they recede into the distance. **perspiration** *See* SWEATING

Perth City on the Swan River, sw Australia; capital of Western Australia. Founded in 1829, the city grew rapidly after the discovery of gold at Coolgardie in the 1890s, the development of the port at Fremantle and the construction of railways to the E in the early 20th century. Industries: textiles, cement, food processing, motor vehicles. Pop. (1993 est.) 1,221,200.

Peru Republic in w South America. *See* country feature **Perugia** City on the Tiber River, central Italy; capital of Perugia province. A major Etruscan city, Perugia passed to Rome in 310 BC. In the 6th century AD it was captured by the Lombards and became a duchy. For centuries Perugia was the scene of various power struggles, before being subdued by the papacy in 1540. In 1860 it was incorporated into a united Italy. Perugia has always been the artistic centre of UMBRIA. The modern economy is based on tourism and commerce. It is renowned for its chocolate. Pop. (1991) 144,732.

Perugino, Pietro Vannucci (1445–1523) Italian painter, an important figure in the art of the early Renaissance. He was a notable fresco painter. His *Christ Delivering the Keys to St Peter*, painted for the Sistine Chapel in Rome, did much to establish his reputation. He was also a skilled portraitist, and was well known for his altarpieces.

Peshawar City in Nw Pakistan, 16km (9mi) E of the KHYBER PASS. An ancient settlement, it has always had great strategic importance. Brought under Muslim rule in the 10th century, it fell to the Afghans in the 16th century. Conquered by the Sikhs in 1834, it was annexed by Britain in 1849. In 1948 it became part of Pakistan. In the 1980s and 1990s it was a base for rebel groups operating in Afghanistan. The city is famous for handicrafts, carpets and leather goods. Pop. (1981) 555,000.

Pestalozzi, Johann Heinrich (1746–1827) Swiss educational reformer whose theories formed the basis of modern elementary education. His books include *How Gertrude Teaches Her Children* (1801).

pesticide Chemical substance that is used to kill pests. A HERBICIDE is used for weeds, an insecticide for insects and a FUNGICIDE for fungal diseases. Pesticides are often harmful chemicals

PERU

Peru's flag was adopted in 1825. The colours are said to have been inspired by a flock of red and white flamingos that the Argentine patriot General José de San Martín saw flying over his marching army when he arrived in 1820 to liberate Peru from Spain.

The Republic of Peru, in w South America, is divided into three geographical areas. Along the Pacific coast lies a narrow strip of desert. Peru's major urban areas, such as the capital, LIMA, are sited beside oases. The centre is dominated by three ranges of the ANDES Mountains. In the foothills of the Cordillera Occidental lies Peru's second-largest city, AREQUIPA. The range includes Peru's highest peak, Mount Huascarán,

at 6,768m (22,205ft). The Cordillera Central merges into the Cordillera Oriental, site of CUZCO and the INCA ruins of MACHU PICCHU. Between the E and W ranges lies the Altiplano Plateau, site of many lakes, including Lake TITICACA. In the E lie forested highlands and the low-lands of the AMAZON basin.

CLIMATE

Lima has an arid climate. EL NIÑO brings infrequent violent storms. Inland, there is more frequent precipitation. The high Andes are permanently snowcapped. The E is hot and rainy.

VEGETATION

The coastal desert oases form Peru's major growing region. Mountain grassland lies on the higher slopes of the Andes. The E is a region of selva, tropical rainforest with trees such as rosewood and rubber. Here the major crop is coca.

HISTORY AND POLITICS

Native American civilizations developed over 10,000 years ago. By c.AD 1200, the Inca had established a capital at Cuzco. By 1500 their empire extended from Ecuador to Chile. In 1532 the Spanish conquistador Francisco PIZARRO captured the Inca ruler ATAHUALPA. By 1533 Pizarro had conquered most of Peru; he founded Lima in 1535. In 1544 Lima became capital of Spain's South American empire. Spain's rule caused frequent native revolts, such as that of TUPAC AMARU. In 1820 José de SAN MARTÍN captured coastal Peru. In 1821 Peru declared independence. Spain still held much of the interior, and Simón BOLÍVAR completed liberation in 1826. In 1836 Peru and Bolivia formed a short-

AREA: 1,285,220sq km (496,223sq mi)

POPULATION: 22,454,000

CAPITAL (POPULATION): Lima (6,386,308)
GOVERNMENT: Transitional republic
ETHNIC GROUPS: Quechua 47%, Mestizo 32%,

White 12%, Aymara 5%

LANGUAGES: Spanish and Quechua (both

RELIGIONS: Christianity (Roman Catholic 93%,

Protestant 6%)

CURRENCY: New sol = 100 centavos

lived confederation. In the War of the Pacific (1879-84) Peru lost some of its s provinces to Bolivia. The early 20th century was characterized by dictatorship and the growing gap between a wealthy oligarchy and the poverty of the native population. From 1968-80 a military junta failed to carry out democratic reforms. Austerity measures, introduced by the civilian government during the 1980s, caused civil unrest. Sendero Luminoso (Shining Path) and the Tupac Amaru Revolutionary Movement (MRTA) have waged an insurgency campaign that has claimed over 30,000 lives. Alberto Fujimori was elected in 1990, and began a series of anti-terrorist measures. In 1992 he suspended the constitution and dismissed parliament. The guerrilla movements leaders were captured. A new constitution was adopted in 1993. Fujimori was re-elected in 1995. In December 1996 MRTA guerrillas mounted a siege of the Japanese embassy in Lima, which lasted for four months before the army intervened.

ECONOMY

Peru is a lower-middle-income developing country (1992 GDP per capita, US\$3,330). Agriculture employs 35% of the workforce. Major crops include beans, maize, potatoes and rice. Coffee, cotton and sugar cane are major exports. Peru lands the world's third-largest fish catch and is the eighth-largest producer of copper ore. Since 1990 Fujimori's regime has instigated free-market reforms, which have reduced inflation and foreign debt, and created economic growth. Inequality is the greatest economic problem.

▲ Pfeiffer One of Hollywood's most popular leading actresses, Michelle Pfeiffer rose to stardom with her role in The Witches of Eastwick in 1987. Since then, she has received three Academy Award nominations. A versatile actress, she has played a wide range of roles, from a gangster's moll in Married to the Mob (1988), to the sheltered southerner who finds independence in Love Field (1992), and the seductive Catwoman in Batman Returns (1992)

and an important factor in their manufacture is that they should decompose after they have performed their function.

Pétain, Henri Philippe (1856–1951) French general and political leader. In World War 1 his defence of VERDUN (1916) made him a national hero. He was appointed commander-in-chief in 1917 and held high positions between the wars. With the defeat of France in 1940, he was recalled as prime minister. He signed the surrender and became head of the collaborationist VICHY regime. He was charged with treason after the liberation of France in 1945 and died in prison. **petal** Part of a flower. The petals of a flower are together known as the corolla. Surrounded by SEPALS, flower petals are often brightly coloured and may secrete nectar and perfume to attract the insects and birds necessary for cross-pollination. Once fertilization occurs, the petals usually drop off.

Peter, Saint (d. c.64) Apostle of Jesus Christ. He was born Simon, son of Jonas, and was a fisherman from Bethsaida, on the Sea of Galilee. He and his brother ANDREW were called by Jesus to be disciples. Jesus gave Simon the name Peter (John 1:42). Peter was one of Jesus' closest and most loyal associates. With James and John, he witnessed the Transfiguration. While Jesus was on trial before the SAN-HEDRIN, Peter denied knowing him three times, just as Jesus had predicted. After Jesus' ascension, Peter was the first publicly to preach Christianity in Jerusalem. He took Christianity to Samaria. Imprisoned by King Herod, he was allegedly rescued by an angel and returned to Jerusalem. In his final years, he seems to have left Jerusalem and undertaken a missionary journey. Roman Catholic theology accepts him as the first head of the Church and the first bishop of Rome, from whom the popes claim succession. His feast day is 29 June.

Peter I (the Great) (1672–1725) Russian tsar (1682–1725), regarded as the founder of modern Russia. After ruling jointly with his half-brother Ivan (1682–89), he gained sole control in 1689. He employed foreign experts to modernize the army, transport and technology, visiting European countries to study developments. He compelled the aristocracy and the church to serve the interests of the state, eliminating ancient tradition in favour of modernization. In the Great Northern War, Russia replaced Sweden as the dominant power in N Europe and gained lands on the Baltic, where Peter built his new capital, St Petersburg. In the E, he warred against Turks and Persians and initiated the exploration of Siberia.

Peter I (1844–1921) King of Serbia (1903–21). He was brought up in exile and educated in France while the Obrenović dynasty ruled Serbia. He was elected king when his father, Alexander Obrenović, was assassinated. He became the first king of the new kingdom of Serbs, Croats and Slovenes (later known as Yugoslavia) in 1918.

Peter II (1923–70) Last king of Yugoslavia (1934–41). He succeeded to the throne at the age of 11. The actual ruler was his uncle, Prince Paul, who was deposed in 1941 by a military coup. Peter ruled for a month until the invasion of the AXIS POWERS, when he fled to London. After the monarchy was abolished in 1945 he settled in the USA.

Peterloo Massacre (1819) Violent suppression of a political protest in Manchester, England. A large crowd demonstrating for reform of Parliament was dispersed by soldiers. Eleven people were killed and 500 injured.

Petipa, Marius (1819–1910) Russian dancer and choreographer. He rose to fame in 1847 as principal dancer at the Maryinski Theatre, St Petersburg, and was choreographer of the Imperial Russian Ballet (1862–1903). His *Don Quixote* (1869), *Sleeping Beauty* (1890) and *Raymonda* (1898) laid the foundations of classical ballet. *See also* KIROV BALLET

petition of right Means by which an English subject could sue the crown; in particular, the statement of grievances against the crown presented by Parliament to Charles I in 1628. It asserted that the crown acted illegally in raising taxation without Parliament's consent, imprisoning people without charge, maintaining a standing army, and quartering soldiers on ordinary householders. It led to the dissolution of Parliament and Charles' period of untrammelled rule.

Petöfi, Sándor (1823–49) Hungarian poet and revolutionary, whose poems reflected his radical views. His writings

include *Versek* (1844) and a novel *A Hóhér Kötele* (1845). His poetry was an inspiration to the patriots of the Hungarian revolution of 1848, in which he was killed.

Petra Ancient city in what is now sw Jordan. It was the capital of the Nabataean kingdom from the 4th century BC. It was captured by the Romans in the 2nd century AD and later declined in importance. Many of its remarkable ruined houses, temples, theatres and tombs were cut from the high, pinkish sandstone cliffs that protected it.

Petrarch, Francesco (1304–74) Italian lyric poet and scholar. Most of his lyric poems, *Rime sparse*, have as their subject "Laura", a woman idealized in the style of earlier poets but seen in a more realistic and human light. Other works, which include an autobiography (1342–58), further illuminate his belief in the compatibility of classical and Christian traditions.

petrel Any of several small oceanic birds related to the ALBATROSS. Most of them nest in colonies and fly over open water, feeding on squid and small fish. They have webbed feet and tubular nostrils. Length: to 42cm (16in). Order Procellariifarmes.

petrochemical Chemical substance derived from PETROLE-UM OR NATURAL GAS. The refining of petroleum is undertaken on a large scale not only for fuels but also for a wide range of chemicals. These chemicals include ALKANES (paraffins) and ALKENES (olefins), BENZENE, TOLUENE, NAPHTHALENE and their derivatives.

petrol (gasoline) Major HYDROCARBON fuel, a mixture consisting mainly of hexane, octane and heptane. One of the products of oil refining, petrol is extracted from crude oil (PETROLEUM). Frequently, other fuels and substances are added to petrol to alter its properties.

petrol engine Most common type of INTERNAL COMBUS-TION ENGINE.

petroleum (crude oil) Fossil fuel that is a complex chemical mixture of HYDROCARBONS. It accumulates in underground deposits and probably originated from the bodies of long-dead organisms, particularly marine plankton. Oil is rarely found at the original site of formation but migrates laterally and vertically until it is trapped. Most petroleum is extracted via oil wells from reservoirs in the Earth's crust sealed by upfolds of impermeable rock or by salt domes that form traps. See also NATURAL GAS; PETROL

petrology Study of rocks, including their origin, chemical composition and location. Formation of the three classes of rocks—IGNEOUS (of volcanic origin); SEDIMENTARY (deposited by water); and METAMORPHIC (either of the other two changed by temperature and pressure)—is studied.

Petronius (d. c.AD 66) Roman writer, assumed author of the *Satyricon*, a humorous tale giving vivid glimpses of contemporary society. He committed suicide when accused of plotting against Emperor Nero.

petunia Genus of flowering plants of the nightshade family that originated in Argentina, and the common name for any of the varieties that are popular as bedding plants. Most varieties derive from the white flowered *P. axillaris* and the violet-red *P. integrifolia*; they may be erect, shrubby or pendant. The bell-shaped flowers have five petals and may be almost any colour. Family Solanaceae.

Pétursson, Hallgrímur (1614–74) Icelandic poet. He led a chequered life in Iceland and Denmark, including periods as a blacksmith and a fisherman, before becoming a priest in 1651. His reputation rests on a single extended work, the *Passiusálmar* or *The Passion Hymns of Iceland* (1666), written after he contracted leprosy.

Pevsner, Antoine (1886–1962) French sculptor, b. Russia. He was initially influenced by CUBISM, but later became a leading exponent of CONSTRUCTIVISM, creating works in bronze and other materials. In the 1930s he concentrated on NON-FIGURATIVE structures such as *Projections in Space*. A later work is *Monument Symbolizing the Liberation of the Spirit* (1956).

pewter Any of several silver-coloured, soft alloys that consist mainly of tin and lead. The most common form has about four parts of tin to one of lead, combined with small amounts of antimony and copper.

peyote (mescal) Either of two species of cactus of the genus *Laphophora* that grow in the USA. The soft-stemmed *L. williamsii* has pink or white flowers in summer and a bluegreen stem. *L. diffusa* has white or yellow flowers. Peyote contains many ALKALOIDS, the principal one being MESCALINE, a hallucinogenic drug.

Pfeiffer, Michelle (1957–) US film actress. After receiving an Oscar nomination for her supporting role in *Dangerous Liaisons* (1988), she gained further nominations for lead performances in *The Fabulous Baker Boys* (1989) and *Love Field* (1992). She also starred in *The Age of Innocence* (1993).

pH A numerical scale that indicates the acidity or alkalinity of a solution. The pH value measures the concentration of hydrogen ions. The scale runs from 0 to 14, and a neutral solution, such as pure water, has a pH of 7. A solution is acidic if the pH is less than 7 and alkaline if greater than 7.

Phaeophyta Taxonomic division (phylum) of the Kingdom Protoctista that consists of the brown ALGAE. Classified by some biologists as plants, the simple organisms belonging to this group are mostly marine, found mainly in the intertidal zone of rocky shores. They include familiar seaweeds such as Fucus (wracks) and Ascophyllum (bladder wrack). The largest, Macrocystis, grows to over 100m (320ft) at up to 0.5m (18in) per day. Sargassum forms vast floating masses in the Sargasso Sea in the mid-Atlantic, with their own distinctive communities of animals and microorganisms.

phagocyte Type of LEUCOCYTE or white blood cell able to engulf other cells, such as bacteria. It digests what it engulfs in the defence of the body against infection. Phagocytes also act as scavengers by clearing the bloodstream of the remains of the cells that die as part of the body's natural processes.

phalanger (possum) Any of about 45 species of mainly nocturnal arboreal marsupials of Australasia. It has opposable digits for grasping branches and the tail is long and prehensile. Family Phalargeridae.

pharaoh Title of the rulers of ancient EGYPT. Though loosely applied to all Egyptian kings, the title was only adopted during the New Kingdom. The pharaoh was considered divine, an incarnation of the god HORUS.

Pharisees Members of a conservative Jewish religious group, prominent in ancient Palestine from the 2nd century BC to the time of the destruction of the second Temple in Jerusalem (AD 70). For much of this period, they constituted a political party opposed to the pagan influences of their Greek and Roman conquerors, but by New Testament times they were largely non-political. They were the founders of orthodox Judaism and were often in conflict with the Sadduces.

pharmacology Study of the properties of drugs and their effects on the body.

pharmacopoeia Reference book listing drugs and other preparations in medical use. Included are details of their formulae, dosages, routes of administration, known side-effects and precautions.

Pharos Island off the coast of N Egypt, in the Mediterranean, connected to the mainland by a causeway built by ALEXANDER THE GREAT. A lighthouse was completed by Ptolemy II in c.280 BC and was considered one of the SEVEN WONDERS OF THE WORLD. According to writers of the time, it was about 135m (450ft) tall and its light could be seen 65km (40mi) away. It was destroyed by an earthquake in 1346. Pharos is now part of the city of Alexandria.

pharynx Cavity at the back of the nose and mouth that extends down towards the OESOPHAGUS and TRACHEA. Inflammation of the pharynx, usually caused by viral or bacterial infection, is known as pharyngitis.

phase Proportion of the illuminated hemisphere of a body in the Solar System (in particular the Moon or an inferior planet) as seen from Earth. The phase of a body changes as the Sun and the Earth change their relative positions. All the phases of the Moon (new, crescent, half, gibbous and full) are observable with the naked eye.

phase In physics, a stage or fraction in the cycle of an oscillation, such as the wave motion of light or sound waves. This is usually measured from an arbitrary starting point or compared with another motion of the same frequency. Two waves

are said to be "in phase" when their maximum and minimum values happen at the same time. If not, there is a "phase difference", as seen in interference phenomenon. Phase can also refer to any one of the states of MATTER.

pheasant Game bird of the genus *Phasianus* originally native to Asia, introduced into Europe and naturalized in North America. PEACOCKS and GUINEA FOWL belong to the same family. Males are showy, with brownish green, red and yellow feathers; females are smaller and brownish. Length: up to 89cm (35in). Family Phasianidae.

phenol Aromatic compound group whose members each have an attachment of a hydroxyl group to a carbon atom forming part of a BENZENE ring. The simplest of the family is also called phenol or carbolic acid (C₆H₅OH). Phenols are colourless liquids or white solids at room temperature. They are used by the chemical and pharmaceutical industries for such products as aspirin, dye, fungicide, explosive and as a starting material for nylon and epoxy resin.

phenomenology School of modern philosophy founded by Edmund HUSSERL and influential in the development of EXISTENTIALISM. Husserl argued that philosophy should focus on human consciousness. Objects of consciousness (phenomena) were always mediated by the conscious mind. In contrast to EMPIRICISM or deductive LOGIC, Husserl concentrated on the description of subjective experience through intuition rather than analysis. *See also* HEIDEGGER, MARTIN; SARTRE, JEAN-PAUL

phenotype Physical characteristics of an organism resulting from HEREDITY. Phenotype is distinct from GENOTYPE, since not all aspects of genetic make-up manifest themselves. pheromone Substance secreted externally by certain animals that influences the behaviour of members of the same species. Common in mammals and insects, these substances are often sexual attractants. They may be a component of body products such as urine, or secreted by specific glands.

Phidias (490–430 BC) Sculptor of ancient Greece. During his lifetime he was best known for two gigantic chrysele-phantine (gold and ivory) statues, one of Athena for the PARTHENON and the other of Zeus for his temple at Olympia. The Zeus was one of the Seven Wonders of the World. He also worked on the Parthenon friezes.

Philadelphia City and port at the confluence of the Delaware and Schuylkill rivers, SE Pennsylvania, USA. The site was first settled by Swedes in the early 17th century. The city was founded by William PENN in 1681. By 1774 it was a major commercial, cultural and industrial centre of the American colonies and played an important part in their fight for independence. The CONTINENTAL CONGRESSES were held in the city and the DECLARATION OF INDEPENDENCE was signed here in 1776. The Constitutional Convention met in Philadelphia and adopted the US Constitution in 1787. Philadelphia served as capital of the USA from 1790 to 1800. Industries: shipbuilding, textiles, chemicals, clothing, electrical equipment, vehicle parts, metal products, publishing and printing, oil refining, food processing. Pop. (1990) 1,585,577. Philip, Saint (active 1st century AD) One of the original 12 APOSTLES of JESUS CHRIST. Philip came from Bethsaida, on the Sea of Galilee. Later Christian tradition says he preached in Asia Minor and met a martyr's death. His feast day is 3 May (in the West) or 14 November (in the East). He appears to be a different person from Philip the Evangelist, who was one of the seven DEACONS who aided the apostles and, according to later tradition, became bishop of Tralles, now in Turkey. His feast day is 9 June.

■ pheasant The golden pheasant (Chrysolophus pictus) is found in the highlands of central China. This pheasant is distinguished by its yellow head, rump and lower back, and by its golden collar edged in blue-black with red underparts. The golden pheasant is a member of a very diverse order (Galliformes), but all members have naked feet, no airsacs in the neck and unfeathered nostrils.

Philip II (1165–1223) (Philip Augustus) King of France (1180–1223). Greatest of the French medieval kings, he increased the royal domain by marriage, by exploiting his feudal rights, and by war. His main rival was HENRY II of England. Philip supported the rebellions of Henry's sons, fought a long war against RICHARD I, and during the reign of JOHN, occupied Normandy and Anjou. English efforts to regain them were defeated at Bouvines in 1214. Philip persecuted Jews and Christian heretics, joined the Third Crusade but swiftly withdrew, and opened the crusade against the Albigenses in s France.

Philip IV (the Fair) (1268–1314) King of France (1285–1314). Partly to pay for wars against Flanders and England, he expelled the Jews (1306), confiscating their property. Claiming the right to tax the clergy involved him in a long and bitter quarrel with Pope Boniface VIII. He used assemblies later called the STATES GENERAL to popularize his case. After the death of Boniface (1303), Philip secured the election of a French pope, Clement V, based at Avignon.

Philip VI (1293–1350) King of France (1328–50). First of the house of Valois, he was chosen to succeed his cousin, Charles

IV, in preference to the rival claimant, EDWARD III of England. After the outbreak of the HUNDRED YEARS WAR (1337), many of his vassals supported Edward. Philip suffered serious defeats in the naval battle of Sluys (1340) and at CRÉCY (1346). **Philip II** (382–336 BC) King of Macedonia (359–336 BC). He conquered neighbouring tribes and gradually extended his rule over the Greek states, defeating the Athenians at Chaeronea in 338 BC and gaining reluctant acknowledgment as king of Greece. He was preparing to attack the Persian empire when he was assassinated, leaving the task to his son, ALEXANDER THE GREAT.

Philip II (1527–98) King of Spain (1556–98) and king of Portugal (1580–98). From his father, the Emperor Charles V, he inherited Milan, Naples and Sicily, the Netherlands, as well as Spain with its huge new empire in the New World. War with France ended at Château-Cambrésis (1559), but the revolt of the Netherlands began in 1566. A defender of Roman Catholicism, Philip launched the unsuccessful Armada of 1588 to crush the English who, as fellow Protestants, aided the Dutch. In the Mediterranean, the Ottoman Turks presented a continuing threat, in spite of their defeat at LEPANTO (1571).

PHILIPPINES

This flag was adopted in 1946, when the country won its independence from the United States. The eight rays of the large sun represent the eight provinces that led the revolt against Spanish rule in 1898. The three smaller stars stand for the three main island groups.

The Republic of the Philippines, in Southeast Asia, consists of over 7,000 islands, of which 1,000 are inhabited. LUZON and MINDANAO islands constitute over 66% of land area. Around Manila Bay (Luzon) lies the capital, MANILA, and the second-largest city, QUEZON CITY. The islands are mainly mountainous with

several active volcanoes, one of which is the highest peak, Mount Apo, at 2,954m (9,692ft). Narrow coastal plains give way to forested plateaux. Earthquakes are common.

CLIMATE

The Philippines has a tropical climate, with high annual temperatures. The dry season runs from December to April, but the rest of the year is wet. Much of the rainfall is due to typhoons.

VEGETATION

Mangrove swamps line many coasts. Over 33% of the land is forested. Much of the land is fertile.

HISTORY AND POLITICS

Islam was introduced in the late 14th century. In 1521 the Portuguese navigator Ferdinand MAG-ELLAN landed near Cebu. In 1565 Spain began its conquest of the islands. In 1571 the Spanish founded Manila, and named the archipelago Filipinas, after Philip II. It became a vital trading centre, subject to frequent attack from pirates. In 1896 the Filipinos revolted against Spanish rule and declared independence. In the SPANISH-AMERICAN WAR (1898), the USA defeated the Spanish navy in Manila Bay. Filipinos seized Luzon. Manila was captured with US help. In the Treaty of Paris (1898) the islands were ceded to the USA. From 1899 to 1902 Filipinos fought against US control. The Commonwealth of the Philippines was established in 1935. Manuel Luis QUEZON became the first president. In 1941 the Japanese invaded and captured Manila by 1942. General MACARTHUR was forced to withdraw and US forces were ousted from BATAAN. In 1944 the USA began to reclaim the islands. In **AREA:** 300,000sq km (115,300sq mi) **POPULATION:** 64,259,000

CAPITAL (POPULATION): Manila (1,587,000) **GOVERNMENT:** Multiparty republic

ETHNIC GROUPS: Tagalog 30%, Cebuano 24%, Ilocano 10%, Hiligaynon Ilongo 9%, Bicol

6%, Samar-Leyte 4%

LANGUAGES: Filipino (Tagalog) and English

(both official)

RELIGIONS: Christianity (Roman Catholic 84%, Philippine Independent Church or Aglipayan

6%, Protestant 4%), Islam 4%

CURRENCY: Philippine peso = 100 centavos

1946 the Philippines became an independent republic. The USA was granted a 99-year lease on military bases (subsequently reduced to 25 years from 1967). In 1965 Ferdinand MARCOS became president. Marcos' response to mounting civil unrest was brutal. In 1972 he declared martial law. In 1981 Marcos was re-elected amid charges of electoral fraud. In 1983 the leader of the opposition, Benigno Aquino, was assassinated. His widow, Cory AQUINO, succeeded him. Marcos claimed victory in 1986 elections, but faced charges of electoral fraud. Cory Aquino launched a campaign of civil disobedience. The USA withdrew its support for the corrupt regime and Marcos was forced into exile. Aquino's presidency was marred by attempted military coups. In 1992 Fidel Ramos succeeded Aguino as president. The USA closed its military bases at the end of 1992. In 1996 an agreement was reached with the Moro National Liberation Front, ending 24 years of rebellion on Mindanao. It allows the creation of a autonomous Muslim state.

ECONOMY

The Philippines is a lower-middle-income developing country (1992 GDP per capita, US\$2,550). The economy is beginning to recover from the mismanagement of the Marcos' years. Agriculture employs 45% of the workforce. It is the world's second-largest producer of rice and the world's fourth-largest producer of bananas. The raising of livestock, forestry and fishing are important activities.

Philip V (1683–1746) King of Spain (1700–46). Because he was a grandson and a possible successor of Louis XIV of France, his accession to the Spanish throne provoked the War of the Spanish Succession. By the Treaty of UTRECHT (1713), he kept the Spanish throne at the price of exclusion from the succession in France and the loss of Spanish territories in Italy and the Netherlands.

Philip, Prince, Duke of Edinburgh (1921–) Husband of Queen ELIZABETH II of Britain and Prince Consort. He was born in Corfu, the son of Prince Andrew of Greece, and educated in Britain. He became a naturalized British citizen and took the surname Mountbatten. In 1947 he married Elizabeth after becoming the Duke of Edinburgh. He was created a prince in 1957.

Philippines Republic in the sw Pacific Ocean, SE Asia. *See* country feature

Philistine Member of a non-Semitic people who lived on the s coast of modern Israel, known as Philistia, from $c.1200 \, \text{BC}$. They clashed frequently with the Hebrews. Today the term philistine may be applied to a person indifferent to culture.

Phillips, Wendell (1811–84) US social reformer. In 1836 he made a speech in Boston in favour of emancipation of slaves. He became a close associate of abolitionist William Lloyd Garrison and was president of the Antislavery Society (1865–70). He also advocated women's and workers' rights and temperance.

philodendron Genus of house plants native to tropical America. Philodendrons have shiny, heart-shaped leaves. Height: 0.1–1.8m (4in–6ft). Family Araceae.

philology Study of both language and literature. In addition to phonetics, grammar and the structure of language, philology also includes textual criticism, ETYMOLOGY, and the study of art, archaeology, religion and any system related to ancient or classical languages.

philosophy Study of the nature of reality, knowledge, ethics and existence by means of rational enquiry. The oldest known philosophical system is the Vedic system of India, which dates back to the middle of the 2nd millennium BC or earlier. Like other Eastern philosophies, it is founded upon a largely mystical view of the universe and is integrated with India's main religion, HINDUISM. From the 6th century BC, Chinese philosophy was largely dominated by CONFUCIANISM and TAOISM. Also in the 6th century, Western philosophy began among the Greeks with the work of THALES of Miletus. Later pre-Socratic philosophers included PYTHAGORAS, EMPEDO-CLES, Anaxagoras, Parmenides, HERACLITUS, ZENO OF ELEA and Democritus. Greek philosophy reached its high point with Socrates, who laid the foundations of ethics; PLATO, who developed a system of universal ideas; and ARISTOTLE, who founded the study of LOGIC. ZENO OF CITIUM evolved the influential philosophy of stoicism, which contrasted with the system of EPICUREANISM, founded by EPICURUS. A dominant school of the early Christian era was NEOPLATONISM, founded by Plotinus in the 3rd century AD. The influence of Aristotle and other Greeks pervaded the thought of Muslim philosophers, such as AVICENNA and AVERRÖES, and the Spanishborn Jew, Moses Maimonides. In the work of scholastic philosophers such as ABÉLARD, Albertus Magnus, Saint Thomas Aquinas and William of Occam, philosophy became a branch of Christian theology. Modern scientific philosophy began in the 17th century, with the work of DESCARTES. His faith in mathematics was taken up by LEIB-NIZ. In England, HOBBES integrated his materialist world view with a social philosophy. The 18th-century empiricists included BERKELEY and HUME. The achievements of KANT in Germany and the French Encyclopedists were also grounded in science. In the 19th century, a number of diverging movements emerged, among them the classical idealism of HEGEL, the dialectical materialism of MARX and ENGELS, the POSI-TIVISM of COMTE, and the work of KIERKEGAARD and NIET-ZSCHE, which emphasized the freedom of the individual. In the 20th century, dominant movements included EXISTEN-TIALISM, LOGICAL POSITIVISM, PHENOMENOLOGY and VITALISM. See also AESTHETICS; EPISTEMOLOGY; METAPHYSICS

phlebitis Inflammation of the wall of a vein. It may be caused

by infection, trauma, underlying disease, or the presence of VARICOSE VEINS. Symptoms include localized swelling and redness. Treatment includes rest and anticoagulant therapy.

phloem Vascular tissue for distributing dissolved food materials in plants. Phloem tissue contains several types of cells. The most important are long, hollow cells called sievetube cells. Columns of sieve tubes are joined end to end, allowing passage of materials from cell to cell. The sieve tubes are closely associated with "companion cells", which have dense cytoplasm and many MITOCHONDRIA and are thought to produce the energy needed to transport the food substances (see ACTIVE TRANSPORT). Phloem may also contain fibres that help to support the tissue. See also XYLEM

phlogiston Odourless, colourless and weightless material believed by early scientists to be the source of all heat and fire. Combustion was believed to involve the loss of phlogiston. The phlogiston theory was proved erroneous when the true nature of combustion was explained by Antoine LAVOISIER.

Phnom Penh (Phnum Pénh) Capital of Cambodia, in the s of the country, a port at the confluence of the Mekong and Tonle Sap rivers. Founded in the 14th century, the city was the capital of the Khmers after 1434. It became the permanent capital of the country in 1865. Occupied by the Japanese during World War 2, it was extensively damaged during the Cambodian civil war. After the communists took over in 1975, the population was drastically reduced when many of its inhabitants were forcibly removed to work in the country-side. Industries: rice-milling, brewing, distilling, fish processing, cotton. Pop. (1994 est.) 920,000.

phobia Irrational and uncontrollable fear that persists despite reassurance or contradictory evidence. Psychoanalytic theory suggests that phobias are actually symbolic subconscious fears and impulses.

Phobos Larger of the two SATELLITES of Mars, discovered in 1877 by Asaph Hall. It is a dark, irregular body, measuring $27 \times 22 \times 19 \text{ km}$ ($17 \times 14 \times 12 \text{ mi}$), and may well be a captured asteroid. It has two large craters, named Stickney and Hall.

Phoenicia Greek name for an ancient region bordering the E Mediterranean coast. The Phoenicians were related to the Canaanites. Famous as merchants and sailors, they never formed a single political unit, and Phoenicia was dominated by Egypt before c.1200 BC and by successive Near Eastern empires from the 9th century BC. The Phoenician city-states, such as Tyre, Sidon and Byblos, reached the peak of their prosperity in the intervening period, but the Phoenicians dominated trade in the Mediterranean throughout the Bronze Age. Expert navigators, they traded for tin in Britain and sailed as far as West Africa. The Phoenicians founded colonies in Spain and North Africa, notably CARTHAGE.

Phoenician mythology Beliefs current in the Phoenician city-states of the E Mediterranean $c.500~\rm BC$. The most ancient god was El, revered as the father of all gods and the creator of man. Closely related to the Hebrew Yahweh, he was a remote, benevolent deity, usually depicted as an old man, but was also noted for his sexual powers. Baal, the storm god and the god of fertility, occupied an important place in the divine hierarchy. With lightning as his weapon, he defended the divine order against the ever-present menace of Chaos. Asherah was generally seen as a female counterpart to El. Anath, the goddess of love and war, was the consort of Baal; a ferocious figure in battle, she also helped Baal in his many conflicts. The goddess Astarte was subordinate to Anath.

Phoenix Capital of Arizona, USA, on the Salt River. Founded in 1870, the city expanded after agriculture in the area had been made possible by using the water of the Salt River for irrigation. It became the capital in 1889. Industries: computer parts, aircraft, fabricated metals, machinery, textiles, clothing, food products. Phoenix is a popular winter sports resort. Pop. (1990) 983,403.

phoenix Mythological eagle-like bird linked with sun-worship, especially in ancient Egypt. Of gold and scarlet plumage, only one phoenix could exist at a time, usually with a life span of about 500 years. When death approached, the phoenix built a nest of aromatic plant material and was then consumed by fire. From the ashes of the pyre rose a new phoenix.

▲ piano Each key (1) of an upright piano controls a separate check (2), escapement (3), hammer (4), damper (5) and string (6) When a key is depressed, a felt covered hammer is thrown against the strings for that particular pitch. At the same time a felt covered damper is lifted allowing the strings to vibrate. The hammer quickly bounces away from the strings, allowing a maximum vibration. When the key is released the damper falls back onto the strings. The hammers are connected to the keys via a series of levers, called the action, involving an escapement and a check, which catches the hammer

pholidota Small order of mammals, containing only one genus, *Manis*, in the family Manidae; its members are called PANGOLINS. Some species are entirely toothless and feed almost exclusively on ants and termites.

phoneme Minimum unit of significant sound; a speech sound distinguishing meaning. The phonemes "p" and "b" distinguish "tap" from "tab".

phonetics Study of the sounds of speech, divided into three main branches: articulatory phonetics (how the speech organs produce sounds); acoustic phonetics (the physical nature of sounds, mainly using instrumental techniques); and auditory phonetics (how sounds are received by the ear and processed). Linguists have devised notation systems to allow the full range of possible human speech sounds to be represented. See also LINGUISTICS

phosgene Colourless, toxic gas, chemical name carbonyl chloride (COCl₂). It was used as a poison gas in World War 1, but is now used in the manufacture of various dyestuffs and resins. Properties: b.p. 8.2°C (46.8°F), m.p.-118°C (-180.5°F)

phosphate Chemical compounds derived from phosphoric acid (H_3PO_4) . The use of phosphates as fertilizers can cause environmental damage.

phosphor Substance capable of luminescence (storing energy and later releasing it as light). They are used in coating inside cathode-ray tubes and in fluorescent lamps.

phosphorescence Form of luminescence in which a substance emits light of one wavelength. Unlike fluorescence, it may persist for some time after the initial excitation. In biology, phosphorescence is the production of light by an organism without associated heat, as with a firefly. In warm climates, the sea often appears phosphorescent at night, as a result of the activities of millions of microscopic algae.

phosphoric acid Group of ACIDS, the chief forms of which are tetraoxophosphoric acid (H_3PO_4) (formerly orthophosphoric acid), metaphosphoric acid (HPO_3) and heptaoxodiphosphoric acid ($H_4P_2O_7$) (formerly pyrophosphoric acid). Tetraoxophosphoric acid is a colourless liquid obtained by the action of sulphuric acid on phosphate rock (calcium phosphate) and is used in fertilizers, soaps and detergents. Metaphosphoric acid is obtained by heating tetraoxophosphoric acid and is used as a dehydrating agent. Heptaoxodiphosphoric acid is formed by moderately heating tetraoxophosphoric acid or by reacting phosphorus pentoxide (P_2O_5) with water and is used as a catalyst and in metallurgy.

phosphorus (symbol P) Common nonmetallic element of group V of the periodic table, discovered by Hennig Brand in 1669. It occurs, as PHOSPHATES, in many minerals; apatite is the chief source. The element is used in making PHOSPHORIC ACID for detergents and fertilizers. Small amounts are used in insecticides and in matches. Phosphorus exhibits ALLOTROPY. Properties: at.no. 15; r.a.m. 30.9738; r.d. 1.82 (white), 2.34 (red); m.p. 44.1°C (111.38°F) (white); b.p. 280°C (536°F) (white); most common isotope P³¹ (100%).

photocell See PHOTOELECTRIC CELL

photocopying Reproduction of words, drawings or photographs by machine. In a photocopying machine, a light shines on the item to be copied, and an optical system forms an image of it. Various techniques may be used to reproduce this image on paper. In a modern plain-paper copier, the image is projected onto an electrically charged drum, coated with the light-sensitive element selenium. Light makes the selenium conduct electricity, so bright areas of the drum lose their charge. The dark areas, which usually correspond to image detail, retain their charge, and this attracts particles of a fine powder called toner. Electrically charged paper in contact with the drum picks up the pattern of toner powder. A heated roller fuses the powder so that it sticks to the paper and forms a permanent image.

photoelectric cell (photocell) Device that produces electricity when light shines on it. It used to be an electron tube with a photosensitive cathode, but nearly all modern photocells are made using two electrodes separated by light-sensitive semiconductor material. Photoelectric cells are used as switches (electric eyes), light detectors (burglar alarms),

devices to measure light intensity (light meters), and power sources (solar cells).

photoelectric effect Liberation of electrons from the surface of a material when light, ultraviolet radiation, x-rays or gamma rays fall on it. The effect can be explained only by the QUANTUM THEORY: PHOTONS in the radiation are absorbed by atoms in the substance and enable electrons to escape by transferring energy to them.

photography Process of obtaining a permanent image of an object, either in black and white or in colour, on treated paper or film. In black and white photography, a CAMERA is used to expose a film to an image of the object to be photographed, for a set time. The film is covered on one side with an emulsion containing a silver halide (silver bromide or silver chloride). Exposure makes the silver compound easily reduced to metallic silver when treated with a developer. The action of the developer is to produce a black deposit of metallic silver particles on those parts of the film that were exposed to light, thus providing a "negative" image. After fixing in "hypo" (thiosulphate) and washing, the negative can be printed by placing it over a piece of sensitized paper and exposing it to light so that the silver salts in the paper are affected in the same way as those in the original film. The dark portions of the negative let through the least light, and the image on the paper is reversed back to a positive. Colour photography works on a similar, but more complex, process.

photon Quantum of ELECTROMAGNETIC RADIATION, such as light; a "particle" of LIGHT. The energy of a photon equals the frequency of the radiation multiplied by PLANCK's constant. Absorption of photons by atoms and molecules can cause excitation or ionization. A photon may be classified as a stable elementary particle of zero rest mass, zero charge and spin 1, travelling at the velocity of light. It is its own antiparticle. Virtual photons are thought to be continuously exchanged between charged particles and thus to be the carriers of ELECTROMAGNETIC FORCE.

photoperiodism Biological mechanism that governs the timing of certain activities in an organism by reacting to the duration of its daily exposure to light and dark. For example, the start of flowering in plants and the beginning of the breeding season in animals are determined by day length. *See also* BIOLOGICAL CLOCK

photosphere Visible surface of the SUN. It is a layer of highly luminous gas about 500km (300mi) thick and with a temperature of about 6,000K, falling to 4,000K at its upper level. The photosphere is the source of the Sun's visible spectrum. The lower, hotter gases produce the continuous emission spectrum, while the higher, cooler gases absorb certain wavelengths. Sunspots and other visible features of the Sun are situated in the photosphere.

photosynthesis Chemical process occurring in green plants, algae and many bacteria, by which water and carbon dioxide are converted into food and oxygen using energy absorbed from sunlight. The reactions take place in the CHLOROPLASTS. During the first part of the process, light is absorbed by CHLOROPHYLL and splits water into hydrogen and oxygen. The hydrogen attaches to a carrier molecule and the oxygen is set free. The hydrogen and light energy build a supply of cellular chemical energy, adenosine triphosphate (ATP). Hydrogen and ATP convert the carbon dioxide into sugars, including glucose and starch.

phototropism Growth of a plant in response to the stimulus of light. Cell growth increases on the shaded side of the plant, resulting in curvature towards the source of light. Auxin hormones are involved in this process.

Phrygia Historic region of w central Anatolia. A prosperous kingdom was established by the Phrygians, immigrants from SE Europe, early in the 1st millennium BC, with its capital at Gordion. MIDAS was a legendary Phrygian king. In the 6th century BC Phrygia was taken over by Lydia, then by Persia and later empires.

phylloxera Small, yellowish insect of the order Homoptera. It is a pest on grape plants in Europe and w USA. It attaches itself to the leaves and roots and sucks the plant's fluids, resulting in the eventual rotting of the plant. It destroyed all of

France's native root stock of vitis vinifera. Family Phylloxeridae; species: *Phylloxera vitifoliae*.

phylogenetics Study of the evolutionary relationships between organisms. In **molecular phylogeny**, the evolutionary distances between organisms are analysed by comparing the DNA sequences of specific GENES. At the most fundamental level, molecular phylogeny has revealed that all known organisms evolved from a common ancestor and can be grouped into five KINGDOMS, whose members are more closely related to each other than to members of other kingdoms.

phylum In the systematic categorization of living organisms, a major group within the animal KINGDOM. It comprises a diverse group of organisms with a common fundamental characteristic. In plant classification, the analogous category is sometimes called division. *See also* TAXONOMY

physical chemistry Study of the physical changes associated with chemical reactions and the relationship between physical properties and chemical composition. The main branches are THERMODYNAMICS, concerned with the changes of energy in physical systems; chemical kinetics, concerned with rates of reaction; and molecular and atomic structure. Other topics include ELECTROCHEMISTRY, SPECTROSCOPY and some aspects of NUCLEAR PHYSICS.

physical units Units used in measuring physical quantities. For example, the KILOGRAM unit of mass is defined as the mass of a specified block of platinum. Other masses are measured by weighing them and comparing them, directly or indirectly, with this. Units are of two types: base units that, like the kilogram, have fundamental definitions; and derived units that are defined in terms of these base units. Various systems of units exist, founded on certain base units. They include Imperial units (foot, pound, second), CGS units (centimetre, gram, second) and MKS units (metre, kilogram, second). For all scientific purposes, SI UNITS have been adopted. physics Branch of science concerned with the study of MAT-TER and ENERGY. Physics seeks to identify and explain their many forms and relationships. Modern physics recognizes four FUNDAMENTAL FORCES in nature: GRAVITATION, which was first adequately described by Isaac Newton; ELECTROMAG-NETIC FORCE, codified in the 19th century by MAXWELL'S equations; WEAK NUCLEAR FORCE, which is responsible for the decay of some subatomic particles; and STRONG NUCLEAR FORCE, which binds together atomic nuclei. The latter is some 1012 times stronger than the weak force and is the least understood in physics. Branches of physics include PARTICLE PHYSICS, geophysics, BIOPHYSICS, ASTROPHYSICS and NUCLEAR PHYSICS. Physics may also be divided into six fundamental theories: Newtonian MECHANICS, THERMODYNAMICS, ELEC-TROMAGNETISM, STATISTICAL MECHANICS, RELATIVITY and QUANTUM MECHANICS.

physiology Branch of biology concerned with the functions of living organisms, as opposed to their structure (anatomy). **physiotherapy** (physical therapy) Use of various physical techniques to treat disease or injury. Its techniques include massage, manipulation, exercise, heat, hydrotherapy, the use of ultrasonics and electrical stimulation.

 \mathbf{pi} (π) Symbol used for the ratio of the circumference of a circle to its diameter. It is an IRRATIONAL NUMBER, and an approximation to five decimal places is 3.14159. The ratio 22/7 is often used as a rougher approximation.

Piaf, Edith (1915–63) French cabaret singer, real name Edith Giovanna Gassion. Piaf began singing at the age of 17 in the cafés of Paris. Her recording career spanned nearly 30 years, and the emotional impact of her voice in songs such as *Non, je ne regrette rien* won her an international reputation.

Piaget, Jean (1896–1980) Swiss psychologist. In the 1920s and 1930s he developed a comprehensive theory of the intellectual growth of children. He wrote several influential books, including *The Child's Conception of the World* (1926), *The Origin of Intelligence in Children* (1954) and *The Early Growth of Logic in the Child* (1964).

piano (pianoforte) Musical instrument whose sound is made with strings struck by hammers that are moved from a keyboard. Its invention (c.1709) is attributed to Bartolomeo Cristofori. Its name, from the Italian *piano* (soft) and *forte*

(strong or loud), was adopted because its range of volume (as of tonal quality) far exceeded that of earlier instruments. The modern grand piano, much larger, louder and more resonant than the 18th-century piano, was developed in the early 19th century.

Picardy Region and former province of N France, on the English Channel; it includes Somme, and parts of Pas-de-Calais, Oise and Aisne départements. It was a French province from 1477 until the French Revolution, when it was replaced by a smaller département. Picardy was the scene of heavy fighting during WORLD WAR 1. The area is made up of the plateau to the N of Paris, where wheat and sugar beet are grown; the valley of the Somme, where industrial centres such as Amiens are located; and the coast, where fishing is important. Area: 19,399sq km (7,488sq mi) Pop. 1,810,700. **picaresque** (Sp. *picaro*, rogue or knave) Term first applied to an early genre of prose fiction, such as Cervantes' *Don Quixote* (1615), in which a roguish hero has a series of adventures, providing the author with a means for satirical comment. In a general sense, the term is often used to refer to fic-

tion that is episodic in structure.

Picasso, Pablo (1881-1973) Spanish painter, sculptor, graphic artist, designer and ceramicist. Art historians often divide his work into separate periods. During his "Blue" and "Rose" periods (1900–07), he turned from portrayals of poor and isolated people to representations of harlequins, acrobats and dancers in warmer colours. In 1904 he settled in Paris and became the centre of a group of progressive artists and writers. In 1906 he began analysing and reducing forms. The result was his spectacular canvas, Les Demoiselles d'Avignon (completed 1907), which is now seen as a watershed in the development of contemporary art. The fragmentary forms in the painting also heralded CUBISM. In the 1920s he produced solid classical figures but at the same time he was exploring SURREALISM. He started creating more violent and morbid works, which culminated in Guernica (1937). Picasso's sculpture ranks as highly as his painting. He was one of the first to use assembled rather than modelled or carved materials. The most famous example is his Head of a Bull, Metamorphosis (1943), which consists of a bicycle saddle and handlebars. He was also an excellent printmaker and illustrated numerous books.

Piccard, Auguste (1884–1962) Swiss physicist who explored the STRATOSPHERE and deep seas. In 1931 a hydrogen balloon carried an airtight aluminium sphere, containing Piccard and an assistant, to an altitude of almost 15,800m (51,800ft). This was the first ascent into the stratosphere. From 1948 he experimented with designs for a diving vessel called a bathyscaphe. In 1953 Piccard and his son Jacques descended in the bathyscaphe *Trieste* to a depth of about 3,100m (10,000ft) in the Mediterranean Sea. In 1960 Piccard

■ Picasso The most famous, prolific and versatile artist of the 20th century, Pablo Picasso was the driving force behind most of the radical art movements that occurred in the first half of the century. No single artist of the period had a greater expressive and emotional range. He produced remarkable paintings, sculptures, collages, lithographs and ceramics, and also designed stage sets and costumes for theatre and ballet.

▲ pig Among nature's most efficient and omnivorous scavengers, there are a number of pure-bred pigs. The large white or Yorkshire (A) is the dominant breed in Britain. The saddlebacks (B) are popular free-range stocks in England, but are mainly used for cross breeding. The sandy-coloured Tamworth (C) was traditionally a forest pig. The China (D) and Chester White (E) are popular in the USA, along with the long red Duroc (F), but are uncommon in other countries.

▲ pigeon Homing pigeons can successfully navigate home over hundreds of kilometres, from sites never previously visited. It is thought they use the stars to navigate with at night, while during the day they rely on the position of the Sun. Experiments have also shown that homing pigeons have a navigational back up using the Earth's magnetic fields.

and a naval officer used the same craft in the Pacific Ocean to reach a record of 10,900m (35,800ft) below the surface.

piccolo Woodwind musical instrument of the FLUTE family. About half the size of the flute and pitched one octave higher, it is played in the same way.

Pickford, Mary (1893–1979) US film actress, b. Gladys Mary Smith, famous in silent films. These include *Poor Little Rich Girl* (1917), *Pollyanna* (1919) and *Little Lord Fauntleroy* (1921). In 1919 she established the United Artists Corporation with Charlie Chaplin, Douglas Fairbanks and D.W. Grifftth. **Picts** Ancient inhabitants of E and N Scotland. By the 8th century they had a kingdom extending from Caithness to Fife, and had adopted Christianity. To the w and s of the Picts, invaders from Ireland had established the kingdom of Dalriada; in 843 its king, Kenneth I, also became king of the Picts, uniting the two kingdoms into the kingdom of Scotland.

pidgin Simplified form of a language, differing from other LINGUA FRANCAS by comprising a very limited vocabulary and being used for communication between people who do not speak the same language. Most pidgins in use today are based on English, French, Spanish or Portuguese, with a certain number of native words and structures added. The Pidgin English of Papua New Guinea (Tok Pisin) is an official national language.

Piedmont (Piemonte) Region of NW Italy, bounded to the N, w and s by mountains, and to the E by the Po Valley; it comprises the provinces of Alessandria, Asti, Cuneo, Novara, Torino and Vercelli. Already an important region in Roman times, it was later subject to Lombard, then Frankish rule. Under the influence of Savoy from the early 15th century, it became part of the kingdom of Sardinia in 1720. In the early 19th century it was the focus of the movement for Italian independence, joining a united Italy in 1861. The Po Valley has excellent farmland. Products: grain, vegetables, fruit, dairy. Industries: winemaking, motor vehicles, textiles, glass, chemicals. Area: 25,400sq km (9,807sq mi). Pop. (1991) 4,302,565. Pierce, Franklin (1804-69) 14th US president (1853-57). He represented New Hampshire in the US House of Representatives (1833-37) and the Senate (1837-42), when he resigned. He remained politically active, with an interval of service in the Mexican War, and supported the COMPROMISE OF 1850. He gained the Democratic presidential nomination as a compromise candidate and was elected in 1852. The most notable feature of his presidency was his endorsement of the Kansas-Nebraska Act (1854), which resulted in nearcivil war in Kansas between pro- and antislavery settlers.

Piero della Francesca (1415–92) (Piero dei Francheschi) Italian painter. His most important work is the FRESCO series depicting the *Legend of the True Cross* (finished *c*.1465) for the choir of San Francesco, Arezzo. He later embraced HUMANISM at Federico da Montefeltro's court at Urbino.

Pierre Capital of South Dakota, USA, on the Missouri River opposite Fort Pierre. Originally the capital of the Aricara Native Americans, it was a trading settlement in the early 19th century before being established as a railway terminus in 1880. It became the permanent state capital in 1904. Its economy is based on government services and agriculture (grain, cattle). Pop. (1990) 12,906.

Pietism Influential Christian spiritual movement within Protestantism, founded in the late 17th century by a German Lutheran minister, Philipp Spener (1635–1705). Its aim was to revitalize evangelical Christianity by emphasizing spiritual rather than theological or dogmatic issues.

piezoelectric effect Creation of positive electric charge on one side of a nonconducting crystal and negative charge on the other when the crystal is squeezed. The pressure results in an electric field that can be detected as voltage between the opposite crystal faces. The effect has been used in gramophone pickups, crystal microphones and cigarette lighters.

pig Any of numerous species and varieties of domestic and wild swine of the family Suidae. The male is generally called a boar; the female, a sow. A castrated boar is usually known as a hog. It is generally a massive, short-legged omnivore with thick skin bearing short bristles. Wild pigs include the wart hog, wild BOAR, bush pig and babirusa.

pigeon (dove) Any of a large family of wild and domestic birds found throughout temperate and tropical parts of the world, but concentrated in s Asia and the Australian region. Pigeons have small heads, short necks, plump bodies and scaly legs and feet. Plumage is loose but thick. Length: to 46cm (18in). Family Columbidae; typical genus, *Columba*.

Piggott, Lester (1935–) British jockey. Champion apprentice in 1950, Piggott went on to be champion jockey 11 times (1960–82). Closely associated with the Epsom Derby, he rode a record 9 winners. By 1995 he had won 4,493 races. He retired in 1996.

pigment Coloured, insoluble substance used to impart colour to an object and added for this purpose to paints, inks and plastics. They generally function by absorbing and reflecting light, although some luminescent pigments emit coloured light.

pigmentation In biology, a natural chemical that gives colour to TISSUES. In humans, the skin, hair and iris are coloured by the pigments MELANIN and carotene, together with the HAEMOGLOBIN in ERYTHROCYTES (red blood cells), which also acts as a pigment.

pika Any of 12 species of short-haired relatives of the RABBIT. They live in cold regions of Europe, Asia and W USA. Length: to 20cm (8in). Genus *Ochotona*.

Pike, Zebulon Montgomery (1779–1813) US explorer. An army officer, he was sent to explore the newly purchased Louisiana Territory, and also led expeditions to Colorado and New Mexico (1806–07). Pike discovered but failed to climb Pike's Peak, in SE Colorado. He was killed in the WAR OF 1812. **pike** Predatory, freshwater fish found in E North America and parts of Europe and Asia. It has a shovel-shaped mouth and a mottled, elongated body. Length: to 137.2cm (54in); weight: to 20.9kg (46lb) Family Esocidae; genus *Esox*.

pike perch Freshwater food and game fish of Central Europe, where it includes the zander, and of North America, where it is related to the walleye and sauger. A dark olive, mottled fish, the pike perch has an elongated body and large head and mouth. Length: to 91.4cm (3ft); weight: to 11.3kg (25lb). Family Percidae; species *Stizostedion vitreum*.

pilchard Marine food fish resembling a herring, found in shoals along most coasts except those of Asia. They are caught in millions and support a huge canning industry. The young are sometimes called SARDINES. Length: less than 45.7cm (18in). Family Clupeidae; species Sardina pilchardus. Pilgrimage Religiously motivated journey to a shrine or other holy place in order to gain spiritual help or guidance, or for the purpose of thanksgiving. Pilgrimages are common to many religions, particularly in the East. A Muslim should make the pilgrimage to MECCA, where devotions last two weeks, at least once in his life. This pilgrimage is known as the HAJJ. Since the 2nd century AD, Christians have made pilgrimages to Palestine, to the tomb of the Apostles Peter and Paul in Rome, and to that of James in Santiago de Compostela in Spain.

Pilgrims (Pilgrim Fathers) Group of English Puritans who emigrated to North America in 1620. After fleeing to Leiden, Netherlands, in 1608, seeking refuge from persecution in England, they decided to look for greater religious freedom by founding a religious society in America. They sailed from Plymouth, England, on the MAYFLOWER and founded the PLYMOUTH COLONY in present-day Massachusetts.

pill, the Popular term for oral contraceptives based on female reproductive hormones. They work by preventing ovulation. Two types of synthetic hormone, similar to OESTROGEN and PROGESTERONE, are generally used, although the former alone is effective in preventing ovulation; the later helps to regulate the menstrual cycle. Possible side-effects include headache, HYPERTENSION, weight-gain, and a slightly increased risk of THROMBOSIS. *See* CONTRACEPTION

Pilsen See Plzeň

Pilsudski, Józef (1867–1935) Polish general and statesman. He was instrumental in securing Poland's independence. During World War 1 he led Polish forces against Russia, hoping to establish a Polish state. After independence, Pilsudski became head of state. His attempt to create a larger Polish state during the Polish-Soviet War failed, although he inflicted a remarkable defeat on the invading Russians in

1920. He retired in 1923, but seized power again in 1926, establishing an authoritarian personal rule that lasted until his death.

Pima Tribe of Native North Americans speaking an Uto-Aztecan tongue, and closely related to the Papago. They occupied the Gila and Salt river valleys in s Arizona, where some 8,000 still reside today. They are the descendents of the ancient Hohokam people.

pimpernel Small, trailing annual plant of the genus *Anagallis*, native to Britain and the USA. The single, small, five petalled flowers are scarlet, white or blue. The yellow pimpernel, a creeping European plant of shady areas, is *Lysimachia nemorum*. Family Primulaceae.

Pinckney, Charles (1757–1824) US politician. He was the youngest member of the Continental Congress (1784–87) and played a major role at the Constitutional Convention (1785–87). As minister to Spain (1801–05), he secured Spanish acceptance of the Louisiana Purchase. He served as South Carolina's governor and led Congressional opposition to the Missouri Compromise.

Pincus, Gregory Goodwin (1903–67) US biologist who helped to develop the contraceptive PILL using synthetic HORMONES. Pincus wrote several articles on hormones and a book, *The Eggs of Mammals* (1936).

Pindar (522–438 BC) Greek poet known for his choric lyrics and triumphal odes. Of the 17 volumes of Pindar's works known to his contemporaries, only 44 odes survive, written to celebrate victories in athletic games.

pine Any of various evergreen, cone-bearing trees of the genus *Pinus*, most of which are native to cooler temperate regions of the world. Many have two types of shoots, some with needle-like leaves, and others with deciduous, scale-like leaves. The reproductive organs may be catkins or cones. Many species are valued for soft wood, wood pulp, oils and resins. Family: Pinaceae.

pineal body Small gland attached to the under-surface of the vertebrate brain. In human beings, it has an endocrine function, secreting the hormone melatonin, which is involved in daily rhythms. *See also* ENDOCRINE SYSTEM

pineapple Tropical, herbaceous, perennial plant, cultivated in the USA, South America, Asia, Africa and Australia; also the fruit of the plant. The fruit is formed from the flowers and bracts and grows on top of a short, stout stem bearing stiff, fleshy leaves. The fruit is eaten fresh, tinned, or made into juice. Height: to 1.2m (4ft). Family Bromeliaceae; species *Ananas comosus*.

Pinkerton, Allan (1819–84) US detective, b. Scotland. He moved to the USA in 1842, and became a detective on the Chicago police force, resigning in 1850 to establish his own agency, Pinkerton's National Detective Agency. He organized and headed a federal intelligence service (1861).

Pink Floyd British rock group formed in 1964 with original members Syd Barrett, Roger Waters, Nick Mason and Rick Wright. Barrett was replaced by David Gilmour in 1968. Over the next 15 years the band became famous for staging vast, theatrical concerts. Their most acclaimed albums are *Dark Side of the Moon* (1973) and *The Wall* (1979).

pinna Flap of skin and cartilage that comprises the visible, external part of the EAR. It helps to collect sound waves and direct them into the ear canal.

Pinochet Ugarte, Augusto (1915–) Ruler of Chile (1973–89). He led the military coup that overthrew Salvador ALLENDE and subsequently headed a four-man junta, taking the title of president under a new constitution in 1981. His policies were pursued by ruthless means, including torture and murder. After a referendum (1988) in which a majority voted against extending his presidency, he permitted free elections and accepted civilian rule, while retaining command, until 1998, of the armed forces.

Pinter, Harold (1930–) British playwright. His first play, The Room (1957), met with critical disapproval, but he followed it with successes such as The Birthday Party (1958), The Caretaker (1960), The Homecoming (1965), Old Times (1971) and No Man's Land (1975). His recent plays include Party Time (1991) and Moonlighting (1993). In most of his plays, ordinary characters and settings are presented in an atmosphere of mystery and fear.

Pinyin System of spelling used to transliterate ideographic Chinese characters into the Roman alphabet. It is a phonetic system (it represents the sounds of words) and was officially adopted by the People's Republic of China in 1958.

pipefish Any of numerous species of marine fish found in the shallow, warm and temperate waters of the Atlantic and Pacific oceans. Closely related to the seahorse, it has a pencillike body covered with bony rings. Its mouth is at the end of a long snout. Length: to 58.4cm (23in). Family Syngnathidae.

Piper, John (1903–92) British watercolour painter and art critic. Some of his most striking works are the pictures of bomb-damaged buildings that he made during World War 2. After 1950, he designed stage sets for operas and created stained glass windows.

pipit (fieldlark, titlark) Any of more than 50 small, brown, inconspicuous birds that resemble LARKS in habits and appearance. They are found worldwide. The plumage of both sexes is a similar streaked brown or greyish colour, with a long, white-edged "wag" tail. Length: 15cm (6in). Family Motacillidae; genus *Anthus*.

Piraeus Seaport city in SE Greece, 8km (5mi) sw of Athens; largest Greek port. Piraeus was planned c.490 BC and rapidly developed into a major sea outlet. It was destroyed by the Roman general SULLA in 86 BC and fell into decline. In the 19th century, following Greek independence, a process of reconstruction led to the creation of the modern naval and commercial port. It is the centre of a modern communications network with all the Greek islands. Industries: shipbuilding, oil-refining, textiles, chemicals. Pop. (1991) 182,671.

Pirandello, Luigi (1867–1936) Italian dramatist, novelist and short-story writer. Among his plays are *Six Characters in Search of an Author* (1921) and *As You Desire Me* (1930). His novels include *The Late Mattia Pascal* (1923). His work explores the boundaries between reality and illusion. He won the 1934 Nobel Prize for literature.

Piranesi, Giovanni Battista (1720–78) Italian engraver and architect. He lived in Rome where he became famous for his *Vedute*, 137 etchings of the ancient and modern city (1745). The one existing building that he designed is the Church of Santa Maria del Priorato in Rome (1764–65).

piranha (piraya) Tropical, freshwater, bony fish that lives in rivers in South America. It is a voracious predator, with formidable teeth and an aggressive temperament. Piranhas usually travel and attack in shoals and can pose a serious threat to much larger creatures. Length: to 24in (61cm). Family Characidae; genus *Serrasalmus*.

Pisa City on the River Arno, Tuscany, w central Italy. Already an important Etruscan town, Pisa prospered as a Roman colony from c.180 BC. In the Middle Ages it was a powerful maritime republic. It later came under Florentine domination. Industries: tourism, textiles, glass, machine tools. Pop (1992 est.) 108,000.

Pisanello (1395–1455) (Antonio Pisano) Italian painter and medallist. Working in the International Gothic style, he drew detailed studies of birds, people and costumes. His medals of important people of his time are of great historic value.

◄ pineapple An important cash crop in some tropical regions, pineapples bear fleshy fruit. The fruit can be eaten fresh, but the majority is tinned or turned into pineapple juice.

▲ pine The lodgepole pine (*Pinus contorta*) grows in w North America, reaching a height of 18m (60ft). It is a small, vigorous mountain tree that is hardy to an altitude of 3,500m (11,000ft).

▲ piranha The red piranha (Rooseveltiella natterei) of South America is notorious for its ferocity. Its powerful jaws have sharp teeth, and it makes up for its relatively small size − 35cm (14in) − by swimming in large shoals. These represent a threat to larger fish, land animals, and even humans. They feed in bouts, rather than continuously, and use their sense of smell to locate their prey.

Pisano, Nicola (1225–84) Italian sculptor. In Pisa he executed his first masterpiece, the pulpit for the Baptistry (1260). In his work on the cathedral pulpit in Siena (1265–68), he was aided by his son, **Giovanni** (*c*.1250–*c*.1320), whose taste in decoration was influenced by the French Gothic style. Giovanni executed two other pulpits: for Sant' Andrea, Pistoia (1298–1301) and Pisa cathedral (1302–10).

Piscator, Ervin Friedrich Max (1893–1966) German stage director. He developed the concept of EPIC THEATRE, which BRECHT incorporated into the work of the Berliner Ensemble. Piscator shared the conviction that theatre should be a political medium. See also EXPRESSIONISM

Pisces (the Fishes) Inconspicuous equatorial constellation situated on the ecliptic between Aquarius and Aries; it is the 12th sign of the Zodiac.

Pisistratus (605–527 BC) Athenian ruler. He became leader of the popular party in Athens. He seized control by force in 560 BC but was overthrown in 554 BC and driven into exile. With support from Thebes and Argos, he regained power in 541 BC and ruled as "tyrant" until his death.

Pissarro, Camille (1830–1903) French painter who adopted IMPRESSIONISM and tried POINTILLISM. In the 1880s he experimented with the pointillist theories of Georges SEURAT but abandoned them in the 1890s for a freer interpretation of nature. His works include *Louvre from Pont Neuf* (1902).

pistachio Deciduous tree native to the Mediterranean region and E Asia. It is grown commercially for the edible greenish seed (the pistachio nut) of its wrinkled red fruit. Height: to 6m (20ft). Family Anacardiaceae; species *Pistacia vera*.

pistil Female organ located in the centre of a flower. It consists of an OVARY, a slender STYLE and a STIGMA, which receives POLLEN.

pistol Firearm held and fired in one hand. The first were matchlocks, in which a glowing fuse ignited the charge; by the end of the 16th century, wheel-locks and the cheaper flintlocks were also in use. The invention of the percussion cap in 1815 enabled pistol technology to advance rapidly, and Samuel Colt's revolver of 1835 was the first reliable repeating firearm. Since then pistols have become capable of automatic fire.

Pitcairn Island Volcanic island in the central s Pacific Ocean forming (together with the uninhabited islands of Henderson, Ducie and Oeno) a British crown colony. First sighted in 1767, Pitcairn was settled in 1790 by mutineers from the British ship HMS *Bounty*. Some of their descendants still live on the island. The principal economic activity is the growing and exporting of fruit. Area: 4.6sq km (1.7sq mi). Pop. (1994) 56. **pitch** Quality of sound that determines its position in a musical scale. It is measured in terms of the frequency of sound waves (measured in hertz) – the higher the frequency, the higher the pitch. It also depends to some extent on loudness and timbre: increasing the intensity decreases the pitch of a low note and increases the pitch of a high one.

pitchblende See URANINITE

pitcher plant Any of several species of INSECTIVOROUS PLANT of the tropics and sub-tropics. Insects are trapped in the vase-shaped leaves, which are lined with bristles. Trapped insects decompose and are absorbed as nutrients by plant cells. The flower is usually red. Height: 20–61cm (8–24in). Family Sarraceniacea; genera *Sarracenia* and *Nepenthes*.

Pitt, William, the Younger (1759–1806) British statesman, prime minister (1783–1801, 1804–06). The second son of William Pitt, earl of Chatham, he entered Parliament in 1781, became chancellor of the exchequer in 1782, and shortly after became Britain's youngest prime minister, aged 24. He resigned in the face of George III's refusal to consider CATHOLIC EMANCIPATION. He returned to power in 1804 and died in office. His reputation rests chiefly on his reforming financial and commercial policies in the 1780s, which restored British prosperity and prestige after the disaster of the AMERICAN REVOLUTION. During his administrations, the India Act (1784), the Constitutional Act (1791) dividing Canada into French and English provinces, and the Act of Union with Ireland (1800) were passed.

Pittsburgh City and port at the confluence of the Allegheny

and Monongahela rivers, sw Pennsylvania, USA. Fort Duquesne was founded on the site by the French c.1750. It was captured by the British in 1758 and renamed Fort Pitt. Pittsburgh grew as a steel manufacturing centre in the 19th century (the industry is now in decline). Industries: glass, machinery, petroleum products, electrical equipment, publishing, coal mining, oil and natural gas extraction. Pop. (1990) 369,379.

pituitary gland Major gland of the ENDOCRINE SYSTEM, located at the base of the BRAIN. In human beings it is about the size of a pea and is connected to the HYPOTHALAMUS by a stalk. It produces many HORMONES, some of which regulate the activity of other endocrine glands, while others control growth.

Pius V, Saint (1504–72) Pope (1568–72), b. Antonio Ghislieri. He was an energetic reformer of the Church and enemy of Protestantism. He excommunicated Queen ELIZABETH I of England in 1570. During his reign, he tightened the rules of INQUISITION and succeeded in eliminating Protestantism from Italy. He was canonized in 1712.

Pius VII (1742–1823) Pope (1800–23), b. Barnaba Gregorio Chiaramonti. He secured the Concordat of 1801 with NAPOLEON I. After Napoleon took Rome in 1808 and annexed the PAPAL STATES in 1809, Pius excommunicated him. Pius was removed and imprisoned until 1814. On his restoration he encouraged the reform of religious orders and education.

Pius IX (1792–1878) Pope (1846–78), b. Giovanni Maria Mastai-Ferrett. He was driven from Rome (1848–50), but restored by NAPOLEON III. The PAPAL STATES were seized by the Italian nationalists in 1860, and Rome itself incorporated into the kingdom of Italy, which in 1870 Pius refused to accept. He defended German Catholics from persecution by BISMARCK. In 1869 Pius convened the First VATICAN COUNCIL, which proclaimed the principle of PAPAL INFALLIBILITY.

Pius XII (1876–1958) Pope (1939–58), b. Eugenio Pacelli. Fearing political reprisals, he failed to denounce the Nazis and the persecution of Jews during World War 2. He was more openly hostile to communism. On matters of doctrine, he maintained a conservative policy, although he appointed local bishops in non-Western countries and created a non-Italian majority among the cardinals.

Pizarro, Francisco (1471–1541) Spanish *conquistador* of the INCA empire of Peru. He served under CORTÉS and led expeditions to South America (1522–28). Having gained royal support, he led 180 men to Peru in 1530. They captured and later murdered the Inca leader ATAHUALPA, and took Cuzco, the capital (1534). Pizarro acted as governor of the conquered territory, founding Lima in 1535.

placenta Organ in mammals (except monotremes and marsupials) that connects the FETUS to the UTERUS of the mother. Part of the placenta contains tiny blood vessels through which oxygen and food are carried from the mother to the embryo via the umbilical cord and wastes are carried from the embryo to the mother's bloodstream to be excreted. The placenta secretes hormones that maintain pregnancy and is discharged from the mother's body as the afterbirth, immediately after delivery.

plagioclase Type of FELDSPAR. Plagioclase minerals occur in IGNEOUS and METAMORPHIC rocks. Off-white, or sometimes pink, green or brown, they are composed of varying proportions of the silicates of sodium and calcium with aluminium. They show an oblique cleavage and have triclinic system crystals. Hardness 6–6.5; s.g. 2.6.

plague Acute infectious disease of man and rodents caused by the bacillus *Yersinia pestis*. In man it occurs in three forms: bubonic plague, most common and characterized by vomiting, fever and swellings of the lymph nodes called "buboes"; pneumonic plague, in which the lungs are infected; and septicaemic plague, in which the bloodstream is invaded. Treatment is the administration of vaccines, bed rest, antibiotics and sulpha drugs. *See also* BLACK DEATH

plaice Marine flatfish found along the w European coast. An important food fish, it is brown or grey with orange spots. Length: to 90cm (3ft); weight: to 11.8kg (26lb). Family Pleuronectidae; species *Pleuronectes platessa*.

Plaid Cymru (Party of Wales) Welsh nationalist political party, founded in 1925 as Plaid Genedlaethol Cymru. Its first member of the House of Commons was elected in 1966. It

advocates Welsh independence (from the United Kingdom) within the European Union.

plainsong (plainchant) Collection of unharmonized liturgical melodies of the Western Church, traditionally performed unaccompanied. Plainsong goes back to the beginning of the Christian era. The melodies use free rhythms, following the rhythms of the words set. The range of the melodies is usually small, and the musical "scales" they employ derive from the "modes" of ancient Greek music. In the 6th century, plainsong was reformed, supposedly at the behest of Pope GREGORY I ("the Great"). In this reformed state it was known as Gregorian chant.

Planck, Max Karl Ernst Ludwig (1858–1947) German theoretical physicist whose revolutionary QUANTUM THEORY helped to establish modern physics. In 1900 he came to the conclusion that the frequency distribution of BLACK BODY radiation could only be accounted for if the radiation was emitted in separate "packets" called quanta, rather than continuously. His equation, relating the energy of a quantum to its frequency, is the basis of quantum theory. **Planck's constant** is a universal constant (symbol h) of value 6.626×10^{-34} joule seconds, equal to the energy of a quantum of electromagnetic radiation divided by the radiation frequency. He was awarded the 1918 Nobel Prize for physics.

plane In mathematics, a flat surface such that a straight line joining any two points on it lies entirely within the surface. Its general equation in the three-dimensional CARTESIAN COORDINATE SYSTEM is ax + by + cz = d, where a, b, c and d are constants.

planet Large, non-stellar body in orbit around a star, shining only by reflecting the star's light. In our Solar System there are nine major planets, as opposed to the thousands of small bodies known as ASTEROIDS or minor planets. *See also* Mercury; Venus; Earth; Mars; Jupiter; Saturn; Uranus; Neptune; Pluto

planetarium Domed building in which a projector displays an artificial sky in order to demonstrate the positions and motions of the Sun, Moon, planets and stars relative to the Earth. The projector was invented in 1913 by Walter Bauersfeld of the Zeiss Optical Company.

plankton All the floating or drifting life of the ocean, especially that near the surface. The organisms are very small and move with the currents. There are two main kinds: phytoplankton, floating plants such as DIATOMS and dinoflagellates; and zooplankton, floating animals such as radiolarians, plus the larvae and eggs of larger marine animals. They are a vital part of the food chain.

plant Multicellular organism whose cells have cellulose cell walls and contain CHLOROPLASTS or similar structures (plastids). They develop from DIPLOID embryos and have a regular alternation of HAPLOID and diploid generations in their life cycle. Most plants are green and make their own food by PHOTOSYNTHESIS. A few are colourless PARASITES or SAPRO-PHYTES. Simple plants reproduce by means of SPORES, while more advanced plants produce SEEDS and FRUITS. Plants show a wide range of biochemistry; some produce chemicals such as ALKALOIDS, NARCOTICS and even cyanide; others secrete substances into the soil to prevent other plants growing near them. Many of these chemicals form the bases for the development of drugs. Plants are classified on the basis of their morphology (shape and structure). The most important phyla are: the Bryophyta (BRYOPHYTES), which include the mosses and liverworts; LYCOPODOPHYTA, or CLUB MOSS-ES; Sphenophyta (HORSETAILS); Filicinophyta (FERNS); Cycadophyta (CYCADS); Ginkgophyta (GINKGO); Coniferophyta (CONIFERS); and Angiospermophyta (ANGIOSPERMS). See also ALTERNATION OF GENERATIONS

Plantagenet English royal dynasty (1154–1485). The name encompasses the Angevins (1154–1399) and the houses of Lancaster and York. They are descended from Geoffrey of Anjou and Matilda, daughter of Henry I. The name was adopted by Richard, duke of York and father of Edward IV, during the Wars of the Roses.

plantain Plant with a rosette of basal leaves and spikes of tiny, greenish-white flowers; it grows in temperate regions and was used for medicinal purposes. Family Plantaginaceae; genus *Plantago*. The name plantain is also given to a tropical banana plant believed to be native to SE Asia and now cultivated throughout the tropics. It has fleshy stems, bright green leaves and green fruit that is larger and starchier than a banana. It is eaten cooked. Height: to 10m (33ft). Family Musaceae; species *Musa paradisiaca*.

plant classification System devised to group PLANTS according to relationships among them. Plants are known by common names that often vary from area to area, but have only one correct scientific name. *See* TAXONOMY

plant genetics Science of heredity and variation in plants. Research in GENETICS since 1900 has supplied the principles of plant breeding, especially HYBRIDIZATION. The development of consistently reliable and healthy first-generation crosses (F1 hybrids) has revolutionized the growing of food crops, ornamental annuals and bedding plants. Genetic engineers grow cell and TISSUE CULTURES by the replication or cloning of sterile plant types. They also concentrate on isolating individual GENES with the aim of producing new colour varieties for traditional flowers, improving the flavour of food crops, breeding resistance to pests and herbicides, and lengthening the shelf life of harvested crops. See also GENETIC ENGINEERING

plaque Abnormal deposit building up on a body surface, especially the film of saliva and bacteria that accumulates on teeth. Dental plaque leads to tooth decay and gum disease.

plasma In physics, an ionized gas that contains about the same amount of positive and negative IONS. Plasma, often described as the fourth state of MATTER, occurs at enormous temperatures, as in the interiors of the Sun and other stars and in fusion reactors.

plastic Synthetic material composed of organic molecules, often in long chains called POLYMERS, that can be shaped and then hardened. The weight and structure of the molecules determine the physical and chemical properties of a given compound. Plastics are synthesized from common materials, mostly from petroleum. CELLULOSE comes from cotton or wood pulp, CASEIN from skimmed milk, others from chemicals derived from plants. Thermoset plastics, such as BAKELITE, stay hard once set, while thermoplastics, such as POLYETHYLENE, can be resoftened by heat. New biodegradable plastics, more expensive to produce, are environmentally friendly because they eventually decompose.

plastic surgery Branch of surgery that involves the reconstruction of deformed, damaged or disfigured parts of the body. Cosmetic surgery, such as face-lifts, is performed solely to improve appearance.

■ Pitt the Younger The British statesman William Pitt became prime minister when he was only 24, the youngest man to achieve that position. An ambitious and determined politician, he led the country for 20 years. His great parliamentary rival was Charles James Fox.

plastid Type of organelle found in the cells of plants and green algae. Chloroplasts and leucoplasts are two examples of plastids, which have a double membrane and contain DNA.

Plata, Río de la Estuary in se South America formed by the junction of the Paraná and Uruguay rivers at the border between Argentina and Uruguay. It was first explored by Europeans in the early 16th century. The cities of Buenos Aires and Montevideo lie on its s and n shores respectively. It is 270km (170mi) long, and 190km (120mi) wide at its mouth. Area: c.35,000sq km (13,500sq mi).

platelet Colourless, usually spherical structures found in mammalian BLOOD. Chemical compounds in platelets, known as factors and cofactors, are essential to the mechanism of blood clotting. The normal platelet count is about 300,000 per cu mm of blood.

plate tectonics Theory or model to explain the distribution. evolution and causes of the Earth's crustal features. It proposes that the Earth's CRUST and part of the upper MANTLE (the LITHOSPHERE) is made up of several separate, rigid slabs, termed plates, which move independently forming part of a cycle in the creation and destruction of crust. The plates collide or move apart at the margins, and these produce zones of earthquake and volcanic activity. Three types of plate boundary can be identified. At a constructive or divergent margin, new basaltic magma originating in the mantle is injected into the plate. The crusts are forced to separate and an oceanic ridge is formed. At a destructive or convergent margin, plates collide and one plate moves under the other. This occurs along oceanic trenches. The recycling of crust by subduction results in the melting of some crustal material, and volcanic island arcs (such as the islands of Japan) are produced. Material that cannot be subducted is scraped up and fused onto the edge of plates. This can form a new continent or add to existing continents. Mountain chains are explained as the sites of former subduction or continental collision. At a conservative margin, plates move past each other along a transform fault. Plate movement is thought to be driven by convection currents in the mantle. See also SEAFLOOR SPREADING

Plath, Sylvia (1932–63) US poet. Her verse includes *The Colossus* (1960) and *Ariel* (1965). The latter was published after her suicide, as were *Crossing the Water* (1971), *Winter Trees* (1971), *Johnny Panic and the Bible of Dreams* (1977) and *Collected Poems* (1981). She wrote one novel, *The Bell Jar* (1963). Her most effective work is characterized by intensely personal, confessional elements. She was married to the British poet Ted HUGHES.

The discovery that the continents are carried along on the top of slowly moving crustal plates provided the mechanism for the drift theories to work. The plates converge and diverge

along margins marked by seismic and volcanic activity. Plates diverge from mid-ocean ridges where molten lava pushes up and forces the plates apart at a rate of up to 3.75cm (1.5in) a year; converging plates form either a trench (where the oceanic plates sink below the lighter continental rock) or mountain ranges (where two continents collide).

platinum (symbol Pt) Lustrous, silver-white metal, one of the TRANSITION ELEMENTS. Discovered in 1735, it is chiefly found in certain ores of nickel. Malleable and ductile, it is used in jewellery, dentistry, electrical-resistance wire, magnets, thermocouples, surgical tools, electrodes and other laboratory apparatus, and as a CATALYST in catalytic converters for car exhausts. It is chemically unreactive and resists tarnishing and CORROSION. Properties: at.no. 78; r.a.m. 195.09; r.d. 21.45; m.p. 1,772°C (3,222°F); b.p. 3,800°C (6,872°F); most common isotope Pt¹⁹⁵ (33.8%).

Plato (427-347 BC) Ancient Greek philosopher and writer who formulated an ethical and metaphysical system based upon philosophical IDEALISM. From $c.407~\mathrm{BC}$ he was a disciple of Socrates, from whom he may have derived many of his ideas about ethics. Following the trial and execution of Socrates in 399 BC, Plato withdrew to Megara, after which he is believed to have travelled extensively in Egypt, Italy and Sicily. He visited Syracuse in Sicily three times, in about 388, 367 and 361-360 BC, during the reigns of the tyrants Dionysius I and II. Plato sought to educate Dionysius II as a philosopher-king and to set up an ideal political system under him, but the venture failed. Meanwhile, in Athens, Plato set up his famous ACADEMY (c.387 BC). In the Academy he taught several young people, including ARISTOTLE. In addition to being a philosopher of great influence, Plato wrote in the form of dialogues, in which Socrates genially interrogates another person, demolishing their arguments. All of Plato's 36 works survive. His most famous dialogues include Gorgias (on rhetoric as an art of flattery), Phaedo (on death and the immortality of the soul) and the Symposium (a discussion on the nature of love). Plato's greatest work was the Republic, an extended dialogue on justice, in which he outlined his view of the ideal state.

Platt Amendment (1901) US legislation effectively making CUBA a US protectorate after the SPANISH-AMERICAN WAR. It was included in the Cuban constitution of 1901, and provided the legal basis for the US occupation of Cuba (1906–09). It was repealed in 1934, although the USA retained the right to maintain its naval base on Guantánamo Bay.

platypus Monotreme mammal of Australia and Tasmania. It is amphibious, lays eggs and has webbed feet, a broad tail and a soft duck-like bill. The male has a poison spur on the hind foot. It is 60cm (24in) long and eats small invertebrates. Family Ornithorhynchidae; species *Ornithorhynchus anatinus*.

Plautus, Titus Maccius (254–184 BC) Roman comic playwright. His works, such as *Miles Gloriosus* (*The Braggart Soldier, c.*211 BC), were modelled on Greek originals. His plays typically combine farcical plots with amusing, low-life characters and witty dialogue. Shakespeare's *The Comedy of Errors* (1593) derives from Plautus' *Menaechmi* (*The Two Menaechmuses*).

plebeian General body of Roman citizens, as distinct from the small PATRICIAN class. In the early years of the Republic they were barred from public office and from marrying a patrician. The gulf between the two classes gradually closed. By the 3rd century BC there was little legal distinction between them, although social differences remained.

Pléiade, La Group of seven 16th-century French poets. They were Pierre de RONSARD, the leader of the group, Joachim du Bellay (1522–60), Jean-Antoine de Baïf (1532–89), Rémy Belleau (1528–77), Estienne Jodelle (1532–73), Pontus de Tyard (1522–1605) and Jean Dorat (1508–88). Among the earliest writers of the French RENAISSANCE, they advocated French as a literary language instead of Latin and Greek.

Pleiades Young OPEN CLUSTER in the constellation Taurus, popularly called the Seven Sisters. Although only six or seven stars are visible to the naked eye, there are in fact over a thousand embedded in a reflection NEBULA. The brightest member is Alcyone, which is more than 300 times as luminous as the Sun. The cluster lies just over 400 light years away.

Pleistocene Geological epoch that began about 2 million years ago, during which humans and most forms of familiar mammalian life evolved. Episodes of climatic cooling in this epoch led to widespread glaciation in the Northern Hemi-

sphere, and the Pleistocene is the best-known ice age in the Earth's history. It ended around 8,000 BC.

Plekhanov, Georgy Valentinovich (1857–1918) Russian revolutionary. After leading populist demonstrations, he was exiled in 1880 and adopted Marxism. He worked with LENIN until 1903 when, as leader of the MENSHEVIKS, he split with him. He returned to Russia in 1917 and died shortly after the Bolshevik Revolution.

pleura Double membrane that lines the space between the lungs and the walls of the chest. The fluid between the pleura lubricates the two surfaces to prevent friction during breathing movements.

pleurisy Inflammation of the PLEURA. It is nearly always due to infection, but may arise as a complication of other diseases. **Plimsoll, Samuel** (1824–98) British social reformer. As a radical member of Parliament (1868–80), he was chiefly responsible for the Merchant Shipping Act (1876). This act enforced government inspection of shipping and required merchant ships to have a line, subsequently known as the Plimsoll line, painted on their hulls to indicate safe loading limits.

Pliny the Elder (AD 23–79) (Gaius Plinius Secundus) Roman author of *Historia Naturalis* (*Natural History*). His one major surviving work, it covers a vast range of subjects, although it is an uncritical mixture of fact and fiction.

Pliny the Younger (AD 62–114) (Gaius Plinius Caecilius Secundus) Roman administrator. The nephew and adopted son of PLINY THE ELDER, he became a senator and governor of Bythnia (c.112). He is best known for his correspondence with the Emperor Trajan, which provides a unique record of the life of a Roman gentleman.

Pliocene Last era of the TERTIARY period. It lasted from 5 to 2 million years ago and preceded the PLEISTOCENE. Animal and plant life was not unlike that of today.

PLO See PALESTINE LIBERATION ORGANIZATION

Plotinus (205–270) Ancient philosopher, the founder of NEOPLATONISM. He opened a school in Rome c.244. In essence, he conceived of the universe as a hierarchy proceeding from matter, through soul and reason, to God. God was pure existence, without form. His pupil and biographer Porphyry compiled and edited Plotinus' writings into six books of nine chapters each, known as the *Enneads*.

plover Any of several species of wading shorebirds, many of which migrate long distances over open seas from Arctic breeding grounds to Southern Hemisphere wintering areas. It has a large head, a plump grey, brown or golden speckled body, and short legs. Length: to 28cm (11in). Family Charadriidae; genera include *Charadrius* and *Pluvialis*.

Plowright, Joan Anne (1929–) British actress. Her classical talents were mainly displayed at Chichester and the National Theatre, London, often in conjunction with her husband Laurence OLIVIER. Her modern works included the first performances of John OSBORNE's *The Entertainer* (1957) and Arnold WESKER's *Roots* (1959).

plum Fruit tree, mostly native to Asia and naturalized in Europe and North America, widely cultivated for its fleshy, edible fruit, which has a hard "stone" at the centre. The most common cultivated plum of Europe and Asia is *Prunus domestica*; in North America, the Japanese plum (*Prunus salicina*) is crossed with European varieties to give several cultivated strains. Family Rosaceae.

pluralism In politics, theory that state power is wielded by a number of groups with conflicting interests, none of which is able to establish absolute authority. In philosophy, pluralism is the name given to the theory that there are many ultimate substances, rather than one (as in MONISM). Pluralism can also mean the holding of more than one office at the same time, especially within the Church.

Plutarch (46–120) Greek biographer and essayist. His best known work is *The Parallel Lives*, which consists of biographies of soldiers and statesmen. Lesser known, but also of great interest, are Plutarch's *Moralia*, which comprise essays and dialogues on ethical, literary and historical subjects.

Pluto Smallest and outermost planet of the Solar System. Independently, William H. Pickering and Percival LOWELL calculated the possible existence of Pluto. The planet was

eventually located in 1930 by Clyde Tombaugh within 5° of Lowell's predicted position. Pluto seems to have a mottled surface with light and dark regions, and signs of polar caps. The surface is covered with icy deposits consisting of 98% nitrogen, with traces of methane, and also probably water, carbon dioxide and carbon monoxide. Pluto has a single moon, Charon, which is so large that some astronomers consider Pluto/Charon as a double planet.

Pluto Roman god of the underworld, equivalent to the Greek god HADES. He ruled over the land of the dead and was also a god of wealth, since his realm contained all underground mineral riches.

plutonium (symbol Pu) Silver-white radioactive metallic element of the ACTINIDE SERIES. It was first synthesized in 1940 by Glenn Seaborg and associates at the University of California at Berkeley by deuteron (heavy hydrogen) bombardment of URANIUM. It is found naturally in small amounts in uranium ores. Pu²³⁹ (half-life 2.44×10⁴ years) is made in large quantities in breeder reactors; it is a fissile element used in NUCLEAR REACTORS and nuclear weapons. The element is very toxic and absorbed by bone, making it a dangerous radiological hazard. Properties: at.no. 94; r.d. 19.84; m.p. 641°C (1,186°F); b.p. 3,232°C (5,850°F); most stable isotope Pu²⁴⁴ (half-life 7.6×10⁷ years). *See also* TRANSURANIC ELEMENTS

Plymouth City and port on the Tamar estuary, Devon, sw England. In 1588 Sir Francis Drake set out from Plymouth to attack the Spanish Armada, and the Mayflower sailed for America from here in 1620. Plymouth was severely damaged by bombing in World War 2. It is an important naval base, and has ferry links with France and Spain. Industries: China clay, machine tools, precision instruments. Pop. (1991) 243,373.

Plymouth Brethren Strictly Puritan sect of evangelical Christians, founded in Ireland in the late 1820s by J.N. Darby, an ordained Anglican. Their name comes from their having established their first English centre at Plymouth in 1831. In 1849 they split into two groups, the "Open Brethren" and the "Exclusive Brethren", and have since split further.

Plymouth Colony First colonial settlement in New England (founded 1620). The settlers were a group of about 100 Puritan Separatist PILGRIMS, who sailed on the MAYFLOWER and settled on what is now CAPE COD Bay, Massachusetts. They named the first town after their port of departure. Lacking a royal charter, government was established by the "Mayflower Compact". During the first winter nearly half the settlers died. Plymouth Colony became part of the province of Massachusetts in 1691.

Plzeň (Pilsen) City in w Czech Republic. Founded in the 13th century by King Wenceslaus II, it was a focal point for Roman Catholic resistance during the HUSSITE Wars. It is a centre for heavy industry (machine tools, motor cars, armaments), and is internationally famous for its beer. Pop. (1990) 175,000.

pneumoconiosis Occupational disease principally of miners working in confined and dusty conditions. Caused by inhaling irritants, often only as minute specks, the disease inflames and can finally destroy lung tissue.

pneumonia Inflammation of the LUNG tissue, most often caused by bacterial infection. Most at risk are the very young, the aged, and those whose immune systems have been undermined by disease or certain medical treatments. The commonest form is pneumococal pneumonia, caused by the bacterium *Streptococcus pneumoniae*. Symptoms include fever, chest pain, coughing and the production of rust-coloured sputum. Treatment is with ANTIBIOTICS.

pneumothorax Presence of air in the pleural space between the lungs and the chest wall. It may arise spontaneously or be caused by injury or disease. The lung is liable to collapse because it is prevented from expanding normally. **Po** Italy's longest river, in N Italy. It rises in the Cottian Alps near the French border, and flows E to empty into the Adriatic Sea. The Po valley is an important industrial and agricultural region, and water from the river is used extensively in irrigation schemes. Length: 650km (405mi).

Pocahontas (1595–1617) Native American princess and early colonial heroine. According to legend she saved the life of John SMITH, leader of the JAMESTOWN colonists, when he

▲ plum A hybrid of two other fruits, the cherry plum and the sloe, the plum tree (*Prunus domestica*) is a hardy tree that thrives in temperate regions worldwide.

PLUTO: DATA

Diameter (equatorial): 2,324km (1,444mi)

Mass (Earth=1): 0.002

Volume (Earth=1): 0.01

Density (water=1): 2.03

Orbital period: 247.7 years

Rotation period: 6.375 days

Average surface temperature:

-230°C (-382°F)

was about to be killed by her father, POWHATAN. Captured by the colonists in 1613, she adopted their customs and in 1614 married John Rolfe. She died during a visit to England.

Po Chü-i (772–846) Chinese poet of the T'ANG period. He served in various administrative posts. He wrote poems of social protest in simple, everyday language. Among the best known is *The Everlasting Wrong* (or *Song of the Everlasting Sorrow*) (806).

podiatry Treatment and care of the foot. Podiatrists treat such conditions as corns and bunions and devise ways to accommodate foot deformities.

Poe, Edgar Allan (1809–49) US poet and short-story writer. Much of his finest poetry, such as *The Raven* (1845), deals with fear and horror in the tradition of the GOTHIC NOVEL. Other works include the poem *Annabel Lee* (1849), and the stories *The Fall of the House of Usher* (1839), *The Murders in the Rue Morgue* (1841) and *The Pit and the Pendulum* (1843). poet laureate Title conferred by the British monarch on a poet whose duty is then to write commemorative verse on important occasions. The position has been held by, among others, Robert Southey (1813–43), Wordsworth (1843–50), Tennyson (1850–92), John Masefield (1930–67) and Sir John Betjeman (1972–84). Ted Hughes has been the poet laureate since 1984.

poetry Literary medium that employs the line as its formal unit, and in which the sound, rhythm and meaning of words are all equally important. Until the modern introduction of the concept of FREE VERSE, poetry was characteristically written in regular lines with carefully structured METRES, often with RHYMES. *See also* LITERATURE; PROSE

pogrom Russian term for a destructive riot, generally applied to attacks on Jews in Russia in the late 19th and early 20th centuries. They were usually carried out by anti-Semitic mobs, encouraged by the policies of the tsarist government and often instigated by local authorities.

poikilothermic (ectothermic) Describes an animal whose body temperature fluctuates with the temperature of its surroundings, often referred to as cold-blooded. Reptiles, amphibians, fish and invertebrates are cold-blooded. They can control their body temperature only by their behaviour – by moving in and out of the shade, or orientating themselves to absorb more or less sunlight. *See also* HOMEOTHERMIC

Poincaré, (Jules) Henri (1854–1912) French mathematician. He worked on CELESTIAL MECHANICS, winning an award for his contribution to the theory of orbits. In 1906, independently of EINSTEIN, he obtained some of the results of the special theory of RELATIVITY. He attempted to make mathematics accessible to the general public in such works as *The Value of Science* (1905) and *Science and Method* (1908).

Poincaré, Raymond Nicolas Landry (1860–1934) French statesman. He served in several government posts and was prime minister (1912–13) before becoming president (1913–20). An ardent nationalist and conservative, he accepted his opponent CLEMENCEAU as premier in 1917, in the cause of national unity. Poincaré was again prime minister in 1922–24 and 1926–29. He ordered the occupation of the RUHR in 1923 to force German payment of REPARATIONS.

poinsettia Showy house plant native to Mexico. It has tapering leaves and tiny yellow flowers centred in leaf-like red, white or pink bracts. In its natural environment, the tree grows to about 5m (16ft). Height: to 60cm (2ft) when potted. Family Euphorbiaceae; species *Euphorbia pulcherrima*.

pointer Smooth-coated sporting and gun dog that was developed in the 17th century for hunting. It can be trained to indicate the direction in which game lies by standing motionless, aligning its muzzle, body and tail. It has a wide head with a solid muzzle. The strong lean body is set on muscular legs. The short dense coat can be white with black or brown markings. Height: to 63cm (25in); weight: to 27kg (60lb).

Point Four program US plan to share its scientific and technological knowledge with less developed countries. The plan received its name after it was first proposed by President TRUMAN in his 1949 inaugural address. The plan was funded by the USA, the United Nations and the recipient countries. By 1950 the plan had been included in general US foreign policy.

pointillism (Fr. *pointiller*, to dot) Technique of painting in regular dots or small dashes of pure colour, developed from NEO-IMPRESSIONISM by Georges SEURAT. When looked at from a distance, the dots create a vibrant optical effect.

poison ivy North American shrub that causes a severe, itchy rash on contact with human skin. It has greenish flowers and white berries. Species *Rhus radicans* and *R. toxicodendron*. Family Anarcardiaceae.

Poitier, Sidney (1924–) US actor and director. His early films were *No Way Out* (1950) and *Porgy and Bess* (1959). He won an Academy Award for *Lilies of the Field* (1963). His later films include *Guess Who's Coming to Dinner* (1967), *In the Heat of the Night* (1967) and *For Love of Ivy* (1968). Directorial credits include *Stir Crazy* (1980) and *Sneakers* (1992).

Poitiers City on the River Clain, w central France; capital of Vienne département and chief town of Poitou-Charentes region. Poitiers was the ancient capital of the Pictones (a Gallic tribe), and an important centre of early European monasticism. In the 5th century, the city fell to the Visigoths, who were in turn defeated by the Merovingian king Clovis I (507). In Poitiers, in 732, the Franks halted the advance of the Muslim Saracens. The Battle of Poitiers (1356) was an important English victory in the HUNDRED YEARS WAR. The modern city possesses many historical buildings. Industries: metallurgy, printing, chemicals, electrical equipment. Pop. (1990) 107,625.

poker Card game believed to have originated in Europe in the 16th century. Basically a gambling game, the object is to win the pot (all the bets that are made after each card is dealt) by holding the best combination of cards (in same suit, in pairs or triples, or in numerical sequence), or by bluffing the other players into withdrawing.

Poland Republic in central Europe. See country feature

Polanski, Roman (1933–) Polish actor and director. He established his reputation with the short film *Two Men and a Wardrobe* (1958). His first full-length film, *Knife in the Water* (1962), was followed by *Repulsion* (1965) and *Cul de-Sac* (1966). Later films include *Rosemary's Baby* (1968), *Macbeth* (1971), *Chinatown* (1974) and *The Tenant* (1976). He also achieved major successes with *Tess* (1980), *Bitter Moon* (1992) and *Death and the Maiden* (1994).

polar bear Large white bear that lives on Arctic coasts and ice floes. It spends most of its time at sea on drifting ice, often swimming for many miles. It preys chiefly on seals and is hunted for fur and meat. Length: 2.3m (7.5ft); weight: to 400kg (900lb). Species *Thalarctos maritimus*.

Polaris See Pole Star

polarized light Light waves that have electromagnetic vibrations in only one direction. (Ordinary light vibrates in all directions perpendicular to the direction of propagation.) Scientists distinguish between three types: plane-polarized, circularly polarized and elliptical-polarized light, each depending on the net direction of the vibrations. Polarizing sunglasses use a Polaroid material to reduce the glare from light polarized by reflection from horizontal surfaces.

Pole, Reginald (1500–58) English cardinal, the last Roman Catholic archbishop of Canterbury. A grand-nephew of EDWARD IV, he was made dean of Exeter in 1527 by HENRY VIII, who was his cousin. He opposed Henry's divorce of CATHERINE OF ARAGON and moved to Italy during the REFORMATION, returning to England in 1554 as papal legate to the Roman Catholic Queen MARY I. She made him archbishop of Canterbury in 1556.

pole Generally either of the two points of intersection of the surface of a sphere and its axis of rotation. The Earth has four poles: the North and South geographic poles, where the Earth's imaginary axis meets its surface; and the north and south magnetic poles, where the Earth's magnetic field is most concentrated. A bar magnet has a north pole, where the magnetic flux leaves the magnet, and a south pole, where it enters. A pole is also one of the terminals (positive or negative) of a battery, electric machine or circuit.

polecat Any of several species of small, carnivorous, nocturnal mammals that live in wooded areas of Eurasia and N Africa; especially *Mustela putorius*, the common polecat. It has a slender body, long bushy tail, anal scent glands, and

Poland's flag was adopted when the country became a republic in 1919. Its colours were taken from the 13th-century coat of arms of a white eagle on a red field. This coat of arms still appears on Poland's merchant flag.

he Republic of Poland is mostly lowland, forming part of the great European plain. The N, lagoon-lined, Baltic Sea coast includes the ports of GDAŃSK and SZCZECIN, and the mouths of the VISTULA and ODER rivers. There are many lakes, especially in the NE. The central plains include Poland's capital, WARSAW, and the cities of Poznań, Lódz and Lublin. Poland's best farmland is in the SE Polish uplands. Beyond the cities of KATOWICE and KRAKÓW, the land rises to Mount Rysy, at 2,499m (8,199ft), in the CARPATHIAN MOUNTAINS. In the sw lies the region of SILESIA, and its capital WROCLAW.

CLIMATE

Poland has a continental climate, with warm summers and bitterly cold, snowy winters. The N coast is much milder than the s highlands.

VEGETATION

Forests cover c.30% of Poland. Nearly 50% of the land is arable.

HISTORY

In the 9th century AD Slavic tribes unified the region. The Piast dynasty came to power. Boleslav I became the first king of Poland (1025), but the kingdom disintegrated in the 12th century. Ladislas I reunified Poland in

1320, but the dynasty collapsed under the might of the TEUTONIC KNIGHTS. The 16th-century rule of the JAGIELLO dynasty is regarded as Poland's "golden age". In 1569 Poland and Lithuania were united. In JOHN II's reign, Poland was plundered by Sweden, Russia and Turkey, JOHN III Sobieski restored some prestige, but his death brought division. Following the War of Succession (1733-35) Russia dominated Polish affairs. In 1772 and 1793 Poland was partitioned between Austria, Prussia and Russia. The defeat of a Polish revolt in 1795 led to further partition. and Poland ceased to exist. The Congress of Vienna (1814-15) established a small, semiindependent Polish state based on Kraków. Polish uprisings in 1848 and 1863 against Russian dominance led to more impositions. In World War 1 Poland initially fought with Germany against Russia, but Germany occupied Poland. Poland regained its independence in 1918. In 1920 Poland recaptured Warsaw from Russia. In 1921 Poland became a republic. The 1920s and 1930s were a period of dictatorship and military rule. In September 1939, following a secret pact between Hitler and Stalin, Germany invaded and Poland was partitioned between the Soviet Union and Germany. Britain declared war. Following the German invasion of the Soviet Union, all of Poland fell

under German rule. The Nazis established concentration camps, such as AUSCHWITZ. Over 6 million Poles perished. Only 100,000 Polish Jews, from a pre-war community of over 3 million, survived the HOLOCAUST, Polish resistance intensified. In 1944 a provisional government was established. In August 1944 the Warsaw uprising began, but was ruthlessly crushed by the Germans. In 1945 Poland regained its independence. It lost land in the E to the Soviet Union, but gained sections of Prussia from Germany. In 1949 Poland joined the Council for Mutual Economic Assis-TANCE (COMECON). In 1952 Poland became a people's republic, modelled on the Soviet constitution. In 1955 it was a founder member of the Warsaw Pact. Uprisings in 1956 led to the formation of a more liberal administration, led by Wladyslaw GOMULKA. The collectivization of agriculture was reversed, and restrictions on religious worship were relaxed. Inflation and recession during the 1970s led to further riots and political protests. In 1980 striking dockers in Gdańsk, led by Lech WALESA, formed a trade union called SOLIDARITY, which gained popular support. In 1981 General Jaruzelski declared martial law; Solidarity was banned and its leaders arrested. Continuing recession and civil unrest led to the lifting of martial law in 1983. Following reforms in the Soviet Union, Solidarity was legalized and won free elections in 1989. In 1990 the Communist Party was disbanded and Walesa became president.

AREA: 312,680sg km (120,726sg mi) POPULATION: 38,356,000

GOVERNMENT: Multiparty republic

LANGUAGES: Polish (official)

CURRENCY: Zloty = 100 groszy

Orthodox 2%)

CAPITAL (POPULATION): Warsaw (1,653,300)

ETHNIC GROUPS: Polish 98%, Ukrainian 1%

RELIGIONS: Christianity (Roman Catholic 94%,

POLITICS

In 1995 elections, Walesa was defeated by the leader of the Democratic Left Alliance, Aleksander Kwasniewski. In 1996 Poland ioined the Organization for Economic Cooperation and Development (OECD). Poland has faced huge problems in the transition to a market economy. In 1997 it was invited to join NATO. Parliamentary elections in 1997 were won by a centre-right coalition.

ECONOMY

Before World War 2, Poland had a mainly agricultural economy. Under communism, industry expanded greatly. Today, 27% of the workforce is employed in agriculture and 37% in industry. Upper Silesia is the richest coal basin in Europe. Poland is the world's fifth-largest producer of lignite and seventh-largest producer of bituminous coal. Copper ore is also a vital mineral resource. Manufacturing accounts for c.24% of exports. Poland is the world's fifth-largest producer of ships. Agriculture remains important. Major crops include barley, potatoes and wheat. The transition to a market economy has doubled unemployment, and increased foreign debt. Economic growth is slowly returning.

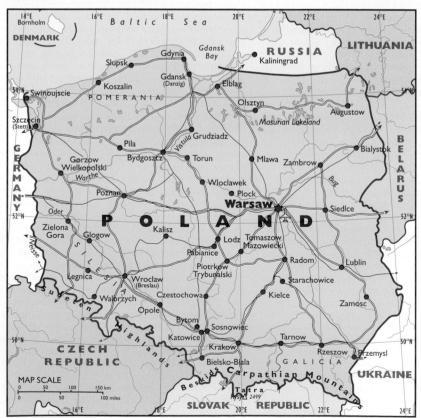

535

▲ poliomyelitis A viral disease that affects the human nervous system, poliomyelitis (polio) can often cause paralysis. Cells of the throat and intestines are the first to become infected. Virus absorption to the cell surface occurs (A), followed by penetration of the cell. Within the cell the virus protein coat is shed, releasing a coiled nucleic acid strand (B). Nucleic acid replication occurs (C), each new strand becoming surrounded by a protein coat (D). As many as 500 new infectious viruses are released as the cell bursts and

▲ pollen Pollen grains are found in pollen sacs, which are in the anthers (part of the starnens). Pollen grains are safe and effective storers of the male gametes (sex cells). They come in all shapes and sizes depending on the species of plant. The selection shows mistletoe (A), venus fly trap (B), spinach (C), honeysuckle (D), touch-me-not (E), cotton (F), rice (G), dandelion (H) and hollyhock (I).

brown to black fur known as fitch. It eats small animals, birds and eggs. Length: 45.7cm (18in). Family Mustelidae.

Pole Star (Polaris, North Star) Important navigational star, nearest to the N celestial star. It is in the constellation Ursa Minor and always marks due N.

police Body of people concerned with maintaining civil order and investigating breaches of the law. The first independent police force was established in Paris in 1667, becoming a uniformed force in 1829. Britain's first regular professional force was the Marine Police Establishment in 1800. The Metropolitan Police was created by Sir Robert PEEL in 1829. The New York City Police Department was formed in 1844.

poliomyelitis Acute viral infection of the nervous system affecting the nerves that activate muscles. Often a mild disease with effects limited to the throat and intestine, it is nonetheless potentially serious, with paralysis occurring in 1% of patients. It becomes life-threatening only if the breathing muscles are affected, in which case the person may need artificial ventilation. It has become rare in developed countries since the introduction of vaccination in the mid-1950s.

Polish National language of Poland, spoken by virtually all of the country's 39 million people. It belongs to the Slavonic family of Indo-European Languages. Polish is written in the Roman (Latin) alphabet, but with a large number of diacritical marks to represent the various Slavonic vowels and consonants.

Polish Corridor Strip of land along the River VISTULA, dividing East Prussia from the rest of Germany, and providing Poland with access to the Baltic Sea (1919–39). It was created by the Treaty of VERSAILLES after World War 1, when Poland became independent. The city of GDAŃSK, near the mouth of the Vistula, was made a free city but, dominated by Germans, excluded Polish enterprise. The arrangement caused disputes between Germany and Poland, exploited by HITLER to justify his invasion of Poland in 1939.

politburo (political bureau) Administrative and policy-making body of the Soviet Communist Party. Formerly called the presidium, it consisted of 11–12 full members and 6–9 candidate members chosen by the Party's central committee. **political party** Group organized for the purpose of electing candidates to office and for promoting a particular set of political principles. *See* articles on individual parties.

politics Sphere of action in human society in which power is sought in order to regulate the ways in which people shall live together. For a society to engage in politics, it must conceive of society as being in a state of perpetual change. A political society accepts the need for perpetually changing the rules in order to make them accord with altered circumstances.

Polk, James Knox (1795–1849) 11th US president (1845–49). During his administration, California and New Mexico were acquired as a result of the US victory in the MEXICAN WAR (1846–48), which Polk's aggressive policy had largely provoked. He also gained Oregon through the Oregon Treaty (1846). Other policy goals that he achieved were reduction of the tariff and restoration of an independent treasury.

polka Lively Bohemian folk dance. It became fashionable in Paris in the 1940s, and thereafter in Europe and the Americas. It is sometimes performed as a ballroom dance.

pollen Yellow, powder-like SPORES that give rise to the male sex cells in flowering plants. Pollen grains are produced in the anther chambers on the STAMEN. When the pollen lands on the STIGMA of a compatible plant, it germinates, sending a long pollen tube down through the STYLE to the OVARY. During this process, one of its nuclei divides, giving rise to two male nuclei (the equivalent of male sex cells or GAMETES), one of which fuses with a female sex cell in fertilization. The other sex cell fuses with two more of the female nuclei to form a special tissue, the endosperm. In many species, this tissue develops into a food store for the embryo in the seed. *See also* POLLINATION; ALTERNATION OF GENERATIONS

pollination Transfer of POLLEN from the STAMEN to the STIG-MA of a flower. Self-pollination occurs on one flower and cross-pollination between two flowers on different plants. Incompatibility mechanisms in many flowers prevent selfpollination. Pollination occurs mainly by wind and insects. Wind-pollinated flowers are usually small and produce a large quantity of small, light, dry pollen grains. Insect-pollinated flowers are usually brightly coloured, strongly scented, contain nectar, and produce heavy, sticky pollen.

Pollock, Jackson (1912–56) US painter. A leading figure in ABSTRACT EXPRESSIONISM. He began experimenting with ABSTRACT ART in the 1940s. In 1947 he began pouring paint straight onto the canvas. Instead of brushes he used sticks or knives to create the surface patterns. This method has been called ACTION PAINTING. His works include *The Blue Unconscious* (1946) and *Lavender Mist* (1950).

poll tax Tax of a fixed sum imposed on all liable individuals. Such taxes were occasionally levied by medieval governments: one provoked the PEASANTS' REVOLT (1381) in England. Southern US states after the Civil War made the right to vote dependent on payment of a poll tax, a device to disenfranchise poor blacks. A poll tax called the Community Charge, introduced in Britain in 1989, was withdrawn after civil disobedience.

pollution Spoiling of the natural environment, generally by industrialized society. Pollution is usually a result of an accumulation of waste products, although excess of noise or heat that has adverse effects on the surrounding ecology is also considered as pollution.

Pollux (Beta Geminorum) Brightest star in the constellation Gemini; a red giant. Characteristics: apparent mag. 1.15; absolute mag. 0.7; spectral type KO; distance 35 light-years. Polo, Marco (1254–1324) Venetian traveller in Asia. In 1274 he accompanied his father and uncle on a trading mission to the court of KUBLAI KHAN, the MONGOL emperor of China. According to his account, he remained in the Far East more than 20 years, becoming the confidant of Kublai Khan and travelling throughout China and beyond. His account, *The Description of the World*, became the chief source of European knowledge of China for centuries.

polo Field game played on horseback. Two teams of four players, on a field up to 182m (600ft) by 273m (900ft), each try to hit a small ball into a goal using flexible mallets. A game consists of four, six or eight chukkas (periods), each 7.5 minutes long; additional chukkas may be played to decide a game if the scores are tied. Each player may use several ponies during a game. Polo originated in Persia in ancient times, and spread throughout Asia. It was revived in India in the 19th century, and was taken up by British army officers there. It was first played in Britain in 1868, and is also played in the USA.

polonium (symbol Po) Rare radioactive metallic element of group VI of the PERIODIC TABLE, discovered in 1898 by Marie CURIE. It is found in trace amounts in uranium ores and may be synthesized. Properties: at.no. 84; r.d. 9.40; m.p. 254°C (489°F); b.p. 962°C (1,764°F); most stable isotope Po²⁰⁹.

Pol Pot (1928–) Cambodian ruler. Pol Pot became leader of the communist KHMER ROUGE, which overthrew the US-backed government of Lon Nol in 1975. He instigated a reign of terror in Cambodia (renamed Kampuchea). The intellectual elite were massacred and city-dwellers driven into the countryside. Estimates suggest that 1 to 4 million people died. Pol Pot's regime was overthrown by a Vietnamese invasion in 1979. He continued to lead the Khmer Rouge until after the Vietnamese withdrawal (1989). In 1997 it was reported that Pol Pot had been sentenced to life imprisonment by a Khmer Rouge court for the murder of a Khmer Rouge comrade.

poltergeist Noisy spirit or ghost, supposedly responsible for unexplained sounds and activity. Such noises often occur during seances and allegedly attest to the presence of supernatural beings.

polyanthus Any of a group of spring-flowering, perennial primroses of the genus *Primula*. They occur mainly in the N temperate zone, and may be almost any colour. They have basal leaves and disc-shaped flowers, branching from a common stalk to form a ball-like cluster. Height: to 15cm (6in). Family Primulaceae.

Polybius (200–120 BC) Greek historian. A leader in the Achaean Confederation, he was deported as an honoured hostage to Rome in 168 BC. He became a friend of SCIPIO AFRICANUS MINOR and accompanied him to Spain and Africa.

He was present at the destruction of Carthage in 146 BC and later acted as intermediary between Rome and the Achaeans. **polychlorinated biphenyl (PCB)** Any of several stable mixtures – liquid, resinous or crystalline – of organic compounds. They are fire-resistant and are used as lubricants and heat-transfer fluids. The use of PCBs has been restricted since 1973 because they are toxic and their resistance to decomposition in streams and soils poses a threat to wildlife.

polyester Class of organic substance composed of large molecules arranged in a chain or a network and formed from many smaller molecules through the establishment of ESTER linkages. Polyester fibres are resistant to chemicals and are made into ropes and textiles.

polyethylene POLYMER of ETHENE. It is a partially crystalline, lightweight, thermoplastic RESIN, with high resistance to chemicals, low moisture absorption and good insulating properties. polygamy Marriage in which more than one spouse is permitted. More often it is used to denote polygyny (several wives) than polyandry (several husbands). Polygamy is legal and commonplace in many nations, notably many Muslim and African countries.

polygon Plane geometric figure having three or more sides intersecting at three or more points (vertices). They are named according to the number of sides or vertices: triangle (three-sided), quadrilateral (four-sided), hexagon (six-sided). A regular polygon is equilateral (has sides equal in length) and equiangular (has equal angles).

polygraph See LIE DETECTOR

polyhedron In geometry, three-dimensional solid figure whose surface is made up of polygons. The polygons are called the faces of the polyhedron, and the points at which they meet are the vertices.

polymer Substance formed by the union of from two to several thousand simple molecules (monomers) to form a large molecular structure. Some, such as cellulose, occur in nature; others form the basis of plastics and synthetic resins.

polymerase chain reaction (PCR) Chemical reaction, speeded up by an ENZYME, that is used to make large numbers of copies of a specific piece of DNA, starting from only one or few DNA molecules. It enables scientists to make large enough quantities of DNA to be able to analyse it or manipulate it. The starting piece of DNA may be extracted from an organism, it may have been synthesized in the laboratory, or it may be a forensic sample taken from the scene of a crime. PCR is extremely important in GENETIC ENGINEERING and GENETIC FINGERPRINTING.

Polynesia One of the three divisions of OCEANIA and the general term for the islands of the central Pacific Ocean; MICRONESIA and MELANESIA lie to the w. The principal islands in Polynesia are the Hawaiian Islands, Phoenix Islands, Tokelau Islands, the Samoa group, Easter Island, Cook Islands and French Polynesia. Because of their Maori population, the two larger islands of New Zealand are also usually included. The islands are mostly coral or volcanic in origin. The inhabitants show physical similarities, and share common cultural and linguistic characteristics.

polynomial Sum of terms that are powers of a variable. For example, $8x^4 - 4x^3 + 7x^2 + x - 11$ is a polynomial of the fourth degree (the highest power is four). In general a polynomial has the form $a_0x^n + a_1x^{n-1} + a_2x^{n-2} + \dots + a_{n-2}x^2 + a_{n-1}x + a_n$, although certain powers of x and the constant term a_n may be missing. The values a_n , a_{n-1} , etc., are the coefficients of the polynomial.

polyp Body type of various species of animals within the phylum Cnidaria. It has a mouth surrounded by extensible tentacles and a lower end that is adapted for attachment to a surface. It is distinct from the free-swimming medusa. It may be solitary, as in the SEA ANEMONE, but is more often an individual of a colonial organism such as CORAL.

polyp In medicine, swollen mass projecting from the wall of a cavity lined with mucous membrane, such as the nose. Although usually benign, some growths can be cancerous.

polyphony Vocal or instrumental part music in which the compositional interest centres on the "horizontal" aspect of each moving part rather than on the "vertical" structure of

chords. The golden age of polyphonic music was the 16th century, and masters of that time included Giovanni PALEST-RINA and William BYRD.

polysaccharide Any of a group of complex CARBOHY-DRATES made up of long chains of monosaccharide (simple-sugar) molecules. GLUCOSE is a monosaccharide, and the polysaccharides STARCH and CELLULOSE are both polymers of glucose. Higher carbohydrates are all polysaccharides and will decompose by HYDROLYSIS into a large number of monosaccharide units. Polysaccharides function both as food stores (starch in plants and GLYCOGEN in animals) and as structural materials (cellulose and PECTIN in the cell walls of plants, and CHITIN in the protective skeleton of insects).

polystyrene Synthetic organic POLYMER, composed of long chains of the aromatic compound styrene. It is a strong thermoplastic RESIN, acid- and alkali-resistant, non-absorbent and an excellent electrical insulator.

polytheism Belief in or worship of many gods and goddesses. The ancient Egyptian, Babylonian, Greek and Roman religions were all poytheistic, as were the religions of the Americas before European settlement. HINDUISM is a modern polytheistic religion. *See also* ANCESTOR WORSHIP; ANIMISM; MONOTHEISM

polyunsaturate Type of FAT or OIL that has molecules of long CARBON chains with many double bonds. Polyunsaturated fats exist in fish oils and most vegetable oils. At room temperature, unsaturated oils are liquids and SATURATED FATS are solids. (The oils of semisoft margarines contain both double bonds and single bonds.) Polyunsaturates, which have low or no CHOLESTEROL content, are widely used in margarines and cooking oils. They are considered to be healthier than saturated fats. **polyvinyl chloride (PVC)** White, tough, solid thermoplastic

that is a polymer of vinyl chloride. A PVC can be softened and made elastic with a plasticizer. Easily coloured and resistant to weather and fire, PVC is used to produce a variety of products, including fibres, windows, electrical insulation, pipes, vinyl flooring, audio discs, and coatings for raincoats and upholstery. Pombal, Sebastião José de Carvalho e Mello, Marquês de (1699–1782) Portuguese statesman, minister for foreign affairs (1750–56). Chief minister from 1756, Pombal was virtual ruler of Portugal until the death of King Joseph in 1777. He increased royal power at the expense of the old nobility, curbed the INQUISITION and, in 1759, expelled the JESUITS. Influenced by the principles of enlightened despo-

tion and army, and encouraged trade with Brazil. **pomegranate** Deciduous shrub or small tree native to w
Asia. It has shiny, oval leaves and orange-red flowers. The
round fruit has a red, leathery rind and numerous seeds coated with edible pulp. Family Punicaceae; species *Punica*

tism, he also reformed the administration, economy, educa-

Pompadour, Jeanne-Antoinette Poisson, Marquise de (1721–64) Influential mistress and confidante of Louis XV after 1745. A strong influence on the court and on official appointments, she was a great patron of the arts, befriending DIDEROT and encouraging the publication of the *Encyclopédie*. Pompeii Ancient Roman city in se Italy, buried by volcanic eruption in AD 79. Pompeii was founded in the 8th century BC and ruled by Greeks, Etruscans and others before it was conquered by Rome in 89 BC. The eruption of Mount VESUVIUS was so sudden and violent that about 2,000 died and the city was swiftly covered by volcanic ash, preserving ordinary houses intact until excavation began in the 18th century.

Pompey (106–48 BC) (Gnaeus Pompeius Magnus) Roman general. He fought for SULLA in 83 BC and campaigned in Sicily, Africa and Spain. He was named consul with Crassus in 70 BC and fought a notable campaign against MITHRIDATES VI of PONTUS in 66 BC. In 59 BC he formed the first triumvirate with Crassus and his great rival, Julius CAESAR. After the death of Crassus, Pompey joined Caesar's enemies, and civil war broke out in 49 BC. Driven out of Rome by Caesar's advance, Pompey was defeated at Pharsalus in 48 BC and fled to Egypt, where he was murdered.

Pompidou, Georges Jean Raymond (1911–74) French statesman. He served on DE GAULLE's staff from

▲ pollination Flowers are adapted to different pollination methods. Non-specialized simple flowers, such as the buttercup (A), can be pollinated by a variety of means. Other flowers can only be pollinated by one method. There are bird-pollinated flowers, such as the hummingbird-pollinated hibiscus (B); bee-specialized flowers, including the gorse (C); and wind-pollinated flowers, such as the catkins found on the hazel (D).

▲ pomegranate The flesh of the pomegranate (Punica granatum), a fruit about the size of an apple, is densely packed with seeds that scatter when the fruit is burst. The pale yellow seeds are surrounded by a bright red, fleshy coating, which has a refreshing, astringent flavour. Although native to w Asia, it is now cultivated in warm regions throughout the world.

▲ pondweed The weedy, aquatic plant pondweed (Potamogeton sp.) is among the first flowering plants to colonize wetland areas. Over time, they encourage sediment to build up around the wetland edges, creating areas of shallower water where other species can take root. The run-off of agricultural chemicals, such as fertilizers. encourages the rapid growth of pondweed, accelerating the rate of evolution of wetland areas, often to a degree that can damage the habitat for other species of plants and animals.

1944 and was a member of the powerful council of state (1946–57), becoming premier in 1958. He was not reappointed when the Gaullists won the June election in 1968. After De Gaulle's resignation, he succeeded him as president (1969–74). He died in office.

Ponce de León, Juan (1460–1521) Spanish explorer. A veteran of COLUMBUS' second voyage, he conquered Puerto Rico for Spain (1508–09) and in 1513 led an expedition to explore rumoured islands north of Cuba. He reached land near what is now St Augustine, Florida. He returned in 1521 with a colonizing expedition and received an arrow wound from which he later died.

pondweed Any of numerous species of a family of aquatic, perennial, flowering plants of the genus *Potamogeton*, found mostly in temperate regions in freshwater lakes, but also in brackish and salt water. Most pondweeds have spike-like flowers that stick out of the water, and submerged or floating leaves. Family Potamogetonaceae. The Canadian pondweed, *Elodea canadensis*, has short, strap-like, curled leaves, and can spread rapidly by fragmenting. Family Hydrocharitaceae. Pontiac's Rebellion (1763–66) Native American rising against the British. Pontiac (d.1769) was an Ottawa chief who led a loose association of allies hostile to the British

against the Bitish. Pointae (d.1769) was all OTIAWA Chief who led a loose association of allies hostile to the British takeover of Quebec (1760). A number of outposts in the Great Lakes region were overrun. News of the French withdrawal from North America weakened the campaign, which soon collapsed, but it prompted a British proclamation excluding colonists from land west of the Appalachians.

pontifex Priest of ancient Rome, a member of the college of priests who organized Rome's state religion. Since the 5th century AD, the title *Pontifex Maximus* has been in use in a Christian context as a designation for the pope.

Pontius Pilate (active 1st century AD) Roman prefect or procurator (governor) of Judaea at the time when JESUS CHRIST was crucified. Pilate was made procurator of Judaea in AD 26 and earned a reputation for arrogance and cruelty. He died after AD 36.

Pontormo, Jacopo Carucci (1494–1557) Italian painter. The striking scene *Vertumnus and Pomona* (1520–21) is thought to have been painted by him, and it shows the neurotic qualities characteristic of the MANNERISM he practised. He worked on an ambitious FRESCO scheme for San Lorenzo, Florence, from 1546 until his death; it was destroyed in the 18th century. Other paintings include *The Madonna* (1518), *The Visitation* (1516) and *Deposition* (c.1527).

Pontus Ancient kingdom of NE Anatolia (Turkey). The coastal cities were colonized by Greeks in the 6th–5th centuries BC and retained virtual autonomy under the Persian empire. The kingdom of Pontus reached the height of its power under MITHRIDATES VI, the Great, who conquered Asia Minor, gained control of the Crimea, and threatened Rome. After Mithridates' defeat by Pompey (65 BC), Pontus was divided up under Roman rule, but it maintained its commercial prosperity.

pony Any of several breeds of small horses, usually solid and stocky. They are commonly used as children's saddle horses, for show and for draught. Types include the hardy Shetland pony; the Dartmoor and Exmoor ponies of Cornwall, Somerset and Devon; the grey Highland pony; the Welsh pony; and the Welsh Cob. Height: 115–145cm (45–57in) at the shoulder.

Pony Express US relay mail service that operated between Saint Joseph, Missouri, and Sacramento, California, in 1860–61. About 25 riders changed horses at 190 staging posts on the 3,200km (1,800mi) journey. The scheduled time for the journey was ten days, less than half the time taken by stagecoach. The service was gradually discontinued as the telegraph system was established.

poodle Breed of dog believed to have originated in Germany. Bred originally to retrieve from water, its intelligence has made it a popular pet. It has a rounded skull and long, straight body, and a high-set tail, often docked. The thick, wiry coat is commonly clipped into an ornate style. The main sizes are standard, miniature and toy. Height: (standard) more than 38cm (15in) at the shoulder.

pool Type of billiards game of US origin. One version is

played with eight single-colour balls and seven striped balls (all numbered 1 to 15), plus a white cue ball, on a rectangular table with four corner pockets and two side pockets. Rules vary locally, although the most popular version divides the striped balls and the single-colour balls, except the black ball, between the two players (or two teams), so that the black ball (number 8) is the last to be potted.

poor laws English legislation designed to prevent begging and vagrancy. Introduced in the 16th century and consolidated in the Poor Law Act of 1601, they required individual parishes to provide for the local poor. Later, workhouses were established. Poor-law amendments of 1834 sought to provide uniform assistance by a system of national supervision, but relief was maintained at a low level and workhouses were designed to discourage the unemployed. The social reforms of the 20th century replaced the poor-law system.

pop art Movement inspired by consumerist images and popular culture that flourished in the USA and Britain from the late 1950s to the early 1970s. Artists, such as Roy LICHTENSTEIN, rejected notions of high and low culture equating to good and bad taste, and borrowed ideas from comic books, advertisements, packaging, television and cinema. British artist Richard Hamilton described pop art as "popular, transient, expendable, low-cost, mass-produced, young, witty, sexy, gimmicky, glamorous and Big Business".

Pope See PAPACY

Pope, Alexander (1688–1744) British poet. He wrote lyric and elegiac poetry and published fine translations of HOMER (1720 and 1726) and *Imitations of Horace* (1733). Among his finest work are the satires, which include the mock epic *The Rape of the Lock* (1714), *The Dunciad* (1728) and *An Epistle to Dr Arbuthnot* (1735).

poplar Any of a number of deciduous, softwood trees of the genus *Populus*, native to cool and temperate regions. The oval leaves grow on stalks, and flowers take the form of catkins. Some species are called cottonwoods because of the cotton-like fluff on their seeds. Height: to 60m (200ft). Family Salicaceae. The yellow poplar of the USA, also called the tulip tree, bears orange-yellow, tulip-like flowers. Family Magnoliaceae; species *Liriodendron tulipifera*.

Popocatépetl Snow-capped, dormant volcano in central Mexico, 72km (45mi) SE of Mexico City. The crater contains sulphur deposits. Height: 5,452m (17,887ft).

Popper, Sir Karl Raimund (1902–94) British philosopher of natural and social sciences, b. Austria. He proposed his theory of falsification in *The Logic of Scientific Discovery* (1934), saying scientific "truth" cannot be absolutely confirmed. His other books on the philosophy of science include *The Poverty of Historicism* (1957), *Conjectures and Refutations* (1963) and *Objective Knowledge* (1972).

poppy Any annual or perennial plant of the genus *Papaver*, family Papaveraceae, or any related plant. About 100 species of the genus exist. They have bright red, orange or white flowers, often with dark centres, with four thin, overlapping petals and two thick sepals; all produce the milky sap, LATEX. The unripe capsules of the Asian opium poppy are used to produce the drug OPIUM. Plants closely related to the true poppy include the California poppy and the Welsh poppy.

popular front Alliance of left-wing political parties. In Europe, such alliances were formed in the 1930s partly in reaction to threats from the extreme right and with the encouragement of the Soviet Union. A popular-front government came to power in France, under Léon BLUM (1936–37), and in Spain (1936), where it provoked a military revolt and civil war. In more recent times, revolutionary parties in many African and Asian countries have adopted the name.

Populist Party (officially People's Party) US political party active in the 1890s. It originated among farmers' alliances in the South and West at a time of agrarian discontent. It won seats in local and state elections in 1890 and nominated a presidential candidate, James B. Weaver, in 1892, advocating free silver (unlimited minting of silver coins) and nationalization of transport. In 1896 the party supported the Democratic candidate, William Jennings Bryan. After 1908 it gradually disintegrated.

▲ poppy Cultivated since the Middle Ages, the opium poppy (Papaver somniferum) is the natural source of the drug opium and its derivatives, morphine and heroin. These are extracted from the latex of the seed pods. The seeds themselves are used as cattle food and as a source of oil. The dramatic flower makes the plant a popular garden ornamental.

porcelain White, glass-like, non-porous, hard, translucent ceramic material. Porcelain is widely used for tableware, decorative objects, laboratory equipment and electrical insulators. It was developed by the Chinese in the 7th or 8th century. True or hard-paste porcelain is made of kaolin (white china clay) mixed with powdered petuntse (FELDSPAR) fired at about 1,400°C (2,550°F). Soft-paste porcelain is composed of clay and powdered glass, fired at a comparatively low temperature, lead glazed and refired.

porcupine Short-legged, mostly nocturnal herbivorous rodent with erectile, defensive quills in its back. Old World porcupines of the family Hystricidae have brown to black fur with white-banded quills and are terrestrial. New World porcupines of the family Erethizontidae are smaller with yellow to white quills and are arboreal. The largest European and African rodent, the African crested porcupine (*Hystrix cristata*) attains a length of about 80cm (31in).

pornography Visual or aural material presenting erotic behaviour that is intended to be sexually stimulating, and is lacking in artistic or other forms of merit. It is often considered to be demeaning to both sexuality and to the body; many people, especially some feminists, have called for a total ban. Pornographic content, however, is difficult to assess, because the response of individuals varies. Consequently, although there is legal CENSORSHIP in most countries, the interpretation of the law is subjective.

porphyria Group of rare genetic disorders in which there is defective METABOLISM of one or more porphyrins, the breakdown products of haemoglobin. It can produce a wide range of effects, including intestinal upset, HYPERTENSION, weakness, abnormal skin reactions to sunlight, and mental disturbance. A key diagnostic indicator is that the patient's urine turns reddish-brown if it is left to stand. There is no specific remedy and treatment tends to be supportive.

porpoise Small, toothed whale with a blunt snout. Found in most oceans, the best known is the common porpoise of the Northern Hemisphere. Its body is black above and white below. Length: to 1.5m (5ft). Family Delphinidae; species *Phocaena phocaena*.

Porsche, Ferdinand (1875–1951) German car manufacturer who designed the Volkswagen Beetle. In 1934 Porsche produced plans for an affordable car that the Nazis named Volkswagen ("people's car") and promised to mass produce. Production did not start until 1945. Porsche also produced sports cars.

port Fortified wine produced in the Douro Valley, N Portugal. It may be white, tawny (translucent brown) or red, and contains 17–20% alcohol. A vintage port is aged in oak casks for 15 to 20 years. From the 17th to the early 20th centuries, manufacture relied on trade with Britain, using ships sailing from Oporto on the Douro estuary.

Port-au-Prince Capital of Haiti, a port on the SE shore of the Gulf of Gonâve, on the w coast of Hispaniola. It was founded by the French in 1749, becoming the capital in 1770. Industries: tobacco, textiles, cement, coffee, sugar. Pop. (1992) 1,255,078.

Porter, Cole (1891–1964) US composer and lyricist. The majority of his many musicals for stage and film were vastly successful. They include *Gay Divorcee* (1932), *Anything Goes* (1934), *Kiss me Kate* (1948) and *High Society* (1956). Among his most popular songs are *Night and Day, Let's Do It, Begin the Beguine* and *In the Still of the Night*.

Porter, Katherine Anne (1890–1980) US author. She won acclaim with her first collection of short stories, *Flowering Judas* (1930). Subsequent works include *Pale Horse, Pale Rider* (1939), *The Leaning Tower* (1944), and her best-known work, *Ship of Fools* (1962). Her collected short stories won a Pulitzer Prize in 1965.

Portillo, Michael Denzil Xavier (1953–) British politician, secretary of state for defence (1995–97). He became a Conservative member of Parliament in 1984. In 1994 he became secretary of state for employment. His right-wing Euroscepticism saw him often at odds with official Conservative Party policy, and he lost his seat in the 1997 general election.

Portland City and port on the Willamette River, NW Oregon.

■ porcupine Protection for the porcupine (the Indian porcupine, Hystrix indica, is shown here) is provided by a coat of spines. It can erect these when danger threatens. The spines are loosely attached and may become embedded in predators.

First settled in 1845, it developed as a major port for exporting timber and grain after 1850. It was a supply station for the California goldfields and the Alaska gold rush (1897–1900). It is Oregon's largest city. Industries: shipbuilding, timber, wood products, textiles, metals, machinery. Pop. (1990) 437,319.

Portland Largest city and port in Maine, USA. Due to its deep natural harbour on Casco Bay, a settlement (Falmouth) was established here in 1632. The town grew rapidly under the MASSACHUSETTS BAY COMPANY. In 1775 it was devastated by the British during the American Revolution. From 1820–32 it acted as state capital. The modern city is an oil terminus and shipping centre with important commercial links with MONTREAL. Pop. (1990) 64,538.

Port Louis Capital of Mauritius, a seaport in the NW of the island. It was founded by the French in 1735. Taken by the British during the Napoleonic Wars, it grew in importance as a trading port after the opening of the Suez Canal. The main export is sugar; other industries include electrical equipment and textiles. Pop. (1993) 144,250.

Port Moresby Capital of Papua New Guinea, on the SE coast of New Guinea. Settled by the British in the 1880s, its sheltered harbour was the site of an important Allied base in World War 2. It developed rapidly in the post-war period. Exports: gold, copper, rubber. Pop. (1990) 193,242.

Port of Spain Capital of Trinidad and Tobago, on the NW coast of Trinidad. Founded by the Spanish in the late 16th century, it was seized by Britain in 1797. From 1958–62 it was the capital of the Federation of the West Indies. It is a major Caribbean tourist and shipping centre. Pop. (1990) 58,400.

Porto-Novo Capital of Benin, West Africa, a port on the Gulf of Guinea near the border with Nigeria. Settled by 16th-century Portuguese traders, it later became a shipping point for slaves to America. It was made the country's capital at independence in 1960, but COTONOU is assuming increasing importance. Today it is a market for the surrounding agricultural region. Exports: palm oil, cotton, kapok. Pop. (1982) 208,258.

Port Said City and seaport in NE Egypt, at the entrance to the SUEZ CANAL. Founded in 1859, at the beginning of the construction of the Suez Canal, it was a major coal-bunkering station. By the end of the 19th century it was Egypt's chief port after ALEXANDRIA. Although its harbour was closed to shipping in 1967, following war with Israel, it remained a fuelling station for ships using the canal. It was reopened in 1974. Industries: fishing, tobacco, cotton, textiles. Pop. (1990) 461,000.

Portsmouth City and seaport in Hampshire, s England; Britain's principal naval base. The area was first settled in the late 12th century and was already a base for warships when the naval dockyard was laid down in 1496. Industries: engineering, ship repairing, electronics. Pop. (1991) 174,697.

Portsmouth City on the Elizabeth River (opposite Nor-FOLK, to which it is connected by bridge and tunnel), SE Virginia, USA. Founded in 1752, it was the scene of fighting in both the American Revolution and the Civil War. Portsmouth is part of one of the largest naval dockyards and shipyards in the USA. Industries: shipbuilding, chemicals, fertilizers, railway equipment, plastics. Pop. (1990) 103,907.

Portugal Republic on the w of the Iberian Peninsula, sw Europe. *See* country feature, page 540

Portuguese National language of both Portugal and Brazil, spoken by about 10 million people in Portugal and 100 million in Brazil. In addition, another 15 million people speak it in Angola, Mozambique and other former Portuguese colonies. A ROMANCE LANGUAGE, it is closely related to Spanish.

Portuguese man-of-war Colonial COELENTERATE animal found in marine subtropical and tropical waters. It has a bright blue gas float and long, trailing tentacles with highly poisonous stinging cells. It is not a true jellyfish: the tentacles are actually a cluster of several kinds of modified medusae and POLYPS. Length: to 18m (60ft). Class Hydrozoa; genus *Physalia*.

Poseidon In Greek mythology, god of all waters, and brother of Zeus and Pluto, identified with the Roman god NEPTUNE. Poseidon controlled the monsters of the deep, created the horse (he was the father of PEGASUS) and sired Orion and Polyphemus. He is always represented holding a trident.

positivism Philosophical doctrine asserting that "positive" knowledge (definite or scientific facts) can be obtained through direct experience. Positivism was first proposed by Auguste COMTE and was a dominant system of 19th-century philosophy. LOGICAL POSITIVISM was developed in the 20th century, initially by the philosophers of the Vienna Circle, as an attempt to link "positive knowledge" to the strict application of logic. positron Particle that is identical to the ELECTRON, except

positron Particle that is identical to the ELECTRON, except that it is positively charged, making it the antiparticle of the electron. It was observed in 1932 in cosmic RADIATION by Carl

ANDERSON. It is also emitted from certain radioactive nuclei. Electron-positron pairs can be produced when GAMMA RADIA-TION interacts with matter. See also ELEMENTARY PARTICLE

positron emission tomography (PET) Medical imaging technique (used particularly on the brain) that produces three-dimensional images. Radioisotopes, injected into the bloodstream prior to imaging, are taken up by tissues where they emit POSITRONS that produce detectable photons.

possum Popular name for any of the PHALANGERS of Australasia. The term is also an American word for the OPOSSUM of the USA

post-impressionism Various movements in painting that developed (c.1880–c.1905), especially in France, as a result of or reaction to IMPRESSIONISM. Roger Fry, the British painter and theorist, invented the term when he organized the exhibition *Manet and the post-impressionists* at the Grafton Gallery, London, in 1910. SEURAT was an important member of the post-impressionists, although his style is more accurately described as NEO-IMPRESSIONISM. The work of these artists varies stylistically but they are linked by their rejection of impressionist NATURALISM.

PORTUGAL

Portugal's flag was adopted in 1910 when the country became a republic. The green represents Henry the Navigator (1394–1460), who sponsored many Portuguese explorers. The red symbolizes the monarchy. The shield reflects Portugal's leading role in world exploration.

The Republic of Portugal lies on the w side of the IBERIAN PENINSULA. The Atlantic coastal plain includes the capital, LISBON, and OPORTO. In the s lies the ALGARVE. In central Portugal, the Serra da Estrela contains Portugal's highest peak, at 1,991m (6,352ft). The TAGUS and DOURO river valleys support most of Portugal's agriculture. Portugal also includes the autonomous islands of the AZORES and MADEIRA. The overseas territory of MACAU will return to China in 1999.

CLIMATE

Portugal has a maritime climate. Compared to other Mediterranean lands, summers are cooler and winters are milder. Most rain falls in winter.

VEGETATION

Forests cover c.36% of Portugal. It is the world's leading producer of cork, made from the bark of the cork oak. Olive trees are common. Almond, carob and fig trees are found in the far s.

HISTORY AND POLITICS

Visigoths conquered the region in the 5th century AD. In 711 they were ejected by the Moors. In 1139 Alfonso I defeated the Moors. Portugal's independence was recognized by Spain in 1143. The reconquest was completed in 1249, when the Moors were removed from the Algarve. JOHN I founded the Aviz dynasty in 1385 and launched Portugal's colonial and maritime expansion. His son, HENRY THE NAVIGATOR, captured the Azores and Madeira. The reign of Manuel I was Portugal's "golden age". By 1510 Portugal had established colonies in Africa, Asia and South America. The fall of the Aviz dynasty brought PHILIP II

AREA: 92,390sq km (35,670sq mi) **POPULATION:** 9,846,000

CAPITAL (POPULATION): Lisbon (2,561,000) GOVERNMENT: Multiparty republic ETHNIC GROUPS: Portuguese 99%, Cape

Verdean, Brazilian, Spanish, British LANGUAGES: Portuguese (official)

RELIGIONS: Christianity (Roman Catholic 95%, other Christians 2%)

CURRENCY: Escudo = 100 centavos

of Spain to the throne. For the next 60 years, Portugal was subject to Spanish control. JOHN IV established the Braganza dynasty (1640-1910). In the 18th century Marquês de POMBAL reformed Portugal's institutions and rebuilt Lisbon. JOHN VI was forced to flee to Brazil during the PENINSULA WAR (1808-14). His son, PEDRO I, declared Brazilian independence in 1822. In 1910 Portugal became a republic. In 1926 a military coup overthrew the government. Antonio de Oliveira SALAZAR became prime minister in 1932. The terms of the 1933 constitution enabled Salazar to become w Europe's longest-serving dictator. The Estado Novo (New State) was repressive and the economy stagnated. In 1968 Salazar was replaced by Marcello Caetano. Failure to liberalize the regime and the cost of fighting liberation movements in Portugal's African colonies led to a military coup in 1974. In 1975 many Portuguese colonies gained independence. In 1976 a new liberal constitution was adopted. In 1986 Portugal joined the European Community and Marco Soares became president. The Portuguese economy emerged from recession. In 1996 Soares was replaced by Jorge Sampaio.

ECONOMY

Portugal joined the European Exchange Rate Mechanism in 1992. Manufacturing accounts for 33% of exports. Textiles, footwear and clothing are major exports. Portugal is the world's fifthlargest producer of tungsten. Agriculture and fishing remain important. Portugal is the world's eighth-largest producer of wine. Olives, potatoes, and wheat are also grown. Tourism is a rapidly growing sector (1992 receipts, US\$3.7 million).

post-modernism Originally, an architectural movement that started in the 1970s in reaction to the monotony of international MODERNISM. Its exponents sought new ways to merge anthropomorphic details or traditional design elements with 20th-century technology. The term is no longer restricted to architecture. In literature, post-modernism is characterized by works that refer to their own fictionality. In the early 1980s the concept of post-modernism exploded into popular culture. The visual arts, television, and particularly advertising, were seen as producing the most exciting and creative work, again characterized by an anarchic, iconoclastic, parodic and technically inventive approach. See also DECONSTRUCTION

post-mortem (autopsy) Dissection of a body to determine the cause of death. It is performed to confirm a diagnosis or to establish the cause of an unexpected death. Morbid anatomy (the examination of the dead) is a branch of PATHOLOGY.

post-natal depression Mood disorder, characterized by intense sadness, which may develop in a mother within a few days of childbirth. It ranges from mild cases of the "baby blues", which are usually short-lived, to the severe depressive illness known as puerperal psychosis.

Post Office UK public corporation formed in 1969 from the General Post Office (GPO). Mail delivery, its sole function until the 19th century, is still a Post Office monopoly. Private post, at rates related to distance, was first delivered in 1635; Hill's penny post of 1840 standardized the rate. The GPO set up a savings bank (1861), a telegraph service (1870) and nationalized existing private telephone companies in 1912.

post-traumatic stress disorder Anxiety condition that may develop in people who have been involved in or witnessed some horrific event. It is commonly seen in survivors of battles or major disasters. The condition is characterized by repeated flashbacks to distressing events, hallucinations, nightmares, insomnia, edginess and depression. It usually recedes over time, but as many as 10% of sufferers are left with permanent psychological disability.

potash Any of several potassium compounds, especially potassium oxide (K_2O) , potassium carbonate (K_2CO_3) and potassium hydroxide (KOH). Potash is mined for use as fertilizer because potassium is an essential element for plant growth. Potassium carbonate is used for making soap and glass, and potassium hydroxide for soap and detergents.

potassium (symbol K) Common metallic element first isolated in 1807 by Sir Humphry DAVY. Its chief ores are sylvite, carnallite and polyhalite. Chemically it resembles sodium. Potassium in the form of POTASH is used as a fertilizer. The natural element contains a radioisotope K⁴⁰ (half-life 1.3 × 10⁹ yr), which is used in the radioactive dating of rocks. Properties: at.no. 19; r.a.m. 39.102; density 0.86; m.p. 63.65°C (146.6°F); b.p. 774°C (1,425°F); most common isotope K³⁰ (93.1%). See also ALKALI METALS

potato Plant native to Central and South America and introduced into Europe by the Spaniards in the 16th century. Best grown in a moist, cool climate, it has oval leaves and violet, pink or white flowers. The potato itself is an edible TUBER. The leaves and green potatoes contain the alkaloid solanine and are poisonous if eaten raw. Family Solanaceae; species *Solanum tuberosum*.

Potawatomi Algonquian-speaking Native Americans. Originally united with the OTTAWA and the OJIBWA, these semi-sedentary hunter-farmers were driven by the Sioux SE from Wisconsin, migrating as far as Indiana before being driven w by white settlers. They were eventually settled on reservations in Oklahoma, Kansas, Michigan and Wisconsin, where they now number about 2,000.

potential difference Difference in electric potential between two points in a circuit or electric field, usually expressed in volts. It is equal to the work done to move a unit electric charge from one of the points to the other. *See also* ELECTROMOTIVE FORCE (EMF)

potential energy Type of ENERGY an object possesses because of its vertical position in the Earth's gravitational field; also the energy stored in a system such as a compressed spring or in an oscillating system such as a pendulum. An object on a shelf has potential energy given by mgh,

where m is its mass, g the acceleration due to gravity, and h the height of the shelf.

Potomac River in E USA. It rises in West Virginia at the confluence of the North and South Branch rivers, and flows E and SE to Chesapeake Bay on the Atlantic coast, forming the boundaries of Maryland-West Virginia and Maryland-Virginia. The river is navigable for large ships as far as Washington, D.C. Length: 462km (287mi).

Potsdam City on the River Havel, E Germany; capital of Brandenburg state. During the 18th century it was a residence of the Prussian royal family. The 1805 Peace of Potsdam strengthened the alliance between Russia and Prussia against France. The POTSDAM CONFERENCE took place here in 1945. Industries: food processing, textiles, pharmaceuticals, electrical equipment. Pop. (1990) 138.700.

Potsdam Conference (July–August 1945) Summit meeting of Allied leaders in World War 2 held in Potsdam, Germany. The main participants were US president TRUMAN, Soviet leader STALIN and the British prime minister, at first CHURCHILL, later ATTLEE. It dealt with problems arising from Germany's defeat, including the arrangements for military occupation and the trial of war criminals, and issued an ultimatum to Japan demanding surrender.

Potter, Beatrix (1866–1943) British children's author who created the characters of Peter Rabbit, Jemima Puddleduck, Squirrel Nutkin and others in her animal stories. Her first books were *The Tale of Peter Rabbit* (1901) and *The Tailor of Gloucester* (1902). More than 23 books followed, enhanced by her delicate drawings.

Potter, Dennis (1935-94) English playwright. He is best known for his television plays, notably Brimstone and Treacle (1976), Pennies from Heaven (1978), Blue Remembered Hills (1979) and The Singing Detective (1986). His unusual approach to dramatic form and his use of direct language often aroused controversy. He completed Cold Lazarus and Karaoke just before his death, and they were screened in 1996. pottery Objects shaped of clay and hardened by fire or dried in the sun. The making of pottery is dependent on the plasticity and durability of clay after firing. The finished object can be divided into three categories: earthenware, the ordinary pottery dating from primitive times, baked at 700°C (1,292°F) or lower; stoneware, fired at up to 1,150°C (2,102°F), less porous, and until modern times produced more commonly in the Far East than in Europe; and PORCE-LAIN, fired at 1,400°C (2,552°F). After a clay pot is formed and dried it is fired in a kiln; glaze is then applied, and the not is refired.

potto Slow-moving African primate with large eyes and a pointed face; it is nocturnal and arboreal. The common potto has sturdy limbs, a short tail and small spines formed by the neck vertebrae. Its woolly fur is grey-red. Length: 37cm (15in), excluding the tail. Species *Perodicticus potto*.

Poulenc, Francis (1899–1963) French composer and a member of Les Six. Spontaneity and melodiousness characterize his works, which include ballets, notably *Les Biches* (1923), orchestral works, chamber music, piano music and songs. He also composed two operas: the comic *Les Mamelles de Tirésias* (1944) and the religious drama *Dialogues des Carmélites* (1957).

poultry Collective term for domestic fowl reared as a source of meat and eggs. Chickens are the most important domesticated bird in the world. They are the major source of eggs and an important meat source. These light-skeletoned birds have short, weak wings, strong legs, chin wattles and a head comb. Males are known as cocks; females as hens; and castrated males as capons. Various breeds have been developed for particular use. Some, such as Rhode Island, Wyandotte and Plymouth Rock, are raised for meat and eggs. Others, such as White Plymouth Rock, Cornish and Rock Cornish, mainly supply meat. Species *Gallus domesticus*. Other forms of poultry are DUCK, GOOSE, GUINEA FOWL and TURKEY.

pound Imperial unit of weight equal to 0.453kg. It became a unit of currency when a pound (lb) weight of silver was divided into 240 penny units. The pound STERLING has been the main unit of English currency since the Middle Ages.

▲ potato The growth of the potato (Solanum tuberosum) takes three to seven months depending on variety. The tuber is covered with earth in fertile ground and shoots its stems through "eyes" in the skin surface (A). At six weeks a large canopy of leaf growth develops and tubers grow (B) on underground shoots. Leaf growth is dried chemically (C) to aid lifting.

▲ Pound The US expatriate poet and critic Ezra Pound had a major influence on 20th-century Anglo-American literature, influencing writers such as Hemingway, Eliot and Joyce.

Pound, Ezra Loomis (1885–1972) US poet and literary critic. Pound was a leading figure in literary MODERNISM and a founder of IMAGISM and VORTICISM. He was also one of the 20th century's most controversial political voices. Pound emigrated to England in 1907. His early experimental works Exultations and Personae (both 1909) established him as a leading member of the avant-garde. In 1924 he moved to Italy, and during World War 2 he made pro-fascist, anti-Semitic broadcasts to the USA. In 1945 Pound was escorted back to the USA and indicted for treason. He was judged mentally unfit to stand trial and confined to a mental hospital (1946–58). He spent the rest of his life in Italy. His masterpiece is the epic Cantos (1925–60), an ambitious reconstruction of Western civilization in free verse.

Pound, Roscoe (1870–1964) US jurist and educator. He is noted for his belief that laws should be compatible with popular attitudes and adaptable to social and economic changes. His works include *Law and Morals* (1924) and *Outlines and Lectures on Jurisprudence* (1914).

Poussin, Nicolas (1594–1665) French painter who worked mainly in Rome. At first inspired by MANNERISM, he later concentrated on antique art, specializing in mythological subjects. In the late 1630s he turned to more elaborate Old Testament and historical themes. Among his notable works are *The Eucharist* (1644–48) and *The Seven Sacraments* (1648).

Powell, Anthony Dymoke (1905–) British novelist. He is best known for *A Dance to The Music of Time*, a series of 12 novels that portrays the snobbish world of the English upper classes after World War 1, beginning with *A Question of Upbringing* (1951) and ending with *Hearing Secret Harmonies* (1975). His later work includes the novel *The Fisher King* (1986) and four volumes of autobiography.

Powell, "Bud" (Earl) (1924–66) US jazz pianist and composer. A key figure in the development of BEBOP, he gained a grounding with the Louis Armstrong All Stars (1953–66) and played with Charlie PARKER, Thelonius MONK and Charlie MINGUS.

Powell, Cecil Frank (1903–69) British physicist. During the 1930s, he developed a technique to record SUBATOMIC PARTICLES directly onto film. In 1947 he used this method at high altitude to investigate COSMIC RADIATION and discovered a new particle, the pion (pi MESON). This discovery supported the theory of nuclear structure proposed by Hideki YUKAWA. Powell subsequently discovered the antiparticle of the pion and the decay process of kaons (K mesons). He was awarded the 1950 Nobel Prize for physics.

Powell, Colin Luther (1937–) US general. He fought in the VIETNAM WAR and rose through the ranks to be national security adviser (1987–89) and the first African-American chairman of the JOINT CHIEFS OF STAFF (1989–93) during the Gulf War.

Powell, Michael (1905–90) and **Pressburger, Emeric** (1902–88) Powell and Pressburger were one of the most influential director/screenwriter partnerships in cinema history. Their collaboration began with *The Spy in Black* (1939). Their production company, The Archers, was responsible for some of Britain's greatest film masterpieces. Their wartime films, such as *The Life and Death of Colonel Blimp* (1943), *A Canterbury Tale* (1944) and *A Matter of Life and Death* (1946), were intended as propaganda pieces. Other classics include *Black Narcissus* (1946) and *The Red Shoes* (1948).

power In physics, rate of doing work or of producing or consuming energy. It is a measure of the output of an engine or other power source. James WATT was the first to measure power; he used the unit called HORSEPOWER. The modern unit of power is the WATT.

Powhatan (1550–1618) Chief of the Powhatan Confederacy of Native North Americans. This confederacy controlled the region of America around Jamestown, Virginia, at the time of the first English settlement (1607). The confederacy included c.30 peoples, with Powhatan's capital at Werowocomoco. According to legend, the colonists' leader, John Smith, was saved from execution by the intercession of Pocahon-Tas, Powhatan's daughter. Later, Powhatan approved her marriage to another colonist, John Rolfe, and thereafter maintained friendly relations with the colony until his death.

Powys County in E central Wales; the administrative centre is Llandrindod Wells. There are Iron Age and Roman remains. Offa's Dyke and the later Norman castles were built as border defences by the Welsh and English. During the Middle Ages, Powys was a powerful kingdom. The county includes fertile lowland valleys, highlands and plateau regions. It is drained by the Usk, Wye and Taff rivers. Sheep and cattle are reared. Agriculture and forestry are the main occupations. Area: 5,077sq km (1,960sq mi). Pop. (1991) 117,647.

Poznań City on the Warta River, w Poland. One of the oldest Polish cities, it became the seat of the first Polish bishopric in 968. It was the centre of Polish power in the 15th–17th centuries. In 1793 it passed to Prussia. The Grand Duchy of Poznań was created in 1815 as part of Prussia, but the area reverted to Poland in 1919. Industries: metallurgy, agricultural machinery, electrical equipment, chemicals, textiles. Pop. (1993) 589,700.

pragmatism Philosophical school holding the view that the truth of a proposition has no absolute standing but depends on its practical value or use. Primarily supported by US philosophers, it was first proposed by C. S. Peirce and was adopted by William James and John Dewey.

Prague (Praha) Capital of the Czech Republic, on the River Vltava. Founded in the 9th century, it grew rapidly after Wenceslaus I established a German settlement in 1232. In the 14th century it was the capital of BOHEMIA. It was the capital of the Czechoslovak republic (1918–93). It was occupied throughout World War 2 by the Germans and liberated by Soviet troops in 1945. Prague was the centre of Czech resistance to the Soviet invasion in 1968. It is an important commercial centre. Industries: engineering, iron and steel, chemicals, glass, furniture, printing. Pop. (1990) 1,215,000.

Prague Spring (1968) Short-lived political and social reorganization in Czechoslovakia. From 1945 Czechoslovakia was subject to the hard-line communist policies of the Soviet Union. In January 1968 Alexander DUBČEK, a liberal communist, gained power and initiated reforms intended to create "socialism with a human face". Political prisoners were freed, censorship abolished, the power of central bureaucracy curbed and non-communist political parties legalized. In August, Soviet tanks rolled into Prague, imposing a Soviet occupation on a furious, but powerless populace.

prairie Region of treeless plain. The prairies of North America extend from Ohio through Indiana, Illinois and Iowa to the Great Plains, and N into Canada. The pampas of s South America, the Ilanos of N South America and the steppes of central Europe and Asia correspond to the North American prairies.

prairie chicken Chicken-sized, pale brown GROUSE of W USA. It has brown and black, pointed tail feathers and white neck feathers. During courtship displays, the male erects his neck feathers by inflating orange neck air sacs. Species *Tympanuchus cupido*.

prairie dog Squirrel-like rodent of w North America, named after its barking cry. It has a short tail and its fur is grizzled brown to buff. Active by day, it feeds on plants and insects and lives in communal burrows that are interconnected to form colonies. Length: 30cm (12in). Genus *Cynomys*. See also GROUND SQUIRREL

praseodymium (symbol Pr) Silver-yellow metallic element of the LANTHANIDE SERIES. It was first isolated in 1885 by Carl von Welsbach. Its chief ores are monazite and bastnasite. Soft, malleable and ductile, praseodymium is used in carbon electrodes for arc lamps, and its green salts are used in coloured glasses, ceramics and enamels. Properties: at.no.59; r.a.m. 140.9077; r.d. 6.77; m.p. 931°C (1,708°F); b.p. 3,512°C (6,354°F); only one isotope Pr¹⁴¹ (100%).

prawn Any of numerous species of edible crustaceans in the order Decapoda; it is generally larger than a SHRIMP but smaller than a LOBSTER. Typical genera include *Penaeus*, *Pandalus*, *Crangon* and *Nephrops*, which includes the Dublin bay prawn or Norway lobster. Large prawns are called scampi.

Praxiteles (370–330 BC) Greek sculptor whose graceful style epitomized the 4th-century BC Greek ideal. In ancient times his most famous work was the *Aphrodite from Cnidus* (350 BC), of which there are several copies.

prayer Act of thanking, adoring, conferring with or petitioning a divine power; also the form of words used for this purpose. Many religions have set forms for praying. In some religions, it is customary to kneel in prayer, while in others people stand, sit or lie prone while praying. Muslims recite prayers while facing in the direction of MECCA. In Christianity, the service book of the Anglican Communion contains customary prayers and is known as the Book of COMMON PRAYER. Among Roman Catholics, such regulated forms are found in a missal. Prayer can also be the private devotional act of an individual using his or her own words to praise or petition a god for guidance or strength.

praying mantis See MANTIS

Precambrian Oldest and longest era of Earth's history, lasting from the formation of the Earth about 4,600 million years ago to the beginning of a good fossil record about 590 million years ago. Precambrian fossils are extremely rare. Primitive bacteria and CYANOBACTERIA have been identified in deposits more than 3,000 million years old.

precession Wobble of the axis of a spinning object. It occurs as a result of the torque on the spin axis, which increases as the angle of precession increases. The Earth precesses about a line through its centre and perpendicular to the plane of the ECLIPTIC extremely slowly (a complete revolution taking 25,800 years) at an angle of 23.5°. The motion of a GYROSCOPE is another consequence of precession, because the entire ring containing the spinning wheel and its axle precesses around the support pivot.

precipitate Formation of an insoluble solid in a liquid either by direct reaction or by varying the liquid composition to diminish the solubility of a dissolved compound.

precipitation In meteorology, all forms of water particles, whether liquid or solid, that fall from the atmosphere to the ground. Distinguished from cloud, fog, dew and frost, precipitation includes rain, drizzle, snow and hail. Measured by rain and snow gauges, the amount of precipitation is expressed in millimetres or inches of liquid water depth.

pre-Columbian art and architecture Arts of Mexico, Central America and the Andean region of South America before colonization. In the MAYA Classical period, beginning c.200 AD, many cities or ceremonial centres were built in Central America. Pyramid temples were also built by the TEOTIHUACÁN, Zapotec and Mixtec cultures. These cultures were succeeded by TOLTEC and AZTEC civilizations in the post-Classical period (900–1300 AD). Monumental building was achieved without wheels or the use of the arch; surfaces were often decorated with dazzling patterns. In the Andean region, the early Chavin sculptures were succeeded by the Mochica, the Tiahuanaco and finally, in the 14th century, by the rich temple architecture and sophisticated engineering of the INCA. Gold-working, weaving and sculpture were other important pre-Columbian arts.

predestination Christian doctrine that a person's ultimate spiritual salvation or condemnation by God has been ordained in advance. According to this doctrine, people are at birth committed to the events of life, and their fate at death is already mapped out for them. As possible solutions to the problem of how this doctrine affects free will, three propositions have been put forward: the first is to refute the doctrine altogether (Pelagianism); the second is to state that God never intended to save everybody (Predestinarianism); and the third is to qualify the premise by seeing God's prevision as conditional and subject to possible revision depending on the will and spirituality of the individual. This last position is the solution to which most Christians adhere. The concept of predestination is also found in ISLAM.

pregnancy Period of time from conception until birth, in humans normally about 40 weeks (280 days). It is generally divided into three 3-month periods called trimesters. In the first trimester, the EMBRYO grows from a small ball of cells to a FETUS *c*.7.6cm (3in) in length. At the beginning of the second trimester movements are first felt and the fetus grows to about 36cm (14in). In the third trimester the fetus attains its full body weight. *See also* LABOUR

prehistory Term to describe the period of human cultural

development before the invention of writing. See Bronze Age; Iron Age; Mesolithic; Neolithic; Palaeolithic; Stone Age **prelude** In music, a preliminary movement that serves to introduce a work of which it may or may not formally be a part. It was often used as the first movement of a suite. The popularity of Chopin's piano preludes led to its associations with a short piece of an imaginative nature.

premature birth Birth of a baby prior to 37 weeks' gestation or weighing less than 2.5kg (5.5lb). Premature babies are more at risk than those born at full term and require special care.

preposition Linguistic category or part of speech that shows the relationship (such as position or direction) between its complement and some other word in the sentence. In the English phrase, "The book on the table", the word *on* specifies the relationship between the word. *book* and the prepositional complement *table*.

Pre-Raphaelite Brotherhood (PRB) Name adopted in

1848 by a group of young English painters who joined forces

to revitalize British art. The most prominent members of the PRB were Dante Gabriel Rossetti, John Everett Millais and William Holman Hunt. They attracted fierce criticism for their rejection of RAPHAEL but were helped by the support of John Ruskin. By 1853 the PRB had largely dissolved but Rossetti maintained the name, and under his influence a second wave of Pre-Raphaelite painting began in the 1860s, which lasted well into the 20th century. See also MORRIS, WILLIAM Presbyterianism Major form of Protestant Christianity that became the national CHURCH OF SCOTLAND in 1690. It arose in the mid-16th century from the teachings of John CALVIN in Switzerland, and was taken to Britain by the Scottish religious reformer John KNOX. Ministers, occasionally called pastors, are elected by their congregations and confirmed in their office by the Presbytery, a group of ministers from the local area. Members of the Presbytery are responsible for ordaining and installing (and removing) Church ministers. Once ordained, the minister carries out his work assisted by elders and trustees. Annually each presbytery sends delegates to a synod and to a General Assembly. In 1972 the Presbyterian Church of England (formed 1876) united with the CONGREGATIONAL Church of England and Wales. There are Presbyterian Churches all over the world, particularly in North America, where the Presbyterian Church (USA) was formed in 1983 through the merger of several older groups. Prescott, John Leslie (1938-) British statesman, deputy

Prescott, John Leslie (1938–) British statesman, deputy prime minister and secretary of state for environment, transport and the regions (1997–). Prescott became a Labour MP in 1970 and in 1975–79 he simultaneously served as a member of the European Parliament. He joined the shadow cabinet in 1983. In 1994 he became Tony BLAIR's deputy. His "on-the-stump" campaigning helped Labour win a landslide victory in the 1997 general election.

Prescott, William Hickling (1796–1859) US historian. An expert on the Spanish conquests in America, his vigorous prose and solid scholarship placed him among the first rank of historians. His most famous works are *A History of the Conquest of Mexico* (1843) and *A History of the Conquest of Peru* (1847). **prescription** Order written by a doctor, dentist or veterinary surgeon for drugs or other medication to be dispensed by a pharmacist. It should give details of the quantity of drugs to be dispensed, the dosage required, the route of administration (such as by mouth) and any precautions.

president Usual title for the head of a republic. In the USA the president is elected by voters (through the ELECTORAL COLLEGE) for a term of four years and not exceeding two terms. The president is supreme military commander, appoints Supreme Court justices, ambassadors and other high officials, has the authority to make treaties with foreign countries (with the advice and consent of two-thirds of the SENATE), grants pardons and vetoes legislation. Presidential power is limited by the system of checks and balances.

Presley, Elvis (1935–77) US singer who dominated rock and roll from his first recordings in 1953 until 1963. *Jailhouse Rock, Hound Dog, Heartbreak Hotel* and *Love Me Tender* are among his most successful songs. He also starred in films, such as *Love Me Tender* (1956) and *Follow That Dream* (1962).

▲ Prague Hradčany Castle overlooks the beautiful old city and the River Vltava. A large complex, most of it dates from the reign of Holy Roman Emperor Charles IV. Within the complex is St Vitus cathedral, which contains the tomb of Saint Wenceslas; the Royal Palace, which is the seat of the presidents; and many other important buildings.

▶ Primates Because primates have large brains, they can learn complex skills and pass them down through the generations. Chimpanzees, for example, demonstrate high intelligence in their use of tools. They have been observed using sticks to "fish" for termites. Young chimpanzees learn this by observing their parents — aged between two and three years, they manipulate sticks as a form of play, and by the time they are four, they have mastered the use of the tool.

press See NEWSPAPER

pressure In physics, the force on an object's surface divided by the area of the surface. The SI unit is the pascal (symbol Pa); 1 pascal is equal to the pressure exerted by a force of 1 newton on an area of 1m². In meteorology, the millibar (symbol mb), which equals 100 pascals, is commonly used.

Prester John Legendary ruler of a Christian kingdom in Asia in the Middle Ages. European Christians hoped to make an alliance with him against the Muslims in the age of the CRUSADES. The origin of the legend may have been Ethiopia, where the COPTIC CHURCH had survived throughout the Middle Ages. Pretoria City in Gauteng province, South Africa. It was founded in 1855 by Marthinus Pretorius. It became the capital of the Transvaal in 1860 and of the South African Republic in 1881. The Peace of Vereeniging, which ended the Boer War, was signed here in 1902. In 1910 it became the capital of the Union of South Africa. Pretoria is an important communi-

PRINTED CIRCUIT

A

4

5

B

C

B

F

F

III

III

A silicon chip is manufactured by building up layers on top of a wafer of silicon (1). (A) First a layer of silicon dioxide (2), an insulator, is laid down followed by photo-sensitive photoresist (3). Photoresist hardens when hit by ultraviolet light (4). By using a mask (5) the area to be hardened can be controlled. (B) The unhardened area shielded by the mask can then be rinsed

out with a solvent (6). The photoresist is then removed by hot gases. (C) The same process is used to apply a conducting polysilicon (7). Again ultraviolet light fixes the photoresist (8) in the unmasked area. (D) A solvent removes the photoresist. (E) N-type silicon, which only carries a negative charge, is then created by doping of the silicon base. (F) A

third masking process creates shafts (9) to the n-type silicon. (G) An aluminium layer is then applied. (H) A fourth masking forms electrical contacts connecting the layers of silicon. Hundreds of chips are simultaneously made on a single wafer of silicon (10) before they are eventually separated (11) and mounted individually for use.

cations centre. Industries: steel production, car assembly, railway engineering, diamond mining. Pop. (1990) 1,080,187.

Previn, André George (1929–) US conductor, pianist and composer, b. Germany. His early career was as a jazz pianist and musical director of Hollywood film scores, for which he won Academy Awards on four occasions. He was principal conductor of the London Symphony Orchestra (1968–79). He became music director of the Los Angeles Philharmonic Orchestra in 1986.

Prévost d'Exiles, Antoine François (1697–1763) (L'abbé Prévost) French novelist who lived as, alternately, a Jesuit novice, soldier and forger. His most famous work, *Manon Lescaut* (1731), is the seventh novel of a series *Mémoires et* aventures d'un homme de qualité (1728–31).

Priam In Greek legend, the king of Troy at the time of the war with Greece. He had been installed as king in his youth by HERACLES, but by the time of the Ten Years' War was an old man. His sons HECTOR and PARIS were killed by the Greek forces. He was killed by Neoptolemus, the son of ACHILLES.

Price, (Mary) Leontyne (1927–) US soprano. She made a triumphant debut at the Metropolitan Opera, New York, in 1961 in Verdi's *II Trovatore*. She later appeared in many of the world's leading opera houses.

prickly heat Skin rash caused by blockage of the sweat glands in hot, humid weather. It occurs most often in infants and obese people. It disappears as the body cools.

prickly pear Cactus with flat or cylindrical joints. It grows in North and South America and has been introduced into Europe, Africa and Australia. The jointed pads have tufts of bristles, and the edible fruit is red and pulpy. Family Cactaceae; genus *Opuntia*.

Pride's purge (1648) Expulsion of c.140 members from the English Long Parliament. It was carried out by Colonel Thomas Pride (d.1658) on the orders of the army council. The aim was to rid Parliament of dissident members still anxious to negotiate with Charles I. The remnant, known as the RUMP Parliament, voted to put Charles on trial.

Priestley, J.B. (John Boynton) (1894–1984) British author and literary critic. His literary criticism includes *The English Novel* (1927) and *Literature and Western Man* (1960). His novels include *The Good Companions* (1929), *Angel Pavement* (1930) and *Bright Day* (1946). Among his plays are *Time and the Conways* (1937) and *An Inspector Calls* (1945), both of which explore his theories of time.

Priestley, Joseph (1733–1804) British chemist and clergyman who discovered OXYGEN in 1774. He also discovered a number of other gases, including AMMONIA and oxides of NITROGEN. He studied the properties of CARBON DIOXIDE. Priestley was an advocate of the later discredited PHLOGISTON theory. primary Method used in the USA to select candidates for an election, in effect an election among the members of a political party. In a direct primary, the commonest type, any number of party members may stand and are voted for in a ballot of all the members. In an open primary, all the parties in an election are involved, and the voter votes for both the party and candidate of his or her choice. In a presidential election year, most US states select delegates to the national party convention in a presidential primary, the delegates having announced which presidential candidate they support.

primary school School providing elementary education for children from compulsory school age. In the UK, primary school education starts at five, and children progress to secondary schools at 11 or 12. Primary schools cater for children throughout key stages 1 and 2 of the National Curriculum.

primate Regional head of an episcopally structured church hierarchy. The term functions as a title. In the Church of England the term serves to describe the Archbishop of Canterbury, who is "Primate of all England", and the Archbishop of York, who is "Primate of England".

Primates Order of mammals that includes MONKEYS, APES and HUMAN beings. Primates, native to most tropical and subtropical regions, are mostly herbivorous, diurnal (day-active), arboreal (tree-dwelling) animals. Their hands and feet, usually with flat nails instead of claws, are adapted for grasping. Most species have opposable thumbs, and all but humans have

opposable big toes. They have a poor sense of smell, good hearing and acute binocular vision. The outstanding feature of primates is a large complex brain and high intelligence. Primate characteristics are less pronounced in the relatively primitive prosimians (tree shrews, BUSHBABIES, LORISES and TARSIERS) and are most pronounced in the more numerous and advanced anthropoids (monkeys, apes and human beings).

prime minister Chief executive and head of government in a country with a parliamentary system. He or she is usually the leader of the largest political party in PARLIAMENT. The office evolved in Britain in the 18th century, along with the CABINET system and the shift of power away from the crown towards the House of Commons.

prime number Positive or negative integer, excluding one and zero, that has no FACTORS other than itself or one. Examples are 2, 3, 5, 7, 11, 13 and 17. The integers 4, 6, 8, ... are not prime numbers since they can be expressed as the product of two or more primes.

primitivism Russian form of EXPRESSIONISM. It developed c.1905–20 and was influenced by Russian folk art, FAUVISM and CUBISM. It was characterized by simplified forms and powerful colour, used principally to depict scenes from working-class life. MALEVICH worked in the style early in his career; other exponents were Larionov and Gontcharova.

Primo de Rivera, Miguel (1870–1930) Spanish dictator (1923–30). He staged a coup in 1923 with the support of King Alfonso XIII. He dissolved parliament and established a military dictatorship modelled on the government of MUSSOLINI. He restored order, stimulated economic improvement and helped to end the revolt of Abd-el-Krim in Morocco (1926). He was forced from power shortly before his death.

primrose Any of numerous species of herbaceous, generally perennial plants of the genus *Primula*, which grow in the cooler climates of Europe, Asia, Ethiopia, Java and North America. It has a tuft of leaves rising from the rootstock and clustered flowers of pale yellow to deep crimson. In Britain the name refers to *Primula vulgaris*. Family Primulaceae.

Prince (1960–) US singer-songwriter and guitarist, b. Prince Rogers Nelson. A prolific songwriter and recording artist, he first achieved major success with the album *Purple Rain* (1984). Other albums include *Sign o' the Times* (1988), *Lovesexy* (1988) and *Diamonds and Pearls* (1990). In 1995 he became "the artist formerly known as Prince".

prince Royal title first used after the breakup of the CAR-OLINGIAN empire in the 9th century. In the UK, the heir to the English throne has customarily received the title Prince of Wales since 1301. Other sons of the monarch are also designated "prince".

Prince Edward Island Province in E Canada, an island in the Gulf of St Lawrence off the coast of New Brunswick and Nova Scotia; the capital is Charlottetown. The island was discovered by Jacques Cartier in 1534. In the early 18th century, it was colonized by French settlers as the Ile St Jean. Ceded to Britain in 1763, it was renamed in 1799 and became a province of Canada in 1873. Fishing and agriculture are the most important economic activities. Area: 5,657sq km (2,184sq mi). Pop. (1993 est.) 131,600.

Princeton Borough in w central New Jersey, USA; a leading academic and research centre. Princeton was settled in the late 17th century. An important battle in the American Revolution took place here in January 1777, when George Washington defeated the British forces. Princeton University, part of the Ivy League, was established in 1746. Pop. (1990) 12,016.

printed circuit Network of electrical conductors chemically etched from a layer of copper foil on a board of insulating material such as plastic, glass or ceramic. It interconnects components such as capacitors, resistors and integrated circuits (CHIPS). The printed circuit board (PCB) represents one stage in the miniaturization of electronic circuits. See also INTEGRATED CIRCUIT (IC)

printing Technique for multiple reproduction of images, such as text and pictures. In ancient China and Japan, carved wooden blocks were inked to print pictures. From the 10th century, the Chinese used separate pieces of type, so that each page could be printed from arrangements of standard charac-

ters. Metal type made by casting first appeared in Korea around 1403. In Europe, GUTENBERG and CAXTON developed the use of letterpress in the 1400s. Printing expanded rapidly in the 1700s and 1800s. LITHOGRAPHY enabled printers to produce impressive colour prints. For text, stereotype printing plates were cast from the pages of type, so that the type could be re-used for setting other pages. Typesetting machines speeded up the process of setting up pages. The invention of photography in the 1820s led to the development of new techniques for reproducing photographs in print, such as the HALFTONE PROCESS. More recently, production speeds have greatly increased with the application of photosetting, in which the type is set photographically on sheet film, and OFF-SET printing. Today, many publications are produced using a WORD PROCESSOR to enter the text. Desktop publishing programs allow images of the text and pictures to be arranged on screen. The computer data is used to print sheet film for each page, and the film images are transferred to printing plates.

prion Infective agent that appears to consist simply of a protein. Prions are thought to cause diseases such as CREUTZFELD-JAKOB DISEASE and kuru in humans, BOVINE SPONGIFORM ENCEPHALOPATHY (BSE) in cattle, and SCRAPIE in sheep. It is not yet understood how prions work; unlike viruses and bacteria, they do not contain DNA or RNA.

prism In mathematics, a solid geometrical figure whose ends are congruent (most commonly triangles) and perpendicular to the length, with the other faces rectangles. The volume of a prism is equal to the area of the end multiplied by the length of the prism. In physics, a prism is a piece of transparent material, such as glass, plastic or quartz, in which a light beam is refracted and split into its component colours (spectrum).

prisoner of war (POW) In international law, military personnel captured by the enemy in an armed conflict between states. Their treatment is generally expected to be humane. The terms of the first international convention on prisoners of war, signed at the Hague peace conference of 1899, were widened by the 1907 Hague Convention and by the subsequent Geneva Convention of 1949.

privateer Privately owned vessel with a government commission to capture enemy shipping. Their government licences, called letters of marque, distinguished privateers from pirates. Crews were unpaid but were allowed to keep the booty. Privateering was at its height from the 16th to the 18th century. It was outlawed by most European powers in the Declaration of Paris (1856) and abolished by the Hague Conference of 1907.

When light hits a prism it is refracted by the two surfaces it hits (1, 2). White light splits into the spectrum (3) because each of the colours of spectrum have varying wavelengths. For

example, the short wavelengths of blue and indigo are refracted more than the colours further down the spectrum with longer wavelengths such as orange and red.

privatization Transfer of state-run enterprises to private ownership. It is the opposite of NATIONALIZATION. In the 1980s policy-makers in some European countries, as well as Canada, Japan and New Zealand, maintained that economic growth would best be encouraged by governments selling nationalized industries to independent enterprises, which were then free to respond to market forces and create a more efficient and competitive company. By the late 1980s and early 1990s the trend was taken up by former eastern bloc countries.

Privy Council Group of leading advisers to the British monarch. It developed in the Middle Ages out of the King's Council (Curia Regis). As the Cabinet system of government developed, the Privy Council became increasingly restricted in its powers. Its Judicial Committee, established by legislation in 1833, is the final appeal court for most Commonwealth countries.

probability Number representing the likelihood of a given occurrence. The probability of a specified event is the number of ways that event may occur divided by the total possible number of outcomes, assuming that each possibility is equally likely. For instance, in one throw of a six-sided die, there are six possible outcomes, and three of these result in an even number: the probability of throwing an even number is thus 3/6, or 1/2. **probate** Legal term for the certification by a court of law that a document purporting to be the will of a person who has died is valid. The term also applies to the official copy of a will, with the certificate of its having been proved valid.

probation In Britain, sentence of a court of law on a young or first-time offender that allows the offender to remain at liberty, subject to certain conditions and under the supervision of a probation officer. It is not regarded as a conviction. The sentence may last from one to three years, and breach of probation is an offence.

Proclamation of 1763 British government edict, following the French and Indian Wars, designed to restrain encroachment on Native American lands by settlers. It forbade settlement west of the line of the Appalachians and ordered those who had already settled there to vacate the area. Procyon (Alpha Canis Minoris) Brightest star in the constellation of Canis Minor and one of the stars nearest to the Sun. The star, known as Procyon A, has a faint white dwarf companion, Procyon B. Characteristics: apparent mag. 0.34 (A), 10.8 (B); absolute mag. 2.6 (A), 13.1 (B); spectral type F5 (A), wF (B); distance 11.4 light-years.

production In economics, methods by which wealth is produced. It is one of the basic principles of economics. The factors of production are land, labour and capital. Land in this sense includes natural resources, such as minerals, and the wealth of the sea, such as fish.

Profumo, John Dennis (1915–) British politician. Profumo became a Conservative member of Parliament in 1940. In 1960 he joined Harold MACMILLAN as secretary of war. He was forced to resign in 1963 after lying to the House of Commons about his affair with Christine Keeler, who was also involved with a Soviet diplomat.

progesterone Steroid HORMONE secreted mainly by the corpus luteum of the mammalian OVARY and by the PLACENTA during pregnancy. Its principal function is to prepare and maintain the inner lining (endometrium) of the UTERUS for pregnancy. Synthetic progesterone is one of the main components of the contraceptive PILL.

prognosis Doctor's prediction regarding the likely course and outcome of a patient's disorder. The prognosis is based on a doctor's knowledge of the disorder, the patient and the probable effects of treatment.

program (SOFTWARE) Set of instructions that enables a COMPUTER to carry out a task. A typical computer can carry out many tasks including word processing, calculating, drawing, communicating and providing games. Programs can be written in a variety of COMPUTER LANGUAGES, and are usually stored on a magnetic DISK. To make a computer perform a particular task, a program is loaded into the computer's RAM.

programme music (illustrative music) Music that aims to describe a scene or tell a story. It may be contrasted with absolute music, which has no direct references to experiences

outside the music itself. Programme music is an essential concept in the music of the romantic period; perhaps the earliest example from this time is BEETHOVEN'S 6th Symphony (The Pastoral). Symphonic poems by Bedřich SMETANA and Jean SIBELIUS are later instances. See also ROMANTICISM

Progressive Conservative Party (Fr. Parti Progressiste-Conservateur du Canada, formerly Liberal-Conservative Party) Canadian political party formed in 1854 by John A. MACDONALD. The party adopted its present name in 1942. Between 1948 and 1978 the Progressive Conservative Party held office only once (1957–63), under John Diefenbaker. Joe Clark formed a short-lived government (1979–80), but the LIBERAL PARTY was soon back in power. In the 1984 general election, the Progressive Conservatives led by Brian MULRONEY won a landslide victory. In 1988 Mulroney was reelected with a smaller majority. In 1993 he was succeeded by Canada's first woman prime minister, Kim Campbell. Later that year Campbell was heavily defeated by a resurgent Liberal Party led by Jean CHRÉTIEN.

progressive education Movement that began in the late 19th century in Europe and the USA, as a reaction to formal traditional education. In Europe Froebel, Pestalozzi and Montessori were influential in the movement, which aimed to educate "the whole child". In the USA the movement owed much to the philosophy of John Dewey. It led in some cases to what critics termed laxness, and produced a backlash in the form of the "back to basics" movement.

Progressive Party US political party. The original party (Bull Moose Party) was formed in 1912 by the supporters of Theodore ROOSEVELT after he had failed to regain the Republican nomination from William H. TAFT. By splitting the Republican vote, it ensured a Democratic victory. In 1916 the Progressives endorsed the Republican candidate. The name was also applied to the supporters of Robert M. LA FOLLETTE in 1924 and to the dissident Democrats who nominated Henry A. WALLACE in 1948.

Prohibition (1919–33) Period in US history when the manufacture, sale and transport of alcoholic drinks were prohibited. It was instituted by the 18th amendment to the US constitution, confirmed by the Volstead Act (1919). Smuggling, illicit manufacture, corruption of government officials and police, and the growth of organized crime financed by BOOT-LEGGING made it a failure. Prohibition was repealed by the 21st amendment (1933).

projector Instrument with a lens system, used to cast images onto a screen from an illuminated flat object. An **episcope** is a projector for opaque objects such as a printed page; it uses light that is reflected from the object. A **diascope** is a projector for transparent objects such as photographic slides and films; it uses light transmitted through the object. An **epidiascope** can project images from both transparent and opaque objects. A motion-picture or **cine** projector produces moving images from many frames (pictures) on a transparent film.

prokaryote (formerly Monera) Biological KINGDOM that includes BACTERIA and CYANOBACTERIA (formerly blue-green algae). They have more simple cells than other organisms. DNA is not contained in chromosomes in the NUCLEUS, but lies in a distinct part of the CYTOPLASM, called the nucleoid. They have no distinct membrane-surrounded structures (organelles). Cell division is simple and, in the rare cases where SEXUAL REPRODUCTION occurs, genetic material is simply transferred from one partner to another; there are no separate sex cells. In photosynthetic prokaryotes, PHOTOSYNTHESIS takes place on the cell membrane. At present two subkingdoms are recognized: ARCHAEBACTERIA and EUBACTERIA. See also ASEXUAL REPRODUCTION; EUKARYOTE; SYMBIOSIS

Prokhorov, Alexsandr Mikhaylovich (1916–) Soviet physicist who shared the 1964 Nobel Prize for physics with Nikolai Basov and Charles H. Townes. His research in quantum electronics resulted in the development of the MASER and LASER.

Prokofiev, Sergei (1891–1953) Russian composer whose style is characterized by biting dissonances within rich harmony, and brilliant orchestration. His most popular works include the ballets *Romeo and Juliet* (1935) and *Cinderella* (1944); the

Classical (first) Symphony (1918); Peter and the Wolf (1936); and the comic opera The Love for Three Oranges (1921). He also composed film scores, notably Lieutenant Kije (1934), Alexander Nevsky (1938) and Ivan the Terrible (1942–45).

prolapse Displacement of an organ due to weakening of supporting tissues. It most often affects the rectum, due to bowel problems, or the UTERUS following repeated pregnancies.

proletariat Marxist term for those classes of an industrial society that have no source of income other than wages. According to MARX, the proletariat is the true creator of the objects produced by industry, and it would become an irresistible force when the internal contradictions of capitalism weakened the authority of the factory-owning middle class.

promenade concerts Annual concert series organized by the BBC in the Royal Albert Hall, London, where inexpensive standing room is available in the gallery and the stalls. Such concerts originated in Paris in 1833 and from 1838 were given at Drury Lane, Covent Garden and elsewhere. "Proms" in their modern series began at the Queen's Hall, London, in 1895, under the baton of Sir Henry Wood.

Prometheus In Greek mythology, the fire-giver. He created the human race, provided them with reason and stole fire from the gods. For this theft, Zeus had him chained to a rock where an eagle consumed his liver for eternity. In some myths he was rescued by Heracles.

promethium (symbol Pm) Radioactive metallic element of the LANTHANIDE SERIES. It was made in 1941 by particle bombardment of NEODYMIUM and PRASEODYMIUM. Promethium occurs in minute amounts in uranium ores. The isotope Pm¹⁴⁷ is used in phosphorescent paints, x-rays and in nuclear-powered batteries for space vehicles. Properties: at.no. 61; m.p. 1,080°C (1,976°F); b.p. 2,460°C (4,460°F); most stable isotope Pm¹⁴⁵ (half-life 17.7 years).

pronghorn Only extant member of the family Antilocapridae, related to the ANTELOPE. It is a horned, hoofed, herbivorous animal of w USA and N Mexico. The swiftest North American mammal, it is said to be capable of a speed of 80km/h (50mph) over short distances. Height: 3ft (90cm); weight: 45kg (100lb). **pronoun** Linguistic category (part of speech) that has no complete independent meaning and that derives some aspect of meaning from elsewhere. Deictic pronouns take some of their meaning from context, such as *you*, whose meaning changes according to who is speaking and who is addressed. Anaphoric pronouns take some of their meaning from a previous part of what is said or written: in the sentence *The piano stood where everyone could see it, it* refers to the piano mentioned (its antecedent). Types of pronouns are personal, relative, intensive, reflexive, interrogative and demonstrative.

propaganda Systematic manipulation of public opinion through the communications media. Although examples are found in ancient and early modern writings, the most effective propagandists in the 20th century have been totalitarian governments of industrialized states, which are able to control all means of public communication. Many political, economic and social organizations, and pressure groups of all kinds employ some kind of propaganda.

propane Colourless, flammable gas (C_3H_8), the third member of the ALKANE series of HYDROCARBONS. It occurs in natural gas, from which it is obtained; it is also obtained during petroleum refining. Propane is used (as bottled gas) as a fuel, as a solvent and in the preparation of many chemicals. Properties: m.p. -190° C (-310° F); b.p. -42° C (-43.6° F).

propanol (propyl alcohol) Colourless ALCOHOL used as a solvent and in the manufacture of various chemicals. It exists as two ISOMERS. Normal propanol, CH₃CH₂CH₂OH, is a byproduct of the synthesis of METHANOL (methyl alcohol). Isopropanol (isopropyl alcohol), (CH₃)₂CHOH, is a secondary alcohol that is easily oxidized into acetone.

propene (propylene) Colourless, aliphatic hydrocarbon, C_3H_6 , manufactured by the thermal cracking of ETHENE. It is used in the manufacture of a wide range of chemicals including vinyl and acrylic resins. Properties: b.p. -48° C (-54.4° F); m.p. -185° C (-301° F).

prophet Individual who is thought to be a divinely inspired messenger from a god, or is believed to possess the power to

foretell future events. The classic examples of prophets were the holy men and seers who preached by the authority of Yahweh to the Jews of the Old Testament kingdoms of Israel and Judah. Part of the Old Testament consists of books devoted to their preachings and predictions. The term *prophet* also applied to Abraham, Moses and Samuel. John the Baptist fulfilled the role of a New Testament prophet, predicting the coming of the Messiah. In ancient Greece and Rome, divinely inspired prophetesses made oracular pronouncements to those who consulted them. Among Muslims, Muhammad is held to be a prophet, the last of a long line of God's messengers, who included Adam, Abraham, Moses and Jesus Christ. In both Buddhist and Hindu literature predictions occur, and many prophetic reformers have occurred in Hinduism.

proportion Mathematical relation of equality between two ratios, having the form a/b = c/d. A continued proportion is a group of three or more quantities, each bearing the same ratio to its successor, as in 1:3:9:27:81.

proportional representation (PR) System of electoral representation in which the allocation of seats reflects the proportion of the vote commanded by each candidate or party. The main contrast is with a system in which representatives are elected for each of numerous single constituencies. Proportional representation is found in almost all countries other than English-speaking ones and former British colonies.

propylene See PROPENE

prose In LITERATURE, a relatively unstructured form of language. Unlike the metrical discipline of POETRY, prose is more closely connected with the rhythms of everyday speech. With the rise of 18th-century realism in literature and the establishment of the modern novel as a distinctive literary form, prose embedded itself in the nature of fiction as a genre, where previously it had been associated with non-fiction.

Proserpine Roman equivalent of Persephone.

Prost, Alain (1955–) French racing driver. He was Formula 1 champion four times between 1985 and 1993. He is renowned for his technical competence.

prostaglandin Series of related fatty acids, with hormonelike action, present in SEMEN and liver, brain and other tissues. Their biological effects include the lowering of blood pressure and the stimulation of contraction in a variety of smoothmuscle tissues, such as in the UTERUS.

prostate gland Gland in the male reproductive tract surrounding the URETHRA. It secretes specific chemicals that mix with sperm cells and other secretions to make up SEMEN.

prosthesis Artificial substitute for a missing organ or part of the body. Until the 17th century, artificial limbs were made of wood or metal, but innovations in metallurgy, plastics and engineering have enabled lighter, jointed limbs to be made. More recent prosthetic devices include artificial heart valves made of silicone materials.

prostitution Provision of sexual services for reward, usually money. Most prostitutes are women. In Britain prostitution is not strictly illegal, but soliciting, living off the earnings of prostitution, and brothel-keeping are all offences.

protactinium (symbol Pa) Rare radioactive metallic element of the ACTINIDE SERIES, first identified in 1913. Its chief source is URANINITE. Properties: at.no. 91; r.a.m. 231.0359; r.d. 15.4; m.p. 1,200°C (2,192°F); b.p. 4,000°C (7,232°F); most stable isotope Pa²³¹ (half-life 3.25 x 10⁴ yr).

Protectorate In English history, the period in which Oliver Cromwell ruled as lord protector (1653–58), followed by his son Richard (1658–59). The term also describes a state that is controlled by a larger one, without necessarily being under direct colonial rule.

protein Organic compound containing many AMINO ACIDS linked together by PEPTIDE bonds. Living cells use about 20 amino acids, which are present in varying amounts. The order of amino acids in proteins is controlled by the cell's RNA. The most important proteins are ENZYMES, which determine all the chemical reactions in the cell, and ANTIBODIES, which combat infection.

Protestantism Branch of Christianity formed in protest against the practices and doctrines of the old ROMAN CATHOLIC CHURCH. Protestants sought a vernacular Bible to

▲ Proust Once a frequent visitor to the aristocratic salons of Paris at the turn of the century, the French novelist Marcel Proust became a recluse after the death of his mother when he was 34 years old. His 13-volume work, *Remembrance of Things Past*, is written in long, cascading sentences; it is founded on the effects of involuntary memory, the moment when a chance impression obliterates the present and propels one into the past.

replace the Latin VULGATE, and to express individual elements of nationalism. The movement is considered to have started when Martin LUTHER nailed his 95 theses to a Wittenberg church door. His predecessors included John WYCLIFFE and Jan Hus. Later supporters included Ulrich ZWINGLI and John CALVIN, whose interpretation of the Bible and concept of PREDESTINATION had great influence. The Protestants held the EUCHARIST to be a symbolic celebration, as opposed to the Roman Catholic dogma of TRANSUBSTANTIATION, and claimed that because Christ is the sole medium between God and man, his function cannot be displaced by the priests of the church. See also Anglicanism

Proteus In Greek mythology, a sea god, son of Oceanus and Tethys. He is depicted as a little old man of the sea. Proteus possessed the gift of prophecy and the ability to alter his form at will; in an instant he could become fire, flood or a wild beast. **Protista** See PROTOCTISTA

Protoctista Classification of certain unicellular and simple multicellular organisms, including PROTOZOA, ALGAE, BACTE-RIA and FUNGI. The term was introduced to overcome the difficulty of distinguishing such organisms from the true plant and animal KINGDOMS (Plantae and Animalia). This kingdom may include organisms with many nuclei within one cell wall (coenocytes).

proton (symbol p) Stable ELEMENTARY PARTICLE with a positive charge equal in magnitude to the negative charge of the ELECTRON. It forms the nucleus of the lightest isotope of HYDROGEN, and with the NEUTRON is a constituent of the nuclei of all other elements. It is made up of three QUARKS. The proton is a BARYON with a mass 1836.12 times that of the electron. The number of protons in the nucleus of an element is equal to its ATOMIC NUMBER. Protons also occur in primary cosmic rays. Beams of high-velocity protons, produced by particle accelerators, are used to study nuclear reactions.

protoplasm Term referring to the living contents of a plant or animal CELL. It includes both the NUCLEUS and the CYTOPLASM of cells.

protozoa Phylum of unicellular organisms found worldwide in marine or freshwater, free-living and as parasites. These microscopic animals have the ability to move (by CILIA or pseudopodia) and have a nucleus, cytoplasm and cell wall; some contain CHLOROPHYLL. Reproduction is by FISSION or encystment. Length: 0.3mm (0.1in). The 30,000 species are divided into four classes: Flagellata, Cnidospora, Ciliophora and Sporozoa.

Proudhon, Pierre Joseph (1809–65) French journalist and philosopher. His anarchist theories of liberty, equality and justice conflicted with the communism of Karl Marx. In his first book, *Qu'est-ce que la propriété?* (1840), he argued that "property is theft". His greatest work was *Système des contradictions économiques* (1846).

Proust, Marcel (1871–1922) French novelist. Proust's cyclic, semi-autobiographical novel À la recherche du temps perdu is a major work of FRENCH LITERATURE. He was actively involved in the DREYFUS AFFAIR, but asthma and the death of his parents led to his virtual seclusion from 1907. Swann's Way, the first part of Remembrance, appeared in 1913. The

next instalment, Within a Budding Grove (1919), won the Prix Goncourt. Proust completed the 16-volume series shortly before his death. Remembrance offers an extraordinary insight into the relationship between psyche and society, and the distortions of time and memory.

Provençal Variety of the Occitan language, spoken in Provence, SE France. It is a ROMANCE LANGUAGE belonging to the family of INDO-EUROPEAN LANGUAGES. In the Middle Ages, it enjoyed a great literary flowering as the the language of the TROUBADOURS. Provençal is now largely a spoken language.

Provence Region and former province of SE France, roughly corresponding to the present départements of Var, Vaucluse and Bouches-du-Rhône, and parts of Alpes-de-Haute-Provence and Alpes-Maritimes. The coastal area was settled c.600 BC by the Greeks, and the Romans established colonies in the 2nd century BC. The region came under Frankish control in the 6th century AD. It passed to the Holy Roman Empire in the 11th century. It retained its distinctive identity and language (PROVENCAL), and was the focus of a revival of secular literature and music in the Middle Ages. It was finally united with France in 1481. Fruit and vegetables are grown and there is some stock raising. Tourism is the major industry. **Proverbs** Book of the Old Testament, probably the oldest existing example of Hebrew WISDOM LITERATURE. The book's subtitle attributes its authorship to King SOLOMON, but in fact scholars consider that it contains material from various peri-

ods later than Solomon's time. **Providence** Capital of Rhode Island, USA, a port on Providence Bay in NE Rhode Island. The city was founded in 1636 as a refuge for religious dissenters from Massachusetts. It later enjoyed great prosperity through trade with the West Indies. The city played an active role in the American Revolution. Industries: jewellery, electrical equipment, silverware, machine tools, rubber goods. Pop. (1990) 160,728.

Proxima Centauri Nearest star to the Sun, slightly closer than the nearby star Alpha Centauri. It was long thought to be part of the Alpha Centauri system, but some astronomers now believe it to be an unrelated star making a close approach. prozac One of a small group of antidepressants, known as selective serotonin re-uptake inhibitors (SSRIs). They work by increasing levels of serotonin in the brain. Serotonin, or 5-hydroxytryptamine (5-HT), is a NEUROTRANSMITTER involved in a range of functions. Low levels of serotonin are associated with DEPRESSION. See also DRUG

Prud'hon, Pierre Paul (1758–1823) French painter who specialized in portraits and historical themes. A favourite of two French empresses, Josephine and Marie-Louise, he bridged the gap between late 18th- and early 19th-century painting by creating work that was elegant and emotional.

Prussia Historic state of N Germany. The region was conquered by the Teutonic Knights in the 13th century. The duchy of Prussia, founded in the 15th century, passed to the electors of Brandenburg in 1618. They took the title of king of Prussia in 1701. Under Frederick William I and Frederick II in the 18th century, Prussia became a strong military power, absorbing Silesia and parts of Poland. After defeats in the Napoleonic Wars, Prussia emerged again as a powerful state at the Congress of Vienna (1815). In the 19th century Prussia displaced Austria as the leading German power and, under Bismarck, led the movement for German unity, accomplished in 1871. Comprising 65% of the new German empire, it was the leading German state until World War 1. It ceased to exist as a political unit in 1945.

Przewalski's horse (Mongolian wild horse) Only surviving species of the original wild HORSE, found only in Mongolia and Sinkiang. It is small and stocky with an erect black mane. Its red-brown coat is marked with a darker line on the back and shoulders and leg stripes. Height: to 1.5m (4.8ft) at the shoulder. Family Equidae; species *Equus caballus przewalskii*.

psalm Musical hymn or sacred poem. The most famous are contained in the Book of PSALMS, in the Old Testament, some of which are traditionally attributed to DAVID, King of Judah. **Psalms, Book of** Book of the Old Testament, consisting of 150 hymns, lyric poems and prayers. The works were collected over a very long period, at least from the 10th to the 5th

▶ Przewalski's horse Because it is not descended from domestic horses, Przewalski's horse (Equus przewalski) is the last truly wild horse. They still exist in their natural state in a small area of sw Mongolia, although the species thrives in zoos. Numbers have been reduced because they have to compete with livestock for grazing areas and water.

centuries BC, and probably achieved their final form before the 2nd century BC. Most carry titles added afterwards, and 73 are stated to have been composed or collected by King DAVID.

Pseudepigrapha Jewish writings of the period $200 \, \text{BC} - \text{AD}$ 200 that have been falsely attributed to a biblical author. They follow the style and content of authentic Old Testament works. The term refers more widely to almost all ancient Jewish texts that have not been accepted as canonical by the Christian Church. *See also* APOCRYPHA

pseudomorphism In mineralogy, chemical or structural alteration of a mineral without change in shape. It is exemplified by petrified wood: the wood has been gradually replaced by silica.

psittacosis (parrot fever) Disorder usually affecting the respiratory system of birds. Caused by a bacterium, it can be transmitted to human beings, producing pneumonia-like symptoms. Treatment is with ANTIBIOTICS.

psoriasis Chronic recurring skin disease featuring raised, red, scaly patches. The lesions frequently appear on the chest, knees, elbows and scalp. Treatment is with tar preparations, steroids and ultraviolet light. Psoriasis is sometimes associated with a form of ARTHRITIS.

Psyche In Greek mythology, a beautiful mortal woman loved by Eros. She was also the personification of the soul. **psychiatry** Analysis, diagnosis and treatment of mental illness and behavioural disorders. It includes research into the cause and prevention of mental disorders, and the administering of treatment, which is usually carried out by physical means such as drugs and ELECTROCONVULSIVE THERAPY (ECT). Some psychiatrists also use psychotherapeutic techniques.

psychoanalysis Method of therapy devised by FREUD and Josef Breuer in the 1890s for treating behaviour disorders, particularly NEUROSIS. It is characterized by its emphasis on unconscious mental processes and on the treatment of mental disorder by the use of free association and the therapist's interpretation.

psychology Study of mental activity and behaviour. It includes the study of perception, thought, problem solving, personality, emotion, mental disorders and the adaptation of the individual to society. It overlaps with many other disciplines, including Physiology, Philosophy, Artificial intelligence and social anthropology. Central areas of psychology include neuropsychology, which relates experience and behaviour to brain functioning; Cognitive Psychology, which studies thought processes; Social Psychology, in which behaviour is studied in its social context; and Developmental Psychology, which studies the way in which children's cognitive and emotional development takes place. Applied psychology aims to use the discipline's insights into human behaviour in practical fields such as education and industry.

psychopathic personality (antisocial personality) Personality disorder that leads to antisocial behaviour. Such people's behaviour is impulsive, insensitive to the rights of others and often aggressive. There appears to be little anxiety, guilt or neurosis, and psychoanalytic theory regards this disorder as stemming from an incompletely developed SUPEREGO.

psychopharmacology Study of how drugs affect behaviour. Drugs are classified according to their effect: sedative hypnotics, such as barbiturates and alcohol; stimulants, such as amphetamines; opiate narcotics, such as heroin; and psychedelics and hallucinogens, such as LSD.

psychosis Serious mental illness in which the patient loses contact with reality, in contrast to NEUROSIS. It may feature extreme mood swings, delusions or hallucinations, distorted judgement and inappropriate emotional responses. Organic psychoses may spring from brain damage, advanced SYPHILIS, senile dementia or advanced EPILEPSY. Functional psychoses, for which there is no known organic cause, include SCHIZOPHRENIA and manic-depressive psychosis.

psychosomatic Describing a physical complaint thought to be rooted, at least in part, in psychological factors. The term has been applied to many complaints, including asthma, migraine, ulcers and hypertension.

psychotherapy Treatment of a psychological disorder by nonphysical methods. It is carried out either with individuals

■ pterodactyl Living during the late Jurassic and early Cretaceous periods, the flying reptiles known as pterodactyls varied in size. The smallest specimen was the size of a sparrow (1) and the largest was the size of a hawk (2). Like the bats of today, it had a wing membrane (3) attached to an elongated fourth finger, and hind limbs and tail.

or groups and usually involves some sort of "talking cure" and the development of a rapport between patient and therapist. Psychotherapy is often based on PSYCHOANALYSIS, but also sometimes on behaviour therapy or other theories.

ptarmigan Any of three species of northern or alpine grouse, all of which have feathered legs; especially the Eurasian ptarmigan, *Lagopus mutus*. The wings and breast are white in colder months, but in the spring they become a mottled greybrown. It inhabits high barren regions, feeding on leaves and lichens. Length: to 36cm (14in). Family Tetraonidae.

pteridophyte Commonly used name for any of a group of spore-bearing VASCULAR PLANTS. At one time pteridophytes were taken to include CLUB MOSSES, HORSETAILS and FERNS. These plants have similar life cycles but in other respects are quite distinct and are now classified as separate phyla (divisions). See also TRACHEOPHYTE

pterodactyl Any of several species of small pterosaur. Now extinct, pterosaurs were flying reptiles distributed worldwide in Jurassic and Cretaceous times. Pterodactyls were almost tailless, with large toothed beaks and flimsy membranous wings. Fossil remains show a lack of muscular development and the absence of a breast keel. It is therefore believed that pterodactyls were gliders, incapable of sustained flapping flight.

PTFE Chemically inert, solid plastic, known also by the trade names Teflon and Fluon. PTFE is used as a heat-resistant material for heat-shields on spacecraft, as a non-stick coating on cooking utensils and as a lubricant. PTFE is stable up to about 300°C (572°F).

Ptolemy I (367–283 BC) (Ptolemy Soter) King of ancient Egypt, first ruler of the Ptolemaic dynasty. He was a leading Macedonian general of ALEXANDER THE GREAT. Upon Alexander's death in 323 BC, Ptolemy was granted Egypt in the division of Alexander's empire. He assumed the title of king in 305 BC. He made his capital at Alexandria, where he created the famous library. He abdicated in 284 BC in favour of his son.

Ptolemy (90–168) (Claudius Ptolemaeus) Greek astronomer and geographer. He worked at the library of Alexandria, Egypt, a great centre of Greek learning. His main works were *Almagest*, which described an Earth-centred universe, and *Geography*, which provided the basis for a world map.

puberty Time in human development when sexual maturity is reached. The reproductive organs take on their adult form, and secondary sexual characteristics, such as the growth of pubic hair, start to become evident. Girls develop breasts and begin to menstruate; in boys there is deepening of the voice and the growth of facial hair. Puberty may begin at any time from about the age of ten, usually occurring earlier in girls than in boys. The process is regulated by HORMONES.

public limited company (plc) Company with limited liability whose shares are quoted on a stock exchange. Most companies have limited liability, which means that their owners are responsible only for the money originally invested, and not for the whole of the company's debts. Unlike a private limited company, a public limited company may have

▲ Puccini A performance of Verdi's Aida inspired the young Giacomo Puccini to enter a music conservatory and train as a composer. His gift for expressive melodies and harmonies, together with the drama of the libretti, have ensured his operas a permanent place in the world's opera houses. His best-known works are passionate love stories with tragic endings.

any number of shareholders. In the UK such a company puts the abbreviation "plc" after its name.

public sector borrowing requirement (PSBR) Amount a government needs to borrow to cover its expenditure. A government principally raises its money by taxes and excise duties. If it has to spend more than the amount covered by these sources, it must raise the rest by borrowing. To do this, it issues short-term and long-term stocks and BONDS, on which it pays INTEREST. These loans form part of the national DEBT.

Puccini, Giacomo (1858–1924) Italian composer of operas. Among his best-known works, which all combine dramatic libretti with magnificent music, are *La Bohème* (1896), *Tosca* (1900), *Madam Butterfly* (1904) and his last work, incomplete at his death, *Turandot* (1926).

Pueblo Generic name for the several Native American tribes inhabiting the Mesa and Rio Grande regions of Arizona and New Mexico. They belong to several language families, including Keresan, Tewa, Hopi and Zuni. The multi-storeyed buildings of the Zuni gave rise to the legendary "Seven Cities of Cíbola" eagerly sought by the Spaniards.

Puerto Rico Self-governing island commonwealth (in union with the USA) in the West Indies; the most easterly island of the Greater Antilles; the capital is San Juan. First visited by Columbus in 1493, the island remained a Spanish colony until 1898, when it was ceded to the USA. In 1952 it was proclaimed a semi-autonomous commonwealth. The decline in the sugar industry in the 1940s created considerable unemployment. Many Puerto Ricans emigrated to the USA. The island is of volcanic origin, and much of the land is mountainous and unsuitable for agriculture. The principal crops are sugar, tobacco, coffee, pineapples and maize. Industries: tourism, textiles, electronic equipment, petrochemicals. Area: 8,870sq km (3,425sq mi). Pop. (1993 est.) 3,552,039. See WEST INDIES map puff adder Widely distributed African VIPER. Its skin pattern varies, but it usually has yellow markings on brown. It hunts large rodents and its poisonous bite can be fatal to humans. Up to 80 young are born at one time. Length: to 1.2m (4ft). Family Viperidae; species Bitis arietans.

puffball Any of a large order of MUSHROOMS (Lycoperdiales) whose SPORE masses become powdery at maturity and are expelled in "puffs" when the case is pressed. Puffballs are stemless, and some species, but not all, are edible.

puffin Small diving bird of the AUK family (Alcidae), found in large colonies in the Northern Hemisphere. The Atlantic

▲ puffin Feeding entirely on prey that they find under water, puffins (*Fratercula artica*, shown here) can catch small or slow-moving fish for themselves or for their unfledged chicks and can carry as many as ten small fish at a time in their colourful beaks. They nest in large colonies on cliffs by the sea.

Pulleys (1) multiply the effect of a force applied. By passing the rope through four pulleys, the upward pulling force (2) is four times the applied force, which allows a person to lift a weight (3) that they would not normally be able to lift. With four pulleys, however, the rope has to be pulled four times as far to move the weight the same distance. To move the weight up 1m (3.3ft) the rope must be pulled down 4m (13ft).

▲ puma A wild cat found in a variety of habitat types of the New World, the puma (*Felis concolor*) gives birth to between one and six cubs.

puffin (*Fratercula arctica*) has a short neck, a triangular bill with red, yellow and blue stripes, and reddish legs and feet. The puffin lays a single egg in a burrow c.1–2m (3.3–6.6ft) deep on a cliff. Length: c.30cm (12in).

pug Small dog that probably originated in China. It has a large head and a wide-chested, short body. The short coat may be grey, light brown or black with a characteristic black face. Height: to 28cm (11in) at the shoulder; weight: to 8kg (18lb). **Pugin, Augustus Welby Northmore** (1812–52) British architect who helped to design the Houses of Parliament with

architect who helped to design the Houses of Parliament with Sir Charles Barry. Through his works and writings, especially *True Principles of Pointed or Christian Architecture* (1841), he was a leading promoter of the GOTHIC REVIVAL.

Puglia (Apulia) Region in SE Italy, consisting of the provinces of Bari, Brindisi, Foggia, Lecce and Taranto; the capital is Bari. Colonized by the Greeks, it was taken by the Romans in the 3rd century BC. Conquered in turn by Goths, Lombards and Byzantines, it later formed part of the Holy Roman Empire. The region became part of Italy in 1861. Products: wheat, almonds, figs, tobacco, wine, salt. Industries: petrochemicals, iron and steel. Area: 19,357sq km (7,472sq mi). Pop. (1992 est.) 4,049,972.

Pulitzer, Joseph (1847–1911) US newspaper publisher, b. Hungary, who founded the PULITZER PRIZE. He made the *New York World* the USA's largest circulation daily newspaper. He crusaded for oppressed workers and against alleged big business and government corruption.

Pulitzer Prize Annual US awards presented for outstanding achievement in journalism, letters and music. The cost is met by the income from a trust fund left by Joseph PULITZER to the trustees of Columbia University. The first prize was awarded in 1917. There are prizes for fiction, drama, US history, biography, poetry and musical composition.

pulley Simple machine used to multiply force or to change the direction of its application. A simple pulley consists of a wheel, often with a groove, attached to a fixed structure. Compound pulleys consist of two or more such wheels, some movable, that allow a person to raise objects much heavier than he or she could lift unaided.

Pullman, George Mortimer (1831–97) US industrialist and developer of the railway sleeping carriage. The first modern sleeping car went into service in 1865.

pulsar Object emitting radio waves in pulses of great regularity. They were first noticed in 1967 by the British radio astronomer Jocelyn Bell. Pulsars are believed to be rapidly rotating NEUTRON STARS. A beam of radio waves emitted by the rotating pulsar sweeps past the Earth and is received in the form of pulses. Pulsars are gradually slowing down, but some, such as the Vela Pulsar, occasionally increase their spin rate abruptly; such an event is called a glitch. More than 500 pulsars are now known, flashing at rates from about 4 seconds to 1 millisecond.

pulse Regular wave of raised pressure in arteries that results from the flow of blood pumped into them at each beat of the HEART. The pulse is usually taken at the wrist, although it may be observed at any point where an artery runs close to the body surface. The average pulse rate is about 70 per minute in adults. **pulse** Any leguminous plant of the pea family with edible seeds, such as the bean, lentil, pea, peanut and soya bean. The term may also refer to the seed alone. Pulses are a valuable human food crop in developing countries where meat is in short supply. Pulses are also used for oil production. Family Fabaceae/Leguminosae. *See also* LEGUME

puma (mountain lion, cougar) Large cat found in mountains, forests, swamps and jungles of the Americas. It has a small, round head, erect ears and a heavy tail. The coat is tawny with dark brown on the ears, nose and tail; the underparts are white. It preys mainly on deer and small animals. Length: to 2.3m (7.5ft), including the tail; height: to 75cm (30in) at the shoulder. Family Felidae; species *Felis concolor*.

pumice Light rock formed when molten LAVA is blown to a low-density rock froth by the sudden discharge of gases during a volcanic action. It is used as a light abrasive.

pump Device for raising, compressing, propelling or transferring fluids. The lift pump, for raising water from a well, and the bicycle pump are reciprocating (to-and-fro) pumps. In many modern pumps, a rotating impeller (set of blades) causes the fluid to flow. Jet pumps move fluids by forcing a jet of liquid or gas through them.

pumpkin Orange, hard-rinded, edible garden fruit of a trailing annual VINE found in warm regions of the Old World and the USA; a variety of *Cucurbita pepo*. In the USA the pumpkin is also called a squash, especially the winter pumpkin (or squash) *Cucurbita maxima* and *C. moschata*. Family Cucurbitaceae.

punctuated equilibrium Theory, expounded by Stephen Jay Gould and Niles Eldridge in 1972, that is strongly sceptical of the notion of gradual change in the EVOLUTION of the natural world, as advocated by Charles DARWIN. Fossil records rarely document the gradual development of a new SPECIES, rather showing its seemingly sudden appearance. Darwin explains this as owing to gaps in the fossil records. Punctuated equilibrium explains this by invoking a different model of evolution. Each species is predominantly in a steady state (equilibrium), which is punctuated by brief but intense periods of sudden change that give rise to new species.

Punic Wars (264–146 BC) Series of wars between Rome and Carthage. In the First Punic War (264–241 BC), Carthage was forced to surrender Sicily and other territory. In the Second (218–201 BC), the Carthaginians under HANNIBAL invaded Italy and won a series of victories. They were eventually forced to withdraw, whereupon the Romans invaded North Africa and defeated Hannibal. The Third Punic War (149–146 BC) ended in the destruction of Carthage.

Punjab State in N India, bounded w and Nw by Pakistan; the capital is Chandigarh. In the 18th century Sikhs wrested part of the region from Mogul rule and established a kingdom. In 1849 it was annexed by the British. In 1947 the Punjab was split between the new countries of India and Pakistan, the smaller E part going to India. In 1966 this was further reorganized into two states, Haryana and Punjab, which is now the only Indian state with a Sikh majority. Apart from Chandigarh, other major cities include Amritsar and Jullundur. Punjab is mainly a flat plain. Much of the land is irrigated and agriculture is important. Industries: textiles, woollens, electrical goods, machine tools, fertilizers, cereals, cotton, sugar. Area: 50,376sq km (19,450sq mi). Pop. (1991) 20,281,969.

Punjab Province in NE Pakistan, bounded E and S by India; the capital is LAHORE. It was subject to a succession of foreign conquerors, including Aryans, Greeks and the British. The province was formed in 1947, acquiring its present boundaries in 1970. The area lies on an alluvial plain and most of the land under cultivation is irrigated. Agriculture is the chief source of income, with wheat and cotton the major crops. Industries: textiles, machinery, electrical appliances. It is Pakistan's most heavily populated province. Area: 206,432sq km (79,703sq mi). Pop. (1985 est.) 53,840,000.

Punjabi (Panjabi) Language spoken by 50 million people in the Punjab. It belongs to the Indo-Iranian family of INDO-EUROPEAN LANGUAGES and is one of the 15 languages recognized by the Indian Constitution. It has similarities to HINDI but possesses very few borrowings from Persian and Arabic. **punk** Term used to describe music and fashion of the mid-1970s, characterized by raw energy and iconoclasm. Heavily influenced by US bands, such as the New York Dolls, punk was pioneered in Britain by the Sex Pistols and The Clash. Often anti-establishment, the associated fashions in dress, hair and make-up were also designed to shock.

pupa Non-feeding, developmental stage during which an insect undergoes complete METAMORPHOSIS. It generally occurs as part of a four-stage life cycle from the egg, through LARVA, to pupa, then adult. Most pupae consist of a protective outer casing inside which the tissues of the insect undergo a drastic reorganization to form the adult body. Insects that undergo pupation include the many different kinds of BUTTERFLY and BEETLE and many kinds of FLY. The pupa is often called a CHRYSALIS in butterflies and moths.

pupil In the structure of the EYE, circular aperture through which light falls onto the LENS; it is located in the centre of the IRIS. Its diameter changes by reflex action of the iris to control the amount of light entering the eye.

puppet theatre Miniature stage for shows of glove puppets, marionettes, rod puppets, and flat and shadow figures. Such theatres existed in ancient Egypt and in Greece in the 5th century BC, in China, Java and elsewhere in Asia, and reached their peak of popularity in 18th-century Europe. They flourished in the PURITAN period in England when the live theatres were closed.

Purcell, Henry (1659–95) English composer and organist of the Baroque period. He is most famous for his church music, much of which is still frequently performed. His only opera, *Dido and Aeneas* (1689), is regarded as an early masterpiece of the form, and his many other stage works include *The Fairy Queen* (1692).

purgatory Place or state intermediate between HEAVEN and HELL where a soul that has died in a state of grace is purged of its sins before entering heaven. In the teachings of the Roman Catholic Church, souls that die with unforgiven venial and forgiven mortal sins go to purgatory.

Purim Ancient Jewish celebration of thanksgiving, held on the 14th day of the Jewish month of Adar (in February or March). It commemorates the deliverance of the Jews of Persia from a plot to destroy them. The story, which appears in the Old Testament Book of ESTHER, is read on this festival in all synagogue services. The gift of alms to the poor is obligatory, and the festival is associated with a carnival atmosphere. Puritans British Protestants who were particularly influential during the 16th and 17th centuries. They originated in the reign of ELIZABETH I as a faction within the CHURCH OF ENG-LAND; their chief aim was to make it a truly Protestant Church, rather than an Anglo-Catholic one. Following the ideas of CALVIN, they were initially opposed to Anglicanism because of its preoccupation with what they considered to be "popish" practice. However, they later demanded the setting up of Presbyterianism. Many of the parliamentary opponents of JAMES I and CHARLES I in the 17th century were Puritans. Among them were religious separatists who emigrated to America. The English CIVIL WAR (1642-49) resulted from attempts by Puritan parliamentarians to block Charles I's

▲ pumpkin Related to cucumbers, pumpkins are soft-fleshed with a high water content. As food, the rind is removed and the flesh is pulped. As well as serving as food for humans, pumpkins are also cultivated as livestock feed.

◀ Punic Wars To make an effective challenge to Carthage's domination of the w Mediterranean, Rome had to become a naval power. A large fleet was constructed and equipped with boarding devices to allow for the hand-to-hand fighting at which the Romans excelled. As a result, after initial reverses, they inflicted naval defeat on Carthage in the First Punic War.

▲ Pushkin Often called the father of modern Russian literature, Alexander Pushkin demonstrated his talent for poetry while he was still a student in St Petersburg. Influenced by Byron, his romantic masterpiece was Eugene Onegip, a tale of unrequited love.

policies on religious grounds. After the war, the Puritans' zenith was reached when Oliver Cromwell assumed full executive power in 1653. The authority of the Church of England as an Anglican institution was re-established in 1660, although 30 years later Presbyterianism was accepted as the state-supported form of Christianity in Scotland. In England, the Puritans lived on as Dissenters and Nonconformists.

purpura Purplish patches on the skin due to seepage of blood from underlying vessels. Physical injury, vitamin deficiencies, some allergies and certain drugs are among the causes.

pus Yellowish fluid forming as a result of bacterial infection. It comprises blood serum, LEUCOCYTES, dead tissue and living and dead BACTERIA. An ABSCESS is a pus-filled cavity.

Pusan City on the Korea Strait, SE South Korea. It has thrived through its trading links with Japan. The Japanese modernized the city's harbour facilities during their occupation of Korea (1905-45). In the Korean War Pusan acted as the United Nations' supply port. An industrial and commercial centre, Pusan is the nation's leading port and second-largest city. Industries: shipbuilding, iron and steel. Pop. (1990) 3,798,000. Pushkin, Alexander Sergeievich (1799-1837) Russian poet and novelist. He was exiled for his political beliefs in 1820, the year in which his folk poem Ruslan and Lyudmila was published. The Prisoner of the Caucasus (1822) is his response to the beauty of the Crimea and the Caucasus; and the tragedy Boris Godunov (1826) reveals the influence of Byron. Pushkin's masterpiece was the verse novel Eugene Onegin (1833). Other works include the short story The Queen of Spades (1834) and the historical novel The Captain's Daughter (1836). He died in a fight fought over his wife, Natalia.

Pu Yi, Henry (1906–67) Last Emperor of China (1908–11). His reign name was Hsuan Tung. Deposed after the formation of the Chinese republic, he was temporarily rescued from obscurity to become president, later "emperor", of the Japanese puppet state of MANCHUKUO in 1932. Captured by Soviet forces (1945), he was delivered to Mao Zedong and imprisoned (1949–59). He later worked as a gardener in Beijing. **PVC** See POLYVINYL CHLORIDE

pyelitis Inflammation of the pelvis of the KIDNEY, where urine collects before draining into the URETER. More common in women, it is usually caused by bacterial infection. Treatment is with ANTIBIOTICS and copious fluids.

Pym, John (1584–1643) English leader of the parliamentary opposition to King Charles I. In the Long Parliament (1640) he initiated proceedings against Charles' advisers, Strafford and Laud, and took part in drafting the Grand Remonstrance (1641). He was one of the five members whom Charles tried to arrest in the House of Commons (1642), and he helped to arrange the alliance with the Scots in the English Civil War.

Pynchon, Thomas (1937–) US novelist whose works are noted for their offbeat humour and inventiveness. His books include *V* (1963), *The Crying of Lot 49* (1966), *Vineland* (1990), *Deadly Sins* (1993) and *Mason and Dixon* (1997). His best-known work, *Gravity's Rainbow* (1973), won the National Book Award.

Pyongyang Capital of North Korea, in the w of the country, on the River Taedong. An ancient city, it was the capital of the Choson, Koguryo and Koryo kingdoms. In the 16th and 17th centuries it came under both Japanese and Chinese rule. Pyongyang's industry developed during the Japanese occupa-

tion from 1910–45. It became the capital of North Korea in 1948. During the KOREAN WAR it suffered considerable damage. Industries: cement, iron and steel, chemicals, machinery, rubber, textiles. Pop. (1984) 2,639,448.

pyramid In geometry, a solid figure having a polygon as one of its faces (the base), the other faces being triangles with a common vertex. Its volume is one-third of the base area times the vertical height.

Pyramids Monuments on a square base with sloping sides rising to a point. They are associated particularly with ancient EGYPT, where some of the largest have survived almost intact. They served as burial chambers for pharaohs. The earliest Egyptian pyramid was a step pyramid (ZIGGURAT), built *c.*2700 BC for Zoser. Pyramid building in Egypt reached its peak during the 4th dynasty, the time of the Great Pyramid at GIZA. The largest pyramid in the world, it was built for Khufu *c.*2500 BC, and stands 146m (480ft) high with sides 231m (758ft) long at the base. The largest New World ziggurat pyramid was built in Teotihuacán, Mexico, in the 1st century AD; it was 66m (216ft) high with a surface area of 50,600sq m (547,200sq ft).

Pyrenees Range of mountains in s France and N Spain, extending in an almost straight line E to w from the Mediterranean Sea to the Bay of Biscay. They were formed in the Tertiary era. The Pyrenees contain deposits of marble, gypsum and oil, and there are extensive forests. Sheep and goat grazing is the chief farming activity. The highest point is Pico de Aneto, 3,406m (11,168ft). Length: 435km (270mi).

Pyrenees, Peace of the (1659) Treaty between France and Spain after the THIRTY YEARS WAR. France gained territory in Artois and Flanders, and Philip IV of Spain reluctantly agreed to his daughter's marriage to LOUIS XIV. She was to renounce her claim to the Spanish throne in exchange for a subsidy. Because Spain could not pay the subsidy, the renunciation became void, giving Louis a claim on the Spanish Netherlands and resulting in the War of Devolution.

pyrite (fool's gold) Widespread sulphide mineral, iron sulphide (FeS_2), occurring in all types of rocks and veins. It is a brass-yellow colour. It crystallizes as cubes and octahedra, and also as granules and globular masses. It is opaque, metallic and brittle. Hardness 6.5; s.g. 5.0.

pyroxenes Important group of rock-forming, silicate minerals. They are usually dark greens, browns and blacks. Crystals are usually short prisms with good cleavages. Hardness 2.3–4; s.g. 5.5–6.

Pyrrho (360–270 BC) Greek philosopher, considered the founder of SCEPTICISM. His doctrine was that nothing can be known because every statement can be plausibly contradicted; therefore wisdom is in reserved judgement.

Pyrrhus (319–272 BC) King of Epirus (307–302, 295–272 BC). An able general, he fought several battles against Rome. Although he won, the cost was so heavy that victory was useless, hence the term "pyrrhic victory".

Pythagoras (580-500 BC) Greek philosopher and founder of the Pythagorean school. The Pythagoreans were bound to their teacher by rigid vows and were ascetic in their mode of life. They believed in the TRANSMIGRATION OF SOULS and that numbers and their interrelationships constitute the true nature of things in the universe. Pythagoras is credited with many advances in mathematics and geometry, medicine and philosophy. He is said to have been the first to discover the mathematical relationship between the length of a string and the pitch of the sound it makes when vibrating. The theorem that the square of the hypotenuse of a right-angled triangle equals the sum of the squares of the other two sides is named after him, but was in practice already known to the Egyptians and Babylonians. His brotherhood was suppressed at the end of the 6th century, but its doctrines were revived by the Romans c.500 years later. python Name of more than 20 species of non-poisonous snakes of the BOA family (Boidae), found in tropical regions. Like boas, pythons kill their prey (birds and mammals) by squeezing them in their coils. Unlike boas, pythons lay eggs. The reticulated python (Python reticulatus) of SE Asia vies with the anaconda as the world's largest snake, reaching up to about 9m (30ft). Subfamily Pythoninae.

▶ pyramids The three Egyptian

pyramids at Giza are one of the

Seven Wonders of the World, and

the only to have survived virtually

intact into the modern age. The

Khufu, and vast pyramids were

constructed at Giza for Khafre and

Mankaure, also during the fourth

dynasty. Although these are the

pyramids, many others were also

constructed in the Nile Valley and

elsewhere in the country, but they have not been as well

best known of the Egyptian

largest was built for the pharaoh

Qaddafi, Muammar al- (1942-) Libyan political leader. Qaddafi led the coup that toppled the monarchy of King Idris I in 1969. With the title of commander-in-chief of the armed forces and chairman of the Revolutionary Command Council, he effectively became head of state. A militant Arab nationalist, Qaddafi has sought to eradicate all traces of Libya's colonial past and has encouraged a return to strict Islamic principles. He has made a number of unsuccessful attempts to bring Libya into union with other Arab countries. Qaddafi has also given assistance to various revolutionary and terrorist groups. **Qatar** Sheikhdom on the Qatar peninsula in the Persian Gulf; the capital is DOHA. The low-lying land is mostly stony desert, with some barren salt flats. Qatar's territory includes several offshore coral islands, the most important being Habal - an oil storage and export terminal. The climate is hot and humid, and a scant water supply has to be supplemented by desalination schemes. Qatar is heavily dependent on food imports. The sheikhdom's high standard of living is derived from its oil and gas reserves. Oil was first discovered in 1939, and today accounts for c.90% of exports and 80% of income. Oil revenue has been used to diversify Qatar's industrial base and develop agricultural projects. The economy is heavily dependent on an immigrant workforce, many from India or Pakistan. Forty percent of Qatar's population are Sunni Muslims, although only 25% are native Qataris, who are descended from three BEDOUIN tribes. Once a part of the Ottoman empire, Qatar was a British protectorate from 1916 to 1971, when it achieved independence. It is a member of the United Nations, the Arab League and OPEC. It is an absolute monarchy: Sheikh Khalifa bin Hamad Al-Thani became Emir after a coup in 1972. During the 1980s Qatar's status was threatened by the regional dominance of Iran and Iraq and a territorial dispute with BAHRAIN. In the 1991 GULF WAR, Allied coalition forces were deployed on Qatar's territory and Palestinian migrant workers expelled because of the pro-Iraqi stance of the Palestine Liberation Organization (PLO). In 1995 the Emir was overthrown and replaced by his son, Sheikh Hamad bin Khalifa Al-Thani. A further coup (1996) was foiled. Area: 11,437sq km (4,415sq mi). Pop. (1986) 369,079.

Qin (formerly Ch'in) Imperial dynasty of China (221 BC–206 BC) Originating in NW China, the Qin emerged after the collapse of the Zhou dynasty; its founder was Qin Shihuangdi. Qin established the first centralized imperial administration, with the country divided into provinces, each under a governor. Uniformity was encouraged in every sphere, including law, language, coinage, weights and measures. The Great Wall took permanent shape during this period.

Qing (formerly Ch'ing) Imperial Manchurian dynasty of China (1644-1911). It was established by NURHACHI following the collapse of the MING dynasty. Although established in 1636, it was not until the fall of Peking in 1644 that the Qing became the official ruling dynasty. The Qing emperors extended their influence until by 1800 they exercised control over an area stretching from Siam (Thailand) and Tibet to Mongolia and the River Amur. The dynasty weakened in the 19th century, following internal struggles, such as the TAIPING REBELLION, and with the increase of foreign influence, particularly after the OPIUM WARS. It ended with the abdication of Pu YI in 1911 and the establishment of the Chinese republic. Qinghai (Tsinghai) Province in NW China; the capital is Xining (Sining). Although parts of the region have long been under Chinese control, it was occupied mainly by Tibetan and Mongol nomads until recent times. It became a province of China in 1928. A mountainous region, it is the source of some of Asia's greatest rivers, including the HUANG HE, YANGTZE and MEKONG. There is farming of wheat, barley and potatoes, and stock rearing. The province is famous for its horses. Iron ore, coal, oil, salt and potash are extracted. Area: 721,280sq km (278,486sq mi). Pop. (1990) 4,430,000.

Qin Shihuangdi (259–210 Bc) Emperor of China (221–210 Bc). The first emperor of the QIN dynasty, he reformed the bureaucracy and consolidated the GREAT WALL. Excavations of his tomb on Mount Li (near XIAN) during the 1970s revealed, among other treasures, an "army" of c.7,500 life-size terracotta guardians.

Qom City in w central Iran. The burial place of FATIMA, her shrine is a place of pilgrimage for SHITTE Muslims. Industries: textiles, rugs, pottery, glass, shoes. Pop. (1986) 543,139.

quadrant In plane geometry, a quarter of a circle, bounded by radii at right angles to each other and by the arc of the circle. In analytic geometry, it is one of the four sections of a plane divided by an x axis and a y axis. A quadrant is also a device for measuring angles, based on a 90° scale.

quadratic equation Algebraic equation in which the highest exponent of the variable is 2; an equation of the second degree. A quadratic equation has the general form $ax^2 + bx + c$ = 0, where a, b and c are constants. It has, at most, two solutions (roots), given by the formula $x = [-b \pm \sqrt{(b^2 - 4ac)}]/2a$. Quadruple Alliance Alliance between four states, in particular three alliances in Europe in the 18th and 19th centuries. The first was formed in 1718 by Britain, France, the Holy Roman emperor and the Netherlands against PHILIP V of Spain, after he seized Sicily and Sardinia. The second was formed in 1814, by Austria, Britain, Prussia and Russia against NAPOLEON I. After Napoleon's defeat the four partners created the Congress system. The third Quadruple Alliance (1834) consisted of Britain and France in support of Portugal and Spain, where liberal monarchies were threatened by reactionary claimants.

quail Any of a group of Old World gamebirds. The European quail (*Coturnix coturnix*), a small, short-tailed bird with white throat and mottled brownish plumage, is found throughout Europe, Asia and Africa. The Australian quail (*Turnix velox*) is a stocky, brownish bird. Mainly ground-living birds, they scrape for fruits and seeds and nest on the ground. The Japanese quail (*C. coturnix japonica*) is used as a source of meat and eggs in Europe and the USA.

Quakers (officially Society of Friends) Christian sect that arose in England in the 1650s, founded by George Fox. The name derived from the injunction given by early Quaker leaders that their followers tremble at the word of the Lord. Quakers rejected the episcopal organization of the Church of England, believing in the priesthood of all believers and the direct relationship between man and the spiritual light of God. Quakers originally worshipped God in meditative silence unless someone was moved by the Holy Spirit to speak. Since the mid-19th century, their meetings have included hymns and readings. The largest national Quaker Church is in the USA, where it began with the founding of a settlement by William Penn in Pennsylvania (1681). Today, there are c.200,000 Quakers worldwide.

qualitative analysis Identification of the chemical elements or ions in a substance or mixture. *See also* QUANTITATIVE ANALYSIS

quango (Acronym for **Quasi-A**utonomous Non-Governmental **O**rganization) Any of a number of bureaux set up in Britain with government funds. They are responsible for regulating or monitoring various aspects of industrial, political, financial and social welfare. They are not directly elected, but issue reports periodically on their operational findings. There is much public debate about these bodies, resulting from their expense and lack of accountability.

Quant, Mary (1934–) British fashion designer whose offthe-peg, youth-oriented clothing for women – as featured at her own Chelsea boutique and in Carnaby Street – helped make London the focus of world fashion in the mid-1960s.

quantitative analysis Identification of the amount of chem-

Q/q, 17th letter of the English alphabet and a letter employed in the alphabets of other w European languages. It is a consonant and is descended from the Semitic letter goph, which became qoppa in the Greek alphabet. Qoppa was a rarely used letter intended to render the k sound before vowels o and u, and it was superseded by kappa. However, the Romans took it over. retaining its k sound but invariably following it with the letter u. The qu spelling entered all the subsequent Romance languages, and thence came into English. It retains a kw pronunciation, although in French this has been simplified to a k sound. In a few words (mostly proper names) of Arabic origin, the q has no accompanying u and in English it is pronounced as a k in such names as Qatar or Iraq.

ical constituents in a substance or mixture. Chemical methods use reactions such as precipitation (the suspension of small particles in a liquid), NEUTRALIZATION and OXIDATION, and measure volume (volumetric analysis) or weight (gravimetric analysis). Physical methods measure qualities such as density and refractive index (how much light is refracted by a medium).

quantum chromodynamics Study of the properties of QUARKS in which, to explain permissible combinations of quarks to form various ELEMENTARY PARTICLES, each is assigned a colour. Quarks are given one of the three primary colours: red, green and blue. When three quarks combine to form BARYONS, the resulting colour is always white. Antiquarks are given one of the three complementary colours: cyan, magenta and yellow. When a quark combines with an antiquark to form a MESON, the resulting colour is also white. quantum electrodynamics (QED) Use of QUANTUM MECHANICS to study the properties of ELECTROMAGNETIC RADI-ATION and how it interacts with charged particles. For example, the theory predicts that a collision between an ELECTRON and a PROTON should result in the production of a PHOTON of electromagnetic radiation, which is exchanged between the colliding particles.

quantum mechanics Use of QUANTUM THEORY to explain the behaviour of ELEMENTARY PARTICLES. In the quantum world, waves and particles are interchangeable concepts. Louis de BROGLIE suggested in 1924 that particles have wave properties, the converse having been postulated in 1905 by Albert EINSTEIN. Erwin SCHRÖDINGER used this hypothesis in 1926 to predict particle behaviour on the basis of wave properties, but a year earlier Werner Heisenberg had produced a mathematical equivalent to Schrödinger's theory without using wave concepts at all. In 1928 Paul DIRAC unified these approaches while incorporating RELATIVITY into quantum mechanics. The complete modern theory of quantum mechanics was derived by Richard Feynman in the 1940s. See also QUANTUM NUMBERS

quantum numbers In physics, a set of four numbers used to classify electrons and their atomic states. The principal quantum number (symbol n) gives the electron's energy level; the orbital quantum number (symbol l) describes its angular momentum; the magnetic quantum number (symbol m) describes the energies of electrons in a magnetic field; and the SPIN quantum number (symbol m_s) gives the spin of the individual electrons. See also QUANTUM THEORY

quantum theory Together with the theory of RELATIVITY, the foundation of 20th-century physics. It is concerned with the relationship between matter and energy at the elementary or subatomic level and with the behaviour of ELEMENTARY PARTICLES. According to the theory, all radiant energy is emitted and absorbed in multiples of tiny "packets" or quanta. The idea that energy is radiated and absorbed in quanta was proposed in 1900 by Max Planck. Using Planck's work, Albert EINSTEIN quantized light radiation and in 1905 explained the PHOTOELECTRIC EFFECT. In 1913 Niels BOHR used quantum theory to explain atomic structure and the relationship between the energy levels of an atom's electrons and the frequencies of radiation emitted or absorbed by the atom. See also QUANTUM MECHANICS; QUANTUM NUMBERS

quarantine Originally a 40-day waiting period during which ships were forbidden to discharge passengers or freight, to prevent transmission of plague or other diseases. Today, the term refers to any period of isolation legally imposed on people, animals, plants or goods in order to prevent the spread of contagious disease.

quark Any one of six ELEMENTARY PARTICLES and their antiparticles (antiquarks); the constituents of the HADRON group of SUBATOMIC PARTICLES. They occur in one of six "flavours": up, down, top, bottom, charmed and strange. Antiquarks have similar flavours but their charge is opposite that of their corresponding quark. Quarks always exist in combination; free quarks cannot exist.

quarter days Four days, each separated by a quarter of the year, corresponding roughly to the two equinoxes and the two solstices. From the 15th century they were set aside for the paying of instalments towards annual rents and taxes. In England and Ireland the days were Lady Day (25 March), Mid-

summer Day (24 June), Michaelmas Day (29 September) and Christmas Day (25 December).

quartz Rock-forming mineral, the natural form of silicon dioxide (silica), SiO₂. It is widely distributed, occurring in igneous and metamorphic rocks (notably granite and gneiss), and in clastic sediments. It is also found in mineral veins. It forms six-sided crystals. Pure quartz is clear and colourless but the mineral may be coloured by impurities. The most common varieties are colourless quartz (rock crystal), rose, yellow, milky and smoky. The most usual cryptocrystalline varieties, whose crystals can be seen only under a microscope, are CHALCEDONY and FLINT. Quartz crystals exhibit the PIEZOELECTRIC EFFECT and are used in electronic clocks and watches to keep accurate time. Hardness 7; s.g. 2.65.

quartzite METAMORPHIC ROCK usually produced from sandstone, in which the quartz grains have recrystallized. Quartzite is a hard and massive rock. It is usually white, light grey, yellow or buff, but it can be coloured green, blue, purple or black by various minerals.

quasar (quasi-stellar object) In astronomy, an object that appears to be a massive, highly compressed, extremely powerful source of radio and light waves, characterized by a large RED SHIFT. If such red shifts are due to the DOPPLER EFFECT, it can be deduced that quasars are more remote than any other objects previously identified; many are receding at velocities greater than half the speed of light. Their energy may result from the gravitational collapse of a GALAXY or from many SUPERNOVAS exploding in quick succession, although there seems to be no reason why such events should be occurring.

Quasimodo, Salvatore (1901–68) Italian poet. He published five volumes of verse during the 1930s, the first of which, *Waters and Land* (1930), established him as the leading Italian hermeticist. He was imprisoned for anti-fascist conduct in World War 2, and his later poetry is informed by his social views. He was also a prodigious translator, as well as a noted critic and editor. He was awarded the 1959 Nobel Prize for literature.

Quaternary Most recent period of the CENOZOIC era, beginning about 2 million years ago and extending to the present. It is divided into the PLEISTOCENE epoch, characterized by a periodic succession of great ice ages, and the HOLOCENE epoch, which started some 10,000 years ago.

quattrocento (It. fourteen hundred) Art history term applied to the 15th-century Italian Renaissance. Venice was its cultural centre, and leading figures included the painters Fra Angelico, Fra Filippo Lippi, Masaccio and Uccello; the architects Brunelleschi and Alberti; and the sculptors Donatello and Ghiberti.

Quayle, (James) Dan (Danforth) (1947-) US vice president (1989-93). A rich Indiana lawyer, he was a Republican congressman (1977-81) and senator (1981-88). In 1988 he was chosen by George Bush to act as his running mate. Quayle's tenure was marked by several public relations gaffes. Quebec (Québec) Province in E Canada; the largest province in area and second-largest in population; the capital is QUEBEC and the largest city is MONTREAL. Jacques CARTIER discovered the E coast of Canada in 1534. The port of Québec was the first settlement to be established (1608), and from there the French pushed w. The entire area was ceded to Britain by treaty in 1763 and became a British colony. With the establishment of the Dominion of Canada in 1867, Quebec became a province. In the later 20th century the French-speaking inhabitants of the province intensified their demands for recognition of their cultural heritage, including complete independence. In a 1995 referendum a tiny majority of the population voted against independence for Quebec. Most of the province is on the Canadian Shield and is relatively uninhabited. The lowlands along the ST LAWRENCE River are the centre of industry and agriculture; the area's small farms provide vegetables, tobacco and dairy produce. The province yields vast quantities of hydroelectric power and timber. Copper, iron, zinc, asbestos and gold are mined. Area: 1,540,687sq km (594,860sq mi). Pop. (1991) 6,895,963.

Quebec (Québec) City and seaport on the St Lawrence River, s QUEBEC province, Canada; capital of Quebec province.

Samuel de Champlain established a French trading post on the site of Quebec in 1608. Captured by the British in 1629, the city was returned to France and became the capital of New France in 1663. It was ceded to Britain in 1763. The city served as the capital of Lower Canada (1791–1841) and of the United Provinces of Canada (1851–55, 1859–65), before becoming capital of Quebec province in 1867. Quebec has in recent years become a focal point for Canada's French-speaking separatists. Industries: shipbuilding, paper, leather, textiles, machinery, canned food, tobacco, chemicals. Pop. (1991) 167,517.

Quebec Act (1774) Act of British Parliament creating a government for Quebec. It set up a council to assist the governor and recognized the Roman Catholic Church and the French legal and landholding systems in the former French colony. Quebec's boundary was extended south to the Ohio River, a cause of resentment among the 13 North American colonies.

Quechua Most widely spoken of all Native South American languages, with about 5 million speakers in Peru, 1.5 million in Bolivia and 500,000 in Ecuador. Originally the language of the great INCA empire, it is related to Aymará, the two forming the Quechumaran family.

Queen Anne style Art history term applied to a British style of decorative arts (especially furniture) popular during the reign (1702–14) of Queen Anne. The style is characterized by elegance and simplicity. Curved cabriole legs are a distinctive feature, as are inlay, veneering and lacquerwork.

Queen Mother See ELIZABETH

Queens Largest borough of New York CITY, on the w end of Long Island, se New York State, USA. First settled by the Dutch in the early 17th century, the area came under English control in 1664. It became a borough of Greater New York in 1898. Queens has La Guardia and John F. Kennedy International airports and St John's University (1870). It is a residential and industrial area and its manufacturing industries produce consumer goods for New York City. Area: 280sq km (108sq mi). Pop. (1990) 1,951,598.

Queensberry, John Sholto Douglas, Marquess of (1844–1900) British nobleman who sponsored the Queensberry rules – the basis of the rules for modern boxing. Drafted mainly by John G. Chambers of the British Amateur Athletic Club, the Queensberry rules were standardized in 1889. In 1895 Queensberry publicly insulted Oscar WILDE because of the latter's association with Queensberry's son, Lord Alfred Douglas. Wilde unsuccessfully sued Queensberry for libel and was convicted of homosexual practices.

Queen's Counsel (QC) Member of the Bar appointed to senior rank on the recommendation of the LORD CHANCELLOR (in Scotland of the Lord Justice General).

Queensland State in NE Australia; the capital is Brisbane. Queensland was originally part of New South Wales and served as a penal colony (1824-40). It became a separate colony in 1859 and a state within the Commonwealth of Australia in 1901. Nearly 50% of Queensland lies N of the Tropic of Capricorn and there are rainforests in the N. The GREAT DIVIDING RANGE separates the fertile coastal strip from the interior plains. Its chief crops are sugar cane, wheat, cotton and tropical fruits. Beef cattle are important. The main industry is mining, and there are are valuable mineral deposits (copper, lead, zinc, bauxite, oil and natural gas). Area: 1,727,530sq km (667,000sq mi). Pop. (1993 est.) 3,155,400. quetzal Forest bird of Central America. The male is bright green above and crimson below with iridescent green tail plumes forming a 60cm (2ft) train. The Aztecs and Mayas regarded the quetzal as sacred and wore the tail plumes ceremonially. The duller female nests in a hole, often in a tree, and lays two eggs, which are incubated by both parents. Family Trogonidae; species Pharomachrus mocinno.

Quetzalcoatl God of CENTRAL AND SOUTH AMERICAN MYTHOLOGY, a principal deity of the TOLTECS, MAYA and AZTECS. Quetzalcoatl took the form of a feathered serpent. Essentially a creator, who made the human race by fertilizing

bones with his own blood, he was associated with agriculture and the arts. A legend telling of his exile from his homeland is probably based on a ruler who took his name. CORTÉS landed in Mexico in 1519 on the god's birthday, and since Quetzalcóatl was expected to return in man's form, the Aztecs associated Cortés with the god.

Quezon, Manuel Luis (1878–1944) Philippine statesman, first president of the Commonwealth of the Philippines (1935–44). Quezon was imprisoned for his part in the revolt against US rule in 1901. After his release, he became leader of the Nationalist Party and, as commissioner to the US (1909–16), secured the passage of the Tydings-McDuffie Bill (1934) that paved the way for independence. An autocratic president, Quezon instigated administrative reforms. His strengthening of Philippine defences failed to prevent Japan's invasion, and Quezon formed a govenment-in-exile in the US. Quezon City City on LUZON island, adjacent to MANILA, N Philippines. Second-largest city in the Philippines, it was named after Manuel Luis QUEZON and was capital of the Philippines from 1948 to 1976. It is mainly a residential area but has a thriving textile industry. Pop. (1990) 1,632,000.

Quiché Mayan group of Native South Americans located in the highlands of w Guatemala. Archeological remains show large pre-conquest population centres and an advanced civilization. Today, the Quiché are the largest Native American group in Guatemala.

quicksilver See MERCURY

quietism Mystical Christian movement begun by a Spanish priest, Miguel de Molinos, in the 17th century. It achieved great influence in 17th-century France and in the Wesleyan movement in 18th-century Britain. Its adherents believed that only in a state of absolute surrender to God was the mind able to receive the saving infusion of grace.

quince Shrub or small tree native to the Middle East and central Asia. Its greenish-yellow fruit is used in preserves. Height: to 6.1m (20ft). Family Rosaceae; species *Cydonia oblonga*

Quine, Willard Van Orman (1908–) US philosopher and mathematical logician. Quine focused on language as a logical system. Having changed his philosophical position many times during his career, he retains his importance mainly through the valuable discussion he provoked. Quine's writings include A System of Logistics (1934), Mathematical Logic (1940), Two Dogmas of Empiricism (1951), Word and Object (1960) and Philosophy of Logic (1969).

quinine White, crystalline substance isolated in 1820 from the bark of the cinchona tree. It was once widely used in the treatment of MALARIA but has been largely replaced by drugs that are less toxic and more effective.

quinsy Inflammation of the tonsils, caused by an abscess, often a complication of TONSILLITIS. It is generally treated with ANTIBIOTICS.

Quisling, Vidkun (1887–1945) Norwegian fascist leader during World War 2. A former minister of defence (1931–33), Quisling founded the National Union Party (1933), based on the German Nazi Party. In 1940 he collaborated with the invading Germans, and they set him up as a puppet ruler during their occupation of Norway. After the war, he was shot as a traitor.

Quito Capital of Ecuador, at 2,850m (9,260ft), N central Ecudaor. Quito lies almost on the Equator. The site was originally settled by Quito Native Americans, and was captured by the INCAS in 1487. It was taken by Spain in 1534, and liberated from Spanish rule in 1822 by Antonio José de SUCRE. A cultural and political centre, it is the site of the Central University of Ecuador (1787) and has a notable observatory. The 17th-century cathedral is the burial place of de Sucre. Products include textiles and handicrafts. Pop. (1990) 1,100,847.

Qumran Ancient village on the NW shore of the Dead Sea, in the Israeli-occupied West Bank. In 1947 the DEAD SEA SCROLLS (writings of a Jewish sect that settled in Qumran $c.100~\rm BC-AD~68$) were found in nearby caves.

▲ quetzal The resplendent quetzal (*Pharomachrus mocinno*) is a rare, perching bird found in tropical rainforests from s Mexico to Costa Rica. The Aztec and Maya worshipped the bird, associating it with the god Quetzalcoatl. The quetzal is the national bird of Guatemala.

R/r, the 18th letter of the English alphabet, used in the alphabets of other W European languages, It is a consonant and is descended from the Semitic letter resh, meaning head. It passed almost unchanged into the Greek alphabet as rho and from there to the Roman alphabet. Numerous sorts of sound in the world's languages are transliterated by r. In the most widely used forms of modern English, an r is not pronounced at all after a vowel or between a vowel and a consonant (for, card). It is only pronounced when immediately followed by a vowel, as in rug.

▲ Rabin Because of his willingness to compromise with the Palestinians in the quest for peace in the Middle East, Israeli prime minister Yitzhak Rabin was assassinated by an Israeli extremist in 1995. He rose to prominence as a member of the military establishment and entered politics in the 1970s as a member of the Labour Party. Rabin served two terms as prime minister.

Ra (Re) In EGYPTIAN MYTHOLOGY, Sun god of Heliopolis and lord of the dead. He sailed his sun boat across the sky by day and through the underworld by night. He is most often depicted as falcon-headed, with a solar disc on his head.

Rabat Capital of Morocco, on the Atlantic coast, N Morocco. Rabat dates from Phoenician times, but the fortified city was founded in the 12th century by the ALMOHAD ruler, Abd al-Mumin. In later years it became a refuge for Moors expelled from Spain. Under French rule (from 1912) it was made the capital of the protectorate of Morocco. Notable sights include the 12th-century Hassan Tower. Industries: hand-woven rugs, textiles, food processing. Pop. (1982) 518,616.

rabbi Person qualified through study of the Hebrew Bible and the Talmud to be the chief religious leader of a Jewish congregation and the person responsible for education and spiritual guidance in Judaism. In some countries, such as the UK, Jews are led on a national basis by a chief rabbi. Modern Israel has a rabbinic council with two chief rabbis, one representing the Sephardic tradition, the other representing the Ashkenazi rite.

rabbit Long-eared, herbivorous mammal of the family Leporidae, including the European common rabbit and the American cottontail. The common rabbit is *Oryctolagus cuniculus* and has thick, soft, greyish-brown fur. The wide variety of domesticated rabbits are also of this species. Length: 35–45cm (14–18in); weight: 1.4–2.3kg (3–5lb). *See also* HARE

Rabelais, François (1494–1553) French humanist and satirist. Rabelais is famed for his classic series of satires, now known collectively as *Gargantua and Pantagruel*. The series itself consists of *Pantagruel* (1532), *Gargantua* (1534), *Le Tiers Livre* (1546), *Le Quart Livre* (1552) and *Le Cinquième Livre* (1564). Although condemned as obscene by theologians and the Sorbonne, Paris, the books became widely popular.

rabies (hydrophobia) Viral disease of the central nervous system. It can occur in all warm-blooded animals, but is especially feared in dogs due to the risk of transmission to human beings. The incubation period varies from a week or two to more than a year. It is characterized by severe thirst, although attempting to drink causes painful spasms of the larynx; other symptoms include fever, muscle spasms and delirium. Once the symptoms have appeared, death usually follows within a few days. Anyone bitten by a rabid animal may be saved by prompt injections of rabies vaccine and antiserum.

Rabin, Yitzhak (1922–95) Israeli statesman, prime minister (1974–77, 1992–95). As chief of staff (1964–68), Rabin directed Israeli operations in the Stx Day War (1967). He was ambassador to the USA (1968–73) before becoming prime minister. As minister of defence (1984–90), Rabin directed operations against the Palestinian INTIFADA and, having regained leadership of the Labour Party from his collegue and rival, Shimon Peres, became prime minister for the second time. In 1993 Rabin reached an agreement with the PALESTINE LIBERATION ORGANIZATION (PLO), promising progress towards Palestinian autonomy in the occupied territories. In November 1995 he was assassinated by an Israeli extremist.

race Informal classification of the human species according to hereditary (genetic) differences. Different racial characteristics arose among geographically separated populations partly through adaptation to differing environments across many generations. However, as there is no evidence of genetic racial distinctions anthropologists reject the term.

Rachmaninov, Sergei (1873–1943) Russian composer and pianist. A gifted concert pianist, Rachmaninov left Russia for the USA in 1918. His Piano Concerto No.2 (1901), *Rhapsody on a Theme of Paganini* (1934) and Symphony No.2 (1907) are among his most popular works. He composed songs, four piano concertos and various other works.

Racine, Jean Baptiste (1639–99) French classical dramatist whose early plays, such as *La Thebaïde* (1664) and *Alexandre le Grand* (1665), were influenced by contemporaries such as Corneille. Racine's later plays, such as *Britannicus* (1669), *Bérénice* (1670), *Mithridate* (1673) and *Phèdre* (1677), are cornerstones of FRENCH LITERATURE.

racism Doctrine advocating the superiority of one human RACE over some or all others. From time to time it has been the avowed policy of certain countries and regimes which, as

a result, sanctioned slavery and discriminatory practices, such as the apartheid system practised in South Africa from the 1940s to the late 1980s. Racism was defined by UNESCO in 1967 as "anti-social beliefs and acts which are based on a fallacy that discriminatory inter-group relations are justifiable on biological grounds".

Rackham, Arthur (1867–1937) British illustrator and watercolourist, whose work was inspired by the goblins, fairies and weird beasts of Nordic folk tales. Among his best-known illustrations are the ones he created for Charles LAMB's *Tales from Shakespeare* (1899), *Grimm's Fairy Tales* (1900) and *The Arthur Rackham Fairy Book* (1933).

racoon (raccoon) Stout-bodied, omnivorous, mostly nocturnal mammal of North and Central American wooded areas. Racoons have a black, mask-like marking across their eyes and a long, black-banded tail. They have agile and sensitive front paws and typically dip for food in water. The seven species include the North American *Procyon lotor*. Length: 40–61cm (16–24in); weight: 10–22kg (22–48lb). Family Procyonidae.

racquets Game played by two or four people in an enclosed 18.3×9.1m (60×30ft) court. Each player uses a gut-strung racket with a circular head. On the front wall, a service line is painted at a height of 2.9m (9.6ft), and a fixed wooden board, extends 68.6cm (27in) up from the floor. These are the markers that determine when a ball is in play. A serve must be above the service line and must land behind a short line, 7.3m (24ft) from the back wall. Games are played to 15 points. See also SQUASH radar (acronym for radio detecting and ranging) Electronic system for determining the direction and distance of objects. Developed during World War 2, it works by the transmission of pulses of RADIO waves to an object. The object reflects the pulses, which are detected by an antenna. By measuring the time it takes for the reflected waves to return, the object's distance may be calculated, and its direction ascertained from the alignment of the receiving radar antenna.

radar astronomy Branch of astronomy in which radar pulses, reflected back to Earth from celestial bodies in the solar system, are studied for information concerning their distance from Earth, their orbital motion, and large surface features. Techniques developed for radar mapping of planetary surfaces have proved particularly important for cloud-covered VENUS. radian Angle formed by the intersection of two radii at the centre of a circle, when the length of the arc cut off by the radii is equal to one radius in length. Thus, the radian is a unit of angle equal to $c.57.295^{\circ}$, and there are 2π radians in 360° . radiation Transmission of energy by SUBATOMIC PARTICLES or electromagnetic waves. See ELECTROMAGNETIC RADIATION radiation, cosmic (cosmic rays) Streams of SUBATOMIC PAR-TICLES from space that constantly bombard the Earth at velocities approaching the speed of light. Primary cosmic rays are high-energy RADIATION that comes from the Sun and other sources in outer space. They consist mainly of atomic nuclei and PROTONS. When primary cosmic rays strike gas molecules in the upper atmosphere they yield showers of secondary cosmic rays, which consist of energetic protons, NEUTRONS and pions. Further collisions yield muons, ALPHA PARTICLES, POSITRONS, ELECTRONS, GAMMA RADIATION and PHOTONS.

radiation, heat Energy given off from all solids, liquids or gases as a result of their temperature. The energy comes from the vibrations of atoms in an object and is emitted as ELECTRO-MAGNETIC RADIATION, often in the form of INFRARED WAVES.

radiation, nuclear Particles or ELECTROMAGNETIC RADIATION emitted spontaneously and at high energies from atomic nuclei. Possible causes include RADIOACTIVE DECAY, which yields ALPHA PARTICLES, BETA PARTICLES, GAMMA RADIATION and, more rarely, POSITRONS. It can also result from spontaneous FISSION of a nucleus, with the ejection of neutrons or gamma rays.

radiation sickness Illness resulting from exposure to sources of ionizing radiation, such as x-rays, gamma rays or nuclear fallout. Diarrhoea, vomiting, fever and haemorrhaging are symptoms. Severity depends upon the degree of radiation, and treatment is effective in mild cases.

radio Method of communication between a transmitter and a receiver of radio waves (*see* ELECTROMAGNETIC RADIATION). The term is most often used for the receiver of a sound broad-

cast. A radio signal of fixed FREQUENCY (the carrier wave) is generated at the transmitter. The sound to be broadcast is converted by a MICROPHONE into a varying electrical signal that is combined with the carrier by means of MODULATION. This is passed to an AERIAL from which it is transmitted into the atmosphere. At the receiver, an aerial intercepts the signal, and it undergoes "detection", the reverse of modulation, to retrieve the sound signal. It is amplified through a loudspeaker that reproduces the sound. Television uses radio waves to send sound and picture signals, and RADAR transmits pulses of radio waves. New technology has enabled digital signals to be carried via radio waves. See also AMPLITUDE MODULATION (AM); BROADCASTING; FREQUENCY MODULATION (FM)

radioactive decay Process by which a radioactive ISOTOPE (radioisotope) loses SUBATOMIC PARTICLES from its nucleus and so becomes a different element. The disintegration of the nuclei occurs with the emission of ALPHA PARTICLES (helium nuclei) or BETA PARTICLES (electrons), often accompanied by GAMMA RADIATION. The two processes of alpha decay or beta decay cause the radioisotope to be transformed into a chemically different atom. Alpha decay results in the nucleus losing two protons and two neutrons; beta decay occurs when a NEU-TRON changes into a PROTON, with an ELECTRON (beta particle) being emitted in the process. Thus, the ATOMIC NUMBER changes in both types of decay and an isotope of another element is produced, which might also be radioactive. In a large collection of atoms, there is a characteristic time (the HALF-LIFE) after which one-half of the total number of nuclei would have decayed. This time varies from millionths of a second to millions of years, depending on the isotope concerned. The activity of any radioactive sample decreases exponentially with time. See also CARBON DATING

radioactivity Spontaneous emission of RADIATION from an atomic nucleus. The process by which a radioactive nucleus disintegrates is known as RADIOACTIVE DECAY.

radio astronomy Study of radio waves (ELECTROMAGNETIC RADIATION with wavelengths from about 1mm to many metres) that reach the Earth from objects in space. Observations can be made using a RADIO TELESCOPE. Radio noise from the Milky Way was discovered in 1931 by Karl JANSKY and the subject grew rapidly after World War 2. The number of radio sources increases with distance, demonstrating that the Universe has been evolving with time. This, combined with the discovery at radio wavelengths of the cosmic microwave background, is strong evidence in favour of the Big Bang theory of the origin of the Universe.

radio galaxy GALAXY that emits strong ELECTROMAGNETIC RADIATION of radio frequency. These emissions seem to be produced by the high-speed motion of ELEMENTARY PARTICLES in strong magnetic fields.

radiography Use of x-RAYS to record the interiors of opaque bodies as photographs. Industrial x-ray photographs can show assembly faults and defects in metals. In medicine and dentistry, radiography is invaluable for diagnosing bone damage, tooth decay and internal disease. Using modern scanning techniques, cross-sectional outlines of the body can be obtained showing organs, blood vessels and diseased parts.

radiology Medical speciality concerned with the use of RADIATION and radioactive materials in the diagnosis and treatment of disease. See also RADIOGRAPHY; RADIOTHERAPY

radio telescope Instrument used to collect and record radio waves from space. The basic design is the large single dish or parabolic reflector, up to 100m (330ft) in diameter. Radio waves are reflected by the dish via a secondary reflector to a focus, where they are converted into electrical signals. The signals are amplified and sent to the main control room, where there is further amplification before analysis and recording. See also RADIO ASTRONOMY; TELESCOPE

radiotherapy In medicine, the use of RADIATION to treat tumours or other pathological conditions. It may be done either by implanting a pellet of a radioactive source in the part to be treated, or by dosing the patient with a radioactive isotope or by exposing the patient to precisely focused beams of radiation from a machine such as an x-ray machine or a particle accelerator. Synthesized radioisotopes are the most effective; cobalt-

60 is often used as it produces highly penetrating gamma radiation. In the treatment of various types of CANCER, the radiation slows down the proliferation of the cancerous cells.

radish Annual garden vegetable developed from a wild plant

native to the cooler regions of Asia. Its leaves are long and deeply lobed; the fleshy root, which may be red, white or black, is eaten raw. Family Brassicaceae; species *Raphanus sativus*. **radium** (symbol Ra) White, radioactive, metallic element of the ALKALINE-EARTH METALS, first discovered (1898) in pitch-blende by Pierre and Marie Curie; the metal is present in uranium ores. It is used in RADIOTHERAPY. Radium has 16 isotopes, which emit alpha, beta and gamma radiation, as well as heat. RADON gas is a decay product. Properties: at.no. 88;

(2,084 °F); most stable isotope Ra²²⁶ (half-life 1,622 years). **radius** In anatomy, one of the two forearm bones, extending from the elbow to the wrist. The radius rotates around the ULNA, permitting the hand to rotate and be flexible.

r.a.m. 226.025; r.d. 5.0; m.p. 700°C (1,292°F); b.p. 1,140°C

radon (symbol Rn) Radioactive gaseous element, a NOBLE GAS. It was first discovered in 1899 by Ernest RUTHERFORD. The 20 known isotopes, which are alpha particle emitters, are present in the Earth's atmosphere in trace amounts. Radon is mainly used in medical RADIOTHERAPY. Chemically, it is mostly inert but does form fluoride compounds. Properties: at.no. 86; r.d. 9.73; m.p. -71°C (-95.8°F); b.p. -61.8°C (-79.24°F); most stable isotope Rn²²² (half-life 3.8 days). **RAF** See AIR FORCE, ROYAL

Raffles, Sir Thomas Stamford (1781–1826) British colonial administrator, founder of Singapore. When Java returned to Dutch rule (1816), he bought the island of Singapore for the British East India Company (1819). Under his guidance it developed rapidly into a prosperous free port.

rafflesia Parasitic plant native to Sumatra and Java. It grows as a PARASITE on the roots of jungle vines and has no stem or leaves. The foul-smelling, reddish-brown flowers are 1m (3.25ft) in diameter, the world's largest flowers. Family Rafflesiaceae; species Rafflesia arnoldii.

Rafsanjani, Hojatoleslam Ali Akbar Hashemi (1934–) Iranian cleric and statesman, president of Iran (1989–97). After Khomeini's triumphant return in 1979, Rafsanjani became speaker of the Iranian parliament. A leading figure in the new theocracy, he was acting commander of the armed forces in the final stages of the Iran-Iran War. Following Khomeini's death in 1989, Rafsanjani became president. His presidency witnessed a slight easing of tension in relations with the West. raga (Sanskrit, colour) In Indian music, a sequence of five to seven notes that is used exclusively for the duration of a performance as a basis for improvisation. Its basic structure can

▲ Rafsanjani Iranian president
Rafsanjani trained with Ayatollah
Khomeini at Qom before Khomeini
was forced into exile. Following
the overthrow of Shah Pahlevi,
Rafsanjani served in Khomeini's
revolutionary government. After
the conclusion of the Iran-Iraq War,
Rafsanjani concentrated on the
reconstruction of Iran. Defeated in
1997 elections, he was succeeded
by Ayatollah Khamenei.

▲ ragwort There are around 1,200 species of ragwort (also known as groundsel) around the world. Some are cultivated specially as garden plants; others grow wild. Many species, including the common ragwort (Senecio jacobaea) are poisonous to livestock, but others have medicinal uses, helping to heal wounds and to bring on or increase menstrual flow.

be written in the form of a scale. Mood or atmosphere are created by emphasizing certain parts.

ragwort Any of several plants with daisy-like flowers, including the common ragwort (*Senecio jacobaea*), which bears flat-topped clusters of yellow flower heads. Height: to 1.3m (4ft). Family Asteraceae/Compositae.

rail Slender, long-legged marsh bird. Rails are shy, generally nocturnal and often emit melodious calls. They lay 8–15 eggs in a reed-and-grass ground nest. Length: 10–45cm (4–18in). Family Rallidae. Typical genus *Rallus*.

railway (railroad) Form of transport in which carriages (wagons or bogies) run on a fixed track, usually steel rails. Railways date from the 1500s, when wagons used in mines were drawn by horses along tracks. English mining engineer Richard TRE-VITHICK built the first steam LOCOMOTIVE in 1804. In 1825 George Stephenson's Locomotion became the first steam locomotive to pull a passenger train, on the Stockton and Darlington Railway. The first full passenger-carrying railway, the Liverpool and Manchester Railway, was opened in 1830, using Stephenson's Rocket. The growth of rail fed the Industrial Revolution. In the USA, Tom Thumb was the first domestically produced steam locomotive (1830). The first transcontinental railroad was completed in 1869, when the Union Pacific Railroad from Nebraska met the Central Pacific Railroad from California at Utah. The world's first UNDERGROUND RAILWAY to carry passengers was the City and South London Railway in 1890. Steam locomotives are still used in India, but most countries use electric, diesel or diesel-electric locomotives. Modern developments include high-speed trains, such as the Japanese "Bullet" train or the French TGV (Train à Grande Vitesse), that travel at an average speed of c.300km/h (185mph). Magley (magnetic levitation) trains use magnetic forces to hold them above a guide rail. The decrease in friction permits even greater speeds. Air trains hover above the track by an air cushion. Trains that do not run on wheels are usually propelled by the magnetic forces of a linear electric motor, or by jet engine.

rain Water drops that fall from the Earth's atmosphere to its surface, as opposed to fog or dew which drift as suspensions, and snow or hail which fall as ice particles. Warm air passing over the sea absorbs water vapour and rises in thermal currents, or on reaching a mountain range. The water vapour condenses and forms clouds, which account for the usually heavier annual rainfall on windward, compared to leeward, mountain slopes. See also HYDROLOGICAL CYCLE; PRECIPITATION

rainbow Multicoloured band, usually seen as an arc opposite to the Sun or other light source. The primary bow is the one usually seen; in it the colours are arranged from red at the top to violet at the bottom. A secondary bow, in which the order of the colours is reversed, is sometimes seen beyond the primary bow. The colours are caused by reflection of light within spherical drops of falling rain, which cause white light to be dispersed into its constituent wavelengths. The colours usually seen are those of the visible SPECTRUM: red, orange, yellow, green, blue, indigo and violet.

rainforest Dense forest of tall trees that grows in hot, wet regions near the Equator. The main rainforests are in Africa, central and s America, and sE Asia. They comprise 50% of the timber growing on Earth and house 40% of the world's animal and plant species. They also, through PHOTOSYNTHESIS, supply most of the world's oxygen. This is why the present rapid destruction of the rainforests (up to 20 million ha are destroyed

annually to provide timber and land for agriculture) is a cause of great concern. Also, clearing rainforest contributes to the GREENHOUSE EFFECT and may lead to GLOBAL WARMING. There are many species of broad-leaved evergreen trees in rainforests, which grow up to 60m (180ft) tall. The crowns of other trees, up to 45m (135ft) tall, form the upper canopy of the forest. Smaller trees form the lower canopy. Climbing vines interconnect the various levels, providing habitats for many kinds of birds, mammals and reptiles. Very little light penetrates to the forest floor, which consequently has few plants. Rainforest trees provide many kinds of food and other useful materials, such as fibrous kapok and the drugs quinine and curare.

Rainier III (1923–) Ruler of Monaco. He succeeded his grandfather Louis II in 1949 and married actress Grace Kelly in 1956. They had three children.

Rainier, Mount Peak in w central Washington, USA; the highest point in the Cascade Range. It was first climbed in 1870. The summit of this ancient volcano is the centre of the greatest single-peak glacier system in the United States. Height: 4,395m (14,410ft).

raisin Dried, sweet, seedless GRAPE. Special varieties are grown, particularly in Australia and w USA.

Rajasthan State in NW India, on the border with Pakistan; the capital is JAIPUR. Other major cities include UDAIPUR, JODHPUR and Jaisalmer. Rajasthan was the homeland of the RAJPUTS. Rajasthan state was formed in 1950 and enlarged in 1966. The THAR DESERT in the w is inhabited by pastoral nomads. The E is part of the DECCAN plateau, where wheat, millet and cotton are grown with the aid of irrigation. Coal, marble, mica and gypsum are mined. Industries: handicrafts, cotton milling. Area: 342,266sq km (132,149sq mi). Pop. (1991) 44,005,990.

Rajneesh, Shree (1931–90) (Chandra Mohan Jain) Indian religious leader who founded a religious movement based on what he called "loving meditation". Bhagwan Rajneesh established his meditation movement during the early 1970s, with centres in Poona and other locations in India. The movement soon spread to Europe, and later to the USA.

Rajput Predominantly Hindi warrior caste from NW India. They became powerful in the 7th century AD, gaining control of an historic region named Rajputana. After the Muslim conquests in the 12th century they retained their independence, but by the early 17th century had submitted to the MOGUL EMPIRE. In the early 18th century they extended their control. In the 19th century most of their territorial gains were lost to the Marathas, Sikhs and the British empire. During the colonial period much of Rajputana retained its independence under local princely rule. After Indian independence in 1947 most of the princes lost their powers. See also RAJASTHAN

Raleigh, Sir Walter (1552–1618) English soldier, explorer and writer. A favourite courtier of ELIZABETH I, he organized expeditions to North America, including the failed attempt to found a colony in Virginia (now North Carolina). He fought in France and against Spain and sat in Parliament. On JAMES I's ascension to the throne, he was imprisoned (1603–16) for treason, writing his *History of the World*. He was released in order to lead an expedition to Guiana in search of the gold of EL DORADO, but was betrayed to the Spanish. At Spanish insistence, Raleigh returned to prison and was executed for treason. Raleigh Capital of North Carolina, USA, in the E central part of the state. Founded in 1792 as state capital, it was named after Sir Walter Raleigh. It is a market centre for the cotton and tobacco trade. Industries: food processing, textiles, electronic equipment. Pop. (1990) 207,951.

RAM (random access memory) INTEGRATED CIRCUITS (chips) that act as a temporary store for computer PROGRAM and DATA (information). To run a program on a COMPUTER, the program is first transferred from a MAGNETIC DISK, or other storage device, to RAM. RAM also holds documents produced when the program is used. Another part of RAM stores the images to be displayed on the screen. The contents of RAM are lost when the computer is switched off.

Rama Hero of the RAMAYANA. A chivalrous husband, obedient to sacred law, he was considered to be the seventh incarnation of VISHNU. His name became synonymous with God. Ramadan Ninth month of the Islamic year, set aside for

► rail Native to marshes all around the world, rails are poor fliers that rely on their dull coloration for protective camouflage. Their strong legs allow them to run through dense undergrowth. The Ypecaha wood rail (*Aramides ypecaha*) shown here is found in Brazil, Paraguay, Uruguay and Argentina.

fasting. Throughout Ramadan, the faithful must abstain from food, drink and sexual intercourse between sunrise and sunset. They are also encouraged to read the whole of the Koran in remembrance of the "Night of Power", when MUHAMMAD is said to have received his first revelation from ALLAH via the angel Gabriel.

Ramakrishna (1836–86) (Gadadhar Chatterji) Hindu spiritual teacher who taught that all religions were basically united in a common goal of union with the same God. His chief disciple, Swami Vivekananda, founded (1897) the Ramakrishna Mission in India, which perpetuates Ramakrishna's teaching.

Ramayana (Romance of Rama) Epic poem of ancient India. Written in *c*.300 BC along with the MAHABHARATA, it is ascribed to the poet Valmiki and comprises 24,000 couplets in seven books. It concerns the life of RAMA and his wife, Sita.

Rambert, Dame Marie (1888–1982) British ballet dancer, teacher and choreographer, b. Poland. She was a member (1912–13) of DIAGHILEV'S BALLETS RUSSES and was special advisor to NIJINSKY in the first performance of Stravinsky's *The Rite of Spring* (1913). She founded her own school in 1920, which became known as the Ballet Rambert in 1935.

Rameau, Jean Philippe (1683–1764) French composer and musical theorist. Rameau's most famous opera is *Castor et Pollux* (1737). Among his other stage works is the dramatic ballet *Les Indes Galantes* (1735).

Ramsay, Allan (1713–84) Scottish portrait painter. The Scottish counterpart of GAINSBOROUGH and Joshua REYNOLDS, Ramsay settled in London where, during 1760, he was appointed painter to George III in preference to his rival, Reynolds. His style, graceful and Italianate, lent itself especially well to female portraiture, such as *The Artist's Wife* (1755).

Ramsay, Sir William (1852–1916) British chemist. Working with Lord RAYLEIGH, he discovered ARGON in air. Later he discovered HELIUM, NEON and KRYPTON. He was knighted in 1902 and awarded the 1904 Nobel Prize for chemistry.

Ramses II Egyptian king of the 19th dynasty (r.1290–1224 BC). He reigned during a period of unprecedented prosperity and power. His efforts to confirm Egypt's dominant position in Palestine and to regain her possessions and influence in Syria, led to a major clash with the HITTITES at Kadesh in 1285 BC. A truce was agreed in 1269 BC, and Ramses later married a Hittite princess. He built many splendid monuments, including the temple at ABU SIMBEL.

Ramses III Egyptian king of the 20th dynasty (r.c.1194–1163 BC). He defended Egypt from attacks by Libya and the Sea Peoples. Later in his reign, however, Egypt withdrew into political and cultural isolation and the priesthood became the centre of power.

Ramsey, Sir Alf (Alfred) (1920–) English football manager and player. Ramsay was a fullback for Southampton and Tottenham Hotspur, and made 32 appearances for England (1948–53). He began his managerial career with Ipswich Town, helping them win the League Championship (1962) before managing (1963–74) the national team. Ramsay created and guided England's World Cup-winning side (1966).

Rand See WITWATERSRAND

Randolph, Edmund (1753–1813) US lawyer and statesman. Randolph was aide to George Washington during the AMERICAN REVOLUTION. At the CONSTITUTIONAL CONVENTION (1787), he proposed the Virginia Plan, influencing the shape of the American Constitution. Randolph was the first US attorney general (1789–94) and was secretary of state (1794–95).

Rangi In the creation myth of the Maoris, Rangi is the sky god who forms such a close embrace with the Earth goddess, Papa, that their unborn children cannot emerge. When they are finally separated, Light and Darkness make their first appearance in the world. Rangi also figures in other OCEANIC MYTHOLOGY.

Rangoon (Yangon) Capital of Burma (Myanmar), a seaport on the Rangoon River. The site of an ancient Buddhist shrine, Rangoon was made capital of Burma in 1886 when the British annexed the whole country. It was the scene of heavy fighting between British and Japanese forces in World War 2. It is the country's chief trade centre. Industries: oil refining, timber, rice, iron ore. Pop. (1983) 2,458,712.

Ranjit Singh (1780–1839) Indian maharaja, founder of the

RAILWAY

Modern railways have trains, such as the Eurostar, with bogies that use an articulated air suspension system. This has great weight savings. The bogies (1) link the carriages, which are attached to a metal frame (2) through a ball joint (3). Instead of each carriage having a bogie at either end, there is a single suspension unit between two carriages. Dampers (4) modify articulation to improve passenger comfort. The black rings between the frame and the wheel unit are the air suspension units.

Sikh kingdom of the Punjab. At the age of 12, he became the ruler of a small territory in NW India. He absorbed neighbouring states, and in 1799 established his capital at Lahore. In 1803 he took possession of the Sikh holy city of Amritsar. He established the E boundary of his kingdom on the Sutlej river. Turning his attention to the W and N, he captured Peshawar and Kashmir. His kingdom collapsed after his death.

Rank, J. (Joseph) Arthur (1888–1972) British industrialist and film magnate, chairman of many film companies. Rank promoted the British film industry at a time when Hollywood and US film companies had a virtual monopoly.

Ransome, Arthur Mitchell (1884–1967) British writer. As a journalist, Ransome covered the Russian Revolution (1917). He is best-known for his perennially popular children's novels, *Swallows and Amazons* (1930) and *Peter Duck* (1933).

rap Form of dance music that became popular during the early 1980s. Rap has its roots in the improvised street poetry of African-American and Hispanic teenagers in New York. The music places an emphasis on DJs who mix different tracks together, sometimes "scratching" for increased effect. rape Plant grown for animal fodder and for its small, black seeds, which yield rape oil, used industrially as a lubricant. It has curly, blue-green leaves, small, yellow flowers and slen-

der seed pods. Family Brassicaceae; genus Brassica.

rape Crime of sexual intercourse without the victim's consent, often involving the use of force, implied or actual. If the victim is considered incapable of giving consent (for example because s/he is below the age of consent), this is known as statutory rape, and evidence of lack of consent is not required. Usually applied to male use of force against women, in some US states a man can prosecute for rape. Marital rape is now considered a crime in the UK and in many US states. Raphael (1483–1520) (Raphael Sanzio or Raphael Santi) Italian painter, one of the finest artists of the High RENAIS-SANCE. Born in Urbino, Raphael absorbed HUMANISM as a child. One of his most important commissions was the decoration of the four stanze (rooms) in the Vatican. He only completed two of these but the first, the Stanza della Segnatura, gave him the chance to exercise his skills to the full. The room contains two large FRESCOS, the School of Athens and the Disputà, both of which show Raphael's mastery of PERSPECTIVE. After Bramante's death he became architect to St Peter's, Rome.

Raphael Biblical archangel who, with MICHAEL, GABRIEL, and Uriel, serves as a messenger of God. According to passages in the apocryphal Book of Tobit and the pseudigraphical Second Book of Enoch, he is one of the seven holy angels who present the prayers of the saints to God.

rare earth See LANTHANIDE SERIES

raspberry Fruit grown in Europe, North America and Asia. The black, purple or red fruit is eaten fresh or preserved. Canes, rising from perennial roots, bear fruit the second year. Family Rosaceae; species *Rubus idaeus*.

Rasputin, Grigori Yefimovich (1872–1916) Russian

▲ rape Widely cultivated throughout China, India and Europe, rape (*Brassica napus*) produces seeds that have an oil content of 40–50%. Once it is extracted, the oil is used for cooking, lubrication, fuel and the manufacture of soap and rubber. The seed residue is used for animal feed and fertilizer. Rape fields are easily identified by the bright yellow colour of the flowers.

▲ raspberry Popular as a wild fruit from ancient times, raspberries (*Rubus* sp.) have been cultivated since the early 17th century. The fruits grow on usually thorny bushes, although thornless varieties also exist. There are more than 200 varieties of raspberry in Asia, where the fruit is thought to have originated.

peasant mystic. Rasputin exercised great influence at the court of NICHOLAS II because of his apparent ability to cure crown prince Alexis' haemophilia. He attracted suspicion because of his advocacy of sexual ecstasy as a means of religious salvation. Rasputin was poisoned by a group of nobles in 1916, and when this failed, he was shot and drowned.

Rastafarianism West Indian religion focusing on veneration of Ras Tafari (HAILE SELASSIE I). The movement was started in Jamaica in the 1920s by Marcus GARVEY. He advocated a return to Africa in order to overcome black oppression. Followers of Rastafarianism follow a strict diet, and are forbidden various foods including pork, milk and coffee.

rat Any of numerous small RODENTS found worldwide. Most species are herbivorous. The best known are the black rat (*Rattus rattus*) and brown rat (*R. norvegicus*), both of the family Muridae. They carry diseases and destroy or contaminate property and food. Both live everywhere that humans live.

ratio Number relating two numbers or two quantities of the same kind, such as two prices or two lengths, that indicates their relative magnitude. Ratios, as of the numbers 3 and 4, can be written as a fraction 3/4, or with a colon (3:4).

rationalism Philosophical theory that knowledge about the nature of the world can be obtained solely by reason, without recourse to experience. Rationalist philosophers, such as DESCARTES, LEIBNIZ and SPINOZA, argued that reality could be logically deduced from "self-evident" *a priori* premises. It is usually contrasted with EMPIRICISM. In theology, rationalism holds that faith be explicable by human reason rather than divine revelation.

rational number Number representing the ratio of two integers, the second of which is not zero. Thus, 1/2, 18/11, 0, -2/3 and 12 are all rational numbers. Any rational number can be represented as a terminating decimal (such as 1.35) or a recurring decimal (such as 18/11 = 1.636363...). See also IRRATIONAL NUMBERS

ratite Group of large, usually flightless birds with flat breastbones instead of the keel-like prominences found in most flying birds. Ratites include the OSTRICH, RHEA, CASSOWARY, EMU, KIWI and the unusual flying tinamou.

rattan Climbing PALM native to the East Indies and Africa. Its stems can grow to 150m (500ft). They are used for making ropes and furniture. Family Arecacae/Palmae; genus Calamus. rattlesnake Any of about 30 species of venomous New World pit vipers characterized by a tail rattle of loosely connected segments of unshed skin. It ranges from Canada to South America, usually in arid regions. Most are blotched with dark diamonds, hexagons or spots on a lighter background. They feed mostly on rodents. Length: 30cm–2.5m (1–8ft). Family Viperidae. See also SNAKE

Rauschenberg, Robert (1925–) US painter and graphic artist. Influenced by Marcel Duchamp and Jasper Johns, Rauschenberg was a pioneer of POP ART in the 1950s. Works, such as *Bed* (1955) and *Monogram* (1959), combined the painting techniques of ABSTRACT EXPRESSIONISM with collages and assemblages of "junk".

Ravel, (Joseph) Maurice (1875–1937) French composer, a leading exponent of IMPRESSIONISM. Ravel's piano compositions include *Jeux d'eau* (1901), *Gaspard de la nuit* (1908), *Le Tombeau de Couperin* (1917) and two concertos. Among his orchestral works are *Rhapsodie espagnole* (1907) and *Bolero* (1927). He also composed the ballet *Daphnis and Chloe* (1912), and the song cycle *Shéhérazade* (1903).

raven Large bird of the crow family found in deserts, forests and mountainous areas of the Northern Hemisphere. It has a long, conical bill, shaggy throat feathers, a wedge-shaped tail and black plumage with a purple sheen. It eats carrion or any other animal food. Length: to 68cm (27in). Family Corvidae. Ravenna City in Emilia-Romagna, NE Italy. It was the capital of the Western Roman Empire in the 5th century AD. It subsequently briefly became capital of the Ostrogothic kingdom and then the seat of the Byzantine government in Italy. An independent republic in the 13th century, it was under papal rule from the 16th–19th centuries, becoming part of the kingdom of Italy in 1860. Industries: petroleum, natural gas, furniture, cement, fertilizers, sugar refining. Pop. (1991) 135,834.

Ray, John (1627–1705) English naturalist whose work on plant and animal classification later influenced Carl LINNAEUS and CUVIER. He was the first to distinguish the two main types of flowering plants as MONOCOTYLEDONS and DICOTYLEDONS.

Ray, Man (1890–1976) US photographer, painter, sculptor and film-maker, the founder of the New York DADA movement with Marcel DUCHAMP and Francis Picabia. Ray is best known for photographs produced without a camera by placing objects on light-sensitive paper and exposing them to light.

Ray, Satyajit (1921–92) Indian film director. Ray introduced Indian cinema to the West. His "Apu Trilogy" – *Pather Panchali* (1955), *The Unvanquished* (1956) and *The World of Apu* (1959) – is a beautiful, humanist series of films about life in post-colonial India. Other films include *The Big City* (1963), *The Hero* (1966) and *The Visitor* (1992).

ray Any of several species of cartilaginous, mostly marine fish related to the SKATE, SHARK and CHIMAERA. The ray is flattened dorso-ventrally; its body extends sideways into large, wing-like pectoral fins that are "flapped" while swimming. The tail is narrow and may be whip-like or bear poisonous spines. Electric (torpedo) rays stun their prey with electrical charges of up to 200 volts. Length: 1.5m (5ft).

Rayleigh, John William Strutt, Lord (1842–1919) British physicist. His work was chiefly concerned with various forms of wave motion. He was awarded the 1904 Nobel Prize for physics for his discovery (with William RAMSAY) of the noble gas ARGON and for work on gas densities.

rayon Fine, smooth FIBRE made from solutions of CELLULOSE. It was the first synthetic textile fibre. Viscose rayon, the most common, is spun-dried and has a strength approaching NYLON. Acetate rayon is made of filaments of cellulose ACETATE.

razor-billed auk (razorbill) Stocky, penguin-like seabird that lives along coastlines in the cold parts of the Northern Hemisphere. It is black and white with a white-ringed, narrow bill. Length: 41cm (16in). Species *Alca torda*.

razor shell Bivalve MOLLUSC. Its long, hinged shells, each shaped like the blade of a cut-throat razor, are common on beaches of the Northern Hemisphere. Family Solenidae.

Reading City in s central England, at the confluence of the Thames and Kennet rivers; county town of BERKSHIRE. The area was occupied by the Danes in the 9th century. Industries: ironware, engineering, electronics. Pop. (1991) 128,877.

reading Ability to comprehend visual symbols representing language, usually in the form of written or printed characters. Opinions differ over the precise physical nature of this process, as they do also over whether the language involved – phonetic, non-phonetic or ideographic – is influential in the speed of learning and the retention of vocabulary.

Reagan, Ronald Wilson (1911—) 40th US president (1981–89). A well-known film actor, Reagan joined (1962) the Republican Party and became governor of California (1966–74). Nominated as presidential candidate at his third attempt in 1980, he defeated the incumbent Jimmy Carter. Surviving an assassination attempt (1981), Reagan introduced large tax cuts and reduced public spending, except on defence. By the end of his second term, budget and trade deficits had reached record heights. Fiercely anti-communist, Reagan adopted an aggressive foreign policy, invading Grenada (1983) and undermining the Sandinista regime in Nicaragua. While pursuing his Strategic Defence Initiative (SDI, or "Star Wars"), he made a historic DISARMAMENT treaty (1987) with Mikhail GORBACHEV that ushered in a new era in US-Soviet relations.

▶ rattlesnake Not normally aggressive, rattlesnakes try to avoid confrontation by warning of their presence. Their unmistakable and menacing rattle is produced by "bells" of hard skin on the end of the tail. The amount of venom they produce far exceeds that needed to kill the rodents that form their usual prey. They can also use it to protect themselves against large predators.

realism Broad term in art history, often interchangeable with NATURALISM. It is frequently used to define art that tries to represent objects accurately and without emotional bias. It also denotes a movement in 19th-century French art, led by COURBET, that revolted against conventional, historical or mythological subjects and focused on unidealized scenes of modern life. Superrealism is a 20th-century movement, in which real objects are depicted in very fine detail so that the overall effect appears unreal. *See also* SOCIALIST REALISM

realism Philosophical doctrine according to which universal concepts, as well as tangible things, exist in their own right, outside the human mind that recognizes or perceives them. The idea developed from a medieval view that "universals" are real entities rather than simply names for things. Realism was thus opposed to NOMINALISM. Some philosophers rejected this view in favour of moderate realism, which held that "universals" exist only in the mind of God. See also IDEALISM real number Any number that is a RATIONAL NUMBER or an IRRATIONAL NUMBER. Real numbers exclude imaginary numbers (the square roots of negative quantities). See also COMPLEX NUMBER

real tennis Medieval game played with racket and ball on a basically rectangular indoor court surrounded by walls, three out of four of which are surmounted by a sloping roof; there are other hazards at each end. The game was first played during the 12th century in French monastic cloisters. In Australia it is called "royal tennis", although in the USA it is "court tennis". Both rules and scoring are extremely complex.

Rebellion of 1837 Risings in favour of self-rule in Upper and Lower Canada (Ontario and Quebec). In Upper Canada, the rising was led by William Lyon Mackenzie and soon fizzled out. The revolt in Lower Canada, led by Louis Papineau, was more serious, and was severely suppressed. The outbreaks led to the Durham report and the union of Upper and Lower Canada (1841).

receptacle Biological structure that serves as a container for reproductive cells or organs in plants. In flowering plants, the receptacle is the enlarged end of a stalk to which the flower is attached. In ferns, it is the mass of tissue that forms the sporangium (the spore-bearing organ). In some seaweeds, it is the part that seasonally becomes swollen and carries the reproductive organs.

recession In economics, phase of the business cycle associated with a declining economy. Its manifestations are rising unemployment, contracting business activity and decreasing purchasing power of consumers. Government policy, such as cuts in government spending or taxes, may be used to stimulate and expand the economy during a recession. If a recession is not checked, it can degenerate into a DEPRESSION.

Recife City and port on the Atlantic coast, NE Brazil; the capital of Pernambuco state. Originally settled by Portuguese in the 1530s, it was under Dutch occupation in the 17th century. It is now a major port and shipping centre, exporting sugar, cotton and coffee. Pop. (1991) 1,290,149.

reciprocal Quantity equal to the number 1 divided by a specified number. The reciprocal of 2 is $\frac{1}{2}$, and the reciprocal of $\frac{1}{2}$ is 2.

recombinant DNA research Branch of GENETIC ENGINEERING involving the transferral of a segment of DNA from a source organism into a host organism (typically a microbe). The transferred segment is spliced into the host's overall DNA structure, thus altering the information contained in its GENETIC CODE. When the host undergoes asexual cell division, each product cell carries a replica of the new DNA. In this way numerous clones of the new cell can be made. *See* RESTRICTION ENZYME

Reconstruction In US history, the process of restoring the former Confederate states to the Union after the Civil War. It was the cause of fierce controversy within Congress. The relatively pro-Southern approach of President Andrew Johnson led to his impeachment. The Republicans were determined to establish the political and civil rights of blacks, and they succeeded in imposing the programme known as Radical Reconstruction over the presidential veto. It alienated many Southern whites, and growing violence in the 1870s required the pres-

ence of federal troops. When Rutherford B. HAYES became president (1877), he withdrew the troops, Southern Republican governments collapsed, and Reconstruction was abandoned.

recorder Simple Woodwind musical instrument, popular in Europe since the 15th century. It comprises an end-blown straight tube with eight finger-holes. Modern recorders include soprano, descant, tenor and bass instruments.

recording Storing of signals that represent sound or images, on a medium such as a plastic disc or magnetic tape. In disc recording, the sounds or images being recorded are electronically modified and converted into movements of a stylus. The stylus cuts an original lacquer disc, which is then electroplated to make a master negative for pressing out plastic copies. In magnetic recording, sound is recorded on tape with a TAPE RECORDER; a VIDEO RECORDING machine records sound and vision. Recent advancements in recording techniques include digital methods of recording, and the development of laser technology for the revolutionizing invention of the COMPACT DISC (CD). See also DIGITAL AUDIO TAPE (DAT)

rectangle Four-sided geometric figure (quadrilateral), the interior angles of which are right angles and each pair of opposite sides is of equal length and is parallel. It is a special case of a PARALLELOGRAM.

rectifier Component of an electric CIRCUIT that converts alternating current (AC) into direct current (DC). The rectifier is usually a semiconductor DIODE. See also ELECTRIC CURRENT rectum In humans and many other vertebrates, last part of the

large INTESTINE, where the faeces are stored prior to voiding. **recycling** Natural and manufactured processes by which substances are broken down and reconstituted. In nature, elemental cycles include the CARBON CYCLE, NITROGEN CYCLE and HYDROLOGICAL CYCLE. Natural cyclic chemical processes include the metabolic cycles in the bodies of living organisms. Manufactured recycling includes the use of bacteria to break down organic wastes to harmless, or even beneficial,

red admiral Distinctive European butterfly with red bars on the wings and black wing-tips spotted with white. The caterpillar is dark with light side stripes and branching spikes. Family Nymphalidae; species *Vanessa atalanta*.

substances. Large quantities of inorganic waste, such as metal

scrap, glass bottles and building spoil, are recycled.

red algae Taxonomic group (PHYLUM) of reddish ALGAE, the Rhodophyta. They are numerous in tropical and subtropical seas. Most are slender, branching seaweeds that form shrublike masses. Some become encrusted with calcium carbonate and are important in reef formation. Rhodophytes have red and purplish pigments, which help to absorb light for photosynthesis. They also have CHLOROPHYLL. They have complex life cycles with two or three distinct stages, involving ALTERNATION OF GENERATIONS.

Red Army Army of the former Soviet Union. It was characterized by a high degree of political control, and was institutionalized at all levels with a system of commissars. During World War 2 the Red Army grew to more than 20 million men. It was renamed the Soviet Army in 1946. The Red Army was also the name of the Chinese revolutionary guard before it was formally renamed the People's Liberation Army.

red blood cell See ERYTHROCYTE

Red Cross International organization that seeks to alleviate human suffering, particularly through disaster relief and aid to war victims. It is composed of more than 150 independent national societies in most countries, with central headquarters ▼ ray Found in all oceans, the various species of electric ray (Dasyatis sp.) use the electric charge they can generate both for stunning prey and warding off predators — the shock of between 35 and 60 volts may be strong enough to stun humans. They feed on smaller animals and have specially adapted teeth for crushing shells.

▲ Reagan Appearing in more than 50 films from the time of his Hollywood debut in the 1930s, Ronald Reagan was a celebrity in the USA before he entered politics in the mid-1960s. Genial and optimistic, and highly skilled in televisual presentation, he was very popular, particularly with the right wing of the Republican Party. A few years after leaving office, he admitted that he was suffering from Alzheimer's Disease and received a great deal of public sympathy.

▲ Redford Although he is best known for his starring roles in films from Butch Cassidy and the Sundance Kid (1969) to Indecent Proposal (1993), Robert Redford began his acting career on the Broadway stage, where he starred in the 1963 production of Barefoot in the Park which he later filmed. Always highly selective in choosing his film roles, he began to direct in the 1980s. He also established the Sundance Institute in Utah, a training centre for young independent film-makers and the home of an annual US Film Festival

in Geneva, Switzerland. It is staffed largely by volunteers. The name comes from its symbol: a red cross on a white background. The International Red Cross was awarded the Nobel Peace Prize in 1917 and 1944. The organization is known as the Red Crescent in most Muslim countries.

redcurrant Widely cultivated shrub and its small, round, red, edible fruit; it is closely related to the blackcurrant. Family Grossulariaceae; species Ribes silvestre.

red dwarf Star at the lower end of the main sequence. Red dwarfs have masses of between 0.8 and 0.08 of a solar mass. They are of small diameter, relatively low surface temperature (2500-5000K) and low absolute magnitude.

Redford, Robert (1937-) US film actor, director and producer. Redford shot to fame appearing opposite Paul NEWMAN in Butch Cassidy and the Sundance Kid (1969). His popularity increased with films such as The Candidate (1982) and All the President's Men (1976). Redford won an Academy Award for his directorial debut Ordinary People (1980). Other films include A River Runs Through It (1992) and Quiz Show (1994). Redgrave Name of a family of British actors and actresses. Sir Michael (1908–85), also a director and writer, made major stage appearances in Shakespeare's Hamlet, Macbeth and As You Like It. He appeared in many films, including The Way to the Stars (1945) and The Browning Version (1951). His children are actors. Vanessa (1937-) won an Academy Award as Best Supporting Actress in Julia (1977). Her other films include Prick Up Your Ears (1987) and Howard's End (1992). Corin (1939–) has acted on stage and television, and Lynn (1943–) received an Oscar nomination for Georgy Girl (1966). Red Guards Chinese youth movement active in the Cul-TURAL REVOLUTION (1966-68). They were named after the groups of armed workers who took part in the Russian Revolution (1917). The Chinese Red Guards attacked revisionists, Westerners and alleged bourgeois influences. Originally encouraged by MAO ZEDONG, they caused severe social disorder and were suppressed after 1968.

Red Jacket (1758-1830) (Otetiani) Native American chief of the SENECA. He was called Red Jacket from his association with the British colonial army during the AMERICAN REVOLU-TION. He astutely exploited the differences between rival groups, and in the WAR OF 1812 supported the USA against the British. During his chieftainship he was a powerful advocate of the preservation of Iroquois traditions.

Redon, Odilon (1840-1916) French painter and graphic artist. He was an influential exponent of SYMBOLISM. He worked mainly in black and white, creating a fantasy world of weird amorphous creatures, insects and human heads with plant bodies. In the 1890s he began painting mythological scenes and flower paintings in radiant colours.

Red Sea Narrow arm of the Indian Ocean between NE Africa and the Arabian Peninsula, connected to the Mediterranean Sea by the Gulf of Suez and the Suez Canal. With the building of vessels too large for the canal and the construction of pipelines, the Red Sea's importance as a trade route has diminished. Max. width: c.320km (200mi). Area: 438,000sq km (169,000sq mi). redshank Eurasian wading bird of the SANDPIPER family. It has a long slender bill, mottled grey, brown and white plumage, and characteristic slender red legs. Length: to 28cm (11in). Family Scolopacidae; species Tringa totanus.

red shift (z) Lengthening of the wavelength of light or other ELECTROMAGNETIC RADIATION from a source, caused either by the source moving away (the DOPPLER EFFECT) or by the expansion of the Universe (cosmological RED SHIFTS). It is defined as the change in the wavelength of a particular spectral line, divided by the rest wavelength of that line. The Doppler effect results from motion through space; cosmological red shifts are caused by the expansion of space itself stretching the wavelengths of light travelling towards Earth.

reduction See OXIDATION-REDUCTION

redwood See SEQUOIA

Reed, Sir Carol (1906-76) British film director. He won an Academy Award for Oliver (1968). Other films include Penny Paradise (1938), The Fallen Idol (1948), The Third Man (1949), Trapeze (1956) and The Agony and Ecstasy (1965).

Reed, Lou (1944-) US singer-songwriter and guitarist, b.

Louis Firbank. Reed formed the cult rock band Velvet Underground in 1965. Following the group's demise in the 1970s. he pursued a solo career, achieving widespread popularity with Transformer (1972), and the single "Perfect Day".

reed Aquatic GRASS native to wetlands throughout the world. The common reed (Phragmites communis) has broad leaves, feathery flower clusters and stiff smooth stems. Dry reed stems are used for thatching, construction and musical pipes. Height: to 3m (10ft). Family Poaceae/Gramineae.

reed instrument Musical instrument that produces sound when an air current vibrates a fibre or metal tongue. In a CLAR-INET, a beating reed vibrates against a hole at the end of the tube. The OBOE and BASSOON have double-reed mouthpieces, the two tongues vibrating against each other when blown.

reef Rocky outcrop lying in shallow water, especially one built up by CORALS or other organisms.

referendum Political process in which legislation or constitutional proposals are put before all voters for approval or rejection. This direct form of voting was known in Greece and other early democracies and is widely used today in certain countries, most notably Switzerland.

reflection Change in direction of part or all of a WAVE. When a wave, such as a light or sound wave, encounters a surface separating two different media, it is bounced back into the original medium. The incident wave (striking the surface), reflected wave and the normal (line perpendicular to the surface) all lie in the same plane; the incident wave and reflected wave make equal angles with the normal.

reflex action Rapid involuntary response to a particular stimulus - for example, the "knee-jerk" reflex that occurs when the bent knee is tapped. It is controlled by the nervous system.

reflex camera Camera that allows the user to view and focus through the lens of the camera. A plane mirror and prism reflect the scene through the lens on to a ground glass screen. When the photographer presses the shutter on a single-lens reflex (SLR) camera, the mirror flips back and light reaches the film. A twin-lens reflex (TLR) camera has two sets of lenses, one for viewfinding, the other for passing light directly onto the film.

reflexor See MUSCLE

Reform Acts British acts of Parliament extending the right to vote. The Great Reform Bill (1832) redistributed seats in the House of Commons to include large cities that were previously unrepresented. It also gave the vote to adult males occupying premises worth at least £10 a year. The second Reform Act (1867) extended the FRANCHISE to include betteroff members of the working class. The acts of 1884 and 1885 gave the vote to most adult males. Women over 30 gained the vote in 1918, and the Representation of the People Act (1928) introduced universal adult suffrage.

Reformation Sixteenth-century movement that sought reform of the universal Catholic Church of Western Christendom and resulted in the development of PROTESTANTISM. More than a revolt against the ecclesiastical and doctrinal authority of the church, it also represented a protest by many theologians and scholars against the interference of the church in politics and the questionable activities of the contemporary clergy, notably the sale of INDULGENCES and holy relics. The influence of Martin Luther during the 1520s was significant, and the effect of the Reformation was felt first in Germany, then in Switzerland (with John CALVIN), England, Scotland and Scandinavia, and finally in parts of France. In England, the Reformation was at first more political than religious. King HENRY VIII, angry over the refusal of Pope CLEMENT VII to grant him a divorce from CATHERINE OF ARAGON, passed an Act of Supremacy (1534) rejecting papal authority and making himself head of the Church of England. It became known as the Anglican Church, developing its own liturgy in the English language. See also COUNTER-REFORMATION

Reformed church Any Christian denomination that came into being during the REFORMATION by separating, as a congregation, from the old universal Catholic Church (the Western Church). More specifically, Reformed churches are those churches that adopted CALVINISM in preference to LUTHERANISM. In the USA, the largest Reformed churches,

▲ reflection The top diagram shows the reflection of an image in a mirror. The image reflects back with an angle of reflection the same as the angle of incidence. The image, however, appears to the eye to be behind the mirror on an extension of the angle of reflection. The bottom line drawing illustrates that the angle of reflection is always the same as the angle of incidence, whether the angle is acute or oblique.

such as the Dutch Reformed Church and the Evangelical and Reformed Church, originated from N European countries, particularly Holland and Germany.

refraction Bending of a wave, such as a light or sound wave, when it crosses the boundary between two media, such as air and glass, and undergoes a change in velocity. The incident wave (striking the surface), refracted wave and the normal (line perpendicular to the surface) all lie in the same plane. The incident wave and refracted wave make an angle of incidence, *i*, and an angle of refraction, *r*, with the normal. The index of refraction for a transparent medium is the ratio of the speed of light in a vacuum to its speed in the medium. It is also equal to sin *i*/sin *r*. Snell's law states that this ratio is constant for a given interface.

refrigeration Process by which the temperature in a refrigerator is lowered. In a domestic refrigerator, a refrigerant gas such as AMMONIA or freon is first compressed by a pump and cooled in a condenser where it liquefies. It is then passed into an evaporator where it expands and boils, absorbing heat from its surroundings and thus cooling the refrigerator. It is then passed through the pump again to be compressed. Refrigeration is also used for air conditioners.

refugee Person who leaves their native land because of expulsion or to avoid persecution and seeks asylum in another country. The United Nations High Commission for Refugees (UNHCR) is responsible for the welfare of refugees.

Regency style Style of art and architecture fashionable when the future George IV was Prince Regent (1811–20) and during his reign. A period of great variety, it generally denotes designs that are extremely elegant and refined.

regeneration Biological term for the ability of an organism to replace one of its parts if it is lost. Regeneration also refers to a form of ASEXUAL REPRODUCTION in which a new individual grows grows from a detached portion of a parent organism.

Regensburg (Fr. *Ratisbon*) City and port at the confluence of the Danube and Regen rivers, Bavaria, s Germany. Founded by the Romans as Castra Regina, it was captured by Charlemagne in 788. During the 13th century Regensburg flourished on the commercial trade with the Middle East and India and became an imperial free city. From 1663 to 1806 it was the seat of the Imperial Diet. In 1810 Regensburg was annexed to Bavaria, and in 1853 was made a free port. Pop. (1990) 123,700.

reggae Form of West Indian popular music. It first achieved prominence in the mid-1960s, growing out of rock-steady and ska. It is characterized by a hypnotically repetitive back beat. Modern variations on the form include ragga and lover's rock. Bob MARLEY was largely responsible for bringing reggae to a worldwide audience.

Reich, Steve (1936–) US composer. His works are characterized by transforming musical patterns. Many of his compositions were written for his percussion ensemble, Steve Reich and Musicians, who achieved fame with *Drumming* (1971).

Reich, Wilhelm (1897–1957) Austrian psychoanalyst and clinical assistant (1922–28) to Sigmund Freud. In the USA from 1939, he claimed to have discovered "orgone" energy, a primal force in the atmosphere. The function of the sexual orgasm was to discharge orgone energy. Reich claimed to have invented an orgone box, which would release this energy. In 1950 he was imprisoned for fraud and died in gaol.

Reichstag German parliament building. Erected 1884–94, the Reichstag is where the lower legislative assembly of Germany met until 1933, when it was severely damaged in a fire. After the reunification of Germany in 1990, it once again served as the meeting place of Germany's parliament.

Reign of Terror (June 1793—July 1794) Phase of the French Revolution. It began with the overthrow of the Girondins and the ascendancy of the Jacobins under Robespierre. Against a background of foreign invasion and civil war, opponents were ruthlessly persecuted and c.1,400 executed by the GUILLOTINE. The Terror ended with a coup on 27 July 1794 in the National Convention, when Robespierre and leading Jacobins were arrested and executed.

Reims City on the River Vesle, NE France; a port on the Aisne-Marne Canal. CLOVIS I was baptized and crowned here in 496, and it was the coronation place of later French kings. Reims is

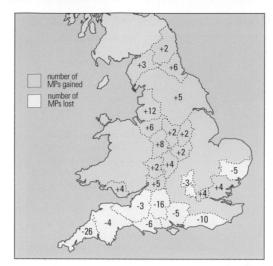

century, many of the agricultural boroughs whose population had steadily declined still returned members to Parliament, whereas the new, densely populated industrial areas were unrepresented. Some of the seats taken away from the underpopulated boroughs by the Reform Bill were redistributed among these industrial centres, while others were used to increase county representation.

■ Reform Acts In the early 19th

the centre of the champagne industry. Other industries: woollen goods, metallurgy, chemicals, glass. Pop. (1990) 180,620.

reincarnation Passage of the soul through successive bodies, causing the rebirth of an individual and the prolonging of his or her existence on Earth. In HINDUISM and BUDDHISM, an individual's KARMA (earthly conduct) determines the condition into which one is born in the next life.

reindeer (caribou) Large DEER of northern latitudes, which ranges from Scandinavia across Siberia to North America. It has thick fur and broad hoofs, which help to spread the animal's weight on snow. It stands up to 1.4m (4.6ft) tall at the shoulders, and feeds on grasses and saplings in the summer and lichens it finds beneath the snow in the winter. It is domesticated for meat and as a pack animal by the Lapps. Both sexes have antlers. Species *Rangifer tarandus*.

Reinhardt, "Django" (Jean-Baptiste) (1910–1953) Belgian jazz guitarist. Django blended folk music with jazz and swing styles and is noted for his improvisations. In 1934 he formed a quintet with the violinist Stéphane Grappelli and they played as the "Hot Club". He also played in the USA with Duke Ellington.

relative atomic mass (r.a.m.) (formerly atomic weight) Mass of an atom of the naturally occurring form of an element divided by 1/12 of the mass of an atom of carbon-12. The naturally occurring form may consist of two or more isotopes, and the calculation of the r.a.m. must take this into account.

relative density (r.d.) (formerly specific gravity) Ratio of the DENSITY of a substance to the density of water. Thus, the relative density of gold is 19.3: it is about 19 times denser than an equal volume of water.

relative molecular mass (formerly molecular weight) Mass of a molecule, the sum of the relative atomic masses of all its atoms. It is the ratio of the average mass per molecule of an element or compound to one twelfth of the mass of an atom of carbon-12. The molecular masses of reactants (elements or compounds) must be known in order to make calculations about yields in a chemical reaction.

◄ reindeer Always found in herds, reindeer (Rangifer tarandus) migrate vast distances between summer and winter feeding grounds. They are adapted to two different environments: tundra and woodland. Their large hoofs can spread when they walk on snow or soft ground.

12 3 10010

Remote sensing satellites (1) view the Earth from space using various sensors and cameras. The ways of looking at the Earth are divided between active and passive. Active devices, such as optical cameras and infra-red scanners, pick up reflected radiation. Active instruments send out radio pulses and record the return signal. One of the strengths of active scanning is the ability to see through cloud. The satellites, powered by a solar sail (2), use orbits which take them over the whole of the Earth over a series of days (3). Images of the Earth's surfaces are beamed down to ground stations (4) in digital form (5), and are converted into pictures by computers (6)

relativity Theory, proposed by Albert Einstein, based on the postulate that the motion of one body can be defined only with respect to that of a second body. This led to the concept of a four-dimensional space-time continuum in which the three space dimensions and time are treated on an equal footing. The special theory, put forward in 1905, is limited to the description of events as they appear to observers in a state of uniform relative motion. The more important consequences of the theory are: (1) that the velocity of light is absolute, that is, not relative to the velocity of the observer; (2) that the mass of a body increases with its velocity, although appreciably only at velocities approaching that of light; (3) that mass (m) and energy (E) are equivalent, that is, $E = mc^2$, where c is the velocity of light (this shows that when mass is converted to energy, a small mass gives rise to large energy); (4) the Lorentz-Fitzgerald contraction, that is, bodies contract as their velocity increases, again only appreciably near the velocity of light; and (5) an object's sense of elapsed time expands, "time dilation". The general theory of relativity, completed in 1915, is applicable to observers not in uniform relative motion. This showed the relation of space and GRAVITATION. The presence of matter in space causes space to "curve", forming gravitational fields; thus gravitation becomes a property of space itself. The existence of black holes is postulated as a consequence of this.

relief (It. *rilievo*, projection) Three-dimensional sculpture projecting from a flat background. In *alto-rilievo* (high relief) the protrusion is great, *basso-rilievo* (low relief) protrudes only slightly, and *mezzo-rilievo* is between the two.

religion Code of beliefs and practices formulated in response to a spiritual awareness of existence. It may involve either faith in a state of existence after earthly death, or a desire for union with an omnipotent spiritual being, or a combination of the two. Polytheistic religions, such as those of ancient Egypt, Greece and Rome, entailed the worship of many distinct gods or personifications of nature. Many cultures classified their deities into hierarchies known as pantheons; some religions, such as HINDUISM, still have such pantheons. Other ancient religions, some of which incorporated belief in a state of existence after death, were more of a system of ethical philosophy concentrating on metaphysical contemplation (for example, BUDDHISM and TAOISM). The ancient Hebrews were among the first people to worship a single omniscient and omnipotent being, YAHWEH. He gave them His protection in return for their total faith and obedience. Common to all religions dominated by a single omnipotent force (monotheistic religions such as JUDAISM,

CHRISTIANITY and ISLAM) is the idea that the power is all places at once, and that it is beyond the physical plane occupied by humans. In many religions, both monotheistic and polytheistic, sacrifice to an individual god or to God is an important element, either in propitiation, or to redeem the faithful from some wrongdoing, or in thanksgiving.

Religion, Wars of (1562–98) Series of religious conflicts in France. At stake was freedom of worship for HUGUENOTS (Protestants), but it was also a struggle between crown and nobility. The Huguenot leaders were, successively, Louis I de CONDÉ, Caspard de Coligny and Henry of Navarre (later HENRY IV). The Catholic party was led by the House of GUISE. The crown, represented by CATHERINE DE' MEDICI and her sons, CHARLES IX and HENRY III, attempted to pursue a moderate Catholic line. The first three civil wars (1562-63, 1567-68, 1568-70) ended in the Treaty of St Germain (1570), which granted concessions to the Protestants. Hostilities recommenced with the SAINT BARTHOLOMEW'S DAY MASSACRE (1572). The fifth civil war (1574-76) resulted in the Edict of Beaulieu that granted freedom of worship to Huguenots. The Catholic party formed a Holy League and the edict was revoked, prompting renewed conflict. Henry III's naming of Henry of Navarre as his heir led to the War of the Three Henrys (1585-89). Henry IV emerged victorious and the Edict of NANTES (1598) extended toleration to the Huguenots.

Remarque, Érich Maria (1898–1970) German novelist, b. Erich Paul Remark. A World War 1 veteran, his best-known novel, *All Quiet on the Western Front* (1929), is a savage indictment of war. The sequel *The Road Back* (1931) concerns Germany's post-war collapse and readjustment.

Rembrandt Harmenszoon van Rijn (1606–69) Dutch painter and graphic artist. Between 1625 and 1631 he painted many self-portraits. He settled in Amsterdam (1631–32), becoming highly regarded as a painter of group portraits such as the Anatomy Lesson of Dr Tulp (1632). By 1636 he was painting in the richly detailed BAROQUE style typified by the Sacrifice of Abraham (1636). In 1642, the year his first wife died giving birth to their son, he finished his famous group portrait, The Corporalship of Captain Frans Banning Cocq's Civic Guards (or The Night Watch). By 1656 he was so deeply in debt that he withdrew from society. During these later years he produced some of his greatest works, such as Jacob Blessing the Sons of Joseph (1656) and The Jewish Bride (late 1660s). His works total more than 300 paintings, some 300 etchings and 1,000 drawings.

Remembrance Sunday Second Sunday of November, the annual commemoration in the UK of the armed forces who died in World War 1 and World War 2. After World War 1, the dead were remembered on Armistice Day, 11 November, the date of the World War 1 cease-fire. Remembrance Sunday was introduced in Britain after World War 2.

Remington, Frederic (1861–1909) US painter and sculptor. His romantic depictions of cowboys and Native Americans became immensely popular. His works include *The Scout, Friends or Enemies* (1908) and the bronze *Bronco Buster*.

remote sensing Any method of obtaining and recording information from a distance. The most common sensor is the CAMERA; cameras are used in aircraft, satellites and space probes to collect information and transmit it back to Earth (often by radio). The resulting photographs provide a variety of information, including archeological evidence and weather data. MICROWAVE sensors use radar signals that can penetrate cloud. Infrared sensors can measure temperature differences over an area. Data from sensors is processed by computers.

Remus See Romulus and Remus

Renaissance (Fr. rebirth) Period of European history lasting roughly from the mid-15th century to the end of the 16th century. The word was used by late 15th-century Italian scholars to describe the revival of interest in classical learning. It was helped by the fall of Constantinople to the Ottoman Turks in 1453, which resulted in the transport of classical texts to Italy. In Germany, the invention of a printing press with moveable type assisted the diffusion of the new scholarship. In religion, the spirit of questioning led to the REFORMATION. In politics, the Renaissance saw the rise of

assertive sovereign states - Spain, Portugal, France and England – and the expansion of Europe beyond its own shores, with the building of trading empires in Africa, the East Indies and America. The growth of a wealthy urban merchant class led to a tremendous flowering of the arts. See also RENAIS-SANCE ARCHITECTURE; RENAISSANCE ART; RENAISSANCE MUSIC Renaissance architecture Architectural style that began in Italy in the 15th century and spread throughout Europe

until the advent of MANNERISM and the BAROQUE in the 16th and 17th centuries. Revolting against GOTHIC ARCHITECTURE, it used Roman motifs. In Italy, BRUNELLESCHI and ALBERTI studied the Roman ruins. In France, the style was first employed by Lescot, who was commissioned by Francis I to work on the Louvre (1546). In other European countries, classical forms were integrated with medieval motifs.

Renaissance art Style that emerged in Italy in the 15th century, heavily influenced by classical Greek or Roman models and by the new HUMANISM. In painting, the decisive differences between Gothic and Renaissance painting emerged in Florence in the early 15th century. These differences included: the development of PERSPECTIVE; a new interest in composition and colour harmonies; the increasing use of secular or pagan subject matter; the rise of portraiture; constant experimentation to develop new skills; and a growing concern for the expression of the individual artist. The creators of High Renaissance painting were LEONARDO DA VINCI, MICHELANGELO and RAPHAEL. The ideas of the Italian artists were taken to France and N Europe and emulated with national variations. Renaissance literature found an early exponent in PETRARCH; other Italian Renaissance literary figures include DANTE and MACHIAVELLI. By the 16th century the Renaissance literary movement had reached N Europe, where it inspired much poetry and history writing and culminated, in England, in the dramas of Shakespeare.

Renaissance music Music composed in Europe from c.1400 to 1600. It was mainly religious vocal POLYPHONY, usually MASSES and MOTETS. Non-religious music at this time was mainly in the form of songs - Italian and English MADRIGALS, French chansons, German Lieder - and some instrumental music for organ, clavier, lute, or for small ensembles. Renaisssance composers include PALESTRINA, LASSO, BYRD and GABRIELI.

renewable energy (alternative energy) ENERGY from a source that can be replenished or that replenishes itself and is more environmentally safe than traditional energy forms such as COAL, GAS OF NUCLEAR ENERGY. SOLAR ENERGY harnesses the rays of the Sun. TIDAL POWER stations use the gravitational force of the Sun and Moon on the ocean. Wave power harnesses the natural movement of the sea. The power of rivers and lakes can be tapped by damming the flow and using turbines to generate HYDROELECTRICITY. WIND POWER schemes have existed for centuries in the form of WINDMILLS. Another, less well-known, renewable source is the GEOTHERMAL ENER-GY produced in the Earth's crust.

Reni, Guido (1575-1642) Italian painter who became the leading master of Bolognese art. His most celebrated works include Massacre of the Innocents (1611), Aurora (1613) and Atlanta and Hippoinenes (c.1625).

Rennes City at the confluence of the Ille and Vilaine rivers, NW France; capital of Ille-et-Vilaine département. During the Middle Ages, Rennes served as capital of Brittany under the Angevin dukes. In the 16th century it became the seat of the parliament of Brittany. Rennes suffered heavy bombing in World War 2. Industries: leather, printing, textiles, electronic equipment, motor vehicles, oil refining. Pop. (1990) 199,396.

rennet Substance used to curdle milk in cheesemaking. It is obtained as an extract from the inner lining of the fourth stomach of calves and other young ruminants, and is rich in rennin, an ENZYME that coagulates the casein (protein) of milk.

Renoir, Jean (1894–1979) French director and actor, son of Pierre Auguste Renoir. His major films include Nana (1926), Madame Bovary (1934), La Règle du Jeu (1939), French Cancan (1955), and C'est la Revolution (1967). In 1975 he won an honorary Academy Award for lifetime achievement.

Renoir, Pierre Auguste (1841-1919) French impression-

ist painter. In 1874 he contributed to the first exhibition of IMPRESSIONISM and masterpieces of this period include La Loge (1874) and Le Moulin de la Galette (1876). In the early 1880s he became interested in the human figure with such works as Bathers (1884–87) and After the Bath (c.1895).

reparations War damage payments, especially those demanded by the victorious Allies from the defeated Central Powers at the Treaty of VERSAILLES (1919). The USA did not ratify the treaty and waived all reparation claims.

repetitive strain injury (RSI) Pain and reduced mobility in a limb, most often the wrist, caused by constant repetition of the same movements. The symptoms arise from inflammation of the tendon sheaths because of excessive use. RSI is an occupational disorder mostly seen in assembly line workers and keyboard operators.

Representatives, House of See House of Representa-

repression Process by which unacceptable thoughts or memories are kept in the UNCONSCIOUS so that they cannot cause guilt or distress. In Freudian psychology, it is part of the function of the ego, whereby it controls the primal and instinctual urges of the id. Repressed desires find an outlet in dreams, and are believed to be at the root of various neurotic disorders.

reproduction Process by which living organisms create new organisms similar to themselves. Reproduction may be sexual or asexual, the first being the fusion of two special reproductive cells from different parents, and the second being the generation of new organisms from a single organism. ASEXUAL REPRODUCTION is the more limited, found mainly in PROTOZOA, some INVERTEBRATES and in many plants. By contrast, almost all living organisms have the capacity for SEXUAL REPRODUCTION. In the majority of cases the species has two kinds of individuals - male and female with different sex functions. Male and female sex cells (in animals, sperm and egg) fuse to produce a new cell, the ZYGOTE, which contains genetic information from both parents, and from which a new individual develops. Alternatively, organisms may be HERMAPHRODITES, each individual of the species having male and female functions, so that when two of them mate each individual fertilizes the other's eggs. Sexually reproducing plants (or generations) are called GAME-TOPHYTE; ones which reproduce asexually, SPOROPHYTE. See also ALTERNATION OF GENERATIONS; POLLEN

reptile Any one of about 6,000 species of VERTEBRATES distributed worldwide. Reptiles are cold-blooded. Most lay volky eggs on land. Some species - particularly SNAKES carry eggs in the body and bear live young. The skin is dry and covered with scales or embedded with bony plates. Their limbs are poorly developed or non-existent. Those with limbs usually have five clawed toes on each foot. There are now four living orders: Chelonia (TURTLES); Rhynchocephalia ▼ Renoir Bal du Moulin de la Gallete, Montmartre (1876). The impressionist painter Auguste Renoir delighted in painting the human figure, particularly women. This example clearly shows how he explored the effects of light and shadow on faces and bodies, which was typical of his early work. From the 1880s, influenced by a trip to Italy and study of the Old Masters, his style became more linear, moving away from the free brushwork of the 1870s

(TUATARA); Squamata (scaly reptiles such as snakes and LIZARDS); and Crocodilia (ALLIGATORS and CROCODILES).

republic State in which sovereignty is vested in the people or their elected or nominated representatives. A republic may also be understood to be a state in which all segments of society are enfranchised and the power of the state is limited.

Republican Party US political party. It was organized in 1854 as an amalgamation of WHIGS and Free-Soilers, with workers and professional people who had formerly been known as Independent Democrats, Know-Nothings, Barnburners or Abolitionists. Its first successful presidential candidate was Abraham LINCOLN (elected 1860) and the Republican Party dominated US politics for the rest of the century. In the 20th century, the Republicans have usually been the minority party to the DEMOCRATIC PARTY in Congress, especially in the House of Representatives. There was a Republican president for all but four years between 1969 and 1993. Under presidents Ronald REAGAN and George BUSH, the Republican Party swung to the right and seemed to have captured the popular vote, until Bill CLINTON's charismatic campaign restored Democratic fortunes. The Senate and House of Representatives, however, remained in Republican control.

requiem Solemn choral service for the dead sung in Roman Catholic Churches. Mozart, Verdi and Berlioz, among others, have composed requiems.

resin (rosin) Artificial or natural POLYMER that is generally viscous and sticky. Artificial resins include polyesters and epoxies and are used as adhesives and binders. Natural resins are secreted by various plants. Oleoresin, secreted by conifers, is distilled to produce turpentine; rosin remains after the oil of turpentine has been distilled off.

resistance (symbol *R*) Property of an electric conductor, calculated as the ratio of the voltage applied to the conductor to the current passing through it. The SI unit of resistance is the OHM. It represents the opposition to the flow of electric current. *See also* RESISTOR

resistance movement Underground organizations that worked against German rule in occupied countries of Europe during World War 2. In some countries, such as Poland and Yugoslavia, they were strong enough to mount armed resistance. Elsewhere, as in France, the Low Countries and Scandinavia, their role was confined to sabotage and intelligence. **resistivity** (symbol ρ) Electrical property of materials. Its value is given by $\rho = AR/I$, where A is the cross-sectional area of a conductor, I is its length and R is the RESISTANCE. Resistivity is generally expressed in units of ohm-metres and is a measure of the resistance of a piece of material of given size.

resistor Electrical CIRCUIT component with a specified RESISTANCE. Resistors limit the size of the current flowing. Those for electronic circuits usually consist of carbon particles mixed with a ceramic material and enclosed in an insulated tube. Resistors for carrying larger currents are coils of insulated wire. resonance Increase in the amplitude of vibration of a mechanical or acoustic system when it is forced to vibrate by an external source. It occurs when the FREQUENCY of the applied force is equal to the natural vibrational frequency of the system. Large vibrations can cause damage to the system. resources In economics, a country's collective means of support. Economists divide resources into four categories: land, labour, capital and raw materials.

respiration Series of chemical reactions by which complex molecules (food molecules) are broken down to release energy in living organisms. These reactions are controlled by ENZYMES, and are an essential part of METABOLISM. There are two main types of respiration: AEROBIC and ANAEROBIC. In aerobic respiration, oxygen combines with the breakdown products and is necessary for the reactions to take place. Anaerobic respiration takes place in the absence of oxygen. In most living organisms, the energy released by respiration is used to convert ADP (adenosine diphosphate) to ATP (adenosine triphosphate), which transports energy around the cell. At the site where the energy is needed, ATP is converted back to ADP, with the aid of a special enzyme, and energy is released. The first stages of respiration take place in the cytoplasm and the later stages in the MITOCHONDRIA.

respiratory system System in air-breathing animals concerned with GAS EXCHANGE. The respiratory tract begins with the nose and mouth, through which air enters the body. The air then passes through the LARYNX and into the TRACHEA. The trachea at its lower end branches into two bronchi, each BRONCHUS leads to a LUNG. The bronchi divide into many bronchioles, which lead in turn to bunches of tiny air sacs (ALVEOLI), where the exchange of gases between air and blood takes place. Exhaled air leaves along the same pathway.

response, conditioned Learned pairing of a response to an artificial stimulus. In the classic experiments of PAVLOV, dogs were taught to associate the ringing of a bell with their being given food, and they began to salivate just at the sound of the bell. The dog's salivation in these experiments was the conditioned response.

Restoration In English history, the re-establishment of the monarchy in 1660. After the death of Oliver Cromwell, his son and successor, Richard, was unable to prevent growing conflict or restrain the increasing power of the army. He resigned (1659), and the crisis was resolved by the march of General Monck from Scotland. Army leaders backed down and a new Parliament was elected. From exile, CHARLES II issued the Declaration of Breda (1660), promising an amnesty to opponents (except those directly responsible for the execution of CHARLES I), payment of the arrears in the army's wages, and religious toleration. He was invited by a new Parliament to resume the throne. The term Restoration is often extended to the period following 1660, and is especially associated with a flowering of English literature, notably in RESTORATION DRAMA. In French history, it refers to the restoration of the Bourbons (1814-30) after the defeat of Napoleon. **Restoration drama** Plays and performances in the period following the restoration of CHARLES II, when the theatres were reopened. The drama reflected the laxity of court morals through broad satire, farce, wit and bawdy comedy. Distinguished playwrights included DRYDEN and CONGREVE.

restriction enzyme ENZYME used in GENETIC ENGINEERING to cut a molecule of DNA at specific points, in order to insert or remove a piece of DNA. There are many different restriction enzymes; each cuts the DNA at a specific sequence of bases, allowing great precision in genetic engineering.

resurrection Rising of the dead to new life, either in heaven or on Earth. JUDAISM, CHRISTIANITY and ISLAM all hold that at the end of the world there will come a Day of Judgement on which those worthy of eternal joy will be allowed to draw near to God, while those unworthy will be cast out into darkness. The term also applies to the rising of JESUS CHRIST from the dead on the third day after his crucifixion.

resuscitation Measures taken to revive a person who is on the brink of death. The most successful technique available to the layman is mouth-to-mouth resuscitation. Medical staff receive instruction in cardiopulmonary resuscitation (CPR), which involves the use of specialized equipment and drugs to save patients whose breathing and/or heartbeat suddenly stop. retail price index (RPI) Governmental measure of changing retail prices in Britain, from which the rate of inflation is calculated. It is based on a constant selection of goods, weighted according to their importance in a household's budget.

retina Inner layer of the EYE, composed mainly of different kinds of NEURONS, some of which are the visual receptors of the eye. Receptor cells (cones and rods) are sensitive to light. Cones respond to the spectrum of visible colours; rods respond to shades of grey and to movement. The rods and cones connect with sensory neurons, which in turn connect with the optic nerve, which carries the visual stimuli to the brain.

retriever Sporting dog originally used to kill or cripple downed game and return it to the hunter; today it is also used to locate game and is a popular pet. The main breeds include the golden retriever and the Labrador retriever.

retrovirus Any of a large family of VIRUSES (Retroviridae) that, unlike other living organisms, contain the genetic material RNA (ribonucleic acid) rather than the customary DNA (deoxyribonucleic acid). In order to multiply, retroviruses make use of a special enzyme to convert their RNA into DNA, which then becomes integrated with the DNA in the

cells of their hosts. Diseases caused by retroviruses include Acquired Immune Deficiency Syndrome (AIDS).

Réunion Volcanic island in the Indian Ocean, in the Mascarene group, c.700km (440mi) E of Madagascar, forming an overseas département of France; the capital is St Denis. Discovered in 1513 by the Portuguese, it was claimed by France in 1638. The island became an overseas département in 1948 and part of an administrative region in 1973. Exports: sugar, rum, maize, tobacco. Area: 2,510sq km (969sq mi). Pop. (1994 est.) 645,000.

Reuters News agency that transmits international news between major cities worldwide. It originated as a service between Britain and continental Europe, using the telegraph. It is jointly owned by Australian, New Zealand and British newspapers. It was founded by Paul Reuter in the 1850s.

Revelation (Apocalypse) Last book of the New Testament. It was written perhaps as late as AD 95 by St John the Divine. In highly allegorical and prophetic terms, it concentrates on depicting the end of Creation, the war between good and evil, the Day of Judgment, and the ultimate triumph of good.

Revere, Paul (1735–1818) American silversmith and patriot, famous for his ride from Charlestown to Lexington, Massachusetts. Revere made his ride on the night of 18 April 1775 to warn the colonists of Massachusetts of the approach of British troops at the start of the AMERICAN REVOLUTION. It was commemorated in Longfellow's poem, "Paul Revere's Ride" (1863).

reversible reaction Chemical reaction in which the products can change back into the reactants. Thus, nitrogen and hydrogen can be combined to give ammonia (as in the HABER PROCESS) and ammonia may be decomposed to nitrogen and hydrogen. Such processes yield an equilibrium mixture of reactants and products. See also CHEMICAL EQUILIBRIUM

revisionism Political theory derived from MARXISM. Eduard Bernstein, the first Marxist revisionist, asserted (1890) that capitalism was not in crisis, and that the transition to SOCIALISM would be a matter of peaceful evolution. This conflicted directly with orthodox Marxist belief in the inevitable collapse of capitalism. After 1945 the term was used by communist regimes to condemn political movements that threatened official party policy.

revolution Movement of a planet or other celestial object around its orbit, as distinct from ROTATION of the object on its axis. A single revolution is the planet's or satellite's "year".

revolution In a political sense, fundamental change in values, political institutions, social structure and leadership brought about by a large-scale, successful revolt. The totality of change distinguishes it from coups, rebellions and wars of independence, which seek and achieve only particular changes. The term is also used to indicate great economic and technical changes, such as the Industrial Revolution.

Revolutions of 1848 Series of revolutions in European countries which broke out within a few months of each other. The general cause was the frustration of liberals and nationalists with the governing authorities, and a background of economic depression. The risings began with the February Revolution against Louis Philippe in France, which resulted in the foundation of the Second Republic. It inspired revolts in Vienna (forcing the resignation of Metternich), and among the national minorities under Austrian rule. In Germany, liberals forced Frederick William IV to summon a constitutional assembly, while advocates of German unification hoped to achieve their aim in the Frankfurt Parliament.

Revolutions of 1989 Popular risings in East European states against communist governments. Long-suppressed opposition to Soviet-dominated rule erupted spontaneously in most of the Soviet satellite states. Within months, the communists were driven from power and a democratic system installed. They were followed by the withdrawal of the constituent republics of the Soviet Union which, though unwelcome to Moscow, also encountered little serious resistance.

revue Theatrical entertainment purporting to give a review, usually satirical, of current fashions, events and personalities. **Reykjavík** Capital of Iceland, a port on the sw coast. Founded *c*.870, it was the island's first permanent settlement. It

expanded during the 18th century and became the capital in 1918. During World War 2 it served as a British and US air base. Industries: food processing, fishing, textiles, metallurgy, printing and publishing, shipbuilding. Pop. (1993) 101,824.

Reynolds, Albert (1933—) Irish statesman, taoiseach (1992–94). Reynolds entered the Dáil in 1977 and quickly joined the Fianna Fáil cabinet. He was dismissed in 1991 after trying to displace the prime minister, Charles Haughey, but when Haughey was forced to resign, Reynolds succeeded him. Fianna Fáil lost their majority in 1992 elections and he was forced into coalition with the Labour Party. Reynolds and the British prime minister, John Major, issued the Downing Street Declaration (1993). In 1994 the Labour Party withdrew its support and he was forced to resign.

Reynolds, Sir Joshua (1723–92) English portrait painter and writer on art. The first president (1768) of the ROYAL ACADEMY OF ARTS, he espoused the principles of the "Grand Manner" style in his *Discourses*. These writings describe how painting, through allusions to classical, heroic figures, can be a scholarly activity. His masterpiece portraits are remarkable for their individuality and sensitivity to the sitter's mood, many of whom are painted in classical poses.

rhapsody Musical term applied in the 19th and 20th centuries to orchestral works, usually performed in one continuous movement and most often inspired by a nationalist or romantic theme.

rhea Either of two species of large, brownish, flightless, fastrunning South American birds resembling a small OSTRICH. They feed mostly on vegetation and insects. Height: to 1.5m (5ft). Family Rheidae.

Rhee, Syngman (1875–1965) Korean statesman, first president (1948–60) of South Korea. Rhee was imprisoned (1898–1904) for his opposition to Japanese rule, before living (1912–45) in exile in the USA. In 1919 he became leader of a government-in-exile. After World War 2 he was leader of US-occupied South Korea. His presidency was marked by the KOREAN WAR. Rhee's staunch anti-communist policy attracted the support of the US. His regime became increasingly authoritarian and corrupt. Re-elected for a fourth time, accusations of vote-rigging sparked riots and Rhee was forced to resign.

rhenium (symbol Re) Silver-white metallic element, one of the TRANSITION ELEMENTS, which have incomplete inner electron shells. Discovered in 1925, rhenium is found in molybdenite and PLATINUM ores from which it is obtained as a byproduct. It is heavy and used in alloys in thermocouples, camera flashlights and electronic filaments, and is also a useful catalyst. Properties: at.no. 75; r.a.m. 186.2; r.d. 21.0; m.p. 3,180°C (5,756°F); b.p. 5,627°C (10,160°F); most common isotope Re¹⁸⁷ (62.93%).

rheostat Variable RESISTOR for regulating an electric current. The resistance element may be a metal wire, carbon or a conducting liquid. Rheostats are used to adjust generators, to dim lights and to control the speed of electric motors.

rhesus Medium-sized, yellow-brown MACAQUE monkey of India. Short-tailed, it has a large head with a bare face, large ears and closely spaced, deep-set eyes. Height: 60cm (2ft). Species *Macaca mulatta*.

rhetoric Art of discourse and persuasive speaking; language, written or spoken, designed to impress or persuade. Rhetoric is valued in public speaking, but the sophistication of many of its modern techniques may have led rhetoricians – such as politicians – to be more distrusted by a better-informed public.

rheumatic fever Inflammatory disorder characterized by fever and painful swelling of the joints. Rare in the modern developed world, it mostly affects children and young adults. An important complication is possible damage to the heart valves, leading to rheumatic heart disease in later life.

rheumatism General term for a group of disorders whose symptoms are pain, inflammation and stiffness in the bones, joints and surrounding tissues. Usually some form of ARTHRITIS is involved.

Rhine (Rhein, Rhin or Rijn) River in w Europe. It rises in the Swiss Alps and flows N, bordering on or passing through Switzerland, Austria, Liechtenstein, Germany, France and the Netherlands to enter the North Sea at Rotterdam. The Rhine

▲ rhea The flightless rhea roams the pampas of South America in flocks of up to 30. Its height enables it to detect danger even in high grass and it can run faster than a horse. The male rhea is responsible for incubation of eggs.

➤ rhinoceros The yellow-billed oxpecker (Buphagus africanus) and the African White Rhino (Cerato therium simum) have a symbiotic relationship. The oxpecker, a type of African starling, feeds by pulling ticks from the animal's hide and sipping blood that oozes from tick wounds. The rhino benefits from the removal of the parasites.

is navigable to ocean-going vessels as far as Basel in Switzerland and is a major transport route for some of w Europe's most industrialized areas. Length: c.1,320km (820mi).

Rhineland Region in w Germany along the w bank of the River Rhine. It includes Saarland and Rhineland-Palatinate, and parts of Baden-Württemberg, Hesse and North Rhine-Westphalia. It was the scene of heavy fighting in the later stages of World War 2.

rhinitis Inflammation of the mucous membrane of the nose. It may be an allergic reaction (such as HAY FEVER) or a symptom of a viral infection, such as the common cold.

rhinoceros (rhino) Massive, herbivorous mammal native to Africa and Asia. Rhinos have thick skin and poor eyesight, and are solitary grazers or browsers. In the heat of the day they like to wallow in muddy pools. Now rare except in protected areas, rhinos are illegally hunted for their horns (believed to have aphrodisiac properties). Weight: 1–3.5 tonnes. Family Rhinocerotidae.

rhizoid Fine hairlike growth used for attachment to a solid surface by some simple organisms, such as certain fungi and mosses. The rhizoid lacks the conducting TISSUES of a root.

rhizome Creeping, root-like underground stem of certain plants. It usually grows horizontally, is rich in accumulated starch, and can produce new roots and stems asexually. Rhizomes differ from roots in producing buds and leaves. *See also* TUBER

Rhode Island State in NE USA, on the Atlantic coast in New England; the smallest state in the USA; the capital is PROVIDENCE. Other major cities include Warwick, Pawtucket and Cranston. The region was first settled in 1636 by people from Massachusetts seeking religious freedom. It was granted a royal charter in 1663. It was occupied by British troops during the American Revolution. Much of the land is forested, but there is some dairy farming. Potatoes, hay, apples, oats and maize are the chief crops, and fishing is significant. Other industries: textiles, fabricated metals, silverware, machinery, electrical equipment and tourism. Area: 3,144sq km (1,214sq mi). Pop. (1993 est.) 1,000,012.

Rhodes, Cecil John (1853–1902) South African statesman, b. Britain. Rhodes emigrated to Natal in 1870 and made a fortune in the Kimberley diamond mines. He dreamed of building a British empire that stretched from the Cape to Cairo. In 1880 he founded the De Beers Mining Company. In 1885 he persuaded the British government to establish a protectorate over Bechuanaland. Rhodes founded (1889) the British South Africa Company, which occupied Mashonaland and Matabeleland, thus forming Rhodesia (now Zambia and Zimbabwe). Rhodes was prime minister (1890–96) of Cape Colony. The discovery of his role in Leander JAMESON's attempt to overthrow Paul KRUGER in the TRANSVAAL led to his resignation.

Rhodes (Ródhos) Greek island in the SE Aegean Sea; the largest of the Dodecanese archipelago. It was colonized by the Dorians c.1000 BC and later conquered at different times by Persia, Sparta, Athens, Macedon, Rome and the Byzantine empire. The island was captured in 1310 by the KNIGHTS HOSPITALLERS, who defended it against the Turks for more than 200 years. It was taken by the Ottoman Turks in 1522. Ceded

to Italy in 1912, it was awarded to Greece in 1947. The chief city is Rhodes. Products: wheat, tobacco, cotton, olives, fruits, vegetables. Area: 1,400sq km (540sq mi). Pop. (1981) 88,000. **Rhodesia** Former name of a territory in s central Africa. The area was developed by Cecil Rhodes. In 1923 Southern Rhodesia became a self-governing British colony, and in 1924 Northern Rhodesia was made a British protectorate. In 1953 the two Rhodesias were united with Nyasaland (now MALAWI) in the Central African Federation. When the federation was dissolved (1963), Northern Rhodesia achieved independence as ZAMBIA. The name Rhodesia was used by Southern Rhodesia until it achieved independence as ZIMBABWE (1980).

rhodium (symbol Rh) Silver-white metallic element, one of the TRANSITION ELEMENTS. Discovered in 1803, it is associated with PLATINUM and its chief source is as a by-product of NICKEL smelting. It resists tarnish and corrosion and is used in hard platinum alloys and jewellery. Properties: at. no. 45; r.a.m. 102.906; r.d. 12.4; m.p. 1,966°C (3,571°F); b.p. 3,727°C (6,741°F); most common isotope Rh¹⁰³ (100%).

rhododendron Large genus of shrubs and small trees that grow in the acid soils of cool temperate regions in North America, Europe and Asia. Primarily evergreen, they have leathery leaves and bell-shaped white, pink or purple flowers. Family Ericaceae. *See also* AZALEA

Rhodophyta See RED ALGAE

rhombus Plane figure with all of its sides equal in length but no right angles. A rhombus is a type of PARALLELOGRAM whose diagonals bisect each other at right angles.

Rhône River in w Europe. It rises in the Rhône Glacier in s Switzerland, runs through the Bernese Oberland, flows w to Lake Geneva and then crosses the French border. It continues s through Lyon and Avignon to Arles, where it branches into the Grand Rhône and the Petit Rhône, which both enter the Mediterranean w of Marseilles. Length: 813km (505mi).

rhubarb Perennial herbaceous plant native to Asia and cultivated in cool climates throughout the world for its edible leaf stalks. It has large poisonous leaves and small white or red flowers. Height: to 1.2m (4ft). Genus *Rheum*.

rhyme Identity of similarity of final sounds in two or more words, such as keep/deep and baking/shaking. Rhyme is used in poetry to reinforce METRE. End rhymes establish verse lines, while internal rhymes emphasize rhythmic structures.

rhythm and blues Form of popular music. It developed as an urban form of the BLUES, and was also influenced by JAZZ. An energetic and relatively simple music, it was the basis of ROCK AND ROLL.

rib Long, curved bones that are arranged in pairs, extending sideways from the backbone of vertebrates. In fish and some reptiles they extend the length of the spine; in mammals they form the framework of the chest, and protect the lungs and heart. There are 12 pairs of ribs in humans.

Ribbentrop, Joachim von (1893–1946) German diplomat and politician. Von Ribbentrop joined the Nazi Party in 1932 and became foreign affairs adviser to HITLER in 1933. He initiated the Nazi-Soviet Pact (1939), but steadily lost influence during World War 2. At the NUREMBERG TRIALS (1946), he was convicted of war crimes and hanged.

Ribera, José (1591–1652) Spanish painter and graphic artist. His early work, like that of CARAVAGGIO, used dark shadows, but Ribera was capable of expressing great tenderness. His late paintings, such as *The Clubfooted Boy* (1642), are often richly coloured and softly modelled. Until the Napoleonic Wars, he and Bartolomé MURILLO were the only Spanish painters of international repute.

riboflavin VITAMIN B_2 of the B complex, lack of which impairs growth and causes skin disorders. It is a coenzyme important in transferring energy within cells. Soluble in water, riboflavin is found in milk, eggs, liver and green vegetables.

ribonucleic acid See RNA

ribosome Tiny structure in the CYTOPLASM of EUKARYOTE cells, involved in synthesizing PROTEIN molecules. Proteins are made up of specific sequences of AMINO ACIDS, and segments of DNA, called GENES, contain the instructions for individual proteins. The DNA molecule is too large to escape from the CELL nucleus into the cytoplasm, but a "copy" is

▲ rhizome Unlike other plant storage organs, rhizomes are not replaced annually. They grow continually, branching as they do so, and each growing tip produces aerial shoots. The oldest parts slowly die off. Shown here is the rhizome of Solomon's seal (Polygonatum multiflorum).

made in the form of messenger RNA, and this travels to the ribosomes. Ribosomes attach themselves to the messenger RNA, then assemble the amino acids in the correct sequence to form a particular protein. Ribosomes are made up of proteins and ribosomal RNA. See also GENETIC CODE

Ricardo, David (1772–1823) British political economist. Ricardo advocated minimal state interference and a free market. His labour theory of value (that the price of commodities reflects the labour involved in their production), advanced in *Principles of Political Economy and Taxation* (1817), had a strong influence on Karl MARX.

rice Plant native to SE Asia and Indonesia, cultivated in many warm humid regions, and the main grain food for Middle and Far East countries. It provides a staple diet for half the world's population. It is an ANNUAL grass; the seed and husk is the edible portion. It is usually grown in flooded, terraced paddies with hard subsoil to prevent seepage. Species *Oryza sativa*.

Richard I (1157–99) King of England (1189–99), known as Richard the Lion-Heart, or *Coeur de Lion*. He was involved in rebellions against his father, HENRY II, before succeeding him. A leader of the Third CRUSADE (1189–92), he won several victories but failed to retake Jerusalem. He was a prisoner (1192–94) of Emperor HENRY VI. Meanwhile, his brother, JOHN, conspired against him in England, while in France PHILIP II invaded Richard's territories. The revolt in England was contained, and from 1194 until his death, Richard endeavoured to restore the ANGEVIN empire in France.

Richard II (1367-1400) King of England (1377-99), son of EDWARD THE BLACK PRINCE. Richard succeeded his grandfather, EDWARD III, and soon was faced with the PEASANTS' REVOLT (1381). His reign was marked by conflict with the barons. Richard's uncle, JOHN OF GAUNT, led a council of regency until 1381. On the orders of the "lords appellant", the "Merciless Parliament" (1388) executed many of Richard's supporters. Richard reasserted control and reigned ably until he began to assume authoritarian powers. In 1397-98 he exacted his revenge on the lords appellant by having the duke of Gloucester murdered and the duke of Hereford (son of John of Gaunt) banished. In 1399 Richard confiscated Gaunt's estates. Hereford led a successful revolt and was crowned HENRY IV. Richard was imprisoned and died in mysterious circumstances. Richard III (1452-85) King of England (1483-85). As Duke of Gloucester, he ably supported his brother, EDWARD IV, in N England. When Edward died, Richard became protector and had the young King EDWARD V declared illegitimate and took the crown himself. Edward and his younger brother, the "Princes in the Tower", subsequently disappeared. Richard's numerous enemies supported the invasion of Henry Tudor (HENRY VII) in 1485. Richard's death at the battle of Bosworth ended the Wars of the Roses.

Richards, I.A. (Ivor Armstrong) (1893–1979) British literary critic and theorist. Richard's emphasis on close reading and verbal analysis of literary works is expounded in *The Principles of Literary Criticism* (1924) and *Practical Criticism* (1929). *See also LITERARY CRITICISM*

Richards, Viv (Isaac Vivian Alexander) (1952–) West Indian cricketer, b. Antigua. Richards made his test debut in 1974, and was West Indies captain (1985–1991). He played county cricket in England for Somerset (1974–86) and Glamorgan (1990–93), and in Australia for Queensland (1976–77). Richards retired from test cricket in 1991. He scored 8,540 runs in 121 Test matches, including 24 centuries.

Richardson, Sir Ralph David (1902–83) British actor. Richardson's distinguished stage career included fine Shake-spearean performances, yet he was equally at home in plays such as Harold PINTER's No Man's Land (1975). He received Oscar nominations for his film roles in The Heiress (1949) and Greystoke: The Legend of Tarzan, Lord of the Apes (1984).

Richardson, Samuel (1689–1761) English novelist and printer. Richardson wrote his first work of fiction, the NOVEL *Pamela* (1740–41), after the age of 50. It was followed by two more novels of letters, *Clarissa* (1747–48), and *Sir Charles Grandison* (1753–54). His work prompted FIELD-ING's parodies *An Apology for the Life of Shamela Andrews* (1741) and *Joseph Andrews* (1742).

Richardson, Tony (1928–91) British film and stage director. Richardson's first stage production was John OSBORNE's *Look Back in Anger* (1956). Following the success of his films *The Entertainer* (1960) and *A Taste of Honey* (1961), Richardson won an Academy Award for *Tom Jones* (1963). His later films, such as *Joseph Andrews* (1976), were less popular.

Richelieu, Armand Jean du Piessis, Duc de (1585–1642) French cardinal and statesman. A protégé of MARIE DE MÉDICIS and a cardinal from 1622, Richelieu became chief of the royal council in 1624. He suppressed the military and political power of the HUGUENOTS, but tolerated Protestant religious practices. He alienated many powerful Catholics by his assertion of the primacy of state interests. He survived several aristocratic plots against him. In the THIRTY YEARS WAR, he formed alliances with Protestant powers against the HABSBURGS. His more scholarly interests resulted in the foundation of the ACADÉMIE FRANÇAISE (1635).

Richler, Mordecai (1931–) Canadian novelist. His satirical novels, such as *The Apprenticeship of Duddy Kravitz* (1959), explore the Jewish ghetto of his native Montreal, while the experience of North Americans in the UK is wryly observed in *Cocksure* (1968) and *St Urbain's Horseman* (1971). Later novels include *Joshua Then and Now* (1980) and *Solomon Gursky Was Here* (1989).

Richmond Capital of Virginia, USA, in E central Virginia, and a port on the James River. Settled in 1637, the city was made state capital in 1779. During the US Civil War it became capital (1861) of the Confederate States until it fell to Union forces in 1865. Industries: metal products, tobacco processing, textiles, clothing, chemicals, publishing. Pop. (1990) 203,056. Richter, Burton (1931–) US physicist. Working with a very powerful particle accelerator, he discovered (1974) a new subatomic particle (which he named psi); it is a type of MESON. For this work Richter shared the 1976 Nobel Prize for physics with Samuel Ting, who had discoverd the same particle during independent experiments.

Richter scale Classification of earthquake magnitude set up in 1935 by the US geologist Charles Richter. The scale is logarithmic – each point on the scale increases by a factor of ten – and is based on the total energy released by an earthquake, as opposed to a scale of intensity that measures the damage inflicted at a particular place.

rickets Disorder in which there is defective growth of bone in children; the bones fail to harden sufficiently and become bent. Due either to a lack of VITAMIN D in the diet or to insufficient sunlight to allow its synthesis in the skin, it results from the inability of the bones to calcify properly.

Ridley, Nicholas (1500–55) English bishop and Protestant martyr. He was made bishop of Rochester (1547) and of London (1550). As chaplain to Thomas Cranmer he helped to compile the BOOK OF COMMON PRAYER (1549). In 1553 he supported the Protestant Lady Jane Grey against the Catholic Mary I (Mary Tudor). Convicted of heresy under Mary, he was burned at the stake.

Riefenstahl, Leni (1902–) German film director who was employed by Adolf Hitler to make propaganda films. Riefenstahl's films include *The Blue Light* (1932), *Triumph Of The Will* (1934) and *Olympische Spiele* (1936).

Riel, Louis (1844–85) French-Canadian revolutionary, leader of the *métis* (people of mixed French and native descent) in the Red River rebellion in Mantroba (1869–70). When it collapsed he fled to the USA. In 1884 he led resistance to Canada's western policies in Saskatchewan and set up a rebel government in 1885. He was captured and subsequently executed for treason.

Riemann, Georg Friedrich Bernhard (1826–66) German mathematician who laid the foundations for much of modern mathematics and physics. He worked on integration, functions of a complex variable, and differential and non-Euclidean geometry, which was later used in the general theory of RELATIVITY.

Rietveld, Gerrit Thomas (1888–1964) One of the leading 20th-century Dutch architects. His masterwork, the Schröder House, Utrecht (1924), was arguably the most modern European house of its time. He also designed De Stul

RHODE ISLAND Statehood:

29 May 1790 Nickname : Ocean State

State bird : Rhode Island Red

State flower :

Violet

State tree :

State motto :

Hope

▲ Richards The greatest attacking batsman of his generation, Viv Richards became (1980) the first West Indies player to make 100 centuries in first-class cricket. He scored more test runs than any other West Indies player in history −8,540 runs, at an average of 50.23.

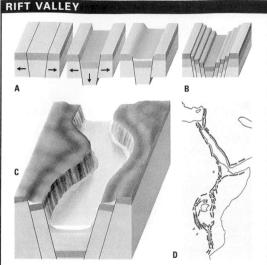

Rift valleys are formed by tension between two roughly parallel faults (A), causing downward earth movement resulting in the formation of a graben (trough of land between two faults). Sometimes a number of parallel faults results in land sinking in steps (B). A typical example of a step-faulted rift valley is shown (C). A series of block faults can occur on either side of a graben, sometimes tilting in the process of creating the block-faulted rift valley. The East African Rift Valley (D) is perhaps the world's best example of this geological formation.

rifle FIREARM with spiral grooves (rifling) along the inside of the barrel to make the bullet spin in flight, thereby greatly increasing range and accuracy over that of a smooth bore weapon. Not until the Minié rifle (1849) were rifled weapons widely used. During the 19th century, breech-loading and magazine rifles were developed, and since World War 2, assault rifles, capable of fully automatic fire, have come into general use.

Rift Valley (Great Rift Valley) Steep-sided, flat-floored valley in sw Asia and E Africa. It runs from N Syria, through the Jordan Valley and the Dead Sea, and then continues as the trough of the Red Sea through E Africa to the lower valley of the Zambezi River in Mozambique. Dotted along its course are a number of significant lakes, including TANGANYIKA and Turkana. Length: c.6,400km (4,000mi).

rift valley Depression formed by the subsidence of land between two parallel faults. Rift valleys are believed to be formed by thermal currents within the Earth's MANTLE that break up the CRUST into large slabs or blocks of rock, which then become fractured.

Riga Capital of Latvia, on the River Daugava, on the Gulf of Riga. Founded at the beginning of the 13th century, in 1282 it joined the Hanseatic League, becoming a major Baltic port. It was taken by Peter the Great in 1710. In 1918 it became the capital of independent Latvia. In 1940, when Latvia was incorporated into the Soviet Union, thousands of its citizens were deported or executed. Under German occupation from 1941, the city reverted to Soviet rule in 1944 and subsequently suffered further deportations and an influx of Russian immigrants. In 1991 it reassumed its status as capital of an independent Latvia. Industries: shipbuilding, engineering, electronic equipment, chemicals, textiles. Pop (1991) 910,200.

rigor mortis Stiffening of the body after death brought about by chemical changes in muscle tissue. Onset is gradual from minutes to hours, and it disappears within about 24 hours.

Riley, Bridget (1931–) British painter, a leading exponent of OP ART. She paints mostly black and white patterns (influenced by Vasarely), creating dazzling optical effects which

cover the entire surface of the painting and create an illusion of constant movement and change.

Rilke, Rainer Maria (1875–1926) German lyric poet, b. Prague. Rilke's first volume, *The Book of Hours* (1899–1903), was inspired by visits to Russia. During a 12-year sojourn in Paris he developed the "object poem", used in *New Poems* (1907–08); thereafter he published little until 1922, when *Sonnets to Orpheus* and his existential masterpiece *Duino Elegies* both appeared.

Rimbaud, Arthur (1854–91) French anarchic poet, who influenced SYMBOLISM. Rimbaud had a stormy relationship with Paul VERLAINE, under whose tutelage he wrote *The Drunken Boat* (1871). In 1873 they separated and *A Season in Hell* appeared. Rimbaud abandoned poetry to travel in Europe and North Africa, returning to Paris shortly before his death. *Les Illuminations* was published by Verlaine in 1886 as the work of the late Arthur Rimbaud.

Rimsky-Korsakov, Nikolai Andreievich (1844–1908) Russian composer, one of the RUSSIAN FIVE. His operas include *The Snow Maiden* (1881) and *The Golden Cockerel* (1907), and among his most popular orchestral works are *Sheherazade* (1888), *Capriccio espagnole* (1887) and *The Flight of the Bumblebee* from the opera *Tsar Saltan* (1900).

ringworm Fungus infection of the skin, scalp or nails. The commonest type of ringworm is athlete's foot (*tinea pedis*). It is treated with antifungal preparations.

Rio de Janeiro City on Guanabara Bay, SE Brazil. Discovered by Europeans in 1502, it was later colonized by the French, then the Portuguese. By the 18th century it was a major outlet for gold mined in the hinterland. In 1763 it became the seat of the viceroy and from 1834 to 1960 it was Brazil's capital. The second-largest city in Brazil, it is its commercial and industrial centre. Its warm climate and beaches make it a popular tourist resort. There are large shanty towns surrounding the city. Industries: coffee, sugar refining, shipbuilding, pharmaceuticals, publishing and printing, engineering, textiles. Pop. (1991) 5,336,179.

Rio Grande River in North America. It rises in the San Juan Mountains of sw Colorado, and flows generally s through New Mexico. It forms the border between Texas and Mexico and empties into the Gulf of Mexico just E of Brownsville, Texas, and Matamoros, Mexico. The river is largely unnavigable, and is used for irrigation and hydroelectricity. Length: *c*.3.035km (1.885mi).

riot Uncontrolled crowd violence, usually resulting in indiscriminate destruction. Most modern police forces include special riot squads, with fully protective clothing. Methods of crowd control include water cannon, CS gas (tear gas), plastic bullets and, in some countries, electronic stun guns.

Risorgimento (It. resurgence) Nationalist movement (1859-70) resulting in the unification of Italy. With the restoration of Austrian and Bourbon rule in 1815, revolutionary groups formed, notably the Young Italy movement of MAZZINI, whose aim was a single, democratic republic. Mazzini's influence was at its peak in the REVOLUTIONS OF 1848. In Sardinia-Piedmont (the only independent Italian state), the aim of the chief minister, CAVOUR, was a parliamentary monarchy under the royal house of Savoy. Securing the support of France under Napoleon III in a war against Austria, Cavour acquired much of Austrian-dominated N Italy in 1859. In 1860 GARIBALDI conquered Sicily and Naples. Although Garibaldi belonged to the republican tradition of Mazzini, he cooperated with Cavour, and the kingdom of Italy was proclaimed in 1861 under Victor Emmanuel II of Savoy. Other regions were acquired later. Rome, the future capital, was seized when the French garrison withdrew in 1870.

river Large, natural channel containing water, which flows downhill under gravity. A river system is a network of connecting channels. It can be divided into tributaries which collect water and sediment, the main trunk river, and the dispersing system at the river's mouth where much of the sediment is deposited. The discharge of a river is the volume of water flowing past a point in a given time. The velocity of a river is controlled by the slope, its depth and the roughness of the river bed. Rivers carry sediment as they flow, by the processes of

▶ Rio de Janeiro Famous for its carnival, held annually before Lent, Rio de Janeiro is the second-largest city in Brazil. it has many remarkable buildings and monuments, ranging from 17- and 18th-century churches to striking examples of modern architecture. Its Copacabana beach is world-famous.

traction (rolling), saltation (jumping), suspension (carrying) and solution. Most river sediment is carried during flood conditions, but as a river returns to normal flow it deposits sediment. This can result in the erosion of a river channel or in the building up of flood plains, sand and gravel banks. All rivers tend to flow in a twisting pattern, even if the slope is relatively steep, because water flow is naturally turbulent. Over time, on shallow slopes, small bends grow into large meanders. The current flows faster on the outside of bends eroding the bank while sedimentation occurs on the inside of bends where the current is slowest. This causes the curves to exaggerate forming loops. Rivers flood when their channels cannot contain the discharge. Flood risk can be reduced by straightening the channel, dredging sediment or making the channel deeper by raising the banks. See also DELTA; LEVÉE; OXBOW

Rivera, Diego (1886–1957) Mexican painter, married to fellow artist Frida Kahlo. Rivera is one of Mexico's three great 20th-century muralists (the others being Orozco and Siqueiros). He often used symbolism and allegory to depict events in Mexico's history, and to express his hope for a Marxist future. His work adorns public buildings in Mexico City.

Riviera Region of SE France and NW Italy, on the Mediterranean Sea, extending 370km (230mi) from Cannes, France, to La Spezia, Italy. Its spectacular scenery and mild climate make it a leading tourist centre. Resorts include NICE and CANNES in France, MONTE CARLO in Monaco, and San Remo and Alassio in Italy. Products: flowers, olives, grapes and citrus fruits.

Riyadh Capital of Saudi Arabia, in the E central part of the country, *c*.380km (235mi) inland from the Persian Gulf. In the early 19th century it was the domain of the Saudi dynasty, becoming capital of Saudi Arabia in 1932. The chief industry is oil refining. Pop. (1994 est.) 1,500,000.

RNA (ribonucleic acid) Chemical (nucleic acid) that controls the synthesis of PROTEIN in a cell and is the genetic material in some viruses. The molecules of RNA in a cell are copied from DNA and consist of a single strand of nucleotides, each containing the sugar ribose, phosphoric acid, and one of four bases: adenine, guanine, cytosine or uracil. Messenger RNA carries the information for protein synthesis from DNA in the cell NUCLEUS to the RIBOSOMES in the CYTOPLASM. Transfer RNA brings amino acids to their correct position on the messenger RNA. Each AMINO ACID is specified by a sequence of three bases in messenger RNA.

Roach, Hal (1892–1992) US film producer. He is best remembered for his silent comedy shorts. Co-founder of The Rolin Film Company in 1915, he encouraged Harold LLOYD, LAUREL AND HARDY, and Will ROGERS. He was awarded an honorary Academy Award in 1984.

roach European freshwater carp found in muddy or brackish waters. Colours include silver, white and green. Length: to 40cm (16in). Family Cyprinidae; species *Rutilus rutilus*.

road runner Fast-running, desert cuckoo that lives in sW USA. It has a crested head, streaked brownish plumage, long, strong legs and long tail. It feeds on ground animals including snakes, which it kills with its long, pointed beak. Family Cuculidae; species *Geococcyx californianus*.

Robbe-Grillet, Alain (1922–) French novelist and theoretician, one of the originators of the NOUVEAU ROMAN in the 1950s. He later worked in films, writing the screenplay for *Last Year at Marienbad* (1961) and directing *Trans-Europe Express* (1966). His books include the novels *The Erasers* (1953), *Jealousy* (1957), *Topology of a Phantom City* (1976) and *Djinn* (1981), and the critical work *Towards a New Novel* (1963).

Robbins, Jerome (1918–) US dancer, choreographer and director. He created roles in FOKINE's Bluebeard (1941) and Lichine's Helen of Troy (1942). He also devised ballet sequences for Broadway musicals, including The King and I (1951, and the film version which he directed, 1956), West Side Story (1957, filmed 1961) and Fiddler on the Roof (1964).

Robert I (the Bruce) (1274–1329) King of Scotland (1306–29). He was descended from a prominent Anglo-Norman family with a strong claim to the crown. He swore fealty to EDWARD I of England (1296) but joined a Scottish revolt against the English in 1297. He later renewed his allegiance to Edward, but his divided loyalties made him suspect. After

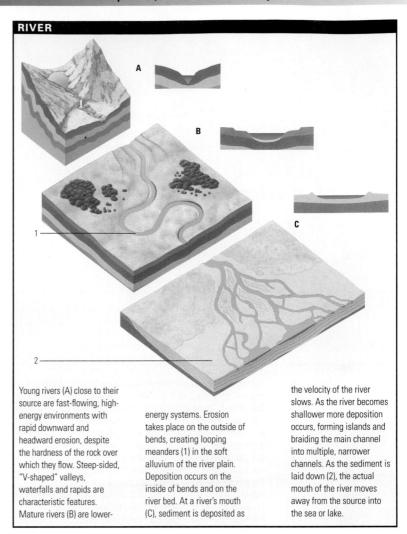

killing a powerful rival, John Comyn, he had himself crowned king of Scotland (1306) but, defeated at Methven (1306) by the English, he fled the kingdom. Returning on Edward's death (1307), the Bruce renewed the struggle with increasing support. In 1314 he won a famous victory over the English at BANNOCKBURN. The battle secured Scottish independence, which was finally recognized in the Treaty of Northampton (1328).

Robert II (1054–1134) (Robert Curthose) Duke of Normandy (1087–1106). The eldest son of William the Conqueror, he disputed Normandy and England with his younger brothers, WILLIAM II and HENRY I, and played a prominent part in the First CRUSADE (1096–99). In 1106 he was defeated and captured by Henry and imprisoned for life.

Robespierre, Maximilien François Marie Isidore de (1758–94) French revolutionary leader. Elected to the National Assembly in 1789, he advocated democracy and liberal reform. In 1791 he became leader of the JACOBINS, and

■ Rivera La Civilisation
Tarasque: Dying Material. Despite being interested in cubism and influenced by the work of Henri Rousseau, Diego Rivera's work is rooted in the Mexican tradition. Characteristic of his style are simplified, flat geometric forms in expressive colours.

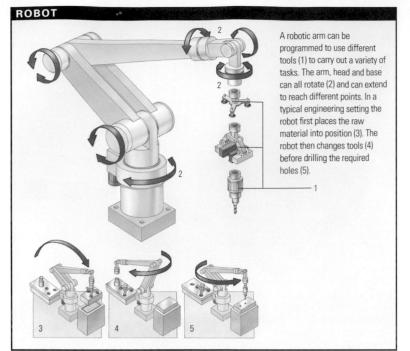

▲ rocket The space shuttle has three main components when it is launched. The orbiter (1) is attached to an external fuel tank (2), which is bracketed by booster rockets (3). The booster rockets are filled with solid fuel, and once the fuel has been burnt, the boosters are jettisoned and return to Earth by parachute (4). The solid fuel is a mixture of an iron oxide catalyst, an oxidizer, and powdered aluminium. The liquid oxygen (5) and liquid hydrogen (6), contained in the external fuel tank, feed the shuttle's three main engines (7).

gained credit when his opposition to war with Austria was justified by French defeats. With the king and the GIRONDINS discredited, Robespierre led the republican revolution of 1792 and was elected to the National Convention. His election to the Committee of Public Safety (June 1793) heralded the REIGN OF TERROR, in which hundreds died on the guilloine. Ruthless methods seemed less urgent after French victories in war, and Robespierre was arrested in the coup of 9th Thermidor (27 July) 1794 and executed.

robin Small Eurasian bird, with a characteristic red-orange breast. Length: to 14cm (5.5in). Family Turdidae; species *Erithacus rubecula*. The much larger American robin (*Turdus migratorius*) is a member of the thrush family and is about 25cm (10in) long.

Robin Hood Legendary English outlaw. Medieval tradition describes him as a displaced nobleman living with his outlaw band in Sherwood Forest, near Nottingham. Robin robbed the rich and gave to the poor, fighting a running battle with the sheriff of Nottingham but remaining loyal to the king.

Robinson, Edwin Arlington (1869–1935) US poet. His first volume of poems, *The Torrent and The Night Before* (1896), was followed by *The Town down the River* (1910), *The Man against the Sky* (1916) and *The Three Taverns* (1920). He was awarded the Pulitzer Prize in 1921, 1924 and 1927.

Robinson, Jackie (Jack Roosevelt) (1919–72) US baseball player, the first African-American player in the major leagues. Signed by the Brooklyn Dodgers in 1947 after a year in the International League, he compiled a batting average of .311 before retiring in 1956. He helped the Dodgers to six World Series.

Robinson, Mary (1944—) Irish stateswoman, president of the Irish Republic (1990–97). Robinson entered politics as a senator in 1969. In 1990 her attempt to become a Labour MP failed, but she astonished her opponents by gaining the presidency. Robinson's stand on human rights, support for the campaign to liberalize laws on abortion and divorce gave the office of president far more public exposure and significance.

Robinson, Sugar Ray (1920–89) US boxer, b. Walker Smith. Undefeated world welterweight champion from 1946 to 1950, he won the middleweight title five times in the 1950s. He fought the last of his 21 world title bouts in 1961. robot Automated machine used to carry out various tasks. Robots are often computer-controlled, the most common type having a single arm that can move in any direction. Such robots are used to carry out various tasks in car manufacturing. Rob Roy (1671–1734) Scottish outlaw. A member of the

proscribed clan MacGregor, he took part in the JACOBITE rising of 1715 and was engaged in a long feud with the Duke of Montrose. He was twice captured and twice escaped, before making his peace with the government in 1722.

rock Solid material that makes up the Earth's crust. Rocks are classified by origin into three major groups: IGNEOUS ROCKS; SEDIMENTARY ROCKS; and METAMORPHIC ROCKS.

rock Form of popular music characterized by amplified guitars and singing, often with repetitive lyrics and driving rhythms. Rock extended from ROCK AND ROLL and RHYTHM AND BLUES in the 1950s, and drew on earlier BLUES and FOLK MUSIC of rural USA to become a major form of cultural expression in the 1960s. Its offshoots include heavy metal, grunge and PUNK.

rock and roll Form of popular music. Originating in the USA in the early 1950s, it appealed largely to a white audience who found its forerunner, RHYTHM AND BLUES, inaccessible. It was popularized by Bill Haley and the film *Rock Around the Clock* (1956).

Rockefeller, John Davison (1839–1937) US industrialist and philanthropist. In 1863 Rockefeller built an oil refinery in Cleveland, which was incorporated in 1870 into the Standard Oil Company of Ohio. On retirement, he devoted his attention to charitable corporations, donating *c*.US\$550 million. In 1913 he founded the Rockefeller Foundation.

rocket Missile or craft powered by a rocket engine. Most of its volume contains fuel; the remainder is the payload (such as an explosive, scientific instruments or a spacecraft). **Liquidfuelled** rockets use a fuel (such as liquid hydrogen) and an oxidizer (usually liquid oxygen), which are burned together in the engine. **Solid-fuelled** rockets have both fuel and oxidizer in a solid mixture. Rockets can be single-stage or multi-stage. They are the only known propulsion systems that can function in a vacuum and so are essential for space exploration.

Rocky Mountains Major mountain system in w North America. Extending from Mexico to the Bering Strait, N of the Arctic Circle, the mountains form the continental divide. The highest point is Mount ELBERT.

rococo Playful, light style of art, architecture and decoration that developed in early 18th-century France. It soon spread to Germany, Austria, Italy and Britain. Rococo brought to interior decoration swirls, scrolls, shells and arabesques. It was also applied to furniture, porcelain and silverware.

rodent Any member of the vast order Rodentia, the most numerous and widespread of all mammals, characterized by a pair of gnawing incisor teeth in both the upper and lower jaws. Numbering close to 2,000 species, including rats, mice, squirrels, beaver, dormice, porcupines and guinea pigs, rodents live throughout the world. Most are small and light.

rodeo Sport with origins in the practical work of a COWBOY. A major entertainment in North America, its seven main events are saddle bronco (unbroken horse) riding, bareback bronco riding, bull-riding, calf-roping, single-steer roping and team-roping, and steer-wrestling.

Rodgers, Richard Charles (1902–79) US composer of Broadway musicals. He worked first with Lorenz Hart and then with Oscar Hammerstein on successful musicals, including Oklahoma! (1943), Carousel (1945), South Pacific (1949), The King and I (1951) and The Sound of Music (1959).

Rodin, Auguste (1840–1917) French sculptor, one of the greatest European artists of his time. Rodin's first major work, *The Age of Bronze* (1878), caused a scandal because the naked figure was so naturalistic. His next great project was *The Gates of Hell*, unfinished studies for a bronze door for the Musée des arts décoratifs. It provided him with the subjects for further great sculptures, including *The Thinker* (1880), *The Kiss* (1886) and *Fugit Amor* (1897). Perhaps his most extraordinary work is the full-length bronze of Balzac, completed in 1897.

Rodrigo, Joaquin (1901–) Spanish composer. He made his name with his *Concierto de Aranjuez* (1939), for guitar and orchestra. He also wrote concertos for violin, cello, piano, harp and flute as well as other pieces for guitar and orchestra. Roethke, Theodore (1908–63) US poet. His debut book of verse, *Opera House*, appeared in 1941. He published other collections, including *The Waking: Poems 1933–53*

(1953), which won both a Pulitzer Prize and the National Book Award.

Rogers, Ginger (1911–95) US actress and dancer. Rogers became famous in the 1930s for several film musicals costarring Fred ASTAIRE, including *Flying Down To Rio* (1933) and *Top Hat* (1934). She also appeared on stage.

Rogers, Richard (1933—) British architect. Rogers' bestknown buildings include the Pompidou Centre, Paris (codesigned with Renzo Piano, 1971–77) and the Lloyds building in London (1978–80). He designs his buildings "inside-out" to allow for servicing without disrupting the interior. See also COMMUNITY ARCHITECTURE; MODERNISM

Rogers, Will (William Penn Adair) (1879–1935) US comedian who appeared in VAUDEVILLE as a cowboy and joined the Ziegfeld Follies in 1914. Through his contributions to film, radio and a syndicated newspaper column, he became known as the "cowboy philosopher".

Roget, Peter Mark (1779–1869) British physician, physiologist and man of letters. He helped to establish London University and is especially remembered for his *Thesaurus of English Words and Phrases* (1852).

role In social science, a person's perception of how to act in a given situation. For children, learning roles is central to the process of social development. Formal roles, such as teachers, and doctors, help to define our behaviour in impersonal situations, while informal roles, such as husband and mother, are founded on personal relationships. *See also* STATUS

roller Any of several species of Eurasian birds that roll over in flight. An occasional visitor to Britain, *Coracius garrulus*, has blue-green plumage and flies as far north as Sweden; it usually winters in Africa. Family Coraciidae.

roller skating Recreational activity in which a metal skate is attached to each foot, beneath which are free-running wheels. The traditional skate uses pairs of hard rubber rollers. An alternative form since the mid-1980s has three or more rubber wheels in line ("blade skating").

Rolling Stones, The British rock group, formed in 1962 around vocalist Mick Jagger (1943—), guitarist Keith Richards (1943—), bassist Bill Wyman (1941—) and drummer Charlie Watts (1942—). Their rebellious posturing courted great controversy and publicity. Both Jagger and Richards were convicted of drug offences, and a founder member, Brian Jones, died after a drugs overdose (1969). Early hit singles included "Satisfaction" (1965), "Paint it Black" (1966) and "Jumpin' Jack Flash" (1968). Million-selling albums include Beggar's Banquet (1968) and Exile on Main Street (1972).

Rollins, "Sonny" (Theodore Walter) (1930–) US jazz saxophonist. Influenced by Charlie Parker, he played with many of the bebop greats, including Max Roach, Bud Powell, Thelonious Monk and Miles Davis.

ROM (Read-Only Memory) Integrated circuits (chips) that act as a permanent store for DATA (information) required by a computer. The contents of ordinary ROM chips are set by the manufacturer and cannot be altered by the user. The stored data is available to the computer's MICROPROCESSOR whenever the computer is switched on.

Roman art and architecture Classical art and architecture of ancient Rome. Prior to 400 BC, Roman art was largely ETRUSCAN art in the form of tomb decorations, after which Greek influence became dominant. Few examples of later Roman painting have survived: the best examples are found in the Italian towns of POMPEII and Herculaneum. Another common art form was Mosalc. Floors and walls were decorated mostly in elaborate geometric patterns, but mosaics were also created to depict everyday scenes, or gods and goddesses. In sculpture the Romans excelled in portrait busts and reliefs. In architecture notable features include the adoption of the ARCH, VAULT and DOME. Fine examples include the Pantheon and Colosseum in Rome.

Roman Britain Period of British history from the Roman invasion (AD 43) in the reign of CLAUDIUS I until *c*.410. The occupation included Wales but not Ireland nor most of Caledonia (Scotland). Its northern frontier was marked by HADRIAN'S WALL from *c*.130. Only the English lowlands were thoroughly Romanized, but in that region Roman rule brought a

period of prosperity unmatched for more than 1,000 years. Britain was ruled as a province under Roman governors. Roman power disintegrated in the 3rd century. By 400, attacks from Ireland, Scotland and the continental mainland were increasing and Roman troops were withdrawn to deal with enemies nearer home. In 410 the Emperor Honorius warned the Britons to expect no further help. Local Romano-British kings held out for more than 100 years before lowland Britain was overrun by the ANGLO-SAXONS.

Roman Catholic Church Christian denomination which acknowledges the supremacy of the pope (see PAPACY; PAPAL INFALLIBILITY). An important aspect of doctrine is the primacy given to the Virgin MARY, whom Roman Catholics believe to be the only human being born without sin (IMMACULATE CONCEPTION). Before the REFORMATION in the 16th century, the word "Catholic" applied to the Western Church as a whole, as distinguished from the Eastern ORTHODOX CHURCH based at Constantinople. The Reformation led to a tendency for the Roman Catholic Church to be characterized by rigid adherence to doctrinal tradition from 16th to the early 20th century. The desire for a reunited Christendom led to a more liberal attitude in the mid-20th century. There are some 600 million Roman Catholics worldwide, with large numbers in s Europe, Latin America, and the Philippines. The government of the Church is episcopal, with archbishops and bishops responsible for provinces and dioceses. The priesthood is celibate. The centre of the Roman Catholic liturgical ritual is the MASS or EUCHARIST. Since the second Vatican Council (1962-65), the Roman Catholic Church has undergone marked changes, notably the replacement of Latin by the vernacular as the language of the liturgy.

romance (Old French *romanz*, vulgar tongue) Literary form, typically a heroic tale or ballad usually in verse. The form derives from the medieval narratives of TROUBADOURS. The romance spread throughout Europe during the 12th century, was used in English by CHAUCER, remaining popular through the 16th century.

Romance languages Indo-European languages that evolved from LATIN. They include Italian, French, Spanish, Portuguese, Romanian, Catalan, Provençal and Romansh (a language spoken in parts of Switzerland).

Roman empire Mediterranean empire established after the assassination of Julius CAESAR (27 BC), whose power centre was ancient ROME. The Romans adopted the culture of ancient Greece, but their empire was based on military power and ROMAN LAW. In terms of technology and arguably culture, Roman civilization was not surpassed in Europe until the Renaissance. By the death of Augustus, the first emperor, in AD 14, the empire included most of Asia Minor, Syria, Egypt and the whole North African coast. In the 1st-2nd centuries AD Britain was conquered; in the E, Roman rule extended to the Caspian Sea and the Persian Gulf, and further territory, including DACIA (Transylvania), was added in SE Europe. The empire was at its greatest extent at the death of TRAJAN (AD 117), when it included all the lands around the Mediterranean and extended to N Britain, the Black Sea and Mesopotamia. HADRIAN (r.117-138) called a halt to further expansion. Rome reached the height of its power during the first 150 years of imperial rule, becoming a city of grand, monumental buildings with per■ Rolling Stones Formed in the 1960s, the Rolling Stones remain one of the most successful rock and roll bands. With their aggressive music and overtly sexual and political lyrics, they contrasted with the Beatles in the 1960s. In the 1970s, their extravagantly staged worldwide tours increased their popularity. They continue to tour and record, though Bill Wyman has been replaced by Darryl Jones.

During the imperial period of Roman art, from the 1st to the 3rd century AD, jewellery-making reached a level not surpassed in Europe until the Renaissance in the 16th century. Early on, the snake motif was very popular, along with other decorative styles borrowed from Greek and Etruscan culture. Soon, however, Roman jewellery began to make greater use of gemstones and intricate,

pierced decoration.

▲ Roman art and architecture

haps 1 million inhabitants. In the 3rd century AD pressure from Germanic tribes and the Persians, plus economic difficulties, contributed to the breakdown of government. Armies in the provinces broke away from Rome. DIOCLETIAN restored order, and from his time the empire tended to be split into E and W divisions. Constantine founded (330) an E capital at Constantinople. Rome was increasingly challenged by different peoples, such as the Goths who sacked the city in 410. By 500 the Roman empire in the west had ceased to exist. The Eastern or BYZANTINE EMPIRE survived until 1453.

Romanesque Architectural and artistic style that spread throughout w Europe during the 11th and 12th centuries. English Romanesque architecture includes Anglo-Saxon and Norman styles.

Romania Balkan republic in SE Europe. See country feature Romanian Official language of Romania, spoken by up to 25 million people in Romania, Macedonia, Albania and N Greece. It is a language belonging to the Romance branch of the Indo-European family. Originally written in CYRILLIC characters, Romanian has used the Roman alphabet since 1860.

Roman law System of CIVIL LAW developed between 753 BC and the 5th century AD, which forms the basis of the civil law in many parts of the world. Roman law was enacted originally by the PATRICIANS, then, increasingly after 287 BC, by the PLEBEIAN assemblies. From 367 BC magistrates (praetors) proclaimed the legal principles (edicta) which became an important source of law known as jus honorium. The emperor could also enact laws and by the mid-2nd century AD became the sole creator of laws. Roman law can be divided into two parts: jus civile, or civil law, which applied only to Roman citizens and which was codified in the TWELVE TABLES of 450 BC; and jus gentium, which gradually merged into jus civile, originally applying to foreigners in Rome and to others within Roman lands who were not citizens. Roman law was codified by the Emperor Justinian I (r.527-64) and was adapted by many of the barbarian invaders of the Empire.

Roman numeral Letter used by the ancient Romans and succeeding civilizations in Europe to represent numbers before the adoption of Arabic numerals. There were seven individual letters: I (1), V (5), X (10), L (50), C (100), D (500) and M (1000). Combinations were used to represent the numbers. From 1 to 10 they ran: I, II, III, IV, V, VI, VII, VIII, IX and X. The tens ran: X, XX, XXX, XL, L and so on up to XC, which represented 90. The ancients used Roman numerals for commerce and mathematics. Modern applications include numbering the preliminary pages of a book and numbering paragraphs or subparagraphs in a document.

Romanov Russian imperial dynasty (1613–1917). Michael, the first Romanov tsar, was elected in 1613. His descendants, especially Peter I (THE GREAT) and CATHERINE II (THE GREAT), a Romanov only by marriage, transformed Russia into the largest empire in the world. The last Romanov emperor, Nicholas II, abdicated in 1917 and was later murdered with his family by the BOLSHEVIKS.

Romans In the New Testament, a letter by St PAUL to the Christians of Rome. It was written *c.*57 AD, probably while

Paul was in Corinth. In it, he declares the universality of the saving power of God realized in the life, death and resurrection of Jesus.

romanticism Late 18th- and early 19th-century art movement. Its exponents valued individual experience and intuition, rather than the orderly, concrete universe of classical artists. For this reason, romantics and classicists are often seen as opposites, but in fact they shared a belief in IDEALISM, as opposed to the exponents of REALISM and RATIONALISM. An emphasis on nature rather than science was also a characteristic. Leading literary romantics include GOETHE, SHELLEY, BYRON, KEATS, WORDSWORTH and SCHILLER. William BLAKE was both a romantic poet and artist. Other artists include DELACROIX, Caspar David FRIEDRICH, GÉRICAULT and TURNER. romanticism Period of music history lasting from c.1800 to 1910. It is characterized by the importance given to emotional expression and imagination, in contrast to the restraint and strict forms of the CLASSICAL era. Orchestras expanded as composers experimented with unusual and colourful orchestration to express extra-musical influences. Leading romantic composers include WAGNER, BERLIOZ, MENDELSSOHN, SCHU-MANN, CHOPIN and LISZT.

Romany (Gypsy) Nomadic people and their language. Romanies are believed to have originated in N India, and now inhabit Europe, Asia, America, Africa and Australia. They first appeared in Europe in the 15th century. Their nomadic lifestyle has aroused prejudice, often resulting in persecution. Their folklore is part of popular tradition. The Romany language originated in N India, and like HINDI and SANSKRIT to which it is related, it belongs to the Indo-Iranian branch of the family of INDO-EUROPEAN LANGUAGES. Many Romanies today speak it as a second language, but there is little written Romany.

Rome (Roma) Capital of Italy, on the River Tiber, w central Italy. Founded in the 8th century BC, it was probably an Etruscan city-kingdom in the 6th century BC. The Roman Republic was founded $c.500~{\rm BC}$. By the 3rd century BC Rome ruled most of Italy and began to expand overseas. In the 1st century AD the city was transformed as successive emperors built temples, palaces, public baths, arches and columns. It remained the capital of the Roman empire until 330 AD. It was sacked in the 5th century during Barbarian invasions and its population (already in decline) fell rapidly. In the Middle Ages Rome became the seat of the papacy. It was sacked again in 1527 by the army of the emperor Charles V. The city began to flourish once more in the 16th and 17th centuries. Italian troops occupied it in 1870, and in 1871 it became the capital of a unified Italy. The 1922 Fascist march on Rome brought Mussolini to power, and he did much to turn Rome into a modern capital city. It is also home to the VATICAN CITY. Industries: tourism, pharmaceuticals, chemicals, oil refining, engineering, textiles, food processing, films, printing and publishing, banking and finance. Pop. (1991) 2,775,250.

Rome, ancient Capital of the Roman republic. According to tradition, Rome was founded in 753 BC by ROMULUS AND REMUS. By 509 BC the Latin-speaking Romans had thrown off the rule of ETRUSCAN kings and established an independent republic dominated by an aristocratic elite. Its history was one of continual expansion, and by 340 BC Rome controlled Italy s of the River Po. By the 3rd century BC the PLEBEIAN class had largely gained political equality. The PUNIC WARS gave it dominance of the Mediterranean in the 2nd century BC, when major eastward expansion began with the conquest of the Greek lands around the Aegean. The republic was strained by social division and military dictatorship. Spartacus' slave revolt was crushed by POMPEY, who emerged as SULLA's successor. Pompey and Julius CAESAR formed the First Triumverate (60 BC). Caesar emerged as leader and greatly extended Rome's territory and influence. His assassination led to the formation of the ROMAN EMPIRE under AUGUSTUS (27 BC).

Rome, Treaties of (1957) Two agreements establishing the European Economic Community, now the European Com-MUNITY (EC), and the EUROPEAN ATOMIC ENERGY COMMIS-SION (EURATOM). The 1957 treaty was extensively amended by the Single European Act (1986) and the MAASTRICHT TREATY (1992), but still forms the basis of the EUROPEAN UNION (EU).

► Romanesque The enduring monuments of Romanesque architecture are the churches and cathedrals of the period. Many regional differences in style existed. Dating from the 11th century, Monza Cathedral in Lombardy, shown here, is a prime example of a central Italian Romanesque building. The dominant feature of its façade is the striped pattern of facing material, a common motif of the Italian Romanesque - surface ornamentation was very important. The entrance is elaborated with columns, another popular design feature, with a rose window above.

Rommel, Erwin (1891-1944) German general. Rommel commanded tanks in France in 1940 and later led the AFRIKA Korps in a victorious campaign in North Africa, until defeated by the British at EL ALAMEIN (1942). Transferred to France in 1943, he was unable to repel the invasion of Nor-MANDY, and was wounded. Implicated in the plot against Hitler in July 1944, he committed suicide.

Romulus and Remus In Roman mythology, founders of ROME. Twin brothers, they were said to be sons of Mars. Amulius, who had usurped the throne, ordered the babies to be drowned in the Tiber. They survived and were suckled by a wolf, before being found by a shepherd, Faustulus. They built a city on the site of their rescue. Romulus killed Remus during a quarrel.

Ronsard, Pierre de (1524-85) French poet and leader of the PLÉIADE. His Odes (1550) and Les Amours (1552) brought him fame and royal patronage. Other works inclde the incomplete national epic La Franciade (1572) and Sonnets pour Hélène (1578), some of his finest love poems.

Röntgen, Wilhelm Konrad (1845–1923) German physicist. In 1895 he discovered X-RAYS, for which he was awarded the first Nobel Prize for physics in 1901. He also did important work on electricity, the specific heats of gases and the heat CONDUCTIVITY of crystals.

röntgen (symbol R) Former unit used to measure X-RAY or gamma-ray RADIATION. One röntgen causes sufficient ionization to produce a total electric charge of 2.58×10^{-4} coulombs on all the positive (or negative) ions in one kilogram of air. The unit has been replaced by the SI unit, the GRAY (symbol Gy).

rook Large gregarious European bird of the CROW family. It has glossy black plumage, but commonly loses the feathers from about its face. It feeds on grain and insects, and has a characteristic raucous cry. Family Corvidae; species Corvus frugilegus.

Roosevelt, (Anna) Eleanor (1884-1962) US reformer and humanitarian, wife of Franklin ROOSEVELT. She was a supporter of social causes, including civil rights. She served as US delegate to the UN (1945-52, 1961-62) and chairman of the UN Commission on Human Rights (1946-51).

Roosevelt, Franklin D. (Delano) (1882-1945) 32nd US president (1933-45). Roosevelt served in the New York Senate as a Democrat, as assistant secretary of the navy under Woodrow Wilson (1913-20) and was vice-presidential candidate in 1920. In 1921 he lost the use of his legs as a result of

ROMANIA

Romania's flag, adopted in 1948, uses colours from the arms of the provinces, which united in 1861 to form Romania. A central coat of arms, added in 1965, was deleted in 1990 after the fall of the Communist regime under the dictator Nicolae Ceaușescu.

AREA: 237,500sq km (91,699sq mi)

POPULATION: 23,185,000

CAPITAL (POPULATION): Bucharest (2,350,984) GOVERNMENT: Multiparty republic

ETHNIC GROUPS: Romanian 89%, Hungarian

7%, Romany (Gypsy) 2% LANGUAGES: Romanian (official)

RELIGIONS: Romanian Orthodox 87%, Roman

Catholic 5%, Greek Orthodox 4%) currency: Romanian leu = 100 bani

he Balkan republic of Romania is dominated by a central plateau. The Carpathian Moun-TAINS run in a horseshoe-shape from N to SW, and frame the region of TRANSYLVANIA. Eastern and S Romania form part of the DANUBE river basin; the site of the capital, BUCHAREST. The Danube's delta, near the Black Sea, is one of Europe's most important wetlands. The port of Constanța lies on the Black Sea coast. The extreme w lowlands include the city of TIMIŞOARA.

CLIMATE

Romania has hot, dry summers and cold winters. It is one of the sunniest places in Europe, with over 2,000 hours of sunshine every year.

VEGETATION

Arable land accounts for c.66% of Romania. Forests cover 28%; oak predominates at lower levels, beech and conifer on the higher slopes, and mountain pastures near the summits.

HISTORY

Modern Romania roughly corresponds to ancient DACIA, which was conquered by the Romans in AD 106. The Dacians assimilated Roman culture and language, and the region became known as Romania. In the 14th century, the principalities of WALLACHIA (S) and MOLDAVIA (E) were formed. Initially, the princes retained local autonomy, but in the 18th century the Ottoman empire dominated Romania. In the late 18th century, the Turkish empire began to break up. Russia captured Moldavia and Wallachia in the Russo-Turkish War (1828-29). Romanian nationalism intensified and the two provinces were united in 1861. The Congress of Berlin (1878) ratified Romania as an independent state, and in 1881 CAROL I became king. Neutral at the start of World War 1, Romania joined the Allies in 1916, but was occupied by German forces in 1917. The Allied victory led to Romania acquiring large regions, such as Transylvania. In 1927 MICHAEL became king, but surrendered the throne to his father, CAROL II, in 1930. Political instability and economic inequality led to the growth of fascism and anti-Semitism. At the start of World War 2, Romania lost territory to Bulgaria, Hungary, and the Soviet Union. In 1940 Michael was restored. Ion Antonescu became dictator and, in June 1941, Romania joined the German invasion of the Soviet Union. Over 50% of Romanian Jews were exterminated during World War 2. In 1944 Soviet troops occupied Romania, Antonescu was overthrown and Romania surrendered. In 1945 a communist-dominated coalition assumed power, led by Gheorghe Gheorghiu-Dej. In 1947 Romania became a People's Republic. In 1952 Romania adopted a Soviet-style constitution. Industry was nationalized and agriculture collectivized. In 1949 Romania joined the Council of Mutual Economic Assistance (COMECON), and in 1955 became a member of the Warsaw Pact. In 1965 Gheorghiu-Dej was succeeded by Nicolae CEAUŞESCU. Rapid industrialization and political repression continued. In December 1989 Ceauşescu and his wife were executed. Ion ILIES-CU, a former Communist official, led a provisional government. In May 1990 elections, the National Salvation Front, led by Ion Iliescu, won a large majority. A new constitution was approved in 1991. Ion Iliescu was re-elected in 1992. In 1994, economic crisis forced the Social Democracy Party of Romania (PDSR) into a coalition with the nationalist Party of Romanian National Unity (PUNR). In 1995 Romania applied to join the European Union. In 1996 presidential and legislative elections, Emil Constantinescu and his centre-right coalition emerged victorious.

ECONOMY

Communism's over-concentration on heavy industry devastated Romania's economy. Today, industry accounts for 40% of GDP. Oil, natural gas, and antimony are the main mineral resources. Agriculture employs 29% of the workforce and constitutes 20% of GDP. Romania is the world's second-largest producer of plums (after China). It is the world's ninth-largest producer of wine. Other major crops include maize and cabbages. Economic reform is slow. Unemployment and foreign debt remain high.

▲ rosemary A strongly flavoured culinary herb, rosemary (Rosmarius officinalis) leaves are used as a seasoning for meat and fish. Its aromatic oil is used in perfumes and medicines. Since the earliest times, the plant has symbolized remembrance and faithfulness.

polio. He was governor of New York (1928–32) and won the Democratic candidacy for president. He was elected in 1932. To deal with the Great Depression, he embarked upon his New Deal, designed to restore the economy through direct government intervention. He was re-elected in 1936 and won an unprecedented third term in 1940 and a fourth in 1944. When World War 2 broke out in Europe, he gave as much support to Britain as a neutral government could until the Japanese attack on Pearl Harbor ended US neutrality. He died in office and was succeeded by Harry S. Truman.

Roosevelt, Theodore (1858–1919) 26th US president (1901–09). Roosevelt gained national fame as the organizer of the Rough Riders in the Spanish-American War (1898). He became Republican governor of New York in 1899, and vice president in 1901. Following the assassination of William McKinley (1901) Roosevelt became president, and he was re-elected in 1904. A vigorous progressive, Roosevelt moved to regulate monopolies through anti-trust legislation. Abroad, he expanded US power and prestige, gaining the Panama Canal and taking an increasing role in world affairs. His mediation after the Russo-Japanese War won him the Nobel Peace Prize (1905). After retiring in 1909, he challenged his successor, President Taft for the presidency in 1912 as leader of his National Progressive Party (Bull Moose Party). The Republican split resulted in a Democratic victory.

root Underground portion of a VASCULAR PLANT that serves as an anchor and absorbs water and minerals from the soil. Some plants, such as the dandelion, have taproots with smaller lateral branches. Other plants, such as the grasses develop fibrous roots with lateral branches.

root In mathematics, fractional POWER of a number. The SQUARE ROOT of a number, x, is written as either \sqrt{x} or $x^{-\frac{1}{2}}$. The fourth root of x may be written in radical form as $4\sqrt{x}$ or in power form as $x^{\frac{1}{2}}$. The fourth root of 16, for example, is 2 since $2\times2\times2\times2=16$.

root nodule Small swelling in the roots of various plants, such as LEGUMES, that contain nitrogen-fixing bacteria. *See also* NITROGEN CYCLE; NITROGEN FIXATION

Rorschach test (ink-blot test) In psychology, test used to analyse a person's motives and attitudes when these are projected into ambiguous situations. The individual is presented with 10 standardized ink blots and interpretation is based on the description of them.

rosary Form of meditational prayer that contemplates the life of Jesus and the Blessed Virgin Mary within the Catholic and Orthodox churches. A rosary is also the string of beads on which a count may be kept of the number of prayers said. **rose** Wild or cultivated flowering shrub of the genus *Rosa*. Most roses are native to Asia, several to America, and a few to Europe and Nw Africa. The stems are usually thorny, and flowers range in colour from white to yellow, pink, crimson and maroon; many are fragrant. There are about 150 species. Family Rosaceae.

Roseau Capital of Dominica, in the Windward Islands, a port on the sw coast at the mouth of the River Roseau. The city was burned by the French in 1805, and virtually destroyed by a hurricane in 1979. Tropical vegetables, oils, spices, limes and lime juice are exported. Pop. (1991) 15,853. **rosebay willowherb** *See* WILLOWHERB

Rosebery, Archibald Philip Primrose, 5th Earl of (1847–1929) British statesman, Liberal prime minister (1894–95). Rosebery was foreign secretary (1886, 1892–94) under GLADSTONE. When Gladstone retired, Queen VICTORIA called on Rosebery to become prime minister. A controversial figure, his appointment caused a split in the LIBERAL PARTY and the Conservative Party won the ensuing election. Rosebery became leader of the imperialist wing of the Liberal Party.

rosemary Perennial evergreen herb of the mint family. It has small, needle-like leaf clusters of small pale-blue flowers. Sprigs of rosemary are commonly used as a flavouring. Family Lamiaceae/Labiatae; species *Rosmarinus officinalis*.

Rosenberg, Alfred (1893–1946) Leading ideologist of the German National Socialist (Nazi) Party. Russian-born, he propounded the superiority of the German race, purveying anti-Semitic doctrine as editor of the party newspaper and in

his book *The Myth of the 20th Century* (1934). In 1941 he became minister for the occupied eastern regions. After the war he was executed as a war criminal.

Rosenberg Case (1951–53) US espionage case. A New York couple, Julius and Ethel Rosenberg, were found guilty of passing atomic bomb secrets to Soviet agents. They became the first US civilians executed for espionage.

Roses, Wars of the (1455–85) English dynastic civil wars. They are named after the badges of the rival royal houses of York (white rose) and Lancaster (red rose). Both houses were descended from Edward III. The Lancastrian king, HENRY VI, was challenged by Richard, Duke of York, who gained brief ascendancy after the battle of St Albans (1455). The Lancastrians recovered control, but in 1460 Richard, supported by the powerful Earl of WARWICK, forced Henry to recognize him as his heir. Richard was killed months later, but the Yorkist victory at Towton (1461) put his son on the throne as EDWARD IV. In 1469 Warwick changed sides and Edward was deposed, but returned to win the decisive victory of Tewkesbury (1471). A final phase of the wars began with the seizure of the throne by RICHARD III in 1483. He was defeated and killed at Bosworth, when Henry Tudor (HENRY VII) won the crown with support from both houses.

Rosetta stone Slab of black basalt inscribed with the same text in Egyptian HIEROGLYPHICS, demotic (a simplified form of Egyptian hieroglyphs) and Greek script. By comparing the three versions, first Thomas Young (1818) and later Jean-François Champollion (1822) deciphered the hieroglyphs, leading to a full understanding of hieroglyphic writing.

rosewood Any of several kinds of ornamental hardwoods derived from various tropical trees. The most important are Honduras rosewood, *Dalbergia stevensoni*, and Brazilian rosewood, *D. nigra*. It varies from a deep, ruddy brown to purplish and has a black grain. Family Fabiaceae/Leguminose

Rosh ha-Shanah Jewish New Year and first day of the month of Tishri (generally in September). It is the day on which a ceremonial ram's horn (*shophar* or *shofar*), is blown to call sinners to repentance; the day called the Day of Judgement or of Remembrance; and the day which begins the Ten Days of Penitence that end with the Day of Atonement, YOM KIPPUR.

Rosicrucians Esoteric, secret, worldwide society using supposedly magical knowledge, drawn from ALCHEMY. The name comes from pamphlets published by Christian Rosenkreutz *c.*1615, of whom there is no other record. The modern movement has splintered into several factions.

Ross, Betsy (1752–1836) US seamstress. She is said to have made the first American stars and stripes flag.

Ross, Diana (1944–) US popular singer. Ross began a career with the vocal trio, The Supremes, whose Motown hits included "Where Did Our Love Go?" (1964) and "Baby Love" (1964). In 1969 she left to pursue a solo career. Her hits include "Reach Out and Touch (Somebody's Hand) (1970).

Ross Dependency Region of Antarctica that includes Ross Island, the coast along the Ross Sea and nearby islands. It has been under the jurisdiction of New Zealand since 1923. Area: land mass, *c*.415,000sq km (160,000sq mi); ice shelf, *c*.450,000sq km (174,000sq mi).

Rossellini, Roberto (1906–77) Italian film director and producer. His post-war films, such as *Open City* (1945), were landmarks in post-war NEO-REALISM. During the 1950s he made a series of films with his wife, Ingrid BERGMAN, such as *Stromboli* (1949).

Rossetti, Christina Georgina (1830–94) British poet, sister of Dante Gabriel Rossetti. Her most enduring work is contained in *Goblin Market and Other Poems* (1862) and *The Prince's Progress and Other Poems* (1866).

Rossetti, Dante Gabriel (1828–82) British poet and painter, brother of Christina ROSSETTI. He was a founding member of the PRE-RAPHAELITE BROTHERHOOD. After the group dispersed, Rossetti developed a distinctive style of medieval romanticism. He painted his wife (Elizabeth Siddal) on numerous occasions. Rossetti worked with William MORRIS, but became a recluse and died of drug addiction.

Rossini, Gioacchino Antonio (1792–1868) Italian opera composer. Rossini's comic operas, including *The Barber of*

Seville (1816) and La Cenerentola ("Cinderella", 1817), demonstrate his wit and sense of melody. His serious operas include William Tell (1829).

Rosso, II (1495–1540) (Giovanni Battista Rosso) Italian painter and decorative artist. He collaborated with Primatic-cio in decorating the royal palace at FONTAINEBLEAU and helped to found the FONTAINEBLEAU SCHOOL.

Rostand, Edmond (1868–1918) French poet and dramatist. His major verse plays include *Cyrano de Bergerac* (1897), *L'Aiglon* (1900) and *Chantecler* (1910).

Rostropovich, Mstislav Leopoldovich (1927–) Soviet musician, who established a reputation as one of the century's best cellists. Leading composers such as SHOSTAKOVICH, PROKOFIEV and BRITTEN dedicated works to him.

rotation Turning of a celestial body about its axis. In the Solar System, the Sun and all the planets, with the exception of Uranus and Venus, rotate from w to E.

Roth, Philip (1933–) US novelist and short-story writer. He established his name with the collection of stories, *Goodbye Columbus* (1959). His later works, including *Zuckerman Bound* (1985), *Operation Shylock* (1993), *Sabbath's Theater* (1995) and *American Pastoral* (1997), are overshadowed by the success of his best-known novel *Portnoy's Complaint* (1969).

Rothko, Mark (1903–70) US painter, b. Russia. A leader of the New York School, he developed a highly individual style featuring large, rectangular areas of thinly layered, pale colours arranged parallel to each other. Towards the end of his life, Rothko introduced darker colours, notably maroon and black. Examples of this phase can be seen in his nine paintings from the late 1950s, entitled Black on Maroon and Red on Maroon.

Rothschild Commercial and banking dynasty founded by Meyer Amschel Rothschild (1744–1812), son of a money changer in the Jewish ghetto of Frankfurt. His five sons established branches in the financial centres of Europe and the family fortune was made during the Napoleonic wars. The Rothschilds were one of the chief financial powers in the 19th century but developments in state financing late in the century reduced their influence. The family continues to be active in banking and as winemakers.

rotifer (wheel animacule) Microscopic metazoan found mainly in freshwater. Although it resembles ciliate PROTOZOA, it is many-celled with a general body structure similar to that of a simple worm. Rotifers may be elongated or round, and are identified by a crown of cilia around the mouth. Class Rotifera. Rotterdam City at the junction of the Rotte and the New Meuse rivers, w Netherlands; chief port and second-largest city in the Netherlands. Founded in the 14th century, it expanded with the construction of the New Waterway (1866-72), making it accessible to ocean-going vessels. In 1940 the centre was devastated by German bombing. In 1966 the opening of the Europort harbour made Rotterdam one of world's largest ports. It has a huge transit trade with industrial areas of Europe, in particular the RUHR in Germany. Industries: shipbuilding and ship repairing, petrochemicals, electronic goods, textiles, paper, motor vehicle assembly, clothing, brewing, oil refining, machinery. Pop. (1994) 598,521.

rottweiler German cattle dog. The short-backed, strong body is set on muscular, medium-length legs and the tail is commonly docked. The short, coarse, flat coat is black with brown markings. Height: to 68.5cm (27in) at the shoulder; 34–41kg (75–90lb).

Rouault, Georges (1871–1958) French painter, printmaker and designer. Studying under Gustave Moreau with Matisse, he became acquainted with FAUVISM. A mental crisis turned him towards more painful subjects. By the 1930s, he had designed book illustrations, ceramics and tapestries as well as the sets for Diaghilev's ballet, *The Prodigal Son* (1929). After 1940 Rouault concentrated exclusively on religious art.

Rouen City and port on the River Seine, NW France; capital of Seine-Maritime département. Already important in Roman times, by the 10th century Rouen was capital of Normandy and one of Europe's leading cities. Under English rule (1066–1204, 1419–49), it was the scene of Joan of Arc's trial and burning in 1431. Badly damaged in World War 2, it was later rebuilt.

Industries: textiles, flour milling, iron foundries, petrochemicals, perfumes, leather goods. Pop. (1990) 102,723.

roulette Game of chance in which people gamble on which of 37 numbered slots (38 in the USA) in a spinning wheel a small white ball will end up in when the wheel stops. Gamblers place their bets on a table marked out with the numbers. The bank wins all stakes if the ball stops on 0 (and 00 in the USA). **Roundheads** Name given to Puritans and other supporters of Parliament during the English CtvII. War. It was originally a derogatory nickpame for Puritans who cut their hair short, in contrast to the ringlets of the CAVALIERS (Royalists).

roundworm Parasite of the class Nematoda, which inhabits the intestine of mammals. It breeds in the intestine. The larva bores through the intestinal wall, is carried to the lungs in the bloodstream and crawls to the mouth where it is swallowed. Length: 15–30cm (6–12in).

Rousseau, Henri (1844–1910) French painter, greatest of all naive painters. Rousseau is best known for his scenes from an imaginary tropical jungle, such as *Surprised!* (*Tropical Storm with Tiger*) (1891) and *The Dream* (1910).

Rousseau, Jean Jacques (1712-78) French philosopher of the Age of Reason, whose ideas about society helped to shape the political events that resulted in the French Revolution. Rousseau was born a Protestant in Geneva, Switzerland and became a Roman Catholic in the 1730s, but later in his life he reconverted to Protestantism in order to regain his citizenship rights in Geneva. In 1740 Rousseau moved to Paris and soon devoted himself to a career as a writer and composer. He contributed articles on music to the Encyclopédie of DIDEROT in the 1740s, and finally won fame for his essay, Discourses on Science and the Arts (1750). In The Social Contract (1762), he argued that man had been corrupted by civilization. His ideas on individual liberation from the constraints of society were developed in the novel Émile (1762). He described his early, wandering life in an autobiography, Confessions, published posthumously in 1782.

Rousseau, Théodore (1812–67) French painter, leading member of the Barbizon School. He was at the forefront of the open-air movement in landscape painting, and from 1836 he worked in the forest of Fontainebleau near Paris.

rowing Using oars to propel a boat; a leisure activity and a sport. It was unofficially included in the Olympic Games in 1900 and became a full Olympic event in 1904. Modern racing boats hold crews of two, four or eight, each crew member using both hands to pull one oar (to use two oars is sculling). A coxswain steers for eights and directs the crew; pairs and fours may or may not have a coxswain. See also BOAT RACE

■ Rossetti Beata Beatrix
(c.1864–70). One of the founders
of the Pre-Raphaelite Brotherhood,
the artist and poet Dante Gabriel
Rossetti had a lush and romantic
painting style. Although his poetry
was first published when he was
19, he remained virtually unknown
as a poet until late in life. His
paintings had a great influence on
other artists, particularly the
symbolists.

Rowntree, Benjamin Seebohm (1871–1954) British businessman and sociologist. In 1889 he joined the family chocolate firm and introduced employees' pensions (1906), a five-day week (1919), and employee profit-sharing (1923).

Royal Academy of Arts (RA) British national academy of the arts, founded by George III in 1768 and based in London. Members aimed to raise the status of the arts by establishing high standards of training and organizing annual exhibitions. Royal Greenwich Observatory UK national astronomical observatory, founded at Greenwich, London, in 1675. After World War 2 the observatory moved to Herstmonceux in Sussex and, in 1990, it relocated to Cambridge. The RGO operates the UK telescopes at the Roque de los Muchachos Observatory on La Palma in the Canary Islands.

Royal Marines British soldiers who serve at sea. The marines are also a mobile force, which can be put ashore at any time to operate as conventional soldiers. Their first success was the capture of Gibraltar in 1704. The Royal Marines played a significant role in both World Wars.

Royal Navy Fighting force that defends Britain's coastal waters and its merchant shipping. The first naval fleet in Britain was built by Alfred the Great in 878 to fight off the Viking raids. In the 16th century Henry VII built the first specialist naval ships and established the first dockyards. The following centuries saw a struggle for naval supremacy between Britain, France and The Netherlands, culminating in the Battle of Trafalgar. The British victory heralded the supremacy of the Royal Navy that lasted into the 20th century. Since World War 2 the role of the Royal Navy has diminished because of cuts in the defence budget.

Royal Opera House (originally Covent Garden Theatre) Home of The Royal Opera and, from 1946, of Sadler's Wells Ballet (now The Royal Ballet). The theatre was first opened in 1732 and the present building was completed in 1858. The Royal Opera traditionally performs works in their original language. See also ENGLISH NATIONAL OPERA (ENO)

Royal Shakespeare Company (RSC) State-subsidized British theatrical repertory company, based in Stratford-upon-Avon. Originally known as the Shakespeare Memorial Company, it received a royal charter in 1961. In 1960 it established a second base in London and performed Shakespeare-an plays alongside other classical and contemporary pieces.

Royal Society British society founded in 1660 and incorporated two years later. Its aim was to accumulate experimental evidence on a wide range of scientific subjects, including medicine and botany as well as the physical sciences. In the 20th century, the Royal Society became an independent body of scientists encouraging research.

Royal Society for the Prevention of Cruelty to Animals (RSPCA) British organization established in 1824 to prevent cruelty and promote kindness to animals. The RSPCA has its headquarters at Horsham, Sussex. Its inspectors investigate cases of cruelty to animals and, if necessary, bring offenders to court. There are similar organizations in Northern Ireland, Scotland and the Republic of Ireland.

RSI Abbreviation of REPETITIVE STRAIN INJURY

RSPCA Abbreviation of the Royal Society for the Prevention of Cruelty to Animals (RSPCA)

rubber Elastic solid obtained from the latex of the RUBBER TREE. Natural rubber consists of a POLYMER of cis-isoprene and is widely used for tyres and other applications, especially after VULCANIZATION. Synthetic rubbers are polymers tailored for specific purposes.

rubber plant Evergreen FIG native to India and Malaysia. Tree-sized in the tropics, juvenile specimens are grown as houseplants in temperate regions. Once cultivated for its white LATEX to make India rubber, it has large, glossy, leathery leaves and a stout, buttressed trunk. Height: to 30m (100ft). Family Moraceae; species *Ficus elastica*.

rubber tree Any of several South American trees whose exudations can be made into RUBBER; especially *Hevea brasiliensis* (family Euphorbiaceae), a tall softwood tree native to Brazil but introduced to Malaysia. The milky exudate, called LATEX, is obtained from the inner bark by tapping and then coagulated by smoking over fires or chemically.

rubella See GERMAN MEASLES

Rubens, Peter Paul (1577–1640) Flemish painter, engraver and designer, the most influential BAROQUE artist of N Europe. Rubens began to gain an international reputation with his huge, vigorous TRIPTYCHS, *Raising of the Cross* (1610–11) and *Descent from the Cross* (1611–14). He worked for many of the royal families of Europe and his most notable commissions included 25 gigantic paintings of Marie de' Medicis; a series of scenes depicting the life of James I for the Banqueting House, London; and a group of over 100 mythological paintings for Philip IV of Spain.

Rubicon Ancient name for the River Fiumicino in N central Italy. It formed the border between Italy and Cisalpine Gaul. In 49 BC Julius CAESAR precipitated civil war by "crossing the Rubicon" into Italy with his army.

rubidium (symbol Rb) Silver-white metallic element of the ALKALI METALS (group I of the periodic table). It was discovered in 1861 by the German chemist Robert BUNSEN and the German physicist Gustav KIRCHHOFF. The element has few commercial uses; small amounts are used in photoelectric cells. It chemically resembles SODIUM but is more reactive. Properties: at. no.37; r.a.m. 85.4678; r.d. 1.53; m.p. 38.89°C (102°F); b.p. 688°C (1,270°F); most common isotope Rb⁸⁵ (72.15%).

Rubik, **Ernö** (1944–) Hungarian architect, designer and puzzle maker. He shot to fame after he patented the Rubik's Cube, a mathematical puzzle that he invented in 1974.

Rubinstein, Arthur (1887–1982) US pianist, b. Poland. He made his debut with the Berlin Symphony Orchestra in 1901. He first played in the USA in 1906 and became famous for his interpretations of Chopin and Spanish composers.

ruby Gem variety of the mineral CORUNDUM (aluminium oxide), whose characteristic red colour is due to impurities of chromium and iron oxides. The traditional source of rubies is Burma. Today, synthetic rubies are widely used in industry.

rudd (red eye) Fish related to the MINNOW. In the USA it is called pearl ROACH. Found also in Europe, N and W Asia, the rudd is a large, full-bodied fish with reddish fins. Length: to 40.6cm (16in); weight: to 2kg (4.5lb). Family Cyprinidae; species *Scardinius erythrophthalmus*.

Rudolf I (1218–91) German king (1273–91), founder of the HABSBURG dynasty. His election as king ended a period of anarchy (1250–73). He set out to restore the position of the monarchy, and won the duchies of Austria, Styria, and Carniola from Ottokar II of Bohemia (1278). He was never crowned emperor, and failed to persuade the electors to confirm his son, Albert I, as his successor, though in 1298 Albert eventually succeeded to the German throne.

Rudolf II (1552–1612) Holy Roman emperor (1576–1612). Son and successor of the Emperor Maximilian II, he moved the imperial capital to Prague, which became a brilliant centre of the RENAISSANCE. His opposition to Protestantism caused conflict in Bohemia and Hungary. A Hungarian revolt was suppressed by his brother and eventual successor, Matthias, to whom he ceded Hungary, Austria, Moravia (1608), and Bohemia (1611).

ruff Bird of the SANDPIPER family (Scolopacidae). The male is noted for a collar of long feathers about its neck, and for its antic courtship performances. The female is called a reeve. The ruff migrates across N Europe and N Asia to Africa and India. Species *Philomachus pugnax*.

rugby Ball game for two teams in which an oval ball may be handled as well as kicked. There are two codes, union and league, but the purpose in each is the same: to touch the ball down in the opposition in-goal area for a try, which allows a kick at the H-shaped goal (a conversion). Kicks must pass over the crossbar between the line of the posts. Players may not pass the ball forward or knock it forward when attempting to catch it. The field of play is rectangular, 100m (330ft) long and 55–68m (180–225ft) wide, and play consists of two 40-minute halves. Rugby union is a 15-a-side game, which used to be restricted to amateurs. It is most popular in Britain, France, South Africa, New Zealand and Australia. Rugby league is a 13-a-side game for professionals and amateurs, played mostly in England, Australia, New Zealand and France. Recent developments are bringing about closer affinity between the codes.

▲ ruminant Impalas are found in the grasslands of central and E Africa. Like other ruminants, they can regurgitate food in small amounts once it has been partly digested, for chewing again. reswallowing, and further digestion. This enables them to obtain a lot of food in a short time, then retreat to a safe, sheltered place to digest it. When grazing, an impala grasps vegetation between its spade-like incisors (1) and a hard upper pad (2) and pulls it up rather than biting it off. The molars (3) are ideal for chewing. The gap between incisors and molars (4) allows the tongue to mix food with saliva. The powerful masseter muscle (5) moves the jaw up and down, while other facial muscles move it laterally for grinding.

Ruhr River in Germany; its valley is Germany's manufacturing heartland. The River Ruhr rises in the Rothaargebirge Mountains, and flows w for 235km (146mi) to join the River Rhine at Duisburg. Major cities on its banks include Essen, Dortmund and Mülheim. In the 19th century, the Krupp and Thyssen families intensively mined the region's high-quality coking coal and developed massive steelworks. In 1923–25 France and Belgium occupied the Ruhr in order to compel Germany to pay the agreed war reparations. During World War 2 its many armaments factories marked it out as a major Allied target, and more than 75% of the region was destroyed. The post-war decline in demand for coal led to a shift to light industry and the region regained prosperity.

Ruisdael, Jacob van (1628–82) Dutch landscape painter. Jacob brought to his paintings of the flat northern landscape an unusual breadth and accuracy. Among his many works are *Wooded Landscape* (c.1660) and *Windmill at Wijk* (c.1670). **rum** Alcoholic spirit made by the fermentation of molasses and other sugar-cane products, which are then distilled. When

distilled, rum is colourless, but storage in wooden casks and the addition of caramel give it a brown colour.

Rumi (1207–73) Persian poet, b. Jalāl ad-Dīn ar-Rūmī. A theologian and teacher whose huge body of work – some 30,000 couplets and numerous *rubaiyat* or quatrains – was inspired by SUFISM. Rumi is generally regarded as Persia's finest poet. His main work is the epic *Mathnawi* (or *Masnavī*). ruminant Cud-chewing, even-toed, hoofed mammal. They include the okapi, chevrotain, DEER, GIRAFFE, ANTELOPE, CATTLE, SHEEP and GOAT. All except the chevrotain have four-chambered stomachs, and they are known for re-chewing food previously swallowed and stored in one of the chambers.

Rump Parliament (1648–53) Name given to the LONG PARLIAMENT in England after 140 members were expelled. Unrepresentative and quarrelsome, it was dissolved by Oliver CROMWELL in 1653. It was recalled after the collapse of the PROTECTORATE in 1659, and expelled members were reinstated. Runcie, Robert Alexander Kennedy (1921–) British Anglican clergyman, Archbishop of Canterbury (1980–91). Runcie was ordained in 1951 and became bishop of St. Albans in 1970. He signed a pledge to move toward unity with the Roman Catholic Church during Pope John Paul II's historic trip to the UK in 1982.

Rundstedt, Gerd von (1875–1953) German field marshal, one of Adolf Hitler's most successful army commanders. In 1939 he was called out of retirement to take a leading part in the Polish and French campaigns. He commanded an army group during the invasion of the Soviet Union but was dismissed after being forced to retreat. Rundstedt later returned to active service as commander of the German forces in France. In September 1944 he directed the "Battle of the Bulge", Germany's last attempt to halt the Allied advance in the west.

Runeberg, Johan Ludvig (1804–77) Finnish-Swedish poet. Among his works are two epics, *The Moose Hunters* (1832) and *Hanna* (1836), and the patriotic poems of the Russo-Swedish War, *Songs of Ensign Stal* (1848–60).

runes Angular characters or letters of an alphabet formerly used by Germanic peoples in early medieval times. Also called *futhark* after its first six letters (f, u, th, a, r, and k), the runic alphabet may have been developed by an unknown Germanic people from a N Italian alphabet.

runner Long, thin stem that extends along the surface of the soil from the axil of a plant's leaf, and serves to propagate the plant. At points (nodes) along its length, a runner has small leaves with buds that develop shoots and roots and turn into small independent plants as the runner dies. Runners are produced by such plants as strawberries and creeping buttercups. See also ASEXUAL REPRODUCTION

Rupert, Prince (1619–82) British military commander, b. Bohemia and raised in the Netherlands. Rupert's uncle, Charles I, made him commander of the cavalry in the English CIVIL WAR. He was undefeated until Marston Moor (1644). Rupert was dismissed after the Royalist defeat at Naseby (1645) and he surrendered at Bristol. He led raids against English shipping during the Protectorate period and, back in England after the Stuart restoration, served as an admiral in the Dutch wars.

rupture See HERNIA

Rurik (d.c.879) Semi-legendary leader of the Varangians (VIKINGS) in Russia and first Prince of Novgorod. He established his rule c.862, a date usually taken as marking the beginning of the first Russian state. The capital was moved to Kiev under Rurik's successor, Oleg, and members of his dynasty ruled there, and later in Moscow, until the 16th century, eventually being replaced by the ROMANOVS.

rush Any of about 700 species of perennial tufted bog plants found in temperate regions. It has long, narrow leaves and small flowers crowded into dense clusters. The most familiar rush is *Juncus effusus*, found in Europe, Asia, North America, Australia and New Zealand. It has brown flowers and ridged stems. Height: 30–152cm (1–5ft). Family Juncaceae.

Rush-Bagot Convention British-US agreement of 1817 providing for disarmament of the US-Canadian border. Besides ensuring an unfortified frontier, it agreed limits for ships of the two countries in the Great Lakes.

Rushdie, Salman (1947–) British novelist, b. India. Rushdie's early works, including the Booker Prize-winning *Midnight's Children* (1981), were eclipsed by his *Satanic Verses* (1988). This novel incited the condemnation of Islamic extremists who perceived the book as BLASPHEMY, and he was sentenced to death by Ayatollah KHOMEINI. In hiding since, he has written a number of works, including a children's book, *Haroun and the Sea of Stories* (1990), and the novel *The Moor's Last Sigh* (1995).

Ruskin, John (1819–1900) British author, artist and social reformer. A strong religious conviction was the basis for Ruskin's advocacy of Gothic naturalism as the best style through which to praise God. His ideas are outlined forcefully in his books on architecture: *The Seven Lamps of Architecture* (1849) and *The Stones of Venice* (three vols., 1851–53). His five-volume work *Modern Painters* (1834–60) championed the paintings of J.M.W. TURNER and after 1851 he supported the PRE-RAPHAELITE BROTHERHOOD.

Russell, Bertrand Arthur William, 3rd Earl (1872–1970) Welsh philosopher, mathematician and social reformer. His most famous work, the monumental *Principia Mathematica* (1910–13), written in collaboration with A.N. WHITEHEAD, set out to show exactly how mathematics was grounded in LOGIC. He also wrote various philosophical works, and his best-selling *History of Western Philosophy* appeared in 1946. Russell was a lifelong pacifist except during World War 2 and was a constant campaigner for educational and moral reforms. From 1949 he increasingly advocated nuclear disarmament. He was imprisoned twice (1918, 1961) for his activities on behalf of peace. He won the 1950 Nobel Prize for literature.

Russell, George William (1867–1935) Irish poet, essayist, journalist and painter, who wrote under the pen name A.E. A leading figure of the Irish literary renaissance, he published many collections of romantic and often mystical poetry, among them *The Divine Vision* (1904) and *Midsummer Eve* (1928).

Russell, John, 1st Earl (1792–1878) British statesman, Liberal prime minister (1846–52, 1865–66). Russell became a Whig MP in 1813. As paymaster general, he introduced the Great Reform Bill (1832). Russell was one of the founders of the Liberal Party. Conservative divisions over the repeal of the Corn Laws helped Russell succeed Sir Robert Peel as prime minister. His first administration collapsed following the resignation of his foreign secretary, Viscount Palmerston. Russell returned as foreign secretary (1852–55) in Aberdeen's coalition, but retired after accusations of incompetent handling of the Crimean War. He returned as foreign secretary (1859–65) under Palmerston and became prime minister again on Palmerston's death. His second term was curtailed by the defeat of a new Reform Bill (1866). See also Reform ACTS

Russell, Ken (1927–) British film director. Russell's debut feature film was *French Dressing* (1963). His adaptation of *Women in Love* (1969) established his reputation for extravagence and controversy. *The Music Lovers* and *The Devils* (both 1971) reinforced this perception. Other films include Tommy (1975), *Altered States* (1980) and *Gothic* (1987).

Russia Federation in E Europe and N Asia. See country feature, p.580

▲ rush A decorative aquatic plant, the flowering rush (Butomus umbellatus) has an attractive, three-petalled flower that grows above the surface of the water. The long leaves have parallel veins without a central vein or midrib.

▲ Rushdie After the publication of the novel Satanic Verses (1988), the Iranian ayatollah Khomeini imposed a fatwa (death penalty) on the author Salman Rushdie.

The death threats against him (and his publishers and translators) were serious enough to drive him into hiding under police protection. He has continued to publish both works of fiction and essays. In recent years, he has begun to increase his public appearances.

In August 1991, Russia's traditional flag, first used in 1699, was restored as Russia's national flag. When Russia formed part of the Soviet Union, this flag was replaced by the hammer and sickle.

he Russian Federation is the world's largest country. The URALS form a natural border between European and Asian Russia (SIBERIA). About 25% of Russia lies in Europe, w of the Urals. European Russia contains about 80% of Russia's population, including the capital, Moscow. It is predominantly a vast plain. The CAUCASUS Mountains form Russia's sw border with Georgia and Azerbaijan, and include Europe's highest peak, Mount ELBRUS, at 5,633m (18,481ft). Grozny, capital of CHECHENYA, lies close to the Georgian border. The port of ASTRAKHAN lies on the shore of the CASPIAN SEA, the world's largest inland body of water, ST PETERSBURG, Russia's second-largest city, is a Baltic seaport. ARCHANGEL is the major White Sea port. European Russia's major rivers are the Don and the Volga (Europe's longest river). Volgograp lies on the banks of the Volga. SIBERIA is a land of plains and plateaux, with mountains in the E and S. It is drained by the rivers OB, YENISEI, and LENA. The industrial centre of Novosibirsk lies on the River Ob. Close to the Mongolian border lies Lake BAIKAL (the world's deepest lake). On its shores lies IRKUTSK. VLADIVOSTOCK is the major port on the Sea of Japan. SAKHALIN and the KURIL ISLANDS have often been a source of conflict with Japan. The KAMCHATKA PENINSU-LA contains many active volcanoes.

CLIMATE

The climate varies from N to S and also from W to E. Moscow has a continental climate with cold, snowy winters and warm summers. Siberia has a much harsher and drier climate. In Northern Siberia, winter temperatures often fall below $-46^{\circ}\text{C}~(-51^{\circ}\text{F})$.

VEGETATION

The far N is tundra. Mosses and lichens grow during the short summer, but the subsoil is permafrost. To the s is the taiga, a vast region of coniferous forest. In the w and E are mixed forests of conifer, oak and beech. South-central Russia contains large areas of former steppe, most of which is now under the plough; its dark chernozem soils are among the world's most fertile. The semi-desert lowlands around the Caspian Sea are hardy grassland. The Caucasus Mountains have lush forests of oak and beech.

HISTORY AND POLITICS

Traditionally, the Varangian king, RURIK, established the first Russian state in *c*.AD 862. His successor, Oleg, made Kiev, his capital and the state became known as Kievan Rus. VLADIMIR I adopted Greek Orthodox Christianity as the state religion in 988. VLADIMIR and Kiev vied for political supremacy. In 1237–40, the Mongol TATARS conquered Russia and established the GOLDEN HORDE. Saint ALEXANDER NEVSKI became Great Khan of Kiev. In the 14th

century Moscow gradually grew in importance, and the Grand Duchy of Moscow was established in 1380. IVAN III (THE GREAT) greatly extended the power of Moscow, began the construction of the KREMLIN, and completed the conquest of the Golden Horde in 1480. In 1547 IVAN IV (THE TERRIBLE) was crowned tsar of all Russia. Ivan the Terrible conquered the Tatar khanates of KAZAN (1552) and Astrakhan (1556), gaining control of the Volga River, and began the conquest of Siberia. Following the death of Boris GODUNOV (1605), Russia was subject to foreign incursions and ruled by a series of usurpers. In 1613 Michael founded the ROMANOV tsarist dynasty which ruled Russia until 1917. The reign (1696-1725) of PETER I (THE GREAT) marked the start of the westernization and modernization of Russia: central governmental institutions were founded, and the AREA: 17,075,000sq km (6,592,800sq mi)

POPULATION: 149,527,000

CAPITAL (POPULATION): Moscow (8,881,000)
GOVERNMENT: Federal multiparty republic
ETHNIC GROUPS: Russian 82%, Tatar 4%,
Ukrainian 3%, Chuvash 1%, more than 100
other nationalities

LANGUAGES: Russian (official)
RELIGIONS: Christianity (mainly Russian
Orthodox, with Roman Catholic and
Protestant minorities), Islam, Judaism
CURRENCY: Russian rouble = 100 kopecks

Church was subordinated to the Crown. Centralisation was achieved at the expense of increasing the number of serfs. Russia expanded w to the Baltic Sea, and St Petersburg was founded in 1703. Peter made it his capital in 1712. In 1762 CATHERINE II (THE GREAT) became empress. Under her authoritarian government, Russia became the greatest power in continental Europe, acquiring much of Poland, Belarus and Ukraine. ALEXANDER I's territorial gains led him into direct conflict with the imperial ambitions of Napoleon I. Napoleon captured Moscow in 1812, but his army was devastated by the harsh Russian winter. The Decembrist Conspiracy (1825) unsuccessfully tried to

prevent the accession of NICHOLAS I. Nicholas' reign was characterized by the battle against liberalization. At the end of his reign, Russia became embroiled in the disastrous CRIMEAN WAR (1853-56). ALEXANDER II undertook much-needed reforms, such as the emancipation of the serfs. ALEXANDER III's rule was more reactionary, but continued Russia's industrialization, helped by the construction of the Trans-Siberian Railway. Alexander was succeeded by the last Romanov tsar, NICHOLAS II. In the 1890s, drought caused famine in rural areas and there was much discontent in the cities. Defeat in the RUSSO-JAPANESE WAR (1904-05) precipitated the RUSSIAN REVOLU-TION OF 1905. Nicholas II was forced to adopt a new constitution and establish an elected duma (parliament). The democratic reforms were soon reversed, revolutionary groups were brutally suppressed, and POGROMS were encouraged. The Russian Social Democratic Labor Party was secretly founded in 1898, supported primarily by industrial workers. In 1912 the Party split into Bolshevik and Menshevik factions. Russia's support of a Greater Slavic state contributed to the outbreak of World War 1. Russia was ill-prepared for war, and suffered great hardship. The RUSSIAN REVOLUTION (1917) had two main phases. In March, Nicholas II was forced to abdicate (he and his

family were executed in July 1918), and a provisional government was formed. In July, KERENSKY became prime minister, but failed to satisfy the radical hunger of the SOVIETS. In November 1917, the Bolsheviks, led by LENIN, seized power and proclaimed Russia a Soviet Federated Socialist Republic. In 1918, the capital was transferred to Moscow. Under the terms of the Treaty of Brest-Litovsk (1918), Russia withdrew from World War 1, but was forced to cede much territory to the Central Powers. For the next five years, civil war raged between the Reds and Whites (monarchists and anti-communists), complicated by foreign intervention. The Bolsheviks emerged victorious, but Russia was left devastated. In 1922 Russia was united with Ukraine, Belarus, and Transcaucasia (Armenia, Azerbaijan and Georgia) to form the Union of Soviet Socialist Republics (USSR). (for history 1922–91, see SOVIET UNION)

In June 1991 Boris YELTSIN was elected President of the Russian Republic. In August 1991 communist hardliners arrested the Soviet president Mikhail GORBACHEV and attempted to capture the Russian parliament in Moscow. Democratic forces rallied behind Yeltsin, and the coup was defeated. Yeltsin emerged as the major power player. On 25 December 1991, Gorbachev resigned as president of the USSR, and on 31 December, the Soviet Union was dis-

solved. The Russian Federation became a cofounder of the COMMONWEALTH OF INDEPEN-DENT STATES (CIS), composed of former Soviet Republics. In March 1992, a new Federal Treaty was signed between the central government in Moscow and the autonomous republics within the Russian Federation. Chechenya refused to sign, and declared independence. Yeltsin's reforms were frustrated by institutional forces, forcing him to dissolve parliament in September 1993. Parliamentary leaders formed a rival government, but the coup failed. In December 1993 a new democratic constitution was adopted. Yeltsin's progress in the democratization of political institutions and reform of the social economy was slow. A central political problem was the representation of Russia's diverse minorities. Many ethnic groups demanded greater autonomy within the Federation. In 1992 direct rule was imposed in Ingush and North Ossetia. From 1994 to 1996, Russia was embroiled in a costly civil war in the secessionist state of Chechenya. In May 1996, despite concern about his ill-health, Yeltsin was reelected. The biggest problem he faced was the parlous state of the economy, and there were nationwide protests (1997) about wage arrears.

ECONOMY

Under Soviet rule, Russia was transformed from an essentially agrarian economy into the world's second greatest industrial power (after the United States). By the 1970s, concentration on the military-industrial complex and the creation of a bloated bureaucracy had caused the economy to stagnate. Gorbachev's policy of PERESTROIKA was an attempt to correct this structural weakness. Yeltsin sped up the pace of reform. In 1993 the command economy was abolished, private ownership was re-introduced and mass privitization began. By 1996, 80% of the Russian economy was in private hands. Inflation is falling, but remains high (1995, 131%), and the economy is slowly emerging from recession. The biggest economic problem is the size of Russia's foreign debt (1995, US\$120,000 million). Industry employs 46% of the workforce and contributes 48% of GDP. Mining is the most valuable activity. Russia is rich in resources, it is the world's leading producer of natural gas and nickel, and the world's third largest producer of crude oil, lignite and brown coal. It is the world's second largest manufacturer of aluminium and phosphates. Light industries, producing consumer goods, are growing in importance. Most farmland is still government-owned or run as collectives. Russia is the world's largest producer of barley, oats, rye, and potatoes. It is the world's second-largest producer of beef and veal.

This stamp, one of a set of five entitled "Protected Animals", was issued in 1985 by the USSR (CCCP in the Cyrillic alphabet). It shows the hopping rodent, Satunin's jerboa.

▲ Ruth Nicknamed "the Bambino", Babe Ruth was one of the best baseball players of all time. A talented pitcher, his batting skills led him to achieve a career home-run record that lasted more than 25 years after his death. He spent the bulk of his career with the New York Yankees and their stadium, built while he was on the team, was known as "the house that Ruth built". A physically large person, his colourful personality was even bigger, and he was a major US celebrity of the 1920s and 1930s.

Russian Official language of the Russian Federation and several other republics that once belonged to the former Soviet Union. It is the primary language of c.140 million people and is a second language for millions more. It is the most important of the Slavic languages, which form a subdivision of the family of INDO-EUROPEAN LANGUAGES. It is written in the CYRILLIC alphabet.

Russian architecture Architectural style that began as a regional variety of Byzantine architecture in the 10th century with the Christianization of Russia. Important centres of architectural activity developed at Kiev, Novgorod, and Pskov. Early churches were built of wood. The Cathedral of Sancta Sophia, Kiev (1018–37) was the first stone construction. The distinctive, onion-shaped dome was introduced in the 12th century at the Cathedral of Sancta Sophia, Novgorod. Although the Byzantine influence remained strong, during the 15th century Russia was subject to a series of western European trends, and Italian architects built the KREMLIN in a Renaissance style. Peter the Great and Catherine brought ROCOCO and neoclassical principles to St Petersburg. In the 19th century a revival of medieval Russian architecture occurred.

Russian art Paintings and sculpture produced in Russia after c.1000 AD, as distinct from the earlier SCYTHIAN art. In the Middle Ages, Russian art carried on BYZANTINE ART traditions, and was primarily religious. After the fall of Constantinople (1453), Russia regarded itself as the spiritual heir of Byzantium. Even so, its finest artworks were largely produced by foreigners. This began to change in the latter part of the 19th century, when Ilya Repin and the Wanderers breathed new life into Russian art. This led to an extraordinarily fruitful period in the early 20th century, when Russia was at the heart of new developments in MODERNISM, SUPREMATISM and CONSTRUCTIVISM.

Russian Five Group of Russian composers, active in St Petersburg during the 1860s and 1870s, who hoped to create a truly Russian style of music. They were Mily BALAKIREV, Alexander BORODIN, César Cui, Modest MUSSORGSKY and Nikolai RIMSKY-KORSAKOV.

Russian literature Literary works of Russia until 1917, then of the Soviet Union until 1991. Thereafter, the literature properly belongs to the individual Russian republics. Russian literature has its origins in religious works dating from c.1000 AD, when Christianity came to Russia. They include biographies of saints, chronicles, hymns and sermons. After the 1600s, western influences are found. ROMANTICISM beginning in the late 1700s - dominated by Nikolai Karamzin (Letters of a Russian Traveller, 1790) and Alexander Pushkin (Boris Godunov, 1825) – gave way to the realism of novelists and dramatists such as Leo Tolstoy (War and Peace, 1869), Fyodor Dosto-EVSKY (The Brothers Karamazov, 1879), Anton CHEKHOV (Uncle Vanya, 1899) and Maxim Gorky (The Lower Depths, 1902). The revolutionary feelings that dominated the early part of the 20th century in Russia witnessed a literary revival. Major figures included the symbolist poet Alexander Blok (The Twelve, 1918) and the post-symbolists such as Vladimir MAYAKOVSKY. After the Russian Revolution (1917), many writers fled overseas to escape censorship at home. The authors who remained had to depict only favourable images of the Soviet Union. The major authors of this period were Boris PASTERNAK and Alexei Tolstoy (Road to Calvary, 1941). Criticism of the regime was published, however, in works by novelists Alexander Solzhenitsyn (One Day in the Life of Ivan Denisovich, 1962) and Yuri Trifonov (Another Life, 1975), and by poet Alexander Tvardovsky.

Russian Orthodox Church See Orthodox Church Russian Revolution (1917) Events in Russia that resulted, first, in the founding of a republic (March) and, second, in the seizure of power by the Bolsheviks (November). (In the calendar in use at the time, the two stages took place in February and October.) Widespread discontent, a strong revolutionary movement, and the hardships of World War 1 forced Tsar Nicholas II to abdicate in March. A provisional government was formed by liberals in the Duma (parliament), which represented only the middle classes. Its aim was to make Russia into a liberal democracy and to defeat Germany. Workers and peasants had different desires: greater social and economic equality

and an end to the war. The provisional government faced a challenge from the powerful, socialist SOVIET in Petrograd (St Petersburg), which in May formed a coalition government that included Alexander Kerensky, prime minister from July, and other socialists. The launching of a new military offensive, combined with disappointing reforms, discredited the government and the socialist parties associated with it. Meanwhile, soviets sprang up in many cities; while in rural areas, peasants seized land from the gentry, and at the front, soldiers deserted. In the cities, the Bolsheviks secured growing support in the soviets. In November, at the order of Lenin, they carried out a successful coup in Petrograd. The Kerensky government folded, but a long civil war ensued before Lenin and his followers established their authority throughout Russia.

Russian Revolution of 1905 Series of violent strikes and protests against tsarist rule in Russia. It was provoked mainly by defeat in the RUSSO-JAPANESE WAR (1904–05). It began on Bloody Sunday (22 January), when a peaceful demonstration in St Petersburg was fired on by troops. Strikes and peasant risings spread, culminating in a general strike in October, which forced the tsar to institute a democratically elected duma (parliament). By the time it met in 1906, the government had regained control. Severe repression followed.

Russo-Japanese War (1904–05) Conflict arising from the rivalry of Russia and Japan for control of Manchuria and Korea. The war opened with a Japanese attack on Port Arthur (Lüshum). Russian forces suffered a series of defeats on land and at sea, culminating in the Battle of Mukden (February–March 1905) and the annihilation of the Baltic fleet at Tsushima (May). Russia was forced to surrender Korea, the Liaotung Peninsula and s Sakhalin to Japan.

rust In botany, group of fungi that live as PARASITES on many kinds of higher plants. Rusts damage cereal crops and several fruits and vegetables. They have complex life cycles that involve growth on more than one host plant.

rust Corrosion of iron or its alloys by a combination of air and water. Carbon dioxide from the air dissolves in water to form an acid solution that attacks the iron to form iron (II) oxide. This is then oxidized by oxygen in the air to reddish-brown iron (III) oxide. Rusting may be prevented by GALVANIZING.

Ruth, "Babe" (George Herman) (1895–1948) US base-ball player. Ruth held the career home-run record (714) until surpassed (1974) by Hank AARON. His record of 60 home runs in one season was not beaten until the season was extended from 154 to 162 games. He played for the Boston Red Sox (1914–19), New York Yankees (1920–34) and Boston Braves (1935). He was elected to the Baseball Hall of Fame in 1936.

Ruth Eighth book of the Old Testament recounting the story of Ruth, a young Moabite widow. It tells of her devotion to Naomi, her Hebrew mother-in-law; her decision to leave her own land and settle in Israelite territory; and her eventual marriage to the wealthy Boaz, whereby she becomes the great-grandmother of Israel's greatest leader, King DAVID.

ruthenium (symbol Ru) Silver-white metallic element, one of the TRANSITION ELEMENTS. It was discovered in 1827 and first isolated in 1844. Ruthenium is found in PLATINUM ores. It is used as a catalyst, and its alloys are used in electrical contacts and to colour glass and ceramics. Properties: at.no. 44; r.a.m. 101.07; r.d. 12.41; m.p. 2,310°C (4,190°F); b.p. 3,900°C (7,052°F); most common isotope Ru¹⁰² (31.61%).

Rutherford, Ernest, Lord (1871–1937) British physicist, b. New Zealand, who pioneered modern NUCLEAR PHYSICS. Rutherford discovered and named alpha and beta radiation, named the nucleus, and proposed a theory of the radioactive transformation of ATOMS for which he received the 1908 Nobel Prize for Chemistry. In Cambridge, under J.J. THOMSON, he discovered the uranium radiations. At McGill University, Canada, he formed the theory of atomic disintegration with Frederick Soddy (1877–1965). At Manchester (1907), he devised the nuclear theory of the atom and, with Niels BOHR, the idea of orbital electrons. In 1919, at the Cavendish Laboratory, his research team became the first to split an atom's nucleus. He predicted the existence of the neutron, later discovered by James Chadwick.

rutile Black to red-brown oxide mineral, titanium dioxide

(TiO2), found in igneous and metamorphic rocks and quartz veins. It occurs as long, prismatic crystals in the tetragonal system and as granular masses. It has a metallic lustre, is brittle and is used as a gemstone. Hardness 6-6.5; s. g. 4.2.

Ruwenzori Mountain range in central Africa on the Uganda-Zaïre border, between lakes Albert and Edward. The highest peak is Mount Margherita, 5,109m (16,763ft). Length of range: 121km (75mi).

Ruyter, Michiel de (1607-76) Dutch seaman, one of his country's greatest naval commanders. During the First Anglo-DUTCH WAR (1652-54) he reached the rank of vice admiral. In the Second Anglo-Dutch War (1665-67), he commanded the fleet that defeated the English off Dunkirk (1666). In 1667 he sailed up the Medway, destroying much of the English fleet. He was again victorious in the Third Anglo-Dutch War (1672–74), inflicting severe losses on an Anglo-French force. Rwanda Republic in E central Africa. See country feature

Ryder Cup Biennial competition in which a team of professional male golfers from the USA plays a team from Europe. The event consists of eight 18-hole foursomes, eight 18-hole four-balls and sixteen 18-hole singles.

rye Hardy cereal grass originating in sw Asia and natural-

ized throughout the world. It grows in poor soils and colder climates than most other cereals can stand. It has flower spikelets that develop one-seeded grains. It is used for flour, as a forage crop and for making alcoholic drinks. Height: to 0.9m (3ft). Family Poaceae/Gramineae; species Secale cereale.

Ryle, Sir Martin (1918-84) British physicist and radio astronomer. After studying radar during World War 2, he went to Cambridge University where he pioneered RADIO ASTRONOMY. He also catalogued radio sources, which led to his discovery of QUASARS.

Ryukyu Islands Japanese archipelago in the w Pacific Ocean, extending c.970km (600mi) between Kyūshū and Taiwan; it separates the East China Sea (w) from the Philippine Sea (E). Inhabited since early times, the islands were invaded by China in the 14th century and by Japan in the 17th century, and were relinquished by China to Japan in 1879. After World War 2 they were administered by the USA, being restored to Japan in 1972. The group includes OKINAWA, Amami and Sakishima. Agriculture and fishing are the chief occupations. Area: c.2,200sq km (850sq mi). Pop. (1984 est.) 1,161,000.

RWANDA

Rwanda's flag has the red, yellow and green colours used on the flag of Ethiopia, Africa's oldest independent nation. These three colours symbolize African unity. The 'R' distinguishes Rwanda's flag from the flag of Guinea. Rwanda adopted this flag in 1961.

AREA: 26,340sq km (10,170sq mi) POPULATION: 7,526,000

CAPITAL (POPULATION): Kigali (234,500)

GOVERNMENT: Republic

ETHNIC GROUPS: Hutu 90%, Tutsi 9%, Twa 1% LANGUAGES: French and Kinyarwanda (both

official)

RELIGIONS: Christianity 74% (Roman Catholic 65%), traditional beliefs 17%, Islam 9% currency: Rwanda franc = 100 centimes

Rwanda is Africa's most densely populated country. It is a small state in the heart of Africa, bordered by Uganda (N), Tanzania (E), Burundi (s), and Zaïre (w). The w border is formed by Lake Kivu and the River Ruzizi. Rwanda has a rugged landscape, dominated by high, volcanic mountains, rising to Mount Karisimbi, at 4,507m (14,787ft). The capital, KIGALI, stands on the central plateau. East Burundi consists of stepped plateaux, which descend to the lakes and marshland of the Kagera National Park on the Tanzania border.

CLIMATE

Rwanda's climate is moderated by altitude. Rainfall is abundant. The dry season is June-August.

VEGETATION

The lush rainforests in the w are one of the last refuges for the mountain gorilla. Many of Rwanda's forests have been cleared, 35% of the land is now arable. The steep mountain slopes are intensively cultivated. Despite contour ploughing, heavy rain has caused severe soil erosion.

HISTORY AND POLITICS

Twa pygmies were the original inhabitants of Rwanda, but Hutu farmers began to settle (c.1,000 AD), gradually displacing the Twa. In the 15th century, Tutsi cattle herders migrated from the N, and began to dominate the Hutu. By the late 18th century, Rwanda and Burundi formed a single Tutsi-dominated state, ruled by a king (mwami). In 1890, Germany conquered the area and subsumed it into German East Africa. During World War 1, Belgian forces occupied (1916) both Rwanda and Burundi. In 1919 it became part of the Belgian League of Nations mandate territory of Ruanda-Urundi (which in 1946 became a UN trust territory). The Hutu majority became more vociferous in their demands for political representation. In 1959 the Tutsi mwami died. The ensuing civil war between Hutus and Tutsis claimed over 150,000 lives. Hutu victory led to a mass exodus of Tutsis. The 1960 elections were won by the Hutu Emancipation Movement, led by Grégoire Kayibanda. In 1961 Rwanda declared itself a republic. Belgium recognised independence in 1962. Kayibanda became president.

Rwanda was subject to continual Tutsi incursions from Burundi and Uganda. In 1973 Kayibanda was overthrown in a military coup, led by Major General Habyarimana. In 1978 Habyarimana became president. During the 1980s, Rwanda was devastated by drought. Over 50,000 refugees fled to Burundi. In 1990 Rwanda was invaded by the Tutsi-dominated Rwandan Patriotic Front (RPF), who forced Habyarimana to agree to a multiparty constitution. UN forces were drafted in to oversee the transition. In April 1994 Habyarimana and the Burundi president were killed in a rocket attack on their aircraft. The Hutu army and militia launched a premeditated act of genocide against the Tutsi minority, killing between 500,000 and one million Tutsis within three months. In July 1994 an RPF offensive toppled the government and created 2 million Hutu refugees. A government of national unity, comprised of both Tutsis and moderate Hutus, was formed. Over 50,000 people died in the refugee camps in E Zaïre, before international aid arrived. Hutu militia remained in control of the camps, their leaders facing prosecution for genocide. Many refugees remain fearful of Tutsi reprisals. The sheer number of refugees (1995, one million in Zaïre and 500,000 in Tanzania) has destabilized regional politics.

ECONOMY

Rwanda is a low-income developing country (1992 GDP per capita, US\$710). Most people are subsistence farmers. Crops include bananas, beans, cassava, and sorghum. Some cattle are raised, mainly by Tutsis. Rwanda's most valuable crop is coffee, accounting for over 70% of exports. Tea, pyrethrum, and tin are also exported. Rwanda has few manufacturing industries.

S/s, the 19th letter of the English alphabet and a letter employed in the alphabets of other w European languages. It is descended from the Semitic letter sin or shin, a name meaning tooth. which had a sound somewhat like the modern English sh. The Greeks had various letters for sibilants, but after about 600 BC they used mainly sigma for s. The letter as we know it today achieved its final form after adoption into the Latin alphabet.

Saarinen, Eero (1910–61) US architect and designer, b. Finland. His work provides a link between EXPRESSIONISM and the INTERNATIONAL STYLE. One of his most exciting buildings was the TWA terminal at New York's Kennedy Airport (1956–62). Other notable designs include the General Motors Technical Center in Warren, Michigan (1948–56) and the US Embassy, London (1955–61).

Saarland State in sw Germany on the borders with France (s) and Luxembourg (w); the capital is Saarbrücken. Belonging intermittently to France, the Saar was finally ceded to Prussia after the defeat of Napoleon I in 1815. France administered the region after World War 1 but in a 1935 plebiscite 90% of the people voted for German administration. French forces again occupied the Saar after World War 2. Saarland finally gained the status of a West German state in 1967. The valley of the River Saar is occupied by blast furnaces and steel works which exploit local coal and nearby iron ore. There is little agriculture, and some market gardening. Area: 2,570sq km (992sq mi). Pop. (1989 est.) 1,054,000.

Sabah, Sheikh Jabir al Ahmad al- (1928–) (Jabir III) Emir of Kuwait (1977–). A member of the ruling family of al-Sabah, a dynasty founded by Sheikh Sabah al-Awal (r.1756–72), he succeeded Sabah III al Salim. When Iraq invaded Kuwait (1990), Jabir took refuge in Saudia Arabia and set up a government in exile. He returned to Kuwait in 1991.

Sabah (North Borneo) State of MALAYSIA and one of the four political subdivisions of the island of Borneo. Ceded to the British in 1877, it remained the British Protectorate of North Borneo until 1963, when it became an independent state of the Malaysian Federation. The terrain is mountainous and forested. The capital is Kota Kinabalu (1990 pop. 208,484). The main products include oil, timber, rubber, coconuts and rice. Area: 76,522sq km (29,545sq mi). Pop. (1990) 1,736,902.

Sabbatarianism Religious doctrine of certain Protestants that Sunday, the Christian Sabbath, should be observed as a holy day of rest. Sabbatarianism began in Britain during the Puritan interregnum (1649–60). After the Sunday Entertainments Act of 1932, which empowered local authorities to license Sunday entertainment, Sabbatarianism lost much of its force in England, but remained strong in parts of Scotland and Wales.

Sabbath Seventh day of the week, set aside as a sacred day of rest. For Jews, the Sabbath runs from sunset on Friday to sunset on Saturday. Christians set aside Sunday for their Sabbath, making it a day of worship and rest from labour.

Sabin, Albert Bruce (1906–93) US virologist, b. Russia. In 1957 Sabin developed a live virus oral vaccine against poliomyelitis. It replaced Jonas SALK's inactivated virus vaccine.

Sabines Ancient people of central Italy. They inhabited the Sabine Hills NE of Rome, and part of the early Roman population was Sabine in origin. After sporadic fighting, the Sabines were conquered in 290 BC and gradually Romanized. sable MARTEN native to Siberia. It has been hunted almost to extinction for its thick, soft, durable fur, which is dark brown, sometimes flecked with white. Length: to 60cm (24in). Family Mustelidae; species *Martes zibellina*.

sabre-toothed tiger Popular name for a prehistoric member of the CAT family (Felidae) that existed from the OLIGOCENE period to the PLEISTOCENE period. It had extremely long canine teeth adapted to killing large herbivores. Subfamily Machairodontinae, genus *Smilodon*.

saccharide Organic compound based on SUGAR molecules. Monosaccharides include GLUCOSE and FRUCTOSE. Two sugar molecules join together to make a disaccharide, such as LACTOSE or SUCROSE. POLYSACCHARIDES have more than two sugar molecules. *See also* CARBOHYDRATE

saccharin Synthetic substance used as a substitute for SUGAR. It is derived from TOLUENE. In 1977 it was tenuously linked with some forms of cancer in humans, and is no longer widely used. Formula: $C_7H_5NO_3S$.

Sachs, Nelly (1891–1970) German-Jewish poet and dramatist. She escaped from Nazi Germany in 1940 and her works, such as *In the Houses of Death* (1947) and *Later Poems* (1965), bear witness to the suffering of European Jewry. Her

best-known play is *Eli: A Mystery Play of the Sufferings of Israel* (1951). She shared the 1966 Nobel Prize for literature. **Sackville-West, Vita (Victoria Mary)** (1892–1962) British poet and novelist. A friend of the writer Virginia Woolf and a member of the Bloomsbury Group, her best-known works include *The Edwardians* (1930), *All Passion Spent* (1931), and the long poem *The Land* (1926).

sacrament Symbolic action in which the central mysteries of a religious faith are enacted and which, on some accounts, confers divine grace upon those to whom it is given or administered. For Protestants there are two sacraments: BAPTISM and the Lord's Supper (see Last Supper). In the Roman Catholic and Eastern Orthodox Churches, the sacraments are baptism, CONFIRMATION, the EUCHARIST, holy ORDERS, matrimony, PENANCE, and the anointing of the sick.

Sacramento State capital and inland port of central California, USA, on the Sacramento River (which, at 560km/370mi, is the state's longest). It was the focal point of the 1848 gold rush, becoming the state capital (1854). A 69km (43mi) channel links it to an arm of San Francisco Bay, and the city also benefits from a large US Army depot and the McClellan Air Base. Industries: missile development, transport equipment, food processing, bricks. Pop. (1992) 382,816.

sacrifice Offering or destruction of precious objects – food and drink, flowers and incense, animals and human beings – for religious purposes. Sacrifices are made in order to maintain a relationship with a god or in the hope of winning divine favour or to atone for guilt.

Sadat, (Muhammad) Anwar (al-) (1918–81) Egyptian statesman, president (1970–81). A close associate of NASSER, he was vice president (1964–66, 1969–70), and succeeded Nasser as president. After the costly ARAB-ISRAELI WARS of 1973, he sought peace with ISRAEL and visited Israel in person in 1977. A historic Egypt-Israel peace treaty was signed in 1979. Sadat was assassinated by Muslim fundamentalists. Sadducees Jewish sect active in Judaea from c.200 BC until the fall of Jerusalem in AD 70. By the time of Jesus, the main difference between the Sadducees and the Pharisees was the

former's refusal to recognize the oral traditions surrounding

the Scriptures as part of Hebrew Law.

Sade, Donatien Alphonse François, Marquis de (1740–1814) French novelist and playwright. De Sade is one of the founders of the modern French prose style. Imprisoned for sexual offences, he wrote many novels renowned for their licentiousness, among them *Justine* (1791) and *Juliette* (1797). Safavid Persian dynasty (1501–1722) that established the territorial and SHIITE theocratic principles of modern Iran. The dynastic founder, Shah Ismail, claimed descent from a Shiite SUFISM order, and the state adopted Shiism as the state religion. His successor, ABBAS I, accepted the Ottoman occupation of w Iran and concentrated on subduing the threat to Iran's E borders. He captured Hormuz, Karbala and Najaf. His death created a power vacuum and Iran's borders contracted. Shah Husayn's fixation on the capture of Bahrain enabled Afghan troops to overrun the country. His forced

safety glass Form of glass that is less hazardous than ordinary glass when broken. One form of safety glass consists of two sheets of plate glass bonded to a thinner, central sheet of transparent plastic. If an impact breaks the glass, the plastic holds the fragments in place. Bullet-proof glass consists of several layers of glass and plastic. Wired glass has an embedded wire mesh to hold the fragments in place. Toughened glass is treated to make it stronger than ordinary glass. When shattered, it forms small blunt fragments.

abdication in 1722 marked the end of Safavid rule.

safety lamp Lamp that can be used safely in mines. Its oil burns inside a wire mesh cylinder, which conducts away much of the heat, so that any explosive firedamp (methane) in the air is not ignited. Today, most miners use electric lamps. See also Sir Humphry DAVY

safflower Annual plant with large red, orange or white flower heads that are used in making dyestuffs. The seeds yield oil, which is used in cooking and in the manufacture of MARGARINE. Family Asteraceae/Compositae; species *Carthamus tinctorius*.

▲ sabre-toothed tiger A fierce, carnivorous mammal, the sabre-toothed tiger (*Smilodon* sp.) lived in North and South America during the Pleistocene period. It possessed two long fangs and a wide-opening jaw structure that enabled it to kill its prey by stabbing and slashing at its throat. *Smilodon* was more powerfully built than a modern tiger, but is not thought to have been a fast runner, and probably ambushed its prey at waterholes.

saffron (autumn CROCUS) Perennial crocus, native to Asia Minor and cultivated in Europe. It has purple or white flowers. The golden, dried stigmas of the plant are used as a flavouring or dye. Family Iridaceae; species *Crocus sativus*. **saga** In old Norse Literature (especially Icelandic), prose narrative that relates the lives of historical figures. The sagas were written between the 7th and 14th centuries. Notable examples include the *Gísla saga*, the *Njáls saga*, and the *Heimskringla* by Snorri Sturluson (1179–1241).

sage Common name for a number of plants of the MINT family (Lamiaceae/Labiatae) native to the Mediterranean region. The best-known is *Salvia officinalis*, an aromatic perennial herb used widely for seasoning. Height: 15–38cm (6–15in). **sagebrush** Aromatic shrub common in arid areas of w North America. The common sagebrush has small, silvery-green leaves and bears clusters of tiny white flower heads. Height: to 2m (6.5ft). Family Asteraceae/Compositae; species *Artemisia tridentata*.

Sagittarius (the archer) Southern constellation between Scorpio and Capricorn. Rich in stellar CLUSTERS, this region of the sky also contains much interstellar matter. The brightest star is Epsilon Sagittarii (*Kaus Australis*), magnitude 1.8. In astrology, it is the ninth sign of the zodiac, represented by a centaur firing a bow and arrow.

sago palm (fern palm) Feather-leaved PALM tree native to swampy areas of Malaysia and Polynesia. Its thick trunk contains sago, a starch used in foodstuffs. The sago grows for 15 years, flowers once and then dies when the fruit ripens. Height: 1.2–9.1m (4–30ft). Family Arecaceae/Palmae; species *Metroxylon sagu*.

saguaro Large CACTUS native to Arizona, California and Mexico. White, night-blooming flowers appear when the plant is 50 to 75 years old. Its red fruit is edible. Height: to 12m (40ft). Family Cactaceae; species *Carnegiea gigantea*.

Sahara World's largest desert, with an area of c.9,065,000sq km (3,500,000sq mi), covering nearly a third of Africa's total land area. It consists of Algeria, Niger, Libya, Egypt and Mauritania, the s parts of Morocco and Tunisia, and the N parts of Senegal, Mali, Chad and Sudan. It extends c.4,800km (3,000mi) w to E from the Atlantic Ocean to the Red Sea, and stretches c.1,900km (1,200mi) N to S from the ATLAS Mountains to the SAHEL. The annual rainfall is usually less than 10cm (4in) and there is very little natural vegetation. Twothirds of the Sahara is stony desert, and the topography ranges from the Tibesti Massif (N Chad) at 3,350m (11,000ft) to the Qattara Depression (Egypt) at 133m (436ft) below sea level. The numerous natural and man-made oases act as vital centres for water, crop farming and transport, and the Sahara's two million inhabitants are concentrated around them. The two main ethnic groups are the Tuareg and the Tibu. Nomads continue to herd sheep and goats. Four land routes have been constructed across the desert but transportation is still primarily by camel and horse. Mineral deposits include salt, iron ore, phosphates, oil and gas.

Sahel Band of semi-arid scrub and savanna grassland in Africa, s of the Sahara. It extends through Senegal, s Mauritania, Mali, Burkina Faso, N Benin, s Niger, N Nigeria and s central Chad. Over the past 30 years, the Sahara has encroached on the N Sahel in the world's most notorious example of DESERTIFICATION. Attention was first drawn to the plight of the region by the famine of 1973, when hundreds of thousands of people died.

Saigon See Ho CHI MINH CITY

sailing See YACHT

saint Man or woman who has manifested exceptional holiness and love of God during his or her life. In the New Testament, all believers are called saints, but since the 2nd century the title has usually been reserved for men and women of the most outstanding merit. In the Roman Catholic and Eastern Orthodox churches, individual saints are regarded as having a special relationship with God and are therefore venerated for their perceived role as intercessors. The Protestant reformers of the 16th century abolished the veneration of saints, saying that all believers have access to God through Christ. See also CANONIZATION

St Andrews Royal burgh and university town in Fife, on the NE coast of Scotland. It was the ecclesiastical capital of Scotland until the Reformation. The rules of golf were devised at the Royal and Ancient Golf Club. Pop. (1981) 11,400.

Saint Bartholomew's Day Massacre (24 August 1572) Mass murder of HUGUENOTS (French Protestants) on St Bartholomew's feast day. The Huguenot leaders had gathered in Paris for the marriage of Henry of Navarre (later HENRY IV). On orders from CATHERINE DE' MÉDICI, a bungled attempt was made on the life of Gaspard de Coligny. The plot's failure led to a plan for a more widespread slaughter. With the support of the king, CHARLES IX, the massacre began when soldiers killed Coligny and other Huguenot leaders. It soon spread and continued in the provinces until 3 October. Modern estimates suggest that c.70,000 people died. St Bernard Swiss mountain and rescue dog with excellent scenting abilities; from the 17th century it has been used to find people lost in deep snow. It has a massive head with a short deep muzzle, and a dense white and red coat. Height: to 74cm (29in) at the shoulder; weight: to 77kg (170lb).

Saint-Exupéry, Antoine de (1900–44) French novelist and aviator. His experiences as a pilot provided the material for his novels, which include *Southern Mail* (1928), *Night Flight* (1931) and *Flight to Arras* (1942). He is best known for his classic fable *The Little Prince* (1943). He was killed in World War 2.

St George's Capital and port on the sw coast of GRENADA, West Indies. Founded in 1650 as a French settlement, it was capital (1885–1958) of the British WINDWARD ISLANDS. The town is built round a submerged volcanic crater that forms the horseshoe-shaped St George's Bay. Industries: rum distilling, sugar processing, tourism. Pop. (1989) 35,742.

St Germain, Treaty of (1919) Part of the peace settlement after World War 1. It established the new republic of Austria from the old AUSTRO-HUNGARIAN EMPIRE.

St Helena Rocky island in the s Atlantic, 1,920km (1,190mi) from the coast of w Africa; the capital is Jamestown. Discovered by the Portuguese in 1502, it was captured by the Dutch in 1633. It passed to the British East India Company in 1659 and became a British crown colony in 1834. It is chiefly known as the place of NAPOLEON I 's exile (he died here in 1821). It is now a UK dependent territory and administrative centre for the islands of ASCENSION and TRISTAN DA CUNHA. It services ships and exports fish and handicrafts. Area: 122sq km (47sq mi). Pop. (1995) 5,644.

▲ sage Many culinary herbs, such as sage (*Salvia* sp.), are members of the Labiatae family. Sage has had a variety of medicinal uses for thousands of years. The word "sage" (meaning wise) derives from the ancient belief that the herb enhanced people's memories.

■ sago palm Flourishing in SE Asian freshwater swamps, the sago palm (*Metroxylon sagu*) is a primary source of carbohydrate in tropical regions. Just before flowering, the palm is cut, and the pith of the trunk is ground down to make sago flour.

▲ St Paul's The Gothic cathedral of old St Paul's (the portico of which was added by Inigo Jones) had to be pulled down following the Great Fire of London in 1666. The cathedral we see today was rebuilt (1675−1710) by Sir Christopher Wren. The plan is a Latin cross, 140m (460ft) long by 30m (100ft) wide. At the crossing, eight piers carry the dome, one of London's most famous landmarks. The wooden model for Wren's earlier design has been preserved.

reduced to 2,560m (8,312ft) with a deep horseshoe crater. Two more eruptions occurred in the following two weeks, and it is predicted to erupt again in the early 21st century.

St John of Jerusalem, Knights Hospitallers of See KNIGHTS HOSPITALLERS

St John's Port and capital of Antigua, in the Leeward Islands, West Indies. During the 18th century, St John's was the headquarters of the Royal Navy in the West Indies. Industries: tourism, rum, sugar, cotton. Pop. (1992) 38,000.

St John's Provincial capital and major port of Newfoundland, Canada, on the SE coast of Newfoundland Island. Founded in 1583, St John's is one of the oldest settlements in North America. Industries: fishing and fish processing, iron, shipbuilding, textiles, paper. Pop. (1991) 171,859.

St Kitts-Nevis Self-governing state in the Leeward Islands, West Indies. The state includes the islands of Saint Kitts (Saint Christopher), Nevis and Sombrero. Basseterre (on Saint Kitts) is the capital (1992 pop. 12,605). The islands were discovered in 1493 by COLUMBUS, and settled by the English (1623) and the French (1624). Anglo-French disputes over possession were settled in Britain's favour in 1783 by the Treaty of Paris, and the islands achieved self-government in 1967. Nevis held a referendum for independence in May 1998. Industries: tourism, sugar, cotton, salt, coconuts. Area: 311sq km (120sq miles). Pop. (1991) 40,618. See West Industries map

Saint Laurent, Louis Stephen (1882–1973) Canadian statesman, prime minister (1948–57). A distinguished lawyer, he was justice minister and attorney-general (1941–46). Saint Laurent succeeded W.L. Mackenzie KING as leader of the Liberal Party and prime minister.

Saint Laurent, Yves (1936–) French fashion designer. He began by designing clothes for individual customers, but established himself from 1962 as a pioneer of ready-to-wear dresses mass-produced in standard sizes.

St Lawrence Major Canadian river, in SE Ontario and S Quebec provinces, flowing from the NE end of Lake Ontario to the Gulf of St Lawrence. The river forms the boundary between the USA and Canada for *c*.184km (114mi) of its total of 1,244km (760mi). Since the completion of the ST LAWRENCE

SEAWAY in 1959, the river has been navigable to all but the very largest vessels. The St Lawrence system of canals, locks and dams generates much of the hydroelectric power used in Ontario and in New York state. Length: 1,050sq km (650mi).

St Lawrence Seaway Waterway in Canada and the USA. Built in the 1950s, it connects the Great Lakes with the Atlantic Ocean. The St Lawrence Seaway extends about 750km (470mi) from N of Montreal down to the N shore of Lake Erie. The main part of the waterway consists of a series of canals and locks that bypass the rapids along the St Lawrence River. The waterway also includes the Welland Canal, which by-passes the Niagara Falls. The St Lawrence Seaway allows ocean-going vessels to reach industrial lakeside ports of central North America, such as Detroit, Chicago and Toronto.

St Louis US city and port in E Missouri, on the Mississippi River near its confluence with the Missouri. The second-largest city in Missouri, St Louis was founded (1763) by the French. It was held by Spain from 1770 to 1800, returned briefly to France, and then ceded to the USA in the LOUISIANA PURCHASE (1803). St Louis grew rapidly into one of the largest US river ports. Industries: mineral processing, brewing, chemicals, transport equipment. Pop. (1992) 383,733.

St Lucia Volcanic island in the Windward group, West Indies; the capital is Castries (1992 pop. 53,883). The island changed hands 14 times between France and Britain before being ceded to Britain in 1814. It finally achieved full self-government in 1979. Mountainous, lush and forested, its tourist income is growing rapidly, especially from cruise ships. The principal export crop is bananas. Area: 616sq km (238sq mi). Pop. (1991) 133,308. *See* WEST INDIES map

St Mark's Basilica in Venice. Begun in 829 to enshrine the remains of the city's patron saint, St Mark, it was restored after a fire in 976. It was later demolished and rebuilt in the 11th century in the BYZANTINE style.

St Moritz Winter-sports centre and tourist resort, on Lake St Moritz, E Switzerland, at an altitude of 1,822m (5,980ft). The site of the 1928 and 1948 Winter Olympics, it is the home of the Cresta Run. Surrounded by the peaks of Corvatsch (3,303m/10,837ft), Nair and Corviglia, St Moritz is also noted for its curative mineral springs. Pop. (1991) 8,700.

St Paul US state capital and port of entry, on the E bank of the Mississippi River, E MINNESOTA. In 1849 St Paul was made capital of Minnesota territory. When Minnesota was admitted to the Union in 1858, it became the state capital, developing rapidly as a river port and transportation centre. Modern-day St Paul is a major manufacturing and distribution centre. Industries: computers, electronics, printing, automobiles. Pop. (1992) 268,266.

St Paul's Anglican cathedral in London, built (1675–1710) on the site of a medieval cathedral that had been destroyed in the Great FIRE OF LONDON in 1666. It was designed by Sir Christopher WREN in the classical style.

St Peter's Great Christian BASILICA in the VATICAN CITY. In 1506 Pope Julius II laid the foundation stone on the site of an earlier structure over the grave of St Peter. The church was completed in 1615 during the reign of Pope Paul V, under the architectural supervision of Carlo Maderno (1556–1629).

St Petersburg (formerly Petrograd and Leningrad) Secondlargest city in Russia and a major Baltic seaport at the E end of the Gulf of Finland, on the delta of the River Neva. Founded in 1703 by PETER I (THE GREAT), the city was the capital of Russia from 1712 to 1918. It was the scene of the Decembrist revolt (1825) and the Bloody Sunday incident in the Russian Revolution of 1905. Renamed Petrograd in 1914, it was a centre of the political unrest that culminated in the RUSSIAN REVOLUTION. The workers of Petrograd were the spearhead of the 1917 revolution, and the city was renamed Leningrad (1924). It suffered extensive damage during World War 2 and has been massively rebuilt. Renamed St Petersburg (1991), following the break-up of the Soviet Union, it enjoys federal status within the Russian Republic. Industries: shipbuilding, heavy engineering, brewing, publishing, electronics, chemicals. Pop. (1994) 4,883,000. St Pierre and Miquelon Group of eight small islands in the Gulf of St Lawrence, sw of Newfoundland, Canada. The

capital is St Pierre (1990 pop. 5,000) on the island of the same

name; Miquelon is the largest island. The group was claimed for France in 1535 and since 1985 has been a "territorial collectivity", sending delegates to the French parliament. Fishing is the most important activity, and has led to disputes with Canada. Area 242sq km (93sq mi). Pop. (1990) 6,392.

Saint-Saëns, Charles Camille (1835–1921) French composer, pianist and organist. He composed prolifically in all forms and is best remembered for his opera Samson and Delilah (1877), the Third Symphony (1886), the Carnival of the Animals (1886) and the Danse Macabre (1874).

St Sophia See Hagia Sophia

St Valentine's Day Massacre (14 February 1929) Gangland killings in Chicago, Illinois. The perpetrators, disguised as policemen, were gunmen of Al Capone and the seven victims were members of a rival gang in the profitable bootlegging business during the Prohibition era.

St Vincent and the Grenadines Island state of the Windward Islands, West Indies, situated between St Lucia and Grenada. The capital is Kingstown (1991 pop. 26,233). It comprises the volcanic island of St Vincent and five islands of the Grenadine group, the best known of which is Mustique. St Vincent remained uncolonized until British settlement in 1762. After wresting control from the French in 1783, the British deported most of the native Carib population, who were replaced by African slave labour. St Vincent was part of the British Windward Islands colony (1880–1958) and of the West Indies Federation (1958–62). Self-government was granted in 1969, followed by full independence within the Commonwealth in 1979. Agriculture dominates the economy; major crops include arrowroot, bananas and coconuts. Area: 388sq

km (150sq mi). Pop. (1991) 106,499. See West Indies map Sakhalin (Jap. Karafuto) Island off the E coast of Russia, between the Sea of Okhotsk and the Sea of Japan. The capital is Yuzhno-Sakhalinsk (1992 pop. 174,000). Settled by Russians and Japanese in the 18th and 19th centuries, it came under Russian control in 1875. Japan regained the s in 1905, but was forced to cede it again in 1945. The island is mountainous and forested, with a harsh climate. Grains and potatoes are grown in the s. Sakhalin's chief importance lies in its deposits of coal and iron ore; oil, extracted in the NE, is piped to the Russian mainland. Other industries: timber, fishing, canning. Area: 76,400sq km (29,500sq mi). Pop. (1989) 709,000. Sakharov, Andrei Dimitrievich (1921-89) Soviet physicist and social critic. His work in nuclear FUSION was instrumental in the development of the Soviet HYDROGEN BOMB. An outspoken defender of civil liberties, he created the Human Rights Committee in 1970 and received the 1975 Nobel Peace Prize. He was elected in 1989 to the Congress of the Soviet Union People's Deputies. His books include Sakharov Speaks (1974) and My Country and My World (1975).

Saki (1870–1916) (Hector Hugh Munro) Scottish writer, b. Burma. His reputation rests on his short stories, among them the collections *Reginald* (1904), *Reginald in Russia* (1910) and *Beasts and Superbeasts* (1914).

Saladin (1138–93) (Salah ad-din) Muslim general and founder of the Ayyubid dynasty. From 1152, he was a soldier and administrator in Egypt. Appointed grand vizier in 1169, he overthrew the FATIMIDS in 1171 and made himself sultan. After conquering most of Syria, he gathered widespread support for a JIHAD to drive the Christians from Palestine (1187). He reconquered Jerusalem, provoking the Third Crusade (1189). Saladin's rule restored Egypt as a major power and introduced a period of stability and growth.

Salamanca City on the River Tormes, w Spain, capital of Salamanca province. It was the scene of a victory for the British over the French in the Peninsular War (1812) and served as capital (1937–38) for the insurgents during the Spanish CVIL WAR. Industries: pharmaceuticals, food processing, chemicals, tanning, brewing, flour, wool. Pop. (1991) 162,544. salamander Any of 320 species of amphibians found worldwide, except in Australia and polar regions. It has an elongated body, a long tail and short legs. Most species lay eggs, but some give birth to live young. The largest European species, the fire salamander (Salamandra salamandra), may attain a length of 28cm (11in). Order Urodela.

Salazar, António de Oliveira (1889–1970) Portuguese statesman, dictator (1932–68). Salazar's restored Portugal's economy and became prime minister. He imposed a new, authoritarian constitution (1933) and crushed domestic opposition with the help of the army and secret police. Salazar supported General Franco in Spain and remained neutral in World War 2. Post-war economic reform was cancelled out by the cost of suppressing independence movements in Portugal's colonies. Political opposition to his regime intensified. Incapacitated by a severe stroke, Salazar was removed from office. Salem State capital of Oregon, USA, on the Willamette River. Founded in 1840 by Methodist missionaries, it was made territorial capital in 1851 and state capital in 1859. Industries: timber, paper, textiles, food canning, meat packing, high-technology equipment. Pop. (1990) 112,050.

Salem City on Massachusetts Bay, NE Massachusetts, USA, 22km (14mi) NE of Boston. First settled in 1626, Salem achieved notoriety for its witchcraft trials (1692), when 19 people were hanged. During the 17th and 18th centuries, the city prospered as a centre for shipbuilding and a port for the export trade to China. Industries: electrical products, leather goods, textiles, tourism. Pop. (1990) 38,090.

salicylic acid Colourless, crystalline solid (C₇H₆O₃), derivatives of which are used as analgesics (including ASPIRIN, acetylsalicylic acid), antiseptics, dyes and liniments. It occurs naturally in plants, including willow bark and oil of wintergreen.

Salieri, Antonio (1750–1825) Italian composer. As court composer in Vienna, he composed many operas, much sacred music, vocal and orchestral works.

Salinger, J.D. (Jerome David) (1919–) US novelist. A reclusive figure, Salinger achieved fame with his first and only novel, *Catcher in the Rye* (1951). His other works are collections of short stories, including *Franny and Zooey* (1961), *Raise High the Roof Beam, Carpenters* and *Seymour: An Introduction* (both 1963).

Salisbury Former name of the capital of Zimbabwe, named after British prime minister, R.A. Salisbury. See also Harare Salisbury, Robert Arthur Talbot Gascoyne-Cecil, 3rd Marquess of (1830–1903) British statesman, prime minister (1885–86, 1886–92, 1895–1902). Salisbury entered Parliament as a Conservative in 1853 and served in Benjamin Disraeli's administration (1874–80), first as secretary for India and then as foreign secretary. On Disraeli's death (1881), he became leader of the opposition to William GLADSTONE's government. In each of Salisbury's three terms in office he also served as foreign secretary, guiding Britain's imperial and colonial affairs. Despite initial success, his diplomacy of "splendid isolation" resulted in the SOUTH AFRICAN WARS (1899–1902). Salisbury was succeeded by his nephew, Arthur BALFOUR.

Salish Native North American tribe, formerly occupying an area in w Montana; they later moved to the Flathead Lake region. They gave their name to one of the major language families of the Native Americans. Today c.3,000 Salish occupy several reservations in Washington, Oregon and Idaho.

saliva Fluid secreted into the mouth by the SALIVARY GLANDS. In vertebrates, saliva is composed of c.99% water with dissolved traces of sodium, potassium, calcium and the ENZYME amylase. Saliva softens and lubricates food to aid swallowing, and amylase starts the digestion of starches.

salivary glands Three pairs of GLANDS located on each side of the mouth that form and secrete SALIVA. The parotid gland, just below and in front of each ear, is the largest; the submaxiallary gland is near the angle of the lower jaw; and the sublingual gland is under the side of the tongue.

Salk, Jonas Edward (1914–95) US medical researcher. Salk developed the first vaccine against POLIOMYELITIS in 1952. It used an inactivated poliomyelitis virus.

salmon Marine and freshwater fish of the Northern Hemisphere. Most species are silvery and spotted until the spawning season when they turn dark or red. The Pacific salmon (*Oncorhynchus*) hatches, spawns, and dies in freshwater, but spends its adult life in the ocean. The Atlantic salmon (*Salmo salar*) is a marine trout that spawns in rivers on each side of the Atlantic Ocean and then returns to the sea. Weight: to 36kg (80lb). Family Salmonidae.

▲ salamander The fire salamander (Salamandra salamandra, top) is found in central, s and w Europe, Nw Africa and sw Asia. Its bright coloration acts as a warning to potential predators. Within the skin of the fire salamander are many glands that secrete a sticky, irritant fluid that wards off larger predators and can be fatal to smaller animals. Although the fire salamander obtains oxygen mainly through gas exchange on the surface of its body, it has a set of primitive lungs. The dusky salamander (Desmognathus sp., bottom), however, has no lungs. Respiration is carried out entirely through surface gas exchange. This is achieved by maintaining the moisture of its skin by secretions from mucous glands.

▲ Salinger US author J.D. Salinger is famous for his depictions of lonely characters frustrated by a boring and conformist world. His only novel, *The Catcher in the Rye* (1951), is an enduringly popular tale of disaffected youth. He has been twice married and divorced, and now lives in rural seclusion while continuing to write and study Zen philosophy.

Salmond, Alex (Alexander Elliott Anderson) (1954–) Scottish politician, national convener (1990–) of the Scottish NATIONAL PARTY (SNP). Salmond was elected to Parliament in 1987. Despite pressing for full Scottish independence, he agreed to participate in a devolved assembly for Scotland.

salmonella Several species of rod-shaped bacteria that cause intestinal infections in human beings and animals. *Salmonella typhi* causes TYPHOID FEVER; other species cause GASTROENTERITIS. The bacteria are transmitted by carriers, particularly flies, and in food and water.

Salome (active 1st century AD) Daughter of Herodias and stepdaughter of Herod Antipas. She conspired with her mother to have JOHN THE BAPTIST executed.

salsa Cuban-inspired popular music. The term was first applied to Latin music produced in New York in the early 1970s. Salsa is a percussive and brass-led big band music. It also embraces a number of different dance forms, including rumba, mambo and guaracha.

salsify (oyster plant, vegetable oyster) Hardy biennial plant with a taproot. It is grown as a vegetable and prized for its oyster-like flavour. Height: to 1.2m (4ft). Family Asteraceae/Compositae; species *Tragopogon porrifolius*.

salt Ionic compound formed, along with water, when an ACID is neutralized by a BASE. The hydrogen of the acid is replaced by a metal or ammonium ion. Salts are typically crystalline compounds. They usually dissolve in water to form a solution that can conduct electricity.

Salt Lake City State capital in N central Utah, USA, 21km (13mi) E of Great Salt Lake. Founded in 1847 by the MORMONS under Brigham YOUNG, it grew rapidly to become capital of the Territory of Utah (1856) and the State of Utah (1896). Salt Lake City is the world headquarters of the Mormon Church. Zinc, gold, silver, lead and copper are mined nearby. Other industries: food processing, missiles, rocket engines, oil-refining, tourism, printing and publishing. Pop. (1992) 165,835.

Salvador (Bahia) Seaport city in E central Brazil, capital of Bahia state. Founded as Bahia by the Portuguese in 1549, it grew with the slave market and sugar cane plantations. It was the capital of Brazil until 1763. Industries: oil refining, petrochemicals, food processing, tobacco, sugar, coffee, industrial diamonds. Pop. (1991) 2,056,000.

Salvador, El See El Salvador

Salvation Army Christian society devoted to the propagation of the gospel among the working classes. Its origin was the Christian Revival Association, founded (1865) in London by William BOOTH. It became (1867) the East London Christian Mission, and then in 1878 the Salvation Army. Members were given ranks and led by "General" Booth. Under the leadership of Booth's son, Bramwell, it gained a worldwide following.

Salween (Nu Chiang or Nu Jiang in China; Mae Nam Khong in Burma and Thailand) River in Southeast Asia. It rises in the Tibetan Plateau, E Tibet, and flows s through Yünnan province,

► Sampras US tennis player Pete Sampras celebrates his 1995 Wimbledon singles title. Born in Washington D.C., Sampras dominated men's singles in the mid-1990s. He is renowned for his

mid-1990s. He is renowned for his fast and devastatingly accurate serve and strong volleys. Distressed and saddened by the loss of his coach and friend Tim Gullikson, who died of cancer, in 1997 Sampras pledged \$100 for every ace he served to go to a variety of organizations involved

cutting deep gorges through the terrain. It empties into Burma's Gulf of Martaban, an inlet of the Andaman Sea. It forms many rapids along its course and despite its length of $c.2,800 \mathrm{km}$ (1,750mi) is navigable for only 120km (75mi) upstream.

Salzburg City on the River Salzach, NW Austria, capital of the alpine Salzburg state. It grew around a 7th-century monastery, and for more than 1,000 years was ruled by the archbishops of Salzburg. It became part of Bavaria in 1809, but was returned to Austria by the Congress of Vienna. The birthplace of Mozart and the home of several music festivals, its most important industry is tourism. Pop. (1991) 144,000.

Samaria Ancient region and town of central Palestine. It was built as the capital of the northern kingdom of Israel in the 9th century Bc. Conquered by Shalmaneser in 722–721 Bc, Samaria was later destroyed by John Hyrcanus I and rebuilt by HEROD THE GREAT. See also SAMARITANS

Samaritans Descendants of those citizens of Samarian who escaped deportation after their kingdom was overrun by the Assyrians in 722–721 BC. The Jews to the south rejected them. The Samaritans call themselves "Children of Israel" (Bene-Yisreal) and their sole religious scripture is the Torah. samarium (symbol Sm) Grey-white metallic element of the LANTHANIDE SERIES. First identified spectroscopically in 1879, its chief ores are monazite and bastnasite. Samarium is used in carbon-arc lamps, as a neutron absorber in NUCLEAR REACTORS and as a catalyst. Some samarium alloys are used in making powerful permanent magnets. Properties: at.no. 62; r.a.m. 150.35; r.d. 7.52; m.p. 1,072°C (1,962°F); b.p. 1,791°C (3,256°F); most common isotope Sm¹⁵² (26.72%).

Samarkand City in the fertile Zeravshan valley, SE Uzbekistan. One of the oldest cities in Asia, it was conquered by ALEXANDER THE GREAT in 329 BC. A vital trading centre on the SILK ROAD, it flourished in the 8th century as part of the UMAYYAD empire. Samarkand was destroyed in 1220 by GENGHIS KHAN, but became (1370) capital of the Mongol empire of TAMERLANE. Ruled by the Uzbeks from the 16th century, it was captured by Russia in 1868, though it remained a centre of Muslim culture. Products: cotton, silk, leather goods, wine, tea, carpets, canned fruit, motor vehicle parts. It is a major scientific research centre. Pop. (1990) 370,000.

Samoa Volcanic island group in the s Pacific, comprising the independent state of Western Samoa and the US-administered American Samoa. Extending *c.*560km (350 mi), the islands are predominantly mountainous and fringed by coral reefs. The majority of the population are indigenous Polynesians. The first European discovery of the islands was in 1722. **Sampras, Pete** (1971–) US tennis player. In 1990, Sampras became the youngest-ever winner of the US Open singles and also won the first Grand Slam Cup. He has won Wimbledon four times (1993–95, 1997), the US Open three times (1993, 1995–96) and the Australian Open (1994, 1997).

Samson Israelite judge and Old Testament hero renowned for his great physical strength. Samson was a Nazarite, whose strength lay in his long hair. When his mistress, Delilah, discovered this, she had his hair cut off while he slept and handed him over to his enemies, the PHILISTINES. Samson regained his strength as his hair regrew, and when called upon to display his strength in the Philistine Temple of Dagon, he pulled down its central pillars and roof, killing himself and thousands of his captors.

Samuel Ninth and tenth books of the OLD TESTAMENT. Through the stories of Samuel, the prophet and judge, and of SAUL and DAVID, Israel's first two kings, they describe the transition of ISRAEL from a collection of tribes under separate chiefs to a single nation ruled through a monarchy. Historically, the events belong roughly to the 11th century BC.

Samurai Member of the elite warrior class of feudal Japan. Beginning as military retainers in the 10th century, the samurai came to form an aristocratic ruling class. They conformed to a strict code of conduct, known as BUSHIDO ("the way of the warrior"). Under the TOKUGAWA shōgunate in the 17th–19th centuries, they were divided into hereditary subclasses and increasingly became bureaucrats and scholars.

San (Bushmen) Khoisan-speaking people of s Africa. They have lived in the region for thousands of years and until

with the disease

recently had a hunting and gathering culture. About half still follow the traditional ways, mostly in the Kalahari region of Botswana and Namibia.

Sana'a (San'a) Capital and largest city of Yemen, 65km (40mi) NE of the Red Sea port of Hodeida. Situated on a high plateau at 2,286m (7,500ft), it claims to be the world's oldest city, founded by Shem, eldest son of Noah. During the 17th century and from 1872 to 1918 it was part of the Ottoman Empire. In 1918 it became capital of an independent Yemen Arab Republic, and in 1990 capital of the new, unified Yemen. It is noted for its handicrafts. Agriculture (grapes) and industry (iron) are also important. Pop. (1988) 427,502.

San Andreas fault Geological FAULT line extending more than 965km (600mi) through California. It lies on the boundary between the North American and the Eastern Pacific plates of the Earth's crust. PLATE TECTONIC movement causes several thousand EARTHQUAKES each year, although only a few are significant. SAN FRANCISCO lies close to the fault line, and is prone to earthquake damage. The most destructive earthquake occurred in 1906, when it horizontally displaced land around the fault by up to 6.4m (21ft) and killed 503 people. Notable tremors also occurred in 1989 and 1994.

San Antonio City on the San Antonio River, s central Texas, USA. It was founded on the site of the mission-fort San Antonio de Valero (the Alamo), and was the scene of the legendary Mexico-Texas struggles in 1836. It has adhered to five flags in its colourful history: Spain, Mexico, Republic of Texas, the Confederacy and the USA. Industries: aircraft, meat packing, electronics, oil refining, chemicals, wood products, financial services and tourism. Pop. (1992) 966,437.

sanctions Punitive action taken by one or more states against another stopping short of direct military intervention. Sanctions can include the cessation of trade, severing of diplomatic relations, the use of a blockade, and the breaking of cultural and sporting contacts.

Sand, George (1804–76) French novelist, b. Amandine Aurore Lucie Dupin. Her novels, such as *Lélia* (1833) and *Mauprat* (1837), advocate women's right to independence. Her later work includes the novels of rural life with which she is often associated, as well as an autobiography.

sand Mineral particles worn away from rocks by EROSION, individually large enough to be distinguished with the naked eye. Sand is composed mostly of QUARTZ, but black sand (containing volcanic rock) and coral sand also occur.

sandalwood Any of several species of Asian trees of the genus *Santalum*, many of which are PARASITES on the roots of other plants. The fragrant wood is used in carving and joss sticks. The distilled oil is used in perfumes and medicines. Height: to 10m (33ft). Family Santalaceae.

Sandburg, Carl (1878–1967) US poet. His first volume of poetry, *Chicago Poems*, appeared in 1916. Other collections include *Cornhuskers* (Pulitzer Prize, 1918), *Smoke and Steel* (1920), *Good Morning, America* (1928) and *The People, Yes* (1936). Sandburg also won Pulitzer Prizes for his *Complete Poems* (1950) and the second volume of his biography of Abraham Lincoln (1939).

sand hopper (sand flea) Any of several species of small, terrestrial crustaceans. The nocturnal European sand hopper (*Talitrus saltator*) lives on beaches near the high tide mark, emerging to feed on organic debris. Length: to 1.5cm (0.6in). Order Amphipoda; family Talitridae.

San Diego City in s California, USA, almost adjoining Tijuana on the Mexican border. Located on a fine natural Pacific harbour, it was founded in 1769 as a mission. It has a huge naval base and is an important centre for scientific research (especially oceanography). Industries: aerospace, electronics, fishing and fish canning, shipbuilding, food processing, clothing, furniture, tourism. Pop. (1992) 1,148,851.

Sandinista (Sandinista National Liberation Front) Revolutionary group in Nicaragua. They took their name from Augusto Cesar Sandino, who opposed the dominant Somoza family and was killed in 1934. The Sandinistas overthrew the Somoza regime in 1979, and formed a government led by Daniel Ortega Saavedra. In power they were opposed by right-wing guerrillas, the CONTRA, supported by the USA.

The conflict ended when the Sandinista agreed to free elections. They lost, but the Contra were disbanded and the Sandinista remain an influential political force.

sandpiper Wading bird that breeds in cold regions and migrates long distances to winter in warm areas, settling in grass or low bushes near water. It feeds on invertebrates and nests in a grass-lined hole in the ground. Length: 15–60cm (6–24in). Family Scolopacidae.

sandstone Sedimentary Rock composed of sand grains cemented in such materials as SILICA or calcium carbonate. Its hardness depends on the character of the cementing material. San Francisco City and port in w California, USA, on a peninsula bounded by the Pacific Ocean (w) and San Francisco Bay (E), which are connected by the Golden Gate Strait. Founded by the Spanish in 1776, it was captured (1846) by the US in the Mexican War. A gold rush (1848) swelled the town's population. The Pony Express and the completion of the railroad (1869) brought more settlers, and saw the emergence of Chinatown. Devastated by an earthquake and fire in 1906, it was quickly rebuilt and prospered with the opening of the Panama Canal. Industry developed rapidly and San Francisco became the leading commerical city on the West Coast. It was a major supply port for the war in the Pacific. Its mild climate and cosmopolitan air make it a major tourist centre. Other industries: finance, shipbuilding, food processing, oil refining, aircraft, fishing, printing and publishing. Pop. (1992) 728,921 Sanger, Frederick (1918-) British biochemist who became the first person to win two Nobel Prizes for chemistry. He was awarded the first in 1958 for finding the structure of INSULIN. His second prize came in 1980 (shared with the US molecular biologists Walter Gilbert and Paul Berg) after work on the chemical structure of nucleic acids.

Sanhedrin Ancient Jewish religious council, prominent in Jerusalem during the period of Roman rule in Palestine. The Great Sanhedrin is believed to have served as a legislative and judicial body on both religious and political issues. Jesus Christ appeared before the Sanhedrin after his arrest.

San José Capital and largest city of Costa Rica, in central Costa Rica, capital of San José province. Founded c.1736, it succeeded Cartago as capital of Costa Rica in 1823 and soon became the centre of a prosperous coffee trade. Products: coffee, sugar cane, cacao, vegetables, fruit, tobacco. Pop. (1992) 303,000.

San Jose City in w California, USA, 64km (40mi) SE of San Francisco. Founded in 1777, it was California's capital from 1849–1851. San Jose is the centre of a rich fruit-growing region, but is best known as the focal point of "Silicon Valley", the hub of the US computer industry. Pop. (1992) 801,331.

San Jose scale Scale insect introduced into California in c.1880 from E Asia. Now spread across the USA, these insects suck juices from trees and shrubs, often destroying the plants. Length: 2.5mm (0.1in). Family Diaspididae; species *Quadraspidiotus perniciosus*.

San Juan Capital, largest city and major port of PUERTO RICO, on the NE coast of the island. It has one of the finest harbours in the West Indies. Founded in 1508, the port prospered during the 18th and 19th centuries, and in 1898 was captured by the USA during the Spanish-American War. The city is the commercial and financial centre of Puerto Rico. Exports: coffee, tobacco, fruit, sugar. Industries: cigars and cigarettes, sugar refining, rum distilling, metal products, pharmaceuticals, tourism. Pop. (1990) 437,745.

San Marino World's smallest republic and perhaps Europe's oldest state, in the Apennines, near the Adriatic Sea, NE Italy. According to legend, it was founded in the early 4th century AD. Its mountainous terrain has enabled it to retain a separate status, becoming an independent commune in the 13th century. The economy is largely agricultural. Manufacturing is also important, but tourism is vital to the state's income. While San Marino has its own currency and stamps, Italian and Vatican City equivalents are widely used. It possesses its own legislative assembly, the Great and General Council, which elects Captains Regent as heads of state. There are two towns: Serraville (1991 pop. 7,264), and the capital San Marino (1993 pop. 4,335). Area: 61sq km (24sq mi). Pop. (1993) 24,003.

San Martín, José de (1778–1850) South American revolutionary. He led revolutionary forces in Argentina, Chile and Peru, gaining a reputation as a bold commander and imaginative strategist. After defeating the Spanish in Argentina, he gained the element of surprise in Chile (1817–18) by crossing the Andes, San Martín captured Peru (1821) after an unexpected naval attack. He surrendered his effective rule of Peru to Simón Bolívar in 1822 and retired to Europe.

San Salvador Capital and largest city of El Salvador, in central El Salvador. Founded in 1524 near the volcano of San Salvador, which rises to 1,885m (6,184ft) and last erupted in 1917, the city has been frequently damaged by earthquakes. The main industry is the processing of coffee grown on the rich volcanic soils of the area. Other manufactures include beer, textiles and tobacco. Pop. (1992) 422,570.

Sanskrit Classical language of India, the literary and sacred language of HINDUISM, and a forerunner of the modern Indo-Iranian languages spoken in N India, Pakistan, Nepal and Bangladesh. Sanskrit was brought to India (c.1500 BC) by immigrants from the NW. It was the language in which the VEDAS were written. This old form of the language (Vedic Sanskrit) gradually became simplified, achieving its classical form c.500. Sanskrit is one of the INDO-EUROPEAN LANGUAGES. Although only c.3,000 Indians are able to speak Sanskrit today, it has been designated one of India's national languages.

Sanskrit literature Classical literature of India. The two main periods in Sanskrit literature are the Vedic (c.1500–c.200 BC) and the overlapping Classical (c.500 BC–c.AD 1000). The Vedic period produced the VEDAS, the earliest works in Sanskrit literature and among the most important. Later Vedic literature included the UPANISHADS, which discuss the essence of the universe. The early classical period contributed the MAHABHARATA and the RAMAYANA. They are significant both as literature and as Hindu sacred works.

Santa Anna, Antonio López de (1794–1876) Mexican general and dictator. Santa Anna was the dominant political figure in Mexico from 1823 to 1855, sometimes as president, sometimes unofficially as the result of a coup. In 1836 he failed to subdue the rebellion in Texas, but regained power after gallant action against a French raid on Vera Cruz (1838). After his failure in the Mexican War (1846–48), he went into exile. He returned to power in 1853, but was overthrown in 1855.

Santa Claus Variant of the Dutch name *Sinte Klaas*, itself a version of the name Saint Nicholas, who was Bishop of Myra sometime during the 4th century. Santa Claus has become associated with the feast of Christmas and is identified with Father Christmas in North America, the UK and some former Commonwealth countries.

Santa Cruz de Tenerife Capital of the CANARY ISLANDS and largest city in TENERIFE. Founded in 1494, it has a fine harbour and exports fruit, vegetables and sugar cane. Industries: oil refining, tourism. Pop. (1991) 189,317.

Santa Fe State capital of New Mexico, USA, at the foot of the Sangre de Cristo Mountains. The oldest US capital city, it was founded (c.1609) by the Spanish and acted as a centre of Spanish–Native American trade for more than 200 years. In 1680 the Pueblos expelled the Spanish, but it was recaptured in 1692. Mexico became independent in 1821, and trade with the USA opened up. Santa Fe functioned as the w terminus of the Santa Fe Trail. In 1846 US troops captured the city, and in 1850 the region became US territory, achieving statehood in 1912. Today it is primarily an administrative, tourist and resort centre. Pop. (1992) 59,004.

Santayana, George (1863–1952) US philosopher and poet, b. Spain. After 1939 Santayana withdrew from the world, a seclusion reflected in the moral detachment of his writing. He stressed both the biological nature of the mind and its creative and rational powers. His works include *The Sense of Beauty* (1896), *The Life of Reason* (1905–06), *Skepticism and Animal Faith* (1923) and the popular novel *The Last Puritan* (1935).

Santer, Jacques (1937–) Luxembourg statesman, president of the European Union (1994–). Santer was a member of the Luxembourg Chamber of Deputies before being elected to the European Parliament, of which he was vice president (1975–77). He was prime minister of Luxembourg (1984–94).

Santiago Capital of Chile, in central Chile on the River Mapocho, 90km (55mi) from the Atlantic coast. Founded in 1541, it was destroyed by an earthquake in 1647. Most of Santiago's architecture is post-1850. It is the nation's administrative, commercial and cultural centre, accounting for nearly a third of the population. Industries: textiles, pharmaceuticals, food processing, clothing, footwear. Pop. (1992) 4,385,381 (greater metropolitan area 5,180,757).

Santo Domingo (formerly Ciudad Trujillo, 1936–61) Capital and chief port of the Dominican Republic, on the s coast of the island, on the River Ozama. Founded in 1496, the city is the oldest continuous European settlement in the Americas. It was the seat of the Spanish viceroys in the early 1500s, and base for the Spaniards' conquering expeditions until it was devastated by an earthquake in 1562. It houses more than a third of the country's population, many of whom work in the sugar industry. Pop. (1991) 2,055,000.

São Paulo City on the River Tietê, sɛ Brazil, capital of São Paulo state, located almost exactly on the Tropic of Capricorn. Founded by the Jesuits in 1554, it grew as the base for expeditions into the interior in search of minerals. It expanded in the 17th century as a trading centre for a large coffee region. While its large quantities of agricultural produce are now shipped through its port of Santos, São Paulo has become a major and diverse industrial centre attracting migrants from the interior. It is the world's fastest-growing metropolis. Pop. (1991) 9,646,185 (metropolitan area 16,567,317). São Paulo state houses up to 60% of Brazil's industry and most of its sugar production. Pop. (1991) 31,588,925.

São Tomé and Príncipe Country in the Gulf of Guinea, 300km (200mi) off the w coast of Africa. The capital is São Tomé. The republic consists of two main islands, São Tome (the largest) and Príncipe. The islands are volcanic and mountainous, the vegetation predominantly tropical rainforest. The islands were discovered (uninhabited) in 1471 and, in 1483, a settlement was established at São Tomé. In 1522 the islands became a Portuguese colony. The Dutch controlled the islands from 1641 to 1740, but the Portuguese regained control and established plantations in the latter half of the 18th century. The official language is Portuguese and the major religion is Roman Catholicism. The islands became independent when the Portuguese pulled out in 1975, ushering in 16 years of Marxist rule. Cocoa, coffee, bananas and coconuts are grown on plantations, and their export is the republic's major source of income. Area: 1,001sq km (387sq mi). Pop. (1995) 131,100. sap Fluid that circulates water and nutrients through plants. Water is absorbed by the roots and carried, along with minerals, through the XYLEM to the leaves. Sap from the leaves is distributed throughout the plant.

sapphire Transparent to translucent gemstone variety of CORUNDUM. It has various colours produced by impurities of iron and titanium, the most valuable being deep blue.

Sappho Greek poet who was writing during the early 6th century BC. Her passionate love poetry, written on the island of Lesbos (from which the word lesbian derives) was regarded by PLATO as the expression of "the tenth MUSE".

saprophyte Plant that obtains its food from dead or decaying plant or animal tissue. Generally it has no CHLOROPHYLL. Included are most fungi and some flowering plants.

Saracens Name applied by the ancient Greeks and Romans to the Arab tribes who threatened their borders. The name was later extended to include all Arabs and eventually all Muslims. As a term similar to "Moors", it was used particularly by medieval Christians to denote their Muslim enemies. Sarajevo Capital of Bosnia-Herzegovina, on the River Miljacka. Sarajevo fell to the Turks in 1429 and became a flourishing commercial centre in the Ottoman empire. Passing to the Austria-Hungarian empire in 1878, the city was a centre of Serb and Bosnian resistance to Austrian rule. On 28 June 1914 the Austrian Archduke Franz Ferdinand and his wife were assassinated here by a Serbian nationalist (an act that helped to precipitate World War 1). In 1991 Bosnia-Herzegovina declared its independence from Yugoslavia, and a bloody war ensued between Croatian, Bosnian and Serbian forces. Sarajevo became the focal point of the war between Bosnian Serb troops and Bosnian government forces. The city lay under prolonged siege, often without water, electricity or basic medical supplies. Persistent shelling from the surrounding hills devastated the city. After the 1995 Dayton Peace Accord, Sarajevo in effect became a Bosnian city, with the 1991 population figure of 526,000 drastically reduced as many Serbs fled.

Sarasvati In Hindu mythology, goddess of the arts, sciences and eloquent speech. Depicted as a beautiful young woman, she is credited with the invention of the Sanskrit language. She later became the consort of BRAHMA.

Saratoga, Battle of US victory in the AMERICAN REVOLUTION, fought in upper New York (1777). In the series of battles comprising the Saratoga campaign in September and October, the British were prevented from linking up with other forces at Albany in a move designed to win the Hudson valley. Surrounded, the British were forced to surrender to the Americans under Horatio GATES. The US victory persuaded the French to intervene against Britain.

Sarawak Largest state of Malaysia, in NW Borneo, comprising a highland interior and swampy coastal plain; the capital is Kuching City. Ruled as an independent state by Britain after 1841, it was made a British protectorate in 1888 and a crown colony in 1946. Sarawak became a part of Malaysia in 1963, triggering a three-year dispute with Indonesia. Oil is an increasingly important product alongside the traditional coconuts, rice, rubber and sago. Area: 124,449sq km (48,050sq mi). Pop. (1990) 1,648,217.

sarcoma Cancerous growth or TUMOUR arising from muscle, fat, bone, blood or lymph vessels or connective tissue. *See also* CANCER

sardine Small marine food fish found worldwide. It has a laterally compressed body, a large toothless mouth, and oily flesh. Length: to 30cm (1ft). Species include the California *Sardinops caerulea*, South American *Sardinops sagax* and the European sardine, or PILCHARD, *Sardina pilchardus*. Family Clupeidae.

Sardinia Mountainous island of Italy, 208km (130mi) w of the Italian mainland, separated by the Tyrrhenian Sea. Farming and fishing are the chief occupations of this sparsely vegetated island. Wheat, barley, grapes, olives and tobacco are grown and sheep and goats are reared. Salt extraction is important, and other minerals include coal, lead, magnesium, manganese and zinc. The only large city is Cágliari, the capital. A trading centre for the Phoenicians, Greeks, Carthaginians and Romans, Sardinia became a kingdom in 1720, and in 1861 its king, Victor Emmanuel II, became the first king of Italy. Area: 24,090sq km (9,300sq mi). Pop. (1992) 1,651,902. Sargasso Sea Area of calm, barely moving water in the N Atlantic between the West Indies and the Azores, which takes its name from the large quantities of floating seaweed (Sargassum) covering its surface.

Sargent, John Singer (1856–1925) US painter. Greatly influenced by VELÁZQUEZ and HALS, he is best-known for his glamorous and elegant portraits.

Sargent, Sir (Harold) Malcolm (Watts) (1895–1967) British conductor. Particularly noted for his choral work, he conducted the Royal Choral Society from 1928 and the BBC Symphony Orchestra from 1950 to 1957.

Sargon I (2334–2279) King of Akkad (*c*.2316–*c*.2279 BC). One of the first of the great Mesopotamian conquerors, he was a usurper who founded his capital at Agade (Akkad), from which his kingdom took its name. He conquered SUMERIA and upper Mesopotamia and extracted tribute from lands as far w as the Mediterranean.

Sargon II (d. 705 BC) King of Assyria (721–705 BC). He conquered Samaria in 721 BC and according to tradition dispersed those Israelites who became the "lost tribes" of Israel. He established an imperial administration and defeated his enemies before being killed in battle against the Cimmarians. Sark One of the CHANNEL ISLANDS of the United Kingdom, divided into Great Sark and Little Sark, which are connected by a causeway. Sark is part of the Bailiwick of GUERNSEY with a feudal organization dating from the late 17th century. There are no cars and the residents pay no income tax. The

population swells in the summer with an influx of tourists. Area: 5.5sq km (2.1sq mi). Pop. (1991) 575.

Saroyan, William (1908–81) US novelist, short-story writer and dramatist. He followed the success of his first play, *My Heart's in the Highlands* (1939), with the Pulitzer Prizewinning *The Time of Your Life* (1939). His subsequent works were less successful, although *The Cave Dwellers* (1957) received some critical acclaim.

sarsaparilla Tropical perennial vine of the genus *Smilax*, native to Central and South America, whose roots are the source of a chemical used to give an aromatic flavour to medicines and drinks. The main species used are *S. aristolochiae-folia*, *S. regelii* and *S. febrifuga*. Family Liliaceae.

Sartre, Jean-Paul (1905–80) French philosopher and writer. Sartre was the leading advocate of EXISTENTIALISM. His debut novel, Nausea (1939), depicted man adrift in a godless universe, hostage to his own angst-ridden freedom. Sartre was a fighter in the French Resistance during World War 2. During the war he began to write plays, such as Huis Clos (No Exit) (1944). His major philosophical work is Being and Nothingness (1943). After the war Sartre wrote a trilogy of novels, The Roads to Freedom (1945–49), and founded (1945) the philosophy periodical Modern Times. His complex relationship with Marxism is explored in Critique of Dialectical Reason (1960). Sartre refused the 1964 Nobel Prize for literature on "personal" grounds, but is later said to have accepted it. He had a long-term relationship with Simone de BEAUVOIR.

Saskatchewan Province in w central Canada, the southern half on the fertile Great Plains and the northern half in the lakestrewn Canadian Shield. The cultivation of wheat is the most important agricultural activity, but oats, barley, rye, flax and rapeseed are also grown. The province's rich mineral deposits include uranium, copper, zinc, gold, coal, oil, natural gas and the world's largest fields of potash. Most industries process raw materials, and steel is also manufactured. The principal cities are Saskatoon (1991 pop. 186,058), Regina (the capital, pop. 179,178), Prince Albert (34,181), and Moose Jaw (33,593). The first permanent white settlement was in 1774, but development was slow until the construction of the transcontinental Canadian Pacific Railroad in 1885. Saskatchewan was admitted to the Dominion of Canada in 1905. Area: 570,113sq km (251,700sq mi). Pop. (1991) 988,928.

sassafras Small E North American tree with furrowed bark, green twigs, yellow flowers and blue berries. Oil from the roots is used to flavour root beer. Family Lauraceae; species *Sassafras albidum*.

Sassanid (Sassanian) Royal dynasty of Persia (Iran) (AD 224–651). Founded by Ardashir I (r.224–241), the Sassanids revived the native Persian traditions of the ACHAEMENIDS, confirming ZOROASTRIANISM as the state religion. There were about 30 Sassanid rulers, the most important after Ardashir being Shapur II (309–379); Khoshru I (531–579), and Khoshru II (590–628), whose conquest of Syria, Palestine and Egypt marked the height of the dynasty's power. The Sassanids were finally overthrown by the Arabs.

Sassoon, Siegfried (1886–1967) British poet and author. His disillusionment with military service in World War 1 inspired some of his most memorable poetry. The semi-autobiographical trilogy *The Complete Memoirs of George Sherston* (1937) includes his most famous novel, *Memoirs of a Fox-hunting Man* (1928). His poetry was collected in 1961.

SAT In the USA, acronym for Scholastic Aptitude Test, a nationwide test taken by high-school students wanting to go to university. In the UK, acronym for Standard Assessment Task, nationwide tests taken by school children at the ages of 7, 11, 14 and 16 to examine their progress with the National Curriculum. *See also* APTITUDE TEST

Satan Name for the DEVIL. Satan first appeared in the Old Testament as an individual angel, subordinate to God. Gradually, however, Satan took on a more sinister role. In the New Testament, he was the devil who tempted JESUS CHRIST. Satan emerged in medieval Christian theology as the chief devil, ruler of hell and source of all evil.

satellite Celestial body orbiting a planet or star. In the Solar System, planets with satellites are the Earth (1), Mars (2),

▲ Sartre French philosopher, playwright and novelist Jean-Paul Sartre studied at the Sorbonne in Paris with Simone De Beauvoir, who remained his close associate. He was influenced by German philosophers including Heidegger and Marx, and wrote several works of literary criticism. Outspoken against US involvement in Vietnam, he supported the student rebellion in Paris (1968).

SATURN: DATA

Diameter (equatorial):
120,536km (74,901mi)
Mass (Earth=1): 95.2
Volume (Earth=1): 744
Density (water=1): 0.71
Orbital period: 29.46 years
Rotation period: 10h 13m 59s
Average surface temperature:
-180°C (-356°F)

Jupiter (13), Saturn (10), Uranus (5) and Neptune (2). Those of the Earth and Mars are rocky. The satellites of the others are believed to consist of ice or frozen methane and ammonia.

satellite, artificial Spacecraft placed in orbit around the Earth or other celestial body. Satellites can perform many tasks and send back data or pictures to the Earth. **Communications** satellites relay microwave signals from one part of the Earth to another. **Navigation** satellites transmit radio signals that enable navigators to determine their positions. *Sputnik 1*, the world's first artificial satellite, launched on 4 October 1957.

satellite television Television services transmitted to viewers via communications satellites in orbit around the Earth. Television companies beam their signals to the satellites from ground stations. The satellites relay the signals back to viewers' dish-shaped receiving aerials.

Satie, Erik (1866–1925) French composer. Rebelling against Wagnerian ROMANTICISM, he developed a deceptively simple style in piano pieces such as *Trois Gymnopédies* (1888). He also composed the ballets *Parade* (1917) and *Relâche* (1924), and a choral work, *Socrate* (1918).

satire Literary work in which human foibles and institutions are mocked, ridiculed and parodied. In Roman times, a satire was a poem in hexameters, a form established by the work of Lucilius, HORACE and JUVENAL. In the Middle Ages it often took the form of fabliaux or bestiaries, using animal characters to illustrate typical human failings. Since Thomas Morei's Utopia (1516), utopian or dystopian fiction, such as Zamyatin's We (1924) and Swift's Gulliver's Travels (1726), has frequently been used as a medium for satire. Dramatists have often employed the form, as in the plays of Aristophanes, Ben Jonson, Mollère, Oscar Wilde and Bertolt Brecht.

Sato, Eisaku (1901–75) Japanese statesman, prime minister (1964–72). Sato held a number of cabinet posts (1948–64) before becoming prime minister. His term in office is notable for its foreign policy successes, such as the restoration of relations with South Korea (1965). Sato negotiated the return (1972) of OKINAWA from the USA. A provision that US forces were allowed to remain on the island, however, inflamed public opinion. In 1974 he was awarded the Nobel Peace Prize.

saturated compound In organic chemistry, compounds in which the carbon atoms are bonded to one another by single COVALENT BONDS, not by the more reactive double or triple bonds. For this reason, they tend to be unreactive.

saturated fat Organic fatty compounds, the molecules of which contain only saturated FATTY ACIDS combined with GLYCEROL. These acids have long chains of carbon atoms which are bound together by single bonds only. See also SAT-URATED COMPOUNDS

saturated solution In chemistry, a SOLUTION containing so much of a dissolved compound (solute) that no more will dissolve at the same temperature.

Saturn Sixth planet from the Sun and second-largest in the SOLAR SYSTEM. Viewed through a telescope it appears as a flattened golden yellow disk encircled by white rings. The rings are made up of particles ranging from dust to objects a few metres in size, all in individual orbits. The main rings are only a kilometre or so thick. Voyager space probes revealed the ring system to be made up of thousands of separate ringlets. Saturn has an internal heat source, which probably drives its weather systems. It is assumed to be composed predominantly of hydrogen, and to have an iron–silicate core about five times the Earth's mass, surrounded by an ice mantle of perhaps twenty Earth masses. The upper atmosphere contains 97% hydrogen and 3% helium, with traces of other gases.

satyr In Greek mythology, god of the woods and attendant of DIONYSUS. Sensual and lascivious, satyrs were later depicted by the Romans as goat-legged, goat-bearded men with budding horns. Satyr is also the common name for any butterfly of the Satyridae family.

Saud, Abdul Aziz ibn (1880–1953) Founder and first king of Saudi Arabia (1932–53). As leader of the Saudi dynasty, he was forced into exile in 1891 by the rival Rashid dynasty. He returned in 1902 and captured Riyadh in a surprise attack. Thereafter, he extended his authority, driving out the Turks and the Hashemites and founding the modern Saudi state in 1932.

Saudi Arabia Arabic kingdom on the Arabian Peninsula, sw Asia. See country feature

Saul (active late 11th century BC) First king of the Hebrew state of ancient Israel (c.1020–c.1000 BC). He was the son of Kish, a member of the tribe of Benjamin. Saul was anointed by the prophet Samuel and acclaimed as king by all Israel. For much of his reign he waged war against Israel's threatening neighbours, notably the PHILISTINES, the Ammonites, and the Amalekites. He and his sons eventually died in battle against the Philistines on Mount Gilboa. The story of Saul is contained in the First Book of Samuel, the ninth book of the Old Testament.

sauna Wood-lined room in which a wood-fired stove (or an electric heater) raises the temperature to between 60 and 95°C (140–203°F). It also refers to the activity of sitting in the heated room and sweating profusely, often leaving and returning to the heat several times. The sauna was originally a semi-religious exercise pioneered by the Finns.

Saussure, Ferdinand de (1857–1913) Swiss linguist, founder of modern linguistics. Saussure delivered (1907–11) a series of lectures at the University of Geneva, which were published posthumously (1916) as *Course in General Linguistics*. For Saussure, language was a system of signs whose meaning is defined by their relationship to each other. His work laid the foundation for STRUCTURALISM and SEMIOTICS.

savanna Plain with coarse grass and scattered tree growth, particularly the wide plains of tropical and subtropical regions. An extensive example is the savanna of the East African tableland.

Savannah City and port on the Savannah River, E Georgia, USA. The oldest city in Georgia, it was founded in 1733 and became the seat of the colonial government in 1754. During the American Revolution it was initially captured by the British in 1778 and resisted all attempts at invasion until 1782. The city prospered on the tobacco and cotton trade, despite a devastating fire in 1796. During the American Civil War it remained a Confederate stronghold until December 1864. Today, it is still a major port whose exports include tobacco, cotton and sugar. Industries: chemicals, petroleum, paper products, rubber, tourism. Pop. (1992) 138,908.

Savimbi, Jonas (1934–) Angolan political leader. Prominent in the struggle for independence from Portugal, Savimbi formed (1966) the National Union for the Total Independence

SATELLITE, ARTIFICIAL

Four artificial satellite orbits around the globe are illustrated. Two are equatorial: one, a geostationary satellite orbits at 35,900km (21,500mi) (1), another has a lower orbit (2). A polar orbit, as used by remote sensing satellites, is shown running vertically around the Earth (3) and the last is an angled elliptical orbit used by communications satellites for the high latitudes of the Earth (4). The diagrams above the orbital map show the launching of an Intelsat communication satellite by a NASA shuttle (5) and the two main types of satellites. To prevent them being knocked off course by fluctuations in the Earth's magnetic field, satellites are given centrifugal stability in one of two ways. The first is to rotate the whole satellite as is the case in "spinners" such as the Intelsat satellite (6). The other method is to have gyroscopes placed within the satellite (7).

Saudi Arabia's flag was adopted in 1938. It is the only national flag with an inscription as its main feature. The Arabic inscription above the sword means "There is no God but Allah, and Muhammad is the Prophet of Allah".

he kingdom of Saudi Arabia occupies about 75% of the Arabian peninsula in sw Asia. More than 95% of the land is desert. The Gulf of AOABA and the RED SEA lie off the w coast. The w coastal lands are divided into two main regions: the Hejaz (boundary) plain in the NW, which includes the holy cities of MECCA and MEDINA, and Saudi Arabia's main port, JIDDAH. In the sw, is the Asir (inaccessible) highland region, which contains the country's highest point, Sawda, at 3,133m (10,279ft). The Tihama is a narrow, fertile sw coastal plain. In the centre lies the Najd (plateau), which contains Saudi Arabia's capital, RIYADH. The plateau descends E to the Al Hasa lowlands. This region is the centre of the Saudi oil industry, and contains Saudi Arabia's largest oasis. In the N is the Nafud Desert. The s of Saudi Arabia is dominated by the bleak Rub' al Khali (Empty Quarter), the world's largest expanse of sand.

CLIMATE

Saudi Arabia has a hot, dry climate. Summer temperatures in Riyadh often exceed 40°C (104°F). The Asir highlands have an average rainfall of 300–500mm (12in–20in). The rest of the country has less than 100mm (4in).

Grass and shrub provide pasture on the w highlands and parts of the central plateau. The deserts contain few plants, except around oases.

HISTORY

Mecca is the holiest place in Islam. It was the birthplace of the Prophet Muhammad in AD 570. and is the site of the KAABA. In the 18th century, the Wahhabi (a strict Islamic sect) gained the allegiance of the Saud family, who formed ar independent state in Neid. With the support of the Bedouin, the Wahhabi rapidly conquered most of the Arabian peninsula. In the 1810s the region was conquered by Turkey. Abdul Aziz ibn SAUD laid the foundations of the modern state of Saudi Arabia. In 1902 Ibn Saud captured Riyadh, and by 1906 had taken the whole of the Neid. In 1913 the Turkish province of Al Hasa also fell. In 1920 Ibn Saud captured the Asir. and by 1925 he had conquered the Hejaz. In 1932 the territories were combined to form the kingdom of Saudi Arabia. Ibn Saud became king, ruling in accordance with the sharia of Wahhabi Islam. Oil was discovered in 1936 by the US company Arabian Standard Oil, which later became the Arabian American Oil Company (Aramco). In 1945 Saudi Arabia joined the

AREA: 2,149,690sq km (829,995sq mi)

POPULATION: 15,922,000

CAPITAL (POPULATION): Riyadh (1,500,000)
GOVERNMENT: Absolute monarchy
ETHNIC GROUPS: Arab (Saudi 82%, Yemeni

10%, other Arab 3%)
LANGUAGES: Arabic (official)

RELIGIONS: Islam 99% (almost exclusively

Sunni), Christianity 1%

currency: Saudi riyal = 100 halalah

Arab League. In 1953 Ibn Saud died, and was succeeded by his eldest son, King Saud, who ruled with the aid of Crown Prince Faisal. Saud's concern at the growing power of Nasser's Egypt was heightened by the overthrow of the Yemen royal family by pro-Nasser republican forces. Saud sent troops to Yemen to aid the monarchists. In 1964 Saud was overthrown, and Faisal became king. In 1970 Saudi troops were withdrawn from Yemen. In 1971 British troops withdrew from the Gulf. Faisal supported the creation of the United Arab Emirates and sought to increase national ownership of Saudi's oil wealth. In 1974 Saudi Arabia agreed to a 60% share in Aramco. In 1975 King Faisal was assassinated, and Crown Prince Khalid became king. Khalid's conservativism was challenged by the growth of Islamic fundamentalism, especially in Iran. In 1979 Shiite fundamentalists captured the Great Mosque in Mecca. The rebellion was brutally suppressed. Saudi Arabia's support for Iraq in the Iran-Iraq War (1980-88) led to Iranian attacks on Saudi shipping. In 1982 Khalid died and was succeeded by Prince Fahd. In 1990 over 1,400 pilgrims died in a stampede during the HAJJ. When Iraq invaded Kuwait in 1990, King Fahd invited coalition forces to protect it against possible Iraqi aggression. Saudi air and land forces played a significant role in the Allied victory in the GULF WAR (1991).

POLITICS

The king retains supreme authority, advised by a 90-man Consultative Council of royal nominees (established in 1963). In 1996 the council's president ruled out elections on Islamic grounds. Saudi Arabia has no formal constitution. It attracts much international criticism for human rights abuses, especially for its state executions, and treatment of women and minorities.

ECONOMY

Saudi Arabia is the world's largest producer and exporter of crude oil. It has c.25% of the world's known oil reserves, and in 1994 supplied over 13% of world demand. Oil and oil products make up 85% of its exports. Oil revenue has been used to develop education, services, light industry, farming, and purchasing of military hardware. The construction of desalination plants has played an important part in improving the supply of freshwater. In the mid-1980s, world oil prices slumped dramatically and many infrastructure projects were abandoned. Agriculture employs 48% of the workforce, although only 1% of the land is fertile. Crops grown in Asir and at oases include dates and other fruits, vegetables and wheat. Some nomadic livestock herders remain. Mecca is visited by more than 1.5 million pilgrims a year, making this a vital addition to state revenue.

▲ saxifrage The rue-leaved saxifrage (Saxifrage tridacty/lites) thrives in dry conditions and is capable of growing on rocks and walls. It is a member of the widespread family Saxifragaceae, whose name in Latin means "breaker of rocks".

of Angola (UNITA). After independence (1975), he launched a guerrilla war against the MPLA government. In 1991 President Dos Santos and Savimbi signed a peace agreement. Savimbi refused to recognise the 1992 re-election of Dos Santos and civil war resumed. UNITA's dwindling support forced him to accept the Lusaka Protocol (1994), paving the way for a government of national unity. Savimbi, however, refused the vice presidency. Fighting resumed as UNITA retained military control of c.50% of Angola. In 1997 the UN imposed sanctions on UNITA for failing to comply with the Lusaka Protocol.

savings and loan association US financial institution that is organized as a mutual, issuing shares or ownership certificates to its depositors. Savings and loan associations (S&Ls) take deposits, on which the shares are based, and provide mortgage loans, as well as real estate and business loans. High-risk loan policies in the early 1980s led to many bankruptcies in the recession of the late 1980s, and the US government was forced to bail them out, at a high price.

Savonarola, Girolamo (1452–98) Italian religious reformer. Savonarola's sermons attacked the corruption and decadence of the papacy and the state of Florence. After the death of Lorenzo de' Medici (1494), Savonarola became spiritual and political leader of the city. His support for the invasion of Charles VIII of France infuriated Pope Alexander VI, and he was excommunicated in 1497. Public hostility to Savonarola's austere regime intensified. He was arrested and hanged for heresy.

Savoy Area of SE France, bounded by Lake Geneva (N), the River Rhône (W), the Dauphiné (s) and the Alps of Italy and Switzerland (E); it includes the départements of Haute Savoie and Savoie. It was part of the first Burgundian kingdom, the kingdom of Arles and, in the 11th century, the Holy Roman Empire (as a county). In 1416 it became a duchy and its area was enlarged, incorporating parts of France, Switzerland and Italy. An Italian state in the 16th century, it was part of the kingdom of SARDINIA after 1713. Savoy was annexed by France in 1792, returned to Sardinia in 1815, and finally ceded to France by the Treaty of Turin in 1860.

sawfish Any of several species of sharklike, flat bodied RAYS that live in tropical marine and brackish waters. It has a grey or black-brown body with an elongated, saw-toothed snout resembling a flat blade. Length: to 5m (16ft). Family Pristidae; genus *Pristis*.

sawfly Any of 400 species of primitive, plant-feeding WASPS that lack a narrow waist between thorax and abdomen. Most typical sawflies are included in the family Tenthredinidae. Length: to 20mm (0.8in). Order Hymenoptera.

Saxe-Coburg-Gotha Duchy in Saxony, Germany, whose ruling dynasty intermarried with many royal families. After Prince Albert married the English Queen VICTORIA, Saxe-

Anglo-Saxon kingdoms

Celtic kingdoms

Mercia

East Anglia

Essex

Wessex

Sussex

Coburg-Gotha became the name of the English royal house until it was changed to Windsor in 1917.

saxifrage Perennial plant of the genus *Saxifraga* native to temperate and mountainous regions of Europe and North America. The leaves are massed at the base and the branched clusters of small flowers are white, pink, purple or yellow. Height: to 61cm (2ft). Family Saxifragaceae.

Saxons Ancient Germanic people. They appear to have originated in N Germany and perhaps s Denmark. By the 5th century they were settled in NW Germany, N Gaul and s Britain. In Germany they were eventually subdued by CHARLEMAGNE. In Britain, together with other Germanic tribes, known collectively as ANGLO-SAXONS, they evolved into the English.

Saxony Federal state and historic region in E central Germany; the capital is DRESDEN. Initially it referred to the homeland of the SAXONS in NW Germany. It then successively became a duchy, a collection of fiefdoms, an electoral region, a duchy again, and finally (1815-71) comprised the Prussian province of Saxony and the kingdom of Saxony. After 1945 the province of Saxony was united with Anhalt to form the state of Saxony-Anhalt, with MAGDEBURG as its capital. From 1871-1918 the kingdom of Saxony was part of the German Empire. In the aftermath of World War 1, the kingdom was made a state of the Weimar Republic, with Dresden as its capital. After World War 2, it joined the German Democratic Republic (East Germany). Following German reunification in 1991, it became a state in the Federal Republic of Germany. Area: 18,409 sq km (7,106 sq mi). Pop. (1993 est.) 4,608,000. Saxony-Anhalt Federal state in s Germany, with Lower Saxony to the NW and Saxony to the SE; the capital is MAGDE-BURG. The region is mainly plains with the Harz Mountains rising in the sw of the state. Predominantly an industrial region, its major manufactures are machine and transport equipment. The history of the region coincides with that of SAXONY until 1871, when it became a state of the German empire. After World War 2, the Red Army briefly occupied the region and the district was abolished in 1952. Following German reunification in 1991, Saxony-Anhalt was reformed as a federal state of Germany. Other major cities include Halle and Dessau. Area: 20,445sq km (7,892sq mi). Pop. (1994) 2,759,213.

saxophone Musical instrument with a single reed, conical metal tube and finger keys. It was invented by Adolphe Sax in the 1840s. Four members of the saxophone family are commonly used today; these are the soprano (in B), the alto (in E), the tenor (in B) and the baritone (in E). They are mostly used in jazz.

Sayers, Dorothy L. (Leigh) (1893–1957) British novelist and playwright, best known for her detective fiction. Her first novels featured Lord Peter Wimsey, a titled detective who appeared in 10 books including *Whose Body?* (1923) and *Gaudy Night* (1935). She later wrote religious dramas and was noted as a translator of DANTE.

scabies Contagious infection caused by a female mite, *Sarcoptes scabiei*, which burrows into the skin to lay eggs. It can be seen as a dark wavy line on the skin and is treated with antiparasitic creams.

scabious Any annual or perennial plant of the genus *Scabiosa* of the TEASEL family (Dipsacaceae), native to temperate parts of Europe and Asia, and the mountains of E Africa. They have rosettes of leaves and leafy stems. There are many cultivated garden varieties. Devil's bit scabious belongs to the genus *Succisa* and the sheep's bit scabious, *Jasione montana*, is a member of the bellflower family (Campanulaceae).

Scafell Pike Highest peak in England, at 978m (3,210ft) high, part of the Scafell range in the LAKE DISTRICT, NW England.

scalar Mathematical quantity that has only a magnitude, as opposed to a VECTOR, which also has direction. Mass, energy and speed are scalars.

scale In biology, small hard plate that forms part of the external skin of an animal. It is usually a development of the SKIN layers. In most fish, scales are composed of bone in the dermal skin layer. The scales of reptiles and those on the legs of birds are horny growths of the epidermal skin layer and are composed mostly of the fibrous protein KERATIN.

► Saxons In the course of the

6th and 7th centuries, the once-

unified Roman province of Britain

was split into a collection of petty

kingdoms: barbarian Saxon in the

s and E, Celtic in the w and N.

Organized by family and clan, the Saxon kingdoms developed

into seven more stable entities. The frontiers, however, were

personal rather than hereditary,

and the balance of power was

not constant, kingship was

constantly changing.

scale In music, term for the ordered arrangement of intervals that forms the basis of musical composition. There are many types of scale. In Western music the most important has been the seven-note diatonic scale, both in its major and minor forms. The 12-note CHROMATIC scale has a regular progression of semitones.

scallop Edible BIVALVE mollusc. One shell, or valve, is usually convex and the other almost flat. The shell's surface is ribbed (scalloped). Most scallops have a row of eyes that fringe the fleshy mantle. Width: 2.5–20cm (1–8in). Family Pectinidae.

Scandinavia In physicial geography, the N European peninsular countries of SWEDEN and NORWAY. In a broader, cultural sense it also includes DENMARK, FINLAND, ICELAND and the FARÖE ISLANDS. The climate ranges from subarctic in the N to humid continental in the centre and marine in the w and sw. The terrain is mountainous in the w with swift-flowing streams. In the E the land slopes more gently and there are thousands of lakes, notably in Finland. Part of the region lies within the Arctic Circle, where tundra predominates. Denmark and s Sweden have the best farmland. A large proportion of the land is forested, there are rich mineral deposits, particularly of iron ore and copper, and fishing is still important. The largest cities are STOCKHOLM and GOTHENBURG in Sweden; Oslo in Norway; COPENHAGEN in Denmark, and HELSINKI in Finland. Area: c.1,258,000sq km (485,250sq mi). Scandinavian art Art in the Nordic countries dates back to the end of the Ice Age, when the first rock carvings were made. There was a tendency to use intricate interlacing patterns, which reached a peak in the stonework and wood-carving of the Viking period (c.800-c.1050). Throughout the Middle Ages and beyond, Scandinavian art was in the shadow of other European cultures. It was only at the end of the 18th century that artists of international standing began to emerge. Chief among these was Edvard MUNCH.

scandium (symbol Sc) Silver-white metallic element of group III of the periodic table discovered in 1879. It is found in thortveitite and, in small amounts, in other minerals. Scandium is a soft metal used as a radioactive tracer and in nickel alkaline storage batteries. Chemically it resembles the rarearth metals of the LANTHANIDE SERIES. Properties: at.no. 21; r.a.m. 44.956; r.d. 2.99; m.p. 1,539°C (2,802°F); b.p. 2,832°C (5,130°F); most common isotope Sc⁴⁵ (100%).

scanning In medicine, use of a non-invasive system to detect abnormalities of structure or function in the body. Detectable waves (x-rays, gamma rays, ultrasound) are passed through the part of the body to be investigated and the computer-analyzed results are displayed as images on a viewing screen.

scarab beetle Any of several different species of broad beetles distributed worldwide. Most, including the June bug, Japanese beetle and rhinoceros beetle, are leaf chafers. A smaller group, including the DUNG BEETLE, are scavengers. Family Scarabaeidae.

Scargill, Arthur (1938–) British trade union leader. Scargill became a miner at the age of 18. He was a member (1955–62) of the Young Communist League before joining the Labour Party. In 1981 he became president of the National Union of Mineworkers (NUM). Scargill's attempt to confront Margaret THATCHER'S Conservative government's programme of pit closures and anti-union legislation led to a miner's strike (1984–85). The strike split the miners' and Labour movements. In 1995 he formed the Socialist Labour Party.

Scarlatti, Alessandro (1660–1725) Italian Baroque composer who laid the foundations of the musical idioms that shaped musical thought to the time of Beethoven. His genius is displayed in his dramatic music and he is known as the founder of OPERA SERIA.

Scarlatti, (Giuseppe) Domenico (1685–1757) Italian composer, son of Alessandro SCARLATTI. He settled in Spain and is primarily known for his harpsichord sonatas, of which he composed more than 500. He is considered the founder of modern keyboard technique.

scarlet fever (scarlatina) Acute infectious disease, usually affecting children, caused by BACTERIA in the *Streptococcus pyogenes* group. It is characterized by a bright red body rash, fever, vomiting and a sore throat. It is treated with ANTIBIOTICS.

■ saxophone Named after its 19th-century inventor, Adolphe Sax, the saxophone is a single reed instrument which combines features of the oboe and the clarinet and is usually keyed in Earlo B. It is shown here complete (top right) and with its mouthpiece (A) and neckpiece (B) separate.

scattering In physics, deflection of the path of SUBATOMIC PARTICLES by ATOMS. It is the means by which the structure of atoms was discovered. Ernest RUTHERFORD, Hans GEIGER and Ernest Marsden fired ALPHA PARTICLES through thin metal films and noted their scattering. Rutherford then predicted the existence of the atomic nucleus (positively charged and centrally placed in the atom). Most knowledge of ELEMENTARY PARTICLES has been obtained by scattering experiments carried out in particle ACCELERATORS.

scepticism Philosophical attitude that asserts the uncertainty of all knowledge and the impossibility of obtaining absolute knowledge. Sceptics consequently take the view that the only course of action is to suspend judgment and adopt a mood of mental tranquillity and indifference.

Scheele, Karl Wilhelm (1742–86) Swedish chemist who discovered OXYGEN. He discovered it in 1771, but publication of his discovery was delayed and the credit went to Joseph PRIESTLEY. He made other important discoveries, including CHLORINE, GLYCEROL and a number of organic acids.

Schelling, Friedrich Wilhelm Joseph von (1775–1854) German philosopher who elaborated Fichte's view that there is a single reality. Ultimately, he asserted, PANTHEISM merges into total MYSTICISM. The clearest accounts of his philosophy appear in First Sketch of a System of Nature Philosophy (1799) and System of Transcendental Idealism (1800).

Schiele, Egon (1890–1918) Austrian painter, one of the greatest exponents of EXPRESSIONISM. His characteristic paintings portray anguished or isolated naked figures whose distorted bodies reflect their mental pain. Schiele also produced landscapes and semi-allegorical pictures.

Schiller, Johann Christoph Friedrich von (1759–1805) German dramatist, historian and philosopher. He wrote STURM UND DRANG plays in blank verse: Don Carlos (1787), Wallenstein (1800), Mary Stuart (1801), Maid of Orleans (1801) and William Tell (1804). His "Ode to Joy" is set to music in the last movement of Beethoven's Ninth Symphony. schism Split or division within a Church, sect or other religious organization, or a breakaway from a church. Before the Protestant Reformation, there were two other important schisms within Christianity. An escalating series of disputes culminated in a complete break between the Eastern (ORTHO-DOX) Church and the Western (ROMAN CATHOLIC) Church in 1054. The so-called GREAT SCHISM occurred in the 14th and 15th centuries and involved a split within the Roman Catholic Church itself. This schism was eventually resolved by a meeting of bishops called the Council of Constance (1417). schist Large group of METAMORPHIC ROCKS that have been made cleavable, causing the rocks to split into thin plates leaving a wavy, uneven surface.

schizophrenia One of a group of psychotic disorders marked primarily by disturbances of cognitive functioning, particularly thinking and speech. As well as the characteristic loss of contact with reality, symptoms include hallucinations and delusions, and muffled or inappropriate emotions.

▲ scallop The various scallops (Pecten sp.) are found in offshore waters in many parts of the world. The shell of the scallop has been used as decorative embellishment since Roman times, and was also used as an emblem by the pilgrims who travelled to the cathedral of St James of Santiago de Compostela, Spain.

A scarab beetle The fierce-looking Hercules beetle (*Dynastes hercules*) is a type of scarab beetle. The male (shown here) can grow up to 20cm (8in) and possesses a large horn that grows up to 10cm (4in) from its head. Unlike the male, the female does not possess a horn, and its wing cases are covered in a layer of red hairs.

Schlegel, August Wilhelm von (1767–1845) German poet, critic and scholar. From 1798, he was one of the leading propagandists of the German romantic movement, which he influenced with his translations of the plays of Shakespeare (1797–1810).

Schlesinger, Arthur Meier, Jr (1917–) US historian. Schlesinger achieved prominence with *The Age of Jackson* (1945). He became a leading liberal intellectual in the era of the Cold War, serving as special assistant to President John F. KENNEDY (1961–64). His *A Thousand Days* (1965), an account of the Kennedy administration, was followed by *Robert Kennedy and His Times* (1978).

Schleswig-Holstein Federal state and historic region in NW Germany; the capital is Kiel. It occupies the s of the Jutland peninsula and extends from the River Elbe to the border with Denmark. The land is mainly flat and fertile. The Kiel Canal links the North Sea with the Baltic. The region's principal economic activities of shipping and fishing are concentrated along the Baltic coast and its excellent natural harbours. The River Eider forms the historic border between Schleswig and Holstein. In the early 12th century, the duchy of Holstein was created as part of the Holy Roman Empire, while Schleswig was made a fiefdom independent of Danish control. They were twice united under the Danish crown, but not incorporated into the Danish state. In 1848 Frederick VII proclaimed the complete union of Schleswig with Denmark, the predominantly German population of both duchies rebelled, and the German Confederation occupied the two duchies. The 1852 Treaty of London re-established the duchies' personal union with Denmark. In 1863 Denmark again tried to incorporate Schleswig into the state proper. Prussia and Austria declared war. In 1865 Schleswig was administered by Prussia, and Holstein by Austria. The resulting tension led to the Austro-Prussian War (1866). Prussian victory created the state of Schleswig-Holstein. In 1920, following a plebiscite, the N part of Schleswig was returned to Denmark. In 1937 the city of Lübeck was incorporated into the German state of Schleswig-Holstein. Area: 15,738sq km (6,075sq mi). Pop. (1993 est. 2,695,000).

Schlieffen Plan German war strategy devised by Alfred von Schlieffen, chief of staff (1891–1905). It was designed for a possible war against France and Russia. An all-out attack in the w would rapidly defeat the French, enabling Germany to transfer its full force to the E against Russia, whose mobilization would be slower. A modified version was put into effect in 1914.

Schliemann, Heinrich (1822–90) German archaeologist. In 1871 he began excavations in Hisarlik, Turkey, which he believed to be the site of the Homeric city of Troy. He uncovered nine superimposed towns; later excavations indicated that the seventh layer was probably the Homeric Troy. Schmidt, Helmut (1918–) Chancellor of West Germany (1974–82). He became chairman of the Social Democratic Party (SDP) in 1967, and was minister of defence (1969–72) and finance (1972–74) before succeeding Willy Brandt as chancellor of the Federal Republic of West Germany. He won the elections of 1976 and 1980 but was forced to resign in 1982 when the Free Democrats, coalition partners of the SDP, withdrew their support.

Schnabel, Artur (1882–1951) Austrian pianist and composer who lived in the USA after 1939. He was best known as

an interpreter of the classical repertoire, including Mozart and Beethoven, whose 32 piano sonatas he edited and recorded.

Schoenberg, Arnold Franz Walter (1874–1951) Austrian composer. In early works, such as *Verklärte Nacht* (1899), Schoenberg extended the chromaticism of ROMANTICISM. The song cycle *Das Buch der hängenden Gärten* (1908) and the expressionist opera *Erwartung* (1909) revolutionized modern music by abandoning TONALITY. Schoenberg's form of SERIAL MUSIC, known as TWELYE-TONE MUSIC, was first employed in Suite for Piano (1923). His operatic masterpiece, *Moses und Aron*, remained unfinished at his death.

scholasticism Medieval philosophy that attempted to join faith to reason by synthesizing theology with classical Greek and Roman thought. Scholasticism was first explored by John Scotus Erigena in the 9th century and by ANSELM OF CANTERBURY in the 11th century. Its greatest thinkers were Albertus Magnus and Thomas AQUINAS in the 13th century and DUNS SCOTUS at the turn of the 14th century.

school Place of EDUCATION, usually at primary or secondary level. In Western countries there are usually two or three parallel school systems: one provided by the state and financed by taxpayers; one financed partly by churches in conjunction with the state or parents; and the third privately financed by parents. The term "public school" is used of some private schools in the UK and of some state schools in the USA.

Schopenhauer, Arthur (1788–1860) German philosopher, whose exposition of the doctrine of the will opposed the idealism of HEGEL and influenced NIETZSCHE, WAGNER and others. Schopenhauer's system, described in his main work, *The World as Will and Idea* (1819), was an intensely pessimistic one. The will to endure was an individual's prime motivation and the negation of will and desire provided the possibility of escape from pain.

Schrödinger, Erwin (1887–1961) Austrian physicist, who formulated a quantum mechanical wave equation. He went on to found the science of quantum WAVE MECHANICS and shared the 1933 Nobel Prize for physics with the British physicist Paul DIRAC. The wave equation was based on a suggestion by the French physicist Louis de Broglie that moving particles have a wave-like nature.

Schubert, Franz Peter (1797–1828) Austrian composer whose symphonies represent the final extension of the CLASSI-CAL SONATA form, and whose songs are the height of ROMANTI-CISM in lyricism. Among his more popular works are symphonies such as the Eighth ("Unfinished", 1822) and the Ninth in C major (1825). He wrote more than 600 songs to the lyrics of such poets as Heine and Schiller; these include the cycles Die schöne Müllerin (1823) and Winterreise (1827). In his tragically short lifetime he also composed much chamber music, and his String Quintet (1828) is a masterpiece.

Schumacher, Michael (1969–) German racing driver. Schumacher began Formula 1 racing in 1991 and soon joined the Benetton team. He won his first Grand Prix (Belgium) in 1992. Schumacher won the world drivers' championship in 1994 and 1995. He switched to race for Ferrari in 1996. A gifted driver, Schumacher narrowly failed to win the 1997 title.

Schumann, Clara Josephine Wieck (1819–96) German pianist and composer, wife of Robert SCHUMANN. She was an outstanding interpreter of the works of her husband and of their friend Brahms. She composed chamber works, piano pieces and songs, mainly for her own concerts.

Schumann, Robert Alexander (1810–56) German composer and leading figure of ROMANTICISM. Schumann's piano compositions include *Kinderszenen* (1838), *Carnaval* (1834–35) and *Waldscenen* (1848–49). Among his best song cycles is *Frauenliebe und Leben* ("Women's Love and Life", 1840). His "Spring" Symphony (1841) and Piano Concerto (1841–45) are among his best orchestral works.

Schütz, Heinrich (1585–1672) German composer who wrote the earliest German opera, *Dafne* (1627), now lost. Most of his surviving works were written for the church.

Schwarzkopf, Dame Elisabeth (1915–) German soprano known for her versatility in recitals, oratorios and opera. She sang with the Berlin State Opera from 1938 to 1942 and became principal soprano of the Vienna State Opera in 1944.

1 racing driver Michael Schumacher is renowned for his ability to produce fast qualifying

► Schumacher German Formula

times by obtaining the optimum "set-up" for his car. Following two successive world championship victories with Benetton, Schumacher switched to Ferrari. In 1997, despite the car's unreliability, he only narrowly failed to become Ferrari's first world champion since Jody Scheckter (1979). Schumacher was fined for shunting Jacques Villeneuve in the deciding race of the championship.

She specialized in Richard Strauss, Mozart, Schubert and Hugo Wolf and made many fine recordings.

Schwarzkopf, H. Norman (1934–) US general. A Vietnam veteran, Schwarzkopf was deputy commander of the US forces that invaded Grenada (1983). As supreme commander of the Allied forces in the Gulf War (1991), he liberated Kuwait from Iraqi occupation. After retiring from the army, he published his memoirs, *It Doesn't Take a Hero* (1992).

Schweitzer, Albert (1875–1965) Theologian, musician, medical missionary and philosopher. Schweitzer was born in Alsace and spent most of his life in Gabon (then French Equatorial Africa), where he founded the Lambaréné Hospital in 1913. He was honoured as a scientist and humanitarian, and as an organist and an expert on J.S. Bach. He was awarded the 1952 Nobel Peace Prize. His works include Kant's Philosophy of Religion (1899) and Out of My Life and Thought (1931).

Schwitters, Kurt (1887–1948) German DADA artist and writer. He is best known for his invention of *Merz* to denote art that was made from refuse. Schwitters constructed elaborate sculptures and even room interiors from such "found objects" as old newspapers and tram tickets.

sciatica Severe pain in the back and radiating down one or other leg, along the course of the sciatic nerve. It is usually caused by inflammation of the sciatic nerve or by pressure on the spinal nerve roots.

science fiction Literary genre in which reality is subject to certain transformations in order to explore man's potential and his relation to his environment; these transformations are usually technological and the stories set in the future or in imaginary worlds. The birth of the modern genre is generally dated to the US comic strip *Amazing Stories* (1926). Until the 1960s most science fiction involved adventure stories set in space. Some writers, such as Isaac ASIMOV, explored the paradoxes contained in purely scientific ideas; others, including Ray BRADBURY, stressed the moral implications of their stories.

scientology "Applied religious philosophy" based on a form of psychotherapy called dianetics, which was founded (1954) by L. Ron HUBBARD in California, USA. It advocates confrontation with, and assimilation of, painful experiences from the past to achieve true mental health. The movement is officially known as the Church of Scientology. It has aroused contraversy over its methods of recruiting and keeping members.

troversy over its methods of recruiting and keeping members. **Scilly, Isles of** Archipelago of more than 140 isles and islets in the Atlantic Ocean off the coast of Cornwall, sw England, 45km (28mi) sw of Land's End; the capital is Hugh Town (St Mary's). The terrain is mostly rocky, and many shipwrecks lie off the coasts. The combination of mild climate and heavy rainfall make the islands a good environment for growing flowers and early spring vegetables. Tourism is an increasingly important industry. Only five of the islands are inhabited: St Mary's (the largest), Tresco, St Martin's, St Agnes and Bryher. Total pop. (1991) 2,900.

Scipio Africanus Major (236–183 BC) (Publius Cornelius Scipio) Roman general in the second of the Punic Wars. He defeated the Carthaginian forces in Spain in 209 BC. Elected consul in 205, he invaded North Africa with a volunteer army and defeated Hannibal at Zama in 202 BC, earning the honorary surname Africanus. He was again elected consul in 194, but later retired from public life, disillusioned by attacks from opponents jealous of his popularity.

Scipio Africanus Minor (185–129 BC) (Publius Cornelius Scipio Aemilianus) Roman general of the third of the Punic Wars. He took the name of his grandfather-by-adoption, SCI-PIO AFRICANUS MAJOR. He destroyed Carthage in 146 BC, bringing the Punic wars to an end, and in 133 BC ended a long war in Spain by destroying the city of Numantia.

sclerosis Degenerative hardening of tissue, usually due to scarring following inflammation or as a result of ageing. It can affect the brain and spinal cord, causing neurological symptoms, or the walls of the arteries.

Scorpio Eighth astrological sign of the ZODIAC. The ancients identified it with the scorpion which caused the death of the hunter Orion and stung the horses of Phaëthon. The Sun enters the sign on 24 October and leaves it on 21 November.

scorpion Any of numerous species of ARACHNIDS that live in

■ scorpion The sting of the scorpion is worked by opposing muscles fixed to the base of the sting, which contract and relax, forcing the sharp tip into its prey's tissue. The poison, stored in the poison gland, is forced down and out of the tip of the sting by muscles located around the gland.

warmer regions throughout the world. It has two main body sections, two eyes, a pair of pedipalps (pincers) and a long slender tail ending in a curved, poisonous sting. Length: to 17cm (7in). Class Arachnida; order Scorpionida.

Scorsese, Martin (1942–) US film director. Scorsese's first major film was Mean Streets (1973), a story of Italian-American gangland brutality. Success followed for Alice Doesn't Live Here Anymore (1975). Scorsese often cast Robert DE NIRO in leading roles, such as in Taxi Driver (1976), Raging Bull (1980) and The King of Comedy (1983). His Last Temptation of Christ (1988) courted controversy and censure. Other films include Goodfellas (1990), Cape Fear (1991), The Age of Innocence (1993) and Casino (1995).

Scotland Northern part of the main island of Great Britain, and a constituent of the United Kingdom of Great Britain and Northern Ireland; the capital is EDINBURGH. The largest city is GLASGOW. Scotland is administratively divided into nine regions and three island authorities. Its jagged coastline features many islands (including the ORKNEY and SHETLAND ISLANDS), lochs (including LOMOND and NESS) and firths. Major Scottish rivers include the TAY, CLYDE, Dee and Forth. Scotland can be broadly divided into three geographical regions: the Southern Uplands, immediately N of the English border, which are sparsely populated, hilly moorland; the Central Lowlands, where the majority of the population live; and the HIGHLANDS, including BEN NEVIS. In prehistory Scotland was inhabited by the Picts. Kenneth I united the lands of the Picts and the Scots in AD 843. In 1174, with the development of feudalism, Scotland was made a fiefdom of England. In 1189 Richard I granted Scottish freedom, but the enmity between England and Scotland (in alliance with France) continued. Edward I forced the Scots to submit, only for William WALLACE to lead a Scottish revolt. ROBERT I (THE BRUCE) recaptured much Scottish land and defeated the English at the Battle of Bannockburn (1314); this led to England's recognition of Scottish independence in 1328. The 15th century was characterized by internal factionalism and weak government. JAMES IV and many Scottish nobles were killed at the Battle of Flodden (1513). The Protestant REFORMATION quickly took root in Scotland via the preaching of John Knox. In 1513 JAMES V cemented the French alliance by marrying Mary of Guise, a French Catholic. When her daughter, MARY, QUEEN OF Scots, assumed the throne in 1561, England supported the Scottish Protestants, and France backed the Catholics. The Protestant faction forced Mary to relinquish the throne in 1567. Her son, James VI, assumed the Scottish crown, and in 1601 he was also crowned JAMES I of England, thereby uniting the English and Scottish thrones. The Scots opposed Charles I in the English CIVIL WAR but the King's concessions to PRESBYTERI-ANISM won the support of the COVENANTERS. The GLORIOUS REVOLUTION re-established Presbyterianism as the Scottish national church. The massacre of the Macdonald clan by

▲ Scott British Antarctic explorer Robert Scott and his four companions pulled heavy sledges by hand across the high polar plateau in their trek to the South Pole in 1910–12. All five died, and their bodies were later recovered along with Scott's diaries, scientific collections and letters to the widows of his companions. The story of their tragic journey has entered into British folklore.

▲ sea horse Related to the pipe fishes – family Syngnathidae - (back), the sea horse (Hippocampus sp) is the only fish with a prehensile tail, which it uses to cling to seaweed. The sea horse swims weakly with an upright stance, and is carried along by ocean currents.

➤ sea anemone Having no rigid structures, the sea anemone supports itself by circulating water around its central cavity (1). Water is drawn down through siphonoglyphs (grooves) (2) at the side of the cavity, and is expelled up the centre. The tentacles (3) can be withdrawn by individual retractor muscles

WILLIAM III at Glencoe in 1692 tarnished enthusiasm for his rule, and JACOBITE agitation prompted the constitutional union of the two crowns in the Act of UNION (1707). At CULLODEN Moor (1746) the Jacobite insurgency was finally suppressed with the defeat of the Highlanders led by Prince Charles Edward STUART. (See United Kingdom for subsequent history). The principal agricultural activity is the rearing of livestock; oats and potatoes are the chief crops. Coal mining and heavy industry dominated the economy of the central lowlands by the end of the 19th century, but declined in the 1980s. The discovery of North Sea oil and natural gas in the 1970s benefited the Scottish economy. Other important industries include textiles, whisky, beer and fishing. The SCOTTISH NATIONAL PARTY (SNP) gained support during the 1970s, but a 1979 referendum for a separate Scottish assembly was defeated. A 1997 referendum voted overwhelmingly in favour of devolution. Scotland retains its own church, education and legal system. Area: 77,167sq km (29,797sq mi). Pop. (1991) 4,998,567. Scotland Yard Name given to the London headquarters of the Metropolitan Police and synonymous with the CRIMINAL INVESTIGATION DEPARTMENT (CID). Originally located in Scotland Yard, off Whitehall, it was moved to New Scotland Yard in 1890 and to further new premises in 1967.

Scots Originally a Celtic people from N Ireland. They were Gaelic speaking. Their raids on the w coast of Roman Britain from the 3rd to the 5th century failed to establish independent settlements in Wales or NW England. In the 5th century, however, they were able to establish the kingdom of Dalriada in Pictish territory. From the 11th century the term has been applied to those people living in Scotland.

Scott, Sir George Gilbert (1811–78) British architect, prominent figure in the GOTHIC REVIVAL. Scott achieved a reputation with his design for the church of St Nicholas, Hamburg. He was involved in restoration work for churches and cathedrals. He designed the Albert Memorial (1862–70), the Foreign Office and St Pancras Station, London.

Scott, Sir Giles Gilbert (1880–1960) British architect. Scott designed the new Anglican Cathedral in Liverpool, the last major example of the GOTHIC REVIVAL. His other important works include the New Bodleian Library, Oxford, and Waterloo Bridge over the River Thames, London.

Scott, Ridley (1937–) English film director. *Alien* (1979) and *Blade Runner* (1982) were seminal science-fiction offerings. *Thelma and Louise* (1991) was another genre-breaking box-office success.

Scott, Robert Falcon (1868–1912) British Antarctic explorer. Scott's first expedition to the South Pole, in the *Discovery*, (1901–04) ended in failure. His second expedition (1910–12) reached the Pole, but found that Roald AMUNDSEN had got there first. Beset by blizzards on their return journey, Scott and his party perished within 18km (11mi) of safety. His diaries were published as *Scott's Last Expedition* (1913). **Scott, Sir Walter** (1771–1832) Scottish novelist and poet. He began his career with a collection of old Scottish ballads,

Minstrelsy of the Scottish Border (1802–03). The wider fame brought by The Lay of the Last Minstrel (1805) was consolidated by the poems Marmion (1808) and The Lady of the Lake (1810). In 1814 he turned to historical fiction. His first novel, the anonymously published Waverley (1814), was an immediate success and was followed by a series of Scottish novels, including Rob Roy (1817) and The Heart of Midlothian (1818). Among his later novels are Ivanhoe (1819), Kenilworth (1821) and Quentin Durward (1823).

Scottish (Scots) Dialect of English traditionally spoken in Scotland and regarded by some experts as a distinct GERMAN-IC language. It is also called Lowland Scots (or Lallans), to distinguish it from the Scots GAELIC (or broad Scots) spoken in the Scottish Highlands, and to differentiate it from the English of Scotland's middle class. It developed from the Northumbrian dialect of Early English before AD 700. Over the following 600 or 700 years, it spread throughout Scotland. Before the union of the English and Scottish crowns in 1603, the Scottish language was both a national language and an official court language. The language continues as a spoken dialect in many areas, and as a vehicle for a vibrant literature. Scottish National Party (SNP) UK political party, founded in 1928. The SNP grew out of the Scottish Home Rule Association, formed in 1886, and gained its first MP in 1945. During the 1960s it significantly expanded its support base, gaining around 20% of the Scottish vote in most subsequent general elections. It advocates Scotland's independence (from the UK) within the European Union. See also Alex SALMOND Scouts See Boy Scouts and GIRL GUIDES

scrapie Fatal disease of sheep and goats that affects the central nervous system, causing staggering and itching that makes an infected animal scrape itself against various objects. It is caused by a slow-acting, virus-like, microscopic particle called a PRION. The animal usually dies within six months of exhibiting the first symptoms. The disease is thought to be related to BOVINE SPONGIFORM ENCEPHALOPATHY and CREUTZFELDT-JAKOB DISEASE (CJD).

scree (talus) Heap of rock waste lying at the bottom of a cliff. It is made up of particles that have been loosened from the cliff rock by weathering.

screening In medicine, a test applied either to an individual or to groups of people who, although apparently healthy, are known to be at special risk of developing a particular disease. It is used to detect treatable diseases while they are still in the early stages.

Scriabin, Alexander Nicolas (1872–1915) Russian composer and pianist. He wrote highly original piano music in which he used chords built in fourths instead of the conventional major and minor triads. His most significant works include ten piano sonatas, *The Poem of Ecstasy* (1908), three symphonies and numerous short piano pieces.

scribe Court secretary in ancient times; in Judalsm, member of a class of scholars expert in Jewish law. From the late 6th century, the Scribes functioned as teachers and interpreters of the Mosaic law contained in the Torah. At first they were priests, but later there arose a class of lay experts in the Torah, who not only preserved and elucidated biblical law but by the time of Christ were also involved in the dispensation of justice. scriptures Sacred writings of a religion. In Christianity, they are the books of the Old Testament, with or without those of the APOCRYPHA. As used in the New Testament, the term refers primarily to the Old Testament. Scripture, in the singular, is a collective term for biblical writings in general. Outside the Christian context, it is possible, for example, to speak of the Koran as the scripture of Islam or the Vedas as the scriptures of Hinduism.

scuba diving Diving with the use of self-contained underwater breathing apparatus, or scuba. The equipment usually consists of tanks of compressed air connected to a demand regulator. This controls the air flow to the mouth. Other equipment includes a wet suit to insulate the diver from the cold, and a weighted belt, a face mask and flippers.

sculpture Art of creating forms in three dimensions, either in the round or in relief. Techniques employed include carving (in wood, stone, marble, ivory, etc.), modelling (in clay,

Seafloor spreading in the Atlantic Ocean

Seafloor spreading in the Indian Ocean and continental plate collision

wax, etc.), or casting (in bronze and other metals). The history of sculpture parallels that of PAINTING. The early civilizations of Egypt, Mesopotamia, India and the Far East were rich in sculpture. The Greeks developed a style of relief and free-standing sculpture. Roman sculptors were profoundly influenced by the Greeks, but forsook the Greek ideal in portraiture, which they enriched with individual characterization. Medieval European sculpture was frequently a feature of ROMANESQUE and Gothic churches, many of which were covered with carvings. Highly stylized in the Romanesque period, this architectural sculpture became more representative in the Gothic era. Prior to the RENAISSANCE, individual sculptors rarely achieved fame. The Florentine Renaissance was enriched by the works of such masters as GHIBERTI, DONATEL-LO, and MICHELANGELO. High BAROQUE sculpture is exemplified in the works of the architect-sculptor BERNINI in Rome. Pierre Puget was the movement's leading exponent in France where, in the 18th century, it was superseded by NEO-CLASSI-CISM. This extended into the 19th century, when it was rivalled and replaced by a movement of realist sculpture, such as that of RODIN. African, Aztec and other ethnic and ancient sculpture have stimulated great modern sculptors such as Picasso, Modigliani, Brancusi and Moore.

scurvy Disease caused by a deficiency of VITAMIN C (ascorbic acid), which is contained in fresh fruit and vegetables. It is characterized by weakness, painful joints and bleeding gums. **Scylla** In Greek mythology, a female sea monster. Once a beautiful nymph beloved of POSEIDON, she was changed by CIRCE into a long-necked, six-headed beast. She lived with CHARYBDIS beside the Straits of Messina between Sicily and Italy and devoured sailors.

Scythians Nomadic people who inhabited the steppes N of the Black Sea in the 1st millennium BC. In the 7th century BC their territory extended into Mesopotamia, the Balkans and Greece. Powerful warriors, their elaborate tombs contain evidence of great wealth. Pressure from the Sarmatians confined them to the Crimea $(c.300 \, \text{BC})$ and their culture disappeared.

SDLP Acronym for Social Democratic Labour Party SDP Acronym for Social Democratic Party

sea anemone Sessile, polyp-type COELENTERATE animal found in marine pools and along rocky shores. It has a cylindrical body with tentacles around its mouth; the colour varies according to species. Height: to 20cm (8in). Class Anthozoa; genera include *Tealia*, *Anemonia* and *Metridium*.

sea cow See DUGONG

sea cucumber Marine ECHINODERM found in rocky areas. It is a cylindrical animal with a fleshy body in five parts around a central axis; it has branched tentacles around the mouth. Edible species are smoked and dried. Species include the cotton-spinners (*Holothuria* spp). Class Holothuroidea.

seafloor Floor of the oceans, which includes a variety of different landforms. The major features of the seafloor are continental shelf, the continental rise, the abyssal floor, seamounts, oceanic trenches and oceanic ridges. The abyssal or deep ocean floor is *c*.3km (1.8mi) deep and is mostly made of basaltic rock covered with fine-grained (pelagic) sediment consisting of dust and the shells of marine organisms. Oceanic trenches are up to 11km (7mi) deep, typically 50–100km

Oceanic and continental plate collision

(30–60mi) wide and may be thousands of km long. Oceanic ridges are long, linear volcanic structures that tend to occupy the middle of seafloors; they are the sites of crustal spreading. See also OCEAN; CONTINENTAL MARGIN; SEAFLOOR SPREADING seafloor spreading Theory that explains how continental drift occurs. It proposes that ocean floor is moved laterally as new basalt rock is injected along mid-ocean ridges and so the ocean floor becomes older with increasing distance from the ridge. See also PLATE TECTONICS

sea horse Marine fish found in shallow tropical and temperate waters. It swims in an upright position and has an outer bony skeleton of platelike rings, a mouth at the end of a long snout, and a curled, prehensile tail with which it clings to seaweed. The male incubates the young in a brood pouch. Length: 3.8–30.5cm (1.5–12in). Family Syngnathidae.

seal Any of several species of carnivorous, primarily marine, aquatic mammals. It feeds on fish, crustaceans and other marine animals; various species are hunted for meat, hides, oil and fur. Species of true, earless seals such as the leopard seal (*Hydrurga leptonyx*), hooded seal (*Cystophora cristata*) and bearded seal (*Erignathus barbatus*) are included in the family Phocidae. They swim with powerful strokes of their hind flippers and sinuous movements of the whole trunk, but are clumsy on land and move by wriggling. Members of the eared family Otariidae have longer fore flippers, used for propulsion, and use all four limbs when moving on land. They include fur seals (genera *Callorhinus* and *Arctocephalus*) and species of SEA LION. Order Pinnepedia.

sea lion Any of five species of SEALS that live in coastal waters of the Pacific and feed primarily on fish and squid. They have streamlined bodies and long fore flippers for propulsion. The males of all species, except the California sea lion (*Zalophus californianus*), have manes. The largest species is the Steller sea lion (*Eumetopias jubata*); it may reach 3.3m (11ft) in length. Order Pinnepedia; family Otariidae.

Seaplane Aircraft that can land on and take off from water. **Floatplanes** have large floats that support the fuselage above the water. **Flying boats** float on their boat-shaped hulls, with small floats supporting the wings. Both floatplanes and flying boats may be fitted with wheels so that they can take off and land on the ground too. Such aircraft are called amphibians.

sea slug (nudibranch) Any of numerous species of marine gastropod molluses, related to snails and found worldwide. They have no shells, quills or mantle cavities, frequent shallow water and feed mainly on sea anemones. Order Nudibranchia. **seasonal affective disorder (SAD)** Mental depression apparently linked to the seasonally changing amount of light. Sufferers experience depression during autumn and winter.

seasons Four astronomical and climatic periods of the year based on differential solar heating of the Earth as it makes its annual revolution of the Sun. The Northern Hemisphere receives more solar radiation when its pole is aimed towards the Sun in summer and less in winter when it is aimed away, whereas the opposite holds for the Southern Hemisphere. The seasons begin at the vernal (spring) and autumnal EQUINOXES and the winter and summer SOLSTICES.

SEATO Acronym for Southeast Asia Treaty Organization (SEATO)

■ seafloor spreading The vast ridges that divide the Earth's crust beneath each of the world's oceans mark the boundaries between tectonic plates that are gradually moving in opposite directions. As the plates shift apart, molten magma rises from the mantle to seal the rift and the seafloor slowly spreads toward the continental landmasses. The rate of spreading has been calculated by magnetic analysis of the rock at c.3.75cm (1.5in) a year in the North Atlantic Ocean. Underwater volcanoes mark the line where the continental rise begins. As the plates meet, much of the denser ocean crust dips beneath the continental plate and melts back into the magma.

▲ seal The harn seal (Phoca groenlandica, top) is a true seal. It breeds in North Atlantic and Arctic oceans and migrates s in winter. They feed on large plankton and fish, and grow to a length of nearly 2m (6.5ft), and can weigh up to 180kg (400lb). The northern fur seal (Callorhinus ursinus, bottom), unlike the harp seal, is an eared seal, It migrates in winter from the Bering Sea to California and Japan. It feeds on squid, fish and crustacea. They too grow to 2m (6.5ft) and an adult male can weigh between 180 and 300kg (400-650lb).

➤ secretary bird Found in sub-Saharan Africa, the secretary bird (Sagittarius serpentarius) gets its name from the feathers that protrude behind its head, resembling quill pens. It is a well-known snake killer and runs after its prey on foot in a zig-zag fashion. The snake is killed by a blow from the foot, followed by battering from the wings. The secretary bird is so unlike other members in the same order that it is placed in a separate family.

Seattle City and seaport in w Washington, USA, on Elliott Bay between Lake Washington and Puget Sound. Settled in 1851, it developed with the construction of the railway, the Alaska Gold Rush (1897), and the opening of the Panama Canal (1914), and is an important shipping point for Alaska and the Far East. Industries: aerospace, shipbuilding, precision instruments, building materials, chemicals, timber, food processing, fishing, tourism. Pop. (1992) 519,598.

sea urchin Spiny ECHINODERM animal found in marine tidal pools along rocky shores. Round with long, radiating (often poisonous) moveable spines, its skeletal plates fuse to form a perforated shell. Class Echinoidae.

seaweed Any of numerous species of brown, green or red ALGAE, found in greatest profusion in shallow waters on rocky coasts. KELPS are the largest forms. Many species are important for the manufacture of fertilizers or food, or as a valuable source of chemicals such as iodine. Kingdom Protoctista.

sebaceous gland Gland in the skin producing the oily substance sebum, which is secreted onto the skin and hair, making them water-repellent and supple.

Sebastian, Saint (d. c.AD 288) Roman Christian martyr. Legend says that he was a favourite of the emperor DIOCLETIAN who, on learning that Sebastian was a Christian, condemned him to be killed by arrows. He survived and later voluntarily appeared before Diocletian, who this time had him beaten to death. His feast day is January 20th.

Sebastiano del Piombo (1485–1547) (Sebastiano Luciani) Italian painter of the VENETIAN SCHOOL. He went to Rome in 1511 to create a series of mythological FRESCOS at the Villa Farnese. Some of his best works are his portraits, including his portrayal of Pope Clement VII (1526).

seborrhoea Disorder of the SEBACEOUS GLANDS characterized by over-production of sebum that results in red, scaly patches on the skin and dandruff.

secant In TRIGONOMETRY, ratio of the length of the hypotenuse to the length of the side adjacent to an acute angle in a right-angled triangle. The secant of angle A is usually abbreviated to sec A, and is equal to the reciprocal of its COSINE.

secession Formal separation from an organized body. The term is usually applied to the withdrawal of a political unit from the state of which it formed a part. A notable example was the secession of 11 Southern states from the USA to form the CONFEDERATE STATES OF AMERICA in 1861.

second (symbol s) SI unit of time defined as the time taken for 9,192,631,770 periods of vibrations of the electromagnetic radiation emitted by a caesium-133 atom. It is commonly defined as 1/60 of a minute. *See also* PHYSICAL UNITS

secondary school Schools providing education for pupils after primary school. The ages at which pupils transfer from primary to secondary schools in the UK vary in different education authorities. It is usually at age 11. In some areas, with middle schools, transfer is at 12, and in independent schools it

is usually at 13. Some secondary schools cater for the 11–16 age range, others for 11–18.

second coming Christian belief that JESUS CHRIST will one day return to Earth. He will sweep away the present world order, establish his kingdom, deal with his enemies and reward those who have been faithful to him.

Second World War See WORLD WAR 2

secretary bird Bird of prey found in Africa, s of the Sahara. It is pale grey with black markings and has quill-like feathers behind its ears, large wings, and long legs and tail. It feeds on reptiles, eggs and insects, and lays its eggs in a tree nest. Height: 1.2m (4ft). Species *Sagittarius serpentarius*.

secretary of state Name for several government officers in Britain. The office dates from the 14th century, when the king's secretary was a leading adviser on matters of state. There are now secretaries of state for many departments. In the USA, the name is given to the cabinet member responsible for formulating and implementing foreign policy.

secretion Production and discharge of a substance, usually a fluid, by a cell or a GLAND. The substance so discharged is also known as a secretion. Secretions include ENZYMES, HORMONES, saliva and sweat.

Secret Service, US US law enforcement agency within the Treasury Department. It is charged with the job of stopping all counterfeiting and forging of US money, and with the protection of political figures.

Securities and Exchange Commission (SEC) US federal agency. Its general objective is to provide the fullest possible disclosure to the investing public and to protect the interest of the public and investors against malpractice in the securities and financial markets.

sedative Drug used for its calming effect, to reduce anxiety and tension; at high doses it induces sleep. Sedative drugs include NARCOTICS, BARBITURATES and BENZODIAZEPINES.

sedge Any of numerous species of grass-like perennial plants, especially those of the genus *Carex*, widely distributed in temperate, cold and tropical mountain regions, usually on wet ground or in water. Cultivated as ornamental plants, they have narrow leaves and spikes of brown, green or greenish yellow flowers. Family Cyperaceae.

Sedgemoor, Battle of (1685) Defeat of the English rebellion led by the Duke of MONMOUTH against James II. An attempt to launch a surprise night attack by the untrained rebel forces ended in disaster.

sediment In geology, a general term used to describe any material (such as gravel, sand, and clay) that is transported and deposited by water, ice, wind, or gravity. The term includes material such as lime that is transported in solution and later precipitated, and organic deposits such as coal and coral reefs. sedimentary rock Type of rock formed of mineral or organic particles that have been moved by the action of water, wind or glacial ice (or have been chemically precipitated from solution) to a new location. Following a process of compaction and cementation, particles usually form layers of sedimentary rock. Seebeck effect Thermoelectric effect important in the thermocouple for temperature measurement. If wires of two dif-

mocouple for temperature measurement. If wires of two different metals are joined at their ends to form a circuit, a current flows if the junctions are maintained at different temperatures. See also Peltier EFFECT

seed Part of a flowering plant that contains the embryo and food store. It is formed in the ovary by FERTILIZATION of the female GAMETE (*see* POLLEN). Food may be stored in a special tissue called the endosperm, or it may be concentrated in the swollen seed leaves (COTYLEDONS). Seeds are the unit of dispersal of flowering plants and conifers. *See also* GERMINATION **Segovia, Andrés** (1893–1987) Spanish guitarist. Segovia helped establish the guitar as a concert instrument, adapting it to the complex music of modern composers and transcribing early contrapuntal music.

Segrè, Emilio Gino (1905–89) US physicist, b. Italy, who shared the 1959 Nobel Prize for physics with Owen Chamberlain for the discovery of the antiproton. In 1937 Segrè discovered TECHNETIUM, the first element to be artificially produced, and in 1940 he helped to discover ASTATINE and plutonium-239. See also ANTIMATTER

segregation Separation of a specific group from the rest of society on the grounds of race, religion, sex, etc. In recent times, the term has been most often applied to racial separation enshrined in law, as in the southern states of the USA before the civil rights movement, or in South Africa in the era of apartheid.

Seine River in N central France. It rises in Langres Plateau near Duon and flows NW through Paris to enter the English Channel near Le Havre. It is connected to the rivers Loire, Rhône, Meuse, Schelde, Saône, and Somme by a network of canals. With its main tributaries (Aube, Marne, Oise, Yonne, Loing and Eure), the Seine drains the entire Paris Basin. The most important river of N France, it is navigable for most ocean-going vessels as far as ROUEN, 560km (350mi) of its full course of 776km (482mi).

seismology Study of seismic waves, the shock waves produced by earthquakes. The velocity of seismic waves varies according to the material through which they pass. Primary (P) and secondary (S) waves are transmitted by the solid Earth. Only P waves are transmitted through fluid zones. The movement of seismic waves is detected and recorded by instruments called seismographs. *See also* EARTHQUAKE

Selassie, Haile See HAILE SELASSIE

Selene In Greek mythology, goddess of the Moon, daughter of Hyperion and sister of Helios (the Sun) and Eos (the Dawn). Each night she drove her chariot across the sky, as her brother Helios, the Sun god, had done during the day.

selenium Grey METALLOID element of group VI of the periodic table, discovered in 1817 by J.J. BERZELIUS. Its chief source is a by-product in the electrolytic refining of copper. The element resembles sulphur. It is extensively used in PHOTOELECTRIC CELLS, SOLAR CELLS, XEROGRAPHY and red pigments. Properties: at.no. 34; r.a.m. 78.96; r.d. 4.79; m.p. 217°C (422.6°F); b.p. 684.9 °C (1,265°F); most common isotope Se⁸⁰ (49.82%). Seles, Monica (1973—) US tennis player, b. Yugoslavia. Seles won her first major championship (French Open, 1990) when only 16 years old. She also won the US Open (1991), and the Australian Open in three successive years (1991—93). Seles' career was briefly halted in 1993 when she was stabbed by a fan of her rival, Steffi Graf. She resumed competitive play in 1995 and reclaimed her Australian title in 1996.

Seleucids Hellenistic dynasty founded by Seleucus I, a former general of Alexander the Great, in 306–281 BC. Centred on Syria, it included most of the Asian provinces of Alexander's empire, extending from the E Mediterranean to India. War with the Ptolemies of Egypt and, later, the Romans, steadily reduced its territory. In 63 BC its depleted territory became the Roman province of Syria.

Seleucus Name of two kings of Syria. **Seleucus I** (c.355–281 BC) was a trusted general of Alexander the Great and founder of the Seleucid dynasty. By 281 BC he had secured control of Babylonia, Syria and all of Asia Minor, founding a western capital at Antioch to balance the eastern capital of Seleucia, in Babylon. He appeared to be on the brink of restoring the whole of Alexander's empire under his rule when he was murdered. **Seleucus II** (r.247–226 BC) spent his reign fighting Ptolemy III of Egypt and Antiochus Hierax, his brother and rival, losing territory to both.

Seljuk Nomadic tribesmen from central Asia who adopted Islam in the 7th century and founded the Baghdad sultanate in 1055. Their empire included Syria, Mesopotamia and Persia. Under Alp Arslan, they defeated the Byzantines at Manzikert in 1071, which led to their occupation of Anatolia. They revived Sunni administration and religious institutions, checking the spread of Shiite Islam and laying the organizational basis for the future Ottoman administration. In the early 12th century the Seljuk empire began to disintegrate, and the Seljuk states were conquered by the Mongols in the 13th century.

Sellafield Site of a nuclear power station on the Irish Sea coast in Cumbria, NW England. Then known as Windscale, it opened in 1956. In 1957 a fire led to a serious radioactive emission. Between 1968 and 1979 it discharged over 180kg (397lb) of plutonium into the Irish Sea, the world's largest discharge of nuclear waste. In 1979 the site was renamed as part of an effort to improve its image. In 1990 reports revealed that

the children of Sellafield workers had an increased risk of leukemia due to radiation exposure levels at the site.

Sellers, Peter (1925–80) English comedy actor. His success began in radio comedy with *The Goon Show* (1951–59). During the 1950s, he starred in various EALING STUDIOS black comedies such as *The Ladykillers* (1955) and *The Naked Truth* (1957). International recognition came in 1963 with *Dr. Strangelove* and the first of *The Pink Panther* series. Sellers won a Best Actor Academy Award for his final role in *Being There* (1979).

semantics Branch of LINGUISTICS and PHILOSOPHY concerned with the study of meaning. In historical linguistics, it generally refers to the analysis of how the meanings of words change over time. In modern linguistics and philosophy, semantics seeks to assess the contribution of word-meaning to the meanings of phrases and sentences, and to comprehend the relationship among and between words and the things they refer to, or stand for.

semen Fluid in a male that contains sperm from the TESTES and the secretions of various accessory sexual glands. In human beings each ejaculate is normally *c*.3 to 6ml by volume and contains *c*.200 to 300 million SPERM.

semiconductor Substance with electrical CONDUCTIVITY between that of a CONDUCTOR and an insulator. The conductivity increases as temperature increases. A semiconductor consists of elements, such as GERMANIUM and SILICON, or compounds, such as aluminium phosphide, with a crystalline structure. At normal temperatures, some electrons break free and give rise to n-type (negative) conductivity with the electrons as the main carriers of the electric current. The holes (electron deficiencies) left by these electrons give rise to p-type (positive) conductivity with the holes as the main carriers. Impurities are usually added to the semiconductor material in controlled amounts to add more free electrons or create more holes. A semiconductor junction is formed when there is an abrupt change along the length of the crystal from one type of impurity to the other. Such a p-n junction acts as a very efficient RECTIFIER and is the basis of the semiconductor DIODE. Semiconductors are also used in transistors and photoelectric cells. Seminole Native North American tribe that separated from

Seminole Native North American tribe that separated from the main Creek group in the late 18th century and fled s into Florida under pressure of wars with white settlers. Today, c.12,000 descendants of the Seminole live in Florida and Oklahoma. In 1832 Seminole leaders signed a treaty agreeing to move to Oklahoma. Some members of the tribe opposed the move and began a series of successful attacks against the US

■ Seles US tennis player
Monica Seles is renowned for
her ruthless competitiveness,
fast court speed and ferocious
groundstrokes. Her long rivalry
with Steffi Graf was interrupted
when Seles was stabbed by one
of Graf's fans. Seles tried to
bring a case for damages against
the German Tennis Federation,
claiming that she was not
provided with sufficient
protection, but was unsuccessful.

army. The US army was unable to defend itself and suffered c.1,500 casualties. In 1841, it changed its strategy and began the systematic destruction of Seminole crops and villages. The Seminole were forced to surrender (1842) and move west.

semiotics (semiology) Study of signs and symbols, both visual and linguistic, and their function in communication. Pioneers of semiotics include Charles Sanders PEIRCE and Ferdinand de SAUSSURE. Roland BARTHES and Claude LÉVISTRAUSS developed the principles of semiotics into STRUCTURALISM. Semiotics is important in the disciplines of psychology, linguistics, anthropology, logic and mathematics.

Semiramis In Assyrian mythology, a queen and goddess, wife of Ninus, founder of Nineveh. Daughter of a fish goddess and the god of wisdom, she was reared by doves. After the death of Ninus she ruled alone, founded the city of Babylon, and led victorious armies against numerous enemies until, opposed by her son, she took the form of a dove and flew away. Semites Peoples whose native tongue belongs to the group of Semitic Languages. They originally inhabited an area in Arabia and spoke a common language, Proto-Semitic, from which the Semitic languages descend. Among the modern Semites are Arabs, native Israelis and many Ethiopians.

Semitic languages Group of languages spoken by peoples native to N Africa and the Middle East and forming one of the five branches of the Afro-Asiatic language family. The Semitic languages are divided into three sub-branches: North West Semitic (including Hebrew, Aramaic and Eblaite); North East Semitic (consisting of Akkadian); and Central and Southern Semitic (including Arabic, South Arabian and Ethiopic). Only Hebrew and Arabic have survived to develop modern forms. Aramaic survives as a liturgical language among a small number of tiny, isolated Assyrian Christian communities in the Middle East.

Senate Upper house of the US legislature, which together with the HOUSE OF REPRESENTATIVES forms the CONGRESS. It is composed of two senators from each state, who are elected for six-year terms. Elections are held every other year, with about one third of the Senate elected at a time. There are usually 16 standing committees, and committee chairs retain their positions for as long as their party has a majority of the votes. The approval of a simple majority of the Senate is necessary for major presidential appointments, and a two-thirds majority for treaties. The Senate can initiate legislation except on fiscal matters. Officially, the presiding officer of the Senate is the vice president, but the position is often delegated.

Senate, Roman Chief governing body of the Roman republic. It originated as a royal council under the early kings. By the 2nd century BC it controlled all matters of policy. Senators were chosen for life by the CENSORS and at first were mainly former CONSULS. They numbered 300, raised to 600 under SULLA, to 900 by CAESAR, and reduced to 600 under AUGUSTUS. Plebeians gained entry in the 4th century BC. Under the empire, the emperor's control of military and civil officials gradually restricted the senate to judicial matters and to the city government in Rome. Under the late empire, senatorial status was extended on a massive scale to the landowning elite.

Sendak, Maurice (1928–) US author and illustrator of imaginative books for children. Sendak's *Where the Wild Things Are* was awarded the Caldecott Medal in 1964. Other books he wrote and illustrated include *Higglety Pigglety Pop, or, There Must Be More To Life* (1967), *In the Night Kitchen* (1970) and *Outside Over There* (1981).

Seneca (4–65) Roman Stoic philosopher, a major influence on European literature. He wrote 12 books of *Moral Essays* and numerous philosophical letters. His tragedies, based on Greek models, included *Phaedra*. Seneca fell from Nero's favour in AD 62 and committed suicide.

Seneca Most populous division of the IROQUOIS CONFEDERACY; a tribe of Native North Americans who inhabited N New York. Today, c.850 so-called "Seneca" live in Oklahoma, where they moved in 1832; the main eastern group totals c.7,000 in New York, Ontario and Pennsylvania.

Seneca Falls Convention (1848) Women's rights convention held at Seneca Falls, New York. Elizabeth STANTON and Lucretia Mott organized the convention, the first aimed at

obtaining equal rights for women. About 300 people attended, and a "Declaration of Sentiments" was issued.

Senegal Republic on the NW coast of Africa. See country feature

Senghor, Léopold Sédar (1906—) Senegalese statesman and poet. Senghor was the first president (1960–80) of the republic of Senegal. He developed the concept of négritude, which stressed the importance of the oral tradition in Africa. Poetic volumes, such as Songs of the Shade (1945), are intended for voice with musical accompaniment. Senghor was the Sengalese deputy (1945–58) at the French national assembly. He founded the Sengalese Progressive Union which pressed for independence from France. As president, Senghor led (1974) Senegal into the West African Economic Community. He was the first African to be elected to the Académie Française (1984).

Senna, Ayrton (1960–94) Brazilian racing driver. Senna began Formula 1 racing in 1984. His first Grand Prix victory (Portugal) was in 1985. Senna won a total of 41 Grands Prix and three world drivers' championships (1988, 1990, 1991). He died in a crash at the San Marino Grand Prix.

senna Plants, shrubs and trees of the genus *Senna* native to warm and tropical regions; some species grow in temperate areas throughout the world. They have rectangular, feathery leaves and yellow flowers. Family Fabaceae/Leguminosae.

Sennacherib (d.681 BC) King of ASSYRIA (704–681 BC). Son and successor of SARGON II, he led expeditions to subdue Phoenicia and Palestine in 701 BC, and defeated the Elamite-Chaldean alliance in 691 BC. He destroyed Babylon in 689 BC and, with the peace of his empire thus assured, devoted himself to rebuilding his capital, NINEVEH. See also ASHURBANIPAL

Sennett, Mack (1884–1960) US film director, producer and actor whose many short, slapstick comedies enlivened the age of silent films. Films made by his Keystone company brought fame to Charlie Chaplin, Mabel Normand, Fatty Arbuckle and the Keystone Kops.

senses Means by which animals gain information about their environment and physiological condition. The five senses (SIGHT, HEARING, TASTE, SMELL and TOUCH) all rely on specialized receptors on or near the external surface of the body. Seoul (Kyongsong) Capital of South Korea, on the River Han. The political, commercial, industrial and cultural centre of South Korea, it was founded in 1392 as the capital of the Yi dynasty. It developed rapidly under Japanese governorship (1910-45). After World War 2, Seoul was the headquarters for the US army of occupation. Following the 1948 partition, it became capital of South Korea. Seoul's capture by North Korean troops precipitated the beginning of the KOREAN WAR, and the following months witnessed the city's virtual destruction. In March 1951 it became the headquarters of the UN command in Korea and a rebuilding programme commenced. By the 1970s it was the hub of one of the most successful economies of Southeast Asia. In 1996, Seoul was the scene of violent student demonstrations for reunification with North Korea. Pop. (1994) 10,799,000.

sepal Modified leaf that makes up the outermost portion of a flower bud. Although usually green and inconspicuous once the flower is open, in some species, the sepals look like the petals.

separation of powers Principle in the USA that aims to prevent despotic rule by a system of checks and balances between the different branches of government. It was a guiding principle of the founders of the US CONSTITUTION. The three branches of government (executive, legislative and judicial) act as checks on each other.

Sephardim Descendants of the Jews of medieval Spain and Portugal and others who follow their customs. Iberian Jews followed the Babylonian rather than the Palestinian Jewish tradition and developed their own language, Ladino. After the expulsion of the Jews from Spain (1492), many settled in parts of the Middle East and North Africa under the Ottoman empire. Continuing persecution led many of them to form colonies in Amsterdam and other cities of NW Europe.

Sepoy Rebellion Alternative name for the INDIAN MUTINY sepsis Destruction of body tissue by disease-causing (patho-

genic) bacteria or their toxins. Local or widespread inflammation may occur, possibly followed by NECROSIS, the death of tissue. Treatment is with ANTIBIOTICS.

septicaemia Term for severe SEPSIS or BLOOD POISONING

Septuagint Earliest surviving Greek translation of the Hebrew Bible (the OLD TESTAMENT), made for the Greek-speaking Jewish community in Egypt in the 3rd and 2nd centuries BC. It contains the entire Jewish Canon plus the Apocrypha. The Septuagint is divided into four sections: the law, history, poetry and prophets. It is still used by the Greek Orthodox Church.

sequoia Two species of giant evergreen conifer trees native to California and s-Oregon: the giant sequoia (*Sequoiadendron giganteum*) and the Californian redwood (*Sequoia sempervirens*). Their height, up to 100m (330ft), has made them a natural wonder of the USA. Family Taxodiaceae.

Sequoia National Park Park in the SIERRA NEVADA, E California, USA. Established in 1890, it features groves of giant SEQUOIA. The park contains many High Sierra peaks including Mount WHITNEY, the highest US mountain outside Alaska. Area: 156,679ha (386,862acres).

Serbia Balkan republic that, combined with the smaller

republic of Montenegro, forms the rump federal state of YUGOSLAVIA. The republic is bounded N by Hungary, E by Romania and Bulgaria, s by MACEDONIA, sw by Albania and Montenegro, w by Bosnia-Herzegovina and NW by Croatia. It includes the formerly autonomous Yugoslav provinces of Vojvodina (N) and Kosovo (S). The capital is BELGRADE, other major cities include Niš (Serbia), Novi Sad (Vojvodina) and Pristina (Kosovo). The republic can be geographically divided between the mountainous s and the fertile N plain drained by the DANUBE, Sava, Tisza and Morava rivers. Vojvodina is the principal agricultural area, producing fruit and grain. Serbia is the main industrial area, with mining and steel manufacture. Kosovo is a poor region with large coal deposits. History The area was settled by Serbs in the 7th century AD, and they adopted Orthodox Christianity under BYZANTINE rule. Serbia became the leading Balkan power until, in 1389, it was defeated by the Ottoman Turks. The Ottomans divided the territory and installed a puppet regime. In 1459 Serbia became a province of the Ottoman empire. The 18th-century decline of the Ottoman empire encouraged Serbian nationalism. In 1829 Serbia gained autonomy under Russian protection. In 1867 Milan Obrenović began a war in support of a rebellion in

SENEGAL

This flag was adopted in 1960 when Senegal became independent from France. It uses the three colours that symbolize African unity. It is identical to the flag of Mali, except for the five-pointed green star. This star symbolizes the Muslim faith of most of its people.

Senegal, on the NW coast of Africa, contains the continent's most westerly point, the volcanic Cape Verde, on which the capital, DAKAR, stands. It entirely surrounds The GAMBIA. The Atlantic coastline from St Louis to Dakar is sandy. Plains cover most of Senegal, though the land rises gently in the SE. The N forms part of the SAHEL. The main rivers are the Sénégal, which forms the N border, and the Casamance in the s. The River Gambia flows into The Gambia.

CLIMATE

Dakar has a tropical climate, with a rainy season between June and September. Temperatures are higher inland. Rainfall is greatest in the s.

VEGETATION

Desert and semi-desert cover NE Senegal. In central Senegal, dry grasslands and scrub pre-dominate. Mangrove swamps border parts of the

s coast. The far s is a region of tropical savanna, though large areas have been cleared for farming. Senegal has several protected parks, the largest is the Niokolo-Kobo Wildlife Park.

HISTORY AND POLITICS

During the 6th-10th centuries Senegal formed part of the empire of ancient Ghana. Between the 10th and 14th centuries the Tukolor state of Tekrur dominated the Sénégal valley. The ALMORAVID dynasty of Zenega Berbers introduced Islam, and it is from the Zenega that Senegal got its name. In the 14th century the Mali empire conquered Tekrur. In the early 15th century, the Wolof established the Jolof empire. The SONGHAI empire began to dominate the region. In 1444 Portuguese sailors became the first Europeans to reach Cape Verde. Trading stations were rapidly established in the area. In the 17th century, Portuguese influence was replaced by France and the Netherlands. France gradually gained control of the valuable slave trade and founded St Louis in 1658. By 1763 Britain had expelled the French from Senegal and, in 1765, set up Senegambia, the first British colony in Africa. France regained control of the region in 1783. In the mid-19th century France battled for control of the interior. Dakar was founded in 1857. In 1895 Senegal became a French colony within the federation of French West Africa. In 1902 the capital of this huge empire was transferred from St Louis to Dakar. Dakar became a major trading centre. In 1946 Senegal joined the French Union. In 1959 Senegal joined French Sudan (now Mali) to form the Federation of Mali. Senegal withdrew in 1960,

AREA: 196,720sq km (75,954sq mi)

POPULATION: 7,736,000

CAPITAL (POPULATION): Dakar (1,729,823)
GOVERNMENT: Multiparty republic
ETHNIC GROUPS: Wolof 44%. Fulani-Tukulor

24%, Serer 15%

LANGUAGES: French (official)

RELIGIONS: Islam 94%, Christianity (mainly Roman Catholic) 5%, traditional beliefs and

others 1%

CURRENCY: CFA franc = 100 centimes

and became an independent republic within the French community. Léopold Sédar SENGHOR was Senegal's first post-colonial president. Following an unsuccessful coup (1962), Senghor gradually assumed wider powers. During the 1960s, Senegal's economy deteriorated and a succession of droughts caused starvation and widespread civil unrest. During the 1970s, s Senegal acted as a base for guerrilla movements in Guinea and Portuguese Guinea (modern Guinea-Bissau). In 1974 Senegal was a founding member of the West African Economic Community. In 1981 Senghor was succeeded by Abdou Diouf, and Senegalese troops suppressed a coup in The Gambia. In 1982 the two countries were joined in the Confederation of Senegambia, but the union was dissolved in 1989. From 1989 to 1992 Senegal was at war with Mauritania. In 1993 elections Diouf was re-elected for a third term. Internal conflict continued, particularly in the s Casamance region where a secessionist movement has gathered strength.

ECONOMY

Senegal is a lower-middle-income developing country (1992 GDP per capita, US\$1,750). Agriculture employs 81% of the workforce, mainly at subsistence level. Food crops include cassava, millet and rice. Senegal is the world's sixthlargest producer of groundnuts, its major cash crop and export. France is the major market. Phosphates are Senegal's chief mineral resource, but it also refines oil. Dakar is a busy port with many industries. Fishing is an important activity.

Bosnia and Herzegovina against Turkish rule. Russia intervened to aid Serbia and, in 1878, Turkey finally granted Serbia complete independence. In 1903 King Alexander Obrenović was assassinated, and PETER I became king. When Austro-Hungary annexed Bosnia and Herzegovina in 1908, Serbia responded by forming the Serbian League. In 1912 the alliance defeated the Turks but disintegrated amidst factional feuding. In 1913 Serbia defeated Bulgaria in the second Balkan War. The expansion of Serbian territory in the BALKAN WARS antagonized Austria and the assassination of the Austrian Archduke Franz Ferdinand led to the outbreak of World War 1. In 1918 Serbia became the leading partner of the kingdom of the Serbs, Croats and Slovenes, renamed YUGOSLAVIA in 1929. During World War 2, Yugoslavia was occupied and divided by the German army. Resistance was two-fold: Josip Tito led the Yugoslav communist partisans, and Draža Mihajović led the Serbian nationalists (Chetniks). In 1946 Serbia became an autonomous republic within Tito's neo-communist Yugoslavia. In 1987 President Slobodan MILOŠEVIĆ restated nationalist claims for a Greater Serbia, including Vojvodina, Kosovo and Serb-populated areas in Croatia, Bosnia-Herzegovina and Macedonia. In 1989 Serbian troops were sent to suppress Albanian nationalism in Kosovo and, in 1991, Serbia prevented Croatia from assuming presidency of the federation. Croatia and SLOVENIA responded by declaring independence and the Serbian-controlled Yugoslav army invaded. In 1991 the army withdrew from Slovenia. In 1992 a UN-brokered cease-fire was agreed between Serbia and Croatia, allowing Serbia to keep the territory it had captured. Serbian troops quickly seized nearly 75% of the newly recognized republic of Bosnia-Herzegovina and pursued a policy of "ethnic cleansing": forcibly resettling, incarcerating or killing Muslims and repopulating villages with Serbs. The UN imposed sanctions on the Serbian regime, but atrocities continued to be committed by both sides. In 1995 Bosnian Serb troops captured UN protected areas, and Western governments and NATO launched air-strikes against Serb targets. Bosnia-Herzegovina and Croatia began a successful new offensive against Serbia and reclaimed much lost territory. The US-brokered Dayton peace accord (November 1995) divided Bosnia-Herzegovina into two provinces. Ratko MLADIĆ and Radovan KARADŽIĆ were charged with genocide and other war crimes. Democratic elections were held in Serbia (1996), but Milošević refused to recognize opposition victories. Following mass peaceful demonstrations in Belgrade, Milošević was forced to concede some of the Zajedno coalition's victories. In 1997 Milošević resigned the Serbian presidency in order to become president of Yugoslavia. According to independent monitors, the ensuing election of Milan Milutinović as Serbian president was "fundamentally flawed". In 1998 Montenegro sought greater independence.

Serbs Slavic people who settled in the Balkans in the 7th century and who became Christians in the 9th century. They were distinguished from Croats and Slovenes by their use of the Cyrillic, not the Roman, alphabet. Most of them now live in Serbia but there are Serb minorities in Bosnia and Croatia. **serf** Person legally bound to a lord. In feudal Europe, serfs were obliged to provide labour and other services and were usually bound to the land, holding a portion for their own use. Serfdom virtually disappeared in w Europe by the end of the Middle Ages, but persisted in Russia and parts of E Europe until the 19th century.

serial music Technique of musical composition in which a work is structured on a fixed series of notes; the series is repeated in various permutations for the duration of the work. The TWELVE-TONE MUSIC of Arnold SCHOENBERG is a form of serial music.

Sermon on the Mount Address given by JESUS CHRIST to his disciples and a huge crowd of other listeners on one of the hills above GALILEE. It presents many of the now familiar Christian teachings. *See also* BEATITUDES

serotonin Chemical found in cells of the gastrointestinal tract, blood platelets and brain tissue, concentrated in the midbrain and HYPOTHALAMUS. It is a vasoconstrictor and has an important role in the functioning of the nervous system and in the stimulation of smooth muscles.

serpentine Group of sheet silicate minerals, hydrated magnesium silicate $(Mg_3Si_2O_5(OH)_4)$. Serpentine minerals come in various colours, usually green, although sometimes brownish, with a pattern of green mottling. They have monoclinic system crystals. They are commonly used in decorative carving; fibrous varieties are used in asbestos cloth. Hardness 2.5–4; s.g. 2.5–2.6.

serum Clear fluid that separates out if blood is left to clot. It is essentially of the same composition as plasma, but without fibrinogen and clotting factors.

serval (bush cat) Orange and black spotted, dog-like cat found in grassy areas of sub-Saharan Africa. It has a narrow head and long legs, neck and ears. Length: body 70–100cm (30–40in); tail 35–40cm (14–16in); weight: 6.8–11.3kg (15–25lb). Family Felidae; species *Felis serval*.

Servetus, Michael (1511–53) Spanish physician and theologian. Servetus published (1531–32) his unorthodox opinions concerning the TRINITY. In medicine, he discovered that blood circulates through the lungs. Forced to flee from the INQUISITION, Servetus was equally unwelcome among Reformation theologians. Under the orders of John CALVIN, he was arrested and tried in Geneva and burned as a heretic.

servomechanism Device that provides remote control to activate a mechanism. An input signal, such as a radio impulse or mechanical movement, is converted into a mechanical output such as a lever movement or amplified hydraulic force. The device usually forms part of a control system. Some servomechanisms, such as the autopilot of an aircraft, incorporate a feedback mechanism that makes them independent of human control.

sesame Tropical plant native to Asia and Africa. It is also cultivated in Mexico and sw USA for its oil and seeds, both used in cooking. An annual, it has oval leaves, small pink or white flowers, and seed capsules along the stem. Height: 61cm (2ft). Family Pedaliaceae; species *Sesamum indicum*.

Sessions, Roger (1896–1985) US composer whose complex and highly individual works include a Violin Concerto (1935), eight symphonies, a concertino for chamber orchestra (1972) and various piano and organ works.

Seth, Vikram (1952–) Indian novelist and poet. He came to attention with his award-winning 1983 travelogue, *From Heaven Lake*. His epic *A Suitable Boy* (1993) is one of the century's longest English novels. Seth has also published four volumes of poetry, including *All You Who Sleep Tonight* (1990).

Seth Egyptian god. Although a beneficent god in predynastic Egypt, Seth became associated with darkness and was later identified as a god of evil and the antagonist of HORUS.

Seton, Saint Elizabeth Ann (1774–1821) US teacher and charity organizer. She joined the Roman Catholic Church in 1805 and soon became a leader in church works. She founded a school for girls in Maryland, prepared the way for the US parochial school system, and organized the American Sisters of Charity. She was sanctified in 1975. Her feast day is 4 January. sets In mathematics, a defined collection of objects. The objects are called the elements or members of the set. The number of members can be finite or infinite, or even be zero (the empty set). Various relations can exist between two sets, A and B: A equals B if both sets contain exactly the same members; A is included in or is a subset of B if all members of A are members of B; disjoint sets have no members in common; overlapping sets have one or more common members. Operations on sets produce new sets: the union of A and B contains the members of both A and B; the intersection of A and B contains only those members common to both sets.

setter Long-haired hunting dog used to locate game and stand on point until the hunter arrives; it also retrieves on command. Setters were first bred in 16th-century England. Modern types include English, Irish and Gordon.

set theory Branch of mathematics developed by Georg Cantor in the late 19th century. It is based on George BOOLE's work on mathematical logic, but it manipulates sets of abstract or real objects rather than logical propositions. It is concerned with the properties of SETS and can be applied to most other branches of mathematics.

Settlement, Act of (1701) English parliamentary statute

regulating the succession to the throne. The purpose of the act was to prevent the restoration of the Catholic STUART monarchy, the last surviving child of Queen Anne having died. It settled the succession on Sophia of Hanover, granddaughter of James I, and her heirs, providing they were Protestants. The crown was inherited (1714) by Sophia's son, who became George I of England.

Seurat, Georges Pierre (1859–91) French painter and founder of NEO-IMPRESSIONISM. From 1876 to 1884 he developed his theory of colour vision known as POINTILLISM, which was based on the juxtaposition of pure colour dots. His paintings include *Bathing at Asnières* (1883–84) and *Sunday in Summer on the Island of La Grande-Jatte* (1886).

Sevastopol (Sebastopol) Black Sea port on the sw of the Crimean Peninsula, Ukraine. Founded in 1783 by Catherine II, it was fortified in 1804. Sevastopol became home to the Russian Black Sea fleet and was the major strategic objective of the Crimean Wark, besieged from October 1854 to September 1855. The Russians sank their own fleet to block the harbour entrance, and inflicted heavy Allied casualties before evacuating the city. The fortifications were destroyed, only to be raised again after 1871. By 1890 the city was again a functioning naval base. During World War 2 Sevastopol was besieged for eight months before surrendering to the Germans in July 1942. It was recaptured in 1944 and again reconstructed. In 1995 Ukraine agreed to allow the Russian fleet to maintain its Sevastopol base in return for Ukrainian ownership of 19% of the fleet. Pop. (1993) 366,000

Seven Days' Battles (1862) Engagement of the US CIVIL WAR that ended the PENINSULAR CAMPAIGN. In the final, ferocious battle at Malvern Hill, near Richmond, Virginia, the Union forces of General George McClellan won a tactical victory. Heavy casualties forced McClellan to withdraw, leaving the field to the Confederates under Robert E. LEE.

Seventh-day Adventists Christian denomination whose members expect Jesus Christian to return to earth in person. They hold the Sabbath on Saturday and accept the BIBLE literally as their guide for living. The sect was formally organized in the USA in 1863, and today it is the largest ADVENTIST denomination, with followers in many countries.

Seven Weeks War See Austro-Prussian War

Seven Wonders of the World Group of fabled sights that evolved from various ancient Greek lists. They were, in chronological order: the Pyramids of Egypt; the Hanging Gardens of Babylon; the statue of Zeus by Phidias at Olympia; the temple of Artemis at Ephesus; the mausoleum at Halicarnassus; the Colossus of Rhodes; and the Pharos at Alexandria.

Seven Years War (1756-63) Major European conflict that established Britain as the foremost maritime and colonial power, and ensured the survival of Prussia as a major power in central Europe. The war was a continuation of the rivalries involved in the War of the Austrian Succession (1740-48). Britain and Prussia were allied (with Prussia undertaking nearly all the fighting in Europe) against Austria, Russia, France and Sweden. FREDERICK II (the Great) of Prussia fought a defensive war against superior forces. Only his brilliant generalship and the withdrawal of Russia from the war in 1762 saved Prussia from being overrun. Overseas, Britain and France fought in North America, India and West Africa, with the British gaining major victories. At the end of the war, the Treaty of Paris (1763) confirmed British supremacy in North America and India, while the Treaty of Hubertusberg left Prussia in control of Silesia.

Severn Longest river in the UK, flowing 290km (180mi) through Wales and w England. It rises on Mount Plynlimon in w Wales, flows NE to Shrewsbury, turns SE and then SW to enter the Bristol Channel through a wide estuary. Major tributaries include the rivers Vyrnwy, Teme and Stour. The Severn is connected by canal to the rivers Thames, Mersey and Trent. The Severn Road Bridge (1966) is one of the world's longest suspension bridges. A second road bridge was opened in 1996.

Severus, Lucius Septimius (146–211) Roman emperor (193–211). Severus was proclaimed emperor by his troops, who marched on Rome and persuaded the Senate to confirm

him. To secure his position, he dissolved the Praetorian Guard, and proclaimed himself posthumously adopted by the Emperor MARCUS AURELIUS (d.180). He divided (208) Britain into two provinces and launched a campaign to conquer Scotland. Repulsed, he died at York.

Seville River port on the River Guadalquivir, capital of Seville province, sw Spain. Ruled by the Romans from the 2nd century BC to the 5th century AD, it was taken by the Moors in 712 and conquered by Ferdinand III in 1248. The port exports fruit (notably oranges) and wine from the fertile area. Industries: agricultural machinery, shipbuilding, chemicals, textiles, spirits, porcelain, shipping, tourism. Pop. (1991) 659,126.

Sèvres In ceramics, high-quality porcelain made from 1765 to the present day at a factory in the Paris suburb of Sèvres, France. Pieces are either of soft-paste (a porcellaneous substance) or hard-paste (true porcelain).

Sèvres, Treaty of (1920) Peace treaty between Turkey and its European opponents in World War 1 that imposed harsh terms on the Ottoman sultan. It was not accepted by the Turkish nationalists led by ATATÜRK, who fought a war for Turkish independence (1919–22). The treaty, never ratified, was superseded by the Treaty of LAUSANNE (1923).

Seward, William H. (1801–72) US statesman. Seward lost the Republican nomination for president (1860) to Abraham LINCOLN, who appointed him secretary of state. He succeeded in maintaining good relations with Europe during the Civil War, and his handling of the TRENT AFFAIR averted British recognition of the Confederacy. Seward was wounded in the shooting that killed Lincoln, but continued in office under Andrew JOHNSON, negotiating (1867) the purchase of Alaska. sex Classification of an organism into male or female, denoting the reproductive function of the individual. In mammals the presence of sex organs, OVARIES in the female, TESTES in the male, are primary sexual characteristics. Secondary sexual characteristics such as size, coloration, and hair growth are governed by the secretion of SEX HORMONES. In flowering plants, the female sex organs are the carpel, including the ovary, STYLE and STIGMA, and the male organs the STAMENS. Male and female organs may occur in the same flower or on separate flowers or plants. See also SEXUAL REPRODUCTION

sex hormones Chemical "messengers" secreted by the gonads (TESTES and OVARIES). They regulate sexual development and reproductive activity and influence sexual behaviour. In males they include TESTOSTERONE, made by the testes; in females, the sex hormones OESTROGEN and PROGESTERONE are produced by the ovaries.

sexism Discrimination against and subordination of people on the basis of their SEX. It may result from prejudice, stereotyping or social pressure. *See also* WOMEN'S RIGHTS MOVEMENT **sextant** Optical instrument for finding LATITUDE (angular distance N or S of the Equator). A sextant consists of a frame with

■ Seville A Moorish watchtower in Seville, s Spain. Seville was the centre of the Moorish kingdom in Spain from 712 to 1248, and was also the major port in Spanish colonial history. Its cathedral, built around an existing mosque, is the world's largest Gothic church. Seville's April fair is famous for its flamenco dancing.

a curved scale marked in degrees, a movable arm with a mirror at the pivot, a half-silvered glass and a telescope. The instrument measures the angle of a heavenly body above the horizon, which depends on the observer's latitude. A set of tables gives the corresponding latitude for various angles measured.

sexual intercourse Term used to describe sexual relations between people. The term is most commonly used to describe the insertion of the male's penis into the female's vagina. *See also* CONTRACEPTION; HOMOSEXUALITY; ORGASM; SEXUAL REPRODUCTION

sexually transmitted disease (STD) Any disease that is transmitted by sexual activity involving the transfer of body fluids. It encompasses a range of conditions that are spread primarily by sexual contact, although they may also be transmitted in other ways. These include ACQUIRED IMMUNE DEFI-CIENCY SYNDROME (AIDS), pelvic inflammatory disease, cervical cancer and viral HEPATITIS. Older STDs, such as SYPHILIS and GONORRHOEA, remain significant public health problems. sexual reproduction Biological process of reproduction involving the combination of genetic material from two parents. It occurs in different forms throughout the plant and animal kingdoms. This process gives rise to variations of the GENOTYPE and PHENOTYPE within a species. GAMETES, HAPLOID sex cells produced by MEIOSIS, contain only half the number of CHROMOSOMES of their parent cells (which are DIPLOID). At fertilization, the gametes, generally one from each parent, fuse to form a ZYGOTE with the diploid number of chromosomes. The zygote divides repeatedly and the cells differentiate to give rise to an EMBRYO and, finally, a fully formed organism.

Seychelles Republic consisting of more than 100 islands in the Indian Ocean, c.970km (600mi) N of Madagascar. Seychelles comprises two geologically distinct island groups: the volcanic, **Granitic** group are to the NE, and include the three main, inhabited islands of Mahé, Praslin and La Digue. Mahé is home to over 80% of the republic's people; Seychelles' capital, Victoria, lies on its NE coast. To the sw lie the **Outer** group of coral islands. In 1502 Vasco da Gama explored the islands and named them the "Seven Sisters". The islands were colo-

nized by the French in 1756, who established spice plantations worked by slaves from Mauritius. In 1794 the archipelago was captured by the British during the Napoleonic Wars and, in 1814, became a dependency of Mauritius. In 1903 the Seychelles became a separate crown colony. In 1976 they achieved full independence within the Commonwealth. In 1977 a coup established Albert René as president. In 1981 South African mercenaries attempted to overthrow the government. Continued civil unrest and another failed coup in 1987, led to the first multiparty elections in 1991. In 1993 Albert René was elected for a fourth term. Creole is the widest spoken language. Tourism is the largest industry; exports include coconuts and tuna. Area: 453sq km (175sq mi). Pop. (1993 est.) 72,250

Seyfert galaxy Class of galaxies that have extremely bright, compact nuclei and whose spectra show strong emission lines. Most are spiral galaxies. About 1% of all galaxies are Seyferts. They emit strongly at ultraviolet and infrared wavelengths, and exhibit a degree of short-term variability. Some are strong x-ray sources but few are particularly strong radio emitters.

Sezession Radical movement (formed 1897) of young Austrian artists who organized their own exhibitions in defiance of the traditional organizations and aligned themselves with progressive European contemporaries. The first president was Gustav KLIMT. Other members included Oskar KOKOSCHKA and, later, Egon SCHIELE.

Shackleton, Sir Ernest Henry (1874–1922) Irish Antarctic explorer. He led an expedition (1907–09) which got to within 155km (97mi) of the South Pole. On his second expedition (1914–16), his ship was crushed by ice and his men marooned on a small island. Shackleton's successful rescue mission, which he described in *South* (1919), is one of the epics of polar exploration.

shad Saltwater food fish of the HERRING family that swims upriver to spawn. Shads are prized for their roe. Deep-bodied, they have a notch in the upper jaw for the tip of the lower jaw. Length: to 75cm (30in). Family Clupeidae.

Shaffer, Peter (1926–) British dramatist. After establishing his reputation with *Five Finger Exercise* (1960), Shaffer wrote

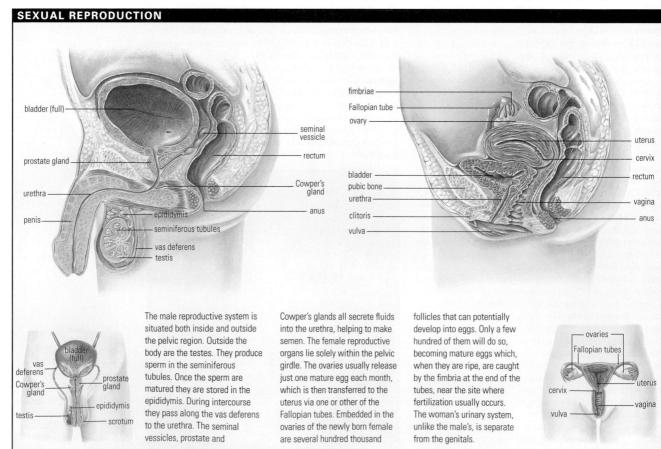

a double-bill, *The Private Ear and The Public Eye* (1962). *The Royal Hunt of the Sun* (1964), *Black Comedy* (1965) and *Equus* (1973) were produced by the National Theatre, London. Other works include *The Battle of Shrivings* (1970).

Shaftesbury, Anthony Ashley Cooper, 1st Earl of (1621–83) English statesman. Shaftesbury was a member of the Commonwealth council of state under Oliver Cromwell. Dismayed by the autocracy of the Protectorate, he supported the Restoration of Charles II (1660) and was rewarded with the chancellorship. Opposed to the earl of Clarendon, Shaftesbury became lord chancellor (1672) but was soon dismissed. His determination to prevent the succession of the Catholic James II drove him to found (1673) the Whig Party in opposition to Danby. Shaftesbury's support for the duke of Monmouth led to his exile (1682) in Holland.

Shaftesbury, Anthony Ashley Cooper, 7th Earl of (1801–85) British social reformer. He was the chief driving force behind the acts that prohibited employment of women and young children in mines (1842) and restricted the working day to ten hours (1847).

Shah Jahan (1592–1666) Mogul emperor of India (1628–58). Third son of Jahangir, he secured his succession by killing most of his male relatives. His campaigns expanded the Mogul dominions and accumulated great treasure. Though relatively tolerant of Hinduism, he made Islam the state religion. Shah Jahan was responsible for building the Taj Mahal and the vast ornamental chambers of the Red Fort at Delhi, which became his capital.

Shahn, Ben (1898–1969) US painter, lithographer and photographer, b. Lithuania. Shahn's work reflected his concern for social and political justice, notably the DREYFUS AFFAIR. In the 1930s he worked with Diego RIVERA on murals for the Rockefeller Center, New York. He was involved with the Farm Security Administration, painting and photographing rural poverty. **Shaka** (1787–1828) King of the ZULU. He claimed the throne c.1816 and reorganized the Zulu, forming a powerful army and extending his control over all of what is now Kwazulu-Natal. He remained on good terms with the white government in the Cape, but his cruel and arbitrary rule provoked opposition at home and he was murdered by his half brothers.

Shakers US religious sect known under various more formal names, including the United Society of Believers in Christ's Second Appearing. The nickname was derived from the shaking and dancing that was part of their ritual. They were originally an offshoot of the QUAKERS in England, a few of whom emigrated and formed (1775) a community near Albany, New York. By c.1850, they had up to 6,000 members. Shakers believed in communal property, pacifism, sexual equality, celibacy and the sanctity of labour.

Shakespeare, William (1564–1616) English poet and dramatist, b. Stratford-upon-Avon, Warwickshire. By 1592 Shakespeare was established in London, having already written the three parts of *Henry VI*. By 1594 he was a member of the Lord Chamberlain's Men and in 1599 a partner in the Globe Theatre (now rebuilt), where many of his plays were presented. He retired to Stratford-upon-Avon around 1613. His 154 *Sonnets*, which were first published in 1609, stand among the finest works of English poetry. The plays are usually divided into four groups – the historical plays, the comedies, the tragedies and the late romances – and their plots are generally drawn from existing sources. The first collected edition of the plays, the First Folio, was published in 1623 and ran to three editions in the 17th century.

shale Common SEDIMENTARY ROCK formed from mud or clay. Characterized by very fine layering, it may contain various materials such as fossils, carbonaceous matter and oil.

shallot Perennial plant native to w Asia and widely cultivated in temperate climates. It has thin, small leaves and clustered bulbs, with a mild, onion-like flavour. Family Liliaceae; species *Allium cepa*.

shaman Tribal witch doctor or medicine man believed to be in contact with spirits or the supernatural world, and thought to have magical powers. Shamanism is found among the ESKIMOS and NATIVE AMERICANS and in Siberia, where the term originated. African equivalents also exist. *See also* ANIMISM

shamrock Plant with three-part leaves, usually taken to be *Trifolium repens* or *T. dubium*, the national emblem of Ireland. Legend tells that St Patrick used it to symbolize the Trinity. Other plants called shamrock include *Oxalis acetosella* and *Medicago lupulina*. Family Fabiaceae/Leguminosae.

Shang (Yin) Early Chinese dynasty (c.1523–c.1030 BC). Successors to the Hsia (Xia) dynasty, the Shang was based in the valley of the Huang He (Yellow River). During the Shang period, the Chinese written language was perfected, techniques of flood control and irrigation were practised, and artefacts were made in cast bronze.

Shanghai City in SE China, 22km (13mi) from the Yangtze (Changjiang) delta, the largest city in China, and a major port. By the Treaty of Nanking (1842), Shanghai was opened to foreign trade, which stimulated economic growth. The USA, Britain, France and Japan all held their own areas within the city. Occupied by the Japanese in 1937, it was restored to China at the end of World War 2 and fell to the communists in 1949. Industries: textiles, steel, chemicals, publishing, rubber products, farm machinery, shipbuilding, pharmaceuticals, financial services. Pop. (1993) 8,760,000.

Shankar, Ravi (1920–) Indian musician. He was responsible for popularizing the SITAR and Indian music in general in the West. Shankar founded the National Orchestra of India and was music director of All-India Radio (1948–56). He toured Europe and the USA extensively during the 1960s and 1970s.

Shannon Longest river in the Republic of Ireland and the British Isles. It rises on Cuilcagh Mountain in Nw County Cavan and flows s through loughs Allen, Ree and Derg, then s across the central plain of Ireland to Limerick, and w to enter the Atlantic Ocean between Loop Head and Kerry Head. The Shannon separates Connacht from the provinces of Leinster and Munster. Length: 370km (230mi)

Shapley, Harlow (1885–1972) US astronomer who provided the first accurate model of the MILKY WAY. By observing CEPHEID VARIABLE stars in globular clusters, he calculated the distance to each cluster in the galaxy, obtaining a picture of its shape and size.

share index Indicator used to show the movement of the prices of SHARES on a STOCK EXCHANGE. Indices usually take a price or capitalization-weighted sample of the share prices of a top rated group of companies on a given stock exchange. Examples include the Nikkei Dow in Tokyo, the FTSE-100 in London, and the Dow Jones in New York.

shares Documents representing money invested in a company in return for membership rights in the ownership of that company. Shares are expressed in monetary units. Shareholders regularly receive payment of dividends that depend on the net profit of the company. In the USA, the term stock is usually used instead of share. In the UK, although the definitions have become blurred, **stocks** usually mean fixed-interest securities such as those issued by government.

Sharia Traditional law of ISLAM, believed by Muslims to be the result of divine revelation. It is drawn from a number of sources, including the KORAN and a collection of teachings and legends about the life of MUHAMMAD known as the *Hadith*.

Sharjah Capital of the sheikdom of Sharjah, third largest of the seven UNITED ARAB EMIRATES, on the Persian Gulf, E Arabia. A British protectorate until 1971, the sheikdom is part of a prosperous oil- and gas-producing area. Pop. (1984) 125,000. **shark** Torpedo-shaped, cartilaginous fish found in subpolar

SHAKESPEARE'S PLAYS

Histories: (date written) Henry VI (part I) (1589-90) Henry VI (part II) (1590-91) Henry VI (part III) (1590-91) Titus Andronicus (1590–94) Richard III (1592-93) King John (1595-97) Richard II (1595) Henry IV (part I) (1596) Henry IV (part II) (1597) Henry V (1599) Julius Caesar (1599) Troilus and Cressida (1601-02) Timon of Athens (1605-09) Antony and Cleopatra (1606-07) Coriolanus (1607–08)

Comedies:

Henry VIII (1613)

The Comedy of Errors (1590–94) Love's Labour's Lost (1590–94) The Two Gentlemen of Verona (1592 - 93)The Taming of the Shrew (1592) A Midsummer Night's Dream (1595)The Merchant of Venice (1596-98) The Merry Wives of Windsor (1597)Much Ado About Nothing (1598) As You Like It (1599) Twelfth Night (1600-02) All's Well That Ends Well (1602-03)Measure for Measure (1604-05)

Tragedies:

Romeo and Juliet (1595–96) Hamlet (1600–01) Othello (1604) King Lear (1605–06) Macbeth (1605–06)

Late Romances:

Pericles (1607–08) Cymbeline (1609–10) The Winter's Tale (1611) The Tempest (1613)

▼ shark The mako shark (Isurus oxyrhyncus) belongs to the mackerel shark family, the same family to which the great white belongs. A ferocious predator, the mako's streamlined body enables it to swim at speeds of over 65km/h (40mph). Makos are found in the Atlantic, Pacific and Indian oceans, and like the great white, have been known to attack humans. Adults reach over 3.7m (12ft) and weigh up to 400kg (880lb).

to tropical marine waters. They have well-developed jaws, bony teeth, usually 5 gill slits on each side of the head and a characteristic, lobe-shaped tail with a longer top lobe. Sharks are carnivorous and at least 10 species are known to attack humans. There are about 250 living species. Order Selachii. See also Dogfish; Hammerhead; whale shark; white shark sharp In musical notation, an accidental sign placed before a note or immediately after the clef to indicate that the note it refers to should be sounded a semitone higher. It is designated by the sign 4.

Sharpeville Black township, N of Vereeniging, South Africa, scene of a massacre by security forces in March 1960. A large gathering of local people demonstrating against the pass laws failed to obey orders to disperse. The police opened fire, killing 67 people and wounding 186. The massacre led to greater militancy in the struggle against APARTHEID and focused international attention on South Africa.

Shatt al Arab Channel in SE Iraq, formed by the confluence of the rivers TIGRIS and EUPHRATES. It flows SE to the Persian Gulf through a wide delta. Forming the Iraq-Iran border, its lower course was the scene of bitter fighting between the two countries during the IRAN-IRAQ WAR (1980–88).

Shaw, George Bernard (1856–1950) Irish dramatist, critic and member of the FABIAN SOCIETY. Shaw transformed Victorian theatre, rejecting melodrama in favour of socially conscious drama. Although many of his plays were comedies, they expressed his often radical political and philosophical ideas. His first play was Widower's Houses (1892). Mrs Warren's Profession (1893) was considered immoral and banned from performance. Arms and the Man (1894) was Shaw's first publicly performed play. Other early plays include Candida (1897). Plays such as Man and Superman (1905) and Major Barbara (1905) were first performed at the Royal Court, London. Pygmalion (1913) was turned later into the musical My Fair Lady (1956). Other major plays include Heartbreak House (1920), Back to Methuselah (1922) and Saint Joan (1923). The prefaces to his plays were published separately. Shaw received the 1925 Nobel Prize for literature. Shearer, Alan (1970-) English footballer. Shearer began (1988) his professional career with Southampton. A powerful striker, in 1992 he joined Blackburn Rovers. The following season he became the first player to score 100 goals in the Premier League. In 1996 he was the leading scorer in the European Championship and moved to Newcastle for a world record transfer fee of £15 million.

shearwater Seabird related to the ALBATROSS and PETREL. Most species are brown or black with pale underparts. Shearwaters live most of their lives on the ocean; they feed on fish and squid, and burrow nests in coastal cliffs. Length: 19–56cm (7.5–22in). Family Procellariidae.

Sheba (Saba) Ancient kingdom of s Arabia celebrated for its trade in gold, spices and precious stones. According to the Bible, the Queen of Sheba visited Jerusalem to hear the wisdom of SOLOMON in the 10th century BC.

sheep Ruminants of the genus *Ovis*, and those of the less numerous genera *Pseudois* and *Ammotragus*. Domestic sheep, *O. aries*, are now bred for WOOL, fur (karakul) and meat. Wild species are found in the mountains of Europe, Asia, Africa and North America. All are of the Family Bovidae.

sheepdog Any of several breeds of dog that were originally bred to herd and guard sheep. The term includes such breeds as the Old English sheepdog, Shetland sheepdog, COLLIE, border collie and GERMAN SHEPHERD. Today, border collies are those most commonly used for the original purpose.

Sheffield City and county district in South Yorkshire, N England. A hilly city, it lies at the confluence of the River Don and its tributaries, the Sheaf, Rivelin and Lordey. It is a major industrial centre, noted for its steel and steel by-products. Pop. (1991) 501,202.

shell In biology, the hard protective case of various MOLLUSCS. The case is secreted by the epidermis of the mollusc and consists of a protein matrix strengthened by calcium carbonate.

Shelley, Mary Wollstonecraft (1797–1851) British novelist, daughter of Mary WOLLSTONECRAFT. She eloped with Percy SHELLEY in 1814 and married him in 1816. Her later

works of fiction, which include *The Last Man* (1826) and *Lodore* (1835), have been eclipsed by her first novel, *Frankenstein* (1818).

Shelley, Percy Bysshe (1792–1822) English poet. A committed atheist, Shelley was expelled (1811) from Oxford University for his beliefs. His radical pamphlets forced him into hiding in Wales, where he wrote *Queen Mab* (1813). *Alastor* (1816) reflects his political idealism. From 1818 he lived in Italy with his second wife, Mary Shelley. *The Cenci* (1819) is a five-act tragedy. The Peterloo Massacre (1819) prompted *The Mask of Anarchy. Prometheus Unbound* (1820), a four-act lyrical drama, is a masterpiece of ROMANTICISM. *Julian and Maddalo* (1924) explores his friendship with Lord Byron. Smaller poems include "Ode to the West Wind" (1819), and "To a Skylark" (1820). The death of John Keats inspired *Adonais* (1821). Shelley drowned in a boating accident.

shellfish Common name for edible shelled MOLLUSCS and CRUSTACEA. Shelled molluscs include CLAMS, MUSSELS, OYSTERS and SCALLOPS; crustaceans include SHRIMPS, LOBSTERS and CRABS.

Shenyang Capital of Liaoning province, NE China. Once capital of the QING dynasty, it is the centre of a group of communes that grow rice, cereals and vegetables under intensive cultivation. Industries: aircraft, machine tools, heavy machinery, cables, cement. Pop. (1993) 3,860,000.

Shepard, Alan Bartlett, Jr (1923–) US astronaut. In 1961 he became the first American to be launched into space. Shepard commanded *Apollo 14* on its flight to the Moon in 1971, and was the fifth man to walk on the lunar surface.

Shepard, Sam (1943–) US playwright. His plays include *Icarus's Mother* (1965), *The Tooth of Crime* (1972), *Buried Child* (1978), for which he won a Pulitzer Prize, and *True West* (1983). He has acted in films of his own screenplays, including *Paris, Texas* (1984) and *Fool for Love* (1985).

Sheridan, Philip Henry (1831–88) US general. An agressive Union commander in the American CIVIL WAR, he reorganized and led the cavalry of the Army of the Potomac (1864). Commanding the Army of the Shenandoah, he devastated the Shenandoah valley. In the final campaign he forced Lee's surrender at Appomattox (1865).

Sheridan, Richard Brinsley (1751–1816) British dramatist and politician. He excelled in comedies of manners, such as *The Rivals* (1775) and *The School for Scandal* (1777). Entering Parliament as a member of the Whigs in 1780, he became one of the most brilliant orators of his generation.

Sherman, William Tecumseh (1820–91) US military commander. During the American CIVIL WAR (1861–65) he took part in the first battle of BULL RUN and in the capture of Vicksburg. He won the battle of ATLANTA and led the "March to the Sea" from Atlanta to Savannah in 1864.

Sherrington, Sir Charles Scott (1857–1952) British physiologist. A pioneer in the study of the nervous system, he established physiological psychology with his book *The Integrative Action of the Nervous System* (1906). He shared the 1932 Nobel Prize for physiology or medicine.

sherry Fortified wine with a characteristic raisiny flavour produced by a special method of vinification and expert blending. Drier apéritif sherries include fino, manzanilla and amontillado; sweeter, dessert sherries include oloroso, amoroso, golden and cream. True sherry comes from Jerez, Spain.

Sherwood, Robert Emmet (1896–1955) US writer. He wrote comedies and socially significant dramas such as Waterloo Bridge (1930), Reunion in Vienna (1931), The Petrified Forest (1934), the Pulitzer Prize-winning Idiot's Delight (1936), and Abe Lincoln in Illinois (1938). His memoir Roosevelt and Hopkins was published in 1948.

Sherwood Forest Ancient royal hunting ground in Nottinghamshire, central England. Famous as the home of the legendary ROBIN HOOD, some of the original forest remains. Part of it is protected in a country park, which has some of Britain's oldest and biggest oaks.

Shetland Islands Group of c.100 islands NE of the Orkneys, $210 \mathrm{km}$ ($130 \mathrm{mi}$) off the N coast of Scotland, constituting an administrative region. Settled by Norse invaders in the 9th century, the islands were seized by Scotland in 1472. The prin-

▲ Shaw George Bernard Shaw, here pictured aged 90, was one of the most prolific dramatists of the 20th century. He first came to public attention as a journalist and critic. Many of Shaw's plays reflect his political commitment to socialism and pacifism, and expose the iniquities of the English class system. Heartbreak House (1920) is a witty indictment of the aristocracy in World War 1.

cipal islands are Mainland (which has the main town of Lerwick), Yell, Unst, Whalsay and Bressay. The islands are rocky with thin soils, but oats and barley are grown in places. Fishing and livestock are important, and the islands are famous for Shetland Ponies. The region is also noted for its woollen clothing. More recently, oil and tourism have become major industries. Area: 1,433sq km (553sq mi) Pop. (1991) 22,522. Shetland pony One of the smallest types of light horse. Originating in the Shetland Islands, it has been introduced to most parts of the world. It has been used for draught or

Originating in the Shettland Islands, it has been introduced to most parts of the world. It has been used for draught or road work and makes an ideal child's mount. Height: typically 71cm (28in) at the shoulder; weight: 169kg (350lb).

Shevardnadze Eduard Ambrosievich (1928—) Georgia

Shevardnadze, Eduard Ambrosievich (1928–) Georgian statesman, president (1992–). A close ally of Mikhail Gorbachev, Shevardnadze was Soviet foreign minister (1985–90). He oversaw the Soviet withdrawal from Afghanistan and worked on détente with the West. Warning of impending dictatorship, Shevardnadze resigned in 1990 and formed the Democratic Reform Movement. As president of Georgia, he sought Russian help to overcome supporters of the deposed leader, Zviad Gamsakhurdia. Shevardnadze escaped assassination attempts in 1995 and 1998.

Shiite (Arabic, *shiat Ali*, supporter of Ali) Second-largest branch of Islam. Shiites believe that the true successor of MUHAMMAD was ALI, whose claim to be CALIPH was not recognized by SUNNI Muslims. It rejects the *Sunna* (the collection of teachings outside the KORAN) and relies instead on the pronouncements of a succession of holy men called IMAMS. The SAFAVID dynasty in Iran were the first to adopt Shi'a as a state religion. One of the principal causes of the Iranian revolution was Shah PAHLAVI's attempt to reduce clerical influence on government. Ayatollah KHOMEINI'S Shiite theocracy stresses the role of Islamic activism in liberation struggles. After the 1991 Gulf War the Iraqi Shiites opposed the oppressive regime of Saddam HUSSEIN, but were defeated in the marshlands of s Iraq. The Ismailjs of the Indian subcontinent are the other major Shiite grouping.

Shikoku Smallest of the four main islands of Japan, s of Honshū and E of Kyūshū. The interior is mountainous and extensively forested, and most settlements are on the coast. The principal cities are Matsuyama, Takamatsu and Tokushima. Products: rice, tea, wheat, timber, fish, tobacco, fruit, soya beans, camphor, copper. Area 18,798sq km (7,258sq mi). Pop. (1995) 4,183,000.

Shilton, Peter (1949–) English footballer. Shilton set a record number of England caps (125) between his debut in goal (1970) and a World Cup semi-final (1990). From 1992 to 1995 he was player-manager of Plymouth Argyll. By 1997 he had made more than 1,000 league appearances.

shingles (herpes zoster) Acute viral infection of sensory nerves. Groups of small blisters appear along the course of the affected nerves, and the condition can be very painful.

Shinto (Jap. way to the gods) Indigenous religion of Japan. Originating as a primitive cult of nature worship, it was shaped by the influence of CONFUCIUS and, from the 5th century, BUDDHISM. A revival of the ancient Shinto rites began in the 17th century and contributed to the rise of Japanese nationalism in the late 19th century. Shinto has many deities in the form of spirits, souls and forces of nature.

ship Vessel for conveying passengers and freight by sea. The earliest sea-going ships were probably Egyptian, making voyages to the E coast of Africa in c.1500 BC. In China, extensive sea voyages were being made by ships that carried more than one mast and featured a rudder in c.200 AD, some 1,200 years before such ships appeared in Europe. In the Mediterranean region, the galleys of the Greek, Phoenician and Roman navies combined rows of oars with a single square sail, as did the Viking longboats, which were capable of withstanding violent seas. By the 14th and 15th centuries, carracks and galleons were being developed to fulfil the exploration of the New World. Fighting ships of the 17th and 18th centuries included frigates of various designs. Sailing freighters culminated in the great clippers of the late 19th century, some of which had iron hulls. A century or so earlier, the first steamships had been built. They were powered by

■ Shearer English striker Alan Shearer became England captain for the 1996 European Championship. He later moved from Blackburn Rovers to Newcastle United for a world record £15 million transfer fee. Injury forced him to miss much of the 1997—98 season. Shearer recovered in time for the 1998 World Cup.

wood or coal-burning steam engines that drove large paddle wheels, hence the term paddlesteamer. In 1819 the first Atlantic crossing was made by "steam-assisted sail", and this crossing soon became a regular service. By the mid-19th century, steamships, such as Brunel's Great Britain (1844), were driven by propellers, or screws. Marine steam TURBINES were developed at the turn of the 19th century and gradually replaced reciprocating (back-and-forth cranking) steam ENGINES for large vessels, early examples being the ocean liners of the 1900s. Oil, rather than coal, soon became the favoured fuel for large marine engines. Diesel engines were developed in the early 1900s, but were considered unreliable and, although less expensive to run, they did not replace steam turbines until the 1970s. Some of the newest military ships and icebreakers are fitted with nuclear engines in which heat from a NUCLEAR REACTOR raises steam in boilers to drive steam turbines. See also AIRCRAFT CARRIER; BOAT; SUBMARINE Shiraz Capital of Fars province, in the Zagros Mountains, sw Iran. An ancient city established near Persepolis, Shiraz was an artistic centre from the 4th century. From the 7th century it was a trade centre, and in the 9th century it developed into a place of Muslim pilgrimage. Shiraz was the capital (1750-94) of Persia, and many buildings date from that period. Still noted for its wine and carpets; other products include metalwork, textiles, cement and sugar. Pop. (1991) 965,117. Shiva (Siva) Major god of HINDUISM. A complex god who transcends the concepts of good and evil, Shiva represents both reproduction and destruction (a combination of contradictory qualities is not uncommon in Hinduism). He periodically destroys the world in order to create it once more. He takes little part in the affairs of humanity, although his wife, KALI, is actively involved in them.

■ ship Worldwide expansion of Europe's trading empire during the 18th century was made possible by ships, such as the heavily armed East Indiaman shown here.

S

shock Acute circulatory failure, possibly with collapse. Caused by disease, injury or emotional trauma, it is characterized by weakness, pallor, sweating and a shallow, rapid pulse. In shock, blood pressure drops to a level below that needed to oxygenate the tissues.

Shockley, William Bradford (1910–89) US physicist who, with his colleagues, John Bardeen and Walter Brattain, invented the Transistor. They shared the 1956 Nobel Prize for physics. In 1947 they produced a point-contact transistor and a junction transistor.

shock therapy See Electroconvulsive therapy

shoebill stork (whale-headed stork) Tall wading bird found in papyrus marshes of tropical NE Africa. It has a shoe-shaped bill with a sharp hook, a short neck, darkish plumage and long legs. It feeds at night on small animals, including lungfish, frogs and turtles. Height: to 1.4m (4.6ft). Family Balaenicipitidae; species *Balaeniceps rex*.

shōgun Title of the military ruler of Japan, first conferred upon Yoritomo in 1192. The Minamoto (1192–1333), Ashikaga (1338–1568) and Tokugawa (1603–1868) shōgunates in effect ruled feudal Japan, although the emperor retained ceremonial and religious duties. The shōgunate ended with the Mejii Restoration in 1868.

Sholokhov, Mikhail Alexandrovich (1905–84) Soviet novelist. Sholokhov became famous for his novel about his native land, *Tikhy Don* (1928–40); translated as *And Quiet Flows the Don* (1934) and *The Don Flows Home to the Sea* (1940). He was awarded the 1965 Nobel Prize for literature.

Shona Bantu-speaking people of E Zimbabwe. Shona society is based on subsistence agriculture and is centred on small villages, abandoned when local resources are exhausted. Their culture is noted for its pottery, music and dance.

shooting Competitive sport involving firearms, in which a competitor, or team of competitors, fires at stationary or moving targets. The three main types of shooting are rifle, pistol and clay-pigeon shooting. Within rifle shooting, the three basic classes of competition are for air rifle, small-bore and largebore rifle; all but air rifle shooting are Olympic sports. The two main forms of pistol shooting, rapid-fire (or silhouette) and free shooting, are both Olympic sports. There are three disciplines of clay-pigeon shooting - Olympic trench, skeet and down-the-line shooting. The first two types are Olympic sports. **shorthand** System of writing, used to record speech quickly. Phonetic shorthand systems first appeared during the 18th century, and the most famous system, Pitman's shorthand, was published in 1837. All the sounds of the English language are represented by 49 signs for consonants and 16 signs to indicate vowels. The Gregg system of phonetic shorthand, widely taught in the USA, has a script based on ordinary writing.

Short Parliament (1640) English Parliament that ended 11 years of personal rule by Charles I. Charles was forced to summon Parliament to raise revenue through taxation for war against Scotland. When it refused his demands, he dissolved it, but had to summon the Long Parliament a few months later. Shoshone (Shoshoni) Native North Americans of the Uto-Aztecan language group. They occupy reservations in California, Idaho, Nevada, Utah and Wyoming. They were divided into the Comanche, the Northern, the Western and the Wind

River Shoshone. They now number c.9,500. **Shostakovich, Dmitri Dmitrievich** (1906–75) Russian composer. Shostakovich's use of contemporary western musical developments in his compositions did not conform with Soviet SOCIALIST REALISM. His opera *The Lady Macbeth of the Misenk District* (1934) received international acclaim but was later criticized in *Pravda*. Other works were deliberately more conventional. He composed 15 symphonies, 13 string quartets, ballets, concertos, piano music, film music and vocal works.

shot put Field event in which an athlete throws a heavy metal ball from a position close to the neck by means of a swift extension of the arm. The athlete must remain inside the throwing circle. Men throw a 7.3kg (16lb) shot; women a 4kg (8lb 13oz) shot. The shot put has been an Olympic event since 1909.

shoulder In human anatomy, mobile joint at the top of the arm. It consists of the ball-and-socket joint between the upper arm bone (HUMERUS) and the SHOULDER BLADE (scapula).

shoulder blade (scapula) In vertebrates, either of two large, roughly triangular, flat bones found one on either side of the upper back. They provide for the attachment of muscles that move the forelimbs. *See also* SHOULDER

show trial Trial of a defendant charged with a "crime" that has political overtones. The term is closely associated with trials held in the former Soviet Union under STALIN. Show trials are staged with maximum publicity in order to make a political point both to foreign observers and to the defendant's sympathizers.

shrew Smallest mammal, found throughout the world. It is an active, voracious insectivore that eats more than its own weight daily. Family Soricidae.

shrike (butcherbird) Small perching bird found worldwide, except in South America and Australia. It dives at its prey – insects, small birds, mice – hitting them with its strong, hooked bill and then impaling them on a sharp fence post, twig or thorn. Family Laniidae

shrimp Mostly marine, swimming crustacean. Its compressed body has long antennae, stalked eyes, a beak-like prolongation, segmented abdomen with five pairs of swimming legs, and a terminal spine. There are true, sand and pistol shrimps. Large edible shrimps are often called PRAWNS or scampi. Length: 5–7.5cm (2–3in).

Shropshire (Salop) County in W England; the county town is Shrewsbury. Shropshire is crossed by the River Severn. To the N of the river the land is generally low-lying, and to the S it rises to the Welsh hills. Part of Mercia in Anglo-Saxon history, after the Norman Conquest it became part of the Welsh Marches. The economy is primarily agricultural. Mineral deposits include coal, and industries include metal products. Area: 3,490sq km (1,347sq mi). Pop. (1991) 406,387.

Shrove Tuesday Day before Ash Wednesday, which is the first day of LENT. In many countries, the day is associated with celebrations symbolizing the final self-indulgence before the Lenten period of self-denial. It corresponds with MARDI GRAS in France and the French-influenced s USA, and with *Fastnacht* in Germany.

shrub Woody perennial plant of limited height, usually less than 10m (30ft) high. Instead of having a main stem, it branches at or slightly above ground level into several stems. **sial** In geology, uppermost of the two main rock-classes in the Earth's crust. Sial rocks are so called because their main constituents are silicon and aluminium. They make up the material of the continents and overlay the SIMA.

Siam See THAILAND

Siamese twins Identical twins who are born physically joined together, sometimes with sharing of organs. Surgical separation is usually possible.

Sian See XIAN

Sibelius, Jean Julius Christian (1865–1957) Finnish composer whose work represents the culmination of nationalism in Finnish music. He wrote chamber music and works for piano and organ, but is best known for his orchestral works, including seven symphonies, a violin concerto (1903–35) and the tone poems *En Saga* (1892) and *Finlandia* (1899).

Siberia (Sibir) Extensive region of Asian Russia, extending E to w from the Ural Mountains to the Pacific Ocean, and N to S from the Arctic Ocean to the steppes of Kazakstan and the border with Mongolia. The region includes areas of tundra, taiga and steppe, almost half of it is forested. Drained chiefly by vast north-flowing rivers OB, YENISEI and LENA and their tributaries, Siberia can be divided into five geographical areas: (1) the w Siberian plain, between the URALS and the Central Plateau, favours dairy farming, but wheat, oats, flax, potatoes, rve and sugar beet are also grown. Two-thirds of the population live in the sw, where industry is concentrated in cities, such as NOVOSIBIRSK and OMSK, and in the Kuznetz Basin, which has large coal deposits; (2) the Central Siberian plateau, between the Yenisei and Lena rivers. Krasnoyarsk lies on the Yenisei and the city of Yakutsk on the Lena. The region is Russia's chief producer of gold, mica, diamonds and aluminium, and forestry is an important industry; (3) the NE Siberian mountains lie to the E of the Lena. The region is sparsely populated due to the Arctic climate. Verkhoyansk is the world's coldest perma-

▲ shoebill stork Although it displays some behavioural similarities to pelicans and herons, the shoebill stork (Balaeniceps rex) is the sole member of a separate bird family, Balaenicipidae. It uses its distinctive, shovel-like bill to dig in the mud to find the fish and aquatic animals on which it feeds. Despite its large size and clumsy, sluggish appearance on land, it is a graceful flyer with broad wings. Silent and solitary birds, shoebills have unwebbed feet that are specially adapted to walking on marshy land.

nent settlement. The breeding of reindeer, fishing and sealhunting are the chief occupations; (4) the mountains of the s Trans-Baikal region form the watershed between the Pacific and the Arctic. The major city is Irkutsk, close to Lake BAIKAL; (5) the volcanic and mountainous KAMCHATKA peninsula. The Russian Cossacks conquered Siberia between 1581 and 1644, although the Far Eastern territory was held by the Chinese until 1860. Mining developed in the 19th century, and the region was used as a penal colony for political prisoners by the Russian empire and its Soviet successors. Settlement on a large scale came only after the construction of the Trans-Siberian RAILWAY between 1881 and 1905; Siberia's population doubled between 1914 and 1946. The economic development of the region was rapid. The importance of Siberian grain to Russian agriculture was emphasized during World War 2, and in the 1950s Khrushchev encouraged the cultivation of land in the sw. The 1960s witnessed the development of vast hydroelectric schemes in the Trans-Baikal region. Area 13,807,000sq km (5,331,000sq mi). Pop. (1994) 35,605,000.

Sibyl Prophetess of Greek and Roman mythology. The Sibyl of Cumae offered nine books of her prophecies to Tarquinius Superbus of Rome. He refused her price so she began burning the books until he bought the remaining three for the price she had asked for all nine. They were consulted in times of national emergency.

Sichuan (Szechwan) Province in sw China, almost completely surrounded by mountains, and the most populous in the country; the capital is Chengdu. The E part of the region comprises the heavily populated Red Basin, the most prosperous area of China. Sichuan is China's leading producer of rice, maize and sweet potatoes, while soya beans, barley and fruit are also grown. Livestock, including cattle, pigs, horses and oxen, are reared, particularly in the w. Salt, coal and iron are mined; other products include rapeseed-oil and silk, for which Sichuan was once world famous. Area: 569,215sq km (219,774sq mi). Pop. (1990) 106,370,000.

Sicily Largest and most populous island in the Mediterranean Sea, off the sw tip of the Italian peninsula, comprising (with nearby islands) an autonomous region of Italy. The capital is PALERMO; other major cities include MESSINA. It is separated from Italy by the narrow Strait of Messina. Mostly mountainous, Mount ETNA, at 3,323m (10,902ft), is the highest volcano in Europe. There are fertile valleys in the central plateau, and agriculture is the economic mainstay. Strategically situated between Europe and Africa, from the 5th-3rd centuries BC it was a battleground for the rival Roman and Carthaginian empires and, following the first Punic War in 241 BC, became a Roman province. At the end of the 11th century, the island and s Italy were conquered by the Normans. In 1266 the throne passed to Charles of Anjou, whose unpopular government caused the Sicilian Vespers revolt of 1282 and the election of an Aragónese king. In 1302 peace terms led to Aragón keeping Sicily, while s Italy became the Angevin kingdom of Naples. In 1735 the two regions were reunified under the rule of the Bourbon Don Carlos (Charles III of Spain). Centuries of centralization under Spanish imperial rule led to the crowning of Ferdinand I as King of Two Sicilies in 1816. Sicilian independence revolts of 1820 and 1848-49 were ruthlessly suppressed. In 1860 Garibaldi liberated the island and it was incorporated into the new, unified state of Italy. Grain, olives, wine, and citrus fruits are the principal products; tourism is also important. Sicily remains one of the poorest local economies in Europe. Area: 25,706sq km (9,925sq mi). Pop. (1992) 4,997,705.

Sickert, Walter Richard (1860–1942) British painter. Sickert attracted a circle of progressive painters to his studio and inspired them to form the Camden Town Group and later the London Group. He was a precursor of the 1950s "kitchen sink" school of drama in his rejection of "nice" subjects in favour of drab domestic interiors, sordid bedroom scenes and a spirit of desperate boredom, as in *Ennui* (c.1914).

sickle-cell disease Inherited blood disorder featuring an abnormality of HAEMOGLOBIN. The haemoglobin is sensitive to a deficiency of oxygen and it distorts ERYTHROCYTES, causing them to become rigid and sickle shaped. Sickle

cells are rapidly lost from the circulation, giving rise to anaemia and jaundice.

Siddhartha Gautama See BUDDHA

sidereal period Orbital period of a planet or other celestial body with respect to a background star. It is the true orbital period. **Sidereal time** is local time reckoned according to the rotation of the Earth with respect to the stars. The sidereal day is 23 hours, 56 minutes and 4 seconds of mean solar time, nearly 4 minutes shorter than the mean solar day. The sidereal year is equal to 365.25636 mean solar days.

sidewinder (horned rattlesnake) Nocturnal RATTLESNAKE found in deserts of SW USA and Mexico. It has horn-like scales over the eyes and is usually tan with a light pattern. It loops obliquely across the sand, leaving a J-shaped trail. Length: to 75cm (30in). Family Viperidae; species *Crotalus cerastes*. The term is also used to describe desert-dwelling snakes of the Old World that move in a similar way.

Sidney, Sir Philip (1554–86) English poet, diplomat and courtier. His works include the intricate pastoral romance *Arcadia* (1590) and the sonnet sequence *Astrophel and Stella* (1591). *The Defence of Poesie* (also known as the *Apology for Poetry*), which was originally published with *Arcadia*, is a milestone of English literary theory. Sidney died with legendary gallantry at the Battle of Zutphen.

Siegfried In ancient Germanic literature, hero figure who corresponds with Sigurd in Norse mythology, although accounts vary. In the story of Brunhild he is slain, but elsewhere he is generally victorious in his adventures. He plays a major part in the epic tale of the Nibelungenlied and in WAGN-ER's operatic adaptation of that tale, The Ring of the Nibelung. Siemens German brothers, who were associated with the electrical engineering industry. Ernst Werner von Siemens (1816-92), developed an electric telegraph system in 1849. With Karl (1829–1906) he set up subsidiaries of the family firm in London, Vienna and Paris. Frederich (1826-1904) and Karl Wilhelm (later William) (1823–83) developed a regenerative furnace that was used extensively in industry. Karl Wilhelm introduced (1843) an ELECTROPLATING process to Britain. Siena Capital of Siena province, Tuscany, central Italy. It is one of Italy's foremost tourist attractions. The town lends its name to the vellow-brown pigment sienna, present in the region's soil, and the area is famous for its orange marble. Founded by the Etruscans, Siena became a commune in the 12th century. During the 13th century, it rapidly expanded to rival Florence, and was the centre of the Ghibelline faction. In the mid-16th century, it fell under the control of the Medici. In art history, it is especially famed for its Sienese School of painting (13th-14th centuries). Pop. (1990) 58,278

Sienkiewicz, Henryk (1846–1916) Polish novelist and short-story writer. He gained international recognition with *Quo Vadis?* (1896), and was awarded the 1905 Nobel Prize for literature. He glorified his country's struggle for nationhood in the trilogy *With Fire and Sword* (1884), *The Deluge* (1886) and *Pan Michael* (1887–88).

Sierra Leone Republic on the w coast of Africa; the capital is FREETOWN. **Land and climate** The coast contains several deep estuaries in the N, with lagoons in the s, but the most prominent feature is the mountainous Freetown (or Sierra Leone) peninsula. North of the peninsula is the River Rokel estuary, w

■ shrew Among the smallest of the mammals, shrews inhabit forests all around the world: two examples are tree shrews (Tupaia glis, top), which live in SE Asia, and forest elephant shrews (Petrodromus tetradactylus, bottom), found in Kenya and SW Africa. Because they are extremely active with very high metabolic rates, shrews must eat constantly just to stay alive: they will die of starvation if they are deprived of food for even a few hours. Although they have poor vision, they have keen senses of smell and hearing, and loud noises can cause them to faint or even to drop dead. They produce a foul-smelling secretion from special glands on their backs, which protects them from most mammalian predators, but this does not deter many birds of prey, including hawks and owls.

S

Africa's best natural harbour. Behind the coastal plain, the land rises to mountains, with the highest peak, Loma Mansa, reaching 1,948m (6,391ft). Sierra Leone has a wet, tropical climate, with the heaviest rainfall between April and October. The s is dry in January and February, while the dry season in the N runs from December to March. Swamps cover large areas near the coast. Inland, much of the original rainforest has been destroyed and replaced by low bush and coarse grassland. The N is largely covered by tropical savanna. Economy Sierra Leone has a low-income economy. Agriculture employs 70% of the workforce, mainly at subsistence level. Chief food crops include cassava, maize and rice. Cash crops include cocoa and coffee. The most valuable exports are minerals, including diamonds, bauxite and rutile (titanium ore). Sierra Leone has few manufacturing industries. History Portuguese sailors reached the coast in 1460. In the 16th century the area became a source of slaves. Freetown was founded (1787) as a home for freed slaves. In 1808 the settlement became a British crown colony. In 1896 the interior was made a protectorate. In 1951 the protectorate and colony were united. In 1961 Sierra Leone gained independence within the Commonwealth of Nations. In 1971 it became a republic. In 1978 the All People's Congress became the sole political party. A 1991 referendum voted for the restoration of multiparty democracy, but in 1992 a military group seized power. A civil war began between the government and Revolutionary United Front (RUF). The RUF fought to end foreign interference and to nationalize the diamond mines. Following multiparty elections in February 1996, a civilian government was installed led by Ahmad Tejan Kabbah. In November 1996 Kabbah and the RUF signed a peace agreement ending the war, which had claimed more than 10,000 lives. Another military coup, led by Major Johnny Paul Koroma, seized power in May 1997. The Economic Community of West African States (ECOWAS) imposed sanctions and Nigeria led an intervention force. In October 1997 an agreement was reached to restore Kabbah.

Sierra Madre Principal mountain range in Mexico, from the US border to SE Mexico and extending s into Guatemala. It comprises the Sierra Madre Occidental, Sierra Madre Oriental, Sierra Madre del Sur, and the sub-range Sierra Madre del Guatemala. The ranges enclose the central Mexican plateau and have long been a barrier to E-W travel. The main range is 2,400km (1,500mi) long and *c*.16–480km

(10–300mi) wide. The highest peak is Orizaba (Giltaltepetl) in the Sierra Madre Oriental, at 5,700m (18,700ft).

Sierra Nevada Mountain system in E California, USA. In the E it rises steeply from the Great Basin, while the w edge slopes more gently down to the Central Valley of California. The snow-fed rivers are used to irrigate the Central Valley and also to provide hydroelectric power. Mount WHITNEY, 4,418m (14,494ft), is the highest peak. The range is 650km (400mi) long.

sight Sense by which form, colour, size, movement and distance of objects are perceived. Essentially, it is the detection of light by the EYE, enabling the formation of visual images. **Sigismund** (1368–1437) Holy Roman emperor (1411–37), and king of Germany (1410–37), Hungary (1387–1437) and Bohemia (1419–37). As king of Hungary, he was defeated by the OTTOMANS in 1396 and 1427. In Bohemia he was challenged by the HUSSITES revolt. As emperor (crowned 1433),

he was partly responsible for ending the GREAT SCHISM

(1415). He secured the succession for Albert II, his son-in-

law, the first ruler of the HABSBURG dynasty. **Signac, Paul** (1863–1935) French painter. Signac was the

main theoretical writer of NEO-IMPRESSIONISM, especially in D'Eugène Delacroix au néo-impressionisme (1899). Towards the second half of his life, his painting became much freer and his colour more brilliant, such as View of the Port of Marseille (1905).

sign language Non-phonetic means of personal communication, using hand symbols, movements and gestures. It is used as a primary means of communication among deaf people or people with impaired hearing.

Sikhism Indian religion founded in the 16th century by NANAK, the first Sikh GURU. Combining HINDU and MUSLIM teachings, it is a MONOTHEISTIC religion whose adherents believe that their one God is the immortal creator of the universe. All human beings are equal, and Sikhs oppose any CASTE system. The path to God is through prayer and meditation, but nearness to God is only achievable through divine grace. Sikhs believe in REINCARNATION, and are taught to seek spiritual guidance from their guru or leader. Begun in PUNJAB as a pacifist religion, Sikhism (under Nanak's successors) became an activist military brotherhood and a political force. All Sikh men came to adopt the surname Singh ("lion"). Since Indian independence, Sikh extremists have periodically agitated for an independent Sikh state (Khalistan). In 1984 the leader of a Sikh fundamentalist revival, Sant Jarnail Singh Bhindranwale (1947-84), was killed by government forces at the Golden Temple of AMRITSAR, and in retaliation Indira GANDHI was assassinated by her Sikh bodyguard. More than 1.000 Sikhs died in the ensuing riots.

Sikh Wars Two wars (1845–46, 1848–49) between the SIKHS and the British in NW India. After the death of RANJIT SINGH in 1839, disorder affected the Sikh state in the PUNJAB. When Sikh forces, including many non-Sikhs, crossed the frontier on the River Sutlej, the British declared war. After several battles involving heavy casualties on both sides, the British advanced to Lahore where peace was agreed (1846). The conflict was renewed two years later, but superior British artillery led to a heavy Sikh defeat at Gujarat (1849). The Sikhs surrendered and the Punjab was annexed to British India.

Sikkim State in N India, bounded by Tibet, China (N and NE), Bhutan (SE), India (S) and Nepal (W), with its capital at Gangtok (1991 pop. 25,024). The terrain is generally mountainous, rising to Mount Kanchenjunga, at 8,591m (28,185ft), the world's third-highest peak. The original inhabitants of the area were the Lepchas, but after the 17th century Sikkim was ruled by the rajas of Tibet. It had come under British influence by 1816, and after British withdrawal from India in 1947, Sikkim became independent. Political unrest led to the country becoming an Indian protectorate in 1950, and it was made an associate state in 1975. Agriculture is the main source of income, with maize, rice, barley, fruits, tea and cardamom among the main crops; the tourist industry is growing. Area: 7,096sq km (2,734sq mi). Pop. (1991) 406,457.

Silesia Historic region in E central Europe, now mostly lying in sw Poland, with the remainder in N Czech Republic and SE

SIERRA LEONE

RELIGIONS: Traditional beliefs 51%, Islam 39%, Christianity 9%

Germany. A former Polish province, it passed from Poles to Bohemians in the 14th century, became part of the Habsburg empire, and was seized by Prussia from Austria in 1742. In World War 2 it was invaded by the Soviet Union, but in 1945 a greater part of the land was returned to Poland by the terms of the POTSDAM CONFERENCE. Upper Silesia is primarily an industrial region of mining and metals, centring on KATOWICE; Lower Silesia, with a milder climate, is more agricultural.

silica Silicon dioxide, a compound of SILICON and oxygen (SiO₂). It occurs naturally as QUARTZ and chert (which includes FLINT). Silica and silicate minerals are the main constituents of 95% of all rocks and account for 59% of the Earth's crust. Silica is used in the manufacture of glass, ceramics and SILICONE.

silicon (symbol Si) Common, grey, nonmetallic element of group IV of the periodic table. Silicon is found only in combinations, such as SILICA and silicate. It is the second most abundant element in the Earth's crust (27.7% by weight). Silicon "chips" are extensively used in microprocessors. Properties: at.no. 14; r.a.m. 28.086; r.d. 2.33; m.p. 1,410°C (2,570°F); b.p. 2,355°C (4,271°F); most common isotope Si²⁸ (98.21%).

silicone Odourless and colourless polymer based on SILI-CON. Silicones are inert and stable at high temperatures, and are used in lubricants, varnishes, adhesives, water repellents, hydraulic fluids and artificial heart valves.

silicosis Chronic, occupational, lung disease, caused by prolonged inhalation of SILICA dust in occupations such as mining and stone grinding.

silk Natural fibre produced by many creatures, notably the SILKWORM. The many kinds of silk cloth include crépe, satin, taffeta and velvet. Almost all silk is obtained from silkworms reared commercially; a single cocoon can provide between 600 and 900m (2,000–3,000ft) of filament. When the cocoons have been spun, the silk farmer heats them to kill the insects inside. The cocoons are then soaked to unstick the fibres, and the strands from several cocoons are unwound together to form a single thread of yarn. The Chinese were the first to use silk. Sicily was one of the first European production centres and the industry spread to Italy, Spain and France. Silk manufacturing developed in England in the 17th century. China is still the largest producer of raw silk.

Silk Road (Silk Route) Ancient trade route linking China with Europe, the major artery of all Asian land exploration before AD 1500. For 3,000 years the manufacture of silk was a secret closely guarded by the Chinese. Silk fetched extravagant prices in Greece and Rome, and the trade became the major source of income for the Chinese ruling dynasties. By 100 BC 12 caravan trains were making the perilous annual journey along the Silk Road, and the tax on the trade provided a third of all the HAN dynasty's revenue. The silk trade began to decline in the 6th century, when the SILKWORM's eggs were smuggled to Constantinople and the secret was exposed. During the 13th century, European merchants (including MARCO POLO in 1271) travelled along the Silk Road when it was controlled by the Mongols. In the 14th century trade became possible via a sea route to the Far East.

silk-screen printing (serigraphy) In PRINTING, a means of producing a print, generally on paper. A screen composed of a mesh of silk or man-made fibres is stretched over a wooden frame; a design is "stopped out" (painted) on the mesh, using glue, varnish, gelatin or a paper stencil. To make the print, ink is taken across the screen with a squeegee; the pressure of this pushes the ink through the unstopped areas of the mesh. Several screens may be used to build up a multi-coloured print.

silkworm Moth CATERPILLAR that feeds chiefly on MULBER-RY leaves. The common domesticated *Bombyx mori* is raised commercially for its SILK cocoon. Length: 7.5 cm (3in). Family Bombycidae

Sillitoe, Alan (1928–) British novelist and short-story writer. Sillitoe's best-known novel was Saturday Night and Sunday Morning (1958; filmed in 1960). The Loneliness of the Long-distance Runner (1959) is his most celebrated novella. More recent novels include The Flame of Life (1974), The Open Door (1989), Leonard's War (1991) and Snowdrops (1993).

silt Mineral particles produced by the weathering of rock.

These particles, varying in size between grains of sand and clay, are carried along in streams and rivers, to be deposited in the gently flowing lower reaches of rivers. When the river overflows its bank, the silt deposit forms fertile land.

Silurian Third oldest period of the PALAEOZOIC era, 438–408 million years ago. Marine invertebrates resembled those of Ordovician times, and fragmentary remains show that jawless fish began to evolve. The earliest land plants (psilopsids) and first land animals (archaic mites and millipedes) developed. Mountains formed in NW Europe and Greenland.

silver (symbol Ag) White, metallic element in the second series of TRANSITION ELEMENTS in the periodic table. It occurs in argentite (a sulphide) and horn silver (a chloride), and is also obtained as a by-product in the refining of copper and lead. Silver ores are scattered throughout the world, Mexico being the major producer. Silver is used for some electrical contacts and on some PRINTED CIRCUITS. Other uses include jewellery, ornaments, coinage, mirrors, and silver salts for light-sensitive materials used in photography. The metal does not oxidize in air, but tarnishes if sulphur compounds are present. Properties: at.no. 47; r.a.m. 107.868; s.g. 10.5; m.p. 961.93°C (1,763°F), b.p. 2,212°C (4,104 °F); most common isotope Ag¹⁰⁷ (51.82%).

silverfish (bristletail) Primitive, grey, wingless insect found throughout the world. It lives in cool, damp places feeding on starchy materials such as food scraps and paper. It gets its name from the silvery scales that cover its body. Length: 13mm (0.5in). Family Lepismatidae; species *Lepisma saccharina*.

sima In geology, undermost of the two main rock-classes that make up the Earth's crust, so called because its main constituents are silicon and magnesium. It underlies the SIAL of the continents.

Simenon, Georges (1903–89) French novelist. He published more than 500 novels and many more short stories. His character Maigret, a Parisian police inspector, is one of the best-known creations in 20th-century DETECTIVE FICTION.

simile Figure of speech comparing two things. It differs from ordinary comparisons in that it compares, for effect, things usually considered dissimilar and sharing only one common characteristic, as, for example, in the phrase "his fleece was white as snow".

Simon, Neil (1927–) US playwright. Simon's plays include Come Blow Your Horn (1961), Barefoot in the Park (1963), The Odd Couple (1965), the musical Sweet Charity (1966), They're Playing Our Song (1979) and Little Me (1982). His films include California Suite (1978), Seems Like Old Times (1980), I Ought to Be in Pictures (1982) and Brighton Beach Memoirs (1986), adapted from his stage play.

Simon, Paul (1942–) US singer-songwriter. With Art Garfunkel, he formed the pop duo "Simon and Garfunkel", whose album *Sound of Silence* (1966) sold more than a million copies. Other albums include *Scarborough Fair* (1966), *Bookends* (1968) and *Bridge over Troubled Water* (1970), soon after which the duo split up. Simon's solo career included the African-influenced *Graceland* (1986).

Simpson, O.J. (Orenthal James) (1947–) US football player. "O.J." was a running back for the Buffalo Bills (1969–77) and the San Francisco 49ers (1978–79), setting season records for most yards gained (2,003, 1973) and most touchdowns (23, 1975). He later pursued a successful career as an actor and sports commentator. In 1994 he was arrested on a charge of murdering his wife and her male friend. The jury found him not guilty, but in 1997 a civil jury found him liable for wrongful death, and he was fined US\$30 million.

Simpson, Wallis Warfield Spencer, Duchess of Windsor (1896–1986) Wife of the Duke of Windsor, the former King Edward VIII of England. A US divorcee, she began her association with Edward when he was Prince of Wales. Their relationship caused controversy and was the pretext for Edward's abdication in December 1936. Having divorced her second husband, Ernest Simpson, she married Edward in 1937. **simultaneous equations** Two or more equations that can be manipulated to give common solutions. In the simultaneous equations x+10y=25 and x+y=7, the problem is to find values of x and y, such that those values are solutions of both

▲ silverfish Because they feed on starchy materials, including paste, paper, fabric and wallpaper, silverfish (Lepisma saccharina) can be highly destructive in cool, damp, dark interiors such as basements, archives and other storage facilities. However, they can be controlled with the use of insecticides or poisonous baits.

▲ Simpson American football star 0.J. Simpson ranked second in the all-time list of yards gained (11,236). In 1994 he was charged with murdering his wife. The trial was given worldwide media coverage, and public opinion on the case highlighted racial divisions within US society.

the equations simultaneously. This can be done by subtracting the two equations to give a single equation in y, which can then be solved. Substituting the value of y in either equation gives the value of x.

sin State or instance of being or acting in a way that is contrary to the ideals of righteousness propounded by a religion. In Christianity, the seven deadly sins are anger, avarice, envy, gluttony, lust, pride and sloth. In Islam, the only sin is to deny that Allah is the only God. *See also* ORIGINAL SIN

Sinai Peninsula constituting a protectorate of Egypt, bounded by the Gulf of Suez and the Suez Canal (w), the Gulf of Aqaba and the Negev Desert of Israel (E), the Mediterranean Sea (N) and the Red Sea (s). It is a barren plateau region, sandy in the N, rising to granite ridges in the s, and still inhabited chiefly by nomads. The peninsula is the site of Jabal Musa (Mount Sinai). It was the scene of fierce fighting in the Arab-Israell Wars (1956, 1967, 1973). After being occupied by the Israelis in 1967, it was returned to Egypt in 1982. The region is divided into two Egyptian governorates of North and South Sinai. Total area: 58,714sq km (22,671sq mi). Pop. (1991 est.) 264,000, all but 41,000 in North Sinai.

Sinatra, Frank (Francis Albert) (1915–) US popular singer and actor. Sinatra began his career in the jazz bands of

Harry James and Tommy Dorsey. His interpretations of standards, on albums such as *Songs for Swinging Lovers* (1956) and *Come Fly with Me* (1958) are definitive. Sinatra won an Academy Award for his supporting role in *From Here to Eternity* (1953). Other films include *Guys and Dolls, The Man With The Golden Arm* (both 1955) and *The Manchurian Candidate* (1962). He married Ava Gardner and later Mia Farrow.

Sinclair, Upton Beall (1878–1968) US novelist and social reformer. Sinclair's debut novel, *The Jungle* (1906), exposed the Chicago meat-packing industry. Other novels include *The Money Changers* (1908), *King Coal* (1917) and *Dragon's Teeth* (1942, part of an 11-volume *roman-fleuve* entitled *World's End*), for which he won a Pulitzer Prize.

Sind Province in s Pakistan, bounded by India (E and s) and the Arabian Sea (sw); the provincial (and national) capital is KARACHI. HYDERABAD is the next largest city. It largely consists of the alluvial plain and delta of the River INDUS. The region is hot and arid. Under Arab rule from the 7th to 11th centuries, it then fell under Turkish Muslim control. Islam has historically been the major governmental, social and cultural influence. The region was captured by the British in 1843 and administered as part of British India until 1937. An autonomous province from 1937 until partition in 1947, Sind

SINGAPORE

Singapore's flag was adopted in 1959 and it was retained when Singapore broke away from the Federation of Malaysia in 1963. The crescent stands for the nation's ascent. The stars stand for Singapore's aims of democracy, peace, progress, justice and equality.

singapore is a small republic at the stip of the MALAY PENINSULA. It consists of the large Singapore Island, and 59 small islets, 20 of which are inhabited. Singapore Island is c.42km (26mi) wide and 28km (14mi) across. It is linked to the peninsula by a 1,056m- (3,465ft-) long causeway. The land is mostly low-lying; the highest point, Bukit Timah, is only 176m (577ft) above sea level. Its strategic position, at the convergence of some of the world's most vital shipping lanes, has ensured its success.

CLIMATE

Singapore has a hot, humid equatorial climate, with temperatures averaging 30°C (86°F). Total average annual rainfall, 2,413mm (95in). Rain occurs (on average) 180 days each year.

VEGETATION

Rainforest once covered Singapore, but forests

now cover only 5% of the land. Today, most of Singapore is urban land. The distinction between island and city has all but disappeared. Farmland covers 4% of the land and plantations of permanent crops make up 7%.

HISTORY AND POLITICS

According to legend, Singapore was founded in 1299. It was first called Temasak (sea town), but was renamed Singapura (city of the lion). Singapore soon became a busy trading centre within the Sumatran Srivijaya kingdom. Javanese raiders destroyed it in 1377. Subsumed into Johor, Singapore became part of the powerful MALACCA sultanate. In 1819 Sir Thomas Stamford RAFFLES of the British EAST INDIA COMPANY leased the island from Johor, and the Company founded the city of Singapore. In 1826 Singapore, Pinang, and Malacca formed the Straits Settlement. Singapore soon became the most important British trading centre in Southeast Asia, and the Straits Settlement became a Crown Colony in 1867. Despite British defensive reinforcements in the early 20th century, Japanese forces seized the island in 1942. British rule was restored in 1945. In 1946 the Straits Settlement was dissolved and Singapore became a separate colony. In 1959 Singapore achieved self-government. Following a referendum, Singapore merged with Malaya, SARAWAK, and SABAH to form the Federation of MALAYSIA (1963). In 1965 Singapore broke away from the Federation to become an independent republic within the Commonwealth of Nations.

AREA: 618sq km (239 sq mi) POPULATION: 3,003,000

CAPITAL (POPULATION): Singapore City

(2,812,000)

GOVERNMENT: Multiparty republic **ETHNIC GROUPS:** Chinese 78%, Malay 14%,

Indian 7%

LANGUAGES: Chinese, Malay, Tamil and

English (all official)

RELIGIONS: Buddhism, Taoism and other traditional beliefs 54%, Islam 15%, Christianity 13%, Hinduism 4% CURRENCY: Singapore dollar = 100 cents

The People's Action Party (PAP) has ruled Singapore since 1959. Its leader, Lee Kuan Yew. served as prime minister from 1959 until 1990, when he resigned and was succeeded by GOH CHOK TONG. Under the PAP, the economy has expanded rapidly. The PAP has been criticized by human rights groups for its authoritarian social policies and suppression of political dissent. Goh Chok Tong and the PAP were decisively re-elected in 1997.

ECONOMY

Singapore is a high-income economy (1992 GDP per capita, US\$18,330). It is one of the world's fastest growing (tiger) economies. Historically, Singapore's economy has been based on transshipment, and this remains a vital component. It is one of the world's busiest ports, annually handling over 290.1 million tonnes of cargo (1994). The post-war economy has diversified. Singapore has a highly skilled and productive workforce. The service sector employs 65% of the workforce; banking and insurance provide many jobs. Manufacturing is the largest export sector. Industries include computers and electronics, telecommunications, chemicals, machinery, scientific instruments, ships, and textiles. It has a large oil refinery. Agriculture is relatively unimportant. Most farming is highly intensive, and farmers use the latest technology and scientific methods.

received many Muslim refugees after the creation of Pakistan. The major economic activity is agriculture. Grain, cotton, sugar cane, fruits and tobacco are grown. Sind is also famous for its handicrafts. Area: 140,914sq km (54,428sq mi). Pop. (1985 est.) 21,682,000.

Sindhi Language of Pakistan and India, spoken by c.15 million people in the province of Sind, s Pakistan, and across the border in India. It is related to Sanskrit and Hindi, belonging to the Indic branch of the Indo-European Languages.

sine In a right-angled triangle, ratio of the length of the side opposite an acute angle to the length of the hypotenuse. The sine of angle A is usually abbreviated to $\sin A$.

Singapore Island republic in SE Asia. See country feature Singer, Isaac Bashevis (1904–91) US novelist and shortstory writer, b. Poland. Singer's novels of Jewish life, written in Yiddish, include The Family Moskat (1950), The Magician of Lublin (1960), The Slave (1962), Shosha (1978) and The Penitent (1983). He was awarded the 1978 Nobel Prize in literature. Singer's Collected Stories was published in 1982.

Singer, Isaac Merrit (1811–1875) US inventor of a rock drill (1839) and of a single-thread sewing machine (1852). Singer's machine allowed continuous and curved stitching.

Sinhalese People who make up the largest ethnic group of Sri Lanka. They speak an INDO-EUROPEAN LANGUAGE and practise THERAVADA Buddhism.

Sinn Féin (Gaelic, Ourselves Alone) Irish republican, nationalist party founded in 1905 by Arthur GRIFFITH. It seeks to bring about a united IRELAND. Sinn Féin became a mass party after the EASTER RISING (1916). It won 75% of the vote in the last all-Ireland election (1918) and formed an Irish assembly (the Dáil Éireann) led by Éamon DE VALERA. A two-year war of independence was fought between Britain and the IRISH REPUBLICAN ARMY (IRA), led by Michael Collins. The Anglo-Irish Treaty (1921) partitioned Ireland into the Irish Free State and Northern Ireland. Sinn Féin was split and the country plunged into civil war. The pro-treaty wing (FINE GAEL), led by William Cosgrave, formed a government. De Valera, leader of the anti-treaty wing, withdrew from Sinn Féin and formed FIANNA FÁIL (1926). In 1938 the remaining republican intransigents joined the outlawed IRA. In 1969 two groups emerged that mirrored the factions of the Provisional and Official IRA. "Official" Sinn Féin became the Workers Party. The Provisionals refused to recognize the authority of Dublin or Westminster. In 1986 Sinn Féin contested elections in the Irish republic. The president of Sinn Féin, Gerry ADAMS, has been elected to Westminster three times (1983, 1987, 1997).

Sino-Japanese Wars Two wars between China and Japan, marking the beginning and the end of Japanese imperial expansion on the Asian mainland. The first (1894-95) arose from rivalry for control of Korea. In 1894 Japanese influence helped to provoke a rebellion in Korea. Both states intervened, and the Japanese forces swiftly defeated the Chinese. China was forced to accept Korean independence and ceded territory including Taiwan and the Liaotung peninsula. The latter was returned after European pressure. The second war (1937-45) developed from Japan's seizure of Manchuria (1931), where it set up the puppet state of MANCHUKUO. Further Japanese aggression led to war, in which the Japanese swiftly conquered E China, driving the government out of Peking (Beijing). US and British aid was despatched to China (1938) and the conflict merged into World War 2, ending with the final defeat of Japan in 1945. Sino-Tibetan languages Large family of languages. It includes Chinese, Tibeto-Burman, Tai, and possibly Miao (Meo) and Yao, spoken in S China and SE Asia.

sinus Hollow space or cavity, usually in bone. Most often the term refers to the paranasal sinuses, any of the four sets of air-filled cavities in the skull near the nose.

Sioux (Dakota) Group of seven NATIVE AMERICAN tribes inhabiting Minnesota, Nebraska, North and South Dakota and Montana. The tribes concluded several treaties with the US government during the 19th century, and finally agreed in 1867 to settle on a reservation in sw Dakota. The discovery of gold in the Black Hills and the rush of prospectors brought resistance from Sioux chiefs. The last confrontation resulted in the massacre of more than 200 Sioux at the battle of

Wounded Knee in 1890. The Sioux culture was typical of the Americans of the Great Plains. By the late 1990s, the Sioux numbered more than 50,000.

siren Aquatic, tailed AMPHIBIAN of North America. The adult is neotenic (reaches sexual maturity while retaining the larval physical form). These eel-like animals have external gills, tiny forelegs and minute eyes. They have no hind legs. Length: to 92cm (36in). Family Sirenidae. *See also* SALAMANDER

Sirens In Greek mythology, three sea nymphs with women's heads and birds' bodies. They lived on a rocky island near the straits of Messina, home to SCYLLA and CHARYBDIS, and their beautiful singing was believed to attract sailors onto the rocks. Sirius (Alpha Canis Majoris) Brightest star visible from Earth, in the northern constellation of Canis Major. Its lumi-

nosity is 23 times that of the Sun. **sirocco** Wind often arising over the Sahara Desert, picking up moisture from the Mediterranean Sea, and bringing hot,

rainy weather to the Mediterranean coast of Europe. **sisal** (sisal hemp) Plant native to Central America and cultivated in Mexico, Java, E Africa and the Bahamas. Fibres from the leaves are used for rope, matting and twine. Family Agavaceae; species *Agave sisalana*. *See also* AGAVE

Sistine Chapel Private chapel of the popes in the VATICAN, painted by some of the greatest artists of RENAISSANCE Italy. It was built between 1473 and 1481 for Pope Sixtus IV. The side walls were decorated with FRESCOS by PERUGINO, Pinturicchio, BOTTICELLI, GHIRLANDAIO and Signorelli. Its most celebrated features are the ceiling, window lunettes and altar wall painted by MICHELANGELO between 1508 and 1541.

Sisulu, Walter (1912–) South African civil rights activist, a fierce opponent of APARTHEID. Sisulu became secretary general of the AFRICAN NATIONAL CONGRESS (ANC) in 1949. The ANC was declared illegal in 1961 and Sisulu, Nelson MANDELA and six others were sentenced (1964) to life imprisonment. Sisulu was released (1989) as part of the reforms of F.W. DE KLERK and, after the legalization of the ANC, became its deputy president (1991–94).

Sisyphus In Greek mythology, founder and king of CORINTH. He was punished for trying to trick Thanatos (Death) by being condemned to the underworld to work for eternity, pushing a rock to the top of a steep hill. The rock rolled back to the base of the hill as soon as Sisyphus reached the summit.

sitar Indian stringed musical instrument with a gourd-like body and long neck. It has three to seven strings, tuned in fourths or fifths, and a lower course of 12 strings.

Sitting Bull (1831–90) North American Sioux leader. With others, he led the attack on Custer's US cavalry at the Battle of Little Bighorn (1876). He was captured in 1881 and imprisoned for two years. Later, he joined the Wild West Show of Buffalo Bill. Accused of anti-white activities, he was arrested again in 1890 and killed in the ensuing skirmish. Sitwell, Dame Edith (1887–1964) English poet. Sitwell's anthology Wheels (1916) encouraged experimentalism in British verse. She contributed the words to William Walton's Façade (1922). Sitwell also wrote a biography of Alexander Pope (1930) and the English Eccentrics (1933).

■ sitar Originally developed in India in the 14th century, the sitar is either played solo, or in an ensemble with tabla (small kettle-drums) and a tambura (a lute-like instrument that produces a droning sound). Popularized by Ravi Shankar, it has also been used in Western music since the 1960s.

Sitwell, Sir Osbert (1892–1969) English author, brother of Dame Edith SITWELL. He wrote the words for William WALTON'S oratorio *Belshazzar's Feast* (1931). He is chiefly remembered for his five volumes of family reminiscences, including *Left Hand, Right Hand* (1945) and *Noble Essences* (1950).

SI units (Système International d'Unites) Internationally agreed system of units, derived from the mks (metre, kilogram and second) system. SI units are now used for many scientific purposes and have replaced the fps (foot, pound and second) and cgs (centimetre, gram and second) systems. The seven basic units are: the METRE (m), KILOGRAM (kg), SECOND (s), AMPERE (A), KELVIN (K), MOLE (mol) and CANDELA (cd).

Six, Les Collective name for six French composers who were organized as a group by Jean Cocteau in 1917. The members were Georges Auric, Louis Durey, Arthur Honegger, Darius MILHAUD, Francis POULENC and Germaine Tailleferre.

Six Day War Episode of the Arab-Israeli Wars. Israeli forces rapidly defeated the four Arab states (Egypt, Jordan, Syria and Iraq). Israel gained control of the old city of Jerusalem, Jordanian territory on the West Bank (of the River Jordan), the Golan Heights and the Sinai Peninsula, including the Gaza Strip.

skate Flattened food fish belonging to the RAY family, living mainly in shallow temperate and tropical waters. The pectoral fins are greatly expanded to form wing-like flaps. Length: to about 2.5m (8ft). Family Rajidae.

skating See ICE SKATING; ROLLER SKATING

skeletal muscle In human beings and other mammals, the most plentiful of the three types of MUSCLE comprising the bulk of the body. It is also known as **voluntary muscle** because it is under conscious control, or as striated muscle

because of its characteristic striped appearance under the microscope. See also INVOLUNTARY MUSCLE

skeleton Bony framework of the body of a VERTEBRATE. It supports and protects the internal organs, provides sites of attachment for muscles and a system of levers to aid locomotion. *See also* EXOSKELETON

Skelton, John (1460–1529) English poet. Skelton was tutor to the young Henry VIII, and took holy orders in 1498. He wrote satires on the court, the clergy and Cardinal Wolsey. His work includes *Speak*, *Parrot*, *Colin Clout*, *Why Came Ye Not to Court?* and the long secular morality play *Magnyficence* (c.1516). *Philip Sparrow* (c.1505), an elegy for a court pet bird, is his most widely known poem.

skiing Method of "skating" on snow using flat runners (skis) made of various materials, attached to ski-boots; the skier may also use hand-held poles to assist balance. The principal forms of competitive skiing are Alpine skiing, ski jumping, cross-country skiing and freestyle skiing. Freestyle skiing was added to the Winter Olympic schedule in 1994; the other disciplines have been Olympic sports since 1924.

skin Tough, elastic outer covering of invertebrates. In mammals, it is the largest organ of the body and serves many functions. It protects the body from injury and from the entry of some microorganisms and prevents dehydration. Nerve endings in the skin provide the sensations of touch, warmth, cold and pain. It helps to regulate body temperature through sweating, regulates moisture loss, and keeps itself smooth and pliable with an oily secretion from the SEBACEOUS GLANDS. Structurally the skin consists of two main layers: an outer layer (EPIDERMIS) and an inner layer (DERMIS). The top layer of epidermis is made of closely packed dead cells constantly shed as microscopic scales. Below this is a layer of living cells that contain pigment and nerve fibres, and that divide to replace outer layers. The dermis contains dense networks of connective tissue, blood vessels, nerves, glands and hair follicles.

skink Common name for any of more than 600 species of LIZARDS of tropical and temperate regions. They have cylindrical bodies, cone-shaped heads and tapering tails. They live in various habitats and eat vegetation, insects and small invertebrates. Length: to 66cm (26in). Family Scincidae.

Skinner, Burrhus Fredric (1904–90) US psychologist. Skinner developed the concept of operant conditioning (the control of behaviour by its consequences or reinforcements). His many books include *Science and Human Behaviour* (1953), *Beyond Freedom and Dignity* (1971) and a controversial novel about social engineering *Walden II* (1948).

skittles Indoor bowling game, once popular in the UK but since the 1960s largely superseded by ten-pin BOWLING. Skittles is usually played by two teams with a hard flattened ball that is rolled down an "alley" to strike the nine skittles (or pins). **Skopje** Capital of Macedonia, on the River Vardar. Founded in Roman times, it became the capital of the Serbian empire in the 14th century, fell to the Ottoman Turks in 1392, and was incorporated into Yugoslavia in 1918. Most of the city was destroyed in the 1963 earthquake. Industries: metals, textiles, chemicals, glassware. Pop. (1994) 440,577.

skull (cranium) In vertebrates, brain case that supports and protects the brain, eyes, ears, nose and mouth.

skunk Nocturnal, omnivorous mammal that lives in the USA, Central and South America. It has powerful anal scent glands, which eject a foul-smelling liquid, used in defence. It has a small head and a slender, thickly furred body with short legs and a large bushy tail. The coat is black with bold white warning markings along the back. The most common species is the striped skunk, *Mephitis mephitis*. Length: to 38cm (15in); weight: 4.5kg (10lb). Family Mustelidae.

skydiving Sport in which parachutists jump from 3,500m (12,000ft) and free-fall to c.650m (2,000ft) before opening their parachutes. Competition skydiving has events based on accuracy, in which the parachutist aims for a target area, and events based on style, in which a series of manoeuvres are performed by one or more parachutists.

Skye Largest island in the Inner Hebrides, off the Nw coast of Scotland, with the chief town of Portree. Its spectacular scenery makes it a popular holiday attraction. A bridge to the

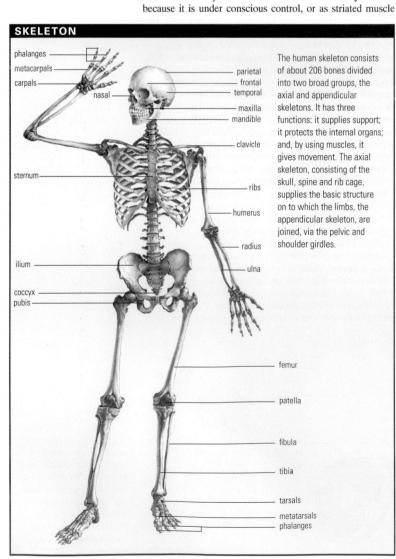

mainland was opened in 1996. Occupations include rearing livestock, weaving and fishing. Area: 1,735sq km (670sq mi). Pop. (1991) 8,139.

skyscraper Very tall building. True skyscraper construction, in which the metal skeleton supports both floors and walls, was introduced (1885) by William Le Baron Jenney. The world's tallest skyscrapers are the twin Petronas Towers in Kuala Lumpur, Malaysia, which rise to 452m (1,483ft).

slander In law, oral defamation of a person's character made in the presence of one or more witnesses. *See also* LIBEL

slang Non-standard, colloquial form of idiom or vocabulary that is highly informal and often full of obscure or colourful imagery. Slang may be restricted to certain social, ethnic, occupational, hobby, special-interest or age groups.

slate Grey to blue, fine-grained, homogeneous METAMORPHIC ROCK, which splits into smooth, thin layers. It is formed by the metamorphosis of SHALE, and is valuable as a roofing material. Slav Largest ethnic and linguistic group of peoples in Europe. Slavs are generally classified in three main divisions: the East Slavs (the largest division) include the Ukrainians, Russians and Belorussians; the South Slavs include the Serbs, Croats, Macedonians and Slovenes (and frequently also the Bulgarians); the West Slavs comprise chiefly the Poles, Czechs, Slovaks and Wends.

slavery Social system in which people are the property of their owner, and are compelled to work without pay. Slavery of some kind was common to practically all ancient societies and to most modern societies until the 19th century. Common in ancient Egyptian, Roman and Greek societies, an extreme form of slavery also existed in the Americas from the 16th century, where the need for cheap labour in European colonies was not satisfied by enslaving Native Americans or by acquiring poor Europeans as servants. This situation gave rise to the highly organized and profitable Atlantic slave trade. Ships sailed from ports such as Liverpool with guns and other goods, which were exchanged for slaves in states on West African coasts. The slaves were sold in markets in the Caribbean, Brazil and North America, mainly to work on farms and plantations. On the return journey, the ships carried colonial produce from the Americas to Europe. An estimated 15 million Africans were sold into slavery. Millions more died on the voyage across the Atlantic. By the late 18th and early 19th century slavery had been abolished throughout much of Europe; it was declared illegal in Britain in 1807 and outlawed in 1833. Most South American states abolished it soon after gaining independence. In the USA, slavery was one cause of the CIVIL WAR and was formally ended when the aims of the EMANCIPATION PROCLAMATION (1863) were incorporated in the 13th amendment to the US Constitution (1865). Isolated cases of slavery were discovered in China and some areas of Africa in the 1990s, and it is likely that some form of slavery will be discovered periodically.

Slavic languages (Slavonic languages) Group of languages spoken in E Europe and the former Soviet Union, constituting a major subdivision of the family of INDO-EUROPEAN LANGUAGES. The main ones in use today are Russian, Ukrainian and Belorussian (East Slavic); Polish, Czech, Slovak and Sorbian or Lusatian, a language spoken in E Germany (West Slavic); and Bulgarian, Serbo-Croat, Slovenian and Macedonian (South Slavic). Some Slavic languages are written in the Cyrillic alphabet, others in the Roman.

sleep Periodic state of unconsciousness from which a person or animal can be roused. During an ordinary night's sleep there are intervals of deep sleep associated with rapid eye movement (REM) sleep. It is during this REM sleep that dreaming occurs. Studies have shown that people deprived of sleep become grossly disturbed. Sleep requirement falls sharply in old age. Difficulty in sleeping is called INSOMNIA.

sleeping sickness (trypanosomiasis) Disease of tropical Africa caused by a parasite transmitted by the TSETSE FLY. It is characterized by fever, headache, joint pains and anaemia. Ultimately it may affect the brain and spinal cord, leading to profound lethargy and sometimes death.

sleepy sickness Popular term for a rare viral disease of the brain, ENCEPHALITIS lethargica, characterized by

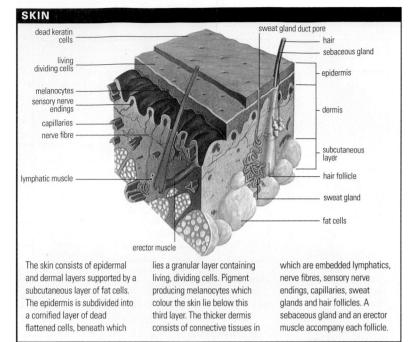

headache and drowsiness progressing to coma. It occurs in epidemic and sporadic forms and, most notoriously, was the cause of an epidemic that followed World War 1, leaving many helpless survivors.

slime mould Any of a small group of strange, basically single-celled organisms that are intermediate between the plant and animal kingdoms. During their complex life cycle they pass through several stages. These include a flagellated swimming stage, an amoeba-like stage, a stage consisting of a slimy mass of protoplasm with many nuclei, and a flowering sporangium stage.

slipped disc (prolapsed intervertebral disc) Protrusion of the soft inner core of an intervertebral disc through its covering, causing pressure on the spinal nerve roots. It is caused by a sudden mechanical force on the spine. It causes stiffness and SCIATICA. There are various treatments available.

sloe See blackthorn

sloth Any of several species of slow-moving, herbivorous Central and South American mammals. It has long limbs with long claws and spends most of its life climbing in trees, where it generally hangs upside down. Length: to 60cm (2ft); weight: to 5.5kg (12lb). Family Brachipodidae.

Slovak Official language of the Slovak Republic, spoken by about 5 million people. It is closely related to Czech, and is considered distinct largely for political reasons.

▲ sloth Like only a few other herbivores, sloths survive on a particularly poor diet of tough leaves by means of a lifestyle that involves very little expenditure of energy. They sleep a lot and move extremely slowly. In fact, they have only half the musculature of most mammals, and their food may take a whole week to pass through the digestive system. There are two species of two-toed sloth (*Choleopus*). The one shown here has two toes on its front legs and three on its back legs.

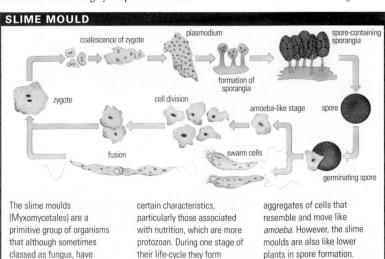

SLOVENIA

AREA: 20,251sq km (7,817sq mi)
POPULATION: 1,996,000
CAPITAL (POPULATION):
Ljubljana (268,000)
GOVERNMENT: Multiparty republic

Slovak Republic Republic in central Europe. *See* country feature

RELIGIONS: Christianity

(mainly Roman Catholic)

currency: Tolar = 100 stotin

ETHNIC GROUPS: Slovene 88%,

LANGUAGES: Slovene

Croat 3%, Serb 2%, Bosnian 1%

Slovenia Mountainous republic in SE Europe; the capital is LJUBLJANA. Slovenia was one of the six republics that made up the former YUGOSLAVIA. Much of the land is mountainous, rising to 2,863m (9,393ft) at Mount Triglav in the Julian Alps in the NW. Central and E Slovenia contain hills and plains drained by the Drava and Sava rivers, while central Slovenia contains the Karst region, an area of limestone landscapes. Here, surface water flows downwards through swallow holes into deep caves, including the Postojna caves near Ljubljana, which are the largest in Europe. Climate The short coast has a mild Mediterranean climate, but inland the climate is more continental. The mountains are snowcapped in winter and E Slovenia has cold winters and hot summers. Rain occurs in every month in Ljubljana and late summer is the rainiest season. Vegetation Farmland covers c.35% of the land and forests about 50%. Mountain pines grow on higher slopes, with beech, oak and hornbeam at lower levels. The Karst region is largely bare of vegetation because of the lack of surface water. History The ancestors of the Slovenes, the w branch of a group of the South SLAVS, settled in the area c.1,400 years ago. From the 13th century until 1918, Slovenia was ruled by the Austrian HABSBURGS. In 1918 Slovenia became part of the Kingdom of the Serbs, Croats and Slovenes, which was renamed Yugoslavia in 1929. During World War 2, Slovenia was invaded and partitioned between Italy, Germany and Hungary, but after the war, Slovenia again became part of Yugoslavia. From the late 1960s, some Slovenes demanded independence, but the central government opposed the break-up of the country. When communism collapsed throughout E Europe in 1990, elections were held and a non-communist coalition government was established. Slovenia's declaration of independence led to fighting between Slovenes and the Yugoslav federal army. Slovenia did not, however, become a battlefield like other parts of the former Yugoslavia. The European Community (EC) recognized Slovenia's independence in 1992. Elections in 1993 and 1996 resulted in coalition governments, led by the Liberal Democrats. In 1996 Slovenia applied to join the European Union (EU). Economy Despite problems of economic transition and war in other parts of former Yugoslavia, Slovenia is an upper-middle-income developing country. Manufacturing is the leading activity. Major manufactures include chemicals, machinery, transport equipment, metal goods, and textiles. Agriculture employs 8% of the workforce; fruits, maize, potatoes and wheat are major crops, and many farmers raise cattle, pigs and sheep.

slow-worm (blind-worm) European snake-like, legless

lizard of grassy areas and woodlands. It is generally brownish; the female has a black underside. It has pointed teeth and feeds primarily on slugs and snails. Length: to 30cm (12in). Family Anguidae; species *Anguis fragilis*.

slug Mostly terrestrial gastropod MOLLUSC, identified by the lack of shell and uncoiled viscera. It secretes a protective slime, which is also used to aid locomotion. Length: to 20cm (8in). Class Gastropoda; subclass Pulmonata; genera *Arion*, *Limax. See also* SEA SLUG

small intestine Part of the DIGESTIVE SYSTEM that, in humans, extends – about 6m (20ft) coiled and looped – from the STOMACH to the large INTESTINE, or colon. Its function is the digestion and absorption of food. See also DUODENUM; ILEUM **smallpox** Formerly a highly contagious viral disease characterized by fever, vomiting and skin eruptions. It remained endemic in many countries until the World Health Organization (WHO) campaign, launched in the late 1960s; global eradication was achieved by the early 1980s.

smell (olfaction) Sense that responds to airborne molecules. The olfactory receptors in the nose can detect even a few molecules per million parts of air.

smelt Small, silvery food fish related to SALMON and TROUT. It lives in the N Atlantic and Pacific oceans and in North American inland waters. Family Osmeridae.

smelting Heat treatment for separating metals from their ORES. The ore, often with other ingredients, is heated in a furnace to remove non-metallic constituents. The metal produced is later purified.

Smetana, Bedřich (1824–84) Czech composer. Smetana's masterpiece, *The Bartered Bride* (1866), is one of the greatest folk operas. Among other popular works is the cycle of symphonic poems *Má Vlast* (My Country, 1874–79), which includes the *Vltava* (Moldau).

Smirke, Robert (1781–1867) English neo-classical architect, one of the chief promoters of the Greek revival in British architecture. Smirke's most famous building is the British Museum, begun in 1823, with its impressive Ionic façade. He also designed the Covent Garden Theatre (1808–09).

Smith, Adam (1723–90) Scottish philosopher, regarded as the founder of modern economics. Smith's book *The Wealth of Nations* (1776) was enormously influential in the development of Western CAPITALISM. It outlined the theory of the division of labour. In place of MERCANTILISM, Smith proposed the doctrine of laissez–faire: that governments should not interfere in economic affairs and that free trade increases wealth.

Smith, Bessie (1895–1937) US singer, known as the "Empress of the BLUES". In 1923 Smith made her recording debut and sold more than two million records. Her powerful voice and poignant phrasing accompanied early jazz greats, such as Louis Armstrong. Her popularity plummeted during the Depression. She died after being refused treatment at a whites-only hospital following a serious car accident.

Smith, lan Douglas (1919-) Rhodesian statesman, prime minister (1964-78). Smith entered parliament in 1948. He founded (1961) the Rhodesia Front Party, and sought independence from Britain. In 1965 Smith's white minority regime issued a unilateral declaration of independence (UDI). Persistent international sanctions and guerrilla warfare forced his government to accept free elections (1980). Smith was defeated by Robert Mugabe's Zimbabwe African National Union (ZANU). Smith continued to lead white opposition to Mugabe. Smith, John (1580-1631) English soldier and colonist. Smith took the leading role in establishing the first English colony in North America, at JAMESTOWN (1607). Exploring Chesapeake Bay, he was captured by Powhatan and possibly saved from death by Powhatan's daughter, POCAHONTAS. By obtaining maize from the local people Smith saved the colony from starvation in 1608. He returned to England in 1609, later writing his Description of New England (1616).

Smith, John (1938–94) British politician, b. Scotland. Smith entered parliament in 1970 as a Labour MP. He served in James Callaghan's government, and acted as shadow chancellor (1987–92). Smith was elected leader of the Labour Party in 1992. His sudden death saw a mass public outpouring of tributes. He was succeeded by Tony Blair.

Smith, Joseph (1805–44) US religious leader and founder of the Mormon Church of Jesus Christ of the Latter Day Saints (1830). His *Book of Mormon* (1830) was based on sacred writings he claimed were given to him on golden plates by a heavenly messenger named Moroni. In 1830 Smith and his followers set out to found the New Zion. In 1844 Smith was jailed on a charge of treason at Carthage, Illinois, where he was murdered by a mob.

Smith, Stevie (1902–71) British poet, b. Florence Margaret Smith. Smith first came to public notice with *Novel on Yellow Paper* (1936). Her witty and often pathetic poetry was collected in 1975 and includes the title poem of her 1957 volume *Not Waving But Drowning*.

Smithsonian Institution US independent trust, based in Washington, D.C. Created in 1846, the Institution funds research, publishes the results of explorations and investigations, and preserves for reference over 65 million items of scientific, cultural and historical interest.

smog Dense atmospheric mixture of smoke and fog or chemical fumes, commonly occurring in urban or industrial areas. It is most dense during temperature inversions.

Smolensk City on the upper reaches of the River Dnieper,

near the Belarus border, E Russia; capital of Smolensk oblast. First mentioned in 882 BC, it was an important medieval commercial centre on the routes from Byzantium to the Baltic, and from Moscow to Warsaw. The capital of Belorussia in the 12th century, it was sacked (1238–1240) by the Mongols. In the 15th and 16th centuries it was a battleground for Polish and Russian forces. In 1812 Napoleon I seized the city and burned it in retreat from the Russian army. Occupied (1941–43) by German forces, it was the scene of some of the fiercest fighting in World War 2. It remains an important transport and distribution centre. Industries: linen, textile machines, timber, electrical goods, flour milling, distilling, brewing. Pop. (1994) 353,000.

Smollett, Tobias George (1721–71) Scottish novelist and surgeon. Smollett's debut novel, *The Adventures of Roderick Random* (1748), drew on his naval experience. *The Adventures of Peregrine Pickle* (1751) was in the same bawdy, PICARESQUE vein. His masterpiece is *The Expedition of Humphrey Clinker* (1771), a comic, epistolary novel. Smollett also translated Voltaire and Cervantes and edited several periodicals.

smooth muscle See involuntary muscle

smut Group of plant diseases caused by parasitic fungi, also called smuts, that attack many cereals. The diseases are

SLOVAK REPUBLIC

This flag, using the typical red, white and blue Slavonic colours, dates back to 1848. The Slovak Republic adopted it in September 1992, prior to independence on 1 January 1994. The three blue mounds in the shield represent three mountain ranges.

The Slovak Republic (Slovakia) in central Europe is dominated by the CARPATHIAN MOUNTAINS. The Tatra range on the N border include the republic's highest peak, Gerlachovka, at 2,655m (8,711ft). To the s is a fertile lowland, drained by the River Danube, on whose banks stands the capital, Bratislava.

CLIMATE

The Slovak Republic has a continental climate, with cold, dry winters and warm, wet summers. Bratislava has average temperatures ranging from -3°C (27°F) in January to 20°C (68°F) in July, and an average annual rainfall of 600mm (24in). The highlands are much colder and wetter.

VEGETATION

Forests cover 41% of the Slovak republic. Evergreen trees predominate in the mountains. Beech, birch, linden and oak are more characteristic of lowland areas. Arable land accounts for another 31% of land use.

HISTORY

Slavic peoples settled in the region in the 5th and 6th centuries AD. In the 9th century the area formed part of the empire of MORAVIA. In the 10th century it was conquered by the MAGYARS, and for nearly 900 years the region was dominated by Hungary. At the end of the 11th century, it was subsumed into the kingdom of Hungary. In the 16th century, the Ottoman empire conquered much of Hungary, and Slovakia was divided between the Turks and the Austrians. From 1541-1784 Bratislava served as the Habsburg capital. The joint rule of MARIA THERESA and Joseph II pursued a policy of Magyarization, which increased nationalist sentiment. The AUSTRO-HUNGARIAN EMPIRE was formed in 1867, and continued the suppression of native culture. Many Slovaks fled to the USA. During World War 1, Slovak patriots fought on the side of the Allies. After the defeat of Austro-Hungary (1918), Slovakia was incorporated into Czechoslovakia as an autonomous region (for 1918-93 history, see CZECHOSLOVAKIA)

The Czechs dominated the union, and many Slovaks became dissatisfied. Following the MUNICH AGREEMENT (1938), part of Slovakia became an independent state, while much of s Slovenia (including Kosice) was ceded to Hungary. In March 1939 Slovakia gained nominal independence as a German protectorate. In August 1939 Hitler invaded Czechoslovakia, and Slovakia became a Nazi puppet state. In 1944 Soviet troops liberated Slovakia, and in 1945 it returned to Czechoslovakia. The Prague Spring (1968) saw the introduction of a federal structure, which survived the Soviet invasion. The

AREA: 49,035sq km (18,932sq mi)

POPULATION: 5,297,000
CAPITAL (POPULATION): Bratislava (440,421)

GOVERNMENT: Multiparty republic

ETHNIC GROUPS: Slovak, Hungarian, with small groups of Czechs, Germans, Gypsies, Poles,

Russians and Ukrainians LANGUAGES: Slovak (official)

RELIGIONS: Christianity (Roman Catholic 60%,

Protestant 6%, Orthodox 3%) currency: Slovak koruna

dramatic collapse of Czech communism in 1989, spurred calls for independence. Elections in 1992 were won by the Movement for a Democratic Slovakia, led by Vladimir Mečiar. The federation was dissolved on 1 January 1993, and the Slovak Republic became a sovereign state, with Mečiar as prime minister.

POLITICS

Mečiar was re-elected in 1994 elections. The Slovak Republic has maintained close relations with the Czech Republic. In 1996 the Slovak Republic and Hungary ratified a treaty enshrining their respective borders and stipulating basic rights for the 560,000 Hungarians in the Slovak Republic. The greatest challenge facing the new political regime is the inherited inefficient and centrally planned economy.

ECONOMY

Pre-1948, the economy was primarily agrarian. Communism developed heavy industry. Post-independence, governments have attempted to diversify industrial ownership and production. The transition was painful: industrial output fell; unemployment and inflation rose. In 1995 the privatization programme was suspended. Manufacturing employs 33% of the workforce. Bratislava and Kosīce are the chief industrial cities. Major products include ceramics, machinery and steel. Farming employs 12% of the workforce. Crops include barley and grapes for wine-making. Tourism, drawn by winter sports, is growing. The economy is slowly improving.

named after the sooty black masses of reproductive spores produced by the fungi. See also PARASITE

Smuts, Jan Christiaan (1870–1950) South African statesman, prime minister (1919–24, 1939–48). Smuts was a guerrilla commander during the SOUTH AFRICAN WARS (1899–1902), but afterwards worked with Louis BOTHA to establish the Union of South Africa (1910). During World War 1, he suppressed a pro-German revolt, commanded British forces in East Africa, and became a member of the British war cabinet. Upon Botha's death, Smuts succeeded as prime minister. He formed a second administration after James HERTZOG opposed entry into World War 2. After the war, Smuts was defeated by the APARTHEID policies of the Nationalist Party.

Smyrna See Izmir

snail Terrestrial, marine or freshwater gastropod mollusc. It has a large fleshy foot, antennae on its head, and a coiled protective shell encasing an asymmetric visceral mass. It may breathe through gills (aquatic species) or through a kind of air-breathing lung (terrestrial species), and has a radula – a rasping organ in its mouth. Some species, such as the Roman snail (*Helix pomatia*), are edible. Length: to 35cm (14in). Class Gastropoda.

snake Any of some 2,700 species of legless, elongated REP-TILES forming the suborder Serpentes of the order Squamata (which also includes LIZARDS). There are 11 families. They range in length from c.10cm (4in) to more than 9m (30ft). There are terrestrial, arboreal (tree-dwelling), semi-aquatic and aquatic species; one group is entirely marine; many are poisonous. They have no external ear openings, eardrums or middle ears; sound vibrations are detected through the ground. Their eyelids are immovable and their eyes are covered by a transparent protective cover. The long, forked, protractile tongue is used to detect odours. Their bodies are covered with scales. Poisonous snakes have hollow or grooved fangs, through which they inject venom into their prey. See individual species snakebite Result of an injection of potentially lethal snake venom into the bloodstream. There are three types of venomous SNAKE: the Viperidae, subdivided into true vipers and pit vipers, whose venom causes internal haemorrhage; the Elapidae (including cobras, mambas, kraits), whose venom paralyzes the nervous system; and the Hydrophidae, Pacific sea snakes with venom that disables the muscles. Treatment is with anti-venoms.

snapdragon Any of several species of PERENNIAL plants of the genus *Antirrhinum*, with sac-like, two-lipped, purple, red, yellow or white flowers. The common snapdragon (*A. majus*) is a popular garden plant. Height: 15–91cm (0.5–3ft). Family Scrophulariaceae.

snapper Marine food fish found in tropical waters of the Indo-Pacific and Atlantic oceans. Length: to 90cm (3ft); weight: 50kg (110lb). The 250 species include the red snapper (*Lutianus campechanus*), yellowtail (*Ocyurus chrysurus*) and Atlantic grey (*L. griseus*). Family Lutjanidae.

snipe Any of several species of migratory, long-billed, wading shorebirds found in swampy grasslands and coastal areas throughout the world. It is generally mottled brown and buff. Length: 30cm (12in). Family Scolopacidae; genus *Gallinago*. **snooker** Game usually for two players, played on a billiards table, using 15 red balls, 6 coloured balls – yellow, green, brown, blue, pink, black – and 1 white cue ball. Each player in turn attempts to knock a red ball into a pocket; if successful, the player may then try to pot a coloured ball; if successful again, the player may go on to another red, and another colour. The turn ends when no ball is potted or when a penalty is incurred. Colours potted are returned to their original positions on the table until all the reds have been potted; the

colours are then potted in ascending order of values and remain off the table.

Snow, C.P. (Charles Percy), Baron (1905–80) British novelist, scientist and civil servant. He is especially remembered for his lecture *The Two Cultures and the Scientific Revolution* (1959), which diagnosed a radical divide between scientists and literary intellectuals, and for his 11-volume novel sequence, known collectively as *Strangers and Brothers* (1940–70), which includes *The Corridors of Power* (1963).

snow Flakes of frozen water that fall from clouds to the Earth's surface. Snowflakes are symmetric (usually hexagonal) crystalline structures.

Snowdon Mountain in Gwynedd, NW Wales. Much of the area is included in the Snowdonia National Park, established in 1951. Snowdon has five peaks, one of which, at 1,085m (3,560ft), is the highest in England and Wales.

snowdrop Low-growing perennial plant of the Mediterranean region, widely cultivated as a garden ornamental. The drooping, green and white, fragrant flowers appear early in spring. The common snowdrop (*Galanthus nivalis*) has narrow leaves; height: to 15cm (6in). Family Amaryllidaceae.

Soane, Sir John (1753–1837) British architect. One of the most original of all British architects, Soane developed his own personal style of CLASSICISM. He designed the Bank of England (1795–1827).

soap Cleansing agent made of salts of fatty acids, used to remove dirt and grease. Common soaps are produced by heating fats and oils with an alkali, such as sodium hydroxide or potassium hydroxide. Soap consists of long-chain molecules; one end of the chain attaches to grease while the other end dissolves in the water, causing the grease to loosen and form a floating scum. *See also* DETERGENT

Sobers, Sir Gary (Garfield St Aubrun) (1936—) Barbadian cricketer, perhaps the game's greatest all-rounder. Sobers played 93 test matches for West Indies (39 as captain), scoring 8,032 runs and taking 235 wickets. He played county cricket for Nottinghamshire and, against Glamorgan (1968), became the first player to score six sixes in an over in first-class cricket. Soccer See FOOTBALL, ASSOCIATION

Social and Liberal Democrats (SLDP) Official name of the LIBERAL DEMOCRATS

social contract Concept that society is based on the surrender of natural freedoms by the individual to the organized group or state in exchange for personal security. The concept can be traced back to the ancient Greeks and was developed by Thomas Hobbes, John Locke, and by Jean Jacques ROUSSEAU in *The Social Contract* (1762).

social democracy Political ideology concerning the introduction of socialist ideals without an immediate overhaul of the prevailing political system. Before 1914, MARXIST parties of central and eastern Europe termed themselves social democrats. Contemporary social democracy, however, has been invoked by those wishing to distinguish their socialist beliefs from the dogmas of Marxist parties. See also Christian Democrats; Social Democratic Party (SDP); Social Democratic Labour Party (SDLP); Socialism

Social Democratic Labour Party (SDLP) Political party in Northern Ireland that leans towards SOCIALISM. It favours eventual unification of the province with the Republic of Ireland. Founded in 1970, its leader (1983–) was civil rights activist John HUME. The party seeks to use non-violent, constitutional methods to attain its goals.

Social Democratic Party (SDP) Political party in England (1981–90), centrist in political outlook. At the general elections of 1983 and 1987, the party joined forces with the Liberal Party to create the Liberal-SDP Alliance. By the second election, however, the two parties were already in the process of merging to form the LIBERAL DEMOCRATS.

social history Branch of HISTORY that focuses on the ordinary lifestyle of people in communities of all types and sizes at specific times and places. *See also* ETHNOLOGY

socialism System of social and economic organization in which the means of production are owned not by private individuals but by the community, in order that all may share more fairly in the wealth produced. Modern socialism dates

▶ snail Remarkably adept at exploring new habitats, snails originated in the sea, but gradually the c.22,000 species adapted to life on dry land, losing their gills and evolving airbreathing lungs. Most species of land snail, such as Helix pomatia, shown here, live on the ground and are dull in coloration. A few species are arboreal: these tend to be brightly coloured. Others have returned to aquatic environments and must surface periodically to breathe.

from the late 18th–early 19th centuries. With the REVOLUTIONS OF 1848, socialism became a significant political doctrine in Europe. Karl MARX, whose *Communist Manifesto* was published in that year, believed that socialism was to be achieved only through the class struggle. Thereafter, a division appeared between the revolutionary socialism of Marx and his followers, later called COMMUNISM or Marxism-Leninism, and more moderate doctrines that held that socialism could be achieved through education and the democratic process. In Russia, the revolutionary tradition culminated in the RUSSIAN REVOLUTION of 1917. From the moderate wing, social democratic parties, such as the British LABOUR PARTY, emerged. They were largely instrumental in mitigating the effects of the market economy in w Europe through political measures and for securing social justice and welfare.

Socialist Party US political party. It was formed in 1901 by the unification of the Social Democratic Party and the Socialist Labor Party. Dedicated to the state ownership of all public utilities and important industries, its best-known leaders were Eugene V. Debs and Norman Thomas.

socialist realism State policy on the arts, promoted by the Soviet Union from the 1930s–80s. It asserted that all the arts should appeal to ordinary workers and should be inspiring and optimistic in spirit. Art that did not fulfil these precepts was effectively banned, and most serious writers, artists and composers were forced underground or into exile.

social psychology Field that studies individuals interacting with others in groups and with society. Topics include attitudes and how they change, prejudice, rumours, aggression, altruism, group behaviour, conformity, and social conflict. There is some overlap with SOCIOLOGY.

social security Public provision of economic aid to help alleviate poverty and deprivation. In 1883 Germany became the first country to adopt social security legislation, in the form of health insurance. By the end of the 1920s, public social security provisions had been adopted throughout Europe. In 1909 the UK adopted an old-age pension scheme, and in 1911 LLOYD GEORGE drafted the National Insurance Act to provide health and unemployment insurance. In 1946 the National Insurance Act and the National Health Service Act were passed. In 1948 the National Assistance complemented these, and the Welfare State and the National Health Service (NHS) were born. In the USA, as part of the NEW DEAL, the Social Security Act (1935) was adopted. It provided unemployment compensation, old-age pensions and federal grants for state welfare programs, but covered only those in commercial and industrial occupations. This was expanded in 1939. In 1965 Congress enacted the Medicare programme, which provided medical benefits for persons over 65 and the Medicaid programme for the poor. Such programmes have proved costly, and many governments are seeking to encourage private provision and/or welfare reform.

Social Security, UK Department of UK government department responsible for the payment of universal benefits (such as child benefit), the means-testing of other benefits, and collection of NATIONAL INSURANCE contributions. It also administers the social fund and the legal aid scheme. *See also* SOCIAL SECURITY

social work Community assistance and/or care. Social workers monitor the well-being of families known to have problems and sometimes have the power to remove children from parents deemed to be dangerously violent or abusive. They may be asked to assist the police in dealing with juvenile suspects. They also help various handicapped, homeless or unemployed people.

Society Islands South Pacific archipelago, part of FRENCH POLYNESIA; the capital is PAPEETE on TAHITI. The archipelago is divided into two groups of mountainous, volcanic and coral islands. Only eight are inhabited. The larger Windward group includes the islands of Tahiti, Moorea, Maio, and the smaller Mehetia and Tetiaroa. The Leeward group includes Raiatéa (the largest and site of the chief town, Uturoa), Tahaa, Huahine, Bora-Bora and Maupiti. Tourism is the most important industry, with 148,000 people visiting the islands in 1993. The economy is primarily agricultural, and the major

crop is copra, with coconut trees dominating the coastal plains. The islands were first sighted by Europeans in 1607. The French claimed the islands in 1768. In 1769 the islands were visited by James Cooκ, who named them after the Royal Society. In 1843 they were made a French protectorate and in 1880 became a French colony. In 1946 they became a French overseas territory. The principal language is Tahitian. Area: 1,446sq km (558sq mi). Pop. (1992) 165,000.

Society of Jesus See JESUITS

sociobiology Study of how genes can influence social behaviour. A basic tenet of biology is that physical characteristics, such as structure and physiology, evolve through natural selection of those traits that are most likely to guarantee an organism's survival. Sociobiologists hold the controversial view that this selection process also applies to social behaviour.

sociology Scientific study of society, its institutions and processes. It examines areas such as social change and mobility, and underlying cultural and economic factors. Auguste Comte invented the term "sociology" in 1843, and since the 19th century numerous complex and sophisticated theories have been expounded by Herbert Spencer, Karl MARX, Emile DURKHEIM, Max WEBER and others.

Socotra Island territory in the Indian Ocean, s of the Arabian Peninsula, with the capital at Tamridah. Strategically placed at the entrance to the Red Sea, it was taken as a protectorate by the British in 1866. In 1967 it chose to join South Yemen and is now administered by Yemen. The mountainous terrain includes peaks rising to *c*.1,520m (5,000ft). The economy is based on stock-rearing, but exports include tobacco, ghee, dates, myrrh, frankincense, aloes and pearls. Area: 3,100sq km (1,200sq mi). Pop. (1992) 12,000.

Socrates (469-399 BC) Greek philosopher, who laid the foundation for an ethical philosophy based on the analysis of human character and motives. None of Socrates writings survive. Information about his life and philosophy is found in the dialogues of his pupil, PLATO, and the Memorabilia of XENOPHON. The son of a sculptor, he fought in the PELOPON-NESIAN WARS. In 429 BC, according to Plato's Apology, the ORACLE at DELPHI pronounced Socrates the wisest man in Greece. Socrates' methodology was based on the DIALECTIC. Unlike the SOPHISTS, he believed that moral excellence is attained through self-knowledge. For Socrates, knowledge and virtue were synonymous; immorality was founded on ignorance. Socrates' criticism of tyranny attracted powerful enemies and he was charged with impiety and corrupting the young. Condemned to death, he drank the poisonous draft of hemlock required by law.

soda Any of several sodium compounds, especially sodium carbonate (Na₂CO₃), usually manufactured from common salt (sodium chloride, NaCl) and ammonia by the Solvay process. The anhydrous (lacking water) form is known as soda ash; washing soda is hydrated sodium carbonate (Na₂CO₃.10H₂O) **sodium** (symbol Na) Common silvery-white metallic element, one of the ALKALI METALS, first isolated in 1807 by Sir Humphry DAVY. It occurs in the sea as salt (sodium chloride) and in many minerals. Its chief source is sodium chloride, from which it is extracted by electrolysis. The soft reactive metal is used in petrol additives and as a heat-transfer medium in nuclear reactors. Properties: at.no. 11; r.a.m. 22.9898; r.d. 0.97; m.p. 97.81°C (208.05°F); b.p. 882°C (1,620°F).

sodium bicarbonate (sodium hydrogen carbonate, NaHCO₃, popularly known as bicarbonate of soda) White, crystalline salt that decomposes in acid or on heating to release carbon dioxide gas. It has a slightly alkaline reaction and is an ingredient of indigestion medicines.

sodium carbonate See SODA

sodium chloride Common salt (NaCl). It is the major mineral component of seawater, making up 80% of its dissolved material. Sodium chloride is also the major ELECTROLYTE of living cells, and the loss of too much salt, through evaporation from the skin or through illness, is dangerous. It is used as a seasoning, to cure and preserve foods, and in the chemical industry.

Sodom and Gomorrah In the Old Testament, cities locat-

▲ snake Many snakes feed on small nocturnal mammals, and must find their prey in the semidarkness. They do so with the aid of heat-sensitive organs located in pits on the upper jaw (1). The heat sensors feed the information to the same part of the brain as the eyes. In this way snakes can see a thermal image of the animal superimposed on its visual image.

▲ Sobers West Indian cricketer Sir Gary Sobers was perhaps cricket's greatest all-rounder. A talented left-handed batsmen and fine fast-medium and spin bowler, Sobers is the only player to score more than 8,000 test runs and take more than 200 test wickets. He held the record for the highest test innings (365 not out) from 1958 to 1994. Sobers was knighted in 1975.

ed s of the DEAD SEA, notorious for their carnality and vice. God could not find even ten good men within Sodom, and so destroyed both it and Gomorrah with fire and brimstone. LOT and his family were allowed to escape the disaster, but Lot's wife lagged behind, was turned to a pillar of salt, and died.

Sofia (Sofija) Capital of Bulgaria and Sofia province, in w central Bulgaria, at the foot of the Vitosha Mountains. Known for its hot mineral springs, Sofia was founded by the Romans in the 2nd century AD. It was ruled by the Byzantine Empire (as Triaditsa) from 1018 to 1185. Sofia passed to the second Bulgarian empire (1186–1382), and then to the Ottoman empire (1382–1878). Sofia was captured by Russia in 1877 and chosen as the capital of Bulgaria by the Congress of Berlin. Industries: steel, machinery, textiles, rubber, chemicals, metallurgy, leather goods, food processing. Pop. (1990) 1,141,142.

softball Game similar to BASEBALL in which a lighter bat, a larger and softer ball, and a smaller field are used. It is played by two teams of nine or ten people. The rules are close to those of baseball except for the pitching delivery (underhand) and the number of innings (seven instead of nine). Softball was originally invented as an indoor game in Chicago in 1888. The sport is governed by the Amateur Softball Association (founded 1934). The International Softball Federation coordinates competition in more than 20 nations.

software Computer Program and any associated data file. The term software is used to distinguish these coded instructions and data from computer HARDWARE, or equipment. *See also* CD-ROM; MAGNETIC DISK

soil Surface layer of the Earth, capable of supporting plant life. It consists of undissolved minerals produced by the weathering and breakdown of surface rocks, organic matter, water and gases. Many different types of soil exist and are characterized by a series of distinct horizons (layers).

solar cell Device that converts sunlight directly to electricity. It normally consists of a *p*-type (positive) silicon crystal coated with an *n*-type (negative) one. Light radiation causes electrons to be released and creates a POTENTIAL DIFFERENCE so that current can flow between electrodes connected to the two crystals. The cells are about 10% efficient. Solar cells are often used to power small electronic devices, such as pocket calculators. Several thousand cells may be used in panels to provide power of a few hundred watts.

solar constant Steady rate at which energy from the Sun is received from just outside the Earth's atmosphere. Its value is *c.*1.353 kilowatts per square metre (perpendicular to the Sun's rays)

solar energy Heat and light from the Sun consisting of ELECTROMAGNETIC RADIATION, including heat (infrared rays), light and radio waves. About 35% of the energy reaching the Earth is absorbed; most is spent evaporating moisture into clouds, and some is converted into organic chemical energy by PHOTOSYNTHESIS in plants. All forms of energy (except

NUCLEAR ENERGY) come ultimately from the Sun. SOLAR CELLS are used to power instruments on spacecraft, and experiments are being conducted to store solar energy in liquids from which electricity can be generated.

solar flare Sudden and violent release of matter and energy from the Sun's surface, usually from the region of an active group of SUNSPOTS. Flares emit radiation right across the electromagnetic spectrum. Particles are emitted, mostly electrons and protons and smaller numbers of neutrons and atomic nuclei. A flare can cause material to be ejected in bulk in the form of prominences. When energetic particles from flares reach the Earth, they may cause radio interference, magnetic storms and more intense aurorae.

Solar System Sun and all the celestial bodies that revolve around it: the nine PLANETS, together with their SATELLITES and ring systems, the thousands of ASTEROIDS and COMETS, meteoroids, and other interplanetary material. The boundaries of the Solar System lie beyond the orbit of Pluto to include the Kuiper Belt and the Oort Cloud of comets. The Solar System came into being nearly 5,000 million years ago, probably as the end-product of a contracting cloud of interstellar gas and dust.

solar wind Particles accelerated by high temperatures of the solar CORONA to velocities great enough to allow them to escape from the Sun's gravity. The solar wind deflects the tail of the Earth's magnetosphere and the tails of comets away from the Sun.

sole Marine flatfish found in the Atlantic Ocean from NW Africa to Norway, especially *Solea solea*. A food fish, which is farmed in some countries, it is green-grey or black-brown with dark spots. Length: to 60cm (24in). Family Soleidae.

Solemn League and Covenant (September 1643) Agreement between the Long Parliament and the Scots during the English Civil War. In return for Parliament's promise to reorganize the established church on a Presbyterian basis, the Scots agreed to raise an army in the North of England against Charles I. The Scottish help led directly to the Parliamentary victory over the Royalists at Marston Moor. solid State of matter in which a substance has a relatively fixed shape and size. The forces between atoms or molecules are strong enough to hold them in definite locations (about which they can vibrate) and to resist compression. See also CRYSTAL; GAS; LIQUID

Solidarity Polish organization that provided the chief opposition to the communist regime during the 1980s. The National Committee of Solidarity, led by Lech WALESA, was founded in 1980 among dockworkers in GDANSK. Solidarity organized strikes and demanded economic reform, but soon acquired a political, revolutionary character. Banned from 1981, it reemerged as a national party, winning the free elections of 1989 and forming the core of a new democratic government.

solid-state physics Physics of SOLID materials. From the study of the structure, binding forces, electrical, magnetic and thermal properties of solids has come the development of the SEMICONDUCTOR, MASER, LASER and SOLAR CELL.

Solomon (d. 922 BC) King of Israel (c.972–922 BC), son of DAVID and Bathsheba. His kingdom prospered thanks partly to economic relations with the Egyptians and Phoenicians, enabling Solomon to build the Jerusalem TEMPLE. His reputation for wisdom reflected his interest in literature, although the works attributed to him, including the Song of Solomon, were probably written by others.

Solomon Islands Melanesian archipelago and nation in the sw Pacific Ocean, SE of New Guinea; the capital is Honiara (on Guadalcanal). Solomon Islands include several hundred islands scattered over 1,400km (900mi) of the Pacific Ocean. The principal islands are volcanic, mountainous and densely covered by equatorial rainforest. The N Solomons have a tropical oceanic climate, but further s there is a longer cool season. The largest island is Guadalcanal, and other inhabited islands include Choiseul, Malaita, New Georgia, San Cristobal (Makira), Santa Isabel (Ysabel) and the Shortland islands. The coastal plains support c.90% of the population and are used for subsistence farming. The vast majority of the population are indigenous Melanesians. The main languages are Melane-

A solar (photovoltaic) cell (A) is made up of two silicon semiconductors between metal contacts protected by a grid. One of the silicon semiconductors tends to collect positive charge (1), the other negative (2), creating a potential difference. As light photons (3) hit the p-n semiconductor junction between the semiconductors (4) they displace electrons which are attracted to the positive semiconductor. The metal contacts (5) connect the two charged areas, exploiting the potential difference and creating a current

sian dialects, but English is the official tongue. The first European discovery of the islands was by the Spanish in 1568. The islands resisted colonization until the late 19th century. In 1893 the s islands became a British protectorate, while the N was controlled by the Germans from 1895. In 1900 Germany ceded its territory to Britain. During World War 1, Bougainville and Buka (now in Papua New Guinea) were occupied by Australian troops and were mandated to Australia in 1920. In 1942 the s islands were occupied by Japanese troops. After heavy fighting, particularly on Guadalcanal, the islands were liberated by US troops in 1944. In 1976 the Solomons became self-governing and, in 1978, achieved full independence within the Commonwealth. Coconuts (providing copra and palm oil) are the major products, but tuna is the biggest export earner and lumber the main industry. Area: c.27,900sq km (10,800sq mi). Pop. (1993) 349,500.

solstice Either of the two days each year when the Sun is at its greatest angular distance from the celestial equator, leading to the longest day and shortest night (summer solstice) in one hemisphere of the Earth, and the shortest day and longest night (winter solstice) in the other hemisphere. In the Northern Hemisphere the summer solstice occurs on about 21 June and the winter solstice on about 22 December.

Solti, Sir Georg (1912–97) (Gyuri Stern) British conductor, b. Hungary. Solti was music director of Covent Garden Opera (now ROYAL OPERA), London (1961–71); Orchestre de Paris (1971–75); and the Chicago Symphony Orchestra (1969–91). In the 1930s he acted as assistant to Arturo Toscanini, before being forced by the Nazis to flee to Switzerland. An outstanding operatic music director, Solti was the first conductor to record (1965) Wagner's entire *Ring* cycle. He was knighted in 1971. A brilliant orchestral trainer, Solti's prolific output places him as one of the world's most versatile conductors.

solubility Mass (grams) of a SOLUTE that will saturate 100 grams of SOLVENT under given conditions to give a SATURATED SOLUTION. Solubility generally rises with temperature, but for a few solutes, such as calcium sulphate, increasing temperature decreases solubility in water.

solute Gaseous, liquid or solid substance that is dissolved in a SOLVENT to form a SOLUTION. Many solids dissolve in water. Liquids can dissolve in liquids, and some gases, such as hydrogen chloride (HCl), are soluble in water.

solution Liquid (the SOLVENT) into which another substance (the SOLUTE) is dissolved, or a liquid consisting of two or more chemically distinct compounds, inseparable by filtering. The amount of a solute dissolved in a solvent is called the concentration. *See also* MIXTURE; SATURATED SOLUTION

solvent Liquid that dissolves a substance (the SOLUTE) without changing its composition. Water is the most universal solvent, and many inorganic compounds dissolve in it. Ethanol, ether, acetone and carbon tetrachloride are common solvents for organic substances. *See also* SOLUTION

Solzhenitsyn, Alexander (1918–) Russian novelist. Sentenced to a forced labour camp in 1945 for criticizing Stalin, he was subsequently exiled to Ryazan but was officially rehabilitated in 1956. His novels include *One Day in the Life of Ivan Denisovich* (1962), *The First Circle* (1968), *Cancer Ward* (1968) and *August 1914* (1971). He was awarded the 1970 Nobel Prize for literature. Criticism of the Soviet regime in *The Gulag Archipelago* (1974) led to his forced exile to the West. Solzhenitsyn returned to Russia in 1994.

Somalia Republic in E Africa. *See* country feature, p.624 **Somerset** County on the Bristol Channel, sw England. Somerset is divided into five districts, with the administrative centre at Taunton (1991 pop. 93,969). Other major towns include Yeovil and Bridgewater. The region is generally lowlying in the centre, and is drained chiefly by the rivers Avon, Exe, and Parrett. Much of the land is given over to agriculture. Dairy farming and fruit growing are the most important economic activities and the region is noted for Cheddar cheese and cider. Limestone is mined. Area: 3,452sq km (1,332sq mi). Pop. (1991) 460,368.

Somme, Battle of the Major World War 1 engagement along the River Somme, N France. It was launched by the British commander Douglas Haig on July 1, 1916. On the

first day the British suffered over 60,000 casualties in a futile attempt to break through the German lines. A desperate trench war of attrition continued until the offensive was abandoned on 19 November 1916. Total casualties were over one million, and the British had advanced only 16km (10mi). A second battle around St Quentin (March—April 1918) is sometimes referred to as the Second Battle of the Somme. A German offensive, designed to secure a victory before the arrival of US troops, was halted by Anglo-French forces.

Somoza García, Anastasio (1896–1956) Central figure in Nicaraguan politics from 1936, when he ousted President Sacasa. Somoza created both a dictatorial government and a political dynasty; he was succeeded in office by his two sons, Luis and Anastasio. The Somoza regime was overthrown in the SANDINISTA revolution (1979).

sonar Underwater detection and navigation system. The letters stand for sound navigation and ranging. The system emits high-frequency sound that is reflected by underwater objects and detected on its return.

sonata Musical composition, usually instrumental, in several movements. In the BAROQUE era, sonatas were usually written for two melodic parts, a bass part and a continuo. Arcangelo Corelli wrote many trio sonatas, usually for two violins and basso continuo. In the CLASSICAL period, the sonata became a more clearly defined form for one or two instruments. The movements, usually three or four in number, are in closely related keys. The second movement of a sonata is generally slow in tempo and the third and perhaps fourth movements faster (allegro or presto). Sonata form is a widely used structure for a piece of music. See MUSICAL FORM Sondheim, Stephen (1930-) US composer and lyricist. Sondheim made his mark on Broadway in 1957 with the lyrics for West Side Story. His first success as a lyricist-composer was A Funny Thing Happened on the Way to the Forum (1962). Sondheim's reputation was enhanced by works such as A Little Night Music (1972), Sunday in the Park with George (1984) and Assassin (1991).

Songhai West African empire, founded *c*.AD 700. In 1468 Sonni Ali captured the market city of TIMBUKTU and the Songhai empire acquired control of most of the trade in w Africa. Sonni was succeeded by Askia Muhammad I, who further increased their stranglehold on trade routes. The empire began to disintegrate because of factional in-fighting. The Songhai peoples still control much of the trans-Saharan trade.

sonic boom Sudden noise produced by shock waves from an aircraft flying faster than sound. The shock waves are formed by the build-up of sound waves at the front and back of the aircraft. These waves spread out and sweep across the ground behind the aircraft, often causing a double bang.

sonnet Poem of 14 lines, most often in iambic pentameter and usually employing Petrarchan or Shakespearean rhyme schemes. The **Petrarchan** consists of an octet and a sextet, usually with an *abbaabbacdecde* rhyme scheme. The **Shakespearean**, having a final rhyming couplet, is *ababcdcdefefgg*. **Sons of Liberty** American colonial group. This secret organization began, principally in Connecticut and New York, to protest against the Stamp Act (1765). It was dedicated to working for freedom and liberty in the 13 British colonies.

Sontag, Susan (1933–) US writer, critic and essayist. Sontag is perhaps best-known for her cultural criticism, such as *Against Interpretation* (1966). She has also written novels and short stories, including *The Benefactor* (1963) and *Death Kit* (1967). The influence of Roland BARTHES and STRUCTURALISM are particularly evident in her *Illness as Metaphor* (1978) and *Aids and its Metaphors* (1986).

Sophia (1630–1714) Electress of Hanover, granddaughter of James I and the widow of the elector of Hanover. Sophia was recognized as heir to the English throne by the Act of Settlement (1701), to ensure a Protestant succession and prevent the return of the Catholic Stuarts. When she died, her son, the current elector, became king as GEORGE I.

sophists Professional Greek teachers of the 5th–4th centuries BC. Although not a formal school, they emphasized the intellectual and rhetorical skills needed to succeed in ancient Greek society, and regarded law and ethics as convenient human

▲ Solzhenitsyn Russian writer Alexander Solzhenitsyn served with distinction in the Red Army in World War 2, but his criticism of strict censorship in Russia led to all except his first novel being banned. His works are mostly semi-autobiographical and expose corruption in Russian society while supporting socialism.

inventions with no basis in natural law. Serious philosophers, such as Socrates and Plato, disapproved of them.

Sophocles (496-406 BC) Greek playwright. Of his 100 plays, only seven TRAGEDIES and part of a Satyr play remain. These include Ajax, Antigone (c.442-441 BC), Electra (409 BC), Oedipus Rex (c.429 BC) and Oedipus at Colonus (produced posthumously). Sophocles introduced a third speaking actor and increased the members of the chorus from 12 to 15. soprano Highest singing range of the human voice. The normal range may be given as two octaves upwards from middle C, although exceptional voices may reach notes considerably higher. Sopranos have always been important in opera, with various types of soprano (dramatic, lyric or coloratura) taking different types of roles.

Sorbonne College of the University of Paris, founded in 1253 by Robert de Sorbon (1201-74) and located in what is now the Latin Quarter of Paris. Established for the education of students of theology, it was for centuries an intellectual centre of Roman Catholic religious thought, but towards the end of the 19th century it became purely secular.

sorghum Tropical cereal grass native to Africa and cultivated worldwide. Types raised for grain are varieties of Sorghum vulgare that have leaves coated with white waxy blooms and flower heads that bear up to 3,000 seeds. It yields meal, oil, starch and dextrose (a sugar). Height: 0.5-2.5m (2-8ft). Family Poaceae/Gramineae.

sorrel (dock) Herbaceous perennial plant native to temperate regions. It has large leaves that can be cooked as a vegetable and small green or brown flowers. Height: to 2m (6ft). Family Polygonaceae; genus Rumex, especially Rumex acetosa.

Sosnowiec See KATOWICE

Sotho Major cultural and linguistic group of s Africa. It includes the Northern Sotho of TRANSVAAL, South Africa, the Western Sotho (better known as the Tswana) of Botswana, and the Southern Sotho (Basotho or Basuto) of LESOTHO. Although dominating the rural territories they inhabit, the four million or so Sotho share those areas with people of other Bantu-speaking tribes. Many work and live in the urban areas and surrounding townships.

Soto, Hernando de See De Soto, Hernando

soul Non-material or non-tangible part of a person that is the central location of his/her personality, intellect, emotions and will; the human spirit. Most religions teach that the soul lives on after the death of the body.

AREA: 637,660sq km (246,201sq mi)

ETHNIC GROUPS: Somali 98%, Arab 1%

currency: Somali shilling = 100 cents

CAPITAL (POPULATION): Mogadishu (1,200,000)

GOVERNMENT: Single-party republic, military

LANGUAGES: Somali and Arabic (both official).

Ethiopia fought for control of the Ogaden Desert,

POPULATION: 9,204,000

dominated

English, Italian RELIGIONS: Islam 99%

SOMALIA

This flag was adopted in 1960, when Italian Somaliland in the south united with British Somaliland in the north to form Somalia. The colours are based on the United Nations flag and the points of the star represent the five regions of East Africa where Somalis live.

s and N highlands. Drought is a persistent problem. Temperatures on the plateaux and plains regularly reach 32°C (90°F). VEGETATION

a plateau, nearly 1,000m (3,300ft) high. In the N is a highland region. The s contains the only

CLIMATE Rainfall is light; the wettest regions are in the far

rivers, the Juba and the Scebeli.

Somalia occupies part of the E Horn of Africa. A narrow, mostly barren, coastal

plain borders the Indian Ocean and the Gulf of

Aden. The capital, MOGADISHU, is also Soma-

lia's major port. In the interior, the land rises to

Much of Somalia is dry grassland or semidesert. There are areas of wooded grassland, with trees such as acacia and baobab. Plants are most abundant in the the lower Juba valley.

HISTORY AND POLITICS

In the 7th century, Arab traders established coastal settlements and introduced Islam. Mogadishu was founded c.900 as a trading centre. The interest of European imperial powers increased after the opening of the Suez Canal (1869). In 1887 Britain established a protectorate in what is now N Somalia. In 1889 Italy formed a protectorate in the central region, and extended its power to the s by 1905. In 1896 France established a colony in modern-day DJIBOUTI. In 1936 Italian Somaliland was united with the Somali regions of Ethiopia to form Italian East Africa. During World War 2, Italy invaded (1940) British Somaliland. In 1941 British forces reconquered the region, and captured Italian Somaliland. In 1950 Italian Somaliland returned to Italy as a UN trust territory. In 1960 both Somalilands gained independence and joined to form the United Republic of Somalia. The new republic was faced with pan-Somali irredentists, calling for the creation of a "Greater Somalia" to include the Somali-majority areas in Ethiopia, Kenya and Djibouti. In 1969 the army, led by Siad Barre, seized power and formed a socialist, Islamic republic. During the 1970s, Somalia and

inhabited mainly by Somali nomads. Ethiopia forced Somalia to withdraw (1978), but resistance continued forcing one million refugees to flee to Somalia. In 1991 Barre was overthrown and the United Somali Congress (USC), led by Ali Mahdi Muhammad, seized power. Somalia disintegrated into civil war between rival clans. The Ethiopia-backed Somali National Movement (SNM) gained control of NW Somalia, and seceded as the Somaliland Republic (1991). Mogadishu was devastated by an attack from the Somali National Alliance (SNA), led by General Muhammad Aideed. War and drought resulted in a devastating famine, which claimed thousands of lives. The UN was slow to provide relief, and when aid arrived was unable to secure distribution. US marines led a task force to secure food distribution, but became embroiled in conflict with Somali warlords, destroying the headquar-

ECONOMY

ters of General Aideed. After the deaths of UN troops, US marines withdrew in 1994. Civil

strife continued, and in 1996 Aideed was killed.

The lack of a central government contributed to

the deaths of thousands of Somalis in flooding

(1997). The Cairo Declaration (December 1997)

held out hope of an end to factional feuding and

the installation of a transitional government.

Somalia is a low-income developing country, shattered by drought and civil war (1992 GDP, US\$1,1000). Many Somalis are nomadic herdspeople. Live animals, hides and skins are the major exports. Bananas are grown in the s.

624

soul music Form of popular music. The term designates black music that developed in the 1960s from rhythm and blues. Soul is also used generically to describe music that possesses a certain "soulful" quality. Its influence has extended into many popular musical styles. *See also* MOTOWN

sound Physiological sensation perceived by the brain via the EAR, caused by an oscillating source, and transmitted through a material medium as a sound wave. The velocity at which a sound wave travels through a medium depends on the ELASTICITY of the medium and its density. If the medium is a gas, the sound wave is longitudinal and its velocity depends on the gas temperature. The speed of sound in dry air at STANDARD TEMPERATURE AND PRESSURE (STP) is 331mps (750mph) and depends on the height above sea level. Pure sounds are characterized by PITCH, TIMBRE and intensity (the rate of flow of sound energy).

sound barrier Name for the cause of an aircraft's difficulties in accelerating to a speed faster than that of sound. When approaching the speed of sound, an aircraft experiences a sudden increase in drag and loss of lift. These are caused by the build-up of sound waves to form shock waves at the front and back of the aircraft. The problems were solved by designing aircraft with smaller surface area, swept-back wings and more powerful engines. *See also* SONIC BOOM

sound recording Conversion of sound waves into a form that can be stored and reproduced. Thomas EDISON's phonograph (1877) recorded sound vibrations as indentations made by a stylus on a revolving cylinder wrapped in tinfoil. Emile Berliner's gramophone improved the process by using a zinc disc instead of a cylinder. The volume was amplified by the addition of acoustical horns, which were replaced before World War 1 by valve amplifiers. Moulded thermoplastic records were introduced in 1901. In 1927 and 1928 patents were issued in the USA and Germany for MAGNETIC RECORDING processes. Later innovations include high-fidelity (hi-fi), stereophonic and quadrophonic reproduction. Modern recordings on COMPACT DISC (CD) usually employ laser-scanned digital signals.

Sousa, John Philip (1854–1932) US composer and bandmaster. He composed about 100 marches, including *Semper Fidelis* (1888) and *The Stars and Stripes Forever* (1896). He also composed numerous operettas, of which the most famous is *El Capitan* (1896).

sousaphone Largest BRASS musical instrument of the TUBA family. It was introduced by John Sousa to fortify the bass section of US military bands.

South Africa Republic in s Africa. See country feature, p.626 South African Wars Two wars between the Afrikaners (Boers) and the British in South Africa. The first (1880–81) arose from the British annexation of the Transvaal in 1877. Under Paul KRUGER, the Transvaal regained autonomy, but further disputes, arising largely from the discovery of gold and diamonds, provoked the second, greater conflict (1899–1902), known to Afrikaners as the Second War of Freedom and to the British as the Boer War. It was also a civil war between whites; black Africans played little part on either side. In 1900 the British gained the upper hand, defeating the Boer armies and capturing Bloemfontein and Pretoria. Boer commandos fought a determined guerrilla campaign but were forced to accept British rule in the peace treaty signed at Vereeniging (1902).

South America Fourth-largest continent, the southern of the two continents of America, in the Western Hemisphere, connected to North America by the isthmus of PANAMA. Land South America is surrounded by the Caribbean Sea (N), the Atlantic Ocean (E), and the Pacific Ocean (W). Politically, it is divided into 12 independent nations: BRAZIL and ARGENTINA (the two largest), BOLIVIA, CHILE, COLOMBIA, ECUADOR, GUYANA, PARAGUAY, PERU, SURINAM, URUGUAY and VENEZUELA, plus the French overseas département of French Guiana. It is c.7,650km (4,750mi) long (Punta Gallinas, Colombia to Cape Horn, Chile), and at its widest (near the Equator) c.5,300km (3,000mi). Structure and geology South America's w edge towers above the rest of the continent, which slopes downwards towards the Atlantic Ocean, except for the Guiana and Brazilian Highlands which form the continental shield. The ANDES, which stretch from Colombia to Chile, con-

tain the highest peaks of the Americas, and ACONCAGUA (Argentina) is the tallest mountain outside Asia. PATAGONIA, a semi-arid plateau composed of rocky terraces, lies to the E of the Andes. The middle of the continent is marked by a series of lowlands, including the GRAN CHACO. The ATACAMA DESERT, a coastal strip in N Chile, is the driest place on Earth. Major islands include the FALKLAND ISLANDS (a British crown colony) and the GALÁPAGOS (a territory of Ecuador). Lakes and rivers Excluding Lake MARACAIBO (13,512sq km/5,217sq mi) as an extension of the Gulf of Venezuela, the largest lake in South America is Lake TITICACA, on the Peru-Bolivia border, covering 8,290sq km (3,200sq mi). Lengthy rivers combine to form three major systems that reach the Atlantic. The AMAZON is the world's second-longest river (after the Nile). With its many substantial tributaries, it drains the biggest of the world's river basins. Flowing s is the Paraguay-PARANÁ system, and NE is the ORINOCO. Climate and vegetation Except in the mountains and the s, the climate remains generally warm and humid. Much of the N supports tropical RAINFOREST, while lowlands in the extreme N and the central region have a cover of tropical grass. The Pampas, s of the Tropic of Capricorn, are temperate grasslands, but vegetation is scarce to the far SE of the mountains. Pine and other temperate forests grow along the sw coast. People Some Incas (Quechuas) still remain in the Andes, as do some Mapucho (Araucanians) in Chile. But the majority of the population is mestizo (of dual Indian and European descent), except in Argentina, s Brazil, Chile and Uruguay, whose population is primarily European. Since the early 19th century many Europeans (especially Italians) and Asians (particularly Japanese) have migrated to Argentina and Brazil. Sizable black populations exist in Brazil, Colombia, French Guiana and Venezuela, descendants of slaves brought from Africa to work in the sugar cane, coffee, rubber and cotton plantations. The majority of South Americans live in urban areas close to the coast. São PAULO is the world's fastest-growing city. Latin American Spanish and Portuguese are the dominant languages and Roman Catholicism is the major religion. Economy Subsistence farming is important, with c.30% of the workforce working 15% of the land, most of which is owned by Europeans. Chief exports include cash crops, such as coffee, bananas, sugar cane and tobacco. The drugs industry is also important: Peru and Colombia are major cultivators of coca leaves, and Colombia supplies over 50% of the world's illegal trade in cocaine. Industrial development and mineral exploitation has been dominated by Europe and the USA. Since 1945 South American countries have sought greater economic independence, yet reliance on banking finance has often led to a burden of debt. Another drawback has been the scarcity of continental coal reserves and the over-dependence on petroleum, especially from Venezuela's Maracaibo region. The Guiana and Brazilian highlands have large deposits of iron ore and the Andes range has many copper reserves. Bolivia has large tin mines, and Brazil has reserves of manganese. However, despite the industrialization of some countries, particularly Brazil, Venezuela and Argentina, most countries remain industrially underdeveloped. In the 1970s and 1980s, the rush for economic growth and industrialization was often at the expense of the continent's rainforests. Worldwide treaties in the 1990s have attempted to slow down the deforestation, but with little success. Also, industrialization has exacerbated South America's high inflation and huge debt crises. Recent history The early 1900s saw a number of conflicts within and between countries of the region. Notable among these were the territorial Chaco Wars (1928-30, 1932-35) between Bolivia and Paraguay. South American republics failed to become world powers until the end of World War 2, helped by the formation of the United Nations in 1945 and the Organization of American States (OAS) in 1948. Many countries have swung between military dictatorships and democratic governments, mainly caused by wildly fluctuating economic fortunes, which in turn have brought about extremes of wealth and poverty, leading to unrest and instability. The periodic repressive regimes have been often the focus for international condemnation of human rights abuses. In the 1980s and 1990s, international pressure,

▲ sorghum The most widely cultivated grain in Africa, sorghum is also commonly grown in Asia and the USA. It is more tolerant of a hot climate than corn and many other grains and is extremely resistant to drought. High in carbohydrates, it is usually eaten after being ground into a paste and made into bread, cakes or porridges. It is also used extensively in the manufacture of beer.

South Africa's flag was first flown in 1994 when the country adopted a new, non-racial constitution. It incorporates the red, white and blue of former colonial powers, Britain and the Netherlands, together with the green, black and gold of black organizations.

South Africa is the southernmost country in Africa. A narrow coastal margin includes: the Indian Ocean port of DURBAN; the dry S tablelands, Little and Great Karoo; CAPE TOWN, on the CAPE OF GOOD HOPE; and part of the NAMIB DESERT. The interior forms part of the African plateau. The plateau rises in the E to an escarpment more than 2,000m (6,000ft) high, on the fringe of which lies BLOEMFONTEIN. Sowero, Johannesburg and Pretoria, all lie on the N of the escarpment. The highest peaks are in the Drakensberg range, on the E border of Lesotho. In the N, lies part of the KALAHARI Desert. In the NE, are the WITWATERSRAND goldfields. KIMBERLEY has the largest diamond mines. The KRUGER NATIONAL PARK lies on the border with Mozambique. The longest river is the ORANGE.

CLIMATE

Most of South Africa is subtropical. The sw has a Mediterranean climate. Much of the plateau is arid, and the Namib Desert is almost rainless.

VEGETATION

Grassland covers much of the high interior, with tropical savanna in lower areas. Forest and woodland cover only 3% of the land, and fynbos (scrub vegetation) is found in the Cape region.

HISTORY

The indigenous people of South Africa are the SAN. The first European settlement was not until 1652, when the Dutch EAST INDIA COMPANY founded a colony at Table Bay. Dutch AFRIKAN-ERS (Boers) established farms, employing slaves. From the late 18th century, conflict with the XHOSA intensified, as the Boers trekked inland. In the early 19th century, Britain gained control of the Cape. Following Britain's abolition of slavery in 1833, the Boers began the GREAT TREK. They met with fierce resistance, particularly from the ZULU kingdom. The Boer republics of TRANSVAAL and Orange FREE STATE were established in 1852 and 1854. The discovery of diamonds and gold in the 1870s and 1880s increased the pace of colonization, and Britain sought to gain control of Boer- and Zulu-held areas. The British defeated the Zulu in the Zulu WAR (1879), and Zululand was annexed to Natal (1897). In 1890 Cecil RHODES became governor of Cape Colony, Britain defeated the Boers in the SOUTH AFRICAN WARS (1880-81, 1899-1902). The Union of South Africa was formed in 1910, with Louis BOTHA as prime minister. In 1912 the AFRICAN NATIONAL CONGRESS (ANC) was founded. During World War 1, South Africa captured NAMIBIA (1915), and after the war it was mandated to the Union. In 1919 Jan SMUTS succeeded Botha as prime minister. In 1931 Smuts'

AREA: 1,219,916sq km (470,566sq mi) POPULATION: 39.790.000

CAPITAL (POPULATION): Cape Town (legislative, 2,350,157); Pretoria (administrative, 1,080,187);

Bloemfontein (judicial, 300,150) GOVERNMENT: Multiparty republic ETHNIC GROUPS: Black 76%, White 13%,

LANGUAGES: Afrikaans, English, Ndebele, North Sotho, South Sotho, Swazi, Tsonga, Tswana, Venda, Xhosa, Zulu (all official) RELIGIONS: Christianity 68%, Hinduism 1%,

Islam 1%

currency: Rand = 100 cents

Coloured 9%, Asian 2%

successor and Nationalist Party founder (1914), James HERTZOG, realized Afrikaner ambitions as South Africa achieved full independence within the Commonwealth of Nations. Smuts regained power in 1939 and South Africa joined the Allies in World War 2. The Nationalist Party won the 1948 election, advocating a policy of APARTHEID. Apartheid placed economic, social and political restrictions on non-whites. The ANC began a campaign of passive resistance, but after the Sharpeville massacre (1960), Nelson MANDELA formed a military wing. In 1961, faced by international condemnation, Prime Minister Hendrik VERWOERD established South Africa as a republic. In 1964 Mandela was jailed. Verwoerd was assassinated in 1966, and was succeeded by B.J. VORSTER. Vorster used South African forces to prevent black majority rule in South Africa's neighbouring states. The crushing of the Soweto uprising (1976) sparked a new wave of opposition. In 1978 P.W. BOTHA was elected prime minister. During the 1970s, four bantustans (homelands) gained nominal independence. External economic sanctions forced Botha to adopt a new constitution (1984), which gave Indian and Coloured minorities limited political representation; black Africans were still excluded. From 1985 to 1990 South Africa was in a state of emergency: Archbishop Desmond Tutu pressed for further sanctions. In 1989 President F.W. DE KLERK began the process of dismantling apartheid. In 1990 Mandela was released and resumed leadership of the ANC. Clashes continued between the ANC and Chief BUTHELEZI's Zulu Inkatha movement. In 1994 the ANC won South Africa's first multi-racial elections, and Mandela became president. The homelands were reintegrated and South Africa was divided into nine provinces. In 1995 a Truth and Reconciliation Commission, headed by Tutu, was set up to investigate political crimes committed under apartheid. In 1997 Thabo Mbeki replaced Mandela as president of the ANC.

ECONOMY

Mining forms the base of Africa's most industrialized economy. South Africa is the world's leading producer of gold and fifth-largest producer of diamonds. Chromite, coal, copper, iron ore, manganese, platinum, silver and uranium are also mined. Sanctions, falling gold price, and civil and industrial strife created prolonged recession. Unemployment stood at 45% (1995). Major manufactures include chemicals, iron and steel. Agriculture employs over 33% of the workforce. Major products include fruits, grapes for wine-growing, maize, meat and sugar cane.

particularly from the USA, has been brought to bear on those governments, notably Bolivia and Colombia, who are either unwilling or unable to control the production and export of vast quantities of cocaine. Total area: c.17,793,000sq km (6.868,000sq mi); Highest mountain Aconcagua 6.960m (22,834ft) Longest river Amazon 6,450km (4,010mi) Population 299,000.000 Largest cities São Paulo 16,567,317; Buenos Aires 11,652,050; Rio de Janeiro 5,336,179.

Southampton Port and county district in Hampshire, s England. At the head of Southampton Water and a port since Roman times, Southampton is Britain's principal passenger port and a major commercial port, now heavily containerized. Industries: shipbuilding, engineering, oil refining. Pop. (1994) 214,000.

South Australia State on the Great Australian Bight, s central Australia. The capital is ADELAIDE, home to 60% of the state's population. Other major cities include Salisbury and Elizabeth. The area is hilly in the E (Flinders Ranges) and the N (Musgrave Ranges), and in the w are parts of the Great Victoria Desert and the Nullarbor Plain. The Murray, in the SE, is

the only important river and farming is mainly confined to this area. Barley, oats, wheat, rye and grapes (notably in the Barossa Valley) are the chief crops, and livestock are grazed in the N. Important mineral deposits include iron ore, uranium, silver, lead, salt, gypsum, opals, coal and natural gas. Industries: heavy metal mining; transport equipment. Whyalla has the largest shipyards in Australia. The s coast of Australia was visited by the Dutch in 1627, the first English colonists arrived in 1836, and the region was federated as a state in 1901. Area: 984,380sq km (379,760sq mi). Pop. (1994) 1,471,000.

South Carolina State on the Atlantic Ocean, SE USA: the capital and largest city is COLUMBIA. The main port is CHARLESTON. The land rises from the coastal plain to the rolling hills of the Piedmont plateau to the BLUE RIDGE MOUN-TAINS in the NW. The region is drained by many rivers, including the SAVANNAH, which forms most of the Georgia border. Major crops include tobacco, soya beans, maize, sweet potatoes and groundnuts. Timber and fishing are still sources of employment, but tourism is now the state's second biggest source of income after textiles and clothing. The English were

NORTH MEXICO ATLANTIC OCEAN COLOMBI ECUADOR B R MATO GROSSO PACIFIC OCEAN d FALKLAND IS ■ LIMA Capital Cities

■ South America In the N of South America is the Amazonian rainforest, the world's largest area of tropical rainforest. Its rapid deforestation is a major cause of environmental concern. The Atacama Desert, in N Chile, is the driest place on Earth. The imposing Andes ranges run parallel to the w. Pacific coast. In the far s of the continent lies Cape Horn, a cold, isolated region notorious for its violent storms. Spanish and Portuguese colonization of South America began in the 16th century. Native cultures, such as the Inca, were conquered or converted to Roman Catholicism. In the early 19th century much of the continent gained independence. The descendants of European settlers, however, continued to dominate South American politics and economics. The inequitable distribution of land and power has been a major cause of political instability.

SOUTH CAROLINA Statehood:

23 May 1788

Nickname:

The Palmetto State

State hird .

Carolina wren

State flower:

Carolina jessamine

State tree : Palmetto

State motto:

Prepared in mind and resources

SOUTH DAKOTA

Statehood:

2 November 1889 Nickname :

The Sunshine State

State bird :

Ring-necked pheasant State flower:

American pasqueflower

State tree :

Black Hills spruce

State motto :

Under God the people rule

the first permanently to settle the area from 1663. South Carolina became a royal province in 1729 and a plantation society evolved based on rice, indigo and cotton. One of the original 13 US states (1789), it was the first to secede from the Union and the first shots of the Civil War were fired at FORT SUMTER. The state was devastated in 1865 by Union troops. Area: 80,432sq km (31,055sq mi). Pop. (1992) 3,602,854.

South China Sea Part of the Pacific Ocean, surrounded by se China, Indochina, the Malay Peninsula, Borneo, the Philippines and Taiwan; connected to the East China Sea by the Formosa Strait. The world's largest "sea", its chief arms are the Gulf of Tonkin and Gulf of Thailand. The Si, Red, Mekong, and Chao Phraya rivers flow into it. Area 2,300,000sq km (848,000sq mi). Average depth: 1,140m (3,740ft).

South Dakota State in N central USA, on the GREAT PLAINS. The capital is PIERRE; the largest cities are Sioux Falls and Rapid City. The land rises gradually from the E to the Black Hills (featuring Mount Rushmore) in the w and the Badlands in the sw, with the Missouri River bisecting the state. One-fifth of the area w of the river is semi-arid plain, inhabited mainly by Native Americans, and the rest is divided into large cattle and sheep ranches. East of the Missouri, livestock rearing is important and wheat, maize, oats, soya beans and flax are also grown. Meat-packing and food processing are by far the most important industries. South Dakota is the largest producer of gold in the USA, but tin, beryllium, stone, sand and gravel are also mined. French trappers claimed the region for France in the 1740, and the USA acquired part of the land in the Louisiana Purchase (1803). Trading and military posts were the only settlements until the 1850s. Dakota Territory was formed in 1861. The discovery (1874) of gold in the Black Hills led to an increase in population, and the territory was divided into the states of North and South Dakota, both of which joined the Union in 1889. Area: 199,551sq km (77,047sq mi). Pop. (1992) 708,411.

Southeast Asia Region bounded by India, China and the Pacific Ocean, and comprising Burma, Thailand, Malaysia, Cambodia, Laos, Vietnam, Philippines, Singapore and Indonesia. Area: c.4,500,000sq km (1,750,000sq mi).

Southeast Asia Treaty Organization (SEATO) Regional defence agreement signed by Australia, New Zealand, France, Pakistan, the Philippines, Thailand, Britain and the USA in Manila in 1954. It was formed in response to communist expansion in Southeast Asia. With administrative headquarters in Bangkok, SEATO had no standing forces. Some members were unwilling to support the USA in the VIETNAM WAR and SEATO was abandoned in 1977. The non-military aspects of the treaty were replaced by the Association of Southeast Asian Nations (ASEAN).

Southey, Robert (1774–1843) British poet and prose writer, poet laureate (1813–43). His long epic poems include *Thalaba the Destroyer* (1801), *Madoc* (1805), *The Curse of Kehama* (1810) and *Roderick the Last of the Goths* (1814).

South Georgia Island in the s Atlantic Ocean, c.1,750km (1,100mi) E of Tierra del Fuego. Mountainous and barren, it rises to 2,934m (9,626ft). A British dependency administered from the FALKLANDS, the island has a research station and garrison but no permanent population.

South Glamorgan County on the Bristol Channel, s Wales; the capital is CARDIFF. South Glamorgan is divided into two districts, Cardiff and the Vale of Glamorgan. The Vale of Glamorgan is fertile agricultural land, and the major economic activity is dairy farming. Cardiff is an industrial district. Industries: engineering, steel. Area: 416sq km (161sq mi). Pop. (1991) 383,000.

South Island Larger of the two principal islands that comprise New Zealand. Its chief cities are Christchurch, Dunedin and Invercarguill. The Southern Alps extend the length of the island and separate the thickly forested w coast from the broad Canterbury Plains in the E. Cereal growing, sheep and cattle rearing, and dairying are important on the Plains, and tourism is a valuable source of income in almost all parts. Area: 150,461sq km (58,093sq mi). Pop. (1991) 881,540.

South Pole Southernmost geographical point on the Earth's

surface. The magnetic south pole is located *c*.2,400km (1,500mi) from the geographical South Pole. It lies 2,992m (9,816ft) above sea level *c*.500km (300mi) s of the Ross Ice Shelf. It was first reached (1911) by Roald AMUNDSEN.

South Sea Bubble (1720) Speculation in the shares of the English South Sea Company ending in financial collapse. The South Sea Company was founded in 1711 for trade in the Pacific. Shares sold so well and interest was so high that in 1720 the company volunteered to finance the national debt. The result was intensive speculation with a 900% rise in the price of shares, until the bubble burst in September 1720, bankrupting investors and closing banks. Credit for saving the company and the government was given to Robert WALPOLE.

South West Africa See Namibia

South West Africa People's Organization (SWAPO) Political organization, formed in 1960 in South West Africa (now Namibia). SWAPO's aim was to achieve independence for Namibia and to this end declared itself at war with South Africa. Soon after Angola gained independence in 1975, SWAPO established guerrilla bases there. In 1978 these bases were attacked by South Africa. Peace talks in Geneva (1981) failed, and in 1984 SWAPO refused to cooperate with the rival Multi-Party Conference (MCP) in drawing up a timetable for independence. When independence was achieved, SWAPO fought a general election in 1989 and gained 57% of the votes and 75% of the seats in the constituent assembly. In 1990 SWAPO leader, Sam NUJOMA, became president.

South Yorkshire Metropolitan county in N central England. The county is divided into four districts, with Barnsley its administrative centre. South Yorkshire's only city is SHEFFIELD, but other other major towns include Doncaster and Rotherham. The area includes the PEAK DISTRICT National Forest and the western Pennine moors. The River Don flows E across the county. Following the Industrial Revolution, the county's prosperity depended on its heavy industry, and its major industries still include iron, steel and coal mining. Area: 1,561sq km (603sq mi). Pop. (1991) 1,249,300.

soviet Russian revolutionary workers' council. Soviets appeared briefly in the 1905 revolution and again in 1917. The Petrograd (St Petersburg) Soviet, led by TROTSKY, was the leading organization in the BOLSHEVIK revolution of November 1917. In the Soviet Union, soviets were organized at every level from village upwards. At the top was the Supreme Soviet, the chief legislative body.

Soviet Union (officially Union of Soviet Socialist Republics, USSR) Former federal republic, successor to the Russian Empire and the world's first communist state. The Soviet Union was formed on 30 December 1922 and, when dissolved on 31 December 1991, was the largest country in the world. The Bolshevik regime, led by Lenin, came to power in the RUSSIAN REVOLUTION (1917). Lenin's government survived civil war (1918-22) and famine by instituting a centralized command economy. In 1921 the New Economic Policy (NEP) marked a return to a mixed economy. In 1922 a treaty of union was signed by the republics of RUSSIA, UKRAINE, Belorussia, and Transcaucasia. In 1923 a new constitution was adopted establishing the supremacy of the COMMUNIST PARTY OF THE SOVIET UNION (CPSU), and the Supreme Soviet as the highest legislative body. Lenin died in January 1924, and a power struggle ensued between Leon Trotsky and Josef STALIN. Stalin emerged the victor and Trotsky was expelled in 1927. In 1928 the first five-year plan was adopted. It transformed Soviet agriculture and industry: collective and state farms were imposed on the peasantry, and industrialization was accelerated. The urban population rapidly doubled. The collectivization schemes led directly to the Ukraine famine (1932-34), which claimed over seven million lives. State control infiltrated all areas of society, and was sometimes brutally imposed by the secret police. The systems of control led to the creation of a massive bureaucratic administration. The murder (1934) of Sergei Kirov led to the Stalinist purges, and a wave of terror in 1936-38. Supposed dissidents within the government, party and army were sentenced to death, or sent to the Siberian gulags. The purges also targeted Soviet Jews and other ethnic groups. In 1936 Transcaucasia was divided into

the republics of GEORGIA, ARMENIA, and AZERBAIJAN. In August 1939 Stalin concluded a non-aggression pact with Hitler. Germany and the USSR invaded Poland and divided up the country. In 1940 Soviet expansion incorporated the Baltic states of LITHUANIA, LATVIA and ESTONIA into the Union. A costly war with Finland led to the formation of the Karelo-Finnish republic. On 22 June 1941 Germany invaded Russia. The failure of the siege of Stalingrad (1943) led to the surrender of 330,000 Axis troops, and was a decisive turningpoint in WORLD WAR 2. The Red Army launched a counteroffensive that liberated much of E Europe. World War 2 devastated the Soviet Union. It is estimated that 25 million Soviet lives were lost. The Soviet Union and the USA emerged as the two post-war superpowers. Their antagonistic ideologies and ambitions led to the COLD WAR. Not only had Soviet territory increased, but its European sphere of influence extended into Albania, Bulgaria, Czechoslovakia, East Germany, Hungary, Poland, and Romania. The importance of the military-industrial sector in Soviet politics was greatly enhanced. In 1948 the Soviet army attempted to blockade the western sectors of Berlin. In 1949, when NATO was formed, the Soviet Union exploded its first atomic bomb. In March 1953 Stalin died and a collective leadership was installed. In 1955 the WARSAW PACT was established as the communist counterpart to NATO. In 1956, at the 20th CPSU Congress, Nikita KHRUSHCHEV made his famous secret speech denouncing Stalin as a dictator. In October 1956 a Hungarian uprising against Moscow domination was crushed by Soviet troops. In 1958 Khrushchev won the battle for succession. He began a policy of liberalization. Economic decentralization entailed a reduction in the bloated bureaucracy. Huge areas of "virgin land" were opened to grain cultivation in order to prevent further famine. New alliances were formed with worldwide anti-colonial movements and Khrushchev formulated a policy of peaceful coexistence with the West. The Cold War shifted into a technological battle to produce more powerful weapons of mass destruction, and a "Space Race". In 1957 the Soviet Union launched Sputnik 1, the world's first artificial satellite, and in 1961 Yuri Gagarin became the first man in space. Also in 1961, the Berlin Wall was built to divide East from West Berlin, and Khrushchev went further in his attacks on the Stalin regime. In 1962 the CUBAN MISSILE CRISIS shattered the Cold War stand-off, and the world stood at the brink of nuclear war. Khrushchev agreed to remove Soviet missiles and catastrophe was avoided. In October 1964 Khrushchev was removed from office by a conservative collective leadership headed by Leonid Brezhnev and Alexsei Kosygin. They were determined to reverse Khruschev's liberal reforms and improve the Soviet economy. Brezhnev ruled by consensus and brought close political associates such as Yuri ANDROPOV (KGB chief) and Andrei GROMYKO (foreign minister) into his politburo. He instituted cautious economic reforms and agricultural production increased dramatically. In foreign affairs, the "Brezhnev doctrine" preserved the right of the Soviet Union to intervene in communist states to preserve international communism. The doctrine was invoked to stem the liberalization of Czechoslovakia, and on August 21, 1968 Warsaw Pact troops invaded to crush the "Prague Spring". Internal dissent was not tolerated. Leading dissident scientists and intellectuals, such as Alexander Solzhenitsyn and Andrei SAKHAROV, were sent to prison or forced into exile. Many Soviet Jews emigrated in the early 1970s. The Cold War created a series of indirect conflicts between the USA and the USSR in Asia and Africa. In 1969 an era of superpower détente began with a series of STRATEGIC ARMS LIMITATION TALKS (SALT) resulting in the signing of SALT I by Brezhnev and Nixon in 1972. In 1975 the Helsinki Accords recognized the post-war European borders. In 1977 Brezhnev was elected president and a new constitution was formed. In 1979 SALT II was signed, but the Soviet invasion of Afghanistan ended the period of détente and the treaty was never ratified by the USA. In 1980 the USA led a boycott of the Moscow Olympics, and placed new, intermediate range Pershing II missiles on European soil. The Soviet economy stagnated with the stabilization of world oil prices, and its outdated manufacturing technolo-

promoted a series of advisors, including Mikhail GORBACHEV, to implement the reforms but Andropov died after only 15 months in office. He was replaced by a hardline Brezhnevite, Konstantin Chernenko. Chernenko died 13 months later, and (in March 1985) Gorbachev became general secretary. He began a process of economic restructuring (PERESTROIKA) and political openness (GLASNOST). Dissidents were released and restraints on emigration were lifted, but the CHERNOBYL disaster (1986) provided the first real test of glasnost. Gorbachev began a new détente initiative, focusing on nuclear DISARMA-MENT. A series of meetings with Ronald Reagan led to the Intermediate Nuclear Forces (INF) Treaty, which agreed to scrap intermediate-range nuclear missiles. The Soviet Union agreed to halt the disastrous war in Afghanistan and all its troops withdrew by February 1989. Perestroika continued Andropov's reduction of the bureaucracy, and allowed a more mixed economy. Restructuring was hampered, however, by opposition from conservatives (anxious to prevent change) and radicals led by Boris YELTSIN, who urged more far-reaching policy shifts. In 1988 Gorbachev convened a conference of the CPSU (the first since 1941) at which parliamentary elections were approved. In March 1989 the first pluralist elections since 1917 were held. Gorbachev was elected state president. A tide of reform swept over Eastern Europe; by the end of 1989 every communist leader in the Warsaw Pact had been overthrown. The constituent republics of the Soviet Union began to clamour for secession. In 1989 Gorbachev and Bush declared an end to the Cold War. The West promised economic support to the Soviet Union, but the political and economic situation deteriorated. The Baltic republics, KAZAK-STAN, and Georgia demanded independence. Armenia and Azerbaijan fought for control of Nagorno-Karabakh. In March 1990 the newly-elected Soviet parliament authorized the private ownership of the means of production: the central economic principle of MARXISM had been removed. The CPSU fractured, and Boris Yeltsin resigned from the party. Amid the breakdown in federal government structures, the economy declined by 4%. In December 1990 Gorbachev gained emergency presidential powers, and the conservatives demanded action to prevent the disintegration of the Union of Soviets. Paratroopers were sent to Latvia and Lithuania to prevent secession. Miners went on strike, calling for Gorbachev's resignation. Eduard SHEVARDNADZE resigned and formed the Democratic Reform Movement. In June 1991 a new Union Treaty was drafted that devolved power to the republics and reconstituted the federal government. It was approved by nine republics, but Armenia, the Baltic states, Georgia, and MOLDOVA refused to cooperate. Also in June 1991, Boris Yeltsin was elected president of the Russian republic. In July 1991 Gorbachev attended the Group of Seven (G7) summit and signed the Strategic Arms Reduction Treaty (START), reducing the number of long-range missiles. On 18 August 1991 a coup was launched against Gorbachev by hardliners led by Vice President Yanayev and Defence Minister Dmitri Yazov. Gorbachev was kept under house arrest in Crimea, while the coup leaders assumed control of the media and sent tanks into Moscow to capture the Russian Parliament and Boris Yeltsin. The coup failed and Gorbachev was reinstated on 22 August 1991. The republics declared their independence from federal control. Yeltsin emerged as the new political power-broker. He banned the CPSU, took control of the Russian army, and forced Gorbachev to suspend the Russian Communist Party. Gorbachev resigned as general secretary of the CPSU. In September 1991 the Baltic states of ESTONIA, Latvia and Lithuania were granted independence. On 8 December 1991 Russia, Ukraine and BELARUS formed the COMMONWEALTH OF INDEPENDENT STATES (CIS). By the end of December, the republics of Armenia, Azerbaijan, Kazakstan, KYRGYZSTAN, Moldova, TAJIKISTAN, TURKMENISTAN, and UZBEKISTAN had all joined the CIS. On 25 December 1991 Gorbachev resigned as president of the USSR, and a week later the Soviet Union was officially dissolved.

gy. After Brezhnev's death (1982), Andropov became leader.

He began a series of far-reaching economic reforms targeting

centralization, corruption, inefficiency, and alcoholism. He

▲ Soviet Union St Isaac's Cathedral, St Petersburg. In the early years of the Soviet era, religious bodies were persecuted. Many priests and bishops were killed during the unrest following the Russian Revolution of 1917 and churches were plundered of their valuable relics. It was not until Gorbachev came to power that relations with the Russian Orthodox Church really improved. Relics were returned, it was granted legal status and restrictions on worship were lifted.

▲ soya bean Now grown extensively throughout the world, soya beans are native to China where they were first cultivated some 4,000 years ago. They were introduced into North America in 1880. Their flowers vary from pure white to light purple. The beans themselves are yellow, brown or black, depending on the variety. Cultivation has spread in response to the increasing world demand for protein. The main areas of cultivation are the USA, with more than half of world production, and the Far East, notably China, Japan and Korea The crop is also spreading into parts of South America, especially Brazil, and Africa.

Soweto (South-West Township) Group of black townships of more than a million people on the outskirts of JOHANNES-BURG, South Africa. In June 1976 Soweto attracted international attention, when a student demonstration against the compulsory teaching of Afrikaans in Bantu schools sparked a series of riots against the APARTHEID regime. The police brutally suppressed the disturbances, killing 618 people. Comprising mostly sub-standard government housing, it remained a focus of protest. Pop. (1991 official) 597,000.

soya bean Annual plant native to China and Japan. It has oval, three-part leaves and small lilac flowers. Grown internationally for food, forage, green manure and oil, its seed is an important source of PROTEIN. Height 60cm (24in). Family Fabaceae/Leguminosae; species *Glycine max*.

Soyinka, Wole (1934–) Nigerian playwright, novelist and poet. Soynika's plays include *The Lion and the Jewel* (1963), *Madmen and Specialists* (1970), *Jero's Metamorphosis* (1972) and *A Play of Giants* (1984). *The Road* (1965), *Season of Anomy* (1973) and *Death and the King's Horseman* (1975) are among his most powerful novels. Soyinka was detained (1967–69) without trial during the Nigerian civil war and remains a vocal opponent of the military regime. He was awarded the 1986 Nobel Prize for literature.

space Open expanse between matter. RELATIVITY states that space and TIME are aspects of one thing. More usually, space is taken to mean the Universe beyond the Earth's atmosphere, the vast region in which the density of matter is low.

space exploration Using spacecraft to investigate outer space and heavenly bodies. Sputnik 1, launched into Earth orbit by the Soviet Union on 4 October 1957, was the first artificial satellite. Soviet cosmonauts, and their American equivalents, astronauts, orbited the Earth soon after. Unmanned space probes crash-landed on the Moon, sending back pictures to Earth during the descent. Then came soft landings, and probes made to orbit the Moon showed its hidden side for the first time. By 1968, Soviet space scientists had developed techniques for returning a Moon orbiter safely to the Earth. In 1969, the US Apollo 11 mission became the first to place a man on the Moon. By that time, the Soviet Union had sent probes to explore Mars and Venus. Chronology: First probe to land on the Moon: Luna 2, launched 12 Sept 1959. First manned spaceflight: Yuri GAGARIN, 12 April 1961. First closeup pictures of Mars: Mariner 4, received 14 July 1965. First person to walk on the Moon, Neil ARMSTRONG, 20 July 1969. First pictures from surface of another planet: Venera 9, received from Venus on 22 October 1975. First probes to land on Mars, Viking 1 and 2, July 1976. Fly-bys of Voyager 2: Jupiter (1979), Saturn (1981), Uranus (1986), Neptune (1989). First SPACE SHUTTLE: Columbia, launched 12 April 1981. Giotto probe, launched 1985, flew within 600km (380mi) of Halley's Comet, sending back photographs and data. Galileo project, launched October 1989, photographed the asteroids Gaspra (1991) and Ida (1993), dropped a sub-probe (1995) into Jupiter's atmosphere and provided detailed data on Galilean satellites; Clementine probe (1994), discovered what are thought to be water-ice deposits in craters of the Moon; Solar and Heliospheric Observatory (SOHO) probe, launched 1995, will provide data on the Sun's interior until 2000; Mars Pathfinder mission, launched December 1996, landed on Mars to deploy a "microrover" (Sojourner) to explore and collect rock samples.

space research Scientific and technological investigations that gather knowledge through SPACE EXPLORATION. The physical makeups and behaviours of stars, planets and other cosmic materials were first determined by optical and radio telescopes, and more recently by the orbiting HUBBLE SPACE TELESCOPE launched in 1990 by NASA. Research projects have been carried into space by artificial SATELLITES, the SPACE SHUTTLE, space stations, and space probes. The data has been used in various fields ranging from medical to military. space shuttle Re-usable rocket-powered US spacecraft. The main part of the shuttle, the orbiter (of which four have been built, Columbia, Challenger, Discovery and Atlantis), looks

like a bulky jet aircraft with swept-back wings. It ferries people

and equipment between the ground and Earth orbit. It takes off

attached to a large fuel tank, using its own three rocket engines, assisted by two booster rockets. The boosters are jettisoned about two minutes after launch and are later recovered for reuse. Six minutes later, the orbiter's main engines cut off and the external fuel tank is dumped. Manoeuvring engines then put the craft into the required orbit. When returning to Earth, these engines provide reverse thrust to slow the craft down for descent into the atmosphere. It glides down and lands on a runway. The first space shuttle, *Columbia*, was launched into orbit it carries satellites for release into orbit. On mission 25 in January 1986, the shuttle *Challenger* exploded soon after launch, killing all seven people on board. A leak had allowed burning gases from a booster rocket to ignite the fuel in the main tank. **space station** Orbiting structure in space for use by astro-

space station Orbiting structure in space for use by astronauts and scientists. Space laboratories, such as *Skylab*, are space stations built for scientists to carry out a variety of experiments, study the solar system and observe distant parts of the Universe. They are capable of supporting astronauts for many months. The Russian space station *Mir* has suffered a series of accidents and faults, which suggest that is ending its working life.

spacesuit Sealed garment enabling an astronaut to function in space. It is made from several layers of material and has a helmet with a plastic visor. The suit provides insulation from extremes of temperature, and protection from harmful radiation from the Sun and bombardment by tiny particles called micrometeoroids. Inside the suit, a breathing gas (oxygen) must be supplied. A built-in cooling system prevents the astronaut from overheating.

space-time Central concept in RELATIVITY theory, that unifies the three space dimensions with time to form a four-dimensional frame of reference. In 1907, the German mathematician Hermann Minkowski explained relativity theory by extending three-dimensional geometry to four dimensions. A line drawn in this space represents a particle's path both in space and time. spadix In some flowering plants, a spike of small flowers; it is generally enclosed in a sheath called a SPATHE. A familiar example is the CUCKOOPINT (Arum maculatum).

Spain Kingdom on the E Iberian Peninsula. *See* country feature, p.632

spaniel Any of several breeds of sporting dogs that may be trained to locate and flush game, and sometimes to retrieve on command. Land spaniels include the springer, cocker, and toy breeds. Water spaniels are usually RETRIEVERS.

Spanish Major world language, spoken as an official language in Spain, South America (except Brazil, French Guiana, Guyana and Surinam), all of Central America, Mexico, Cuba, the Dominican Republic and Puerto Rico. It is also spoken in a number of other countries, notably the USA and former Spanish dependencies such as the Philippines. Its total number of speakers is more than 200 million. Spanish is a member of the Romance group of INDO-EUROPEAN LANGUAGES but its vocabulary contains a large number of words of Arabic origin, the result of Moorish domination of Spain for many centuries.

Spanish-American War (1898) Conflict fought in the Caribbean and the Pacific, between Spain and the USA. The immediate cause was the sinking of the US battleship *Maine* at Havana. Fighting lasted ten weeks (April-July). Spanish fleets in the Philippines and Cuba were destroyed. Spanish troops in Cuba surrendered after defeat at San Juan Hill, where Theodore ROOSEVELT led the Rough Riders. The USA also seized Guam and Wake Island, annexed Hawaii and the Philippines. The Treaty of Paris forced Spain to cede Puerto Rico.

Spanish Armada See Armada, Spanish

Spanish art Artistic tradition beginning with the Palaeolithic cave paintings at Altamira. Successively occupied by the Romans, Visigoths and Moors. Spain's earliest native traditions were the Mozarabic and Mudéjar styles, which blended Moorish and Christian elements. As the country was reconquered from the Moors, Spain drew closer to artistic developments in the rest of Europe. By the 16th century, it was the most powerful force on the continent, and this period coincided with the career of its first true genius, El Greco. The golden era of Spanish art was the 17th century. Leading figures

from this epoch include Diego Velázquez, José RIBERA and Francisco de Zurbarán. In later years, Francisco Goya was a master of ROMANTICISM, and Pablo PICASSO was the dominant figure in 20th-century art.

Spanish literature One of the major early works is the epic poem Cantar de Mío Cid (c.1140). Major figures of the 14th and 15th centuries include the poet Juan Ruiz (c.1283-1350). The most important work of fiction of the 15th century was the novel La Celestina (1499). French and Italian influences predominate until the 16th century, when a truly Spanish literature emerged. The late 16th and 17th centuries are known as the Golden Age. Miguel de CERVANTES' Don Quixote de la Mancha (1605-15) is a masterpiece of European literature. Other major figures include Luis de GÓNGORA Y ARGOTE, Lope de VEGA CARPIO and Pedro Calderón de la Barca. The 18th century witnessed a decline in Spanish writing, saved by the rise of ROMANTICISM. Costumbrismo (sketches of Spanish life and customs) flourished in the 19th century. In the early 20th century, the writers of the Generation of '98 re-examined Spanish traditions. The Spanish Civil War (1936-39) drove many Spanish writers into hiding, and its reverberations can be seen in the grim realism of much of the work that followed. MoD-ERNISM exerted an influence on formal technique and narrative style; the Generation of 1927 group of poets were also inspired by SURREALISM. Probably the most important Spanish writer of the 20th century, however, was Federico GARCÍA LORCA.

Spanish Sahara Former name of Western Sahara Spanish Succession, War of the (1701–14) Last of the series of wars fought by European coalitions to contain the expansion of France under Louis XIV. It was precipitated by the death of the Spanish king, Charles II, without an heir. He willed his kingdom to the duke of Anjou (later PHILIP V), Louis' grandson. England and the Netherlands supported archduke of Austria's (later Emperor CHARLES VI) claim to the Spanish throne. The ensuing war marked the emergence of Britain as a maritime and colonial power. The Spanish succession was settled by the compromise of the Peace of UTRECHT, with Philip attaining the Spanish throne on condition that he renounce any claim to France, and Britain and Austria receiving substantial territorial gains. Exhaustion of the participants, especially France, helped ensure general peace in Europe until the outbreak of the War of the Austrian Succession in 1740. Spark, Dame Muriel (1918-) British novelist, short-story

writer and poet. Spark's collected poems and short stories were published in 1967, but she is best known for her novels, which include *Memento Mori* (1959), *The Ballad of Peckham Rye* (1960), *Girls of Slender Means* (1963), *The Mandelbaum Gate* (1965) and *Symposium* (1990). *The Prime of Miss Jean Brodie* (1961) is a portrait of a charismatic schoolmistress.

sparrow Any of a number of small FINCH-like birds that live in or around human settlements. Typical is the house sparrow. The male has a chestnut mantle, grey crown and rump and black bib. The female is duller and lacks the bib and grey rump. Sparrows feed, roost and dust-bathe in noisy, twittering flocks. Basically seed-eaters, with a preference for grain, they are widely regarded as pests. They also eat fruit, worms and household scraps. Length: 14.5cm (5.75in). Family Ploceidae; species *Passer domesticus*.

Sparta City-state of ancient Greece, near the modern city of Sparti. Founded by Dorians after c.1100 BC, Sparta conquered Laconia (SE Peloponnese) by the 8th century BC and headed the Peloponnesian League against Persia in 480 BC. In the PELOPONNESIAN WARS (431–404 BC) it defeated its great rival, ATHENS, but was defeated by THEBES in 371 BC and failed to withstand the invasion of PHILIP II of Macedon. In the 3rd century BC Sparta struggled against the Achaean League, subsequently joining it but coming under Roman dominance after 146 BC. The ancient city was destroyed by Alaric and the Goths in AD 395. Sparta was famous for its remarkable social and military organization.

Spartacists Members of the German political party called the Spartacus League, which broke away from the Social Democrats during World War 1. Led by Karl LIEBKNECHT and Rosa LUXEMBURG, the Spartacists refused to support the war effort and rejected participation in the post-Versailles republican government. They instigated a number of uprisings, including one in Berlin in 1919, after which they were brutally repressed and their leaders murdered.

Spartacus (*d*.71 BC) Thracian gladiator in Rome who led a slave revolt known as the Third Servile (Gladiatorial) War (73–71 BC). His soldiers devastated the land and then moved south towards Sicily, where they were eventually defeated by CRASSUS with POMPEY's aid. Spartacus died in battle.

spasm Sustained involuntary muscle contraction. It may occur in response to pain, or as part of a generalized condition, such as spastic paralysis or TETANUS.

▲ spaniel Although now very popular as pets, spaniels were originally bred to frighten game birds from undergrowth, much as beaters are employed to do now. Others can be trained to retrieve downed fowl. Originating in Spain, they were developed extensively in Britain.

A space shuttle flight has three distinct parts. The first is reaching orbit. The orbiter (1) is propelled upward from the launch platform by two solid fuel boosters (2) and the

shuttle's three engines (3), fed with liquid oxygen and liquid hydrogen fuel from the external tank (4). After the boosters have burnt out they detach (5), and float to the surface of the

Earth by parachute. The external tank detaches later and burns up in the Earth's upper atmosphere. The second phase now commences. Once in orbit, the shuttle floats upside

down above the Earth with its cargo bay doors (6) open to help dispel heat. Satellites (7) are launched from the cargo bay, and can be retrieved with the use of an arm (8).

While in orbit, the shuttle manoeuvres using helium-fuelled thrusters in the nose (9). Finally, the shuttle returns to land unpowered. The orbiter is shielded from the

enormous heat generated on re-entering the Earth's atmosphere by ceramic tiles (10) on its outer surface. A parachute (11) slows the vehicle on the runway.

The colours on the Spanish flag date back to those used by the old kingdom of Aragón in the 12th century. The present design, in which the central yellow stripe is twice as wide as each of the red stripes, was adopted in 1938, during the Spanish Civil War.

he Kingdom of Spain occupies 80% of the Iberian peninsula. The central Spanish regions of ARAGÓN, CASTILE-LA MANCHA, and CASTILE-LEÓN form part of a vast plateau (the Meseta), in the centre of which lies the capital, MADRID. The plateau is drained by the EBRO and TAGUS rivers. ZARAGOZA lies on the Ebro, and TOLEDO on the Tagus. The Cantabrian Mountains lie between LEÓN and the N coastal regions of GALICIA and ASTURIAS. BILBAO and PAMPLONA are the major cities in BASOUE COUNTRY. The PYRENEES form a natural border with France, and extend s into NAVARRE and CATALONIA. BARCELONA lies on the Costa Brava. On the E Mediterranean coast lie the ports of VALENCIA and CARTAGENA, and the BALEARIC ISLANDS. ANDALUSIA includes the cities of SEVILLE and CÓRDOBA, and Spain's highest peak, Mulhacén, at 3,478m (11,411ft), in the Sierra Nevada, close to the city of GRANADA. Many Spanish holiday resorts, such as MÁLAGA, are found on the Costa del Sol. The status of GIBRALTAR is disputed with Britain.

CLIMATE

The *Meseta* has hot summers and cold winters. The s coast has Europe's mildest winters. Winter snowfall is heavy on the high mountains.

VEGETATION

Forests cover 32% of Spain, mostly in the mountainous regions. Grassland and scrub cover much of the *Meseta*, but 30% of land is arable.

HISTORY

Iberians and BASQUES were Spain's early inhabitants. In the 9th century BC, the Phoenicians established trading posts on the s coast. In c.600BC Greek merchants set up colonies. In c.237 BC the Carthaginian general HAMILCAR BARCA conquered most of the peninsula. By the 1st century AD, most of Spain had fallen to the Romans; it became a prosperous province. From c.AD 400, Germanic tribes swept into Spain. During the 5th-8th centuries, Visigoths controlled s Spain. In 711 the Moors defeated the Visigoths. Spain was rapidly conquered (except Asturias and the Basque Country) and an independent Muslim state founded (756). The ALHAMBRA is testimony to the splendour of Moorish architecture. The Basques established the independent kingdom of Navarre. Asturias acted as the base for the Christian reconquest. In 1479 Castile and Aragón were united by the marriage of FERDINAND V and ISABELLA I. The reconquest of Granada (1492) saw Ferdinand and Isabella become rulers of all Spain. The Inquisition was used to ensure Catholic supremacy through persecution and conversion. Columbus' discovery of America (1492) brought vast wealth and Spain became the leading imperial power. The 16th century was Spain's golden age. In 1519 Charles I became CHARLES V, Holy Roman emperor. The supremacy of the HABSBURGS was established. The extension and centralization of power was continued by PHILIP II, who gained Portugal (1580). Spanish naval power was dented by the

AREA: 504,780sq km (194,896sq mi)
POPULATION: 39.085.000

CAPITAL (POPULATION): Madrid (3,121,000) GOVERNMENT: Constitutional monarchy ETHNIC GROUPS: Castilian Spanish 72%, Catalan 16%, Galician 8%, Basque 2% LANGUAGES: Castilian Spanish (official),

Catalan, Galician, Basque

RELIGIONS: Christianity (Roman Catholic 97%)

currency: Peseta = 100 céntimos

defeat of the Spanish ARMADA (1588). During the 17th century, Spain's political and economic power declined. The War of the SPANISH SUCCES-SION (1701-14) resulted in the accession of PHILIP V, and the establishment of the BOURBON dynasty. CHARLES III brought the church under state control. CHARLES IV's reign ended in French occupation, and the appointment of Joseph Bonaparte as king. Spanish resistance led to the restoration of the Bourbons in 1813. Many of Spain's New World colonies gained independence. The accession of ISABELLA II resulted in civil war with the CARLISTS. A shortlived constitutional monarchy and republic was followed by a further Bourbon restoration under ALFONSO XII and Alfonso XIII. Spain remained neutral during World War 1. In 1923 PRIMO DE RIVERA established a dictatorship. He was forced to resign (1930) and a second republic was proclaimed. The Popular Front won 1936 elections, and conflict between republicans and nationalists, such as the FALANGE, intensified. With the backing of the Axis powers, the nationalists led by General FRANCO emerged victorious from the Spanish CIVIL WAR (1936-39), and Franco established a dictatorship. Spain did not participate in World War 2. During the 1960s most of Spain's remaining colonies gained independence. In 1975 Franco died, and a constitutional monarchy was established under JUAN CARLOS. Spain began a process of democratization and decentralization. Spain joined NATO (1982) and the European Community (1986).

POLITICS

There is a historic tension between central government and the regions. Since 1959 the militant Basque organization ETA has waged a campaign of terror. In 1977 the Basque Country (*Pais Vasco*), Catalonia and Galicia gained limited autonomy. In 1996 the government were forced to call early elections after allegations of complicity in an illegal anti-terrorist campaign. After 13 years in office, the Spanish Socialist Workers' Party (PSOE) were defeated. José María AZNAR formed a minority administration.

ECONOMY

Spanish economic revival began in the 1950s, based on tourism (1992 receipts, US\$21,181 million) and manufacturing. It has rapidly transformed from a largely poor, agrarian society into a prosperous industrial nation. Agriculture now employs only 10% of the workforce. Spain is the world's third-largest wine producer. Other crops include citrus fruits, tomatoes and olives. Sheep are the main livestock. Spain is the world's sixth-largest car producer. Other manufactures include ships, chemicals, electronics, metal goods, steel and textiles. It lacks mineral resources. Unemployment remains high (1996, 22%).

spathe Broad leaf-like organ that spreads from the base of, or enfolds, the SPADIX of certain plants.

Speaker Presiding officer in the US HOUSE OF REPRESENTATIVES. (S)he is elected from the majority party by the House. His/her powers include the appointment of select committees, the referral of bills and the signing of documents on behalf of the House. The speaker follows the vice president in presidential succession. In the UK, the speaker of the House of Commons presides over debates but has no other formal powers.

spearmint Common name of *Mentha spicata*, a hardy PERENNIAL herb of the MINT family (Lamiaceae/Labiatae). Its leaves are used for flavouring, especially in sweets. Oil distilled from spearmint is used as a medicine. The plant has pink or lilac flowers that grow in spikes.

Special Branch Department within every British police force that is technically affiliated to MI5, the intelligence bureau within the Home Office. Its duties are to investigate and deter all activities against the interests of the state, to protect visiting foreign rulers and dignitaries, and to monitor the immigration and naturalization of foreign nationals.

species Group of physically and genetically similar individuals that interbreed to produce fertile offspring under natural conditions. Each species has a unique two-part Latin name, the first part being the GENUS name. So far, more than 1.5 million plant and animal species have been identified. *See also* TAXONOMY, BINOMIAL NOMENCLATURE

specific gravity See RELATIVE DENSITY

specific heat capacity Heat necessary to raise the temperature of 1 kilogram of a substance by 1 kelvin (1°C). It is measured in J/kgK (J equals joule).

spectroscopy Branch of OPTICS dealing with the measurement of the wavelength and intensity of lines in a SPECTRUM. The main tool in this study is the spectroscope. It produces a spectrum and a spectrograph photographs it. An analysis of the spectrogram can reveal the substances causing the spectrum by the position of emission and absorption lines and bands. A spectrometer is a calibrated spectroscope capable of precise measurements.

spectrum Arrangement of ELECTROMAGNETIC RADIATIONS ordered by wavelength or frequency. The visible light spectrum is a series of colours: red, orange, yellow, green, blue, indigo and violet. Each colour corresponds to a different wavelength of light. A spectrum is seen in a rainbow or when white light passes through a PRISM. This effect, also seen when visible light passes through a DIFFRACTION grating, produces a continuous spectrum in which all wavelengths (between certain limits) are present. Spectra formed from objects emitting radiations are called emission spectra. These occur when a substance is strongly heated or bombarded by electrons. An absorption spectrum, consisting of dark regions on a bright background, is obtained when white light passes through a semitransparent medium that absorbs certain frequencies. A line spectrum is one in which only certain wavelengths or "lines" appear. See SPECTROSCOPY

speedwell Common name applied to herbaceous plants of many species of the genus *Veronica* found throughout the world. Germander speedwell, *V. chamaedrys*, is a common British wild flower. Family Scrophulariaceae.

Speke, John Hanning (1827–64) British explorer of E Africa. After service in India, Speke joined Richard Burton in an expedition to Somalia (1854) and, on behalf of the Royal Geographical Society, to the E African lakes (1856). In Burton's absence he reached Lake Victoria, which he identified as the source of the Nile.

speleology Scientific study of CAVES and cave systems. Included also are the hydrological and geological studies of the formation of STALAGMITES and STALACTITES, and the influence of groundwater conditions on cave formation.

Spence, Sir Basil (1907–76) Leading British architect. He was famous for his modernist design for the new Coventry Cathedral (1951, consecrated in 1962). Other works include the Household Cavalry Barracks (1970) at Knightsbridge, London, and the British Embassy in Rome (1971).

Spencer, Sir Stanley (1891–1959) British painter. During World War 2 Spencer was a war artist and painted a series of

large pictures showing shipbuilding on the Clyde. *The Resurrection* (1923–27) is set in his local churchyard and includes portraits of both himself and his wife, Hilda. Spencer is also known for his nude paintings, the most famous of which is the so-called *Leg of Mutton Nude* (1937).

Spender, Stephen Harold (1909–95) British poet. Spender was a member of the AUDEN circle in the 1930s and his autobiography, *World within World* (1951), is a powerful evocation of the generation. His best verse, such as "I Think Continually of Those Who Were Truly Great", is a combination of lyricism and political commitment. His *Collected Poems* 1928–1985 appeared in 1985. Spender was knighted in 1983.

Spengler, Oswald (1880–1936) German philosophical historian. In *The Decline of the West* (1918–22), he expounded his theory that all civilizations are subject to an inevitable process of growth and decay, concluding that Western civilization was ending. His theory had some appeal in Germany in the 1930s.

Spenser, Edmund (1552–99) English poet. Spenser's debut volume was the pastoral *The Shepheardes Calender* (1579), dedicated to Sir Philip SIDNEY. His sonnet sequence *Amoretti* was published with *Epithalamion* in 1595. Spenser's masterpiece is *The Faerie Queene* (1589–96), a heroic romance and moral allegory. Other works include *Four Hymns* and *Prothalamion* (both 1596).

sperm (spermatozoon) Motile male sex cell (GAMETE) in sexually reproducing organisms. It corresponds to the female OVUM. The head of the sperm contains the genetic material of the male parent, while its tail or other motile structure provides the means of moving to the ovum to carry out FERTILIZATION.

spermatophyte Seed-bearing plant, including most trees, shrubs and herbaceous plants. It has a stem, leaves, roots and a well-developed vascular system. The dominant generation is the SPOROPHYTE. The Five Kingdoms scheme classifies seed plants as several distinct phyla: the Angiospermophyta (flowering plants), Coniferophyta (conifers), Ginkgophyta (ginkgo or maidenhair tree), Cycadophyta (cycads) and Gnetophyta (a group of cone-bearing desert plants).

sperm whale Largest of the toothed WHALES. It has a squarish head and feeds on squid and cuttlefish. Species *Physeter catodon*.

sphalerite (blende) Sulphide mineral composed of zinc sulphide (ZnS), an important source of ZNC. It has cubic system tetrahedral crystals or granular masses. It is white when pure, but more commonly yellow, black, or brown with a resinous lustre. Hardness 3.5–4; s.g. 4.

sphere 3-D geometric figure formed by the locus in space of points equidistant from a given point (the centre). The distance from the centre to the surface is the radius, r. The volume is $(4/3)\pi r^3$ and the surface area is $4\pi r^2$.

spherical trigonometry Branch of mathematics that deals with the sides, angles and areas of spherical triangles, that is, portions of the surface of a sphere bounded by three arcs or great circles. *See also* TRIGONOMETRY

sphincter Ring of muscle surrounding a body orifice which can open it or seal it off. Important sphincters include the pyloric sphincter in the stomach and the anal sphincter.

sphinx Mythical beast of the ancient world, usually represented with the head of a person and the body of a lion. In Greek mythology, the riddle of the Sphinx of Thebes was solved by OEDIPUS, so destroying her evil power. Although found throughout the Middle East, images of sphinxes were especially popular in Egypt, where thousands were built. The most famous is the Great Sphinx near the Pyramids at Giza. sphygmomanometer Instrument used to measure blood pressure. The device incorporates an inflatable rubber cuff connected to a column of mercury with a graduated scale. The cuff is wrapped around the upper arm and inflated to apply pressure to a major artery. When the air is slowly released, the pressure readings can be ascertained from the scale.

spice Food flavouring consisting of the dried form of various plants. Spices were used in medieval times to disguise the taste of food that was overripe or decaying, and as preservatives. They also had medicinal and religious functions.

spider Any of numerous species of terrestrial, invertebrate, ARACHNID arthropods found worldwide. Spiders have an

▲ spider When spinning its web for catching prey, the spider first casts out a thread of silk to form a horizontal strut. A second, drooping thread is trailed across below the bridge-line. Halfway along the second thread, the spider drops down on a vertical thread until it reaches a fixed object (A). It pulls the silk taut and anchors it, forming a "Y" shape, the centre of which forms the hub of the web. The spider then spins the framework threads and the radials, which are linked together at the hub (B). After spinning the remainder of the radials, a wide, temporary spiral of dry silk is laid down, working from the inside of the web outwards (C). This holds the web together while the spider lays down the sticky spiral. This is laid down starting from the outside and is attached successively to each radial thread (D). The spider eats the remains of the dry spiral as it proceeds. The central dry spirals are left as a platform for the spider, which will often lie in wait there during the night but will retreat to a nearby silk shelter during the day.

▲ Spielberg Steven Spielberg's first feature film was Sugarland Express (1974). With his friend, George Lucas, Spielberg dominated Hollywood in the 1980s with a series of commercial blockbusters, such as E.T. The Extra-Terrestrial (1982). In 1984, he founded his own production company, Amblin', responsible for Back to the Future (1985) and Who Framed Roger Rabbit (1988). Famous for his ability to convey a magical sense of childlike wonder in his "entertainments", Spielberg revealed his ability to tackle serious historical and social events in films such as Schindler's List (1993) - a story of the Holocaust - and Amistad (1997), on slavery in US history.

unsegmented abdomen attached to a cephalothorax by a slender pedicel. There are no antennae; sensory hairs are found on the appendages (four pairs of walking legs). Most species have spinnerets on the abdomen for spinning silk to make egg cases and webs.

spider monkey Medium-sized, arboreal (tree-dwelling) MONKEY found from s Mexico to SE Brazil. It has long, spidery legs, a fully prehensile tail, and is an agile climber, using the tail as a fifth limb. It eats mainly fruit and nuts. Genera *Ateles* and *Brachyteles*.

Spielberg, Steven (1947–) US film director and producer. The success of Jaws (1975) established Speilberg's commercial credientials. Close Encounters of the Third Kind (1977) earned him an Academy Award nomination. The Indiana Jones trilogy began with Raiders of the Lost Ark (1981). Spielberg's mastery of special effects was confirmed by E.T. The Extra-Terrestrial (1982). The Color Purple (1985) and Empire of the Sun (1987) were the first of his films on social history. Jurassic Park (1993) was a phenomenally successful return to "entertainments", making more than \$US200 million within 23 days of its release. Spielberg won a Best Director Academy Award for Schindler's List (1993), a harrowing document of the Holocaust. Other films include Amistad (1997).

spin (symbol s) In QUANTUM MECHANICS, intrinsic angular momentum possessed by some SUBATOMIC PARTICLES, atoms and nuclei. This may be regarded by analogy as the spinning of the particle about an axis within itself. Spin is one of the quantum numbers by which a particle is specified.

spina bifida Congenital disorder in which the bones of the SPINE do not develop properly to enclose the SPINAL CORD. Surgery to close the defect is usually performed soon after birth, but this may not cure disabilities caused by the condition. **spinach** Herbaceous, annual plant cultivated in areas with cool summers. Spinach is used as a culinary herb and as a vegetable. Family Chenopodiaceae; species *Spinacia oleracea*.

spinal cord Tubular, central nerve cord, lying within the SPINE. With the brain, it makes up the CENTRAL NERVOUS SYSTEM. It gives rise to the 31 pairs of spinal nerves, each of which has sensory and motor fibres.

spinal tap (lumbar puncture) Procedure for withdrawing CEREBROSPINAL FLUID from the lumbar (lower back) portion of the spinal cord for laboratory examination to aid diagnosis. **spine** (vertebral column) Backbone of VERTEBRATES, extending from the skull to the tip of the tail and enclosing the SPINAL CORD. The human spine consists of 26 vertebrae interspersed with discs of CARTILAGE. It articulates with the SKULL, ribs and hip bones and provides points of attachment for the back muscles.

spinet Early musical instrument of the HARPSICHORD family with one keyboard and one string to each note. The strings were plucked with a quill or leather plectrum.

spinning Process of making thread or yarn by twisting fibres together. The fibres may be of animal, vegetable or synthetic origin. Machines developed for mechanizing the spin-

A B C

ning process include the spinning wheel, spinning frame (invented by Richard Arkwright), spinning jenny (invented by James Hargreaves), and spinning mule (invented by Samuel Crompton). Today, large machines carry out the same basic process, but at much increased speeds.

Spinoza, Baruch (1632–77) Dutch-Jewish rationalist philosopher, also known as Benedict de Spinoza. He was the son of Portuguese Jews who had been forced by the INQUISITION to adopt Christianity and had eventually fled to the relative religious freedom of the Netherlands. Spinoza argued that all mind and matter were modes of the one key substance, which he called either God or Nature. In *Ethics* (1677), he held that free will was an illusion that would be dispelled by man's recognition that every event has a cause. spiny anteater See ECHIDNA

spiraea Genus of flowering PERENNIAL shrubs native to the Northern Hemisphere. They have small flat leaves and clusters of small white, pink or red flowers. Many of the 100 species are grown as ornamentals. Height: 1.5m (5ft). Family Rosaceae.

spiritualism Belief that, at death, the personality of an individual is transferred to another plane of existence, with which communication from the world of the living is believed to be possible. The channel of such communication is a receptive living person called a medium. Spiritualism as a movement began in the USA in 1848.

spleen Dark red organ located on the left side of the abdomen, behind and slightly below the stomach. It is important in both the lymphatic and blood systems, helping to process LYMPHOCYTES, destroying worn out or damaged red blood cells and storing iron. Removal of the spleen (splenectomy) is sometimes necessary following trauma or in the treatment of some blood disorders.

Split Major port in Croatia on the Dalmatian coast of the Adriatic Sea. Split was held by Venice from 1420 to 1797, when it passed to Austria. It became part of Yugoslavia in 1918. Croatia's second largest city. Tourism was severly disrupted by the wars that followed the break-up of Yugoslavia. Other industries: shipbuilding, textiles, chemicals, cement, timber, wine. Pop. (1991) 189,388.

Spock, Dr Benjamin McLane (1903–98) US author and paediatrician. Spock bestselling work *The Common Sense Book of Baby and Child Care* (1946) called on parents to trust their instincts and show their child warmth and understanding. **Spode, Josiah** (1754–1827) British potter. He gave his name to Spode porcelain, which became the standard English bone china. For this hybrid porcelain he used bone ash and feldspar in the paste as well as china clay and china stone.

spoils system Form of US political patronage. The practice of appointing loyal members of the party in power to public offices was first referred to as the spoils system under Andrew JACKSON. It reached its height c.1860-80 and declined after the Civil Service Act of 1883.

sponge Primitive, multicellular aquatic animal. Its extremely simple structure is supported by a skeleton of lime, silica or spongin. There is no mouth, nervous system or cellular coordination, nor are there any internal organs. Sponges reproduce sexually and by asexual budding. There are about 5,000 species, including the simple sponge genus *Leucosolenia*. Length: 1mm–2m (0.4in–6ft). Phylum: PORIFERA.

spontaneous generation Belief, now discredited, that living organisms arise from non-living matter. It supposedly explained the presence of maggots on decaying meat.

spoonbill Any of several species of wading birds, each with a long bill that is flat and rounded at the tip; species are found in tropical climates. It has large wings, long legs, a short tail, and white or pinkish plumage; it feeds on small plant and animal matter. Length: 90cm (3ft). Family: Threskiornithidae.

spore Small reproductive body that detaches from the parent organism to produce new offspring. Mostly microscopic, spores may consist of one or several cells (but do not contain an EMBRYO) and are produced in large numbers. Some germinate rapidly, others "rest", surviving unfavourable environmental conditions. Spores are formed by FERNS, HORSETAILS, MOSSES, FUNGI and BACTERIA.

sporophyte DIPLOID stage in the life cycle of a plant or

in a group called calareous sponges. Two commercial sponges, *Hippospongia equina* (D) and *Euspongia officinalis* (E), have skeletons of a horny, elastic substance called spongin. After harvesting from the seabed, they are dried, beaten and washed to remove hard debris so that the only part remaining is

► sponge Classified according

to the substance that makes up the supporting skeleton, the

sponges include the breadcrumb sponge *Halichondria panica* (A),

with a skeleton (B) composed of

spicules of silicon. The purse

sponge *Grantia compressa* (C) has a skeleton of calcium

carbonate spicules and is placed

the skeleton.

alga. Usually, the sporophyte gives rise to HAPLOID SPORES which germinate to produce a haploid generation (the GAMETOPHYTE stage), which will produce the GAMETES. In ferns, horsetails, conifers and flowering plants the diploid sporophyte is the dominant phase of the life cycle, the plant body we usually see. In mosses and liverworts, the main plant body is the gametophyte. See also ALTERNATION OF GENERATIONS

sprain Injury to one or more ligaments of a joint caused by sudden over-stretching. Symptoms include pain, stiffness, bruising and swelling. Treatment includes resting and supporting the affected part before gentle mobilization.

sprat (brisling) Small, herring-like commercial fish found in the N Atlantic Ocean. It is slender and silvery. Length: to 12.5 cm (5in). Family Clupeidae; species *Clupea sprattus*.

spring Mechanical device designed to be elastically compressed, extended or deflected. It may be used to store energy, absorb shock or maintain contact between two surfaces.

springbok (springbuck) Small, horned ANTELOPE native to S Africa; the national emblem of South Africa. The reddishbrown colour on the back shades into a dark horizontal band just above the white underside. Height: to 90cm (3ft) at the shoulder. Family Bovidae; species *Antidorcas marsupialis*.

Springfield State capital of Illinois, 298km (185mi) sw of Chicago. Founded in 1818, it became state capital in 1837. The centre of a fertile farming area, its industries include machinery, electronics and fertilizers. Pop. (1992) 106,429.

spruce Various evergreen trees, related to firs, native to mountainous or cooler temperate regions of the Northern Hemisphere. Pyramid-shaped and dense, they have angular rather than flattened needles and pendulous cones. The timber is used in cabinet-making, and some species yield turpentine. Height: to 52m (170ft). Family Pinaceae; genus *Picea*.

Sputnik World's first artificial satellite, launched by the Soviet Union on 4 October 1957. Weighing 83.5kg (184lb) and with a radio transmitter, *Sputnik 1* circled the Earth for several months.

square In geometry, rectangle with four sides of the same length. In arithmetic or algebra, a square is the result of multiplying a quantity by itself: the square of 3 is 9, and the square of x is x^2 .

square root Number or quantity that must be multiplied by itself to give a specified number or quantity. The square root of 4 is 2, i.e. $\sqrt{4} = 2$. A negative number has imaginary square roots

squash Any of several species of vine fruits of various shapes, all of which belong to the genus *Cucurbita*. Squashes are native to the Americas, and are cultivated as vegetables. Family Cucurbitaceae.

squash Ball game played with small, round-headed rackets by two people on an enclosed, rectangular, four-walled court. The wall at the front of the court is marked with three horizontal lines at different heights. The bottom section (the telltale) up to the first line is covered with tin to make a noise when hit by the ball. The ball from the serve must land above the middle line (cut line). Balls hitting the wall above the third line are out. The hollow rubber ball may bounce off front, side, and back walls, but may bounce only once on the floor before it is struck. The object of each point is to make it impossible for the opponent to return the ball. Only the server scores, and the first player to score 9 points wins the game. squid Any of numerous species of marine cephalopod MOL-LUSCS that have a cylindrical body with an internal horny plate (the pen) that serves as a skeleton. It has eight short, suckered tentacles surrounding the mouth, in addition to which there are two longer, arm-like tentacles that can be shot out to seize moving prey. Several species of giant squid (genus Architeuthis) may reach 20m (65ft) in length. Class Cephalopoda; order Teuthoidea.

squint See STRABISMUS

squirrel Any of numerous species of primarily arboreal, diurnal rodents found throughout the world. Species of Eurasia and the Americas, such as the common grey squirrel, red squirrel and flying squirrels, are the best known. Most species feed on nuts, seeds, fruit, insects. Most have short fur and characteristically bushy tails. Family Sciuridae.

squirrel monkey Either of at least two species of small, diurnal, arboreal MONKEYS of tropical South America; it has thick, dark fur and a long, heavy tail. *Saimiri sciureus* has a cap of greyish fur; *S. oerstedi* has a black cap and reddish fur on its back. Both are gregarious and live primarily on fruit. Length: to 40cm (16in); tail: 47cm (19in). Family Cebidae.

Sri Lanka Republic in the Indian Ocean. *See* country feature, p.636

SS (Schutzstaffeln, guards unit) Chief paramilitary force of Nazi Germany. It was originally Hitler's bodyguard but expanded after 1928, under Heinrich HIMMLER, to become the Nazi Party militia and internal police force. With its distinctive black uniform, the SS controlled the GESTAPO and the SD (security organization). It ran the CONCENTRATION CAMPS and, from 1936, controlled the police. After the outbreak of war it formed its own fighting units, notorious for their ferocity, known as the Waffen SS.

Staël, (Anne-Louise-Germaine), Madame de (1766–1817) French woman of letters. One of the most influential intellectual figures of her time, de Staël published two proto-feminist novels, *Delphine* (1802) and *Corinne* (1807), but is best known for her works of social and aesthetic philosophy. They include *A Treatise on the Influence of the Passions upon the Happiness of Individuals and of Nations* (1796), a key text of ROMANTICISM.

Staffordshire County in w central England. The terrain is composed of rolling hills with moorlands in the N. The region is drained chiefly by the River Trent. The county is primarily industrial. It includes the Potteries around STOKE-ON-TRENT and the Black Country, one of the great industrial hubs of England. Stafford (1991 pop. 117,800) is the county town. Area 2,716sq km (1,049sq mi). Pop. (1991) 1,031,035.

stag beetle Large, brown or black BEETLE of Eurasian oak forests; the male bears large antler-like mandibles. The larvae feed on rotten wood. Length: to 8cm (3in). Family Lucanidae; species *Lucanus cervus*.

stained glass Coloured glass used for decorative, often pictorial effect in windows. In its purest form, stained glass is made by adding metal-oxide colouring agents during the manufacture of glass. Shapes cut from the resulting sheets are then arranged to form patterns or images. These shapes are joined and supported by flexible strips of lead that form dark, emphatic contours. Details are painted onto the glass surfaces in liquid enamel and fused on by heat.

stainless steel Group of iron alloys that resist corrosion. Besides carbon, contained in all steels, stainless steels contain from 12% to 25% chromium. This makes the steel stainless by forming a thin, protective oxide coating on the surface. Most also contain nickel. Other metals and non-metals may be added to give the steel particular properties.

stalactite Icicle-like formation of CALCIUM CARBONATE found hanging from the roofs of caves. It is made by the precipitation of LIMESTONE out of water that has seeped into limestone caves. **stalagmite** Deposit of crystalline CALCIUM CARBONATE rising from the floor of a cavern, and formed by dripping water that has seeped into limestone caves.

Stalin, Joseph (1879-1953) (Joseph Vissarionovich Dzhugashvili) Leader of the Soviet Union (1924-53). He supported LENIN and the Bolsheviks from 1903, adopting the name Stalin ("man of steel") while editing Pravda, the party newspaper. Exiled to Siberia (1913-17), Stalin returned to join the Russian Revolution (1917) and became secretary of the central committee of the party in 1922. On Lenin's death in 1924, he achieved supreme power through his control of the party organization. Stalin outmanoeuvred rivals such as Trotsky and Bukharin and drove them from power. From 1929 he was virtually dictator. Stalin enforced collectivization of agriculture and intensive industrialization, brutally suppressing all opposition, and, in the 1930s, he exterminated all possible opponents in a series of purges of political and military leaders. During World War 2 Stalin controlled the armed forces and negotiated skilfully with the Allied leaders, Churchill and Roosevelt. After the war he reimposed severe repression and forced puppet communist governments on the states of Eastern Europe.

▲ squash Cultivated since prehistoric times, the many varieties of edible squash include the winter squash (*Cucurbita maxima*) shown here. Squash grow in a wide range of colours and shapes. There are also several varieties of inedible squash, which can be dried and put to different uses, serving, for example, as bowls or cups.

▲ squirrel monkey Found in many forested areas of South America, common squirrel monkeys (Saimiri sciureus) spend most of their time in the treetops, feeding on fruit and nuts as well as insects, eggs and young birds. However, they are also known to feed on the ground and to make bold raids on areas of cultivated fruit. Lively and friendly, they commonly live in groups of up to 30 individuals who sleep huddled together on large tree branches. Sometimes they join into large bands numbering several hundred.

Stalingrad See Volgograd

Stalingrad, Battle of (1942-43) Decisive conflict marking the failure of the German invasion of the Soviet Union during World War 2. The city (now Volgograd) withstood a German siege from August 1942 to February 1943, when the German 6th Army under Friedrich von Paulus, surrounded with no prospect of relief, surrendered to the Russian General Zhukov. Total casualties at Stalingrad exceeded 1.5 million.

Stallone, Sylvester (1946-) US film actor and director. Stallone's screenplay and starring role in Rocky (1976) in many ways mirrored his own story. Four sequels followed, three directed by Stallone. The Rambo trilogy developed his macho image. The mid-90s saw a comeback with Demolition Man (1993) and The Specialist (1994).

stamen Pollen-producing male organ of a flower. It consists of an anther, in which POLLEN is produced, on the end of a stalk-like filament. The arrangement and number of stamens is important in the classification of flowering plants.

Stamp Act (1765) First direct tax levied on the American colonies by the British government. Introduced to raise revenue for the defence of the colonies, it required a special stamp on all printed material, including newspapers and legal documents. It aroused widespread opposition, especially in Massachusetts, and was repealed in 1766.

standard deviation In statistics, a measure of dispersion or deviation of scores from the average or mean of the scores. It is written as either ø or s. In a list of numbers, the deviation is found by calculating the difference from the mean of each score in the list. The value of each differing score is then squared, and the mean calculated. The deviation of the resultant mean is the square root of that number.

standard temperature and pressure (STP) (normal temperature and pressure) In chemistry and physics, normal conditions for measurements, especially when comparing the volumes of gases. It is a temperature of 273K or 0°C (32°F), and a pressure: 1 standard atmosphere (101,325 pascals).

standing wave In physics, a wave in which the points of maximum vibration (the antinodes) and the points of no vibration (the nodes) do not move. A standing wave is formed by the interference of waves of equal frequency and intensity travelling in opposite directions.

Stanford-Binet scale Most commonly used English-language APTITUDE TEST for measuring children's IQ. It was formulated (1916) at Stanford University, California.

> AREA: 65,610sq km (25,332sq mi) POPULATION: 17,405,000

GOVERNMENT: Multiparty republic

Lankan Moor 7%

Islam 8%, Christianity 7%

CAPITAL (POPULATION): Colombo (684,000)

ETHNIC GROUPS: Sinhalese 74%, Tamil 18%, Sri

LANGUAGES: Sinhala and Tamil (both official)

RELIGIONS: Buddhism 69%, Hinduism 16%,

currency: Sri Lankan rupee = 100 cents

SRI LANKA

Sri Lanka's flag was adopted in 1951, three years after the country, then called Ceylon, became independent from Britain. The lion banner represents the ancient Buddhist kingdom. The stripes symbolize the minorities - Muslims (green) and Hindus (orange).

lagala, at 2,524m (8,281ft). Nearby, Adam's Peak, at 2,243m (7,359ft), is a pilgrimage centre. The major highland city is KANDY.

CLIMATE

Western Sri Lanka has high temperatures and heavy rainfall. The N and E are drier. The monsoon season is between May and October.

VEGETATION

Over 30% of Sri Lanka is tropical rainforest or woodland. The highlands are more open grassland. Over 14% of land is cultivated for tea and spice gardens, rice fields and sugar plantations.

HISTORY AND POLITICS

The native Veddahs were forced into the mountains c.2,400 years ago by SINHALESE settlers from N India. Some Veddahs remain in remote regions. The Sinhalese founded Anuradhapura in 437 BC, which acted as their capital and a centre of THERAVADA Buddhism, until the arrival of the Tamils in the 8th century AD. The CHOLA dynasty conquered the island in the 11th century. The Sinhalese were gradually forced s. The Portuguese landed in 1505 and formed coastal settlements. In 1658 Portuguese lands passed to the Dutch East India Company. In 1796 the British captured the Dutch colonies, and in 1802 Ceylon became a crown colony. In 1815 Britain captured Kandy. Colonial settlers developed the plantations. In 1948 Ceylon achieved self-government within the Commonwealth of Nations. In the late 1950s, following the declaration of Sinhalese as the official language, communal

violence flared between Tamils and Sinhalese. In 1958 Prime Minister Solomon BAN-DARANAIKE was assassinated. His widow, Sirimovo Bandaranaike, became the world's first woman prime minister (1960). Following a brief period in opposition, she was re-elected in 1970. In 1972 Ceylon became the independent republic of Sri Lanka (resplendent island). The new republic was faced with resurgent demands for a separate Tamil state (Tamil Eelam) in N and E Sri Lanka. In 1983 secessionist demands spiralled into civil war between government forces and the TAMIL TIGERS. In 1987 the Sri Lankan government called for Indian military assistance. Unable to enforce a peace settlement, Indian troops withdrew in 1989. In 1993 President Ranasinghe Premadasa was assassinated. In 1994 Prime Minister Chandrika Bandaranaike Kumaratunga was elected president, and her mother, Srimovo Bandaranaike, became prime minister for the third time. Military offensives against the Tamil Tigers led to the re-capture of Jaffna in 1995. The Tamil Tigers refused to accept devolution and the war, which has claimed over 40,000 lives, continued.

ECONOMY

Sri Lanka is a low-income developing country (1992 GDP per capita, US\$2,850). Agriculture employs 50% of the workforce. Sri Lanka is the world's third-largest producer of tea It is also a leading producer of coconuts and rubber. Manufacturing has increased rapidly and contributes 67% of exports. Products include ceramics, textiles and clothes. Tourism is also important.

Sri Lanka (formerly Ceylon) is a pear-shaped island, separated from SE India by the Palk Strait. A chain of coral islands (Adam's Bridge) almost joins the two countries. Most of Sri Lanka is low-lying. A coastal plain is fringed by cliffs and lagoons. On the sw coast lies the capital, COLOMBO. The s central core of Sri Lanka is

a highland region. The highest peak is Piduruta-

Stanislavsky, Konstantin (1863–1938) (Konstantin Sergeyevich Alekseyev) Russian actor, director and teacher. Stanislavsky's theory of drama, as described in *My Life In Art* (1924), stressed the value of the ensemble and a naturalistic approach, with each actor making emotional contact with their character. *See also* ACTORS' STUDIO

Stanley, Sir Henry Morton (1841–1904) US explorer of Africa. He was born in Wales as John Rowlands, emigrated to the USA at 16 and took the name of a cotton merchant who adopted him. Stanley became a journalist and was commissioned by the *New York Herald* to lead an expedition to E Africa in search of David Livingstone. They met on the shores of Lake Tanganyika in 1871. On a second expedition (1874–77), Stanley crossed the continent from west to East, following the route of the River Congo. He acted as an agent (1879–84) for King Leopold II, helping to establish the Belgian colony of Congo Free State. Stanley's expedition (1887–89) to rescue Emin Pasha from the Sudan resulted in a massive loss of life. He was knighted in 1899.

Stanley (Port Stanley) Capital and chief port of the FALK-LAND ISLANDS, on East Falkland. Originally called Port William, it became capital of the Falkland Islands in 1843. In 1982 it was captured by the Argentinians, precipitating the FALKLANDS WAR. Since 1983 the British army have maintained a base there. Pop. (1991) 2,121

Stanton, Edwin McMasters (1814–69) US statesman. Attorney general under President Buchanan, he was a firm unionist and was appointed secretary of war by Abraham Lincoln (1862). He retained his office under Andrew Johnson and attempted to mediate between the president and the Republican Congress over Reconstruction. Johnson's efforts to dismiss Stanton led to his own impeachment. Stanton was forced to resign (1868) after Johnson was acquitted. Stanton, Elizabeth (1815–1902) US social reformer. Stanton organized the Seneca Falls Convention (1848), the first public assembly in the USA for female suffrage. With Susan B. Anthony, she formed the Woman Suffrage Association.

staphylococcus Spherical bacterium that grows in grape-like clusters and is found on the skin and mucous membranes of human beings and other animals. Pathogenic staphylococci cause a range of local or generalized infections, including PNEUMONIA and SEPTICAEMIA. They may be destroyed by ANTIBIOTICS, although some strains have become resistant.

star Self-luminous ball of gas whose radiant energy is produced by FUSION reactions, mainly the conversion of hydrogen into helium. The temperatures and luminosities of stars are prescribed by their masses. The most massive stars are about 100 solar masses (a hundred times heavier than the Sun). Large stars are very luminous and hot, and therefore appear blue. Medium-sized stars like the Sun are yellow, while small stars are a dull red. The smallest stars contain less than one-twentieth of a solar mass. *See also* BINARY STAR

starch CARBOHYDRATE stored in many plants and providing about 70% of human food in such forms as rice, potatoes and cereals. Animals and plants convert it to GLUCOSE for energy (RESPIRATION). Consisting of linked glucose units, starch exists in two forms: **amylose**, in which the glucose chains are unbranched; and **amylopectin**, in which they are branched. It is made commercially from cereals, maize, potatoes, and other plants, and used in the manufacture of adhesives and foods.

Star Chamber English court of the 15th to 17th centuries, named after its meeting place in Westminster. It arose as a judicial branch of the royal council, which received petitions from subjects and tried offences against the crown. It proved a useful, honest and speedy source of justice under the early TUDORS but was used by CHARLES I to attack his opponents. It was dissolved by Parliament in 1641.

starfish Any of numerous species of marine ECHINODERMS with a central disc body and a five-rayed symmetry resulting in 5 to 40 radiating arms. The mouth is on the underside of the disc and the stomach can be extruded to digest other echinoderms and shellfish. Calcareous spines are embedded in the skin. Starfish move by means of tube feet, which they may also use for pulling open the bivalve molluscs on which they feed. Class Asteroidea.

Stark, Dame Freya Madeline (1893–1993) British explorer and writer. Stark travelled widely in the Middle East, especially Arabia, and gained esteem through her classics of travel literature. *The Valley of the Assassins* (1934) describes her journeys in Iran. Stark's travels in the Hadramaut (Yemen) were recorded in *The Southern Gates of Arabia* (1936).

starling Any of several species of small, aggressive birds found throughout the world. The common Eurasian starling, *Sturnus vulgaris*, is mottled black and brown. It feeds on the ground on insects and fruit, often damaging crops. Length: to 36cm (14in). Family Sturnidae.

Star of David (Shield of David) Six-pointed device formed by opposing two equilateral triangles. Known in Hebrew as *Magen David* or *Mogen David*, it was used as an emblem or magic sign by pagans, Christians, Muslims, and gradually found its way into JUDAISM as a cabbalistic sign. It appears on the flag of the modern state of ISRAEL.

State, US Department of US government department that conducts foreign policy. It is the oldest federal government department, created in 1789, and the secretary of state (foreign minister) is a senior member of the cabinet.

States General National assembly composed of separate divisions, or "estates", each historically representing a different social class. In France the Assembly was divided into three estates – clergy, nobility and commoners – before the FRENCH REVOLUTION. The Dutch parliament still retains the name Estates-General.

states' rights In the USA, the doctrine that the states have authority in matters not delegated to the federal government. The controversy between federal and state jurisdiction reached a peak with John C. CALHOUN's interpretation that a state could refuse to obey a federal law it deemed unconstitutional. This led to the Nullification Crisis (1832) and contributed to secession and the CIVIL WAR. It was also an issue during the civil rights movement of the 1950s and 1960s.

static electricity ELECTRIC CHARGES at rest. Electrically charged objects have either too many or too few ELECTRONS. COULOMB's law describes the forces that charged objects have on each other and relates the force to their charge and the distance between them. Static electricity can be produced by friction. Electrons may then jump off as a spark, shocking anyone touching the object. Lightning is a larger result of static electricity. This form of electricity is studied in **electrostatics**.

statics Branch of MECHANICS that deals with the action of forces on objects at rest. Its topics include finding the resultant (net) of two or more forces; centres of gravity; moments; and stresses and strains. *See also* DYNAMICS

statistical mechanics Branch of physics that studies largescale properties of matter based on the statistical laws of large numbers. The large number of molecules in such a system allows the use of statistics to predict the probability of finding the system in any state. The ENTROPY (disorder or randomness) of the system is related to its number of possible states; a system left to itself will tend to approach the most probable distribution of energy states. *See also* THERMODYNAMICS

statistics Science of collecting and classifying numerical

■ starfish A starfish feeds by surrounding its prey, eventing its stomach through its mouth and partially digesting the food, which is then taken back into the stomach extensions (red). It moves by means of a watervascular system (blue) unique to echinoderms. Water enters through the sieve plate (1) and is drawn by tiny hairs through the five radial canals into the many pairs of tube feet (2) armed with suckers. When the amoulla (3) of each tube foot contracts, water is forced into the foot (illustrated in cross-section), which extends (4) and allows attachment to the hard rock. Muscles in the foot then shorten it (5) forcing water back into the ampulla and drawing the animal forward.

▲ starling With the brightest plumage of its family, the superb starling (*Spreo superbus*) lives in East Africa. Like the other starlings, it is noisy and bold and lives in large colonies, often near villages and towns. In general, the starling family (Sturnidae) is highly adaptable — the common starling had spread throughout North America within 80 years of its arrival (1890).

▲ Statue of Liberty A huge copper monument at the mouth of New York harbour, the Statue of Liberty has become a symbol of the United States. From the base of the pedestal to the top of the torch, it is 93m (300ft) high. In the crown is an observation deck. The statue is inscribed with *The New Colossus*, a sonnet by Emma Lazarus. Lazarus called the statue the Mother of Exiles. "Give me your tired, your poor, Your huddled masses, yearning to breathe free..."

► stealth technology The Lockheed F-117A employs stealth technology to render itself practically invisible to radar. The aircraft's materials and design are such that its radar crosssection (RCS) - the imaginary size of a perfectly reflecting object that would reflect the same amount of energy - is reduced to within the levels of background noise. To achieve this, compromises are required in terms of the aircraft's performance and operating and maintenance costs.

data. Statistics can be **descriptive** (summarizing the data obtained) or **inferential** (leading to conclusions or inferences about larger numbers of which the data obtained are a sample). Inferential statistics are used to give a greater degree of confidence to conclusions, since statistics make it possible to calculate the probability that a conclusion is in error.

Statue of Liberty Large copper statue of a woman, standing on Liberty Island in New York Harbour. A symbol of US democracy, it was a gift from France built to commemorate the 1876 centenary of US independence. It was designed by BARTHOLDI on an iron framework designed and built by Gustave Eiffel. The statue's formal name is *Liberty Enlightening the World*. It stands 46m (150ft) tall to the top of the torch in the goddess' raised right hand. It became a symbol of freedom and opportunity for millions of immigrants who disembarked on nearby ELLIS ISLAND.

status In sociology, a person's social position in a hierarchically arranged western society, based on factors such as lifestyle, prestige, income, and education. Status can be inherited (ascribed) or inferred (achieved) from the acquisition of certain symbols (commodities) seen as representative of wealth or class.

steady-state theory Cosmological theory put forward by Hermann Bondi and Thomas Gold in 1948, and further developed by Fred HOYLE and others. According to this theory, the Universe has always existed; it had no beginning and will continue forever. Although the Universe is expanding, it maintains its average density (steady-state) through the continuous creation of new matter. Most cosmologists now reject the theory because it cannot explain the cosmic microwave background or the observation that the appearance of the Universe has changed with time.

stealth technology Methods used to render an aircraft nearly invisible, primarily to radar or heat detection. To achieve "invisibility", a stealth aircraft must have sympathetic airframe design (all radar-reflecting "hard" edges smoothed away), engine exhaust dampers that mask and disperse jet efflux, and radar absorbent material that "holds" electronic emissions rather than reflecting them. This coating has to be regularly applied, since it is sensitive to water and wear. The US Lockheed F-117A was the first "stealth" aircraft to enter frontline service (1983), followed a decade later by the Northrop B-2. The F-19 stealth fighter was used in the Gulf War (1991).

steam engine Engine powered by steam. In some engines, the steam forces pistons to move along cylinders. This results in a reciprocating (back-and-forth) motion. A mechanism usually changes this into rotary motion. Steam turbines are engines that produce rotary motion directly by using the steam to turn sets of fan-like wheels. The first steam engine was a form of pump, used to remove water from mines, invented in 1689 by English engineer Thomas Savery. In 1712, Thomas Newcomen invented a steam-operated pump with pistons in Britain. From the 1760s, Scottish engineer James Wart produced more efficient steam engines. This led to the use of steam engines to power machinery in factories. British engineer Charles Parsons invented the first practical steam TURBINE in 1884. His machines were so efficient that turbines soon started to replace reciprocating steam engines in power stations.

stearic acid (octadecanoic acid) Common saturated fatty acid ($C_{18}H_{36}O_2$) often found as glyceride in animal and vegetable fats. It is used in ointments, lubricants, creams, candles and soap. Properties: r.d. 0.85; m.p. 70°C (158°F).

Steel, Sir David Martin Scott (1938–) British politician, leader of the Liberal Party (1976–88). Steel entered parliament in 1965 and sponsored the bill that became the 1967 Abortion Act. In 1981 he took the Liberal Party into an electoral alliance with the newly-formed SOCIAL DEMOCRATIC PARTY (SDP). In 1988 the two parties merged to form the LIBERAL DEMOCRATS, and Steel stood down in favour of Paddy ASHDOWN. He was knighted in 1990.

steel Group of iron alloys containing a little carbon. The great strength of steel makes it an extremely important material in construction and manufacturing. The most common type is called plain carbon steel, because carbon is the main alloying material. This kind of steel usually contains less than 1% of carbon by weight. Alloy steels contain some carbon, but owe their special properties to the presence of manganese, nickel, chromium, vanadium or molybdenum. Lowalloy steels, with less than 5% of alloying metals, are exceptionally strong and are used in buildings, bridges and machine parts. *See also* STAINLESS STEEL

Steele, Sir Richard (1672–1729) British essayist and dramatist. In 1709 Steele founded *The Tatler* magazine, which he edited under the pseudonym of Issac Bickerstaff. He also co-founded (1711), with Joseph Addison, *The Spectator*. Of Steele's plays, only *The Conscious Lovers* (1722) has won lasting acclaim.

Steen, Jan (1626–79) Dutch painter. Steen excelled as a painter of children, and his work includes many fine historical, mythological and religious themes. Many of his compositions depict taverns and celebrations.

Stein, Gertrude (1874–1946) US author and critic. Stein was influential in the US expatriate community in Paris. Her prodigious, experimental output includes the novel *Three Lives* (1909) and *The Autobiography of Alice B. Toklas* (1933), a fictionalized account of her life from her lover's point of view.

Steinbeck, John (1902–68) US novelist. Steinbeck first came to notice with *Tortilla Flat* (1935), the success of which was consolidated by the novella *Of Mice and Men* (1937). Later novels include *Cannery Row* (1945), *East of Eden* (1952), and his masterpiece, *The Grapes of Wrath* (1939), which earned him a Pulitzer Prize and a National Book Award. He was awarded the 1962 Nobel Prize for literature. **Steiner, Rudolf** (1861–1925) Austrian philosopher and edu-

cationalist who helped to found the German THEOSOPHY movement. He later developed a philosophy of his own, called anthroposophy, which sought to explain the world in terms of people's spiritual nature or thinking independent of the senses. **stem** Main, upward-growing part of a plant that bears leaves, buds and flowers or other reproductive structures. In VASCULAR PLANTS the stem contains conducting tissues (XYLEM and PHLOEM). In flowering plants this vascular tissue is arranged in a ring (in DICOTYLEDONS) or scattered (in MONOCOTYLEDONS). They may be modified into underground structures (RHIZOMES, TUBERS, CORMS, BULBS). Stems vary in shape and size from the thread-like stalks of aquatic plants to tree-trunks.

Stendhal (1783–1842) (Marie Henri Beyle) French novelist, whose debut work, *Armance*, appeared to critical scorn in 1827. Today, Stendhal is regarded as a major precursor of psychological realism. His masterpiece, *Scarlet and Black* (1830), focuses on Julian Sorel, an anti-hero whose ironic detachment from Parisian society satirizes 19th-century bourgeois morality. His other great work is *Charterhouse of Parma* (1839).

Stephen, Saint (977–1038) Stephen I of Hungary (r.1000–38), the first king of the Árpád dynasty. His chief work was to continue the Christianization of Hungary begun by his father, by endowing abbeys, inviting in foreign prelates, and suppressing paganism. He was canonized in 1083.

Stephen (1097–1154) King of England (1135–54), nephew of Henry I. Stephen usurped the throne on Henry's death, despite an earlier oath of loyalty to Henry's daughter, Matilda. A long civil war (1139–48) began when Matilda's forces invaded. He received support from most of the English barons, who were unwilling to accept a female sovereign. Stephen was captured in 1141, but exchanged for the duke of Gloucester. After the death of his son, Eustace, in 1153, Stephen accepted Matilda's son, the future Henry II, as heir to the throne.

Stephens, Alexander Hamilton (1812–83) US statesman, vice president (1861–65) of the Confederacy. A former governor of Georgia, Stephens opposed secession while upholding the right of a state to secede. As Confederate vice president, he quarrelled with Jefferson Davis over military conscription and other matters, damaging confidence in the government.

Stephenson, George (1781–1848) English engineer, regarded as the father of the locomotive. Stephenson built his first locomotive, *Blucher*, in 1814. His most famous locomotive, *Rocket*, was built in 1829. It ran on the Liverpool to Manchester line, one of the many railway lines that he engineered. Stephenson, Robert (1803–59) English engineer, son of George STEPHENSON. From 1827, Robert Stephenson managed his father's locomotive works. He built several railway lines and tubular bridges, including the Britannia Bridge over the Menai Strait, Wales.

stereoscope Optical device that produces an apparently three-dimensional image by presenting two slightly different plane images, usually photographs, to each eye. Some modern stereoscopes use POLARIZED LIGHT to project images that are viewed through polarized filters.

sterile Inability to reproduce. It may be due to INFERTILITY or, in humans and other animals, to surgical intervention.

sterilization Surgical intervention that terminates the ability of a human or other animal to reproduce. In women, the usual procedure is tubal ligation: sealing or tying off the FALLOPIAN TUBES so that fertilization can no longer take place. In men, a VASECTOMY is performed to block the release of sperm. The term is also applied to the practice of destroying micro-organisms in order to prevent the spread of infection. Techniques include heat treatment, irradiation and the use of disinfecting agents.

sterling Term for British currency. It is used to distinguish the UK pound from those of other currencies and can also be used to describe the quality and standard weight of coins. The sterling silver mark on silver (the stamp of a lion *passant*) represents a purity of more than 90%.

Sterne, Laurence (1713–68) British novelist, b. Ireland. Sterne achieved immediate acclaim following the publication of the first two volumes of the novel *Tristram Shandy* (1760). Sterne's playful, anarchic experiments with form foreshadowed MODERNISM. He adopted the persona of the parson in *Tristram Shandy* for *The Sermons of Mr Yorick* (1760–69). and his second novel, *A Sentimental Journey* (1768).

sternum (breastbone) Flat, narrow bone extending from the base of the front of the neck to just below the diaphragm in the centre of the chest. The top is attached by ligaments to the collarbones and the centre part is joined to the ribs by seven pairs of costal cartilages.

steroid Class of organic compounds with a basic molecular structure of 17 carbon atoms arranged in four rings. Steroids are widely distributed in animals and plants, the most abundant being the sterois, such as cholesterol. Another important group are the steroid HORMONES, including the corticosteroids, secreted by the adrenal cortex, and the sex hormones (OESTROGEN, PROGESTERONE and TESTOSTERONE). Synthetic steroids are widely used in medicine. Athletes sometimes abuse steroids to increase their muscle mass, strength and stamina, but there are harmful side effects. Taking steroids is illegal in sports.

stethoscope Instrument that enables an examiner to listen to the action of various parts of the body, principally the heart and lungs. It consists of two earpieces attached to flexible rubber tubes that lead to either a disc or a cone.

Stevens, Thaddeus (1792–1868) US political leader. As representative from Pennsylvania (1849–53, 1859–68), he was one of the fiercest opponents of slavery in Congress. He successfully opposed the lenient policy of Andrew JOHNSON on Reconstruction and managed the president's impeachment. Stevens, Wallace (1879–1955) US poet. Steven's debut volume, *Harmonium* (1923), includes "Sunday Morning". Through poetry, he attempts to find order in a chaotic world. Other volumes include *The Man with the Blue Guitar* (1937). Steven's *Collected Poems* (1954) won a Pulitzer Prize.

Stevenson, Robert Louis (1850–94) Scottish novelist, essayist and poet. Stevenson is best-known for his classic chil-

dren's adventure stories, such as *Treasure Island* (1883) and *Kidnapped* (1886). His later work includes historical novels, such as *The Black Arrow* (1888) and *The Master of Ballantrae* (1889), as well as the psychological novel *The Strange Case of Dr Jekyll and Mr Hyde* (1886). Stevenson spent the last years of his life on Samoa, where he wrote *The Ebb-Tide* (1894).

Stewart, Jackie (John Young) (1939–) Scottish Formula 1 motor racing driver. Stewart retired from racing in 1973 after winning what was then a record 27 Grands Prix. In 1997 he established his own Formula 1 racing team.

Stewart, James Maitland (1908–97) US film actor, famed for his gangling gait and slow drawl. Stewart's roles in the Frank Capra comedies *You Can't Take It With You* (1938) and *Mr Smith Goes to Washington* (1939) gained plaudits and awards. Further praise followed for his performance in *It's a Wonderful World* (1939). Stewart won a Best Actor Academy Award for the classic *The Philadelphia Story* (1940). He starred in three Hitchcock films: *Rope* (1948), *Rear Window* (1954), and *Vertigo* (1958). Other films include *Anatomy of A Murder* (1959), *The Man who Shot Liberty Valance* (1962), *Shenandoah* (1965) and *The Shootist* (1976).

stick insect Any of numerous species of herbivorous insects of the order Phasmida, which resemble the shape and colour of the twigs upon which they rest; known in North America as walking stick. Some lay eggs that resemble seeds. Length: to 32cm (11in). *See also* LEAF INSECT

stickleback Small fish found in fresh, brackish and salt water. It is usually brown and green, and may be identified by the number of spines along its sides and back. The male builds a nest of water plants and drives the female into it. He then watches the eggs and cares for the young. Length: 8–11cm (3–4.5in). The 12 or so species include the three-spined *Gasterosteus aculeatus*. Family Gasterosteidae.

Stieglitz, Alfred (1864–1946) US photographer, editor, and promoter of modern art. In 1902 Stieglitz founded the Photo-Secession Group. His photographs include classic portraits of his wife, Georgia O'KEEFFE, studies of Manhattan and the cloud images known as "equivalents."

stigma In botany, the free upper part of the STYLE of the female organs of a flower, to which pollen grains adhere before FERTILIZATION.

Stijl, De (Dutch, The Style) Group of modern artists that originated in the Netherlands in 1917. They were associated with the eponymous art periodical co-founded by Piet Mondrian and Theo van Doesburg. De Stijl's aesthetic was an austere use of bold, vertical and horizontal lines, often breaking up primary colours. It was especially influential in architecture, informing the work of Gerrit RIETVELD.

Stimson, Henry Lewis (1867–1950) US statesman. He was secretary of war under President TAFT (1911–13). As secretary of state under President HOOVER (1929–33), he tried to secure international disarmament and formulated the "Stimson doctrine": that the USA would not recognize territorial changes brought about by force. He was Franklin D. ROOSEVELT'S secretary of war throughout World War 2.

stimulant Substance that increases mental alertness and activity. There are a number of stimulants that act on the CENTRAL NERVOUS SYSTEM, notably drugs in the amphetamine group. Many common beverages, including tea and coffee, contain small quantities of the stimulant caffeine.

stingray Any of several species of bottom-dwelling elasmobranch fish that live in marine waters and in some rivers in South America. It has a flattened body, with wing-like fins around the head. It has a long, slender tail which can inflict a venomous sting to stun prey, and can cause injury to human beings. Width: to 2.1m (7ft), Family Dasyatidae.

stinkhorn Any of several species of foul-smelling Basidiomycete fungi. At first, it resembles a small, whitish "egg",

A stick insect Highly modified for the purposes of camouflage, the stick insects of New Guinea, such as Euryacantha horrida shown here, mimic the plants on which they live. Because they look like twigs, which are inedible, they are protected from predators. Their spindly legs are barely noticeable at rest. Some stick insects may remain motionless for hours; others sway backwards and forwards as if moving with a breeze.

■ stickleback Often found in estuaries, the males of the three-spined stickleback (Gasterosteus aculeatus) lure females by adopting a bright red belly colouring and performing a complex mating dance. They also use their colouring to defend territory against other males: they adopt a threatening head-down position that displays the red belly and the iridescent blue head at the same time.

which contains the unripe fruit body (receptacle). When ripe, the receptacle elongates to 10–20cm (4–8in) in height, rupturing the egg. It carries with it a glutinous brownish spore mass that attracts the flies that disperse the spores. Genus *Phallus*.

Stirling, James (1926–) Scottish architect. Stirling is known for his post-modernist designs, such as the Cambridge University History Faculty building (1964–67) and the Clore Gallery extension to the TATE GALLERY, London (1987).

stoat Carnivorous mammal of the WEASEL family. Its slim body is about 30cm (12in) long, including the tail, and it has short legs and moves sinuously. It preys upon rabbits and smaller animals in many temperate and northern parts of the world. In the latter regions its fur turns from red-brown and white to white in winter, when it is known as ermine. Family Mustelidae; species *Mustela ermina*.

stock (gilliflower) Annual plant native to s Europe, South Africa and parts of Asia, cultivated as a garden flower. It has oblong leaves and pink, purple or white flower clusters. Height: to 80cm (30in). Family Brassicaceae/Cruciferae; species *Matthiola bicornis*.

stock See Shares

stock exchange Market in which stocks and SHARES are bought and sold. There are exchanges in major cities throughout the world, the largest being in New York and London.

Stockhausen, Karlheinz (1928–) German composer and theorist, the most successful exponent of ELECTRONIC MUSIC. An example of his work is *Kontakte* (1960), which uses instruments with tape. His seven-part opera, *Licht*, was begun in 1977; four parts have been completed.

Stockholm Port and capital of Sweden, on Lake Mälar's outlet to the Baltic Sea. Founded in the mid-13th century, it became a trade centre dominated by the HANSEATIC LEAGUE. GUSTAVUS I (VASA) made it the centre of his kingdom, and ended the privileges of Hanseatic merchants. Stockholm became the capital of Sweden in 1436 and developed as an intellectual centre in the 17th century. Industrial development dates from the mid-19th century. Industries: textiles, clothing, paper and printing, food processing, rubber, chemicals, shipbuilding, beer, electronics, metal, machine manufacturing. Pop. (1993) 692,954.

Stockton, Robert Field (1795–1866) US naval officer. Stockton served in the War of 1812. In 1821 he played a major role in negotiating rights to what became LIBERIA. Stockton commanded forces in the MEXICAN WAR (1846–48), proclaiming California a US territory.

Stockton-on-Tees Industrial town and unitary authority on the River Tees, NE England. The town developed around the world's first passenger rail service, the Stockton and Darlington Railway (1825). Industries: iron, engineering, chemicals. Pop. (1991) 173,912

Stoics Followers of the school of philosophy founded by ZENO OF CITIUM in $c.300\,$ BC. Founded on the premise that virtue is attainable only by living in harmony with nature, stoicism stressed the importance of self-sufficiency and of equanimity in adversity. The philosophy was first expressed by Chrysippus in the 3rd century BC. It was introduced into Rome in the 2nd century BC, where it found its greatest adherents: SENECA in the 1st century AD, Epictetus in the 1st and 2nd centuries, and the 2nd-century emperor MARCUS AURELIUS.

Stoke-on-Trent City and county district on the River Trent, NW STAFFORDSHIRE, W central England. Stoke is the centre of the Potteries and is noted for its manufacture of china and porcelain. Pop. (1991) 244,637.

Stoker, Bram (Abraham) (1847–1912) Irish novelist. Stoker wrote several novels and a memoir of the actor Henry Irving (1906), but he is best-remembered for the classic, gothic horror novel *Dracula* (1897).

Stokowski, Leopold (Antoni Stanislaw) (1882–1977) US conductor, b. Britain. Stokowski was director (1909–12) of the Cincinnati Symphony and conductor (1912–36) of the Philadelphia Orchestra. He became known for his individual interpretations and flexibility of approach.

stolon Modified horizontal underground or aerial stem growing from the basal node of a plant. Aerial stolons, also called runners, may be slender, as in strawberry, or stiff and arching, as bramble. The stolon produces a new plant at its tip, which puts out adventitious roots to anchor itself. *See also* TUBER; VEGETATIVE REPRODUCTION

stoma In botany, pores found mostly on the undersides of leaves that allow atmospheric gases to pass in and out for RESPIRATION and PHOTOSYNTHESIS. Surrounding each stoma are two guard cells that can close to prevent excessive loss of water vapour. *See also* GAS EXCHANGE; TRANSPIRATION

stomach J-shaped organ, lying to the left and slightly below the DIAPHRAGM in human beings; one of the organs of the DIGESTIVE SYSTEM. It is connected at its upper end to the gullet (OESOPHAGUS) and at the lower end to the SMALL INTESTINE. The stomach itself is lined by three layers of muscle, and a folded mucous layer that contains gastric glands. These GLANDS secrete hydrochloric acid that destroys some food bacteria and makes possible the action of pepsin, the ENZYME that digests PROTEINS. Gastric gland secretion is controlled by the sight, smell and taste of food, and by hormonal stimuli, chiefly the HORMONE gastrin. As the food is digested, it is churned by muscular action into a thick liquid state called chyme, at which point it passes into the small intestine.

Stone, Lucy (1818–93) US feminist who co-organized the first US women's rights convention (1850). Stone established several organizations for women's suffrage and founded (1870) the *Woman's Journal*.

Stone Age Period of human evolution defined by the use of stone tools. The Stone Age dates from the earliest identifiable broken-pebble tools made by human ancestors *c.*2.5 million years ago. The period is generally considered to have ended when metal tools first became widespread during the BRONZE AGE. The Stone Age is usually subdivided into the PALAE-OLITHIC, MESOLITHIC and NEOLITHIC.

stonechat Small thrush found in open heath and scrubland of Europe, Africa and Asia. The plumage of the male is black, white and rust-brown. Stonechats feed on the ground on insects. Species *Saxicola torquata*.

stonecrop Any plant of the genus *Sedum* of the family Crassulaceae, especially creeping sedum (*S. acre*), a succulent, low-growing plant of European origin with pungent, fleshy leaves and yellow flowers found in rocky areas.

stonefish Bottom-dwelling, marine fish that lives in tropical waters of the Indo-Pacific Ocean. It has a warty, slime-covered body and sharp dorsal spines with which it can inflict a painful, sometimes deadly, sting to human beings. Length: to 33cm (13in). Family Synancejidae; species *Synanceja verrucosa*.

▶ stonefly An important source of food for freshwater fish, stoneflies (*Plecoptera* sp.) are hatched in the water and spend most of their lives there. Their nymph stage, during which they are aquatic, lasts from one to four years, while their adult phase, after they have left the water, is only of a few weeks' duration. As adults, they do not fly well and hover over the surface of streams, lakes and rivers. Fishermen often use lures that resemble them.

stonefly (salmon fly) Soft-bodied insect with long, narrow front wings and chewing mouthparts, found throughout the world. The aquatic nymphs have branched gills, and the adults, used as bait by anglers, are brown to black. Length: 5–60mm (0.2–2.5in). Order Plecoptera.

Stonehenge Circular group of prehistoric standing stones within a circular earthwork on Salisbury Plain, s England, 13km (8mi) N of Salisbury. The largest and most precisely constructed MEGALITH in Europe, Stonehenge dates from the early 3rd millennium BC, although the main stones were erected *c.*2000–1500 BC. The large standing bluestones were brought from sw Wales *c.*2100 BC. The significance of the structure is unknown.

Stopes, Marie Charlotte Carmichael (1880–1958) British pioneer of birth control. Stopes campaigned for a more rational and open approach to contraception, establishing the first birth control clinic in Britain in 1921. She wrote *Wise Parenthood* (1918) and *Contraception: Its Theory, History and Practice* (1923; 1931).

Stoppard, Tom (1937–) British dramatist, b. Thomas Straussler. Stoppard won instant fame with *Rosencrantz and Guildenstern are Dead* (1966). Plays, such as *The Real Inspector Hound* (1968) and *Jumpers* (1972), confirmed his ability to combine philosophical speculation with humour and dramatic invention. Storey has made plays for radio (*Artist Descending a Staircase*, 1973) and television (*Professional Foul*, 1977) Other plays include *Arcadia* (1993) and *Indian Ink* (1995).

Storey, David (1933–) British novelist and dramatist. Storey's debut novel, *This Sporting Life* (1960), explored his favourite themes of class conflict and alienation. *Radcliffe* (1963) is perhaps his best-known work. Storey won the Booker Prize for *Saville* (1976). His plays include *Home* (1970).

stork Long-legged wading bird that lives along rivers, lakes, and marshes in temperate and tropical regions, often nesting in colonies in trees. Usually black, white and grey, storks have straight bills, long necks, robust bodies and long broad wings. They are diurnal and feed on small animals and sometimes carrion. Length: 0.8–1.5m (2.5–5ft). Family Ciconiidae.

storm and stress See STURM UND DRANG

Stowe, Harriet Beecher (1811–96) US novelist. A prolific writer, Stowe is best known for *Uncle Tom's Cabin* (1851–52), a powerful anti-slavery novel.

STP See STANDARD TEMPERATURE AND PRESSURE

strabismus (squint) Condition in which the eyes do not look in the same direction. It may result from either disease of or damage to the eye muscles or their nerve supply, or an error of refraction within the eye.

Strachey, (Giles) Lytton (1880–1932) British biographer and essayist, a member of the BLOOMSBURY GROUP. Strachey's works include *Eminent Victorians* (1918), *Queen Victoria* (1921), and *Elizabeth and Essex* (1928). He is often credited with adding the psychological dimension to modern biography. Stradivari, Antonio (1644–1737) Italian violin-maker. Originally an apprentice to Nicolo AMATI, Stradivari perfected violin design. His instruments remain unsurpassed in brilliance of tone.

Strafford, Thomas Wentworth, 1st Earl of (1593–1641) English minister of Charles I. Strafford became the king's chief adviser after the death of the duke of BUCKINGHAM and proved an extremely capable administrator as Lord President of the North (1628–33) and Lord Deputy of Ireland (1633–39). In 1639 Charles made him an earl, but he failed to quell a Scottish rebellion (1640). Strafford was impeached by the LONG PARLIAMENT and he was executed.

Strasberg, Lee (1901–82) US theatrical director. One of the founders of the Group Theatre (1931), he began teaching a "method" approach, based on the the teachings of STANISLAVSKY. In 1947 Strasberg and Elia KAZAN founded the ACTORS' STUDIO. As the Studio's artistic director, he was influential in shaping the careers of many leading Hollywood actors, such as Marilyn Monroe and Al Pacino.

Strasbourg City on the River III, capital of Bas-Rhin département and commercial capital of the Alsace region, E France. Known in Roman times as Argentoratum, the city was destroyed by the Huns in the 5th century. It became part

of the HOLY ROMAN EMPIRE in 923 and developed into an important commercial centre, becoming a free imperial city in 1262. Strasbourg was a centre of medieval German literature, and of 16th-century Protestantism. The city was seized by France in 1681, regained by Germany after the Franco-Prussian War, but recovered by France at the end of World War 1. German troops occupied the city during World War 2. The European Parliament sits in Strasbourg's Palais de l'Europe. Industries: metallurgy, oil and gas refining, machinery, food processing. Its port, on the Rhine, is France's chief grain outlet. Pop. (1990) 252,338.

Strategic Arms Limitation Talks (SALT) Two phases of talks between the USA and the Soviet Union to limit the expansion of nuclear weapons. The talks began in 1969 between Lyndon B. Johnson and Leonid Brezhnev. In 1972 Richard Nixon and Brezhnev signed SALT I. This agreement limited anti-ballistic missile systems and produced an interim accord on intercontinental ballistic missiles (ICBMs). A second phase of meetings between Gerald FORD and Brezhnev resulted in an agreement (1974) to limit ballistic missile launchers. SALT II, signed in Vienna between Jimmy CARTER and Brezhnev, banned new ICBMs and limited other launchers. The Soviet invasion of Afghanistan meant that the treaty was never ratified by the US Senate. Nevertheless, the two superpowers observed its terms until Ronald REAGAN began to increase the US nuclear arsenal. In 1986 SALT was superseded by START (Strategic Arms Reduction Talks) between Mikhail GORBACHEV and Reagan. START ushered in a new era of DISARMAMENT.

Stratford upon Avon Town in Warwickshire, central England. Stratford upon Avon is the birthplace of William Shakespeare and home of the Royal Shakespeare Company (RSC). Industries: tourism, engineering, boatbuilding, textiles. Pop. (1992) 22,800.

Strathclyde Region in w Scotland, bounded N by the Highlands, s by the Southern Uplands, and w by the Atlantic Ocean. Strathclyde is divided into 19 districts. The capital is GLASGOW; other major towns include Paisley, Kilmarnock, Clydebank and Motherwell. The industrial heartland of Scotland, it contains half of Scotland's population. Sites include Loch LOMOND, Glencoe, and the islands of Mull, Arran and Bute. The ancient British or Welsh kingdom of Strathclyde existed from the 5th to 10th centuries. Its capital was at Dumbarton. In the late 9th century the kingdom was devastated by Norse raiders, and the native Welsh dynasty died out. In 945 it was awarded to Scotland, but only incorporated into the Scottish kingdom in the 11th century. Industries: shipbuilding, engineering. Area: 13,529sq km (5,222sq mi) Pop: (1991) 2,248,700

stratigraphy Branch of geology concerned with stratified or layered rocks. It deals with the correlation of rocks from different localities using fossils and distinct rock types.

Strauss, Johann (the Younger) (1825–99) Austrian composer and conductor, son of Johann (1804–49), who was also a conductor and composer. Strauss became extremely popular for his waltzes, such as *The Blue Danube, Tales from the Vienna Woods* and *Wine, Women and Song.* He also composed two popular operettas, *Die Fledermaus* (1874) and *The Gypsy Baron* (1885).

Strauss, Richard (1864–1949) German composer and conductor. Strauss' SYMPHONIC POEMS, such as *Don Juan* (1888),

■ Stonehenge Surrounded by a circular ditch and bank, the stones at Stonehenge, sw England, were arranged in three concentric series: the outermost is a circle of 30 upright stones linked at the top by lintel stones; the second is a circle of singular menhirs; the third is a horseshoe formed by five trilithons (two upright stones joined by a lintel) with a single upright stone (the altar stone) at the open end, facing the rising sun. It has been proposed that Stonehenge was a druid temple, or a huge astronomical observatory or served various other forms of religious function, but its actual use remains uncertain

▲ Strauss Richard Strauss began composing at the age of six. The early part of his career was devoted to the development of the symphonic poem. Pieces such as Tod und Verklärung (1889) betray the romantic influences of Wagner and Liszt. In the early 20th century, Strauss concentrated on opera. With the help of the poet Hugo von Hofmannsthal, operas such as Ariadne auf Naxos (1912) expanded the emotional range of operatic drama.

▲ strawberry Intensively cultivated since the 15th century, the strawberry was brought to Europe by early explorers of the New World. The entire French strawberry industry originates from one common strawberry plat. The fruiting season is short and the fruit is easily perishable once it is picked.

Till Eulenspiegel (1895) and Also sprach Zarathustra (1896), use brilliantly coloured orchestration for characterization. His early operas, Salome (1905) and Elektra (1909), dealt with female obsession. Der Rosenkavalier (1911) also used the dramatic range of the female voice, but in a comic setting.

Stravinsky, Igor Feodorovich (1882–1971) Russian composer who revolutionized 20th-century music. Stravinsky studied (1907–08) with Rimsky-Korsakov. His early ballets, *The Firebird* (1910) and *Petrushka* (1911), were commissioned by Sergei DIAGHILEV for his BALLETS RUSSES. The première of the ballet *The Rite of Spring* (1913) caused a riot because of its dissonance and unfamiliar rhythms. Stravinsky turned to Russian folk themes for *The Wedding* (1923) and neoclassicism in *Pulcinella* (1920). In 1939 he moved to the USA, collaborating with George BALANCHINE on the abstract ballet *Agon* (1957). After composing *The Rake's Progress* (1951), Stravinsky experimented with serial music and TWELVE-TONE MUSIC.

Straw, Jack (1946–) British statesman, home secretary (1997–). Straw entered parliament in 1979. He held several shadow cabinet posts before Labour's victory under Tony BLAIR in the 1997 general election.

strawberry Fruit-bearing plant of the rose family, common in America, Europe and Asia. It has three-lobed leaves and clusters of white or reddish flowers. The large fleshy fruit is dotted with seeds (pips). Family Rosaceae; genus Fragaria. stream of consciousness Literary style in which the thought processes of characters are presented in the disconnected, illogical, chaotic or seemingly random way they might come to them, without the usual literary regard for narrative continuity or linear sequence. Edouard Dujardin's novel Les Lauriers Sont Coupes (1888) is generally regarded as the first example of the style in literature. Generally, it is associated stylistically with early MODERNISM, and in particular the writings of James JOYCE, Virginia WOOLF, and William FAULKNER. Streep, Meryl (1949-) US film actress. Streep is renowned for her close attention to realistic characterization. Her film debut was Julia (1977). After an Academy nomination for The Deer Hunter (1978), Streep won the Best Supporting Actress Oscar for Kramer vs Kramer (1979). Her moving performance as a Holocaust victim in Sophie's Choice (1982) earned her an Oscar as Best Actress. Other films include French Lieutenant's Woman (1981), Silkwood (1983) and Out of Africa (1985).

Streisand, Barbra (1942–) US singer and actress. Streisland achieved fame with her Broadway performance in *Funny Girl* (1964, filmed 1968). She has made numerous recordings and starred in such films as *Hello Dolly* (1969) and *A Star is Born* (1976). Streisland directed, produced and starred in *Yentl* (1983) and *The Prince of Tides* (1993).

streptococcus Genus of gram-positive spherical or oval BACTERIA that grow in pairs or bead-like chains. They live mainly as parasites in the mouth, respiratory tract and intestine. Some are harmless but others are pathogenic, causing SCARLET FEVER and other infections. Treatment is with ANTIBIOTICS.

Stresemann, Gustav (1878–1929) German statesman. Stresemann was the outstanding politician of the Weimar Republic. He concluded the Locarno Pact (1925) and worked to achieve a practicable postwar settlement with Germany's former opponents under the disadvantageous terms imposed by the Treaty of Versailles. Stresemann negotiated Germany's entry into the League of Nations (1926) and shared the 1926 Nobel Peace Prize with Aristide Briand.

stress In physics, internal tension in a material. Tensile stress stretches an object, compressive stress squeezes it, and shearing stress twists it. Fluid stresses are called PRESSURE.

stress In medicine and psychology, mental or physical strain brought on by pressures from the environment. Stress caused by frustrating and difficult work; family or social situations may be a factor in many mental and physical disorders.

Strindberg, (Johan) August (1849–1912) Swedish dramatist and novelist. Strindberg focused on subjective, psychological experience as the location for his plays. Drawing on the insights of Henrik IBSEN and the NATURALISM of Emile ZOLA, plays such as *The Father* (1887) and *Miss Julie* (1888) take a characteristically pessimistic view of gender relations. After suffering a mental breakdown, he produced *A Dream*

Play (1902) and The Ghost Sonata (1907), both of which prefigure the Theatre of the Absurd and German expressionism. **stringed instrument** Musical instrument sounded by the vibration of strings. Instruments fall into different classes, according to the action used to set the strings in motion: bowed, chiefly those of the VIOLIN family; plucked, chiefly the HARP, LUTE and GUITAR; and plucked and struck, such as the cittern and DULCIMER.

stroboscope (strobe) Device that emits regular flashes of light. Stroboscopes usually have a calibrated scale from which the number of flashes per minute can be read. They are used in photography to make multiple exposures of moving subjects and in engineering to apparently "slow down" or "stop" moving objects for observation.

stroke (apoplexy) Interruption of the flow of blood to the brain. It is caused by blockage or rupture of an artery and may produce a range of effects from mild impairment to death. Conditions that predispose to stroke include atherosclerosis and HYPERTENSION. Many major strokes are prevented by treatment of risk factors, including surgery and the use of anticoagulant drugs. Transient ischaemic attacks (TIAs), or "mini-strokes", which last less than 24 hours, are investigated to try to prevent the occurrence of a more damaging stroke.

strong nuclear force One of the four FUNDAMENTAL FORCES in nature. The strongest of the four forces, it binds together protons and neutrons within the NUCLEUS of an atom. Like the WEAK NUCLEAR FORCE it operates at very short distances (a millionth of a millionth of a centimetre), and therefore occurs only within the nucleus. *See also* GRAND UNIFIED THEORY (GUT)

strontianite Carbonate mineral, strontium carbonate (SrCO₃). It has an orthorhombic system, massive or columnar aggregates or hexagonal twinned crystals. It can be pale green, white, grey, yellow or brown. It is found in veins, often in limestone. Hardness 3.5–4; s.g. 3.7.

strontium (symbol Sr) Silvery-white metallic element of the alkaline-earth metals in group II of the periodic table. Resembling CALCIUM physically and chemically, it occurs naturally in strontianite and celestite and is extracted by electrolysis. Strontium salts are used to give a red colour to flares and fireworks. The isotope Sr⁵⁰ (half-life 28 years) is a radioactive element present in fallout, from which it is absorbed into milk and bones; it is used in nuclear generators. at.no. 38, r.a.m. 87.62, r.d. 2.554, m.p. 769°C (1,416°F), b.p. 1,384°C (2,523°F).

structuralism School of critical thought. Ferdinand de SAUSSURE argued that underlying the everyday use of language is a language system (*langue*), based on a relationship of differences. He stressed the arbitrary nature of the relationship between the **signifier** (sound/image) and the **signified** (concept). Initially a linguistic theory, structuralism developed as a mode of critical analysis of cultural institutions and products. It is particularly associated with the notion of a literary text as a system of signs. *See also* DECONSTRUCTION; SEMIOTICS **strychnine** Poisonous ALKALOID obtained from the plant *Strychnos nux-vomica*. In the past it was believed to have therapeutic value in small doses as a tonic. Strychnine poisoning causes symptoms similar to those of TETANUS, with death occurring due to SPASM of the breathing muscles.

Stuart, Charles Edward (1720–88) Scottish prince, known as "Bonnie Prince Charlie" or the "Young Pretender". A grandson of the deposed James II, he led the Jacobites in the rebellion of 1745 ("the '45") on behalf of his father, James Stuart. Landing in the Scottish Highlands without the hoped-for backing of France, he gained the support of many clan chiefs, defeated government troops at Prestonpans, E central Scotland, and marched on London. Lacking widespread help, he was forced to turn back at Derby. His largely Highland force was decimated in the battle of Culloden (1746). Charles escaped to the continent and lived in exile until his death.

Stuart, Gilbert Charles (1755–1828) One of the foremost US portraitists of the late 18th and early 19th century. He is famous for three portraits of George WASHINGTON. These paintings are known as the "Vaughan" type (1795), the "Lansdowne" type (1796) and the "Athenaeum" type (1796). The last is the model for Washington's face on the one-dollar bill. **Stuart, James Francis Edward** (1688–1766) British

claimant to the throne, called the "Old Pretender". The only son of JAMES II, his birth precipitated the GLORIOUS REVOLUTION (1688) and he was brought up in exile. On the death of his father (1701), James was proclaimed king by the JACOBITES. After an abortive attempt to depose ANNE (1708) by invading from Scotland (where support for the Stuart cause was greatest) James served in the French army. The accession of GEORGE I (1714) prompted James to attempt a further unsuccessful uprising. His son was Charles STUART.

Stuart, Mary See MARY II

Stuarts (Stewarts) Scottish royal house, which inherited the Scottish crown in 1371 and the English crown in 1603. The Stuarts were descended from Alan, whose descendants held the hereditary office of steward in the royal household. Walter (d.1326), the sixth steward, married a daughter of King Robert I, and their son, Robert II, became the first Stuart king (1371). The crown descended in the direct male line until the death of James V (1542), who was succeeded by his infant daughter, MARY, QUEEN OF SCOTS. Her son, James VI, succeeded ELIZA-BETH I of England in 1603 as JAMES I. His son, CHARLES I, was executed in 1649 following the English CIVIL WAR, but the dynasty was reborn with the RESTORATION of Charles II in 1660. His brother, JAMES II, lost the throne in the GLORIOUS REVOLUTION (1688) and was replaced by the joint monarchy of William III and Mary II, James' daughter. On the death (1714) of Anne, James' second daughter, the House of Hanover succeeded. James STUART and Charles STUART made several unsuccessful attempts to regain the throne. See also JACOBITES Stubbs, George (1724–1806) British painter and engraver. Stubbs is best-known for the book The Anatomy of the Horse (1766), illustrated with his own engravings. Horses attacked by a lion (1770) reveals a more romantic approach.

sturgeon Large, primitive, bony fish found in temperate fresh and marine waters of the Northern Hemisphere. The ovaries of the female are the source of CAVIAR. It has five series of sharp-pointed scales along its sides, fleshy whiskers and a tapering, snout-like head. Family Acipenseridae; species Atlantic sturgeon (*Acipenser sturio*) length: to 3.3m (11ft), weight: to 272kg (600lb). The Eurasian freshwater sturgeon is also called beluga.

Sturm und Drang ("Storm and Stress") German literary movement that takes its name from a play (1776) by F.M. von Klinger. Sturm and Drang rejected the prevailing neoclassicism in favour of subjectivity, artistic creativity and the beauty of nature. Associated principally with the early works of Johann Wolfgang von Goethe, Friedrich Schiller and Johann Gottfried von Herder, it is seen as a precursor of ROMANTICISM. The movement influenced HAYDN's group of minor-key symphonies.

Stuttgart Capital of Baden Württemberg, sw Germany, on the River Neckar. It was founded in *c.*950 when a German duke, Liutolf, set up a *stuttgarten* (stud farm). The capital of the kingdom of Württemberg (1495–1806), Stuttgart's industrial base expanded rapidly during the 19th century. Historically, it is associated with motor vehicle construction; the Daimler-Benz factory is the world's oldest car-plant (1890). Other industries: electronics, photographic equipment, publishing, wine and beer. Stuttgart was intensively bombed during World War 2, but much of its famous architecture has survived. Pop. (1993) 598,000.

Stuyvesant, Peter (1610–72) Dutch colonial administrator. Stuyvesant became governor of the Caribbean islands of Curaçao, Bonaire and Aruba in 1643, and in 1647 he became director-general of all the Dutch territories, including New Amsterdam (later New York City). He ended Swedish influence in Delaware in 1655, and ruled until the colony was taken over by the English in 1664 and renamed New York.

style In botany, part of a flower – the tube that connects the pollen-receiving STIGMA at its tip to the ovary at its base.

Styx In Greek mythology, the river across which the souls of the dead were ferried by Charon on their journey from the world of the living to the underworld.

subatomic particles Particles that are smaller than ATOMS or are of the types that make up atoms. They can be divided into two groups: the HADRONS, such as protons and neutrons,

which can be further subdivided; and ELEMENTARY PARTICLES, such as quarks and electrons, which cannot be further divided. **sublimation** Direct change from solid to gas, without an intervening liquid phase. Most substances can sublimate at certain pressures, but usually not at atmospheric pressure. *See also* CONDENSATION; EVAPORATION

submarine Seagoing warship capable of travelling both on and under the water. Experimental submarines were used in warfare from the late 18th century. Technical advances in the late 19th century led to the adoption of underwater craft by the world's navies. Early submarines were essentially surface ships with a limited ability to remain submerged. Once underwater, they depended on battery-powered electric motors for propulsion and, with a limited air supply, were soon forced to surface. Submerging is accomplished by letting air out of internal ballast tanks; trimming underwater is done by regulating the amount of water in the ballast tanks with pumps; and surfacing is accomplished by pumping ("blowing") the water out of the tanks. The most modern submarines use nuclear power, which eliminates the need to surface while on operations.

submersible Small craft for underwater exploration, research or engineering. The **bathyscaphe**, invented in the 1940s by Swiss scientist Auguste Piccard, had a spherical chamber attached to a much larger hull, which was used as a buoyancy control device. A new generation of submersibles has evolved since the late 1950s for engineering and research work. A typical craft has a spherical passenger capsule capable of withstanding water pressure down to *c.*3,600m (12,000ft). Attached to this is a structure containing batteries, an electric motor with propeller, lighting, a mechanical arm for gathering samples, and other technical equipment.

subpoena (Lat. under penalty) In law, an order that commands a person to appear before a court or judicial officer to give evidence at a specific time and place. Failure to obey a subpoena is a criminal offence.

subsidies Government assistance to individuals or organizations to benefit the public. They can be direct (for example, cash payments) or indirect (for example, when the government buys goods at artificially high prices or grants tax concessions). They are often used to protect domestic industries by enabling them to offer more competitive prices. Other commonly subsidized enterprises include agriculture, business expansion, housing and regional development. *See also* TARIFF

substitution reaction Chemical reaction in which one atom or group of atoms replaces (usually in the same structural position) another group in a molecule or ion.

subway See UNDERGROUND RAILWAY

succession Orderly change in plant and animal life in a biotic community over a long time period. It is the result of modifications in the community environment. The process ends in establishment of a stable ECOSYSTEM (climax community).

succulent Plant that stores water in its tissues to resist periods of drought. Usually PERENNIAL and evergreen, they have bodies made up of water storage cells, which give them a fleshy appearance. A well-developed CUTICLE and low rate of daytime TRANSPIRATION also conserve water. Succulent plants include CACTUS, LILY and STONECROP.

■ Stubbs Joseph Smith, Lt. of Whittlebury Forest, Northamptonshire, on a dapple grey horse. (c. 1762-64)
A self-taught painter and etcher, George Stubbs used his interest in comparative anatomy to inform his portraits of horses and other animals. He was the most famous animal painter of his time, and his work is still admired for its accuracy and elegance.

2

sucker Any of several species of freshwater fish found from N Canada to Mexico. A bottom-grubber similar to a minnow, it has a thick-lipped mouth for feeding by suction. Length: to 66cm (26in); weight: to 5.4kg (12lb). Family Catostomidae.

Sucre, Antonio José de (1795–1830) South American revolutionary leader, first president of Bolivia (1826–28). De Sucre joined the fight for independence in 1811 and played a key role in the liberation of Ecuador, Peru and Bolivia, winning the final, decisive battle at Ayacucho (1824). With Sinon Bolívar's support, he became president of Bolivia. Native opposition forced his resignation and he was assassinated while working to preserve the unity of Colombia.

Sucre City in s central Bolivia and the legal capital of BOLIVIA, the seat of government being La Paz. Known successively as La Plata, Chuguisaca and Charcas, Sucre was renamed in 1839 after the revolutionary leader and first president of Bolivia, Antonio José de SUCRE. It is a commercial and distribution centre for the surrounding farming region. Industries: cement, oil refining. Pop. (1992) 103,952.

sucrose Common white crystalline sugar, a disaccharide SUGAR ($C_{12}H_{22}O_{11}$) consisting of linked GLUCOSE and FRUCTOSE molecules. It occurs in many plants, but its principal

commercial sources are SUGAR CANE and SUGAR BEET. It is widely used for food sweetening and making preserves. **Sudan** Republic in NE Africa. *See* country feature

sudden infant death syndrome (SIDS) (cot death) Unexpected death of an apparently healthy baby, usually during sleep. The peak period seems to be around two months of age, although it can occur up to a year or more after birth. Claiming more boys than girls, it is more common in winter. The cause is unknown, but a number of risk factors have been

identified, including prematurity and respiratory infection.

Sudetenland Border region of N Bohemia (Czech Republic), including part of the Sudeten Mountains. Largely populated by Germans, Nazi-inspired agitation in the 1930s demanded its inclusion in Germany. Approval for its annexation was given by Britain and France in the MUNICH AGREEMENT (1938). After World War 2 it was restored to Czechoslovakia, and the German population was expelled.

Suez Canal Waterway in Egypt linking Port Said on the Mediterranean Sea with the Gulf of Suez and the Red Sea. The 169km (105mi) canal was planned and built (1859–69) by the Suez Canal Company under the supervision of French canal builder Ferdinand de LESSEPS. In 1875 the British gov-

SUDAN

Adopted in 1969, Sudan's flag uses colours associated with the Pan-Arab movement. The Islamic green triangle symbolizes prosperity and spiritual wealth. The flag is based on the one used in the Arab revolt against Turkish rule in World War 1 (1914–18).

Sudan is Africa's largest country. It extends from the arid SAHARA in the N to an equatorial swamp region (the *Sudd*) in the s. Much of the land is flat, but there are mountains in the NE and SE; the highest point is Kinyeti, at 3,187m (10,456ft). The River NILE (*Bahr el Jebel*) runs S–N, entering Sudan as the White Nile, converging with the Blue Nile at KHARTOUM, and flowing N to Egypt.

CLIMATE

The climate ranges from the virtually rainless N

deserts to the swamplands in the s. Khartoum is prone to summer dust storms (*haboobs*).

VEGETATION

From the bare deserts of the N, the land merges into dry grasslands and savanna. Dense rainforests grow in the s.

HISTORY AND POLITICS

The ancient state of NUBIA extended into N Sudan. In c.2,000 BC it became a colony of EGYPT. From the 8th century BC to c.350 AD, it was part of the Kush kingdom. Christianity was introduced in the 6th century. From the 13th to 15th centuries, N Sudan came under Muslim control, and Islam became the dominant religion. In 1821 MUHAMMAD ALI's forces occupied Sudan. Anglo-Egyptian forces, led by General GORDON, attempted to extend Egypt's influence into the s. Muhammad Ahmad led a MAHDI uprising, which briefly freed Sudan from Anglo-Egyptian influence. In 1898 General KITCHENER's forces defeated the Mahdists, and in 1899 Sudan became Anglo-Egyptian Sudan, governed jointly by Britain and Egypt. Opposition to colonial rule continued until independence in 1956. The s Sudanese, who are predominantly Christians or followers of traditional beliefs, revolted against the dominance of the Muslim N, and civil war broke out. In 1958 the military seized power. Civilian rule was reestablished in 1964, but overthrown again in 1969, when Gaafar Muhammad Nimeri seized control. In 1972 s Sudan was given considerable autonomy, but unrest persisted. In 1983 the imposition of strict Islamic law sparked off furAREA: 2,505,810sg km (967,493 sg mi)

POPULATION: 26,656,000

CAPITAL (POPULATION): Khartoum (476,218)

GOVERNMENT: Military regime

ETHNIC GROUPS: Sudanese Arab 49%, Dinka 12%, Nuba 8%, Beja 6%, Nuer 5%, Azande

3%

LANGUAGES: Arabic (official)

RELIGIONS: Islam 73%, traditional beliefs 17%, Christianity (Roman Catholic 4%, Protestant

2%)

currency: Dinar = 10 Sudanese pounds

ther conflict between the government and the Sudan People's Liberation Army (SPLA) in the s. In 1985 Nimeri was deposed, and a civilian government was installed. In 1989 the military, led by Omar Hassan Ahmed al-Bashir, established a Revolutionary Command Council. Civil war between the SPLA and government forces continued in the s. Various peace initiatives foundered as the SPLA split over the nature of independence from the North. In 1996, Bashir was re-elected, virtually unopposed. The National Islamic Front (NIF) dominated the government and was believed to have strong links with Iranian terrorist groups. In 1996 the UN imposed sanctions on Sudan. In 1997 an SPLA offensive, led by John Garang, made signficant advances. A South African peace initiative (1997) led to the formation of a Southern States' Co-ordination Council. In 1997 the US imposed sanctions on Bashir's regime and the US secretary of state met rebel leaders. Food shortages and a refugee crisis have added to Sudan's economic difficulties.

ECONOMY

Sudan is a low-income economy. Agriculture employs 62% of the workforce. The leading crops are cotton, millet, wheat and sesame. Nomadic herders raise livestock. Mineral resources include chromium, gold, gypsum and oil. Manufacturing industries produce cement, fertilizers and textiles. The main exports are cotton, gum arabic and sesame seeds.

ernment became the major shareholder in the company. In 1955 more than 120 million tonnes of merchandise passed through the canal, much of it oil. In 1956 NASSER nationalized the canal. Israel, Britain and France launched a disastrous attack on Egypt. The canal was closed (1956–57) while repairs were carried out. It was again closed during the 1967 ARAB-ISRAELI WAR. The canal reopened in 1975. In the intervening years, many new ships, especially oil tankers, had became too large to pass through the canal. Loss of revenue forced Egypt to clear and widen the waterway.

Suffolk County in E England, on the North Sea coast; the county town is IPSWICH. The land is mainly low-lying and flat, rising in the sw. The principal rivers are the Orwell, Stour and Waveney. The economy is mainly agricultural, growing cereal crops and sugar beet and rearing sheep, pigs and poultry. Fishing along the coast (especially at Lowestoft, Britain's easternmost point) is in decline. Industries: food processing, farm machinery, fertilizers, finance. Area: 3,807sq km (1,470sq mi). Pop. (1991) 632,266.

suffrage See Franchise

suffragette movement Women's campaign in Britain in the late 19th and early 20th centuries to gain the FRANCHISE. It began in the 1860s, and developed until the founding of the National Union of Women's Suffrage Societies in 1897. Emmeline Pankhurst founded the Women's Social and Political Union in 1903. By 1910 the movement had split into several factions, including the Women's Freedom League (founded 1908). In 1913 Sylvia Pankhurst founded the East London Federation, which organized marches in London. Women of the age of 30 and over were given the vote in 1918.

Sufism Mystic philosophical movement within Islam that developed among the SHITTE communities in the 10th and 11th centuries. Sufis stress the capability of the soul to attain personal union with God. *See also* DERVISH

sugar Sweet-tasting, soluble, crystalline monosaccharide or disaccharide CARBOHYDRATE. The common sugar in food and beverages is SUCROSE. This is also the main sugar transported in plant tissues. The main sugar transported around the bodies of animals to provide energy is GLUCOSE. *See also* SACCHARIDE **sugar beet** Variety of BEET grown commercially for its high SUGAR content, which is stored in its thick white roots. Family Chenopdiaceae; species *Beta vulgaris*.

sugar cane Perennial GRASS cultivated in tropical and subtropical regions throughout the world. After harvesting, the stems are processed in factories, and are the main source of SUGAR. Most cultivated canes are *Saccharum officinarum*. Height: to 4.5m (15ft). Family Poaceae/Gramineae.

Suharto (1921–) Indonesian general and statesman, president (1967–). As supreme commander, Suharto crushed a left-wing coup (1966) against SUKARNO, before assuming the presidency. He was formally elected in 1968 and has been reelected (unopposed) five times. Suharto has overseen the rapid growth of the Indonesian economy. He ordered the invasion (1975) of East Timor, and his autocratic rule has been criticized for frequent abuses of human rights.

Suhrawardi, as- (1155–91) Islamic philosopher and theologian, born in Persia (Iran). He was the founder of the Ishraqi (Illuminationist) school of thought, which embraced elements of ORPHISM, HELLENISM, ZOROASTRIANISM, SUFISM and SHITTE Islam. His thinking is still in evidence among Iranian mystical sects, such as the Nuyah. His principal work is *Kitab Hikmat al-ishraq (The Wisdom of Illumination)*. He was put to death by Malikaz-Zāhir, the son of SALADIN.

suite Musical form, popular in the BAROQUE period, comprising a number of instrumental dances, which differ in metre, tempo and rhythm but are generally all in the same key. The earliest suites date from the 16th century and usually involved only two dances, the pavane and galliard. By the 18th century the dances had become standardized: a prelude, allemande, courante, saraband and gigue. There was some flexibility, and the minuet, gavotte, bourrée and rondeau were often added.

Sukarno (1901–70) Indonesian statesman, first president (1947–67) of Indonesia. Founder of the Indonesian Nationalist Party (1927), Sukarno led opposition to Dutch rule and was frequently imprisoned or exiled (1933–42). At the end of

World War 2 he declared Indonesian independence and became president of the new republic. In the 1950s Sukarno's rule became increasingly dictatorial. He dissolved parliament, declared himself president-for-life (1963), and aligned himself with the communists. The failure of a communist coup (1966) against the leaders of the army weakened Sukarno's position, and he was forced from power. He was succeeded by SUHARTO. Sukkoth (Sukkat) Jewish Feast of TABERNACLES, or Feast of Booths, an autumn festival that lasts for seven days. It commemorates the wandering of the Jews in the desert and their salvation through God. A sukkat, or simple tent of branches, is raised in the synagogue.

Sukkur City on the River Indus, SIND province, w Pakistan. It is the site of the Sukkur Barrage across the Indus, controlling one of the largest irrigation schemes in the world with canals watering more than 12 million hectares (5 million acres) of the Indus valley. Completed in 1932, the dam is 58m (190ft) high and *c*.1,500m (5,000ft) long. Industries: textiles, foodstuffs. Pop. (1991) 350,000.

Sulawesi (formerly Celebes) Large island in E Indonesia, separated from Borneo by the Makasar Strait. Made up of four separate provinces: Utara, Tengah, Selatan and Tenggara; Ujung Pandang is the largest city and main port. A largely mountainous and volcanic island, the highest peak is Mount Rantekombola, at 3,455m (11,335ft). The first European discovery was by the Portuguese in 1512. The Dutch assumed control in the early 17th century and successfully waged war against the native population in the Makasar War (1666–69). In 1950 it became a province of the Indonesian republic. The population is primarily Malayan. Industries: fishing, agriculture. Area: 189,216sqkm (73,031sq mi). Pop. (1990) 12,520,711

Suleiman I (the Magnificent) (1494–1566) Ottoman sultan (1520–66). He succeeded his father, Selim I. Suleiman captured Rhodes from the KNIGHTS HOSPITALLERS and launched a series of campaigns against the Austrian HABSBURGS, defeating the Hungarians at Mohács (1526), and subsequently controlling most of Hungary. His troops besieged Vienna in 1529. Suleiman's admiral, BARBAROSSA, created a navy that dominated the Mediterranean and ensured Ottoman control of much of the North African coastal region. In the E, Suleiman won victories against the Safavids of Persia and conquered Mesopotamia.

Sulla, Lucius Cornelius (138–78 BC) Roman dictator (82–81 BC). Elected consul in 88 BC, he defeated MITHRIDATES VI in spite of the opposition of MARIUS, Cinna and their supporters in Rome. Invading Italy, he captured Rome in 82 BC and massacred his anti-patrician enemies.

Sullivan, Sir Arthur Seymour (1842–1900) British composer famous for a series of operettas written with the librettist W.S. GILBERT. They included *H.M.S. Pinafore* (1878), *The Pirates of Penzance* (1879) and *The Mikado* (1885). Sullivan also composed an opera, *Ivanhoe* (1881), oratorios, cantatas, and church music including many hymns, such as *Onward, Christian Soldiers*.

Sullivan, Louis Henry (1856–1924) US architect. Sullivan was a pioneer of the SKYSCRAPER. His dictum that "form follows function" became a guiding principle in the development of architectural MODERNISM. Sullivan's designs placed emphasis on structure rather than ornamentation. Examples include Wainwright Building, St Louis (1890) and the Carson, Pirie, Scott Department Store, Chicago (1904).

sulphate Salt of SULPHURIC ACID (H₂SO₄). Common sulphates include copper(II) sulphate (CuSO₄) and iron(II) sulphate (FeSO₄).

sulphonamide drug Any of a group of DRUGS derived from sulphanilamide, a red textile dye, that prevent the growth of bacteria. Introduced in the 1930s, they were the first antibacterials, prescribed to treat a range of infections. They were replaced by less toxic and more effective ANTIBIOTICS.

sulphur (symbol S) Nonmetallic element in group VI of the periodic table, known since pre-history (the biblical brimstone). It may occur naturally as a free element or in sulphide minerals such as GALENA and iron pyrites, or in sulphate minerals such as GYPSUM. The main commercial source is native (free) sulphur, extracted by the Frasch process. It is used in the

▲ sugar Sugar beet (left) and sugar cane (right) produce the same sugar — sucrose — but require completely different climatic conditions. Sugar cane is grown as a single crop in tropical regions, while sugar beet forms part of regular crop rotation in Europe, North and South America. Although sugar is extracted by the same method from both sources, the yield of sugar cane is higher.

VULCANIZATION of rubber and in the manufacture of drugs, matches, dyes, fungicides, insecticides and fertilizers. Properties: at.no. 16; r.a.m. 32.064; r.d. 2.07; m.p. 112.8°C (235.0°F); b.p. 444.7°C (832.5°F). Most common isotope S^{32} (95.1%).

sulphuric acid Colourless, odourless, liquid (H₂SO₄), one of the strongest acids known. It is produced by the oxidation of sulphur dioxide (SO₂). Sulphuric acid is a major industrial chemical, used in the manufacture of many acids, fertilizers, detergents, drugs and a wide range of chemicals. Properties: r.d. 1.84; m.p. 10.3°C (50.5°F); b.p. 330°C (626°F).

Sumatra (Sumatera) World's sixth largest island, in W Indonesia. The largest cities (pop. 1990) are Medan (1,685,972), Palembang (1,084,483) and Padang (477,344). Sumatra's w coast is rugged and mountainous, the Barisan Mountains rising to 3,810m (12,500ft), and nearly 60% of the lowland area is jungle. By the 7th century, India had established two states in Sumatra: Melayu and Srivijaya. The Portuguese landed on the island in the 16th century and the Dutch followed a century later. Britain briefly held certain parts of Sumatra in the 18th and 19th centuries. Sumatra became part of newly independent in Indonesia in 1950. The main products are oil (the greatest earner), timber, rubber, tin, tobacco, palm oil, tea, coffee, sisal, and rice. Mining and farming were the chief occupations, but the N is being rapidly industrialized, and Sumatra now accounts for c.75% of Indonesia's total income. Area: 425,000sq km (164,000sq mi). Pop. (1990) 36,505,703. Sumeria World's first civilization, dating from before 3000 BC, in s MESOPOTAMIA. The Sumerians are credited with inventing cuneiform writing, the first basic socio-political institutions, and a money-based economy. Major cities were UR, Kish and Lagash. During the third millennium Sumeria developed into an imperial power. In c.2340 BC, the Semitic peoples of Akkadia conquered Mesopotamia, and by c.1950 BC the ancient civilization had disintegrated.

summer time (daylight saving scheme) System by which clocks in Britain are kept one hour ahead of GMT (Greenwich mean time) throughout the summer. Some other countries have similar daylight saving schemes.

Sumner, Charles (1811–74) US political leader. A passionate abolitionist, he was senator from Massachusetts (1851–74) and a leading Radical Republican during RECONSTRUCTION, supporting the impeachment of President Andrew JOHNSON.

sumo wrestling Traditional and popular sport of Japan. Pairs of wrestlers, who usually weigh more than 160kg (350lb), attempt to force each other out of a ring. The technique employs holds, trips, pushes and falls. A referee monitors the brief bout and keeps score.

Sun Star at the centre of our SOLAR SYSTEM, around which all other Solar System bodies revolve in their orbits. The Sun is a typical, average star. It consists of c.70% hydrogen (by weight) and 28% helium, with the remainder mostly oxygen and carbon. Its temperature, pressure, and density increase towards the centre. Like all stars, the Sun's energy is generated by nuclear fusion reactions taking place under the extreme conditions in the core. This core is c.400,000km (250,000mi) across. Energy released from the core passes up through the radiative zone, which is c.300,000km (200,000mi) thick, then passes through the 200,000km (125,000mi) thick convective zone to the surface, the PHOTOSPHERE, from where it is radiated into space. Most of the Sun's visible activity takes place in this 500km- (300mi-) thick photosphere. Above the photosphere lies the chromosphere, which consists of hot gases and extends for thousands of kilometres. Extending outwards from the chromosphere for millions of kilometres is the CORONA, which emits the SOLAR WIND. The solar wind and the Sun's magnetic field dominate a region of space called the heliosphere, which extends to the boundaries of the Solar System. sunbird Tropical, nectar-feeding songbird of the Old World, often considered a counterpart of the New World hummingbird. The males are usually brightly coloured. Length:

9–15cm (3.5–6in). Family Nectariniidae. **sunburn** Damage to skin caused by prolonged or unaccustomed exposure to sunlight. It varies in severity from redness and soreness to the formation of large blisters, which may be accompanied by shock. Excessive exposure to sunlight is associated with the skin cancer known as melanoma.

sun dance Important and spectacular religious rite of the North American Plains Indians. It was usually held annually in early summer, and was performed around a TOTEM POLE. The sun dance was part of elaborate ceremonies held to reaffirm a tribe's affinity with nature and the universe.

Sunday, Billy (William Ashley) (1862–1935) US Presbyterian revivalist. After three years in professional baseball, Sunday became a famous preacher at huge evangelical meetings across the USA. He preached against the consumption of alcohol, gaining a reputation as a temperance leader.

Sunderland County district at the mouth of the River Wear, SE TYNE AND WEAR, NE England. Once renowned for coalmining and the biggest shipbuilding centre in the world, industries now include chemicals, vehicles, glass, electronics and furniture. Pop. (1991) 289,040.

sundew Any INSECTIVOROUS PLANT of the genus *Drosera*, native to temperate swamps and bogs. Sundews have hairy, basal leaves that glisten with a sticky, dew-like substance that attracts and traps insects. The leaves then fold over the insect, and secrete ENZYMES to digest it. Family Droseraceae.

sunfish North American freshwater fish. A popular angler's fish, similar in appearance to PERCH, it has a continuous dorsal fin containing spiny and soft rays. The 30 species range in size from the blue spotted *Enneacanthus gloriosus* (length: 8.9cm; 3.5in) to the large-mouth bass *Micropterus salmoides* (length: 81.3cm; 32in; weight: 10kg; 22lb). Family Centrarchidae.

sunflower Any of several ANNUAL and PERENNIAL plants of the genus *Helianthus*, native to North and South America. The flower heads resemble huge daisies with yellow ray flowers and a centre disc of yellow, brown or purple. The seeds yield a useful oil. The common sunflower (*H. annuus*) has 30cm (1ft) leaves and flower heads more than 30cm across; height: to 3.5m (12ft). Family Asteraceae/Compositae.

Sung Chinese imperial dynasty (960–1279). The period is divided into the **Northern** (960–1126) and, after the north was overrun by Jurchen tribes, the **Southern** (1127–1279) Sung. After the initial conquests of Chao K'uang-yin, the Sung dynasty was notable for a deliberate reduction in military might, and the development of a powerful civil service. The Southern Sung, with its capital at Hangzhou, was overrun by the Mongols.

Sunni Traditionalist orthodox branch of ISLAM, whose followers are called *Ahl as-Sunnah* (People of the Path). It is followed by 90% of Muslims. Sunnis accept the *Hadith*, the body of orthodox teachings based on Muhammad's spoken words outside the KORAN. The Sunni differ from the SHITTE sect, in that they accept the first four caliphs (religious leaders) as the true successors of MUHAMMAD.

sunspot Region in the Sun's Photosphere which is cooler than its surroundings and appears darker. Sunspots vary in size from c.1,000 to 50,000km (600 to 30,000mi), and occasionally up to c.200,000km (125,000mi). Their duration varies from a few hours to a few weeks, or months for the very biggest. Sunspots occur where there is a local strengthening of the Sun's magnetic field.

sunstroke Potentially fatal condition caused by over-exposure to direct sunlight, in which the body temperature rises to 40.5°C (105°F) or more. Symptoms include hot, dry skin, exhaustion, delirium and coma. Urgent medical treatment is required, possibly in an intensive care unit. Recovery is usual within a day or two.

Sun Yat-sen (1866–1925) Chinese nationalist leader, first president of the Chinese Republic (1911–12). In exile (1895–1911), he adopted his "Three Principles of the People": nationalism, democracy and prosperity. After the revolution of 1911 he became provisional president, but soon resigned in favour of the militarily powerful Yüan Shih-k'ai. As Yüan's leadership became increasingly autocratic, Sun lent his support to the opposition Kuomintang (Nationalist Party).

supercluster See GALAXY CLUSTER

superconductivity Electrical behaviour in metals and alloys that are cooled to very low temperatures. In a superconducting circuit, an electric current flows indefinitely because there is no electrical resistance. Research continues to develop superconductors that function at higher temperatures.

superego In PSYCHOANALYSIS, level of personality that acts as a conscience or censor. It develops as a child internalizes the standards of behaviour defined by the rewards and punishments of parents and society. *See also* EGO; ID

superfluidity Property of a liquid that has no viscosity and therefore no resistance to flow. Helium II – liquid helium at temperatures less than 2K, or -271° C (-456° F) – was the first known superfluid. Helium II apparently defies gravity by flowing up slopes. It also appears to contravene the laws of THERMODYNAMICS, by flowing from a cool region to a warmer one. *See also* CRYOGENICS

Superior, Lake Lake in the USA and Canada, the largest freshwater lake in the world, bordered on the w by Minnesota, on the N and E by Ontario and on the s by Michigan and Wisconsin. The most westerly of the five Great Lakes, it is connected to Lake Huron and the St Lawrence Seaway by the St Mary's River and the Soo (Sault Ste Marie) canals. A centre for commercial and recreational fishing, the lake is also a major commercial transportation route, particularly for grain and iron ore from Duluth, Michigan, USA, and Thunder Bay, Canada. Area: 82,413sq km (31,820sq mi). Maximum depth: *c.*400m (1,300ft).

supernova Stellar explosion in which virtually an entire star is disrupted. For a week or so, a supernova may outshine all the other stars in its galaxy. After a couple of years, the supernova has expanded so much that it becomes thin and transparent. For hundreds or thousands of years the ejected material remains visible as a supernova remnant. A supernova is *c*.1,000 times brighter than a NOVA.

superposition, law of In geology, law that states that in undisturbed layers of sedimentary deposits, younger beds overlie older ones.

supersonic velocity Velocity greater than that of the local

speed of sound. In dry air at STANDARD TEMPERATURE AND PRESSURE (STP), this speed is *c*.331m/s (1,080ft/s) or 1,190km/h (750mph). Its magnitude is usually expressed as a MACH NUMBER. This is the ratio of the speed of a body to the speed of sound in a medium such as air. A velocity in excess of Mach 5 is said to be hypersonic. Any object travelling at supersonic velocity leaves behind a shock wave that a ground observer hears as a SONIC BOOM.

supply and demand, law of Economic balance between goods required and produced. The law of supply indicates that, other things being equal, as the price of an item increases, suppliers are willing to produce more, and as the price decreases producers are willing to produce less. Thus, price and quantity supplied are directly related. The law of demand states the reverse: as prices increase, consumers demand less, and as prices decrease, consumers demand more. Thus, prices and quantity demanded are inversely related.

supply-side economics Policies designed to reduce the role of governments in economic matters. The theory of supply-side economics is that production of goods and services can be stimulated by reducing taxes, thereby increasing the supply of money for investment. It also promotes governmental expenditure that generates industrial activity.

suprematism Abstract art movement launched in Russia in 1915 by Kasimir MALEVICH. Epitomized by the stark geometrical forms of Malevich's painting *White on White* (1919), suprematism had a profound influence on the future development of geometrical ABSTRACT ART and CONSTRUCTIVISM.

Supreme Court, Canadian Highest court of appeal in Canada, established in 1875. Its judgement became final when appeals to the Judicial Committee of the Privy Council in London were ended: for criminal cases in 1933, for civil cases in 1949. It sits in Ottawa and is composed of a chief justice and eight associated judges.

Supreme Court, US US court of final appeal, the highest in the nation. Its duty is to decide and interpret the constitutionality of state and federal legislation and of executive acts. Once the Supreme Court has arrived at a decision, all lower courts must follow it in similar cases. Cases are decided by majority vote. Created by the Constitution of 1787, the Supreme Court is made up of nine justices appointed for life by the president with the advice and consent of the Senate.

Surabaja Port in NE Java, second-largest city in Indonesia and capital of East Java province. An important naval base occupied by Japan in World War 2, the city remains Indonesia's primary naval centre. A fishing and industrial port with shipyards, textile mills, car assembly plants and oil refining, it exports rice, sugar cane, spices, tobacco, maize, tapioca, coffee, cocoa, rubber and copra. Pop. (1990) 2,421,016.

surfing Water sport in which a person lies or stands on a specially designed wooden or fibreglass board, usually 1.22–1.83m (4–6ft) long, and is propelled by the crest of a wave towards the shore.

surgery Branch of medical practice concerned with treatment by operation. Traditionally it has mainly involved open surgery: gaining access to the operative site by way of an incision. However, the practice of using ENDOSCOPES has enabled the development of "keyhole surgery", using minimally invasive techniques. Surgery is carried out under sterile conditions, using local or general ANAESTHESIA.

Surinam (formerly Dutch Guiana) Independent nation in NE South America, on the Atlantic Ocean, bordered by Brazil (s), French Guiana (E), and Guyana (w). Its capital is PARAMARIBO. Land and climate Surinam is made up of the Guiana Highlands plateau, a flat coastal plain and a forested inland region. Its many rivers serve as a source of hydroelectric power. History and politics The region was discovered in 1499 by Spanish explorer Alfonso de Ojeda, but it was the British who founded the first colony (1651). In 1667 it was ceded to Holland in exchange for New Amsterdam (later New York), and in 1815 the Congress of Vienna gave the Guyana region to Britain and reaffirmed Dutch control of "Dutch Guiana". It became officially autonomous in 1954, and in 1975, as Surinam, gained full independence from the Netherlands and membership of the United Nations (UN). In 1980 the military seized control,

▲ Sumeria This Sumerian vessel dates from *c.*3,500 вс. Clay was one of the few raw materials available to the Sumerians. The quality of their glazes and decorations were very advanced. The Sumerians were also renowned for their architecture, notably the stepped-pyramid zigqurats.

▲ sunflower Widely cultivated throughout Europe and North America, the common sunflower (Helianthus annus) produces seeds from which a light, high-quality oil is yielded. This oil is used in cooking, margarine, shortening and confectionery. The nutritious seeds can also be eaten whole or used in breads and cereals for human consumption, or in poultry feed.

SURINAM

AREA: 163,270sq km (63,069 sq mi)
POPULATION: 438,000
CAPITAL (POPULATION):
Paramaribo (200,970)
GOVERNMENT: Multiparty republic
ETHNIC GROUPS: Indian 37

ETHNIC GROUPS: Indian 37%, Creole, 31%, Indonesian 14%, Black 9%, Native American 3%, Chinese 3%, Dutch 1%

LANGUAGES: Dutch (official) RELIGIONS: Roman Catholic 23%, Protestant 19%, Hinduism 27%, Islam 20% currency: Surinam guilder = 100 cents

imposing martial law and banning political parties. Guerrilla warfare disrupted the economy. In 1987 a new constitution provided for a 51-member National Assembly, with powers to elect the president. Rameswak Shankar was elected president in 1988, but was overthrown by another military coup in 1990. In 1991 the New Front for Democracy and Development won the majority of seats in the National Assembly and their leader, Ronald Venetiaan, became president. The constitution was amended in 1992 to limit the power of the military. The 1996 general election resulted in a coalition government, led by Jules Wijdenbosch of the National Democratic Party. **Economy** Surinam's economy depends greatly on the export of bauxite, of which it is one of the world's largest producers. The chief agricultural products are rice, bananas, sugar cane, coffee, coconuts, lumber, and citrus fruits.

surrealism Twentieth-century artistic movement that evolved out of DADA. André BRETON's Surrealist Manifesto (1924) set out the key features of the movement. Taking inspiration from Sigmund FREUD's theories of the unconscious, the surrealists used the techniques of "free association" to produce bizarre imagery and strange juxtapositions to surprise and shock viewers. Important surrealist writers include Paul ÉLUARD, Louis Aragon, Georges Bataille and Benjamin Peret, while painters include Jean ARP, Max ERNST, René MAGRITTE, Salvador DALI, Joan MIRÓ and Paul KLEE. Jean COCTEAU and Luis BUÑUEL directed surrealist films.

Surrey, Henry Howard, Earl of (1517–47) English poet. Like his cousin Catherine Howard, he died on the scaffold, a victim of the bloody power politics of HENRY VIII's court. He wrote some of the earliest English sonnets and, with his translation of two books of the *Aeneid* by VIRGIL, introduced BLANK VERSE into English poetry.

Surrey County in SE England, bordering Greater London. From E to W are the North Downs, which slope down to the Thames Valley. The Wey and the Mole are the principal rivers. Much of the land in the W is devoted to farming, with dairy and market-garden produce, wheat and oats the chief products. Guildford (1991 pop. 122,378) is the county town, but the county council is in Kingston-upon-Thames (pop. 132,996), a Greater London borough no longer in Surrey. Area: 1,679sq km (648sq mi). Pop. (1991) 1,018,003.

surveying Accurate measurement of the Earth's surface. It

is used in establishing land boundaries, the topography of land forms and for major construction and civil engineering work. For smaller areas, the land is treated as a horizontal plane. Large areas involve considerations of the Earth's curved shape and are referred to as geodetic surveys.

suspension Liquid (or gas) medium in which small solid (or liquid) particles are uniformly dispersed. The particles are larger than those found in a COLLOID and will settle if the suspension stands undisturbed.

Sussex Former county in SE England, on the English Channel, since 1974 divided into the counties of EAST SUSSEX and WEST SUSSEX. Area: 3,773sq km (1,457sq mi).

Sussex Kingdom of Anglo-Saxon England, settled by the South Saxons under Aelle (*c*.AD 477). It was allegedly the last Anglo-Saxon kingdom to adopt Christianity (*c*.680). A number of kings of Sussex are known from the 7th and 8th centuries, but at various times they were under the dominance of Mercia. Sussex was absorbed by Wessex in the early 9th century. *See* EAST SUSSEX; WEST SUSSEX

Sutherland, Graham (1903–80) English painter, draughtsman and printmaker. During World War 2 Sutherland was employed as an official artist to record the effects of bomb damage. After the war, he concentrated on religious themes, and created the celebrated tapestry *Christ in Glory* (1962) for Coventry Cathedral. His controversial portrait of Winston Churchill (1954) was destroyed by Lady Churchill on her husband's behalf.

Sutherland, Dame Joan (1926–) Australian coloratura soprano. Sutherland made her London debut in *Die Zauberflöte* (1952), but it was her performance in the title role of Donizetti's *Lucia di Lammermoor* (1959) that earned her worldwide acclaim. She went on to perform in all the world's major opera houses before her retirement in 1990.

sutra Sacred or authoritative text in Indian philosophy or religion. In HINDUISM, it is a concise work for use within an oral tradition. Most philosophical traditions had their own sutras, which were written down in the first few centuries of the Christian era. In Buddhism, a sutra was often a lengthy sacred text dealing with a specific point of doctrine.

suttee Former Indian custom of a widow throwing herself alive on to her husband's funeral pyre. Originally confined to royalty, it was forbidden (1829) under British rule.

Sutton Hoo Archaeological site in Suffolk, SE England. The 1939 excavation of the cenotaph of Raedwald, a Saxon King of East Anglia (d.625), was Britain's richest archaeological find. The digs revealed a Saxon rowing boat 27m (90ft) long. In the centre of the boat lay a wooden funeral chamber, containing silver plate, gold jewellery and coins and bronze armour.

Suva Seaport on the SE coast of Viti Levu Island, in the SW Pacific Ocean, capital of the Fiji Islands. It is the manufacturing and trade centre of Fiji, with an excellent harbour. Exports include tropical fruits, copra and gold. Pop. (1992) 73,500.

Suzhou (Soochow, Su-chow) City on the Grand Canal, Jiangsu province, E central China. Capital of Wu kingdom in the 5th century BC, its famous silk industry developed under the Sung dynasty in the 12th century. It has been noted since 100 BC for its many gardens, temples and canals. Industries: silk, cotton, embroidery, chemicals. Pop. (1991) 706,000.

Suzman, Helen (1917–) South African politician. Suzman was an outspoken opponent of South Africa's APARTHEID regime. Elected to parliament in 1953, she formed the Progressive Party in 1959, and for the next 12 years was the party's only member. Suzman retired from parliament shortly after the election of Nelson MANDELA.

Svalbard Archipelago in the Arctic Ocean, c.640km (400 mi) N of Norway, to which it has officially belonged since 1925. There are nine main islands, of which by far the largest is Spitsbergen. The administrative centre and largest settlement is Longyearbyen on Spitsbergen. Ice fields and glaciers cover more than half the land mass, although the w edge of the islands is ice-free for most of the year. The area abounds in Arctic flora and fauna. The islands are an important wildlife refuge, and protective measures have saved certain mammals from extinction. Animals include polar bear, wal-

▲ Suzman An economics graduate from Witwatersrand University, Helen Suzman became a member of the South African parliament in 1953. As a strong opponent of apartheid, she gradually gained the respect of the black community and of the then ANC leader Nelson Mandela. She was a key figure in the South African Institute of Race Relations, and received the UN Human Rights Award in 1978.

rus and whale. Though Svalbard was discovered by the Vikings in 1194, the islands remained neglected until Willem Barents rediscovered them in 1596. In the 17th century, they were an important whaling centre, and in the 18th century the lands were hunted by Russian and Scandinavian fur traders. Large coal deposits were found on Spitsbergen at the end of the 19th century, and the area was mined by Norway, Russia and Sweden. In 1925 the islands became a sovereign territory of Norway (although over half the population is Russian), in return for allowing mining concessions to other nations. Area: 62,000sq km (24,000sq mi). Pop. (1994) 2,906.

Svevo, Italo (1861–1928) Italian novelist and businessman, b. Ettore Schmitz. Largely psychological and introspective, Svevo's novels include *A Life* (1892), and his comic masterpiece *The Confessions of Zeno* (1923).

Swahili Bantu language of the Niger-Congo family of African languages. It developed as a *lingua franca* and trading language in most of E Africa, becoming the official language of Tanzania in 1967, and of Kenya in 1973. It is also in use in parts of central Africa. It has a large body of literature. **swallow** Any of 75 species of graceful and agile birds with long, tapering wings and a long, forked tail. The common swallow (*Hirundo rustica*), known as the barn swallow in North America, is grey-blue with a light brown underside and red throat markings; it feeds primarily on insects, which it catches in flight. Length: 20cm (8in). Family Hirundinidae.

swamp Low-lying wetland area, found near large bodies of open water. Swamps are characterized by numerous plants and animals, including rushes and sedge in N regions, and species of trees, such as the swamp cypress, in warmer s areas. Swamps can prevent flooding by absorbing flood waters from rivers and coastal regions. *See also* Bog; MARSH **swan** Any of several species of graceful, white or black waterfowl that nest in N Northern Hemisphere and migrate s for winter. Three species, including the Australian Black swan, live in the Southern Hemisphere. Most have broad, flat bills, long necks, plump bodies and dense plumage. They dip their heads under water to feed on plant matter. Length: to 2m (6.5ft). Family Anatidae; genus *Cygnus*.

Swansea (Abertawe) City and county district on Swansea Bay at the mouth of the River Tawe, West Glamorgan, s Wales. The second-largest Welsh city, it is the administrative centre of West Glamorgan. Swansea grew with the export of coal in the 19th century. Formerly noted for its production of steel, it is now dominated by light industry. Pop. (1991) 181,906.

SWAPO Acronym for the Namibian SOUTH WEST AFRICA PEOPLE'S ORGANIZATION

Swaziland Small, landlocked and mountainous kingdom in s Africa, bounded by South Africa (N, W, S) and Mozambique (E); the capital is MBABANE. Land and climate Swaziland can be divided into four regions. In the w, the Highveld, with an average height of 1,200m (3,950ft), makes up 30% of Swaziland. The Middleveld, between 350 and 1,000m (1,150 to 3,300ft), covers 28% of the country, while the Lowveld, with an average height of 270m (890ft), covers another 33%. The Lebombo Mountains, the fourth region, reach 800m (2,600 ft) along the E border. The Lowveld is almost tropical, with an average temperature of 22°C (72°F) and a low rainfall of c.500mm (20in) a year. The altitude moderates the climate in the w, and Mbabane has a climate typical of the Highveld with warm summers and cool winters. Vegetation Meadows and pasture cover c.65% of Swaziland. Arable land covers 8% of the land, and forests only 6%. History and Politics According to tradition, a group of Bantu-speaking people, under the Swazi chief Ngwane II, crossed the Lebombo range and united with local African groups to form the Swazi nation in the 18th century. Under attack from Zulu armies, the Swazi people were forced to seek British protection in the 1840s. Gold was discovered in the 1880s, and many Europeans sought land concessions from the king, who did not realize that in acceding to their demands he was losing control of the land. In 1894 Britain and the Boers of South Africa agreed to put Swaziland under the control of the South African Republic (the Transvaal). At the end of the second SOUTH AFRICAN WAR (1899-1902), Britain took control of the country. In 1968 Swaziland became

an independent constitutional monarchy, with King Sobhuza II as head of state. In 1973 Sobhuza suspended the constitution and assumed supreme power. All political parties were banned in 1978. When Sobhuza died in 1982, his son, Makhosetive, was named as heir. In 1986 he was installed as king, taking the name Mswati III. In 1993 Swaziland held its first ever multiparty elections. Pro-democracy demonstrations forced Mswati to reconsider the ban on political parties. Economy Swaziland is a lower-middle-income developing country (1992 GDP per capita, US\$1,700). Agriculture employs 74% of the workforce, mostly at subsistence level. Farm products and processed foods, including sugar, wood pulp, citrus fruits and canned fruit, are the leading exports. Mining has declined in importance in recent years. Swaziland's high-grade iron ore reserves were used up in 1978, while the world demand for its asbestos has fallen. Swaziland is heavily dependent on South Africa, and the two countries are linked through a customs union.

sweating (perspiring) Loss of water, salts and urea from the body surface of many mammals as a result of the action of certain glands (sweat glands). Sweat glands are situated in the dermis of the skin, and open onto the surface through tiny pores. In humans, they are found all over the body, but in some mammals they are found only on the soles of the feet. Sweating is controlled by the nervous system, and forms an important part of the body's temperature control mechanism. The evaporation of sweat cools the skin and the blood passing through capillaries close to the skin surface. Excessive sweating must be compensated for by increased intake of water and salt.

swede Root vegetable belonging to the mustard family (Brassicaceae/Cruciferae). The large, swollen taproot may be eaten cooked as a vegetable or fed to animals as fodder. Height: *c*.30cm (12in). Species: *B. napus napobrassica*.

Sweden Kingdom on the E half of the Scandinavian peninsula, N Europe. *See* country feature, p.650

Swedenborg, Emanuel (1688–1772) Swedish scientist, philosopher, theologian and mystic. In 1745, after a glittering scientific career in which he wrote many books (notably on metallurgy and metaphysics), Swedenborg gave up worldly

▲ swallow Extremely agile fliers, swallows spend most of their time in the air and feed on the wing. They often migrate extremely long distances: in North America, the common, or barn, swallow (*Hirundo rustica*, above) may summer in Canada and winter in South America. On the other side of the Atlantic, those that summer in Europe migrate to Africa, or the Indian sub-continent in the winter.

SWAZILAND

AREA: 17,360sq km (6,703 sa mi) **POPULATION: 792,000** CAPITAL (POPULATION): Mbabane (38,290) **GOVERNMENT:** Monarchy ETHNIC GROUPS: Swazi 84%, Zulu 10%, Tsonga 2% LANGUAGES: Siswati and English (both official) **RELIGIONS:** Protestant 37% African churches 29%, Roman Catholic 11%, traditional beliefs 21% **CURRENCY:** Lilangeni = 100 cents

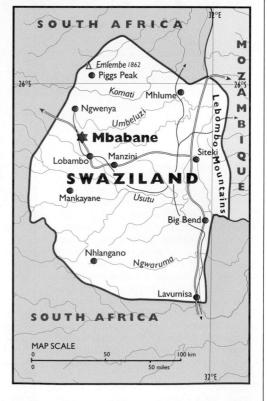

9

learning to concentrate on religious affairs. His religious writings include *Heavenly Arcana* (1749–56), *The New Jerusalem* (1758), and *True Christian Religion* (1771). After his death, the Church of the New Jerusalem carried forward his theology.

Swedish National language of Sweden, spoken by virtually all of its 8.7 million people. It is also spoken by many people in Finland. Closely related to Norwegian and Danish, it is a member of the northern branch of the Germanic family of INDO-EUROPEAN LANGUAGES.

sweet pea Climbing annual plant native to Italy. Widely cultivated as an ornamental, it has fragrant, butterfly-shaped flowers of white, pink, purple, red or orange. Height: to 1.8m (6ft). Family Fabaceae/Leguminosae; species *Lathyrus odoratus*.

sweet potato Trailing plant native to South America and cultivated as a vegetable in Japan, Russia, USA, and the Pacific. Its funnel-shaped flowers are pink or violet. The orange or yellow, tuber-like root is edible. Family Convolvulaceae; species *Ipomoea batatas*.

sweet william Common name for a flowering plant native to Europe. Introduced as a garden plant, it is now a wildflower in the USA. Its flower heads are pink, red or white. Height: to 60cm (24in). Family Caryophyllaceae; species *Dianthus barbatus*.

Swift, Jonathan (1667–1745) Irish satirist and poet. Swift was ordained an Anglican priest in 1694 and became Dean of St Patrick's Cathedral in 1713. His early works include *The Battle of the Books* (1697) and *A Tale of a Tub* (1704). His masterpiece, *Gulliver's Travels* (1726), is a SATIRE on human folies. Swift wrote numerous works criticizing England's treatment of Ireland, including *A Modest Proposal* (1729). His poetry includes *Verses on the Death of Dr Swift* (1739).

swift Any of several species of fast-flying, widely distributed birds. They have hooked bills, wide mouths, long narrow wings and darkish plumage. They typically feed on insects, which they catch in flight, and build nests of plant matter held together with saliva. Length: to 23cm (9in). Family Apodidae.

SWEDEN

Sweden's flag was adopted in 1906. It had been in use since the time of King Gustavus Vasa (r.1523–60), who won many victories for Sweden and laid the foundations of the modern nation. The colours on the flag come from a coat of arms dating from 1364.

AREA: 449,960sq km (173,730sq mi)
POPULATION: 8,678,000
CAPITAL (POPULATION): Stockholm (692,594)
GOVERNMENT: Constitutional monarchy

ETHNIC GROUPS: Swedish 91%, Finnish 3% LANGUAGES: Swedish (official), Finnish RELIGIONS: Christianity (Lutheran 89%, Roman Catholic 2%)

currency: Swedish krona = 100 ore

Sweden is the largest country in SCANDINA-VIAN countries, both in terms of area and population. Most of N Sweden is mountainous; its highest point is Kebnekaise in LAPLAND, at 2,117m (6,946ft). The s lowlands contain two of Europe's largest lakes, Vänern and Vättern, and Sweden's largest cities: the capital, STOCK-HOLM, and GOTHENBURG.

CLIMATE

The climate of s Sweden is moderated by the Gulf Stream. Further N, the climate becomes more severe: at the Arctic Circle, the temperature is below freezing for six months per year.

VEGETATION

Forest and woodland cover c.68% of Sweden. Arable land makes up 7% and grass only 1%.

HISTORY AND POLITICS

The earliest inhabitants of the area were the Svear, who merged with the Goths in the 6th century AD. Christianity was introduced in the 9th century. Swedes are thought to have been among the VIKINGS who plundered areas of s and E Europe between the 9th and 11th centuries. Swedes (Varangians), led by RURIK, also penetrated Russia as far as the Black Sea. In 1319 Sweden and Norway were united under Magnus VII. In 1397 Sweden, Denmark and Norway were united by the Danish Queen Margaret in the Kalmar Union. Her successors failed to control Sweden, and in 1520 Gustavus Vasa led a successful rebellion. He was crowned king, as Gus-TAVUS I, of an independent Sweden in 1523. (Southern Sweden remained under Danish control until 1660.) Gustavus made the monarchy hereditary within the Vasa dynasty and Lutheranism became the state religion. Sweden's power was strengthened by John III's marriage

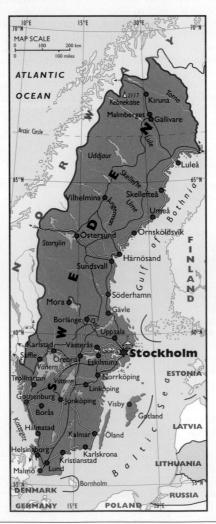

to the king of Poland's sister. Their son, Sigismund III, a Roman Catholic, came to the throne in 1592 but was deposed (because of his religion) by Charles IX in 1599. Charles' son, Gus-TAVUS II, won territory in Russia and Poland, and further victories in the THIRTY YEARS WAR established Sweden as a great European power. CHARLES XII fought brilliant campaigns in Denmark, Poland, Saxony and Russia, but his eventual defeat in Russia (1709) seriously weakened Sweden. The 18th century was marked by internal friction. Gustavus IV (r.1792-1809) brought Sweden into the NAPOLEONIC WARS. Charles XIII (r.1809-18) lost Finland to Russia in 1809, but the Congress of VIENNA granted Norway to Sweden as compensation. Industry grew in the late 19th century. In 1905 the union between Sweden and Norway was dissolved. Under Gustavus V (r.1907-50), Sweden was neutral in both World Wars. In 1946 it joined the United Nations. The current king, Carl XVI Gustaf, succeeded in 1973. In 1995 Sweden joined the European Union. The Social Democrats have been in government almost continuously since 1932. In 1994 they formed a minority government, led by Ingvar Carlsson. In 1996 Carlsson was replaced by Göran Persson. The cost of maintaining Sweden's extensive welfare services has become a major political issue.

ECONOMY

Sweden is a highly developed industrial country (1992 GDP per capita, US\$18,320). It has rich iron ore deposits, but other industrial materials are imported. Steel is a major product, and is used to manufacture aircraft, cars, machinery and ships. Forestry and fishing are important. Farmland covers 10% of the land. Livestock and dairy farming are valuable activities; crops include barley and oats.

swimming Self-propulsion through water as a leisure activity or as a competitive sport. Formal competition was first introduced in 1603 in Japan. The National Swimming Association was formed in England in 1837; the *Fédération Internationale de Natation Amateur* (FINA), the world governing body, was formed by 1908. There are four main strokes – breaststroke, front crawl, backstroke and butterfly. Recognized race distances for men and women, established by the Federation in 1968, range from 100m to 1,500m; there are also relay and medley races. Synchronized swimming also features at the Olympic Games and at the four-yearly world championships, as does DIVING. Swimming is one of the disciplines of the triathlon and the modern PENTATHLON.

Swinburne, Algernon Charles (1837–1909) British poet and critic. Swinburne first attracted attention for his verse drama Atalanta in Calydon (1865). Poems and Ballads (1866), which included "The Garden of Proserpine", shocked Victorian readers with its sexual explicitness. A second series of series of Poems and Ballads (1876) included an elergy to Baudelaire. swing Form of predominantly big-band JAZZ, prevalent in the USA during the 1930s and '40s. It originated in the music of small groups who played a rhythm of four even beats to the bar, as opposed to the the New Orleans style of two beats to the bar. The groups also made more use of soloists, particularly saxophonists. Larger groups, such as those of Duke ELLINGTON and especially Count Basie, made great use of the new possibilities. Their innovations were taken up by white musicians such as Benny Goodman, the Dorsey brothers and Glenn MILLER.

Swithin, Saint (d.862) Anglo-Saxon bishop of WINCHESTER (852–62). Details of his life are sketchy, it is known that he was an adviser to the West Saxon kings Egbert and Ethelwulf. His feast day is 15 July. According to superstition, the weather on St Swithin's Day will last for the next 40 days.

Switzerland Small, landlocked republic in central Europe. *See* country feature, p.652

swordfish (broadbill) Marine fish found worldwide in temperate and tropical seas. A popular food fish, it is silveryblack, dark purple or blue. Its long flattened upper jaw, in the shape of a sword, is one-third of its length and used to strike at prey. Length: to 4.5m (15ft); weight: 530kg (1,180lb). Family Xiphiidae; species *Xiphias gladius*.

sycamore (great MAPLE or false plane) Deciduous tree of the family, native to central Europe and w Asia but widely naturalized. It has deeply toothed, five-lobed leaves, greenish yellow flowers and winged brown fruit. Height: to 33m (110ft). Family Aceraceae; species *Acer pseudoplatanus*.

Sydenham, Thomas (1624–89) English physician, often called the English Hippocrates. He initiated the cooling method of treating SMALLPOX, made a thorough study of epidemics, and wrote descriptions of MALARIA and GOUT.

Sydney State capital of New South Wales, SE Australia, on Port Jackson, an inlet on the Pacific Ocean. Sydney is the oldest and largest city, the most important financial, industrial and cultural centre and the principal port in Australia. The city was founded in 1788 on a natural harbour as the first British penal colony in Australia. Industries: shipbuilding, textiles, motor vehicles, oil refining, building materials, chemicals, brewing, tourism, clothing, paper, electronics. Sydney will host the summer Olympic Games in the year 2000. Pop. (1994) 3,738,500. syllogism Logical argument consisting of three categorical propositions: two premises and a conclusion. It was devised by ARISTOTLE to establish the conditions under which the conclusion of a deductive inference is valid or not valid. A valid conclusion can only come from premises that are logically related to each other. Examples of syllogisms are as follows: All men are mortal; John is a man; therefore John is mortal (valid); All trees have leaves; a daffodil has leaves; therefore a daffodil is a tree (invalid).

symbiosis Relationship between two or more different organisms that is generally mutually advantageous. It is more accurately referred to as MUTUALISM. *See also* PARASITE

symbolism European art and literary movement. Symbolism has its origins in France in the 1880s when it arose as a reaction against the pragmatic REALISM of COURBET and IMPRESSIONISM.

Its exponents wanted to express ideas or abstractions rather than simply imitate the visible world. The most powerful tendency in the movement stemmed from GAUGUIN and Émile Bernard (c.1888). Another less dynamic trend introduced formal innovations into traditional painting. Its chief exponents were Gustave Moreau, Odilon Redon and Puvis de Chavannes. Outside France, BURNE-JONES and MUNCH are considered as Symbolists. In literature, the movement included a group of poets active in the 19th century who were followers of VERLAINE and BAUDELAIRE, such as MALLARMÉ and RIMBAUD in France and writers in English, such as POE and SWINBURNE. symmetry In biology, anatomical description of body form or geometrical pattern of a plant or animal. It is used in the classification of living things (TAXONOMY), and to clarify relationships. In mathematics, a symmetrical figure is one that has an exact correspondence of shape about a point, line or plane. symphonic poem (tone poem) Orchestral piece of the lateromantic period that describes in music a poem, story or other extra-musical programme. The term was first used by Franz LISZT. Till Eulenspiegel and Also sprach Zarathustra by Richard Strauss are perhaps the best-known examples of the genre. See also PROGRAMME MUSIC

symphony Large-scale, musical work for orchestra. It has evolved steadily since the 18th century, when it received its first classical definition in the works of HAYDN and MOZART. A symphony usually has four movements and, in the classical tradition, has its first movement in sonata form. The first symphonies were scored almost exclusively for stringed instruments of the violin family, but in the early 19th century the use of large brass and woodwind sections had become general. Later composers of symphonies include BEETHOVEN, SCHUBERT, SCHUMANN, BRAHMS, BRUCKNER, TCHAIKOVSKY, MAHLER, SIBELIUS and SHOSTAKOVICH.

synagogue Place of assembly for Jewish worship, education and cultural development. Synagogues serve as communal centres, under the leadership of a RABBI, and house the ARK OF THE COVENANT. The first synagogue buildings date from the 3rd century BC, but may go back to the destruction of Solomon's Temple in Jerusalem in 586 BC.

synapse Connection between the nerve ending of one NEURON and the next or between a nerve cell and a muscle. It is the site at which nerve impulses are transmitted using NEUROTRANSMITTERS.

syncline Downward FOLD in rocks. When rock layers fold down into a trough-like form, it is called a syncline (an upward arch-shaped fold is an anticline).

▲ Swift Irish satirist and poet Jonathan Swift also wrote numerous political pamphlets, such as The Conduct of The Allies (1711). He left Ireland in 1689, but returned in 1714 and became a champion of Irish rights. His satirical masterpiece, Gulliver's Travels (1726), describes the travels of Lemuel Gulliver in imaginary lands, such as Lilliput, where he meets the Houyhnhnms and the Yahoos. It skilfully lampoons politicians, religious dissenters, philosophers and scientists, as well as being a parody of travel literature. Journal to Stella (1768) was a collection of letters to a former pupil and close friend. Swift suffered from Ménière's syndrome and was pronounced insane in 1742.

Iridomyrmex ants and the Myrmecodia (ant plant) benefit from a symbiotic relationship. The ants feed on the sugary nectar of the plant. This is produced in nectaries (1) which develop at the base of the flower (2) after the petals and sepals have fallen off. The plant benefits from the vital

minerals in the ants' defecation and waste materials (3), absorbed through the warty inner surface of the chambers (4). The ant plant is epiphytic, growing suspended from trees in upland rain forests, where the soils are often lacking in nutrients. The mineral nutrients provided by the ants

supplement the plants poor diet. As the plant grows, its stem enlarges and develops cavities which are invaded by the ants (5). These chambers do not interconnect, but have separate passages to the outside (6). A complete ant colony soon becomes established in the plant.

syncope See FAINTING

syndicalism Early 20th-century form of SOCIALISM originating in France but also influential in Spain and Italy. It proposed public ownership of the means of production by small worker groups and called for the elimination of central government.

Synge, John Millington (1871–1909) Irish dramatist who was important in the renaissance of IRISH LITERATURE. Synge was one of the organizers of the ABBEY THEATRE in 1904, and his comedy The Playboy of the Western World (1907) caused a riot when first performed. Riders to the Sea (1904) is a paean to the spirit of the Aran islanders. Other works include The Well of the Saints (1905) and Deidre of the Sorrows (1910).

Synoptic Gospels Three of the Gospels of the New Testament (St MATTHEW, St MARK, St LUKE), which present a common account of the life of JESUS CHRIST. St Mark's Gospel is generally held to have been the model for St Matthew's and St Luke's, although most scholars believe that the latter two have gathered some material from a common source known as "Q", which no longer exists.

synovial fluid Viscous, colourless fluid that lubricates the movable joints between bones. It is secreted by the synovial membrane. Synovial fluid is also found in the BURSAE, membranous sacs that help to reduce friction in major joints such as the shoulder, hip or knee.

syntax Branch of grammar that encompasses the body of rules governing the ways in which words are put together to form phrases, clauses and sentences in a language. Syntax also describes the structure of a sentence or of an utterance produced by a writer or speaker.

synthesizer In music, an electronic instrument capable of producing a wide variety of different sounds, pitches and timbres. The modern instrument was invented by Robert Moog in 1964. Computer technology is now used to control the instrument's different functions, enabling synthesizers to replicate non-electronic sounds.

syphilis Sexually transmitted disease caused by the spiralshaped bacterium (spirochete) Treponema pallidum. Untreated, it runs its course in three stages. The first symptom is often a hard, painless sore on the genitals, appearing usually within a month of infection. Months later, the second stage features a skin rash and fever. The third stage, often many years later, brings the formation of growths and serious involvement of the heart, brain and spinal cord, leading eventually to blindness, insanity and death. The disease is treated with ANTIBIOTICS.

> AREA: 41,290sq km (15,942sq mi) POPULATION: 6,905,000

GOVERNMENT: Federal republic

Romansch 1%

Protestant 40%)

Romansch (all official)

CAPITAL (POPULATION): Bern (135,600)

ETHNIC GROUPS: German 64%, French 19%,

LANGUAGES: French, German, Italian and

CURRENCY: Swiss franc = 100 centimes

RELIGIONS: Christianity (Roman Catholic 46%,

Italian 8%, Yugoslav 3%, Spanish 2%,

SWITZERLAND

Switzerland has used this square flag since 1848, though the white cross on the red shield has been Switzerland's emblem since the 14th century. The flag of the International Red Cross, which is based in Geneva, was derived from this flag.

he Swiss Confederation is a mountainous, landlocked country in central Europe. The JURA MOUNTAINS lie on the w border with France. The Swiss ALPS make up about 60% of the country. Switzerland's highest peak is Monte Rosa, at 4,634m (15,217ft). The plateau contains the cities of ZÜRICH, BASEL, LAUSANNE and BERN, and lakes GENEVA and Constance.

CLIMATE

The climate varies with altitude. The plateau has warm summers and cold, snowy winters.

VEGETATION

Grassland covers c.30% of the land and arable land c.10%. Forests cover c.32%, and help to reduce the destructiveness of avalanches.

HISTORY AND POLITICS

Originally occupied by Celtic Helvetii people, the region was taken by Romans in 58 BC. Ruled by FRANKS in the 6th century AD; it was later divided between Swabia and Burgundy. United within the HOLY ROMAN EMPIRE, it came under HABSBURG rule in the 13th century. In 1291 the

CANTONS, Schwyz, Uri and Unterwalden, united against the Habsburgs. Traditionally led by William Tell, the Swiss League expanded and defeated the Habsburgs (1386, 1388). The defeat of Emperor MAXIMILIAN in 1499 brought partial independence. Defeated by the French in 1515, the Swiss adopted neutrality. The REFORMATION caused religious divisions in Switzerland, but the confederation survived to achieve formal independence in 1648. The FRENCH REVOLUTIONARY WARS led to the overthrow of the oligarchy and the establishment of the Helvetic Republic (1798-1803). In 1815 the federation was fully

Jura, the 23rd canton, was created in 1979. A referendum (1986) rejected Swiss membership of the UN to avoid compromising its neutrality. European Community membership was similarly rejected (1992). In 1995 the ruling coalition, led by the Christian Democrats, was re-elected.

A brief civil war led to the constitution of 1848,

turning Switzerland into one federal state.

ECONOMY

Despite lacking natural resources, Switzerland is wealthy and industrialized (1992 GDP per capita, US\$22,580). Manufactures include chemicals, electrical equipment, machinery, precision instruments, watches and textiles. Livestock raising, notably dairy farming, is the chief agricultural activity. Tourism is important, and Swiss banks attract worldwide investment.

re-established. The Congress of VIENNA expanded it to 22 cantons and guaranteed its neutrality. **Syracuse** (Siracusa) Italian seaport city in Sicily, on the Ionian Sea, capital of Syracuse province. Founded by Corinthian Greek colonists in 734 BC, it prospered and established its own colonies, triumphing over the Carthaginians in 480 BC. It grew to become the most important Hellenic city outside Greece, and at one time was probably the world's largest city. Industries: tourism, petrochemicals. Pop. (1992) 127,000.

Syria Arab republic in the N Middle East. *See* country feature **Syriac** Semitic language belonging to the eastern ARAMAIC group. In ancient times it was spoken in Edessa, now Urfa in SE Turkey. Because of the importance of Edessa as a centre of Christianity in the 2nd century, Syriac was adopted by the neighbouring Aramaic Christians and has been used ever since as a liturgical language by Oriental Christians of the Syrian rite. Syriac literature preserves many translations of Greek Christian texts that have not survived in the original Greek.

Szczecin (Stettin) City in NW Poland near the mouth of the River Oder, only 10km (6mi) from the German border. From 1720 Szczecin acted as the main port for BERLIN. The city was returned to Poland by the Potsdam Conference in 1945. Industries: shipbuilding, ironworks, chemicals. Pop. (1993) 414,200. Szechwan See Sichuan

Szell, George (1897–1970) US conductor and pianist, b. Hungary. Szell assisted Richard Strauss at the Berlin State Opera and became its director (1924–30). In 1939 he moved to the USA and became conductor (1942–46) of the Metropolitan Opera, New York. Under Szell's directorship (1946–70), the Cleveland Orchestra became a world-class ensemble.

Szent-Györgyi, Albert von (1893–1986) US biochemist, b. Hungary. He was awarded the 1937 Nobel Prize for physiology or medicine for his work on biological oxidation processes and the isolation of vitamin C. He also studied the biochemistry of MUSCLE, discovering the muscle protein actin. Szilard, Leo (1898–1964) US physicist, b. Hungary. Szilard's early work established the relation between information transfer and ENTROPY. He devised a means of separating radioactive isotopes. He was active in the development of the nuclear bomb and, with Enrico FERMI, created the first sustained nuclear chain reaction based on uranium FISSION.

Szymanowski, Karol (1882–1937) Polish post-romantic composer who did much to promote the nationalist cause in Poland. Szymanowski studied (1906–08) the works of Wagner and Richard Strauss in Germany. His works include two violin concertos (1917, 1933) and the opera *King Roger* (1926).

SYRIA

Syria has used this flag since 1980. It is the flag that was used by the United Arab Republic between 1958 and 1961, when Syria was linked with Egypt and North Yemen. The colours are those used by the Pan-Arab movement.

AREA: 185,180sq km (71,498sq mi)

POPULATION: 12,958,000

CAPITAL (POPULATION): Damascus (1,497,000) **GOVERNMENT:** Multiparty republic

ETHNIC GROUPS: Arab 89%, Kurd 6%
LANGUAGES: Arabic (official)
RELIGIONS: Islam 90%, Christianity 9%
CURRENCY: Syrian pound = 100 piastres

The Arab republic of Syria is divided into two regions. The smaller, densely populated w region comprises a narrow coastal plain and several mountain ranges. The Jabal an Nusayriyah range drops sharply to the Great RIFT VALLEY in the E. In the sw, the Anti-Lebanon range contains Syria's highest peak, Mount Hermon (2,184m, 9,232ft). The capital, DAMASCUS, and ALEPPO lie in fertile valleys. Eastern Syria is mainly grassy plain, and contains the valley of the River Euphrates. In the SE, is the Syrian Desert.

CLIMATE

The coast has a Mediterranean climate, with warm, dry summers and mild, wet winters. To the E, the land becomes drier.

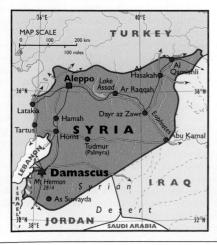

VEGETATION

Only 4% of Syria is forested. Farmland covers *c*.30% of Syria, grassland makes up 44%.

HISTORY AND POLITICS

Syria's location on the trade routes between Europe, Africa and Asia has made it a desired possession of many rulers. The area, including what is now Lebanon and some of modern-day Jordan, Israel, Saudi Arabia and Iraq, was ruled by the HITTITES and by EGYPT during the 15th-13th centuries BC. Under the PHOENICIANS (13th-10th centuries BC), trading cities on the Mediterranean coast flourished. From the 10th century BC, Syria suffered invasions by ASSYRI-ANS and Egyptians. The ACHAEMENID empire provided stability. From the 3rd century BC, the SELEUCIDS controlled Syria, often challenged by Egypt. PALMYRA flourished as a city-state. The Romans conquered the region in AD 63. Christianity was introduced via Palestine. When the ROMAN EMPIRE split in the 4th century, Syria came under BYZANTINE rule. Arabs invaded in AD 637, and most of the population converted to Islam. The UMAYYADS and ABBASID dynasties followed. In the 11th century, Syria was a target of the CRUSADES, but at the end of the 12th century SALADIN triumphed. MONGOL and MAMELUKE rule followed Saladin's death. In 1516 the area became part of the OTTOMAN EMPIRE. European interest in the region grew in the 19th century. During World War 1, Syrian nationalists revolted and helped Britain defeat the Turks. After the war, Syria, now roughly its present size, became a French mandate territory. It achieved independence in 1944.

Syria has supported the Arab cause in the Middle East and has been involved in the Arab-Israeli wars. In 1967 it lost the Golan Heights to Israel, and in 1973 tried unsuccessfully to reclaim them. A UN-patrolled buffer zone was established in the area. It continues to be a source of considerable tension.

Since independence, Syria has suffered from political instability, with many coups. In 1958 Syria joined the United Arab Republic with Egypt and North Yemen. Egypt's increasing power led to Syrian withdrawal from the UAR, and the formation of a Syrian Arab Republic in 1961. The BA'ATH PARTY has been the ruling party since 1963. In 1970 Hafez al-Assan took power through a coup and was re-elected in 1971. A new constitution was adopted in 1973, declaring Syria to be a democratic, socialist state. Assad's stable but repressive regime has attracted international criticism. In the GULF WAR (1991), Syria supported the international coalition against Iraq. In 1994 Syria and Israel held talks over the Golan Heights. These talks, part of an attempt to establish a peace settlement for the entire region, received a setback when a rightwing coalition won the 1996 Israeli elections.

ECONOMY

Syria is a lower-middle-income developing country. Its main resources are oil, hydroelectricity, and its fertile agricultural land. In 1990 crude oil accounted for 45% of exports, but Syria also exports farm products, textiles and phosphates. Agriculture employs 23% of the workforce. The chief crops are cotton and wheat. Syria is rapidly diversifying its industrial base.

T/t, the 20th letter of the alphabet, is derived from the Semitic letter taw (meaning mark) and the Greek letter tau. The Roman letter had the same form as the modern T. In English t nearly always has the sound as in fat and tar, although it is silent in such words as listen and castle, and in words derived from the French, such as depot and debut. The combination with h gives rise to two sounds, as in thin and this, and the combination with i sometimes gives the sound sh, as in action and militia.

Tabernacle Portable shrine used by the Hebrews for worship during their wanderings in Sinai. It was a rectangular tent covered with a curtain of goat's hair and a layer of animal skins and roofed with a ceiling of linen tapestry. Inside the Tabernacle the space was divided into two rooms: the outer room was the Holy Place, and the inner was the Holy of Holies, where God was believed to be present. The Holy of Holies contained the ARK OF THE COVENANT, above which was a slab of gold believed to be the throne of God. After the Hebrews settled CANAAN, there was no further need for the Tabernacle. Eventually its relics were transferred to the temple built by Solomon in Jerusalem. In the Christian church, a tabernacle is a receptacle in which the Blessed Sacrament is reserved for the EUCHARIST, or a recess used for spiritual contemplation.

table tennis Table sport played by two or four people, who use a rubber-covered, wooden bat to hit a small, celluloid ball back and forth across a net 15.2cm (6in) high. The table is 2.7m (9ft) long and 1.5m (5ft) wide. After the serve, the ball must bounce only on the far side of the net. If the ball misses the table or fails to clear the net, a point is scored by the opponent. The winner is the first player to score 21 points, while leading by at least two points.

taboo (tabu) Prohibition of a form of behaviour, object or word. A thing may be regarded as taboo if it is unclean or if it is sacred. Breaking a taboo is believed to bring supernatural retribution and often brings social ostracism or other punishment. The term originates in Tonga.

Tabriz (formerly Tauris) Capital of East Azerbaijan province, NW Iran, in the foothills of Mount Sahand. It is Iran's fourth-largest city. From 1295 it was the chief administrative centre for the Persian empire. It was occupied by the Ottoman Turks and later held by the Russians. Tabriz's proximity to Turkey and the Commonwealth of Independent States makes it an important trading centre. Manufactures: carpets, shoes, soap, textiles. Pop. (1986) 971,482.

tachycardia Increase in heart rate beyond the normal. It may occur after exertion or because of excitement or illness, particularly during fever; or it may result from a heart condition.

Tacitus, Cornelius (55–120) Roman historian. His crisp style and reliability make him one of the greatest of Roman historians. His books include a eulogy for his father-in-law, Agricola, governor of Britain, and the *Annals* and *Histories*, his major works, of which large parts are lost.

tadpole Aquatic larva of a TOAD or FROG; it has feathery gills and a finned tail, and lacks lungs and legs. The tadpoles of most species are herbivores, feeding on algae and other aquatic plants. During METAMORPHOSIS legs are grown, the tail is reabsorbed and internal lungs take the place of gills.

Taegu City in s central South Korea; capital of North Kyöngsang province and the country's third-largest city. Successfully defended by United Nations (UN) troops during the KOREAN WAR, it is the trading centre for a large apple-grow-

ing area. The main industries are textiles, including silk and synthetic fabrics. Pop. (1990) 2,228,834.

tae kwon do Korean martial art. It is a form of unarmed combat developed over 2,000 years in Korea and is characterized by high standing and jump kicks as well as punches. It is practised both for sport and for spiritual development.

Taft, Robert Alphonso (1889–1953) US political leader. Son of President William Howard TAFT, he served in the Ohio state legislature before becoming US senator (1938–53). A conservative Republican, he sponsored the Taft-Hartley Act (1947), which restricted trade unions.

Taft, William Howard (1857–1930) 27th US President (1909–13). After a distinguished legal career, he gained great credit as governor of the Philippines (1901–04) and entered the cabinet of Theodore Roosevelt. He won the Republican nomination for president and was elected in 1908. His lack of political experience and his tendency to side with the conservatives in the Republican Party against the progressives caused increasing dissension. In 1912 Roosevelt, having failed to regain the presidential nomination, set up his own PROGRESSIVE PARTY. With the Republican vote split, the Democrat, Woodrow WILSON, won the election. Taft taught at Yale Law School until 1921, when he was appointed chief justice of the Supreme Court.

Tagore, Rabindranath (1861–1941) Indian poet and philosopher. Immensely gifted in many artistic fields, he wrote novels, essays and plays, but is perhaps best known for his poetic works, notably Gitanjali. He was awarded the Nobel Prize for literature in 1913. Immensely influential in the West as well as in India, he combined the traditions of both cultures. Tagus (Tajo, Tejo) Longest river on the Iberian peninsula, flowing c.1,000km (620mi). The Tagus rises in the Sierra de Albarracin in Teruel, E central Spain. It flows generally sw for 785km (488mi), passing through Toledo, to the Spain-Portugal border. It then winds s to drain into the Atlantic at Lisbon. The Tagus estuary is one of the world's finest natural harbours. Tahiti Island in the s Pacific Ocean, in the Windward group of the Society Islands, the largest in French Polynesia and accounting for over half its population. Charted in 1767 by the British navigator Samuel Wallis and explored by Captain COOK, it was colonized by France in 1880. Tahiti is mountainous, rising to 2,237m (7,339ft), but also fertile, producing tropical fruits, copra, sugar cane and vanilla. Industries: tourism. pearl-fishing, phosphates. Paul GAUGUIN lived and painted here. Area: 1,058sq km (408sq mi). Pop. (1988) 115,820.

Tai Chi Neo-Confucian concept of the Supreme Ultimate, the intrinsic energy of the universe (Chi). A philosophical system was developed in the work of Chou Tun-i (1017–73) and Chu Hsi (1130–1200). *Tai Chi* also refers to the most popular form of exercise in China – a martial arts-based series of slow, flowing movements designed to enhance the effective flow of Chi around the body.

Taipei Capital and largest city of Taiwan, at the N end of the island. A major trade centre for tea in the 19th century, the city was enlarged under Japanese rule (1895–1945) and became the seat of the Chinese Nationalist government in 1949. Industries: textiles, chemicals, fertilizers, metals, machinery. The city expanded from 335,000 people in 1945 to 2,653,000 in 1993.

Taiping Rebellion (1851-64) (1851-64) Revolt in China against the Manchurian QING dynasty, led by a Hakka fanatic, Hung Hsiu-ch'uan. The fighting laid waste to 17 provinces of China and resulted in more than 20 million casualties. The Qing never fully recovered their ability to govern all of China. Taiwan (officially, the Republic of China) Pacific island, separated from the SE coast of the Chinese mainland by the 160km (100mi) Taiwan Strait. The republic comprises the main island of Taiwan, several islets and the Pescadores group. The terrain is mostly mountainous and forested, and the highest peak is Yu Shan at 3,997m (13,113ft). The climate is semi-tropical and subject to typhoons. Agriculture, fishing and forestry are important economic activities, and rice is the principal crop. Spectacular economic growth from the mid-1950s was achieved primarily through low-cost, export-led manufacture of textiles, electrical goods, machinery and transport equipment. In 1590 the Portuguese visited the

island and named it Formosa ("beautiful"), but in 1641 the Dutch assumed full control of the island. They in turn were forced to relinquish control to the Chinese MING dynasty. The QING dynasty captured Taiwan in 1683 and immigration increased. It was ceded to Japan in 1895 after the first Sino-JAPANESE WAR. Following the 1949 mainland victory of the Chinese Communist Party, the vanquished Nationalist KUOMINTANG government (led by CHIANG KAI-SHEK) and 500,000 troops fled to Taiwan. The new Chinese regime claimed sovereignty over the island, and in 1950 a Chinese invasion was prevented by the US Navy. The Nationalists, with continued US military and financial support, remained resolute. By 1965 the economic success of Taiwan had removed the need for US aid. In 1975 Chiang Kai-shek died and a gradual process of liberalization began. In 1979 the USA switched diplomatic recognition from Taipei to Beijing. Immediately prior to the 1996 Taiwanese elections, China dispatched missiles close to the island's coast, reminding the world community of its territorial claims. Lee Teng-hui has been president since 1988.

Taiyuan City in NE China; capital of Shanxi province. The region has rich coal and iron ore deposits. Taiyuan is a major industrial city with iron and steel, chemical and engineering plants and textile industries. Pop. (1990) 1,680,000.

Tajik Native speaker of Tajiki, an Iranian language spoken in Tajikistan and (with some TURKIC elements) in Afghanistan, s Russia and much of central Asia. Tajiks constitute a minority of 30% within Tajikistan.

Tajikistan Republic in central Asia. See country feature

Tai Mahal Muslim MAUSOLEUM near Agra, India, built (1632-54) by the Mogul emperor SHAH JAHAN for his favourite wife, Mumtaz Mahal. The mausoleum was the largest Islamic tomb ever destined for a woman. The Taj stands in a Persian water garden that represents Paradise. With its bulb-shaped dome, intricate inlays of semiprecious stones and rectangular reflecting pool, it is one of the world's most beautiful buildings. takahe Rare, flightless New Zealand bird, related to the RAIL and gallinule. Turkey-sized, it has a heavy, curved bill, a reddish shield on the forehead and bright, blue-green plumage. Family Rallidae; species Notornis mantelli.

Talbot, William Henry Fox (1800–77) British scientist. Talbot improved on the work of Niepce and Daguerre by inventing the first photographic process capable of producing any number of positive prints from an original negative.

▲ Taj Mahal It took more than 20,000 skilled workmen drawn from all over India and Asia more than ten years to complete the mausoleum of the Taj Mahal. The building is intended to symbolize the throne of God.

TAJIKISTAN

Tajikistan's flag was adopted in 1993. It replaced the flag, showing a hammer and sickle, that had been used during the Communist period. The new flag shows a gold crown under an arc of seven stars on the central white band.

he mountainous Republic of Tajikistan lies in SE Central Asia. In the N is the westernmost part of the TIAN SHAN range. In the E lie the snow-capped PAMIRS, including KOMMUNIZMA Pik at 7,495m (24,590ft). The capital, DUSHANBE, lies at the foot of the central Gissar-ALTAI range. In the NW lies part of the Fergana valley on the ancient route to SAMARKAND. In the sw, a plain extends from Dushanbe to the Amudarya River border with Afghanistan and Uzbekistan. Tajikistan is prone to earthquakes.

CLIMATE

Tajikistan has a continental climate. Summers are hot and dry in the lowlands, but winters are long and cold in the mountains. Much of the country is arid, but the SE has heavy snowfalls.

VEGETATION

Vegetation varies greatly according to altitude.

Much of Tajikistan consists of desert or rocky mountain landscapes capped by snow and ice.

HISTORY AND POLITICS

The Tajiks are descendants of Persians who settled in the area c.2,500 years ago. Alexander the Great conquered the region in the 4th century BC. In the 7th century AD Tajikistan was conquered by Arabs, who introduced Islam. In the 9th century it fell to the Persian empire. The Tajik cities of BUKHARA and Samarkand were vital centres of trade and Islamic learning. In the 13th century Tajikistan was overrun by the Mongol hordes. From the 16th to the 19th centuries, Uzbeks ruled the area as the khanate of Bukhara. The fragmentation of the region aided Russian conquest from 1868. Following the RUSSIAN REVOLUTION (1917), Tajikistan rebelled against Russian rule. Though Soviet troops annexed N Tajikistan into Turkistan in 1918, the Bukhara emirate held out against the Red Army until 1921. In 1924 Tajikistan became an autonomous part of the republic of Uzbekistan. In 1929 Tajikistan achieved full republican status, but Bukhara and Samarkand remained in the republic of Uzbekistan, During the 1930s, vast irrigation schemes greatly increased agricultural land. Many Russians and Uzbeks were settled in Tajikistan. As the pace of reform accelerated in Russia, many Tajiks began to demand independence. In 1989 Tajik replaced Russian as the official language, and in 1990 the Tajik parliament declared itself the supreme sovereign body. In 1991 Tajikistan became an independent republic within the COMMONWEALTH OF INDEPENDENT STATES (CIS). In 1992 tension

AREA: 143,100sg km (55,520 sg mi)

POPULATION: 5,465,000

CAPITAL POPULATION: Dushanbe (592,000) GOVERNMENT: Transitional democracy ETHNIC GROUPS: Tajik 62%, Uzbek 24%, Russian 8%, Tatar, Kyrgyz, Ukrainian,

LANGUAGES: Tajik (official)

RELIGIONS: Islam

currency: Rouble = 100 kopecks

between the new government (consisting mainly of former communists) and an alliance of Islamic and democratic groups spiralled into full civil war. The government called for Russian military assistance, and by 1993 the Islamic-Democratic rebels had retreated into Afghanistan. Imamali Rakhmonov was elected president by the Supreme Soviet. Fighting continued along the Afghan border, and the rebels made frequent incursions into Tajikistan. In 1994 a brief ceasefire enabled elections to take place. Rakhmonov was elected president amid an opposition boycott. In 1995 the civil war resumed, and the Russian air force launched attacks on rebel bases in Afghanistan. Further elections in 1995 saw the return of the former communist People's Party of Tajikistan, amid charges of electoral corruption and another opposition boycott. In 1997 a peace agreement was signed formally ending the five-year civil war.

ECONOMY

The poorest former Soviet republic, Tajikistan is a low-income developing country (1992 GDP per capita, US\$1,740). It has faced enormous problems in the transition to a market economy. The cost of civil war devastated its fragile economy. In 1994 Tajikistan ceded much of its economic sovereignty to Russia in return for financial and military assistance. Agriculture is the main activity. Livestock-rearing is important and cotton is the chief product. Tajikistan is rich in resources, such as hydroelectricity, oil, uranium and gold. Aluminium is the major manufactured export. Textiles are an important industry.

talc Sheet silicate mineral, hydrous magnesium silicate, Mg₃Si₄O₁₀(OH)₂. It occurs as rare tabulate crystals in a monoclinic system and as masses. It is used as base for talcum powder and in ceramics. Hardness 1; s.g. 2.6.

Taliban Radical Sunni political movement in Afghanistan. From their headquarters in Kandahar, sw Afghanistan, Taliban militia launched themselves on Afghan society in 1996, vowing to spread Sharia (Islamic law) throughout the country. They soon captured Kabul. Taliban's philosophy is drawn from extremist theologians in Pakistan and other Arab countries.

Tallahassee State capital of Florida, USA. First discovered by Europeans in 1539, it was the site of a Spanish mission. Tallahassee became the capital of Florida Territory in 1824. Industries: chemicals, timber, paper, tourism. Pop. (1992) 130,357.

Talleyrand-Périgord, Charles Maurice de (1754–1838) French statesman. His political ability enabled him to serve in five very different French governments. He was foreign minister under Napoleon I, but turned against him in 1807 and negotiated the restoration of the Bourbon monarchy in 1814. Under Louis Philippe he was ambassador to Britain. Perhaps his greatest service to France was his skilful diplomacy at the Congress of Vienna.

Tallinn (Talin) Capital and largest city of Estonia, on the Gulf of Finland, opposite Helsinki. Founded in 1219 by the Danes, it became a member of the Hanseatic League (1285). It passed to Sweden in 1561 and was ceded to Russia in 1721. Developed in the 19th century for Russia's Baltic Fleet, it remains a major port and industrial centre. Though it was badly damaged in World War 2, the impressive Vyshgorod Castle remains. Industries: machinery, cables, paper, textiles, oilfield equipment. Pop. (1994) 490,000.

Tallis, Thomas (1505–85) English composer famous for his church music. In 1575 he and William BYRD were granted a licence to print music and they published the *Cantiones Sacrae*, a set of motets. His church music includes a setting of Lamentations, two masses and a number of anthems. His contrapuntal skill shows in his 40-part motet, *Spem in alium*, probably written in 1573.

Talmud Body of Jewish religious and civil laws and learned interpretations of their meanings. Study of the Talmud is central to orthodox Jewish faith. The Talmud consists of two elements: the *Mishna* and the *Gemara*. The MISHNA is the written version of a set of oral laws that were handed down from the time of Moses (c.1200 BC); the written version was com-

TANZANIA

Tanzania's flag was adopted in 1964 when mainland Tanganyika joined with the island nation of Zanzibar to form the United Republic of Tanzania. The green represents agriculture and the yellow minerals. The black represents the people, while the blue symbolizes Zanzibar.

The United Republic of Tanzania consists of the mainland republic of Tanganyika and the island republic of ZANZIBAR. A narrow plain borders the Indian Ocean, and includes the largest city, DAR ES SALAAM. The interior is dominated by a plateau between 900 and 1,500m (2,950ft to 4,900ft). The capital, DODOMA, lies in the centre of Tanzania. The plateau is broken by the Great RIFT VALLEY, the w arm of which contains Lake TANGANYIKA. The E arm runs through central Tanzania to meet the w arm near Lake MALAWI (Nyasa). The Serengeti Plain lies on the E shore of Lake VICTORIA. In the NE lies Africa's highest peak, Mount KILIMANJARO, at 5,896m (19,344ft).

CLIMATE

The coastal region is hot and humid, with heavy

rainfall in April and May. The plateau and mountains are much less humid. Mount Kilimanjaro is permanently snow-covered.

VEGETATION

Mangrove swamps and palm groves line the coast. The plateau is vast, open savanna grass or woodland (*miombo*). Tanzania's rich wildlife is protected in national parks, which cover over 12% of the land. Only 5% of land is cultivated.

HISTORY AND POLITICS

Dr Louis Leakey discovered 1.75 million yearold fossils of Homo habilis in OLDUVAI GORGE. Around 2,000 years ago, Arabs, Persians and Chinese probably traded with coastal settlements. In 1498 Vasco da Gama became the first European to land on the Tanzanian coast. For the next 200 years, the Portuguese controlled coastal trade. In 1698 the Portuguese were expelled with the help of Omani Arabs. During the 18th century, ZANZIBAR was the principal centre of the E African ivory and slave trade. In 1841 the sultan moved his capital to Zanzibar. The interior of Tanganyika was opened up by new caravan routes bringing slaves and ivory to the coast for transshipment. In the European scramble for Africa, Tanganvika was subsumed into German East Africa (1887), and the sultanate of Zanzibar became a British protectorate (1890). Resistance to German colonial rule was fierce. The Germans established plantations, built railroads, and missionaries encouraged the spread of Christianity. During World War 1, British and Belgian troops occupied German East Africa (1916), and in 1919 Tanganyika

AREA: 945,090sg km (364,899sg mi)

POPULATION: 27,829,000

CAPITAL POPULATION: Dodoma (203,833)
GOVERNMENT: Multiparty republic

ETHNIC GROUPS: Nyamwezi and Sukuma 21%, Swahili 9%, Hehet and Bena 7%, Makonde

6%, Haya 6%

LANGUAGES: Swahili and English (both official) RELIGIONS: Christianity (mostly Roman Catholic) 34%, Islam 33% (99% in Zanzibar), traditional beliefs and others 33%

currency: Tanzanian shilling = 100 cents

became a British mandate. The British ruled indirectly, via local leaders. In 1961 Tanganyika became the first East African state to gain independence. Julius NYERERE became the first post-colonial president. In 1963 Zanzibar gained independence, and in 1964 Tanganyika and Zanzibar merged to form Tanzania, though Zanzibar retained economic sovereignty. In 1967 Nyerere issued the Arusha Declaration, an outline of his self-help (ujamaa) form of socialism and egalitarianism. Despite promises of decentralization, Tanzania became a one-party state. In 1977 Tanganyika and Zanzibar's ruling parties merged to form the Party of the Revolution (CCM). In 1978 Uganda occupied N Tanzania. In 1979 Tanzanian and Ugandan rebels staged a counter-attack and overthrew the Ugandan president Idi AMIN. In 1985 Nyerere retired and was succeeded by Ali Hassan Mwinyi. In 1992 Mwinyi endorsed the principle of multiparty elections. In 1995 Benjamin Mkapa became the first president to be elected in a multiparty system.

ECONOMY

Tanzania is one of the world's poorest countries (1992 GDP per capita, US\$620). Agriculture employs 85% of the workforce, mainly at subsistence level. Tanganyika's main export crops are coffee, cotton, tea and tobacco, while Zanzibar is the world's largest producer of cloves. Diamonds are the principal mineral resource. Manufacturing is mostly small scale.

pleted by c. AD 200. The Gemara, the interpretation and commentary on the Mishna, was completed by c.500. The Talmud consists of short passages from the Mishna followed by the relevant and extensive part of the Gemara.

tamarind Tropical tree native to Asia and Africa. It has divided (feather-like) leaves and pale yellow flowers, streaked with red. The fruit pulp is used in beverages, food and medicines. Height: 12–24m (40–80ft). Family Fabaceae/Leguminosae; species *Tamarindus indica*.

tamarisk Any of a group of shrubs usually found in semiarid areas. They are DECIDUOUS and have slender branches covered with blue-green, scale-like leaves and clusters of small, white or pink flowers. Height: to 9m (30ft). Family Tamaricaceae; genus *Tamarix*.

tambourine Percussion musical instrument much used by wandering musicians in Europe in the Middle Ages. It comprises a narrow circular frame, made of wood, with a single parchment drumhead and metal jangles attached to the sides. Tamerlane (1336–1405) (Turkish *Timur Leng*, Timur the Lame) Mongol conqueror, b. Uzbekistan. He claimed descent from Genghis Khan. By 1369 Tamerlane had conquered present-day Turkistan and established Samarkand as his capital. He extended his conquests to the region of the Golden Horde between the Caspian and Black Seas. In 1398 he invaded NW India and defeated the Delhi Sultanate. He then turned towards the Mameluke empire, capturing Syria and Damascus. In 1402 he captured the Ottoman sultan Beyazid I

Tamil Language spoken in s India, chiefly in the state of Tamil Nadu on the E coast, by up to 50 million people. In addition, there are about 3 million speakers in N SRI LANKA and about 1 million distributed throughout Malaysia, Singapore, Fiji, Mauritius and Guyana.

at Angora. His death at the head of a 200,000-strong invasion

force of China enabled the reopening of the SILK ROAD. His

vast empire was divided among the Timurid dynasty.

Tamil Tigers Militant TAMIL group in Sri Lanka that seeks independence from the SINHALESE majority. Located mainly in the N and E of the island, the 3 million Tamils are Hindus, unlike the Buddhist Sinhalese. In the 1980s the Tamil Tigers embarked on a campaign of civil disobedience and terrorism. Autonomy for the Tamils was agreed by India and Sri Lanka in 1986, but no date fixed. The Indian army was sent in 1987 but withdrew in 1990, having failed to stop the violence.

Tammany Hall Democratic Party organization in New York City. It evolved from the fraternal and patriotic order of St Tammany, which was founded in 1789, and rapidly became the focal point of resistance to the Federal Party. By 1865 Tammany Hall, under William "Boss" Tweed, had become the most important voice of the Democratic Party in the city and was synonymous with the organized corruption of US urban politics. Not until the 1930s did its power begin to crumble.

tanager Small, brightly coloured, American forest bird with a cone-shaped bill. Tanagers feed on insects and fruit. The scarlet tanager (*Piranga olivacea*) of E North America has black on its wings and tail. Family Emberizidae.

Taney, Roger Brooke (1777–1864) US lawyer, chief justice of the Supreme Court (1836–64). As attorney-general (1831), he aided President Jackson in a struggle with the Bank of the United States. He was appointed associate justice (1835) but was not confirmed by the Senate. The next year a Senate Democratic majority confirmed his appointment as chief justice. An advocate of states' rights, he nonetheless extended the scope and power of the Supreme Court. He was associated with *Dred Scott v. Sandford* (1857), which refused African-Americans the right of citizenship and denied Congress power to forbid slavery in the territories.

T'ang Chinese imperial dynasty (618–907). The early period was a golden age of China, when it was by far the largest, richest and culturally most accomplished society in the world. T'ang armies carried Chinese authority to Afghanistan, Tibet and Korea. Towns grew as trade expanded, new ideas and foreign influences were freely admitted, and the arts flourished. During the 8th century, the dynasty was submerged in civil conflicts.

Tanganyika, Lake Second-largest lake in Africa and the

second-deepest freshwater lake in the world. It lies in E central Africa on the borders of Tanzania, Zaïre, Zambia and Burundi, in the RIFT VALLEY. Area: 32,893sq km (12,700sq mi), depth 1,437m (4,715ft).

tangent In TRIGONOMETRY, ratio of the length of the side opposite an acute angle to the length of the side adjacent to it within a right-angle triangle.

Tangier (Tanger) Port on the Strait of Gibraltar, N Morocco. An ancient Greek, Phoenician and then Roman port, it was later occupied by Moors and taken by the Portuguese in 1471. Tangier was passed to England in 1662, but the English abandoned the city to the Sultan of Morocco in 1684. Under international control from 1904 to 1956 (except during World War 2), it became part of Morocco in 1956. Industries: rugs, pottery, shipping, fishing, tourism. Pop. (1990) 420,000.

tango Ballroom dance that originated in Buenos Aires, Argentina, in the late 19th century. Developed from Argentinian *milonga*, it was a ballroom favourite in Europe and the USA by 1915. It is characterized by quick, long strides and rapid reversals of direction on the balls of the feet.

Tanizaki, Junichiro (1886–1965) Japanese novelist and dramatist. He was influenced by classical Japanese literature and by BAUDELAIRE. His works include *Some Prefer Nettles* (1928–29) and *The Makioka Sisters* (1943–48).

tank Tracked, armoured vehicle mounting a single primary weapon, usually an artillery piece, and one or more machine guns. Modern tanks have an enclosed, fully revolving turret and are heavily armoured; main battle tanks weigh from 35 to 50 tonnes and usually have a crew of four. Developed in great secrecy by the British during World War 1, tanks were first employed at the Battle of the Somme in 1916.

tannin (tannic acid) Any of a group of complex organic compounds derived from tree bark, roots and galls, unripe fruit, tea and coffee. Tannin is used in tanning to cure hides and make leather, in inks and dyes, and as an astringent in medicine.

tansy Any of several mostly perennial plants characterized by fern-like, aromatic leaves and clusters of yellow, button-like flower heads. *Tanacetum vulgare*, native to Eurasia, is a common weed in North America. Height: to 91cm (3ft). Family Asteraceae/Compositae.

tantalum (symbol Ta) Rare, lustrous, blue-grey metallic element. Its chief ore is columbite-tantalite. Hard but malleable, tantalum is used as a wire and in electrical components, chemical equipment and medical instruments. Properties: at. no. 73; r.a.m. 180.948; r.d. 16.6; m.p. 2,996°C (5,425°F); b.p. 5,425°C (9,797°F); most common isotope Ta¹⁸¹ (99.988%).

Tantrism Collective term for religious systems within BUDDHISM, JAINISM and HINDUISM that are based on esoteric practices recorded in sacred texts called Tantras. For Hindus and Jains, the Tantras are post-Vedic (VEDAS) texts that give instruction on how to fulfil worldly (sexual) desires and attain spiritual experiences. The texts contain magic spells and MANTRAS, and give instructions on YOGA and meditative techniques for purifying and controlling the body and mind. For Buddhists, the Tantras are a set of writings attributed to BUDDHA explaining how the believer may attain enlightenment.

Tanzania Republic in E Africa. See country feature

Tao Ch'ien (365–427) Chinese poet, one of the greatest of the Chinese tradition. He developed a simple style that distinguished his work from the ornateness of his contemporaries'. His verse, which has a predominantly Taoist outlook, often extols the pleasures of nature and wine.

Taoism Chinese philosophy and religion considered as being next to CONFUCIANISM in importance. Taoist philosophy is traced to a 6th-century BC classic of LAO TZU, the *Tao Te Ching*. The recurrent theme of this work is the *Tao* (way or path). To follow the *Tao* is to follow the path leading to self-realization. Taoist ethics emphasize patience, simplicity and the harmony of nature, achieved through the proper balance of the *yin*, or female principle, and *yang*, or male principle. As a religion, Taoism dates from the time of Chang Tao-ling, who organized a group of followers in AD 142.

tap dancing Dance in which the toes and heels rapidly tap the floor to emphasize the rhythm of the accompanying music. This type of dance used to be performed in clogs, but ► tapestry By the Middle Ages one of the most common ways of creating tapestries was by using a low-warp loom (A). It had a back roller (1) to carry the unused warp threads, and a front roller (2) to carry the woven tapestry. These, and the drawing board (3), to which the cartoon (4) is pinned, are supported by sturdy side beams (5), A slide block (6) enables the back roller to be moved to tauten the warp threads (7). The treadles (8), connected to heddle bars, are used to cross even and uneven warp threads. The weaver's tools are the bobbins, which carry the colour threads (9), a box wood comb and scrapper (10) to pack down the threads, and a mirror (11) to check the underside (the side that will be seen) of the tapestry during weaving.

▲ tarantula The bite of the tarantula (*Aphonopelma* sp.) is not, in fact, dangerous to humans, though it is powerful enough to kill small birds, amphibians or mice. Found in sw USA and Central America, the body can be up to 7.5cm (3in) long and, including the legs, up to 25cm (10in) across.

► tapir The Brazilian tapir (Tapirus terrestris) is found in South America, from Venezuela to Paraguay. It inhabits wooded or grassy habitats near water and feeds on grass, small shrubs and aquatic plants. Its dark brown colour identifies it as a New World tapir, in contrast to the black-and-white Malayan Tapir.

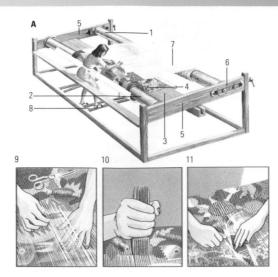

now light shoes are worn, which have metal plates (known as taps) on the toes and the heels.

tape, magnetic Thin strip of plastic, coated on one side with a layer of iron or chromium oxide, used in audio and video tape recorders and computers. During recording, the oxide layer is magnetized by the recording head in a pattern corresponding to the input signal. During playback, the magnetized oxide particles induce an electric current almost identical to the one that produced them.

tape recorder Device which records and plays back sound on magnetically treated tape. Sound is transformed into electric current and fed to a TRANSDUCER, which converts it into the magnetic variations that magnetize the particles on the treated tape. See also TAPE, MAGNETIC; DIGITAL AUDIO TAPE (DAT)

tapestry Hand-woven, plain weave fabric. Used for wall decoration and hangings, tapestry design is a very ancient craft and a few fragments survive from 15th-century BC Egypt. The first great French woollen tapestry came from Arras in the 14th century AD. The most famous designs originated from the GOBELINS factory in Paris. Some 20th-century textile artists use tapestry techniques in their work.

tapeworm Parasite of the genus *Taenia*, which colonizes the intestines of vertebrates, including human beings. Caught from eating raw or under-cooked meat, it can cause serious disease.

tapioca See CASSAVA

tapir Any of several species of nocturnal, plant-eating, hoofed mammals native to forests of tropical South America and Malaysia. The tapir has a large head, a long, flexible snout, a heavy body, short legs and a tiny tail. Length: to 2.5m (7.5ft). Family Tapiridae; genus *Tapirus*.

tar Black or dark brown, complex liquid mixture of HYDRO-CARBON compounds, derived from wood, coal and other organic materials. Tar, from PETROLEUM oil, is a major source of hydrocarbons for the synthesis of pharmaceuticals, pesticides and plastics; cruder tar compounds, such as pitch, are used for road surfacing and protecting timber against rot and pests. Wood tar yields creosote and paraffin.

Tarantino, Quentin (1963—) US film director and screenwriter. His controversial debut feature, *Reservoir Dogs* (1991), established his reputation for violent, discursive films. After writing the script for *True Romance* (1993), he made *Pulp Fiction* (1994). A cult hit, featuring a cameo from Tarantino, it carried references to pop culture and film classics.

tarantula Large, hairy wolf spider of s Europe, once thought to inflict a deadly bite that would cause madness. It spins no web, but chases and pounces on its prey. Length of body: to 2.5cm (1in). Family Lycosidae; species *Lycosa tarentula*. The name is also applied to the sluggish, dark, hairy spiders of sw USA, Mexico and South America. Many species burrow and feed on insects. Length of body: to 7.5cm (3in). Family Theraphosidae; genera *Aphonopelma* and *Eurypelma*.

Tarawa Town on an atoll of the same name in the w Pacific Ocean, capital of KIRIBATI. Located in the N central part of the

group, it is the main trade centre for the islands. Copra, fish and fish products are its principal exports. Pop. (1990) 29,000. **tariff** Tax placed on imports, calculated either as a percentage of the value of the item (ad valorem tariff) or per unit (specific duty). Tariffs may be used to discourage the import of certain types of goods or to adjust for price differentials in order to allow the home country's products to be competitive. **Tarim Basin** Basin in XINJIANG region, NW CHINA, between the TIAN SHAN and Kunlun mountain ranges. Taklamakan Shamo, a desert, covers most of the region, while Turfan depression, China's lowest point, at 154m (505ft), is in the extreme E. The Tarim River is 2,027km (1,260mi) long; formed by the confluence of the Kashgar and Yarkand rivers, it flows E then SE into the basin.

taro Large, tropical plant native to the Pacific Islands and SE Asia and cultivated in other parts of the world for its edible tuberous root. Family Araceae; species *Colocasia esculenta*. tarot Pack of 78 cards originating in their present form in 14th-century Italy. The cards are in two groups: the major arcana and the minor arcana. The 22 cards of the major arcana are all pictorial, numbered and captioned, and are most used today by astrologers and fortune-tellers. The 56 cards of the minor arcana are in four suits, each numbered ace to ten plus four captioned court cards.

tarpon Tropical, marine game fish. Blue and bright silver, it has a long, forked tail. Length: to 1.8m (6ft); weight: to 150kg (300lb). Species include the small Pacific *Megalops cyprinoides* and the large Atlantic *M. atlanticus*. Family Elopidae. tarragon Perennial plant with liquorice-flavoured leaves used fresh or dried in salads, pickles and other food. Family Asteraceae/Compositae; species *Artemisia dracunculus*.

tarsier Any of several species of nocturnal primates of Indonesia. They are small, squat animals with large eyes, long tails and monkey-like hands and feet. Family Tarsiidae; genus *Tarsius*.

tartan Cloth, usually woollen, with a pattern of stripes crossing at right angles. The cross-bars are of different colours and widths, usually on a red or green background. The patterned cloth is now associated mainly with the Highlands of Scotland. Many Scottish clans have their own, unique tartan patterns.

Tartars See Tatars

Tasaday Small group of isolated aboriginal people of the rainforests of s Mindanao in the Philippines. They are foodgathering cave dwellers with a STONE AGE culture.

Tashkent Largest city and capital of Uzbekistan, in the Tashkent oasis in the foothills of the TIAN SHAN mountains, watered by the River Chirchik. It was ruled by the Arabs from the 8th until the 11th century. The city was captured by TAMERLANE in 1361 and by the Russians in 1865. The modern city is a transport and economic centre of the region. Industries: textiles, chemicals, food processing, mining machinery, paper, porcelain, clothing, leather, furniture. Pop. (1990) 2,094,000.

Tasman, Abel Janszoon (1603–59) Dutch maritime explorer who made many discoveries in the Pacific. On his voyage of 1642–43 he discovered Tasmania. He reached New Zealand, but was attacked by Maoris in Golden Bay. He landed on Tonga and Fiji and sailed along the N coast of New Ireland. Although he circumnavigated Australia, he never sighted the mainland coast.

Tasmania Island state of Australia, separated from Victoria by the Bass Strait. The chief cities are HOBART, the state cap-

ital in the s, and Launceston in the N. Tasmania is mountainous and forested, with a temperate maritime climate. The first European discovery was made by Abel Tasman in 1642 and it was named Van Diemen's Land. Captain Cook visited it in 1777 and claimed it for the British, who established a penal colony there. Tasmania became a separate colony in 1825 and it was federated as a state of the Commonwealth of Australia in 1901. Mineral deposits include copper, tin and zinc. The development of hydroelectric power has stimulated the growth of manufacturing. Industries: metallurgy and textiles. Area 68,332sq km (26,383sq mi). Pop. (1991) 452,837.

Tasmanian devil Carnivorous marsupial with a bear-like appearance; it is found only in the forest and scrub of Tasmania. It feeds on a wide variety of animal food, including carrion. Length: to 80cm (31in). Species *Sarcophilus harrisii*.

Tasmanian wolf (thylacine) Largest carnivorous marsupial. It probably became extinct on the mainland of Australia because of relentless hunting, although a few specimens are believed to have survived in forested areas of Tasmania. It has a wolflike appearance, but its coat is marked with transverse dark stripes on the back, hindquarters and tail. Species *Thylacinus cynocephalus*.

TASS News agency of the Soviet Union. The name is an acronym for Telegrafnoye Agentsvo Sovyetskovo Soyuza. Affiliated with press agencies around the world, it was one of the major news services used by the Western press.

Tasso, Torquato (1544–95) Italian poet and prose writer. He was a member of the court at Ferrara from 1565. His masterpiece, *Jerusalem Delivered* (1575), an epic of the First Crusade, became a model for later writers.

taste One of the five SENSES. It responds to the chemical constituents of anything placed in the mouth. In human beings, the taste buds of the tongue differentiate four qualities: sweetness, saltiness, bitterness and sourness.

Tatar Republic Autonomous region in the Russian Federation populated mainly by the TATARS. Tatar nationalism has its origins in the Crimean Autonomous Socialist Republic, founded in 1921. The Republic was dissolved and the entire population deported by Stalin in 1945. After the break-up of the Soviet Union in 1991, many of the 300–400,000 exiled Tatars began to return to the Crimea.

Tatars (Tartars) Turkic-speaking people of central Asia. In medieval Europe the name Tatar was given to many different Asiatic invaders. True Tatars originated in E Siberia and were converted to Islam in the 14th century. They became divided into two groups, one in s Siberia, who came under Russian rule, the other in the Crimea, which was part of the Ottoman empire until annexed by Russia in 1783.

Tate Gallery UK national collection of modern art. The gallery's main building at Millbank was constructed in 1897. It started as a collection of British painting and sculpture, which now ranges from the mid-16th century to the present day. A large extension was added in 1979, and in 1987 the Clore Gallery opened, containing the Turner Bequest. It has branches in Liverpool and St Ives, Cornwall. The old Bankside Power Station, s London, is being converted into a new space for the modern, international art collection. Called the Tate Gallery of Modern Art, it is due to open in the year 2000. Tatlin, Vladimir Evgrafovitch (1885–1953) Russian sculptor. In 1913, influenced by CUBISM and FUTURISM, he instigated the ABSTRACT ART style CONSTRUCTIVISM. He started to use industrial materials such as metal, tin and glass in his work. He is best known for his Reliefs. These were innovative, threedimensional constructions that removed pictorial illusion.

Tatum, Art (Arthur) (1910–56) US jazz pianist. Almost blind since birth, he established a standard for solo jazz piano technique. He made his first recording in 1932. His reputation for technical virtuosity has endured.

Taurus (the Bull) In astronomy, northern constellation on the ecliptic between Aries and Gemini. It contains the Pleiades and Hyades stellar clusters and the Crab Nebula. The brightest star is the 1st-magnitude Alpha Tauri (Aldebaran).

Tavener, John Kenneth (1944–) English composer. He achieved early success with his biblical cantata *The Whale* (1966) and has continued to compose works that are religious

in character and inspiration. The opera *Thérèse* (1973–76) is a fine example of his early style. His conversion to the Eastern Orthodox Church (1977) was accompanied by a move towards a more austere musical style. He continued to explore the spiritual side of human nature. *The Protecting Veil* (1987), for cello and orchestra, was inspired by a feast of the Orthodox Church. **Taverner, John** (c.1490–1545) English composer. Most of his surviving works date from 1526–30. He composed mostly church music, notably masses and motets. His six-voice masses are complex contrapuntal structures; the smaller-scale masses are in a simpler, more restrained style.

taxation Compulsory money payments of various kinds made by members of a civil society to supply the expenditure of public authorities. Taxes are levied both on individuals and on corporations and are of two chief kinds, direct and indirect. Direct taxes are levied on income. Indirect taxes are levied on commodities and services. The fundamental purpose of taxation is to defray government expenditure on defence, social services, administration and the repayment of public debts. Taxation may also be used to reduce the inequality of income and wealth in a community; changing the rate of income tax can either reduce or increase the purchasing power of consumers by altering the level of disposable income. Indirect taxes can check the flow of imports or exports in order to alter the balance of trade.

taxonomy Organization of plants, animals and other organisms into categories based on similarities of genetic sequences, appearance, structure or evolution. The categories, ranging from the most inclusive to the exclusive, are: KINGDOM, phylum, class, order, FAMILY, GENUS, SPECIES (the last two of which are printed in *italics*) and sometimes variety. There are also subphyla, subfamilies, and so on, in some categories. Ancient and extinct animals and plants are included in detailed classifications. *See also* PHYLOGENETICS; PLANT CLASSIFICATION

Tay River in central Scotland, rising in the Grampians and flowing SE to enter the North Sea through the Firth of Tay near Dundee. At 193km (120mi) it is the longest river in Scotland and has the largest drainage basin, 6,200sq km (2,400sq mi) in area. The Tay Bridge (1883–88) crosses the firth at Dundee.

Taylor, Elizabeth (1932–) US film actress, b. Britain. She began her career as a child, attracting attention as the heroine of *National Velvet* (1944). An enduring box-office favourite, she appeared in such films as *A Place in the Sun* (1951), *Cat on a Hot Tin Roof* (1958) and *Who's Afraid of Virginia Woolf?* (1966). Married a total of eight times, she remains a celebrity. Her more recent work has been in television and she has become a crusader in the cause of AIDS research.

Taylor, Frederick Winslow (1856–1915) US industrial engineer who was known as the father of scientific management. He developed management methods for many industries, especially steel mills.

Taylor, Zachary (1784–1850) 12th US president (1849–50). A soldier with little formal education, he fought in the WAR OF 1812. In 1845 he was ordered to occupy Texas, recently annexed, which set off the MEXICAN WAR. From this he emerged as a popular hero. He won the Whig nomination for president and the subsequent election (1848), but died suddenly after only 16 months in office.

Tayside Region in E Scotland, bounded N and W by the Grampians and E by the North Sea. The capital is DUNDEE, and other major cities include Perth, Arbroath and Montrose. The N of the region is mountainous and the S is low-lying farmland. It is drained by the Rivers Tay, Isla, Earn, South Esk and Ericht. The economy is primarily agricultural, the

■ Tasmanian devil The
Tasmanian devil (Sarcophilus harrisii) was once found on the mainland of s Australia but is now confined to remote parts of the island of Tasmania. A nocturnal marsupial, it preys on a variety of animals as well as scavenging. Very strong for its size, its prey is sometimes larger than itself.

▲ Taylor Discovered by Los Angeles talent scouts when she was only a child, Elizabeth Taylor signed a contract with Metro-Goldwyn-Mayer that lasted until the 1960s. After her film debut in 1942, when she was only ten years old, she played juvenile roles throughout the 1940s and graduated to playing romantic leads within ten years. Famous for her violet eyes, she has had a tempestuous personal life, with multiple marriages (two of which were to the actor Richard Burton), treatment for drug and alcohol abuse, and surgery for a brain

Key:

1 enamel

2 capillaries, nerves, lymphatics

3 nuln

4 gum

5 dentine

6 iaw

7 cementum

8 root canal

▲ teeth A human tooth consists of the crown, neck and root. The crown is made up of a dense mineral, enamel, surrounding the hard dentine, which has a soft centre — the pulp. The pulp is filled with blood vessels, lymphatics and the nerve, which reach the tooth through the root canal. The neck adheres to the gum, and the root penetrates the bone, where it is held in place by a ligament and cementum.

major products being beef and dairy products. Area: 7,502sq km (2,896sq mi). Pop. (1991) 383,848.

Tbilisi (Tiffis) Largest city and capital of Georgia, on the upper Kura River. It was founded in the 5th century AD and ruled successively by the Persians, Byzantines, Arabs, Mongols and Turks, before coming under Russian rule in 1801. Tbilisi's importance lies in its location on the trade route between the Black Sea and Caspian Sea. It is now the administrative and economic focus of modern Transcaucasia. Industries: chemicals, petroleum products, locomotives, electrical equipment, beer, wine, spirits. Pop. (1991) 1,279,000.

Tchaikovsky, Peter llyich (1840–93) Russian composer. His gift for melody is apparent in all his works, which include nine operas, four concertos, six symphonies, three ballets and many other pieces. His ballets, among the most famous of all time, are *Swan Lake* (1876), *The Sleeping Beauty* (1889) and *The Nutcracker* (1892); his operas include *Eugene Onegin* (1879) and *The Queen of Spades* (1890).

tea Family of trees and shrubs with leathery, undivided leaves and five-petalled blossoms. Among 500 species is *Camellia sinensis*, the commercial source of tea. Cultivated in moist, tropical regions, tea plants can reach 9m (30ft) in height, but are kept low by frequent picking of the young shoots for tea leaves. The leaves are dried immediately to produce green tea and are fermented before drying for black tea. Family Theaceae.

teak Tree, native to s India, Burma and Indonesia, valued for its hard, yellowish-brown wood. Teak wood is water-resistant and takes a high polish; it is widely used for furniture and in shipbuilding. Height: 45m (150ft). Family Verbenaceae; species *Tectona grandis*.

teal Small, widely distributed river duck; many species have bright plumage. Teal dabble for food from the surface of the water. Family Anatidae, genus *Anas*.

Teapot Dome Scandal (1924) Corruption scandal involving the US government during President HARDING's administration over the fraudulent leasing of oil reserves. The secre-

tary of the interior, Albert Fall, was convicted of accepting bribes and served one year in prison.

tear gas Chemical compound known as a lachrymator, a gas or aerosol that causes an excessive flow of tears. It blinds and incapacitates temporarily without causing permanent injury. tears Salty fluid secreted by glands that moistens the surface of the eye. It cleanses and disinfects the surface of the eye and

also brings nutrients to the CORNEA. **teasel** Any of several species of plants that grow in Europe, the Middle East and the USA. They are prickly plants, with cup-like leaf bases that trap water. Species include fuller's teasel, whose purple flowers heads were used for carding

wool. Family Dipsacaceae. **technetium** (symbol Tc) Silver-grey, radioactive, metallic element, one of the TRANSITION ELEMENTS. Technetium is found in the fission products of uranium and is present in some stars. It is used in radioactive tracer studies. There are 16 known isotopes. Properties: at. no. 43; r.a.m. 98.9062; r.d. 11.5; m.p. 2,172°C (3,942°F); b.p. 4,877°C (8,811°F); most stable isotope Tc⁹⁹ (half-life 2.6 × 106 years).

Technicolor Trade name of the colour film process invented by Herbert T. Calmus and Daniel F. Comstock, still used in the majority of motion pictures. A primitive Technicolor was first seen in 1917, and in 1933 Walt DISNEY used three-colour Technicolor for the animated film *Flowers and Trees*.

technocracy Theory that engineers and scientists should have effective power in economic and social life. The term was coined in the USA in 1919 and was popular in the 1930s. **technology** Systematic study of the methods and techniques employed in industry, research, agriculture and commerce. More often the term is used to describe the practical application of scientific discoveries to industry.

tectonics Deformation within the Earth's CRUST and the geological structures produced by deformation, including folds, faults and the development of mountain chains. *See also* PLATE TECTONICS

Tecumseh (1768–1813) Native American leader. A Shawnee chief, he worked with his brother, known as the Prophet, to unite the Native Americans of the West and resist white expansion. After the Prophet's defeat, he joined the British in the WAR OF 1812. He led 2,000 warriors in several battles and was killed fighting in Upper Canada.

teeth Hard, bone-like structures embedded in the jaws of vertebrates, used for chewing food, defence or other purposes. Mammalian teeth have an outer layer of hard enamel. A middle layer consists of dentine, a bone-like substance that is capable of regeneration. The core of a tooth contains pulp, which is softer and has a blood supply and nerves. *See also* DENTITION

Teflon Trade name for the plastic polytetrafluoroethylene, also known as Fluon. *See* PTFE

Tegucigalpa Largest city and capital of HONDURAS, located in the mountainous central Cordilleras. Founded in the 16th century by the Spanish as a mining town, it became the national capital in 1880. Industries: sugar, textiles, chemicals, cigarettes. Pop. (1991) 670,100.

Tehran Capital of Iran, 105km (65mi) s of the Caspian Sea, in

a strategic position on the edge of the plains and in the foothills of the country's highest mountains. It replaced ISFAHAN as the capital of Persia in 1788. Reza Shah (r.1926–41) demolished the old fortifications and established a planned city. Tehran is now the industrial, commercial, administrative and cultural centre of the country. Its manufactures include cement, textiles, chemicals and, most famously, carpets. Pop. (1991) 6,475,527. **Tehran Conference** (1943) Meeting, in Tehran, of the British, Soviet and US leaders (Winston Churchill, Joseph

British, Soviet and US leaders (Winston Churchill, Joseph Stalin and Franklin D. Roosevelt) during World War 2. It was the first meeting of the "Big Three".

Teilhard de Chardin, Pierre (1881–1955) French JESUIT philosopher and palaeontologist. He worked in China (1923–1946) and shared in the discovery of Peking Man (a fossilized, Stone Age human). His efforts to reconcile scientific views of evolution with Christian faith led to his being asked by his religious superiors not to publish his philosophical works. His best-known work, *The Phenomenon of Man*, was finished in 1938 but published posthumously.

Local telephone exchanges (1) connect local calls (2), which are analogue signals (3). Long-distance calls are routed to the long-distance exchange (4), where they are converted from analogue to digital. Digital snapshots are taken of the analogue signal 8,000 times a second (every 125 microseconds) — enough information to recreate the analogue signal accurately enough for the human ear. This

whole process is called pulse-code modulation. Each eight-bit sample (5) is only 4 microseconds long, which leaves 121 microseconds between each one on the telephone line. To increase capacity, multiplexing combines the samples of up to 25 calls going to the same destination on the same line (6). This is done by feeding all the calls into a memory buffer (7) and then feeding them onto the

long distance line in turn. At the receiving end, the process is reversed and the combined call is again fed into a memory buffer (8), separated (9), passed to the long-distance exchange (10) where it is turned back into an analogue signal (11), and sent to the local exchange (12). From there it is routed to its final destination (13). The process happens so fast that the human ear hears a continuous voice.

Te Kanawa, Dame Kiri (1948–) New Zealand opera singer of Maori origin. She became contracted to the ROYAL OPERA HOUSE, Covent Garden, in 1970, where she came to attention as the Countess in Mozart's *The Marriage of Figaro*. She has since sung in most of the major opera houses. **Tel Aviv** (Tel Aviv-Jaffa) City and port in Israel, on the Mediterranean Sea, c.50km (30mi) w of Jerusalem. The business, cultural, communications and tourist centre of Israel, it was founded in 1909 as a suburb of the port of Jaffa. During the British administration of Palestine (1923–48), the town grew rapidly as Jews fled persecution in Europe. It served as the seat of the transitional government and legislature of the new state of Israel (1948–49), until the capital was moved to JERUSALEM. In 1950 it was merged with Jaffa. Industries: construction, textiles, clothing. Pop. (1994) 355,200.

telecommunications Technology involved in the sending of information over a distance. The information comes in a variety of forms, such as digital signals, sounds, printed words or images. The sending is achieved through TELE-GRAPH, TELEPHONE or RADIO, and the medium may be wires or electromagnetic (radio) waves, or a combination of the two. There are two basic types of message: digital, in which the message is converted into simple, coded pulses and then sent (as in Morse code); and analogue, in which the message – for example, a voice speaking — is converted into a series of electrical pulses that are similar in waveform to the modulations of the original message.

telegraph Any communications system that transmits and receives visible or audible coded signals over a distance. The first, optical, telegraphs were forms of semaphore. Credit for the electric telegraph and its code is generally given to Samuel Morse, who in 1844 inaugurated the first public line between Washington and Baltimore. In 1866 the first permanently successful telegraph cable was laid across the Atlantic, and in 1875 Thomas Edison invented a method of transmitting several messages simultaneously over the same wire.

Telemann, Georg Philipp (1681–1767) German composer. He wrote more than 40 operas, 600 overtures and 44 settings of the Passion. His church music, of more historical importance than his operas, shows his technical mastery.

teleology Explanation of the universe, of natural phenomena, or of biological behaviour, including human conduct, by reference to an end or purpose achieved or thought to be achieved by the thing being explained. Since the advent of modern science in the 17th century, things tend to be explained as having been caused by earlier events. This cause-and-effect approach is known as efficient causation. In teleology, this way of thinking is reversed in an approach called final causation, which explains that things have developed the way they have in order to achieve the effect we now perceive or experience. In the later 18th century, William Paley (1743-1805) applied a form of teleology to biological processes, including human behaviour, explaining biological organisms as complex and ingenious machines devised by an intelligent being specifically to act in the way that they do. As a theory of morality, teleological ethics derives the concept of moral duty or obligation from what is good as a goal or aim to be achieved.

telepathy Form of extrasensory perception involving the transmission and reception of thoughts without using the usual sensory channels. Such transference has never been conclusively proved although claims to telepathy have been extensively investigated.

telephone Instrument that communicates speech sounds over a distance by means of wires or microwaves. In 1876 Alexander Graham Bell invented the prototype, which employed a diaphragm of soft iron that vibrated to sound waves. These vibrations caused disturbances in the magnetic field of a nearby bar magnet, causing an electric current of fluctuating intensity in the thin copper wire wrapped around the magnet. This current could be transmitted along wires to a distant identical device that reversed the process to reproduce audible sound. Later improvements separated the transmitter from the receiver, and replaced the bar magnet with batteries. telephoto lens Camera lens with a long focal length. A true telephoto lens has a focal length longer than the physical

length of the lens, as opposed to a long-focus lens, in which the focal length is equal to the physical length. For a 35mm camera, any lens with a focal length of more than about 80mm may be regarded as a telephoto lens. For larger-format cameras the focal length may be as much as 1,000mm.

telescope Instrument for enlarging a distant object or studying electromagnetic radiation from a distant source. Optical telescopes can use lenses (refracting telescopes) or mirrors (reflecting telescopes); catadioptric telescopes use both in combination. The lens or mirror is the telescope's main light-

The COAST (Cambridge Optical Aperture Synthesis Telescope) telescope, designed and built in Cambridge, s England, is the most powerful optical telescope ever built. Instead of a single enormous reflective surface the Cambridge telescope uses the images collected by three small

and relatively inexpensive optical telescopes, and combines them to form an extremely detailed image. The three telescopes (1) are focused on a single point (2), each one producing a fractionally different picture. As the Earth rotates, the position of the telescopes alters in relation to

the target star or planet. These pictures from different angles are blended together by computer equipment (3) to provide a single, highly detailed image (4). A small portion of light reflected by the telescopes is bled off (5) and used to confirm the targeting of the star as the Earth moves.

gathering part (objective), and its diameter, known as the APERTURE of the telescope, determines its magnifying power. The point at which the objective concentrates the light from the source is its focus, and the distance from the focus to the objective is its FOCAL LENGTH. Refracting telescopes were extensively used after versions were invented by Hans Lippershey (1608) and GALILEO (1609). The problem caused by lens aberration was solved by combining lenses so their aberrations cancel each other out. Reflecting telescopes accomplished this. Sir Isaac Newton built an early astronomical reflector in 1668. Earth-bound telescopes have limitations because the incoming radiation has to pass through the Earth's atmosphere. This ceases to be a problem with telescopes in Earth orbit, such as the HUBBLE SPACE TELESCOPE. Orbiting telescopes can also detect other types of electromagnetic radiation more easily, such as infrared rays, ultraviolet rays, x-rays and gamma rays. Radio telescopes are complex electronic systems that detect and analyse radio waves from beyond the Earth. The first radio telescope was built in 1937 by the US radio engineer Grote Reber. Radio interferometers are arrays of smaller dishes that permit the investigation of even more distant radio sources.

teletext System for transmitting text so that it can be displayed on television receivers. Television companies transmit the text in coded form along with the sound and vision signals. Sets are equipped to receive teletext separately and decode the text signals so that they can be displayed on the screen.

television System that transmits and receives visual images by RADIO waves or cable. A television camera converts the images from light rays into electrical signals. The basis of most television cameras is an image orthicon tube. The electrical signals are amplified and transmitted as VERY HIGH FRE-QUENCY (VHF) or ULTRA HIGH FREQUENCY (UHF) radio waves. Typically a television channel has a bandwidth of 5MHz (5 million cycles per second). The receiver (TV set) operates in reverse to the camera. On reception, the signals are amplified and converted to light again in a CATHODE-RAY TUBE. Colour television has three synchronized image orthicon tubes in the camera, one for each of the three primary colours - red, blue and green. The tube of the receiver has three electron guns and the face of the tube is covered with a mosaic of fine phosphors in groups of three, each emitting only red, blue or green light when struck by a beam. These primary colours merge on the face of the screen to reconstitute the originally transmitted image. See also CABLE TELEVISION; SATELLITE TELEVISION

Telford, Thomas (1757–1834) Scottish civil engineer who built roads, bridges, canals, docks and harbours. His most

The tendon jerk is the simplest reflex action, involving only a sensory receptor neuron (1) and a motor neuron (2). Impulses, such as those created by a hammer tapping a knee, run to and from the muscles (3) and traverse only one segment of the spinal cord (4). This reflex is independent of the brain.

notable achievements were the Caledonian Canal in Scotland, and the 177m (580ft) Menai Strait suspension bridge, connecting Anglesey with mainland Wales.

Tell, William Legendary Swiss hero, leader in the 14th-century war of liberation against Austria. For refusing to salute the cap of Albert I's steward, Gessler, he was made to shoot an arrow through an apple placed on his son's head.

Teller, Edward (1908—) US physicist, b. Hungary, who has been called the father of the HYDROGEN BOMB. He left Europe and settled in the USA in 1935, where he did research on solar energy. During World War 2, he contributed to atomic bomb research with Enrico FERMI and was then involved in the MANHATTAN PROJECT at Los Alamos to produce the bomb. He was also a central figure in developing and testing (1952) the hydrogen bomb.

tellurium (symbol Te) Silver-white, metalloid element. It occurs naturally combined with gold in sylvanite. Its chief source is as a by-product in the electrolytic refining of copper. The brittle element is used in semiconductor devices, as a catalyst in petroleum cracking and as an additive to increase the ductility of steel. Properties: at.no. 52; r.a.m. 127.60; r.d. 6.24; m.p. 449.5°C (841.1°F); b.p. 989.8°C (1,814°F).

Telstar First active communications satellite, launched by the USA on 10 July 1962. It contained a microwave radio receiver, amplifier and transmitter for relaying telephone and television signals. It operated for about 18 weeks, failed for five weeks, and then worked again for a further seven weeks before failing for good.

tempera Painting medium used extensively during the Middle Ages, made of powdered pigments mixed with an organic gum or glue, usually of egg white or egg yolk. Tempera dries quickly and is applied with a sable brush, one thin layer on another, so that the finished effect is semi-opaque and luminous. During the 15th century the more flexible medium of OIL PAINTING began to replace tempera.

temperance movement Organized effort to promote moderation in, or abstinence from, the consumption of alcohol. It probably began in the USA in the early 19th century and spread to Britain and continental Europe. See also PROHIBITION temperature In biology, intensity of heat. In warm-blooded (HOMEOTHERMAL) animals, body temperature is maintained within narrow limits regardless of the temperature of their surroundings. This is accomplished by muscular activity, the operation of cooling mechanisms, such as vasodilation, vaso-constriction and sweating, and metabolic activity. In humans, normal body temperature is about 36.9°C (98.4°F), but this varies with degree of activity. In so-called cold-blooded (POIK-ILOTHERMAL) animals, body temperature varies between wider limits, depending on the temperature of the surroundings.

temperature Measure of the hotness or coldness of an object. Strictly, it describes the number of energy states available to a substance or system. Two objects placed in thermal contact exchange heat energy initially but eventually arrive at thermal equilibrium. At equilibrium, the most probable distribution of energy states among the atoms and molecules composing the objects has been attained. At high temperatures, the number of energy states available to the atoms and molecules of a system is large; at lower temperatures, fewer states are available. At a sufficiently low temperature, all parts of the system are at their lowest energy levels, the ABSOLUTE ZERO of temperature.

tempering Heat treatment to alter the hardness of an ALLOY. The effect produced depends on the composition of the alloy, the temperature to which it is heated, and the rate at which it is cooled. Usually, the metal is heated slowly to a specific temperature, then cooled rapidly.

Temple, Shirley (1928–) US film actress. Probably the most famous of child stars, she became popular through a series of films, including *Rebecca of Sunnybrook Farm* (1938) and *The Blue Bird* (1940). She made several films in the late 1940s but could not find the same success as a young adult. As Shirley Temple Black, she went into politics, serving as the US Ambassador to Ghana (1974–76) and to Czechoslovakia (1989–93).

temple Place of worship for Jews and members of many

L

other religions. Temples were a grand architectural focal point in the religion and culture of ancient Egypt and the Near East. In Mesopotamia, they took the form of elaborate towers called ziggurats. Greek and Roman temples, with beautifully carved statues and columns, were houses fit for the gods. In Judaism, the term refers specifically to the first and second temples built in Jerusalem. Jews today worship in a local synagogue. Temples also exist as places of worship for Muslims, Hindus, Buddhists and Sikhs. Some Evangelical Christian sects and the Mormon Church use the term.

Temple, Jerusalem Most significant shrine of the Jews, originally located on a hilltop known as Temple Mount in what is now East Jerusalem. There have been three temples on the site. The first was built in the 10th century BC by order of SOLOMON as a repository for the ARK OF THE COVENANT. It was destroyed by Nebuchadnezzar, king of Babylon, in 587 BC. A second temple was completed in 515 BC by the Jewish exiles who had returned from Babylon in 537. Between 19 and 9 BC, this second temple was replaced by a more elaborate structure on the orders of HEROD THE GREAT; it was destroyed by the Romans during the Jewish rebellion of AD 70. It has never been rebuilt, but part of its ruins remain as a place of pilgrimage and prayer, known as the WESTERN WALL. Part of the ancient temple site is occupied by the Muslim Dome of the ROCK and al-Aqsa Mosque, both built in the late 7th century. tempo Speed at which a piece of music should be performed, usually indicated on a score, in western music, by Italian words, such as allegro (fast) and adagio (slow).

tench Freshwater food and sport fish of Europe and Asia, belonging to the carp family Cyprinidae. It has a stout, golden yellow body with small scales. Length: to 71cm (28in). Species *Tinca tinca*.

Ten Commandments (Decalogue) Code of ethical conduct held in Judaeo-Christian tradition to have been revealed by God to Moses on Mount Sinai during the Hebrew exodus from Egypt (*c*.1200 BC). They represent the moral basis of the Covenant made by Yahweh (God) with Israel.

tendon Strong, flexible band of CONNECTIVE TISSUE that joins muscle to bone.

tendril Coiling part of stem or leaf, a slender, thread-like structure used by climbing plants for support.

Tenerife Largest of the Canary Islands, Spain, in the Atlantic Ocean, 64km (40mi) wnw of Grand Canary Island. It is a mountainous island, with Pico de Teide, at 3,718m (12,198ft), its highest peak. Products include dates, sugar cane, palms and cotton. Tourism is the mainstay of the economy. The main town is SANTA CRUZ DE TENERIFE. Area 2,059sq km (795sq mi). Pop. (1991) 725,815.

Tennessee State in SE central USA. The capital is NASHVILLE. Other cities include MEMPHIS, CHATTANOOGA and Knoxville. The first European discovery was by Hernando DE Soto in 1540. The French followed a century later, but their claim was ceded to Britain in 1763 and the first permanent settlement was established in 1769. In 1796 Tennessee became the 16th state of the Union. Tennessee's enthusiastic response to the request for volunteers during the MEXICAN WAR (1846-48) earned it the nickname of the Volunteer State. During the American CIVIL WAR, the state was the site of some of the bloodiest battles, including Shiloh (1862) and Chattanooga (1863). In 1866 it became the first southern state to be readmitted to the Union. Christian fundamentalism has exerted a powerful influence, and the teaching of evolution was banned from 1925 to 1967. In the E are the GREAT SMOKY MOUNTAINS and the Cumberland Plateau. Central Tennessee is a BLUEGRASS region famed for its horse-breeding and livestock rearing; w Tennessee has fertile floodplains, drained by the TENNESSEE RIVER, which produce cotton, tobacco and soybeans. Mineral deposits include zinc and coal. Industries: chemicals, electrical equipment, foods, tourism. Area 109,411sq km (42,244sq mi). Pop. (1992) 5,025,621.

Tennessee River River in Tennessee, N Alabama and W Kentucky. Formed by the confluence of the Holston and French Broad rivers, it joins the Ohio at Paducah, Kentucky, and forms part of the Alabama–Mississippi border. The US government's Tennessee Valley Authority (TVA, 1933)

developed the river's hydroelectric potential (nine major dams) and transport facilities, along with irrigation and flood control. Length 1,050km (652mi).

tennis Racket and ball game played either by two (singles) or four (doubles) players. It is sometimes known as lawn tennis, despite being played on concrete, clay, shale and wood as well as grass. The game is played on a court 23.8m (78ft) by 8.2m (27ft) for singles. For doubles play the court is widened to 11m (36ft). It is bisected by a net 0.9m (3ft) high at the centre. On each side of the net there are two service areas marked by rectangular lines. The ball is put into play by the server, who is allowed two attempts to hit it into the opposite service court. One player serves for a complete game. If the opponent returns the ball safely, play continues until one player fails to hit the ball, hits it into the net or hits it outside the confines of the court; his opponent then wins the point. A minimum of four points are required to win a game, which must be won by two clear points. A minimum of six games must be won to win a set, which must be won by either two clear games or by winning the tie-break game, which is played at six games all. Modern tennis evolved from REAL TENNIS in England in the 1860s.

Tennyson, Alfred, 1st Baron (1809–92) (Alfred Lord Tennyson) British poet. He became poet laureate in 1850. His massive oeuvre includes such patriotic classics as "Ode on the Death of the Duke of Wellington" (1852) and "The Charge of the Light Brigade" (1855). He also wrote deeply personal utterances, such as "Crossing the Bar" and the extended elegy for his friend Arthur Henry Hallam, *In Memoriam* (1850), often regarded as his masterpiece. Other notable works include "The Lady of Shalott", *Maud* (1855) and the Arthurian epic finally published as *Idylls of the King* (1872–73).

tenor Range of the human voice, falling below CONTRALTO and above BARITONE. It is the highest natural male voice apart from the COUNTERTENOR.

tension Molecular forces associated with the boundary layer of a liquid. It makes a liquid behave as if there were a "skin" on the surface. Attractive forces in this skin tend to resist disruption, so that a needle or razor blade placed carefully on the surface floats, even though its density is many times that of the liquid.

Teotihuacán Ancient AZTEC city of Mexico, $c.48 \mathrm{km}$ (30mi) N of Mexico City. It flourished between $c.100 \mathrm{\,BC}$ and $c. \mathrm{\,AD}$ 700. It contained huge and impressive buildings, notably the Pyramid of the Sun. At its greatest, $c. \mathrm{\,AD}$ 600, the city housed at least 100,000 people and was the centre of a large empire.

tequila Mexican alcoholic drink distilled from the fermented juice of the AGAVE plant. It is 40–50% alcohol by volume. **terbium** (symbol Tb) Silver-grey, metallic element of the LANTHANIDE SERIES. It is found in such minerals as monazite, gladolinite and apatite. The soft element is used in semiconductors; sodium terbium borate is used in lasers. Properties: at.no. 65; r.a.m. 158.9254; r.d. 8.234; m.p. 1,360°C (2,480°F); b.p. 3,041°C (5,506°F). Single isotope Tb¹⁵⁹

Teresa, Mother (1910–97) (Agnes Gonxha Bojaxhiu) Roman Catholic missionary, b. Albania. She began her missionary work as a teacher in Calcutta, India. In 1948 she was granted permission by the Vatican to leave her convent in order to tend the homeless, starving and sick in Calcutta's slums. Her Order of the Missionaries of Charity was established in 1950 and subsequently extended to other countries. She won the first Pope John XXIII Peace Prize in 1971 and the Nobel Peace Prize in 1979.

Teresa of Avila, Saint (1515–82) (Teresa de Cepeda y Ahumada) Spanish CARMELITE nun and mystic. In 1529 she entered the Convent of the Incarnation at Ávila. From 1558 she set about reforming the Carmelite order for women, whose rules had become weakened. Under her influence, St JOHN OF THE CROSS introduced a similarly restored Carmelite order for men. Her literary works, including an autobiography and the meditative *Interior Castle* (1577), as well as her monastic reforms, led to her canonization in 1622.

terminal velocity Maximum velocity attainable by a falling body or powered aircraft. It is dependent upon the shape of the body, the resistance of the air through which it is moving, and (in the case of aircraft) the thrust of the engines.

TENNESSEE Statehood:

1 June 1796 Nickname:

The Volunteer State **State bird**:

Mockingbird State flower:

Iris State tree : Tulip-poplar State motto :

Agriculture and commerce

A Mother Teresa Recognized throughout the world for her charitable work in the slums of Calcutta, Mother Teresa worked not only with orphaned and handicapped children but also with lepers and other people with disfiguring diseases. There are more than 2,000 nuns in the order she founded, the Missionaries of Charity, who care for the ill and the dying throughout the world.

► termite Built of saliva and soil particles, termite mounds (A) dominate the African savanna. Most termites prefer to eat dead plant material that has been partly softened by fungus. This food supply is limited in dry conditions because fungi need moisture. For this reason Macrotermes termites create fungus chambers (1). These are combs of carton (a mixture of saliva and faecal pellets), which provide a large surface area on which the fungus grows. The fungus flourishes in the humid atmosphere of the nest as it breaks down the faeces in the carton walls. Some termite species dig deep tunnels (2) to find underground water to ensure that the nest is moist enough for the fungus to thrive. The peaks of the mound (3) act as lungs. Air seeps into the main nest from an air cellar below (4). As the fungus breaks down the faecal comb, heat is generated. The hot air rises, via a large central air space (5), into the chimneys (6). The walls of the nest are porous, so carbon dioxide diffuses into the chimneys. The newly oxygenated air loses heat to the air outside and cools, sinking back to the cellar. The royal cell (7) is located in the centre of the nest, where the king (8) and the queen (9) can be protected. The workers, as well as feeding the royal couple. also remove the eggs to the brood chambers (10). There the workers lick the eggs to keep them clean. Most termite species have a variety of castes (B) or types. There are the temporarily winged reproductives (male and female) called alates (1), responsible for setting up colonies, the queen (2), the enlarged abdomen of which produces thousands of eggs, the soldier termites (3), which protect the colony, and the workers (4), which collect food, care for the

queen and serve as builders.

termite Social insect found worldwide in subterranean nests and above-ground mounds. They have a caste system, with a king and queen guarded and tended by soldiers, workers and nymphs. Wood is a common component of their diet, which is digested with the help of symbiotic protozoa or bacteria that live in the termites' intestines. Length: 0.2–2.25mm (0.08–0.9in); queens: to 10cm (4in). Order Isoptera.

tern (sea swallow) Any of several species of graceful seabirds that live throughout the world. The tern is usually white and grey, and has a pointed bill, long pointed wings, a forked tail and webbed feet; it dives for fish and crustaceans. Length: to 55cm (22in). Family Laridae; genus *Sterna*.

terracotta Hard, porous, usually unglazed, yellow, brown or red earthenware (fired CLAY). Terracotta is used in building, sculpture and pottery.

terrapin Any of several species of aquatic TURTLES that live in fresh or brackish water in the USA and South America, especially the diamondback terrapin (*Malaclemys terrapin*). Length: to 23cm (9in). Family Emydidae.

terrier Any of several breeds of dog. Originally trained to dig out game, they have been used to hunt badgers, foxes, weasels and rats. When the quarry is located, the terrier or terriers are sent down to dig it out of its burrow. Separate breeds include the Sealyham terrier, fox terrier and Manchester terrier. Larger breeds, such as the Airedale terrier and Irish terrier, are often used as guard and police dogs.

territory In animal behaviour, the restricted life space of an organism. An area selected for mating, nesting, roosting, hunting or feeding, it may be occupied by one or more organisms and defended against others of the same, or a different, species. **terrorism** Use of violence, sometimes indiscriminately, against persons and property for the nominal purpose of making a political statement. Intending to inspire terror, terrorists act principally in the name of empowering political minorities, and to publicize perceived political grievances.

Tertiary Earlier period of the CENOZOIC era, lasting from 65 million to about 2 million years ago. It is divided into five epochs, starting with the PALAEOCENE and followed by the EOCENE, OLIGOCENE, MIOCENE and PLIOCENE. Early Tertiary times were marked by great mountain-building activity. Both marsupial and placental mammals diversified greatly. Archaic forms of carnivores and herbivores flourished, along with primitive primates, bats, rodents and early whales.

Tesla, Nikola (1856–1943) US electrical engineer and inventor, b. Croatia, who pioneered the applications of high-voltage electricity. He developed arc lighting, the first generator of alternating current (AC) and the high-frequency Tesla coil.

Test Ban Treaty (1963) Agreement signed in Moscow by the Soviet Union, the USA and Britain to cease most tests of nuclear weapons. Nearly 100 other states eventually signed the treaty, although France and China continued to conduct tests in the atmosphere and underwater.

testis (plural testes) Male sex GLAND, found as a pair located in a pouch, the scrotum, external to the body. The testes are made up of seminiferous tubules in which SPERM are formed and mature, after which they drain into ducts and are stored in the epididymis prior to being discharged.

testosterone Steroid HORMONE secreted mainly by the mammalian TESTIS. It is responsible for the growth and development of male sex organs and male secondary sexual characteristics, such as voice change and facial hair.

tetanus (lockjaw) Life-threatening disease caused by the toxin secreted by the anaerobic bacterium *Clostridium tetani*. The symptoms are muscular spasms and rigidity of the jaw, which then spreads to other parts of the body, culminating in convulsions and death. The disease is treated with antitetanus toxin and ANTIBIOTICS.

Tet Offensive Campaign in the VIETNAM WAR. North Vietnamese and VIET CONG troops launched attacks on numerous towns and cities of South Vietnam early in 1968. Although of little strategic effect, the offensive discredited current US military reports that victory over North Vietnam was imminent. **tetracyclines** Group of broad-spectrum antibiotics that are effective against a wide range of bacterial infections.

Teutonic Knights German military and religious order, founded in 1190. Its members, of aristocratic class, took monastic vows of poverty and chastity. During the 13th century the knights waged war on non-Christian peoples, particularly those of Prussia, whom they defeated, annexing their land. They were defeated in 1242 by ALEXANDER NEVSKI and, in 1410, by the Poles and Lithuanians at Tannenberg.

Teutonic mythology Traditional beliefs of the Germanic peoples. Much of the mythology of pre-Christian Germany and Scandinavia is preserved in two Icelandic works, the Eddas. According to the Eddas, before the creation of the world there existed a land of ice and shadows called Niflheim and a land of fire known as Muspellsheim. The two lands together created the first giant, Ymir. ODIN and his brothers killed Ymir and founded the race of gods. They then created the world from parts of Ymir's body, and made the first man and woman from pieces of trees. At the centre of the worlds of gods and men stood a giant ash tree, Yggdrasil. Odin, the head of the AESIR (heroic gods), was the god of poetry and of battle. VALHALLA, a great hall in Asgard, was the resting place of warriors slain in battle. Next in line to Odin was THOR, the god of thunder, rain and fertility. Other members of the Teutonic pantheon included the handsome Balder and Loki, the son of a giant. The Vanir gods, regarded as less important than the Aesir, included Njörd, the sea-god, his son Freyr, a god of fertility, his daughter Frejya, the goddess of love and magic, and Hel, the goddess of death and the underworld.

Texas State in central s USA, bounded by the Gulf of Mexico (SE) and the Rio Grande (SW). Major cities are HOUSTON, DAL-LAS, SAN ANTONIO, AUSTIN (the state capital) and FORT WORTH. The Spaniards explored the region in the early 16th century, and it became part of the Spanish colony of Mexico. By the time Mexico attained independence in 1821, many Americans had begun to settle in Texas. They revolted against Mexican rule and in 1836, after defeating the Mexican army, established the Republic of Texas, recognized by the USA in 1837. Eight years later Texas was admitted to the Union. Eastern Texas has pine-covered hills and cypress swamps; cotton and rice are the main crops and the timber industry is important. Cattle are raised on the plains of the Rio Grande valley, from where the land rises to the Guadalupe Mountains of W Texas and the Great Plains area of the Texas Panhandle in the N. Rich oilfields are the mainstay of the state's economy. Industries: oil refining, food processing, aircraft, electronics. Area 692,405sq km (267,338sq mi). Pop. (1992) 17,682,538. textiles Fabrics, especially those produced by WEAVING yarn. The yarn is made by SPINNING natural or artificial FIBRES. Textiles are used to make clothing, curtains, carpets and many other products. Powered machines for spinning and weaving were introduced in the 18th century.

Tezcatlipoca One of the great gods of the AZTECS. He appears in many different forms but is best known as the god of the night sky and summer sun. He was a protector, a creator, and a harmful wizard, and his cult required human sacrifice.

Thackeray, William Makepeace (1811–63) British novelist and satirist, b. India. The appearance of *Book of Snobs* (1846–47) made his name as a writer. *Vanity Fair* (1847–48), a satirical novel on upper-class London society at the start of the 19th century, is his best-known work. His other novels include *Barry Lyndon* (1844), *Pendennis* (1848–50), *Henry Esmond* (1852), *The Newcomes* (1853–55) and *The Virginians* (1857–59). Thackeray was the founding editor of the *Cornhill Magazine* (1860–1975) as well as a contributor to a number of other publications, including *Punch*.

Thai National language of Thailand, spoken by most of the population. It is closely related to Lao, spoken across the border in Laos. It belongs to the Tai family, possibly a sub-family of the SINO-TIBETAN LANGUAGES group.

Thailand Kingdom in SE Asia. See country feature

thalamus One of two ovoid masses of grey matter located deep on each side of the forebrain. Sometimes called the sen-

sory-motor receiving areas, they fulfil relay and integration functions in respect of sensory messages reaching the BRAIN. **thalassemia** (Cooley's anaemia) Group of hereditary disorders characterized by abnormal bone marrow and erythrocytes (red blood cells). The predominant symptom is ANAEMIA, requiring frequent blood transfusions.

Thales (636–546 BC) First Greek scientist and philosopher of whom we have any knowledge. He is thought to have introduced geometry to Greece. He predicted the eclipse of the Sun that took place in 585 BC.

thalidomide Drug originally developed as a mild hypnotic, but whose use by women in early pregnancy until the early 1960s came to be associated with serious birth deformities. It is still manufactured for occasional use in the treatment of LEPROSY and ACQUIRED IMMUNE DEFICIENCY SYNDROME (AIDS). thallium (symbol Tl) Shiny, metallic element of group III of the periodic table. Soft and malleable, it is obtained as a byproduct of processing zinc or lead sulphide ores. It is used in electronic components, infrared detectors, and optical and infrared glasses. Thallium is a toxic compound, and thallium sulphide is used as a rodent and ant poison. Properties: at.no. 81; r.a.m. 204.37; r.d. 11.85; m.p. 303.5°C (578.3°F); b.p. 1,457°C (2,655°F); most common isotope Tl205 (70.5%).

TEXAS Statehood: 29 December 1845

The Lone Star State

Nickname:

State bird : Mockingbird State flower : Bluebonnet State tree : Pecan

State motto:

Friendship

THAILAND

Thailand's flag was adopted in 1917. In the late 19th century, it featured a white elephant on a plain red flag. In 1916 white stripes were introduced above and below the elephant, but in 1917 the elephant was dropped and a central blue band was added.

AREA: 513,120sq km (198,116sq mi)
POPULATION: 57,760,000
CAPITAL POPULATION: Bangkok (5,572,712)

GOVERNMENT: Constitutional monarchy ETHNIC GROUPS: Thai 80%, Chinese 12%, Malay 4%, Khmer 3%

LANGUAGES: Thai (official)
RELIGIONS: Buddhism 94%, Islam 4%,

Christianity 1%

currency: Thai Baht = 100 stangs

The Kingdom of Thailand is one of ten nations in Southeast Asia. Central Thailand is a fertile plain, drained mainly by the Chao Phraya. A densely populated region, it includes the capital, BANGKOK. To the NE lies the Khorat plateau, which extends to the MEKONG River border with Laos. The NW is mountainous, and includes the second-largest city, CHIANGMAI. The S forms part of the MALAY PENINSULA.

CLIMATE

Thailand has a tropical climate. The monsoon season lasts from May to October. The central plains are much drier than other regions.

VEGETATION

The N includes many hardwood trees, which are being rapidly exploited. The s has rubber plantations. Grass, shrub and swamp make up 20% of land. Arable land, mainly rice fields, covers 33%.

HISTORY AND POLITICS

The Mongol capture (1253) of a Thai kingdom in sw China forced the Thai people s. A new kingdom was established around Sukhothai. In the 14th century, the kingdom expanded and the capital moved to Ayutthaya. The first European contact was in the early 16th century. In the late 17th century, the kingdom was briefly held by the Burmese. European desire to acquire the brilliance of the Thai court resulted in their expulsion for over a century; Thailand remained the only Southeast Asian nation to resist colonization. In 1782 a Thai General became King Rama I, establishing the Chakkri dynasty, which has

ruled ever since. The country became known as Siam, and Bangkok acted as its capital. From the mid-19th century, Siam began a gradual process of westernization. In World War 1, Siam supported the Allies. In 1932 Thailand became a constitutional monarchy. In 1938 Pibul Songgram became premier and changed the country's name to Thailand. In 1941 Pibul, despite opposition, invited Japanese forces into Thailand. Military coups and short-lived civilian governments are characteristic of post-war Thai politics. In 1950 Bhumibol Adulyadej acceded to the throne as Rama IX. In 1957 Pibul was overthrown in a military coup. Public pressure forced elections in 1992, which saw the return of civilian rule. In 1997 the prime minister resigned amid criticism of his government's handling of the economic crisis. A new coalition government, led by the Democrat Party, was formed.

ECONOMY

Thailand is a rapidly industrializing, developing nation, although economic crisis in 1997 led to the devaluation of the currency and the intervention of the International Monetary Fund. It was a founder of the Association of Southeast Asian Nations (ASEAN). Manufacturing and services have grown rapidly. It is a major producer of commercial vehicles. Agriculture employs 66% of the workforce. Thailand is the world's largest producer of pineapples and natural rubber. It is also the fourth-largest producer of rice, buffalo and cassava. Thai silk is among the world's finest. Tourism is a vital source of revenue.

▲ Thatcher Trained as a research chemist and a barrister specializing in tax law, Margaret Thatcher was first elected a Conservative member of Parliament for Finchley, north London, in 1959. She quickly rose to prominence, joining the shadow cabinet in 1967, becoming leader of the party in 1975 and prime minister in 1979. Her forceful personality and determination created considerable worldwide impact. The Russians called her the "Iron Lady". She was also known for her close relationship with US president Ronald Reagan. Since her resignation as prime minister in 1990, she has travelled and lectured internationally, remaining as outspoken as ever.

Thames Longest river in England. It rises in the Cotswold Hills, E Gloucestershire, then flows E across s England and through London to enter the North Sea at The Nore. It is tidal up to Teddington. The Thames Conservancy Board controls the freshwater river; the Port of London Authority administers the river below Teddington. The river is navigable for oceangoing vessels below Tilbury. Length: 338km (210mi).

Thanksgiving Day National holiday in the USA. Originating with the PILGRIMS in 1621, who celebrated the first harvest of the PLYMOUTH COLONY, it was proclaimed an official holiday in 1863.

Thant, U (1909–74) Burmese diplomat, third secretary-general of the United Nations (UN) (1962–72). He was acting secretary-general from 1961 before being elected in his own right. He helped to settle major disputes, including the civil wars in the Congo (Zaïre) in 1963 and Cyprus in 1964.

Thar Desert (Great Indian Desert) Region in NW India and SE Pakistan, between the Aravalli Mountains (E) and the River Indus (W). The region covers parts of RAJASTHAN, GUJARAT, PUNJAB and SIND. The desert areas of Rajasthan now benefit from the Indira Gandhi Canal, 650km (400mi) long, bringing water from the rivers of HIMACHAL PRADESH. Area c.200,000sq km (77,000sq mi).

Thatcher, Margaret Hilda, Baroness (1925-) British stateswoman, prime minister (1979-90). Thatcher was perhaps the most influential British political leader since CHURCHILL. She became a Conservative MP in 1959. She was secretary of state for education and science (1970-74) under Edward HEATH, whom she defeated for the party leadership in 1975. She succeeded James CALLAGHAN, becoming Britain's first woman prime minister. Her government embarked on a radical free-market programme, which became known as "Thatcherism". Her monetarist policies, especially cuts in public spending, provoked criticism and contributed to a recession, but her popularity was restored by victory in the FALKLANDS WAR (1982). Controversial PRIVATIZATION of national utilities boosted government revenue in a period of rapidly rising incomes. The gap between rich and poor widened. Thatcher's determination to curb trade union power provoked a bitter miners' strike (1983-84). She won a third term in 1987, but clashed with cabinet colleagues over economic and social policy, in particular her hostile attitude to the EUROPEAN COMMUNITY (EC). A poll tax (1989) was widely seen as unfair, and Thatcher was forced to resign as party leader and prime minister. She was succeeded by John MAJOR. theatre Building where DRAMA is staged. Its architecture has evolved gradually from early times, when ritual was most often performed in the open air. In medieval Europe, churches were used as dramatic venues. Renaissance architects such as PALLADIO were commissioned to design private theatres with acoustics and perspective in mind. At the same time, popular open stages had evolved in Shakespearean England. By the Restoration, the proscenium arch stage had become established as the only viable form of theatre. Since World War 2, theatrical architecture has again stressed adaptability. theatre See DRAMA

theatre-in-the-round Form of theatrical presentation derived from the ancient arena stage. The audience is seated on all sides of the players, thus creating a sense of informality between the actors and the audience.

Theatre Workshop Drama company founded in London in 1945 by Joan Littlewood. It staged many experimental and politically contentious plays. Several of its productions transferred to the West End, including *The Quare Fellow* (1956) and *Oh, What a Lovely War* (1963).

Thebes City-state of ancient Greece, the dominant power in Boeotia. It was allied with Persia during the Persian Wars, and during the 5th century BC was continually in conflict with Athens. It reached the peak of its power under Epaminondas in the 4th century BC, defeating the Spartans at Leuctra in 371 BC and invading the Peloponnese. The city was largely destroyed after a rising against Alexander the Great in 336 BC.

Thebes Greek name for the ancient capital of Upper Egypt, roughly corresponding to the present-day town of Luxor. **theft** (larceny) Dishonest appropriation of the property of

another. A person is guilty of theft if they deprive another of their rightful property with the intention of doing so.

theism Any of various philosophical and theological systems that profess belief in the existence of one supreme being, who is the creator of the universe. In most theistic systems, human beings have free will, and religious doctrines are usually based on divine revelation. *See also* MONOTHEISM; POLYTHEISM

theocracy Government by religious leaders in accordance with divine law. Theocracies were common in non-literate societies and existed in ancient Egypt and the Orient.

Theocritus (310–250 BC) Greek poet, regarded as the father of pastoral poetry. His work, which influenced generations of later writers from VIRGIL to Matthew ARNOLD, is noted for its vivid expression and perceptive portrayal of rural life.

Theodora Name of three empresses of the BYZANTINE EMPIRE. The most famous Theodora (c.500–48) was the wife of JUSTINIAN I. A courtesan before her marriage, she had such influence that she was almost a joint ruler. The second Theodora (d.867) ruled as regent for her young son Michael III (842–856). She expelled the iconoclasts and restored the worship of images. The third Theodora (980–1056) was coruler from 1042 and was briefly sole empress after the death of Constantine IX Monomachus in 1055.

Theodoric the Great (454–526) King of the Ostrogoths and ruler of Italy. He drove Odoacer from Italy (488) and attempted to recreate the Western Roman empire with himself as emperor. Religious differences and political rivalries frustrated his empire-building, and his kingdom was destroyed by JUSTINIAN I after his death.

Theodosius II (401–50) Eastern Roman (Byzantine) emperor (408–50). An unassertive personality, he was dominated by ministers. His armies repelled Persian invasions, and the fortifications of Constantinople were strengthened. He promulgated the Theodosian Code of laws (438).

theology Systematic study of God or gods. In its narrowest sense, it is the investigation or expression of the beliefs and precepts of a religion. In a much broader sense, theology is intricately related to philosophical and historical studies and strives to achieve an understanding of various beliefs. Such preoccupations exercise the minds of theologians of Islam, Hinduism, and most other religions, as well as Christianity.

theosophy Religious philosophy that originated in the ancient world but was given impetus in 1875 when the Theosophical Society was founded in New York. Modern theosophy continues a mystical tradition in Western thought represented by such thinkers as PYTHAGORAS and PLOTINUS, but is most significant in Indian thought. The main aims of the Theosophical Society are to promote a spiritual brotherhood of all humanity; to encourage the comparative study of religions, philosophy and science; and to develop latent spiritual powers. Belief in the transmigration of souls or REINCARNATION also occupies an important place in theosophical doctrine.

Theravada ("Doctrine of the Elders") Older of the two major schools of Buddhism. The doctrine originated early in the history of Buddhism as a contrast to Mahayana ("greater vehicle"). Theravada Buddhism stresses that sorrow and suffering can be conquered only by the suppression of desire. Desire can be suppressed only if the individual realizes that everything is always in a state of flux and the only stable condition is NIRVANA, an undefinable state of rest. This type of Buddhism is widespread in Sri Lanka and se Asia.

Thérèse of Lisieux, Saint (1873–97) (Marie Françoise Thérèse Martin) French Carmelite nun. She entered the convent at Lisieux at the age of 15. Later she suffered from depression and religious doubts, which she mastered by prayer. She died of tuberculosis. She chronicled her spiritual struggle in a series of letters published in 1898 as *Story of a Soul*. She was canonized in 1925. Her feast day is 1 October. thermal Small-scale, rising current of air produced by local heating of the Earth's surface. Thermals are often used by gliding birds and human-built gliders. *See also* GLIDING

thermionics Study of the emission of electrons or ions from a heated conductor. This is the principle on which electron tubes (valves) work. The heated conductor is the CATHODE and the emitted electrons are attracted to the ANODE. A more

modern aim for thermionics is the design and construction of thermionic power generators.

thermodynamics Branch of physics that studies heat and how it is transformed to and from other forms of ENERGY. The original laws of thermodynamics were developed by observing large-scale properties of systems, with no understanding of the underlying atomic structure. The three existing laws are now calculated from statistical and quantum mechanical principles. The first law states that the change in a system's internal energy is equal to zero, because heat and mechanical work are mutually convertible. The second law says that if a system is left alone, its ENTROPY tends to increase; therefore, an engine cannot convert heat totally into mechanical work. The third law states that a system at absolute zero has an entropy of zero. thermometer Instrument for measuring TEMPERATURE. A MERCURY thermometer depends on the expansion of the metal mercury, which is held in a glass bulb connected to a narrow, graduated tube. Temperatures can also be measured by a gas thermometer and by a resistance thermometer that measures resistance of a conductor. Common scales are the CELSIUS, FAHRENHEIT and KELVIN.

Thermopylae Strategic mountain pass in E central Greece, site of several battles in ancient times. The most famous was the defence of the pass by Leonidas of SPARTA against the Persian invasion of XERXES I in 480 BC.

thermostat Device for maintaining a constant temperature. A common type contains a strip of two metals, one of which expands and contracts more than the other. At a set temperature, the strip bends and breaks the circuit. As it cools, the strip straightens, makes contact and the heating begins again once the circuit is complete.

Theroux, Paul (1941–) US novelist and travel writer. Longtime resident in Britain, he has written short stories and a number of novels, including *Girls at Play* (1969), *The Family Arsenal* (1976), *The Mosquito Coast* (1981), *My Secret Histo*ry (1989) and *My Other Life* (1996). His fiction has been overshadowed by his travel writing, which includes *The Great Railway Bazaar* (1975) and *Riding the Iron Rooster* (1988).

Theseus In Greek mythology, a great hero of many adventures, the son of Aethra by Aegeus, King of Athens, or by the sea god POSEIDON. His most famous exploit was the vanquishing of the MINOTAUR of Crete.

Thespis (6th century BC) Greek writer, according to tradition, the inventor of tragedy. He is also said to have introduced a character separate from the chorus, who provided dialogue by responding to the chorus' comments.

Thessalonians, Epistles to the Two of St Paul's earliest letters, forming the 13th and 14th books of the New Testament. The first letter was written c. AD 50, and the second followed shortly afterwards. The letters contained encouragement and pastoral guidance for the Thessalonians and neighbouring Christian communities.

Thessaloníki (Salonica) Port on the Gulf of Thessaloníki, Greece, the country's second-largest city and capital of Greek Macedonia. Founded $c.315\,$ BC, it flourished under the Romans after 148 BC as the capital of Macedonia. The city was part of the Ottoman empire until 1913, when it was conquered by Greece. Industries: oil refining, textiles, metals, engineering, chemicals, cement, soap. Pop. (1991) 383,967.

thiamine VITAMIN B_1 of the B complex, required for carbohydrate metabolism. Its deficiency causes the disease BERIBERI. Thiamine is found in grains and seeds, nuts, liver, yeast and legumes.

Third Reich Official name of Nazi Germany (1933–45). The first *Reich* (empire) was the Holy Roman Empire, the second the German empire of 1871–1918.

Third World Former term for LESS DEVELOPED COUNTRIES. "First" and "Second" world countries were those of the Western and Eastern blocs respectively.

Thirteen Colonies English colonies in North America that jointly declared independence from Britain (1776) and became the USA. They were: Connecticut, Delaware, Georgia, Maryland, Massachusetts, New Hampshire, New Jersey, New York, North Carolina, Pennsylvania, Rhode Island, South Carolina and Virginia. See also AMERICAN REVOLUTION

Thirty Years War (1618-48) Conflict fought mainly in Germany, arising out of religious differences and developing into a struggle for power in Europe. It began with a Protestant revolt in Bohemia against the HABSBURG emperor, FERDI-NAND II. Both sides sought allies and the war spread to much of Europe. The Habsburg generals Tilly and WALLENSTEIN registered early victories and drove the Protestant champion, CHRISTIAN IV of Denmark, out of the war (1629). A greater champion appeared in GUSTAVUS II (ADOLPHUS) of Sweden, who waged a series of victorious campaigns before being killed in 1632. In 1635 France, fearing Habsburg dominance, declared war on Habsburg Spain. Negotiations for peace were not successful until the Peace of WESTPHALIA was concluded in 1648. War between France and Spain continued until the Peace of the Pyrenees (1659), and other associated conflicts continued for several years. The chief loser in the war, apart from the German peasants, was the emperor, FER-DINAND III, who lost control of Germany. Sweden was established as the dominant state in N Europe, while France replaced Spain as the greatest European power.

thistle Any of numerous species of plants with thorny leaves and yellow, white, pink or purple flower heads with prickly bracts. The field thistle, *Cirsium discolor*, resembles the heraldic thistle, which is the national emblem of Scotland. Family Asteraceae/Compositae.

Thomas, Saint One of the original 12 APOSTLES or disciples of JESUS CHRIST. He has been called "Doubting Thomas" because, after the RESURRECTION of Christ, he refused to believe that the risen Lord had indeed appeared to the other disciples (John 20). Only when Jesus appeared to him and allowed him to touch his wounds did he lay aside his doubts. His feast day is 3 July.

Thomas, Dylan Marlais (1914–53) Welsh poet and short-story writer. A self-styled *enfant terrible*, whose flamboyant alcoholic lifestyle led to his early death in New York, Thomas was a resonant reader of his own and others' poetry, his public persona contributing to the popularity of his powerful, meticulously crafted, often wilfully obscure verse. His first collection appeared when he was 19 years old; his *Collected Poems* was published in 1953. Many of his best short stories appear in *Portrait of the Artist as a Young Dog* (1940) and *Adventures in the Skin Trade* (1955). The "play for voices" *Under Milk Wood*, written in 1952, is perhaps his best-known work.

Thomas, Norman Mattoon (1884–1968) US politician. In 1926 he became leader of the Socialist Party and was its unsuccessful candidate for president six times between 1928 and 1948. A strong anti-communist, he campaigned for social welfare measures, civil rights, free speech and world peace.

Thomas, R.S. (Ronald Stuart) (1913–) Welsh poet. He was a clergyman for more than 40 years. *Song at the Year's Turning* (1955) collected his early verse; it embodies his characteristic concerns with Wales and its working people, and with the implications of his faith. His later work evinces a fierce distrust of the modern world.

Thomas à Kempis See Kempis, Thomas à

Thomas Aquinas, Saint See Aquinas, Saint Thomas

Thomism Philosophy of Saint Thomas AQUINAS, one of the major systems in SCHOLASTICISM. Aquinas blended the philosophy of ARISTOTLE with Christian theology. Using Aristotle's concept of matter and form, he conceived a hierarchy in which spirit is higher than matter, soul higher than body, and theology above philosophy.

Thompson, Emma (1959–) English actress and screenwriter. Her controlled playing in *Howard's End* (1991) won her a Best Actress Academy Award. In 1993 she produced further memorable performances in *Much Ado About Noth*ing and *Remains of the Day. Sense and Sensibility* (1995) won her an Academy Award for best screenplay.

Thomson, Sir George Paget (1892–1975) British physicist, the son of Sir Joseph John Thomson. He shared the 1937 Nobel Prize for physics with Clinton Davisson for their independent work in diffracting ELECTRONS (1927). This work confirmed the wave nature of particles first predicted in 1923 by Louis de Broglie.

Thomson, James (1700-48) Scottish poet. His most

▲ thistle The creeping thistle is a weed, which is common on waste and cultivated land. Like the dandelion, it is a composite. There are about 150 species of Cirsium whose flowers may be violet, mauve, pink, yellow or white

▲ thrip A tiny pest, thrips (order Thysanoptera) are significant for the damage they do to crops and for carrying disease. They have simple, fringed wings — or none at all — and unusual mouthparts with which they suck up plant juices. The onion thrips in both adult and nymphal stages infest a number of hosts to which they may transmit the tomato spotted wilt virus.

famous poem, *The Seasons*, was published in four parts: *Winter* (1726), *Summer* (1727), *Spring* (1728) and *Autumn* (1730). It was used by Haydn as the basis for his oratorio of the same name (1801). Later poems include the patriotic *Liberty* (1734–36). Thomson's sensitivity to nature places him as a forerunner of ROMANTICISM.

Thomson, Sir Joseph John (1856–1940) British physicist. His work on the conductivity of gases led him to the discovery in 1897 of the ELECTRON. He made the Cavendish laboratory at Cambridge University a world-famous centre of atomic research. Thomson was awarded the 1906 Nobel Prize for physics for his investigations into the electrical conductivity of gases. He was the father of George THOMSON.

Thomson, Virgil (1896–1989) US critic and composer. He was music critic for the New York *Herald Tribune* (1940–54). Much influenced by Erik SATIE, his works include the operas *Four Saints in Three Acts* (1928, first production 1934) and *The Mother of Us All* (1947).

Thor In TEUTONIC MYTHOLOGY, god of thunder and lightning, corresponding to JUPITER. The eldest and strongest of ODIN's sons, he was represented as a handsome, red-bearded warrior, benevolent towards humans but a mighty foe of evil. **thorax** In animal anatomy, part between the neck and the abdomen. In mammals it is formed by the rib cage and contains the lungs, heart and oesophagus. In insects it consists of several segments to which legs and other appendages are attached.

Thoreau, Henry David (1817–62) US writer and naturalist. He was friends with the transcendentalist Ralph Waldo EMERSON, who encouraged him to keep the journals from which he quarried much of his later work. An ardent individualist, he experimented in living a near-solitary life, rejecting materialism and finding fulfilment in observing plant and animal life. His essay Civil Disobedience (1849) has influenced many passive resistance movements.

thorium (symbol Th) Radioactive metallic element of the ACTINIDE SERIES, first discovered in 1828. The chief ore is monazite. The metal is used in photoelectric and thermionic emitters. One decay product is RADON-220. Thorium is sometimes used in radiotherapy, and is increasingly used for conversion into uranium-233 for nuclear fission. Chemically reactive, it burns in air but reacts slowly in water. Properties: at.no. 90; r.a.m. 232.0381; r.d. 11.72; m.p. 1,750°C (3,182°F); b.p. 4,790°C (8,654°F); most stable isotope Th²³²(1.41 × 10¹⁰ yrs). thorn apple Plant of the genus *Datura*, especially Jimson weed (*D. stramonium*), a poisonous, annual weed of tropical American origin. It has foul-smelling leaves and large white or violet trumpet-shaped flowers that are succeeded by round prickly fruits. Family Solanaceae.

Thóroddsen, Jón (1819–68) Icelandic novelist. He wrote some lyrics and drinking songs, but is best remembered for his novels, including *Lad and Lass* (1850), the first fully fledged Icelandic novel, and the unfinished *Man and Woman* (1876).

Thoth In Egyptian mythology, the scribe of the gods. He appears as the record keeper of the dead, patron of the arts and learning, inventor of writing, and as creator of the universe. Thoth is depicted as a man with the head of an ibis or of an ape, bearing pen and ink or the lunar disc and crescent. Thrace (Thráki) Ancient SE European country, now divided between Bulgaria, Greece and European Turkey. From 1300-600 BC the Thracian lands extended w to the Adriatic and N to the Danube. By c.600 BC Thrace had lost much of its E lands to the Illyrians and Macedonians, and the Greeks established the colony of Byzantium. In 342 BC Philip II of Macedon conquered the country. After 100 BC it became part of the Roman empire. In the 7th century AD the N of the region was conquered by the Bulgarians, and by 1300 they controlled all Thrace. From 1361–1453 the region was disputed between the Bulgarians and the emerging Ottoman empire, eventually falling to the Turks. In 1885 N Thrace was annexed to Bulgaria. The regions either side of the Maritsa River became known as Eastern Thrace (Bulgaria) and Western Thrace (Turkey). After World War 1, Bulgaria ceded s and most of E Thrace to Greece. The Treaty of Lausanne (1923) restored E Thrace to Turkey, and the region retains these boundaries. A fertile region, its main economic activity is agriculture.

threadworm Small ROUNDWORM of the phylum Aschelminthes. It is commonest in moist tropical regions and resembles a short length of hair or thread. It may inhabit the intestines of human beings and other animals, but can live and breed freely in soil. Species *Oxyurus vermicularis*.

Three Mile Island Island on the Susquehanna River near Harrisburg, Pennyslvania, USA. It is the site of a nuclear power-generating plant where a near-disastrous accident took place in March 1979. The accident involved the failure of the feedwater system, which picks up heat from the system that has circulated through the reactor core. Radioactive water and gases were released into the environment.

thrip Any of numerous species of slender, sucking insects found throughout the world. Species vary in colour, but most feed on plants and some carry plant diseases. Length: to 8mm (0.3in). Order Thysanoptera.

throat See PHARYNX

thrombophlebitis Inflammation of the walls of veins associated with THROMBOSIS. It can occur in the legs during pregnancy.

thrombosis Formation of a blood clot in an artery or vein. Besides causing loss of circulation to the area supplied by the blocked vessel, it carries the risk of EMBOLISM.

thrush (candidiasis) Fungal infection of the mucous membranes, usually of the mouth but also sometimes of the vagina. Caused by the fungus *Candida albicans*, it is sometimes seen in people taking broad-spectrum ANTIBIOTICS.

thrush Any of numerous species of small songbirds of the family Turdidae. The European song thrush (*Turdus philomelos*) is mottled brown with a lighter, speckled breast. North American species include the (North American) robin, bluebird and bluethroat. Length: to 30cm (12in).

thrust Driving force resulting from operation of a propeller, jet engine or rocket engine. An aircraft propeller forces air backwards, and jet and rocket engines expel gases backwards. Thrust is produced in the forward direction in accordance with the third of NEWTON'S LAWS of motion.

Thucydides (460–400 BC) Ancient Greek historian. A commander in the Peloponnesian Wars, his *History of the Peloponnesian War* is a determined attempt to write objective history, and it displays a profound understanding of human motives. **thugs** Murderous gangs in India who preyed on travellers. They were members of a secret society, who killed their victims by ritual strangulation (*thuggee*) in honour of Kali, the Hindu goddess of destruction. They were eliminated by the British *c.*1830–50.

thulium (symbol Tm) Lustrous, silver-white, metallic element of the LANTHANIDE SERIES. Its chief ore is monazite but thulium is as rare as gold. Soft, malleable and ductile, it combines with OXYGEN and the HALOGENS. It is used in arc lighting and portable x-ray units. Properties: at.no. 69; r.a.m. 168.9342; r.d. 9.31 (25°C); 1,545°C (2,813°F); b.p. 1,947°C (3,537°F); most stable isotope Tm¹⁶⁹ (100%).

thunderstorm Electrical storm caused by the separation of electrical charges in clouds. Water drops are carried by updraughts to the top of a cloud, where they become ionized and accumulate into positive charges – the base of the cloud being negatively charged. An electrical discharge (a spark) between clouds, or between a cloud and the ground, is accompanied by light (seen as a LIGHTNING stroke) and heat. The heat expands the air explosively and causes it to reverberate and produce sounds and echoes called thunder.

Thurber, James Grover (1894–1961) US humorist and cartoonist. In 1927 he became a regular contributor of essays, short stories and cartoons to the *New Yorker*. Collections of his essays and stories include *My Life and Hard Times* (1933) and *My World and Welcome to It* (1942), which includes his best-known short story, *The Secret Life of Walter Mitty* (1932).

Thuringia Historic region of central Germany. Its rulers became powerful princes with the HOLY ROMAN EMPIRE in the 11th century. Thuringia was reconstituted as a state (*Land*) in 1920 under the WEIMAR REPUBLIC, but it lost its separate identity in 1952. The main economic activities are manufacturing and cereal cropping. Area: 16,176sq km (6,244sq mi). Pop. (1992) 2,545,808.

Thutmose Name of four kings of the 18th dynasty in ancient EGYPT. Thutmose I (r. c.1525-c.1512 BC) extended his kingdom s into NUBIA, and campaigned successfully in the Near East. He was succeeded by his son, Thutmose II (r. c.1512-c.1504 BC), who married his half-sister, HATSHEPSUT. She ruled as regent for his son, Thutmose III (r. c.1504-1450 BC). Thutmose III expanded the kingdom to its greatest extent, defeating the Mitanni kingdom on the River Euphrates and pushing the s frontier beyond the fourth cataract of the Nile. His grandson, Thutmose IV (r. c.1425-c.1416 BC), continued an expansive policy but also sought to strengthen the empire by peaceful means, marrying a Mitanni princess.

thyme Aromatic garden herb of the MINT family (Lamiaceae/Labiatae), used as an ornamental plant and in cooking. It yields an oil from which the drug thymol is prepared. It has purple flowers. Height: 15–20cm (6–8in). Genus *Thymus*.

thymus gland One of the endocrine GLANDS, located in the upper chest in mammals. In childhood it controls the development of lymphoid tissue and the immune response to infection. Disorder of the thymus may be associated with autoimmune diseases (those caused by the body's own antibodies). See also ENDOCRINE SYSTEM

thyroid gland H-shaped gland of the ENDOCRINE SYSTEM. It lies in the base of the neck, straddling the trachea below the Adam's apple. It secretes hormones, principally THYROXINE. **thyroxine** Hormone secreted by the THYROID GLAND. It contains iodine and helps regulate the rate of metabolism; it is essential for normal growth and development.

Tiananmen Square World's largest public square, covering 40ha (98 acres) in Beijing, China. On the s side, a marble monument is dedicated to the heroes of the revolution. A gate on the the N side leads into the Forbidden City. On 4 May 1919 China's first mass public rally was held in the square, and on 1 October 1949 MAO ZEDONG proclaimed the establishment of the People's Republic of China. In 1966 Mao made his pronouncements on the CULTURAL REVOLUTION to more than a million Red Guards assembled there. In April 1989 a series of nationwide pro-democracy demonstrations culminated in the occupation of the square by protesters. Hundreds of thousands of citizens joined in the demonstrations. On 4 June tanks and troops stormed the square. Official casualties were put at over 200 demonstrators and dozens of soldiers. Eyewitness reports suggest thousands of deaths. The government imposed a yearlong martial law and executed several student leaders.

Tianjin (Tientsin) Port and industrial city on the Hai River, NE China. It is China's third-largest city and the most important international port in N China. Founded in c.300 BC, it became prominent in the late 18th century because of its strategic position en route to Manchuria. In 1860 the British and French obtained the right to use Tianjin as a treaty port. In 1900 the city came under European occupation. Due to its excellent transport links, it remains N China's trading centre. Industries: iron, steel, heavy machinery, transport equipment, textiles, carpets. The city is administered as a special economic zone to encourage inward investment. Pop. (1993) 4,970,000.

Tian Shan (Tien Shan) Mountain range in central Asia, 2,400km (1,500mi) long, forming the border between Kyrgyzstan and Xinjiang, Nw China. At their w edge, the Tian Shan ("Celestial Mountains") divide the Tarim and Junggar Basins. The range then rises to 7,439m (24,406ft) at Peak Pobeda, on the Chinese border with Kazakstan and Kyrgyzstan. The Issyk Kul in Kyrgyzstan is one of the world's biggest mountain lakes.

Tiber (Tevere) River in central Italy. It rises in the Etruscan Apennines, flows s then sw through Rome and empties into the Tyrrhenian Sea at Ostia. The silting of the river has closed Fiumara, one of its two mouths, and its delta continues to expand; the ancient coastal port of Ostia Antica now lies 6km (4mi) inland. Length: 404km (251mi).

Tiberius (42 BC – AD 37) (Tiberius Julius Caesar Augustus) Roman emperor (AD 14–37). He was the stepson of AUGUSTUS, who adopted him as his heir (AD 4). Initially, his administration was just and moderate, but he became increasingly fearful of conspiracy and had many people executed for alleged treason. He left Rome and spent his last years in seclusion on Capri.

Tibet (Xizang) Autonomous region in sw China. The capital and largest city is LHASA. Tibet is the highest region on earth, with an average altitude of 4,875m (16,000ft). An historically inaccessible area, Tibet is surrounded by mountains on three sides. The Tibetan HIMALAYAS include the world's highest mountain, Everest. Nam Co is the world's largest natural salt lake. Many of Asia's greatest rivers, including the YANGTZE, MEKONG, HUANG HE, INDUS and GANGES have their source in Tibet, though its major river is the BRAHMAPUTRA. The area has scant rainfall, and the Brahmaputra valley is the only agricultural area and the location of the major cities. Many of the people remain nomadic pastoralists. Tibet is rich in mineral resources, such as gold, copper and uranium. The Chinese government have built internal highways and links to the Chinese provinces. The principal religion is TIBETAN BUD-DHISM. Until 1959 a large percentage of the urban male population were Buddhist monks (Lamas). From the 7th century, the spiritual leaders of Lamaism (the DALAI LAMA and the PANCHEN LAMA) also acted as the country's temporal rulers. Tibet flourished as an independent kingdom in the 7th century, and in the 8th century Padmasambhava developed the principles of Mahayana Buddhism and founded Lamaism. In 1206 Genghis Khan conquered the region, and it remained under nominal Mongol rule until 1720, when the Chinese QING dynasty claimed sovereignty. At the close of the 19th century the Tibetan areas of Ladakh and Sikkim were incorporated into British India, and in 1906 Britain recognized Chinese sovereignty over Tibet. In 1912 the fall of the Qing dynasty prompted the Tibetans to reassert their independence. China, however, maintained its right to govern, and in 1950 the new communist regime sent its forces to invade. In 1951 Tibet was declared an autonomous region of China, nominally governed by the Dalai Lama. The Chinese government began a series of repressive measures principally targeting the Buddhist monasteries. In March 1959 a full-scale revolt against Chinese rule was suppressed by the Chinese People's Liberation Army. The Dalai Lama managed to flee to N India (Christmas Day 1959), and he established a government-in-exile at Dharamsala. In 1965 China formally annexed Tibet as an autonomous region. The CULTURAL REV-OLUTION banned religious practice and 4,000 monasteries were destroyed. Many thousands of Tibetans were forced into exile by the brutality of the communist regime. Despite the restoration of some of the desecrated monasteries and the reinstatement of Tibetan as an official language, human rights violations continued. Pro-independence rallies in 1987-89 were violently suppressed by the Chinese army. Area: 1,222,070sq km (471,841sq mi). Pop. (1993) 2,290,000.

Tibetan art Virtually all art in Tibet is religious in character, designed to serve the elaborate rituals of TIBETAN BUDDHISM. All artworks are anonymous and most are undated. Paintings come in two forms – wall-paintings and *thangkas*, which are banners, usually displayed in temples or carried in processions. *Thangkas* generally depict scenes from the life of a deity or *mandalas* (patterns used for meditation).

Tibetan Buddhism Distinctive blend of Mahayana Bud-DHISM and Bonism (a pre-Buddhist shamanism). It mixes meditative monasticism with indigenous folk religion and involves a system of reincarnating lamas (monks). Both spiritual and temporal authority reside in the person and office of the DALAI LAMA. King Srong-tsan-gampo (b.617 or 629) sought to bring Buddhist teachers from China and India to Tibet. The Bon priests opposed the new Buddhist ways, and Buddhism was not thoroughly introduced into Tibet until the 8th century. Following reforms initiated by the 11th-century Indian master Atisha, four major sects emerged in Tibetan Buddhism. Of these, the Gelugpa order, to which the Dalai and PANCHEN LAMAS belong, was politically dominant from the 17th century. There are now two Gelugpa sects, the Red and Yellow monks. The Dalai Lama, a member of the latter, became revered as the "Living Buddha" and the spiritual and temporal ruler of Tibet. Each new Dalai Lama is believed to be a reincarnation of his predecessor. The Panchen Lama heads the Red monks.

tibia (shinbone) Inner and larger of the two lower leg bones. It articulates with the FEMUR, or upper leg bone, at the knee

▲ thyme Thyme (*Thymus* vulgaris) has a pungent aroma and retains much of its flavour when dried. It is a favourite herb for Mediterranean cooking and is an essential ingredient of a bouquet garni.

tic Sudden and rapidly repeated muscular contraction, limited to one part of the body, especially the face.

tick Any of numerous species of wingless, bloodsucking ARACHNIDS, the most notable of which are ectoparasites of vertebrates and invertebrates. Many species carry diseases (some fatal) in wild and domesticated animals and in humans Length: to 3mm (0.1in). Class Arachnida; order Acarina.

tidal power Energy harnessed from tidal movement of the Earth's oceans and used by humans. It is economic only where the tidal range is greater than about 4.6m (15ft). Modern schemes involve the use of turbo-generators driven by the passage of water through a tidal barrage.

tide Periodic rise and fall of the surface level of the oceans caused by the gravitational attraction of the Moon and Sun. Tides follow the Moon's cycle of 28 days so they arrive at a given spot 50 minutes later each day. When the Sun and Moon are in conjunction or opposition, the greatest tidal range occurs, called spring tides. When they are in quadrature, when the Moon is half-full, tidal ranges are lowest and are called neap tides.

TIDAL POWER

The power of the sea can be harnessed to generate electricity. Tidal power uses a barrage (1) across an estuary or bay. The barrage contains turbines that can spin with a flow of water in either direction. As the tide comes in gates on the barrage remain closed until a head of water has built up on

the sea side of the structure (2). The gates are then opened (3) and the incoming tide flows through the barrage driving the turbines (4). As the tide falls the process is reversed with the gates closed until the sea has fallen below the level of water retained in the estuary (5). The second form of utilizing the sea

harnesses wave power (6). The key difference is that the turbine (7) is air driven, not turned by water. As a wave hits the shore the force of the water (8) drives air (9) through the turbine blades (10). When the water level drops air is sucked back down through the turbine spinning it again.

Tiepolo, Giovanni Battista (1696–1770) Italian painter. His pictures are full of action, using light, sunny colours, with figures and objects seen in a deep, theatrical PERSPECTIVE. The peak of his career came in the 1750s when he decorated the Kaisersaal and the grand staircase of the Prince Archbishop's Palace in Würzburg.

Tierra del Fuego (Sp. Land of Fire) Archipelago separated from mainland s South America by the Magellan Strait. It consists of one large island and other smaller islands. At the s extremity of the islands lies Cape Horn. The main island is politically divided between Argentina and Chile. The islands remained undiscovered by Europeans until Ferdinand MAGELLAN's landing in 1520. They were not settled until the 1880s, when the discovery of gold and later oil attracted many Europeans, Argentinians and Chileans to the area. The indigenous population was killed by diseases brought by settlers. The mountainous terrain and harsh climate limit economic activity to sheep rearing and oil exploration. Area: 73,746sq km (28,473sq mi). Pop. (1991) 69,450.

Tiffany, Louis Comfort (1848–1933) US painter, designer and a leader of the ART NOUVEAU style in the USA. In 1878 he formed an interior decorating firm, which by 1900 was known as Tiffany Studios. It specialized in what he termed "favrile" glass – freely shaped iridescent glasswork, sometimes combined with various metals.

tiger Large, powerful cat found (in decreasing numbers) throughout Asia, mainly in forested areas. It has a characteristic striped coat of yellow, orange, white and black, with the chin and underparts white. Relying on keen hearing, it hunts for birds, deer, cattle and reptiles. The largest tiger is the Siberian race. Length to 4m (13ft) overall; weight: to 230kg (500lb). Family Felidae; species *Panthera tigris*.

Tigris River in sw Asia. It rises in the Taurus Mountains of E Turkey and flows se through Iraq, joining the River Euphrates to form the Shatt al Arab waterway. The river is liable to sudden flooding, but there are flood-control schemes and the river irrigates more than 300,000ha (750,000 acres). The Tigris is navigable for shallow-draught vessels as far as BAGHDAD. Length: c.1,900km (1,180mi).

till In geology, sediment consisting of an unsorted mixture of clay, sand, gravel and boulders that is deposited directly by the ice of GLACIERS.

timber See wood

timbre Characteristic of a musical sound determined by the number and intensity of the overtones (HARMONICS) produced as well as the principal (fundamental) note. Musical instruments of different types make characteristic sounds because of the different harmonics produced.

Timbuktu Town in N Mali, w Africa. It was founded by the Tuareg people in the 11th century and soon became a centre of Muslim learning. The southern terminus of a Saharan caravan route, it later became famous throughout Europe as a market for slaves and gold. Sacked by the Moroccans in 1591 and seized by the French in 1893, its most important trading commodity today is salt. Pop. (1992 est.) 26,000.

time Perception of a sequential order in all experience; also the interval perceived between two events. A consideration of time falls within the disciplines of physics, psychology, philosophy and biology. Until the theory of RELATIVITY was devised by Albert EINSTEIN, time was conceived of as absolute – a constant one-direction (past to future) flow. Since then the concept of time linked with distance in space ("space-time") has connected time with the relative velocities of those perceiving it. For clocks at velocities approaching that of light, time expands from the point of view of a stationary observer, but it still flows in the same direction.

time scale See GEOLOGICAL TIME

time zone One of 24 divisions of the Earth's surface, each 15° of longitude wide, within which the time of day is reckoned to be the same. At a conference held in Washington, D.C. in 1884, the meridian of Greenwich was adopted as the zero of longitude, and zones of longitude were established. Standard time in each successive zone westwards is one hour behind that in the preceding zone. See also Greenwich Mean Time (GMT)

◀ tiger Once common throughout Asia, the tiger has

suffered much from the reduction

of its habitat. Its greatest threat,

Timişoara City in w Romania, on the Bega River and Canal. An ancient Roman settlement, it was ruled by the MAGYARS from 896, annexed to Hungary in 1010 and ruled by the Turks from 1552 to 1716. It was returned to Austria-Hungary in 1716 and passed to Romania in 1920. Events here in 1989 triggered the fall of the CEAUŞESCU regime. Industries: engineering, tobacco, chemicals, textiles, machinery. Pop. (1993) 325,359.

Timor Largest of the Lesser Sunda Islands in the Malay archipelago; part of INDONESIA. The chief towns are Kupang in the w and Dili in the E. From c.1520 Portuguese spice traders began to settle on Timor. When the Dutch landed in 1620 they settled on the w side. During World War 2 the island was occupied by the Japanese. In 1950 West Timor became part of the Nusa Tenggara Timur province of the newly created Republic of Indonesia. In 1975 the Portuguese abandoned East Timor, and the colony declared its independence. Indonesia immediately invaded, and in 1976 annexed East Timor. The East Timor independence movement FRETILIN has maintained resistance to Indonesian rule amid widespread reports of human rights violations. A mountainous island, its main products are rice, coconuts, coffee and tobacco. Area: 33,857sq km (13,074sq mi). Pop. (both provinces) (1990) 4,015,394.

timpani (kettledrums) Main percussion instruments in a symphony orchestra. Hemispherical vessels of copper or brass with single skins, they are tuned by pedals or screws and struck with sticks with hard felt heads. Military kettledrums, played on horseback, were introduced to Europe by the Crusaders *c*.1100. **Timur** *See* TAMERLANE

tin (symbol Sn) Metalloid element of group IV of the periodic table, known from ancient times. Its chief ore is cassiterite (an oxide). Soft, malleable and resistant to corrosion, tin is used as a protective coating for iron, steel, copper and other metals, and in such alloys as solder, pewter, bronze and type metal. Properties: at.no. 50; r.a.m. 118.69; r.d. 7.29; m.p. 232°C (449.6°F); b.p. 2,270°C (4,118°F); most common isotope Sn¹¹¹8 (24.03%).

Tinbergen, Nikolaas (1907–88) Dutch ethologist. He shared with Konrad LORENZ and Karl von FRISCH the 1973 Nobel Prize for physiology or medicine for his pioneering work in ETHOLOGY. Tinbergen studied how certain stimuli evoke specific responses in animals.

Tintoretto (1518–94) (Jacopo Robusti) Italian painter. Among his notable works are *The Finding of the Body of St Mark* (1562) and *The Last Supper* (1592–94). The former, a masterpiece of dramatic urgency, demonstrates his use of striking perspective effects. The brilliant coloration of his paintings is typically Venetian, while the astonishing foreshortenings and taste for theatricality suggest a more personal style.

Tipperary County in central s Republic of Ireland, in Munster province. The county town is Clonmel. The region is part of the central plain of Ireland but there are hills in the s; the Suir and Shannon are the principal rivers. The soil is fertile and Tipperary is one of the country's best farming regions. Area 4,255sq km (1,643sq mi). Pop. (1991) 132,772.

Tippett, Sir Michael Kemp (1905–98) British composer. Tippett incorporated into his music apparently disparate musical forms and social themes of justice, pacifism and humanism. His first major work was *String Quartet No. I* (1934). His oratorio *A Child of our Time* (1941) was a response to the 1938 Kristallnacht in Nazi Germany. After the war, Tippett concentrated on his first opera, *The Midsummer Marriage* (1952). His second opera, *King Priam* (1962), earned critical praise. A later work, the oratorio *The Mask of Time* (1982) revisits Tippett's musical and philosophical concerns. Other works include four symphonies (1945, 1957, 1972, 1977) and the opera *New Year* (1988). He was knighted in 1966.

Tirana (Tiranë) Capital of Albania, on the Ishm River, central Albania. Tirana was founded in the early 17th century by the Ottoman Turks and became Albania's capital in 1920. In 1946 the communists came to power and the industrial sector of the city was developed. Industries: metal goods, agricultural machinery, textiles. Pop. (1991) 251,000.

Tirol (Tyrol) Federal state in W Austria, bordered N by Germany and S by Italy. The capital is INNSBRUCK. S Tirol is now an autonomous Italian region. The Romans conquered Tirol

however, comes directly from humans due to the increased availability of fire-arms. Reserves have been established in India for the protection of the tiger.

it during the 8th century. In by the Habsburgs. In 1805 varia in return for its support.

in 15 BC, and the Franks held it during the 8th century. In 1363 the province was taken by the Habsburgs. In 1805 Napoleon I awarded Tirol to Bavaria in return for its support. In 1810 Napoleon gave s Tirol to the Italians, but the Congress of Vienna (1815) reunited Tirol with Austria. After World War 1, s Tirol was awarded to Italy. An Alpine region, its economy is now dominated by tourism, with visitors attracted by the beauty of the Tyrolean Alps and the good skiing conditions. Other economic activities are mainly agricultural. Area: 12,647sq km (4,882sq mi). Pop. (1994) 654,753. **Tirpitz, Alfred von** (1849–1930) German admiral. He was

Chiefly responsible for the build-up of the German admiral. He was chiefly responsible for the build-up of the German navy before World War 1. Frustrated by government cut-backs and restrictions on submarine warfare, he resigned in 1916. He later sat in the Reichstag (Parliament) under the WEIMAR REPUBLIC.

tissue Material of a living body consisting of a group of similar and often interconnected cells, usually supporting a similar function. Tissues vary greatly in structure and complexity. In animals they may be loosely classified according to function into epithelial, connective, skeletal, muscular, nervous and glandular tissues.

tissue culture In biology, artificial cultivation of living TISSUE in sterile conditions. Tissue culture in laboratories is used for biological research or to help in the diagnosis of diseases. It is also used a means of propagating plant CLONES. *See also* GENETIC ENGINEERING

Titania In folklore, queen of the fairies and wife of OBERON. In the writing of OVID she represents DIANA at the head of her nymphs. In Shakespeare's *A Midsummer Night's Dream* she quarrels with her husband over a changeling boy.

Titanic British passenger liner that sank on her maiden voyage (14–15 April 1912). The largest vessel of her time, she was sailing from Southampton to New York when she struck an iceberg in the N Atlantic. About 1,500 people were drowned. The disaster resulted in international agreements on greater safety precautions at sea. In 1985 the wreck of the *Titanic* was located on the ocean floor.

titanium (symbol Ti) Lustrous, silver-grey, metallic element, one of the TRANSITION ELEMENTS. A common element, it is found in many minerals, chief sources being ilmenite and RUTILE. Resistant to corrosion and heat, it is used in steels and other alloys, especially in aircraft, spacecraft and guided missiles where strength must be combined with lightness. Properties: at.no. 22; r.a.m. 47.90; r.d. 4.54; m.p. 1,660°C (3,020°F); b.p. 3,287°C (5,949°F); most common isotope Ti⁴⁸ (73.94%).

Titans In Greek mythology, 12 gods and goddesses who were the sons and daughters of URANUS and GAIA. They preceded the Olympians who, led by Zeus, overthrew them.

tithe Tax of one-tenth of income levied to support a religious institution. Tithes were prescribed in the Old Testament and were a major source of church income in medieval Europe. They were generally abandoned in favour of other sources of income in the 19th century.

▼ tides The daily rise and fall of the ocean's tides are the result of the gravitational pull of the Moon and that of the Sun, though the effect of the latter is only 46.6% as strong as that of the Moon. The effect is greatest on the hemisphere facing the Moon and causes a tidal "bulge". When the Sun, Earth and Moon are in line, tide-raising forces are at a maximum and Spring tides occur; high tide reaches the highest values, and low tide falls to low levels. When lunar and solar forces are least coincidental, with the Sun and Moon at an angle (near the Moon's first and third quarters), Neap tides occur, which have a small tidal range.

▶ toad The Surinam toad (*Pipa pipa*) lays 3—10 eggs, which the male fertilizes and presses into the back of the female; her skin swells up, enveloping the eggs within cysts. After carrying her offspring for about 80 days of development, the female moults and the young, miniature toads are released into the water.

Titian (1485–1576) (Tiziano Vecellio) Venetian painter. He trained with BELLINI and GIORGIONE. Titian evolved a brilliant, worldly style demonstrated in three magnificent altarpieces, *The Assumption, Pesaro* and *St Peter Martyr*. He combined the balance of High RENAISSANCE composition with a new dynamism, which heralded the BAROQUE. He liked to use vivid, simple colours and often silhouetted dark forms against a light background. Between 1518 and 1523 he produced some of his finest mythological paintings, the *Worship of Venus, Bacchanal* and *Bacchus and Ariadne*. In the 1540s his paintings were in a vigorous type of MANNERISM. His last work was the powerful *Pietà*, which he designed for his own tomb. Titian's oil technique was freer and more expressive than any earlier style, and he had a revolutionary influence on later artists.

Titicaca Lake in the Andes on the Peru-Bolivia border, draining s through the River Desaguader into Lake Poopó. At an altitude of 3,810m (12,500ft), it is the world's highest navigable body of water. The constant supply of water has enabled the region to grow crops since ancient times. The lake is home to giant edible frogs and is famed for its totora reeds, from which the Uru make their floating island homes and fishing rafts. Area: 8,290sq km (3,200sq mi); max. depth 280m (920ft).

titles Formerly hereditary designations corresponding to rank within a well-defined social hierarchy under an emperor or monarch. Modern-day hereditary titles may still be passed on, but most titles are conferred by a head of state for the lifetime of the recipient only. In the English-speaking world, formal hereditary titles are (in descending order of consequence): king, prince, duke, earl, viscount, baron.

titmouse (tit, chickadee) Small, stubby-bodied and large-headed bird of open woodlands and wooded parks of the Northern Hemisphere and Africa. Most true titmice nest in self-drilled holes or abandoned woodpecker holes. Family Paridae; genus *Parus*. The long-tailed titmice and bush tits of Eurasia and w North America are larger and build closed, often hanging, nests. Subfamily Aegithalinae.

Tito, Josip Broz (1892-1980) Yugoslav statesman. As a Croatian soldier in the Austro-Hungarian army, he was captured by the Russians (1915) but released by the Bolsheviks in 1917. He helped to organize the Yugoslav Communist Party and adopted the name Tito in 1934. He led the successful campaign of the Partisans against the Germans in Yugoslavia during World War 2. In 1945 he established a communist government, holding the office of prime minister (1945-53) and thereafter president, although virtually a dictator. Soviet efforts to control Yugoslavia led to a split between the two countries in 1948. At home, Tito sought to balance the deep ethnic and religious divisions in Yugoslavia and to develop an economic model of communist "self-management". Abroad, he became an influential leader of the Non-Aligned Movement. As later events confirmed, his greatest achievement was to hold the Yugoslavian federation together. titration Method used in analytical chemistry to determine the concentration of a compound in a solution by measuring the amount needed to complete a reaction with another compound. A solution of known concentration is added in measured amounts to a liquid of unknown concentration until the

reaction is complete. The volume added enables the unknown concentration to be calculated.

Titus (AD 39–81) Roman emperor (r.79–81). Elder son of VESPASIAN, he campaigned in Britain and Germany and captured and destroyed Jerusalem in 70 after a Jewish revolt. As emperor, he stopped persecutions for treason, built lavish baths and gained great popularity.

Tlingit NATIVE AMERICAN people of the SE coast of Alaska. Famous for their totem poles (featuring stylized forms of local wildlife), they rely economically on fishing, tourism and government aid.

TNT (2,4,6–trinitrotoluene) Explosive organic compound $(C_7H_5N_3O_6)$ made from TOLUENE by using sulphuric and nitric acids. Its resistance to shock (requiring a detonator to set it off) makes it one of the safest high explosives.

toad Any of numerous species of tail-less amphibians found throughout the world, except Australasia. Most are short and rotund and move with a crawling or hopping gait. Toads are differentiated from frogs by having a rougher, bumpier skin and a rounder body with shorter legs. Length: 2–25cm (1–10in). Order Anura; family Bufonidae. See also TADPOLE toadstool Popular name for the fruiting body of a FUNGUS of the class Basidiomycetae. The name usually refers to inedible species and describes the stool-like appearance of the reproductive organ. It consists of a stem and a cap, on which the spores are borne on gills or in tubes.

tobacco Herb native to the Americas but cultivated throughout the world for its leaves, which are dried and smoked. It has large leaves with no stalk, and white, pink, or red starshaped flowers. *Nicotiana tabacum* is the principal cultivated species. Seeds were brought to Europe in about 1520–30. Settlers in Virginia obtained seeds from the Spanish colonies (1612) and soon tobacco was the major crop of the Virginia colony and America's first export. Leaves are prepared for smoking by curing (drying) and then ageing. Family Solanaceae (NIGHTSHADE family). Height: 0.6– 2m (2–6ft).

Tobago See Trinidad and Tobago

Tocqueville, Alexis de (1805–59) French historian. Sent on a fact-finding tour to the USA by the French government, he produced *Of Democracy in America* (1835), the first indepth study of the US political system. His later work includes *L'Ancien Régime et la Révolution* (1856).

▲ Tito A forceful and charismatic personality, Tito ruled Yugoslavia from 1945 until his death in 1980. By maintaining tight, dictatorial control domestically, he was able to hold the country's various nationalist groups in check. He encouraged decentralization and worker participation in the economy, liberal policies for a Communist country. Internationally, he pursued an independent foreign policy, keeping his distance from the Soviet Union.

Togo Small republic in w Africa, the capital is LOMÉ. It is divided geographically into four regions. The coastal plain is sandy: N of the coast is an area of fertile, clay soil. North again is the Mono Tableland, which reaches an altitude of c.450m (1,500ft), and is drained by the Mono River. The Atakora Mountains are the fourth region. The vegetation is mainly open grassland. The historic region of Togoland comprised what is now the Republic of Togo and w Ghana. From the 17th-19th centuries, the Ashanti raided Togoland, seizing the indigenous inhabitants, the Ewe, and selling them to Europeans as slaves. As a German protectorate from 1884, it developed economically and Lomé was built. At the start of World War 1, Britain and France captured Togoland from Germany. In 1922 it was divided into two mandates, which, in 1942, became UN trust territories. In 1957 British Togoland became part of Ghana. In 1960 French Togoland became independent as the Republic of Togo. In 1961 Slyvanus Olympio became the first president, but was assassinated in 1963. Nicolas Grunitzky became president, but he too was overthrown in a coup in 1967. Ghansimgbe Eyadéma, leader of the military coup, became president in 1972. The constitution of 1979 confirmed Togo as a single-party state, the sole legal party being the Rassemblement du peuple togolais (RPT). Re-elected in 1972 and 1986, Eyadéma was forced to resign in 1991 after pro-democracy riots. Kokou Koffigoh was elected prime minister. Unrest continued with troops loyal to Eyadéma attempting to overthrow Koffigoh. In 1992 a new multi-party constitution was introduced and Evadéma regained some power. In 1993 a rigged election, boycotted by opposition parties, was won by Eyadéma. Elections to the National Assembly were won by an opposition alliance, with whom Eyadéma formed a coalition government in 1994. Most of the population earn a living off the land, with cocoa, coffee and cotton the chief cash crops and palm oil and phosphates the principal exports. Manufacturing is on a small scale.

Tokugawa Japanese family that controlled Japan through the SHŌGUN (1603-1867). The Tokugawa shōgunate was established by Ieyasu Tokugawa (1543-1616) who completed the unification of Japan. The Tokugawa ruled through the provincial nobility (the Daimyo) and they controlled much of the country's wealth and farmland as well as controlling the emperor and priests. They banned Christianity and Western trade and isolated Japan from the rest of the world. The regime declined during the 19th century as their isolationist policy began to crack under Western pressure. The last Tokugawa shōgun was overthrown before the MEIJI RESTORATION (1867). Tokyo (Jap. eastern capital) Capital of Japan, on E central Honshū, at the head of Tokyo Bay. The modern city is divided into distinct districts: Kasumigaseki, Japan's administrative centre; Marunouchi, its commercial centre; Ginza, its shopping and cultural centre; the w shore of Tokyo Bay (including Kawasaki and Yokohama seaport), its industrial centre. Modern Tokyo also serves as the country's educational centre with over 100 universities. Founded in the 12th century as EDO, it became capital of the Tokugawa shōgunate in 1603. In 1868 the Japanese Reformation re-established imperial power, and the last shogun surrendered Edo Castle. Emperor Meiji renamed the city Tokyo and it replaced Kyōto as the capital of Japan. In 1923 an earthquake and subsequent fire claimed over 150,000 lives and necessitated the city's reconstruction; in 1944-45 intensive US bombing destroyed over half the city, and another modernization and restoration programme began. Industries: electronic equipment, cameras, automobile manufacture, metals, chemicals, textiles. Pop. (1994) 7,894,000.

Toledo Capital of Toledo province, in Castilla-La Mancha, on the River Tagus, central Spain. In 1031 the Moors made it the capital of an independent kingdom. The city was fortified and acquired its enduring reputation for quality sword-making. Toledo flourished as a multi-denominational city, with Mudéjar-style synagogues, mosques and churches. In the 16th century, it became the spiritual capital of Catholic Spain and the headquarters of the Spanish Inquisition; Jews and Muslims suffered persecution and the synagogues were converted to churches. During the Spanish CtvII. War the city was under a Loyalist siege (1936). Pop. (1991) 59,563.

Tolkien, J.R.R. (John Ronald Reuel) (1892–1973) English scholar and novelist. A respected academic, Tolkien is now remembered chiefly for the imaginative epic trilogy, *The Lord of the Rings* (1954–55). Both his prose style and the world of fantasy he created are reminiscent of the Norse SAGAS and Anglo-Saxon poetry that he taught at Oxford University.

Tolpuddle Martyrs Name given to six British farm labourers in Dorset, s England, who were sentenced to transportation for forming a trade union (1834). The government was worried by the growth of organized labour, but as unions were not illegal, the Dorset men were charged with taking a seditious oath. After a public outcry, they were pardoned in 1836.

Tolstoy, Leo Nikolaievich, Count (1828–1910) Russian novelist and philosopher. While serving in the army, he took part in the defence of Sebastopol during the CRIMEAN WAR (1853–56); his descriptions of this appeared in the journal *Contemporary* and were noted for their unvarnished picture of the conflict. Having left the army, he wrote his masterpieces *War and Peace* (1865–69) and *Anna Karenina* (1875–77). Tolstoy is regarded as one of the world's greatest novelists.

Toltec (Nuhuatl, master-builder) Ancient Native American civilization, whose capital was Tollán (Tula), Mexico. The Toltec were the dominant people in the region from AD 900 to 1200. Their architecture is characterized by pyramid building. Although theirs was considered a polytheistic culture, images of QUETZALCÓATL predominate. In the 12th century the civilization was gradually supplanted by the AZTEC.

toluene (methylbenzene) Aromatic hydrocarbon ($C_6H_5CH_3$) derived from coal tar and petroleum. It is a colourless, flammable liquid widely used as an industrial solvent and in aircraft and motor fuels. Toluene is also used in the manufacture of TNT. Properties: r.d. 0.87; m.p. $-94.5^{\circ}C$ ($-138.1^{\circ}F$); b.p. $110.7^{\circ}C$ ($231.3^{\circ}F$).

tomato Fruit plant native to the Americas. The plant was cultivated in Europe as early as 1544. It was not eaten until the 16th century because it was believed to be poisonous. Species *Lycopersicum esculentum*. The small cherry tomato is a variety (*L.e. cerasiforme*). Family Solanaceae.

Tomkins, Thomas (1572–1656) Welsh composer. Although employed as organist at Worcester Cathedral (1596–1646), he spent much time in London. He wrote much instrumental music and over 100 anthems; his skill is most evident in his MADRIGALS, particularly *When David heard*.

tomography Technique of X-RAY photography in which details of only a single slice or plane of body tissue are shown. **tonality** Harmonic system that underpins most Western music from the 17th century to the 20th, using the twelve major and minor scales. The notes of the scale, and their corresponding chords and harmonies, have their own hierarchy around the central KEY note.

tone poem See SYMPHONIC POEM

Tonga (Friendly Islands) South Pacific island kingdom, c.2,200km (1,370mi) NE of New Zealand. The archipelago consists of nearly 170 islands in five administrative groups. Only 36 of the islands are inhabited. They are mainly coral atolls, but the w group are volcanic, with some active craters. The largest island is Tongatapu, the seat of the capital, NUKUALOFA, and home to 66% of the population. The N islands were discovered by Europeans in 1616, and the rest by Abel Tasman in 1643. During the 19th century, British missionaries converted the indigenous population to Christianity. In 1900 Tonga became a British protectorate. In 1970 the country achieved independence. The economy is dominated by agriculture, the chief crops are yams, tapioca and fish. Area: 748sq km (289sq mi). Pop. (1991) 103,000.

tongue Muscular organ usually rooted to the floor of the mouth. The tongue contains the TASTE buds and helps to move food around the mouth for chewing and swallowing; animals also use it for lapping fluids and for grooming. In human beings the tongue is vital for the production of speech. See also SENSES

Tonkin (Tongking) Historical region of N VIETNAM; the capital was HANOI. It was ruled by the Chinese (111 BC – AD 939), later becoming independent. In 1801 it was united with ANNAM. In 1883 it became part of the French protectorate of INDOCHINA.

▲ Tolstoy Born into a noble family, as a young man Tolstoy lived a dissolute life in Moscow before joining the army. He did much of his most renowned work before 1879, when he underwent a spiritual crisis culminating in his conversion to a rationalist Christian doctrine. He insisted on living by his new religious principles and renounced his fortune to live as a poor peasant (although remaining for a time in his family home).

▲ tobacco Tobacco is produced mainly from the plant Nicotiana tabacum, which is cultivated throughout the world. The leaves are removed from the plant and dried. Native Americans smoked tobacco leaves and used them medicinally long before Europeans arrived in the New World.

▲ tortoise The North American box tortoise (*Terrapene carolina*) spends most of its time on land. As with other tortoises, it has a massive bony shell made of plates of keratin that are fused to the backbone and ribs. It can pull back its head under the shell when danger threatens.

During World War 2 it was occupied by the Japanese. After the war, France tried to re-established control but was defeated at DIEN BIEN PHU in 1954. Tonkin became part of North Vietnam. **Tonkin Gulf Resolution** (1964) Resolution of the US Congress authorizing the president to take military action in Vietnam in response to attacks on US forces. It was passed at the urging of President Lyndon B. JOHNSON after US destroyers were allegedly attacked by North Vietnamese torpedo boats in the Gulf of Tonkin. See also VIETNAM WAR

tonsillitis Acute or chronic inflammation of the tonsils caused by bacterial or viral infection. It is signalled by fever, sore throat and difficulty in swallowing. Chronic tonsillitis is often treated by surgical removal of the TONSILS (tonsillectomy).

tonsils Two masses of LYMPH tissue located at the back of the throat. They have a pitted surface that easily becomes infected (TONSILLITIS).

tools In archaeology, objects used by early people to assist them to shape their environment. The first tools were probably unshaped stones, sticks or bones. The techniques used for sharpening flints, in particular, are used to distinguish early cultures. Metal was originally introduced for ornament, with native copper the first metal to be worked, $c.6000 \, \mathrm{BC}$.

tooth See TEETH

topaz Transparent, glassy mineral, aluminium fluosilicate, Al₂SiO₄(F,OH)₂, found in pegmatites. Its crystals are orthorhombic system columnar prisms. Topaz is colourless, white, blue or yellow; some large crystals are of gem quality. Hardness 8; s.g. 3.5.

tope Small shark that lives in British waters. It has a greybrown body and feeds near the bottom on small fish. Length: to 2m (6.5ft). Family Carcharinidae; species *Galeorhinus galeus*. Topeka State capital of Kansas, USA, on the Kansas River, 90km (55mi) w of Kansas City. It was founded in 1854 by settlers from New England and became the state capital in 1861. Topeka is a major transport centre for cattle and wheat. The Menninger Clinic, world famous for its treatment of mental illness, is located in the city. Industries: printing, rubber goods, steel products, footwear. Pop. (1992) 120,257.

topiary Practice of trimming densely leaved evergreen shrubs and trees into decorative artificial shapes.

topology Branch of mathematics concerned with those properties of geometric figures that remain unchanged after a continuous deformation process such as squeezing, stretching or twisting. The number of boundaries of a surface is such a property. Any plane closed shape (i.e. any line that eventually comes back to its beginning, all on a single plane) is topologically equivalent to a circle; a cube, a solid cone and a solid cylinder are topologically equivalent to a sphere.

Torah (Hebrew, law) Hebrew name for the PENTATEUCH, the first five books of the Old Testament. The Torah is the body of written Jewish laws contained within these five books. The Torah also describes the complete Jewish Bible.

tornado Funnel-shaped, violently rotating storm extending downwards from the cumulonimbus cloud in which it forms. At the ground its diameter may be only about 100m (310ft). Rotational wind speeds range from 160–480km/h (100–300mph). Tornadoes occur in deep low pressure areas, associated with FRONTS or other instabilities. They occur particularly in E USA.

Toronto Capital of Ontario province and Canada's largest city, on the N shore of Lake Ontario. An inland port at the mouth of the Don River, it is Canada's main banking, financial and manufacturing centre. The site was first visited in 1615 by the French explorer Étienne Brulé. In 1787 the British purchased the site from Native Americans and the settlement of York was founded in 1793. During the WAR OF 1812 the city was twice captured by US troops. In 1834 it was renamed Toronto (meeting place) and it became the capital of Ontario province in 1867. Its development as a major distribution centre was spurred by the 1959 opening of the ST LAWRENCE SEAWAY. Toronto produces over half of all Canada's manufacturing products. Industries: electrical equipment, brewing, printing and publishing, iron and steel, meat packing, aircraft and motor vehicle manufacture. Pop. (1991) 635,395 (metropolitan area 3,893,046).

torpedo Self-propelled underwater missile used by submarines, small surface warships and aircraft to destroy enemy vessels. Modern torpedoes may be launched by rocket boosters and often have internal electronic equipment for guiding the missile to the target.

torpedo ray See RAY

torque Turning effect of a force. A TURBINE produces a torque on its rotating shaft to turn a generator. The output of a rotary engine, such as the familiar four-stroke engine or an electric motor, is rated by the torque it can develop. The unit of measurement is Nm (newton metre).

Torquemada, Tomás de (1420–98) Spanish churchman and grand inquisitor. A DOMINICAN priest and confessor to King FERDINAND V and Queen Isabella I, he was appointed head of the Spanish INQUISITION (1483). He was noted for the severity of his judgments and the harshness of his punishments. Torricelli, Evangelista (1608–47) Italian physicist. Assistant and secretary to Galileo, he is credited with the first man-made Vacuum (the Torricellian vacuum) and the invention of the mercury BAROMETER (1643).

tort In British law, wrongful act or omission that can give rise to a civil action at law, other than concerning breach of contract. The law of tort includes negligence, libel, slander, trespass, false imprisonment and nuisance.

Tortelier, Paul (1914–90) French cellist and composer. His career as one of the world's leading solo cellists began in 1947. His son Yan Pascal Tortelier (b.1947) is a noted conductor.

tortoise Terrestrial or freshwater reptile of the order Chelonia. All tortoises are heavily armoured and enclosed within a high, domed, bony, box-like structure called a carapace (commonly shell). When disturbed, tortoises pull their scaly legs, head and tail into the shelter of the shell. They live in tropical and subtropical regions, and hibernate in temperate countries. They are slow movers, feed almost entirely on plants and live to a great age. Length: usually to 30cm (1ft). A giant species, up to 1.9m (5ft) long, lives in the GALÁPAGOS ISLANDS.

torture Infliction of pain on a person to extract information, a confession or to indulge sadistic inclinations. It has been practised in many cultures. Until the 18th century in Europe, it was considered a legitimate means of extracting a legal confession to a crime. The 1949 Geneva Convention included a clause against torture. Despite this, the use of torture has continued. There has been increasing recognition of "psychological torture", in which disorientation, fear and loss of sleep and self-respect are used instead of or in addition to the application of physical pain.

Tory Party Alternative name for the British CONSERVATIVE PARTY. The name Tory, originally meaning an Irish bandit, was applied insultingly in the 1680s to those who did not oppose a Catholic monarchy. It became the name of the political party that represented the interests of landowners and the Anglican Church in the 18th century. The name Conservative was adopted in 1832, but the earlier name has continued to be used.

Toscanini, Arturo (1867–1957) Italian conductor who became music director at LA SCALA, Milan, in 1898. He conducted the New York Philharmonic Orchestra (1928–36) and founded the NBC Symphony Orchestra in New York in 1937. His interpretations were marked by intense emotionalism and musical subtlety.

▶ toucan The New World counterparts of the hornbills, there are some 35 species of toucans in the forest of tropical America. The large, bright bill of the Toco toucan (*Ramphastos toco*) is typical of the family and is used to reach fruit.

totalitarianism Form of government in which the state tries to acquire total control of every aspect of social and individual activity or thought, by means of controlling the mass media, suppression of opposition and the often violent use of the police or army. The term arose in the 1920s to describe Italian FASCISM and has since been applied to Nazi Germany, the Soviet Union under Stalin and many other states.

totemism Complex collection of ideas held by certain primitive societies about the relationships between human beings and the animals or plants around them. The natural objects or people with which many tribal societies believe they have a kinship or mystical relationship are called totems. Members of a totem group are prohibited from marrying others of the same group and from killing or eating their totem. Elaborate, often secret, rituals form an important part of totemistic behaviour.

totem pole Carved and painted wooden column erected by the Native Americans of the Pacific Coast of the USA and Canada. They are carved with stylized representations of real and mythical animals and men. Their function is closer to that of heraldic crests than of religious symbols. They are usually erected as roof supports, as doorways, as symbols of greeting or as mortuary poles or grave-markers.

toucan Any of 35 species of colourful, gregarious birds of the forests of tropical America, characterized by a large, colourful bill. The plumage is generally red, yellow, blue, black or orange. It feeds on fruit and berries, which may be regurgitated to feed the young. Length: 60cm (2ft). Family Ramphastidae. **touch** One of the five SENSES, functioning by means of specialized nerve receptors in the skin.

Toulon Capital of Var département, on the Mediterranean coast, SE France. Toulon is France's leading naval base and its second-largest Mediterranean port after Marseilles. Originally known as Telo Martius, the city was a Roman naval base and an important port of embarkation for the Crusaders. During the 17th century, Louis XIV and Cardinal Richelieu improved the port's fortifications. In 1942 the French navy was scuttled there to prevent German capture. Industries: shipbuilding and naval repairs. Pop. (1990) 167.619.

Toulouse City on the River Garonne, s France, capital of Haute-Garonne département. Canals connect the city, the fourth-biggest in France, to both the Mediterranean Sea and the Atlantic Ocean. The capital of the Visigoths in the 5th century, it became part of the French crown lands in 1271. It is the centre of France's aeronautic industry. Other industries: paper, textiles, chemicals, fertilizers, armaments. Pop. (1990) 358,688.

Toulouse-Lautrec, Henri Marie Raymond de (1864–1901) French painter and graphic artist, one of the greatest painters of Parisian low life. He chose a career in painting after a childhood accident left his legs deformed. At first he depicted sporting subjects, but in around 1888 he began to illustrate the theatres, cabarets, music-halls, cafés and brothels of Paris. He was profoundly influenced by DEGAS and drew inspiration from GAUGUIN and Japanese wood-block prints. His prints depict powerfully simplified forms; their impact helped to establish the poster as a respected art form.

Tour de France Premier professional road cycling race in Europe. Raced over three weeks from the end of June, it travels over all types of terrain in a series of timed stages. It mostly circles France, occasionally venturing into neighbouring states, and ends in Paris.

Tourette's syndrome (Gilles de la Tourette's syndrome) Rare disorder of movement. It is a lifelong affliction that starts in childhood with tics and involuntary grimaces. Involuntary sounds also frequently occur. Its cause is unknown.

tourmaline Silicate mineral, sodium or calcium aluminium borosilicate, found in IGNEOUS and METAMORPHIC rocks. Its crystals are hexagonal system and glassy, either opaque or transparent. Some are prized as gems. Hardness 7.5; s.g. 3.1.

Tours City on a triangle of land between the Loire and Cher rivers, w central France, capital of Indre-et-Loire département. It was the seat of the French government in 1870 during the siege of Paris. A large wine market, Tours has food processing, electronic and pharmaceutical industries. Pop. (1990) 129,509.

Toussaint L'Ouverture, Pierre Dominique

(1744-1803) Black Haitian independence leader. He took

part in the slave revolt in Haiti in 1790, joined the Spaniards when they attacked the French in 1793, but fought for the French (1794) when they promised to abolish slavery. He virtually controlled the whole island of HISPANIOLA by 1801. In 1802 Napoleon sought to restore French control. Toussaint was forced to surrender and died a prisoner in France. Haiti achieved independence the following year.

Tower Bridge Cantilever bridge over the River Thames in London, built by Sir Horace Jones between 1886 and 1894. The bridge has a pseudo-Gothic tower at each side of the river and a double-leaf mechanism that opens to provide a 76m (250ft) gap.

Tower of London English royal castle. It was begun by, William the Conqueror in 1078 and was extended by later monarchs. It served various functions throughout the centuries, as residence, arsenal, prison and museum. It is associated especially with the imprisonment and execution (on Tower Hill) of traitors.

Townes, Charles Hard (1915–95) US physicist. He invented the first operational MASER in 1953, for which he shared the 1964 Nobel Prize for physics with Alexsandr PROKHOROV and Nikolai BASOV. The MICHELSON-Morley experiment was accurately confirmed with the aid of masers. **toxicology** Study of poisonous substances and their effects on living things.

toxic shock syndrome Potentially fatal condition in which there is a dangerous drop in blood pressure and rapid onset of fever, diarrhoea, vomiting and muscular pains. It is caused by SEPTICAEMIA (blood poisoning) arising from toxins put out by bacteria that normally reside in the body without causing harm. The syndrome is most often seen in young women using tampons during menstruation.

toxin Poisonous substance produced by a living organism. The unpleasant symptoms of many bacterial diseases are due to the release of toxins into the body by the BACTERIA. Many MOULDS, some larger FUNGI and seeds of some higher plants produce toxins. The venom of many snakes contains powerful toxins.

toxoplasmosis Disease caused by the protozoan *Toxoplasma gondii*, which is transmitted from animals to human beings. It produces symptoms that are generally mild and flulike in adults, but it can damage the nervous system, eyes and internal organs.

trace element Chemical elements that are essential to life but normally obtainable from the diet only in small quantities. They are essential to the reactions of ENZYMES and HORMONES. **tracer, radioactive** Radioactive substance that is introduced into the body so that its progress can be tracked by special diagnostic equipment. This technique may help in the diagnosis of conditions such as thyroid disease.

trachea (windpipe) Airway that extends from the larynx to about the middle of the sternum (breastbone). Reinforced with rings of CARTILAGE, it is lined with hair-like CILIA that prevent dirt and other substances from entering the lungs.

▲ Tower Bridge Like other moveable bridges, Tower Bridge in London has two cantilevered arms, each weighing more than 1,100 tonnes. Despite their weight, they can be entirely raised in less than one minute. Famous throughout the world, it is one of the city's most popular tourist attractions. There is a museum dedicated to the Bridge in the top gallery.

tracheophyte In certain classification systems, any VASCU-LAR PLANT of the phylum Tracheophyta. Within this phylum are: psilopsids (leafless, rootless primitive forms, such as whisk fern); sphenopsids (such as HORSETAIL); lycopsids (such as CLUB MOSS); pteropsids (such as FERN); GYM-NOSPERMS and flowering plants.

tracheotomy (tracheostomy) Surgical procedure in which an incision is made through the skin into the TRACHEA to allow insertion of a tube to facilitate breathing. It is done either to bypass any disease or damage in the trachea or to safeguard the airway if a patient has to spend a long time on a mechanical ventilator.

trachoma Chronic eye infection caused by the microorganism Chlamydia trachomatis, characterized by inflammation of the cornea with the formation of pus. A disease of dry, tropical regions, it is the major cause of blindness in the developing world.

Tractarianism See Oxford Movement

tractor Four-wheeled or tracked vehicle for moving and operating heavy implements. Tractors are used mostly in farming and construction. The first tractors were built in the 1870s. Modern tractors have petrol or diesel engines and can haul and power a wide range of implements, including hay balers, crop sprayers and mowing machines.

Tracy, Spencer (1900-67) US film actor, renowned for his intelligent, sincere character portrayals. Making his debut in 1930, he soon became a leading Hollywood actor, appearing in nearly 80 films, of which nine, including Adam's Rib (1949), Pat and Mike (1957) and his last film, Guess Who's Coming to Dinner (1967), were with his on- and off-screen partner, Katharine HEPBURN. He won Academy Awards for Captains Courageous (1937) and Boys Town (1938).

trademark Distinguishing mark, such as a name, symbol or word, attached to goods, which identifies them as made or sold by a particular manufacturer. A trademark must be registered at the patent office to establish an exclusive right to it.

Trades Union Congress (TUC) Permanent association of UK trade unions. The TUC was founded in 1868 to promote trade union principles. Each year it holds an annual assembly of delegates who discuss common problems. It had more than 8,000,000 members in the mid-1990s.

trade union Group of workers organized for the purpose of improving wages and conditions of work. The first trade unions were founded in Britain around the time of the INDUS-TRIAL REVOLUTION. Although some craft and agricultural unions developed before industrialization, the growth of trade unionism paralleled the growth of industry. Trade unions were given restricted legality in Britain in 1825. In 1871 the Trades Union Act put the unions on a firm legal basis, and over the next 150 years, the movement grew steadily. Their rights were progressively curbed in the 1980s under a series of laws sponsored by the Conservative government under Margaret THATCHER. In the USA, the labour unions and their members

▼ trade winds The map shows the direction of the prevailing routes of various explorers who made use of the July winds. Sailors exploring in the 15th and 16th centuries had to find out for themselves how the winds in different zones of the sea change with the season, and chart their

trade winds in July and the

course accordingly

have generally accepted the capitalist system. The movement had become firmly established by 1886 with the founding of the American Federation of Labor (AFL). The AFL primarily represented skilled workers, and it was not until the creation of the Congress of Industrial Organizations (CIO) in 1930 that unskilled labour gained some form of representation. The two organizations merged in 1955 to form the AMERICAN FED-ERATION OF LABOR AND CONGRESS OF INDUSTRIAL ORGANIZA-TIONS (AFL-CIO). See also TOLPUDDLE MARTYRS

trade winds Steady winds that blow westwards towards the equator from subtropical high pressure zones between latitudes 30° and 40° N and S.

Trafalgar, Battle of (1805) British naval victory over the French and Spanish fleets off Cape Trafalgar, Spain. It ended NAPOLEON I's plans for an invasion of England. The victory was secured by the skilful tactics of the British commander. Lord Nelson, who was killed in the battle.

tracedy Form of drama in which a noble hero (the protagonist) meets a fate inherent in the drama's action. Oedipus Rex by SOPHOCLES is an early example, which was unmatched until the tragedies of Christopher MARLOWE. ARISTOTLE's Poetics systematized tragedy and introduced such ideas as anagnorisis (recognition) and catharsis (the purging of pity and terror in the spectator). See also AESCHYLUS; EURIPIDES; GREEK DRAMA

Trajan (53–117) Roman emperor (98–117), b. Spain. He distinguished himself as a general and administrator and was made junior co-emperor by Nerva in 97. With army support, he became emperor on Nerva's death. He conducted major campaigns in DACIA (101-102, 105-106) and against the people of Parthia (113-117), enlarging the Roman empire to

tram Passenger carriage that runs on rails, which are usually sunk into the road. Horse-drawn trams first appeared in New York in 1832. Some later trams were powered by steam locomotives. Trams with electric motors, supplied by overhead cables, became common in the early 1900s. Motor buses and trolleybuses (which are not confined to rails) steadily became more popular, although many European cities retained tramway systems. With increasing concern over pollution, electric trams are attracting renewed interest.

trampolining Leisure pursuit and competitive sport that involves the performance of acrobatic manoeuvres while bouncing on a canvas sheet stretched across a tightly sprung

tranquillizer Drugs prescribed to reduce anxiety or tension and generally for their calming effect. They are used to control the symptoms of severe mental disturbance, such as schizophrenia or manic depression. They are also prescribed to relieve depression. Prolonged use of tranquillizers can produce a range of unwanted side-effects.

Transcaucasia Former Soviet Republic, corresponding to the three constituent republics ARMENIA, AZERBAIJAN and GEORGIA. It was created in 1918 after the Russian Revolu-TION. It was re-formed in 1922 and granted full republic status in 1924. Georgia, Azerbaijan and Armenia were re-established as separate republics in 1936 and became independent nations on the break-up of the Soviet Union in 1991.

transcendentalism School of philosophy that traced its origin to the idealism of Immanuel KANT. It was concerned not with objects, but with our mode of knowing objects. It spread from Germany to England, where Samuel COLERIDGE and Thomas CARLYLE came under its influence. In the mid-19th century it spread to the USA, where it was propagated by a literary circle based in Concord, Massachusetts. In general, it emphasized individual (as opposed to collective) moral and spiritual responsibilities and rejected materialism, returning to nature for spiritual guidance.

transcendental meditation (TM) Meditation technique based partly on Hindu practice and rediscovered in the 20th century by an Indian spiritual teacher, Guru Dev (d.1958). After his death, his pupil the Maharishi Mahesh Yogi introduced the technique to the West. Those who practise TM concentrate on and repeat a MANTRA over and over in order to become relaxed and achieve self-understanding. In physiological terms, TM decreases oxygen consumption and heart rate and increases skin resistance and alpha brain waves, yielding a relaxed mental state differing from sleep or hypnosis.

transducer Device for converting any nonelectrical signal, such as sound or light, into an electrical signal, and vice versa. Examples include microphones, loudspeakers and various measuring instruments used in ACOUSTICS.

transformer Device for converting alternating current at one voltage to another voltage at the same frequency. It consists of two coils of wire coupled together magnetically. The input current is fed to one coil (the primary), the output being taken from the other coil (the secondary).

transform fault Special class of strike-slip fault characteristic of mid-ocean ridges. Because of the transform faults, which are at right-angles to the ridge itself, the MID-ATLANTIC RIDGE does not run in a straight line but in offset steps.

transfusion, blood See BLOOD TRANSFUSION

transhumance Seasonal moving of livestock from one region to another. It occurs in societies that live in zones with extensive climatic changes, such as in the mountainous terrain of the Arctic regions or the deserts of Central Africa.

transistor Electronic device made of SEMICONDUCTOR material that can amplify electrical signals. Transistors were first developed in 1948 by John BARDEEN, Walter BRATTAIN and William SHOCKLEY, making possible many advances in technology, especially in computers, portable radios and televisions, satellites, industrial control systems and navigation.

transition element Metallic elements that have incomplete inner electron shells. They are characterized by variable valencies (combining power) and the formation of coloured ions. *See also* PERIODIC TABLE

translocation In VASCULAR PLANTS, the movement of food materials in solution through the tissues from one part of the plant to another.

transmigration of souls Belief that the soul is reborn in one or more successive mortal bodies; a form of REINCARNATION. A tenet of Asian religions such as BUDDHISM, it was also accepted by the followers of PYTHAGORAS and Orphism in Greece during the 6th century BC. It is still common today in tribal religions such as that of the South African Venda.

transpiration In plants, the loss of moisture as water vapour from leaf surfaces or other plant parts. Most of the water entering plant roots is lost by transpiration. The process is speeded up in light, warm and dry conditions. The flow of water from the roots to the STOMATA is called the transpiration stream.

transplant Surgical operation to introduce organ or tissue from one person (the donor) to another (the recipient); it may also refer to the transfer of tissues from one part of the body to another, as in grafting of skin or bone. Major transplants are performed to save the lives of patients facing death from end-stage organ disease. Organs routinely transplanted include the kidneys, heart, lungs, liver and pancreas. Experimental work continues on some other procedures, including small bowel grafting. Many other tissues are commonly grafted, including heart valves, bone and bone marrow. The oldest transplant procedure is corneal grafting, undertaken to restore the sight of one or both eyes. Most transplant material is acquired from dead people, although kidneys, part of the liver, bone marrow and corneas may be taken from living donors.

transsexuality Act of permanently changing one's sex, or the desire to do so. It may be accomplished partly through hormone treatment or through surgery, and in some countries the change can be accompanied by a legal change of status.

Trans-Siberian Railway Russian railway from Moscow to Vladivostok. The world's longest railway, the major part, E from Chelyabinsk, was built in 1891–1905, giving Russia access to the Pacific via a link with the Chinese Eastern Railway in Manchuria. The total length is c.9,000km (5,750mi). transubstantiation Belief accepted by the Roman Catholic Church that, during the prayer of consecration at the MASS (the EUCHARIST), the "substance" of the bread and wine is changed into the "substance" of the body and blood of JESUS CHRIST, while the "accidents" (the outward forms of bread and wine) remain unchanged. The doctrine was defined at the LATERAN COUNCIL of 1215. The definition involving "substance" and "accidents" was rejected by the architects of the REFORMATION.

transuranic element (transuranium elements) Those elements with atomic numbers higher than that of URANIUM (92), the best known of which are members of the ACTINIDE SERIES (atomic numbers 89 to 103). All transuranic elements are radioactive. Only NEPTUNIUM and PLUTONIUM occur naturally (in minute amounts) but all can be synthesized. The only commercially important element in the group is plutonium, which is used in NUCLEAR WEAPONS and as a fuel for nuclear reactors. Transvaal Former province of South Africa. In 1994-95 Transvaal was divided into Northern Province, Mpumalanga, GAUTENG and NORTH-WEST PROVINCE. The indigenous population are the Bantu-speaking Venda and Sotho peoples. In the 1836 Great Trek, the Boers crossed the River Vaal and began to settle the region. In 1857 the South African Republic was formed. In 1877 the British annexed the republic. After a Boer revolt, the Transvaal was again granted internal self-government in 1881, under the new president, Paul KRUGER. The 1886 discovery of gold in WITWATERSRAND attracted vast numbers of Britons and Germans. The Boers imposed heavy taxation and denied political rights to the newcomers. In 1895 Leander Starr JAMESON launched an incursion into the Transvaal. The "Jameson Raid" failed to ignite a full-scale rebellion, but the resultant tension between the Boers and the British led to the SOUTH AFRICAN WARS. In the 1902 Treaty of Vereeniging, the Transvaal became a British crown colony. In 1907 the region was again allowed self-government, and in 1910 it became a founding province in the Union of South Africa. During the 1960s the apartheid government created separate tribal "homelands" (Bantustans). In 1995 Transvaal ceased to exist as a political entity and was split into four of South Africa's nine new provinces. Transylvania (Romanian, beyond the forest) High plateau region in central and NW Romania, separated from the rest of Romania by the CARPATHIAN MOUNTAINS and the Transylvanian Alps. Its major cities are Cluj-Napoca, Braşov and Sibiu. It became part of the Roman province of DACIA in AD 107. It was conquered by Hungary at the beginning of the 11th century. In 1526 the ruler of Transylvania, John Zapolya, defeated the Hungarian army, and claimed the Hungarian throne as John I. His claim was supported by the Turks who, following Zapolya's death in 1540, occupied Transylvania on the pretext of ensuring his son's succession. For the next two centuries Transylvania retained a semi-independent status as it played off the competing imperial claims of Turkey and Austria. During the 17th century, it flourished as Hungary's intellectual and cultural centre, but in 1765 it became an Austrian province. Hungarian supremacy was re-established in 1867. After World War 1 Hungary ceded the territory to Romania, which embarked on a wholesale process of land redistribution and forced assimilation of other nationalities. Hungary annexed part of Transylvania in World War 2, but was forced to return it in 1947. Transylvania is the legendary home of vampires, publicized in the West by Bram STOKER's Dracula. Trappists Popular name for the CISTERCIANS of the Strict Observance, a religious order of monks and nuns. The order originated in La Trappe Abbey, France, in 1664. They main-

tain complete silence and practise vegetarianism. **trauma** Any injury or physical damage caused by some external event such as an accident or assault. In psychiatry, the term is applied to an emotional shock or harrowing experience.

treason Any act the intention of which is to overthrow the recognized government or harm the head of state. Treason is an extremely serious criminal offence and is punishable by death in many countries. In Britain, treason is defined to include the infliction of death or injury on the monarch, violation of members of the royal family, levying war against the government, or giving assistance to the enemy.

Treasury UK government department responsible for national finance and monetary policy. Dating from the Norman Conquest, when the chancellor and barons exercised control of royal revenues, the Treasury developed from the office of the chancellor of the exchequer. It became a separate ministry in the 19th century.

Treasury, US Department of US federal government department. It is composed of many bureaus and divisions

▶ tree Trees increase in girth by wings of new wood produced annually in temperate zones but less often in the tropics. The cambium (1) produces xylem (2) and phloem (3). They are alive but the heartwood (4) is dead. The medullary rays (5) allow the transport of food across the trunk. Bark (6) is a protective outer coating.

that have four basic functions: formulating and recommending financial, tax and fiscal policies; serving as financial agent for the government; law enforcement; and manufacturing coins and currency.

tree Woody, PERENNIAL plant with one main stem or trunk and smaller branches. The trunk increases in diameter each year, and the leaves may be evergreen or DECIDUOUS. The largest trees, SEQUOIAS, can grow more than 110m (420ft) tall; the bristlecone pine can live for over 5,000 years.

tree creeper Brownish, agile bird that scurries up and down trees in cooler areas of the Northern Hemisphere. It uses its long, slightly down-curved bill to probe for insects under the bark. Length: 13cm (5in). Species *Certhia familiaris*.

tree fern Tree-like FERN of the family Cyatheaceae. Tree ferns grow in tropical and sub-tropical regions, particularly moist mountainous areas. Height: 3–25m (10–80ft). There are 600 species. Phylum Filicinophyta; genus *Cyathea*.

trefoil Any of numerous plants, such as CLOVER, with leaves divided into three parts. Bird's-foot trefoil (*Lotus corniculatus*) is used as hay and forage. Family Fabaceae/Leguminosae.

Trent River in central England, at 274km (170mi) the country's third-longest. It rises on Biddulph Moor, Staffordshire, and flows SE through the Potteries, and then NE across central England to join the River Ouse and form the Humber estuary. Linked by canals to many industrial towns, its major modern use is the provision of water for the cooling of power stations. Trent, Council of (1545–63) Nineteenth ecumenical council of the Roman Catholic Church, which provided the main impetus of the COUNTER REFORMATION in Europe. It met at Trent, N Italy, in three sessions under three popes (Paul III, Julius III, Pius IV). It clarified Catholic doctrine and refused concessions to the Protestants, while also instituting reform of many of the abuses that had provoked the REFORMATION.

Trent Affair (1861) Diplomatic incident between the UK and the USA during the US CIVIL WAR. Union officers seized two Confederate commissioners from the British ship *Trent*. Britain claimed its neutrality had been violated. President LINCOLN, wishing to avoid war with Britain, released the men.

Trenton State capital of New Jersey, USA, on the Delaware River. It was first settled by English Quakers in the 1670s. A city monument commemorates the 1776 battle in which George Washington crossed the frozen Delaware River to defeat Hessian troops during the American Revolution. Industries: ceramics, motor vehicle components, plastics, metal products, rubber goods, steel cables, textiles. Pop. (1992) 87.807.

Trevithick, Richard (1771–1833) British engineer and designer of steam engines. In 1801 he built a steam-powered road vehicle. The following year, he patented a high-pressure steam engine, his most important invention. In 1803 Trevithick built the first steam railway LOCOMOTIVE. In 1816 he went to Peru to install his steam engines in mines.

triad Chinese secret society. It existed in s China from the ear-

liest days of the Qing empire in the 17th century until the 19th century, when the triads lent their support to the TAIPING REBELLION. Today it is said to control Chinese organized crime throughout the world, with its chief centre in Hong Kong.

trial In law, judicial examination or hearing of the facts and passing of sentence in a civil or criminal case. A JURY may or may not be present.

trial by jury Trial by a number of people (usually 12), who are sworn to deliver a verdict in a court of law on the evidence presented. As a method of trial, it developed from an Anglo-Saxon judicial custom. It is now the main method of trying criminal and some civil cases at common law in the Western world. *See also* JURY

Triassic First period of the MESOZOIC era, lasting from 248 to 213 million years ago. Many new kinds of animals developed. On land, the first DINOSAURS roamed. Mammal-like reptiles were common, and by the end of the period the first true MAMMALS existed. In the seas lived the first ichthyosaurs, placodonts and nothosaurs. The first frogs, turtles, crocodilians and lizards also appeared. Plant life consisted mainly of primitive gymnosperms.

tribune Official of ancient Rome. Of the various kinds of tribune, some had military functions, some political. The tribunes of the PLEBEIANS, generally ten in number, who were elected annually, gained an important role under the republic. In the 2nd century BC, the Gracchi brothers used the office of tribune to pursue radical social reforms. See also GRACCHUS **triceratops** Large, horned, ornithischian DINOSAUR of the

late CRETACEOUS period of w North America. The 2.4-m (8-ft) skull carried two 102-cm (40-in) horns above its eyes and a smaller horn at the tip of its snout. Length: 6.1–7.6m (20–25ft); height: 2.4m (8ft); weight: 10 tonnes.

Trieste City on the Gulf of Trieste, at the head of the Adriatic Sea, NE Italy. It was an imperial free port from 1719 to 1891 and became an Austrian crown land in 1867. It was ceded to Italy in 1919, occupied by Yugoslavia in 1945, but was returned to Italy in 1954. It is an important industrial and commercial centre with large shipyards. Industries: steel, tex-

tiles and petroleum. Pop. (1992) 228,398. **triggerfish** Any of several tropical marine fish found in warm shallow Pacific waters, identified by a dorsal fin spine that can be erected to lodge the fish in a coral cavity, as a protection against predators. Length: to 60cm (24in). Family Balistidae; typical genus *Balistoides*.

triglyceride See LIPID

trigonometric function Six ratios of the sides of a right-angled triangle containing a given acute angle – they are the SINE, COSINE, TANGENT, COTANGENT, SECANT and COSECANT of the angle. These functions can be extended to cover angles of any size by the use of a system of rectangular coordinates.

trigonometry Use of ratios of the sides of a right-angled triangle to calculate lengths and angles in geometrical figures. If three sides, or two sides and the included angle, or one side

► tree Trees grow taller than any other living thing but can still survive in miniature form. If the roots are restricted either artificially, as in bonsai perfected in Japan, or by natural means, as when a seed germinates in very thin soil on a mountain, a fully formed tree only a few centimetres high will result. The California redwood, the tallest tree, is closely rivalled by a eucalyptus, such as the mountain ash of Australia. The coconut palm reaches its height of 27m (90ft) in a few years. The English oak is one of 450 species of oak that grow as trees, bushes and shrubs. It enlarges slowly about 4.5m (15ft) - in ten years, but produces wood of prodigious strength. Espeletia grows on snowy ledges over 400m (1,300ft) up in the Sierra Nevada.

and two angles of a triangle are known, then all the other sides and angles may be found.

trilobite Any of an extinct group of ARTHROPODS found as fossils in marine deposits, ranging in age from CAMBRIAN through PERMIAN times. The body was oval, tapering towards the rear, and was covered by a chitinous skeleton. Transverse divisions show segmentation, with each segment bearing a pair of jointed limbs. Most species were bottom-crawling, shallow-water forms, and ranged in size from 6mm (0.25in) to 75cm (30in).

Trinidad and Tobago Republic composed of the two southernmost islands of the LESSER ANTILLES, in the SE Caribbean; the capital is PORT OF SPAIN on Trinidad. The larger island of Trinidad lies only 11km (7mi) off the Venezuelan coast. It is mainly low plains with coastal mangrove swamps. In sw Trinidad lies Pitch Lake, the world's largest natural source of asphalt. The Spanish colonized the island in the 16th century, but it was ceded to Britain in 1802. Tobago lies 30km (19mi) NE of Trinidad. The island, dominated by a mountain ridge, is heavily forested. Scarborough is the principal town. Tobago was initially settled by the British in 1616. After Spanish, Dutch and French rule, in 1803 the island became a British possession. Trinidad and Tobago were integrated into a single crown colony in 1883, becoming an independent state in 1962 and a republic in 1976. In 1990 the prime minister, Arthur Robinson, was captured and later released in an attempted coup. After 1995 elections, a coalition government of the United National Congress and the Alliance for Reconstruction came to power, with Basdeo Panday as prime minister. The economy is dominated by oil and gas production, asphalt and tourism. Area: 5,128sq km (1,980sq mi). Pop. (1990) 1,169,600.

Trinity Central doctrine of Christianity, according to which God is three persons: the Father, the Son and the HOLY SPIRIT or Holy Ghost. There is only one God, but he exists as "three in one and one in three". The nature of the Trinity is held to be a mystery that cannot be fully comprehended. The doctrine of the Trinity was stated in early Christian creeds to counter heresies such as GNOSTICISM. *See also* APOSTLES' CREED; ATHANASIAN CREED; JESUS CHRIST; NICENE CREED

Triple Alliance Name given to several international alliances involving three states. They included the anti-French alliance of Britain, the Netherlands and Sweden of 1668, and the alliance of Britain, France and the Netherlands of 1717, directed against Spanish ambitions in Italy. The most recent was the Triple Alliance of 1882, when Italy joined the Dual Alliance of Austria-Hungary and Germany. In South America, Argentina, Brazil and Uruguay formed a triple alliance in the war against Paraguay (1865–70).

Triple Entente Name given to the alliance of Britain, France and Russia before World War 1. It developed from the Franco-Russian Alliance (1894) formed to counterbalance the threat posed by the TRIPLE ALLIANCE of Germany, Austria and Italy. In 1904 Britain became allied with France in the ENTENTE CORDIALE, and the Anglo-Russian Convention of 1907 completed the Triple Entente.

triple jump In athletics, similar to the LONG JUMP with the exception that from the take-off line a contestant takes two extended leaps on alternate legs to launch into the final jump. Tripoli Capital and chief port of LIBYA, on the Mediterranean Sea. The city was founded as Oea in the 7th century BC by the Phoenicians and was developed by the Romans. From the 7th century AD the Arabs developed Tripoli as a market centre for the trans-Saharan caravans. In 1551 it was captured by the Ottoman Turks. In the 17th century, Tripoli was a notorious base for pirates. In 1911 it was made the capital of the Italian colony of Libya, and during World War 2 it functioned as an important base for Axis forces. Following intensive Allied bombing in 1941-42, the city was captured by the British in 1943. In 1986 Tripoli was bombed by the US Air Force in retaliation for Libya's alleged support of worldwide terrorism. The city is the commercial, industrial, transport and communications centre of Libya. The oases comprise the most fertile agricultural area in N Africa. Pop. (1984) 990,697.

Tripoli Mediterranean port and second-largest city in LEBANON. Tripoli was an important city of the Seleucid and

Roman empires. It was captured in AD 638 by the Arabs. In 1109 the city was conquered by the Crusaders, who developed the city's fortifications. In 1289 Tripoli returned to Islamic rule under the Egyptian MAMELUKES. The Turks held the city until the arrival of the British in 1918, and in 1920 it became a Lebanese city. It suffered severe damage during the 1975–76 Lebanese civil war. The city remains an important centre for trade between Syria and Lebanon, and is the terminus of the oil pipeline from Iraq. Industries: oil refining, textiles, food processing. Pop. (1991) 203,000.

triptych Painting or carving consisting of three panels, traditionally used as an altarpiece. The panels may form one picture, or the outer panels may be separate and subordinate to the central picture.

Tristan (Tristram) Hero of many medieval romances, most commonly as a knight of the Round Table in the Arthurian legends. His fatal love for the Irish princess Isolde (or Iseult) is the subject of Richard Wagner's opera *Tristan and Isolde*.

Tristan da Cunha Group of four islands in the s Atlantic Ocean, located midway between s Africa and South America. The group was discovered in 1506 by the Portuguese and annexed by Britain in 1816. In 1961 Tristan, the only inhabitable island, suffered a volcanic eruption that caused a temporary evacuation. A British overseas territory, it is administered from ST HELENA. Area of Tristan: 98sq km (38sq mi). Pop. (1988) 313, all of whom live in the settlement of Edinburgh.

Triton In Greek mythology, a sea god, son of Poseidon and Amphitrite. He was half man and half fish, with a scaled body, sharp teeth and claws, and a forked fish tail. He had power over the waves and possessed the gift of prophecy.

triumphal arch Massive masonry structure, containing one, two or three arches covered with a flat, oblong attic. Triumphal arches were originally built by the Romans to commemorate specific victories, and in Imperial times only emperors could pass through them. They were decorated with bronze statuary and carved scenes. See also ARC DE TRIOMPHE Trivandrum (Triruvananthapuram) Seaport on the Malabar Coast, sw India, the largest city and capital of Kerala state. It served as capital of Travancore kingdom from 1745 and has an 18th-century fort, housing palaces and fine Hindu temples. Industries: tyres, tiles, plywood, titanium products, textiles, soap, wood and ivory products. Pop. (1991) 524,000.

trogon Brilliantly coloured bird of dark tropical forests in America, Africa and Asia. Trogons nest in holes in trees and feed on fruit and some insect larvae. Length: about 30cm (12in). Family Trogonidae; typical genus *Trogon*.

Trojan Horse Colossal, hollow wooden horse built by the Greeks in the final days of the siege of Troy. Thinking it was a peace offering, the Trojans dragged the horse through the gates, and in the night Greek soldiers who had been hiding within, emerged and opened the city gates to their army.

Trollope, Anthony (1815–82) British novelist. He spent most of his career in the service of the Post Office. From 1847 he published a large body of fiction, which is often seen as epitomizing Victorian society. Best known among his enduringly popular novels are the *Barsetshire chronicles*, which include *The Warden* (1855), *Barchester Towers* (1857) and *Doctor Thorne* (1858), and his novels of the Palliser family, including *Can You Forgive Her?* (1864–65) and *The Way We Live Now* (1874–75). His refreshingly modest and workmanlike approach to his craft is documented in his posthumously published *Autobiography* (1883).

◀ trilobite The trilobite looked rather like today's woodlouse, being covered by a chitinous skeleton. This was divided into: (1) the cephalon or headshield, which carried sensory organs and the glabella, a bump that housed the stomach; (2) the thorax, a region of articulated segments below each of which was a pair of legs; and (3) the pygidium or tail shield. Each limb consisted of a jointed organ for walking, a swimming and breathing organ and a paddle that swept food particles towards the mouth.

▶ trombone The modern trombone developed from the sackbut, which was well established by the 16th century. It quickly became associated with sacred and operatic music, soon becoming a standard member of the orchestra. It is also used in military and brass bands, and in jazz, where its glissando effect is often utilized.

trombone Brass musical instrument with a cylindrical bore, cupped mouthpiece and flaring bell. It is usually played with a slide, except for a variant which has three or four valves. The tenor and bass trombones have a range of three and a half octaves.

Trondheim City on the s shore of Trondheim fjord, central Norway, the third-largest city in Norway. Founded as Nidaros in 997, the city was the political and religious capital of medieval Norway. Until 1906 the kings of Norway were crowned in its 12th-century cathedral. The city exports wood and metal products. Industries: fish canning, brewing, electronics, shipbuilding, clothing, hardware. Pop. (1990) 137,846.

tropical diseases Strictly speaking, all diseases predominantly associated with tropical climates. Major ones are MALARIA, leishmaniasis, trypanosomiasis (SLEEPING SICKNESS), lymphatic filariasis and schistosomiasis (bilharzia). The infectious agents of tropical diseases include viruses, bacteria, protozoa, fungi and worms of various kinds. Many of these disease microbes are spread by insect vectors, such as mosquitoes. tropics See Cancer, Tropic of; Capricorn, Tropic of

tropism (tropic response) Response in growth and orientation of a plant or a part of it in relation to a directional, external stimulus, such as light or water.

Trotsky, Leon (1879–1940) Russian revolutionary leader and theoretician, b. Lev Davidovich Bronstein. A Marxist revolutionary from 1897, he headed the workers' soviet (revolutionary council) in St Petersburg in the RUSSIAN REVOLU-TION OF 1905. Arrested, he escaped abroad and embarked on the work that made him, with LENIN, the leading architect of the Russian Revolution of 1917. Trotsky returned to Russia after the March revolution (1917) and joined the BOLSHEVIKS. As chairman of the Petrograd (St Petersburg) Soviet, he set up the Military Revolutionary Committee to seize power, ostensibly for the Soviet, actually for the Bolsheviks. After the Bolshevik success, he negotiated the peace of Brest-Litovsk, withdrawing Russia from World War 1. As commissar of war (1918-25), he created the Red Army, which won the civil war and made the Bolshevik revolution safe. However, he criticized the growth of bureaucracy in the party, the lack of democracy, and the failure to expand industrialization. He disapproved of Lenin's dictatorial tendencies in power. He fiercely objected to Stalin's adoption of a policy of "socialism in one country", rather than the world revolution in which Trotsky believed. He was driven from power, from the party and eventually from the country. In exile he continued to write prolifically on many subjects. His ideas, though rejected in the Soviet Union, were extremely influential internationally, especially in Third World countries. In 1936 he settled in Mexico, where he was assassinated by a Stalinist agent.

troubadours Poets in the s of France from the 11th to the 14th century who wrote about love and chivalry. Their poems were sung by wandering minstrels called jongleurs. They wrote in the Provençal tongue, the *langue d'oc*, and much of their work, which was highly influential in the development of European lyric poetry, survives in songbooks.

trough In meteorology, area of low atmospheric pressure, usually an extension to a DEPRESSION. The opposite are ridges of high pressure.

trout Any fish of the salmon family (Salmonidae). There are three types of the single species of European trout (*Salmo trutta*), each with a different name. The brown or river trout is small and dark, and does not migrate. The lake trout, of rivers and lakes, is a larger, paler version, and is sometimes migratory. The large, silvery sea trout is definitely migratory

and is sometimes confused with the salmon. Length: to 1m (3ft); weight: to 13.5kg (30lb).

Troy (Ilium) Ancient city at what is now Hissarlik, Turkey, familiar chiefly through HOMER's *Iliad*. Archaeological excavation, begun by Heinrich SCHLIEMANN in the 1870s, suggests that the legend of the Trojan war may be based on an actual episode. Nine cities have been detected in the archaeological strata, dating from *c*.3000 BC and reaching a peak in Troy VI (*c*.1800–1300 BC). Troy VI was ruined by an earthquake. Its successor, Troy VIIA, was destroyed, apparently by enemy attack, *c*.1200 BC, close to the legendary date of the fall of Troy.

Troyes, Chrétien de (active late 12th century) French poet. He was the author of the earliest extant Arthurian romances. Troyes' work includes translations of OVID and the romances *Erec* (after 1155), Cligès (c.1176) and the unfinished *Perceval (Le Conte du Graal)*, which contains the earliest known reference to the legend of the Holy Grail.

Trudeau, Pierre Elliott (1919–) Canadian prime minister (1968–79, 1980–84). He was minister of justice before succeeding Lester Pearson as prime minister. He promoted the economic and diplomatic independence of Canada, reducing US influence. Aided by his French-Canadian origins, he resisted Quebec separatism, imposing martial law to combat separatist terrorism in 1970. Defeated in the elections of 1979, he returned to power in 1980. Autonomy for Quebec was rejected in a referendum (1980), and Trudeau succeeded in winning agreement for a revised constitution (1981).

True Levellers See DIGGERS

Trueman, Fred (Frederick Sewards) (1931–) British cricketer who played for Yorkshire and England. He was a fast bowler and also a first-class fielder. He was the first bowler to take more than 300 wickets in Test matches.

Truffaut, François (1932–84) French film director. His first feature film was *The 400 Blows* (1959). His other films include *Shoot the Pianist* (1960), *Jules and Jim* (1961) and *Pocket Money* (1976). *Day for Night* (1973) won an Academy Award for Best Foreign Language Film. Deeply influenced by Alfred HITCHCOCK and Jean RENOIR, and a leading member of the *nouvelle vague*, he scripted or co-scripted all of his films.

truffle Any of several species of ascomycete FUNGI that grow underground, mostly among tree roots. Most are edible and are highly prized delicacies. Found in Europe, particularly France, and in parts of the USA, they are hunted with trained pigs and dogs that can scent them out. Family Tuberaceae.

Truman, Harry S. (1884–1972) 33rd US president (1945–53). From a farming and small-business background in Missouri, he entered politics in the 1920s and won election to the Senate in 1934. He was vice-presidential candidate with Franklin D. ROOSEVELT in 1944. He became president on Roosevelt's death, and was faced with many difficulties abroad. He approved the use of the atomic bomb to force Japanese surrender (1945), ending World War 2, and adopted a robust policy towards the Soviet Union during the CoLD WAR that followed. He approved the MARSHALL PLAN (1947) and the creation of NATO (1949). Lacking Roosevelt's charisma, Truman was expected to lose the election of 1948, but won narrowly. In the KOREAN WAR he was forced to dismiss the US commander, General MACARTHUR. He declined to run for a second full term in 1952.

Truman Doctrine Principle of US foreign policy under President Truman. It promised US support for any democratic country threatened by foreign domination. In practice, application of the Truman Doctrine was limited. The USA did not act against communist takeovers in Eastern Europe, although it did resist the invasion of South Korea.

trumpet Brass instrument of ancient origin. It has a cylindrical bore in the shape of a flattened loop and three piston valves. It became an important ceremonial instrument in the 15th century and by the late 17th century had become standard in the orchestra.

trunkfish (boxfish) Marine fish that lives in temperate and tropical waters. Its body is almost triangular when seen from the front, with a broad flat ventral region tapering to a narrow

▲ trout The brown trout (Salmo

trutta fario) is found throughout

Asia Minor, Europe and Iceland.

Brown trout show great variety

in shape, colour and markings

and these are dictated by the

nature and quality of the water

and not, as in some flatfish and

Perciformes, in response to

visual stimuli.

dorsal region. Length: to 50cm (20in). Family Ostraciontidae; genus *Lactophrys*.

trust In law, situation in which one person (the trustee) holds property for the benefit of another (the beneficiary). Trusts are generally created by a legal instrument such as a deed or a will. Truth, Sojourner (1797–1883) US abolitionist. Born into SLAVERY in New York State, she was unable to read or write. She was freed by the New York Emancipation Act (1827). Inspired by a religious calling, she became a leading propagandist for abolition of slavery and votes for women. The "micro-rover" on NASA's Mars Pathfinder mission was named after her.

truth State or condition of being true. A truth is something that is deemed to be genuine, an accurate representation of reality, or a statement that accords with proven, provable or observable facts. Defining the distinction between truth and falsity has long been a major preoccupation of philosophers and logicians. Two famous theories for determining the meaning of truth are the correspondence theory, which defines it as "that which corresponds with facts", and the coherence theory, which defines it as "that which conforms with what we have come to accept". Other theories, espoused by pragmatists, take a utilitarian view of truth, defining it as "that which it is good, useful or helpful to believe". This evaluative concept is also important in LOGIC, where either of two truth-values can be assigned to a statement, describing it as either true or false. See also EPISTEMOLOGY; ONTOLOGY

trypsin Digestive enzyme secreted by the pancreas. It is secreted in an inactive form that is converted into active trypsin by an enzyme in the small intestine. It breaks down peptide bonds on the amino acids lysine and arginine. *See also* ALIMENTARY CANAL; DIGESTION; DIGESTIVE SYSTEM

tsar Name of the rulers of Russia, first adopted by Ivan the Terrible in 1547. It is an adaptation of the Latin *caesar*. In 1721 Peter I changed the official title to "emperor", but "tsar" or "czar" continued to be used in popular language until 1917. tsetse fly Any of several species of blood-sucking flies that live in Africa. Larger than a housefly, it has a grey thorax and a yellow to brown abdomen. Females transmit a cattle disease. Almost 80% of flies that bite humans are males, which carry SLEEPING SICKNESS. Length: to 16mm (0.6in). Order Diptera; family Muscidae; genus *Glossina*.

Tsimshian Native American tribe resident in coastal NW British Columbia, Canada and SE Alaska. Some groups retain elements of animist totemic religion, but the original matrilineal social organization has all but disappeared.

Tsiolkovsky, Konstantin Eduardovich (1857–1935) Russian scientist who provided the theoretical basis for space travel. In 1898 he became the first person to stress the importance of liquid propellants in ROCKETS. He also proposed the idea of using multistage rockets to overcome GRAVITATION.

tsunami (seismic sea wave) Ocean wave caused by a submarine EARTHQUAKE, subsidence, or volcanic eruption. Erroneously termed a tidal wave, tsunamis spread radially from their source in ever-widening circles. Tsunamis can travel across oceans at speeds up to 400km/h (250mph) and reach heights of 10m (33ft). The eruption of KRAKATOA (1883) caused a tsunami that drowned over 30,000 people in Java and Sumatra.

Tuareg Fiercely independent BERBERS of Islamic faith, who inhabit the desert regions of N Africa. Their matrilineal, feudal society is based on nomadic pastoralism; it traditionally maintained a class of black, non-Tuareg servants. Tuareg males wear blue veils, while the women are unveiled.

tuatara Nocturnal lizard-like reptile of New Zealand; remarkable for being active at quite low temperatures for a reptile (7°C) and for being the sole surviving member of the primitive order Rhynchocephalia. It is brownish in colour and has an exceptionally well-developed PINEAL BODY on its head, thought to be a vestigial third eye. Length: to 70cm (2.3ft). Species *Sphenodon punctatus*.

tuba Family of BRASS musical instruments, the lowest of the orchestral brass instruments. The tuba has a conical bore and a cupped mouthpiece and usually has four or five valves.

tuber In plants, the short, swollen, sometimes edible under-

ground stem, modified for the storage of food, as in the potato, or as a swollen root (eg dahlia). They enable the plant to survive an adverse season (winter or dry season), providing food for the later development of new shoots and roots.

tuberculosis (TB) Infectious disease caused by the bacillus *Mycobacterium tuberculosis*. It most often affects the lungs (pulmonary tuberculosis), but may involve the bones and joints, skin, lymph nodes, intestines and kidneys. One-third of the world's population is infected, and up to 5% of those infected eventually develop TB. Poor urban living conditions mean that the disease is making a comeback in countries such as the USA and much of Europe, where previously it had been in decline. The BCG vaccine against tuberculosis was developed in the 1920s and the first effective treatment drug, streptomycin, became available in 1944. However, the bacillus is showing increasing resistance to drugs and some strains are multi-resistant.

Tubman, Harriet (1820–1913) US abolitionist. Born a slave, she escaped to the North by following the UNDER-GROUND RAILROAD. She then led *c.*300 fugitive slaves, including her parents, to freedom during the 1850s and became a prominent spokesperson for abolition.

Tubman, William Vacanarat Shadrach (1895–1971) President of Liberia (1944–71). A descendant of US freed slaves who settled the country during the 19th century, Tubman ruled unchallenged until his death. He preserved Liberia's close connections with the USA, maintained prosperity and showed consideration for the customs of the non-Westernized people of the interior.

TUC See Trades Union Congress

Tucana (Toucan) Far southern constellation representing a toucan. Its overall faintness is redeemed by the presence of the small MAGELLANIC CLOUD and a superb globular cluster. It lies 15,000 light years away

Tucson City on the Santa Cruz River, s Arizona, USA. The presidio fort of Tucson was built by the Spanish in 1776 and the city was state capital from 1867 to 1877. Today it is better known as a foothills resort with a dry, sunny climate. It is a shipping port for cotton and cattle. Industries: textiles, meat packing, copper smelting, aircraft parts, electronics, optical instruments. Pop. (1992) 415,079.

Tudjman, Franjo (1922-) Croatian politician and presi-

■ trumpet A modern trumpet is fitted with three valves, which lower the pitch of the instrument by increasing its length; this is done by means of "crooks", which are brought into play when the valves are depressed. Valve no.1, nearest the mouthpiece, lowers the pitch by two semitones; the middle valve, no.2, lowers it by one semitone; and the furthest valve, no.3, by three semitones. A raised valve lets the air pass directly through (1); when the valve is depressed, the air flows through the crook (2).

The diesel turbocharger uses the energy of the exhaust gases to force air into the cylinder via linked impellers (1). First air is sucked into the engine (A). The air is compressed into a space 22 times smaller (B). The compression heats the air. Diesel fuel is then injected in a swirling manner to maximize mixing, accentuated by the shape of the piston head (C). Combustion occurs spontaneously, without the need of a spark plug, pushing the piston down (D). The rotation of the crankshaft pushes the piston up, expelling the waste gases (E).

dent of Croatia (1990—). Tudjman was a professor of history in Zagreb during the 1960s. He was twice imprisoned by the Yugoslavian government for nationalist activities. In 1989 Tudjman founded the Croatian Democratic Union (HDZ) party, which helped form the coalition government of Bosnia-Herzegovina in 1990. He was elected president of newly independent Croatia in 1992 and retained this position during the ensuing civil war. He was re-elected in 1997.

Tudors English royal dynasty (1485–1603). Of Welsh origin, they were descended from Owen Tudor (d.1461), who married the widow of Henry V. Owen Tudor's grandson defeated RICHARD III at Bosworth in 1485 to win the English throne as Henry VII. The dynasty ended with the death of ELIZABETH I in 1603.

Tu Fu (712–70) Chinese poet of the T'ANG dynasty. He wrote about such topics as war, corruption and patriotism. His poetry reflects his troubled personal life and laments the corruption and cruelty that prevailed at court.

tulip Hardy, bulb-forming plant of the genus *Tulipa*, native to Europe, Asia and North Africa. Tulips have long, pointed leaves growing from the base and elongated, cup-shaped flowers that can be almost any colour or combination of colours. Family Liliaceae; genus *Tulipa*.

Tull, Jethro (1674–1741) British agriculturalist. He influenced agricultural methods through his innovations and his writings. He invented a mechanical drill for sowing in 1701 and advocated the use of manure and thorough tilling during the growing period.

Tulsa Port on the Arkansas River, NE Oklahoma, the state's second-largest city. It developed with the 1882 arrival of the Atlantic and Pacific Railroad; the 1901 discovery of oil further accelerated development. Industries: oil refining and research, petroleum products, oilfield equipment, mining, metal goods, aerospace. Pop. (1992) 453,995.

tumbleweed Plant that characteristically breaks off near the ground in autumn and is rolled along by the wind. Height: to 51cm (20in). Family Amaranthaceae; genus *Amaranthus*. **tumour** Any uncontrolled, abnormal proliferation of cells, often leading to the formation of a lump. Tumours are classified as either benign (non-cancerous) or malignant.

tuna See TUNNY

tundra Treeless, level or gently undulating plain characteristic of arctic and subarctic regions. It is marshy with dark soil that supports mosses, lichens and low shrubs, but not trees. It has a permanently frozen subsoil known as PERMAFROST.

tungsten (wolfram, symbol W) Silvery-grey, hard, metallic element, one of the TRANSITION ELEMENTS. Tungsten has the highest melting point of all metals and is used for lamp filaments and in special alloys. Tungsten carbide is used in high-speed cutting tools. Chemically tungsten is fairly unreactive; it oxidizes only at high temperatures. Properties: at.no. 74; r.a.m. 183.85; r.d. 19.3; m.p. 3,410°C (6,170°F); b.p. 5,660°C (10,220°F); most common isotope W¹⁸⁴ (30.64%).

Tunis Capital and largest city of Tunisia, N Africa. Tunis

became the capital in the 13th century under the Hafsid dynasty. Seized by BARBAROSSA in 1534 and controlled by Turkey, it attained infamy as a haven for pirates. The French assumed control in 1881. Tunis' port facilities were greatly improved after independence in 1956. Products include olive oil, carpets, textiles and handicrafts. The ruins of CARTHAGE are nearby. Pop. (1994) 674,100.

Tunisia Small republic in N Africa. See country feature

tunny (tuna) Large marine fish related to MACKEREL, found in tropical and temperate seas. An important commercial fish, it has a blue-black and silvery streamlined body with a large, deeply divided tail. Length: to 4.3m (14ft); weight: to 810kg (1,800lb).

Tupi-Guaraní Combination of two major tribes that now represents the major native cultural population in rural Brazil, Paraguay, and parts of Argentina. The Tupí traditionally inhabit the banks of the lower Amazon and much of coastal Brazil south to Uruguay. The Guaraní, a more scattered grouping, once lived mainly in what is now Paraguay, but migrated into Brazil and Argentina.

turbidity current Dense current in air, water, or other fluid caused by different amounts of matter in suspension. In the ocean, when sediment along the continental shelves breaks off and rushes downslope, the resulting turbidity current carves out submarine canyons and deposits distinctively bedded layers on the ocean floor.

turbine Rotary device turned by a moving fluid (liquid or gas). The modern form of water turbine is like a many-bladed propeller and is used to generate HYDROELECTRICITY. In power stations that burn fuels to produce electricity, the energy released by the burning is harnessed by the blades of jet engine-like steam turbines. As they spin, the turbines turn generators that produce electricity. Modern wind generators produce electricity when the wind turns their rotors. In gas turbines, hot gases from burning fuel turn turbines that can operate generators or other machinery.

turbocharger Device that boosts the performance of an INTERNAL COMBUSTION ENGINE. A TURBINE driven by exhaust gases compresses the fuel/air mixture before it passes through the inlet valve.

turbot Scaleless, bottom-dwelling, European marine FLAT-FISH. It has a broad flat body with both eyes on its greybrown, mottled upper surface, which may also be covered in bony knobs. Length: to 1m (3.3ft). Family Scophthalmidae; species *Scophthalmus maximus*.

Turgenev, Ivan Sergeievich (1818–83) Russian novelist, playwright and short-story writer. His novels often opposed social and political evils and attracted official disapproval. The play A Month in the Country (1855) can be considered the first psychological drama of the Russian Theatre. After the appearance of his masterpiece Fathers and Sons (1862), he left Russia permanently.

turgor pressure Hydrostatic pressure generated in cells of plants and bacteria as a result of the uptake of water by osmosis. Water diffuses through the semi-permeable membrane of the cell, causing the cell to swell; the increase in volume is resisted by the limited elasticity of the cell wall. When water is lost, a plant's cells collapse and it wilts.

Turin (Torino) City on the River Po, NW Italy, the country's fourth-largest city and capital of Piedmont (Piemonte) region. A Roman town under Augustus, Turin became a Lombard duchy from 590 to 636. From 1720 to 1861 it was capital of the Kingdom of Sardinia and a centre of the RISORGIMENTO. Damaged during World War 2, Turin remains an important industrial centre. In 1997 its Romanesque cathedral was badly damaged in a fire, but the TURIN SHROUD was saved. Industries: electronic equipment, chemicals, machinery, rubber, paper, leather goods, pharmaceuticals, wines. Pop. (1992) 952,736.

Turing, Ålan (1912–54) British mathematician. In 1936 he gave a precise description of a theoretical computing device, which foreshadowed the digital computer. During World War 2 he worked as a cryptographer and helped to break the German "Enigma" codes. After the war he supervised the design and construction of the ACE electronic digital computer.

Turin shroud Sheet of very old linen kept in Turin Cathedral, by tradition the cloth in which the body of Christ was wrapped after the Crucifixion. When photographed in 1898, negatives were seen to show the shape of a human figure. In 1988 results of carbon dating tests revealed that the shroud had in fact been made sometime between AD 1260 and 1390, well over a millennium after the death of Christ.

Turkey Republic in SE Europe and Asia. *See* country feature, page 684

turkey North American game bird now widely domesticated throughout the world. The common wild turkey (*Meleagris gallopavo*), once abundant in North America, was overhunted and is now protected. The male, or gobbler, is often bearded. Length: 125cm (50in). Family Meleagrididae.

Turkic languages Six or seven separate subclasses of languages, that together form a branch of the ALTAIC language family. They are remarkable for their grammatical uniformity and structural inter-resemblances and their relative lack of linguistic change over the centuries. The most important member of the group is Turkish.

Turkistan (Turkestan) Historic region of central Asia, inhabited by Turkic-speaking peoples. Western (Russian) Turkistan now consists of the republics of TURKMENISTAN,

UZBEKISTAN, TAJIKISTAN, KYRGYZSTAN and S KAZAKSTAN. It mainly comprises the deserts of KYZYL KUM and Kara Kum. Eastern (Chinese) Turkistan comprises the Chinese region of XINJIANG and includes the TIAN SHAN mountains. Southern Turkistan consisted of part of N Afghanistan. For nearly two centuries Turkistan was the geographical bridge for trade between East and West. The first imperial power to control the region was Persia in 500 BC. In c.330 BC Alexander the GREAT defeated the Persians and for the next few centuries, the region was disputed between Bactria, PARTHIA and China. Market towns developed around the oases, becoming centres for trade and religion. In the 8th century the Arabs conquered the region and the local population were converted to Islam. During the 13th century, the region was controlled by the Mongols, but then fractured into small, independent khanates. In 1867 the Russian empire imposed military rule over the area, and in 1918 Turkistan became an autonomous region within the SOVIET UNION. In 1924 the s part of Turkistan was divided into the republics of Uzbekistan and Turkmenistan. In 1929 Tajikistan became a republic and Kyrgyzstan followed in 1936. The N part of Russian Turkistan was incorporated into the Kazak republic, and Russian Turkistan became known as Soviet Central Asia.

▲ tumour A tumour is a swelling composed of cells that have become independent of the body's control mechanism, so that they rapidly divide, invade and kill surrounding tissue. Cross-sections of a healthy (A) and a diseased liver (B) are shown. The tumour shows a loss of cellular and structural differentiation and is unlike the tissue of origin.

TUNISIA

Tunisia's flag originated in about 1835 when the country was officially under Turkish rule. It became the national flag in 1956, when Tunisia became independent from France. The flag contains two traditional symbols of Islam, the crescent and the star.

AREA: 163,610sq km (63,170sq mi) POPULATION: 8,410,000 CAPITAL POPULATION: Tunis (674,100)

GOVERNMENT: Multiparty republic **ETHNIC GROUPS:** Arab 98%, Berber 1%, French

and other

LANGUAGES: Arabic (official)
RELIGIONS: Islam 99%

CURRENCY: Dinar = 1,000 millimes

The Republic of Tunisia is the smallest country in North Africa. The NW mountain ranges are a comparatively low extension of the ATLAS Mountains. In the centre is a depression, containing the Chott Djerid salt lake. In the s lies part of the SAHARA desert. The fertile coastal lowlands include many fine Mediterranean ports, such as Bizerte and the capital, TUNIS. Kairouan is the fourth most holy city in Islam.

CLIMATE

Coastal regions have a Mediterranean climate, with dry, sunny summers and mild winters with moderate rainfall. Rainfall decreases and temperatures increase to the s.

VEGETATION

Some cork oak forests grow in the $\mbox{\scriptsize N}$ mountains. The s plateaux are covered by steppe with coarse grasses. The Sahara is barren, except around oases.

HISTORY AND POLITICS

In tradition, the Phoenician Queen DIDO founded CARTHAGE in 814 BC. The Romans destroyed the city in 146 BC, and the region was subsumed into the Roman empire. The Arabs invaded in AD 640. The BERBERS slowly converted to Islam and Arabic became the principal language. In 1159 the ALMOHAD dynasty conquered Tunisia. From 1230 to 1574 Tunisia was ruled by the Hafsids. Spain's capture of much of Tunisia's coast led to the intervention of the Ottoman empire, and the rule of Turkish governors (beys) continued into the 20th century. In the 16th cen-

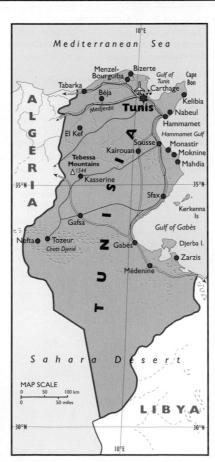

tury Tunisia's harbours were a refuge for Barbary pirates. France invaded in 1881 and Tunisia became a French protectorate (1883). French rule aroused strong nationalist sentiment, and Habib BOURGUIBA formed the Destour Socialist Party (PSD) in 1934.

Tunisia was a major battleground of the North Africa campaigns in World War 2. In 1956 it gained independence. In 1957 the bev was deposed and Tunisia became a republic, with Bourguiba as president. In 1975 Bourguiba was proclaimed president for life. Bourguiba pursued a moderate foreign policy and modernizing domestic policies. The first multiparty elections were held in 1981. Bourguiba's failing health created a succession crisis in the 1980s, and in 1987 he was deposed by Zine el Abidine Ben Ali. The PSD became the Constitutional Democratic Rally (RCD), and Ben Ali won a landslide victory in 1989 elections. He was re-elected in 1994. The hegemony of the RCD remains a problem for its emerging democracy.

ECONOMY

Tunisia is a middle-income developing country (1992 GDP per capita, US\$5,160). It is the world's sixth-largest producer of phosphates. It also exports crude oil. Agriculture employs 26% of the workforce. Tunisia is the world's fourth-largest producer of olives. Other major crops include barley, dates, grapes for wine-making, and wheat. Fishing and livestock-raising are also important. Tourism is a vital source of foreign exchange (1992 receipts, US\$1,074 million). It has been an associate of the EC since 1969.

Turkmenistan Republic in central Asia. The capital is Ash-GABAT. Originally part of the Persian empire, it was overrun by Arabs in the 8th century AD. GENGHIS KHAN invaded in the 13th century, and it subsequently became part of TAMERLANE's vast empire. With the breakup of the Timurid dynasty, Turkmenistan came under Uzbek control. In the 19th century, Russia became increasingly dominant, and in 1899, despite resistance, Turkmenistan became part of Russian Turkistan. In 1925, as part of the Turkistan Autonomous Soviet Socialist Republic, it was absorbed into the Soviet Union. It became independent in 1991 and a full member of the COMMONWEALTH OF INDEPENDENT STATES (CIS) in 1993. President Nivazov (elected 1990) is head of state; his autocratic government prevents any political opposition to the ruling Democratic Party (formerly Communist Party). In a 1994 referendum Niyazov's term of presidency was extended to 2002. Almost 90% of Turkmenistan is covered by the Kara Kum desert, parts of which are irrigated by the Kara Kum canal. The chief crop is cotton and there are large reserves of natural gas and oil.

Turks and Caicos Islands Two island groups of the British West Indies, including more than 40 islands, eight of them inhabited. Discovered in 1512 by PONCE DE LEÓN, the

islands were British from 1766, administered via Jamaica from 1873 to 1959, and a separate crown colony from 1973. Exports include salt, sponges and shellfish, but the islands' main sources of income are now tourism and offshore banking. The capital is Cockburn Town on Grand Turk Island. Area: 430sq km (166sq mi). Pop (1990) 12,350.

Turku (Åbo) Finland's largest port, at the mouth of the Aurajoki River on the Baltic Sea. A Swedish settlement was established in 1157 and in 1220 it became the seat of the first Finnish diocese. It was the national capital until 1812. Industries: steel, shipbuilding, engineering, textiles. Pop. (1994) 162,370.

turmeric Herbaceous, perennial plant originally native to India and cultivated in SE Asia. The dried RHIZOME is powdered for use as seasoning, a yellow dye and in medicines. Family Zingiberaceae; species Curcuma longa.

Turner, Joseph Mallord William (1775-1851) British landscape painter. An associate of the Royal Academy at age 24, he was professor of perspective from 1807-38. His paintings were revolutionary in their representation of light, especially on water. His style changed dramatically in his late works, such as The Slave Ship (1840) and Rain, Steam and Speed (1844). In these the original subjects are almost

TURKEY

Turkey's flag was adopted when the Republic of Turkey was established in 1923. The crescent moon and the five-pointed star are traditional symbols of Islam. They were used on earlier Turkish flags used by the Turkish Ottoman empire.

AREA: 779,450sq km (300,946sq mi)

POPULATION: 58,775,000

CAPITAL POPULATION: Ankara (2,541,899) GOVERNMENT: Multiparty republic ETHNIC GROUPS: Turkish 86%, Kurdish 11%,

Arab 2%

LANGUAGES: Turkish (official) RELIGIONS: Islam 99%

CURRENCY: Turkish lira = 100 kurus

he Republic of Turkey straddles Europe and The Republic of Turkey (THRACE) is a small, fertile region, separated from Asia by the DAR-DANELLES, the BOSPORUS, and the Sea of Marmara. The major city is EDIRNE. ISTANBUL lies on both continents. Anatolia (ASIA MINOR) is a mainly mountainous region, rising in the E to 5,165m (16,945ft) at Mount ARARAT. The plateau region of Central Anatolia includes the capital, ANKARA. The Mediterranean coast is a popular tourist destination.

CLIMATE

Central Turkey has hot, dry summers and cold winters. Western Turkey has a Mediterranean climate. The Black Sea coast has cooler summers.

VEGETATION

Maquis is common in Mediterranean areas. Deciduous forests grow inland, with conifers on the mountains. The plateau is mainly dry steppe.

HISTORY AND POLITICS EPHESUS is one of the many ruins of the ancient Anatolian kingdoms of Ionia and Pontus. In AD 330 Byzantium (Constantinople) became capital of the Roman empire; thence capital of the BYZANTINE EMPIRE (398). In the 11th century, the SELJUKS introduced Islam, and the capital moved to Konya. In 1435 Constantinople was captured by MUHAMMAD II, and it served as capital of the vast OTTOMAN EMPIRE. Defeat in World War 1 led to the sultan signing the harsh Treaty of Sèvres (1920). Nationalists, led by Mustafa Kemal (ATATÜRK), launched a war of independence. In 1923 Turkey became a republic, with Kemal as its president. Kemal's 14-year dictatorship created a secular, Westernized state. In 1938 Atatürk died and was succeeded by Ismet Inönü. Turkey remained neutral throughout most of World War 2. A major post-war recipient of US aid, Turkey joined NATO in 1952. The first multiparty elections were held in 1950. An army coup in 1960 led to the creation of a second republic. In 1965 Süleyman DEMIREL became prime minister. In 1974 Turkey invaded Northern Cyprus; tension with Greece increased. In 1980 a military coup led to martial law. In 1987 martial law was lifted. In 1993 Demirel was elected president, and Tansu Çiller became Turkey's first woman prime minister. In 1995 Necmettin Erbakan of the Islamist Welfare Party (RP) became prime minister. In 1997 tension between the pro-Islamic government and the military led to Erbakan's resignation. A new government, led by Mesut Yilmaz of the secular Motherland Party (ANAP), was appointed by Demirel. Conflict with Kurdish nationalists in E Turkey is a persistent problem, and Turkey has often been accused of human rights violations.

Turkey is a lower-middle income developing country (1992 GDP per capita, US\$5,230). Agriculture employs 47% of the workforce. Turkey is a leading producer of citrus fruits, barley, cotton, wheat, tobacco and tea. It is a major producer of chromium and phosphate fertilizers. Tourism is a vital source of foreign exchange.

obscured in a hazy interplay of light and colour. His work had a profound influence on IMPRESSIONISM.

Turner, Nat (1800–31) US African-American revolutionary. Born a slave, he believed that he was called by God to take violent revenge on whites and win freedom for blacks. With *c*.70 followers, he took a solar eclipse as a sign to begin his insurrection. More than 50 whites were killed before the revolt was crushed. Turner was later captured and hanged.

Turner's syndrome Hereditary condition in females, in which there is only one X chromosome instead of two. It results in short stature, infertility and developmental defects. **turnip** Garden vegetable best grown in cool climates. The edible leaves are large and toothed with thick midribs; the young leaves are eaten as "spring greens". A biennial, it has a large, bulbous, white or yellow, fleshy root, which is cooked and eaten. Diameter: 8–15cm (3–6in). Height: to 55cm (20in). Family Brassicaceae/Cruciferae; species *Brassica rapa*.

turnpike Originally, a tollgate, a barrier across a road to prevent the passage of travellers or goods until a toll had been paid. The money raised was used to keep main roads in repair. The first turnpike act, passed in 1663, was limited to three counties, but turnpike roads became general in the 18th century. The last turnpike trust was dissolved in 1895, although tolls are still levied on certain British roads and road bridges.

turnstone Either of two species of migratory shore birds that use their curved bills to turn over pebbles in search of food; they nest on the Arctic TUNDRA. The vividly marked ruddy turnstone (*Arenaria interpres*) ranges widely in winter. Family Scolopacidae.

Turpin, Dick (1706–39) English highwayman. He engaged in many forms of robbery and was hanged for murder. He became a largely fictional hero; his famous ride to York on Black Bess was performed by an earlier highwayman.

turquoise Blue mineral, hydrated copper aluminium phosphate, found in aluminium-rich rocks in deserts. Its crystal system is triclinic and it occurs as tiny crystals and dense masses. Its colour ranges from sky-blue and blue-green to a greenish grey and it is a popular gemstone. Hardness 6; s.g. 2.7.

turtle REPTILE found on land or in marine and fresh waters. Turtles have the most ancient lineage of all reptiles, preceding even the dinosaurs. They have a bony, horn-covered, boxlike shell (carapace) that encloses shoulder and hip girdles and all internal organs. All lay eggs on land. Terrestrial turtles are usually called TORTOISES, and some edible species found in brackish waters are called TERRAPINS. Marine turtles have smaller, lighter shells. Length: 10cm-2m (4in-7ft). Order Chelonia.

Tuscany Region in central Italy between the Mediterranean coast and the Apennine Mountains; the capital is FLORENCE. Other cities include SIENA and PISA. Tuscany is mostly mountainous with fertile valleys. Agriculture is the most important activity, with cereals, olives and grapes among the main products. Carrara marble is quarried in the NW, and there is mining for lead, zinc, antimony and copper in the SW. Industries: tourism, woollens, chemicals, steel, motor scooters, artisan industries. Area: 22,992sq km (8,877sq mi). Pop (1990) 3,528,735.

Tussaud, Madame Marie (1761–1850) Founder of the waxworks exhibition, b. France as Marie Grosholtz. She modelled wax figures in Paris, and in 1802 went to London with her collection. The present site of the exhibition, in Marylebone Road, London, has been its home since 1884.

Tutankhamun (active c.1350 BC) Egyptian pharaoh of the New Kingdom's 18th dynasty (c.1550–1307 BC). The revolutionary changes introduced by his predecessor, AKHNATEN, were reversed during his reign. The capital was re-established at Thebes (LUXOR) and worship of AMUN reinstated. Tutankhamun's tomb was discovered by Howard Carter in 1922. The only royal tomb of ancient Egypt not completely stripped by robbers, it contained magnificent treasures.

Tutu, Desmond Mpilo (1931–) South African ecclesiastic. A prominent anti-apartheid campaigner, and winner of the Nobel Peace Prize in 1984, Tutu trained as a teacher before becoming an Anglican priest in 1960. Appointed Archbishop of Cape Town in 1986, since 1995 he has been the leader of the Truth and Reconciliation Committee.

TURKMENISTAN KAZAKSTAN RA AFGHANISTAN AREA: 488,100sq km (188,450 sq mi) POPULATION: 3,714,000 CAPITAL (POPULATION): republic LANGUAGES: Turkmen (offi-Ashgabat (or Ashkhabad, ETHNIC GROUPS: Turkmen 72%, cial) Russian 10%, Uzbek 9%, 412.200) RELIGIONS: Islam **GOVERNMENT:** Single party Kazak 3%, Tatar CURRENCY: Manat

Tuvalu (formerly Ellice Islands) Independent republic in w Pacific Ocean, s of the equator and w of the International Date Line. None of the cluster of nine low-lying coral islands rises more than 4.6m (15ft) out of the Pacific, making them vulnerable to predictions of rising sea levels. Poor soils restrict vegetation to coconut palms, breadfruit and bush. The population survive by subsistence farming, raising pigs and poultry, and by fishing. Copra is the only significant export crop, but more foreign exchange is derived from the sale of elaborate postage stamps. The first European to discover the islands (1568) was the Spanish navigator Alvaro de Mendaña. The population was reduced from about 20,000 to just 3,000 in the three decades after 1850 by Europeans abducting workers for other Pacific plantations. The British assumed control in 1892, and it was subsequently administered with the nearby Gilbert Islands (now Kiribati). Tuvalu became a separate self-governing colony, achieving full independence within the Commonwealth in 1978. Area: 24sq km (9.5sq mi). Pop. (1991) 10,090. Twain, Mark (1835–1910) US writer, journalist and lecturer, b. Samuel Langhorne Clemens. He took his pseudonym from the sounding call of steamboatmen on the Mississippi. He was among the first to write novels in the American vernacular. such as The Adventures of Tom Sawyer (1876) and The Adventures of Huckleberry Finn (1884). Although he tends to be categorized as a humorist, his later books, such as The Mysterious Stranger (1916), are frequently bitter and pessimistic.

tweed Rough-textured cloth, usually all wool, from which warm clothes are made. Tweed originated in Scotland, but is now made in many countries. After spinning, the yarn is dyed with local LICHENS, giving the cloth its characteristic smell.

Twelve Tables Laws engraved on wooden tables representing the earliest codification of Roman law, traditionally dated 451–450 BC. They were written by *decemviri* (a committee of 10) at the probable instigation of the plebeians (i.e. commoners). They codified the existing laws and customs of ancient Rome thereby providing a measure of certainty in the administration of the law.

twelve-tone music (twelve-note music) SERIAL MUSIC in which the series contains all twelve notes of the CHROMATIC scale. Its introduction, in the early 20th century, is credited to Arnold SCHOENBERG. This method of composition relies not on the principle of TONALITY, in which the tonic or keynote is the focal centre, but on the relationship between the twelve notes of the chromatic scale. The composer selects the order in which the notes are to be played and the resultant sequence is manipulated throughout the composition. Many composers have experimented with twelve-note music; these include Anton Webern, Alban Berg and Hans Werner Henze.

▲ Tutu The son of a school headmaster, Desmond Tutu studied theology at the University of South Africa and at the University of London before his ordination. An outspoken critic of the apartheid system, Tutu advocated the use of international economic sanctions to force the South African government towards reform. He abhorred the use of violence, even by opponents of apartheid, always working for a peaceful settlement of the country's problems.

▲ tyre In cross-ply tyres (A), the fabric bracing the cords of the tyre run across the tyre in overlapping layers, or plies (1). Additional strips and fillers stiffen the casing and metal bands at the tyre's edge (2). Cross-ply tyres have largely been replaced by radial tyres (B), which have a more complex construction. A radial tyre has the cords reinforcing its sidewall at right angles to the tyre (1), with reinforcing breaker cords of fibre or steel beneath the tread (2). The breaker cords stop the tyre from wobbling on the road, a major cause of tyre wear.

two-stroke engine Engine in which the operation of each piston is in two stages. In the two-stroke cycle, a piston moves up a cylinder to compress a fuel-air mixture in the top. At the same time, more of the mixture is sucked in below the piston. A spark ignites the compressed mixture, causing an explosion. This sends the piston back down the cylinder. The piston forces the fresh fuel-air mixture out from beneath it and along a transfer port leading to the top part of the cylinder. The mixture forces the exhaust gases out from the top of the cylinder. The process then repeats.

Tyler, John (1790–1862) Tenth US President (1841–45). An aristocratic Virginian, he served in Congress and as governor of Virginia. He was a determined supporter of states' rights. The Whigs chose him as vice-presidential candidate with William H. HARRISON and he succeeded to the presidency on Harrison's death (1841). He came into conflict with the nationalistic Whigs in Congress, repeatedly vetoing legislation to create a national bank. His determination to annex Texas bore fruit after he had left office.

Tyler, Wat (d.1381) English leader of the PEASANTS' REVOLT. He was chosen as leader of the rebels in Kent, SE England, and led their march on London. He was eventually killed by the lord mayor of London while parleying with RICHARD II.

Tyndale, William (c.1494–1536) Religious reformer and Bible translator. He started printing an English version of the New Testament in Cologne, Germany, in 1525. After this, Tyndale began translating the Old Testament. He also wrote numerous Protestant tracts. He was eventually captured by the church authorities and burned at the stake as a heretic. His translation later provided a basis for the Authorized Version of the English Bible.

Tyndall, John (1820–1893) Irish physicist who correctly suggested that the blue colour of the sky is due to the scattering of light by particles of dust and other colloidal particles. By 1881 he had helped disprove the theory of spontaneous generation by showing that food does not decay in germ-free air.

Tyne River in NE England. It is formed at the confluence of the North Tyne (which rises in the s Cheviot Hills) and the South Tyne (which rises in Cumbria) and flows E for 48km (30mi) through Newcastle to enter the North Sea near Tynemouth. It was made fully navigable at the end of the 19th century.

Tyne and Wear Metropolitan council in NE England, formed in 1974 from parts of the former counties of NORTHUMBERLAND and DURHAM, and including the former county borough of NEWCASTLE UPON TYNE, which is its administrative centre. A highly industrialized area, its staple industries of coal-mining, iron and steel production and shipbuilding declined after the 1920s. There were signs of a recovery in the 1990s based on various light industries. Area: 537sq km (207sq mi). Pop. (1991) 1,095,152.

typesetting Part of the printing process. In early printing, wooden or metal type was set by hand. In hot-metal type processes, the linotype machine casts a complete line of molten type metal into a mould, and the monotype machine casts individual letters and spaces and arranges these in lines. Most type is now set using photographic or computerized processes.

typhoid fever Acute, sometimes epidemic communicable disease of the digestive system. Caused by *Salmonella typhi*, which is transmitted in contaminated water or food, it is characterized by bleeding from the bowel and enlargement of the

spleen. Symptoms include fever, headache, constipation, sore throat, cough and skin rash.

typhoon Name given in the Pacific Ocean to a HURRICANE, a violent tropical cyclonic storm.

typhus Any of a group of infectious diseases caused by rickettsiae (small bacteria) and spread by parasites of the human body such as lice, fleas, ticks and mites. Epidemic typhus, the result of infection by *Rickettsia prowazekii*, is the most serious manifestation. Associated with dirty, overcrowded conditions, it is mainly seen during times of war or famine.

typography Practice of designing typefaces and type styles mainly for use in printed texts. Typography is widely used in experimental, progressive art and design as well as conventional publishing. Movements that have revolutionized typography include FUTURISM, Dadaism and SURREALISM. Individuals include Eric GILL and MOHOLY-NAGY. The term also refers to the art of fine printing itself. *See also* DADA; TYPESFTTING

typology System of groupings that aids understanding of the things being studied by distinguishing certain attributes or qualities among them that serve to link them together into a closed set of items.

Tyr (Tiw) In Germanic mythology, powerful sky god. He was also associated with war, government and justice. The word Tuesday derives from Tyr's day.

tyrannosaurus Any of several species of large, bipedal, carnivorous, theropod DINOSAURS that lived during late CRETACEOUS times. Its head, 1.2m (4ft) long, was armed with a series of dagger-like teeth. The hind legs were stout and well developed, but the forelegs may have been useless except for grasping at close range. The best-known species is *T. rex*. Length: 14m (47ft); height: 6.5m (20ft).

Tyre Historic city on the coast of modern Lebanon. Built on an island, it was a major commercial port of ancient Phoenicial. It supplied both craftsmen and raw materials, especially cedarwood, for the building of the temple in Jerusalem in the 10th century BC. It established colonies, including Carthage, around the E Mediterranean. Tyre was never successfully besieged until Alexander the Great built a causeway linking the island to the mainland (332 BC). Ruled by successive empires, including the Romans, it was captured by the Arabs in AD 638 and destroyed by the Mamelukes in 1291. It never regained its former eminence. Pop. (1991) 70,000.

tyre Air-filled rubber and fabric cushion that fits over the wheels of vehicles to grip the road and absorb shock. The pneumatic tyre was invented in 1845 but was not commonly used until the end of the century. It consists of a layer of fabric surrounded by a thick layer of rubber treated with chemicals to harden it and decrease wear and tear.

Tyrol See TIROL

Tyrone Largest of the six counties of Northern Ireland, in the sw of the province. The county town is Omagh. Mainly hilly with the Sperrin Mountains in the N and Bessy Bell and Mary Gray in the s, the region is drained by the Blackwater and Mourne rivers. Cereals and root crops are grown and dairy cattle are raised. Industries: linen, whiskey, processed food. Area 3,263sq km (1,260sq mi). Pop. (1990) 153,000.

Tyson, Mike (1966–) US boxer. In 1986 he became the youngest heavyweight champion in boxing history. Known for his devastating punching power, in 1987 he became the first undisputed heavyweight champion for a decade. In 1992 Tyson was convicted of date rape and sentenced to prison. He was released in 1995, and the following year regained his WBC heavyweight championship by stopping Frank Bruno. He was defeated in 1996 by Evander Holyfield. In a rematch in 1997, Tyson was disqualified for biting off part of Holyfield's ear. He was fined and banned from boxing for a year. **Tz'u Hsi** (1835–1908) Empress Dowager of China. As mis-

tress of the Emperor Hsi'en Feng and mother of his only son, she became co-regent in 1861. She remained in power until her death by arranging for the succession of her infant nephew in 1875 and displacing him in a palace coup in 1898. Ruthless, extravagant and reactionary, she abandoned the modernization programme of the "Hundred Days of Reform" and supported the BOXER REBELLION (1900).

Uccello, Paolo (1397–1475) Florentine painter. Celebrated as an early master of PERSPECTIVE, his works include *The Flood* (c.1450) and *The Rout of San Romano* (1454–57).

Udaipur City on Lake Pichola, Rajasthan, NW India. In 1586 it was made capital of the princely state of Udaipur by Udai Singh. The walled city has three palaces. It is an agricultural market and a centre for textiles. Pop. (1991) 309,000.

Uffizi (It. offices) Chief public gallery in Florence, Italy, housing one of the greatest collections of Italian paintings. The palace was built in the 16th century by Giorgio VASARI for the Grand Duke Cosimo I de' Medici and once housed government offices. Painters of the Florentine and other Italian schools are represented, with works by Piero della Francesca, Botticelli, Leonardo da Vinci, Michelangelo, Raphael, Titian and many others, as well as Dutch and Flemish masters.

UFO Abbreviation of UNIDENTIFIED FLYING OBJECT

Uganda Landlocked republic in E Africa. *See* country feature **Ugarit** Ancient city in Nw Syria. Inhabited as early as the 7th millennium BC, it was a great commercial power, trading with Mesopotamia and Egypt. Excavations have revealed a vast palace from the 14th century BC, and many large houses filled with treasures and artefacts.

UHF Abbreviation of ULTRA HIGH FREQUENCY

Ujjain City on the River Sipra, Madhya Pradesh, w central India. Ujjain is one of the seven holy cities of India, and a Hindu pilgrimage centre. Nearby are the ruins of an ancient city dating from the 2nd millennium BC. Pop. (1991) 362,000. **ukiyo-e** Japanese paintings and woodblock prints that were prevalent in the Edo period (1615–1867). Their subject matter included people engaged in everyday activities as well as Kabuki actors. Moronobu (c.1625–95) is generally considered the originator of the true ukiyo-e print; he gained renown for his woodcut illustrations for popular literature. Other famous ukiyo-e printmakers were Harunobu, HIROSHIGE, HOKUSAI, Kiyonaga, Sharaku and UTAMARO.

Ukraine Independent state in E Europe. *See* country feature, page 688

Ukrainian Language spoken by c.40—45 million people in Ukraine. Significant Ukrainian-speaking communities are to be found in Kazakstan, Poland, Romania, Slovak Republic and Siberian Russia. Like Russian and Belarussian, Ukrainian belongs to the E branch of the Slavic family of Indo-European Languages.

ukulele Small guitar, which was developed in Hawaii from the Portuguese guitar. It is shaped like a classical guitar with a wooden body, round sound-hole and fretted fingerboard.

U/u, the 21st letter of the English alphabet and a letter included in the alphabets of several w European languages. Like f, v, w and y, it was derived from the Semitic letter vaw (a name meaning hook), before being adopted by the Greeks and Romans.

UGANDA

The flag used by the party that won the first national election was adopted as the national flag when Uganda became independent from Britain in 1962. The black represents the people, the yellow the sun, and the red brotherhood. The crested crane is the country's emblem.

The Republic of Uganda is a landlocked country in East Africa. Most of Uganda consists of part of the African plateau, which slopes down from c.1,500m (4,921ft) in the s to 900m (2,953ft) in the N. In the w lies an arm of the Great RIFT VALLEY, which contains Lake ALBERT and the Albert NILE. Highland pockets lie in the sw and E. Much of s Uganda is made up of Lake VICTORIA, Africa's largest lake. The capital, KAMPALA, and ENTEBBE lie on the lakeside.

CLIMATE

Uganda's equatorial climate is moderated by altitude. The wettest regions are the w mountains, especially the high Ruwenzori range.

VEGETATION

Nearly 20% of Uganda is covered by lakes or swamps. Some rainforest remains in the s. Wooded savanna covers central and N Uganda.

HISTORY AND POLITICS

In c.1500 the Nilotic-speaking Lwo people formed various kingdoms in sw Uganda, including Buganda (kingdom of the Ganda) and Bunyoro. During the 18th century, the Buganda kingdom expanded and trade flourished. In 1862 a British explorer, John Speke, became the first European to reach Buganda. He was closely followed (1875) by Sir Henry STANLEY. The conversion activities of Christian missionaries led to conflict with Muslims. The kabaka (king) came to depend on Christian support. In 1892 Britain dispatched troops to Buganda, and in 1894 Uganda became a British protectorate. Unlike much of Africa, Uganda attracted Asian, rather than European, settlers. African political representation remained minimal until after World War 2. In 1962 Uganda gained independence, with Buganda's kabaka, Mutesa II, as president and Milton OBOTE as prime minister. In 1966 Mutesa II was forced into exile. In 1967 Buganda's traditional autonomy was restricted, and Obote became executive president. In 1971 Obote was deposed in a military coup, led by Major General Idi Amin. Amin quickly established a personal dictatorship, and launched a war against foreign interference, which resulted in the mass expulsion of Asians. It is estimated that Amin's regime was responsible for the murder of more than 250,000 Ugandans. Obote loyalists resisted the regime from neighbouring TanAREA: 235,880sq km (91,073sq mi)

POPULATION: 18,592,000

CAPITAL POPULATION: Kampala (773,463)
GOVERNMENT: Republic in transition
ETHNIC GROUPS: Ganda 18%, Banyoro 14%,
Teso 9%, Banyan 8%, Basoga 8%, Bagisu
7%, Bachiga 7%, Lango 6%, Acholi 5%
LANGUAGES: English and Swahili (both

official)
RELIGIONS: Christianity (Roman Catholic 40%,

Protestant 29%), traditional beliefs 18%, Islam 7%

currency: Uganda shilling = 100 cents

zania. In 1976 Amin declared himself president for life, and Israel launched a successful raid on Entebbe airport to end the hijack of one of its passenger planes. In 1978 Uganda annexed the Kagera region of NW Tanzania. In 1979 Tanzanian troops helped the Uganda National Liberation Front (UNLF) to overthrow Amin and capture Kampala. In 1980 elections Obote was swept back into office. Amid charges of electoral fraud. the National Resistance Army (NRA) began a guerrilla war. Over 200,000 Ugandans sought refuge in Rwanda and Zaïre. In 1985 Obote was deposed in another military coup. In 1986 the NRA captured Kampala, and Yoweri Museveni became president. Museveni began to rebuild the domestic economy and improve foreign relations. In 1993 the kabaka of Buganda was reinstated as monarch. In 1996 Museveni won Uganda's first direct presidential elections. AIDS is one of the greatest issues facing Uganda; it has the highest number of reported cases in Africa.

ECONOMY

Civil strife greatly damaged Uganda's economy (1992 GDP per capita, US\$860). In 1997 it received money from the World Bank as part of a strategy to ease the debt burden of the world's poorest countries. Agriculture employs 86% of the workforce. Uganda is the world's seventh-largest producer of coffee, which accounts for 90% of exports. Cotton, sugar cane and tea are also exported.

Ukraine's flag was first used between 1918 and 1922. It was readopted in September 1991. The colours were first used in 1848. They are heraldic in origin and were first used on the coat of arms of one of the Ukrainian kingdoms in the Middle Ages.

Likraine (borderland) is the second-largest country in Europe (after Russia). The coastal lowlands include the Black Sea port of ODESSA. CRIMEA is a peninsula region, and contains the vital port of SEVASTOPOL. The DNIEPER River divides Ukraine into E and W. The capital, Kiev, lies on its banks. In the W, the CARPATHIAN MOUNTAINS rise to 2,061m (6,762ft), close to the Romanian border. The fertile central plateau is among the world's greatest producers of wheat and barley. In the E, the DONETS BASIN is one of the world's greatest industrial powerhouses. The cities of KHARKOV and Donetsk are major industrial centres.

CLIMATE

Ukraine's continental climate is moderated by proximity to the Black Sea. Winters are most severe in the NE and the highlands. Rainfall is heaviest in summer.

VEGETATION

The once-grassy central steppe is now mostly under the plough. The s black, chernozem soil is especially fertile. In the N, around the Pripet marshes, are large woodlands, with trees such as ash and oak. Pine forests cover the slopes of the Carpathian and Crimean mountains.

HISTORY

In ancient history the area was successively inhabited by Scythians and Sarmatians, before invasions by the Goths, Huns, Avars and Khazars. The first Ukrainian Slavic communi-

ty originates from this period. In the 9th century, the N regions were united by the Varangians as Kievan Rus. The empire disintegrated under the onslaught of the Mongol hordes. In the late 14th century, Ukraine became part of Lithuania. In 1478 the Black Sea region was absorbed into the Ottoman empire. In 1569 the Lithuanian sector passed to Poland following the Poland-Lithuania union.

Polish rule was marked by the enserfment of the peasantry and persecution of the Ukrainian Orthodox Church. In 1648 refugees from Polish rule (Cossacks) completed Ukraine's liberation. Independence was short-lived due to the emerging power of Russia. A succession of wars resulted (1775) in the division of Ukraine into three Russian provinces. The nationalist movement was barely suppressed and found an outlet in Galicia. Ukraine's industry was developed from the 1860s.

In 1918 (following the Russian Revolution) Ukraine declared independence and was invaded by the Red Army, who were repulsed with the support of the Central Powers. The World War 1 armistice prompted the withdrawal of the Central Powers. A unified, independent Ukraine was once more proclaimed. The Red Army invaded again, this time with greater success. In 1921 w Ukraine was ceded to Poland, and in 1922 E Ukraine became a constituent republic of the Soviet Union. In the 1930s, Lenin's policy of appeasement was replaced by Stalin's autocratic, agricultural collectivization. It caused 7.5 million Ukrainians to die of famine. The 1939 Nazi-Soviet

AREA: 603,700sq km (233,100sq mi)

POPULATION: 52,140,000

CAPITAL POPULATION: Kiev (2,600,000)
GOVERNMENT: Multiparty republic

ETHNIC GROUPS: Ukrainian 73%, Russian 22%, Jewish 1%, Belarussian 1%, Moldovan,

Bulgarian, Polish

LANGUAGES: Ukrainian (official)
RELIGIONS: Christianity (mostly Ukrainian

Orthodox) **CURRENCY:** Hryvna

partition of Poland reunified the Ukraine. In 1940 it also acquired Northern Bukovina and part of Bessarabia from Romania. In 1945 it gained Ruthenia from Hungary and E Galicia from Poland.

After 1945 all Ukrainian land was unified into a single Soviet republic. In 1954 the Crimea was annexed to the Ukraine. Ukraine became one of the most powerful republics in the Soviet Union, contributing 30% of total Soviet industrial output. In 1986 the CHER-NOBYL disaster contaminated large areas of Ukraine. After a unilateral declaration of sovereignty in 1990, Ukraine proclaimed its independence in August 1991. In December 1991 the former Communist leader Leonard Kravchuk was elected president and Ukraine joined the COMMONWEALTH OF INDEPENDENT STATES (CIS). Tensions with Russia over the Crimea, the Black Sea fleet, the control of nuclear weapons, and oil and gas reserves were eased by a 1992 treaty. Crimean independence was refused.

POLITICS

In the 1994 presidential election Leonid Kuchma defeated Kravchuk. Kuchna continued the policy of establishing closer ties with the West, and sped up the pace of privatization. In 1995 direct rule was imposed on Crimea for four months. Subsequent elections saw reduced support for pro-Russian parties. Disputes continue over the extent of the powers of the Crimean legislature.

Есоному

Ukraine was plunged into economic crisis by the rapid dismantling of its command economy. It is a lower-middle income economy (1992 GDP per capita, US\$5,010). Agriculture is important and Ukraine has been called the "breadbasket of Europe". It is the world's leading producer of sugar beet and the second-largest producer of barley. It is also a major producer of wheat. Other crops include maize, potatoes, sunflowers and tobacco. Livestock rearing and fishing are other important activities. Ukraine has extensive raw materials. The Donets Basin is the world's eighth-largest producer of bituminous coal. Krivoy Rog mines are the world's fourth-largest producer of iron ore, and Nikopol is the world's leading manganese ore producer. Many of the coal mines are exhausted, and in 1995 the government closed 19 coal mines. Antiquated technology contributes to the highest mining fatality rate in the world. Despite its hydroelectric and nuclear power stations, Ukraine is reliant on oil and natural gas imports. Ukraine's debt to Russia (1995, US\$500 million) has been offset partly by allowing Russian firms majority shares in many Ukrainian industries.

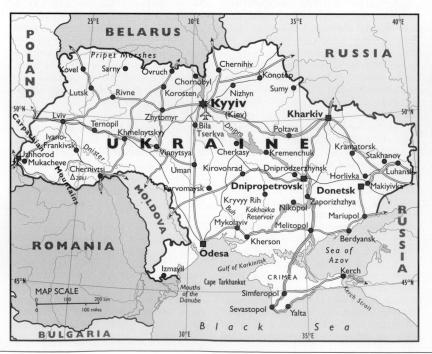

Ulan Bator (Ulanbaatar, formerly Urga) Capital of Mongolia, on the River Tola. Ulan Bator dates back to the founding of the Lamaistic Temple of the Living Buddha in 1639. It grew as a stop for caravans between Russia and China. It was later a focus for the Mongolian autonomy movement. It became the capital in 1921. Noted for its harsh climate and bleak, planned streets, it is the political, cultural and economic centre of Mongolia. Industries: textiles, building materials, leather, paper, alcohol, carpets, glassware. Pop. (1992) 601,000.

Ulanova, Galina (1910–) Russian ballerina. After 1944 she was prima ballerina of the BOLSHOI BALLET. She excelled in *Swan Lake, Giselle* and *Romeo and Juliet*. After her retirement in 1962, she trained dancers with the Bolshoi.

Ulbricht, Walter (1893–1973) East German statesman, leader of East Germany (1950–71). A founder of the German Communist Party, Ulbricht was forced into exile by the rise of fascism, and he spent World War 2 in the Soviet Union. In 1949 he became deputy premier of the newly created German Democratic Republic (East Germany). In 1950 he became general secretary of the Communist Party. Ulbricht established close links with the Soviet Union. The repressive nature of his regime led to a rebellion in 1953; the BERLIN WALL was built (1961) to prevent further defections to the West. In 1971 he was replaced as general secretary by Erich HONECKER.

ulcer Any persistent sore or lesion on the skin or on a mucous membrane, often associated with inflammation. Ulcers may be caused by infection, chemical irritation or mechanical pressure. Ulm Industrial city on the River Danube, Baden-Württemberg, s Germany. Founded before 800, Ulm was an important political and commercial centre of medieval Europe. The major landmark is the Gothic minster (1377), with the tallest spire in the world, at 161m (528ft). In 1805 Napoleon I defeated the Austrian army at the Battle of Ulm. In 1810 it became part of Württemberg. Industries: car manufacture, electrical goods, textiles, food products. Pop. (1993) 114,700. ulna Long bone of the inner side of the forearm. At its upper end it articulates with the HUMERUS and with the RADIUS.

Ulster Most northerly of Ireland's four ancient provinces, consisting of nine counties. Since 1922, six of these counties have been in Northern Ireland, while Cavan, Donegal and Monaghan form Ulster province in the Republic of Ireland. Area: 8,012sq km (3,092sq mi). Pop. (1991) 232,000).

Ulster Unionists Political party in Northern IRELAND, which arose in the late 19th century to defend the six northern provinces of ULSTER from Irish home rule and to maintain the union with Britain. Almost exclusively Protestant, it was the ruling party in Northern Ireland from 1922 until the imposition of direct rule from Westminster in 1972.

ultra high frequency (UHF) Radio waves in the frequency band 300–3,000MHz. UHF waves have a wavelength of c.1m (3ft) or less and are used for television broadcasting.

ultrasonics Study of sound waves with frequencies beyond the upper limit of human hearing (above 20,000Hz). In medicine, ultrasonics are used to locate tumours, produce fetal images and to treat certain neurological disorders. Other applications of ultrasonics include the agitation of liquids to form emulsions and the detection of flaws in metals.

ultraviolet radiation Type of ELECTROMAGNETIC RADIATION of shorter wavelength and higher frequency than visible light. Wavelengths range from 4–400nm (nanometres). Sunlight contains ultraviolet rays, most of which are filtered by the OZONE LAYER. If the ozone layer is weakened, enough ultraviolet can reach the ground to harm living things. Excessive exposure to sunlight can cause sunburn and skin cancer in people with fair skins. Ultraviolet is used medically to sterilize equipment. See also LIGHT; RADIATION

Ulysses See Odysseus

Umayyads (Omayyads) Dynasty of Arabian Muslim caliphs (661–750). From their capital at DAMASCUS, the Umayyads ruled a basically Arab empire, which stretched from Spain to India. They made little effort to convert conquered peoples to Islam, but there was great cultural exchange, and Arabic became established as the language of Islam. They were overthrown by the ABBASIDS.

umbelliferae Family of flowering plants, all of which have

many small flowers borne in umbrella-like clusters (umbels) at the ends of stalks. Umbellifers are mainly herbs and shrubs. Many species are edible, including CARROT, PARSLEY, CELERY, PARSNIP, FENNEL and DILL.

umbilical cord Long cord that connects a developing FETUS with the PLACENTA. At birth, the cord is cut from the placenta, leaving a scar on the baby's abdomen known as the navel.

umbrella bird Any of three species of large tropical American birds, each with a retractile, black, umbrella-like crest, and a long, often tubular-shaped, feathered lappet (tuft) on the throat. The ornate umbrella bird (*Cephalopterus ornatus*) lives in trees and feeds on fruits. Family Cotingidae.

Umbria Region in central Italy comprising the provinces of Perugia and Terni; the capital is PERUGIA. The only land-locked region of Italy, it is traversed by the APENNINES and drained by the River TIBER. Cereal crops, grapes and olives are grown, and cattle and pigs are raised. The medieval hill towns scattered over the countryside attract tourists. Industries: iron and steel, chemicals, textiles, confectionery. Area: 8,456sq km (3,265sq mi). Pop. (1992) 814,796.

UN Abbreviation of the UNITED NATIONS

Un-American Activities Committee, House (HUAC) Committee of the US House of Representatives, established (1938) to investigate political subversion. Created to combat Nazi propaganda, it began by investigating extremist political organizations. After World War 2, encouraged by Senator Joseph McCarthy, it attacked alleged communists in Hollywood and in the federal government. It was abolished in 1975. uncertainty principle In subatomic physics, principle stating that it is not possible to know both the position and the momentum of a particle at the same time, because the act of measuring would disturb the system. It was established by Werner Heisenberg.

Uncle Sam Symbolic figure personalizing the USA. The name was first used during the WAR of 1812. The appearance

Ultrasonic, or ultrasound, scanners send out beams of sound (1) and read the returning echoes to build up a picture of structures below the surface (2). They are commonly used to view fetuses in the womb with the picture displayed on a real-time monitor (3). The sound waves used are above the range of human hearing and are created by piezoelectric crystals in the handset (4). These crystals

change shape when the voltage is switched off. An ultrasonic scanner uses an oscillating voltage to make the crystals vibrate, producing sound of the right frequency. The process is reversed when an echo hits the transducer and the sound wave is converted back into a voltage, which the monitor reads to build up an image. Each handset has dozens of the piezoelectric crystals at its face and by

altering the timing of the oscillations of the voltage, the beam can be steered. When the voltage hits all the crystals at the same time a flat beam is issued (5). By sending the voltage to one end of the row of crystals before the other the beam can be steered (6). The beam of sound can also be focused by hitting the end crystals before the ones on the centre (7).

of Uncle Sam, tall, thin and frock-coated, was developed by 19th-century cartoonists.

unconformity In geology, break in the time sequence of rocks layered one above the other. The gap may be caused by interruptions in the deposition of sediment, ancient erosion, earth movements, or other activity.

unconscious Term in psychology for that part of mental life believed to operate without the individual's immediate awareness or control. It includes memories that the person is not actually thinking about, and the organizing processes underlying speech and reading. In FREUD's analysis, it is the area containing the desires and conflicts of the ID. JUNG believed that part of the unconscious (the collective unconscious) contains inherited concepts, shared by all other human beings.

Underground Railroad Name given to a secret network in the USA organized by free blacks and other abolitionists before the American Civil War to assist slaves escaping from the South. In fact, most escapees reached the North by their own efforts. In the North they were guided through a series of safe houses to a place of safety, often Canada.

underground railway Transport system used in urban areas. The first underground railway was opened in London, in 1863. It was steam-powered and carried passengers between Farringdon and Paddington. Today, many cities throughout the world have underground, electrically powered railway systems for passenger transport.

unemployment Inability of workers who are ready, able and willing to work to find employment. Unemployment is usually expressed as a percentage of the labour force. Cyclical unemployment exists when the level of aggregate demand in the economy is less than that required to maintain full employment. People are laid off, and their jobs simply disappear. Structural unemployment exists when jobs are available and workers are seeking jobs, but they cannot fill vacancies for some reason (for example, they lack proper training, or live too far away). Technological unemployment exists when workers are replaced by machines faster than they can find alternative employment. Seasonal unemployment occurs when workers are unable to find jobs at certain seasons of the year. Such workers are usually engaged in construction, agriculture or the tourist industry. Underemployment is inefficient use of labour (for example, an employer may keep unneeded workers on the payroll when demand falls in order to have experienced help available when demand increases). UNESCO Acronym for UNITED NATIONS EDUCATIONAL, SCI-

entific and Cultural Organization ungulate Mammal with hoofed feet. Most ungulates, including cattle, sheep, pigs and deer, are members of the order Artiodactyla (with an even number of toes). The order Perissodactyla (ungulates with an odd number of toes) consists of horses, tapirs and rhinoceroses. The orders Proboscidea and Hyracoidea, collectively known as sub-ungulates, contain elephants and hyraxes.

UNICEF Acronym for UNITED NATIONS CHILDREN'S FUND **unicorn** In mythology and heraldry, a magical animal resembling a graceful horse or a young goat with one thin conical or helical horn on its forehead.

unidentified flying object (UFO) Any flying object that cannot readily be explained as either a man-made craft or a natural phenomenon. Reports of UFOs have been documented since ancient times. With the development of aeronautics and astronautics the number of sightings has increased enormously. The majority of supposed UFO sightings have various rational explanations, including spy planes, optical floaters (in the observer's eye), weather balloons and artificial satellites.

Unification Church International religious movement founded in South Korea in 1954 by Sun Myung Moon. Its adherents are popularly known as Moonies. The movement's teachings are based on Moon's book *Divine Principle* (1952), which interprets the Bible. The movement aims to re-establish God's rule on Earth through the restoration of the family. The Unification Church is famous for its mass weddings and has been accused of CULT-like practices, such as brainwashing.

unified field theory Attempt to extend the general theory of RELATIVITY to give a simultaneous representation of both grav-

itational and electromagnetic fields. A more comprehensive theory would also include the strong and WEAK NUCLEAR FORCES. Although some success has been achieved in unifying the electromagnetic and weak nuclear forces, the general problem is still unsolved. See also GRAND UNIFIED THEORY (GUT)

Uniformity, Act of (1662) English act of parliament regulating the form of worship in the Church of England after the Restoration of the monarchy. It required all ordained clergy to follow the Book of Common Prayer. The act also required the clergy to repudiate the Solemn League and Covenant, to forswear the taking up of arms against the Crown, and to adopt the liturgy of the Church of England.

Union, Acts of Series of acts uniting ENGLAND with WALES (1536) and SCOTLAND (1707), and Britain with IRELAND (1800). In addition, the 1841 Act of Union united French-speaking Lower CANADA and English-speaking Upper Canada. The Welsh acts incorporated Wales within the kingdom of England, provided Welsh parliamentary representation and made English the official language. The Scottish act united the kingdoms of England and Scotland forming Great Britain. Scotland retained its legal system and Presbyterian Church. In accordance with the Irish act, the Irish legislature was abolished and Ireland was given 32 peers and 100 seats in the British Parliament. The established churches of the two countries were united, and free trade was introduced. The Canadian act led to the establishment of a parliament for the province.

Union of Soviet Socialist Republics Official name for the SOVIET UNION

Unitarianism Version of Christianity that denies the Trinty, accepts God as the father, and rejects the divinity of Jesus Christ. Originally considered a heresy, it flourished in Poland in the 16th century. John Biddle (1615–62) first preached Unitarianism in England in the 1640s. Unitarianism in the 20th century has been identified with liberal politics and the movement for world peace; it has taken an increasingly humanist point of view.

United Arab Emirates (UAE) Federation of the seven independent sheikhdoms of ABU DHABI, DUBAI, Ajman, Ras al-Khaimah, Fujairah, Sharjah and Umm al-Qaiwain. It is bordered by the Persian Gulf (N), Oman (E), Saudi Arabia (W and s) and Qatar (NW). The terrain is flat, consisting mainly of desert. The economy is dominated by crude oil and natural gas production, accounting for c.50% of GDP. Oil was first discovered in Abu Dhabi in the early 1960s, and the 1973 increase in oil prices transformed a relatively impoverished region into one of the world's wealthiest. Formerly known as the Trucial States, the area was a British protectorate from 1892. After World War 2 the sheikhdoms were granted internal autonomy. In 1971 British troops withdrew from the Persian Gulf and the United Arab Emirates was formed. Abu Dhabi is more than six times the size of the other states put together, has the largest population, is the biggest oil producer and provides the federal capital; the city of Abu Dhabi. The other significant populations are Dubai and Sharjah. The population is almost exclusively Muslim (mostly Sunni), though the great majority of inhabitants are expatriate workers. The UAE was part of the international coalition against Iraq in the 1991 Gulf War.

United Kingdom (UK) Kingdom in w Europe. *See* country feature, page 692

United Nations (UN) International organization set up to enable countries to work together for peace and mutual development. It was established by a charter signed in San Francisco in June 1945 by 50 countries. In 1995 the UN had 185 members, essentially all the world's sovereign states except for North and South Korea and Switzerland.

United Nations agencies Executive bodies operating on behalf of and responsible to the UNITED NATIONS (UN). They include: the FOOD AND AGRICULTURE ORGANIZATION (FAO, Rome); INTERNATIONAL ATOMIC ENERGY AGENCY (IAEA, Vienna); the International Civil Aviation Organization (ICAO, Montreal); INTERNATIONAL LABOUR ORGANIZATION (ILO, Geneva); International Maritime Organization (IMO) (IMO, London); INTERNATIONAL MONETARY FUND (IMF, Washington, D.C.); International Telecommunication Union

(ITU, Geneva); United Nations Conference on Trade and Development (UNCTAD, Geneva); UNITED NATIONS EDUCA-SCIENTIFIC AND CULTURAL ORGANIZATION (UNESCO, Paris); United Nations High Commission for Refugees (UNHCR, Geneva); UNITED NATIONS CHILDREN'S FUND (UNICEF, New York); UNIVERSAL POSTAL UNION (UPU, Bern); WORLD BANK (International Bank for Reconstruction and Development or IBRD, New York) and its own agencies the International Development Association (IDA) and the International Finance Corporation (IFC); World Food Council (WFC, Rome); World Food Programme (WFP, Rome); WORLD HEALTH ORGANIZATION (WHO, Geneva); and the WORLD TRADE ORGANIZATION (WTO, Geneva). For internal administration in its main offices in New York, the United Nations has a Secretariat staffed by international personnel.

United Nations Children's Fund (UNICEF) Intergovernmental organization, agency of the UNITED NATIONS (UN). Founded in 1946 (as the United Nations International Children's Emergency Fund), its aim is to assist children and adolescents worldwide, particularly in war-devastated areas and developing countries.

United Nations Educational, Scientific and Cultural Organization (UNESCO) Intergovernmental organization, agency of the UNITED NATIONS (UN). Founded in 1945, it aims to promote peace by improving the world's standard of education, and by bringing together nations in cultural and scientific projects. It also gives aid to developing countries.

United Nations peacekeeping force Military personnel and their equipment placed at the UNITED NATIONS' disposal by member states. The function of the forces is to keep the peace between warring factions anywhere in the world, as requested by the UNITED NATIONS SECURITY COUNCIL. The first UN peacekeeping forces were deployed in the Sinai peninsula and in Beirut in June 1948. The greatest number ever deployed was in Bosnia during the mid-1990s.

United Nations Security Council Council responsible for taking action against any nation or faction considered to represent a threat to the security or continued wellbeing of a member state. Such action can be political, economic or, as a last resort, military. The Council also has the power to hold a formal investigation into matters of common concern. There are five permanent member states: the USA, UK, France, Russia and China.

United States of America (USA) Federal republic of North America; the world's fourth-largest country. *See* country feature, page 694

units See WEIGHTS AND MEASURES

Universal Postal Union (UPU) Specialized agency of the UNITED NATIONS (UN), established in 1947, that regulates international mail services. The Universal Postal Congress is the part of the UPU that determines postal rates and procedures. These are specified in an agreement called the Universal Postal Convention.

universal time System of time reckoning based on the mean solar day, the average interval between two successive transits of the Sun across the Greenwich (0°) meridian.

Universe Aggregate of all matter, energy and space. On a large scale, the universe is considered uniform: it is identical in every part. It is believed to be expanding at a uniform rate, the galaxies all receding from one other. The origin, evolution and future characteristics of the universe are considered in several cosmological theories. Recent developments in astronomy imply a finite universe, as postulated in the Big Bang theory. See also COSMOLOGY; STEADY-STATE THEORY

university Institution of higher learning. Universities grew from the *studia generalia* of the 12th century, which provided education for priests and monks and were attended by students from all parts of Europe. Bologna became an important centre of legal studies in the 11th century. Other great *studia generalia* were founded in the mid-12th century at Paris, OXFORD and CAMBRIDGE. The first Scottish university was founded at St Andrews *c*.1412, the first Irish university at Dublin (Trinity College) in 1591. The oldest US university is HARVARD, which was founded in 1636.

unnilquadium Former name for dubnium, see ELEMENT 104

unsaturated compound In organic chemistry, compound in which two or more carbon atoms are linked, or bonded together, with double or triple bonds. Simple examples are ETHENE and ETHYNE.

untouchables Fifth and lowest *varna* (class) of the Indian CASTE system, making up c.20% of India's population. The term arises from the belief among higher castes, such as BRAHMIN that to touch *panchamas* amounts to ritual pollution or defilement. Although their pariah status and the resultant social injustice were legally abolished in India (1949) and Pakistan (1953), much discrimination remains. *See also* HINDUISM

Upanishads (Sanskrit, session) Texts of HINDUISM, constituting the final stage of Vedic literature. Written in prose and verse, they take the form of dialogues between teacher and pupil. They are of uncertain authorship and date from $c.650\,\mathrm{BC}$ or earlier. Often referred to as the VEDANTA, the Upanishads speculate on reality and man's salvation. See also Brahmanism Updike, John Hoyer (1932-) US writer. Updike is best known for his lyrical chronicles of Rabbit Angstrom, whose relationship crises often reflect contemporary social pressures. The tetralogy began with Rabbit Run (1960) and Rabbit Redux (1971). Rabbit is Rich (1981) won a Pulitzer Prize. The series was completed by Rabbit at Rest (1990). Other novels, which explore sexuality and morality, include Couples (1968) and The Witches of Eastwick (1984, filmed 1987). A regular contributor to New Yorker magazine since 1955, Updike is a master of shorter prose, such as the essay collection Hugging the Shore (1984) and the short-story collection Forty Stories (1987).

Upper Volta Former name (until 1984) of Burkina Faso **Uppsala** (Upsala) Medieval city in E Sweden. Its university was founded in 1477. King Gustavus I (Vasa) is buried in the 15th-century Gothic cathedral. Industries: machinery, building materials, pharmaceuticals, printing, food processing, metal goods. Pop. (1994) 181,000.

Ur (Ur of the Chaldees) Ancient city of SUMERIA, S MESOPOTAMIA. Ur flourished in the 3rd millennium BC, but in c.2340 BC it was conquered by SARGON I. The Akkadian period witnessed the integration of Semitic and Sumerian cultures. In c.2060 BC the great ziggurat was built by King Ur-Nammu. In c.2000 BC much of the city was destroyed by the invading Elamites. In the 6th century BC NEBUCHADNEZZAR briefly restored Ur as a centre of Mesopotamian civilization, but by the 5th century BC it had fallen into terminal decline.

Urals Range of mountains in Russia, traditionally marking the boundary between Europe and Asia. The range extends 2,400km (1,500mi) from the Arctic in the N to the Ural River and the Kazakstan frontier in the s. The mountains are extensively forested and the timber industry is important. The Urals' chief importance lies in their mineral deposits, which include iron ore, oil, coal, copper, nickel, gold, silver, zinc and many precious stones. These resources have given rise to the Urals industrial region. Industrial development was increased under the first two Soviet five-year plans (1929–39) and during World War 2, when many industries were moved

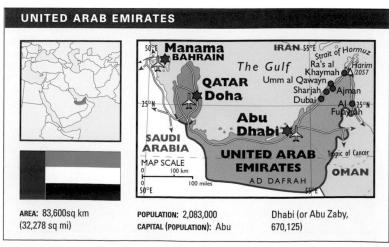

The flag of the United Kingdom was officially adopted in 1801. The first Union flag, combining the cross of St George (England) and the cross of St Andrew (Scotland), dates from 1603. In 1801, the cross of St Patrick, Ireland's emblem, was added to form the present flag.

he United Kingdom of Great Britain and Northern IRELAND is a union of four countries in the British Isles. Great Britain is composed of England, Scotland and Wales. The Isle of MAN and the CHANNEL ISLANDS are selfgoverning UK dependencies. In 1536 England and Wales were formally united. Scotland and England were unified in the 1707 Act of Union. (For land, climate, vegetation, and separate history, see individual country articles)

HISTORY

In the 17th century England's development of

empire was combined with a financial revolution, which included the founding of the BANK OF ENGLAND (1694). Sir Robert WALPOLE'S prime ministership (1721-42) marked the beginnings of CABINET government. Great Britain emerged from the SEVEN YEARS WAR (1756-63) as the world's leading imperial power. GEORGE III's conception of absolute monarchy and resistance to colonial reform led to conflict with parliament and contributed to the AMERICAN REVO-LUTION (1775-83). William PITT (the Younger) Great Britain and Ireland (1801). The AGRICUL-

oversaw the creation of the United Kingdom of

of the doubling of the population from 1801-61. The INDUSTRIAL REVOLUTION brought profound socio-economic changes. The 1820s and 1830s was an era of new reform legislation, including: the Act of CATHOLIC EMANCIPATION (1829); the abolition of SLAVERY (1833); harsh new POOR LAWS (1834); and the extension of the franchise to the middle class in the REFORM ACTS. Sir Robert PEEL's repeal of the CORN LAWS (1846) marked the beginnings of FREE TRADE and the emergence of the Conservative Party from the old Tory Party. The LIBERAL PARTY similarly evolved out of the WHIG PARTY. CHARTISM witnessed the beginnings of a working-class movement. The reign of VICTORIA saw the development of the second British empire, spurred on by the imperial ambitions of Lord PALMERSTON. The historic importance of trade to the UK economy was firmly established. Between 1868 and 1880, UK politics was dominated by DISRAELI and GLADSTONE. The defeat of Gladstone's Home Rule Bill for Ireland (1886) split the Liberal Party. Between 1908 and 1916 Herbert ASQUITH and David LLOYD GEORGE enacted a range of progressive social welfare policies, such as NATIONAL INSURANCE and state pensions. The growing power of Germany led to WORLD WAR 1. GEORGE V changed the name of the British royal family from Saxe-Coburg to Windsor. The Allied victory cost the UK over 750,000 lives. The UK was faced by rebellion in Ireland. The Anglo-Irish Treaty (1921) confirmed the partition of Ireland. The Irish Free State was formed in 1922, and the UK officially became known as the United Kingdom of Great Britain and Northern Ireland. In 1924 Ramsay MACDONALD formed the first LABOUR PARTY government. The COMMONWEALTH OF NATIONS was founded in 1931. In 1936 EDWARD VIII was forced to abdicate in favour of GEORGE VI. Neville CHAMBER-LAIN'S policy of APPEASEMENT towards Nazi Germany's growing imperial ambitions ended in failure. On 3 September 1939, following the German invasion of Poland, Britain declared war. From May 1940 Winston CHURCHILL led a coalition government, which lasted throughout WORLD WAR 2. In 1941 the USA and the Soviet Union joined the battle against Hitler. Germany surrendered in May 1945 and Japan in September 1945. Britain had lost over 420,000 lives, and its economy was devastated. In 1945 elections, the Labour Party was swept back into power, with Clement ATTLEE as prime minister. Attlee began a radical programme of nationalization and increased welfare provision. The MAR-SHALL PLAN aided reconstruction. In 1948 the NATIONAL HEALTH SERVICE (NHS) was created. The British empire was gradually dismantled,

AREA: 243,368sg km (94,202sg mi) POPULATION: 58,780,000

CAPITAL POPULATION: London (6.966.800)

GOVERNMENT: Constitutional monarchy

ETHNIC GROUPS: White 94%, Indian 1%,

currency: Pound sterling = 100 pence

RELIGIONS: Christianity (Anglican 57%, Roman Catholic 13%, Presbyterian 7%, Methodist 4%, Baptist 1%), Islam 1%, Judaism,

TURAL REVOLUTION was both a cause and effect

Pakistani 1%, West Indian 1%

LANGUAGES: English (official)

Hinduism, Sikhism

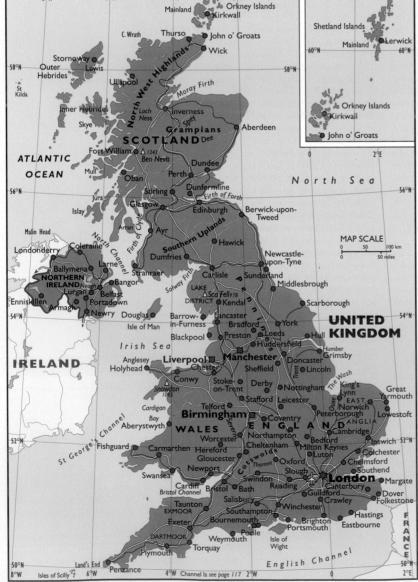

UNITED KINGDOM

beginning with India in 1947. Most newly independent nations joined the Commonwealth. In 1949 the UK joined NATO. In 1951 Churchill returned to power. In 1952 ELIZABETH II succeeded George VI. Anthony EDEN led Britain into the disastrous SUEZ CANAL Crisis (1956). Harold MACMILLAN realized the importance of Europe to UK trade. In 1959 the UK was a founder member of the European Free Trade ASSOCIATION (EFTA). In 1964 Harold WILSON narrowly defeated Alec Douglas-Home. In 1968 the British Army was deployed in Northern Ireland to prevent the violent sectarian conflict that had followed civil rights marches. In 1971, under Edward HEATH, the UK adopted a decimal currency. In 1972 the British parliament assumed direct control of Northern Ireland. In 1973 the UK joined the European Economic Community (EEC). Deep recession led to the introduction of a three-day working week. A miners' strike forced Heath to resign. The discovery of North Sea oil and natural gas decreased Britain's dependence on coal and fuel imports. James CALLAGHAN's inability to control labour unrest led to his defeat in 1979 elections. Margaret

THATCHER became Britain's first woman prime minister. Thatcher introduced MONETARISM and PRIVATIZATION. Unemployment grew as Britain attempted to switch to a more service-centred economy. The FALKLANDS WAR (1982) contributed to Thatcher's re-election in 1983. A miners' strike (1984-85) was followed by further trade union restrictions. In 1987 Thatcher won an unprecedented third general election. Urban decay, economic inequality, and an unpopular POLL TAX forced Thatcher to resign in 1990. John MAJOR signed the MAASTRICHT TREATY and won a surprise victory in the 1992 general election. He was soon forced to remove the pound from the European Monetary System (EMS). His administration was dogged by division over Europe and allegations of sleaze. In the 1997 general election, Tony BLAIR's modernized Labour Party formed the first Labour government for 18 years. The BANK OF ENGLAND rapidly gained independence from central government in the setting of interest rates. In September 1997 referenda on devolution saw Scotland and Wales gain their own legislative assemblies. The Scottish assembly was given tax-varying power.

ECONOMY

The UK is a major industrial and trading nation (1992 GDP per capita, US\$17,160). Despite being a major producer of oil, petroleum products, natural gas, potash, salt and lead, the UK lacks natural resources and has to import raw materials. In the early 20th century, the UK was a major exporter of ships, steel and textiles. Cars remain a major product, but the economy has become more service-oriented, and hightechnology industries, such as television manufacture, have grown in importance. The UK produces only 66% of the food it needs and is reliant on food imports. Agriculture employs only 2% of the workforce. Scientific and mass production methods ensure high productivity. Major crops include hops for beer, potatoes, carrots, sugar beet, strawberries, rapeseed and linseed. Sheep are the leading livestock and wool is a leading product. Poultry, beef and dairy cattle are important. Cheese and milk are major products. Fishing is a major activity. Financial services bring in much-needed revenue. Historic and cultural attractions make tourism a vital income source.

there from w Soviet Union. The highest peak is Mount Narodnaya, rising to 1,894m (6,214ft).

uraninite (pitchblende) Dense radioactive mineral form of uranium oxide, UO₂, the chief ore of URANIUM and the most important source for uranium and radium. The blackish, lustrous ore occurs as a constituent of quartz veins. Hardness 5–6; s.g. 6.5–8.5.

uranium (symbol U) Radioactive, metallic element, one of the ACTINIDE SERIES. It was discovered in 1789 and is now used in nuclear reactors and bombs. The isotope U²³⁸ makes up more than 99% of natural uranium. Chemically, uranium is a reactive metal; it oxidizes in air and reacts with cold water. U²³⁵ is fissionable and will sustain a neutron chain reaction as a fuel for reactors. Uranium is used to synthesize the TRANSURANIC ELEMENTS. Properties: at.no. 92; r.a.m. 238.029; r.d. 19.05; m.p. 1,132°C (2,070°F); b.p. 3,818°C (6,904°F); most stable isotope U²³⁸ (half-life 4.51×10° years).

Uranus Seventh planet from the Sun, discovered (1781) by Sir William HERSCHEL. Uranus is visible to the naked eye under good conditions. Through a telescope it appears as a small, featureless, greenish-blue disc. Like all the giant planets, it possesses a ring system and a retinue of satellites. Like PLUTO, Uranus' axis of rotation is steeply inclined, and its poles spend 42 years in sunlight, followed by 42 years in darkness. Highly exaggerated seasonal variations are, therefore, experienced by both the planet and its satellites. The fly-by of the Voyager 2 probe in 1986 provides most of our current knowledge of the planet. The upper atmosphere is about 83% molecular hydrogen, 15% helium, and the other 2% mostly methane. The five largest satellites were known before the Voyager encounter, which led to the discovery of ten more. All 15 are regular satellites, orbiting in or close to Uranus' equatorial plane. They are all darkish bodies composed of ice and rock. The main components of Uranus' ring system were discovered in 1977 and others were imaged by Voyager.

Uranus In Greek mythology, the original god of the sky, and the husband and son of GAIA, with whom he was father to the TITANS and the CYCLOPES.

Urban II (c.1035–99) Pope (1088–99), b. Odo of Châtillonsur-Marne. Urban carried on the reforms begun by Pope Gre-GORY VII. In 1095, at the Council of Clermont, he launched the idea of the First Crusade. His work as a reformer encouraged the development of the Curia Romana and the formation of the College of Cardinals.

Urban V (c.1310–70) Pope (1362–70), b. Guillaume de Gri-

moard. Crowned at AVIGNON, he tried (in 1367) to return the papacy from Avignon to Rome. Insurrections at Rome and the Papal States forced him back to Avignon in 1370. As pope he made a fruitless attempt to unite the Roman and Orthodox Churches.

Urban VI (1318–89) Pope (1378–89), b. Bartolomeo Prignano. The College of Cardinals declared his election invalid and appointed an antipope, CLEMENT VII, thus beginning the GREAT SCHISM. Urban VI's papacy was marked by confusion and financial losses in the papal states.

Urban VIII (1568–1644) Pope (1623–44), b. Maffeo Barberini. His reign coincided with much of the THIRTY YEARS WAR. Fearing possible domination of the papacy by the HABSBURGS, he supported France and gave little help to German Roman Catholics. An active and knowledgeable patron of the arts, he also approved the establishment of new orders.

Urdu Language belonging to the Indic group of the Indo-Iranian sub-family of INDO-EUROPEAN LANGUAGES. It is the official language of Pakistan but is used as a first language by less than 10% of the population. It is also spoken by most Muslims in India. Urdu has virtually the same grammar as HINDI, the chief difference being that Urdu is written in the ARABIC script. Both derive from SANSKRIT.

urea Organic compound ($CO(NH_2)_2$), a white crystalline solid excreted in URINE. Most vertebrates excrete most of their nitrogen wastes as urea; human urine contains about 25 grams of urea to a litre. Because it is so high in nitrogen, urea is a good fertilizer.

ureter In vertebrates, the long, narrow duct that connects the KIDNEY to the urinary BLADDER. It transports URINE from the kidney.

urethra Duct through which URINE is discharged from the bladder in mammals. In males the urethra is also the tube through which SEMEN is ejaculated.

urethritis Inflammation of the URETHRA. It is usually due to a SEXUALLY TRANSMITTED DISEASE but may also arise from infection.

urine Fluid filtered out from the bloodstream by the KIDNEY. It consists mainly of water, salts and waste products, such as UREA. From the kidneys it passes through the URETERS to the BLADDER for voiding by way of the URETHRA.

urogenital system Organs comprising the body's urinary and reproductive systems. The urinary system consists of the KIDNEYS, URETERS, the BLADDER and URETHRA. In males, the reproductive system consists of paired TESTES located in the

URANUS: DATA

Diameter (equatorial): 51,118km (31,765mi)

Mass (Earth = 1): 14.6

Volume (Earth = 1): 67

Density (water = 1): 1.27

Orbital period: 84.01 years

Rotation period: 17h 14m 0s

Average surface temperature:

-214°C (-417°F)

Surface gravity (Earth = 1): 0.79

The "Stars and Stripes" has had the same basic design since 1777, during the American Revolution. The 13 stripes represent the 13 original colonies in the Eastern United States. The 50 stars represent the 50 states of the

The United States of America is made up of a federal district (the capital WASHINGTON, D.C.) and 50 states (48 of which form a large block of land between Canada and Mexico). The other two states are ALASKA in NW North America, which contains the country's highest peak, Mount McKinley at 6,194m (20,322ft), and the North Pacific archipelago of HAWAII. On the NE border with Canada are the GREAT LAKES. CHICAGO lies on the shore of Lake MICHIGAN. The densely populated E seaboard includes the major cities of Boston, New York, PHILADEL-PHIA and BALTIMORE. The major rivers of the E are the Hudson, Delaware and Potomac. FLORIDA lies on a peninsula between the Atlantic and the Gulf of Mexico, and includes the city of MIAMI. The coastal plain is backed by the APPALACHIANS, including the BLUE RIDGE MOUNTAINS. The central lowlands are drained by the MISSISSIPPI-MISSOURI river system, which forms an enormous delta near NEW ORLEANS. The GREAT PLAINS gently rise to the ROCKY MOUNTAINS, which form the continental divide. Mount Elbert is the highest peak in the Rockies. The COLUMBIA and COLORADO rivers flow into the Pacific Ocean. Between the Rockies and the Pacific coast lie plateaux, basins and ranges. The GRAND CANYON was carved out from the Colorado plateau by the Colorado River. The GREAT BASIN includes SALT LAKE CITY and desert regions including LAS VEGAS and DEATH VALLEY, the lowest point in the western hemisphere, 86m (282ft) below sea level. The Pacific seaboard, including the cities of SAN FRANCISCO, Los Angeles and San Diego, is fringed by mountain ranges such as the SIERRA NEVADA, which includes Mount WHITNEY (the highest peak outside Alaska). The NW CASCADE RANGE contains active volcanoes, such as Mount ST HELENS. SEATTLE lies in the foothills of the range. (see also individual gazetteer articles)

CLIMATE

Temperatures vary from the Arctic cold of Alaska to the intense heat of Death Valley. Of the 48 states, winters are cold and snowy in the N, but mild in the s. The s has have long, hot summers. Rainfall is heaviest in the NW, lightest in the SW. The Gulf of Mexico experiences violent storms.

VEGETATION

Alaska contains forests of conifers. In the N states there are extensive forests, with huge redwoods along the Pacific coast, such as SEQUOIA NATION-AL PARK. In the E, the original deciduous forests only remain in protected areas, such as GREAT SMOKY MOUNTAINS National Park. The dry, central prairies merge into the high steppe of the Great Plains. Large areas of the sw are desert.

HISTORY AND POLITICS

NATIVE AMERICANS arrived perhaps 40,000 years ago from Asia. Vikings, led by LEIF ERICS- son, probably reached North America 1,000 vears ago, but did not settle. European exploration did not begin until the discovery of the New World by Christopher Columbus in 1492. The first permanent European settlement was founded by Spain in 1565 at St Augustine, Florida. The French also formed settlements in LOUISIANA, but the first major colonists were the British, who founded JAMESTOWN, Virginia, in 1607. In 1620 PURITANS landed at Cape Cod, MASSACHUSETTS and founded the PLYMOUTH COLONY. The economic success of Massachusetts encouraged further colonization along the E coast. In 1681 William PENN founded PENNSYL-VANIA. In the southern colonies, SLAVERY was AREA: 9,372,610sq km (3,618,765sq mi)

POPULATION: 259,681,000

CAPITAL (POPULATION): Washington, D.C.

(585, 221)

GOVERNMENT: Federal republic

ETHNIC GROUPS: White 80%, African-American

12%, other races 8%

LANGUAGES: English (official), Spanish, more than 30 others

RELIGIONS: Christianity (Protestant 53%, Roman Catholic 26%, other Christian 8%),

Islam 2%, Judaism 2%

currency: US dollar = 100 cents

used to develop plantations. During the 18th century, British MERCANTILISM (especially the NAVIGATION ACTS) restricted commercial growth. The GREAT AWAKENING and the development of higher education promoted greater cultural self-consciousness. The defeat of the French in the French and Indian Wars (1754-63) encouraged independence movements. Benjamin FRANKLIN's failure to win concessions from the British led to the AMERICAN

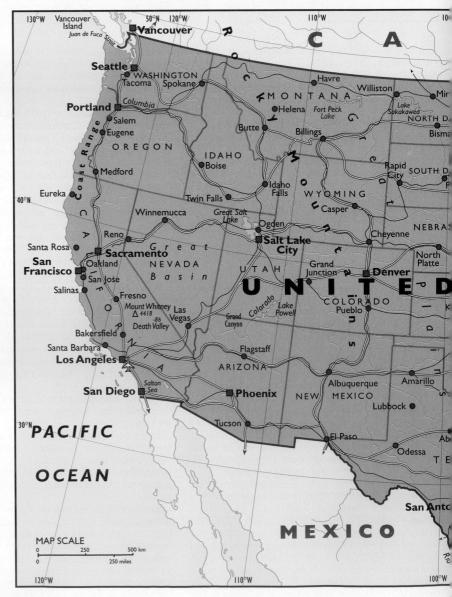

REVOLUTION (1775-83), which ended British rule in the THIRTEEN COLONIES. George WASH-INGTON, commander-in-chief of the Continental Army, became the first president. The ARTICLES OF CONFEDERATION (1777) produced weak central government, and were superseded by the CONSTITUTION OF THE UNITED STATES (1787). The Bank of the United States was created in 1791. US politics became divided between the FEDERALIST PARTY and the DEMOCRATIC REPUB-LICAN PARTY. In 1796 the Federalist president John Adams passed the Alien and Sedition ACTS (1798). The XYZ AFFAIR saw armed confrontation with France. In 1801 the Democratic-Republican Thomas JEFFERSON became president. Jefferson negotiated the LOUISIANA PUR-CHASE (1803), which nearly doubled the size of the USA. James MADISON led the USA into the WAR OF 1812, which cemented the nation's independence and culminated in the MONROE DOCTRINE (1823), which sought to protect the western hemisphere from European interference. The Missouri Compromise (1820) papered over the growing conflict between the commercial, industrial North and the cotton plantations of the pro-slavery South. The Demo-

cratic-Republican Party became simply the DEMOCRATIC PARTY. Andrew JACKSON's presidency furthered the westward expansion of the FRONTIER. The march to the Pacific became the "manifest destiny" of the USA. In 1841 William HARRISON became the first WHIG president. Texas was acquired (1845) and OREGON Territory (1846). The MEXICAN WAR (1846-48) confirmed US acquisitions. The 1848 discovery of gold in California prompted a rush of settlers. Territorial expansion was achieved at the expense of Native Americans, who were forced onto reservations. The addition of states to the Union intensified the conflict between free and slave states. The repeal of the Missouri Compromise led to the founding of the anti-slavery REPUBLICAN PARTY (1854). In 1861 Abraham LINCOLN became the first Republican president. The southern states seceded as the Confederate STATES OF AMERICA. The American CIVIL WAR (1861-65) claimed over 600,000 lives and devastated the country. The Union victory resulted in the abolition of slavery. The enforced RECON-STRUCTION of the South was highly unpopular. Ulysses S. Grant's administration was plagued by corruption. In 1867 the USA bought Alaska

from Russia. The late 19th century was the era of the railroad, which sped industrialization and urban development. The gleaming, steel skyscrapers symbolized opportunity and millions of European immigrants were attracted to the USA. In 1886 the AMERICAN FEDERATION OF LABOR was founded. The SPANISH-AMERICAN WAR (1898) heralded the emergence of the USA as a major world power. Hawaii was annexed. Construction of the PANAMA CANAL began in 1902. In 1917 Woodrow WILSON led the USA into WORLD WAR 1. The economic boom and PROHIBITION of the 1920s was followed by the GREAT DEPRESSION of the 1930s. Franklin D. ROOSEVELT'S NEW DEAL attempted to restore prosperity. The Japanese bombing of PEARL HARBOR (7 December 1941) prompted US entry into WORLD WAR 2. Rearmament fuelled economic recovery. Harry S. TRUMAN became president on Roosevelt's death in 1945. The use of atomic bombs led to Japan's surrender. The USA was a founder member of NATO. Post-war tension with the Soviet Union led to the COLD WAR and spurred the space race. In order to stem the spread of communism, US forces fought in the Korean War (1950-53). In 1955 Martin Luther KING launched the CIVIL RIGHTS movement. The start of John F. KENNEDY's presidency was marred by the CUBAN MISSILE CRISIS (1962). Kennedy's assassination (22 November 1963) shocked the nation. Lyndon Johnson led the USA into the VIETNAM WAR (1965-73). Anti-Vietnam protests were coupled with civil unrest. On 20 July 1969 Neil ARMSTRONG became the first man on the Moon. In 1974 Richard Nixon was forced to resign by the WATERGATE SCANDAL. The CAMP DAVID AGREE-MENT crowned Jimmy CARTER's foreign policy initiatives. The start of Ronald REAGAN's presidency (1981-89) marked the deepest recession since the Great Depression. Economic recovery brought increases in defence spending. Reagan's loosening grip on power was highlighted by the IRAN-CONTRA AFFAIR (1987-88). Following the collapse of Soviet communism in 1991, George BUSH proclaimed a New World Order. Despite the success of the GULF WAR (1991), domestic recession led to Bush's defeat in 1992. Bill CLINTON's reform programme was largely blocked by a Republican-dominated SENATE. Despite allegations of financial and personal scandal, economic recovery led to Clinton's reelection in 1996.

ECONOMY

The USA is the world's largest manufacturing nation (1992 GDP per capita, US\$23,760). The 1992 NORTH AMERICAN FREE TRADE AGREE-MENT (NAFTA) with Canada and Mexico created the world's largest trading bloc. The USA is the world's largest farm producer. Agriculture is highly mechanized, employing only 2% of the workforce. Major products include poultry, beef and dairy cattle. Leading crops include cotton, hops for beer, fruits, groundnuts, maize, potatoes, soya beans, tobacco and wheat. Fishing is important. The USA's chief natural resources include oil, natural gas and coal. Timber and paper manufacture are important. Major industries include cars, chemicals, machinery, computers and printing. California is the leading manufacturing state. Services form the largest sector, including finance and tourism (1992 receipts, US\$53,361 million).

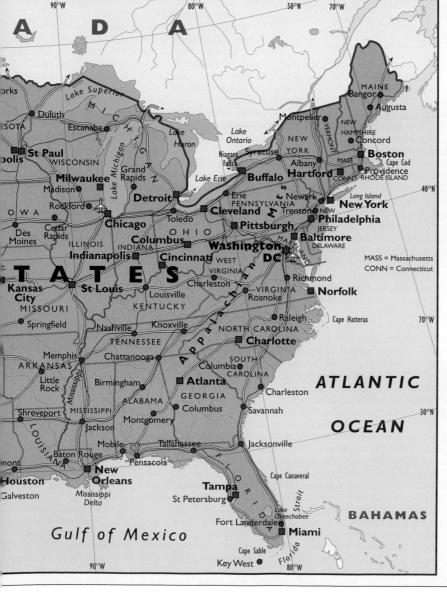

AREA: 177,410sq km (68,498 sq mi)
POPULATION: 3,116,802
CAPITAL (POPULATION):
Montevideo (1,383,660)
GOVERNMENT: Multiparty
republic
ETHNIC GROUPS: White 86%.

Mestizo 8%, Mulatto or Black 6% LANGUAGES: Spanish

BRA Z ARGENTI Tacuarembó N Paysandú Fray Bentos RUGUAY Treinta v Durazno Mercedes Minas Colonia A501 Rio de Las Piedras ● Maldonado Montevideo ATLANTIC OCEAN ARGENTINA

RELIGIONS: Christianity (Roman Catholic 66%, Protestant 2%), Judaism 1% currency: Uruguay peso = 100 centésimos

(official) Juda

scrotum; accessory glands; and the PENIS. In females, the reproductive system consists of: paired OVARIES; Fallopian tubes, which provide a passage from the ovaries to the UTERUS; the CERVIX; and the VAGINA.

urology Medical speciality concerned with the diagnosis and treatment of diseases of the urinary tract in women and of the urinary and reproductive systems in men.

Ursa Major (Great Bear) Northern constellation, whose main pattern, consisting of seven stars, is known as the **Plough** or **Big Dipper**. Five of the Plough stars make up a CLUSTER.

Ursa Minor Constellation that contains the north celestial pole. Its brightest star is Alpha, the POLE STAR. The constellation's seven main stars make a pattern resembling a faint and distorted plough.

Ursula, Saint (active 4th century AD) Legendary virgin and martyr, who according to some traditions was a British princess. She was especially honoured at Cologne, where she is said to have been slain by the HUNS with her 11 (or in some reports 11,000) virgins on their return from a pilgrimage to Rome. She has become the patron of many educational establishments, including the Ursuline order.

urticaria See HIVES

Uruguay Republic in South America; the capital is MONTE-VIDEO. Land and climate Uruguay consists of low-lying plains and hills, rising to a highest point, Mirador Nacional, which is only 501m (1,644 ft) above sea level. The main river in the interior is the Río Negro. The URUGUAY River, which forms the country's w border, flows into the Río de la PLATA, a large estuary leading into the South Atlantic Ocean. Uruguay has a mild climate, with rain throughout the year, though droughts sometimes occur. The summer months are pleasantly warm, especially near the coast. Grasslands cover 77% of Uruguay and arable land about 7%. Trees such as acacia, aloe, eucalyptus and willow grow along the river valleys. Uruguay also has commercial tree plantations, including trees such as quebracho. History The original Native American inhabitants of Uruguay have largely disappeared. Many were killed by Europeans, others died of European diseases, while some fled into the interior. The first European to arrive in Uruguay was a Spanish navigator in 1516, but few Europeans settled there until the late 17th century. In 1726 Spanish settlers founded Montevideo in order to prevent the Portuguese gaining influence in the area. By the late 18th century, Spaniards had settled in most of the country, and Uruguay became part of a colony called the Viceroyalty of La Plata, which also included Argentina, Paraguay, and parts of Bolivia, Brazil and Chile. In 1820 Brazil annexed Uruguay, ending Spanish rule. In 1825 Uruguayans, supported by Argentina, began a struggle for independence and finally, in 1828, Brazil and Argentina recognized Uruguay as an independent republic. Social and economic development were slow in the 19th century, with many revolutions and counter-revolutions. Following the election of Batlle y Ordóñez as president in 1903, however, Uruguay became a more democratic and stable country. From the 1950s, economic problems caused unrest. Terrorist groups, notably the Tupumaros, carried out murders and kidnappings. The army crushed the Tupumaros in 1972, and then took over the government in 1973. Repressive military rule continued until 1984, when civilian rule was re-established. However, economic difficulties and high foreign debts continued to threaten stability, provoking massive emigration. Julio María Sanguinetti, who had led Uruguay back to civilian rule in the 1980s, was re-elected president in 1994. Economy Uruguay is an upper-middle-income developing country (1992 GDP per capita, US\$ 6,070). Agriculture employs only 5% of the workforce, but farm products, notably hides and leather goods, beef and wool, are the leading exports, while the main crops include maize, potatoes, sugar beet and wheat. The leading manufacturing industries, situated mainly in and around Montevideo, are concerned with processing farm produce. Other manufactures include beer, cement, textiles and tyres. Tourism is important.

Úruguay River in SE South America. Rising in S Brazil and forming part of the boundary between Rio Grande do Sul and Santa Catarina states, it flows sw to form the boundary between Argentina and S Brazil, and then Argentina and Uruguay. It empties into the Río de la PLATA. Length: *c*.1,600km (1,000mi).

USA Abbreviation of United States of America

USSR Abbreviation of Union of Soviet Socialist Republics, see SOVIET UNION

Ustinov, Peter Alexander (1921–) British actor and dramatist. His plays include *The Love of Four Colonels* (1951) and *Romanoff and Juliet* (1956). He has acted in many films, including *Billy Budd* (1962), which he also directed. In recent years he has won a reputation as an entertaining raconteur.

usury Lending of money at an excessive or unlawful rate of interest. Before the Middle Ages any payment for the borrowing of money was regarded as usury by Christians. In the late Middle Ages reasonable interest on a loan became acceptable when the lender risked capital.

Utah State in the w USA in the ROCKY MOUNTAINS; the state capital is SALT LAKE CITY, other cities include Provo and Ogden. The region was ceded to the USA at the end of the MEXICAN WAR in 1848, and Utah was admitted to the Union in 1896. The influence of the MORMON CHURCH is strong in the state, and in 1857–58 there were conflicts between federal troops and the Mormons. In the N, the Wasatch Range separates the mountainous E from the Great Basin, which includes the GREAT SALT LAKE. The arid climate hinders agriculture, but hay, barley, wheat, beans and sugar beet are grown with irrigation. The chief farming activity is stock raising. Mining is also important: there are rich deposits of copper, petroleum, coal, molybdenum, silver, lead and gold. With many national parks and monuments, tourism is vital to the economy. Area: 219,931sq km (84,915sq mi). Pop. (1992) 1,811,215.

Utamaro, Kitagawa (1753–1806) Japanese master of the UKIYO-E woodblock colour print, the first Japanese artist to become famous in the West. He excelled in depicting birds, flowers and feminine beauty. His works were strongly erotic, precise, graceful and immensely popular.

Ute Shoshonean-speaking tribe of Native North Americans. They were fierce, nomadic warriors, who engaged in warfare with other Native American tribes and hunted bison. Today *c*. 4,000 live on reservations in Colorado and Utah.

uterus (womb) Hollow muscular organ located in the pelvis of female mammals. It protects and nourishes the growing FETUS until birth. The upper part is broad and branches out on

▲ Ustinov Of French and Russian parentage, Peter Ustinov was born in London. A successful actor and playwright, in recent years he has become best known for his one-man shows, which provide him with the opportunity to portray a variety of characters.

each side into the FALLOPIAN TUBES. The lower uterus narrows into the CERVIX, which leads to the VAGINA. Its muscular walls are lined with ENDOMETRIUM (mucous membrane), to which the fertilized egg attaches itself. See also MENSTRUAL CYCLE **Uthman** See OTHMAN

utilitarianism Branch of ethical philosophy. It holds that actions are to be judged good or bad according to their consequences. An action is deemed to be morally right if it produces good results. Utilitarianism was developed during the late 18th and 19th centuries by the English philosophers Jeremy BENTHAM, James MILL and J.S. MILL.

Uto-Aztecan languages Family of NATIVE AMERICAN languages spoken in sw USA and Mexico. It includes COMANCHE, of Oklahoma, and SHOSHONE, spoken in some w states. In Mexico it includes NAHUATL (the language of the Aztecs), Tarahumara and Mayo.

Utopianism (Gk. no place) Projection of ideal states or alternative worlds, which are ordered for the benefit of all and where social ills have been eradicated. Sir Thomas More's Utopia (1516) outlines his notion of an ideal commonwealth based entirely on reason. It critically describes contemporary social existence, while prescribing a transcendent, imaginative vision of the best of all possible worlds. Enlightenment philosophers, such as Jean Jacques Rousseau, portrayed a vision of a pre-feudal European Golden Age. Other writers such as Saint-Simon, Charles FOURIER and Robert OWEN outlined ideal communities based on cooperation and economic self-sufficiency. Karl MARX and Friedrich ENGELS valued the satirical social insights of utopianism but rejected its unscientific analysis of political and economic realities. By the late 19th century, the utopian novel had become an established literary genre. Works such as Erewhon (1872) by Samuel But-LER were popular and influential. The spread of totalitarianism in Europe during the 1930s encouraged dystopian novels, such as Brave New World (1932) by Aldous HUXLEY and 1984 (1949) by George ORWELL.

Utrecht City on the Oude Rijn River, central Netherlands. Utrecht is the fourth-largest city in The Netherlands. It has been a trading centre since medieval times. It was the scene of the Peace of UTRECHT (1713). The old city includes the 14th-century St Martin's Cathedral. Utrecht is a major cultural, financial and rail centre. Industries: steel, machinery, textiles, electrical equipment. Pop. (1994) 234,106.

Utrecht, Peace of (1713-14) Series of treaties that ended the War of the SPANISH SUCCESSION. It confirmed the BOUR-BON King PHILIP V on the Spanish throne on condition that he renounced any claim to the throne of France. Austria received the Spanish Netherlands and extensive Italian territories; Britain gained Gibraltar, Minorca and provinces of E Canada. Uttar Pradesh State in N India, bordering Nepal and Tibet; the capital is LUCKNOW. The heartland of early HINDU civilization, it is the hub of India's Hindi-speaking region and is by far the most populous Indian state. The region has the foothills of the Himalayas to the N and hills in the s, enclosing a low-lying plain drained by the GANGES and its tributaries. The economy is based on agriculture, mainly cereals, sugar cane, rice and pulses, and the mining of coal, copper, bauxite and limestone. Industries: cotton and sugar processing. Area: 294,413sq km (113,673sq mi). Pop. (1991) 139,112,287.

Utzon, Jørn (1918–) Danish architect. He is internationally known as the designer of the much admired Sydney Opera House in Australia.

Uzbekistan Republic in central Asia; the capital is TASHKENT. **Land and climate** The Republic comprises plains in the w and highlands in the E. The main rivers, Amu Darya and Syr Darya, drain into the ARAL SEA. So much water has been diverted from these rivers to irrigate farmland that the Aral Sea has shrunk from 66,900sq km (25,830sq mi) in 1960 to 33,642sq km (12,989sq mi) in 1993. The dried-up lake area has become desert, like much of the rest of the country. Uzbekistan has a continental climate, with cold winters and hot summers. The w is extremely arid, with an aver-

age annual rainfall of c.200mm (8in), but parts of the highlands in the E have three times as much rain. Grassy steppe occurs in wetter areas, with forests on the mountain slopes. History and politics Turkic people first settled in the area that is now Uzbekistan c.1,500 years ago and Islam was introduced in the 7th century AD. MONGOLS invaded in the 13th century, and in the late 14th century TAMERLANE ruled a great empire from SAMARKAND. Turkic Uzbek people conquered the region in the 16th century and gradually the area was divided into states (khanates). Russia controlled the area in the 19th century. Following the Russian Revolution (1917), the communists took over, establishing the Uzbek Soviet Socialist Republic in 1924. Under communism, all aspects of Uzbek life were controlled; religious worship was discouraged, but education, health, housing and transport services were improved. The communists also increased cotton production, but caused great environmental damage in the process. In the 1980s, when reforms were introduced in the Soviet Union, the Uzbeks demanded greater freedoms. In 1990 the Uzbek government unilaterally declared itself sovereign. In 1991, following the break-up of the Soviet Union, Uzbekistan became independent. Uzbekistan retained links with Russia through membership of the COMMONWEALTH OF INDEPENDENT STATES (CIS). On 29 December 1991, Islam Karimov, leader of the People's Democratic Party (formerly the Communist Party), was elected president. In 1992 and 1993 many opposition leaders were arrested. In order to avoid internal disruption, Karimov asserted that economic reforms would be slow. Elections in 1994-95 resulted in a sweeping victory for the People's Democratic Party. A 1995 referendum extended President Karimov's term in office until 2000. Economy Uzbekistan is a lower-middle-income developing country (1992 GDP per capita, US\$2,650). The government controls most economic activity. Uzbekistan produces coal, copper, gold, oil and natural gas, while manufactures include agricultural machinery, chemicals and textiles. Agriculture is important, with cotton the main crop. Other crops include fruits, rice and vegetables; cattle, sheep and goats are raised. Uzbekistan's exports include cotton, gold, textiles, chemicals and fertilizers.

Uzbeks Turkic-speaking people, originally of Persian culture, who form 71% of the population of the Republic of UZBEKISTAN. They took their name from Uzbeg Khan (d. 1340), a chief of the GOLDEN HORDE. By the end of the 16th century, the Uzbeks had extended their rule to parts of Persia, Afghanistan and Chinese Turkistan. Their empire was never united, and in the 19th century its various states were absorbed by Russia.

UTAH
Statehood:
4 January 1896
Nickname:
The Beehive State
State bird:
Sea gull
State flower:
Sego lily
State tree:
Blue spruce
State motto:

Industry

UZBEKISTAN

C.::::

AREA: 447,400sq km (172,740sq mi) POPULATION: 21,206,800 POPULATION: Tashkent (2,094,300)

ETHNIC GROUPS: Uzbek 71%, Russian 8%, Tajik 5%, Kazak 4%, Tatar 2%, Kara-Kalpak 2%, Crimean Tatar, Korean, Kyrgyz, Ukrainian, Turkmen

LANGUAGES: Uzbek (official)
RELIGIONS: Islam
CURRENCY: Som

V/v, the 22nd letter of the alphabet, derived (as were f, u and v) from the Semitic letter vaw, meaning hook. It was identical to u in the Greek and Roman alphabets, the Romans using it both as a vowel (u) and a consonant (v), and was not differentiated from u in English until the Middle Ages. In modern English v has only the one consonant sound, as in vole and wove.

V1, V2 rockets (abbreviation for *Vergeltungswaffen*, vengeance weapons) V-1s, popularly known as **doodlebugs**, **flying bombs** or **buzz bombs**, were pilotless aircraft, powered by a pulse-jet engine, with a guidance system composed of a distance-measuring device, a gyrocompass and an altimeter. Launched by the Luftwaffe against SE England in June 1944, they carried about a tonne of high explosive. Later the same year, England was subjected to attacks by the V-2, a long-range, ballistic missile carrying a 1-tonne warhead to a range of 320km (200mi), with an altitude of 95–110km (60–70mi). It was powered by a mixture of liquid oxygen and ethyl alcohol, and was the precursor of postwar missiles.

vaccination Injection of a VACCINE in order to produce IMMUNITY against a disease. In many countries, children are vaccinated routinely against infectious diseases.

vaccine Agent used to give IMMUNITY against various diseases without producing symptoms. A vaccine consists of modified disease organisms, such as live, weakened VIRUSES, or dead ones that are still able to induce the production of specific ANTIBODIES within the blood. See also IMMUNE SYSTEM

vacuole Membrane-bound, fluid-filled cavity within the CYTOPLASM of a CELL. Vacuoles perform various functions including the discharge of wastes from cell metabolism.

vacuum Region of extremely low pressure. Interstellar space is a high vacuum, with an average density of less than 1 molecule per cubic centimetre; the highest man-made vacuums contain less than 100,000 molecules per cubic centimetre.

vacuum flask Container for keeping things (usually liquids) hot or cold. A vacuum flask is made with double, silvered, glass walls, separated by a near VACUUM. This vessel is held in an insulated metal or plastic case. The vacuum reduces heat transfer by CONDUCTION of CONVECTION between the contents and the surroundings. The silvering on the glass minimizes heat transfer by radiation.

vagina Portion of the female reproductive tract, running from the CERVIX of the UTERUS to the exterior of the body. Tube-like in shape, it receives the PENIS during sexual intercourse. Its muscular walls enable it to dilate during childbirth. valence (valency) "Combining power" of a particular element, equal to the number of single chemical bonds one atom can form or the number of electrons it gives up or accepts when forming a compound. Hydrogen has a valency of 1, carbon 4 and sulphur 2, as seen in compounds such as methane (CH₄), carbon disulphide (CS₂) and hydrogen sulphide (H₂S).

Valencia City in E Spain, capital of the province of Valencia, situated on the River Turia. The region of Valencia comprises the provinces of Alicante, Castellón and Valencia. Originally settled by the Romans, the city was conquered by the Moors in the 8th century, eventually becoming capital of the independent Moorish kingdom of Valencia. In the Spanish CIVIL WAR it was the last Republican stronghold to fall to Nationalist forces. It is an agricultural, industrial and communications centre. Industries: electrical equipment, chemicals, textiles, shipbuilding, vehicles, machinery, fruit, wine. Tourists are drawn by the city's many fine buildings. Pop. (1991) 752,909. Valencia City in N Venezuela, capital of Carabobo state. It was the capital of Venezuela in 1830, when the country was proclaimed independent of Greater Colombia. It is an industrial and transport centre. Industries: textiles, paper, cement, glass, soap, furniture vehicles, brewing. Pop. (1990) 903,076. Valentine, Saint Name traditionally associated with two legendary saints of the 3rd century: Valentine of Rome and Valentine of Interamna (modern Terni). The former was a Roman priest and physician; the latter, the Bishop of Terni. Little is known about either of them. The martyrdom of both is commemorated on 14 February. The custom of lovers exchanging cards on St Valentine's Day possibly has its roots in the pagan Roman festival of Lupercalia, an ancient fertility rite celebrated in Rome on 15 February.

Valentino, Rudolph (1895–1926) US silent-film star, b. Italy. Valentino's smouldering blend of passion and melancholy wooed female audiences in the 1920s. His films include *Four Horseman of the Apocalypse* (1921), *The Sheik* (1921), *Blood and Sand* (1922) and *The Eagle* (1925). Valentino's early death caused hysteria among his fans.

valerian (garden heliotrope) Plant native to Europe and N Asia and naturalized in the USA. It has pinkish or pale purple flower clusters. Height: to 1.2m (4ft), Family Valerianaceae; species *Valeriana officinalis*.

Valéry, Paul (1871–1945) French poet and critic. Influenced by SYMBOLISM and MALLARMÉ in particular, Valéry's masterpiece is *La Jeune Parque (The Young Fate*, 1917). Other works, such as *Le Cimetière marin* (1920) and *Charmes* (1922), cemented his lyrical, abstract style. Valéry's *Notebooks* (1957–60) record his thoughts on a wide range of issues. He was elected to the Académie Française (1925).

Valhalla In Norse mythology, the Hall of the Slain, where chosen warriors enjoyed feasts with the god Odn. It is depicted as a glittering palace, with golden walls and a ceiling of burnished shields.

Valium Proprietary name for diazepam, a sedative drug in the BENZODIAZEPINE group. It is used in the treatment of anxiety, muscle spasms and epilepsy.

Valkyries In Norse mythology, warlike handmaidens of the god Odin, who selected and conducted to Valhalla those slain heroes who merited a place with him.

Valladolid City on the River Pisuerga, Nw central Spain, capital of Valladolid province. The city was liberated from the Moors by Castilian kings in the 10th century. There is a 12th-century Romanesque church and a monument to Christopher Columbus, who died in the city. Valladolid's university, founded in 1346, is one of the oldest in Spain. Industries: vehicles, railway engineering, chemicals, flour milling, metalwork, textiles. The province produces fruit, wine and cereals. Pop. (1991) 328,365.

Valletta Port and capital of Malta, on the NE coast of the island. It was founded in the 16th century and named after Jean Parisot de la Valette, Grand Master of the Order of the Knights of St John, who organized the reconstruction of the city after repelling the Turks' Great Siege of 1565. Notable buildings include the Royal University of Malta (1592) and the Cathedral of San Giovanni (1576). Industries: shipbuilding and repairs, transshipment, tourism. Pop. (1995) 102,571. valley Elongated, gently sloping depression of the Earth's surface. It often contains a stream or river that receives the drainage from the surrounding heights. A U-shaped valley was probably formed by a glacier, a V-shaped one by a stream. The term may also be applied to a broad, generally flat area that is drained by a large river.

Valois, Dame Ninette de (1898–) Irish ballerina and choreographer, b. Edris Stannus. She danced (1923–26) with Diaghilev's BALLETS RUSSES. In 1931 she founded the Sadler's Wells Ballet School, which later became the Royal Ballet.

Valparaíso Main port of Chile and capital of Valparaíso region, 100km (60mi) w of Santiago. Founded in 1536, Valparaíso has always been vulnerable to earthquakes. As well as Chile's chief port, it is also a cultural centre, with two universities and museums of fine arts and natural history. Industries: chemicals, textiles, sugar refining, vegetable oils, paint. Pop. (1992) 276,736.

value-added tax (VAT) Indirect tax imposed in most European countries. Introduced in Britain in 1971, it consists of a series of taxes (calculated as a percentage) levied on goods (or services) in the various stages of their manufacture until the point of sale.

valves In anatomy, structures that prevent the backflow of blood in the HEART and VEINS. Heart valves separate and connect the two atria and ventricles, the right ventricle and the pulmonary artery, and the left ventricle and the aorta.

vampire bat Small, brown bat that lives in tropical and subtropical America. It uses its sharp teeth to slice the skin of resting animals (including human beings) and then laps up their blood. Length: 7.6cm (3in); wingspan 30cm (12in). Family Desmodontidae; species *Desmodus rotundus*.

vanadium (symbol V) Silver-white, metallic element, one of the TRANSITION ELEMENTS. Discovered in 1801, the malleable and ductile metal is found in iron, lead and uranium ores and in coal and petroleum. It is used in steel alloys to add strength and heat resistance. Chemically, vanadium reacts with oxygen and other nonmetals at high temperature. Properties: at.no. 23; r.a.m. 50.9414; r.d. 6.1 at 18.7°C; m.p. 1,890°C (3,434°F); b.p. 3,380°C (6,116°F); most common isotope V_{51} (99.76%).

Van Allen radiation belts Two rings of radiation trapped by the Earth's magnetic field in the upper atmosphere. The belts contain high-energy, charged particles.

Vanbrugh, Sir John (1664–1726) English BAROQUE architect and dramatist, who worked with and was influenced by Sir Christopher WREN. Vanbrugh took London by storm with his witty RESTORATION comedies, *The Relapse (1696) and The Provok'd Wife (1697)*, before turning to architecture. Blenheim Palace (1705–20) and Castle Howard (1699–1726) are among Vanbrugh's architectural masterpieces.

Van Buren, Martin (1782–1862) Eighth US President (1837–41). Van Buren served (1921–28) in the US Senate. As Andrew Jackson's secretary of state, his opposition to John C. Calhoun's idea of Nullification earned him the vice-presidency (1832–36) and the Democratic nomination. An advocate of States' Rights, his presidency was plunged into crisis by the lack of federal intervention in the economic depression (1837). In foreign affairs, Van Buren sought conciliation with Great Britain over the Aroostook War. He was heavily defeated by William Henry Harrison in the 1840 presidential elections. Van Buren's opposition to the annexation of Texas and extension of Slavery lost him the Democratic nomination in 1844.

Vancouver City on the s shore of Burrard Inlet, s British Columbia, Canada. It is Canada's third-largest city and principal Pacific port. The area was first explored in 1792 by Captain George Vancouver. The building of the Canadian Pacific Railway allowed it to grow into the largest city on Canada's w coast. Its excellent sea and air links make it one of North America's leading centres for transport and communication with countries of the Pacific Rim. Vancouver's beautiful harbour setting, pleasant climate and terminus of both trans-Canadian railroads make it a magnet for tourists. It has two universities: British Columbia (1908) and Simon Fraser University (1963). Industries: tourism, timber, oil refining, shipbuilding, fish-processing. Pop. (1991) 471,844 (conurbation 1,602,502).

Vancouver Island Island off the Pacific coast of British Columbia, Canada. Captain Cook visited it in 1778, it became a British Crown colony in 1849 and part of British Columbia in 1866. The largest island off the w coast of N America, the interior is rugged and forested. The main city, VICTORIA, is the province's capital. Industries: timber, fishing, copper, coalmining, tourism. Area: 32,137sq km (12,408sq mi).

Vandals Germanic tribe who attacked the Roman empire in the 5th century AD. They looted Roman Gaul and invaded Spain in 409. Defeated by the GOTHS, they moved farther south and invaded North Africa (429), establishing a kingdom from which they controlled the w Mediterranean. They sacked Rome in 455. The Vandal kingdom was destroyed by the Byzantine general Belisarius in 533–534.

Van de Graaff generator Machine that generates high voltages by concentrating electrical charges on the outside of a hollow conductor. Positive or negative charges are sprayed onto a vertically moving belt that carries them up to a large hollow metal sphere where voltage builds up. An applied voltage of *c.*50,000 volts can generate up to 10 million volts.

Van der Waals, Johannes Diderik (1837–1923) Dutch physicist. He was awarded the 1910 Nobel Prize for physics for his work on gases and the gas equation that he derived. The Van der Waals equation takes into account intermolecular attraction and repulsion, which were ignored by the KINETIC THEORY of gases.

Van der Waals forces Weak forces of mutual attraction that contribute towards cohesion between neighbouring ATOMS OF MOLECULES. They are named after Johannes VAN DER WAALS.

Van Diemen's Land Original name of TASMANIA. It was discovered by Abel TASMAN in 1642 and named in honour of the Governor-General of the Dutch East Indies. It became part of New South Wales in 1803, was made a separate colony in 1825, given self-governing status in 1850 and named Tasmania in 1855.

Van Dyck, Sir Anthony (1599–1641) Flemish portrait and religious painter. Van Dyck worked in RUBENS' studio before travelling abroad. His portraits of the aristocracy, such as

Marchesa Elena Grimaldi (c.1625), were widely copied. In 1632 Van Dyck was invited to England by Charles I, who made him court painter and a knight. The elegance and sophistication of his depictions of the English aristocracy was the model for portraiture until John Singer SARGENT.

Vane, Sir Henry (1613–62) English statesman. A Puritan, Vane was briefly governor (1636–37) of Massachusetts, before returning to domestic politics. A proponent of the abolition of episcopacy in the Long Parliament, he was dismissed by Charles I. During the English Civil. War, Vane secured the Solemn League and Covenant (1643) with Scotland. He negotiated with Charles I and was opposed to the king's execution. Vane was a member of the Commonwealth council of state, but fell out with Oliver Cromwell. After the Restoration (1660), Vane was convicted of treason and executed.

Van Gogh, Vincent (1853-90) Dutch painter, a leading exponent of EXPRESSIONISM and a formative influence on modern art. Van Gogh was a lay preacher to Belgium coal miners before suffering a psychological crisis. Virtually self-taught, his early works, such as The Potato Eaters (1885), are MILLETinfluenced studies of working-class life . In 1886 he left Holland for Paris, where his palette was transformed by POST-IMPRESSIONISM, experimenting briefly with POINTILLISM. In 1888 he moved to Arles, Provence, where he was joined by GAUGUIN. Suffering from mental illness and depression, Van Gogh cut off part of his left ear after a quarrel with Gauguin. His paintings from this period include the Sunflower series (1888) and the Night Café (1888). Van Gogh entered an asylum at Saint Rémy, where he painted a series of intense landscapes, such as Starry Night (1889). These paintings are executed with heavy brushwork in heightened, flame-like colour, with passionate expression of light and emotion. He committed suicide in Auvers. In a brief and turbulent life, Van Gogh sold only one painting and was supported by his younger brother Théo.

vanilla Climbing orchid native to Mexico. The vines bear greenish-yellow flowers that produce seed-pods 20cm (8in) long, which are the source of the flavouring vanilla. Family Orchidaceae; species *Vanilla planifolia*.

Vanuatu Volcanic island group in the sw Pacific Ocean, c.2,300km (1,430mi) E of Australia. The group consists of 13 large islands and 70 islets, the majority of them mountainous,

■ Van Dyck Portrait of King Charles 1 wearing the Order of the Garter. Born in Antwerp, Sir Anthony Van Dyck was one of the great masters of 17th-century portraiture. In 1632 he was invited to England by Charles 1 and became court painter. Van Dyck completed a vast number of commissions, often using assistants to paint the backdrop. His refined and restrained style perfectly suited the dignified and patriarchal sensibilities of the European aristocracy.

▼ Varanasi The holiest of Hindu cities. Varanasi is sited close to the confluence of two holy rivers, the Ganges and the Yamuna. The water of the Ganges is considered to be purifying by Hindus, and multitudes of pilgrims descend the Ghats (flights of steps) down to the river each day to bathe. The Ghats are also the site of open funeral pyres, where bodies are burned and the ashes washed into the Ganges in the belief that the dead will be released from the earthly cycle of rebirths and enter heaven.

which form a chain *c*.725km (450mi) in length. The main islands are Espiritu Santo, Efate (which has the capital Vila, 1992 pop. 19,750), Malekula, Pentecost, Malo and Tanna. Discovered in 1606 by Pedro Fernandez de Queiros, the group was settled by the English and French in the early 1800s. Governed jointly by France and Britain as the New Hebrides from 1906, the islands became a republic in 1980. Industries: fishing, farming, mining. Copra accounts for almost half of export earnings. Area: 12,190sq km (4,707sq mi). Pop. (1996 est.) 160,000.

Van Vleck, John (Hasbrouck) (1899–1980) US mathematician and physicist. Van Vleck studied the behaviour of electrons in non-crystalline, magnetic materials. In the 1930s, he was the first scientist to use QUANTUM MECHANICS to explain the phenomenon of MAGNETISM. For this work, Van Vleck shared the 1977 Nobel Prize for physics.

vaporization (volatilization) Conversion of a liquid or solid into its vapour, such as water into steam. Some solids (such as ammonium chloride), when heated, pass directly into the vapour state, this is known as SUBLIMATION.

vapour pressure Pressure exerted by a vapour when it evaporates from a liquid or solid. When as many molecules leave to form vapour as return (in an enclosed space), this equilibrium is called a saturated vapour pressure. When a solid is dissolved in a liquid, the vapour pressure of the liquid is reduced by an amount proportional to the solid's relative molecular mass.

Varanasi (Benares, Banoras) City on the River Ganges, Uttar Pradesh state, N India. One of the holiest cities for Hindus, Varanasi annually attracts millions of pilgrims who bathe in the river. Buddha is reputed to have preached his first sermon nearby. Silk brocade, brassware and jewellery are among the city's specialist industries. Pop. (1991) 1,026,000. Varèse, Edgard (1885–1965) French composer, a leading advocate of 20th-century experimental music. Varèse experimented with new rhythms and timbres and dissonant harmonies in his works, such as *Hyperprism* (1923) for wind instruments and percussion and *Déserts* (1954) for taperecorded sound. He concentrated on ELECTRONIC MUSIC after the early 1950s.

Vargas, Getúlio Dornelles (1883–1954) Brazilian statesman, president (1930–45, 1951–54). Governor (1928–30) of Rio Grande do Sul, Vargas led a successful revolt after being defeated in presidential elections. His autocratic regime was bolstered by the army. Vargas established a corporative state, but there were few signs of economic improvement. His refusal to grant elections led to a military coup. Vargas' second term was tainted by scandal and and he was forced to resign.

variable In mathematics, symbol used to represent an unspecified quantity. Variables are used to express a range of possible values. For example, in the expression $x^2 + x + 1$, the quantity x may be assigned the value of any real number; here x is said to be an independent variable. If y is defined by $y = x^2 + x + 1$, then y is a dependent variable because its value depends on the value of x.

variable star Star whose brightness varies with time. Intrinsic variables are stars that vary because of some inherent feature. In extrinsic variables, external factors, such as eclipses or dust, affect the amount of light reaching us from the star.

variation In biology, differences between members of the same SPECIES. Variation occurs naturally due to heredity and to differences in the environment during development. *See also* ADAPTATION; EVOLUTION

variation In music, a variety of treatments upon a single theme. Successive statements of the theme are altered by such means as simple elaboration, change of key or change of time signature.

varicose veins Condition where the VEINS become swollen and distorted. They can occur anywhere in the body, but are commonly found in the legs.

varnish Solution of a RESIN or a plastic that dries to form a hard, transparent, protective and often decorative coating. Varnishes may have a matt or glossy finish. Pigments are often added to colour the varnish.

Varuna In ancient Hindu mythology, the supreme ruler and possessor of universal power. He is worshipped as the upholder of moral order, and is closely identified with the Moon.

Vasari, Giorgio (1511–74) Italian painter, architect and biographer. Vasari's fame now rests on his history of Italian art, *The Lives of the most excellent Painters, Sculptors and Architects* (1550). This lively account is the single most important document of Italian RENAISSANCE art. In architecture he is noted for his design for the UFFIZI.

Vasco da Gama See GAMA, VASCO DA

vascular bundle Strand of conductive tissue that transports water and dissolved mineral salts and nutrients in a VASCULAR PLANT. They extend from the roots, through the stem, and out to the leaves. They consist of two types of tissue: XYLEM, which conducts water from the roots to the shoot and is located towards the centre of the bundle; and PHLOEM, which conducts salts and nutrients and forms the outer regions of the bundle.

vascular plant Plant with vessels to carry water and nutrients within it. All higher plants – FERNS, CONIFERS and FLOW-ERING PLANTS – have a vascular system (XYLEM and PHLOEM). vasectomy Operation to induce male sterility, in which the tube (vas deferens) carrying sperm from the testes to the penis is cut. A vasectomy is a form of permanent CONTRACEPTION, although in some cases the operation is reversible.

vasoconstrictor Any substance that causes constriction of blood vessels and, therefore, decreased blood flow. Examples include NORADRENALINE, angiotensin and the hormone vasopressin (also known as anti-diuretic hormone).

vasodilator Any substance that causes widening of the blood vessels, permitting freer flow of blood. Vasodilator drugs are mostly used to treat HYPERTENSION and ANGINA. **VAT** See VALUE-ADDED TAX

Vatican, The Short name for the VATICAN CITY or the Vatican Palace. The Vatican Palace is the residence of the pope within the Vatican City. A building of well over 1,000 rooms clustered around a number of courtyards, it contains the papal apartments, the offices of the Vatican City state secretariat, state reception rooms, the Vatican Museums, the Vatican Archive and the Vatican Library.

Vatican City Independent sovereign state, existing as a walled enclave on the w bank of the River TIBER, within the city of ROME. It is the official home of the PAPACY and an independent base for the Holy See (governing body of the ROMAN CATHOLIC CHURCH). The first papal residence was established in the 5th century, and it has been the papal home ever since (apart from a brief spell at AVIGNON in the 14th century). Vatican City did not achieve full independence until 1929. The world's smallest nation, its population of c.1,000 (mostly unmarried males) includes the Pope's traditional Swiss Guard of 100. The Commission, appointed to administer the Vatican's affairs, has its own radio service, police and railway station and issues its own stamps and coins. The treasures of the Vatican, notably Michelangelo's frescos in the SISTINE CHAPEL and ST PETER's, attract huge numbers of tourists and pilgrims. The Vatican library contains a priceless collection of manuscripts. The official language is Latin. Area: 0.44sq km (0.17sq mi).

Vatican Council, First (1869–70) 20th ecumenical council of the Roman Catholic Church. Convened by Pope Pius IX to refute various contemporary ideas associated with the rise of liberalism and materialism, it is chiefly remembered for its declaration of PAPAL INFALLIBILITY.

Vatican Council, Second (1962–65) 21st ecumenical council of the Roman Catholic Church. It was convened by Pope John XXIII to revive and renew Christian faith and move the Church into closer touch with ordinary people. Among the most significant results were the introduction of the Mass in the vernacular, a greater role for lay people, and a greater tolerance for other sects and other religions.

vaudeville US equivalent of the British MUSIC HALL variety entertainment. Its rise and fall followed the same pattern as its European counterpart, having its heyday in the late 19th century and eventually succumbing to the cinema's popularity.

Vaughan, Henry (1622–95) Welsh poet. One of the META-PHYSICS POETS, Vaughan's verse was inspired by the religious poetry of George HERBERT. His masterpiece, *Silex Scintillans* (1650, revised 1655), meditates on man and nature.

Vaughan, Sarah (1924–90) US singer. Vaughan's operatic style contrasted with the naturalism of Ella FITZGERALD. Her early work with Billy Eckstine led to the recording of "Lover Man" with Dizzy Gillespie. Often with full orchestral accompaniment, Vaughan sang with the bands of Duke Ellington and Count Basie. Albums include *After Hours* (1961).

Vaughan Williams, Ralph (1872–1958) British composer. Vaughan Williams' interest in English folk music is apparent in his three Norfolk Rhapsodies (1905–07), and his instrumental arrangement Fantasia on Greensleeves. He also used elements of English Tudor music in his Mass in G Minor (1923) for unaccompanied chorus. He wrote nine symphonies, the best known of which are the Sixth Symphony (1947) and the Sinfonia Antarctica (1952). Other works include The Lark Ascending (1914) and the opera Pilgrim's Progress (1951).

vault Curved roof or ceiling usually made of stone, brick or concrete. The simple "barrel" vault is semi-cylindrical; the "groin" vault consists of two barrel vaults intersected at right-angles; the "ribbed groin" is the same as the groin vault except that it has ribs to give the edges extra support; the so-called Gothic vault has four pointed compartments; the "fan" vault has a delicate, fan-like appearance. English masons developed the "fan" vault in the 15th century using tracery to make it more elaborate, as in King's College Chapel, Cambridge.

Västerås Inland port at the mouth of the River Svartan on Lake Malaren, E Sweden. Founded in 1100, it was an important medieval city and was the scene of several diets, including the Diet of Västerås Recess in 1527, which formed the Lutheran State Church, and the diet of 1544, which made the Swedish throne hereditary. Industries: engineering, electronics, iron ore, timber, metal goods, textiles, glass. Pop. (1994) 122,988.

Veblen, Thorstein Bunde (1857–1929) US sociologist and economist. Veblen wrote *The Theory of the Leisure Class* (1899), in which he introduced the idea of conspicuous consumption. He founded the institutionalist school, believing that economics must be studied in the context of social change.

vector In mathematics, a quantity that has both a magnitude and a direction, as contrasted with a SCALAR, which has magnitude only. For example, the VELOCITY of an object is specified by its speed and the direction in which it is moving; similarly, a FORCE has both magnitude and direction. Mass is a scalar quantity, but WEIGHT (the force of gravity on a body) is a vector.

Vedanta (Sanskrit, conclusion of the VEDAS) Best known and most popular form of Indian philosophy; it forms the foundation for most modern schools of thought in HINDUISM. One of the most influential Vedanta schools was that expounded by the 7th–8th-century philosopher Sankara. This school holds that the natural world is an illusion. There is only one self, Brahman-Atman; ignorance of the oneness of the self with Brahman is the cause of rebirth. The system includes a belief in the TRANSMIGRATION OF SOULS and the desirability of release from the cycle of rebirth. See also UPANISHADS

Vedas Ancient and most sacred writings of HINDUISM. They consist of series of hymns and formulaic chants that constituted a Hindu LITURGY. There are four Vedas: *Rig Veda*, contain-

ing a priestly tradition originally brought to India by ARYANS; *Yajur Veda*, consisting of prayers and sacred formulas; *Sama Veda*, containing melodies and chants; and Atharva Veda, a collection of popular hymns, incantations and magic spells. The Vedas were composed over a long period, probably between *c*.1500 and 1200 BC.

Vega (Alpha Lyrae) White, main-sequence star in the constellation of Lyra; the fifth-brightest star in the sky. Its luminosity is 50 times that of the Sun.

Vega Carpio, Félix, Lope de (1562-1635) Spanish poet and Spain's first great dramatist. A prolific writer, only c.300 of his major works survive, including the plays Peribáñez and the Commander of Ocaña (c.1610) and All Citizens Are Soldiers (c.1613). His poems cover a wide variety of forms and genres. vegetable As opposed to ANIMAL, a form of life that builds up its tissues by means of growth using the energy of sunlight, carbon dioxide from the air, and the green pigment CHLOROPHYLL. This process is known as PHOTOSYNTHESIS. Vegetables, or green plants, need also to be supplied with water and mineral salts, which are usually present in the soil. vegetarianism Practice of abstaining from eating meat and fish. A minority of vegetarian purists, known as vegans, further exclude from their diet all products of animal origin, such as butter, eggs, milk and cheese. Vegetarianism has a religious basis in many cultures, particularly among various Jain, Hindu and Buddhist sects.

vegetative reproduction Form of ASEXUAL REPRODUCTION in higher plants. It involves an offshoot or a piece of the original plant (from leaf, stem or root) separating and giving rise to an entire new plant. It may occur naturally, as in strawberries reproducing by runners, or artificially, as in a house plant cutting yielding a new plant.

vein In mammals, vessel that carries deoxygenated blood to the heart. An exception is the pulmonary vein, which carries

■ vault Concrete enabled the Romans to build vaults of a size unequalled until the introduction of steel construction. Concrete vaults were supported on timber centring, which was removed after the concrete set. In some cases, vaults were built of brick ribs (1), filled with concrete (2) to lighten the weight on the centring and avoid cracking. The simplest vault was the barrel, wagon or tunnel (3) - basically a prolonged rounded arch - which was used for small spans and simple oblong structures with parallel sides. The cross-vault (4). formed by two barrels intersecting at right angles, was used over square apartments, or over long corridors divided by piers into square bays, each covered with a cross-vault.

Veins carry blood to the heart. The returning venous blood moves slowly due to low pressure, and the veins can collapse or expand to accommodate variations in blood flow. Movement relies on the surrounding muscles, which contract (1) and compress the vein. Pulsation of adjacent arteries (2) has a regular pumping effect. Semilunar valves (3) are found at regular intervals throughout the larger veins and these allow the blood to move only in one direction.

oxygenated blood from the lungs to the left upper chamber of the heart. See also ARTERY; VENA CAVA

Velázquez, Diego Rodriguez de Silva y (1599–1660) Spanish painter. Velázquez was strongly influenced by MANNERISM and the work of CARAVAGGIO, but he quickly developed a personal style that combined NATURALISM with a deep spirituality. He painted religious works and dignified GENRE PAINTINGS, notably *The Old Woman Cooking Eggs* (1618). In 1623 Velázquez became court painter to King Philip IV of Spain. During the 1630s and 1640s he produced a striking series of royal and equestrian portraits. A trip to Italy resulted in the superb portrait of *Pope Innocent X* (1650). Towards the end of his life, Velázquez continued to paint with dazzling brushwork, culminating in *The Maids of Honour* (c.1656). Unknown outside Spain until the early 19th century, he came to exercise a powerful influence on European artists, especially MANET.

velocity Rate of motion of a body in a certain direction. Its symbol is ν . Velocity is a VECTOR (magnitude and direction), whereas speed, which does not specify direction, is a SCALAR. **vena cava** Main VEIN of vertebrates that supplies the HEART with deoxygenated blood, emptying into its right atrium.

veneer Extremely thin sheet of wood, or a thin sheet of a

precious material such as ivory or tortoise-shell, which gives furniture or other objects the appearance of being more valuable than they are. Veneers may also be used as decorative shapes inlaid into a surface.

venereal disease (VD) Any of the diseases transmitted through sexual contact, chief of which are SYPHILIS, GONOR-RHOEA and chancroid. Syphilis is caused by the bacterium *Treponema pallidum*. PENICILLIN and its derivatives can still cure syphilis in its early stages. Gonorrhoea is caused by the gonococcus bacterium and if diagnosed early may be treated with SULPHONAMIDE DRUGS.

Venetian School School of Italian painting that flourished in the 15th, 16th and 18th centuries. It was noted for the sumptuousness and radiance of its colour. Early Venetian masters included the BELLINI and Vivarini families, who were followed by its greatest exponents, TITIAN and GIORGIONE. TINTORETTO and VERONESE represent the transition from RENAISSANCE to BAROQUE, while TIEPOLO, CANALETTO and GUARDI revived Venetian painting in the 18th century.

Venezuela Republic in N South America. *See* country feature Venice (Venezia) City on the Gulf of Venice, at the head of the Adriatic Sea, N Italy, capital of Venetia region. It is built on 118

VENEZUELA

Venezuela's flag, adopted in 1954, has the same basic tricolour as the flags of Colombia and Ecuador. The colours were used by the Venezuelan patriot Francisco de Miranda. The seven stars represent the provinces in the Venezuelan Federation in 1811.

AREA: 912,050sq km (352,143sq mi)

POPULATION: 21,378,000

CAPITAL (POPULATION): Caracas (1,824,892)

GOVERNMENT: Federal republic **ETHNIC GROUPS:** Mestizo 67%, White 21%,

Black 10%, Native American 2% LANGUAGES: Spanish (official)

RELIGIONS: Christianity (Roman Catholic 94%)

currency: Bolívar = 100 céntimos

The w part of the Republic of Venezuela contains the Maracaibo lowlands, which surround the the oil-rich Lake Maracaibo, and the city of MARACAIBO. Arms of the ANDES mountains extend across most of N Venezuela. Situated in this region are CARACAS and VALENCIA. A low-lying region, drained by the River ORINOCO, lies between the N mountains and the Guiana Highlands in the SE. The Guiana Highlands contain ANGEL FALLS, the world's highest waterfall, with a total drop of 980m (3,212ft).

CLIMATE

Venezuela has a tropical climate. Lowland temperatures are always high, but the mountains are cooler and wetter. Much of the country has a marked dry season from December to April.

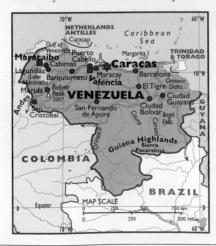

VEGETATION

About 34% of Venezuela is forested, with dense rainforest in the Orinoco basin and in the Guiana Highlands. Tropical savanna covers the lowlands; mountain grassland occurs in the highlands. Only *c.*4% of the land is cultivated.

HISTORY

The original inhabitants of Venezuela were the Arawak and Carib Native Americans. The first European to arrive was Christopher COLUMBUS, who sighted the area in 1498. In 1499 Amerigo VESPUCCI explored the coastline and nicknamed the country Venezuela (little Venice). Spanish settlements were soon established and German explorers, notably Nikolaus Federmann, completed the conquest. Venezuela became part of the Spanish colonial administrative area of New Granada. In the late 18th century, uprisings against Spanish rule were led by Francisco de Miranda. Simón Bolívar liberated Venezuela (1821) and it became part of Greater Colombia, a republic that also included Colombia, Ecuador and Panama. In 1830 Venezuela became a separate state. The mid- to late-19th century was marked by political instability and civil war. Venezuela was ruled by a series of dictators: Guzmán Blanco was followed by Joaquín Crespo and then Cipriano Castro, under whom financial corruption reached new heights. Juan Vicente Gómez's long and autocratic rule (1908-35) provided the stability for Venezuela to pay off its debts, helped by international interest in its rich oilfields.

In 1945 a pro-democracy military junta, led by Rómulo Betancourt, gained control. In 1948

Rómulo Gallegos was elected president, but a military coup the same year re-established a dictatorship. Popular uprisings in 1958 brought a return to democracy, with Betancourt as president. Venezuela became increasingly prosperous, but left-wing uprisings, notably two revolts in 1962 (covertly supported by Fidel Castro), led to much violence. In 1976 Venezuela nationalized its oil industry, using the money to raise living standards. A slump in oil prices in the 1980s damaged the economy. In 1989 Carlos Andrés Pérez of the Democratic Action Party became president. He introduced free-market economic reforms, but inflation and unemployment continued to rise. In 1992 there were two failed military coups and in 1993 Pérez resigned after charges of corruption.

POLITICS

In 1994 Rafael Caldera became president, promising to moderate the reforms that had led to recession. Caldera's austerity measures have provoked civil unrest.

ECONOMY

Venezuela is an upper-middle-income developing country (1992 GDP per capita, US\$8,520). Industry employs 17% of the workforce. The major industry is petroleum refining, centred around Maracaibo. Other industries include aluminium and steel production, centred around Ciudad Guayana. Oil accounts for 80% of the exports. Other exports include bauxite, aluminium and iron ore. Agriculture employs 13% of the workforce. Major crops include bananas and other fruits, coffee, maize, rice and sugar cane.

islands, separated by narrow canals, in the Lagoon of Venice, and joined by causeway to the mainland. Settled in the 5th century, it became a vassal of the Byzantine empire until the 10th century. After defeating Genoa in 1381, Venice became the most important European sea-power, engaging in trade in the Mediterranean and Asia. Its importance declined in the 16th century, and it was ceded to Austria in 1797, becoming part of Italy in 1866. Venice is the site of many churches, palaces and historic buildings, and it is one of Europe's foremost attractions, drawing more than two million tourists a year. Tourism imposes a massive strain on a city already suffering from erosion, subsidence and pollution. Industries: glass-blowing, textiles, petrochemicals. Pop. (1992) 305,617.

Venn diagram In mathematics, diagrammatical representation of the relations between mathematical SETS or logical statements, named after the British logician John Venn (1834–1923). The sets are drawn as geometrical figures that overlap whenever different sets share some elements.

ventilation In biology, the process by which air or water is taken into and expelled from the body of an animal and passed over a surface across which GAS EXCHANGE takes place. Ventilation mechanisms include BREATHING, by which air is drawn into the LUNGS for gas exchange across the wall of the ALVEOLI, and the movements of the floor of a fish's mouth, coupled with those of its GILL covers, which draw water across the gills.

ventricle Either of the two lower chambers of the HEART **venture capital** Outside capital provided for a business Venture capital is often needed to start up new businesses or to expand existing businesses. It is provided by MERCHANT BANKS or investment and private investors.

Venturi, Robert (1925–) US architect. Venturi argued that architectural MODERNISM was banal. His stress on the importance of "vernacular" or contextual architecture heralded POSTMODERNISM. His publications include Complexity and Contradiction in Architecture (1966) and Learning from Las Vegas (1972), whose consumer architecture is contrasted with the postmodern approach. His buildings include Chestnut Hill Villa (1962) and Gordon Wu Hall, Princeton University (1984).

Venus Second planet from the Sun, it is almost as large as the Earth. Visible around dawn or dusk as the so-called morning star or evening star, it is the most conspicuous celestial object after the Sun and Moon. A telescope shows the planet's dazzling, yellowish-white cloud cover, with faint markings. Venus's very high surface temperature was indicated by measurements at radio wavelengths in 1958. Space probes revealed more about the surface. A gently undulating plain covers two-thirds of Venus. Highlands account for a further quarter, and depressions and chasms the remainder. Most of the surface features are volcanic in origin. The atmosphere consists of 96% carbon dioxide and 3.5% nitrogen, with traces of helium, argon, neon, and krypton. Venus has no satellites.

Venus Roman goddess originally associated with gardens and cultivation, but also with the ideas of charm, grace and beauty. She became identified with the Greek goddess APHRODITE, and hence also personified love and fertility.

verb Linguistic category (part of speech) found in all languages, consisting of words typically denoting an action, an event or a state (for example, in English, to run, to snow, to depend). Typical verbs are associated with one or more "arguments", such as subject and direct object. In English, verbs may be intransitive or transitive; intransitives have one argument (she sneezed) and transitives two, or rarely more (she played snooker, she taught him Russian). Verbs may carry grammatical information, including: person (as grammatical agreement with the subject); tense (relating to when the verb took place); aspect (whether what is meant is complete or incomplete at some reference time); number (whether any of the arguments are singular or plural); and voice (which argument serves as subject). In other languages, verbs may encode different information. A list of all forms of a verb is called its paradigm, and this may be regular (predictable by a rule) or irregular. The most irregular verbs in a language are often those in most frequent use and with the most general meaning. verbena Genus of annual and perennial trees, shrubs and

herbs, native to the Western Hemisphere. Some species are popular garden plants and have pink, red, white or purple flowers. Family Verbenaceae: there are about 250 species.

Verdi, Giuseppe (1813–1901) Italian composer, one of the supreme operatic masters of the 19th century. Verdi's early operas displayed an original and lively talent and a promising sense of the dramatic. Up to 1853 his masterpieces were *Rigoletto* (1851), *Il trovatore* (1853) and *La traviata* (1853). *Aïda* (1867) shows a development in style, with richer and more imaginative orchestration. With Verdi's last three operas, *Don Carlos* (1884), *Otello* (1887) and *Falstaff* (1893), Italian opera reached its greatest heights. Among other compositions are several sacred choral works, including the *Requiem* (1874).

verdict Conclusive pronouncement of a court of law. The verdict at most courts is either "guilty" or "not guilty" of the charge, although in some countries (including Scotland) there is the third alternative of "not proven". Whether the verdict is delivered by court authorities or by a panel of jurors depends on the type of court. Verdicts may be subject to appeal, if permission is granted, and may be overturned altogether if new and conclusive evidence appears at a later stage.

Verdun, Battle of (February–December 1916) Campaign of World War 1. A German offensive in the region of Verdun made initial advances, but was checked by the French under General Pétain. After a series of renewed German assaults, the Allied offensive on the Somme drew off German troops and the French regained the lost territory. Total casualties were estimated at one million.

Verlaine, Paul (1844–96) French poet. Verlaine's early poetry, *Poèmes Saturniens* (1866) and *Fêtes Galantes* (1869), was influenced by BAUDELAIRE, with whom he is grouped as one of the *fin de siècle* decadents (an appellation amply fulfilled by his lifestyle). An intense relationship with RIMBAUD ended violently. While in jail (1874–75), Verlaine wrote *Songs Without Words* (1874), an early work of SYMBOLISM. Returning to Catholicism, his later poetry deals with the conflict between the spiritual and the carnal. His critical work includes the famous study *The Accursed Poets* (1884).

Vermeer, Jan (1632–75) Dutch painter, one of the most celebrated of all 17th-century Dutch painters. Early mythological and religious works gave way to a middle period featuring the serene and contemplative domestic scenes for which he is best known. The compositions are extremely simple and powerful, and the colours are usually muted blues, greys and yellows. He treated light and colour with enormous delicacy, as in the superb landscape, *View of Delft (c.*1660). Towards the end of his life, Vermeer began to paint in a heavier manner and his work lost some of its mysterious charm.

Vermont State in New England, NE USA, on the Canadian border. The state capital is MONTPELIER; other major cities include Burlington. The Green Mountains range N-s and dominate the terrain; most of the w border of the state is formed by Lake Champlain. Samuel de CHAMPLAIN discovered the lake in 1609, but the region was not settled permanently until 1724. Land grant disputes with New Hampshire and New York persisted for many years. Vermont declared its independence in 1777, retaining this unrecognized status until it was admitted to the Union in 1791. The region is heavily forested and arable land is limited. Dairy farming is by far the most important farming activity. Mineral resources include granite, slate, marble and asbestos. Industries: pulp and paper, food processing, computer components, machine tools. Area: 24,887sq km (9,609sq mi). Pop. (1992) 571,334. Verne, Jules (1828–1905) French author. Verne is chiefly remembered for his imaginative adventure stories, and he is often considered one of the founding fathers of science fiction. His popular novels include Journey to the Centre of the Earth (1864), Twenty Thousand Leagues Under the Sea (1869) and Around the World in Eighty Days (1873).

Verona City on the River Adige, NE Italy, capital of Verona province. The city was captured by Rome in 89 BC and still has a Roman amphitheatre. It prospered under the Della Scala family in the 13th and 14th centuries, and was held by Austria from 1797 to 1866, when it joined Italy. Industries: textiles, chemicals, paper, printing, wine. Pop. (1992) 255,492.

VENUS: DATA

Diameter (equatorial):

12,104km (7,521mi)

Mass (Earth = 1): 0.815

Volume (Earth = 1) 0.86

Density (water = 1): 5.25

Orbital period: 224.7 days

Rotation period: 243.16 days

Average surface temperature:

480°C (896°F)

Surface gravity (Earth = 1) 0.90

VERMONT Statehood: 4 March 1791

Nickname :

The Green Mountain State

State bird : Hermit thrush State flower :

Red clover **State tree**: Sugar maple **State motto**:

Freedom and unity

▲ vicuña Native to the high Andes, the vicuña (Vicugna vicugna) lives in small herds of six to twelve females with a single male. Prized for its expensive, fine fur, the vicuña was hunted to near extinction in the 1970s, until reserves were established to protect the species. It is specially adapted to living at high altitudes, with an extremely high concentration of very efficient red blood cells that allow it to absorb oxygen quickly from the thin air.

Veronese, Paolo Caliari (1528–88) Italian painter and decorative artist. A prominent member of the VENETIAN SCHOOL, Veronese excelled at painting large scenes featuring flamboyant pageants. He also painted religious and mythological themes. He ran into trouble with the Inquisition for his irreverent treatment of *The Last Supper* (1573), and had to rename it the Feast in the House of Levi. Other celebrated works are his decorative frescos for the Villa Barbaro near Treviso, and his ceiling, *Triumph of Venice*, for the Doge's Palace.

veronica (speedwell) Widely distributed genus of annual and perennial plants of the figwort family. The small flowers are white, blue or pink. Height: 7.5–153cm (3in–5ft). Family Scrophulariaceae; the genus includes about 250 species.

verruca In medicine, form of WART on the sole of the foot, which is painful because it is forced to grow inwards. Like other warts, it is due to infection with the human papillomavirus.

Versailles City in N France, 16km (10mi) wsw of Paris, capital of Yvelines département. It is famous for its former royal palace, now a world heritage site visited by two million tourists a year. Louis XIII built his hunting lodge at Versailles. In 1682 Louis XIV made Versailles his royal seat and transformed the lodge into a palace with extensive gardens. The architects Louis LE VAU, Jules HARDOUIN-MANSART and Robert de Cotte built the monumental palace in a French classical style. The interior was designed by Charles LEBRUN, and includes the royal apartments and the Hall of Mirrors. The magnificent gardens were landscaped by André LE NÔTRE. The park also contains the Grand and Petit Trianon palaces. It was a royal residence until the French Revolution (1789). It was the scene of the signing of several peace treaties, notably at the conclusion of the Franco-Prussian War and World War 1. Pop. (1990) 91,030.

Versailles, Treaty of (1919) Peace agreement concluding WORLD WAR 1, signed at VERSAILLES. The treaty represented a compromise between US President Wilson's FOURTEEN POINTS and the demands of the European allies for heavy penalties against Germany. German territorial concessions included Alsace-Lorraine to France, and smaller areas to other neighbouring states, as well as the loss of its colonies. The Rhineland was demilitarized, strict limits were placed on German armed forces, and extensive reparations for war damage were imposed. The treaty also established the LEAGUE OF NATIONS. It was never ratified by the USA, which signed a separate treaty with Germany in 1921.

versification Art or practice of composing metrical lines. The terms verse and POETRY are often used interchangeably. When distinctions are made, verse is characterized by structure and form, and poetry by intensity of feeling and imaginative power.

vertebra One of the bones making up the SPINE (backbone), or vertebral column. Each vertebra is composed of a large solid body from the top of which wing-like processes project to either side. It has a hollow centre through which the SPINAL CORD passes. The human backbone is composed of 26 vertebrae (the 5 sacral and 4 vertebrae of the coccyx fuse together to form two solid bones), which are held together by ligaments and INTERVERTEBRAL DISCS.

vertebrate Animal with individual discs of bone or cartilage called VERTEBRA, which surround or replace the embryonic NOTOCHORD to form a jointed backbone enclosing the spinal column. The principal division within vertebrates is between FISH and partly land-adapted forms (AMPHIBIANS), and the wholly land-adapted forms (REPTILES, BIRDS and MAMMALS, although some mammals, such as whales, have adapted to a totally aquatic existence). Phylum CHORDATA; subphylum Vertebrata.

vertigo Dizziness, often accompanied by nausea. It is due to disruption of the sense of balance and may be produced by ear disorder, reduced flow of blood to the brain caused by altitude, emotional upset or spinning rapidly.

vervet monkey See GUENON

Verwoerd, Hendrik Frensch (1901–66) South African statesman, prime minister (1958–66), b. Holland. A vocal advocate of APARTHEID, Verwoerd promoted the policy of

"separate development" (physical separation) of the races. He led South Africa out of the British Commonwealth in 1961. Verwoord was assassinated by a white extremist.

very high frequency (VHF) Range or band of radio waves with frequencies between 30 and 300MHz and wavelengths between 1 and 10m (3–33ft). This band is used for TELEVISION and FREQUENCY MODULATION (FM) radio broadcasts to provide high-quality reception.

Vespasian (AD 9–79) (Titus Flavius Vespasianus) Roman emperor (69–79). A successful general and administrator, he was leading the campaign against the Jews in Palestine when he was proclaimed emperor by his soldiers. He proved a capable ruler, extending and strengthening the empire, rectifying the budget deficit, widening qualifications for Roman citizenship and adding to the monumental buildings of Rome. **vespers** Evening office of the Western Church. It is a service of thanksgiving and praise, in which the liturgy consists of psalms, a reading from the Bible, the Magnificat canticle, a hymn and a collect. Celebrated in the late afternoon, it is the basis of the Anglican service of evensong.

Vespucci, Amerigo (1454–1512) Italian maritime explorer. Vespucci was possibly the first to realize that the Americas constituted new continents, which were named after him by the German cartographer Martin Waldseemüller in 1507. He made at least two transatlantic voyages (1497–1504).

Vesta In Roman religion, goddess of fire and purity, supreme in the conduct of religious ceremonies. Her priestesses were the VESTAL VIRGINS. Vesta was the guardian of the hearth and the patron goddess of bakers.

vestal virgins In ancient Rome, priestesses of the cult of VESTA, who tended the sacred fire in the Temple of Vesta and officiated at ceremonies in the goddess' honour. The vestals remained in the service of the temple for up to 30 years under vows of absolute chastity, violation of which was punishable by burial alive.

Vesuvius (Vesuvio) Active volcano on the Bay of Naples, s Italy. The earliest recorded eruption was in 79 AD, when POMPEII and HERCULANEUM were destroyed. The height of the volcano changes with each of the 30 or so eruptions recorded since Roman times.

veterinary medicine Medical science that deals with diseases of animals. It was practised by the Babylonians and Egyptians some 4,000 years ago. In the late 18th century schools of veterinary medicine were established in Europe.

VHF Abbreviation of VERY HIGH FREQUENCY(VHF)

vibraphone Percussion musical instrument with metal bars of different lengths that are struck with sticks or mallets to produce various notes. Tubes beneath the bars vibrate at the same frequency as the bar above and magnify the sound. viburnum Genus of flowering shrubs and small trees, native to North America and Eurasia. All have small, fleshy fruits containing single flat seeds. There are about 120 species. Family Caprifoliaceae.

vicar Priest in the CHURCH OF ENGLAND who is in charge of a parish. In the ROMAN CATHOLIC CHURCH, the term "vicar" is used to mean "representative". The pope is called the Vicar of Christ. A **vicar apostolic** was originally a BISHOP representing the pope. Today, a vicar apostolic is appointed to govern territories that have not yet been organized into dioceses. A **vicar general** is appointed by and represents a bishop in the administration of a diocese. *See also* CURATE; PAPACY

Vicenza Industrial city in NE Italy, 64km (40mi) w of Venice. Founded as a Ligurian settlement, it was taken by Venice in 1404 and held by Austria from 1797 until 1866, when it was united with Italy. An important rail junction, its industries include steel, machinery, chemicals, textiles, printing, glass and gold jewellery. Pop. (1992) 107,481.

Vichy Government During World War 2, regime of SE France after the defeat by Germany in June 1940. Its capital was the town of Vichy, and it held authority over French overseas possessions as well as the unoccupied part of France. After German forces occupied Vichy France in November 1942, it became little more than a puppet government.

Vicksburg, Siege of (1863) Offensive by Union forces under General Grant during the US CIVIL WAR. The capture

of Vicksburg, Mississippi, on 4 July gave the Union forces control of the Mississippi River and split the Confederacy in two. **Vico, Giambattista** (1668–1744) Italian philosophical historian. In his *New Science* (1725, revised 1730 and 1744), Vico advanced the arguments of historicism: that all aspects of society and culture are relevant to the study of history, and that the history of any period should be judged according to the standards and customs of that time and place. Since the

19th century he has been regarded as one of the greatest

philosophers of history.

Victor Emmanuel II (1820–78) King of Italy (1861–78). He succeeded his father, Charles Albert, as king of Piedmont-Sardinia in 1849. From 1852, guided by his able minister, Conti di CAVOUR, he strengthened his kingdom, formed a French alliance, and consequently defeated Austria (1859–61). In 1861 he assumed the title of king of Italy. Rome became his new capital after French troops withdrew (1870).

Victor Emmanuel III (1869–1947) King of Italy (1900–46). He appointed Benito Mussollni prime minister in 1922. Although Mussolini established a dictatorship, the king retained the power to dismiss him, and eventually did so in 1943. Victor Emmanuel abdicated in 1946.

Victoria (1819-1901) Queen of Great Britain and Ireland (1837-1901) and empress of India (1876-1901). A granddaughter of GEORGE III, she succeeded her uncle, WILLIAM IV. In 1840 she married her first cousin, Prince Albert of SAXE-COBURG-GOTHA. During her reign, the longest in English history, the role of the monarchy was established as a ceremonial, symbolic institution, with virtually no power but much influence. Victoria learned statecraft from her first prime minister, Lord MELBOURNE, and was greatly influenced by the hard-working Prince Albert. After Albert's death (1861) she went into lengthy seclusion and her neglect of public duties aroused republican sentiments. Her domestic popularity was restored when she became Empress of India and with the golden (1887) and diamond (1897) jubilee celebrations. Among later prime ministers, she maintained excellent terms with Benjamin DISRAELI (who astutely flattered her) but was on frosty terms with William GLADSTONE (who lectured her). She reigned over an empire containing 25% of the world's people and 30% of its land. Britain's trade and industry made it the world's richest country.

Victoria State in SE Australia, bounded by the Indian Ocean, the Bass Strait and the Tasman Sea. The capital is MELBOURNE (home to more than 66% of the state population); other major cities are Geelong, Ballarat and Bendigo. The region was part of New South Wales until 1851, when it became a separate colony. The population increased rapidly after 1851, when gold was discovered at Ballarat and Bendigo. Victoria became part of the Commonwealth of Australia in 1901. The area is crossed by the Australian Alps and other ranges of the Eastern Highlands. Irrigation is used extensively to grow wheat, oats, barley, fruit and vegetables, while sheep and dairy cattle are also important. Brown coal, natural gas and oil are the chief mineral resources. Industries: motor vehicles, textiles, food processing. Area: 227,620sq km (87,813sq mi). Pop. (1991) 4,487,000.

Victoria City on SE VANCOUVER ISLAND, capital of BRITISH COLUMBIA province, SW Canada. Founded in 1843, it developed during the gold rush in 1858 as a supply base for prospectors. Industries: timber, paper, shipbuilding, fish processing, deep-sea fishing, tourism. It also has a large naval base. Pop. (1991) 71,228.

Victoria (Victoria Nyanza) Lake in E central Africa, bordered by Uganda, Kenya and Tanzania. The second-largest freshwater lake in the world, it is the chief reservoir of the River Nile. Its long coastline provides harbours for coastal towns, notably KAMPALA, Kisumu and Mwanza. Area: 68,000sq km (26,000sq mi).

Victoria Falls Waterfalls on the River Zambezi, on the border of Zimbabwe and Zambia. Formed by water erosion along a fracture in the Earth's crust, they are divided by islets into five main sections. The first European discovery was in 1855 by David Livingstone. Maximum drop: 108m (355ft); width over 1,700m (5,580ft).

vicuña Graceful, even-toed, hoofed South American mammal. The smallest member of the CAMEL family, it is humpless and resembles the LLAMA. Its silky coat is tawny brown with a yellowish bib under the neck. Vicuña wool was used by the Inca kings and is still expensive and rare. Height: 86cm (34in) at the shoulder; weight: 45kg (100lb). Family Camelidae; species *Vicugna vicugna*.

Vidal, Gore (1925–) US novelist, playwright and essayist, b. Eugene Luther Vidal. Vidal's debut novel, Williwaw (1946), drew on his experiences in World War 2. The City and the Pillar (1948), a frank account of homosexuality, was a bestseller. His satires include Myra Breckinridge (1968) and its sequel Myron (1974). Political satires include Washington DC (1967) and the trilogy Burr (1976), 1876 (1976) and Lincoln (1984). Vidal also wrote the screenplay for Suddenly Last Summer (1958). Other works include Hollywood (1990) and Live from Golgotha (1992).

video Term used in television and computing to refer to electronic vision signals, and to equipment and software associated with visual displays. The picture component of a television signal is often referred to as the video. See also VIDEO RECORDING video disc Vinyl disc coated with a reflective, metallic surfacing. On one side of the reflective surface is etched a spiral of microscopic pits corresponding to digital information that can be picked up by a laser scanner and converted electronically to video pictures and sound. Since the late 1980s video discs have been almost entirely superseded by the smaller, more comprehensive type of COMPACT DISC (CD) called a CD-ROM.

video game Game using electronically generated images displayed on a screen. Some video games test the skill of a single player, whilst other games allow two or more players to compete. See also VIRTUAL REALITY

videotape recording Recording and reproducing sound and moving pictures using magnetic tape. The video recorder developed from the audio magnetic tape recorder, from which it differs significantly in two respects: video tape is wider to accommodate the picture signals; and the relative speed at which the tape passes the magnetic head is greater in order to deal with the larger amount of informa-

A videotape recorder (camcorder) converts an image into an electrical signal, which can then be stored on magnetic tape (1). Light from an image (2) is focused by a series of lenses (3) and then split into its component colours by a prism (4). The red, green and blue light strike separate light-sensitive chips (5) that

reproduce them in electronic form. The magnetic tape is housed in a protective case (6) that opens when inserted into the camcorder. The recording head (7) is angled and records information onto the tape in diagonal bands of magnetic particles (8). The helical scanning allows more information to be stored on a

length of tape. A microphone (9) picks up sound, which is laid down in parallel to the visual information. Camcorders have a small television screen in the eyepiece (10) that allows the operator to play back and review the pictures taken. The camcorder can also be plugged directly into the television and the images played back.

► Vikings The Vikings were those Scandinavians who left their homelands between c.AD 800 and 1050, intent on trade, piracy or settlement. Those from present-day Norway began their expansion by settling in the Orkneys and Shetland, fulfilling a need for land. It is believed that there may have been overpopulation and land shortage in Norway at this time; an additional reason may have been the growth of an absolutist monarchy in Norway. From the Orkneys and Shetland, the Vikings moved to N England, Ireland, the Faröe Isles and the Isle of Man, where the chiefs founded towns to further trade and act as bases for pirate attacks. In the Atlantic, the Norsemen discovered new lands - Iceland, Greenland and North America. However, settlement of America was impossible due to overly long lines of communication. The Danes settled in the E lowlands of England, and concentrated their activities along the coasts of the North Sea and Channel - in France and in Frisia. Some ventured further afield to Spain and the Mediterranean. The Swedes journeyed into Russia, and acquired considerable wealth. The Vikings were extremely fine seamen and skilful shipbuilders; they also developed fairly sophisticated means of land transport. They were vitally important in Europe's trade and there is evidence that they had commercial connections with all

the contemporary known world.

essary for recording and reproducing pictures. See also

videotext General term for the methods by which information can be brought to a television screen. Information that is transmitted by the broadcasting authority in parallel with the ordinary TV signals, and that may be screened simultaneously with or independently from other channels, is known as teletext. The system that brings information to the screen from a computer databank via a telephone landline is called videotex. Vienna (Wien) Capital of Austria, on the River DANUBE. Vienna became an important town under the Romans, but after their withdrawal in the 5th century it fell to a succession of invaders from E Europe. The first HABSBURG ruler was installed in 1276 and the city was the seat of the HOLY ROMAN EMPIRE from 1558 to 1806. Occupied by the French during the NAPOLEONIC WARS, it was later chosen as the site of the Congress of VIENNA. As the capital of the Austro-Hungarian EMPIRE, it was the cultural and social centre of 19th-century Europe under the emperor FRANZ JOSEPH. It suffered an economic and political collapse following the defeat of the Central Powers in World War 1. After World War 2, it was occupied (1945-55) by joint Soviet-Western forces. Vienna's historical buildings include the 12th-century St Stephen's Cathedral, the Schönbrunn (royal summer palace) and the Hofburg (a former residence of the Habsburgs). Industries: chemicals, textiles, furniture, clothing. Vienna is the third-largest German-speaking city (after Berlin and Hamburg). Pop. (1993) 1,589,052.

Vienna, Congress of (1814–15) European conference that settled international affairs after the Napoleonic Wars. It attempted, as far as possible, to restore the Europe of pre-1789, and it disappointed the hopes of nationalists and liberals. Among steps to prevent future European wars, it established the Congress system and the German Confederation, a loose association for purposes of defence.

Vienna Boys' Choir Austrian choir comprising 22 boys between the ages of eight and fourteen years. It was founded in 1498 as the choir of the court chapel. One of the world's best-known choirs, it tours regularly and makes recordings.

Vientiane (Viangchan) Capital and chief port of Laos, on the River Mekong, close to the Thai border, N central Laos. It was the capital of the Lao kingdom (1707–1828). The city became part of French INDOCHINA in 1893 and in 1899 became the capital of the French protectorate. Industries: textiles, brewing, cigarettes, hides, wood products. It is a major source of opium for world markets. Pop. (1992) 449,000.

Viet Cong Nickname for the Vietnamese communist guerrillas who fought against the US-supported regime in South Vietnam during the VIETNAM WAR. After earlier, isolated revolts against the government of Ngo Dinh DIEM, the movement was unified (1960) as the National Liberation Front (NLF), modelled on the VIET MINH.

Viet Minh Vietnamese organization that fought for independence from the French (1946–54). It resisted the Japanese occupation of French INDOCHINA during World War 2. After the war, when the French refused to recognize it as a provisional government, it began operations against the colonial forces. The French were forced to withdraw after their defeat at DIEN BIEN PHU (1954).

Vietnam Republic in SE Asia. See country feature

Vietnamese National language of VIETNAM, spoken by c.70 million people. It is part of the Muong branch of the Mon-Khmer sub-family of Asiatic languages and derives much of its vocabulary from Mandarin Chinese.

Vietnam War (1954-75) Conflict between US-backed South Vietnam and the VIET CONG, who had the support of communist North Vietnam. It followed the defeat of the French at DIEN BIEN PHU (1954) and the partition of Vietnam. South Vietnamese elections were cancelled in 1956 by President Ngo Dinh DIEM. Ho CHI MINH denounced the action and the Viet Cong launched an insurgency. Fuelled by fear of the spread of communism, the US supported the Diem government and sent its first troops in 1961. The US received token support from its allies in the Pacific region, and North Vietnam was supplied by China and the Soviet Union. Diem was overthrown and executed in 1963. In 1965 the US began bombing North Vietnam. As fighting intensified, US troops were committed in greater numbers: by 1968 there were more than 500,000. In spite of US technological superiority and air supremacy, military stalemate ensued. The unrepresentative South Vietnamese government, US involvement in war crimes, heavy casualties and daily TV coverage made the war highly unpopular in the USA. A peace agreement, negotiated by Henry Kissinger and Le Duc Tho, was signed in Paris in 1973. In 1975 South Vietnam was overrun by North Vietnamese forces, and the country was united under communist rule. The war had cost 50,000 American lives, 400,000 South Vietnamese and one million Viet Cong and North Vietnamese. Vignola, Giacomo Barozzi da (1507-73) Italian architect who succeeded MICHELANGELO as architect of ST PETER'S (1567-73). His Gesú church, Rome (1568), with its revolutionary design uniting clergy and congregation more closely, has been widely copied. His other major works include the Palazzo Farnese, Caprarola (1559), and the Tempieto di San Andrea, Rome (1550).

Vigny, Alfred de (1797–1863) French poet, dramatist and novelist. Pessimistic in tone, his work often emphasizes the lonely struggle of the individual in a hostile universe, as in the quintessential romantic drama *Chatterton* (1853). His best poems are found in *Poems Ancient and Modern* (1826), and his fiction includes the pioneering French historical novel *Cinq-Mars* (1826). *See also* ROMANTICISM

Vigo, Jean (1905–34) French film director. An original, lyrical film-maker, Vigo died tragically young of leukaemia. His anarchic debut feature, *Zéro de Conduite* (1933), was banned in France until 1945. *Atalante* (1934), his second and last feature, is an elegant amalgam of social realism and poetic lyricism, set in a dream-like Parisian landscape.

Vigo Seaport city on Vigo Bay, Galicia, NW Spain, near the Portuguese border. It was the scene of a naval battle in 1702, when an Anglo-Dutch fleet attacked Spanish galleons carrying a cargo of gold from the New World. Industries: fishing, fish processing and canning, boat-building. Pop. (1991) 274,629.

Vikings Scandinavian, seaborne marauders, traders and settlers, who spread throughout much of Europe and the North Atlantic region in the 9th to 11th centuries. The Viking expansion seems to have been caused by rapid population growth and consequent scarcity of good farming land, as well as the desire for new sources of wealth. It was made possible by their advanced maritime technology, which enabled them to cross N European waters in a period when other sailors feared to venture out of sight of land. They were in many respects more advanced than other European peoples, notably in metalwork. Although they first appeared in their "longships" as raiders on the coasts of NW Europe, later groups came to settle. Swedes, known as Varangians, founded the first Russian state at Novgorod, and traded via the River Volga in Byzantium and Persia. Danes conquered much of N and E England. Norwegians created kingdoms in N Britain and Ireland, founding Dublin (c.840) and other cities; they also colonized Iceland and established settlements in Greenland. A short-lived settlement, VINLAND, was established in North America by LEIF ERICSSON in c.1003. In the early 10th century, the Vikings settled in NORMANDY. Anarchic conditions in 10th-century Scandinavia resulted in the formation of larger, more powerful kingdoms, and Viking

V

expansion declined. It was renewed in a different form with the conquest of England by King Sweyn of Denmark in 1013 and the Norman Conquest of 1066.

Viking space mission US space project to investigate conditions on MARS (1976). Two spacecraft, Viking 1 and Viking 2, each attached to separate vehicles that orbited the planet, made the first successful landings on Mars. They transmitted much information back to Earth, including dramatic photographs of the surface. See also SPACE EXPLORATION

Villa, "Pancho" (Francisco) (1877–1923) Mexican revolutionary leader. He began as an outlaw and later joined the forces of Francisco MADERO (1909). He sided with Venustiano CARRANZA for some time, but later supported Emiliano ZAPATA. Angered by US recognition of Carranza's government, Villa murdered US citizens in N Mexico and New Mexico. In 1920 he was granted a pardon in return for agreeing to retire from politics. He was assassinated three years later.

villa Large country house of the Roman empire and post-Roman period. In ancient Rome, they were the private residences of important citizens. They had spacious reception rooms, often with mosaic floors and sometimes even underfloor heating. Villa-Lobos, Heitor (1887–1959) Brazilian composer and conductor. Villa-Lobos' *Chôros* compositions were influenced by Brazilian folk music and the music of Claude Debussy. His range of works includes operas, ballets, symphonies, religious and chamber music. His nine *Bachianas Brasileiras* are a Brazilian transcription of the music of J.S. Bach.

Villehardouin, Geoffroi de (1150–1213) French historian. He was a leader of the Fourth CRUSADE, of which he wrote an incomplete account, *Conquest of Constantinople*, which was the first historical chronicle in French.

villi In anatomy, small, finger-like projections of a MUCOUS MEMBRANE such as that which lines the inner walls of the SMALL INTESTINE. They increase the absorptive surface area of the gut. In digestion, intestinal villi absorb most of the products of food broken down in the STOMACH, DUODENUM and ILEUM.

Villon, François (1430–1463) French lyric poet, b. François de Montcorbier or François des Loges. He led a troubled life after killing a priest in 1455. Villon wrote the famous *Ballad of a Hanged Man* while awaiting execution in 1462 (the sentence was later commuted to banishment). Among his other major works are *Le Petit Testament*, a satirical will in verse, and *Le Grand Testament*, which is in part a lament for lost youth.

VIETNAM

Vietnam's flag was first used by forces led by Ho Chi Minh during the liberation struggle against Japan in World War 2 (1939–45). It became the flag of North Vietnam in 1945. It was retained when North and South Vietnam were reunited in 1976.

AREA: 331,689sq km (128,065sq mi)

POPULATION: 72,500,000

CAPITAL (POPULATION): Hanoi (1,088,862)

GOVERNMENT: Socialist republic

ETHNIC GROUPS: Vietnamese 87%, Tho (Tay), Chinese (Hoa), Tai, Khmer, Muong, Nung

LANGUAGES: Vietnamese (official)
RELIGIONS: Buddhism 55%, Christianity

(Roman Catholic 7%)

currency: Dong = 10 hao = 100 xu

The Socialist Republic of Vietnam occupies an S-shaped strip of land in Southeast Asia. The coastal plains include two densely populated river delta regions: in the N, the Red River delta is the site of Hanoi and Haiphong; in the S, the Mekong delta contains Ho Chi Minh City. Inland, the Annam Cordillera forms much of the boundary with Cambodia. In the NW, the highlands extend into Laos and China.

CLIMATE

Vietnam has a tropical climate. The summer months are hot and wet, with monsoon winds. The driest months, January to March, are cooler.

VEGETATION

Forests cover c.30% of Vietnam and include teak and ebony trees. About 17% of the land is farmed. There are some mangrove swamps.

HISTORY AND POLITICS

In 111 BC China seized Vietnam, naming it ANNAM. In 939 it became independent. In 1558 it split into two parts: TONKIN in the N, ruled from Hanoi; and Annam in the s, ruled from Hué. In 1802, with French support, Vietnam was united as the empire of Vietnam, under Nguyen Anh. The French took Saigon in 1859, and by 1887 had formed INDOCHINA from the union of Tonkin, Annam and Cochin China.

Japan conquered Vietnam during World War 2 and established a Vietnamese state under Emperor Bao Dai. After the war, Bao Dai's government collapsed, and the nationalist VIET MINH, led by Ho CHI MINH, set up a Vietnamese republic. In 1946 the French tried to reassert

control and war broke out. Despite aid from the USA, they were finally defeated at DIEN BIEN

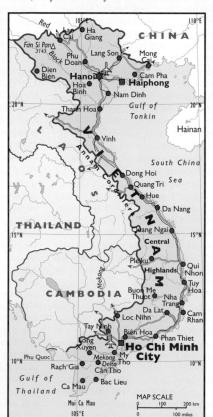

PHU. In 1954 Vietnam was divided along the 17th parallel, with North Vietnam under the communist government of Ho Chi Minh and South Vietnam under the French-supported Bao Dai. In 1955 Bao Dai was deposed and Ngo Dinh DIEM was elected president. Despite his authoritarian regime, Diem was recognized as the legal ruler of Vietnam by many western countries. North Vietnam, supported by China and the Soviet Union, extended its influence into South Vietnam, mainly through the VIET CONG. The USA became increasingly involved in what they perceived to be the fight against communism. The conflict soon escalated into the VIETNAM WAR. After US forces were withdrawn in 1975, Ho Chi Minh's nationalist forces overran South Vietnam and it surrendered. In 1976 the reunited Vietnam became a socialist republic. In the late 1970s Vietnam invaded Cambodia, defeating the KHMER ROUGE government. It withdrew its troops in 1989. Vietnam's weak economy was improved in the late 1980s and 1990s with the introduction of free-market economic reforms, known as Doi Moi. In 1995 it became a member of ASEAN.

ECONOMY

Vietnam is a low income developing country (1992 GDP per capita, US\$1,010). Agriculture employs 67% of the workforce. The main crop is rice, of which it is the world's fifth-largest producer. Other crops include bananas, coffee, groundnuts and rubber. Vietnam also produces oil, phosphates and coal; natural gas resources have been found.

▲ violin Late 17th-century violin. The violin was perfected in Italy by the Amati, Stradivari and Guarneri families from 1650 to 1740. The brilliance of violin tone soon overwhelmed the softer tones of the viols, which died out.

▲ virginal Related to the harpsichord, and producing a similar plucked sound, the virginal was a small keyboard instrument without legs. The best collection of virginal music is the Fitzwilliam Virginal Book (1606–16), consisting of pieces by English composers such as John Bull, William Byrd and Giles Farnaby.

VIRGINIA Statehood:

25 June 1788

Nickname:

Old Dominion

State bird:

Cardinal

State flower:

Flowering dogwood

State tree :

Flowering dogwood State motto :

Thus always to tyrants

Vilnius Capital of Lithuania, on the River Nerisr. Founded in 1323 as the capital of the grand duchy of Lithuania, the city declined after the union of Lithuania-Poland. Vilnius was captured by Russia in 1795. After World War 1 it was made capital of an independent Lunuania. In 1939 Soviet troops occupied the city and, in 1940, Lithuania became a Soviet republic. During World War 2 the city was occupied by German troops, and its Jewish population was all but exterminated. In 1944 it reverted to its Soviet status. In 1990 Lithuania unilaterally declared independence, leading to clashes with Soviet troops and pitched battles on the streets of Vilnius. In 1991 the Soviet Union recognized Lithuanian independence. Despite World War 2 bombing, the old city retains many of its historic synagogues, churches and civic buildings, as well as remnants of its 14th-century castle and fortifications. Industries: engineering, chemicals, textiles, food processing. Pop. (1994) 578,700. Vincent de Paul, Saint (1581–1660) French priest. As a young man he was said to have been captured by Barbary pirates and to have spent two years as a slave in Tunisia. After his return to Paris, he began a mission to the peasantry, founding the Congregation of the Mission (or Lazarists). In 1633 he helped to found the Sisters of Charity of St Vincent de Paul) to minister to the sick, the old and orphans. He was canonized in 1737.

vine Plant with a long, thin stem that climbs rocks, plants and supports. To aid their climb, vines develop modifications such as tendrils, disc-like holdfasts, adventitious roots and runners. Examples are tropical LIANA, wild GRAPE, and morning glory.

vinegar Any of various types of liquid condiment and preservative based on a weak solution of ETHANOIC ACID. It is produced commercially by the fermentation of alcohol. The major type of vinegar is known as malt vinegar which, when distilled, becomes white (or clear) vinegar. Vinegar can also be processed from cider or wine.

Vinland Region of North America settled by VIKINGS from Greenland led by LEIF ERICSSON in c.1003. The existence of land w of Greenland had been reported a few years earlier. Leif stayed for one season only, but at least two other expeditions settled there briefly. Vinland was soon abandoned, apparently because of the hostility of local people.

viol Fretted STRINGED INSTRUMENT, played with a bow. It is held on or between the knees and, in its most usual shape, has sloping shoulders and a flat back. The six strings are tuned in fourths, in the same manner as the LUTE. A possible derivative, the modern DOUBLE BASS, is perhaps the only type of viol to survive; it shows its ancestry by being tuned in fourths (unlike members of the violin family, which are tuned in fifths).

viola STRINGED INSTRUMENT of the VIOLIN family. It is slightly larger than the violin and its four strings are tuned a fifth lower. It is the tenor member of a string quartet.

violet Any of about 400 species of herbs and shrublets of the genus *Viola*, found worldwide. Violets may be annual or perennial, with 5-petalled flowers that grow singly on stalks; usually blue, violet, lilac, yellow, or white. Family Violaceae. violin Stringed instrument. It is thought to have derived from the *lira da braccio*, a Renaissance bowed instrument, and the rebec. It was perfected in Italy by the AMATI, STRADIVARI and Guarneri families between 1650 and 1740. The body is assembled from curved, wooden panels, the front pierced by two f-shaped sound-holes. Four taut strings are played by drawing a bow across them, or sometimes by plucking them with the fingers (pizzicato).

violoncello See CELLO

viper Any of 150 species of poisonous SNAKES characterized by a pair of long, hollow, venom-injecting fangs in the front of the upper jaw. The fangs can be folded back when not in use. The common adder (*Vipera berus*) of Europe and E Asia has a dark, zigzag band along its back. Length: to 3m (10ft). Family Viperidae.

Virgil (70–19 BC) (Publius Vergilius Maro) Roman poet. Virgil gained a high literary reputation in Rome with the *Eclogues* (42–37 BC) and the *Georgics* (37–30), a pastoral but instructive work on farming and country life. His greatest work was the Aeneid, which established him as an epic poet. It relates the

adventures of the Trojan hero Aeneas, and echoes the themes of Homer's *Odyssey* and *Iliad*. Unfinished at his death, it was published at the command of Emperor AUGUSTUS.

virginal Musical instrument of the HARPSICHORD family. The strings, a single set running nearly parallel to the keyboard, are plucked by quills. Two keyboards, differing in size and pitch, were sometimes incorporated into the same case. Virginals were particularly popular in 16th- and 17th-century England. virgin birth Christian doctrine teaching that Jesus Christ was conceived by the Blessed Virgin MARY through the power of the HOLY SPIRIT and without the involvement of a human male. That Jesus had no earthly father is a basic tenet of Roman Catholicism, all the Eastern Orthodox Churches, and most Protestant Churches.

Virginia State in E USA, on the Atlantic coast, the most northerly of the "southern states"; the capital is RICHMOND. The coastal plain is low-lying. In the w, the Piedmont Plateau rises to the Blue Ridge Mountains, and there are extensive forests. The first permanent British settlement in North America was at JAMESTOWN (1607). Virginia evolved an aristocratic plantation society based on vast tobacco holdings. Virginia's leaders were in the forefront of the American Revolution. During the CIVIL WAR, Richmond acted as the Confederate capital, and Virginia was the main battleground of the war. Virginia was readmitted to the Union in 1870. Farming is an important part of Virginia's economy, and the chief crops include tobacco, peanuts, grain, vegetables and fruits. Dairying and poultry are also widespread. Industries: chemicals, shipbuilding, fishing, transport equipment. Coal is the most important mineral deposit. Stone, sand and gravel are quarried. Area: 105,710sq km (40,814sq mi). Pop. (1992) 6,394,481.

Virginia Beach City on the Atlantic Ocean, SE Virginia. Site of the Cape Henry memorial cross (commemorating the first landing of English colonists, 1607), and of the oldest brick house in the USA, it is a rapidly expanding tourist centre with good beaches and recreational facilities. Its economy is helped by market gardening and nearby military complexes. The population increased by nearly 60% between 1980 and 1992, making it the state's largest city. Pop. (1992) 417,061.

Virgin Islands, British British colony in the West Indies. It is a group of 36 islands, which form part of the ANTILLES group between the Caribbean Sea and the Atlantic Ocean; the capital is Road Town (on Tortola, the main island). First settled in the 17th century, the islands formed part of the LEEWARD ISLANDS colony until 1956. The chief economic activity is tourism. Area: 130sq km (59sq mi). Pop. (1993 est.) 17,000. See WEST INDIES map

Virgin Islands, US Group of 68 islands in the Lesser ANTILLES, in the West Indies. They are administered by the USA with the status of an "unincorporated territory". The chief islands are St Croix and St Thomas, which includes the capital Charlotte Amalie (1990 pop. 12,331). Spanish from 1553, the islands were Danish until 1917, when they were bought by the USA for US\$25 million in order to protect the northern approaches to the newly completed PANAMA CANAL. Livestock and sugar cane are the chief farming activities, but tourism is the biggest money earner. Industries: oil refining, aluminium, textiles, rum, pharmaceuticals, perfumes. Area 344sq km (133sq mi). Pop. (1990) 101,809. See WEST INDIES map

Virgin Mary See MARY

Virgo (Virgin) Equatorial constellation on the ecliptic between Leo and Libra. It lies in a region of the sky that has many galaxies and galaxy clusters. The brightest star is the 1st-magnitude Alpha Virginis, or Spica.

virology Study of VIRUSES. The existence of viruses was established in 1892 by D. Ivanovski, a Russian botanist, who found that the causative agent of tobacco mosaic disease could pass through a porcelain filter impermeable to BACTERIA. The introduction of the electron microscope in the 1940s made it possible to view viruses.

virtual reality Use of computer graphics to simulate a threedimensional environment that users can explore as if it were real. A virtual reality system can allow an architect to see what the inside of a building will look like before construction begins. Computer images are produced using the architect's drawings of the building. Some video games use virtual reality to simulate space-flight adventures and ball games.

virus Submicroscopic infectious organism. Viruses vary in size from 10 to 300 nanometres and contain only genetic material in the form of DNA or RNA. Viruses are incapable of independent existence: they can grow and reproduce only when they enter another cell, such as a bacterium or animal cell, because they lack energy-producing and protein-synthesizing functions. When they enter a cell, viruses subvert the host's metabolism so that viral reproduction is favoured. Control of viruses is difficult because harsh measures are required to kill them. The animal body has, however, evolved some protective measures, such as production of INTERFERON and of ANTIBODIES directed against specific viruses. Where the specific agent can be isolated, VACCINES can be developed, but some viruses change so rapidly that vaccines become ineffective.

Visconti, Luchino (1906-76) Italian film director, b. Count Don Luchino Visconti di Modrone. Visconti's debut film was Ossessione (1942), which pioneered the Italian NEO-REALISM school. His other films include Senso (1953), Rocco and His Brothers (1960), Death in Venice (1971) and Conversation Piece (1975). An eminent and significant film-maker, Visconti's later work was characterized by a more opulent, grander style. He also received acclaim for his theatre and opera work, and is seen as being responsible for the fame of Maria CALLAS. Visconti Italian family that ruled Milan from the 13th century until 1447. Ottone Visconti (c.1207-95) was appointed archbishop of Milan in 1262, and used his position to become the first Visconti signore (lord) of Milan. Supporters of the anti-papal GHIBELLINES, the Visconti established control over Lombardy in the 14th century, and in 1349 the title of signore became hereditary. Visconti lordship of Milan passed to the Sforza family in 1447.

viscosity Resistance to flow of a FLUID because of internal friction. The more viscous the fluid, the slower it flows. Viscosity is large for liquids and extremely small for gases.

Vishnu Major god of HINDUISM; one of the supreme triad of gods, along with Brahma and Shiva. Vishnu was mentioned as a sun god in the VEDAS (c. 1500–c.1200 BC). Over the next 1,000 years or more, his importance grew and he became an amalgam of local cultic gods and heroes. In mythology, Vishnu is worshipped as a preserver and restorer. According to Hindu tradition, he reigns in heaven with his wife Lakshmi, the goddess of wealth. From time to time, he comes into the world to fight evil, assuming a different incarnation each time. His incarnations have included Rama and Krishna. In art, Vishnu is depicted as a young man with four hands holding a shell, discus, mace and lotus.

Visigoths See GOTH

vision See SIGHT

Vistula (Wisla) Longest river in Poland. It rises in the Carpathian Mountains of w Poland and flows Nw through Warsaw, then Nw through Toruń to enter the Gulf of Danzig at Gdańsk. The major waterway of Poland, it serves a large area through a tributary system. Canals link it with other important rivers both E and w. Length: 1,090km (675mi).

vitalism Philosophical theory that all living organisms derive their characteristic qualities from a universal life force. Vitalists hold that the force operating on living matter is peculiar to such matter and is quite different from any forces of inanimate bodies. In the late 20th century, few scientists give vitalism much credence, but it has influenced many forms of alternative medicine.

vitamin Organic compound that is essential in small amounts to the maintenance and healthy growth of all animals. Vitamins are classified as either water-soluble (B and C) or fat-soluble (A, D, E and K). They are usually taken in the diet, but today most can be made synthetically. Some are synthesized in the body. Many vitamins act as coenzymes, helping ENZYMES in RESPIRATION and other metabolic processes. Lack of a particular vitamin can lead to a deficiency disease. Vitamin E is important in reproduction and many other biological processes. Vitamin D helps the body absorb phosphorus and calcium. It is essential for the normal growth of bone and teeth. Existing in human skin (activated by sunlight), vitamin D is also found in

VIRTUAL REALITY

A data glove measures the movements of the wearer's hand and allows the user to manipulate objects in virtual reality. Fibre optic cables (1) on the glove detect the flexing of the hand. Light travels up and down the cables (2). When the cables are bent (3) they no longer reflect light back to the interface board (4). A position sensor (5) detects the movement of the glove in three dimensions. Fingertip padding (6) convinces the user they are touching an actual object.

fish-liver oil, yeast and egg yolk. **Vitamin C** (ascorbic acid) is commonly found in many fruits and vegetables. It helps the body resist infection and stress, and is essential to normal metabolism. **Vitamin B** is actually a group of 12 vitamins, important in assisting the process by which energy is produced in the body (RESPIRATION). Vitamin B_1 (THIAMINE) occurs in yeast and cereals. Another B vitamin is niacin (nicotinic acid) found in milk, meat and green vegetables. Vitamin B_{12} is needed for the formation of blood cells. It is found especially in meat, liver and eggs. **Vitamin A** (retinol), found in fish liver oil, is important for healthy eyes. *See also* RIBOFLAVIN

Vitruvius (active early 1st century AD) Roman architect and engineer. His encyclopedic *De Architectura* (before AD 27) covers almost every aspect of ancient architecture, including town planning, types of buildings and materials. It is the only work of its type to survive from the ancient world.

Vitus, Saint (active 4th century) Italian martyr. Secretly raised as a Christian by his nurse, he was put to death during the persecutions of DIOCLETIAN. He is the patron saint of actors. Vivaldi, Antonio (1675–1741) Italian composer. A master of the CONCERTO and a virtuoso violinist, Vivaldi helped to standardize the three-movement concerto form and to develop the *concerto grosso* (a concerto for two or more solo instruments). His best-known work is *The Four Seasons* (1725).

viviparity (vivipary) Process or trait among animals of giving birth to live young. Placental mammals show the highest development of viviparity, in which the offspring develops inside the body, within the mother's UTERUS.

vivisection Dissection of living bodies for experimental purposes. Work with laboratory animals in testing drugs, vaccines and pharmaceuticals frequently involves such dissections. The ethical issue of experimenting on living animals is a matter of controversy. *See also* ANIMAL RIGHTS

Vladimir I (the Great) (956-1015) Grand Duke of Kiev and first Christian ruler of Russia (980-1015). Vladimir raised an army of VIKING mercenaries in 979 and conquered Polotsk and Kiev. Proclaimed prince of all Russia, he extended Russian territories, conquering parts of Poland and Lithuania. Impressed by accounts of Constantinople, he became a Christian and married a Byzantine princess (988). St Vladimir, as he is also called, established the Greek Orthodox faith in Russia. Vladimir City on the N bank of the River Klyazma, Russia. Founded early in the 12th century by Vladimir II of Kiev, it is one of Russia's oldest cities. The grand dukes of Moscow were crowned here in the 14th century. Tourists are drawn partly by three 12th-century buildings - the two cathedrals and the Golden Gate (a fortified city gate). Industries: chemicals, cotton textiles, plastics, tractors, machine tools, electrical goods. Pop. (1994) 338,000.

Vladivostock Main port, naval base and cultural centre of SIBERIA, Russia, located around a sheltered harbour on the Pacific coast, 50km (30mi) from the Chinese border. Founded in 1860 as a military post, the city developed as a naval base after 1872. Vladivostock is the main E terminus of the TRANS-SIBERIAN RAILWAY. The harbour is kept open in winter by ice-

▲ virus The human adenovirus is of the type responsible for colds and sore throats. The virus is colour coded for ease of identification. The casing consists of 252 protein molecules (capsomeres) arranged into a regular icosahedron (20 faces). This structure occurs in many viruses. representing the most economical packing arrangement around the DNA inside. Twelve of the capsomeres, located at the points of the icosahedron, are five-sided pentagon bases (yellow). The remaining 240 are six-sided hexons (green). Five of these (green-yellow) adjoin each penton base, from which extends a single fibre (red) tipped with a terminal structure (blue) that begins cell entry.

▶▼ volcano Volcanoes (A) are formed when molten lava (1) from a magma chamber (2) in the Earth's crust forces its way to the surface (3). The classic coneshaped volcano is formed of alternating layers of cooled lava and cinders (4) thrown out during an eruption. Side vents (5) can occur and when offshoots of lava are trapped below the surface, laccoliths (6) are formed. When a volcano's lava has a low silica content, the lava flows easily creating a low-angle, shield cone (B). Cinder cones (C) are created by volcanoes that produce ash and cinders not lava during eruptions. The layers of ash and cinders do not have the stability to create the classic cone-shaped volcano. When a magma chamber collapses, a caldera (D) is formed as the centre of the volcanic cone follows suit. Lakes (1) often fill the resulting crater and subsequent upsurges of lava can create islands (2).

breakers and is a major base for fishing fleets. Industries: ship repairing, oil refining, metal-working, timber products, food processing. Pop. (1994) 637,000.

Vlaminck, Maurice (1876–1958) French painter, graphic artist and writer. One of the leading exponents of FAUVISM, he painted with colours squirted straight from the tube, producing exuberant landscapes, which were partly inspired by the work of VAN GOGH. In 1908 he began using darker colours and studied CÉZANNE in an attempt to give his painting more weight.

vocal cords See LARYNX

vocational education Instruction in industrial or commercial skills. A range of levels of vocational training and qualification are available from schools and colleges, often in collaboration with organizations concerned to improve training and quality standards in particular areas of employment.

Voice of America (VOA) Radio station subsidized by the US government. It presents news, other generally factual information and cultural programmes aimed primarily at US troops serving abroad. VOA was originally set up by the US Office of War Information in 1943–44 to broadcast war news and propaganda both to US troops and to English-speaking listeners in Europe and elsewhere.

Vojvodina Autonomous province in N Serbia, bordered by Croatia, Hungary and Romania. The capital is Novi Sad. From 1849 to 1860 it was the independent crown land of Vojvodina, but it was ceded to Yugoslavia in 1920. Given nominal autonomy by Belgrade in 1946, it remains firmly part of Serbia. Only around 50% of the population are Serbs: the rest are Hungarian (19%), Croats, Slovaks and Romanians. The province is densely populated with a fertile agricultural plain. Industries: fruit, cattle, food processing. Area: 8,301sq mi (21,500sq km). Pop. (1991) 2,013,889.

volcanism (vulcanism) Volcanic activity. The term includes all aspects of the process: the eruption of molten and gaseous matter, the building up of cones and mountains, and the formation of LAVA flows, geysers and hot springs.

volcano Vent from which molten rock or LAVA, solid rock debris and gases issue. Volcanoes may be of the central vent type, where the material erupts from a single pipe, or of the fissure type, where material is extruded along an extensive fracture. Volcanoes are usually classed as active, dormant, or extinct.

vole Short-tailed, small-eared, prolific RODENT that lives in the Northern Hemisphere. Most voles are greyish-brown, herbivorous ground-dwellers and are small. The semi-aquatic water vole is the largest. Length: to 18cm (7in). Family Cricetidae.

Volga Europe's longest river, at 3,750km (2,330mi), in E European Russia. The river rises in the Valdai Hills, then flows E past Rzhev to Kazan, where it turns s. It continues sw to Volgograd, and then sE to enter the Caspian Sea below Astrakhan. The Volga is connected to the Baltic Sea by the Volga-Baltic Waterway, to Moscow by the Moscow Canal, and to the Sea of Azov (and the Black Sea) by the Volga-Don Canal. Many dams and hydroelectric power stations have been constructed along its course. Navigable for *c*.3,550km (2,200mi), it carries about two-thirds of Russia's river freight traffic.

Volgograd Major Russian inland port on the River Volga,

the E terminus of the Volga-Don Canal. During the Civil War that followed the Russian Revolution, it was defended by Bolshevik troops under Stalin (1918–20), and was renamed Stalingrad in his honour (1925). In the winter of 1942–43 it was almost completely destroyed in a fierce battle that halted the German advance. Rebuilt after World War 2 and renamed Volgograd in 1961, it is a major rail and industrial centre. Industries: oil-refining, shipbuilding, chemicals, aluminium, steel, farm vehicles. Pop. (1992) 1,031,000.

volleyball Game in which a ball is volleyed by hand over a net across the centre of a court by two six-a-side teams. The court is 18m (59ft) long by 9m (29ft 6in) wide; the top of the net is 2.4m (8ft) high. The object of the game is to get the ball to touch the ground within the opponents' half of the court, or to oblige an opponent to touch the ball before it goes directly out of court. Only the serving team can score, and failure to score loses service; 15 points wins a set, and a game is the best of five sets. Volleyball has been included in the Olympic Games since 1964.

volt (symbol V) SI unit of electric potential and ELECTROMOTIVE FORCE (EMF). It is the POTENTIAL DIFFERENCE between two points on a conducting wire carrying a current of one ampere when the power dissipated is 1 watt.

Volta West African river, c.470km (290mi) long, formed by the confluence of the Black Volta and White Volta rivers at New Tamale, central Ghana. The river flows s into the Gulf of Guinea at Ada. In 1965 it was dammed at Akosombo to form Lake Volta.

Voltaire (1694-1778) (François Marie Arouet) French philosopher, historian, playwright and poet; the outstanding figure of the French ENLIGHTENMENT. Voltaire spent much of his life combating intolerance and injustice and attacking institutions, such as the Church. While in the Bastille (1717), Voltaire wrote his first tragedy Oedipe (1718). In 1726 Voltaire was beaten and returned to the Bastille for insulting a nobleman. While in exile in England (1726-29), he was strongly influenced by John LOCKE and Issac NEWTON and wrote a classic biography of Charles XII of Sweden. Back in France, Voltaire wrote several tragedies and the eulogistic Philosophical Letters (1734), which provoked official censure. Voltaire corresponded for many years with Frederick II (THE GREAT) and contributed to DIDEROT's Encyclopédie. His best-known work, the philosophical romance Candide (1759), was published anonymously. Other works which express his philosophy of RATIONALISM include Jeannot et Colin (1764) and Essay on Morals (1756). The Dictionnaire philosophique (1764) is a collection of his thoughts on contemporary matters.

voltmeter Instrument for measuring the voltage (POTENTIAL DIFFERENCE) between two points in an electrical CIRCUIT. Voltmeters are always connected in parallel with the components whose voltages are being measured. A voltmeter has a high internal resistance compared with the resistance across which it is connected. *See also* AMMETER

volume Amount of space taken up by a body. Volume is measured in cubic units, such as cm³ (cubic centimetres).

voluntary muscle See SKELETAL MUSCLE

vomiting Act of bringing up the contents of the stomach by way of the mouth. Vomiting is a reflex mechanism that may be activated by any of a number of stimuli, including dizziness, pain, gastric irritation or shock. It may also be a symptom of serious disease.

Von Braun, Wernher (1912–77) US engineer, b. Germany. In World War 2 Von Braun was responsible for building the V-2 rocket. In 1945 he went to the USA, where he developed the Jupiter rocket that took the first US satellite, *Explorer 1*, into space (1958). Von Braun joined the NATIONAL AERONAUTICS AND SPACE ADMINISTRATION (NASA) in 1960 and developed the Saturn rocket that took astronauts to the Moon.

Vondel, Joost von den (1587–1679) Dutch poet and dramatist. Vondel struggled against the handicaps of humble birth, limited education and religious persecution to produce outstanding work based on biblical and classical sources. Of his trilogy of plays, *Lucifer* (1654), a tragedy, *Adam in Exile* (1664) and *Noah* (1667), the first is generally regarded as his masterpiece. He also wrote in various poetic genres.

Vonnegut, Kurt, Jr (1922–) US novelist. Vonnegut often draws on the conventions of fantasy to satirize the horrors of the 20th century. His novels, which experiment with time and narrative structure, include *Player Piano* (1952), *Slaughterhouse-Five* (1969) and *Hocus Pocus* (1991). Vonnegut's short stories were collected in *Welcome to the Monkey House* (1968). Other works include *Three Complete Novels* (1995).

Von Neumann, John (1903–57) US mathematician, b. Budapest. After leaving Hungary in 1919 he studied at various European universities before settling at Princeton University, New Jersey, USA, in 1930. His early contribution to quantum theory was followed by work on the atomic bomb at Los Alamos. He did important work in the early development of computers and was also responsible for the development of GAME THEORY.

voodoo Religious belief of African origin. It is prevalent in parts of Africa, but is better known as the national religion of Haiti. Adherents believe in the reincarnate qualities of Loa, which include deified ancestors, local gods and Roman Catholic saints. Loa possesses the believers during dreams or ceremonies, which include dancing and hypnotic trances.

Voronezh Industrial port on the River Voronezh, w central Russia, capital of the Voronezh oblast. Founded as a fortress in 1586, it became a shipbuilding centre under Peter I. During World War 2 the city was almost totally destroyed and most of it has been rebuilt. Industries: locomotives, machinery, synthetic rubber, oil, chemicals, food processing, cigarettes, television sets. Pop. (1992) 958,000.

Voroshilov, Kliment Yefremovich (1881–1969) Soviet statesman, president (1953–60). Voroshilov joined the Bolsheviks in 1903 and took an military role in the RUSSIAN REVOLUTION (1917). He was a Red Army commander in the civil war (1918–20) before becoming commissar for defence (1925–40). Voroshilov commanded the Red Army on the Nw front in World War 2. He became president on the death of STALIN, but was implicated in a plot against Khruschev and resigned.

Vorster, Balthazar Johannes (1915–83) South African statesman, prime minister (1966–78). Imprisoned during World War 2 as a Nazi sympathizer, Vorster was a staunch advocate of APARTHEID under Hendrik VERWOERD and succeeded him as prime minister and Nationalist Party leader. He established Transkei as a "bantustan" and suppressed the Soweto uprising (1976). Vorster invaded Angola to try and prevent Namibian independence. He became president in 1978, but corruption charges forced his resignation (1979).

vortex Eddy or whirlpool observed in FLUID motion. Vortices cannot occur in ideal (nonviscous) fluid motion, but they are important in the study of real fluids. In particular, the vortices occurring behind aerofoils are of great interest in aerodynamic design.

vorticism British art movement. Derived from CUBISM and Italian FUTURISM, it originated in 1913 with Wyndham Lewis' attempt to express the spirit of the time in harsh angular forms derived from machinery. David Bomberg, Ezra Loomis Pound, Henri Gaudier-Brzeska and Jacob Epstein were also members of the movement.

voting Process employed to choose candidates for public office or to decide controversial issues. Early forms were by voice or sign, but the secret ballot became popular in order to eliminate the possibility of intimidation and corruption. Voters usually mark a piece of paper and deposit it in a ballot box, but in the USA voting machines, operated by polling levers, are commonly in use.

Voting Rights Act (1965) US legislation authorizing federal authorities to check registration and voting procedures in order to protect rights of black voters in nine southern states. Within a year of its passage, the number of blacks registered in five Deep South states had increased by almost 50%.

Voyager program SPACE EXPLORATION programme to study JUPITER, SATURN, URANUS and NEPTUNE, using two unmanned craft launched in 1977. The two Voyager probes were launched 16 days apart from Kennedy Space Center at CAPE CANAVERAL, Florida, USA. They beamed back close-up pictures of Jupiter in 1979. The probes then passed Saturn, and showed the structure of the planet's rings. Voyager II went on to study Uranus in 1986 and Neptune in 1989. Both probes have now left the Solar System.

Vulcan (Volcanus) Roman god of fire and volcanoes, identified with the Greek god HEPHAESTUS. His temples were prudently sited outside city walls. Often invoked to avert fires, he was associated with thunderbolts and the Sun.

vulcanization Chemical process, discovered 1839, of heating SULPHUR or its compounds with natural or synthetic RUBBER in order to improve the rubber's durability and resilience. Vulgate Oldest surviving version of the complete BIBLE, compiled and translated, mostly from Greek, into Latin by St JEROME from 382. The text was revised several times and was used universally in the Middle Ages. In 1546 it was promoted as the official Latin translation by the Council of TRENT.

vulture Large, keen-sighted, strong-flying bird that feeds on carrion. New World vultures, found throughout the Americas, include the turkey BUZZARD and king vulture; family Cathartidae. Old World vultures, related to eagles, are found in Africa, Europe and Asia, and include the Egyptian vulture and the griffon vulture; family Accipitridae. See also CONDOR vulva In human females, the external genitalia. Extending downwards from the clitoris (a small, sensitive, elongated, erectile organ), a pair of fleshy lips (labia majora) surround the vulvar orifice. Within the labia majora, two smaller folds of skin (labia minora) surround a depression called the vestibule, within which are the urethral and vaginal openings. Vyatka (formerly Kirov) City and river port on the w bank of the River Vyatka, w Russia; capital of Kirov region. Founded as Khlynov in 1174, it was annexed by Ivan III in 1489. The city was renamed Vyatka in 1780 and then known as Kirov from 1934 to 1992. It has a 17th-century cathedral. Industries: metal products, agricultural machinery, meat processing, timber, leather, furs. Pop. (1992) 493,000.

▲ vulture The red-headed turkey vulture (Cathartes aura) is a New World vulture, found in mountainous regions from Canada to the Magellan Strait. It has a sharply hooked bill, with fleshy seres across the top, through which the nostrils open. A scavenger, it is not as strong as other birds of prey and relies on its keen sight to spot carrion.

W/w, the 23rd letter of the English alphabet and a letter included in the alphabets of several w European languages. Like f, u, v and y, it was derived from the Semitic letter vaw (a name meaning hook). The Greeks adopted vaw into their alphabet as upsilon. The Romans made two letters out of upsilon - Y and V. The V was first pronounced as a modern English w and later as a modern English v. Norman-French writers of the 11th century created the modern form of the letter by doubling a u or v to represent the Anglo-Saxon letter wynn, which had no counterpart in their alphabet. In modern English w is silent in such words as answer and wring. In some words introduced by the combination wh, the w is today not sounded (as in who and whom). But in which, what, white and whisk, a voiceless form of w is used.

Waco City on the River Brazos, central Texas. Settled as a ferry-crossing in 1849 on a former Waco (Huaco) Indian colony, it became a major transport and agricultural centre. In 1993 FBI agents stormed the nearby headquarters of the Branch Davidians religious sect, resulting in a fire in which 80 cult members died. Industries: cotton, grain, tyres, paper, furniture, clothing, glass, aircraft parts. Pop. (1992) 103,997

Wagner, Otto (1841–1918) Austrian architect. His book *Moderne Architektur* (1895) had wide influence throughout Europe, particularly on his pupils Joseph Olbrich and Josef Hoffman.

Wagner, Richard (1813–83) German composer. His works consist almost entirely of operas, for which he provided his own libretti. His early operas include *Der fliegende Holländer* (1843), *Tannhäuser* (1845) and *Lohengrin* (1850). With *Tristan and Isolde* (1865) and the four-part *The Ring of the Nibelung* (1851–76) the genius of Wagner is fully displayed. His rich, chromatic style gives the music great emotional depth, and the complex, everdeveloping web of LEITMOTHES, which are heard in the voices and in the orchestra, propel the drama. Other operas include *The Mastersingers of Nuremberg* (1868) and the sacred stage drama *Parsifal* (1882).

wagtail Any of several species of mainly Old World birds that live near streams; it wags its long tail while foraging for insects. Family Motacillidae.

Waikato Longest river in New Zealand, in central and NW North Island. It rises from Lake Taupo in the central highlands, and flows NNW into the Tasman Sea. Hydroelectric schemes from eight dams along the river provide power for most of North Island. The river is navigable for 129km (80mi) of its 425km (264mi) course.

Wailing Wall See WESTERN WALL

Waitangi, Treaty of (1840) Pact between Britain and several New Zealand MAORI tribes. The agreement protected and provided rights for Maoris, guaranteeing them possession of certain tracts of land, while permitting Britain formally to annex the islands and purchase other land areas.

Wake Island Largest of three small coral islands, known collectively as Wake Island, enclosing a lagoon in the w Pacific Ocean. The atoll was discovered by the Spaniards (1568) and later named by the British in 1796. It was annexed by the USA (1898) and became a naval base. It was captured by the Japanese in 1941 and recaptured by the USA in 1945. Walcott, Derek (1930–) Caribbean poet and playwright. His numerous plays include Henri Christophe (1950), Drums and Colours (1961), O Babylon (1978) and Viva Detroit (1992), but he is perhaps best known as a poet. His verse, the first volume of which was published in 1948, was collected in

Waldemar IV (1320–75) (Waldemar Atterday) King of Denmark (1340–75). He restored the Danish kingdom after a century of disintegration by a mixture of force, diplomacy and persuasion. In 1367 his enemies, including the HANSEATIC LEAGUE, combined to drive him from the country. He regained the throne in 1371 with the peace of Stralsund (1370).

1986. He was awarded the 1992 Nobel Prize for literature.

Waldenses Small Christian sect founded in the 12th century. It had its origins in the "Poor Men of Lyons", the followers of Peter Waldo of Lyons. The Waldenses renounced private property and led an ascetic life. They repudiated many Roman Catholic doctrines and practices, such as INDULGENCES, PURGATORY and MASS for the dead, and denied the validity of SACRAMENTS administered by unworthy priests. The movement flourished briefly in the 13th century, but

The movement nourished briefly in the 15th century, or

active persecution extinguished it except in the French and Italian Alps. Persecution continued until the Waldenses received full civil rights in 1848. In the later 19th century, many Waldenses emigrated to the Americas.

Waldheim, Kurt (1918–) Austrian politician, fourth secretary-general of the UNITED NATIONS (UN) (1972–81). He succeeded U THANT as secretary-general, but proved to be a weak appeaser of the major powers. His tenure was tainted by revelations of his Nazi war record and he was replaced by PÉREZ DE CUÉLLAR.

Waldo, Peter (1140–1218) French religious reformer after whom the WALDENSES are named. He sent out disciples, known as Poor Men, to read to the common people from the Bible. He preached without ecclesiastical authorization and was excommunicated.

Wales, Prince of See Charles (Prince of Wales)

Wales Principality of the UNITED KINGDOM, occupying a broad peninsula in w Great Britain; the capital is CARDIFF. Other major cities include SWANSEA. Land and climate In the N lies Wales' highest peak, SNOWDON, at 1,085m (3,560ft). ANGLESEY lies off the NW coast. The Black Mountains lie in the SE. The border regions and coastal plains are lowlands. The principal rivers are the SEVERN and Dee. On average, Cardiff experiences twice as much annual rainfall as London. Winter sees the heaviest rains. History The Celtic-speaking Welsh stoutly resisted Roman invasion in the first centuries AD. St DAVID introduced Christianity in the 5th century. In the 10th century, political power was centralized. In the 11th century, the English conquered the border counties and established the Welsh Marches. In 1284 the Welsh were forced to relinquish their independence, and in 1301 Prince Edward (later EDWARD II) became Prince of Wales. In the early 15th century, Owain GLYN DWR led spirited resistance to English rule. The accession of the Welsh TUDOR dynasty to the English throne paved the way for the Act of UNION (1536) of England and Wales. Wales supported the Royalist cause in the English Civil War. In the late 19th century, Wales became the world's leading producer of coal. Rapid industrialization brought large social problems, such as unemployment and poverty. From the 18th century Wales had been a centre of nonconformism, and Calvinism injected new life into Welsh nationalism. The Church of England was disestablished in Wales in 1914. The Welsh nationalist party (PLAID CYMRU) was founded in 1926. The post-war Labour government, consisting of many Welsh members, nationalized industry and began to deal with regional inequality. In 1966 Plaid Cymru gained its first seat in the House of Commons. A 1979 referendum voted against devolution. The maintenance of a distinct Welsh culture has been strengthened by the teaching of Welsh in schools and a separate Welsh-language television channel (1982). A 1997 referendum approved, by the narrowest of margins, the establishment of a separate Welsh Assembly in Cardiff. Economy North Wales is predominantly agricultural, with the world's greatest density of sheep. Dairy farming is also important. Tourism is important in the coastal region of GWYNEDD. The S valleys and coastal plain are Wales' industrial heartland. The late 20th-century decline of its traditional heavy industries of coal and steel has been only partly offset by investment in light industries, such as electronics. Unemployment remains high (1996, 8.3% of the workforce). Area: 20,761sq km (8,016sq mi). Pop. (1994) 2,913,000.

Walesa, Lech (1943–) Polish labour leader and president (1990–95). In August 1980 he organized SOLIDARITY, an independent self-governing trade union. Walesa became a symbol of the Polish workers' determination to have a greater voice in government affairs. In 1981 the government outlawed Solidarity; Walesa was interned until late 1982 as part of the government's effort to silence opposition. In 1983 he was awarded the Nobel Peace Prize. Following reforms in the Soviet Union, Solidarity was legalized and won free elections in 1989. In 1990 the Communist Party was disbanded and Walesa became president. He was defeated in 1995 elections.

Walker, William (1824–60) US adventurer in Central America. He led an armed band that attempted to seize land in Mexico in 1853. He made a similar invasion of Nicaragua

▶ wallaby The pretty-faced wallaby (wallabia pattyr) inhabits the grassy hills and woodlands of Queensland and New South Wales. Its hopping gait is very efficient at high speeds, but at low speeds it is clumsy, using its forelegs and tail for support.

in 1855, with US business support, and set himself up as president (1856). He was expelled in 1857. In 1860 he made a sortie into Honduras, but was captured and shot.

walking stick See STICK INSECT

wallaby Any of various medium-sized members of the KAN-GAROO family of MARSUPIAL mammals, occurring chiefly in Australia. All species are herbivorous, feeding in open grassland at night. They move fast in a series of leaps, using both strong hind legs simultaneously, balanced by the tail. Length: head and body 45–105cm (18–41in); tail 33–75cm (13–30in). Family Macropodidae.

Wallace, Alfred Russel (1823–1913) British naturalist and evolutionist. Wallace developed a theory of NATURAL SELECTION independently of but at the same time as Charles DARWIN. He wrote *Contributions to the Theory of Natural Selection* (1870), explaining the theory of EVOLUTION.

Wallace, George Corley (1919–) US politician. As Democratic governor of Alabama in 1962, he attempted unsuccessfully to block federal efforts to end racial segregation in Alabama state schools (1962–66). In 1972, while campaigning for the Democratic presidential nomination, he was shot and paralysed from the waist down. In 1982 he was again elected state governor, this time, having abandoned his segregationist views, with support from black voters.

Wallace, Henry Agard (1888–1965) US politician. As vice president (1941–45) under Franklin D. ROOSEVELT, he worked to promote goodwill in Latin America. From 1945–46 he was secretary of commerce under President TRUMAN. In 1948 he was the unsuccessful Progressive Party candidate for president. Wallace, Sir William (1270–1305) Scottish nationalist leader. He led resistance to the English king, EDWARD I, in 1297–98. He defeated an English army at Stirling Bridge (1297) and pursued them over the border. In 1298, confronted by Edward with a large army at Falkirk, he was defeated. He went into hiding, but was eventually captured and executed.

Wallachia (Walachia, Valahia) Historic region in Romania, formerly the principality between the River Danube and the Transylvanian Alps. It is said to have been established in 1290 by Ralph the Black, vassal of the king of Hungary, from whom the region secured temporary independence in 1330. It gradually came under the domination of the Turks, whose suzerainty was acknowledged in 1417. Wallachia and MOLDAVIA became protectorates of Russia under the Treaty of Adrianople (1829) and by their union formed the state of ROMANIA in 1859. An important agricultural region, it has been developed industrially since World War 2. Industries: chemicals, heavy machinery. Area: 76,599sq km (29,575sq mi).

Wallenstein, Albrecht Eusebius Wenzel von (1583–1634) German general. During the THIRTY YEARS WAR (1618–48), he was commander of the armies of the Holy Roman Empire. He won a series of victories in the late 1620s but lost the battle of Lützen in 1632. He was later convicted of treason, dismissed and then assassinated.

Waller, Fats (1904–43) US jazz and blues pianist and composer, real name Thomas Waller. He wrote many successful tunes, including *Honeysuckle Rose* and *Ain't Misbehavin'*.

wallflower Any of several species of perennial plants of the genera Cheiranthus and Erysimum, commonly cultivated in Europe and USA. The European wallflower, C. cheiri, has lance-shaped leaves and red, orange, yellow or purple flowers. Height: to 90cm (36in). Family Brassicaceae/Cruciferae. Wallis, Sir Barnes Neville (1887-1979) British aeronautical engineer and inventor, best known for his invention of the bouncing bomb during World War 2. In the 1920s he designed the airship R100 and in the 1950s the first swing-wing aircraft. Wallis and Futuna French territory in the s Pacific Ocean, w of Samoa. It comprises two small groups of volcanic islands, the Wallis Islands and the Hoorn Islands. The principal islands are Uvea, Futuna and Alofi, with Uvea containing 60% of the population and the capital of Mata-Utu (1983 pop. 815). Timber is the main export. The French took the islands in 1842 and in 1959 they became an overseas territory. The islands' economy is based on subsistence agriculture of copra, cassava, yams, taro and bananas. Pop. (1993 est.) 14,400.

Walloons French-speaking people of s Belgium, as opposed

to the Flemish-speaking people of the N. They inhabit chiefly the provinces of Hainaut, Liège, Namur and s Brabant. In the 1990s they numbered about 3,000,000.

walnut Deciduous tree native to North and South America, Europe and Asia. It has smoother bark than HICKORY, to which it is related, and is grown for timber, ornament and nuts. Height: to 50m (165ft). Family Juglandaceae; genus Juglans. Walpole, Horace, 4th Earl of Orford (1717–97) British writer. His Gothicization of his house near London represents a milestone in architectural taste; his bizarre novel *The Castle of Otranto* (1764) established a parallel fashion for the Gothic in literature. Walpole's lasting reputation, however, rests on his letters, which provide a portrait of life in Georgian England.

Walpole, Sir Robert, 1st Earl of Orford (1676–1745) British politician. Although he resigned as chancellor of the exchequer in 1717 after developing the first sinking fund, he restored order after the South Sea Bubble crisis in 1720. He returned as chancellor of the exchequer and first lord of the Treasury in 1721. He was forced to resign in 1742 because of opposition to his pacific foreign policy.

walrus Arctic seal-like mammal; it has a massive body and a large head. Its tusks, developed from upper canine teeth, can reach 1m (39in) in length and are used to rake up the sea-bed in search of molluscs and to climb up onto ice floes. Length: to 3.7m (12ft). Family Odobenidae; species Odobenus rosmarus. Walsingham, Sir Francis (1532–90) English statesman, a leading minister of ELIZABETH I. He was a zealous Protestant, who set up an efficient intelligence system, based on bribery, to detect Catholic conspiracies. He produced the evidence that led to the conviction and execution of Mary, QUEEN OF SCOTS. Walter, Bruno (1876-1962) German conductor, b. Bruno Walter Schlesinger. After a series of posts in Europe, he went to the USA in 1939. From 1941-57 he worked with the MET-ROPOLITAN OPERA COMPANY, New York. He was highly regarded for his interpretations of Richard Strauss and Mahler. Walter, Hubert (d.1205) English statesman. As bishop of Salisbury, he joined RICHARD I on the Third CRUSADE and later negotiated his ransom. Appointed archbishop of Canterbury and chief justiciar (1193), he was virtual ruler of England in Richard's absence.

Walter, Thomas Ustick (1804–87) US architect. He is best remembered for his extensions to the Captrol at Washington, D.C. He also designed the interior of the Library of Congress. Walther von der Vogelweide (1170–1230) German poet, considered the greatest MINNESINGER of the Middle Ages. He produced poems of enduring immediacy, such as the popular *Unter den Linden*.

Walton, Ernest Thomas Sinton (1903–95) British physicist. He shared the 1951 Nobel Prize for physics with John Cockcroff for the development in 1929 of the first nuclear particle accelerator. In 1931 they produced the first artificial nuclear reaction without radioactive isotopes, using high-energy protons to bombard lithium nuclei.

Walton, Sir William Turner (1902–83) British composer. His best-known works, all of which are characterized by colourful harmony and orchestration, include the jazz-oriented Façade (1923), the oratorio Belshazzar's Feast (1931) and the viola concerto (1929). He also composed the opera Troilus and Cressida (1954) and the coronation marches for George VI and Elizabeth II, Crown Imperial (1937) and Orb and Sceptre (1953).

waltz Dance performed by couples to music in triple time. This graceful ballroom dance came into fashion in the early

▲ walnut Walnut trees are commercially valuable for their wood and nuts. Before the fruits harden into nuts they can be used for pickling, but once mature, they burst from their green casing and the edible nuts can be removed from the hard outer shell.

▼ walrus A unique relative of the seal, the walrus (*Odobenus* rosmarus) is assigned a family of its own. It is a gregarious animal, and has a tough hide and a thick fat layer, which helps protect against cold as well as the tusks of other walruses.

The Wankel rotary engine (A) compresses and ignites a petrol/air mixture with a spark plug like a normal combustion engine, but does so with a rotating three-sided rotor (1) not an in-line action. The explosion of the fuel/air mixture drives a crankshaft (2) passing through the centre of the cylinder. (3) The

movement of the rotor sucks air into the cylinder and, as it continues to rotate, seals the inlet (so valves are not needed) and then compresses the mixture as it continues to turn. The spark plugs (4) then ignite the mixture, which expands, rotating the piston and driving the crankshaft. The

burned fuel is expelled through an outlet (5) as the piston turns pulling in more air to repeat the process (6). The seals (7) at the edge of the piston's faces are very important in creating the vacuum needed to pull in the fuel/air mixture and in compressing the mixture. A complete cycle is shown (B).

19th century, having developed during the previous century from south-German folk dances, such as the *Ländler*.

Wang Mang (33 BC – AD 23) Emperor of China. A usurper, he overthrew the HAN dynasty and proclaimed the Hsin (New) dynasty in AD 8. Opposition from landowners and officials forced him to withdraw the reforms and his one-emperor dynasty, which divides the Early Han from the Later Han, ended with his assassination.

Wankel rotary engine Petrol engine with rotors instead of pistons, invented by German engineer Felix Wankel in the 1950s. Each triangular rotor turns inside a close-fitting casing. Gaps between the casing and rotor form three crescent-shaped combustion chambers. Each chamber goes through a sequence of events similar to those in a FOUR-STROKE ENGINE with pistons.

wapiti Large deer of North America, closely related to the Old World red deer, second only to the ELK in size. It is greybrown with a whitish rump and dark, brown-black legs, head and neck; its antlers may reach a span of 1.5m (5ft). Height:

► Warhol Born in Pittsburgh, USA, Andy Warhol was a successful commercial artist in New York before becoming a leading exponent of Pop art. In 1966 he collaborated with Lou Reed and his band the Velvet Underground on a pioneering tour of multimedia shows. He was shot and almost killed by Valerie Solanas, a radical feminist, in 1968. In the 1970s and '80s he remained active, producing improvisational and experimental films as well as a magazine and portraits.

to 1.5m (5ft); length: to 2.5m (7.5ft). Family Cervidae; species Cervus canadensis.

war Military combat between large communities, nations and/or groups of nations. All-out (nuclear) war between major powers using modern weapons would undoubtedly result in what is known as "mutually assured destruction" (aptly abbreviated to MAD). Other forms of war include civil war, in which factions within one state or community struggle for supremacy, and guerrilla war, in which partisan forces harass occupying or government troops by making surprise attacks and immediate strategic withdrawals. A considerable portion of the national budgets of virtually every nation remains geared towards instigating or reacting to war.

warbler Numerous birds of two families, one in the Old World (Sylviidae) and the other in the New World (Parulidae). Old World warblers include the hedge sparrow and tailorbird. Most New World warblers have brighter plumage.

war crimes Violations of international laws of war. The modern conception of war crimes followed the atrocities committed in the era of World War 2, which was followed by the NUREMBERG TRIALS, the first trials of war criminals. The civil wars in BOSNIA-HERZEGOVINA and RWANDA were marked by atrocities. See also GENEVA CONVENTION.

Warhol, Andy (1928–87) US painter, printmaker and filmmaker, innovator of POP ART. He achieved immediate fame with his stencil pictures of Campbell's soup cans and his sculptures of Brillo soap pad boxes (1962). In 1965 he gave up art to manage the rock group *The Velvet Underground*. He continued to make films, which often have a voyeuristic quality.

warlords Rulers who hold local authority by force of arms. The term is applied, in particular, to regional military leaders in China in the late 19th and early 20th centuries.

warm-blooded See HOMEOTHERMAL

War of 1812 (1812–1815) Conflict between the USA and Britain. The main source of friction was British maritime policy during the Napoleonic Wars, in which US merchant ships were intercepted. Difficulties on the border with Canada also contributed. The US invasion of Canada failed, although Britain suffered defeats on Lake Erie and on the w frontier. The end of the Napoleonic Wars (1814) freed more British forces. They imposed a naval blockade and captured Washington, burning the White House. A US naval victory on Lake Champlain ended the British threat to New York, and New Orleans was saved by the victory of Andrew Jackson, which occurred after peace had been agreed, unknown to the combatants, in Europe.

war powers In the USA, constitutional powers given to the president as supreme military commander. They include the power to appoint armed forces officers with consent of Senate. Congress alone is empowered to declare war, but presidents have carried out military actions without congressional approval or a formal declaration of war, as in ordering troops into Korea and Vietnam.

warrant Legal document of three main kinds. It may be a writ conferring some title or authority upon a person, a command delivered to an officer to arrest an offender, or a citation or summons.

Warren, Earl (1891–1974) US politician and jurist. Appointed by President Eisenhower as chief justice of the SUPREME COURT (1953–69), he began the "Warren Revolution" that lasted until his retirement. Some of the Warren Court's noteworthy cases include: Brown v. Board of Education of Topeka (1954), which made segregation in the public schools unconstitutional; Engel v. Vitale (1962), which prohibited prayers in public schools; and Miranda v. Arizona (1966), which made it obligatory that a suspect be informed of his rights, be provided with free state counsel, and be given the right to remain silent. See also Warren Commission.

Warren, Robert Penn (1905–89) US poet, novelist and critic. In his fiction, which includes the Pulitzer Prize-winning novel *All the King's Men* (1946), Warren concentrated on Southern themes and characters. He was awarded the prize twice more, for the poetry collections *Promises* (1957) and *Now and Then* (1978). He was nominated the first American poet laureate in 1986.

W

Warren Commission (1963–64) US presidential commission that investigated the assassination of President Kennedy. It was headed by Earl Warren. After taking evidence from 552 witnesses, it concluded that the act had been committed by Lee Harvey Oswald, acting alone; denial of a conspiracy was not universally accepted.

Warrington County district in central N Cheshire, England; created in 1974 under the Local Government Act (1972). Area: 176sq km (68sq mi). Pop. (1974 est.) 163,800.

Warsaw Capital and largest city of Poland, on the River Vis-TULA. Its first settlement dates from the 11th century. In 1596 it became Poland's capital and developed into the country's main trading centre. From 1813–1915 it was controlled by Russia, and during World War 1 it was occupied by German troops. In 1918 it was liberated by Polish troops. The 1939 German invasion and occupation of Warsaw marked the beginning of World War 2. In 1940 the Germans isolated the Jewish ghetto, which contained 500,000 people, and following a brutal suppression of a Jewish uprising in February 1943, they killed over 40,000 survivors. In January 1945, when the Red Army liberated Warsaw, they found only 200 surviving Jews. After World War 2, the old town was painstakingly reconstructed. Warsaw is a major transport and industrial centre. Industries: steel, cars, cement, machinery. Pop. (1993) 1,653,300.

Warsaw Pact Agreement creating the Warsaw Treaty Organization (1955), a defensive alliance of the SOVIET UNION and its communist allies in Eastern Europe. It was founded after the admission of West Germany to the NORTH ATLANTIC TREATY ORGANIZATION (NATO), the equivalent organization of Western Europe. Its headquarters were in Moscow and it was effectively controlled by the Soviet Union. Attempts to withdraw by Hungary (1956) and Czechoslovakia (1968) were forcibly denied. It was officially dissolved in 1991 after the collapse of the Soviet Union.

wart Raised and well-defined small growth on the outermost surface of the skin, caused by the human papillomavirus. It is usually painless unless in a pressure area, as with a VERRUCA. wart hog Wild, tusked PIG native to Africa. It has a brownish-black skin with a crest of thin hair along the back. Height: about 76cm (2.5ft) at shoulder; weight: 90kg (200lb). Family Suidae; species *Phacochoerus aethiopicus*.

Warwick, Richard Neville, Earl of (1428–71) English magnate known as "the Kingmaker", who held the balance of power during the Wars of the Roses. After the death of Richard of York, he was the chief power in the kingdom (1461–64). Breaking with Richard's son, EDWARD IV, Warwick changed sides, and restored Henry VI to the throne in 1470. Edward returned with fresh troops and Warwick was defeated and killed at the Battle of Barnet.

Warwickshire County in central England. The land is gently rolling, rising to the Cotswold Hills in the s, and is drained chiefly by the River Avon. Cereals are the principal crops and dairy cattle and sheep are raised. There is growing light industry, especially near Nuneaton, Rugby and Leamington. The county town of Warwick (1992 pop. 116,299), Kenilworth and Stratford upon Avon all draw considerable numbers of tourists. Area: 1,981sq km (765sq mi). Pop. (1991) 484,287. Washington, Booker T. (Taliaferro) (1856–1915) US

Washington, Booker T. (Taliaferro) (1856–1915) US educator and black leader. Born a slave, he gained an education after the Civil War and became a teacher. He advocated self-help, education and economic improvement as preliminaries to the achievement of equality for blacks, and believed in compromise with white segregationists. He had considerable influence among whites as a spokesman for black causes. Washington, Denzel (1954–) US film actor. His first major film role was as Steven Biko, in the anti-apartheid film Cry Freedom (1987). He was chosen by Spike Lee to play the leads in Mo' Better Blues (1990) and Malcolm X (1992). Other notable credits include Mississippi Masala (1992), Philadelphia (1993) and Devil in a Blue Dress (1995).

Washington, George (1732–99) Commander of the colonial forces during the AMERICAN REVOLUTION and first president of the USA (1789–97). A wealthy Virginian, he fought with distinction in the FRENCH AND INDIAN WARS and in 1775 was chosen by the CONTINENTAL CONGRESS as commander in

chief. With victory achieved, he resigned (1783), but was recalled from retirement to preside over the Constitutional Convention at Philadelphia (1787). In 1789 he was elected, unopposed, as president of the new republic and re-elected in 1793. He was criticized by Jefferson and his associates for supporting strong federal institutions and for what they regarded as his pro-British policy during the FRENCH REVOLU-TIONARY WARS. Washington declined a third term as president. Washington State in the extreme NW USA, bounded on the N by British Columbia, Canada, E by Idaho, s by Oregon and w by the Pacific Ocean. The state capital is OLYMPIA and the largest city is SEATTLE. In the NW is the navigable Puget Sound, along which lie Washington's major industrial and commercial cities. Washington is dominated by the CASCADE RANGE, which crosses the state from N to S. Mount RAINIER and Mount ST HELENS are notable peaks in the range. The coastal region to the w of the range is one of the wettest areas of the USA and has dense forest; the region to the E of the Cascades is mostly treeless plain with low rainfall. An important wheat-producing area, the plateau is dependent on irrigation schemes. The COLUMBIA RIVER is one of the world's best sources of hydroelectricity, and is also used for irrigation. The Spanish discovered the mouth of the Columbia River in 1775, and in 1778 Captain Cook established the area's fur trading links with China. In 1792 George Vancouver mapped the Puget Sound and Robert Gray sailed down the Sound and established the US claim to the region. The claim was strengthened by the Lewis and Clark Expedition (1805) and the establishment of an American Fur Company trading post by John Jacob Astor in 1811. From 1821-46 the region was administered by the Hudson's Bay Company. In 1846 a treaty with the British fixed the boundary with Canada, and in 1847 most of present-day Washington state became Oregon Territory. In 1853 Washington Territory was created. Exploitation of its forests and fisheries attracted settlement, and Washington was admitted to the Union in 1889. It is the leading producer of apples in the USA. Industries: food processing, timber, aluminium, aerospace, computer technology. Area: 172,431sq km (66,581sq mi). Pop. (1992) 5,142,746. Washington, D.C. Capital of the USA, on the E bank of the

Washington, D.C. Capital of the USA, on the E bank of the POTOMAC River, covering the District of Columbia and extending into the neighbouring states of Maryland and Virginia. The site was chosen as the seat of government in 1790, and the city was planned by the French engineer Pierre Charles L'Enfant. Construction of the White House began in 1793 and of the CAPITOL the following year. Congress moved from Philadelphia in 1800. During the WAR OF 1812 the city was occupied by the British and many public buildings were burned (1814), including the White House and the Capitol. Washington is the legislative, judicial and administrative centre of the USA. The main governmental buildings are the Library of Congress, the PENTAGON, the SUPREME COURT, the SENATE, the HOUSE OF REPRESENTATIVES and Constitution Hall. Despite its role, Washington has severe social problems; many of its large black population live in slum housing. Pop. (1992) 585,221.

Washington, Treaty of (1871) Agreement settling a number of disputes involving the USA, Britain and Canada. The most serious was the question of the ALABAMA CLAIMS, which was submitted to international arbitration. US—Canadian disputes over fisheries and the border were also resolved.

wasp Any insect of the stinging Hymenoptera that is neither a bee nor an ant. The common wasp (*Vespa vulgaris*) has a yellow body ringed with black. Adults feed on nectar, tree sap and fruit. Length: to 3cm (1.2in). Family Vespidae.

water Odourless, colourless liquid (H₂O) that covers about 70% of the Earth's surface and is the most widely used solvent. Essential to life, it makes up from 60–70% of the human body. It is a compound of hydrogen and oxygen with the two H–O links of the molecule forming an angle of 105°. This asymmetry results in polar properties and a force of attraction (hydrogen bond) between opposite ends of neighbouring water molecules. These forces maintain the substance as a liquid, in spite of its low molecular weight, and account for its unusual property of having its maximum density at 4°C (39.2°F). Properties: r.d. 1.000; m.p. 0°C (32°F); b.p. 100°C (212°F).

▲ Washington The first president of the USA, George Washington was an outstanding military commander and statesman. He was highly influential in securing the adoption of the Constitution, and, after his election, strictly avoided overstepping the constitutional bounds of presidential power. Washington tried but failed to remain aloof from partisan struggles. The resignation of Thomas Jefferson led to the creation of a two party system, and Washington aligned himself with the Federalists during his second term. In his famous farewell address he warned the USA against forming permanent alliances with foreign powers and being drawn into European

WASHINGTON Statehood: 11 November 1889 Nickname: The Evergreen State

State bird : Willow goldfinch State flower :

Coast rhododendron
State tree:

Western hemlock
State motto:
Alki (Native American for "by and by")

▶ water buffalo The Asiatic water buffalo (Bubalus bubalis) feeds on river and lakeside vegetation. Both sexes carry large horns, but the males are generally larger and can weigh almost a tonne. Wild water buffalo are extremely fierce and have been known to kill fully grown tigers. The domesticated animals are used to pull ploughs and carts, but produce little milk.

▲ weathering Weathering is the breakdown of rock in place. It occurs in two main ways: physical (A and C) and chemical (B), and usually in combination. At the surface, plant roots and animals such as worms break down rock turning it into soil (A). In chemical weathering (B), soluble rocks such as limestone (1) are dissolved by ground water, which is a very mild solution of carbonic acid. Acid rain caused by sulphate pollution (2) also attacks the rock. The water can create cave systems deep below the surface. Both heat and cold can cause physical weathering (C). When temperatures drop below freezing, freeze-thaw weathering can split even the hardest rocks such as granite (4). Water that settles in cracks and joints during the day expands as it freezes at night (5). The expansion cleaves the rock along the naturally occurring joints (6). In deserts, rock expands and contracts due to the extremes of cooling and heating, resulting

in layers of rock splitting off.

water boatman Aquatic insect found worldwide. Its body is grey to black, oval and flat, with fringed, oarlike hind legs. Length: about 15mm (0.6in). Order Hemiptera; family Corixidae. The carnivorous "backswimmers" of the family Notonectidae are also sometimes called water boatmen.

waterbuck (waterbok) Large, gregarious, coarse-haired ANTELOPE, native to Africa's of the Sahara, and the Nile Valley. There are six species. Length: 1.4–2.1m (4.5–7ft); height: 1.1–1.5m (3.6–4.9ft) at the shoulder. Family Bovidae; genus *Kobus*.

water buffalo (caraboa) Large ox, widely domesticated in much of the tropical world; it is feral in some parts of India. Height: to 1.8m (6ft) at the shoulder. Family Bovidae; species *Bubalus bubalis*.

watercolour Paint that is made from a pigment ground up with a water-soluble gum, such as gum arabic; also a painting that is rendered in this medium.

watercress Floating or creeping plant found in running or spring waters. The succulent leaves, divided into small, oval leaflets, have a pungent flavour and are used in salads and soups. The clustered flowers are white. Height: 25cm (10in). Family Brassicaceae/Cruciferae; species Nasturtium officinale. water cycle See HYDROLOGICAL CYCLE

water flea Any of numerous species of small, chiefly freshwater branchiopod crustaceans, especially those within the genus *Daphnia*, which are common throughout the world. Order Cladocera. *See also* CRUSTACEA

Waterford County in Munster province, on the Atlantic Ocean, s Republic of Ireland. It is a mountainous region, drained chiefly by the rivers Blackwater and Suir. The raising of beef and dairy cattle and sheep is the chief agricultural activity. Industries: fishing, food processing, tanning and glassware. The county town of Waterford (1991 pop. 40,300) is an important port. Area: 1,838sq km (710sq mi). Pop. (1991) 91,624.

waterfowl Birds, including species of DUCK, GOOSE and SWAN, found throughout most of the world. Large flocks migrate from cool nesting grounds to warm winter homes. All have short bills, short legs, and dense plumage underlaid by down. Undomesticated species are known as wildfowl in Britain. Order Anseriformes.

Watergate scandal (1972–74) US political scandal that led to the resignation of President Nixon. It arose from an attempted burglary of the Democratic Party's national head-quarters in the Watergate Building, organized by members of Nixon's re-election committee. Evidence of the involvement of the administration provoked investigations by the Senate and the justice department, which ultimately implicated Nixon. He was pardoned by his successor, Gerald Ford, but his closest advisers were prosecuted and convicted.

water hyacinth Aquatic herb native to the American tropics. It has swollen petioles that float in water and spikes of violet flowers. Family Pontederiaceae; species *Eichhornia crassipes*. water lily Any of about 90 species of freshwater plants widely distributed in temperate and tropical regions. They have leaves that float at the surface, and showy flowers of white, pink, red, blue or yellow. Family Nymphaeaceae; genera *Nymphaea*, *Nuphar*, *Nelumbo* and *Victoria*.

Waterloo, Battle of (1815) Final engagement of the

NAPOLEONIC WARS, fought *c*.20km (12mi) from Brussels, Belgium. Allied forces were commanded by the Duke of Wellington, against Napoleon's slightly larger French forces. Fighting was even until the Prussians, under Marshal Blücher, arrived to overwhelm the French flank, whereupon Wellington broke through the centre. The battle ended Napoleon's Hundred Days and resulted in his second and final abdication.

watermelon Trailing annual VINE native to tropical Africa and Asia and cultivated in warm areas worldwide. Its edible fruit has a greenish rind, red flesh and many seeds. Family Cucurbitaceae; species Citrullus lanatus. See also GOURD

water mill Machinery powered by the flow of water past a waterwheel. Water mills were invented about 2,000 years ago to grind grain into flour.

water moccasin (cottonmouth) Venomous semi-aquatic SNAKE of SE USA. It is a pit VIPER, closely related to the COPPERHEAD. It vibrates its tail and holds its white mouth open when threatened. Length: to 1.2m (4ft). Family Viperidae; species Agkistrodon piscivorus.

water polo Game devised as an aquatic form of FOOTBALL. It is played by two teams of seven people in a pool. At each end of the pool is a net-enclosed goal defended by one player per team. The game has been an Olympic event since 1900. water power See HYDROELECTRICITY

water skiing Leisure activity and competitive sport in which a person skis across the surface of water while being towed by a motor-boat. Competition skiing comprises three disciplines: the slalom, jumping and tricks. In the slalom, skiers are towed several times through a series of staggered buoys. In jumping, each skier must ski up and over a wooden ramp. For the tricks, skiers devise their own 20-second routines of complex manoeuvres.

water table In geology, level below which the ground is saturated. The height of the water table gradually changes, moving up or down depending on the recent rainfall. Water located below the water table is called GROUND WATER.

Watson, James Dewey (1928–) US geneticist and biophysicist. He is known for his role in the discovery of the molecular structure of deoxyribonucleic acid (DNA), and he shared the 1962 Nobel Prize for physiology or medicine with Francis CRICK and Maurice Wilkins. Watson later helped to break the GENETIC CODE of the DNA base sequences and found the ribonucleic acid (RNA) messenger that carries the DNA code to the cell's protein-forming structures.

Watson, John Broadus (1878–1958) US psychologist, the founder of BEHAVIOURISM in the USA. His work did much to make psychological research more objective, and his point of view was continued in the work of B. F. SKINNER.

Watson-Watt, Sir Robert Alexander (1892–1973) British physicist. He was a major influence on the rapid development of RADAR in World War 2. In 1941 he helped to establish the US radar system.

Watt, James (1736–1819) Scottish engineer. In 1765 Watt invented the condensing steam engine. In 1782 he invented the double-acting engine, in which steam pressure acted alternately on each side of a piston. With Matthew Boulton, Watt coined the term "horsepower". The unit of power is called the WATT in his honour.

watt Unit of power in the SI system of units. A machine consuming one JOULE of energy per second has a power output of one watt. One horsepower corresponds to 746 watts. A watt is also a unit of electrical power, equal to the product of voltage and current.

Watteau, Jean-Antoine (1684–1721) French painter. Watteau's early work was influenced by the Flemish genre painter David Teniers, as seen in his early painting *La Marmotte*. He is best known for his *fêtes galantes*, notably his masterpiece *Departure for the Islands of Cythera* (1717), which is an early example of ROCOCO.

Watts, George Frederick (1817–1904) British painter and sculptor. He produced complicated, moralistic allegories such as *Hope* (1886). Watts' best-known sculpture is an equestrian statue called *Physical Energy* (1904).

Waugh, Evelyn Arthur St John (1903–66) British novelist. He established his reputation with *Decline and Fall*

W

(1928). Vile Bodies (1930), A Handful of Dust (1934) and Put Out More Flags (1942) reflect inter-war British upper-class life, while Brideshead Revisited (1945) is informed by the Roman Catholicism to which he was converted in 1928. Among his other major works is the Sword of Honour trilogy — Men at Arms (1952), Officers and Gentlemen (1955) and Unconditional Surrender (1961).

wave In oceanography, moving disturbance travelling on or through water but that does not move the water itself. Wind causes waves by frictional drag. Waves not under pressure from strong winds are called swells. Waves begin to break on shore or "feel bottom" when they reach a depth shallower than half the wave's length. When the water depth is about 1.3 times the wave height, the wave front is so steep that the top falls over and the wave breaks.

wave In physics, carriers of energy from place to place. Waves are caused by disturbances that result in some sort of oscillation. These oscillations then spread out (propagate) as waves. The velocity depends on the type of wave and on the medium. Electromagnetic waves, such as light, consist of varying magnetic and electric fields vibrating at right angles to each other and to the direction of motion; they are transverse waves. Sound waves are transmitted by the vibrations of the particles of the medium itself, the vibrations being in the direction of wave motion; they are longitudinal waves. Sound waves, unlike electromagnetic waves, cannot travel through a vacuum or undergo polarization. Both types of waves can undergo REFLECTION, REFRACTION and give rise to INTERFERENCE phenomena. A wave is characterized by its WAVELENGTH and FRE-QUENCY, the VELOCITY of wave motion being the product of wavelength and frequency. See also ELECTROMAGNETIC RADIA-TION; POLARIZED LIGHT; WAVE AMPLITUDE; WAVE FREQUENCY

wave amplitude Peak value of a periodically varying quantity. This peak value may be either positive or negative, as the quantity varies either above or below its zero value.

wave dispersion Alteration of the refractive index of a medium with wavelength. It occurs with all electromagnetic waves but is most obvious at visible wavelengths, causing light to be separated into its component colours. Dispersion is seen when a beam of light passes through a refracting medium, such as a glass PRISM, and forms a SPECTRUM. Each colour has a different wavelength, and so the prism bends each colour in the light a different amount. See also REFRACTION

wave frequency Number of complete oscillations or wave cycles produced in 1 second, measured in HERTZ. It can be calculated from the wave velocity divided by wavelength. By QUANTUM THEORY, the frequency of any ELECTROMAGNETIC RADIATION (such as light, radio waves and x-rays) is proportional to the energy of the component photons.

wavelength (symbol \(\lambda\)) Distance between successive points of equal phase of a WAVE. The wavelength of water waves could be measured as the distance from crest to crest. The wavelength of a light wave determines its colour. Wavelength is equal to the wave VELOCITY divided by the WAVE FREQUENCY. Wave mechanics Version of QUANTUM MECHANICS developed in 1926 by Erwin Schrödinger. It explains the behaviour of electrons in terms of their wave properties. Although quickly superseded by a more complex formulation by Paul DIRAC, it is still widely used in calculations.

wax Solid, insoluble substance of low melting point that is mouldable and water-repellent. There are three forms: animal, vegetable and mineral. The first two are simple lipids consisting of esters of fatty acids; mineral waxes include paraffin wax made from petroleum. Synthetic waxes are of diverse origins and include POLYETHYLENES. Waxes are used in the manufacture of lubricants, polishes, cosmetics and candles and to waterproof leather and coat paper.

waxwing Any of a few species of small, grey-brown birds with distinctive black markings on the head, a small crest and characteristic red or red-and-yellow waxy tips on the secondary wing feathers. They are found in the forests of Eurasia and North America and feed on berries and fruit. Length: to 20cm (8in). Family Bombycillidae; genus Bombycilla.

Wayne, Anthony (1745–96) US general. He served under George Washington in the Revolutionary War campaigns

around New York and Pennsylvania, and in 1779 he led the successful night attack on Stony Point, New York. In 1781–83 he fought in the South. After the war, he defeated the Ohio Native Americans in the Battle of Fallen Timbers (1794) and signed the Treaty of Greenville, the first to recognize Native American title to US lands.

Wayne, John (1907–79) US film actor, b. Marion Michael Morrison. His first major success was in *Stagecoach* (1939). He made many more films, including *She Wore a Yellow Ribbon* (1949), *The Man Who Shot Liberty Valance* (1962), *True Grit* (1969), for which he received an Academy Award for Best Actor, and *The Shootist* (1976).

Waziristan Arid and mountainous region in North-West Frontier province, NW Pakistan, on the Afghanistan border. It is divided into N and S Waziristan. In the N, Wazir tribes live in fortified mountain villages and farm the fertile valleys. In S Waziristan, the semi-nomadic Mashud tribes live in tent camps and graze their livestock on the hills. Waziristan became an independent territory in 1893. In 1947 it was incorporated into Pakistan, but with the support of Afghanistan it has struggled to create an independent Pushtu state. Area: 11,585sq km (4,473sq mi). Pop. (1981 est.) 545,000.

weak nuclear force (weak interaction) One of the four FUN-DAMENTAL FORCES in physics. It causes radioactive decay. The weak nuclear force can be observed only in the subatomic realm, being of very short range. It is weaker than the ELEC-TROMAGNETIC FORCE and the strong nuclear force (the strongest of the forces) but stronger than GRAVITATION.

weasel Any of several species of small, carnivorous, mostly terrestrial mammals of Eurasia, N Africa, and North and South America. Most species have small heads, long necks, slender bodies and long tails. Reddish-brown with light coloured underparts, some species turn completely white in winter. Weasels are fierce predators, eating eggs and rodents. Length: 50cm (20in) overall. Family Mustelidae; Genus Mustela.

weather forecasting Prediction of features and effects of the weather. Factors measured include temperature, precipitation, storms and fair weather, land travel and sea conditions, using data gathered from weather stations and satellites and a variety of calculating and mapping techniques.

weathering Breakdown and chemical disintegration of rocks and minerals at the Earth's surface by physical and chemical processes. In physical weathering in cold, wet climates, water seeping into cracks in the rock expands on freezing, so causing the rock to crack further and to crumble. Extreme temperature changes in drier regions, such as deserts, also cause rocks to fragment. Chemical weathering can lead to a weakening of the rock structure by altering the minerals of a rock and changing their size, volume and ability to hold shape. Unlike EROSION, weathering does not involve transportation.

Weaver, James Baird (1833–1912) US politician. He represented Iowa in the House of Representatives (1879–81) and was the presidential candidate of the GREENBACK PARTY in 1880. He returned to Congress (1885–89) and was a founder of the POPULIST PARTY, gaining more than one million votes as its presidential candidate in 1892.

weaverbird Any of several species of short-billed, often yellow-and-black, finch-like birds that weave complex nests from grass and leaves. The weaverbirds are gregarious insect-eaters of hot, dry areas. The African *Ploceus cucullatus* knots strands of grass together. Length: to 22cm (7.5in). Family Ploceidae.

weaving Process of making fabric by intertwining two sets of threads. A loom is threaded with a set of warp threads. The weft thread is wound round a shuttle and passed between the warp threads, which are separated according to the desired pattern. A reed keeps the woven rows tightly packed.

Webb, Beatrice (née Potter) (1858–1943) and Sidney (1859–1947) British social historians and politicians. Sidney Webb was one of the founders of the Fabian Society. The Webbs founded the London School of Economics (1895) and helped to found the *New Statesman* magazine (1913).

Weber, Carl Maria von (1786–1826) German composer, conductor and pianist. He helped to establish a German national style in his operas *Der Freischütz* (1821) and *Euryan*-

▲ weaverbird The weaverbird's nest is built by the male. Using no adhesive, he loops, twists and knots leaf strips to make an enclosed hanging structure. Starting with a ring attached to a forked twig (1), he gradually adds a roof and entrance (2). When the finished nest is accepted by the female, she inserts soft, feathery grass tops or feathers to make a thick, soft lining around the egg chamber base. Young male birds' first nests are untidy: gradually, however, they learn how to make neater and better nests, using good vision and well-coordinated head movements to direct claws and beak to manipulate the nest material.

the (1823). He also composed piano and chamber music, concertos and the popular *Invitation to the Dance* (1819).

Weber, Max (1864–1920) German sociologist. He advanced the concept of "ideal types", generalized models of social situations, as a method of analysis. In his work *The Protestant Ethic and the Spirit of Capitalism* (1904–05), he put forward the idea that CALVINISM was influential in the rise of capitalism. Webern, Anton von (1883–1945) Austrian composer. His *Passacaglia* was written using late-Romantic tonality. Influenced by his teacher, SCHOENBERG, Webern adopted atonality, as in the *Six Bagatelles* (1913), and then TWELVE-TONE MUSIC, notably in his symphony (1928). His works are typically extremely short and characterized by strict counterpoint.

Webster, Daniel (1782–1852) US statesman. A famous lawyer and orator, he defended the interests of New England in Congress, opposing the WAR OF 1812. Although opposed to the extension of slavery, he engineered the COMPROMISE OF 1850, which solved the crisis over whether the new state of California should be slave-holding or free. He negotiated the Webster-Ashburton Treaty (1842), fixing the boundary between Maine and Canada.

Webster, John (1580–1634) English dramatist whose reputation rests upon his two great tragedies: *The White Devil* (c.1612) and *The Duchess of Malfi* (1614). Both plays explore the theme of revenge using macabre language.

Webster, Noah (1758–1843) US lexicographer and writer. He completed his monumental, two-volume *American Dictionary of the English Language*, containing 70,000 words, in 1828. A second edition appeared in 1840, and the work has continued to be revised regularly since then.

Wedekind, "Frank" (Benjamin Franklin) (1864–1918) German dramatist whose use of theatre anticipated that of EXPRESSIONISM and influenced BRECHT. His plays include Spring Awakening (1906) and Lulu, which appeared in two parts: Earth-Spirit (1902) and Pandora's Box (1905).

wedge In mechanics, an example of the inclined plane. It is used to multiply an applied force while changing its direction of action. For example, if a metal or wooden wedge is driven into a block of wood then a force is exerted by the wedge at right angles to the applied force and greater than it.

Wedgwood, Josiah (1730–95) British potter. He pioneered the large-scale production of pottery at his Etruria works near Stoke-on-Trent and became famous for his creamware. He is best known for his jasper ware, which gave expression to the contemporary interest in the revival of classical art.

weed Uncultivated or unwanted plant. Weeds are a threat to commercial crops because they compete for water and sunlight, and harbour pests and diseases.

weedkiller See HERBICIDE

Weelkes, Thomas (*c*.1575–1623) English madrigal composer and organist. Almost 100 of his madrigals have survived, the finest being sets of five- and six-part madrigals.

weever Any of four species of small fish that commonly bury themselves in sand in European and Mediterranean coastal waters. Poison spines on the dorsal fin and gill covers can inflict a painful sting. Family Trachinidae; genus *Trachinus*.

weevil Any of numerous species of beetle that are pests to crops, especially the numerous snout beetles (time weevils), with long, down-curved beaks for boring into plants. Family Curculionidae, the largest in the animal kingdom.

Wegener, Alfred Lothar (1880–1930) German geologist, meteorologist and Arctic explorer. In *The Origin of Continents and Oceans* (1915) he was the first to use scientific argument in support of a theory of CONTINENTAL DRIFT.

weight Force of attraction on a body due to GRAVITATION. An object's weight is the product of its MASS and the gravitational field strength at that point. Mass remains constant, but weight depends on the object's position on the Earth's surface, decreasing with increasing altitude.

weightlessness Condition experienced by an object on which the force due to GRAVITATION is neutralized. Such an object is said to have zero gravity and no weight; it floats and cannot fall. Weightlessness can be experienced in space and during free fall. The adverse effects on the human body of prolonged weightlessness (called hydrogravics) include

decreased circulation of blood, less water retention in tissues and the bloodstream, and loss of muscle tone.

weightlifting Sport in which weights at the end of a bar are lifted over the head. Competitions are conducted according to weight classes that range from bantamweight to heavyweight. In a weightlifting competition, each participant uses three standard lifts known as two-hand press, clean-and-jerk, and snatch. The competitor who lifts the greatest combined total of weights wins. It has been an Olympic event since 1920.

weights and measures Agreed units for expressing the amount of some quantity, such as capacity, length or weight. Early measurements were based on body measurements and on plant grains. The French introduced the metric system in 1799, in which the unit of length, the metre, was taken as one ten millionth of the distance from the Equator to the North Pole. A litre was the volume occupied by one kilogram of water. See also SI UNITS

Weil, Simone (1909–1943) French philosopher and writer. In the late 1930s she had the first of several mystical experiences that drew her to the ROMAN CATHOLIC CHURCH. During World War 2, she became an activist in the French Resistance. Most of her works were published after her death, and include *Gravity and Grace* (1947) and *Waiting for God* (1951).

Weill, Kurt (1900–50) German composer. He is best known for his satirical operas, which include *Der Protagonist* (1926) and *Rise and Fall of the City of Mahagonny* (1927), the latter with libretto by BRECHT. Weill parodied commercial music as a means of social criticism. *The Threepenny Opera* (1928) was a modern version of John Gay's *Beggar's Opera*, again with libretto by Brecht. After moving to the USA in 1935, Weill composed musicals for Broadway. His wife, Lotte LENYA, was a respected interpreter of his work.

Weimar City in the state of Thuringia, E central Germany. Founded in 975 and chartered in 1348, the city was capital of the Saxe-Weimar duchy from 1547–1918. It reached its zenith in the 18th century as the continent's literary capital. The 19th century witnessed a gradual artistic decline. In 1919 the German National Assembly convened here to establish the WEIMAR REPUBLIC, and Walter Gropius founded the BAUHAUS school of art. Pop. (1991) 59,100.

Weimar Republic (1919–33) Popular name for the republic of Germany created after World War 1. It was named after the German city where the constitution was drawn up (1919). It was hampered with severe economic difficulties. The Weimar constitution was suspended after Adolf HITLER became chancellor and the republic was superseded by the THIRD REICH.

Weinberg, Steven (1933—) US physicist who in 1967, independently of Pakistani physicist Abdus Salam, proposed a theory that unifies the ELECTROMAGNETIC and WEAK NUCLEAR FORCES between subatomic particles—now known as the electroweak force. Later experiments proved the Salam-Weinberg hypothesis to be true. In 1979 they shared the Nobel Prize in physics with Sheldon Glashow, who had earlier proposed a similar theory. See also GRAND UNIFIED THEORY (GUT)

Weismann, August (1834–1914) German biologist. His essay discussing the germ plasm theory, *The Continuity of the Germ Plasm* (1885), proposed the immortality of the germ line cells as opposed to body cells. It was influential in the development of modern genetic study.

Weiss, Peter (1916–82) Swedish dramatist, b. Germany. His reputation was established with *The Persecution and Assassination of Jean-Paul Marat as Performed by the Inmates of the Asylum of Charenton Under the Direction of the Marquis de Sade* (1964), more commonly known as *Marat/Sade*. Other plays include *The Investigation* (1965) and *Trotsky in Exile* (1970). His final play was *The New Investigation* (1981).

Weissmüller, Johnny (1904–84) US swimmer and actor. He won gold medals at the 1924 and 1928 Olympics and later played Tarzan in a series of successful Hollywood films.

Weizmann, Chaim (1874–1952) Zionist leader, first president of Israel (1948–52). Born in Russia, he became a naturalized British subject in 1910. He played the chief part in securing the BALFOUR DECLARATION (1917). He was president of the World Zionist Organization (1920–31,1935–46), provisional president of Israel (1948) and elected president from 1949.

Weld, Theodore Dwight (1803–95) US campaigner for the abolition of slavery. He was leader of the more moderate wing of the abolitionist movement. In 1839 he published, with his wife Angelina Grimké, *American Slavery As It Is*.

welding Technique for joining metal parts, usually by controlled melting. Several welding processes are used. In fusion welding, the parts to be joined are heated together until the metal starts to melt. On cooling, the molten metal solidifies to form a permanent bond between the parts. Such welds are usually strengthened with filler metal from a welding rod or wire. In are welding, an electric arc heats the work and filler metal. In oxyacetylene welding, the heat is provided by burning acetylene gas in oxygen. In resistance or spot welding, the heat is generated by passing an electric current through the joint. In brazing and soldering, the temperature used is sufficient to melt the filler metal, but not the parts that it joins.

welfare state Description of a state that takes responsibility for the health and subsistence of its citizens. Limited forms of welfare were introduced by Western governments, such as that of BISMARCK in Germany, in the late 19th century. Comprehensive policies covering the whole of society were introduced after World War 2, particularly in Scandinavian countries and the UK, an influential example being the NATIONAL HEALTH SERVICE (NHS) See also SOCIAL SECURITY

well Shaft sunk vertically in the Earth's CRUST through which water, oil, natural gas, brine, sulphur or other mineral substances can be extracted. Artesian wells are sunk into water-bearing rock strata, the AQUIFERS, from which water rises under pressure in the wells to the surface.

Welles, (George) Orson (1915–85) US actor and director. His first publicly shown film, *Citizen Kane* (1940), was a great critical success and won an Oscar for its screenplay. As an actor, he starred in the classic *The Third Man* (1949) and acted in and directed *Touch of Evil* (1958). Disenchanted with Hollywood, Welles went into self-imposed exile from the USA, directing European productions, including *The Trial* (1963), *Chimes at Midnight* (1966) and *The Immortal Story* (1968).

Wellington, Arthur Wellesley, Duke of (1769–1852) British general and politician, prime minister (1828–30). He commanded allied forces in the PENINSULAR WAR (1808–14) against Napoleon, driving the French back over the Pyrenees. He represented Britain at the Congress of VIENNA (1814–15). Together with the Prussian General von Blücher, he defeated Napoleon at the Battle of WATERLOO in 1815. He became a Tory cabinet minister in 1818 and prime minister in 1828.

Wellington Capital of New Zealand, in the extreme s of North Island, on Port Nicholson, an inlet of Cook Strait. First visited by Europeans in 1826, it was founded in 1840. In 1865 it replaced Auckland as capital. Wellington's excellent harbour furthered its development as a transport and trading centre. Industries: textiles, clothing, transport equipment, machinery. Pop. (1994) 329,000.

Wells, H.G. (Herbert George) (1866–1946) British author. His reputation was established with his science fiction novels *The Time Machine* (1895), *The Invisible Man* (1897) and *The War of the Worlds* (1898). Later novels, including *Love and Mr Lewisham* (1900), *Kipps* (1905), *Tono-Bungay* (1909) and *The History of Mr Polly* (1910), draw on the experiences more directly related in his 1934 *Experiment in Autobiography. Ann Veronica* (1909) and *The New Machiavelli* (1911) reflect his strong interest in sociology and politics.

Welsh (*Cymraeg*) Language of Wales. It is spoken natively by less than 19% of the Welsh population, chiefly in the rural north and west of the country. It belongs to the Brittonic subbranch of the Celtic family of INDO-EUROPEAN LANGUAGES, and is closely related to Breton and Cornish. It survives more strongly than most other CELTIC LANGUAGES.

Welsh National Party See PLAID CYMRU

Welsh pony Light saddle horse of a breed known in Wales since Saxon times. It has a short muscular body and great endurance. Its coat may be grey, bay, chestnut or black. Height: to 1.2m (48in) at the shoulder; weight: to 225kg (500lb).

Welty, Eudora (1909–) US author. Among her works are *Delta Wedding* (1946) and *The Ponder Heart* (1954). Collections of her stories, which are usually set in rural Mississippi,

include A Curtain of Green (1941) and The Golden Apples (1949). Later collections include The Eye of the Story (1978), containing essays and reviews, and Collected Stories of Eudora Welty (1980).

Wembley Complex of sports stadiums in Wembley, Nw London. The outdoor Empire Stadium, with its twin towers, built for the 1924 Empire Exhibition, is used for the finals of the FA Cup, Football League Cup and Rugby League Cup, as well as England's home international football matches. In the nearby Empire Pool, a covered arena, ice shows and pop concerts share the facilities with boxing, show-jumping and other sports. In 1996 Wembley was granted funding for a complete rebuild to make it the official National Sports Stadium.

Wenceslas, Saint (907–29) Prince of Bohemia and patron saint of the Czechs. In *c*.925 he overthrew his mother who, as regent, persecuted Christians. He continued the Christianization of the country, which, together with his submission to the Germans, aroused opposition. He was killed by his brother and successor, Boleslav I.

Wenceslaus (1361–1419) King of the Germans (1378–1400) and king of Böhemia (1378–1419) as Wenceslaus IV. He succeeded his father, the Emperor CHARLES IV, but was never crowned emperor and was deposed in 1400.

Wentworth, William Charles (1793–1872) Australian journalist and politician. In 1824 he founded the *Australian* newspaper, which he used to promote the cause of self-government for the Australian colonies. His activism was the most important factor leading to the granting of self-government by the British Parliament in 1842.

werewolf In folklore, a person who metamorphoses into a wolf at night but reverts to human form by day. Some werewolves can change form at will; in others the change occurs involuntarily, under the influence of a full moon.

Werfel, Franz (1890–1945) Austrian dramatist, novelist, and poet. His religious, historical and modernist dramas include *The Trojan Women* (1915), *Paulus Among the Jews* (1926) and *Jacobowsky and the Colonel* (1943). *The Forty Days of Musa Dagh* (1933), *Embezzled Heaven* (1939), *The Song of Bernadette* (1941) and *Star of the Unborn* (1946) are among Werfel's most famous novels. His popular expressionist poetry, found in *The Friend of the World* (1911) and *Each Other* (1915), expressed his love for mankind.

Wergeland, Henrik Arnold (1808–45) Norwegian poet and patriot. Such works as *Jan van Huysum's Flowerpiece* (1840) and *The English Pilot* (1844) helped to establish his reputation as Norway's national poet.

Werner, Alfred (1866–1919) Swiss chemist. He was awarded the 1913 Nobel Prize for chemistry for his coordination theory of VALENCE. This theory correctly suggested that metals have coordinate bonds that would make ISOMERS possible in inorganic compounds.

Wesker, Arnold (1932–) British playwright and director. His plays have socialist themes, and his reputation was established with the trilogy *Chicken Soup with Barley* (1958), *Roots* (1959) and *I'm Talking about Jerusalem* (1960). Other works include *Chips with Everything* (1962), *The Friends* (1970), *The Old Ones* (1972) and *Love Letters on Blue Paper* (1978). Wesley, Charles (1707–88) English evangelist and hymnwriter, brother of John Wesley. He was ordained in 1735 and in 1738 he underwent a evangelical conversion. He wrote nearly 6,000 hymns, including "Hark! the herald angels sing" and "Love divine, all loves excelling".

Wesley, John (1703–91) British theologian and evangelist who founded METHODISM. With his brother Charles WESLEY, he founded the Holy Club at Oxford in 1729. In 1738 he underwent a personal, religious experience during a Moravian meeting and this laid the foundation upon which he built the Methodist movement. Wesley's *Journal* (1735–90) records the great extent of his itinerant preaching.

Wessex Anglo-Saxon kingdom established in Hampshire, sw England. Traditionally founded by Cerdic (r.519–534), by the beginning of the 9th century it had extended its territory to include much of s England. Egbert (r.802–39) became overlord of all England, but his successors relinquished much of their kingdom to the invading Danes. Alfred The Great

▲ Welles Film director Orson Welles' reputation was established by *Citizen Kane* (1940), which he directed, produced and starred in. Widely acknowledged as one of the greatest films of all time, it was certainly one of the most influential. Welles was also notorious for his dramatization for radio of H.G. Wells' *War of the Worlds* (1938), which was so vivid that thousands of listeners believed the broadcast real and reacted with panic and hysteria.

managed to resist further Danish encroachment, and Wessex was the only English kingdom to escape Danish conquest.

West, Benjamin (1738–1820) US painter. He settled in Britain, where he became historical painter to George III and a leader of NEO-CLASSICISM. His best-known paintings are *Death of Wolfe* (1771) and *Penn's Treaty with the Indians* (1772).

West, Mae (1893–1980) US actress. Her first film was *Night After Night* (1932); other films include *She Done Him Wrong* (1933) and *My Little Chickadee* (1940). She is known for her overt sexuality and the spicy wit of her characterizations.

West, Nathanael (1903–40) US novelist and scriptwriter, b. Nathan Wallenstein Weinstein. He wrote just four novels: *The Dream Life of Balso Snell* (1931), *Miss Lonelyhearts* (1933), *A Cool Million* (1934) and *The Day of the Locust* (1939), all of which are concerned with the barrenness of contemporary life. West, Dame Rebecca (1892–1983) British novelist and critic, b. Cicily Isabel Fairfield. She is best known for her first novel, *The Return of the Soldier* (1918), the story of a shell-shock victim. Her political works include *The Meaning of Treason* (1949) and *A Train of Powder* (1955). She also wrote perceptive psychological novels such as *The Thinking Reed* (1936) and *Birds Fall Down* (1966). Her last publication, *1900*, appeared in 1982.

West Bank Region w of the River Jordan and NW of the Dead Sea. Under the United Nations (UN) plan for the partition of Palestine (1947), it was designated an Arab district. It was administered by Jordan after the first Arab-Israeli War (1948) but captured by Israel in the Six Day War (1967). In 1988 Jordan surrendered its claim to the Israeli-occupied West Bank to the PALESTINE LIBERATION ORGANIZATION (PLO) led by Arafat. Under the agreement of 1994 between Arafat and the Israeli government of Rabin, limited autonomy in the West Bank was conceded to the newly formed Palestinian National Authority (PNA). Difficulties created by the growth of Israeli settlements, security disputes and the accession (1996) of a less conciliatory government in Israel threatened to disrupt progress towards total Israeli withdrawal.

West Bengal State in NE India bordering Nepal, Bhutan and Sikkim (N), Bangladesh and Assam state (E), the Bay of Bengal (s) and Bihar and Orissa states (W). The state capital is CALCUTTA. It was formed in 1947 after the independence of India and Pakistan, and the partitioning of the former British province of Bengal into Hindu West Bengal (India) and Mus-

lim East Bengal (East Pakistan). West Bengal absorbed the state of Cooch Bihar in 1950. In the 1970s, political instability was caused by Muslim-Hindu disputes, large refugee immigration from newly created BANGLADESH and Maoist Naxalite disturbances. The state is highly industrialized, its cities attracting vast numbers of male migrants from neighbouring agrarian states. Industries: vehicles, steel, fertilizers, chemicals. Agricultural products: rice, fish, jute, oilseeds, tea, tobacco. Area: 88,752sq km (34,258sq mi). Pop. (1991) 68,077,965. Western Type of popular fiction and film, native to the USA, featuring "cowboys" and "Indians" in a Wild West setting. It first appeared in the form of short stories and novels in the "pulp" magazines of the late 19th century. Owen Wister's The Virginian (1902) is perhaps the most defining influence on the form, and Zane Grey its most prolific exponent. The Squaw Man (1914), one of the first Hollywood Westerns, set a trend for a whole new breed of movie cowboy, such as Tom Mix, Roy Rogers, Buck Jones and "Hopalong Cassidy". More recent examples of the genre have re-evaluated the treatment of Native Americans by settlers.

Western Australia State in Australia, bordered by the Timor Sea (N), the Indian Ocean (W and S), South Australia state and the Northern Territory (E). The capital is PERTH; other major cities are Mandurah, Kalgoorlie, Bunbury and Fremantle, Perth's ocean port. Western Australia was first visited by Dirck Hartog in 1616, but settlement did not begin until 1826, when a penal colony was founded. The first free settlement was in 1829. By far the country's largest state, it was governed by New South Wales until 1831, becoming a state of the Commonwealth of Australia in 1901. The climate is mainly tropical or sub-tropical and over 90% of the land is desert or semidesert. Only the sw, which has a temperate climate, is permanently settled. The Swan River, the only significant water source, drains this region. The raising of sheep and cattle is the main agricultural activity, but the production of cereals, fishing and forestry are also important. Western Australia is the country's major gold-producing state; there is also mining for iron ore, coal, nickel, uranium, bauxite, phosphates, mineral sands, oil and natural gas. Wine became a major earner in the 1980s. Area: 2,525,500sq km (975,095sq mi). Pop. (1991) 1,586,393. Western Cape Province in sw South Africa, bounded by the Indian Ocean to the s and Atlantic Ocean to the w. The capital is Cape Town; other major towns include Simonstown and

▶ West Indies Stretching for 3,200km (2,000mi), the island chain of the West Indies divides the Atlantic Ocean from the Caribbean. The region is famed for its great natural beauty, while its thousands of kilometres of sandy, secluded beaches make the West Indies a popular holiday destination.

W

Stellenbosch. Formerly part of Cape Province, Western Cape was formed in 1994. Its chief physical features are Table Mountain (1,087m) and the rugged Swartberg Range (up to 2,325m). Robben Island was the site of a prison used to house political prisoners during the APARTHEID era. The main economic activity is agriculture, with fruit and tobacco growing, dairy farming and sheep rearing. There is an important fishing industry, and an offshore gas field is exploited in Mossel Bay. Industries: chemicals, machinery, metal goods, textiles. Area: 129,390sq km (50,500sq mi). Pop. (1993) 3,620,200.

Western Isles Administrative area of Scotland (consisting of the Outer HEBRIDES) and a general term for all the Hebridean islands. The largest island is Lewis, on whose E coast lies Stornoway (1981 pop. 8,640), the administrative capital. Area: 2,898sq km (1,120sq mi). Pop. (1994) 29,600. Western Sahara (formerly Spanish Sahara) Desert territory on the Atlantic coast of NW Africa, bordering N with Morocco, NE with Algeria and E and S with Mauritania; the capital is El Aaiún. The territory comprises two districts: Saguia el Hamra in the N and Río de Oro in the s. The population is composed of Arabs, Berbers and pastoral nomads, most of whom are Sunni Muslims. Agriculture is dominated by livestock-rearing. The first European discovery was in 1434, but the area remained unexploited until the 19th century, and even then Spain controlled only the coastal area. In 1957 a nationalist movement temporarily overthrew the Spanish, but in 1958 the Spanish regained control of the region and merged Saguia el Hamra and Río de Oro to form the province of Spanish Sahara. In 1963 large phosphate deposits were discovered. In 1973 the Polisario Front began a guerrilla war, which eventually forced a Spanish withdrawal in 1976. Within a month, Morocco and Mauritania had partitioned the country. Polisario (backed by Algeria) continued to fight for independence, unilaterally renaming the country the Saharawi Arab Democratic Republic. In 1979 Mauritania withdrew and Morocco assumed full control. In 1982 the Saharawi Republic was granted membership of the Organization of African Unity (OAU) and, by 1988, controlled most of the desert up to the Moroccan defensive line. Fragile cease-fires were agreed in 1988 and 1991. A promised referendum failed to materialize and c.200,000 Saharawis continue to live in refugee camps, mostly in Algeria. Talks between Moroccan and Western Saharan government delegations took place in 1997. Area: 266,769sq km (102,680sq mi). Pop. (1993 est.) 214,000.

Western Samoa Independent island republic in the s Pacific Ocean, encompassing the w half of the SAMOA island chain. The capital, Apia (on Upolu), has 66% of the total population. Western Samoa comprises the two large, volcanic, mountainous islands of Savai'i and Upolu, the smaller islands of Manono and Apolima, and several uninhabited islets. Extensive lava flows on Savai'i have made much of the island uninhabitable. The cradle of Polynesian culture, the islands became a German protectorate under the terms of an 1899 treaty. In 1914 New Zealand seized them and they were administered by New Zealand from 1920-61, first under a League of Nations mandate and then a United Nations trusteeship. Resistance to New Zealand rule led to a plebiscite and, in 1962, Western Samoa became an independent state within the Commonwealth. Under a friendship treaty, New Zealand administers the republic's foreign affairs. Much of the workforce is engaged in subsistence agriculture. The chief exports are coconut oil, taro and copra. Area: 2,840sq km (1,097sq mi). Pop. (1991) 161,298.

Western Wall (Wailing Wall) Place in Jerusalem sacred to all Jews. It is a remnant of a wall of the great TEMPLE destroyed by the Romans in AD 70. It is the focus of many pilgrimages.

West Glamorgan County in s Wales on the Bristol Channel; the administrative centre is SWANSEA. Now divided into four districts (Lliw Valley, Neath, Port Talbot and Swansea), the area has been renowned for its metallurgical industry since the 18th century. In the 20th century, anthracite mining and oil refining are important industries, while tourists are attracted by the rugged Gower Peninsula. Area: 820sq km (317sq mi). Pop. (1991) 361,428.

West Indies Chain of islands encircling the Caribbean Sea

and separating it from the Atlantic Ocean, extending from Florida to Venezuela. Geographically they are divided into three main groups: the BAHAMAS, and the Greater and Lesser ANTILLES. Most islands are now independent, but were formerly British, Spanish, French or Dutch possessions. The indigenous population was killed by the colonial powers, who fought for possession of the islands. They were transformed by the introduction of sugar cane in the 17th century, fuelling the slave trade from Africa. See individual country articles

Westinghouse, George (1846–1914) US engineer and inventor. The best known of his hundreds of inventions was the air brake, which made high-speed rail travel safe. He formed the Westinghouse Electric Company in 1886.

Westmeath County in Leinster province, N central Republic of Ireland, bounded by the counties of Meath, Cavan, Roscommon and Offaly. The county town is Mullingar. It is mainly low-lying with many lakes or loughs, including Sheelin and Rees, and is drained by the rivers SHANNON, Inny and Brosna. The main economic activity is cattle raising. Area 1,763sq km (681sq mi). Pop. (1991) 61,880.

West Midlands Metropolitan county in central England. It is divided into seven council districts: BIRMINGHAM (the administrative centre), COVENTRY, Dudley, Sandwell, Solihull, Walsall and Wolverhampton. The other major town is West Bromwich. Area: 899sg km (347sg mi). Pop. (1991) 2-551.671.

Westminster, City of Part of the LONDON borough of Westminster since 1965. Westminster was the site of a monastery from 785, and is where EDWARD THE CONFESSOR built WESTMINSTER ABBEY. Parliament met in Westminster Palace until a fire in 1834 led to the building of the Houses of Parliament (1840–67). Pop. (1991) 174,718.

Westminster, Statutes of English acts of the reign of EDWARD I. The first (1275) and second (1285) statutes enshrined Edward's extensive overhaul of medieval English law. A further statute of 1290 is sometimes called the third statute of Westminster. The Statute of Westminster of 1931 granted autonomy to the dominions in the British empire.

Westminster Abbey Church in London where, since WILLIAM THE CONQUEROR, most English monarchs have been crowned, and many buried. The first church was built by EDWARD THE CONFESSOR in 1050. HENRY III began work on the present structure in 1245. Various additions were made later.

Weston, Edward (1886–1958) US photographer. He developed his style in the 1920s, influenced by Alfred STIEGLITZ. His aim was to give new meaning to mundane objects.

Westphalia Historic region of w Germany between the rivers Rhine and Weser. From 1180 it was a duchy under the archbishops of Cologne. Briefly a kingdom during the NAPOLEONIC WARS, it became a province of Prussia in 1816. Westphalia, Peace of (1648) Series of treaties among the states involved in the THIRTY YEARS WAR. Peace negotiations began in 1642 in cities of Westphalia, leading to the final settlement. In Germany, the peace established the virtual autonomy of the German states, which diminished the authority of the Holy Roman emperor. The peace also established the ascendancy of France, the power of Sweden in N Europe, and the decline of Spain.

West Sussex Non-metropolitan county in SE England. It is divided into seven districts: Chichester (the county town), Adur, Arun, Crawley, Horsham, Mid-Sussex and Worthing. Area: 2,016sq km (778sq mi). Pop. (1991) 702,290.

West Virginia State in the Appalachian Mountain region, E central USA; the capital is Charleston. Settlers from Virginia crossed the Appalachian and Allegheny Mountains in the 1700s, settling the Ohio Valley. The region was then part of Virginia, but political and economic disagreements arose between the new settlements and those in the E. When Virginia seceded from the Union in May 1861 there was much opposition in the w, and it was admitted to the Union as West Virginia in 1863. Hay, tobacco, maize and apples are the principal crops, but West Virginia has rich mineral deposits and is the leading US producer of bituminous coal. Some 65% of the state is forested, much of it with valuable hardwoods. Industries: glass, chemicals, steel, machinery, tourism. Area: 62,629sq km (24,181sq mi). Pop. (1992) 1,808,860.

WEST VIRGINIA

Statehood: 20 June 1863

Nickname :

The Mountain State

State bird : Cardinal

State flower:

Rhododendron

State tree : Sugar maple

State motto : Mountaineers are always

free

▶ whale Among the largest and most intelligent animals that have ever lived, whales all belong to the order Cetacea. The beluga whale (Delphinapterus leucas, A) is an Arctic species, and travels in schools of many hundreds. It grows to 4.25m (17ft). The pilot whale (Globicephala sp., B) is found in most oceans except the polar seas. They migrate between cold and warm waters depending on the season. The Californian grey whale (Eschrichtius glaucus, C) is confined to the North Pacific. From the N seas they migrate s in winter to breed in the shallow. warmer seas off Baja California and South Korea. They feed on plankton, which they strain from the water by means of baleen plates (1). They grow to 9m (30ft).

West Yorkshire Metropolitan county in N central England. It is divided into five districts: BRADFORD, Calderdale, Kirklees, LEEDS and Wakefield (the county town). Area: 2,036sq km (786sq mi). Pop. (1991) 2,013,693.

Wexford County in Leinster province, SE Republic of Ireland. The county town is Wexford (1991 pop. 9,500). The land is mostly low-lying but rises to the Blackstairs Mountains in the w. The chief river is the Slaney. Wexford is primarily an agricultural county; wheat is the chief crop, and cattle raising is important. Area 2,351sq km (908sq mi). Pop. (1991) 102,069. Weyden, Rogier van der (1400–64) Netherlandish painter. In 1436 he became official painter to the city of Brussels, where he lived for the rest of his life. His finest works include *Deposition* (before 1443). He excelled at inventive compositions.

whale Any of several species of large aquatic mammals; it has a fish-like body with paddle-like flippers, and a tail flattened horizontally into flukes for locomotion. It spends its whole life in water. Two main groups exist: toothed whales and baleen whales. Toothed whales (Odontoceti) have simple teeth and feed primarily on fish and squid. They include the bottle-nosed whale, SPERM WHALE and BELUGA. Baleen whales (Mysticeti), including the right whale, BLUE WHALE and California grey whale, have no teeth but carry comb-like plates of horny material (baleen or whalebone) in the roof of the mouth. These form a sieve, through which the whales strain KRILL on which they feed. Order Cetacea. The order also includes DOLPHINS and PORPOISES. See also WHALING

whale shark Largest species of shark; it lives in tropical waters worldwide. Brownish to dark grey with white or yellow spots and stripes, this docile, egg-laying fish often travels near the surface. Length: 9m (30ft). Family Rhincodontidae; species *Rhincodon typus*.

whaling Industry involved in the pursuing and catching of whales for their oil and flesh. Originating in the Middle Ages, the modern whaling era began in the 1850s with the development of harpoons with explosive heads. After 1925 oceangoing factory ships were sent to the Antarctic. Since that time most larger whale species have been hunted to near-extinction. In 1986 the International Whaling Commission (IWC) agreed a moratorium on commercial whaling. Whaling for "scientific purposes" by Japan, Iceland and Norway continued. In 1990 Norway claimed that whale numbers were high enough to sustain hunting; however, public opposition remains strong.

Wharton, Edith Newbold (1862–1937) US novelist. She is best known for *Ethan Frome* (1911), a grim portrait of New England farm life, and her polished anatomies of New York society, *The House of Mirth* (1905) and *The Age of Innocence* (1920), for which she became the first woman to be awarded a Pulitzer Prize.

wheat Cereal grass originating in the Middle East. Cultivated there since 7000 BC, it is now grown worldwide. It is used for BREAD, PASTA, cake and pastry flour. Wheat is also used in the preparation of MALT, dextrose and ALCOHOL. Family Poaceae/Gramineae.

Wheatstone, Sir Charles (1802–75) British physicist and inventor. In 1843, with William Cooke, he improved the Wheatstone bridge, a device for measuring electrical resistance. In 1837 they patented an electric TELEGRAPH. Wheatstone also invented the harmonica and concertina.

wheel Circular structure that revolves around a central axis.

Before the wheel was invented, heavy loads were sometimes moved by rolling them on logs or on rounded stones. More than 5,000 years ago, sections of tree trunks were cut to form the first wheels for carts. Spoked wheels were introduced several hundred years later. Eventually, the wheel was used in simple machines, such as the waterwheel and potter's wheel. wheel and axle Machine based on the principle that a small force applied to the rim of a wheel will exert a larger force on an object attached to the axle. The MECHANICAL ADVANTAGE is the ratio of the radius of the wheel to that of the axle.

whelk Edible marine GASTROPOD distributed worldwide on seashores. It has a coiled shell, with a smooth rim and a notch at the end. Family Buccinidae. Length: 13–18cm (5–7in).

Whig Party Semi-formal parliamentary grouping in the UK from the late 17th to the mid-19th century. The word Whig was used by the Tory supporters of JAMES II for politicians who wished to exclude the Duke of York from the throne. The Whig Party thus became those people who promoted the GLO-RIOUS REVOLUTION of 1688 and who applauded the HANOVER-IAN SUCCESSION of 1714. Between 1714 and the accession of George III in 1760, the Tories were so discredited by association with the JACOBITES that most politicians became Hanoverian Whigs, even in opposition to a Whig ministry. In the reign of George III, Toryism gradually reasserted itself. Whiggism became the party of religious toleration, parliamentary reform and opposition to slavery. From the appointment of PITT as prime minister in 1783 until 1830 the Whigs remained in opposition (with one brief exception). They then returned to office under Lord GREY, passing the Great Reform Act of 1832. By the mid-19th century they had come to be replaced by, or known as, the Liberal Party.

Whigs One of the two major US political parties from 1834–54. It was a coalition party and had the support of eastern capitalists, western farmers and southern plantation owners. The party elected two presidents, William Henry Harrison in 1840 and Zachary Taylor in 1848. The issue of slavery split the Whigs, however, and the REPUBLICAN PARTY emerged from its disintegration in 1854.

whinchat Small Eurasian THRUSH that commonly inhabits grassy coastal areas in England. It has a brown, mottled back with a white rump and distinctive red breast. The dark head is clearly marked by a white eye-stripe. Length: to 13cm (5in). Species Saxicola rubetra.

whip UK government officer whose duty is to see that government supporters attend debates and vote in divisions. It is also the name for the notices that they send to members of Parliament. There are also opposition whips.

whippet Sporting dog that was originally bred in England for racing and hare coursing. It is capable of running at speeds of 56.5km/h (35mph). It resembles a small GREYHOUND. Height: to 56cm (22in) at the shoulder; weight: to 11kg (24lb). whippoorwill See NIGHTJAR

whirligig beetle Medium-sized, dark-coloured water beetle often seen resting or gyrating on the surface of a still pool. They prey on small insects. Family Gyrinidae.

whirling dervish See Dervish

whirlpool Circular motion of a fluid. Whirlpools in rivers occur in regions where waterfalls or sharp breaks in topographic continuity make steady flow impossible. See also VORTEX

Whiskey Rebellion (1794) Revolt against the US government in w Pennsylvania. It was provoked by a tax on whisky, and was the first serious challenge to federal authority. Collection of the tax met violent resistance, but when President Washington called out the militia, the rebellion collapsed.

whisky (Irish or US whiskey) Alcoholic spirit made by distilling fermented cereal grains. Scotch whisky and Irish whiskey are both distilled from barley that has been allowed to sprout, then roasted, and finally "mashed" and distilled. In the USA, maize and rye are used to produce bourbon whiskey (corn) and rye whiskey. After distillation, refined whisky spirit is 70–85% alcohol by volume; all whiskies are therefore heavily diluted. Almost all whiskies are blended.

whist Card game for four people playing as two pairs of partners. The aim is to accumulate "tricks" – sets of cards, one from each player, in which the player of the highest-value card

▲ wheat Along with rice, wheat is the world's most important food crop. The kernels of the plant are ground into flour, which can then be used to make a variety of foods. Wheat remains green in colour until it ripens, becoming golden-brown.

W

"takes the trick". The object of ordinary whist is to amass more tricks than any other player. Other whist games include contract whist, in which players specify how many tricks they will make; and solo whist, in which one player contracts to make tricks and all the others conspire to thwart him or her.

Whistler, James Abbott McNeill (1834–1903) US painter and etcher who lived mainly in England. His pictures, such as *Nocturne in Black and Gold* (1877), are characterized by serenity. He was an accomplished and prolific etcher, producing some 400 plates.

Whitby Coastal town in N Yorkshire, England, at the mouth of the River Esk. St Hilda founded an abbey here in 657, which was destroyed by the Danes in the 9th century. The abbey, rebuilt in the 13th century, today lies in ruin. In c.663 the Synod of Whitby was held at the abbey. The subsequent break with the Celtic church placed the English church in line with mainstream European Christian theology. An important medieval port and former whaling town, Whitby has historic links with Captain Cook, whose ship Endeavour was built in Whitby shipyard. Pop. (1981) 13,380.

White, Edward Douglass (1845–1921) US politician, chief justice of the Supreme Court (1910–21). Appointed chief justice by President Taft, he was considered a conservative. He is best known for his "rule of reason" interpretation of the Sherman Antitrust Act, which dissolved the Standard Oil Company and the American Tobacco Company (1911). He is also responsible for upholding the constitutionality of the Adamson Act (1916), which set an eight-hour day for railroad workers.

White, Gilbert (1720–93) British naturalist. He held curacies at Selborne in Hampshire, devoting himself to the study of natural history around his parish. His famous *The Natural History and Antiquities of Selborne* (1789) consists of letters to his fellow naturalists.

White, Patrick Victor Martin Sale (1912–90) Australian novelist, b. Britain. His novels, concerned with the nature of the Australian experience, include *The Tree of Man* (1955), *Voss* (1957), *Riders in the Chariot* (1961), *The Vivisector* (1970), *The Eye of the Storm* (1973), *A Fringe of Leaves* (1976) and *The Twyborn Affair* (1979). In 1973 he became the first Australian to win a Nobel Prize for literature.

White, T.H. (Terence Hanbury) (1906–64) British author. His autobiographical England Have My Bones attracted notice in 1936, but he is best known for his Arthurian tetralogy The Once and Future King, collectively published in 1958. White, Walter (1893–1955) US civil rights leader. As an officer of the NATIONAL ASSOCIATION FOR THE ADVANCEMENT OF COLORED PEOPLE (NAACP), he campaigned for desegregation, voting rights, and prevention of lynching. He also wrote several books in the cause of justice for blacks, including his autobiography, A Man Called White (1948).

white ant See TERMITE

whitebait Young of several types of European HERRING. Length: to 5cm (2in). The name is also given to a tropical marine fish found in Australian waters. This fish, *Galaxias attentuatus*, is elongated with its dorsal fin set far back. Family Galaxiidae. Length: to 10cm (5in).

white blood cell See LEUCOCYTE

white dwarf High-density type of star about the size of the Earth, but with a mass about that of the Sun. White dwarfs are of low luminosity and gradually cool down to become cold, dark objects.

whitefish (cisco or lake herring) Any of several species of freshwater food fish that live in Eurasia and the USA. It is silvery, with large scales and a small mouth. Length: to 150cm (59in); weight: to 29kg (63lb). Family Salmonidae.

White Friars See CARMELITES

Whitehead, Alfred North (1861–1947) British philosopher and mathematician. In his "philosophy of organism" he attempted a synthesis of modern science and metaphysics. The system is presented in his *Process and Reality* (1929). His three-volume *Principia Mathematica* (1910–13), written in collaboration with Bertrand Russell, proved an enduring influence on contemporary philosophy.

White House Official residence of the US president in Washington, D.C. It was designed in the neo-classical style

by James Hoban in 1792 and completed in 1800. After being burned down during the British invasion in 1814, it was rebuilt and the porticoes were added in the 1820s.

white shark (great white shark) Aggressive shark found in tropical and subtropical waters worldwide. It has a heavy body, a crescent-shaped tail and saw-edged triangular teeth; it is grey, blue or brown with a white belly. Length: to 11m (36ft); weight: to 2,180kg (7,000lb). Family Isuridae; species Carcharodon carcharias.

whitethroat Small bird of the Old World WARBLER family (Sylviidae). It breeds in undergrowth in w Eurasia and NW Africa and winters in Africa and India. It has drab brown plumage with red-brown wing patches, a long white-edged tail and a white throat. Length:13cm (5in). Genus Sylvia.

white whale See BELUGA

whiting Several unrelated food fish. The European whiting (Merlangus merlangus) is a haddock-like fish of the COD family, Gadidae. It is found primarily in the North Sea, where it feeds on invertebrates and small fish. It is silver with distinctive black markings at the base of the pectoral fin. Length: to 70cm (28in). Other fish commonly called whitings include the kingfish, Menticirrhus saxatilis, and the freshwater WHITEFISH, Coregonus clupeaformis.

Whitlam, Edward Gough (1916—) Australian statesman, prime minister (1972–75). Whitlam became leader of the Australian Labor Party in 1967. His government ended compulsory conscription and relaxed Australia's stringent immigration laws. In 1975 the administration was unable to pass a budget; Whitlam was dismissed by the governor general, an action that highlighted Australia's constitutional relationship with the UK. In December 1977, after a crushing defeat in the general election, Whitlam resigned as party leader.

Whitman, Walt (Walter) (1819–92) US poet and essayist. Whitman's collection of poems *Leaves of Grass* (1855) is considered a classic of US literature. *Drum Taps* (1865), which draws on his experience of medical service in the American Civil War, and *Sequel to Drum Taps* (1865), which includes his famous elegies to Abraham Lincoln, "When Lilacs Last in the Dooryard Bloom'd"and "O Captain! My Captain!", were both incorporated into the much-expanded 1867 edition of *Leaves of Grass*.

Whitney, Eli (1765–1825) US inventor and manufacturer. He invented the COTTON GIN (1793), which revolutionized cotton picking in the South and turned cotton into a profitable export. After 1798 he manufactured muskets at a factory in New Haven, Connecticut, which was one of the first to use mass-production methods.

Whitney, Mount Second-highest peak in the USA (after Mount McKinley), at 4,418m (14,495ft). Situated on the E edge of Seouoia National Park, it is part of the Sierra Nevada range in E California.

Whitsun See PENTECOST

Whittier, John Greenleaf (1807–92) US poet and editor. A Quaker, he quickly became involved in the abolitionist movement and much of his verse is anti-slavery in theme. His works include *Poems Written During the Progress of the Abolition Question* (1838), Lays of My Home and Other Poems (1843), Voices of Freedom (1846), Songs of Labor (1850) and Among the Hills and Other Poems (1869).

Whittington, Dick (Richard) (1358–1423) English merchant, lord mayor of London on several occasions (1397–1420). The son of a knight, he became wealthy dealing in fine cloths. He made loans to Henry IV and Henry V and endowed many charitable institutions. He is, however, best known as the subject of a legend about a poor boy and his cat who come to London to make their fortune.

whooping cough (pertussis) Acute, highly contagious childhood respiratory disease. It is caused by the bacterium

▲ whelk Found in temperate waters, the whelk (Baccinum sp.) can be eaten or used as bait. Whelks are scavengers and carnivores. They hold on to their victim, usually a crab or lobster, using their large muscular foot. They then bore a hole through the shell using an extensible proboscis tipped with an abrasive radula, through which they feed.

■ whiting The European
whiting (Merlangus merlangus) is
found primarily in the North Sea,
where it feeds on invertebrates
and small fish. It is an important
commercial fish and congregates
in large shoals.

Bordetella pertussis and is marked by spasms of coughing, followed by a long-drawn intake of air, or "whoop". It is frequently associated with vomiting and severe nose bleeds. Immunization reduces the number and severity of attacks.

Whorf, Benjamin Lee (1897–1941) US structural linguist. He formed the Whorf hypothesis (or Sapir-Whorf hypothesis), which states that "the structure of language influences thought processes and our perception of the world around us".

whortleberry See BILBERRY

Wichita City at the confluence of the Arkansas and Little Arkansas rivers, s central Kansas. Established in 1864 as a trading post, Wichita developed with the arrivals of the Chisholm Trail and then the railroad (1872). A cattle town and later a wheat centre, its commercial growth was spurred by the discovery of oil (1915) and by development of its aircraft industry (1920). It is by far the largest city in Kansas. Industries: aviation, railroad workshops, oil refining, grain processing, meat-packing. Pop. (1992) 311,746.

Wicklow County in Leinster province, E Republic of Ireland. Wicklow is the county town. The terrain is dominated by the Wicklow Mountains, but there are fertile lowland areas. The Liffey, Slaney and Avoca are the chief rivers. Sheep and cattle are reared and cereals grown. Low-grade copper ores are mined and the scenery attracts many tourists. Area 2,025sq km (782sq mi). Pop. (1991) 97,265.

widgeon River duck with mainly brownish plumage. It feeds on the surface of the water and engages in complex courtship displays. Species include the North American *Mareca americana* and European *Mareca penelope*.

Wieland, Christoph Martin (1733–1813) German novelist and poet. His works include prose translations of 22 of Shakespeare's plays – the first to be made in German – and the novels *Agathon* (1766–67); *Peregrinus Proteus* (1791) and *Aristipp* (1800–01). He also wrote the verse epic *Oberon* (1780).

Wieland, Heinrich Otto (1877–1957) German chemist. He was awarded the 1927 Nobel Prize for chemistry for his research into BILE acids. He showed them to have a STEROID skeleton and thus found that they were structurally related to CHOLESTEROL. He also did research into oxidation reactions occurring in living tissues and discovered that they involved the removal of hydrogen, not the addition of oxygen.

Wiener, Norbert (1894–1964) US mathematician and originator of CYBERNETICS. He contributed to the study and development of the COMPUTER and to the understanding of feedback systems that control the behaviour of humans and machines.

Wiesbaden City on the River Rhine at the foot of the Taunus Mountains, w central Germany; state capital of Hessen. Founded in the 3rd century BC and later a Roman spa

► Wilde A supporter of the Aesthetic movement, Oscar, Wilde shocked and enthralled London society with his flamboyant style and caustic wit. He gave an acclaimed lecture tour in the USA, where, when asked on his arrival at customs if he had anything to declare, he reputedly replied "Only my genius". He married in 1884 and had two sons. He was financially ruined by bringing an unsuccessful court case for libel, and was himself then prosecuted and convicted for homosexuality. He spent his final years living in effective exile in France

town, Wiesbaden remains famous for its mineral springs. It became a free imperial city c.1241 and capital of the Duchy of Nassau from 1806–66, when it passed to Prussia. Industries: wine-making, metal goods, chemicals, cement, publishing, tourism. Pop. (1993) 269,600.

Wiesel, Elie (1928–) US writer, b. Romania. The sole family survivor from the Nazi concentration camp at Auschwitz, Wiesel became a US citizen in 1963. His writings try to ensure that the Holocaust is not forgotten. He won the Nobel Peace Prize in 1986 for his work on behalf of oppressed peoples. His first three accounts of concentration camp survivors, Night (1958), Dawn (1960) and The Accident (1961), are known in collected form as the Night Trilogy. Other novels include The Town Beyond the Wall (1962), A Beggar in Jerusalem (1968), The Fifth Son (1985) and The Forgotten (1989).

Wight, Isle of Island and non-metropolitan county off the s coast of England, separated from the mainland (Hampshire) by the Solent. Newport is the county town. The island's mild climate and attractive scenery make it a popular tourist destination. It is divided into two administrative districts: South Wight and Medina (also the principal river). Cowes is a famous yachting centre. Area: 318sq km (147sq mi). Pop. (1991) 124,577.

Wigner, Eugene Paul (1902–95) US physicist, b. Hungary. During World War 2 Wigner worked on the MANHATTAN PROJECT. He was the first physicist to apply group theory to QUANTUM MECHANICS. With this technique, he discovered the law of conservation of parity. For his work on the structure of the atomic nucleus, Wigner shared the 1963 Nobel Prize for physics with Hans Jensen and Maria Goeppert-Mayer.

wigwam Shelter used by Native North Americans of the E woodlands area of the USA. Wigwams were made from bark, reed mats or thatch, spread over a pole frame. They should not be confused with the conical, skin-covered tepees of the Native Americans of the Plains.

Wilberforce, William (1759–1833) British social reformer, leader of the campaign in Britain to end the slave trade. His impassioned speeches helped to effect the legal abolition of the trade in 1807.

wild boar Tusked, cloven-hoofed mammal of the PIG family that lives wild in forested areas of Eurasia and Africa. Length: to 1.8m (6ft); weight: to 200kg (450lb). Family Suidae; species Sus scrofa.

Wilde, Oscar (1854–1900) (Oscar Fingal O'Flahertie Wills) Irish dramatist, poet, prose writer and wit. He wrote one novel, *The Picture of Dorian Grey* (1891), but most characteristic of his gift for dramatizing serious issues with epigrammatic wit are his plays, which include *Lady Windermere's Fan* (1892), *A Woman of No Importance* (1893), *An Ideal Husband* (1895) and his masterpiece *The Importance of Being Earnest* (1895). He was convicted of homosexual practices in 1895 and sentenced to two years' hard labour. While in prison he wrote *The Ballad of Reading Gaol* (1898).

wildebeest See GNU

Wilder, Billy (1906–) US film director and screenwriter, b. Germany. His creative partnership with Charles Brackett began with comedy scripts, such as Ninotchka (1939). Double Indemnity (1944) is a classic FILM NOIR. Wilder won Academy Awards for best director, best picture and shared the best screenplay prize with Brackett for The Lost Weekend (1945). Their last collaboration, Sunset Boulevard (1950), also earned them a best screenplay Oscar. Wilder's solo career proved just as successful with films such as The Seven Year Itch (1955) and Some Like it Hot (1959). Wilder won further Academy Awards for best picture and best director for The Apartment (1960).

Wilder, Thornton Niven (1897–1975) US novelist and playwright. He received the Pulitzer Prize for his novel *The Bridge of San Luis Rey* (1927). He is perhaps best known for his plays, which include *Our Town* (1938) and *The Skin of Our Teeth* (1942), for which he also won Pulitzer Prizes.

Wilderness Campaign (May 1864) Engagement in the American Civil War fought in woodland 80km (50mi) Nw of Richmond, Virginia. It was the opening engagement of a fourweek campaign of attrition by Ulysses S. Grant against the Confederate Army of Northern Virginia led by Robert E. Lee. Wilhelmina (1880–1962) Queen of the Netherlands

(1890–1948). She helped to keep the country neutral in World War 1 and often intervened in political affairs. During World War 2, she led the government in exile in England and became a symbol of Dutch independence. She abdicated in favour of her daughter, Juliania, in 1948.

Wilkes, John (1727–97) British radical politician and journalist. He was expelled from Parliament for his savage criticism of George III and his government in the political journal *North Briton* (1763). His prosecution under a general warrant was condemned in the courts, a landmark in civil liberty. The refusal of Parliament to readmit him as member for Middlesex after he had been elected three times encouraged the movement towards parliamentary reform.

Wilkinson, Sir Geoffrey (1921–) British chemist. His work on organometallic sandwich compounds earned him a Nobel Prize for chemistry in 1973, which he shared with Ernst Fischer, who worked independently on the same subject.

Wilkinson, James (1757–1825) US general. He served in the AMERICAN REVOLUTION but was forced to resign his commission (1778) because of his part in the CONWAY CABAL. In 1784 Wilkinson moved to Kentucky and joined a conspiracy with the Spanish governor of Louisiana to gain trade monopolies for himself and to give Kentucky to Spain. When war broke out with Native Americans in Ohio, Wilkinson returned to active service under Anthony WAYNE. As governor of Louisiana (1805–06), he conspired with Aaron BURR to take a large segment of the West to form Burr's own republic. When Burr was brought to trial, Wilkinson became the chief prosecution witness and avoided prosecution. Returning to the army, he was quickly dismissed after failing to capture Montreal in the WAR of 1812.

will In law, a clear expression of intent by a person (the testator) concerning the disposal of his or her effects after death. The testator must be of sound mind and legal age, and the will must be witnessed by two competent people who are not beneficiaries. It may be altered or revoked by the testator at any time, with due legal process.

Willemstadt Capital of NETHERLANDS ANTILLES, on Curaçao Island, West Indies. Willemstadt is a free port, exporting oil from Venezuela and coffee. Oil refining and tourism are the major industries, although it also has the largest dry dock in the Americas. Pop. (1986) 50,100.

William I (1797–1888) King of Prussia (1861–88) and emperor of Germany (1871–88). He was regent for his brother, FREDERICK WILLIAM IV, from 1858. His suppression of revolution in 1848–49 earned him his reputation as a reactionary, but as king he displayed sensible pragmatism and followed the advice of his minister, BISMARCK. He supported the unification of Germany, but accepted his proclamation as emperor reluctantly, fearing a reduction in Prussia's status.

William II (1859–1941) Emperor of Germany (1888–1918). He modelled himself on his grandfather, WILLIAM I, but lacked his good sense. Clashing with BISMARCK, he dismissed him in 1890 and assumed leadership of the government himself. His aggressive foreign policy, including the construction of a navy to challenge the British, antagonized Britain, France and Russia. Many historians regard his policies as largely responsible for the outbreak of World War 1 (1914). During the war, William was exclusively concerned with military matters. He abdicated after the armistice (November 1918).

William I (the Conqueror) (1027–87) King of England (1066–87) and Duke of Normandy (1035–87). Supported initially by Henry I of France, he consolidated his position in Normandy against hostile neighbours. On the death of EDWARD THE CONFESSOR, he claimed the throne, having allegedly gained the agreement of King HAROLD in 1064. He defeated and killed Harold at the battle of HASTINGS (1066) and subsequently enforced his rule over the whole kingdom. He rewarded his followers by grants of land, eventually replacing almost the entire feudal ruling class, and intimidated potential rebels by rapid construction of castles. He invaded Scotland (1072), extracting an oath of loyalty from MALCOLM III Canmore, and Wales (1081), although he spent much of his reign in France. He ordered the famous survey known as the DOMESDAY BOOK (1086).

William II (Rufus) (1056–1100) King of England (1087–1100). He was the second surviving son of WILLIAM I (THE CONQUEROR). His elder brother, Robert Curthose (Robert II), was Duke of Normandy, and William had to crush revolts by Anglo-Norman lords in Robert's favour. He invaded the duchy twice, and in 1096 Robert mortgaged it to him to raise cash for the First Crusade. He invaded Scotland, later killing MALCOLM III (1093), annexed Cumbria and subdued Wales (1097). He was killed hunting in the New Forest allegedly though improbably, by accident.

William III (of Orange) (1650-1702) Prince of Orange and king of England, Scotland and Ireland (1689-1702). He was born after the death of his father, William II, and succeeded him as the effective ruler of the United Provinces (Netherlands) in 1672. In 1677 he married Mary (later MARY II), daughter of JAMES II of England. Following the GLORIOUS REVOLUTION (1688), he and Mary, strong Protestants, replaced the Catholic James II. They ruled jointly until her death in 1694. After crushing Jacobite revolt in Scotland and Ireland (1690), William devoted himself to his lifelong task of resisting the forces of Louis XIV of France, a threat to the Netherlands in particular. He spent much of the 1690s campaigning, eventually forcing the exhausted French to sign the Peace of Ryswick (1697). In 1699 he organized the alliance that was to defeat the French in the War of the SPANISH SUCCESSION. Never popular in England, William approved the BILL of RIGHTS (1689) and other measures that diminished the royal prerogative.

William IV (1765–1837) King of Great Britain and Ireland and elector of Hanover (1830–37). Third son of George III, he succeeded unexpectedly aged 65 after a long career in the navy. Nicknamed "Silly Billy", he was well-meaning though unkingly. He assisted the passage of the Great Reform Bill (1832), by creating new peers to give the government a majority in the House of Lords.

William I (1772–1843) King of the Netherlands (1815–40) whose kingdom included Belgium and Luxembourg. He fought in the French Revolutionary and Napoleonic wars. His forceful government offended liberals and Roman Catholics, and a revolution in Belgium (1830) was followed by Belgian independence (1839). Compelled to accept a more liberal constitution restricting his powers, he abdicated in favour of his son, William II.

William I (the Lion) (1143–1214) King of Scotland (1165–1214). He succeeded his brother Malcolm IV and forged what was later called the "Auld Alliance" with France. Captured by the English during an attempt to regain Northumbria, he was forced to swear fealty to HENRY II (1174). He bought back his kingdom's independence from RICHARD I in return for a cash payment towards the Third Crusade in 1189. William the Lion established the independence of the church, under the pope, and strengthened royal authority in the north.

William I (the Silent) (1533–84) Prince of Orange, leader of the revolt of the Netherlands against Spanish rule. In 1572 he became the leader of a broad coalition in the Low Countries that opposed Spanish rule on the principle of religious tolerance. It broke down in 1579 when the Catholic s provinces, seeking reconciliation with Spain, broke away. William continued as stadholder of Holland and leader of the N provinces until he was assassinated in Delft.

William of Occam (1285–1349) English scholastic philosopher and theologian. Contributing to the development of formal logic, he employed the principle of economy known as Occam's Razor. As a Franciscan monk, he upheld Franciscan ideas of poverty against Pope John XXII and was excommunicated. In 1328 he was imprisoned in Avignon, France, but he escaped and fled to Munich, where he later died.

William of Wykeham (1324–1404) English bishop and political leader. As bishop of Winchester from 1367, he was prominent in royal counsels. He served as chancellor (1367–71) under EDWARD III and again (1389–91) under RICHARD II. He founded Winchester College, Winchester and New College, Oxford.

Williams, Ralph Vaughan See Vaughan Williams, Ralph Williams, Roger (1603–83) US Puritan minister, b. England. He emigrated to Boston with his family in 1631, but his

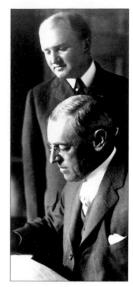

▲ Wilson US president Woodrow Wilson strove to keep the USA neutral during World War 1, but was forced to declare war by unrestricted German submarine attacks on US ships. In his war message to Congress, he stated that "the world must be made safe for democracy". His subsequent public speeches did much to consolidate national support behind the war effort. Domestically, his "New Freedom" initiative brought constitutional amendments to prohibition and women's suffrage

▲ willow The willows (family Salicaceae) are fairly small trees, the European willow growing to 10m (35ft). The seeds are light, wind dispersed and contain little food. They often grow by water where rapid germination is effected.

liberal notions and support for Native Americans antagonized the Puritan authorities. He was expelled from the Massachusetts Colony in 1635 and sought shelter with the Narragansett. Buying land from them, he founded Providence, the earliest settlement in Rhode Island, in 1636.

Williams, Ted (Theodore Samuel) (1918–) US baseball player. He won six batting titles and hit 521 home runs. He played for the Boston Red Sox (1939–42, 1946–60) and was the last player to have a .400 season batting average.

Williams, Tennessee (Thomas Lanier) (1911–83) US playwright. Many of his plays are set in the American South; an oppressive climate often reflects the characters' smouldering passions. Williams' first Broadway play, *The Glass Menagerie* (1945), won the New York Drama Critics Circle Award. He received the Pulitzer Prize for A Streetcar Named Desire (1947) and Cat on a Hot Tin Roof (1955). Other plays include Suddenly Last Summer (1958), Sweet Bird of Youth (1959) and The Night of the Iguana (1961).

Williams, William Carlos (1883–1963) US poet. His monumental achievement was *Paterson* (1946–58), a five-volume epic of American life as seen in the microcosm of a New Jersey town. His *Pictures from Brueghel* (1962) won a posthumous Pulitzer Prize and his *Collected Poems* appeared in 1986–88.

Williamson, Malcolm (1931–) Australian composer who was made Master of the Queen's Music in 1975. Williamson has composed symphonies, concertos, choral works and operas, of which his best known is *Our Man in Havana* (1963). Willkie, Wendell (1892–1944) US lawyer and politician. Willkie was a leading opponent of Franklin D. ROOSEVELT'S NEW DEAL, which proposed large-scale government intervention in the economy. He ran against Roosevelt as the Republican nominee in 1940. In his book *One World* (1943) he advocated the formation of a post-war international organization. will-o'-the-wisp (Jack-o'-lantern) Mysterious light sometimes seen at night in marshy areas. It is thought to be due to

willow Deciduous shrub and tree native to cool or mountainous temperate regions. It has long, pointed leaves, and flowers borne on CATKINS. Familiar species include the weeping willow (Salix babylonica) with drooping branches, and pussy willow (S. caprea) with fuzzy catkins. Family Salicaceae.

the spontaneous combustion of marsh gas (METHANE).

willowherb Any of several species of perennial plants with willow-like leaves, especially *Epilobium angustifolium*, the fireweed or rosebay willowherb. It has a long unbranched stem with narrow leaves and purple-red flowers. Height: to 1m (3.3ft). Family Onagraceae; genus *Epilobium*.

Wilmington City in N Delaware, USA, at the junction of the Delaware and Christina rivers and Brandywine Creek. The first settlement in Delaware (1638), Wilmington was founded by Swedes. It was later enlarged by Dutch and British settlers and became the state's largest city. It is an important industrial centre with shipyards, railway shops and chemical manufacturing plants. Pop. (1992) 72,411.

Wilson, August (1945–) African-American playwright. His plays, the most well known of which include *Joe Turner's Come and Gone* (1986) and *The Piano Lesson* (1988), draw extensively from Wilson's own experiences. *Fences* won the Pulitzer Prize in 1987.

Wilson, Charles Thomson Rees (1869–1959) British physicist. He invented the Wilson cloud chamber used to study radioactivity, x-rays and cosmic rays. It uses water droplets to track ions left by passing radiation. For this invention, he shared the 1927 Nobel Prize for physics with Arthur COMPTON. Wilson, Edmund (1895–1972) US literary critic and author. He was editor of Vanity Fair (1920–21) and literary editor of The New Republic (1926–31). His influential critical work includes Axel's Castle (1931) on SYMBOLISM; To the Finland Station (1940) on European revolutionary traditions; and Patriotic Gore (1962) on the literature of the American Civil War.

Wilson, Sir (James) Harold (1916–95) (Baron Wilson of Rievaulx) British statesman, prime minister (1964–70, 1974–76). Wilson entered Parliament as a Labour member in 1945 and was president of the Board of Trade (1945–51). In 1951 he resigned from ATTLEE's cabinet over the imposition of medical prescription charges. In 1963 Wilson succeeded Hugh

GAITSKELL as Labour leader (1963). He won a narrow election victory (1964). His administration was faced with a foreign policy dilemma when Rhodesia's white-minority government unilaterally declared independence. Faced with domestic economic crisis, he was forced to impose strict price and income controls and devalue the currency. In the 1970 general election Wilson was defeated by HEATH. Conflict between Labour's left- and right-wings over nationalization and membership of the European Economic Community (EUROPEAN COMMUNITY) threatened to divide the party. Nevertheless, in 1974 Wilson returned to power at the head of a minority Labour government. In 1976 he unexpectedly resigned and was succeeded by Jim CALLAGHAN. In 1983 he was made a life peer.

Wilson, (Thomas) Woodrow (1856-1924) 28th US president (1913–21). As governor of New Jersey (1910–12), he gained a reputation as a progressive Democrat. In 1912 he unexpectedly gained the Democratic nomination. The split in the Republican vote between TAFT's REPUBLICAN PARTY and Theodore ROOSEVELT'S PROGRESSIVE PARTY handed Wilson the presidency. His "New Freedom" reforms included the establishment of the FEDERAL RESERVE SYSTEM (1913). Several amendments to the US Constitution were introduced, including PROHIBITION (18th, 1919) and the extension of the FRANCHISE to women (19th, 1920). The MEXICAN REVOLU-TION brought instability to the s border and Wilson ordered John Pershing's intervention. Wilson's efforts to maintain US neutrality at the start of WORLD WAR 1 aided his re-election in 1916. The failure of diplomacy and continuing attacks on US shipping forced Wilson to declare war on Germany (April 1917). His FOURTEEN POINTS (January 1918) represented US war aims and became the basis of the peace negotiations at the VERSAILLES peace conference (1919). He was forced to compromise in the final settlement, but succeeded in securing the establishment of the LEAGUE OF NATIONS. Domestic opposition to the League was led by Henry Cabot LODGE, and the Republican-dominated Senate rejected it. In October 1919 Wilson suffered a stroke and became an increasingly marginal figure for the remainder of his term.

wilt Any of a group of plant diseases characterized by yellowing and wilting of leaves and young stems, often followed by death of the plant. Wilt diseases are caused by bacteria or fungi that grow in the sapwood and plug water-conducting tissues or disrupt the plant's water balance in some other way. Wiltshire County in s England; the county town is Trowbridge. Dominated by Salisbury Plain and the Marlborough Downs, the county's historic sites attract many tourists. STONE-HENGE and Avebury Hill are England's oldest monuments, built over 4,000 years ago. Wiltshire was an important centre of SAXON culture. Much of this rural county is given over to agriculture, but industry is becoming increasingly important to the local economy. Swindon, the principal manufacturing town, is one of the fastest-growing urban areas of England. Industries: textiles, farm machinery, food processing, electrical goods. Area: 3,481sq km (1,344sq mi). Pop. (1991) 564,471.

Wimbledon Popular name for the All England Lawn Tennis Championships played annually at the All England Club, Wimbledon, a sw suburb of London. It is the world's foremost championship played on grass. It was first held in 1877 and was open only to amateurs until 1968. The championships have been held at the present ground since 1922.

winch Drum that turns to pull or release a rope, cable or chain. A winch is used to raise, lower or pull heavy loads. The device may be motor-driven or operated by hand.

Winchester County town of Hampshire, on the River Itchen, s central England. Known as Venta Belgarum by the Romans, it became capital of the Anglo-Saxon kingdom of Wessex in 519 AD. During the reign of Alfred The Great, it was capital of England. Despite the increasing influence of London, Winchester retained its importance as a centre of learning and religion throughout the medieval period. Much of the old city remains, including a 14th-century Gothic cathedral and ruins of a Norman castle. Pop. (1991) 96,386. wind Air current that moves rapidly parallel to the Earth's surface. (Air currents in vertical motion are called updraughts or downdraughts.) Wind direction is indicated by wind or

▲ wind Onshore winds (A) generally occur during the day. The land is heated by the Sun, causing the air over it to rise. As the warm air rises it is replaced by cooler air overlying the sea. At night, because the land loses heat quicker than the sea, air flows down hillsides out to sea, where the air is relatively warmer, generating offshore breezes (B).

weather vanes, wind speed by ANEMOMETERS and wind force by the BEAUFORT WIND SCALE. Steady winds in the tropics are called TRADE WINDS. MONSOONS are seasonal winds that bring predictable rains in Asia. Föhns (foehns) are warm, dry winds produced by compression accompanied by temperature rise as air descends the lee of mountainous areas in the Alps; a similar wind called CHINOOK exists in the Rockies. SIROCCOS are hot, humid Mediterranean winds.

Windermere Largest lake in England, in the LAKE DISTRICT, Cumbria. It is linked to Morecambe Bay by the River Leven; the town of Windermere lies on the E shore of the lake. Length: c.17km (10mi); Max. width 1.6km (1mi).

Windhoek Capital and largest city of Namibia, situated some 300km (190mi) inland from the Atlantic at a height of 1,650m (5,410ft). Originally serving as the headquarters of a Nama chief, in 1892 it was made the capital of the new German colony of South-West Africa. It was taken by South African troops in World War 1. In 1990 it became capital of independent Namibia. An important world trade market for karakul sheepskins, its industries today include diamonds, copper and meat-packing, Pop. (1992) 126,000.

wind instrument Musical instrument that is sounded by blowing, which sets the air inside it vibrating. Wind instruments may be classified into two types: WOODWIND and BRASS. windmill Machine powered by the wind acting on sails or vanes. The earliest windmills were built in the Middle East in the 7th century. They spread to Europe in the Middle Ages. Their use was widespread during the early years of the INDUSTRIAL REVOLUTION, but declined with the development of the STEAM ENGINE in the 19th century. See also RENEWABLE ENERGY window In computing, a rectangle displayed on the screen of a COMPUTER that displays what is stored in a particular part of the machine's memory or in some other storage device. A window may show text, graphics or other work in progress. The contents of a window are shown in text, often accompanied by symbols called icons.

windpipe See TRACHEA

wind power Harnessing of wind energy to produce power. Since the 1970s, advanced aerodynamic designs have been used to build wind turbines that generate electricity. The largest of these, on Hawaii, has two blades, each 50m (160ft) long, attached to a 20-storey high tower. Individual turbines are often grouped in strategic locations (wind farms) to maximize the generating potential. Wind power is a cheap form of RENEWABLE ENERGY, but cannot as yet produce sufficiently large amounts of electricity to provide a realistic alternative to fossil fuel and nuclear power stations. See also WINDMILLS

Windsor, Duke of See EDWARD VIII

Windsor Castle English royal residence, 32km (20mi) w of London. It was founded by WILLIAM I to defend the Thames valley. Besieged by rebellious barons in the reign of John, it was never captured, although it was occupied by parliamentary forces during the CIVIL WAR. The castle has been frequently extended, reconstructed and restored, but retains the appearance of a medieval fortress. In 1992 it was damaged by fire.

wind tunnel Chamber in which scale models and even fullsize aircraft and road vehicles are tested in a controlled airflow. Some wind tunnels can reproduce extreme conditions of wind speed, temperature and pressure. Models of bridges and other structures are tested in wind tunnels to check that winds cannot set up destructive vibrations.

Windward Islands Southern group of the Lesser Antilles islands, se West Indies. They extend from the Leeward Islands to the NE coast of Venezuela. The principal islands are MARTINIQUE, GRENADA, DOMINICA, ST LUCIA, ST VINCENT AND THE GRENADINES group. The islands, volcanic in origin, are mountainous and forested. Tropical crops are grown, including bananas, spices, limes and cacao, but tourism is the leading industry. The islands were inhabited by the indigenous Carib until colonization began in the 17th century. The next two centuries witnessed a struggle for control between France and Britain. Britain eventually controlled all the islands, with the exception of Martinique. See West Indies map

wine Alcoholic beverage made from the fermented juice (and some solid extracts) of fruits, herbs and flowers – but

classically from the juice and skins of grapes. The three standard grape wine colorations are white, red and rosé, depending on the grape used and whether, and for how long, the grape skins are left on. For white wine the grapes are fermented without the skin; for red wine the whole grape is used; for rosé wine the skins are removed after fermentation has begun. Dry wines are fermented until all the sugar has turned to alcohol; sweet wines are fermented for less time so that some sugar remains. Champagne is bottled while it is still fermenting. Table wines contain 7–15% alcohol by volume; fortified wines such as SHERRY contain added BRANDY, giving a 16–23% alcohol content.

wings In biology, specialized organs for flight that are possessed by most birds, many insects and certain mammals and reptiles. The forelimbs of a bird have developed into such structures. Bats have membranous tissue supported by the digits ("fingers") of the forelimbs. Insects may have one or two pairs of veined or membranous wings.

Winnebago Native American tribe that in the 1820s and 1830s ceded its tribal lands in sw Wisconsin and Nw Illinois to the US government. Linguistically part of the Siouan language group, the tribe's 3,000 members live mostly in reservations in Nebraska and Wisconsin.

Winnipeg Capital of Manitoba, Canada, at the confluence of the Assiniboine and Red rivers, in the s of the province. Founded in 1812 by the Hudson's Bay Company, the town came under the control of the Canadian government in 1870. It grew after the completion of the Canadian Pacific Railroad (1882) and is now the major city of the Canadian prairies. It has one of the world's largest wheat markets and vast flour mills, grain elevators and food-processing plants. Pop. (1991) 616,790.

Winnipeg, Lake Resort lake in s central Manitoba province, the third-largest in Canada. It was used extensively by early fur traders and explorers in the 18th century. Fed by the Red, Saskatchewan and Winnipeg rivers, and drained by the Nelson River to Hudson Bay, it is believed to be a remnant of the glacial Lake Agassiz. Area: 24,514sq km (9,465sq mi).

wire Strand of metal, made by drawing a rod through progressively smaller holes in metal dies. The drawing process toughens steel, so that a rope or cable made from steel wire is much stronger than an undrawn steel rod of the same diameter. Copper and aluminium wires are used to make electric CABLES. If flexibility is important, each conductor is made of several fine strands of wire instead of one thick one.

wireworm Long cylindrical larva of a click beetle of N temperate woodlands. It is generally brown or yellow and is distinctly segmented. Most species live in the soil, and may

A wind generator converts the energy of the wind into electricity. Three-bladed variable pitch designs are the most efficient. Variable pitch means the attitude of the blades (1) can be changed. By altering the pitch (2) of the blades they can generate at maximum efficiency in varying

wind conditions. The whole rotor assembly rotates (3) into the wind. The blades turn a prop shaft (4), which links to a generator (5) through gearing (6). The largest wind farms have thousands of linked turbines and can produce the same power as a fossil fuel power station.

WISCONSIN Statehood: 29 May 1848 Nickname:

The Badger State
State bird:
Robin

State flower: Wood violet

State tree : Sugar maple State motto :

Forward

cause serious damage to the roots of cultivated crops. Family Elateridae. The name also refers to any of the smooth-bodied MILLIPEDES of the family Paraiulidae.

Wisconsin State in N central USA, sw of the Great Lakes and E of the River Mississippi. Madison is the state capital and Milwaukee the largest city. The land is rolling plain that slopes gradually down from the N. There are numerous glacial lakes. The French claimed the region in 1634, Britain took it in 1763, and it was ceded to the USA in 1783. Settlement of the region was slow. The Territory of Wisconsin was established in 1836 and admitted to the Union in 1848. Wisconsin is the leading US producer of milk, butter and cheese. The chief crops are hay, maize, oats, fruit and vegetables. Wisconsin's most valuable resource is timber: 45% of the land is forested. Mineral deposits include zinc, lead, copper, iron and sand and gravel. Industries: food processing, farm machinery, brewing, tourism. Area: 145,438sq km (56,154sq mi). Pop. (1992) 4,992,664.

wisdom literature Collection of writings and sayings in the Hebrew Bible. From the Old Testament it includes the Books of Proverbs, Ecclesiastes and Job, and the Song of Solomon. From the Apocrypha it includes the Books of Ecclesiasticus and the Wisdom of Solomon.

Wise, Stephen Samuel (1874–1949) US rabbi of Reform Judaism and leader of the Zionist movement, b. Hungary. In 1907 he founded the Free Synagogue in New York to create a pulpit that was free from restraints, stressing democracy. He was a founder of the Zionist Organization of America and of the American Jewish Congress.

wisent See BISON

wisteria Genus of hardy, woody vines, native to North America, Japan and China. They have showy, fragrant, pendulous flower clusters of purplish-white, pink or blue. Family Fabaceae/Leguminosae.

witchcraft Exercise of supernatural occult powers, usually due to some inherent power rather than to an acquired skill such as sorcery. In Europe it originated in pagan cults and in mystical philosophies such as GNOSTICISM, which believed in the potency of both good and evil in the universe. In some societies the belief in spirits is associated with attempts to control them through witchcraft for harmful or beneficial ends.

witch doctor (shaman) Person regarded as supernaturally powerful, especially in Africa. Witch doctors fight or control evil spirits and may heal the sick using herbs and rituals.

witch hazel Shrubs and small trees of the genus *Hamamelis*, native to temperate regions, mostly in Asia. They bloom in late autumn or early spring. The common witch hazel (*Hamamelis virginiana*) has yellow flowers. Family Hamamelidaceae.

witness Legal term referring to a person who testifies in court to facts within his/her knowledge. In most western legal systems, a witness is usually required to take an oath swearing truthfulness prior to testifying, and he/she is then first examined (questioned) by the party who offers him/her and then cross-examined by the opposing party.

Witt, Jan de (1625–72) Dutch political leader. A republican and opponent of the House of Orange, he became grand pensionary and effectively head of government in 1653. He defeated the English in the second of the DUTCH WARS (1665–67). In 1672 resigned after a French invasion, the accession of WILLIAM OF ORANGE as stadholder (which he had long resisted), and an attempt on his life. He and his brother, Cornelis, were killed by Orangist partisans a few months later. Wittenberg Town on the River Elbe, Sachsen-Anhalt state, E central Germany. Founded by Frederick III, Wittenberg's university became the cradle of the Protestant REFORMATION during the time Martin Luther and Phillip MELANCHTHON were teaching there. Today Wittenberg is primarily a mining and industrial centre, producing chemicals, rubber goods, machinery and foodstuffs. Pop. (1993) 47,200.

Wittgenstein, Ludwig (1889–1951) Austrian philosopher. His masterwork, *Tractatus Logico-philosophicus* (1921), influenced LOGICAL POSITIVISM, arguing the strict relationships between language and the physical world. After 1929 he criticized this initial hypothesis in his Cambridge lectures, which were published posthumously as *Philosophical Investigations* (1953). He claimed that language was only

a conventional "game", in which meaning was affected more by context than by formal relationships to reality.

Witwatersrand (Rand) Series of parallel mountain ranges over 1,500m (5,000ft) high, forming a watershed between the Vaal and Olifant rivers, in former Transvaal, NE South Africa. The region extends c.100km (62mi) E and w of Johannesburg. Gold was first discovered in 1884 and mining began two years later. Witwatersrand still produces c.30% of the total world output of gold. Silver is recovered as a by-product of gold refining. Coal and manganese are also mined and there are many ancillary industries in the region.

woad (dyerswoad) Biennial or perennial herb once grown as a source of blue dye. It was probably introduced by the early Britons to dye clothing and paint their bodies. A native of Eurasia, it bears small four-petalled, yellow flowers. Height: 90cm (3ft). Family Brassicaceae/Cruciferae; species *Isatis tinctoria*.

Wodehouse, P.G. (Sir Pelham Grenville) (1881–1975) British novelist, short-story writer, playwright and lyricist. He began his writing career in 1902 and wrote over 100 humorous books. His best-known creations are Bertie Wooster and his valet Jeeves, who feature in a number of books from 1917–71. During World War 2, Wodehouse's illadvised radio broadcasts from Berlin outraged British public opinion, and he became an American citizen in 1955.

Woden See Odin

Wöhler, Friedrich (1800–82) German chemist who first isolated ALUMINIUM and BERYLLIUM and discovered calcium carbide. In 1828 his synthesis of UREA (from ammonium cyanate) was the first synthesis of an organic chemical compound from an inorganic one; it contributed to the foundation of modern organic chemistry.

Wolf, Hugo (1860–1903) Austrian composer, regarded as one of the finest exponents of *Lieder* (a type of song). He produced in rapid succession five "songbooks". He set poems by Mörike (1888), Eichendorff (1888–89), Goethe (1888–89), Spanish authors (1889–90) and Italian poets (1891, 1896).

wolf Wild, dog-like carnivorous mammal, once widespread in the USA and Eurasia, especially the grey wolf (*Canis lupus*), which is now restricted to the USA and Asia. It is powerfully built, with a deep-chested body and a long, bushy tail. It has earned a reputation for savagery and cunning from occasional attacks on livestock and human beings. Length: to 2m (6.6ft), including the tail. Family Canidae.

Wolfe, James (1727–59) British general. He commanded the force that captured Quebec by scaling the cliffs above the St Lawrence River and defeating the French, under Montcalm, on the Plains of Abraham (1759). This victory resulted in Britain's acquisition of Canada. Wolfe's death in action made him an almost legendary hero.

Wolfe, Thomas Clayton (1900–38) US writer. His reputation rests on his sequence of four sprawling autobiographical novels, Look Homeward, Angel (1929), Of Time and the River (1935), The Web and the Rock (1939) and You Can't Go Home Again (1940).

Wolfe, Tom (Thomas Kennerley) (1931–) US journalist and novelist. Wolfe established his reputation in the 1960s with essays on American counter-culture such as *The Electric Kool-Aid Acid-Test* (1968). His novel *The Bonfire of the Vanities* (1987) demonstrates a sharp observation encapsulating the spirit of the age.

wolfram See TUNGSTEN

wolframite Black to brown mineral, iron-manganese tungstate (Fe,Mn)WO₄. The chief ore of TUNGSTEN, it occurs as crystals in the monoclinic system, or as granular masses. It is found in quartz veins and pegmatites associated with granitic rocks, and also in high temperature hydrothermal veins in association with other minerals. Hardness 5–5.5; s.g. 7–7.5

Wolfram von Eschenbach (1170–1220) German poet. His only complete work is the Middle High German epic *Parzival*. A masterpiece of medieval literature, it introduced the Grail legend into German.

Wollstonecraft, Mary (1759–97) British author. Her *Vindication of the Rights of Women* (1792) was FEMINISM's first great work. She was the mother of Mary Wollstonecraft SHELLEY. Wolof People of Senegal who speak a language belonging to

▲ wolf The shy, nocturnal maned wolf (*Chrysocyon brachyurus*) is found in deciduous forests and plains of South America. As with other plains' predators, it feeds on almost anything from small animals to fruit. It is not a true wolf, however, but a member of the canine family.

the NIGER-CONGO family. In the 15th century a Wolof empire dominated West Africa and traded in slaves with the Portuguese. They were converted to ISLAM in the 18th century.

Wolsey, Thomas (1475–1530) English cardinal and statesman, lord chancellor (1515–29). After the accession of Henry VIII in 1509, Wolsey acquired major offices of church and state. He became archbishop of York (1514) and then cardinal and lord chancellor (1515). As chancellor, Cardinal Wolsey controlled virtually all state business. His attempts to place England at the centre of European diplomacy ended in failure. Despite becoming papal legate (1518), Wolsey's ambition to become pope was never realized. Domestically, he made powerful enemies through his method of raising taxes through forced loans, his conspicuous wealth and his pluralism. Wolsey gave Hampton Court Palace to Henry VIII, but his failure to obtain the king a divorce from Catherine of Aragon brought about his ruin. Thomas More replaced Wolsey as chancellor. Charged with high treason, Wolsey died before his trial.

wolverine Solitary, ferocious mammal native to pine forests of the USA and Eurasia, the largest member of the WEASEL family. Dark brown, with lighter bands along the sides and neck, it has a bushy tail and large feet. Length: 91cm (36in); weight: 30kg (66lb). Species *Gulo gulo*.

womb See UTERUS

wombat Either of two species of large, rodent-like marsupial mammals of SE Australia and Tasmania. Both species are herbivorous, primarily nocturnal and live in extensive burrows. The common wombat, *Vombatus ursinus*, has coarse black hair and small ears. The hairy-nosed wombat, *Lasiorhinus latifrons*, has finer, grey fur and large ears. Length: to 1.2m (3.9ft). Family Vombatidae.

women's rights movement Broad term for the international movement that began in the early 19th century to promote and work for the equality of women. Originally concentrating on women's suffrage, the movement has since worked for equality of employment opportunity and pay, freedom from unjust social, political and theological expectations within society, and an awakening of physical, intellectual and emotional awareness for women. See also FEMINISM; SUFFRAGETTE MOVEMENT

Wonder, Stevie (1950–) US SOUL singer and songwriter, b. Steveland Judkins Morris. Blind from birth, Wonder was a precocious polymath, playing the harmonica, keyboard, guitar and drums. In 1961 he joined Morown Records. His first album *Little Stevie Wonder: A 12-year-old Musical Genius* was an instant hit. Consistently successful, his albums include *Talking Book* (1972), *Innervisions* (1973), *Songs in the Key of Life* (1976) and *Hotter Than July* (1980).

Wood, Sir Henry Joseph (1869–1944) British conductor. He conducted the London Promenade Concerts from 1895–1944. The concerts are now named after him.

then rolled with ink, and

pressed against paper (4). The

negative image of the carving.

resulting print appears as a

wood. A flat piece of wood is

needed from the centre of a

(2) are then used to cut

log (1). Various different tools

wood Hard substance that forms the trunks of trees; it is the XYLEM (the vascular tissue of a woody plant), which comprises the bulk of the stems and roots, supporting the plant. It consists of fine cellular tubes arranged vertically within the trunk, which accounts for the grain found in all wood. The relatively soft, light-coloured wood is called sapwood. The non-conducting, older, darker wood is called heartwood, and is generally filled with RESIN, gums, mineral salts and TANNIN. The two chief types are softwoods, from CONIFERS such as OAK. Wood is commonly used as a building material, fuel, to make some types of PAPER, and as a source of CHARCOAL, CELLULOSE, ESSENTIAL OIL, LIGNIN, tannins, dyes and SUGAR.

woodcock Any of five species of reddish-brown shorebirds that nest in cool parts of the Northern Hemisphere and winter in warm areas. Both the Eurasian *Scolopax rusticola* and American *Philohela minor* insert their long, sensitive, flexible bills into swampy ground to find worms. Length: to 34cm (14in). Family Scolopacidae.

woodcut Oldest method of printing, using designs carved into wood. The carving produces a negative image, the carved areas representing blank spaces while the flat areas retain the ink. Woodcuts were invented in China in the 5th century AD and became popular in Europe in the Middle Ages.

wood engraving Print made by incising a design on the flat, polished, transverse section of a block of hardwood. Textural and linear effects can be achieved by varying the pressure and direction of the cutting strokes. This technique developed from the less sophisticated WOODCUT in 18th-century England.

woodlouse (sowbug) Terrestrial, isopod crustacean found worldwide, living under damp logs and stones, and in houses. It has an oval, segmented body, feeds mainly on vegetable matter, and retains its eggs in a brood pouch. Length: 20mm (0.75in). Order Isopoda; Genus *Oniscus*.

woodpecker Tree-climbing bird found almost worldwide. Woodpeckers have strong pointed beaks and long protrudable tongues, which in some species have harpoonlike tips for extracting insect larvae. They have two toes pointing forward, and black, red, white, yellow, brown or green plumage; some are crested. The tail is stiff and helps to support the bird's body when pressed against a tree trunk. Family Picidae.

Woods, Tiger (1975–) US golfer. Woods won the US amateur championship three times (1994, 1995, 1996) before turning professional. In 1997 he won the US Masters at Augusta. He won with the lowest-ever total score and by the largest margin of victory. In doing so he became not only the youngest player to win a Masters, but also the first black man to do so. By early 1998 he was ranked no.1 in the world.

Woodstock Name given to a music festival held between 15 and 17 August 1969 near Bethel, sw of Woodstock, New York, USA. Forced to shift from the original Woodstock location because of residents' protests, *c*.450,000 people arrived for the free outdoor concert. The event was a celebration of both the music and aspirations of the hippie generation.

woodwind Family of musical WIND instruments that are traditionally made of wood but now often metal. They are played by means of a mouthpiece containing one or two reeds. The FLUTE and PICCOLO, however, are exceptional in that they are played by blowing across a hole. Other woodwind instruments include the CLARINET, SAXOPHONE (both single reed) and the OBOE, COR ANGLAIS and BASSOON (all double reed).

woodworm (furniture beetle) Larva of various species of beetles that burrow in wood. When present in large numbers ■ woodpecker The ivory-billed woodpecker (Campephilus principalis) is the largest of the North American woodpeckers and is one of the rarest birds in the world. It is believed to be nearly extinct now; any that remain are thought to inhabit swamp forests in se USA and Cuba. Native American chiefs once adorned their belts with its bill and plumes, but tree felling has now removed most of the big trees in which it breeds.

▲ woodwind The woodwind family of musical instruments is an important grouping in the modern orchestra. Shown above are the reed instruments: the bassoon (A), oboe (B), cor anglais (C), clarinet (D) and bass clarinet (E). The saxophone is sometimes included in this group. Sound is produced by the vibration of an air column, which is set in motion by the movement of the reed. Altering the length of the vibrating column, by closing or opening holes on the body of the instrument, produces different notes

woodworms can cause extensive damage. Their presence can be detected by holes in the wood from which the adult beetles have emerged. Genera include *Anobium* and *Lyctus*.

wool Soft, generally white, brown or black animal fibre that forms the fleece of sheep. Wool is also the name of the yarns and textiles made from the fibres after spinning, dyeing and weaving. The fibres, composed chiefly of KERATIN, are treated to remove a fat called lanolin, which is used in some ointments. Woolf, Virginia (1882–1941) British novelist and critic. Her novels, which often use the STREAM OF CONSCIOUSNESS style associated with MODERNISM, include Mrs Dalloway (1925), To the Lighthouse (1927), Orlando (1928) and The Waves (1931). Between the Acts, her final novel, was published posthumously. A member of the BLOOMSBURY GROUP, her long essay A Room of One's Own (1929) is a key text of feminist criticism. Her critical essays, including Modern Novels (1919) and The Common Reader (1925), are integral to modernist literary theory.

Woolworth, Frank Winfield (1862–1919) US businessman. In 1879 he opened his first shop in Utica, New York. The Woolwoth Building (1913), New York, was the world's largest building, 241m (792ft). By the time of his death, Woolworths was a chain of over 1,000 stores in the USA and abroad.

Worcester County town of HEREFORD AND WORCESTER, on the River SEVERN, w central England. Worcester was founded c.680. Its 13th–14th century cathedral is the burial place of King John. King Charles II's defeat by Oliver Cromwell at Worcester (1651) was the final battle of the English Civil War. Industries: Royal Worcester porcelain (manufactured here since 1751) and Worcester sauce. Pop. (1991) 81,700.

word processor Computer system used for compiling and printing text. The system may be designed just for this purpose, in which case it is called a dedicated word processor. More common is a general-purpose personal computer running a word-processing program. Text typed on the computer keyboard is displayed on the screen. Any errors are easily corrected before a "printout", or "hard copy", is produced on a printer connected to the computer. If required, the text can be stored in code on a magnetic disk for future use.

Wordsworth, William (1770–1850) British poet, a leading figure of ROMANTICISM. He collaborated with Samuel Taylor COLERIDGE on *Lyrical Ballads* (1798). The collection concluded with Wordsworth's poem "Tintern Abbey". His preface to the second edition (1800) outlined the aims of English romanticism, which through the use of everyday language enabled "the spontaneous overflow of powerful feelings". Critics derided his style. In 1799 he and his sister Dorothy moved to the Lake District; his poetry always bound up with a love of nature. *The Prelude*, a long autobiographical poem, was completed in 1805 but only published posthumously in 1850. After *Poems in Two Volumes* (1807), which includes "Ode: Intimations of Immortality", it is generally recognized that his creativity declined. In 1843 he succeeded Robert SOUTHEY as POET LAUREATE.

work In physics, energy transferred in moving a force. It equals the magnitude of the force multiplied by the distance moved in the direction of the force. If the force opposing movement is the object's weight mg (where m is the object's mass and g is the acceleration due to gravity), the work done in raising it a height h is mgh. This work has been transferred

to the object in the form of POTENTIAL ENERGY; if the object falls a distance, the KINETIC ENERGY at the bottom of the fall equals the work done in raising it.

workhouse Former English institution for the unemployed. Workhouses originated from the houses of correction provided for vagabonds by the POOR LAW of 1601, but officially they date from 1696, when workhouses were established by the Bristol Corporation. A general act permitting workhouses in all parishes was passed in 1723. That act denied relief to those people who refused to enter a workhouse. Workhouses declined in the late 18th and early 19th centuries, but were revived by the Poor Law of 1834. With the advent of welfare reforms, workhouses had fallen into disuse by the early 20th century.

Works Progress Administration (WPA) National project in the USA created by Congress in 1935 under Franklin D. ROOSEVELT'S NEW DEAL to stimulate national economic recovery. Billions of dollars were contributed to the scheme in which work programmes provided jobs for the unemployed.

World Bank (International Bank for Reconstruction and Development, IBRD) Intergovernmental organization, a specialized agency of the UNITED NATIONS since 1945. Its role is to make long-term loans to member governments to aid their economic development. The major part of the bank's resources are derived from the world's capital markets. Its headquarters are in Washington, D.C

World Council of Churches International fellowship of Christian Churches formed in Amsterdam, the Netherlands, in 1948. Its aim is to work for the reunion of all Christian Churches and to establish a united Christian presence in the world. Its membership consists of some 300 churches. Its headquarters are in Geneva, Switzerland.

World Cup Worldwide competition for national association

FOOTBALL teams, held every four years. The winner receives the Jules Rimet trophy. Qualifying rounds take place over the previous two years on a geographical league basis. The finals are organized by the Fédération Internationale de Football Associations (FIFA), football's governing body. Only the winners of each group, the host nation, and the previous winner automatically qualify for the finals. There are also world cup competitions in other sports, notably rugby, cricket and hockey. World Health Organization (WHO) Intergovernmental organization, a specialized agency of the UNITED NATIONS. Founded in 1948, it collects and shares medical and scientific information and promotes the establishment of international standards for drugs and vaccines. WHO has made major contributions to the prevention of diseases such as malaria, polio, leprosy and tuberculosis and the eradication of smallpox. Its headquarters are in Geneva, Switzerland.

World Meteorological Organization (WMO) Intergovernmental organization, a specialized agency of the UNITED NATIONS since 1950. It promotes cooperation in meteorology through the establishment of a network of meteorological stations worldwide, and by the mutual exchange of weather information. Its headquarters are in Geneva, Switzerland.

world music Generic term used to describe ethnic or ethnically influenced music. As part of a growing interest during the 1980s in non-Western music, many artists, such as Peter Gabriel and Paul Simon, began to draw particularly on the traditions of African culture, bringing together a variety of diverse styles and musicians.

World Service Department of BBC Radio, based in London, that transmits daily news, cultural and entertainment programmes in English worldwide, and on a regular basis in more than 30 other languages relayed to specific countries and regions. The first broadcasts overseas began in 1932. See BRITISH BROADCASTING CORPORATION (BBC)

World Trade Organization (WTO) Body sponsored by the UNITED NATIONS to regulate international TRADE. The WTO was established on 1 January 1995, to replace the GENERAL AGREEMENT ON TARIFFS AND TRADE (GATT). The WTO took over GATT's rules with increased powers, and brought intellectual property rights, agriculture, clothing and textiles, and services under its control.

World War 1 (1914–18) (Great War) International conflict precipitated by the assassination of the Austrian Archduke

► World War 1 The infantry of the 15th Brigade on 9 July 1918, under direct observation of the enemy near Morlancourt, Belgium, keep low down in the trenches. They are here seen at a bomb crater so close to the enemy lines that they could hear the Germans talking while the picture was being taken.

W

FRANZ FERDINAND by Serbs in Sarajevo (28 June 1914). Austria declared war on Serbia (July 28), Russia mobilized in support of Serbia (from July 29), Germany declared war on Russia (August 1) and France (August 3), and Britain declared war on Germany (August 4). World War 1 resulted from growing tensions in Europe, exacerbated by the rise of the German empire since 1871 and the decline of Ottoman power in the Balkans. The chief contestants were the Central Powers (Germany and Austria) and the Triple Entente (Britain, France and Russia). Many other countries were drawn in: Ottoman Turkey joined the Central Powers in 1914, Bulgaria in 1915. Italy joined the Western Allies in 1915, Romania in 1916 and, decisively, the USA in 1917. Russia withdrew following the RUSSIAN REVOLUTION (1917). In Europe fighting was largely static. The initial German advance through Belgium was checked at the MARNE, and the Western Front settled into a war of attrition, with huge casualties but little movement. On the Eastern Front the initial Russian advance was checked by the Germans, who overran Poland before stagnation set in. An Anglo-French effort to relieve the Russians by attacking GALLIPOLI (1916) failed. Italy and Austria became bogged down on the Isonzo front. Campaigns were also fought outside Europe, against the Turks in the Middle East and the German colonies in Africa and the Pacific. Only one major naval battle was fought, at JUTLAND (1916). The naval blockade of Germany caused severe food shortages and helped to end the war. An armistice was agreed in November 1918 and peace treaties were signed at VERSAILLES (1919). Casualties were high: c.10 million people were killed.

World War 2 (1939–45) International conflict arising from disputes provoked by the expansionist policies of Germany in Europe and Japan in the Far East. During the 1930s APPEASE-MENT failed to check the ambitions of the HITLER regime in Germany. Having made a defensive pact with the Soviet Union (August 1939), Germany invaded Poland, whereupon Britain and France declared war (September 3). In 1940 German BLITZ tactics resulted in the rapid conquest of Denmark, Norway, the Low Countries and France (June). Inability to gain command of the air prevented a German invasion of Britain, although bombing devastated British cities and German submarines took a heavy toll of Britain's merchant fleets. Italy, under Mussolini, having annexed Albania (1939) and invaded Greece (1940), joined Germany in 1941. Germany invaded Greece, where the Italians had been checked, and Yugoslavia. In June the Germans, violating the pact of 1939, invaded the Soviet Union, advancing to the outskirts of Moscow and Leningrad (St Petersburg). Italian defeats by the British in North Africa also drew in German troops, who threw back the British. In the Pacific the Japanese attack on PEARL HARBOR (December 1941) drew the USA into the war. Japan rapidly overran SE Asia and Burma, but the battle of Midway (June 1942) indicated growing US naval and air superiority. From 1942 the tide in Europe turned against Germany. Defeat at STALINGRAD (January 1943) was followed by a Soviet advance that drove the Germans out of the Soviet Union by August 1944. Defeats in North Africa in 1942–43 led to the Allied invasion of Italy, forcing the Italians to make peace (September 1943). German troops then occupied Italy, where they resisted the Allied advance until 1945. In June 1944 Allied forces invaded Normandy, liberated France and advanced into Germany, linking up with the Soviets on the River Elbe (April 1945). Germany surrendered in May. Japan continued to resist, but surrendered in August after atomic bombs were dropped on Hiroshima and Nagasaki. Estimates of the numbers killed in World War 2 exceed 50 million. The great majority of the dead were civilians, many murdered in Nazi CONCENTRATION CAMPS. Politically, two former allies, the USA and the Soviet Union, emerged as dominant world powers, with antagonistic ideologies.

Worldwide Fund for Nature (WWF) International organization, established in Britain in 1961. Its headquarters are in Gland, Switzerland. It raises voluntary funds for the conservation of endangered wild animals, plants and places.

worm Any of a large variety of wriggling, limbless creatures with soft bodies. Most worms belong to one or other of four

main groups: ANNELIDS, FLATWORMS, nematodes (ROUND-WORMS) and ribbon worms.

Worms Industrial town on the River Rhine, Rhineland Palatinate, w Germany. In the 5th century it became the capital of the kingdom of Burgundy. Worms was made a free imperial city in 1156. It was annexed to France in 1797 but passed to Hesse-Darmstadt state in 1815. The French occupied the city from 1918–30, and much of it was destroyed during World War 2. Today it is a centre of the wine industry. Pop. (1991) 77,430.

Worms, Concordat of (1122) Agreement between the Holy Roman Emperor Henry V and Pope Calixtus II settling the investiture conflict, a struggle between the empire and the papacy over the control of church offices. The emperor agreed to the free election of bishops and abbots and surrendered his claim to invest them with the spiritual symbols of ring and staff. They were, however, to pay homage to him as feudal overlord for their temporal possessions.

Worms, Diet of (1521) Conference of the Holy Roman Empire presided over by Emperor Charles V. Martin Luther was summoned to appear before the Diet to retract his teachings, which had been condemned by Pope Leo X. Luther refused to retract them and the Edict of Worms (25 May 1521) declared him an outlaw. The Diet was one of the most important confrontations of the early Reformation.

wormwood Genus (*Artemisia*) of aromatic bitter shrubs and herbs, including common wormwood (*A. absinthium*), a European shrub that yields a bitter, dark green oil used to make absinthe. Family Asteraceae/Compositae.

Wounded Knee, Massacre at (1890) Last engagement in the conflict between Native Americans and US forces. Fearing a rising by the SIOUX, US troops arrested several leaders. Chief SITTING BULL was killed resisting arrest. Another group was arrested a few days later and brought to Wounded Knee, South Dakota. A shot was fired and the troops opened fire. About 300 people, including women and children, were killed.

Wren, Sir Christopher (1632–1723) English architect, mathematician and astronomer. After the FIRE OF LONDON (1666), Wren designed more than 50 new churches in the City of London based on syntheses of CLASSICAL, RENAISSANCE and BAROQUE ideas; the greatest of these is ST PAUL'S Cathedral. Other works include Chelsea and Greenwich hospitals, London, and the Sheldonian Theatre, Oxford.

wren Small, insect-eating songbird of temperate regions of Europe, Asia and most of the New World. Many species have white facial lines. The typical winter wren (*Troglodytes troglodytes*) has a slender bill, upright tail and dark brownish plumage; length: to 10cm (4in). Family Troglodytidae.

wrestling Sport in which two unarmed opponents try to throw each other to the ground or to secure each other in an unbreakable hold, by means of body grips, strength and adroitness. The two major competitive styles are Greco-Roman (most popular in continental Europe), which permits no tripping or holds below the waist, and freestyle, which permits tackling, leg holds and tripping (most popular in Britain and the USA). A match consists of three periods of three minutes each; points are awarded for falls and other manoeuvres. Competitive wrestling originated in ancient Greece, where it was regarded as the next most important event after discusthrowing in the Olympic Games. Wrestling has been an Olympic event since 1904. See also SUMO WRESTLING

Wright, Frank Lloyd (1869–1959) US architect, regarded as the leading modernist designer of private housing. Wright worked as assistant to Louis SULLIVAN in the Chicago School of architecture, before his first independent design in 1893. His distinctive "organic" style of low-built, prairie-style houses was designed to blend in with natural contours and features. Influenced by JAPANESE ART AND ARCHITECTURE, Wright's open-plan approach to interiors was highly influential. His use of materials and mechanical construction techniques was radical. Notable buildings include: Robie House, Chicago (1909); "Falling Water", Bear Run, Pennsylvania (1936–37); and the Guggenheim Museum, New York (1946–59).

Wright, Joseph (1734–97) English painter. He made a speciality of industrial and scientific subjects, most notably in *An Experiment on a Bird in the Air Pump* (1768). Returning from

▲ wren Wrens are songbirds, and the winter wren (*Troglodytes*) troglodytes) shown here is one of the best singers. It is the only species of wren native to the Old World, but is also found in N Asia and North America.

▲ Wright brothers On 17
December 1903 Wilbur and
Orville Wright made the world's
first flights in a power-driven,
heavier-than-air machine. The
aircraft cost less than \$1,000 to
construct. The first flight, by
Orville, lasted only 12 seconds;
the fourth flight, by Wilbur,
lasted 59 seconds. In 1909, after
further tests and improvements,
the brothers established the
Wright Company in New York
City to manufacture aircraft.

time spent in Italy, Wright moved to Bath in 1775, hoping to emulate the success of GAINSBOROUGH. Disappointed in this, he settled in Derby, concentrating on poetic landscapes.

Wright, Richard (1908–60) US novelist. He is best known for the novel *Native Son* (1940), which describes the life of an African-American youth in white-dominated Chicago, and *Black Boy* (1945), an account of the author's boyhood in the South. He also wrote short stories and non-fiction.

Wright brothers Wilbur (1867–1912) and Orville (1871–1948), US aviation pioneers. They assembled their first aircraft in their bicycle factory. In 1903 Orville made the first piloted flight in a power-driven plane at Kitty Hawk, North Carolina. This flight lasted just 12 seconds, and attracted little attention. In 1908 Wilbur made longer and higher flights in France and Orville was equally successful in the USA. The brothers eventually convinced military authorities and manufacturers to invest in powered aircraft.

writing Process or result of making a visual record for the purpose of communication by using symbols to represent the sounds or words of a language. Writing systems fall into the following categories: ideographic (using signs or symbols that represent concepts or ideas directly rather than the sound of words for them); pictographic (in which a picture or sign represents the meaning of a word or phrase); syllabic (in which signs represent groups of consonants and vowels); and alphabetic (in which symbols stand for individual speech sounds or certain combinations of sounds). The Chinese dialects have long made use of ideographic symbols. Ancient Egyptian HIEROGLYPHICS and CUNEIFORM scripts from Mesopotamia and other regions of the ancient Middle East are originally pictographic, although later examples are syllabic. The LINEAR SCRIPTS of ancient Crete and Greece are syllabic, as is the modern Japanese Katakana. The Phoenicians were the first to use a phonetic system, with an ALPHABET of signs representing speech sounds. The Greek and Roman alphabets in use for most modern non-Asiatic languages are descended from the Phoenician one.

Wroclaw (formerly Breslau) Industrial city and port on the River Oder, sw Poland; capital of lower Silesia. Originally a Slavic settlement, it was destroyed by the MONGOLS in 1241. Rebuilt by the Austrians from 1526, it was ceded to Prussia in 1741. It developed as a trade centre in the 19th century and was badly damaged in World War 2. It became part of Poland under the terms of the Potsdam Conference (1945). Industries: heavy machinery, processed food, electrical equipment, textiles, paper, timber, chemicals. Pop. (1993) 643,600.

Wuhan City and river port at the confluence of the Han and Yangtze rivers; capital of Hubei province, central China. Wuhan developed after being declared a treaty port following the Opium Wars of the 19th century. It grew further with the arrival of the railway and China's first modern iron and steel plants in 1891. Wuhan itself was formed in 1950 by the merger of Hankow, Hanyang and Wuchang. It is now the industrial and commercial hub of central China. Despite being 970km (600mi) from the sea, the port handles many oceangoing vessels. Industries: cotton and textiles, iron, steel, heavy machinery, cement, soap. Pop. (1993) 3,876,000.

Wundt, Wilhelm (1832–1920) German psychologist. Wundt established the first laboratory for experimental psychology in 1879 at Leipzig. He did much to convince early psychologists that the mind could be studied with objective, scientific methods. His major publication is *Principles of Physiological Psychology* (1873–74).

Würzburg Capital of Lower Franconia, Bavaria, on the River Main, w central Germany. Made an episcopal see by St Boniface in 741, the city was secularized by the Treaty of Lunéville in 1801 and annexed to Bavaria two years later. It is the heart of a wine-producing region. Pop. (1993) 129,200.

Wyatt, Sir Thomas (1503–42) English poet and courtier, a pioneer of the English SONNET. He was popular at Henry VIII's court although, as an alleged former lover of Anne BOLEYN and friend of Thomas Cromwell, he was briefly imprisoned in 1536 and 1541. His son, also Thomas Wyatt, led Wyatt's Rebellion (1554), an attempt to prevent the marriage of Mary I to the Catholic Philip II of Spain.

Wycliffe, John (1330–84) English religious reformer. Under the patronage of JOHN OF GAUNT, he attacked corrupt practices in the Church and the authority of the pope, condemning in particular the Church's landed wealth. His criticism became increasingly radical, questioning the authority of the pope and insisting on the primacy of scripture, but he escaped condemnation until after his death. His ideas were continued by the LOLLARDS in England and influenced Jan Hus in Bohemia.

Wyeth, Andrew Newell (1917–) US painter. His best-known painting is *Christina's World* (1948). He was trained by his father, the illustrator N.C. Wyeth, and is known for his naturalistic portraits. His son James (1946–) is also a noted painter and artist.

Wyler, William (1902–81) US film director, famous for his long, meticulously crafted, single takes. Wyler won three best director and best picture Academy Awards for *Mrs Miniver* (1942), *The Best Years of Our Lives* (1946) and *Ben-Hur* (1959). Other credits include *Jezebel* (1938), *Wuthering Heights* (1939), *The Little Foxes* (1941) and *Roman Holiday* (1953).

Wyndham, John (1903–69) British novelist. Wyndham is known for science-fiction "disaster" novels, of which his first, *The Day of the Triffids* (1951), is best-known. Other works include *The Kraken Wakes* (1953), *The Chrysalids* (1955) and *The Midwych Cuckoos* (1957).

Wyoming State in NW USA, bounded N by Montana, E by South Dakota, s by Colorado, sw by Utah and w by Idaho; the state capital is CHEYENNE. Other major cities are Jasper and Laramie. Wyoming has the nation's smallest state population. The landscape is dominated by mountains and four million hectares (10 million acres) of forest. The ROCKY MOUNTAINS cross the state from NW to SE. To the E of the Rockies lie the rolling grasslands of the GREAT PLAINS, and the centre of the state is also high plains country. The N of the state is primarily tall grass plain, where buffalo roamed and were hunted by the CROW and then the SIOUX. Today, it is fertile farmland and cattle ranch country. YELLOWSTONE NATIONAL PARK is the oldest and largest US national park, occupying the entire NW corner of Wyoming. Many rivers flow down from the mountains, including the North Platte and the Snake. Following the LOUISIANA PURCHASE (1803), the USA had by 1846 acquired the entire territory of Wyoming through treaties. Nineteenthcentury development was linked to the fur trade and westward migration along the Oregon Trail. The 1860s marked the first dramatic arrival of new settlers: the Bozeman Trail was opened (1864) and the railway was completed (1868). By the end of the 1870s, the Native American population had been placed on reservations. The next 20 years were marked by a rise of vigilante groups to deal with cattle rustlers and outlaws, and in 1890 Wyoming became the 44th state of the Union. Tourism is a vital industry, with the state's natural beauty attracting over seven million annual visitors. While cattle ranching, sheep and wheat farming remain important to the economy, Wyoming is primarily an oil-producing state. Oil was discovered in the 1860s, and in 1993 output totalled 87.7 million barrels. Other important mineral resources include coal and uranium. Area: 253,596sq km (97,913sq mi). Pop. (1992) 464,736.

Wyszynski, Cardinal Stefan (1901–81) Polish Roman Catholic cardinal. As Polish archbishop of Gniezno and Warsaw and Primate of Poland from 1948, he protested to communist authorities against the accusations launched against the Church during the trial of Bishop Kaczmarek of Kielce. In 1952 Pope Pius XII appointed him cardinal. Wyszynski was imprisoned from 1953–56. In 1957 he was allowed to go to Rome to receive the honour of a cardinal's hat. In the late 1970s and early 1980s, as leader of Poland's Roman Catholics, he played an active mediating role between the workers and government authorities.

Wythe, George (1726–1806) US lawyer and judge. He held office in colonial Virginia and, as a delegate to the Continental Congress, signed the Declaration of Independence (1776). At the instigation of his former student, Thomas Jefferson, he was appointed the first professor of law in the USA, at the College of William and Mary (1779–90).

WYOMING Statehood :

10 July 1890

Nickname : The Equality State

State bird : Meadowlark

State flower: Indian paintbrush

State tree :

Cottonwood

State motto: Equal rights **x-chromosome** One of the two kinds of sex-determining CHROMOSOME; the other is the Y-CHROMOSOME. In many organisms, including humans, females carry two x-chromosomes in their DIPLOID cell nuclei, while males carry one x- and one y-chromosome. Non-sexual characteristics are also carried on the x-chromosome, for example the genes for one form of colour blindness and for haemophilia. *See also* GENETICS; HEREDITY

Xenakis, Yannis (1922-) Greek composer. Xenakis studied music under Arthur Honegger and Olivier Messiaen and architecture under Le Corbusier. His first composition, Metastasis (1954), was based on an architectural design. Some of Xenakis' work is TWELVE-TONE MUSIC and he has been a pioneer of the use of computers and mathematical models in the compositional process. Other works include Stratégie (1962). **xenon** (symbol Xe) Gaseous nonmetallic element, one of the NOBLE GASES. Discovered in 1898, xenon is present in the Earth's atmosphere (about one part in 20 million) and is obtained by fractionation of liquid air. Colourless and odourless, it is used in light bulbs, lasers and arc lamps for cinema projection. The element, which has 9 stable isotopes, forms some compounds, mostly with FLUORINE. Properties: at.no. 54: r.a.m. 131.30; r.d. 5.88; m.p. -111.9°C (-169.42°F); b.p. -107.1°C (-160.8°F); most common isotope Xe¹³² (26.89%). Xenophanes of Colophon (560–478 BC) Travelling Greek poet and philosopher. Xenophanes proposed a version of pantheism, holding that all living creatures have a common natural origin. His work survives only in fragmentary form. Xenophon (430–354 BC) Greek historian. Xenophon studied with Socrates, whose teaching he described in Memora-

Xenophon (430–354 BC) Greek historian. Xenophon studied with Socrates, whose teaching he described in *Memorabilia*. His best-known work is *Anabasis*, an account of his march with a Greek mercenary army across Asia Minor in 401–399 BC in support of a pretender to the Persian throne. Other works include a history of Greece from 411 to 362 BC. **xerography** Most common process used for Photocopying. **xerophyte** Any plant that is adapted to survive in dry conditions, in areas subject to drought or in physiologically dry areas such as salt marshes and acid bogs, where saline or acid conditions make the uptake of water difficult. A succulent, such as a CACTUS, has thick fleshy leaves and a stem for storing water. Other adaptations include the ability to reduce water loss by shedding leaves during drought, or having waxy or hairy leaf coatings or reduced leaf area.

Waxy of hairy leaf coatings of reduced leaf area.

Xerxes I (519–465 BC) King of Persia (486–465 BC). Succeeding his father, DARIUS I, he regained Egypt and crushed a rebellion in Babylon before launching his invasion of Greece (480 BC). After his fleet was destroyed at the Battle of Salamis he retired, and the defeat of the Persian army in Greece at the Battle of Plataea ended his plans for conquest. He was later assassinated by one of his own men. See also PERSIAN WARS.

Xhosa (Xosa) Group of related BANTU tribes. The Xhosa

Xhosa (Xosa) Group of related Bantu tribes. The Xhosa moved from E Africa to the vicinity of the River Great Fish, s Africa, in the 17th–18th centuries. They were defeated and subjected by Europeans in 1835. In culture they are closely related to the Zulu. Today, the 2.5 million Xhosa live in the Eastern Cape and form an important part of South Africa's industrial and mining workforce. Xhosa is the most widely spoken African language in South Africa.

Xiamen Seaport city in Fujian province, SE China. As Amoy, it flourished in the 19th century after being declared an open port by the Treaty of Nanking (1842). Xiamen gained extra strategic importance after the communists took control of the Chinese mainland (1949), and in 1981 was granted the status of a "special economic zone", accelerating its role as the centre of growing trade between China and Taiwan. Pop. (1993) 470,000.

Xian (Sian, formerly Changan) Capital of Shaanxi province, at the confluence of the Wei and Huang He rivers, Nw China. Inhabited since 6000 BC, from 255 to 206 BC it was the site of Xianyang, the capital of the QIN dynasty. The elaborate tomb of the dynastic founder, Emperor QIN SHIHUANGDI, is a world heritage site and major tourist attraction. Changan was the focus for the introduction of Buddhism to China, and in 652 the Big Wild Goose pagoda was built here. In the following centuries it became a major centre for other religious missionaries. The Great Mosque was built in 742. At the start of

the 10th century, Changan was the world's largest city. Known as Xian since the MING dynasty (1368–1644), extant monuments from this period include the 14th-century Drum and Bell towers. The Hua Qing curative hot springs were the site of the 1936 Xian Incident, when Chiang Kai-shek was held hostage until he agreed to a united Nationalist-Communist Chinese front against the Japanese. It is an important commercial centre of a grain-growing region. Industries: cotton, textiles, steel, chemicals. Pop. (1993) 2,360,000.

Xingu Brazilian river, rising in central Mato Grosso state. It flows N for 1,979km (1,230mi) and empties into the River Amazon at its delta. It courses through rainforest and is navigable only in its lower reaches. The area focused international attention on the plight of Native Americans when a government proposal to dam the Xingu meant the flooding of tribal land. The dam and hydroelectric scheme was completed in December 1994 at a cost of US\$3.2 billion.

Xinjiang (Mandarin, "new frontier"; Sinkiang or Chinese Turkistan) Autonomous region in NW China, bordered by Tajikistan, Kyrgyzstan and Kazakstan (N and W), Mongolia (E) and Kashmir and Tibet (s); the capital is Ürümqi. Xinjiang includes the Dzungarian Basin to the E and the Tarim Basin to the W. The ALTAI, TIAN SHAN and Kunlun mountains frame the region to the N, W and S respectively. First conquered by the Chinese in the 1st century BC, Xinjiang changed hands many times in the following centuries. From the 13th to 18th centuries it was loosely controlled by the Mongols. In 1756 the QING dynasty assumed control of the region. It was made a Chinese province in 1881. It is a mainly agricultural region growing wheat, cotton, maize, rice, millet, vegetables and fruit. Livestock rearing (particularly sheep) is also important. The area is rich in minerals including oil, copper, zinc, gold and silver. Industries: iron and steel, chemicals, textiles. Area: 1,647,435sq km (636,075sq mi). Pop. (1990) 15,370,000.

x-ray Electromagnetic ray of shorter wavelength, or higher frequency, than visible light, produced when a beam of electrons hits a solid target. X-rays were discovered in 1895 by the German physicist Wilhelm RÖNTGEN. They are normally produced for scientific use in x-ray tubes. Because they are able to penetrate matter that is opaque to light, x-rays are used to investigate inaccessible areas, especially of the body. See also RADIOGRAPHY

x-ray astronomy See ASTRONOMY

x-ray crystallography Use of x-rays to discover the molecular structure of CRYSTALS. It uses the phenomenon of x-ray diffraction, the scattering of an x-ray beam by the atomic structure of a crystal, and has been used to show that DNA can produce crystals.

xylem Transport TISSUE of a PLANT, which conducts water and minerals from the ROOTS to the rest of the plant and provides support. The most important cells are long, thin tapering cells called xylem vessels. These cells are dead and have no cross-walls; they are arranged in columns to form long tubes, up which water is drawn. As water evaporates from the leaves (TRANSPIRATION), water is drawn across the leaf by OSMOSIS to replace it, drawing water out of the xylem. This suction creates a tension in the xylem vessels, and the side walls are reinforced with rings or spirals of LIGNIN, a rigid substance, to prevent them collapsing. Tiny holes in the walls of the xylem vessels (pits) allow water to cross from one tube to another. In trees, the xylem becomes blocked with age, and new xylem forms towards the outside of the trunk to replace it. The core of dead, non-functioning xylem remains an essential part of the support system. See also PHLOEM; VASCULAR BUNDLE

xylophone Tuned PERCUSSION instrument. It is made of hardwood bars arranged as in a piano keyboard and played with mallets. The modern xylophone normally has a range of four octaves, extending from middle C upwards.

XYZ Affair (1797–98) Diplomatic incident that strained US relations with France. President John ADAMS sent three representatives to renegotiate the French-US alliance of 1778, which had given way to hostility after the signing of JAY'S Treaty (1794). Three French agents, known as X, Y and Z, demanded bribes and a loan before negotiations began, causing an uproar in the USA and the recall of its commissioners.

X/x, the 24th letter of the English alphabet and a letter included in the alphabets of several w European languages. Its origins are obscure, though some experts have suggested that it developed from a Semitic character called samekh. A letter resembling a modern X existed in the Greek alphabet, it was called chi and had the sound kh (rather like the ch in Scottish loch). It could, however, also represent the cluster of sounds ks: this was the form adopted by the Romans. In English, x generally has a ks sound, as in fix and exercise, although in unaccented syllables before vowels it is more like gz (as in examine). This gz pronunciation is also found in the word exit with some speakers. With a following u, x is pronounced as ksh (as in luxury), and as the initial letter in words derived from Greek it has come to be pronounced like a z (as in xylophone).

Y/y, the 25th letter of the English alphabet and a letter included in the alphabets of several w European languages. It was derived (as were f, u, v and w) from the Semitic letter vaw. It was adopted by the Greeks as upsilon. The Romans made two letters out of upsilon - Y and V. They only employed Y when writing words derived from Greek but using Roman characters. In modern English y may represent a consonant or a vowel sound. It functions as a consonant in such words as yell or young. As a vowel letter, it duplicates some of the sounds of the letter i and is found in such words as hymn, hype and day.

▲ yam Commercially important in € Asia and in tropical America, the yam (*Dioscorea* sp.) produces thick, starchy rhizomes, often weighing up to 30lb (13.6kg). These are a valuable food source and form part of the staple diet of many people worldwide, especially in Africa.

yacht Boat used for sport and recreation, powered by sail or motor. Sailing yachts, which are usually fore and aft rigged, vary from 6m (20ft) to over 30m (98ft) long and include cutters, schooners, ketches, sloops and yawls, as well as other types. Those fitted with diesel or petrol engines are usually classified as cruising, or motor, yachts. Although most yachts are used for vacationing and cruising, it has been an international sport since 1851, when the Royal Yacht Squadron (formed at Cowes, England, in 1812) offered a silver cup as a prize for a race of 97km (60mi) around the Isle of Wight. The race was won by the schooner America, owned by the members of the New York Yacht Club (established 1844), and has since been known as the AMERICA'S CUP. The Admiral's Cup is an international race held biennially since 1957 at Cowes. The Observer Single-Handed Transatlantic Race has been held every four years since 1960. The Olympics have competitions in seven yachting categories.

Yahweh Personal name of the God of the ancient Israelites of the OLD TESTAMENT. God revealed His name to Moses when He called to him out of the burning bush at Mount Horeb (Sinai) (Exodus 3:14). In Hebrew, it was made up of four consonants, YHWH, and was apparently related to the Hebrew verb "to be". Most English translations render it as "I am". See also JEHOVAH

yak Large, powerful, long-haired ox, native to Tibet, with domesticated varieties throughout central Asia; it inhabits barren heights up to 6,000m (20,000ft). Domesticated varieties are generally smaller and varied in colour; they breed freely with domestic cattle. Wild yaks have coarse, black hair, except on the tail and flanks, where it hangs as a long fringe. The horns curve upward and outward. Height: to 1.8m (6ft) at the shoulder. Family Bovidae; species Bos grunniens.

Yakutia (officially Republic of Sakha) Constituent republic of the Russian Federation, in NE Siberia; the capital is Yakutsk. The region is bounded by the Laptev and East Siberian Seas (N) and the Stanovoy Range (s). It is the largest Russian republic and one of the coldest inhabited regions, with more than 40% of the territory within the Arctic Circle. The principal rivers are the LENA, Yana, Indirka and Kolyma. A third of the population is Yakut, a Turkic-speaking people who settled in the Lena basin from the 13th-15th century. They are noted bone-carvers, iron-workers and potters. The area was colonized by Russia during the 17th century, and many of the Yakuts were forcibly converted from SHAMANISM to Christianity. A republic of the former Soviet Union (1922–91), Yakutia became a member of the new Russian Federation in 1992. Agriculture is only possible in the s. The major industry is diamond mining and processing. Other important minerals include gold, silver, lead and coal. Timber is an important industry in the taiga regions. Area: 3,103,200sq km (1,200,000sq mi) Pop. (1994) 1,060,700.

Yale University Institute of higher education, in New Haven, Connecticut, USA. Founded in 1701, its current charter dates from 1745. It is a member of the IVY LEAGUE.

Yalow, Rosalyn (1921–) US biochemist. In the 1950s Yalow found that some people who received INSULIN injections developed antibodies against the hormone. She discovered that insulin, labelled with radioactive iodine, combined with the antibodies; from this she developed radio-immunological tests to detect and measure the amount of insulin present. She shared the 1977 Nobel Prize in physiology or medicine for her development of a method of detecting peptide HORMONES in the blood.

Yalta Conference (February 1945) Meeting of the chief Allied leaders of WORLD WAR 2 at Yalta in the Crimea, s Ukraine. With victory over Germany imminent, ROOSEVELT, CHURCHILL and STALIN met to discuss the final campaigns of the war and the post-war settlement. Agreements were reached on the foundation of the United Nations (UN); the territorial division of Europe into "spheres of interest"; the occupation of Germany; and support for democracy in liberated countries. Concessions were made to Stalin in the Far East in order to gain Soviet support against Japan.

yam Any of several species of herbaceous vines that grow in warm and tropical regions; also the large, tuberous roots of several tropical species, which are edible. The plant is an annual, with a long, climbing stem, lobed or unlobed leaves and small clusters of greenish, bell-shaped flowers. The SWEET POTATO is also sometimes called a yam. Family Dioscoreaceae; genus *Dioscorea*.

Yamoussoukro Capital of Ivory Coast since 1983. Originally a small Baouké tribal village and birthplace of Ivory Coast's first president, Felix HOUPHOUËT-BOIGNY, it has developed rapidly into the administrative and transport centre of Ivory Coast. Yamoussoukro's Our Lady of Peace Cathedral (consecrated by Pope John Paul II in 1990) is the world's largest Christian church. Pop. (1988) 106,786.

Yamuna (Jumna) River in N central India. It rises in the Himalayas and flows s and SE. The Yamuna's confluence with the GANGES at ALLAHABAD is one of the most sacred Hindu sites. The TAJ MAHAL at AGRA lies on its bank. Navigable for almost its entire length, the Yamuna was once an important trade route, but is now primarily used for irrigation. Length: c.1,380km (860mi).

Yang, Chen Ning (1922–) US physicist, b. China. With T.D. Lee, he studied the decay of K MESONS, which seemed to break down in two different ways. In 1956 they concluded that in these weak interactions PARITY need not be conserved. They shared the 1957 Nobel Prize for physics.

Yangtze (Chang Jiang) River in China, the longest in Asia and third-longest in the world. Rising in the Kunlun Mountains in NE Tibet, it flows 6,300km (3,900mi) through the central Chinese provinces to the East China Sea near Shanghai. It was joined to the HUANG HE by the Grand Canal in 610. Navigation becomes difficult at the spectacular Yangtze Gorges, between CHUNGKING and Yichang, but after Yichang (site of the huge Gezhouba Dam) it enters the fertile lowlands of Hubei province. The Yangtze and its main tributaries traverse one of the world's most populated areas, providing water for irrigation and hydroelectricity. It is China's most economically important waterway. The government's controversial Three Gorges dam scheme E of Fengjie, destined to take 15 years to complete, will create a reservoir c.600km (375mi) long, displacing some 1.2 million people.

Yanomami Native American tribal group living chiefly in the rainforests of N Brazil and S Venezuela. Traditionally semi-nomadic hunter-gatherers, during the 1980s and 1990s much of their land was lost to road-builders, logging companies and gold prospectors, causing the population to fall to around 18,000. Their plight raised international concern.

Yaoundé Capital of Cameroon, w Africa. Located in beautiful hills on the edge of dense jungle, it was founded by German traders in 1888. During World War 1 it was occupied by Belgian troops, and later acted as capital (1921–60) of French Cameroon. Since independence it has grown rapidly as a financial and administrative centre with strong Western influences. It is the site of the University of Cameroon (1962). The city also serves as a market for the surrounding region, notably in coffee, cacao and sugar. Pop. (1991) 750,000.

yard Imperial unit of length equal to 3 feet (ft). One yard (yd) equals 0.9144 metres (m).

Yaroslavl (Jaroslavl') City and river port on the Volga, w central Russia; capital of Yaroslavl oblast. The oldest town on the Volga (founded 1010 by Yaroslavl the Great), it was capital of Yaroslavl principality when absorbed by Moscow in 1463. From March to July 1612 it served as Russia's capital, and still boasts many historic buildings. It is a major rail junction. Industries: linen, diesel engines, construction equipment, oil refining, petrochemicals, plastics. Pop. (1994) 631,000.

yaws (framboesia) Contagious skin disease found in the humid tropics. It is caused by a spirochete (*Treponema pertenue*) related to the organism causing SYPHILIS. Yaws, however, is not a SEXUALLY TRANSMITTED DISEASE (STD), but is transmitted by flies and by direct skin contact with the sores. It may go on to cause disfiguring bone lesions.

y-chromosome One of the two kinds of sex-determining CHROMOSOME; the other is the X-CHROMOSOME. Many male organisms have one x- and one y-chromosome in their DIPLOID cell nuclei. Sperm cells contain either an x- or y-chromosome, and since female ova (egg cells) always contain an

Y

x-chromosome, the resulting offspring is either XY (male) or XX (female). The y-chromosome is smaller than the x- and contains fewer GENES.

year Length of time taken by the Earth to circle once round the Sun in its orbit. It is defined in various ways, such as the sidereal year, which is timed with reference to the fixed stars. yeast Any of a group of single-celled microscopic FUNGI found in all parts of the world in the soil and in organic matter. Yeasts reproduce asexually by BUDDING or FISSION. Yeasts are also produced commercially for use in baking, brewing and wine-making. They occur naturally as a bloom (white covering) on grapes and other fruit.

Yeats, W.B. (William Butler) (1865-1939) Irish poet and dramatist, often cited as the greatest English language poet of the 20th century. Yeats was a co-founder (1904) of the ABBEY THEATRE, Dublin. His play Cathleen Ni Houlihan (1902) is often cited as the beginning of the renaissance in IRISH LITERA-TURE. Yeats' early poetry, collected in The Wanderings of Oisin, and Other Poems (1889), shows the influence of mysticism. His unrequited love for Maud Gonne inspired him into more directly nationalist statements. The poetry in Responsibilities (1914) acted as contemporary commentary. Following the creation of the Irish Free State, Yeats served (1922-28) as a senator. His mature, symbolist poetry, such as A Vision (1925), often adopted dramatic voices. Works from this second phase include Michael Robartes and the Dancer (1921, which contains "The Second Coming" and "Easter 1916") and The Tower (1928, which contains "Sailing to Byzantium"). Yeats was awarded the 1923 Nobel Prize for literature.

yellow fever Acute infectious disease marked by sudden onset of headaches, fever, muscle and joint pain, jaundice and vomiting; the kidneys and heart may also be affected. It is caused by a VIRUS transmitted by mosquitoes in tropical and subtropical regions. It may be prevented by vaccination.

Yellowstone National Park Park in Nw Wyoming and reaching into Montana and Idaho, USA. Established in 1872, it is the oldest and one of the largest US national parks. Formed by volcanic activity, the park contains almost 10,000 hot springs (including the giant Hot Springs) and 200 geysers (the most famous of which is "Old Faithful"). Other scenic attractions include Yellowstone River and the petrified forests. It is one of the world's greatest wildlife sanctuaries. In 1988 large-scale forest fires devastated much of the park. Area: 900,000ha (2.22 million acres).

Yeltsin, Boris Nikolayevich (1931–) Russian statesman, first democratically elected president of the Russian Federation (1991–). He was Communist Party leader in Ekaterinburg (Sverdlovsk) before joining (1985) the reforming government of Mikhail Gorbachev, also becoming party chief in Moscow. His criticism of the slow pace of Perestroika led to demotion in 1987, but his popularity saw him elected as president of the Russian Republic in 1990. His prompt denunciation of the attempted coup against Gorbachev (August 1991) established his political supremacy. Elected president of the Russian Federation, he presided over the dissolution of the SOVIET UNION and the termination of Communist Party rule. Economic disintegration, rising crime, and internal conflicts, notably in Chechnya, damaged his popularity. Failing health reduced his effectiveness, but he was re-elected in 1996.

Yemen Republic on the s tip of the Arabian peninsula. *See* country feature, page 736

Yenisei (Yenesey) River in central Siberia, Russia. Formed by the confluence of the Bolshoi Yenisei and the Maly Yenisei at Kyzyl, it flows for 4,090km (2,540mi) w then N through the Sayan Mountains and across Siberia, forming the w border of the central Siberian plateau, emptying into the Yenisei Gulf on the Kara Sea. A large hydroelectric station has been built at Krasnoyarsk. The river is a source of sturgeon and salmon. A shipping route, some of its sections are frozen in winter. When the river is combined with the Angara (its major tributary), it is the world's fifth-longest river, at 5,550km (3,445mi).

Yerevan Capital of Armenia, on the River Razdan, s CAUCASUS. One of the world's oldest cities, it was capital of Armenia from as early as the 7th century (though under Persian control). A crucial crossroads for caravan routes between

India and Transcaucasia, it is the site of a 16th-century Turkish fortress. It is a traditional wine-making centre. Industries: chemicals, plastics, cables, tyres, metals, electrical appliances, vodka. Pop. (1994) 1,254,000.

Yerkes Observatory Observatory of the University of Chicago, at Williams Bay, Wisconsin, USA. It was founded (1897) by George Ellery HALE. Its main instrument is a 1m (40in) refractor, still the largest in the world.

Yevtushenko, Yevgeny (1933–) Russian writer. During the 1960s, Yevtushenko headed a new wave of nonconformist, modern Soviet poetry. Explicitly rejecting SOCIALIST REALISM, Yevtushenko's rhetorical poetry anticipated GLASNOST in its examination of Soviet history. His most famous work, *Babi Yar* (1961), was a direct indictment of Soviet anti-semitism. Other works include *Precocious Autobiography* (1963) and *The Bratsk Station* (1965). His *Collected Poems* appeared in 1991. **Yew** Any of a number of evergreen shrubs and trees of the genus *Taxus*, native to temperate regions of the Northern Hemisphere. They have stiff, narrow, dark green needles, often with pale undersides, and red, berry-like fruits. Height: to 25m (80ft). Family Taxaceae.

Yiddish Language spoken by Jews living in central and E Europe and other countries (including the USA) with Jewish communities. It first developed in w Europe in the 10th and 11th centuries and was taken E with migrating Jews. It is basically a variety of German, with many Hebrew, Aramaic, French, Italian and Slavic words added. It is written using the Hebrew alphabet. It contains many English borrowings and in the USA has passed many words and expressions into English. Yin Alternative transliteration of the Shang dynasty

yin and yang Interaction of two complementary forces in the universe, as described in the Chinese philosophy of TAO-ISM. Yin and yang are two cosmic energy modes comprising the Tao or the eternal, dynamic way of the universe. Earth is yin, the passive, dark, female principle; heaven is yang, the active, bright, male principle. All the things of nature and society are composed of combinations of these two principles of polarity, which maintain the balance of all things. The hexagrams of the BOOK OF CHANGES embody yin and yang.

YMCA Abbreviation of YOUNG MEN'S CHRISTIAN ASSOCIATION

yoga (Sanskrit, union) Term used for a number of Hindu disciplines to aid the union of the soul with God. Based on the Yoga sutras of Patañjali (active 2nd century BC), the practice of yoga generally involves moral restraints, meditation, and the awakening of physical energy centres through specific postures (asanas) or exercises. Devoted to freeing the soul or self from earthly cares by isolating it from the body and the mind, these ancient practices became popular in the West during the second half of the 20th century as a means of relaxation, self-control and enlightenment.

Yogyakarta (Jogjakarta) City in s Java, Indonesia. Founded in 1749, it is the cultural and artistic centre of Java. Capital of a Dutch-controlled sultanate from 1755, it was the scene of a revolt (1825–30) against colonial exploitation. During the 1940s it was the centre of the Indonesian independence movement and, in 1949, acted as the provisional capital of Indonesia. Its many visitors are drawn by the 18th-century palace, the Grand Mosque, the religious and arts festivals, and its proximity to the BOROBUDUR temple. The major industry is handicrafts. Pop. (1990) 412,392.

Yokohama Port and major industrial city on the w shore of Tokyo Bay, se Honshū, Japan. Japan's main port for many years, it is now its second-largest city. Yokohama grew from a small fishing village to a major port after opening to foreign trade in 1859. It served as Tokyo's deep-water harbour and was a vital silk-exporting centre. The city has been rebuilt wice: once after the devastating earthquake in 1923, and again following intensive Allied bombing during World War 2. Many of the modern port and industrial facilities have been built on land reclaimed from the sea. Industries: iron, steel, shipbuilding. Pop. (1994) 3,265,000.

yolk Rich substance found in the eggs or ova of most animals except those of placental mammals. It consists of fats and proteins and serves as a store of food for the developing embryo.

▲ Yeats One of the greatest figures in 20th-century literature, W.B. Yeats was born in a suburb of Dublin, Ireland. At art school he developed an interest in mysticism, the occult and Irish mythology, which provided the inspiration for much of his poetry. Yeats played a major role in the Irish cultural renaissance and produced powerful, nationalist works, one of which, Cathleen Ni Houlihan (1902), is thought to have inspired the Easter Rising of 1916.

A Yeltsin Educated at Urals Polytechnic, Russian Federation president Boris Yeltsin began his career in the construction industry. He gained a reputation as an outspoken, hands-on reformer, and passed in and out of favour with the politburo during the perestroika reforms of the 1980s. As president, he is a progressive advocate of price deregulation, privatization and nuclear disarmament.

yolk sac Membranous sac-like structure in the eggs of most animals. It is attached directly to the ventral surface or gut of the developing embryo in the eggs of birds, reptiles and some fish, and contains YOLK. The term also refers to an analogous sac-like membrane that develops below the mammalian embryo. It contains no yolk but is connected to the umbilical cord.

Yom Kippur (Day of Atonement) Most solemn of Jewish feasts. It is the last of the Ten Days of Penitence that begin the New Year. On this day, set aside for prayer and fasting, humanity is called to account for its sins and to seek reconciliation with God. Yom Kippur is described as the Sabbath of Sabbaths, because the break from work is almost complete, and Jews must abstain from food, drink and sex.

Yonkers City on the Hudson River, SE New York state, USA. Land was originally purchased from Native Americans in 1639 by the Dutch West India Company. The acquittal of John Peter ZENGER here in 1735 helped set up freedom of the press in the USA. Yonkers has various museums (including the Hudson River Museum) and research institutions. Industries: elevators (since 1852), chemicals, cables, telephone parts, art supplies. Pop. (1992) 186,063.

York City and county district in NORTH YORKSHIRE, N Eng-

land. Located at the confluence of the Ouse and Foss rivers, it was an important Roman military post, an Anglo-Saxon capital, a Danish settlement and then the ecclesiastical centre of the North of England. York Minster cathedral dates from the 13th century. Its old buildings and museums make tourism important. Industries: engineering (including rail workshops), confectionery, precision instruments. Pop. (1991) 98,745.

York, Archbishop of Second-highest office of the CHURCH OF ENGLAND. The acts of the Council of Arles (314) mention a bishop of York, but the early Christian community in York was destroyed by Saxon invaders. The uninterrupted history of the present see began with the consecration of Wilfrid as bishop of York in 664. York was raised to the dignity of an archbishopric in 735, when Egbert was given the title PRIMATE of the Northern Province. The archbishop is now called Primate of England (the Archbishop of CANTERBURY is Primate of all England).

York, House of English royal house, a branch of the PLAN-TAGENETS. During the Wars of the Roses, rival claimants from the houses of York and LANCASTER contended for the crown. The Yorkist claimant, Richard, Duke of York, was a great-grandson of EDWARD III. His son gained the crown as EDWARD IV. The defeat of Edward's brother, RICHARD III, by HENRY VII in 1485 brought the brief Yorkist line to a close.

YEMEN

Yemen's flag was adopted in 1990 when the Yemen Arab Republic (North Yemen) united with the People's Democratic Republic of Yemen (South Yemen). This simple flag is a tricolour of red, white and black; colours associated with the Pan-Arab movement.

AREA: 527,970sq km (203,849sq mi)

POPULATION: 11,282,000

CAPITAL (POPULATION): Sana'a (427,502) GOVERNMENT: Multiparty republic ETHNIC GROUPS: Arab 96%. Somali 1%

LANGUAGES: Arabic (official)
RELIGIONS: Islam

currency: Yemen rial = 100 fils

The Republic of Yemen lies on the s tip of the Arabian peninsula. Much of Yemen's interior forms part of the Rub al Khali (Empty Quarter) desert. The desert is bisected by a central plateau. A narrow coastal plain borders the Red and Arabian seas. The Arabian coastal plain includes ADEN, the former capital of South Yemen, and the fertile Hadramaut valley. The w plain is backed by highlands, which rise to over 3,600m (12,000ft) near the capital SANA'A.

CLIMATE

Most of Yemen is hot and rainless, except during the monsoon month of August. The highlands are the wettest part of Arabia and the temperature is moderated by altitude.

VEGETATION

Palm trees grow along the coast. Plants such as acacia and eucalyptus flourish in the interior.

Thorn shrubs and mountain pasture are found in the highlands. The Rub al Khali (Empty Quarter) is a barren desert.

HISTORY AND POLITICS

The ancient kingdom of SHEBA (Saba) flourished in present-day s Yemen between c.750 BC and 100 BC. The kingdom was renowned for its advanced technology and wealth, gained through its strategic location on important trade routes. The region was invaded by the Romans in the 1st century BC. Islam was introduced in AD 628. The Rassite dynasty of the Zaidi sect established a theocratic state, which lasted until 1962. The FATIMIDS conquered Yemen in c.1000. In 1517 the area became part of the Ottoman empire, and largely remained under Turkish control until 1918. In the 19th century the Saudi Wahhabi sect ousted the Zaidi imams, but were in turn expelled by Ibrahim Pasha. In 1839 Aden was captured by the British. In 1937 Britain formed the Aden Protectorate. Following the defeat of the Ottomans in World War 1, Yemen was ruled by Imam Yahya of the Hamid al-Din dynasty. In 1945 Yemen joined the Arab League. In 1948 Yahya was assassinated. Crown Prince Ahmed became imam. From 1958 to 1961 Yemen formed part of the United Arab Republic (with Egypt and Syria). A 1962 army revolution overthrew the monarchy and formed the Yemen Arab Republic. Civil war ensued between republicans (aided by Egypt) and royalists (aided by Saudi Arabia and Jordan). Meanwhile, the Aden Protectorate became part of the British Federation of South Arabia. In 1967 the National Liberation Front forced the British to withdraw from Aden and founded the People's Republic of South Yemen. Marxists won the ensuing civil war in South Yemen and renamed it the People's Democratic Republic of Yemen (1970). Border clashes between the two Yemens were frequent throughout the 1970s, and erupted into full-scale war (1979). Following lengthy negotiations, the two Yemens merged to form a single republic in 1990. Yemen's support for Iraq in the Gulf War (1991) led to the expulsion of 800,000 Yemeni workers from Saudi Arabia. A coalition government emerged from 1993 elections, but increasing economic and political tensions between North and South led to civil war in 1994. The South's brief secession from the union ended with victory for the Northern army. In 1995 agreement was reached with Saudi Arabia and Oman over disputed boundaries, but Yemen clashed with Eritrea over the Hanish Islands in the Red Sea. Presidential elections are due in 1999.

ECONOMY

Civil strife has devastated Yemen's economy, seriously damaging the country's infrastructure, such as the oil refinery at Aden. Yemen is a low-income developing nation (1992 GDP per capita, US\$2,410). In 1995 inflation and unemployment stood at over 50%, forcing Yemen to borrow from the International Monetary Fund. Agriculture employs 63% of the workforce, mainly at subsistence level. The major economic activity is livestock-raising, principally sheep. Crops include sorghum, wheat and barley. Oil extraction began in the NW in the 1980s. Natural gas is also exploited.

Y

Yorkshire See North Yorkshire, South Yorkshire and West Yorkshire

Yorkshire terrier Small, long-haired dog originally bred in Lancashire and Yorkshire, England, in the 19th century. It has a compact body and short legs. The tail is commonly docked. The silky coat is generally blue-grey and tan. Height: to 20cm (8in) at the shoulder; weight to 3kg (7lb).

Yorktown, Siege of (1781) Last major military campaign of the AMERICAN REVOLUTION. Trapped on the peninsula of Yorktown, Virginia, 7,000 British troops under Lord Cornwallis surrendered to superior US and French forces, after attempts to relieve them had failed.

Yoruba People of sw Nigeria of basically Christian or Islamic faith. Most are farmers, growing crops that include yams, maize and cocoa. Many live in towns built around the palace of an *oba* (chief) and travel daily to their outlying farms.

Yosemite National Park Spectacular national park, established 1890, in the SIERRA NEVADA range of central California, USA. Yosemite means "grizzly bear", and the park was named after the river that runs through it. It is a mountainous area of glacial gorges and granite cliffs rising to the 3,990m (13,090ft) of Mount Lyell. Yosemite Falls, the highest waterfall in North America, drops 739m (2,425ft) in two stages. Other features include Half Dome Mountain and the vertical rock-face of El Capitan. Area: 308,335ha (761,320 acres).

Young, Brigham (1801–77) US religious leader, founder of SALT LAKE CITY. An early convert to the Church of Jesus Christ of Latter-Day Saints (MORMONS), Young took over the leadership when Joseph SMITH, the founder, was killed by a mob in 1844. Young held the group together through persecutions and led their westward migration (1846–47) to UTAH, where he organized the settlement that became Salt Lake City. He was governor of Utah Territory (1850–57).

Young, "Cy" (Denton True) (1867–1955) US baseball player. He became the game's top pitcher with 511 victories. In 1904 he pitched the first perfect game (no hit, no run, no batter reaching first base). Young played for the Cleveland Indians (1890–98, 1909–11), St Louis Cardinals (1899–1900), Boston Red Sox (1901–08) and the Boston Braves (1911). He was elected to the Baseball Hall of Fame in 1937.

Young, Thomas (1773–1829) British physicist and physician. He revived the wave theory of light first put forward in the 17th century by Christiaan Huygens. He helped present the Young-Helmholtz theory of colour vision and detailed the cause of ASTIGMATISM. He studied elasticity, giving his name to the tensile elastic (Young's) modulus. Young was also an Egyptologist who helped decipher the ROSETTA STONE.

Young Men's Christian Association (YMCA) Christian association for young men established (1844) in London by George Williams. Its aim is to develop Christian morals and leadership qualities in young people. Clubs were soon formed in the USA and Australia, and the world alliance of the YMCA was formed in Geneva in 1855. Women were accepted as members in 1971. See also Young Women's Christian Association (YWCA)

Young Turks Group of Turks who wished to remodel the OTTOMAN EMPIRE and make it a modern European state with a liberal constitution. Their movement began in the 1880s with unrest in the army and universities. In 1908 a Young Turk rising, led by ENVER PASHA and his chief of staff Kemal ATATÜRK, deposed Sultan Abdul Hamid II and replaced him with his brother, Muhammad V. Following a 1913 coup d'etat Enver Pasha became a virtual dictator. Under Kemal Atatürk, the Young Turks merged into the Turkish Nationalist Party.

Young Women's Christian Association (YWCA) Christian association for young women; the counterpart of the YOUNG MEN'S CHRISTIAN ASSOCIATION (YMCA). Two YWCA groups were founded simultaneously in 1855 in different parts of England, and the associations merged in 1877. The YWCA provides accommodation, education, recreation facilities and welfare services to young women and has local branches in more than 80 countries.

Ypres, Battles of Several battles of World War 1 fought around the Belgian town of Ypres. The first (October–November 1914) stopped the German "race to the sea" to capture the

Channel ports, but resulted in the near destruction of the British Expeditionary Force. The second (April–May 1915), the first battle in which poison gas was used, resulted in even greater casualties, without victory to either side. The third (summer 1917) was a predominantly British offensive. It culminated in the Passchendaele campaign, the costliest campaign in British military history, which continued until November.

ytterbium (symbol Yb) Silver-white, metallic element of the LANTHANIDE SERIES. First isolated in 1828, ytterbium's chief ore is monazite. The shiny, soft element is malleable and ductile and is used to produce steel and other alloys. Properties: at.no. 70: r.a.m. 173.04; r.d. 6.97; m.p. 824°C; (1,515°F), b.p. 1,193°C (2,179°F); most common isotope Yb¹⁷⁴ (31.84%).

yttrium (symbol Y) Silver-grey, metallic element in group III of the periodic table. First isolated in 1828, it is found associated with LANTHANIDE elements in monazite sand, bastnasite and gadolinite. It resembles the lanthanides in its chemistry. Yttrium was found in lunar rock samples collected by the Apollo 11 space mission. Its compounds are used in phosphors and communications devices, such as colour television picture tubes and superconducting ceramics. Properties: at.no. 39; r.a.m. 88.9059; r.d. 4.47; m.p. 1,523°C (2,773°F); b.p. 3,337°C (6,039°F); most common isotope Y⁸⁹ (100%).

Yüan (1246–1368) Mongol dynasty in China. Continuing the conquests of Genghis Khan, Kublai Khan established his rule over China, eliminating the last Sung claimant in 1279. Kublai Khan returned the capital to Beijing and promoted construction and commerce. Chinese literature took new forms during the Mongol period. Native Chinese were excluded from government, and foreign visitors, including merchants such as Marco Polo, were encouraged. Among the Chinese, resentment of alien rule was aggravated by economic problems, including runaway inflation. The less competent successors of Kublai were increasingly challenged by rebellion, culminating in the victory of the Ming.

Yucatán State in the N part of the Yucatán Peninsula, SE Mexico; the capital is Mérida. The terrain is low-lying, covered in places with scrub and cactus thickets. Once the centre of the MAYA civilization, Yucatán was conquered by the Spanish in the 1540s. The region is a major producer of henequen (sisal hemp used for cordage). Other products: tobacco, sugar, cotton, tropical fruits. Fishing is an important industry. Area: 38,508sq km (14,868sq mi). Pop. (1990) 1,362,940.

yucca Genus of c.40 species of SUCCULENT plants native to s USA, Mexico and the West Indies. Most species are stemless, forming a rosette of leaves, or have a trunk. The flowers grow in clusters and are white, tinged with yellow or purple. The leaves are poisonous. Height: to 10m (33ft). Family Liliaceae. Yugoslavia Balkan republic in SE Europe. See country feature, page 738

Yukawa, Hideki (1907–81) Japanese physicist. In the 1930s he proposed that there was a nuclear force of very short range (less than 10⁻¹⁵m) strong enough to overcome the repulsive force of protons and that diminished rapidly with distance. Yukawa predicted that this force manifested itself by the transfer of particles between NEUTRONS and PROTONS. In 1947 his theory was confirmed by the discovery of the pion (pi MESON) by Cecil POWELL. In 1949 he was awarded the Nobel Prize for physics for his prediction of the existence of the meson.

Yukon River Fourth-longest river in North America, deriving its name from a Native American word for "great". It rises at Lake Tagish on the border of British Columbia, Canada, and flows N and NW through Yukon Territory across the border into Alaska. It then flows sw to enter the Bering Sea. The lower course of the river was explored by Russians in 1836–37; the upper course by Robert Campbell in 1843. It was a major transportation route during the Klondike Gold Rush. It is navigable for *c*.2,858km (1,775mi) of its 3,185km (1,980mi) course, but is ice-bound from October to June. The river teems with salmon.

Yukon Territory Small territory in the extreme Nw of Canada, bounded by the Arctic Ocean (N), Northwest Territories (E), British Columbia (s) and Alaska (w); the capital and largest town is Whitehorse. The N consists of Arctic waste and is virtually uninhabited. Further s there is spectacular mountain

scenery with lakes and coniferous forests. The region is drained by the YUKON and MACKENZIE rivers. The climate is harsh, with freezing winters and short summers. The region was first explored by fur traders from the HUDSON'S BAY COMPANY after 1840. The KLONDIKE GOLD RUSH brought over 30,000 prospectors in the 1890s. In 1991 the Canadian government recognized the land claims of the indigenous Yukon (First Nation) Native Americans. Farming is extremely limited, but a few cereal crops and vegetables are grown in the valleys. The principal activity is mining, with deposits including lead, zinc and gold. Forestry and tourism are economically important. Area: 483,450sq km (186,675sq mi). Pop. (1991) 27,797.

Yunnan (South of the Clouds) Province in s central China, bounded by Laos and Vietnam (s) and Burma (w); the capital is Kunming. Its remote, mountain location enabled Yunnan to retain an independent status until conquered by the Mongols

in 1253. In 1659 it became a province of China, and it was captured by Chinese communist forces in 1950. Yunnan is divided, along ethnic lines, into eight autonomous districts, which are home to many of China's minority nationalities. It is renowned for the rich diversity of its wildlife, particularly rare plant species. Agriculture is restricted to a few plains, with rice the major crop. Its valuable mineral resources include deposits of tin, tungsten, copper, gold, silver. Mining and timber are the main industries. Area: 436,200sq km (168,482sq mi). Pop. (1990) 36,750,000.

Yurok Native American tribe formerly residing around the estuary of the Klamath River, California, USA, and speaking an Algonquian language. Reduced in number to fewer than 1,000, the group is now scattered along the N Californian coast. **YWCA** Abbreviation of YOUNG WOMEN'S CHRISTIAN ASSOCIATION

YUGOSLAVIA

Yugoslavia's flag was adopted in 1992. Yugoslavia now consists of two republics, Serbia and Montenegro, which were formerly part of the socialist Federal People's Republic of Yugoslavia, which also included Bosnia-Herzegovina, Croatia, Macedonia and Slovenia.

he Federal Republic of Yugoslavia now consists of Serbia and Montenegro. The rump Yugoslav federation has not gained international recognition as the successor to the Socialist Federal Republic of Yugoslavia created by Josip Tito. In 1991 the federation began to disintegrate when SLOVENIA, CROATIA and MACEDONIA declared independence. In 1992 Bosnia-Herze-GOVINA followed suit. A narrow coastal strip on the Adriatic Sea includes Montenegro's capital, Podgorica. The interior of Montenegro consists largely of barren karst, including parts of the DINARIC ALPS and the BALKAN MOUNTAINS. Kosovo is a high plateau region. Serbia is dominated by the fertile lowland plains of the DANUBE, on whose banks lie the capital BEL-GRADE and the N city of Novi SAD. (See individual country/republic articles for pre-1918 history and post-independence events.)

CLIMATE

The coastal Mediterranean climate gives way to the bitterly cold winters of the highlands. Belgrade has a continental climate.

VEGETATION

Forests cover about 25% of the republic, while farmland and pasture cover more than 50%.

HISTORY

Serbian-led demands for the unification of South Slavic lands were a major contributing factor to the outbreak of WORLD WAR 1. In 1918 the "Kingdom of Serbs, Croats and Slovenes" was formed under the Serbian king, PETER I. He was succeeded by ALEXANDER I in 1921. In 1929 Alexander formed a dictatorship and renamed the country Yugoslavia. PETER II's reign was abruptly halted by German occupation (1941) in World War 2. Yugoslav resistance to the fascist puppet regime was stout. The main resistance groups were the communist partisans led by Tito and the royalist chetniks. In 1945 Tito formed the Federal People's Republic of Yugoslavia. In 1948 Yugoslavia was expelled from the Sovietdominated Cominform. Tito adopted an independent foreign policy. In domestic affairs, agricultural collectivization was abandoned (1953), and new constitutions (1963, 1974) devolved power to the constituent republics in an effort to quell unrest. Following Tito's death in 1980, the country's underlying ethnic tensions began to re-surface. In 1986 Slobodan MILŎSEVIĆ became leader of the Serbian Communist Party. In 1989 he became president of Serbia and called for the creation of a "Greater Serbia". Federal troops were used to suppress demands for autonomy in Albanian-dominated Kosovo. In 1990 elections, non-communist parties won majorities in every republic, except Serbia and Montenegro. Serbian attempts to dominate the federation led to the formal secession of Slovenia and Croatia in June 1991. The Serb-dominated Federal army

AREA: 102,173sq km (39,449sq mi) **POPULATION:** 10,469,000

CAPITAL (POPULATION): Belgrade (1,168,454) **GOVERNMENT:** Federal republic

ETHNIC GROUPS: Serb 62%, Albanian 17%, Montenegrin 5%, Hungarian, Muslim, Croat LANGUAGES: Serbo-Croatian (official) RELIGIONS: Christianity (mainly Serbian

Orthodox, with Roman Catholic and Protestant minorities), Islam

currency: Yugoslav new dinar = 100 paras

launched a campaign against the Croats, whose territory included a large Serbian minority. A cease-fire was agreed in January 1992. The European Community (EC) recognized Slovenia and Croatia as separate states. Bosnia-Herzegovina's declaration of independence in March 1992 led to a brutal civil war between Serbs, Croats and Bosnian Muslims. In April 1992 Serbia and Montenegro announced the formation of a new Yugoslav federation and invited Serbs in Croatia and Bosnia-Herzegovina to join. Serbian military and financial aid to the Bosnian Serb campaign of "ethnic cleansing" led the United Nations to impose economic sanctions on Serbia. The threat of further sanctions prompted Milošević to sever support for the Bosnian Serbs. In 1995 Milošević signed the Dayton Peace Accord, which ended the Bosnian war. In 1996 local elections, the Serbian Socialist (formerly Communist) Party was defeated in many areas. In early 1997 massive and prolonged public demonstrations in Belgrade forced Milošević to acknowledge the poll results. Later in 1997 Milošević resigned the presidency of Serbia in order to become president of Yugoslavia. In Montenegro, tension remains high between pro- and anti-independence factions.

ECONOMY

Yugoslavia's lower-middle income economy has been devastated by civil war and economic sanctions (1992 GDP per capita, US\$4,000). Hyperinflation is one of the greatest economic problems. The war has also seen a collapse in industrial production. Natural resources include bauxite, coal and copper. Oil and natural gas are exploited from the N Pannonian plains and the Adriatic Sea. Under Tito, the manufacturing sector was greatly expanded, especially around Belgrade. Manufactures include aluminium, cars, machinery, plastics, steel and textiles. Agriculture remains important.

Z

Zacharias, Saint (d.752) (Zachary) Pope (741–52). He strengthened the Holy See, and during his papacy he achieved a 20-year truce with the LOMBARDS. Along with St BONIFACE, he established cordial relations with the FRANKS by supporting the accession of PEPIN III (THE SHORT) to the Frankish throne.

Zacharias Variant spelling of ZECHARIAH

Zagreb Capital of Croatia, on the River Sava. Founded in the 11th century, it became capital of the Hungarian province of Croatia and Slavonia during the 14th century. The city was an important centre of the 19th-century Croatian nationalist movement. In 1918 it was the meeting place of the Croatian diet, which broke all ties with Austria-Hungary. It later joined a new union with Serbia in what was to become Yugoslavia. In World War 2, Zagreb was the capital of the Axis-controlled, puppet Croatian state. It was wrested from Axis control in 1945, and became capital of the Croatian Republic of Yugoslavia. Following the break-up of Yugoslavia in 1992, Zagreb remained capital of the newly independent state of Croatia. The old city has many places of historical interest, including a Gothic cathedral and a Baroque archiepiscopal palace. Zagreb has a university (founded 1669) and an Academy of Arts and Sciences (1861). It is also the industrial and manufacturing heart of Croatia. Industries: steel, cement, machinery, chemicals. Pop. (1991) 726,770.

zaibatsu Large industrial conglomerates in Japan formed after the Meiji Restoration (1868). Headed by powerful families such as Mitsui and Mitsubishi, they came to dominate the Japanese economy in the early 20th century. Though broken up during the US occupation after 1945, they subsequently reformed and reclaimed their dominant position.

Zaïre (officially Democratic Republic of Congo) Republic in w central Africa. *See* country feature, p.740

Zaïre River See Congo

Zambezi River in s Africa. Rising in NW Zambia, it flows in a rough "S" shape through E Angola and W Zambia before turning E to form part of the Zambian border with Namibia and the entire border with Zimbabwe (including the VICTORIA FALLS). It crosses the widest part of Mozambique and turns set to empty into the Indian Ocean. There is great potential for the generation of hydroelectricity along the river's course, and it has two of Africa's biggest dams: Kariba (Zambia-Zimbabwe) and Cabora Bassa (Mozambique). Length: 2,740km (1,700mi).

Zambia Landlocked republic in s central Africa. *See* country feature, p.741

Zanzibar Island region of TANZANIA, in the Indian Ocean, off the E coast of Africa; the capital is Zanzibar. The first European discovery was by Vasco da Gama in 1499, and the Portuguese quickly established colonial rule. In the late 17th century it came under the control of the Omani Arabs, and developed into the major centre of the East African ivory and slave trade. The slave trade was halted in 1873, and in 1890 the sultanate of Zanzibar was made a British protectorate. In 1963 it became an independent state and a member of the Commonwealth. Tension between the Arab ruling class and indigenous Africans (who formed the majority of the population) led to the overthrow of the sultanate. In 1964 Zanzibar and Tanganyika merged to form the United Republic of Tanzania. Zanzibar retained control over domestic affairs. During the 1980s and 1990s, conflict developed between secessionist and mainland centralist forces. In 1993 a regional parliament for Zanzibar was established. The two largest population groups are the indigenous Hadimu and Tumbatu. The major religion is Sunni Muslim, and the main language is Swahili. The chief export is cloves and the biggest industry is fishing. Area: 1,660sq km (641sq mi). Pop. (1988) 375,539.

Zapata, Emiliano (1880–1919) Mexican revolutionary leader. Zapata's Indian peasant army supported Francisco MADERO's successful coup (1910) against Porfirio DíAZ. Madero's failure to meet his demands for radical agrarian reform, such as the return of *haciendas* (great estates) to native Mexican communal ownership, led to the MEXICAN REVOLUTION. In pursuit of "land and liberty", Zapata captured much of s Mexico. Allied with "Pancho" Villa, he opposed the regimes of Victoriano HUERTA and Venustiano

CARRANZA and captured Mexico City (1914–15). Zapata was murdered by an agent of Carranza.

Zaporizhzhya (Ukrainian, Beyond the rapids) City on the River DNIEPER, SE UKRAINE. The area was settled in the 16th century by Zaporozhye Cossacks, leaders of the Ukrainian nationalist movement. In 1770 Zaporizhzhya was founded as a fortress, and in 1775 the Russian army of Catherine II forced the removal of the Cossacks. In the early 19th century, the fortress became a town, known as Aleksandrovsk until 1921. Zaporizhzhya consists of the old city and the new industrial area, development of which began in the 1930s with the construction of the Dneproges dam and a large hydroelectric plant. It is now one of the Ukraine's leading industrial complexes, producing aluminium, iron and steel, motor vehicles and chemicals. Pop. (1991) 897,000.

Zaragoza (Saragossa) City on the River Ebro, NE Spain; capital of Zaragoza province and Aragón region. The city was taken by the Romans in the 1st century BC and by Moors in the 8th century. In 1118 it was captured by Alfonso I of Aragón, who made it his capital. It was the scene of heroic resistance against the French in the Peninsular War (1808–09). Its main landmark is the Moorish palace of Aljafarería. Other sites include the cathedrals of La Seo and El Pilar. The city is an important commercial and communications centre. At the heart of an agricultural region, it acts as a distribution point for wine, olives and cereal. Industries: heavy machinery, textiles. Pop. (1991) 586,219.

Zarathustra See ZOROASTER

Zatopek, Emil (1922–) Czechoslovakian athlete. He won a gold medal in the 10,000m at the 1948 Olympics and three gold medals (5,000m, 10,000m and the marathon) at the 1952 Olympics. From 1948 to 1954 he was unbeaten over 10,000m. Zealots Jewish sect, active in opposition to Roman rule at the time of Jesus Christ and after. They refused to agree that Jews could be ruled by pagans, led resistance to the Roman census of AD 6, pursued a terrorist campaign, and played an important role in the rising of AD 66. Their activities continued into the 2nd century.

zebra Any of three species of strikingly patterned, striped, black-and-white, equine mammals of the grasslands of Africa; the stripes are arranged in various patterns, according to species. It has long ears, a tufted tail and narrow hooves. Height: to 140cm (55in) at the shoulder. Family Equidae; genus *Equus*.

zebu (Brahman cattle) Numerous, domestic varieties of a single species of ox, native to India. Zebu have been used extensively in Asia and Africa, and have been introduced to the New World as livestock. Species *Bos indicus*.

Zechariah (Zachariah) Any of several biblical personalities. One of the most significant was a Jewish prophet of the late 6th century BC. He prophesied the rebuilding of the TEMPLE in JERUSALEM by the Jews who had returned from exile in BABYLON. In the Book of Zechariah, the 11th book of the 12 minor prophets of the OLD TESTAMENT, he described visions of four horsemen patrolling God's world, four horns symbolizing the destruction of Israel's enemies, and six other night visions prefiguring the coming of God in judgment. Many of Zechariah's images were taken up in the REVELATION of St John the Divine. The other important Zechariah was the priest mentioned in the GOSPEL according to St LUKE as the father of St JOHN THE BAPTIST. According to the New Testament account (Luke 1), Zechariah was visited by the angel GABRIEL, who foretold the birth of John to Zechariah's wife Elizabeth. For doubting Gabriel's prophecy, Zechariah was struck dumb until the time of John's circumcision.

Zedillo, Ernesto (1951–) Mexican statesman, president (1994–). Zedillo joined the Institutional Revolutionary Party (PRI) in 1971, and entered the presidential race after the PRI's candidate Luis Colosio was assassinated (1994). He received just over 50% of the vote. Zedillo promised to combat unemployment and tackle the failing economy. Within a few months, however, he was forced to devalue the peso.

Zeeman effect In physics, effect produced by a strong magnetic field on the light emitted by a radiant body; it is observed as a splitting of its spectral lines. It was first observed in 1896

Z/z, the 26th and last letter of the English alphabet and a letter also included in the alphabets of many other w European languages. It is derived from the Semitic letter zayin, which passed into Greek as zeta where it was given its present form. It was higher up the order in these alphabets (6th or 7th) and was not needed by the Romans until they began to use Greek words in the 2nd century AD, at which time they added it as the last letter of their alphabet. In English z is a consonant, usually pronounced as a voiced counterpart of s, as in zoo. The same letter represents a palatal form of this sound (zh), in such words as seizure and azure.

Zaïre's flag was adopted in 1971. It uses the Pan-African colours first used on the flag of Ethiopia, Africa's oldest independent country. The central emblem, a burning torch, symbolizes the revolutionary spirit of the nation.

aïre (the second-largest country in Africa) Zaire (the second-largest country) Congo basin is the world's second-largest drainage system. Behind a narrow Atlantic coastline, on the opposite bank of the Congo from Brazzaville, lies Zaïre's capital, KIN-SHASA. North central Zaïre consists of a high plateau, 1,000-1,400m (3,300-4,600ft) high, and includes the city of KISANGANI. In the E, the plateau rises to 5,109m (16,762ft) in the RUWENZORI Mountains. Lakes ALBERT and Edward form much of Zaïre's NE border with Uganda. Lake Kivu lies along its border with Rwanda, Lake TANGANYIKA forms the entire border with Tanzania. All the lakes lie in an arm of the Great RIFT VALLEY. The s highland province of Shaba (Katanga) includes Zaïre's second-largest city, Lubumbashi.

CLIMATE

Much of Zaïre has an equatorial climate, which features high temperatures and heavy rainfall throughout the year. The s has a more subtropical climate.

VEGETATION

Dense equatorial rainforests grow in N Zaïre. The s plateau is an area of savanna and swamps.

By c.1000 AD, Bantu-speakers had largely displaced the native pygmy population. From the 14th century large Bantu kingdoms began to emerge. In 1482 a Portuguese navigator became the first European to reach the mouth of the Congo. In the 19th century slave and ivory traders formed powerful states. Henry Morton STANLEY's explorations (1874-77) into the interior established the route of the Congo. In 1878 King LEOPOLD II of Belgium employed Stanley to found colonies along the Congo. In 1885 Leopold proclaimed the foundation of the Congo Free State. Leopold's personal empire was gradually extended, and concessionaires were granted control of the lucrative rubber trade. Sir Roger CASEMENT'S denunciation of the inhuman exploitation of the native population resulted in international criticism. In 1908 Belgium responded by establishing direct control as the colony of Belgium Congo. European companies exploited African labour to develop the copper and diamond mines. Internal opposition to colonial rule was banned. In 1958 the French offered the Congo a free vote on independence. Nationalists in Belgium Congo demanded similar elections. In June 1960 independence was granted as the Republic of the Congo. Patrice LUMUMBA

HISTORY

AREA: 2,344,885sq km (905,365 sq mi) **POPULATION:** 42,552,000

CAPITAL (POPULATION): Kinshasa (3,804,000) GOVERNMENT: Single-party republic ETHNIC GROUPS: Luba 18%, Kongo 16%, Mongo 14%, Rwanda 10%, Azande 6%, Bandi and Ngale 6%, Rundi 4%, Teke, Boa,

Chokwe, Lugbara, Banda LANGUAGES: French (official)

RELIGIONS: Christianity (Roman Catholic 48%, Protestant 29%, indigenous Christian churches 17%), traditional beliefs 3%, Islam

1%

currency: Zaïre = 100 makuta

became prime minister. Belgium had not properly secured institutional changes and the state rapidly fractured. The mineral-rich province of Katanga demanded independence. Belgian troops, sent to protect its citizens and mining interests, were replaced by UN troops. In September 1960 Joseph MOBUTU, commander-inchief of the Congolese National Army, seized power. Lumumba was imprisoned and later murdered. In 1963 UN and government forces combined to force Katanga to drop its demands for secession. Following the withdrawal of UN troops in 1964, Belgium Congo was again plunged into civil war. Belgian troops once more intervened. In 1965 Mobutu proclaimed himself president. Mobutu began a campaign of "Africanization": Leopoldsville became Kinshasa (1966); the country and river renamed Zaïre (1971); Katanga became Shaba (1972); and Mobutu adopted the name Mobutu Sese Seko. Zaïre became a one-party state. Unopposed, Mobutu was re-elected in 1974 and 1977. Political repression and endemic corruption led to renewed civil war in Shaba (1977-78). Secessionist forces were again defeated with European aid. An ailing Mobutu, whose personal wealth was estimated at US\$5 billion, came under increasing pressure to reform. In 1990 he was forced to allow the formation of opposition parties. National elections were repeatedly deferred and a succession of transitional governments remained under Mobutu's control. In 1995 millions of Hutus fled from RWANDA into E Zaïre, to escape possible Tutsi reprisals. In 1996 rebel forces, led by Laurent Kabila, launched a successful offensive against Mobutu's regime. Mobuto was forced into exile. Zaïre was renamed the Democratic Republic of Congo. Kabila's presidency held out the hope of democratic reforms.

ECONOMY

Zaïre is a low-income developing country (1992 GDP per capita, US\$523). It is the world's leading producer of cobalt and the second-largest producer of diamonds (after Australia). Copper is the major export. Zaïre has enormous potential for hydroelectricity; the Inga dam, near Kinshasa, is one of the world's largest. A major economic problem is an inadequate infrastructure, especially the poor standard of the roads. Agriculture employs 71% of the workforce, mainly at subsistence level. Palm oil is the most vital cash crop. Other cash crops include cocoa, coffee, cotton and tea. Food crops include bananas, cassava, maize and rice. Corruption and hyperinflation are major obstacles to economic growth.

by Pieter Zeeman. The effect has been useful in investigating the charge/mass ratio and magnetic moment of an ELECTRON.

Zeffirelli, Franco (1923–) Italian theatre, opera and film director. Zeffirelli worked at Covent Garden on Cavalleria rusticana, at Stratford-upon-Avon on Othello, and on Broadway on The Lady of the Camellias. Renowned for their sumptuous and rich production, his films include The Taming of the Shrew (1966), Romeo and Juliet (1968) and Brother Sun and Sister Moon (1973). His major success, Jesus of Nazareth (1978), was originally made for television.

Zeiss, Carl (1816–88) German manufacturer of optical instruments. In 1846 Zeiss established a factory at Jena and made various optical components, including lenses, binoculars and microscopes.

Zen Japanese school of BUDDHISM, initially developed in China, where it is known as Ch'an. Instead of doctrines and scriptures, Zen stresses mind-to-mind instruction from master to disciple in order to achieve *satori* (awakening of Buddhanature). There are two major Zen sects. **Rinzai** (introduced to Japan from China in 1191) emphasizes sudden enlightenment and meditation on paradoxical statements. The **Soto** sect (also brought from China, in 1227) advocates quiet meditation. In its

secondary emphasis on mental tranquillity, fearlessness and spontaneity, Zen has had a great influence on Japanese art and architecture. Zen priests also inspired Japanese literature, the tea ceremony and the No drama. In recent decades, a number of Zen groups have emerged in Europe and the USA.

Zend-Avesta (AVESTA) Sacred book of ZOROASTRIANISM. The word *Zend* means tradition or commentary.

Zenger, John Peter (1697–1746) US printer and journalist, b. Germany. Editor of the *New York Weekly Journal* (1733), Zenger attacked Governor William Cosby and was jailed for libel in 1734. He was later tried by a jury and acquitted. His case established truth as a defence for libel and made Zenger a symbol of the freedom of the press. He was public printer of New York (1737) and New Jersey (1738).

zenith In astronomy, point on the CELESTIAL SPHERE that is directly overhead. The zenith distance of a heavenly body is the angle it makes with the zenith. It is diametrically opposite the NADIR.

Zenobia Queen of PALMYRA (r. c.267–272). She ruled as regent for her young son after the death of her husband. Palmyra was an ally of Rome, but Zenobia made it so powerful, conquering Egypt in 269, that the Romans resolved to

ZAMBIA

Zambia's flag was adopted when the country became independent from Britain in 1964. The colours are those of the United Nationalist Independence Party, which led the struggle against Britain and ruled until 1991. The flying eagle represents freedom.

Zambia is a landlocked country in s Africa. Most of the country consists of a highland plateau between 900m and 1,500m (2,950ft and 4,920ft) high. The ZAMBEZI and Luangwa river valleys are the only low-lying areas. In the NE, the Muchinga Mountains rise above the flat plateau. The highest peak, 2,067m (6,781ft), lies close to the Lake TANGANYIKA border with Tanzania. Lake Mweru lies on the border with Zaïre. Lake Bangweulu lies in the marshlands of Northern Province. The Zambezi forms Zambia's entire s border with Botswana and Zimbabwe. The spectacular VICTORIA FALLS and the manmade Lake Kariba lie on its banks.

CLIMATE

Although Zambia lies in the tropics, tempera-

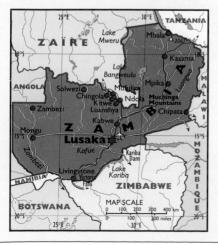

tures and humidity are moderated greatly by altitude. The rainy season lasts from November to March. Rainfall is greatest in the N.

VEGETATION

Grassland and wooded savanna cover much of Zambia. There are also several swamps. Evergreen forests exist in the drier sw.

HISTORY

In c.800 AD Bantu-speakers migrated to the area. By the late 18th century, Zambia was part of the copper and slave trade. The Scottish explorer David LIVINGSTONE made the first European discovery of Victoria Falls in 1855. In 1890 the British South Africa Company, managed by Cecil RHODES, made treaties with local chiefs. The area was administratively divided into NW and NE Rhodesia. Local rebellions were crushed. Intensive mining of copper and lead saw the development of the railroad in the early 1900s. In 1911 the two regions were joined to form Northern Rhodesia. In 1924 Northern Rhodesia became a British Crown Colony. The discovery of further copper deposits increased European settlement and the migration of African labour. In 1946 mineworkers formed the first national mass movement. In 1953 Britain formed the federation of Rhodesia (including present-day Zambia and Zimbabwe) and Nyasaland (now Malawi). In 1963, following a nationwide campaign of civil disobedience, the federation was dissolved. In 1964 Northern Rhodesia achieved independence within the Commonwealth of Nations as the republic of Zambia. Kenneth KAUNDA, leader of the United Nationalist IndeAREA: 752,614sq km (290,586 sq mi)

POPULATION: 9,196,000

CAPITAL (POPULATION): Lusaka (982,000)
GOVERNMENT: Multiparty republic

ETHNIC GROUPS: Bemba 36%, Maravi (Nyanja)

18%, Tonga 15%

LANGUAGES: English (official)

RELIGIONS: Christianity (Protestant 34%, Roman Catholic 26%, African Christians 8%).

traditional beliefs 27%

CURRENCY: Kwacha = 100 ngwee

pendence Party (UNIP), became Zambia's first president. Zambia was faced with problems of national unity, European economic dominance, and tension with the white-minority government in Rhodesia. Following his re-election in 1968, Kaunda established state majority holdings in Zambian companies. Zambia supported the imposition of economic sanctions on Rhodesia. In 1972 Kaunda banned all opposition parties, and won the uncontested 1973 elections. In 1990 a new multiparty constitution was adopted. The Movement for Multiparty Democracy (MMD) won a landslide victory in 1991 elections. The MMD leader, Frederick Chiluba, became president. In 1993 Chiluba declared a state of emergency. Legislation excluded Kaunda from contesting the 1996 presidential elections. Chiluba was resoundingly re-elected following a UNIP boycott. The government faced charges of electoral fraud. In 1997 a military coup was crushed.

ECONOMY

Zambia is the world's fifth-largest producer of copper ore, which accounts for 80% of exports. It is also the second-largest producer of cobalt ore. Zambia also mines lead, zinc and silver. Zambia's dependence on mineral exports constitutes a structural imbalance. The MMD's introduction of free market reforms and privatization has seen a large influx of aid and the reduction of national debt. Agriculture employs 38% of the workforce. Maize is the chief food crop. Cash crops include cassava, coffee, sugar cane and tobacco.

Z

crush her. Aurelian defeated her in Syria, and captured Palmyra in 272.

Zeno of Citium (*c*.334–*c*.262 BC) Greek philosopher and founder of the STOICS. Zeno attended lectures by various philosophers before formulating his own philosophy. Proceeding from the CYNIC concept of self-sufficiency, he stressed the unity of the universe and the brotherhood of men living in harmony with the cosmos. Zeno claimed virtue to be the only good and wealth, illness and death to be of no human concern. **Zeno of Elea** (495–430 BC) Greek philosopher. A disciple of Parmenides, he sought to reveal logical absurdities in theories of motion and change, using paradoxical arguments.

zeolite Group of alumino-silicates that contain sodium, calcium or barium and loosely held water that can be continuously expelled on heating. Some zeolites occur as fibrous aggregates, while others form robust, non-fibrous crystals. Zeolites vary in hardness from 3 to 5 and in specific gravity from 2 to 2.4. They include analcime, NaAlSi₂O₆·H₂O, stilbite, NaCa₂ (Al₅Si₁₃)O₃₆·14H₂O, and natrolite, Na₂Al₂Si₃O₁₀·2H₂O.

Zephaniah (active *c.*630 BC) OLD TESTAMENT prophet. Zephaniah was named as the author of the Book of Zephaniah, the ninth of the 12 books of the Minor Prophets. He condemned Israel's religious and political corruption and stressed the certainty of God's judgment against Israel.

Zeppelin, Ferdinand, Count von (1838–1917) German army officer and inventor. Zeppelin served in the armies of Württemburg and Prussia. While an observer with the Union army during the US Civil War (1861–65) he made his first balloon ascent. In 1900 he invented the first rigid airship, which was called Zeppelin after him.

Zeus In Greek mythology, the sky god, lord of the wind, clouds, rain and thunder. He is identified with the Roman god, JUPITER. Zeus was the son of Rhea and Cronus, whom he deposed. Zeus was the supreme deity of the Olympians. He fathered huge numbers of children by his wives and others, often seducing goddesses, nymphs and mortal women, by taking the form of an animal.

Zhao Ziyang (1918–) Chinese statesman, who played a leading part in China's economic modernization. Zhao joined the Chinese COMMUNIST PARTY in 1938 and during the 1960s acted as party secretary of Guangdong province. He was dismissed by MAO ZEDONG during the CULTURAL REVOLUTION, but rehabilitated and restored to his post in 1971. In 1975 he was appointed party secretary of Sichuan province. Zhao introduced radical economic reforms, which vastly improved industrial and agricultural production. He was made premier in 1980. In 1987 LI PENG replaced him as premier and Zhao became general secretary. With the support of DENG XIAOPING, his liberal economic reforms moved China towards a market economy. In 1989 Zhao was dismissed from office and placed under house arrest for advocating negotiation with the prodemocracy demonstrators in TIANANMEN SQUARE.

Zhejiang (Chekiang) Province in SE China, s of the River Yangtze and on the East China Sea; the capital is Hangzhou. It was the centre of the Sung dynasty in the 12th and 13th centuries. Many of Zhejiang's cities were razed during the Taiping Rebellion (1850–65). A mountainous region, it is one of China's most populous areas and includes the Zhoushan Archipelago. To encourage inward capital investment, it is part of the special economic zone of Shanghai. The major river is the Qiantang. Mount Tianmu is on the tourist and pilgrimage trails. Over a third of the region is pine or bamboo forest. The chief crops are rice and tea. Major industries include silk production and fishing. Area: 101,830sq km (39,300sq mi). Pop. (1990) 40,840,000.

Zhou Chinese dynasty (1030–221 BC). After the nomadic Zhou overthrew the SHANG dynasty, Chinese civilization spread to most parts of modern China, although the dynasty never established effective control over the regions. The Late Zhou, from 772 BC, was a cultural golden age, marked by the writings of Confucius and Lao Tzu, and a period of rising prosperity. As the provincial states grew in power, the Zhou dynasty disintegrated.

Zhou Enlai (1898–1976) Chinese statesman. Zhou was a founder of the Chinese COMMUNIST PARTY. As a member of the

Communist-Kuomintang alliance (1924-27), he directed the general strike (1927) in Shanghai. When CHIANG KAI-SHEK broke the alliance, Zhou joined the Long March (1934-35). He was the chief negotiator of a renewed peace (1936-46) with nationalist forces. After the establishment of a communist republic, Zhou became prime minister (1949-76) and foreign minister (1949-58). Although publicly supportive of the Cul-TURAL REVOLUTION, he protected many of its intended victims. Zhu De (1886–1976) Chinese communist military leader. Zhu helped to overthrow (1912) the MANCHU dynasty. In 1922 he met ZHOU ENLAI and joined the Chinese Communist Party. In 1928 Zhu joined forces with MAO ZEDONG, and led his section of the Fourth Red Army on the LONG MARCH (1934-35). Commander in chief during the Second Sino-Japanese War, he retained the post after the establishment of a communist republic (1949). Zhu held several important party posts before being denounced during the CULTURAL REVOLUTION.

Zhukov, Georgi Konstantinovich (1896–1974) Soviet military commander and politician. Zhukov fought in the Russian Revolution (1917) and in the ensuing civil war (1918–20). During World War 2 he led the defence of Moscow (1941) and defeated the German siege of Stalingrad and Leningrad (1943). In 1945 Zhukov led the final assault on Berlin. After STALIN's death, he became defence minister (1955). Although supportive of Nikita Khruschev's reforms, he was removed from office in 1957. He was rehabilitated in the 1960s, receiving the Order of Lenin in 1966.

Ziegler, Karl (1898–1973) German chemist. Ziegler shared the 1963 Nobel Prize for chemistry with Giulio Natta for research into POLYMERS. He discovered a technique that used a resin with metal ions attached as a catalyst in the production of POLYETHYLENE. He also conducted research into aromatic compounds and organometallic compounds.

ziggurat Religious monument originating in Babylon and Assyria. It was constructed as a truncated, stepped Pyramid, rising in diminishing tiers, usually square or rectangular. The shrine at the top was reached by a series of ramps. Ziggurats date from 3000–600 BC, and the one at UR still stands.

Zimbabwe Republic in s central Africa. *See* country feature **zinc** (symbol Zn) Bluish-white, metallic element of group II of the periodic table, known from early times. Chief ores are SPHALERITE, smithsonite and calamine. Zinc is a vital trace element, found in erythrocytes. It is used in many alloys, including brass, bronze, nickel and soft solder. It is corrosiveresistant and used in galvanizing iron. Zinc oxide is used in cosmetics, pharmaceuticals, paints, inks, pigments and plastics. Zinc chloride is used in dentistry and to manufacture batteries and fungicides. Properties: at.no. 30; r.a.m. 65.38; r.d. 7.133; m.p. 419.6°C (787.3°F); b.p. 907°C (1,665°F); most common isotope Zn⁶⁴ (48.89%).

Zinnemann, Fred (1907–97) US film director, b. Austria. Zinnemann won his first Academy Award for the short film *That Mothers Might Live* (1938). He moved into commercial features and won his second Oscar for the western *High Noon* (1952). Zinneman won a third award for *A Man For All Seasons* (1966). Other films include *From Here to Eternity* (1953) and *Julia* (1978). His autobiography *A Life in the Movies* was published in 1992.

Zinoviev, Grigori Evseyevich (1883–1936) Russian revolutionary. A self-educated lawyer, Zinoviev joined the Bolsheviks in 1903, and was active in the Russian Revolution of 1905. He was a close collaborator of Lenin in exile (1908–17). In the Russian Revolution (1917), Zinoviev voted against seizing power but remained a powerful figure in ST Petersburg and was appointed head of the Communist International in 1919. Though he sided with Stalin against Trotsky in 1922, Zinoviev was later expelled from the party and eventually executed. The "Zinoviev letter" (1924), urging the British Communist Party to revolt, may have contributed to the subsequent electoral defeat of the Labour government, but has since proved to be a forgery.

Zion Hill in E Jerusalem, Israel. Zion was originally the hill on which a Jebusite fortress was built. It now refers to the hill on which the TEMPLE was built. It is a centre of Jewish spiritual life and symbolic of the Promised Land.

7

Zionism Jewish nationalist movement advocating the return of Jews to the land of Zion (Palestine). Though it represents a desire expressed since the Jewish DIASPORA began in the 6th century BC, the modern Zionist movement dates from 1897, when Theodor Herzl established the World Zionist Congress at Basel, Switzerland. In 1917 it secured British approval for its objective in the BALFOUR DECLARATION, and Jewish immigration to Palestine increased in the 1920s and 1930s. In 1947 the United Nations voted to partition Palestine between Jews and Arabs, leading to the foundation of the state of Israel.

zircon Orthosilicate mineral, zirconium silicate (ZrSiO₄), found in IGNEOUS and METAMORPHIC rocks and in sand and gravel. It displays prismatic crystals. It is usually light or reddish brown, but can be colourless, grey, yellow or green. It is used widely as a gemstone because of its hardness and high refractive index. Hardness 7.5; s.g. 4.6.

zirconium (symbol Zr) Greyish-white, metallic element, one of the TRANSITION ELEMENTS. Zirconium was first discovered in 1789 by the German chemist Martin Klaproth, and its

chief source is ZIRCON. Lunar rocks collected during the Apollo space missions show a higher content of zirconium than Earth ones, and zirconium exists in meteorites and stars, including the Sun. Chemically similar to titanium, it is used in ceramics and in alloys for wire and absorption of neutrons in nuclear reactors. Properties: at.no. 40; r.a.m. 91.22; r.d. 6.51; m.p. 1,852°C (3,366°F); b.p. 4,377°C (7,911°F); most common isotope Zr⁵⁰ (51.46%).

zither STRINGED INSTRUMENT. It consists of a resonator in the form of a wooden box with 30 to 45 strings stretched over it. A few of the strings are stretched over a fretted board for melody; the rest are used for accompaniment. The melody strings are plucked with the fingers or a plectrum.

zodiac (Gk. circle of animals) Belt on the celestial sphere that forms the background for the motions of the Sun, Moon and planets (except Pluto). The zodiac is divided into twelve **signs**, which are named after the constellations they contained at the time of the ancient Greeks: Aries, Taurus, Gemini, Cancer, Leo, Virgo, Libra, Scorpio, Sagittarius, Capricorn, Aquarius

ZIMBABWE

Zimbabwe's flag, adopted in 1980, is based on the colours used by the ruling Zimbabwe African National Union Patriotic Front (ZANU-PF). Within the white triangle is the Great Zimbabwe soapstone bird, the national emblem. In Bantu, Zimbabwe means stone house.

Zimbabwe is a landlocked country in s Africa. It consists mainly of a plateau 900 to 1,500m (2,950 to 4,900ft) high, between the ZAMBEZI and LIMPOPO rivers. The principal land feature is the High Veld, a ridge running from NE to SW. HARARE lies on the NE edge of the ridge. BULAWAYO lies on the sw edge. The Middle Veld is the site of many large ranches. Below 900m (2,950ft) is the Low Veld. Highlands lie on the E border with Mozambique.

CLIMATE

The subtropical climate varies according to altitude. The Low Veld is much warmer and drier than the High Veld. November to March is mainly hot and wet. Winter in Harare is dry but cold.

VEGETATION

Wooded savanna covers much of Zimbabwe. The Eastern Highlands and river valleys are forested. There are many tobacco plantations.

HISTORY AND POLITICS

Bantu-speakers migrated to the region in AD 300. By 1200 the SHONA had established a kingdom in Mashonaland, E Zimbabwe. GREAT ZIMBABWE was the capital of this advanced culture. Portugal formed trading links in the early 16th century. In 1837 the Ndebele displaced the Shona from w Zimbabwe, and formed Matabeleland. In 1855 David LIVINGSTONE made the first European discovery of VICTORIA FALLS. In 1888 Matabeleland became a British protectorate. In 1889 the British South Africa Company, under Cecil RHODES, was granted a charter to exploit the region's mineral wealth. Native revolts were crushed and the area became Southern Rhodesia (1896). In 1923 it became a British crown colony. European settlers excluded Africans from participation in the government and economy. In 1953 Southern Rhodesia, Northern Rhodesia (now Zambia) and Nyasaland (Malawi) became a federation. In 1961 Joshua Nkomo formed the Zimbabwe African People's Union (ZAPU). In 1963 the federation dissolved and African majority governments were formed in Zambia and Malawi. Southern Rhodesia became simply Rhodesia. Robert MUGABE formed the Zimbabwe African National Union (ZANU). In 1964 the white nationalist leader Ian SMITH became prime minister. Nkomo and Mugabe were imprisoned. In 1965 Smith made a unilateral declaration of independence (UDI) from Britain. The UN imposed economic sanctions. In 1969 Rhodesia became a republic. In 1974 Nkomo and Mugabe were released. Smith's refusal to implement democratic reforms intensified the guerrilla war between ZAPU and ZANU rebels and the Smith government aided by South Africa's apartheid regime. The 1979 Lancaster AREA: 390,579sq km (150,873sq mi)

POPULATION: 10,583,000

CAPITAL (POPULATION): Harare (1,184,169) GOVERNMENT: Multiparty republic ETHNIC GROUPS: Shona 71%, Ndebele 16%, other Bantu-speaking Africans 11%,

Europeans 2%

LANGUAGES: English (official)

RELIGIONS: Christianity 45%, traditional beliefs

40%

currency: Zimbabwe dollar = 100 cents

House Agreement established a timetable for full independence. ZANU won a decisive victory in 1980 elections and Robert Mugabe became prime minister. In 1982 Nkomo was dismissed from the cabinet. Mugabe was decisively re-elected in 1985. In 1987 ZANU and ZAPU merged. The post of prime minister was abolished as Mugabe became executive president. In 1988 Nkomo became vice president. Despite the formation of an opposition party, the Zimbabwe Unity Movement, Mugabe was easily re-elected in 1990. In 1991 ZANU-PF abandoned Marxism. In 1996 Mugabe was elected for a fourth term.

ECONOMY

Zimbabwe is a low-income developing country (1992 GDP per capita US\$1,970). The postindependence emigration of most of the white population removed vital capital. The government's redistribution of land to the African population via compulsory purchase schemes has been tainted by government corruption. Agriculture employs 70% of the workforce. Zimbabwe is the world's largest exporter of tobacco. Other cash crops include cotton, sugar and beef. Maize is the main food crop. It has valuable mineral resources, especially around the Great Dyke, a low ridge that crosses the High Veld. Mining accounts for 20% of exports. Zimbabwe is the world's fourth-largest producer of asbestos and fifth-largest producer of chromium ore. Gold and nickel are mined. In 1990 the government began to introduce free market reforms. The restructuring of the command economy has resulted in high unemployment. The servicing of national debt remains an economic problem.

▲ Zola Born in Paris, the son of an Italian engineer, Émile Zola worked as a journalist before becoming a short-story writer and novelist. With Flaubert, the Goncourts and Turgenev, he helped develop the "naturalist school", which held that the novel should be strictly scientific. To this end, Zola employed scientific techniques and observations in his novels, often describing professions and lifestyles in minute, and sometimes sordid, detail. He died by accidentally inhaling charcoal fumes from a blocked chimney.

and Pisces. The constellations inside the Zodiac do not now correspond to those named by the ancients, because precession of the Earth's axis has meanwhile tilted the Earth in a different direction. To modern astronomers the zodiac has only historical significance. See also ASTROLOGY; ASTRONOMY

Zola, Émile Edouard Charles Antoine (1840–1902) French novelist. Zola became widely known following the publication of his third book, the novel *Thérèse Raquin* (1867). For the next quarter of a century he worked on what became the Rougon-Macquart sequence (1871–93), a 20-novel cycle telling the story of a family during the Second Empire; it established Zola's reputation as the foremost exponent of NATURALISM in fiction. The sequence includes his famous novels *The Drunkard* (1877), *Nana* (1880), *Germinal* (1885) and *The Human Animal* (1890). In 1898 he wrote a famous letter, beginning "J'Accuse", which denounced the punishment of Alfred Dreyfus. This led to a brief exile in England and, after the vindication of Dreyfus, a hero's return. *See also* DREYFUS AFFAIR

Zollverein German customs union formed in 1834 by 18 German states under Prussian leadership. By reducing tariffs and improving transport, it promoted economic prosperity. Nearly all other German states joined the Zollverein by 1867, despite Austrian opposition. It represented the first major step towards the creation of the German empire (1871).

zoo (zoological gardens) Public or private institution in which living animals are kept and exhibited. Wild animals have been kept in captivity since the beginning of recorded history. Organized public zoos, sometimes called menageries or aquariums (for fish), have been operating for more than 500 years in Europe. Today, non-profit-making organizations or zoological societies run most zoos in a scientific manner. They are organized for public recreation as well as for scientific and educational purposes. The emphasis is on conservation of endangered species and exhibiting animals in natural settings. zoology Study of animals; combined with BOTANY, it comprises the science of BIOLOGY. It is concerned with the structure of the animal and the way in which animals behave, reproduce and function, their evolution and their role in interactions with humankind and their environment. There are various subdivisions of the discipline, including TAXONOMY, ECOLOGY, PALAEONTOLOGY, ANATOMY, and zoogeography (the distribution of animals). ANTHROPOLOGY is an extension of zoology. See also EMBRYOLOGY; GENETICS; MORPHOLOGY

zoonosis Any infection or infestation of VERTEBRATES that is transmissible to human beings.

zooplankton Animal portion of the PLANKTON. It consists of a wide variety of microorganisms, including COPEPOD and larval forms of higher animals. It is an important constituent of the ocean's food chain. There are few levels or areas of the ocean that have no zooplankton.

Zoroaster (c.628–c.551 BC) (Zarathustra) Ancient Persian (Iranian) religious reformer and founder of ZOROASTRIANISM. At the age of 30, he saw the divine being AHURA MAZDAH in the first of many visions. Unable to convert the petty chieftains of his native region, Zoroaster travelled to E Persia, where in Chorasmia (now in Khorasan province, NE Iran) he converted the royal family. By the time of Zoroaster's death (tradition says that he was murdered while at prayer), his new religion had spread to a large part of Persia. Parts of the AVESTA, the holy scripture of Zoroastrianism, are believed to have been written by Zoroaster himself.

Zoroastrianism Religion founded by ZOROASTER in the 6th century BC. It was the state religion of PERSIA from the middle of the 3rd century AD until the mid-7th century. Viewing the world as being divided between the spirits of good and evil, Zoroastrians worship AHURA MAZDAH as the supreme deity, who is forever in conflict with Ahriman, the spirit of evil. They also consider fire sacred. The rise of Islam in the 7th century led to the decline and near disappearance of Zoroastrianism in Persia. Today, the Parsi comprise most of the adherents of Zoroastrianism, which has its main centre in BOMBAY, India.

Zulu Bantu people of South Africa, most of whom live in KwaZulu-Natal. They are closely related to the Swazi and the Xhosa. The Zulus have a patriarchal, polygamous society

with a strong militaristic tradition. Traditionally cereal farmers, they possessed large herds of cattle, considered to be status symbols. Under their leader Shaka, they fiercely resisted 19th-century colonialism. The predominant religion is now Christianity, although ethnic religions are still common. They are organized politically into the INKATHA movement under Chief Mangosutho BUTHELEZI.

Zululand Historic region of South Africa, now part of KwaZulul-Natal.

Zulu War (1879) Conflict in South Africa between the British and the Zulu. Fearing a Zulu attack, the Afrikaners of Transvaal requested British protection. The British high commissioner demanded that the Zulu king, Cetewayo, disband his army. He refused, and the Zulu made a surprise attack at Isandhlwana, killing 800 British soldiers. Lacking modern weapons, the Zulu were checked at Rorke's Drift and decisively defeated at Ulundi.

Zuni Pueblo Native Americans who live on the Zuni reservation in w New Mexico, USA. The present pueblo is on the site of one of the seven Zuni villages discovered by Marcos de Niza in the early 16th century and identified as the mythical Seven Cities of Cibola. In 1540 CORONADO sacked the villages, and following a revolt in 1680 the Pueblo abandoned the site for fear of Spanish reprisal. Modern Zuni maintain their tradition and skills.

Zürich City on the River Limmat, at the NW end of Lake Zürich, in the foothills of the Alps, N Switzerland; the country's largest city. Conquered by the Romans in 58 BC, the city later came under Alemanni and then Frankish rule. It became a free imperial city in 1218 and joined the Swiss Confederation in 1351. In the 16th century it was a focal point of the Swiss Reformation. Ulrich Zwingli founded Swiss Protestantism at Zürich's cathedral in 1523. In the 18th and 19th centuries, the city developed as a cultural and scientific center. It has the Swiss National Museum and many old churches. Zürich is the commercial hub of Switzerland and has numerous banking and financial institutions. Industries: motor vehicles, machinery, paper, textiles, electrical products, printing and publishing, tourism. Pop. (1991) 840,000.

Zwingli, Ulrich (1484–1531) Swiss Protestant theologian and reformer. Zwingli was ordained as a Roman Catholic priest in 1506, but his studies of the New Testament in Erasmus' editions led him to become a reformer. By 1522 he was preaching reformed doctrine in Zürich, a centre for the Reformation. More radical than Martin Luther, Zwingli regarded communion as mainly symbolic and commemorative. He died while serving as a military chaplain with the Zürich army during a battle against the Catholic cantons at Kappel.

Zworykin, Vladimir Kosma (1889–1982) US physicist and inventor, b. Russia, a pioneer of TELEVISION. In 1929 Zworykin joined the Radio Corporation of America (RCA), becoming its director of electronic development and (in 1947) a vice president. Zworykin and his colleagues developed the iconoscope, the forerunner of the modern television camera tube, and the kinescope, a CATHODE-RAY TUBE for TV sets. In 1928 he patented a colour television system. He also invented the ELECTRON MICROSCOPE and developed a secondary emission multiplier for a sensitive radiation detector. In 1967 Zworykin received the National Medal of Science for his inventions and contributions to medical research.

zygote In sexual reproduction, a cell formed by fusion of a male and a female GAMETE. It contains a DIPLOID number of CHROMOSOMES, half contributed by the SPERM, half by the OVUM. Through successive cell divisions, the zygote will develop into an EMBRYO.

Zyuganov, Gennady (1944—) Russian politician. During the 1970s and 1980s, Zyuganov moved up the Soviet Communist Party hierarchy, taking positions focused on ideology and propaganda. In 1993 he became chairman of the executive committee of the reconstituted Russian Communist Party and was elected to the State Duma (the lower house of the Russian parliament). The Communist Party gained the largest number of votes in 1995 elections and Zyuganov mounted a strong challenge in the 1996 presidential elections. He was defeated by a coalition of Boris Yeltsin and Aleksander Lebed.

READY REFERENCE

PROFILE OF THE EARTH

11-111

VIII-IX

XIII

Planet Earth Inside the Earth Selected Earth records Climate records **Beaufort scale** Wind-chill factors Continents Oceans Longest rivers **Highest mountains** Largest islands Largest inland lakes and seas Major earthquakes **Highest waterfalls**

PEOPLES AND COUNTRIES IV

World population Most populous countries Least populous countries Largest countries **Smallest countries** Largest cities **Richest countries** Largest economies Energy sources by nation World tourism Major established religions Major languages Transport networks

SCIENCE AND NUMBERS V-VII **Abundance of elements** Alloys SI units Roman numerals Gemstones SI derived units **Physical constants** Chemical elements Geometric shapes (plane figures) Mohs' scale of hardness Geometric figures Conversions Selected relative densities **Prime numbers** Squares, cubes and roots Power of numbers Perfect numbers SI prefixes

Polygons

LEADERS US presidents **UK** prime ministers German chancellors French leaders Canadian prime ministers Spanish prime ministers UN secretaries-general Russian and Soviet leaders Japanese emperors Australian prime ministers New Zealand prime ministers South African leaders Indian prime ministers Popes since AD 1000 Chinese leaders

SPORT

X-XII

Summer Olympic Games Winter Olympic Games 1996 Summer Olympic Games gold medallists 1996 Summer Olympic Games leading medal winners Skiing World Cup **Athletics World Championship** venues Formula 1 motor racing champion drivers and teams FIFA World Cup football finals **UEFA European Championship** European Cup **European Cup-Winners Cup UEFA Cup English Football League winners English FA Cup Tour de France British Open golf champions**

Rugby Union World Cup **Rugby Union Five Nations** Championship Gymnastics world champions Ice skating world champions Hockey world champions Snooker world champions Commonwealth Games venues Cricket World Cup finals Cricket UK county champions **English Grand National Epsom Derby**

Wimbledon singles champions

Davis Cup

SIGNS AND SYMBOLS Musical symbols Greek alphabet Codes and alphabets Chess - opening position Mathematical symbols Symbols in common use **NATO** alphabet Accents

GENERAL INFORMATION XIV-XVI Seven Wonders of the World Greek gods of mythology Roman gods of mythology Kings and queens of England and

Britain Kings of France Russian tsars Basic time periods Months of the year Days of the week Easter 1998-2006 Chinese calendar Signs of the zodiac Major fixed Christian feasts Movable Christian feasts Notable national days Year spans Aristocratic ranks (UK) **Nobel Peace Prize** Academy Awards ("Oscars") **Best Film Poets Laureate**

Plays of William Shakespeare **Booker Prize Archbishops of Canterbury** Chess world champions Vehicle production **European Union members** Longest rail and road tunnels Military officer ranks (UK)

PLANET EARTH

Mean distance from the Sun 149,500,000km (92,860,000mi) Average speed around the Sun 108,000km/h (66,600mph) Age c.4,500,000,000 years

5,975 million million million tonnes Mass 5,515 times that of water Density

1,083,207,000,000cu km (260,000,000,000cu mi) 509,450,000sq km (196,672,000sq mi) Volume

Area

149,450,000sq km (57,688,000sq mi) = 29.3% of total area Land surface 360,000,000sq km (138,984,000sq mi) = 70.7% of total Water surface area

Equatorial circumference 40.075km (24.902mi) Polar circumference 40.008km (24.860mi) 12,756km (7,926mi) Fauatorial diameter 12,714km (7,900mi) Polar diameter

INSIDE THE EARTH							
Density Temp		erature	State	Thickness			
2.8	< 500°C	(930°F)	Solid	0-30km	(0-18mi)		
2.9	< 1,100°C	(2,010°F)	Solid	20-80km	(12-50mi)		
4.3	< 1,400°C	(2,550°F)	Molten	c.700km	(435mi)		
5.5	< 1.700°C	(3,090°F)	Solid	c.1,700km	(1,050mi)		
10.0	< 2,300°C	(4,170°F)	Molten	c.2,100km	(1,305mi)		
13.5	< 5,500°C	(9,930°F)	Solid	c.1,370km	(850mi		
	2.8 2.9 4.3 5.5 10.0	Density Temp 2.8 < 500°C 2.9 < 1,100°C 4.3 < 1,400°C 5.5 < 1,700°C 10.0 < 2,300°C	Density Temperature 2.8 < 500°C	Density Temperature State 2.8 < 500°C	Density Temperature State Thic 2.8 < 500°C		

SELECTED EARTH RECORDS

Greatest tides Deepest gorge Longest gorge Deepest lake Highest navigable lake Deenest cave Longest cave system

Deepest valley

Longest glacier

Bay of Fundy, Nova Scotia, Canada, 16.3m (53.5ft) River Colca, Peru, 3,205m (10,515ft)

Grand Canyon, Arizona, USA, 350km (217mi) Lake Baikal, Siberia, Russia, 1,620m (5,315ft) Lake Titicaca, Peru/Bolivia, 3,812m (12,506ft)

Réseau Jean Bernard, Haute-Savoie, France, 1,602m (5,256ft) Mammoth Cave, Kentucky, USA, 560km (348mi)

Kali Gandaki, Nepal, 5,883m (19,300ft) Lambert-Fisher Ice Passage, Antarctica, 515km (320mi)

Dead Sea, Israel/Jordan, 395m (1,296ft) Deepest depression

CLIMATE RECORDS

Temperature

Highest recorded temperature: Al Aziziyah, Libya, 58°C (136.4°F), 13 September 1922 Highest mean annual temperature: Dallol, Ethiopia, 34.4°C (94°F), 1960-66 Longest heatwave: Marble Bar, w Australia, 162 days over 38°C (100°F), 23 October 1923 to 7 April 1924

Lowest recorded temperature (outside poles): Verkhoyansk, Siberia, -68°C (-90°F), 6 February 1933*

Lowest mean annual temperature: Polus Nedostupnosti (Pole of Cold) Antarctica, -57.8°C (-72°F)

Precipitation

Driest place: Arica, N Chile, 0.8mm (0.03in) per year (60-year average) Longest drought: Calama, N Chile. No recorded rainfall in 400 years to 1971 Wettest place (average): Tututendo, Colombia. Mean annual rainfall 11,770mm (463.4in) Wettest place (12 months): Cherrapunji, Meghalaya, NE India, 26,470mm (1,040in), August 1860 to August 1861

Wettest place (24-hour period): Cilaos, Réunion, Indian Ocean, 1,870mm (73.6in), 15-16 March 1952

Heaviest hailstones: Gopalganj, Bangladesh, up to 1.02kg (2.25lb), 14 April 1986[‡] Heaviest snowfall (continuous): Bessans, Savoie France, 1,730mm (68in) in 19 hours, 5-6 April 1969

Heaviest snowfall (season/year): Paradise Ranger Station, Mt Rainier, Washington, USA, 31,102mm (1,224.5in), 19 February 1971 to 18 February 1972

Pressure and winds

Highest barometric pressure: Agata, Siberia, 1,083.8mb (32in) at altitude 262m (862 ft), 31 December 1968

Lowest barometric pressure: Typhoon Tip, 480km (300mi) w of Guam, Pacific Ocean, 870mb (25.69in), 12 October 1979

Highest recorded wind speed: Mt Washington, New Hampshire, USA, 371km/h (231mph), 12 April 1934[§]

Windiest place: Commonwealth Bay, George V Coast, Antarctica, where gales reach over 320km/h (200mph)

- Verkhovansk also registered the greatest annual range of temperature: -70°C to 37°C (-94°F to 98°F)
- † Cherrapunji also holds the record for rainfall in one month: 930mm (37in) fell in July 1861
- ‡ Killed 92 people
- § Three times as strong as hurricane force on the Beaufort Scale

	sq km	sq mi
Europe		
Great Britain [8]	229,900	88,700
Iceland	103,000	39,800
Ireland	84,400	32,600
Novaya Zemlya (N)	48,200	18,600
Sicily	25,700	9,900
Corsica	8,700	3,400
Asia		
Borneo [3]	743,000	287,400
Sumatra [6]	425,000	164,000
Honshū [7]	230,800	89,100
Sulawesi	189,200	73,000
Java	126,500	48,800
Luzon	104,700	40,400
Mindanao	95,000	36,600
Hokkaidō	83,500	32,200
Sakhalin Sri Lanka	76,400 65,600	29,500 25,300
011 241114	03,000	23,300
Africa Madagascar [4]	587,000	226,700
Socotra	3,100	1,200
Réunion	2,510	969
North America		
Greenland [1]	2,175,000	840,000
Baffin Island [5]	507,500	195,900
Victoria Island [9]	212,200	81,900
Ellesmere Island [10]	196,200	75,800
Cuba	110,860	42,800
Newfoundland	96,000	37,100
		29,500
Hispaniola Jamaica	76,500	4,200
Puerto Rico	11,000 8,900	3,400
	8,900	3,400
South America Tierra del Fuego	47,000	18,100
Falkland Island (E)	6,800	2.600
	0,000	2,000
Oceania* New Guinea [2]	885,800	342,000
New Zealand (s)	150,500	58,100
New Zealand (N)	114,700	44,300
New Zealand (N)	68,300	26,400
Tasmania		

* Geographers consider Australia to be a continental landmass

LARGEST INLAND LAKES AND SEAS Location

	Location	Sq KIII	sq iiii
Europe			
Lake Ladoga	Russia	17,700	6,800
Lake Onega	Russia	9,600	3,700
Saimaa system	Finland	8,000	3,100
Vänern	Sweden	6,500	2,100
Asia Caspian Sea [1]	W. Central Asia	371,000	143,000
Aral Sea* [6]	Kazakstan/	33,640	13.000
,	Uzbekistan	,-	,
Lake Baikal [9]	Russia	31,500	12,200
Tonlé Sap	Cambodia	20,000	7,700
Lake Balkhash	Kazakstan	18,400	7,100
		-	
Africa Victoria Nyanza [3]	East Africa	68.000	26,000
Lake Tanganyika [7]	Central Africa	33,000	12,700
Lake Malawi [10]	East Africa	29,600	11,400
Lake Chad	Central Africa	26,000	10,000
Lake Turkana	Ethiopia/Kenya	8,500	3,300
Lake Volta [†]	Ghana	8,480	3,250
North America			
Lake Superior [2]	Canada/USA	82,400	31,800
Lake Huron [4]	Canada/USA	59,600	23,010
Lake Michigan [5]	USA	58,000	22,300
Great Bear Lake [8]	Canada	31,800	12,280
Great Slave Lake	Canada	28,400	11,000
Lake Erie	Canada/USA	25,700	9,900
Lake Winnipeg	Canada	24,500	9,500
Lake Ontario	Canada/USA	19,700	7,600
Lake Nicaragua	Nicaragua	8,000	3,100
South America			
Lake Titicaca [‡]	Bolivia/Peru	8,300	3,200
Lake Poopó	Peru	2,800	1,100
Australia			
Lake Eyre§	Australia	9,300	3,600
Lake Torrens§	Australia	5,800	2,200
Lake Gairdner§	Australia	4,800	1,900

* Shrinking in area due to environmental factors: until the 1980s it was the world's 4th largest † Artificial lake created by Akosombo Dam (1966) ‡ Lake Maracaibo, in Venezuela, is far larger at 13,260 sq km (5,120 sq mi), but is linked to the Caribbean by a

narrow channel and therefore not an "inland" lake § Salt lakes that vary in size with rainfall

BEAUFORT SCALE

Named after the 19th-century British naval officer who devised it, the Beaufort Scale assesses wind speed according to its effects. Originally designed in 1806 as an aid for sailors, it has since been adapted for use on land and was internationally recognised in 1874.

Scale	Wind	Name	
	km/h	mph	
0	0-1	0-1	Calm
1	1-5	1-3	Light air
2	6-11	4-7	Light breeze
3	12-19	8-12	Gentle breeze
4	20-28	13-18	Moderate
5	29-38	19-24	Fresh
6	39-49	25-31	Strong
7	50-61	32-38	Near gale
8	62-74	39-46	Gale
9	75-88	47-54	Strong gale
10	89-102	55-63	Storm
11	103-117	64-72	Violent storm
12-17	118+	73+	Hurricane

WIND-CHILL FACTORS

A combination of cold and wind makes the human body feel cooler than the actual air temperature. The charts below give approximate equivalents for combinations of wind speed and temperature. In sub-zero temperatures, even moderate winds will significantly reduce effective temperatures: if human skin was exposed to winds of 48km/h (30mph) in a temperature of –34°C (-30°F) it would freeze solid in 30 seconds.

	16	32	48						Wind speed (mph)		
			40	64*	- 350	10	20	30	40*		
15	11	9	8	6	30	16	4	-2	-5		
10	6	3	2	-1	20	3	-10	-18	-21		
5	1	4	-5	-8	10	-9	-24	-33	-37		
0	-8	-14	-17	-19	0	-2	-39	-49	-53		
-5	-14	-21	-25	-27	-10	-34	-53	-6	-69		
-10	-20	-28	-33	-35	-20	-46	-67	-79	-84		
-15	-26	-36	-40	-43	-30	-58	-81	-93	-100		
-20	-32	-42	-48	-51	-40	-71	-95	-109	-115		

*Wind speeds of more than c.64km/h (40mph) have only a marginally greater cooling effect

Continent Area		Highest point above sea level			Lowest point below sea level				
	sq km	sq mi	%		m	ft		m	-
Asia	44,391,000	17,139,000	29.8	Mt Everest (China/Nepal)	8,848	29,029	Dead Sea, Israel/Jordan	-396	-1,30
Africa	30,000,000	11,700,000	20.3	Mt Kilimanjaro, Tanzania	5,895	19,340	Lake Assal, Djibouti	-153	-50
North America	24,454,000	9,442,000	16.2	Mt McKinley, Alaska	6,194	20,321	Death Valley, California, USA	-86	-28
South America	17,793,000	6,868,000	11.9	Mt Aconcagua, Argentina	6,960	22,834	Peninsular Valdés, Argentina	-40	-13
Antarctica	14,200,000	5,500,000	9.4	Vinson Massif	4.897	16,066	*		
Europe	10,360,000	4,000,000	6.7	Mt Elbrus, Russia	5,633	18,481	Caspian Sea, W. Central Asia	-28	-9
Oceania	8,945,000	3,454,000	5.7	Puncak Jaya (Ngga Pulu), Indonesia	5,029	16,499	Lake Eyre (N), South Australia	-15	-5

Ocean		Area			e depth	Greatest known depth		
	sq km	sq mi	%	m	ft		m	f
Pacific	166,000,000	69,356,000	49.9	4,300	14,100	Mariana Trench	11,033	36,198
Atlantic	82,000,000	32,000,000	25.7	3,700	12,100	Puerto Rico Trench*	8,650	28,370
Indian	73,600,000	28,400,000	20.5	4,000	13,000	Java Trench	7,725	25,344
Arctic	13,986,000	5,400,000	3.9	1,330	4,300	Molloy Deep	5,608	18,399

	Location	m	ft		Location	m	ft
Europe				Ruwenzori	Uganda/Zaire	5,109	16,763
Elbrus*	Russia	5,633	18,481				
Mont Blanc ^{†‡}	France/Italy	4,810	15,781	North America			
Monte Rosa [‡]	Italy/Switzerland	4,634	15,203	Mt McKinley (Denali) [‡]	USA (Alaska)	6,194	20,321
also				Mt Logan	Canada	6,050	19,849
Matterhorn (Cervino) [‡]	Italy/Switzerland	4,478	14,691	Citlaltépetl (Orizaba)	Mexico	5,700	18,70
Jungfrau	Switzerland	4,158	13,642	Mt St Elias	USA/Canada	5,489	18,008
Grossglockner	Austria	3,797	12,457	Popocatépetl	Mexico	5,452	17,887
Mulhacen	Spain	3,478	11,411	also			
Etna	Italy (Sicily)	3,340	10,958	Mt Whitney	USA	4,418	14,495
Zugspitze	Germany	2,962	9,718	Tajumulco	Guatemala	4,220	13,845
Olympus	Greece	2,917	9,570	Chirripo Grande	Costa Rica	3,837	12,589
Galdhopiggen	Norway	2.468	8,100	Pico Duarte	Dominican Rep.	3,175	10,417
Ben Nevis	UK (Scotland)	1,343	4,406	1 100 Dualto	Болинсан пор.	0,170	10,417
8				South America			
Asia [§]				Aconcagua#	Argentina	6,960	22,834
Everest	China/Nepal	8,848	29,029	Ojos del Salado	Argentina/Chile	6,863	22,516
K2 (Godwin Austen)	China/Kashmir	8,611	28,251	Pissis	Argentina	6,779	22,241
Kanchenjunga [‡]	India/Nepal	8,586	28,169	Mercedario	Argentina/Chile	6,770	22,211
.hotse [‡]	China/Nepal	8,516	27,939	Huascarán [‡]	Peru	6,768	22,204
Makalu [‡]	China/Nepal	8,481	27,824				
Cho Oyu	China/Nepal	8,201	26,906	Oceania			
Dhaulagiri [‡]	Nepal	8,172	26,811	Puncak Jaya	Indonesia (W Irian)	5,029	16,499
√lanaslu (Kutang)‡	Nepal	8,156	26,758	Puncak Trikora	Indonesia (W Irian)	4,750	15,584
Nanga Parbat	Kashmir	8,126	26,660	Puncak Mandala	Indonesia (W Irian)	4,702	15,427
Annapurna [‡]	Nepal	8,078	26,502	Mt Wilhelm	Papua New Guinea	4.508	14,790
also				also			
Kommunizma Pik	Taiikistan	7.495	24,590	Mauna Kea	USA (Hawaii)	4 205	13 796
Ararat	Turkey	5,165	16,945	Mauna Loa	USA (Hawaii)	4,169	13,678
Gunong Kinabalu	Malaysia (Borneo)		13,455	Mt Cook (Aorangi)	New Zealand	3,764	12,349
ujiyama (Fuji-san)	Japan	3,776	12,388	Mt Kosciusko	Australia	2,228	7,310
Africa				Antarctica			
Kilimanjaro	Tanzania	5,895	19,340	Vinson Massif	_	4,897	16.066
VIt Kenya	Kenya	5,200	17,058	Mt Tyree		4,965	16,289

* Caucasus Mountains include 14 other peaks higher than Mont Blanc, the	highest point in non-Russian Europe
---	-------------------------------------

^{**} Laucasus Mountains include 14 other peaks nigher than Mont Blanc, the highest point in non-Russian Europe

† Highest point is in France; the highest point wholly in Italian territory is 4,760m (15,616Hz)

† Many mountains, especially in Asia, have two or more significant peaks; only the highest ones are listed here

† The ranges of Central Asia have more than 100 peaks over 7,315m (24,000ft); thus the first 10 listed here constitute the world's 10 highest mountains # Highest mountain outside Asia

Name	Total height		Location	River	Highest fall	
	m	ft			m	ft
Angel	980	3,212	Venezuela	Caroni	807	2,648
Tugela	947	3,110	Natal, South Africa	Tugela	410	1,350
Utigård	800	2,625	Nesdale, Norway	Jostedal Glacier	600	1,970
Mongefoseen	774	2,540	Mongebekk, Norway	Monge	_	
Yosemite	739	2,425	California, USA	Yosemite Creek	739	2,425
Østre Mardøla Foss	656	2,154	Eikisdal, Norway	Mardals	296	974
Tyssestrengane	646	2,120	Hardanger, Norway	Tysso	289	948
Cuquenán	610	2,000	Venezeula	Arabopó	_	_
Sutherland	580	1,904	Otago, New Zealand	Arthur	248	815
Takkakaw	502	1,650	British Columbia, Canada	Daly Glacier	365	1,200
Ribbon	491	1,612	California, USA	Ribbon Fall Stream	491	1,612

The greatest falls by volume are the Boyoma (formerly Stanley) Falls on the River Congo (Zaïre), with a mean annual flow of 17,000 cu m/sec (600,000 cu ft/sec). The Niagara Falls and the Victoria Falls (Mosioa Tunya, "the smoke that thunders") are 4th and 9th respectively, in terms of volume; though both are relatively modest in height.

	Outflow	km	n
Europe			
Volga	Caspian Sea	3,750	2,33
Danube	Black Sea	2,859	1.77
Ural*	Caspian Sea	2,535	1,57
Asia			
Yangtze [3]	Pacific Ocean	6,300	3,90
Yenisey-Angara [5]	Arctic Ocean	5,550	3,44
Huang He [6]	Pacific Ocean	5,500	3,40
Ob-Irtysh [7]	Arctic Ocean	5,410	3,36
Amur [10]	Pacific Ocean	4,400	2,73
Mekong [9]	Pacific Ocean	4,180	2,60
Africa			
Nile [1]	Mediterranean	6,700	4,16
Congo (Zaïre) [8]	Atlantic Ocean	4,670	2,90
Niger	Atlantic Ocean	4,180	2,60
Zambezi	Indian Ocean	2,740	1,70
North America			
Mississippi-Missouri	[4] Gulf of Mexico	6,050	3,76
Mackenzie	Arctic Ocean	4,240	2,63
Missouri	Mississippi	4,120	2,56
Mississippi	Gulf of Mexico	3,780	2,35
Yukon	Pacific Ocean	3.185	1,98
Rio Grande	Gulf of Mexico	3,030	1,88
Arkansas	Mississippi	2,335	1,450
Colorado	Pacific Ocean	2,333	1,450
South America			
Amazon [2]	Atlantic Ocean	6,430	3,990
Paraná-Plata	Atlantic Ocean	4,000	2,400
Purus	Amazon	3,350	2,080
Madeira	Amazon	3,200	1,990
Sao Francisco	Atlantic Ocean	2,900	1,800
Australia			
Murray-Darling	Southern Ocean	3.750	2,830
Darling	Murray	3,070	1,905
Murray	Southern Ocean		1,600
Murrumbidaee	Murray	1,690	1,050

Year	Location	Magnitude [†]	Deaths
1906	San Francisco, USA	8.3	503
1906	Valparaiso, Chile	8.6	22,000
1908	Messina, Italy	7.5	83,000
1920	Gansu (Kansu), China	8.6	180,000
1923	Yokohama, Japan	8.3	143,000
1927	Nan Xian, China	8.3	200,000
1932	Gansu (Kansu), China	7.6	70,000
1933	Honshū, Japan	8.9 [‡]	2,990
1935	Quetta, India§	7.5	60,000
1939	Chillan, Chile	8.3	28,000
1939	Erzincan, Turkey	7.9	30,000
1964	Anchorage, Alaska	8.4	131
1970	N Peru	7.7	86,794
1976	Guatemala	7.5	22,778
1976	Tangshan, China	8.2	252,000
1978	Tabas, Iran	7.7	25,000
1980	El Asnam, Algeria	7.3	20,000
1985	Mexico City, Mexico	8.1	4,200
1988	NW Armenia	6.8	55,000
1990	N Iran	7.7	36,000
1993	Maharastra, India	6.4	30,000
1995	Kobe, Japan	7.2	5,000
1995	Sakhalin Island, Russia	7.5	2,000
1997	Ardabil, Iran	5.5	965

^{*} Since 1900 † On the Richter scale ‡ Highest ever recorded § Now Pakistan

Date M	illions	Date	Millions	Date	Millions
2000вс	100	1800	900	1970	3,700
1000BC	120	1850	1,250	1980	4,450
1	180	1900	1,620	1990	5,245
1000	275	1920	1,860	1995	5,735
1250	375	1930	2.070	2000*	6,100
1500	420	1940	2,300	2050*	11,000
1650	500	1950	2,500		
1700	615	1960	3,050		

OF BORILLOUS COUNTRIES

* United Nations "medium" es	timates
------------------------------	---------

Country	Census		Estimate
China	1,130,510,638	('91)	1,187,997,000
India	846,302,688	('91)	879,548,000
USA	248,709,873	('90)	255,020,000
Indonesia	179,378,946	('90)	191,170,000
Brazil	146,825,475	('91)	156,275,000
Russia	147,021,869	('89)	149,527,000
Japan	125,568,504	('95)*	124,336,000
Bangladesh	111,455,000	('91)	119,288,000
Pakistan	84,253,644	('81)	115,520,000
Mexico	81,249,645	('90)	89,538,000
Nigeria	88,514,501	('93)	88,515,000
Germany	77,916,332	('88)†	80,569,000
Vietnam	64,411,713	('89)	69,306,000
Philippines	60,559,116	('90)	64,259,000
Iran	55,837,163	('91)	59,964,000
Turkey	56,473,035	('90)	58,775,000
UK	54,156,067	('91)	57,848,000
Thailand	58,336,072	('93)*	57,760,000
Italy	56,778,031	('91)	57,782,000
France	56,615,100	('90)	57,372,000
Egypt	48,205,049	('86)	55,163,000
Ethiopia	42,019,418	('84)‡	55,117,000
Ukraine	51,452,034	('89)	52,200,000

LEAST POPULOUS COUNTRIES*

Population	
1,000	t
8,100	(1990)
10.090	(1991)
13.870	(1986)
24.003	(1993)
29.972	(1990)
	(1990)
	(1991)
	(1994)
61,599	(1993)
	1,000 8,100 10,090 13,870 24,003 29,972 28,777 40,618 54,000

^{*} Only independent sovereign states are listed

MAJOR ESTABLISHED RELIGIONS

The figures are estimates, based primarily on UN reports and statistics released by most of the religious bodies. The table does not include the various folk and tribal religions of Africa and Asia, which could total as many as 300 million adherents, including over 10 million Shamanists.

Religion	Millions	Religion	Millions
Christianity	1,780	Confucianism*	350
Roman Catholic	1,010	Buddhism *†	320
Protestant	365	Taoism*	25
Orthodox	175	Sikhism	19
Anglican	75	Judaism	18
Islam	1.050	Baha'ism	5.9
Sunni	960	Jainism	3.8
Shia (Shi'ite)	90	Shintoism†	3.5
Hinduism	720		

^{*} The number of practising Confucians, Buddhists and Taoists in China cannot be accurately estimated; there are about 6 million Confucians outside China

LARGEST COUNTRIES

No.	Country	Area	
		sq km	sq mi
1.	Russia*	17,075,400	6,595,830
2.	Canada [†]	9,970,610	3,849,660
3.	USA	9,809,155	3,787,319
4.	China [‡]	9,536,720	3,682,130
5.	Brazil§	8,547,400	3,300,410
6.	Australia#	7,682,300	2,966,145
7.	India¶	3,165,595	1,222,332
8.	Argentina	2,780,400	1,073,596
9.	Kazakstan	2,717,300	1,049,155
10.	Sudan**	2,505,813	967,570
11.	Algeria	2,381,741	919,662
12.	Zaïre	2,344,885	905,365
13.	Saudi Arabia	2,149,690	829,998
14.	Mexico	1,967,183	759,589
15.	Indonesia	1,919,443	741,098
16.	Libya	1,759,540	679,358
17.	Iran	1,648,000	636,346
18.	Mongolia	1,566,500	604,250
19.	Peru	1,285,216	496,223
20.	Chad	1,284,000	495,790

^{*} Largest country in Asia and in Europe † Largest in North America † Excluding Taiwan § Largest in South America # Largest in Oceania ¶ Excluding parts of Jammu and Kashmir occupied by Pakistan and China ** Largest country in Africa

SMALLEST COUNTRIES

Country	Area	
	sg km	sq mi
Vatican City	0.4	0.2
Monaco	1.9	0.7
Nauru	21	8
Tuvalu	26	10
San Marino	61	23.5
Liechtenstein	160	62
Marshall Islands	181	70
St Kitts and Nevis	261	101
Maldives	298	115
Malta	316	122

LARGEST CITIES

UN estimates for "urban agglomerations", which take no account of administrative boundaries.

City	Country	1994 Est.	2015 Proj.
Tokyo-Yokohama	Japan	26,518,000	28,700,000
New York	USA	16,271,000	17,600,000
São Paulo	Brazil	16,110,000	20,800,000
Mexico City	Mexico	15,525,000	18,800,000
Shanghai	China	14,709,000	23,400,000
Bombay	India	14,496,000	27,400,000
Los Angeles	USA	12,232,000	14,300,000
Beijing	China	12,030,000	19,400,000
Calcutta	India	11,485,000	17,600,000
Seoul	S. Korea	11,451,000	13,100,000
Jakarta	Indonesia	11,017,000	21,200,000
Osaka-Kōbe-Kyōto		10,585,000	10,600,000

MAJOR LANGUAGES

There are more than 5,000 languages in the world, 845 of them in India alone. The tables below give the approximate numbers of native speakers (their "mother tongue") and the populations of countries where the language has official status.

Language	Millions	Language	Millions
Native speak	ers	Korean	70
Chinese	1,070	Tamil	68
English	487	Marathi	67
Hindi	382	Vietnamese	62
Spanish	363		
Bengali	203	Official popul	ations
Arabic	188	English	1,420
Portuguese	187	Chinese	1,070
Japanese	126	Hindi	800
German	119	Spanish	290
Urdu	96	Russian	275
Punjabi	89	French	220
Javanese	77	Arabic	190
French	73	Portuguese	185
Telugu	72	Malay	165

Country	GNP*
USA	7,100,007
Japan	4,963,587
Germany	2,225,343
France	1,451,051
UK	1,094,734
Italy	1,088,085
China	744,890
Brazil	579,787
Canada	573,695
Spain	532,347
South Korea	435,135
Netherlands	371,039
Australia	337,909
Russia	331,948
Iran	330,000
India	319,660
Mexico	304,596
Switzerland	286,014
Argentina	278,431
Taiwan	258,852

^{*} Gross National Product in US\$ (1995)

Country	GNP*
Luxembourg	41,210
Switzerland	40,630
Japan	39,640
Liechtenstein	35,000
Norway	31,250
Denmark	29,890
Germany	27,510
USA	26,980
Austria	26,890
Singapore	26,730
France	24,990
Iceland	24,950
Belgium	24,710
Sweden	23,750
Hong Kong	22,990
Bermuda	21,500
Netherlands	20,710
Canada	19,380
Italy	19,020
Australia	18,720

^{*} GNP per capita in US\$ (1995). UK=\$18,700

ENERGY SOURCES BY NATION

Percentages of power sources in selected countries

Country	Fossil fuels	power	Nuclear power
Saudi Arabia	100	_	_
Denmark	97.8	0.1	_
Australia	89.7	10.3	_
Netherlands	95.3	0.2	4.5
China	81.5	18.5	_
Italy	78.0	20.5	_
India	76.4	21.8	1.8
UK	76.2	1.9	21.9
Russia	73.7	15.4	10.9
USA	70.1	9.4	19.9
Germany	67.9	3.7	28.4
Japan	63.9	11.9	24.0
Spain	46.1	18.2	35.3
Belgium	39.1	1.3	59.6
Canada	22.5	60.7	16.8
France	13.5	13.6	72.9
Brazil	6.5	92.9	0.6
Sweden	4.7	43.1	52.2
Iceland	0.2	93.5	_

WORLD TOURISM				
Country	Arrivals from abroad (1992)	Receipts as % of GDP (1992)		
France	59,590,000	1.9		
USA	44,647,000	0.9		
Spain	39,638,000	4		
Italy	26,113,000	1.8		
Hungary	20,188,000	3.3		
Austria	19,098,000	7.6		
UK	18,535,000	1.3		
Mexico	17,271,000	2		
China	16,512,000	0.9		
Germany	15,147,000	0.6		
Canada	14,741,000	1		
Switzerland	12.800.000	3.1		

TRANSPORT NETWORKS

Road and rail networks for the leading countries of the world (1995), given in thousands

Total road network			Total rail i	networ	k
Country	km	mi	Country	km	mi
USA	6,277.9	3,901	USA	239.7	148.9
India	2,962.5	1,840.9	Russia	87.5	54.4
Brazil	1,824.4	1,133.7	India	62.5	38.8
Japan	1,130.9	702.7	China	54	33.6
China	1,041.1	646.9	Germany	40.4	25.1
Russia	884	549.3	Australia	35.8	22.2
Canada	849.4	527.8	Argentina	34.2	21.3
France	811.6	504.3	France	32.6	20.3
Australia	810.3	503.5	Mexico	26.5	16.5
Germany	636.3	395.4	Poland	24.9	15.8
Romania	461.9	287	S. Africa	23.6	14.7

^{*} No official estimate since the last census † Combination of Federal Republic (61,241,700) and Democratic Republic (16,674,632)

[‡] Then including Eritrea (2,449,152)

[†] Has a permanent all-male population of about 1,000

[†] Many people in the Far East, notably in Japan, claim to adhere to more than one religion and figures are therefore only approximate at best

Tankards Joining metals

ABUNDANCE OF ELEMENTS

Universe: It is estimated that up to 99% of the known universe is made up of hydrogen and helium, with hydrogen in a ratio of 20:1 to helium and some 10,000:1 of other elements. The next, in order, are oxygen, carbon, nitrogen, silicon, magnesium, neon, sulphur and iron.

Earth's crust*	%	Living things	%	Sea water [†]	%
Oxygen	46.6	Oxygen	62.0	Oxygen	85.7
Silicon	27.7	Carbon	20.0	Hydrogen	10.7
Aluminium	8.1	Hydrogen	10.0	Chlorine	1.9
Iron	5.0	Nitrogen	3.0	Sodium	1.1
Calcium	3.6	Calcium	2.5	Magnesium	0.1
Sodium	2.8	Phosphorous	1.14		
Potassium	2.6	Chlorine	0.16		
Magnesium	2.1	Sulphur	0.14		
Titanium	0.44	Potassium	0.11		
Hydrogen	0.14				

^{*} Igneous rocks in the lithosphere † Average ocean concentration

SI UNITS

The Systéme International d'Unités is the worldwide standard system of units used by scientists. Originally proposed in 1960, it is based on seven basic units.

Measurement	Unit	Symbol
Basic units		
Length	metre	m
Mass	kilogram	kg
Time	second	5
Electric current	ampere	Δ
Thermodynamic temperature	kelvin	K
Amount of substance	mole	mo
Luminous intensity	candela	CC
Supplementary units		
Plane angle	radian	rac
Solid angle	steradian	SI
Derived units Frequency	hertz	Hz
Force	newton	N
	pascal	Pa
Pressure, stress	joule	Га
Work (energy, heat) Power	watt	W
	coulomb	C
Electric charge Electromotive force		V
	volt ohm	ν
Electric resistance	011111	
Electric conductance	siemens	S
Electric capacitance	farad	H
Inductance	henry	Wb
Magnetic flux	weber	VV D T
Magnetic flux density	tesla	
Illuminance	lux	,lx
Luminous flux	lumen	Im
Radiation exposure	roentgen	
Radiation activity	becquerel	Bq
Radiation absorbed dose	gray	Gy
Radiation dose equivalent	sievert	Sv
Celsius temperature	°Celsius	°C

ROMAN NUMERALS

P	rabic	Roman
	1 2	I II
	3	III IV
	5	V
	6 7	VI
	8	VIII IX
	10 11	X
	12	XII
	13 14	XIII XIV
	15 16	XV XVI
	17 18	XVII
	19 20	XIX
-		
	30 40	XXX XL
	50 60	L
	70 80	LXX
	90	XC
	100 200	C CC
	300 400	CCC
	500 1,000	D M
١.	5,000	Ž,
	0,000 00,000	$\frac{C}{\overline{\Lambda}}$

ALLOYS

Name	Composition of metals	Common uses
Aluminium bronze	90% copper, 10% aluminium	Marine engineering
Manganese bronze	95% copper, 5% manganese	Marine engineering
Gun metal bronze	90% copper, 10% tin	"Copper" coins
Silicon bronze	Copper with silicon and small amounts of iron, nickel, manganese	Telegraph wires
Bell metal	Copper with 15% or more tin	Casting bells
Red brass	85% copper, 14% zinc, 1% tin	Plumbing
Yellow brass	67% copper, 33% zinc	Door handles
Nickel silver (cupronickel)	55% copper, 27% zinc, 18% nickel	"Silver" coins
Steel	99% iron, 1% carbon	Cutlani liattlan
Stainless steel	Iron with 0.1-2.0% carbon, up to	Cutlery, kettles,
	27% chromium or 20% tungsten or 15% nickel and lesser amounts of other elements	pans, etc
18-carat gold	75% gold, 25% gold and copper	Jewellery
Palladium (white gold)	90% gold, 10% palladium	Jewellery
Sterling silver	92.5% silver, 7.5% copper	Jewellery
US silver	90% silver, 10% copper	Jewellery
Dentist's amalgam	70% mercury, 30% copper	Filling teeth
Type metal	82% lead, 15% antimony, 3% tin	Printing
Pewter	91% tin, 7.5% antimony, 1.5% copper	Tankards
Coldor	Load tip	laining matala

GEMSTONES

Solder

Diamond, emerald, ruby and sapphire were formerly classified as "precious" stones, with others termed "semi-precious". This division is usually no longer made.

Lead, tin

Mineral	Colour	Mohs' no.	Birthstone
Agate	Striped grey-white, blue	6.5-7.0	May
Amber*	Yellow, honey	2.0-2.5	_ ′
Amethyst	Purple	7.0	February
Aquamarine [†]	Pale blue-green	7.5	March
Beryl	Green, blue, pink	7.5	_
Bloodstone	Dark green with red spots	7.0	March
Carnelian§	Green and yellow shades	8.5	August
Chrysoberyl [‡]	Green and yellow	8.5	June
Coral*	Varies, often red	Soft	_
Diamond	Clear (pure), various colour tints	10.0	April
Emerald#	Green	7.5-8.0	May
Garnet	Red and other various colours	6.5-7.0	January
Jade	Green	6.5-7.0	
Lapis lazuli	Azure blue	6.5-7.0	September
Moonstone	Whitish blue	6.0-6.5	June
Onyx	Various, black and white stripes	6.5-7.0	July
Opal	Milky white, black, rainbow streaks	5.5-6.5	October
Pearl*	White, pearl grey	Soft	June
Quartz	Clear	7.0	April
Rose quartz	Pink	7.0	October
Ruby	Red	9.0	July
Sapphire	Blue	9.0	September
Smoky quartz	Smoky brown, red, yellow	7.0	
Topaz	Blue, yellow, greenish, pink, clear	8.0	November
Tourmaline	Black, blue-black, red, green	7.0-7.5	October
Turquoise	Sky blue, greenish blue-grey	6.0-7.0	December

^{*} Amber (fossilized plant resin), coral (skeletal remains of microscopic warm water creatures) and pearl (secretions in molluscs, notably mussels and oysters) are organic gems † Blue-green beryl ‡ Alexandrite – also called cat's eye when brownish § Also called cornelian # Green beryl

SI DERIVED UNITS

Measurement	Unit	Symbol
Area	square metre	m ²
Volume	cubic metre	m ³
Velocity	metre per second	m s ⁻¹
Acceleration	metre per second squared	m s ⁻²
Angular velocity	radian per second	rad s-1
Angular acceleration	radian per second squared	rad s-2
Density	kilogram per cubic metre	kg m ⁻³
Momentum	kilogram metre per second	kg m s ⁻¹
Angular momentum	kilogram metre squared per second	kg m ² s ⁻¹
Mass rate of flow	kilogram per second	kg s ⁻¹
Volume rate of flow	cubic metre per second	m ³ s ⁻¹
Torque	newton metre	N m
Surface tension	newton per metre	N m ⁻¹
Dynamic viscosity	newton second per metre squared	N s m ⁻²
Kinematic viscosity	metre squared per second	m ² s ⁻¹
Thermal coefficient	per °Celsius, or per kelvin	°C-1, or K-1
Thermal conductivity	watt per metre °C	W m ⁻¹ °C ⁻¹
Heat capacity	joule per kelvin	J K-1
Specific latent heat	joule per kilogram	J kg ⁻¹
Specific heat capacity	joule per kilogram kelvin	J kg ⁻¹ K ⁻¹
Velocity of light	metre per second	m s ⁻¹
Permeability	henry per metre	H m ⁻¹
Permittivity	farad per metre	F m-1
Electric force	volt per metre	v m ⁻¹
Electric flux density	coulomb per metre squared	C m ⁻²

PHYSICAL CONST	ANTS		
Universal constant	Symbol	Value	Unit
speed of light in vacuum permeability of vacuum permittivity of vacuum Newtonian constant	$\begin{matrix} c \\ \mu_0 \\ \epsilon_0 \end{matrix}$	299,792,458 12.566370614 8.854187817	ms ⁻¹ 10 ⁻⁷ NA ⁻² 10 ⁻¹² Fm ⁻¹
of gravitation Planck constant	G h	6.67259 6.6260755	10 ⁻¹¹ m ³ kg ⁻¹ s ⁻² 10 ⁻³⁴ Js
Electromagnetic constants elementary charge	е	1.60217733	10 ⁻¹⁹ C
Electron electron mass electron specific charge	m _e -e/m _e	9.1093897 -1.75881962	10 ⁻³¹ kg 10 ¹¹ Ckg ⁻¹
Muon, proton, and neutron muon mass proton mass neutron mass	$\begin{array}{c} m_{\mu} \\ m_{p} \\ m_{n} \end{array}$	1.8825327 1.6726231 1.6749286	10 ⁻²⁸ kg 10 ⁻²⁷ kg 10 ⁻²⁷ kg
Physico-chemical constants Avogadro constant atomic mass constant Faraday constant molar gas constant Boltzmann constant	N _A ,L m _u F R k	6.0221367 1.6605402 96,485.309 8.314510 1.380658	10 ²³ mol ⁻¹ 10 ⁻²⁷ kg · Cmol ⁻¹ Jmol ⁻¹ K ⁻¹ 10 ⁻²³ JK ⁻¹

Name	Symbol	Atomic	Relative	Valency	Melting	Boiling	Date of	Name	Symbol	Atomic	Relative	Valency	Melting	Boiling	Date o
		number	atomic mass	s*point °C	point °C		discovery			number	atomic ma	ss*	point °C	point °C	discover
Actinium	Ac	89	(227)	_	1,230	3,200	1899	Mercury	Hg	80	200.59	1, 2	-38.9		c.1500E
Aluminium	Al	13	26.98154	3	660.2	2,350	1827	Molybdenum	Mo	42	95.94	3, 4, 6	2,610	5,560	177
Americium	Am	95	(243)	3, 4, 5, 6	995	2,600	1944	Neodymium	Nd	60	144.24	3	1,010	3,068	188
Antimony	Sb	51	121.75	3.5	630.5	1,750	с.1000вс	Neon	Ne	10	20.179	0	-248.7	-246.1	189
Argon	Ar	18	39.948	0	-189.4	-185.9	1894	Neptunium	Np	93	237.0482	4, 5, 6	640	3,902	194
Arsenic	As	33	74.9216	3.5	613	_	1250	Nickel	Νi	28	58.70	2, 3	1,453	2,732	17
Astatine	At	85	(210)	1, 3, 5, 7	302	377	1940	Niobium	Nb	41	92.9064	3, 5	2,468	4,742	180
Barium	Ba	56	137.34	2	725	1,640	1808	Nitrogen	N	7	14.0067	3, 5	-210	-195.8	177
Berkelium	Bk	97	(247)	3, 4	986	_	1949	Nobelium	No	102	(255)	_	_		195
Beryllium	Be	4	9.01218	2	1,285	2,470	1798	Osmium	0s	76	190.2	2, 3, 4, 8	3,045	5,027	190
Bismuth	Bi	83	208.9804	3, 5	271.3	1,560	1753	Oxygen	0	8	15.9994	2	-218.4	-183	177
Boron	В	5	10.81	3	2,079	3,700	1808	Palladium	Pd	46	106.4	2, 4, 6	1,552	3,140	180
Bromine	Br	35	79.904	1, 3, 5, 7	-7.2	58.8	1826	Phosphorus	P	15	30.97376	3, 5	44.1	280	166
Cadmium	Cd	48	112.40	2	320.9	765	1817	Platinum	Pt	78	195.09	2, 4	1,772	3,800	173
Caesium	Cs	55	132.9054	1	28 4	678	1860	Plutonium	Pu	94	(244)	3, 4, 5, 6	641	3,232	19
Calcium	Ca	20	40.08	2	839	1,484	1808	Polonium	Po	84	(209)	_	254	962	18
Californium	Cf	98	(251)	_	_	_	1950	Potassium	K	19	39.098	1	63.2	777	180
Carbon	C	6	12.011	2.4	3,550	4,200	_	Praseodymium	n Pr	59	140.9077	3	931	3,512	18
Cerium	Ce	58	140.12	3, 4	798	3,257	1803	Promethium	Pm	61	(145)	3	1,080	2,460	19
Chlorine	CI	17	35.453	1, 3, 5, 7	-101	-34.6	1774	Protactinium	Pa	91	231.0359	_	1,200	4,000	19
Chromium	Cr	24	51.996	2, 3, 6	1,890	2,672	1797	Radium	Ra	88	226.0254	2	700	1,140	18
Cobalt	Co	27	58.9332	2, 3	1,495	2,870	1735	Radon	Rn	86	(222)	0	-71	-61.8	18
Copper	Cu	29	63.546	1, 2	1,083	2,567	с.8000вс	Rhenium	Re	75	186.207	_	3,180	5,627	19
Curium	Cm	96	(247)	3	1,340		1944	Rhodium	Rh	45	102.9055	3	1,966	3,727	18
Dubnium [‡]	Db	104	(261)	_	_		1969	Rubidium	Rb	37	85.4678	1	38.8	688	18
Dysprosium	Dv	66	162.50	3	1,409	2,335	1896	Ruthenium	Ru	44	101.07	3, 4, 6, 8	2,310	3,900	183
Einsteinium	Es	99	(254)	_	.,		1952	Samarium	Sm	62	150.35	2, 3	1,072	1,791	18
Erbium	Er	68	167.26	3	1,522	2,863	1843	Scandium	Sc	21	44.9559	3	1,539	2,832	18
Europium	Eu	63	151.96	2, 3	822	1,597	1896	Selenium	Se	34	78.96	2, 4, 6	217	684.9	18
Fermium	Fm	100	(257)		-		1952	Silicon	Si	14	28.086	4	1,410	2,355	18
Fluorine	F	9	18.9984	1	-219.6	-188.1	1886	Silver	Ag	47	107.868	1	961.9	2,212	c.4000
Francium	Fr	87	(223)	1	30	650	1939	Sodium	Na	11	22.98977	i	97.8	882	180
Gadolinium	Gd	64	157.25	3	1,311	3,233	1880	Strontium	Sr	38	87.62	2	769	1,384	18
Gallium	Ga	31	69.72	2, 3	29.78	2,403	1875	Sulphur	S	16	32.06	2, 4, 6	112.8	444.7	10
Germanium	Ge	32	72.59	4	937.4	2.830	1886	Tantalum	Ta	73	180.9479	5	2,996	5,425	18
Gold	Au	79	196.9665	1.3	1.063	2,800	1000	Technetium	Tc	43	(97)	6, 7	2,172	4,877	19
Hafnium	Hf	72	178.49	4	2,227	4,602	1923	Tellurium	Te	52	127.60	2, 4, 6	449.5	989.8	17
lelium	He	2	4.0026	0	-272	268.9		Terbium	Tb	65	158.9254	3	1,360	3.041	18
Holmium	Но	67	164.9304	3	1.470	2,300	1878	Thallium	TI	81	204.37	1.3	303.5	1,457	18
	Н	1	1.0079	1	-259.1	-252.9		Thorium	Th	90	232.0381	4	1,750	4,790	18
Hydrogen ndium	In	49	114.82	3	156.6	2,080	1863	Thulium	Tm	69	168.9342	3	1,545	1,947	18
	in	53	126.9045	3 1, 3, 5, 7		184.4		Tin	Sn	50	118.69	2, 4	232	2,270	c.3500
odine	İr	77	192.22		113.5	4,130	1804	Titanium	Ti	22	47.90	3, 4	1,660	3,287	17
ridium				3, 4	2,410			Tungsten§	W	74					
ron	Fe	26	55.847	2, 3	1,540	2,760	c.4000BC				183.85	. 6	3,410	5,660	17
Crypton	Kr	36	83.80	0	-156.6	-152.3		Unnilpentium [†]		105	(262)	1 6	1 122	2 010	19
Lanthanum	La	57	138.9055	3	920	3,454	1839	Uranium	U	92	238.029	4, 6	1,132	3,818	17
_awrencium	Lr	103	(256)	_		4.740	1961	Vanadium	V	23	50.9414	3, 5	1,890	3,380	18
Lead	Pb	82	207.2	2, 4	327.5	1,740		Xenon	Xe	54	131.30	0	-111.9	-107.1	18
ithium	Li	3	6.941	1	180.5	1,347	1817	Ytterbium	Yb	70	173.04	2, 3	824	1,193	19
utetium	Lu	71	174.97	3	1,656	3,315	1907	Yttrium	Y	39	88.9059	3	1,510	3,300	18
Magnesium	Mg	12	24.305	2	648.8	1,090	1808	Zinc	Zn	30	65.38	2	419.6	907	18
Manganese	Mn	25	54.9380	2, 3, 4, 6, 7	1,244	1,962	1774	Zirconium	Zr	40	91.22	4	1,852	4,377	17
Mendelevium	Md	101	(258)				1955								

^{*} Relative atomic mass; values given in parentheses are for radioactive elements whose relative atomic mass cannot be given precisely without knowledge of origin, and is the atomic mass number of the isotope of longest known half-life † Also called hahnium, nielsbohrium, rutherfordium, or element 105 ‡ Also called unnilquadium (Unq) or element 104 § Also called wolfram

GEOMETRIC SHAPES (PLANE FIGURES)

TYPES OF TRIANGLE

All the sides are the same length and all the angles are equal. Two sides are of the same length and two angles are of equal size. All sides are different lengths and all the angles are of different sizes. Equilateral Isosceles Scalene Acute angle A triangle with three acute angles, each less than 90° Right angle A triangle containing one right angle (90°).

Obtuse angle A triangle containing one obtuse angle (over 90°).

Isosceles Scalene **Equilateral** Acute-angle Right-angle Obtuse-angle

TYPES OF QUADRILATERAL

All the sides are the same length and all the angles are right angles. Opposite sides are the same length and all angles are right angles. Square Rectangle Rhombus All sides are the same length but none of the angles are right angles. Parallelogram Opposite sides are parallel to each other and of the same length. One pair of the opposite sides is parallel.

Adjacent sides are equal length and the diagonals intersect at right angles. Trapezium Kite

MOHS' SCALE OF HARDNESS

The scale is not regular. Diamond, the hardest known natural substance, is 90 times harder than corundum.

Mineral	Hardness	Simple hardness test
Talc	1.0	Crushed by fingernail
Gypsum	2.0	Scratched by fingernail
Calcite	3.0	Scratched by copper coin
Fluorspar	4.0	Scratched by glass
Apatite	5.0	Scratched by knife blade
Feldspar	6.0	Scratched by quartz
Quartz	7.0	Scratched by steel file
Topaz	8.0	Scratched by corundum
Corundum	9.0	Scratched by diamond
Diamond	10.0	_

SELECTED RELATIVE DENSITIES

Relative density (or specific gravity) is the density (at 20°C/68°F) of a solid or liquid relative to (divided by) the maximum density of water (at 4°C/39.2°F). The relative density of a gas is its density divided by the density of hydrogen at the same pressure and temperature.

Substance	R.D.	Substance	R.D.
Alcohol	0.8	Perspex	1.2
Aluminium	2.7	Petroleum	0.8
Balsa wood	0.2	Pitch	1.1
Benzene	0.7	Plaster of Paris	1.8
Butter	0.9	Platinum	21.9
Charcoal	0.4	Polystyrene	1.06
Copper	8.9	Polythene	0.93
Cork	0.25	PVĆ	1.4
Diamond	3.5	Sand	1.6
Gold	19.3	Sea water	1.03
Granite	2.7	Silver	10.5
Ice (at 0°C/32°F)	0.92	Stainless steel	7.8
Lead	11.3	Talc	2.8
Limestone	2.6	Tar	1.0
Marble	2.7	Teak	0.9
Milk	1.03	Tin	7.3
Nylon	1.14	Tungsten	19.3
Olive oil	0.9	Turpentine	0.85
Osmium*	22.57	Uranium	19.0
Paraffin	0.8	Water	1.0

^{*} Most dense of all measurable elements

POWER OF NUMBERS

Factor	Number	Name		
10 ²	100	Hundred		
103	1,000	Thousand		
106	1,000,000	Million		
109	1,000,000,000	Billion		
10 12	1,000,000,000,000	Trillion		
10 15	1,000,000,000,000,000	Quadrillion		
10 18	1,000,000,000,000,000,000	Quintillion		
10 100	1 with 100 zeroes	Googol		

In Britain, one billion was traditionally used for a million million (US trillion), while in the USA the billion repesented a thousand million, From 1 January 1975. the UK has employed the US system in its finances. with a billion standing for £1,000 million. Since then, the American system has been adopted throughout the English-speaking world.

SI PREFIXES

Prefix	Symbol	Power	Multiple in full
Exa-	Е	1018	1,000,000,000,000,000,000
Peta-	Р	1015	1,000,000,000,000,000
Tera-	T	1012	1,000,000,000,000
Giga-	G	109	1,000,000,000
Mega-	M	106	1,000,000
Kilo-	k	103	1,000
Hecto-	h	102	100
Deca-	da	10 ¹	10
Deci-	d	10-1	0.1
Centi-	С	10-2	0.01
Milli-	m	10-3	0.001
Micro-	μ	10-6	0.000001
Nano-	n	10-9	0.000000001
Pico-	p	10-12	0.000000000001
Femto-	f	10-15	0.000000000000001
Atto-	a	10-18	0.000000000000000001

GEOMETRIC FIGURES

Shape	Circumference	Area
circle	2πr	πr ²
parallelogr	am	lh
(I = length, I	h = perpendicular distand	ce to side parallel to I
rectangle		lw
(I = length,	w = width)	
triangle		1/2lh
triangle		1/2111
Shape	Volume	Surface area
	Volume 1/3πr ² h	,
Shape cone		Surface area
Shape cone	1/3πr²h	Surface area
Shape cone (h = perpen	1/3πr²h ndicular height)	Surface area πr²+πrl
Shape cone (h = perpen cylinder	1/3πr²h ndicular height) πr²h 1/3Bh	Surface area πr²+πrl

Pythagoras' theorem: $a^2 = b^2 + c^2$ $\pi = 3.1415926$

r = radius

PRIME NUMBERS

These are whole numbers that have only two factors the number itself and the number one. The only even prime number is two: all other prime numbers are odd. These are the prime numbers below 100.

3 5 7 11 13 17 19 23 29 31 37 41 43 47 53 59 61 67 71 73 79 83 89 97

SQUARES, CUBES AND ROOTS

No.	Square	Cube	Square root	Cube root
1	1	1	1	1
2	4	8	1.414	1.260
3	9	27	1.732	1.442
4	16	64	2	1.587
5	25	125	2.236	1.710
6	36	216	2.449	1.817
7	49	343	2.646	1.913
8	64	512	2.828	2
9	81	729	3	2.080
10	100	1,000	3.162	2.154
11	121	1,331	3.317	2.224
12	144	1,728	3.464	2.289
13	169	2,197	3.606	2.351
14	196	2,744	3.742	2.410
15	225	3,375	3.873	2.466
16	256	4,096	4	2.520
17	289	4,913	4.123	2.571
18	324	5,832	4.243	2.621
19	361	6,859	4.359	2.668
20	400	8,000	4.472	2.714
25	625	15,625	5	2.924
30	900	27,000	5.477	3.107
40	1600	64,000	6.325	3.420
50	2500	125,000	7.071	3.684

PERFECT NUMBERS

Numbers that are equal to the sum of all their factors, excluding themselves. The lowest is 6 (1+2+3) and next come 28 (1+2+4+7+14); 496; then 8,128; then 33,550,336.

POLYGONS

Name	Number of sides	Each internal angle	Sum of internal angles
Triangle	3	60°	180°
Square	4	90°	360°
Pentagon	5	108°	540°
Hexagon	6	120°	720°
Heptagon	7	128.6°	900°
Octagon	8	135°	1,080°
Nonagon	9	140°	1,260°
Decagon	10	144°	1,440°
Undecagon	11	147.3°	1,620°
Dodecagon	12	150°	1,800°

CONVERSIONS

Length	
1 inch (in)	= 2.54 centimetres (cm)
10 0	= 25.4 millimetres (mm)
1 foot (ft)	= 0.3048 metre (m)
1 yard (yd)	= 0.9144 metre
1 mile (mi)	= 1.6093 kilometres (km)
1 centimetre	= 0.3937 inch
1 metre	= 3.2808 feet $= 1.0936$ yards
1 kilometre	= 0.6214 mile

Area 1 square inch

= 6.4516 square centimetres 1 square foot = 0.0929 square metre = 0.4047 hectare 1 acre 1 sq mile = 2.5899 square kilometres

1 square centimetre = 0.155 square inch = 10.7639 square feet 1 square metre 1 hectare = 2.471 acres 1 square kilometre = 0.3861 square mile

Volume

1 cubic inch = 16.3871 cubic centimetres 1 cubic foot = 0.0283 cubic metre

= 1.3030 cubic yards

1 cubic yard = 0.7646 cubic metre = 0.061 cubic inch 1 cubic centimetre = 35.3147 cubic feet 1 cubic metre

1 cubic metre Canacity

1 UK fluid ounce (fl oz) = 0.02841 litre (I) 1 US fluid ounce = 0.02961 litre 1 UK pint (pt) = 0.56821 litre 1 US pint = 0.47321 litre 1 UK gallon = 4.546 litres

1 US gallon = 3.7854 litres 1 litre = 35.1961 fluid ounces (UK) = 33.814 fluid ounces (US) = 1.7598 pints (UK) = 2.1134 pints (US)

= 0.22 gallon (UK) = 0.2642 gallon (US) 1 US cup = 8 fluid ounces 1 UK pint = 1.2 US pints 1 UK gallon = 1.2009 US gallons = 0.83 UK pint = 0.8327 UK gallon 1 US pint 1 US gallon

Weight*

1 ounce (oz) = 28.3495 grams (g) 1 pound (lb) = 0.454 kilograms (kg) 1 UK ton = 1.016 tonnes 1 US ton = 0.9072 tonne

= 0.0353 ounce 1 gram 1 kilogram = 2.205 pounds

1 tonne = 0.9842 UK ton = 1.1023 US tons = 1.1199 US tons 1 UK ton

1 US ton = 0.8929 UK ton

°Celsius to °Fahrenheit: x9, ÷5, +32 °Fahrenheit to °Celsius: -32, x5, ÷9

Energy

Temperature

1,000 British thermal units (Btu) = 0.293 kilowatt hour = 1 therm 100,000 British thermal units 1 UK horsepower = 550 ft-lb per second = 745.7 watts

1 US horsepower = 746 watts

Nautical length and speed

= 6,080 feet UK nautical mile International nautical mile = 6,076.1 feet = 0.9994 UK nautical mile

1 knot = 1 UK nautical mile per hour = 1.15 mph

Petroleum

1 barrel = 34.97 UK gallons = 42 US gallons = 0.159 cubic metres

Precious stones

1 troy ounce = 480 grains 1 metric carat = 200 milligrams

Type sizes

72 1/4 points = 1 inch 1 didot point = 0.376 mm 1 pica em = 12 points

*Avoirdupois † Work, heat

US	PRESIDENTS			
No.	President	Years	Party	Age*
1.	George Washington	1789-97	Federalist	57
2.	John Adams	1797-1801	Federalist	61
3.	Thomas Jefferson	1801-09	Dem-Rep	57
4.	James Madison	1809-17	Dem-Rep	57
5.	James Monroe	1817-25	Dem-Rep	58
6.	John Quincy Adams	1825-29	Dem-Rep	57
7.	Andrew Jackson	1829-37	Democrat	61
8.	Martin Van Buren	1837-41	Democrat	54
9.	William H. Harrison [†]	1841	Whig	68
10.	John Tyler	1841-45	Whig	51
11.	James K. Polk	1845-49	Democrat	49
12.	Zachary Taylor [†]	1849-50	Whig	64
13.	Millard Fillmore	1850-53	Whig	50
14.	Franklin Pierce	1853-57	Democrat	48
15.	James Buchanan	1857-61	Democrat	6
16.	Abraham Lincoln [‡]	1861-65	Republican	1 52
17.		1865-69	Nat. Union	56
18.	Ulysses S. Grant#	1869-77	Republican	1 46
19.		1877-81	Republicar	
20.	James A. Garfield [‡]	1881	Republican	
21.	Chester A. Arthur	1881-85	Republicar	
22.		1885-89	Democrat	4
23.	Benjamin Harrison	1889-93	Republicar	
24.	Grover Cleveland	1893-97	Democrat	5!
25.	William McKinley [‡]	1897-1901	Republicar	-
26.	Theodore Roosevelt	1901-09	Republican	
27.	William H. Taft	1909-13	Republican	
28.	Woodrow Wilson	1913-21	Democrat	5
29.		1921-23	Republicar	-
30.	Warren Harding ^T	1921-23		5
	Calvin Coolidge		Democrat	
31.	Herbert Hoover	1929-33	Republican	
32.	Franklin D. Roosevelt [†]	1933-45	Democrat	5
33.	Harry S. Truman	1945-53	Democrat	6
34.	Dwight D. Eisenhower	1953-61	Republica	
35.	John F. Kennedy [‡]	1961-63	Democrat	4
36.	Lyndon Johnson	1963-69	Democrat	5
37.		1969-74	Republica	
38.	Gerald Ford**	1974-77	Republica	
39.		1977-81	Democrat	5
40.	Ronald Reagan	1981-89	Republica	
41.	George Bush	1989-93	Republica	
42.	Bill Clinton	1993-	Democrat	4

* At inauguration; Kennedy was the youngest, Reagan the oldest † Died in office and succeeded by the vice president ‡ Assassinated in office and succeeded by the vice president § A Democrat, Johnson was nominated vice president by Republicans and elected with Lincoln on a National Union ticket # Born Hiram Grant ¶ Resigned in face of impeachment proceedings following the Watergate scandal
** Born Leslie Lynch King

CANADIAN PRIME MINISTERS

Years	Prime Minister	Party
1896-1911	Wilfrid Laurier	Liberal
1911-17	Sir Robert Borden	Conservative
1917-20	Sir Robert Borden	Unionist [†]
1920-21	Arthur Meighen	Conservative
1921-26	William Lyon Mackenzie King	Liberal
1926	Arthur Meighen	Conservative
1926-30	William Lyon Mackenzie King	Liberal
1930-35	Richard Bennett	Conservative
1935-48	William Lyon Mackenzie King	Liberal
1948-57	Louis St Laurent	Liberal
1957-63	John Diefenbaker	Conservative
1963-68	Lester Pearson	Liberal
1968-79	Pierre Trudeau	Liberal
1979-80	Joe Clark	Conservative
1980-84	Pierre Trudeau	Liberal
1984	John Turner	Liberal
1984-93	Brian Mulroney	Conservative
1993	Kim Campbell	Conservative
1993-	Jean Chrétien	Liberal

† National Liberal and Conservative

UN SECRETARIES-GENERAL

Secretary-General	Country	Tenure
Trygve Lie	Norway	1946-53
Dag Hammarskjöld	Sweden	1953-61
U Thant	Burma	1962-71
Kurt Waldheim	Austria	1971-81
Javier Pérez de Cuéllar	Peru	1982-92
Boutros Boutros Ghali	Egypt	1992-96
Kofi Annan	Ghana	1997-

Years	Prime Minister	Party	Years	Prime Minister	Party
1721-42	Sir Robert Walpole	Whiq	1868	Benjamin Disraeli	Conservative
1742-43	Earl of Wilmington	Whig	1868-74	William Gladstone	Liberal
1743-54	Henry Pelham	Whig	1874-80	Benjamin Disraeli	Conservative
1754-56	Duke of Newcastle	Whig	1880-85	William Gladstone	Liberal
1756-57	Duke of Devonshire	Whig	1885-86	Marguis of Salisbury	Conservativ
1757-62	Duke of Newcastle	Whig	1886	William Gladstone	Liberal
1762-63	Earl of Bute	Tory	1886-92	Marguis of Salisbury	Conservativ
1763-65	George Grenville	Whig	1892-94	William Gladstone	Liberal
1765-66	Marguis of Rockingham	Whig	1894-95	Earl of Rosebery	Liberal
1766-67	Earl of Chatham*	Whig	1895-1902	Marguis of Salisbury	Conservativ
1767-70	Duke of Grafton	Whig	1902-05	Arthur Balfour	Conservativ
1770-82	Lord North	Tory	1905-08	Henry Campbell-Bannerman	Liberal
1782	Marguis of Rockingham	Whig	1908-15	Herbert Asquith	Liberal
1782-83	Earl of Shelbourne	Whig	1915-16	Herbert Asquith	Coalition [§]
1783	Duke of Portland	Coalition	1916-22	David Lloyd George	Coalition§
1783-1801	William Pitt [†]	Tory	1922-23	Andrew Bonar Law	Conservativ
1801-04	Henry Addington	Tory	1923-24	Stanley Baldwin	Conservativ
1804-06	William Pitt†	Tory	1924	Ramsay MacDonald	Labour
1806-07	Lord Grenville	Whia	1924-29	Stanley Baldwin	Conservativ
1807-09	Duke of Portland	Coalition	1929-31	Ramsay MacDonald	Labour
1809-12	Spencer Perceval	Tory	1931-35	Ramsay MacDonald	National#
1812-27	Earl of Liverpool	Tory	1935-37	Stanley Baldwin	National#
1827	George Canning	Torv	1937-40	Neville Chamberlain	National#
1827-28	Viscount Goderich	Tory	1940-45	Winston Churchill	Coalition
1828-30	Duke of Wellington	Tory	1945-51	Clement Attlee	Labour
1830-34	Earl Grey	Whig	1951-55	Winston Churchill	Conservativ
1834	Viscount Melbourne	Whig	1955-57	Anthony Eden	Conservativ
1834-35	Sir Robert Peel	Tory	1957-63	Harold Macmillan	Conservativ
1835-41	Viscount Melbourne	Whig	1963-64	Alec Douglas-Home	Conservativ
1841-46	Sir Robert Peel	Conservative	1964-70	Harold Wilson	Labour
1846-52	Lord John Russell [‡]	Whig	1970-74	Edward Heath	Conservativ
1852	Earl of Derby	Conservative	1974-76	Harold Wilson	Labour
1852-55	Earl of Aberdeen	Peelite	1976-79	James Callaghan	Labour
1855-58	Viscount Palmerston	Liberal	1979-90	Margaret Thatcher	Conservativ
1858-59	Earl of Derby	Conservative	1990-97	John Major	Conservativ
1859-65	Viscount Palmerston	Liberal	1997-	Tony Blair	Labour
1865-66	Earl Russell‡	Liberal	1331-	Tony Dian	Labout
1866-68	Earl of Derby	Conservative			

* William Pitt the Elder † William Pitt the Younger ‡ Lord John Russell later became the Earl Russell § Coalition governments; Lloyd-George was Liberal # National Coalition governments; Chamberlain was Conservative

GERMAN CHANCELLORS

1871-90 1890-94 1894-00 1900-09 1909-17 1917	ors of the German Empire Prince Otto von Bismarck- Count Leo von Caprivi Prince Chlodwig von Hoh. Prince Bernhard von Bülo Theobald von Bethmann-h	-Schillingsfirst w	
1890-94 1894-00 1900-09 1909-17 1917	Count Leo von Caprivi Prince Chlodwig von Hoh. Prince Bernhard von Bülo Theobald von Bethmann-l	-Schillingsfirst w	
1894-00 1900-09 1909-17 1917 1917-18	Prince Chlodwig von Hoh. Prince Bernhard von Bülo Theobald von Bethmann-H	w	
1900-09 1909-17 1917 1917-18	Prince Bernhard von Bülo Theobald von Bethmann-H	w	
1909-17 1917 1917-18	Theobald von Bethmann-H		
1917 1917-18			
1917-18		łollweg	
	1917 George Michaelis 1917-18 Count George von Hertling 1918 Prince Maximilian of Baden 1918 Friedrich Ebert		
1918			
1918			
Chancelle	ors of the Weimar Republic		
1919	Philipp Scheidemann	SPD	
1919-20	Gustav Bauer	SPD	
1920	Hermann Müller	SPD	
1920-21	Konstantin Fehrenbach	Centre-Catholic	
1921-22	Joseph Wirth	Centre	
1922-23	Wilhelm Cuno	_	
1923	Gustav Stresemannn	D. Volk	
1923-25	Wilhelm Marx	Centre	
1925-26	Hans Luther	_	
1926-28	Wilhelm Marx	Centre	
1928-30	Hermann Müller	SPD	
1930-32	Heinrich Brüning	Centre	
1932	Franz von Papen	National	
1932-33	Curt von Schleider	_	
1933-45	Adolf Hitler*	Nazi	
Chancell	ors of the Federal German F		
1949-63	Konrad Adenauer	CDU	
1963-66	Ludwig Erhard	CDU	
1966-69	Kurt Georg Kiesinger	CDU	
1969-74	Willy Brandt ^T	SPD	
1974-82	Helmut Schmidt	SPD	
1982-90	Helmut Kohl	CDU	

* Führer from 1934 to 1945 † Adopted name of Karl

Herbert Frahm ‡ Chancellor of reunited Germany

Years	President	Party
Presidents	of the Fifth Republic	
1958-69	Charles de Gaulle	Gaullist
1969-74	Georges Pompidou	Gaullist
1974-81	Valéry Giscard d'Estaing	UDF
1981-95	François Mitterrand	PS
1995-	Jacques Chirac	RPR
Prime Min	isters of the Fifth Republic	
1962-68	Georges Pompidou	Gaullist
1968-69	Maurice Couve de Murville	Gaullist
1969-72	Jacques Chaban-Delmas	Gaullist
1972-74	Pierre Mesmer	Gaullist
1974-76	Jacques Chirac	Gaullist
1976-81	Raymond Barre	_
1981-84	Pierre Mauroy	PS
1984-86	Laurent Fabius	PS
1986-88	Jacques Chirac	Gaullist
1988-91	Michel Rocard	PS
1991-92	Edith Cresson	PS
1992-93	Pierre Bérégovoy	PS
1993-95	Edouard Balladur	RPR
1995-97	Alain Juppé	RPR
1997-	Lionel Jospin	PS

FRENCH LEADERS

	SH PRIME MINIST	
Years	Prime Minister	Party
1939-73	Francisco Franco*	Falange
1973-76	Carlos Navarro	_
1976-81	Adolfo Suárez	UCD
1981-82	Leopoldo Sotelo	UCD
1982-96	Felipe González	PS0E
1996-	José María Aznar	Popular

* Franco titled himself "Chairman of the Council of Ministers" from 1936 . After his death, the monarchy was restored, in the person of Juan Carlos.

RUSSIAN AND SOVIET LEADERS

etary of the Communist Party	
Joseph Stalin (b. Dzhugashvili)	
Georgi Malenkov	
Nikita Khrushchev	
Leonid Brezhnev	
Yuri Andropov	
Konstantin Chernenko	
Mikhail Gorbachev	
	Joseph Stalin (b. Dzhugashvili) Georgi Malenkov Nikita Khrushchev Leonid Brezhnev Yuri Andropov Konstantin Chernenko

President of the Russian Federation 1917 Leo Kamenev 1917-19 Yakov Sverdlov 1919-22 Mikhail Kalinin

President of	the Union of Soviet Socialist Republic
1919-46	Mikhail Kalinin
1946-53	Nikolai Shvernik
1953-60	Kliment Voroshilov
1960-64	Leonid Brezhnev
1964-65	Anastas Mikoyan
1965-77	Nikolai Podgorny
1977-82	Leonid Brezhnev
1092-92	Vaccili Kuznetcov*

1977-62 Lebnia di Pezniev 1982-83 Vassili Kuznetsov* 1983-84 Yuri Andropov 1984 Vassili Kuznetsov* 1984-85 Konstantin Chernenko 1985 Vassili Kuznetsov* 1985-88 Andrei Gromyko 1988-91 Mikhail Gorbachev[†]

Chairman of the Council of Ministers[‡]

1917	Georgy Lvov
1917	Alexander Kerensky
1917-24 [§]	Vladimir Ilyich Lenin (b. Ulyanov)
1924-30 [§]	Aleksei Rykov
1930-31 [§]	Genrikh Yagoda
1931-41 [§]	Vyacheslav Molotov
1941-53 [§]	Joseph Stalin (b. Dzhugashvili)
1953-55	Georgi Malenkov
1955-58	Nikolai Bulganin
1958-64	Nikita Khrushchev
1964-80	Alexei Kosygin
1980-85	Nikolai Tikhonov
1985-90	Nikolai Ryzhkov
1990-91	Yuri Maslyukov [#]
1991	Valentin Payloy

Russian President

1991- Boris Yeltsin

Russian Prime Ministers 1991- Viktor Chernomyrdin

AUSTRALIAN PRIME MINISTERS

Years	Prime Minister	Party
1900-03	Edmund Barton	Protectionist
1903-04	Alfred Deakin	Protectionist
1904	John Watson	Labor
1904-05	George Reid	Free Trade
1905-08	Alfred Deakin	Protectionist
1908-09	Andrew Fisher	Labor
1909-10	Alfred Deakin	Fusion*
1910-13	Andrew Fisher	Labor
1913-14	Joseph Cook	Liberal
1914-15	Andrew Fisher	Labor
1915-17	William Hughes	National Labor
1917-23	William Hughes	Nationalist
1923-29	Stanley Bruce	Nationalist
1929-32	James Scullin	Labor
1932-39	Joseph Lyons	United Australia
1939	Earle Page	Country
1939-41	Robert Menzies	United Australia
1941	Arthur Fadden	Country
1941-45	John Curtin	Labor
1945	Francis Forde	Labor
1945-49	Joseph Chifley	Labor
1949-66	Robert Menzies	Liberal
1966-67	Harold Holt	Liberal
1967-68	John McEwen	Country
1968-71	John Gorton	Liberal
1971-72	William McMahon	Liberal
1972-75	Gough Whitlam	Labor
1975-83	Malcolm Fraser	Liberal
1983-91	Bob Hawke	Labor
1991-96	Paul Keating	Labor
1996-	John Howard	Liberal-National

^{*} Protectionist-Free Trade Alliance

INDIAN PRIME MINISTERS

Years	Prime Minister	Government
1947-64	Jawaharlal Nehru	Congress
1964	Gulzari Lal Nanda	Congress
1964-66	Lal Shastri	Congress
1966	Gulzari Lal Nanda	Congress
1966-77	Indira Gandhi	Congress
1977-79	Morarji Desai	Janata
1979-80	Charan Singh	Coalition
1980-84	Indira Gandhi	Congress (I)
1984-89	Rajiv Gandhi	Congress (I)
1989-90	V.P. Singh	Coalition
1990-91	Chandra Shekhar	Janata
1991-96	P.V. Narasimha Rao	Congress (I)
1996-97	H.D. Deve Gowda	Coalition
1997-	Inder Kumar Gujral	Coalition

NEW ZEALAND PRIME MINISTERS

Years	Prime Minister	Party
940-49	Peter Fraser	Labour
1949-57	Sidney Holland	National [†]
1957	Keith Holyoake	National
1957-60	Walter Nash	Labour
1960-72	Keith Holyoake	National
1972	John Marshall	National
972-74	Norman Kirk	Labour
1974	Hugh Watt [‡]	Labour
1974-75	Wallace Rowling	Labour
1975-84	Robert Muldoon	National
1984-89	David Lange	Labour
1989-90	Geoffrey Palmer	Labour
1990	Michael Moore	Labour
1990-96	Jim Bolger	National
1997-	Jenny Shipley	National

† Formed from merger of Reform Party and United Party in 1936 ‡ Acting Prime Minister

JAPANESE EMPERORS Years **Emperor** Era 1867-1912 Mutsuhito Meiii 1912-26 Yoshihito Taishō 1926-89 Hirohito Shōwa 1989-Akihito Heisei

SOUTH AFRICAN LEADERS

Until the Republic of South Africa left the Commonwealth in 1961 the Governor-General performed the role of President, and until 1984, when the prime ministership was abolished, the presidential function remained largely non-political.

Prime Minister	Party
Louis Botha	South Africa Party
Jan Christiaan Smuts	South Africa Party
James Hertzog	National
Jan Christiaan Smuts	United
Daniel Malan	National
Johannes Strijdom	National
Hendrik Verwoerd	National
Johannes Vorster	National
Pieter Botha	National
President	
Pieter Botha	National
F.W. de Klerk	National
Nelson Mandela	ANC
	Louis Botha Jan Christiaan Smuts James Hertzog Jan Christiaan Smuts Daniel Malan Johannes Strijdom Hendrik Verwoerd Johannes Vorster Pieter Botha President Pieter Botha F.W. de Klerk

CHINESE LEADERS

Chairman	of the Communist Party
1935-76	Mao Zedong (Mao Tse-tung)
1976-81	Hua Guofeng (Huo Kuo-feng)
1981-82	Hu Yaobang (Hu Yao-pang)

General Secretary of the Communist Party 1982-87 Hu Yaobang (Hu Yao-pang) 1987-89 Zhao Ziyang (Chao Tzu-yang) 1989- Jiang Zemin (Chiang Tse-min)

President	
1949-59	Mao Zedong (Mao Tse-tung)
1959-68	Liu Shaogi (Liu Shao-ch'i)
1968-75	Dong Biwu (Tung Pi-wu)
1975-76	Zhu De (Chu Te)
1976-78	Song Qingling (Sung Ch'ing-ling)
1978-83	Ye Jianying (Yeh Chien-ying)
1983-88	Li Xiannian (Li Hsien-nien)
1988-93	Yang Shangkun (Yang Shang-k'un)

Jiang Zemin (Chiang Tse-min)

Prime Minister

1993-

1949-76	Zhou Enlai (Chou En-lai)
1976-80	Hua Guofeng (Huo Kuo-feng)
1980-87	Zhao Ziyang (Chao Tzu-yang)
1987-	Li Peng (Li P'eng)

From 1978 until his death on 19 February 1997, effective control of China's politics and economic policy was in the hands of "paramount leader" Deng Xiaoping (Teng Hsiao-ping), State Vice-Premier and Chief of Staff to the People's Liberation Army.

POPES SINCE 1000 AD

PUPES	SINCE IUU	UAD					
999-1003 1003 1004-09 1009-12 1012-24 1024-32 1032-44 1045 1045-46 1046-47 1047-48 1048-54 1055-57 1057-58 1059-61 1061-73 1073-85 1086-87 1088-99 1099-1118 1118-19 119-24 1124-30 1130-43 1144-45 1145-53 1153-54	Sylvester II John XVII John XVIII Sergius IV Benedict VIII John XIX Benedict IX Sylvester III Benedict IX Gregory VI Clement II Benedict IX Damasus II Leo IX Victor II Stephen IX Nicholas II Alexander II Gregory VII Victor III Urban II Paschal II Callixtus II Honorius II Innocent II Celestine II Lucius II Eugenius III Lanatasius IV	1181-85 1185-87 1187-91 1191-98 1198-1216 1216-27 1227-41 1241-241 1243-54 1254-61 1261-64 1265-68 1271-76 1276 1276 1276-77 1277-80 1281-85 1285-87 1294-1303 1303-04 1305-14 1316-34 1334-42 1342-52 1352-62	Lucius III Urban III Gregory VIII Clement III Clestine III Innocent III Honorius III Gregory IX Celestine IV Innocent IV Alexander IV Urban IV Clement IV Gregory X Innocent V Adrian V John XXI [‡] Nicholas III Martin IV Honorius IV Voniface VIII Benedict XI Clement V John XXII Clement V John XXII Innocent V III II I	1389-1404 1404-06 1406-15 1417-31 1431-47 1447-55 1455-58 1458-64 1464-71 1471-84 1484-92 1492-1503 1503 1503-13 1513-21 1522-23 1523-34 1534-49 1550-55 1555-59 1559-65 1566-72 1572-85 1585-90 1590-91 1591 1592-1605	Boniface IX Innocent VII Gregory XII Martin V Eugenius IV Nicholas V Callixtus III Pius II Paul II Sixtus IV Innocent VIII Alexander VI Pius III Julius II Leo X Adrian VI Faul III Julius III V Pius IV Pius IV Pius IV Pius IV Pius IV Cregory XIII Sixtus V Urban VII Gregory XIV Innocent IX Clement VIII	1623-44 1644-55 1655-67 1667-69 1670-76 1676-89 1689-91 1691-1700 1700-21 1721-24 1724-30 1730-40 1740-58 1758-69 1759-74 1775-99 1800-23 1823-29 1829-30 1831-46 1846-78 1878-1903 1903-14 1914-22 1922-39 1939-58 1958-63 1963-78 1978-	Urban VIII Innocent X Alexander VII Clement IX Clement X Innocent XI Alexander VIII Innocent XII Innocent XII Innocent XII Innocent XIII Benedict XIV Clement XII Benedict XIV Clement XIII Clement XIII Fius VII Fius VII Fius VII Fius VIII Fius VIII Fius VIII Fius XII Fius X
					Clement VIII		
1153-54 1154-59	Anastasius IV Adrian IV	1362-70 1370-78	Urban V Gregory XI	1605 1605-21	Leo XI Paul V	1978-	John Paul II
1159-81	Alexander III	1378-89	Urban VI	1621-23	Gregory XV		
l .							

^{*} Kuznetzov was Acting President on three occasions † Executive President 1990-91 ‡ Equivalent of Prime Minister of the USSR § From the advent of Lenin to the death of Stalin (1917-53) the Council of Ministers was replaced by the Council of People's Commissars # Acting Chairman

[†] Became the Liberal Party in 1944 ‡ Coalition

SUMMER OLYMPIC GAMES

The VIth Olympiad of 1916 was scheduled for Berlin. The XIIth Olympiad of 1940 was scheduled for Tokyo, later changed to Helsinki, and the XIIIth Olympiad of 1944 was scheduled for London. The XXVII Olympiad of 2000 will be held in Sydney, Australia.

Games	Year	Venue C	ompetitors	Sports	Events	Leading medal- winning nation
I	1896	Athens, Greece	200	9	43	Greece (47)*
II	1900	Paris, France	1,225	24	166	France (102)
III	1904	St Louis, USA	687	16	104	USA (238)
IV	1908	London, UK	2,035	21	110	Great Britain (145)
V	1912	Stockholm, Sweden	2,537	13	102	Sweden (65)
VII*	1920	Antwerp, Belgium	2,668	21	154	USA (94)
VIII	1924	Paris, France	3,092	17	126	USA (99)
IX	1928	Amsterdam, Netherlan	nds 3,014	14	109	USA (56)
X	1932	Los Angeles, USA	1,408	14	117	USA (103)
ΧI	1936	Berlin, Germany	4,066	19	129	Germany (89)
XIV	1948	London, UK	4,099	17	136	USA (84)
XV	1952	Helsinki, Finland	4,925	17	149	USA (76)
XVI	1956	Melbourne, Australia	3,184	17	151	Soviet Union (98)
XVII	1960	Rome, Italy	5,346	17	150	Soviet Union (99)
XVIII	1964	Tokyo, Japan	5,140	19	163	Soviet Union (96)†
XIX	1968	Mexico City, Mexico	5,530	18	172	Soviet Union (107)
XX	1972	Munich, West German	ny 7,123	21	195	Soviet Union (99)
XXI	1976	Montreal, Canada	6,028	21	198	Soviet Union (125)
XXII	1980	Moscow, Soviet Union	5,217	21	204	Soviet Union (195)
XXIII	1984	Los Angeles, USA	6,797	21	221	Soviet Union (174)
XXIV	1988	Seoul, South Korea	8,465	23	237	Soviet Union (132)
XXV	1992	Barcelona, Spain	9,364	24	257	Unified Team (111)
XXVI XXVII	1996 2000	Atlanta, USA Sydney, Australia	10,744	29	271	USA (101)
XXVIII	2004	Athens, Greece				

* USA won 11 gold medals, but only 19 in total † USA won 36 gold medals to Soviet Union's 30, but only 92 in all ‡ Former Soviet republics. The Olympics were also held in 1906.

WINT	TER	OLYMPIC GAN	1ES			
Games	Year	Venue	Competitors	Sports E	vents	Leading medal - winning nation
1	1924	Chamonix, France	258	5	14	Norway (17)
11	1928	St Moritz, Switzerlan	d 464		14	Norway (15)
Ш	1932	Lake Placid, USA	252		14	USA (12)
IV	1936	Garmisch, Germany	668	6	17	Norway (15)
V	1948	St Moritz, Switzerlan	d 669	7	22	Norway/Sweden (10)
VI	1952	Oslo, Norway	694	6	22	Norway (16)
VII	1956	Cortina d'Ampezzo, It	taly 820		24	Soviet Union (14)
VIII	1960	Squaw Valley, USA	665		27	Soviet Union (21)
IX	1964	Innsbruck, Austria	1,091	8	34	Soviet Union (25)
X	1968	Grenoble, France	1,158	8	35	Norway (14)
XI	1972	Sapporo, Japan	1,006	8	35	Soviet Union (16)
XII	1976	Innsbruck, Austria	1,123	8	37	Soviet Union (27)
XIII	1980	Lake Placid, USA	1,072	8	38	East Germany (23) [†]
XIV	1984	Sarajevo, Yugoslavia	1,274	8	39	Soviet Union (25) [‡]
XV	1988	Calgary, Canada	1,423	8	46	Soviet Union (29)
XVI	1992	Albertville, France	1,801	10	57	Germany (26)
XVII	1994	Lillehammer, Norway	1,737	10	61	Norway (26)§
XVII	1998	Nagano, Japan	2,180	8		Germany (29)

† Soviet Union won 10 gold medals to East Germany's 9, but only 22 in total ‡ East Germany won 9 gold medals to the USSR's 6, but only 24 in total § Russia won 11 gold medals to Norway's 10, but only 23 in total

SKIING WORLD

	Overall winner
Men	
	M. Giradelli (L)
1992	P. Accola (S)
1993	M. Giradelli (L)
1994	K. Aamont (N)
1995	A. Tomba (I)
1996	L. Krus (N)
1997	L. Alphand (F)
Won	ion
	P. Kronberger (A)
	P. Kronberger (A)
	A. Wachter (A)
	V. Schneider (S)
	V. Schneider (S)
1995	
	K. Seizinger (G)

1996 SUMMER OLYMPIC GAMES -LEADING MEDAL WINNERS

Country	Gold	Silver	Bronze	Total
USA	44	32	25	101
Russia	26	21	16	63
Germany	20	18	27	65
China	16	22	12	50
France	15	7	15	37
Italy	13	10	12	35
Australia	9	9	23	41
Cuba	9	8	8	25
Ukraine	9	2	12	23
South Korea	7	15	5	27
Poland	7	5	5	17
Hungary	7	4	10	21
Spain	5	6	6	17
Romania	4	7	9	20
Netherlands	4	5	10	19
Greece	4	4	0	8
Czech Republic	4	3	4	11
Switzerland	4	3	0	7
Denmark*	4	1	1	6
Turkey*	4	1	1	6
Canada	3	11	8	22

Countries are listed in order of gold medals won.
* Equal standing: listed in alphabetical order

1996 SUMM	ER OLYMPIC GA	AIVIES (JOLD MEDALLI	
ATHLETICS	Men	Country	Women	Country
Track events				
100 metres	Donovan Bailey	Canada	Gail Devers	USA
200 metres	Michael Johnson	USA	Marie-José Perec	France
400 metres	Michael Johnson	USA	Marie-José Perec	France
800 metres	Vebjoern Rodal	Norway	Svetlana Masterkova	Russia
1,500 metres	Noureddine Morcelli	Algeria	Svetlana Masterkova	Russia
5,000 metres	Venuste Niyongabo	Burundi	Wang Jungxia	China
10,000 metres	Haile Gebresilasie	Ethiopia	Fernanda Ribeiro	Portugal
Marathon	Josia Thugwane	S. Africa	Fatuma Roba	Ethiopia
100m hurdles	_	_	Ludmilla Engquist	Sweden
110m hurdles	Allen Johnson	USA	_	_
400m hurdles	Derrick Adkins	USA	Deon Hemmings	USA
3,000m stp.	Joseph Keter	Kenya		_
10km walk	_	_	Yelena Nikolayeva	Russia
20km walk	Jefferson Perez	Ecuador	_	_
50km walk	Robert Korzeniowski	Poland		
4 × 100m relay	[Bailey/Esmie/	Canada	[Devers/Gaines/	USA
	Gilbert/Surin]		Miller/Torrance]	
4 imes 400m relay	[Harrison/Maybank/	USA	[Graham/Malone/	USA
,	Mills/Smith]		Miles/Stevens]	
Field events				
High jump	Charles Austin	USA	Stefka Kostadinova	Bulgaria
		USA		
Long jump	Carl Lewis		Chioma Ajunwa	Nigeria
Triple jump	Kenny Harrison	USA	Inessa Kravets	Ukraine
Pole vault	Jean Galfione	France		First and
Javelin	Jan Zelezny	Czech R.	Heli Rantanen	Finland
Shot put	Randy Barnes	USA	Astrid Kumbernuss	Germany
Discus	Lars Riedel	Germany	Ilke Wyludda	German
Hammer	Balazs Kiss	Hungary	· —	_
Multi-discipline				
Heptathlon	_	_	Ghada Shouaa	Syria
Decathlon	Dan O'Brien	USA	_	_
SWIMMING	Men	Country	Women	Country
		-		
50m freestyle	Alexander Popov	Russia	Amy van Dyken	USA
50m freestyle 100m freestyle	Alexander Popov Alexander Popov	Russia Russia	Amy van Dyken Le Jingyi	USA China
50m freestyle 100m freestyle 200m freestyle	Alexander Popov Alexander Popov Danyon Loader	Russia Russia NZ	Amy van Dyken Le Jingyi Claudia Poll	USA China CRC
50m freestyle 100m freestyle 200m freestyle 400m freestyle	Alexander Popov Alexander Popov	Russia Russia	Amy van Dyken Le Jingyi Claudia Poll Michelle Smith	USA China CRC Ireland
50m freestyle 100m freestyle 200m freestyle 400m freestyle 800m freestyle	Alexander Popov Alexander Popov Danyon Loader Danyon Loader	Russia Russia NZ NZ	Amy van Dyken Le Jingyi Claudia Poll	USA China CRC
50m freestyle 100m freestyle 200m freestyle 400m freestyle 800m freestyle 1,500m freestyle	Alexander Popov Alexander Popov Danyon Loader Danyon Loader — Kieren Perkins	Russia Russia NZ NZ — Australia	Amy van Dyken Le Jingyi Claudia Poll Michelle Smith Brooke Bennett	USA China CRC Ireland USA
50m freestyle 100m freestyle 200m freestyle 400m freestyle 800m freestyle 1,500m freestyle 100m breaststroke	Alexander Popov Alexander Popov Danyon Loader Danyon Loader — Kieren Perkins Fred Deburghgraeve	Russia Russia NZ NZ — Australia Belgium	Amy van Dyken Le Jingyi Claudia Poll Michelle Smith Brooke Bennett — Penelope Heyns	USA China CRC Ireland USA — S. Africa
50m freestyle 100m freestyle 200m freestyle 400m freestyle 800m freestyle 1,500m freestyle 100m breaststroke 200m breaststroke	Alexander Popov Alexander Popov Danyon Loader Danyon Loader Kieren Perkins Fred Deburghgraeve Norbert Rozsa	Russia Russia NZ NZ — Australia Belgium Hungary	Amy van Dyken Le Jingyi Claudia Poll Michelle Smith Brooke Bennett — Penelope Heyns Penelope Heyns	USA China CRC Ireland USA S. Africa S. Africa
50m freestyle 100m freestyle 200m freestyle 400m freestyle 800m freestyle 1,500m freestyle 100m breaststroke 200m breaststroke	Alexander Popov Alexander Popov Danyon Loader Danyon Loader Kieren Perkins Fred Deburghgraeve Norbert Rozsa Jeff Rouse	Russia Russia NZ NZ — Australia Belgium Hungary USA	Amy van Dyken Le Jingyi Claudia Poll Michelle Smith Brooke Bennett — Penelope Heyns Penelope Heyns Beth Botsford	USA China CRC Ireland USA — S. Africa S. Africa USA
50m freestyle 100m freestyle 200m freestyle 400m freestyle 800m freestyle 1,500m freestyle 100m breaststroke 200m breaststroke 200m backstroke	Alexander Popov Alexander Popov Danyon Loader Danyon Loader — Kieren Perkins Fred Deburghgraeve Norbert Rozsa Jeff Rouse Brad Bridgewater	Russia Russia NZ NZ — Australia Belgium Hungary USA USA	Amy van Dyken Le Jingyi Claudia Poll Michelle Smith Brooke Bennett — Penelope Heyns Penelope Heyns Beth Botsford Krisztina Egerszegi	USA China CRC Ireland USA — S. Africa S. Africa USA Hungary
50m freestyle 100m freestyle 200m freestyle 400m freestyle 800m freestyle 1,500m freestyle 100m breaststroke 200m backstroke 200m backstroke 100m butterfly	Alexander Popov Alexander Popov Danyon Loader Danyon Loader — Kieren Perkins Fred Deburghgraeve Norbert Rozsa Jeff Rouse Brad Bridgewater Denis Pankratov	Russia Russia NZ NZ — Australia Belgium Hungary USA USA Russia	Amy van Dyken Le Jingyi Claudia Poll Michelle Smith Brooke Bennett —————————————————————————————————	USA China CRC Ireland USA S. Africa S. Africa USA Hungary USA
50m freestyle 100m freestyle 200m freestyle 400m freestyle 800m freestyle 1,500m freestyle 100m breaststroke 200m backstroke 100m backstroke 100m butterfly 200m butterfly	Alexander Popov Alexander Popov Danyon Loader Danyon Loader Kieren Perkins Fred Deburghgraeve Norbert Rozsa Jeff Rouse Brad Bridgewater Denis Pankratov Denis Pankratov	Russia Russia NZ NZ — Australia Belgium Hungary USA USA Russia Russia	Amy van Dyken Le Jingyi Claudia Poll Michelle Smith Brooke Bennett Penelope Heyns Penelope Heyns Beth Botsford Krisztina Egerszegi Amy van Dyken Susan O'Neill	USA China CRC Ireland USA — S. Africa USA Hungary USA Australi
50m freestyle 100m freestyle 200m freestyle 400m freestyle 800m freestyle 1,500m freestyle 100m breaststroke 200m backstroke 200m backstroke 100m butterfly	Alexander Popov Alexander Popov Danyon Loader Danyon Loader ————————————————————————————————————	Russia Russia NZ NZ — Australia Belgium Hungary USA USA USA Russia Russia Hungary	Amy van Dyken Le Jingyi Claudia Poll Michelle Smith Brooke Bennett — Penelope Heyns Penelope Heyns Beth Botsford Krisztina Egerszegi Amy van Dyken Susan O'Neill Michelle Smith	USA China CRC Ireland USA — S. Africa S. Africa USA Hungary USA Australi Ireland
50m freestyle 100m freestyle 200m freestyle 400m freestyle 800m freestyle 1,500m freestyle 100m breaststroke 200m backstroke 100m backstroke 100m butterfly 200m butterfly	Alexander Popov Alexander Popov Danyon Loader Danyon Loader — Kieren Perkins Fred Deburghgraeve Norbert Rozsa Jeff Rouse Brad Bridgewater Denis Pankratov Denis Pankratov Attila Czene Tom Dolan	Russia Russia NZ NZ — Australia Belgium Hungary USA USA Russia Russia	Amy van Dyken Le Jingyi Claudia Poll Michelle Smith Brooke Bennett Penelope Heyns Penelope Heyns Beth Botsford Krisztina Egerszegi Amy van Dyken Susan O'Neill	USA China CRC Ireland USA S. Africa S. Africa USA Hungary USA Australi Ireland Ireland
50m freestyle 100m freestyle 200m freestyle 400m freestyle 800m freestyle 1,500m freestyle 100m breaststroke 200m breaststroke 200m backstroke 200m butterfly 200m butterfly 200m medley	Alexander Popov Alexander Popov Danyon Loader Danyon Loader Kieren Perkins Fred Deburghgraeve Norbert Rozsa Jeff Rouse Brad Bridgewater Denis Pankratov Denis Pankratov Attila Czene Tom Dolan [Davis/Hall/Olsen/	Russia Russia NZ NZ — Australia Belgium Hungary USA USA USA Russia Russia Hungary	Amy van Dyken Le Jingyi Claudia Poll Michelle Smith Brooke Bennett — Penelope Heyns Penelope Heyns Beth Botsford Krisztina Egerszegi Amy van Dyken Susan O'Neill Michelle Smith	USA China CRC Ireland USA — S. Africa S. Africa USA Hungary USA Australi Ireland
50m freestyle 100m freestyle 200m freestyle 400m freestyle 800m freestyle 1,500m freestyle 100m breaststroke 200m backstroke 200m backstroke 100m butterfly 200m medley 400m medley	Alexander Popov Alexander Popov Danyon Loader Danyon Loader — Kieren Perkins Fred Deburghgraeve Norbert Rozsa Jeff Rouse Brad Bridgewater Denis Pankratov Denis Pankratov Attila Czene Tom Dolan	Russia NZ NZ NZ — Australia Belgium Hungary USA USA Russia Russia Hungary USA USA	Amy van Dyken Le Jingyi Claudia Poll Michelle Smith Brooke Bennett — Penelope Heyns Penelope Heyns Beth Botsford Krisztina Egerszegi Amy van Dyken Susan O'Neill Michelle Smith Michelle Smith Michelle Smith Tow/Martino/ Thompson/van Dyken	USA China CRC Ireland USA S. Africa S. Africa USA Hungary USA Australii Ireland USA
50m freestyle 100m freestyle 200m freestyle 200m freestyle 400m freestyle 800m freestyle 1,500m freestyle 1,500m freestyle 100m breaststroke 100m backstroke 100m backstroke 100m butterfly 200m butterfly 200m medley 400m medley 4 × 100m	Alexander Popov Alexander Popov Danyon Loader Danyon Loader Kieren Perkins Fred Deburghgraeve Norbert Rozsa Jeff Rouse Brad Bridgewater Denis Pankratov Denis Pankratov Attila Czene Tom Dolan [Davis/Hall/Olsen/	Russia Russia NZ NZ — Australia Belgium Hungary USA USA Russia Russia Hungary USA	Amy van Dyken Le Jingyi Claudia Poll Michelle Smith Brooke Bennett Penelope Heyns Penelope Heyns Beth Botsford Krisztina Egerszegi Amy van Dyken Susan O'Neill Michelle Smith Michelle Smith [Fox/Martino/	USA China CRC Ireland USA S. Africa S. Africa USA Hungary USA Australia Ireland USA
50m freestyle 100m freestyle 200m freestyle 400m freestyle 400m freestyle 800m freestyle 1,500m freestyle 100m breaststroke 200m backstroke 200m backstroke 200m butterfly 200m butterfly 200m medley 4 × 100m freestyle relay 4 × 200m	Alexander Popov Alexander Popov Danyon Loader Danyon Loader — Kieren Perkins Fred Deburghgraeve Norbert Rozsa Jeff Rouse Brad Bridgewater Denis Pankratov Denis Pankratov Attila Czene Tom Dolan [Davis/Hall/Olsen/ Schumacher] [Berube/Davis/	Russia NZ NZ NZ — Australia Belgium Hungary USA USA Russia Hungary USA USA USA	Amy van Dyken Le Jingyi Claudia Poll Michelle Smith Brooke Bennett — Penelope Heyns Penelope Heyns Beth Botsford Krisztina Egerszegi Amy van Dyken Susan O'Neill Michelle Smith Michelle Smith Michelle Smith Tow/Martino/ Thompson/van Dyken	USA China CRC Ireland USA S. Africa S. Africa USA Hungary USA Australii Ireland USA
50m freestyle 100m freestyle 200m freestyle 400m freestyle 400m freestyle 400m freestyle 1,500m freestyle 1,500m freestyle 100m breaststroke 200m breaststroke 200m backstroke 200m butterfly 200m butterfly 200m medley 400m medley 4 × 100m freestyle relay	Alexander Popov Alexander Popov Danyon Loader Danyon Loader Kieren Perkins Fred Deburghgraeve Norbert Rozsa Jeff Rouse Brad Bridgewater Denis Pankratov Denis Pankratov Attila Czene Tom Dolan [Davis/Hall/Olsen/ Schumacher]	Russia NZ NZ NZ — Australia Belgium Hungary USA USA Russia Hungary USA USA USA	Amy van Dyken Le Jingyi Claudia Poll Michelle Smith Brooke Bennett — Penelope Heyns Penelope Heyns Beth Botsford Krisztina Egerszegi Amy van Dyken Susan O'Neill Michelle Smith Michelle Smith [Fox/Martino/ Thompson/van Dyken] [Jackson/Taormina/	USA China CRC Ireland USA S. Africa S. Africa USA Hungary USA Australi Ireland USA
50m freestyle 100m freestyle 200m freestyle 200m freestyle 400m freestyle 800m freestyle 1,500m freestyle 1,500m freestyle 100m breaststroke 100m backstroke 100m backstroke 100m butterfly 200m medley 400m medley 4 × 100m freestyle relay 4 × 200m freestyle relay freestyle relay	Alexander Popov Alexander Popov Danyon Loader Danyon Loader Kieren Perkins Fred Deburghgraeve Norbert Rozsa Jeff Rouse Brad Bridgewater Denis Pankratov Denis Pankratov Attila Czene Tom Dolan [Davis/Hall/Olsen/ Schumacher] [Berube/Davis/ Hudepohl/Schumacher]	Russia Russia NZ NZ — Australia Belgium Hungary USA Russia Russia Hungary USA USA	Amy van Dyken Le Jingyi Claudia Poll Michelle Smith Brooke Bennett Penelope Heyns Penelope Heyns Beth Botsford Krisztina Egerszegi Amy van Dyken Susan O'Neill Michelle Smith Michelle Smith I[Fox/Martino/ Thompson/van Dyken] Jackson/Taormina/ Teuscher/Thompson/	USA China CRC Ireland USA S. Africa USA Hungary USA Australia Ireland USA USA
50m freestyle 100m freestyle 200m freestyle 200m freestyle 400m freestyle 400m freestyle 1,500m freestyle 1,500m freestyle 100m breaststroke 100m backstroke 100m backstroke 100m butterfly 200m butterfly 200m medley 4 × 100m freestyle relay 4 × 200m freestyle relay 4 × 100m	Alexander Popov Alexander Popov Danyon Loader Danyon Loader Kieren Perkins Fred Deburghgraeve Norbert Rozsa Jeff Rouse Brad Bridgewater Denis Pankratov Denis Pankratov Attila Czene Tom Dolan [Davis/Hall/Olsen/ Schumacher] [Berube/Davis/ Hudepohl/Schumacher] [Hall/Henderson/	Russia Russia NZ NZ — Australia Belgium Hungary USA Russia Russia Hungary USA USA	Amy van Dyken Le Jingyi Claudia Poll Michelle Smith Brooke Bennett — Penelope Heyns Penelope Heyns Beth Botsford Krisztina Egerszegi Amy van Dyken Susan O'Neill Michelle Smith Michelle Smith Michelle Smith [Fox/Martino/ Thompson/van Dyken] [Jackson/Taormina/ Teuscher/Thompson] [Beard/Botsford/	USA China CRC Ireland USA S. Africa USA Hungary USA Australia Ireland USA USA
50m freestyle 100m freestyle 200m freestyle 200m freestyle 400m freestyle 800m freestyle 1,500m freestyle 1,500m freestyle 100m breaststroke 100m backstroke 100m backstroke 100m butterfly 200m medley 4 × 100m freestyle relay 4 × 200m freestyle relay 4 × 100m medley relay 100m medley 100m freestyle relay	Alexander Popov Alexander Popov Danyon Loader Danyon Loader Kieren Perkins Fred Deburghgraeve Norbert Rozsa Jeff Rouse Brad Bridgewater Denis Pankratov Denis Pankratov Attila Czene Tom Dolan [Davis/Hall/Olsen/ Schumacher] [Berube/Davis/ Hudepohl/Schumacher] [Hall/Henderson/ Linn/Rouse]	Russia Russia NZ NZ — Australia Belgium Hungary USA USA Russia Russia Hungary USA USA USA USA	Amy van Dyken Le Jingyi Claudia Poll Michelle Smith Brooke Bennett Penelope Heyns Penelope Heyns Beth Botsford Krisztina Egerszegi Amy van Dyken Susan O'Neill Michelle Smith Michelle Smith Kichelle Smith Jackson/Taormina/ Teuscher/Thompson Beard/Botsford/ Martino/van Dyken	USA China CRC Ireland USA S. Africa S. Africa USA Hungary USA Australia Ireland USA USA USA
50m freestyle 100m freestyle 200m freestyle 400m freestyle 400m freestyle 400m freestyle 1,500m freestyle 100m breaststroke 100m backstroke 200m backstroke 200m butterfly 200m medley 4 × 100m freestyle relay 4 × 200m freestyle relay 4 × 100m medley relay DIVING	Alexander Popov Alexander Popov Danyon Loader Danyon Loader Kieren Perkins Fred Deburghgraeve Norbert Rozsa Jeff Rouse Brad Bridgewater Denis Pankratov Attila Czene Tom Dolan [Davis/Hall/Olsen/ Schumacher] [Berube/Davis/ Hudepohl/Schumacher] [Hall/Henderson/ Linn/Rouse]	Russia Russia NZ NZ Australia Belgium Hungary USA USA Russia Russia Hungary USA USA USA USA USA	Amy van Dyken Le Jingyi Claudia Poll Michelle Smith Brooke Bennett — Penelope Heyns Penelope Heyns Beth Botsford Krisztina Egerszegi Amy van Dyken Susan O'Neill Michelle Smith Michelle Smith Michelle Smith Grow/Martino/ Thompson/van Dyken [Jackson/Taormina/ Teuscher/Thompson] [Beard/Botsford/ Martino/van Dyken]	USA China CRC Ireland USA S. Africa S. Africa USA Hungary USA Australia Ireland USA USA USA USA
50m freestyle 100m freestyle 200m freestyle 200m freestyle 400m freestyle 800m freestyle 1,500m freestyle 1,500m freestyle 1,500m breaststroke 100m backstroke 100m backstroke 100m butterfly 200m medley 4 × 100m freestyle relay 4 × 200m freestyle relay 4 × 100m medley relay 100m medley 100m medley 100m medley 100m freestyle relay 100m medley	Alexander Popov Alexander Popov Danyon Loader Danyon Loader Kieren Perkins Fred Deburghgraeve Norbert Rozsa Jeff Rouse Brad Bridgewater Denis Pankratov Denis Pankratov Attila Czene Tom Dolan [Davis/Hall/Olsen/ Schumacher] [Berube/Davis/ Hudepohl/Schumacher] [Hall/Henderson/ Linn/Rouse] Men Xiong Ni	Russia Russia NZ NZ — Australia Belgium Hungary USA USA Russia Russia Hungary USA USA USA USA USA	Amy van Dyken Le Jingyi Claudia Poll Michelle Smith Brooke Bennett Penelope Heyns Penelope Heyns Beth Botsford Krisztina Egerszegi Amy van Dyken Susan O'Neill Michelle Smith Michelle Smith Michelle Smith [Fox/Martino/ Thompson/van Dyken] Jackson/Taormina/ Teuscher/Thompson] [Beard/Botsford/ Martino/van Dyken] Women Fu Mingxia	USA China CRC Ireland USA S. Africa USA Hungary USA Australii Ireland USA USA USA USA USA Country
50m freestyle 100m freestyle 200m freestyle 400m freestyle 400m freestyle 400m freestyle 1,500m freestyle 1,500m freestyle 100m breaststroke 100m backstroke 200m butterfly 200m butterfly 200m butterfly 200m medley 4 × 100m freestyle relay 4 × 200m freestyle relay 4 × 100m medley relay DIVING 3m springboard 10m platform	Alexander Popov Alexander Popov Danyon Loader Danyon Loader Kieren Perkins Fred Deburghgraeve Norbert Rozsa Jeff Rouse Brad Bridgewater Denis Pankratov Denis Pankratov Attila Czene Tom Dolan [Davis/Hall/Olsen/ Schumacher] [Berube/Davis/ Hudepohl/Schumacher] [Hall/Henderson/ Linn/Rouse] Men Xiong Ni Dmitri Saoutine	Russia Russia NZ NZ Australia Belgium Hungary USA USA Russia Russia Hungary USA	Amy van Dyken Le Jingyi Claudia Poll Michelle Smith Brooke Bennett Penelope Heyns Penelope Heyns Beth Botsford Krisztina Egerszegi Amy van Dyken Susan O'Neill Michelle Smith Michelle Smith Michelle Smith [Fox/Martino/ Thompson/van Dyken] Jackson/Taormina/ Teuscher/Thompson] [Beard/Botsford/ Martino/van Dyken] Women Fu Mingxia	USA China CRC Ireland USA S. Africa USA Hungary USA Australia Ireland USA USA USA USA USA Country China
50m freestyle 100m freestyle 200m freestyle 200m freestyle 400m freestyle 800m freestyle 1,500m freestyle 1,500m freestyle 1,500m breaststroke 100m backstroke 100m backstroke 100m butterfly 200m medley 4 × 100m freestyle relay 4 × 200m freestyle relay 4 × 100m medley relay 1 × 100m medley relay	Alexander Popov Alexander Popov Danyon Loader Danyon Loader Kieren Perkins Fred Deburghgraeve Norbert Rozsa Jeff Rouse Brad Bridgewater Denis Pankratov Denis Pankratov Attila Czene Tom Dolan [Davis/Hall/Olsen/ Schumacher] [Berube/Davis/ Hudepohl/Schumacher] [Hall/Henderson/ Linn/Rouse] Men Xiong Ni Dmitri Saoutine	Russia Russia NZ NZ Australia Belgium Hungary USA USA Russia Russia Hungary USA	Amy van Dyken Le Jingyi Claudia Poll Michelle Smith Brooke Bennett — Penelope Heyns Penelope Heyns Beth Botsford Krisztina Egerszegi Amy van Dyken Susan O'Neill Michelle Smith Michelle Smith Michelle Smith Gray/Martino/ Thompson/van Dyken] Jackson/Taormina/ Teuscher/Thompson [Beard/Botsford/ Martino/van Dyken] Women Fu Mingxia Fu Mingxia	USA China CRC Ireland USA S. Africa USA Hungary USA Australia Ireland USA USA USA USA Country China China
50m freestyle 100m freestyle 200m freestyle 200m freestyle 400m freestyle 400m freestyle 1,500m freestyle 1,500m freestyle 1,500m freestyle 100m breaststroke 100m backstroke 200m backstroke 200m butterfly 200m butterfly 200m medley 4 × 100m freestyle relay 4 × 200m freestyle relay 4 × 100m medley relay DIVING 3m springboard 10m platform Water-polo Synchonized swim GYMNASTICS Women	Alexander Popov Alexander Popov Danyon Loader Danyon Loader Eigen Perkins Fred Deburghgraeve Norbert Rozsa Jeff Rouse Brad Bridgewater Denis Pankratov Denis Pankratov Attila Czene Tom Dolan [Davis/Hall/Olsen/ Schumacher] [Berube/Davis/ Hudepohl/Schumacher] [Hall/Henderson/ Linn/Rouse] Men Xiong Ni Dmitri Saoutine	Russia Russia NZ NZ Australia Belgium Hungary USA USA Russia Russia Hungary USA	Amy van Dyken Le Jingyi Claudia Poll Michelle Smith Brooke Bennett — Penelope Heyns Penelope Heyns Beth Botsford Krisztina Egerszegi Amy van Dyken Susan O'Neill Michelle Smith Michelle Smith Michelle Smith Michelle Smith Michelle Smith Jackson/Taormina/ Teuscher/Thompson [Jackson/Taormina/ Teuscher/Thompson] [Beard/Botsford/ Martino/van Dyken] Women Fu Mingxia Fu Mingxia	USA China CRC Ireland USA S. Africa S. Africa USA Hungary USA
50m freestyle 100m freestyle 200m freestyle 200m freestyle 400m freestyle 400m freestyle 1,500m freestyle 1,500m freestyle 1,500m freestyle 100m breaststroke 100m backstroke 100m backstroke 100m butterfly 200m butterfly 200m butterfly 200m medley 4 × 100m freestyle relay 4 × 200m freestyle relay 4 × 200m freestyle relay 4 × 100m medley relay DIVING 3m springboard 10m platform Water-polo Synchonized swim GYMNASTICS	Alexander Popov Alexander Popov Danyon Loader Danyon Loader Eigen Perkins Fred Deburghgraeve Norbert Rozsa Jeff Rouse Brad Bridgewater Denis Pankratov Denis Pankratov Attila Czene Tom Dolan [Davis/Hall/Olsen/ Schumacher] [Berube/Davis/ Hudepohl/Schumacher] [Hall/Henderson/ Linn/Rouse] Men Xiong Ni Dmitri Saoutine	Russia Russia NZ NZ Australia Belgium Hungary USA USA Russia Russia Hungary USA	Amy van Dyken Le Jingyi Claudia Poll Michelle Smith Brooke Bennett Penelope Heyns Penelope Heyns Beth Botsford Krisztina Egerszegi Amy van Dyken Susan O'Neill Michelle Smith Michelle Smith Michelle Smith [Fox/Martino/ Thompson/van Dyken] Jackson/Taormina/ Teuscher/Thompson] [Beard/Botsford/ Martino/van Dyken] Women Fu Mingxia Fu Mingxia	USA China CRC Ireland USA S. Africa S. Africa USA Hungary USA

Women			
All-round	Lilia Podkopayeva	Ukraine	
Floor exercises	Lilia Podkopayeva	Ukraine	
Balance beam	Shannon Miller	USA	
Assymetrical bars	Svetlana Chorkina	Russia	
Vault	Simona Amanar	Romania	
Team event	[Chow/Dawes/Miller/Moceanu/Phelps/Strug]	USA	
Mon			

realli event	[Gilow/Dawes/Willer/Woceand/Theips/Gdag]	oon
Men		
All-round	Li Xiaoshang	China
Floor exercises	Ioannis Melissanidis	Greece
Rings	Chechi Yuri	Italy
Parallel bars	Rustam Sharipov	Ukraine
Horizontal bar	Andreas Wecker	Germany
Pommel horse	Li Donghua	Switzerland
Vault	Alexei Nemov	Russia
Team event	[Charkov/Krukov/Nemov/Podgorni//Trush/Voropaev]	Russia

ATHLETICS WORLD CHAMPIONSHIP VENUES					
Year	Venue	Year	Venue	Year	Venue
1987	Rome, Italy	1993	Stuttgart, Germany	1997	Athens, Greece
1991	Tokyo, Japan	1995	Gothenburg, Sw'n	1999	Seville, Spain

France

FOR	MULA 1 MOTO	R RACING	CHAMPIONS	
Year	Driver	Country	Car	Constructors' Cup
1951	Juan Fangio	Argentina	Alfa Romeo	_
1952	Alberto Ascari	Italy	Ferrari	_
1953	Alberto Ascari	Italy	Ferrari	_
1954	Juan Fangio	Argentina	Maserati,	_
			Mercedes-Benz	
1955	Juan Fangio	Argentina	Mercedes-Benz	_
1956	Juan Fangio	Argentina	Lancia-Ferrari	_
1957	Juan Fangio	Argentina	Maserati	
1958	Mike Hawthorn	England	Ferrari	Vanwall
1959	Jack Brabham	Australia	Cooper-Climax	Cooper-Climax
1960	Jack Brabham	Australia	Cooper-Climax	Cooper-Climax
1961	Phil Hill	USA	Ferrari BRM	Ferrari BRM
1962	Graham Hill	England		Lotus-Climax
1963	Jim Clark	Scotland	Lotus-Climax	Ferrari
1964	John Surtees	England Scotland	Ferrari Lotus-Climax	Lotus-Climax
1965	Jim Clark Jack Brabham	Australia	Brabham-Repco	Brabham-Repco
1966 1967		New Zealand	Brabham-Repco	Brabham-Repco
1967	Denny Hulme Graham Hill	England	Lotus-Ford	Lotus-Ford
1969	Jackie Stewart	Scotland	Matra-Ford	Matra-Ford
1909	Jochen Rindt	Austria	Lotus-Ford	Lotus-Ford
1971	Jackie Stewart	Scotland	Tyrell-Ford	Tyrell-Ford
1972	Emerson Fittipaldi	Brazil	Lotus-Ford	Lotus-Ford
1973	Jackie Stewart	Scotland	Tyrell-Ford	Lotus-Ford
1974	Emerson Fittipaldi	Brazil	McLaren-Ford	McLaren-Ford
1975	Niki Lauda	Austria	Ferrari	Ferrari
1976	James Hunt	England	McLaren-Ford	Ferrari
1977	Niki Lauda	Austria	Ferrari	Ferrari
1978	Mario Andretti	USA	Lotus-Ford	Lotus-Ford
1979	Jody Scheckter	South Africa	Ferrari	Ferrari
1980	Alan Jones	Australia	Williams-Ford	Williams-Ford
1981	Nelson Piquet	Brazil	Brabham-Ford	Williams-Ford
1982	Keke Rosberg	Finland	Williams-Ford	Ferrari
1983	Nelson Piquet	Brazil	Brabham-BMW	Ferrari
1984	Niki Lauda	Austria	McLaren-Porsche	McLaren-Porsche
1985	Alain Prost	France	McLaren-Porsche	McLaren-Porsche
1986	Alain Prost	France	McLaren-Porsche	Williams-Honda
1987	Nelson Piquet	Brazil	Williams-Honda	Williams-Honda
1988	Ayrton Senna	Brazil	McLaren-Honda	McLaren-Honda
1989	Alain Prost	France	McLaren-Honda	McLaren-Honda
1990	Ayrton Senna	Brazil	McLaren-Honda	McLaren-Honda
1991	Ayrton Senna	Brazil	McLaren-Honda	McLaren-Honda
1992	Nigel Mansell	England	Williams-Renault	Williams-Renault
1993	Alain Prost	France	Williams-Renault	Williams-Renault
1994	Michael Schumacher	Germany	Benetton-Ford	Williams-Renault
1995	Michael Schumacher	Germany	Benetton-Renault	Williams-Renault
1996	Damon Hill	England	Williams-Renault Williams-Renault	Williams-Renault Williams-Renault
1997	Jacques Villeneuve	Canada	vviiilams-nenault	vviiilams-nenault

Year	Men*	Country	Team	Women*	Country	Team
1981	Yuri Korolev	USSR	USSR	Olga Bicherova	USSR	USSR
1983	Dmitri Belozerchev	USSR	China	Natalya Yurchenko	USSR	USSR
1985	Yuri Korolev	USSR	USSR	Oksana Omelinchuk &	USSR	USSR
				Yelena Shushunova	USSR	
1987	Dmitri Belozerchev	USSR	USSR	Aurelia Dobre	Romania	Romani
1989	lgor Korobichinsky	USSR	USSR	Svetlana Boginskaya	USSR	USSR
1991	Grigori Misutin	USSR	USSR	Kim Zmeskal	USA	USSR
1993	Vitaly Scherbo	Belarus	†	Shannon Miller	USA	†
1994	Ivan İvankov	Belarus	†	Shannon Miller	USA	†
1995	Li Xiaoshuang	China	China	Lilia Podkopayeva	Ukraine	Romani
1997	Ivan Ivankov	Belarus	China	Svetlana Khorkina	Russia	Romani

^{*} Combined exercises (all-round champion) \dagger No team championships were held

Year	Winner	Country	Venue	Score
1981	Bill Rogers	USA	Sandwich	276
1982	Tom Watson	USA	Troon	284
1983	Tom Watson	USA	Royal Birkdale	275
1984	Severiano Ballesteros	Spain	St Andrews	276
1985	Sandy Lyle	Scotland	Sandwich	282
1986	Greg Norman	Australia	Turnberry	280
1987	Nick Faldo	England	Muirfield	279
1988	Severiano Ballesteros	Spain	Royal Lytham	273
1989	Mark Calcavecchia*	USA	Troon	275
1990	Nick Faldo	England	St Andrews	270
1991	Ian Baker-Finch	Australia	Royal Birkdale	272
1992	Nick Faldo	England	Muirfield	272
1993	Greg Norman	Australia	Sandwich	267
1994	Nick Price	Zimbabwe	Turnberry	268
1995	John Daly	USA	St Andrews	282
1996	Tom Lehman	USA	Royal Lytham	271
1997	Justin Leonard	USA	Troon	272

^{*} Won title after a play-off

Year	Venue	Attendance	Winners		Runners-up	
1930	Montevideo	90,000	Uruguay*	4	Argentina	
1934	Rome	50,000	Italy*	2 [†]	Czechoslovakia	
1938	Paris	45,000	Italy	4	Hungary	
1950	Rio de Janeiro	199,854	Uruguay	2	Brazil	
1954	Berne	60,000	West Germany	3	Hungary	
1958	Stockholm	49,737	Brazil	5	Sweden*	
1962	Santiago	68,679	Brazil	3	Czechoslovakia	
1966	London	93,802	England*	4 [†]	West Germany	
1970	Mexico City	107,412	Brazil	4	Italy	
1974	Munich	77,833	West Germany*	2	Netherlands	
1978	Buenos Aires	77,000	Argentina*	3	Netherlands	
1982	Madrid	90,080	Italy	3	West Germany	
1986	Mexico City	114,580	Argentina	3	West Germany	
1990	Rome	73,603	West Germany	1	Argentina	
1994	Los Angeles	94,194	Brazil	0^{\ddagger}	Italy	
1998	Paris	W. W. W. W. W. W. W. W. W. W. W. W. W. W				

Year	Men	Country	Women	Country
1981	Scott Hamilton	USA	Denise Biellmann	Switzerland
1982	Scott Hamilton	USA	Elaine Zayak	USA
1983	Scott Hamilton	USA	Rosalynn Sumners	USA
1984	Scott Hamilton	USA	Katarina Witt	E. Germany
1985	Aleksandr Fadeyev	USSR	Katarina Witt	E. Germany
1986	Brian Boitano	USA	Debbie Thomas	USA
1987	Brian Orser	Canada	Katarina Witt	E. Germany
1988	Brian Boitano	USA	Katarina Witt	E. Germany
1989	Kurt Browning	Canada	Midori Ito	Japan
1990	Kurt Browning	Canada	Jill Trenary	USA
1991	Kurt Browning	Canada	Kristi Yamaguchi	USA
1992	Viktor Petrenko	CIS (Ukraine)	Kristi Yamaguchi	USA
1993	Kurt Browning	Canada	Oksana Bayiul	Ukraine
1994	Elvis Stojko	Canada	Yuka Sato	Japan
1995	Elvis Stojko	Canada	Lu Chen	China
1996	Todd Eldredge	USA	Michelle Kwan	USA
1997	Elvis Stojko	USA	Tara Lipinski	USA

Year	Winner	Country
1979	Bernard Hinault	France
1980	Joop Zoetemelk	Netherlands
1981	Bernard Hinault	France
1982	Bernard Hinault	France
1983	Laurent Fignon	France
1984	Laurent Fignon	France
1985	Bernard Hinault	France
1986	Greg LeMond	USA
1987	Stephen Roche	Ireland
1988	Pedro Delgado	Spain
1989	Greg LeMond	USA
1990	Greg LeMond	USA
1991	Miguel Induráin	Spain
1992	Miguel Induráin	Spain
1993	Miguel Induráin	Spain
1994	Miguel Induráin	Spain
1995	Miguel Induráin	Spain
1996	Bjarne Riis	Denmark
1997	Jan Ullrich	Germany

DAV	IS CUP
Year	Winners
1979	USA
1980	Czechoslovakia
1981	USA
1982	USA
1983	Australia
1984	Sweden
1985	Sweden
1986	Australia
1987	Sweden
1988	West Germany
1989	West Germany
1990	USA
1991	France
1992	USA
1993	Germany
1994	Sweden
1995	USA
1996	France
1997	Sweden

WIM	BLEDON SING	GLES CHAM	IPIONS	
Year	Men	Country	Women	Country
1980 1981 1982 1983 1984 1985 1986 1987 1988 1989 1990 1991 1992 1993 1994	Bjorn Borg John McEnroe Jimmy Connors John McEnroe John McEnroe Boris Becker Boris Becker Pat Cash Stefan Edberg Boris Becker Stefan Edberg Michael Stich Andre Agassi Pete Sampras	Sweden USA USA USA USA W. Germany W. Germany Australia Sweden W. Germany Sweden USA USA USA USA	Evonne Goolagong* Chris Evert† Martina Navratilova Martina Navratilova Martina Navratilova Martina Navratilova Martina Navratilova Martina Navratilova Steffi Graf Steffi Graf Steffi Graf Steffi Graf Steffi Graf Steffi Graf Steffi Graf Conchita Martinez	Australia USA
1995 1996 1997	Pete Sampras Richard Krajicek Pete Sampras	USA Netherlands USA	Steffi Graf Steffi Graf Martina Hingis	Germany Germany Switz

^{*} Then Evonne Goolagong-Cawley; she had also won in 1971 under her maiden name † Then Chris Evert-Lloyd; she had also won in 1974 and 1976 under her maiden name

UEFA EUROPEAN CHAMPIONSHIP

Year	Winners	Year	Winners
1960	Soviet Union	1980	West Germany
1964	Spain*	1984	France*
1968	Italy*	1988	Netherlands
1972	West Germany	1992	Denmark
1976	Czechoslovakia	1996	Germany

*Host nation

Year	Winners	Year	Winners
1970	Feyenoord	1984	Liverpool [†]
1971	Ajax Amsterdam	1985	Juventus
1972	Aiax Amsterdam	1986	Steaua Buchares
1973	Ajax Amsterdam	1987	FC Porto
1974	Bayern Munich*	1988	PSV Eindhoven [†]
1975	Bayern Munich	1989	AC Milan
1976	Bayern Munich	1990	AC Milan
1977	Liverpool	1991	R. Star Belgrade
1978	Liverpool	1992	Barcelona
1979	Nottingham Forest	1993	AC Milan [‡]
1980	Nottingham Forest	1994	AC Milan
1981	Liverpool	1995	Ajax Amsterdam
1982	Aston Villa	1996	Juventus†
1983	SV Hamburg	1997	Bor, Dortmund

* Won after replay † Won on penalties ‡ Olympique Marseilles won the final but were stripped of the title by UEFA for financial irregularities

EUROPEAN CUP-WINNERS CUP

Year	Winners	Year	Winners
1970	Manchester City	1984	Juventus
1971	Chelsea*	1985	Everton
1972	Glasgow Rangers	1986	Dynamo Kiev
1973	AC Milan	1987	Ajax Amsterdam
1974	FC Magdeburg	1988	Mechelen
1975	Dynamo Kiev	1989	Barcelona
1976	Anderlecht	1990	Sampdoria
1977	SV Hamburg	1991	Manchester U.
1978	Anderlecht	1992	Werder Bremen
1979	Barcelona	1993	AC Parma
1980	Valencia [†]	1994	Arsenal
1981	Dynamo Tbilisi	1995	Real Zaragoza
1982	Barcelona	1996	Paris St Germain
1983	Aberdeen	1997	Barcelona

* Beat Real Madrid 2-1 in replay † Beat Arsenal 5-4 on penalties

UEFA CUP

Year	Winners	Year	Winners
1970	Arsenal	1984	Tottenham H. [†]
1971	Leeds United*	1985	Real Madrid
1972	Tottenham H.	1986	Real Madrid
1973	Liverpool	1987	AFK Gothenburg
1974	Fevenoord	1988	Bayer Leverkusen [†]
1975	Bor. M'gladbach	1989	Napoli
1976	Liverpool	1990	Juventus
1977	Juventus*	1991	Inter-Milan
1978	PSV Eindhoven	1992	Ajax Amsterdam*
1979	Bor. M'gladbach	1993	Juventus
1980	Eintracht F'furt*	1994	Inter-Milan
1981	Ipswich Town	1995	Parma
1982	AFK Gothenburg	1996	Bayern Munich
1983	Anderlecht	1997	Schalke [†]

* Won on away goals rule † Won on penalties

HOCKEY WORLD CHAMPIONS

Year	Winners	Year	Winners
Men		Women	
1971	Pakistan	1974	Netherlands
1973	Netherlands	1976	West Germany
1975	India	1978	Netherlands
1978	Pakistan	1981	West Germany
1982	Pakistan	1983	Netherlands
1986	Australia	1986	Netherlands
1990	Netherlands	1990	Netherlands
1994	Pakistan	1994	Australia

RUGBY UNION WORLD CUP

Year	Venue	Winners	Runners-up	Score
1987	Auckland	N. Zealand	France	29-9
1991	Twickenham	Australia	England	12-6
1995	Johannesburg	S. Africa	N. Zealand	15-12

RUGBY UNION FIVE NATIONS CHAMPIONSHIP

Year	Winners	Year	Winners
1982	Ireland	1990	Scotland
1983	France, Ireland*	1991	England
1984	Scotland	1992	England
1985	Ireland	1993	France
1986	France,	1994	Wales
	Scotland*	1995	England
1987	France	1996	England
1988	France, Wales*	1997	France
1989	France	1998	France

*Title shared - points difference did not count

CRICKET WORLD CUP FINALS

Year	Venue	Winners	Runners-up	Margin	
1975	Lord's	West Indies	Australia	17 runs	
1979	Lord's	West Indies	England	92 runs	
1983	Lord's	India	West Indies	43 runs	
1987	Calcutta	Australia	England	7 runs	
1992	Melbourne	Pakistan	England	22 runs	
1996	Lahore	Sri Lanka	Australia	7 wkts	

CRICKET UK COUNTY CHAMPIONS

Year	Winners	Year	Winners
1980	Middlesex	1989	Worcestershire
1981	Nottinghamshire	1990	Middlesex
1982	Middlesex	1991	Essex
1983	Essex	1992	Essex
1984	Essex	1993	Middlesex
1985	Middlesex	1994	Warwickshire
1986	Essex	1995	Warwickshire
1987	Nottinghamshire	1996	Leicestershire
1988	Worcestershire	1997	Glamorgan

FA	CUP WINNER	s	
Year	Winners		

Year	Winners	Year	Winners
1970	Chelsea*	1984	Everton
1971	Arsenal	1985	Manchester U.
1972	Leeds United	1986	Liverpool
1973	Sunderland	1987	Coventry City
1974	Liverpool	1988	Wimbledon
1975	West Ham U.	1989	Liverpool
1976	Southampton	1990	Manchester U.*
1977	Manchester U.	1991	Tottenham H.
1978	Ipswich Town	1992	Liverpool
1979	Arsenal	1993	Arsenal*
1980	West Ham U.	1994	Manchester U.
1981	Tottenham H.*	1995	Everton
1982	Tottenham H.*	1996	Manchester U.
1983	Manchester U.*	1997	Chelsea

*Won replay after first final was drawn

FOOTBALL LEAGUE CHAMPIONS

Season	Winners	Season	Winners
1969-70	Everton	1983-84	Liverpool
1970-71	Arsenal	1984-85	Everton
1971-72	Derby County	1985-86	Liverpool
1972-73	Liverpool	1986-87	Everton
1973-74	Leeds United	1987-88	Liverpool
1974-75	Derby County	1988-89	Arsenal
1975-76	Liverpool	1989-90	Liverpool
1976-77	Liverpool	1990-91	Arsenal
1977-78	Nottingham F.	1991-92	Leeds United
1978-79	Liverpool	1992-93	Manchester U.
1979-80	Liverpool	1993-94	Manchester U.
1980-81	Aston Villa	1994-95	Blackburn R.
1981-82	Liverpool	1995-96	Manchester U.
1982-83	Liverpool	1996-97	Manchester U.
	1969-70 1970-71 1971-72 1971-72 1972-73 1973-74 1974-75 1976-77 1977-78 1978-79 1979-80 1980-81 1981-82	1969-70 Everton 1970-71 Arsenal 1971-72 Derby County 1972-73 Liverpool 1973-74 Leeds United 1974-75 Derby County 1975-76 Liverpool 1976-77 Liverpool 1977-89 Liverpool 1979-80 Liverpool 1980-81 Aston Villa 1981-82 Liverpool	1969-70 Everton 1983-84 1970-71 Arsenal 1984-85 1971-72 Derby County 1985-86 1972-73 Liverpool 1986-87 1973-74 Leeds United 1987-88 1975-75 Derby County 1988-89 1975-76 Liverpool 1989-90 1976-77 Liverpool 1990-91 1977-78 Nottingham F. 1991-92 1978-90 Liverpool 1992-93 1979-80 Liverpool 1993-94 1980-81 Aston Villa 1994-95 1981-82 Liverpool 1995-96

SNOOKER	WORLD	CHAMPIO	NS

Year	Winner	Country
1981	Steve Davis	England
1982	Alex Higgins	N. Ireland
1983	Steve Davis	England
1984	Steve Davis	England
1985	Dennis Taylor	N. Ireland
1986	Joe Johnson	England
1987	Steve Davis	England
1988	Steve Davis	England
1989	Steve Davis	England
1990	Stephen Hendry	Scotland
1991	John Parrott	England
1992	Stephen Hendry	Scotland
1993	Stephen Hendry	Scotland
1994	Stephen Hendry	Scotland
1995	Stephen Hendry	Scotland
1996	Stephen Hendry	Scotland
1997	Ken Doherty	Ireland

COMMONWEALTH GAMES VENUES

The first Inter-Empire Sports meeting was held at Crystal Palace, London in 1911.

Games	Year	Venue	
I *	1930	Hamilton, Canada	
*	1934	London, England	
111*	1938	Sydney, Australia	
IV*	1950	Auckland, New Zealand	
V [†]	1954	Vancouver, Canada	
VI [†]	1958	Cardiff, Wales	
VII [†]	1962	Perth, Australia	
VIII [†]	1966	Kingston, Jamaica	
IX [‡]	1970	Edinburgh, Scotland	
	1974	Christchurch, New Zealand	
ΧI [§]	1978	Edmonton, Canada	
XII§	1982	Brisbane, Australia	
XIII§	1986	Edinburgh, Scotland	
XIV§	1990	Auckland, New Zealand	
ΧV [§]	1994	Victoria, Canada	
XVI§	1998	Kuala Lumpur, Malaysia	

* British Empire Games † British Empire and Commonwealth Games ‡ British Commonwealth Games § Commonwealth Games

ENGLISH GRAND NATIONAL

Year	Horse	Jockey
1981	Aldaniti	Bob Champion
1982	Grittar	Dick Saunders
1983	Corbiere	Ben De Haan
1984	Hallo Dandy	Neale Doughty
1985	Last Suspect	Hywel Davies
1986	West Tip	Richard Dunwoody
1987	Maori Venture	Steve Knight
1988	Rhyme 'n' Reason	Brendan Powell
1989	Little Polveir	Jimmy Frost
1990	Mr Frisk	Marcus Armytage
1991	Seagram	Nigel Hawke
1992	Party Politics	Carl Llewellyn
1993	Race void owing to fa	alse start
1994	Minnehoma	Richard Dunwoody
1995	Royal Athlete	Jason Titley
1996	Rough Quest	Mick Fitzgerald
1997	Lord Gyllene	Tony Dobbin

EPSOM DERBY

Year	Horse	Jockey
1981	Shergar	Walter Swinburn
1982	Golden Fleece	Pat Eddery
1983	Teenoso	Lester Piggott
1984	Secreto	Christy Roche
1985	Slip Anchor	Steve Cauthen
1986	Shahrastani	Walter Swinburn
1987	Reference Point	Steve Cauthen
1988	Kahyasi	Ray Cochrane
1989	Nashwan	Willie Carson
1990	Quest For Fame	Pat Eddery
1991	Generous	Alan Munro
1992	Dr Devious	John Reid
1993	Commander-in-Chief	Michael Kinane
1994	Erhaab	Willie Carson
1995	Lammtarra	Walter Swinburn
1996	Shaamit	Michael Hills
1997	Benny the Dip	John Gosden

CODES AND ALPHABETS

α	A	alpha
3	$_{\Gamma}^{\mathrm{B}}$	beta
Υ	Γ	gamma
6	Δ E	delta
y S	E	epsilon
,	Z	zeta
η	H	eta
)	θ	theta
	I	iota
(K	kappa
1	Λ	lambda
r	\mathbf{M}	mu
,	N Ξ О П Р	nu
5	三	xi
)	O	omicron
Т	П	pi
)	P	rho
r, s	Σ T	sigma
	T	tau
,	Υ	upsilon
þ	Φ	phi
(.	X	chi
ş	Ψ	psi
)	Ω	omega

		LIADETO	
Letter	Morse code	Braille	Semaphore
Α	•-	•:	/
В		•	-•
С		••	\•
D		••	!
Е	•	::	•/
F	••-•	•••	•-
G		••	•
Н	••••		-;
1	••	::	>
J		••	!_
K		•	ļ
L	•-••		,./
М		••	/-
N	-•		^
0			<u>.</u>
Р	••		_!
Q			/
R	•-•		
S	•••	:	-•
T	-		\!
U	••-		\./
V	•••-	•••••	Ţ
W	•		
Χ		• •	<
Υ			\ <u>.</u> _
Z		••	:

			NIN				
QR P	QN P	QB P	Q P	K P	KB P	KN P	KR P
	1	4	¥	Ż	1	1	H
<u>i</u>	1	İ	1	<u>1</u>	1	İ	İ
登選	立公					益	<u> </u>
P QR	P QN	P QB	P Q	P K	P KB	P KN	P KR
Abbrev	/iations	1					
K Kir KB Kir KN Kir KR Kir	shop ng ng's bis ng's kni ng's roo iight	ght		Q (0 QB (0 QN (0 QR (0			

+	plus; positive	
-	minus; negative	
±	plus or minus; positive or negative;	
	degree of accuracy	
×	multiplied by ("times") (3×2)	
÷	divided by $(6 \div 2)$	
/	divided by; ratio of (2:1)	
!	factorial (4! = $4 \times 3 \times 2 \times 1$)	
=	equal to	
≠	not equal to	
=	identical with	
≢	not identical with	
_ △	corresponds to	
i	ratio of (2:1)	
111	proportionately equals (2:3 :: 4:6)	
~	approximately equal to; equivalent to;	
	similar to	
>	greater than	
≫	much greater than	
≯	not greater than	
<	less than	
<	much less than	
< <	not less than	
≯ ∨ ♥ ♦ № ₩ 8	greater than or equal to	
≦	less than or equal to	
	directly proportional to	
()	parentheses	
() [] {} ∞	brackets	
{}	braces	
∞	infinity	
→ √ 3/, 4/	approaches the limit	
3/ 4/	square root	
V, V	cube root, fourth root, etc	
%′	per cent	
	prime; minute(s) of arc; foot/feet	
	double prime; second(s) of arc; inch(es)	
0	arc of circle	
	degree of arc	9
-	equiangular	
1	perpendicular	
	parallel	
$\begin{array}{c} \stackrel{\underline{\vee}}{=} \\ \stackrel{\underline{\vee}{=} \\ \stackrel{\underline{\vee}}{=} \\$	therefore	
	because	
Δ	increment	
<u>7</u>	summation	
JII	product	
J	integral sign	

BASIC MATHEMATICAL SYMBOLS

ACCEN1	r s	
Name	Example	Name
Acute	é	Diaeres
Asper	'o	Grave
Breve	ă	Macron
Cedilla	Ç	Tilde
Circumflex	ô	Umlaut

Example

è ā ñ ü

NATO	ALPHABET		
Letter	Code name	Letter	Code name
Α	Alpha	N	November
В	Bravo	0	Oscar
C	Charlie	Р	Papa
D	Delta	Q	Quebec
E	Echo	R	Romeo
F	Foxtrot	S	Sierra
G	Golf	Т	Tango
Н	Hotel	U	Uniform
1	India	V	Victor
J	Juliet	W	Whisk(e)y
K	Kilo	X	X-ray
L	Lima	Υ	Yankee
M	Mike	Z	Zulu

©	copyright	10.5	
R	registered	×	irritant
п	ditto	H	high voltage
TM	trademark	. Mc	highly
9	female	1	flammable
3	male		oxidizing/ supports fire
Ġ	disabled	*	radiation (laser)
Ô	first aid	((_{\(\(\)\)}))	radiation (non- ionising)
i	information	4.4	radioactive
25	recycling		toxic

SYMBOLS IN COMMON USE

ampersand (and)

at; per (in costs)

corrosive

www.explosive

&

@

SEVEN WONDERS OF THE ANCIENT WORLD

Designated in the 2nd century BC by the Greek poet, Antipatus of Sidon

Name	Date built
Egyptian Pyramids	From <i>c.</i> 2700 BC
Hanging Gardens of Babylon	6th century BC
Temple of Artemis (Diana) at Ephesus, Asia Minor	6th century BC
Statue of Zeus at Olympia, Greece	с.430 вс
Mausoleum at Halicarnassus (now, Bodrum) Asia Minor	4th century BC
Colossus of Rhodes	с.292-280 вс
Pharos of Alexandria, Egypt	с.280 вс

GREEK GODS OF MYTHOLOGY

Aeolus: God of the winds Aphrodite: Goddess of love, beauty and procreation Apollo: God of beauty, poetry and music Ares: God of war Artemis: Goddess of the Moon, hunting and fertility Athene: Goddess of wisdom; protectress of Athens Boreas: God of the north wind Cronus: God of harvests Cybele: Goddess of fertility and the mountains Demeter: Goddess of fruit, crops and vegetation Dionysus: God of wine Eos: Goddess of the dawn Eros: God of love Gaia: Goddess of the earth Hades (Dis): God of the Underworld Hebe: Goddess of youth Hecate: Goddess of magic, ghosts and witchcraft Helios: God of the Sun Henhaestus: God of fire and metalcraft Hera: Goddess of women, marriage; queen of heaven Hermes: God of science, commerce and physicians; messenger of the gods Hestia: Goddess of the hearth Iris: Goddess of the rainbow; messenger of the gods Morpheus: God of dreams Nemesis: Goddess of vengeance and retribution Nike: Goddess of victory Oceanus: God of the waters Pan: God of pastures, forests, flocks, and herds Persephone: Goddess of the underworld Poseidon: God of the sea

ROMAN GODS OF MYTHOLOGY

Zeus: Overlord of the Olympian gods and goddesses;

Rhea: Mother of the gods Uranus: God of the sky

lord of heaven

Apollo: God of the Sun Aurora: Goddess of the dawn Bacchus: God of wine Bellona: Goddess of war Ceres: Goddess of agriculture Cupid: God of love Diana: Goddess of fertility, hunting, and the Moon Faunus: God of prophecy Flora: Goddess of flowers Janus: God of gates and doors Juno: Goddess of marriage and women Jupiter: Supreme god and god of the sky Lares: Gods of the household and descendants Libitina: Goddess of funerals Maia: Goddess of growth and increase Mars: God of war Mercury: Messenger god; god of commerce Minerva: Goddess of wisdom, the arts, and trades Mithras: God of the Sun, light and regeneration Neptune: God of the sea Ops: Goddess of fertility Pales: Goddess of flocks and shepherds Pluto: God of the Underworld Pomona: Goddess of fruit trees and fruit Proserpine: Goddess of the Underworld Saturn: God of seed time and harvest Venus: Goddess of beauty and love Vertumnus: God of the seasons Vesta: Goddess of the hearth Vulcan: God of fire

Years	Monarch	Age*	R'd [†]	Years	Monarch	Ag
KINGS AND	QUEENS OF ENGLAND			1413-22	Henry V	
West Saxon	Kings (House of Cerdic)			1422-61	Henry VI#	
802-839	Egbert [‡]	_	37		,	
839-858	Ethelwulf	-	19	House of York		
858-860	Ethelbald	_	2	1461-83	Edward IV¶	
860-866	Ethelbert	_	6	1483	Edward V	
866-871	Ethelred I	_	5	1483-85	Richard III	
871-899	Alfred (the Great)	52	28	-		
899-924	Edward (the Elder)	55	25	House of Tudo	or	
924-939	Athelstan (the Glorious)	45	15	1485-1509	Henry VII	
939-946	Edmund I	25	6	1509-47	Henry VIII	
946-955	Edred	32	9	1547-53	Edward VI	
955-959	Edwy (the Fair)	18	3	1553	Jane (Lady Jane Grey)**	
959-975	Edgar (the Peaceful)	32	16	1553-58	Mary I (Mary Tudor)	
975-978	Edward I (the Martyr)	17	3	1558-1603	Elizabeth I	
978-1016	Ethelred II (the Unready)	47	38			
1016	Edmund II (Ironside)	2	7m	KINGS AND O	UEENS OF BRITAIN	
				House of Stua	rt	
Danish Kings	s (House of Denmark)			1603-25	James I (VI of Scotland)	
1016-35	Canute (Cnut) [‡]	40	19	1625-49	Charles I	
1035-40	Harold I (Harefoot)	23	4	1649-60	Commonwealth ^{††}	
1040-42	Hardecanute (Harthacnut)		2	1660-85	Charles II	
010 12	Transcount (Translational)			1685-88	James II	
Nest Saxon	Kings (restored)				1 December 1688 to 12 Febr	uarv
1042-66	Edward II (the Confessor)	61	23	1689-1702	William III	uuiy
1066	Harold II (Godwinesson)	45	10m	and to 1694	Mary II	
	, , , , , , , , , , , , , , , , , , , ,	10	10111	1702-14	Anne	
House of No	rmandy					
1066-87	William I (the Conqueror)‡	60	20	House of Hand		
1087-1100	William II (Rufus)	41	12	1714-27	George I (Elector of Hano	ver)
1100-35	Henry I (Beauclerc)	67	35	1727-60	George II	
1135-54	Stephen [§]	53	18	1760-1820	George III	
				1820-30	George IV	
	ou (Plantagenets)			1830-37	William IV	
1154-89	Henry II (Curtmantle)	56	34	1837-1901	Victoria	
1189-99	Richard I (the Lionheart)	42	9		asing a second of	
1199-1216	John (Lackland)	48	17		e-Coburg and Gotha	
1216-72	Henry III	65	56	1901-1910	Edward VII	
1272-1307	Edward I (Longshanks)	68	34			
1307-27	Edward II	43	19	House of Win	dsor ⁺⁺	
1327-77	Edward III	64	50	1910-36	George V	
1377-99	Richard II	33	22	1936	Edward VIII§§	
				1936-52	George VI	
House of Lar	ıcaster			1952-	Elizabeth II	
1399-1413	Henry IV	47	13			

* On death † Duration of reign in years (m = months, d=days) ‡ Became ruler by conquest § Son of William's daughter Adele and Stephen, Count of Blois; sometimes given as the monarch of the House of Blois # Deposed March 1461, restored October 1470, deposed April 1471, and killed in Tower of London May 1471 ¶ Acceded March 1461, deposed October 1470, restored April 1471 ** Edward was forced to name Lady Jane as his successor and a Council of State proclaimed her Queen; Mary, proclaimed Queen by the Council, had Jane beheaded in 1554 †† 1649-53 Council of State; 1653-58 Oliver Cromwell, Lord Protector; 1658-60 Richard Cromwell (son), Lord Protector ‡‡ Name changed from the German Saxe-Coburg and Gotha on 17 July 1917 (during World War 1) §§ Abdicated at the age of 42

KINGS OF FRANCE

Dates	King	Relationship
House of V	alois*	
1328-50	Philip VI	Grandson of Philip III
1350-64	John II	Son of Philip VI
1364-80	Charles V	Son of John II
1380-1422	Charles VI	Son of Charles V
1422-61	Charles VII	Son of Charles VI
1461-83	Louis XI	Son of Charles VII
1483-98	Charles VIII	Son of Louis XI
1498-1515	Louis XII	Great-grandson of Charles V
1515-47	Francis I	Cousin of Louis XII
1547-59	Henry II	Son of Francis I
1559-60	Francis II	Son of Henry II
1560-74	Charles IX	Brother of Francis II
1574-89	Henry III	Brother of Charles IX
House of E	Bourbon	
1589-1610		Son of Queen of Navarre
1610-43	Louis XIII	Son of Henri IV
1643-1715	Louis XIV	Son of Louis XIII
1715-74	Louis XV	Great-grandson of Louis XIV
1774-93 [†]	Louis XVI	Grandson of Louis XV
Restoratio	n	
1814-24	Louis XVIII	Brother of Louis XVI
1824-30 [‡]	Charles X	Brother of Louis XVIII
1830-48	Louis Philippe	Son of Duke or Orléans [§]
from 987 to † Louis XV while in pr ‡ Louis XI.	o 1322 II, son of Louis i ison 1793-95	rom 741 to 986, the Capets XVI, was nominally king were nominally kings in 1830, s respectively

Years	Tsar
House of Rurik	
1547-84	Ivan IV (the Terrible)
1584-98	Theodore I
1598	Irina
House of Godunov	
1598-1605	Boris Godunov
1605	Theodore II
Usurpers*	
1605-06	Dimitri III
1606-10	Basil IV
House of Romanov	Carlotte Anna Carlotte
1613-45	Michael Romanov
1645-76	Alexei
1676-82	Theodore III
1682-96	Peter I and Ivan V (brothers)
1696-1725	Peter I (the Great)
1725-27	Catherine I
1727-30	Peter II
1730-40	Anna Ivanovna
1740-41	Ivan VI
1741-62	Elizabeth
1762	Peter III
1762-96	Catherine II (the Great)
1796-1801	Paul I
1801-25	Alexander I
1825-55	Nicholas I
1855-81	Alexander II
1881-94	Alexander III
1894-1917	Nicholas II

Age*

49 39

40 21 2_m

12

16

42 44

48 23

54 24

67

51 13

32

67 13

76 33

81 59

67 10

71

68 9

70 25

77

56 15

1689

R'd†

23 52

37 15 6

9d

51

12

63

10m

^{*} Interregnum (no tsar) from 1610-13

BASIC TIME PERIODS

Year	Time taken by the Earth to revolve around the Sun, or 365,24 days
Leap Year	Calendar year of 366 days, 29 February
Month	being the additional day. It offsets the difference between the calendar year (365 days) and the solar year Approximate time taken by the Moon to revolve around the Earth. The 12 months of the year in fact vary from 28 days (29 in
Week	a Leap Year) to 31 days Artificial period of 7 days, not based on astronomical time
Day	Time taken by the Earth to complete one rotation on its axis; 1 day = 24 hours =
Hour	1,440 minutes = 86,400 seconds 24 hours make one day. Usually the day is divided into hours AM (ante meridiem, or before noon) and PM (post meridiem, or after noon), although most timetables now use the 24-hour system, from midnight to midnight
Minute Second	1/60 of an hour = 60 seconds 1/60 of a minute

Recurring intervals Annual Yearly Perennial Year after year Bi-annual Every 2 years; twice a year Bi-monthly Every 2 months; twice a month

Every 2 weeks; twice a week

Daily (especially with temperature)

Month	S OF THE YEAR Derivation
WOULD	Derivation
January	From the Roman month Januarius and named after Janus – god of doors, gates and new beginnings [31 days]
February	From the Roman month Februarius and named after Februa, festival of purification on the 15th [28 days, and 29 in Leap Years]
March	From the Roman month of Martius and named after Mars, god of war [31 days]
April	From the Roman month Aprilis – possibly derived from the Latin <i>aperire</i> in reference to the blossoming of spring [30 days]
May	From the Roman month Maius, after Maia, goddess of growth [31 days]
June	From the Roman month Junius and named after Juno, goddess of marriage [30 days]
July	From the Roman month Julius and named after the Emperor Julius Caesar in 44BC [31 days]
August	From the Roman month Augustus and named after the Emperor Augustus in 8BC [31 days]
September	
October	8th month of the early Roman calendar, from the Latin octo (eight) [31 days]
November	9th month of the early Roman calendar, from the Latin novem (nine) [30days]

10th month of the early Roman calendar,

from the Latin decem (ten) [31 days]

December

Day	Derivation
Sunday	Named after the Sun
Monday	Named after the Moon
Tuesday	Named after Tiw or Tiu, Anglo-Saxon equivalent of the Norse god of battle Tyr
	son of Odin
Wednesday	Named after Woden, the Anglo-Saxon equivalent of Odin, chief of Norse gods
Thursday	Named after Thor, Norse god of thunder and sky, eldest son of Odin
Friday	Named after Frigg, Norse goddess of love and fertility, wife of Odin
Saturday	Named after Saturn, the Roman god of agriculture and fertility

Year	Ash Wednesday	Easter Sunday
1998	25 February	12 April
1999	17 February	4 April
2000	8 March	23 April
2001	28 February	15 April
2002	13 February	31 March
2003	5 March	23 April
2004	25 February	11 April
2005	9 February	27 March
2006	1 March	16 April

CHINESE CALENDAR

Bi-weekly

Diurnal

Animal	Years (1901-2008)								
Buffalo or Cow	1901	1913	1925	1937	1949	1961	1973	1985	1997
Tiger	1902	1914	1926	1938	1950	1962	1974	1986	1998
Rabbit	1903	1915	1927	1939	1951	1963	1975	1987	1999
Dragon	1904	1916	1928	1940	1952	1964	1976	1988	2000
Snake	1905	1917	1929	1941	1953	1965	1977	1989	2001
Horse	1906	1918	1930	1942	1954	1966	1978	1990	2002
Goat	1907	1919	1931	1943	1955	1967	1979	1991	2003
Monkey	1908	1920	1932	1944	1956	1968	1980	1992	2004
Rooster or Chicken	1909	1921	1933	1945	1957	1969	1981	1993	2005
Dog	1910	1922	1934	1946	1958	1970	1982	1994	2006
Pig	1911	1923	1935	1947	1959	1971	1983	1995	2007
Rat	1912	1924	1936	1948	1960	1972	1984	1996	2008

Although officially banned in 1930 the ancient Chinese calendar is still widely used in China, and the New Year (the second new moon after the beginning of winter) is a national holiday. It also remains in use in Tibet, Malaysia and other parts of Southeast Asia. Based on the lunar year, it comprises 12 months of 29 or 30 days, each starting with a new moon. A month is repeated seven times during each 19-year cycle.

NOTABLE NATIONAL DAYS

Country Date Na		Date	Name	Anniversary				
	Australia	Jan 26	Australia Day	Birth of the Commonwealth of Australia (1901)				
	Brazil	Sep 7	Independence Day	Decl. of independence from Portugal (1822)				
	Canada	Jul 1	Canada Day	Birth of the Confederation of Canada (1867)				
	China	Oct 1-2	National Days	Proclamation of the People's Republic (1949)				
	France	Jul 14	National Day	Storming of the Bastille prison (1789)				
	Germany	Oct 3	Unity Day	Unification of West and East Germany (1990)				
	Italy	Jun 2	National Day	Foundation of the Republic (1946)				
	Japan	Dec 17	Emperor's Birthday	Birthday of Akihito (1933)				
	Russia	Jun 12	Independence Day	Decl. of Russian Federation's sovereignty (1991)				
	USA	Jul 4	Independence Day	Declaration of independence from Britain (1776)				

MOVABLE CHRISTIAN FEASTS

Ash Wednesday (first day in Lent) falls between 4 February and 10 March Mothering Sunday (4th Sunday in Lent) falls between 29 February and 4 April

Palm (Passion) Sunday is the Sunday before Easter Good Friday is the Friday before Easter

Easter Day falls between 22 March and 25 April

Ascension Day (40 days after Easter) falls between 30 April and 3 June

Pentecost (Whit Sunday, 7 weeks after Easter) falls between 10 May and 13 June Trinity Sunday is the Sunday after Pentecost

Corpus Christi is the Thursday after Trinity Sunday

Advent Sunday (first Sunday of Advent) is the Sunday nearest to 30 November

YEAR SPANS

Decade

50 Half-century

100 Century 1,000 Millenium

Centenary

200 Bicentenary 300 Tricentenary

Quadricentenary

500 Quincentenary

ARISTOCRATIC RANKS (UK)

King

Prince (royal duke)

3 Duke

Marquess

Earl

Viscount Baronet

MAJOR FIXED CHRISTIAN FEASTS

Saint's Days vary between different branches of Christianity and calendars and are not included here.

January 1 Solemenity of Mary, Mother of God January 6 Epiphany January 11 Baptism of Jesus Conversion of the Apostle Paul January 25 February 2 Presentation of Jesus (Candlemas Day) February 22 The Chair of the Apostle Peter March 25 Annunciation of the Virgin Mary June 24 Birth of John the Baptist August 6 Transfiguration August 15 Assumption of the Virgin Mary August 22 Queenship of Mary September 8 Birthday of the Virgin Mary September 14 Exaltation of the Holy Cross October 2 Guardian Angels November 1 All Saints

November 2 All Souls November 9

Dedication of the Lateran Basilica November 21 Presentation of the Virgin Mary December 8 Immaculate Conception

December 25 Christmas Day Holy Innocents December 28

NOBEL PEACE PRIZE

Year Winner(s)

1973	Henry Kissinger (US) [‡]	1986	Elie Wiesel (US)
1974	Sean MacBride (Ireland), Eisaku Sato (Japan)	1987	Oscar Arias Sánchez (Costa Rica)
1975	Andrei Sakharov (Soviet Union)	1988	United Nations peacekeeping forces*
1976	Mairead Corrigan & Betty Williams (UK)§	1989	Dalai Lama (Tibet)
1977	Amnesty International*	1990	Mikhail Gorbachev (Soviet Union)
1978	Menachem Begin (Israel), Anwar Sadat (Egypt)	1991	Aung San Suu Kyi (Burma)
1979	Mother Teresa of Calcutta (Macedonia-India)	1992	Rigoberta Menchú (Guatemala)
1980	Adolfo Pérez Esquivel (Argentinia)	1993	Frederik W. de Klerk and Nelson Mandela
1981	Office of UN High Commissioner for Refugees*		(South Africa)
1982	Alva Myrdal (Swedish), Alfonso Robles (Mexico)	1994	Yasser Arafat (Palestine), Shimon Peres &
1983	Lech Walesa (Poland)		Yitzhak Rabin (Israel)
1984	Archbishop Desmond Tutu (South Africa)	1995	Joseph Rotblat (UK)
1985	International Physicians for the Prevention of	1996	Bishop Belo & José Ramos Horta (East Timor)
	Nuclear War*		

Year Winner(s)

* Prize awarded to organization rather than to individual(s) ‡ Le Duc Tho (Vietnam) declined § Northern Ireland

12 SIGNS OF THE ZODIAC

The dates when the Sun is in each astrological sign are approximate.

Sign	Element	Symbol	Dates
Aries	Fire	Ram	Mar 21-Apr 19
Taurus	Earth	Bull	Apr 20-May 20
Gemini	Air	Twins	May 21-Jun 21
Cancer	Water	Crab	Jun 22-Jul 22
Leo	Fire	Lion	Jul 23-Aug 22
Virgo	Earth	Virgin	Aug 23-Sep 22
Libra	Air	Scales	Sep 23-Oct 23
Scorpio	Water	Scorpion	Oct 24-Nov 21
Sagittarius	Fire	Archer	Nov 22-Dec 21
Capricorn	Earth	Goat	Dec 22-Jan 19
Aquarius	Air	Water-carrier	Jan 20-Feb 18
Pisces	Water	Fishes	Feb 19-Mar 20

ACADEMY AWARDS ("OSCARS") - BEST FILM					
Year	Film	Year	Film		
1975	One Flew Over the Cuckoo's Nest	1986	Platoon		
1976	Rocky	1987	The Last Emperor		
1977	Annie Hall	1988	Rain Man		
1978	The Deer Hunter	1989	Driving Miss Daisy		
1979	Kramer vs. Kramer	1990	Dances With Wolves		
1980	Ordinary People	1991	The Silence of the Lambs		
1981	Chariots of Fire	1992	Unforgiven		
1982	Gandhi	1993	Schindler's List		
1983	Terms of Endearment	1994	Forrest Gump		
1984	Amadeus	1995	Braveheart .		
1985	Out of Africa	1996	The English Patient		

POET	S LAUREATE		
1668	John Dryden*	1813	Robert Southey
1689	Thomas Shadwell	1843	William Wordsworth
1692	Nathum Tate	1850	Alfred, Lord Tennyson
1715	Nicholas Rowe	1896	Alfred Austin
1718	Laurence Eusden	1913	Robert Bridges
1730	Colley Cibber	1930	John Masefield
1757	William Whitehead [†]	1968	Cecil Day Lewis
1785	Thomas Warton	1972	Sir John Betjeman
1790	Henry Pye	1984	Ted Hughes
			3

*The post was not officially established until 1668, though the previous laureates had included Ben Jonson † Appointed after Thomas Gray declined ‡ Appointed after Samuel Rogers declined

BOOKER PRIZE

ARCHBI	SHUPS	UF C	ANTE	RBUR	
Vears	Na	me			

Years	Name
1896-1902	Frederick Temple [†]
1903-28	Randall Thomas Davidson
1928-42	Cosmo Gordon Lang
1942-44	William Temple†
1945-61	Geoffrey Francis Fisher
1961-74	Arthur Michael Ramsey
1974-80	Frederick Donald Coggan
1980-91	Robert Alexander Kennedy Runcie
1991-	George Leonard Carey

† Died in office

CHESS WORLD CHAMPIONS (MEN)

Reign	Player	Country
1866-1894	Wilhelm Steinitz*	Austria
1894-1921	Emanuel Lasker	Germany
1921-1927	José Capablanca	Cuba
1927-1935	Alexander Alekhine	France
1935-1937	Max Euwe	Netherlands
1937-1946 [†]	Alexander Alekhine	France
1948-1957	Mikhail Botvinnik	Soviet Union
1957-1958	Vassily Smyslov	Soviet Union
1958-1960	Mikhail Botvinnik	Soviet Union
1960-1961	Mikhail Tal	Soviet Union
1961-1963	Mikhail Botvinnik	Soviet Union
1963-1969	Tigran Petrosian	Soviet Union
1969-1972	Boris Spassky	Soviet Union
1972-1975	Bobby Fischer‡	USA
1975-1985	Anatoly Karpov	Soviet Union
1985-	Gary Kasparov	Soviet Union /Azerbaijan

* Official world championship dates from 1888 † Alekhine's death and the reorganization of the sport meant there was no champion 1946-48 † Unbeaten: defaulted title after refusing to accept ICC rules for championship match

PLAYS OF WILLIAM SHAKESPEARE Title (in order of composition) Principal Characters

Title (in order of composition)			
Title (in order of composition) Henry VI Part 1 Henry VI Part 2 Henry VI Part 3 Titus Andronicus Richard III The Comedy of Errors Love's Labour's Lost The Two Gentlemen of Verona The Taming of the Shrew Richard II Romeo and Juliet A Midsummer Night's Dream King John The Merchant of Venice Henry IV Part 1 Henry IV Part 2 Much Ado About Nothing Henry V Julius Caesar As You Like It Twelfth Night Hamlet, Prince of Denmark The Merry Wives of Windsor Troilus and Cressida All's Well That Ends Well Measure for Measure Othello			
King Lear			
Macbeth			
Antony and Cleopatra Coriolanus			

Antony and Cleopatra Coriolanus Timon of Athens Pericles, Prince of Tyre Cymbeline The Winter's Tale The Tempest Henry VIII Henry, Talbot Henry, Margaret Henry, Margaret Titus, Aaron Richard, Clarence Antipholus, Dromio Ferdinand, Berowne Valentine, Proteus Petruchio, Katherine Richard, Bolingbroke Romeo, Juliet Oberon, Titania John, Arthur Antonio, Shylock Henry, Hal, Hotspur Henry. Falstaff, Hal Beatrice, Benedick Henry, Pistol Brutus, Antony Rosalind, Orlando Orsino, Viola, Olivia Hamlet, Ophelia Falstaff, Ford Troilus, Cressida Bertram, Helena Vincentio, Angelo Othello, lago, Desdemona Lear, Cordelia, Regan Gloucester, Goner Macbeth, Lady Macbeth, Banquo Antony, Cleopatra Coriolanus, Volumnia Timon, Apemantus Pericles, Marina Imogen, lachimo Leontes, Perdita Prospero, Miranda Henry, Catherine

Year	Author and title
1981	Salman Rushdie Midnight's Children
1982	Thomas Keneally Schindler's Ark
1983	J. M. Coetzee Life and Times of Michael K
1984	Anita Brookner Hotel du Lac
1985	Keri Hulme The Bone People
1986	Kingsley Amis The Old Devils
1987	Penelope Lively Moon Tiger
1988	Peter Carey Oscar and Lucinda
1989	Kazuo Ishiguro The Remains of the Day
1990	A. S. Byatt Possession
1991	Ben Okri The Famished Road
1992	Michael Ondaatje The English Patient

 1992 Michael Ondaatje The English Patient Barry Unsworth Sacred Hunger
 1993 Roddy Doyle Paddy Clarke Ha Ha Ha
 1994 James Kelman How Late It Was. How I

1994 James Kelman How Late It Was, How Late 1995 Pat Barker The Ghost Road 1996 Graham Swift Last Orders

Arundhati Roy The God of Small Things

WORLD VEHICLE PRODUCTION

Manufacturer	Country*	Total (1993)
General Motors	USA	7,785,000
Ford	USA	5,277,600
Toyota	Japan	4,450,000
Volkswagen	Germany	3,018,650
Nissan	Japan	2,817,800
Chrysler	USA	2,348,000
Mitsubishi	Japan	1,954,000
Fiat	Italy	1,786,600
Honda	Japan	1,762,200
Renault	France	1,761,300
Peugeot-Citroën	France	1,751,650
Mazda	Japan	1,093,700

*Country where corporations are based and which account for the bulk of production

13

11 59

8.1

7.35

1980

1965

EUROPEAN UNION MEMBERS

	Area		Pop'n ('000)	Date of joining	European commission-	Members in
	Sq km	Sq mi	(000)	Joining	ers (1997)	European Parliament
Austria	83,850	32,374	7,796	1995	1	21
Belgium*	30,510	11,780	10,131	1957	1	25
Denmark†	43,070	16,629	5,216	1973	1	16
Finland	338,130	130,552	5,099	1995	1	16
France*	551,500	212,934	57,800	1957	2	87
Germany*	356,910	137,803	81,338	1957	2	99‡
Greece	131,990	50,961	10,400	1981	1	25
Ireland	70,280	27,135	3,560	1973	1	15
Italy*	301,270	116,320	56,930	1957	-2	87
Luxembourg*	2,590	1,000	407	1957	18	6
Netherlands*	41,526	16,033	15,424	1957	1	31
Portugal	92,390	35,670	9,902	1986	1	25
Spain	504,780	194,896	39,190	1986	2	64
Sweden	449,960	173,730	8,816	1995	1	22
UK	243,368	94,202	58,784	1973	_ 2	87
					20	626

Applications for membership

Applications of membersing Turkey (1987), Malta (1990), Cyprus (1991), Switzerland# (1992), Poland, Hungary (1994), Slovakia, Latvia, Estonia, Lithuania (1995), Czech Republic (1996)

* Founder member of the European Economic Community (following the Treaty of Rome, signed 25 March 1957) † Greenland exercised its autonomous right granted under the Danish Crown to secede from the Community in 1985 ‡ Includes the President, Klaus Hänsch of Germany (as at 1 January 1997) § President of the EC Jacques Santer (as at 1 January 1997) # In a subsequent referendum the people of Switzerland voted against joining the European Economic Area

Name Location Length Date Rail km Honshū-Hokkaidō, Japan 53.9 33.86 1988 Seikan Eurotunnel England-France 49.94 31.03 1996 Dai-shimuzu Honshū, Japan 22.17 13.78 1982 Simplon I & II Alps, Switzerland-Italy 1906, 1922 1992 12 56 Road Swiss Alps British Columbia, Canada St Gotthard 16.32 10.25 1980 1989 Rogers Pass 14.66 9.1 8.12 1978 Austrian Alps 14 Arlbera

LONGEST RAIL AND ROAD TUNNELS

France-Italy

France-Italy

Fréjus

Mont Blanc

Army	Royal Navy	Royal Air Force
Field Marshal General Lieutenant-General Major-General Brigadier Colonel Lieutenant-Colonel Major Captain Lieutenant	Admiral of the Fleet Admiral Vice-Admiral Rear Admiral Commodore Captain Commander Lieutenant-Commander Lieutenant Sub-Lieutenant Midshioman	Marshal of the Royal Air Force Air Chief Marshal Air Marshal Air Vice-Marshal Air Commodore Group Captain Wing Commander Squadron Leader Flight Lieutenant Flying Officer Pilot Officer